ART ACROSS TIME

ART ACROSS TIME

THIRD EDITION

LAURIE SCHNEIDER ADAMS

John Jay College
City University of New York

Boston Burr Ridge, IL Dubuque, IA Madison, WI New York San Francisco St. Louis
Bangkok Bogotá Caracas Kuala Lumpur Lisbon London Madrid Mexico City
Milan Montreal New Delhi Santiago Seoul Singapore Sydney Taipei Toronto

To the Memory of Howard McP. Davis
and Rudolf Wittkower

The **McGraw·Hill** Companies

 Higher Education

Published by McGraw-Hill, an imprint of The McGraw-Hill Companies, Inc., 1221 Avenue of the Americas, New York, NY 10020. Copyright © 2007, 2002, 1999, by Laurie Schneider Adams. All rights reserved. No part of this publication may be reproduced or distributed in any form or by any means, or stored in a database or retrieval system, without the prior written consent of The McGraw-Hill Companies, Inc., including, but not limited to, in any network or other electronic storage or transmission, or broadcast for distance learning.

This book is printed on acid-free paper.

1 2 3 4 5 6 7 8 9 0 DOW/DOW 0 9 8 7 6

ISBN-13 (softcover): 978-0-07-296525-4
ISBN-10 (softcover): 0-07-296525-8
ISBN-13 (hardcover): 978-0-07-296979-5
ISBN-10 (hardcover): 0-07-2969792

Editor in Chief: *Emily Barrosse*
Publisher: *Lisa Moore*
Marketing Manager: *Sharon Loeb*
Developmental Editor: *Julia Moore*
Project Managers: *April Wells-Hayes and Christina Gimlin*
Manuscript Editor: *Carol Flechner*
Layout: *Roberta Flechner*
Art Director: *Jeanne Schreiber*
Text Designers: *Linda Robertson and Jeanne Schreiber*
Cover Designer: *Linda Robertson*
Art Editors: *Robin Mouat and April Wells-Hayes*
Illustrators: *Patti Isaacs and John McKenna*
Photo Research Coordinator: *Alexandra Ambrose*
Photo Research: *Robin Sand*
Production Supervisor: *Randy Hurst*
Composition: *9/11.5 Versailles by Prographics*
Printing: *Pantone 195c, 70# Focus Gloss by RR Donnelley Willard*

Cover art: Benozzo Gozzoli (1420–1497), detail of *The Adoration of the Magi,* fresco, 1459. Palazzo Medici Riccardi, Florence, Italy. Photo: Erich Lessing/Art Resource, NY (front cover); Scala/Art Resource, NY (back cover).

Credits: The credits section for this book begins on page C-1 and is considered an extension of the copyright page.

Library of Congress Cataloging-in-Publication Data
Adams, Laurie.
 Art across Time / Laurie Schneider Adams. — 3rd ed.
 p. cm.
 Includes bibliographical references and index.
 ISBN 0-07-296525-8 (alk. paper)
 1. Art — History. I. Title.

N5300.A3 2006
709—dc22
 2005058443

The Internet addresses listed in the text were accurate at the time of publication. The inclusion of a Web site does not indicate an endorsement by the authors or McGraw-Hill, and McGraw-Hill does not guarantee the accuracy of the information presented at these sites.

www.mhhe.com

Contents in Brief

Contents

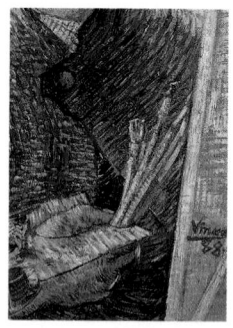

PART ONE

2 The Ancient Near East 51

3 Ancient Egypt 81

4 The Aegean 117

PART TWO

5 The Art of Ancient Greece 136

6 The Art of the Etruscans 189

7 Ancient Rome 209

8 Early Christian and Byzantine Art 266

PART THREE

9 The Early Middle Ages 318

10 Romanesque Art 365

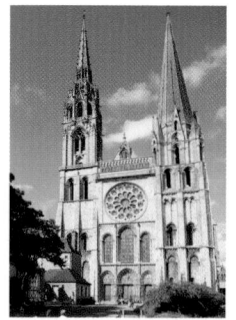

11 Gothic Art 394

12 Precursors of the Renaissance 449

PART FOUR

13 The Early Renaissance 480

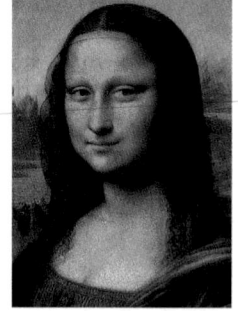

14 The High Renaissance in Italy 542

15 Mannerism and the Later Sixteenth Century in Italy 583

16 Sixteenth-Century Painting and Printmaking in Northern Europe 604

PART FIVE

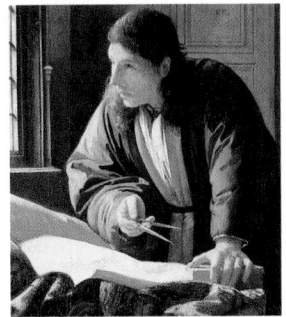

17 The Baroque Style in Western Europe 626

18 Rococo and the Eighteenth Century 677

PART SIX

22 Nineteenth-Century Impressionism 772

23 Post-Impressionism and
the Late Nineteenth Century 803

PART SEVEN

27 Abstract Expressionism 906

28 Pop Art, Op Art, Minimalism, and Conceptualism 929

29 Innovation, Continuity, and Globalization 951

Maps

Preface

We are bombarded with images from birth and tend to assume that we understand their meaning. But the paradoxical fact is that, although children read pictures before words, a picture is more complex than a word—hence the proverbial "a picture is worth a thousand words." One aim of *Art across Time* is, therefore, to introduce readers to the complexity of images, while also surveying the history of those images. Context is a particular area of concern, for works of art lose much of their meaning if separated from the time and place in which they were created. Context also includes function, patronage, and the character and talent of the individual artist.

The complexity of the visual arts has led to different approaches to reading images. Throughout the text, therefore, there are discussions of methodology as well as new boxes entitled "Methods of Interpretation," and there is a brief survey of the modern methodologies of art-historical interpretation in the Introduction.

While comprehensive, *Art across Time* avoids an encyclopedic approach to art history and attempts instead a more manageable narrative that is suitable for a one-year survey course. Certain key works and artists are given more attention than in some books, while other works and artists are omitted entirely. An effort is made to present the history of art as a dynamic narrative grounded in scholarship, a narrative that is a dialogue between modern viewers and their past.

"Windows on the World"

Sections entitled "Window on the World" provide an introduction to the art of certain non-Western cultures. They highlight specific periods within cultures, particularly when they are thematically related to, or have significantly influenced, Western art. Some of the Windows—such as Aboriginal rock paintings in the chapter on prehistory and Japanese woodblock prints in the chapter on Impressionism (Chapter 22)— are placed within Western chapters. Others—for example, those dealing with the Indus Valley civilization, Mesoamerica, and the Far East—are placed chronologically between Western chapters. The Windows offer a sense of the range of world art and remind readers that the history of Western art is only one of many art-historical narratives. These narratives reflect the differences, as well as the similarities, between cultures and emphasize the complexity of the visual arts by taking Western readers far afield of their accustomed territory and exposing them to unfamiliar ways of thinking about the arts. As with the European artists of the early twentieth century who collected African and Oceanic sculpture in search of new, non-Classical ways of representing the human figure, so viewers who encounter such works for the first time are encouraged to stretch their own limits of seeing and understanding.

Boxes

Within chapters, readers will find boxes that encapsulate background information necessary for the study of art. These boxes take students aside, without interrupting the flow of the text, to explain media and techniques as well as different philosophies of art from Plato to Marx, Burke to Freud, and Winckelmann to Greenberg. Significant works of literature related to the arts are also covered: epics such as *Gilgamesh*, the *Iliad* and the *Odyssey*, the *Edda*, and *Beowulf*, as well as excerpts of Romantic, Dada, and contemporary poetry. One box shows Beauford Delaney quoting Balzac, an example of a personal artistic genealogy within the broader narrative of art history. Another illustrates the symbolism of color in Roman marble sculptures.

Illustration Program

The illustrations in *Art across Time* are in a consistently large format, which encourages careful looking. All of the paintings are reproduced in color, and the percentage of color is higher than in any other survey text presently on the market. Two shades of black are used for the black-and-white illustrations, resulting in greater tonal density, and all illustrations are printed on a five-color press for optimal quality. Occasionally, more than one view of a sculpture or a building is illustrated to give readers a sense of its three-dimensional reality. This has been increased for the third edition.

A new feature in the illustration program of this edition is the placement of "Connections"—small, repeated images —to show thematic continuity in the arts. Thus, for example, a small figure of Titian's *Venus of Urbino* accompanies Manet's *Olympia*. A similar system is also used for comparative purposes.

Architectural discussions are enhanced with labeled plans, sections, and axonometric diagrams. Diagrams of the Mesopotamian cone mosaic technique, of the Greek lost-wax method, of altarpieces, and of lithography and cantilever have been added. Many of the picture captions include anecdotes or biographical information about the artists; these are intended to encourage readers to identify with painters, sculptors, and architects, and they also provide a sense of the role of artists in society. Maps both define geographical context and indicate changing national boundaries over time.

Other Pedagogical Features

Languages as well as the visual arts have a history, and the etymology of art-historical terms is, therefore, provided. This reinforces the meanings of words and reveals their continuity through time. In the chapter on ancient Greece, transcriptions of terms and proper names are given according to Greek spelling, with certain exceptions in deference to convention: Acropolis, Euclid, Socrates, and Laocoön, all of which would be spelled with a "k" rather than a "c" in Greek. Likewise, Roman names and terms are given according to Latin transcription. The first time an art-historical term appears in the text, it is **boldfaced** to indicate that it is also defined in the glossary at the back of the book.

At the end of each chapter, a chronological time line of the works illustrated is useful for review purposes. This lists contemporaneous developments in other fields as well as cross-cultural artistic developments, and it contains selected images for review.

New to the Third Edition

At the request of reviewers and adopters of the second edition, the text is divided into seven parts. Each two-page part opener incorporates a time line that, in addition to placing key works of art in a chronological continuum, highlights other important developments relevant to the cultural contextualization of art. The part openers have been redesigned for the third edition and now include an introductory paragraph surveying developments covered in each part. The Introduction, formerly Chapter 1, has been updated.

In addition to the numerous text refinements, several substantial changes should be noted. The Window on the World for Mesoamerica has been rewritten, and Georgia Riley de Havenon, a pre-Columbian specialist, has contributed sections on Aztec and Andean art. The coverage of the Renaissance and Gothic periods has been reorganized. With the help of Robert Maxwell of the University of Michigan, Gothic diagrams have been redrawn to improve accuracy and pedagogy. Additional diagrams have been included and the number of color plates has been expanded in the Windows as well as throughout the text.

Finally, the last chapter has been updated to include recent artistic developments—especially globalization.

Supplements

Interactive CD-ROM

Art across Time's Core Concepts in Art CD-ROM, available free to students with every new copy of the textbook in any of its iterations, provides valuable supplemental materials. Below is a brief description and table of contents.

Description Conceived, designed, and written by students for students under the leadership of Bonnie Mitchell (Bowling Green State University), one of the preeminent multimedia designers, *Art across Time's* Core Concepts in Art CD-ROM provides supplemental exercises and information in the areas students experience difficulties.

Contents

- **Elements of Art:** Allows students to interact with the formal elements of art by working through over 70 interactive exercises illustrating line, shape, color, light, dark, and texture.
- **Art Techniques:** Takes students on a tour of art studios. *Art Techniques* illustrates working with a variety of media from bronze pouring, to painting, to video techniques with extensive, narrated video segments.
- **Chapter Resources:** Study resources correlated to each chapter of *Art across Time;* both a review and test preparation. Students will find key terms, chapter summaries, and a self-correcting study quiz to help prepare for in-class tests, midterms, and finals. Also included is an exercise on methodologies that demonstrates the application of different methods to Van Eyck's *Arnolfini Portrait*.
- **Research and the Internet:** Introduces students to the research process from idea generation, to organization, to researching on- and off-line, and includes guidelines for incorporating sources for term papers and bibliographies.
- **Study Skills:** Helps your students adjust to the rigors of college work. The *Study Skills* section of the CD-ROM provides practical advice on how to succeed at college.

Online Learning Center

Recently, the Internet has played an increasing role in college education; *Art across Time* is, therefore, supported by an Online Learning Center <http://www.mhhe.com/artacrosstime> that offers additional resources for students wishing to quiz themselves. They can send the results to their instructor via e-mail, link to additional research topics on the World Wide Web, use the pronunciation guide, follow links to artists, and more.

Student Study Guide

The student study guides are designed as chapter-by-chapter workbooks to accompany *Art across Time*. Perforated pages allow professors to assign exercises to be handed in along with each reading assignment. The exercises include brief essays, fill-in-the-blanks, matching artists with works and works with their sites. In addition, students are asked to identify key figures and define terms.

Finally, slide sets for qualifying adopters and an instructor's manual complete the impressive supplemental support package for *Art across Time*. For more information, please contact your local McGraw-Hill sales representative, or e-mail <art@mcgraw-hill.com>.

Acknowledgments

Many people have been extremely generous with their time and expertise during the preparation of this text. John Adams has helped on all phases of the book's development. Marlene Park was especially helpful during the formative stages of the one-volume text. Others who have offered useful comments and saved me from egregious errors include Steve Arbury, Paul Barolsky, Hugh Baron, James Beck, Allison Coudert, Jack Flam, Sidney Geist, Mona Hadler, Ann Sutherland Harris, Arnold Jacobs, Donna and Carroll Janis, Genevra Kornbluth, Carla Lord, Maria Grazia Pernis, Catherine Roehrig, Elizabeth Simpson, Leo Steinberg, and Rose-Carol Washton Long.

For invaluable assistance with the chapters on antiquity, I am indebted to Larissa Bonfante, Professor of Classics at New York University; Ellen Davis, Associate Professor of Art and Archaeology at Queens College, CUNY; and Oscar White Muscarella of the Department of Ancient Near Eastern Art at the Metropolitan Museum of Art, New York. Carol Lewine, emerita, Queens College, CUNY, lent her expertise to the medieval chapters and Mark Zucker, professor at Louisiana State University, vetted the Renaissance and Baroque chapters.

For assistance with illustrations, I have to thank, among others, ACA Galleries, Margaret Aspinwall, Christo and Jeanne-Claude, Anita Duquette, Michael Findlay, Georgia de Havenon, the Flavin Institute, Duane Hanson, M. Knoedler and Co., Inc., John Perkins, Carroll Janis, Ronald Feldman Gallery, Robert Miller Gallery, Pace Gallery, and Allan Stone Gallery.

For assistance in developing the third edition, I would like to thank Julia Moore and, at McGraw-Hill, Joseph Hanson and Lyn Uhl. April Wells-Hayes and Christina Gimlin shepherded the book through production, and Robin Sand did an excellent job of researching the photographs. The expert editing of Carol Flechner improved the text immeasurably, and the effective layout is due to the finely honed skills of Roberta Flechner. Jeanne Schreiber deserves high praise for the new design of the third edition and the excellent quality of the covers. Thanks also to Linda Toy and Alexis Walker for their expertise and commitment to the quality of the book.

Reviewers

Thanks to our reviewers of the third edition: Roger Aikin, Creighton University; Steve Arbury, Radford University; Peter Barr, Siena Heights College; Vince Bodily, Ricks College; Kelly Dennis, University of Connecticut; Kimberly Francev, University of Arizona; Mitchell Frank, Carleton University; Richard Green, Eastern Arizona College; Pamela Hall, Glendale Community College; Kim Hartswick, George Washington University; LuAnn S. Kanabay, University of Connecticut; Janette Knowles, Ohio Dominican University; Ellen Konowitz, State of Universty of New York at New Paltz; Jane Kyle, University of Portland; Lisa Livingston, Modesto Junior College; David Ludley, Clayton College & State University; Virginia Marquardt, Marist College; Floyd Martin, University of Arkansas-Little Rock; Dr. Andrew Marvick, Southwestern Oklahoma State University; Beth A. Mulvaney, Meredith College; Fr. James Neilson O. Praem, St. Norbert College; Mallory O'Connor, Santa Fe Community College; Michelle Pacansky-Brock, Sierra College; Donald Paoletta, Nebraska Wesleyan University; Kristin Ringelberg, Elon College; Gil Rocha, Richland Community College; Jerry Soneson, University of Northern Iowa; Carolyn Tate, Texas Tech University; Rita Tekippe, State of Universty of West Georgia; Radford Thomas, Radford University; Gavin Townsend, University of Tennessee-Chattannoga; Anne Betty Weinshenker, Montclair State.

Introduction

Why Do We Study the History of Art?

We study the arts and their history because they teach us about our own creative expressions and those of our past. Studying the history of art is one way of exploring human cultures—both ancient and modern—that have not developed written documents. For example, the prevalence of animals in the prehistoric cave paintings of western Europe reveals the importance of animals in those societies. Female figurines with oversized breasts and hips express the wish to reproduce and ensure the survival of the species. Prehistoric structures, whether oriented toward earth or sky, provide insights into the beliefs of early cultures. If such objects had not been preserved, we would know far less about ancient cultures than we now do.

We would also know less about ourselves, for art is a window onto human thought and emotion. For example, van Gogh's self-portraits are explicitly autobiographical. From what is known about his life, he was sustained by his art. In figure **I.1** he depicts himself in front of a painting that we do not see, even though we might suspect that

it, too, is a self-portrait. For there are several elements in the painting that assert the artist's presence. Van Gogh's self-image predominates; he holds a set of brushes and a palette of unformed paint composed of the same colors used in the picture. At the center of the palette is an intense orange, the distinctive color of his beard, as well as

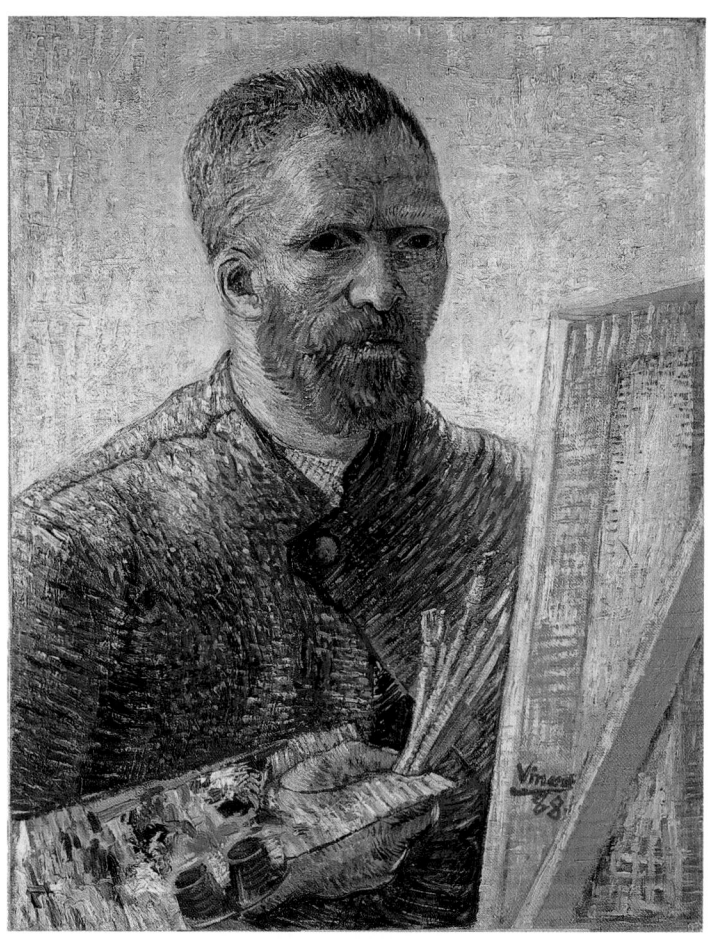

I.1 Vincent van Gogh, *Self-Portrait before his Easel*, 1888. Oil on canvas; 25¾ × 19⅞ in. (65.5 × 50.5 cm). Rijksmuseum, Amsterdam. Vincent van Gogh Foundation.

The Western Tradition

"Western art" is the product of a group of cultures that have historically been thought of as sharing common traditions. Some of these cultures, such as that of medieval France, developed in the Western Hemisphere, but others, such as that of ancient Babylon (in modern Iraq), did not. Likewise, some cultures that were geographically western, such as that of the Maya (in modern Mexico and Central America), have not traditionally been considered part of the West. This book follows the conventional (Western) usage of the terms *Western* and *non-Western*: the Western world comprises North America and Europe, as well as ancient Egypt and the ancient Near East, while the non-Western world comprises all areas and traditions outside those boundaries. It is important, however, to be aware that these categories are based as much on ideas about culture as on geography.

of his name (Vincent) and the date ('88), with which he simultaneously signs both the painting we see and the painting we do not see.

The arts exemplify the variety of creative expression from one culture to the next. This book surveys the major periods and styles of Western art (see box, p. 1), with certain highlights of non-Western art included to give readers a sense of differences—as well as similarities—between works of art around the world.

In the West, the major visual arts fall into three broad categories: pictures, sculpture, and architecture. Pictures (from the Latin word *pingo,* meaning "I paint") are two-dimensional images (from the Latin *imago,* meaning "likeness"), with height and width, and are usually flat. Pictures are not only paintings, however: they include mosaics, stained glass, tapestries, drawings, prints, and photographs.

Sculptures (from the Latin word *sculpere,* meaning "to carve"), unlike pictures, are three-dimensional: besides height and width, they have depth. Sculptures have traditionally been made of a variety of materials such as stone, metal, wood, and clay. More modern materials include glass, plastics, cloth, string, wire, television monitors, and even animal carcasses.

Architecture, which literally means "high (*archi*) building (*tecture*)," is the most utilitarian of the three categories. Buildings are designed to enclose and order space for specific purposes. They often contain pictures and sculptures as well as other forms of visual art. Some ancient Egyptian tombs, for example, were filled with statues of the deceased. Many churches are decorated with sculptures, paintings, mosaics, and stained-glass windows illustrating the lives of Christ and the saints. And Buddhist caves and temples contain sculptures and paintings representing events in the life of the Buddha.

One powerful motive for making art is the wish to leave behind after death something of value by which to be remembered. The work of art symbolically prolongs the artist's existence. This parallels the pervasive feeling that by having children one is ensuring genealogical continuity into the future. Several artists have made such a connection. In an anecdote about Giotto, the fourteenth-century Italian artist, the poet Dante asks Giotto why his children are so ugly and his paintings so beautiful; Giotto replies that he paints by the light of day but reproduces in the darkness of night. According to his biographers, Michelangelo said that he had no human children because his works were his children. The twentieth-century Swiss artist Paul Klee also referred to his pictures as children and equated artistic genius with procreation. His German contemporary Josef Albers cited this traditional connection between creation and procreation in relation to color: he described a mixed color as the offspring of two original colors, and compared it to a child who combines the genes of two parents.

Related to the role of art as a memorial is the wish to preserve one's likeness after death. Artists are often commissioned to paint **portraits,** or likenesses, of specific people. They also make self-portraits—likenesses of themselves. "Painting makes absent men present and the dead seem alive," wrote Leon Battista Alberti, the fifteenth-century Italian humanist. "I paint to preserve the likeness of men after their death," wrote Albrecht Dürer in sixteenth-century Germany.

See figure 16.11. Albrecht Dürer, *Self-Portrait,* 1500.

The Artistic Impulse

Art is a vital and persistent aspect of human experience. But where does the artistic impulse originate? We can see that it is inborn by observing children, who make pictures, sculptures, and model buildings before learning to read or write. Children trace images in the earth, build snowmen and sand castles, and decorate just about anything—from their own faces to the walls of their houses. All are efforts to impose order on disorder and to create form from formlessness. Although it may be difficult to relate an Egyptian pyramid or a Greek temple to a child's sand castle or toy tower, all express the natural impulse to build.

In the adult world, creating art is a continuation and development of the child's inborn impulse to play. This is clear from the statements of artists themselves: Picasso said that he was unable to learn math because every time he looked at the number 7 he thought he saw an upside-down nose. The self-taught American artist Horace Pippin described his impulse to attach drawings to words when learning to spell.

Chronology

The Christian calendar, traditionally used in the West, is followed throughout this book. Other religions, such as Hinduism, Buddhism, Islam, and Judaism, have different dating systems.

Dates before the birth of Jesus are followed by the letters B.C., an abbreviation for "before Christ." Dates after his birth are denoted by the letters A.D., from the Latin phrase *anno Domini,* meaning "in the year of our Lord." The newer terms B.C.E. ("before the common era," equivalent to B.C.) and C.E. ("common era," equivalent to A.D.) are considered more religiously neutral, but they are less historical. There is no year 0, so A.D. 1 immediately follows 1 B.C. If neither B.C. nor A.D. accompanies a date, A.D. is understood. When dates are approximate or tentative, they are preceded by "c.," an abbreviation for the Latin word *circa,* meaning "around."

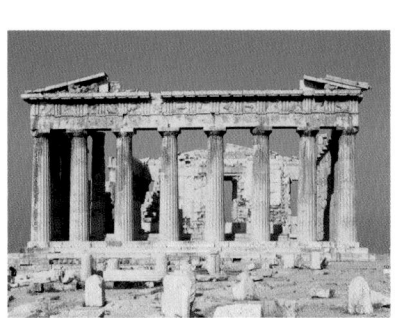

See figure 4.27. "Mask of Agamemnon," from Mycenae, c. 1500 B.C.

As early as the Neolithic era (in western Europe c. 6000/4000–2000 B.C. [see box] and the seventh millennium in the Near East), skulls were modeled into faces with plaster, and shells were inserted into the eye sockets. In ancient Egypt, a pharaoh's features were painted on the outside of his mummy case so that his *ka,* or soul, could recognize him. The Mycenaeans made gold death masks of their kings, and the Romans preserved the images of their ancestors by carving marble portraits from wax death masks.

It is not only the features of an individual that are valued as an extension of self after death. A **patron,** someone who commissions (sponsors) works of art, often ordered more monumental tributes. For example, the Egyptian pharaohs spent years planning and overseeing the construction of their pyramids, not only in the belief that such monumental tombs would guarantee their existence in the afterlife, but also as a statement of their power while on earth. In ancient China, the emperor Qin was buried with a "bodyguard" of several thousand life-sized **terra-cotta** statues of warriors, chariots, and horses (fig. I.2). Their function was literally to guard his body in the afterlife.

In fifth-century-B.C. Athens, the Parthenon was built to house a colossal sculpture of the patron goddess Athena and, at the same time, to embody the intellectual and creative achievements of Athenian civilization. Over two thousand years later, Louis XIV, king of France, built his magnificent palace at Versailles as a monument to his political power, to his reign, and to the glory of France. And in the same period in India, the Mughal emperor Shah Jahan commissioned the Taj Mahal as a memorial to his wife, Mumtaz Mahal (fig. I.3).

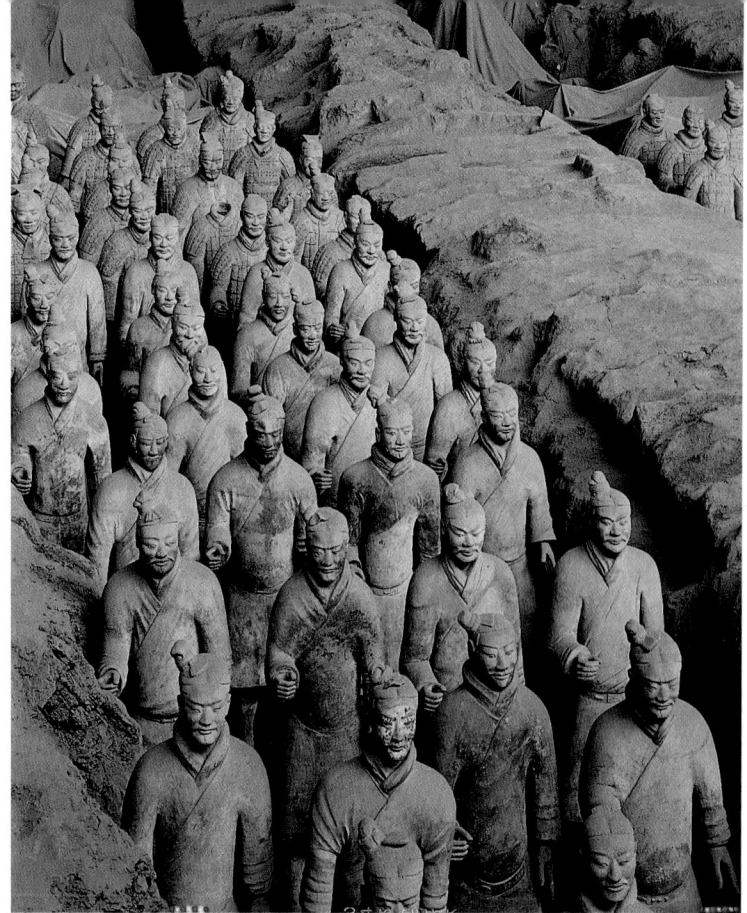

I.2 Bodyguard of the emperor Qin, terra-cotta warriors, Qin dynasty (221–206 B.C.), in situ. Lintong, Shaanxi Province, China.

I.3 (below) Taj Mahal, Agra, India, 1632–1648.

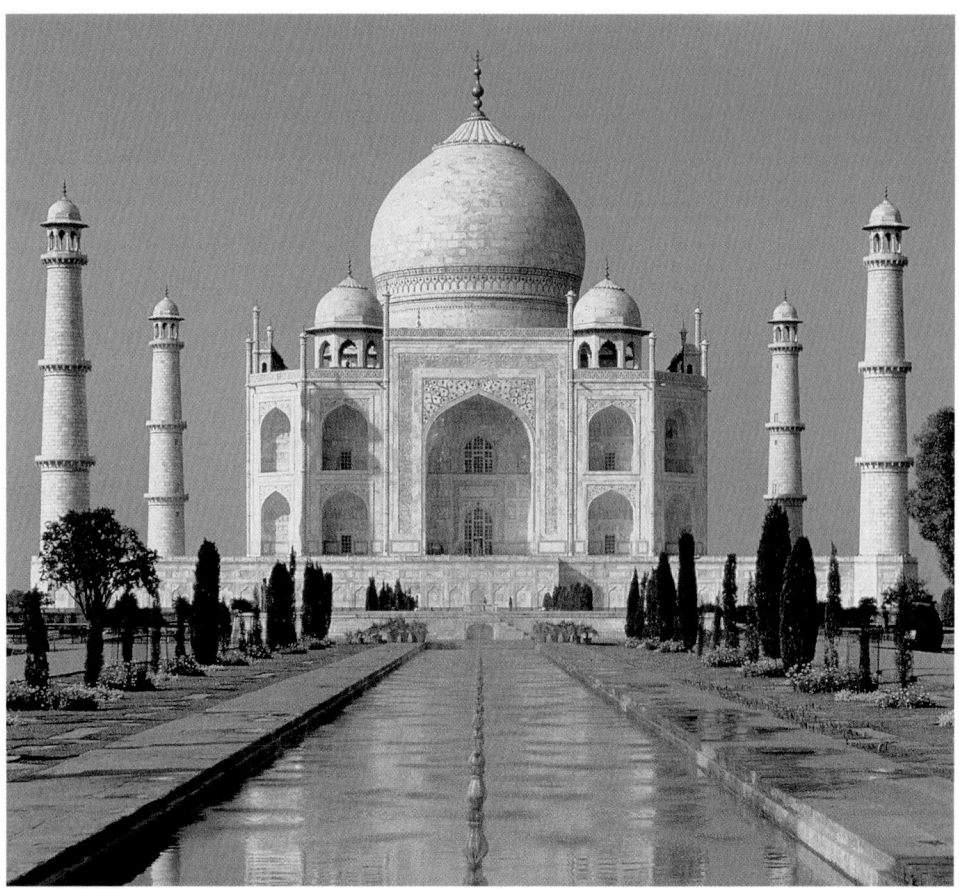

See figure 5.48. The Parthenon, Athens, 448–432 B.C.

Why Is Art Valued?

Works of art are valued not only by artists and patrons, but also by entire cultures. In fact, the periods of history that we tend to identify as high points of human achievement are those in which art was most highly valued and encouraged.

During the Gothic era in Europe (c. 1200–1400/1500), a significant part of the economic activity of every cathedral town revolved around the construction of its cathedral, the production of sculpture, and the manufacture of stained-glass windows. In medieval India, the construction of a Hindu temple brought similar economic benefits, the largest temples supporting permanent communities of artists and other temple workers. The fourteenth- and fifteenth-century banking families of Italy spent enormous amounts of money on art to adorn public spaces, churches, chapels, and private palaces.

Today institutions as well as individuals fund works of art, and there is a flourishing art market throughout the world. More people than ever before buy and enjoy art —often as an investment—and the auctioning of art has become an international business. Art theft is also international in scale, and the usual motive is money. Well-known stolen works may be difficult to fence and thus are often held for ransom. The outrage that a community feels when some works of art disappear (or are vandalized) reflects their cultural importance. Various ways in which art is valued are explored below.

Material Value

Works of art may be valued because they are made of a precious material. Gold, for example, was used in Egyptian art to represent divinity and the sun. These associations recur in Christian art, which reserved gold for the background of religious icons (the word **icon** is derived from the Greek word *eikon,* meaning "image") and for halos on divine figures. During the Middle Ages in Europe, ancient Greek bronze statues were not valued for their **aesthetic** character (their beauty), nor for what they might have revealed about Greek culture. Instead, their value lay in the fact that they could be melted down and re-formed into weapons. Through the centuries art objects have been stolen and plundered, in disregard of their cultural, religious, or artistic significance, simply because of the value of their materials. Even the colossal cult statue of Athena in the Parthenon disappeared without a trace, presumably because of the value of the gold and ivory from which it was made.

Intrinsic Value

A work of art may contain valuable material, but that is not the primary basis on which its quality is judged. Its intrinsic value depends largely on the general assessment of the artist who created it and on its own aesthetic character.

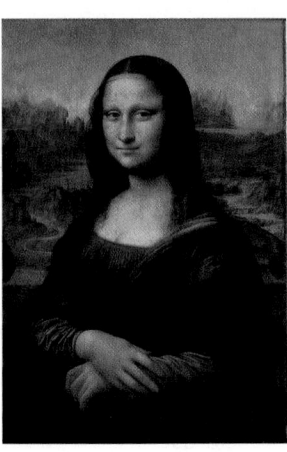

See figure 14.16. Leonardo da Vinci, *Mona Lisa*, c. 1503–1505.

The *Mona Lisa,* for example, is made of relatively modest materials—paint and wood— but it is a priceless object nonetheless and arguably the Western world's most famous image (see fig. 14.16). Leonardo da Vinci, who painted it around 1503 in Italy, was acknowledged as a genius in his own day, and his work has stood the test of time. The works of van Gogh have also endured, although he was ignored in his lifetime. Intrinsic value is not always apparent; it varies in different times and places, as we can see in the changing assessment of van Gogh's works. "Is it art?" is a familiar question that expresses the difficulty of defining "art" and of recognizing the aesthetic value of an object (see box, p. 5).

Religious Value

One of the traditional ways in which art has been valued is in terms of its religious significance. Paintings and sculptures depicting gods and goddesses make their images accessible. Such buildings as the Mesopotamian **ziggurat** (stepped tower), temples in many cultures, and Christian churches have served as symbolic dwellings of the gods, relating worshipers to their deities. Tombs express the belief in an afterlife. During the European Middle Ages, art often served an educational function. One important way of communicating Bible stories and legends of the saints to a largely illiterate population was through the sculptures, paintings, mosaics, wall hangings, and stained-glass windows in churches. Beyond its didactic (teaching) function, the religious significance of a work of art may be so great that entire groups of people identify with the object.

Nationalistic Value

Works of art have nationalistic value inasmuch as they express the pride and accomplishment of a particular culture. Nationalistic sentiment was a primary aspect of the richly carved triumphal arches of ancient Rome, which were gateways for returning military victors. Today, as in the past, statues of national heroes stand in parks and public squares in cities throughout the world.

Sometimes the nationalistic value of art is related to its religious value. In such cases, rulers take advantage of the patriotism of their subjects to impose a new religious system and to enhance its appeal through the arts. In the fourth century, under the Roman emperor Constantine, art was used to reinforce the establishment of Christianity as

Brancusi's *Bird:* Manufactured Metal or a Work of Art?

A trial held in New York City in 1927 illustrates just how hard it can be to agree on what constitutes "art." Edward Steichen, a prominent American photographer, had purchased a bronze sculpture entitled *Bird in Space* (fig. **I.4**) from the Romanian artist Constantin Brancusi, who was living in France. Steichen imported the sculpture to the United States, whose laws do not require payment of customs duty on original works of art as long as they are declared to customs on entering the country. But when the customs official saw the *Bird,* he balked. It was not art, he said: it was "manufactured metal." Steichen's protests fell on deaf ears. The sculpture was admitted into the United States under the category of "Kitchen Utensils and Hospital Supplies," which meant that Steichen had to pay $600 in import duty.

Later, with the financial backing of Gertrude Vanderbilt Whitney, an American sculptor and patron of the arts, Steichen appealed the ruling of the customs official. The ensuing trial received a great deal of publicity. Witnesses discussed whether the *Bird* was a bird at all, whether the artist could make it a bird by calling it one, whether it could be said to have characteristics of "birdness," and so on. The conservative witnesses refused to accept the work as a bird because it lacked certain biological attributes, such as wings and tail feathers. The more progressive witnesses pointed out that it had birdlike qualities: upward movement and a sense of spatial freedom. The court decided in favor of the plaintiff. The *Bird* was declared a work of art, and Steichen got his money back. In today's market, Brancusi *Birds* would sell for millions of dollars.

I.4 Constantin Brancusi, *Bird in Space*, 1928. Bronze, unique cast; 54 × 8½ × 6½ in. (137.2 × 21.6 × 16.5 cm). Museum of Modern Art, New York. Given anonymously. Brancusi objected to the view of his work as abstract. In a statement published shortly after his death in 1957, he declared: "They are imbeciles who call my work abstract; that which they call abstract is the most realist, because what is real is not the exterior form but the idea, the essence of things."

well as imperial power. Centuries earlier, the Indian emperor Ashoka had commissioned monuments throughout his realm to proclaim his conversion to Buddhism. Both Constantine and Ashoka patronized the arts in the service of revolutionary developments in politics and religion.

See figure 7.40. Arch of Constantine, Rome, c. A.D. 313.

Works of art need not represent national figures or even national or religious themes to have nationalistic value. In 1945, at the end of World War II, the Dutch authorities arrested an art dealer, Hans van Meegeren, for treason. They accused him of having sold a painting by the great seventeenth-century Dutch artist Jan Vermeer to Hermann Goering, the Nazi Reichsmarschall and Hitler's most loyal supporter. When van Meegeren's case went to trial, he lashed out at the court: "Fools!" he cried, "I painted it myself." What he had sold to the Nazis was actually his own forgery, and he proved it by painting another "Vermeer" under supervision while in prison. It would have been treason to sell Vermeer's paintings, which are considered national treasures, to the German enemy.

Another expression of the nationalistic value of art can be seen in recent exhibitions made possible by shifts in world politics. Since 1989, which marked the end of the Cold War between communist Eastern Europe and the West, Russia has been sending works of art from its museums for temporary exhibitions in the United States. In such circumstances, the traveling works become a kind of diplomatic currency, improving relations between nations.

The nationalistic value of certain works of art has frequently made them spoils of war. When ancient Babylon was defeated by the Elamites in c. 1170 B.C., the victors stole the stele of Naram-Sin (see fig. 2.17) and the law code of Hammurabi (see fig. 2.21). In the early nineteenth century, when Napoleon's armies overran Europe, they plundered thousands of works that are now part of the French national art collection in the Musée du Louvre, in Paris.

When the nineteenth-century German archaeologist Heinrich Schliemann excavated ancient Troy, in modern Turkey, he removed a hoard of gold from the site and brought it to Germany. During World War II, the Russians invaded Germany and took the treasure to Russia. They later denied any knowledge of its whereabouts, admitting only in 1994 that they had it. The issue that then arose was who owned the gold—Turkey, Germany, or Russia. The Turks argued that it was theirs by right of origin, the Germans claimed that they had excavated and essentially "discovered" it, and the Russians pointed out that they had been victors in the war (which Germany had started).

The nationalistic value of art can be so great that countries whose works have been taken go to considerable lengths to recover them. Thus, at the end of World War II, the Allied armies assigned a special division to recover the vast numbers of artworks stolen by the Nazis. A United States army task force discovered Hermann Goering's two personal hoards of stolen art in Bavaria, one in a medieval castle and the other in a bomb-proof tunnel in nearby mountains. The task force arrived just in time, for Goering had equipped an "art train" with thermostatic temperature control to take "his" collection to safety. At the Nuremberg war trials, Goering claimed that his intentions had been purely honorable: he was protecting the art from air raids.

Another example of the nationalistic value of art can be seen in the case of the Elgin Marbles. In the early nineteenth century, when Athens was under Turkish rule, Thomas Bruce, seventh earl of Elgin, obtained permission from Turkey to remove sculptures from the Parthenon and other buildings on the Acropolis. At huge personal expense (£75,000), Lord Elgin sent the sculptures by boat to England. The first shipment sank, but the remainder of the works reached their destination in 1816 and the British Museum in London purchased the sculp-

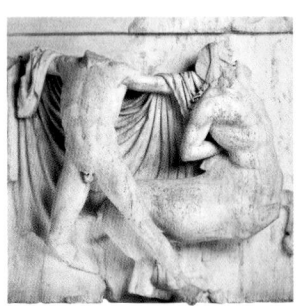

See figure 5.53. Lapith and Centaur, from south metope XXVII of the Parthenon, 5th century B.C.

tures for only £35,000. The Elgin Marbles, also known as the Parthenon Marbles, are still in the British Museum, where they are a tourist attraction and are studied by scholars. For years, the Greeks have been pressing for the return of the sculptures, but the British have refused. This kind of situation is a product of historical circumstance. Although Lord Elgin broke no laws and probably saved the sculptures from considerable damage, he is seen by many Greeks as having looted their cultural heritage.

Modern legislation in some countries is designed to avoid similar problems by restricting or banning the export of national treasures. International cooperation agreements (protocols) attempt to protect cultural property and archaeological heritage worldwide.

Psychological Value

Another symbolic value of art is psychological. Our reactions to art span virtually the entire range of human emotion. They include pleasure, fright, amusement, avoidance, and outrage.

One of the psychological aspects of art is its ability to attract and repel us, and this is not necessarily a function of whether or not we find a particular image aesthetically pleasing. People can become attached to a work of art, as Leonardo was to his *Mona Lisa* (see fig. 14.16). Instead of

delivering it to the patron, Leonardo kept the painting until his death. Conversely, one may wish to destroy certain works because they arouse anger. In London in the early twentieth century, a suffragette slashed Velázquez's *Rokeby Venus* (see fig. 17.54) because she was offended by what she

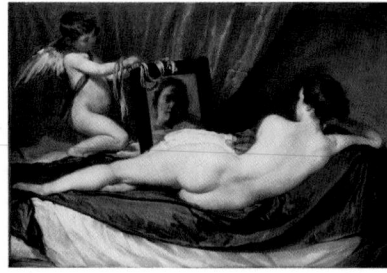

See figure 17.54. Diego Velázquez, *Venus with a Mirror (Rokeby Venus)*, c. 1648.

considered to be its sexist representation of a woman. During the French Revolution of 1789, mobs protesting the injustices of the royal family destroyed statues and paintings of earlier kings and queens. In 1989 and 1990, when Eastern Europe began to rebel against communism, the protesters tore down statues of their former leaders. In Afghanistan, the fundamentalist Islamic Taliban regime blew up colossal statues of the Buddha because the statues were figurative and thus seen as not conforming to the rules of the Koran (Qu'ran). In so doing, the Taliban breached the UNESCO Convention of 1972 and the Geneva Convention riders of 1977 and 1997. Both forbid the destruction of cultural property. All these examples illustrate intense responses to the symbolic power of art.

Art and Illusion

Before considering illusion and the arts, it is necessary to point out that when we think of illusion in connection with an image, we usually assume that the image is true to life, or naturalistic (cf. **naturalism**). This is often, but not always, the case. With certain exceptions, such as some Judaic and Islamic art, Western art was mainly representational until the twentieth century. **Representational, or figurative,** art depicts recognizable natural forms or created objects (see p. 24). When the subjects of representational pictures and sculptures are so convincingly portrayed that they may be mistaken for the real thing, they are said to be illusionistic (cf. **illusionism**). Where the artist's purpose is to fool the eye, the effect is described by the French term ***trompe-l'oeil.***

The deceptive nature of pictorial illusion was simply but eloquently stated by the Belgian Surrealist painter René Magritte in *The Betrayal of Images* (see box, p. 7). This work is a convincing (although not a *trompe-l'oeil*) rendition of a pipe. Directly below the image, Magritte reminds the viewer that in fact it is not a pipe at all—"*Ceci n'est pas une pipe*" ("This is not a pipe") is Magritte's explicit message. To the extent that observers are convinced by the image, they have been betrayed. Even though Magritte was right about the illusion falling short of reality, the observer nevertheless enjoys having been fooled.

Images and Words

Artists express themselves through a visual language which has pictorial, sculptural, and architectural, rather than verbal, elements. As a result, no amount of description can replace the direct experience of viewing art. As discussed on pages 18–23, the artist's language consists of formal elements such as line, shape, space, color, light, dark, and so forth, whereas discussion about art is in words. Imagine, for example, if the words in Magritte's *The Betrayal of Images* (fig. **I.5**) read "This is a pipe" *(Ceci est une pipe)* or even only "Pipe," instead of "This is not a pipe" *(Ceci n'est pas une pipe)*. Although we might receive the same meaning of "pipeness" from both the word and the image, our experience of the verbal description would be quite different from our experience of its subject.

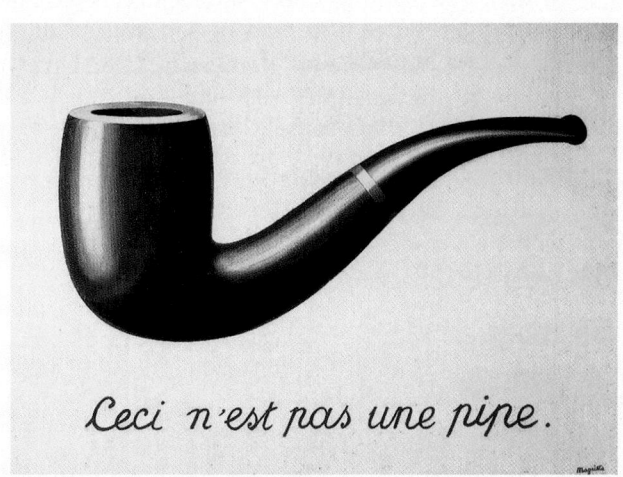

I.5 René Magritte, *The Betrayal of Images* ("This is not a pipe"), 1928. Oil on canvas; 23½ × 28½ in. (55.0 × 72.0 cm). Los Angeles County Museum of Art, California.

The pleasure produced by *trompe-l'oeil* images is reflected in many anecdotes, perhaps not literally true but illustrations of underlying truths. For example, the ancient Greek artist Zeuxis was said to have painted grapes so realistically that birds pecked at them. In the Renaissance, a favorite story recounted that the painter Cimabue was so deceived by Giotto's realism that he tried to brush off a fly that Giotto had painted on the nose of a painted figure. The twentieth-century American sculptor Duane Hanson was a master of *trompe-l'oeil*. He used synthetic materials to create statues that look so alive that it is not unusual for people to approach and speak to them.

In these examples of illusion and *trompe-l'oeil*, artists produce only a temporary deception. But such may not always be the case. For instance, the Latin poet Ovid relates the tale of the sculptor Pygmalion, who was not sure whether his own statue was real. Disillusioned by the infidelities of women, Pygmalion turned to art and fashioned a beautiful girl, Galatea, out of ivory. He dressed her and brought her jewels and flowers. He undressed her and took her to bed. During a feast of Venus (the Roman goddess of love and beauty), Pygmalion prayed for a wife as lovely as his *Galatea*. Venus granted his wish by bringing the statue to life.

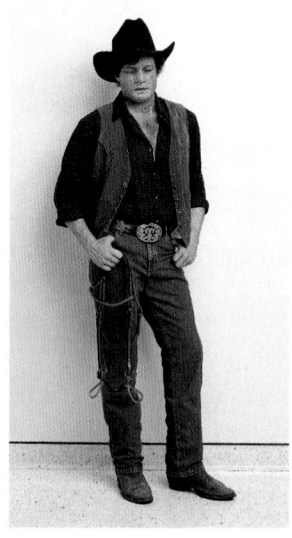

See figure 29.6. Duane Hanson, *The Cowboy*, 1995.

Artists and Gods

The fine line between reality and illusion, and the fact that gods are said to create reality and artists create illusion, have given rise to traditions equating artists with gods. Both are seen as creators, the former making replicas of nature and the latter making nature itself. Alberti referred to the artist as an *alter deus,* Latin for "other god," and Dürer said that artists create as God did. Leonardo wrote in his *Notebooks* that artists are God's grandsons and that painting, the grandchild of nature, is related to God. Giorgio Vasari, the Italian Renaissance biographer of artists, called Michelangelo "divine," a reflection of the notion of divine inspiration. The nineteenth-century American painter James McNeill Whistler declared that artists are "chosen by the gods."

Artists have been compared with gods, and gods have been represented as artists. In ancient Babylonian texts, God is described as the architect of the world. In the Middle Ages, God is sometimes depicted as an architect drawing the universe with a compass (fig. **I.6**). Legends in the Apocrypha, the unofficial books of the Bible, portray Christ as a sculptor who made clay birds and breathed life into them. Legends such as these are in the tradition of the supreme and omnipotent male artist-as-genius, and they reflect the fact that the original meaning of *genius* was "divinity."

The comparison of artists with gods, especially when artists make lifelike work, has inspired legends of rivalry between these two types of creator. Even when the work itself is not lifelike, the artist may risk incurring divine anger. For example, the Old Testament account of the Tower of Babel illustrates the dangers of building too high and rivaling God by invading the heavens. God reacted by confounding the speech of the builders so that they seemed to each other to be "babbling" incomprehensibly. They scattered across the earth, forming different language groups. In the sixteenth-century painting by the

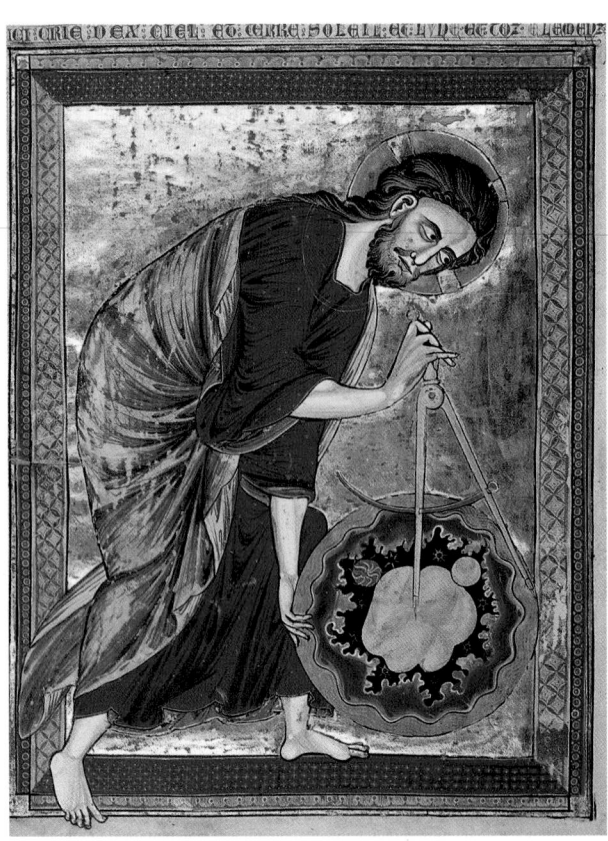

I.6 *God as Architect (God Drawing the Universe with a Compass),* from the *Bible moralisée,* Reims, France, fol. Iv, mid-13th century. Illumination; 8⅓ in. (21.2 cm) wide. Österreichische Nationalbibliothek, Vienna.

Flemish artist Pieter Bruegel the Elder (fig. **I.7**), the Tower of Babel seems about to cave in from within, although it does not actually do so. Bruegel's tower is thus a metaphor for the collapsed ambition of the builders. A related story is told by the Roman historian Pliny: the emperor Nero angered the god Jupiter by erecting a colossal statue of himself. Jupiter destroyed the image of the presumptuous mortal with a thunderbolt.

Some legends endow sculptors and painters with the power to create living figures without divine intervention. In Greek mythology, the sculptor Daedalos was reputed to have made lifelike statues that could walk and talk. Prometheus, on the other hand, was not satisfied with merely lifelike works: he wanted to create life itself. Since the ancient Greeks believed that human beings were made of earth (the body) and fire (the soul), Prometheus knew that he needed more than clay to create living figures. He therefore stole fire from the gods, and they punished him with eternal torture.

I.7 Pieter Bruegel the Elder, *The Tower of Babel,* 1563. Tempera on panel; 3 ft. 9 in. × 5 ft. 1 in. (1.14 × 1.55 m). Kunsthistorisches Museum, Vienna.

Art and Identification

Reflections and Shadows: Legends of How Art Began

Belief in the power of images extends beyond the work of human hands. In many societies, not only certain works of art but also reflections and shadows are thought to embody the spirit of an animal or the soul of a person. Ancient traditions trace the origin of image making to drawing a line around a reflected image or shadow. Alberti recalled the myth of Narcissus—a Greek youth who fell in love with his own image in a pool of water—and compared the art of painting to the reflection. The Roman writer Quintilian, on the other hand, identified the first painting as a line traced around a shadow. A Buddhist tradition recounts that the Buddha was unable to find an artist who could paint his portrait. As a last resort, he had an outline drawn around his shadow and filled it in with color himself.

A Greek legend attributes the origin of sculpture to a young woman of Corinth, who traced the shadow of her lover's face cast on the wall by lamplight. Her father, a potter, filled in the outline with clay, which he then **fired** (burned in a kiln). This story became particularly popular during the Romantic period in Europe and has been memorialized in *The Corinthian Maid* (fig. **I.8**) by the English painter Joseph Wright of Derby. Legends such as this indicate that works of art are inspired not only by the impulse to create form, but also by the discovery or recognition of forms that already exist and the wish to capture and preserve them.

Image Magic

People in many cultures believe that harm done to an image of someone will hurt the actual person. In sixteenth-century England, Queen Elizabeth I's advisers summoned a famous astrologer to counteract witchcraft when they discovered a wax effigy of the queen stuck through with pins.

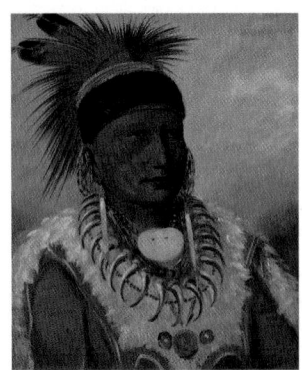

See figure 20.25. George Catlin, *The White Cloud, Head Chief of the Iowas,* 1844–1845. Oil on canvas; 28 × 22⅞ in. (71.1 × 58.1 cm). National Gallery of Art, Washington, D.C.

Sometimes, usually in cultures without strong traditions of figural art, people fear that pictures of themselves may embody—and snatch away—their souls. Many nineteenth-century Native Americans objected to having their portraits painted. One of the outsiders who did paint their portraits was George Catlin, whose memoirs record suspicious and occasionally violent reactions. Even today, with media images permeating so much of the globe, people in remote areas may resist being photographed for fear of losing themselves if their image is taken away. In fact, the very language we use to describe photography reflects this phenomenon: we "take" pictures and "capture" our subjects on film.

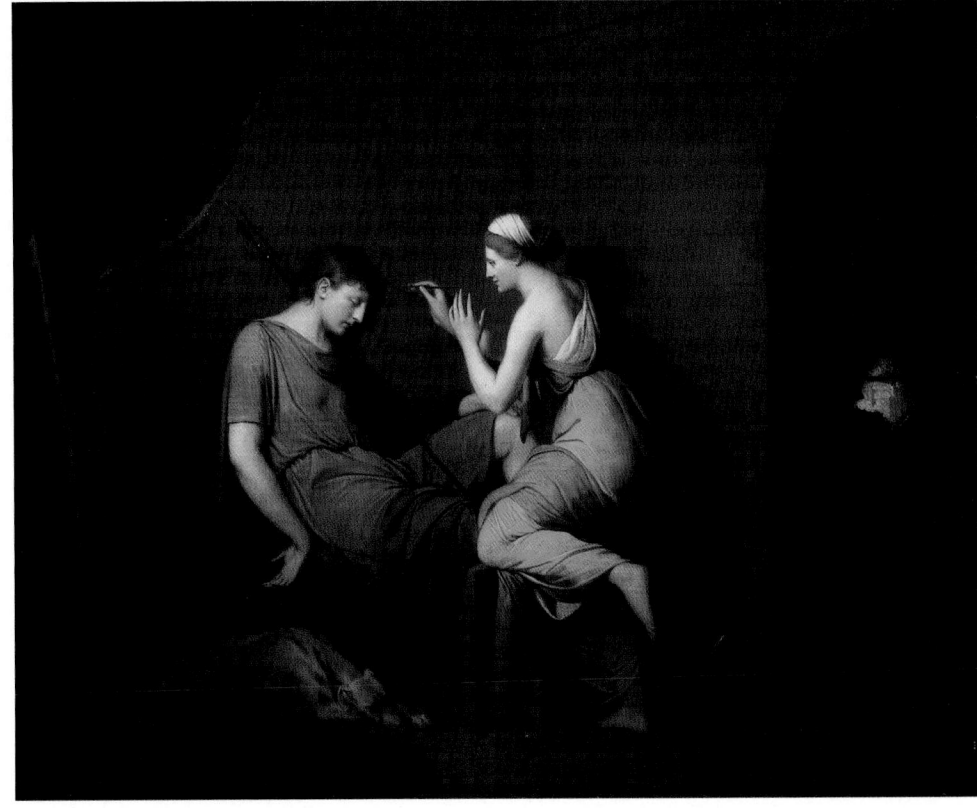

I.8 Joseph Wright of Derby, *The Corinthian Maid,* 1782–1784. Oil on canvas; 41⅞ × 51½ in. (1.06 × 1.30 m). National Gallery of Art, Washington, D.C. Paul Mellon Collection.

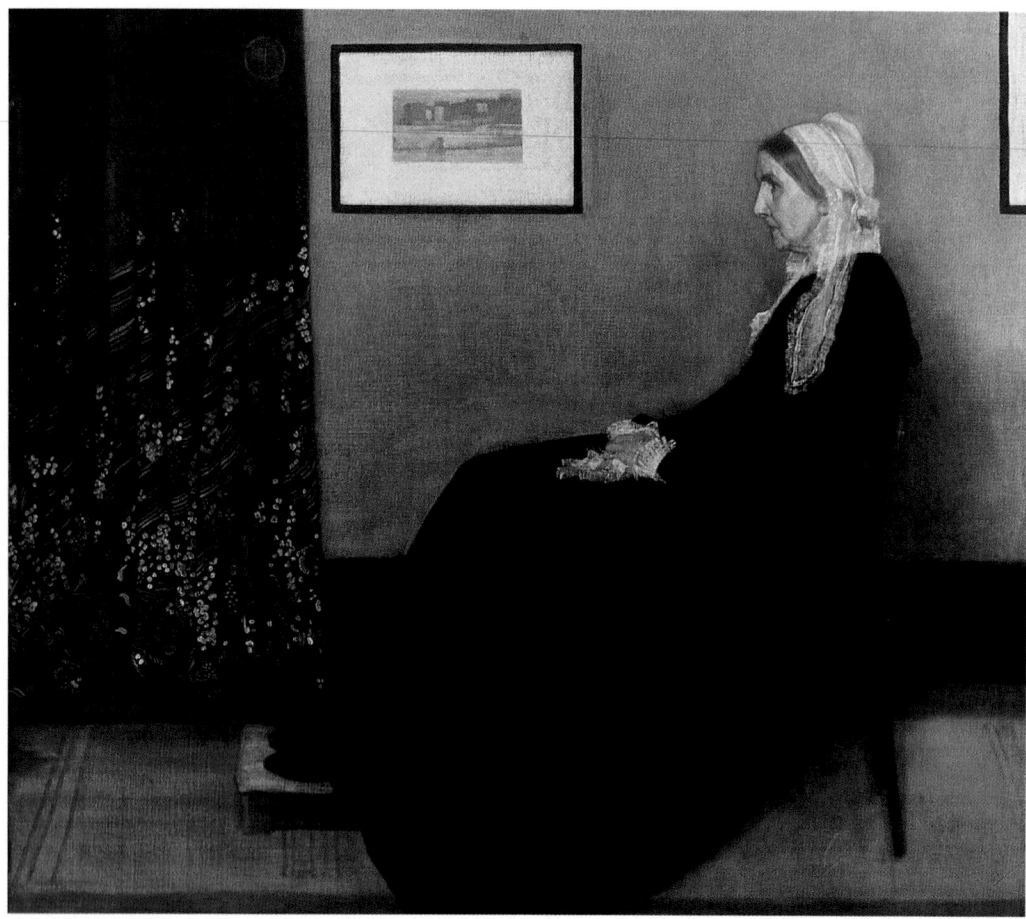

I.9 James Abbott McNeill Whistler, *Arrangement in Black and Gray (Portrait of the Artist's Mother)*, 1871. Oil on canvas; 4 ft. 9 in. × 5 ft. 4½ in. (1.45 × 1.64 m). Musée d'Orsay, Paris.

Portraits can also create very strong impressions. The nineteenth-century English art critic John Ruskin fell in love with an image on two separate occasions. He became so enamored of the marble tomb effigy of Ilaria del Caretto in Lucca, Italy, that he wrote letters home to his parents describing the statue as if it were a living girl. Later, when Ruskin was in a delusional state, he persuaded the Accademia, a museum in Venice, to lend him a painting of Saint Ursula by the sixteenth-century artist Carpaccio. Ruskin kept it in his room for six months and became convinced that he had been reunited with his former fiancée, a young Irish girl named Rose la Touche, whom he merged in his mind with the painted saint. A less extreme form of the identification of a woman with an image concerns Whistler's famous portrait of his mother (fig. **I.9**). "Yes," he replied when complimented on the picture. "One does like to make one's mummy just as nice as possible."

The ability to identify with images and the sense that a replica may actually contain the soul of what it represents have sometimes led to an avoidance of images. Certain religions prohibit their adherents from making pictures and statues of their god(s) or of human figures in sacred contexts. In Judaism, the making of figurative images is expressly forbidden in the second commandment: "Thou shalt not make unto thee any graven image, or any likeness of any thing that is in heaven above, or that is in the earth beneath, or that is in the water under the earth" (Exodus 20:4). Before receiving these instructions, the Israelites had been worshiping a golden calf, which Moses destroyed when he brought them the Commandments. Years later, the prophet Jeremiah declared both the pointlessness and the dangers of worshiping objects instead of God the Creator.

In Islam, as in Judaism, the human figure is generally avoided in religious art. The founder of Islam, the prophet Muhammad, condemned those who would dare to imitate God's work by making figurative art. As a result, Islamic art developed its characteristic emphasis on complex patterns.

During the Iconoclastic Controversy in the eighth and ninth centuries, Christians argued vehemently over the potential dangers of creating any images of holy figures. Like the Jews, Christians wishing to destroy existing images and to prohibit new ones believed that such works of art would lead to idolatry, or worship of the image itself rather than what it stood for.

A different interpretation of this connection between images and gods can be seen in Hindu beliefs about religious sculpture, which is intensely figurative. Hindu statues are considered available for their associated deities to inhabit. Because they are thought capable of changing their outer appearances in order to become manifest and

comprehensible to human worshipers, the gods can enter sculptures that have the appropriate forms. Hindu sculpture is thus conceived of as a sacred vessel for the divine presence.

In the modern era, as societies have become increasingly technological, traditional imagery seems to have lost some of its magic power. But art still engages us. A peaceful **landscape** painting, for example, provides a respite from everyday tensions as we contemplate its rolling hills or distant horizon. A **still life** depicting fruit in a bowl reminds us of the beauty inherent in objects we take for granted. And it remains true that abstract works of art containing no recognizable objects or figures can involve us in the rhythms of their shapes, the movements of their lines, and the moods of their colors. Large public sculptures, many of which are **nonrepresentational**, mark our social spaces and humanize them. Architecture, too, defines and enriches our environment. In addition, contemporary images, many in electronic media, exert power over us in both obvious and subtle ways by drawing on our image-making traditions. Movies and television affect our tastes and aesthetic judgments. Advertising images influence our decisions—what we buy and which candidates we vote for. Computer-based digital art is one of the fastest growing art fields. Such modern media use certain traditional techniques of image making to convey their messages.

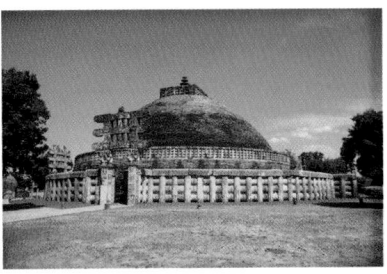

See figure W3.10. The Great Stupa at Sanchi, Madhya Pradesh, India, 3rd century B.C.

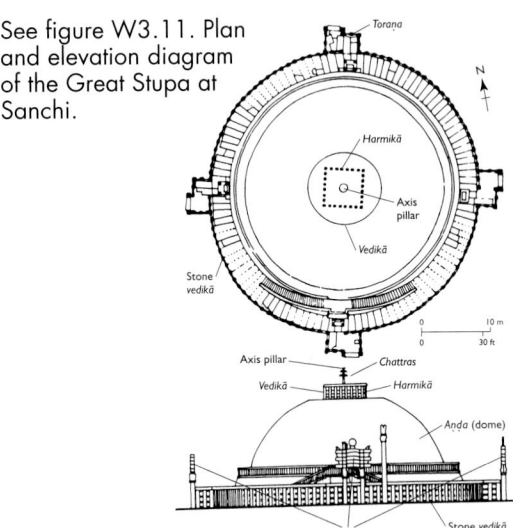

See figure W3.11. Plan and elevation diagram of the Great Stupa at Sanchi.

Architecture

As is true of pictures and sculptures, architecture evokes a response by identification. A building may seem inviting or forbidding, gracious or imposing, depending on how its appearance strikes the viewer. One might think of a country cottage as welcoming and picturesque, or of a haunted house as endowed with the spirits of former inhabitants who inflict mischief on trespassers.

Architecture is more functional, or utilitarian, than pictures and sculptures. Usually the very design of a building conforms to the purpose for which it was built. The criterion for a successful building is not only whether it looks good, but also whether it fulfills its function well. A hospital, for example, may be aesthetically pleasing, but its ultimate test is whether it serves the patients and medical staff adequately. A medieval castle was not only a place to live, it was also a fortress requiring defensive features such as a moat, drawbridge, towers, small windows, and thick, crenellated walls.

Beyond function, the next most important consideration in architecture is its use of space. The scale (size) of buildings and the fact that, with very few exceptions, they can enclose us make our responses to them significantly different from our reactions to pictures or sculptures. Pictures convey only the illusion of space. Sculptures occupy actual, three-dimensional space, although the observer generally remains on the outside of that space looking in.

In the ancient world, many buildings, such as Egyptian pyramids and Greek temples, were intended to be experienced either exclusively or primarily from the outside. But a Buddhist **stupa** had a solid core and, therefore, no interior at all. Its hemispherical shape represented the Buddha's original burial mound, which became a symbol of the cosmos. Worshipers enter the sacred space surrounding a stupa through a gateway marking the transition from the ordinary to the spiritual world. They walk around the perimeter of the stupa in a ritual **circumambulation** that reiterates the Buddha's own spiritual journey. When religious structures do have interiors, access to their inner sanctuaries is frequently restricted. Psychologically as well as aesthetically, therefore, our response to architecture is incomplete until we have experienced it physically. Because such an experience involves time and motion as well as vision, it is particularly challenging to describe architecture through words and pictures.

The experience of architectural space appears in everyday language. We speak of "insiders" and "outsiders," of being "in on" something, and of being "out of it." The significance of "in" and "out" recurs in certain traditional architectural arrangements. In parts of the ancient world, the innermost room of a temple, its sanctuary, was considered the most sacred, the "holy of holies," which only a high priest or priestess could enter. Likewise, an appointment with a VIP is often held in an inner room that is generally closed to the public at large. Access is typically through a series of doors, so that in popular speech we say of people who have influence that they can "open doors."

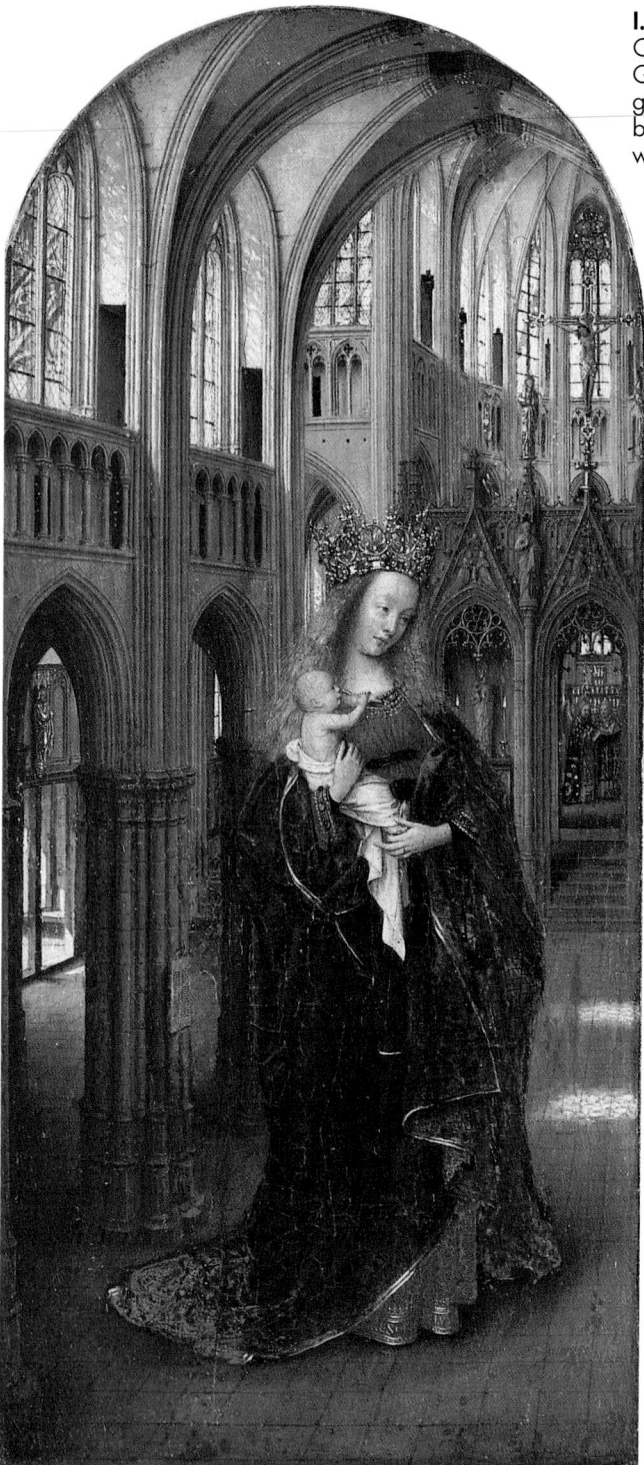

I.10 Jan van Eyck, *The Virgin in a Church,* c. 1410–1425. Oil on panel; 12¼ × 5½ in. (31.0 × 14.0 cm). Gemäldegalerie, Staatliche Museen, Berlin. It is thought that, given the narrowness of this picture, it may originally have been part of a **diptych**—a work consisting of two panels—in which case the other section is lost.

relationship between motherhood and architecture gave rise to a popular metaphor equating the Virgin Mary (as mother of Christ) with the Church building. This metaphor is given visual form in Jan van Eyck's fifteenth-century painting *The Virgin in a Church* (fig. **I.10**). Here Mary is enlarged in relation to the architecture, identifying her with the Church as the House of God. Van Eyck portrays an intimacy between the Virgin and Christ that evokes both the natural closeness of mother and child and the spiritual union between the human and the divine.

This union is an important aspect of the sense of space in religious architecture. The vast interior spaces of Gothic cathedrals, for example, are awe-inspiring, making worshipers feel small compared to an all-encompassing God. The upward movement of the interior space, together with the tall towers and spires on either side of the entrance, echo the Christian belief that paradise is up in the heavens. The rounded spaces of certain other places of worship, such as the domed ceilings of some mosques, likewise symbolize the dome of heaven. In a sense, then, these religious buildings stand as a kind of transitional space between earth and sky, between our limited time on earth and beliefs about infinite time, or eternity.

Just as we respond emotionally and physically to the open and closed spaces of architecture, so our metaphors indicate our concern for the structural security of our buildings. "A house of cards" or a "castle in the air" denotes instability and irrational thinking. This notion is reflected in the old joke "Neurotics build castles in the air, and psychotics live in them." Since buildings are constructed from the bottom up, a house built on a "firm foundation" can symbolize stability, rational thinking, forethought, and advance planning. In the initial stages of a building's conception, the architect makes a plan. Called a **ground plan,** or floor plan, it is a detailed drawing of each story of the structure, indicating where walls and other architectural elements are located. Although in everyday speech we use the term *to plan* in a figurative sense, unless the architect constructs a literal and well-thought-out plan, the building, like a weak argument, will not stand up.

Our identification with the experience of being inside begins before birth. Unborn children exist in the enclosed space of their mother's womb, where they are provided with protection, nourishment, and warmth. This biological reality has resulted in a traditional association between women and architecture. The inner sanctum of Hindu temples, for example, is called a **garbha griha,** meaning "womb chamber." In medieval Christianity, the intuitive

Why Do We Collect Art?

In antiquity, art was valued as booty taken from conquered peoples. In ancient Egypt, Babylon, China, and India, looted art was exhibited in temples and palaces to enhance

the power of rulers and priests. Even today, the value of art as military booty has not been entirely eliminated. In 1992, when the National Museum in Kabul, Afghanistan, was hit by rockets, looters pillaged the collection. Afghanistan's location made it a crossroads of trade for thousands of years, and this was reflected in unique objects from many different cultures that have now disappeared. Experts believe that some of these thefts were "commissioned" by agents working for unscrupulous collectors.

Ancient cultures have a long history of royal and aristocratic art collecting. In Europe, art collecting for the intrinsic value of the works began in Hellenistic Greece (323–31 B.C.). Romans plundered Greek art and also had a thriving industry copying Greek art, which was collected, especially by emperors. During the Middle Ages, the Christian Church was the main collector of art in Europe.

Interest in collecting ancient art revived in the West during the Renaissance and continued in royal families for several centuries. Some of these royal collections became the basis for major museums—in the late eighteenth century, the Louvre was opened in Paris, and the Russian and British royal collections were opened to the public in the early nineteenth century. By that time more and more private individuals collected art, and since then dealers, auction houses, museums, and the media have further expanded collecting.

Archaeology and Art History

The works of art illustrated in this book are the subject of two academic fields: archaeology and art history. Archaeology (from the Greek words *archaios,* meaning "old" or "beginning," and *logos,* meaning "word") is literally a study of beginnings. The value of such study was expressed by the German author Johann Wolfgang von Goethe in 1819 as follows:

> He who'd know what life's about
> Three millennia must appraise;
> Else he'll go in fear and doubt,
> Unenlightened all his days.[1]

A related sentiment was expressed by Sigmund Freud when he declared that "only a good-for-nothing is not interested in his past."

The primary aim of the archaeologist is the reconstruction of history from the physical remains of past cultures. These remains are not confined to the arts, but can be anything from bone fragments and debris, safety pins and frying pans, to entire water-supply systems of buried cities. Unvandalized graves protected from the elements and hidden from the view of potential plunderers yield some of the best evidence. On occasion, cities such as Pompeii and Herculaneum in southern Italy are discovered relatively intact, providing a remarkable glimpse of the past. In its early days in the nineteenth century, archaeology was largely the province of amateur explorers and collectors of antiquities. There was little or no concern for preserving the cultural or historical context of the finds.

Today archaeology is more scientific and professional, calling on many other disciplines to assist with analyzing its discoveries by material, stylistic type, function, and date, as well as in preserving them (see box, p. 14). Ecology, for example, elucidates aspects of the natural environment, some of which can be used for dating. Statistics indicating population size and growth in a particular culture can clarify its development and longevity. Other fields that contribute to archaeology include chemistry, physics, computer science, linguistics (where there is evidence of writing), sociology, anthropology, and art history.

Art history is the study of the history of the visual arts. It should be distinguished from art appreciation, which is primarily about aesthetics. Philosophers of both the East and the West have discussed the nature of aesthetics since antiquity. While art history has a venerable tradition in China, it did not become an academic discipline in the West until the nineteenth century. Art history in the West has traditionally dealt with the analysis of individual works of art and their grouping into larger categories of style. Art historians recognize that many factors contribute to the production of a work, including its culture (time and place), artist, patron, medium, and function. Art history is used by archaeologists as well as other scholars studying everyday life, religious practices, means of warfare, and so forth. Stylistic analysis of works of art helps archaeologists date layers of cultures and is of great importance to cultural and economic historians in determining patterns of trade.

How Do We Approach Art?

The complexity of images has led to the development of various interpretative approaches. Principal among these so-called methodologies of art-historical analysis are formalism, iconography and iconology, Marxism, feminism, biography and autobiography, semiology, deconstruction, and psychoanalysis. Generally, art historians approach works using some combination of these methods.

The Methodologies of Art

Formalism Chronologically, the earliest codified methodology is **formalism**, which grew out of the nineteenth-century aesthetic of "Art for Art's Sake"—artistic activity as an end in itself. Adherents of pure formalism view works of art independently of their context, function, and content. They respond to the formal elements and to the aesthetic effect that the arrangement of those elements creates. Two philosophers, Plato in ancient Greece and Immanuel Kant in eighteenth-century Germany, can be seen as precursors of formalist methodology. They

The Archaeological Dig

Archaeologists locate buried cultures by observing anomalies in topography such as earth mounds, traces of roads, and the geological disposition of rocks and minerals. Aerial photography is particularly helpful for this purpose. The location chosen for excavation is known as the site. Typically, each site has a director, a trained archaeologist who oversees the excavation. Under the director are various supervisors, staffers, and volunteers. Architectural drawings are made to record the remains of buildings and reconstruct their original plans. Finds are photographed, drawn, catalogued, and analyzed by specialists. A conservator advises on preserving objects. A foreman hires and oversees local workers and attends to necessities such as food, water, and medical supplies.

Archaeological Dating Techniques

The role of archaeology in studying prehistoric periods (i.e., those for which no contemporary written records exist) is crucial. Central to archaeological methods is the establishment of time sequences for events and objects. During the twentieth century a number of techniques have been developed for arriving at the age of ancient objects and the chronology of prehistoric events.

Through **stratigraphy** (the geological study of the layers [strata] of the earth), objects deposited in these layers can be dated. Stratigraphy rests on the principle—known as the Law of Superposition—that, in the absence of external factors, older (earlier) materials in an archaeological deposit are found lower than newer (later) materials. By careful excavation and meticulous record keeping, archaeologists are able to relate objects to each other both vertically (to determine their relative chronology) and horizontally (for clues to cultural patterns within individual periods).

Seriation, another method of fixing relative dates, is based on the reconstruction of changes in style or type that can be observed in archaeological artifacts (e.g., tools, ceramics) over time. For instance, in any group of examples of a particular kind of object, the percentage of the total is small at the start of its production phase, increases as the object becomes popular and widely used, and decreases through its phases of declining popularity and eventual disuse.

Dendrochronology (tree-ring dating) is the study of information contained in the annual growth layers of trees. It was discovered in 1917 that trees in any particular area have identical sequences of wide and narrow rings, each ring corresponding to one year's growth. This natural phenomenon has allowed archaeologists to reconstruct historic and prehistoric ring sequences and to assign accurate dates to prehistoric sites. Dendrochronology is valuable in areas such as North America and Europe, where there is an abundance of wood and charcoal remains, but is of less value where such materials are scarce.

Radiocarbon dating, which was first developed in 1947, provides a method of determining the precise age of carbonized wood and other organic materials such as antler, bone, and shell. Each living organism has a trace of radiocarbon (carbon 14), which begins to decay when death occurs. By measuring the residual carbon 14 content of an object, it is possible to establish, within fairly narrow limits, its actual age.

Archaeometry involves the application of analytical techniques from the physical sciences and engineering to archaeological materials. Its interdisciplinary nature requires close cooperation between the archaeologists and experts in various fields in dating objects. The work of the archaeometrist is facilitated by computer analysis, with its potential for storing vast amounts of data.

believed in an ideal, essential beauty that transcends time and place. Other formalist writers on art did relate changes in artistic style to cultural change. This approach was demonstrated by the Swiss art historian Heinrich Wölfflin, considered one of the founders of modern art history. In his *Principles of Art History*, first published in German in 1915, he demonstrated the respective formal consistency of Renaissance and Baroque styles.

In order to grasp the effect of formal elements, we take as an example Brancusi's *Bird in Space* (see fig. I.4). Imagine how different it would look lying in a horizontal plane. A large part of the effect of the work depends on its verticality. But it also has curved outlines, sleek proportions, and a highly reflective bronze surface. Its golden color might remind one of the sun and thus reinforce the association of birds and sky. Imagine the *Bird* made of another material (Brancusi did make some white marble *Birds*); its aesthetic effect would be very different.

Even more radical an idea: what if the texture of the *Bird* were furry instead of hard and smooth? Consider, for example, the *Fur-covered Cup, Saucer, and Spoon* of 1936 (fig. I.11) by the Swiss artist Meret Oppenheim. When we experience the formal qualities of texture in these two sculptures, we respond to the *Bird* from a distance, as if it were suspended in space, as the title indicates. But the *Cup* evokes an immediate tactile response because we think of drinking from it, of touching it to our lips, and its furry texture repels us. At the same time, however, the *Cup* amuses us because of its contradictory nature. Whereas our line of vision soars vertically *with* the *Bird, we* instinctively withdraw *from* the *Cup*.

Iconography and Iconology In contrast to formalism, the **iconographic** method emphasizes content over form in individual works of art. The term itself denotes the "writing" (*graphe* in Greek) of an image (from the Greek

I.11 Meret Oppenheim, *Fur-covered Cup, Saucer, and Spoon (Le Déjeuner en Fourrure)*, 1936. Cup 4⅜ in. (10.9 cm) diameter; saucer 9⅜ in. (23.7 cm) diameter; spoon 8 in. (20.2 cm) long; overall height 2⅞ in. (7.3 cm). Museum of Modern Art, New York.

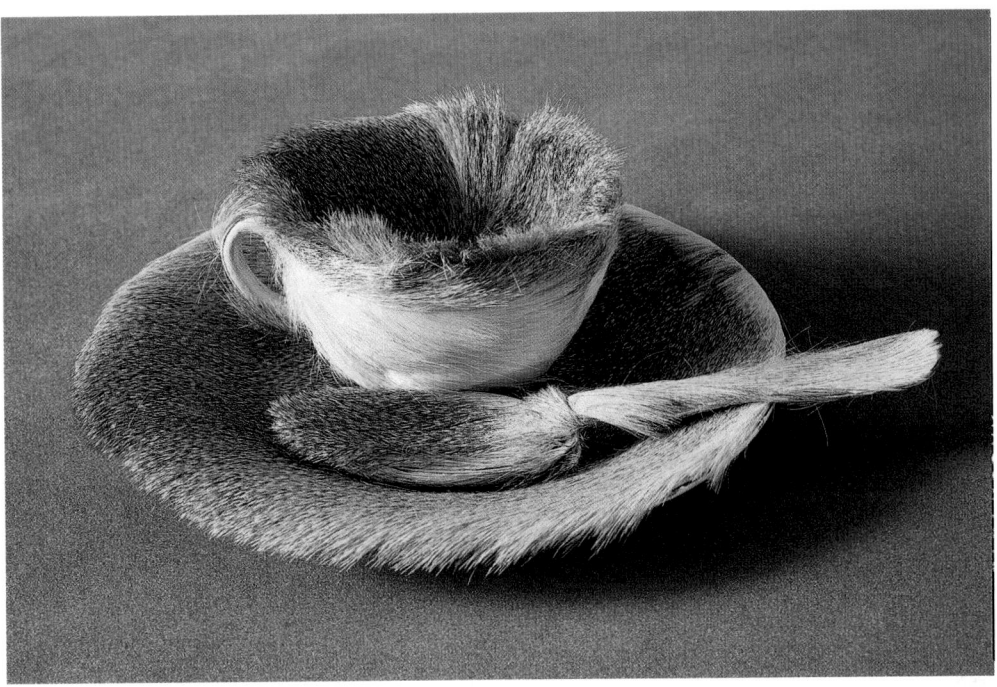

word *eikon*), and implies that a written text underlies an image. In Bruegel's *Tower of Babel* (see fig. I.7) the biblical text is Genesis 11:6, in which God becomes alarmed at the height of the tower. He fears that the builders will invade his territory and threaten his authority. The iconographic elements of Bruegel's picture include the tower as well as the figures and other objects depicted. The actual tower referred to in the Bible was probably a ziggurat commissioned by King Nebuchadnezzar of ancient Babylon, who is depicted with his royal entourage at the lower left of the picture. He has apparently come to review the progress of the work, which—according to the text—is about to stop. Bruegel shows this by the downward pull at the center of the tower that makes it seem about to cave in. He also refers to God's fear that the tower will reach into the heavens by painting a small, white cloud overlapping the top of the tower. The cloud thus heightens dramatic tension by referring to the divine retribution that will follow. Recognizing the symbolic importance of this iconographic detail significantly enriches our understanding of the work as a whole.

Iconology refers to the interpretation or rationale of a group of works, which is called a **program.** In a Gothic cathedral, for ex-

See figure 11.11. West façade of Chartres Cathedral, France, c. 1140–1150.

ample, an iconographic approach would consider the textual basis for a single statue or scene in a stained-glass window. Iconology, on the other hand, would consider the choice and arrangement of subjects represented in the entire cathedral and explore their interrelationships.

Marxism The Marxist approach to art history derives from the writings of Karl Marx, the nineteenth-century German social scientist and philosopher whose ideas were developed into the political doctrines of socialism and communism. Marx himself, influenced by the industrial revolution, was interested in the process of making art and its exploitation by the ruling classes. He contrasted the workers (proletariat) who create art with the property-owning classes (the bourgeoisie) who exploit the workers, and believed that this distinction led to the alienation of artists from their own productions. Marxist art historians, and those influenced by Marxism, study the relationship of art to the economic factors (e.g., cost and availability of materials) operating within its social context. They analyze patronage in relation to political and economic systems. Marxists study form and content not for their own sake, but for the social messages they convey and for evidence of the manipulation of art by the ruling class to enhance its own power.

A Marxist reading of the message of Bruegel's *Tower* might associate the builders with the proletariat and God with the bourgeoisie. In between is Nebuchadnezzar, who, because he is a king, is not punished as the workers are. It is they who assume the brunt of God's anger; their language is confounded and they are scattered across the earth, whereas Nebuchadnezzar continues to rule his empire. Bruegel emphasizes the greater importance of Nebuchadnezzar in relation to the workers by his larger size, his

upright stance, and his royal following. The workers are not only much smaller, but some kneel before the king.

Feminism Feminist methodology assumes that the making of art, as well as its iconography and its reception by viewers, is influenced by gender. Like Marxists, feminists are opposed to pure formalism on the grounds that it ignores the message conveyed by content. Feminist art historians have pointed out ways in which women have been discriminated against by the male-dominated art world. They have noted, for example, that before the 1970s the leading art-history textbooks did not include female artists. Through their research, they have also done a great deal to establish the importance of women's contributions to art history as both artists and patrons—rescuing significant figures from obscurity as well as broadening our sense of the role of art in society. Feminists take issue with traditional definitions of art and notions of artistic genius, both of which have historically tended to exclude women. The fact that traditionally it has been difficult for women to receive the same training in art as men, due in part to family obligations and the demands of motherhood and partly to social taboos, is an issue that the feminists have done much to illuminate.

Taking the example of this introductory chapter, a feminist might point out that of all the illustrations of works of art only one is by a woman (Meret Oppenheim, see fig. I.11). Furthermore, its subject is related to the woman's traditional role as the maker and server of food in the household. At the same time, the work is a visual joke constructed by a woman that combines female sexuality with eating and drinking. The "household" character of the *Cup* contrasts with the "divine" character of *God as Architect* (*God Drawing the Universe with a Compass*) (fig. I.6). As depicted in this Introduction, the male figures are gods, kings, soldiers, and workers, whereas female figures (except *The Corinthian Maid,* fig. I.8) are mothers.

Biography and Autobiography Biographical and autobiographical approaches to art history interpret works as expressions of their artists' lives and personalities. These methods have the longest history, beginning with the mythic associations of gods and artists described above. Epic heroes such as Gilgamesh and Aeneas are credited with the architectural activity of building walls and founding cities. The anecdotes of Pliny the Elder about ancient Greek artists have a more historical character, which was revived in fourteenth-century Italy. Vasari's *Lives of the Artists,* written in the sixteenth century, covers artists from the late thirteenth century up to his own time and concludes with his autobiography. From the fifteenth century on, the genre of biography and autobiography of artists has expanded into various literary forms—for example, sonnets (Michelangelo), memoirs (Vigée-Lebrun), journals (Delacroix), letters (van Gogh), and, more recently, films and taped interviews.

The biographical method emphasizes the notion of authorship and can be used to interpret iconography, using the artist's life as an underlying "text." This being said, there are certain standard conventions in artists' biographies and autobiographies that are remarkably consistent and that arise in quite divergent social and historical contexts. These conventions parallel artists with gods, especially in the ability to create illusion. They also include episodes in which an older artist recognizes talent in a child destined to become great, the renunciation of one's art (or even suicide) when confronted with the work of superior artists, sibling rivalry between artists, artists who are rescued from danger by their talent, and women as muses for (male) artists.

Whistler's portrait of his mother (see fig. I.9) obviously has autobiographical meaning. By placing his own etchings on the wall beside her, he relates her dour personality to his black-and-white drawings and etchings, rather than to his more colorful paintings. Vincent van Gogh's *Self-Portrait before His Easel* (1888) in figure I.1 is one of many self-portraits that reflect the artist's inner conflicts through the dynamic tension of line and color. In works such as these, it is possible to apply the biographical method because the artist's identity is known and because he makes aspects of himself manifest in his imagery. When works are entirely anonymous, such as Emperor Qin's "bodyguard" (fig. I.2), biographical readings in terms of the artist(s) are more difficult, although they may sometimes be applied to the patron.

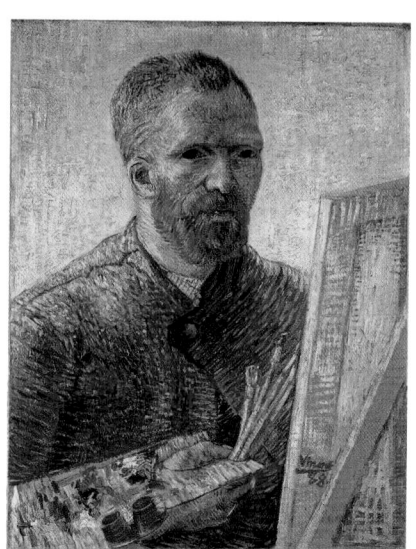

See figure I.1. Vincent van Gogh, *Self-Portrait before His Easel,* 1888.

Semiology Semiology—the science of signs—takes issue with the biographical method and with much of formalism. It has come to include elements of structuralism, poststructuralism, and deconstruction. Structuralism developed from a branch of language study called structural linguistics in the late nineteenth and early twentieth centuries as an attempt to identify universal and meaningful patterns in various cultural expressions. There are several structuralist approaches to art, but in general they diverge from the equation of artists with gods, from the Platonic notion of art as *mimesis* (making exact copies of nature), and from the view that the meaning of a work is conveyed exclusively by its author.

In the structural linguistics of the Swiss scholar Ferdinand de Saussure, a "sign" is composed of "signifier" and "signified." The former is the sound or written element (such as the four letters p-i-p-e) and the latter is the concept of what the signifier refers to (in this case, a pipe). A central feature of this theory is that the relation between signifier and signified is entirely arbitrary. Saussure insists on that point specifically to counter the notion that there is an ideal essence of a thing (as stated by Plato and Kant). He is also arguing against the tradition of a "linguistic equivalent." The notion of linguistic equivalents derived from the belief that, in the original language spoken by Adam and Eve, words matched the essence of what they referred to so that signifier and signified were naturally related to each other. Even before Adam and Eve, the logocentric (word-centered) Judaic God had created the world through language: "Let there be light" made light, and "Let there be darkness" made darkness. The New Testament Gospel of John (1:1) takes up this notion again, opening with "In the beginning was the Word."

For certain semioticians, however, some relation between signifier and signified is allowed. These would agree that Magritte's painted pipe is closer to the idea of pipeness than the four letters p-i-p-e. But most semioticians prefer to base stylistic categories on signs rather than on formal elements. For example, Magritte's pipe and Oppenheim's cup do not resemble each other formally, and yet both have been related to Dada and Surrealism. Their similarities do not lie in

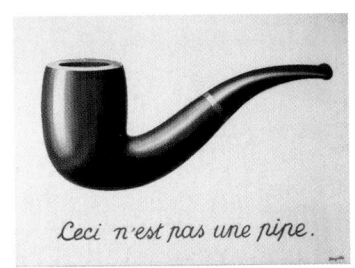

See figure I.5. René Magritte, *The Betrayal of Images* ("This is not a pipe"), 1928.

shared formal elements, but rather in their ability to evoke surprise by disrupting expectations. We do not expect to read a denial of the "pipeness" of a convincing image of a pipe written by the very artist who painted it. Nor do we expect fur-covered cups and spoons because the fur interferes with their function. The unexpected—and humorous—qualities of the pipe and the cup could be considered signs of certain twentieth-century developments in imagery. Another element shared by these two works is the twentieth-century primacy of everyday objects, which can also be considered a sign.

Deconstruction The analytical method known as deconstruction is most often associated with Jacques Derrida, a French poststructuralist philosopher who writes about art and written texts. Derrida's deconstruction opens up meanings rather than fixing them within structural patterns. But he shares with the structuralists the idea that works have no ultimate meanings conferred by their authors.

Derrida's technique for opening up meanings is to question assumptions about works. Whistler's mother (see fig. I.9), for example, seems to be sitting for her portrait, but we have no proof from the painting that she ever did so. Whistler could have painted her from a photograph or from memory, in which case our initial assumption about the circumstances of the work's creation would be incorrect, even though the portrait is a remarkably "truthful" rendering of a puritanical woman.

Derrida also opens up the Western tendency to binary pairing: right/left, positive/negative, male/female, and so forth. He notes that one of a pair evokes its other half and plays on the relationship of presence and absence. Since a pair of parents is a biological given, where, a Derridean might ask, is Whistler's father? In the pairing of father and mother, the present parent evokes the absent parent. There is, in Whistler's painting, no reference to his father, only to himself via the etchings hanging on the wall. The absent father, the present mother, the etchings of the son—the combination invites speculation about their relationships: was the son trying to displace the father? Such psychological considerations lead us to the psychoanalytic methodologies.

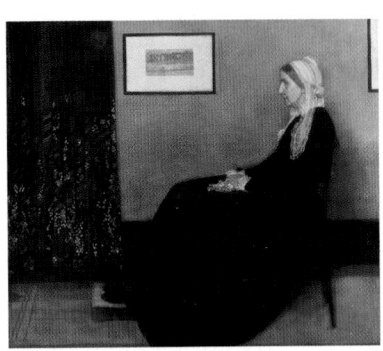

See figure I.9. James Abbott McNeill Whistler, *Arrangement in Black and Gray (Portrait of the Artist's Mother)*, 1871.

Psychoanalysis The branch of psychology known as psychoanalysis was originated by the Austrian neurologist Sigmund Freud in the late nineteenth century. Like art history, psychoanalysis deals with imagery, history, and creativity. Like archaeology, it reconstructs the past and interprets its relevance to the present. The imagery examined by psychoanalysts is found in dreams, waking fantasies, jokes, slips of the tongue, and neurotic symptoms, and it reveals the unconscious mind (which, like a buried city, is a repository of the past). In a work of art, personal imagery is reworked into a new form that "speaks" to a cultural audience. It thus becomes part of a history of style (and, for semioticians, of signs).

Psychoanalysis has been applied to art in different ways and according to different theories. In 1910 Freud published the first psychobiography of an artist, in which he explored the personality of Leonardo da Vinci through the artist's iconography and working methods. For Freud, the cornerstone of psychoanalysis was the Oedipus complex, which refers to various aspects of children's relationships to their parents. In the case of a boy, the Oedipus complex includes his wish for a romance with his mother and the elimination of his father. The Oedipus complex of a girl is

more complicated because her first love object is her mother and she is expected to grow up and love a man.

As we have seen, the Oedipus complex can be applied to Whistler's painting of his mother. An oedipal reading of that work is enriched by the fact that it contains an under-painting—a preliminary painting covered up by the final painting—of a baby. An oedipal reading of Brancusi's *Bird* would have to consider the artist's relationship to his peasant father, an ignorant and abusive man who would have preferred his son to have been born a girl. In that light, the sculpture has been interpreted as a phallic self-image, declaring its triumph over gravity and outshining the sun. With *Bird in Space,* Brancusi symbolically "defeats" his father and "stands up" for himself as a creator.

According to classical psychoanalysis, works of art are "sublimations of instinct" through which instinctual energy is transformed by work and talent into aesthetic form. The ability to sublimate is one of the main differences between humans and animals, and it is necessary for creative development in any field. Because art is expressive, it reveals aspects of the artist who creates it, of the patron who funds it, and of the culture in which it is produced.

How Do We Talk about Art?

The visual arts have their own language, and the artist thinks in terms of that language, just as a musician thinks in sounds and a mathematician in numbers. The basic visual vocabulary consists of the so-called **formal elements,** which include line, shape, space, color, light, and dark. When artists combine these elements in a characteristic way, they are said to have a **style.** In order to describe and analyze a work of art, it is helpful to be familiar with the artist's perceptual vocabulary.

Composition

In its broadest sense, the **composition** of a work of art is its overall plan or structure. It denotes the relationship among component parts, and it involves balance and harmony, the relationships of parts to each other and to the whole work, and the effect on the viewer. The composition of a work depends on how the formal elements are arranged and is distinct from the subject matter, content, or theme.

Plane

A **plane** is a flat surface having a direction in space. Brancusi's *Bird* (fig. I.4) rises in a vertical plane, Magritte's *pipe* (fig. I.5) lies in a relatively horizontal plane, and the figure of God in *God as Architect (God Drawing the Universe with a Compass)* (fig. I.6) bends over to create two diagonal planes. Stonehenge (see fig. 1.22) is a building that

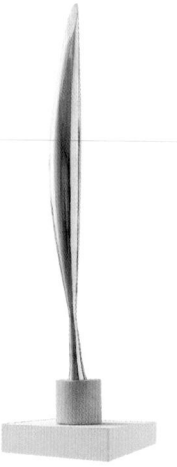

See figure I.4. Constantin Brancusi, *Bird in Space,* 1928.

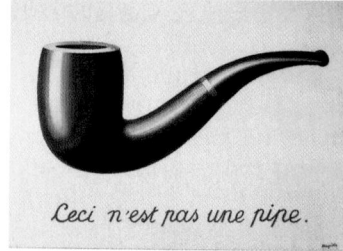

See figure I.5. René Magritte, *The Betrayal of Images* ("This is not a pipe"), 1928.

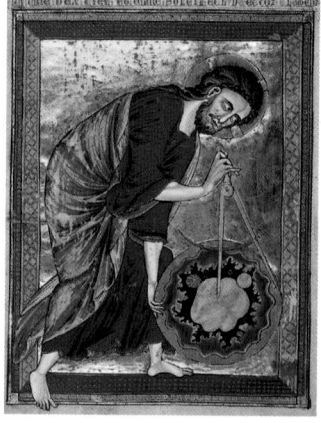

See figure I.6. *God as Architect (God Drawing the Universe with a Compass),* mid-13th century.

occupies a circular plane because it is round, whereas the towers of Gothic cathedrals are vertical planes and Greek temples lie in horizontal planes.

A plane can also be thought of as a flat surface. We thus speak of a **picture plane** when referring to the flat surface of a painting or a **plane of relief** when referring to the surface of a relief sculpture (see Chapter 1).

Balance

In a successful composition, the harmonious blending of formal elements creates **balance.** The simplest form of balance is **symmetry,** in which there is an exact correspondence of parts on either side of an axis or dividing line. In other words, the left side of a work is a mirror image of the right side. The Taj Mahal (fig. I.3) is a symmetrical building, meaning that if we draw a line through its center, we will have two equal parts.

Balance can also be achieved by nonequivalent elements. In *God as Architect (God Drawing the Universe with a Compass)* (fig. I.6), the weight of the figure is not evenly distributed on either side of the central axis. But

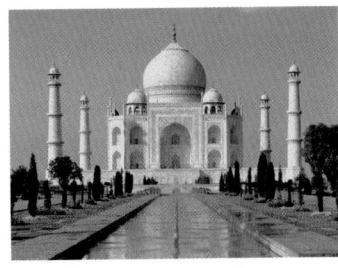

See figure I.3. Taj Mahal, Agra, India, 1632–1648.

even though the parts are not arranged symmetrically, there is an equilibrium between them that produces an aesthetically satisfying result. This is known as **asymmetrical balance.**

Line

A line is the path traced by a moving point. For the artist, the moving point is the tip of the brush, pen, crayon, or whatever instrument is used to create an image on a surface. In geometry, a line has no width or volume; its only quality is inherent in its location, a straight line being defined as the shortest distance between two points. In the language of art, however, a line can have many qualities, depending on how it is drawn (fig. **I.12**). A vertical line seems to stand stiffly at attention, a horizontal line lies down, and a diagonal seems to be falling over. Zigzags have an aggressive, sharp quality, whereas a wavy line is more graceful and, like a curve, more naturally associated with the outline of the human body. Parallel lines are balanced and harmonious, implying an endless, continuous movement, while perpendicular, converging, and intersecting lines meet and create a sense of force and counterforce. The thin line (a) seems delicate, unassertive, even weak. The thick one (b) seems aggressive, forceful, strong. The undulating line (c) suggests calmness, like the surface of a calm sea, whereas the more irregularly wavy line (d) implies the reverse. The angular line (e) climbs upward like the edge of a rocky mountain. (Westerners understand (e) as going up and (f) as going down, since we read from left to right.)

Expressive Qualities of Line Many of the lines in figure I.12 are familiar from geometry and can, therefore, be described formally. But the formal qualities of line also convey an expressive character because we identify them with our bodies and our experience of nature. By analogy with a straight line being the shortest distance between two points, a person who follows a straight, clear line in thought or action is believed to have a sense of purpose. "Straight" is associated with rightness, honesty, and truth, while "crooked"—whether referring to a line or a person's character—denotes the opposite. We speak of a "line of work," a phrase adopted by the former television program *What's My Line?* When a baseball player hits a line drive, the bat connects firmly with the ball, and a "hardliner" takes a strong position on an issue.

Regular Lines

Vertical Horizontal Curved

Diagonal Spiral Zigzag

Wavy or S-shaped Dotted

Lines in Relation to Each Other

Parallel Perpendicular (at right angles) Converging Intersecting

Irregular Lines

(a) (b) (c)

(d) (e) (f)

I.12 Lines.

I.13 Lines used to create facial expressions.

It is especially easy to see the expressive impact of lines in the configuration of the face (fig. **I.13**). In (a), the upward curves create a happy face, and the downward curves of (b) create a sad one. These characteristics of upward and downward curves actually correspond to the emotions as expressed in natural physiognomy. And they are reflected in language when we speak of people having "ups and downs" or of events being "uppers" or "downers."

Alexander Calder's (1898–1976) *Cat* (fig. **I.14**) merges the linear quality of the written word with the pictorial quality of what the word represents. The curve of the *c* outlines the face, a dot stands for the eye, and a slight diagonal of white in the curve suggests the mouth. The large *A* comprises the body, feet, and tail, while the tiny *t* completes the word, without interfering with reading the ensemble as a cat. The figure seems to be walking because the left diagonal of the *A* is lower than the right one, and the short horizontals at the base of the *A* suggest feet. Not only is this cat a self-image—*C A* are the artist's initials reversed—but it contradicts the semiotic argument that signifier (*c-a-t*) and signified (the mental image of a cat) have no natural relation to each other.

I.14 Alexander Calder, *Cat*, 1976. 22 × 30 in. (55.9 × 76.2 cm).

The importance of line in the artist's vocabulary is illustrated by an account of two ancient Greek painters, Apelles, who was Alexander the Great's portraitist, and Apelles' contemporary Protogenes. Apelles traveled to Rhodes to see Protogenes' work, but when he arrived

at the studio, Protogenes was away. The old woman in charge of the studio asked Apelles to leave his name. Instead, Apelles took up a brush and painted a line of color on a panel prepared for painting. "Say it was this person," Apelles instructed the old woman.

When Protogenes returned and saw the line, he recognized that only Apelles could have painted it so well. In response, Protogenes painted a second, and finer, line on top of Apelles' line. Apelles returned and added a third line of color, leaving no more room on the original line. When Protogenes returned a second time, he admitted defeat and went to look for Apelles.

Protogenes decided to leave the panel to posterity as something for artists to marvel at. Later it was exhibited in Rome, where it impressed viewers for its nearly invisible lines on a large surface. To many artists, the panel seemed a blank space, and for that it was esteemed over other famous works. After his encounter with Protogenes, it was said that Apelles never let a day go by without drawing at least one line. This anecdote was the origin of an ancient proverb, "No day without a line."

Shape

Lines enclosing space create shapes. Shapes are another basic unit, or formal element, used by artists. There are regular and irregular shapes. Regular ones are geometric and have specific names. Irregular shapes are also called "biomorphs," or biomorphic (from the Greek words *bios*, "life," and *morphe*, "shape"), because they seem to move like living, organic matter (fig. **I.15**).

Expressive Qualities of Shape Like lines, shapes can be used by artists to convey ideas and emotions. Open shapes create a greater sense of movement than closed shapes (see fig. I.15). Similarly, we speak of open and closed minds. Open minds allow for a flow of ideas, flexibility, and the willingness to entertain new possibilities; closed minds, in contrast, are not susceptible to new ideas.

Specific shapes can evoke associations with everyday experience. Squares, for example, are symbols of reliability, stability, and symmetry. To call people "foursquare" means that they are forthright and unequivocal, that they confront things "squarely." If something is "all square," a certain equity or evenness is implied; a "square meal" refers to both the amount and content of the food. When the term "brick" is applied to people, it means that they are good-natured and reliable. Too much rectangularity, on the other hand, may imply dullness or monotony—to call someone "a square" suggests overconservatism or conventionality.

The circle has had a special significance for artists since the Neolithic era. In the Roman period, the circle was considered a divine shape and thus most suitable for temples. This view persisted in the Middle Ages and the Renaissance, when the circle was considered to be the ideal church plan—even though such buildings were rarely constructed.

I.15 Shapes.

I.16 Drawing of solid shapes showing hatching and cross-hatching. The lines inside the objects create the illusion that they are solid and also suggest that there is a source of light coming from the upper left and shining down on the objects. Such lines are called modeling lines.

Lines are two-dimensional, but the use of **modeling** lines to form **hatching** or **crosshatching** (fig. **I.16**) creates the illusion of mass and volume, making a shape appear three-dimensional. Hatching and crosshatching can also suggest shade or **shading** (the gradual transition from light to dark) on the side of an object that is turned away from a light source.

Light and Color

The technical definition of light is electromagnetic energy of certain wavelengths that, when it strikes the retina of the eye, produces visual sensations. The absence, or opposite, of light is dark.

Rays of light having certain wavelengths create the sensation of color, which can be demonstrated by passing a beam of light through a prism (fig. **I.17**). This breaks the light down into its constituent **hues**. Red, yellow, and blue are the three **primary colors** (hues) because they cannot

I.17 The visible spectrum has seven principal colors—red, orange, yellow, green, blue, indigo (or blue-violet), and violet—that blend together in a continuum. Beyond the ends is a range of other colors, starting with infrared and ultraviolet, which are invisible to the human eye. If all the colors of the spectrum are recombined, white light is again reproduced.

be produced by mixing any other colors. A combination of two primary colors produces a **secondary color**: yellow and blue make green, red and blue make purple, yellow and red make orange. A **tertiary color** is made by mixing a secondary and a primary color.

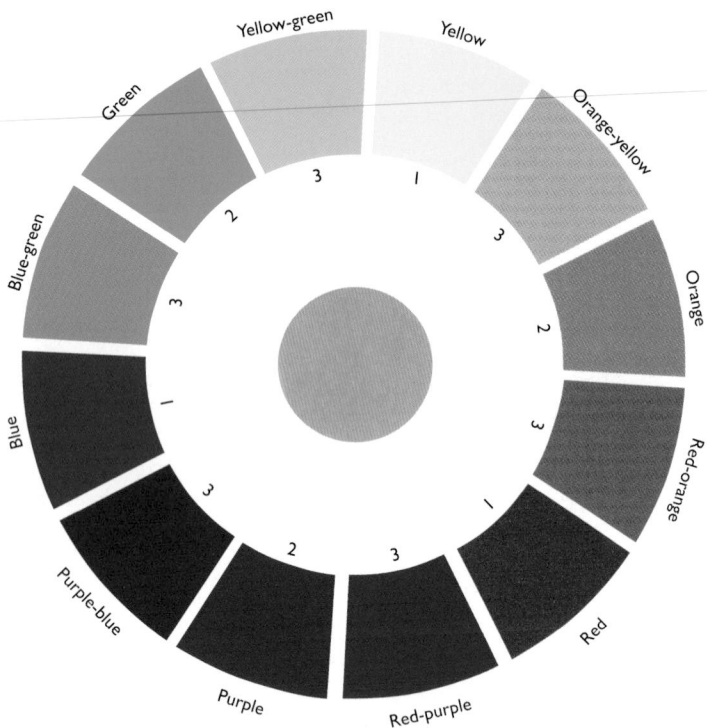

I.18 The color wheel. Note that the three primary colors—red, yellow, and blue—are equally spaced around the circumference. They are separated by their secondary colors. Between each primary color and its two secondary colors are their related tertiaries, giving a total of twelve hues on the rim of the wheel.

The **color wheel** (fig. I.18) illustrates the relationships between the various colors. The farther away hues are, the less they have in common and the higher their contrast. Hues directly opposite each other on the wheel (red and green, for example) are the most contrasting and are known as **complementary colors.** They are often juxtaposed when a strong, eye-catching contrast is desired. Mixing two complementary hues, on the other hand, has a neutralizing effect and lessens the intensity of each. This can be seen in figure I.18 as you look across the wheel from red to green. The red's intensity decreases, and the gray circle in the center represents a "standoff" between all the complementary colors.

The relative lightness or darkness of an object is its **value,** which is a function of the amount of light reflected from its surface. Gray is darker in value than white but lighter in value than black. The value scale in figure I.19 provides an absolute value for different shades.

Value is characteristic of both **achromatic** works of art—those with no color, consisting of black, white, and shades of gray—and **chromatic** ones (from the Greek word *chroma,* meaning "color"). On a scale of color values

(fig. I.20), yellow reflects a relatively large amount of light, approximately equivalent to "high light" on the neutral scale, whereas blue is equivalent to "high dark." The normal value of each color indicates the amount of light it reflects at its maximum intensity. The addition of white or black would alter its value (i.e., make it lighter or darker) but not its hue. The addition of one color to another would change not only the values of the two colors, but also their hues.

Intensity, which is also called **saturation,** refers to the relative brightness or dullness of a color. Dark red (red mixed with black) is darker in value, but less intense than pink (red mixed with white). There are four methods of changing the intensity of colors. The first is to add white. Adding white to pure red creates light red or pink, which is lighter in value and less intense. If black is added, the result is darker in value and less intense than pure red. If gray of the same value as the red is added, the result is less intense but retains the same value. The fourth way of changing a color's intensity is to add its complementary hue. This makes the mixed color less intense and more neutral than the original.

I.19 This ten-step value scale breaks the various shades from white to black into ten gradations. The choice of ten is arbitrary because there are many more values between pure white and pure black. Nevertheless, it illustrates the principle of value gradations.

I.20 A color value scale. The central row contains a range of neutrals from white to black; the rows above and below match the twelve colors from the color wheel with the neutrals in terms of the amount of light reflected from each.

Expressive Qualities of Color Just as lines and shapes have expressive qualities, so too do colors. Artists select colors for their effect. Certain ones appear to have intrinsic qualities. Bright or warm colors convey a feeling of gaiety and happiness. Red, orange, and yellow are generally considered warm, perhaps because of their associations with fire and the sun. It has been verified by psychological tests that the color red tends to produce feelings of happiness. Blue and any other hue containing blue—green, violet, blue-green—are considered cool, possibly because of their association with the sky and water. They produce feelings of sadness and pessimism.

Colors can also have symbolic significance and suggest abstract qualities. A single color, such as red, can have multiple meanings. It can symbolize danger, as when one waves a red flag in front of a bull. But to "roll out the red carpet" means to welcome someone in an extravagant way, and we speak of a "red-letter day" when something particularly exciting has occurred. Yellow can be associated with cowardice, white with purity, and purple with luxury, wealth, and royalty. We might call people "green with envy," "purple with rage," or "in a brown study" if they are quietly gloomy.

Texture

Texture is the quality conveyed by the surface feel of an object. This may be an actual surface or a simulated or represented surface. The surface of Oppenheim's *Fur-covered Cup* (see fig. I.11), for example, is actually furry,

but the gold of Mary's crown in figure I.10 is simulated. The cup is made of real fur, whereas van Eyck has painted the crown so that it only looks like real gold.

See figure I.11. Meret Oppenheim, *Fur-covered Cup, Saucer, and Spoon (Le Déjeuner en Fourrure),* 1936.

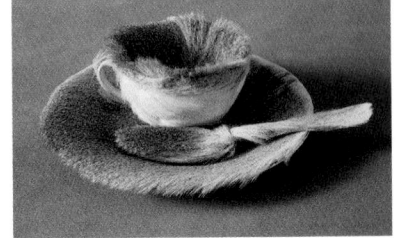

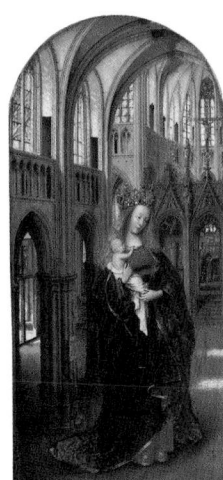

See figure I.10. Jan van Eyck, *The Virgin in a Church,* c. 1410–1425.

Stylistic Terminology

Subject matter refers to the actual elements represented in a work of art, such as figures and objects or lines and colors. **Content** refers to the themes, values, or ideas in a work of art, as distinct from its form. The following terms are used to describe representational, or figurative, works of art that depict their subject matter so that it is relatively recognizable:

- **naturalistic:** depicting figures and objects more or less as we see them. Often used interchangeably with "realistic."
- **realistic:** depicting figures and objects to resemble their actual appearances, rather than in a distorted or abstract way.

- **illusionistic:** depicting figures, objects, and the space they occupy so convincingly that the appearance of reality is achieved.

Note that an image may be representational without being realistic. Figures **I.21–I.24** are recognizable as images of a cow and are therefore representational, but only figures I.21–I.23 can be considered relatively naturalistic.

If an image is representational but is not especially faithful to its subject, it may be described as

- **idealized:** depicting an object according to an accepted standard of beauty.
- **stylized:** depicting certain features as nonorganic surface elements rather than naturalistically or realistically.
- **romanticized:** depicting its subject in a nostalgic, emotional, fanciful, and/or mysterious way.

I.21 Theo van Doesburg, study 1 for *Composition (The Cow),* 1916. Pencil on paper; 4⅝ × 6¼ in. (11.7 × 15.9 cm). Museum of Modern Art, New York. Purchase.

I.22 Theo van Doesburg, study 2 for *Composition (The Cow),* 1917. Pencil on paper; 4⅝ × 6¼ in. (11.7 × 15.9 cm). Museum of Modern Art, New York. Purchase.

I.23 Theo van Doesburg, study 3 for *Composition (The Cow),* 1917. Pencil on paper; 4⅝ × 6¼ in. (11.7 × 15.9 cm). Museum of Modern Art, New York. Gift of Nelly van Doesburg.

I.24 Theo van Doesburg, study for *Composition (The Cow),* c. 1917 (dated 1916). Tempera, oil, and charcoal on paper; 15⅝ × 22¾ in. (39.7 × 57.8 cm). Museum of Modern Art, New York. Purchase.

If the subject matter of a work has little or no relationship to observable reality, it may be called

- **nonrepresentational** or **nonfigurative:** the opposite of representational or figurative, implying that the work does not depict (or claim to depict) real figures or objects.
- **abstract:** describes forms that do not accurately depict real objects. The artist may be attempting to convey the essence of an object rather than its actual appearance. Note that the subject matter may be recognizable (making the work representational), but in a nonnaturalistic form.

The transition from naturalism to geometric abstraction is encapsulated in a series by the early-twentieth-century Dutch artist Theo van Doesburg (figs. I.21–I.25). He gradu-ally changed his drawing of a cow from I.21, which could be called naturalistic, figurative, or representational, to image **I.25**, which is an abstract arrangement of flat squares and rectangles. In I.21 and I.22, the cow's form is recogniz-able as that of a cow—it is composed of curved outlines and a shaded surface that creates a three-dimensional illu-sion. In image I.23, the cow form is still recognizable, espe-cially since it follows I.21 and I.22. It is now devoid of curves but still shaded—it has become a series of volumet-ric (solid, geometric) shapes. Even in image I.24, the gen-eral form of the cow is recognizable in terms of squares, rectangles, and triangles, but there is no longer any shad-ing. As a result, each distinct color area is flat. In image I.25, however, the shapes can no longer be related to the original natural form. It is thus a pure abstraction and is also nonfigurative and nonrepresentational.

I.25 Theo van Doesburg, study for *Composition (The Cow)*, c. 1917. Oil on canvas; 14¾ × 25 in. (37.5 × 63.5 cm). Museum of Modern Art, New York. Purchase.

CHAPTER PREVIEWS

PREHISTORY TO THE BRONZE AGE IN WESTERN EUROPE

Paleolithic (c. 50,000–c. 8000 B.C.)
 Ice Age ends c. 30,000 B.C.
 Use of stone tools and weapons
 Hunting-and-gathering life style
 First evidence of sculpture (c. 25,000 B.C.)
 First evidence of painting (c. 25,000 B.C.)
 Shamanism
Rock Paintings of Australia
 The Dreaming
 Mesolithic (c. 8000–6000/4000 B.C.)
 Tassili rock painting, Algeria
 Transition to agriculture
 Neolithic (c. 6000/4000–c. 1500 B.C.)
 Settled communities
 Megalithic architecture
 Ggantija Temple, Malta
 Stonehenge, England

THE ANCIENT NEAR EAST, c. 9000–300 B.C.

Neolithic (c. 9000–5th millennium B.C.)
 Jericho skulls; Çatal Hüyük; polytheism
Mesopotamia (c. 4500–c. 600 B.C.)
 Ziggurats; urbanization; cylinder seals
 Cuneiform; the *Epic of Gilgamesh*
 Akkad: Sargon; Naram-Sin
 Neo-Sumerian: Gudea
 Babylon: Hammurabi's law code
 Assyrian Empire, Neo-Babylonian Empire
Anatolia: Hittite Empire (c. 1450–1200 B.C.)
Neo-Babylonian Empire (612–539 B.C.)
Iran (c. 5000–331 B.C.); Achaemenid Empire
Scythians (8th–4th centuries B.C.); Animal Style

ANCIENT EGYPT, c. 5450–31 B.C.

Predynastic (5450–3100 B.C.)
Unification of Upper and Lower Egypt (3100 B.C.)
 Palette of Narmer: pharaonic rule; polytheism
Old Kingdom (2649–2150 B.C.)
 Beginning of monumental royal art and architecture
 Middle Kingdom (c. 1991–1700 B.C.)
New Kingdom (1550–1070 B.C.)
 Amarna period (c. 1349–1336 B.C.)
 Akhenaten's monotheism: worship of the Aten
Nubia: cross-cultural influences

THE AEGEAN, c. 3000–1100 B.C.

Cycladic Bronze Age (c. 3000–1100 B.C.): marble idols
Minoan (c. 3000–1100 B.C.)
 Myth of Europa; palace at Knossos; Linear A
Thera destroyed (c. 1500 B.C.); frescoes
Mycenae (c. 1600–1100 B.C.)
 Citadels; megaron; Cyclopaean masonry; tholos tombs; Linear B
 Trojan War (c. 1180 B.C.)

The human race existed for many millennia before producing works of art. We do not know how or when art began; but since their appearance, the arts have provided us with visual records of cultures, of history, and of the human creative impulse. Paleolithic (Old Stone Age) artists carved small-scale sculptures and painted life-size images on cave walls. In Neolithic (New Stone Age) periods, when settled communities formed, monumental stone architecture began.

The rise of cities and the invention of writing (c. 3000 B.C.) in ancient Mesopotamia (modern Iraq) ushered in a period of enormous artistic creativity, including the first literary epic—the *Epic of Gilgamesh*. Ancient Egypt was home to one of the world's longest-lasting civilizations, ruled from about 3100 B.C. to 31 B.C. by dynasties of pharaohs. Their monumental royal art has been preserved by elaborate burials and a dry climate. North of Egypt, Cycladic artists created marble idols dating from the Bronze Age (c. 3000–1100 B.C.). On the Mediterranean island of Crete, the palace period of the seafaring Minoans flourished from about 2000 B.C. but declined when the island was invaded around 1400 B.C. by Mycenaeans from the Greek mainland. The warrior culture of Mycenae is immortalized not only in its impressive art and architecture, but also in the Homeric epics that recount the Trojan War (c. 1180 B.C.) and its aftermath—the *Iliad* and *Odyssey*—and in the dramatic works of later Greek playwrights.

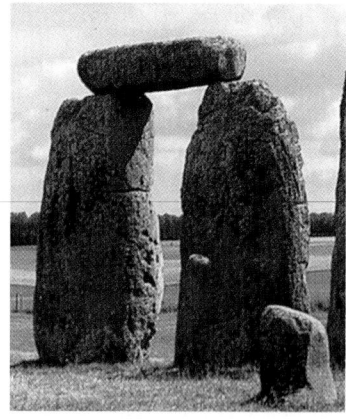

1

The Art of Prehistory

Who are we? Where do we come from? Where are we going? These are the three most universal questions. They are about time—past, present, and future—as well as about the nature of the human condition. The more we know about our past, the better we understand our present. We will begin by going back in time to early periods of the human race in western Europe, to the study of prehistory (see map, p. 32). Prehistory refers to the time before people developed writing systems and, therefore, before the existence of written documents. In one sense, the term *prehistory* is a misnomer because objects and images are actually historical records of a sort. The challenge lies in discovering how to read such nonverbal information.

The Stone Age in Western Europe

To organize the vast span of prehistory, scholars currently divide the Stone Age in western Europe into three large time periods. The dates of these periods fluctuate as new research reshapes our understanding of prehistoric societies. Paleolithic (from the Greek words *paleos,* meaning "old," and *lithos,* meaning "stone") is the earliest of the three periods. It is subdivided into three shorter periods: Lower (beginning c. 1,500,000 years ago), Middle (beginning c. 100,000/200,000 years ago), and Upper (beginning c. 45,000/50,000 years ago). The Mesolithic ("middle stone") period extends from around 8000 to 6000 B.C. in southeastern Europe, and around 8000 to 4000 B.C. throughout the rest of Europe. The Neolithic ("new stone") period dates from about 6000/4000 to 2000 B.C. and continues for another thousand years in northwestern Europe.

The designation of these early periods as Stone Age derives from people's dependence on tools and weapons made of stone. As metalworking technology developed in

different regions at different times, metal would eventually supersede stone for many purposes. Then, as now, technological and social change went hand in hand, bringing the Stone Age to a gradual close.

Upper Paleolithic (c. 50,000/45,000–c. 8000 B.C.)

By the beginning of the Upper Paleolithic era in Europe, our own subspecies, *Homo sapiens sapiens* (literally "wise wise man"), had supplanted the earlier *Homo sapiens* people, who had developed complex cultures. We can gain some understanding of what Paleolithic society may have been like by interpreting physical remains. But because ideas cannot be fossilized, there is much that will never be known.

Inferences about Paleolithic religion have been drawn from ritual burial practices. Red ocher—possibly symbolizing blood—was sprinkled on corpses, and various objects of personal adornment (such as necklaces) were buried with them. Bodies were arranged in the fetal position, often oriented toward the east and the rising sun, which must have seemed reborn with every new day. Such practices have been interpreted as a sign of belief in life after death and offer some insight into the way Paleolithic people answered the third question posed at the start of this chapter: Where are we going?

Paleolithic cultures were nomadic, subsisting by hunting and gathering, and moving from place to place in search of food. They lived communally, building shelters at cave entrances and under rocky overhangs. Their tents were made of animal skins and their huts of mud, plant fibers, stone, and bone. Fire had already been used for some 600,000 years, and there is evidence of hearths in Paleolithic homes.

Although the invention of writing was still a long way off, people made symbolic marks on hard surfaces, such as bone and stone, possibly to keep track of time. The sophis-

tication of Upper Paleolithic art suggests that language had also been developed, which in itself requires a sense of sequence and time.

The earliest surviving works of Western art correspond roughly to the final stages of the Ice Age in Europe and date back to about 30,000 B.C. Before that time, objects were made primarily for utilitarian purposes, although many have aesthetic qualities. It is important to remember, however, that our modern, Western concept of "art" would almost certainly have been alien to prehistoric people. For them, as for many later cultures, an object's aesthetic value was inseparable from its function.

Upper Paleolithic Sculpture
(c. 25,000 B.C.)

Upper Paleolithic artists produced a wide range of small sculptures made of ivory, bone, clay, and stone. These depict humans, animals, and combinations of the two. Many show a high level of technical skill, with finely carved lines representing natural surface details. Artists created other portable objects such as spear throwers (sticks against which spear shafts were fitted to increase the range and impact of the spear), musical instruments, and objects of personal adornment (such as beads and pendants).

Perhaps the most famous Paleolithic sculpture is the small limestone statue of a woman, the so-called *Venus of Willendorf* (fig. **1.1a, b,** and **c**), variously dated from 25,000 to 21,000 B.C. Although this figure can be held in the palm of one's hand, it is a monumental object with a sense of organic form. The term *monumental* can mean literally "very big" or, as is the case here, "having the quality of appearing very big." In fact, the *Venus of Willendorf* is only 4⅜ inches (11.5 cm) high. It is evidence of a well-developed aesthetic sensibility and was **carved** by an experienced artist (see box, p. 30). The rhythmic arrangement of bulbous oval shapes emphasizes the head, breasts, torso, and thighs. The scale of these parts of the body in relation to the whole is quite large, while the facial features, neck, and lower legs are virtually eliminated. The arms, resting on the breasts, are so undeveloped as to be hardly noticeable.

The *Venus of Willendorf* is a strikingly expressive figure. But what, we might ask, did she mean to the artist who carved her? And what was her function in her cultural context? Unfortunately, we can only speculate. The artist has emphasized those parts of the body related to reproduction and nursing. Furthermore, a comparison of the front with the side and back shows that, although it is **a sculpture in the round** (see box, p. 30), more attention has been lavished on the front. This suggests that the figure was intended to be viewed from the front.

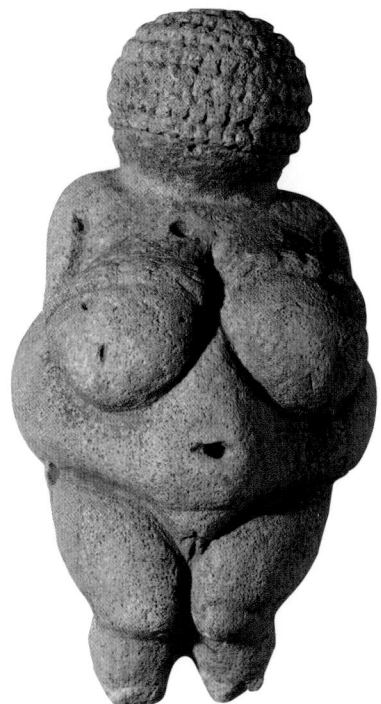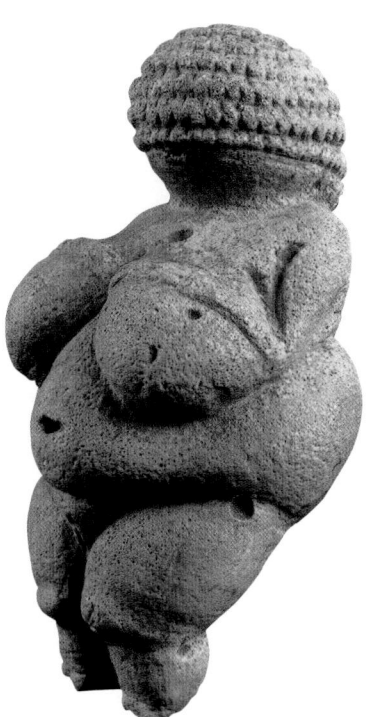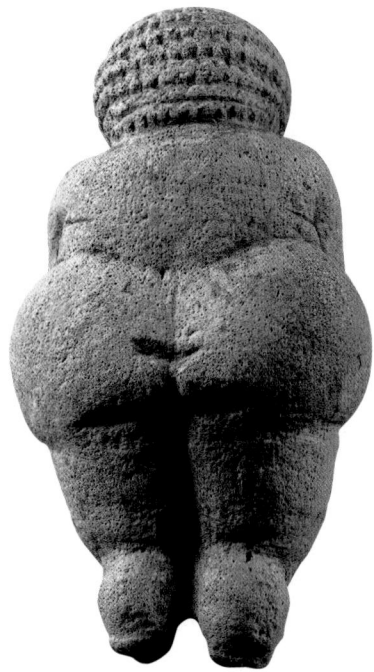

1.1a, b, and **c** *Venus of Willendorf*, from Willendorf, Austria, c. 25,000–21,000 B.C. Limestone; 4⅜ in. (11.5 cm) high. Naturhistorisches Museum, Vienna.

Carving

Carving is a subtractive technique in which a sculptor uses a sharp instrument such as a knife, gouge, or chisel to remove material from a hard substance such as bone, wood, or stone. After an image is shaped, it can be sanded, filed, or polished. The *Venus of Willendorf* was not polished, although some Paleolithic sculptures were. It is made of limestone, which does not polish as well as other types of stone.

The *Venus of Willendorf* is one of a number of prehistoric female figurines that scholars have nicknamed *Venus* (after the much later Roman goddess of love and beauty), although there is no evidence as to who, if anyone, the figurines were meant to represent. They all exaggerate the breasts and hips, suggesting a cultural preoccupation with fertility, on which the survival of the species depends. Unlike many Upper Paleolithic art forms, these female figurines are found throughout Europe and are thought to be roughly contemporaneous (c. 25,000–21,000 B.C.). Some, like the *Venus of Willendorf,* are relatively naturalistic; others are abstract. Their interpretation as fertility goddesses is one possibility among several. Another theory suggests that these figures were used for some kind of ritual exchange between groups of people during periods of environmental instability, when such interaction would have been necessary for collective survival.

Most prehistoric sculptures are in the round, but Paleolithic artists also made **relief** sculpture (see box). A good example of relief is the so-called *Venus of Laussel* (fig. **1.2**), which has traces of the red ocher **pigment** (see box) also

1.2 *Venus of Laussel*, from Laussel, Dordogne, France, c. 25,000–23,000 B.C. Limestone; 17⅜ in. (44.0 cm) high. Fouilles Lalanne, Musée d'Aquitaine, Bordeaux, France.

Categories of Sculpture

Sculpture in the round and in **relief** are the two most basic categories of sculpture. Sculpture in the round refers to any sculpture that is completely detached from its original material so that it can be seen from all sides, such as the *Venus of Willendorf* (fig. 1.1a, b, c). The *Venus of Laussel* (fig. 1.2) remains partly attached to its original material, in this case limestone, so that it is shown in relief—that is, there is at least one angle from which the image cannot be seen. Sculpture in relief is more pictorial than sculpture in the round because some of the original material remains and forms a background plane.

There are different degrees of relief. In **high relief,** the image stands out relatively far from the background plane. In **low relief,** also called bas-relief (*bas* means "low" in French), the surface of the image is closer to the background plane. When light strikes a relief image from an angle, it casts a stronger shadow on high relief than on low relief and thus defines the image more sharply. Reliefs can also be **sunken,** in which case the image or its outline is slightly recessed into the surface plane, as in much ancient Egyptian carving (see Chapter 3).

Pigment

Pigment (from the Latin word *pingere*, meaning "to paint") is the basis of color, which is the most eye-catching aspect of most paintings. Pigments are colored powders made from organic substances, such as plant and animal matter, or inorganic substances, such as minerals and semiprecious stones. Cave artists either applied powdered mineral colors directly to damp walls or mixed their pigments with a liquid, the **medium** or **binder,** to adhere them to dry walls.

Technically, the medium is a liquid in which pigments are suspended (but not dissolved). The term **vehicle** is often used interchangeably with "medium." If the liquid binds the pigment particles together, it is referred to as the binder or binding medium. Binders help paint adhere to surfaces, increasing the durability of images. Cave painters used animal fats and vegetable juices, water, or blood as their binding media.

Pigment is applied to the surface of a painting, called its **support.** Supports vary widely in Western art—paper, canvas, pottery, even faces and the surface of one's body. For the cave artist, the walls of the cave were the supports.

Modeling

Modeling, unlike carving, is an additive process and its materials (such as clay) are pliable rather than hard. The primary tools are the artist's hands, especially the thumbs, although various other tools can be used. Until the material dries and hardens, the work can still be reshaped.

Clay that has been heated (fired) in a **kiln** (a special oven) is more durable and waterproof. A Paleolithic kiln for firing clay statues of women and animals has been found in eastern Europe, and a variety of finely crafted, decorated clay vessels was made in western Europe during the Neolithic period.

1.3 Bison with turned head, from La Madeleine, Tarn, France, c. 11,000–9000 B.C. Reindeer horn; 4⅛ in. (10.5 cm) long. Musée des Antiquités Nationales, Saint Germain-en-Laye.

present on the *Venus of Willendorf*. Although there is no archaeological evidence, the red color might have represented the blood of childbirth, an association reinforced by the form itself. The pelvis and breasts are exaggerated, although the arms are slightly more prominent than those of the *Venus of Willendorf*. In her right hand, the *Venus of Laussel* holds an animal horn.

In addition to female figurines, Upper Paleolithic artists produced portable representations of animals. Most often found are horses, bison, and oxen; less frequently found are deer, mammoths, antelope, boar, rhinoceri, foxes, wolves, bears, and an occasional fish or bird. A bison carved from reindeer horn (fig. **1.3**) illustrates the naturalism of Paleolithic animal art. The finely

incised (cut) lines of the beard and the sharp turn of the head reveal a keen observation of detail as well as the capacity to render the illusion that the animal is turning in space.

Two sculptures of bison were found more than 700 yards (640 m) inside a cave at Tuc d'Audoubert in Ariège, in the Dordogne region of France (fig. **1.4**). The animals are naturalistically **modeled** (see box) in high relief from the clay floor of the cave. Their manes and facial features, on the other hand, are incised, probably with a sharp flint blade. The Tuc d'Audoubert bison seem to emerge from the ground as if rising out of the cave's mud floor. This merging of natural and created form is characteristic of much Stone Age art.

1.4 Bison, Tuc d'Audoubert cave, Ariège, Dordogne, France, c. 13,000–8000 B.C. Unbaked clay; each animal approx. 2 ft. (61.0 cm) long.

Prehistoric Europe.

Upper Paleolithic Painting in Spain and France (c. 30,000–c. 10,000 B.C.)

Most surviving European Paleolithic cave paintings are lo-cated in over two hundred caves in the cliffs of northern Spain, especially the Pyrenees Mountains, and the Périgord and Dordogne regions in France. The concentration of cave art in this part of Europe has puzzled scholars. Some now think that the treeless plains, uncovered as the glaciers retreated northward, would have supported unusually large herds of animals, which in turn would have sup-ported whatever human populations existed in the area. The well-preserved state of these cave paintings when they

were first discovered was due mainly to the fact that most of the caves are limestone and had been sealed up for thousands of years. After exposure to the modern atmosphere and visitor traffic, the paintings began to deteriorate so rapidly that some caves have been closed to the public.

Like the Tuc d'Audoubert bison, the paintings that have survived are primarily found deep within caves, in interiors that are difficult to reach and uninhabitable. They seem to have served as sanctuaries where fertility, initiation, and hunting rituals were performed and seasonal changes re-corded. The predominance of animal representa-tions is in part a reflection of the importance of hunting. But the animals most often depicted do not coincide with those that were hunted most, suggesting that these images had other meanings as well.

Cosquer and Chauvet Two Upper Paleolithic caves were discovered in the 1980s and 1990s in southern and southeastern France. In 1985, the deep-sea diver Henri Cosquer found a passage 121 feet (36.88 m) below sea level near Marseilles. An ascending passage led to a cave, now named after him, that had remained above sea level when the coastal water level rose, cutting it off from land. Six years later, Cosquer discovered a wealth of art—paintings and engravings—on the walls and ceilings of the cave. The images have been securely dated to two periods. The first group, dating to about 25,000 B.C., consists of stenciled hands surrounded by red and black pigment, and of repeated indented lines called "finger trac-ings." The second group, from c. 16,000 B.C., con-sists of painted and engraved animals.

One of the most unusual features of Cosquer cave art is the large number of sea animals, including seals, auks, a fish, and forms presently interpreted as jellyfish (fig. **1.5**). Also unusual is the fact that precise dating is possible because samples of the charcoal used in the paintings, as well as pieces of charcoal recovered from the cave floor, have been sub-jected to radiocarbon testing (see box, p. 14).

In 1994, three speleologists (cave explorers) found the entrance to an underground cave complex in the Ardèche Valley, in southeast France. They came upon an interior chamber, now named for Jean-Marie Chauvet, a member of the team. The cave proved to be the largest so far known in this region and contains over three hundred wall paintings, engravings, Paleolithic bear skeletons and a bear's skull set on a rock, evidence of fires, and footprints. Radiocarbon analysis indicates a very early date of around 30,000 B.C. for some of the paintings, which are generally outlined in red or black pigment. As at other Upper Paleo-lithic caves in southern France and northern Spain, they

1.5 Jellyfish, Cosquer cave, near Marseilles, France, c. 25,000 B.C. Painting on a black stalagmite.

represent mainly animals along with some signs—especially red dots and handprints. These animal images are unusual, however, in that there are many rhinoceri and large felines.

Spotted figures identified as a panther and a hyena (fig. **1.6**) are, according to the explorers, unprecedented in cave art of the Ardèche region. They are outlined in red ocher, which is characteristic of the animals close to the cave entrance. The curved edges and the rock itself impart a sense of natural bulk similar to that found elsewhere in Paleolithic animal art. Also conveyed is the hyena's characteristic aggression: its head, accentuated by the spots, juts forward on a downward diagonal that visually overwhelms the smaller animal below.

1.6 Hyena and panther, Chauvet cave, Ardèche Valley, France, c. 25,000–17,000 B.C. Red ocher on limestone wall. Courtesy of J. Clottes, the Regional Office of Cultural Affairs, Rhône-Alpes, and the Ministry of Culture and Communication (Direction du Patrimoine, sous Direction de l'Archéologie).

1.7 Mammoths and horses, Chauvet cave, Ardèche Valley, France, c. 25,000–17,000 B.C. Engraving on limestone wall. Courtesy of J. Clottes, the Regional Office of Cultural Affairs, Rhône-Alpes, and the Ministry of Culture and Communication (Direction du Patrimoine, sous Direction de l'Archéologie).

Altogether, thirty-four images of mammoths were found at Chauvet, of which twenty-one are engraved into the rock and thirteen are painted. The two superimposed engraved examples in figure **1.7** are depicted as if following an engraved horse, whose mane is indicated by a thick line. This one was placed over a series of parallel incised lines identified as claw marks by explorers. The overlap-ping images are unexplained but may have been made at different times and ritually repeated. Note that we see *through* the animals in a way that is not naturalistic, and it is not clear whether the significance of the superimposi-tion is formal or iconographic.

The so-called "Lion Panel," part of which is shown in fig-ure **1.8**, represents various species of animals proceeding

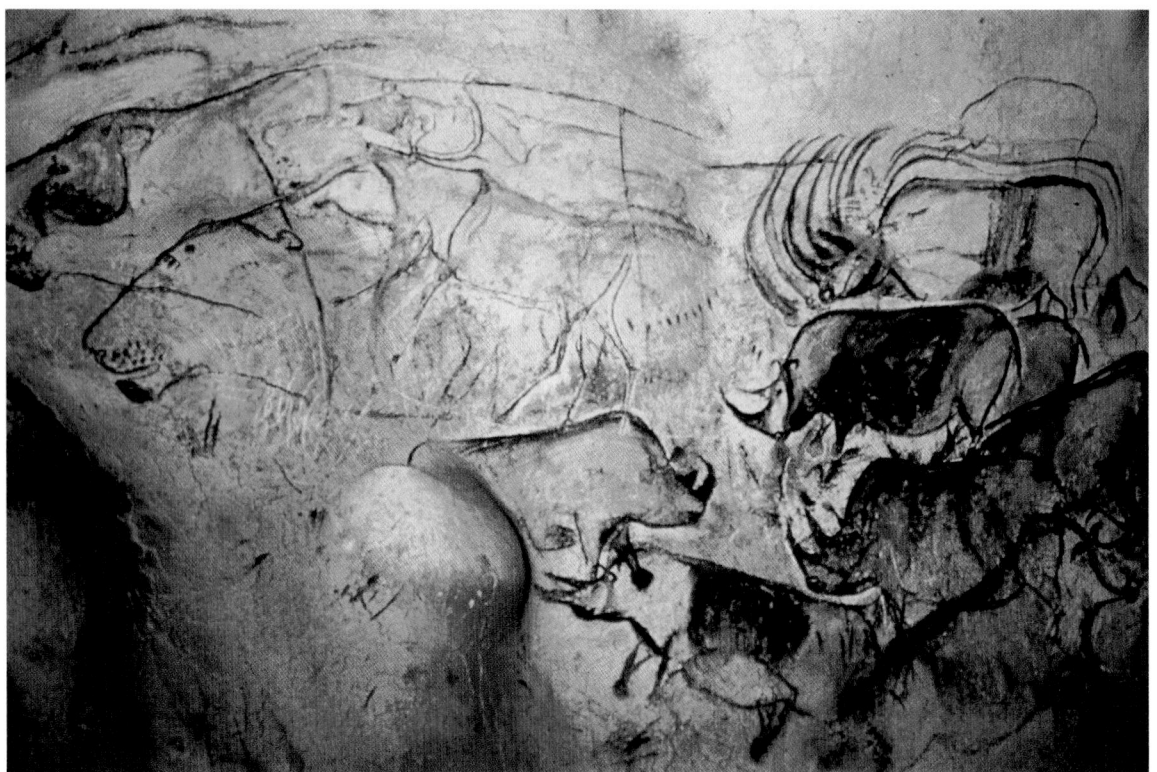

1.8 Left section of the "Lion Panel," Chauvet cave, Ardèche Valley, France, c. 25,000–17,000 B.C. Black pigment on limestone wall. Courtesy of J. Clottes, the Regional Office of Cultural Affairs, Rhône-Alpes, and the Ministry of Culture and Communication (Direction du Patrimoine, sous Direction de l'Archéologie).

across a niche in the wall. Visible here are three large lions and numerous smaller, but more densely painted, rhinoceri. Some are shaded, which enhances the sense of massive bulk. One faces a group that seems to be moving toward it. It is not clear whether this is a coherent scene or a ritual repetition. Some are superimposed—those at the top—while the others are spread across the surface of the wall. Under the painting of the lions, traces of red pigment can be seen, as well as the outline of a deer. Like the other animals rendered in black, these are deep within the interior of the cave, suggesting that the red paintings precede the black ones chronologically.

Since the Cosquer and Chauvet caves are recent discoveries, explorers and archaeologists are in the early stages of studying them. As with all finds, the caves expand our knowledge even as they raise new questions.

Pech-Merle At Pech-Merle, in the Dordogne region of France, several handprints have been found on cave walls and are also quite common elsewhere in the Paleolithic period. The hands were placed against a wall with the fingers spread out (fig. **1.9**). Pigment was then applied around them, leaving the shape of the hand visible. Sometimes, the hand itself was covered with pigment and pressed onto the wall. Handprints were also made by pressing against a damp clay wall to leave an impression. The example in figure 1.9 is a small hand of the first type, and it is juxtaposed with black shapes.

The significance of these hands has proved to be elusive. According to one scholar, André Leroi-Gourhan (see box, p. 39), the hand is a female sign and the dots a male one. Another scholar, Henri Breuil, believed such hand-

prints may have been made during initiation ceremonies. Many of the hands appear to be missing one or more fingers, a fact that has elicited several interpretations—from ritual amputation to frostbite. Another hypothesis is that they represent a code of hand signals used by hunters to communicate silently while stalking their prey (similar signals are still used today in certain hunting societies).

Shamanism

Shamanism exists today in certain small-scale societies throughout the world and seems to have been a feature of some prehistoric cultures. Shamans, from the Tunguso-Manchurian word *saman* (meaning "to know"), function as intermediaries between the human and the spirit worlds. They communicate with spirits by entering a trance—induced by rhythmic movement or sound, hallucinogenic drugs, fasting, and so forth—during which one or more spirits "possess" them. Shamans are revered healers and problem solvers in their communities and are feared for the harm they could do if angered. They foretell the future, cure the sick, and assist in such rites of passage as birth and death. Shamans are highly individualistic, often living on the fringes of society, and do not participate in organized religion. They generally wear ritual costumes made of animal skins and horns or antlers (see fig. 1.10a and b), and carry ritual objects such as rattles. Dancing and chanting typically accompany shamanic ceremonies.

1.9 Handprints, Pech-Merle, Dordogne, France, c. 16,000 B.C. The cave at Pech-Merle is an underground complex that seems to have been in use periodically for about five thousand years. In addition to handprints, the cave paintings include animals and geometric signs.

Trois-Frères Cave art has often been interpreted as evidence of an intimate relationship between image making and religious practice. Figure **1.10**, from the cave of Trois-Frères in Ariège, shows a hybrid creature—part human, part animal—in the midst of superimposed animals. Human figures are rare in Upper Paleolithic cave art, and their interpretation is debated. This particular painting seems to represent either a ritual or a supernatural event.

In contrast to the animals, which are nearly always in profile, this creature turns and stares out of the rock. His pricked-up ears and alert expression suggest that he is aware of an alien presence. The figure can be read as a man dressed as a stag. His pose and costume suggest that he may be a shaman (see box, p. 35) engaged in a ceremonial identification with the animal. Alternatively, the figure can be interpreted as an animal-god.

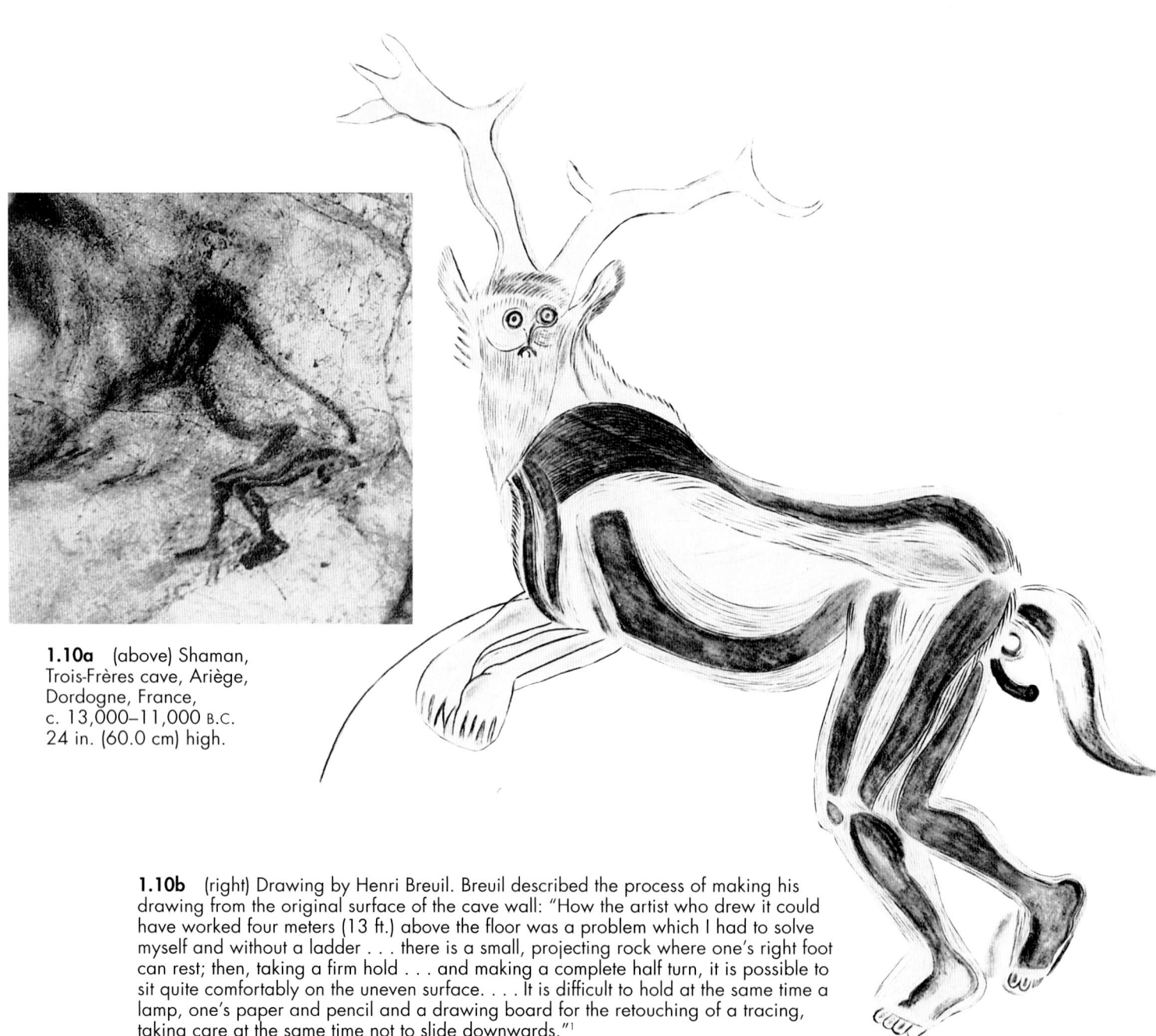

1.10a (above) Shaman, Trois-Frères cave, Ariège, Dordogne, France, c. 13,000–11,000 B.C. 24 in. (60.0 cm) high.

1.10b (right) Drawing by Henri Breuil. Breuil described the process of making his drawing from the original surface of the cave wall: "How the artist who drew it could have worked four meters (13 ft.) above the floor was a problem which I had to solve myself and without a ladder . . . there is a small, projecting rock where one's right foot can rest; then, taking a firm hold . . . and making a complete half turn, it is possible to sit quite comfortably on the uneven surface. . . . It is difficult to hold at the same time a lamp, one's paper and pencil and a drawing board for the retouching of a tracing, taking care at the same time not to slide downwards."[1]

Lascaux The most famous examples of cave art in France are the wall paintings at Lascaux, in the Dordogne (figs. **1.11**, **1.12**, **1.13**, **1.14**). Located deep within the recesses of the caves, they consist of a wide range of animal species and a few human stick figures painted with earth-colored pigments—brown, black, yellow, and red. The pig-

ments were ground from minerals such as ocher, hematite, and manganese and applied to the natural white limestone surfaces of the walls. The Lascaux artists created their figures by first drawing an outline and then filling it in with pigment. The pigment itself was stored in hollow bones plugged at one end, which may also have been used

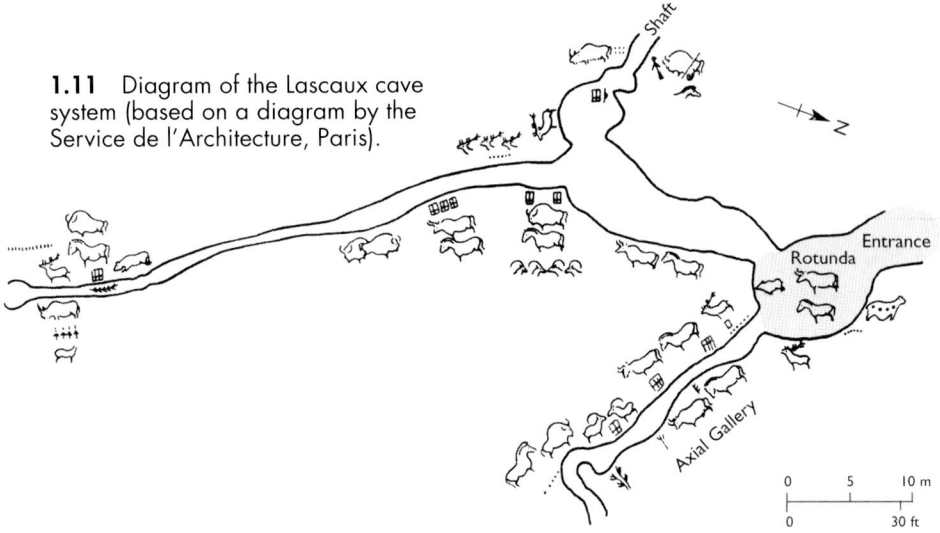

1.11 Diagram of the Lascaux cave system (based on a diagram by the Service de l'Architecture, Paris).

1.12 Hall of Running Bulls, Lascaux, Dordogne, France, c. 15,000–13,000 B.C. Paint on limestone rock; individual bulls 13–16 ft. (3.96–4.88 m) long. Note that the white bulls are superimposed over other animals. At Lascaux, as at Chauvet, artists did not always cover up previous representations before adding new ones.

1.13 "Chinese Horse," Lascaux, Dordogne, France, c. 15,000–13,000 B.C. Paint on limestone rock; horse 5 ft. 6 in. (1.42 m) long. The animal acquired its nickname because it resembles Chinese ceramic horses of the Han dynasty.

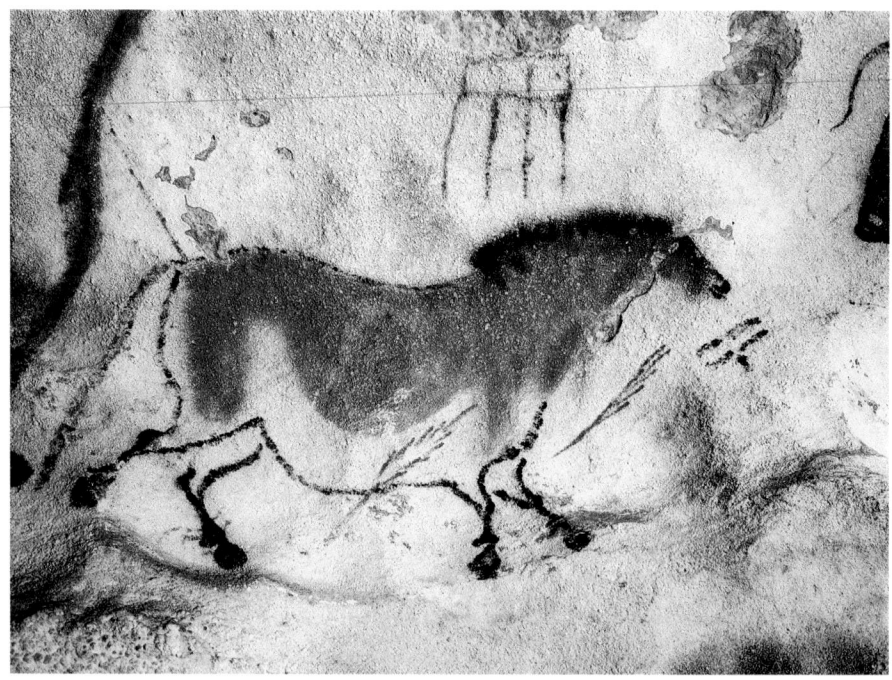

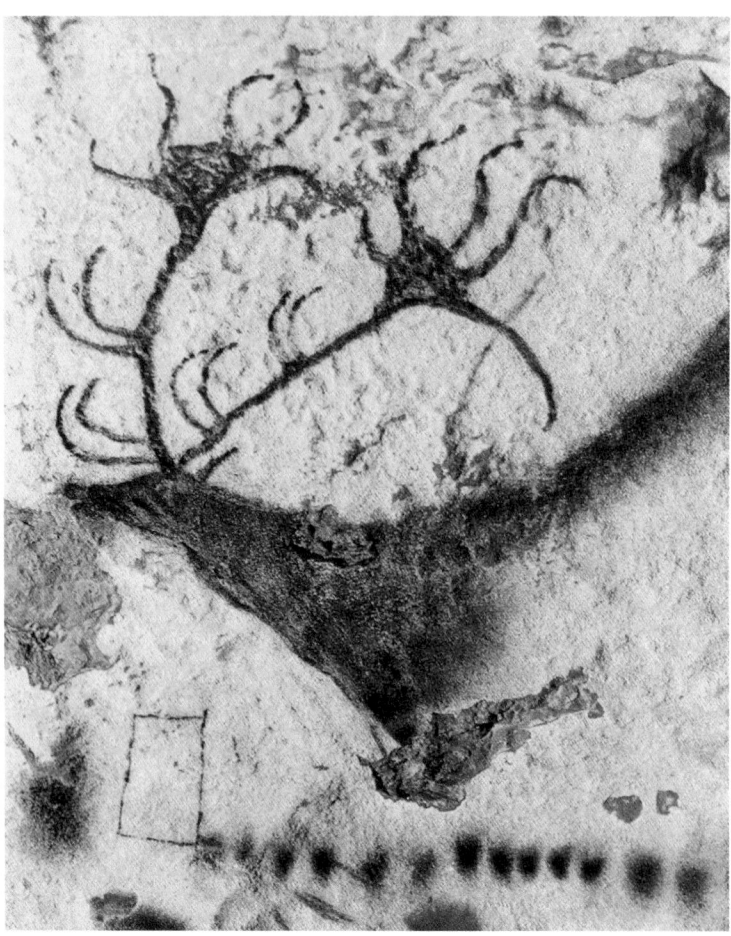

1.14 Reindeer, Lascaux, Dordogne, France, c. 15,000–13,000 B.C. Paint on limestone rock. Stags are less common than horses in Paleolithic art. Like the horse, however, this figure has a pronounced dorsal curve that enhances the impression of downhill movement.

to blow the pigment onto the walls. Some of these bone tubes, still bearing traces of pigment, have been found in the caves. These finds, and their interpretation, exemplify the way in which deductions about the use of objects in a prehistoric society are made. Perhaps if the bones containing pigment had been found out of context—that is, far from the paintings—different conclusions about their use might have been drawn.

The Lascaux animals are among the best examples of the Paleolithic artist's ability to create the illusion of motion and capture the essence of certain species by slightly exaggerating characteristic features. Since many Lascaux animals are superimposed, they have been read as examples of image magic. According to this theory, the act of making the image was an end in itself, possibly a symbolic capture of the animal by fixing its likeness on the cave wall.

One Lascaux painting that has given rise to different interpretations is the so-called "Chinese Horse" (fig. 1.13), whose sagging body suggests pregnancy and the imminent delivery of a foal. The two diagonal forms in this detail, one almost parallel to the horse's neck and the other overlapping its lower outline, have been variously identified as plants or as arrows. Because of their similarity to surviving specimens, they may be harpoons. Leroi-Gourhan argues that they are phallic symbols, and therefore male signs, while he reads the lines above the horse as female. The animal's pregnant appearance would be consistent with the paired male-female imagery of Leroi-Gourhan's structuralist approach (see box, p. 39).

METHODS OF INTERPRETATION

Dating and Meaning of the Cave Paintings

Dating

The French abbot Henri Breuil was the dominant figure in studies of western European cave painting from the early twentieth century until his death in 1961. He dated cave paintings according to a system of development in which "primitive" (in the sense of "schematic" or "abstract") images preceded naturalistic ones. In particular, he noted that some animals are rendered with profile heads and frontal horns, which he called "twisted perspective."

In the 1980s, the French scholar André Leroi-Gourhan developed a system dividing cave painting into four styles that also progressed from "primitive" to complex and naturalistic. Today, however, scholars reject the notion of both an identifiable origin of cave painting and of its stylistic progression. They read artistic development more dynamically, as undergoing various stylistic shifts influenced by changes in technology and other cultural factors. Current scholarship also emphasizes the diversity of Upper Paleolithic art from place to place. The "animal art" of cave paintings in southern France and northern Spain exemplifies one such regional style.

Meaning

In the nineteenth century, reflecting the popular view of "Art for Art's Sake," works of art were thought to have been created for purely aesthetic purposes. Cave paintings were believed to have been made by male artists in their leisure time. In his personal mythic account of the first artist, Whistler described this "first artist" as a man who declined to hunt or fight. Instead, he "stayed by the tents with the women, and traced strange devices with a burnt stick upon a gourd . . . this devisor of the beautiful—who perceived in Nature . . . certain curvings, as faces are seen in the fire—this dreamer apart, was the first artist."[2]

At the turn of the century, the French archaeologist Salomon Reinach read art mainly in social terms. In his view, cave painting was the act of creating an image in order to influence reality, especially to produce magic that would ensure a successful hunt. In the 1920s, Breuil elaborated the notion of cave paintings as attempts at magical control of reality. He also believed that the caves themselves were used as religious sanctuaries in which worship and initiation rites took place.

Leroi-Gourhan's interpretations were based on anthropological structuralism, which sought to identify universal structures in thought, social organization, and cultural expressions such as myth and religion. He disagreed with the hunting-magic theories and devised instead a system of reading certain signs as binary oppositions of male and female forces. For example, he interpreted triangles, ovals, and rectangles as female, and barbed shapes, dots, and short marks as signifying the phallus (see fig. 1.14). Subsequent interpretations have identified multiple sign systems, each with its own symbols, meanings, and functions.

The most recent views locate the significance of cave painting in an environmental context. Thus the depictions of animals reveal changes in season (for instance, a bison's heavy winter coat) and climate (such as the presence of particular species). The concentration of cave art in southwest France and northern Spain is now thought to indicate a corresponding increase in the population of those areas. As a result, rituals and ceremonies involving art became necessary, possibly to reinforce political power.

Fig. 1.7. Mammoths and horses, Chauvet cave.

Fig. 1.9. Handprints, Pech-Merle.

Fig. 1.13. "Chinese Horse," Lascaux.

Fig. 1.14. Reindeer, Lascaux.

Fig. 1.16. Standing bison, Altamira cave.

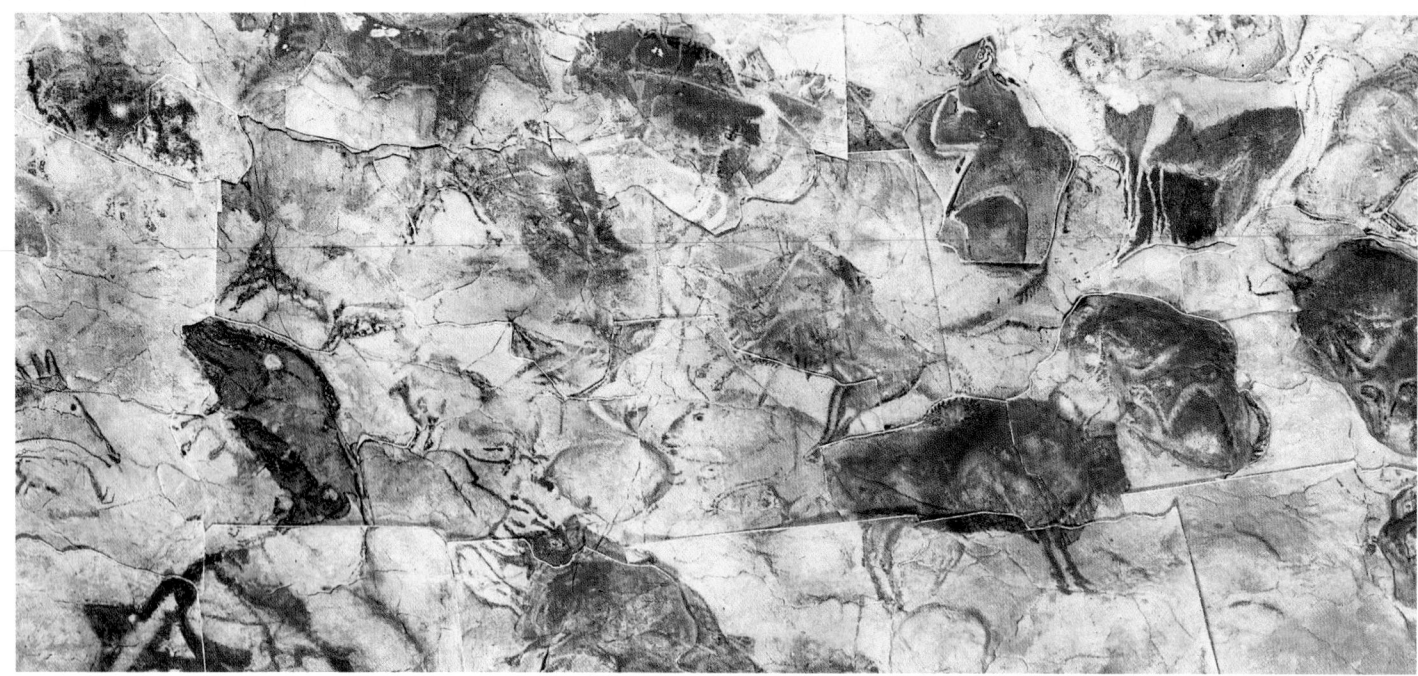

1.15 Ceiling view, Altamira cave, Spain, c. 12,000 B.C. The outlines, limbs, and manes are of black manganese. The interiors are mainly of red ocher with some shading.

Another remarkable group of cave paintings was discovered in 1879 in Santander, Spain (figs. **1.15** and **1.16**). Here the natural bulges in the rock correspond to the contours of various animals—mainly bison, but also boar, horses, deer, and a wolf. Artists perceived the outline in nature and then enhanced the forms with reds, yellows, and browns, and shaded them in black. In addition to paint, carving was used to shape the figures. The standing bison (fig. 1.16) illustrates the monumentality of Stone Age animal representations. The artist has emphasized the bison's thick neck and shoulder muscles, where its main physical strength resides, in contrast to its small head and thin legs.

1.16 (below) Standing bison, Altamira cave, Spain, c. 12,000 B.C. 6 × 5 ft. (1.8 × 1.5 m). The shaded application of ocher creates the impression of a three-dimensional mass. The black outline and details are of manganese.

Window on the World One

Rock Paintings of Australia
(c. 75,000/50,000 B.C.–the Present)

Rock paintings, carvings, and other art objects have continued to be produced since the Stone Age by certain cultures around the world. A few of these societies that have persisted into our own era appear to have something in common with those of Paleolithic western Europe. There is uncertainty in dating works created by such cultures and in pinning down the antiquity of their mythological traditions.

Nevertheless, these "modern Stone Age" societies may provide valuable clues to the way art functioned in prehistoric Europe.

In the outback of Australia, hunting-and-gathering societies, called Aboriginal, have had an unusually long history. Revolutionary archaeological finds in 1996 in a remote part of northwestern Australia at the site of Jinmium challenged basic assumptions about when

and where humans evolved (see map). Stone tools and other objects from this site suggest that Australia was inhabited as long ago as 174,000 B.C. Carved rocks discovered there may be roughly 75,000 years old. Recent evidence—a red ocher "crayon"—indicates that people may have been making rock paintings for the past 75,000 years. If accepted, these dates are far older than scholars had believed

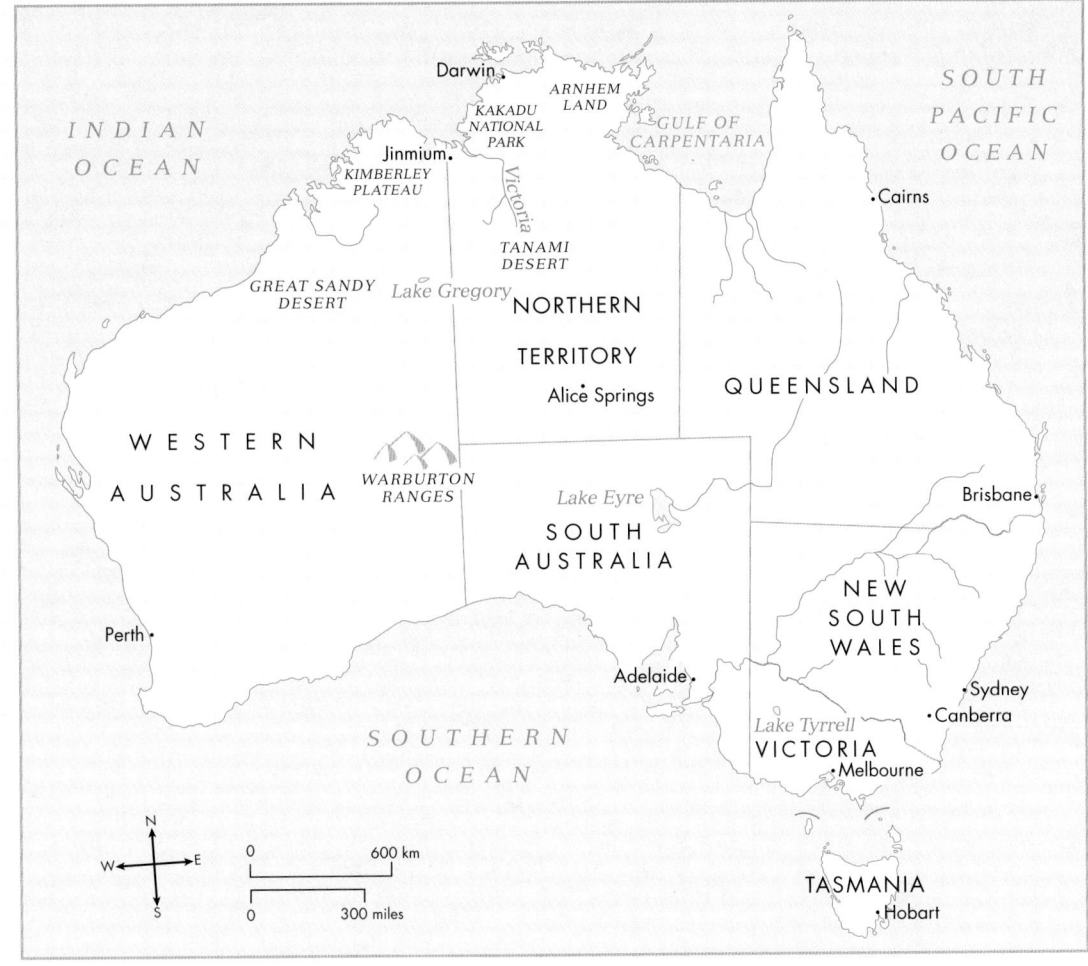

Australia.

possible. Australia is an island that had been relatively isolated from the rest of the world until the eighteenth and nineteenth centuries. Nevertheless, there are remarkable visual similarities between European Paleolithic and Aboriginal rock paintings, including handprints, naturalistic animals, and hunting scenes.

Aside from these works, our knowledge of ancient Aboriginal mythology, ritual, tradition, and social customs comes from contemporary Aborigines. Their society is divided into clans that "own" certain myths and sacred images. Myth and imagery thus assume a concrete value and are considered to be cultural possessions. They have a totemic (ancestral) significance, and it is thus possible that many of the animals represented in Australian rock art are, in fact, totems of particular clans.

The ancestral character of Australian Aboriginal art and religion is related to what has been translated into Western languages as the "Dreaming." This phenomenon is not a sleep dream, but rather a mythological plane of existence. For Aborigines, "Dreamtime" is the order of the universe, which encompasses cosmological time from its beginning to an indefinite future. Included in Dreamtime are ancestors who created and ordered the world and the human societies that populate it. Dreamtime is accessible through the performance of certain rituals—such as creating rock paintings—accompanied by singing and chanting. In the Aboriginal Dreaming, therefore, is contained a wealth of cultural mythology, much of which is revealed in the visual arts.

The Wandjinas, or Cloud Spirits, for example, appear in numerous rock pictures, usually painted in black, red, and yellow on a white ground (fig. **W1.1**). They combine human with cloud forms and are ancestral creators from the Dreamtime. According to Aboriginal myth, Wandjinas made the earth, the sea, and the human race. They are depicted frontally with large heads, massive upper bodies, and lower bodies that taper toward the feet. Around their heads are feathers and lightning. Their faces typically lack mouths, although the eyes and nose are present. If Wandjinas are offended, they unleash lightning and cause rains and flooding, but they can also bring fertility. Paintings of them are believed to have special powers and, therefore, are approached with caution.

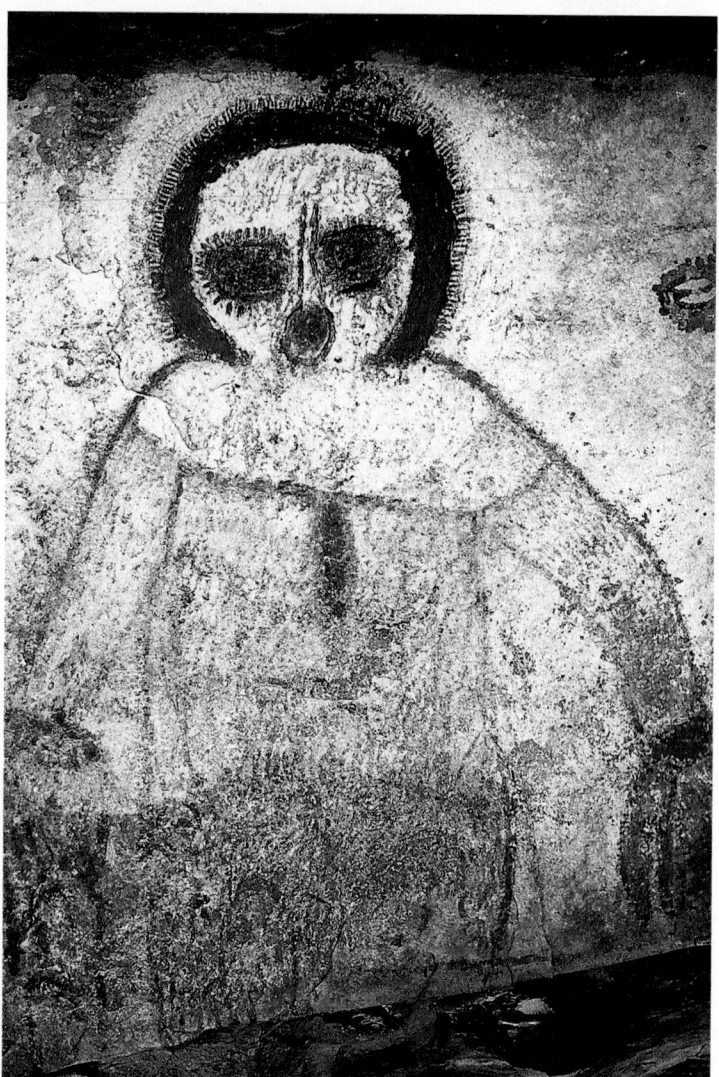

W1.1 Wandjina, Rowalumbin, Barker River, Napier Range, Kimberley, Australia. These rock paintings were discovered in 1837 by an expedition led by George Grey. He described his first view of the Wandjinas as follows: "They appeared to stand out from the rock; and I was certainly rather surprised at the moment that I first saw this gigantic head and upper part of a body bending over and staring down at me."[3]

The oldest identifiable style of Aboriginal rock painting, referred to as the Mimi style, is found in Arnhem Land in northern Australia (fig. **W1.2**). Mimi, in Aboriginal myth, are elongated spirits living in rocks and caves. They are taller than humans and are so light that they can be blown away and destroyed by the wind. If a Mimi entices a man to its cave and tricks him into eating its food or sleeping with a Mimi woman, then the human turns into a Mimi and cannot return to his human condition. Mimi are often represented hunting, as they are in figure W1.2, and are believed to have taught hunting to the Aborigines.

The kangaroo, which is indigenous only to Australia and adjacent islands, is a frequent subject of Aboriginal rock art. Kangaroos have been hunted for thousands of years, probably as a source of food. Those represented in figure **W1.3** are trying to escape from a group of hunters, who are both male and female. That the kangaroos are hopping is clear from their poses—the one in the center has just landed and tilts slightly back on its feet. The kangaroo on the left leans forward as if it were trying to regain its balance. In paintings such as this, Aboriginal artists used two relatively different styles: a naturalistic one for animals and a schematic one for humans. This distinction is also a characteristic of western European Upper Paleolithic cave paintings.

The kangaroo in figure **W1.4** is a good example of the **polychrome** (consisting of more than one color) "X ray" style. It is rendered in brown and white as if displaying the inner organic structure of bone and muscle. Because of its flattened pose, it is stylized rather than naturalistic. The fish-shaped head reflects the appearance of aquatic animals in Aboriginal rock iconography that took place following a rise in sea level around 8000 B.C. The skeletal figure on the right is the fearsome Lightning Man, who is surrounded by an electrical circuit.

W1.2 Mimi hunters, Kakadu National Park, Arnhem Land, Northern Territory, Australia. Rock painting. In the Mimi style, as here, figures are painted in red ocher. These hunters carry spears and boomerangs.

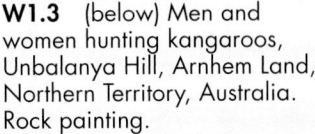

W1.3 (below) Men and women hunting kangaroos, Unbalanya Hill, Arnhem Land, Northern Territory, Australia. Rock painting.

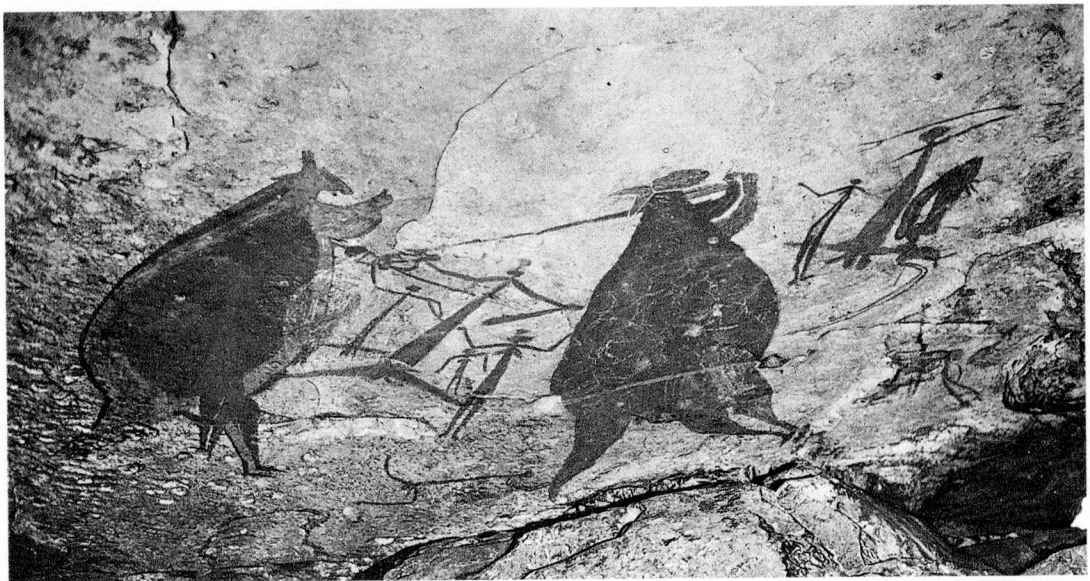

W1.4 Kangaroo with Lightning Man, Nourlangie Rock, Kakadu National Park, Arnhem Land, Northern Territory, Australia. Rock painting. In Dreamtime, the Lightning Man, called Namarrkon or Namarragon, lived in the sky and carried a lightning spear. He tied stone clubs to his knees and elbows so that he would always be prepared to hurl thunder and lightning. For most of the year he lived at the far ends of the sky, absorbing the light of the Sun Woman. When the wet season came, he descended to the earth's atmosphere in order to keep an eye on the human race. When displeased, he hurled spears of lightning across the sky and onto the earth. Some 30 miles (48 km) east of Oenpelli, there is a taboo Dreaming site where Namarrkon is said to have settled. This site is avoided by Aborigines, who fear his wrath.

Mesolithic
(c. 8000–c. 6000/4000 B.C.)

The Mesolithic era was a period of transition more noteworthy for its important cultural and environmental changes than for its artistic legacy. It followed the end of the Ice Age and the rapid development of a more temperate climate about 11,000 B.C. With the retreat of the glaciers, forests expanded. Animals that had been hunted in the Paleolithic era died out or migrated, and people began to congregate around bodies of water, where fishing became a major source of food. By the end of the Mesolithic period, many nomadic hunter-gatherer societies had become increasingly settled, differentiated, predominantly agricultural communities.

An African rock painting of the fifth to fourth millennium B.C. from the Sahara appears to represent the period of transition from nomadic hunting and gathering to farming (fig. **1.17**). It shows human figures and domesticated cattle from the Tassili, in modern-day Algeria. Both the figures—who resemble contemporary cattle herders in parts of Africa—and the animals are rendered with considerable naturalism and freedom of movement.

Neolithic
(c. 6000/4000–c. 2000 B.C.)

In western Europe, as elsewhere throughout the world, the revolutionary shift from hunting and gathering to farming led to a more settled existence and contributed to the development of a new art form: monumental stone architecture.

The two most impressive types of monumental Neolithic architecture in western Europe are the limestone tombs and temples on Malta, an island between Italy and North Africa, and a type of structure known as a megalith found in parts of France, Spain, Italy, and northern Europe (especially Great Britain). Megaliths (from the Greek word *megas*, meaning "big") are built of huge stones without the use of mortar.

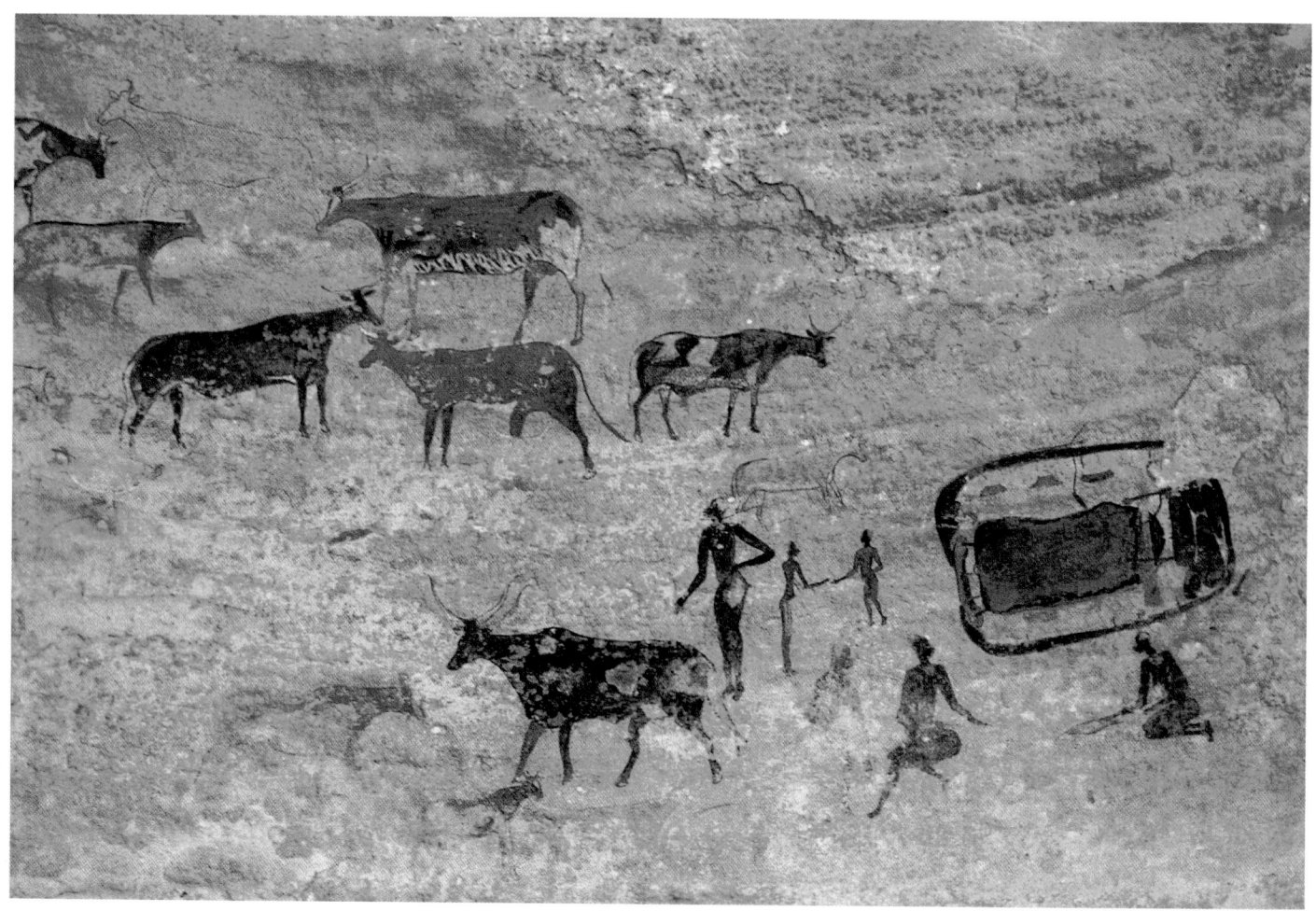

1.17 Saharan rock painting, Tassili, Algeria, Cattle or Pastoralist period, 5th–4th millennium B.C. Photo: Sonia Halliday, Weston Turville, United Kingdom.

Malta

The megaliths on Malta and the adjoining island of Gozo are now dated to before 3000 B.C. Maltese temples are freestanding structures, the products of a civilization that lasted some eight hundred years and then disappeared following an invasion. The biggest temple, Ggantija (meaning "Tower of the Giants"), discovered on Gozo, is located on a hill and faces downward. Its **façade** (front) was originally nearly 50 feet (15.24 m) high, and its exterior was constructed of rough, uncut limestone slabs, which were rolled to the site on limestone balls. The diagram in figure **1.18** shows that the exterior wall surrounded two temples. The one to the south, at the left, is earlier, and its sanctuary, which is **trilobed** (i.e., having three rounded projections), is larger than the oval space preceding it. In the northern temple, at the right, the sizes are reversed—the sanctuary is small compared with the oval forecourt in front of it.

Attention was focused on the elaborate interior sanctuaries, which were reached through a series of decreasing and expanding spaces. The narrower spaces contained a **parapet** (a wall around a terrace or balcony), and one curve of the oval forecourt of the southern temple is lined with platforms that resemble altars. There is also evidence that the stone oval at the entrance to this temple was a hearth used in ceremonies and rituals.

Seventeen temples have been excavated so far on Malta. These, like Ggantija, show evidence of libations (poured offerings), divination (forecasting the future), collective human burial, and the presence of an important priesthood. Animal sacrifices—especially of rams and pigs—were performed in the Maltese temples. Artistic production in this religious context includes paintings and sculptures on the walls of the innermost sacred chambers, as well as many female figures.

The most dramatic surviving statue from the Maltese temples is the fragment of a huge figure, possibly a mother goddess (fig. **1.19**). Her large, bulbous

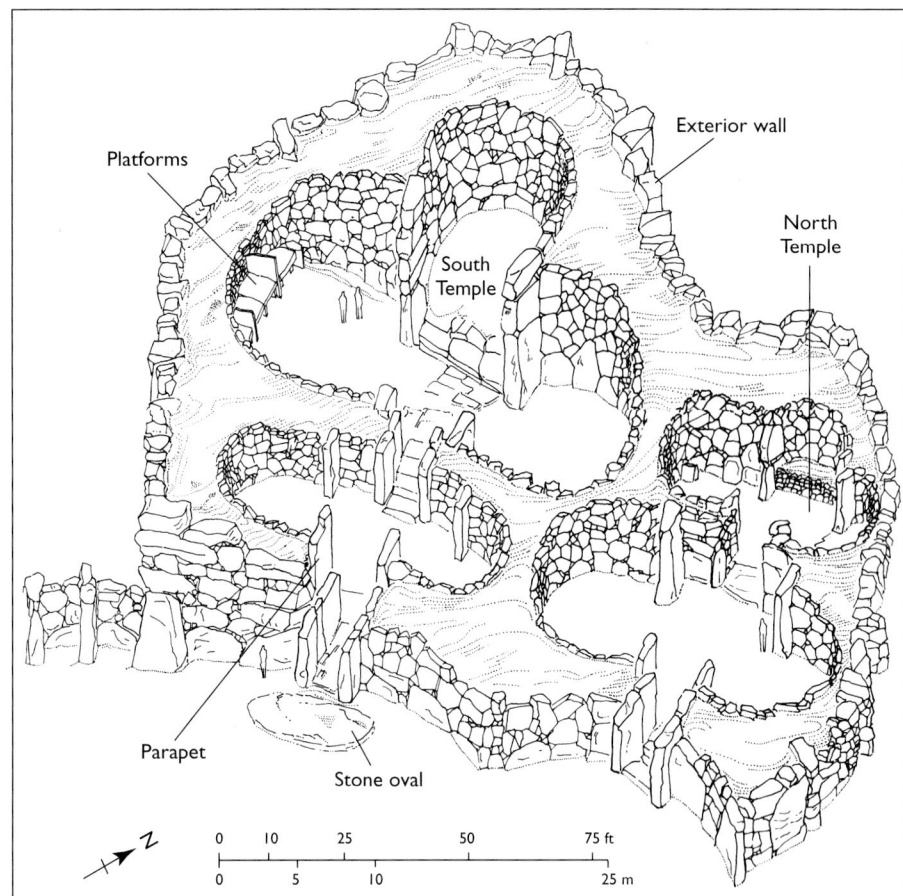

1.18 (above) Reconstruction drawing of the temple at Ggantija, Gozo, Malta.

1.19 "Mother goddess," Tarxien, Malta, before 2500 B.C. Stone fragment.

legs, covered to just below the knees by a pleated skirt, leave no doubt that in her original state she was an imposing and literally gigantic figure. This colossal statue and the abundance of smaller obese female figures point to the presence of a fertility cult. A number of them were ritually covered around the legs with red ocher, suggesting the blood of childbirth, while the rounded plans (see fig. 1.18) of the megalithic tombs and temples on Malta have been interpreted as symbolizing wombs.

The connection between an earth goddess and human burial is most direct at the Maltese site of Hal Saflieni, where a **necropolis**—city of the dead—has yielded the remains of over 7,000 human bodies in addition to statues of females. On Malta, the combination of womblike architectural space with the sculptures of obese women argues for the importance of a chthonian (underground) goddess. At Ggantija, holes apparently provided worshipers with access to the underworld through ritual libations poured into them. Images of the sick or crippled and sculptures of reclining females suggest that the temple was endowed with curative powers. These seem to have been thought most effective if the invalid lay on the sanctuary floor.

Northern Europe

The Neolithic megaliths in Ireland, Britain, France, Spain, and Italy are of a different character from those discovered on Malta. In northern Europe, three distinctive types of stone structure regularly occur: the **menhir, dolmen,** and **cromlech**—these terms are Celtic in origin (see box, p. 48). They are not only visually impressive and mysterious reminders of the ancient past, but are also imbued with fascinating symbolic associations. For megalithic builders, stone as a material was an integral part of cults honoring dead ancestors. Whereas most Neolithic dwellings in western Europe were made of impermanent material such as wood, the tombs—or "houses of the dead"—were of stone so that they would outlast mortal time. Even today we associate these qualities of durability and stability with stone. For example, we speak of things being "written in stone" when we mean that they are unchanging and enduring, and to "stonewall" means to hold up a proceeding for as long as possible. One who is "stoned" is unable to move because of excessive consumption of alcohol or other drugs.

Menhirs Menhirs (from two Celtic words: *men*, meaning "stone," and *hir*, meaning "long") are unhewn or slightly shaped single stones **(monoliths)**, usually standing upright in the ground. They were erected individually, in clusters, or in rows as at Carnac (fig. **1.20**) in Brittany, probably an important Neolithic religious center in what is now northern France. Menhirs have been interpreted as symbolizing the phallic power of the male fertilizing Mother Earth.

1.20 Alignment of menhirs, Carnac, Brittany, France, c. 4000 B.C. Stone; 6–15 ft. (1.83–4.57 m) high. The Carnac menhirs, numbering almost three thousand, are arranged in parallel rows nearly 13,000 ft. (4000 m) long. A small village has grown up around the menhirs.

1.21 Dolmen, Carnac, Brittany, France, c. 4000 B.C.

Dolmens Dolmens (from the Celtic word *dol*, meaning "table") are chambers or enclosures consisting of two or more vertical stones supporting a large single stone, much as legs support a table (fig. **1.21**). The earliest dolmens were built as tombs, each enclosing a body. Later additions turned them into passageways. Some interior dolmen walls were decorated with carvings, and others were painted. Occasionally a pillar stood in the center of a burial chamber. Dolmens, like menhirs, were imbued by Neolithic people with symbolic associations. In contrast to the impermanence of houses built for the living (usually made of mud, plant fibers, and wood), stone burial monuments functioned as links between present time and eternity.

Cromlechs Cromlechs (from the Celtic words *crom*, meaning "circle," and *lech*, meaning "place") are megalithic structures in which groups of menhirs are arranged to form circles or semicircles. By far the greatest number of Neolithic stone circles is found in Britain. Cromlechs must have played a major role in their cultures since the effort required to build them was extraordinary. Although the function and symbolism of their circular forms have not been determined, cromlechs clearly marked sacred spaces.

The most famous Neolithic cromlech in western Europe is Stonehenge (fig. **1.22**), which was built in several stages from roughly 2800 to 1500 B.C. Rising dramatically from Salisbury Plain in southern England, Stonehenge has fascinated its visitors for centuries. The plan in figure **1.23** indicates all stages of construction (Neolithic and later), with the dark sections showing the megalithic circles as they stand today. Many of the original stones have now fallen. The aerial view in figure 1.22 shows the present disposition of the remaining stones and the modern pathway traversed by tourists.

This circular area of land on a gradually sloping ridge was a sacred site before 3000 B.C. Originally, barrows (burial mounds) containing individual graves were surrounded by a ditch roughly 350 feet (107 m) in diameter. A mile-long

1.22 Stonehenge, Salisbury Plain, England, c. 2800–1500 B.C. Diameter of circle 97 ft. (29.57 m); height approx. 13 ft. 6 in. (4.00 m). Interpretations of this remarkable monument have ranged from the possible—a kind of giant sundial used to predict seasonal change and astronomical phenomena—to the purely fanciful—a Druid ritual site or a form of architectural magic conjured by Merlin, King Arthur's magician.

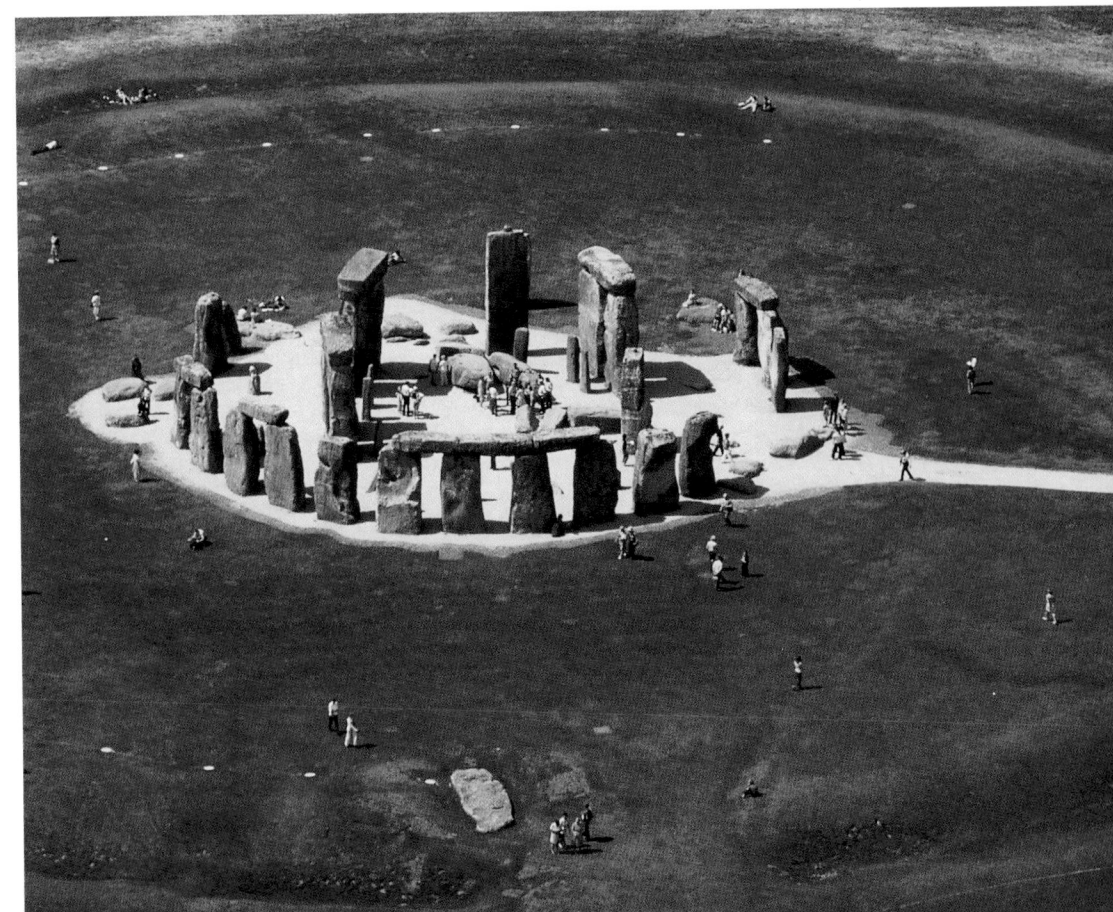

The Celts

Celtic terms are used for Neolithic megaliths in western Europe because a large number of them are located in regions later inhabited by Celtic peoples.

The Celts were first identified in the basin of the upper Danube River and southern Germany in the second millennium B.C. Although of mixed origins, they spoke related Indo-European languages. From the early ninth century B.C., the Celts began to migrate throughout western Europe, occupying France, Spain, Portugal, northern Italy (they sacked Rome in 390 B.C.), the British Isles, and Greece. Gaelic-speaking Celts settled in Ireland, Scotland, England, and Wales, and Celtic dialects are still spoken in Great Britain, Ireland, and northern France.

The rigidly organized social structure of the Celts was ruled by a chief. They worshiped many gods and believed in the immortality of the soul. Celtic priests, called Druids, supervised education, religion, and the administration of justice. The rich Celtic oral tradition forms the basis of much European folklore.

Modern scholars disagree about the distinctiveness of the Celts as a separate people. Some scholars argue that there is a nationalistic aspect to the distinction between Celts and other ethnic groups, while others point to ancient Roman textual references to the Celts, suggesting that they were indeed a distinct group.

"avenue" was hollowed out of the earth and ran in an east–west direction. Fifty-six pits (known as Aubrey Holes after their seventeenth-century discoverer) were added inside the circular ditch and filled with rubble or cremated human bones. Around the same period, the Heel Stone, a block of sarsen (a local sandstone) 16 feet (4.88 m) high, was set in place outside the ditch in the entrance causeway to the northeast. The first stone circle, consisting of smaller stones called bluestones, imported from Wales (over 100 miles, or 160 km, away), was constructed around 2500 B.C.

Over the next four hundred years, a new group of people settled in western Europe and was assimilated into the native population. The origin of these Beaker People, so called after their beaker-shaped pottery, is still a matter of debate. They brought with them a knowledge of metalworking, new building techniques, and pottery. Partly as a consequence of new technology, the Stone Age gave way to the Bronze Age. Nevertheless, before the total disappearance of the Stone Age in western Europe, its most famous architectural monument was completed, apparently by the Beaker People themselves. In the final stages of construction at Stonehenge, huge sarsen blocks were brought to the site from Marlborough Downs, a distance of some 20 miles (32 km). From these larger monoliths, the outer circle and inner U-shape were constructed.

The cromlech at Stonehenge is a series of concentric circles and horseshoe- or U-shaped curves (see figs. 1.22 and 1.23). The outer circle is a **post-and-lintel construction** (fig. 1.24; see box). Each post is a sarsen block 13 feet

1.23 Plan of Stonehenge.

Post-and-Lintel Construction

In this system of construction, vertical uprights (posts) support a horizontal element (the lintel). Figure **1.24** is a diagram of the most basic single post-and-lintel form, called a **trilithon.** In later eras, this simple system was elaborated into highly complex structures.

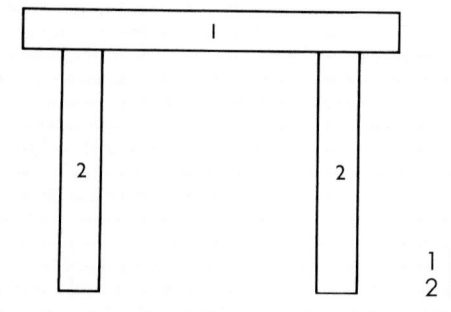

1 Lintel
2 Post

1.24 Post-and-lintel construction.

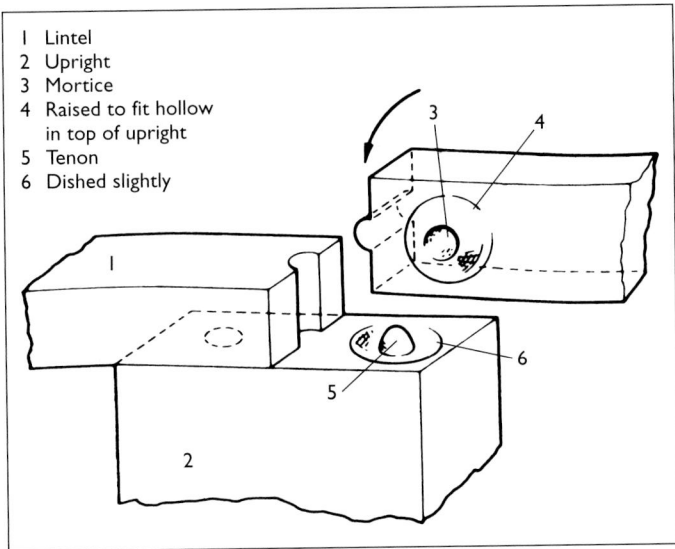

1 Lintel
2 Upright
3 Mortice
4 Raised to fit hollow
 in top of upright
5 Tenon
6 Dished slightly

1.25 Lintel and tenon.

(3.96 m) high and is rougher on the outside than on the inside, bulging at its center and then gradually tapering at the top. Projecting above each post was a **tenon,** which fitted into a hole carved out of the lintel (fig. **1.25**). For the outer wall, the lintels were slightly curved to create a circle when attached end to end.

From the inside ring (fig. **1.26**), one can see part of the outer ring and several individual posts and lintels. A second, inner circle consists entirely of single upright bluestones. Inside those are five very large **trilithons** (a pair of sarsen posts supporting a single lintel) arranged in a U-shape. An even smaller U-shape of bluestones parallels the arrangement of the five posts-and-lintels. Within the U of bluestones, one stone lies on the ground. This is referred to as the "altar stone," although there is no evidence that it was ever used as an altar. We do not know how bluestones weighing up to 40 tons (40,640 kg) and sarsens weighing up to 50 tons (50,800 kg) were transported or how the lintels were raised above the posts, but such engineering feats required large-scale social organization and an enormous commitment of resources over a long period of time.

While continuing archaeological activity steadily increases our knowledge of Stonehenge, we still cannot identify its function with absolute certainty. Clearly the presence of circular stone rings throughout western Europe points to a common purpose. Some scholars think that rites, processions, and sacred dances were held in and around the megalithic structures, celebrating the resurgence of life in spring and summer. These practices correlate with what we know of early agricultural societies, for which the timing of seasonal change was of crucial importance.

Also consistent with agricultural preoccupations are interpretations of Stonehenge and other megalithic struc-

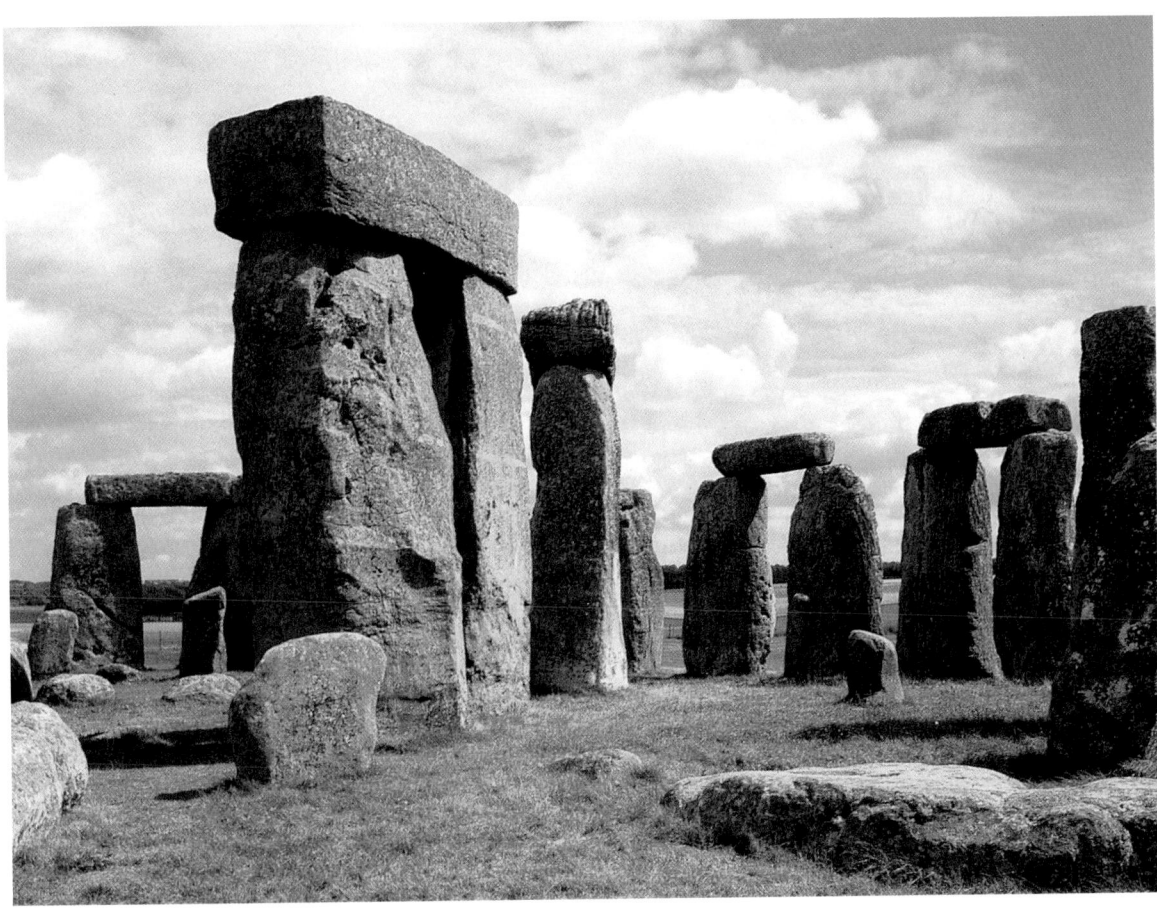

1.26 The inside ring of Stonehenge.

tures as astronomical observatories, used to predict lunar eclipses and to keep track of time. At Stonehenge, for example, the absence of a roof reinforces the relationship of the structure with the sky and celestial phenomena. Carnac (see fig. 1.20) has been described as an observatory in which each menhir functions as a point on a landscape graph. Elsewhere, direct evidence of astronomical markings on carved stones has been found. The circular monuments in particular are aligned according to the positions of the sun and moon at critical times of year. Earlier cromlechs were oriented toward sunrise at the winter solstice, and later ones at the summer solstice. At Stonehenge, the avenue is aligned with the rising summer sun. An observer standing in the middle of the circle about 1800 B.C. would have seen the sun rise over the Heel Stone on June 21, the summer solstice. Other stones are aligned with the northernmost and southernmost points of moonrise.

The greatest megalithic monument of the Neolithic era in western Europe was also among the last. Around 2000 B.C., as the use of metal increased, the construction of large stone monuments began to decline.

Style/Period	Works of Art	Cultural/Historical Developments
ROCK PAINTINGS OF AUSTRALIA c. 75,000 B.C.–PRESENT **Men and women hunting kangaroos**	Wandjina (**W1.1**) Mimi hunters (**W1.2**) Men and women hunting kangaroos (**W1.3**) Kangaroo with Lightning Man (**W1.4**) **Kangaroo with Lightning Man**	 **Wandjina**
UPPER PALEOLITHIC c. 50,000–10,000 B.C. **Venus of Willendorf**	*Venus of Willendorf* (**1.1**) *Venus of Laussel* (**1.2**) Jellyfish (**1.5**), Cosquer cave Hyena (**1.6**), Chauvet cave Mammoths (**1.7**), Chauvet cave "Lion Panel" (**1.8**), Chauvet cave Handprints (**1.9**), Pech-Merle Hall of Running Bulls (**1.12**), Lascaux "Chinese Horse" (**1.13**), Lascaux Reindeer (**1.14**), Lascaux Shaman (**1.10**), Ariège Bison (**1.4**), Tuc d'Audoubert Altamira cave (**1.15**), Santander Standing bison (**1.16**), Santander Bison with turned head (**1.3**), La Madeleine	Hunting and gathering Evidence of recording time Use of stone tools Last Ice Age (18,000–15,000 B.C.) **Standing bison**
MESOLITHIC c. 8000–c. 6000/4000 B.C.	Saharan rock painting (**1.17**), Tassili	Bow and arrow invented (c. 10,000 B.C.) Wheat and barley cultivated (c. 9000 B.C.)
NEOLITHIC c. 6000/4000– c. 2000/1800 B.C. **Mother goddess**	Menhirs (**1.20**), Carnac Dolmen (**1.21**), Carnac Temple at Ggantija (**1.18**), Gozo Stonehenge (**1.22, 1.23, 1.26**), Salisbury Mother goddess (**1.19**), Tarxien **Stonehenge**	Development of agriculture; domestication of sheep and goats (c. 6000 B.C.) Megalithic monuments Copper smelting developed (c. 4500 B.C.) Invention of the potter's wheel (c. 4500–4000 B.C.) 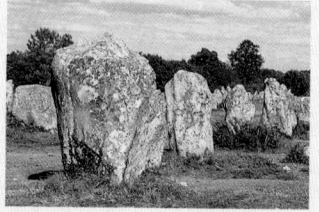 **Carnac**

c. 75,000 B.C. 50,000 B.C. 10,000 B.C. 2000 B.C.

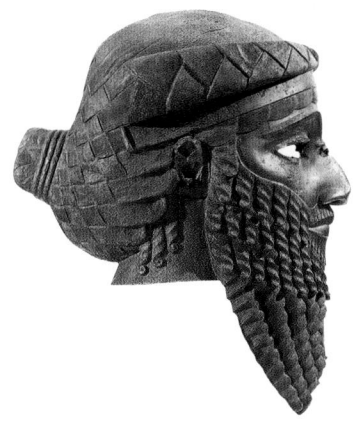

2

The Ancient Near East

I t was in the ancient Near East (see map) that people first invented writing, which enabled communities to keep records and create a permanent body of literature. The Near East produced the first known epic poetry, written history, religious texts, and economic records. These provide insights into the origins of human thought and civilization. They also shed light on the artistic products of ancient Near Eastern civilization in a way that is not possible for preliterate times. Before exploring the invention of writing and its relation to art history, however, we shall consider the rise of Neolithic cultures in this part of the world (see box, p. 52).

The Neolithic Era

Neolithic cultures developed some four thousand years earlier in the Near East than in Europe. As with Neolithic cultures in western Europe, those in the Near East emerged during the transition from a nomadic way of life to a more settled one that was centered around agriculture and animal herding. Droughts and floods made growing crops and establishing permanent communities difficult in certain areas. In response, people learned to manage water supplies by building large-scale irrigation systems. The social structures that made this possible—that is, organized labor and stabilized political power—contributed to the development of increasingly complex urban societies.

The ancient Near East and the Middle East.

Chronology of the Ancient Near East and Principal Sites

NEOLITHIC ERA	Jericho (in the West
c. 9000–4500/4000 B.C.	Bank)
	Çatal Hüyük (in
	modern Turkey)
MESOPOTAMIA	Modern Iraq
Uruk period	Uruk
c. 3500–3100 B.C.	
Sumer	Sumer
Early Dynastic period	Tell Asmar
c. 2800–2300 B.C.	Ur
Akkad	Akkad
c. 2300–2100 B.C.	
Neo-Sumerian period	Lagash
c. 2100–1900/1800 B.C.	
Babylon	Babylon
Old Babylonian period	
c. 1800–1600 B.C.	
Neo-Babylonian period	
c. 612–539 B.C.	
Assyrian Empire	Assur
c. 1300–612 B.C.	
ANATOLIA	Modern Turkey
Hittite Empire	Hattusas (modern
c. 1450–1200 B.C.)	Boghazköy)
ANCIENT IRAN c. 5000–331 B.C.	Modern Iran
Achaemenid Persia	Persepolis (near
559–331 B.C.	modern Shiraz)
THE SCYTHIANS	Modern Russia and
8th–4th centuries B.C.	Ukraine

2.1 Neolithic plastered skull, from Jericho, c. 7000 B.C. Life-sized. Archaeological Museum, Amman, Jordan. Skulls such as this reflect an attempt to reconstitute the image of the dead person by modeling the features in plaster. The hair was painted, and cowrie shells were embedded into the eye sockets.

to a much later settlement at the site. His success lives on today in the refrain of the spiritual: "Joshua fought the battle of Jericho, and the walls came tumbling down."

Jericho's walls protected a city of rectangular houses and public buildings made of mud brick and erected on stone foundations. Mud brick was the mainstay of ancient Near Eastern architecture, used for ordinary buildings as well as for public architecture. Manufactured from an inexpensive, readily available material, it was easy to work with and suited to the climate. The walls of Jericho's mud-brick houses were plastered and painted.

In addition to providing shelter for the living, dwellings in Jericho housed the dead. Corpses buried under the floors indicate a concern with protective ancestors, a conclusion reinforced by one of the most intriguing archaeological finds, the so-called "Jericho Skulls" (fig. **2.1**). These uncanny skull "portraits" are almost literal renderings of the transition between life and death. The dead person's detached skull served as a kind of **armature** on which to rebuild the face and presumably to preserve the memory of the deceased.

Agricultural rituals celebrated fertility and the vegetation cycles of birth–death–rebirth. Perhaps the most constant artistic and religious presence in the Neolithic religions of the Near East was a female deity and her male counterpart. Neolithic architecture reflects increasingly elaborate concepts of sacred space in which religious buildings symbolize the cosmic world of the gods. Archaeologists have also excavated mud-brick fortification walls and found evidence of town planning.

Jericho

The Neolithic settlement of Jericho, located in the West Bank, is one of the world's oldest fortified sites. It was originally built c. 8000–7000 B.C., when it was surrounded by a ditch and walls 5 to 12 feet (1.52 to 3.65 m) thick, from which rose a tower some 30 feet (over 9 m) high. The biblical account of Joshua's attack on Jericho (Joshua 6) refers

Çatal Hüyük

Similar burials in houses are found at the site of Çatal Hüyük in Anatolia (modern Turkey). Dating from c. 6500–5500 B.C., it is the largest Neolithic settlement site so far discovered in the ancient Near East.

In the ruins of Çatal Hüyük, archaeologists unearthed evidence of one of the most developed Neolithic cultures, in which agriculture and trade were well established and stoneware and ceramics were made. The layout of the town suggests that it was planned without streets (fig. **2.2**). Instead, one-story mud-brick houses were connected to each other by their rooftops, and scholars assume that ladders provided access from ground level; it is possible that this was for defense. Windows were small, and a ventila-

2.2 Reconstruction of Çatal Hüyük, Turkey.

tion shaft allowed smoke from ovens and hearths to escape. The interiors of the houses were furnished with built-in benches made of clay, probably used for seats and beds.

Skeletons were buried under floors and benches. Some of the skeletons were coated with red ocher, while the necks and heads of others were decorated with blue and green pigments. Deposits of jewelry and weapons accompanied the remains, suggesting that they were thought necessary in an afterlife.

Little is known of the religious beliefs at Çatal Hüyük since it was a preliterate culture. However, archaeologists have identified chambers that may have functioned as shrines. Male and female deities appear in human form, standing or seated with their sacred animals (fig. **2.3**).

2.3 Anatolian goddess giving birth, from Çatal Hüyük, Turkey, c. 6500–5700 B.C. Baked clay; 8 in. (20.3 cm) high. Museum of Anatolian Civilizations, Ankara, Turkey. The monumental— specifically steatopygous—forms are reminiscent of the *Venus of Willendorf* (see fig. 1.1) and other prehistoric fertility figures. This particular figure was found in a clay bin, and its original context is unknown.

The Çatal Hüyük shrines contained murals painted on a white plaster background with natural pigments bound with fats. They illustrate hunting scenes, rituals, human hands, geometric patterns, and a variety of unidentified symbols. Bovine heads and horns are also illustrated at Çatal Hüyük.

Mesopotamia

Mesopotamia (in modern Iraq) was the center of ancient Near Eastern civilization. Its name is derived from the Greek words *mesos* (middle) and *potamos* (river). Mesopotamia is literally the "land between the rivers"—the Tigris and the Euphrates. The Mesopotamian climate was harsh, and its inhabitants developed irrigation to make the land fertile. The southern and western terrain was open and without natural protection; as a result, Mesopotamian cities were vulnerable to invasion and accessible to trade.

The Neolithic period in Mesopotamia ended c. 4500/4000 B.C. It was followed by urbanization and the construction of the first known monumental temples, dedicated to each city's patron deity or deities. Mesopotamian temples were oriented with their corners toward the four cardinal points of the compass, reflecting religious beliefs that related sacred architecture to earth and sky (see box).

Some temples were decorated with **cone mosaics** (figs. 2.4 and 2.5). Thousands of long, thin cones made of baked clay were embedded in mud walls and columns, leaving

2.4 (right) Cone mosaics, from Uruk, c. 3500 B.C. Staatliche Museen, Berlin.

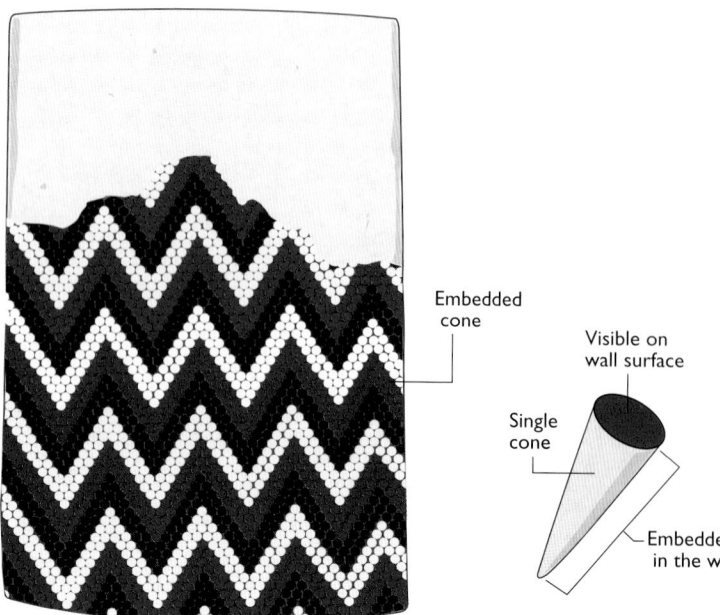

Embedded cone

Visible on wall surface

Single cone

Embedded in the wall

only the circular ends of the cones visible. They were dipped in black, red, or tan pigments and arranged in geometric patterns. Since they also reinforced the walls, the cones served a structural as well as an aesthetic purpose.

Technological advances in early Mesopotamia included the potter's wheel and metalworking. Metallurgy brought about substantial changes in spheres of activity ranging from warfare to art. Metal weapons were superior to stone, and objects such as drinking vessels and ornaments could now be fashioned from new materials.

2.5 (left) Diagram of the cone mosaic technique.

Mesopotamian Religion

Mesopotamian religion was polytheistic (from the Greek words *poly,* meaning "many," and *theos,* meaning "god") —that is, people believed in many deities. These gods were represented anthropomorphically (human in form and character), but were superhuman in power and immortal. The main gods were

Enlil	God of the air: a productive, beneficent creator who ensures good harvests
Anu	Supreme god of the heavens
Enki (Akkadian Ea)	God of water, arts and crafts, and wisdom
Ninhursag	The Great Mother and Lady of the Mountain, goddess of the earth, and Anu's consort
Utu (Akkadian Shamash)	Sun god, judge, and protector—see figure 2.21
Nanna (Akkadian Sin)	God of the moon
Inanna (Akkadian Ishtar)	Goddess of fertility, love, and war
Nergal and **Ereshkigal**	Queen and king of the underworld, who rule from a lapis lazuli palace with seven gates

Our knowledge of Mesopotamian religious practices comes from cuneiform (see p. 58) texts of prayers, rituals, legends, and myths. The mythological texts are primarily literary in nature, and some show remarkable parallels to the Old Testament.

The Sumerians conceived of the universe as created by a primal sea. By "universe" they meant a flat earth, the vault of heaven, and the atmosphere in between. Sun, moon, planets, stars, and deities existed within this atmosphere. The human race was created out of clay for the sole purpose of serving the gods. When people died, their spirits were ferried across a river into a gloomy existence below the earth—hence the numerous inscriptions on tablets, in temples, and on sculptures asking the gods for a long life.

Ceremonies were performed in Mesopotamian temples before a god's image, which was conceived of as literally inhabited by the god. Such images enjoyed a royal life, being fed, clothed, and housed (along with their entire families) in the temple.

The Uruk Period (c. 3500–3100 B.C.)

The city of Uruk (called Erech in the Bible and Warka in present-day Iraq) has given its name to a period sometimes known as Protoliterate, when the earliest writing developed. This coincides with the rise of city-states (powerful, independent cities that rule allied territories) within the Uruk period, beginning around 3500 B.C.

It is possible that the festival in honor of the goddess Inanna (see box, p. 56) is the subject of the impressive alabaster vase (fig. **2.6**) found at Uruk. It is 3 feet (91.4 cm) in height and is decorated with four horizontal bands **(registers)** of low relief. In the top register, a goddess receives a figure carrying a basket of fruit. In the next register, nude men proceed from right to left, also bearing offerings. In the third register, rams alternate with ewes and march around the vase in the opposite direction. Barley stalks alternate with date palms at the

2.6 Carved vase, from Uruk, c. 3500–3000 B.C. Alabaster; height 36 in. (91.4 cm). Iraq Museum, Baghdad. The abundance of vegetation in the iconography of this vase reinforces its relationship to festivals of seasonal renewal and rebirth. The association of these rites with Inanna is almost certainly derived from the role of the Neolithic mother goddess.

Inanna

Evidence of the Mesopotamian goddess of fertility, love, and war is found in precincts dedicated to her as early as the fourth millennium B.C. Inanna to the Sumerians and Ishtar to the Akkadians, she was the wife of the shepherd-god Dumuzi, referred to in the Bible as Tammuz. Their courtship and sacred marriage, his death and return, and her descent into the underworld are sung in several Mesopotamian hymns.

Inanna had multiple aspects to which these hymns were addressed. She was the "holy priestess of heaven," "thundering storm," "lady of evening and of morning," and "joy of Sumer." She was also fearsome and had to be propitiated with offerings such as the alabaster vase in figure 2.6, which may depict Inanna herself. One of the hymns to Inanna has been translated as follows:

> In the pure places of the steppe,
> On the high roofs of the dwellings,
> On the platforms of the city,
> They make offerings to her:
> Piles of incense like sweet-smelling cedar,
> Fine sheep, fat sheep, long-haired sheep,
> Butter, cheese, dates, fruits of all kinds.[1]

In the course of the third millennium B.C., Inanna became the central deity in the most important rite of Sumer's New Year festival. In the *hieros gamos* (sacred marriage), the Sumerian king (who stood for Dumuzi) and a priestess (standing for Inanna) were married in a ceremonial reenactment of the divine union. The purpose of the rite was to ensure agricultural fertility in the coming year.

2.7 Female head, from Uruk, c. 3500–3000 B.C. White marble; 8 in. (20.3 cm) high. Iraq Museum, Baghdad.

bottom. The abundance of vegetal iconography on this vase suggests its association with agricultural festivals of renewal and rebirth.

Several stylistic **conventions** evident here remain characteristic of ancient Near Eastern art throughout its history. Though the figures are stocky and modeled three-dimensionally, they occupy a flat space, which is partly defined by their poses. Legs and heads are in profile, the torsos turn slightly, and the eyes are frontal, creating a composite or synthesized view of the human form. There is no indication of space extending back behind the figures, who walk as if on a thin ledge. In the top register, figures and objects seem suspended in mid-air.

Despite the flat space of the Uruk vase and of much relief and pictorial art in ancient Mesopotamia, the white marble head of a female (fig. **2.7**), also from Uruk, demonstrates the artist's command of three-dimensional form. The eyebrows meet over the nose (a convention of Mesopotamian statues), and the face is organically modeled. The cheeks bulge slightly, creating the natural line from the nose to the corners of the mouth, and the lower lip curves outward from an indentation above the chin.

Asymmetrical cheeks and the slight rise of the right side of the upper lip create the impression of an individual personality. The figure's eyebrows would originally have been **inlaid** (set into the surface), and other additions, such as hair and eyes, have probably disappeared.

Ziggurats

The ziggurat, derived from an Assyrian word meaning "raised up" or "high," is a uniquely Mesopotamian architectural form. Mesopotamians believed that each city was under the protection of a god or gods to whom the city's inhabitants owed service, and they built imitation mountains, or ziggurats, as platforms for those gods. Mountains were believed to embody some of the immanent powers of nature: they were sources of the life-giving water that flowed into the plains and made agriculture possible. The Mesopotamian goddess Ninhursag, a source of nourishment, was also the Lady of the Mountain. As a symbolic mountain, therefore, the ziggurat satisfied one of the basic requirements of sacred architecture—namely, the creation of a transitional space between people and their gods.

2.8 The White Temple on its ziggurat, Uruk, c. 3500–3000 B.C. Stone and polished brick; temple approx. 80 × 60 ft. (24.38 × 18.29 m); ziggurat c. 140 × 150 ft. (42.70 × 45.70 m) at its base and 30 ft. (9.10 m) high. It was called the "White Temple" because of the white paint on its outer walls.

Ziggurats are examples of **load-bearing construction,** a system of building that began in the Neolithic period. Their massive walls had small openings or none at all. They were usually solid, stepped structures, tapering toward the top, with wide bases supporting the entire weight of the ziggurat.

At Uruk the earliest surviving ziggurat (fig. **2.8**) dates from between 3500 and 3000 B.C. It was a solid clay structure reinforced with brick and asphalt. White pottery jars were embedded into the walls, their rims creating a surface pattern of white circles framing the dark round spaces of their interiors.

The Uruk ziggurat supported a shrine, the "White Temple," which was accessible by a stairway. Like the ziggurat, the temple was oriented toward the four cardinal points, an arrangement that became standard. Figure **2.9** shows the plan of the rectangular White Temple, which is believed to have been dedicated to Anu, the sky god. It was divided into several rooms off a main corridor (the *cella*), which contained the altar. The temple probably housed a statue of the god, although no such statue has been found. Ziggurats remained characteristic structures throughout Mesopotamian history and became increasingly elaborate as belief systems and technology evolved.

1 Ramp
2 Stairway
3 *Cella* (or main corridor)
4 Entrance
5 Altar

N

0 10 20 m
0 30 60 ft

2.9 Plan of the White Temple.

2.10 Cylinder seal and impression, from Uruk, c. 3500–3000 B.C. Greenish black serpentine; 1.16 in. (29.5 mm) high, diameter 1 in. (25.0 mm). The Pierpont Morgan Library, New York. The scene shown has been interpreted as a leather shop (note the man carrying an animal hide).

Cylinder Seals

The earliest examples of **cylinder seals,** which are classed as **glyptic art** (from the Greek word *glyptos,* meaning "carved"), were produced during the Uruk period. The seal in figure **2.10** is a small stone cylinder into which an image has been carved. In a process known as **intaglio** printing, the seal's hard, incised surface would have been pressed against a soft surface, leaving a raised impression of the animals in reverse. When a cylinder seal was rolled across a clay tablet or the closure on a container, it created a continuous band of images. Seal impressions were used originally to designate ownership, to keep inventories and accounts, and later to legalize private and state documents. They offer a rich view of Mesopotamian iconography and of the development of pictorial style during a three-thousand-year period.

From Pictures to Words

The use of seal impressions to designate ownership contributed to the development of writing. In the course of the Uruk period, abstract wedge-shaped characters began to appear on clay and stone tablets (fig. **2.11**). The earliest known written language comes from Sumer, in southern Mesopotamia, and persisted as the language of the priestly and intellectual classes throughout Mesopotamian history. Its script is called **cuneiform** from the Latin word *cuneus,* meaning "wedge." After c. 2300 B.C., a Semitic language, Akkadian, belonging to a people who may have come from the west, became more prevalent than Sumerian. The Sumerian and Akkadian cultures coexisted for many centuries, and their languages roughly correspond to the two main geographical divisions of Mesopotamia—Sumer and Akkad. Both lie between the Tigris and Euphrates rivers, Sumer in the south and Akkad in the north.

Some time after the invention of writing, a Mesopotamian literature developed. The written word, which originated in response to a practical need for daily record-keeping, became a tool of creative expression. Much epic poetry of Mesopotamia deals with the origins of gods and humans, the history of kingship, the founding of cities, and the development of civilization (see box). These themes are also familiar in later literature. A Sumerian flood myth in which the human race is nearly destroyed, for example, describes an event much like the biblical flood (Genesis 6–8). According to Sumerian tradition, the flood occurred shortly before the invention of writing and, therefore, separated preliterate Mesopotamia from its literate, historical era.

2.11 Clay tablet with the pictograph text that preceded cuneiform, probably from Jemdet Nasr, Iraq, c. 3000 B.C. 3¼ × 3¼ in. (8.0 × 8.0 cm). British Museum, London. Sumerians used a numerical system with a base of 60, as well as a decimal system.

The *Epic of Gilgamesh* is the oldest surviving epic poem, and it is preserved on cuneiform tablets from the second millennium B.C. It recounts Gilgamesh's search for immortality as he undertakes perilous journeys through forests and the underworld, encounters gods, and struggles with moral conflict. The opening lines introduce Gilgamesh as the hero who saw and revealed the mysteries of life:

> The one who saw the abyss . . .
> . . . he who knew everything, Gilgamesh,
> who saw things secret, opened the place hidden,
> and carried back word of the time before the Flood.[2]

Gilgamesh finally attains immortality as the builder of Uruk's walls. He establishes urban civilization and lays the foundations of historical progress. The poem also refers to his having "cut his works into a stone tablet." Just as the megalithic builders of Neolithic Europe revered stone as a permanent material, so Gilgamesh founded a city ringed with stone walls and ensured that the record of his achievements was written in stone. This is consistent with the historical fact that the earliest writing was actually inscribed on stone or clay tablets. The works of Gilgamesh were thus literally as well as figuratively "carved in stone."

Sumer: Early Dynastic Period (c. 2800–2300 B.C.)

The gradual transition to full literacy occurred during the growth of approximately a dozen powerful city-states ruled by dynasties, or royal families. Lists of these ancient Sumerian rulers have survived. Other documents provide the picture of a society in which people played increasingly specialized roles (such as canal builders, artisans, merchants, and bureaucrats) under the administration of a class of priests.

Tell Asmar

Many small cult figures were produced during the Early Dynastic period, such as those from Tell Asmar (figs. **2.12** and **2.13**), a Sumerian site about 50 miles (80 km) north-

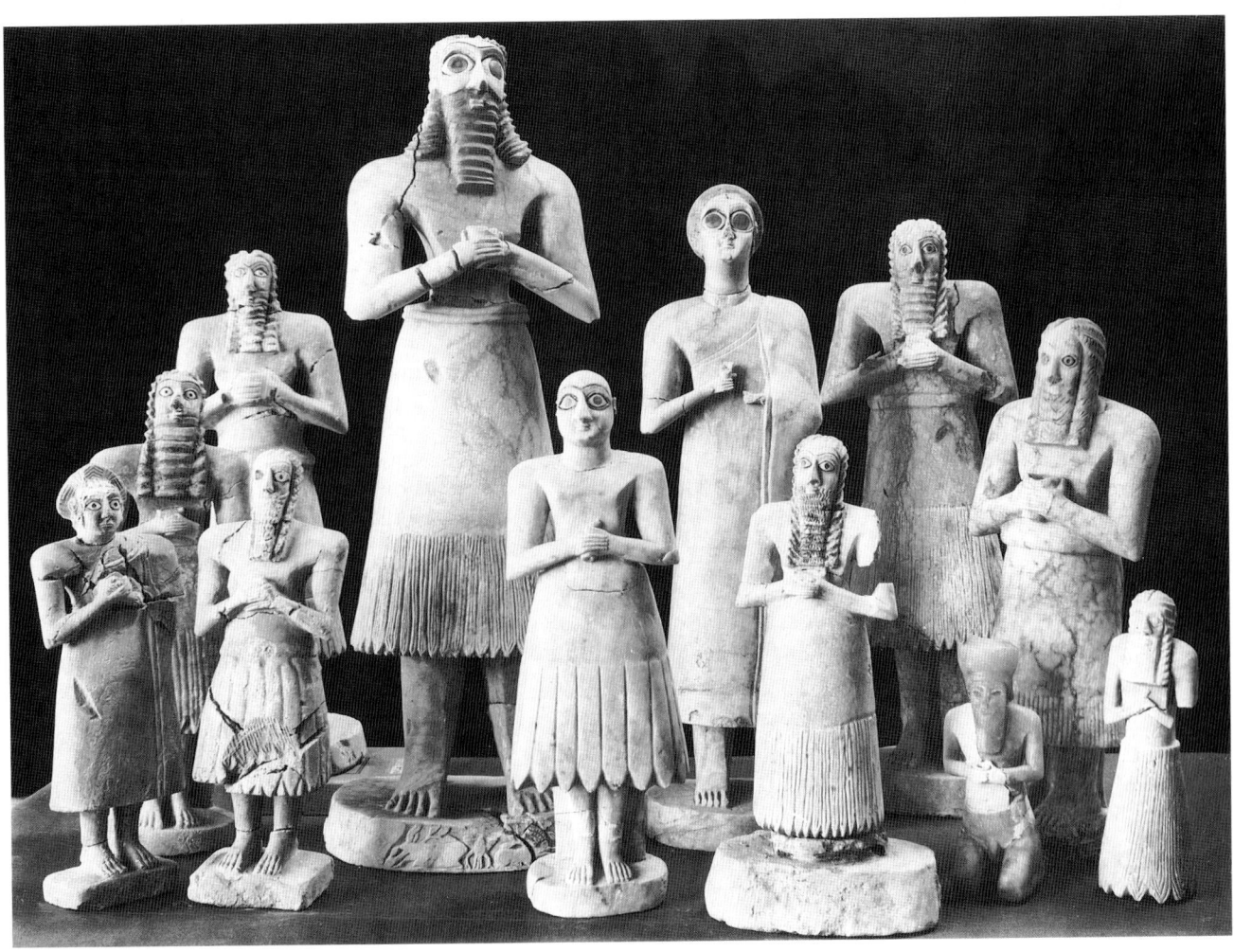

2.12 Statues from the Abu Temple at Tell Asmar, c. 2700–2500 B.C. Limestone, alabaster, and gypsum; tallest figure approx. 30 in. (76.3 cm) high. Iraq Museum, Baghdad, and Oriental Institute, University of Chicago.

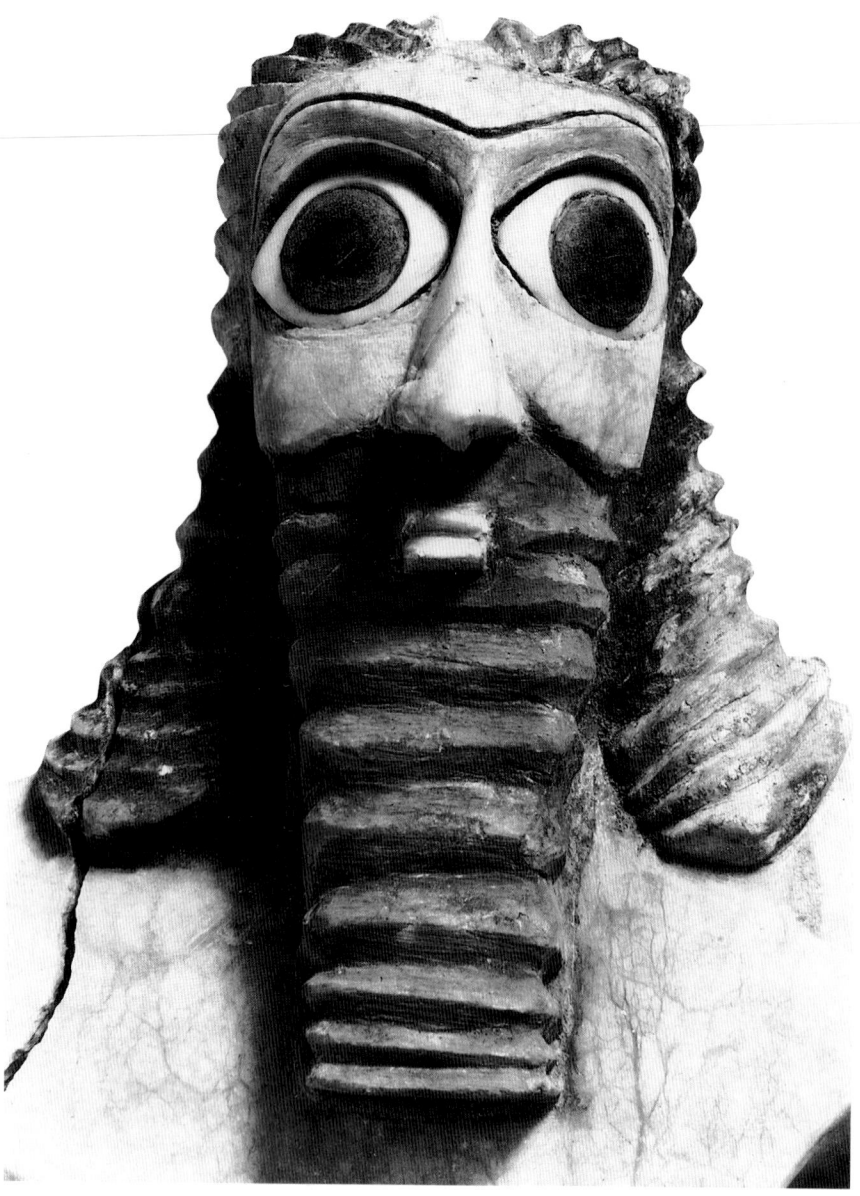

2.13 Head of a large male figure dedicated to the god Abu (detail of fig. 2.12).

ing status whose sizes were determined by the amount of money their donors paid for them. As such, these figures are rendered with so-called **hierarchical proportions,** a convention equating size with status.

The statues are cylindrical, and many stand on curved bases, reflecting the Mesopotamian preference for rounded sculptural shapes. Also characteristic, as in the Uruk head (see fig. 2.7), is the combination of stylization—visible here in the horizontal ridges of the males' hair and beards—with suggestions of organic form in the cheeks and chin. The frontal poses and vertical planes of these figures endow them with an air of imposing solemnity. Their frontality is further emphasized by the prominence of large, wide-open eyes staring straight ahead. The importance accorded the eye in these figures indicates that they are in the presence of divinity.

Ur

At the Sumerian site of Ur, the English archaeologist Sir Leonard Woolley (1880–1960) discovered evidence of the richness of Early Dynastic culture. The most impressive finds came from the "royal" cemetery, so called because of the great wealth of materials recovered there and the power reflected in the organization, construction, and furnishing of the burials. They were filled with chariots, harps, sculptures, headdresses, and jewelry. In addition, bodies of people who may have been ritually killed in order to provide companions for the royal family in the afterlife were also found.

The elegant lyre sound box (fig. **2.14a**) from Ur indicates the importance of music and musical instruments in Sumerian society. The significance of the gold bearded bull's head and the inlay decoration at the front of the box (fig. **2.14b**) is uncertain, but it is likely that they served a ritual purpose and had mythological meaning. Certainly the motif of the bull's head is known from as early as around 6000 B.C., when it was one of the manifestations of the male god at Çatal Hüyük. At Ur, the head was combined with a stylized human beard of **lapis lazuli,** illustrating the ancient Near Eastern taste for combinations of species.

Figure **2.15** (p. 62) shows a restored Sumerian lyre from Ur presently located in the British Museum in London. The box itself is hollow in order to improve the quality of the sound.

east of modern Baghdad, in Iraq. Most hold a cup, but some hold a flower or branch. Male and female are distinguished by costume. Men tend to wear less above the waist than women (in this case, the bare-chested men wear skirts, whereas the women wear robes that cover one shoulder). The figures are made of pale stone, their hair, beards, and other features emphasized with black pitch. The eyes are shells, and the pupils are inlaid with black limestone. The largest male statue has no attributes of divinity and is, therefore, thought to represent an important or wealthy person dedicating himself to the god Abu. All the statues probably represent worshipers of vary-

2.14a and **b** The scorpion-man, who appears in the bottom scene on the front of the box, may be one of the fearsome guardians of the sun described in the *Epic of Gilgamesh*. In addition to hybrid forms combining animals with other animals and animals with humans, ancient Near Eastern art is populated by animals—such as the goat holding a cup and walking upright—who act like humans. These figures could represent either mythological creatures or people dressed as animals.

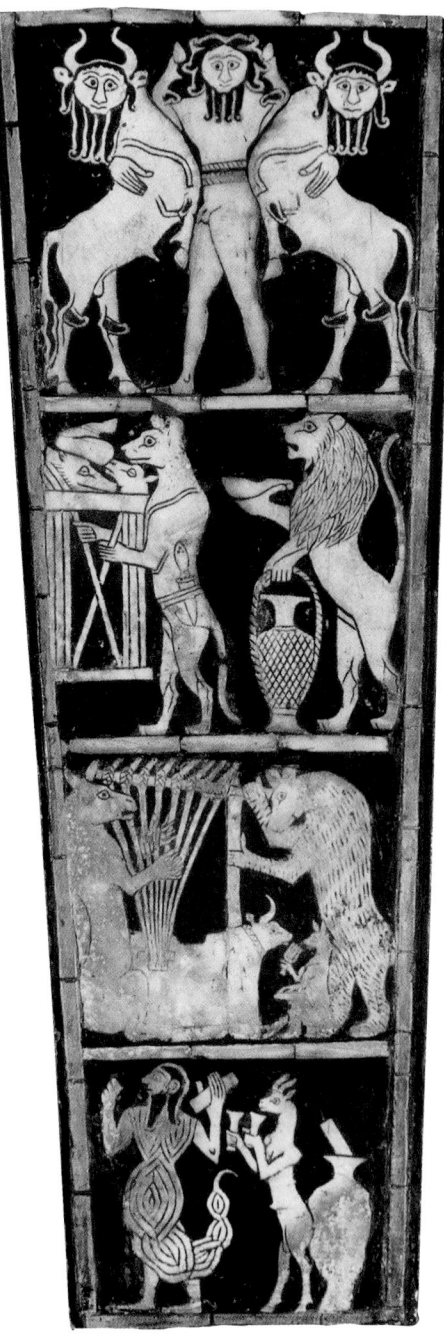

2.14a Lyre sound box, from the tomb of Queen Puabi, Ur, c. 2685 B.C. Wood with inlaid gold, lapis lazuli, and shell; approx. 13 in. (33 cm) high. University Museum, University of Pennsylvania, Philadelphia.

2.14b Inlay from the front of a sound box (detail of fig. 2.14a).

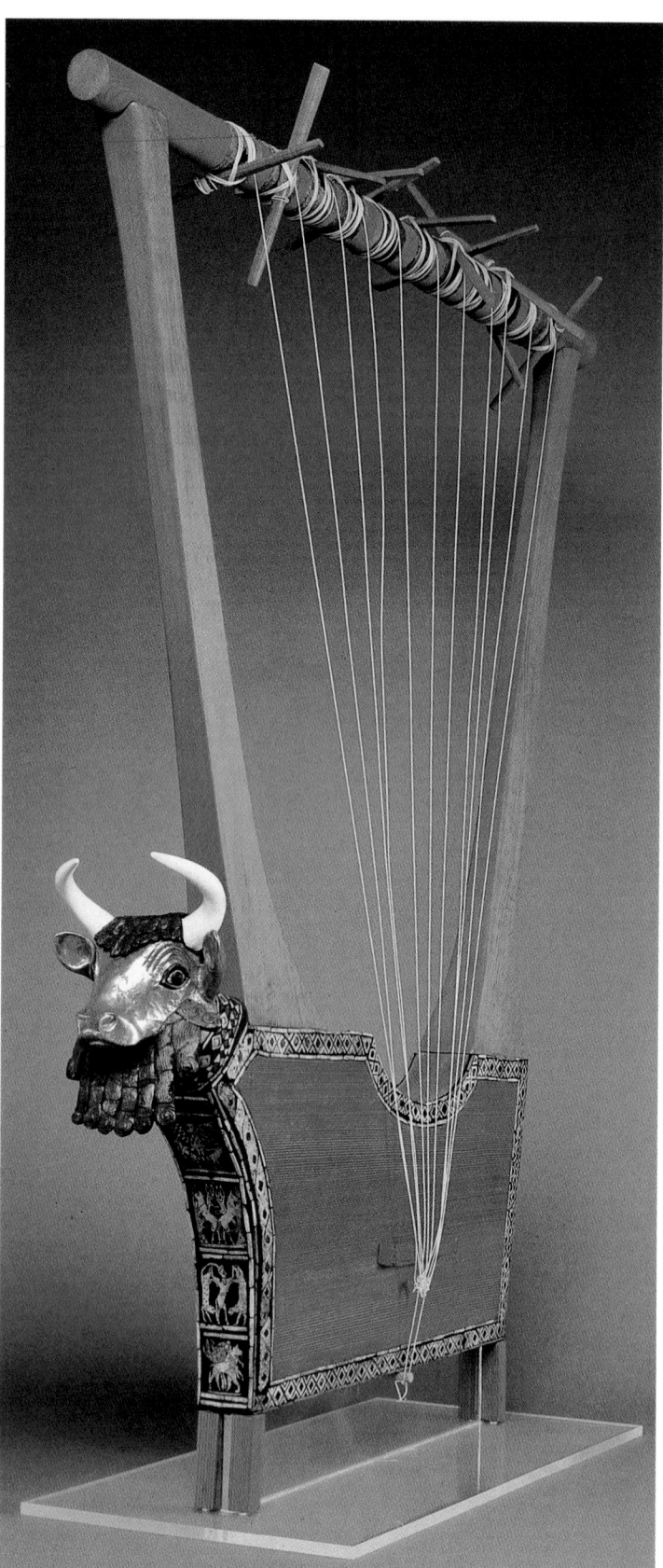

2.15 Restoration of a Sumerian Lyre, from Ur, c. 2600 B.C. Wood, gold leaf, and inlay; height of bull's head c. 12 in. (30 cm). British Museum, London.

Akkad (c. 2300–2100 B.C.)

The Akkadians were a Semitic-speaking Mesopotamian people who lived to the north of Sumer. We know little about them before their territorial expansion in the twenty-fourth century B.C. From their capital at Akkad (near modern Baghdad), the Akkadians dominated one city-state after another until they ruled Mesopotamia. They assimilated much of Sumerian culture, but there were some important changes. City-states were now subordinate to a larger political entity, an empire, and Akkadian became the dominant language. Some Akkadian gods were merged with those of Sumer, and some Akkadian rulers elevated themselves to divine status.

The founder of the Akkadian dynasty, Sargon I, reigned for over half a century, from c. 2300 to 2250 B.C. (see box), gaining control of most of Mesopotamia and the lands beyond the Tigris and Euphrates rivers. A near-life-sized bronze head (fig. **2.16**) may be his portrait. Its high level of artistry and technical skill indicates that metal sculpture on a monumental scale was not new, but earlier examples have not survived. It was made by the *cire-perdue*, or lost-wax, method discussed in Chapter 5 (see p. 154). Throughout history metal objects were often melted down for reuse, making large-scale metal sculptures from antiquity rare today. This head, found in debris, is all that remains of a full-length statue.

The power of this work resides in the self-confident facial features emerging from the framework of stylized hair. The eye sockets would originally have been inlaid with precious stones, which have since been gouged out—possibly by enemies seeking to mutilate the head. At the back of the head, the hair is bound in a bun and is elaborately designed in a regular arrangement of surface patterns. Large curved eyebrows meet on the bridge of an assertive nose. A striking V-shape frames the lower face in the form of a beard made of spiraling curls. In this head, the energy and rhythm of the stylizations combine with an organic facial structure to produce an air of regal determination.

Sargon of Akkad

With Sargon, we encounter another "first" in Western history—namely, the legendary birth story of one who is destined for greatness. These tales typically link humble origins to later fame. Sargon's story is inscribed on a tablet and recounts his lowly illegitimate birth. His mother sends him down a river in a basket (which resonates with the biblical account of Moses in the bulrushes). A man named Akki, who is drawing water, finds Sargon and raises him as his own son. Later, Sargon rules in the city of Agade, or Akkad, the inhabitants of which are called Akkadians.

The stele of Naram-Sin is an impressive image of the king's power, for it proclaims the military, political, and religious authority of Naram-Sin. He is identified as a god by the horned cap of divinity and dominates the scene by his large size and central, elevated position. His straight back and fearless stance are manifestations of virility and his potency as both man and ruler. Around his neck he wears a necklace with a protective bead. Also exerting a protective force are the stars shining prominently over Naram-Sin. Together with the landscape details, they reflect the Akkadian taste for depicting nature.

Two defeated enemies are before the ruler, one praying for mercy and the other trying to pull a spear from his neck. Naram-Sin

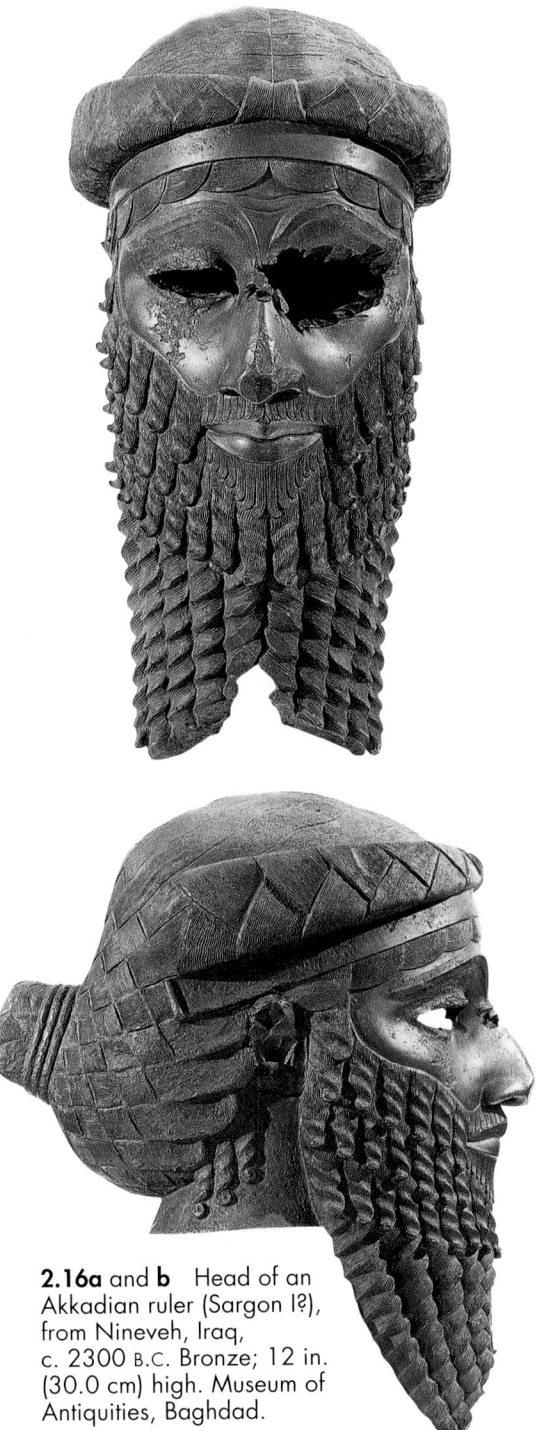

2.16a and **b** Head of an Akkadian ruler (Sargon I?), from Nineveh, Iraq, c. 2300 B.C. Bronze; 12 in. (30.0 cm) high. Museum of Antiquities, Baghdad.

Sargon I's grandson, Naram-Sin, recorded his victory over a mountain people, the Lullubians, in a commemorative **stele** (fig. **2.17**)—an upright stone marker. This form of record keeping used inscriptions and/or relief images to commemorate important events. When the *Epic of Gilgamesh* says that the hero "cut his works into a stone tablet" (see box, p. 59), the author was probably referring to a stele. Today when we speak of "making one's mark," we mean essentially the same thing as the Mesopotamians did when they made marks in stone "markers" that were intended to last.

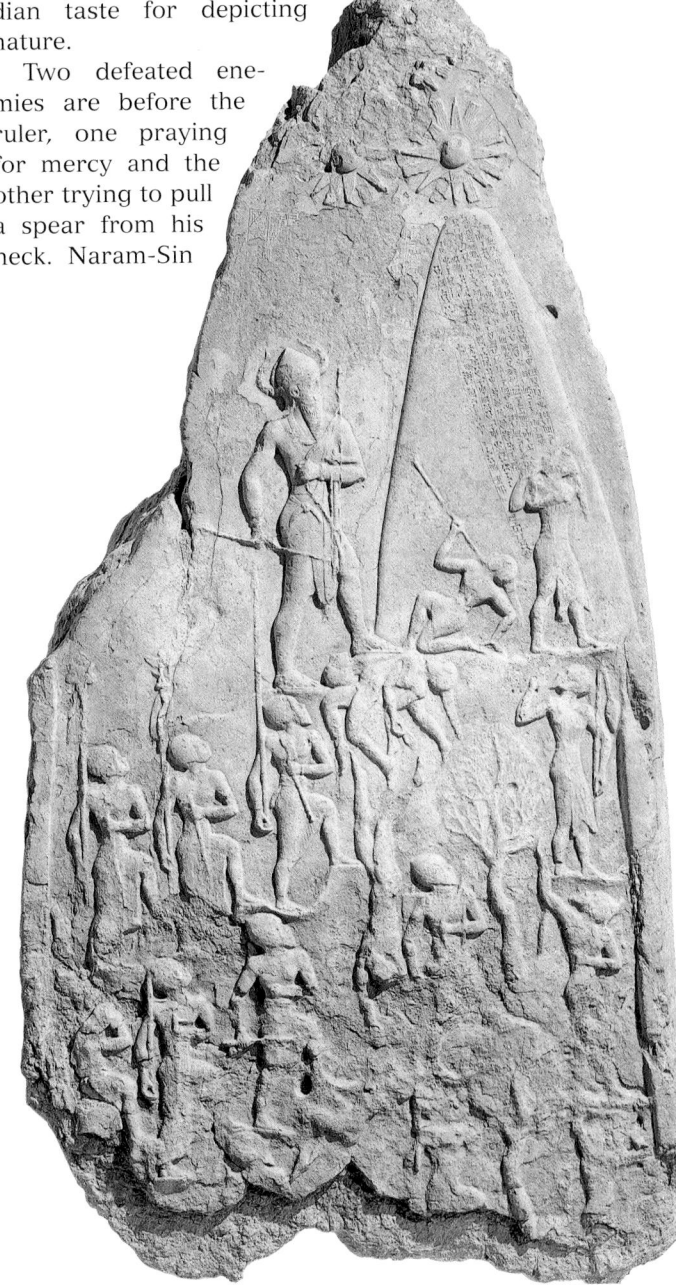

2.17 Victory stele of Naram-Sin, from Susa, c. 2254–2218 B.C. Pink sandstone; 6 ft. 6 in. (1.98 m) high. Louvre, Paris. This stele suffered an ironic twist of fate when it was taken as booty by invaders. What had been created to mark an Akkadian victory was looted to mark their defeat.

and his victorious followers march unhindered up the mountain while the defeated soldiers fall. This opposition exemplifies the convention in which going up denotes success and downward movement denotes failure or death. In a related convention, Naram-Sin steps on a defeated foe, indicating triumph. Furthermore, the nudity of Naram-Sin's victims indicates that they are dead. To the degree that Naram-Sin's own body is exposed, the artist was displaying an image of physical perfection that was a sign of his inherent "goodness," or "rightness," as a ruler. He is intentionally portrayed with his right side most visible to the viewer, in keeping with a Mesopotamian belief that a ruler's right side—including his right arm and right ear—had to be both intact and well formed for his state to prosper.

Neo-Sumerian Culture (c. 2100–1900/1800 B.C.)

After flourishing for about two hundred years, the Akkadian dynasty was defeated by the Guti—mountain people from the northeast who ruled Mesopotamia for roughly sixty years. Only the city-state of Lagash managed to hold out, and it prospered. When the Sumerians overthrew the Guti, there was a revival of Sumerian culture in the newly united southern city-states, a period referred to as Neo-Sumerian.

2.18 Head of Gudea, from Lagash, Iraq, c. 2100 B.C. Diorite; 9 in. (22.9 cm) high. Museum of Fine Arts, Boston. Francis Bartlett Donation of 1912.

Lagash

Gudea, the ruler of Lagash after the period of Guti dominance, initiated an extensive construction program that included several temples. His building activity was made possible by his ability to maintain peace in his own territory, despite continual political upheavals surrounding Lagash. Gudea embodied the transition between gods and humans. Just as the ziggurats linked earth with the heavens, so Mesopotamian rulers were viewed as the gods' chosen intermediaries on earth. Such ideas formed the basis for the continuing belief in the divine right of kings.

Gudea's image is familiar from a series of similar statues made of diorite, a hard black stone, which had to be imported. He either stands or sits, usually with hands folded in an attitude of prayer (figs. **2.18** and **2.19a** and **b**). Whether standing or seated, Gudea wears a robe over his left shoulder leaving his right shoulder bare; the bottom of the robe flares out slightly into a bell curve. He either is bald or wears a round cap (fig. 2.18), which is decorated with rows of small circles formed by incised spiral lines.

Gudea's affinity with the Sumerian gods is revealed in his account of a dream in which a god instructed him to restore a temple. In the dream, Gudea saw the radiant, joyful image of the god Ningirsu wearing a crown and flanked by lions. He was accompanied by a black storm bird, while a storm raged beneath him. Ningirsu told Gudea to build his house; but Gudea did not understand until a second god, Nindub, appeared with the plan of a temple on a lapis lazuli tablet.

The Gudea in figure 2.19a is compact; there is no space between the arms and the body, and the neck is short and thick. This contraction of space contributes to Gudea's monumentality, as does his controlled and dignified pose. The typical Mesopotamian combination of organic form with surface stylization can be seen in the juxtaposition of the incised eyebrows (fig. 2.18) with the more naturalistically modeled cheeks and chin.

The temple plan resting on Gudea's lap (fig. 2.19b) identifies his role as an architectural patron. His gesture of prayer establishes his relation with the gods and their divine patronage as revealed in his dream (see caption). In the ancient world, dreams were thought of as external phenomena, usually messages through which gods communicated with mortals, especially kings. As such, dreams,

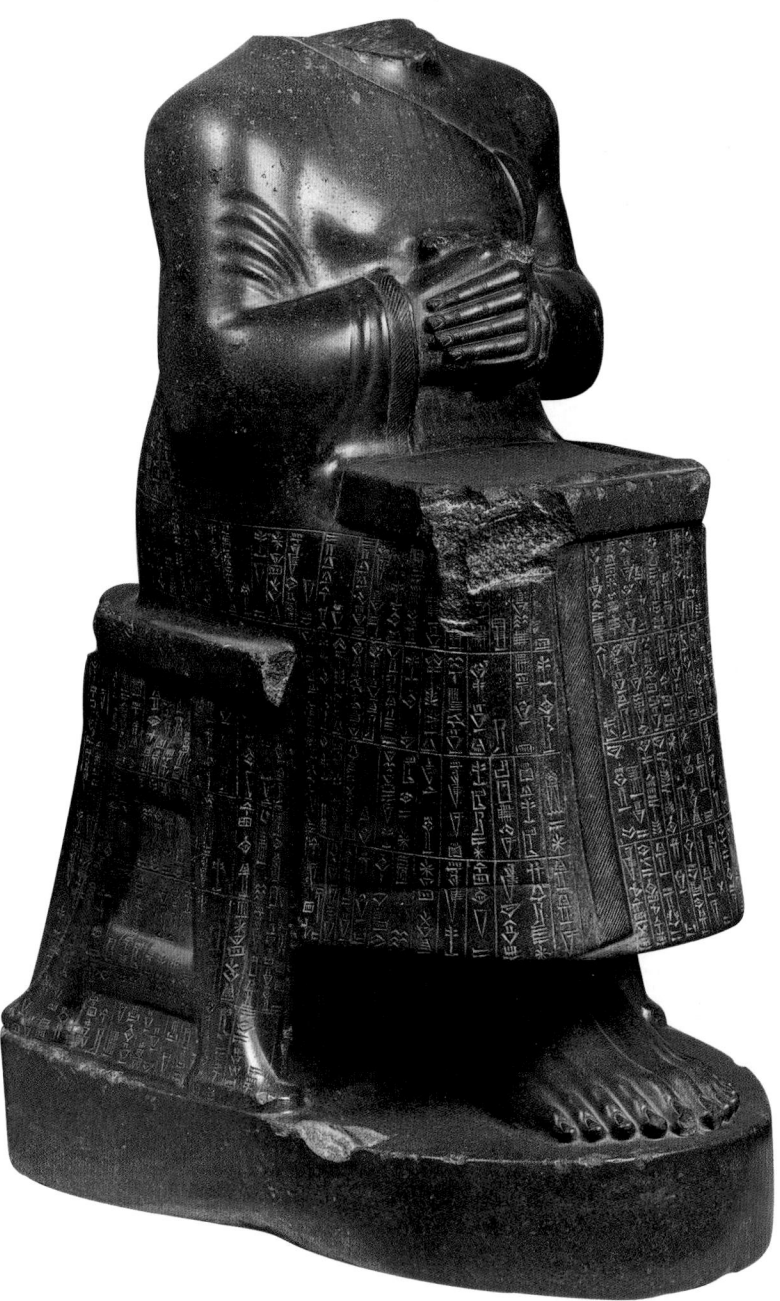

2.19a Gudea with a temple plan, from Lagash, Iraq, c. 2100 B.C. Diorite; 29 in. (73.7 cm) high. Louvre, Paris.

2.19b Detail of the temple plan on Gudea's lap.

like temples, could establish a link between people and their gods. And it was precisely in those terms that Gudea described his completed temple. He said that it rose up from the earth and reached toward heaven, that its radiance illuminated his country. The metaphor in which the temple is a source of light relates the structure to the radi-ant Ningirsu, who appears in the dream. The dream itself is a source of intellectual light, or enlightenment, originating with the gods and transmitted to their earthly representative in the person of Gudea. In all of these images, the temple, like dream and dreamer, functions as a symbolic bridge between heaven and earth.

The Ziggurat of Ur

The Neo-Sumerian period reached a peak under Ur-Nammu, the first king of its last important dynasty, the Third Dynasty of Ur. He supervised the construction of the great ziggurat at Ur (fig. **2.20**), which is more complex than the one in Uruk. Three stages were constructed around a mud-brick core and culminated in a shrine, accessible by a short stairway on the northeast side. The mud brick was faced with baked brick embedded in mortar made of bitumen (a type of asphalt). Leading to a vertical gate, which provided the only point of entry to the upper levels, were three long stairways, each composed of one hundred steps. The ziggurat walls curve gradually outward while sloping toward the center of the structure, which functioned aesthetically to reduce the rigidity of straight walls. The ancient Near Eastern preference for rounded sculptural shapes thus carried over into architectural design.

A cuneiform tablet records Ur-Nammu's contribution to the building process. It states that the god Marduk ordered him to build the ziggurat with a secure foundation and stages that reach to the heavens: "I caused baked bricks to be made," the ruler declared; ". . . I caused streams of bitumen to be brought by the Canal Arahtu. . . . I took a reed and myself measured the dimensions. . . . For my Lord Marduk I bowed my neck, I took off my robe, the sign of my royal blood, and on my head I bore bricks and earth."[3] The area around Ur-Nammu's ziggurat was eventually expanded into a sacred architectural complex containing several temples, workshops, factories, and a commercial center with law courts.

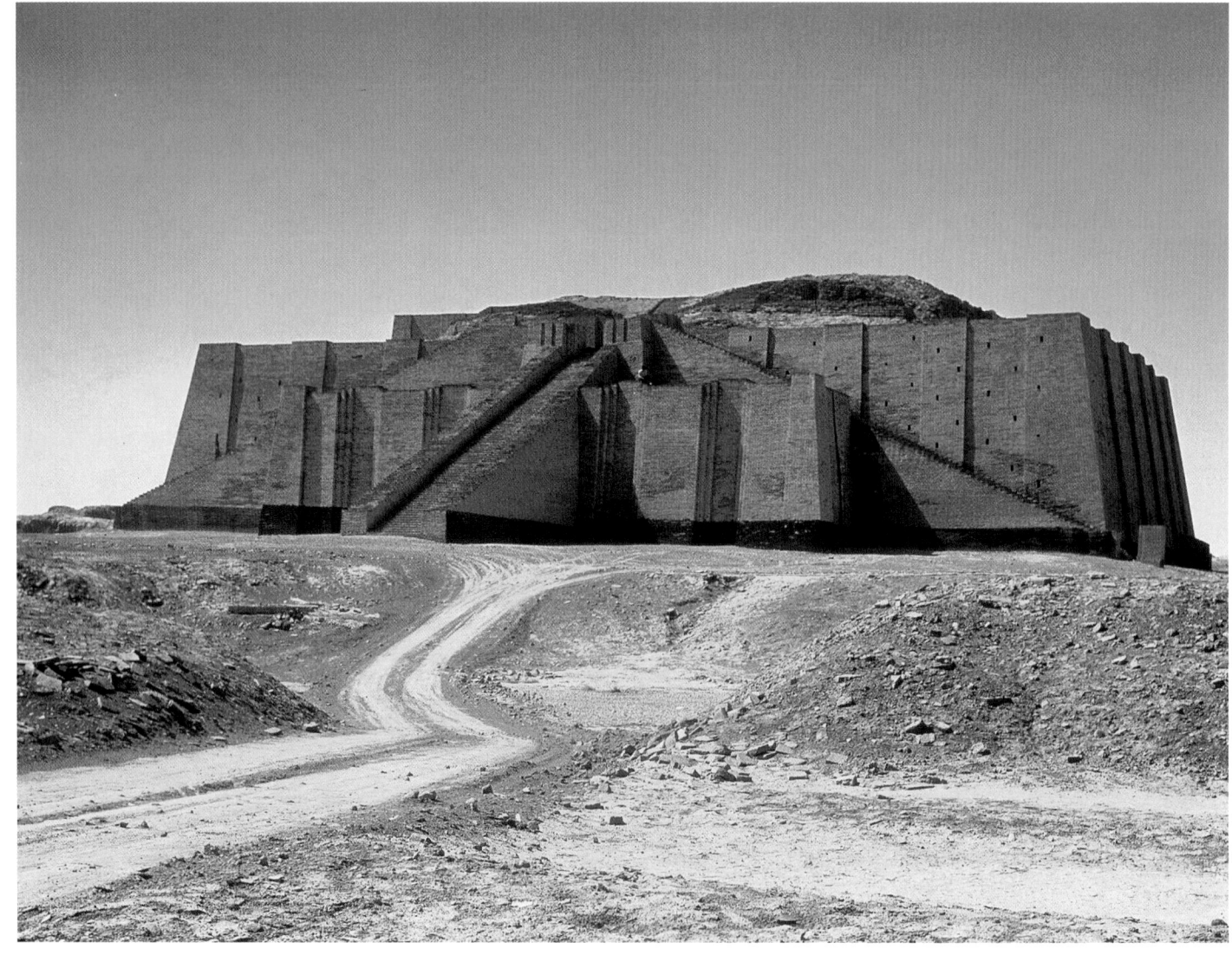

2.20 Nanna ziggurat, Ur, c. 2100–2050 B.C.

Babylon (c. 1900–539 B.C.)

When the last Neo-Sumerian king was overthrown by foreign invaders, Mesopotamia reverted to rule by independent city-states. Over the next few centuries, continuing warfare, as well as invasions from all directions, led to the frequent rise and fall of different cultural groups. Mesopotamia was next united under the Amorites, a Semitic-speaking people from Arabia, who established their capital at Babylon and ushered in the Old Babylonian period (c. 1800–1600 B.C.).

The most famous king of the Amorite dynasty was Hammurabi (flourished c. 1792–1750 B.C.). Hammurabi is best known for his law code (see box), which he inscribed on a black basalt stele (fig. **2.21a** and **b**). The text was based on local Sumerian legal traditions and remains an important historical document, articulating the relationship

The Law Code of Hammurabi

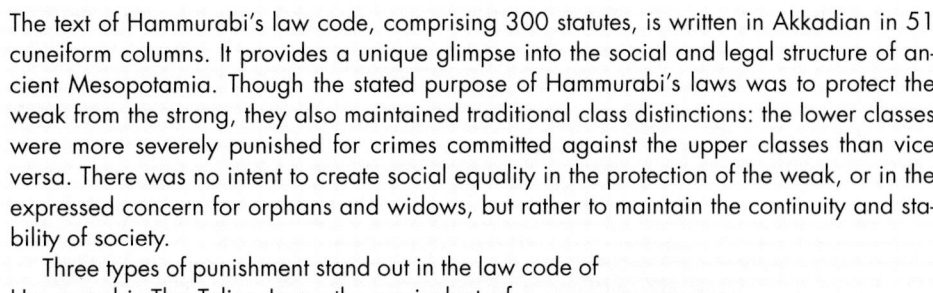

The text of Hammurabi's law code, comprising 300 statutes, is written in Akkadian in 51 cuneiform columns. It provides a unique glimpse into the social and legal structure of ancient Mesopotamia. Though the stated purpose of Hammurabi's laws was to protect the weak from the strong, they also maintained traditional class distinctions: the lower classes were more severely punished for crimes committed against the upper classes than vice versa. There was no intent to create social equality in the protection of the weak, or in the expressed concern for orphans and widows, but rather to maintain the continuity and stability of society.

Three types of punishment stand out in the law code of Hammurabi. The Talion Law—the equivalent of the biblical "eye for an eye"—operated in the provision calling for the death of a builder whose house collapsed and killed the owner. In some cases, the punishment fit the crime; for example, if a surgical patient died, the doctor's hand was cut off. Perhaps the most illogical punishment was the ordeal in which the guilt or innocence of an accused adulteress depended on whether she sank or floated when thrown into water.

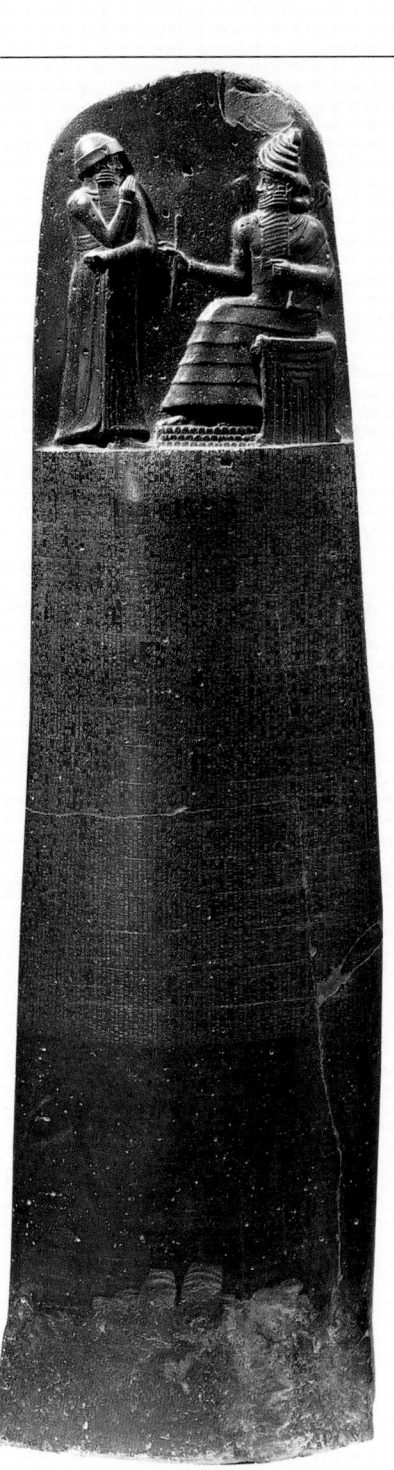

2.21b (right) Stele (detail of fig. 2.21a).

2.21a (left) Stele inscribed with the law code of Hammurabi, Susa, capital of Elam (now in Iran); c. 1792–1750 B.C. Basalt; height of stele approx. 7 ft. (2.13 m), height of relief 28 in. (71.10 cm). Louvre, Paris. Hammurabi stands before the Akkadian sun god, Shamash, who is enthroned on a symbolic mountain. Shamash wears the horned cap of divinity and an ankle-length robe. He holds the ring and rod of divine power and justice, and rays emanate from his shoulders. Here the conventional pose of the god in relief sculpture serves a double purpose: the torso's frontality communicates with the observer, while the profile head and legs turn toward Hammurabi. Hammurabi receives Shamash's blessing on the law code, which is inscribed on the remainder of the stele. The god's power over Hammurabi is evident in his greater size; were Shamash to stand, he would tower over the mortal ruler.

of law to society. Its cultural importance is reflected in its value as booty: Hammurabi's stele, like Naram-Sin's, was carried off to Susa (a rival city-state east of the Tigris River) by invading Elamite armies.

Babylon was sacked by Hittites from Anatolia (see below) c. 1600 B.C., ending the Old Babylonian period. For the next half millennium, Mesopotamia was under the control of a weak foreign dynasty, the Kassites, one of many groups penetrating the region from western Iran. This was a time of great political and cultural turmoil. Despite the disruption in patterns of trade, however, influences from farther west—what are now Syria, Egypt (see Chapter 3), and the Aegean world (see Chapter 4)—did reach Mesopotamia through immigrants from these lands. Meanwhile, Babylon remained a renowned cultural center.

Anatolia: The Hittites (c. 1450–1200 B.C.)

The Hittites were Indo-Europeans who settled in Anatolia around 2000/1900 B.C. Their capital city, Hattusas, was located in modern Boghazköy, in central Turkey. Like the Mesopotamians, they kept records in cuneiform on clay tablets, which were stored on shelves, systematically catalogued and labeled as in a modern library. These archives, comprising thousands of tablets, are the first known records in an Indo-European language. Because their written records have survived, the cultural and artistic achievements of the Hittites are well documented.

The Hittites cremated their dead and buried the ashes and bones in urns, so that they left little large-scale tomb art. There is, however, much evidence of monumental palaces, temples, cities, and massive fortified walls decorated with reliefs. The predominance of fortifications and the location of palaces and **citadels** (elevated, fortified cities) reflect the need for protection from invading armies as well as the military power of the Hittites themselves.

The western entrance to the citadel at Hattusas (fig. **2.22**) is a good example of the monumental fortified **Cyclopaean** (see Chapter 4) walls constructed by the Hittites. The guardian lions are a traditional motif in ancient art because of the belief that lions never sleep. Here they project forward from the stone wall as if emerging from natural into man-made form. Their heads and chests are in high relief, while some details, such as the mane, fur, and eyes, are incised. At 7 feet (2.13 m) tall, they would have towered over anyone approaching the gate.

The most distinctive Hittite sculptures are, like the guardian lions, in relief, usually carved on the lower levels of city walls. Figure 2.23 is an over-life-sized representation of a powerful Hittite war god. He is armed and helmeted, and wears a short tunic. Conforming to ancient Near Eastern convention, his head and legs are depicted in profile with his torso in front view. And, as in the art of Mesopotamia, the sculptor has achieved a remarkable synthesis of stylization (the eye and kneecaps) with organic form. As in the stele of Naram-Sin, this relief projects an image of divine authority, and, like the guardian lions, the war god symbolically protects the city.

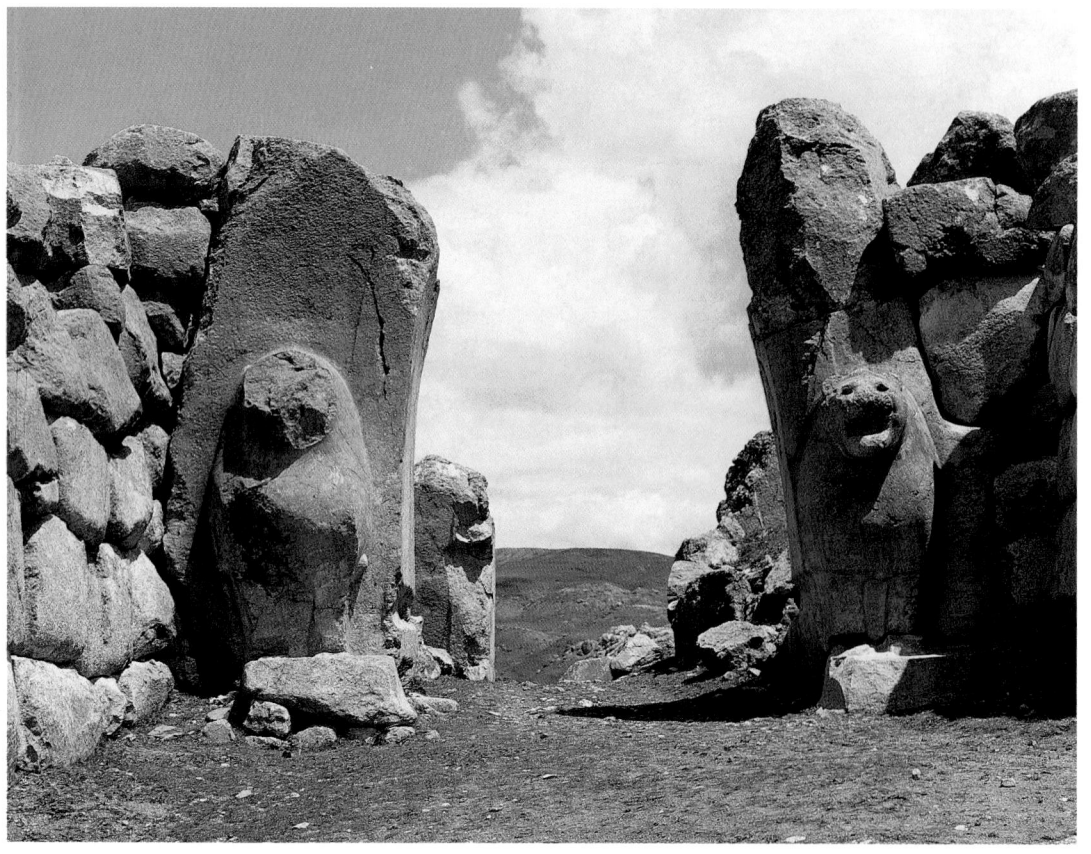

2.22 Lion Gate (Royal Gate), Hattusas, Boghazköy, Turkey, c. 1400 B.C. Stone; lions approx. 7 ft. (2.13 m) high. The lions face the visitor approaching the citadel. The direct confrontation, combined with the open, roaring mouths, served as a warning and symbolically protected the inhabitants.

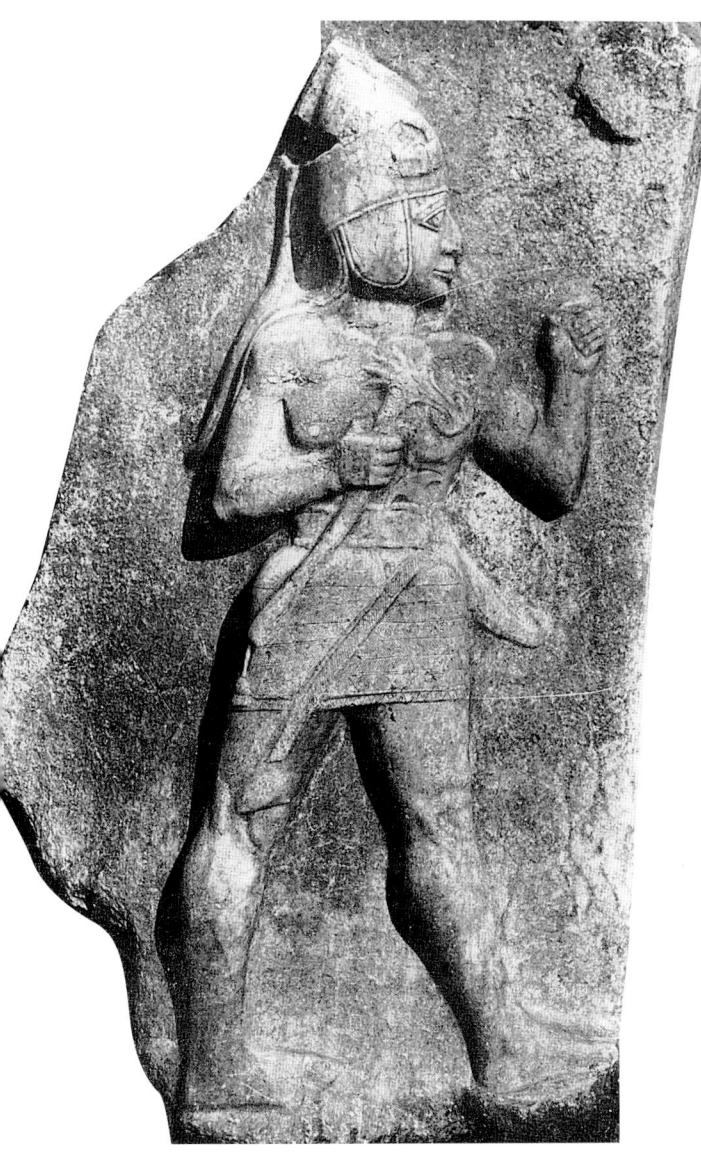

2.23 Hittite war god, from the King's Gate, Hattusas, Boghazköy, Turkey, c. 1400 B.C. 6 ft. 6¾ in. (2.00 m) high.

The Assyrian state is particularly well documented through both its texts and the remains of architectural and sculptural projects undertaken to reflect the might and glory of its kings (see box). The region in and around Assyria had a great deal more stone available than the rest of Mesopotamia. As a result, the Assyrians' determination to memorialize their accomplishments in stone could be satisfied without importing materials.

Assyrian military strength grew rapidly under Assurnasirpal II. The only known sculpture in the round representing him (fig. **2.24**) depicts an imposing figure in a rigid frontal pose. He wears an ankle-length robe, his arms are close to his body, and his stylized hair and beard fill the space around his neck. He holds the scepter of kingship in his right hand and a mace in his left. Inscribed across his chest are his name, titles, and conquests. In contrast to Gudea, whose inscriptions record his architectural achievements, Assurnasirpal II's statue proclaims his god-given power.

The king's might is also the theme of alabaster reliefs that lined the walls of his palace in present-day Nimrud

Assyria (c. 1300–612 B.C.)

A northern Assyrian city-state emerged as the next unifying force in Mesopotamia. Located along the Tigris in modern Syria, its capital city was named for Assur, the chief Assyrian deity, equivalent in authority to the Babylonian Marduk (whom he closely resembled) and the Sumerian Enlil. Excavations carried out in Assur in the early twentieth century uncovered a culture extending back to 3000 B.C. At the end of Hammurabi's reign in c. 1750 B.C., Assur had become a prominent fortified city. By 1300 B.C. Assur's rulers were in communication with the leaders of Egypt, indicating that they had achieved international status. Assyria borrowed much from Babylon, which remained culturally prominent during its political decline, as well as from foreign cultures to the west.

Assyrian Kings

Under Assurnasirpal II (reigned 883–859 B.C.), Assyria became a formidable military force. His records are filled with boastful claims detailing his cruelty. He says that he dyed the mountains red, like wool cloth, with the blood of his slaughtered enemies. From the heads of his decapitated enemies he erected a pillar, and he covered the city walls with their skins.

The first imperial king, Tiglath-Pileser I (reigned c. 1114–1076 B.C.), recorded his intent to conquer the world and claimed that the god Assur had commanded him to do so.

The last powerful king of Assyria, Assurbanipal II (reigned 668–633 B.C.), combined cruelty with culture. He established a great library, consisting of thousands of tablets recording the scientific, historical, literary, religious, and commercial achievements of his time. Also included in his collection were the Mesopotamian creation and flood epics, which were deciphered in the late nineteenth century. Today, most of Assurbanipal's library is in the British Museum in London.

2.24 King Assurnasirpal II, from Nimrud, Iraq, c. 883–859 B.C. British Museum, London.

and Khorsabad. Figure **2.25** shows Assurnasirpal II standing at the back of a horse-drawn chariot, his bow and arrow aimed at a rearing lion. The king's dominance over lions, a favorite subject in Assyrian art, is a metaphor for the subjugation of his enemies. The dynamic energy of the scene is reinforced by opposing diagonal planes and the accentuation of muscular tension. Overlapping of the horses creates an illusion of three-dimensional space.

The battle relief in figure **2.26** represents a city at war, with Assyrian invaders shooting arrows and attacking the defenders' walls with a battering ram. At the center of the relief, two wounded enemy soldiers have toppled from the ramparts and plunge to their deaths. Here, too, opposing diagonals convey energetic movement. The upper figures are cut off by the **crenellated** fortifications, and the bowmen at the right overlap each other, enhancing pictorial depth. The wealth of such details in the Assyrian reliefs, and in Assyrian art generally, makes them particularly valuable as cultural records.

An unusually empathic relief from the reign of Assurbanipal II represents a lioness who has been mortally wounded in the king's lion hunt (fig. **2.27**). The powerful musculature of the animal's forelegs and shoulders is sharply—and tragically—contrasted with the limp hindquarters. Pierced through by three arrows and bleeding heavily from her wounds, the lioness drags her lifeless rear legs and roars in pain.

Over the course of the empire's history, the Assyrian capital shifted several times. The palace that king Sargon II (reigned 721–705 B.C.) built at Dur Sharrukin (present-day Khorsabad, in the far north) is the most fully excavated large-scale example, revealing the complexity of Assyrian royal architecture.

Figure **2.28** (p. 72) is the plan of the palace, a mud-brick structure on a **plinth** (platform), whose rectangular rooms lay at right angles to each other. Number 5 on the plan (the concentric squares at the left) denotes Sargon's ziggurat. This was built in several levels, which were formed from a ramp in the shape of a squared-off spiral that decreased in size

as it approached the top. This meant that priests and other high-status worshipers moved continuously around the structure as they ascended it.

Access to the palace required entering the huge gate of the citadel and traversing the open square. A ramp was provided so that chariots could be driven across the square to the palace gate. The approach to the throne room itself was through a carefully controlled program of architectural and sculptural propaganda, designed to intimidate visitors. They would have entered the palace complex through one of the entrances at the lower end of a courtyard (4 on the plan). From the courtyard, they would proceed to the ambassadors' courtyard (3), whose monumental reliefs, like those carved during the reign of Assurnasirpal II, reminded viewers of the king's military achievements on the one hand and his relationship with the gods on the other. In order to reach the throne room (2), visitors had to pass through an entrance guarded by monumental limestone figures called **Lamassu** (fig. **2.29**, p. 79).

Twice as tall as the Hittite lions guarding the gateway at Hattusas (see fig. **2.22**), the Lamassu were divine genii combining animal and human features—in this case, the body and legs of a bull with a human head. The hair, beard, and eyebrows are stylized. The figure wears the cylindrical, three-horned crown of divinity. As is typical of ancient Near Eastern art, the Lamassu combines naturalism—the suggestion of bone and muscle under the skin—with surface stylization—the areas of patterned texture across the body. Rising from above the forelegs in a sweeping curve are wings that fill the limestone blocks from which the Lamassu is carved.

The wings draw the eye of the viewer to the side of the Lamassu, a transition reinforced by the "re-use" of the forelegs in the side view, which essentially creates a "fifth leg." This striking visual device enhances the architectural function of an entrance, which is to mark a point of access: the Lamassu appears to confront approaching visitors and simultaneously to stride past them. By narrowing the space through which visitors must pass, the Lamassu builds up tension as one approaches the king. Sargon's palace was thus an elaborate structural and pictorial

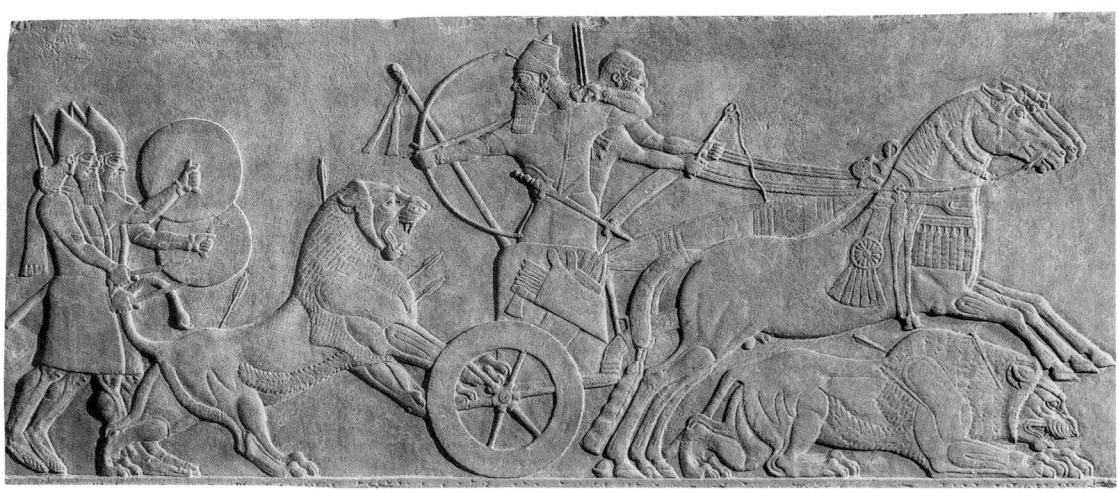

2.25 King Assurnasirpal II hunting lions, from Nimrud, Iraq, c. 883–859 B.C. Alabaster relief; 3 ft. 3 in. × 8 ft. 4 in. (99.0 cm × 2.54 m). British Museum, London.

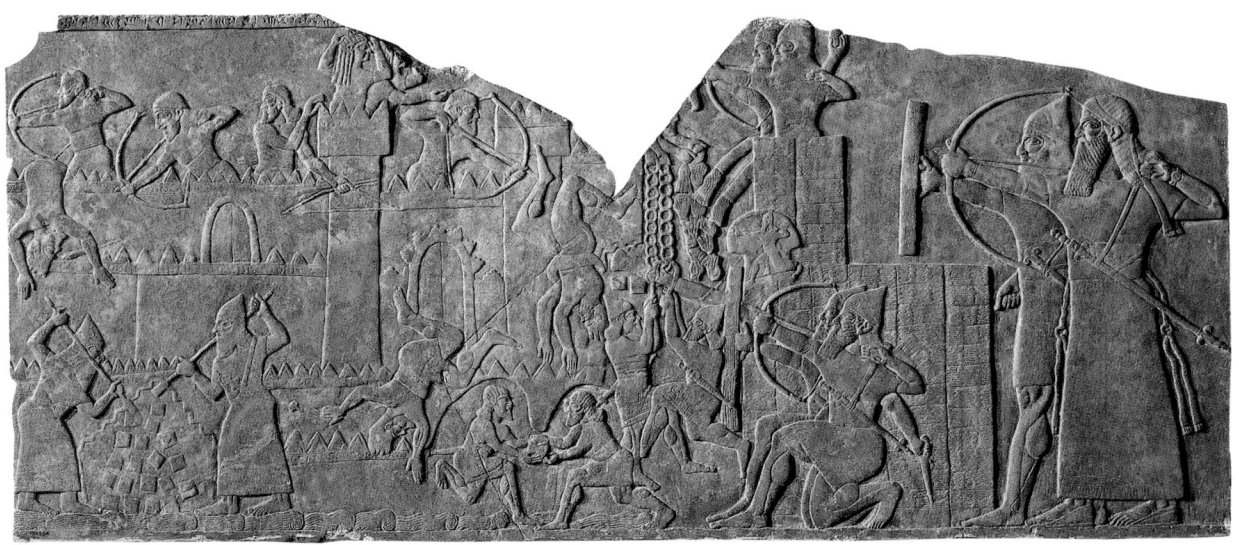

2.26 City attacked with a battering ram, palace of King Assurnasirpal II, Nimrud, Iraq, c. 883–859 B.C. Relief; approx. 39 in. (99.0 cm) high. British Museum, London.

2.27 *Dying Lioness* (detail of the *Great Lion Hunt*), from the palace of King Assurbanipal II, Nineveh, c. 668–627 B.C. Alabaster relief; height 13¾ in. (33.7 cm). British Museum, London.

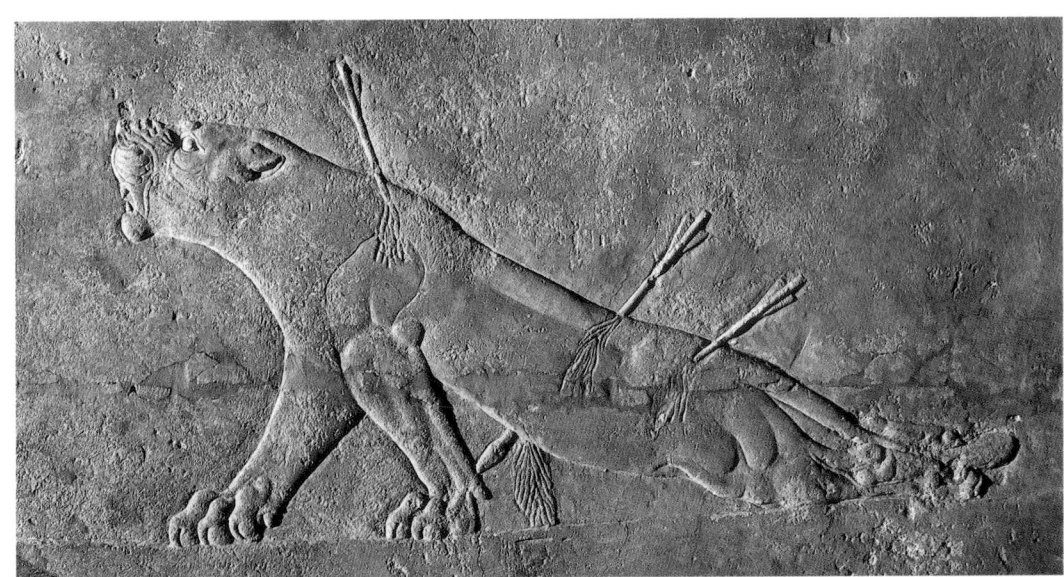

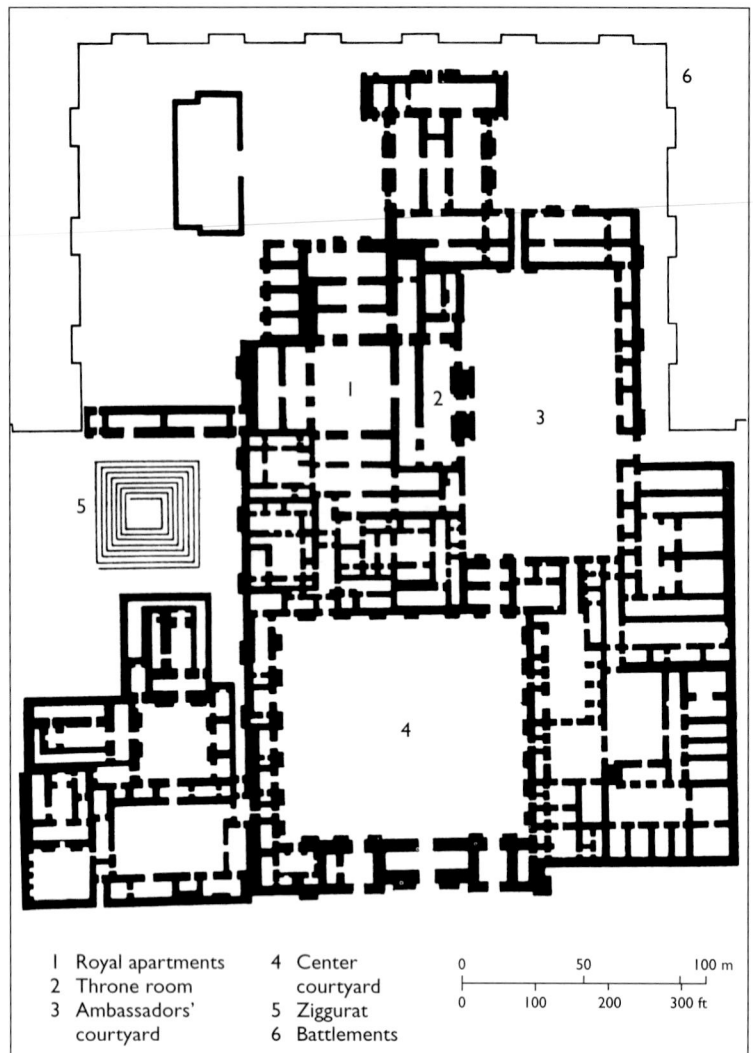

I	Royal apartments	4	Center
2	Throne room		courtyard
3	Ambassadors'	5	Ziggurat
	courtyard	6	Battlements

2.28 Plan of Sargon II's palace. Sargon's pride in his palace and his wish to be remembered for it are revealed in his so-called Great Inscription: "Palace of Sargon, the great king, the powerful king, king of legions, king of Assyria, viceroy of the gods at Babylon, king of the Sumers and of the Akkads, favorite of the great gods. The gods Assur, Nebo [god of knowledge, literature, and agriculture], and Marduk have conferred on me the royalty of the nations, and they have propagated the memory of my fortunate name to the ends of the earth."[4] The throne room (2) was decorated with murals, and the walls of the ambassadors' courtyard (3) were highlighted with reliefs. The ziggurat (5) differed from others in Mesopotamia in having elaborate surface movement created by recesses in the walls and crenellations at the top.

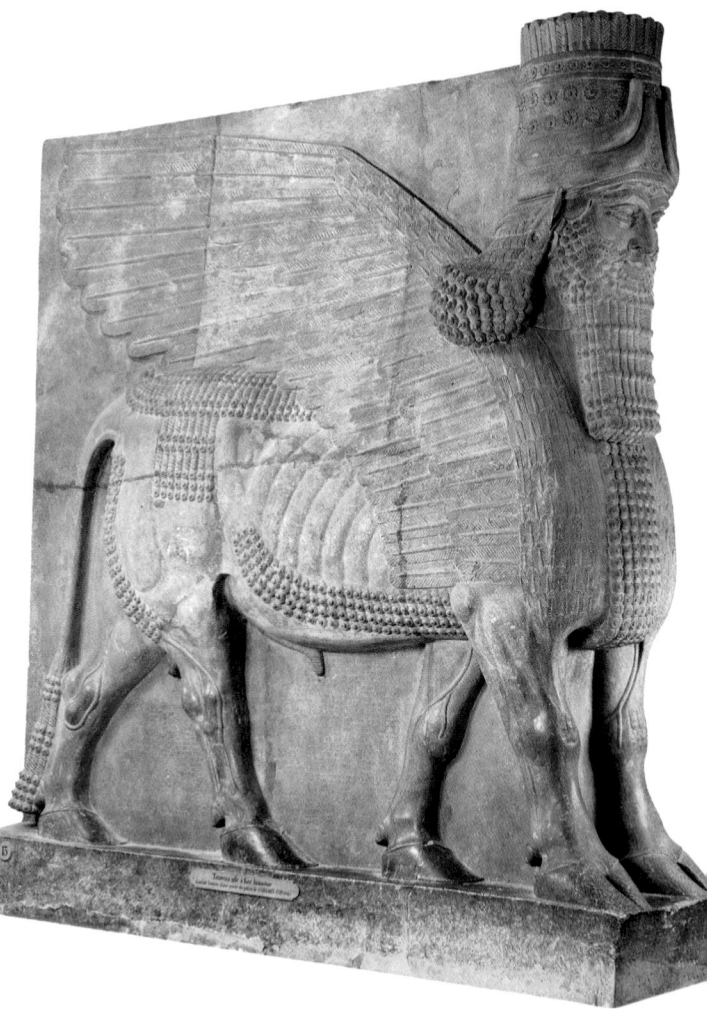

2.29 Lamassu, from the gateway, Sargon II's palace at Dur Sharrukin (now Khorsabad, Iraq), c. 720 B.C. Limestone; 14 ft. (4.26 m) high. Louvre, Paris. The ancient visitor to the palace would experience the Lamassu first as standing and then as walking. The Lamassu stands as the observer faces him and walks as he passes by, all the while seeming to keep an eye out for the king's protection.

expression of the notion that power resides in an interior space, access to which becomes a rite of passage. Once visitors entered the throne room, they were confronted with brightly painted walls and a throne backed up against a wall. Inscribed on the base of the throne were warnings against rebellion and revolution.

With the rise of Assyrian palace architecture, the importance of the ziggurat declined. Originally, Mesopotamian palaces had been adjuncts to the ziggurat and places from which a ruler administered a city-state. Under the militaristic Assyrians, the relationship between religious and administrative centers changed. The power of the Assyrian king was now reflected in immense fortifications and reliefs showing his victories and his cruelty, and the ziggurat became an accessory to the palace.

Throughout its history the Assyrian empire faced constant pressure from within and without, and its militaristic art reflects the chronic warfare necessary to maintain control of its territory. Within a century after Sargon II's reign, the Assyrian Empire collapsed. Its capital at Nineveh fell in 612 B.C. to an alliance of Medes (from what is today Iran) and Scythians (originally from modern Russia and the Ukraine). Babylonian clay tablets record the events surrounding the end of Assyrian power and the rise of a Neo-Babylonian Empire.

The Neo-Babylonian Empire (612–539 B.C.)

Babylon had been ruled by Assyria for about two and a half centuries when the new southern dynasty reversed the balance of power. The greatest of the Neo-Babylonian kings, Nebuchadnezzar (reigned 604–562 B.C.), restored some of Babylon's former splendor.

Among the many architectural monuments that Nebuchadnezzar commissioned for his capital city was a ziggurat dedicated to the god Marduk, which is thought to have been the Tower of Babel referred to in the Bible (see p. 8). Another was the Ishtar Gate (fig. **2.30**), one of eight gateways with round **arches** (see box) that spanned a

Round Arches

An arch may be thought of as a curved lintel connecting two vertical supports, or posts. The round arch, as used in the Ishtar Gate, is semicircular and stronger than a horizontal lintel. This is because a round arch carries the thrust of the weight onto the two vertical supports rather than having all the stress rest on the horizontal. The Greeks, Etruscans, and Romans developed rounded arches for many other purposes besides gateways (see Chapters 5, 6, and 7). Later still, in medieval Europe, round arches were revived in Romanesque churches and cathedrals (see Chapter 10).

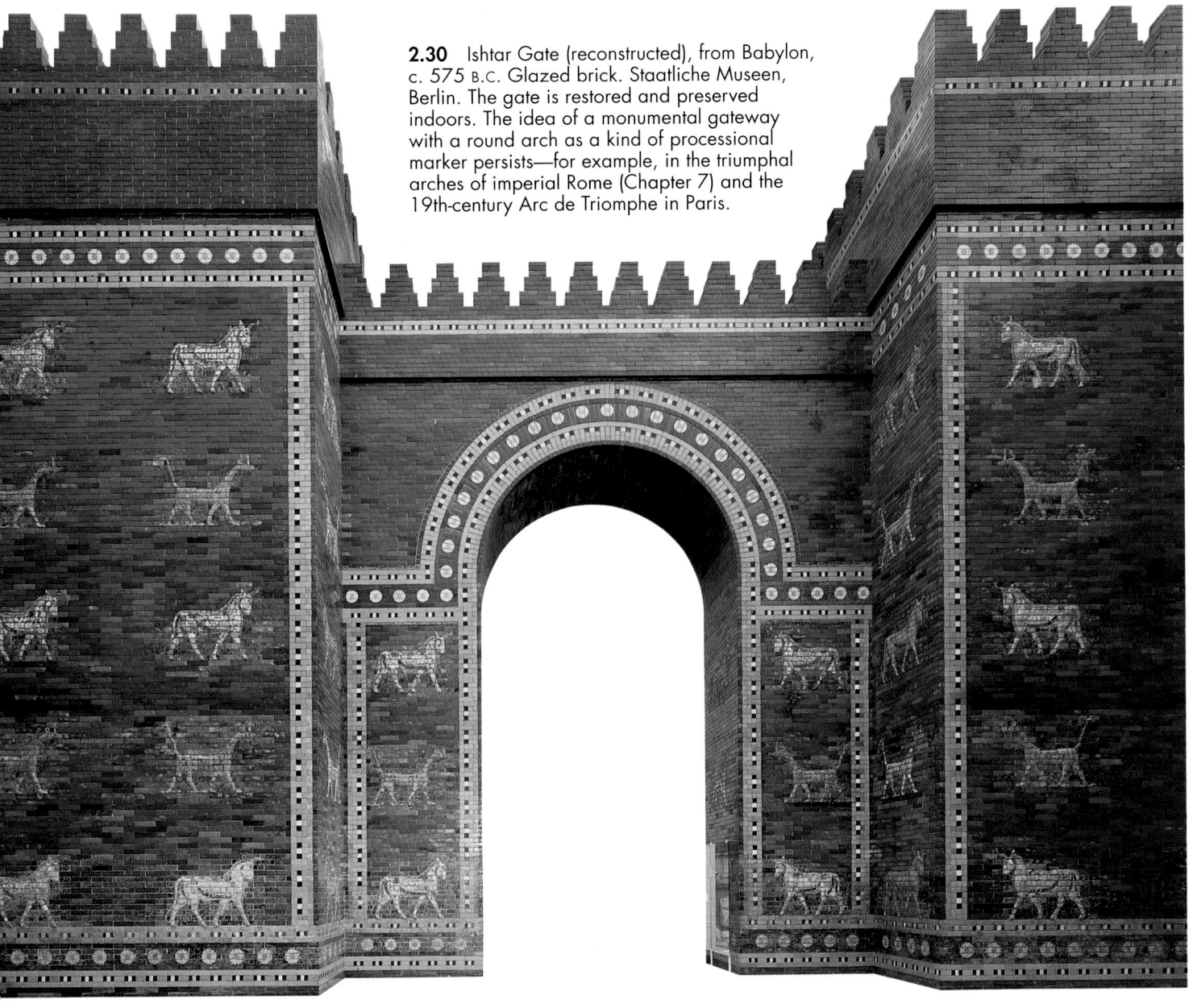

2.30 Ishtar Gate (reconstructed), from Babylon, c. 575 B.C. Glazed brick. Staatliche Museen, Berlin. The gate is restored and preserved indoors. The idea of a monumental gateway with a round arch as a kind of processional marker persists—for example, in the triumphal arches of imperial Rome (Chapter 7) and the 19th-century Arc de Triomphe in Paris.

processional route through the city. The gate was named in honor of the Akkadian goddess of love, fertility, and war. It was **faced** (covered on the surface) with **glazed** bricks (see box). Set off against a deep blue background are rows of bulls and dragons (sacred to Marduk) in relief. They proceed in horizontal planes either toward or away from the arched opening. Geometric designs in white and gold frame the animal imagery and outline the gate's architectural forms.

In 539 B.C. Babylon came under the rule of yet another conqueror, Cyrus the Great of Persia (modern Iran), and became part of the Achaemenid Empire.

Iran (c. 5000–331 B.C.)

To the east of Mesopotamia lay ancient Iran, whose name derives from the Indo-European Aryans, and by the fifth millennium B.C. a distinctive pottery style had emerged. A large painted pottery beaker from Susa, the capital of Elam in the southwest, exemplifies the artistic sophistication of the early Iranians (fig. **2.31**). It combines elegant form with a preference for animal subjects, which are characteristic of Iranian art. The central image is a stylized goat, whose body is composed of two curved triangles; its head and tail are smaller triangles, with individual hairs on the beard and tail rendered as nearly parallel lines. The two large curved horns are particularly striking. They occupy two-thirds of the framed space and encircle a stylized plant form.

The goat stands still and upright in contrast to the dogs, whose outstretched forelegs suggest that they are racing around the upper part of the beaker. A sense of slower movement is created by the repeated long-necked birds, who seem to be parading along the top row in the opposite direction. By using the largest visible surface of the beaker for

the standing goats (there is a second one on the other side) and the top two registers for the repeated animals, the artist creates a unity between the painted images and the three-dimensional form of the object.

An unusual sculpture dating from 3100–2999 B.C. merges the form of a bull with a human pose (fig. 2.32; see box). The figure wears a patterned skirt and kneels as if before a deity. Extended forward between the hooves is a spouted vessel that may have been an offering. Small limestone pebbles inside the figure suggest that it was used as a rattle or cult instrument. Its shiny surface and compact tension contribute to its curious combination of elegance and monumentality. Because this figure is unique in ancient art, and because its original context is unknown, its significance has so far eluded researchers.

The Scythians (8th–4th centuries B.C.)

The influence of early Iranian art persists in the much later animal art of the Scythians, a migratory people originally from southern Russia. Because they were nomadic, the Scythians' art was portable. It is characterized by vivid forms and a high degree of technical skill. A stag from the seventh century B.C. (fig. **2.33**) is typical of Scythian gold objects.

This one was used to decorate a shield. Its pose matches the description by the fifth-century-B.C. Greek historian Herodotos of animals that were typically sacrificed by the Scythians. The artist has captured a naturalistic likeness of the animal, while at the same time forming its antlers into an abstract series of curves and turning its legs into birds. Such visual metaphors, in which the forms of one animal are transformed into those of another, are characteristic of Scythian animal art. They also enhance the illusion of motion; although it is clear from the folded, bird-shaped legs that the stag is static, there is a sense of movement in the curvilinear patterning.

2.31 Beaker, from Susa, capital of Elam (now in Iran), c. 5000–4000 B.C. Painted pottery; 11¼ in. (28.6 cm) high. Louvre, Paris. The images painted on the beaker are consistent with the fact that the viewer is more aware of its circularity at the rim and base than on the broader surface in between.

Destroying the Archaeological Record

Objects such as the kneeling bull in figure **2.32** create significant problems for archaeologists and raise questions about the plunder of archaeological sites. This particular work, like many others from ancient civilizations around the world, is certainly authentic (i.e., not a modern forgery), but it has no **provenience.** That is, it appeared on the art market without any record of its place of origin. Presumably because it was one of thousands of objects plundered for profit, the circumstances of its removal from the ground are unknown. It can be identified as Proto-Elamite on the basis of stylistic and iconographic analysis, through comparison with related works excavated in known circumstances, but it cannot be assigned a specific context. We do not know, for example, what city it is from or whether it might have been found in a house, a palace, or a temple; its purpose is also unknown. Once the archaeological record of such an object is destroyed, a piece of history is lost forever. As a work of art, from a purely aesthetic point of view, the figure is immensely satisfying. As a visual document and expression of a time and place, it remains a mystery.

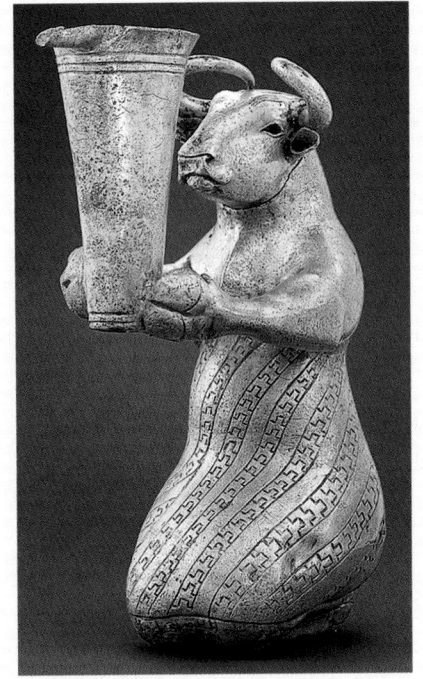

2.32 Kneeling bull, southwest Iran, Proto-Elamite, 3100–2999 B.C. Silver; height 6⁷⁄₁₆ in. (16.3 cm), width 2½ in. (6.3 cm). Metropolitan Museum of Art, New York. Purchase, Joseph Pulitzer Bequest, 1966.

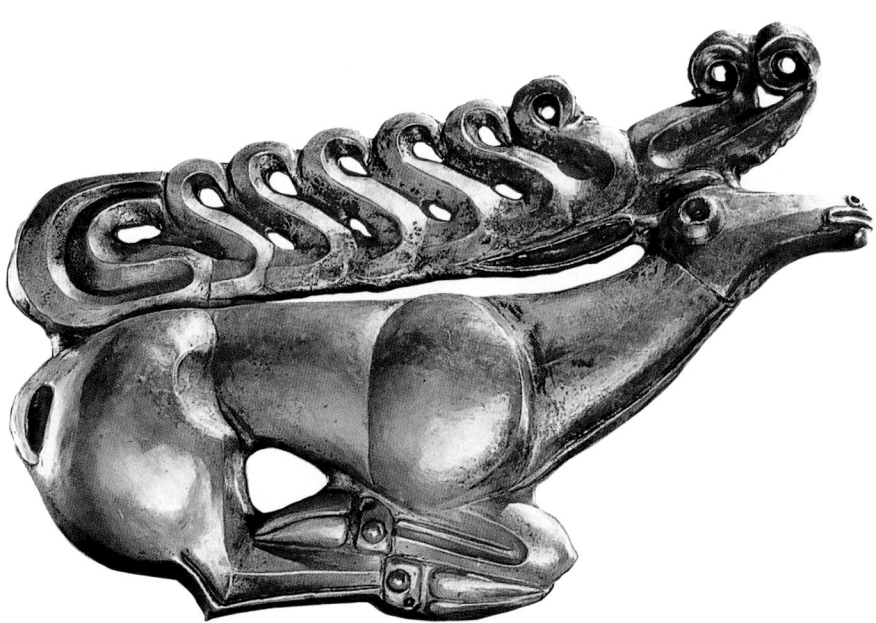

2.33 Stag, from Kostromskaya, Russia, 7th century B.C. Chased gold; 12½ in. (31.7 cm) long. State Hermitage Museum, St. Petersburg. As with the Paleolithic cave paintings and carvings of western Europe (see Chapter 1), this Scythian work is the product of artists familiar with the animals around them.

Recent Discoveries: The Filippovka Cemetery

In 1986, excavations began in the nomadic cemetery at Filippovka, located in the Eurasian steppes north of the Caspian Sea. The twenty-five burials discovered there yielded remarkable gold objects, despite having been plundered. Most impressive are the twenty-six stags dating to the fourth century B.C., of which figure **2.34** is an example. It is made of wood covered in hammered gold, which is attached with bronze nails. The base is silver over wood. Stylizations are evident in the body markings, and the elaborate, curvilinear antlers are reminiscent of the earlier Scythian shield emblem (see fig. 2.33). But scholars are debating both the dates of the burials and the identity of the culture that produced them.

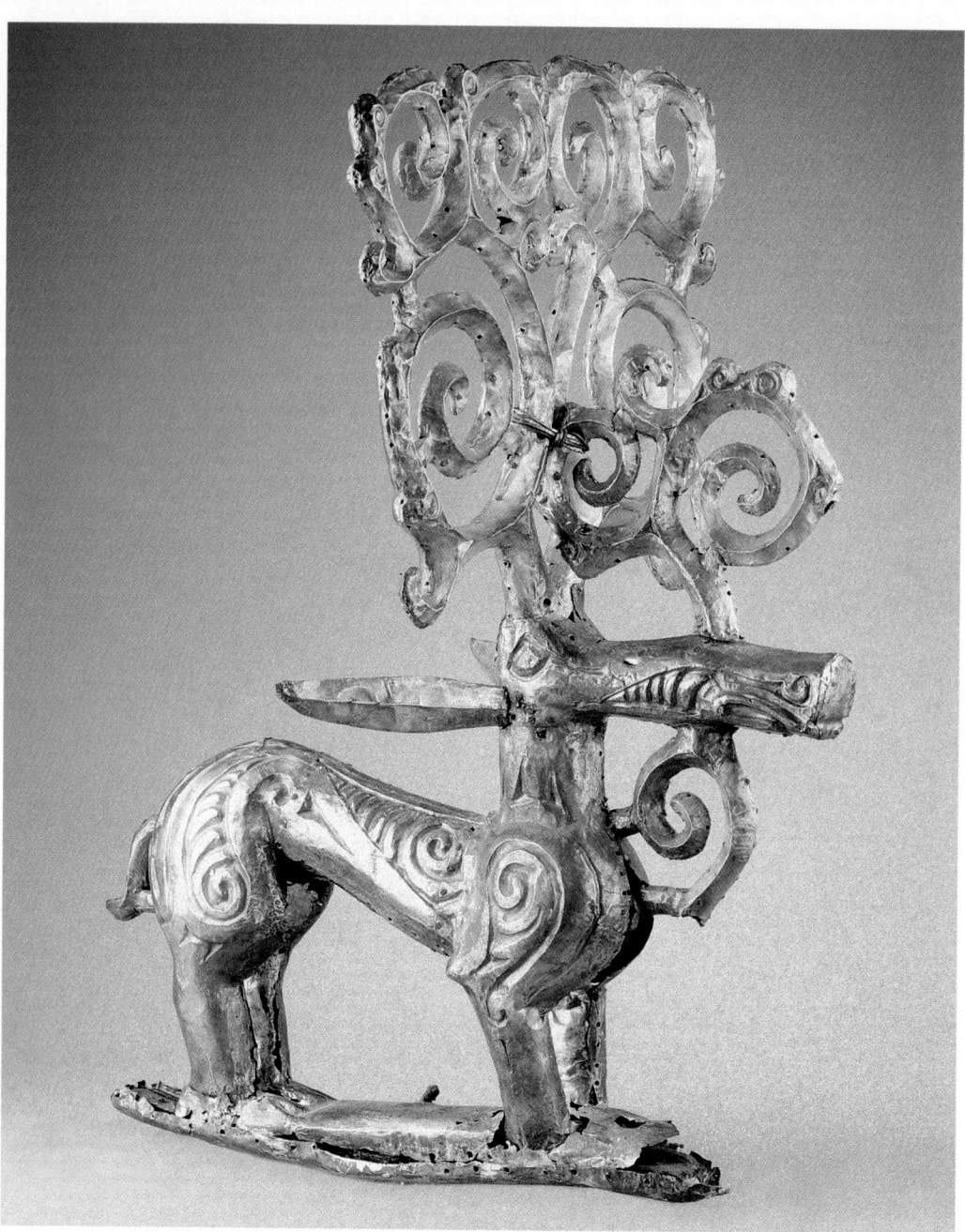

2.34 Stag, 4th century B.C. Gold, silver, bronze, and wood; 20 in. (50.0 cm) high. Archeological Museum, Ufa.

Achaemenid Persia (539–331 B.C.)

The Persians, Indo-European–speaking people affiliated with the Medes, settled southeast of Susa in a region of Iran now known as Fars. The Assyrian empire was brought down by a coalition of Medes, Scythians, and Babylonians in 612 B.C., creating a power vacuum. King Cyrus II (reigned 559–530 B.C.), called Cyrus the Great, founded the Persian Achaemenid dynasty, which was to become the largest empire in the ancient world. He first conquered the Medes, followed by Lydia (in Anatolia) and, in 539 B.C., Babylon (in Mesopotamia). Cyrus's son seized Egypt, and under later rulers the Achaemenids' vast territory stretched as far as the Aegean islands. The Assyrians —who had preceded the Persians as empire builders in the ancient Near East—influenced the Persians in several ways, most notably in their manner of celebrating kingship.

The Persians followed the religious teachings of Zoroaster (c. 628–551 B.C.), who taught that the world's two central forces were light and dark: Ahuramazda was light and Ahriman was dark. There were no Achaemenid temples since religious rituals were held outdoors, where fires burned on altars. The most elaborate Achaemenid architectural works were palaces, of which the best example is at Persepolis (literally, in Greek, "city of the Persians"). It was begun c. 520 B.C. by Darius I (reigned 521–486 B.C.), and work continued over many years under his successors, especially Xerxes and Artaxerxes I. The palace at Persepolis was built on a stone platform 40 feet (12.19 m) high and consisted of multicolumned buildings. Access to the platform was along a double stairway leading to the main gate, which was known as "All Lands."

The most important structure was the Apadana (Audience Hall; fig. **2.35**), where the king received foreign delegations. This and the throne room were huge squares that gave onto open verandas and contained tall, imposing stone columns.

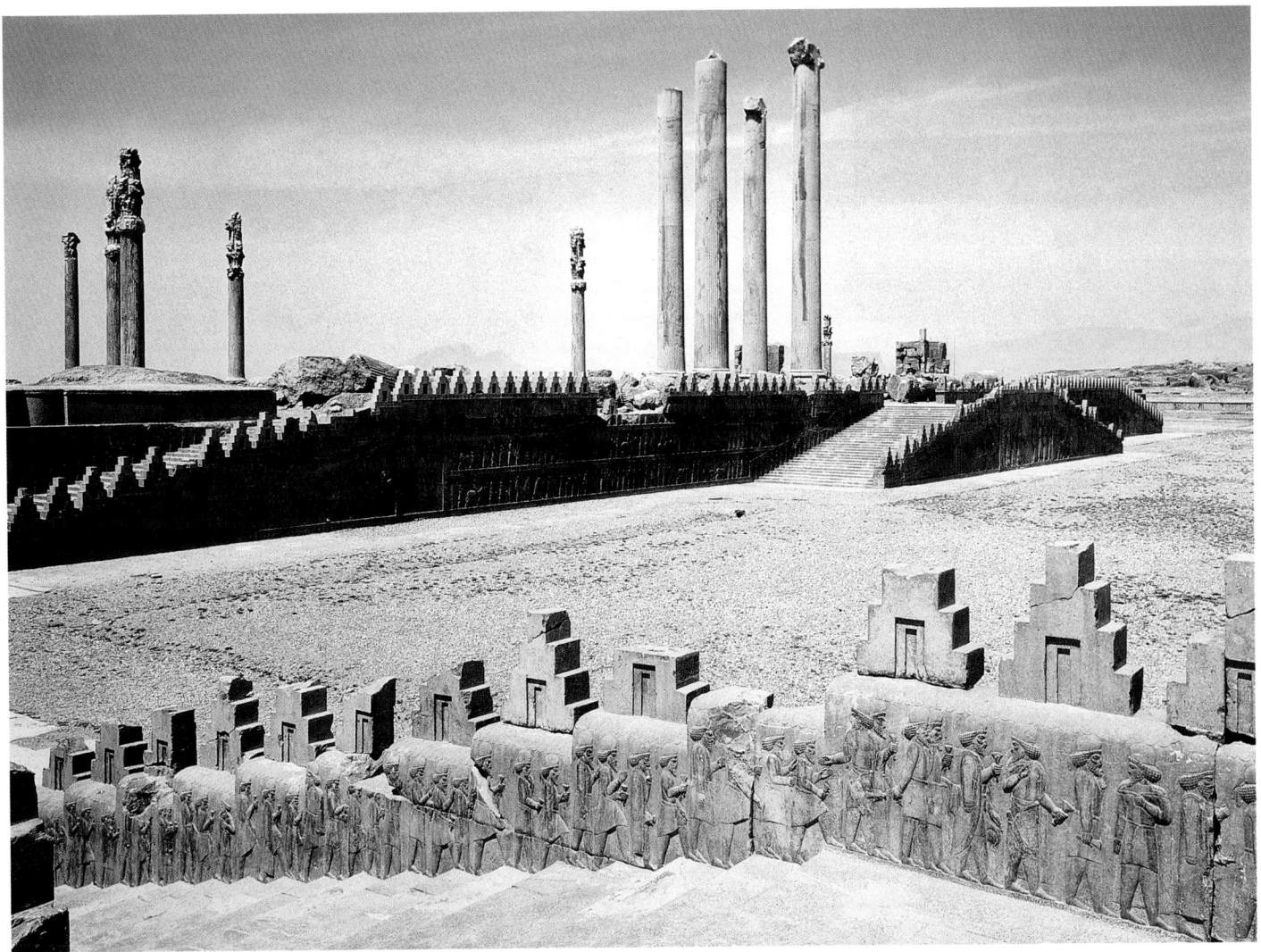

2.35 Apadana (Audience Hall) of Darius and stairway, Persepolis (in modern Iran), c. 500 B.C. Approx 250 ft.² (23.23 m²). The Apadana was decorated with one hundred columns 40 feet (12.19 m) high. Originally painted, the shafts show influences from other cultures, including Egypt (Chapter 3) and Greece (Chapter 5), but the bull capitals were unique to Persia.

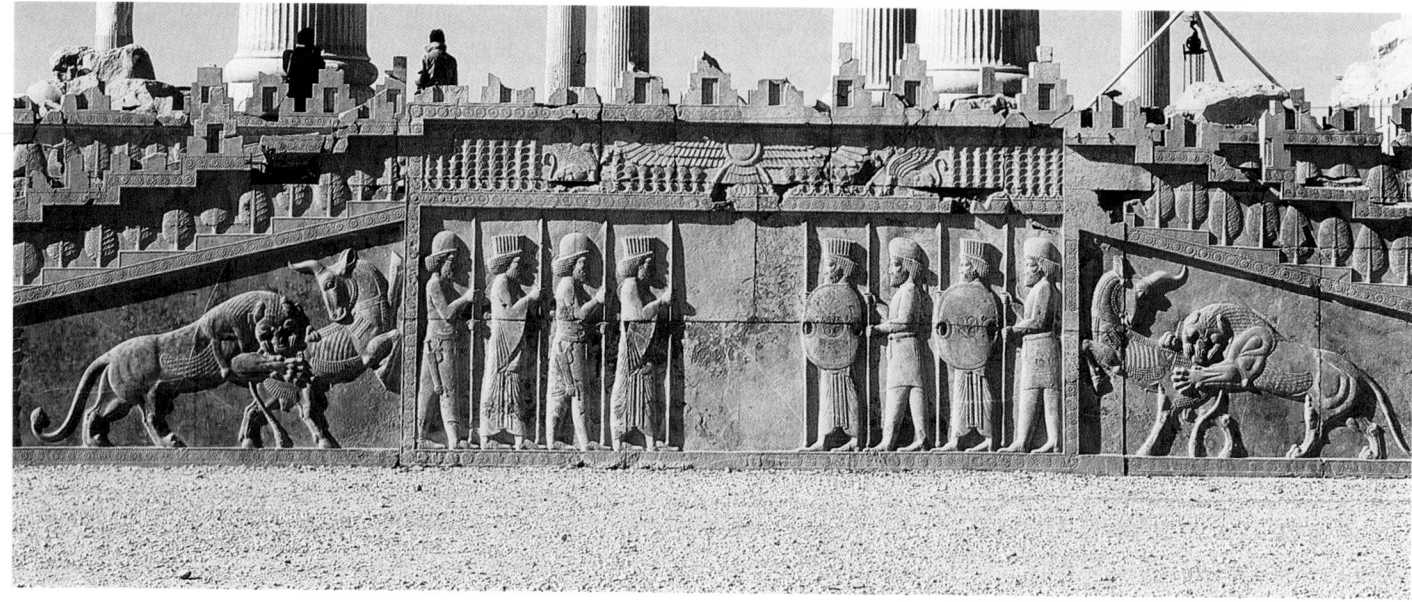

2.36 Royal guards, relief on the stairway to the Audience Hall of Darius, Persepolis, c. 500 B.C. Photo: R. Ottria.

Reliefs lining the walls and stairways were originally painted and emphasized the king's grandeur. In contrast to the aggressive military scenes on Assyrian reliefs, Persian reliefs depict solemn tribute bearers calmly presenting offerings to the king. This distinction is consistent with the political styles of the two civilizations: unlike the cruel repression that characterized the Assyrian Empire, the Persian Empire was generally administered in an orderly and tolerant way. The wall in figure **2.36** shows members of the king's royal guard, whose broad, slightly curved drapery folds contribute to the sense of slow, ceremonial movement. Their stylizations, particularly the curvilinear

hair and beard patterns, are typically Achaemenid. Vast numbers of such figures, like the repeated columns of the Apadana and the columned halls of Persepolis (see box), are intended to focus attention on the centrality and greatness of the king. The motif of the lion attacking the bull is characteristic of Achaemenid art.

Paired bulls facing in opposite directions (fig. **2.37**) were set on top of the capitals at Persepolis. The bulls themselves form the **impost block,** whose function was to carry the wooden ceiling beams on a "saddle" created by joining the bulls' foreparts. With their legs tucked under them, the bulls illustrated here convey a sense of calm. The representation of bulls at the palace associates the king with the power and virility that this animal traditionally embodies. Bull capitals at Persepolis may also be an architectural metaphor for the position of the king as "head of state."

Some of the iconography at Persepolis was assimilated from different Near East cultures. For example, motifs included crenellated walls like those of Sargon's palace at Khorsabad, Assyrian-derived guardians of gateways, and Egyptian and Greek architectural elements. The Achaemenid capital city was described in an inscription of Darius, referring to his palace in Susa: "This is the palace I erected. . . . Its ornament was brought from afar."[5] According to Darius, Babylonians dug the earth, packed the rubble, and

2.37 Bull capital, Persepolis, c. 500 B.C.

Columns

A **column,** like a **pillar,** is a tall, slender upright. Columns can be freestanding and sculptural, but they are usually architectural supports—the "posts" of the post-and-lintel system of elevation. At Persepolis, columns consist of three main parts: a lower **base,** a vertical **shaft,** and a **capital** on top on which the horizontal lintel rests. The term *capital* comes from the Latin word *caput,* meaning "head," and refers to its position at the top of the column.

molded the brick. Cedar timber came from Lebanon and was transported by Assyrians to Babylon. Gold came from Sardis and Bactria, silver and copper from Egypt, and ivory from Ethiopia. The stonecutters were Ionians and Sardians (from Sardis, in Lydia).

Achaemenid artists were also expert in metalwork. The gold lion drinking vessel in figure **2.38** is clearly an object fit for a king. Not only the intrinsic value of its material, but also the complexity of its design and structure, suggest that it comes from a royal workshop. It is formed from several pieces of gold, but their sophisticated fusion makes it difficult to locate the joints. Thin gold threads were used—altogether over 144 feet (44 m) of them—for the cup itself. Like the bulls on the Persepolis capital, the gold lion conveys a sense of compressed space and muscular tension. Its combination of stylized elements—such as the horseshoe-shaped leg muscle, the bulges on either side of the nose, the wing feathers and body hair—with convincing organic form is typical of much ancient Near Eastern art. So is the metamorphosing of the work from one form (the lion) into another (the drinking vessel). But the specific nature of the stylizations and the merging of elegance with monumental power are characteristic of the Achaemenid aesthetic.

Persian domination of the Near East came to an end nearly 200 years after Darius I began the palace at Persepolis. In 331 B.C., Alexander the Great, king of Macedonia (the northern part of modern Greece), conquered the Achaemenids and went on to create an even larger empire (see Chapter 5).

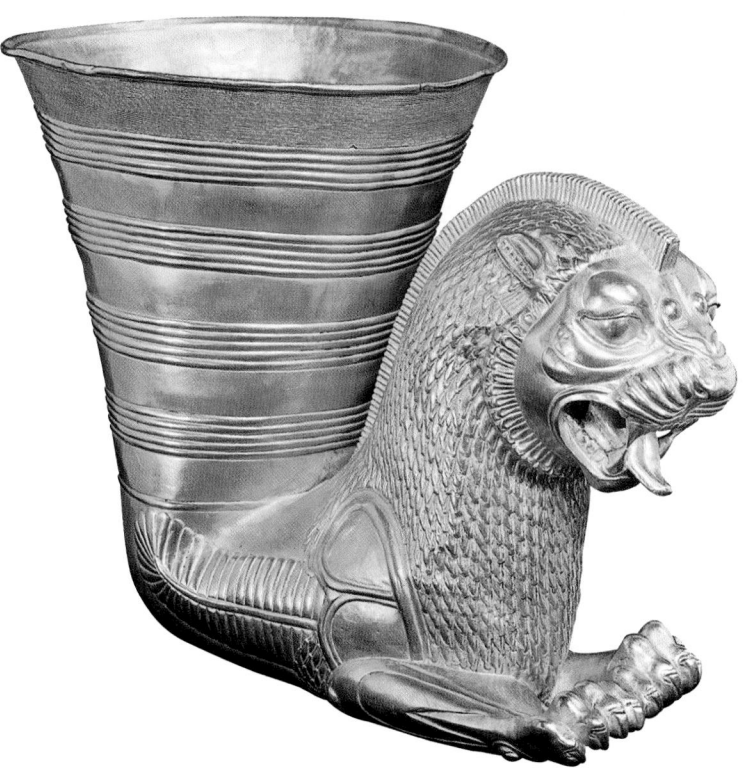

2.38 Achaemenid drinking vessel, Persian, 5th century B.C. Gold; 6¾ × 9 in. (17.1 × 22.9 cm). Metropolitan Museum of Art, New York. Fletcher Fund, 1954 (54.3.3). Photograph © 1982 Metropolitan Museum of Art.

	Style/Period	Works of Art	Cultural/Historical Developments

9000 B.C.

NEOLITHIC
c. 9000–4500/4000 B.C.

Plastered skull (**2.1**), Jericho
Reconstruction of Çatal Hüyük (**2.2**)
Anatolian goddess (**2.3**), Çatal Hüyük
Two leopards (**2.4**), Çatal Hüyük

Development of agriculture; domestication of sheep and goats (c. 6000 B.C.)
Earliest cities in Mesopotamia (5000–4000 B.C.)
Copper smelting developed (c. 4500 B.C.)

Plastered skull

5000 B.C.

ANCIENT IRANIAN
c. 5000–331 B.C.

Beaker (**2.31**), Susa
Kneeling bull (**2.32**), Iran

Kneeling bull

4000 B.C.

URUK
c. 3500–3100 B.C.

Cylinder seal impression

Cone mosaics (**2.5**), Uruk
Carved vase (**2.6**), Uruk
Female head (**2.7**), Uruk
White Temple, ziggurat (**2.8**), Uruk
Cylinder seal (**2.10**), Uruk
Clay tablet, pictographic text (**2.11**), Iraq

First bronze casting (c. 4000 B.C.)
Sumerians settle at site of Babylon (4000–3000 B.C.)
Height of Sumerian civilization (3500–3000 B.C.)
Development of cuneiform script in Sumer (3500–3000 B.C.)

3000 B.C.

SUMERIAN
Early Dynastic
c. 2800–2300 B.C.
Neo-Sumerian
c. 2100–1900/1800 B.C.

Statues (**2.12**), from Tell Asmar
Lyre sound box (**2.14**), Ur
Head of Gudea (**2.18**), Iraq
Gudea with temple plan (**2.19**), Iraq
Ziggurat (**2.20**), Ur

Gilgamesh, legendary king of Uruk (2750 B.C.)
Great Pyramids built at Giza, Egypt (2500 B.C.)
First known epic poem, the *Epic of Gilgamesh*, recorded on cuneiform tablets (2000–1000 B.C.)

Tell Asmar head

2000 B.C.

AKKADIAN
c. 2300–2100 B.C.

Head of Akkadian ruler (**2.16**)
Victory stele of Naram-Sin (**2.17**)

OLD BABYLONIAN
c. 1800–1600 B.C.

Stele, law code of Hammurabi (**2.21**)

Victory stele of Naram-Sin

Sargon I (?)

HITTITE
c. 1450–1200 B.C.

Lion Gate (**2.22**), Boghazköy
Hittite war god (**2.23**), Boghazköy

Beginning of Judaism (1200 B.C.)
End of the Trojan War (c. 1180 B.C.)

1000 B.C.

ASSYRIAN
c. 1300–612 B.C.

Lamassu

Assurnasirpal II (**2.24**), Nimrud
Assurnasirpal II and Lions (**2.25**), Nimrud
City attacked with a battering ram (**2.26**), Nimrud
Sargon II's palace (**2.28**), Khorsabad
Lamassu (**2.29**), Khorsabad
Dying Lioness (**2.27**), Nineveh

Phoenicians develop alphabetic script (c. 1100 B.C.)
Israelite kingdom founded; reign of David and his son Solomon (reigned 961–922 B.C.)

Hittite war god

Dying Lioness

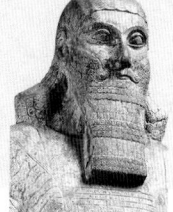

Assurnasirpal II

SCYTHIAN
8th–4th centuries B.C.

Stag (**2.33**), Kostromskaya

500 B.C.

NEO-BABYLONIAN
612–539 B.C.

Ishtar Gate (**2.30**), Babylon

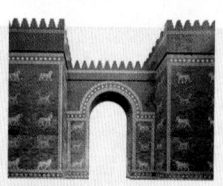

Ishtar Gate

Neo-Babylonian Empire reaches zenith under Nebuchadnezzar (reigned 604–562 B.C.); conquest of Egypt (605) and Jerusalem (586)
Birth of Buddha (c. 563 B.C.)
Birth of Confucius (c. 550 B.C.)

300 B.C.

ACHAEMENID
539–331 B.C.

Apadana of Darius (**2.35**), Persepolis
Royal guards (**2.36**), Persepolis
Bull capital (**2.37**), Persepolis
Achaemenid drinking vessel (**2.38**)
Stag (**2.34**), Filippovka

Birth of Herodotos, "father of history" (485 B.C.)

Stag

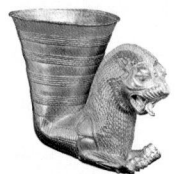

Achaemenid drinking vessel

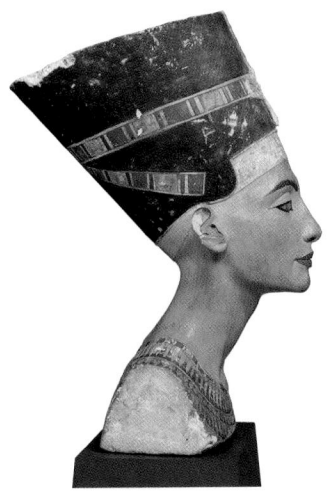

3

Ancient Egypt

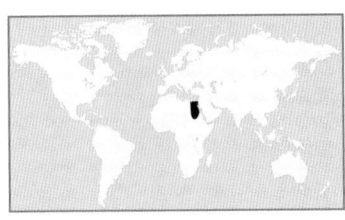

The Gift of the Nile

Located in northeast Africa (see map), Egypt was the site of one of the most powerful and longest-lasting civilizations in the ancient world. In the Neolithic period, before about 7000 B.C., farming communities had settled along the banks of the Nile. The inhabitants used stone tools and made ivory and bone objects and hand-built pottery. Until its unification around 3100 B.C., ancient Egypt had been divided into Upper Egypt in the south and Lower Egypt in the north. Egypt was defined by its most important geographical feature, the Nile, the world's longest river. Because annual floods kept the land fertile, Egypt was called "the gift of the Nile." The Nile flows northward for some 4,160 miles (6695 km) from its source in central Africa through Egypt. At Memphis, near Cairo, the Nile divides and spreads into its delta, a wide alluvial triangle of about 14,500 square miles (23,335 km²), now lush and fertile but in antiquity a region of marsh and scrub. From the delta, the river empties into the Mediterranean Sea.

The search for the source of the Nile became an obsession with nineteenth-century explorers. In fact, however, the Nile is a combination of two rivers. Rainfall in the highlands of east-central Africa drains into a series of lakes, especially Lake Victoria, to form the headwaters of the White Nile. After flowing north through a large area of swamp, the river reaches Khartoum, where it joins its twin, the Blue Nile, rising in the Ethiopian mountains. North of Khartoum, the Nile enters what was ancient Nubia, where vegetation and marshland give way to desert on either side. At six points, the river passes over outcrops of rock known as the cataracts (huge waterfalls—from the Greek word *katarrhaktes,* meaning "down-swooping"). At the northernmost of these, the First Cataract, the Nile enters Lower Egypt at Aswan.

Rainfall in central Africa and melting snows from the Ethiopian highlands caused the Nile to flood each year, reaching its highest point in Egypt by the end of August. The average flood level measured nearly 25 feet (8 m), high enough to flood the whole valley up to the edge of the desert but not so high as to overwhelm villages and dikes. When the waters receded, the soaked earth was covered with a fresh deposit of rich, dark silt. This led the Egyptians to call their land Kemet ("The Black") as opposed to

Hymn to Hapy

Hapy was the personification of the Nile and was regularly honored with festivals and hymns. This one, from which only excerpts are given, was written during the Middle Kingdom:

> Hail to you, Hapy,
> Spring from earth,
> Come to nourish Egypt! . . .
>
> Who floods the fields that Re has made,
> To nourish all who thirst;
> Lets drink the waterless desert,
> His dew descending from the sky . . .
>
> When he is sluggish, noses clog,
> Everyone is poor;
> As the sacred loaves are pared,
> A million perish among men.
> When he plunders, the whole land rages, . . .
>
> Food provider, bounty maker,
> Who creates all that is good!
> Lord of awe, sweetly fragrant,
> Gracious when he comes . . .
>
> Conqueror of the Two Lands,
> He fills the stores,
> Makes bulge the barns,
> Gives bounty to the poor.[1]

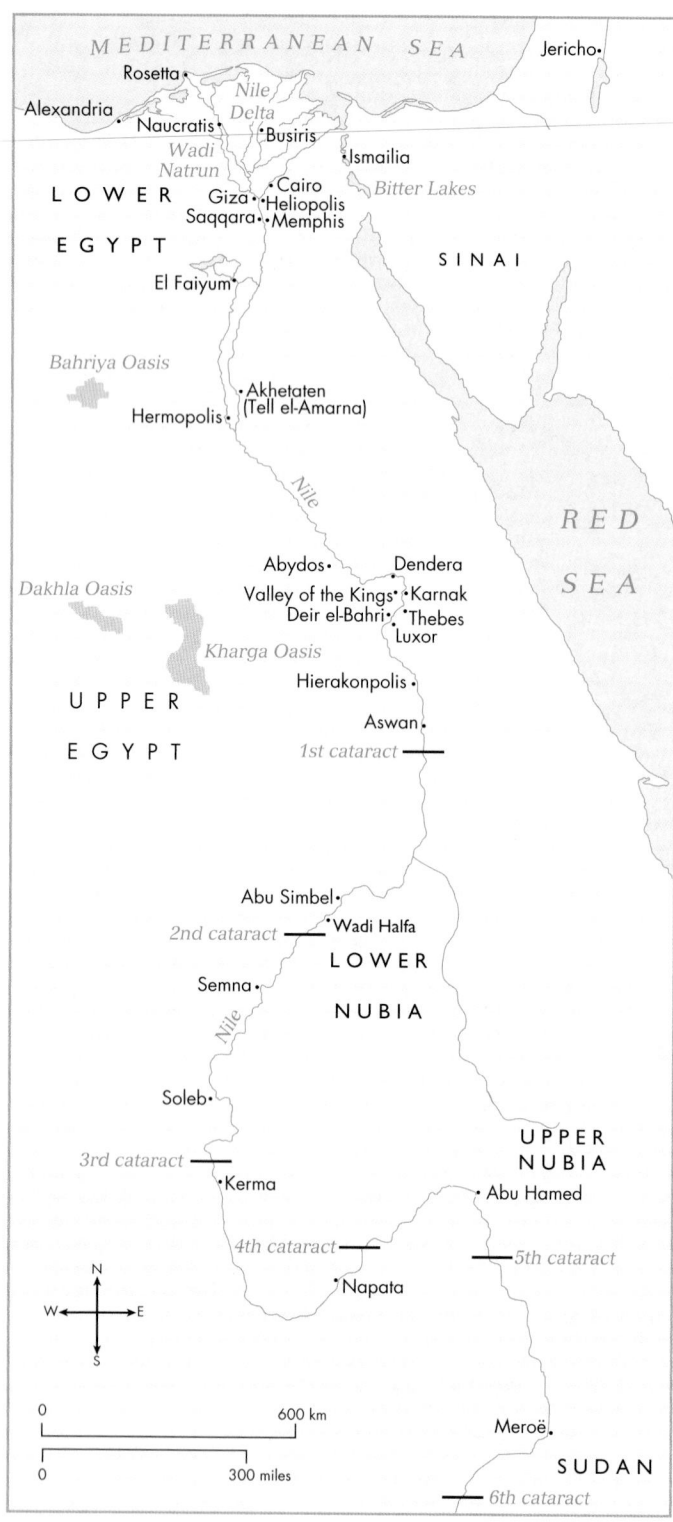

Ancient Egypt and Nubia.

the desert, Deshret ("The Red"). By autumn, the land was once again ready for planting, its fertility renewed.

This pattern was generally predictable from year to year, as were the sunny, cloudless skies. Occasionally, however, the Nile failed to rise to the expected levels, and the resulting food shortages reminded the Egyptians of their

dependence on the annual flood. This concern is reflected in a hymn to the Nile god Hapy (see box) as well as in the Bible (Genesis 41), in which Joseph interprets the pharaoh's dream of seven fat and seven lean cattle as meaning seven years of plenty and seven of famine. The predictability of life—the rising and setting of the sun, the monthly waxing and waning of the moon, the annual flood, sowing and harvesting—induced in the ancient Egyptians a sense of order and inevitability. Every natural phenomenon, especially the daily return of the sun and the annual flood of the Nile, seemed a continual rebirth, and this theme was central to the development of Egyptian religion.

Religion

The Egyptians, like their Near Eastern neighbors, were polytheists. Gods were manifest in every aspect of nature. They influenced human lives and ordered the universe. They could appear in human or animal form, or as various combinations of humans and animals.

Archaeological evidence suggests that prehistoric Egyptian religion consisted of local gods and cults that were confined to a particular district, or *nome*. After the unification of Upper and Lower Egypt c. 3100 B.C., the importance of these local deities increased or diminished with the military and political fortunes of their districts. For example, the sky god Horus, usually represented as a falcon, was originally a local god who later achieved national status.

Egyptian gods had spheres of influence that could intersect or overlap, producing numerous compound deities. Single gods could also have multiple aspects—such as Horus-the-child, representing the potential power of a child, and Horus-in-the-horizon, denoting the power of daybreak or sunset.

The result of this belief system was a pantheon (meaning "all the gods" of a people, from the Greek words *pan*, meaning "all," and *theoi*, meaning "gods") of enormous complexity (see box). Over time, the number was increased by the introduction of foreign gods into Egypt. Like most polytheists, the Egyptians did not find the religious ideas of other cultures incompatible with their own, and they incorporated new deities either singly or in combination. This process of fusion is known as syncretism. One such syncretistic immigrant assimilated into the Egyptian pantheon was the Syrian goddess Astarte, who was related to the Babylonian Ishtar (see Chapter 2).

The Pharaohs

From approximately 3100 B.C., Egypt was ruled by pharaohs (kings) whose control of the land and its people was virtually absolute. Egyptian monumental art on a vast scale begins with pharaonic rule, originating when King Menes united Upper and Lower Egypt. Much of our knowledge of Egyptian chronology comes from ancient

Egyptian Gods

A few of the principal gods of ancient Egypt in their most typical guises are listed here:[2]

Amon Great god of Thebes; identified with Ra as Amon-Ra; sacred animals, the ram and goose

Anubis Jackal god, patron of embalmers; god of the necropolis, who ritually "opens the mouth" of the dead

Aten God of the sun disk; worshiped as the great creator god by Akhenaten

Bes Helper of women in childbirth, protector against snakes and other dangers; depicted as a dwarf with features of a lion

Hapy God of the Nile in flood; depicted as a man with pendulous breasts, a clump of papyrus (or a lotus) on his head, and bearing tables laden with offerings

Hathor Goddess with many functions and attributes; often depicted as a cow, or woman with a cow's head or horned headdress; mother, wife, and daughter of Ra; protector of the royal palace; domestic fertility goddess; identified by the Greeks with Aphrodite (see Chapter 5)

Horus Falcon god, originally the sky god; identified with the king during his lifetime; the son of Osiris and Isis, and avenger of the former

Isis Divine mother, wife of Osiris, and mother of Horus; one of four protector goddesses, guarding coffins and canopic jars

Maat Goddess of truth, right, and orderly conduct; depicted as a woman with an ostrich feather on her head

Mut Wife of Amon; originally a vulture goddess, later depicted as a woman

Osiris God of the underworld, identified as the dead king; depicted as a mummified king

Ptah Creator god of Memphis, patron god of craftsmen; depicted as a mummy-shaped man

Ra (Re) Falcon-headed sun god of Heliopolis, supreme judge; often linked with other gods, whose cults aspire to universality (e.g., Amon-Ra); depicted as falcon-headed

Serapis Ptolemaic period; combines characteristics of Egyptian (Osiris) and Greek (Zeus) gods

Seth God of storms and violence; brother and murderer of Osiris, rival of Horus; depicted as a pig, ass, hippopotamus, or other animal

king lists, the most comprehensive of which was compiled in the fourth century B.C. by a priest, Manetho. His list begins with the legendary reign of the gods, followed by that of the human kings from Menes to Alexander the Great. Manetho divided Egyptian history into thirty dynasties, or royal families (a thirty-first was added later).

One problem with Manetho's list has been to identify the sequence of the names. Since Egypt had no absolute system of dating (such as B.C./A.D.), each pharaoh treated the first year of his reign as the year one. However, with the help of other king lists, inscriptions naming more than one king, references to astronomical observations that can be precisely dated, and correlations with evidence from outside Egypt, nineteenth- and twentieth-century scholars have compiled a relative chronology (see box, p. 84). Nevertheless, even this changes as new archaeological discoveries are made.

Modern scholars have divided Egyptian history into Predynastic and Early Dynastic periods, followed by the Old, Middle, and New Kingdoms, and the Late Dynastic period. These were punctuated by "intermediate periods" of anarchy or central political decline as well as by periods of foreign domination. For thousands of years following Menes' unification, Egypt had many periods of durable power, when artists worked for the state and its rulers within the confines of a political and religious hierarchy.

Between the Middle and New Kingdoms, there was a period of more than one hundred years during which a group of Semitic rulers, based in the northeastern Delta, controlled Lower Egypt. Known as the Hyksos, from the Egyptian word *heqau-khasut* (meaning "princes of foreign countries"), these rulers are credited with having introduced the horse-drawn chariot to Egypt. During the New Kingdom, some important changes occurred. For example, the first queen to have assumed pharaonic status and to have presided over an artistic revival, Hatshepsut (see p. 103), co-ruled Egypt with Thutmose III from c. 1479 to 1458 B.C., and later the pharaoh Akhenaten (reigned c. 1349–1336 B.C.) made revolutionary changes in the hierarchy of gods.

From the end of the New Kingdom, Egypt's preeminent position as a powerful monarchy was weakened by foreign infiltration. During the Late Dynastic period, Egypt twice fell under Persian rule—from 525 to 404 B.C. and again in 343 B.C. In 332 B.C., the Persians were defeated by Alexander the Great, who annexed all Persian territory, including Egypt, to his empire. After his death in 323 B.C., control of Egypt passed to the Macedonian general Ptolemy, whose successors ruled until the Roman conquest in 30 B.C. His descendants established the capital of Egypt at Alexandria, on the Mediterranean coast just west of the Delta, and infused Egypt with ideas from the Greek-speaking world.

Chronology of Egyptian Kings
(all dates before 664 B.C. are approximate)

Predynastic period		5450–3100 B.C.
Early Dynastic period	Dynasties 1–2	3100–2649 B.C.
Old Kingdom	Dynasties 3–6	2649–2150 B.C.
First Intermediate period	Dynasties 7–11	2143–1991 B.C.
Middle Kingdom	Dynasties 12–14	1991–1700 B.C.
Second Intermediate period	Dynasties 15–17 (including the Hyksos period)	1640–1550 B.C.
New Kingdom	Dynasties 18–20	1550–1070 B.C.
Third Intermediate period	Dynasties 21–25	1070–660 B.C.
Late Dynastic period	Dynasties 26–30	688–343 B.C.
	Persian kings	343–323 B.C.
Ptolemaic period	Macedonian kings	323–31 B.C.

The Egyptian Concept of Kingship

For the ancient Egyptians, kingship was a divine state. As in Mesopotamia (Chapter 2), kings mediated between their people and the gods. In Egypt, however, the kings were themselves considered gods. They ruled according to the principle of *maat,* divinely established order (personified by Maat, the goddess of truth and orderly conduct; cf. box, p. 83). From the Third Dynasty, the compound god Amon-Ra, in the guise of the reigning pharaoh, was believed to impregnate the queen with a son who would be heir to the throne. This divine conception by Amon-Ra was part of each pharaoh's official personality and iconography. A queen could be either the king's mother or his principal wife. Marriages occasionally took place between a pharaoh and his sister, half sister, or daughter, when this was politically useful. The ambiguous position of the queen by comparison with that of the pharaoh reflects her complementary role. Certain exceptions notwithstanding, Egyptian kingship was not for women. The queen was the king's means of renewal by providing him with male heirs to the throne or with daughters for creating alliances through advantageous marriages.

In entering into incestuous marriages, the king, like the gods, was distinct from the general population of Egypt. Although there are many uncertainties about daily life in ancient Egypt, texts indicate that monogamous marriage was considered a positive and natural state, and that the Egyptian commoner tended to have one wife at a time. Infidelity, especially if committed by the wife, was grounds for divorce, as were impotence, infertility, dislike of a wife, or the wish to marry another woman. A primary purpose of marriage was the production of children, and household deities of fertility—including Hathor and Bes—were worshiped in the home. In Egypt, as in the Near East, homosexuality was viewed as counterproductive to the ideal of fertility. Widows and orphans were disadvantaged members of society, although adoption was an established institution.

Despite the gaps in our knowledge, it seems clear that Egyptian kingship derived its divinity from the association of pharaohs with gods. The royal family modeled its behavior on that of the gods, separating itself from those it ruled. Egyptian kings did not maintain power by setting an example to the public at large, but rather by their distinction from it. In the transfer of kingship from father to son or some substitute for a son, Egypt created another avenue of identification with the gods.

The Palette of Narmer

The links between divine and earthly power noted in earlier civilizations reappear in an important Egyptian ritual object, the Palette of Narmer (figs. **3.1** and **3.2**). It dates from the beginning of pharaonic rule and is an excellent example of an image of power. On both sides, the palette is decorated in low relief. The large scene in figure 3.1 is depicted according to certain conventions that lasted for over two thousand years in Egypt. For example, King Narmer (thought to be Menes, the first pharaoh) is the biggest figure—his size and central position indicate his importance. His composite pose, in which head and legs are rendered in profile view with eye and upper torso in frontal view, is an Egyptian convention. This is a conceptual, rather than a naturalistic, approach to the human figure, for the body parts are arranged as they are understood and not as they are seen in reality. The entire body is flat, as is the kilt, with certain details such as the kneecaps rendered as stylizations, rather than as underlying organic structure.

Narmer wears the tall, white conical crown of Upper Egypt (the *hedjet*) and threatens a kneeling enemy with a mace. He holds him by the hair, an act that symbolizes conquest and domination. Two more enemies, either fleeing or already dead, occupy the lowest register of the palette. Behind Narmer on a suspended horizontal strip is a servant whose small size, like the low positions of the enemies, identifies him as less important than the king. In Egypt, as in Mesopotamia, therefore, artists used a system

3.1 Palette of Narmer, from Hierakonpolis, c. 3100 B.C. Slate; 25 in. (63.5 cm) high. Egyptian Museum, Cairo. This is called the Upper Egypt side because Narmer wears the white crown.

3.2 Palette of Narmer (reverse of fig. 3.1). This is called the Lower Egypt side because the pharaoh wears the red crown.

of hierarchical proportions. The servant holds Narmer's sandals, showing that the king is on holy ground (just as Muslims remove their shoes before entering a mosque). In front of Narmer, at the level of his head, is Horus, the falcon god of sky and kingship, who, with a human hand, holds a captive human-headed creature at the end of a rope. From the back of this figure rise six **papyrus** plants, which represent Lower Egypt. The image of Horus dominating symbols of Lower Egypt parallels Narmer, crowned as the king of Upper Egypt and subduing an enemy.

At the top center of each side of the palette is a rectangle known as a *serekh* (see box, p. 86). A *serekh* contained a king's name in hieroglyphs (pictures symbolizing words that were the earliest Egyptian writing system; see p. 86). On either side of the *serekh*, frontal heads of the cow goddess Hathor indicate that she guards the king's palace.

The other side of the palette (fig. 3.2) contains three registers below the Hathor heads and the pharaoh's name. At the top, Narmer wears the red crown of Lower Egypt (the *deshret*). His sandal bearer is behind him, and he is preceded by standard-bearers. At the far right, ten decapitated enemies lie with their heads between their feet. These figures are meant to be read from above, as a row of bodies lying side by side. Such shifting viewpoints are characteristic of Egyptian pictorial style.

Two felines, roped by bearded men, occupy the central register. Their elongated necks frame an indented circle similar to those that held liquid for mixing eye makeup on smaller palettes. This one, however, was found as a dedication in a temple and is larger than those used in everyday life. Although derived from such palettes, the Palette of Narmer was most likely a ceremonial, rather than a

Royal Names: *Serekhs* and Cartouches

During the First, Second, and Third Dynasties, the chief name, or "Horus name," of the reigning pharaoh was written in the top half of a rectangular frame known as a *serekh*, a flattened representation of his palace. This was symbolic of the king as the god Horus, himself depicted as a falcon surmounting the *serekh*.

During the third millennium B.C., it became customary for kings to take five titled names. The Horus name was followed by "He of the Two Ladies," signifying that the king was under the protection of two goddesses, the Wadjet of Lower Egypt and the Nekhbet of Upper Egypt. The third name was "Horus of Gold," a reference to the sunlit sky. In the Fourth Dynasty, a fourth name was added, "King of Upper and Lower Egypt," known as the *prenomen*, or throne name; it was enclosed in a cartouche, a rectangle with a semicircle at either end, signifying the passage of the sun around the universe and the pharaoh's dominion over it. Completing the series of five titles was a second cartouche, containing the *nomen*, or birth name, "Son of Ra" (the sun god).

Figure **3.3** is a diagram of the *serekh* from the Palette of Narmer, and figure **3.4** shows Akhenaten's cartouches.

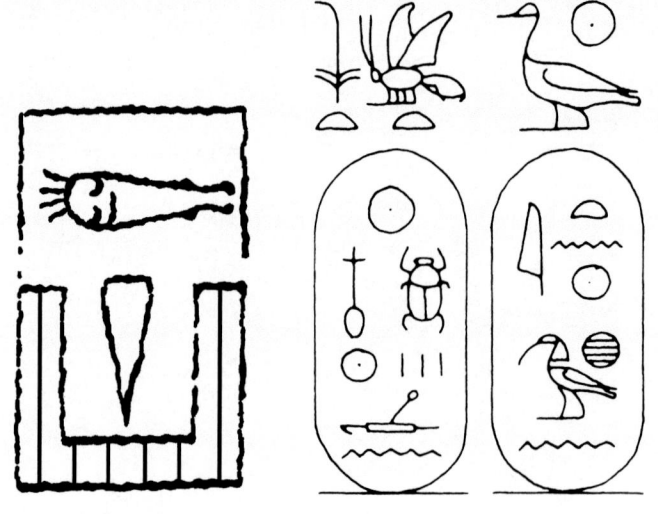

3.3 *Serekh* from the Palette of Narmer.

3.4 Cartouches of Akhenaten.

practical, object. It is not certain what the felines, called serpopards, mean, but their intertwined necks could refer to Narmer's unification of Egypt (signified by his two crowns). In the lowest register, a bull—probably a manifestation of Narmer himself—subdues another fallen enemy before architectural symbols.

Every image on the palette conveys Narmer's might and importance. He is protected by the gods. He is taller, more central, and more powerful than any other figure. He destroys his enemies and their cities. The iconographic message of this work is a political one. Like much of the Egyptian art that survived the next two thousand years, the Palette of Narmer is a statement of power, for it celebrates the king's divine right to rule and illustrates his ability to do so.

Writing and History

By around 3100 B.C., the Egyptians were using a form of picture writing known as hieroglyphic (from the Greek words *hieros,* or "sacred," and *glypho,* "I carve"). This method of writing was slow, so for everyday purposes the Egyptians developed a faster system, an abridged form of hieroglyphic called hieratic.

In the seventh century B.C., a simpler form of writing, known as demotic (because it was used by the ordinary people, *demos* in Greek), became standard for all but religious texts. These three systems—hieroglyphic, hieratic, and demotic—remained in use until the Christian era, when they were replaced by Coptic, which was composed of Greek letters and supplemented by seven demotic signs. From the fifth century A.D. to 1822, reading ancient Egyptian scripts was a lost art.

In 1799, soldiers of Napoleon's French Expeditionary Force, working on fortifications at the village of Rashid (called Rosetta by Europeans) in the western Delta, discovered a slab of black basalt—the Rosetta Stone (fig. **3.5**)—built into an old wall. The importance of the Rosetta Stone lay in its three separate inscriptions, each a version of the same text in a different script and two languages—hieroglyphics, demotic, and Greek. The Greek version was soon translated and found to be a decree passed by a council of Egyptian priests in honor of the first anniversary of the coronation of the pharaoh Ptolemy V Epiphanes (205–180 B.C.).

Primary credit for deciphering the Rosetta Stone goes to Jean-François Champollion (1790–1832), a young French scholar who realized that hieroglyphs could be divided into two categories: ideograms, which recorded an idea pictorially, and phonograms, which denoted sounds representing one or more consonants (the Egyptian script had no vowels), independent of their meaning. Some hieroglyphs could be either ideograms or phonograms, depending on their context. Ideograms were also used as determinatives, which helped to indicate the meaning of a word spelled phonetically (e.g., a hieroglyph

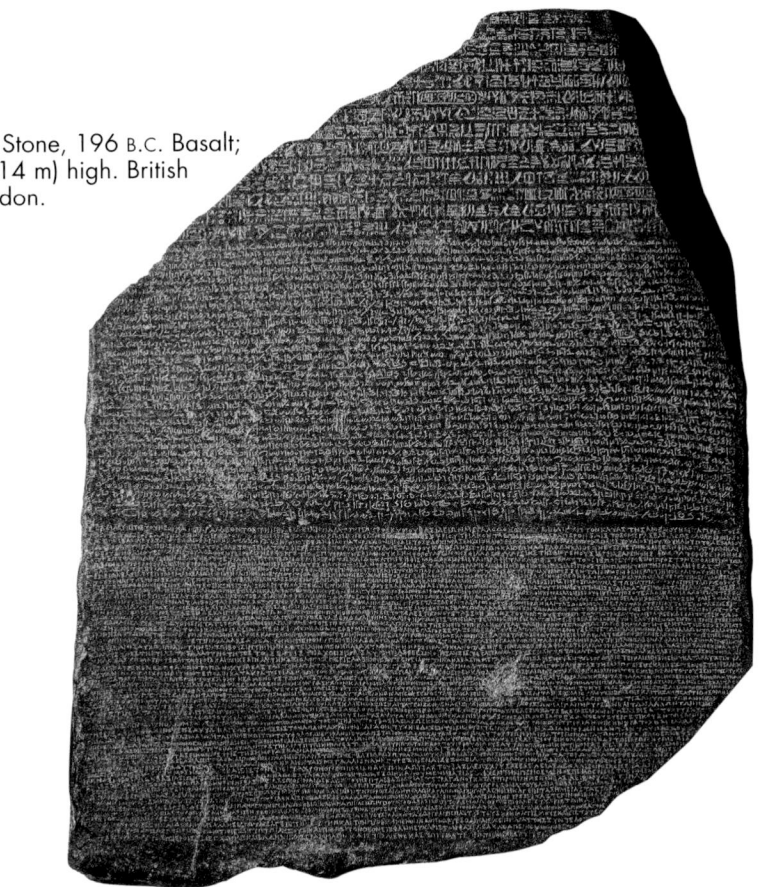

3.5 Rosetta Stone, 196 B.C. Basalt; 3 ft. 9 in. (1.14 m) high. British Museum, London.

of walking legs to indicate motion, or of a hawk, the fastest bird, to represent swift things in general or anything for which speed is an attribute).

The stone was probably about 5 to 6 feet (1.52–1.82 m) high originally, with a rounded top (now missing) that contained the winged disk of Horus of Edfu depicted over the figure of Ptolemy V standing in the presence of various gods. A similar scene on a stele of 182 B.C., with the text of the same decree, enabled scholars to fill in the missing portions around the edge of the stone.

Once the Egyptian text on the Rosetta Stone was deciphered, the meanings of thousands of preserved Egyptian texts became available for study. Reading the king lists was the starting point for establishing a chronology of ancient Egypt, and other texts have clarified ancient Egyptian art and its cultural context.

The Egyptian View of Death and the Afterlife

For the ancient Egyptians, death was not the end of life but the transition to a similar existence on another plane. To ensure a fortuitous afterlife, the deceased had to be physically preserved along with earthly possessions and other reminders of daily activities. This was first achieved by simple burial in the dry desert sands. Later, coffins insulated the body, and artificial means of preservation were used. But in case the body of the deceased did not last, an image could serve as a substitute. The dead person's *ka* (soul) was believed able to enter the surrogate before journeying to the next world.

The *ka* was only one aspect of the Egyptian triple concept of the spirit. In its aspect as a "double," the *ka* was viewed as the life force that continued after death and permitted the deceased to eat and drink offerings provided by relatives and priests. The *akh* was more detached from the body than the *ka* and resided in the heavens as the spiritual transformation of the dead person. The third aspect of the spirit, the *ba,* was literally in touch with the deceased, and its mobility in and out of the body was reflected in its depiction in art as a bird with a human head.

Procedures such as mummification highlight the ancient Egyptian preoccupation with a material existence in the afterlife. Enormous resources were devoted to providing for the dead, both on an individual level and, in the case of the royal family and its court, on a grand scale involving the whole society. Much of the art and writings that have survived is funerary, preserved in the desert for thousands of years.

Mummification

The Egyptians evolved a seventy-day process of embalming corpses. According to the Greek historian Herodotos (*History* II.85–90), writing in the fifth century B.C., the first step was the removal of the internal organs, except for the heart, which was believed to be the seat of understanding and was therefore left intact. The body was then packed in dry natron (a natural compound of sodium carbonate and sodium bicarbonate found in Egypt), which dehydrated the cadaver and dissolved its body fats. Then the corpse was washed, treated with oils and ointments, and bandaged with as many as twenty layers of linen in a way that conformed to its original shape. The substances applied to its skin caused the body to turn black; later travelers took this to mean that the body had been preserved with pitch, for which the Arabic term is *mumiya*—hence the English terms *mummy* and *mummification*. Ornaments placed on the body or inside the wrappings included amulets (charms against evil or injury), scarabs (representations of dung beetles used as protective devices, symbolic of the sun; fig. 3.6), *wedjats* (eyes of Horus; fig. 3.7), and *djeds* (pillars symbolizing stability).

No less important than preservation of the body was the preservation of organs that had been removed. These were embalmed and placed in four so-called **canopic jars** (fig. 3.8), but the brain was discarded as useless. Each jar held a particular organ and was under the protection of one of Horus's four sons. Each son had a characteristic head (man, baboon, jackal, and falcon). Until c. 1300 B.C., the jars had human-headed stoppers, but later they were

carved in the form of the head of the relevant protective deity. Even in the Late Period, when the organs were usually wrapped and replaced in the body cavity, a substitute set of canopic jars was left at the burial site.

Before c. 2000 B.C., a mask made of linen stiffened with plaster **(cartonnage)** was molded to the contours of the face, creating an effect reminiscent of the skulls from Neolithic Jericho (see fig. 2.1). After that time, a separate mask often covered the face, and these came to be made from valuable materials, including, for those who could afford it, gold.

A single mummy might have been nested inside several coffins. Eventually, the mummy's shape—bandaged and masked—became the model for the coffin itself. Coffins were made of wood or cartonnage and placed inside stone sarcophagi.

3.6 Diagram of a scarab.

3.7 Diagram of a *wedjat* (the eye of Horus).

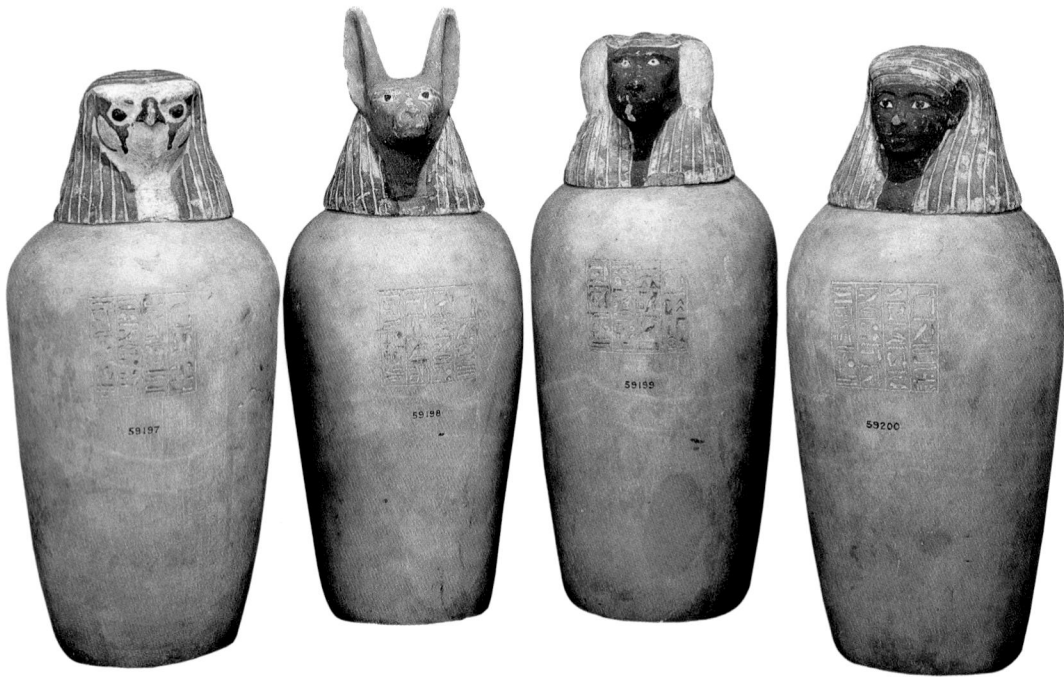

3.8 Canopic jars of Neshkons. British Museum, London.

Funerary Texts

Funerary texts written on tomb walls, coffins, and papyrus reveal the Egyptian use of words as magic to protect the deceased. These texts contain spells designed to preserve the dead person's name and pleas for his well-being in the afterlife. They recount his virtues, attest to his good character, and invoke the protection of his body from harmful creatures such as snakes and scorpions. Over seven hundred different formulas have been identified, but no single tomb contains a complete set of the texts. At first, Pyramid Texts were confined to the pyramids of the pharaohs, but around the twentieth century B.C. they begin to appear on nonroyal coffins, which may be evidence of a relaxation of royal prerogatives.

The Pyramid Text quoted below, known as *Utterance 407*, is from the east wall of the antechamber of the pyramid of Teti (Sixth Dynasty) at Saqqara. It describes the king joining the sun god Re after death and refers to the Opening of the Mouth ritual (see p. 105), followed by the assertion that he will become a judge in the afterlife:

> Teti has purified himself:
> May he take his pure seat in the sky!
> Teti endures:
> May his beautiful seats endure!
> Teti will take his pure seat in the bow of
> Re's bark:
> The sailors who row Re, they shall row Teti!
> The sailors who convey Re about lightland,
> They shall convey Teti about lightland!
> Teti's mouth has been parted,
> Teti's nose has been opened,
> Teti's ears are unstopped.
> Teti will decide matters,
> Will judge between two,
> Teti will command one greater than he!
> Re will purify Teti,
> Re will guard Teti from all evil![3]

During the Middle Kingdom, the wooden coffins of private individuals were inscribed with Coffin Texts, which included myths and funerary incantations. Also from this period are the earliest known maps—called the *Book of Two Ways*—designed to help the dead find their way in the perilous transition from life to afterlife, the journey through the underworld. They were also guided by the *Book of the Dead,* the modern name for the compilations of religious and magical texts found in numerous burials, which the ancient Egyptians called the *Chapter of Coming Forth by Day.* The title refers to the ability of the deceased to leave their tombs. Although no complete copy of this book exists, numerous extracts have survived.

From Hatshepsut's reign on, the *Book of the Dead* was written on papyrus. The example in figure **3.9** shows a high priest of Amon (at the right) presenting an offering to Osiris. The god holds the crook and flail—originally instruments of animal husbandry and planting—which signify fertility and rebirth. His green face alludes to his role as a vegetation god.

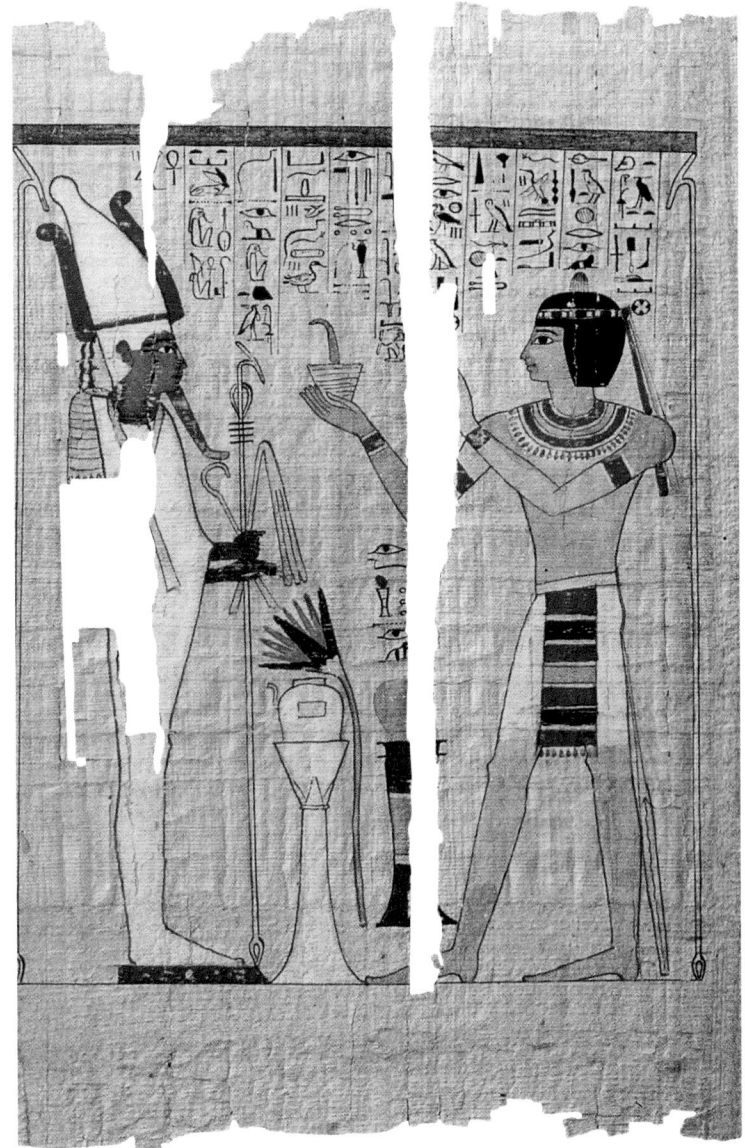

3.9 Vignette from Paynedjem's *Book of the Dead,* from Thebes, Twenty-first Dynasty, c. 990–969 B.C. Painted papyrus; height 13 in. (33.0 cm). The British Museum.

The Old Kingdom
(c. 2649–2150 B.C.)

Menes's unification of Egypt was followed by long periods of relatively stable, highly centralized government during which artists worked for the state and its rulers within the confines of a political and religious hierarchy. Egyptian artists worked, as did their contemporaries in Mesopotamia, for individual patrons as well as for the state. Since the ruling classes controlled the wealth in these hierarchical societies, their art is both more impressive and often better preserved than that of less wealthy patrons. We see this clearly in funerary art. Those in power could afford durable materials such as stone for their memorials, as well as precious materials such as gold and gems, and could finance elaborate burial sites designed to endure for eternity.

Pyramids

The most monumental expression of the Egyptian pharaoh's power was the pyramid, his burial place and zone of passage into the afterlife. Pyramids were preceded by smaller structures called **mastabas**, from the Arabic word for "bench" (fig. **3.10**). These were originally made of mud brick and later were faced with cut stones. A mastaba is a single-story trapezoidal structure containing a vertical shaft leading to an underground burial chamber where the dead body lay in a **sarcophagus** (from the Greek words *sarcos,* meaning "flesh," and *phagein,* "to eat"). Another room (the *serdab*), located at ground level, contained the *ka* statue of the deceased. Adjoining this was an additional room for receiving mourners with offerings.

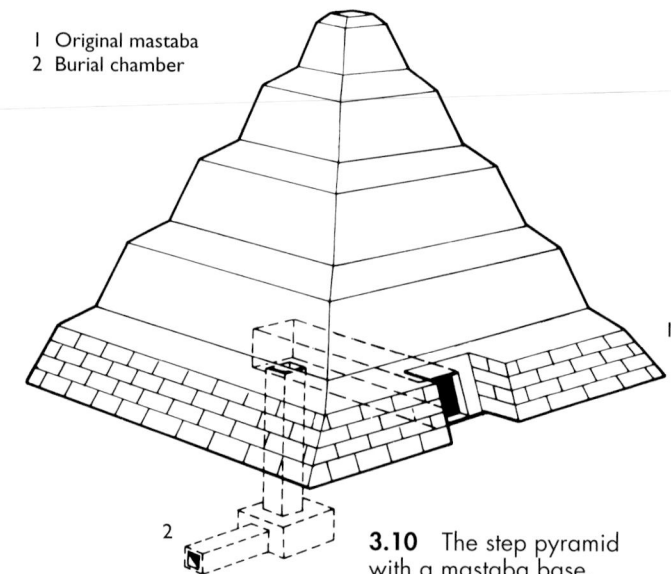

1 Original mastaba
2 Burial chamber

3.10 The step pyramid with a mastaba base.

Eventually, the number of underground chambers was increased in some mastabas to accommodate burials of entire families.

From 2630 to 2611 B.C., King Zoser's architect, Imhotep, constructed a colossal structure within a sacred architectural precinct at Saqqara, on the west bank of the Nile about 30 miles (48 km) south of Cairo. To the basic mastaba Imhotep added five more mastaba forms of decreasing size, one on top of the other, resulting in a **step pyramid** (fig. **3.11**). Inside, a vertical shaft some 90 feet (27.43 m) long led to the burial chamber. The exterior was faced with limestone, most of which has now disappeared. The purpose of Zoser's building complex was to function as a vast

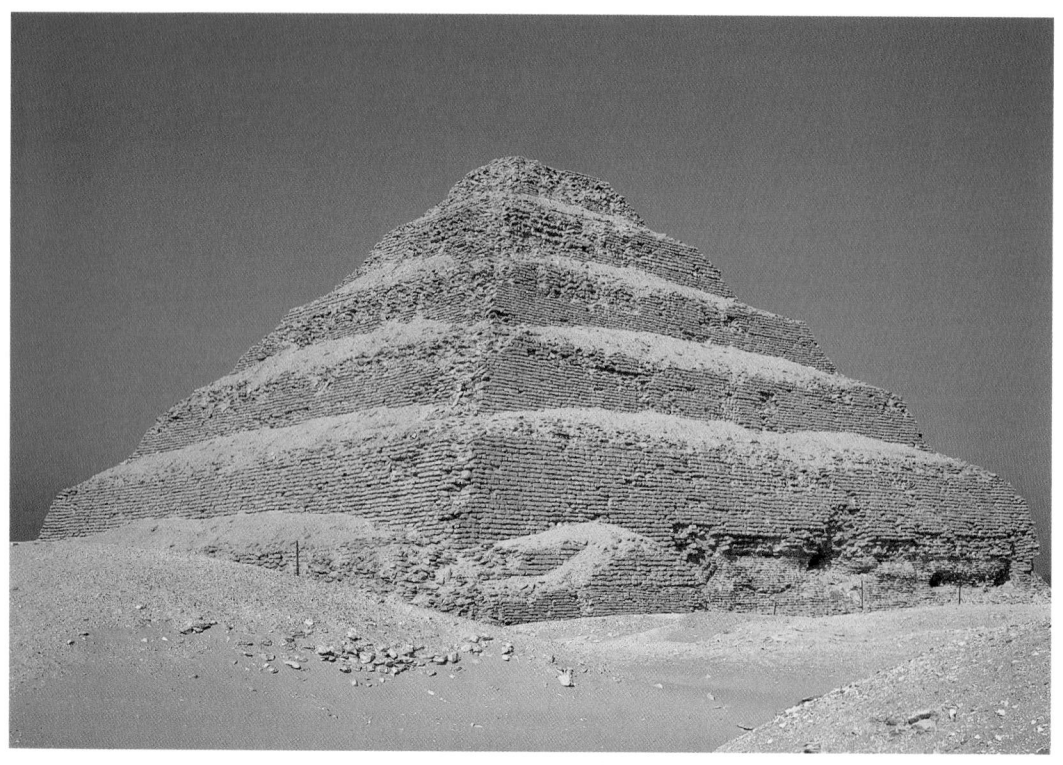

3.11 Step pyramid, funerary complex of King Zoser, Saqqara, Egypt, c. 2630–2611 B.C. Limestone; 200 ft. (61.00 m) high. Its architect, Imhotep, was a priest at Heliopolis and is reputed to have been the first Egyptian to build monumental stone structures. His name is inscribed inside the pyramid, where he is designated "First after the King of Upper and Lower Egypt." He became a legendary figure in ancient Egypt, revered for his wisdom as a magician, astronomer, and healer, and was worshiped as a god.

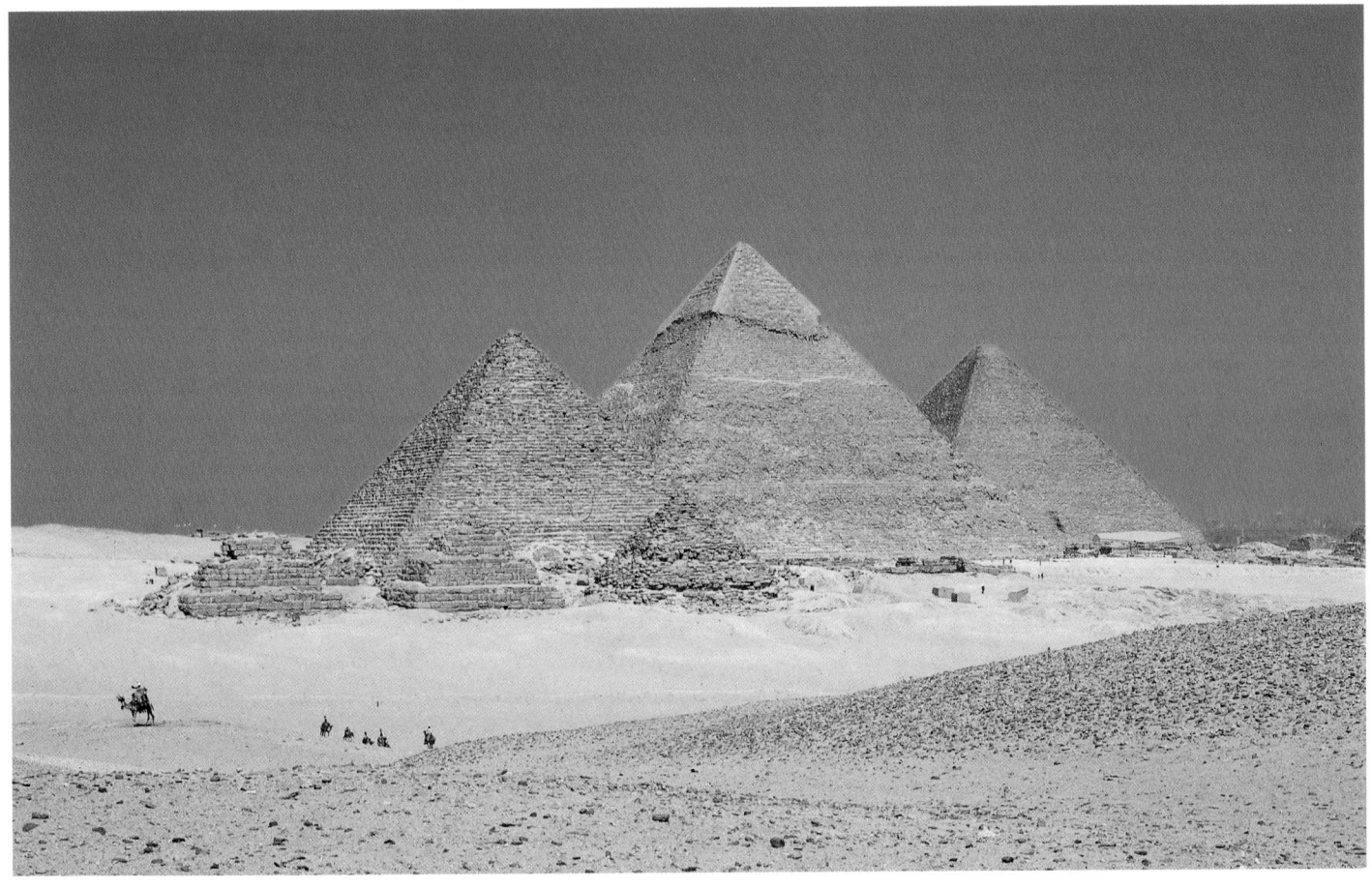

3.12 Pyramids at Giza, Egypt, c. 2551–2472 B.C. Limestone; pyramid of Khufu approx. 480 ft. (146.00 m) high, base of each side 755 ft. (230.00 m) long. The Giza pyramids were built for three Old Kingdom pharaohs of the Fourth Dynasty: Khufu (c. 2551–2528 B.C.), Khafre (c. 2520–2494 B.C.), and Menkaure (c. 2490–2472 B.C.). Khufu's pyramid—the largest of the three—was over twice as high as Zoser's step pyramid at Saqqara.

architectural "stage set"—some of the buildings were only façades backed with rubble—to serve him in the afterlife. Later on, the site was maintained as a cult center for both Zoser and Imhotep. In contrast to Mesopotamia, where it is the name of the royal patron that has lasted, at Saqqara it was the architect who received credit for the conception and execution of the building.

The next major development in pyramid design was the purely geometric pyramid, an evolution of Imhotep's step pyramid. Four triangular sides slant inward from a square base so that the apexes of each triangle meet over the center of the square. Originally, the sides were smooth and faced with polished limestone. A capstone, probably gilded, reflected the sun and signified the pharaoh's divine solar identification. Surveying techniques made it possible to orient the four corners of the plan precisely to the cardinal points of the compass. The purpose of this was to align the pyramids with significant positions of the sun.

Of the eighty-odd pyramids known to exist, the three outstanding examples were built by, and for, three Old Kingdom pharaohs of the Fourth Dynasty: the pyramid of Khufu (the largest, known as the Great Pyramid); the pyra-

mid of his son Khafre, 22 feet (6.71 m) shorter and 15 percent smaller in volume; and the pyramid of Khafre's son Menkaure, only 10 percent of the size of Khufu's (fig. **3.12**). All three are near Cairo at Giza, on the west bank of the Nile, facing the direction of sunset (symbolizing death), as was customary for Old Kingdom burial sites. Across the river to the northeast was Heliopolis (from the Greek words *helios,* meaning "sun," and *polis,* or "city"), the center of the cult associated with the sun god Ra.

Although the Giza monuments have been surrounded by desert since antiquity, recent archaeological excavations suggest that the site was once a river harbor. Each of the pyramids was connected by a causeway (elevated road) to its own valley temple at the edge of the original floodplain of the Nile. Upon the death of the king, his body was transported across the Nile by boat to the valley temple. It was then carried along the causeway to its own funerary temple, where it was presented with offerings of food and drink, and the Opening of the Mouth ceremony was performed (see p. 105).

The pyramid was intended primarily as a resting place for the king's body, and burial chambers were constructed

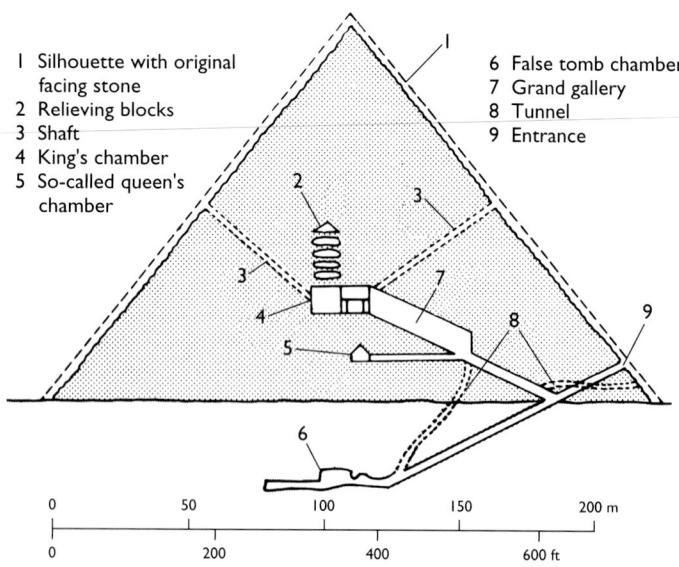

1 Silhouette with original facing stone
2 Relieving blocks
3 Shaft
4 King's chamber
5 So-called queen's chamber
6 False tomb chamber
7 Grand gallery
8 Tunnel
9 Entrance

3.13 Cross section of the pyramid of Khufu.

either in the rock under the pyramid or in the pyramid itself. In Khufu's case (fig. **3.13**), the burial chamber is in the middle of the pyramid, slightly less than halfway between the ground and the top. It is reached by a sloping passageway that runs into the grand gallery, an enormous foyer 153 feet long and 28 feet high (46.63 × 8.53 m) with a

corbeled roof (see Chapter 4). The king's chamber measures 34 by 17 feet (10.33 × 5.16 m), and its roof is composed of nine slabs of granite weighing 400 tons. The granite sarcophagus containing the body of Khufu was so large that it could not have been moved through the passages of the pyramid. Instead, it was placed in the chamber, and the pyramid was built around it.

In addition to the king's chamber, there were smaller chambers, possibly for the body of the queen, the organs of the deceased, and worldly goods for the journey to the afterlife. The chambers were connected by a maze of passages, including dead-ends designed to foil grave robbers. In this latter objective, the builders failed; during the Middle Kingdom a succession of thieves penetrated the pyramids at Giza and plundered them.

Construction of the pyramids was a considerable feat of engineering and organization. Herodotos (c. 484–430 B.C.), who traveled to Egypt in the fifth century B.C. and questioned the priests at Heliopolis, reported that the laborers "worked in gangs of a hundred thousand men, each gang for three months"[4] (*History* II.124). Some of the workers were probably seasonal—for example, peasants during the flooding of the Nile—but there would also have been a core of full-time masons and other craftsmen. Housing for 4,000 workers has been excavated near the pyramid of Khafre.

The pyramids at Giza were part of a vast funerary complex (fig. **3.14**) that included temples, chapels for offerings and ceremonies, mastabas for noble families, and cause-

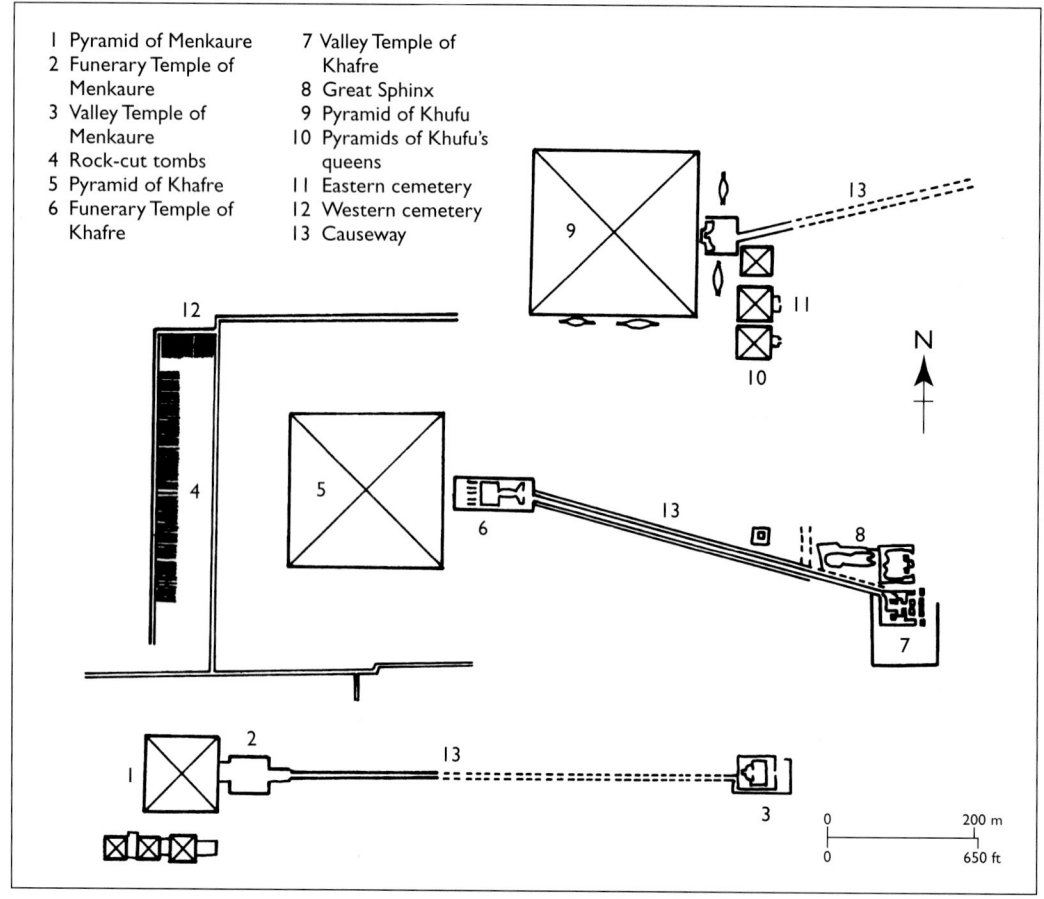

1 Pyramid of Menkaure
2 Funerary Temple of Menkaure
3 Valley Temple of Menkaure
4 Rock-cut tombs
5 Pyramid of Khafre
6 Funerary Temple of Khafre
7 Valley Temple of Khafre
8 Great Sphinx
9 Pyramid of Khufu
10 Pyramids of Khufu's queens
11 Eastern cemetery
12 Western cemetery
13 Causeway

3.14 Plan of the Giza funerary complex.

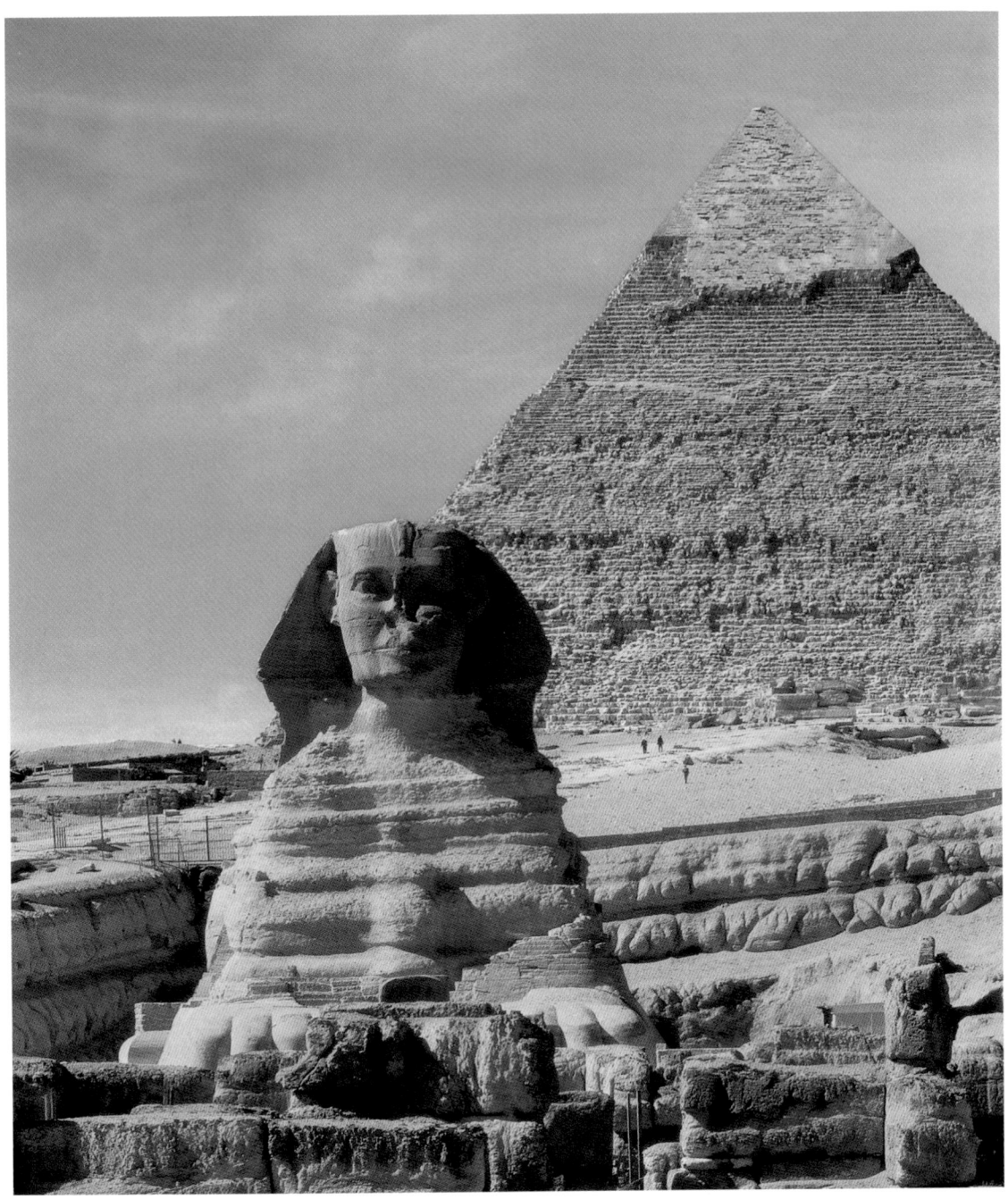

3.15 Colossal statue of Khafre, known as the Great Sphinx, Giza, c. 2520–2494 B.C. Sandstone; 66 ft. (20.12 m) high, 240 ft. (73.15 m) long.

ways linking the structures. From the pyramid of Khafre, a processional road led to his valley temple, guarded by the Great **Sphinx** (fig. **3.15**), a colossal human-headed creature with a lion's body carved out of the living rock. The location of the sphinx suggests that it represented Khafre

himself. It also faces the rising sun, which reinforces its association with the pharaoh. Surrounding the sphinx's head is the trapezoidal pharaonic headcloth (the *Nemes* headdress) that fills up the naturally open space above the shoulders and enhances the sculpture's monumentality.

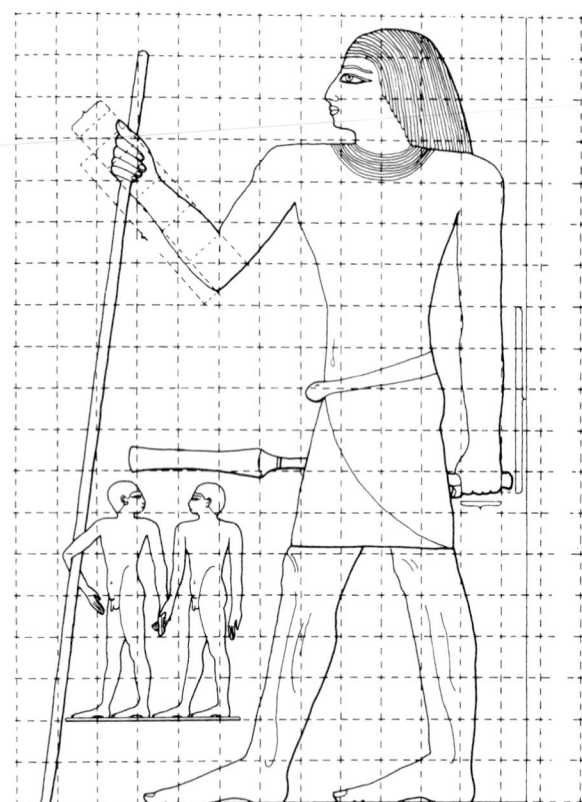

3.16 Egyptian proportional grid.

The Egyptian System of Proportion

Egyptian artists used a grid system to control the proportions of human figures (fig. **3.16**) in art. This allowed them to make identical multiples of statues such as the one illustrated in figure 3.17. The proportional system followed by Egyptian artists changed only slightly over time, a reflection of the unusual stability of Egyptian art. This system could be adjusted to any scale, from small statuettes (see fig. 3.24) to colossal works such as the Giza sphinx, ensuring exact proportions for each. It could be used for paintings and reliefs as well as for free-standing sculptures.

In figure 3.16, the distance from the hairline to the ground is 18 units, from the base of the nose to the shoulder 1 unit, and from the fingers of a clenched fist to the elbow 4½ units. Note the characteristic way of depicting the human body: the shoulders and the one visible eye are frontal; the head, arms, and legs are in profile, whereas the waist is nearly in profile but is turned sufficiently to show the navel. One purpose of this system was to arrive at a conventional, instantly recognizable image.

Sculpture

Nearly all the Egyptian sculpture that has been preserved was originally created for tombs or temples. Egyptian artists followed certain conventions for sculptures both in the round and in relief. The more important the personage represented, the more rigorously the conventions were observed.

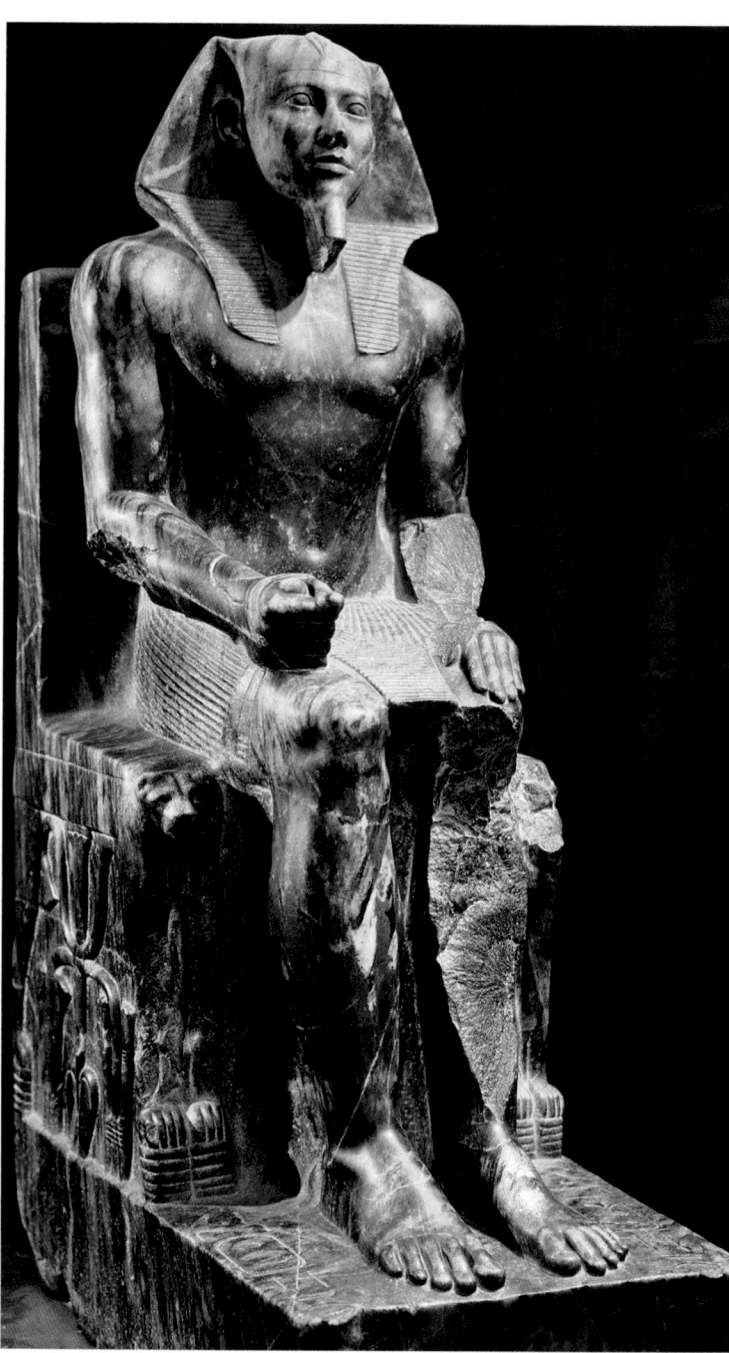

3.17a (front view) Seated statue of Khafre, from Giza, c. 2520–2494 B.C. Diorite; 5 ft. 6 in. (1.68 m) high. Egyptian Museum, Cairo.

An over-life-sized diorite statue of Khafre (fig. **3.17a, b**) illustrates the conventional representation of a seated pharaoh. Khafre sits in an erect, regal posture, both hands on his lap, his right fist clenched and his left hand lying flat above his knee. The sculptor began with a rectangular block of stone to which the planes of the figure still conform. Khafre's throne and its base comprise a stepped arrangement with two verticals (corresponding to the king's torso, upper arms, and calves) meeting three horizontals (his forearms, thighs, and feet) at right angles. Spaces between body and throne are eliminated because the original diorite remains, serving to unify the king and his throne. The symbolic identification of king and throne is thus formally enhanced by the sculptors of this period.

The lions carved on Khafre's throne are the king's guardians and images of regal power in their own right. Horus, who protects the back of Khafre's head, was the son of Isis, a mother goddess called the "Pharaoh's throne." Both gods reinforce Khafre's divine right of kingship. The association of a ruler and his throne is reflected in modern usage when we refer to the "seat of power."

A good example of standing figures from the Old Kingdom can be seen in the statue of Khafre's son Menkaure (whose pyramid at Giza is illustrated in figure 3.12) and Queen Khamerernebty (fig. **3.18a**). The artist began with an upright rectangular block, which remains visible in the base, between the figures, and at the back (fig. **3.18b**).

The statue of Khafre and that of Menkaure and Khamerernebty were found in their valley temple along with a series of similar figures. Their function was to embody the *ka* of the royal personages and to receive food and drink brought by worshipers. Priests were believed to have the magic power to transform the images into real people who could eat the offerings.

The sculptures of Prince Rahotep and his wife Nofret (fig. **3.19**, p. 97) also exhibit distinctions between representations of male and female. Princess Nofret is fully clothed, and her right hand lies flat, protruding from her garment. Her husband wears only a lower garment, and both fists are clenched. Since the soft limestone from which these figures are carved is porous, their original paint has been preserved. This fortunate circumstance reveals the elaborate jewelry worn by aristocratic Egyptian women and the stylized eye outlines also current in Mesopotamian art. The difference in Rahotep's brown skin tone and Nofret's, which is yellow ocher, is a convention of Egyptian painting and painted sculpture to distinguish male from female. Note also the hieroglyphs on the slab behind the figures; they denote the names and titles of the couple.

3.17b (side view) Seated statue of Khafre.

METHODS OF INTERPRETATION

Menkaure and Khamerernebty, an Old Kingdom Pharaoh and His Queen (fig. 3.18); Formalism, Iconography, Feminism, Context

The rectangular block of stone from which this statue was carved is retained in the final sculpture, making the king and queen literally and figuratively "set in stone." In this case, the formal elements reinforce the iconographic meaning of the figures. The king is taller, his shoulders are broader, his pose is more rigid, his fists are tighter, and his assertive left leg is extended farther forward than the queen's. He wears the traditional trapezoidal *Nemes* headdress and ceremonial beard typical of Old Kingdom pharaohs. These formal and symbolic features create the impression that he is more forceful and more powerful than she. The flattening of the tunic suggests solidity and forcefulness, and contrasts with the queen's garment, which is formed more softly around the curves of her body.

Feminist art historians have identified the queen's pose as indicating her support of the pharaoh. That she places one arm around his waist and the other on his arm has been interpreted as the queen conferring power on her spouse. This interpretation is consistent with the cultural context of ancient Egyptian royalty, which was matrilineal in character. Egyptians recognized that maternity is always more certain than paternity. Nevertheless, despite the important role of the queen, her more naturalistic depiction signified a lesser rank than the king's in the strict and accepted hierarchy of Egyptian society.

Because of the importance of eternal life in Egyptian religion, representations of kings and queens emphasized their association with the gods. The very choice of the medium had meaning in ancient Egypt. For this reason, hard stone, such as obsidian, granite, diorite, and slate —the latter used to carve King Menkaure and his queen—was the preferred medium for royal sculpture. Stone was the longest-lasting, most durable sculptural material the Egyptians had available.

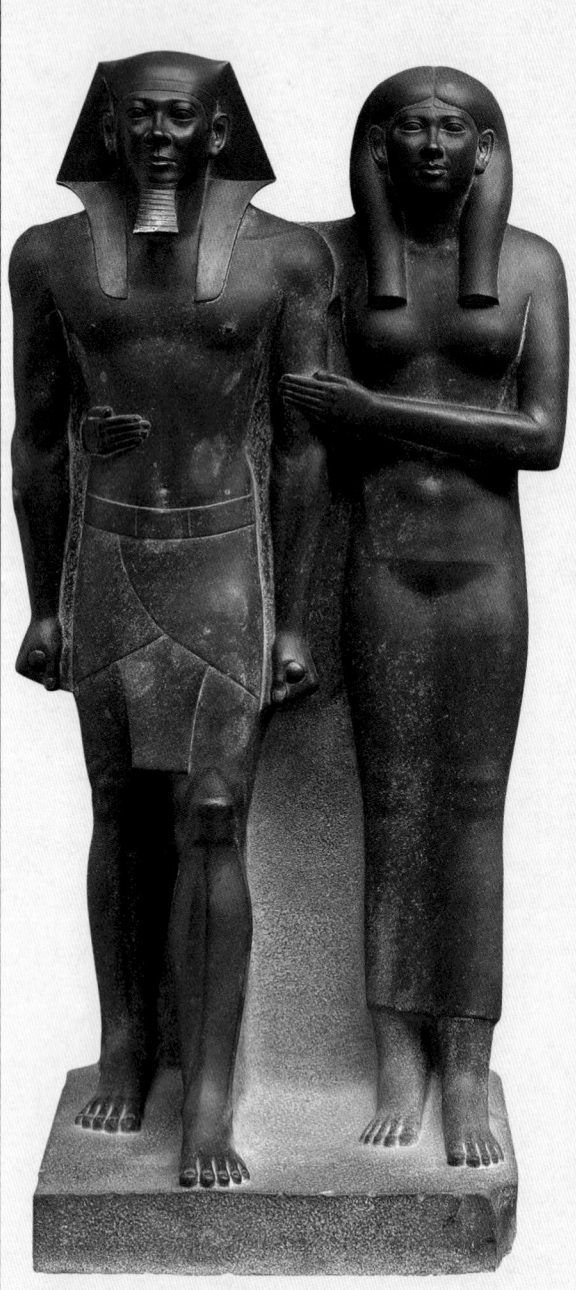

3.18a Menkaure and Queen Khamerernebty, from Giza, 2490–2472 B.C. Slate; 4 ft. 6½ in. (1.39 m) high. Courtesy, Museum of Fine Arts, Boston.

3.18b Side view of figure 3.18a.

3.19 Prince Rahotep and his wife Nofret, c. 2551–2528 B.C. Painted limestone; 3 ft. 11¼ in. (1.20 m) high. Egyptian Museum, Cairo. The eyes are inlaid with rock crystal; facial features and Nofret's headband and necklace are painted.

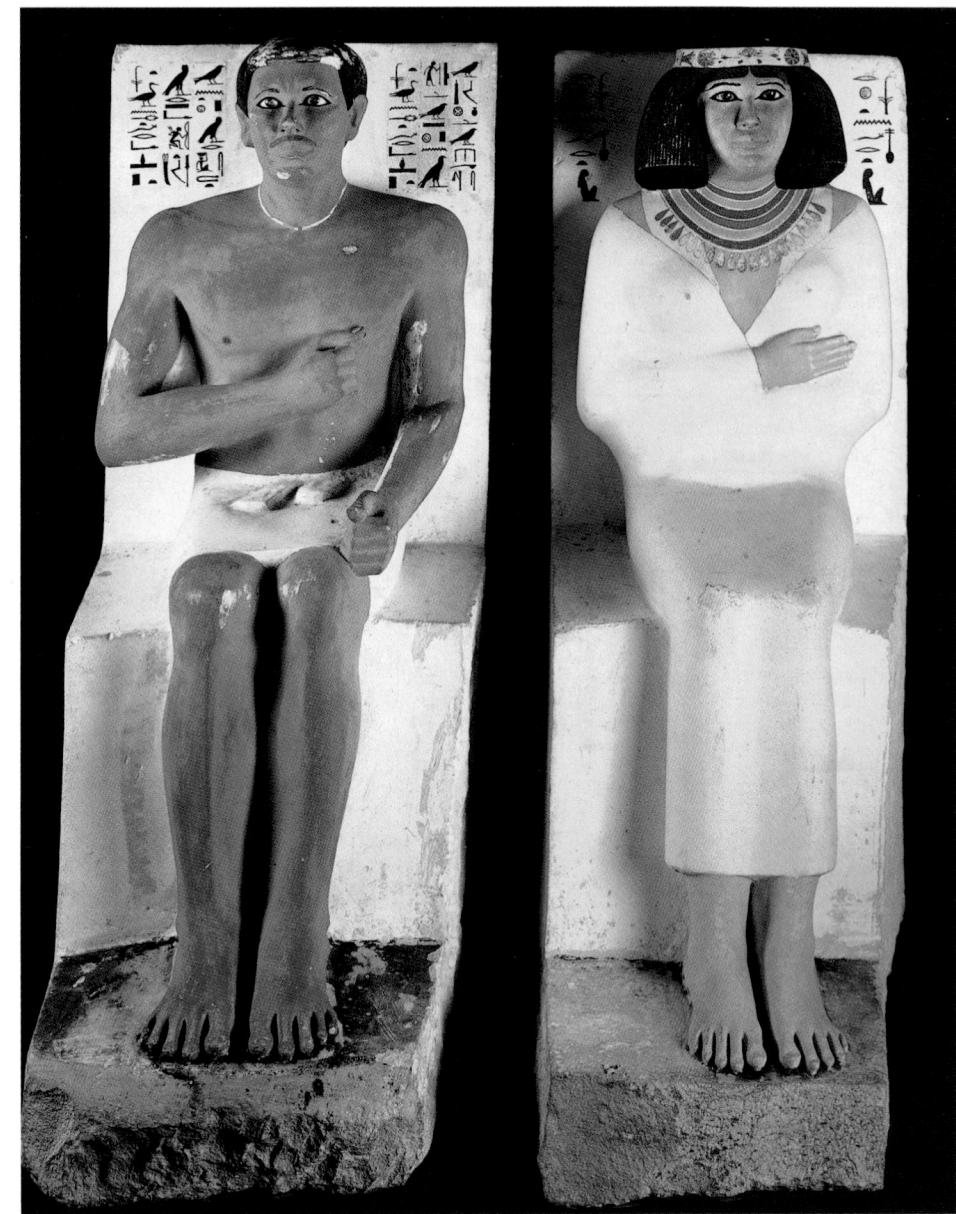

3.20 Seated scribe, from Saqqara, c. 2551–2528 B.C. Limestone; 21 in. (53.3 cm) high. Louvre, Paris. The scribe retains his original paint, which makes his eyes seem lifelike. In ancient Egypt, scribes were among the most educated people, having to study law, mathematics, and religion, as well as reading and writing.

Compared with the sculptures of Khafre and Rahotep, the seated scribe (fig. **3.20**) is less monumental though no less impressive. He sits cross-legged, in the pose that is conventional for scribes. A papyrus scroll (see box, p. 98) extends across his lap, and his right hand is poised to write. In contrast to statues of pharaohs and nobles, the lower rank of the scribe allows the sculptor to reflect his relatively individual character. Furthermore, the sculptor has cut away the limestone between the arms and body as well as around the head and neck, thereby reducing the monumentality of this statue as compared with that of Khafre. The depiction of the scribe is also more personalized than that of either Khafre or Rahotep—he has a roll of fat around his torso, a potbelly, and sagging breasts. This particular scribe must have been of high status because he had his own tomb.

Papyrus Manuscripts

The most important Egyptian writing surface was made from the papyrus plant, which grew in the marshes along the Nile. Papyrus stems were cut into lengths of about 12 inches (30.5 cm). The rind was peeled off and the pith cut lengthwise into thin slices. One layer of slices was laid side by side with a second layer on top of it at right angles. The two layers were bonded together by pressing, with no adhesive other than the natural starch of the papyrus. Once dry, the resulting smooth and light-colored surface was polished with a wood or stone tool. Papyrus sheets could be joined together at the edges (with the fibers running in the same direction) and then rolled up into scrolls.

Pigments for writing texts were solid tablets made of carbon (black) or of ground ocher (red) that were then mixed with gum. They were dissolved as the scribe wet his brushes and rubbed them over the tablet's surface—much as watercolor paint is used today. Brushes were made from the trimmed stems of other marsh plants. Bristles, which held a supply of wet pigment, were made by chewing one end of their stems to separate the fibers. During the Late period, pens were also used; these were made from reeds that had been cut to a point and split in two at the tip.

The Middle Kingdom (c. 1991–1700 B.C.)

Monumental architecture continued in the Middle Kingdom, though much of it was destroyed by New Kingdom pharaohs for use in their own colossal building projects. Besides pharaohs' pyramids, a new form of tomb was introduced. This was rock-cut architecture, in which the sides of cliffs were excavated to create artificial cave chambers. Rock-cut tombs became popular with aristocrats and high-level bureaucrats in the Eleventh and Twelfth Dynasties.

Middle Kingdom sculpture is often somewhat more naturalistic, and royal figures less imposing than in the Old Kingdom. Forms tend to be more rounded, and faces show occasional hints of an expression. Although the graceful seated statue of Lady Senuwy (figs. **3.21** and **3.22**) retains the closed space between arms and body, and lower legs and seat, associated with statues of Old Kingdom pharaohs, there is a narrow space behind the figure that emphasizes the gradual curve of the wig and back. Compared with the statue of Nofret (see fig. 3.19), Lady Senuwy is slim and her features more delicate. Hers is one of the finest and most elegant large-scale statues from the Middle Kingdom.

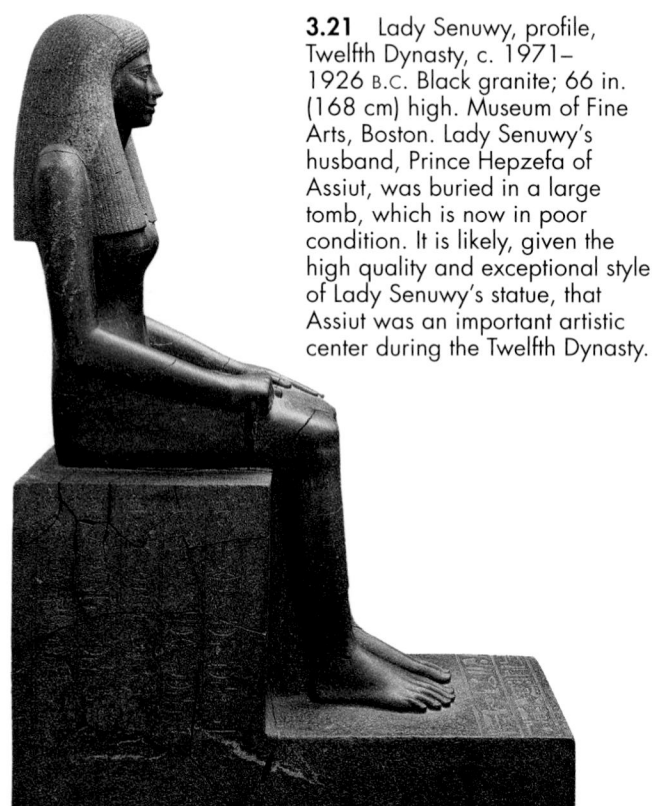

3.21 Lady Senuwy, profile, Twelfth Dynasty, c. 1971–1926 B.C. Black granite; 66 in. (168 cm) high. Museum of Fine Arts, Boston. Lady Senuwy's husband, Prince Hepzefa of Assiut, was buried in a large tomb, which is now in poor condition. It is likely, given the high quality and exceptional style of Lady Senuwy's statue, that Assiut was an important artistic center during the Twelfth Dynasty.

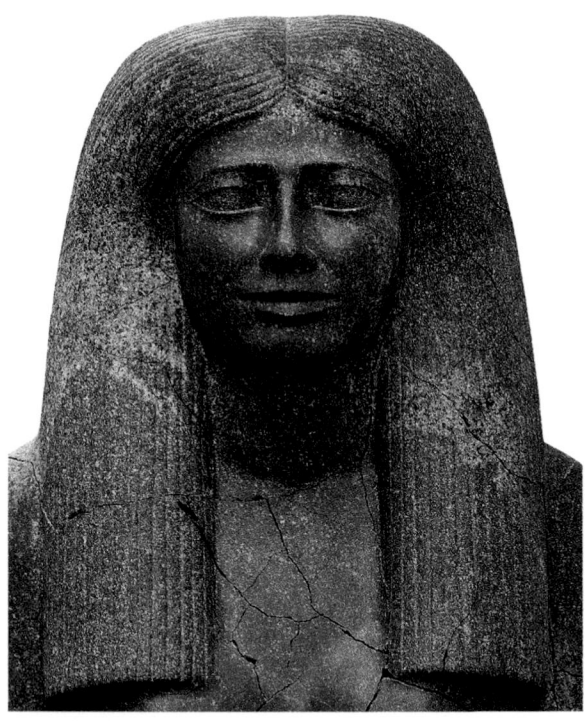

3.22 Lady Senuwy (front view of fig. 3.21).

3.23 Sesostris I, from Lisht, Twelfth Dynasty, c. 1971–1926 B.C. Wood. Egyptian Museum, Cairo.

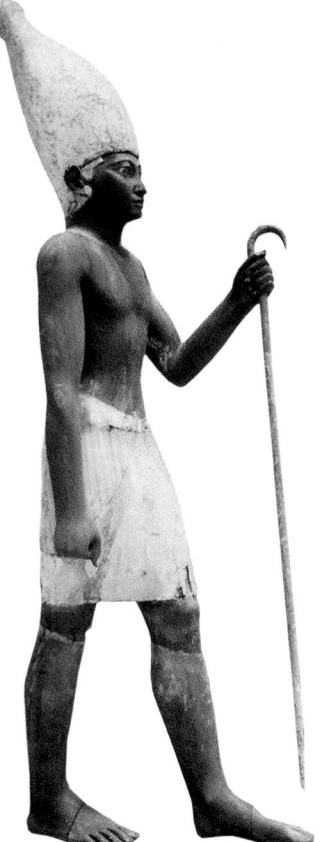

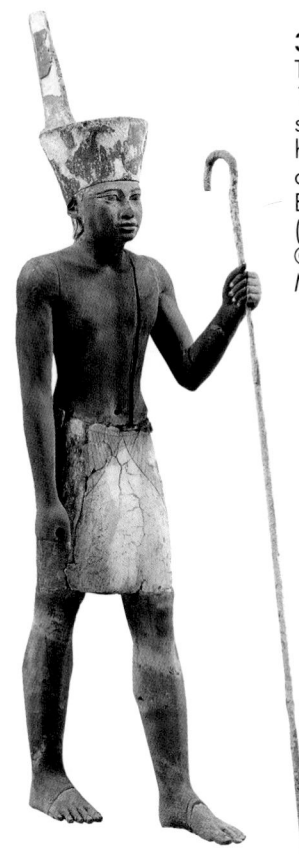

3.24 Sesostris I, from Lisht, Twelfth Dynasty, c. 1971–1926 B.C. Painted wood and stucco; 23 in. (58.5 cm) high. Metropolitan Museum of Art, New York. Gift of Edward S. Harkness, 1914 (14.3.17). Photograph © 1993 Metropolitan Museum of Art.

3.25 Sesostris III, c. 1878–1841 B.C. Quartzite; 6½ in. (16.5 cm) high. Metropolitan Museum of Art, New York. Gift of Edward S. Harkness, 1926.

The political turbulence and invasions of the First Intermediate period that preceded the Middle Kingdom disrupted confidence in the pharaoh's absolute divine power. Although pharaonic rule quickly reasserted itself, certain works of art reflect a new national mood. This can be seen by comparing two well-preserved wooden statuettes of Sesostris I (figs. **3.23** and **3.24**) with the fragmentary portrait of Sesostris III (fig. **3.25**). The figure of Sesostris I on the left wears the conical white crown of Upper Egypt (the *hedjet*); the other figure, the red crown of Lower Egypt (the *deshret*). Because these are made of wood, they are entirely carved in the round. Nevertheless, they are slimmer and less imposing than the Old Kingdom images of Khafre (see fig. 3.17) and Menkaure (see fig. 3.18).

The portrait of Sesostris III is one of the best examples of the new approach to royal representation in the Middle Kingdom. Sesostris III referred to himself as the shepherd of his people, and his portrait seems to show concern. There are bags under his eyes, and his cheeks are fleshy. Worry lines crease the surface of his face, and his forehead forms into a slight frown. This is no longer solely an image of divine, royal power. Instead, by departing from earlier conventions of royal representation, the sense of a specific personality emerges.

3.26 Painted coffin of Djehuty-nekht, from Bersheh, Twelfth Dynasty, c. 1971–1926 B.C. Cedar. Museum of Fine Arts, Boston.

The coffin in figure **3.26** illustrates some of the textural qualities of Middle Kingdom painting. The detailed, occasionally illusionistic patterns were drawn by an artist with a fine linear sensibility. Slight shading creates a tactile quality enhanced by the grain of the cedar surface. The eyes are those of Horus and are framed above the painted "false door" of the coffin over which they keep watch. The "door" itself allowed the *ka* to leave and reenter the coffin at will.

The New Kingdom (c. 1550–1070 B.C.)

After the instability of the Second Intermediate period, during which the so-called Hyksos invasion occurred, Egypt once again recovered its political equilibrium. The pharaohs of the New Kingdom reestablished control of the en-

tire country and reasserted their power. They expanded into the surrounding regions of the north and south to form an empire of enormous wealth.

Temples

As durable and impressive as the tombs, Egyptian temples provided another way of establishing the worshiper's relationship with the gods. The first known Egyptian temples in the Neolithic period were in the form of huts preceded by a forecourt. From the time of Menes at the beginning of the dynastic period, a courtyard, hallway, and inner sanctuary were added. The columned hallway, called a **hypostyle** (from the Greek words *hupo*, meaning "under," and *stulos*, "pillar"), is shown in its fully developed New Kingdom form in figure **3.27**. It was constructed in the post-and-lintel system of elevation and had two rows of tall central columns flanked by rows of shorter columns on either side.

3.27 (above) Model of the hypostyle hall, temple of Amon-Ra, Karnak, Egypt, c. 1294–1213 B.C. Metropolitan Museum of Art, New York. Bequest of Levi Hale Willard, 1890. The central hypostyle columns have capitals that seem to grow upward and curve outward from the shaft like the lotus blossom. The shafts were covered with painted low-relief scenes and hieroglyphs. Their enormous scale is hard to imagine from a photograph, but the base of each column would reach to the waist of an adult of average height. The side columns are derived from the papyrus plant.

The Pylon Temple The standard Egyptian temple, called a **pylon** temple after the two massive sloping walls (pylons) flanking the entrance, was designed symmetrically along a single axis. The plan in figure 3.28 is typical, showing the spaces through which worshipers moved from the bright outdoors into the courtyard. As they approached the entrance, they were flanked by rows of identical statues facing each other. Some temple entrances were flanked by **obelisks** (tall, tapering, four-sided pillars ending in a pointed tip called a **pyramidion**) and colossal royal statues (fig. 3.29).

Beyond the courtyard stood the hypostyle hall, its massive columns casting shadows and creating an awe-inspiring atmosphere. The upper, or **clerestory**, windows let in small amounts of light that enhanced the effect of the shadows. Most

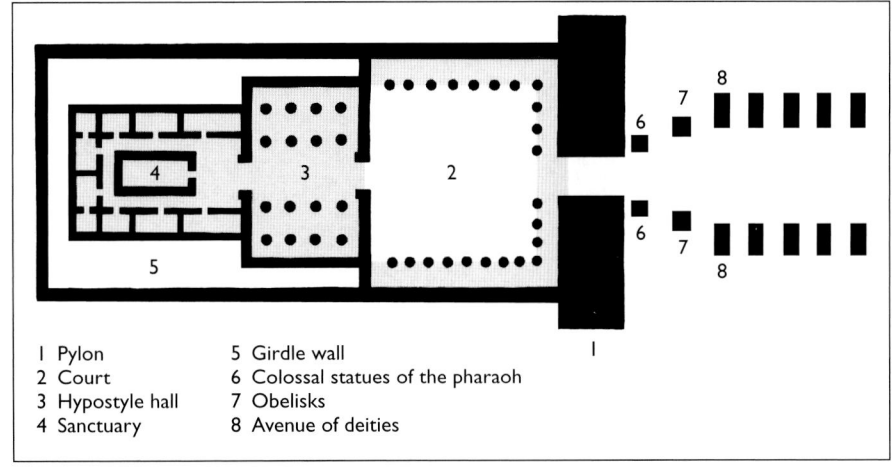

1 Pylon	5 Girdle wall
2 Court	6 Colossal statues of the pharaoh
3 Hypostyle hall	7 Obelisks
4 Sanctuary	8 Avenue of deities

3.28 (above) Plan of a typical pylon temple.

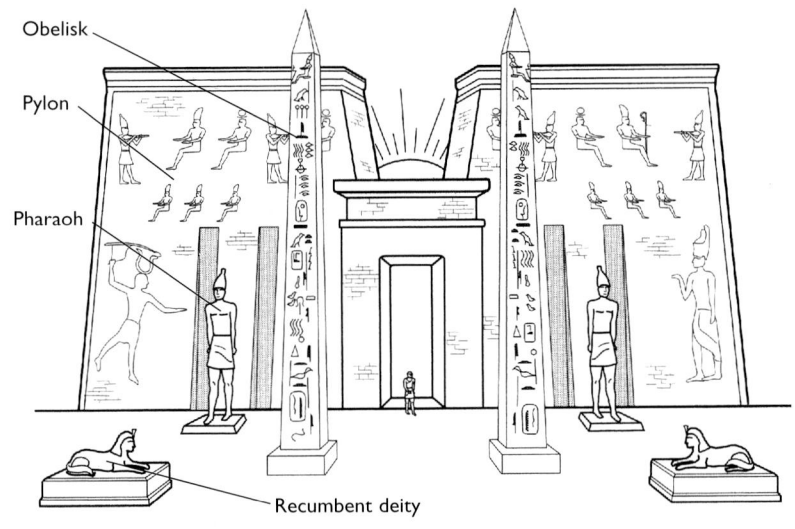

3.29 (left) Diagram of a pylon façade. The obelisks were derived from the sacred *benben* stone, worshiped as a manifestation of Amon at Heliopolis. At dawn, the rays of the rising sun caught the *benben* stone before anything else, and the stone was thus believed to be the god's dwelling place. The obelisks flanking the pylon entrance were arranged in relation to positions of the sun and moon and, like the pyramids, were probably capped with gold.

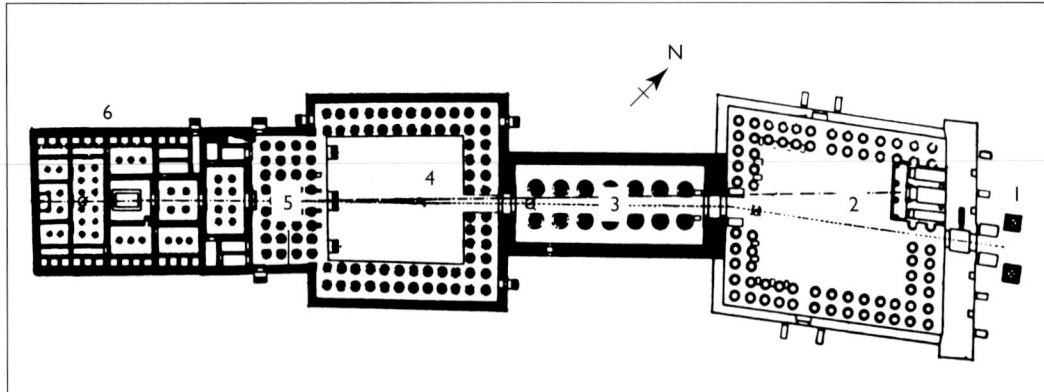

3.30 Plan of the temple of Amon-Mut-Khonsu, Luxor, Egypt, begun c. 1390 B.C. Reading the plan from right to left, number 1 refers to the pylons, flanking the entrance. From the entrance, one proceeded through three open-air, colonnaded courtyards (2, 3, 4). Then the worshiper was plunged into the darkened and mysterious realm of the hypostyle hall (5), beyond which lay the sanctuary complex (6).

people never entered the temples, but watched from the outside the processions for which the temples were planned. Occasionally the elite were allowed to enter the courtyards, while the priests carried the images of the gods in and out of the innermost sanctuaries in boat-shaped shrines called barks. The transitional quality of this architecture is carefully designed to evoke the feeling of a mysterious enclosure—a space inhabited by pharaohs and gods.

The New Kingdom temple at Luxor is dedicated to a triad of gods: Amon-Mut-Khonsu. This triad was worshiped at the New Kingdom capital city of Thebes, and its importance

steadily increased. The plan of the temple (fig. **3.30**) shows that the hut and courtyard of the Neolithic era had developed into a much more elaborate structure. At the far end is the sanctuary—the "holy of holies"—a small central room with four columns shown at the far left of the plan. It was there that the priests tended the statues of the gods.

Ancient Egyptian temples were considered microcosms of the universe, and as such they contained both earthly and celestial symbolism. Column designs were derived from the vegetation of Egypt and represented the earth (see caption). Inside the temple (fig. **3.31**), the original ceil-

3.31 Court and pylon of Ramses II (1279–1213 B.C.) and colonnade and court of Amenhotep III (1390–1352 B.C.), temple of Amon-Mut-Khonsu, Luxor, Nineteenth Dynasty. Columns 30 ft. (9.00 m) high. Here the foreground columns are constructed in the form of bundles of papyrus reeds, and those behind are lotus flowers. Papyrus represented Lower Egypt and lotus represented Upper Egypt.

ing was painted blue and decorated with birds and stars denoting its symbolic role as the cosmos.

It is clear from Egyptian temple architecture, as well as from the pyramids, that colossal size was highly regarded. The scale of these structures emphasized the enormous power of the gods and the pharaoh, and made ordinary worshipers feel insignificant by comparison. Similarly, the vast numbers of colossal columns were intended to create an overwhelming effect. There were many large statues of the pharaoh lining the temple courtyards, as there were rows of sphinxes preceding the entrances. This insistence on repetition was designed to impress worshipers with the king's power and fertility.

Hatshepsut's Mortuary Temple and Sculpture The Eighteenth Dynasty is notable for its female pharaoh, Hatshepsut (reigned c. 1473–1458 B.C.), the wife and half sister of Thutmose II. When Thutmose II died, *his* son by a minor queen, Thutmose III, was underage. Around 1479 B.C., Hatshepsut became regent for her stepson/nephew but exerted her right to succeed her father and was crowned king of Egypt in 1473 B.C. Although female rulers of Egypt were not unprecedented, Hatshepsut's assumption of specifically male aspects of her office—such as the title of king—was a departure from tradition. Despite her successor's attempts to obliterate her monuments, many of them survive to document her productive reign.

It is not known why Hatshepsut became king nor why Thutmose III tolerated it. Hatshepsut's strong character and political acumen must have contributed to her success. She claimed that her father had chosen her as king, and she used the institution of co-regency to maintain her power without having to eliminate her rival. Above all, she selected her officials wisely, particularly Senenmut, who was her daughter's guardian as well as her first minister and chief architect.

Hatshepsut, like other pharaohs, assumed royal titles and iconography, and had her own divine conception depicted in her temple reliefs. In keeping with the conventional scene, the compound god Amon-Ra was shown handing the *ankh* symbol (☥), hieroglyph for "life," to Hatshepsut's mother, Queen Ahmose. In this imagery, Hatshepsut proclaimed her divine right to rule Egypt as king. She also referred to herself in texts as the female Horus, evoking the traditional parallel between a pharaoh and Horus. (Horus was the falcon-headed son of the underworld god Osiris, born after the murdered Osiris was brought back to life. Horus claimed kingship as the son of the dead Osiris. Likewise, when the Egyptian throne was handed down from father to son, it was seen as a symbolic transfer from Osiris to Horus.)

Despite acknowledging her female gender, Hatshepsut chose to be represented as a man in many of her statues. The example in figure **3.32** depicts her in the traditional assertive pose of standing pharaohs, wearing a ceremonial headdress and beard. Instead of the clenched fists of

Old Kingdom pharaohs such as Menkaure (see fig. 3.18), Hatshepsut extends her arms forward and lays her hands flat on her trapezoidal garment.

The main architectural achievement of Hatshepsut's reign was the terraced mortuary temple at Deir el-Bahri

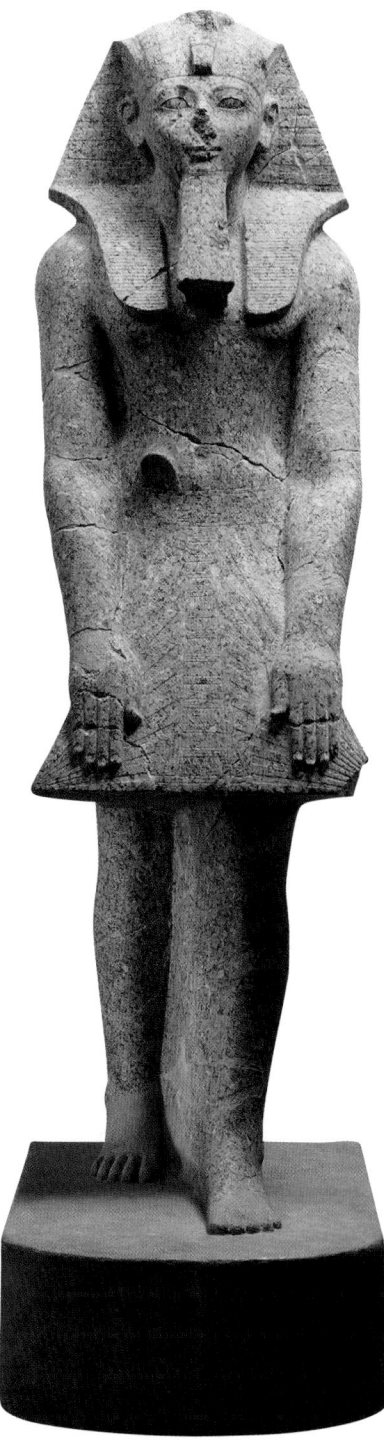

3.32 Statue of Hatshepsut as pharaoh, Eighteenth Dynasty, c. 1473–1458 B.C. Granite; 7 ft. 11 in. (2.41 m) high. Metropolitan Museum of Art, New York. Hatshepsut was the second known queen who ruled Egypt as pharaoh. The earlier queen, Sobekneferu, ruled in the Twelfth Dynasty but, unlike Hatshepsut, did not preside over an artistic revival.

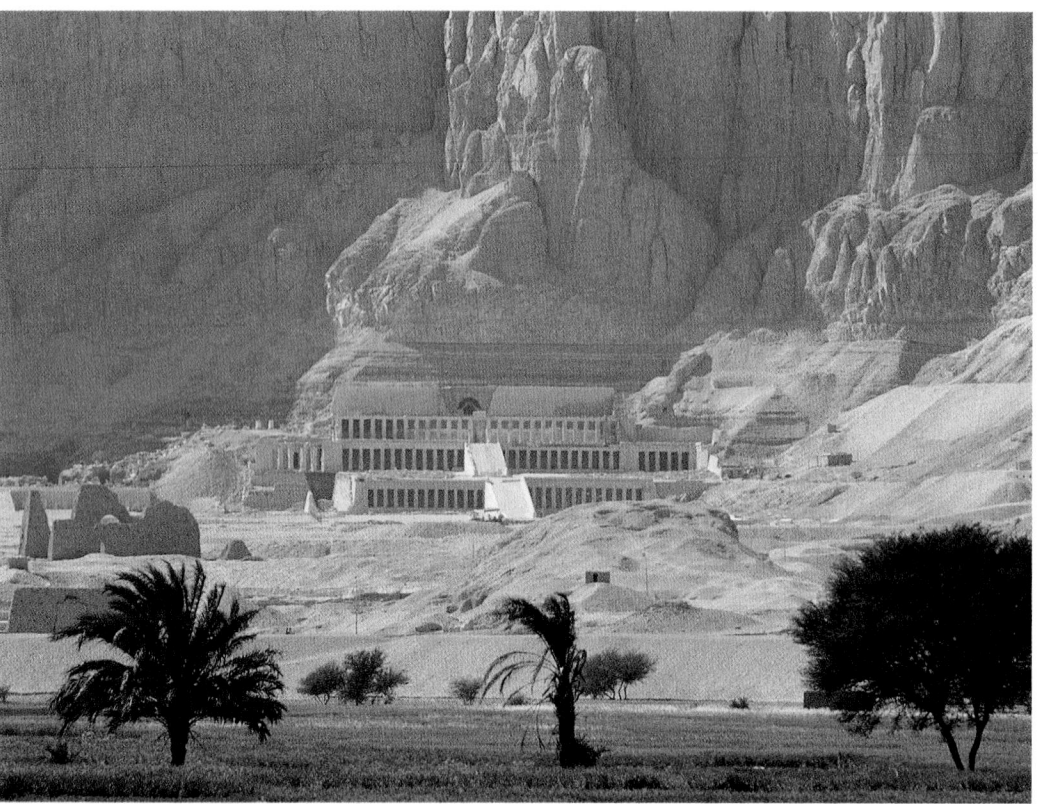

3.33 Funerary temple of Queen Hatshepsut, Deir el-Bahri, Egypt, Eighteenth Dynasty. Sandstone and rock. Construction of this temple began in the reign of Thutmose I (1504–1492 B.C.) and continued during the reign of his daughter Hatshepsut (1473–1458 B.C.). Most of the projecting colonnades have been restored after vandalism during the reign of Thutmose III (1479–1425 B.C.). They adorn the three large terraces, which are connected to each other by ramps. The inner sanctuary is located inside the cliff.

(fig. **3.33**). The primary function of the Egyptian mortuary temple was twofold: first, to worship the king's patron deity during his lifetime and, second, to worship the king himself after his death. The function of the Deir el-Bahri complex as a mortuary temple for both Hatshepsut and her father reinforced her image as his successor. At the same time, the major deities Amon, Hathor, and Anubis were worshiped in shrines within the temple complex. On the exterior, terraces with rectangular supports and polygonal columns blended impressively with the vast rocky site.

Hatshepsut's architect Senenmut was the main artistic force behind the temple and its decoration. His special status is reflected in the fact that his tomb, which was never completed, was begun inside the royal religious complex, and its unfinished ceiling was decorated with texts usually reserved for a pharaoh's burial.

In the black granite statue in figure **3.34**, Senenmut holds his ward, the young princess Nefrura, daughter of Hatshepsut. The figures are frontal, and, despite their rather iconic, even rigid poses, there is a suggestion of protectiveness in Senenmut's large hands enveloping his ward. This iconography projects an image of his close relationship with the pharaoh.

At the end of Hatshepsut's reign, Thutmose III, then in his late twenties, finally assumed sole power (c. 1458 B.C.). He demolished the images and cartouches of Hatshepsut and emphasized his own role as the successor of his father, Hatshepsut's brother/spouse Thutmose II. Whereas Hatshepsut's reign had been notable for diplomacy, Thutmose III became a great conqueror, gaining control of Nubia and invading the Near East.

3.34 Statue of Senenmut and Nefrura, Eighteenth Dynasty, c. 1473–1458 B.C. Black granite; 24 in. (61.0 cm) high. British Museum, London. The number of statues of Senenmut is exceptional for an official who was not a member of the royal family. The fate of Nefrura at the end of Hatshepsut's reign is not known.

3.35 Nebamun hunting birds, from the tomb of Nebamun, Thebes, Egypt, c. 1390–1352 B.C. Fragment of a painting on gypsum plaster. British Museum, London.

Painting

Walls of Egyptian New Kingdom tombs and temples were covered with reliefs and paintings. Both provided the *ka* with familiar scenes from the earthly existence of the deceased. They also offer the modern viewer a wealth of information about life in ancient Egypt.

Mural Painting A painting on gypsum plaster from the tomb of Nebamun (fig. **3.35**), a New Kingdom official, shows him hunting birds. He is accompanied by his wife and daughter, and surrounded by animals and landscape. Following the conventional Egyptian pose, his head and legs are in profile, his torso and eye are frontal, and he wears a trapezoidal kilt. Nebamun's wife and daughter are small and curvilinear by comparison, continuing the Old Kingdom tradition of increasing naturalism for decreasing rank. Paintings of this period, however, were slightly more naturalistic than those of the Old Kingdom. Note that Nebamun's wife is rendered with brown skin rather than with the conventional lighter skin of Egyptian women in art, as seen in the statues of Rahotep and Nofret (see fig. 3.19). The birds turn more freely in space than the human figures, and on the fish there is evidence of shading, which conveys a sense of volume.

Papyrus A New Kingdom painting on papyrus from the *Book of the Dead* (fig. **3.36**) illustrates the Opening of the Mouth ceremony, which ritually "opened the mouth" of the dead body and restored its ability to breathe, feel,

hear, see, and speak. In this scene, described in the rows of hieroglyphics at the top, the ritual is performed on the Nineteenth Dynasty mummy of the scribe Hunefer. Reading the image from left to right, we see a priest in a leopard skin, an altar, and two priests in white garments with

3.36 Opening of the Mouth ceremony, from the *Book of the Dead* of Hunefer, New Kingdom, Nineteenth Dynasty, c. 1295–1186 B.C. Pigment on papyrus. British Museum, London.

upraised ritual objects. Two mourning women are directly in front of the upright mummy. Behind the mummy is Anubis, the jackal-headed mortuary god. The two forms behind him are a stele covered with hieroglyphs and surmounted by a representation of Hunefer appearing before a god, and a stylized tomb façade with a pyramid on top. Note the similarity between the iconography of the power-revealing scene at the top of the stele and that on the law code of Hammurabi (see fig. 2.21). Both are images of power and signify communication between the god and a mortal. In both, the seated god combines a frontal and profile pose, while the smaller mortal—as if commanding less space—is more nearly in profile.

In spite of the remarkable social, political, and artistic continuity of ancient Egypt, it is clear from the fresco fragment in figure 3.35 and from Hunefer's papyrus that certain changes had occurred in the nearly sixteen hundred years between the beginning of the Old Kingdom and the end of the New Kingdom. The most important cultural change, however, took place in around 1353 B.C., some four years into the reign of a revolutionary pharaoh, Amenhotep IV.

The Amarna Period (c. 1349–1336 B.C.)

Generations of scholars have tried to answer the questions surrounding King Amenhotep IV, who challenged the entrenched religious cults and threatened the very existence of the established priesthood that had held power in Egypt for centuries. By the Fourth Dynasty, the sun god Ra had superseded Horus as the supreme deity. Ra's cult was introduced north of Cairo at Heliopolis, the city of the sunrise. By the Twelfth Dynasty, Amon had superseded Ra in this position; and then in the Eighteenth Dynasty, Amenhotep IV adopted a new, and unpopular, religious system that was relatively monotheistic.

His primary god was the Aten, represented as the sun disk, and Amenhotep accordingly changed his name to Akhenaten (meaning "servant of the Aten"). He effaced the names and images of the other gods. Presumably to escape the influence of the priests, he moved the capital down the Nile (i.e., north) from the major cult center of Thebes to Akhetaten (now known as Tell el-Amarna, from which the term for this period is derived). Akhenaten chose the site and name for his new capital because the sun rising over the horizon at that point resembled the hieroglyph for sunrise.

The following stanza from the "Hymn to Aten" reflects the revolutionary character of Akhenaten's change from a polytheistic belief system to the worship of a single, all-powerful god:

> You are the one God,
> shining forth from your possible incarnations
> as Aten, the Living sun,
> Revealed like a king in glory, risen in light,
> now distant, now bending nearby.

> You create the numberless things of this world
> from yourself, who are One alone—
> cities, towns, fields, the roadway, the River;
> And each eye looks back and beholds you
> to learn from the day's light perfection.
> O God, you are in the Sun-disk of Day,
> Over-seer of all creation
> —your legacy
> passed on to all who shall ever be;
> For you fashioned their sight, who perceive your universe,
> that they praise with one voice
> all your labors.[5]

Nothing is known of the origin of Akhenaten's ideas, which greatly influenced artistic style during his reign. Statues of Akhenaten (fig. **3.37**) and his family differ dramatically from those of traditional pharaohs. He looks as if he had unusual, if not deformed, physical features. Here Akhenaten holds the crook (now partly broken off) and flail, attributes of Osiris and of Egyptian royalty. He wears the combined *hedjet* and *deshret* crowns of Upper and Lower Egypt. Carved into the surface of his body—by his right shoulder and at his waist—are his cartouches (see fig. 3.4).

Despite the traditional attributes of pharaonic power and the iconography of royalty, Akhenaten broke with artistic convention. Rather than always being represented as an assertive and dominating king identified with the gods, Akhenaten often shows himself as a priest of Aten. In the statue illustrated in figure 3.37, however, he is shown as a pharaoh, despite being elongated, thin, potbellied, and curvilinear. Although some scholars believe that Akhenaten suffered from acromegaly—a condition caused by an overactive pituitary gland, resulting in enlarged hands, feet, and face—others think these proportions reflect changes consistent with his religious and social innovations. More recent scholarship argues that the Amarna style reflects an exaggeration of Akhenaten's actual appearance. The entire royal family, and eventually others as well, were similarly represented.

The best-known sculpture from Akhenaten's reign is a painted limestone bust of his wife, Nefertiti (fig. **3.38**). The well-preserved paint adds to its naturalistic impression. This is enhanced by the organically modeled features, the sense that taut muscles lie beneath the surface of the neck, and the open space created by the long, elegant curves at the sides of the neck. Instead of wearing the queen's traditional headdress, Nefertiti's hair is covered by a tall crown, creating an elegant upward motion.

A small relief in which Akhenaten and Nefertiti play with their three daughters illustrates some of the stylistic and iconographic changes under Akhenaten (fig. **3.39**). The king and queen are seated and rendered with a naturalism unprecedented for Egyptian royal figures. Their fluid, curved outlines—repeated in their drapery patterns—add a new sense of individual motion within three-dimensional space, which is enhanced by the flowing bands of material behind their heads.

3.38a, b Bust of Nefertiti (side and back views), Amarna period, 1349–1336 B.C. Painted limestone, approx. 19 in. (48.3 cm) high. Ägyptisches Museum, Staatliche Museen, Berlin. Nefertiti was Akhenaten's principal wife, even though, presumably for diplomatic reasons, he also had Mittani and Babylonian wives. Nefertiti was given artistic prominence and was important in Akhenaten's sun cult. The blue crown in this sculpture is unique to her.

3.37 Akhenaten, from Karnak, Egypt, 1353–1350 B.C. Sandstone; approx. 13 ft. (3.96 m) high. Egyptian Museum, Cairo. Akhenaten was the son of Amenhotep III and his principal wife, Tiy. Amenhotep III ruled Egypt for thirty-eight years. During Tiy's lifetime, he married a Mittani (from Mesopotamia), two Babylonian princesses, and then made his own daughter his principal wife.

3.39 Akhenaten and Nefertiti and their children, Amarna period, 1349–1336 B.C. Limestone relief; 13 × 15 in. (33.0 × 38.1 cm). Staatliche Museen, Berlin.

Although the children are represented with the unnatural proportions of miniature adults, their behavior and relative freedom of movement endow them with a childlike character. The child on Nefertiti's lap points eagerly toward her father, while the other one, perched on her shoulder, seems to be pulling on her mother's earring. Akhenaten holds a third child, whom he kisses. The intimacy of a scene such as this reflects the new humanity characteristic of the Amarna style.

Hieroglyphs are carved at the top of the scene; several cartouches are visible on the right. In the middle of the hieroglyphs is the sun disk Aten, with rays of light that end in hands—some holding the *ankh* hieroglyph—which seem to reach out to the royal family. Unlike earlier representations of gods in Egyptian art, Aten was embodied in the pure shape of the circle rather than in human or animal form.

Akhenaten's new cult posed a danger to the established priesthood and its traditions. At the close of his seventeen-year reign, despite certain innovations, Egypt reverted to its previous beliefs, reinstated the priestly hierarchy, and revived traditional artistic style. Akhenaten's tomb has been identified, but his mummy has never been located. Subsequent Egyptian rulers did their best to eradicate all traces of his religion and its expression in art.

Tutankhamon's Tomb

After Akhenaten's death, the pharaoh Tutankhamon (reigned c. 1336–1327 B.C.) returned to the worship of Amon, as his name indicates. He died at eighteen, and his only claim to historical significance is the fact that his tomb, with its four burial chambers, was discovered intact. In 1922 an English Egyptologist, Howard Carter, was excavating in the Valley of the Kings, to the west of the Nile and the New Kingdom temples of Karnak and Luxor. To the delight of his patron, Lord Carnarvon, Carter found one tomb whose burial chamber and treasury room had not yet been plundered. It yielded some five thousand works of art and other objects, including the mummified body of the king himself.

Tutankhamon's mummy wore a solid gold portrait mask (fig. **3.40**). It was inlaid with blue glass in imitation of lapis lazuli, a blue stone considered valuable by the Egyptians because it had to be imported from Afghanistan or Iran. Three coffins, one inside the other, protected the mummy. All three were in the form of the king as Osiris. The two outer coffins were made of gilded wood; the innermost coffin was solid gold and weighed 243 pounds (110 kg). The mummy and its three coffins rested inside a large rectangular stone sarcophagus. The coffinette in figure **3.41** is one of four that contained the pharaoh's organs. These small coffins were housed in a wooden shrine that was placed in another room of the tomb. Each was made of beaten gold, decorated with inlaid colored glass and semiprecious stones. The shape of

the canopic coffins conforms to that of the large coffins, and they also depict Tutankhamon as Osiris with the crook and flail.

A comparison of Tutankhamon's effigy with the images produced under Akhenaten shows that the rigid, frontal pose has returned. The natural spaces are closed, thus restoring the conventional iconography of kingship. Like Akhenaten, Tutankhamon holds the crook and flail. Protecting his head are two goddesses, Wadjet the cobra and Nekhbet the vulture. The wings wrapped around Tutankhamon's upper body belong to the deities on his forehead, and their claws hold signs indicating the unity of Upper and Lower Egypt. In this iconography, Tutankhamon, like Narmer nearly nineteen hundred years earlier, is represented as being under divine protection and as the ruler over a vast domain.

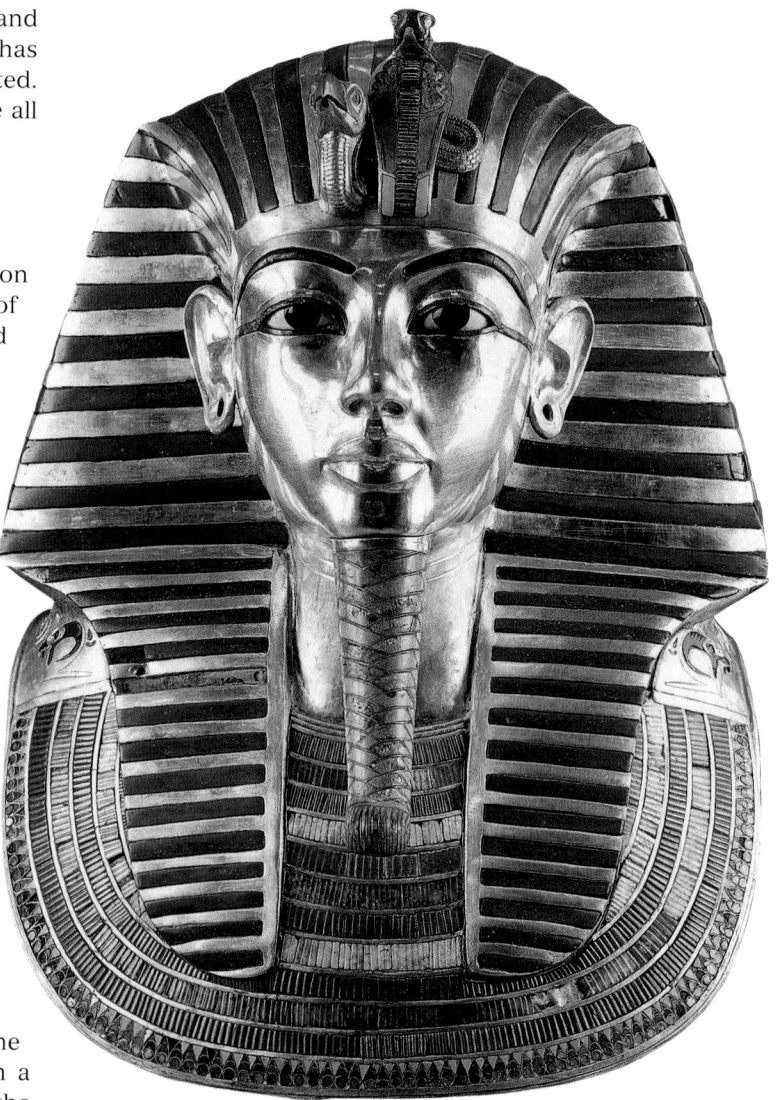

3.40 Mask of Tutankhamon, c. 1327 B.C. Gold inlaid with enamel and semiprecious stones. Egyptian Museum, Cairo.

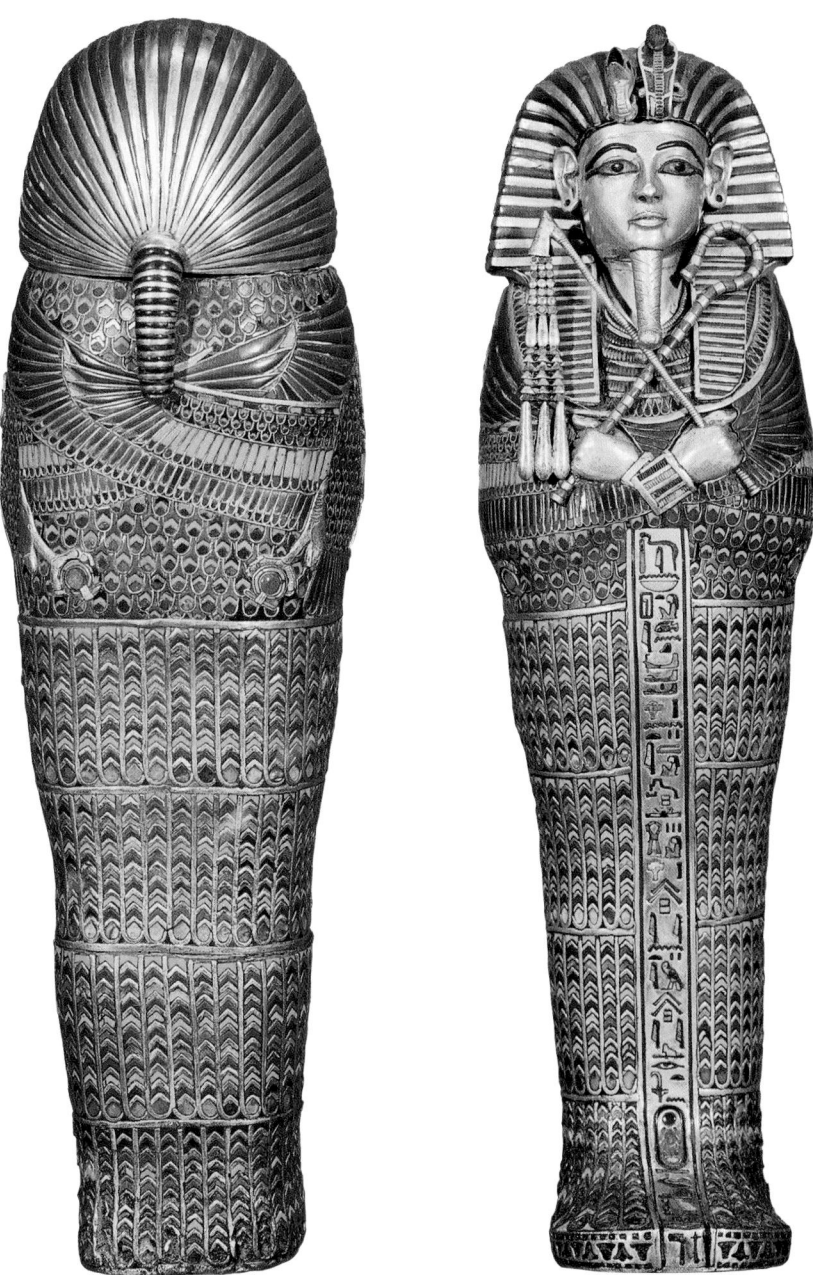

3.41 Canopic coffinette (coffin of Tutankhamon), c. 1327 B.C. Gold inlaid with enamel and semiprecious stones; 15¾ in. (40.0 cm) high. Egyptian Museum, Cairo.

Over forty years after Carter's discovery, the contents of Tutankhamon's tomb became one of the world's most popular and widely traveled museum exhibitions, appearing in Paris, London, Russia, and the United States. But Lord Carnarvon did not live to see it. Just five months after Tutankhamon's tomb was opened, Carter's patron died of an infection, which the popular press attributed to the mummy's curse.

Egypt and Nubia

Throughout the history of ancient Egypt, in written texts and in works of art, there are continual references to other lands in the Near East and on the African continent. The land called Punt by the Egyptians, for example, is believed to have been located to the southeast along the Red Sea. It

3.42 King and queen of Punt, from Hatshepsut's funerary temple, Deir el-Bahri, c. 1473–1458 B.C. Painted relief. Egyptian Museum, Cairo.

was a source of exotic spices and incense, and appears as the destination of an Egyptian expedition on reliefs from Hatshepsut's Deir el-Bahri temple. According to those reliefs, Punt was rich in palm trees and giraffes, and was ruled by a heavy (steatopygous) woman (fig. **3.42**). To date, however, little is known of Punt and its relation to Egyptian trade. It remains for archaeologists to explore further this part of the ancient world.

Early Kush

Much more information is available about the land south of the Nile's first cataract (now southernmost Egypt and the Sudan), which was called Nubia by the Romans. To the

Egyptians, this area was variously the Land of the Bow (after the Nubians' standard weapon), the Land of the South, and Kush. As in Egypt, the Nile's floods were crucial to the development of Nubian culture, which was enhanced by the wealth of its natural resources—gold, copper, and semiprecious gems—and its location along a major African trade route. As a result of these advantages, Nubia had links to sub-Saharan Africa, to Egypt, and to the Mediterranean world.

In Neolithic Nubia, agriculture had developed, and cattle was domesticated. Artisans began making distinctive pottery that was technically and artistically accomplished. The finest Nubian work is the "eggshell" pottery, so called for the thinness of its walls. The two examples in figure **3.43** are decorated with fingerprints (on the right) and designs derived from basket weaving (on the left). In the former, the artist simultaneously creates a design and makes a personal signature, or "mark." In the latter, the artist incorporates the material "history" of the craft into the surface pattern.

During the Old Kingdom, Egypt frequently raided Nubia, usually for natural resources and probably also to capture slaves. By the Middle Kingdom, however, Egypt had definite plans to subjugate Lower (northern) Nubia, and Twelfth Dynasty pharaohs invaded the region with a view to mining copper and gold, and taking control of the valuable trade route. Their successes were reinforced by the construction of massive fortresses and a highly organized communication system.

Reconquest

When the Egyptian delta was conquered by the Hyksos c. 1600 B.C., the Kushites seized the opportunity to expand their own power. They moved north to Aswan by the first cataract, took control of the trade route, and enjoyed considerable cultural expansion. Once the Hyksos were expelled, however, the Egyptians recolonized Nubia. The Egyptian viceroy who ran the administration of Nubia bore the titles "King's Son of Kush" and "Overseer of the

3.43 Nubian "eggshell" vessels, c. 3100–2890 B.C. Ceramic; left, 6⅛ in. (15.4 cm) high; right, 4⅞ in. (12.2 cm) high. British Museum, London.

3.44 Nubians bringing offerings to Egypt, Thebes, Nineteenth Dynasty, c. 1295–1186 B.C. Fresco. British Museum, London.

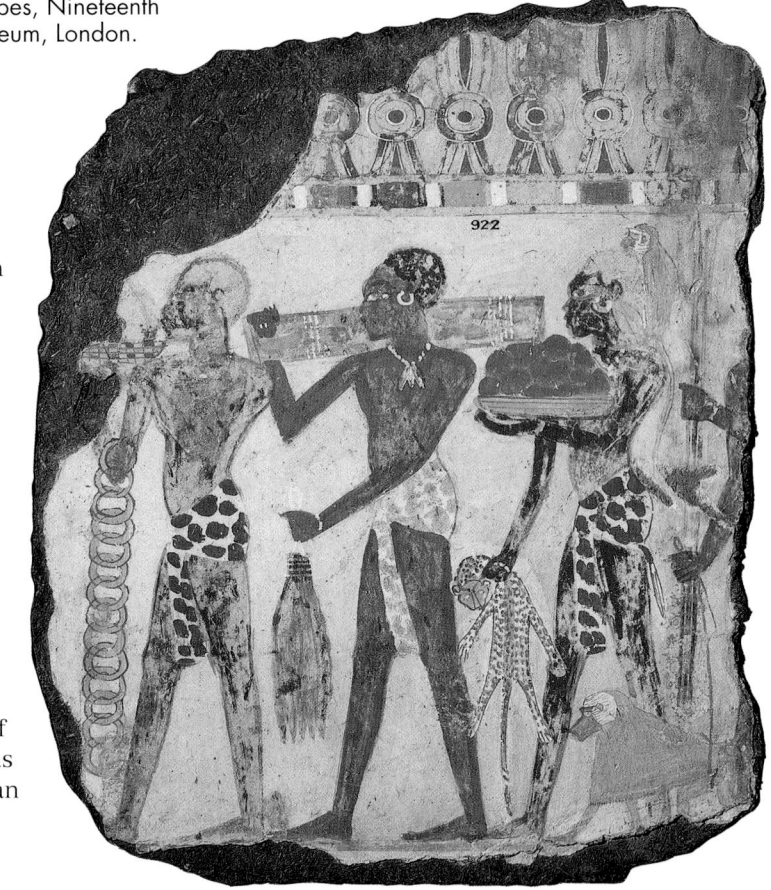

Southern Lands." Egypt once again profited from Nubian gold mines and imported Nubian captives for labor or slave markets and even to work as policemen.

A Nineteenth Dynasty fresco fragment from Thebes depicts Nubians with gifts for the Egyptian pharaoh (fig. **3.44**). The man at the left carrying interlocked gold rings is followed by another with ebony logs and giraffe tails. A monkey perches on the third figure, who holds a leopard skin and carries a basket of fruit. Behind him, the arms of a fourth man leading a monkey on a leash are visible.

A painted relief from the Theban tomb of Huy, Nubia's viceroy under Tutankhamon, shows Heqanufer, the local prince of Mi'am, bowing to the pharaoh (fig. **3.45**). A princess follows in an ox-drawn chariot. Works such as these illustrate the natural resources of Nubia—especially gold—that the Egyptians wanted, as well as the degree to which Nubians adopted Egyptian culture.

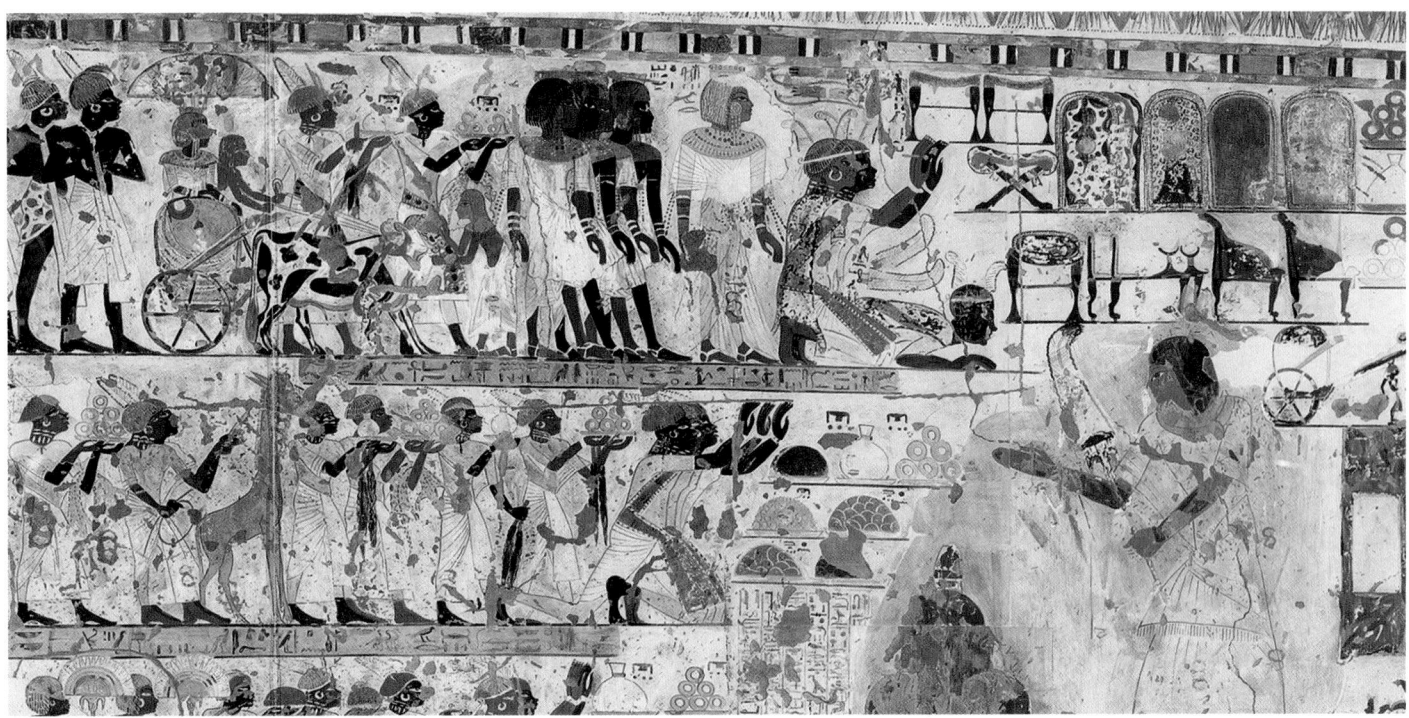

3.45 Presentation of Nubian tribute to Tutankhamon (restored), tomb chapel of Huy, Thebes, Eighteenth Dynasty, c. 1336–1327 B.C. Wall painting; 6 × 17¼ ft. (1.82 × 5.24 m). Metropolitan Museum of Art, New York. Egyptian Exhibition of Metropolitan Museum of Art. Rogers Fund, 1930 (30.4.21).

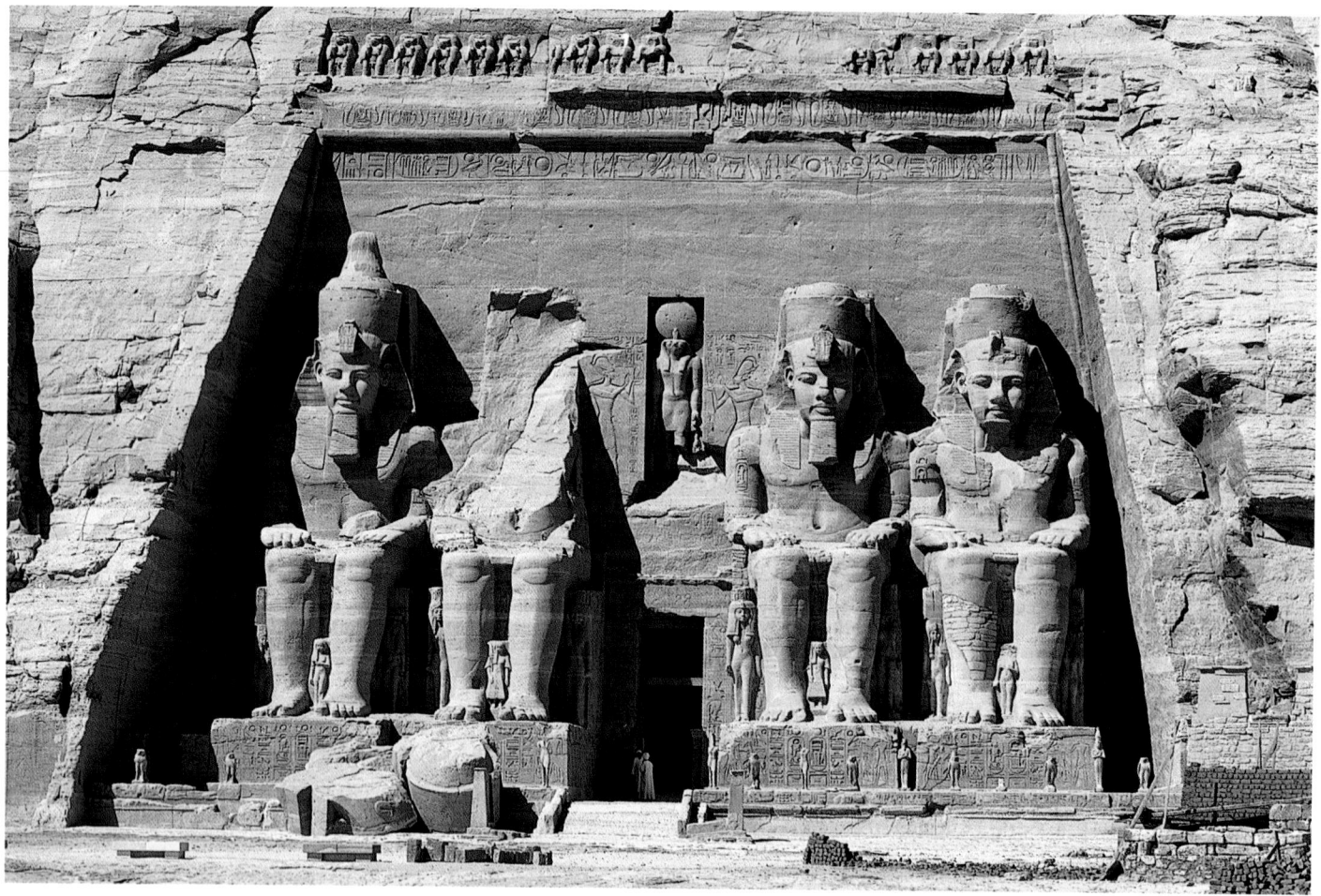

3.46 Temple of Ramses II, Abu Simbel, Nubia, 1279–1213 B.C.

In the course of the New Kingdom's Eighteenth and Nineteenth Dynasties, the Egyptians built their most imposing temples in Nubia. Figure **3.46** shows the façade of Ramses II's rock-cut temple at Abu Simbel, one of a series of six colossal structures south of Aswan. Four huge seated statues of Ramses II represent him in a traditional royal pose. The trapezoidal shapes of the ceremonial beards and headdresses are formal echoes of the space framing them. Ramses' purpose in having such works constructed in Nubia was to proclaim to the Nubians his identification with the gods Amon and Ra, as well as to emphasize Egyptian domination over Nubia. A smaller temple nearby, dedicated to his wife, Queen Nefertari, conveyed her identification with the goddess Hathor (Ra's wife). Pharaoh and queen together, therefore, presided over Nubia, asserting their divinity in vast monuments of stone (see box).

During the last hundred years of the New Kingdom (c. 1170–1070 B.C.), both Egypt and Nubia declined. The Egyptian colonial administration collapsed along with its building programs. And Nubia, with a decreasing population, entered three hundred years of obscurity.

The "Fifty" Sons of Ramses II: A Recent Archaeological Find

In 1995, an excavation led by the American archaeologist Kent Weeks revealed the largest New Kingdom tomb so far known in Egypt's Valley of the Kings. Although robbed in antiquity, the tomb is a rich find, still in the early stages of excavation. It contains at least sixty-seven chambers, and inscriptions indicate that fifty or more of Ramses II's sons were buried there (very few human remains have been recovered to date). It was formerly assumed that each male member of the royal family had a separate tomb; this new evidence, therefore, raises questions about family relationships at the highest level of Egyptian society as well as about communal burial practices in ancient Egypt.

The Napatan Period

Beginning in the eighth century B.C., Nubia (still called Kush by the Egyptians) reemerged into what would be an era of artistic development and political influence. Scholars divide this phase of Nubian history into two distinct stages. In the earlier stage, called Napatan after a religious center, Nubians invaded Egypt and established Kushite control of their former colonizers. Four Kushite kings of Egypt in the Twenty-fifth Dynasty conquered the country, revived artistic production, and continued the Egyptian cult of Amon.

The small granite sphinx of Taharqo reflects the appropriation of Egyptian pharaonic iconography by Nubian kings and their use of Egyptian artistic conventions (fig. **3.47**). Although endowed with Nubian facial features, Taharqo's sphinx wears the pharaonic headcloth and is protected by Wadjet the cobra and Nekhbet the vulture on his forehead. There is also a cartouche in sunken relief on his chest.

Meroë

In the seventh century B.C., the Assyrians (see Chapter 2) invaded Egypt and ousted the Kushite kings. By the third century B.C., a new stage of Nubian cultural development can be identified. The economic and artistic high point of this period is referred to as Meroitic, after the site of Meroë, south of Napata. Royal Kushite burials shifted from Napata to Meroë when Meroitic culture began to absorb influences from sub-Saharan Africa on the one hand and from Greece (Chapter 5) and Rome (Chapter 7) on the other. Meroë's location in relation to important trade routes between Africa, the Red Sea, and the Mediterranean contributed to its significance. It imported bronze, glass, and silver, and exported ebony, ivory, and gold. Meroë also provided the Roman emperors with elephants. Under the Greek Ptolemies (323–30 B.C.), who ruled Egypt after Alexander the Great wrested it from the Persians, the Kushites continued to trade with Egypt.

Archaeological exploration of Meroë is still incomplete, but the significance of the area in antiquity is clear from classical accounts. In about 430 B.C., Herodotos (*History* II.29) described the arduous journey by boat, followed by forty days on foot and another boat trip from Aswan to Meroë. He reported that two important Greek gods, Zeus and Dionysos (see Chapter 5), had penetrated Meroë and were worshiped there. At the same time, however, it is clear from inscriptions that Egyptian gods such as Amon and Isis were the objects of popular cults. There were also indigenous Nubian gods. In religious beliefs, therefore—as in politics, economics, and the arts—Meroë was a melting pot that contributed to, and was a result of, its strategic international position.

3.47 Sphinx of Taharqo, from Temple T, Kawa, Nubia, 690–664 B.C. 29⅜ in. (74.7 cm) high.

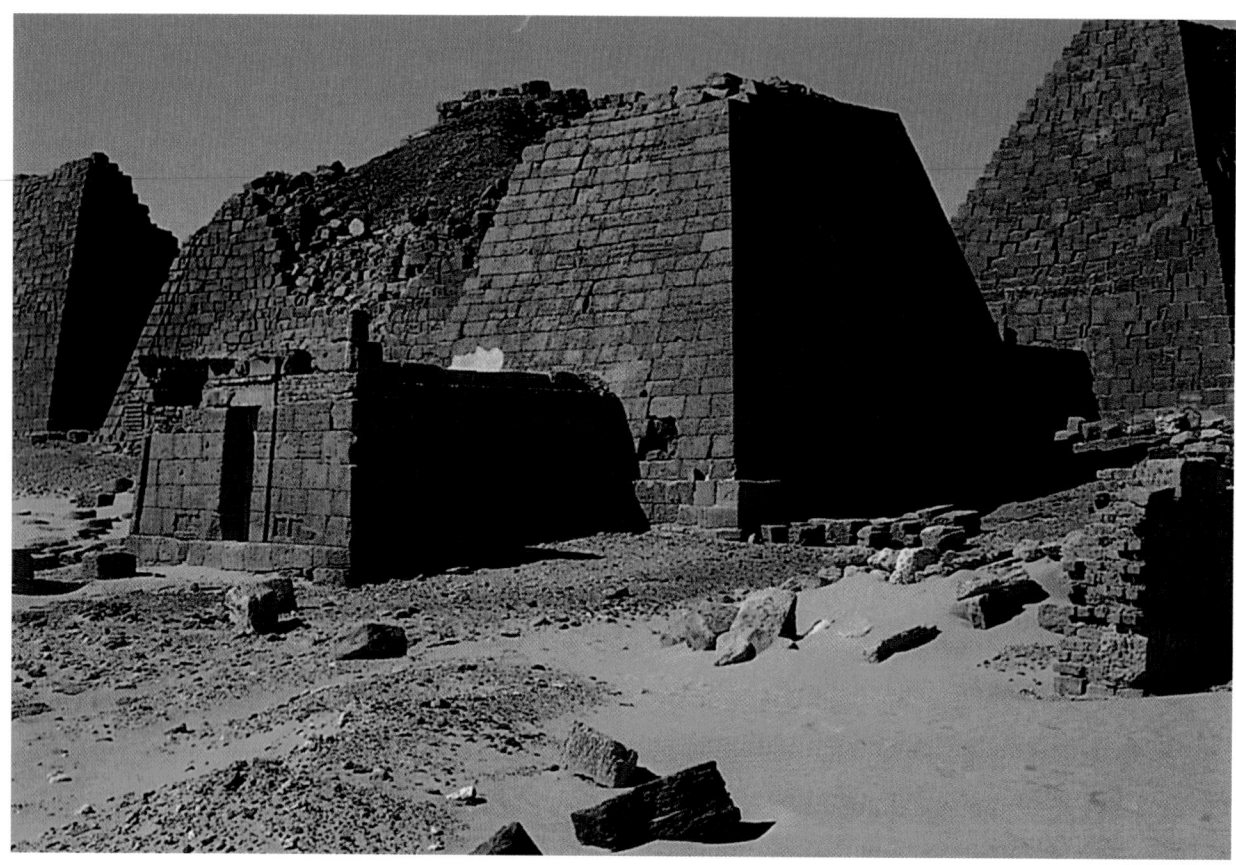

3.48 Ruins of the Meroë pyramids, Nubia, 3rd–1st century B.C.

Meroitic inscriptions dating from the second century B.C. have been discovered, but they are imperfectly understood. Since no related languages have survived, scholars once again must rely on physical evidence. The most impressive buildings from Meroë are the pyramids, whose ruins are illustrated in figure **3.48**. They are derived from Egyptian pyramids but rise more steeply than those at Giza and have flat, rather than pointed, caps. Scholars believe that these flat tops may each have supported a sun disk, indicating worship of a sun god. Burial chambers were underground, and the deceased, as in Egypt, were mummified. The outer stone blocks, and the structures themselves, are smaller than Old Kingdom Egyptian royal pyramids. They are closer in form to New Kingdom examples built for private individuals, even though those at Meroë were royal tombs.

In 1820–1821, a French traveler, F. Cailliaud, accompanied the Egyptian army into the Sudan and made drawings of the pyramids at Meroë. The example in figure **3.49** belonged to Queen Amanishakheto (first century B.C.) and was in a relatively good state of preservation. According to Cailliaud's drawing, the entrance, inspired by Egyptian temple pylons, was decorated with reliefs of the ruler's triumph over Meroë's enemies. Excavations of the interior of

the pyramid were carried out some thirteen years later by the Italian physician Giuseppe Ferlini. His account of the excavation reflects the careless and unscientific procedures current in nineteenth-century archaeology, including the destruction of some objects and the removal of others from the site.

Among the goldwork from Amanishakheto's tomb were nine so-called shield rings, of which figure **3.50** is a typical example. The god Amon is depicted in the guise of a naturalistic ram's head under a sun disk. Behind the disk is a chapel façade with smaller circles flanked by uraei. Blue glass is fused into the circle, which is soldered onto its gold background. The red glass on top of the sun disk was glued into the gold circle. It is not certain what purpose was served by the shield rings, but it is possible that they were pendants similar to the decorative pieces worn by Sudanese women of today on their foreheads.

The excavation of Amanishakheto's tomb confirms Meroë's artistic independence from Egypt as well as its absorption of Egyptian and Greek forms. Stonecutters from Greece may have worked at Meroë. Amanishakheto's tomb has also contributed to our knowledge of local society, the position of women, and the organiza-

3.49 Tomb of Amanishakheto, Meroë, Nubia, late 1st century B.C. Drawing from F. Cailliaud, *Voyage à Méroé* (Paris, 1823–27), plate XLI.

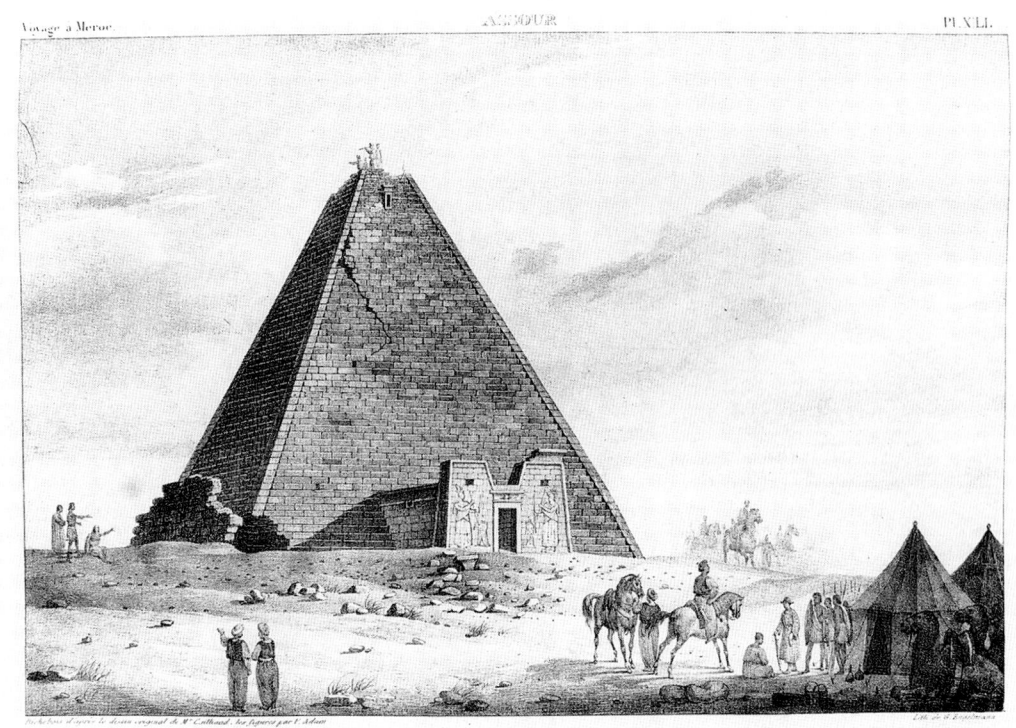

tion of the royal family in this part of sub-Saharan Africa. The king's mother, who was given the title Kandake, was below the king in the royal hierarchy, but in certain cases, such as Amanishakheto's, the Kandake herself ruled. This is reflected in a New Testament text referring to a eunuch "under Candace [Kandake] queen of the Ethiopians" (Acts 8:27).

After the first century A.D., Nubian civilization fell into a gradual decline. The Ethiopian kingdom of Axum rivaled Meroë for trade routes, particularly with Rome. Meroë was occupied by nomads during the fourth century, which marked the end of the region's thriving culture. From the sixth to the twelfth centuries, Christianity (Chapter 8) made inroads into Nubia, and trade with Mediterranean cultures, especially Egypt, was revived. For the next four hundred years, Nubia was infiltrated by various groups. In the fourteenth century, it became predominantly Islamic (Chapter 9).

Egypt itself underwent a series of conquests, first by the Assyrians (c. 673–657 B.C), followed by the Persians in 525 B.C., and by Alexander the Great in 332 B.C. In 58 B.C., the Romans invaded Egypt and annexed it in 30 B.C. Since the early seventh century, Egypt has been part of the Islamic world.

3.50 "Shield ring" with ram's head of Amon before a chapel, Meroë, Nubia, c. 200 B.C. Gold, glass paste, and carneol; 2½ in. (2.5 cm) high. Ägyptisches Museum, Staatliche Museen zu Berlin.

Style/Period	Works of Art	Cultural/Historical Developments
PREDYNASTIC c. 5450–3100 B.C. **EARLY DYNASTIC** 3100–2649 B.C.	Palette of Narmer (**3.1, 3.2**), Hierakonpolis **Step pyramid**	Egypt unified under a single pharaoh (3100 B.C.) Hieroglyphic writing appears (c. 3100 B.C.)
OLD KINGDOM c. 2649–2150 B.C. **Palette of Narmer**	Step pyramid (**3.11**), Saqqara Rahotep and Nofret (**3.19**) Pyramids at Giza (**3.12**) Seated scribe (**3.20**), Saqqara The Great Sphinx (**3.15**), Giza Seated statue of Khafre (**3.17**), Giza Menkaure and Khamerernebty (**3.18**), Giza	Copper widely used in Egypt (2700 B.C.) Egyptian conquest of Nubia (2600 B.C.) Potter's wheel in common use in Mesopotamia (c. 2500 B.C.) Egyptians discover use of papyrus (2500–2000 B.C.) **Seated scribe**
MIDDLE KINGDOM c. 1991–1700 B.C. **Painted coffin of Djehuty-nekht**	Painted coffin of Djehuty-nekht (**3.26**) Lady Senuwy (**3.21, 3.22**) Sesostris I (**3.23, 3.24**) Sesostris III (**3.25**) **Sesostris III**	*Gilgamesh* epic written in Sumer (c. 2000 B.C.) Earliest Minoan palace built at Knossos, Crete (c. 2000 B.C.) Nile floods used for irrigation purposes (2000–1500 B.C.) The Hyksos establish themselves in Egypt (c. 1600–1550 B.C.) Horse-drawn chariot introduced to Egypt (c. 1600–1550 B.C.)
NEW KINGDOM c. 1550–1070 B.C. The Armana Period c. 1349–1336 B.C. **Bust of Nefertiti** Egypt and Nubia **Sphinx of Taharqo**	Funerary temple of Queen Hatshepsut (**3.33**) Hatshepsut as pharaoh (**3.32**) Senenmut and Nefrura (**3.34**) Nebamun hunting birds (**3.35**) Canopic jars of Neshkons (**3.8**) Akhenaten (**3.37**), Karnak Akhenaten and Nefertiti and their children (**3.39**) Bust of Nefertiti (**3.38**) Mask of Tutankhamon (**3.40**) Small coffin of Tutankhamon (**3.41**) Temple of Amon-Mut-Khonsu (**3.31**), Luxor Opening of the Mouth ceremony (**3.36**) Temple of Amon-Ra (**3.27**), Karnak Nubian "eggshell" vessels (**3.43**) Nubians bringing offerings to Egypt (**3.44**), Thebes King and queen of Punt (**3.42**), Deir el-Bahri Painted relief (**3.45**), Huy, Thebes Temple of Ramses II (**3.46**), Abu Simbel Paynedjem's *Book of the Dead* (**3.9**), Thebes Sphinx of Taharqo (**3.47**), Kawa Meroë pyramids (**3.48**), Nubia Shield ring with Amon as ram (**3.50**), Meroë Tomb of Amanishakheto (**3.49**), Meroë	Citadel at Mycenae (Greece) constructed (c. 1600–1500 B.C.) The Hyksos expelled from Egypt (1550 B.C.) Dominance of Mycenaean Greeks in eastern Mediterranean (1400–1200 B.C.) Destruction of palaces on Crete (c. 1400 B.C) Akhenaten's religious reforms (1353–1336 B.C.) Death of Tutankhamon (c. 1327 B.C.) Exodus of the Hebrews, led by Moses, from Egypt to Canaan (mid-13th century B.C.) Egypt invaded by the "sea peoples" (c. 1230 B.C.) Beginning of Judaism (c. 1200 B.C.) Iron in common use (c. 1200 B.C.) Dorians invade Greece from the north (c. 1100 B.C.) Egypt loses control of Nubia (c. 1100 B.C.) Phoenicians develop alphabetic script (1100 B.C.) **Tomb of Amanishakheto** **Senenmut and Nefrura**

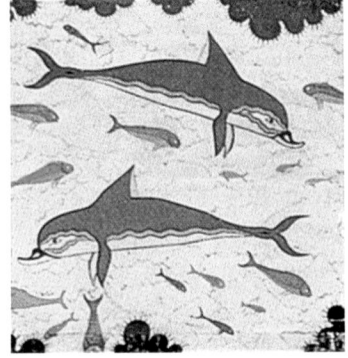

4

The Aegean

From about 3000 to 1100 B.C., three distinct cultures—Cycladic, Minoan, and Mycenaean—flourished on the islands in the Aegean Sea and on parts of mainland Greece (see map). These cultures chronologically overlapped the Old, Middle, and New Kingdoms of ancient Egypt (see Chapter 3), and there is evidence of contact between them. Before the late nineteenth century, however, Aegean culture was known only in myths and legends—most of the works of art discussed in this chapter were discovered around 1850 or later. As a result, much less is known of the Aegean cultures than of those in Egypt and the ancient Near East.

Cycladic Civilization (c. 3000–11th century B.C.)

The Cyclades, so named because they form a circle (from the Greek word *kuklos*), are a group of islands in the southern part of the Aegean Sea. Typical of many island populations, the inhabitants of the Cyclades were accomplished sailors, fishermen, and traders. They also hunted and farmed, the latter requiring permanent village settlements. Cycladic culture is essentially prehistoric because of the absence of a writing system. Scholars, therefore, rely on physical evidence and written accounts dating from the later, historical period of Greece (beginning around 900 B.C.). In the fifth century B.C., for example, Herodotos described the inhabitants of the Cyclades as notorious pirates. But the earliest surviving artistic evidence of Cycladic culture dates from the Bronze Age, when people learned to make bronze from copper and tin. Many works of art, including pottery, metalwork, and marble sculpture from Cycladic graves, have a provenience despite extensive plundering.

The most impressive examples of Cycladic art are sculptures that date from the early Bronze Age and are made of marble. They range in height from nearly 5 feet (1.5 m) (figs. **4.1** and **4.2**) to only a few inches (fig. **4.3**). Today they are called idols (from the Greek word *eidolon,* meaning "image"), and they are thought to have been objects of worship. Most were found lying down in graves.

Figures of females are much more numerous than those of males. Their purpose is unknown, but it is assumed that they were carried in religious processions, for they are unable to stand on their own. The large female in figure 4.1 has long, thin proportions, with the breasts and pubic triangle accentuated. The view from the side (fig. 4.2) shows that the idol forms a narrow vertical, extending at the back

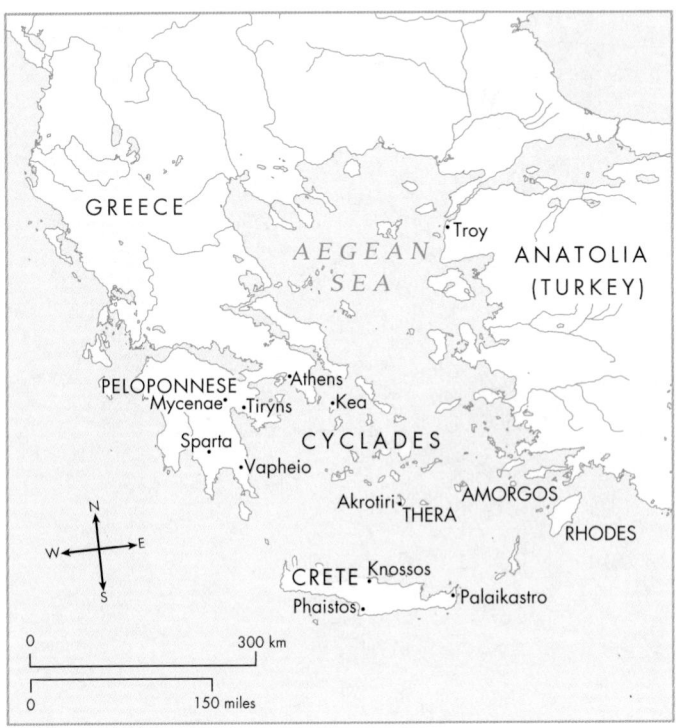

The ancient Aegean.

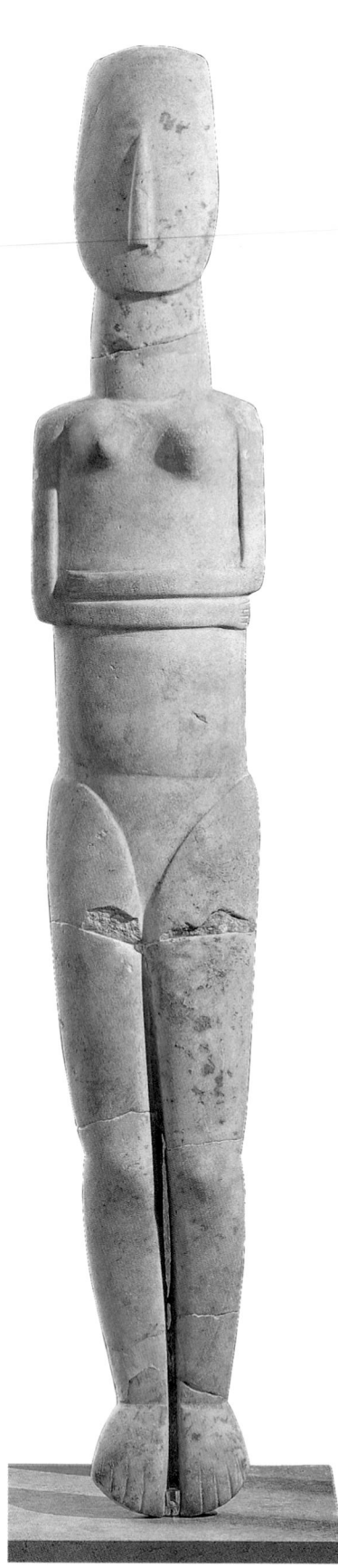

from the top of the head to the hips. Legs and feet fall into three slight zigzag planes, and the angle of the feet makes it impossible for them to support the statue.

Seen from the front, the figure is composed mainly of geometric sections. Note that the head is a slightly curving rectangle—its only articulated feature is the long, pyramidal nose. The neck is cylindrical, and the torso is divided into two squares by the horizontals of the lower arms. Although the overriding impression of its shapes is geometric, certain features, such as the breasts and knees, have a convincing organic quality and seem to protrude naturally from beneath the surface of the body. Despite formal differences between the Cycladic idols representing women and earlier prehistoric sculptures such as the *Venus of Willendorf* (see fig. 1.1) and the so-called Mother Goddess of Malta (see fig. 1.19), all seem to be images of divine female power.

The male Cycladic idols are composed mainly of cylindrical shapes and are often depicted playing musical instruments. The man in figure 4.3 plays a double pipe and tilts his head so far back that it is nearly at a right angle to his neck. The area of greatest formal movement in this sculpture is where the diagonals of the arms and pipe meet the tilting head and long neck. Arms, legs, and torso are shorter and sturdier than those of the female. The relative solidity of this statue is reinforced by the horizontal plane of the feet and their little **pedestal**, which provide actual support.

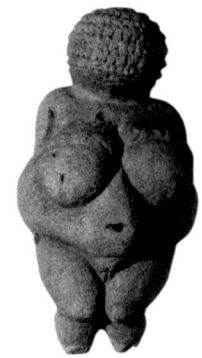

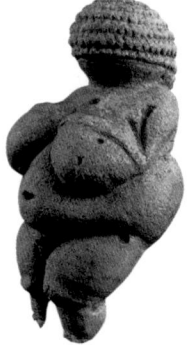

4.1 (left) Female Cycladic idol, from Amorgos, 2700–2300 B.C. Marble; 4 ft. 10½ in. (1.49 m) high. National Archaeological Museum, Athens.

4.2 (right) Female Cycladic idol (side view of fig. 4.1).

See figures 1.1a and b. *Venus of Willendorf*, from Austria, c. 25,000–21,000 B.C.

Minoan Civilization
(c. 3000–c. 1100 B.C.)

The modern Greek island of Crete, to the south of the Cyclades and northwest of the Nile Delta, was the home of another important Bronze Age culture. It was destroyed twice, once in 1700 B.C. by an earthquake and again, two or three centuries later, by an invasion from the Greek mainland. The culture that flourished on Crete was all but forgotten until the early twentieth century, when the British archaeologist Sir Arthur Evans (1851–1941) decided to search for it. Inspired by his knowledge of later Greek myths about the pre-Greek Aegean, Evans initiated excavations that would establish a historical basis for the myths.

In Greek mythology (see box, p. 142), Crete was the home of King Minos, son of Zeus and the mortal Europa. Minos broke an oath to Poseidon, who had guaranteed his kingship. In revenge, the sea god caused Minos's wife to fall in love with a bull. The offspring of their unnatural union was the Minotaur, a monstrous creature, part man and part bull, who lived at the center of a labyrinth in the palace of Minos at Knossos. Every year the Minotaur killed and ate seven girls and seven boys sent as annual tribute from Athens on the Greek mainland to Knossos.

Eventually, the Athenian hero Theseus killed the Minotaur and was rescued by Minos's daughter Ariadne from the labyrinth. They set sail from Crete and landed on the island of Naxos, where Theseus deserted Ariadne. The Greek wine god Dionysos found Ariadne and married her. Theseus, meanwhile, had sailed home to Athens, but he forgot the prearranged signal to his father, King Aegeus, indicating that he was returning safely. Believing his son dead, Aegeus threw himself into the sea and drowned. The Aegean Sea is named after the unfortunate king.

The Palace at Knossos

Sir Arthur Evans called the culture he discovered Minoan, after the legendary King Minos. *Minos* may be either a generic term for a ruler, like the designations *king* and *pharaoh*, or the name of a particular ruler. The major Minoan site was Knossos, which had been inhabited since early Neolithic times. Its palace (figs. **4.4** and **4.5**) was the traditional residence of Minos and the largest of several known palaces on Crete.

In Greek mythology, the palace was called a "labyrinth," which Evans believed originally meant "house of the double axe." The latter was a cult object in the Minoan era and is represented in paintings and reliefs throughout the palace at Knossos. Double axes may have been used to sacrifice bulls, which were sacred animals in ancient Crete. The later Greek meaning of *labyrinth*, a complex, mazelike structure, may have been applied to the palace because of the asymmetrical, meandering arrangement of rooms, corridors, and staircases (see figure **4.4**). Greek coins of Knossos that were minted in the historical period generally contained maze patterns.

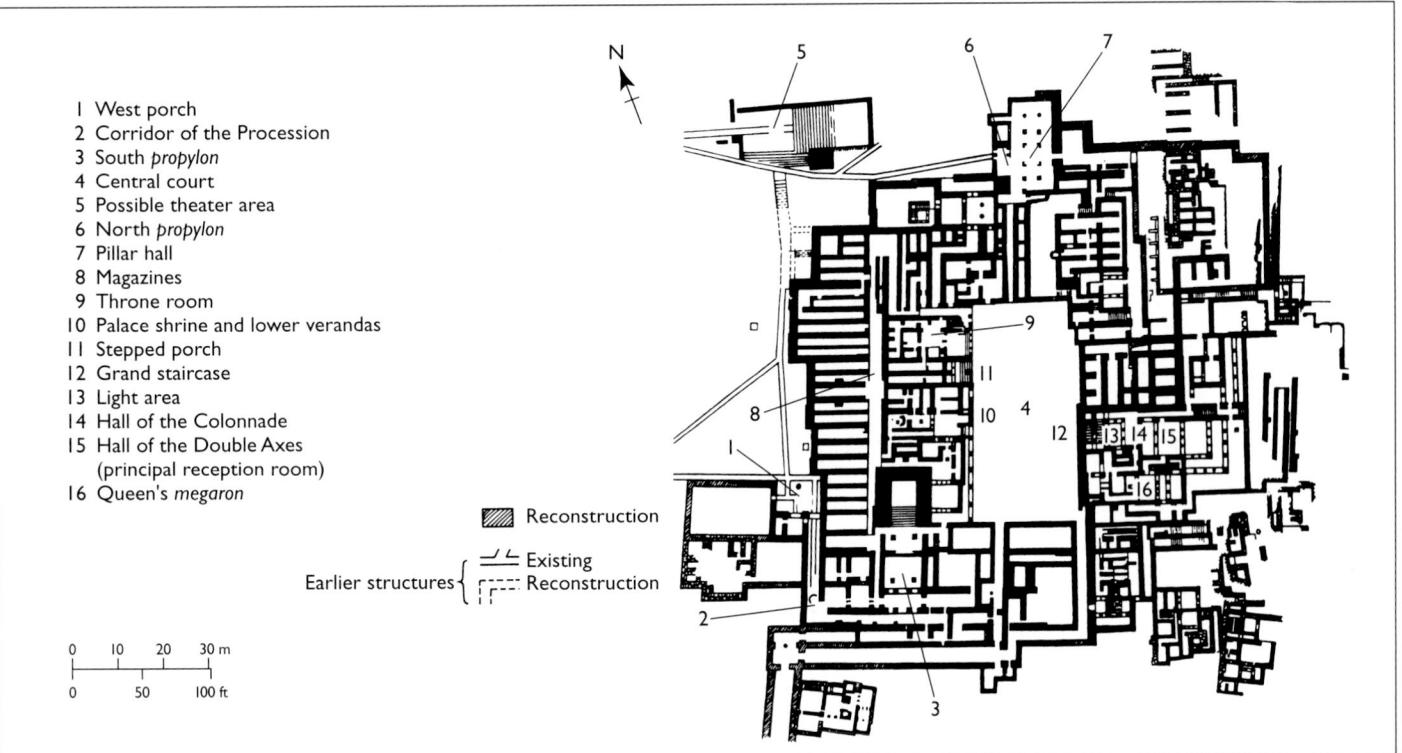

1 West porch
2 Corridor of the Procession
3 South *propylon*
4 Central court
5 Possible theater area
6 North *propylon*
7 Pillar hall
8 Magazines
9 Throne room
10 Palace shrine and lower verandas
11 Stepped porch
12 Grand staircase
13 Light area
14 Hall of the Colonnade
15 Hall of the Double Axes
 (principal reception room)
16 Queen's *megaron*

Reconstruction

Earlier structures { Existing / Reconstruction

0 10 20 30 m
0 50 100 ft

4.4 Plan of the palace of Minos, Knossos, Crete, 1600–1400 B.C. Area approx. 4 acres (1.6 hectares).

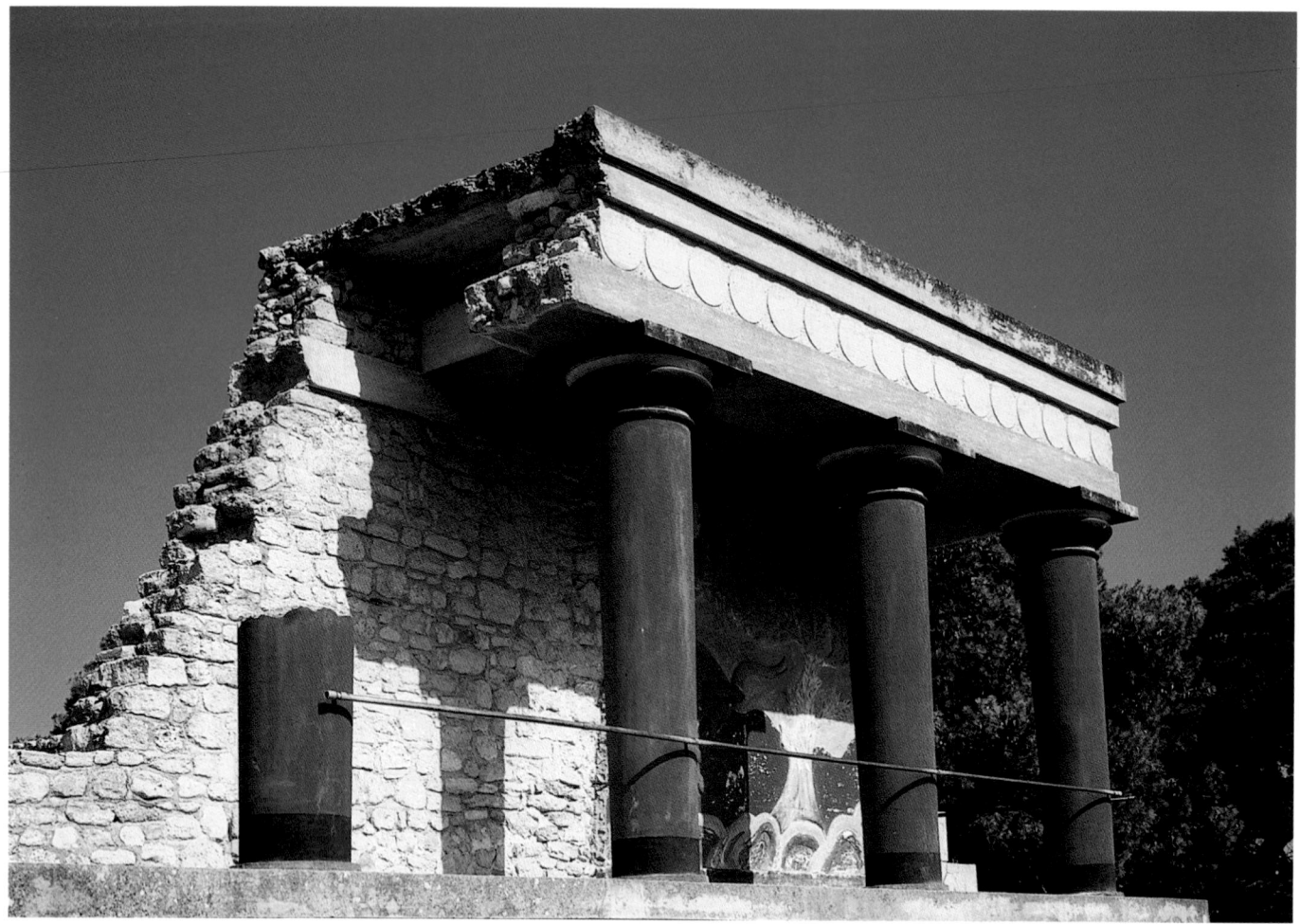

4.5 Partly restored west portico of the north entrance passage with a reconstructed relief fresco of a charging bull, palace of Minos, Knossos, Crete.

The palace itself was not fortified since Crete is an island and had a large naval fleet, which protected it against invasion. Like other Aegean and Near Eastern palaces, Knossos was more than a royal residence; it also served as a commercial and religious center. Industry, trade, and justice were administered from the palace, which had a well-organized system for receiving and distributing local agricultural products and imported luxury goods. Much of this wealth was stored in large terra-cotta (literally "cooked earth") jars.

Minoan Fresco

Minoan wall paintings are *buon* (true) *fresco*—pigments mixed with water and applied to damp lime (calcium-based) plaster. As the plaster dries, the coloring bonds with it, making *buon fresco* more durable than *fresco secco*. Minoan artists used *fresco secco*, in which paint is applied to a dry wall, for additional details. The details in *secco* were painted over the true fresco, which had to be applied quickly before the plaster dried.

The palace at Knossos is constructed according to the post-and-lintel system of elevation, with low ceilings and stone masonry walls. The short, wooden columns that taper downward are unique in the ancient world. Those visible in figure 4.5 have been reconstructed on the basis of fragments of **fresco painting** (see box).

The so-called *Toreador Fresco* (fig. **4.6**) is perhaps the best-known wall painting from Knossos. It represents a charging bull, two girls, and one boy. The girl at the left grasps the bull's horns, the boy somersaults over his back, and the girl at the right stands ready to catch him. Given the sacred character of the bull in the Minoan era and the myth of the Minotaur, it is believed that this fresco depicts a ritual sport, possibly involving the sacrifice of the bull, the athletes, or both. As in Egyptian paintings, females are depicted with lighter skin color than males, and in each case a profile head is combined with a frontal eye. In other ways, however, the Minoan paintings differ from those of Egypt—in the predominance of curvilinear form and the dynamic movements of figures in space. Although in the *Toreador Fresco* three different human figures are represented, their poses correspond to a sequence of movement that could be made by a single figure. Such depictions of time and sequencing are more characteristic of Minoan

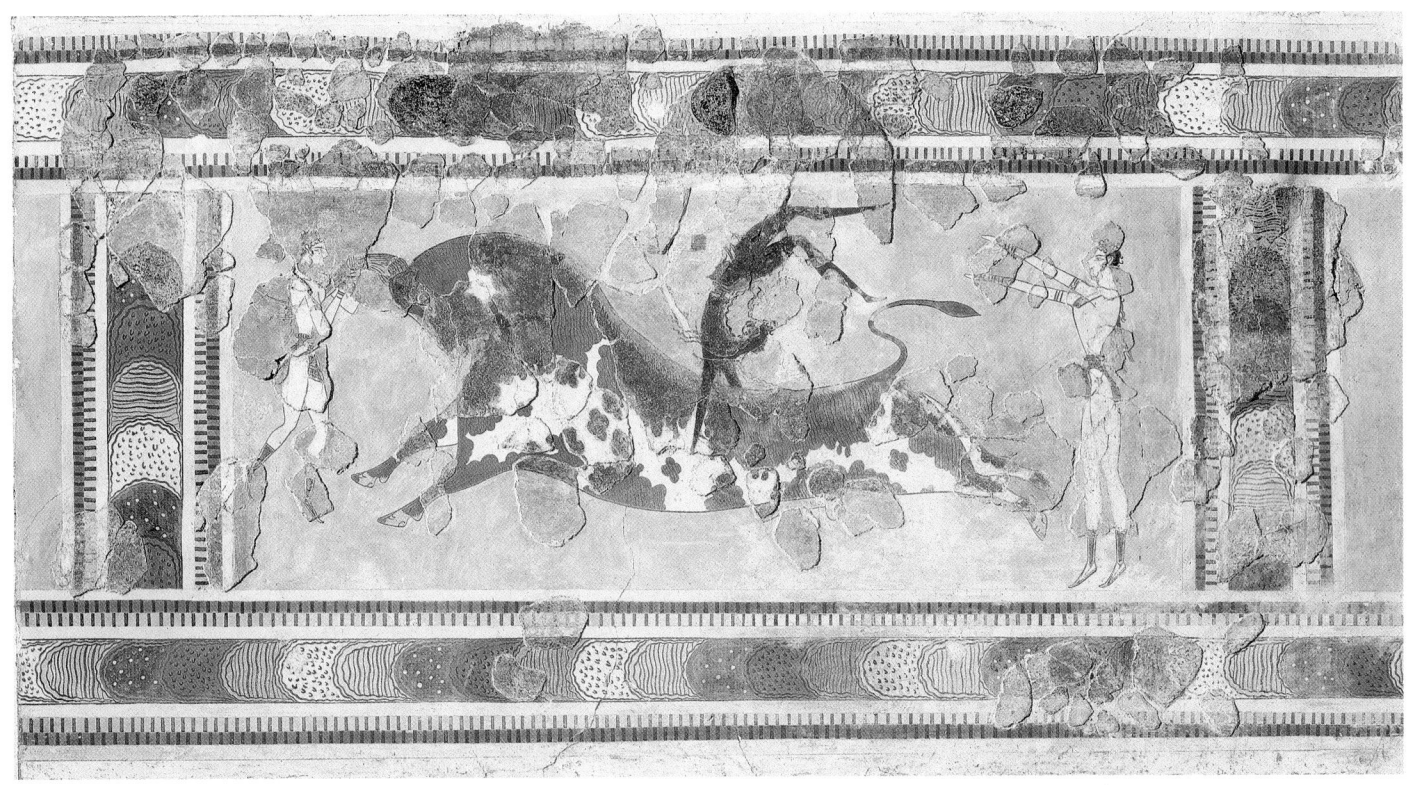

4.6 *Toreador Fresco,* from Knossos, Crete, c. 1500 B.C. Reconstructed fresco; 32 in. (81.3 cm) high (including border). Archaeological Museum, Herakleion, Crete. This wall painting was discovered in fragmentary condition and has been pieced back together. The darker areas belong to the original mural; the lighter sections are modern restorations. The abundance of bull imagery at Knossos was almost certainly related to the myth of the Minotaur and to the worship of the bull in Minoan religion.

than of Egyptian iconography. The border designs simulate different colored stones.

The sea-faring economy of ancient Crete can be seen in the attention to aquatic iconography at Knossos. This is apparent in the queen's **megaron,** in the fresco showing dolphins and other forms of sea life (fig. **4.7**). The predominance of curves and the impression of lively movement— the dolphins appear to be leaping freely in the waves—is characteristic of Minoan pictorial style.

One of the most imposing, although heavily restored, Knossos frescoes decorated the so-called "throne room" (fig. **4.8**). The throne—actually a stone chair—is made of gypsum; its seat is indented and tilted back for increased comfort. Scholars generally believe that a woman, probably a priestess, sat here as part of a religious ritual, for symbolic griffins such as those in the fresco behind the throne always flank a female in Aegean art. These griffins, a mixture of eagle and lion, are set in a landscape of undulating terrain and tall flowers.

Though posed symmetrically and stylized, the griffins are rendered with curved outlines and rudimentary shading that creates a sense of three-dimensional contour. By placing some of the plants behind the animals, the artist has enhanced the illusion of depth. The expansive, generalized quality of this particular landscape, which differs from the more constrained and detailed Egyptian landscapes, is characteristic of Aegean painting.

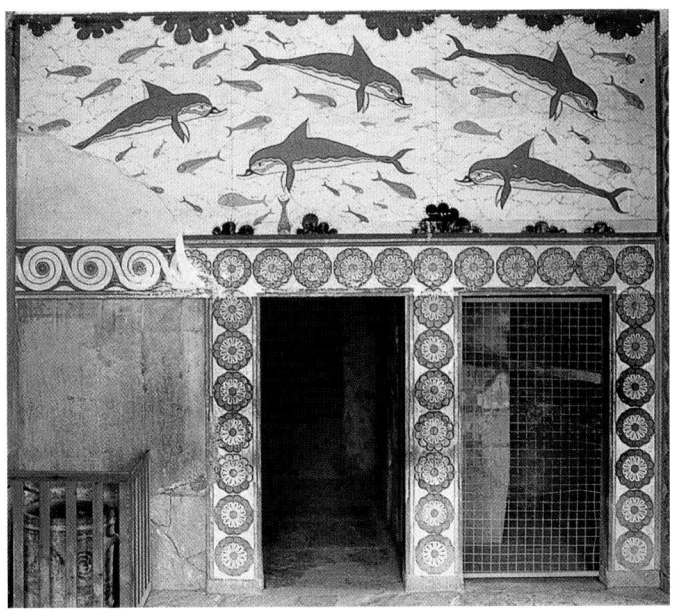

4.7 The queen's *megaron,* palace of Minos, Knossos, Crete, c. 1600–1400 B.C.

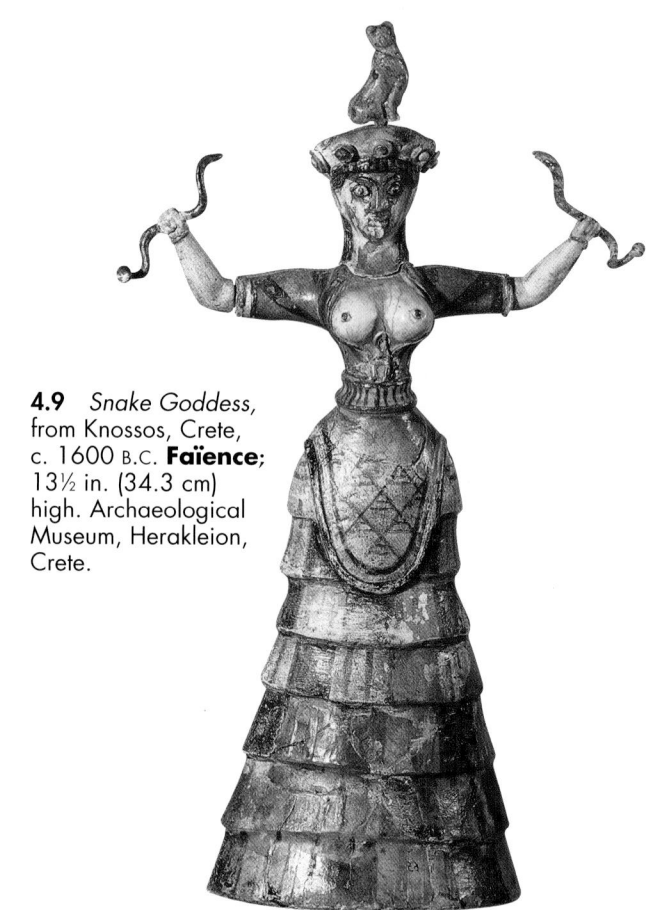

4.8 View of the "throne room," palace of Minos, Knossos, Crete, with a heavily restored fresco depicting griffins.

Minoan Religion

Little is known of Minoan religious beliefs. We have only archaeological evidence to shed light on Minoan religion because scholars have been unable to decipher the Minoan language (see box). Shrines were located on mountaintops or inside the palaces, which played an important role in religious ceremonies. Images of what seem to be priests and priestesses, of bulls, double axes, trees, columns, and elevated poles occur in scenes of religious ceremonies. Trees, pillars, and poles were venerated in rites celebrating the coming of spring, apparently a practice dating back to the Bronze Age.

Another recurring motif in Minoan art is a female—a goddess or priestess—holding snakes. This frontal figure has a thin, round waist and wears a conical flounced skirt. Her breasts are exposed, and a cat perches on top of her headdress. Faïence is a technique for glazing earthenware and other ceramic vessels by using a glass paste, which, after firing, produces bright colors and a lustrous sheen. The precise significance of the small statue of the so-called *Snake Goddess* (fig. **4.9**) is not known. However, the motif of a male or female deity dominating animals, referred to as the "Master" or "Mistress of the Beasts," occurs earlier in the ancient Near East and later in Greek art. As creatures of the earth, snakes were associated with fertility and agriculture, and did not have the evil connotations with which they later became endowed in the West.

4.9 *Snake Goddess*, from Knossos, Crete, c. 1600 B.C. **Faïence**; 13½ in. (34.3 cm) high. Archaeological Museum, Herakleion, Crete.

In the Aegean, two kinds of script, Linear A and Linear B, are preserved on clay tablets. Linear A, the written Minoan script and language, developed about 2000 B.C. and remains undeciphered. Linear B came into use by about 1400 B.C. Linear B adapted the Minoan script to write early Greek after the Mycenaean domination of Crete. Because it was used mainly for inventory lists and palace records, Linear B (which was deciphered in 1952) provides evidence of Mycenaean administration but reveals little about religion and social practices.

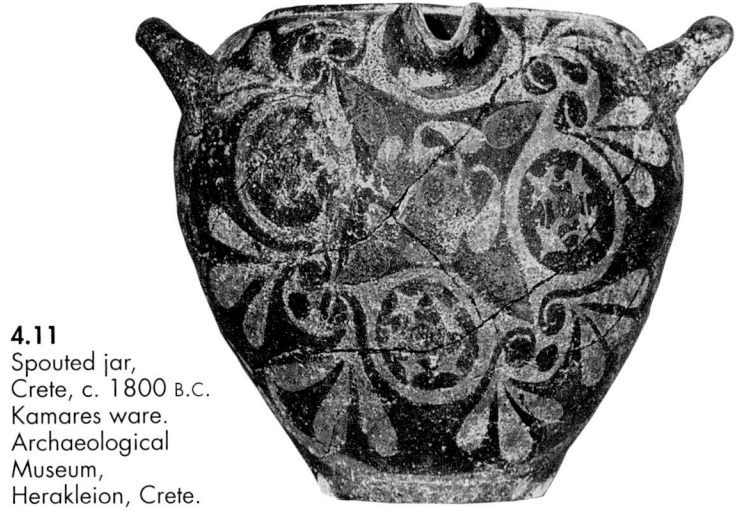

4.11
Spouted jar,
Crete, c. 1800 B.C.
Kamares ware.
Archaeological
Museum,
Herakleion, Crete.

4.10 Upper part of the Harvester Vase, from Hagia Triada, Crete, c. 1650–1450 B.C. Serpentine; diameter 4½ in. (11.3 cm). Archaeological Museum, Herakleion, Crete.

The so-called Harvester Vase (fig. **4.10**), a serpentine **rhyton** used in religious rituals, dates to around 1500 B.C. and reflects the Minoan tradition of lively, dynamic representation. Its relief decoration exemplifies Minoan skill in carving and depicts a procession of men setting out to harvest. One man, shaking a sistrum (rattle) and singing, is followed by three more singers. Others carry long forked harvest implements that form curved diagonals, echoing both the shape of the vase and the exuberance of the figures.

Pottery

The spouted jar from the older palace at Knossos illustrates an early pottery type called Kamares ware, dating to c. 1800 B.C. (fig. **4.11**). (The term *Kamares* is from the Kamares Cave, in the mountains above Phaistos, where examples of this type of pottery were first discovered.) Compared with Egyptian imagery, the Kamares example is, like the Harvester Vase, freer and more curvilinear. The abstract pattern formed by white lines on the characteristic blue-black ground of Kamares ware suggests floral design, with its undulating motion and whirling, circular arrangement of shapes. A few details are enhanced by orange, which adds to the vibrant quality of the jar's design. Kamares ware is an art of shape and color in which patterns are integrated in a balanced, organic manner with the shape of the vessel.

The Octopus Vase (fig. **4.12**) from Palaikastro is also enlivened by vigorous surface design related to natural forms. Although the image of an octopus and other forms of sea life are discernible on the vase, the artist's obvious delight in the swirling patterns of the arms and their little round suction cups retains an abstract character. These, in turn, are repeated formally in the large oval eyes of the octopus, which echo the holes made by the handles and seem to stare directly at the viewer. The iconography of this object, like the dolphins in the queen's *megaron*, reflects the fact that the Minoans were seafarers.

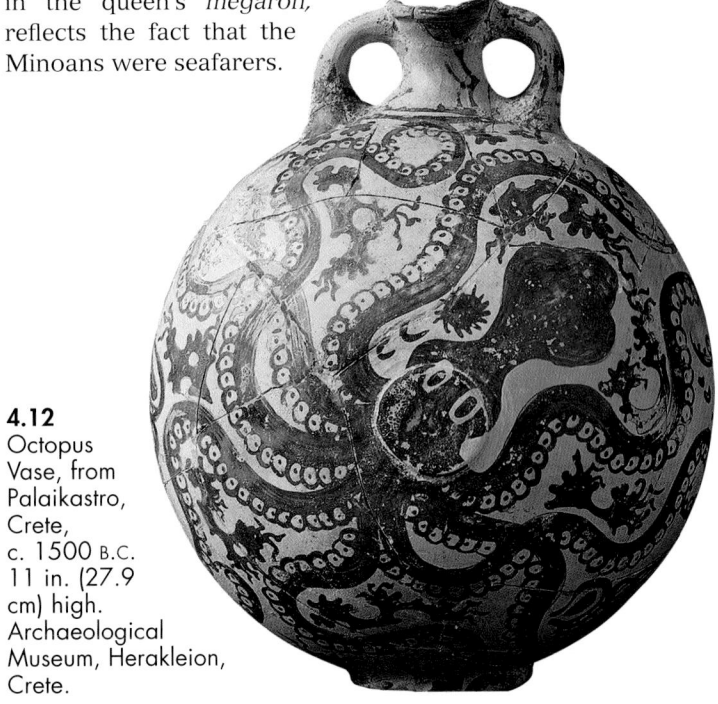

4.12
Octopus
Vase, from
Palaikastro,
Crete,
c. 1500 B.C.
11 in. (27.9
cm) high.
Archaeological
Museum, Herakleion,
Crete.

Recent Discoveries at Thera

In the 1960s, the island now known as Santorini in the southern Cyclades yielded exciting new archaeological material. Called Thera by the ancient Greeks, Santorini is a volcanic island, parts of which are covered with thick layers of ash and pumice.

The Greek archaeologist Spyridon Marinatos began to excavate near the modern town of Akrotiri, on the south coast of the island facing Crete. His excavations confirmed that an enormous volcanic eruption had buried a flourishing Cycladic culture of the late Bronze Age with a well-developed artistic tradition. The date of this disaster has been placed as late as 1500 B.C. or as early as around 1628 B.C.—in either case, occurring during the heyday of Minoan civilization. Since no human remains have been found in the ashes, the inhabitants were evidently able to evacuate the island before the volcano erupted.

The geographical location of Thera, north of Crete, places it squarely within the trading and seafaring routes of the Aegean, Egypt, Syria, and Palestine. To date, archaeologists have uncovered large portions of an ancient and affluent town. The paved, winding streets and houses of stone and mud brick indicate a high standard of living. Homes had basements for storage, workroom space, and upper-story living quarters. Implements for grinding grain reflect an active farming as well as seafaring economy. Walls, as in Crete, were reinforced with timber and straw for flexibility in the event of earthquakes. Interior baths and toilets were connected by clay pipes to an extensive drainage and sewage system under the streets. Such elaborate attention to comfortable living conditions is not found again in the West until the beginning of the Roman Empire over a thousand years later (see Chapter 7).

The Frescoes

Equally remarkable was the attention paid to art in Theran culture. The walls of public buildings as well as private houses were decorated with frescoes, which constitute an important new group of paintings. They represent a wide range of subjects: landscapes, animals, people engaging in sports and rituals, boats, and battles. When first discovered, most of the frescoes were covered with volcanic ash, which had to be carefully removed by brush. The paintings had fallen from the walls and were restored piece by piece to their original locations.

Theran pictures are characteristically framed at the top with painted borders, often created by abstract geometric patterns. The most significant painting discovered on Thera is the large *Ship Fresco,* the left section of which is reproduced in figure **4.13.** It was painted in a long horizontal strip, or **frieze,** that extended over windows and doorways (fig. **4.14**). The scene includes harbors, boats, cities and villages, human figures, landscape, sea life, and land animals, all of which provide information about the culture of ancient Thera. Some of the houses have several stories, the boats are propelled by paddles and sails, and the style of dress is distinctively Theran.

Various interpretations of the *Ship Fresco* have been proposed, from the straightforward return of a fleet to the depiction of a ceremonial rite. Although there is some overlapping to show depth, the landscape is rendered with no sense of spatial diminution and appears to "frame" the city. Distance is indicated by proximity to the top of the fresco—boats below; buildings on land; hills, trees, and animals at the horizon. The leaping dolphins, like the stags being chased by a lion in figure **4.15,** seem to reflect the general aura of excitement that pervades the scene.

4.13 *Ship Fresco* (left section), from Akrotiri, Thera, c. 1650–1500 B.C. 15¾ in. (40 cm) high. National Archaeological Museum, Athens.

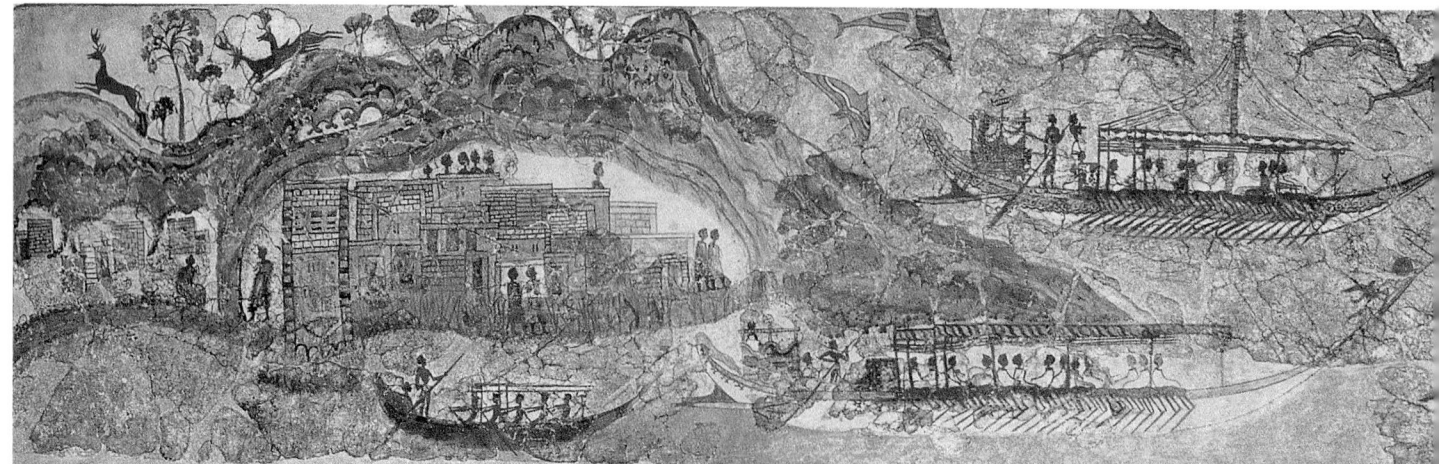

4.14 Diagram showing the original arrangement of the *Ship Fresco* at Akrotiri, in situ.

4.15 (below) *Ship Fresco* (detail of stags in fig. 4.13). This fragment, depicting the two stags pursued by a mountain lion, shows the cracks where the fresco has been pieced together. Thousands of such fragments have been dusted, saturated with acetone to remove moisture, sent to a conservation laboratory, photographed, glued to matching fragments, and then reassembled on the wall in an aluminum frame.

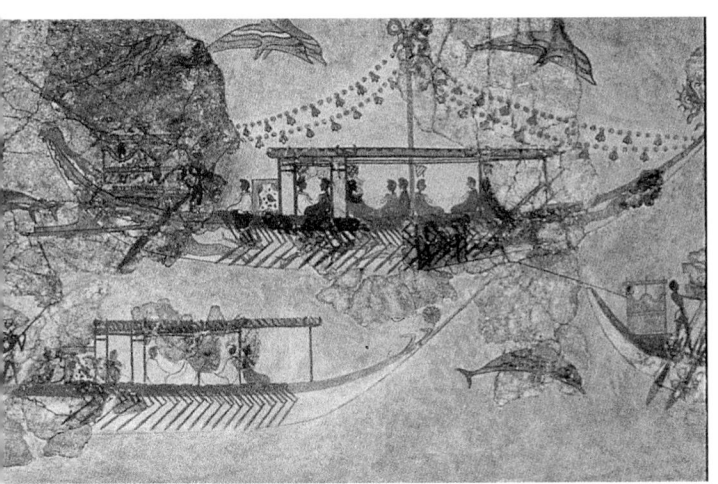

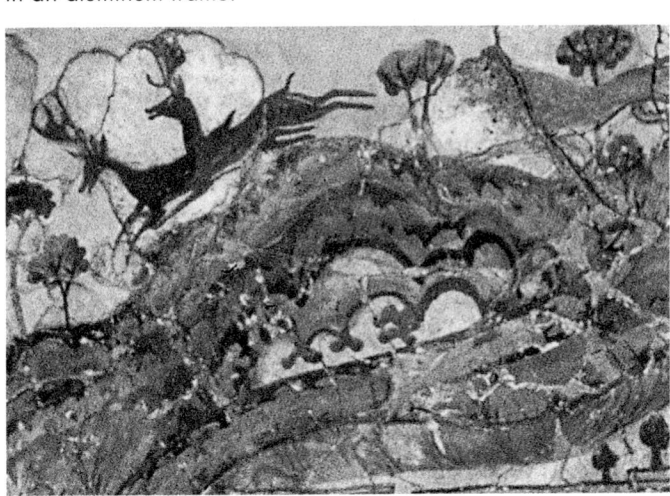

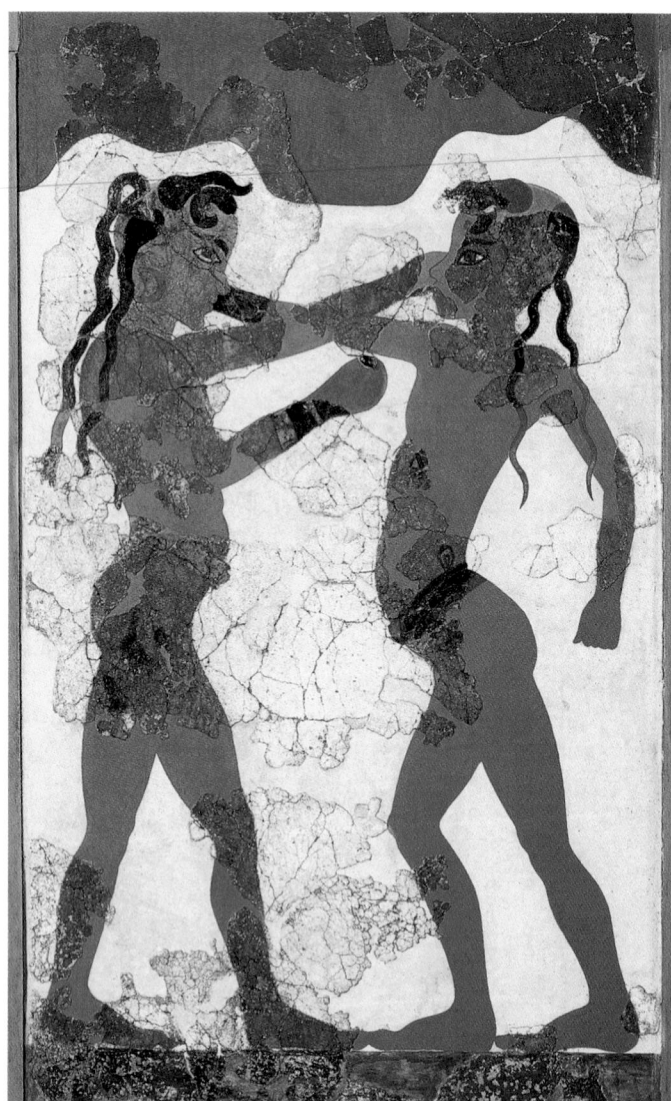

4.16 *Boxing Children*, from Akrotiri, Thera, c. 1650–1500 B.C. Fresco; 9 ft. × 3 ft. 1 in. (2.74 × 0.94 m) high. National Archaeological Museum, Athens.

The fresco of *Boxing Children* (fig. **4.16**) offers a larger-scale depiction of human figures than does the *Ship Fresco*. As is true of painted figures from Egypt and Crete, these stand on a flat base rather than in a naturalistic space. They also retain the convention of a frontal eye in a profile face. Like Minoan figures and in contrast to Egyptian ones, the curved outlines and shifting planes of movement create a sense of vigorous, sprightly energy. The significance of these boxers remains controversial, but it is likely that they are engaged in a coming-of-age ritual. The boy to the left wears jewelry and is receiving a blow from the boy to the right. His lighter face and upwardly turned eye show that he has been hit by his opponent and is in pain. This emphasis suggests that he is the initiate.

In contrast to the boxers, the so-called *Crocus Gatherer* (fig. **4.17**) is light-skinned, following the convention of Minoan and Egyptian representations of females. She holds a basket in her left hand and reaches for a flower with her

right. Although her body is frontal—she is in a squatting position—she turns her head to speak to a companion. Her curly black hair, whose ringlets echo the lines of her ear, is held in place by a blue headband. She wears a large earring and three necklaces, a short-sleeved dress and an overskirt. The stylized outline of her eye is reminiscent of ancient Near Eastern eye outlines (see fig. 2.7), although her physiognomy is more specific. Again more like Minoan than Egyptian painting, she is set in a spacious landscape amid mountains and rocks. The iconography of this fresco is based on religious ritual. Crocuses are the source of saffron, which was considered valuable for medicinal as well as for ritual purposes. The girl depicted here is one of four collecting saffron for presentation to a nature goddess, who is depicted on a raised platform receiving the saffron from a monkey.

When hitherto unknown cultures such as that on Thera are uncovered for the first time, modern views of history are necessarily modified. The precise role of Thera in the Minoan era remains to be determined. Some people believe it is the source of the story of the lost Atlantis, described by Plato in his *Timaeus* and *Kritias;* others strongly disagree. In any case, new archaeological finds reveal the dynamic, ever-changing nature of our perception of history.

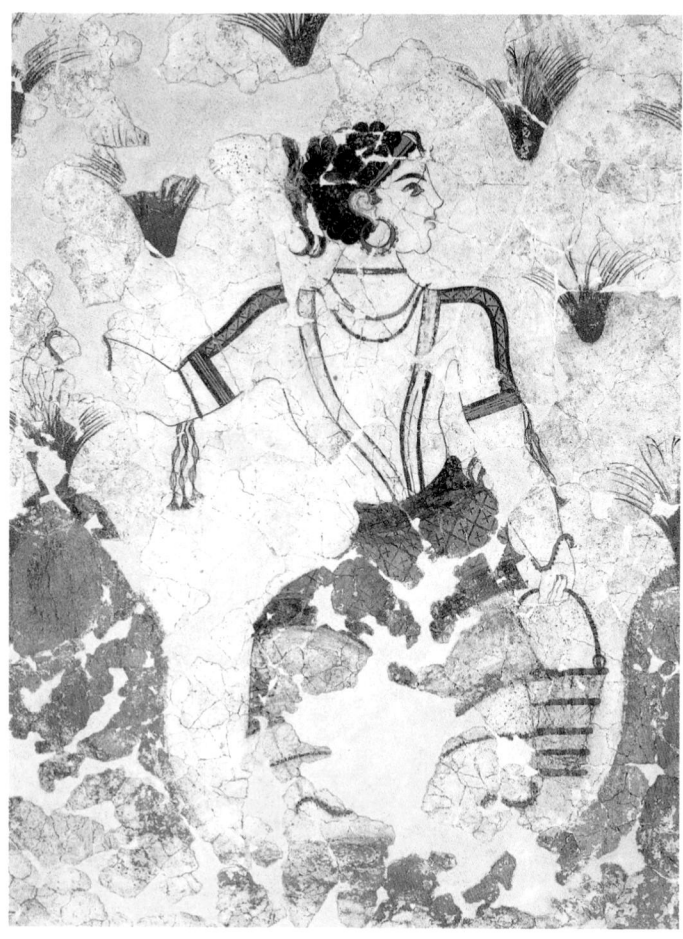

4.17 *Crocus Gatherer*, from Thera, pre-1500 B.C. Fresco; approx. 35 × 32 in. (88.9 × 81.3 cm). National Archaeological Museum, Athens.

Mycenaean Civilization (c. 1600–1100 B.C.)

In the late 1860s, Heinrich Schliemann, a successful German businessman, became an archaeologist. Like Evans, Schliemann was convinced that certain Greek myths were based on historical events. He focused his search on the legends of the Trojan War and its heroes described by Homer (see box, p. 128). In 1870, Schliemann first excavated the site of Troy on the west coast of Turkey. Years later he excavated Mycenae, the legendary city of Agamemnon, in the northeast of the Peloponnese, on the Greek mainland. The subsequent excavations of other similar Greek sites have revealed that a Mycenaean culture flourished between c. 1600 and 1100 B.C. After the eruption of Thera, the Aegean was dominated by the Mycenaeans, who began by conquering Crete and ruling the island from Knossos.

Also called Late Helladic after "Hellas," the historical Greek name for Greece (*Greece* was the name used by the Romans), Mycenaean culture takes its name from its first excavated and foremost site of Mycenae. Here, as elsewhere, the citadel was built on a hilltop and fortified with massive stone walls. The palace, or *megaron* (literally "large room" in Greek), was rectangular. One entered the *megaron* through a front porch supported by two columns and continued through an antechamber into the throne room, where four columns surrounded a circular hearth (fig.

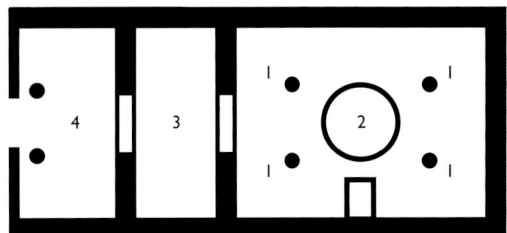

4.18 Plan of a Mycenaean *megaron*. Within a rectangular structure, the throne room had four columns (1) enclosing a circular hearth (2) in the center. Access to the throne room was through an antechamber (3) and a front porch (4) with two columns.

4.18). The king's throne was centered and faced the hearth. This arrangement had pre-Mycenaean antecedents on the Greek mainland and would be elaborated in later Greek temple architecture.

Like the Minoans, the Mycenaeans apparently had no temples separate from their palaces. Shrines have been found within the palaces, which were lavishly decorated and furnished with precious objects and painted pottery. Figure **4.19** shows a reconstruction of the *megaron* at Mycenae. The walls, floors, and perhaps the interior columns were covered with paintings.

The best-preserved fresco from Mycenae has similarities with Minoan fresco style. The so-called Mycenaean

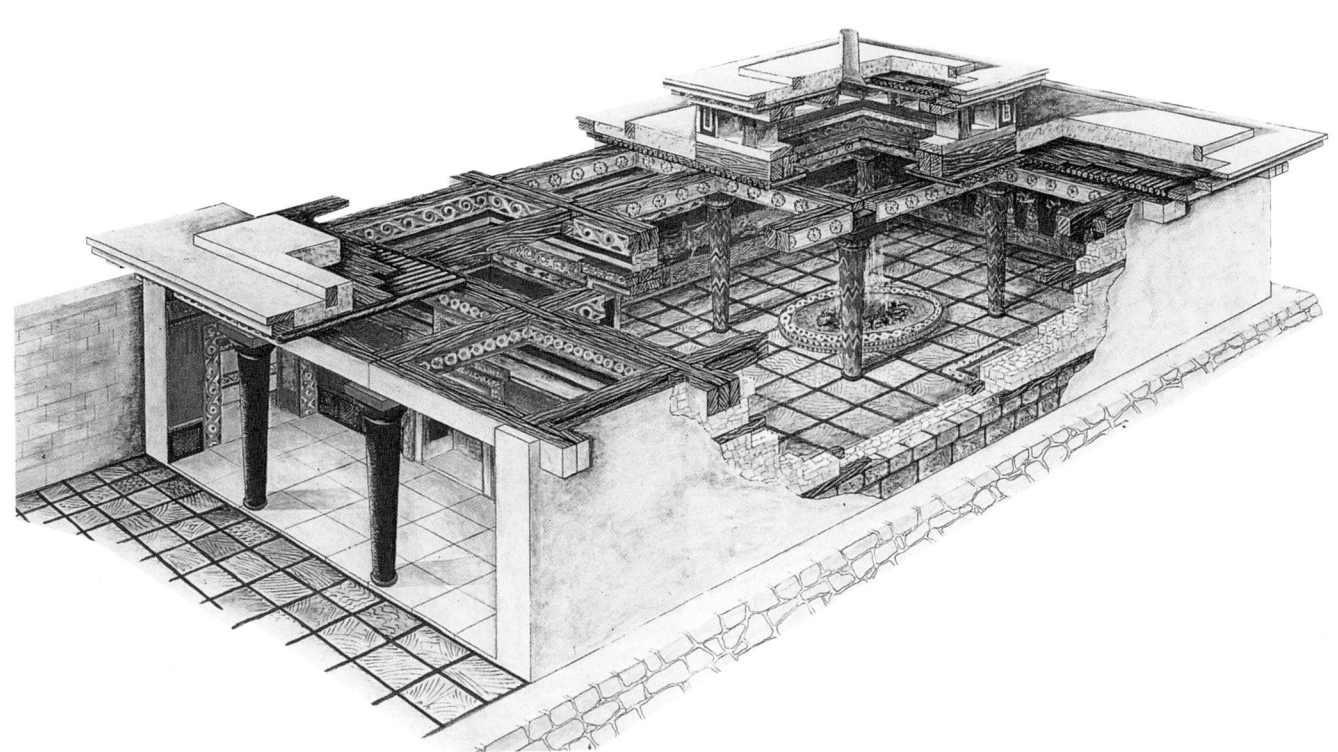

4.19 Reconstruction drawing of the *megaron* at Mycenae showing the front porch with two columns and the interior hearth enclosed by four columns.

The Legend of Agamemnon

Mycenae was the legendary home of King Agamemnon, who led the Greek army against King Priam of Troy in the Trojan War. Agamemnon's brother, King Menelaus of Sparta, had married Helen, known throughout history as the beautiful and notorious Helen of Troy. Priam's son Paris abducted Helen, and Agamemnon was pledged to avenge the offense against his family. But as soon as the Greek fleet was ready to sail, the winds refused to blow because Agamemnon had killed a stag sacred to the moon goddess Artemis. As recompense for the stag, and in return for allowing the winds to blow, Artemis exacted the sacrifice of Agamemnon's daughter Iphigenia.

Ten years later the war ended, and Agamemnon returned to Mycenae, bringing with him the Trojan seeress Kassandra. He was murdered by his wife, Klytemnestra, who had not forgiven him for Iphigenia's death, and her lover, Aegisthos. Agamemnon's children, Orestes and Elektra, then killed Klytemnestra and Aegisthos to avenge their father's death.

These tales were well known to the historical Greeks: the Trojan War from the *Iliad*, written in the eighth century B.C. and attributed to Homer; and the tragedy of Agamemnon's family from plays of Aeschylos and Euripides (fifth century B.C.).

"Goddess" (fig. **4.20**) was discovered in the cult center of the citadel. Her face is rendered in profile with a frontal eye, but her naturalism is enhanced by the curvilinear form of her body. She smiles slightly and seems to contemplate the necklace held in her right hand. The thin black lines framing her torso, outlining her eye, and defining her eyebrow recall those of the Theran *Crocus Gatherer* (see fig. 4.17). Her elaborate jewelry and coiffure indicate that she was a personage of high status, even possibly a goddess.

Unlike the nobility, most people lived in small stone and mud-brick houses below the citadel. In times of siege, they sought refuge within its walls. The defensive fortifications of the Mycenaean cities reflect a society more involved in war than were the Minoans and, thus, more concerned with protection from invaders. These considerations led to building the thick, monumental walls that surround most Mycenaean citadels. They were constructed of large, rough-cut, irregular blocks of stone such as those visible in figures **4.21** and **4.22.** Because of the enormous weight of such stones, the later Greeks called the walls Cyclopaean (see box, p. 130).

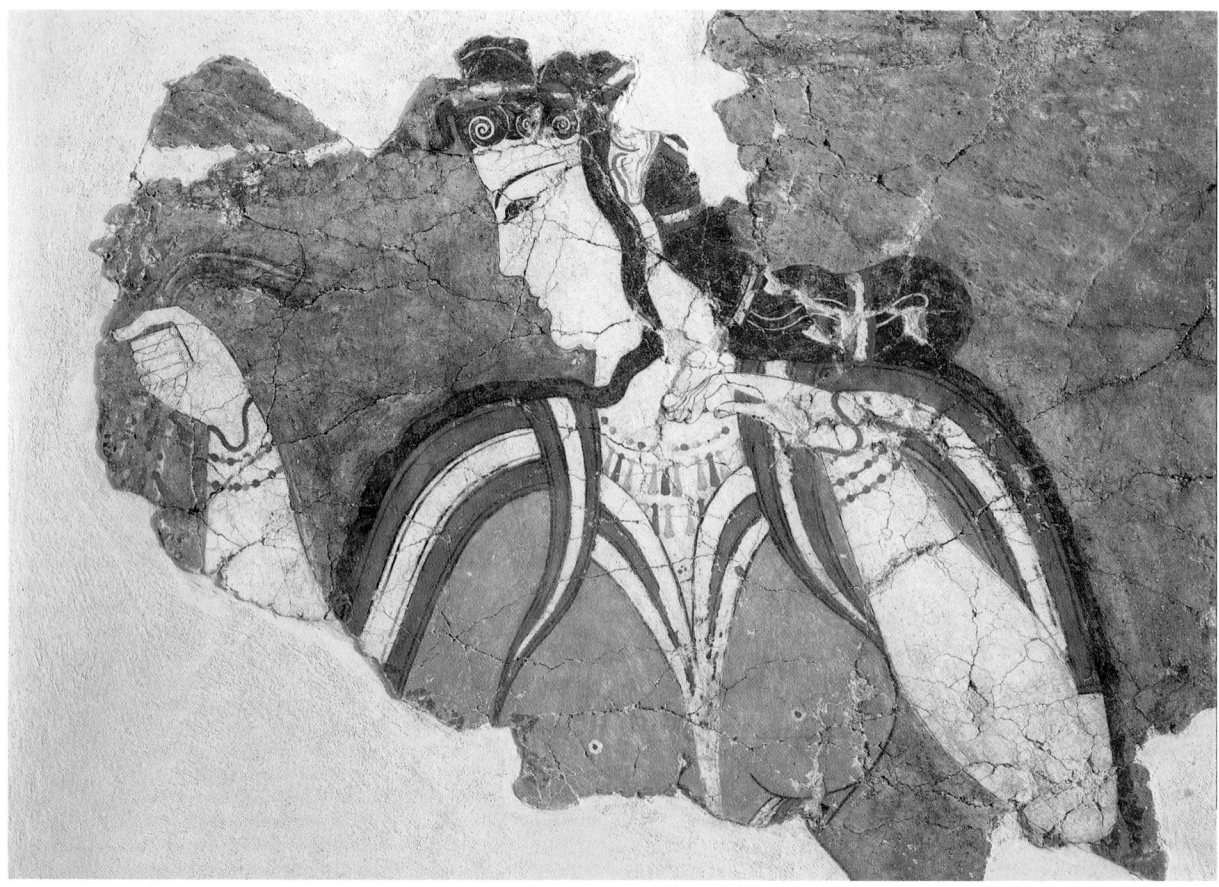

4.20 "Goddess," from the citadel of Mycenae, c. 1200 B.C. Fresco. National Archaeological Museum, Athens.

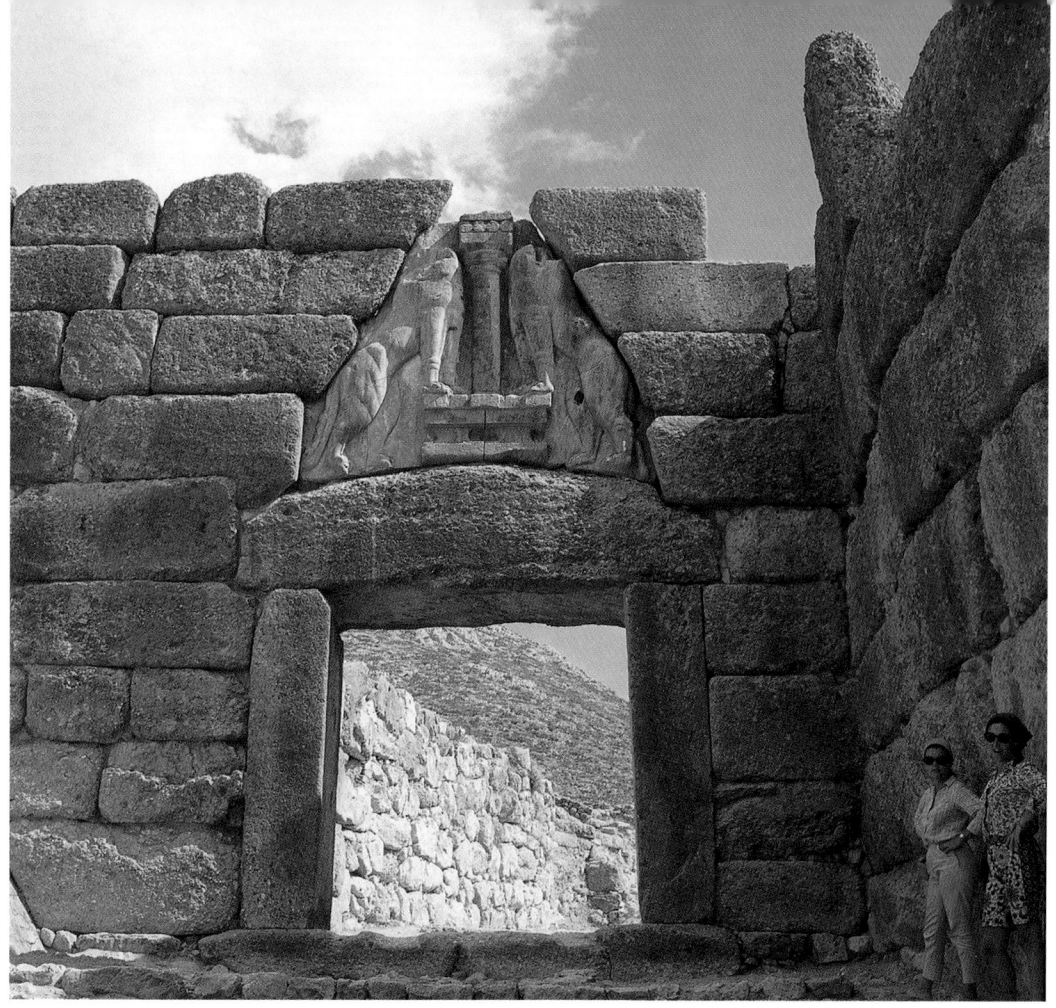

4.21 Lion Gate, Mycenae, 13th century B.C. Limestone; approx. 9 ft. 6 in. (2.90 m) high.

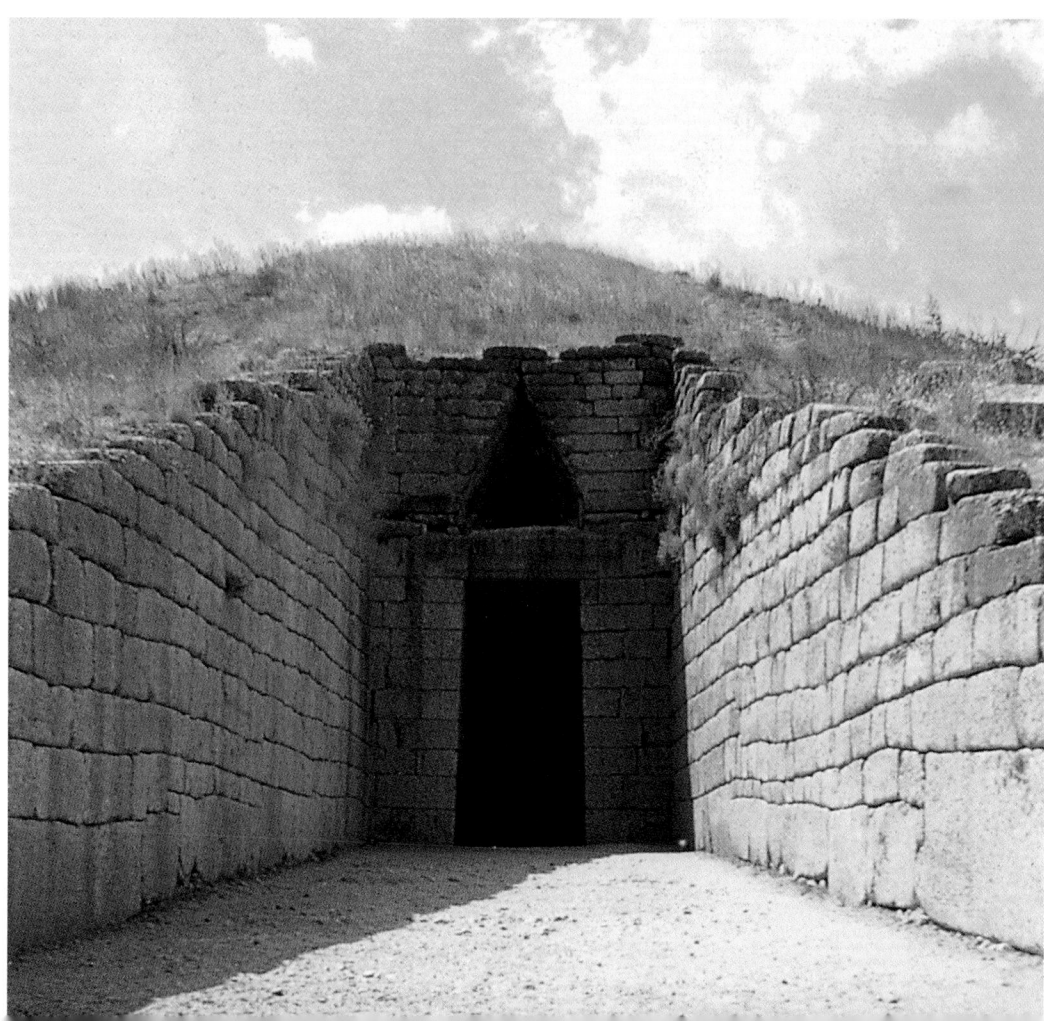

4.22 Façade and *dromos* of the Treasury of Atreus, Mycenae, 13th century B.C. Originally the door was framed by half columns made of gypsum.

The Lion Gate crowned the entrance to the citadel of Mycenae (fig. 4.21), which was centered authoritatively at the end of a long approachway. Its opening is framed by a post-and-lintel structure, and the triangular section over the lintel is called a relieving triangle because it lessens the weight on the lintel. This was formed by **corbeling**, or arranging layers, called **courses**, of stones so that each level projects beyond the lower one. When the stones meet at the top they create an arch. Filling in the triangle is a relief of two lions placing their paws on a concave Minoan altar. They flank a Minoan-style column, which is a symbol of the Nature Goddess. The relief is thus an image showing the lions obedient to the goddess as "Mistress of the Beasts" and the power immanent in her symbol. The heads of the lions are missing. Originally they were carved separately to project frontally and fulfill their traditional role as guardians.

The largest and most dramatic surviving structure at Mycenae exemplifies the culmination of Mycenaean royal

Cyclopaean Masonry

Cyclopaean masonry is named for a mythological race of giants, or Cyclopes, who were believed strong enough to lift the blocks of stone found at Mycenaean sites. The Cyclopes are described by Homer in the *Odyssey* as having a single round eye in the center of their foreheads (the name derives from the Greek words *kuklos*, meaning "circle," and *ops*, meaning "eye"). In Book 9 of the *Odyssey*, Odysseus escapes from the Cyclops Polyphemos by putting out his single eye with a stake (cf. fig. 5.6) and tying himself and his men to the undersides of a flock of sheep.

tomb architecture in the thirteenth century B.C. This tomb, or **tholos** (Greek for "round building"), has been called both the Treasury of Atreus and the tomb of Agamemnon, who was Atreus's son (figs. 4.22 and **4.23**). It is not known who was buried there, but because of its enormous size, it was doubtless intended for royalty.

Figure 4.23 shows a section of the ceiling with corbeled courses in a circular arrangement of rectangular stones corresponding to the curved sides. The courses diminish in diameter as they approach the top of the chamber, which is crowned by a round capstone. Most likely the construction of such large tombs had been influenced by the design of smaller *tholoi* used earlier for communal burials on Crete.

One entered the *tholos* through a *dromos*, or roadway, 118 feet (36.00 m) long, whose walls were faced with rectangular stone blocks (see figs. 4.22 and **4.24**). Above the

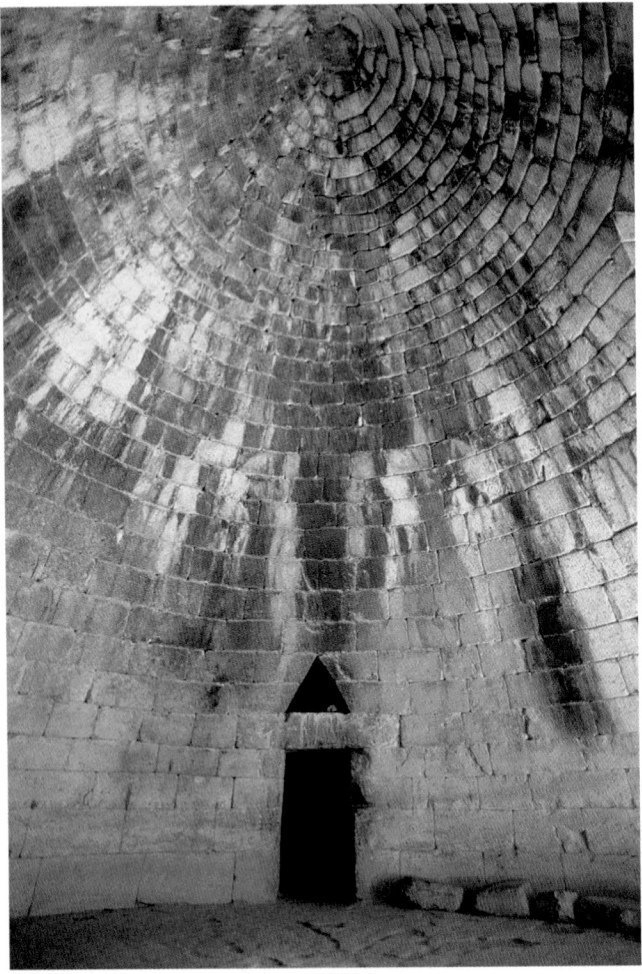

4.23 Interior of a *tholos* tomb, showing the entrance lintel and a door to the side chamber, Treasury of Atreus, Mycenae, 13th century B.C. Diameter of interior 43 ft. (13.11 m), height 40 ft. (12.00 m); doorway 17 ft. 8 in. × 8 ft. 10 in. (5.38 × 2.69 m).

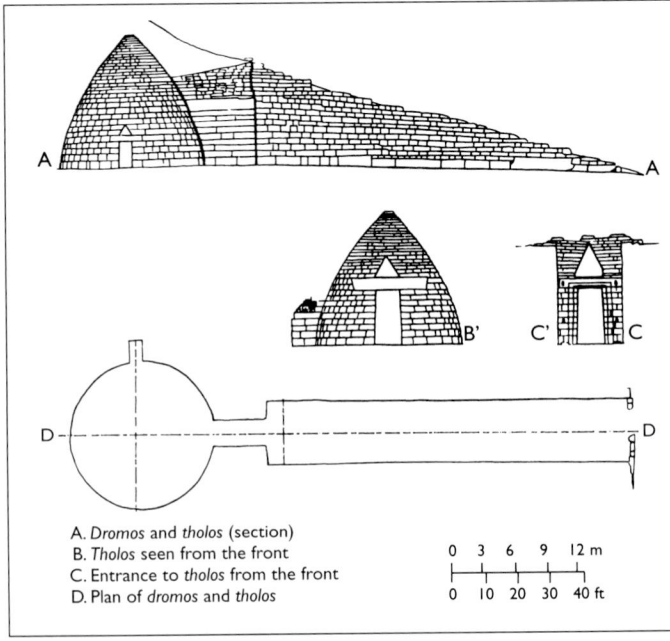

A. *Dromos* and *tholos* (section)
B. *Tholos* seen from the front
C. Entrance to *tholos* from the front
D. Plan of *dromos* and *tholos*

0 3 6 9 12 m
0 10 20 30 40 ft

4.24 Plan and sections of a *tholos*.

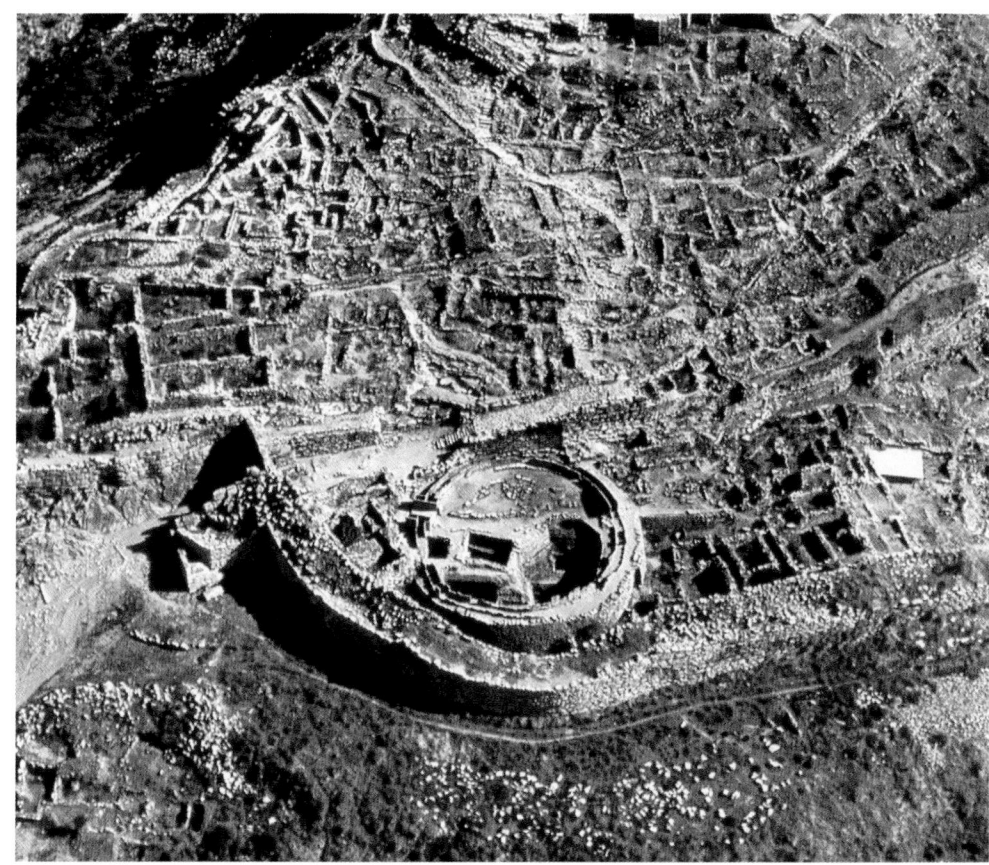

4.25 Aerial view of Grave Circle A and its surroundings, Mycenae.

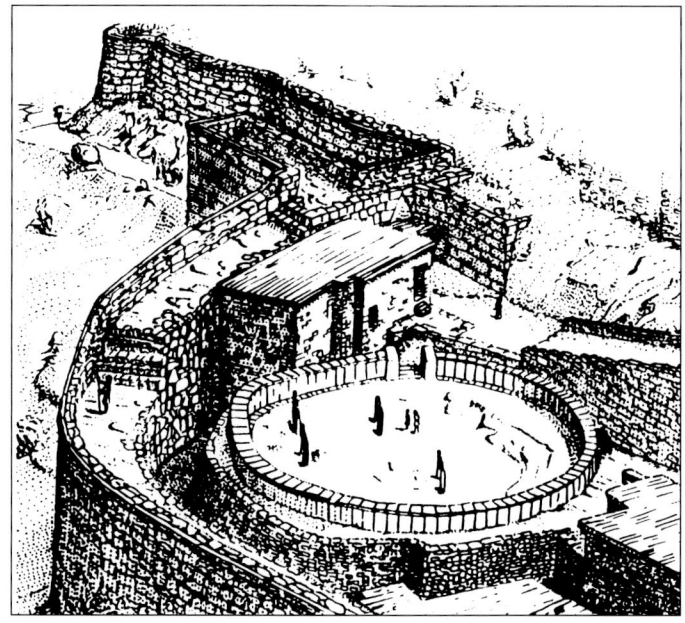

4.26 Reconstruction drawing of Grave Circle A, Mycenae, as it looked in the late 13th century B.C.

rectangular entrance to the *tholos* was an enormous lintel weighing over 100 tons. It separates the doorway from a triangle that relieves the weight borne by the lintel.

Once the dead body had been placed inside the *tholos,* the door was closed and the entrance walled up with stones until such time as it had to be reopened for later burials. All that would have been visible from the exterior was the mound of earth covering the tomb and the *dromos.* Unfortunately, both of the royal tombs discussed above were plundered before their modern excavation. However, excavations of unplundered graves, especially the earlier shaft graves at Mycenae, have yielded remarkable objects.

There is some connection between the *tholoi* and earlier Mycenaean shaft graves, which were set within circular walls. One such grave circle inside the citadel can be seen in the aerial view in figure **4.25**. The reconstruction of these ruins (fig. **4.26**) shows the massive, Cyclopaean walls and the disposition of the graves within them.

The mask in figure **4.27**, the so-called "Mask of Agamemnon," is a good example of the goldwork found in the shaft graves of Mycenae, although the gold was imported. The mask may have covered the face of a ruler Schliemann called "Agamemnon" but who actually lived three hundred years earlier. Despite stylizations such as the scroll-shaped ears, the more distinctive features—the thin lips and curved

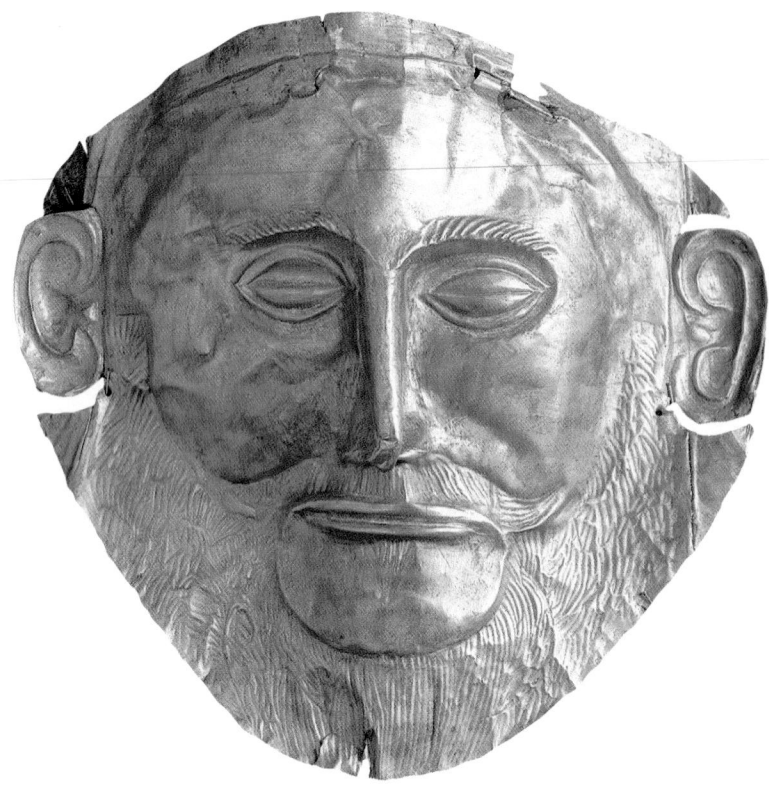

4.27 "Mask of Agamemnon," from Mycenae, c. 1500 B.C. Beaten gold; approx. 12 in. (30.5 cm) high. National Archaeological Museum, Athens. Although little is known of Mycenaean religion, it is likely that such death masks were intended to guarantee a dead person's identity in the afterlife.

mustache—are those of a particular person, indicating that this was a death mask.

Two gold cups from a *tholos* tomb at the site of Vapheio, in the region around Sparta (fig. **4.28**), were also buried with a king. There is some controversy over the origin of the two cups, but the one on the left seems to be the work of a Minoan artist, while the one on the right is Mycenaean. The scene on the left cup shows a man tying up a bull, possibly for the ritual Minoan bull sport. Landscape forms —trees and earth—are depicted with considerable natural-

ism. Also reflecting a concern for naturalism is the sense of time, noted above in the *Toreador Fresco* (see fig. 4.6): here the bull first sniffs the ground and then is enticed by a cow. The man's thin waist and flowing curvilinear outlines recall the human figures in Minoan painting.

The cup on the right is Mycenaean in execution. It is cruder than the Minoan cup and stresses the violence of a struggling bull caught in a net. The style of the Mycenaean cup is more powerful than that of the Minoan one, and its forms are generally more abstract. The relief on both cups

4.28 Minoan and Mycenaean cups from Vapheio, near Sparta, c. 16th century B.C. Gold; 3½ in. (8.9 cm) high. National Archaeological Museum, Athens.

was made using the *repoussé* technique (from the French word *pousser,* meaning "to push"), in which an artist hammers out the scenes from the inside of the cup. Final details were added on the outside. On the Vapheio cups a smooth lining of gold was attached on the inside.

The rediscovery of the Minoan-Mycenaean civilizations in the late nineteenth and early twentieth centuries, and the more recent finds at Thera, have restored some missing links of Western history. Minoan and Mycenaean cultures came to light as a result of the conviction of a few scholars —notably Sir Arthur Evans, Heinrich Schliemann, and Spyridon Marinatos—that certain old legends and myths had a basis in fact. There remains much to be learned, and archaeologists continue to probe the earth for clues to the past. Although the fall of Mycenae was followed by several hundred years of a so-called "Dark Age," about which we have archaeological but no literary information, the Aegean cultures provide a transition from Egypt and the ancient Near East to the later art and culture of historical Greece, which is the subject of the next chapter.

Style/Period	Works of Art	Cultural/Historical Developments
CYCLADIC c. 3000–11th century B.C.	Female Cycladic idol (**4.1, 4.2**), Amorgos Male Cycladic flute player (**4.3**), Keros	
MINOAN c. 3000– c. 1100 B.C.	Kamares jar (**4.11**), Knossos Harvester Vase (**4.10**), Hagia Triada Palace of Minos (**4.4, 4.5**), Knossos *Snake Goddess* (**4.9**), Knossos "Throne room," griffin fresco (**4.8**), Knossos The queen's *megaron* (**4.7**), Knossos *Toreador* Fresco (**4.6**), Knossos Octopus Vase (**4.12**), Palaikastro	Great Pyramids built at Giza (c. 2551–2472 B.C.) Linear A used in Crete (c. 2000 B.C.) Earthquake destroys Crete (c. 1700 B.C.) Earthquake destroys Thera (modern Santorini) (c. 1628–1500 B.C.) Linear B used in Crete and Greece (c. 1400 B.C.)
Thera c. 1650–1500 B.C.	*Ship Fresco* (**4.13–4.15**), Thera *Boxing Children* (**4.16**), Thera *Crocus Gatherer* (**4.17**), Thera	
MYCENAEAN c. 1600–1100 B.C.	Mycenaean *megaron* (**4.18, 4.19**) "Mask of Agamemnon" (**4.27**), Mycenae Vapheio cups (**4.28**), near Sparta Lion Gate (**4.21**), Mycenae Treasury of Atreus (**4.22–4.24**), Mycenae "Goddess" fresco (**4.20**), Mycenae	Beginning of decline of Mycenaean power (c. 1200 B.C.) Iron comes into common use (c. 1200 B.C.) Trojan War; sack of Troy (c. 1180 B.C.) Mycenae destroyed (c. 1100 B.C.) Dorians invade Greece from the north (c. 1100 B.C.)

Cycladic idol

Toreador Fresco

Boxing Children

"Mask of Agamemnon"

Queen's megaron

Vapheio cup

3000 B.C.

1200 B.C.

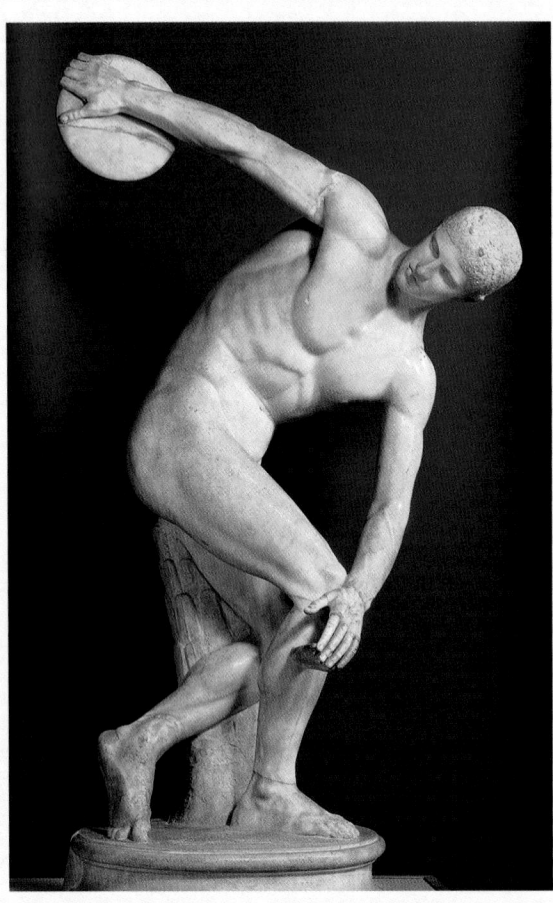

CHAPTER PREVIEWS

THE ART OF ANCIENT GREECE, c. 800–1st CENTURY B.C.

Homeric epics written down (c. 800 B.C.)
Greek alphabet; Delphic oracle; Olympian gods
Battle of Marathon: Persian defeat (490 B.C.)
Philosophy: Plato; Socrates; Aristotle
Theater: Aeschylos; Sophokles; Euripides; Aristophanes
"Man is the measure of all things"
Vase painting; mosaics; monumental sculpture
Orders of architecture: Doric; Ionic; Corinthian
Periklean Athens (c. 450–400 B.C.)
 The Parthenon; canon of Polykleitos
 Herodotos ("father of history")
Peloponnesian War: Sparta defeats Athens
Alexander the Great dies (323 B.C.)
Hellenistic period

THE ART OF THE ETRUSCANS , c. 1000–100 B.C.

Naval control of the Mediterranean (7th–5th century B.C.)
Necropoleis (cities of the dead); ash urns; tomb frescoes; temples;
 mirrors; bronze sculpture
Status of women; augury

China: Neolithic to First Empire, c. 5000–206 B.C.
 Bronze Age: Shang; Zhou
 Iron Age: Emperor Qin (Shihuangdi)
 Unification of China; Great Wall (begun 3rd century B.C.)
 Piece-mold bronze casting; calligraphy
 Terra-cotta army

ANCIENT ROME, 6th CENTURY B.C.–4th CENTURY A.D.

Lengendary founding by Romulus and Remus (753 B.C.)
Rule by kings to 509 B.C.
Republic (509–27 B.C.); Latin language; government by senate and
 patricians
 Punic Wars against Carthage (264–146 B.C.)
Empire (27 B.C.–A.D. 476)
 Augustus first emperor; Virgil's *Aeneid*
 Domestic architecture; public buildings; concrete
 The Forum; round arches; domes; barrel vaults
 Assimilation of Greek forms and Greek gods
 Portraiture; wall paintings; country villas
 Rome falls to Germanic invaders (A.D. 476)

South Asia, c. 2700 B.C.–3rd Century A.D.
 Indus Valley civilization (2700–1750 B.C.)
 Stamp seals; bronze and stone sculpture
 Vedas and Upanishads
 Buddha born (563 B.C.)
 Development of Buddhism: Ashoka's pillars; stupas
 Gandharan and Mathuran sculpture

EARLY CHRISTIAN AND BYZANTINE ART, 1st–9th CENTURIES

Crucifixion of Jesus (c. A.D. 33)
Constantine's Edict of Milan (A.D. 313)
Early Christian art: catacombs, Old Saint Peter's
 Martyria, mosaics, basilicas
Byzantine Empire: Justinian and Theodora (6th century)
 San Vitale; Hagia Sophia; domes on pendentives
 The codex (Vienna Genesis)
 Iconoclastic Controversy (8th–9th centuries)

Developments in Buddhist Art, 1st–7th Centuries
 India: Gupta sculpture; Ajanta Caves
 China: Silk Roads; Yungang Caves; Longmen Caves
 Paradise sects

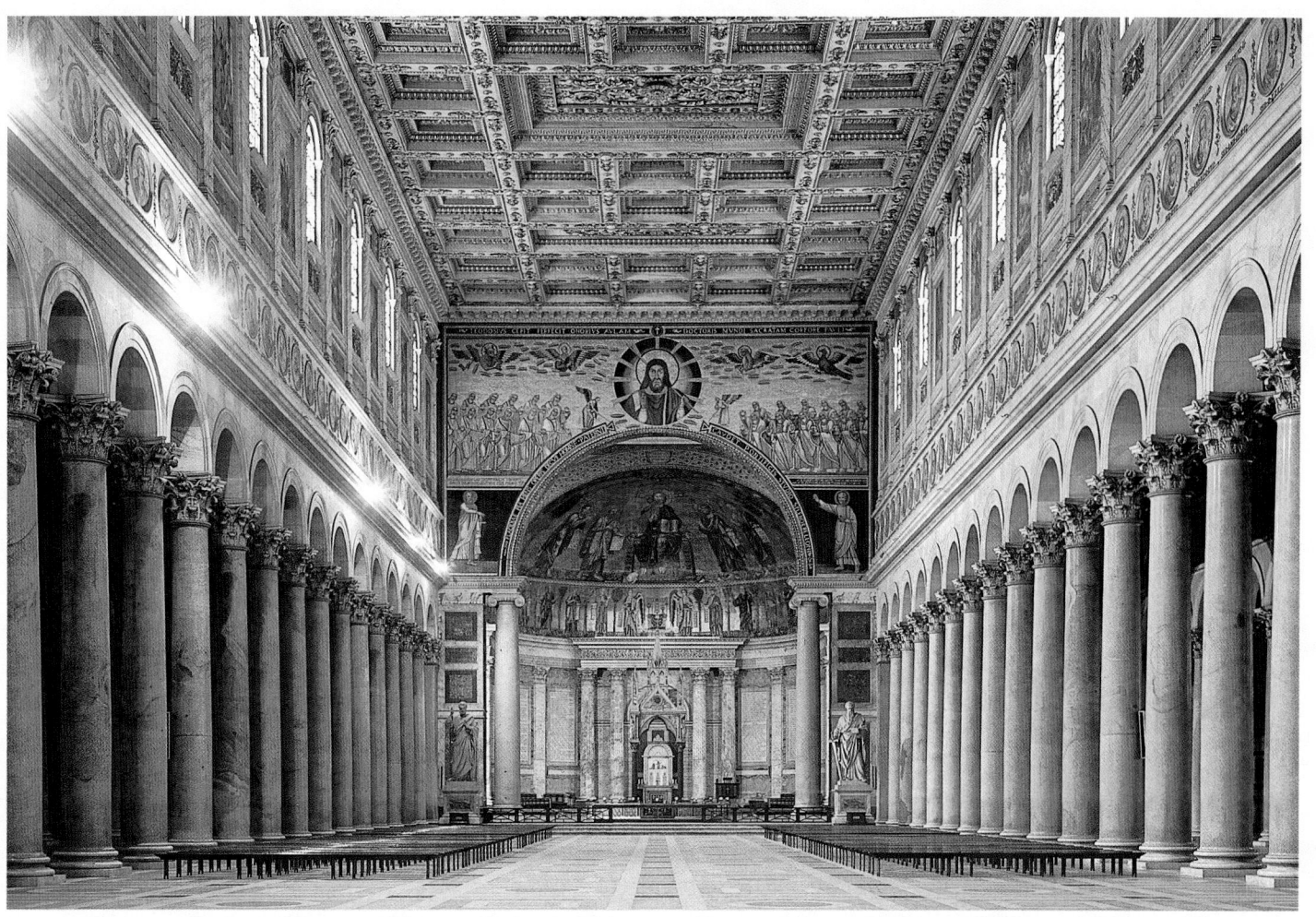

The historical period of Greece dates from about 800 B.C. and provides the basis of much of Western culture—its art and architecture, theater, philosophy, poetry, and politics. From approximately 450 B.C. to 400 B.C., the Classical style flourished and continues to influence Western art to the present day. The civilization of Etruria (c. 1000–100 B.C.), located on the Italian peninsula, is distinctive but less well known than that of Greece because we cannot read its language. Etruscan culture influenced Rome, which rose to power in the early sixth century B.C. and formed a republic. Under Augustus (ruled 27 B.C.–A.D. 14), however, Rome became an empire and remained as such until A.D. 476, the official date of the fall of Rome. Beginning in the first century A.D., the teachings of Jesus challenged the divinity of the Roman emperor. By the fourth century, Christianity had become the dominant religion in Rome, and the arts were transformed to suit the needs and beliefs of Christians.

Meanwhile, evidence from the Indus Valley (c. 2700–1750 B.C.), in modern Pakistan, suggests early contact with Mesopotamia. In the Far East, the prevailing religions—Hinduism and, from the sixth century B.C., Buddhism— inspired figurative sculptures, paintings, and temples on a vast scale.

5

The Art of Ancient Greece

The time referred to as the historical Greek period emerged some four hundred years after the decline of the Minoan-Mycenaean cultures around 1100 B.C. (see map). Because the art of writing had been lost, little is known of Greek history from 1100 to 800 B.C. From around 800 B.C. until the end of the first century B.C., Greek culture is relatively well documented, including the achievements of its artists, writers, philosophers, and scientists. These have had a significant and long-lasting impact on Western civilization. Writing was revived, and the Greek language has persisted relatively unchanged to the present day. The Greek alphabet was an adaptation of Phoenician, a Near Eastern Semitic language. The English word *alphabet,* in fact, combines the first two letters of the Greek alphabet—*alpha* and *beta,* equivalent to the Semitic *aleph* and *beth,* and to the modern English *A* and *B.*

The exact origins of the Hellenes, as the Greeks called themselves, are unknown. By around 800 B.C., two related Greek peoples had settled in Greece—the Dorians, who inhabited the mainland, and the Ionians, who occupied the easternmost strip of the mainland (including Athens), the Aegean islands, and the west coast of Anatolia (modern Turkey). Later, the Greeks established colonies in southern Italy, Sicily, France, and Spain. As such colonizing activity suggests, the Greeks were accomplished sailors, and their economy depended to some degree on maritime trade. They were also successful in cultivating their rocky terrain and in manufacturing pottery and metal objects.

selves as the most civilized culture in the world, a view reflected in their sense of being a single people, superior to all others. The modern meaning of the word *barbarian* is "uncivilized" or "primitive," but for the ancient Greeks any foreigner was a barbarian (*barbaros*). Greeks considered anyone who spoke a foreign language—unintelligible words sounding like "bar-bar"—to be less civilized than they.

Greece was not only the most civilized country in its own estimation, it was also the most central. The site of the sacred oracle at Delphi (see box, p. 138), where futures were foretold, omens read, and dreams interpreted, was called the *omphalos,* or navel, of the world. The oracle, actually a priestess believed to be divinely inspired, advised on political matters as well as on private ones. As a result, the Delphic oracle drew emissaries from all over the Mediterranean world and became an established center of international influence. Inscribed in stone at Delphi was the prescription "Know thyself," which expressed a new emphasis on individual psychology and personal insight.

There was also a new perception of history. Rather than marking the passage of time in terms of kings and dynasties, as the Egyptians and the Mesopotamians had, the Greeks reckoned time in Olympiads—four-year periods beginning with the first Olympic Games, held in 776 B.C. The games (called Panhellenic, meaning "all the Greeks") were restricted to Greek-speaking competitors and reinforced the Greek sense of cultural unity. The Olympic Games were so important that all wars on Greek territory were halted so that athletes could travel safely to Olympia to participate. In this way, the destructive forces of battle were transformed into the more peaceful pursuit of athletic competition.

Cultural Identity

Greece was not unified by a strong sense of its identity as a nation until the invasions of 490 and 480 B.C. by the Persians, who were long-standing enemies of the Greeks. But after defeating the Persians, the Greeks thought of them-

Government and Philosophy

The Athenians abhorred the rule of autocratic kings and pharaohs that characterized other Mediterranean cultures. When the Greek rebels Harmodios and Aristogeiton killed the son of the tyrant Peisistrates in the sixth century B.C.,

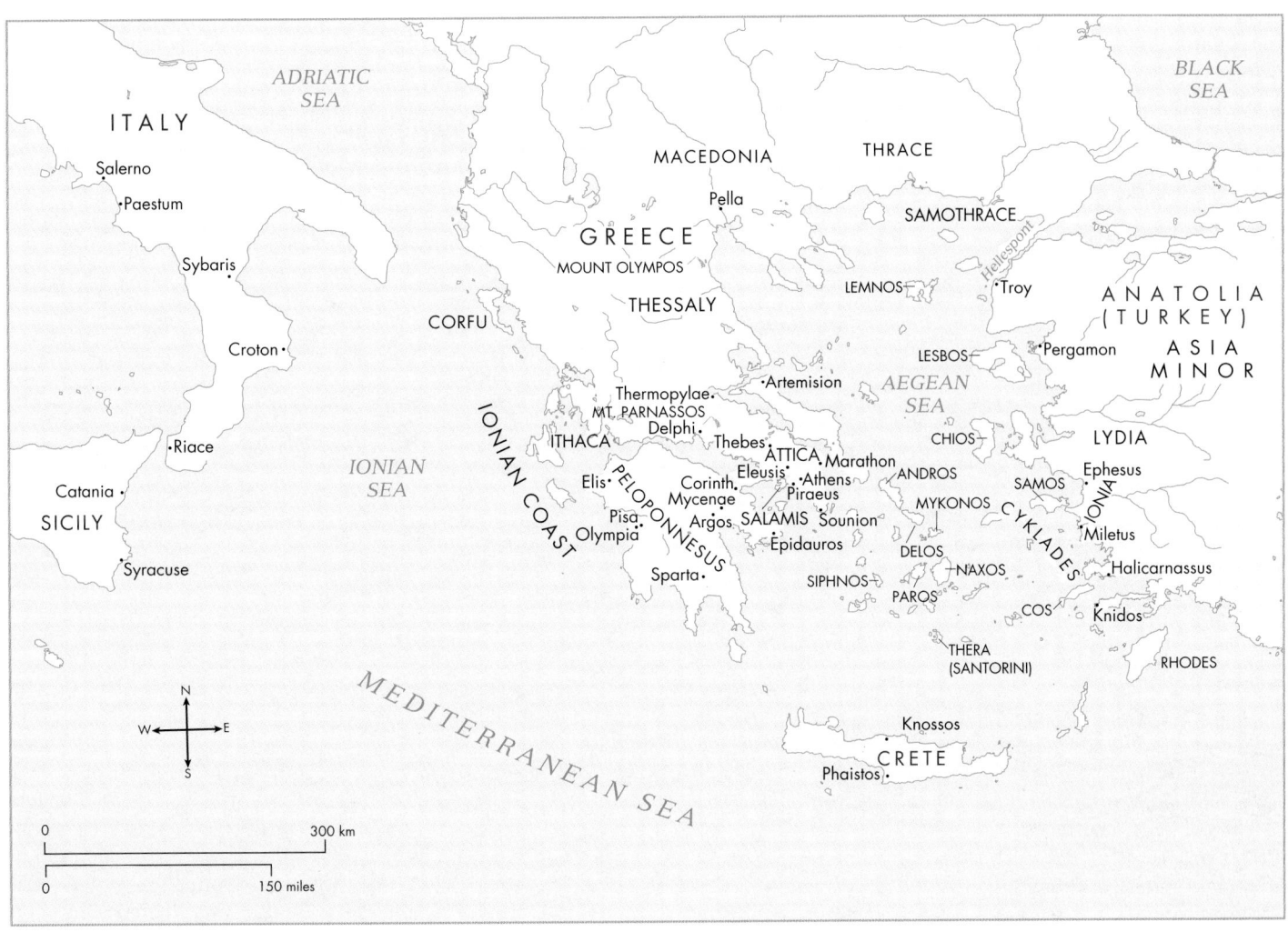

Ancient Greece and the eastern Mediterranean.

Athens honored them as champions of liberty. The Athenian citizens commissioned portrait statues of the heroes —this was one of the highest honors in ancient Greece because it preserved an individual's fame for posterity. The Persians symbolically challenged Athenian liberty by plundering the statues of Harmodios and Aristogeiton, which were not replaced until 477/6 B.C., after the Greek victory over Persia.

The Greek aversion to tyranny led to the establishment of independent city-states. Each city-state, or *polis*, required some degree of citizen participation in its government. Even though the Greeks, like most ancient Mediterranean cultures, kept slaves and did not allow women to engage in politics (see box, p. 140), the *polis* was an important foundation of modern democracy. The ideas embodied in the Athenian democracy of the second half of the fifth century B.C. inspired Thomas Jefferson, when he wrote the Declaration of Independence and framed the American Constitution in the late eighteenth century. The very word *democracy* is derived from the Greek words *demos* (people) and *kratos* (power).

Greek philosophers discussed the nature of government at length. Foremost among them is Plato (c. 428–348 B.C.). His writings include *The Republic* and *The Laws,* which examine his ideal state and the laws required for its proper functioning. Plato's spokesman and teacher, Socrates (see box on p. 141 and fig. 5.3), had developed a new method of teaching known as Socratic dialogue—a process of question and answer through which the truth of an argument is elicited from the student. Demanding close observation of nature and human character, the Socratic method reflects the Greek interest in the centrality of man in relation to the natural world, which is consistent with the Greek artists' pursuit of naturalism and the study of human form.

Aristotle (384–322 B.C.), Plato's most distinguished student and tutor of Alexander the Great, stands out among the ancient Greek philosophers for the diversity of his interests. In addition to natural sciences such as botany, physics, and physiology, Aristotle wrote on philosophy, metaphysics, ethics, politics, logic, rhetoric, and poetry. His *Poetics* established the basis for subsequent discussions of

tragedy, comedy, and epic poetry in Western literary criticism. Aristotle did not discuss the visual arts as specifically as Plato had (see box, p. 140), but his views on aesthetics have had a substantial influence on Western philosophy.

Philosophy and science, like philosophy and aesthetics, were very much interrelated in ancient Greece. In the sev- enth century B.C., for example, Thales of Miletos had founded the first Greek school of philosophy and argued that the origin of all matter was water. In the sixth century B.C., the Pythagorean philosophers of Samos recognized that the earth was a sphere. It was here that the Pythago- rean theorem was formulated: $A^2 + B^2 = C^2$ (the square

Delphi

The Greek site of Delphi on the northern slopes of Mount Par- nassos in Phokis was one of the most spectacular settings in the ancient world—and it remains so today. In the Mycenaean era (c. 1600 B.C.), Delphi had been a sanctuary dedicated to the Titan earth goddess Gaia. By the eighth century B.C., it had become the sanctuary of Apollo, whose temple lies at the beginning of the Sacred Way (figs. **5.1** and **5.2**). According to Greek myth, when Apollo left Delos, he went to Delphi and killed the Python, a dragon that guarded the oracle and stood for the mysterious power of the underworld. In this transfer of Delphi from Gaia and the Python to Apollo, the Greeks saw a development from the forces of darkness to the rationality of light, from the primitive to the intellectual, and from a matriar- chal past to patriarchy.

Delphi was also the site of the Pythian Games. At first these contests were held every eight years and were reserved for music and poetry in honor of Apollo. From 582 B.C., the games were expanded to include athletics, as at Olympia, and took place every four years. The victors were rewarded with a wreath from Apollo's sacred laurel tree and with a portrait statue erected in the sanctuary.

5.1 Temple of Apollo at Delphi, east view, 346–320 B.C.

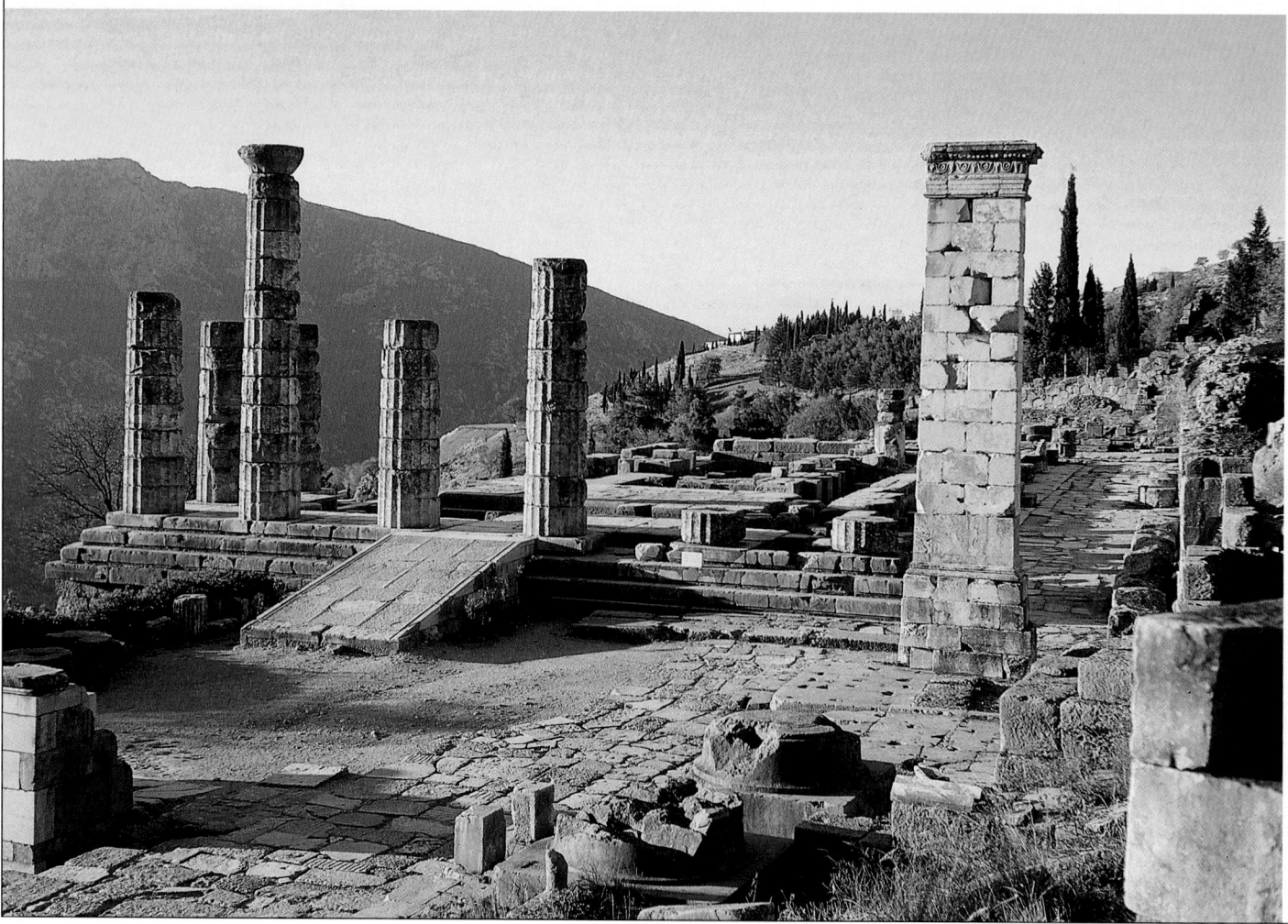

of the hypotenuse of a right-angled triangle is equal to the sum of the squares of the other two sides). Similar mathematical relationships determined the proportions of Classical Greek temples (see p. 158). In the fourth century B.C., Euclid developed number theory and plane geometry.

Literature and Drama

The literary legacy of Greece is one of the most remarkable bequeathed to Western civilization. The *Iliad,* attributed to Homer, is the account of the Trojan War and its heroes, and the *Odyssey* tells the story of Odysseus's ten-year

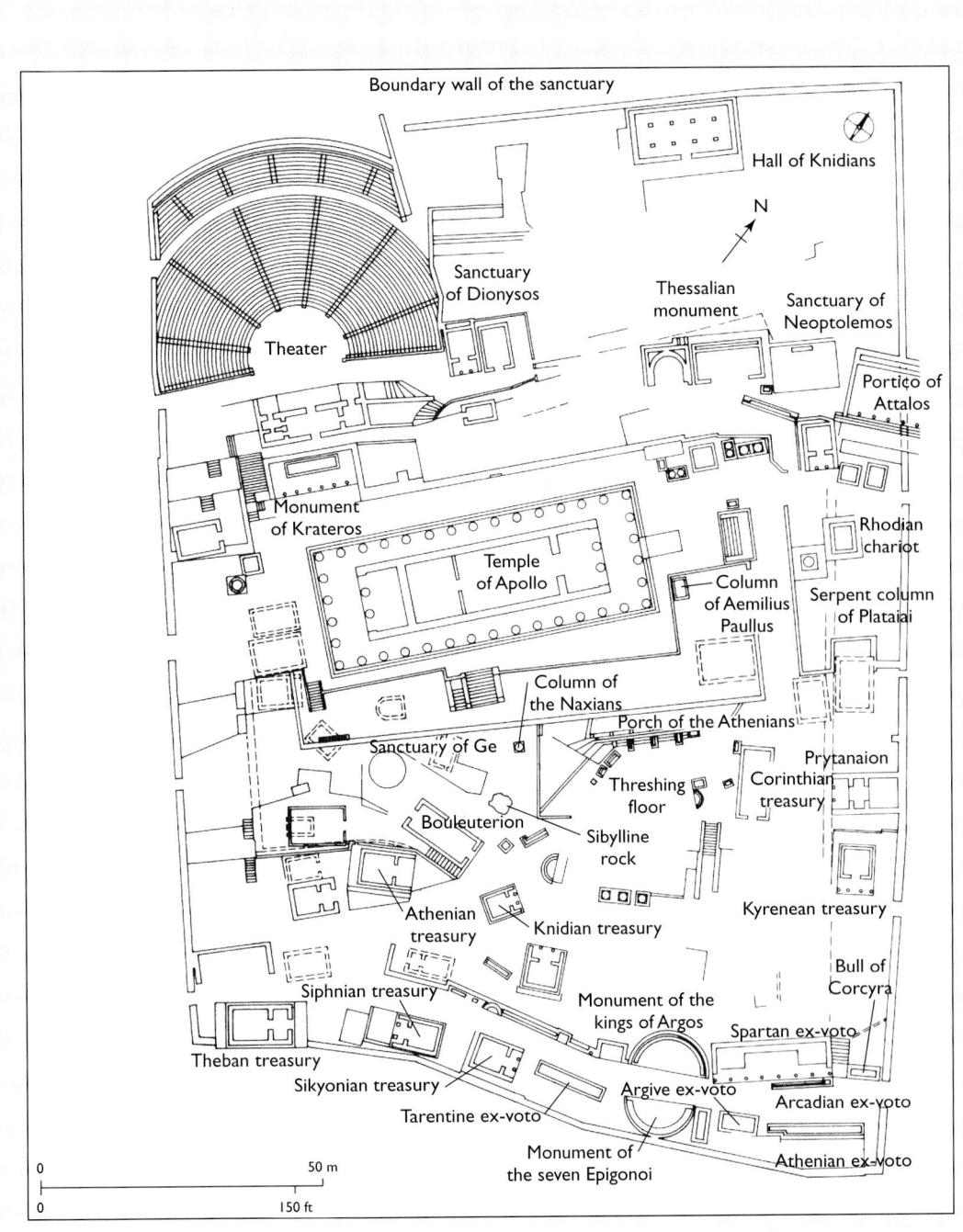

Boundary wall of the sanctuary

Hall of Knidians

N

Theater

Sanctuary of Dionysos

Thessalian monument

Sanctuary of Neoptolemos

Portico of Attalos

Monument of Krateros

Temple of Apollo

Column of Aemilius Paullus

Rhodian chariot

Serpent column of Plataiai

Column of the Naxians

Porch of the Athenians

Sanctuary of Ge

Threshing floor

Sibylline rock

Bouleuterion

Prytanaion

Corinthian treasury

Athenian treasury

Knidian treasury

Kyrenean treasury

Siphnian treasury

Monument of the kings of Argos

Bull of Corcyra

Spartan ex-voto

Theban treasury

Sikyonian treasury

Tarentine ex-voto

Argive ex-voto

Arcadian ex-voto

Monument of the seven Epigonoi

Athenian ex-voto

5.2 Plan of the sanctuary at Delphi.

0 50 m

0 150 ft

Women in Ancient Greece

In the period of Greek history depicted by Homer, aristocratic women led lives of relative independence, as did the women of Sparta from the sixth century B.C. onward. In Athens and other parts of Greece during the Classical period (fifth century B.C.), however, women lived under severe constraints. They ventured outside the house mainly for religious processions and festivals restricted to women, and could not vote or hold public office. In the words of Aristotle: "The deliberative faculty is not present at all in the slave, in the female it is inoperative, in the child undeveloped."

In the private sphere, women occupied segregated quarters of the house. Greek marriages were monogamous. As in all ancient cultures, marriage was an economic transaction arranged by the parents of the couple, generally within a circle of relatives so as to preserve property within the family. The woman was usually much younger than the man, and the couple often had no previous acquaintance. If an unmarried woman had no brothers, she was obliged upon the death of her father to marry his closest relative in order to carry on the family.

Once married, a woman became her husband's responsibility. She had no independent status, and her life was devoted to childbearing and looking after the family and household. Perikles is quoted by the Greek historian Thucydides (c. 460–400 B.C.) as having said that a woman should "be spoken of as little as possible among men, whether for good or ill." Women could own nothing apart from personal possessions and could not be party to any transaction worth more than a nominal amount. A man could divorce his wife by declaration before witnesses; a wife could do so only by taking her husband to court and proving serious offenses.

Athenian men were required by law to marry daughters of Athenian citizens. As a result, some men developed relationships outside marriage with *hetairai*—companions who often were courtesans. *Hetairai* generally came from Ionia and were more intellectual and better educated than Athenian women. The best-known *hetaira* of the fifth century B.C. is the Milesian Aspasia, who was the companion of Perikles. He eventually divorced his wife to marry her.

Ideas about female emancipation begin to appear in literature from the end of the fifth century B.C., and some of the most memorable characters in Greek plays are females, although they were acted by male youths. From the fourth century onward—and increasingly so in the Hellenistic period (323 B.C. to the first century)—education was accessible to some women, and there are reports of women studying philosophy and painting, and writing poetry.

The Roman historian Pliny the Elder mentions by name one Iaia of Kyzikos, who lived in the early first century B.C. Her "hand," he wrote, "was quicker than that of any other painter, and her artistry was of such high quality that she commanded much higher prices than the most celebrated painters of the same period."

Sappho, the most famous poetess in antiquity, lived at the turn of the seventh century B.C. and was much admired by Plato and other writers. Little is known of her life except that she was born on the island of Lesbos (from which comes the word *lesbian*). Her poems, inspired by Aphrodite, tell of her love for girls as well as for boys and were accompanied by the music of the lyre. Today her work survives only in fragments, but she is known to have written nine books of odes, elegies (poems that mourn the dead), and *epithalamia* (lyric odes to a bride and bridegroom). She composed in various meters—the Sapphic meter is believed to have been her invention.

Plato on Artists

Great philosopher though he was, Plato did not have much use for artists. In Book X of *The Republic,* he proposes banishing them from his ideal state. For Plato, art had no reality except as technique (*techne*) and as imitation (*mimesis*) of nature. But nature itself, he argued, is *only* a mere shadow of the essential truth, which he called the "Good and Beautiful" (*kalos k'agathos*), and it is the philosopher, rather than the poet or artist, who is capable of interpreting it.

The original creator, according to Plato, is God, who creates in relation to the philosophical essence. Craftsmen and artisans are below God, for they make useful objects that, like nature, merely reflect the essential. The painter, who makes an image of the object, is lower still and, therefore, even further from the truth.

Poets do not fare much better than artists in Plato's ideal state for, in his view, they appeal to passion rather than to truth. Although Plato loved Homer, he recommended banishing his works along with those of the artists and admitting only hymns to God and poetry praising famous men.

journey home to Ithaca after the war. These epic poems were originally recited and then were written down sometime around 800 B.C. They are noteworthy for their literary style and emphasis on the power and psychology of human heroes. The same is true of the tragedies of Aeschylos, Sophokles, and Euripides and the comedies of Aristophanes, all of which laid the foundation of Western theater. Aeschylos's trilogy *The Oresteia,* written during the fifth century B.C., dramatized the tragedy of Agamemnon's family after his return to Mycenae from the Trojan War (see p. 186). And it was Sophokles who gave the world the Oedipus plays, from which Freud recognized that poets had understood human psychology long before the development of psychoanalysis. Events and characters of Greek literature were often illustrated by artists, whose interest in psychology paralleled that of the writers and philosophers.

Socrates: "Know Thyself"

Socrates (470–399 B.C.) left no writings. He was the philosophical spokesman and central figure of Plato's *Dialogues* who advocated self-knowledge in the search for truth. Ultimately a martyr to his intellectual integrity, Socrates chose death rather than exile from the Athens he loved. He explains the philosophical rationale for his choice in Plato's *Apology*.

Figure **5.3** reflects the appearance of Socrates as described by the Athenian general Alkibiades in Plato's *Symposium*. Alkibiades compares Socrates to two unattractive satyrs (mythological creatures who are part human and part goat), Silenos and Marsyas (the latter found the flute that Athena had discarded and challenged Apollo to a musical contest). Silenos was associated with the drunken orgies of Dionysos, and Alkibiades notes that small statues of Silenos found in Athenian shops open up to reveal the image of a god. Similarly, he says, Socrates' words open up into images of Truth and Beauty: "They are ridiculous when you first hear them; . . . he clothes himself in language that is like the skin of the wanton Satyr." The ignorant laugh, but whoever looks below the surface sees the divine beauty in his words. According to Alkibiades, these words have even more charm than the music of Marsyas, for Socrates charms and stirs the souls of his listeners. "I saw in him," Alkibiades says, "divine and golden images of such fascinating beauty that I was ready to do in a moment whatever Socrates commanded."

5.3 *Socrates*, 1st or 2nd century A.D. Roman copy of an original by Lysippos. Marble; 10 in. (27.5 cm) high. British Museum, London.

"Man Is the Measure of All Things"

The ancient Greek contributions to Western civilization are inextricably linked to this saying, which set Greece apart from other ancient Mediterranean cultures. In Greek religion, gods were not only **anthropomorphic** (human in form), but had human personalities and conflicts (see box, p. 142). They participated in human events, such as the Trojan War, and tried to influence their outcomes. The gods are referred to as the Olympians because they resided on Mount Olympos after having overthrown their primitive, cannibalistic forerunners, the so-called Titans.

Greece also differed from other Mediterranean cultures, especially Egypt, in its view of death and rituals for the dead. For example, the Greeks believed that certain rituals were necessary for the "shade" of the deceased to pass into the shadowy underworld of Hades. Without proper burial rituals, a spirit might be condemned to wander restlessly forever. To memorialize the deceased, the Greeks erected modest grave markers.

The surviving works of art from ancient Greece emphasize the individual above all. In contrast to the adherence to tradition of Egyptian art, Greek art evolved rapidly from stylization toward naturalism. The treatment of nature and humanity's place in it—ideal as well as actual—differentiated the Greek use of **canons** of proportion from the Egyptian grid. In Greek art, measurements were in relation to human scale and organic form.

The Greek attitude to artists indicated a new interest in the relationship of creators to their work. As far as one can tell, the Greeks were the first Western people to sign their works (for example, fig. 5.7). They were also the first to mention female as well as male artists, indicating that—despite the restricted role of women in Greek society—a few exceptional women achieved professional success. The Greeks gave their artists a new status consistent with their cultural view that man, rather than gods, is the "measure of all things."

Greek Gods and Roman Counterparts

Greek god	Function/subject	Attribute	Roman counterpart
Zeus (husband and brother of **Hera**)	King of the gods, sky	Thunderbolt, eagle	**Jupiter**
Hera (wife and sister of **Zeus**)	Queen of the gods, women, marriage, maternity	Veil, cuckoo, pomegranate, peacock	**Juno**
Athena (daughter of **Zeus**)	War in its strategic aspects, wisdom, weaving, protector of Athens	Armor, shield, *gorgoneion*, Nike	**Minerva**
Ares (son of **Zeus** and **Hera**)	War, carnage, strife, blind courage	Armor	**Mars**
Aphrodite	Love, beauty	**Eros** (her son)	**Venus**
Apollo (son of **Zeus** and **Leto**)	Solar light, reason, prophecy, medicine, music	Lyre, bow, quiver	**Phoebus**
Helios (later identified with **Apollo**)	Sun		**Phoebus**
Artemis (daughter of **Zeus** and **Leto**)	Lunar light, hunting, childbirth	Bow and arrow, dogs	**Diana**
Selene (later identified with **Artemis**)	Moon	Crescent moon	
Hermes (son of **Zeus** and **Maia**)	Male messenger of the gods, trickster and thief; good luck, wealth, travel, dreams, eloquence	Winged sandals, winged cap, *caduceus* (winged staff entwined with two serpents)	**Mercury**
Hades (brother of **Zeus**, husband of **Persephone**)	Ruler of the underworld	**Cerberos** (a triple-headed dog)	**Pluto**
Dionysos (son of **Zeus** and **Semele**)	Wine, theater, grapes, panther skin	*Thyrsos* (staff), wine cup	**Bacchus**
Hephaistos (son of **Hera**)	Fire, the art of the blacksmith, crafts	Hammer, tongs, lameness	**Vulcan**
Hestia (sister of **Zeus**)	Hearth, domestic fire, the family	Hearth	**Vesta**
Demeter (sister of **Zeus**)	Agriculture, grain	Ears of wheat, torch	**Ceres**
Poseidon (brother of **Zeus**)	Sea	Trident, horse	**Neptune**
Herakles (son of **Zeus** and a mortal woman, the only hero admitted by the gods to Mount Olympos and granted immortality)	Strength	Lion skin, club, bow and quiver	**Hercules**
Eros (son of **Aphrodite**)	Love	Bow and arrow, wings	**Amor/Cupid**
Iris	Female messenger of the gods (especially of **Hera**), rainbow	Wings	
Hebe (daughter of **Zeus** and **Hera**)	Cup bearer of the gods, youth	Cup	
Nike	Victory	Wings	**Victoria**
Persephone (daughter of **Zeus** and **Demeter**, wife of **Hades**)	The underworld	Scepter, pomegranate	

Painting and Pottery

The earliest Greek style, called Geometric (c. 1000–700 B.C.), is known only from pottery and small-scale sculpture. The Orientalizing style (c. 700–600 B.C.) shows influences from Eastern art, and, around the same time, monumental sculptures began to develop. The broad stylistic categories of Greek art that follow Orientalizing are Archaic, Classical, and Hellenistic.

Geometric Style (c. 1000–700 B.C.)

Since most of the monumental mural paintings of ancient Greece have been lost, the development of pictorial style is best known through images on pottery (see box, p. 145). The earliest recognizable style in Greek art after the destruction of the Mycenaean cultures c. 1100 B.C. is Geometric. The lively, rectilinear **meander patterns** circling the body of the *amphora* (or two-handled storage jar) in figure **5.4** are typical of developed Geometric pottery design. Each pattern is framed by horizontal borders that encircle the pot to emphasize its shape, and two rows

of stylized animals decorate the neck. Because the original function of the *amphora* was to serve as a grave marker, its main scene is a *prothesis* (lying-in-state of the dead). The deceased lies on a horizontal bier, held up and flanked by rows of figures who create a sense of motion through ritual gestures of mourning. Their torsos are composed of flat black triangles, and their heads are rounded. Typical of Geometric vase painting are the flat, two-dimensional renderings and the lively, stylized forms painted in a dark glaze (actually a **slip,** or refined clay) over a light-colored surface.

Orientalizing Style (c. 700–600 B.C.)

In the eighth century B.C., influences from the Near East and Egypt enter Greek art in a recognizable way. The Greek assimilation of Eastern iconography reflects contact and trade as well as an interest in the artistic possibilities of certain motifs and forms.

In the Orientalizing *amphora* shown in figure **5.5**, dated c. 675–650 B.C., the shapes have become larger and more curvilinear than those of the Geometric style, and the geometric patterns are now relegated to borders of the mythological representations. The scene on the neck

5.4 Geometric *amphora*, 8th century B.C. Terra-cotta; 5 ft. 1 in. (1.55 m) high. National Archaeological Museum, Athens.

(fig. **5.6**) illustrates Odysseus and his men driving a stake into the eye of the Cyclops Polyphemos. The poses of Odysseus and his companion show similarities with earlier Aegean painting, particularly the nearly frontal shoulder, profile legs and head, and frontal eye. As in Minoan and Theran nudes (see the *Boxing Children* in figure 4.16), there is a hint of a turn at the waist to account for the spatial discrepancy between torso and legs.

On the body of the vase, the artist has represented the beheading of Medusa by the hero Perseus (see box, p. 146). Medusa's two immortal Gorgon sisters, shown in figure 5.6, are running from her decapitated body lying horizontally in figure 5.5. The Gorgon heads resemble those on bronze cauldrons that were imported into Greece from the Near East, and the protruding snakes suggest the cauldron **protomes**, or tops of animals. Both events depicted on this *amphora* represent Greek heroes—Odysseus and Perseus—as destroying the primitive forces of terror (Medusa) and cannibalism (Polyphemos).

In Book IX of the *Odyssey,* the one-eyed Titan, the Cyclops Polyphemos, imprisons the Greek Odysseus and his men in his cave on the island of Sicily. After Polyphemos devours six of the men, Odysseus gives him wine and blinds him with a large stake. The cunning Odysseus has previously told the Cyclops that his name is Nobody, so that when Polyphemos calls for help he can only report that Nobody is harming him. The next day, Odysseus and his men tie themselves to the underbellies of Polyphemos's sheep. When in the morning Polyphemos sends his sheep out of the cave to graze, he feels their backs to make sure that the Greeks are not using his sheep to escape. But he does not feel their undersides, and so Odysseus and the rest of his men go free.

5.5, 5.6 *Polyphemos Painter, amphora,* 675–650 B.C. Terra-cotta; 4 ft. 8 in. (1.42 m) high. Eleusis Museum, Eleusis.

Archaic Style (c. 600–480 B.C.)

The painting technique used during the Archaic period (from the Greek word *archaios,* meaning "old") is known as **black-figure** (c. 600–480 B.C.) (see box). The *amphora* with a scene of *Achilles and Ajax Playing a Board Game* is an excellent example (fig. **5.7**). Patterning still functions as a border device, and, as in Orientalizing, the central image is a narrative scene. Exekias, the most insightful and dramatic black-figure artist known to us, was a panel painter as well as a vase painter. In this scene, he transforms the personal rivalry between the two Greek heroes of the Trojan War into a board game. He emphasizes the intense concentration of Homer's protagonists by the combined diagonals of their spears and their gaze, all of which focus our attention on the game board. Ajax and Achilles are identified by inscriptions. They wear elaborately patterned cloaks, arm and thigh armor enlivened with elegant spiral designs, and greaves (shin protectors). The stylized frontal eye persists from Mesopotamian, Egyptian, and Aegean art, but here the postures are rendered more three-dimensionally.

This *amphora* was signed by Exekias as both potter and painter. He integrates form with characterization to convey the impression that Achilles, the younger warrior on the left, will win the game. On the right, Ajax leans farther forward than his opponent so that the level of his head is slightly lower, and he has removed his helmet. Achilles' helmet and tall crest indicate his dominance.

5.7 Exekias, *amphora* showing *Achilles and Ajax Playing a Board Game,* 540–530 B.C. Terra-cotta; entire vessel 24 in. (60.9 cm) high. Musei Vaticani, Rome.

Greek Vase Media and Shapes

Greek vases were made of terra-cotta. On **black-figure** vases, the artist painted the figures in black silhouette with a slip made of clay and water. Details were added with a sharp tool by incising lines through the painted surface and exposing the orange clay below. The vase was then fired (baked in a kiln) in three stages. The final result was an oxidation process that turned the surface of the vase reddish-orange and the painted areas black.

For **red-figure** vases, the process was reversed. Figures were left in red against a painted black background, and details were painted in black.

On **white-ground** vases, a wash of white clay formed the background. Figures were then applied in black, and additional colors were sometimes added after the firing.

As early as the Archaic period, certain shapes of vase became associated with specific uses (fig. **5.8**).

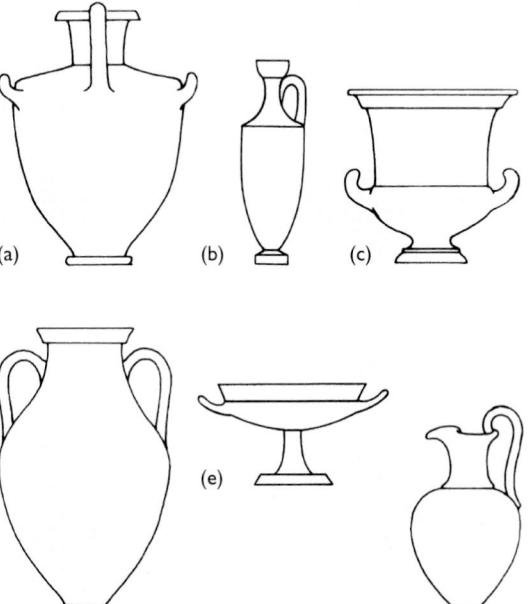

5.8 Greek vase shapes include (a) the **hydria,** a water jar with three handles; (b) the **lekythos,** a flask for storing and pouring oil; (c) the **krater,** a bowl for mixing wine and water (the Greeks drank their wine diluted); (d) the **amphora,** a vessel for storing honey, olive oil, water, or wine; (e) the **kylix,** a drinking cup; and (f) the **oenochoe,** a jug for pouring wine.

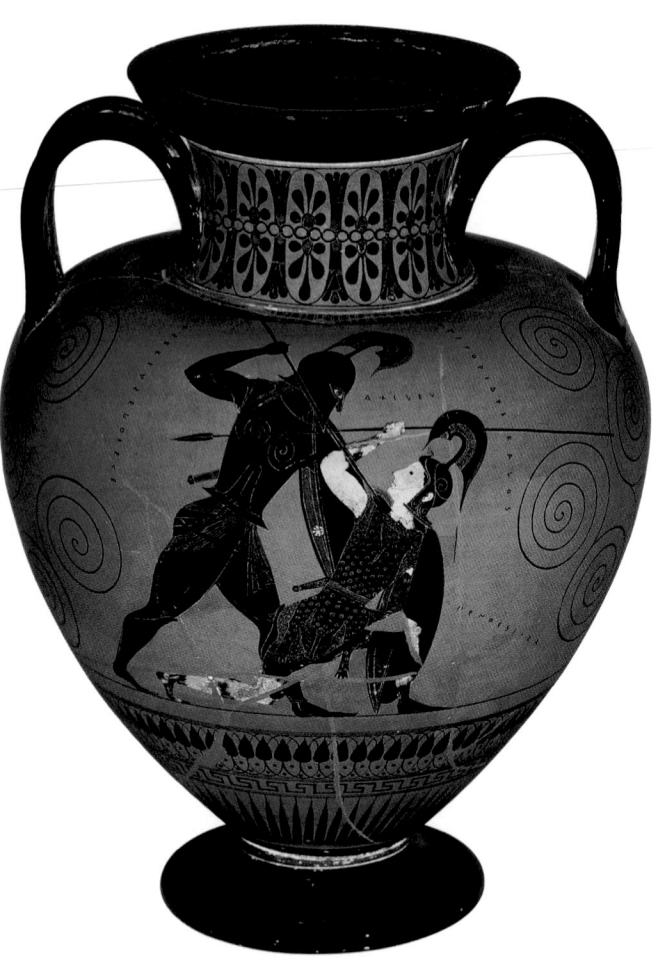

5.9 Exekias, *amphora* showing *Achilles and Penthesilea*, c. 525 B.C. Terra-cotta; 16¼ in. (41.3 cm) high. British Museum, London.

In another vase painting, Exekias uses the power of the gaze and the device of diagonal spears to enhance the tragic love between Achilles and the Amazon queen Penthesilea (fig. **5.9**). The Greek hero leans forward, his entire body a forceful, towering diagonal, and drives his spear into the neck of his opponent. Identified with the luxurious East by her leopard skin, Penthesilea is on her knees in defeat. Both figures, as in the previous example, are partly three-dimensional, but their heads are in strict profile. With blood gushing from her neck, Penthesilea turns back, and her eye rolls upward to indicate that she is dying. Achilles, in turn, gazes at her and, at the point of her death, falls in love with her. Compared with the scene in figure 5.7, the confrontation here is intensified by the "locked in" gaze of the two combatants and is unrelieved by the intervening board game. Exekias's ability to capture such dramatic moments is consistent with contemporary developments in Greek theater and foreshadows Classical tragedy.

Medusa

Medusa, the only mortal of the three Gorgon sisters, turned to stone any man who looked at her. She had snaky hair, glaring eyes, fanged teeth, and emitted a loud roar. Following the wise advice of Athena to look at her only in the reflection of his shield, Perseus decapitated Medusa. He gave her head to Athena, who adopted it as her shield device. The Medusa head, or *gorgoneion*, subsequently became a popular armor decoration in the West, symbolically petrifying—that is, killing—the enemies of its wearer.

Late Archaic to Classical Style
(c. 530–400 B.C.)

The **red-figure** painting technique was introduced in the late Archaic period and continued to be used until the fourth century B.C. It permitted freer painting and the representation of more natural form than had been possible in black-figure. Furthermore, the red color now used for skin tones was closer to the actual skin color of the Greeks than black had been.

The scene of the abduction of Europa on a bell *krater* of about 490 B.C. by the so-called Berlin Painter (fig. **5.10**) illustrates the transition from black-figure to red-figure painting. The decorative surface patterns have decreased, and more attention is given to organic form and movement. Black lines indicating the folds of Europa's dress appear three-dimensional in form and suggest the motion of her

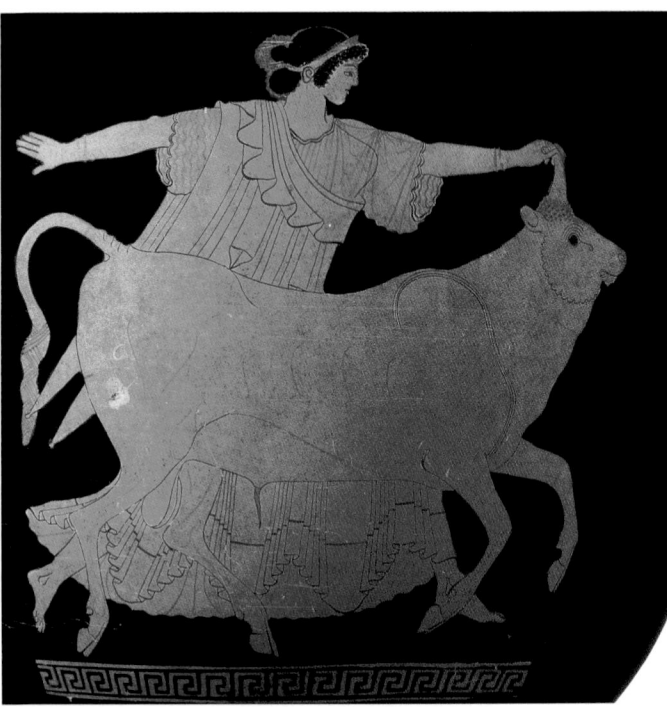

5.10 Berlin Painter, bell *krater* showing *The Abduction of Europa*, c. 490 B.C. Terra-cotta; whole vessel 13 in. (33.0 cm) high. Museo Archeologico, Tarquinia. In this scene, Zeus takes the form of a bull and abducts the mortal Europa. The Greeks would have recognized the irony of the unsuspecting Europa being fascinated by Zeus' horn and rushing to her fate.

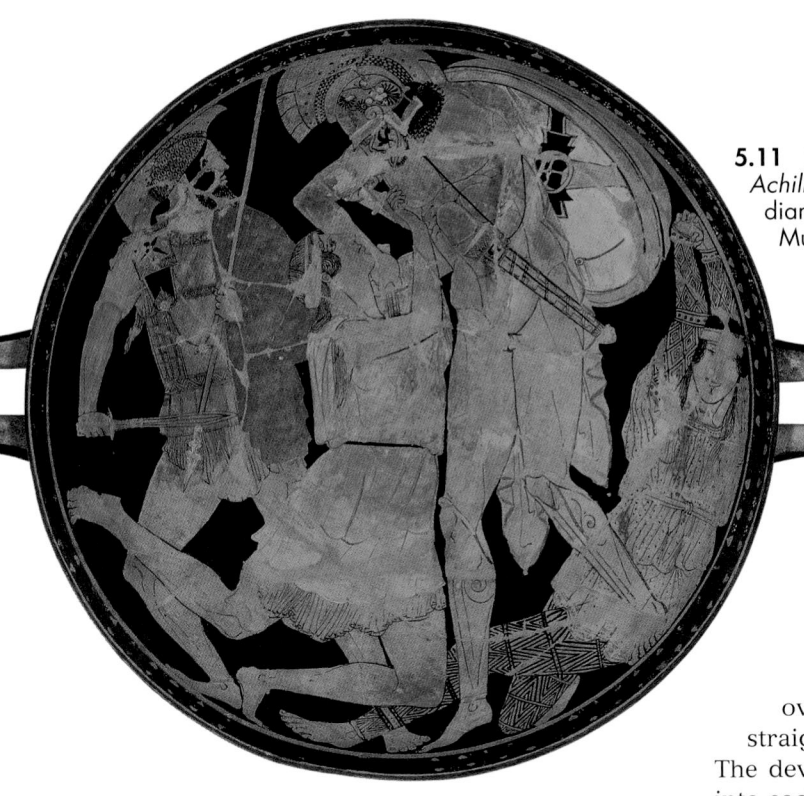

silea Painter (fig. **5.11**). Here, the large figures seem about to burst the rim of the cup and suggest that the scene was based on a larger mural painting. At the right, a dead Amazon curves in line with the frame, while a vigorous Greek readies his dagger and spear at the left. In the center, Achilles and Penthesilea enact their tragic fate. Compared with the black-figure version by Exekias, this is more crowded, the figures are closer together, and there is more overlapping. We see Achilles plunging his sword straight down into the Amazon, as she clasps his breast. The development of the profile eye allows them to gaze into each other's eyes, turning the physical action of Exekias's scene into a psychological interaction.

body—especially the large step that she takes with her heels lifted off the ground.

By some thirty-five years later, red-figure painting had become less stylized, and human figures were represented with greater naturalism. This development can be seen in another painting of *Achilles and Penthesilea* by the Penthe-

In addition to increased organic form, the Greek painters of the mid-fifth century B.C. began to set figures in nature and to depict elements of landscape. The *kalyx krater* by an artist known as the Niobid Painter has an unidentified scene on one side (fig. **5.12**); the other, depicting *The Death of the Children of Niobe* (the Niobids) (fig. **5.13**), has

5.12 Niobid Painter, *kalyx krater*, side showing an unidentified scene, c. 455–450 B.C. 21¼ in. (53.9 cm) high. Louvre, Paris.

5.13 Niobid Painter, *kalyx krater*, side showing *The Death of the Children of Niobe*, c. 455–450 B.C. 21¼ in. (53.9 cm) high. Louvre, Paris.

a rudimentary tree and sloping terrain. Niobe was a mortal woman who boasted that she was greater than Leto because she had fourteen children. To punish Niobe for her arrogant pride, which the Greeks called *hubris,* Apollo (the son of Zeus and Leto) and his twin sister, Artemis, who were expert archers, killed all of Niobe's children. Figure 5.13 shows Artemis removing an arrow from her quiver while Apollo takes aim at his next victim. The gods' power is emphasized by the fact that they tower over the mortals, two of whom lie dead, draped over the rocky landscape in the foreground.

Classical to Late Classical Style
(c. 450–323 B.C.)

During the late fifth century B.C., a technique of painting known as **white-ground** became popular on *lekythoi,* which were used as grave dedications. The example in figure **5.14,** of c. 410 B.C., shows a warrior sitting by a grave.

5.14 Reed Painter, *Warrior by a Grave* (white-ground *lekythos*), c. 410 B.C. Terracotta; 18⅞ in. (48.0 cm) high. National Archaeological Museum, Athens. The use of foreshortening, which depicts the round shield as an oval because it is partly turned, indicates the Greek artist's interest in rendering forms as they appear in natural, three-dimensional space.

He is rendered as if in a three-dimensional space—his body moves naturally, bending slightly at the waist, and his head inclines as if in meditation or mourning. The drapery falls over his legs as it would in reality, and his left leg and shield are **foreshortened** (that is, they are shown in perspective).

The Greek interest in naturalism led to a delight in illusionism and *trompe-l'oeil.* Zeuxis, for example, as mentioned in the Introduction, was reputed to have painted grapes that fooled birds into believing they were real. By the late fifth century, Zeuxis was painting from live models and, therefore, directly from nature. One anecdote relates that he died laughing while staring at his painting of an old woman and that he painted Helen of Troy as a *hetaira*—a courtesan—and charged admission when the picture was exhibited.

During the fourth century B.C, Apelles of Kos (see the Introduction) reputedly painted such realistic horses that live horses neighed when they saw them. Apelles became Alexander the Great's court painter (see below); one of his portraits, depicting Alexander with a thunderbolt, was so realistic that the fingers seemed to stand out from the picture plane. Apelles also painted Alexander's mistress, Pancaspe, and fell in love with her. As a measure of his esteem for Apelles, Alexander gave Pancaspe to him.

Apelles, like Zeuxis, had a sense of humor. He liked to hide when his works were exhibited so that he could hear viewers' comments. On one occasion, when a shoemaker observed that the artist had made a mistake in his rendition of a sandal strap, Apelles corrected it. Later the same shoemaker criticized a leg, and Apelles objected to his presumption, telling him not to rise above the sandal, which was his only area of expertise. This became the origin of the expression "Let a shoemaker stick to his last."

Mosaic

The best-preserved examples of large-scale Greek pictorial style are mosaics from the Hellenistic period (c. 323–31 B.C.). The so-called "Alexander Mosaic" in figure **5.15** is a Roman copy of a Greek fresco of around 300 B.C. It depicts Alexander the Great defeating the Persian king Darius II at the Battle of Issos (333 B.C.). Radical foreshortening—as in the central horse, seen from the rear—and the use of shading to convey a sense of mass and volume enhance the naturalistic effect of the scene. Repeated diagonal spears, clashing metal, and the crowding of men and horses evoke the din of battle. Alexander (fig. **5.16**) sweeps into battle at the left, his wavy hair typical of royal portraiture as established in Greek art of the fourth century B.C. He rides a war-horse and focuses his gaze on the Persian leader, who is in a chariot. Darius turns to confront Alexander, but the chariot driver whips the horses as he tries to escape in the opposite direction. At the same time, action is arrested by dramatic details such as the fallen horse and the Persian soldier in the foreground who watches his own death throes reflected in a shield (fig. **5.17**).

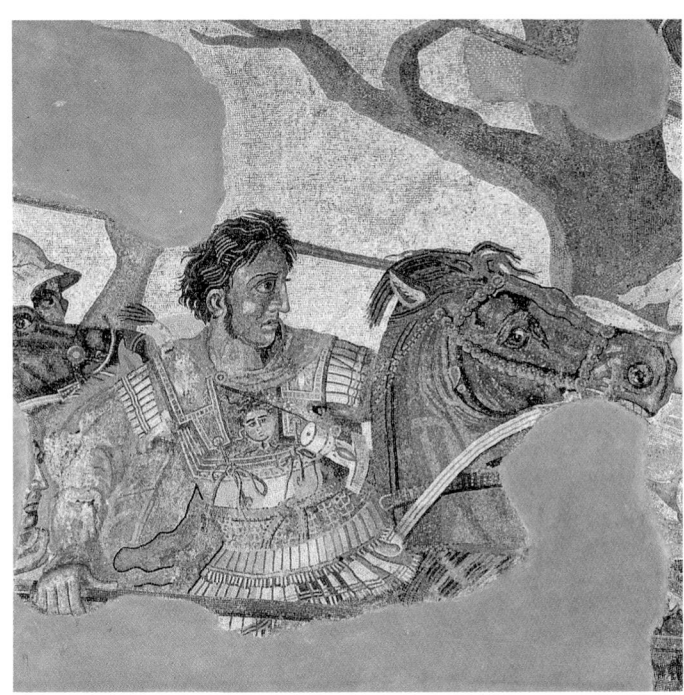

5.15 *Battle of Issos,* from the House of the Faun, Pompeii, 1st century B.C., after an original Greek fresco of c. 300 B.C. Mosaic; 106¾ × 201½ in. (271.1 × 511.8 cm). Museo Archeologico Nazionale, Naples. Also known as the "Alexander Mosaic," this work is made of colored ***tesserae***—little tiles. They are arranged in gradual curves called *opus vermiculatum* ("worm work") because they seem to replicate the slow motion of a crawling worm. Monumental mosaics such as this one were found on the floors of houses of the wealthy.

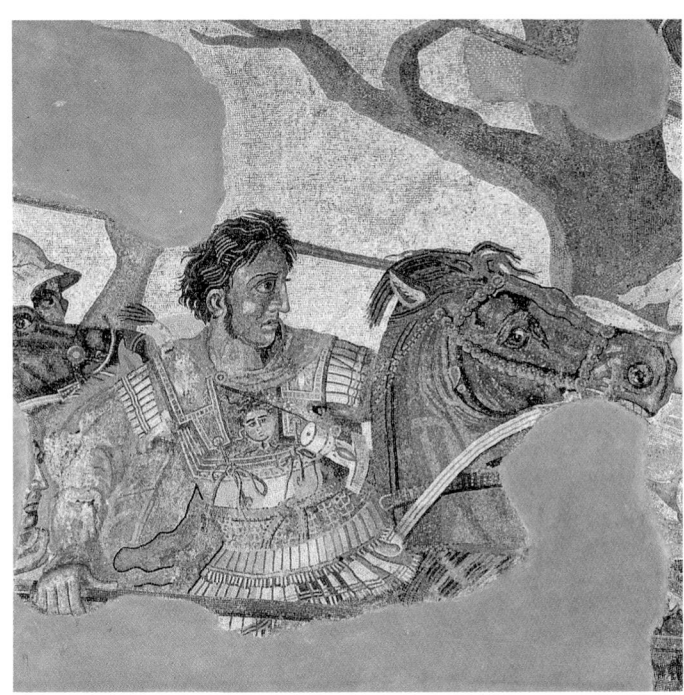

5.16 Detail of figure 5.15, showing Alexander.

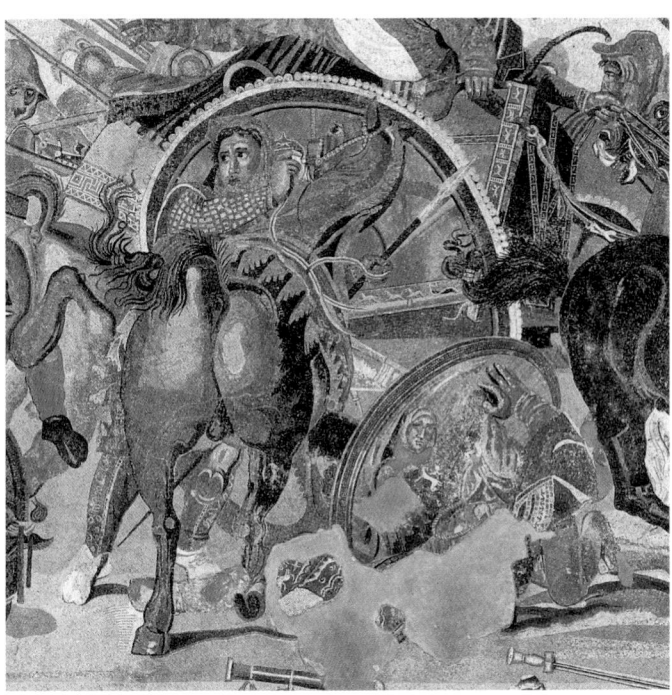

5.17 Detail of figure 5.15, showing a dying Persian.

Sculpture

Orientalizing Style: The Lions of Delos
(7th century B.C.)

The row of impressive white marble lions (fig. **5.18**) on the island of Delos continues the traditional guardian function of such animals. Located in the middle of the Cyclades, Delos is a small island that was an important trading center inhabited from the third millennium B.C. Delos had been revered as Apollo's sanctuary because it was the god's birthplace. According to the myth, Zeus seduced Leto, a daughter of the Titans. His jealous wife, Hera, pursued the pregnant Leto until the latter found refuge on a barren rock in the sea. There she gave birth to the twin gods Apollo and Artemis, and thereafter Delos became a fertile island.

Because of its importance as a religious site, Delos was subjected to a long-lasting struggle for control. In the late seventh century B.C., it was under the rule of the neighboring island of Naxos. The Naxians erected the marble lions on the road leading north from the temple of Leto, and today five of them survive. They sit on their haunches, looking alert and ready to spring. The sense of contained energy combined with monumental form and stylization—most evident in the rib cage—is characteristic of the early Greek styles. At the same time, the simplicity of the lions and their gleaming marble surfaces recall the Cycladic idols that had been produced in the Bronze Age.

The ancient belief that lions sleep with their eyes open accounts for the guardian function of the Delos lions, as it had in Egypt, the Aegean, and the Near East. Their focus on the temple of Apollo's mother is consistent with the traditional association of lions with the sun, which continues to the present day in the zodiac: Leo (the lion) is the house of the sun.

Archaic Style (c. 600–480 B.C.)

Monumental sculpture of human figures began in Greece during the Archaic period. It is not known why the Greeks began making such works when they did, but it is clear that the early Archaic artists were influenced by Egyptian technique and convention.

In creating life-sized human figures, the Greeks learned from the Egyptians how to carve blocks of stone but adapted the technique to suit their own tastes. The *New York Kouros* (fig. **5.19**) was made around 600 B.C. A comparison of this figure with the statue of Menkaure (see fig. 3.18) highlights the similarities and differences between Egyptian and Archaic Greek life-sized statues of standing males. The *Kouros* maintains the standard Egyptian frontal pose. His left leg extends forward with no bend at knee, hips, or waist, and his arms are at his sides, fists clenched and elbows turned back. Nevertheless, the artist has made changes to emphasize human anatomy. The *Kouros* is cut away from the original rectangular block of marble, leaving open spaces between the arms and the body and

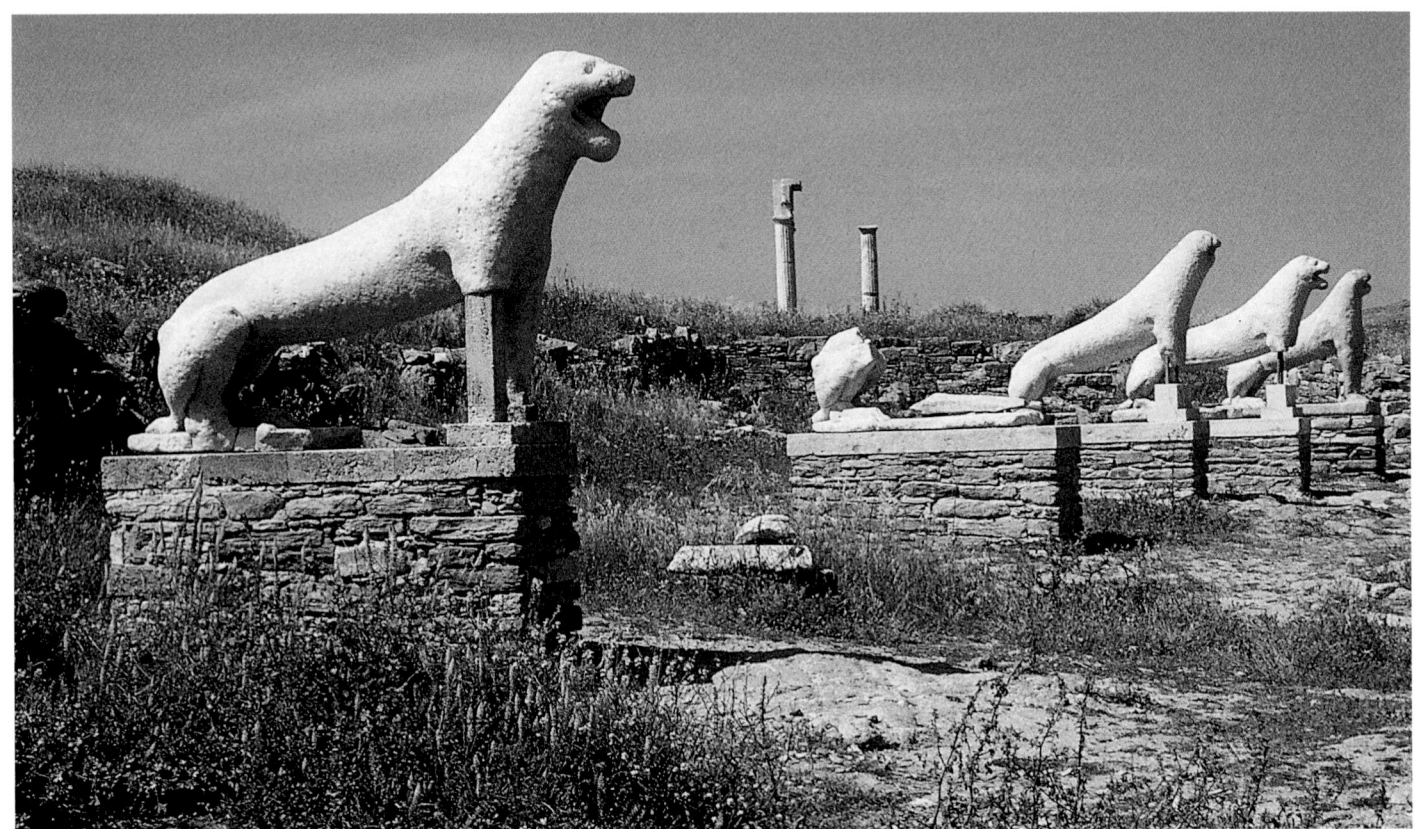

5.18 Terrace of the Lions, Delos, 7th century B.C. Marble; over-life-sized.

5.19c *New York Kouros,* detail of stylized hair.

——— **CONNECTIONS** ———

See figure 3.18. Menkaure and Queen Khamerernebty, 2490–2472 B.C.

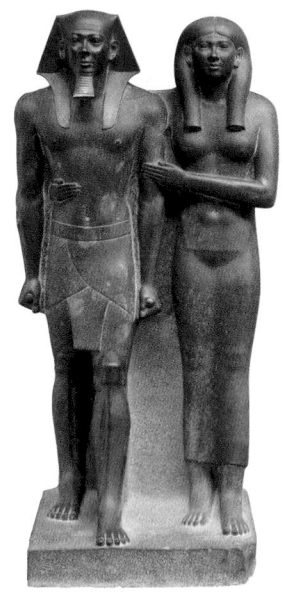

5.19a (left) *New York Kouros* from Attica, c. 600 B.C. Marble; 6 ft. (1.84 m) high. Metropolitan Museum of Art, New York. Fletcher Fund, 1932. *Kouros,* Greek for "boy" (*kouroi,* plural), is used to denote a type of standing male figure, typically carved from marble and usually commemorative in nature. Generally the *kouroi* either were grave markers or represented individuals honored in religious sanctuaries. Since this *kouros* appeared on the antiquities market with no provenience and has no identifying inscription, it is named for its present location. It is the earliest known life-sized sculpture of a standing male from the Archaic period.

5.19b (right) *New York Kouros* (side view of fig. 5.19a).

5.20 Cheramyes Master, *Hera of Samos,* from Samos, 570–560 B.C. Marble; 6 ft. 3½ in. (1.91 m) high. Louvre, Paris.

between the legs. This openness and the smaller shoulders decrease the tension and monumentality of the *New York Kouros* when compared with Menkaure.

In contrast to the rectangularity of Egyptian convention, the emphasis on the anatomy of the *Kouros* increases its tension. Various features of the *Kouros* are curved—the round kneecaps topped by two arcs and the lower outline of the rib cage. The hair is composed of small circles arranged in parallel rows, ending in a bottom row of cones. It falls over the back of the shoulders but does not fill up as much space as Menkaure's wig.

The most obvious difference between the *Menkaure* and the *New York Kouros* is the nudity of the latter. The Greek convention of nudity for male statues from the Archaic period signals the interest in human form, whereas Archaic statues of females were clothed for reasons of propriety. Furthermore, the stance of the *Kouros* is centered over the two legs, which, together with the muscular definition, suggests the power to move.

In the *Hera of Samos* (fig. **5.20**), as in the Delos lions, we find the characteristic Archaic combination of tension and geometric form. A votive figure, dedicated to Hera by a man whose name is engraved on the skirt, it originally stood outside the temple of Hera on the island of Samos. The statue is cylindrical, and the *chiton* (linen dress) is smooth except for finely incised folds. The upper part seems more three-dimensional, revealing the shape of the arms and breasts beneath. The elegance of this figure and the unified flow of curves at the bottom of the *chiton* create an unusual synthesis of grace and monumentality.

Archaic sculptures of standing women are referred to as *korai* (singular *kore,* Greek for "girl"). The *Peplos Kore* (fig. **5.21**) is named for her *peplos* (a woolen dress, pinned at the shoulders). Her pose is slightly less rigid than that of the earlier *New York Kouros,* as she bends her left arm forward. Compared with the *Hera,* the garment of the *Peplos Kore* reveals the contours of the body. Further distinguishing the *Peplos Kore* from earlier Archaic figures is the so-called "Archaic smile," which accentuates the fact of being alive. The artist has handled the smile organically by curving the lips upward and raising the cheekbones in response.

Early Classical Style (c. 480–450 B.C.)

From 499 to 494 B.C., Athens gave aid to the Ionian cities in their unsuccessful revolt against Persia. This provoked Darius the Great, king of Persia, to invade mainland Greece in 490 B.C., only to be defeated by the Athenians at the Battle of Marathon. Another invasion in 480 B.C. by Darius's son Xerxes was finally repelled in 479 B.C; this marked the end of Persian efforts to conquer Greece. A change in artistic style seems to have coincided with the Persians' final departure from Greek soil. The Early Classical style, sometimes called Severe (because the smile has disappeared and the forms are simpler) or Transitional

(because it bridges the gap between Archaic and Classical), produced radical changes in the approach to the human figure.

The best example of the new developments can be seen in the marble *Kritios Boy,* attributed to the sculptor Kritios (fig. **5.22**). It is not known if the sculpture was made before or after the Persian Wars, but it reflects a moment of self-awareness in Greek history that is marked by the change from Archaic to Early Classical. Stylization has decreased, remaining primarily in the smooth, wavy hair and the circle of curls around the head. The flesh now seems to cover an organic structure of bone and muscle. The Archaic smile has disappeared, and the face, like the body, has

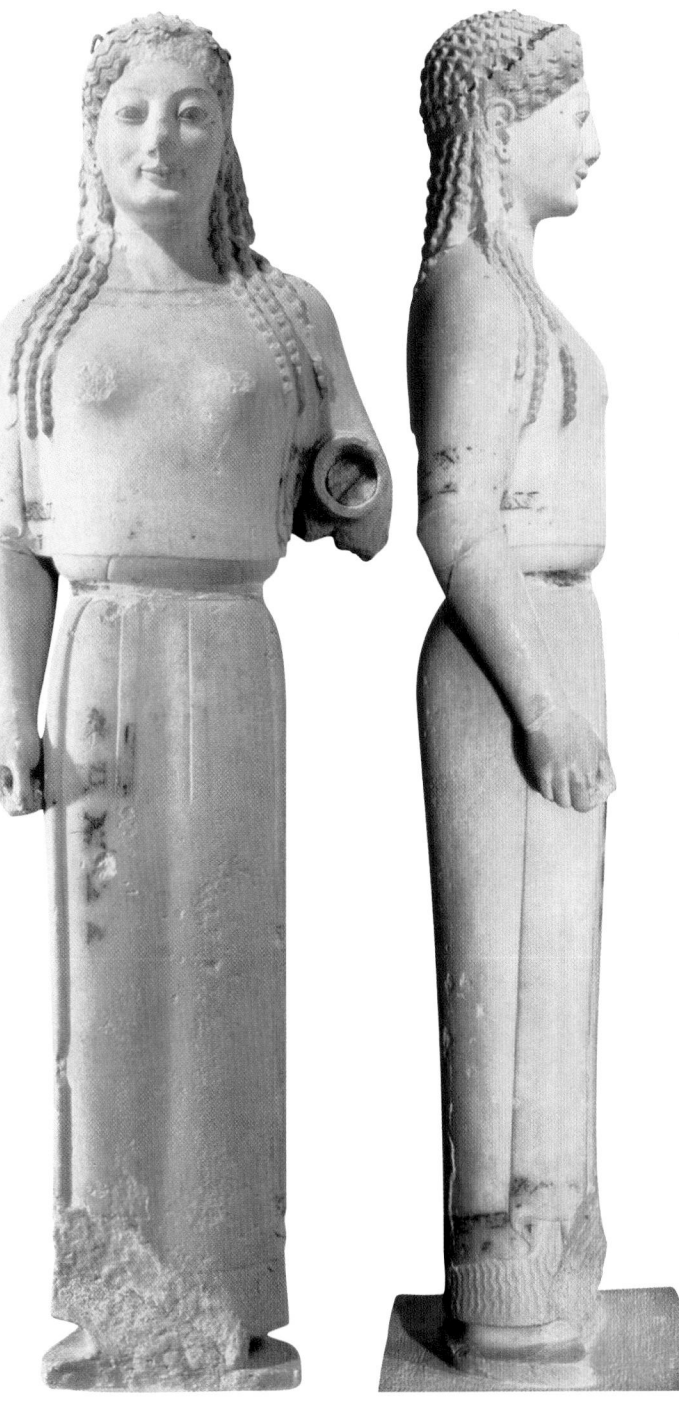

5.21a *Peplos Kore,*
c. 530 B.C. Parian marble;
3 ft. 11⅜ in. (1.21 m) high.
Acropolis Museum, Athens.
The *Peplos Kore* retains
traces of paint on her dress
and in her eyes, reminding
us that Greek artists
originally used color to
enliven the appearance
of their white marble
figures.

5.21b *Peplos Kore* (side
view of fig. 5.21a).
Recent research indicates
that the *Peplos Kore* is
a representation of
Athena.

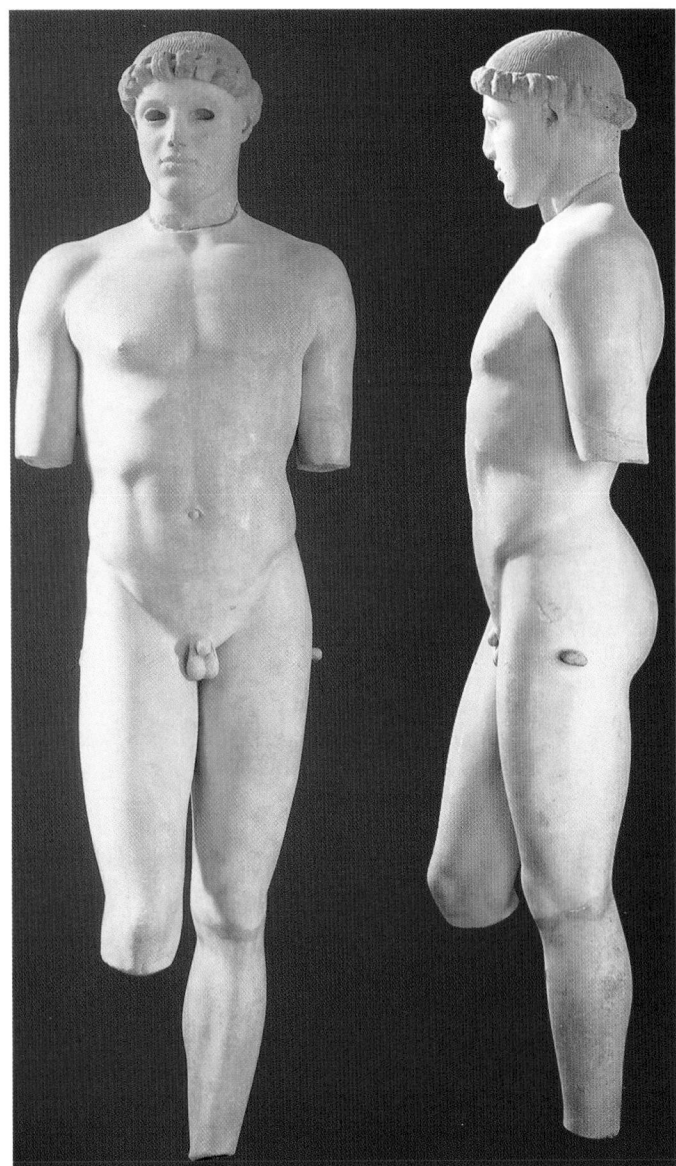

5.22a, b The *Kritios Boy,* from the Acropolis, Athens,
c. 480 B.C. Parian marble; 33⅞ in. (86.1 cm) high. Acropolis
Museum, Athens.

The Lost-Wax Process

In casting bronze by the **lost-wax** method (also known by the French term ***cire-perdue***), the artist begins by molding a soft, pliable material such as clay or plaster into the desired shape and covering it with wax. A second coat of soft material is superimposed on the wax and attached with pins or other supports. The wax is then melted and allowed to flow away, leaving a hollow space between the two layers of soft material. The artist pours molten bronze into the mold, the bronze hardens as it cools, and the mold is removed. The bronze is now in the shape originally formed by the "lost" wax. It is ready for tooling, polishing, and the addition of features such as glass or stone eyes and ivory teeth to heighten the organic appearance of the figure.

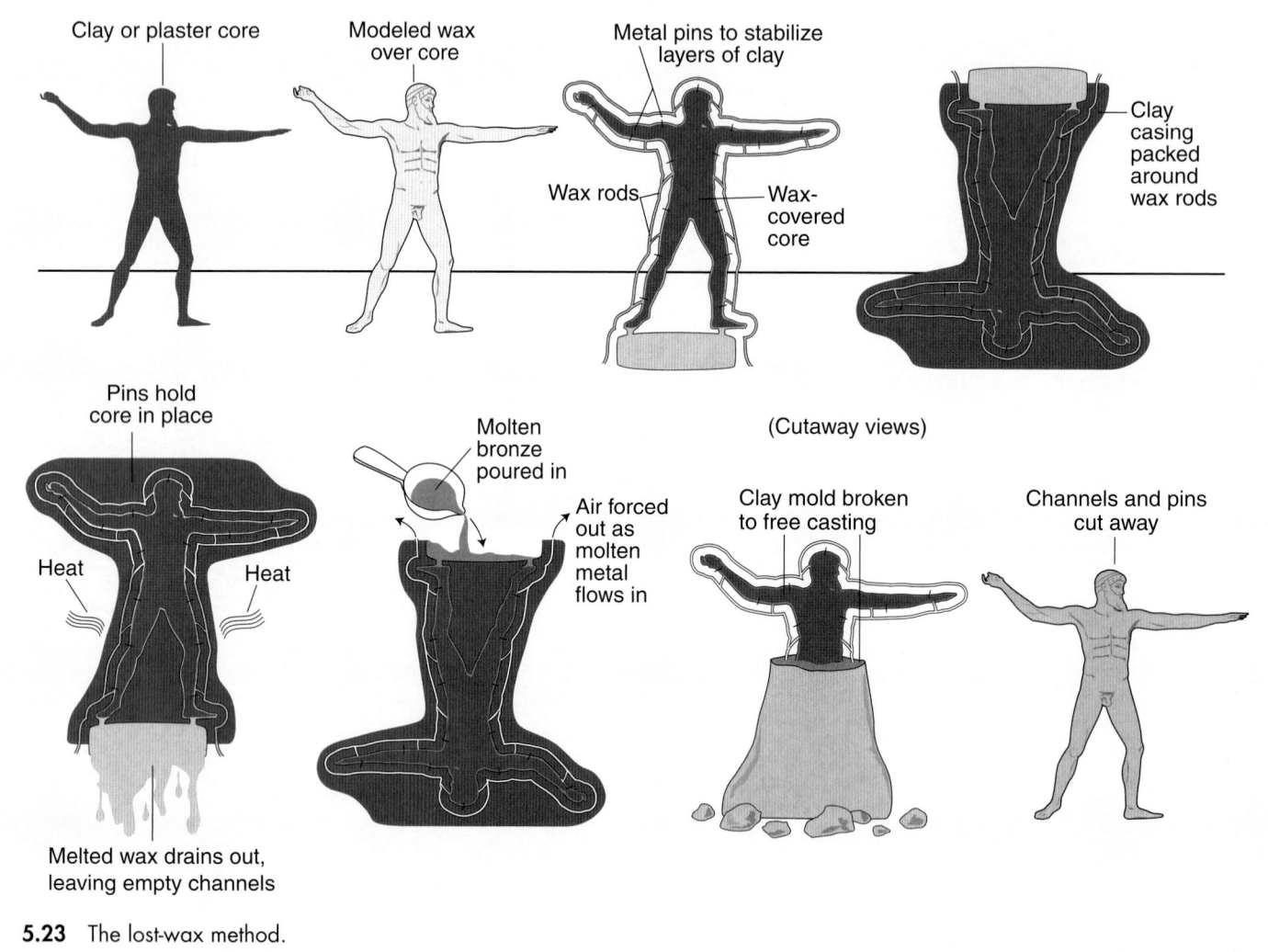

5.23 The lost-wax method.

become idealized and neutral in expression. But perhaps the most important developments are that the head is turned slightly, and the right leg, which is forward, bends at the knee so that the left leg appears to hold the body's weight. The torso shifts so that the right hip and shoulder are lowered, a pose referred to as ***contrapposto*** (from the Latin words *positus,* meaning "positioned," and *contra,* meaning "against"). For the first time, a contrast between rigid and relaxed elements allows the viewer to feel the inner workings of the human body.

Another Early Classical development, which originated in the Archaic period, was the widespread use of bronze as a medium for large-scale sculpture cast by the **lost-wax** process (see box). For smaller objects, however, bronze casting had been used since the Aegean period. Of the few Greek over-life-sized bronzes that have survived, the bronze

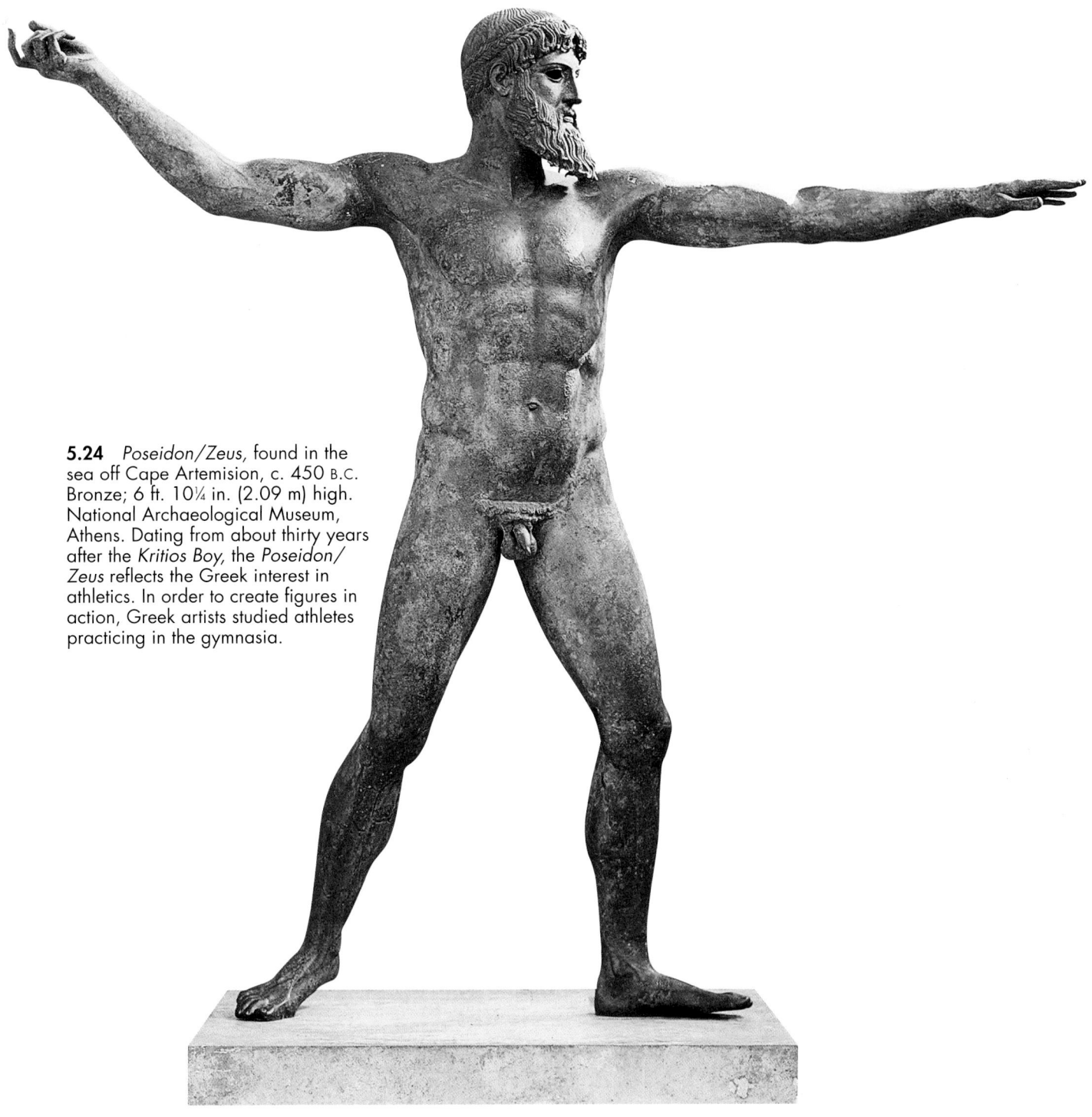

5.24 *Poseidon/Zeus,* found in the sea off Cape Artemision, c. 450 B.C. Bronze; 6 ft. 10¼ in. (2.09 m) high. National Archaeological Museum, Athens. Dating from about thirty years after the *Kritios Boy,* the *Poseidon/ Zeus* reflects the Greek interest in athletics. In order to create figures in action, Greek artists studied athletes practicing in the gymnasia.

statue representing either Zeus hurling his thunderbolt or Poseidon his trident (fig. **5.24**) is one of the most impressive. By virtue of his pose, the god seems to command space. He focuses his aim, tenses his body, and positions himself as if ready to shift his weight, perfectly balanced between the ball of his right foot and his left heel. His slightly bent knees create the impression that he will spring at any moment. The intensity of his concentration and the

force of an imminent thrust extend the viewer's experience of the sculpture toward the weapon's destination.

The Early Classical *Diskobolos* (*Discus Thrower*) is known only from Roman copies in marble (fig. **5.25**). The bronze original was cast by Myron between c. 460 and 450 B.C. A formal analysis of the statue shows that its design is based on the intersection at the neck of two arcs. One arc can be traced from the head, through the curve of

the back to the left heel, and another from one hand to the other. The overriding movement of the *Diskobolos* is circular—the torso twists forward and brings the shoulders into line with the right thigh. This creates a unity of form, echoed by the domed head, the round discus and base, and finally the pose itself. For, in fact, Myron did not so

much create a pose as freeze in time the circular motion of a pivoting athlete.

In 1972, a pair of original Greek bronzes known as the *Warriors from Riace* was discovered in the sea off the southern coast of Italy near Riace. The figure illustrated here (fig. **5.26**) is in a remarkably good state of preserva-

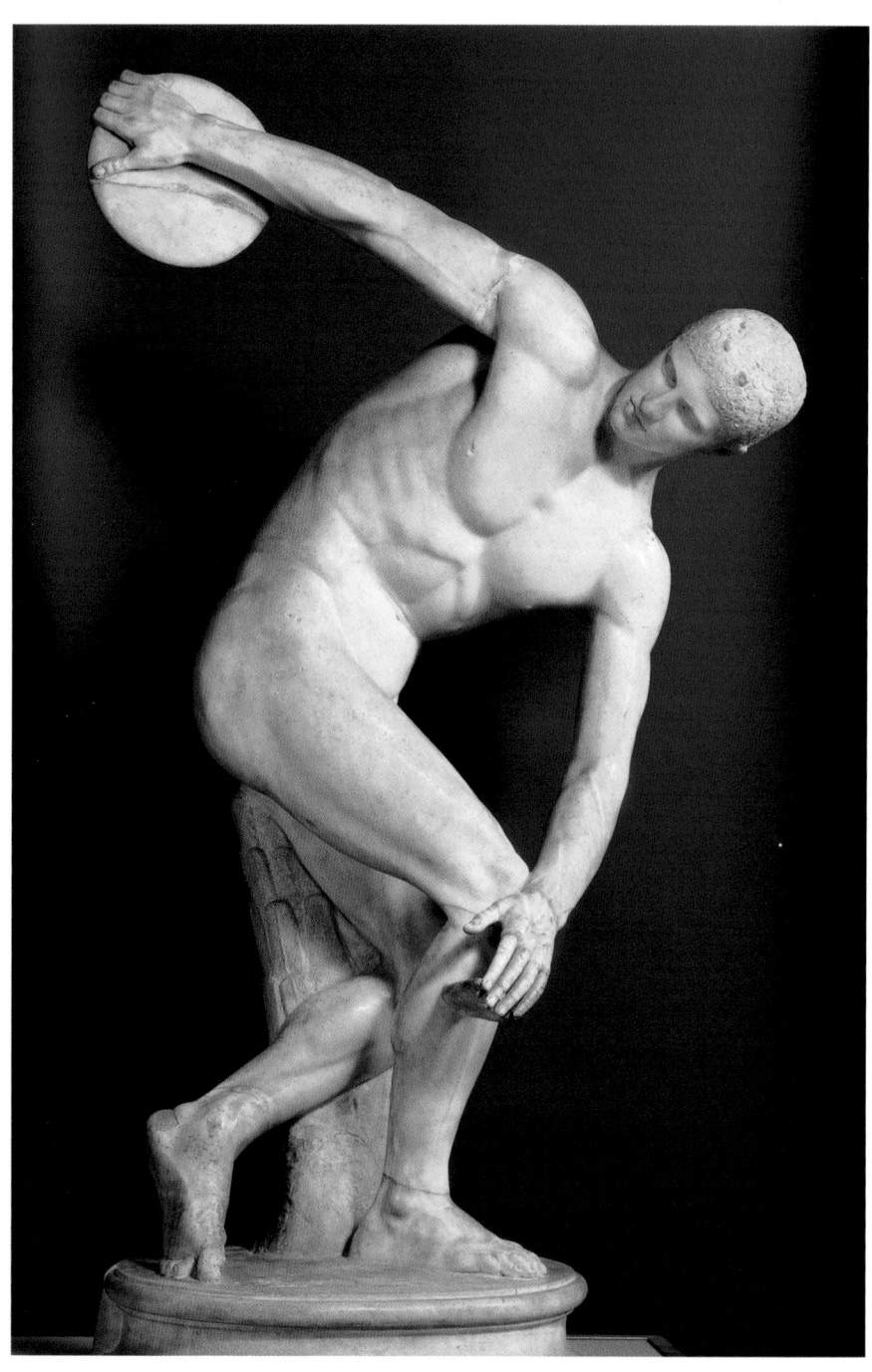

5.25 Myron, *Diskobolos* (*Discus Thrower*), 460–450 B.C. Marble copy of a bronze original; 5 ft. (1.53 m) high. Museo delle Terme, Rome.

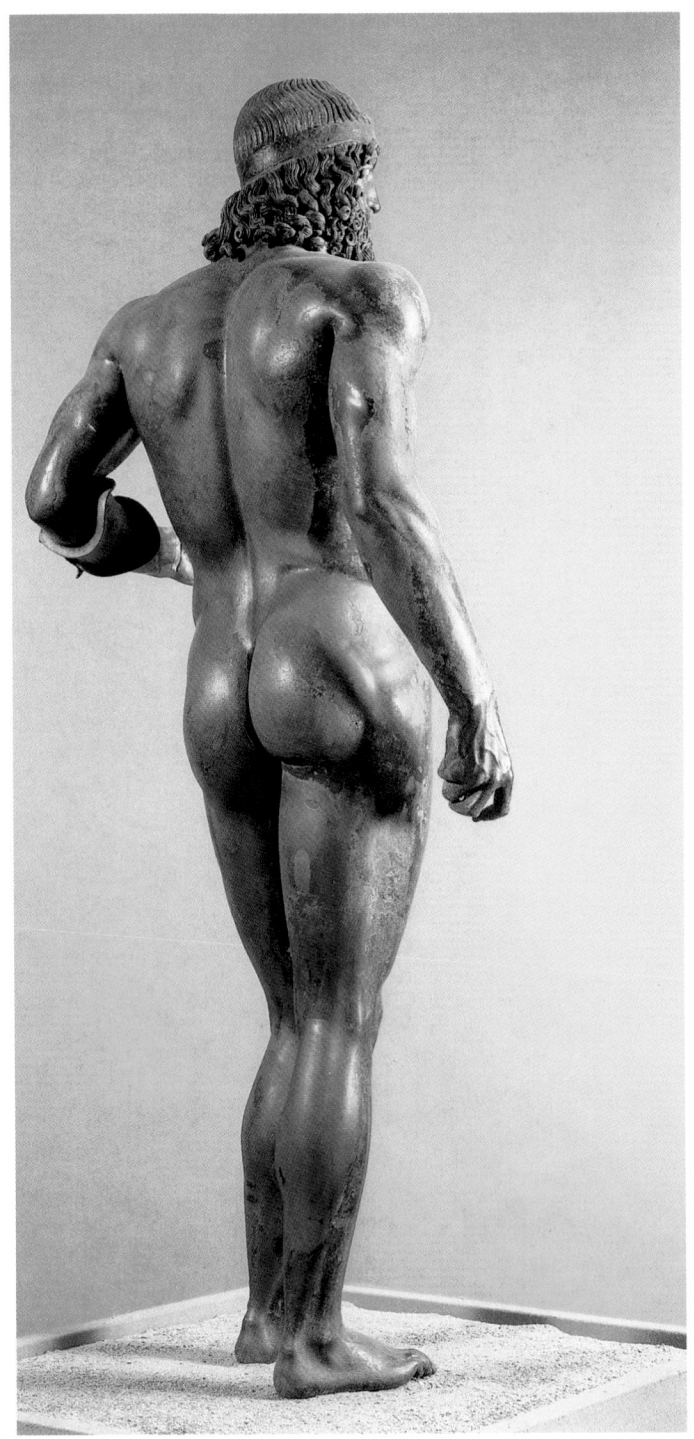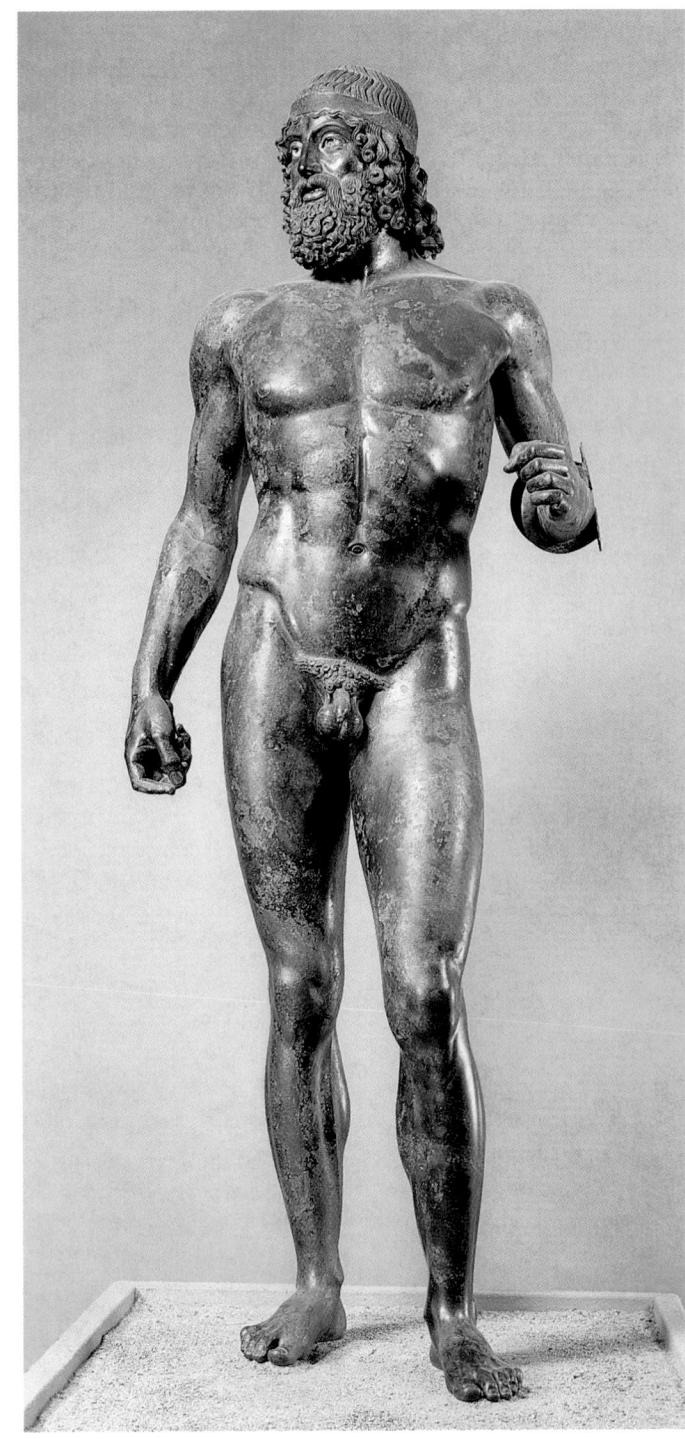

5.26a, b *Warrior from Riace*, c. 450 B.C. Bronze with bone, glass paste, and copper inlay; 6 ft. 6⅘ in. (2.00 m) high. Museo Nazionale, Reggio Calabria, Italy.

tion after extensive restoration work. Inlaid eyes (made of bone and glass paste), copper eyelashes, lips, and nipples, and silver teeth create a vivid, lifelike impression compared with statues that have lost such details. Most scholars assign a date of about 450 B.C. to the work, placing it at the end of Early Classical and the beginning of Classical. The dome-shaped head and flat, curvilinear stylizations of the hair are Early Classical elements, whereas the self-confident, dynamic pose and organic form are characteristic of Classical style.

Classical Style (c. 450–400 B.C.)

The fifty-year span of Greek history from about 450 to 400 B.C. is referred to as the Classical, or High Classical, period. It corresponds to the aftermath of the Persian Wars, when Greek art evolved from the lavish designs of the Orientalizing and Archaic styles. The association of the Near Eastern cultures with luxury and opulence led the Greeks to reject the earlier, more decorative styles in favor of a new simplicity.

The modern term *classical,* which has multiple meanings—including "traditional," "lasting," and "of high quality"—referred originally to the Greek accomplishments of the second half of the fifth century B.C. Works of art produced in this period not only reflect the cultural and intellectual achievements of Greece itself; they have also had a far-reaching influence on subsequent Western art and culture. It is virtually impossible to understand any aspect of Western development without some familiarity with the achievements of Classical Greece.

Polykleitos of Argos

Polykleitos of Argos was esteemed by his contemporaries, and his work is thought of as the embodiment of Classical style. He is known to have created a canon (see box) that is no longer extant. Most of his sculpture was cast in bronze and is known today only through later Roman copies in marble. Ancient records document the fact that the *Doryphoros* (*Spear Bearer*) was originally bronze (fig. **5.27**). The figure held a spear in his left hand and stands like the

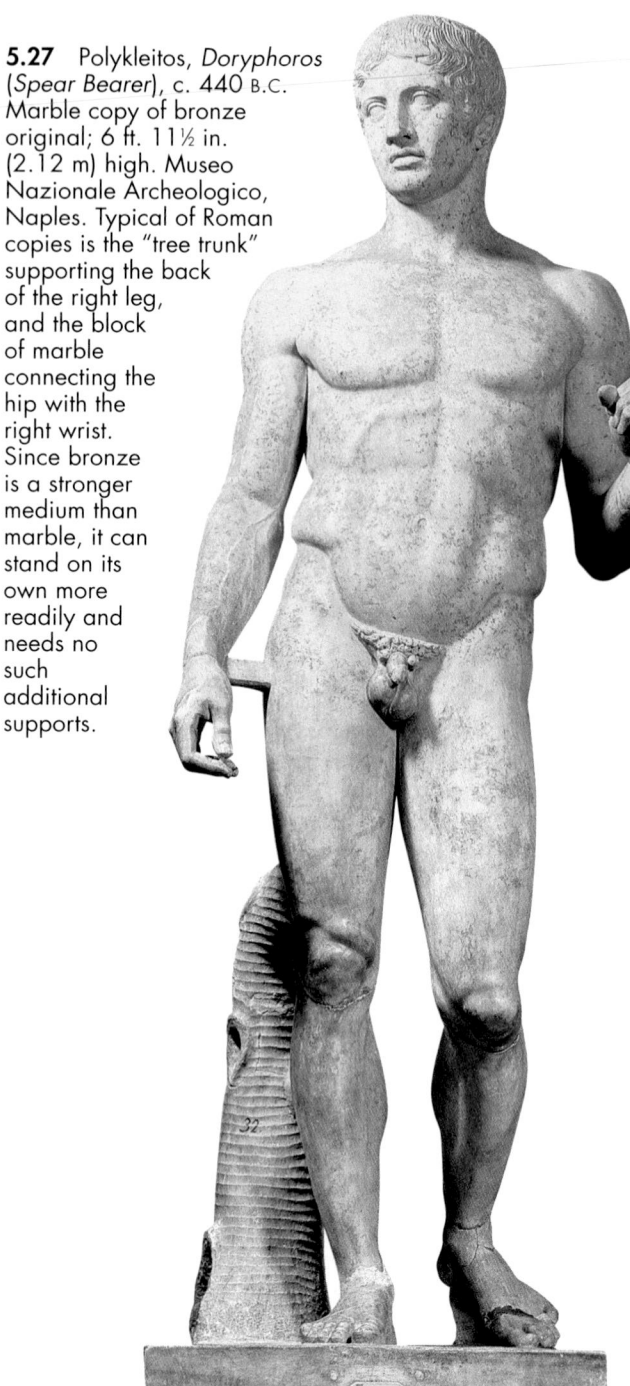

5.27 Polykleitos, *Doryphoros* (*Spear Bearer*), c. 440 B.C. Marble copy of bronze original; 6 ft. 11½ in. (2.12 m) high. Museo Nazionale Archeologico, Naples. Typical of Roman copies is the "tree trunk" supporting the back of the right leg, and the block of marble connecting the hip with the right wrist. Since bronze is a stronger medium than marble, it can stand on its own more readily and needs no such additional supports.

The Canon

Polykleitos called his *Spear Bearer* the "Canon," and he is said to have made it to embody the ideas in a lost treatise of the same name. It dealt with a series of proportions that related the body parts to each other and to the whole—for example, the finger to the hand, the hand to the forearm, the forearm to the arm. For Polykleitos, the application of consistent measurements, *symmetria* (*not* the equivalent of the modern term *symmetry*), was a means of achieving beauty.

The concept of *symmetria* was deeply rooted in Greek philosophy, which considered the orderliness of the universe to depend on regularity of measurement. *Symmetria* makes it possible for people to understand the world. It is the emphasis on the intelligible appearance that gives Greek art its ideal character.

Symmetria was also applied to architecture. Iktinos, one of the architects of the Parthenon (see p. 170), also wrote a treatise, which has disappeared. Modern measurements of the Parthenon reveal that the ratio 4:9 consistently governs its proportions. For example, the ratio of (a) the distance from the base of the columns to the top of the frieze to (b) the width of the façade is 4:9, as is the ratio of the width of the façade to the width of the long side.

Kritios Boy, although with a slight increase in *contrapposto* and in the inclination of the head. The gradual S-motion of the body is more pronounced, and there is a greater sense of conviction in the body's underlying organic structure—notably the bulging kneecaps, the rib cage, and veins in the arms. The head is dome-shaped, as in the *Kritios Boy* and the *Diskobolos,* but the hair is longer and more three-dimensional. The result is a figure with a sense of organic animation.

A marble replica of a bronze sometimes attributed to Polykleitos is the *Wounded Amazon* of c. 430 B.C., which also embodies Classical style (fig. **5.28**). Compared with

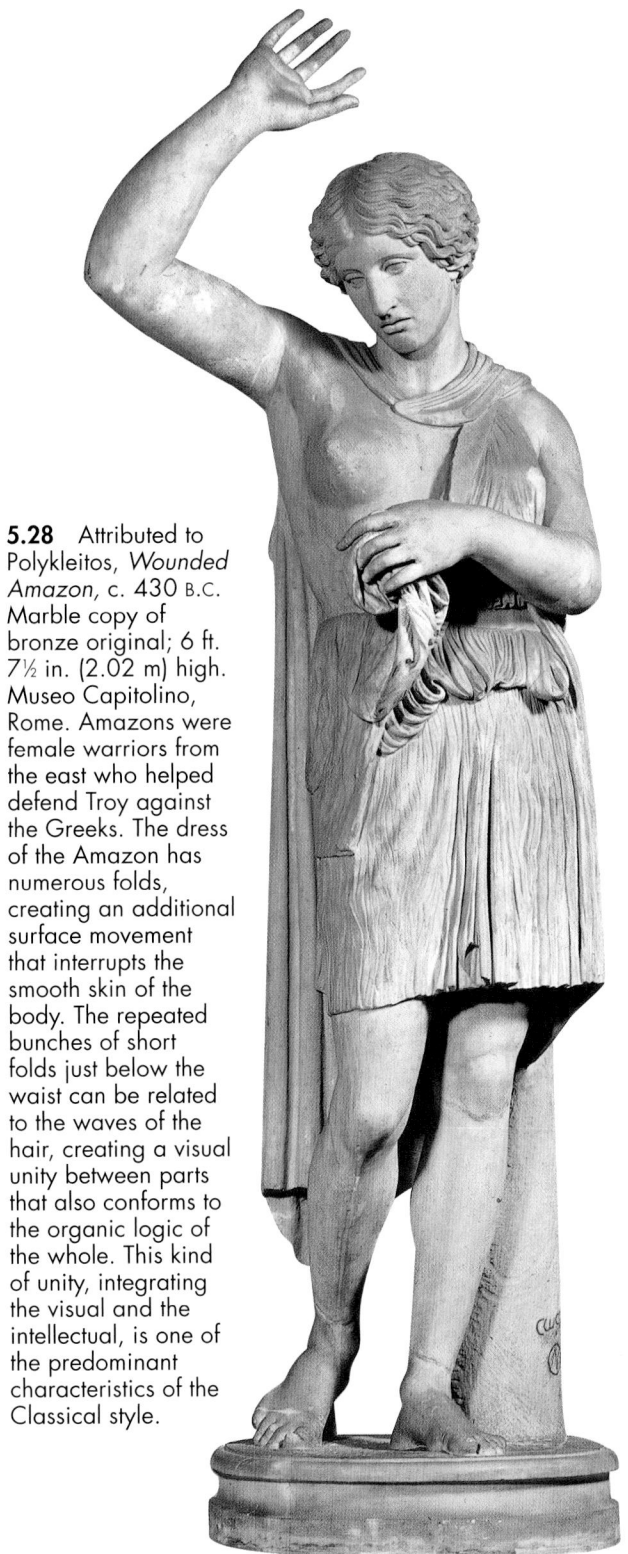

5.28 Attributed to Polykleitos, *Wounded Amazon,* c. 430 B.C. Marble copy of bronze original; 6 ft. 7½ in. (2.02 m) high. Museo Capitolino, Rome. Amazons were female warriors from the east who helped defend Troy against the Greeks. The dress of the Amazon has numerous folds, creating an additional surface movement that interrupts the smooth skin of the body. The repeated bunches of short folds just below the waist can be related to the waves of the hair, creating a visual unity between parts that also conforms to the organic logic of the whole. This kind of unity, integrating the visual and the intellectual, is one of the predominant characteristics of the Classical style.

nicely proportioned and symmetrical in form (not necessarily in pose) but lack personality and facial expression. These qualities are evident in the *Amazon,* who turns toward a wound in her right side without indicating any pain or discomfort. The Classical preference for idealization thus overrides narrative content. Such conventions of Classical taste not only are evident in sculpture, but also reflect those of fifth-century-B.C. Greek theater. No violence or impropriety was performed on stage: when the plot involved such events, they were narrated by a messenger.

Grave Stelae

In the late fifth century, particularly in Athens, wealthy families began to erect grave monuments over burials. Representations of the deceased were shown as if alive in front of an architectural façade.

In the Stele of Hegeso (fig. 5.29), the deceased gazes at a necklace that she has removed from the box held by her servant. The clothes reveal naturalistic forms and poses, while also creating their own graceful rhythms. Both Hegeso and her servant gaze downward, somewhat languidly, and convey an air of melancholy.

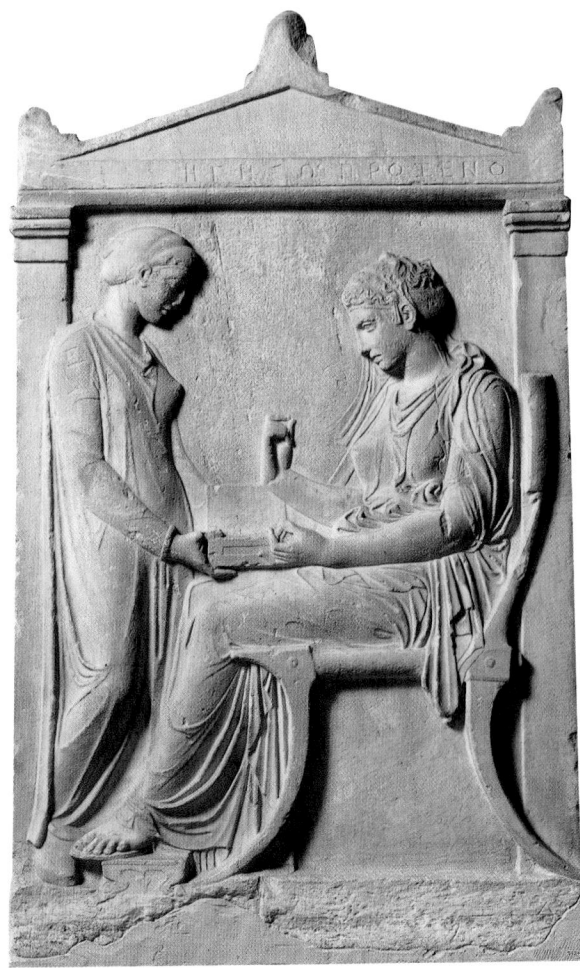

the Archaic *Peplos Kore* of a century earlier (fig. 5.21), the figure is relaxed; her body turns somewhat languidly, and she inclines her head and twists at the waist. The Archaic stylizations have disappeared, as has the smile. The hair is parted in the middle and seems to grow from the scalp. Whereas Archaic drapery has a columnar, architectural quality, Classical drapery follows the form and movement of the body.

Classical artists idealized the human form. Figures are usually young, with no trace of physical defect. They are

5.29 Stele of Hegeso, c. 410–400 B.C. Marble; 5 ft. 9 in. (175.2 cm) high. National Archaeological Museum, Athens.

The Development of Greek Architecture and Architectural Sculpture

1 *Naos* (inner sanctuary)
2 Hallway separated from the *naos* by a solid wall
3 Base of cult statue
4 Solid wall
5 Column of peristyle
6 *Pronaos* (front porch)
7 *Opisthodomos* (back porch)
8 Steps

The Greeks, like all ancient peoples, thought of temples as houses for the gods. In Greece, the temple plan was derived from the *megaron* plan found in Mycenaean palaces (see p. 127). At its most basic, the *megaron* consisted of a rectangular room with a front porch (**portico**), having two columns. The god's cult statue was housed in the main room (the ***naos***) and faced toward the east to an outdoor altar where sacrifices were performed. The main rituals inside the temple involved the care of the statue itself, usually ceremonial dressing and cleaning. Temple interiors also became sanctuaries for fugitives.

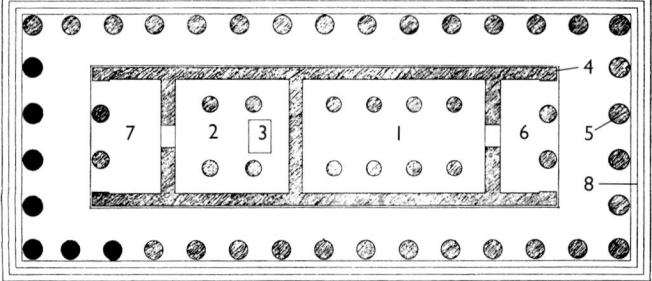

5.30 Plan of the temple of Apollo at Corinth.

Archaic Style (c. 600–480 B.C.)

In the course of the sixth century B.C., during the Archaic period, the basic temple form was developed further, often into two rooms with interior columns, front and back porches, and an outer colonnade on all sides. This latter feature was, in part, influenced by the monumental temples of Egypt, which had huge stone columns, capitals, and bases. In Greece, the proportions changed and the size diminished in accordance with human scale and the maxim that "man is the measure of all things." As in Egypt, the system of elevation was post and lintel, but in Greece the columns were placed on the outside of the building and formed a wall of columns separate from the *naos;* such temples are referred to as **peripteral**. The façades were elaborated by the Greeks into the so-called **Orders** of architecture (see box, p. 162).

Figure **5.30** is the plan of Apollo's temple on the mainland at Corinth. Constructed around 550 B.C., it is early Doric, and some of the massive, fluted columns are still standing (fig. **5.31**). Their shafts rise directly from the top step and have no base. The capitals, which are reminiscent of Minoan capitals, support the remnants of a horizontal architrave. We can see from the plan that the temple had a second room (the *opisthodomos*) behind the *naos* that housed the cult statue of Apollo.

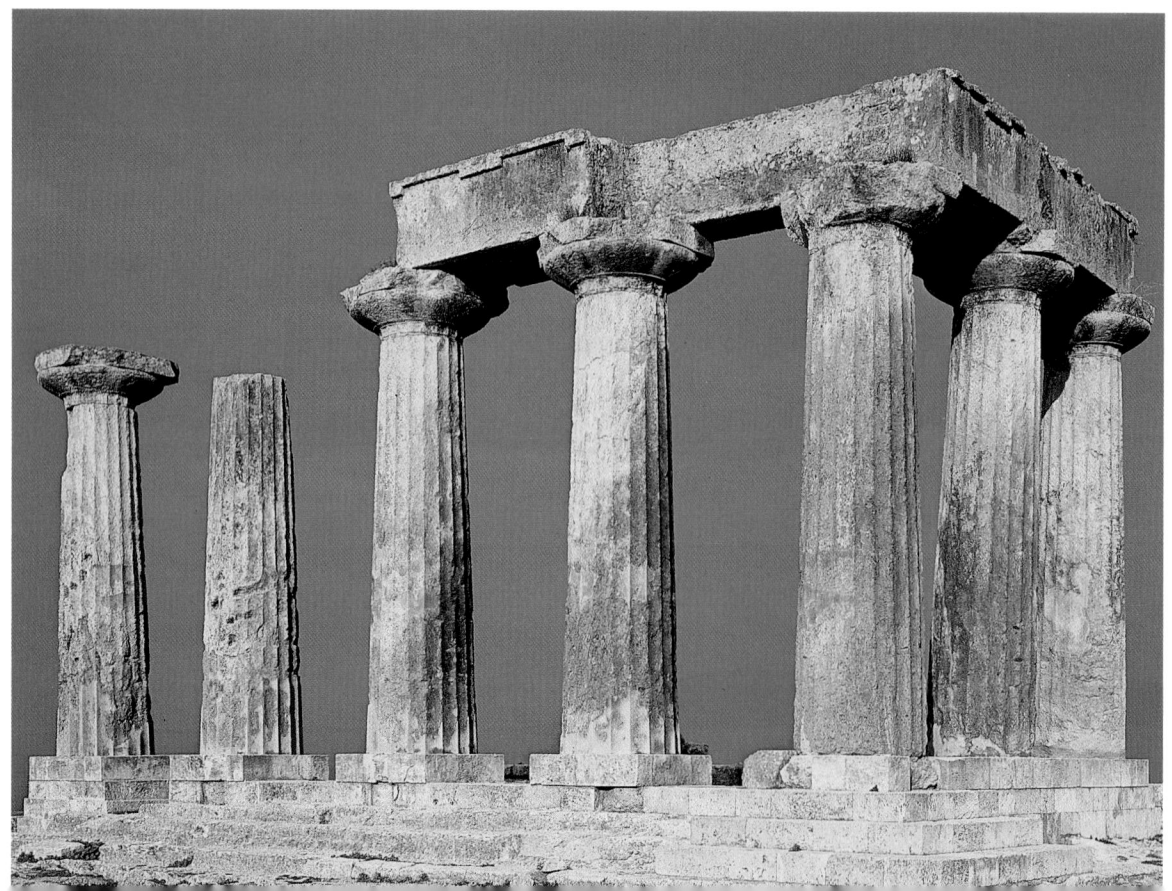

5.31 View of the temple of Apollo at Corinth, c. 550 B.C. Limestone, originally faced with stucco.

5.32 Reconstruction of the façade of the Siphnian Treasury in the sanctuary of Apollo at Delphi, 530–525 B.C. Delphi Museum.

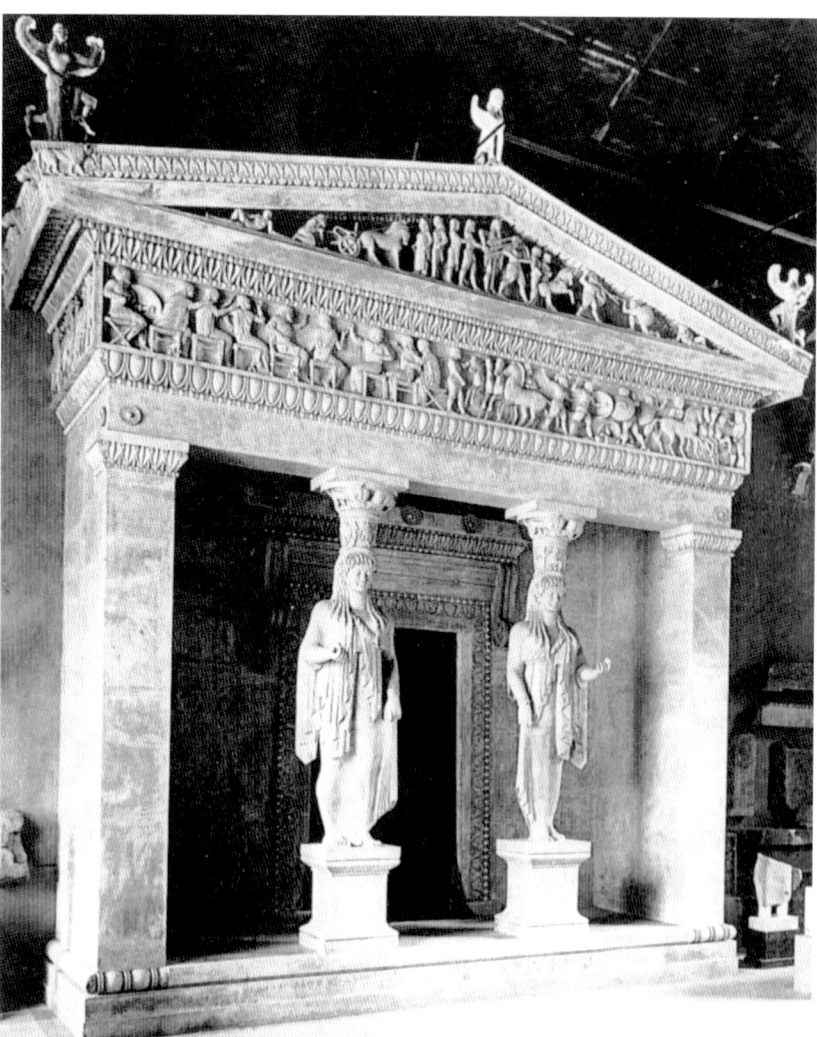

In many cases, the *opisthodomos* was reserved for the safekeeping of valuables dedicated to the god and eventually became an official treasury. Sometimes treasuries were separate buildings, consisting of a front porch connected to a rectangular room that housed costly objects dedicated by individual cities at the large sanctuaries. An Archaic treasury of this kind in the Ionic Order can be seen in the reconstructed Siphnian Treasury (fig. **5.32**) from the sanctuary at Delphi.

The small treasury, 12 feet (3.66 m) in height, was built by the inhabitants of the Ionian island of Siphnos. The reconstruction in figure 5.32 shows a well-proportioned structure decorated with relief sculpture on the continuous Ionic frieze and sculpture on the triangular pediment. This is part relief, but the upper section is cut away at the back. The two **caryatids**, the statues of women functioning as columns, are early examples of their type; the earliest are also found at Delphi, in the Knidian Treasury. The winged sphinxes at the apex of the pediment were ultimately derived from Near Eastern prototypes. At the corners are winged females representing Nike, the Greek goddess of victory. Their lively grace, enhanced by the curves of their wings, adds a decorative element to the relatively ornate Ionic building. The **egg and dart** and **leaf and dart** patterns bordering various elements of the façade increase the richness of the design by comparison with the heavy structural appearance of Apollo's Doric temple at Corinth.

The subject of the frieze, a scene from the Trojan War, lends itself to action. The seated deities on the frieze (fig. **5.33**), representing Aphrodite, Artemis, and Apollo, are arguing about the outcome of the war with an intensity conveyed through animated gestures and stylized surface patterns. The two goddesses lean forward, while Apollo turns back toward them. His turn is unusual in Archaic art, for it reflects an attempt to suggest three-dimensional spatial movement. He is shown in back view from the waist up, but his head and legs are in profile. The drapery curves indicate a new awareness of the naturalistic twist required by such a pose and hint at the shoulder blade under the flesh.

5.33 Seated gods from the Ionic frieze of the Siphnian Treasury. Parian marble; height of frieze 24¾–26⅞ in. (62.8–68.3 cm).

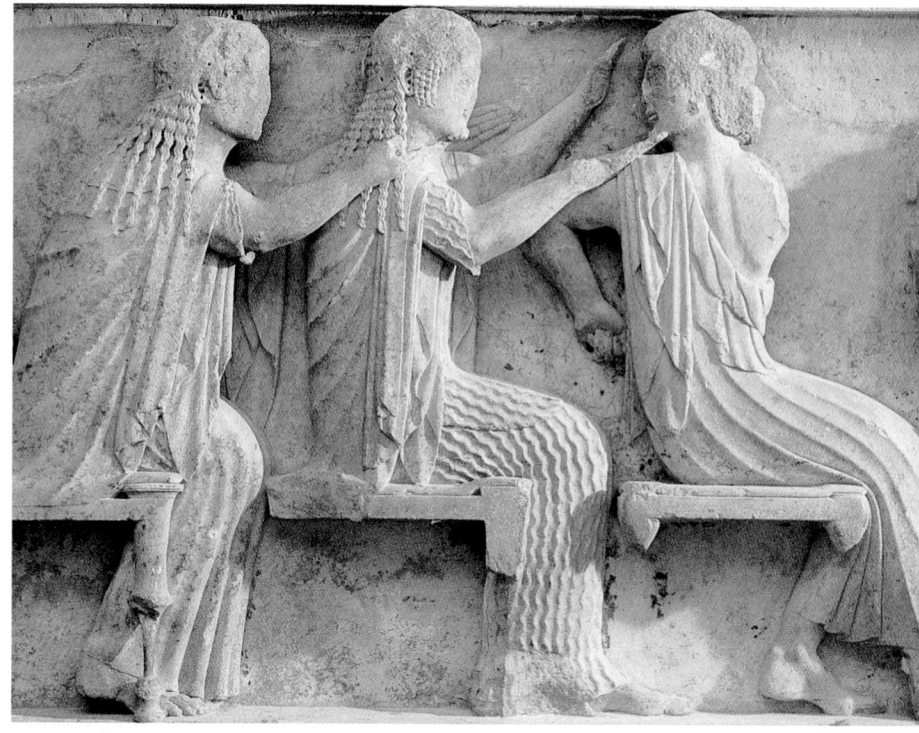

The Orders of Greek Architecture

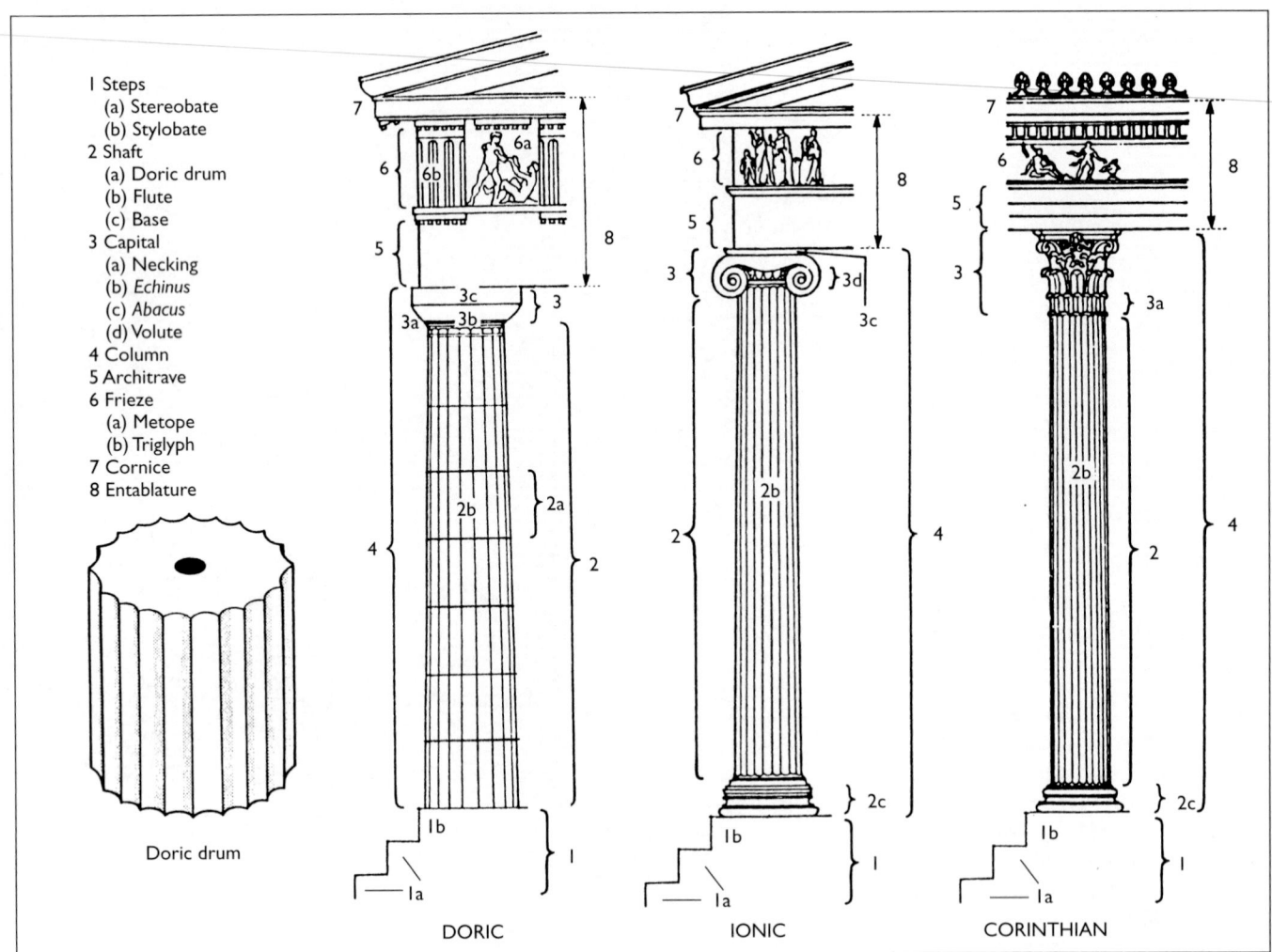

1 Steps
 (a) Stereobate
 (b) Stylobate
2 Shaft
 (a) Doric drum
 (b) Flute
 (c) Base
3 Capital
 (a) Necking
 (b) *Echinus*
 (c) *Abacus*
 (d) *Volute*
4 Column
5 Architrave
6 Frieze
 (a) Metope
 (b) Triglyph
7 Cornice
8 Entablature

Doric drum

DORIC IONIC CORINTHIAN

5.34 Doric, Ionic, and Corinthian Orders.

The Doric and Ionic Orders of Greek architecture (fig. **5.34**) had been established by about 600 B.C. and were an elaboration of the post-and-lintel system of elevation (see p. 48). Ancient Greek buildings, like the sculptures, were more human in scale and proportion than those in Egypt. And unlike the animal-based forms of ancient Iran, the Greek Orders were composed of geometric sections, each with its own individual meaning and logic. Each part was related to the others and to the whole structure in a harmonious, unified way.

The oldest Order, the Doric, is named for the Dorians, who lived on the mainland. Ionic—after Ionia, which includes the Ionian islands and the west coast of Anatolia—is an eastern Order. Its greater elegance results from taller, thinner proportions and curvilinear elements and surface decoration. The Corinthian capital is most easily distinguished by its **acanthus**-leaf design.

Doric Order

The Doric Order begins with a base of three steps. Its shaft rises directly from the top step (the **stylobate**), generally to a height about five and a half times its diameter at the foot. The **shaft** is composed of individual sections—**drums**—cut horizontally and held together in the middle by a metal dowel (peg) encased in lead. Shallow, concave grooves known as **flutes** are carved out of the exterior of the shaft. Doric shafts do not stand in an exact vertical plane, but curve outward from about a quarter of the way up. The resulting bulge, or **entasis** (Greek for "stretching"), indicates that the Classical Greeks thought of their architecture as having an inner organic structure, with a capacity for muscular tension.

At the top of the shaft, three elements make up the Doric capital, which forms both the head of the column and the transition to the horizontal lintel. The **necking** is a snug band at

the top of the shaft. Above it is the ***echinus*** (Greek for "hedgehog" or "sea urchin")—a flat, curved element, like a plate, with rounded sides. The *echinus* forms a transition between the curved shaft and the flat, square ***abacus*** (Greek for "tablet") above. The *abacus*, in turn, creates a transition to the **architrave**—literally, a "high beam."

The architrave is the first element of the **entablature** (note the "tabl," related to "table"), which forms the lintel of this complex post-and-lintel system. The **frieze,** above the architrave, is divided into alternating sections—square **metopes** and sets of three vertical grooves, or **triglyphs** (from Greek *tri,* meaning "three," and *glyphos,* meaning "carving"). Finally, projecting over the frieze is the top element of the entablature—the thin, horizontal **cornice.** In Classical architecture, a triangular element known as a **pediment** rested on the cornice, crowning the front and back of the building.

The harmonious relationship between the parts of the Doric Order is achieved by formal repetitions and logical transitions. The steps, sides of the *abacus,* architrave, metopes, frieze, and cornice are rectangles lying in a horizontal plane. The columns, spaces between columns, flutes, and triglyphs are vertical. The schematic outline of the three steps, the *echinus,* and each individual drum would be a trapezoid (a quadrilateral with two parallel sides).

Groups of three predominate: three steps; a capital consisting of necking, *echinus,* and *abacus;* triglyphs; and the entablature, which is made up of the architrave, frieze, and cornice. The sudden shift from the horizontal steps to the vertical shaft is followed by a gradual transition via the capital to the entablature. The pediment may be read as a logical, triangular crown completing the trapezoid formed by the outline of the steps.

Ionic Order

The more graceful Ionic Order has a round base with an alternating convex and concave profile. The shaft is taller in relation to its diameter, and the fluting is narrower and deeper. Elegant **volutes** (**scroll** shapes) replace the Doric *echinus* at each corner and virtually eclipse the thin *abacus.* In the Ionic frieze, the absence of triglyphs and metopes permits a continuous narrative extending its entire length.

Corinthian Order

There is no evidence of the existence of the Corinthian Order earlier than the latter part of the fifth century B.C. The origin of the term *Corinthian* is obscure, but it suggests that the acanthus-leaf capital was first designed by the metalworkers of Corinth and later transferred to marble. Unlike Doric and Ionic columns, Corinthian columns were used mainly in interiors by the Greeks—they were associated with luxury and, therefore, with "feminine" character.

Early Classical Style (c. 480–450 B.C.)

The temple of Zeus at Olympia, in the Peloponnese, shows the development of Doric architecture in the transitional Early Classical period. It was finished around 457 B.C., but the cult statue, which was one of the Seven Wonders of the ancient world, was not completed and installed until about twenty years later. Although it has long since been destroyed, the statue has been reconstructed from its image on coins (fig. **5.35**); the diagram shows a section (fig. **5.36**)

5.35a, b After Phidias, *Head of Zeus* and *Enthroned Zeus,* 2nd century B.C. Obverse and reverse of a coin minted by the Roman emperor Hadrian to celebrate the 228th Olympiad in A.D. 133. Staatliche Museen, Berlin, and Archaeological Museum, Florence.

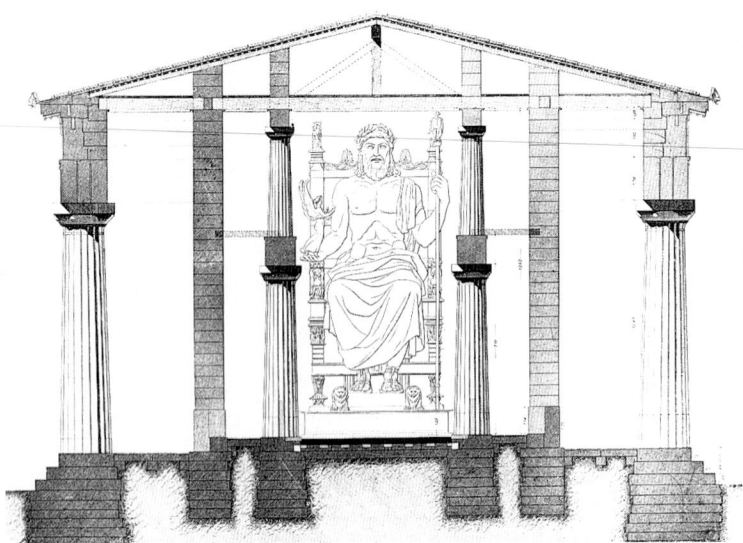

5.36 Sectional drawing of the temple of Zeus at Olympia, *465–457* B.C., showing the cult statue seen from the façade. The cult statue was the work of Phidias and was made later. It was a colossal statue, originally around 40 feet (12.19 m) high, and made of **chryselephantine** (from the Greek words *chrusos*, meaning "gold," and *elephantos*, meaning "ivory"), attached to a wooden frame.

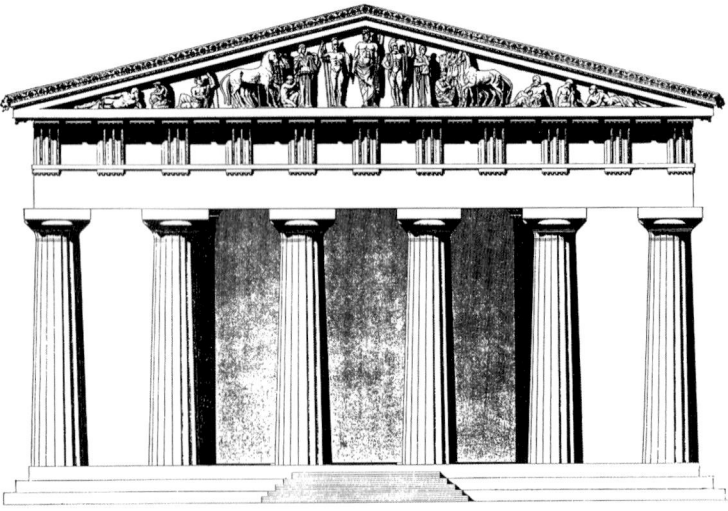

5.37 Reconstructed east façade of the temple of Zeus at Olympia.

as viewed from the east façade (fig. **5.37**). The proportions of the plan (fig. **5.38**), as compared with those of Apollo's temple at Corinth (see fig. 5.30), have decreased in length by the space of two columns. The building had a long, single *naos* with two rows of seven interior columns and an outer colonnade in a ratio of six columns to thirteen—at Corinth the ratio was six columns to fifteen.

The subject of the east pediment (fig. **5.39**) is the chariot race between Oinomaos, the old mythical king of Pisa, and Pelops, a young man who hoped to win the hand of the king's daughter. Because Oinomaos had been warned by an oracle that his son-in-law would kill him, he challenged his daughter's suitors to a race. Each previous unsuccessful suitor had been put to death, but Pelops had the linch-

pin removed from the wheel of Oinomaos's chariot, which overturned and killed the king, thus fulfilling the prophecy. At the center of the pediment, Zeus stands with Oinomaos and Pelops, who has won the race. The two quadrigas (chariots drawn by four horses) on either side refer to the life-and-death race, and at each corner are unidentified reclining figures. To the Eleans, who built the temple, the story of Oinomaos and Pelops mirrored their own victory over the Pisans.

The west pediment (fig. **5.40**) represents the mythical battle between the Lapiths (a Greek tribe) and the Centaurs, who were part human and part horse. According to this myth, the Lapiths invited the Centaurs to a wedding, at which the latter became drunk and tried to rape

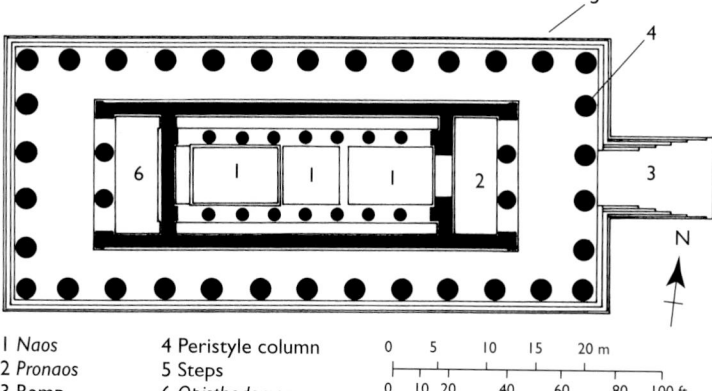

5.38 Plan of the temple of Zeus at Olympia.

1 *Naos*
2 *Pronaos*
3 Ramp
4 Peristyle column
5 Steps
6 *Opisthodomos*

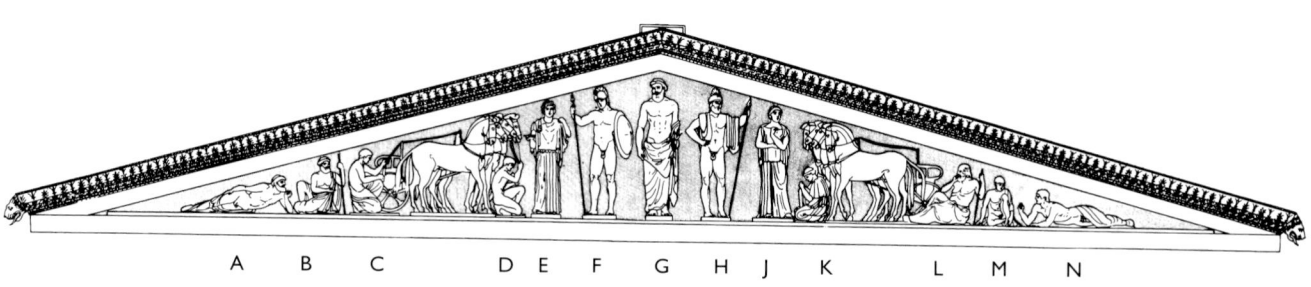

5.39 Reconstruction drawing (after Studniczka) of the east pediment of the temple of Zeus at Olympia: *A.* unidentified reclining figure; *B.* seer; *C.* Myrtilos with Oinomaos's chariot; *D.* youth; *E.* Sterope; *F.* Oinomaos; *G.* Zeus; *H.* Pelops; *J.* Hippodameia; *K.* girl in front of Pelops's chariot; *L.* seer; *M.* squatting youth; *N.* unidentified reclining figure.

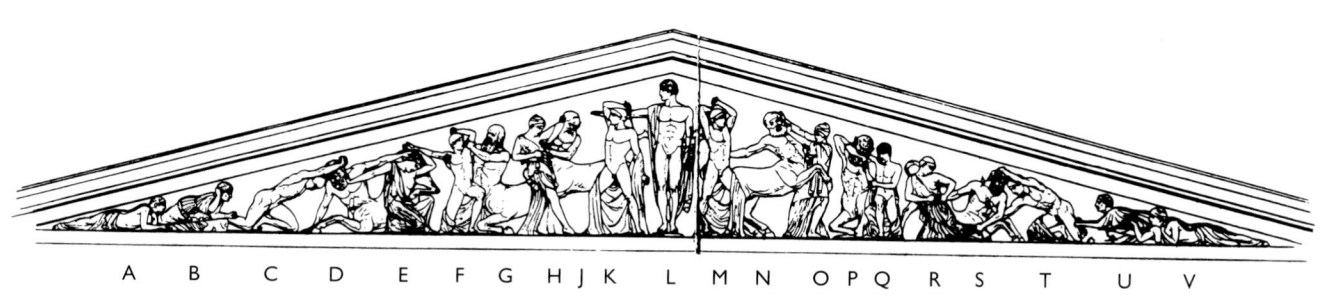

5.40 Reconstruction drawing (after Treu) of the west pediment of the temple of Zeus at Olympia: *A, B.* two Lapith women; *C, D, E.* Lapith rescues a Lapith woman from attack by a Centaur; *F, G.* Centaur assaults a Lapith boy; *H, J, K.* Perithöos protects his bride from a Centaur; *L.* Apollo; *M, N, O.* Theseus battles with a Centaur for a Lapith woman; *P, Q.* Centaur sinks his teeth into a Lapith boy's arm; *R, S, T.* Lapith protects a Lapith woman from attack by a Centaur; *U, V.* Lapith women watching the battle.

the Lapith boys and girls. Apollo's imposing presence at the center of the scene refers to his personification of intellect and reason (fig. **5.41**). He symbolically holds back the forces of disorder and irrationality as he directs the action with his gesture. Apollo's power and rectitude are implicit in his "straight," vertical pose, using only his outstretched *right* arm and divine gaze to control the Centaurs.

The geometric clarity of Apollo's commanding pose and gesture is contrasted with the energetic zigzags of the

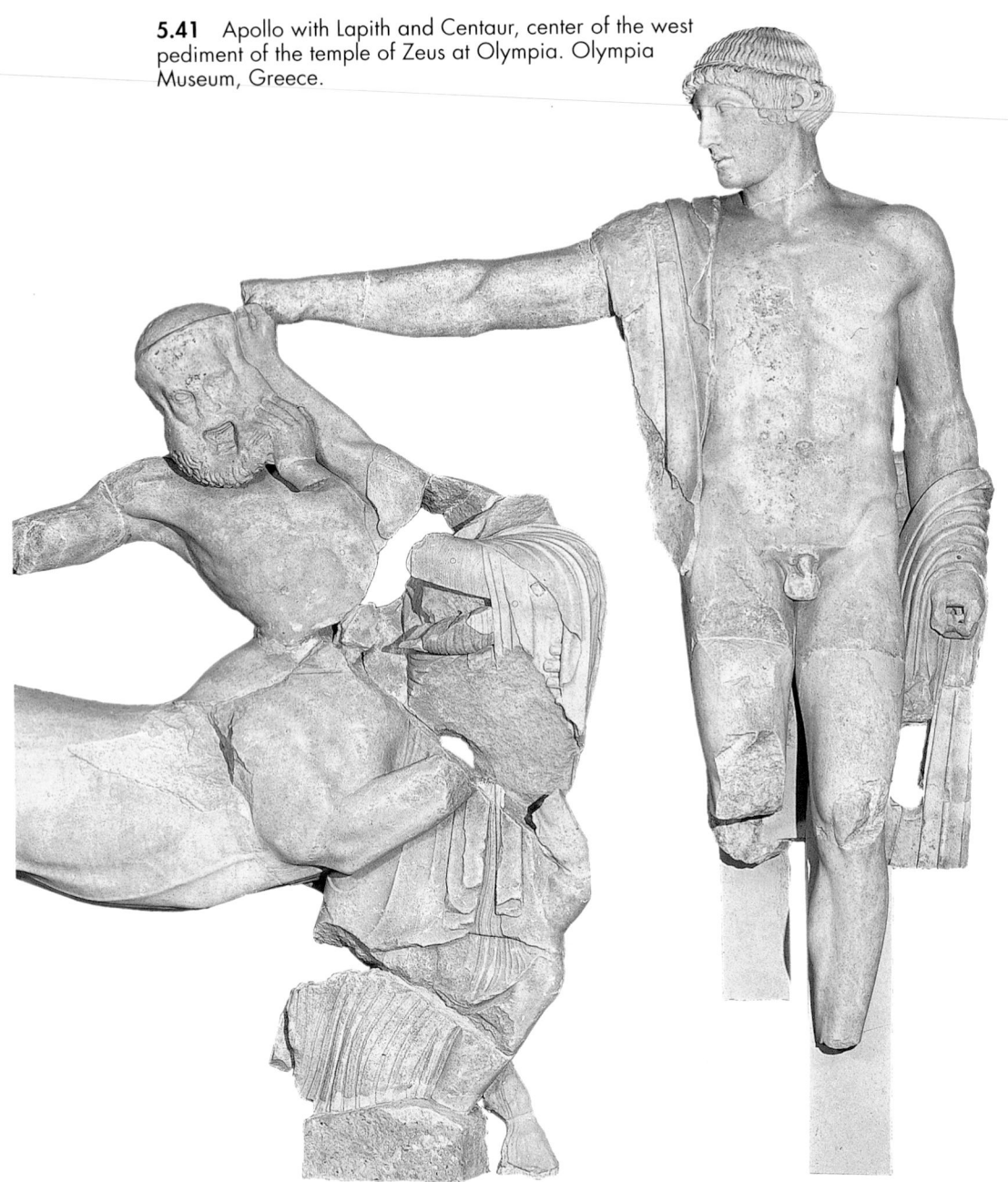

5.41 Apollo with Lapith and Centaur, center of the west pediment of the temple of Zeus at Olympia. Olympia Museum, Greece.

Centaur and its contorted facial expression. Apollo is idealized through his youthful form and calm demeanor, whereas the Centaur's features suggest old age, with straining muscles and bulging veins. But some stylization—the patternistic treatment of the god's hair, ending in carefully arranged curls—persists. Nevertheless, compared with the Archaic sculptures on the Siphnian Treasury, the Olympian sculptures, like the *Kritios Boy* and the *Diskobo-*

los, convey the new simplicity and subtlety of the Early Classical style.

The Olympia **metopes** depicted the twelve Labors of Herakles, six on the west and six on the east over the two porches (figs. **5.42, 5.43,** and **5.44**). As a site sacred to Zeus and a center of politics and athletics, the sanctuary at Olympia had special significance for the Greeks. This is reflected in the iconography of the temple's sculptural

The Labors of Herakles

By the Archaic period, Olympia, which had long been a sacred sanctuary, was a cult center in honor of Zeus. Zeus' son Herakles established the borders of the Olympian precinct and was the legendary founder of the Olympic Games. The combination of brain and brawn that made Herakles a model for Greek athletes is illustrated by the twelve Labors he performed for Eurystheus, king of Tiryns (a Mycenaean site), at the command of the Delphic oracle. Because of his Labors and other exploits, Herakles was granted immortality by the gods.

As represented on the metopes of the temple of Zeus in Olympia, Herakles is endowed with intelligence and a canny problem-solving ability as well as with strength. In four instances, he is assisted by Athena, who typically offers wise advice, and in two by Hermes. Herakles performs six Labors on the Greek mainland (depicted on the west metopes at Olympia) and six in foreign lands (on the east metopes). They are as follows:

1. Herakles kills the Nemean lion. The lion's skin becomes one of his attributes.

2. The Lernean Hydra was a poisonous water snake with seven heads that regenerated whenever one was cut off. Herakles cut off the heads and burned the stumps to prevent the heads from growing back.

3. Herakles kills the dangerous birds in the marshes of Stymphalos (depicted here bringing them back to Athena).

4. Herakles ropes and captures the huge Cretan bull.

5. Herakles tames Artemis's sacred Keryneian hind.

6. Herakles kills Hippolyte, the Amazon queen, and steals her magic girdle.

7. Herakles captures the Erymanthian boar alive by chasing it into a snowfield and catching it in a net. He brings it to the king, who hides in a storage jar.

continued on p. 168

5.42 *Athena, Herakles and Atlas, the Golden Apples of the Hesperides,* metope from the east side of the temple of Zeus at Olympia. Marble; 5 ft. 3 in. (1.60 m) high.

The Labors of Herakles

continued

8. Herakles tames the mares of Diomedes, king of Thrace, by feeding them the flesh of their own master.

9. Herakles travels to an island at the extreme west of Oceanos (the river believed to encircle the earth). There he kills the triple-bodied monster, Geryon, as well as the guardian dog and giant, and brings back Geryon's herd of oxen.

10. Herakles had to obtain the Golden Apples from the Tree of Life in the north African garden of the Hesperides. He offers to relieve Atlas from the burden of carrying the world on his shoulders if Atlas will obtain the apples for him. In the metope illustrated here (fig. 5.42), Herakles supports the world, his head bowed by its weight, while Atlas holds the apples. Having accomplished his mission, Atlas is reluctant to resume his burden, but Athena (on the left) persuades him to do so.

11. Herakles drags into daylight the three-headed dog Kerberos, guardian of Hades. In this task, Herakles is assisted by Hermes, who leads souls to the underworld.

12. The Augean stables in Elis housed huge herds of cattle, whose dung had not been cleared for thirty years. Herakles wagered the king that he could clean the stables in a single day. He made two holes in the stable walls, through which he diverted the River Alpheios, thereby accomplishing his task.

5.43 Olympia, diagram of the west end of the *naos* from the temple of Zeus, showing the Labors of Herakles: 1. Herakles kills the Nemean lion; 2. Herakles battles the Lernean Hydra; 3. Herakles brings the Stymphalian birds to Athena; 4. Herakles captures the Cretan bull; 5. Herakles tames the Keryneian hind; 6. Herakles kills the Amazon queen Hippolyte.

5.44 Olympia, diagram of the east end of the *naos* from the temple of Zeus, showing the Labors of Herakles: 7. Herakles with the Erymanthian boar; 8. Herakles with one of the mares of Diomedes; 9. Herakles kills Geryon; 10. Herakles and the Golden Apples of the Hesperides; 11. Herakles and Kerberos; 12. Herakles cleans the Augean stables.

program. On the east pediment, a myth was represented in free-standing sculptures, which alluded to recent historical events. For years, two neighboring Greek cities, Elis and Pisa, had been vying for control of Olympia. Finally, around 470 B.C., Pisa was destroyed by the Eleans. As a result of its victory, Elis increased its wealth and used the money to build a temple dedicated to Zeus. The temple's sculptural program was designed in such a way that the ancient myth could be read in relation to contemporary events.

Classical Style (c. 450–400 B.C.)

Athens, the capital of modern Greece, is located on the Saronic Gulf, just inland from the port of Piraeus. In the second half of the fifth century B.C., Athens was the site of the full flowering of the Classical style in the arts. This section considers that culmination as it was embodied in the buildings on the Acropolis (figs. **5.45** and **5.46**), particularly the Parthenon. The Acropolis (from the Greek words *akros,* meaning "high" or "upper," and *polis,* meaning "city") is an elevated rock supporting several temples, precincts, and other buildings. During the Mycenaean period, it had

been a fortified citadel, and its steep walls made the Acropolis difficult for invaders to scale.

The Classical period in Athens is also called the Age of Perikles, after the Greek general and statesman (c. 500–429 B.C.) who initiated the architectural projects for the Acropolis. He planned a vast rebuilding campaign to celebrate Athenian art and civilization after the devastation of the Persian Wars. The Propylaea (entranceway) and the Parthenon (447–432 B.C.) were completed during his lifetime, but work on the Nike Temple (427–424 B.C.) and the Erechtheum (421–405 B.C.) was not begun until after his death.

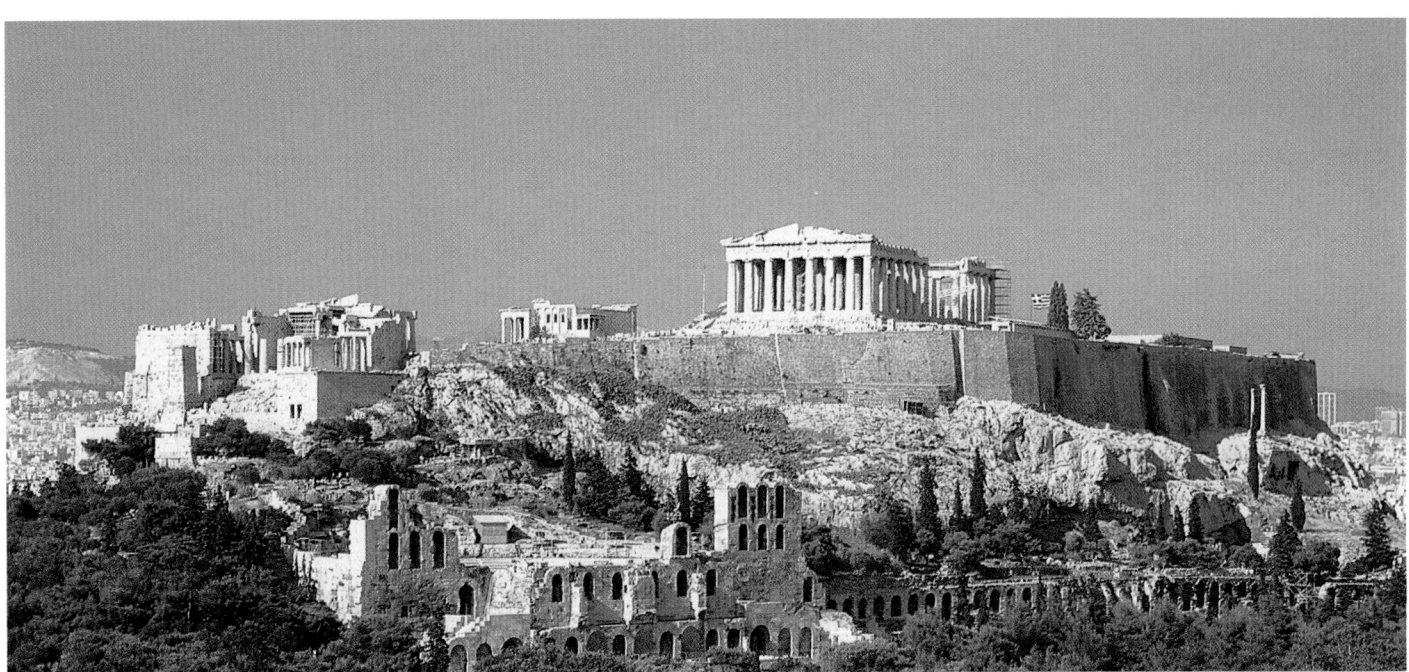

5.45 View of the Acropolis, Athens.

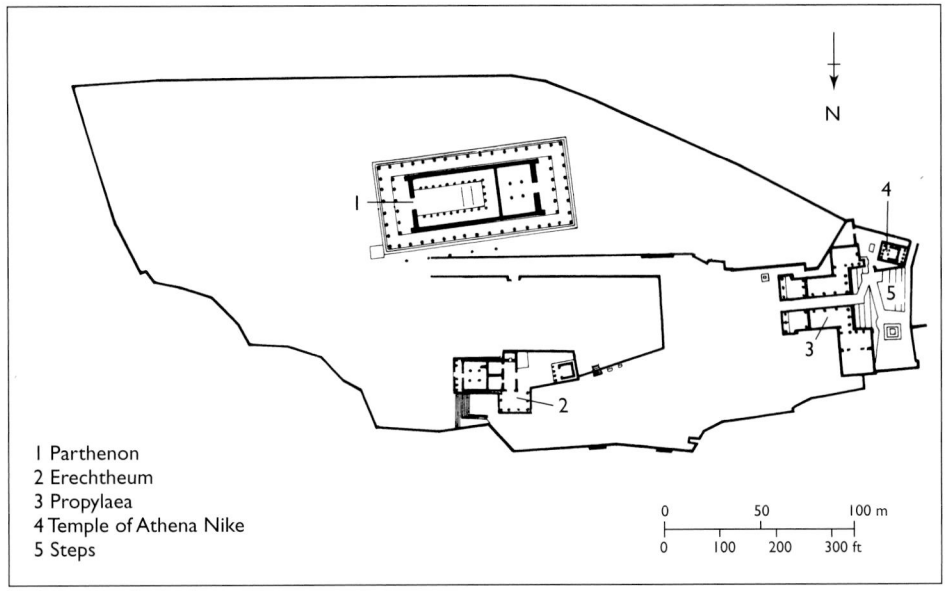

5.46 Plan of the Acropolis. This plan includes only the four Classical buildings that were rebuilt after the destruction of the Acropolis at the end of the Persian Wars (c. 480 B.C.). Like most Greek temples, they were made of marble, which was quarried from the local mountain, Pentelikos.

1 Parthenon
2 Erechtheum
3 Propylaea
4 Temple of Athena Nike
5 Steps

Financing for Perikles' building program had come from the Delian League. Because of Athens' sea power, it was able to force the rest of Greece to buy its protection against the Persian invaders. The treasury that housed the funds was located in Apollo's sanctuary on the island of Delos, but the treasure was transferred to the Athenian Acropolis in 454 B.C.

Athenian political rhetoric, which claimed to protect other Greek cities in the league, informs the iconography of the buildings on the Acropolis. It was also Perikles' justification for spending the war chest on art and architecture in Athens. The controversy that arose over this issue is described in Plutarch's *Life of Perikles*: Perikles' political enemies in the Athenian assembly accused him of disgracing their city by taking the league's money. "Surely," they argued, "Hellas is insulted with a dire insult and manifestly subjected to tyranny when she sees that with her own enforced contributions for the war [against the Persians], we are gilding and bedizening our city, which, for all the world like a wanton woman, adds to her wardrobe precious stones and costly statues and temples worth their millions."[1]

Perikles replied that, as long as Athens waged war for her allies "and kept off the Barbarians," she alone deserved the money. "Not a horse, not a hoplite [a heavily armed Greek foot-soldier], but money simply" was, according to Perikles, the only contribution of the other Greek cities. And furthermore, once Athens had sufficiently equipped itself for war, it was only natural that she "should apply her abundance to such works as, by their completion, will bring her everlasting glory." This, he added, would also provide employment for many workers.

The Parthenon (448–432 B.C.)

The Parthenon was designed by the architects Iktinos and Kallikrates (see box). Phidias, a leading Athenian artist of his generation and a friend of Perikles, supervised the sculptural decorations. Completed in 432 B.C. as a temple to Athena, the patron goddess of Athens, the Parthenon celebrates Athena in her aspect as a virgin goddess. *Parthenos,* the Greek word for "virgin" (and the root of the word *parthenogenesis,* meaning "virgin birth"), was one of Athena's epithets.

The Parthenon (figs. **5.47, 5.48,** and **5.49**) stands within a continuum of Doric temples. We have seen two earlier examples—at Corinth and at Olympia—but no previous Greek temple expresses Classical balance, proportion, and

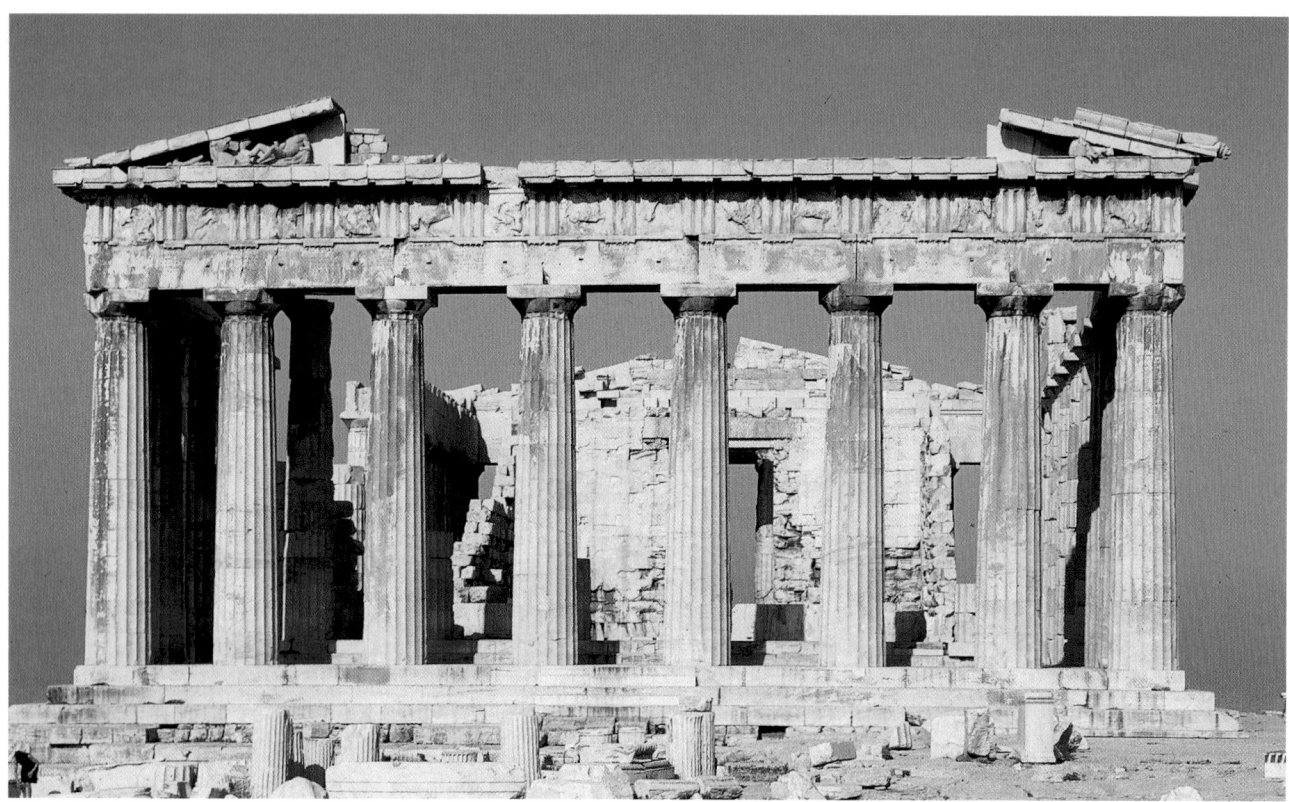

5.47 East end of the Parthenon, Athens, 447–438 B.C. Pentelic marble; 111 × 237 ft. (33.83 × 72.23 m). Once through the Propylaea at the western edge of the Acropolis, the visitor emerges facing east. Ahead and a little to the right are the remains of the western wall of the Parthenon. Its damaged state reflects centuries of neglect and misuse. In the 5th century A.D. the Parthenon became a Christian church, and in the 15th century the Turks conquered Athens and converted the temple into a mosque. They stored gunpowder in the building! When it was shelled by artillery in 1687, most of the interior and many sculptures were destroyed. Centuries of vandalism and looting, plus modern air pollution, have further contributed to the deterioration of the Parthenon.

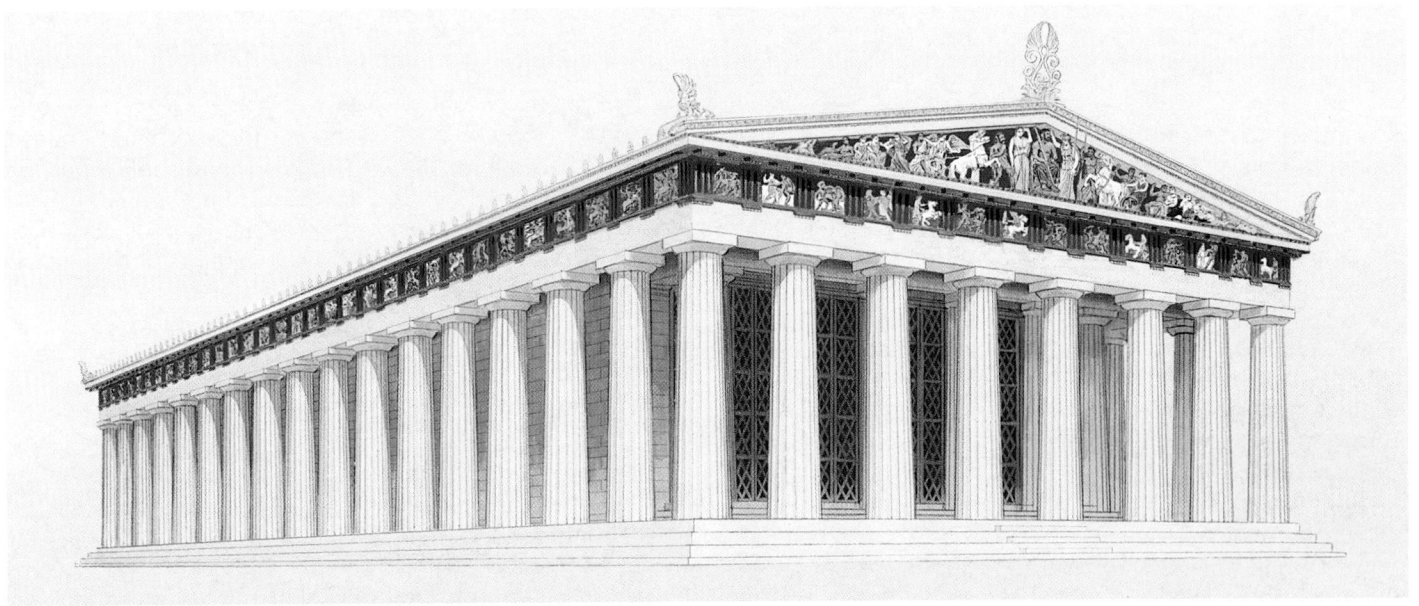

5.48 Reconstruction of the Parthenon, Athens. View of the east façade and south wall. The metopes and pediment sculptures are also reconstructed and show that they were originally painted.

Plan of the Parthenon

The Parthenon is constructed as a rectangle that is divided into two smaller rectangular rooms. A front and back porch and a **peristyle** (**colonnade**), supported by the three steps of the Doric Order, complete the structure. The temple was made entirely of marble, which was cut and fitted without the use of mortar.

The three lines on the perimeter of the plan represent the steps. The black circles indicate columns—those comprising the peristyle number eight on the short sides (east and west) and seventeen on the long sides (north and south), counting the corner columns twice. Each corner column serves a short and a long side, creating a smooth visual transition between them.

The inside wall of the Parthenon, supported by two steps, consists of six columns on a front and back porch, leading to a solid wall with a doorway to an inner room. The solid walls are indicated by thick black lines.

The western entrance leads to the smaller room, which served as a treasury. The eastern entrance leads to the *naos*, or inner sanctuary. It was originally dominated by a monumental gold and ivory (**chryselephantine**) statue of Athena —its base is indicated on the plan by the rectangle inside the *naos*. An inner rectangle of Doric columns repeats the shape of the room and surrounds the statue on three sides.

Although constructed primarily in the Doric Order, the Parthenon had two features that were Ionic. First, there were four Ionic columns inside the treasury. And second, a continuous Ionic frieze, which cannot be seen on the plan, ran around the top of the outside of the inner wall. The inclusion of Ionic elements in the Parthenon expresses the Athenian interest in harmonizing the architectural and sculptural achievements of both eastern and western Greece.

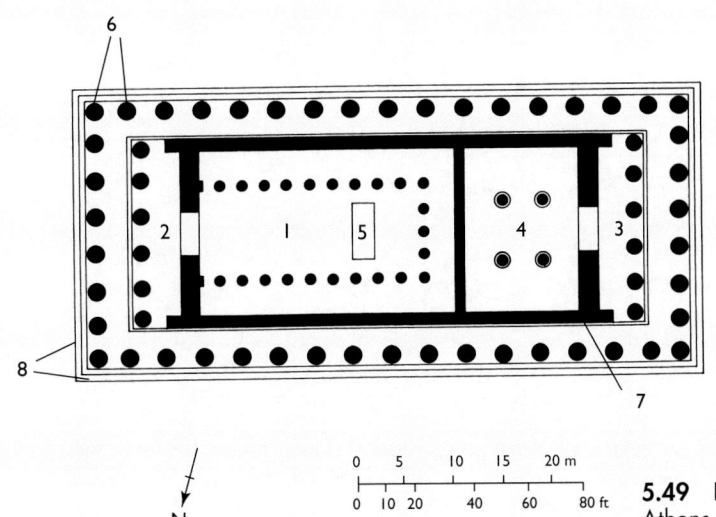

1 *Naos*
2 *Pronaos*
3 *Opisthodomos*
4 Treasury
5 Base of Athena's statue
6 Peristyle columns
7 Solid wall
8 Steps (stereobate and stylobate)

0 5 10 15 20 m
0 10 20 40 60 80 ft

5.49 Plan of the Parthenon, Athens.

N

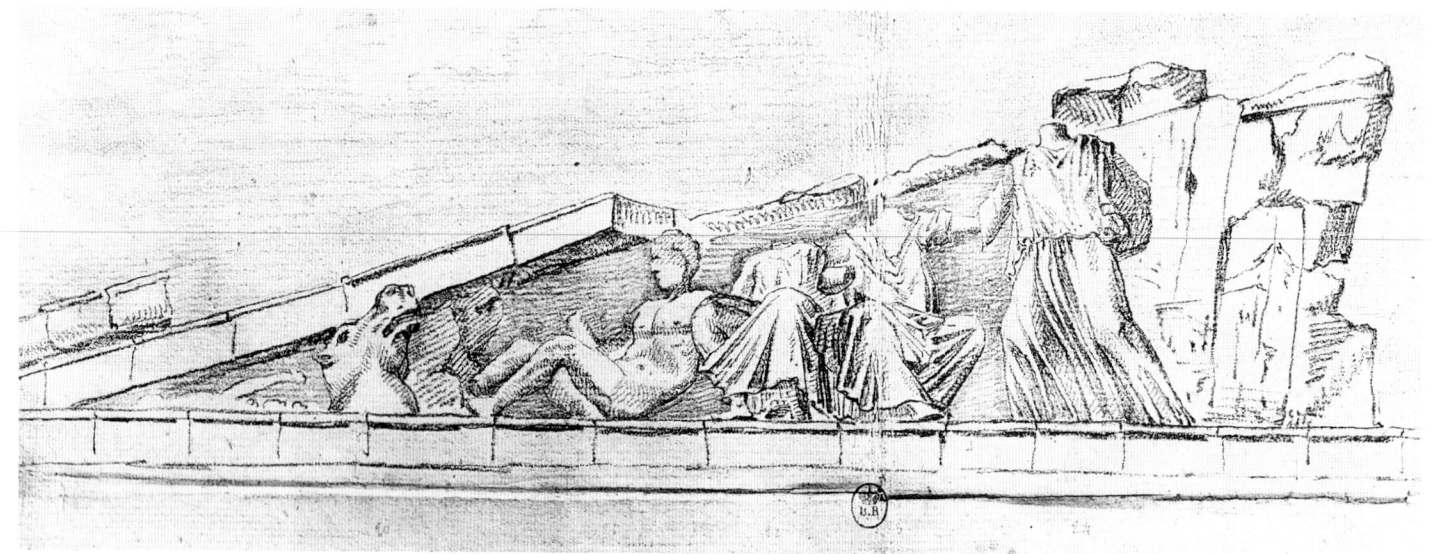

5.50a, b *The East Pediment of the Parthenon in 1674,* from a drawing by Jacques Carrey, sculptures finished by 432 B.C. Bibliothèque Nationale, Paris. Greek temple sculptures and their background areas were originally painted. The sculptures in the broken center section of this pediment originally represented Athena's birth on Mount Olympos: Zeus was in the middle, and a Nike crowned Athena with a laurel wreath. According to the myth, Hephaestos struck Zeus on the head with an axe, and Athena emerged fully grown and armed. As the goddess of wisdom as well as of war and weaving, she was born like an idea from the head of the supreme god.

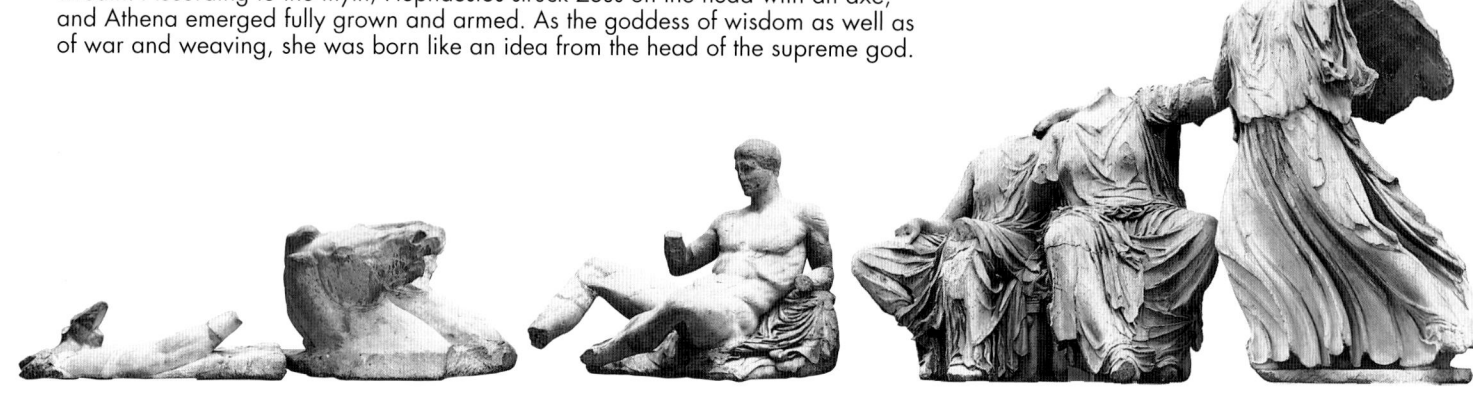

5.51 Sculptures from the left side of the east pediment of the Parthenon, finished by 432 B.C. Pentelic marble; left figure 5 ft. 8 in. (1.73 m) high. British Museum, London. The pediments are almost 100 feet (30.50 m) wide at the base and 11 feet (3.35 m) high at the central peak. The depth of the pediment bases is, however, only 36 inches (91.4 cm), thus restricting the space available for the sculptures. Since the sides of the pediments slope toward the corner angles, Phidias had to solve the problem of fitting the sculptures into a diminishing triangular space.

unity to the same extent as the Parthenon. Its exceptional aesthetic impact is enhanced by its so-called refinements, which are slight architectural adjustments to improve the visual impression of the building. For example, lines that look like horizontals actually curve upward toward the middle, thereby correcting the tendency of the human eye to perceive a long horizontal as curving downward toward the center. Other refinements involve the columns, all of which tilt slightly inward; those toward the corners of the building are placed closer together, creating a sense of stability and the illusion of a frame at each end.

The Parthenon sculptures, located in four sections of the building, were integrated harmoniously with the architecture. Their narrative content proclaimed the greatness of Classical Athens.

The Pediments A drawing of 1674 by the Frenchman Jacques Carrey illustrates the condition of the pediments at that time (fig. **5.50**). Carrey's rendering of the sculpture on the east pediment reveals a relatively good state of preservation, although the central figures had by then disappeared. The three goddesses on the left half of the east pediment (fig. **5.51**)—possibly Iris or Hebe, and Demeter and Persephone, reading from the viewer's right to left— are posed so that they fit logically into the triangular space. Their repeated diagonal planes relate to the two diagonals of the pediment, while the graceful curves of their garments harmonize with the architectural curves of the Doric order below. The reclining male nude to the left could be either Herakles or Dionysos. His limbs, like those of the goddesses, form a series of zigzags. His torso forms a gentle curve, repeated in the domed head and organic musculature. Despite the naturalism of the pose and organic form, however, this figure is idealized: there is no facial expression or individual personality.

Mirroring the two seated females and the male on the left

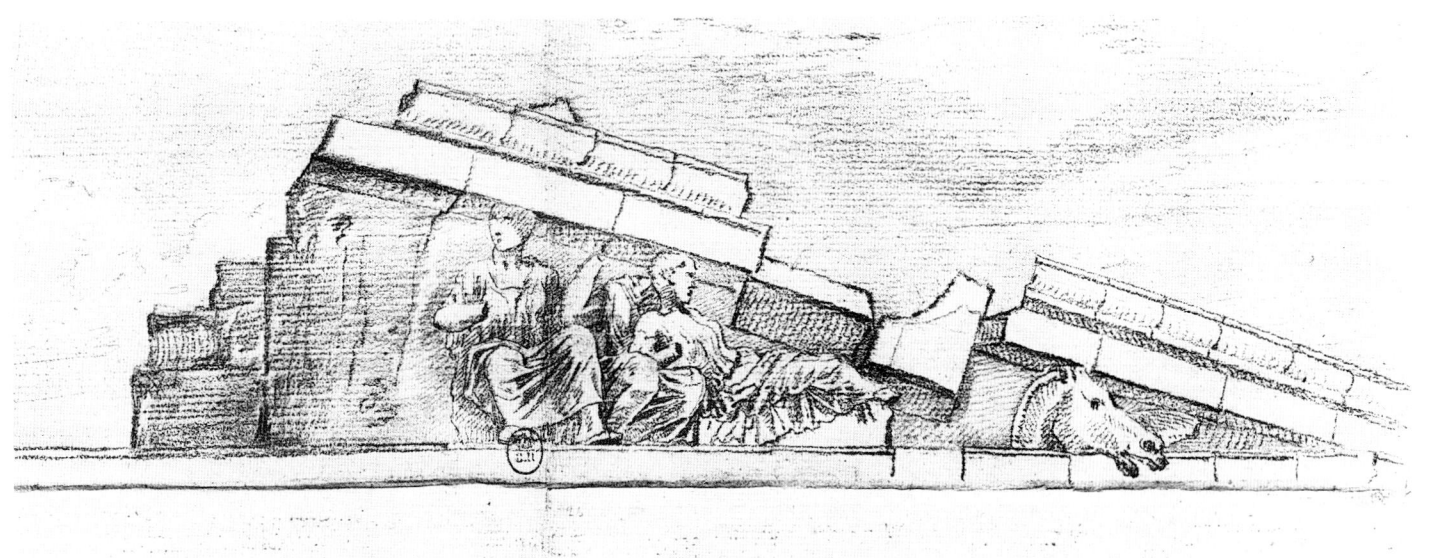

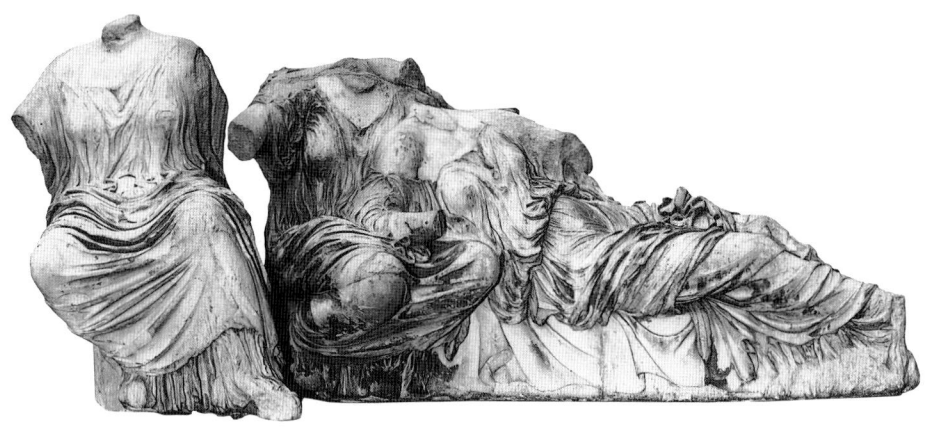
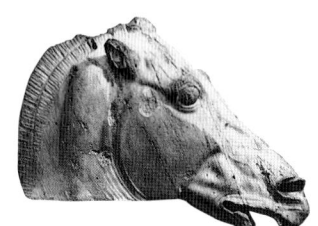

5.52a Sculptures from the right side of the east pediment of the Parthenon. Pentelic marble; left figure, 4 ft. 5 in. (1.35 m) high. British Museum, London. At the far left corner of the pediment, Helios's horses mark the rising of the sun because Athena was born in the east at dawn. The horse of the moon descends at the far right corner. The location of the scene on this pediment also corresponds to the sunrise in the east. The artist has thus formally integrated sculpture and architecture with iconography, time, and place.

5.52b A reconstruction of the three female figures in figure 5.52a, based on fragments found on the Acropolis.

of the pediment is the group of three goddesses on the right (fig. **5.52**). Their identity has been disputed by scholars because they have no attributes. Though posed slightly differently from their counterparts on the left, the groups otherwise match each other closely. The reclining goddess relates to Dionysos/Herakles, and the two seated figures balance those of Demeter and Persephone in their poses and in the curvilinear garments outlining their bodies.

The most striking correspondence between the two sides of the east pediment occurs at the angles. On the far left are the marble remnants of Helios' horses, pulling the chariot of the sun. They rise, beginning their daily journey across the

sky. On the far right, a single horse's head descends, echoing the triangular corner of the pediment (see fig. 5.52a). This horse, from the chariot of the moon goddess Selene, shows Phidias's understanding of anatomy, which he transformed into the Classical aesthetic. He creates the illusion of a triangular cheek plate with one curved side, blood vessels, and muscles pushing against the inside of the skin. The right eye seems to bulge from its socket, and the ear and mane to emerge convincingly from beneath the surface. The open mouth forms another triangular area, echoing the head, the cheek plate, and the pediment itself.

The Doric Metopes The Parthenon metopes illustrate four mythological battles. The best preserved were originally on the south frieze and represent the battle between Lapiths and Centaurs—also the subject of the west pediment at Olympia. The violent energy of the battle (fig. **5.53**) contrasts dramatically with the relaxing gods on the east pediment. The strong diagonals of the Lapith, the repeated curved folds of his cloak, and the backward thrust of the Centaur enliven the metope.

The other three metope battles depicted Greeks against Amazons on the west, the Trojan War on the north, and Olympians overthrowing Titans on the east. Each set of metopes expressed an aspect of the Greek sense of superiority. The Lapiths and Centaurs demonstrated the universal human conflict between animal instinct or lust

—exemplified by the drunken Centaurs—and rational self-control—embodied by the Lapiths. The Greek victory over the Amazons dramatized the triumph of Greek warriors over the monstrous female warriors from the East. In the Trojan War, West again triumphed over East, and in the clash between Titans and Olympians, the more civilized Greek gods wrested control of the universe from their primitive, cannibalistic predecessors. As at Olympia, the sculptural program of the Parthenon represented mythological battles as a way of alluding to actual victories. The political subtext of the battles on the Parthenon metopes is thus the Athenian triumph over the Persians.

The Ionic Frieze Over the outside of the inner (*naos*) wall and colonnades of the Parthenon (figs. **5.54** and **5.55**), an Ionic frieze 525 feet (160.02 m) long illustrated the Great Panathenaic procession (fig. **5.56**). This was held every four years, and the entire city participated in presenting a sacred *peplos* to Athena. The continuous nature of the Ionic frieze, uninterrupted by triglyphs, is consistent with its content. Thus the shape of the frieze corresponds with the form of a procession. In order to maintain the horizontal plane of the figures, Phidias adopted a sculptural convention of **isocephaly** (from the Greek words *isos*, meaning "equal" or "level," and *kephale*, meaning "head"). When a work is isocephalic, all the heads are set at approximately the same level.

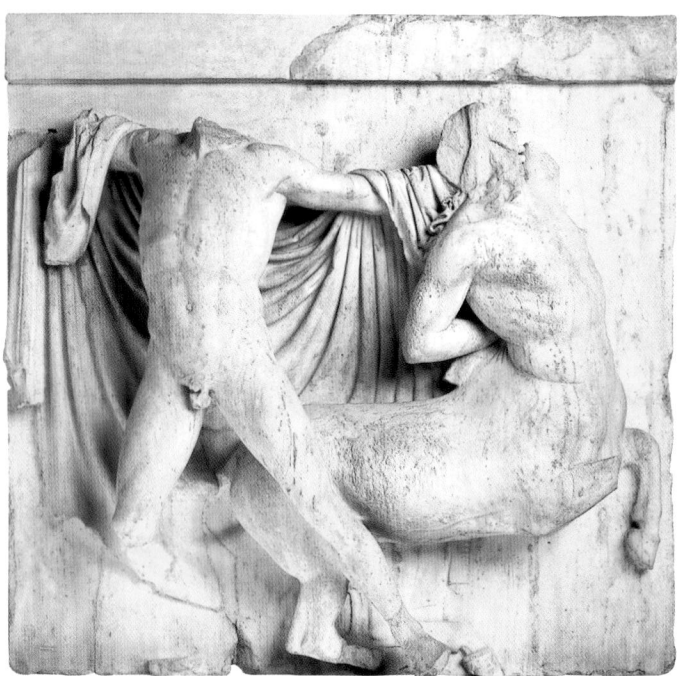

5.53 Lapith and Centaur, from south metope XXVII of the Parthenon. Pentelic marble; 4 ft. 5 in. (1.35 m) high. British Museum, London. Each metope is approximately 4 feet square (1.22 m²) and contains high-relief sculpture. There were fourteen metopes on the short east and west sides, and thirty-two on the long north and south sides. Most are scenes of single combat.

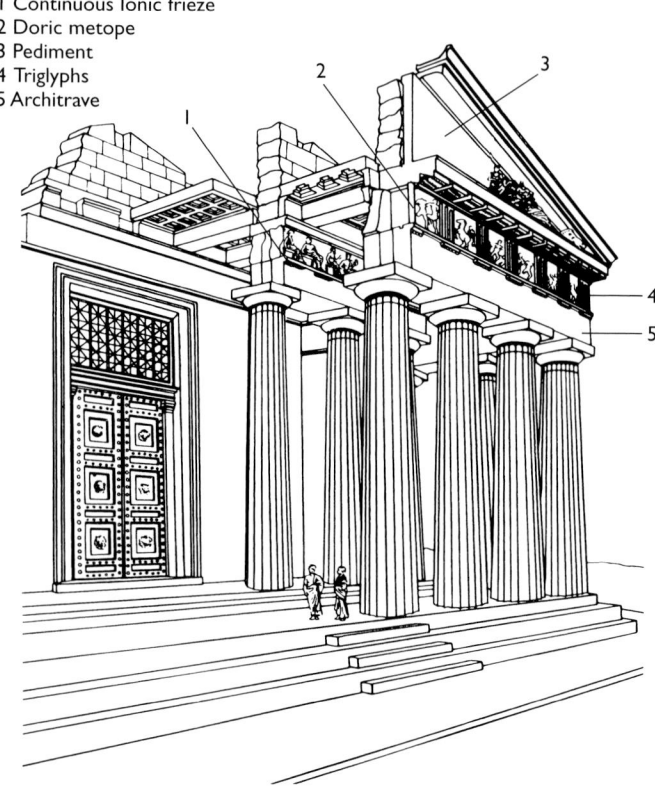

1 Continuous Ionic frieze
2 Doric metope
3 Pediment
4 Triglyphs
5 Architrave

5.54 Cutaway perspective drawing (after G. Niemann) of the Parthenon showing the Doric and Ionic friezes and a pediment.

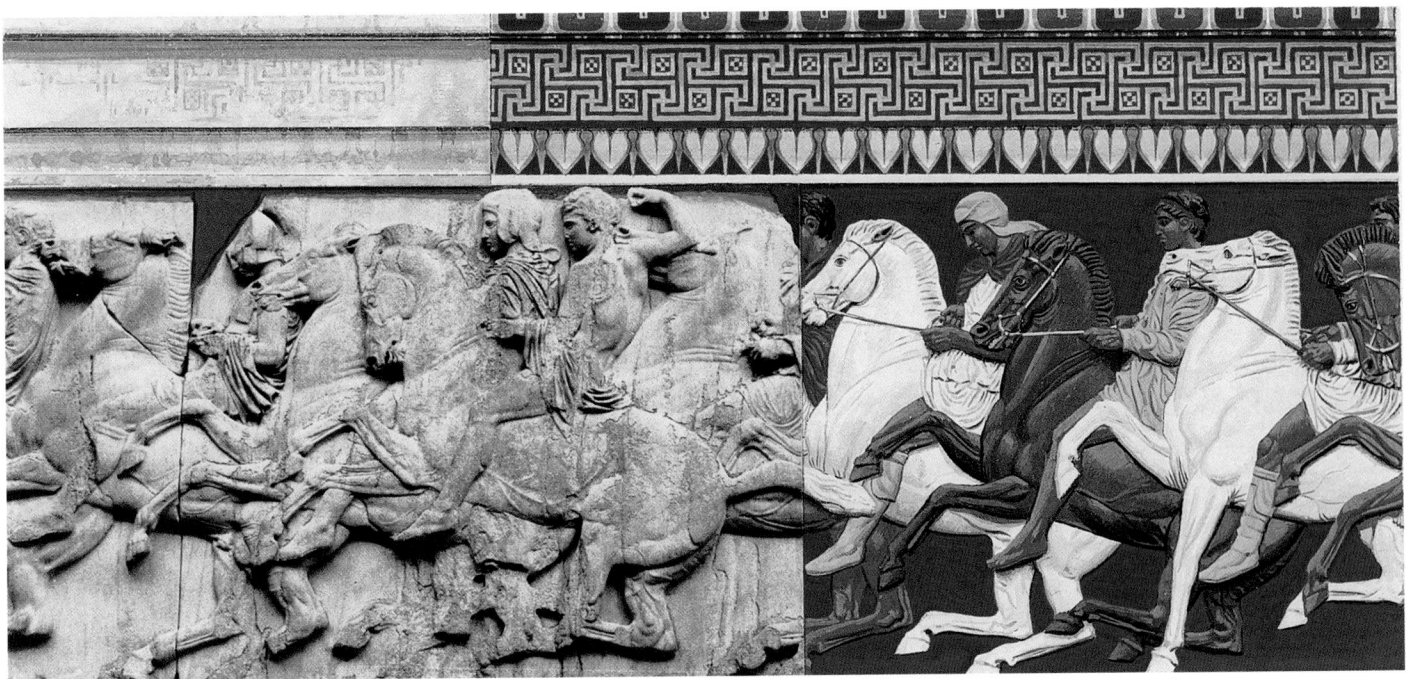

Labels on figure 5.55:
pediment
cornice
triglyphs
metope
Doric frieze
entablature
architrave
abacus
echinus
capital
necking
shaft
Ionic frieze
flutes

5.55 The Parthenon, looking up through the outer Doric peristyle at the Ionic frieze.

5.56 Equestrian group from the north Ionic frieze of the Parthenon, c. 442–439 B.C. Pentelic marble; 3 ft. 5¾ in. (1.06 m) high. British Museum, London. This illustrates Phidias's device of making the horses small in relation to the riders. He carved the horses' legs in higher relief than their bodies and heads. The effect is to cast heavier shadows on the lower part of the frieze, which, together with the multiple zigzags, increases the illusion of movement. This illustration shows the frieze partially restored, based on surviving paint traces.

The Naos The *naos* contained the cult statue of Athena. In the reconstruction in figure **5.57**, she is armed and represented in her aspect as the goddess of war. She stands and confronts her viewers directly, wearing Medusa's severed head on her leather aegis and holding a statue of Nike (goddess of victory) in her right hand and a shield in her left. Both the shield and the pedestal were decorated with reliefs by Phidias. The colossal scale of this statue was unprecedented and reflected Athena's importance as the patron goddess of Athens. (Phidias's statue of Zeus at Olympia was later, even though the temple predated the Parthenon.) Athena's central position in the Parthenon pediments and the offering of the *peplos* in the Ionic frieze signified her wisdom and power as well as the Athenians' devotion to her. The sectional drawing in figure **5.58**

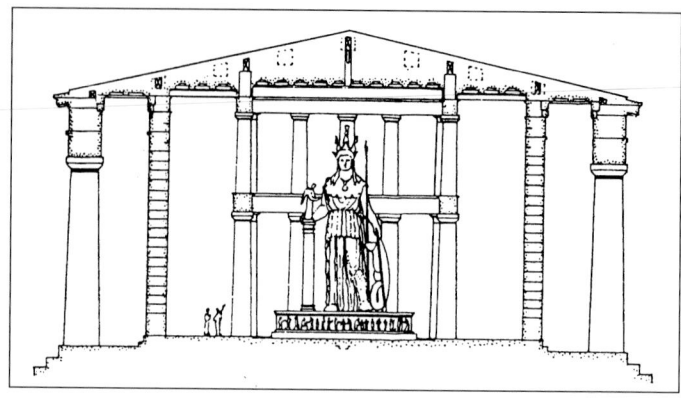

5.58 Sectional drawing showing the cult statue of Athena from the entrance of the Parthenon.

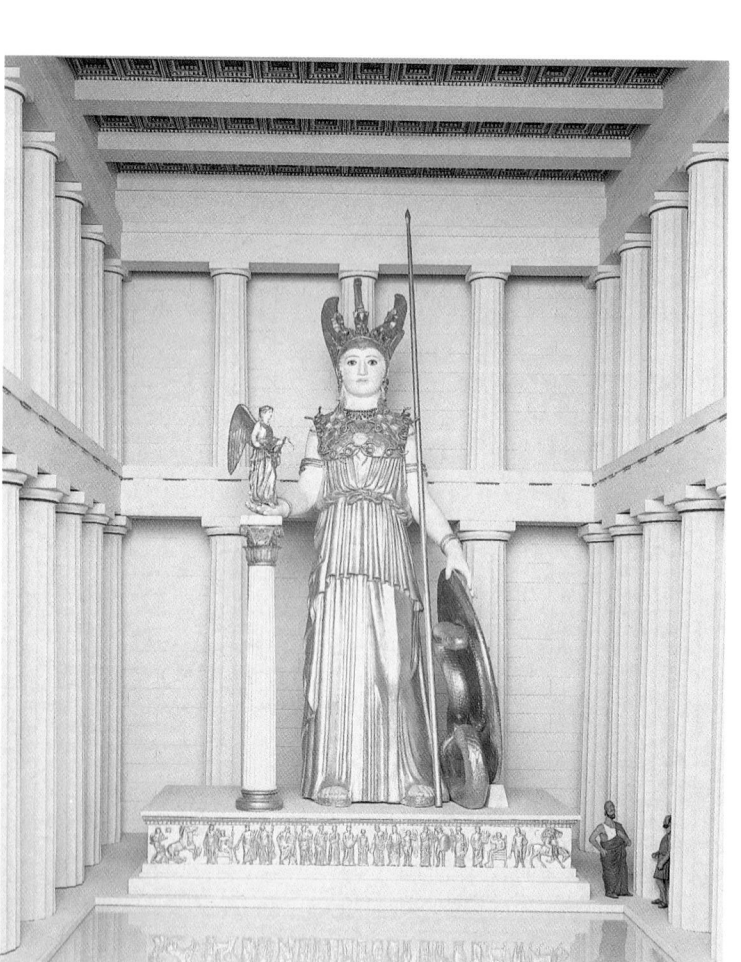

5.57 Neda Leipen and Sylvia Hahn, reconstruction of Phidias's *Athena*, from the *naos* of the Parthenon, original dedicated 438 B.C. Wood covered with gold and ivory plating; model approx. 4 ft. (1.22 m) high. Royal Ontario Museum, Toronto. The statue of Athena was over-life-sized, standing 40 feet (12.19 m) high on a pedestal. Phidias constructed the statue around a wooden frame, covering the skin area with ivory, and the armor and drapery with gold. The original statue has long since disappeared and has been reconstructed from descriptions, small copies, and images on coins.

shows her position in the temple as seen from the entrance. Comparing this with the section of Zeus' temple at Olympia, we can see that the Parthenon is wider, which gives it a lighter, less box-like quality that reflects the pleasing proportions of Classical architectural style.

The Temple of Athena Nike Athena was honored as the goddess of victory in the small marble Ionic temple of Athena Nike crowning the southern edge of the Acropolis (fig. **5.59**). It has a square *naos,* and a front porch, with four Ionic columns and three steps at the front and back. The small size and graceful Ionic Order of the Nike temple contrast with the heavier proportions of the Doric columns in the Parthenon.

The Nike temple, like the Parthenon, celebrated a military victory, but it is not known which one. The issue is complicated by the fact that it was designed before the Parthenon but finished later. Gold statues of Nike were originally housed in the temple but have since disappeared. The best surviving sculpture from the Nike temple is the relief of *Nike Adjusting Her Sandal* (fig. **5.60**) on a **balustrade** of the parapet. This figure combines a graceful, curved torso with diagonal planes in the legs. The sheer, almost transparent drapery (called "wet drapery" because it appears to cling to the body) falls in a pattern of elegant, repeated folds. Behind Nike are the remnants of her open wings. Their smooth surfaces contrast with the folds of the drapery and, at the same time, echo and frame the torso's curve.

The Erechtheum The Erechtheum (fig. **5.61**) stands on the northern side of the Acropolis, opposite the Parthenon. It replaced an old temple to Athena that housed a wooden, Archaic statue of the goddess. The temple was destroyed by the Persians, but the Athenians decided to leave the ruins to remind citizens of the sacrilegious act of sacking the Acropolis. A more complex Ionic building than the Nike temple, the Erechtheum is built on an uneven site. The eastern room was dedicated to Athena Polias, or Athena in her aspect as patron of the city.

5.60 *Nike Adjusting Her Sandal,* from the balustrade of the temple of Athena Nike, 410–409 B.C. Pentelic marble; 3 ft. 5¾ in. (1.06 m) high. Acropolis Museum, Athens.

5.59 Temple of Athena Nike from the east, Acropolis, Athens, 427–424 B.C. Pentelic marble.

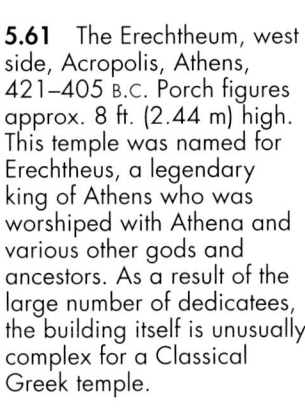

5.61 The Erechtheum, west side, Acropolis, Athens, 421–405 B.C. Porch figures approx. 8 ft. (2.44 m) high. This temple was named for Erechtheus, a legendary king of Athens who was worshiped with Athena and various other gods and ancestors. As a result of the large number of dedicatees, the building itself is unusually complex for a Classical Greek temple.

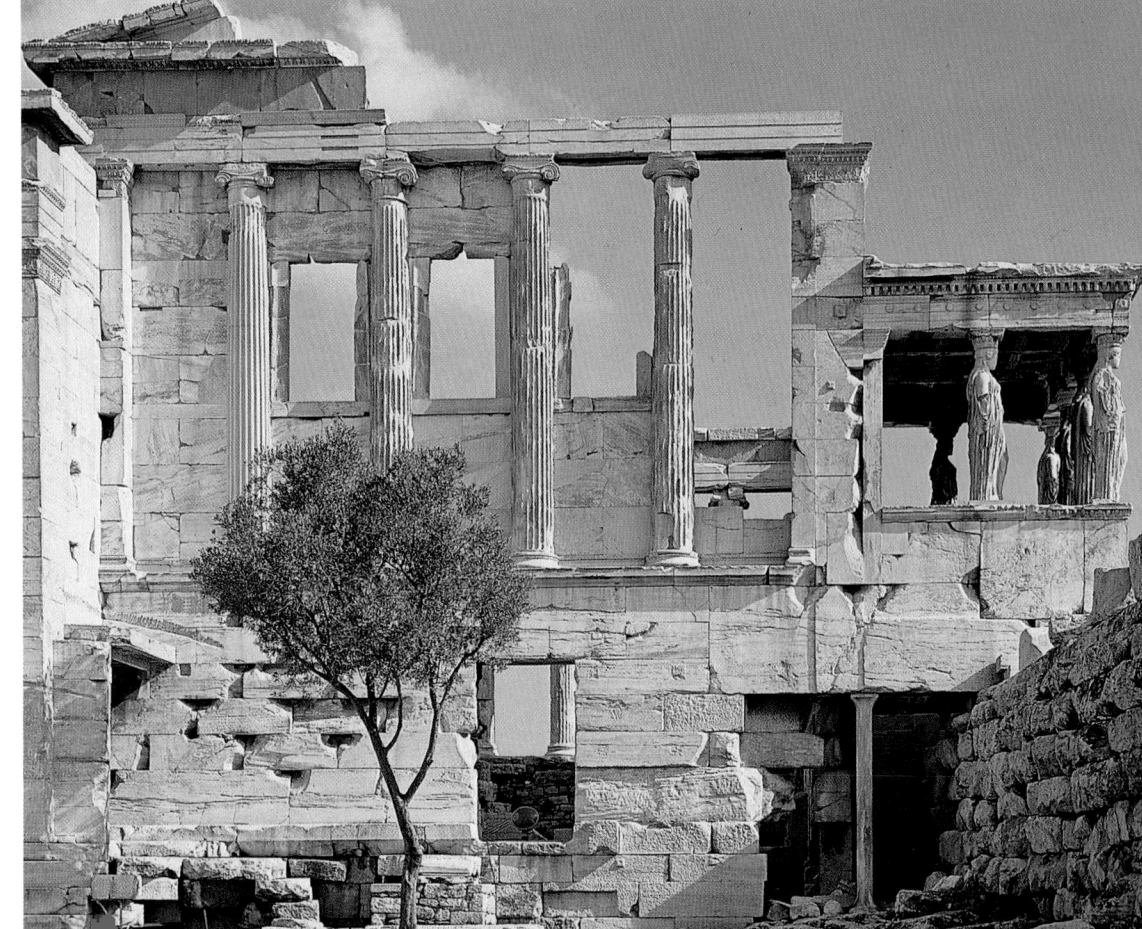

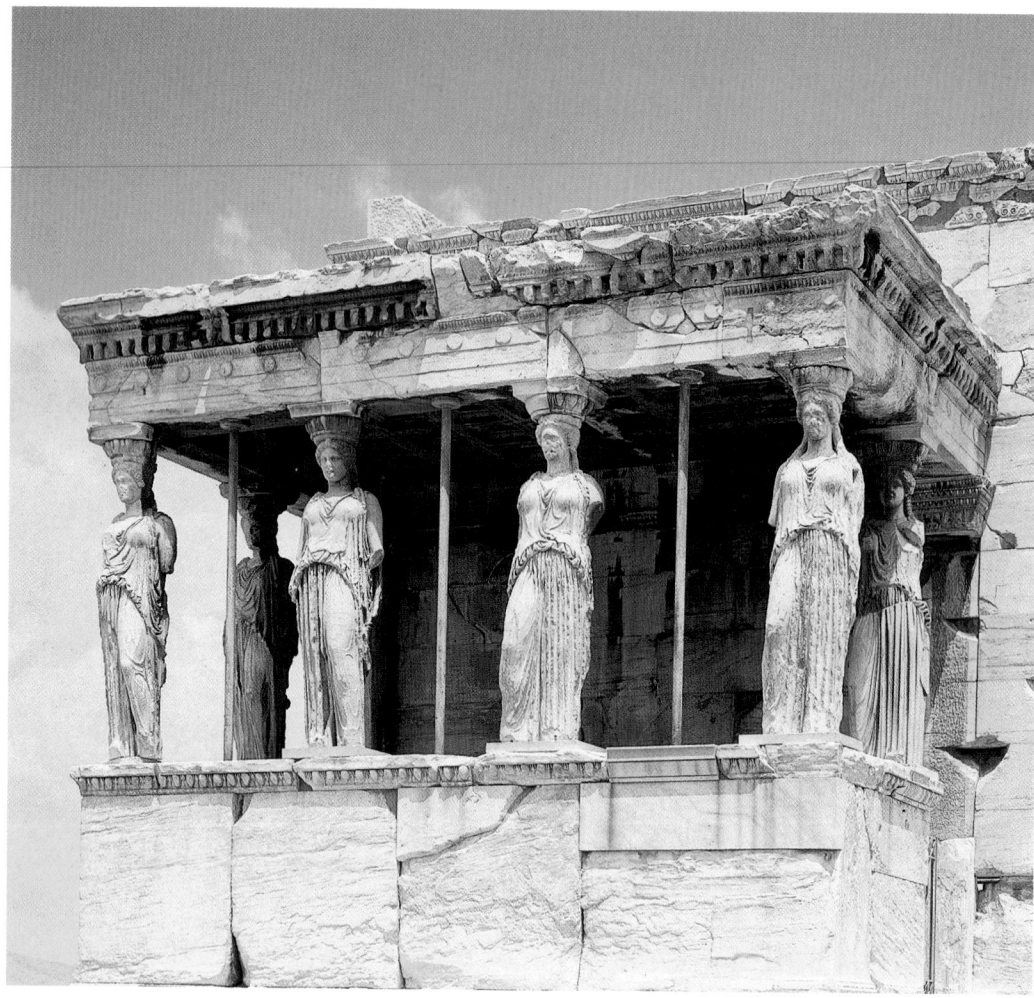

5.62 The caryatid porch of the Erechtheum, south side.

The small southern porch (fig. **5.62**) is distinctive for its six caryatids, a convention already in place in the Siphnian Treasury (see fig. 5.32). But these now stand in a relaxed *contrapposto* pose; the drapery defines the body in an ideal form characteristic of the Classical style. As an ensemble, a perfect symmetry is maintained so that each set of three, right and left, is a mirror image of the other. The two corner caryatids, like the corner columns of the Parthenon, are perceived as being aligned with the front figures when viewed from the front and with the side figures when viewed from the sides, thus creating a smooth visual transition between front and side.

In the metaphorical transformation of columns into human form, several features are necessarily adapted. For example, the vertical drapery folds covering the support leg recall the flutes of columns. In the capital over the caryatid's head, the volute is omitted; but the *echinus* has been retained in the molded headdress, which creates a transition from the head to the *abacus*. At the same time, the headdress is an abstract geometric form, related to or-

ganic human form only by its proximity to the head. Whereas the Doric *echinus* effects a transition from vertical to horizontal and from curved elements to straight, the headdress satisfies the additional transition from human and organic to geometric and abstract. These caryatids thus illustrate the harmonious metaphorical relationship between ideal and organic, and between human and abstract form, that characterizes Classical style.

Late Classical Style (4th century B.C.)

By the end of the fifth century B.C., Athens had lost her political supremacy. Other Greek city-states, especially Sparta, began to exert political and military power over Greece. In the fourth century B.C., Philip II of Macedon, in northeastern Greece, conquered the Greek mainland, and his son Alexander the Great extended his empire. Nevertheless, the intellectual leaders of that period, notably Plato and Aristotle, continued to flourish in Athens.

5.63 Theater at Epidauros, c. 350 B.C. Stone; diameter 373 ft. (113.69 m). Curved rows of stone seats formed an inverted conical space in these impressive structures. Behind the *orchestra* was the rectangular stone backdrop, or *skene* (from which the modern English word *scene* is derived), and actors entered from the sides.

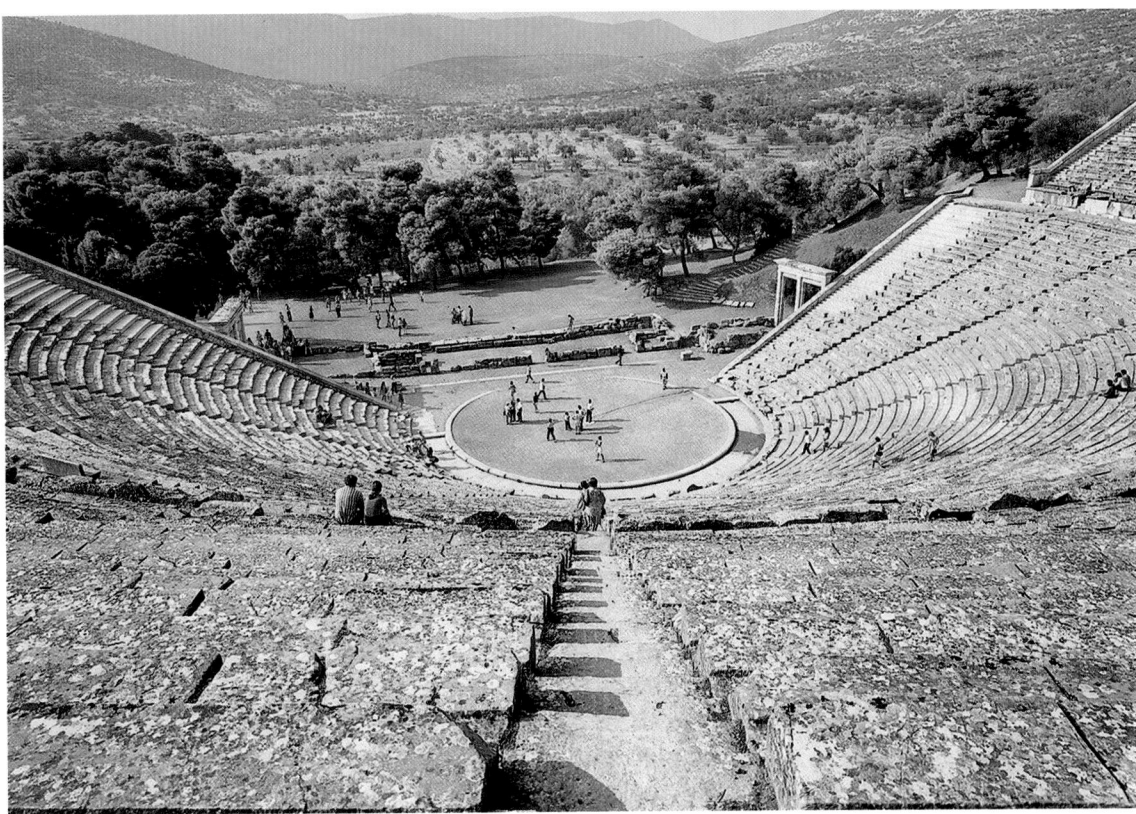

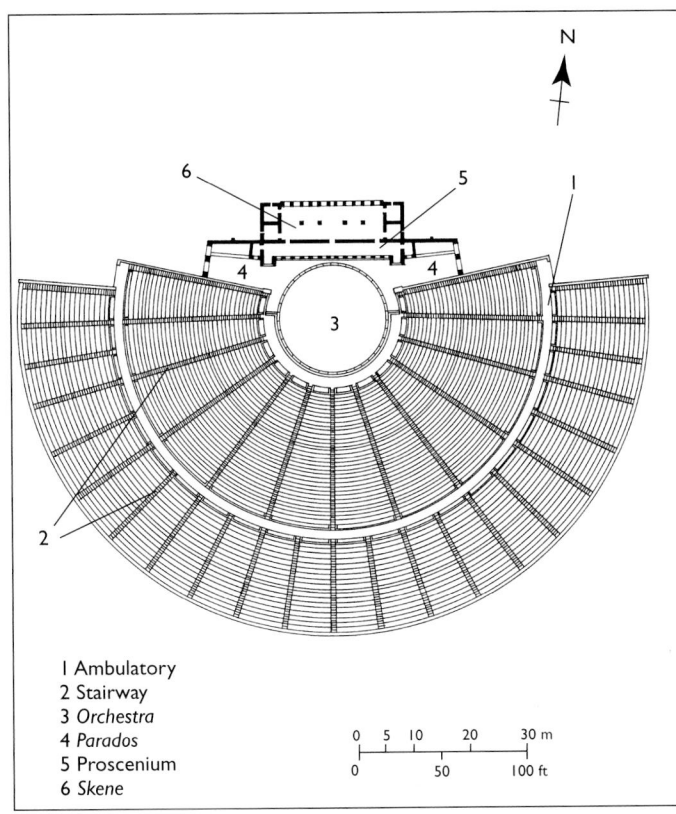

1 Ambulatory
2 Stairway
3 *Orchestra*
4 *Parados*
5 Proscenium
6 *Skene*

5.64 Plan of the theater at Epidauros.

The outdoor theater came into its own as an architectural form after the fifth century B.C. (see box). The best example is the theater at Epidauros (figs. **5.63** and **5.64**). It had a slightly more than semicircular seating area, with radiating stairways and a walkway a little more than halfway up—not unlike a modern sports arena. The auditorium was built around the *orchestra* (literally a place for dancing), a round space for the chorus where the action of the play unfolded. This was about 80 feet (24.38 m) in diameter and contained an altar dedicated to Dionysos.

Greek Theater

Greek theater originally grew out of rituals performed in honor of the wine god, Dionysos. The early theaters were hollow spaces in the hills, and in the fifth century B.C. these were developed to incorporate wooden benches arranged around an opening in a rock. Thus virtually embedded in nature, these theaters integrated drama with landscape. It was in such theaters—one was located below the Acropolis in Athens—that the great dramas by Aeschylos, Sophokles, and Euripides were performed. Greek theater began with a chorus of actors who sang and danced, and gradually individual roles performed by separate players emerged.

Sculpture

The leading Athenian sculptor of the Late Classical style was Praxiteles. A gentle S-shape, sometimes called the "Praxitelean curve," outlines the stance of Praxiteles' most famous statue, the *Aphrodite of Knidos* (fig. **5.65**), which is known only from Roman copies. The Aegean island of Kos originally commissioned the *Aphrodite* but rejected the finished work because of its nudity; the statue was then accepted by the Anatolian city of Knidos. Praxiteles' goddess has emerged from her bath and is shown standing beside a water jar (*hydria*). She picks up her garment with her left hand and, while the gesture of her right hand implies modesty, at the same time it calls attention to her nudity. Compared with Classical sculptures, the *Aphrodite* has slightly fleshier proportions and a heavier, fuller face.

More than any previous Greek sculptor, Praxiteles celebrated the female nude. In fact, it was with this work that the female entered the canon of beauty in Greek art, which had been restricted to the male nude. The *Aphrodite* was admired by the Knidians, who exhibited it in such a way that viewers could completely encircle it. Some later anecdotes emphasize the erotic qualities of the statue. Others emphasize its realism, relating, for example, that the goddess emerged from the waves off the coast of Anatolia to see her likeness. So astonished was she by its accuracy that she cried out, "Where did Praxiteles see me naked?"

Lysippos of Sikyon (near Corinth), who was famous for his portrayals of athletes and portraits of great men, was among the important Greek sculptors of the fourth century B.C. whose work survives mainly in Roman copies. He introduced a new, more naturalistic approach to representing the human figure. In so doing, he became the key artist in the transition from Late Classical to Hellenistic style. His genius brought him to the attention of Alexander the Great, who made him his court sculptor.

The Roman historian Pliny the Elder (see Chapter 7) distinguished between the canon of Polykleitos, exemplified by the *Doryphoros*

5.65 Praxiteles, *Aphrodite of Knidos*, c. 350 B.C. Marble; 6 ft. 8¾ in. (2.05 m) high. Musei Vaticani, Rome.

(see fig. 5.27), and the newer style of Lysippos. Whereas Polykleitos's figures were idealized youths, according to Pliny, Lysippos preferred thinner bodies, smaller heads, more detailed hair, and an increase in surface movement. The result was a taller, lighter appearance and a livelier stance. This, in Pliny's view, changed external form in the direction of greater emotional accuracy. It also took into account the position of the viewer in relation to the sculpture by opening up the space around its central axis. One effect of Lysippos's canon can be seen in the *Apoxyomenos* (literally, in Greek, "one scraping himself")—originally a bronze and now known only in a Roman marble copy (fig. **5.66**). It represents a victorious athlete scraping the oil off his arm with a strigil.

The two views illustrated in figure 5.66 show the turn in the athlete's body compared with the relaxed *Doryphoros*, who stands within a single vertical axis. Here there is more movement away from the center because of the wider opening between the legs and the outstretched arms. The athlete seems to swivel, which draws observers into his space and engages them with his action.

Lysippos's sculpture of Socrates—the example shown here is a statuette (see fig. 5.3)—corresponds to Plato's description of his teacher's character. Socrates is represented as if walking slowly and thinking deeply, his wrinkled brow conveying a pensive mood. He is known to have been considered ugly and faunlike, with a snub nose, flowing mustache and beard, small rounded shoulders, and a potbelly; yet it is an affectionate rendition. When this sculpture is juxtaposed with the *Apoxyomenos,* some idea of Lysippos's range of types and character becomes clear.

See figure 5.3. *Socrates,* 1st or 2nd century A.D.

5.66a, b Lysippos, *Apoxyomenos* (*Athlete with a Strigil*), Roman copy of a bronze original of c. 320 B.C. Marble; 6 ft. 9 in. (2.05 m) high. Musei Vaticani, Rome. According to Pliny, this sculpture was particularly admired by the Roman emperor Tiberius, who had it moved from the public baths to his bedroom but returned it after the Roman citizens protested their loss.

Fourth-Century Grave Stelae

A similar taste for individual characterization can be seen in the grave stelae of the Late Classical period (fig. **5.67**). Compared with the Stele of Hegeso (see fig. 5.29), the relief here is more deeply carved so that the deceased youth resembles a freestanding figure leaning against a marble wall. He has died in the prime of life, a loss accentuated by the sculptor through the youth's heroic form and the representation of the aged, grieving father at the right. The weeping boy seated on the steps at the left and the dog sniffing the ground add touches of pathos that became typical of Greek art in subsequent centuries.

The Late Classical style formed a transition between the idealized sculptures of the second half of the fifth century B.C. and the Hellenistic style. In Hellenistic art, idealism gave way to increasing melodrama, and new types of representation developed.

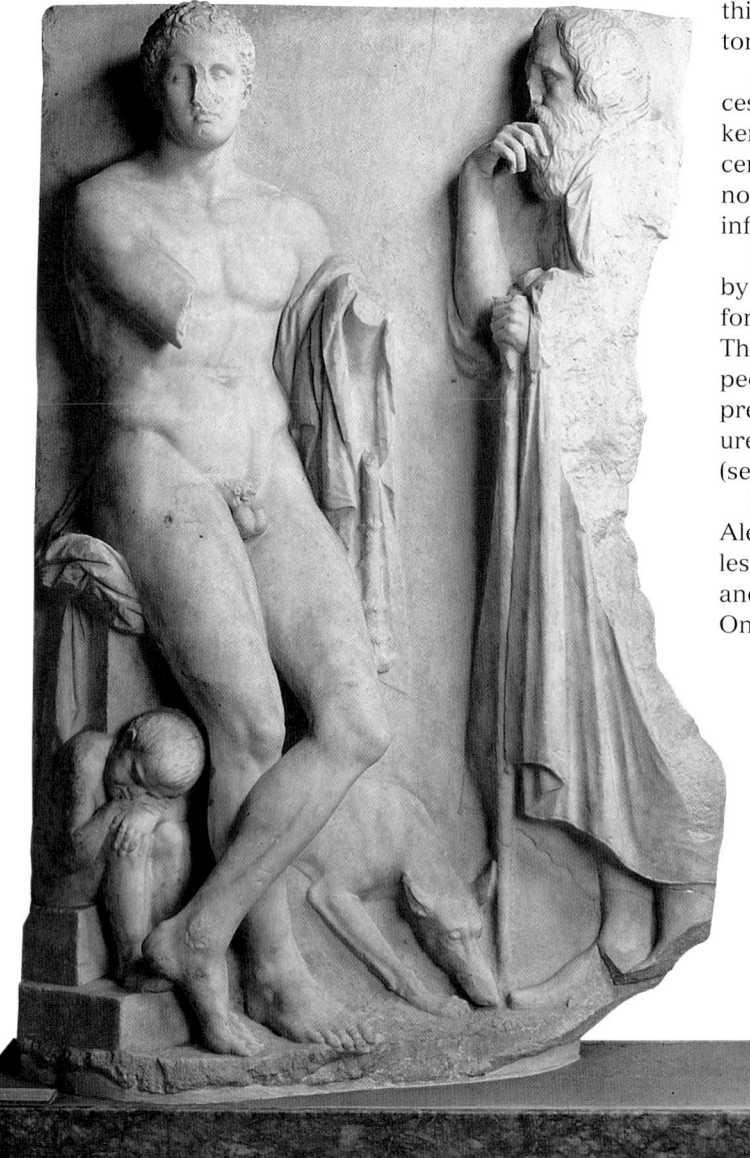

5.67 Attic grave stele, from near Athens, c. 350–330 B.C. Marble; 5 ft. 6 in. (1.68 m) high. National Archaeological Museum, Athens.

Hellenistic Sculpture (323–31 B.C.)

The Hellenistic period extended from the death of Alexander the Great (323 B.C.) to the beginning of the Roman Empire under Augustus, who assumed power in 31 B.C. and became emperor four years later (see Chapter 7). The term *Hellenistic* refers to the spread of Greek culture beyond Greece—especially to the East—as a result of Alexander's conquests.

When Philip II, king of Macedon, died in 336 B.C., his monarchy had already begun to dominate Greece. Within eleven years, his son Alexander had subjugated the rest of Greece and conquered Egypt, Phoenicia, Syria, and Persia (the latter in revenge for Xerxes' invasion of Greece). In 325 B.C., he pushed the limits of his kingdom to the Punjab, but rebellious troops forced his return westward. Wherever Alexander went, the process of Hellenization followed until it encompassed virtually the entire Middle East. But even though Greek culture was dominant during this period, it was exposed to diverse languages and customs and was therefore enriched by cross-fertilization.

Alexander died at the age of thirty-three. No single successor emerged after his death, and his kingdom was broken up into independent monarchies. During the second century B.C., European tribes invaded Greece from the north, and the Romans (see Chapter 7) began to exert their influence in Europe and the Mediterranean.

Hellenistic style continues the developments introduced by Lysippos and further expands the diversity of sculpture formally and iconographically as well as psychologically. There is an increase in portrait types, children and old people are represented, theatricality and melodrama express extremes of emotion, and the inner character of figures is conveyed through an emphasis on formal realism (see *Socrates*, fig 5.3).

Lysippos had established the official royal image of Alexander, but none of those portraits survives. Nevertheless, the type he created is known through descriptions and posthumous portraits of Alexander by later artists. One such example from the site of Pergamon in western

5.68a Head of Alexander, from Pergamon, c. 200 B.C. Marble; 1 ft. 4 in. (0.41 m) high. Archaeological Museum, Istanbul.

5.68b Alexander (side view of fig. 5.68a).

Turkey shows Alexander's slightly tilted head, as if he is gazing toward the heavens, with dreamy eyes, parted lips, fleshy facial texture, and a furrowed brow (fig. **5.68**). The wavy hair, brushed upward at the center of his forehead, became characteristic of Alexander's portraits (see fig. 5.16), and the general type was used in the Hellenistic period as a standard for all royal portraiture.

The full-length portrait of the orator Demosthenes by Polyeuktos, also a Roman copy, is an example of Hellenistic interest in character (fig. **5.69**). Demosthenes' life was beset by difficulties, including financial hardship and a speech impediment. He was a serious stutterer as a young man, but he trained himself to become the greatest public speaker in Athens. His political enemies succeeded in having him exiled from Athens on a trumped-up charge of corruption. In Polyeuktos's rendition, Demosthenes is an elderly, haggard man, with long, thin arms. His furrowed brow, concentrated gaze, and clenched fist convey extreme tension. The difficulties of his life are an integral part of the statue, which endows the portrait with a new, biographical accuracy.

The *Demosthenes* was one of several statues representing Athenian heroes opposed to the Macedonian rule of Athens that were set up in the *agora* (marketplace) of the city. Demosthenes was forced by the Macedonians to flee Athens. When he reached the island of Poros, he drank poison rather than submit to the enemy. An inscription on the base of the sculpture reads: "If your strength had equalled your resolution, Demosthenes, the Macedonian Ares [i.e., Alexander the Great] would never have ruled the Greeks."[2]

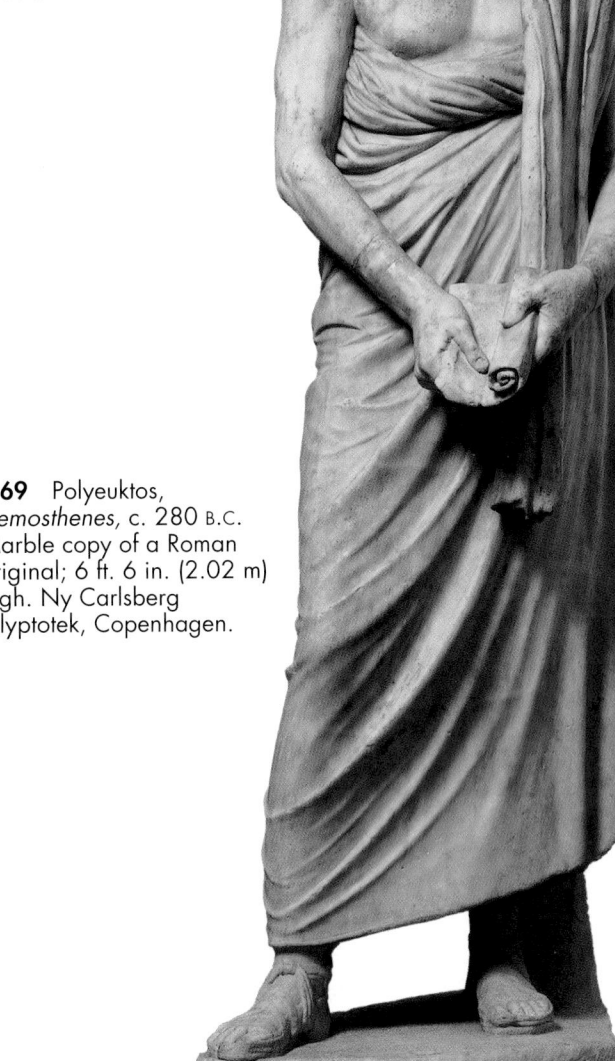

5.69 Polyeuktos, *Demosthenes*, c. 280 B.C. Marble copy of a Roman original; 6 ft. 6 in. (2.02 m) high. Ny Carlsberg Glyptotek, Copenhagen.

The outstretched wings and swirling clothes of the *Winged Victory* from Samothrace (fig. **5.70**) evoke the pressure of the wind as she descends from the heavens on the prow of a ship to commemorate a naval victory. The wind whips her garment with a sense of movement more activated than in Classical sculpture, and her wings are outspread in triumph. The forward diagonal of her torso seems forced against the elements, and the position of her wings suggests that they have not yet settled. Adding to the sense of movement are the drapery masses sweeping across the front of the body, which are contrasted with the seemingly transparent drapery at the torso. The more deeply cut folds also increase the areas of shadow in the skirt swirling around her legs, making it appear darker as well as heavier than the drapery covering the torso. From the side, the diagonal planes of the body and of the outspread wings come into view.

Another type of Hellenistic sculpture can be seen in the marble *Aphrodite of Melos*, also known as the *Venus de Milo* (fig. **5.71**). This is a kind of revival style, for

5.70 (left) *Winged Nike* (*Winged Victory*), from Samothrace, c. 190 B.C. Marble; approx. 8 ft. (2.44 m) high. Louvre, Paris. The shifting spatial thrusts of the Nike are characteristic of the new Hellenistic command of form and motion in space.

5.71 (right) *Aphrodite of Melos* (also called *Venus de Milo*), c. 150–125 B.C. Marble; height 6 ft. 10 in. (2.08 m). Louvre, Paris.

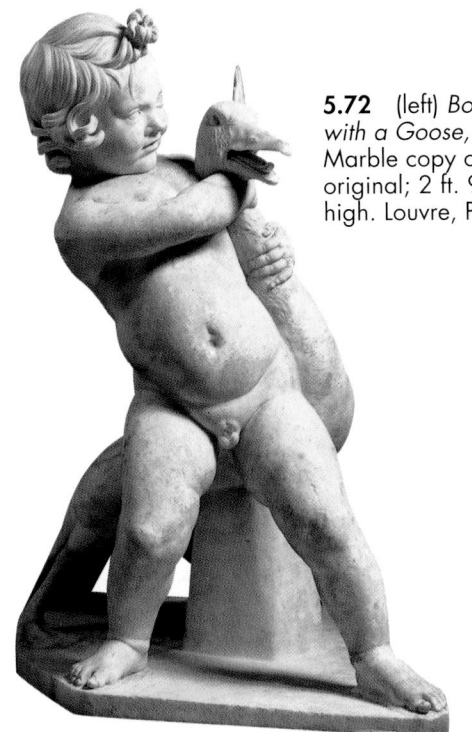

5.72 (left) *Boy Wrestling with a Goose*, c. 150 B.C. Marble copy of a Roman original; 2 ft. 9½ in. (0.85 m) high. Louvre, Paris.

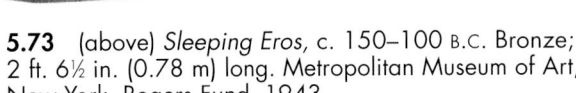

5.73 (above) *Sleeping Eros*, c. 150–100 B.C. Bronze; 2 ft. 6½ in. (0.78 m) long. Metropolitan Museum of Art, New York. Rogers Fund, 1943.

the figure recalls the sensual females carved by Praxiteles in the Late Classical period (see fig. 5.65). The proportions are fleshier than Classical-style proportions, and the draperies reveal the shape and movement of the bent leg. In addition, the sharp *contrapposto* and pronounced S-shaped curve echo those of Praxiteles' *Aphrodite of Knidos.*

Hellenistic sculptures of children show a variety of types that reflects the new approach to realism. The *Boy Wrestling with a Goose,* for example, is a study in contained energy locked in conflict (fig. **5.72**). He is depicted as a naturalistic toddler, with baby fat and childlike proportions. His stance is slightly precarious, as he leans backwards while strangling the goose. The repeated diagonals and open spaces draw viewers into the work and lead them to the formal climax of the struggle—the juxtaposition of the boy's head with that of the goose.

By contrast, the bronze sculpture of the *Sleeping Eros* depicts relaxation (fig. **5.73**). The god's weight lies heavily on the slanted surface of his support, and his arm hangs limply in response to the force of gravity. Although Eros twists at his waist and the diagonals open up spaces, all the tension of the wrestling boy is gone.

The bronze *Boxer* from around the turn of the first century B.C. reveals the ravaging effects of this violent sport (fig. **5.74**). His face, turned awkwardly over his right shoulder, is covered with scars. He wears the leather knuckle straps worn by Greek boxers which inflicted serious injury on their opponents. He himself has a broken nose and teeth, as well as cauliflower ears from years of being hit. His arms are still muscular, but his ribs are beginning to protrude from his chest, indicating the sagging flesh of age. Neither the function nor the context of this

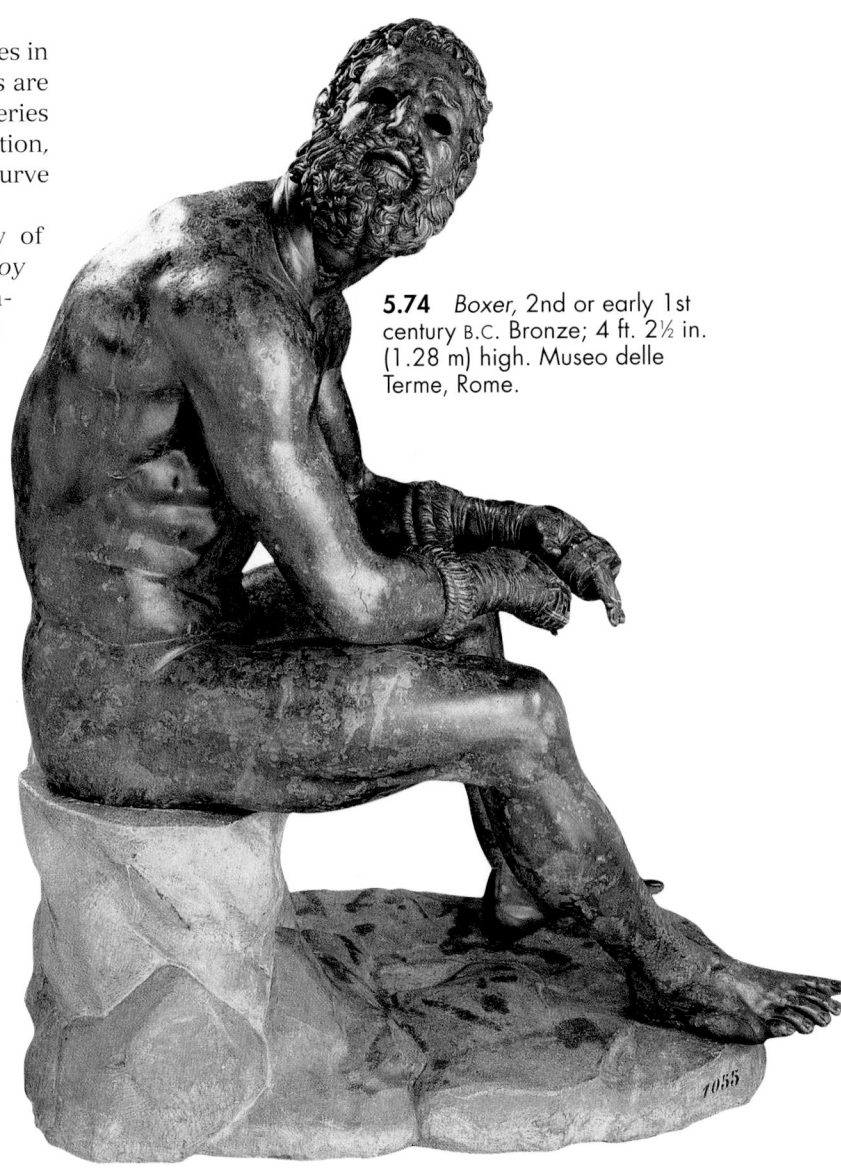

5.74 *Boxer,* 2nd or early 1st century B.C. Bronze; 4 ft. 2½ in. (1.28 m) high. Museo delle Terme, Rome.

figure is known, but it shows—in a realistic, rather than an idealized, way—a man who has weathered a lifetime of fighting.

The Hellenistic interest in melodramatic pathos is again evident in the sculptural group of *Laocoön and His Two Sons* (fig. **5.75**), a Roman adaptation of a Hellenistic work. It depicts an incident from the end of the Trojan War in which Laocoön and his sons are devoured by a pair of serpents (see box). The choice of such a moment lends itself to the Hellenistic taste for violent movement. The zigzags and strenuous exertions of the human figures are bound by the snakes winding around them.

In the *Laocoön,* Classical restraint and the symmetry of the Parthenon sculptures have been abandoned. There is extra weight to the left as the tail of the snake encircles and pins down Laocoön's right arm. A counterbalancing diagonal is produced by the sharp turn of his head and is repeated by the leg, torso, and head of the boy on the right. In contrast to the Classical *Wounded Amazon* of Polykleitos (fig. 5.28), Laocoön and his children express pain through facial contortion and physical struggle—bulging muscles, veins, flesh pulled taut against the rib cage.

In the Great Altar of Zeus erected at Pergamon (fig. **5.76**), the Hellenistic taste for emotion, energetic movement, and exaggerated musculature is translated into relief sculpture. The two friezes on the altar celebrated the city and its superiority over the Gauls, who were a constant threat to the Pergamenes. Inside the structure, a small frieze depicted the legendary founding of Pergamon.

The Trojan Horse

According to a lost Homeric epic, the Greeks constructed a colossal wooden horse and filled it with armed soldiers. They tricked the Trojans into believing it was an offering to Athena that the Trojans should take inside their city walls. Laocoön, a Trojan seer, warned the Trojans that he did not trust the Greeks, "even bearing gifts." Thereupon, Athena sent two serpents to kill the seer and his children. The Trojans took this as a sign that Laocoön was not to be believed and accordingly opened their gates and pulled in the horse. The Greek soldiers emerged, let in the rest of the Greek army, and sacked Troy. References to the story are also found in the *Odyssey* (IV.271, VIII.492, XI.523).

Outside, the traditional depiction of the gods fighting the Titans was transformed. In a detail illustrating Athena's destruction of Alkyoneus (fig. **5.77**), a son of the Titan earth goddess Gaia (Apollo's predecessor at Delphi) (see p. 138), the energy inherent in the juxtaposed diagonals seems barely contained. This mythical battle between pre-Greek Titans and Greek Olympians recurs in Hellenistic art partly as a result of renewed political threats to Greek supremacy. But unlike the Classical version on the Parthenon metopes, that at Pergamon is full of melodrama, frenzy, and pathos.

King Attalos I defeated the powerful Gauls, who invaded Pergamon in 238 B.C. This victory made Pergamon a major political force. Later, under the rule of Eumenes II (197–c. 160 B.C.), the monumental altar dedicated to Zeus was built to proclaim the victory of Greek civilization over the barbarians. Greece tried to reassert its superiority, as Athens had done in building the Parthenon following the Persian Wars. But Hellenistic art, especially in its late phase, reflects the uncertainty and turmoil of the period. By the end of the first century B.C., the Romans were in complete control of the Mediterranean world, and, with the ascendancy of Augustus in 31 B.C., the scene was set for the beginning of the Roman Empire.

Compared with the art of the other Mediterranean cultures we have surveyed, Greek art stands out for its prime concern with the expression of what is human. This is equally reflected in the science, philosophy, government, literature, theater, and religion of ancient Greece. As far as one can tell from surviving texts, the Greeks were the first in the West to write historically about art and artists. Of the Greek styles covered in this chapter, it is the Classical style that has had the most lasting impact on Western art and thought. The very notion of "Classical" has set a standard to which Western artists have responded in various ways. Subsequent styles, as well as individual artists, can be seen as both continuing the Classical tradition and rebelling against it. In either case, indifference to the Classical achievements was—and remains—virtually impossible.

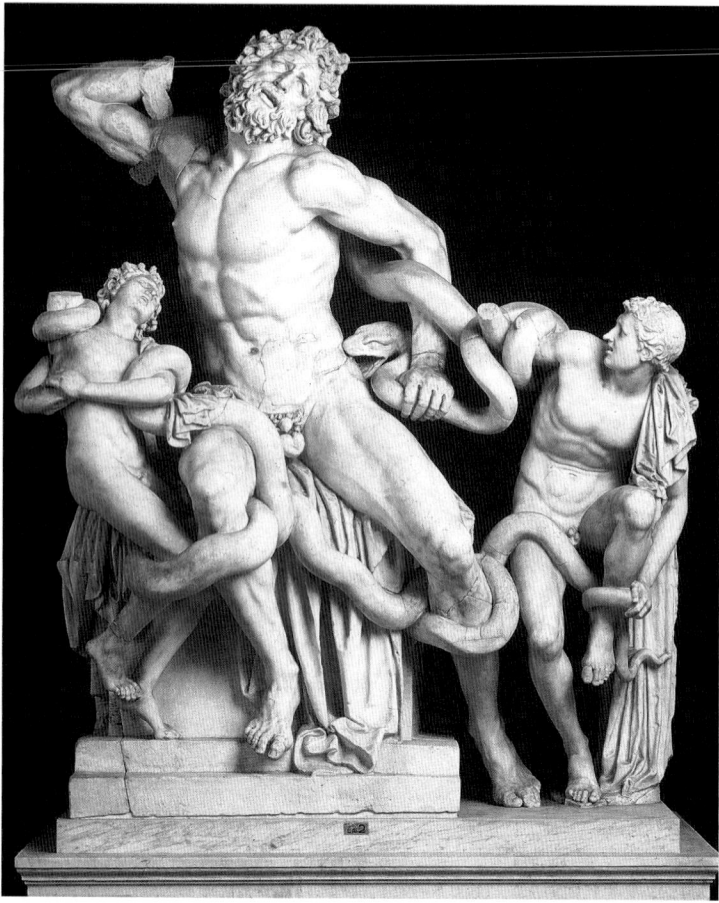

5.75 *Laocoön and His Two Sons.* Marble; 7 ft. (2.13 m) high. Musei Vaticani, Rome. The figures of Laocoön and his son on the viewer's left are 1st-century-A.D. Roman copies of a Hellenistic statue. The boy on our right is a Roman addition.

5.76 Great Altar of Zeus, west front, reconstructed and restored, from Pergamon, c. 180 B.C. Marble; height of the frieze, 7 ft. 6 in. (2.29 m). Pergamonmuseum, Berlin. The altar originally stood within the elaborate enclosure, in the open air, reminding the viewer of Zeus' role as supreme ruler of the sky.

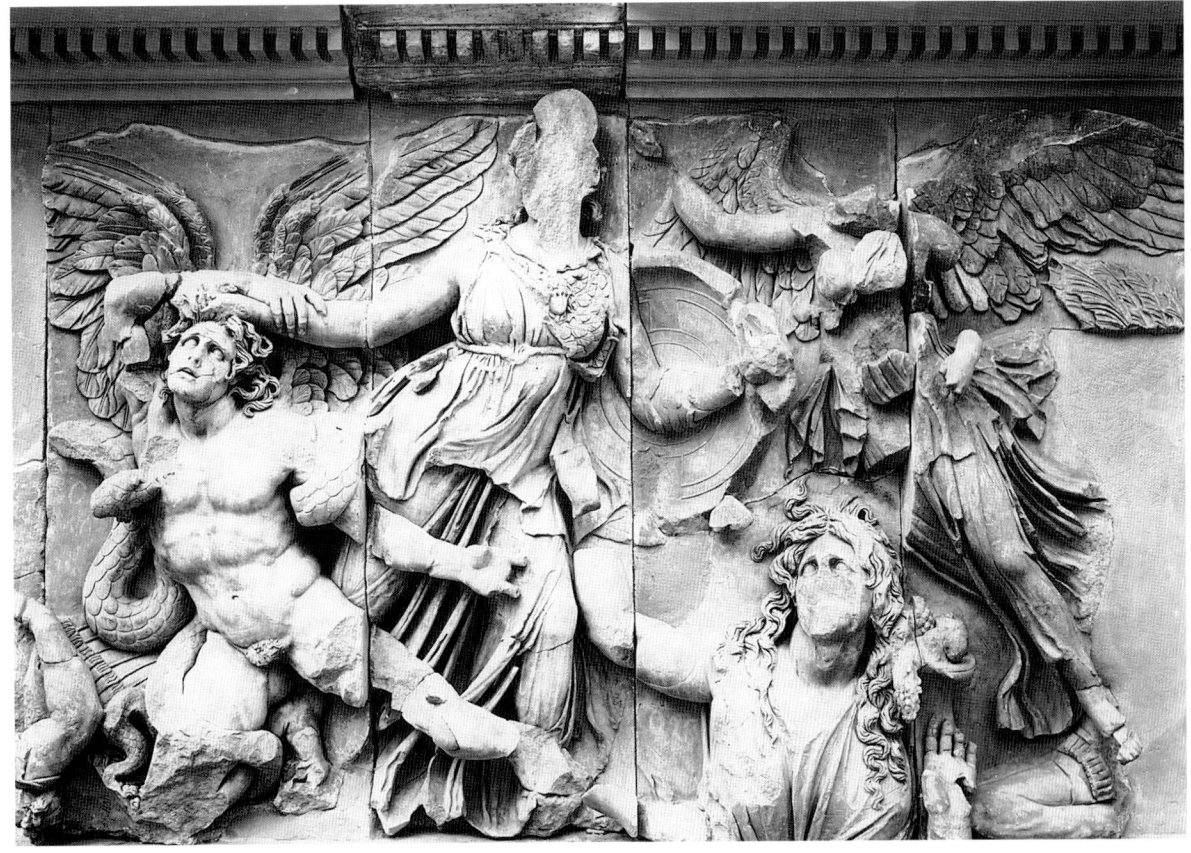

5.77 *Athena Battling with Alkyoneus,* from the great frieze of the Pergamon altar, east section, c. 180 B.C. Marble; 7 ft. 6 in. (2.29 m) high. Antikensammlung, Staatliche Museen, Berlin.

Summary of Greek Style and Techniques

Vase Painting
Geometric (c. 1000–700 B.C.)
Orientalizing (c. 700–600 B.C.)
Black-Figure (c. 600–480 B.C.)
Red-Figure (c. 530–400 B.C.)
White-Ground (begins c. 420 B.C.)

Monumental Sculpture
Orientalizing (c. 700–600 B.C.)
Archaic (c. 600–480 B.C.)
Early Classical (c. 480–450 B.C.)
High Classical (c. 450–400 B.C.)
Late Classical (c. 400–323 B.C.)
Hellenistic (c. 323–31 B.C.)

Style/Period	Works of Art	Cultural/Historical Developments

GEOMETRIC
c. 1000–700 B.C.

Terrace of the Lions

Geometric *amphora* (**5.4**)

Geometric *amphora*

Development of heroic legend in Greece: Homer's poems (*Iliad* and *Odyssey*) put into present form (8th century. B.C.)
Etruscans settle central Italy (c. 900–700 B.C.)
Adoption of Phoenician alphabet by Greeks (c. 800 B.C.)
Traditional date for beginning of Olympic Games (776 B.C.)
First Greek colony on Italian mainland (Cumae) (750 B.C.)

ORIENTALIZING
c. 700–600 B.C.

Athenian *amphorae* (**5.5, 5.6, 5.9**)
Terrace of the Lions (**5.18**), Delos

Circumnavigation of Africa by Phoenicians (c. 600 B.C.)
Coins used as units of currency imported from Asia Minor into Greece (c. 650 B.C.)

ARCHAIC
c. 600–480 B.C.

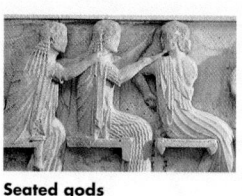

Achilles and Ajax

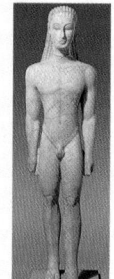

New York Kouros

New York Kouros (**5.19**), Attica
Cheramyes Master, *Hera of Samos* (**5.20**), Samos
Temple of Apollo (**5.31**), Corinth
Exekias, *Achilles and Ajax Playing a Board Game* (**5.7**)
Siphnian Treasury (**5.32–5.33**), Delphi
Temple of Apollo (**5.1**), Delphi
Peplos Kore (**5.21**)
Exekias, *Achilles and Penthesilea* (**5.9**)

Seated gods

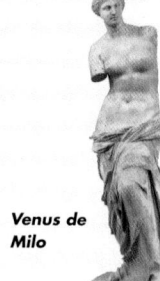

Venus de Milo

Solon's reforms in Athens (593 B.C.)
Thales of Miletus, beginning of natural philosophy (585 B.C.)
Pythagoras, Greek mathematician and philosopher (581–497 B.C.)
Pisistratos tyrant of Athens (560 B.C.)
Cyrus of Persia gains control of Media (550 B.C.)
Persians conquer Asia Minor (546 B.C.)
Roman Republic established (509 B.C.)
First democratic government established in Greece (510–508 B.C.)
Persian Wars (499–449 B.C.); Ionian cities revolt from Persia with aid of Athens (499 B.C.); Athenians defeat Persians at Battle of Marathon (490 B.C.)
Use of lost-wax process begins in Greece (6th century B.C.)

EARLY CLASSICAL
c. 480–450 B.C.

Berlin Painter, *Abduction of Europa* (**5.10**)
Kritios, *Kritios Boy* (**5.22**)
Myron, *Diskobolos* (**5.25**)
Temple of Zeus (**5.36–5.44**), Olympia
Penthesilea Painter, *Achilles and Penthesilea* (**5.11**)
Niobid Painter, *kalyx krater* (**5.12–5.13**)
Poseidon/Zeus (**5.24**)
Warrior from Riace (**5.26**), Reggio Calabria

Herodotos, the "father of history" (c. 485–424 B.C.)
Aeschylos, *Oresteia* (458 B.C.)
Beginning of Perikles' dominance (458 B.C.)
Age of Greek drama: Aeschylos (523–456 B.C.), Sophokles (496–406 B.C.), Euripides (c. 480–406 B.C.), Aristophanes (c. 450–c. 385 B.C.)

CLASSICAL
c. 450–400 B.C.

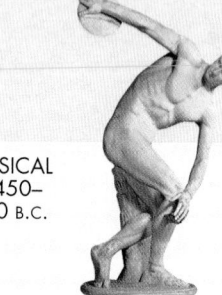

Diskobolos

Reed Painter, *Warrior by a Grave* (**5.14**)
The Parthenon (**5.47, 5.50–5.58**), Athens
Polykleitos, *Doryphoros* (**5.27**)
Polykleitos, *Wounded Amazon* (**5.28**)
Temple of Athena Nike (**5.59–5.60**)
The Erechtheum (**5.61–5.62**), Acropolis, Athens
Stele of Hegeso (**5.29**)

Hippokrates, Greek physician, the "father of medicine" (c. 460–c. 377 B.C.)
Demokritos, Greek philosopher and scientist who developed an atomic theory of the universe (c. 460–c. 370 B.C.)
Age of Classical Greek philosophy: Socrates (470–399 B.C.), Plato (c. 428–348 B.C.), Aristotle (384–322 B.C.)
Beginning of the Parthenon (448 B.C.)

LATE CLASSICAL
c. 400–300 B.C.

Theater (**5.63**), Epidauros
Praxiteles, *Aphrodite of Knidos* (**5.65**)
Attic grave stele (**5.67**)

The Peloponnesian War; Athens defeated by Sparta; Spartan hegemony in Greece (404–371 B.C.)
Trial and death of Socrates (399 B.C.)
Plato, *The Republic* (c. 380–360 B.C.)
Alexander the Great conquers Egypt, Palestine, Phoenicia, and Persia (333–331 B.C.)

HELLENISTIC
323–31 B.C.

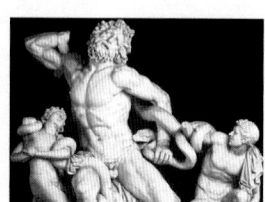

Laocoön and His Two Sons

Lysippos, *Apoxyomenos* (**5.66**)
Lysippos, *Socrates* (**5.3**)
Polyeuktos, *Demosthenes* (**5.69**)
Battle of Issos (**5.15**)
Head of Alexander (**5.68**), Pergamon
Winged Nike (**5.70**), Samothrace
Aphrodite of Melos (**5.71**)
Boy Wrestling with a Goose (**5.72**)
Sleeping Eros (**5.73**)
Bronze Boxer (**5.74**)
Laocoön and His Two Sons (**5.75**)
Altar of Zeus (**5.76–5.77**), Pergamon

Death of Alexander the Great (323 B.C.)
Euclid, *Elements of Geometry* (300 B.C.)
The Colossus of Rhodes (290 B.C.)
Archimedes, Greek mathematician (287–212 B.C.)
Heyday of Alexandria (Egypt) as the center of the new Hellenistic culture (275–215 B.C.)

Sleeping Eros

1000 B.C. 700 B.C. 500 B.C. 450 B.C. 300 B.C.

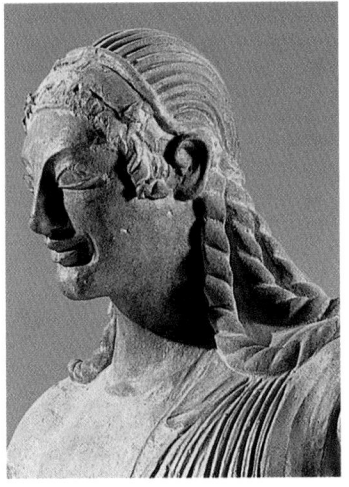

6

The Art of the Etruscans

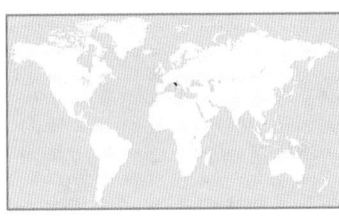

The civilization of the Etruscans, which flourished between c. 1000 and 100 B.C., was contemporary with the Greek culture discussed in the previous chapter. The Etruscans are important in Western history in their own right and because of their relationship to Greece and Rome. Their homeland, Etruria (modern Tuscany), occupied the west-central part of the Italian peninsula. It was bordered on the south by the river Tiber, which runs through Rome, and on the north by the Arno (see map).

The Greeks called the Etruscans Tyrrhenians, after whom the sea was named, and the Romans called them Tusci or Etrusci. Like the Greeks, the Etruscans never formed a single nation but coexisted as separate city-states with their own rulers. Unlike the Romans, they never established an empire.

Although Herodotos thought that the Etruscans had come from Lydia, in modern Turkey, scholars now believe that they were indigenous to, or at least developed their civilization in, Italy. They lived as a distinct group of people whose culture contributed to, and benefited from, the larger Mediterranean world. From the seventh to the fifth century B.C.—the period of their greatest power—the Etruscans controlled the western Mediterranean with their fleet and were an important trading nation. They rivaled the Greeks and the Phoenicians, and established commercial trade routes throughout the Aegean, the Near East, and North Africa. At the same time, the Etruscans were largely responsible for extending Greek influence to northern Italy and Spain.

The Etruscan language resembles none other that is presently known, and its origin is uncertain. The alphabet was taken from Greek in the seventh century B.C. In contrast to Greek script but similar to Phoenician (from which the Etruscan alphabet, like the Greek, ultimately derives), Etruscan is written from right to left. Etruscan literature—

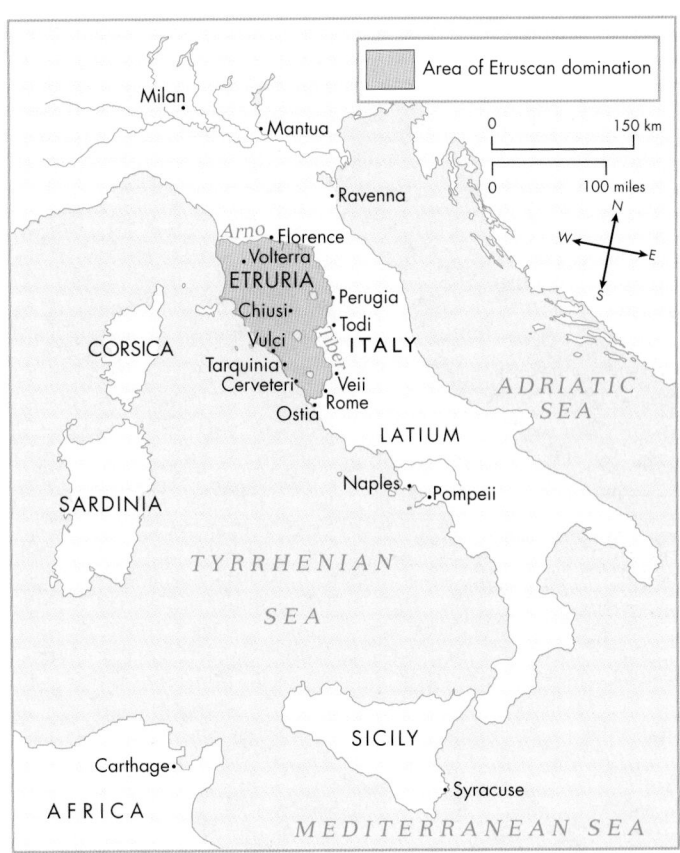

Etruscan and Roman Italy.

which, according to Roman sources, was rich and extensive —has all but disappeared. The writing that has survived is mostly in the form of epitaphs on graves or religious texts. Only a few Etruscan words, most of which are names and inscriptions, have been deciphered.

Our major source of information about the Etruscans comes from the tombs and *necropoleis,* which the Romans left undisturbed and which are buried under modern Italian towns. Most of these were carved out of rocky ground,

especially in the south, and their contents provide by far the richest examples of Etruscan art. Very few Etruscan buildings have survived, partly because of the nature of the materials used—wood, mud, and tufa (see box). There are some remains of fortifications and urban organization, with streets arranged in a grid pattern.

Architecture

Greece was the inspiration for large-scale architecture in Etruria. The idea of erecting temples within open-air sanctuaries and sacred precincts came from Greece, and remains of temple foundations indicate that Etruscan plans were based on Greek prototypes. Late Archaic Etruscan temples, however, are distinct from the Greek in having gabled porches but not pediments. Etruscan architects used **wattle and daub** construction for the superstructure by reinforcing branches (wattle) with clay and mud (daub). Stone was used only for the podium. Roofs were tiled, and decorative sculpture was made of terra-cotta. Greek Archaic architecture, as well as the aristocratic social order, was favored in Etruria, where it lasted into the fifth century B.C.

The temple of Apollo at Veii (fig. **6.1**) has been reconstructed according to Etruscan temple proportions described by the Roman architect and engineer Vitruvius (see box) of the Augustan period (30 B.C.–A.D. 14). In addition to the plan, the Etruscans incorporated the Greek wooden roof and *pronaos*. In contrast to those in Greek temples, however, these are set on a high podium rather than on steps, and the side walls are solid. This arrangement emphasizes the entrance wall as being at the front of the temple, whereas the Greek use of colonnaded walls minimizes the distinction between front and sides. It also gives Etruscan temples a heavier, more massive quality than their Greek counterparts.

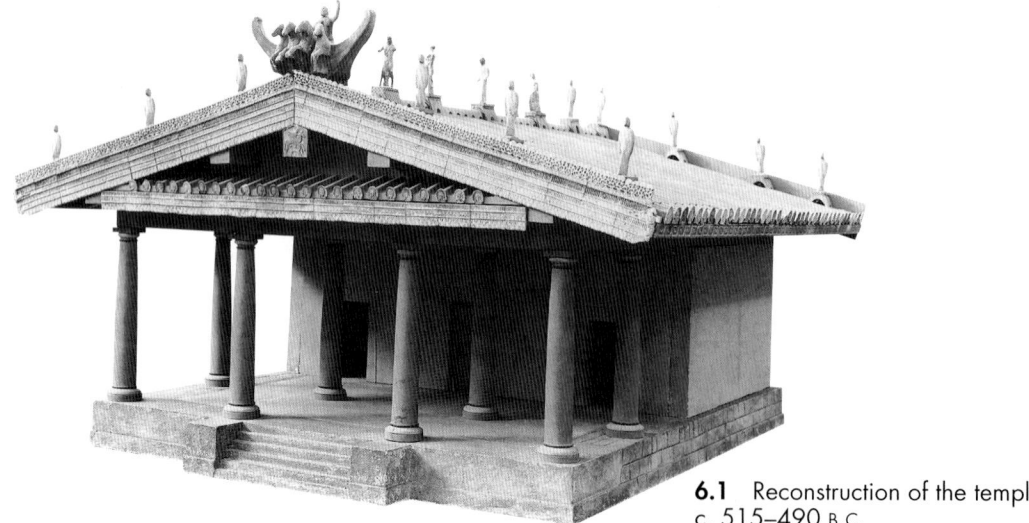

6.1 Reconstruction of the temple at Veii, c. 515–490 B.C.

Pottery and Sculpture

In the Iron Age (Villanovan period, named for the site near modern Bologna in northern Italy), the Etruscans had elaborate burials that included objects of iron, bronze, and ivory. The Etruscans adopted—and adapted—such Greek social customs as the *symposium* (drinking party) and the practice of banqueting in a reclining position. For these functions they imported thousands of Greek vases. Etruscan tombs have yielded most of these imported Greek black- and red-figure vases, which were important sources of Greek pictorial style in Italy. Scenes and characters from Greek mythology liberally populate Etruscan imagery. A particularly rich source for these images appears in engravings on the backs of bronze mirrors, which were an Etruscan specialty (see fig. 6.6).

The few surviving examples of Etruscan sculpture indicate a thriving industry in bronze. Like the Greeks, Etruscan artists cast bronze by the lost-wax method. The statue of a nursing she-wolf of around 500 B.C., the so-called *Capitoline Wolf*, captures the aggressive anger of a mother protecting her cubs (fig. **6.2**). She turns and becomes tense, as if suddenly startled, and bares her teeth at an unseen intruder. The stylized patterns of fur, especially around the neck, have affinities with Greek Archaic style.

The bronze *Wounded Chimera* from the fourth century B.C. depicts the mythological monster with a lion's body, a serpent's tail, and a goat's head—here emerging from the back (fig. **6.3**). The figure originally belonged to a group showing the Greek hero Bellerophon, who rode the winged horse Pegasus and killed the Chimera. Its pose convincingly indicates a readiness to spring toward an adversary. The hair along the spine literally stands on end; fear is

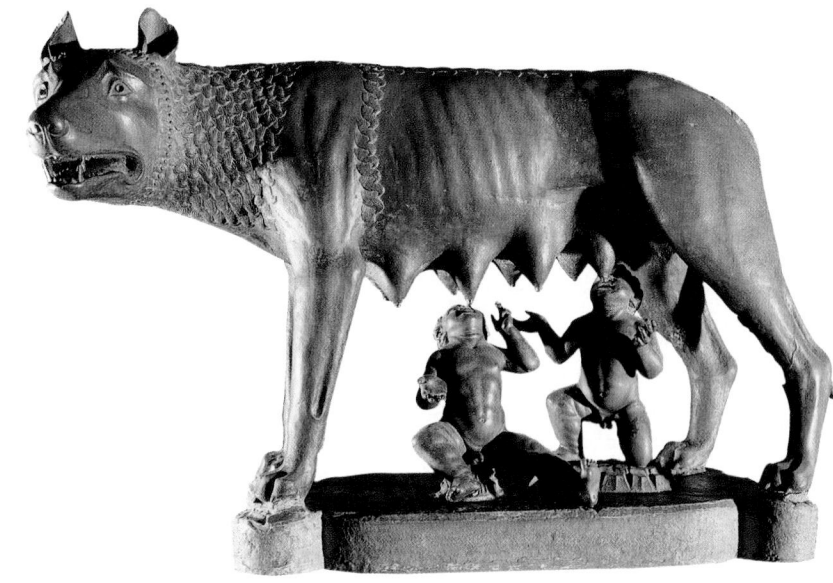

6.2 *Capitoline Wolf,* c. 500 B.C. Bronze; 2 ft. 9½ in. (85.1 cm) high. Museo Capitolino, Rome. The popular association of this statue with the tale of Romulus and Remus, the legendary founders of Rome, prompted the Renaissance addition of the human twins seen here. In ancient Rome, a live wolf kept on the Capitoline Hill reminded citizens of the legend. And, according to the orator and statesman Cicero, a statue similar to this one was also displayed in antiquity, but it was destroyed by lightning. The image of a wolf nursing Romulus and Remus remains the symbol of Rome today. In the context of Etruscan art, the wolf was intended as a protective guardian.

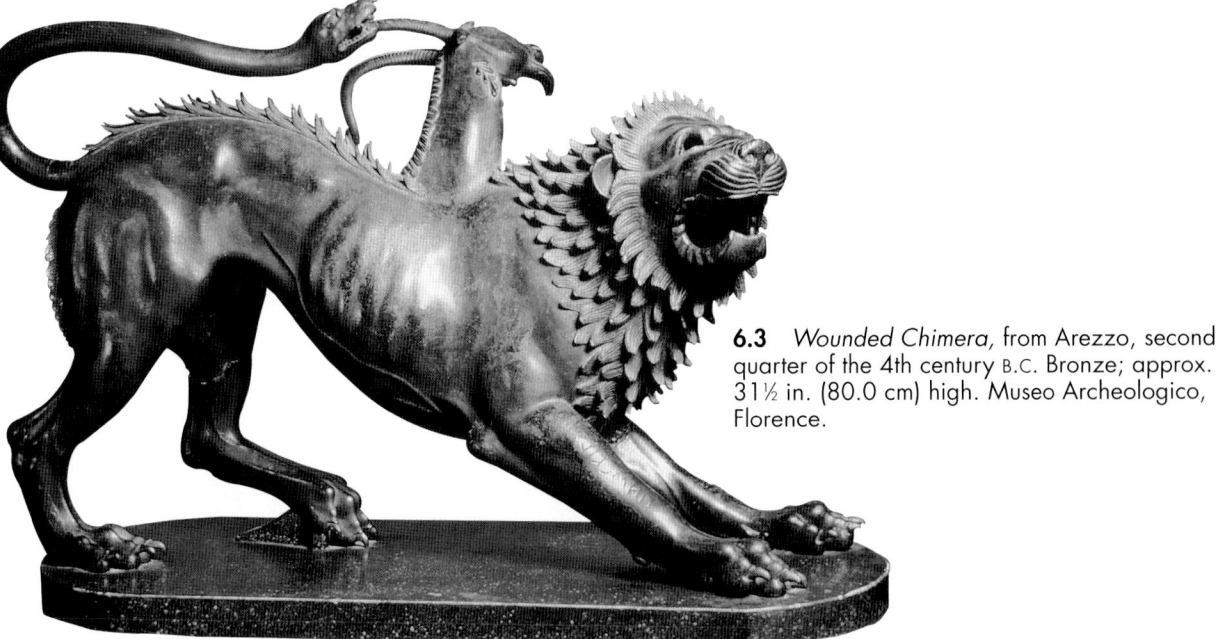

6.3 *Wounded Chimera,* from Arezzo, second quarter of the 4th century B.C. Bronze; approx. 31½ in. (80.0 cm) high. Museo Archeologico, Florence.

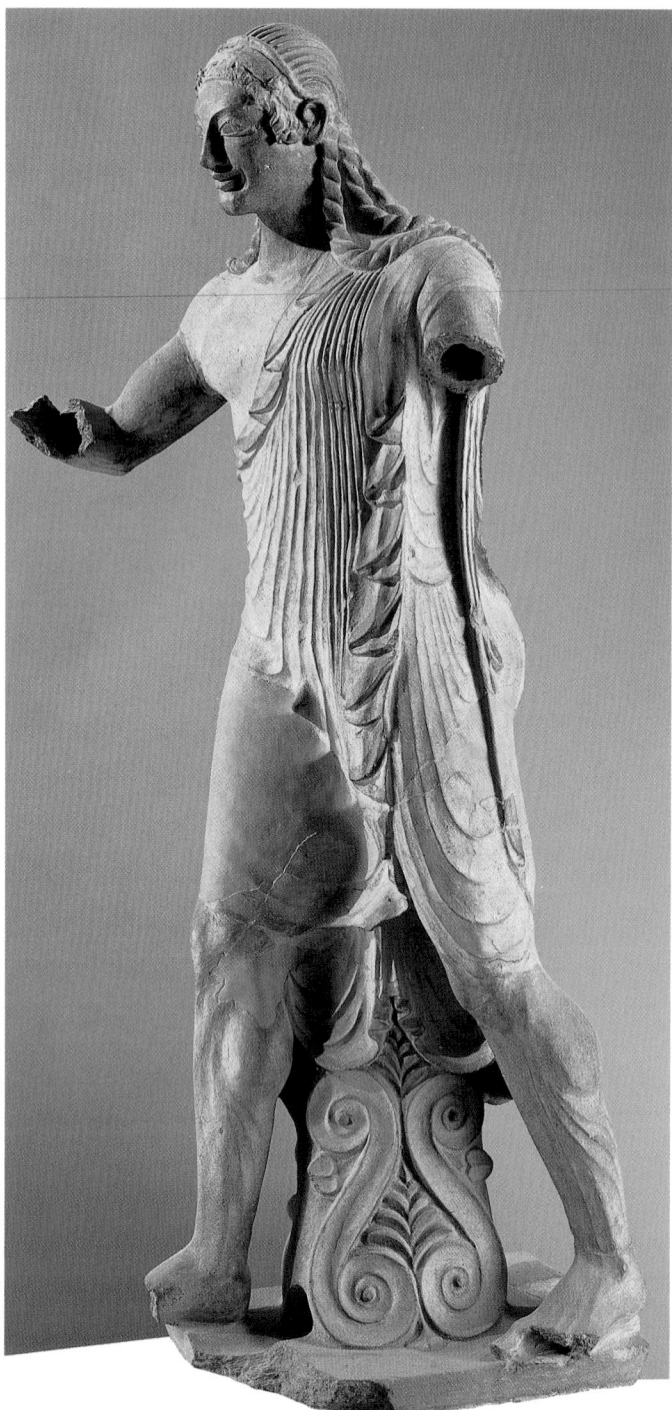

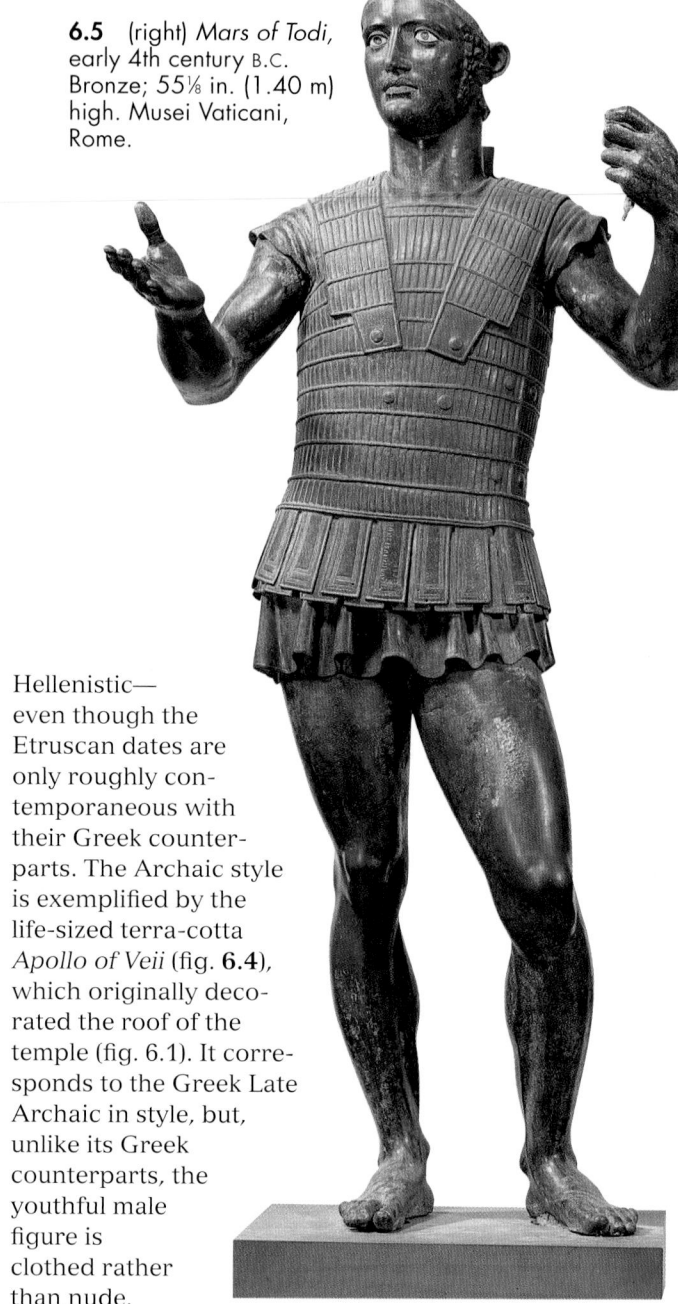

6.5 (right) *Mars of Todi*, early 4th century B.C. Bronze; 55⅛ in. (1.40 m) high. Musei Vaticani, Rome.

6.4 *Apollo of Veii*, from Veii, c. 515 B.C. Painted terra-cotta; approx. 5 ft. 10 in. (1.78 m) high. Museo Nazionale di Villa Giulia, Rome. Terra-cotta was a favorite Etruscan material for sculpture. It was modeled while still wet, and the smaller details were added with hand tools. In this statue, Apollo's energetic forward stride reflects the Etruscan interest in gesture, motion, and posture.

suggested through the open mouth, turned head, and raised eyebrows. The Archaic stylizations, especially the mane and whiskers, are similar to certain Achaemenid motifs (see Chapter 2) and hark back to the Near East.

To a considerable extent, the development of Etruscan art paralleled that of Greece, and the same terms are used to designate stylistic categories—Archaic, Classical, and

Hellenistic— even though the Etruscan dates are only roughly con- temporaneous with their Greek counter- parts. The Archaic style is exemplified by the life-sized terra-cotta *Apollo of Veii* (fig. **6.4**), which originally deco- rated the roof of the temple (fig. 6.1). It corre- sponds to the Greek Late Archaic in style, but, unlike its Greek counterparts, the youthful male figure is clothed rather than nude.

The *Apollo* has some organic form (around the chest, for example), but the curvilinear stylizations and flat surface patterns of the drapery folds are more characteristic of Archaic. The same is true of the diagonal calf muscles fanning out from below the knees, with the lines on top of the feet suggest- ing that the toes continue to the ankles. The stylized hair, arranged in long locks, and the smile also belong to Greek Archaic convention. Despite the Greek influence on the *Apollo,* however, the sharp clarity of its forms and styliza- tions, as well as its determined stride, is characteristic of the forcefulness of early Etruscan art.

Closer to Greek Classical style is the bronze *Mars of Todi* (fig. **6.5**), dating from the early fourth century B.C. Named for the site of its discovery at Todi, north of Rome, it is the only nearly life-sized Etruscan bronze known from

before the second century B.C. Although later than the Greek Classical period, the *Mars* has certain affinities with the *Spear Bearer* (see fig. 5.27), especially its *contrapposto* pose. The figure represents a warrior (hence the designation Mars, after the Roman god of war). He wears a leather cuirass (breastplate) and a tunic, and he holds a libation bowl in his right hand and the remnant of a lance, on which he probably leaned, in his left. The rendering of the anatomy is organic, but the pose seems self-consciously animated compared with the relaxed pose of the *Spear Bearer,* and the anatomy is not unified as it is in Greek Classical sculpture.

Women and Etruscan Art

The Etruscans differed from the Greeks in their attitude toward women. Judging from Etruscan art, Etruscan women participated more in public life with their husbands and held higher positions than in ancient Greece—a state of affairs of which the patriarchal Greeks heartily disapproved. Wealthy Etruscan women were also unusually fashion-conscious and wore elaborate jewelry commensurate with their rank.

The abundance of bronze mirrors that have been excavated from Etruria were used exclusively by women (fig. **6.6**)—a conclusion based on the fact that mirrors are found only in the graves of women. They were typically decorated with mythological scenes, and their inscriptions indicate that the women to whom they belonged were literate. Etruscan artists frequently depicted myths in which women dominate men by being older, more powerful, or higher in divine status. The scene illustrated here shows the adult Herakles being breastfed by the goddess Uni, the Etruscan equivalent of Hera, in the presence of male and female divinities.

6.6a, b Scene and diagram from the back of a mirror from Volterra showing Uni (Hera) nursing Herakles in the presence of other gods, c. 300 B.C. Engraved bronze. Museo Archeologico, Florence. The Greek version of the myth illustrated here is known only from literature and does not appear in Greek art. It recounts the story of Zeus deceiving Hera into nursing—as a sign of acceptance and adoption—his son Herakles (meaning "the glory of Hera") by the mortal woman Alkmene. But Hera pulled away, and the milk from her breast spurted into the heavens, creating the Milky Way. In the Etruscan version, which is also represented on two other mirrors, Uni willingly nurses Herakles (Hercle in Etruscan). The fact that he is an adult reflects his acceptance into the pantheon of the gods and his attainment of immortality. Two gods, Aplu (the Etruscan Apollo) and Nethuns (the Etruscan Neptune), and two unidentified goddesses witness the initiation ritual. Behind Uni, another witness holds up a tablet with the inscription "This shows how Hercle became Uni's son." The satyr at the top of the mirror drinks wine—the antithesis of milk in Etruscan religion.

Funerary Art

The Etruscans clearly believed in an afterlife that was closer to the Egyptian concept than to the Greek, but it is not known what their view of that afterlife was. It seems to have been as materialistic as in ancient Egypt, since items used in real life such as mirrors, jewelry, weapons, and banquet ware accompanied the deceased. Of particular importance in the Etruscan view of death was the journey to the afterlife.

Cinerary Containers

In the seventh century B.C. and earlier, many Etruscans cremated their dead. They buried the ashes in individual tombs or cinerary urns, which often had lids in the form of human heads. The vessels themselves sometimes had body markings to indicate whether the remains were those of a male or a female.

In figure **6.7**, both the urn and the wide-backed chair on which it stands are made of bronze, but the head is terracotta. Its individualized features suggest that it was intended to convey at least a general likeness of the deceased. The metaphorical nature of this object, in which the body, base, and handles of the urn are equated with the corresponding human anatomy, implies a religious significance. The container of the ashes was intended to symbolize a reversal of the process of cremation, as if to keep the dead person alive through his or her image.

6.7 Cinerary urn, from Chiusi, 7th century B.C. Hammered bronze and terra-cotta; approx. 33 in. (83.8 cm) high. Museo Etrusco, Chiusi.

6.8 *Mater Matuta*, from Chianciano, near Chiusi, 460–440 B.C. Limestone; life-sized. Museo Archeologico, Florence.

Much later in date is an unusual limestone cinerary statue of a monumental female with a swaddled child lying across her lap (fig. **6.8**). The sad expression characteristic of Greek Severe style—Early Classical—is appropriate for this Etruscan funerary figure. On either side of the chair or throne is a sphinx, which testifies to the importance of the figure—probably a goddess and perhaps a protector of mothers who died in childbirth. This figure corresponds chronologically to the beginning of the Greek Classical style. Although the woman is organically sculpted and the drapery outlines her body, she nonetheless retains the stylized hair and general air of mournfulness typical of the Early Classical period.

Many cinerary urns took the form of houses and provide us with a a glimpse of Etruscan domestic architecture. The Iron Age urn from the Villanovan civilization, for example, is in the form of a hut, the first known house type in

6.9 Urn in the shape of a hut, from Tarquinia, 9th–8th century B.C. Museo Archeologico, Tarquinia.

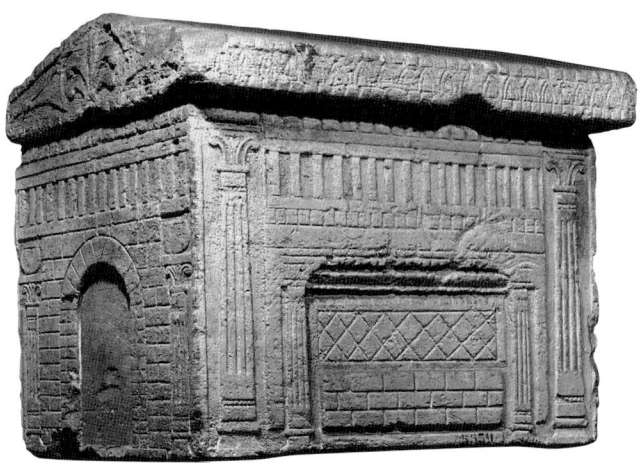

6.10 Cinerary urn in the form of a house, from Chiusi, c. 700–650 B.C. Museo Archeologico, Florence.

central Italy (fig. **6.9**). It consists of a single room enclosed by a circular wall and has a thatched roof supported by interior vertical posts. The example shown in figure **6.10** may have represented an upper-class house or palace, for it has an elegant, symmetrical façade with an arched doorway and a second-story gallery. (The arch, which was invented in Mesopotamia and used in Greece, was assimilated by the Etruscans and later elaborated by the Romans.) At the corners of the urn, Corinthian **pilasters** reinforce the structure. These are the flat, vertical elements resembling columns that project from, and are engaged in, the wall. The lid of the urn corresponds to the roof, with a curved pediment over the entrance and a palmette relief in the center.

Architectural urns provide clues to the development of Etruscan sculptural and architectural styles. The human-headed urns reflect both a wish to preserve the likeness of the deceased and the importance of ancestors who were considered divine in the afterlife. Urns-as-houses express the metaphor in which the tomb or burial place is a "house for the dead."

Tombs

The attitudes to death suggested by objects such as the urns recur in the Etruscan custom of building larger-scale architectural tombs to "house" their families. Tombs were originally small and intended for individual burials, but beginning in the seventh century B.C. several rock-cut chambers were covered by larger earth mounds, or **tumuli,**

and grouped together to replicate cities. In fact, it is from these Etruscan *necropoleis* that scholars have been able to reconstruct entire city and town plans and to elicit information about the urban architecture of Etruria.

The plan of the burial site known as the Tomb of the Shields and the Chairs at Cerveteri (fig. **6.11**) has a complex arrangement: the stepped passage (**1** on the plan) is flanked by similar tomb chambers (**2**), accessible through a door on each side of the entrance; at the far end is a set of three rooms (**4**); the central room (**3** on the plan and

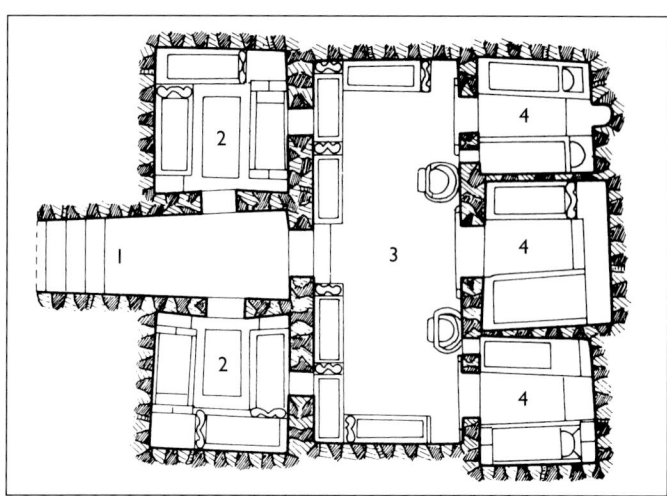

6.11 Plan of the Tomb of the Shields and the Chairs, Cerveteri, c. 550 B.C. Approx. 29 × 34 ft. (8.84 × 10.36 m).

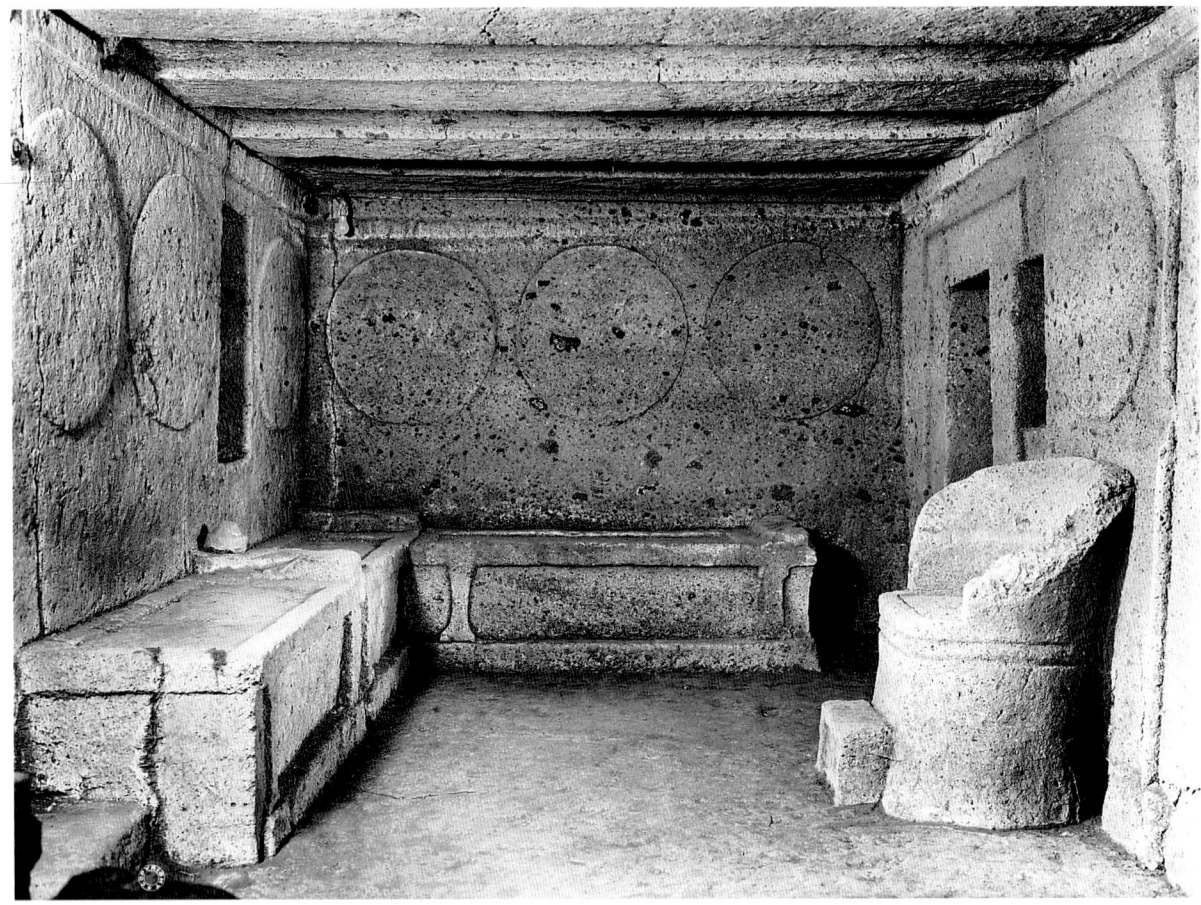

6.12 Interior of the central room, Tomb of the Shields and the Chairs (number 3 in fig. 6.11), Cerveteri, c. 550 B.C. Tufa; approx. 29 × 11½ ft. (8.84 × 3.51 m).

fig. **6.12**) has walls decorated with reliefs of round shields. There is a door at the right, with a lintel over the opening, and rectangular windows. Built-in furniture includes benches and a typically Etruscan curved-back chair with a footstool similar to that in the cinerary urn (see fig. 6.7). Funerary complexes such as this combined the universal need to provide burials with the particular Etruscan association of tombs with houses. They were intended to be dwelling places for the deceased.

Sarcophagi

Etruscan artists developed a new funerary iconography, which they translated into monumental sculpture in the sarcophagi of wealthy individuals. For example, a painted terra-cotta sarcophagus of around 520 B.C. from Cerveteri is in the form of a dining couch (fig. **6.13**). Like the urns, it was made to contain cremated remains rather than the bodies of the deceased. The figures represent a mar-

ried couple—the family unit was an important element in Etruscan art and society. The wife and husband are given similar status, reflecting the position of women in ancient Etruria. The covering over them alludes their marital state. They are rendered with Archaic features—long, stylized hair, smiles with corresponding raised cheekbones and upwardly slanting eyes, a circular cap for the woman and neatly parted hair for the man. The elegance of their curves and soft areas of their bodies, their finely pleated drapery, and almond-shaped eyes indicate contact with Greek Ionia. In contrast to Greek sculpture, however, these figures have no sense of skeletal structure and "stop" abruptly at the waist, indicating the Etruscan preference for stylistic effects over anatomical accuracy. The sharp bend at the waist and the animated gestures create the illusion of lively, sociable dinner companions, reclining in the style adopted for banqueting from the Greeks. The light flickering in the tomb, visible when opened by family members, would make the couple seem alive, as if to deny the fact of their deaths.

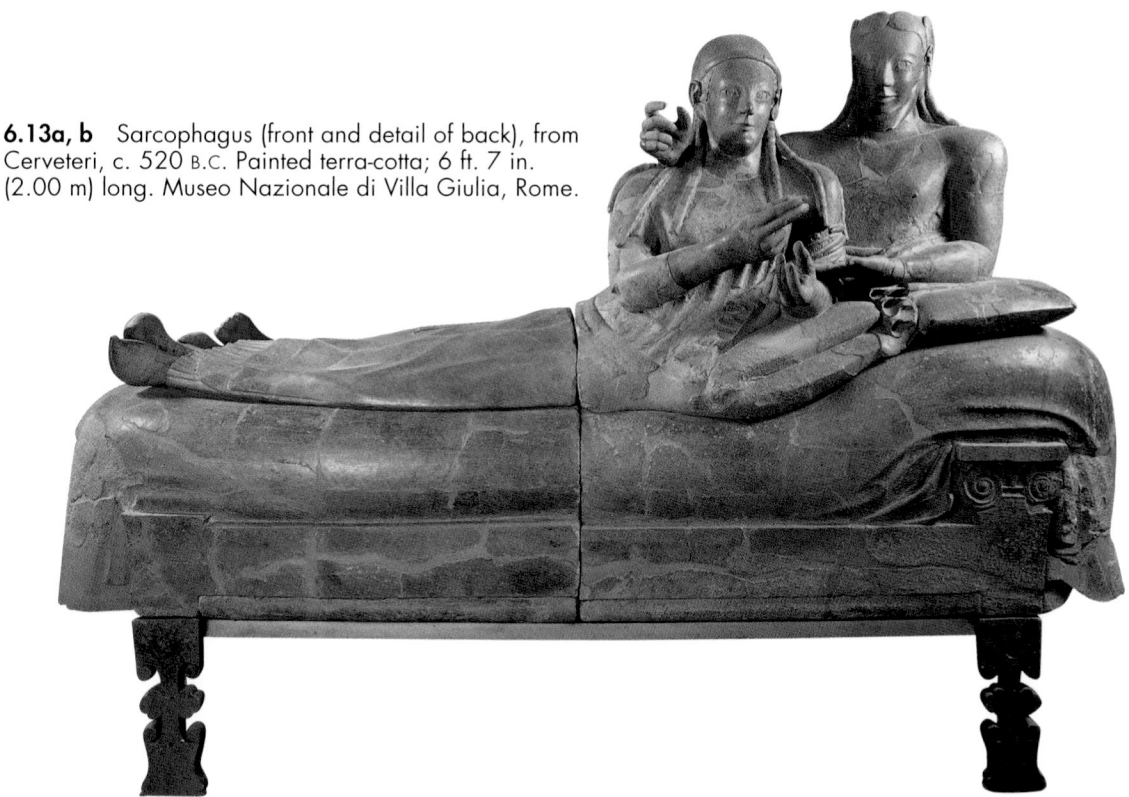

6.13a, b Sarcophagus (front and detail of back), from Cerveteri, c. 520 B.C. Painted terra-cotta; 6 ft. 7 in. (2.00 m) long. Museo Nazionale di Villa Giulia, Rome.

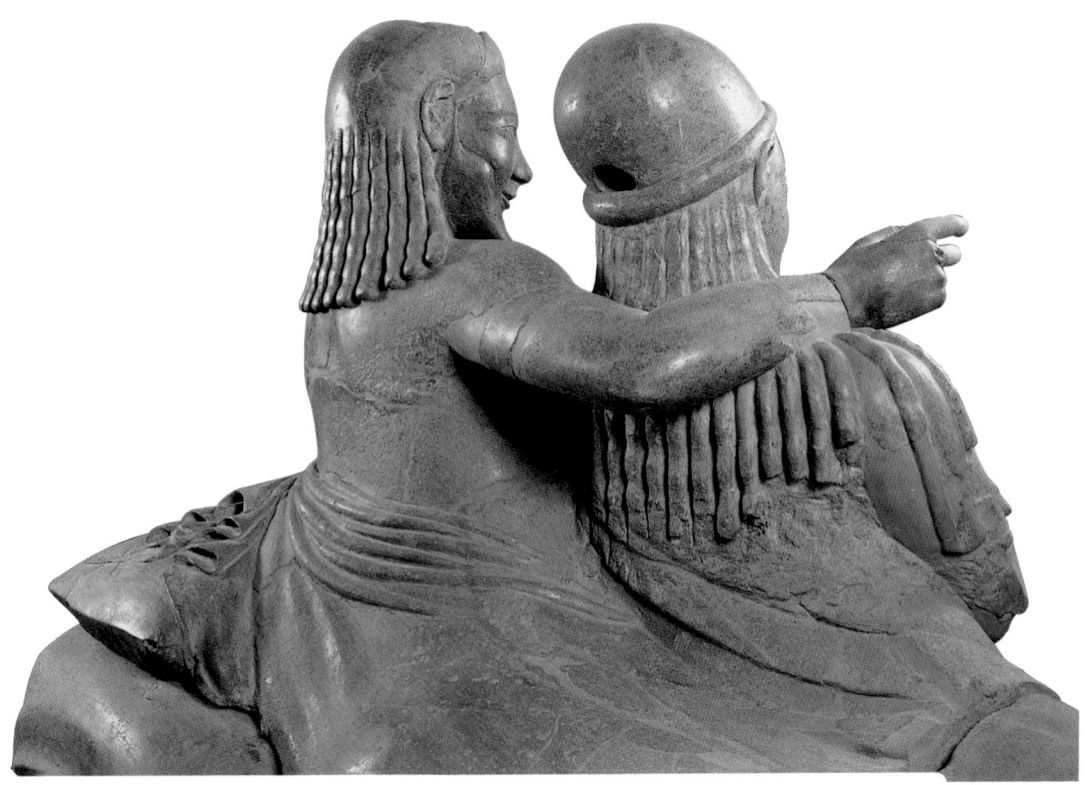

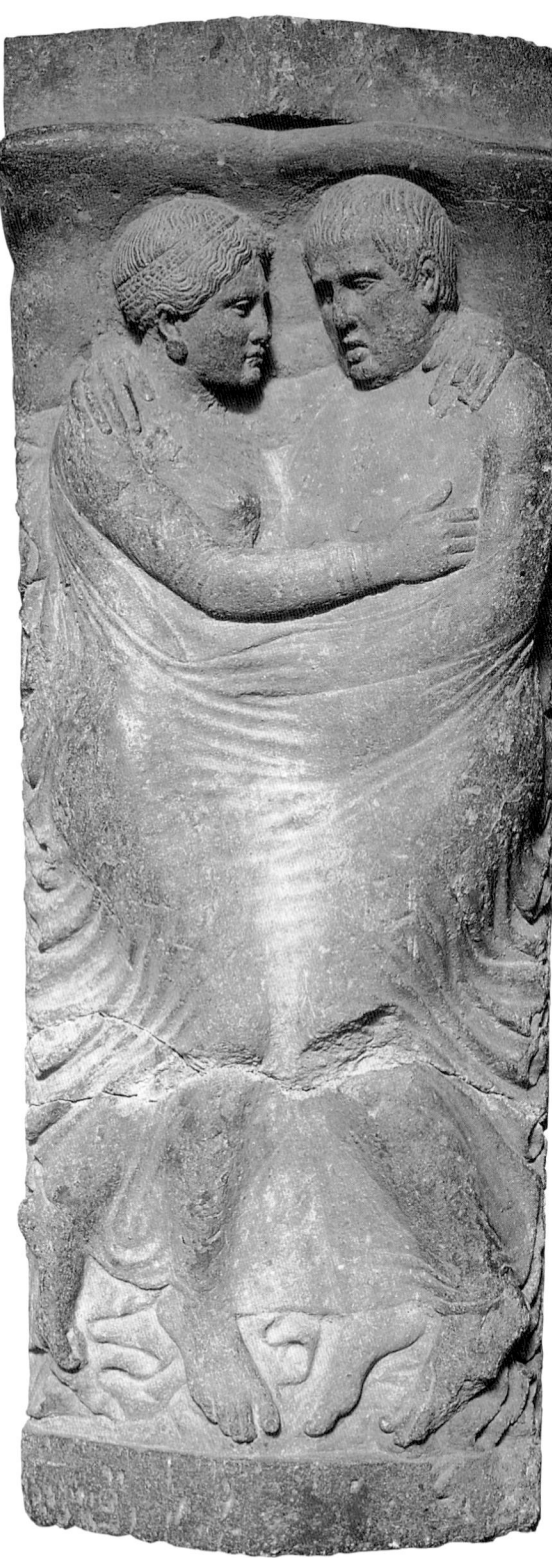

6.14 Sarcophagus of Ramtha Visnai, from Vulci, c. 300–280 B.C. Limestone; 7 ft. 1¾ in. × 2 ft. 6¾ in. (2.18 × 0.78 m). Courtesy Museum of Fine Arts, Boston. Gift of Mr. and Mrs. Cornelius C. Vermeule III. This restful scene expresses the ancient identification of sleep with death. The correlation is virtually universal—in Greek mythology, for example, Sleep and Death were twins—but in Etruscan tomb iconography the metaphor is rendered literally.

Another, later type of Etruscan sarcophagus contains a lid representing individual figures or couples in bed. A sarcophagus lid from Vulci (fig. **6.14**) shows an embracing husband and wife. The folds of the covering echo the curves of the arms, with shorter, more animated curves and diagonals over the zigzags of legs and feet.

In contrast to Greek art, Etruscan art shows the loving relationship between married couples. Here the pair, again with a covering over both of them, are nude above the waist, locked in a mutual gaze for eternity. Their nudity signifies their continuing sexual union even in death. Such public displays of affection between husband and wife were unheard of in Greek art and society, where men consorted more openly with courtesans (*hetairai*) than with their spouses.

Tomb Paintings

Etruscans used painted images as well as architecture and sculpture in the service of the dead. Hundreds of paintings have been discovered in the underground tombs of Tarquinia, a site northwest of Rome rich in archaeological finds. Tomb paintings were usually frescoes, although occasionally tempera was applied to dry plaster. Similar paintings probably adorned public and private buildings, but none has survived. Until the fourth century B.C., the most frequently represented subjects in Etruscan tomb paintings were funeral rites or optimistic scenes of aristocratic pleasures—banquets, sports, dances, and music making. Yet hints of death do appear, even in the sixth century B.C.

A painting from the Tomb of the Augurs, in Tarquinia, dates from c. 510 B.C. and represents two mourners (fig. **6.15**). The figures stand on a horizontal ground line flanking the closed door leading to the underworld, and there is little indication of depth. Plant stems rise directly from the ground line and are the same brownish color. Aside from the blue leaves, the colors of the costume match the solemn mood. The mourners wear a simple, light yellow garment that falls to about mid-calf, but their shorter outer garment is black, as are their boots. Their gestures are the traditional stylized gestures of mourning and have a theatrical quality. They direct our attention to the closed door that leads to the next life, an image that reaffirms the architectural metaphor equating house and tomb. The form of the door, with the horizontal lintel at the top extending beyond the sides, is similar to the actual door visible in the Tomb of the Shields and the Chairs (see fig. 6.11).

A fresco in the Tomb of the Leopards at Tarquinia shows men and women reclining on banqueting couches while servants wait on them (fig. **6.16**). The seated banqueters have the same bend at the waist and animated gestures as the couple on the Cerveteri sarcophagus (see fig. 6.13), but their heads are in profile. Colors are mainly terra-cotta tones of brown on an ocher background, with drapery patterns, wreaths, plants, and other details in blues, greens, and yellows. As in Egyptian, Minoan, and Greek painting, Etruscan women are rendered with

6.15 *Mourners at the Door of the Other World,* Tomb of the Augurs, Tarquinia, c. 510 B.C. Note that the boots worn by the mourners resemble those of the war god in the Hittite relief from Boghazköy (see fig. 2.23). Pointed boots are typically worn by mountain people and are another example of influence from the Greek Ionian cities and Asia Minor. The scene at the right shows two wrestlers and the gold and bronze bowls for which they are competing.

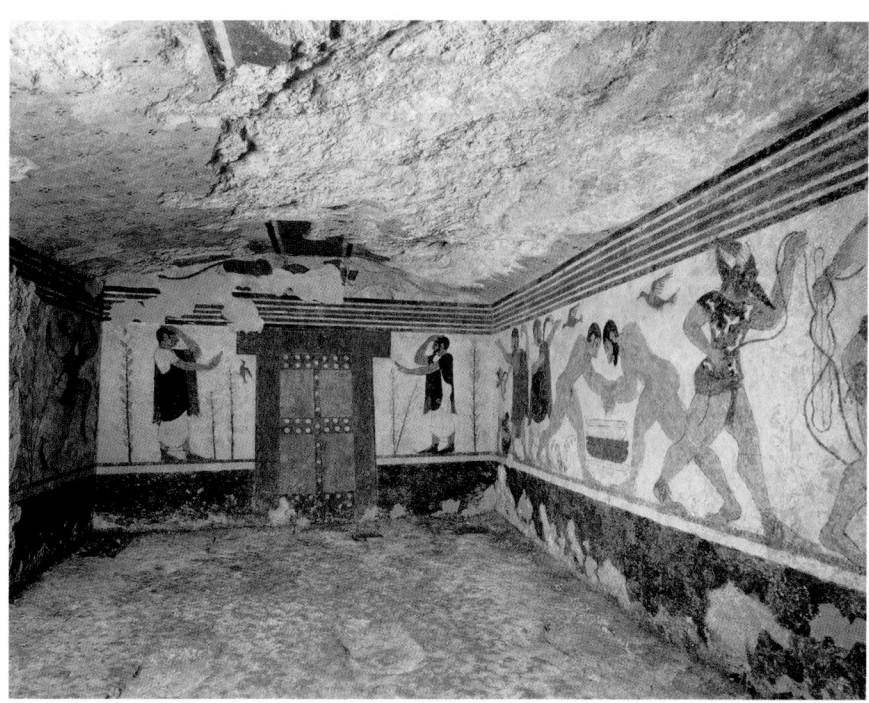

See figure 2.23. Hittite war god, from the King's Gate, Hattusas, Boghazköy, Turkey, c. 1400 B.C.

6.16 Tomb of the Leopards, Tarquinia, 480–470 B.C. Fresco. Here the influence of Egyptian and Aegean painting is quite evident. Women are lighter skinned than men, profile heads contain a frontal eye, and figures are outlined in black and dark brown.

lighter skin coloring than men. Above the banqueting scene, two leopards flank a stylized plant and symbolically protect the tomb from evil.

Compared with paintings in Greece, Etruscan paintings disregard anatomical accuracy and naturalistic movement in space, and the overall impression is one of spontaneity. Even though figure 6.16 illustrates an interior scene, for example, the presence of trees indicates a willingness to merge what is naturally outside with what is architecturally inside.

The Etruscans remained a culturally distinct group, retaining their own language, religion, and customs for nearly a millennium. Occupying a large section of Italy for much of the period of the Roman Republic, Etruscans were independent of the Romans in language and religious beliefs. Yet they taught the Romans a great deal about engineering, building, drainage, irrigation, and the art of augury—how to read the will of the gods and foretell the future from the entrails of animals and the flight of birds. In matters of fashion and jewelry, the Etruscans were the envy of Greek and Roman women alike. Their technical skill and craftsmanship prompted advances in jewelry, such as gold granulation, as well as in dentistry. Etruscans made bridges and dentures that enhanced oral health and were cosmetically pleasing.

Etruscan kings ruled Rome until the establishment of the Roman Republic in 509 B.C. By the early third century B.C., Etruria had become part of Rome's political organization, and two centuries later it had succumbed to full Romanization.

Style/Period	Works of Art	Cultural/Historical Developments
ETRUSCAN c. 1000–100 B.C. *Apollo of Veii* *Capitoline Wolf*	Urn shaped as a hut (**6.9**), Tarquinia Urn shaped as a house (**6.10**), Chiusi Cinerary urn (**6.7**), Chiusi Tomb of the Shields and the Chairs (**6.12**), Cerveteri Sarcophagus (**6.13**), Cerveteri *Apollo of Veii* (**6.4**) Temple at Veii (**6.1**) Tomb of the Augurs (**6.15**), Tarquinia *Capitoline Wolf* (**6.2**), Rome Tomb of the Leopards (**6.16**), Tarquinia *Wounded Chimera* (**6.3**), Arezzo *Mater Matuta* (**6.8**), Chianciano *Mars of Todi* (**6.5**) Engraved bronze mirror (**6.6**), Volterra Sarcophagus of Ramtha Visnai (**6.14**), Vulci *Wounded Chimera* *Tomb of the Augurs*	Etruscan civilization begins (1000 B.C.) Legendary founding of Rome by Romulus (c. 753 B.C.) Foundation of Ostia, near Rome, by the Etruscans (700–600 B.C.) Rome declared a republic; last king, Tarquin the Proud, expelled (509 B.C.) High point of Etruscan power in Italy (early 5th century B.C.) Wars between Greece and Persia (490–449 B.C.) Latin League, under leadership of Rome, formed against Etruscans (494 B.C.) Rebuilding of Acropolis in Athens (c. 480 B.C.) Age of Perikles in Athens (458–429 B.C.) Etruscan influence in Italy begins to wane (450–400 B.C.) Veii destroyed by Romans (396 B.C.) Death of Alexander the Great (323 B.C.) Etruscans become subject to Rome (295 B.C.) Rome controls Italy south of the Po valley (268 B.C.) First Punic War between Rome and Carthage (264–241 B.C.) *Cinerary urn* *Mater Matuta*

The left margin timeline reads: 1000 B.C., 800 B.C., 500 B.C., 200 B.C.

China: Neolithic to First Empire
(c. 5000–206 B.C.)

The Tomb of Emperor Qin: I
(late 3rd century B.C.)

It is not only in the West that people created tombs with a view to taking their lives with them into death. In 1974, a group of peasants in the Chinese province of Shaanxi discovered evidence of an ancient burial hidden in an enormous mound of earth (see fig. I.2). Subsequent archaeological excavations revealed this to have been the burial of Shihuangdi, who became known as Emperor Qin (ruled 221–206 B.C.) after the states he ruled. He was the first emperor of a united China, and it is from his name, Qin (pronounced *ch'in*), that the name China is derived. A later historian described Shihuangdi's tomb chamber (which has not yet been opened) as

> filled with [models of (?)] palaces, towers, and [a] hundred officials, as well as precious utensils. . . . Artisans were ordered to install mechanically triggered crossbows set to shoot any intruder. With quicksilver the various waterways of the empire, the Yangtze and Yellow Rivers, and even the great ocean itself were created and made to flow and circulate mechanically. The heavenly constellations were depicted above and the geography of the earth was laid below. Lamps were fueled with whale oil so that they might burn forever without being extinguished.[1]

While not every detail of this account has been confirmed, it is certain that Shihuangdi unified China in the late

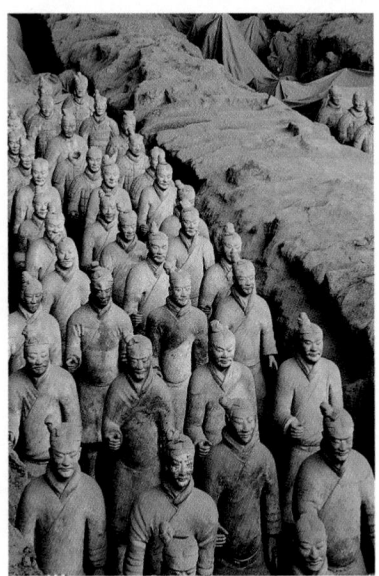

See figure I.2. Bodyguard of the emperor Qin, terra-cotta warriors, Qin dynasty (221–206 B.C.), in situ. Lintong, Shaanxi Province, China.

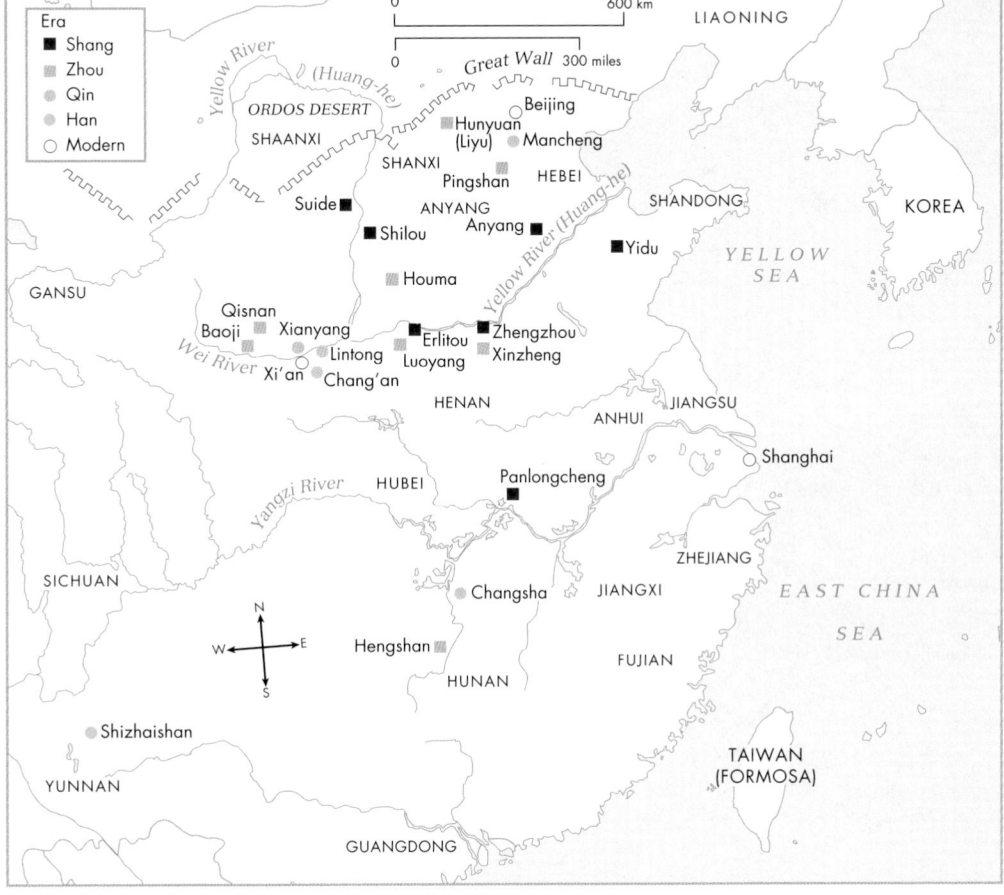

Chinese archaeological sites.

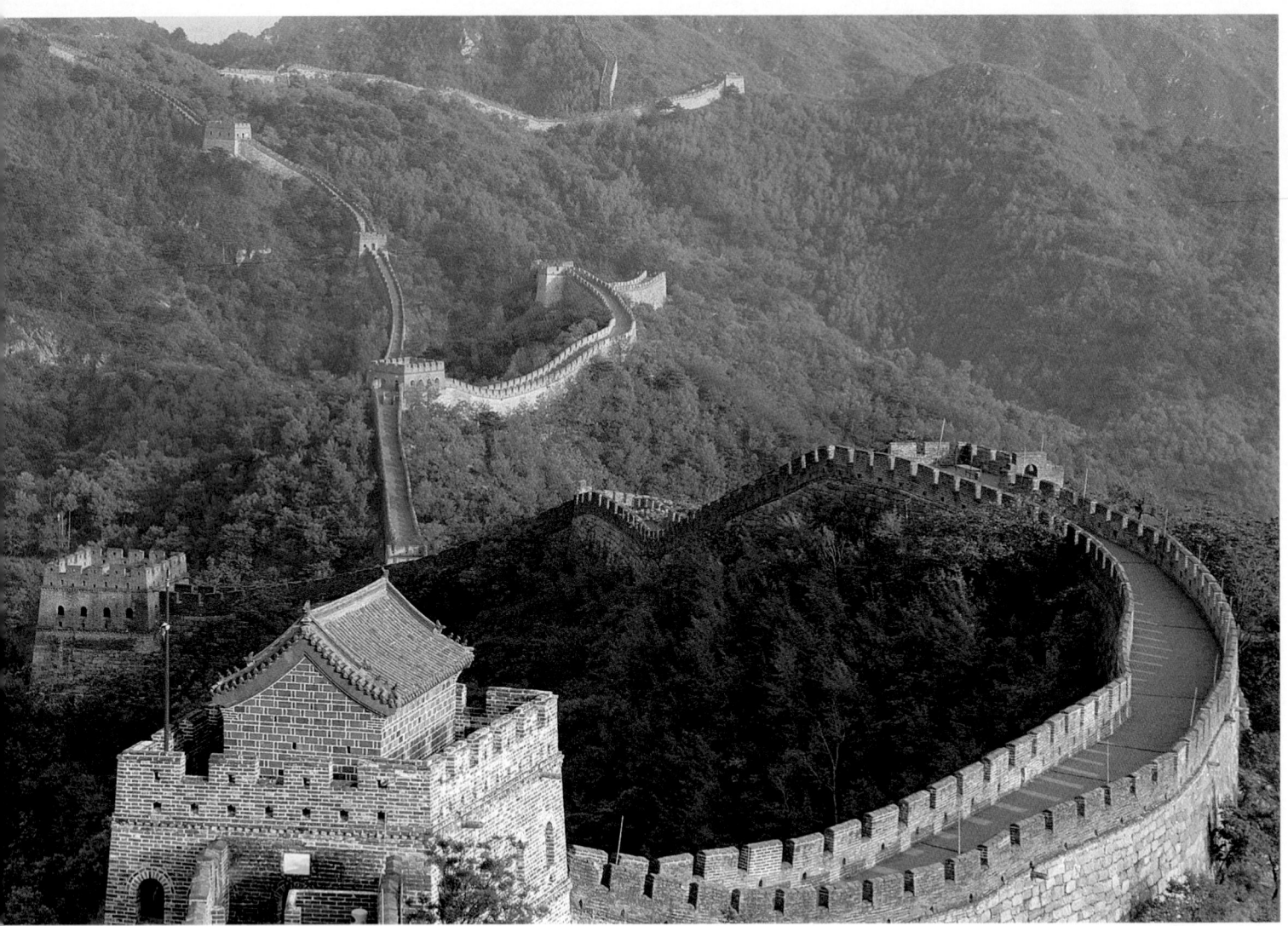

W2.1 The Great Wall, near Beijing, China, begun third century B.C. Length approx. 1,500 miles (2,414 km), height and width approx. 25 ft (7.62 m).

third century B.C., installed himself as emperor, financed monumental building campaigns and the arts with a view to solidifying his political position, and strengthened the country he ruled. Among his lasting accomplishments was the codification of the law, which he was famous for ruthlessly enforcing. He standardized weights, measures, and currency, established a

written language, and adopted a canon for imperial art. His administrative system and division of China into provinces has lasted to the present day. He constructed a national network of roads, which facilitated the efficient mobilization and movement of troops. Emperor Qin also commissioned monumental palace architecture, and most of the Great Wall of China was built during his reign.

Parts of the Great Wall were already in place, but Qin ordered its reconstruction and completion as another means of unifying the country. It discouraged invasion along the borders. As a feat of engineering, the Great Wall was prodigious, requiring the work of around 700,000 laborers. All told, the wall extended some 1,500 miles. Figure **W2.1** shows a small section of the wall outside of Beijing and several of its watchtowers.

Precursors: Neolithic to the Bronze Age
(c. 5000–221 B.C.)

Prior to the Qin dynasty, China had a long cultural and artistic tradition. In contrast to the Mediterranean world, whose civilizations rose and fell (that of Egypt lasted the longest), China has maintained a cultural continuity from the Neolithic era to the present. Although the origins of Chinese culture are obscure, legends refer to an early Bronze Age Xia dynasty and to stages in civilization brought about by heroes known as the Five Rulers.

There is evidence that between the fourth and third millennia B.C. pottery production was thriving. Crude Mesolithic pottery had been replaced by thin-walled, wheel-thrown wares: first, earthenware with black and red painted

Major Periods of Early Chinese History

BRONZE AGE

| Shang Dynasty | c. 1700–1050 B.C. |
| Zhou Dynasty | c. 1050–221 B.C. |

IRON AGE

| Qin Dynasty | 221–206 B.C. |

Bronze is an alloy of copper and tin. Although the earliest manufactured metal objects were made exclusively of copper, it was soon discovered that adding tin increased its hardness, lowered its melting point, and made it easier to control.

In the Stone Age, most artifacts had been made from easily portable materials such as bone, clay, and stone. The introduction of bronze was a watershed in China, as in other civilizations, and precipitated a significant shift in the nature of its society. Sources of copper and tin had to be discovered, the ore mined, and the metal extracted. This was a huge undertaking as far as copper was concerned since its ore yields only a tiny proportion of refined metal. Elaborate kilns and fires of great intensity were needed to melt the large batches of metal. Cooling the finished objects to avoid cracks and other defects required constant supervision. Such tasks could be accomplished only in a society that was settled (i.e., nonnomadic) and in which labor was specialized.

The Chinese produced bronze vessels in twenty-seven basic shapes by an indigenous technique derived from pottery making. This differed from the lost-wax method (see p. 154) popular in Greece and elsewhere. First, a clay model of the vessel was made, and then it was encased with an outer layer of damp clay. When the outer layer dried, it was cut off in sections and fired to form a mold. Meanwhile, a thin layer was removed from the model, which became the core of the mold. The sections of the mold were reassembled around the core and held in place by bronze pegs (**spacers**). Molten bronze was then poured into the space between the mold and the core through a pouring duct. The thickness of the final object was a function of the difference in size between core and mold. When the bronze had cooled, the mold and core were removed, and the surface of the bronze was polished with abrasives.

Ancient Chinese bronzes remain unsurpassed in the technical virtuosity of their ornamentation. Decoration was an integral part of the casting process, created by designs on the inner surface of the mold. Portions of especially complicated pieces were cast separately and fitted together. This piece-mold process made it possible to cast vessels of enormous size

1 The core
2 Mold sections
3 Finished work

W2.2 Diagram showing the Chinese system of bronze casting.

with elaborate surface ornamentation. It was not until the late Bronze Age that the Chinese began to cast bronze by the simpler lost-wax process, which permitted more flexibility of design but required more finishing after casting.

decoration, and then polished black vessels. By the third and second millennia B.C., jade was being imported from Siberia and carved into stylized animal figurines and other ceremonial objects.

Bronze was first used in the second millennium B.C. in the fertile valley of the Yellow River (see map), and its importance as both medium and symbol in ancient China cannot be overestimated (see box and fig. **W2.2**). As a material, bronze was of great value. It denoted power and was associated with the aristocracy, who monopolized its manufacture, use, and distribution. Social rank was measured by the number and size of bronzes one owned. Bronze was also used for weapons, which led to new success in warfare, and productivity in general increased as a result of improved metal tools. Ritual objects—preferably made of bronze—served the dead as well as the living, and bronze vessels containing offerings were dedicated to deceased ancestors. These were often used by shamans, who were members of the ruling aristocracy. They performed sacrifices to the spirits of ancestors or gods, who, in turn, were believed to protect the living. In times of war, the ritual bronzes were melted down and made into weapons to be recast into vessels when peace returned.

The two main Bronze Age dynasties were the Shang (c. 1700–1050 B.C.) and the Zhou (c. 1050–221 B.C.). The Shang was a complex agricultural society with a class system, an administrative bureaucracy, and urban centers. City walls were made of earth,

Writing: Chinese Characters

The Chinese writing system uses characters that represent entire words instead of letters in an alphabet. These characters have been written and read—in columns, running from top to bottom and right to left—for at least 3,000 years. Because of the sophistication of the earliest known characters, their prototypes may have originated as long ago as 4000 B.C., when they were applied to perishable materials such as textiles and leather. At Anyang, China's first city and capital of the Shang dynasty (c. 1700–1050 B.C.), archaeologists found characters written on oracle bones used in divination. Archivists at the Shang court wrote with brush and ink on slices of bamboo or wood that were then bound into books.

Figure **W2.3** shows the evolution of oracle script into seal script (still used for carved seals today) and finally into the same characters' standard modern forms. Many of the 4,500 Shang characters known, of which one-third have been identified, were **pictographs** (literally "written pictures"), or styl-ized renderings of specific objects: the sun is circular; the moon is a partial circle (showing its changing shape in contrast to that of the sun); rivers consist of wavy lines; and mountains have three peaks facing upward. Other characters called **ideographs** (literally "written concepts") were more abstract, representing ideas through combinations of pictographs. The combination of sun and moon, for example, forms the idea of brightness.[2]

Chinese characters have become less pictorial over the centuries. Today about 90 percent of the 10,000 commonly used characters (out of a repertory of nearly 50,000) are composed of elements that convey meaning coupled with elements indicating pronunciation. Thus the combination of the character for "female person" with a character for the sound ma creates the notion of "mother." The five traditional styles in which the characters are written have been in use for at least 2,000 years, and writing is considered the highest art form in China.

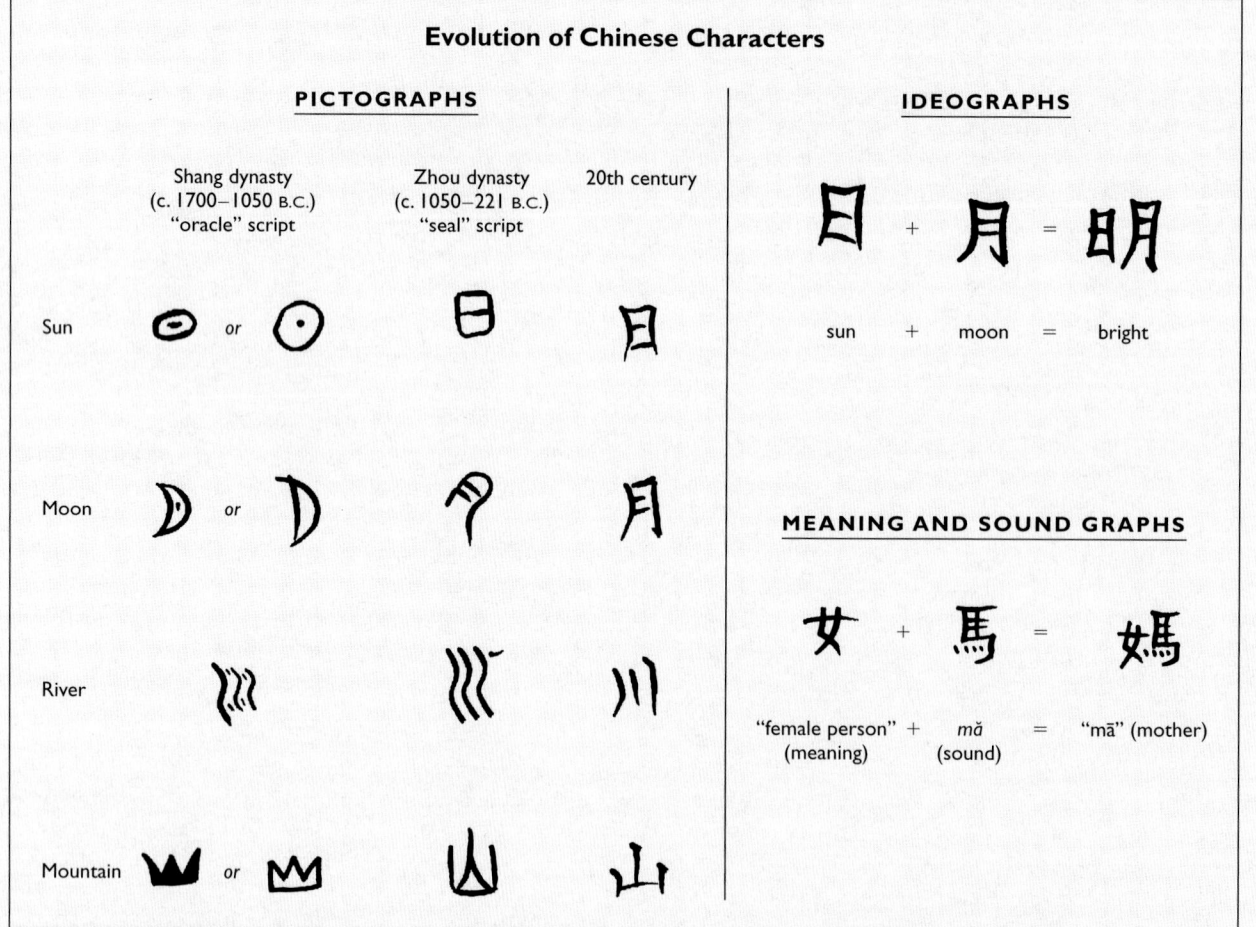

W2.3 Chinese characters showing pictographs (oracle and seal script), ideographs, and meaning/sound graphs.

and there is evidence of some monumental architecture in the later Shang period. Of particular note are rectangular halls, over 90 feet (27.43 m) in length, with interior pillars arranged symmetrically. The Shang dynasty also produced the earliest form of China's **calligraphic** writing system. This is known from inscriptions on so-called oracle bones used in divination rites in the mid-second millennium B.C. (see box and fig. W2.3).

The four-ram wine vessel (fig. **W2.4**) is a good example of Shang dynasty bronze casting in the Anyang region of modern Hunan Province. Four rams, decorated in low relief with an abstract motif of crested birds, project from the body of the vessel, their legs forming its base. Above the rams, around the vessel's shoulder, are four horned drag-ons. The entire surface is enlivened by curvilinear patterns that create an unusual synthesis of naturalism and geometric abstraction. While the insistence on symmetry (fig. **W2.5**) arrests formal movement, the surface patterns animate the object.

The Zhou originated in modern Shanxi. A predominantly warrior cul-ture, they conquered the Shang and established a feudal state that lasted for eight hundred years. Their chief god was conceived of as heaven (*tian*) and as the father of the Zhou king, reinforcing his imperial power. The late Zhou period produced the two great philosophies of China, Daoism and Confucianism (see box). In the arts, the Zhou continued and elabo-rated Shang styles and techniques, especially in bronze. Whereas Shang forms can usually be identified, Zhou forms, though reminiscent of natural shapes, are elusive.

During the late Zhou dynasty, China underwent several centuries of so-cial upheaval. There is evidence of new influence from the animal art of the Scythian nomads (see Chapter 2), particularly in the **interlace** pat-terns and motifs characterized by metaphorical transitions from organic to geometric forms. This type of shift-ing imagery can be seen in a late Zhou **finial** (an ornament at the top of an object) rendered in the shape of a

W2.4 Four-ram wine vessel, Ningziang Xian, Hunan Province, China, Shang dynasty, c. 1300–1030 B.C. Bronze; 23 in. (58.4 cm) high, 75 lbs. 14 oz. weight. Historical Museum, Beijing.

W2.5 Four-ram wine vessel (detail of fig. W2.4).

Chinese Philosophy

Daoism and Confucianism were the two great philosophies of ancient China. Daoism is based on the *Daode jing*, a text at-tributed to its legendary founder, Laozi, and thought to have been written in the fourth century B.C. It teaches individualism and transcendence through direct connection with the natural world. According to the *Daode jing*, "*Dao* [the Way] invari-ably does nothing and yet there is nothing that is not done."³ Confucius (whose Chinese name is Kongzi, 551–479 B.C.), on the other hand, emphasized strict adherence to social con-ventions and rituals—based on those of the Shang and Zhou dynasties—for the proper functioning of the state. Confucius's teachings were collected in the *Analects*, among whose max-ims is "Devote yourself earnestly to the duties due to men, and respect spiritual beings, but keep them at a distance. This may be called wisdom."⁴ These two disparate philosophies have been reflected in Chinese art for the past two thousand years.

W2.6
Dragon finial, from Qin-Zun, China, late Zhou dynasty, 3rd century B.C. Bronze inlaid with gold and silver; 5 ft. ⁵⁄₁₆ in. (1.53 m) high. Cleveland Museum of Art.

The Tomb of Emperor Qin: II
(late 3rd century B.C.)

Some 700,000 people labored for fifteen years to build the Qin emperor's tomb complex. According to the historian's account cited above, Qin tried to take the entire universe with him—not just his friends, family, and possessions. In fact, he took approximately 7,000 life-sized painted terra-cotta warriors and horses, which were equipped with real chariots and bronze weapons. Their purpose was to provide Shihuangdi with a military bodyguard in the afterlife.

The hierarchy of military rank from infantryman to officer is represented in Emperor Qin's soldiers, deployed outside the burial chamber according to contemporary battle strategy. Although the figures conform to ideal types, they convey a sense of personality that is just short of portraiture. The hollow torsos are supported by sturdy cylindrical legs. Small details made separately were stuck to the surface while the clay was still wet. When the statues dried, they were fired, painted, and set on bases.

One of these, a terra-cotta kneeling archer (fig. **W2.7**), shows the warrior holding his bow and wearing plated armor and a kilt. His raised cheekbones and eyebrows, along with the slight suggestion of a smile, give him an air of individuality despite his conventional pose. The detail of the back of his head (fig. **W2.8**) shows incised lines, representing hair that has been tightly pulled into a topknot and

W2.7 Kneeling archer, from the tomb of Emperor Qin (trench 10, pit 2), Lintong, Shaanxi Province, 221–206 B.C. Terra-cotta; life-sized. Shaanxi Provincial Museum.

W2.8 Kneeling archer (detail of fig. W2.7).

dragon (fig. **W2.6**), a masterpiece of formal complexity as the dragon both bites, and is bitten by, a bird. Such iconographic representations of oral aggression and transformation are similarly expressed in certain objects of the European Middle Ages (see fig. 9.24).

Shihuangdi began his reign as the centuries of upheaval known as the Warring States period (475–221 B.C.) came to an end. His wish to perpetuate his life after death had a long tradition in China. Until the fourth century B.C., in the late Zhou dynasty, rulers continued to be buried with their belongings and their animals. Slaves and servants, relatives and other members of the nobility were ritually killed in order to accompany the deceased. By the end of the Bronze Age in China, however, human sacrifice for burials had ceased. Wooden figures, or *mingi* (meaning "substitutes"), were used instead.

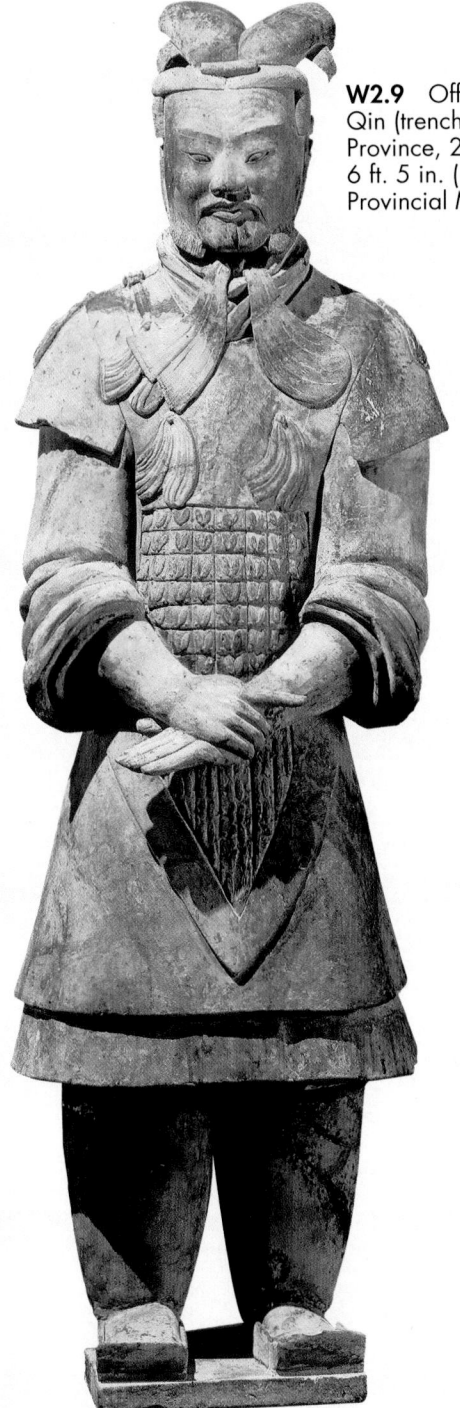

W2.9 Officer, from the tomb of Emperor Qin (trench 4, pit 2), Lintong, Shaanxi Province, 221–206 B.C. Terra-cotta, 6 ft. 5 in. (1.96 m) high. Shaanxi Provincial Museum.

W2.10 Officer (detail of fig. W2.9).

strands of braids. Also visible are the modeling marks, made by the artist's thumbs, at the back of the neck and in the folds of the scarf. The statue of an officer (figs. **W2.9** and **W2.10**) stands upright, his hands forming a ritual gesture. He frowns slightly, as if weighing an important tactical decision, and his high rank is denoted by height and costume. In addition to an armored tunic, he wears a double

robe with wide sleeves and an elaborate headdress tied under his chin. The terra-cotta cavalryman (fig. **W2.11**) is shorter and more plainly attired. He wears the short robe and vest that made riding easier and replaced the long robe worn before 300 B.C. He stands at attention and holds the reins of his horse, whose saddle replicates the leather and bronze of a real saddle.

At the time of writing, Emperor Qin's burial chamber remains to be excavated, partly because it is thought to have been booby-trapped to protect against vandals. The burial chamber was located below streams and sealed off with bronze as another protective device. The emperor's 7,000 bodyguards, like the army that defended his imperial power, served as guardians of his body.

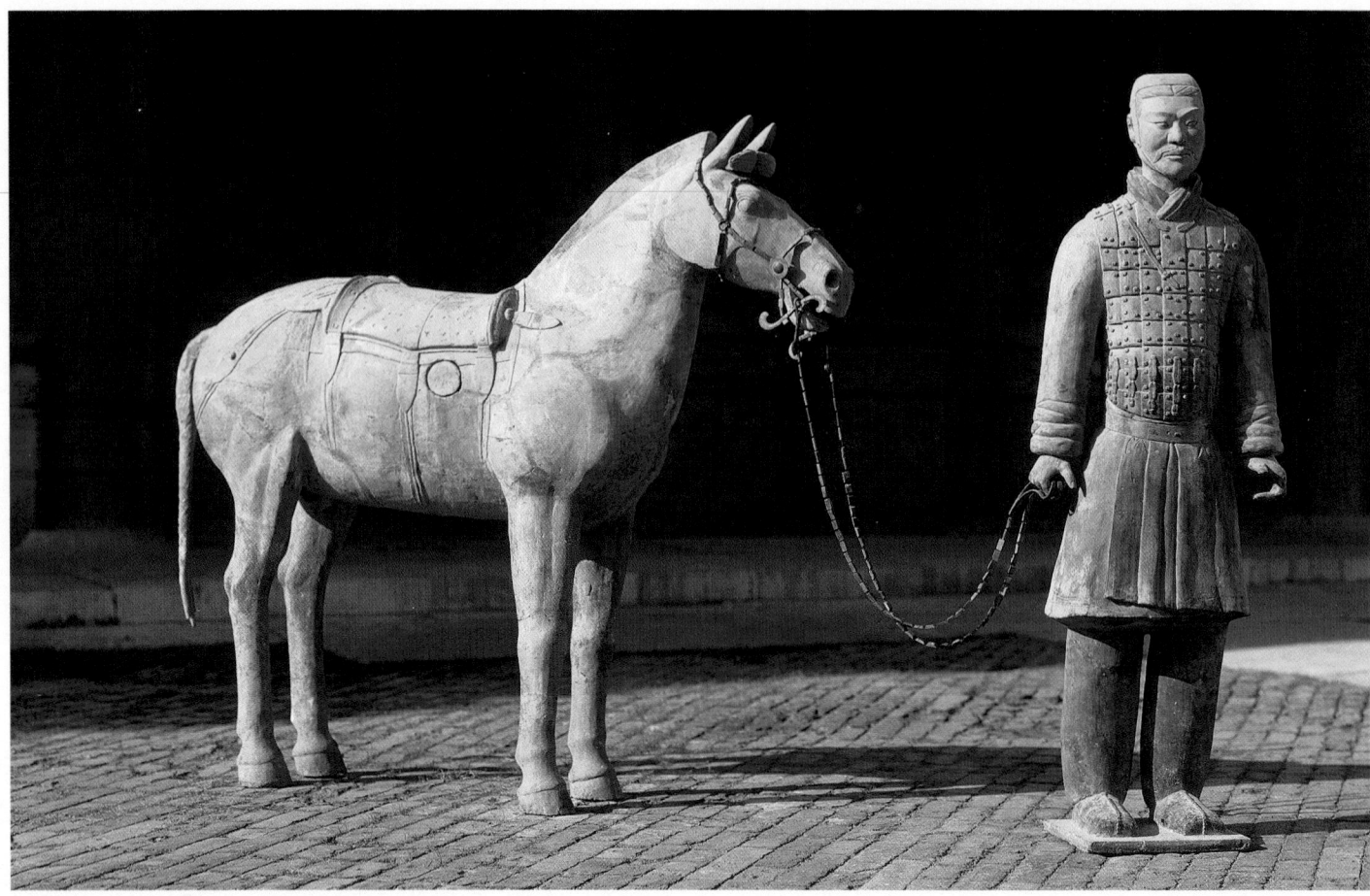

W2.11 Cavalryman, from the tomb of Emperor Qin (trench 12, pit 2), Lintong, Shaanxi Province, 221–206 B.C. Terra-cotta; man 5 ft. 10 in. (1.79 m) high, horse 5 ft. 7½ in. (1.69 m) high. Shaanxi Provincial Museum.

	Style/Period	Works of Art	Cultural/Historical Developments	
5000 B.C.	NEOLITHIC 8000–2000 B.C.		Production of pottery on the wheel (4th–3rd millennium B.C.) Jade imported and carved (3rd–2nd millennium B.C.)	
2000 B.C.	SHANG DYNASTY 1700–1050 B.C.	**Four-ram wine vessel** Four-ram wine vessel (**W2.4**)	Bronze manufactured; early calligraphy; urban development; oracle-bone divination (c. 1700–1050 B.C.)	
1000 B.C.	ZHOU DYNASTY 1050–221 B.C.	Dragon finial (**W2.6**), Qin-Zun Tomb of Emperor Qin, terra-cotta warriors (**W2.7–W2.11**)	Feudalism; *Daode jing;* Confucius; Scythian influence (c. 1050–221 B.C.) Sun Tzu's *The Art of War* (5th–3rd century B.C.) Unification of China; Great Wall (late 3rd–1st century B.C.)	**Tomb of Emperor Qin, terra-cotta warrior**
200 B.C.		**Dragon finial** **Tomb of Emperor Qin, terra-cotta warrior**		

7

Ancient Rome

The political supremacy of Athens lasted only about fifty years; Rome's endured for five hundred. Greece had been unified culturally, but Rome's empire became a melting pot of cultures and ideas. Despite Greece's belief in its own superiority over the rest of the world, it had never achieved long-term political unity. The political genius of Rome lay in its ability to encompass, govern, and assimilate cultures very different from its own.

As time went on, Roman law made it increasingly easy for people from distant regions to attain citizenship, even if they had never been to Rome. Nevertheless, there was no doubt that the city itself was the center of a great empire. Rome's designation of itself as *caput mundi*—"head of the world"—signified its position as the hub of world power.

From the death of Alexander the Great in 323 B.C., Rome began its rise to power in the Mediterranean. By the first century A.D., the Roman Empire extended from Armenia and Mesopotamia in the east to the Iberian Peninsula in the west, from Egypt in the south to the British Isles in the north (see map). Everywhere the Roman legions went,

The Roman Empire, A.D. 14–284.

they took their culture with them, particularly their laws, their religion, and the Latin language. Only Greece and the Hellenized world kept Greek, rather than Latin, as the official language.

Roman citizenship was accessible to many more people than Athenian citizenship had been, and the position of women in Roman society was more dignified than in Athens. Instead of being confined to their quarters, they ate with their husbands and were free to go out without a chaperone. Upper-class women were involved in law, literature, and politics.

Before the second century B.C., Roman marriage, which was a contract, took the form of transfer of control of the woman from her father to her husband. To some degree, this required the bride's consent. If a woman lived with a man for a year without being absent for more than two nights, the couple was considered legally married. From the second century B.C. onward, the pace of emancipation accelerated. Married women could retain their legal identity, controlling their property, managing their affairs, and becoming independently wealthy. Divorce was more common, and during the empire laws were passed to encourage marriage and to increase the birthrate.

In religion and art, the Romans identified their own gods with counterparts in the Greek pantheon and adopted Greek iconography. Roman artists copied Greek art, and Roman collectors imported Greek works by the thousands. Although Greek monumental paintings have not survived, they, too, influenced Roman painters, especially in the Hellenistic period.

Greek art had tended toward idealization, to which the Romans added commemorative and narrative types based on history rather than myth. As in the Hellenistic style, Roman portraitists sought to preserve the features of their subjects. But they went much further in the pursuit of specific likenesses, making wax death masks modeled directly on the face of the deceased and copying them in marble.

The purpose of Roman portraiture was genealogical. As a family record, it connected present with past, just as Aeneas (see box) connected Roman origins with the fall of Troy and, through his mother, Venus, with the gods. Roman interest in preserving family lineage was also reflected in names. The typical Roman family was grouped into a clan, called a *gens,* by which individuals traced their descent. Portraits, whether sculptures or paintings, thus had a twofold function: they both preserved the person's image and contributed to the history of the family. Similarly, Roman reliefs usually depicted historical narratives, commemorating the actions of a particular individual rather than mythical events. Most commemorative reliefs adorned architectural works, and it was in architecture that the Romans were most innovative. At the same time, however, Rome produced an enormous body of literature, some of which dealt primarily with mythological stories derived from Greece. One of the major examples of such work is the *Metamorphoses* of Ovid (43 B.C.–A.D.18) (see box, p. 212).

According to the official chronology, the city of Rome was founded by Romulus in 753 B.C., but legend based on

Virgil's *Aeneid*

During the reign of Rome's first emperor, Augustus, Virgil wrote the *Aeneid,* a Latin epic to celebrate Aeneas as the legendary founder of Rome. Composed in twelve books, it opens with the fall of Troy. Like Odysseus (see Chapter 5) and Gilgamesh (see Chapter 2) before him, Aeneas travels far and wide, even visiting the underworld. Virgil's frequent references to "pius Aeneas" evoke his hero's sense of duty and destiny. They also imply comparison with Augustus and create an image of the emperor as a predestined second founder of Rome—that is, as the ruler of a great empire under divine guidance. The connotations of this epic for the readers of first-century Augustan Rome were apparently that the founding of their city and Roman domination of the world had been the will of the gods.

In the *Aeneid,* Virgil defines the Roman view of its relationship to Greece and to Greek art by emphasizing that Rome's destiny was political rather than artistic:

> Others will cast more tenderly in bronze
> Their breathing figures, I can well believe,
> And bring more lifelike portraits out of marble;
> Argue more eloquently, use the pointer
> To trace the paths of heaven accurately
> And accurately foretell the rising stars.
> Roman, remember by your strength to rule
> Earth's peoples—for your arts are to be these:
> To pacify, to impose the rule of law,
> To spare the conquered, battle down the
> proud.[1]

Greek myth traces the origins of Rome and the Latin people to a different hero, namely, Aeneas. Tradition had it that the local twins Romulus and Remus were abandoned as infants and nursed by a wolf (see fig. 6.2). Romulus later killed Remus, built Rome on the Palatine Hill, and became its first king. He ruled Rome until the late eighth century B.C. and was followed by six kings, some of whom were Etruscans. In 509 B.C., the last king was overthrown and the Republic was established. For the next five centuries, Rome was ruled by two consuls, a senate, and an assembly. The consuls were elected every year and shared the military and judicial authority of the former kings. The senate was composed of former magistrates, and there was an assembly of citizens.

The Republic lasted until 27 B.C., when Octavian (who later took the title "Augustus") became the first emperor (see box, p. 211). The term *Augustus* originally meant "revered" and had religious connotations, but it came to mean "he who is supreme." *Caesar,* too, came to mean "ruler," as in the German *Kaiser.* For the next three hundred years, Rome was ruled by a succession of emperors. In A.D. 330, the emperor Constantine established an eastern capital of the Roman Empire in Byzantium, which he

Chronology of Roman Periods and Corresponding Works of Art and Architecture

PERIOD AND RULERS

Early Kings
Rule by kings and a senate
Late Kings
Etruscan rulers. Ends 509 B.C.
The Republic (509–27 B.C.)
Rule by Senate and patrician citizens
Punic Wars (264–146 B.C.)

Transition to Empire
Julius Caesar (46–44 B.C.)

Octavian/Augustus (27 B.C.–A.D.14)

Early Empire
Julio-Claudian dynasty (14–68)
 Tiberius (14–37)
 Caligula (37–41)
 Claudius (41–54)
 Nero (54–68)

Flavian dynasty (69–96)
 Vespasian (69–79)
 Titus (79–81)
 Domitian (81–96)

The so-called "Good Emperors" (96–180)
 Nerva (96–98)
 Trajan (98–117)
 Hadrian (117–138)
 Antoninus Pius (138–161)
 Marcus Aurelius (161–180)

A period of political stability
and economic prosperity

Beginning of Decline
 Commodus (180–192)
Political unrest and economic decline
The Severan Dynasty (193–235)
 Septimius Severus (193–211)
 Caracalla (211–217)
 Severus Alexander (222–235)
Anarchy (235–284)
Period of Tetrarchs (284–306)
 Diocletian (284–305) institutes four co-rulers in an
 unsuccessful effort to restore stability to the empire.

Late Empire
 Constantine I (306–337)

WORKS OF ART

Tophet, 8th–1st century B.C. (**7.66**)
"Baby bottle" vessel, 4th–3rd century B.C. (**7.68**)
Mausoleum at Dougga, 2nd century B.C. (**7.69**)
Temple of Portunus, late 2nd century B.C. (**7.23**)
Temple of the Sibyl, early 1st century B.C. (**7.25**)

Villa of the Mysteries, c. 65–50 B.C. (**7.54–7.56**)
Odyssey Landscapes, c. 50–40 B.C. (**7.57**)
Bust of Julius Caesar, mid-1st century B.C. (**7.43**)
Neo-Punic stele, 1st century B.C.–1st century A.D. (**7.67**)
Pont du Gard, late 1st century B.C. (**7.22**)
Ara Pacis, 13–9 B.C. (**7.31–7.33**)
Frescoes from villa at Boscotrecase, 11 B.C. (**7.59**)
Patrician with two ancestor busts, c. A.D. 13 (**7.45**)
Aeneas Fleeing Troy, early 1st century A.D. (**7.65**)
House of the Silver Wedding, early 1st century A.D. (**7.3**)
Augustus of Prima Porta, early 1st century A.D. (**7.48**)

Unknown Barbarian (Parthian?), A.D. 20 (**7.53**)
Young Woman with a Stylus, 1st century A.D. (**7.58**)

Landscape with Boats, 1st century A.D. (**7.60**)
Roman forums, A.D. 46–117 (**7.11**)
Hercules Strangling the Serpents, A.D. 63–79 (**7.62–7.63**)
Colosseum, A.D. 72–80 (**7.19–7.20**)
Still Life of Silver Objects, A.D. 75–76 (**7.61**)
Arch of Titus, A.D. 81 (**7.38–7.39**)
Portrait of a young Flavian lady, c. A.D. 90 (**7.46**)
Portrait of an older Flavian lady, c. A.D. 90 (**7.47**)

City of Timgad, early 2nd century (**7.6**)
Basilica Ulpia, 98–117 (**7.12–7.13**)
Mummy case of Artemidoros, 100–200 (**7.64**)
Trajan's Column, 113 (**7.34–7.35**)
Trajan's markets, early 2nd century (**7.14**)
Bust of Trajan, early 2nd century (**7.44**)
Insulae, 2nd century (**7.4**)

Pantheon, c. 117–125 (**7.27, 7.29–7.30**)
Hadrian's Villa and Canopus, 118–138 (**7.8–7.9**)
Antinous, c. 131–138 (**7.49**)
Equestrian statue of Marcus Aurelius, 164–166 (**7.50**)

Circus at Leptis Magna, early 3rd century (**7.21**)
Baths of Caracalla, 211–217 (**7.17–7.18**)
Caracalla, 3rd century (**7.52**)
Badminton Sarcophagus, c. 220 (**7.42**)

Arch of Constantine, c. 313 (**7.40–7.41**)
Monumental head of Constantine, 313 (**7.51**)
Dacian silver vase and helmet, 4th century (**7.36–7.37**)

Ovid

Another Roman poet who lived during the reign of Augustus was Publius Ovidius Naso (43 B.C.–A.D. 18), known as Ovid. His surviving poems include the *Amores* (which describe love in different moods) and the *Heroides* (love poems in the form of letters from legendary heroines to their husbands or lovers). Ovid's poetry is irreverent and witty. His longest work is the *Metamorphoses*, a hexameter poem in fifteen books. Its theme is the miraculous transformations of gods, and it contains a collection of Greek and Roman myths that has inspired countless works of art. In the Middle Ages, Ovid was applied to Christian themes and "moralized." During the Renaissance, especially in Italy, artists again used Ovid as an iconographic source for works depicting mythological subjects.

In A.D. 8, the emperor Augustus banished Ovid to Tomi on the Black Sea, where he died ten years later. His crime is unknown, but it may have been the immoral theme of his *Ars Amatoria*, a treatise on the arts of seduction.

renamed Constantinople (now Istanbul, in modern Turkey). After this period, the Western Empire, which had kept Rome as its capital, declined. The Goths overran the Western Empire in 476, which is considered to be the date of the fall of Rome.

In contrast to Greek art, Roman art does not show a consistent overall development of style. Instead, stylistic evolution is more clearly seen within certain types of painting, sculpture, and architecture. Further, since the Romans invented or elaborated several categories of works, this chapter is organized according to type; chronological sequences are followed within each type.

Architectural Types

During the empire, the Romans carried out extensive building programs, partly to accommodate their expanding territory and its growing population, and partly to glorify the state and the emperor. In so doing, the Romans assimilated and developed building and engineering techniques from the Near East, Greece, and Etruria. They also recognized the potential of certain building materials, particularly concrete, which allowed them to construct the monumental public buildings that are such an important part of the Roman legacy (see box).

Domestic Architecture

Roman interest in the material comforts of living led to the development of sophisticated domestic architecture. Many examples have been preserved as a result of the eruption of Mount Vesuvius in A.D. 79. Volcanic ash covered Pompeii, near modern Naples, a port noted for agriculture and commerce; the nearby seaside resort of Herculaneum was buried in mud and lava, and was therefore more difficult to excavate than Pompeii. An eyewitness to the eruption of Vesuvius, Pliny the Younger (see box, p. 214), described the disaster from a safe distance across the Bay of Naples, yet both Pompeii and Herculaneum were forgotten until 1592, when a Roman architect digging a canal discovered some ancient ruins. Serious archaeological excavations of the buried cities did not begin until the eighteenth century, and they are still continuing today.

Roman domestic (from the Latin word *domus*, meaning "house") architecture was derived from both Etruscan and Greek antecedents but developed characteristics of its own. The main feature of the Roman *domus* was the *atrium* (figs. **7.2** and **7.3**), a large hall entered through a corridor from the street. The *atrium* roof usually sloped inward, while a rectangular opening, the *compluvium,* allowed rainwater to collect in an *impluvium* (a sunken basin in the floor), from which it was channeled into a separate cistern. The *compluvium* was also the primary source of light in the *domus*. But, by the end of the first century B.C., the peristyle, with its colonnade, had become the focal point of the *domus,* and the *atrium* was little more than a foyer, or entrance hall. Additional rooms surrounding the peristyle included bedrooms, dining rooms, slave quarters, wine cellars, and storage space.

Roman Building Materials

Like the Etruscans, the Romans used brick as a basic building material. Under Augustus, however, marble became popular as a decorative facing over a brick core and was quarried in Carrara. According to Suetonius, the Roman lawyer and author of the *Lives of the Twelve Caesars* (c. A.D. 121), Augustus found Rome a city of brick and left it a city of marble. Today, much ancient Roman marble facing has disappeared because of looting, leaving visible the interior core of many buildings (e.g., the Colosseum, fig. 7.19).

Above all, the Romans built with concrete, a suitable material for large-scale public structures. Their concrete was a rough mixture of mortar, gravel, rubble, and water. It was shaped by wooden frames, and often wedge-shaped stones, bricks, or tiles were inserted into it before it had hardened, for reinforcement and decoration. Alternatively, a facing of plaster, stucco, marble, or other stone was added.

The Romans also used **travertine**—a hard, durable limestone that mellows to a golden yellow— and the soft, easily carved tufa, which had been popular with the Etruscans (see Chapter 6).

Just as the Romans recognized the potential of concrete, which had been invented in the ancient Near East, so too they developed the arch and the **vault** (fig. **7.1**), which had previously been used in the ancient Near East and Etruria.

The round arch may be thought of as a curved lintel used to span an opening. A true arch is constructed of tapered (wedge-shaped) bricks or stones, called **voussoirs,** with a **keystone** at the center. The point at which the arch begins to curve from its vertical support is called the **springing,** because it seems to spring away from it. The arch creates an outward pressure, or thrust, which must be countered by a supporting **buttress** of masonry.

The arch is the basis of the vault—an arched roof made by a continuous series of arches forming a passageway. A row of round arches produces a **barrel** or **tunnel vault,** so called because it looks like the inside of half a barrel or the curved roof of a tunnel. It requires continuous buttressing and is a difficult structure in which to make openings for windows. Vaults formed by a right-angled intersection of two identical barrel vaults are called **groin** or **cross vaults.**

Arches and vaults have to be supported during the process of construction. This is usually done by building over wooden frames known as **centerings,** which are removed when the keystone is in place and the mortar has set.

A **dome** is made by rotating a round arch through 180 degrees on its **axis.** In its most basic form, it is a hemisphere. As is true of arches and vaults, domes must be buttressed, and, since their thrust is equally dispersed in all directions, the buttressing must be from all sides. Domes can be erected on circular or square bases. Ancient Roman domes, such as the one on the Pantheon (see fig. 7.28), were generally set on round bases. Domes on square bases are discussed in Chapter 8.

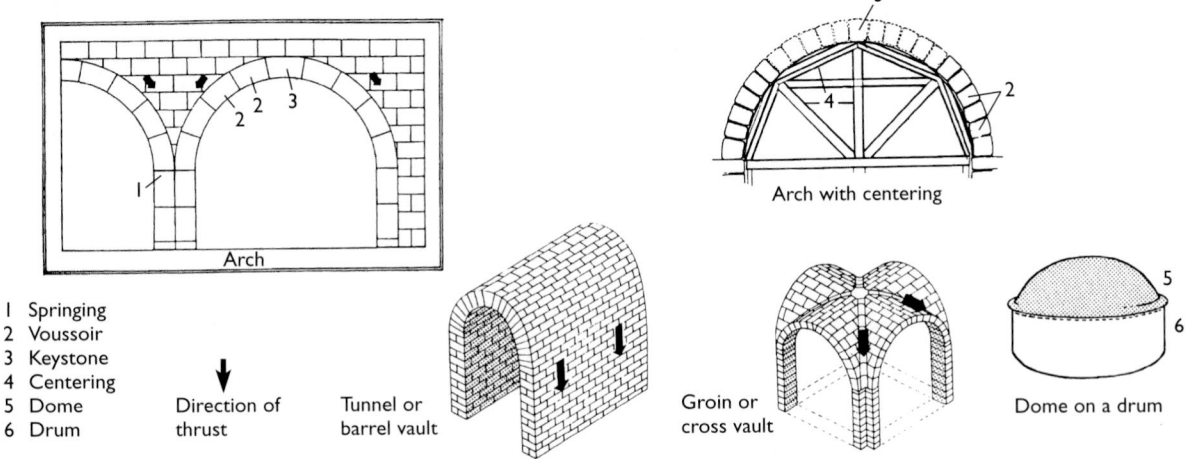

I	Springing
2	Voussoir
3	Keystone
4	Centering
5	Dome
6	Drum

Arch

Direction of thrust

Tunnel or barrel vault

Groin or cross vault

Arch with centering

Dome on a drum

7.1 Arch, arch with centering, tunnel or barrel vault, groin or cross vault, and a dome on a drum.

0 25 m

0 100 ft

7.2 (above) Plan of the House of the Faun, Pompeii, 2nd century B.C. 1. *atrium*; 2. *atrium tetrastylum*; 3, 4. courtyards surrounded by peristyles.

7.3 (right) *Atrium* and peristyle, House of the Silver Wedding, Pompeii, early 1st century A.D. Standing with our backs to the entrance, we can see the *compluvium* in the roof, which is supported by four Corinthian columns. The *impluvium* is in the center of the floor. Visible on the other side of the *atrium* is the *tablinium,* probably used for entertaining and for storing family documents and images of ancestors.

Pliny the Elder and Pliny the Younger

Gaius Plinius Secundus (A.D. 23/24–79), known as Pliny the Elder, was a Roman official who held military and civil positions in North Africa, Gaul (modern France), and Spain, and died in the eruption of Mount Vesuvius. He wrote a history of ancient art as well as works on grammar, military history, and oratory; most of his writings are lost, but his greatest achievement survives: the encyclopedic *Historia naturalis* (*Natural History*). This consists of thirty-seven books, covering topics that range from the elements of the universe, through continental geography and ethnology (of Europe, Asia, and Africa), to human physiology, zoology, botany, and the medicinal properties of plants, and discusses metallurgy as it relates to the use of minerals for medical purposes and to the arts. Pliny's history of ancient art remains a fundamental source.

His nephew, Pliny the Younger, produced voluminous correspondence that includes a vivid account of his uncle's role as commander of the fleet at Misenum, north of Pompeii. When he noticed a column of smoke rising from the nearby mountains, the elder Pliny launched a small boat and went to investigate. He soon realized that he was witnessing an eruption and, under a hail of stones, dictated his observations to a secretary. The next day, he went to the seashore for a closer look and was asphyxiated by the sulfurous fumes.

These houses had plain exteriors without windows. Rooms fronting on the street functioned as shops, or *tabernae* (from which we get the English word "tavern"). Behind the unassuming façades were interiors that were often quite luxurious—decorated with floor and wall mosaics, paintings, and sculptures. The typical professional or upper-class Roman house also had running water and sewage pipes.

For the middle and lower classes, especially in cities, the Romans built concrete apartment blocks or tenements, called *insulae* (the Latin word for "islands")—as in figure **7.4**. According to Roman building codes, the *insulae* could be as high as five stories. On the ground floor, shops and other commercial premises opened onto the street. The upper floors were occupied by families, who lived separately but shared kitchens and other facilities. As early as the first century A.D. Rome's urban population lived in such *insulae*. After they were burned by the great fire during Nero's reign (ruled A.D. 54–68), the *insulae* were rebuilt according to strict fire regulations. Their blocklike construction conformed to the typical town plan of the empire. Such plans were organized like a military camp, or *castra*, in which a square was divided into quarters by two streets intersecting in the middle at right angles. The *cardo* ran from north to south and the *decumanus* from east to west. Each quarter was then subdivided into square or rectangular blocks of buildings, such as the domestic houses and the *insulae*.

A new city, founded under the emperor Trajan (ruled A.D. 98–117) (see p. 231), in Timgad, in North Africa, followed the plan of the *castra* (fig. **7.5**). Its purpose was to provide a retirement colony for Trajan's soldiers. The plan was basically square, with gates for access to the city along roadways. Its relatively good state of preservation is seen in the aerial view in figure **7.6**, which shows the ruins of the theater, the square forum next to it, and the large triple arch spanning the cobbled road.

In addition to urban domestic architecture, the Romans invented the concept of the country **villa** as an escape from the city. Villas varied according to the tastes and means of their owners, and the most elaborate belonged to the emperors. Hadrian's (ruled A.D. 117–138) Villa

7.4 *Insula*, Ostia, reconstruction, 2nd century A.D. Brick and concrete.

7.5 Plan of Timgad, Algeria, early 2nd century A.D.

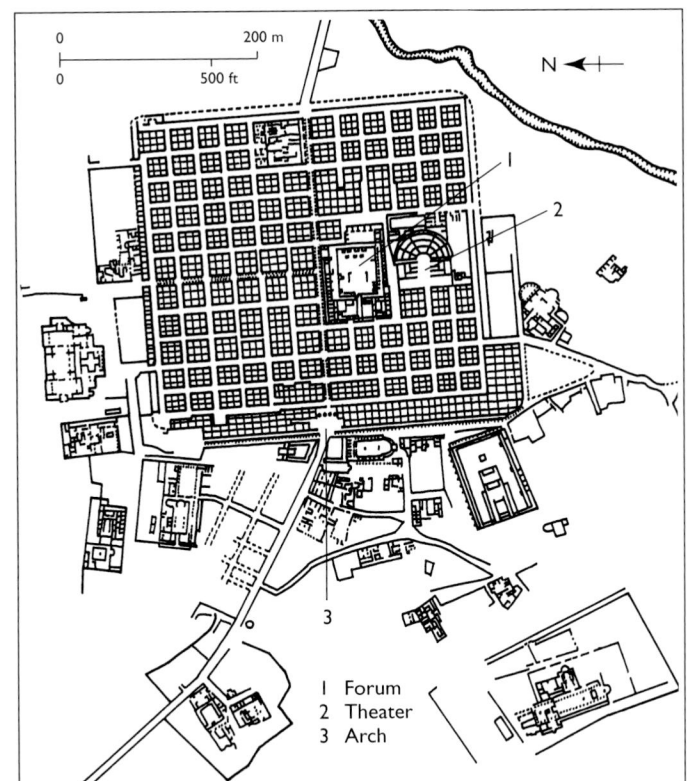

1 Forum
2 Theater
3 Arch

7.6 View from the west of the ruins of Timgad, Algeria, early 2nd century A.D.

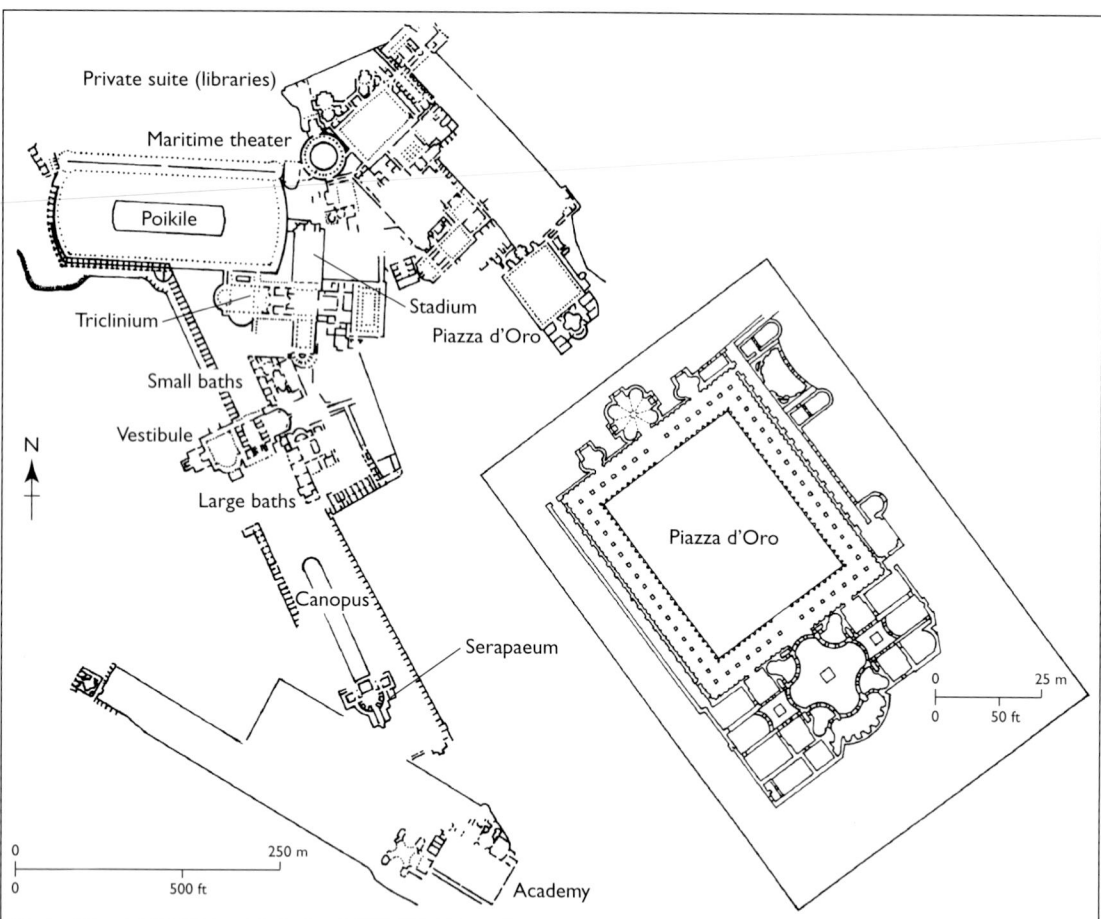

(fig. **7.7**), built from A.D. 118 to 138 near Tivoli, 15 miles (24 km) outside modern Rome, consisted of so many buildings—including libraries containing works in Greek and Latin, baths (fig. **7.8**), courtyards, temples, plazas, and a theater—that it occupied more than half a square mile (1.3 square km).

When Hadrian traveled, he collected ideas for his villa and later had monuments reproduced on its grounds. When visiting Alexandria, for example, Hadrian admired the **Serapaeum,** a temple dedicated to Serapis— the Egyptian god who combined features of Osiris, Zeus, and Hades, and was worshiped as ruler of the universe. Hadrian constructed his own canal and temple, and named them after the Egyptian temple. He used Ionic columns in his Serapaeum and Corinthian columns at the far end of the Canopus (fig. **7.9**) to

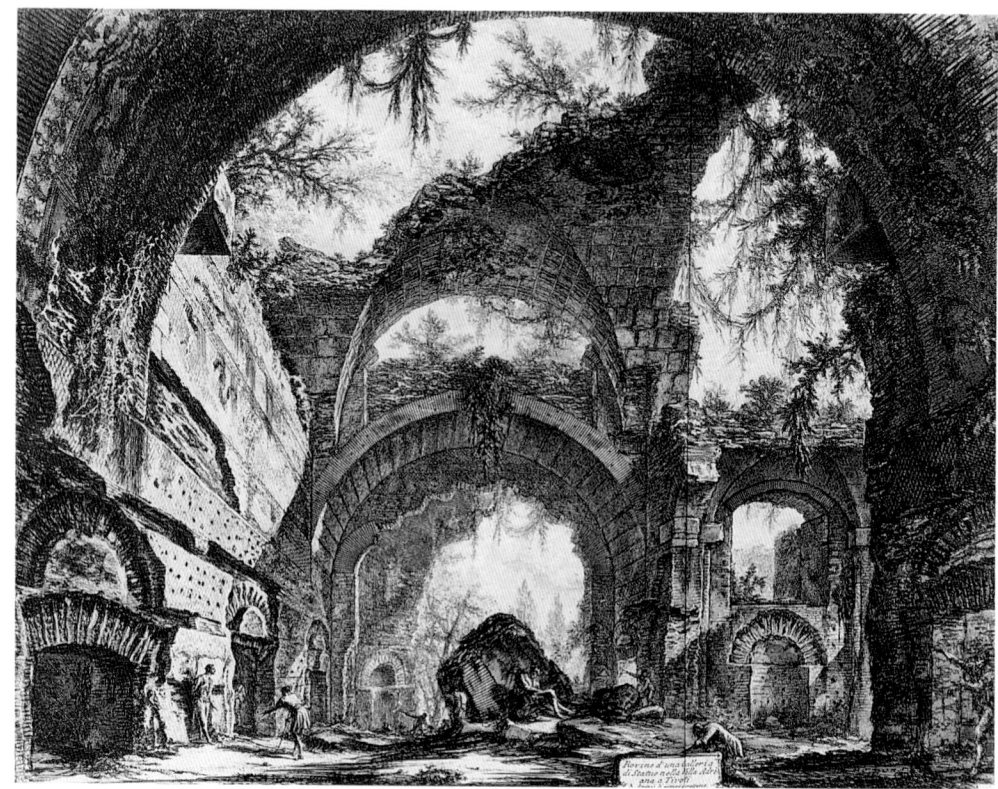

7.8 Piranesi, *The Great Baths, Hadrian's Villa, Tivoli,* from *Views of Rome,* 1770. Etching; 18 × 22 in. (45.7 × 55.6 cm). Istituto Nazionale per la Grafica, Rome.

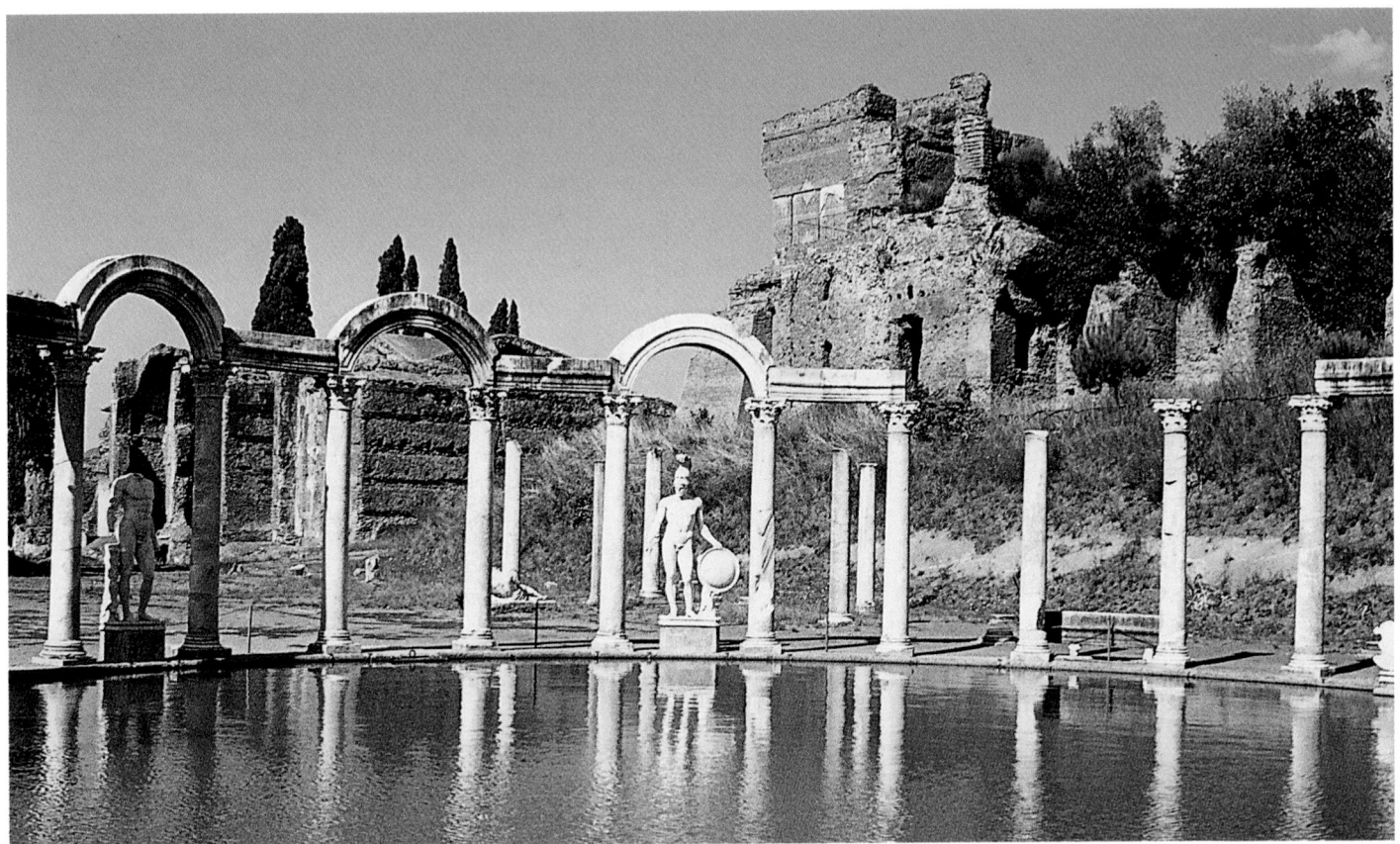

7.9 Canopus, Hadrian's Villa, Tivoli, c. A.D. 123–135.

support a structure of round arches alternating with lintels. Sculptures occupy the arched spaces and the entrance, which also contained fountains.

Public Buildings

As life in Rome and its provinces became increasingly complex, the need for public spaces and public buildings grew. Citizens gathered in open squares, and civic and administrative functions were performed in public buildings. These activities led to the development of two characteristic architectural types, the **forum** and the **basilica**.

The Forum The forum was typically a square or rectangular open space in front of a temple. Originally, the forum was a marketplace, its prototype being the smaller Greek *agora*. It was bounded on three sides by colonnades and on the fourth by a basilica (see below). This gave the forum a sense of order compared with the more random development of the *agora*. In Rome, the first known forum, the Forum Romanum, dates from the sixth century B.C. and it was this particular urban space that was conceived of as *caput mundi*. The Forum Romanum was regularly expanded during the Republic and the empire; but in the first century B.C., the Forum Julium became the prototype for all later imperial forums. Planned by Julius Caesar (see box) and completed by Augustus, it must have presented a magnificent architectural spectacle (it is now in ruins). The

Julius Caesar

Gaius Julius Caesar (c. 100–44 B.C.) was the greatest general and political figure of his generation, and an author famed in his own day for his Classical Latin prose. His sole surviving writings are the *Commentaries*, a personal account of the Gallic and civil wars. By the age of forty, Caesar shared the leadership of Rome with Pompey (his son-in-law) and Crassus, an arrangement known as the First Triumvirate (literally "Three Men"). He was consul in 59 B.C., and proconsul in Gaul (58–49 B.C.), where he waged a series of campaigns, going on to extend Roman rule north to Britain.

In 46 B.C., the senate appointed Caesar temporary dictator in order to give him the power to control growing civil unrest. Caesar used his power to enact several radical measures, including expanding the franchise of the provinces, regulating taxation, and reforming the calendar. His contempt for republicanism and his aristocratic tendencies aroused suspicion, and people feared that he intended to remain dictator permanently. On March 15, 44 B.C., a group of conspirators led by Marcus Junius Brutus and Gaius Cassius stabbed him to death, an event memorialized in Shakespeare's admonition to "beware the Ides of March," the Ides being the Roman term for the fifteenth day of the month.

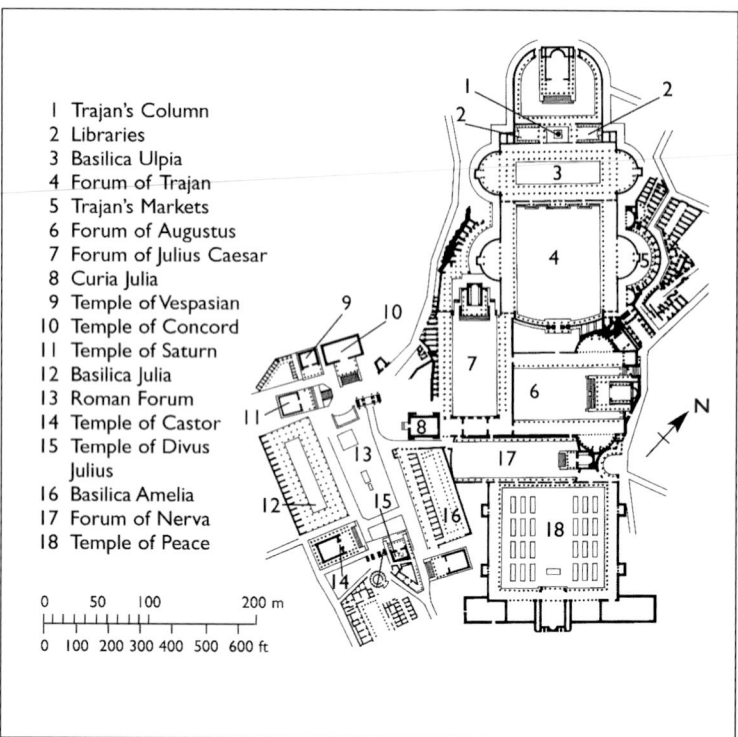

1 Trajan's Column
2 Libraries
3 Basilica Ulpia
4 Forum of Trajan
5 Trajan's Markets
6 Forum of Augustus
7 Forum of Julius Caesar
8 Curia Julia
9 Temple of Vespasian
10 Temple of Concord
11 Temple of Saturn
12 Basilica Julia
13 Roman Forum
14 Temple of Castor
15 Temple of Divus Julius
16 Basilica Amelia
17 Forum of Nerva
18 Temple of Peace

0 50 100 200 m

0 100 200 300 400 500 600 ft

7.10 Plan of the Roman and imperial forums, Rome. When Roman civic leaders wished to address the populace, they entered the forum. Today the term *forum* refers to a place or opportunity for addressing groups of people—candidates for political office are said to have a forum for their views if they can arrange a time and place for voters to hear them speak.

plan in figure **7.10** indicates the variety of forms and the degree to which the Romans added to the basic rectangular conception of the forum, while the reconstruction in figure **7.11** illustrates the layout, fronted by a temple with colonnaded basilicas at the sides.

As a political, religious, social, and commercial center, the forum was a regular feature of most Roman town plans. Gradually, however, the shops were transferred elsewhere, and the forum remained a focal point for civic and social activity. It was a more or less enclosed space, usually restricted to pedestrian traffic. Meeting places for the town council (the *curia*) and the popular assembly (the *comitium*) were integrated into the forum.

The Basilica A basilica (from the Greek word *basilikos,* meaning "royal") was a large roofed building, usually at one end of a forum. It was used for commercial transactions and also served as a municipal hall and law court. According to Vitruvius (see p. 190), basilicas should be located in the warmest site so that in winter businessmen can confer in comfort. Basilicas were typically divided into three **aisles:** a large central aisle was flanked by smaller ones on either side, separated from one another by one or two rows of columns. The extra height of the center aisle, or **nave** (from the Latin word *navis,* meaning "ship," and derived from the idea of an inverted boat), permitted the construction of a second-story wall above the colonnades separating the nave from the aisles. Clerestory windows were built into the additional wall space to admit light into the building.

As shown in figure **7.12**, Trajan's Forum adjoins the Basilica Ulpia (the name "Ulpia" comes from the *gens* to which Trajan belonged), which is basically rectangular in plan with an apse, or curved section, at each end. The apses contained statues of gods or emperors, provided space for legal proceedings, and often included a throne occupied by a statue of the emperor. The huge size of the basilica created a need for lighting, which the Romans solved by piercing the walls with clerestory windows above the colonnades on either side of the nave (fig. **7.13**). The colonnades themselves provided an articulated space for socializing, people awaiting trial, and for those transacting business. Roofing was made of timber and covered with tiles, and the interior was adorned with marble and bronze.

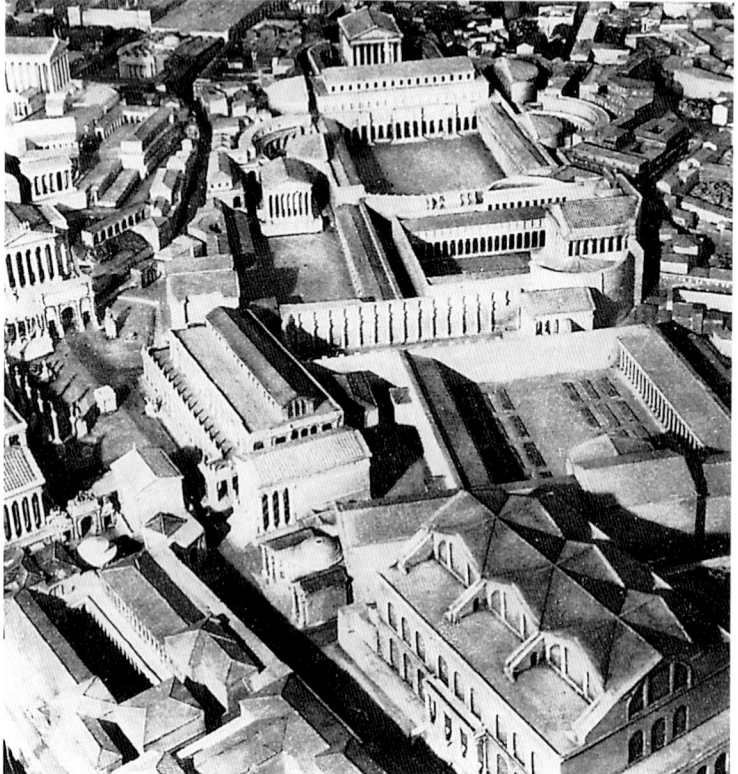

7.11 Reconstruction of the forums, Rome, c. A.D. 46–117. Museo della Civiltà Romana, Rome.

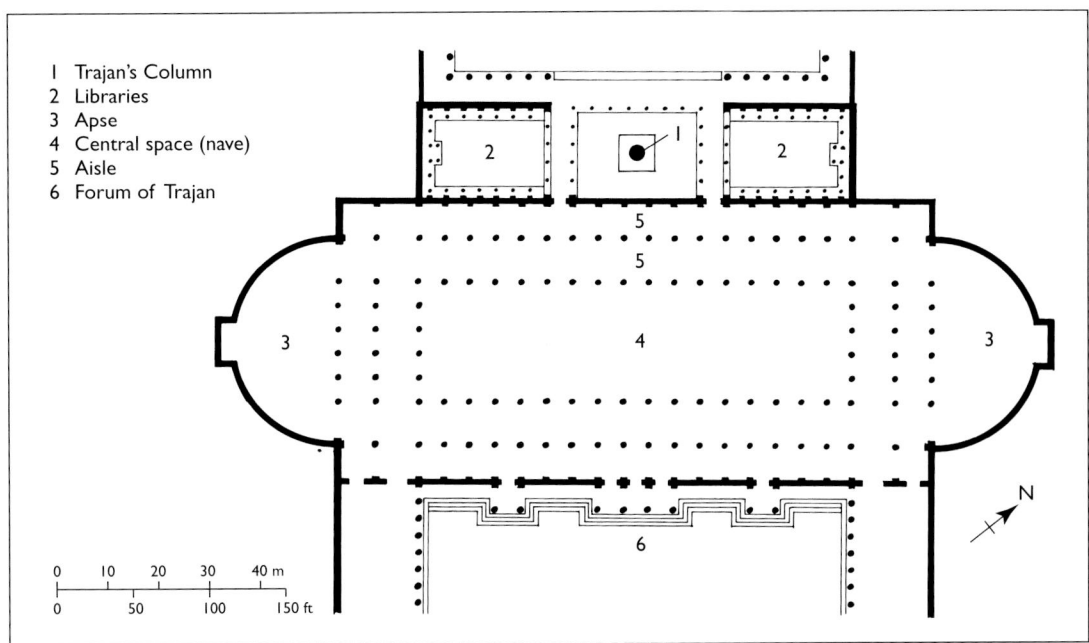

1 Trajan's Column
2 Libraries
3 Apse
4 Central space (nave)
5 Aisle
6 Forum of Trajan

0 10 20 30 40 m
0 50 100 150 ft

7.12 Apollodorus of Damascus, plan of the Basilica Ulpia, Forum of Trajan, A.D. 98–117.

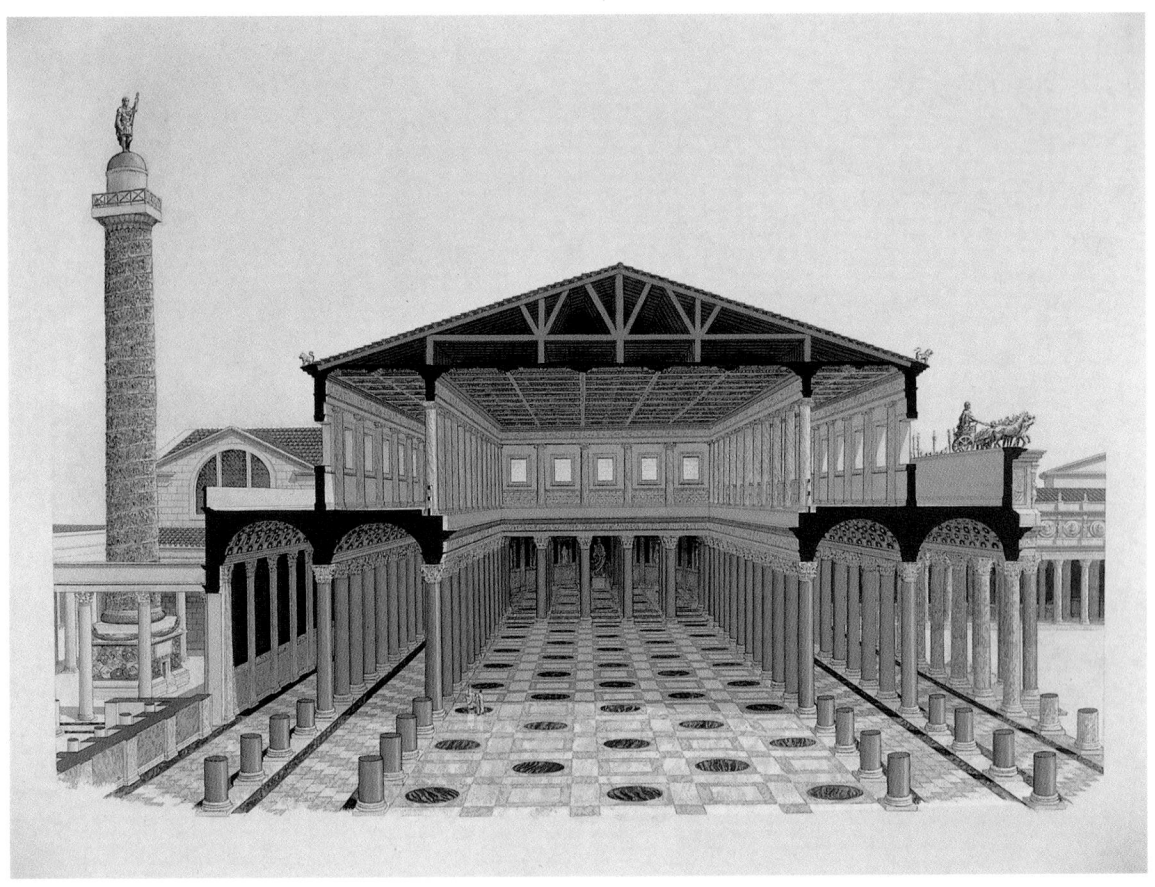

7.13 Reconstructed cross section of the Basilica Ulpia.

7.14 The remains of Trajan's markets as seen from the west.

The Markets of Trajan Trajan's markets were as noteworthy for their huge size as for their innovative engineering and architecture (fig. **7.14**). Their concrete core was faced with brick, with a few details in wood and stone. They were conceived as part of the total urban renovation that included Trajan's Forum (which was faced with marble); the isometric drawing of the surviving markets (fig. **7.15**) shows their structural relation to each other. Their original area is unknown, but they probably contained over 200 rooms (evidence of 127 survives today). The markets rise from the Forum along the incline of the Quirinal Hill.

The view from the west in figure 7.14 gives some idea of the imposing quality and architectural variety of Trajan's markets. They are constructed as a series of tiered, apsidal spaces with barrel-vaulted ceilings. Groin vaults were used for the main hall. In the upper levels, clerestory windows, as in the basilica, provided a source of interior lighting. The rooms housed offices and over 150 shops linked by a complex system of stairways and arcades. Shifting axes, flowing masses and spaces, and patterns of light and shadow created a dynamic interplay of solid forms with voids. As a totality, the markets served a social and commercial function for large numbers of people. The architect exploited the formal appeal of the façade, while departing from traditional columns and colonnades.

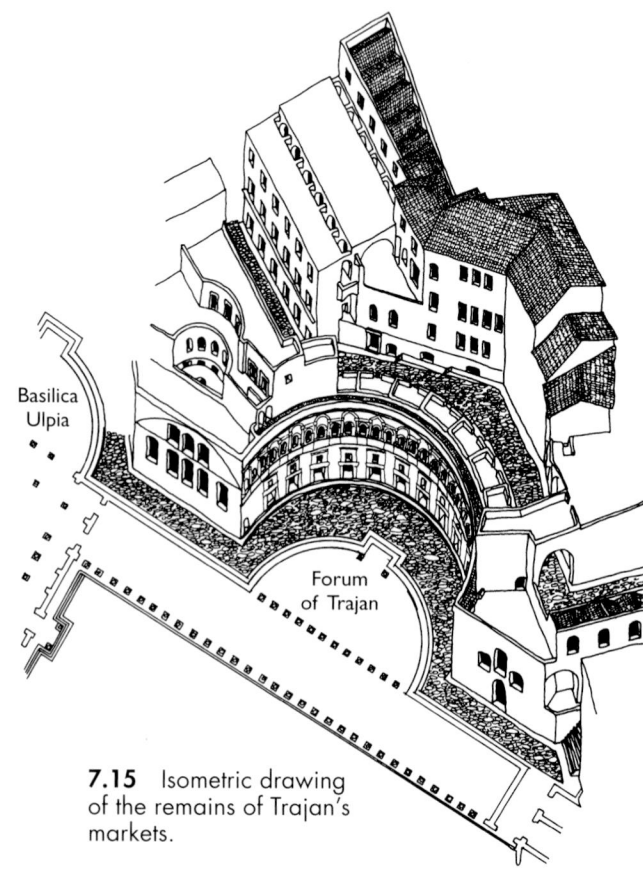

Basilica Ulpia

Forum of Trajan

7.15 Isometric drawing of the remains of Trajan's markets.

7.16 Plan of the Baths of Caracalla, Rome, A.D. 211–217. The total complex occupied approximately 35 acres (130,000 sq. m).

Public Baths Another type of monumental construction popular in ancient Rome was the public bath. Besides being a place for bathing, swimming, and socializing, the public bath was a museum filled with sculpture. It also provided facilities for playing ball, running, and wrestling. Romans attended the baths for health, hygiene, exercise, relaxation, and socializing. Amenities included a cold room (*frigidarium*), a warm room (*tepidarium*), a hot room (*caldarium*), steam rooms, changing rooms, libraries, and gardens.

Although every Roman city throughout the empire had public baths, Rome had the most. A catalogue of Roman buildings of A.D. 354 lists 952 baths of various sizes. Particularly magnificent were the vast baths of the emperor Caracalla, who ruled from A.D. 211 to 217 (figs. **7.16**, **7.17**, and **7.18**). The plan was constructed on two axes with the *frigidarium* at their intersection. As in the typical basilica construction, light entered the baths through clerestory windows and illuminated the myriad surface patterns created by marble, glass, painted decoration, and water.

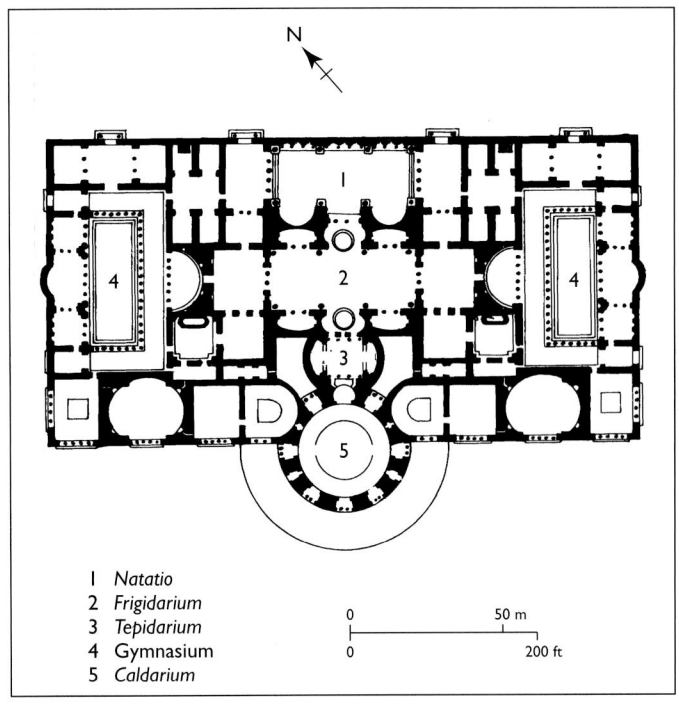

1 *Natatio*
2 *Frigidarium*
3 *Tepidarium*
4 *Gymnasium*
5 *Caldarium*

7.17 Aerial view of the ruins of the Baths of Caracalla, Rome, c. A.D. 211–217. Marble and concrete.

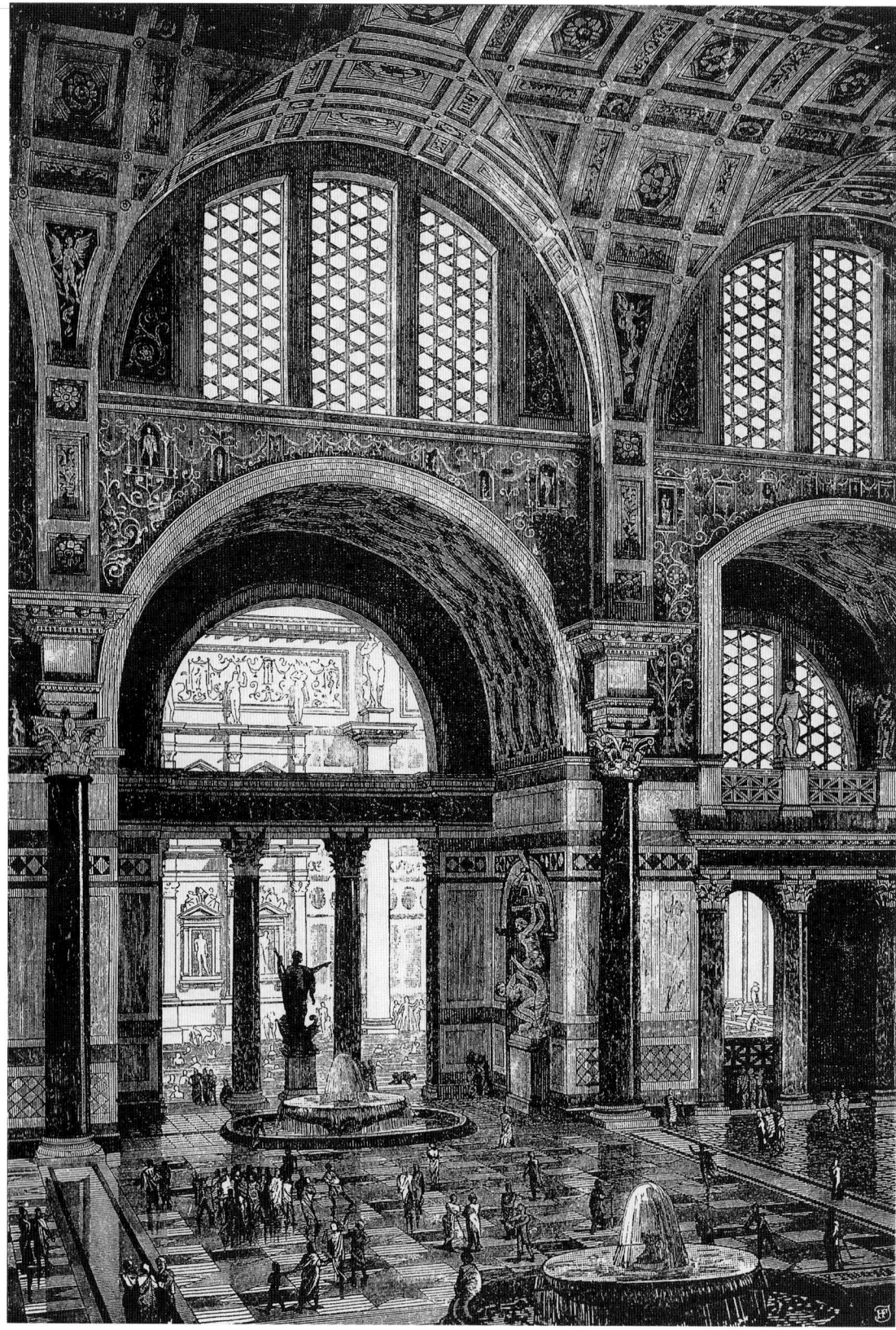

7.18 Restoration drawing of the Baths of Caracalla. The plan in figure 7.16 shows the enormous Corinthian columns that supported the groin vaults of the ceiling in this central hall.

The Colosseum Like the Greeks, the Romans built theaters for plays. In addition, the Romans built **amphitheaters** (from the Greek words *amphi,* meaning "around" or "both," and *theatron,* meaning "theater") for spectator sports, games, and other lavish spectacles. The Colosseum (begun in A.D. 72 under Vespasian and inaugurated in A.D. 80 by his son Titus) (figs. **7.19** and **7.20**) has exterior **arcades** with three stories of round arches framed by entablatures and engaged columns. The ground-floor columns are Tuscan (a later development of Doric), the second-floor columns are Ionic, and those on the third floor are Corinthian. On the fourth floor are small windows and engaged, rectangular Corinthian pilasters. This system, in which the columns are arranged in order of visual as well as structural strength, with the "heaviest" Doric type at the bottom, was regularly followed in Roman

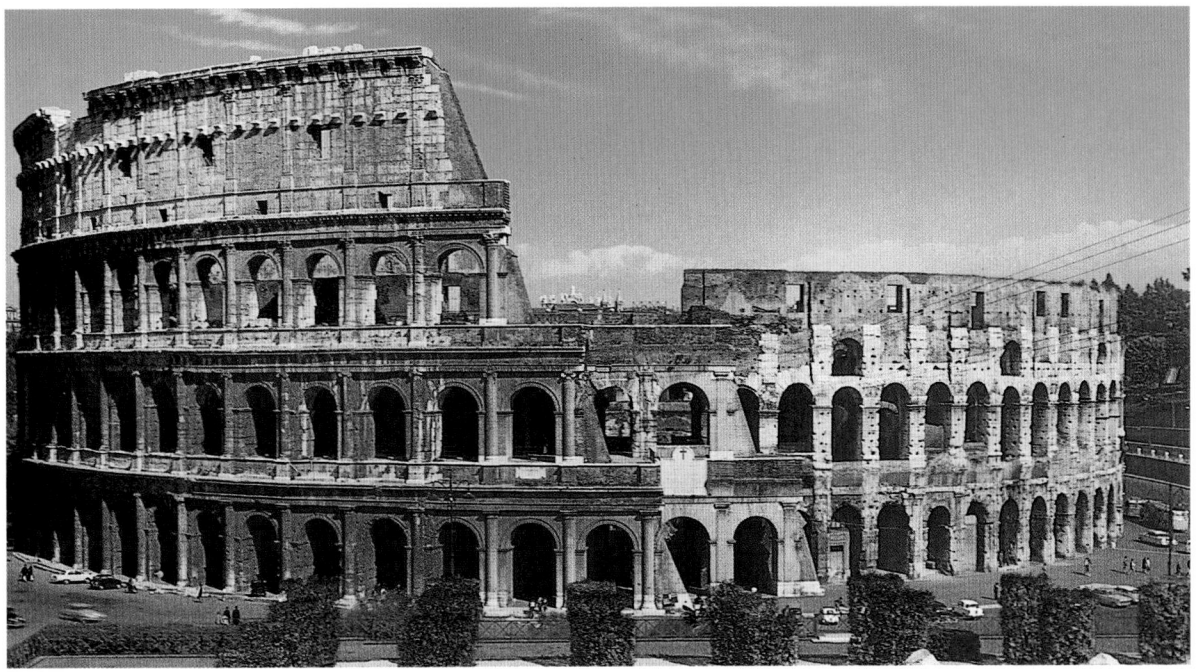

7.19 Side view of the Colosseum, Rome, c. A.D. 72–80. Concrete, travertine, tufa, brick, and marble; approx. 615 × 510 ft. (187.45 × 155.45 m).

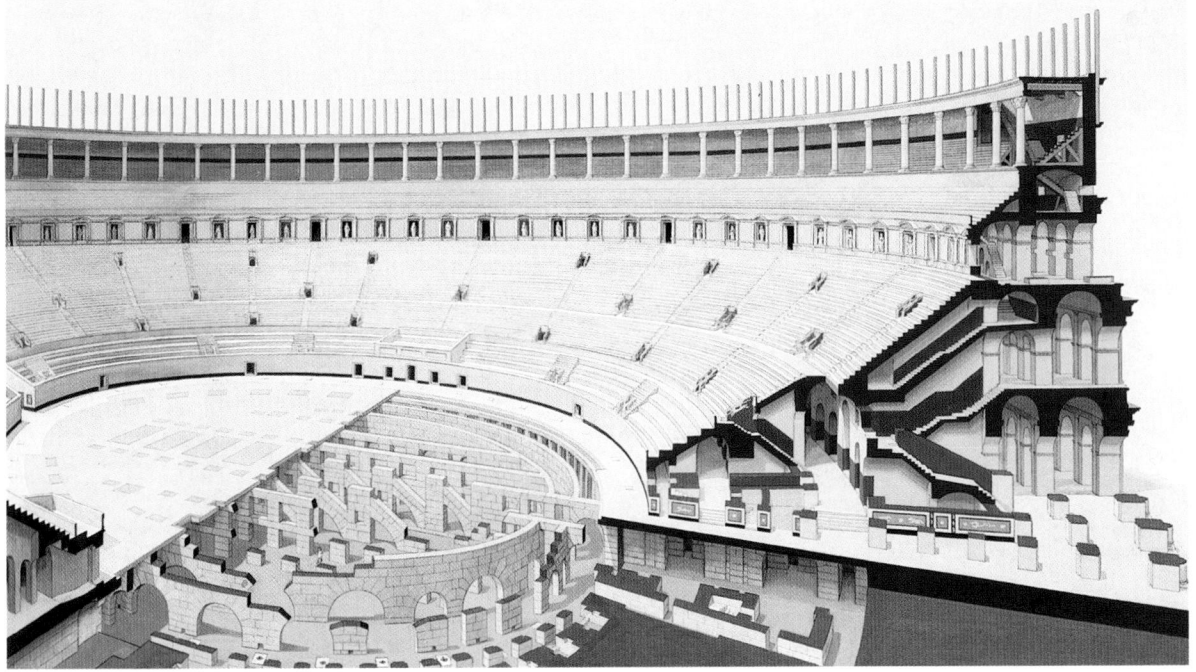

7.20 Reconstructed cutaway section of the Colosseum.

architecture. The surface of the outer wall also becomes flatter as it rises, which carries the viewer's eye upward, while the repeated round arches of the circular arcades direct the eye around the building. The projecting cornice at the very top serves aesthetically to crown the structure.

The term *colosseum* comes from a colossal statue of Nero. Construction of the Colosseum started about A.D. 72 under the emperor Vespasian, who had come to power in A.D. 69. It was inaugurated in A.D. 80, a year after his death. More than 50,000 spectators proceeded along corridors and stairways through numbered gates to their seats. The concrete foundations were 25 feet (7.62 m) deep. Travertine (much of it dismantled and reused in the Middle Ages) was used for the framework of the piers, and tufa and brick-faced concrete were used for the walls between the piers. Originally there was marble on the interior, but it has disappeared.

The Colosseum was built around a concrete core, with an extensive system of halls and stairways for easy access. Two types of vault were used in the corridor ceilings—the simpler barrel vault and the groin vault (also called a cross vault). The upper wall was fitted with sockets, into which

poles were inserted as supports for awnings; these were stretched by sailors across the open top of the arena to protect spectators from the sun. The Colosseum was designed for gladiatorial contests and combats between men and animals, or between animals alone. Because it was located over a pond formerly on Nero's property, it was possible to construct a built-in drainage system for washing away the blood and gore of combat. The Colosseum remains a monument to the political acumen of imperial Rome, offering spectacles that suited the popular taste for cruelty and violence as well as catering to the creature comforts of its citizens.

The Circus Another form of public entertainment in ancient Rome took place in the **circus.** Principally designed for chariot races, the circus could accommodate up to a dozen four-horse chariots. The resulting structures ranged in length from 1,300 to 1,970 feet (about 400 to 600 m). It has been estimated that the Circus Maximus, or Largest Circus, in Rome could hold more than 200,000 spectators. A more typical Roman circus (fig. **7.21**), dating

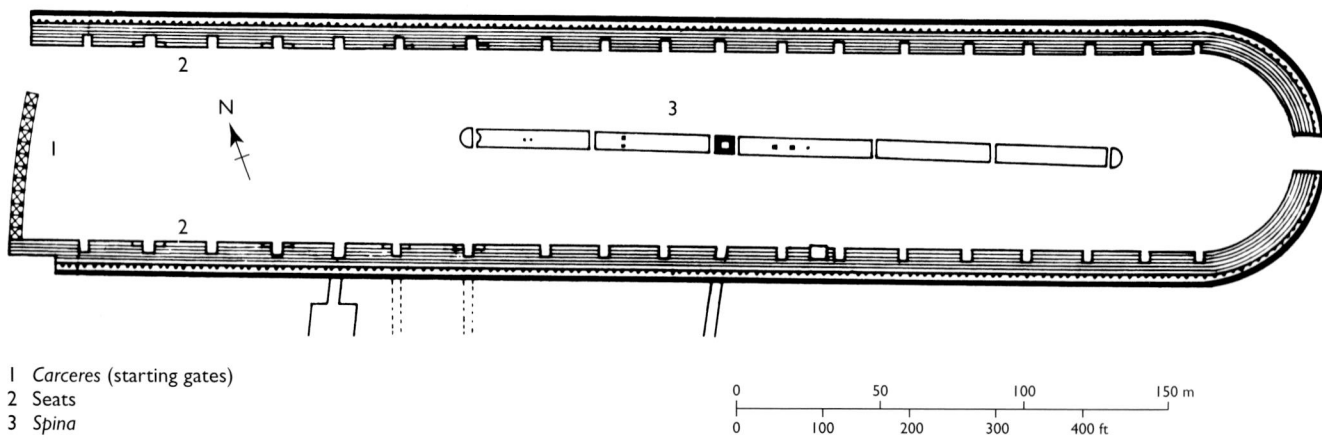

1 *Carceres* (starting gates)
2 Seats
3 *Spina*

7.21 Plan of the circus at Leptis Magna, Libya, early 3rd century. The two long sides and the semicircular eastern end had seats. A low dividing wall, the *spina* ("spine"), ran up the middle of the **arena** (the sandy running surface). It was decorated with statues, fountains, and other ornaments. Conical pillars marked the ends of the wall where the contestants had to turn.

to the early third century A.D., was located at Leptis Magna, in present-day Libya, at the southern extreme of the Roman Empire.

Circus races began from the starting gates, or *carceres* (from the Latin word for "jail": cf. the English word *incarcerate*), because the gates remained closed until the race started. The race itself consisted of seven circuits in a counterclockwise direction. As the racers completed each lap, a marker indicated the number of remaining laps.

The Greek forerunners of the circus were the hippodrome for horse racing and the stadium for footracing. In Greece, however, the need for public spectacles was much more limited. The Roman populace craved entertainment, and the impetus for the huge imperial Roman building programs was as much to satisfy this craving as to express the power inherent in the emperor's ability to finance and execute them.

Aqueducts An example of the Roman ability to turn necessity into practicality was the development of the bridge and **aqueduct** (or conductor of water, from the Latin words *ducere*, meaning "to lead," and *aqua*, meaning "water"). The most impressive example of a section of a Roman aqueduct is the Pont du Gard (fig. **7.22**), located near modern Nîmes in the south of France. Between 20 and 16 B.C., Marcus Agrippa (son-in-law and adviser to Augustus) commissioned an aqueduct system to bring water to Nîmes from natural springs some 30 miles (48.28 km) away. Much of the aqueduct was built below ground or on a low wall, but when it had to cross the gorge of the Gardon River, it was necessary to build a stone bridge to carry it.

The Pont du Gard was constructed in three tiers, each with narrow barrel vaults. Those on the first two tiers are the same size, while the third-story vaults, which carried the channel containing the water, were smaller. The top

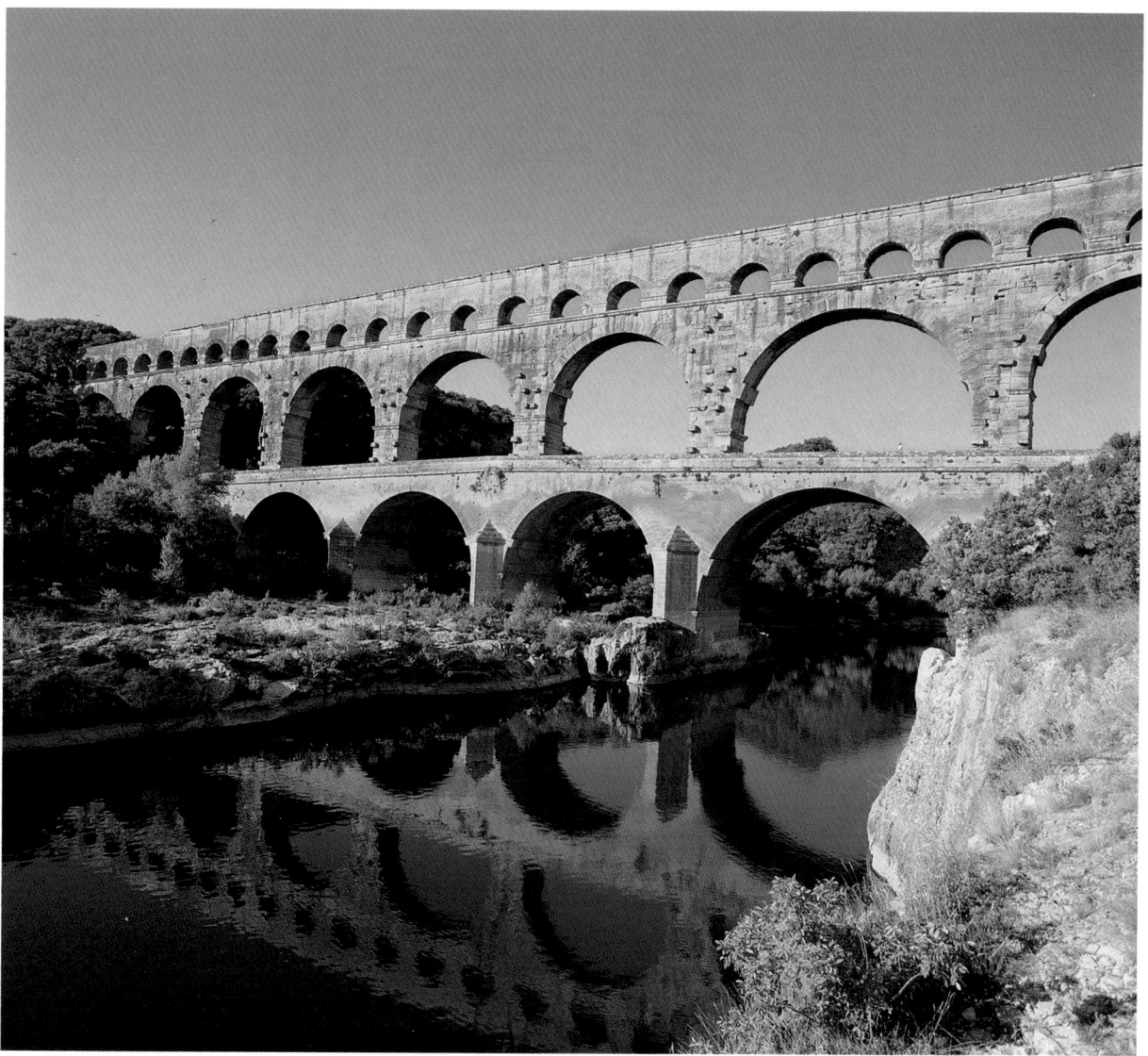

7.22 Pont du Gard, near Nîmes, France, late 1st century B.C. Stone; 854 ft. (260.30 m) long, 162 ft. (49.38 m) high. The aqueduct system maintains a constant decline of 1 to 3,000, resulting in a total drop of only 54 feet (16.46 m) over its whole length of 30 miles (48 km).

vaults and larger ones are in a ratio of 1:4. The voussoirs that make up the arches weigh up to 6 tons (6,096 kg) each. They were precisely cut to standard measurements, **dressed** (shaped and smoothed), and then fitted into place without mortar or clamps.

The vault system of construction was well suited to a massive engineering project such as the Pont du Gard. With the tunnel vaults arranged in a continuous series side by side, the lateral thrust of each vault is counteracted by its neighbor so that only the end vaults need buttressing. The placement of larger vaults below and smaller ones above serves both a structural purpose—support—and an aesthetic one: the repeated arches not only carry water, but also formally carry one's gaze across the river.

CONNECTIONS

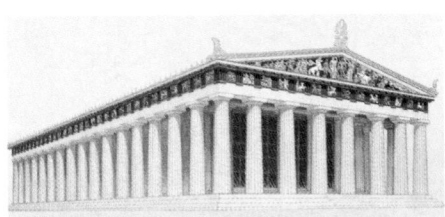

See figure 5.48. Reconstruction of the Parthenon.

Religious Architecture

Temples Roman temples were derived from Greek and Etruscan precedents. From Etruria came the podium (base), the high stairs, and the frontality of the temple (see Chapter 6). From Greece came the columns, the *cella* (equivalent to the Greek *naos*), the porch (*pronaos*), the Orders, the pediment, and the use of stone and marble. Many Greek architects worked in Rome and its provinces following the Roman conquest of Greece in 146 B.C. Their activity led to an infusion of Greek elements and a gradual shift toward the use of marble.

The Temple of Portunus (figs. **7.23** and **7.24**), built in Rome in the late second century B.C., shows Greek influence in the entablature, which is supported on all four sides by slender Ionic columns. The corner columns, as in the Parthenon, serve both the long and the short sides simultaneously. Etruscan influence is apparent in the deeper porch, the raised podium, and the steps, which are restricted to the front porch and thus give the temple a well-defined frontal aspect. Later, during the empire, the frontality of the temple, raised on its podium, seemed to preside over the ritual space before it and was seen as a metaphor for the emperor's domination of the city and its inhabitants.

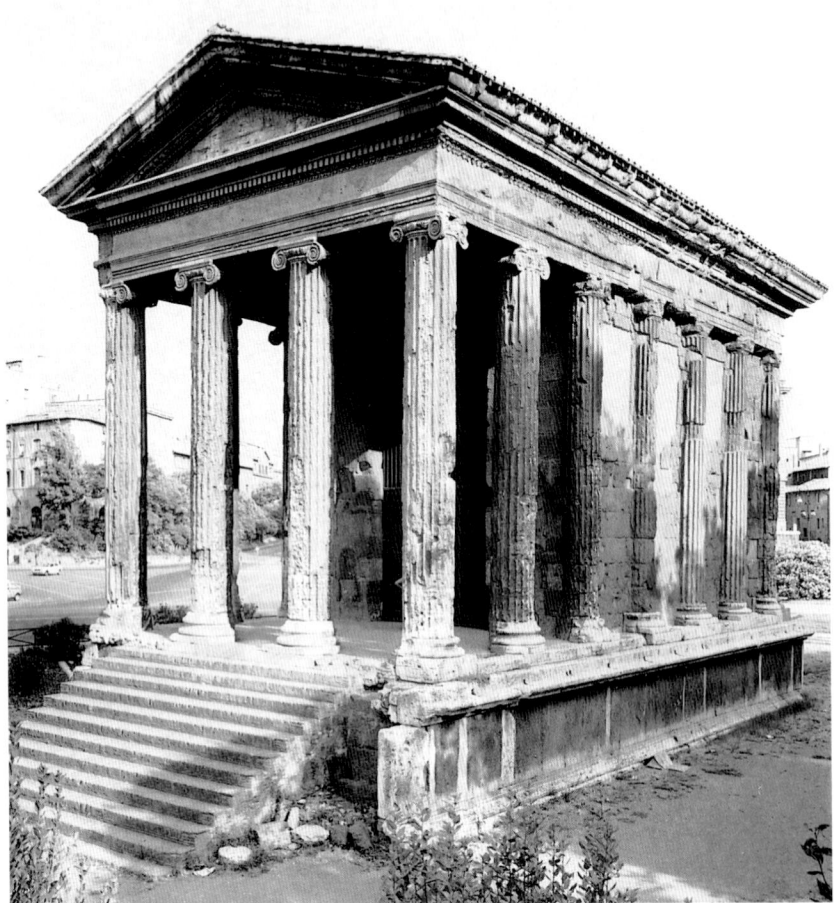

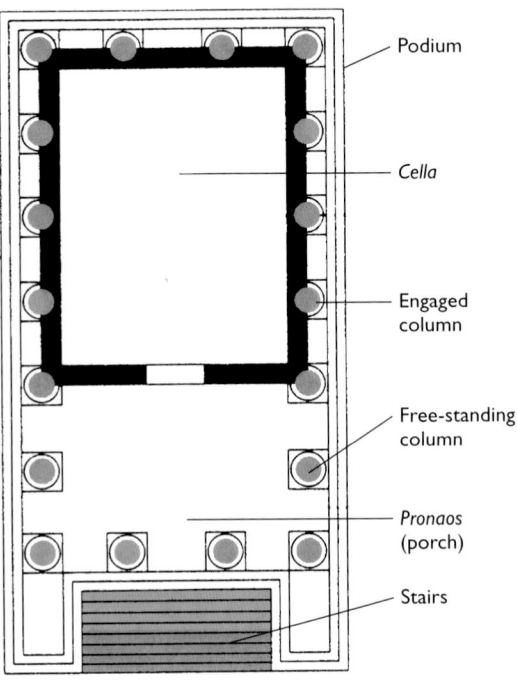

7.23 (left) Temple of Portunus (formerly known as the Temple of Fortuna Virilis), Rome, late 2nd century B.C. Stone.

Podium

Cella

Engaged column

Free-standing column

Pronaos (porch)

Stairs

7.24 Plan of the Temple of Portunus.

One aspect in which the Roman temple differs from the Greek is in the relation of the columns to the wall. Whereas Greek temples are typically **peripteral** (surrounded by a colonnade of freestanding columns), the columns of the Temple of Portunus are freestanding only on the porch. The other columns are engaged in the back and side walls of the *cella*, hence the term *pseudoperipteral*. The Romans had thus moved beyond the Greek use of the column as the primary means of support and the colonnade as the organizing principle of architectural space. In the Temple of Portunus, the solid wall, made of rubble-faced concrete, is the supporting element, and the engaged columns, which originally were faced with travertine, have a purely decorative function.

Another Roman temple type having both Greek and Etruscan elements, and dating from the early first century B.C., can be seen in the circular Temple of the Sibyl at Tivoli (figs. **7.25** and **7.26**; see box). Like the Temple of Portunus, the Temple of the Sibyl stands on a podium. Its eighteen fluted Corinthian columns support an entablature with a continuous frieze of ox heads alternating with garlands. The steps are located only in front of the entrance. It is reminiscent of earlier round temples from Greece, of the *tholos* design of Mycenaean and Etruscan tombs, and of the round Etruscan huts (see fig. 6.9).

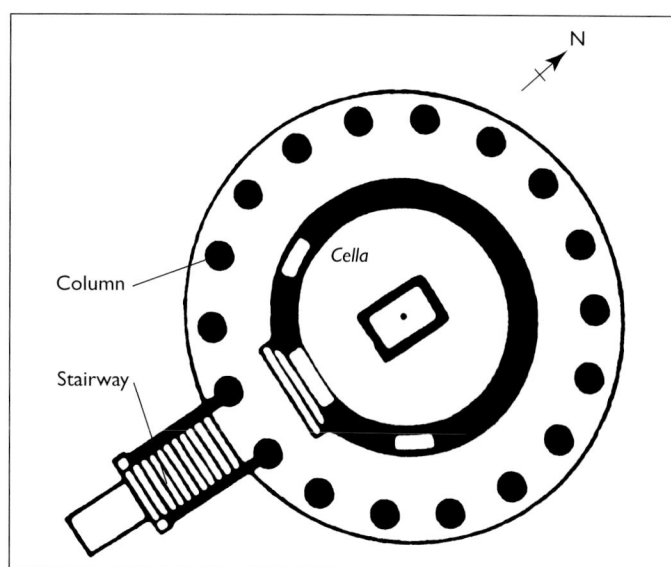

7.26 Plan of the Temple of the Sibyl.

Sibyls

Sibyls were women in Greek and Roman antiquity who interpreted events and predicted the future. They were generally priestesses presiding at oracular sites such as Delphi (see Chapter 5) and were believed to be divinely inspired. In Christian art—for example, on the Sistine Chapel ceiling (see Chapter 14)—they are often represented as having foretold the coming of Christ.

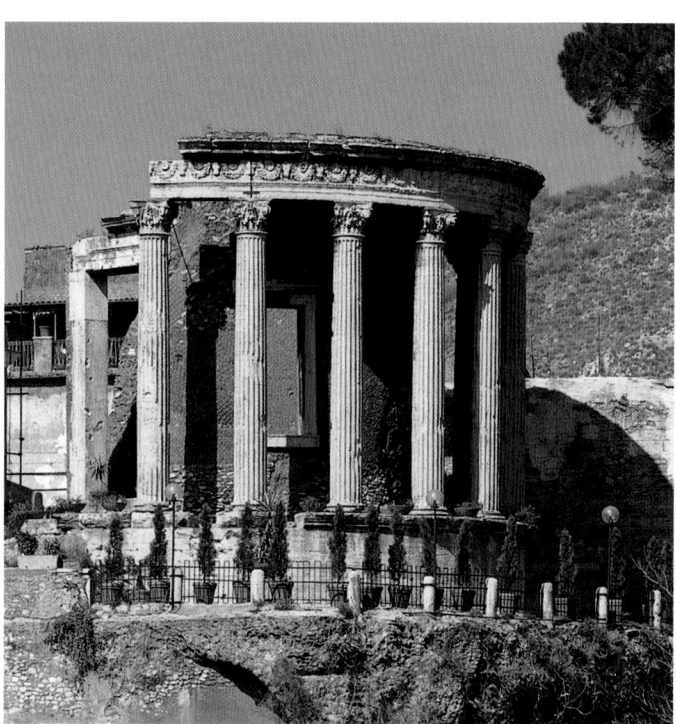

7.25 Temple of the Sibyl, Tivoli, early 1st century B.C. The foundations are of tufa, the temple itself of concrete faced with travertine ashlar. Also known as the Temple of Vesta (goddess of the hearth), the building is thought to be based on an earlier structure in Rome, where the sacred flame of the city was kept. In the eighteenth century, the column-capitals were copied for use on the façade of the Bank of England building in London.

The Pantheon The round plan was used in the Pantheon, the most monumental ancient Roman temple, which was built during the reign of Hadrian (figs. **7.27–7.30**). It consists of two main parts: a traditional rectangular portico supported by massive granite Corinthian columns; and a huge concrete **rotunda** (round structure), faced on the exterior with brick. Inscribed on the pediment of the portico is the name of Augustus's friend Marcus Agrippa, who had dedicated an earlier temple on the same site. The entire Pantheon stands on a podium with steps leading to the portico entrance. The transition from the rectangular entrance portico to the huge cylindrical rotunda creates the impression of moving from a Greek temple into a Roman space. The forecourt masked the striking absence of symmetry between the rectangular portico and the huge, cylindrical rotunda.

Once inside the rotunda, the visitor is confronted by a vast domed space illuminated only from the open *oculus* (Latin for "eye") in the center of the dome (fig. 7.30). The dome and the drum are in perfect proportion, the distance from the top of the dome to the floor being identical with the diameter of the drum. As is evident from the plan, the circle is inscribed in a square. The marble floor consists of

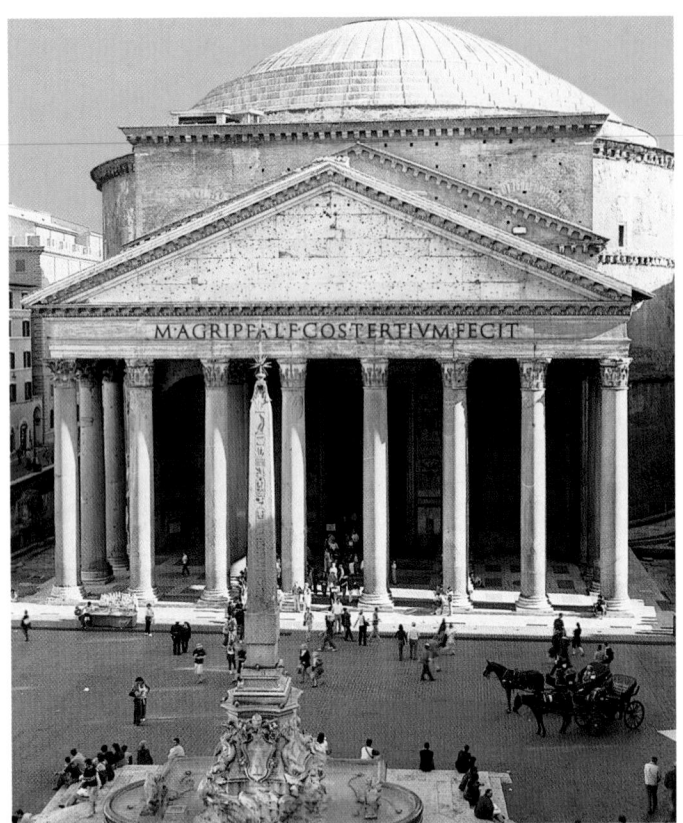

7.27 Exterior view of the Pantheon, Rome, A.D. 117–125. Marble, brick, and concrete. The Pantheon was dedicated in a literal sense to all (*pan*) the gods (*theoi*)—specifically, to the five planets then known (Jupiter, Mars, Mercury, Saturn, and Venus) and possibly also to the sun and moon.

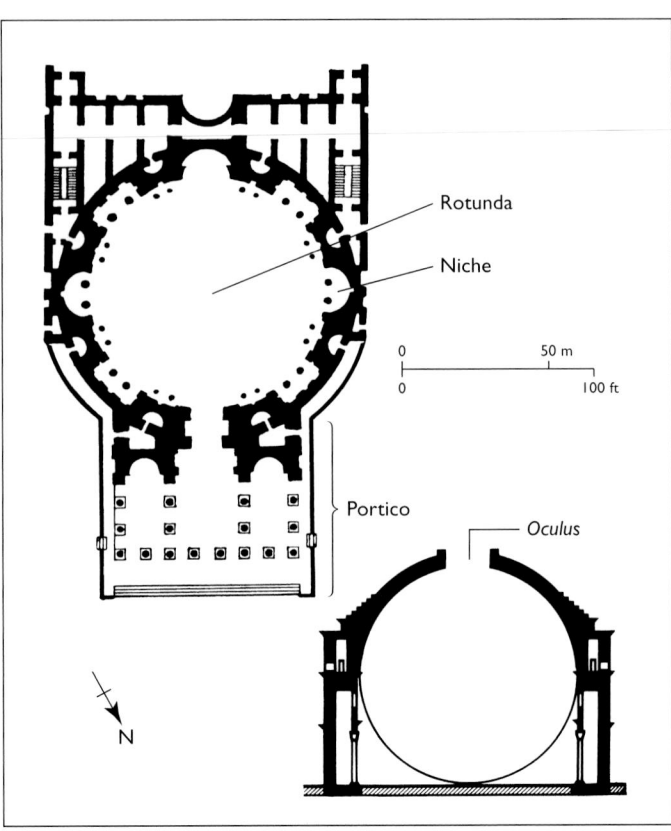

7.28 Plan and section of the Pantheon. The section shows the thickness of the dome tapering toward the top, from approximately 20 to 6 feet (6.09–1.83 m). Note the stepped buttresses on the lower half of the dome.

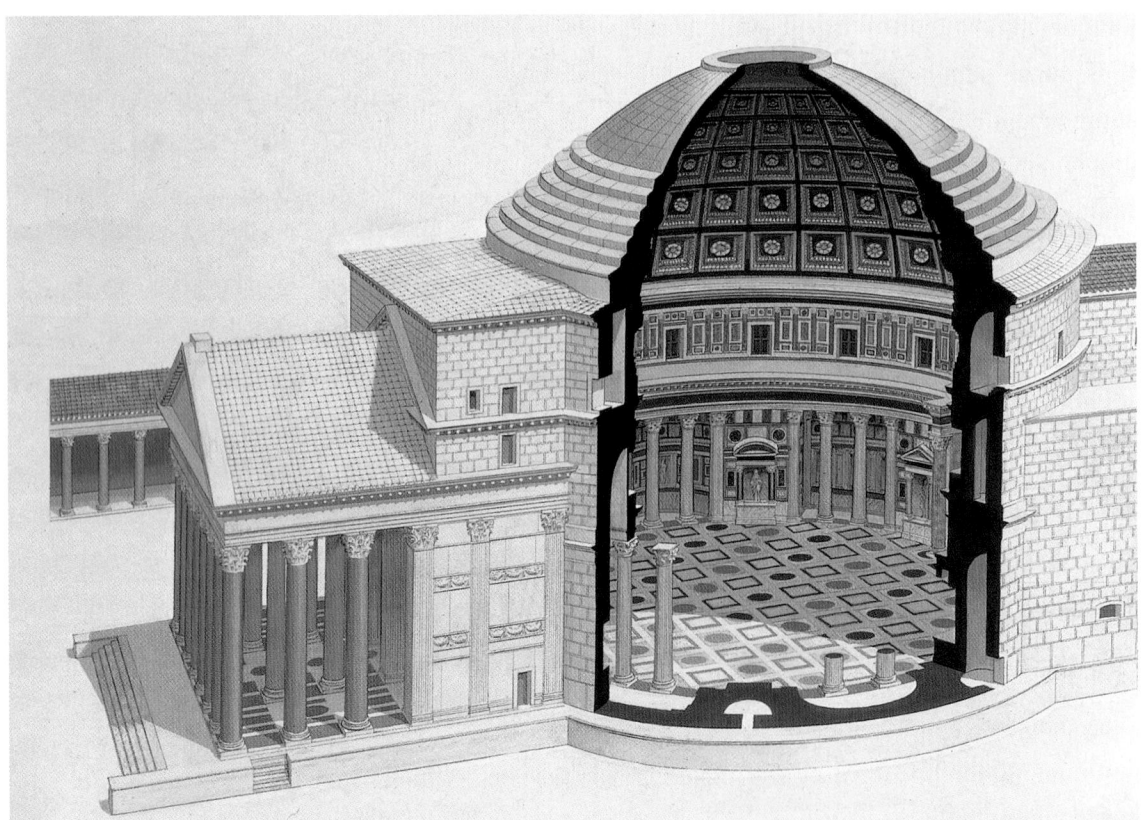

7.29 Reconstruction of the Pantheon with a cutaway of the dome.

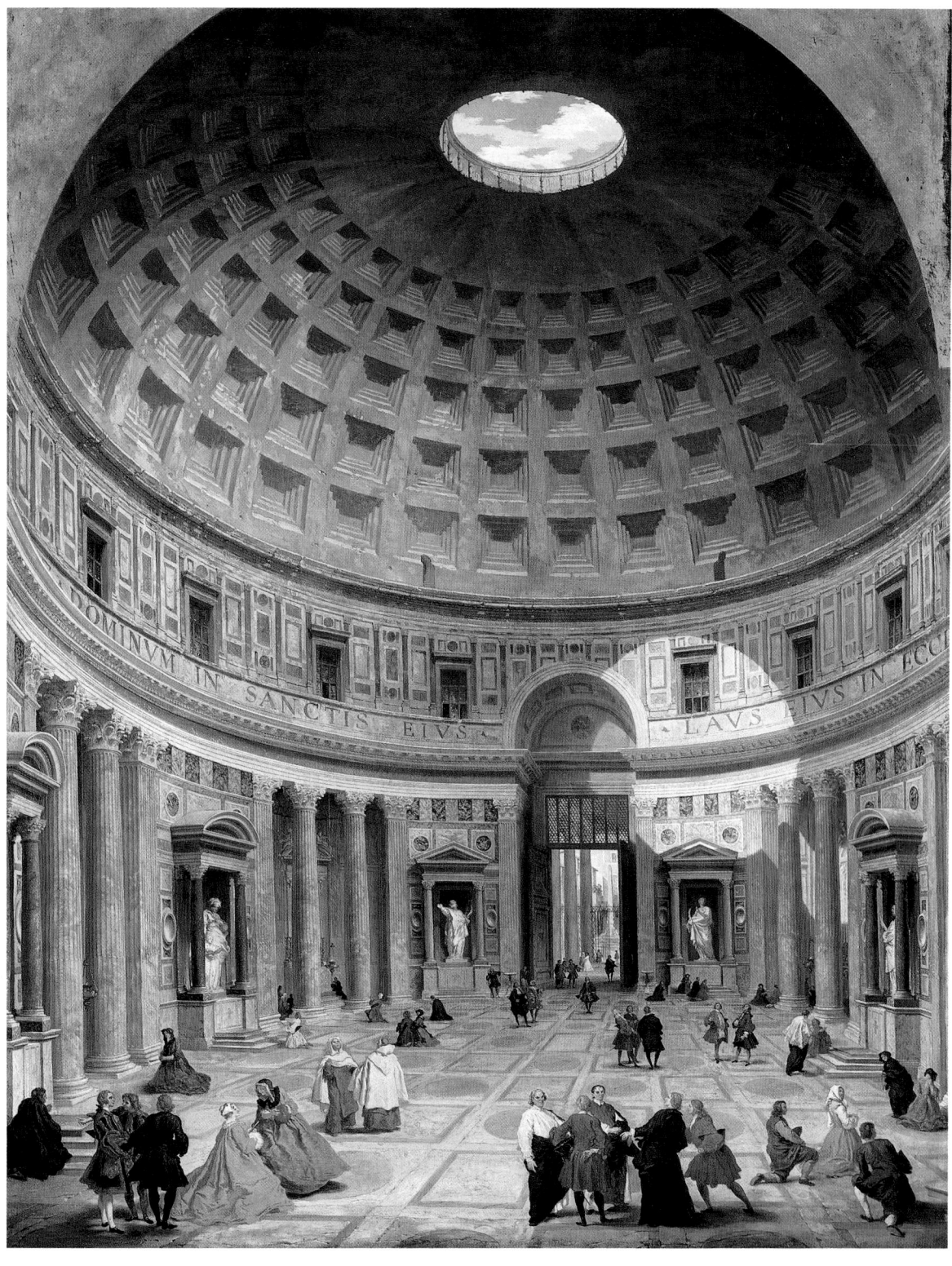

7.30 Giovanni Paolo Panini, *The Interior of the Pantheon*, c. 1740. Oil on canvas; 4 ft. 2½ in. × 3 ft. 3 in. (1.28 × 0.99 m). National Gallery of Art, Washington, D.C. Samuel H. Kress Collection.

patterns of circles and squares, and the walls contain niches (each one for a different deity) with Corinthian columns supporting alternating triangular and rounded pediments. Between each niche is a recess with two huge columns flanked by two corner pilasters. A circular entablature forms the base of a short "second story." This, in turn, bears the whole weight of the dome, which is channeled down to the eight piers.

The dome itself has five **coffered** bands (rows of recessed rectangles in the ceiling), diminishing in size to-

ward the *oculus*. These reduce the weight of the structure and also create an optical illusion of greater height. The coffers were originally painted blue, and each had a gold rosette in the middle, enhancing the dome's role as a symbol of the sky—the dome of heaven. The blue paint repeated the blue sky that was visible through the *oculus*, which cast a circle of light inside the building. This reminded ancient visitors of the symbolic equation between the sun and the eye of Jupiter, the supreme celestial deity of Rome.

Commemorative Architecture

An important category of Roman architecture was developed specifically to commemorate the actions of individuals, usually emperors or generals.

The Ara Pacis The most symbolic marble monument of Augustus's reign was the Ara Pacis (Altar of Peace; fig. 7.31), built between 13 and 9 B.C. It was located on the exercise ground, the Campus Martius (literally the "field dedicated to Mars," god of war), and its purpose was to celebrate the *pax Augusta,* or "Peace of Augustus," after the emperor had made peace with the Gauls and returned to Rome. Like the later Pantheon, the Ara Pacis resolves the conflict between native tradition and Greek culture, and marks the beginning of truly Roman art.

The actual altar (visible here through an opening in the enclosure), which was originally not covered, stood on a podium. Whereas the altar recalled the primitive open-air altars of early Roman times, the reliefs on the exterior of the marble frame were executed in a Classical Greek style. They depict Greek motifs, such as the processional frieze, but the subjects of the reliefs are Roman.

Elegant vine-scroll **traceries**, indicating peace and fertility under Augustus, are represented on the lower half of the frame, while the upper half illustrates the actual procession that took place at the founding of the altar. On the

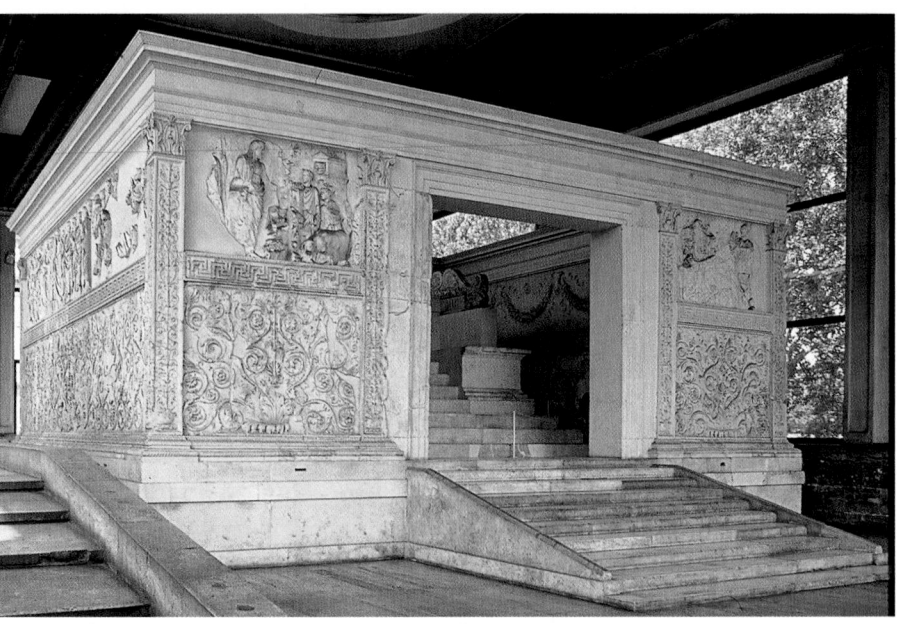

7.31 West side of the Ara Pacis (Altar of Peace), Rome, 13–9 B.C. Marble; outer wall approx. 34 ft. 5 in. × 38 ft. × 23 ft. (10.49 × 11.58 × 7.01 m).

north side, senators and other officials, some with wives and children, are shown proceeding to the entrance. The south side depicts members of the imperial family (fig. 7.32). Not seen in this illustration, the figure of Augustus has his head draped in the manner of the *Pontifex Maximus* (highest priest), the title denoting his role as the state's religious leader. Visible at the left of the relief illustrated are his wife, Livia, and Agrippa, whose covered

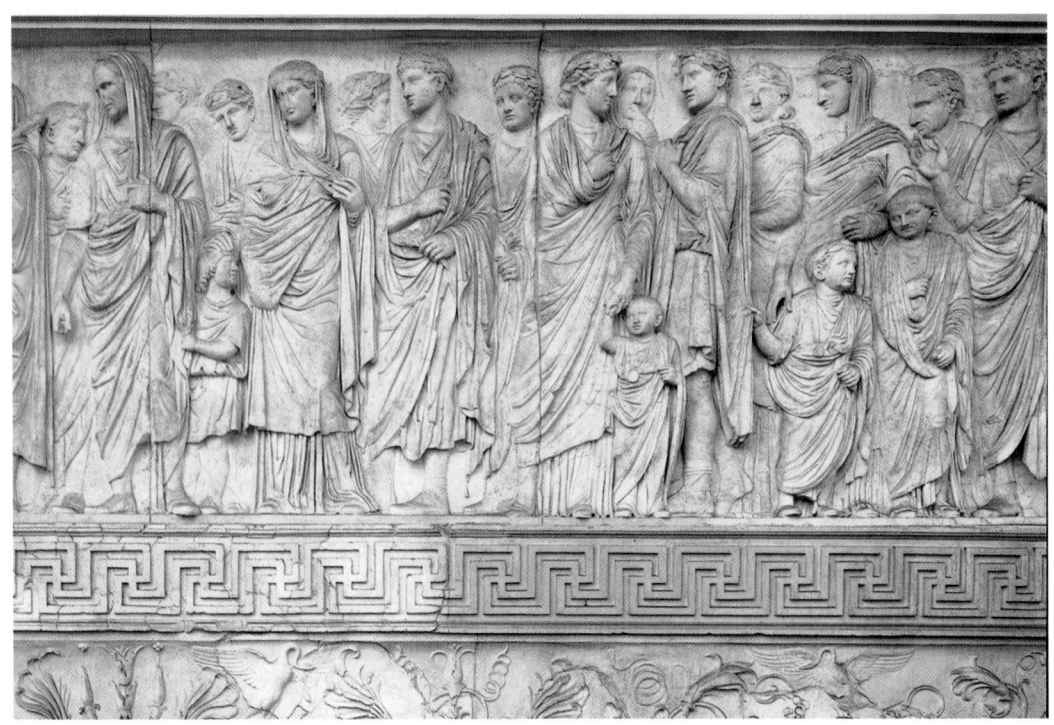

7.32 South side of the Ara Pacis, showing a detail of an imperial procession. Marble relief; approx. 5 ft. 3 in. (1.60 m) high.

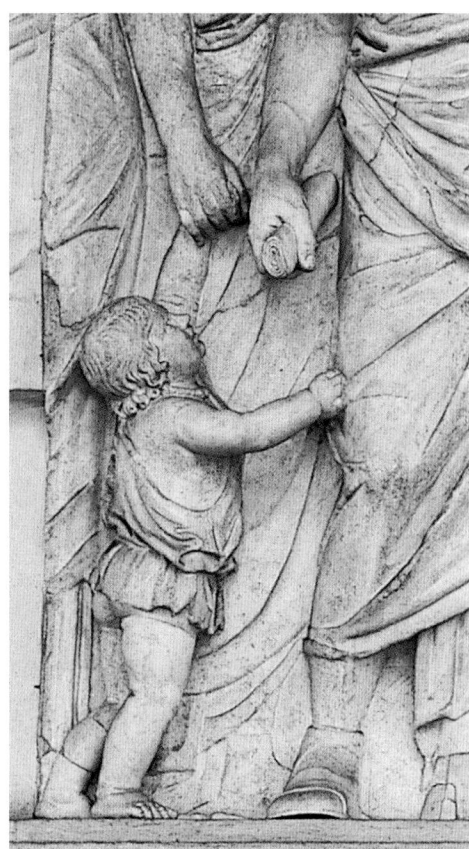

7.33 Ara Pacis, showing a detail of a child tugging at an adult's toga. Note the artist's careful observation of human nature in the child's chubby rolls of fat around his ankles and dimpled elbows and knees. He is tired of walking and wants to be picked up and carried. Such accurate psychological characterization of specific age-related behavior is consistent with the Roman interest in portraiture.

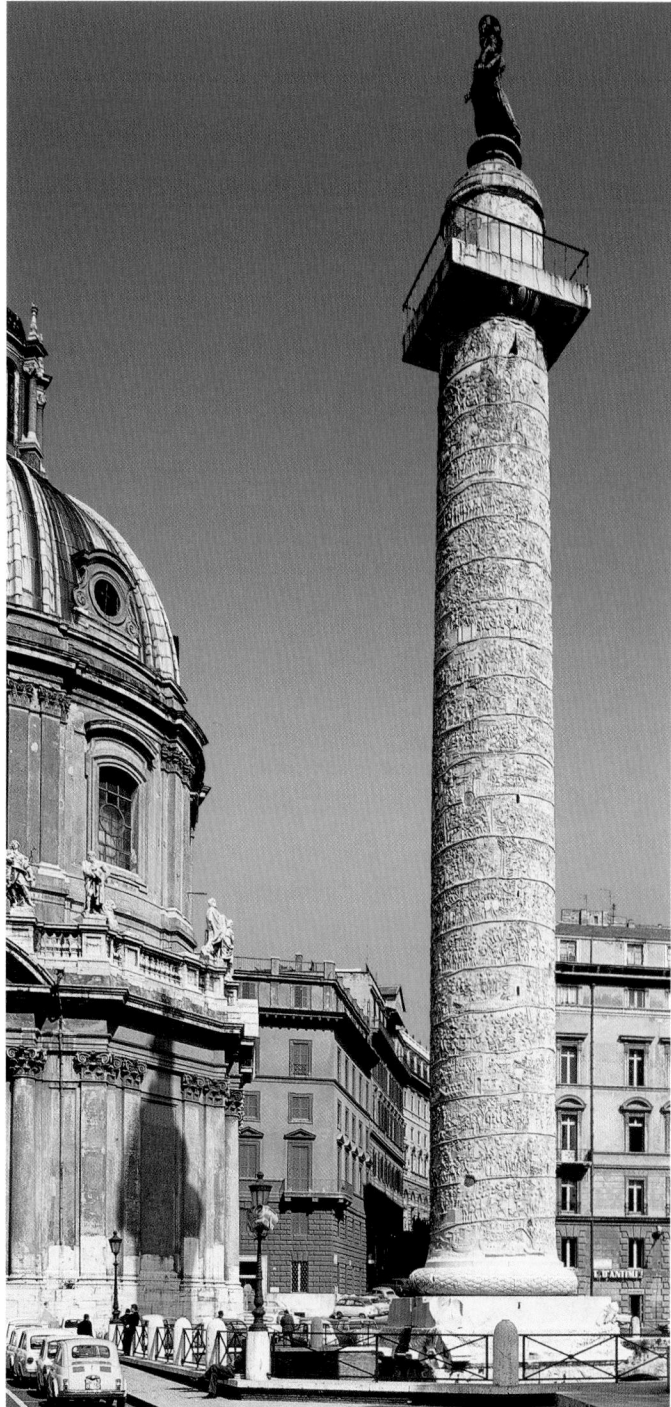

7.34 Trajan's Column, Trajan's Forum, Rome, dedicated A.D. 113. Marble; 125 ft. (38.10 m) high, including base; frieze 625 ft. (190.50 m) long. Although the upper scenes could not have been seen from the ground, they would have been visible from the balconies of nearby buildings. A gilded bronze statue of Trajan, since destroyed, originally stood at the top of the column. It has been replaced by a statue of Saint Peter.

head indicates that he is carrying out a religious rite. The presence of children (fig. **7.33**) refers to the dynastic aims of Augustus, who hoped to found a stable system of succession for the government. He also wanted aristocrats to reproduce, and he granted tax relief for large families, encouraging traditional morality and the importance of the family as an institution.

In contrast to the Greek frieze of the Parthenon, which depicted the Panathenaic procession that took place every four years, the Ara Pacis commemorates a specific event and portrays an actual procession with almost journalistic precision. It includes portraits of the individuals (the priests and others) who participated in the ritual.

Techniques of carving also differ, for the Ara Pacis is in higher relief than the Panathenaic procession, satisfying the Roman taste for spatial illusionism. The highest relief is reserved for the more prominent foreground figures, whose feet project from the base.

Visitors approached the altar by a stairway located on the western side. Each year, magistrates, priests, and vestal virgins (virgins consecrated to the service of Vesta, goddess of the hearth) made sacrifices on it. They ascended the stairs, entered the sacred space, and performed the sacrifices while facing east, toward the sunrise.

Trajan's Column Single, free-standing, colossal columns had been used as commemorative monuments since the Hellenistic period. The unique Roman contribution was the addition of a documentary, ribbonlike narrative frieze, best exemplified in Trajan's Column (fig. **7.34**), which was completed by A.D. 113. It was erected in honor of the emperor's

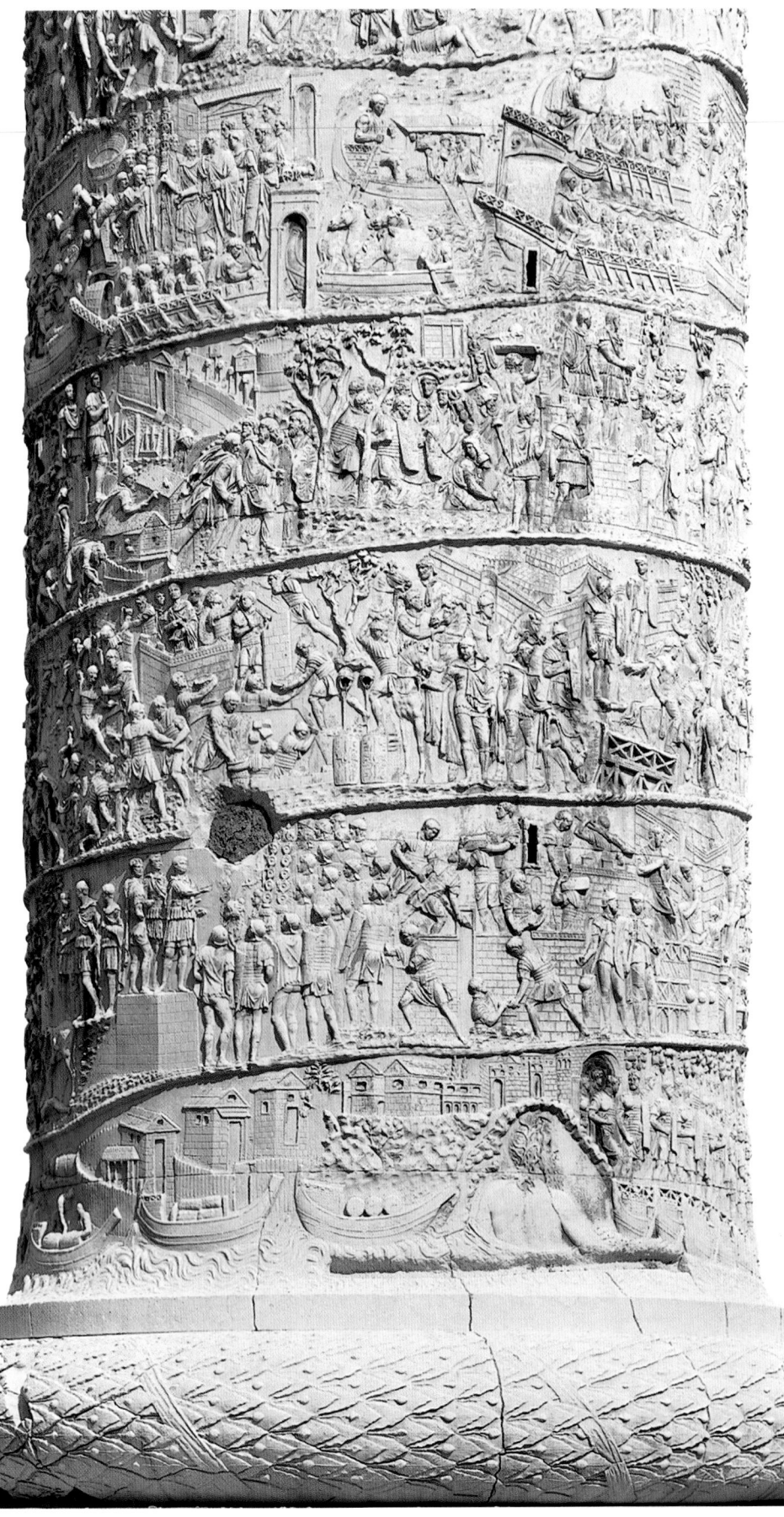

victories over the Dacians, the inhabitants of modern-day Romania (see box). There were originally two libraries flanking the column, one for Greek texts and the other for Latin.

The column consists of marble drums cut horizontally and imperceptibly joined together. Supporting it is a podium decorated with sculptures illustrating the spoils of war and containing a repository for Trajan's ashes. Inside the column shaft, a spiral staircase was illuminated by openings cut into the marble. The exterior shaft is covered with a continuous low-relief spiral sculpture over 625 feet (190.50 m) long and containing some 2,500 figures. In the first three bands of the spiral, at the beginning of the narrative (fig. **7.35**), the Roman army prepares its campaign. On the first level, the personification of the giant bearded river god of the Danube appears under the arch of a cave. He watches as Trajan leads the Roman army out of a walled city. Boats and soldiers fill the river. The second level contains army camps, war councils, reconnaissance missions, and the capture of a spy. Background figures are raised above foreground figures, virtually eliminating any unfilled space. Zigzagging buildings faced with brickwork patterns and the diagonals of the boats add to the sense of surface movement. The formal crowding conveys the bustling activity of armies preparing for war. A powerful commemorative statement and campaign record, the frieze on Trajan's Column is one of the most informative historical documents of life in the Roman army.

7.35 The five lowest bands of Trajan's Column (detail). Marble relief; each band 36 in. (91.4 cm) high.

The Dacians

The Dacians, an Indo-European people related to the Thracians of northern Greece, occupied an area of modern Romania along the Danube. Because of their expertise in metallurgy, especially in working precious material such as gold and silver, they were a natural target for Roman conquest. In A.D. 101, the Romans under Trajan began campaigning against the Dacians and by 106 had occupied the whole country. The wealth of Dacian booty taken by Trajan paid for many Roman buildings and lavish gifts for his soldiers. It also helped to finance the soldiers' retirement colony at Timgad (see p. 214).

7.37 Dacian helmet, 4th century. Gilded silver; 3⅛ in. (8.0 cm) high. National History Museum, Bucharest.

Two objects discovered in a Thracian tomb of the fourth century A.D., which was excavated in 1971, convey some idea of Dacian wealth. The tomb itself was built around a wooden core, approached, as at Mycenae, by a *dromos*. Two funerary rooms yielded precious objects and a chariot. The silver vase in figure **7.36** is in the form of a human head, with stylized plant forms across the forehead and a ring of vases on the neck. The inlaid pupils have disappeared. Characteristics of Greek sculpture and of ancient Near Eastern stylizations indicate the assimilation of features from different Mediterranean cultures. The helmet (fig. **7.37**), with a pair of apotropaic eyes on the front, provides further evidence of such assimilation—in this instance, probably of Scythian influence. The eyes and ears give the helmet an anthropomorphic quality related to that of the vase. Certain details, notably the plant forms and the horned animals depicted in relief at the sides, combine stylization with naturalism in a manner reminiscent of Achaemenid art (see Chapter 2).

7.36 Dacian vase in the shape of a human head, 4th century. Silver; 6½ in. (16.5 cm) high. National History Museum, Bucharest.

The Triumphal Arch The triumphal arch was another Roman innovation that commemorated the military exploits of a victorious general or emperor. It marked a place of ritual passage into a city at the head of an army. These symbolic triumphal arches stood alone and were different from the arches in the city walls, which served as entrances for the populace. The earliest surviving examples of the triumphal arch precede the reign of Augustus by a century. They typically consisted of a rectangular block enclosing one or more round arches, and a short barrel vault like those on the Pont du Gard (see fig. 7.22). Most triumphal arches had either one or three openings. Pilasters framed the openings and supported an entablature, which was surmounted by a rectangular **attic**. This usually bore an inscription and supported sculptures of chariots drawn by horses or, occasionally, by elephants (of which none are extant). Chariots stood for the triumphal and divine power of the emperor, and elephants, imported from Africa, were owned only by emperors. Because of their bulk, strength, and long life, they were symbolic of the emperor's power and immortality.

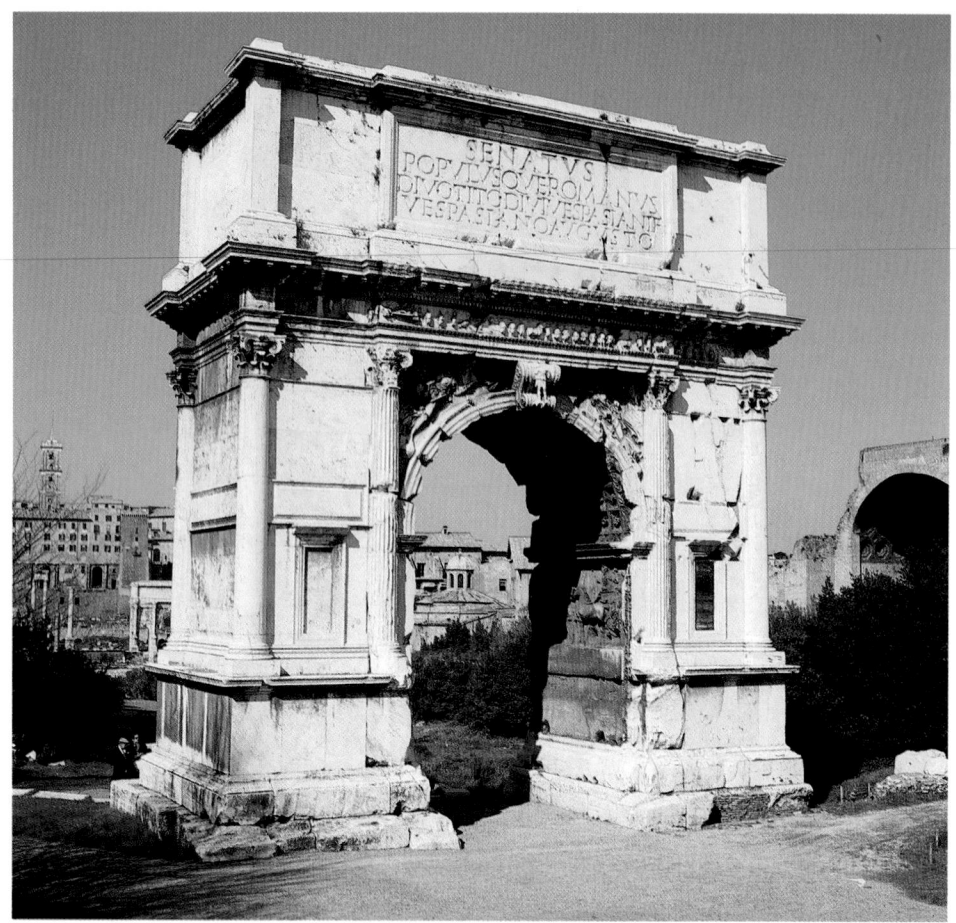

The Arch of Titus (fig. 7.38), erected in A.D. 81 to commemorate Titus's capture of Jerusalem and suppression of a Jewish rebellion in A.D. 70–71, has a single opening. Its columns are of the Composite Order, a Roman Order combining elements of Ionic and Corinthian. On the **spandrels** (the curved triangular sections between the arch and the frame), winged Victories hold laurel wreaths. Reliefs, on either side of the **piers** (large rectangular supports) forming the passageway, depict scenes of Titus's triumphs. In the center of the vault (not visible in fig. 7.38), Titus is carried up to heaven on the back of an eagle, representing his apotheosis.

In a relief on the inner wall (fig. 7.39), Titus's soldiers carry off their booty from the Jewish wars (see box). As in the frieze of the Ara Pacis, the figures project illusionistically from the surface of the relief. Soldiers raise the menorah (the sacred Jewish candelabrum with seven candlesticks), whose weight and prominence reflect

7.38 Arch of Titus, Rome, A.D. 81. Marble over concrete core; approx. 50 ft. (15.24 m) high, approx. 40 ft. (12.19 m) wide. The arch stands on the Via Sacra, or Sacred Way, in Rome. The Latin inscription on the attic proclaims that "the senate and people of Rome (SPQR) [dedicate the arch] to divine Titus, Vespasian Augustus, son of divine Vespasian."

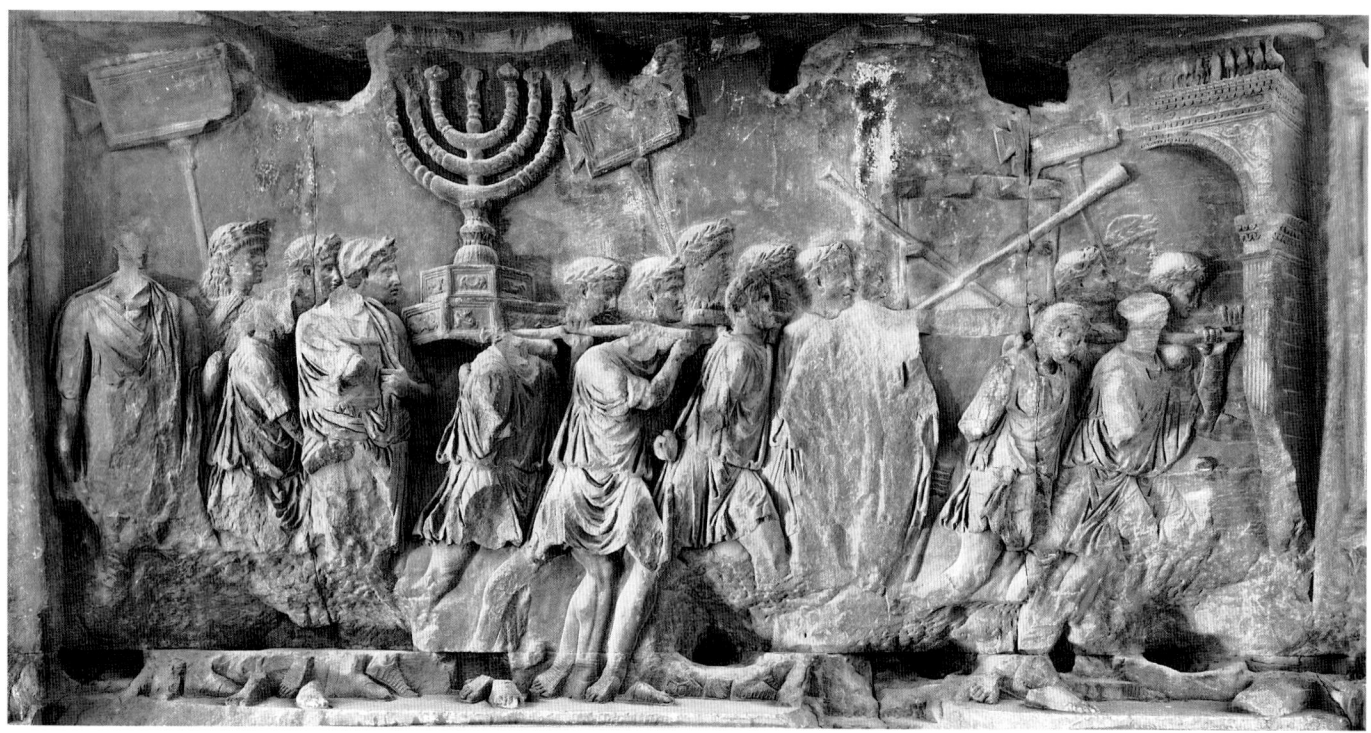

7.39 Relief from the Arch of Titus, detail showing the spoils of the temple of Jerusalem carried in a triumphal procession. Marble; 6 ft. 7 in. (2.00 m) high.

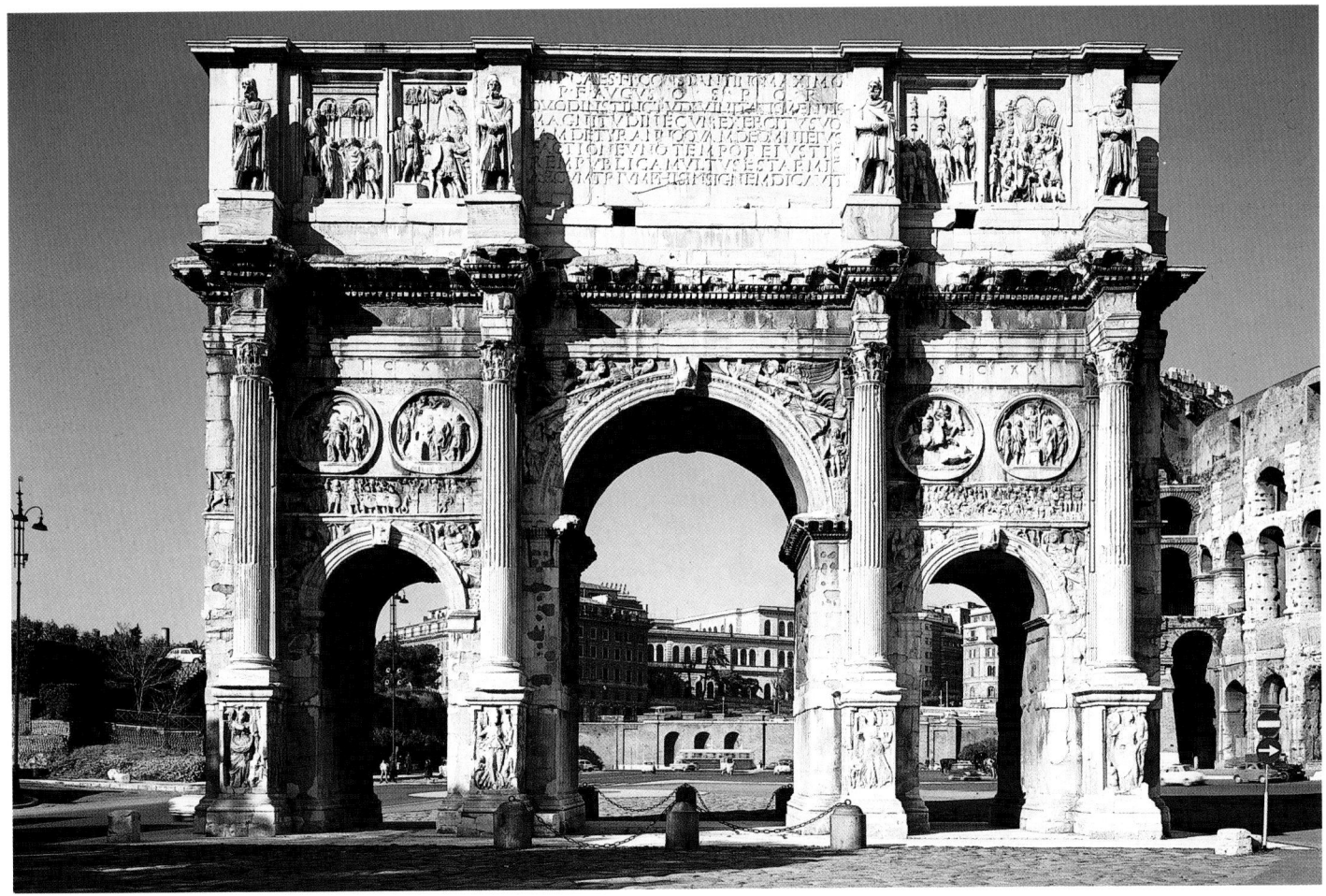

7.40 Arch of Constantine, Rome, c. A.D. 313. Marble; 70 ft. (21.33 m) high, 85 ft. 8 in. (26.11 m) wide.

its importance for the Jews and hence its role as a symbol of Roman victory. The base of the menorah is carved in perspective, reflecting the Roman taste for spatial effects and optical illusion.

Over two hundred years after the dedication of the Arch of Titus, the emperor Constantine the Great (ruled A.D. 306–337) erected the largest triumphal arch in Rome, near the Colosseum (fig. **7.40**). It commemorated his as-

sumption of sole imperial power in 312, after defeating his rival Maxentius at the Battle of the Milvian Bridge. This elaborate arch with three openings is decorated both with original reliefs and with those removed from earlier monuments in honor of other emperors (Trajan, Hadrian, and Marcus Aurelius; see below).

The juxtaposition of reliefs from different periods illustrates certain changes that took place in Roman sculpture

Josephus on the Jewish Wars

Josephus (c. A.D. 37–100), a Jewish soldier and historian, wrote a history of the Jewish wars that covers the capture of Jerusalem by Antiochus Epiphanes in 170 B.C. to Titus's seizure of Jerusalem in A.D. 70 (which he witnessed). Under the Flavian emperors (Vespasian, Titus, and Domitian, who together ruled from A.D. 69 to 96), Josephus was granted Roman citizenship, and he favored cooperation with the Romans. His history includes a description of the triumphal procession celebrating the victory of Vespasian (ruled A.D. 69–79) and his son Titus (ruled A.D. 79–81) after the sack of Jerusalem. His account reflects the Roman love of material splendor and its role in projecting an image of imperial power. He was struck by the abundance of gold and silver objects, which flowed

"like a river," by the Babylonian tapestries, and by jewels set in golden crowns. "The most interesting of all," he wrote,

> were the spoils seized from the temple of Jerusalem: a gold table weighing many talents, and a lampstand, also made of gold, which was made in a form different from that which we usually employ. For there was a central shaft fastened to the base; then spandrels extended from this in an arrangement which rather resembled the shape of a trident, and on the end of each of these spandrels a lamp was forged. There were seven of these, emphasizing the honor accorded to the number seven among the Jews.[3]

Hadrian Constantine Marcus Aurelius

7.41 Medallions (Hadrianic, A.D. 117–138) and frieze (Constantinian, early 4th century) from the Arch of Constantine, Rome. Frieze approx. 3 ft. 4 in. (1.02 m) high.

in the course of the empire. The medallions in figure **7.41** are **spolia**, which are pieces taken from older reliefs and reused in new ones. They date from the early decades of the second century A.D. and are thought to be Hadrianic. On the left, three riders in a landscape hunt a boar. On the right, three worshipers stand before an altar of Apollo.

The horizontal reliefs below the medallions date from Constantine's reign. Constantine himself, now headless, sits at the center and makes a public speech. At either end are statues of Hadrian and Marcus Aurelius, both of whom were influenced by Greek taste. Lined up and listening to Constantine are figures accented by the arrangement of arches and columns. The style of the later reliefs is less naturalistic, more stylized and patterned, than that of the medallions: the proportions of the figures are stubbier, their heads are enlarged, their poses are more repetitious, and their carving is flatter. Since we do not know why reliefs of two different periods appear on the same arch, it is difficult to explain their iconographic relationship or even to confirm that there is one. What is clear, however, is the stylistic change. The reliefs belonging to Constantine's reign are more abstract than the Classical naturalism of the Ara Pacis and the Arch of Titus.

Sculptural Types

Sarcophagi

The Romans produced three basic types of funerary art. Graves were marked in the Greek style by stelae or tombstones with inscriptions, reliefs, or both. Like the Etruscans, Romans used cinerary urns for cremation. But the most typical item of funerary art for the Romans was the sarcophagus, which had been used by the Etruscans and became an expression of status under Hadrian.

The early third-century sarcophagus in figure **7.42** reflects the symbolic use of Greek iconography in Roman art. Four standing nude males representing the seasons occupy *contrapposto* poses reminiscent of the *Doryphoros* (see fig. 5.27), but these are now more self-consciously affected, and the anatomy is differently proportioned. At the center, Bacchus sits astride a panther and holds a *thyrsos* (a phallic staff surmounted by a pine cone). The other figures are traditional participants in Bacchic rites—satyrs, goats, Cupids, and maenads (frenzied female followers of Bacchus). Foliage motifs refer to vines and thus to Bacchus's role as the god of wine.

7.42 *Bacchus and the Four Seasons* (the so-called Badminton Sarcophagus, named for the residence of its former owners in Great Britain), c. A.D. 220. Marble; 3 ft. 3 in. (99.1 cm) high. Metropolitan Museum of Art, New York. Joseph Pulitzer Bequest.

Portraits

Portraiture can be a means of keeping the deceased alive in memory. When the subject of a Roman portrait was an emperor, the image was also a means of extending his authority throughout the empire.

One of the portrait types most characteristic of Rome was the head detached from the body, or **bust.** Busts were usually carved in marble, often from a wax death mask, so that even the most specific physiognomic details—warts and all—were preserved. The portrait of Julius Caesar in figure **7.43** is clearly a likeness, its small but penetrating eyes contrasting with the deep spaces under the eye-brows. Indentations are carved under the cheekbones, creases spread from the sides of the nose, and the figure's left ear is slightly higher than the right. Such facial details create the impression of a specific personality, confident and self-assured, as one would expect of a great general and statesman.

The bust of Trajan, dating from the first half of the second century A.D., is one of many that survive (fig. **7.44**). Known as *optimus princeps,* meaning "the best leader," Trajan was a popular emperor. He improved the quality of life for Roman citizens—for example, establishing the retirement colony at Timgad. He was also considered a military genius, as commemorated in his column (see fig. 7.34).

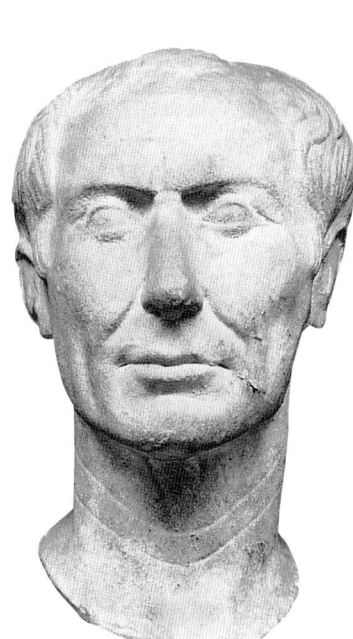

7.43 Bust of Julius Caesar, from Tusculum, mid-1st century B.C. Marble; 13 in. (33.0 cm) high; head 8⅔ in. (22.0 cm) high. Museo di Antichità, Turin.

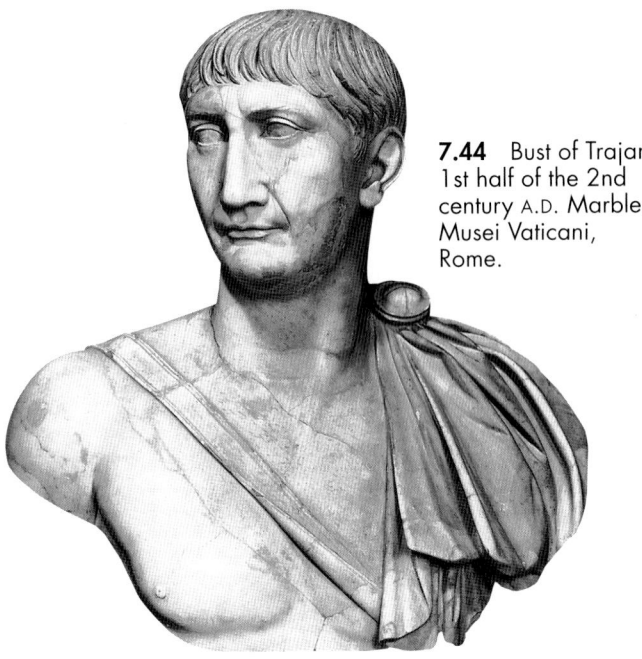

7.44 Bust of Trajan, 1st half of the 2nd century A.D. Marble. Musei Vaticani, Rome.

The portrait bust of Trajan shows the characteristic smooth hair covering his forehead, the long nose, and the prominent chin. The abrupt turn of his head suggests his alert attention to the welfare of his subjects.

The statue of the patrician with two ancestor busts (fig. **7.45**) reflects the importance the Romans placed on preserving family genealogy in stone. The two ancestral images are elderly and appear serious. They are original, but the head of the patrician is a later substitute. The folds of the toga (the round-edged outer garment worn in public by Roman citizens) draw our attention to the two heads. A series of short, horizontally curved folds directs us from the patrician's waist to the bust at the left. A contrasting group of longer folds curves up gradually from the hem to the bust at the right. The toga thus creates a formal unity between the patrician and his ancestors that condenses time by bridging the gap between the dead and the living.

Portraits of upper-class Roman women became popular in the first century A.D.

7.45 Patrician with two ancestor busts, c. A.D. 13. Marble; life-sized. Museo Capitolino, Rome.

Those illustrated here contrast the elaborate coiffure of a young Flavian lady (fig. **7.46**) with the more subdued hairstyle of an older woman (fig. **7.47**). The young woman wears the characteristic curls framing the face and rising upward in a top-heavy fashion. Deep carving creates strong oppositions of light and dark that add to the sense of mass supported by the delicate, smoothly carved surfaces of the face and neck. The older woman's wrinkles and bags under the eyes reveal the results of aging. Her hair weighs down on her head rather than rising up like that of the young woman, and thus corresponds to the "weight" of her

7.46 Portrait of a young Flavian lady, c. A.D. 90. Marble; 2 ft. 1 in. (63.5 cm) high. Museo Capitolino, Rome. Chronology can be determined by women's hair styles in Roman art because women tried to imitate the fashion of the current empress.

7.47 Portrait of an older Flavian lady, c. A.D. 90. Marble; 9½ in. (24.1 cm) high. Museo Laterano, Rome.

age. It also shows the respect accorded "older and wiser" citizens of Rome.

One of the most important subjects of Roman sculpture in the round was, naturally, the emperor himself. In the *Augustus of Prima Porta* (fig. **7.48**), the emperor is portrayed as both orator and general. Even though the head is a likeness, it is idealized. Augustus was seventy-six when he died after a long reign, but this statue represents a self-confident, dominating, and, above all, youthful figure. A possible source for this idealization is the *Doryphoros* of Polykleitos (see fig. 5.27). The similar stance suggests that the artist who made the *Augustus* was familiar with the Greek statue, probably from Roman copies.

The iconography of this statue emphasizes the power of Rome embodied in Augustus as emperor. By his right leg, Cupid (Venus's son) rides a dolphin and serves as a reminder that Augustus traced his lineage to Aeneas (also a son of Venus) and was thus descended from the gods. Among the little reliefs carved on Augustus's armor is Mother Earth with a cornucopia. This refers to the emperor's identification with the land as a source of plenty and to divine favor that has conferred power on Rome, giving it dominion over the earth. The association of Augustus with the earth also has an implied reference to Roman territorial conquests just as the canopy spread out

— **CONNECTIONS** —

See figure 5.27. Polykleitos, *Doryphoros* (*Spear Bearer*), c. 440 B.C.

7.48 *Augustus of Prima Porta,* early 1st century A.D. Marble; 6 ft. 8 in. (2.03 m) high. Musei Vaticani, Rome.

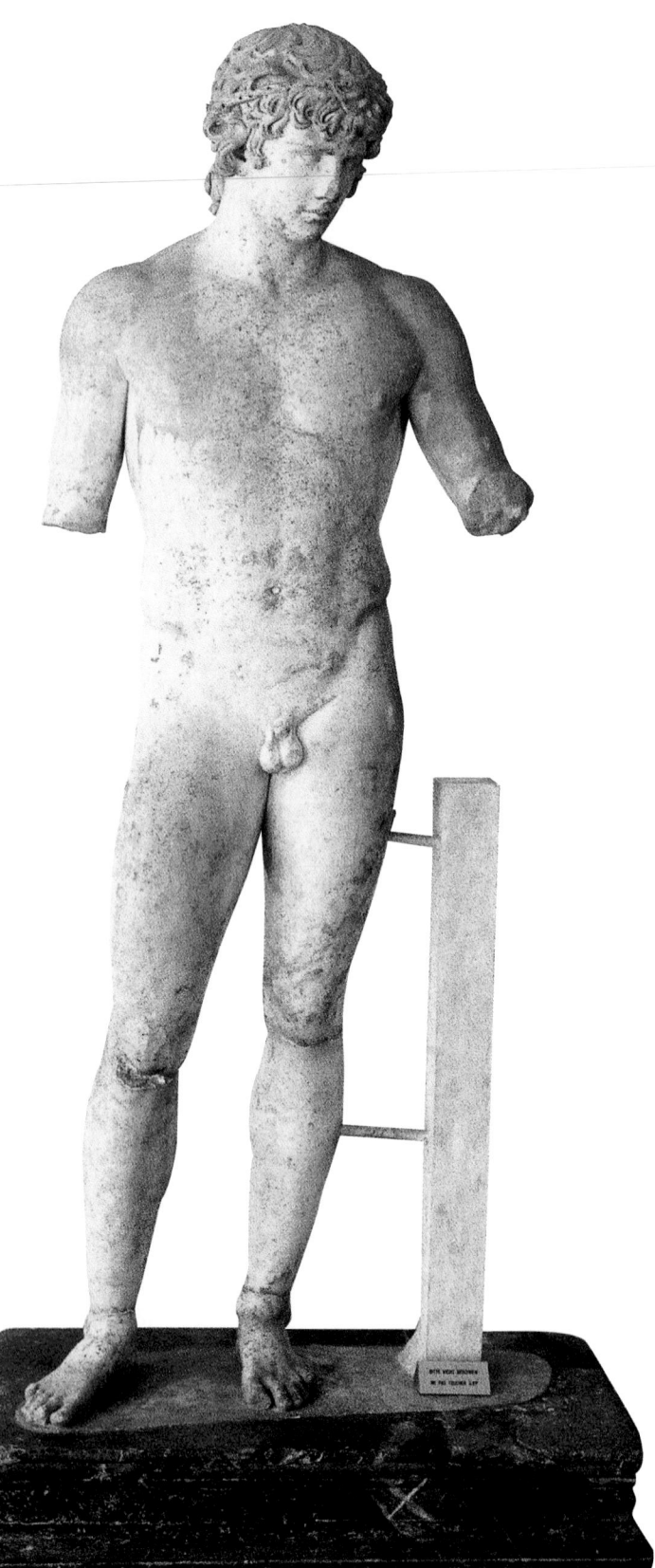

7.49 *Antinous*, c. A.D. 131–138. Marble; 70⅞ in. (180.0 cm) high. Archaeological Museum, Delphi. When Antinous drowned in the Nile in 130, Hadrian was desolate. Priests tried to console him, saying that his beloved had become a star in the constellation of Aquila (the eagle).

by a sky god at the top of the breastplate indicates that Rome is under the protection of the gods. Another scene depicts a Parthian returning a military standard looted from the Romans.

The back of the *Augustus of Prima Porta* is unfinished, indicating that the statue was intended for a niche. Augustus is armed and raises his right hand to address his troops. The fact that he is barefoot may be a reference to his divinization or may indicate that the statue occupied a private space. The Roman deification of Augustus after his death harks back to the equation of god and ruler that was widespread in the ancient world.

The portrait statue of Antinous represents the Bithynian youth of great beauty who was the favorite of the emperor Hadrian (fig. **7.49**). The style of the work reflects Hadrian's attraction to Greek art and philosophy. Antinous drowned in the Nile in A.D. 130, and, after his death, Hadrian founded an Egyptian city (Antinoopolis) in his honor and dedicated many statues to him throughout the Roman Empire. Hadrian donated this particular statue to Apollo's sanctuary at Delphi (see Chapter 5). The relaxed pose, idealization, and naturalistic form of the *Antinous* recall the Classical style of the fifth century B.C. in Greece, and it is likely that it was carved by a Greek artist. The head, with its luxurious curls, and fleshy body reflect Hellenistic influence.

A type of imperial portrait invented by the Romans is the equestrian monument. The only surviving example is an equestrian bronze statue of the emperor Marcus Aurelius (reigned A.D. 161–180) (fig. **7.50**; see box). His beard conforms to the Greek fashion set by Hadrian and signifies that he is a philosopher. Greek influence also explains the organic form of the emperor and his horse. Veins, muscles, and skin folds of the horse are visible as he raises his right foreleg, turns his head, and lifts his left hind leg so

Marcus Aurelius: Emperor and Philosopher

Marcus Aurelius (ruled A.D. 161–180) was a Stoic philosopher and author of the *Meditations*, which he wrote in Greek. He had been interested in the arts from his youth and had the greatest respect for artists. "In their devotion to their art," he wrote, "[they] wear themselves to the bone, and immersing themselves in their tasks, go without washing or eating."[4] Despite Marcus Aurelius's admiration for artists, however, he agreed with Plato (see Chapter 5) that art was mere imitation (*mimesis*) and, therefore, inferior to nature.

that only the tip of his hoof touches the ground. His apparent eagerness to set out is controlled and counteracted by the more sedate emperor, who originally held reins that have since disappeared.

In the fourth century, the emperor Constantine, depicted in a colossal marble head, over 8 feet (almost 3 m) high, which is detached from its body (fig. **7.51**), expressed power in a different way. The head is clearly a portrait, as evidenced by such features as the long nose, cleft chin, clean-shaven cheeks, and thick neck; yet the predominant impression left by this sculpture is derived from its monumental size, the staring geometric eyes, and stylized hair. The restrained Classical character of earlier imperial sculptures has now disappeared, giving way to a new style, which expresses the emperor's power and makes him seem aloof from his subjects.

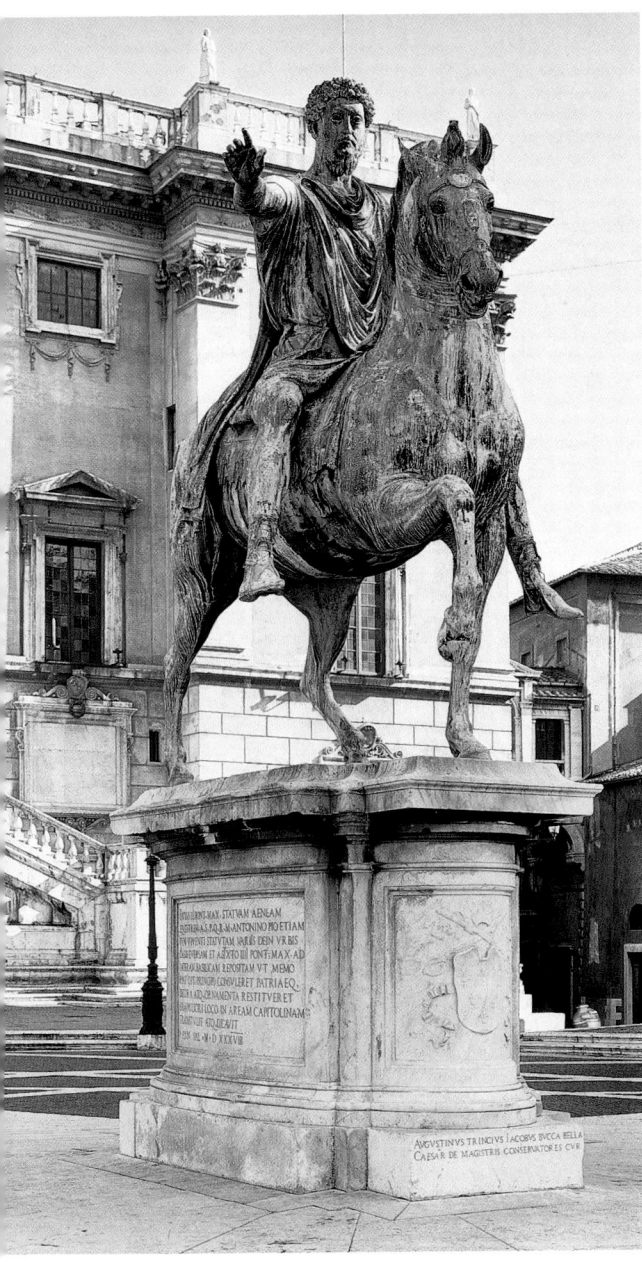

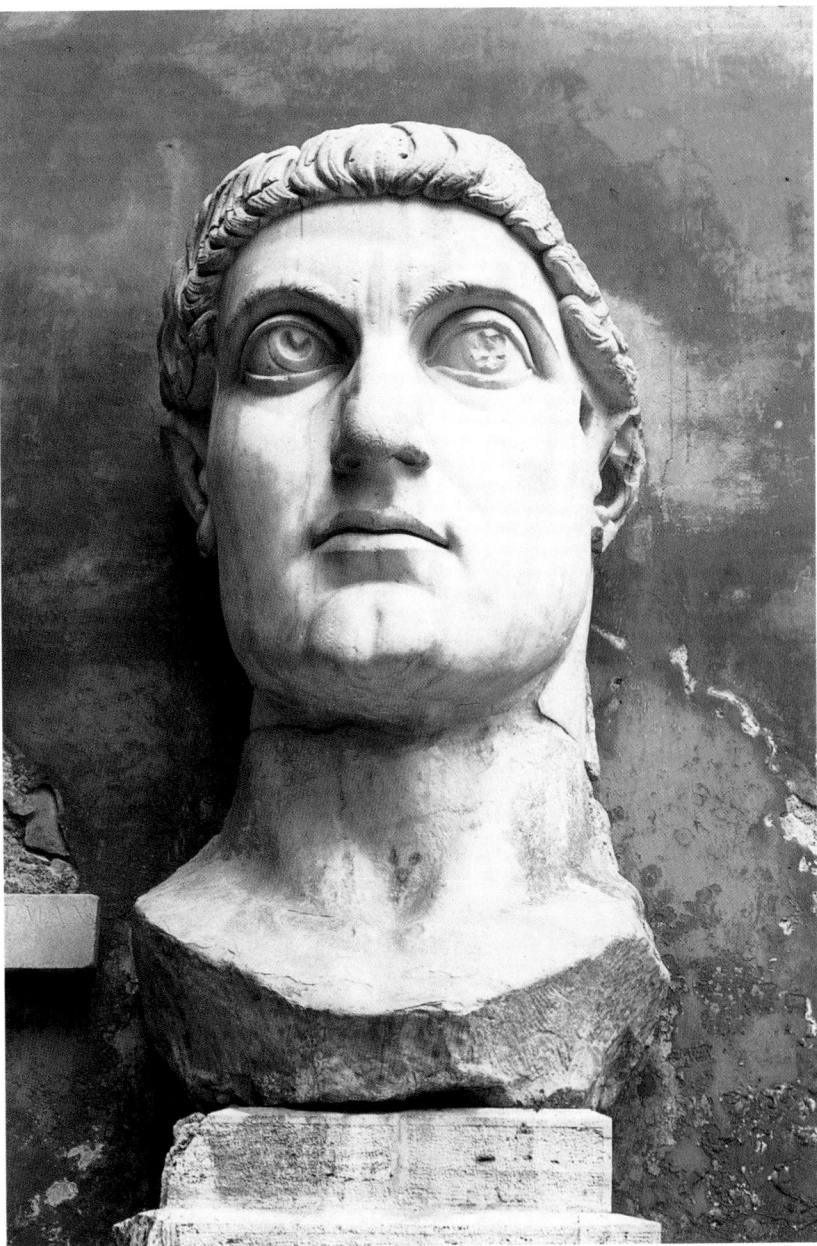

7.50 Equestrian statue of Marcus Aurelius (before restoration), A.D. 164–166. Bronze; 11 ft. 6 in. (3.50 m) high. Piazza del Campidoglio, Rome. In this statue, the emperor is unarmed, and his right arm is extended in the conventional gesture of an orator. But domination and conquest are implied by equestrian iconography. Documents indicate that a conquered enemy originally cowered under the horse's raised foreleg.

7.51 Monumental head of Constantine, from the Basilica of Constantine, Rome, A.D. 313. Marble; 8 ft. 6 in. (2.59 m) high. Palazzo dei Conservatori, Rome. The statue's original location on the throne in the apse of the basilica reflected the emperor's power over the Roman people.

Marble in Ancient Rome: Color Symbolism

The Roman interest in marble is evidenced by Augustus's reputation for having turned Rome from a city of concrete into a city of marble buildings. But sculptors as well as architects used marble, which was quarried throughout the Mediterranean—in Greece, Libya, Egypt, and Asia Minor—and imported by Rome. Different geological conditions produced marble in various colors. For example, a heavy concentration of iron in the earth produced red marble, and colliding plates of earth produced green serpentine; yellow marble is found in North Africa, white marble in Greece, and veined marble (*pavonazzetto*) in Phrygia.

Over time, Roman artists associated the nature and color of marble with specific types of figures and certain symbolic meanings. Red porphyry (the origin of the word *purple*) was the marble of choice for emperors and monumental cult statues. White was used for skin color and nudes. But in some imperial portraits, the skin is black, as it is in statues of Nubians. Figure **7.52** shows a third-century-A.D. bust of the vicious and tyrannical emperor Caracalla (ruled A.D. 211–217) wearing red porphyry; his head and neck are of white (*lunense*) marble. The barbarian in figure **7.53,** in contrast,

has black skin and a costume carved from *pavonazzetto* (white with purple veins). This represents a captive Near Easterner, possibly a Parthian, a member of the culture defeated by Augustus in A.D. 20. The figure has been reconstructed as one support of a tripod; he kneels to show his submission to the Roman emperor. The veined marble reflects the ancient Western view of Easterners as given to luxury and elegant dress—the term *pavonazzetto* means "peacock-like."

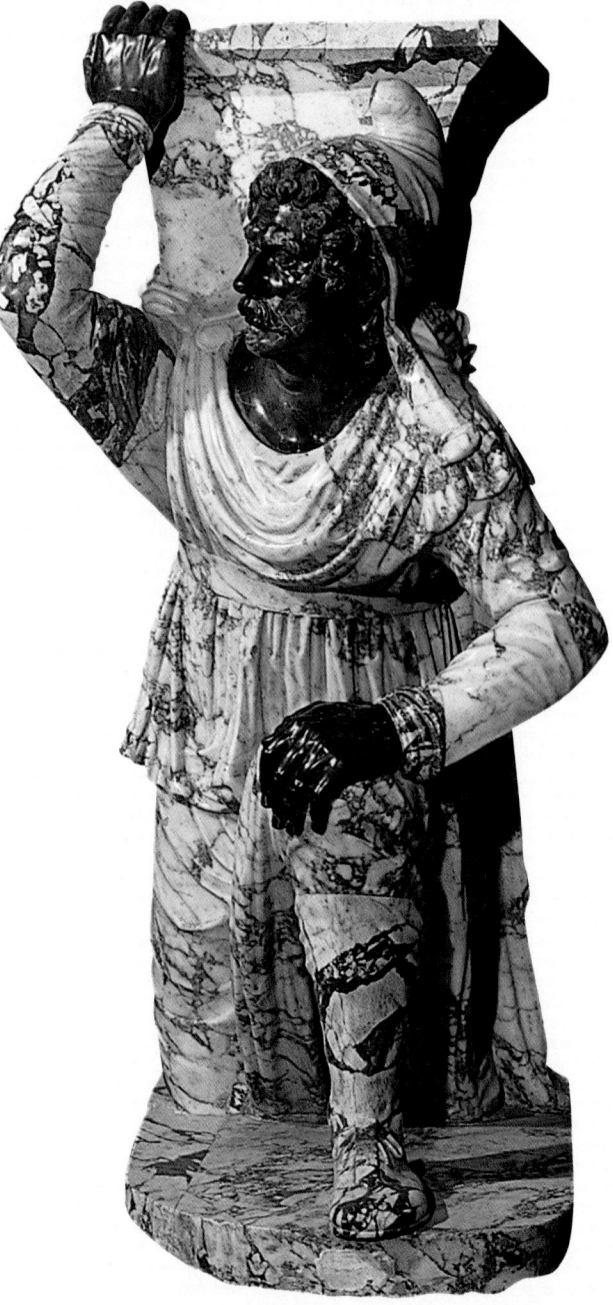

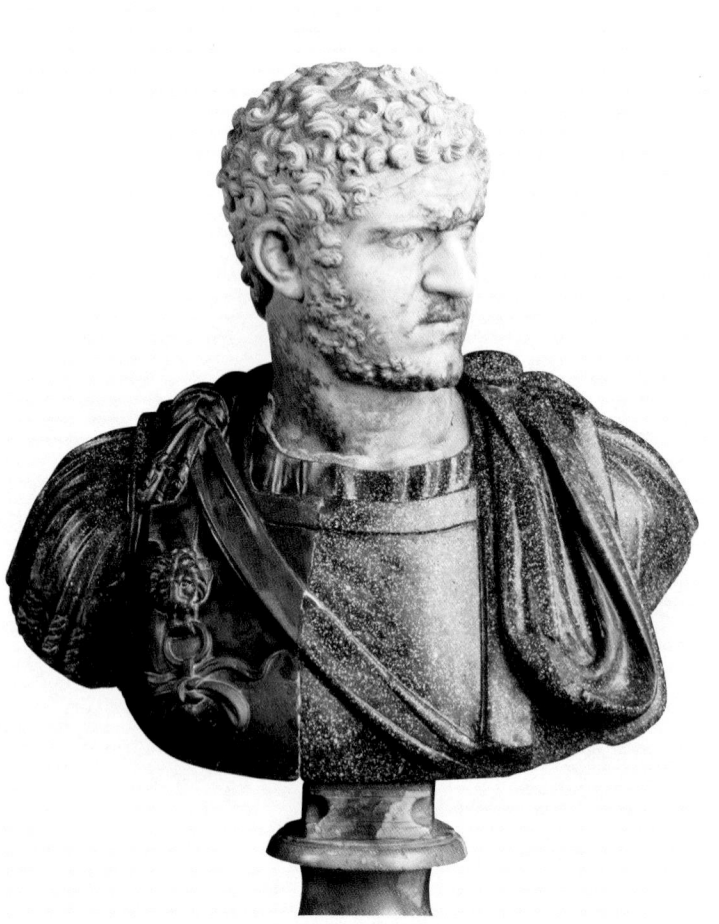

7.52 *Caracalla,* 3rd century A.D. Marble; 2 ft. 4½ in. (71.9 cm) high. Sala degli Imperatori, Museo Capitolino, Rome.

7.53 *Unknown Barbarian (Parthian?),* Augustan period. Marble; 5 ft. 3¾ in. (161.9 cm) high. Museo Archeologico Nazionale, Naples.

Mural Paintings

Roman murals are among the most significant legacies of the eruption of Mount Vesuvius in A.D. 79. Hundreds of wall paintings have been discovered among the ruins of Pompeii and Herculaneum. These provide the greatest evidence of Hellenistic painting, most of which no longer survive.

Roman mural paintings were executed in *buon fresco,* but with small amounts of wax added to increase the surface shine. As a result of the durability of this technique, as well as the covering of volcanic ash, many murals from Pompeii and Herculaneum have survived in relatively good condition, and they provide a remarkable panorama of Roman painting.

Scholars have divided the wall decoration of Pompeian houses into four styles, which are more or less chronological, although there is some overlap. The First Style is found during the period of the Republic (B.C.) and typically simulates the architecture of the wall itself. The Second Style begins under the Republic and continues into the early empire. The Third and Fourth Styles are imperial, ending with the eruption of Vesuvius. Each house was painted according to a particular style, depending on its chronology. As a result, the context of the house is necessary in order to determine the style of its wall paintings.

The best examples of Second Style frescoes are found at a country villa near Pompeii known as the Villa of the Mysteries. In the southwest corner, painted pilasters separate each section of a long narrative illustrating what is thought to be a mystery rite, part of a marriage ritual involving the Greek god Dionysos (Bacchus) and his wife, Ariadne (fig. **7.54**). Nearly life-sized figures, alternately real and mythological, enact the ritual on a shallow, stage-like floor that projects illusionistically beyond the surface of the wall. The vivid red background, known as Pompeian red, contributes to the dynamic and dramatic quality of the scenes. The narrative continues around the walls of the

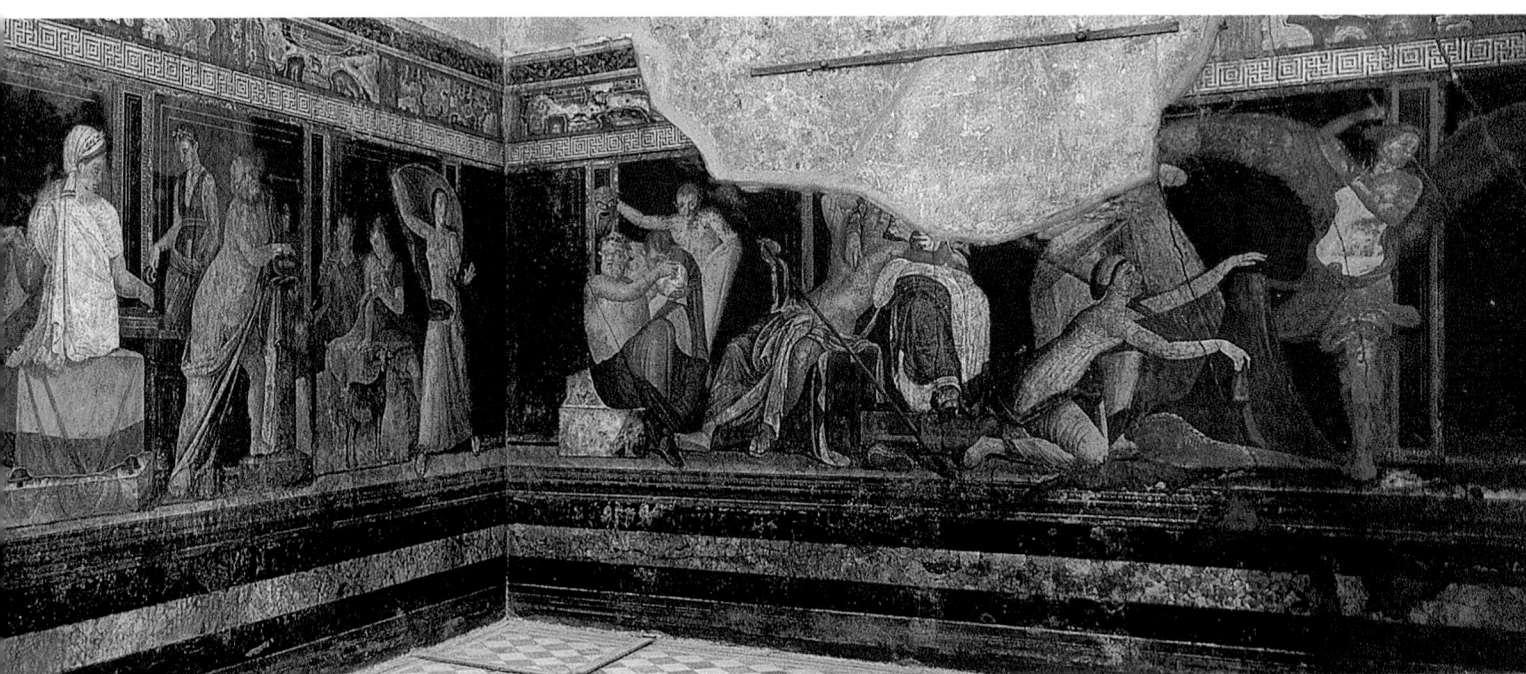

7.54 View of the frescoes at the Villa of the Mysteries, near Pompeii, c. 65–50 B.C.

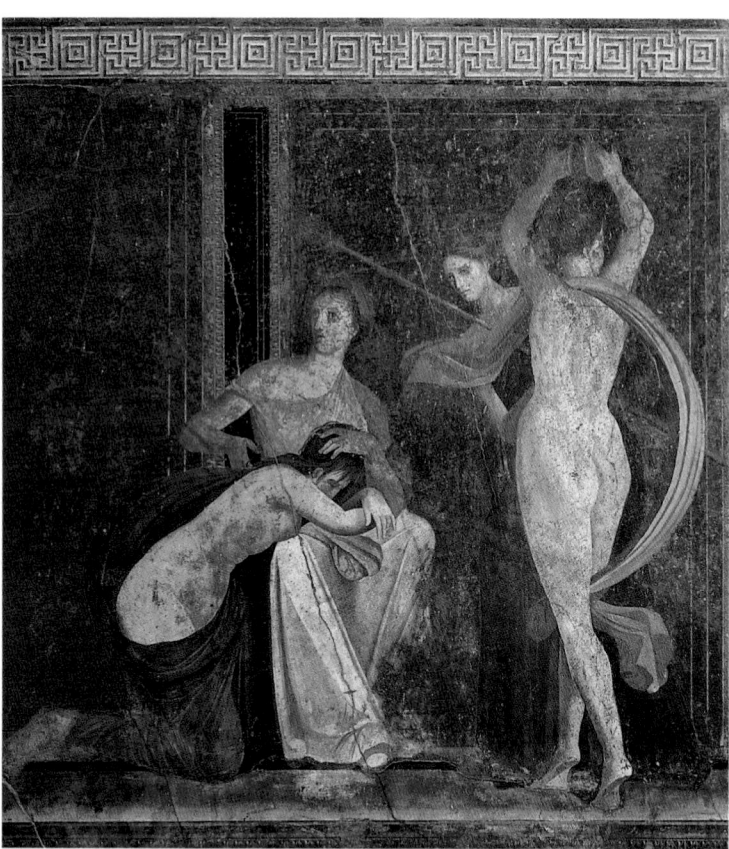

7.55 Fresco from the Villa of the Mysteries, south wall. 5 ft. 3 in. (1.62 m) high.

7.56 *Dancing Satyr*, fresco from the Villa of the Mysteries.

room, uninterrupted by shifts in the actual architecture. Figure **7.55** shows a girl kneeling at the lap of a seated woman while being beaten by a winged woman not visible in this illustration. To the right of the seated figure, a woman holds a *thyrsos,* and in front of her a dancing maenad (a frenzied follower of Bacchus) plays the cymbals. The organic form of the figures and their poses show the artist's command of three-dimensional space and of human anatomy, which points to the influence of Hellenistic style. Above the pilasters is an intricate meander pattern with panels imitating marble grain.

Although neither the exact meaning of these scenes nor their narrative order is agreed upon by scholars, it is clear that a sacred ritual is taking place. Its mysterious character is enhanced by the inconsistent sources of light and absence of cast shadows, which are at odds with the naturalism of the figures and the illusion of three-dimensional space. The *Dancing Satyr* (fig. **7.56**) reinforces the ritual eroticism that is a subtext of the main narrative.

A different type of Second Style painting was discovered in a house on the Esquiline Hill in Rome. The *Odyssey Landscapes* depict scenes from Books X through XII of the *Odyssey.* They transport the viewer from urban Rome to a distant mythological time and place, and depict large-scale landscapes with small figures in pale colors. Their perspective is more atmospheric than linear so that the illusion of depth increases as the forms lose clarity.

Figure **7.57** illustrates a scene from Book X. Odysseus has landed on an island inhabited by cannibalistic giants (the Laestrygonians). They pull on trees, lift up boulders, and carry off Odysseus's sailors for their dinner. Odysseus describes the attack on his men by the Laestrygonians as follows:

The mighty Laestrygonians came thronging from all sides, a host past counting, not like men but like the

Giants. They hurled at us from the cliffs with rocks huge as a man could lift, and at once there rose throughout the ships a dreadful din, alike from men that were dying and from ships that were being crushed. And spearing them like fishes they bore them home, a loathly meal.[5]

The painted scene, as in Homer's description, is filled with action. It is characterized by vigorous curves and diagonals, which are relieved by the more relaxed figures at the left. The artist's attention to details of naturalism, such as the cast shadows, the reflection of the animal drinking from a pool of water, and the background haze, again indicates Hellenistic influence. But the prevalence of landscape with human figures, like the pilaster frames, was a Roman innovation.

Portraiture was common in Roman upper-middle-class houses, and relief sculptures with round frames (**tondos**) were used for portraits of ancestors. But painted tondo portraits such as the Third Style *Young Woman with a Stylus* (fig. **7.58**) were unusual. Shading enhances the cylindrical volume of the neck and the planes of the drapery folds. The head, ringed by curls, echoes the circular frame. Formal unity is thus maintained between figure and frame, yet the artist creates the impression of an individual frozen in thought. The girl wears a hairnet of the type fashionable

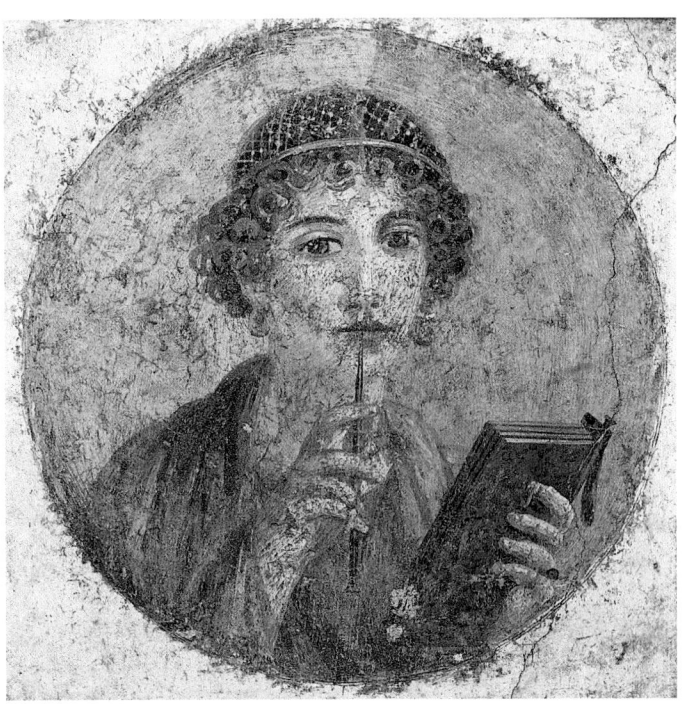

7.58 *Young Woman with a Stylus* (sometimes called Sappho), from Pompeii, 1st century A.D. Fresco; 11⅜ in. (28.9 cm) diameter. Museo Nazionale Archeologico, Naples. The subject holds wax writing tablets in her left hand and a stylus in her right. Her contemplative expression suggests that she is pondering what to write.

7.57 *Odysseus Being Attacked by the Laestrygonians,* from the Esquiline Hill, Rome, c. 50–40 B.C. Fresco; 3 ft. 10 in. (1.16 m) high. Musei Vaticani, Rome.

7.59 Columns and pediment with pavilion, villa at Boscotrecase, near Pompeii, 11 B.C. Fresco; 7 ft. 11 in. × 4 ft. (3.65 × 1.21 m). Metropolitan Museum of Art, New York. Rogers Fund, 1920.

during the reigns of Nero and Vespasian, and the stylus and book suggest that she was literate. More typical of the Third Style is the fresco in figure **7.59**, which creates the illusion of a framed painting on a flat wall. It does not depict distant landscape or narrative. Instead, the artist focuses on thin, delicate ornamentation and sets a miniature arrangement of trees, architecture, and human figures against a refined monochrome background.

A new development in Third Style fresco painting was the villa landscape, in which the architecture is increas-

ingly consistent. An example from Pompeii, the *Landscape with Boats* (fig. **7.60**), shows how nature and architecture have become of primary interest, with people given less prominence than in either the Second Style or in Greek art. Here the buildings are set at oblique angles to the picture plane, which creates a convincing illusionistic recession in space. Behind the buildings are trees and mountains, the shaded surfaces of which enhance the sense of volume, while their placement toward the top of the wall makes them appear to be in the background. Human figures, notably those in the boat, occupy the foreground.

The still life of around A.D. 75–76 in figure **7.61** is an example of the Fourth Style, which combines elements from all three earlier styles. Here, silver objects are set on a table whose spatial projection is indicated by its diagonal recession. The solidity of the silver is indicated by the gradually shaded surfaces. Patches of white suggest light bouncing off a shiny surface. The **highlights**, together with the shading, create an illusion of three-dimensionality, which is characteristic of the Fourth Style.

This fresco was painted on the wall of a tomb enclosure where the *aedile* (public official) Vestorius Priscus, who died at age twenty-two, was buried. The silver is displayed to show the rank and position of the deceased. Shortly after this fresco was painted, Mount Vesuvius erupted and buried Pompeii.

7.60 *Landscape with Boats,* from Pompeii, Third Style, 1st century A.D. Fresco. Museo Nazionale Archeologico, Naples.

7.61 *Still Life of Silver Objects,* from the tomb of Vestorius Priscus, Pompeii, northeastern wall of the enclosure, A.D. 75–76. Fresco.

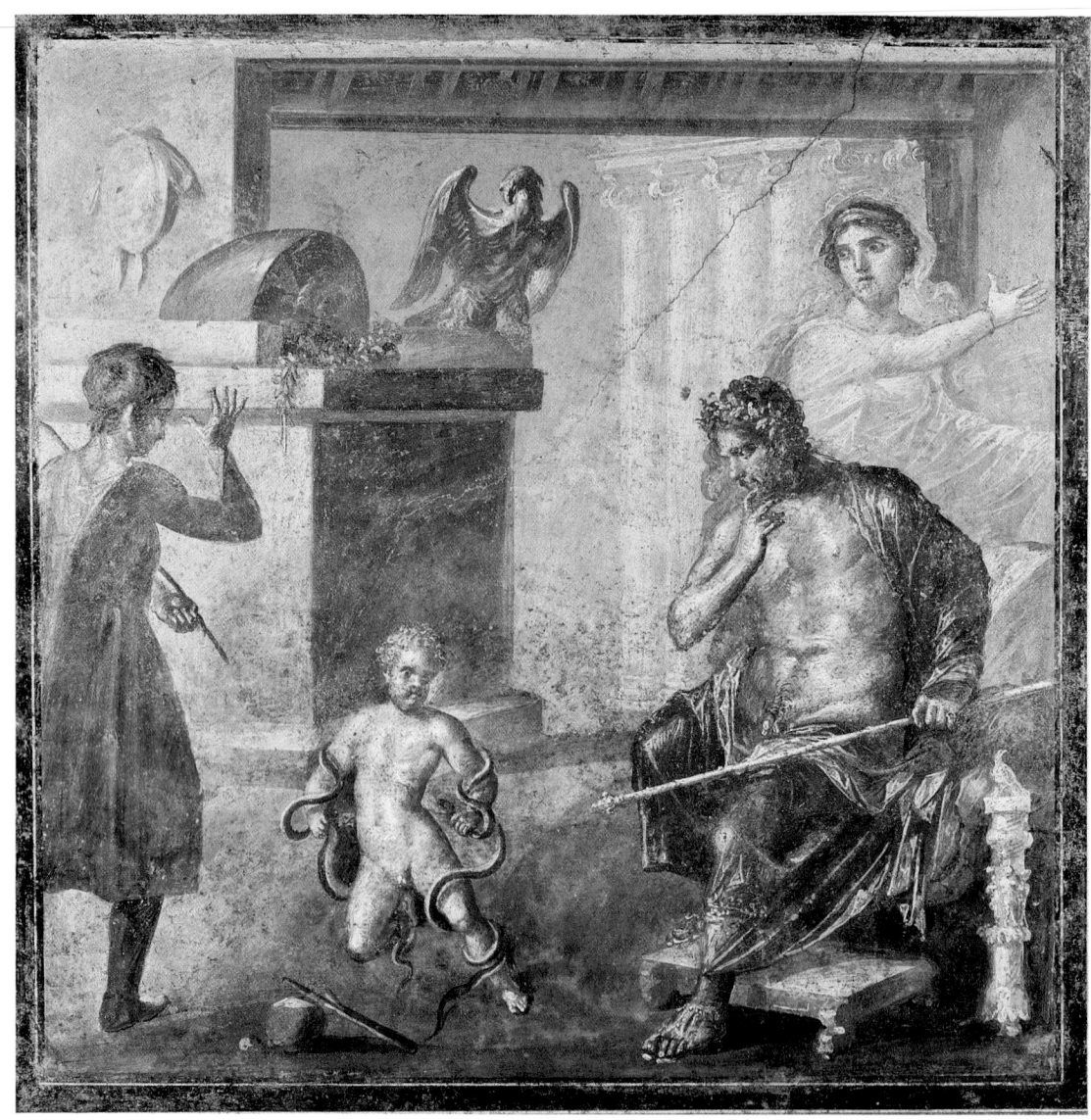

7.62 *Hercules Strangling the Serpents,* House of the Vettii, Pompeii, A.D. 63–79. Fresco.

A more complex narrative mural painting, from the House of the Vettii in Pompeii, represents the Greek myth in which the infant Hercules strangles a pair of snakes (fig. **7.62**). Hercules was the son of Jupiter and the mortal Alkmene. Juno, Jupiter's jealous wife, tried to kill the infant by sending two snakes to his nursery. Her plot failed when Hercules killed the snakes instead.

In this painting, a toddler-age Hercules is the focus of attention. At the right, Alkmene's mortal husband Amphitryon (who believes himself to be Hercules' father) watches in amazement. Alkmene's reaction to her son, however, is more ambivalent. On the one hand, her pose takes her away from the event as she seems to be running out of the picture plane. On the other hand, she turns to stare at Hercules, her riveted gaze enhanced by her wide-eyed expression. The play of shading across the torsos of Amphitryon and Hercules defines the natural structure of their bodies as well as their spatial positions. The figure at the left is rendered from the back, as if he, like the viewer, has just happened on the scene.

7.63 View of *Hercules Strangling the Serpents* in situ, House of the Vettii, Pompeii, A.D. 63–79.

The architectural elements within the picture add to the effect of depth. A slightly receding row of Ionic columns, like the oblique pavilions in figure 7.59, is perspectival. The floor of the room is rendered as a horizontal, enabling the viewer to determine the spatial locations of figures and objects. Amphitryon's footstool and the altar behind Hercules are placed so that each has a corner facing the picture plane. By darkening one side of the altar, the artist creates the illusion that both sides recede. The entire scene thus seems to occupy a convincing, if not mathematically precise, three-dimensional space.

Although the painting represents a Greek myth, certain iconographic details refer to the imperial concerns of Rome. Amphitryon is clearly a ruler, wearing a laurel wreath, enthroned, and holding a scepter. Perched on the altar is the eagle, which is at once a reference to Jupiter

and to the Roman army. In addition, the divine origins of Hercules recall Roman legends tracing the origins of Rome to Aeneas and through him to the Greek gods. Hercules' formal similarity to the Hellenistic sculpture of *Laocoön* (see fig. 5.75) relates the image to the fall of Troy.

Figure **7.63** shows the painting in context with another mythological scene at the right: this depicts Pentheus, the ruler of Thebes, being torn apart and killed by the maenads, who had become enraged at his rejection of Bacchic rites. Here, Pentheus kneels in defeat, surrounded by the frenzied women about to tear him limb from limb. Both the mythological and architectural paintings in this room have the effect of windows cut into the wall, but they do not carry the entire wall into a fictive distance, as do those of the previous styles.

Cross-Cultural Trends

Faiyum Painting

Roman and Greek pictures, sculpture, architecture, religion, and even certain ideas about politics and government had much in common with each other. But the Romans translated what they borrowed from Greece into their own idiom. Greek and Roman culture, together with influences from the entire Mediterranean world, have had an enormous impact on the foundation and development of Western civilization.

Cross-fertilization in the visual arts can be seen in a group of paintings produced in Egypt during the Roman Empire. These works differ considerably from Roman murals at Pompeii and reflect a revival of the vivid illusionism of Greek art. They are believed to have been related to Hellenistic portraiture, of which no examples survive. Most come from the district of Faiyum, an area about 60 miles (97 km) south of Cairo in the Nile Valley. The earliest date to the first decades of the first century A.D., but the majority are from the second and third centuries.

Egypt had continued the practice of mummification (see Chapter 3), but the masks that had previously been placed over the mummy cases were replaced by portraits painted in encaustic on wood and later by tempera on wood. Figure **7.64** shows the mummy case of Artemidoros, a citizen of Faiyum, with his portrait painted directly on the wooden surface. The white tunic over the shoulders is typical of Hellenistic style. The slightly three-quarter view of the face and thick black eyebrows, the highlight on the nose, and shaded modeling of the forms are characteristic of Faiyum portraits and contribute to their realistic effect.

Below the portrait are mythological scenes, including an image of Anubis, the

jackal-headed mortuary god of the dead, in the top register. The stylization of the scenes, compared with the convincing likeness of the portrait, suggests that the ability to recognize the identity of the deceased continued to be a necessary feature of the Egyptian afterlife under Roman rule. In addition, the alert quality of the head, also found in banqueting figures on Etruscan sarcophagi, conveys a sense of immediacy that makes the dead person appear to be alive. Artemidoros, like the wax portrait described by the Greek poet Anakreon (see Chapter 5), indeed seems as if he is about to speak.

Rome and Carthage

The history of the Roman Empire includes extensive cross-cultural influences throughout the Mediterranean world and as far east as modern Pakistan and India. A significant thread of Roman history was intertwined with the North African city of Carthage. Located in Tunisia, Carthage was bordered by Libya on the east and Algeria on the west. It was valuable to Rome for its agricultural produce, marble, and shipbuilding.

The native inhabitants of Tunisia, the nomadic Libyans (known as Berbers), occupied the region from the ninth millennium B.C. In the ninth or eighth century B.C., the Semitic Phoenicians from Tyre, in modern Lebanon, founded Carthage and called it New City. By the sixth century B.C., Carthage was the largest and most prosperous Mediterranean city, and an ally of the Etruscans. From the third to the second century B.C., Carthage was engaged in a series of wars with Rome, which are known as the Punic Wars (from *Poeni,* meaning "Phoenicians"—with its associated adjective *punicus*).

The Punic Wars left their mark on the history and literature of the Roman Empire, and two Carthaginian generals—Hamilcar Barca and his son Hannibal—have assumed legendary proportions. Hannibal performed one of the great feats of military history when he led his army and its elephants over the Alps in 218 B.C. (In the end, however, only one elephant survived.) Two years later, Rome had amassed over 100,000 troops, and in 202 B.C. the Roman general Publius Cornelius Scipio defeated Hannibal. The Romans never forgot how close they

7.64 Mummy case of Artemidoros, from Faiyum, A.D. 100–200. Stucco casing with portrait in encaustic on limewood with added gold leaf; 67.3 in. (170.9 cm) high, 17.7 in. (44.9 cm) wide, 14.4 in. (36.5 cm) deep. British Museum, London.

7.65 *Aeneas Fleeing Troy*, altar relief from Byrsa Hill, Carthage, Tunisia, early 1st century A.D. Bardo Museum, Tunisia.

had come to defeat, and Carthage played a significant role in the legend of the founding of Rome. In the *Aeneid*, Carthage is one of Aeneas's most memorable stops on his journey from Troy to Italy, for there he meets the Carthaginian queen, Dido, who falls in love with him. According to tradition, Dido was originally the princess Elissa of Tyre. She married her uncle, whom her brother the king killed for his money. Elissa fled to Cyprus and then to Tunisia, where she founded the city of Carthage. Early sources relate that the local ruler promised Elissa, now known as Dido, the amount of land that could be enclosed by the hide of an ox. Dido had the hide cut into thin strips and arranged them end to end, thereby enclosing a large area. When Aeneas finally leaves Carthage to follow his destiny to found Rome, Dido commits suicide and dies on a funeral pyre. She calls out for a hero to avenge her and her people—that avenger was Hannibal.

The Carthaginian relief in figure **7.65** shows Aeneas fleeing Troy with his father, Anchises, and son, Ascanius (see p. 210). The carving is provincial, but reflects Roman influence.

The site of Carthage has been known from antiquity, although it was not systematically excavated before the early 1970s, when developers began to threaten the ancient ruins. UNESCO agreed to assist in sponsoring international excavations led by French, British, German, and American archaeological teams. As a result, the historical and cultural past of Carthage has begun to emerge from the mists of legend and myth—much like the Minoan and Mycenaean civilizations.

Dido's role in the history of Carthage, her relationship with Aeneas, and its tragic aftermath are among the legends investigated by archaeologists. The original territory settled by Dido was thought to be on Byrsa Hill, which overlooks the harbor of Carthage. When the excavations were under way, evidence of domestic buildings and a town defended by fortified walls was discovered.

Further excavations have revealed that Carthaginians practiced child sacrifice: there were mass killings in times of stress and sacrifices to appease the city gods, Baal Hammon and Tanit (see box, p. 252). Archaeologists estimate that from 400 to 200 B.C. over 20,000 children between infancy and the age of four were cremated and their ashes buried in the Tophet (fig. **7.66**). Burials were in urns marked by vertical stelae, which show the influence of Greek grave markers (see Chapter 5). The contents of the urns, in contrast, show

7.66 View of the Tophet, Carthage. The Bible (2 Kings 23:10) refers to the Tophet, a site in the Valley of Hinnom near Jerusalem, where the worshipers of Baal sacrificed their children. In the 7th century B.C., the king of Judah destroyed the Tophet and condemned the ritual of child sacrifice.

The Punic Gods

The Punic religion was an amalgam of several Mediterranean influences combined with indigenous elements. The rulers of the Punic pantheon were Baal Hammon, creator of the universe, and his female consort, Tanit. Baal was a storm god related to the Phoenician sky god El, the Egyptian Seth, and the Greek Chronos (called Saturn by the Romans). Baal controlled rain and thunder, and wielded a thunderbolt. As giver of rain, he fertilized the earth and embodied the forces of creativity. Tanit is not a Phoenician name and may have been originally a Libyan fertility goddess. In ancient Carthage, she was queen of the dead, and a mother goddess associated with the Greek Hera and the Roman Juno.

Other important Punic gods were Eshmoun (from Phoenicia), who became equated with Asklepios (the Greek god of medicine), and Melqart, who was god of the city of Tyre and later associated with Hercules.

Egyptian influence—in amulets and in images of the god Ptah (see Chapter 3) and of the apotropaic eye of Horus.

Figure **7.67** is a Neo-Punic stele with engraved signs and an inscription combining Greek and Phoenician letters. The goddess Tanit is shown in her standard iconography as a triangular body with upraised arms and elbows bent to form a right angle. The crescent moon is her emblem, and the sun disk above it is Baal Hammon's. Tanit's sign appears also on thousands of "baby bottle" vessels from the Hellenistic period (fig. **7.68**). The body of the vessel is transformed into a face with two eyes and a nose that functions as a "nipple." Liquid was poured into the "bottle" through the spout at the top. Tanit's emblem beneath the spout probably has symbolic meaning.

The art and architecture of Carthage reflect its cultural mix. Roman and Near Eastern ideas and motifs, together with native traditions, inform many Carthaginian works. The mausoleum at Dougga (fig. **7.69**), for example, is a tomb tower apparently built by a Phoenician architect. His name—Ateban, son of Iepmatath—is inscribed on the monument in a script having both Libyan and Punic characteristics. The Order of the columns is Greek, and they rise, as in most Doric temples, from the top of three steps. The structure is crowned, on the other hand, by the pyramid form characteristic of Egypt. Showing Near Eastern as well as Egyptian influence are the guardian animals at the four corners and the base of the pyramid. The synthetic nature of this mausoleum exemplifies the cross-cultural influences in the North Africa of antiquity.

7.67 Neo-Punic stele with inscription and sign of Tanit, from Teboursouk, Tunisia, 1st century B.C.–1st century A.D.

7.68 "Baby bottle" vessel from a Punic tomb, 4th–3rd century B.C. 4⅓ in. (10.9 cm) high. Bardo Museum, Tunisia.

7.69 Mausoleum, Dougga, Tunisia, 2nd century B.C.

500 B.C.

REPUBLIC
509–27 B.C.

Villa of the Mysteries frescoes

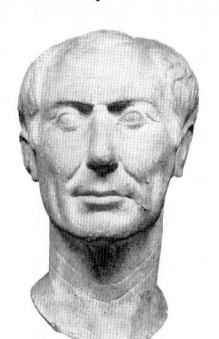

Bust of Julius Caesar

Tophet (**7.66**), Carthage
"Baby bottle" vessel (**7.68**)
Mausoleum (**7.69**), Dougga
Temple of Portunus (**7.23**), Rome
Temple of the Sibyl
 (**7.25**), Tivoli
Villa of the Mysteries
 frescoes (**7.54–
 7.56**), Pompeii
Odyssey Landscapes
 (**7.57**), Rome
Bust of Julius Caesar
 (**7.43**), Tusculum

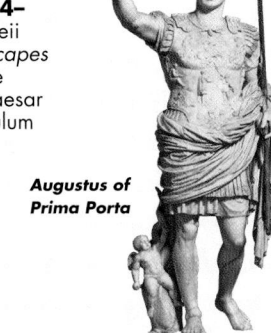

***Augustus of
Prima Porta***

Odyssey Landscapes

Age of Perikles
 in Athens
 (458–429 B.C.)
Etruscan influence in
 Italy begins to wane
 (450–400 B.C.)
First Punic War
 between Rome and
 Carthage (264–
 241 B.C.)
Carthaginians led
 by Hannibal
 invade Italy
 (218–211 B.C.)
Roman expansion:
 annexes Spain
 (201 B.C.); controls Asia Minor, Syria, Egypt,
 Greece (146 B.C.)
Sulla first dictator of Rome (82–79 B.C.)
Slave rebellion led by Spartacus (72–71 B.C.)
Julius Caesar conquers Gaul (58–50 B.C.)
Classical Age of Latin literature (Virgil, Horace, Livy,
 Ovid) (50–10 B.C.)
Flowering of Latin literature (Caesar, Catullus, Cicero,
 Lucretius)
Library of Alexandria destroyed by fire (47 B.C.)
Julius Caesar becomes dictator (46 B.C.)
Caesar reforms Roman calendar; introduction of
 solar year (46 B.C.)
Julius Caesar assassinated (44 B.C.)
Caesar's assassins defeated at Philippi by Octavian
 and Mark Antony (42 B.C.)
Antony marries Cleopatra (37 B.C.)
Julio-Claudian dynasty (27 B.C.–A.D. 68)
Augustus (Octavian) becomes emperor (27 B.C.)

"Baby bottle" vessel

0

EMPIRE
27 B.C.–A.D. 476

Infant Hercules

Arch of Titus

Caracalla

Neo-Punic stele (**7.67**), Teboursouk
Pont du Gard (**7.22**), Nîmes
Ara Pacis (**7.31–7.33**), Rome
Frescoes from villa at Boscotrecase (**7.59**),
 Pompeii
Patrician with two ancestor busts (**7.45**)
House of the Silver Wedding (**7.3**), Pompeii
Augustus of Prima Porta (**7.48**)
Aeneas Fleeing Troy (**7.65**), Carthage
Unknown Barbarian (Parthian?) (**7.53**)
Young Woman with a Stylus (**7.58**), Pompeii
Landscape with Boats (**7.60**), Pompeii
Roman and imperial forums (**7.11**), Rome
Hercules Strangling the Serpents
 (**7.62–7.63**), Pompeii
Colosseum (**7.19–7.20**), Rome
Still Life of Silver Objects (**7.61**), Pompeii
Arch of Titus (**7.38–7.39**), Rome
Portrait of a young Flavian lady (**7.46**)
Portrait of an older
 Flavian lady (**7.47**)
Timgad (**7.6**), Algeria
Basilica Ulpia (**7.13**), Rome
Mummy case of Artemidoros
 (**7.64**), Faiyum
Trajan's Column
 (**7.34–7.35**), Rome
Pantheon (**7.27,
 7.29–7.30**), Rome
Hadrian's Villa
 (**7.8–7.9**), Tivoli
Antinous (**7.49**)
Bust of Trajan (**7.44**)
Insulae (**7.4**), Rome
Statue of Marcus
 Aurelius (**7.50**)
Circus (**7.21**), Libya
Baths of Caracalla (**7.17–7.18**), Rome
Caracalla (**7.52**)
Badminton Sarcophagus (**7.42**)
Dacian vase (**7.36**), Romania
Dacian helmet (**7.37**), Romania
Arch of Constantine (**7.40**), Rome
Head of Constantine (**7.51**), Rome

Artemidoros

Death of Virgil, Roman poet and author of the
 Aeneid (19 B.C.)
Judaea annexed by the Romans (A.D. 6)
Crucifixion of Christ at Jerusalem (c. A.D. 33)
Roman conquest of Britain (A.D. 43–85)
Saint Paul preaches Christianity in Asia Minor and
 Greece; sent to Rome for trial (c. A.D. 60)
Great fire in Rome; Nero persecutes the Christians
 (A.D. 65)
Flavian dynasty (Vespasian, Titus, Domitian)
 (A.D. 69–96)
Revolt of Jews; Romans sack Jerusalem (A.D. 70)
The four Gospels written (A.D. 75–100)
Eruption of Vesuvius, destruction of Pompeii and
 Herculaneum (A.D. 79)
Death of Pliny the Elder (A.D. 79)
The "Five Good Emperors" (Nerva, Trajan, Hadrian,
 Antoninus Pius, Marcus Aurelius) (A.D. 96–180)
Roman Empire at its zenith (A.D. 98–117)
Trajan's conquest of Dacia (A.D. 101–106)
Trajan's conquest of Armenia and Mesopotamia
 (A.D. 113–117)
Dead Sea Scrolls written (c. A.D. 130–168)
Jews expelled from Jerusalem; Jewish diaspora
 begins (A.D. 132–135)
Marcus Aurelius drives back invasions of Goths and
 Huns (c. A.D. 161–180)
Bishop of Rome becomes pope (c. A.D. 200)
Codification of Jewish law in the Mishnah
 (c. A.D. 200)
Imperial residence moved to Constantinople
 (c. A.D. 250)
Edict of Milan; Christianity legalized (A.D. 313)
Sack of Rome by the Visigoths (A.D. 410)

Constantine

Marcus Aurelius

A.D. 500

Developments in South Asia
The Indus Valley Civilization
(to the 3rd century A.D.)

In 326 B.C., Alexander the Great led his armies into the northwest corner of south Asia (see map)—parts of modern Afghanistan, Pakistan, and India—then a part of the Achaemenid Empire (see Chapter 2). In so doing, he was eroding the power of Greece's traditional enemies—the Persians. In the second century B.C. Indo-Greeks ruled to the south, and, later, the Roman Empire established outposts in south Asia.

Building upon a much older network of land and sea trade routes, the unprecedented territorial expansion of Greece and Rome created new contacts linking the Mediterranean and western Europe with parts of the East.

Transmitting cultural influence in the opposite direction—from East to West—were Buddhist missionaries sent to Greece and the Middle East in the third century B.C. by the Indian em-

peror Ashoka (ruled c. 273–232 B.C.). Merchant caravans traveled along the Silk Road, the 5,000 miles (8,047 km) of linked trade routes that stretched from China to Rome by the first century B.C. (see map). From China, they transported great quantities of finished goods such as silk, bronzes, ceramics, and lacquerware. Wool and linen textiles, glassware, and valuable raw materials went eastward from the Mediterranean world. As a result of such exchanges, certain styles and motifs infiltrated Eastern art from the West, while others flowed in the opposite direction.

South Asia.

The Indus Valley Civilization
(c. 2700–1750 B.C.)

The valley of the Indus River is located in modern Pakistan and northwest India, covering a vast area roughly equivalent to that of western Europe. Early in the third millennium B.C., its culture developed from a nomadic to a settled, urban civilization. Compared with the Mesopotamian and Egyptian civilizations, which were also centered around rivers, the Indus Valley culture adapted to a wider variety of natural environments. The first of hundreds of Indus Valley sites to be excavated (in the 1920s) were Mohenjo Daro and Harappa, which appear to have been artistic centers. The high point of Mohenjo Daro culture came in the second half of the third millennium B.C., during which time its population peaked at around 50,000. In addition to monumental stone architecture, archaeologists have found evidence of houses, mostly two stories high, made of mud brick and of more durable baked brick. The excavations

The Buddhist world.

also uncovered sewage systems, bronze and copper tools, large painted vases made on a potter's wheel and fired, and sculptures of terra-cotta, bronze, and stone. At Mohenjo Daro, as at most other large Indus Valley sites, many streets were laid out according to a grid. The ruins of a citadel in the west suggest a need for defensive architecture. It is curious that so far there is no evidence of religious or royal architecture, whether temples, tombs, or palaces. The existence of writing, like urbanization, distinguishes Indus Valley society from other cultures of the region.

Glyptic art, which was popular in Sumer and Akkad (see Chapter 2), is found in the Indus Valley civilization and to some scholars indicates contact with Mesopotamia. But Near Eastern seals are cylinders rolled across a soft surface, while those in the Indus Valley are square and held by a knob at the back. They were stamped face down to make an impression. Whereas Meso-potamian seals were indented so that the images they made were raised, the Indus Valley seals were carved in relief so that their stamped images were indented. The example in figure **W3.1** —one of some 2,000 seals depicting a range of subjects—represents a humped bull, or zebu, standing in a square field with an inscription incorporated into the overall design. The animal's stylized beard and thin, curved horns have a linear quality, while a sense of natural bulk is conveyed through the zebu's

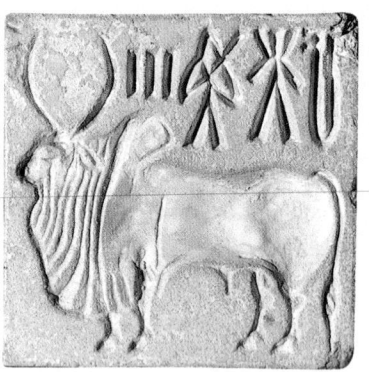

W3.1 Square stamp seal showing a zebu, from Mohenjo Daro, Indus Valley, c. 2300–1750 B.C. White steatite; 1½ in. (3.8 cm) high. National Museum, New Delhi.

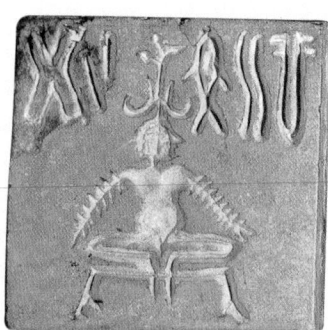

W3.2 Square stamp seal showing a yogi, Indus Valley civilization, c. 2500–1500 B.C. White steatite; approx. 1¼ in. × 1¼ in. (3.2 × 3.2 cm).

body, especially its hindquarters. Such rendering of organic form has remained typical of south Asian art.

Also characteristic is the iconography of the bull, which is often presented —as in Mesopotamia—in connection with human figures. The male figure in figure **W3.2** is seated in what seems to be a meditative yoga pose. He is sometimes horned and ithyphallic (having an erect and prominent phallus), which is probably symbolic of his power and fertility.

No monumental paintings are known from the Indus Valley civilization. Most of the few examples of Indus Valley sculpture from Mohenjo Daro and Harappa reflect the same full-bodied style that characterizes the bull seal, but there are rare examples of more stylized images. A work such as the *Bearded Man* (fig. **W3.3**) from Mohenjo Daro is reminiscent of Mesopotamian art and seems to combine Sumerian qualities with indigenous south Asian forms. Like the humped

bull in figure W3.1, it is a synthesis of compact monumentality, stylization (the beard, hair, ears, and trilobed drapery pattern), and organic quality in the structure of the face (especially the lips and nose). The figure's heavy-lidded, inward gaze, however, contrasts sharply with the wide-eyed stare of Mesopotamian statues such as those from Tell Asmar (see figs. 2.12 and 2.13).

Entirely different in their aesthetic effect, and more purely organic, are

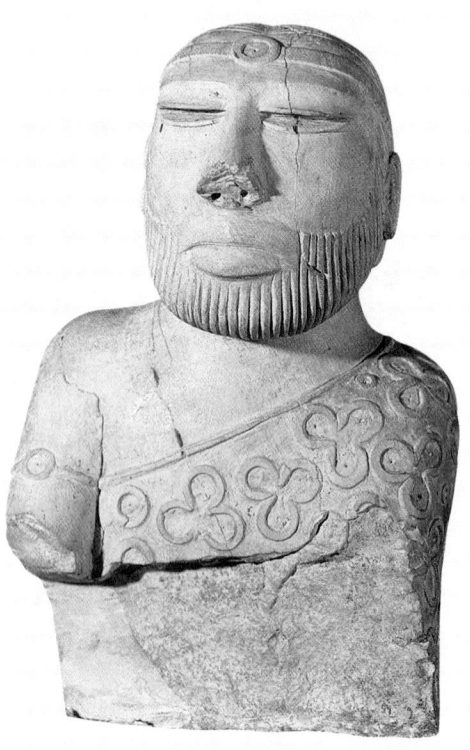

W3.3a, b, c *Bearded Man,* from Mohenjo Daro, Indus Valley, c. 2000 B.C. Limestone; 7 in. (17.8 cm) high. National Museum, New Delhi.

W3.4a, b *Dancing Girl*, from Mohenjo Daro, Indus Valley civilization, c. 2300–1750 B.C. Bronze; 4¼ in. (10.8 cm) high. National Museum, New Delhi.

the nude sculptures (figs. **W3.4** and **W3.5**), which have more in common with later south Asian art. The *Dancing Girl* (fig. W3.4) from Mohenjo Daro is nude except for a necklace and armbands that may have had a ritual purpose. Despite her thin proportions, she conveys an organic quality that derives both from the forms themselves (the indication of bone under the left shoulder, for example) and from the convincingly relaxed pose.

The nude male torso (fig. W3.5) differs from the *Dancing Girl* in its massive proportions and compactness. Its quality of **prana** (the sense that the image itself is filled with living breath) typifies south Asian sculpture. Although it is less than 4 inches (10 cm) high, the torso, like the *Venus of Willendorf* (see fig. 1.1), has the impact of a much larger work. The original meaning and function of this figure is not known, nor is the purpose of the small circles in the shoulders to which arms may have been attached.

The Indus Valley civilization declined around the middle of the eighteenth century B.C., perhaps owing to a combination of floods, invasions, and political overextension.

W3.5a, b, c Nude male torso, from Harappa, Indus Valley, c. 2000 B.C. Red sandstone; 3¾ in. (9.5 cm) high. National Museum, New Delhi.

The Vedic Period

(c. 1600–322 B.C.)

Around 1600–1500 B.C., waves of semi-nomadic Indo-European (Aryan) peoples invaded the Indus Valley and the surrounding regions from the northwest. There is no archaeological record of Aryan cities, burials, or works of art. Most of what we know about the invaders, who spoke an early version of Sanskrit, comes from their sacred literature, the Vedas (see box). One of the later Vedic texts, the Upanishads, describes the Aryan social hierarchy that became the Hindu caste system (see box). Descriptions in the Vedas of Aryan conquests are consistent with the archaeological evidence of fortified cities (citadels) found in the Indus Valley. Likewise, Vedic references to phallic worship by the local population appear to be confirmed by certain images from Harappa and Mohenjo Daro.

The founder of Buddhism (see below), Shakyamuni Buddha, was born Prince Siddhartha Gautama in modern Nepal in the mid-sixth century B.C. Buddha's teachings were a reaction against the traditional Vedic religious hierarchy, controlled by Brahmin priests. Two main Buddhist traditions emerged, both stressing the virtues of compassion and selflessness. One emphasizes the importance of breaking the cycle of reincarnation and achieving *nirvana,* and the other, the attainment of enlightenment for everyone. The latter accepts several buddhas, in addition to Shakyamuni, as well as **bodhisattvas** (those who delay Buddhahood). The first tradition promoted an ascetic, meditative path to spiritual growth, whereas the other taught that prayer and faith could also be routes to salvation. Despite its virtual disappearance from India by the tenth century, Buddhism eventually spread throughout Asia. The first of the Buddhist traditions was adopted primarily in Sri Lanka (formerly Ceylon) and southeast Asia, and the second in China, Japan, and Korea.

Buddha and Buddhism

Prince Siddhartha Gautama is believed to have been born around 563 B.C. in what is now Nepal. According to leg-

The Upanishads

The Upanishads, composed c. 800–600 B.C., are literally "knowledge derived from sitting at the feet of the teacher." These are the final set of Vedic texts. Instead of emphasizing priesthood and ritual, as the second set does, the Upanishads are philosophical and speculative. They illuminate the inner meaning of the earliest Vedas and explore the nature of knowledge and truth.

Individuals undergo numerous births in the cycle of different lives (*samsara*). In what form one is reborn depends on his or her *karma*—accumulated "credit" or "debt" created by a person's good or bad actions. Karmic status reflects one's position in the social hierarchy, known as the caste system. There were four castes: at the top were Brahmin priests, followed by warriors, farmers, and artisans. Lower yet were those without a caste—the "outcasts." Acceptance of one's proper place within this system leads, through a series of progressively better lives, to liberation (*moksha*) from the cycle of rebirth. *Nirvana* is the union of the liberated individual soul with Brahmin, the cosmic soul.

The Early Vedas

The Vedas (from the Sanskrit verb meaning "to know") are collections of Aryan religious literature. For thousands of years, the Vedas were transmitted orally from one generation of Brahmin priests to the next, syllable by syllable. The earliest, which date to the beginning of the second millennium B.C., invoke the Vedic gods in thousands of hymns chanted at sacrificial rituals. A second set codifies ritual practice and serves as handbooks for priests. Vedic priests sacrificed to the gods at fire altars. The fire itself embodied the god Agni (cf. "to ignite"), whose smoke carried offerings upward to the other deities. Agni was born when two sticks of wood were rubbed together, and he was therefore a natural product of the very material he consumed. Indra, the warrior god, personified thunder. Varuna was the guardian of cosmic order, and Rudra (the Howler) destroyed the unrighteous. Uma was the goddess of dawn, and Surya was the sun who crossed the sky in a chariot (as in Greek mythology). Soma, a polymorphous deity associated with an intoxicating elixir, was born, like Aphrodite, from the foam of the sea, and Yama was the god of death.

end, his mother, Queen Maya, gave birth to him through her side, while reaching up to touch a *sal* tree in the Lumbini Grove (figs. **W3.6** and **W3.7**). Siddhartha's father, the head of the Shakya clan, was told in prophecies that his son was destined either to rule the world or to become a great spiri-

tual leader. In accordance with his own preference for the first option, Siddhartha's father raised his son in the sequestered atmosphere of the court. But at the age of twenty-nine, Siddhartha ventured outside the palace walls and encountered the suffering of humanity—disease, old age, and death.

W3.6 *Birth of the Buddha,* relief from Gandhara, India, 2nd–3rd century. Gray schist; 15 in. (38.1 cm) high, 16½ in. (41.9 cm) wide. Ashmolean Museum, Oxford. Queen Maya stands under a *sal* tree in the Lumbini Grove and holds one of its branches. She is surrounded by human and divine attendants. To her right, the Vedic god Brahma receives the infant Siddhartha as he emerges from her side.

Disturbed by what he saw, he renounced materialism, left his wife and family, and rode out to save the world.

At first, Siddhartha became an ascetic and a beggar, devoting himself to meditation. He practiced extreme austerities while continuing his quest for knowledge. But after six years, starving and no closer to his goal, he ended his fast and adopted a moderate Middle Way. Then, in 537 B.C., while meditating under a *pipal* tree, Siddhartha resisted the seductive temptations of the demon Mara and achieved enlightenment. Henceforth this tree was known as the sacred *bodhi* ("enlightenment") tree, and its site as *bodhgaya* ("place of enlightenment"). Siddhartha, having become a buddha ("one who has awakened"), was now known as Shakyamuni ("the sage of the Shakya clan"). He preached his First Sermon in the Deer Park at Sarnath, which set in motion the Wheel (*Chakra*) of the Law (*Dharma*) and founded Buddhism. He spent the remainder of his life traveling and preaching his new philosophy. In 483 B.C., the last great miracle of Shakyamuni Buddha's life, the *Mahaparinirvana,* occurred: when he died, at the age of eighty, the cosmos caused his cremated remains to shine like pearls.

In social terms, Buddhism can be seen as an attempt to reform the rigidity of the caste system. Shakyamuni Buddha taught the Four Noble Truths as the basis of *Dharma,* according to which life is suffering (1), caused by desire (2). But one can overcome desire by conquering ignorance (3), and pursue an upright life by following the Eightfold Path (4):

1. Right understanding
2. Right goals
3. Right speech
4. Right behavior
5. Right calling
6. Right effort
7. Right alertness
8. Right thinking

W3.7 *Dream of Queen Maya,* from Madhya Pradesh, India, Shunga period, 2nd century B.C. 19 in. (48.3 cm) high. Relief from a *vedikā* of the Bharhut stupa, Indian Museum, Calcutta. Queen Maya's dream of a white elephant was interpreted as precognition of her pregnancy with Prince Siddhartha. The perspective of this scene defies our experience of natural reality, giving it a shifting quality. We see Maya from above, while the elephant floating over her is depicted in profile and the attendants at the side of her bed are in back view.

In order to escape suffering, Shakyamuni Buddha advocated the extinction of all desire and all sense of self through meditation and spiritual exercises, which his disciples codified. Shakyamuni established the world's first monastic communities (the *Sangha*), and, after his death, Buddhist monasteries proliferated. Missionary monks spread Buddhist doctrine throughout the world.

Mirroring the multiplicity of Vedic deities, many buddhas emerged around the figure of Shakyamuni. Complementing these were wise and compassionate supernatural beings called bodhisattvas (from the Sanskrit terms for "enlightenment" and "existence"). Bodhisattvas delay their own buddhahood in order to help others attain enlightenment. In art they are identified by their princely attire, and they often flank a buddha. In later periods, the importance of Shakyamuni Buddha was overshadowed by cults of various buddhas and bodhisattvas, especially in the Himalayas and the Far East.

W3.8 Lion capital, Ashokan pillar, from Sarnath, Uttar Pradesh, India, Maurya period, mid-3rd century B.C. Polished chunar sandstone; 7 ft. (2.13 m) high. Museum of Archaeology, Sarnath. According to tradition, the Buddha set in motion the Wheel of the Law (*Dharmachakra*) in his first sermon expounding the Four Noble Truths in the Deer Park at Sarnath.

Buddhist Architecture and Sculpture

The Maurya Period
(c. 321–185 B.C.)

Some eight hundred years after the Aryan invasion, urban culture began to reappear in northern India. The first ruler to unify a large territory after this revival was Chandragupta Maurya, who founded the Maurya dynasty in 321 B.C. From this point on, historical records increase. Chandragupta's grandson, Emperor Ashoka (ruled c. 273–232 B.C.), was one of south Asia's greatest kings, uniting almost all of the Indian subcontinent and parts of central Asia. A dozen years into his reign, at the peak of his military success, he renounced warfare and embraced the nonviolent message of Buddhism, which he promoted throughout his empire and beyond.

Ashoka erected a number of monumental monolithic stone pillars, 50 feet (15.2 m) high. They are thought to have been derived from a Vedic royal tradition of freestanding wooden poles crowned by copper animals, perhaps associated with early tree worship. Like the *bodhi* tree, under which Shakyamuni attained enlightenment, such pillars probably represent the axis of the world. This axis was believed to link heaven and earth, separating as well as connecting them. On these pillars, as on rocks and stone tablets, Ashoka inscribed edicts on Buddhist themes that reflected his political, social, and moral philosophy. Although there is no evidence of a connection between these pillars and later Roman single monumental columns (see p. 231), they clearly served a similar political purpose. Whereas Trajan's Column (cf. fig. 7.34) depicted his military campaigns and stood as a metaphor for both his earthly victories and his future apotheosis, Ashoka's pillars were legislative documents in stone. They, too, by virtue of their height, can be associated with success, and both are crowned by symbols that align the emperor with the gods.

Artistically, the pillars are significant because their capitals constitute the earliest surviving body of Buddhist monumental sculpture. The lion (fig. **W3.8**) and bull (fig. **W3.9**) capitals seem to continue the two iconographic and stylistic traditions evident nearly two thousand years earlier in the Indus Valley. Four lions joined at the back face outward toward east, west, north, and south. They are rigid and emblematic, their whiskers, manes, and claws stylized in a manner reminiscent of Achaemenid sculpture (cf. fig. 2.37). There are strong similarities to the art of Achaemenid Persia in the general

W3.9 Bull capital, Ashokan pillar, from Rampurva, Bihar, India, Maurya period, 3rd century B.C. Polished chunar sandstone; 8 ft. 8 in. (2.64 m) high. National Museum, New Delhi.

concept of animal capitals as well as in the particular stylizations. The Mauryas apparently borrowed portions of their imperial iconography from the more established empire to the west. In contrast, the bull capital is both iconographically and stylistically south Asian. Like the bull in the Mohenjo Daro seal and the nude male torso from Harappa, it is more organically modeled. Massive and fleshy, with a suggestion of underlying bone and muscle structure, it conveys the sense of a living animal.

These capitals demonstrate the Buddhist assimilation of earlier artistic conventions. As in the Near East and Egypt, lions in India are royal animals, and Shakyamuni Buddha himself was referred to as the "lion" of his clan. The bull, as in the Indus Valley seals, denotes fertility and strength. Both the lion and the bull stand on a circular *abacus,* which surmounts a bell-shaped element in the form of lotus petals (signifying purity). The meaning of the dec-

orations in relief on the sides of the *abaci* has been debated by scholars. But the wheel on the lion's *abacus* is certainly Buddha's Wheel of the Law, which was set in motion during his first sermon. Wheel and lion are vertically aligned and, therefore, visually linked to denote the power (the lion) of the Buddha's teaching (the Law, or *Dharma*). The *abacus* of the bull capital is decorated with plant and water designs that refer to the fertility of nature. There can be no doubt that this iconography, like the reliefs on Trajan's Column, was intended to proclaim the power and prosperity of the empire. Together with the edicts on the shafts of the pillars, lion and bull also stand for the power of the Buddha's message.

The Shunga Period
(c. 185 B.C.–A.D. 30)

At the end of Ashoka's reign, India was once again ruled by small republics and local dynasties. One of the latter,

the Shungas of central India, enlarged Ashoka's Great Stupa at Sanchi, India's most characteristic Buddhist monument (fig. **W3.10**). According to Buddhist texts, when the Buddha died (the *Mahaparinirvana*), he was cremated, and his ashes were divided and enshrined in eight **stupas**, or burial mounds. Emperor Ashoka further divided these relics among 64,000 legendary stupas that either have disappeared or have been incorporated into later structures. Stupas thus came to stand for the *Mahaparinirvana,* the last of the four great miracles of Shakyamuni's life. The hemispherical form of the stupa, however, predates Buddhism and, like the monumental pillars, has cosmological significance. Originally, remains or other relics were placed in a hole in the ground into which a pillar was set, and then earth was mounded around the pillar to prevent plundering. With the development of Buddhism under Ashoka, these mounds evolved into monumental stupas.

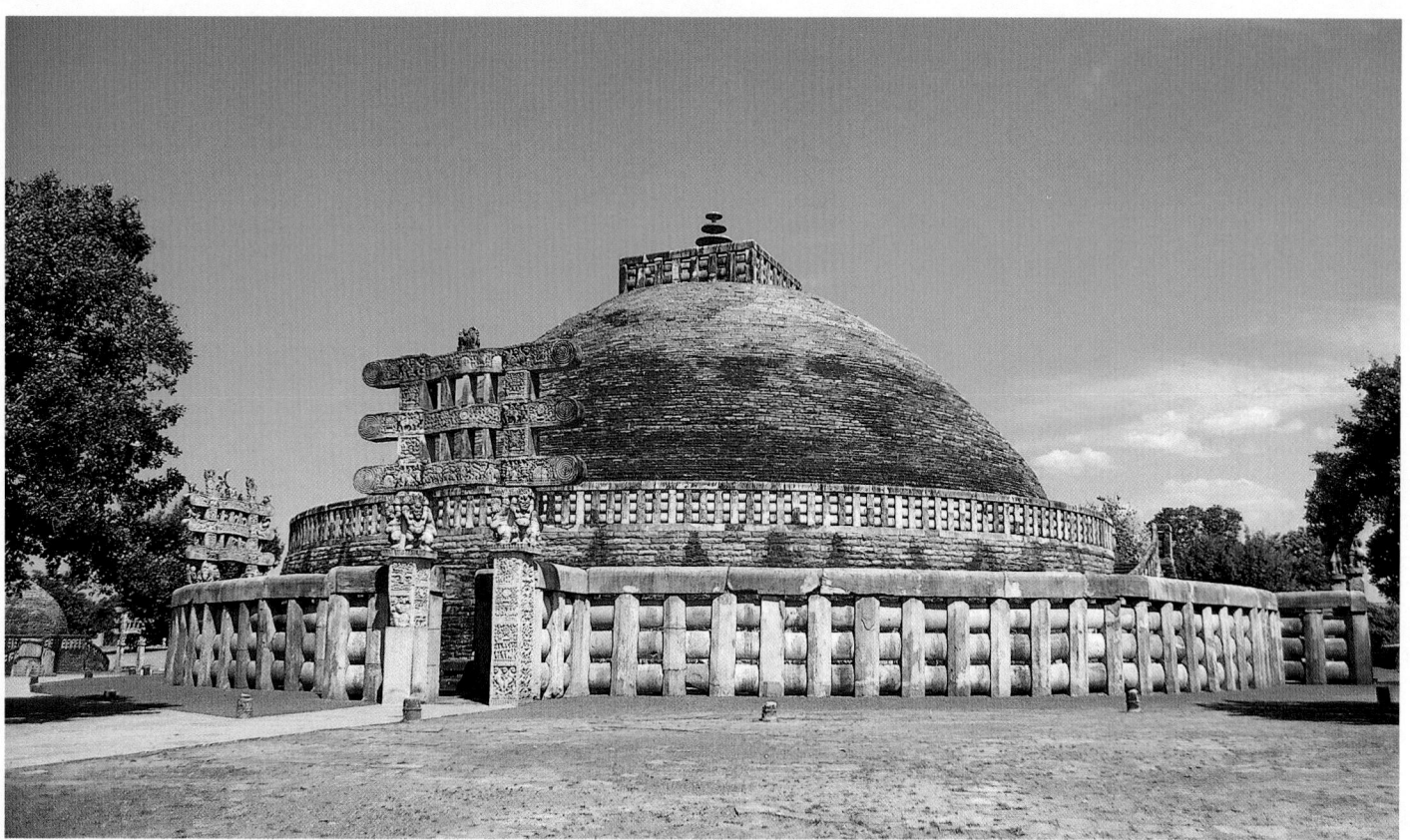

W3.10　Great Stupa at Sanchi, Madhya Pradesh, India, Shunga and early Andhra periods, 3rd century B.C. Diameter over 120 ft. (about 37 m). The cosmological significance of the stupa's organization is evident in its relationship to the worshiper. On entering one of the four *toranas,* one turns left and circumambulates the hemisphere in the direction of the sun (clockwise). In this symbolic passage enclosed by the tall *vedikā,* worshipers leave their worldly time and space and enter the spiritual realm. In so doing, they replicate Shakyamuni Buddha's departure from the world, the *Mahaparinirvana.*

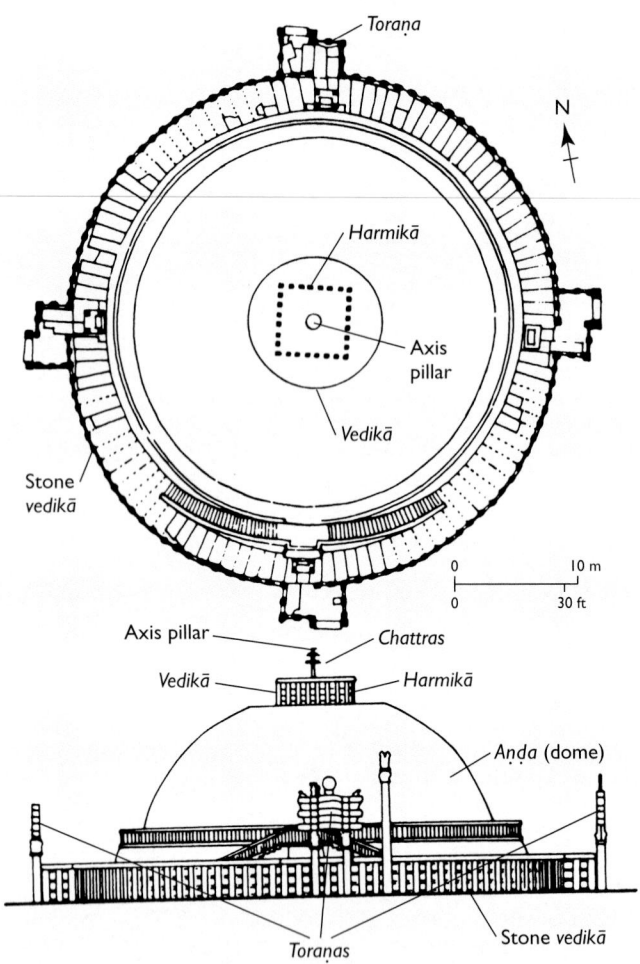

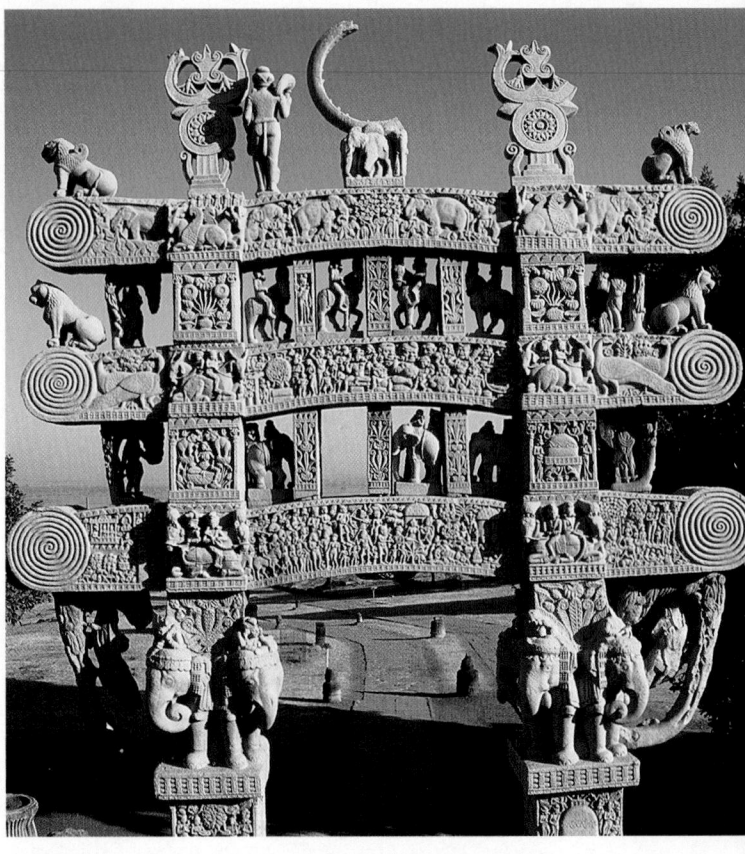

W3.11 Plan and elevation of the Great Stupa at Sanchi.

W3.12 North *toraṇa* at Sanchi, Shunga and early Andhra periods, 1st century B.C.

The Great Stupa at Sanchi, in Madhya Pradesh (figs. W3.10 and **W3.11**), was begun in brick during the reign of Ashoka and evolved further during the Shunga period. The large dome is mainly a product of the first century A.D. The interiors of the stupas were filled with rubble and presumably contained Shakyamuni's relics.

The outline of the stupa is a perfect circle, which Buddhists consider an ideal shape. The stupa was designed as a mandala, or cosmic diagram. The square at the center refers to the **harmikā** on the roof, and the small circle inside the square indicates the axis pillar supporting the **chattras**. The dark outer circle is the **vedikā,** and the four rectangular attachments are the **toraṇas,** oriented to the cardinal points of the compass and reflecting the identification of the stupa with the cosmos.

As is true of Western religious architecture, the stupa creates a transition between one's material and temporal life on earth and the cosmos beyond. The stupa's dome (the **aṇḍa,** meaning "egg") symbolizes the dome of heaven. It supports a square platform (the *harmikā*), enclosed by a railing (the *vedikā*), through which a central axis pillar projects. Attached to the pillar are three umbrella-shaped *chattras*, royal symbols that honor the Buddha. The configuration of the enclosure recalls pre-Buddhist nature worship and the ancient south Asian practice of enclosing a sacred tree with a wooden fence.

Surrounding the stupa is a stone *vedikā* 11 feet (3.35 m) high, based on wooden fences. The *vedikā* is punctuated at the cardinal points by gateways, *toraṇas,* 35 feet (10.67 m) high. These were added in the first century A.D. and also derived from wooden prototypes. An Ashokan pillar and staircase mark the main (southern) entrance to the sacred compound. The north *toraṇa* (fig. **W3.12**) consists of two rectangular posts, on top of which

four elephants and riders support three architraves linked by vertical elements. It is completely covered with relief sculpture. At the top of the *toraṇa*'s posts, two *Dharmachakra* (Wheels of the Law) support tripartite forms symbolizing the *Triratna*—the Three Jewels of Buddhism: the Buddha himself, the *Dharma*, and the *Sangha* (the Buddhist monastic community). The architrave sections directly over the gateway sculptures depict Indian folktales, processions, and battles.

The sections that extend beyond the post depict *jatakās* (stories of the Buddha's previous lives as well as his last life as Shakyamuni). There are also many scenes of Buddhist worship and ceremonies such as one in which Ashoka ritually waters the sacred *bodhi* tree, which stands for the Buddha himself. As is characteristic of early Buddhist art, the Buddha is represented **aniconically**—that is, his presence is indicated only by means of symbols.

Instead of being represented in human form, he appears in metonymic form—as something with which he is associated, such as the *bodhi* tree, his throne, his honorific umbrella (related to the *chattras* at the top of a stupa), or a stupa itself. Another sign of Buddha's presence in art is a pair of footprints that refer to his first baby steps. These, in turn, were associated with an earlier tradition in which a god-king encompasses the world in a few strides.

At Sanchi, the *toraṇas* are decorated with representations of *yakshas* and *yakshīs,* indigenous pre-Buddhist fertility deities, male and female respectively (fig. **W3.13**). The *yakshī* on the bracket both swings from and is entwined in a mango tree, which bursts into life at her touch. Such images are the source for the depiction of Queen Maya giving birth to Siddhartha in the Lumbini Grove (cf. fig. W3.6). The form of the *yakshīs* at Sanchi, like the theme itself, is related to the ancient Indian predilection for sensual, organic sculpture. The voluptuous breasts and rounded belly suggest early pregnancy. The seductive pose is called **tribhaṅga,** or "three bends posture." Together with the prominently displayed pubic area, this pose promises auspicious abundance to worshipers.

The Kushan Period
(c. A.D. 78/143–3rd century)

During the first century A.D., central Asian nomads called Kushans controlled the area now comprising Afghanistan, Pakistan, and northern India. The first extant images of the Buddha in human form date from this period, when Vedic religion still retained enormous popular appeal, partly because of its anthropomorphic gods. As a result, Buddhist artists began to develop an iconography in which buddhas and bodhisattvas were shown in human form.

The move toward representing the Buddha as a man in the Kushan period is first reflected in the Gandharan and Mathuran schools of art. The Gandharan region, located in modern Pakistan, was a crossroads of trade routes and hence a cultural melting pot. As a result, Gandharan artists were familiar with styles and motifs from other areas. It seems that both Greek and Roman artists had worked earlier around Gandhara, accounting for Hellenistic elements in Gandharan images of buddhas and bodhisattvas.

The two most typical images of the Buddha in Gandharan sculpture show him standing or sitting, often with a

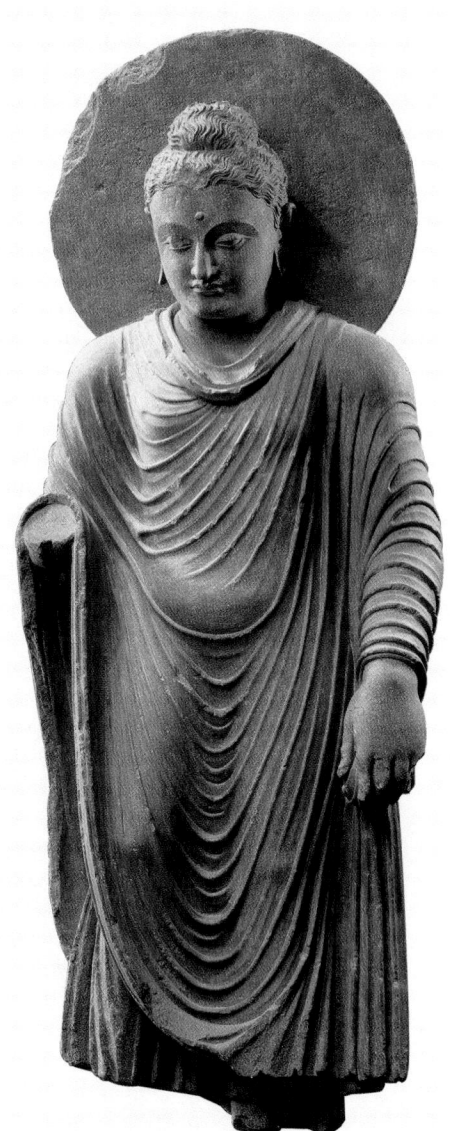

W3.14 *Standing Buddha,* from Gandhara, Afghanistan or Pakistan, Kushan period, 2nd–3rd century. Gray schist; 3 ft. 3 in. (99.0 cm) high. Museum für Indische Kunst, Berlin.

large halo or sun disk behind his head. In figure **W3.14** he is shown wearing a monk's robe, whose deeply carved, rhythmically curving folds recall depictions of togas in Roman sculpture. The statue's organic quality, with its rounded abdomen, is descended from the indigenous artistic tradition of the *prana*-filled nude male torso from Harappa (fig. W3.5).

The *Standing Buddha* displays some traditional identifying physical features of Buddhist iconography. Many of these allude to his role as a spiritual ruler, among them the earlobes, elongated from the weight of heavy royal

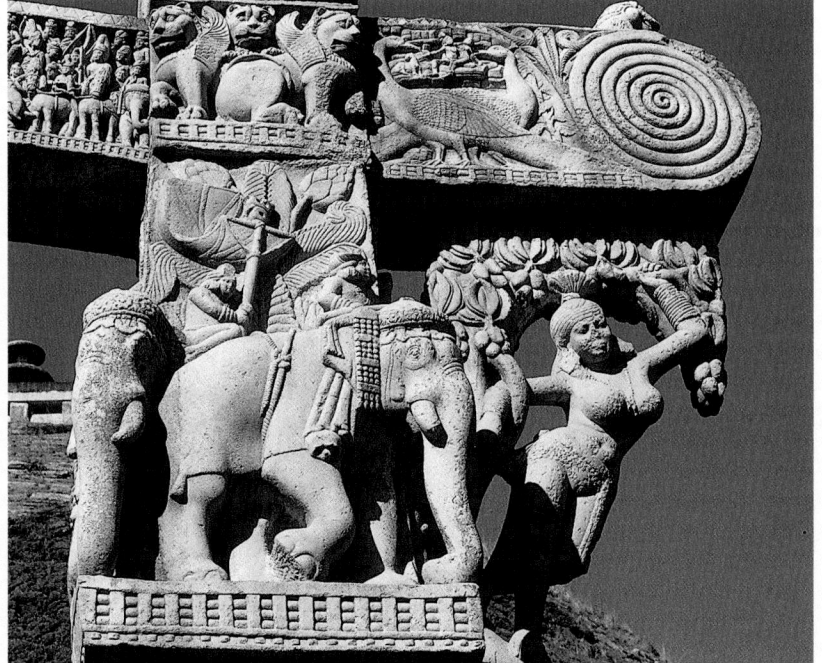

W3.13 *Yakshī*—to the right of the elephant—from the east *toraṇa* at Sanchi, Shunga and early Andhra periods, 1st century B.C. The presence of *yakshīs* in Buddhist art reflects the assimilation of indigenous Indian motifs into Buddhist iconography.

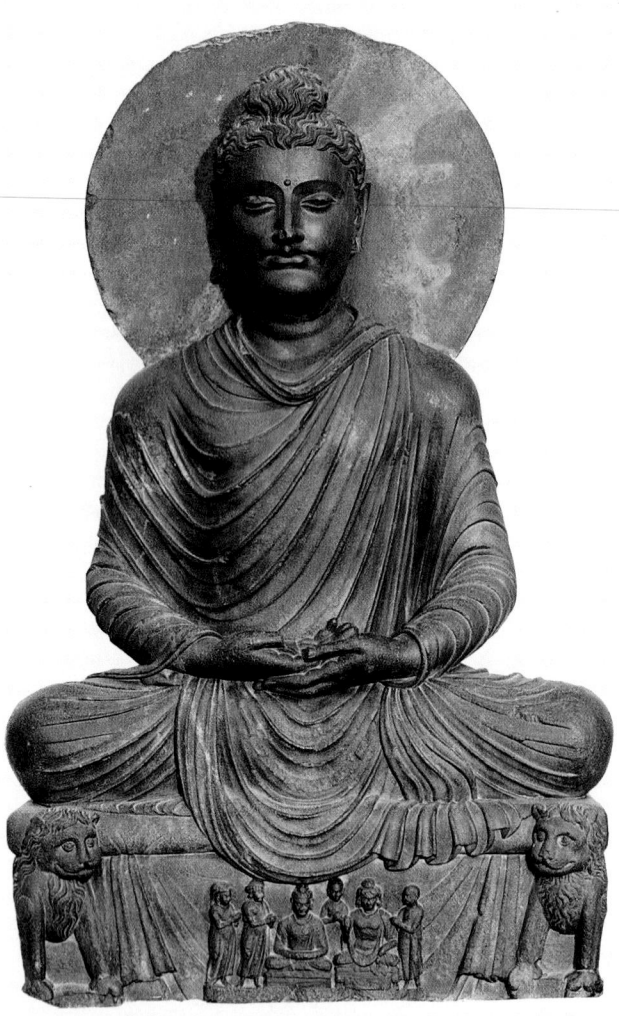

W3.15 *Seated Buddha,* from Gandhara, Afghanistan or Pakistan, Kushan period, 2nd century. Gray schist; 3 ft. 7½ in. (1.10 m) high. National Museums of Scotland, Edinburgh.

W3.16 Model of a stupa from Loriyan Tangai, Gandhara, Afghanistan or Pakistan, Kushan period, 2nd century. Gray schist; 4 ft. 9 in. (1.45 m) high.

earrings. But the earrings themselves are absent because Siddhartha cast aside his princely jewelry when he set out on his spiritual quest. (Bodhisatt-vas, in contrast, are shown wearing royal ornaments, since they are not yet buddhas.) The statue's hair conforms to the shape of the head and is formed into the **ushnīsha,** or topknot. This de-notes the Buddha's great wisdom and is one of the thirty-two auspicious marks of a buddha or an emperor. On the fore-head, the *ūrṇā,* or whorl of hair, is stylized as a small circle. The figure's for-mal unity derives from repeated curves and circles.

The same emphasis on curvilinear forms characterizes the *Seated Buddha* (fig. **W3.15**). The Buddha's hands rest peacefully on his lap, forming the ges-ture (**mudrā**) of meditation (**dhyāna**), in which the hands are held palm up, one resting on the other. *Dhyāna mu-*

drā denotes the intense inner focus through which Shakyamuni attained en-lightenment. On either end of the throne is a lion—in keeping with the ancient tradition of lions guarding royal or sacred personages—symbolizing Shak-yamuni Buddha himself. The face of this seated Buddha, like that of the standing example, is (aside from the fuller lips) reminiscent of beardless Greek and Roman Apollonian types.

Gandharan Buddhist architecture also reflects contemporary religious de-velopments. For example, the second-century stupa at Loriyan Tangai in Gandhara (fig. **W3.16**) is more elabo-rate than the simple hemisphere at Sanchi. Here, a square base supports layered round tiers that end in a small dome. Rising from the dome is an in-verted trapezoidal platform that sup-ports a column of *chattras.* In contrast to the relatively plain plaster surface

of the Sanchi stupa, the stone ma-sonry at the Gandharan stupa is cov-ered with relief sculpture. Hellenistic influence is apparent in specific fea-tures such as the Corinthian pilas-ters and niches formed by round arches.

The degree of Westernization in Gandharan art can be seen by compar-ison with the indigenous south Asian style prevalent at Mathura, south of Delhi. A *Seated Buddha* (fig. **W3.17**) from Mathura, for example, has differ-ent proportions: an hourglass figure, with broad shoulders and a thin waist. The figure's taut, *prana*-filled body is fleshier, its physiognomy less Western, and its drapery folds so finely carved that the cloth appears nearly transpar-ent. The hair is not loose and wavy, but instead is pulled tightly into a topknot —the *ushnīsha*—in the shape of a snail shell.

This representation of the Buddha shows him meditating under the *bodhi* tree at the very moment of his enlightenment. The branches are carved in low relief behind the Buddha's halo, and his facial expression reveals an inner calm. He raises his right hand in the **abhaya mudrā** gesture, which means "have no fear." Compared with Gandharan figures of the Buddha, the Mathuran example communicates more actively with worshipers. Standing behind him are richly dressed attendants with **chaurīs** (fly whisks), another royal symbol honoring the Buddha. Above are wise celestial beings flying toward Shakyamuni to worship him. Like his Gandharan counterpart, the Mathura Buddha sits on a lion throne, the unusual third lion in the center echoing his own dynamic frontal form.

Having established itself in south Asia, Buddhism spread throughout southeast Asia and the Far East. During the Gupta period (fourth through seventh centuries) and its aftermath, Buddhist art in India would undergo remarkable new developments (see "Window on the World Four").

W3.17 *Seated Buddha,* from the Katra Mound, Mathura, Uttar Pradesh, India, Kushan period, early 2nd century. Spotted red sandstone; 2 ft. 3 in. (68.6 cm) high. Government Museum, Mathura.

Style/Period	Works of Art	Cultural/Historical Developments
INDUS VALLEY CIVILIZATION *Dancing Girl*	Stamp seal (**W3.1, W3.2**), Mohenjo Daro *Dancing Girl* (**W3.4**), Mohenjo Daro *Bearded Man* (**W3.3**), Mohenjo Daro Nude male torso (**W3.5**), Harappa *Bearded Man*	Aryan invasion of the Indus Valley (c. 1750 B.C.) Indus Valley script Etruscan civilization begins (1000 B.C.) Urbanization of the Indus Valley (800–700 B.C.) The Upanishads are composed (800–600 B.C.) *Lion capital*
MAURYA PERIOD 321–185 B.C.	Bull capital (**W3.9**) Lion capital (**W3.8**)	Alexander invades south Asia (326 B.C.) Reign of Ashoka (c. 273–232 B.C.)
SHUNGA PERIOD 185 B.C.–A.D. 30	Great Stupa (**W3.10**), Sanchi *Dream of Queen Maya* (**W3.7**), Madhya Pradesh *Yakshī* (**W3.13**), Sanchi North *toraṇa* (**W3.12**), Sanchi	Augustus becomes the first Roman emperor (27 B.C.) Birth of Christ (c. 1 B.C.)
KUSHAN PERIOD c. A.D. 78/143–third century 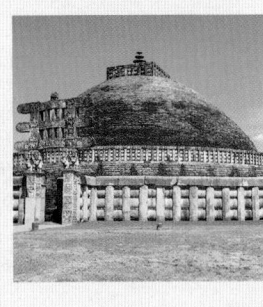 *Great Stupa*	*Seated Buddha* (**W3.15**), Gandhara *Seated Buddha* (**W3.17**), Mathura Stupa (**W3.16**), Gandhara *Birth of the Buddha* (**W3.6**), Gandhara *Standing Buddha* (**W3.14**), Gandhara *Seated Buddha*	Height of the Roman Empire (A.D. 98–117) Trajan conquers Dacia (A.D. 101–106) Dead Sea Scrolls written (c. A.D. 130–168) *Birth of the Buddha*

2300 B.C. A.D. 400

8

Early Christian and Byzantine Art

A New Religion

Around A.D. 33, during the reign of the Roman emperor Tiberius (A.D. 14–37), Jesus Christ was crucified outside the city of Jerusalem, then part of the vast Roman Empire. The teachings of Jesus and his followers led to the establishment of the Christian religion, whose impact on Western art after the fall of the empire cannot be overestimated.

The gradual decline of the Roman Empire and the collapse of its political administration overlapped the development of Christianity, which was a minority religion until the fourth century A.D. In Rome itself, Christianity was first adopted by the urban lower and lower-middle classes, while the aristocracy, for the most part, continued to worship pagan gods. From the second century, however, many educated Romans and some members of the upper classes began to take an interest in the new religion. This encouraged its development and reinforced the emergence of a large, hitherto disenfranchised, segment of society.

For the origins of Christianity, we must look to Judaism and the Near East, which was the site of many religious cults that extended throughout the Mediterranean world, including Rome, during the first century A.D. These persisted into the third century, and most combined the Hellenistic influence spread by Alexander the Great with Eastern elements. Mystery cults centered around the Greek Dionysos, the Egyptian Isis, the Phrygian Kybele, and many others, while the Persians worshiped Mithras and Ahura Mazda. Whether an area was under Greek or Roman control, entrenched local customs persisted. Thus, for example, Egypt continued to worship animals, and its traditional priesthood performed traditional rites. The west coast of Anatolia was the site of a flourishing Greek culture with a cult of Artemis at Ephesus, of Asklepios at Pergamon, and of Apollo at Didyma. At Carthage as well, local versions of Greek deities were worshiped.

Dura Europos

In 1922, the little town of Dura Europos, once at the edge of the Roman Empire in what is now Syria, was discovered and subsequently excavated. Different types of buildings at Dura Europos reflect the multiplicity of religions practiced around the Mediterranean from the first to the fourth centuries A.D. Archaeologists found shrines dedicated to Persian deities as well as pagan Roman temples. A Jewish synagogue dating from around 245 A.D. was, despite biblical injunctions against graven images, decorated with painted scenes from the early books of the Old Testament, the name Christians gave to the Hebrew Bible. Some of the figures are identified by Greek inscriptions.

Figure **8.1** shows the west wall of the synagogue. There are three levels of Old Testament scenes and figures arranged horizontally, interrupted by a Torah niche. The Torah was a parchment or leather scroll containing the text of the Pentateuch, the first five books of the Old Testament (Genesis, Exodus, Leviticus, Deuteronomy, and Numbers). Portions of these books were read aloud on the Sabbath during worship in the synagogue. The Pentateuch was of particular importance because it comprises the Books of Moses and forms the basis of Jewish teaching.

Below the narrative scenes is a row of more emblematic imagery and panels of painted imitation stone. The detail in figure **8.2** depicts *Moses Giving Water to the Twelve Tribes of Israel*. Each tribe is represented as a single figure with upraised arms, standing at the entrance to a tent. These so-called **orant** figures (from the Latin word *orare*, meaning "to pray") symbolized seeking God and praying to him. Above the well is the *menorah* (the sacred Jewish candelabrum with seven candlesticks) framed by a

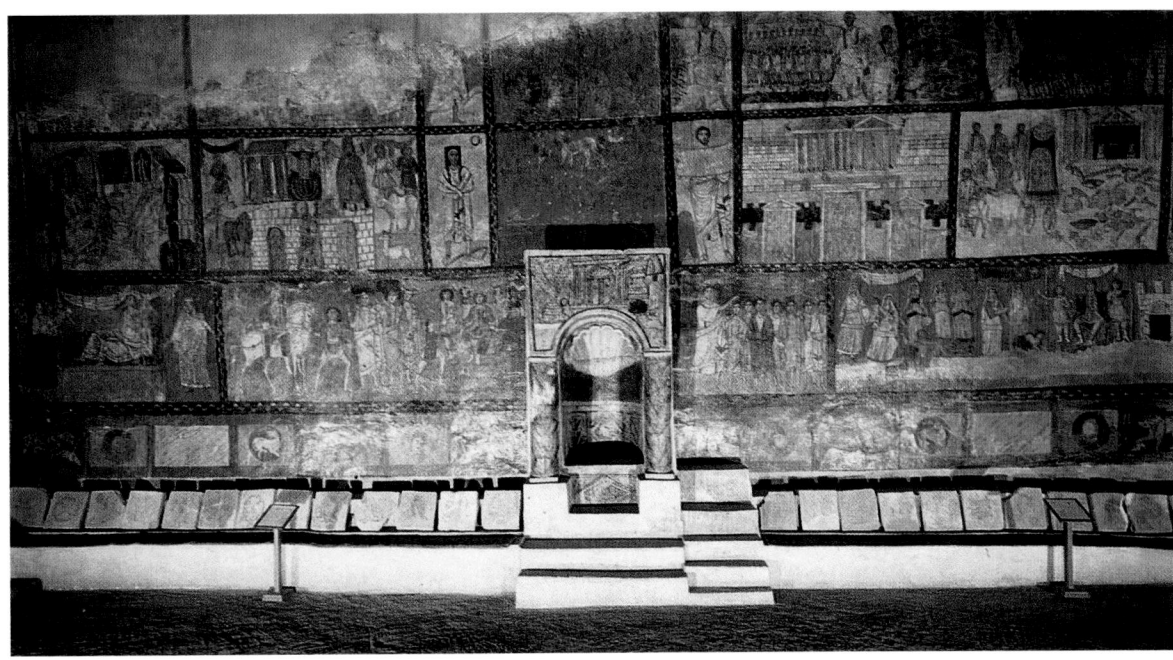

8.1 West wall of Dura Europos synagogue, c. 245. Tempera on plaster (reconstruction). Length of wall approx. 40 ft. (12.19 m). National Museum, Damascus, Syria.

Corinthian portico. Moses himself is a combination of a bearded Old Testament patriarch and a Roman statesman. He wears a toga, and there is a slight suggestion of *contrapposto* in the folds of drapery defining the bend of his right leg.

In addition to the synagogue, there was a Christian baptistery at Dura Europos and a private house where Christians worshiped. By around A.D. 240, the Christian meeting room that had originally held thirty worshipers had expanded to accommodate sixty.

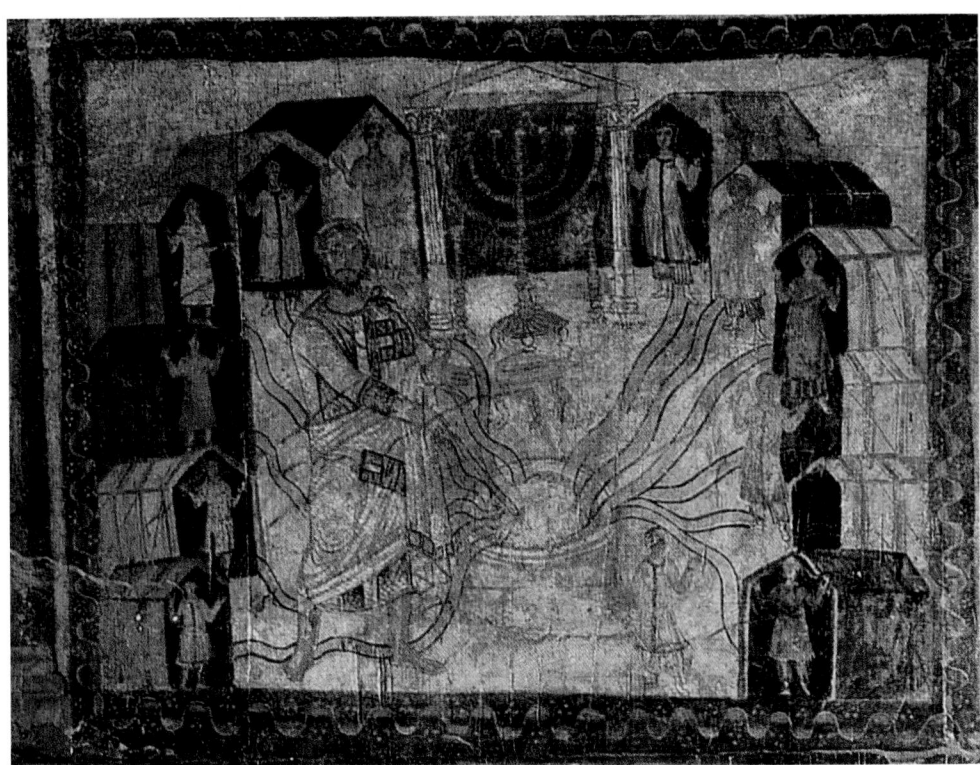

8.2 *Moses Giving Water to the Twelve Tribes of Israel* (detail of fig. 8.1).

Early Developments in Christianity

Many concepts of Christianity were based in Judaism, which also originated in the Near East. Both were founded on written texts that were believed to be the revealed word of God. They were similar in being monotheistic and in teaching a code of ethics to their adherents. As in certain pagan cults, Christianity offered a promise of eternal salvation, but the differences between them were considerable. For example, Christian rituals were not orgiastic, as were the cults of Dionysos, and they did not include animal or blood sacrifices, except in symbolic form. Christ's own sacrifice was foreshadowed in the Last Supper, when the bread stood for his body and red wine for his blood (see box). This celebration was originally performed by Jesus and his followers as part of the Jewish Passover, shortly before his death. He asked his followers to repeat it in his memory, and at first they did so in private dining rooms. It consisted of breaking bread, drinking wine, singing hymns, praying, and reading from the Bible. By the third century A.D., this re-creation of the Last Supper had become the liturgy of the Mass, conducted by a bishop. In the performance of the Mass, also called Holy Communion, the Lord's Supper, or Eucharist (Greek for "thanksgiving"), bread and wine are ritually substituted for the body and blood of Christ. The first detailed description of the Eucharist dates from around A.D. 155, which suggests that by then it was already an established rite.

In pagan texts, however, there is very little reference to Christian ritual before A.D. 250.

Christianity, like Judaism, placed greater emphasis on faith than paganism did and was also more engaged in notions of heresy. The missionary zeal of Christianity was always stronger than in Judaism; among pagans it was practically nonexistent. Many pagan cults were located at specific sites of worship such as sacred caves or islands, while cities had their own gods. Another common theme in paganism that distinguishes it from Christianity was the importance of visibly honoring the gods by various acts and offerings. These were necessary in order to propitiate the gods and appease their anger. In Christianity, the notion of divine retribution is primarily concerned with one's fate at the end of the world. Even though certain human transgressions arouse divine anger—a notable example from Christ's life being when he drove the money changers from the Temple in Jerusalem—Christianity promises salvation to those who repent of their sins.

Finally, Christians differed from the adherents of Near Eastern religions by refusing to worship the Roman emperor as the embodiment of the state. Christian monotheism rejected the Roman and Greek concepts of pantheism as well as the Near Eastern and Egyptian gods. These attitudes set Christianity at odds with the imperial Roman establishment and made its followers subject to persecution by Rome. In the first century A.D. under Nero (see p. 224), the Christians were blamed for the fires that destroyed

Christianity and the Scriptures

Scriptures are literally "what has been written." For Judaism and Christianity, the most authoritative scriptures are collected in the Bible (which is derived from the Greek word *biblos*, meaning "book"). The Jewish Bible consists of the Old Testament, to which Christians have added the New Testament. The Apocrypha (Greek for "secret" or "hidden") are Old and New Testament writings whose authenticity is questioned.

Established by the fourth century A.D., the New Testament was organized into three sections: the Gospels and Acts, the Epistles, and the Apocalypse (or Revelation). The four Gospels are essentially biographies of Jesus, written in about A.D. 70 to 80 by Saints Matthew, Mark, Luke, and John. The authors are called the four Evangelists (from the Greek word *euangelistes*, meaning "bearer of good news"). The Acts relate the works of Jesus's twelve apostles in spreading his teachings. The Epistles (or Letters), most of which were written by Saint Paul, contain further doctrine and advice on how to live as a Christian. The Apocalypse describes the end of the world and Christ's Second Coming as the final judge.

The most important figures in Christian art are the Holy Family, saints, and martyrs. The Holy Family consists of Mary (Christ's mother), Joseph (her husband), and Jesus. A saint is a person canonized by the Church. The term *martyr*, from the Greek word *martus*, originally meant "witness," specifically a witness to Jesus's works. Subsequently, *martyr* came to mean

one who dies for a belief—in this case, Christianity. In Western art, saints, martyrs, and members of the Holy Family are usually depicted with a halo—a circle of light around their heads—to indicate their holiness.

An important distinction between Christian and Roman art can be seen in their respective approaches to history. Romans used works of art to record the past—particularly the exploits and triumphs of their rulers. Christian art focused more on the future as determined by the Christian faith. It was important, therefore, for Christians to encompass as much of the past as possible into present and future. One way in which they did this was by a method of historical revision called typology (from the Greek word *tupos*, meaning "example" or "figure"), which paired figures and events from the Old Testament (the Old Dispensation) with those of the New Testament (the New Dispensation). The purpose of typology was to reveal that history before Jesus had foreshadowed or prefigured the Christian era. Jesus, for example, calls himself greater than Solomon, the Old Testament king known for his wise judgments and temple building. Jesus is referred to as the new Adam, and Mary is the new Eve. Solomon and Adam are thus types for Jesus, and Eve is a type for Mary. As Christianity developed, this typological view of history was expanded to include pagan antiquity and contemporary events as well as the Old and New Testaments.

Frequently Depicted Scenes from the Life of Jesus

The Birth and Childhood of Jesus

In the *Annunciation*, the Virgin Mary is informed by the angel Gabriel that she will give birth to Jesus, the son of God. Often the miraculous conception is indicated by a ray of light, the white dove of the Holy Ghost, or both. When Mary is three months pregnant, she visits her aged, childless cousin Elizabeth (the *Visitation*) and finds her six months pregnant with John the Baptist. The two women are usually shown embracing.

Jesus is born in Bethlehem (the *Nativity*), which is celebrated on December 25 (Christmas). The standard iconography shows Mary reclining, the swaddled infant in a manger with an ox and an ass, and Joseph sleeping or dozing nearby. In the *Adoration of the Magi*, three wise men, or kings, follow a star from the East to Bethlehem in search of a newborn king. They bring gifts of gold, frankincense, and myrrh and kneel to worship Jesus. In the *Presentation in the Temple*, Mary and Joseph bring the infant Jesus to be consecrated at the Temple in Jerusalem. They present him to Simeon. God has promised Simeon that he will see the savior before he dies.

King Herod of Jerusalem has been warned that a newborn will overthrow him. Herod decrees the death of all boys under the age of two (the *Massacre of the Innocents*). Alerted to Herod's plans by an angel, Joseph flees with Mary and Jesus into Egypt (the *Flight into Egypt*).

At the age of twelve, Jesus disputes with the Jewish scholars in the Temple (*Jesus among the Doctors*).

The Ministry and Miracles of Jesus

John the Baptist baptizes Jesus in the river Jordan in the scene of the *Baptism*. The Holy Ghost or God, or both, may be present, usually hovering above Jesus.

Jesus "calls" his apostles in several scenes; the most commonly represented are the *Calling of Matthew*, the tax collector, and of the fishermen Peter and Andrew. Jesus walks on water when the apostles are caught in a storm on the Sea of Galilee. They see Jesus walking toward them on the water. Peter leaves the boat and begins to drown, but Jesus saves him and then calms the storm.

In the *Marriage at Cana*, Jesus is a guest at the celebrations, and, because the bridal couple cannot afford wine, he turns the water into wine. When Jesus takes three of his apostles, Peter, James, and John, to Mount Tabor to pray, he manifests his divine nature to them through the *Transfiguration*. Jesus appears in a heavenly white light, flanked by Moses and Elijah (the most important Old Testament prophet), and God declares that Jesus is his son.

In the *Resurrection of Lazarus*, Jesus restores the deceased Lazarus, brother of Mary and Martha, to life.

The Passion of Jesus

Jesus enters Jerusalem (the *Entry into Jerusalem*) riding a donkey and followed by his apostles. This event is celebrated on Palm Sunday. Inside Jerusalem, Jesus is angered at people transacting business in the Temple. In the *Expulsion of the Money Changers*, he chases them away.

At the *Last Supper*, Jesus announces that one of his apostles will betray him. He institutes the Eucharist, declaring that the bread is his body and the wine his blood. This doctrine is referred to as Transubstantiation. After the Last Supper, as a sign of humility, Jesus washes his apostles' feet (the *Washing of the Feet*). Peter objects and is admonished by Jesus. In the *Betrayal*, Judas accepts a bribe of thirty pieces of silver to identify Jesus to the Romans. He does so in the *Kiss of Judas*, where Jesus is arrested by Roman soldiers. Jesus is then brought before the high priest Caiaphas and the Roman governor Pontius Pilate. He is condemned to be whipped (the *Flagellation*) and crowned with thorns (the *Mocking of Jesus*). He is also tortured and mocked for claiming to be king of the Jews.

Condemned to die by crucifixion, in the *Road to Calvary* Jesus carries his Cross to Calvary (Golgotha), where he is put to death. In the *Deposition*, he is taken down from the Cross, and his followers mourn him (the *Lamentation*). When the Virgin Mary alone mourns Jesus lying across her lap, the scene is referred to as the *Pietà*.

In the *Entombment*, Jesus is placed in his tomb. He is now beyond the confines of natural time and space, and enters the part of hell called Limbo (the *Harrowing of Hell*) to lead certain souls to salvation. Jesus has now become Christ, and three days after his burial, he rises from his tomb (the *Resurrection*), which is celebrated at Easter. When Mary Magdalen sees him, she reaches out to determine if he is real. But he repels her, saying, "Do not touch me" (*Noli me tangere*). Later, Christ meets two of the apostles and shares a meal with them (the *Supper at Emmaus*). In the *Ascension*, Christ rises to heaven in the presence of his mother and the apostles. In the *Pentecost*, the apostles are given the gift of tongues—shown in art as divine flames—with which to speak different languages and carry the message of Jesus throughout the world.

large areas of the city. And in the third century, when Goths and Germans invaded the empire, Christians were again blamed and made scapegoats. The worst persecutions occurred in 303, during the reign of Diocletian. As a result of the political liability of being a Christian in imperial Rome, despite its appeal to the lower classes and the fervor of its adherents, Christianity remained an underground movement for nearly the first three hundred years of its existence. Memorial services were conducted in underground passages—the catacombs—located on the outskirts of

Rome. Rome was never entirely safe for Christians before A.D. 313, when Emperor Constantine issued the Edict of Milan, granting tolerance to all religions, and especially to Christianity.

The Catacombs

Christians as well as Jews were relatively safe from Roman persecution when performing funerary rites in the catacombs, which were underground cemeteries in Rome. The derivation of the term is uncertain, but in Greek *kata* means "down," and in late Latin *cumbere* means "to lie down" (cf. the English *recumbent*). The latter is related to the cubit, an old unit of measurement from the elbow to the tip of the middle finger—that is, the length of the forearm on which one reclines. Under Hadrian, the Roman aristocracy began to renounce cremation of the dead in favor of inhumation, which was practiced by Christians and Jews. Niches cut out of rock in the catacombs contained the bodies, which were closed in by slabs or tiles. According to Roman law, burial grounds were sacrosanct, so the Romans rarely pursued Christians into the catacombs, where some of the earliest examples of Christian art can be found. After the sixth century, the catacombs fell into disuse and were forgotten until their accidental discovery in 1578.

8.3 *Christ as the Good Shepherd,* catacomb of Priscilla, Rome, 2nd–3rd century. Fresco.

Figure **8.3** shows a fresco depicting *Christ as the Good Shepherd* from the catacomb of Priscilla, dating from the late second or early third century. Christ carries a goat on his shoulders, with a second goat, a sheep, and a tree on either side of him. Each tree is surmounted by a bird. The motif of the Good Shepherd, which had been popular in Roman garden statuary and in the literary bucolic tradition, was assimilated by Early Christian artists as a symbol of compassion. Christ as the Good Shepherd was also incorporated into Christian liturgy, with the priest being paralleled with Christ and the congregation with the flock. The Dura Europos baptistery has an earlier example than figure 8.3 of the Good Shepherd in Christian guise, in which he is typologically paired with Adam and Eve.

Constantine and Christianity

Constantine followed Diocletian (ruled A.D. 284–305) as emperor of Rome, but not without a struggle. Under Diocletian, Rome had been ruled by a tetrarchy (a "government of four") consisting of himself and Maximian (designated *Augusti,* or emperors) and two others of lower rank (called Caesars). This arrangement was Diocletian's attempt to defend the weakening borders of the empire from invasions threatened by Persians to the east and Germans to the north. With four leaders, he reasoned, imperial power could be extended outside Rome, and in Rome itself rebellion would be discouraged. But Diocletian's plan failed, for the tetrarchy actually diluted the centralized administrative power of the emperor, a circumstance that is regarded as a significant factor in Rome's decline.

Although Constantine's edicts and some of his letters survive, the primary source for his assumption of sole power is the biography by Eusebius (A.D. 265–340), bishop of Caesarea, in Israel, which describes Constantine's victory over Maximian's son Maxentius at the Milvian Bridge in Rome. According to Eusebius, Constantine saw two visions before the battle. In one, the Cross appeared against a light with the words "In this sign you conquer." In the other, he was told to place the *Chi-Rho*—the first two letters of Christ in Greek—on the shields of his soldiers (see box). After this victory, Constantine issued the Edict of Milan because, according to Eusebius, he recognized the power of the Cross and the Christian God.

Constantine's precise relationship to Christianity is not known, although he clearly took a personal interest in the new religion; Eusebius says that he was baptized, although there is no other evidence of this. In 325, Constantine convened the Council of Nicaea (in modern Turkey), which established the doctrine that Christ and God were equally divine. This was in opposition to the view propagated by Arius of Alexandria and his followers that is referred to as the Arian heresy. Five years later, in 330, Constantine founded a new eastern capital at Byzantium, at least in part because the eastern regions of the Roman Empire were gaining in political importance. It was also there that Christianity had established the firmest foundations by the early years of the fourth century.

Christian Symbolism

Christ means the Anointed, Messiah, Savior, Deliverer and is written in Greek as ΧΡΙΣΤΟΣ. The two letters *X* and *P* (*Chi* and *Rho*) are equivalent to the English *Chr* and, as Christ's monogram, were superimposed and written as

Ichthus, the Greek word for "fish," is an acronym for "Jesus Christ, Son of God, Savior." The *I* is the Greek equivalent of the English *J* (for "Jesus"), *Ch* stands for "Christ," *Th* for *theou* (Greek for "of God"), *U* for *uios* (Greek for "son"), and *S* for *soter* (Greek for "savior"). The *ichthus* and other cryptic signs and symbols were used by Christians to maintain secrecy during the Roman persecutions. Much Early Christian imagery is symbolic in nature and often takes the form of pictorial puzzles known as rebuses. Even after Christianity had become the official religion of Rome and secrecy was no longer necessary, certain images such as the fish, the Cross, the Lamb of God, and the Good Shepherd continued to have symbolic importance in art and liturgy.

The Divergence of East and West

The struggle to establish Christianity as the new official religion of Rome and the resulting controversies reflect the political and religious turmoil of the centuries immediately following the birth of Christ. The title of this chapter is also a reflection of those uncertain times. "Early Christian" is a historical more than a stylistic designation. It refers roughly to the first four centuries A.D. and to Christian works of art made during that period. The term *Byzantine*, derived from the city of Byzantium, is used to describe a style that originated in the Eastern Roman Empire, including works made in Italy under Byzantine influence. At first, the two terms overlap. However, as Rome and the Western Empire were overrun by northern European tribes and the East rose to prominence under Justinian, the distinction between the Eastern and Western empires became more pronounced, and Early Christian and Byzantine cultures grew apart.

The geographical separation and political divergence of East and West was paralleled by a schism (split or division) within the Church itself. In Rome and the Western Empire, the pope was the head of the Church. The Eastern branch of the Church was led by a patriarch, whose power was bestowed on him by the Byzantine emperor.

Corresponding to the East-West division were the artistic styles produced by each branch of the Church. In the West, artists worked in the tradition of Hellenistic and Roman antiquity. This led to a proliferation of medieval styles from the seventh to the thirteenth centuries. Eastern artists were more influenced by Greece and the Orient, and remained so. As a result, the Byzantine style persisted in eastern Europe as late as the sixteenth century. Byzantine art also infiltrated the West, especially Italy, and maintained its influence there until the late thirteenth century. Just as republican and imperial Rome had assimilated other cultures, so Christianity and Christian art absorbed aspects of earlier religions and their iconography. Greek and Roman myths were endowed with Christian meaning and interpreted in a Christian light.

Early Christian Art

Sarcophagi

A good example of continuing Roman imagery in Early Christian art can be seen in the marble sarcophagus in the Church of Santa Maria Antiqua in Rome (fig. **8.4**). The front, visible here, includes Old and New Testament scenes as well as figures combining Roman with Christian meaning. Reading from left to right, the first character is the Old

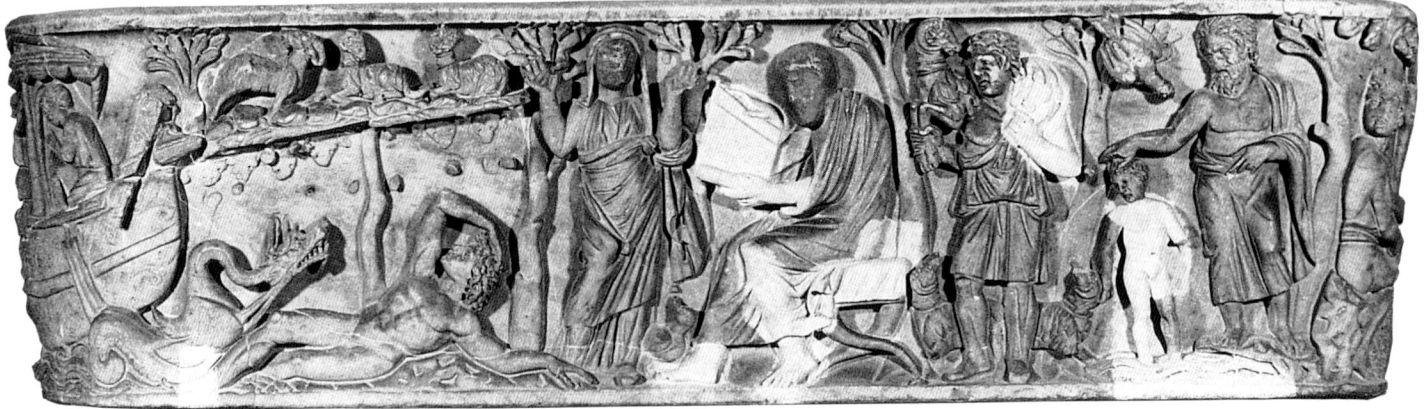

8.4 Early Christian sarcophagus, Santa Maria Antiqua, Rome, 4th century. Marble. Although the Christians continued to decorate their sarcophagi with reliefs, as the Greeks, Etruscans, and Romans had done, they omitted the effigy of the deceased from the cover of the tomb. They also abandoned cremation because they believed in bodily resurrection.

Testament figure of Jonah, who has emerged from the great fish that swallowed him. Jonah's form is based on the idealized, organic Classical reclining nude, while the fish is imaginary. This story was well suited to a Christian sarcophagus since Christians interpreted it as a typological prefiguration of the Resurrection of Christ. Just as Jonah spent three days inside the whale, so Christ was entombed for three days before his Resurrection. An Early Christian viewer would have recognized the implications of this iconography as a metaphor for the resurrection of the person buried in the sarcophagus.

To the right of Jonah on the sarcophagus are two Christian transformations of a Greco-Roman poet and his muse. The seated poet wears a Roman toga but is shown as a Christian poring over a religious text. The muse is also in Classical dress. She stands with her arms raised in a gesture that combines prayer and mourning with a visual reference to Christ's Cross. Spreading out from behind her palms are leafy tree branches, a reminder that the Cross was made of wood. Indeed, trees have replaced columns as architectural dividers between scenes. Because of their relationship to the wood of the Cross, trees were to become a central motif in Christian art.

Next on the right is the Good Shepherd with a sheep on his shoulders. At the far right, a large, bearded John the Baptist stands on the bank of the river Jordan (indicated by wavy lines) and baptizes a small, nude Jesus. In the upper left corner of the scene hovers the dove of the Holy Ghost, a traditional element in the iconography of the Baptism. This is another appropriate scene for a sarcophagus because baptism signifies rebirth into the Christian faith, and thus salvation. These themes—baptism as initiation into the faith and hence into a community—were important aspects of the Early Christian movement.

The opposition of the Baptism on one side of the sarcophagus and Jonah and the whale on the other demonstrates what was to become a traditional typological pairing of left and right in Christian art. This associates the old, or pre-Christian, era with the left, and the new, Christian, era with the right. Such pairing was extended to include standard notions of good and evil, dualities such as light and dark, and so forth. (The negative implications of the Latin word *sinister*, meaning "left," survive in modern-day English.)

Basilicas

Christians worshiped in private homes until the early fourth century. But when Constantine issued the Edict of Milan in A.D. 313, they were free to construct places of worship. From that point on, Christianity was legally protected from persecution and soon became the official religion of the Roman Empire. New buildings were needed to accommodate the large and ever-growing Christian community. Unlike Greek and Roman temples, whose main purpose was to house the statue of a god, Christian churches were designed so that crowds of believers could gather together for worship. With the active support of Constantine, many churches were constructed in very few years—in Constantinople (the name Constantine had given to Byzantium; it is now Istanbul), in Italy, in the Holy Land, and elsewhere in the Roman Empire. Christian churches were modeled on the Roman basilica (see p. 218), a spacious structure designed to hold large numbers of people. Such Early Christian basilicas became the basis for church architecture in western Europe.

Old Saint Peter's None of the early Christian basilicas has survived in its original form, but an accurate floor plan of Old Saint Peter's (fig. 8.5) has been reconstructed (fig. 8.6; see box). The architectural design of the Christian basilica conformed to the requirements of Christian ritual; the altar, where the Mass was performed, was its focal point. The movable communion table used in Christian meeting places before 313 was replaced by a fixed altar that was both visible and accessible to worshipers. Both altar and apse were usually at the eastern end, and the **narthex** (vestibule) at the western entrance became standard in later churches.

The altar's location at the eastern end of the basilica served a symbolic as well as a practical function. It generally supported a crucifix with the image of Christ on the Cross turned to face the congregation. As Christ's Crucifixion took place in the east (Jerusalem), Christian basilicas and most later churches are oriented with the altar in the east. According to tradition, Christ was crucified facing

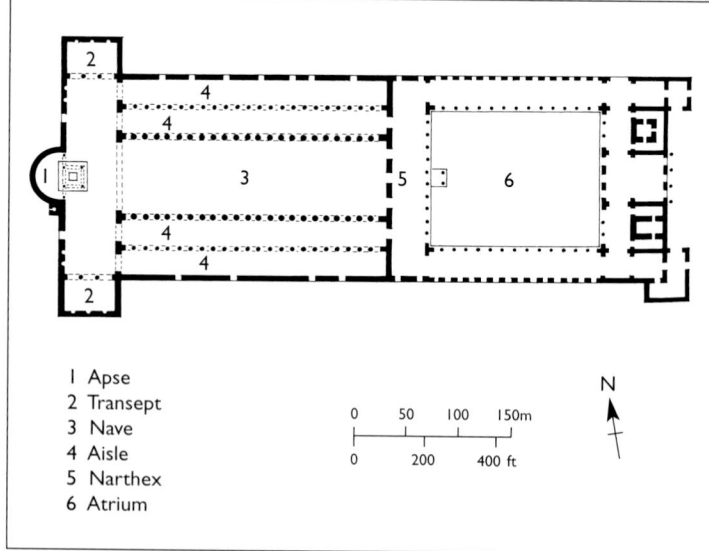

1 Apse
2 Transept
3 Nave
4 Aisle
5 Narthex
6 Atrium

| 0 50 100 150m |
| 0 200 400 ft |

N

8.5 Plan of Old Saint Peter's basilica, Rome, 333–390. Interior approx. 368 ft. (112.16 m) long. Old Saint Peter's was the largest Constantinian church and became the prototype for later churches. Besides being a place of worship, it was the saint's **martyrium** (a building over the grave of a martyr); a marble canopy in the apse marked his grave.

1 Clerestory
2 Apse
3 Nave
4 Aisle

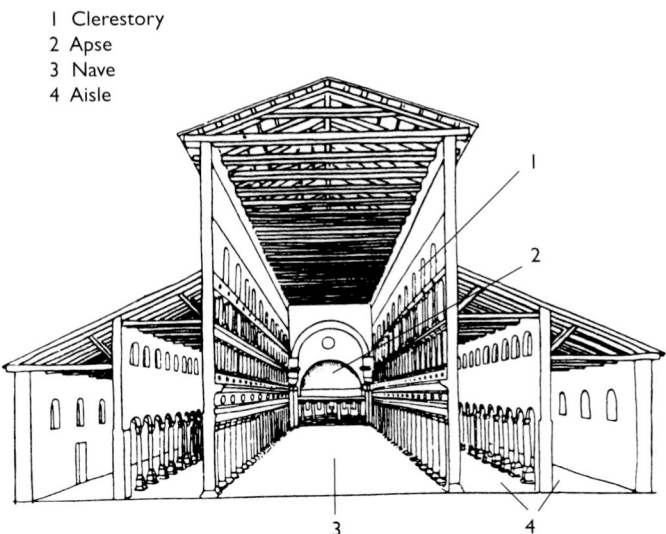

8.6 Reconstruction diagram of the nave of Old Saint Peter's basilica. Old Saint Peter's is similar to the pagan or secular basilica of pre-Christian Rome in having a long nave flanked by side aisles, clerestory windows on each side, an apse, and a wooden **gable** roof. Unlike pagan basilicas, which typically had an apse at each end, Old Saint Peter's had a single one opposite the entrance. The building was demolished in the 16th century when work on the New Saint Peter's began.

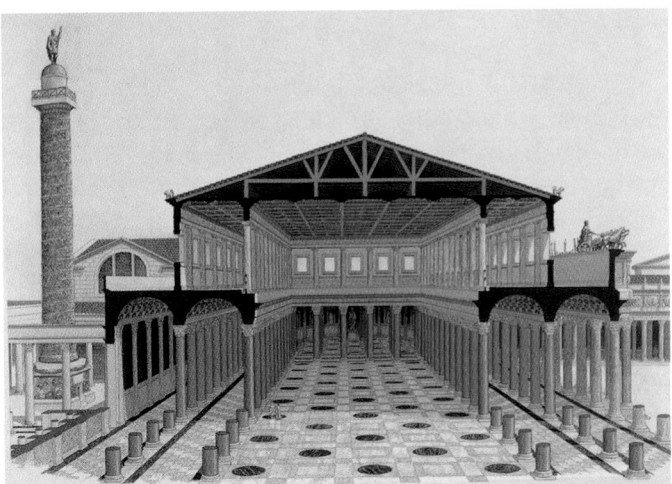

See figure 7.13. Reconstructed cross section of the Basilica Ulpia, A.D. 98–117.

west, and therefore the cross on the altar usually faces the main western entrance of the church building.

Another symbolic aspect of church design was the new use of the apse. In the Roman basilicas, apses had often contained statues of emperors and were also the location of legal proceedings. In Early Christian apses, therefore, the image of Christ as Judge was particularly appropriate. It referred both to the Roman law courts and to the Christian belief in a Last Judgment.

An important new feature in Old Saint Peter's was the addition of a **transept** to the Roman basilica. This consisted of a transverse space, or cross arm, placed at right angles to the nave, and separated the apse from the nave. The transept, which contained a canopy marking Peter's grave, isolated the clergy from the main body of the church. With the transept, the building forms the shape of a cross—hence the adjective **cruciform** to describe basilicas with this feature.

The altar and apse at Old Saint Peter's were framed by a huge triumphal arch—a regular architectural element of Early Christian basilicas. The architects thus transformed the meaning of the Roman triumphal arch from the emperor's triumph to that of Christ.

The exterior of Old Saint Peter's, and of similar churches, was plain brick. The interior, on the other hand, was richly decorated with mosaics, frescoes, and marble columns. Their purpose was not only to exalt the deity, but also to

Saint Peter

Saint Peter was Christ's first apostle. In Matthew 16:13–20, Christ gives Peter the keys to heaven with the words "Upon this rock I will build my church." That statement became the basis for the pope's authority, although interpretations differ as to whether "rock" refers to Peter or to his faith. The name *Peter* comes from the Greek word *petros* (meaning "rock"), from which comes the English word *petrify*, meaning "turn to stone." Rock is also a metaphor for something strong and lasting, as in "solid as a rock" or "Rock of Ages," and here denotes the solid and enduring character of faith. The infinite power of God is also reflected in the phrase from the Old Testament Book of Psalms, "God is my rock."

Saint Peter was the first bishop of Rome. Since that office later became the papacy, he is considered to have been the first pope. The basilica of Old Saint Peter's became the prototypical papal church, although it was in fact an exception to the traditional Christian orientation of churches toward the east and was initially built as a pilgrimage site and covered cemetery. During the fifteenth, sixteenth, and seventeenth centuries, Saint Peter's was rebuilt by several architects (see Chapters 14 and 17), and it is still the seat of papal power today.

teach and inspire the worshipers. The fragmentary mosaic of *Christus-Sol* (Christ as Sun) of around A.D. 250 (fig. **8.7**) is from the Christian Mausoleum of the Julii, which was discovered in a pagan cemetery under Old Saint Peter's. It is a good example of the syncretistic character of Early Christian iconography: the vines of Dionysos, generally associated with the ritual drunken orgies of that god's festivals, have become the True Vine of Christ. The latter came to symbolize the Church body, based on Christ's statement "I am the vine, you are the branches." The pagan sun god, Sol/Apollo, is merged with Christ as Sun. The arms of the Cross and rays of light emanate from his head; he holds an orb, symbolizing the world over which he has dominion, and is accompanied by two horses pulling a chariot (indicated by the wheel). Another feature of this image is the implied association of the Roman emperor with a god, but here his pagan apotheosis is superseded by Christian resurrection.

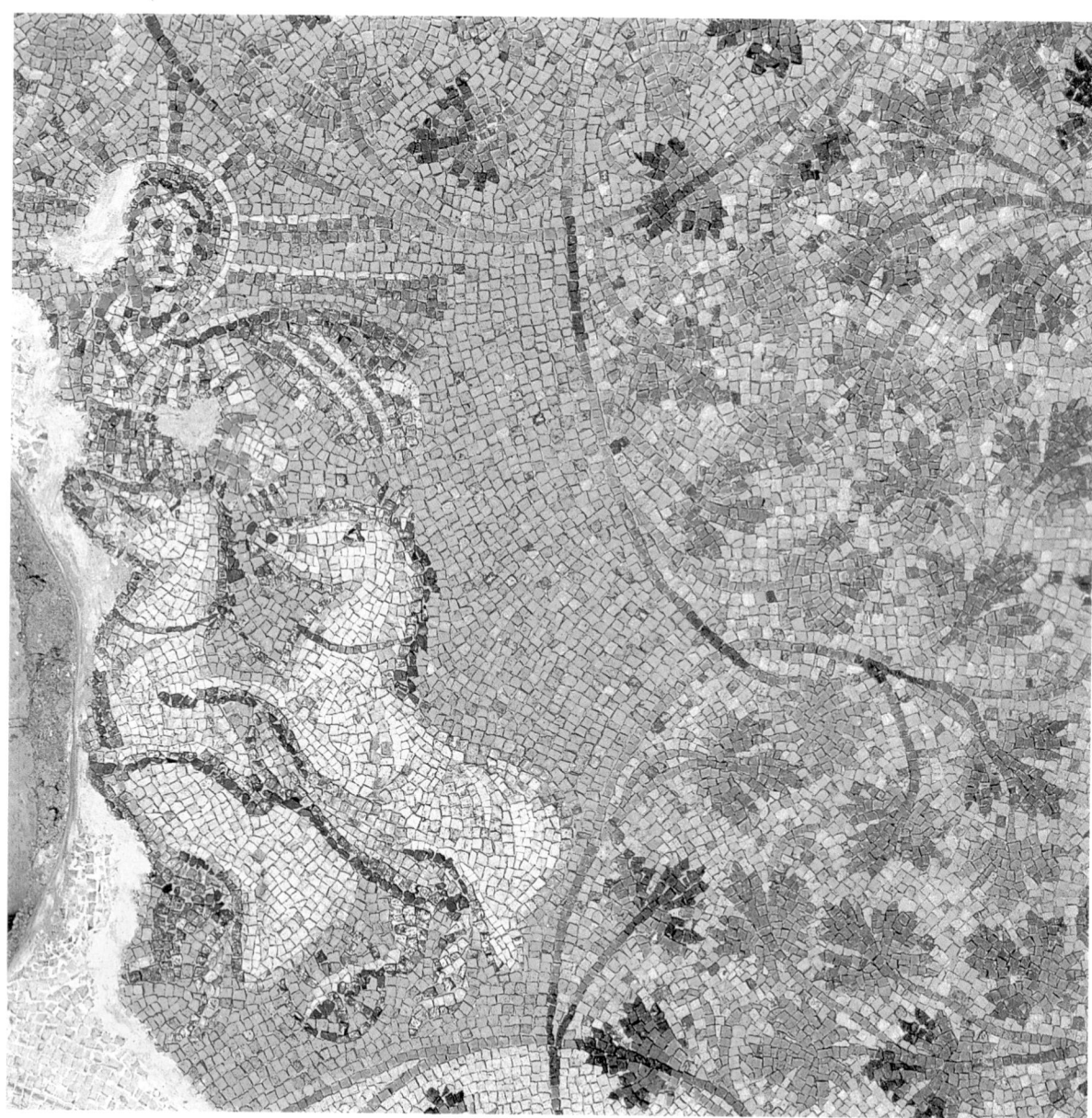

8.7 *Christus-Sol,* from the Christian Mausoleum of the Julii under Saint Peter's necropolis, Rome, mid-3rd century. Vault mosaic.

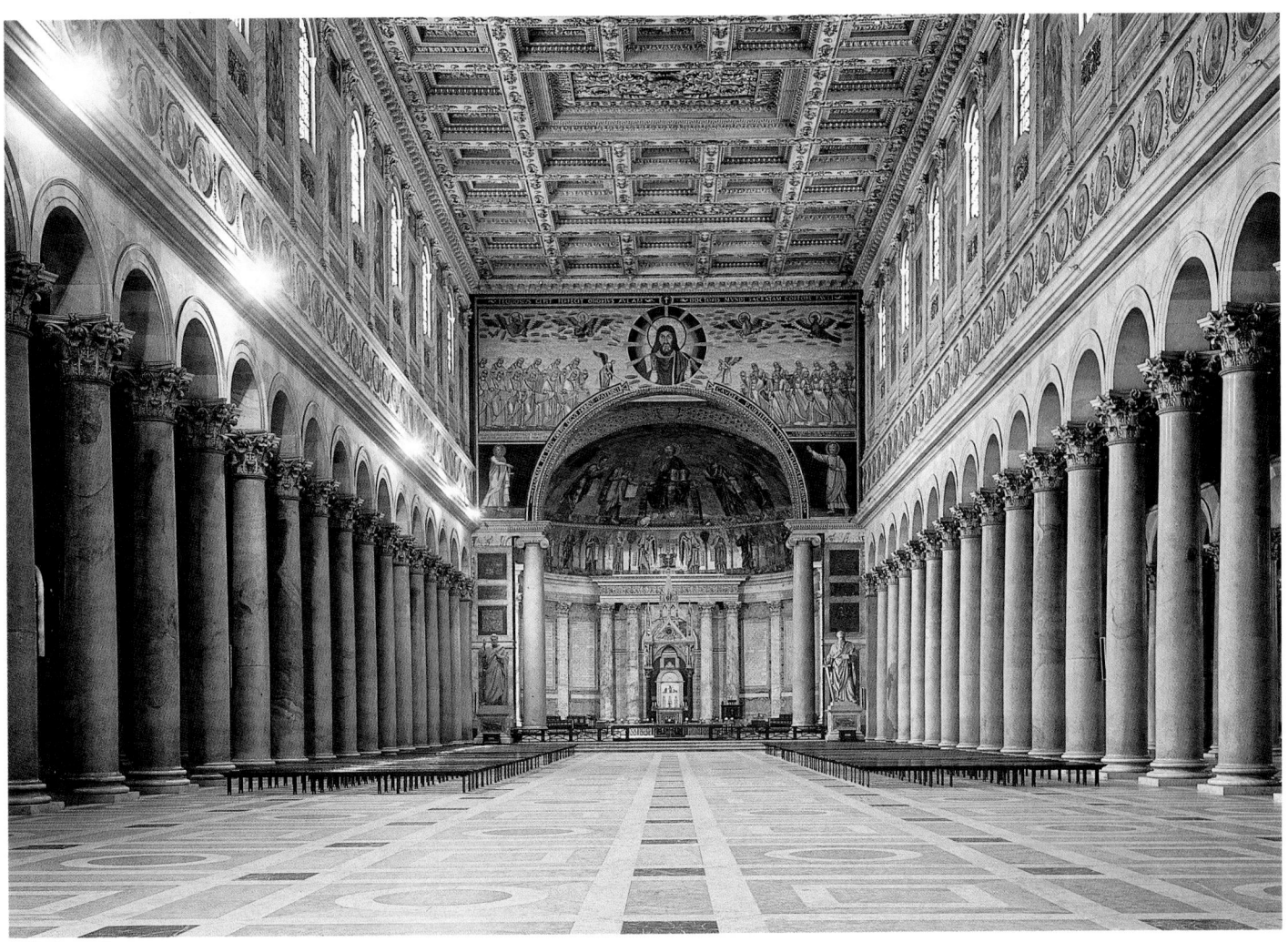

8.8 Saint Paul outside the Walls, Rome, begun 385 and restored after a fire in 1823.

The interior of Saint Paul outside the Walls (fig. **8.8**), although now restored, gives some idea of the original appearance of Early Christian churches. Wooden beams in the ceiling have been replaced by coffers, but the vast basilica-like space remains. Like Old Saint Peter's, it retains the wide nave, aisles, clerestory windows, and apse of the Roman basilica. The triumphal arch has become a chancel arch, which is supported by Ionic columns, whereas those separating the nave from the aisles are Corinthian. The rich mosaic decoration, its iconography, and the predominance of gold contribute to the impressive effect of the interior.

Mosaic Technique

Unlike Hellenistic mosaic, made by arranging pebbles on the floor, Christian mosaic was made by adapting the Roman method of embedding *tesserae* into wet cement or plaster. *Tesserae* (from the Greek word meaning "squares" or "groupings of four") are more or less regular small squares and rectangles cut from colored stone or glass. Sometimes rounded shapes were used. The gold *tesserae* of the Byzantine style were made by pressing a square of gold leaf between two pieces of cut glass.

The term *mosaic* comes from the same word stem as *museum*, a place to house works of art, and *muse*, someone—usually a woman—who inspires an artist to create. When we muse about something, we ponder it in order to open our minds to new sources of inspiration. *Music* is also from the same word stem as *mosaic*.

Centrally Planned Buildings

Another type of structure favored by the Early Christians was the **centrally planned** round or polygonal building. It radiated from a central point and was surmounted by a dome, and it was often attached to a larger structure. Such buildings were used mainly as *martyria*, **baptisteries** (for performing baptisms), or **mausolea** (large architectural tombs). Centrally planned churches contained a central altar or a tomb and a cylindrical core with clerestory windows. A circular barrel-vaulted passage, or **ambulatory** (from the Latin word *ambulare,* meaning "to walk"), extended from between the central space to the exterior walls.

Santa Costanza

The martyrium of Santa Costanza (fig. **8.9**) was built just outside the walls of Rome for Constantine's daughter Constantina, who died in 354. Her sarcophagus was placed opposite the door so that it was in the visitor's direct line of vision upon entering the building. The circular plan includes an inner colonnade of paired columns, separating the central space from the ambulatory and supporting round arches (fig. **8.10**). Composite capitals contain both the Ionic volute and the Corinthian acanthus leaves. The center of the building consists of a tall, cylindrical space surmounted by a dome.

Over the ambulatory, the barrel vaults are decorated with mosaics (see box), again illustrating the syncretistic assimilation of Classical themes by Christian artists. Figure **8.11** shows a detail of the Cupid and Psyche figures, which were reinterpreted by Christian authors as an allegory of the relationship between the body (Cupid) and the soul (Psyche). The circular shapes create the Cupid and Psyche pattern, and the other shapes are filled with birds and vine leaves.

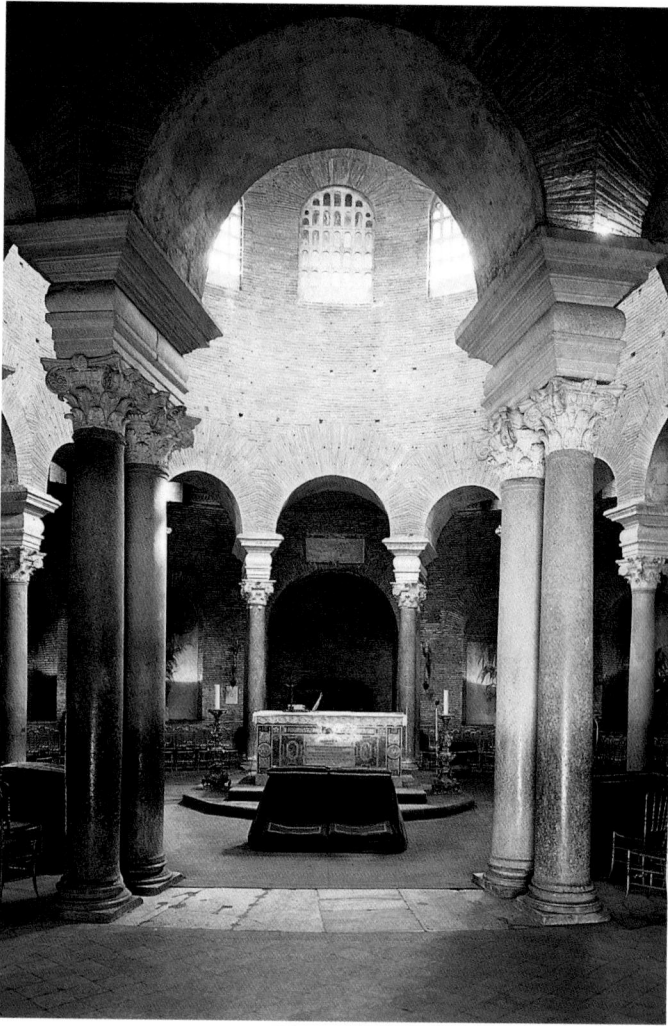

8.9 Cross section and plan of the martyrium of Santa Costanza, Rome, c. 350.

8.10 Interior of Santa Costanza, Rome, c. 350.

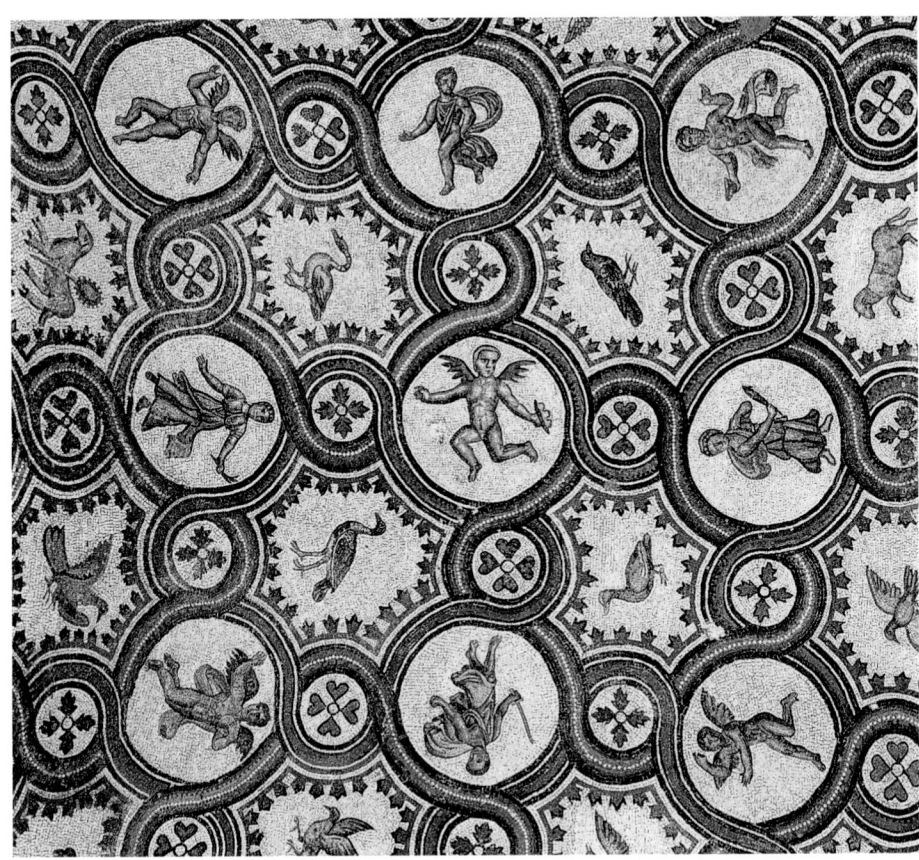

8.11 The ambulatory ceiling of Santa Costanza, Rome, c. 350. Mosaic.

Galla Placidia

The symmetrical cruciform mausoleum of the empress Galla Placidia (c. 390–450) was built in Ravenna, a city on the Adriatic coast of Italy. Galla Placidia was the daughter of Emperor Theodosius I. She was abducted by Alaric the Goth in 410 when his army defeated Rome. Four years later, she married the Goth king Ataulf, who died in 415. Galla Placidia then returned to her Christian family in Constantinople. When her son, Valerian III, was proclaimed emperor, she became regent and remained empress for twenty-five years—from 425 to 450.

Ravenna was of crucial importance to the Byzantine Empire because of its strategic location for trade between East and West. The exterior of Galla Placidia (fig. **8.12**) is of plain brick, but the four arms are varied by **blind niches** (in which there is only a slight recess in the wall) with round arches, a continuous cornice, and four pediments. Inside each arm is a vault, and the taller central crossing is surmounted by a dome. Spectacular mosaics decorate the inner walls and ceiling, and their iconography, which is imbued with sepulchral themes, attests to the piety of

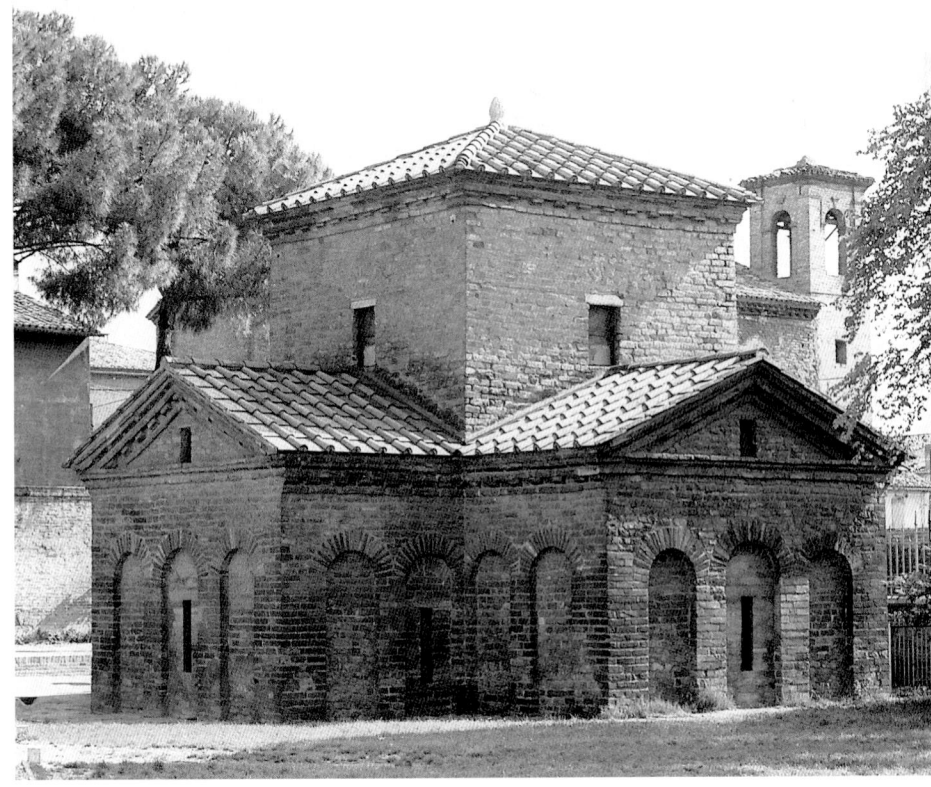

8.12 Exterior of the mausoleum of Galla Placidia, Ravenna, c. 425–426.

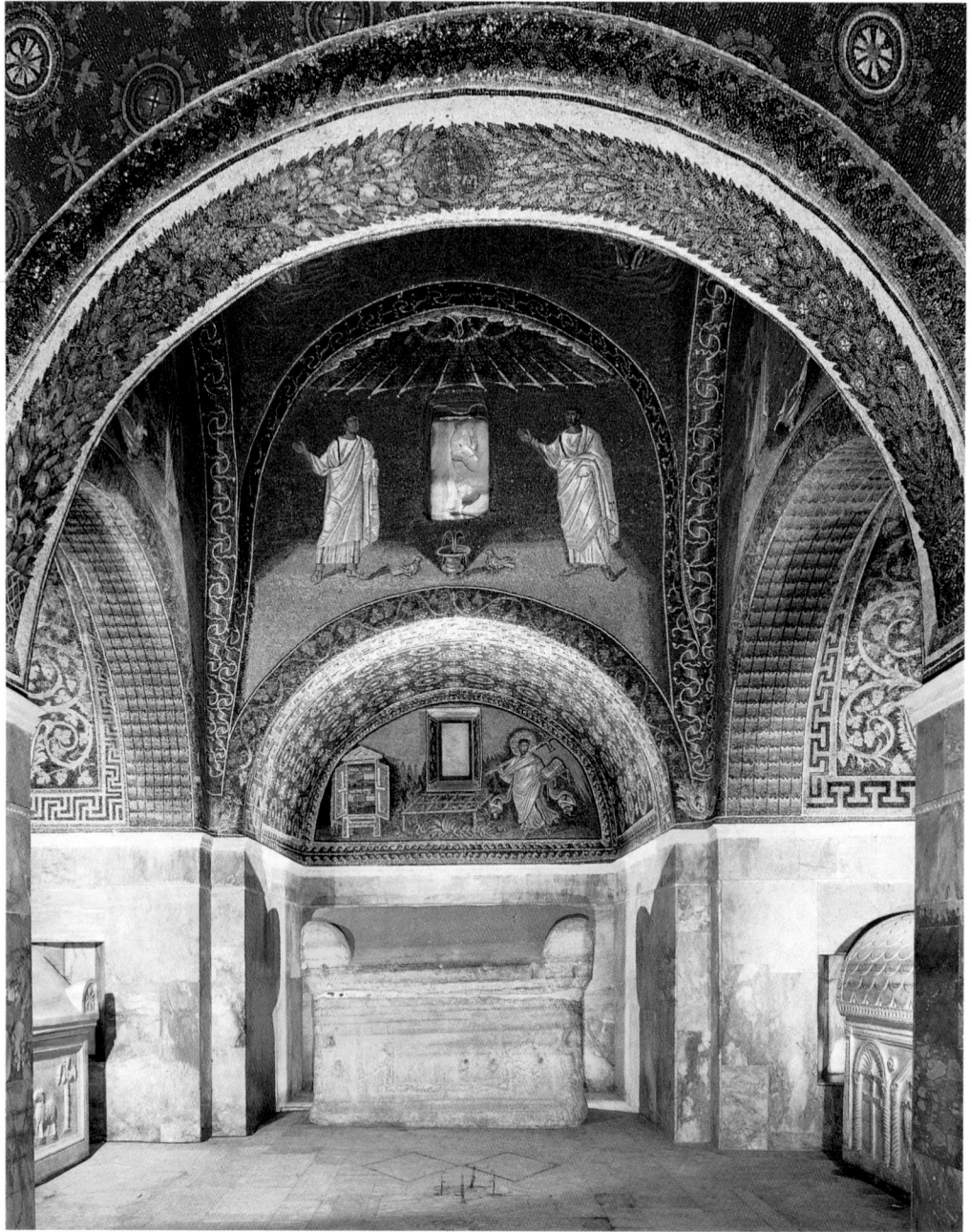

Galla Placidia. Figure **8.13** is a view of a niche mosaic showing two apostles in togas who raise their right hands in the manner of Roman senators. Flanking a fountain are two doves symbolizing Christian souls who drink the baptismal water of eternal life. Below, the *Saint Lawrence* mosaic depicts the saint approaching the gridiron over a bed of fiery coals on which he was martyred. The rich, dark blue ceiling and the barrel vaults over the arms of the building represent the dome of heaven, blanketed with brightly lit stars (figs. 8.14 and 8.15).

Over the entrance is a large lunette (the semicircular wall surface) containing a mosaic of *Christ as the Good Shepherd* (fig. **8.14**). He is surrounded by six sheep, one of which he caresses lightly under the chin. His shepherd's crook has been replaced by a cruciform martyr's staff, which alludes to his own death by crucifixion. Like-

wise, Christ's robe of purple and gold is a sign of his assimilation of the emperor's royal status as well as of his future as King of Heaven. He sits on a rock, which is divided into three steps, evoking both the Trinity (the number 3) and the role of Saint Peter (the rock) in establishing the Church. The landscape setting, Christ's *contrapposto*, the shading and foreshortening of the sheep, and their cast shadows indicate the continuation of Hellenistic naturalism and its assimilation into Christian art. In figure **8.15,** we are looking upward directly at a view of the star-studded barrel vault. Figure **8.16** shows a detail of geometric design that reveals the artist's delight in illusionism. But in the course of the next century, these naturalistic and illusionistic qualities would diminish, giving way to a flattening of space and an increase of spirituality in art.

8.14 *Christ as the Good Shepherd,* the mausoleum of Galla Placidia, Ravenna, c. 425–426. Mosaic.

8.15 Detail of a barrel vault from the mausoleum of Galla Placidia, Ravenna, c. 425–426. Mosaic.

8.16 Detail of a geometric border from the mausoleum of Galla Placidia, Ravenna, c. 425–426. Mosaic.

Justinian and the Byzantine Style

During the fifth century, the western part of the Roman Empire was overrun by Germanic tribes from northern Europe. The Ostrogoths occupied the Italian port city of Ravenna until it was recaptured during the reign of the Byzantine emperor Justinian in A.D. 540. Under Justinian, the Eastern Empire rose to political and artistic prominence (see map).

San Vitale

Because of Ravenna's pivotal geographic position, it became the Italian center of Justinian's empire and the focus of his artistic patronage in Italy. He strove to restore unity to Christendom, and one expression of that effort can be seen in his building programs. Ravenna's most important early Byzantine church, San Vitale (figs. **8.17** and **8.18**), was commissioned by the city's bishop, Ecclesius. Construction continued until its dedication in 547 by Maximian, the archbishop of Ravenna. San Vitale was dedicated to Saint Vitalis, a Roman slave and Christian martyr who became the object of a growing cult from the end of the fourth century.

The exterior of San Vitale (fig. 8.17) is faced with plain brick, unbroken except by buttresses and windows. The domed central core and octagonal plan (fig. 8.18) of San Vitale diverge from the architecture of Western Christendom. Instead of having an east-west orientation along a longitudinal axis with the altar in the east and the entrance in the west, San Vitale is centrally planned. The narthex is

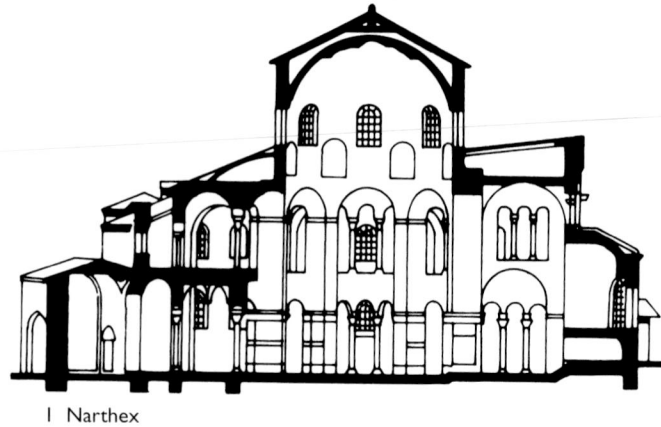

1 Narthex
2 Ambulatory
3 Nave
4 Sanctuary
5 Apse
6 Exedra

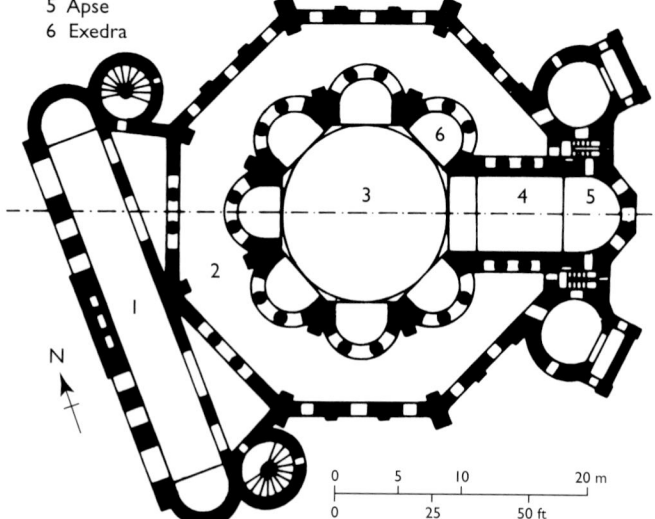

8.18 Plan and section of San Vitale.

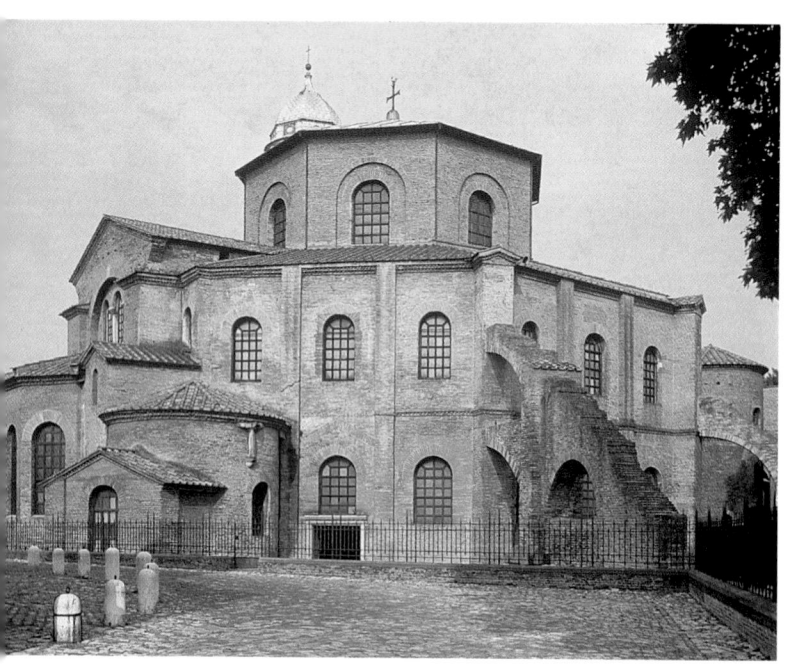

8.17 Exterior of San Vitale, Ravenna, 540–547.

placed on the western side at an angle to the axis of the apse. The circular central space is equivalent to the nave of Western churches and is ringed by eight large pillars supporting eight arches. Beyond the arches are seven semicircular niches and the cross vault containing the altar. Each niche is surrounded by an ambulatory on the floor level and a **gallery** (perhaps reserved for women) on the second story. All three levels—ground, gallery, and clerestory—have arched windows that admit light into the church.

The interior of San Vitale is richly decorated with mosaics and marble, which are illuminated by natural light. Looking eastward, toward the apse and the altar, one can see the large rectangular piers that support the main arches and the columns at the base of the smaller arches (fig. **8.19**). The interior is suffused with a glow of yellow light, resulting from the prevalence of gold in San Vitale's mosaics. They are among the best examples of Byzantine mural decoration.

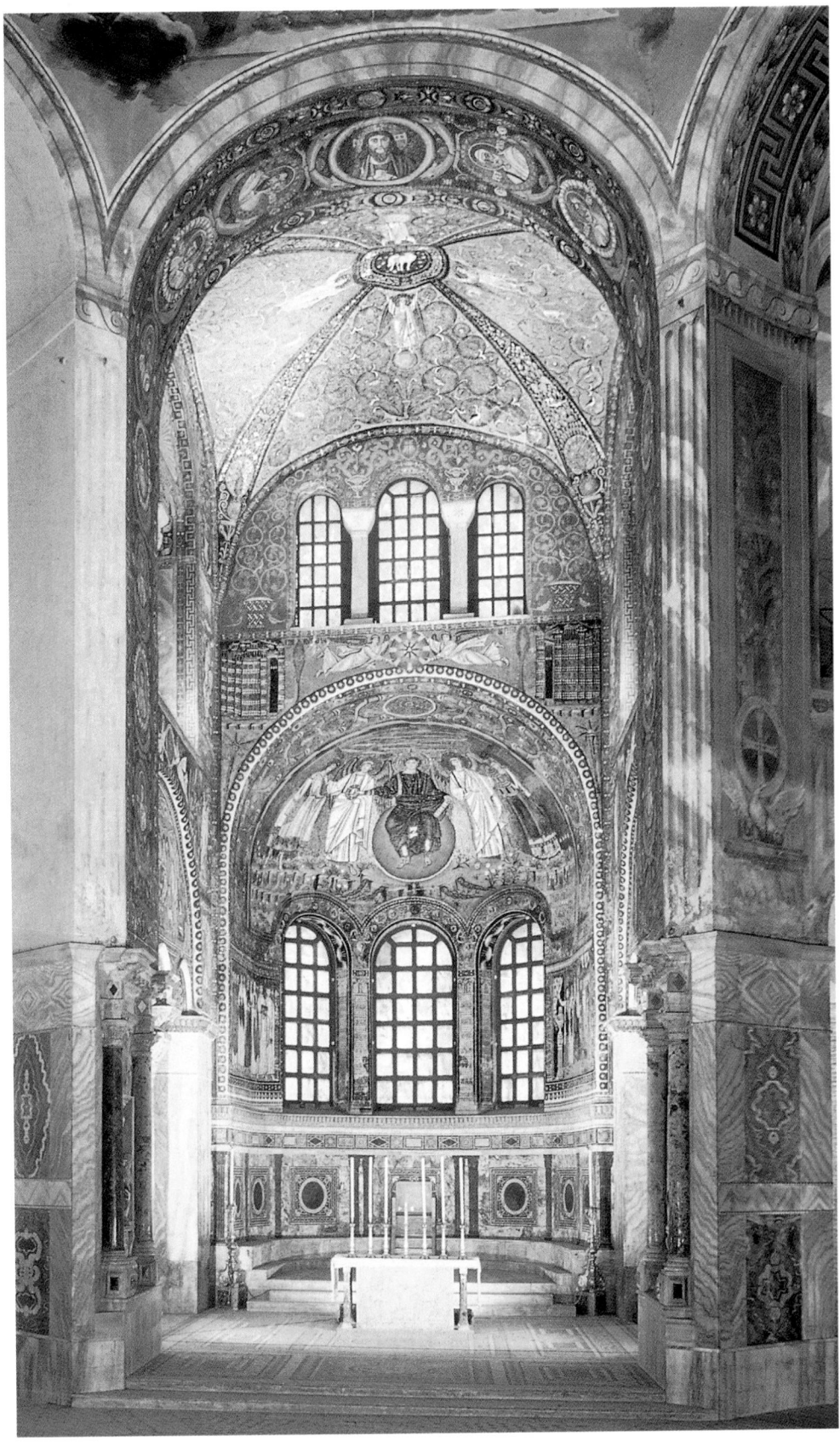

8.19 Interior of San Vitale looking east toward the apse, Ravenna.

8.20 Ceiling of the choir, San Vitale, Ravenna, c. 547. Mosaic.

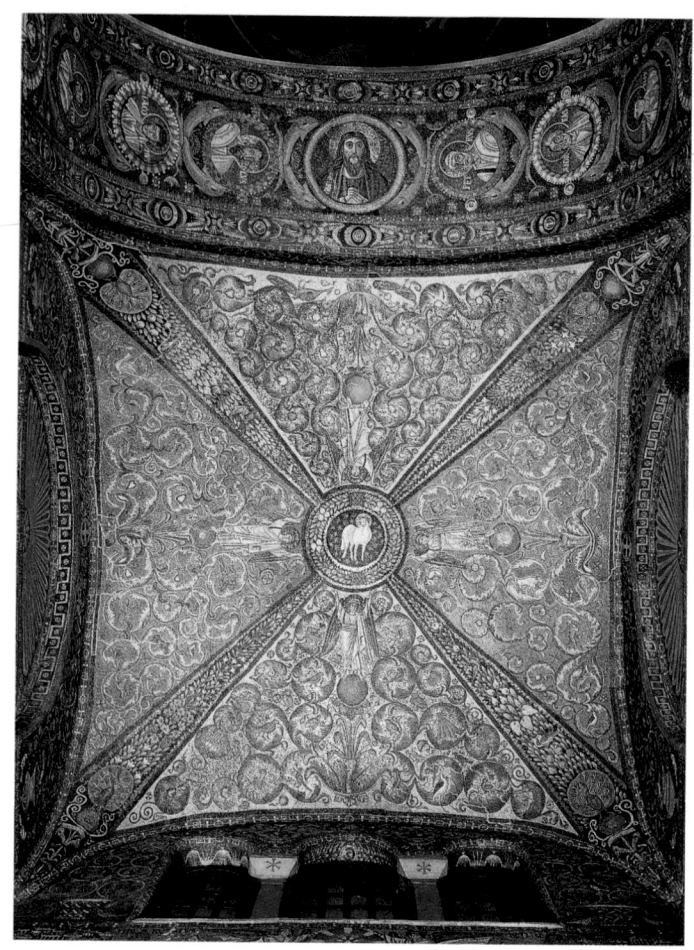

The vaulted choir ceiling (fig. **8.20**) creates a natural architectural division into four curved triangles. Each is decorated with elaborate floral and animal designs. At the center, a circular wreath frames a haloed lamb in a star-studded blue sky. It symbolizes Christ as the Lamb of God (both Christ and the Lamb were associated with sacrifice). Four angels in white, Roman-style draperies stand on blue spheres and hold up the ring encircling the Lamb. Directly across from the Lamb, on the arched entrance to the choir, is Christ in another guise. Again framed by a circle, the bust-length figure of Christ is frontal, dark-haired, and bearded. This is his traditional Eastern (Byzantine) representation. His central position on the arch and his frontality compared with the apostles around him reinforce his triumphal role as leader of the Church.

The capitals, which are decorated with elaborate relief sculpture, no longer conform to the Greek or Roman Orders (fig. **8.21**). Instead, the architect achieved another kind of unity by virtue of geometric repetition. Both parts of the capital are trapezoidal, as is the curved section between the springing of the two arches. The large lower trapezoid is covered with vinescroll decoration, which,

The Byzantine Empire under Justinian I, A.D. 565.

8.21 Detail of a capital, San Vitale, Ravenna, c. 540. Marble.

because of its symbolic associations, had become a popular Christian motif. Note that the five yellow flowers in the center are arranged to form a Greek cross—a cross with four equal arms—that echoes the yellow longitudinal cross in the trapezoid above. The cross is flanked by horses (probably a Near Eastern motif), each in front of a green tree, accentuating the Christian connection between the tree and the Cross of Christ.

The large mosaic (fig. **8.22**) in the apse of San Vitale depicts a young, beardless Christ, based on Western Apollonian prototypes. His halo contains an image of the Cross, and he wears a royal purple robe. Seated on a globe, Christ is flanked by two angels and hands a jeweled crown to Saint Vitalis. On the right, Bishop Ecclesius holds up a model of the church. Although there are still traces of naturalism in the landscape and hints of shading in figures and draperies, the representation is more conceptual than

8.22 Apse mosaic, San Vitale, Ravenna, c. 547.

natural. The draperies do not convey a sense of organic bodily movement in space, and the figures are essentially, if not exactly, frontal. The absence of perspective is evident in the pose of Christ: he is not logically supported by the globe but rather hovers as if in midair.

On the two side walls of the apse are mosaics representing the court of Justinian and his empress, Theodora. On the viewer's left, and Christ's right, is Justinian's mosaic (fig. **8.23**). On Justinian's left (the viewer's right) the archbishop Maximian wears a gold cloak and holds a jeweled cross. He is identified by an inscription and stands with two other members of the clergy. On Justinian's right are court officials and his military guard, showing that his position is protected by the army. The gold background removes the scene from nature, thereby aiming to transport the viewer into a spiritual realm.

Opposite Justinian's mosaic, Theodora is depicted in an abbreviated apse with her court ladies on the right and two churchmen on the left (figs. **8.24** and **8.25**). The fig-

ures in this mosaic, like those in Justinian's, stand in vertical, frontal poses. Their diagonal feet indicate that they are not naturally supported by a horizontal, three-dimensional floor. An illusion of movement is created by repetition and elaborate, colorful patterns, rather than by figures turning freely in space. A good example of this typical Byzantine disregard of perspective appears in the baptismal fountain on the abbreviated Corinthian column at the left of the scene. The bowl tilts forward, which in a natural setting would cause the water to spill out. But the water itself forms a foreshortened oval, thereby creating some degree of three-dimensional illusion. In contrast, Theodora's halo is depicted as a flat circle.

Theodora had grown up in the theater and lived the life of a courtesan until her marriage to the emperor in 523. They became co-regents of the Eastern Empire four years later. Theodora was a woman of great intelligence who advised Justinian on political and religious policy.

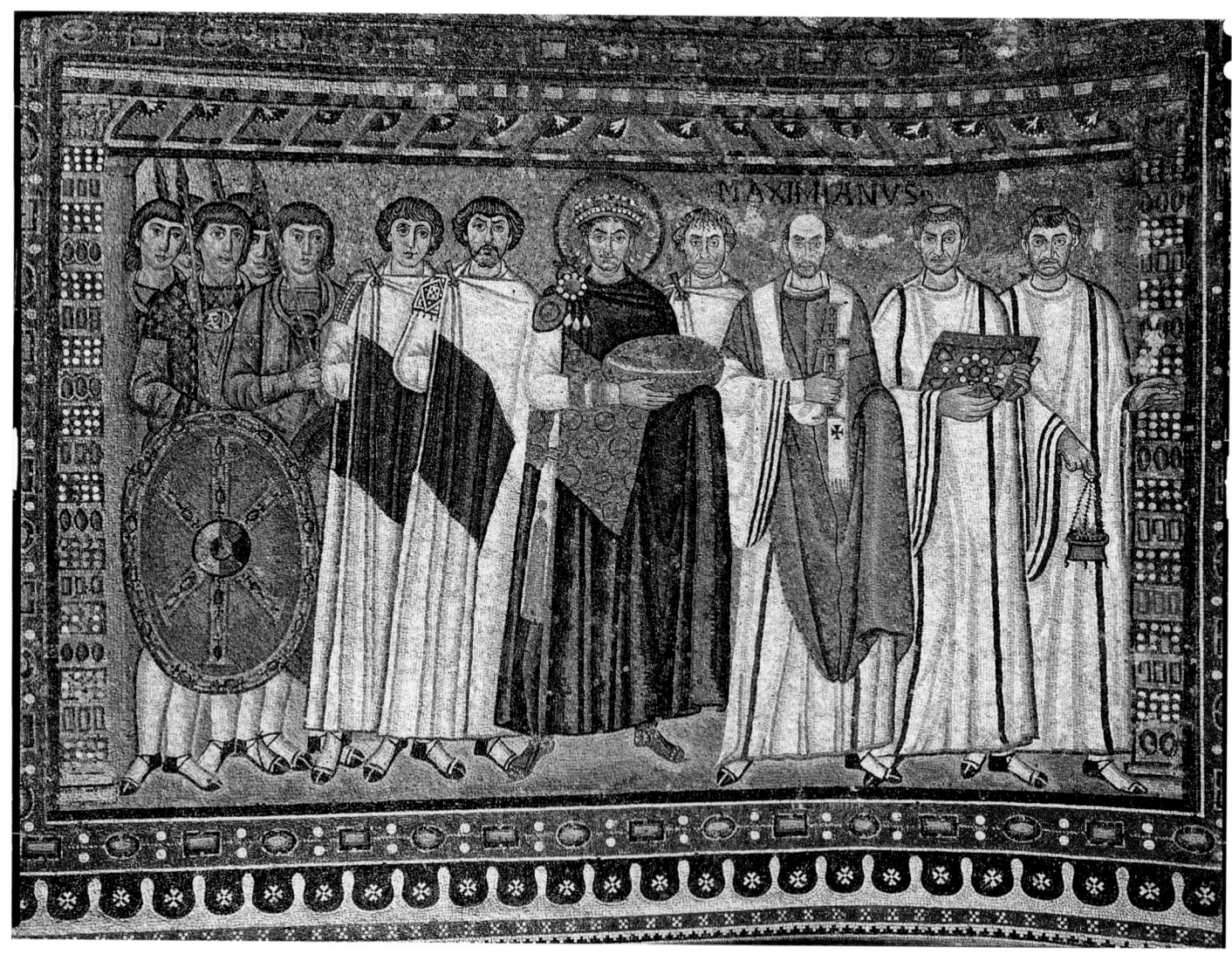

8.23 *Court of Justinian*, apse mosaic, San Vitale, Ravenna, c. 547. 8 ft. 8 in. × 12 ft. (2.64 × 3.65 m).

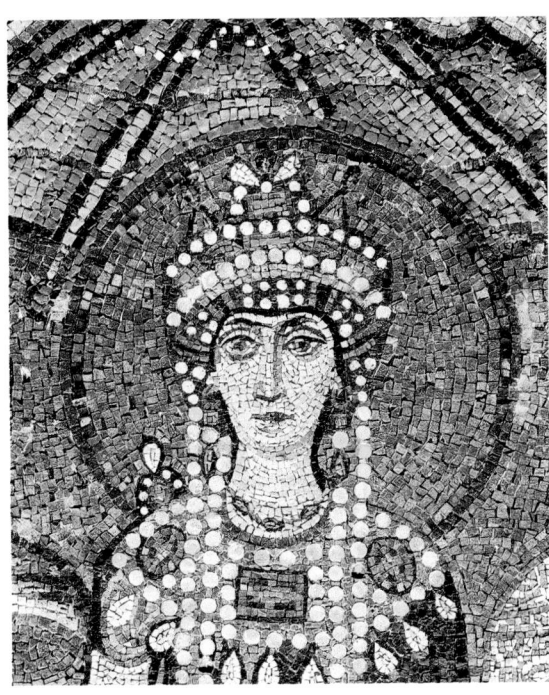

8.24 (left) *Theodora* (detail of fig. 8.25). Here there is still an attempt at shading on the side of the nose and under the chin. Removing the image from the illusion of naturalism, however, is the black outline. The tilted, irregular placement of the *tesserae* creates thousands of small shifting planes that reflect the outdoor light entering the church.

8.25 *Court of Theodora*, apse mosaic, San Vitale, Ravenna, c. 547. 8 ft. 8 in. × 12 ft. (2.64 × 3.65 m).

METHODS OF INTERPRETATION

The Mosaics of Justinian and Theodora, Emperor and Empress of the Byzantine Empire: Formalism, Iconography, Feminism, Biography

The mosaic panels of the Byzantine emperor Justinian and empress Theodora, on the side walls of San Vitale's apse, lend themselves to several methodological approaches of interpretation. The artist designed these images for the specific purpose of showing the power, piety, and wealth of the Byzantine rulers. Formally, Justinian's mosaic is composed of a horizontal phalanx of churchmen and soldiers flanking the emperor. Their frontality forms a figural wall that directly confronts the viewer and creates a sense of unity. Justinian dominates the group by his central placement and royal purple cloak. In addition, his jeweled crown and halo elevate him above the others, accentuating his central importance.

Iconographically, there are a number of details designed to emphasize Justinian's Christian and military power. His halo sanctifies him and reminds viewers that he is the "Holy" Roman emperor, and the purple color of his cloak alludes to the costume of Roman emperors. The soldiers display a shield with the *Chi-Rho* emblem of Constantine, which places Justinian in a direct line of descent from the time of Constantine's conversion to Christianity and the foundation of Byzantium as a new Roman capital.

Reinforcing Theodora's role as co-regent with Justinian, the mosaic of Theodora is across the apse from Justinian's, thus sharing the most sacred area of the church. She is given a great deal of importance as the empress, but, from a **feminist** standpoint, certain subtle formal and iconographic elements show her to be slightly less powerful than her male spouse. Her mosaic is to Christ's left (the viewer's right) instead of in the preferred position on Christ's right (note the idea that the saved are "on the right hand of God"). Theodora, her churchmen, and her ladies-in-waiting are also set farther back in space than the figures in Justinian's mosaic and are proportionally smaller. They thus appear less assertive. The ladies-in-waiting seem particularly "ladylike," dressed as they are in jewels and in elaborately patterned, delicately embroidered robes.

Biography also plays a role in Theodora's iconographic representation, which may have been designed to change her image as a former courtesan and actress. Before marrying Justinian in 523 following their notorious romance, she transformed the memory of her dissolute past by means of a zealous program of moral reform. In her mosaic, she is shown as a pious ruler standing inside an abbreviated apse. She extends a gold bowl toward the baptismal fountain that signifies entry into the Christian faith. Reinforcing the notion that Theodora is a generous and devoted patron of the Church are the three gift-bearing Magi embroidered into the lower section of her purple robe.

The importance of light in Christian art is expressed in Byzantine mosaics such as these by the gold backgrounds and the reflective surfaces of the *tesserae*. Christ as "light of the world" provided the textual basis for such light symbolism. The concept echoes various Eastern sun cults of earlier periods. Constantine, too, used the designation *Sol Invictus* ("Invincible Sun") for himself. So, when the Byzantine artist depicted Justinian and Theodora with halos, it was to emphasize their combined roles as earthly and spiritual leaders.

The style of Justinian's and Theodora's heads is far removed from the type of Roman portraiture that preserved the features of its subjects. However, the stylistic distinction and positioning of people according to their status has been retained. For example, the prominent position of Theodora's mosaic is a function of her status as co-regent with her husband. It is subordinate to Justinian's by virtue of being on Christ's left—traditionally a less exalted position than his right, and Theodora herself is placed farther back in the picture space than Justinian. As a result, her image is less imposing. The emphasis on rank and hierarchy rather than on personality or portraiture reflects the highly structured nature of Byzantine society (see box).

Another, even more subtle aspect of these mosaics is the way in which the artist shows the relationship of the emperor and empress to the central figure of Christ in the semidome of the apse. Despite the frontality of the standing figures, the objects they hold—the offerings of Theodora and Justinian, the crucifix of Maximian, and the gold tome and censer of the churchmen—are extended slightly toward the curved apse wall behind the altar. There is thus a correspondence among the iconography of the mosaics, the formal arrangement of figures and objects, and the architecture of the apse.

The symbolic character of these images is evident not only in their style and iconography but also in the virtual absence of any reference to the biographies of the emperor and empress. Since Justinian had never been to Ravenna, his mosaic had great political importance. It served both as his substitute and as a visual reminder of his power, emphasizing his political allegiance to Constantine and his religious devotion to Christ. By juxtaposing the Byzantine emperor with the local archbishop, the artist also alludes to Justinian's support from Ravenna's ecclesiastical hierarchy.

Maximian's Ivory Throne

In addition to monumental expressions of imperial and Church power in architecture, architectural sculpture, and mosaics, Byzantine artists produced small reliefs, ivories, church furniture, and ornamentation. The largest Early Christian ivory from Justinian's reign is the sixth-century throne of Maximian (fig. **8.26**), which was restored in 1884, 1919, and 1956. It is a high-backed chair, with a semi-circular seat and arms, which may have been a gift from Justinian to the archbishop. Although known as a throne, it was not used as such but was carried as a ritual chair in religious processions, with a silk or velvet cushion probably bearing such jeweled objects as a Gospel book or a cross.

The wooden core of Maximian's throne is covered with ivory plaques, which are elaborately carved in low relief. On the back of the throne are scenes of Christ's childhood and miracles. Old Testament scenes from the life of Joseph, as a prefiguration of Christ, decorate the armrests. In the front, below the seat, are the four Evangelists, individually framed and flanking John the Baptist at the center.

The detail in figure **8.27** shows two Evangelists set in niches framed by round arches and columns carved in spiral patterns. The narrow scallop-shell apses, together with the arches, are designed to look like halos. Each Evangelist carries the characteristic attribute of a book with the Cross on its cover and raises his right hand in the Roman gesture of oratory. Both wear Roman-style togas, whose folds create elaborate curvilinear patterns. The Evangelist at the right tilts his left foot downward so that it overlaps the ground in a diagonal plane like the feet in the mosaics of Justinian and Theodora.

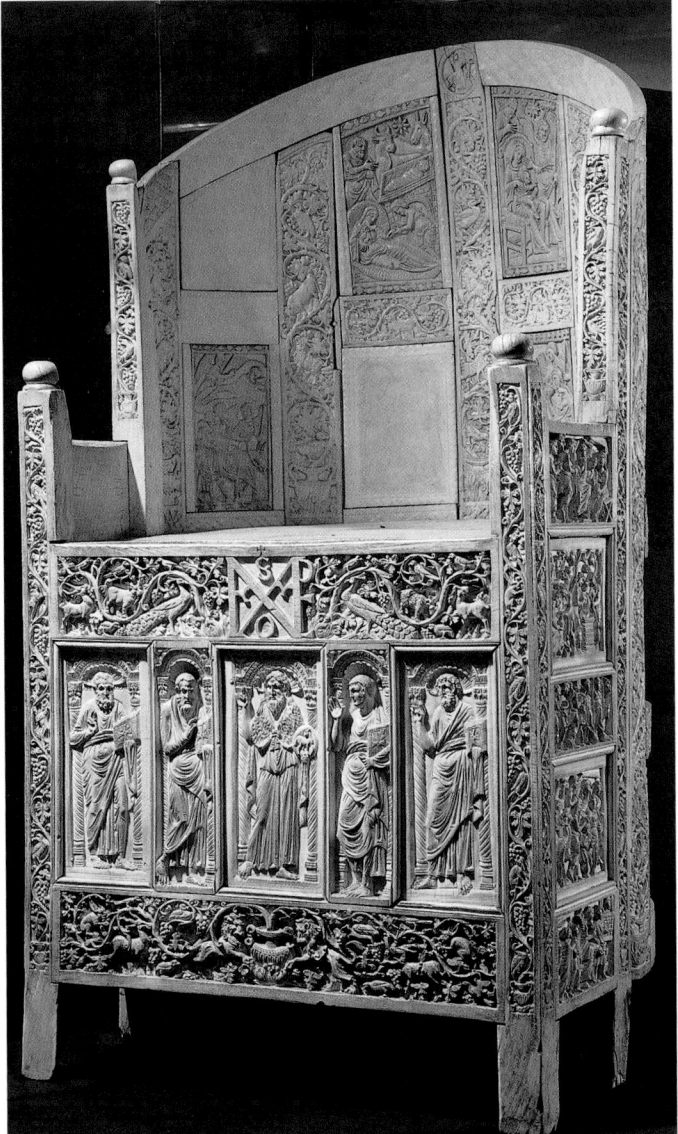

8.26 The throne of Maximian, 545–553. Polished ivory over wooden framework. Museo Arcivescovile, Ravenna. On the front, there are figures of John the Baptist and the four Evangelists (Christ's biographers). The scenes of Joseph on the side—the armrests—"announce" the scenes on the back: the childhood and miracles of Christ. Taken together, the scenes on the throne encompass the time of the Old and New Testaments. It is not known where the throne was made; possibilities include Antioch, Alexandria, Constantinople, and Ravenna itself.

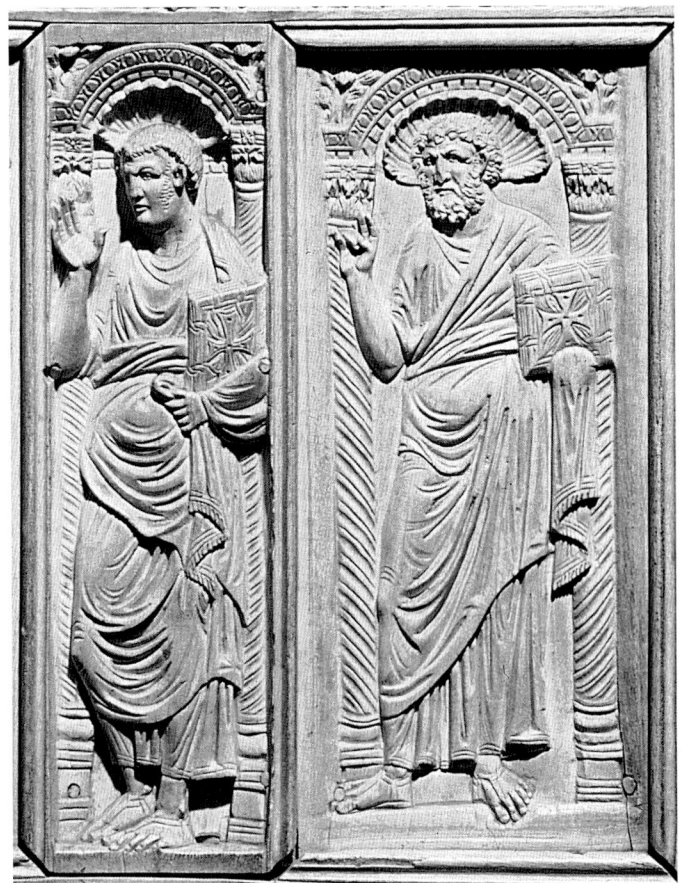

8.27 Two Evangelists, from the front of the throne of Maximian (detail of fig. 8.26).

Hagia Sophia

The undisputed architectural masterpiece of Justinian's reign is the basilica of Hagia Sophia (fig. **8.28**) in Constantinople; the name in Greek is "Holy (*hagia*) Wisdom (*sophia*)." As part of an extensive rebuilding campaign folowing the suppression of a revolt in 532, Justinian commissioned two Greek mathematicians, Anthemius of Tralles and Isidoros of Miletus, to plan Hagia Sophia. They were familiar with the work of Archimedes and particularly interested in the geometry of circles, parabolas, and curved architectural surfaces—all of which are reflected at Hagia Sophia. In their design they successfully combined elements of the basilica with enormous rising vaults, which soar over the biggest domed space to date in the West. The central dome is placed above four arches at right angles to each other and supported by four huge piers. The latter are barely noticeable from the inside because the arches meet at the corners. The piers themselves are supported by buttresses, which can be clearly seen both in the plan (fig. 8.29) and in the exterior view (fig. 8.28).

Whereas in Roman buildings domes were placed on drums, the dome of Hagia Sophia, like the earlier dome in the mausoleum of Galla Placidia, rests on **pendentives**—the four triangular segments with concave sides. Their appearance of suspension, or hanging, gives them their name (from the Latin word *pendere*, meaning "to hang"). They provide the transition from a square or polygonal plan to the round base of a dome or intervening drum and allow the architect to design larger and lighter domes. Pendentives are the principal Byzantine contribution to monumental architecture, and Hagia Sophia is the earliest example of their use on such a grand scale.

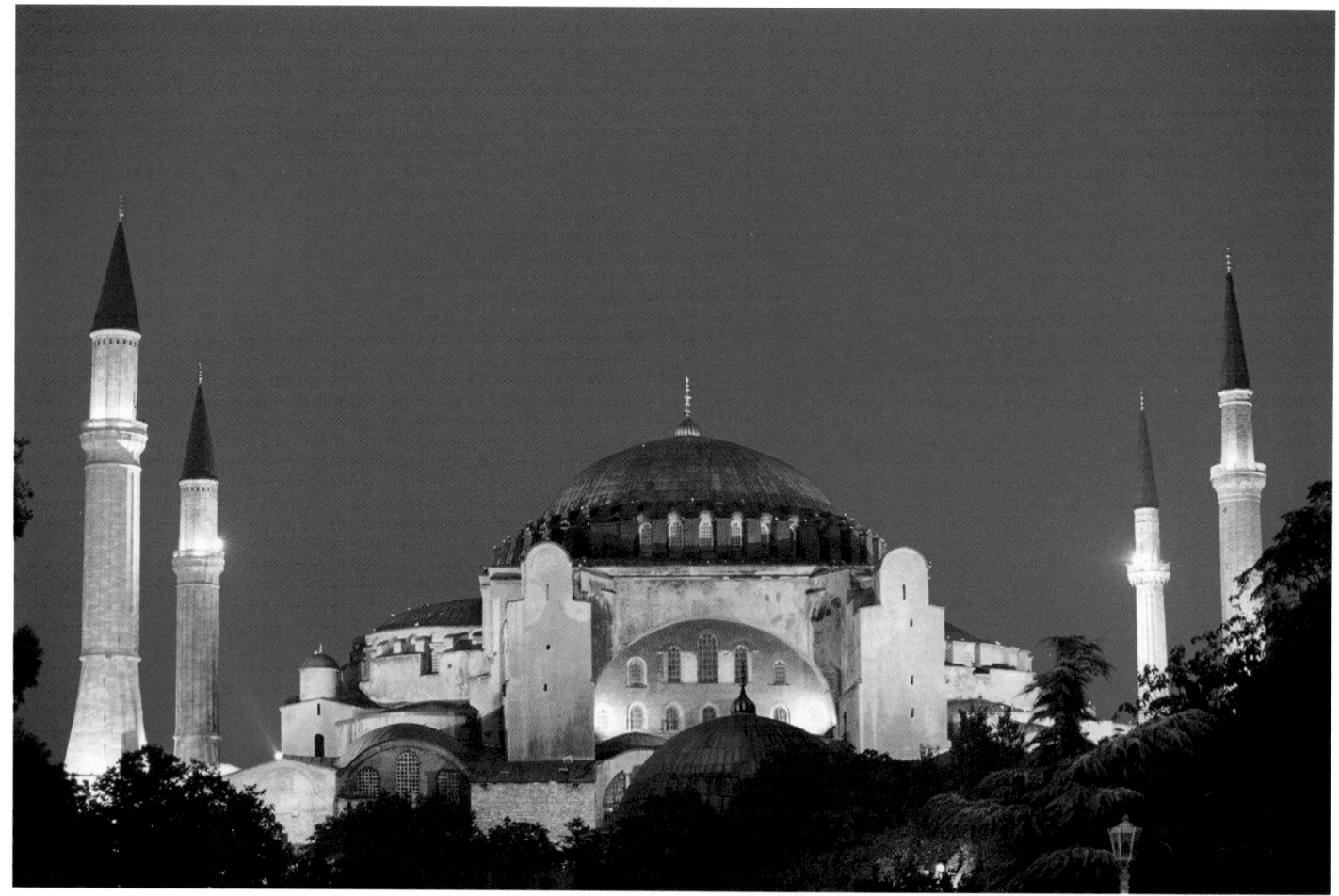

8.28 Hagia Sophia, Constantinople (now Istanbul), illuminated at night, completed 537. The four tall, slender towers, **minarets,** were added when the Turks captured Constantinople in 1453 and Hagia Sophia was converted into a mosque. The Christian mosaics in the interior were largely covered over and replaced by Islamic decorations. Today, Hagia Sophia is a state museum.

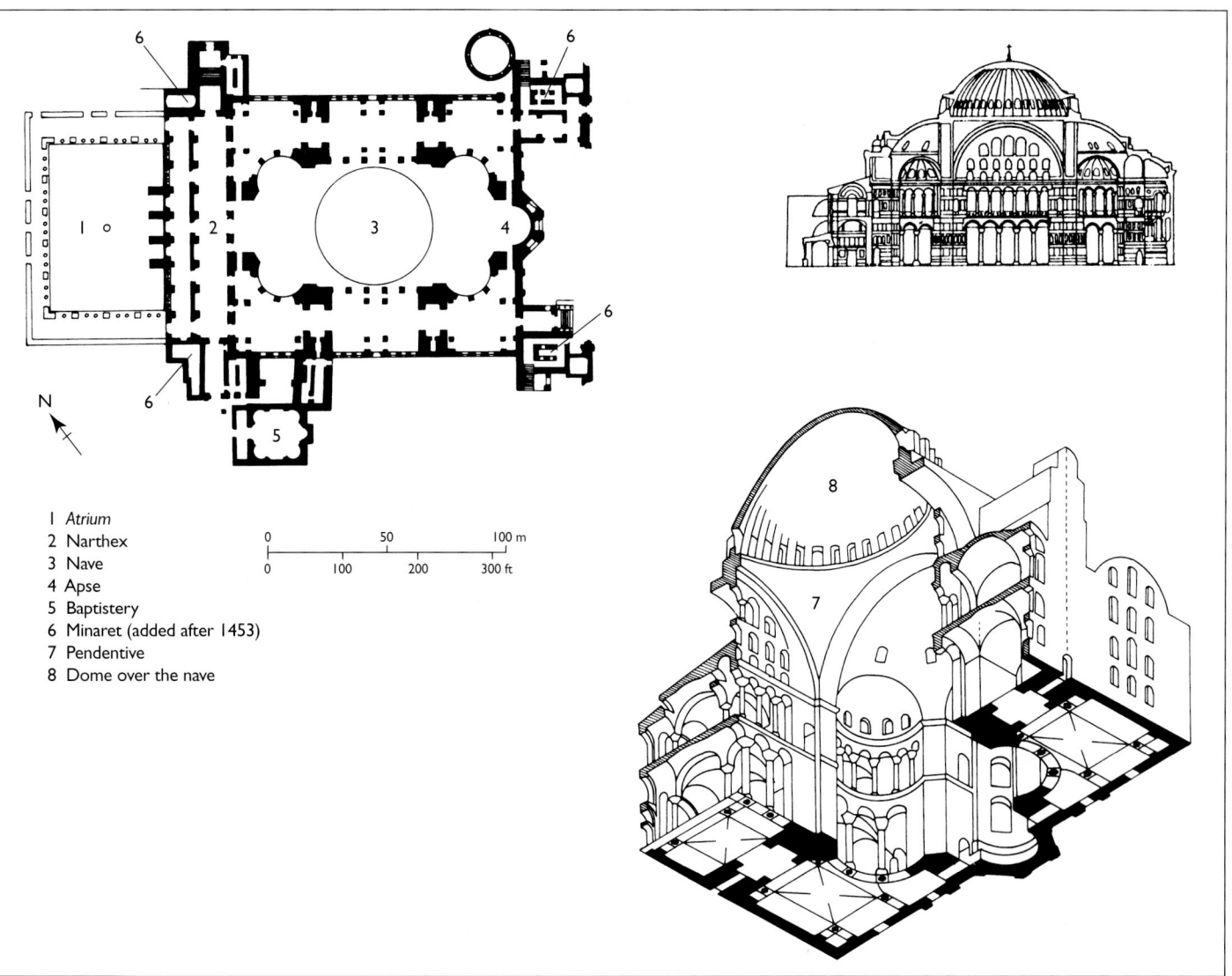

1 Atrium
2 Narthex
3 Nave
4 Apse
5 Baptistery
6 Minaret (added after 1453)
7 Pendentive
8 Dome over the nave

8.29 Plan, section, and **axonometric projection** of Hagia Sophia. Visitors to Hagia Sophia would enter from the west, through an *atrium* that no longer survives (1 on the plan). The double narthex (2) was covered by a row of nine groin vaults. Passing through the narthex, one stood opposite the apse at the far eastern end. The path from narthex to apse, along a longitudinal axis, is reminiscent of an Early Christian basilica. However, instead of a long symmetrical nave surmounted by a gable roof, Hagia Sophia has a huge central square supporting an enormous dome (8). At the eastern and western ends of the square, two semicircles are topped by smaller half domes. Surrounding each half dome are three semicircular apses with open arcades surmounted by even smaller half domes. Running from east to west along the axis are colonnaded side aisles on the first level and colonnaded galleries on the second level. Both are covered by groin vaults. Were it not for the central square, Hagia Sophia would resemble the typical centrally planned church, albeit on a massive scale. Note the impressive effect created by the open space of the nave, the high central dome, and the smaller half domes. The central dome is the earliest example of the use of pendentives on such a grand scale.

Hagia Sophia's dome was constructed of a single layer of brick, a relatively thin shell that minimized the weight borne by the pendentives. Nevertheless, the very size of the dome demanded buttressing. The exterior view (fig. 8.28) shows that each of the forty small windows at the base of the dome is flanked by a small buttress, strengthening from the outside the interior juncture of dome and

pendentives, and transferring the dome's powerful outward thrust downward (see box, p. 291).

On the north and south sides of the nave, there are walls below the arches. Since their load-bearing function has been assumed by the four piers, they can be pierced with arcades and windows (fig. **8.30**). (Nonsupporting walls, which usually have large expanses of windows or

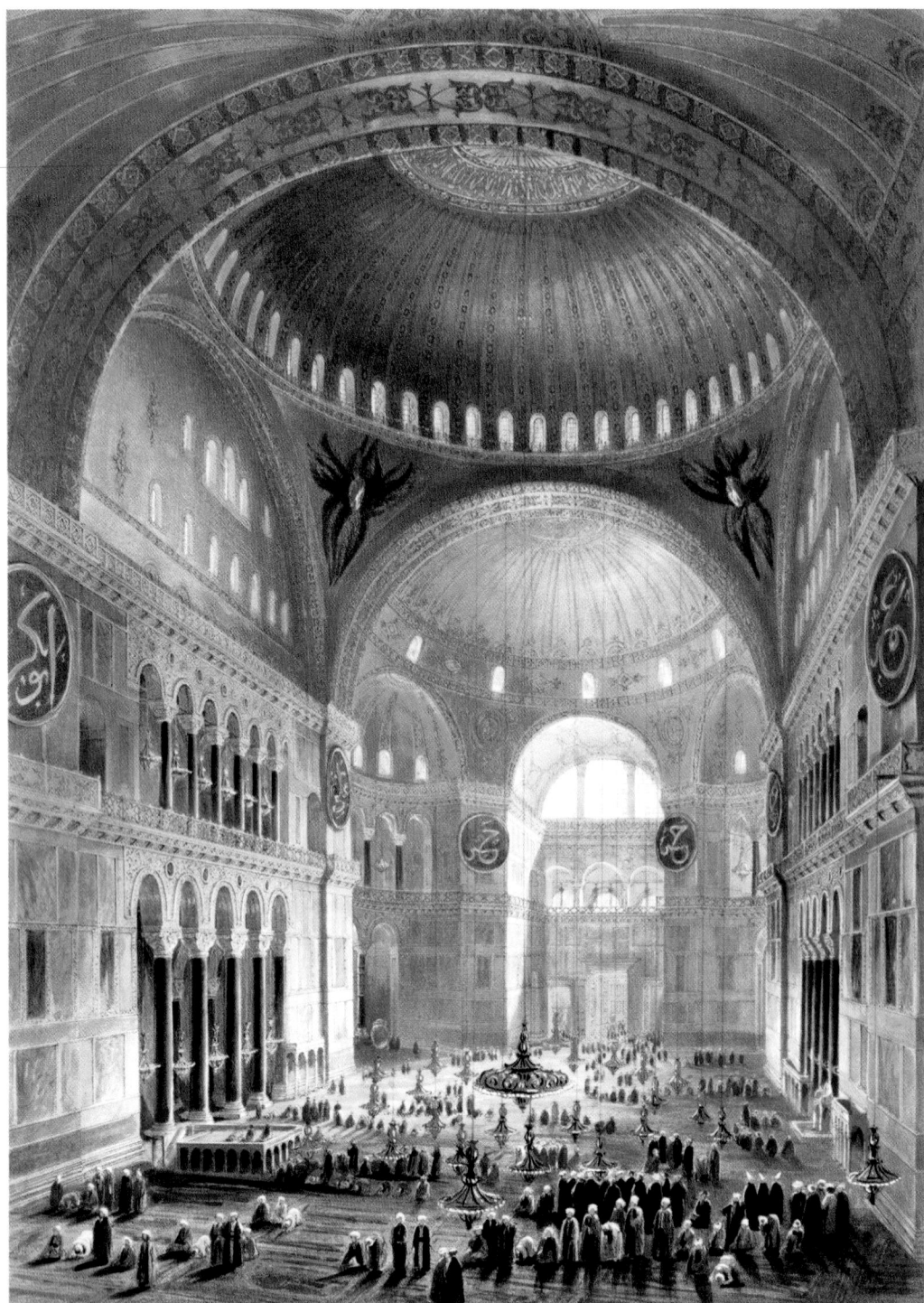

8.30 View of the interior of Hagia Sophia after its conversion to a mosque. Color lithograph by Louis Haghe, from an original drawing by Chevalier Caspar Fussati. This shows the dazzling effect of the mosaic decoration, which produced color and reflected light. Justinian's court historian described the dome as "a sphere of gold suspended in the sky." Recognizing Justinian's ambition to make Constantinople a new Rome, his court poet, Paul the Silentiary, asserted that with Hagia Sophia the Byzantine emperor had indeed caused Constantinople to triumph over its mother city—Rome.

Domes, Pendentives, and Squinches

Domes can be erected on circular or square bases. Ancient Roman domes like that of the Pantheon (see fig. 7.28) were usually on round bases. From the Byzantine era onward, however, it became common to place domes over square or rectangular spaces. This posed the architectural problem of how to create a smooth transition from a cube or rectangle to the round base of the dome or its drum. The two main solutions were the use of structural elements known as pendentives and **squinches.**

Pendentives (figs. **8.31** and **8.33a**) are inwardly curving, triangular sections of vaulting between walls or arches set at right angles to each other. Four pendentives over a cubic space form a circle on which a dome or drum can be placed, as at Hagia Sophia (see fig. 8.30).

Squinches are small single arches (figs. **8.32** and **8.33b**) or a series of concentric corbeled arches (fig. **8.33c**) built across the corners of a square or polygonal space, as at the Great Mosque at Córdoba (cf. fig. 9.7).

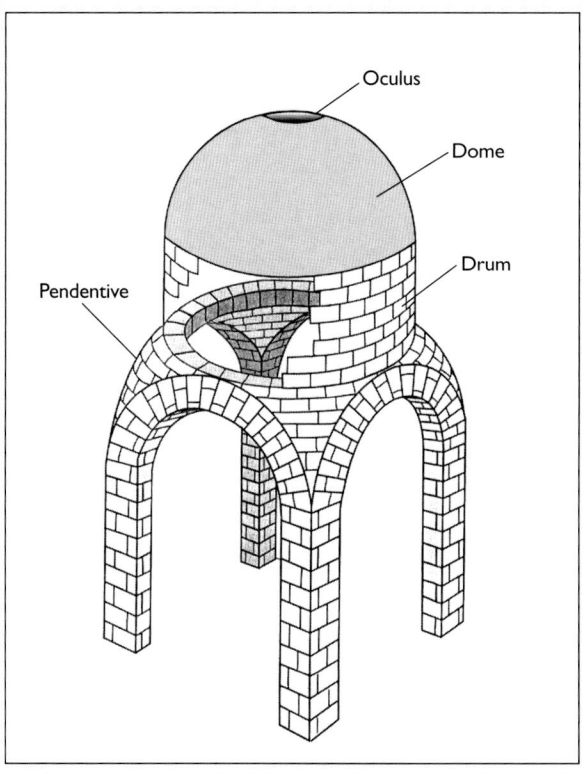

8.31 Dome on pendentives.

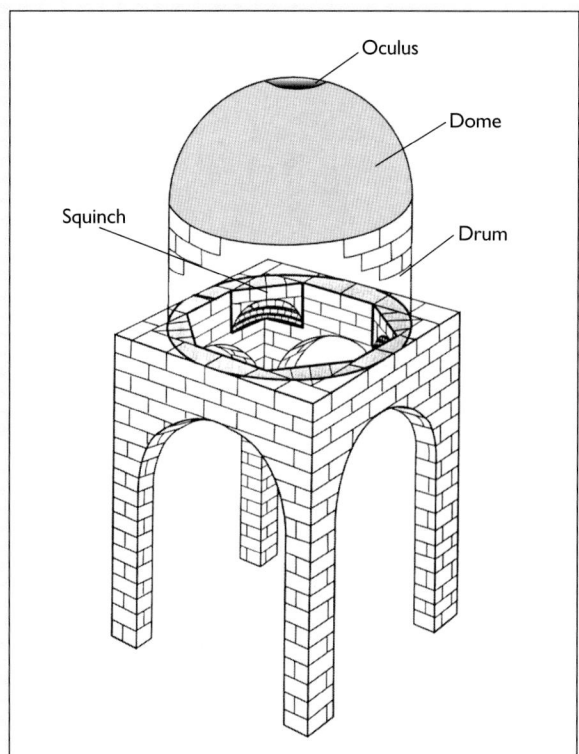

8.32 Dome on squinches.

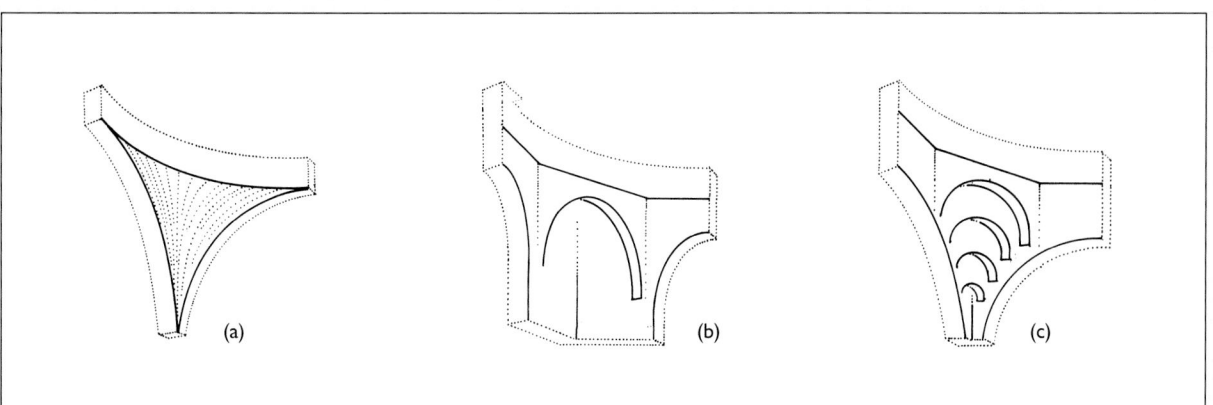

8.33a, b, c a. Pendentive. b. Single-arch squinch. c. Concentric-arch squinch.

other openings, are called **screen walls.**) The extensive use of windows and arcades at Hagia Sophia creates an overwhelming impression of light and space. At floor level, five arches connect the side aisles with the nave. Supporting these arches are large columns with intricately patterned capitals (fig. **8.34**) reminiscent of interlace. The small volutes reflect the persistence of Classical elements (see fig. 5.34), although in rudimentary form. Here they have been overtaken by the dazzling surfaces of the Byzantine style. At the second level, the galleries contain seven arches. The lunettes are pierced by two rows of windows, five over seven, and in each of the half domes there are five windows. Finally, a series of small windows encircling the lower edge of the dome permits rays of light to enter from all directions. Although the actual source of light is

from the exterior, the shimmering reflections and predominance of gold create the impression that it originates from the interior. Justinian's court historian, Procopius of Caesarea, expressed this view when he described the dome as a "sphere of gold suspended in the sky."

Hagia Sophia was essentially an imperial building. In contrast to San Vitale, it was the personal church of the emperor and his court rather than a place of worship for the whole community. The clergy occupied one half of the central space and the emperor and his attendants the other. Like San Vitale, Hagia Sophia served Justinian's desire to unite Christendom under his leadership, to build churches, and to commission works of art that would express his mission as Christ's representative on earth.

--- **CONNECTIONS** ---

See figure 5.34. Diagram of an Ionic capital and the architrave.

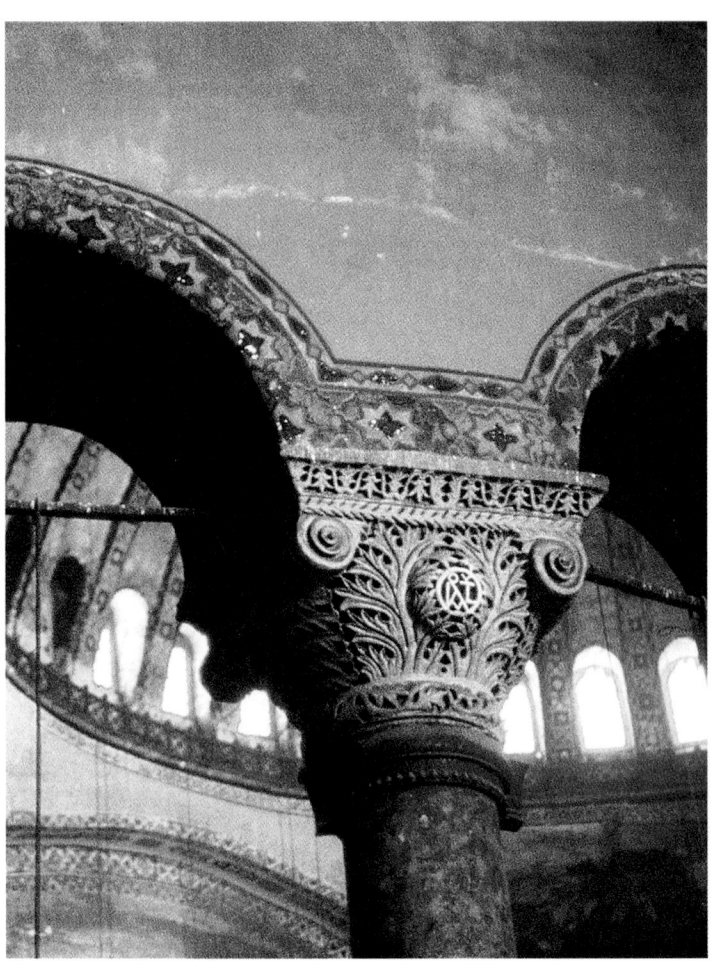

8.34 Detail of arcade spandrels and capital, Hagia Sophia.

The Expansion of Justinian's Patronage

Justinian's desire to extend his patronage as far afield as possible conformed to his imperial ambition. He commissioned buildings not only in Italy and Constantinople, but throughout the Byzantine Empire, including the Balkans, North Africa, and the Near East. Among the most notable examples is the Church of Saint Catherine's monastery on Mount Sinai, which contains a large apse mosaic of *The Transfiguration* (fig. **8.35**). In this work, virtually all traces of landscape have been eliminated. A bearded, frontal Christ is suspended in a flat plane of gold. He is surrounded by a blue **mandorla** (the almond-shaped aureola) and wears white (a sign of his spiritual "transfigured" state), transmitting rays of white light toward the other figures. In this iconography, Christ is literally represented as "the light of the world." Three of his apostles,

Peter, James, and John, fall backward, their awe revealed by their agitated gestures. Moses and Elijah, in contrast, occupy calm, vertical poses on either side of Christ. Compared with the apse mosaic of the *Good Shepherd* in the mausoleum of Galla Placidia (see fig. 8.14), this has a mystical quality that seems to transcend earthly time and space.

The very image of the Transfiguration in a church located on Mount Sinai is imbued with typological meaning, for it was there that Moses had been "transfigured" by light after receiving the Law from God, and it was at *the* Transfiguration that God acknowledged Christ as his son. Christ and the apostles are intended to embody the New Dispensation emerging from, and continuing, the traditions of the Old Dispensation established by Moses and Elijah. The figures in the frame medallions are prophets and apostles.

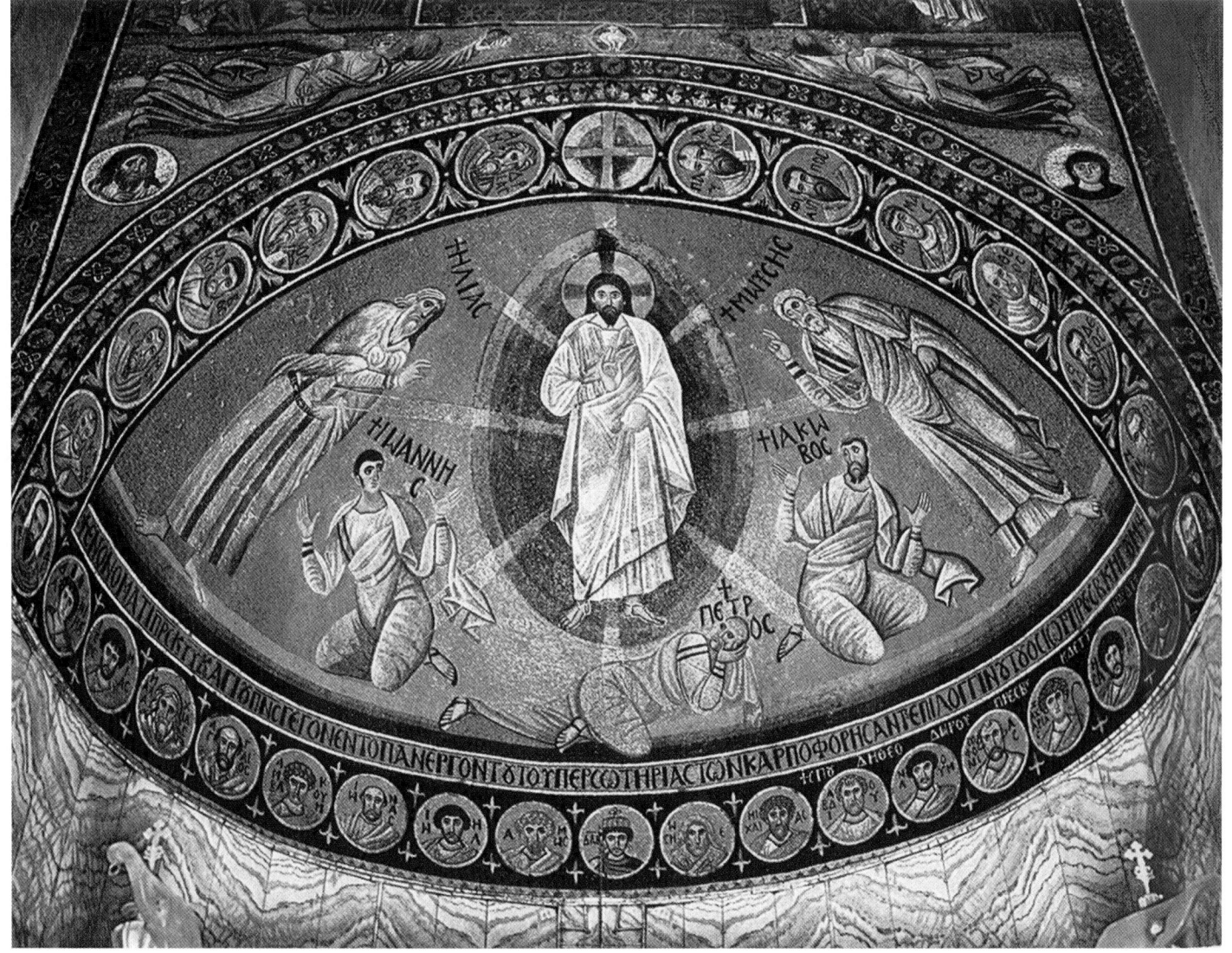

8.35 *The Transfiguration*, Church of Saint Catherine's monastery, Mount Sinai, Egypt, c. 550–565. Mosaic.

The Development of the Codex

Toward the end of first century, a new method of transmitting "miniature" imagery accompanying written texts came into use. This was the **codex**, which was the ancestor of the modern book. The ancient Egyptians, Greeks, and Romans had used the papyrus scroll (*rotulus*) for texts and their illustrations. On average, a *rotulus* measured some 10 to 11 yards (about 9 to 10 m) in length when unrolled. The codex was more practical and easier to manage. Its pages were flat sheets of relatively sturdy **parchment** or **vellum** (calfskin) (see box). They were bound together on one side and covered like a book, which made the codex easier to preserve than the *rotulus*. It was also possible to illustrate (or illuminate) the pages with richer colors. The Latin poet Martial praised the codex, which he called the "book with many folded skins," because it held the complete works of Virgil in a single volume.

The Vienna Genesis

Among the earliest codices to illustrate scenes from the Bible is the Vienna Genesis (its name is derived from its current location, the Nationalbibliothek in Vienna). Originally, the codex had ninety-six folios, of which twenty-four survive; these have forty-eight miniature illustrations. Each sheet is purple, which points to an imperial patron, while the gold and silver script is characteristically Byzantine. Most of the page contains text, relegating the images to the lower section.

Figure **8.36** shows an illustration below the text that depicts an event in the story of Joseph from Genesis. Joseph sits in a prison, which is viewed from above. Outside, a few trees show that landscape, in however rudimentary a form, persisted as a way of setting a scene and conveying a sense of place. To the right of the prison, Potiphar's wife talks with the guard, her modest attire disguising her lust for Joseph. Inside the prison, the pharaoh's jailed butler and baker are unhappy because there is no one to interpret their dreams. Joseph informs them that dreams belong to God and asks what they dreamed. The butler reports his dream of a vine with three branches that sprouted blossoms and grapes, which he pressed into the pharaoh's cup. Joseph informed the butler that in three days the pharaoh would free him to resume his duties. The baker dreamed that he was carrying three white baskets on his head. The top basket was filled with bakemeats for the pharaoh, but birds ate them. Joseph told the baker that in three days the pharaoh would hang him from a tree and birds would eat his flesh. Both interpretations came true: the butler was rehired, and the baker was hanged.

Usually, as in figure **8.37**, there is more than one event depicted on a page. The narrative is continuous, without

8.36 *Joseph Interpreting Dreams in Prison*, from the Vienna Genesis, early 6th century. Illuminated manuscript. Nationalbibliothek, Vienna.

8.37 *Joseph and Potiphar's Wife,* from the Vienna Genesis, early 6th century. Illuminated manuscript. Nationalbibliothek, Vienna. It is not known where the Vienna Genesis was made, although it is believed to have originated in the Near East.

frames or dividers between scenes, and it has been suggested that such narratives are related to the continuous spiral frieze on Trajan's Column (see p. 231). This page depicts additional events from the life of Joseph. At the upper left, Potiphar's wife reclines in a colonnaded bedroom. She tries to lure Joseph, who turns to leave. To the right, continuing from the bedroom, Joseph gazes back toward the scene of the temptation he has resisted. An astrologer wearing a starry cape holds up a spindle. Between him and Joseph, Potiphar's wife tends a baby. In the lower register, one woman carries another infant, while two other women spin.

Image and Icon

A comparison of the small detail of the woman holding the infant in the codex (see fig. 8.37) with a sixth-century fresco from a funerary chapel in the Roman catacombs (fig. **8.38**) highlights some significant differences in Early Christian style and meaning. The Vienna Genesis infant is anonymous and held facing his mother in an ordinary way. His proportions are relatively naturalistic, and he, like the woman, turns as if occupying three-dimensional space.

Represented in the catacomb fresco, on the other hand, are the *Virgin and Child Enthroned;* the figures here are clearly identifiable and command veneration from Christians. They are flanked by saints, while at the left stands the smaller image of the widow buried in the chapel.

Mary sits regally on a jeweled throne and is therefore shown in her aspect as Queen of Heaven. She had been proclaimed *Theotokos* (the "Bearer of God") in 431 at the Council of Ephesus, and this led to a cult of the Virgin. Evidence of that cult can be seen in her majestic portrayal here. Christ, in such images, is the King of Heaven, seated on the throne that is his mother's lap. Unlike the Vienna Genesis infant, however, Christ is frontal, clothed, and rendered as a homunculus (a little man), babylike only in size and setting. His image conforms to the Christian metaphor in which Christ is conceived of as a miraculous baby-king. This type of Virgin and Child (notwithstanding the togas worn by the saints) has an iconic character that is typical of Byzantine style. Images of this kind invite devotion and prayer through direct confrontation of holy personages by worshipers. The Vienna Genesis figures, in contrast, continue in the Classical tradition of relative naturalism. They invite identification by virtue of three-dimensional space and the fact that they participate in a narrative sequence.

An icon (usually a panel painting), as opposed to a work with iconic quality, is an image whose purpose is purely devotional. A good example is the icon of Saint Peter from the monastery of Saint Catherine (fig. **8.39**), showing the bearded saint with a halo, a long cross, and his traditional attribute of the keys to heaven. The degree to which Early Christian icons absorbed elements from pagan styles is reflected in the Roman drapery with shaded folds and in the treatment of the face and neck. The halo is flat, but the buildings behind the figure recede

See fig. 7.58 *Young Woman with a Stylus* (sometimes called *Sappho*), from Pompeii, 1st century A.D.

in perspective. The three tondos of Christ, Mary, and an unknown saint are reminiscent of Roman painted portraits (cf. fig. 7.58).

8.38 *Virgin and Child Enthroned with Saints Felix and Augustus,* 528. Fresco. Commodilla catacomb, Rome.

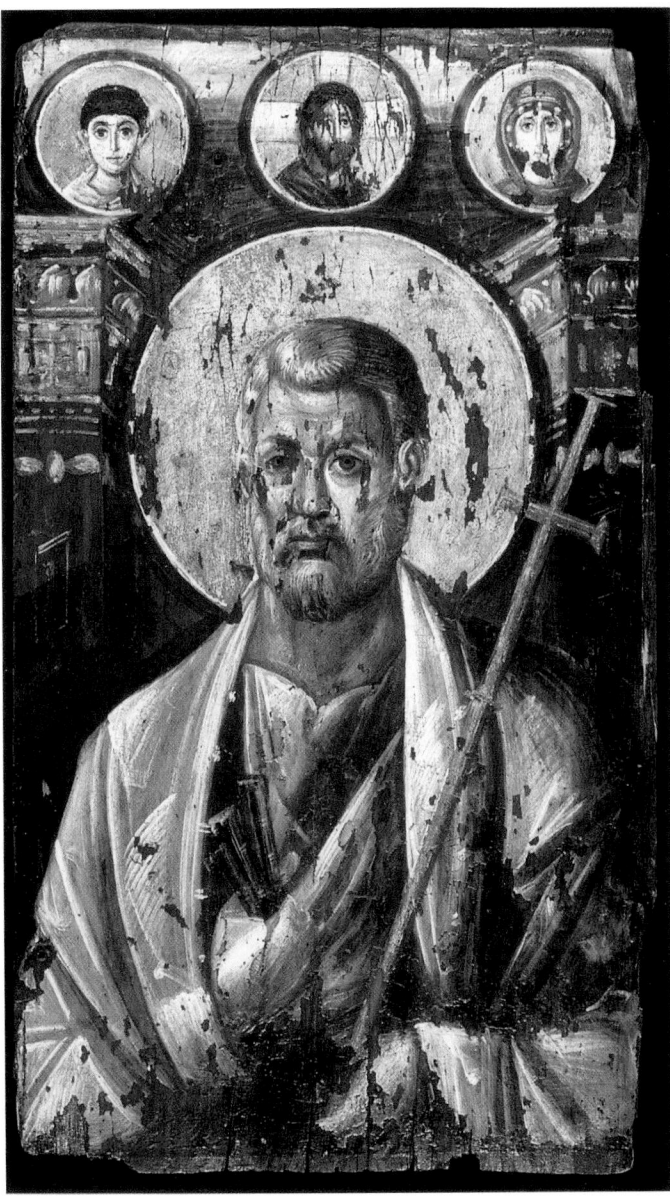

8.39 *Saint Peter*, Church of Saint Catherine's monastery, Mount Sinai, Egypt, 6th or 7th century.

Later Byzantine Developments

The Byzantine style continued in Eastern and Western Christendom for several centuries following the age of Justinian. In the eighth and ninth centuries, the very nature of imagery became a subject of dispute. This is referred to as the Iconoclastic Controversy, in which the virtues and dangers of religious imagery were hotly debated. The Iconoclasts ("breakers of images"), centered in Eastern Christendom, followed the biblical injunction against worshiping graven images, and many of them destroyed works of art. They argued that images of holy figures in human form would lead to idolatry—worship of the image itself rather than what it represented. According to

the Iconoclasts, it was permissible for religious art to depict designs, patterns, and animal or vegetable forms, but not human figures. The Iconophiles (those in favor of images) were centered in the West. They pointed to the tradition that Saint Luke himself had painted an image of the Virgin and Child. In 726, the Iconoclasts gained the support of Emperor Leo III and in 730 succeeded in having an edict issued against graven images, which contributed to the relatively minor role of sculpture in Byzantine art. When the edict was eventually lifted in 843, the Iconophile victory led to a revival of image making and renewed artistic activity in the Byzantine world. Mosaics and paintings were now officially encouraged, but sculpture—because it is three-dimensional—remained unacceptable to the Eastern Church. Byzantine art and architecture persisted throughout the empire, in Italy, and in Constantinople in the later phase of the style. Domed churches based on the Greek cross continued to appeal to Byzantine architects. Their interest in juxtaposing solid geometric forms such as the cube and the hemisphere is also found in metalwork (see box, p. 302).

The eleventh-century monastery churches of Hosios Loukas (dedicated to Saint Luke of Stiris) in Greece provide an example of ecclesiastical architecture removed from the centers of imperial power (figs. **8.40** and **8.41**). Although relatively modest in scale, the buildings have more elaborate exteriors than those of San Vitale. Instead of plain brick, the walls are decorated with patterns created by different colored brick and light stone. The greater variety of architectural spaces is also evident in the asymmetrical planes of the exterior walls.

One church is dedicated to the Virgin Theotokos. It is a simple Greek-cross plan with a dome at the center. The other church, the Katholikon, has a larger dome rising to a greater height and supported by marble paneled walls. The extensive interior mosaics of the Katholikon have uniform gold backgrounds, and the scenes from Christ's life are far less detailed than the mosaics at San Vitale. The iconography of the mosaics reflects post-Iconoclastic efforts to restore the power of imagery.

N

1 Dome over nave
2 Apse
3 Sanctuary dome
4 Dome over crossing

8.40 Plan of the monastery churches of Hosios Loukas (after Diehl), Greece, c. 1020.

The Katholikon, which contained the relics of Saint Luke, is noteworthy for the good state of preservation of its interior decoration. For example, the apse mosaic depicting the *Virgin and Child Enthroned* of around 1020 shows the figures in a gold space, isolated from the natural world (fig. **8.42**). Both are frontal, facing viewers directly and simply. The linear character of their style—despite some shading on the faces and on Mary's draperies—and the flat halos place them in an otherworldly realm. Echoing the strong black frame of Mary's halo is the Greek inscription flanking it, which means "Mother of God." Christ is represented in typical Byzantine fashion as a homunculus. He sits upright and makes a gesture of blessing, signifying his role as universal God and ruler.

8.41 Monastery churches of Hosios Loukas, Greece, c. 1020.

8.42 *Virgin and Child Enthroned*, Katholikon, Hosios Loukas, Greece, c. 1020. Apse mosaic.

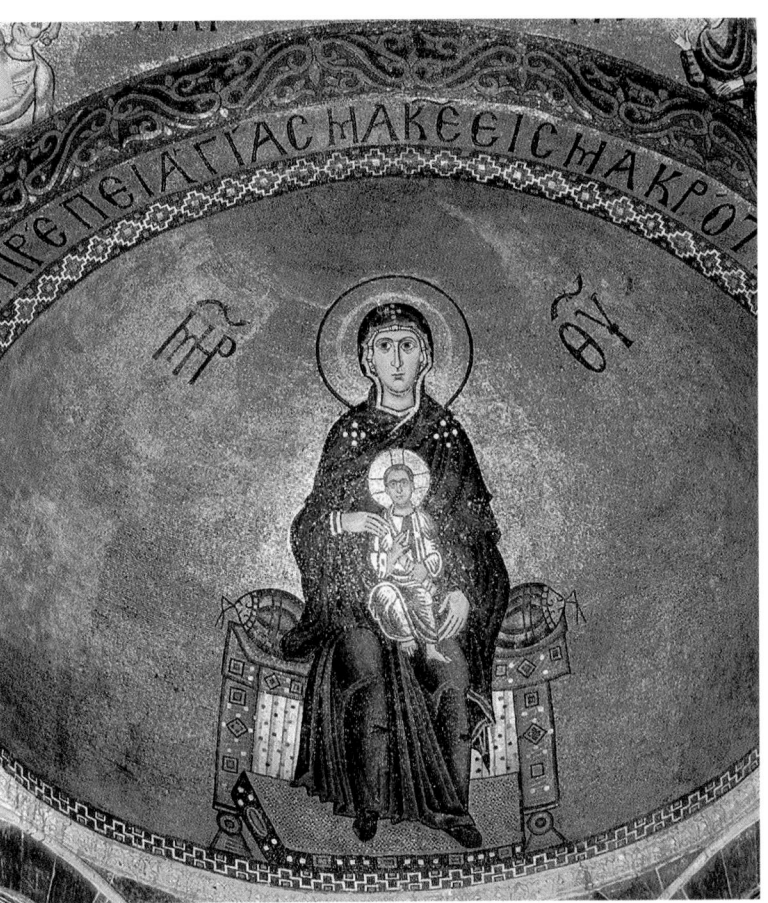

The *Crucifixion* mosaic contains the figures of Christ on the Cross, the Virgin Mary in blue, and Saint John, the youngest apostle, in pink and green (fig. **8.43**). Supporting the Cross is the abbreviated hill of Calvary; symbols of the sun and moon, referring to the eclipse that occurred when Christ died, are visible above the horizontal arm of the Cross. These, like Christ-as-baby-king, denote his future as ruler of the universe. The graceful S-shape of Christ's body defies the gravitational pull necessary for death by crucifixion. Also removing Christ from the natural world is the stylized patterning that makes his bone structure visible on the exterior of his body.

The poses and gestures of Mary and John are appropriate to the scene's death content. Mary's hands, for example, cross over each other, which is a visual echo of the Crucifixion itself. With her left hand she grasps the edge of her veil, as if retreating into herself. At the same time, her extended right hand indicates the sacrifice of her son, at whom she gazes sadly, thereby directing the viewer's attention to the central event. Saint John, on the other hand, leans against his right hand, a traditional gesture of mourning seen on Greek grave stelae (cf. fig. 5.67), which continues as a convention of mourning throughout Christian art. Both Mary and John seem to float in a divine space of gold.

CONNECTIONS

See figure 5.67.
Attic grave stele.

8.43 *Crucifixion*, Katholikon, Hosios Loukas, Greece, c. 1020. Mosaic.

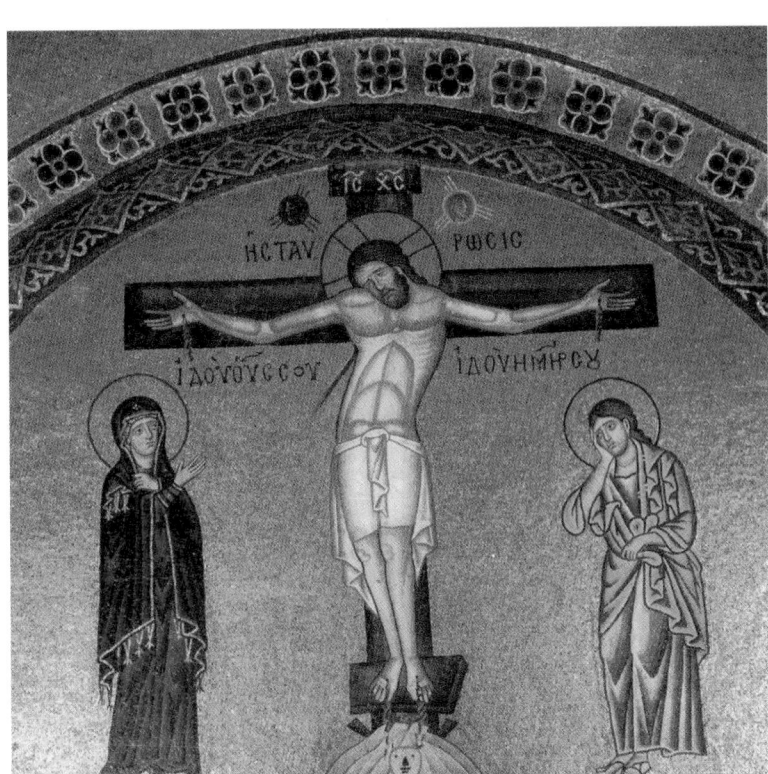

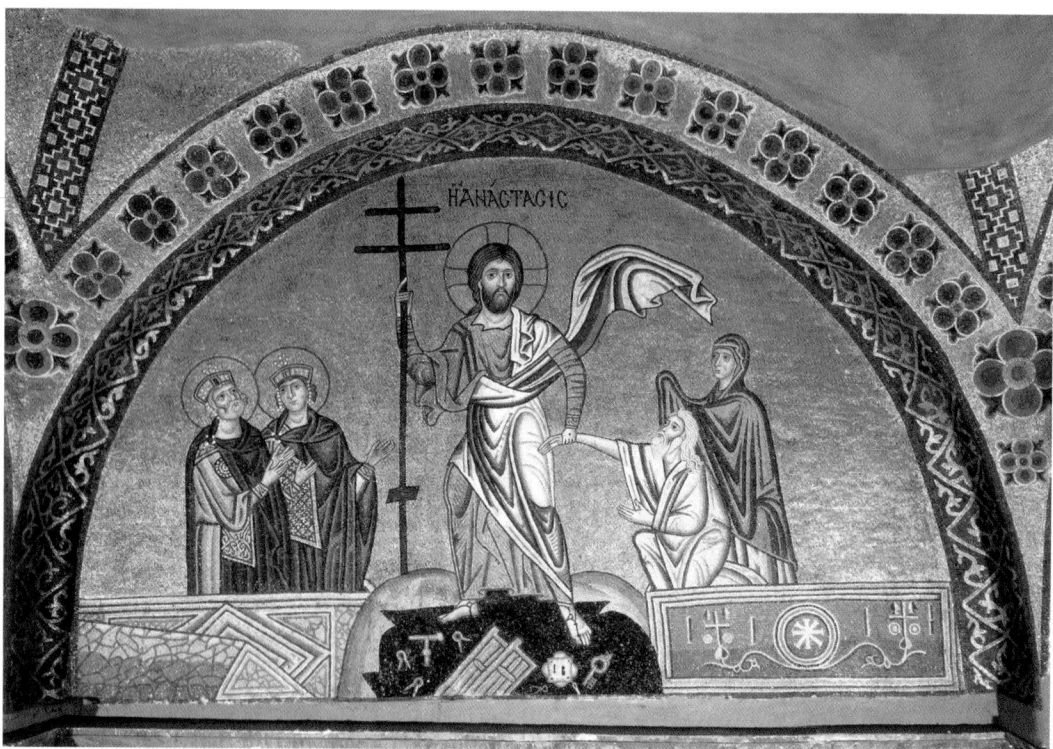

8.44 *Harrowing of Hell,* Katholikon, Hosios Loukas, Greece, c. 1020. Mosaic.

In the *Harrowing of Hell* (fig. **8.44**), Christ is centralized, as in the *Crucifixion*. He faces the viewer as the new Adam, triumphing over death and leading the original Adam to salvation. Eve, typologically paired with Mary, follows behind Adam. At the left, Kings Solomon and David, Old Testament types for Christ, gesture toward the miracle taking place before them. In contrast to Adam and Eve, their regal status is indicated by their robes and jeweled crowns, and their divine roles as ancestors of Christ by their halos.

The late Byzantine image of Christ as *Pantokrator* ("Ruler of All") is an expression of post-Iconoclastic efforts to convey the abstract power of Christ. Such an image decorates the interior dome of the Hosios Loukas Katholikon (fig. **8.45**). It shows Christ at the center, hovering over the space below—an all-encompassing power in human form. This particular image was restored after the earthquake of

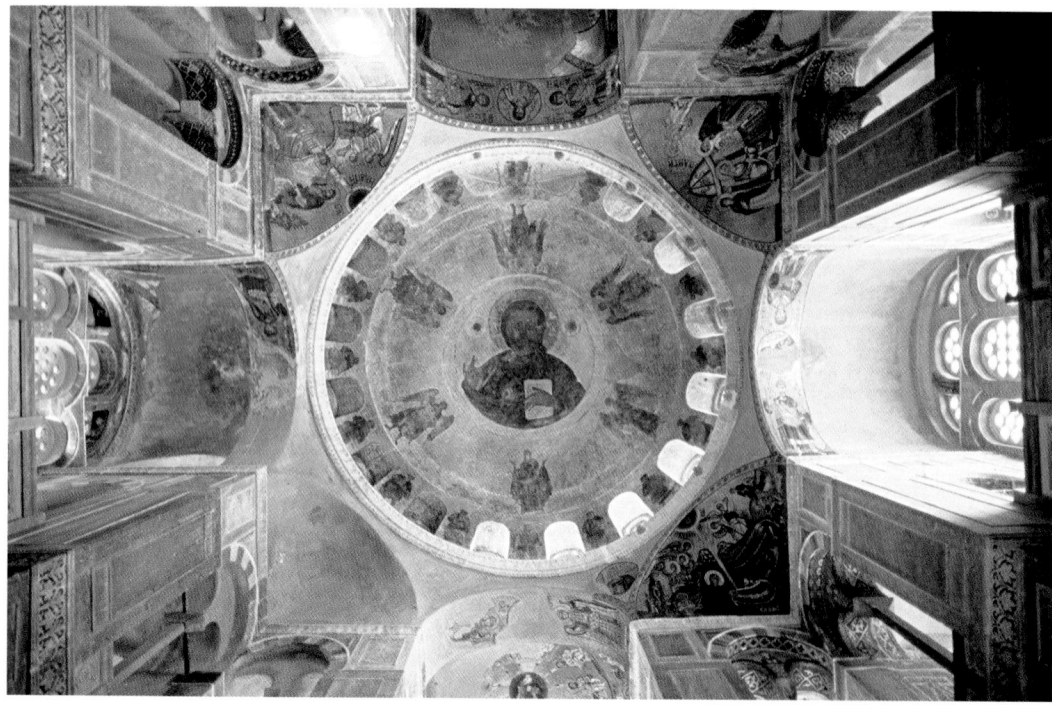

8.45 Central dome and apse, Katholikon, Hosios Loukas, Greece, c. 1020.

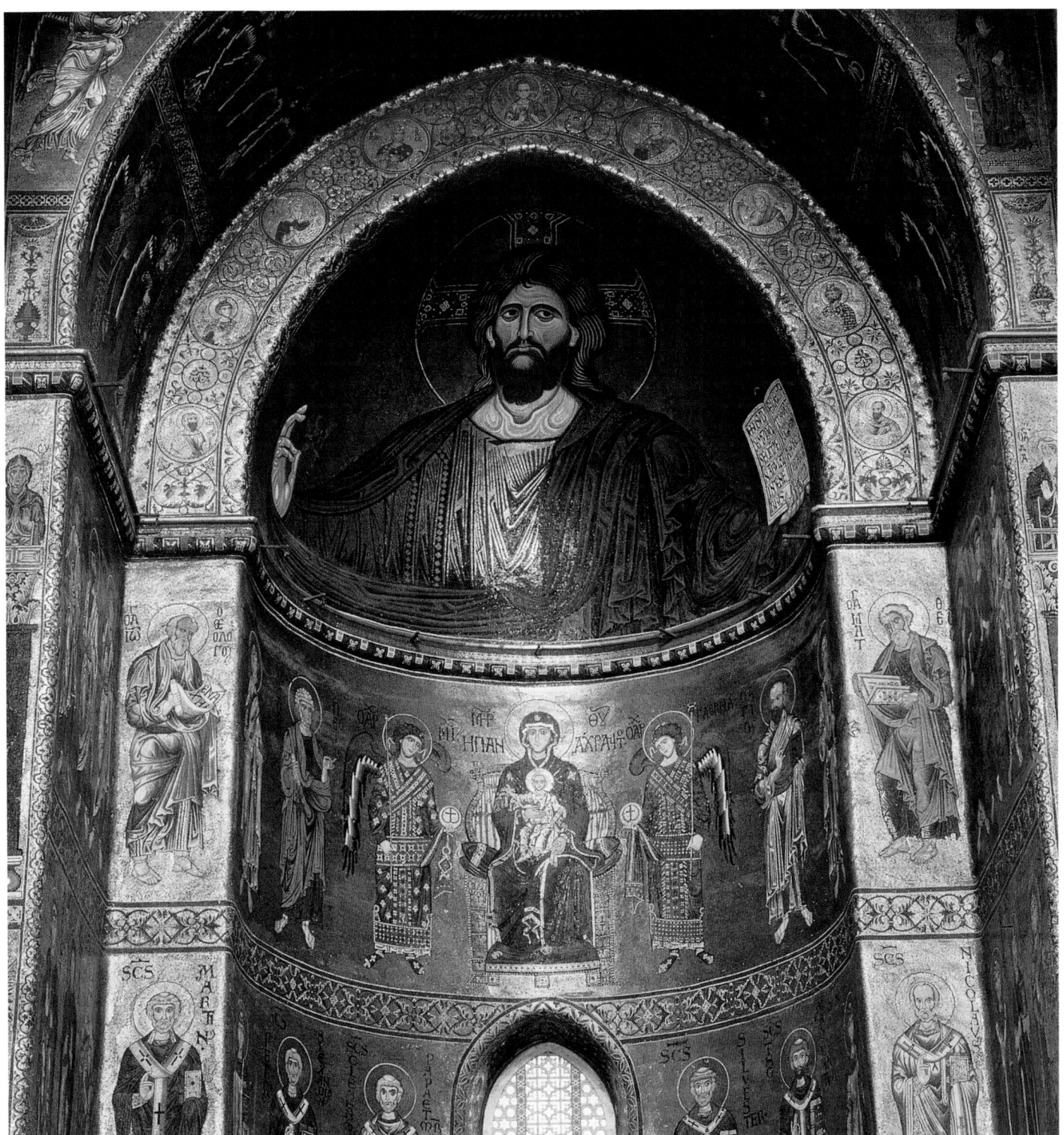

8.46 *Pantokrator*, from the abbey church of Monreale, Palermo, before 1183. Mosaic.

1593 and is not as well preserved as, for example, the twelfth-century *Pantokrator* mosaic from the abbey church of Monreale outside Palermo, in Sicily (fig. **8.46**). The latter is a powerful image of Christ's dominion over the universe. His huge figure fills the upper part of the apse and towers over the enthroned Virgin, his arms and drapery expanding to the sides of the apse. This Christ represents a different order of being from the smaller figures around and below him. The harsh modeling and emphasis on surface patterns—the swirling designs in the face, hair, and neck, as well as the angular drapery folds—enhance the stern character of the *Pantokrator*. The function of such an image is to inspire awe and to command obedience, penance, and faith.

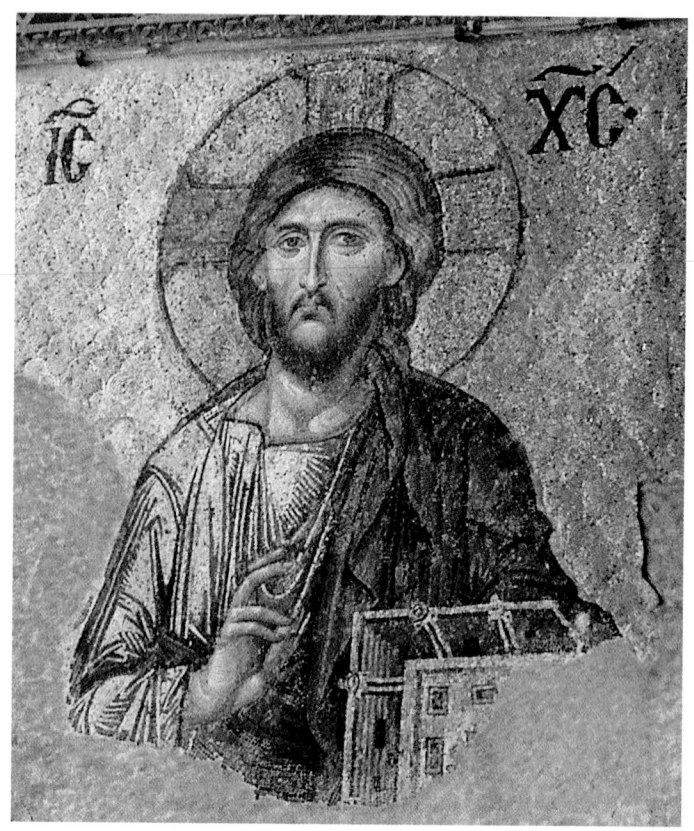

8.47 Christ, detail of a **deësis** mosaic, Hagia Sophia, 13th century. *Deësis* refers to an image showing Christ flanked by the Virgin and John the Baptist.

In contrast to the stern, overpowering image of the *Pantokrator,* the thirteenth-century mosaic of *Christ* from Hagia Sophia shows Christ on a somewhat more human level (fig. **8.47**). Compared with the San Vitale mosaics, in which Justinian and Theodora had been portrayed frontally, outlined in black, and devoid of personality, this Christ turns his head slightly and has an individualized, slightly downcast expression. Although the drapery folds on the left are rendered by dark blue lines, those on the right are slightly shaded. The background is gold, and the halo is entirely flat. The letters *IC* on the left and *XC* on the right stand for "Jesus Christ."

This depiction of Christ illustrates both the persistence of Byzantine style and its accessibility to change. Shading is evident in the cheeks, neck, and right hand. The edges of Christ's form are also indicated by shading rather than by a black outline. The deep eye sockets, the bags under the eyes, the creased forehead, and the downward curve around the mouth convey an air of melancholy.

Byzantine Metalwork

The twelfth-century incense burner in the shape of a domed building (fig. **8.48**) shows the elaborate intricacy of late Byzantine metalwork. Its gold and silver material and the high quality of workmanship suggest that it was made for a court. The shape is that of a secular building (the crosses are a later addition), its centralized square plan having four domed apses between four triangular sections. The latter have curved, pyramidal roofs. Incense was burned inside the structure, and the scent escaped through the openwork spaces.

The meaning of the iconographic motifs, most in repoussé, is not certain. Separating the roof from the walls is a band of rosette and scroll designs in low relief, and animals (including a lion, a griffin, and a centaur) decorate the walls. Figures signifying Courage (an armed man) and Intelligence (a woman pointing to her head) are represented on the double door of one of the apses. Although such personifications are often found in Byzantine court art, their function and meaning in the context of this incense burner are unknown.

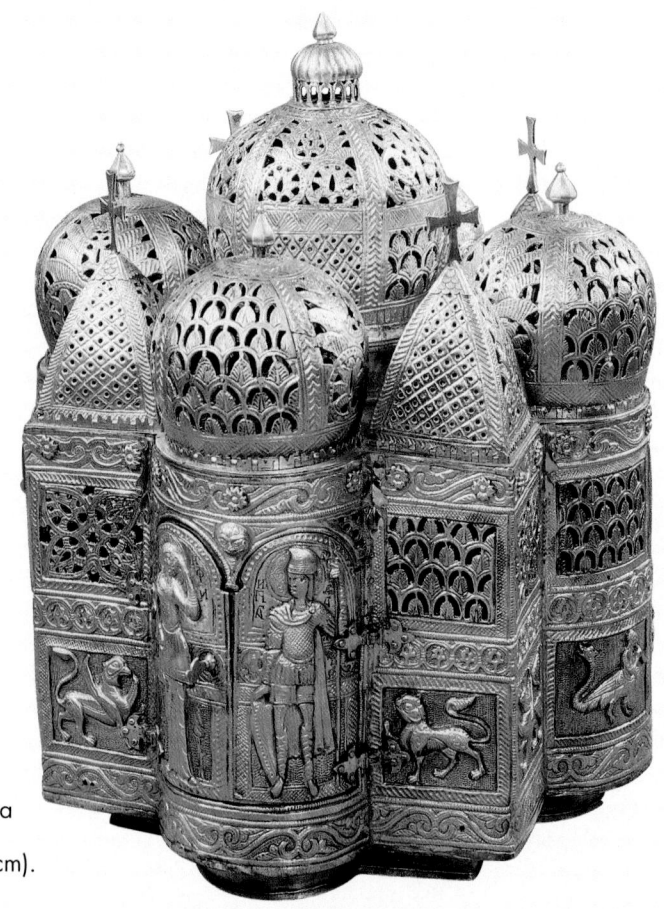

8.48 Incense burner in the shape of a domed building, 12th century. Gilded silver; 14⅛ × 11⅞ in. (35.9 × 30.1 cm). Procuratoria di San Marco, Venice.

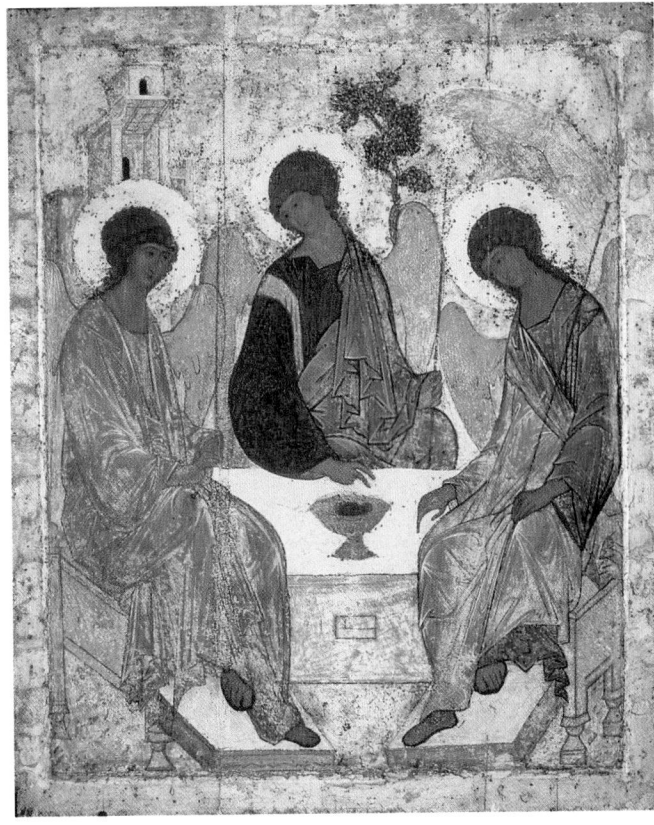

8.49 Andrei Rublev, *Old Testament Trinity*, early 15th century. Panel painting; 55½ × 44½ in. (140.9 × 113.0 cm). Tretyakov Gallery, Moscow.

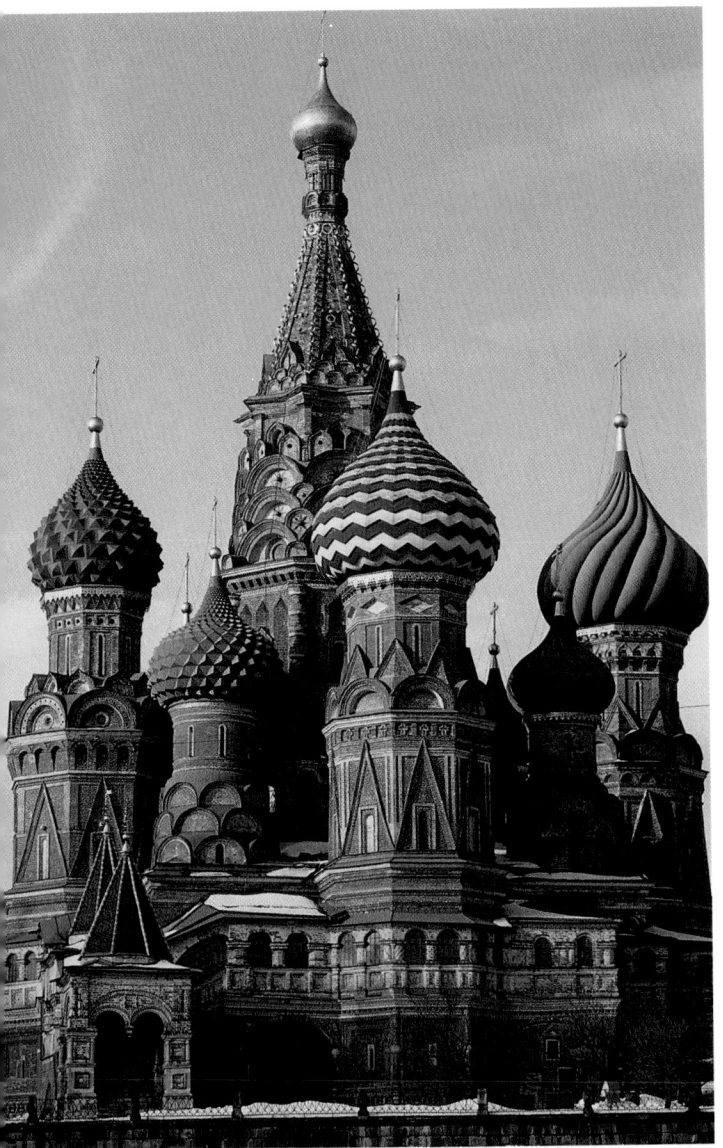

The Byzantine style continued in Russia well beyond the thirteenth century, as can be seen in the icons painted by the monk Andrei Rublev (c. 1370–c. 1430). His *Old Testament Trinity* (fig. **8.49**) depicts the three angels who appeared to Sarah and Abraham (the parents of Isaac) in Genesis 18:1–15. This event, which was later read by Christians as a prefiguration of the Trinity (Father, Son, and Holy Ghost), took on a typological meaning. Despite its damaged condition, Rublev's panel is notable for its rich color and elegant, flowing curves.

Most Russian churches were built up from a wooden core, according to a variation on the centrally planned Greek cross. Saint Basil's Cathedral in Moscow (fig. **8.50**) was commissioned by Tsar Ivan IV (Ivan the Terrible, 1534–1584). Its plan is an octagon, to which are attached eight chapels, each of which is surmounted by an onion dome and commemorates a military victory. Such domes are designed to protect the interior from the elements, especially snow. The colorful patterns and varied, crystalline shapes on the exterior reflect the sunlight and sparkle in much the same way as the *tesserae* of Byzantine mosaics. Legend has it that Ivan the Terrible so admired the cathedral, he had the architects blinded, thereby ensuring that they would never again design anything so great.

8.50 Barma and Postnik, Saint Basil's Cathedral, Moscow, 1554–1560.

Style/Period	Works of Art	Cultural/Historical Developments

A.D. 100

300

EARLY CHRISTIAN
2nd–3rd century

Dura Europos synagogue (**8.1–8.2**)
Christ as the Good Shepherd (**8.3**), Rome
Christus-Sol (**8.7**), Saint Peter's, Rome

Persecution of Christians; catacomb paintings created (2nd century)

EARLY CHRISTIAN/BYZANTINE
4th–5th century

Early Christian sarcophagus (**8.4**), Santa Maria Antiqua, Rome
Old Saint Peter's Basilica (**8.5**), Rome
Santa Costanza (**8.10–8.11**), Rome
Saint Paul outside the walls (**8.8**), Rome
Galla Placidia (**8.12–8.16**), Ravenna

Galla Placidia

The Vienna Genesis

Constantine becomes Roman emperor (306–337)
Edict of Milan; Christianity legalized (313)
Eusebius made bishop of Caesarea (c. 313)
Constantine moves capital of Roman Empire to Byzantium (330)
Books begin to replace scrolls (c. 360)
Sack of Rome by Visigoths, led by Alaric (410)
Spain overrun by Visigoths (414)
Saint Augustine writes *City of God* (426)
Celtic church established in Ireland by Saint Patrick (c. 430)
Attila becomes ruler of the Huns (433)
Flowering of Maya civilization in southern Mexico (late 400s)
Sack of Rome by Goths; fall of Western Roman Empire (476)
Armenian Church secedes from Byzantium and Rome (491)
Ostrogoth kingdom established in Italy by Theodoric (c. 493)

San Vitale

500

1500

EARLY CHRISTIAN/BYZANTINE
6th–15th century

Saint Basil's Cathedral

The Vienna Genesis (**8.36–8.37**)
Virgin and Child Enthroned (**8.38**), Rome
Hagia Sophia (**8.28–8.30**), Istanbul
San Vitale (**8.17, 8.19–8.25**), Ravenna
Throne of Maximian (**8.26–8.27**)
The Transfiguration (**8.35**), Saint Catherine's monastery
Icon of *Saint Peter* (**8.39**), Saint Catherine's monastery
Hosios Loukas (**8.42–8.45**), Greece
Pantokrator, abbey church of Monreale (**8.46**)
Incense burner (**8.48**)
Deësis mosaic (**8.47**)
Rublev, *Old Testament Trinity* (**8.49**)
Saint Basil's Cathedral (**8.50**), Moscow

Incense burner

Justinian becomes eastern Roman (Byzantine) emperor (527–565)
Saint Benedict founds the Benedictine Order (529)
Earliest Chinese roll paintings (c. 535)
Plague devastates Europe (542–594)
Saint David converts Wales to Christianity (c. 550)
Origin of chess in India (c. 550)
Lombard kingdom established in northern Italy (568)
Birth of Muhammad c. 570 (d. 632)
Buddhism firmly established in Japan (c. 575)
Block printing of books in China (c. 600)
Iconoclastic Controversy between the Byzantine emperor and the pope (726)
Start of the First Crusade (1096)
Fall of Constantinople (Byzantium) to the Turks (1453)
Ivan IV (the Terrible) becomes tsar of Russia (1547)

Rublev, Old Testament Trinity

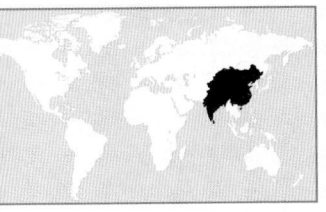

Developments in Buddhist Art
(1st–7th centuries A.D.)

Rock-Cut Architecture

Toward the end of the first millennium B.C., in the low cliffs of western India, there developed a new type of monastic architecture (see map). Mountainsides were chiseled out to create caves that were imitations of freestanding wooden buildings. Most were located near well-traveled trade routes. These caves are of two main types: living spaces for monks called **vihāras,** and large, basilica-like spaces for congregational worship focused on a stupa. The latter are called **chaitya** halls. Vihāras generally consist of small, windowless cells surrounding a broad room used by the monastic community for eating, recitation, studying, and other communal activities. From the fifth century A.D., vihāras often had small shrines opening off the main space (cf. fig. W4.6) that contained sculptures of the Buddha. Early Buddhist caves provide the only physical record of the appearance of the more perishable wooden structures on which they were modeled. There are approximately a thousand such Buddhist sanctuaries dating from the late second century B.C. to the mid-second century A.D. Some evidence indicates that the caves were furnished inside and out with wooden balconies, doors, rafters, and other architectural elements. The interior walls were decorated with mural paintings and tapestries, illuminated by oil lamps.

The most famous examples of rock-cut architecture in India are located in what is now the state of Maharashtra. In keeping with Buddhist practice, these monastic sites were removed from the center of town but were accessible to travelers as well as to local inhabitants. Inscriptions identify the caves' patrons as lay people, monks and nuns, and kings.

Chaitya halls were remarkably similar in both architectural design and religious purpose to later Christian basilicas. A comparison of the interior of the *chaitya* hall at Karli (figs. **W4.1** and **W4.2**), which dates from c. 50–70, with the basilica of Santa Sabina of 423–432 in Rome (fig. **W4.3**) highlights the similarities as well as the differences.

Both have a triple entrance and a long, central nave with a semicircular apse at the far end opposite the entrance. The apse is the most sacred area in the *chaitya* hall, as in the basilica. The nave of the *chaitya* hall is preceded by a shallow space, or **veranda,** which is similar to the narthex of the basilica. Framing the nave of each are

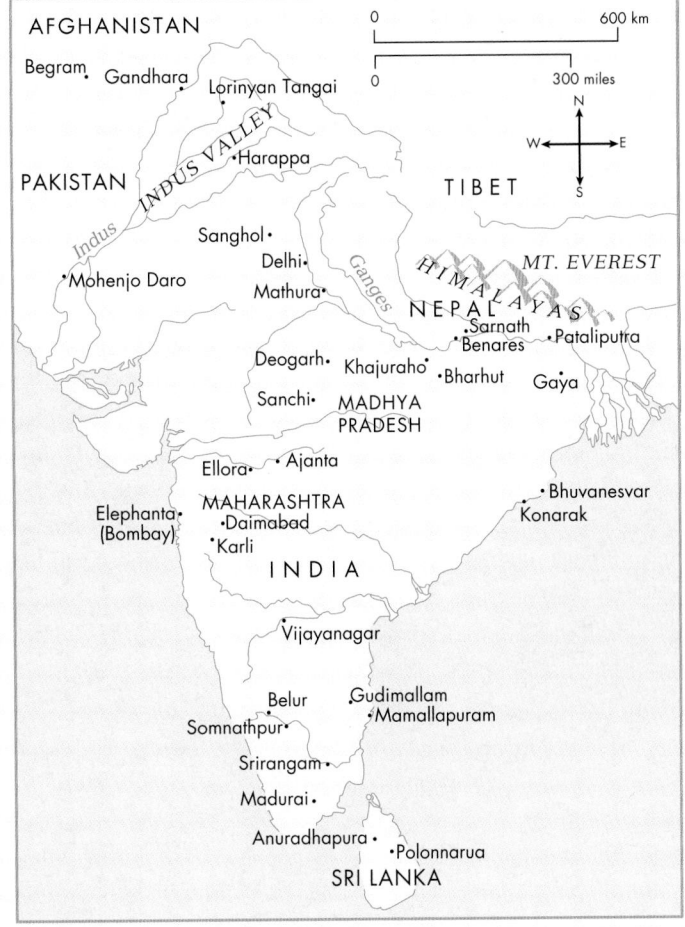

South Asia.

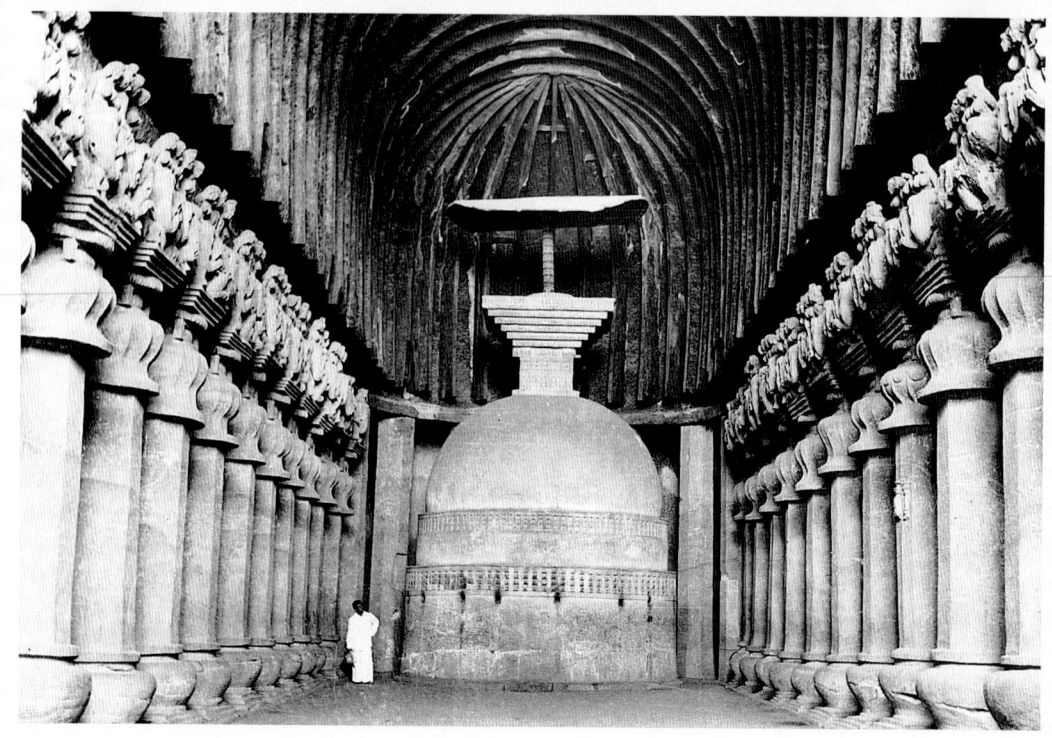

W4.1 *Chaitya* hall, Karli, Maharashtra, India, c. 50–70. Granite; nave 45 ft. (13.71 m) high. The term *chaitya* originally meant a mound or sacred place. It came to mean "place of worship" and was applied to the structure that housed a stupa—itself originally a hemispherical mound.

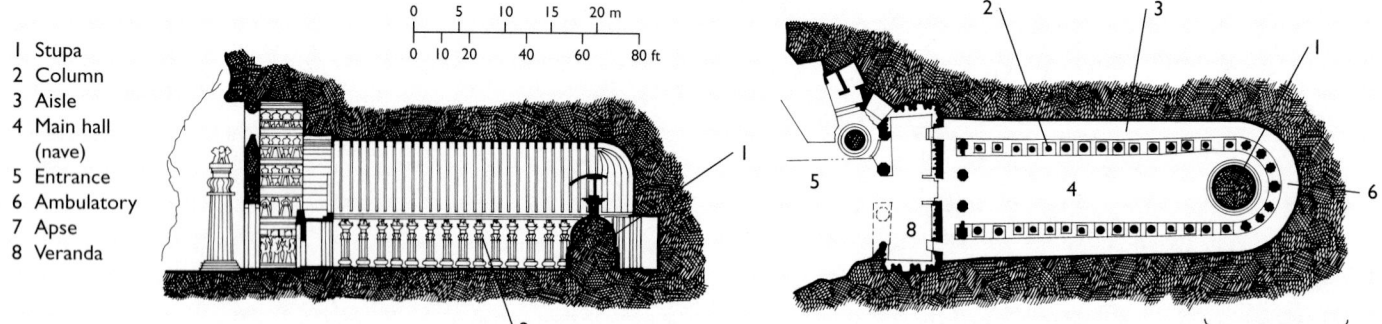

1 Stupa
2 Column
3 Aisle
4 Main hall (nave)
5 Entrance
6 Ambulatory
7 Apse
8 Veranda

W4.2 Plan and section of the *chaitya* hall, Karli, Maharashtra, India.

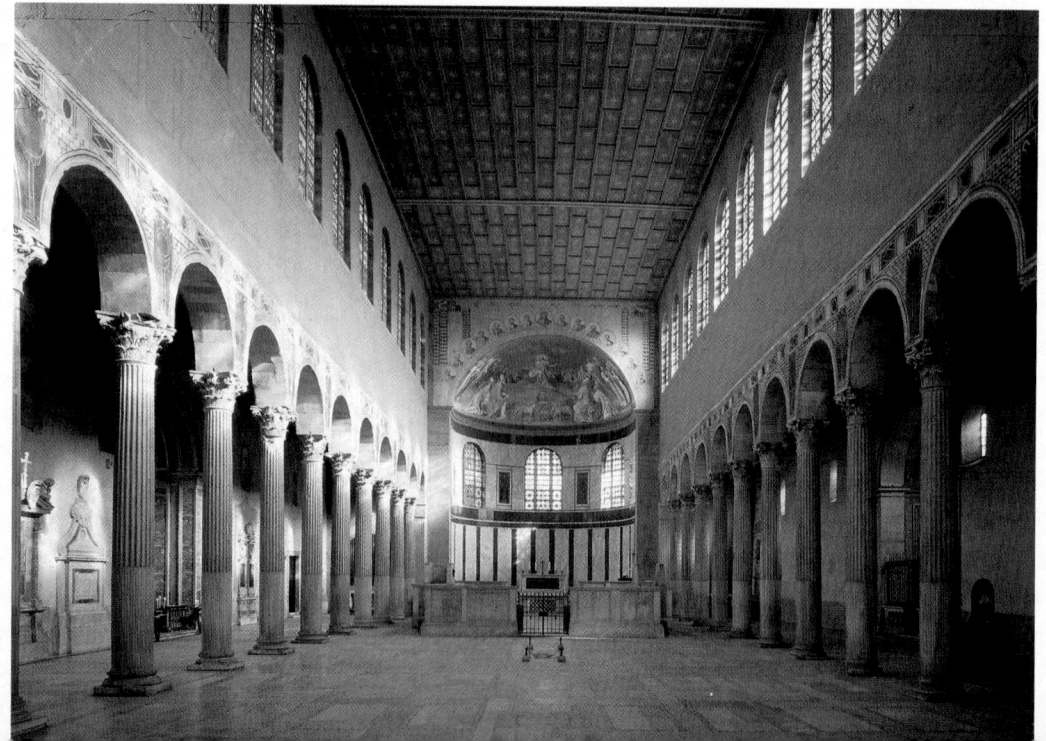

W4.3 Interior of Santa Sabina, Rome, 423–432.

rows of columns, which separate the nave from its side aisles. These, in turn, continue around the apse to form an ambulatory. By circumambulating the stupa (inside the apse of the *chaitya* hall), the Buddhist worshiper replicates the circular path of reincarnation in the quest for *nirvana*.

Often, remains or relics of a Christian saint were buried below the apse of the basilica in an underground **crypt.** Similarly, the apse of the *chaitya* hall contains a stupa (see p. 261), the funerary structure originally placed over the remains of Shakyamuni Buddha. And when worshipers enter the *chaitya* hall —as well as the basilica—they are drawn to the spiritual focal point by the formal arrangement of space and mass.

The *chaitya* hall differs from the basilica in several ways. Instead of a flat ceiling, that of the *chaitya* hall is barrel-vaulted. Its designation as "elephant-backed" reflects the association of the form with organic structure. The curved rafters visible in figure W4.1 are the original wooden elements used to replicate the prototype, rather than

to serve a structural purpose. The columns are thicker than those in Santa Sabina and are composed of a base (in the shape of a water jar), a thick shaft, and a capital, whose bell shape is similar to that on Emperor Ashoka's pillars (see p. 260). Above each bell capital at the Karli *chaitya* hall are two elephants and four riders facing the nave.

Aside from the capitals, there is no sculpture inside the *chaitya* hall at Karli. The veranda, however, is covered with large-scale reliefs; two of the most impressive flank the entrance (fig. **W4.4**). They show a royal **mithuna** (loving couple), whose style reflects an ideal of Indian sculpture that would continue for another nine centuries. Although they are made more monumental by the compact space they inhabit, their poses and gestures are casual and relaxed. The woman stands with her left leg bent behind her right, assuming the sensuous *tribhaṅga* (three-bends pose) of the Sanchi *Yakshī* (see fig. W3.13). Both the man and the woman convey the impression of specific people, possibly donors.

Gupta Sculpture

The Gupta Empire, which flourished in the fourth and fifth centuries, dominated the Ganges Valley and extended into the west and south. Its rulers encouraged developments in art and literature that lasted well beyond the period of their political sway. Though the Guptas were proponents of Hinduism, their patronage of the arts fostered the expansion of Buddhist art as well.

A Gupta figure of the *Preaching Buddha* from Sarnath in northern India (fig. **W4.5**) exemplifies a new type of Buddha image that emerged in the late fifth century. Its iconography reflects the evolution of a canon for depictions of Buddhist figures and is a particularly successful synthesis of iconic and narrative imagery. The figure is severe and still. The eyelids are

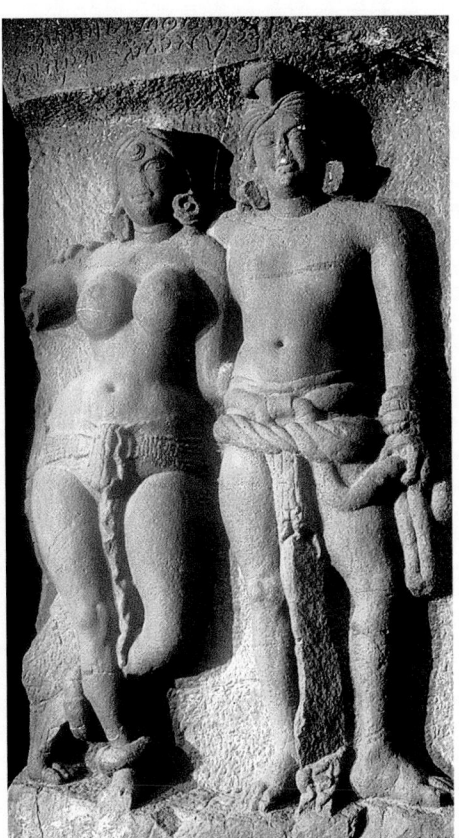

W4.4 (left) *Mithuna* from the façade of the *chaitya* hall, Karli, Maharashtra, India, c. 50–70.

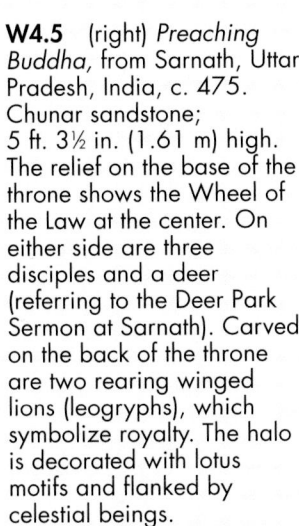

W4.5 (right) *Preaching Buddha*, from Sarnath, Uttar Pradesh, India, c. 475. Chunar sandstone; 5 ft. 3½ in. (1.61 m) high. The relief on the base of the throne shows the Wheel of the Law at the center. On either side are three disciples and a deer (referring to the Deer Park Sermon at Sarnath). Carved on the back of the throne are two rearing winged lions (leogryphs), which symbolize royalty. The halo is decorated with lotus motifs and flanked by celestial beings.

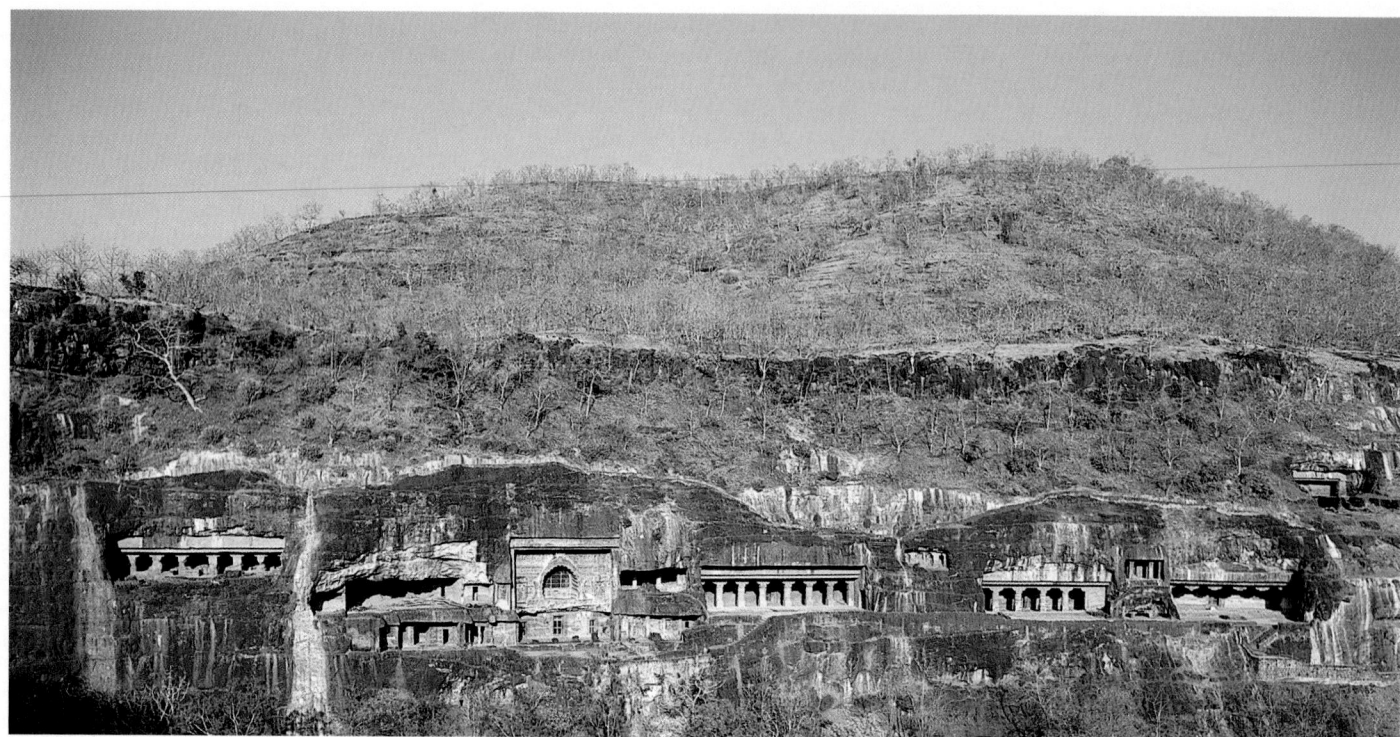

W4.6 The Ajanta Caves, Maharashtra, India, c. 450–500.

lowered, and the legs are folded into a yogic meditation pose. The hands in *Dharmachakra mudrā* symbolize the setting in motion of the Wheel of the Law. In addition to the *ushnīsha, ūrnā,* and elongated earlobes (see p. 263) that were already part of the Buddha's iconography in the Kushan period, the Sarnath figure has many elements that evolved later. These include features drawn from nature such as the snail-shell curls, eyebrows "like an archer's bow," and shoulders "like an elephant's trunk." Another canonical detail is the three rings on the neck. In the indigenous tradition of the *prana*-filled nude male torso from Harappa (see fig. W3.5) and the *Standing Buddha* from Gandhara (see fig. W3.14), this figure radiates a sense of inner energy.

The Ajanta Caves

(late 5th century A.D.)

The artistic legacy of the Gupta dynasty is evident in the spectacular Buddhist monastic site at Ajanta (figs. **W4.6** and **W4.7**). Ajanta is southwest of Sanchi and northeast of Bombay,

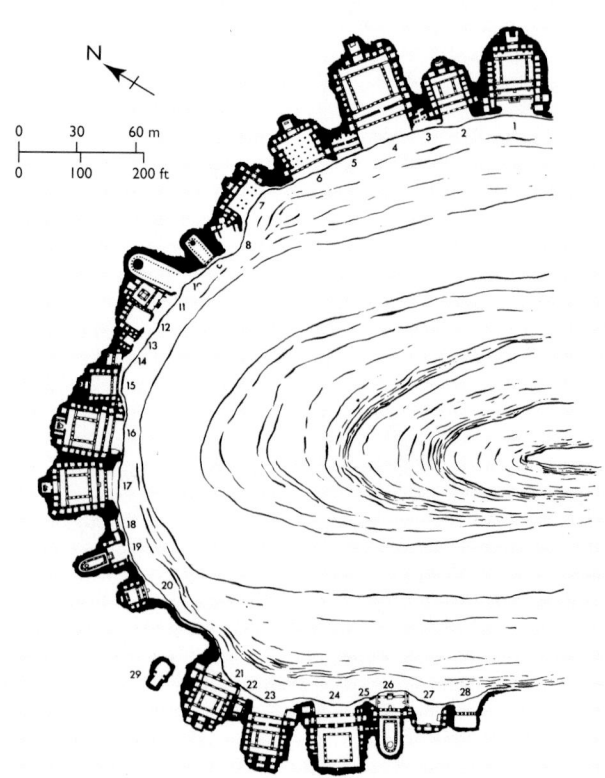

W4.7 Plan of the Ajanta Cave complex, Maharashtra, India, c. 450–500.

close to a strategic mountain pass connecting northern and southern India (see map, p. 305). Altogether there are thirty caves cut into a U-shaped river gorge, out of which *chaitya* halls and *vihāras* were carved in two phases. The earliest dates from the first century B.C. to the first century A.D., and the rest from the second half of the fifth century, when the region was ruled by the Vakataka dynasty.

The two later *chaitya* halls at Ajanta are more elaborate than the earlier one at Karli. The entrance to the *chaitya* hall in Cave 19 (fig. **W4.8**) is particularly well preserved. The view illustrated here shows the large lunette-shaped **chaitya arch** window through which light illuminates the cave and hits the stupa. Compared with the interior of the *chaitya* hall at Karli, much more sculpture and certain architectural features—such as the thick columns with "squashed cushion" capitals supporting a cornice and an upper row of carved reliefs—have been added

> ## Indian Mural Painting
>
> Recent microscopic analysis of the Ajanta murals shows that cave walls were covered with three layers of plaster. The final layer was tinted or painted to create a white ground for the paintings. The paint itself is a kind of tempera, which was probably made by mixing powdered mineral pigments with a gluey binder. Outlines were drawn in reddish brown, and forms were filled in with paint. Blue was rarely used, suggesting that its source was an expensive, imported mineral, perhaps lapis lazuli. Black pigment is thought to have been made from soot.
>
> In addition to texts detailing artistic practice, one of the early sources of information on painting technique in India is the Gupta-period commentary on the *Kamasutra*, a Hindu treatise on the art of love. This describes the language of pose and gesture, the expression of mood and feeling, and the rendering of objects three-dimensionally.

(fig. **W4.9**). The walls are covered with small-scale, repeated painted images of enthroned buddhas with their attendant bodhisattvas.

The stupa is also decorated with reliefs, and its proportions have grown taller and thinner. A monumental statue of Shakyamuni Buddha stands in a niche framed by pillars supporting a *chaitya* arch. Both the axis pillar and *chattras* have become more complex.

Some of the greatest examples of monumental Indian painting survive in four of the Ajanta *vihāras* (see box). Secular paintings from this period are mentioned in texts, but they have not survived. The Ajanta frescoes, like the San Vitale mosaics at Ravenna,

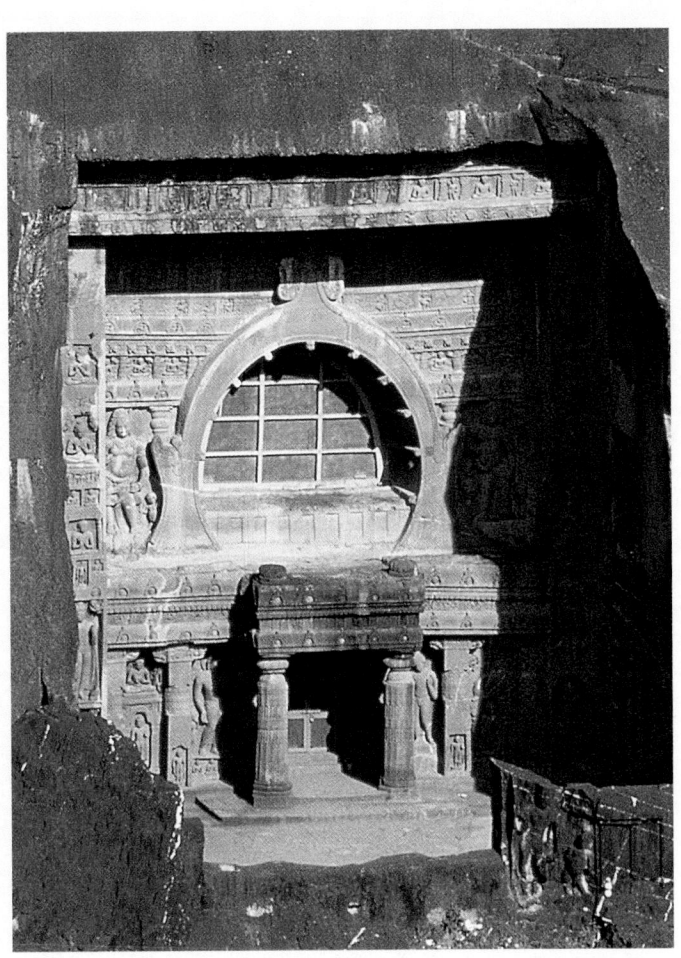

W4.8 *Chaitya* hall entrance, Ajanta Cave 19, Maharashtra, India, c. 450–500.

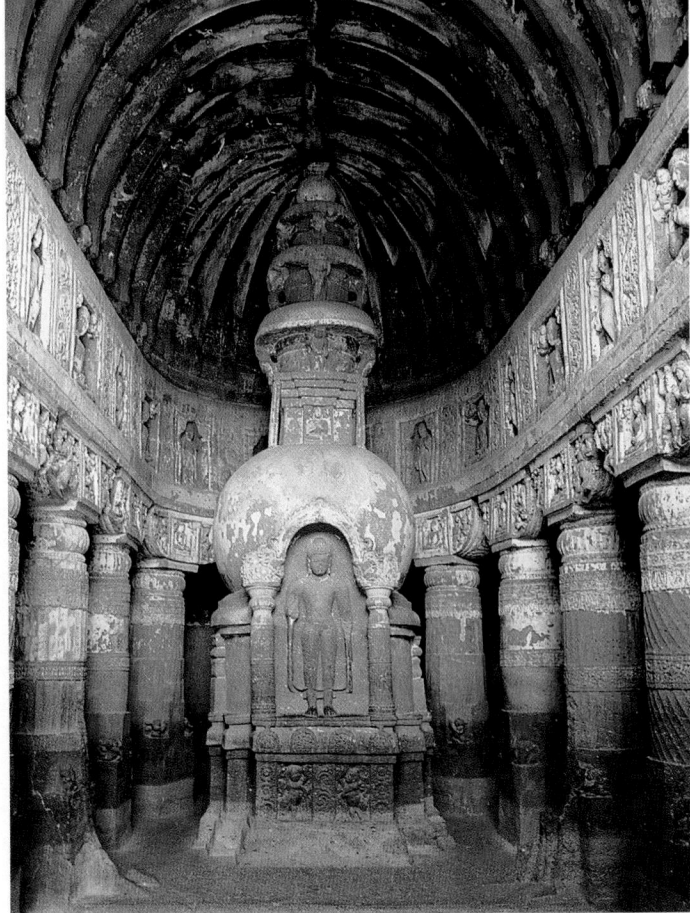

W4.9 *Chaitya* hall interior, Ajanta Cave 19, Maharashtra, India, c. 450–500.

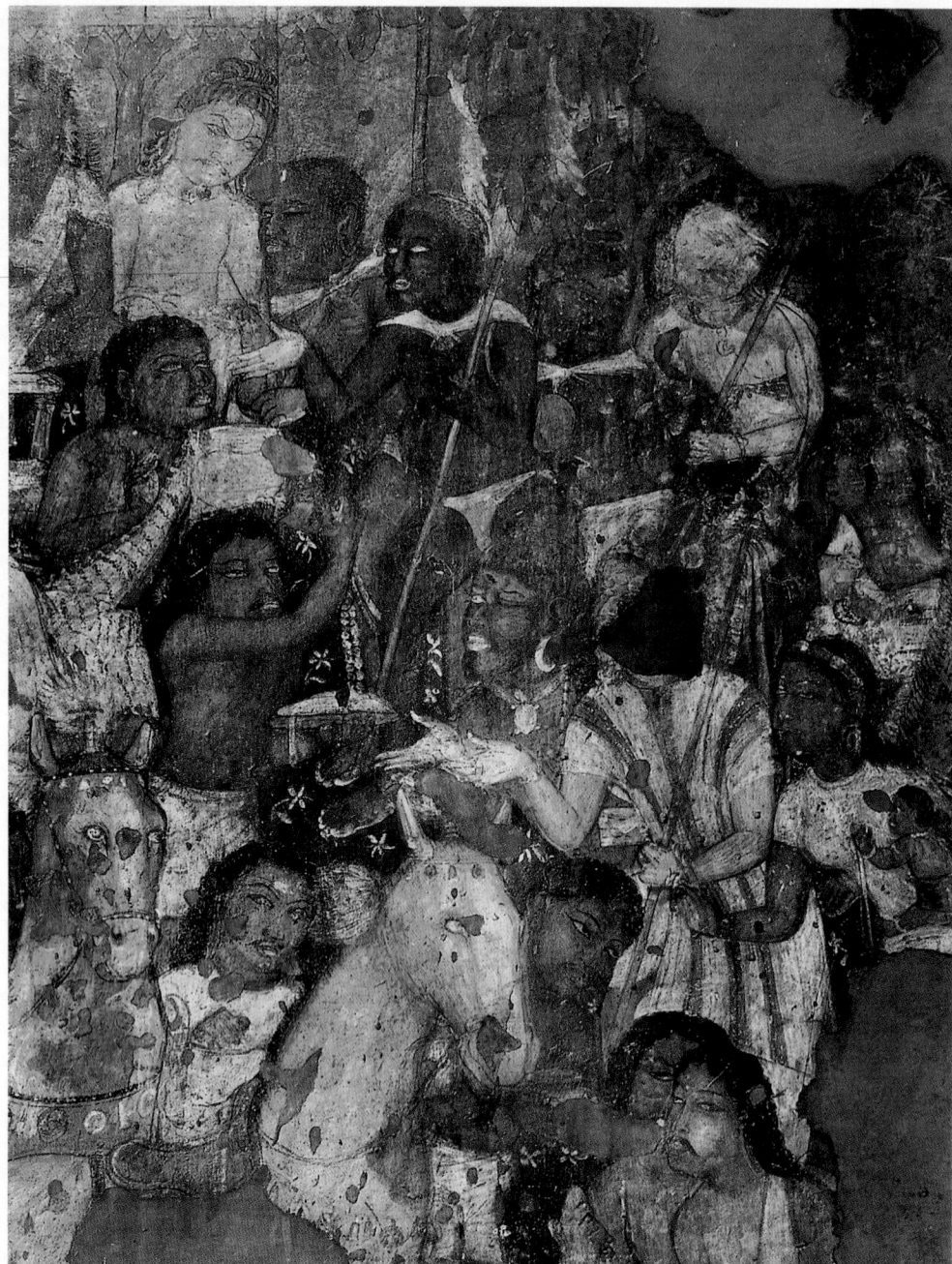

W4.10 *Prince Distributing Alms,* Ajanta Cave 17, Maharashtra, India, c. 450–500.

constitute monumental religious programs with political significance. Their use of rich color and displays of opulence were intended to align political power with religious devotion. The large scene showing a *Prince Distributing Alms* (fig. **W4.10**) illustrates this combination. Despite the generosity of the prince, motivated as it is by his piety, his elaborate entourage, including horses and guards, as well as his rich attire express his love of worldly splendor and his ability to command it.

The famous *Padmapani,* or "Lotus Bearer" (from *padma,* meaning "lotus," and *pani,* meaning "hand"), is one of a pair flanking the entrance to the shrine at the rear of the *vihāra* in Cave 1 (fig. **W4.11**). The head reveals the sensuous naturalism of Indian art also evident in the *Yakshī* at Sanchi (see fig. W3.13). The *Padmapani* in the *tribhaṅga* pose, regally attired and attending the Buddha, is primarily a great emperor serving an even greater lord.

The imposing figure of the *Padmapani* reflects the continuing Indian interest in naturalism, which can be seen in the use of shading to convey organic form—for example, the underside of the chin, the curves of the shoulder and neck, and the natural depressions of the face. In contrast to the Byzantine depiction of spirituality conveyed by flat, vertical planes, frontality, and iconic confrontation with the worshiper, the Ajanta murals convey it by an inner, meditative tranquility.

Even in a devotional scene, such as the *Worship of the Buddha* (fig. **W4.12**) from a pillar in Ajanta Cave 10, the figures turn as if in three-dimensional space. The sense of a natural setting is suggested by the floral designs and the fact that the Buddha's throne is at an oblique angle. Although the halo is flat, the head is rendered in three-quarter view.

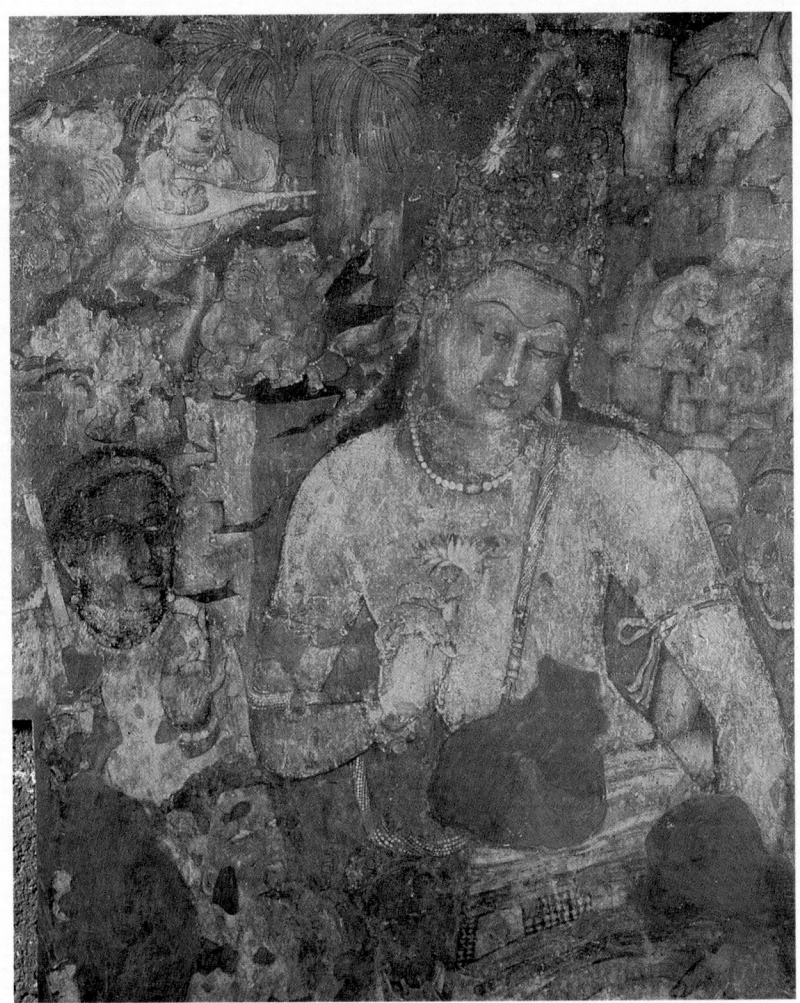

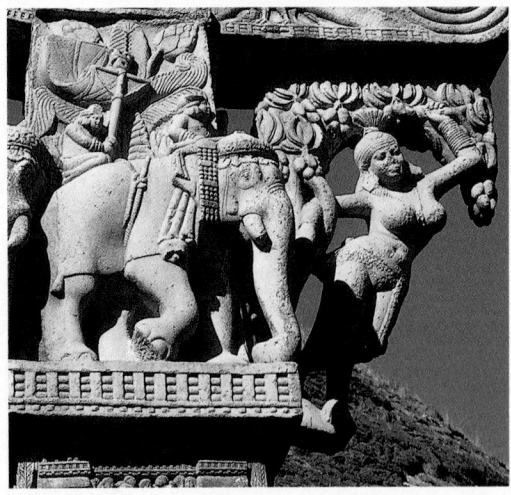

See fig. W3.13 *Yakshī*—to the right of the elephant—from the east *toraṇa* at Sanchi, Shunga and early Andhra periods, 1st century B.C.

W4.11 *Padmapani,* Ajanta Cave 1, Maharashtra, India, c. 450–500.

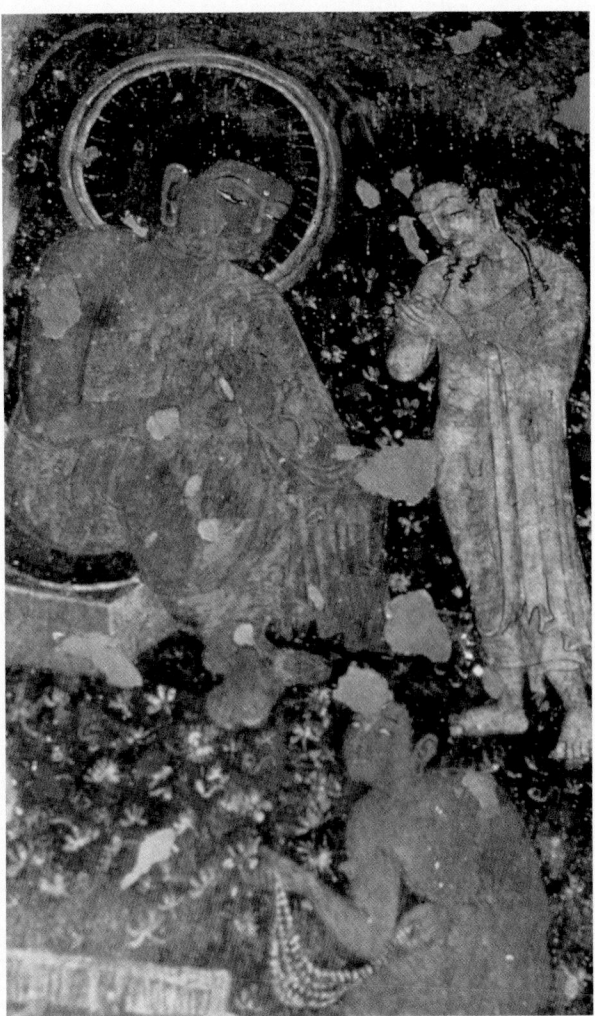

W4.12 *Worship of the Buddha,* from Ajanta Cave 10, Maharashtra, India, c. 450–500. Photo: Robert E. Fisher.

Buddhist Expansion in China

(2nd–7th centuries A.D.)

Buddhism declined in India, where it would become nearly extinct by the thirteenth century. This was due partly to a revival of Vedic religion, which has a complex association with the development of Hinduism. But Buddhism spread throughout much of the rest of Asia, where it has remained a dominant cultural force. It was transmitted along the Silk Roads throughout central Asia to China (see map) in about the first century A.D. and gained a foothold during the Han dynasty (c. 206 B.C.–A.D. 220). Beginning in the second century A.D., Buddhist texts (sutras) were translated from their original Indian languages, Sanskrit and Pali, into Chinese. Only then was Buddhism recognized in China as a school of thought distinct from Daoism. Over the next few centuries, Buddhism brought with it new artistic techniques and styles from central Asia, India, Iran, and the Mediterranean world. The eclectic nature of Chinese art at this time reflects the continuing exchange of goods and ideas. Contemporary accounts, particularly those of Buddhist pilgrims, vividly describe what the travelers saw.

By the fifth century A.D., under the Northern Wei dynasty (386–535), Buddhist art flourished in China. The early Wei rulers were originally from central Asia, and, to consolidate their position in China, they promoted Daoism and Buddhism rather than Confucianism, the established state doctrine. Like Ashoka and Constantine, the Wei presided over monumental building projects, using religion and religious art in the service of political power.

Their first great artistic program was at Yungang, in Shaanxi Province. Caves were cut into the cliffs and colossal statues carved from the existing rock (fig. **W4.13**). At Yungang, the influence of hundreds of central Asian Buddhist caves—themselves based on Indian *vihāras* and *chaitya* halls—is clear. The monumental stone Buddhas carved from these sandstone cliffs also show traces of the Gandharan style.

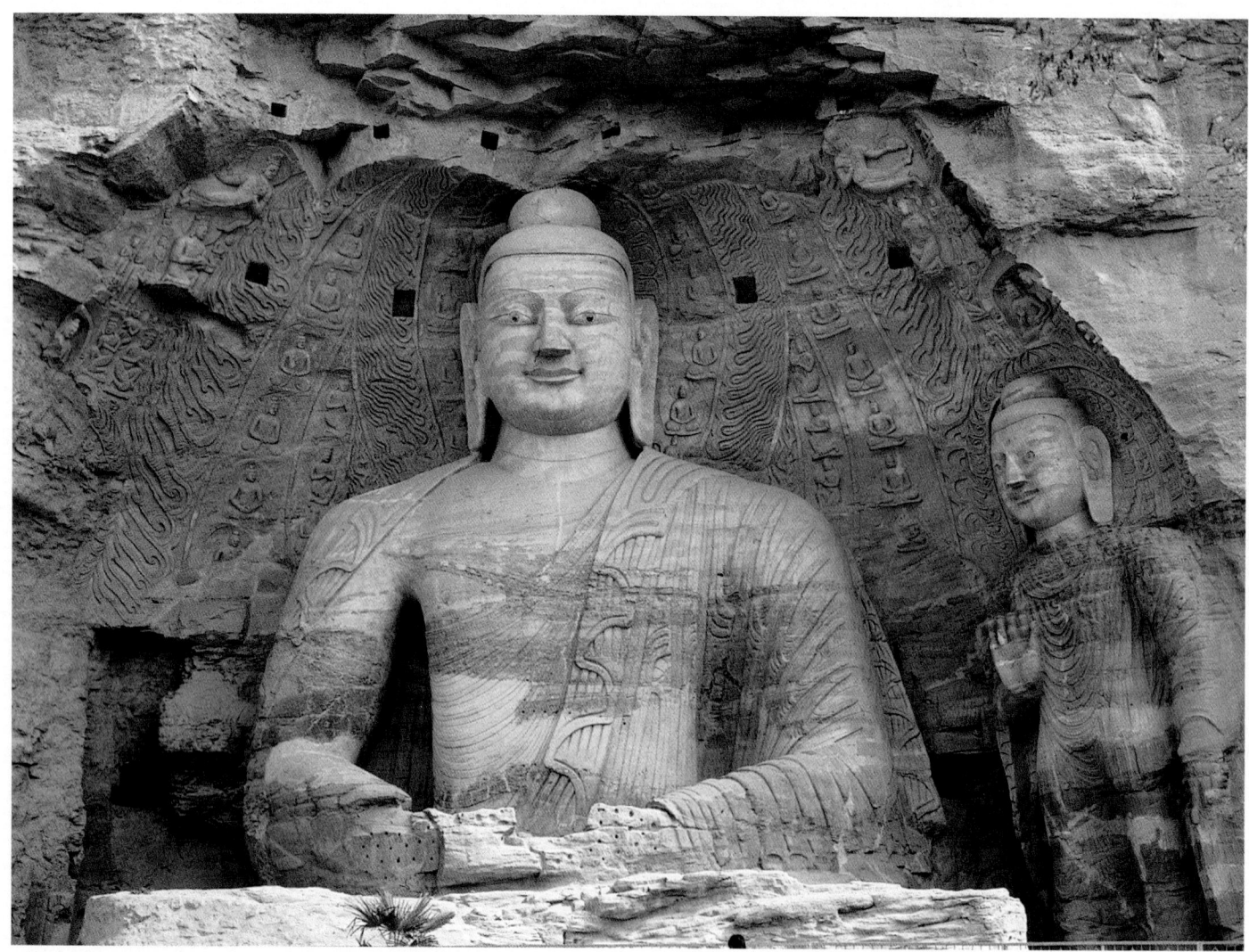

W4.13 Colossal Buddha, from Cave 20, Yungang, Shaanxi Province, China, c. 460–490. 45 ft. (13.71 m) high. For over thirty years, thousands of stoneworkers created such sculptures and carved out cave temples and cells in the Yungang cliffs. The project was proposed to the Wei rulers in 460 by the monk Tanyao.

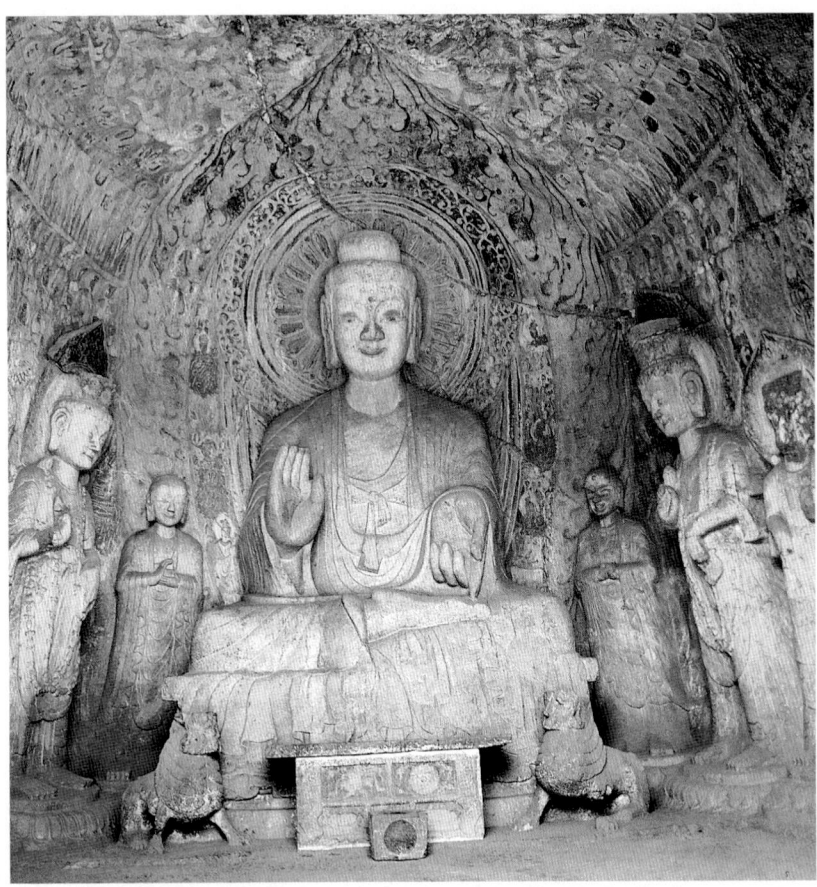

W4.14 *Buddha with Disciples,* from the Pinyang Cave, Longmen, Hunan Province, China, early 6th century.

The Buddha in figure W4.13 bears some resemblance to Gandharan sculpture, particularly in the smooth hair and flowing drapery that covers both shoulders. But the Yungang Buddha is psychologically more remote. All trace of Indian sensuousness has disappeared. The figure retains canonical features such as the *ushnīsha,* elongated earlobes, and monk's robe, but the drapery folds are flatter and more stylized. The combination of the figure's colossal size and impassive gaze seems to elevate this Buddha to a spiritual plane that is beyond human time and place.

In 494, the Wei rulers moved their court southward to Luoyang. There they encountered a different form of Buddhism practiced by the native (Han) Chinese, which offered relief from the cycle of reincarnation through a less difficult route to *nirvana.* Groups known as Paradise Sects promised enlightenment in a resplendent paradise, attainable by anyone through faith, rather

than exclusively through the rigors of monastic life. As in India, the popularity of Shakyamuni Buddha was rivaled by that of buddhas of the Past and Future. The cults of Maitreya and Amitabha, buddhas of the Future, invited believers to be reborn in paradise. These theological changes are noticeable in Buddhist art: for example, some images of Shakyamuni Buddha now appear to relate actively to worshipers. In addition, the number of representations of such buddhas as Maitreya, Amitabha, and Vairochana (the supreme cosmic Buddha) has increased.

When the Wei moved south, they took up a second major artistic program in the caves at Longmen. There the *Buddha with Disciples* (fig. **W4.14**) from the Pinyang Cave is the focal rock-cut image inside the inner chapel. Shakyamuni sits cross-legged on a platform 19 feet (5.79 m) wide. His throne is guarded by the lions of royalty, and he is flanked by disciples. He no longer

bows his head and lowers his eyelids to convey a state of inward meditation. Instead, in accordance with the Lotus Sutra (one of the canonical Buddhist texts) he gazes at worshipers, communicating directly with them. This active connection is reinforced by his enlarged hands: the right is held up in *abhaya mudrā* (the "have no fear" gesture), and the left points downward in *bhumisparsha mudrā* ("calling the earth to witness"). The figure's proportions are more elongated than at Yungang.

Shakyamuni's robe is now a Chinese garment. Its cascading folds are stylized as waterfalls and fishtails. In contrast to the relatively three-dimensional treatment of drapery at Yungang, this Buddha's robe is flatter and more linear; it is composed of repeated patterns. Such stylistic differences reflect the assimilation of foreign models into a more purely Chinese style. Similarly, the Longmen Buddha's full-cheeked, square-jawed facial type, with its almond-shaped eyes and smiling,

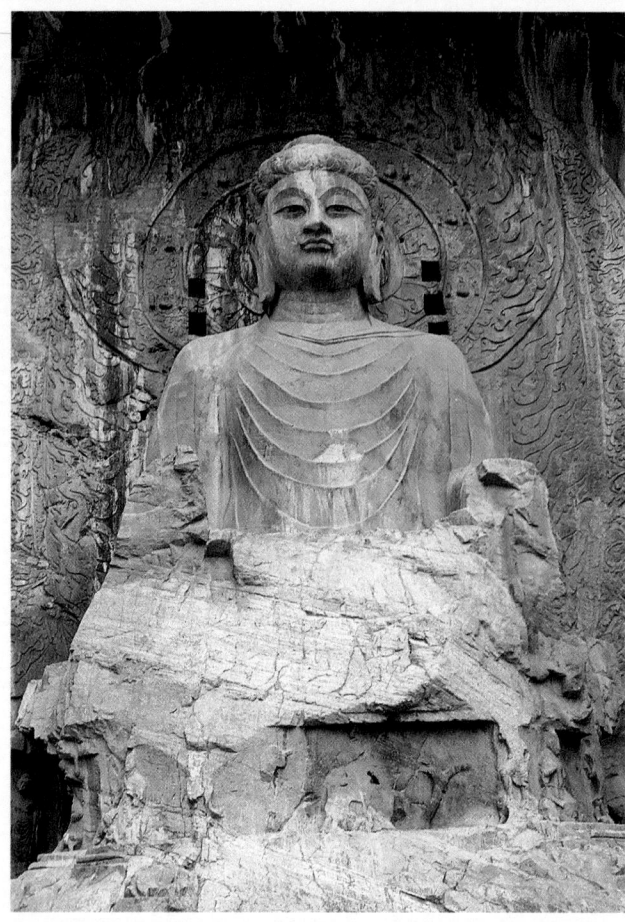

W4.15 *Vairochana Buddha,* Longmen Caves, Hunan Province, China, 672–675. Natural rock; approx. 49 ft. (14.93 m) high.

rosebud mouth, is distinctively Chinese. The flat, elaborately carved mandorla that surrounds the throne is filled with flames symbolizing the light of the Buddha's spirit.

The best example of the Longmen style was created under the Tang Dynasty (618–906), when China was again united and the arts flourished. As Buddhism developed in Tang China, the belief that buddhahood could be attained in this world grew in importance. Mystical rituals were intended to connect the earthly, material world with the formless, absolute world and to guide individuals along the path to spiritual awareness.

Figure **W4.15** depicts *Vairochana Buddha,* the embodiment of Shakyamuni's spiritual nature and the most popular of the Five Great Buddhas of Wisdom. The figure's colossal size and simply rendered form enhance the Buddha's otherworldly quality. The original lotus throne, which has been lost, was conceived of as having one thousand petals, each corresponding to a single Buddhist cosmos with one hundred million Buddhist worlds. Vairochana (meaning "Resplendent") personifies the creativity of Buddhist *Dharma* and the Buddhist view of the universe. In one tradition—Huayen—Vairochana is the Universal Buddha. By association with him, China's emperors legitimized their claim to power.

Style/Period	Works of Art	Cultural/Historical Developments

750 B.C.

0

A.D. 700

BUDDHIST
8th–1st centuries B.C.

Chaitya hall

Ajanta Caves

BUDDHIST
1st–7th centuries A.D.

Worship of the Buddha

Chaitya hall (**W4.1**),
 Karli
Mithuna (**W4.4**),
 Karli
Santa Sabina (**W4.3**), Rome
Ajanta Caves (**W4.6–W4.12**), Maharashtra
Colossal Buddha (**W4.13**), Yungang
Preaching Buddha (**W4.5**),
 Sarnath
Buddha with Disciples
 (**W4.14**), Longmen
Vairochana Buddha
 (**W4.15**), Longmen
 Caves

Colossal Buddha

Legendary founding of Rome by Romulus
 (c. 753 B.C.)
Birth of Siddhartha Gautama, founder of Buddhism,
 in Nepal c. 563 B.C. (d. 483 B.C.)
Birth of Confucius, Chinese philosopher c. 551 B.C.
 (d. 479 B.C.)
Beginning of Iron Age in China
 (c. 500 B.C.)
Age of Perikles in Athens
 (458–429 B.C.)

Crucifixion of Jesus outside
 Jerusalem (c. A.D. 33)
Galla Placidia erects
 mausoleum at Ravenna
 (c. 425)
End of Western Roman
 Empire (476)
 Building of Hagia Sophia, Constantinople
 (532–537)
 Birth of Muhammad, founder of Islam
 (c. 570)

Preaching Buddha

CHAPTER PREVIEWS

EARLY MIDDLE AGES, 5th–10th CENTURIES

Islam: birth of Muhammad in Mecca (c. 570)
 Islamic conquests (7th–8th centuries)
 Mosques; the Koran; calligraphy; Dome of the Rock
Northern Europe: Anglo-Saxon metalwork
 Vikings (c. 800–1000): metalwork; rune stones; picture stones;
 Norse gods; *Beowulf*
 Denmark becomes Christian (965)
 Ireland: illuminated manuscripts; stone crosses; becomes
 Christian (5th century)
Carolingian Europe: Charlemagne crowned Holy Roman emperor in
 Rome (800); Palace Chapel; monastic rule
Ottonian Europe (10th–11th centuries): Saint Michael's at
 Hildesheim; Gospel book of Otto III

Mesoamerica and the Andes, 1500 B.C.–A.D. 1500
 Olmec (c. 1200–900 B.C.): colossal stone heads
 Teotihuacán (c. A.D. 350–650): pyramids; *talud-tablero*
 Maya (c. 1100 B.C.–A.D. 1500): calendars; ball game; *Popul Vuh;*
 Bonampak murals; Chichén Itzá
 Aztec Empire (c. 1300–1525)
 The Andes (c. 2500 B.C.–A.D. 500): Chavín; Paracas; Nazca; Moche;
 Tiwanaku; Wari
 Inka Empire (c. 1438–1522): Machu Picchu

ROMANESQUE, 10th CENTURY–c. 1150

Feudalism; pilgrimage roads; Crusades; relics and reliquaries; *Song
 of Roland*
Sainte-Foy (Conques); Saint-Pierre (Moissac); Saint-Lazare (Autun);
 Pisa
Rib vaults; barrel vaults; groin vaults
Stavelot Triptych; manuscripts
Stave church (Norway); stone interlace
Bayeux "Tapestry"; Battle of Hastings (1066); Norman conquest of
 Britain
Precursors of Gothic: Caen; Durham

GOTHIC, 1147–13th/14th CENTURIES

Abbot Suger, *Book of Suger;* age of cathedrals
Pointed arches; rib vaults; stained glass; flying buttresses
French cathedrals: Chartres; Amiens; Reims
Guilds; Magna Carta (1215); Scholasticism
Sainte-Chapelle; Canterbury; Thomas à Becket
Chaucer, *Canterbury Tales;* Salisbury Cathedral
Spread of Gothic in Europe
19th-century Neo-Gothic
 Saint Patrick's Cathedral, New York

Buddhism and Hinduism in East and South Asia, 6th–13th Centuries
 Paradise sects; pagodas; Horyu-ji; Hinduism; Hindu temples, Angkor Wat and
 Angkor Thom

RENAISSANCE PRECURSORS, 13th–14th CENTURIES

Humanist movement; Petrarch; Boccaccio
Artists: Pisano; Cimabue; Giotto; Duccio; Ambrogio Lorenzetti;
 Orcagna; Simone Martini; Sluter; Limbourg brothers
Dante, *Divine Comedy;* Saint Francis of Assisi
Bubonic plague (Black Death) (1348)
Hundred Years' War (1337–1453)
International Gothic Style

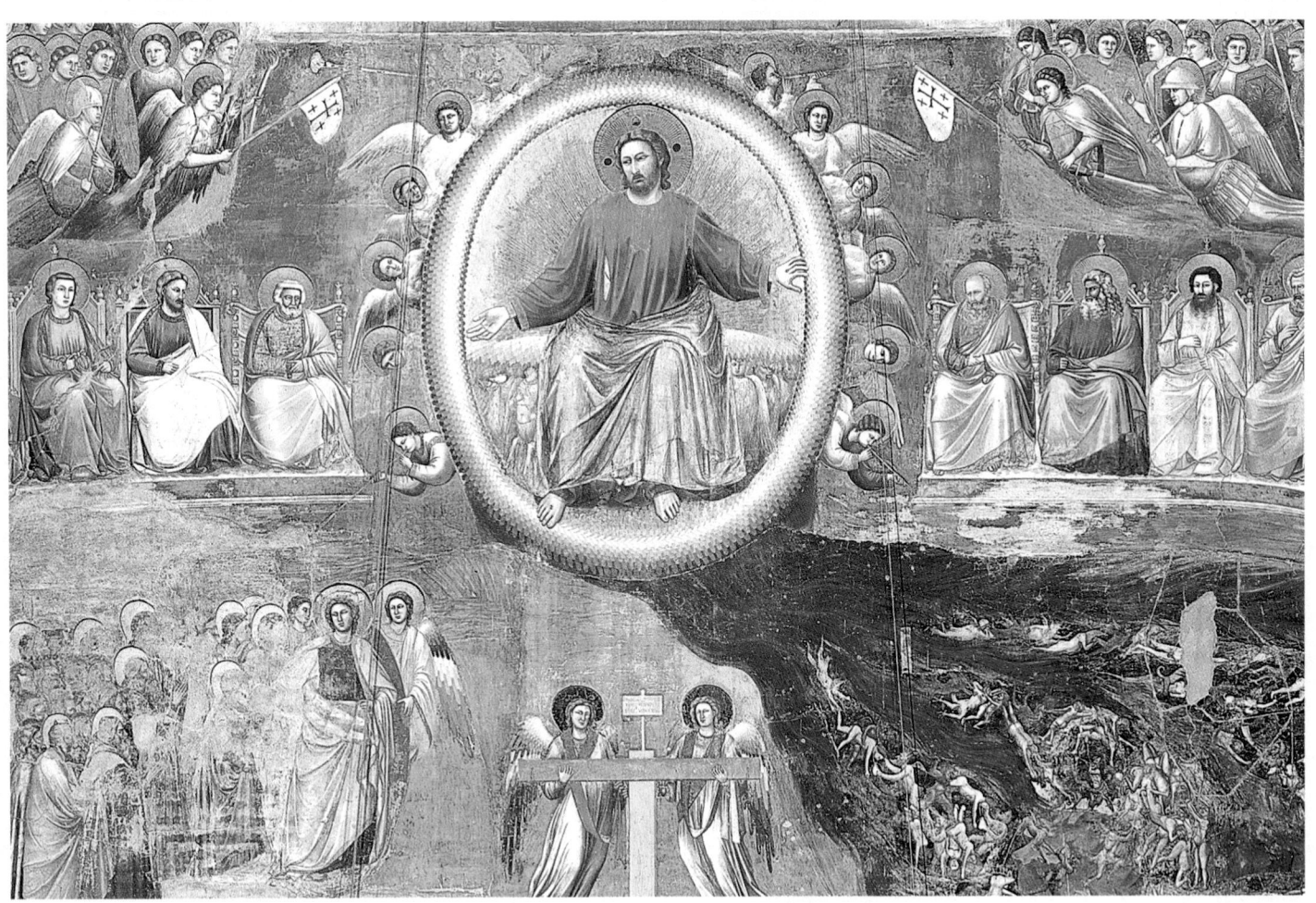

By the Early Middle Ages, Christianity had become the prevailing religion of western Europe, and works of art were commissioned mainly for churches and Christian rulers. But following the rise of Islam in the early seventh century and subsequent Muslim conquests, Islamic art and architecture flourished in Spain until 1492 and influenced certain design patterns elsewhere in Europe. Invasions from the Viking north also introduced new art forms to the Continent.

In architecture, the crowning achievement of the European Middle Ages was the cathedral, with its soaring towers and imposing presence dominating medieval towns. As the Middle Age waned and a new interest in nature and naturalism emerged, Italian authors and artists began studying ancient Greek and Roman art and Greek and Latin texts. This launched the humanist movement, which coincided with the artistic revival called the Renaissance ("rebirth").

In the Far East, Buddhism and Hinduism persisted as major religions, influencing the creation of temples, monasteries, sculptures, and paintings. A synthesis of these two religions inspired the temple complex at Angkor Wat and the colossal towers of the Bayon at Angkor Thom.

In Mesoamerica, a relatively isolated area, several civilizations rose and fell from 1500 B.C. to A.D. 1500. The Aztec and the Inka in particular entered Western consciousness with the Spanish conquests of the sixteenth century.

9

The Early Middle Ages

In western Europe, the term *Middle Ages* generally designates the period following the decline of the Roman Empire through the thirteenth or fourteenth century. *Early Middle Ages,* as used here, covers the period roughly from the seventh to around the end of the tenth century.

As the Roman Empire declined, the Goths invaded much of western Europe and the Visigoths sacked Rome in 410. This hastened the collapse of the Roman imperial hierarchy as well as of Rome's control of its vast territory. In the early eighth century, Moors (from the Roman province of Mauretania in northwest Africa) conquered Spain, which had also been part of the Roman Empire. The Moors brought with them the new religion of Islam, to which they had been converted in the seventh century by Arab conquerors. Islam grew into a powerful force in parts of Europe, particularly in Spain. It flourished until the thirteenth century, when Christian armies reclaimed the Moorish strongholds—the *Reconquista,* or "Reconquest." The last of these was Granada, which fell in 1492, the year that Columbus sailed from Spain in search of a western route to India.

The expansion of Islam, 622–c. 750.

Islam

One of the world's great religions, Islam literally means "surrender [to God]." It was founded by the prophet Muhammad, who was born in Mecca, in western Arabia, around 570. He and his followers fled to the more hospitable neighboring city of Medina in 622, a watershed event called the *Hijra* that marks the starting point of the Islamic calendar. Within two years of Muhammad's death in 632, his successor, the first caliph (ruler) united Arabia under the new faith. Over the next twenty years, Islamic armies conquered large portions of the Byzantine Empire and the Middle East (see map). Controversy over the succession to the caliphate caused a political and religious schism in 661 that persists today. Islam is thus divided into two main sects: Sunni Muslims and Shiite Muslims. As a result of aggressive campaigns of conquest and conversion, a century after its founding Islam stretched from Afghanistan in the east to Portugal, Spain, and southwestern France in the west, where it rivaled Christianity.

Islam carries a relatively simple and straightforward message: the unity of the community of Muslims ("those who surrender") and their equality before Allah (God), who is single and absolute, and whose ultimate prophet was Muhammad. The holy book of Islam, the Koran (Qur'an), is believed to be the word of Allah as revealed to Muhammad in a series of visions. Another text, the Hadith, is a later compilation of traditions. Together, the Koran and the Hadith form the basis of Islamic belief and law. The Five Pillars of the faith are (1) the affirmation that there is no God but Allah and that Muhammad is his messenger; (2) ritual prayer facing the direction of Mecca five times a day; (3) almsgiving; (4) fasting and abstinence during the holy month of Ramadan; and (5) the *hadj,* an annual pilgrimage to Mecca that every devout Muslim strives to make at least once.

The most recent of the world's three monotheistic religions, Islam accepts Moses, Jesus, and others as prophets and forerunners of Muhammad. Like Judaism, Islam discourages the making of images that might be worshiped as idols. Muslim artists thus concentrated their creative energies on the development of nonfigurative forms, not only delighting the eye, but leading the mind to the contemplation of God. As a result, they excelled at calligraphy and geometric patterning.

The Dome of the Rock, Jerusalem

The earliest extant Islamic sanctuary is the Dome of the Rock in Jerusalem (fig. **9.1**). The structure encloses a rock outcropping that is sacred to Judaism and to Christianity as well as to Islam. Its exterior is faced with mosaics and marble. The building, which was inspired by round

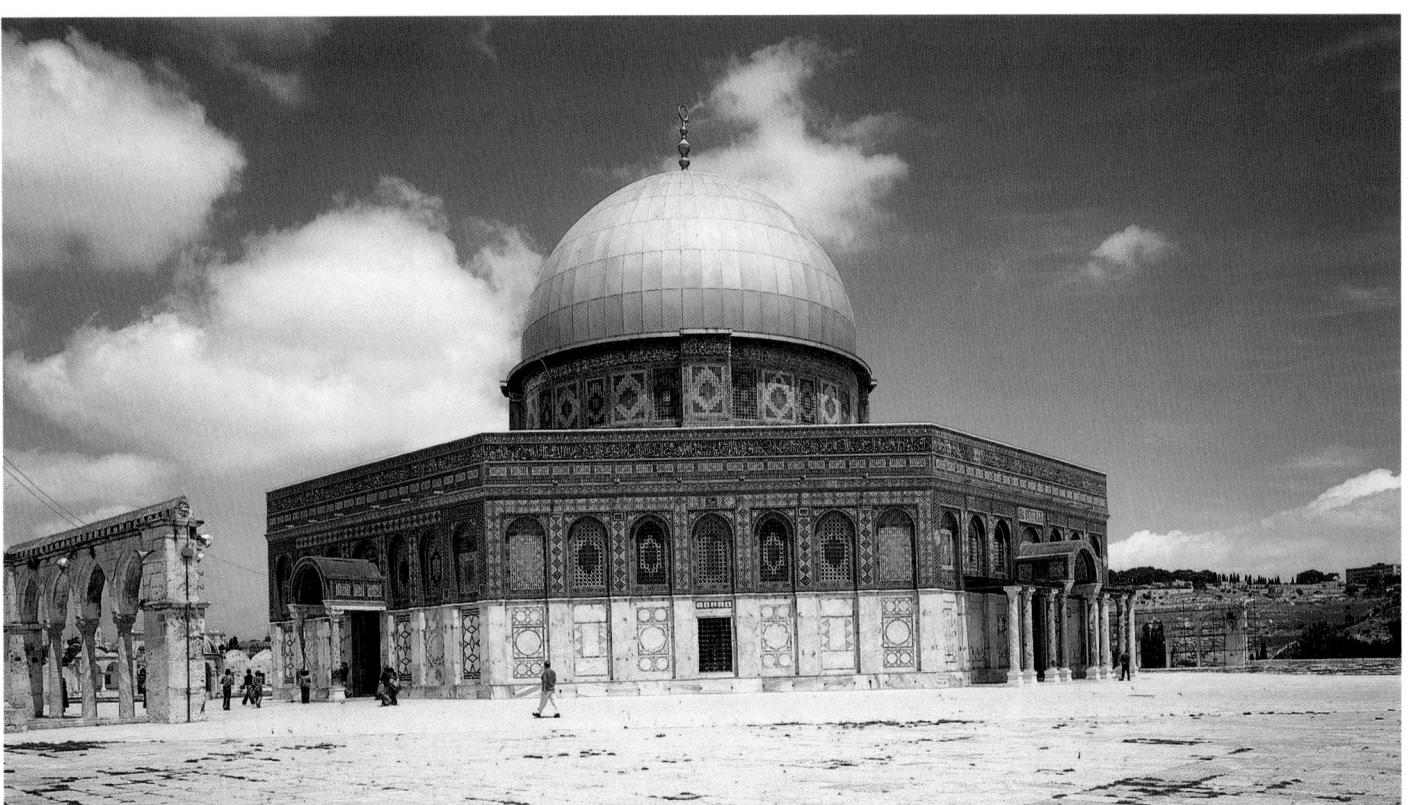

9.1 Dome of the Rock, Jerusalem, late 7th century. Also known as the Mosque of Omar, this was constructed on a 35-acre (14.16 ha) plateau in east Jerusalem. Muslims traditionally regard it as the site from which Gabriel led Muhammad through the heavenly spheres to Allah. Jews know the plateau as the Temple Mount—the location of Abraham's sacrifice of Isaac and of the first Jewish temple, built by King Solomon in the 10th century B.C.

Islamic Calligraphy

"Handwriting is jewelry fashioned by the hand from the pure gold of the intellect," wrote an early authority on Islamic calligraphy.[1]

Since the Koran was originally revealed to Muhammad in the Arabic language, Muslims must read and recite from it only in Arabic. This has meant that, as Islam spread, the Arabic language and Arabic script spread as well. Because of its close association with the sacred text, writing is the most honored art in the Islamic world. It is also the most characteristic, uniting the diverse and far-flung community of believers. Writing adorns not only books, but also ceramics, metalwork, textiles, and buildings (such as the interior of the dome in figure 9.13). A great many calligraphic styles have developed over the centuries.

There are two main groups of scripts: the earliest, Kufic—similar to Western printed letters and used today mainly for headings and formal inscriptions—and cursive, which evolved from the twelfth century on. Figure **9.2** illustrates a page from a ninth- or tenth-century manuscript of the Koran written in Kufic. It shows the Islamic interest in the linear complexity of texts as well as of designs. The abstract, linear rhythms of Islamic calligraphy lend themselves to a variety of visual effects, from the simple strength of early Kufic script to the intricacies of Sultan Suleyman's imperial emblem (fig. **9.3**).

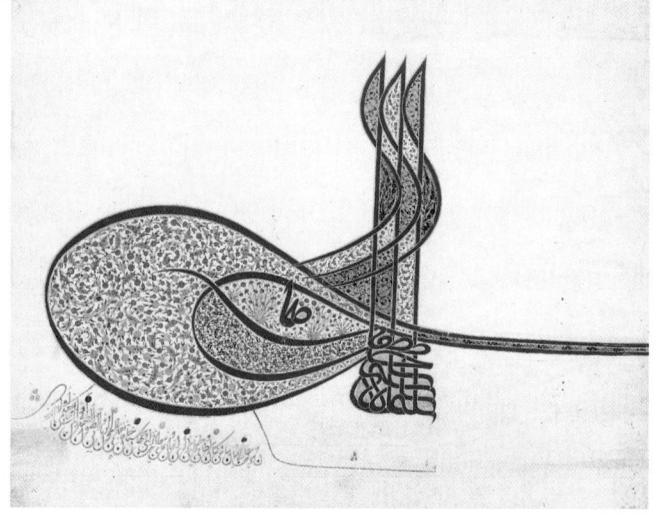

9.3 Illuminated *tugra* of Sultan Suleyman, c. 1555–1560. Ink, paint, and gold on paper; 20½ × 25⅜ in. (52 × 64.5 cm). Metropolitan Museum of Art, New York. Rogers Fund, 1938 (38.149.1). Photograph © 1986 Metropolitan Museum of Art.

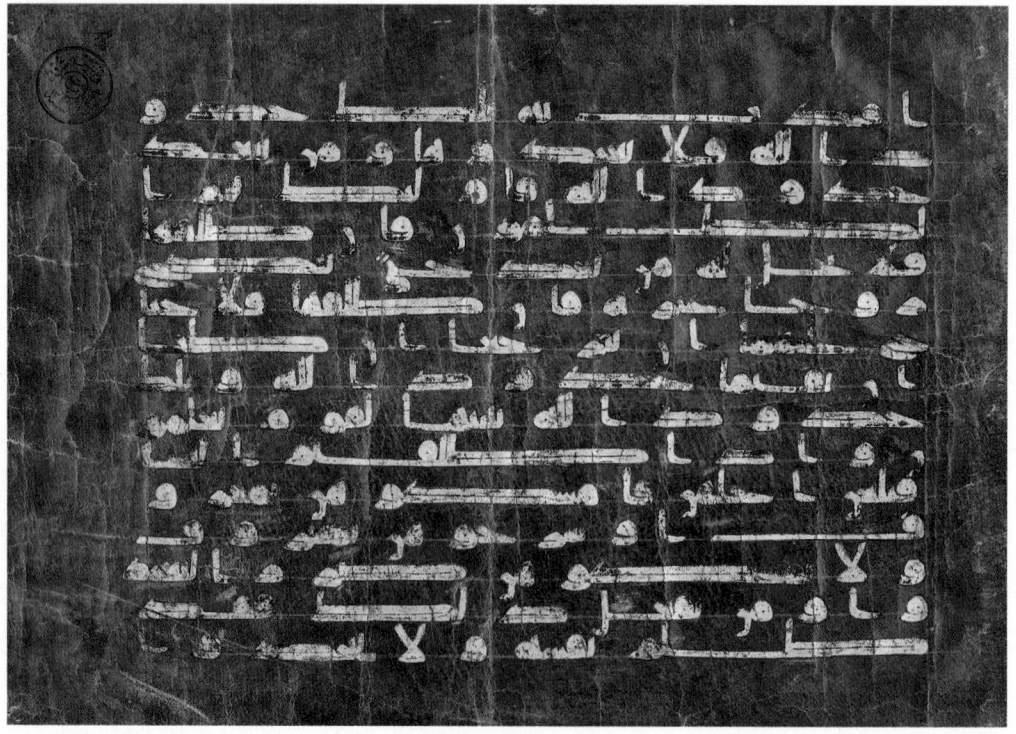

9.2 Page from the Kairouan manuscript of the Koran, written in Kufic, Tunisia, 9th–10th century. Ink, gold, and silver on blue dyed parchment; 11⅓ × 14⅞ in. (28.7 × 37.6 cm). Arthur M. Sackler Museum. Harvard University Art Museums. Francis H. Burr Memorial Fund.

Christian martyria, is a centrally planned octagon. Stylistically, the architectural ornamentation of the Dome of the Rock is a synthesis of Byzantine, Persian, and other Middle Eastern forms. Figure 9.1 illustrates the richness and complexity of the abstract patterning on the exterior, and the brilliant impression made by the **gilded** dome.

This was precisely the effect desired by Caliph Abd al-Malik, who commissioned it. According to a tenth-century source, he wanted a building that would "dazzle the minds" of Muslims and thereby distract them from the Christian buildings in Jerusalem.[2] This sentiment is a variant of the impulse to compete artistically, using height and size to express achievement and power. In the caliph's view, the splendor of his sanctuary would symbolically "blind" Muslims, preventing them from "seeing" beauty in monuments built by other faiths.

Mosques

Although Muslims may pray anywhere as long as they face Mecca, religious architecture became an important part of Islamic culture. In the earliest days of Islam, the faithful gathered to pray in the courtyard of the prophet Muhammad's home. From this developed the primary architectural expression of Islam—the mosque.

There are two main types of mosque: the *masjid* is used for daily prayer by individuals or small groups, while the larger *jāmi'* is used for congregational worship on Fridays, the Muslim sabbath. Although mosques around the world reflect local architectural traditions, most share certain basic features. These are a **sahn,** or enclosed courtyard (less common in later centuries), and a **qibla** (prayer wall) oriented toward Mecca. The *qibla* frequently has a **mihrāb** (small niche) set into it. *Jāmi'* mosques also contain a **minbar,** a pulpit from which an *imam* (religious teacher) leads the faithful. By the end of the seventh century, Muslim rulers were beginning to build larger and more elaborate

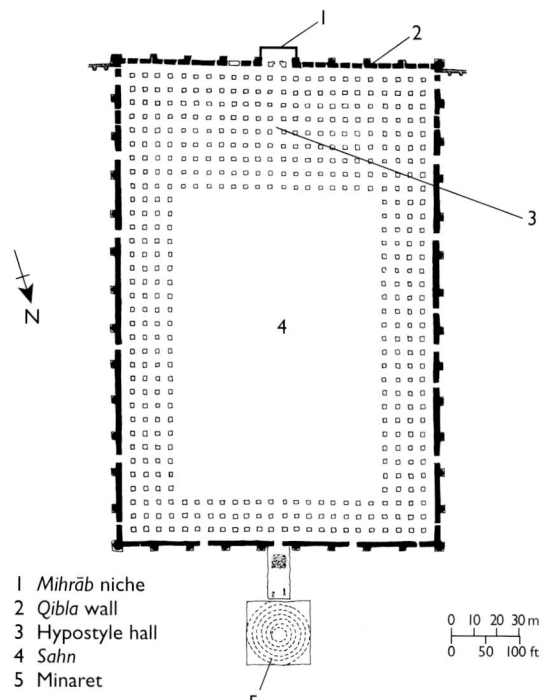

1 *Mihrāb* niche
2 *Qibla* wall
3 Hypostyle hall
4 *Sahn*
5 Minaret

9.5 Plan of the Great Mosque, Samarra, 847–852.

structures. The exterior of a typical mosque includes one or more tall minarets, such as those added to Hagia Sophia when it was changed from a Christian church to a mosque (cf. fig. 8.28). From these towers, a *muezzin,* or crier, calls the faithful to prayer at the five prescribed times each day.

As Islam spread to the West and won more converts, new mosques were needed. The biggest of these was located in Samarra, on the banks of the Tigris River (fig. **9.4**). Built from 847 to 852 by Caliph al-Mutawakkil, it is now in ruins. Nothing remains of the lavish mosaics and painted plaster that decorated the interior. The plan (fig. **9.5**) shows

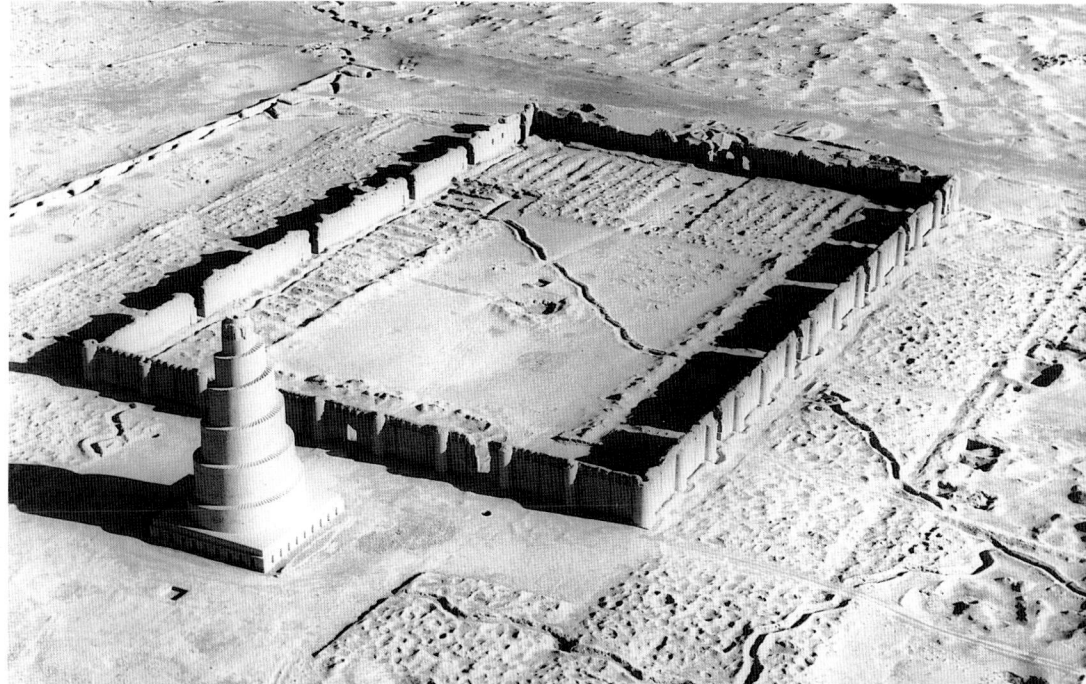

9.4 Great Mosque, Samarra (now in Iraq), 847–852. Approx. 10 acres (4.04 ha). Note the ziggurat style of the minaret, possibly reflecting the impact of Ancient Near Eastern influences on Islamic religious architecture.

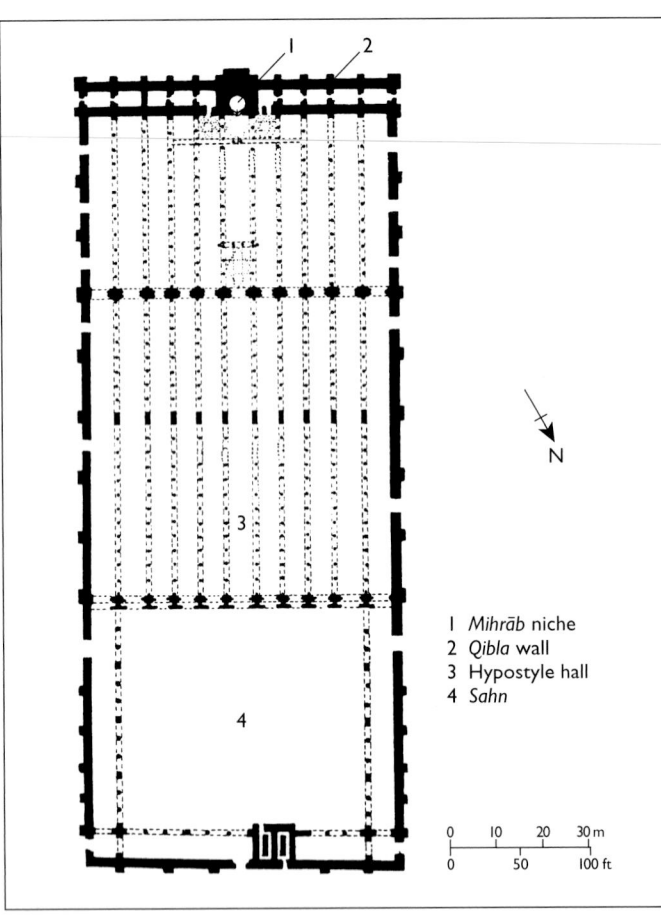

1 *Mihrāb* niche
2 *Qibla* wall
3 Hypostyle hall
4 *Sahn*

9.6 Plan of the Great Mosque, Córdoba, Spain, originally built 786–787. The additions from 832–848 and 961 are shown, but not the final enlargement of 987. The mosque is a rectangular enclosure with its main axis pointing southeast toward Mecca. Because Spain lies west of Mecca, this orientation is symbolic rather than exact.

the location of the 464 supports of the wooden hypostyle roof. These were arranged in rows around a huge, rectangular *sahn*. An unusual feature of this mosque is the single, cone-shaped minaret that rises 60 feet (18.29 m) on the north side. A ramp connects it with the main building, and leading to the top is a spiral stairway.

The most impressive example of a western Islamic mosque is the one built by Abd ar-Rahman I at Córdoba. The first Muslim ruler of Spain, he commissioned the mosque in 785 for his capital (fig. **9.6**). After its original construction (on the site of a church), the Great Mosque was enlarged in 832–848, 961, and 987. In the thirteenth century, Christians gained control of the Córdoba mosque and turned it into a cathedral, but enough of the original mosque survives to convey the magnificence of its design and ornamentation.

The system of double arches in the original mosque is unique, and it was used in each later addition. Filling the hypostyle interior are numerous columns either salvaged or derived from Roman and Early Christian buildings (fig. **9.7**). These columns were relatively short—under 10 feet (3.05 m) high. If they had supported the arches and vaults at that height, the interior illumination would have been

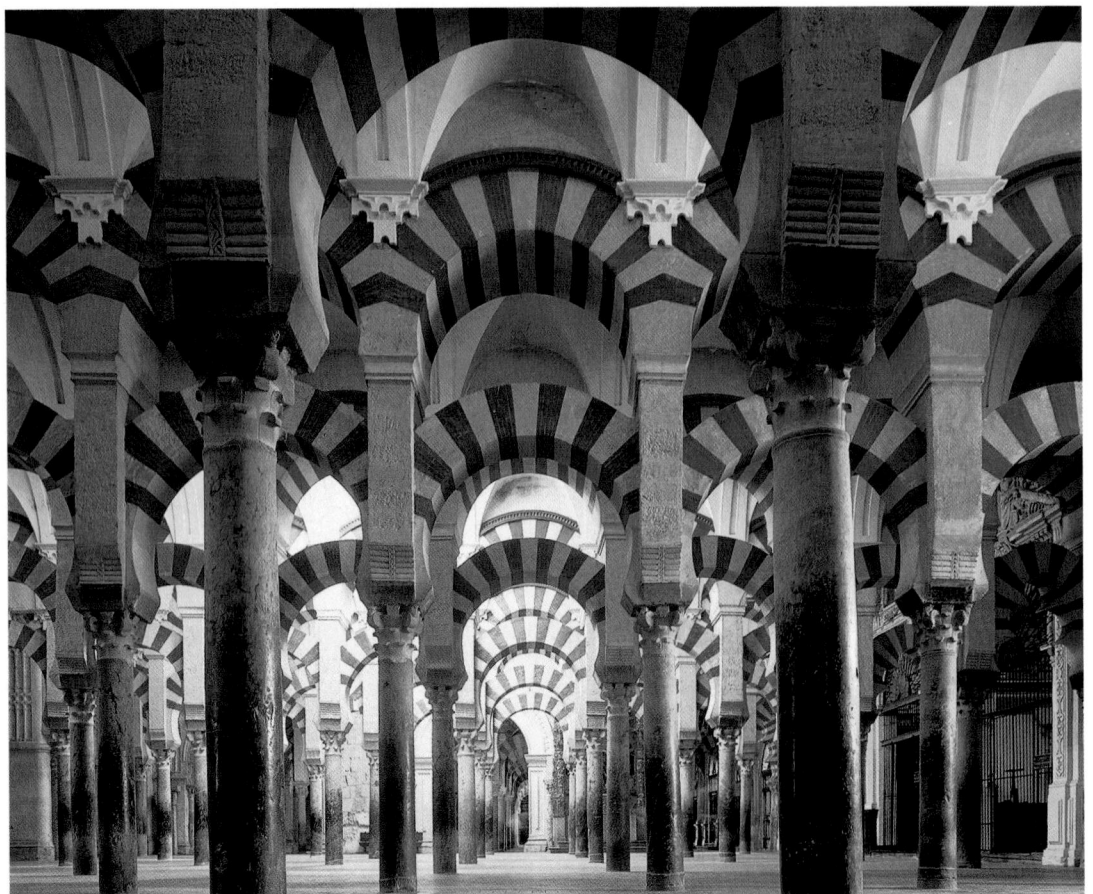

9.7 Arches of the Great Mosque, Córdoba, begun 786–787. Columns 9 ft. 9 in. (2.97 m) high. The interior space is larger than that of any present Christian church.

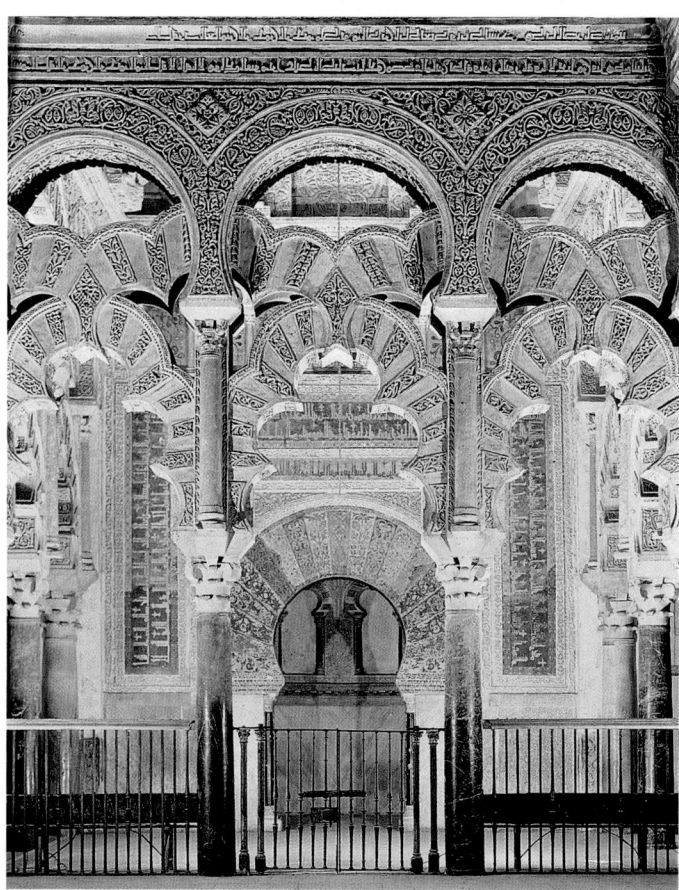

9.8 *Mihrāb* bay, the Great Mosque, Córdoba, c. 961–966.

inadequate. Instead, therefore, the architect constructed a series of double-height, horseshoe-shaped striped arches (using voussoirs of alternating red brick and pale yellow stones) to raise the ceiling height. The second tier of arches springs from posts on top of the lower columns and originally supported a tiled wooden roof. (This was replaced by vaulting in the sixteenth century.) The vast numbers of columns have been likened to a forest, and the colored arches create an impression of continual motion that enlivens the dimly lit interior. The multiplication of architectural elements here breaks up the flow of space, creating a sense of mystery.

As part of the second expansion phase in 961, the caliph ruling at Córdoba built a magnificent *mihrāb* in front of the *qibla* wall. To its north is an area reserved for the caliph and his retinue. This consists of three domed chambers entered through three tiers of lobed arches (fig. **9.8**), which crisscross each other to form an interlaced screen. The domes themselves are built in intricate geometric patterns—all of them different—on eight intersecting stone arches, or ribs. The central dome (fig. **9.9**) and the *qibla* wall have elaborate, Byzantine-inspired mosaics with gold backgrounds. This synthesis of structure and ornament in the Great Mosque at Córdoba became characteristic of later Islamic architecture.

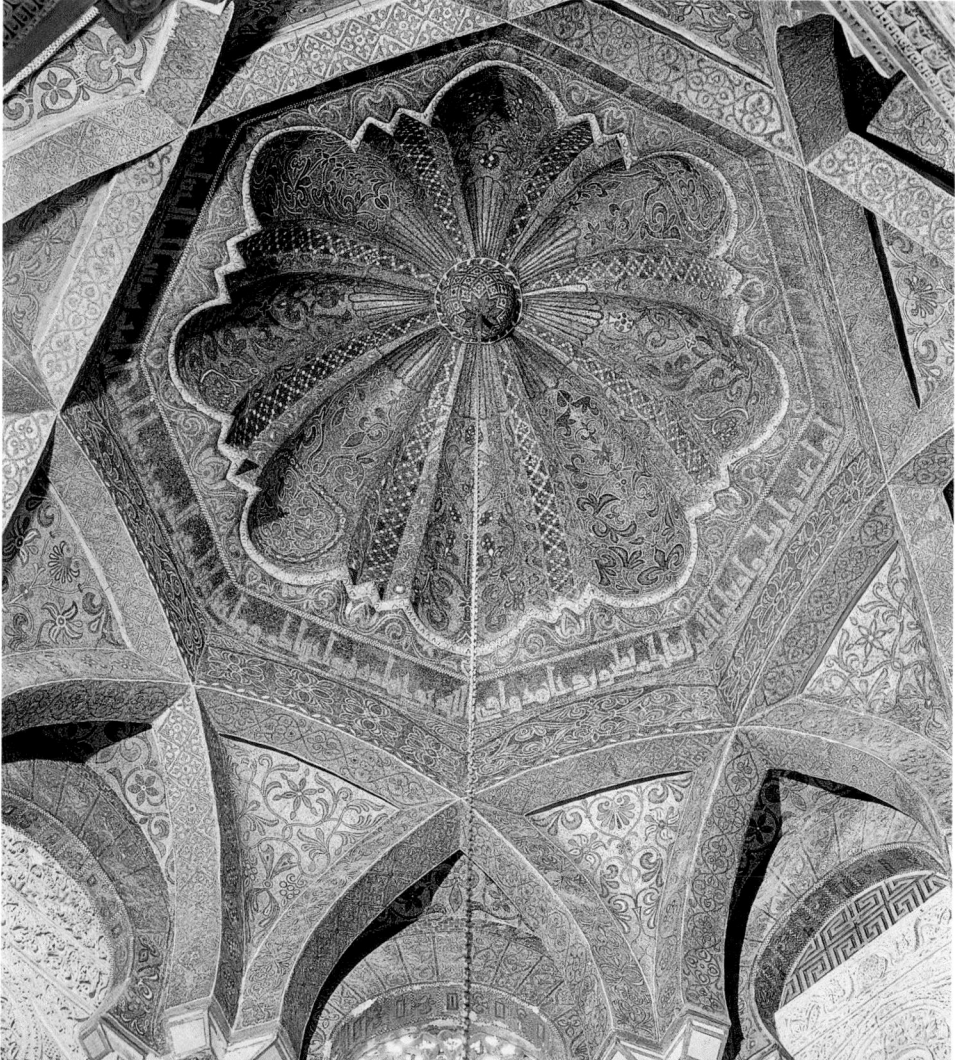

9.9 Dome in front of the *mihrāb*, the Great Mosque, Córdoba, c. 961–976. Mosaic.

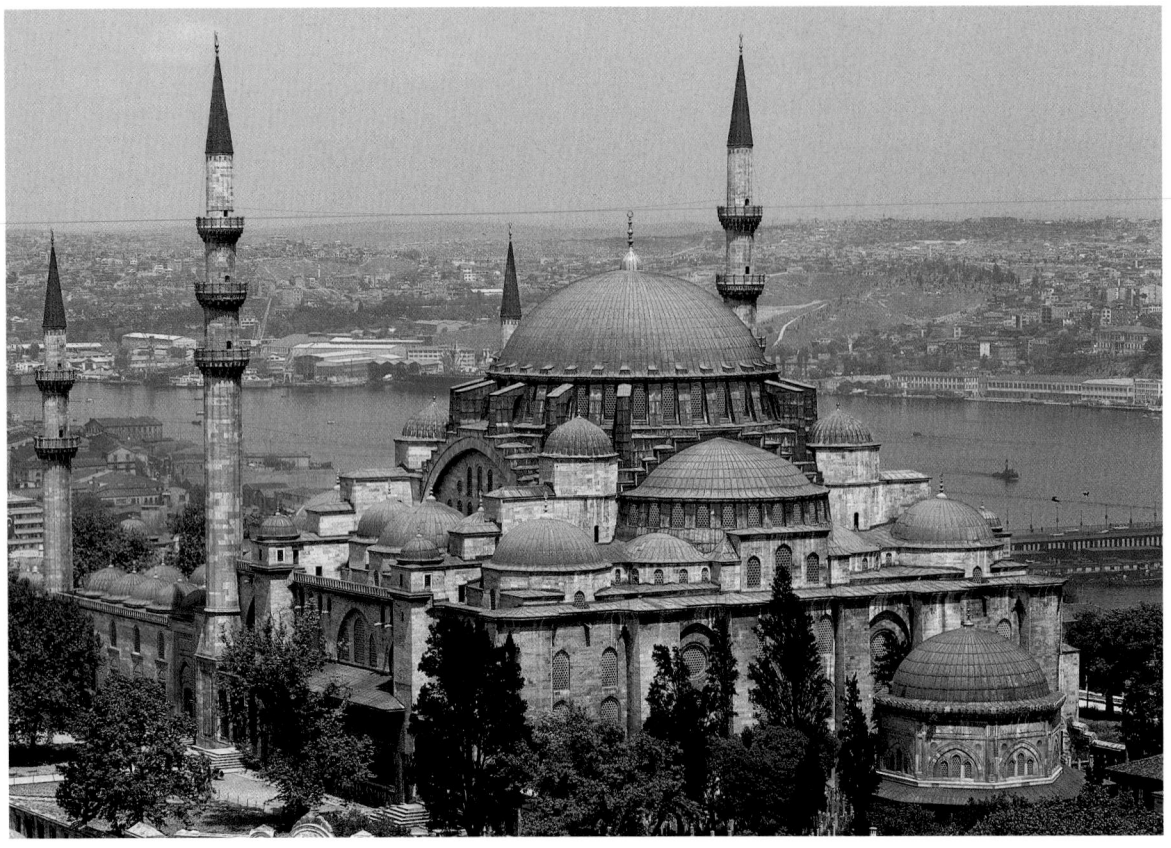

9.10 Sinan the Great, mosque of Suleyman I, Istanbul, Turkey, begun 1550. Sinan was a Greek who converted to Islam and, at the age of 47, became "Architect of the Empire." As supervisor of building in Istanbul and overseer of all public works, he was referrred to as "Architect in the Abode of Felicity."

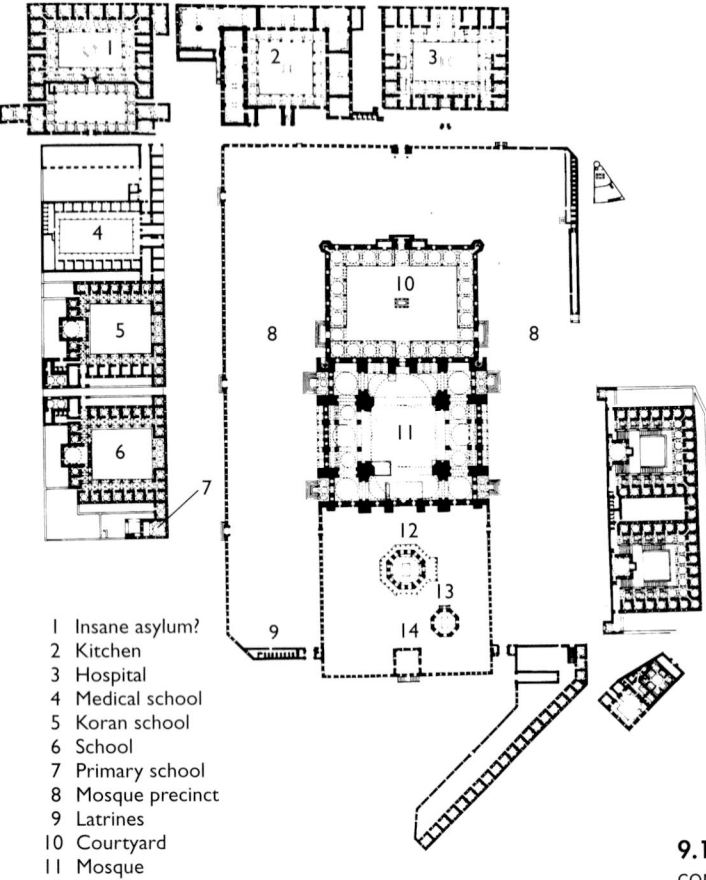

1 Insane asylum?
2 Kitchen
3 Hospital
4 Medical school
5 Koran school
6 School
7 Primary school
8 Mosque precinct
9 Latrines
10 Courtyard
11 Mosque
12 Tomb of Suleyman I
13 Tomb of Haseki Hürrem
14 Room for keeper of
 Islamic school

In 1453, when Constantinople was conquered by the Ottoman Turks from central Asia, the city was renamed Istanbul. The Ottoman Empire grew rapidly, reached a peak in the sixteenth century, and lasted until 1922. It was under the Ottomans that Hagia Sophia (see Chapter 8) was transformed from a Byzantine church into a mosque.

The leading Ottoman architect was Sinan the Great (c. 1491–1588), known as Koca (the Architect). His most important work in Istanbul, the mosque of Suleyman I (figs. **9.10** and **9.11**), was part of an imperial complex begun in 1550. By aligning the mosque with the horizon, Sinan used the elevated site to enhance its monumental effect. His notion of an ideal geometric symmetry—particularly a circle inscribed in a square—is clear from the plan. His domes also express the symbolic significance of the circle as a divine shape with God at its center.

The large central dome, preceded by several levels of smaller domes and stepped, buttressed walls, seems to be bubbling up from the interior of the hill. Four minarets accent the exterior symmetry. The *sahn* (fig. **9.12**) is surrounded by a colonnade of arches, whose sizes correspond to the width of the twenty-four domes they support. The interior of the mosque (fig. **9.13**), despite restoration,

9.11 Plan of the mosque of Suleyman I and the imperial complex, Istanbul. In addition to the mosque, the vast complex includes seven colleges, a hospital and asylum, baths, two residences, a hostel, kitchens, tombs, a school, fountains, wrestling grounds, shops, and a courtyard. Altogether there are five hundred domes, of which the mosque's is the largest.

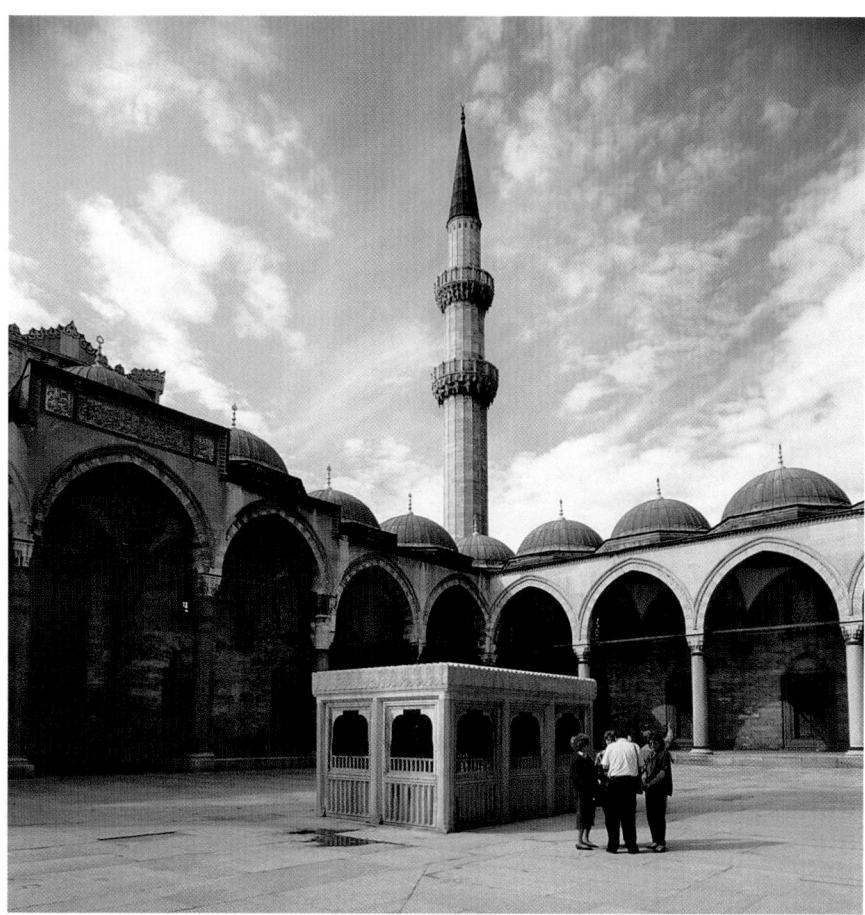

9.12 Courtyard (*sahn*) of the mosque of Suleyman I, Istanbul.

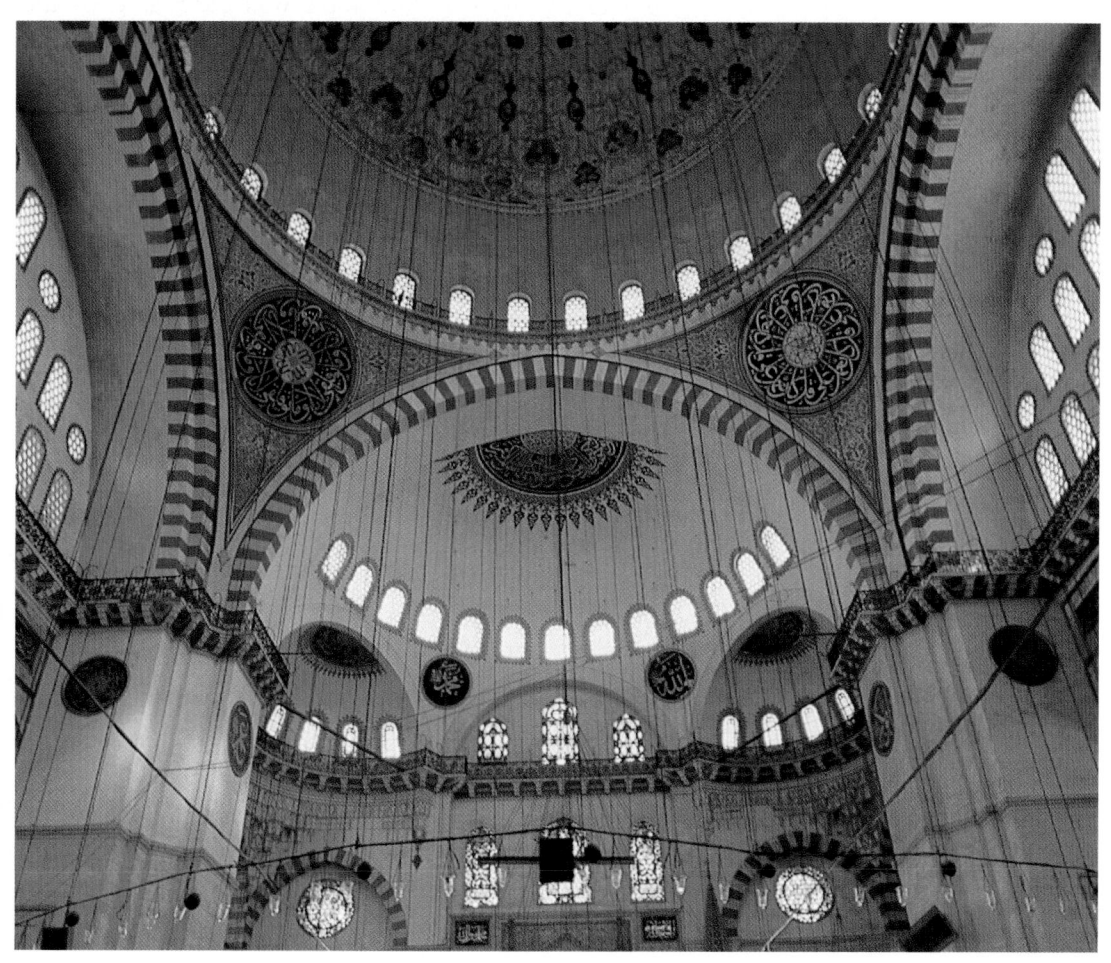

9.13 Interior of the mosque of Suleyman I, Istanbul.

9.14 The Luftullah Mosque, Isfahan, Iran, 1602–1616.

shows the influence of Hagia Sophia, with domes resting on pendentives and many small windows creating an impression of light streaming down from heaven. The *mihrāb* was decorated with blue, red, and white ceramic tiles arranged to create elaborate floral designs.

The seventeenth-century Luftullah Mosque in Isfahan shows the skill of Muslim artists in creating shimmering, jewel-like surfaces composed of intricate floral and calligraphic tilework (fig. **9.14**). These are reminiscent of knotted carpets, for which Persia (modern Iran)—which became part of the Islamic world in the seventh century—was renowned. Their colorful rhythms reflect influences of nomadic textile traditions and of the Ancient Near Eastern taste for geometric patterns (see Chapter 2).

Northern European Art

For all intents and purposes, the early medieval Islamic influence on western Europe and its art was concentrated in the south, for the Austrasian ruler Charles Martel had halted the Muslim invasion of Europe at Tours, in central France. The north (see map, p.328) became a new focus of political and artistic activity, which was more influenced by Germanic tribes than by either Islam or Hellenistic-Roman tradition. The Germanic Angles and Saxons had invaded the British Isles in the fifth century A.D., and the Franks had invaded Gaul (hence the name France). A new craft was developed around the metalwork brought by the invaders.

Anglo-Saxon Metalwork

A good example of Anglo-Saxon metalwork is the seventh-century purse cover from Sutton Hoo in East Anglia on the southeast coast of England (fig. **9.15**). It was part of a purse containing gold coins that was discovered among the treasures of a pagan ship burial. This was a practice in which the deceased was placed in a ship buried under a mound, reflecting the belief that boats carried the dead into the afterlife. The circumstances of the Sutton Hoo burial suggest that the deceased was a royal personage,

for the ship (which in this case was never sent to sea) contained an abundance of treasures. The Anglo-Saxon epic *Beowulf* (see p. 328) describes the lavish burials of kings with armor and other valuable objects.

The purse's decoration is of gold **cloisonné** and crushed dark red garnets. It has echoes of Early Christian **interlace** designs (cf. fig. 8.21) as well as of the Scythian Animal Style (see fig. 2.33) and certain ancient Near Eastern motifs. The taste for flat, crowded, interlaced patterns infiltrated western Europe and continued through the Middle Ages. The arrangement of the decorative sections on the purse cover is symmetrical, as is each individual section or pair of sections. At the top, two geometric shapes filled with gold tracery flank a centerpiece containing four fighting animals whose jaws and legs are extended to form intertwining ribbons. This technique, in which animals merge into a design or into each other, had also been characteristic of Scythian gold objects (cf. fig. 2.33). Below, at the center of the purse cover, are two sets of animals. An eagle and a duck face each other and are symmetrically framed by a pair of frontal men flanked by animals in profile, the latter a motif derived from Ancient Near Eastern iconography. The merging animal forms suggest that the waves of invaders from the fifth century onward brought their artistic styles to western Europe.

9.15 Sutton Hoo purse cover, from East Anglia, England, c. 630. Gold with garnets and *cloisonné* originally on ivory or bone (since lost); 8 in. (20.3 cm) long. British Museum, London. A kidney-shaped gold frame encloses a border of garnets and glass set into *cloisons* (compartments) formed by a network of thin metal strips. At the top, there are three hinged strap holders for attaching the purse to a belt. At the bottom, a gold catch was used to keep the purse closed.

— **CONNECTIONS** —

See figure 8.21. Detail of capital, San Vitale, Ravenna, c. 540.

See figure 2.33. Stag, from Kostromskaya, Russia, 7th century B.C.

Northern Europe in the Middle Ages.

Beowulf

Beowulf is the earliest surviving manuscript of a European epic composed in the vernacular. Although clearly in the tradition of Germanic folklore, it has a strong sense of Christian morality. The epic is believed to have been written down in the eighth century, but the events it describes take place in the sixth century and the text is known from a late tenth-century manuscript.

Beowulf opens with a miracle that occurred in childhood—in the tradition of the births of Sargon of Akkad (see Chapter 2) and Moses. The child is Scyld Scefing, who drifts ashore in a boat and starts a new dynasty in Denmark. "Sent from nowhere," according to the text, "the Danes found him floating with gifts a strange king-child." Clearly this image was informed by echoes of Jesus as a baby king as well as of Moses in the bulrushes.

When Scyld Scefing dies, he is given a ship burial like that in which the Sutton Hoo purse cover was discovered. Scyld's burial ship is described as

> ring-prowed . . .
> icy and eager armed for a king.
> . . . From hills and valleys
> rings and bracelets were borne to the shore.
> No words have sung of a wealthier grave-ship

> swords and ring-mail rich for drifting
> through the foaming tide far from that land.
> .
> At last they hung high upon the mast
> a golden banner then gave him to the sea
> to the mounding waves. . . .[3]

The epic is divided into two main parts. In the first, the hero Beowulf, a Swedish prince, offers his services to the king of Denmark, whose palace is being ravaged by the monster Grendel. Beowulf destroys Grendel and brings its head to the Danish king. In the second part, Beowulf has become a king. In his old age, he is mortally wounded in a battle with a monster. The epic concludes with a description of Beowulf's funeral rites and burial.

The Viking Era (c. 800–1000)

The Vikings were Scandinavian warriors who inhabited Norway, Sweden, and Denmark (Finland and Lapland belonged to different ethnic groups). They were known throughout Europe for their paganism and their ferocious, destructive raids. The best literary sources for Viking society are the sagas (prose narratives dealing with heroic figures and events) of Iceland, which was settled by the Norwegian Harald the Fairhair in the ninth century. The sagas also record the ancient oral traditions of Scandinavia and present a valuable account of its pre-Christian culture (see boxes, p. 330). Inhabited since the Stone Age, Scandinavia was an agricultural society, divided into small communities ruled by kings who were descended from royal families and elected to the throne.

In about 800, the Scandinavians developed sailing ships propelled by oars. This made extensive travel possible, and there is evidence of Viking incursions from Byzantium and the Baltics to northern France, the British Isles, Greenland, and North America. As a result, there are traces of Islamic, Byzantine, and Scythian influence in Viking art. For example, the animal headpost from a ship burial at Oseberg, Norway (fig. **9.16**), is similar in conception to the Scythian lion-head finial from Kul Oba (fig. **9.17**), a site between the Black Sea and the Sea of Azov in Russia. Both works are characterized by a compact monumental form, which is reinforced by the fiercely bared fangs of the lions. These works combine monumentality with elegant stylization, the finial more related to Achaemenid prototypes and the headpost to Anglo-Saxon interlace. Although the function of these objects is unknown, it is likely, given their leonine imagery, that they were guardians.

The pure interlace motif appears on a tenth-century axe from Denmark (fig. **9.18**). Its gold neck and silver inlay indicate the high status of the owner, who is thought to have been a member of Harald Bluetooth's court (see below). The combination of geometric design with natural elements such as foliage and a bird suggests familiarity with Anglo-Saxon metalwork.

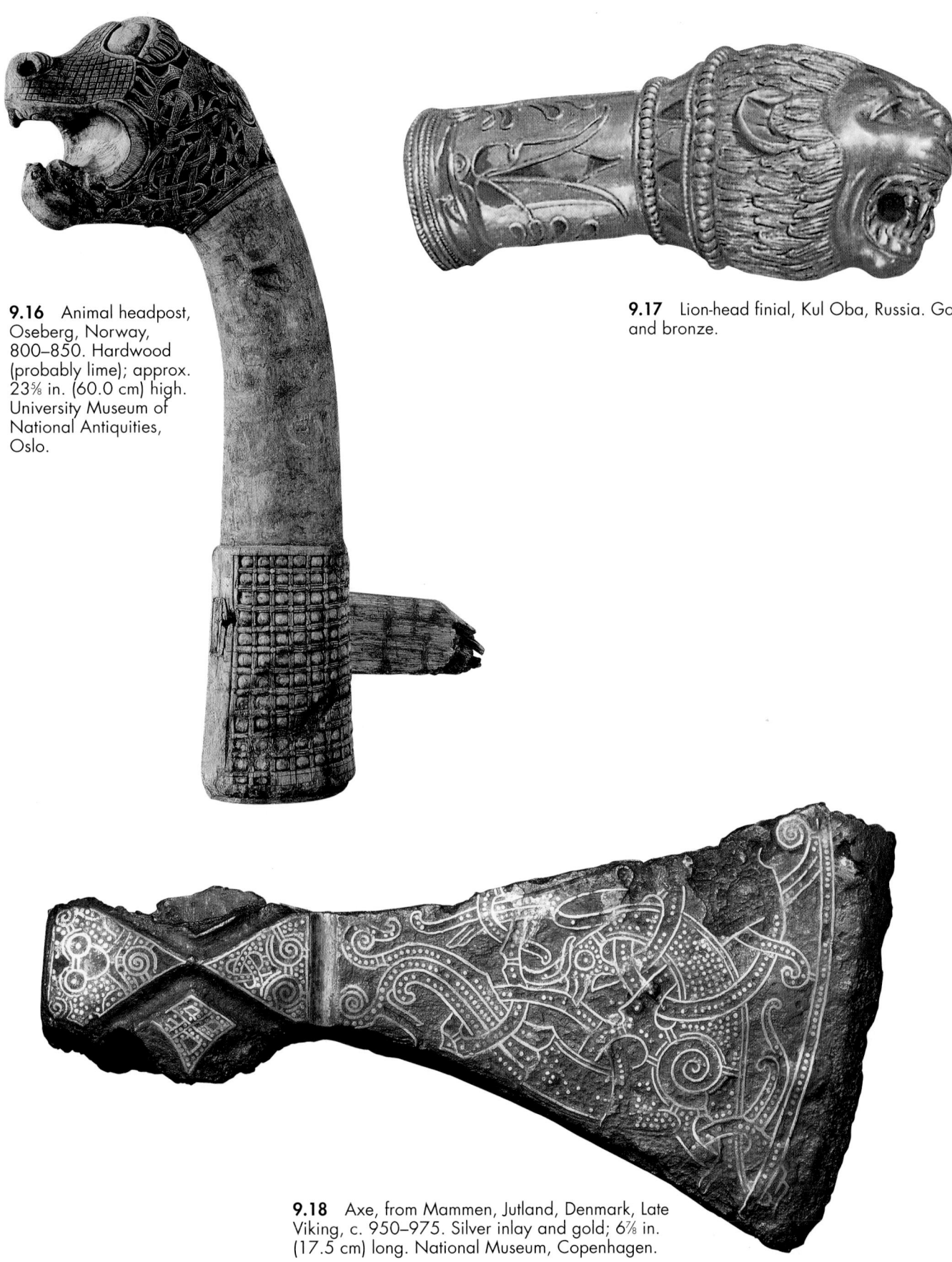

9.16 Animal headpost, Oseberg, Norway, 800–850. Hardwood (probably lime); approx. 23⅝ in. (60.0 cm) high. University Museum of National Antiquities, Oslo.

9.17 Lion-head finial, Kul Oba, Russia. Gold and bronze.

9.18 Axe, from Mammen, Jutland, Denmark, Late Viking, c. 950–975. Silver inlay and gold; 6⅞ in. (17.5 cm) long. National Museum, Copenhagen.

The Scandinavian Cosmos

For the Scandinavians, as for the ancient Greeks, the beginning of time was primeval chaos (*Ginnungagap*), a dark, formless abyss. An excerpt from *Saemund's Edda* (a myth written down in Scaldic by the thirteenth-century Icelandic author Snorri Sturluson) describes the Norse view of chaos:

> In early times,
> When Ymir lived
> Was sand, nor sea,
> Nor cooling wave;
> No earth was found,
> Nor heaven above;
> One chaos all,
> And nowhere grass.[4]

In Norse myth, the ice giant Ymir emerged from the frost and ice blocks that filled the abyss. After he was killed, his blood caused the flood that destroyed his race. Only one giant survived, and, with his wife, he sailed off in a boat to father a new race of giants, the Jotun. (Note the similarity to the Sumerian flood myth and the Old Testament account of Noah.)

Unlike the ancient Greeks, who believed that the anthropomorphic Olympians had destroyed the primitive Giants, the Scandinavian giants continued to exist. They were in conflict with the gods, but they also made alliances with them and occasionally intermarried. In Greek mythology, the cosmic battle between the Giants and the Olympians had already taken place, but in Scandinavia the cosmic battle (*Ragnarok*, or "Twilight of the Gods") between these forces was set in the future, as is the Christian Apocalypse. Whereas in the Judeo-Christian tradition there had been a paradise (the Garden of Eden), in Norse myth peace and prosperity would come only after *Ragnarok*.

The Norse universe was polytheistic. It had been ordered by the chief god, Odin, who scheduled the seasons and established the positions of the sun and moon. He divided the universe into a tri-centric structure:

- **Asgard** The dwelling of the gods and location of Valhalla, where Odin presided over the dead warrior elite preparing for *Ragnarok*.

- **Midgard** Middle Earth, inhabited by people. The gods created Midgard from the dead body of Ymir. His flesh became the earth, his blood the sea, his hair the trees and plants. His skull was emptied and turned upside down to form the dome of heaven, and his brains were scattered and became clouds.

- **Utgard** Outer Earth, home of the Jotun. At the axis of the world was the tree Yggdrasil, where gods held daily council. (There are comparable tree cults elsewhere—for example, in Vedic India and Minoan Crete.)

The Norse Pantheon

GODS	ATTRIBUTES AND QUALITIES
The Aesir	
Odin	God of wisdom, created the first human couple, god of Vikings and royal families, stole poetry from the Jotun and gave it to the human race. He also gave people the secret of writing and the runes. He was a shaman and the ruler of Valhalla.
Thor	God of Thunder, a giant gourmand, protector of the cosmos (comparable to Indra, Zeus, and Jupiter), wields a hammer.
Frigg	Wife of Odin. Fertility.
Baldr	Son of Odin and Frigg. God of Peace.
Heimdall	Son of nine giant mothers. Guardian of the world at the end of the rainbow, originator of social classes.
Loki	Fire god, troublemaker, trickster. Offspring of the Jotun and Odin's blood brother. At *Ragnarok*, Loki sides with the Jotun.
Tyr	God of war.

GODS	ATTRIBUTES AND QUALITIES
The Vanir	
Njord	Sea god.
Frey	Phallic fertility god, brother of Freyja.
Freyja	Goddess of war and beauty; fosters romance and leads the Valkyries.
Divine Groups	
Jotun	Primeval giants.
Volur	Wise women who know the history of the world.
Norns	Fates, female powers who sit under the tree Yggdrasil.
Valkyries	Beautiful immortal virgins with gold and silver armor who decide which warriors will be admitted to Valhalla after their death. They ride magnificent horses that are personifications of clouds.
Elves	Fertility gods. Keepers of ancestor cults.
Dwarfs	Smith gods who inhabit the underground.

Rune Stones and Picture Stones

More specifically native to Scandinavia than interlace are inscriptions on upright boulders known as **rune stones** and images on **picture stones.** The earliest runes (letters of the runic alphabet) date from the third century, when the Vikings arrived in the north. Runes were also used by Germanic tribes, Goths, and Anglo-Saxons. In the Viking era, there were sixteen stick-shaped letters in the alphabet. The runic inscriptions on stones could be memorials or records of voyages, battles, and even daily activities. Only an initiated few could read the rune stones, which were intended to preserve the mythical, literary, and cultural history of Scandinavia.

The early ninth-century rune stone at Rök, in Sweden, has the first known runic inscription of an oral narrative in Scandinavia, a memorial dedicated by a Viking chieftain to his dead son (fig. **9.19**). The inscription on the side shown here praises Tjodrek (the Ostrogoth king Theodoric the Great, d. 520) as a brave king of sea fighters.

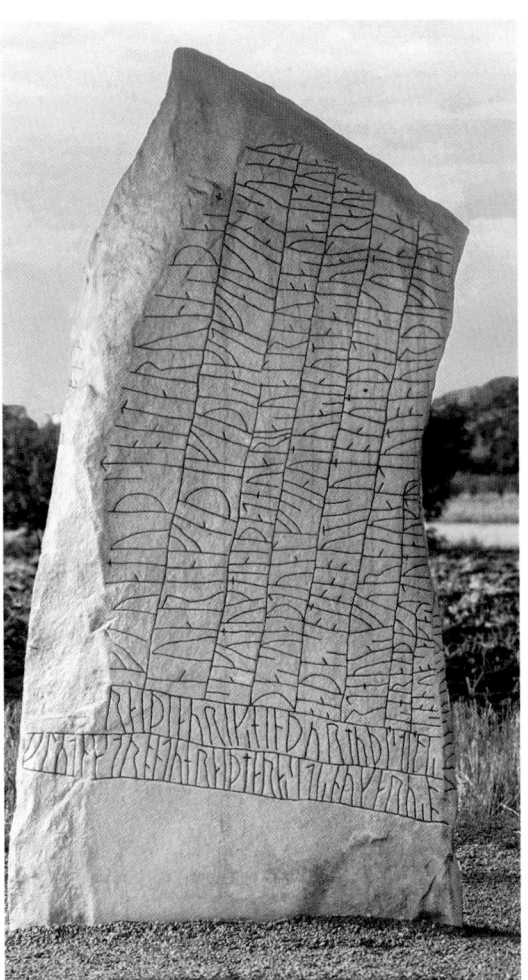

9.19 The Rök stone, Östergötland, Sweden, early 9th century.

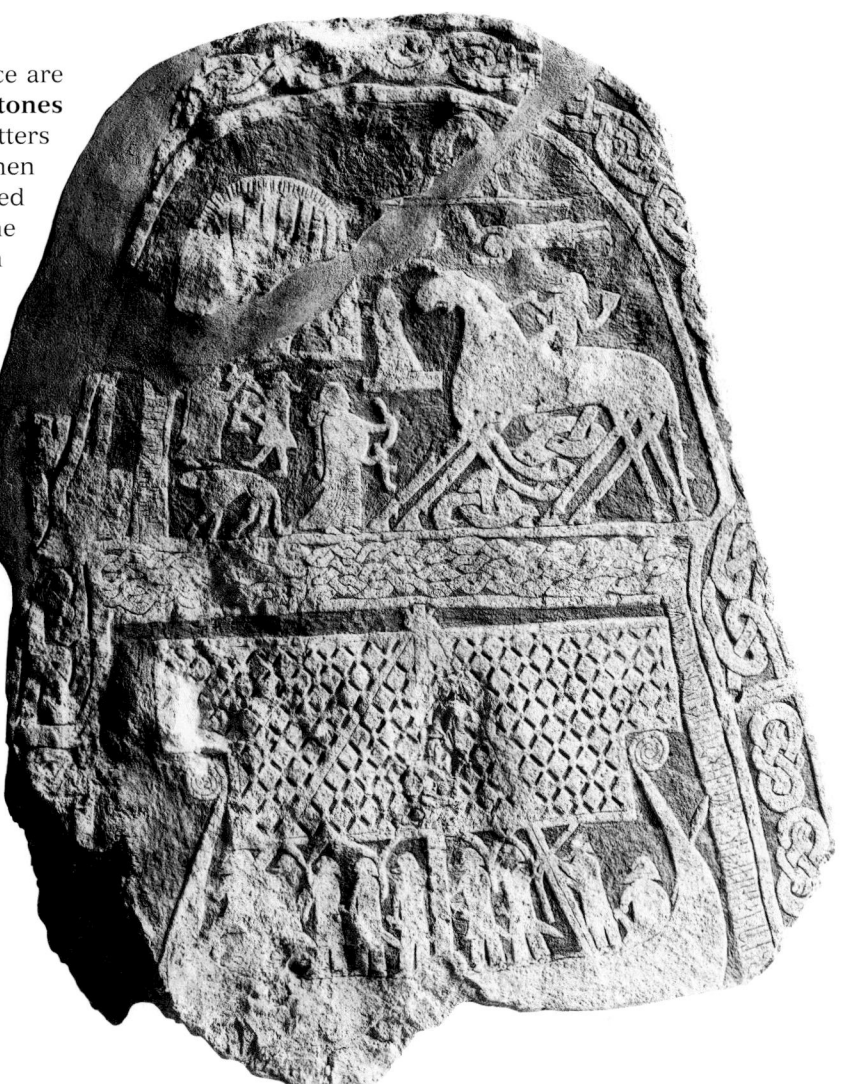

9.20 *Warrior Entering Valhalla,* from Tjangvide, Gotland, Sweden, 8th–9th century. Limestone relief (newly repainted); 5 ft. 9 in. (1.75 m) high. Statens Historiska Museet, Stockholm.

The runic inscription at the side of the example in figure **9.20** says that the stone was "raised for his brother Hjoruv," and the image on the face of the stone confirms its memorial function. At the top, a warrior (presumably Hjoruv) rides Odin's eight-legged horse, Sleipnir, into Valhalla. Above are two more warriors (denoting battle), one falling and the other already dead. Welcoming Hjoruv into Valhalla by extending a drinking horn is a Valkyrie with long hair and a long skirt; a dog follows behind her. Above the dog, another Valkyrie offers a horn to a man with an axe. The shape over these two figures echoes the shape of the stone and represents the halls of Valhalla. On the lower half of the stone is a Viking ship filled with warriors and a sail decorated with a pattern of diamond shapes. This undoubtedly refers to the tradition of ship burials described in *Beowulf* and to the belief that the deceased sail into the afterlife. The scenes are framed with interlace, which also separates the upper and lower halves of the image.

9.21 Harald Bluetooth's rune stone, from Jelling, Denmark, c. 965.
According to a contemporary chronicler, a priest at Harald's court lifted a hot
iron with his bare hands. Miraculously unharmed, he persuaded the king to
become a Christian. An inscription on the other side of the stone states that
"King Harald had these memorials made to Gorm, his father, and to Thyre, his
mother. That Harald who won fame for himself, all Denmark, and Norway and
made the Danes Christian."

Around 965, Denmark became Christian. Prior to that
time, the Viking raids on northwestern Europe had been
successful. But in 934, Germans invaded Denmark and
brought Christian missionaries with them. Some thirty
years later, the Danish king Harald Bluetooth (died c. 987)
converted to Christianity and raised a huge rune stone at
Jelling to commemorate the event (fig. **9.21**). Its surface is
covered with interlace designs that flow into the arms of the
image of Christ, who stands upright, faces front, and wears
a short tunic. This representation is a good example of the
integration of Christian imagery with pagan interlace.

Hiberno-Saxon Art

Because of its remote position, Ireland had escaped occu-
pation by the Romans in the first and second centuries A.D.
and invasion by Germanic hordes in the fifth century. Ac-
cording to tradition, Saint Patrick (c. 387–463) introduced
Christianity into Ireland in the first half of the fifth century,
and for the following 250 years Irish monasteries provided
a haven for European scholars, becoming centers of clas-
sical and theological learning. In the Early Middle Ages,

missionaries from Ireland were partly responsible for the spread of the Christian faith in mainland Europe. Among them was the Irish abbot Saint Columba, who established an outpost on the island of Iona in southwest Scotland from 563 to 597. Together with twelve close followers, he brought Christianity to the neighboring islands and converted all of Scotland.

During this period, there was a flowering of Christian art in Ireland and various other islands off the coast of northern Britain. Its style has been given a number of labels, including Insular and Hiberno-Saxon (*Hibernia* is Latin for "Ireland").

Stone Crosses

From the early seventh century to around 800, pagan interlace patterns were incorporated into Christian art. They were carved in relief on the large stone crosses that still dot the Irish countryside. Three types of interlace adorn the vertical and arms of a cross in Tipperary (fig. **9.22**). At the bottom, a single row of scrolls is repeated in the broken circle. The pedestal design has largely worn away with time. Generally, these Irish monumental crosses mark sacred places on roads.

9.22 Celtic cross, Ahenny, Tipperary, Ireland, late 8th century. Granite. The use of interlace designs for stone carving was probably derived from their previous use in metalwork, as in the Sutton Hoo purse cover (fig. 9.15).

Manuscript Illumination

Another typical use of the pagan interlace in Christian iconography occurs in **illuminated manuscripts** (see box) produced by monks in Irish and English monasteries (see p. 340). The main impetus of their style may have originated in Ireland, and from there it infiltrated England and other parts of western Europe.

The page in figure **9.23** of the *Lion Symbol of Saint John* from the Book of Durrow is a relatively early example of medieval manuscript illumination from the second half of the seventh century. The lion is in profile, its mouth open and teeth bared as if growling or roaring. Note the dense patterning of the surface of its body with red and green diamond shapes. They are accentuated by a yellow outline that merges into stylized muscle, yellow and red feet, and green and brown striations toward the end of the tail. These colors, as well as the dot pattern on the face, are repeated in the interlace inside the border.

The artist has created a strict unity of color and form on this page. In the border, for example, the reds are reserved for the upper and lower sections, thereby repeating the horizontal of the lion's body as well as its color arrangement. The edges are crisp and clear, the colors contrasting, and the surfaces flat like those of the Sutton Hoo purse cover (fig. 9.15). Design-driven optical illusions are created in the interlace, as if a ribbon has been threaded and rethreaded through itself. This kind of illusory, maze-like play was to become more complex in the course of the Middle Ages. Such early medieval illuminated manuscripts

Manuscript Illumination

Illuminated manuscripts are hand-decorated pages of text. Great numbers of these texts were needed because of the importance of the Bible, and especially the Gospels, for the study and spread of Christianity. Most were made during the Middle Ages in western Europe, before the invention of the printing press. (The Chinese are thought to have used movable type from the eleventh century A.D., but printing was not known in Europe before the fifteenth century.) Medieval manuscripts were copied in monastery **scriptoria** (Latin for "writing places"). Medieval scribes had to know Latin and have good penmanship, excellent eyesight, and the ability to read the writing of other scribes whose manuscripts they were copying.

It is not known what tools the scribes had for illuminating the manuscripts, although it is obvious that compasses and rulers were used for the geometric designs. The magnifying glass had not yet been invented. The scribes' pigments consisted of minerals and animal or vegetable extracts. These were mixed with water and bound with egg whites to thicken the consistency. The paint was applied to vellum (as in the early codex), which is high-quality calfskin parchment, specially prepared and dried for manuscripts.

9.23 *Lion Symbol of Saint John,* from the Book of Durrow, fol. 191v, c. 650–700. Illuminated manuscript on vellum; 9⅔ × 5¾ in. (24.5 × 14.5 cm). Library of Trinity College, Dublin, Ireland. This manuscript originally came from either Ireland or Northumbria in England. It represents Saint John the Evangelist as a lion surrounded by a rectangular border filled with interlace. Later, Saint John's symbol was changed to an eagle.

from northern Europe create a world of images that seems totally independent of the humanistic tastes of Greco-Roman tradition.

Perhaps the most famous Early Medieval Hiberno-Saxon illuminated manuscript is the Book of Kells, which dates from the late eighth or early ninth century. Its text consists of the four Gospels, written in Latin in 680 pages. The color and form of the manuscript illuminations have become more complex, with animal and human figures incorporated into the design of the letters. In the *T* of *Tunc*

on the folio illustrated in figure **9.24**, for example, the two arms of the letter stretch into the legs and claws of the animal whose head is in the curve of the *T*. The inside of the curve of the *T* contains more interlacing—notably protozoan creatures with prominent eyes. A small green head evolves into the red border around the *unc* of *Tunc*. At the left border of the page a dragon head emits ribbonlike flames. Human forms have also been added to the repertory. Three sets of small human heads appear in rectangular spaces, two on the right of the folio and one on the left.

9.24 *Tunc Crucifixerant XPI,* from the Book of Kells, fol. 124r, late 8th or early 9th century. Illuminated manuscript on vellum; 9½ × 13 in. (24.1 × 33.0 cm). Library of Trinity College, Dublin, Ireland. This is a page from the Gospel of Matthew (27:38). The scribe has written: "Tunc crucifixerant XPI cum eo duo latrones" (Then they crucified Christ and, with him, two thieves).

Such delight in intricate detail was to continue in border imagery throughout the Middle Ages.

In addition to the obvious visual pleasure these designs gave their artists as well as their viewers, their purpose was to illuminate the "Word of God." The lower half of the page contains a large *Chi* (written as *X*), the beginning of Christ's Greek name and also a visual reference to the Cross. The interlacing that characterizes these manuscripts is thus echoed in the formal assimilation of iconography into text.

The Carolingian Period

The era of the Book of Kells corresponds to an important historical landmark in western Europe. On December 25, 800, the pope crowned Charlemagne (Charles the Great) Roman emperor at Saint Peter's in Rome. When Charlemagne came to power, he ruled a large part of western Europe, including France, Germany, Switzerland, Belgium, Holland, northern Spain, and Italy to the south of Rome. This territory was to be the subject of extensive political and religious controversy between the popes in Rome and the German emperors right up until the nineteenth century. It was named the Holy Roman Empire in the thirteenth century and lasted as such for over six hundred years (see map). Charlemagne was also king of the Franks from 771 to 814.

Charlemagne created a cultural revival intended to enhance his imperial image in the tradition of ancient Rome. The term used to describe the period—*Carolingian*—derives from the name of Charlemagne's grandfather, Charles Martel (*Carolus* is Latin for "Charles"), who had defeated the Muslim invasion at Tours. Under Charlemagne, monasteries expanded the network of learning throughout Europe in which Latin, as the language of the manuscript texts, had been kept alive. Besides the Latin language, Charlemagne wanted to revive other aspects of the Roman past. He established a political organization based on that of ancient Rome and a unified code of laws, created libraries, and pursued a program of educational reform.

To improve education in his empire, Charlemagne hired the English scholar Alcuin of York, in Northumbria, and invited him to his court at Aachen. Alcuin organized cathedral and monastic schools to promote Latin culture and language. He adopted from Aelius Donatus, who had taught Latin grammar and rhetoric in Rome, a curriculum and a grammar book that set the standard in western European schools until the end of the Middle Ages. The curriculum was divided into two sets of disciplines based on the Seven Liberal Arts. The *trivium* consisted of grammar, rhetoric, and dialectic, and the *quadrivium* of geometry, arithmetic, astronomy, and music.

The Palace Chapel

In the last decade of the eighth century, Charlemagne moved his capital and his court to Aachen (Aix-la-Chapelle in French), 45 miles (72 km) southwest of Cologne, near the modern Belgian–Dutch border. There he constructed a palace, together with offices, workshops, and other buildings. Of particular architectural importance was the palace chapel, which doubled as Charlemagne's personal chapel and a place of worship for the imperial court (figs. **9.25**, **9.26**, and **9.27**).

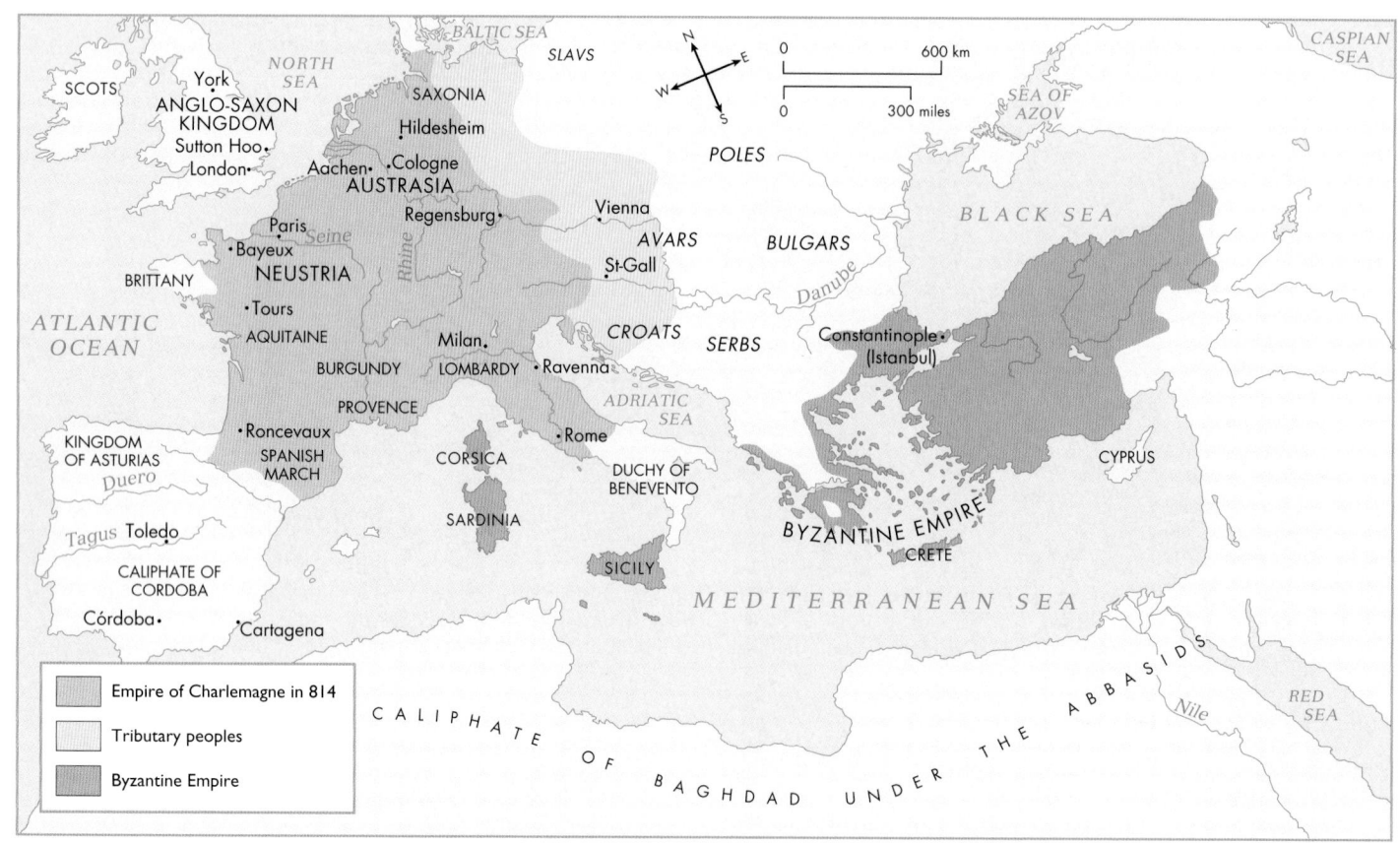

The Holy Roman Empire under Charlemagne, 814.

The palace chapel has certain features in common with the Church of San Vitale in Ravenna (see Chapter 8). Both are large, sturdy, centrally planned buildings; San Vitale is octagonal, and the palace chapel has a sixteen-sided outer wall and an octagonal central core surrounded by an ambulatory supporting a gallery. The gallery opens onto the central area through a series of arches, which allowed Charlemagne and his entourage to observe the celebration of the Mass. At the third level, the central core rises to a clerestory. To the front of the palace chapel, a square entrance flanked by round towers was added, with tower stairs leading to a throne room at the level of the gallery. Originally the chapel also had a walled courtyard around the entrance. From here visitors could catch a glimpse of the emperor at a window in the second level of the façade. This appearance of the ruler, visible to his subjects through a window, was an old royal tradition dating back to ancient Egypt and equating the ruler with the Sun.

Like Justinian, Charlemagne used the arts to enhance his political image. His architect, Odo of Metz, revived the massive piers and round arches of ancient Rome, which reinforced Charlemagne's claim to the Holy Roman Empire. As in the Colosseum (cf. fig. 7.19), the supports of the palace chapel decrease in size as they rise, creating a sense of greater weight at ground level. In the gallery, triple arches are aligned with single round arches, and two central columns with Corinthian capitals stand between each set of piers. The result is a combination of the Justianic central plan with the monumental symmetry and order of the Roman buildings.

9.26 Plan (restored) of Charlemagne's palace chapel, Aachen.

1 Clerestory
2 Rotunda
3 Stair tower
4 Forecourt

9.27 Reconstruction drawing of Charlemagne's palace chapel, Aachen.

9.25 Odo of Metz, interior of Charlemagne's palace chapel, Aachen, 792–805.

Manuscripts

Because education was an important aspect of Charlemagne's Roman revival, manuscripts played a significant role in his efforts to bring back the learning and culture of Roman antiquity. Charlemagne's court at Aachen was the hub of his empire, but manuscripts were portable and thus an important form of artistic and educational communication.

A comparison of three manuscript illuminations made during Charlemagne's reign reflects the evolution of his Roman revival. The page of *Christ Blessing* was commissioned by Charlemagne and his wife, Hildegarde, in 781 from Godescalc, the court scribe (fig. **9.28**). Its dependence on Byzantine icons is clear in the enthroned Christ, who holds a book in his left hand and raises his right in a gesture of blessing. Christ is frontal, his head is framed by a flat halo including a cross, and the folds and edges of his stylized drapery are depicted as black lines. Despite some shading in the face, the slightly oblique footstool, and traces of landscape at the top of the scene, Christ's frontality and the overall patterning flatten the space. Symmetrical interlaced designs on the frame reflect the influence of Hiberno-Saxon art.

The depiction of *Saint John* in figure **9.29**, from the Coronation Gospels, demonstrates both a new interest in naturalism and the persistence of medieval style. The saint is seated in an architectural niche within a landscape. His pen is poised, and his drapery combines surface pattern with an indication of organic form. Shading defines the body contours, especially the face, with the head slightly inclined, although the halo remains flat. The position of the footstool—both inside and outside the frame—reveals the artist's struggle to reconcile early medieval and Greco-Roman traditions.

9.28 Court school of Charlemagne, *Christ Blessing*, from the Godescalc Gospels, Lat. 1203, fol. 3r, 781–783. Text written in gold and silver on vellum; 12 × 8¼ in. (30.5 × 20.9 cm). Bibliothèque Nationale, Paris.

9.29 *Saint John*, from the Coronation Gospels, fol. 178v, late 8th century. Parchment; 12¾ × 10 in. (32.4 × 24.9 cm). Kunsthistorisches Museum, Vienna. Tradition has it that this codex (manuscript book) was discovered in Charlemagne's tomb and opened in the year 1000 by Otto III. It gained its name through the practice of German emperors who swore their coronation oaths on it.

9.30 *Four Evangelists,* from a Carolingian Gospel book, palace chapel school, Aachen, early 9th century.

Revelation and the Four Symbols of the Evangelists

The Book of Revelation, written by Saint John the Divine, is the last book of the New Testament. It opens as follows: "The Revelation of Jesus Christ, which God gave unto him, to shew unto his servants things which must shortly come to pass; and he sent and signified it by his angel unto his servant John: who bare record of the word of God, and of the testimony of Jesus Christ, and of all things that he saw."

While John was on the Greek island of Patmos, Christ is said to have appeared to him and told him to convey his message to the world. The Book of Revelation is believed to be John's account of Christ's word and all that he is shown in heaven. It is a visionary work imbued with Scripture, literary tradition, the early efforts to establish Christianity, and influences from Judaism and Greco-Roman thought.

In Christian art, the four Evangelists are often represented in symbolic forms that are based on Chapters 4 and 5 of Saint John's vision (see fig. 9.30). They are a lion, a bull, a man (or angel), and an eagle. The lion came to stand for Saint Mark, the bull for Saint Luke, the man for Saint Matthew, and the eagle for Saint John.

The *Four Evangelists* (see box) from a Carolingian Gospel book illustrated in figure **9.30** include the saints' symbols set in a landscape indicated by rolling hills. The oblique writing desks and stools define three-dimensional space, while the draperies define the forms and natural movement of the figures. This artist probably came from Constantinople, where the Hellenistic traditions had persisted most strongly.

After Charlemagne's death, a more apocalyptic approach to manuscript painting became the norm in French monasteries. At Tours, in central France, the Vivian Bible, named for the lay abbot Count Vivian, was dedicated to Charles the Bald around 845 to 846. The frontispiece to the Gospels, showing Christ in Majesty with the four Evangelists (fig. **9.31**), reflects a divergence from the Classical style as Charlemagne's revival of Roman antiquity waned.

The space is flatter, and the figures are connected by geometric designs rather than by landscape. In Christ's

9.31 *Christ in Majesty,* Vivian Bible frontispiece, fol. 329v, c. 845–846. Bibliothèque Nationale, Paris.

9.32 Reims school, illustration to Psalm 88, from the Utrecht Psalter, Ms. 32, fol. 51v, c. 825–850. 12⅞ × 9⅞ in. (32.7 × 25.1 cm). University Library, Utrecht.

swirling drapery, the artist departs from the more Classical drapery of the Carolingian Gospels. The Vivian Christ is suspended weightlessly on a flat circle representing the globe, and he is frontal. Although the Evangelists turn in space and their footstools are rendered obliquely, their poses are exaggerated. Saint Mark, in particular, twists his neck unnaturally. Compared with the manuscript paintings produced under Charlemagne, this and other later examples have a frenzied, agitated quality.

The Carolingian prayerbook known as the Utrecht Psalter of c. 825–850 introduced a new correspondence between word and image. The manuscripts created at Charlemagne's court had reflected the belief that biblical texts did not lend themselves to illustration. But the Utrecht Psalter, which was produced in Reims, in northern France, reflects a different view. The psalter itself consisted of the Old Testament Book of Psalms but was illustrated with line drawings in red-brown ink interspersed among the written text. Rather than illustrating a straightforward narrative, these drawings capture the essence of a particular set of metaphorical images. For example, the drawing that accompanies Psalm 88 (fig. **9.32**) includes scenes of the Last Judgment and the Crucifixion in the top half, while the lower half denotes the sufferings of earthly life, with two figures in boats reaching out in supplication and, at the right, a castle on top of which soldiers are killing enemies. These scenes reflect the troubled words of the psalm—for example, verse 7: "Thy wrath lieth hard upon me, and thou has afflicted me with all thy waves;" and verse 9: "Mine eye mourneth by reason of affliction: Lord, I have called daily upon thee, I have stretched out my hands unto thee."

Monasteries

Of all the institutions in western Europe during the Middle Ages, the monastery was particularly important to Charlemagne's plan for controlling conquered territory and directing reforms in art and education (see box). Each monastery included a school, and this created a network through which artists and scholars could communicate with each other. The monastery was also a religious and administrative center, and performed an economic function through its agricultural production.

Charlemagne decided that monasteries should follow the Benedictine Rule, a series of regulations that had been devised by Saint Benedict of Nursia some two hundred years earlier, in the sixth century. According to Benedict's Rule, monks should live communally under the supervision of an abbot, devoting themselves to a strict routine of work, study, and prayer. Charlemagne convened a council of abbots at Aachen to discuss the Rule and draw up a standard plan for Benedictine abbeys (fig. **9.33**). The council sent this plan to the abbot who was rebuilding the Saint Gall monastery in Switzerland, although it is not certain that the plan as it has been drawn up was that of a particular monastery that was ever built.

Figure **9.34** is a model constructed from the plan. About a hundred people were to form a self-sufficient community —almost a small town—occupying an area some 500 by 700 feet (about 152 × 213 m). The entrance to the monastery was from the west, through a passage between a hostel

Monasticism: Chastity, Obedience, and Poverty

Monasticism is a way of religious life in which an individual takes vows of chastity, obedience, and poverty, and serves God in relative seclusion. Monasticism began in the pre-Christian era among Middle Eastern Jews. The first Christian monks date from the third century. Some chose to live as hermits, isolating themselves individually from society and devoting themselves to prayer. Others withdrew into communal groups that formed the basis of the monastic tradition.

Many monks became expert in a particular art or craft, and the monasteries played an important role in medieval cultural life and education. Works of literature, science, and philosophy, in addition to religious texts, have survived in copies handwritten in the scriptoria of the monasteries.

1 Church	9 Workshops	17 Scriptorium and
2 Cloister	10 Brewery and	Library
3 Infirmary	Bakery	18 Dormitory
4 Chapel	11 Stables	19 Refectory
5 Novitiate/	12 Animal pens	20 Kitchens
Infirmary	13 Hostel	21 Cellars
6 Orchard/	14 Guesthouse	22 Hospice for the
Cemetery	15 School	poor
7 Garden	16 Abbot's house	23 Baths and latrines
8 Barn		

9.33 Plan of the monastery of Saint Gall, Switzerland, c. 820. This plan has been drawn from a tracing on five pieces of parchment, itself taken from an earlier document, from which scholars have been able to draw various conclusions about monastic life and architectural practice during the Carolingian period.

and stables. From there a gate led to a semicircular arcade flanked by two cylindrical towers and into the vestibule at the western end of a church. This combination of towers with an entrance, chapels, and galleries at the west of a Carolingian church is known as **westwork** (from the German term *Westwerk*). The church is designed along the lines of a basilica: at the eastern end are a transept, choir, apse, and altar (approached by seven steps); another apse was located at the west. The nave and aisles are screened off from each other. They contain additional altars to make it possible for each priest to say Mass every day.

To the east of the church was a novitiate (a building to house novices, or trainees) and an infirmary. Next to the infirmary stood the physicians' houses and a medicinal herb garden. Conveniently close was the cemetery, which doubled as an orchard. To the south, in the sunniest spot, was a square cloister surrounded by a covered portico, where the monks could walk. The cloister was flanked by the dormitory, with a bathhouse and lavatory, a **refectory** (dining hall), and a cellar. Outbuildings included a bakery, a brewhouse, and barns for farm animals. The plan of Saint Gall lays out the entire ideal monastery in meticulous, practical detail, right down to the shed for pregnant mares and foals.

9.34 Reconstruction model of the monastery of Saint Gall, Switzerland, c. 820. The design of the monastery placed the church at the center and the buildings adjacent to it in approximate order of importance. The library and scriptorium were attached to the church, not far from the main altar. To the north were the abbot's house (connected to the transept by a private passage), guesthouse, and a school. The latter fulfilled Charlemagne's mandate that monasteries provide education even for those not intending to take holy orders.

Charlemagne's grandsons were ineffective rulers, and, by the end of the ninth century, Europe again fell prey to invaders. The Vikings took over Normandy (in northern France), and the Saxons resumed their control of Germany. The Saxon emperor Otto I the Great (ruled 936–973) was crowned by the pope in 962. He continued Charlemagne's revival of Classical antiquity as a way of reinforcing his own imperial position.

The Ottonian Period

Ottonian refers to the three rulers named Otto who stabilized the Holy Roman Empire after the disruptions following Charlemagne's death. Their empire included only Germany and parts of northern Italy, and was therefore smaller than Charlemagne's. The major architectural work of this period was the Benedictine abbey church of Saint Michael's at Hildesheim (figs. **9.35**, **9.36**, and **9.37**). It was commissioned by Bernward, bishop of Hildesheim (c. 960–1022), who had been the tutor of Otto III. Both visited Rome, where they studied ancient ruins.

The massive quality of Charlemagne's palace chapel also characterizes Saint Michael's. Although symmetry is maintained, the architectural variety—towers, round arches, sloping roofs, cylindrical and cubic forms—gives it a formal energy, reflected in the plan of the exterior section (fig. 9.36). The entrances are untypically located at the side aisles; note the triple eastern apses, the large western apse, and circular towers. The restored nave walls (fig. 9.37) are two stories high. The lower level is composed of an arcade, which is unusual in the alternation of a single pier with pairs of columns. Piercing the relatively plain upper story are small windows with round arches, which are the main source of interior illumination.

Saint Michael's bridges the gap between Carolingian architecture and the apparent simplicity of the new Romanesque style (see Chapter 10). Its plan was partly derived from Saint Gall, which, in turn, was related to the basilica. Through their contacts with Rome, Bernward and Otto III adopted Classical architectural features.

The metalwork at Hildesheim also shows the impact of Roman influence on Bernward and Otto. An impressive surviving example, commissioned before 1015, is the pair of bronze doors originally at the entrance (fig. **9.38**), the first large-scale works cast in one piece since antiquity. The emphasis on typology is apparent in the left-right pairing of Old and New Testament scenes, which the medieval viewer would have understood as meaning that the former

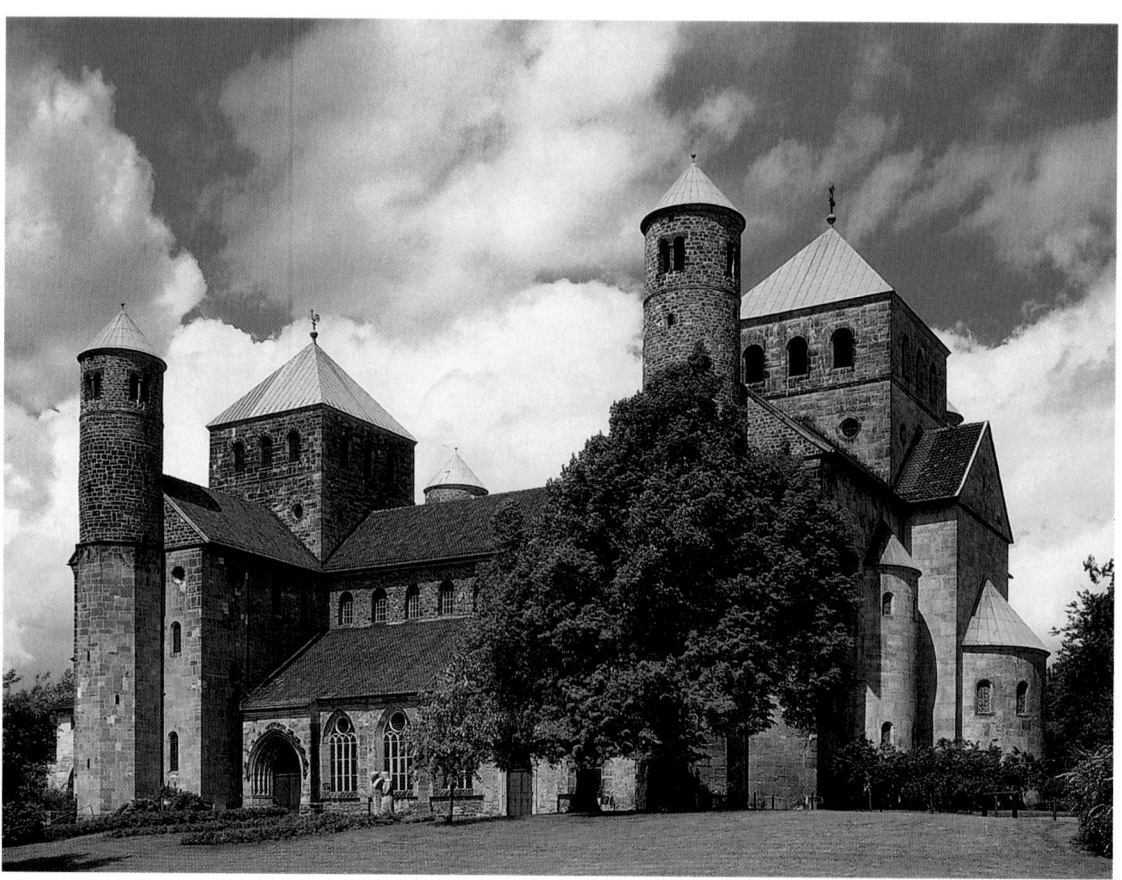

9.35 Restored abbey church of Saint Michael's, Hildesheim, c. 1001–1031. The building was destroyed during World War II.

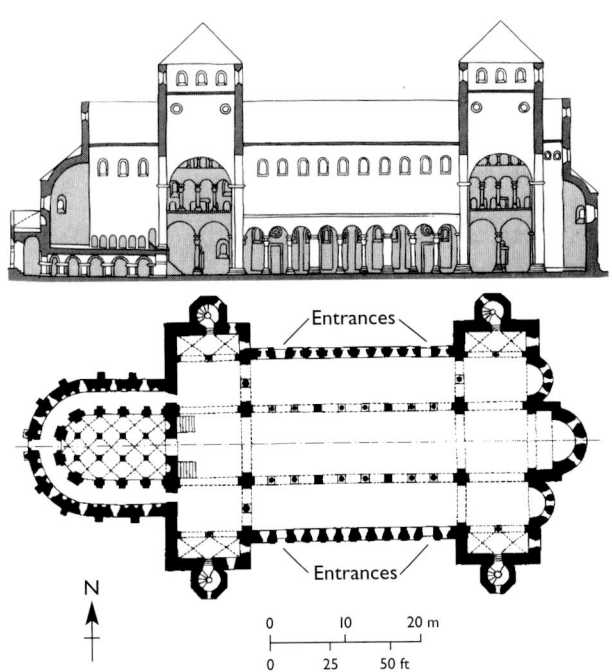

9.36 Section and plan of Saint Michael's, Hildesheim.

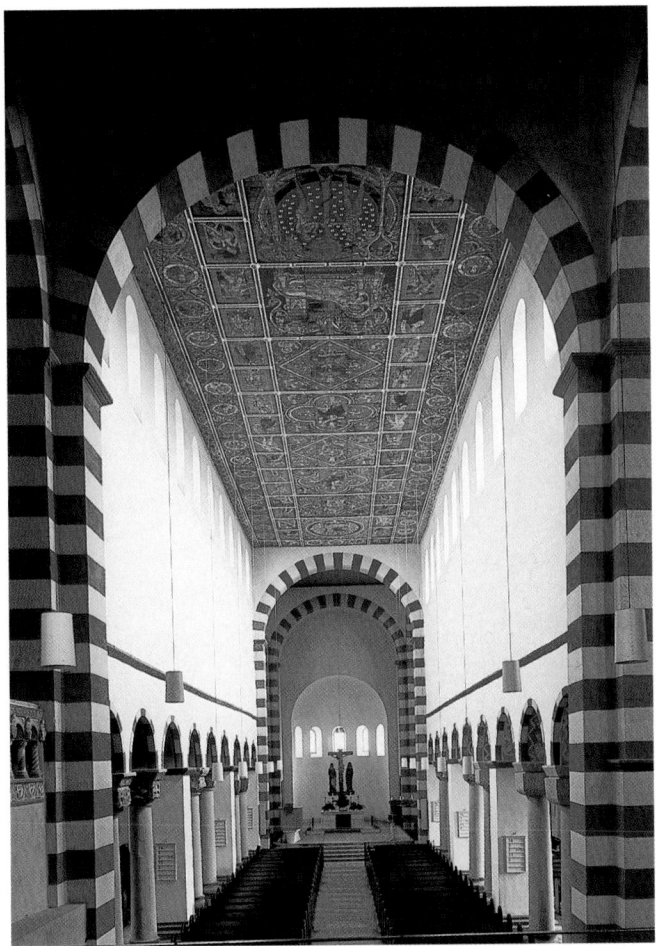

9.37 Restored interior of Saint Michael's, looking west, Hildesheim.

9.38 Bronze doors, Saint Michael's, Hildesheim, completed 1015. 16 ft. 6 in. (5.02 m) high. According to a contemporary biographer, Bishop Bernward was himself an expert goldsmith and bronze caster. He stayed with Otto III at his Roman palace, which was near the church of Santa Sabina (see fig. W4.3). The wooden doors of Santa Sabina are believed to have inspired the bronze doors of Saint Michael's.

prefigured the latter. The horizontal scenes are depicted in relatively high relief, and the thin, lively figures are well within the tradition of Byzantine and Carolingian style.

In the scene of *Adam and Eve Reproached by God* (fig. **9.39**), the tree forms, especially at the far left, resemble Hiberno-Saxon interlace motifs. The serpent is a version of the fantastic creatures that populate works in the traditional Animal Style. But there is also a new dramatic character that is combined with fluid, linear rhythms—for example, the juxtaposition of figure with void. The hierarchy of pose and gesture is clearly delineated: God's superiority is denoted by his taller form, his admonishing gesture, and the fact that he is clothed. Adam cowers before God and covers his nakedness. The diagonal of his back is reinforced by the tree branch above him. He points to Eve behind him, cowering even more than he as she points to the serpent at her feet. The narrative movement starts with God and ends with the serpent (in the Bible, God condemns him to crawl forever on the ground): formal "uprightness" is thus an echo of moral "rightness." Furthermore, the intended left-to-right reading of the scene is a reversal of the biblical text, in which the serpent tempted Eve, who tempted Adam, who angered God.

Ottonian manuscript illuminations also reflect a change from Carolingian style. The two-dimensional, iconic image of Saint Luke in Otto III's Gospel book (fig. **9.40**), compared with the landscape setting of the *Four Evangelists* from the Gospel book of the Aachen court (fig. **9.30**), is an example. Saint Luke sits on a rainbow inside a green mandorla suspended in a gold space. Instead of natural landscape, the Ottonian manuscript depicts an abbreviated rocky platform beneath Luke. This is flanked by two lambs drinking from water that flows from the rocks, but there is no rational

relationship among these forms. Both the water and the lambs are suspended, like the saint, in gold. Their significance here is wholly symbolic, for the rocks denote the church building and the drinking lambs (cf. Christ as the Lamb of God) refer to rebirth through baptism. Whereas the Evangelists in the Aachen codex prepare to write, Saint Luke exuberantly holds up a decorative array of circular clouds containing angels and prophets. Directly over his own halo is the most prominent cloud with his symbol, the bull. Framing the scene are two columns with non-Classical, stylized cabbage-leaf capitals. These support an arch decorated with fanciful interlace that is more three-dimensional than Hiberno-Saxon and Viking examples.

Ottonian ivories also reflect the departure from Carolingian Classicism. This is evident, for example, in the dedication panel from the so-called Magdeburg Antependium (fig. **9.41**). Said to be a gift from Otto I to Magdeburg, it shows a frontal Christ seated on a stylized wreath with his feet resting on a curved platform. He turns to Otto, who presents him with a model of the cathedral Church of Saint Mauritius (a third-century Roman general martyred in Africa). Saint Peter stands at the right, identified by his attribute, the key. The figures on this ivory lack the three-dimensional, organic qualities of Charlemagne's Classical revival. Instead, they are short, stubby, and rather blocklike. Surface patterns on the draperies, as well as in the background, have replaced natural form.

Like the Ottonian abbey of Saint Michael's and the illumination of *Saint Luke* from the Gospel book of Otto III, the ivory is stylistically transitional. It reflects the waning of naturalism at the end of the Carolingian period and the trend toward the more iconic imagery that will become characteristic of Romanesque style.

9.39 *Adam and Eve Reproached by God,* from the bronze doors of Saint Michael's, Hildesheim (detail of fig. 9.38). Approx. 23 × 43 in. (58.3 × 109.3 cm).

9.40 *Saint Luke,* from the Gospel book of Otto III, c. 1000. 13 × 9⅜ in. (33.0 × 23.8 cm). Bayerische Staatsbibliothek, Munich.

9.41 *Christ Enthroned with Saints and Emperor Otto I,* from Milan or Richenau, Ottonian, 962–973. Ivory; 5 × 4½ in. (12.7 × 11.4 cm). Metropolitan Museum of Art, New York.

	Style/Period	Works of Art	Cultural/Historical Developments
300 **400**	EARLY MIDDLE AGES 4th century		Dedication of the city of Constantinople (300) Visigoths sack Rome (410)
	EARLY MIDDLE AGES 5th century		Founding of Constantinople University (425) Last Roman legions leave Britain (476) End of Western Roman Empire (476)
500	EARLY MIDDLE AGES 6th century	 **Sutton Hoo purse cover**	Founding of Essex and Middlesex, kingdoms of Anglo-Saxon England (527) Building of Hagia Sophia, Constantinople (532–537) Building of San Vitale, Ravenna (540–547) Golden era of Byzantine art (c. 550) Saint Columba (c. 521–597) settles on island of Iona and begins conversion of the Picts (563) Birth of Muhammad, founder of Islam (c. 570) Development of Gregorian chant as part of religious services (late 500s) Golden age of Celtic culture (600–800)
600		**Book of Durrow**	
700	EARLY MIDDLE AGES 7th century	Sutton Hoo purse cover (**9.15**), East Anglia Book of Durrow (**9.23**) Dome of the Rock (**9.1**), Jerusalem	Saint Augustine establishes the archiepiscopal See of Canterbury (602) Founding of monastery of Saint Gall (612) Death of Muhammad (632) The Venerable Bede, English writer and historian (673–735)
800	EARLY MIDDLE AGES 8th century	 Celtic cross (**9.22**), Tipperary Coronation Gospels (**9.29**) Evangelistary of Godescalc (**9.28**) Charlemagne's palace chapel (**9.25**), Aachen *Warrior Entering Valhalla* (**9.20**), Tjangvide Book of Kells (**9.24**) **Warrior Entering Valhalla** **Book of Kells**	 **Book of Durrow** *Beowulf*, English epic (early 700s) Moors conquer North Africa and Spain (711–715) Byzantine emperor Leo III bans images in churches and provokes Iconoclastic Controversy (726) Victory of Charles Martel over Muslims at Battle of Tours (732) Charlemagne (742–814) crowned Holy Roman emperor at Rome; consolidates most of Europe into a single kingdom (800) Charlemagne establishes Carolingian schools; study of Latin texts encouraged (c. 800)
900	EARLY MIDDLE AGES 9th century	**Mosque of Suleyman I** Great Mosque (**9.7–9.9**), Córdoba Animal headpost (**9.16**), Oseberg Gospel book (**9.30**), palace chapel school, Aachen Rök stone (**9.19**), Östergötland Monastery of Saint Gall (**9.33–9.34**), Switzerland Utrecht Psalter (**9.32**), Reims Vivian Bible (**9.31**), Paris. Great Mosque (**9.4**), Samarra Kufic Koran (**9.2**), Tunisia	Vikings discover Iceland and invade England (c. 866) **Axe from Mammen**
1000	EARLY MIDDLE AGES 10th century	Axe, Mammen, Jutland (**9.18**) *Christ Enthroned with Saints and Emperor Otto I* (**9.41**) Bluetooth's rune stone (**9.21**), Jelling	Period of Ottonian rule (919–1024) Completion of Koran (935) Beginning of Ottonian architecture (936)
	MIDDLE AGES 11th century	Gospel book of Otto III (**9.40**) Saint Michael's (**9.35, 9.37–9.39**), Hildesheim	Great Schism between Rome and Constantinople (1054)
1200	MIDDLE AGES 12th century		Omar Khayyám writes *Rubaiyat* (c. 1100)
	MIDDLE AGES 13th century	**Tugra of Suleyman**	Saint Thomas Aquinas (1225–1274) writes *Summa theologiae* (1265–1273) Giotto di Bondone born (c. 1267) **Gospel book of Otto III**
1500–1650	BYZANTINE 15th century		Ottomans capture Constantinople, which becomes Turkish capital (1453)
	ISLAMIC 16th–17th centuries	Mosque of Suleyman I (**9.10, 9.12–9.13**), Istanbul Illuminated *tugra* of Sultan Suleyman (**9.3**) Luftullah Mosque (**9.14**), Isfahan	

Window on the World Five

Mesoamerica and the Andes
(1500 B.C.–A.D. 1500)

While the arts and cultures so far considered were flourishing in Europe, Africa, Australia, and the Far East, civilizations also rose and fell in the Americas. The Americas were isolated from the rest of the world by vast oceans, and to date there is scant archaeological evidence of contact. However, there are intriguing formal and conceptual similarities, as well as significant differences, between the cultures of the Americas and other civilizations contemporary with them.

The origins of the Native Americans have been traced to the arrival of Paleolithic peoples from Siberia to Alaska over a land mass (now the Bering Strait) that connected them during the last Ice Age. During the Paleolithic era, migrations to the south from the far north (Alaska and Canada) led to settlements in North and South America. By around 9000 B.C. or earlier, human culture had spread to the southernmost tip of South America. It was not until the fifteenth century that explorers, including Columbus, traveled to the Americas. With their subsequent conquest by Spain in the sixteenth century, many American civilizations were destroyed. The European invaders (particularly the Spanish) affected some of these cultures to such an extent that scholars now divide their history into pre-Columbian and post-conquest periods.

Mesoamerica

The arts of three major civilizations from Mesoamerica—the land mass connecting North and South America—are outlined here. These are Olmec, Teotihuacán, and Maya. Mesoamerica stretches from northern Mexico to Panama and includes the province in Mexico of the Yucatán, Belize, Guatemala, Honduras, and El Salvador (see maps). The archaeology of the region is in a state of flux, although advances have been made in deciphering Mesoamerican writing systems since the 1960s. Nevertheless, the complex nature of these civilizations remains little understood.

Mesoamerica in relation to North and South America.

Mesoamerica.

The history of the region has been divided into three major phases: the Preclassic (or Formative), c. 2000 B.C. to A.D. 250/300; the Classic, c. 300 to 900; and the Postclassic, 900 to 1521. As elsewhere, a period of hunting and gathering (c. 11,000–7500 B.C.) preceded the development of agriculture, monumental stone architecture, and the organization of villages into social and political hierarchies. Examples of pottery as well as of figurines that probably served a fertility function survive from around 1800 B.C. By Late Preclassic, there is evidence of urbanization; temples were constructed on pyramidal platforms, and stone monuments containing portraits and inscriptions were carved.

Although Mesoamerica produced culturally distinctive civilizations and correspondingly distinct styles of art and architecture, certain important similarities appear in several of them. These include the development of (base 20) mathematics, an understanding of astronomy, hieroglyphic writing, books made of fig-bark paper or deerskin, and a complex calendar. The religions were polytheistic, requiring offerings to the gods, bloodletting rituals, and human sacrifice. One of the most intriguing Mesoamerican practices was a ritual ball game, which was played on a large rectangular court. As in modern soccer, players were not supposed to touch the ball with their hands. The movements of the ball were symbolic, apparently conceived of in relation to the sun and moon. Often, captives were forced to play, and losers, according to some scholars, could be sacrificed to the gods.

Olmec

(flourished c. 1200–900 B.C.)

The Olmec civilization, located in present-day Mexico, dates from Early to Middle Preclassic and had a lasting influence on the entire region. As in other areas of Mesoamerica, by around 900 B.C. Olmec society was stratified into a class of commoners and a ruling elite. The elite maintained a flourishing trade in exotic goods that were symbols of authority and status, especially jade, obsidian, and iron pyrites (used for mirrors). Most of the population were

W5.1 *Seated Jaguar,* San Lorenzo, Veracruz, Mexico, Olmec, Early Preclassic, 1200–900 B.C. Basalt; 35½ in. (90.2 cm) high. Because this figure seems to represent shedding tears, it is believed to be an aspect of a rain god or a water deity. Elsewhere in Mesoamerica, the jaguar is the god of the underworld. This figure was found next to an underground canal, which is assumed to confirm its connection to a water cult.

farmers, who supported the priests and rulers with labor and goods.

Monumental stone sculptures of basalt such as the *Seated Jaguar* (fig. **W5.1**) were produced at San Lorenzo, in Veracruz, the oldest known Olmec site. The solid, blocklike forms remain characteristic of Mesoamerican art well into the Late Classic period. Merging with the features of a jaguar— an animal indigenous to Mesoamerica and important in its mythology—is the physiognomy of a human child. The hands and feet are pawlike, but the pose and upright posture are human. Such combinations of human with animal elements are first seen in Olmec sculpture and continue in later Mesoamerican art.

The colossal basalt head in figure **W5.2** is one of ten that have been found at San Lorenzo. These heads, weighing between 5 and 20 tons, representing males, are probably portraits of individual rulers. The fleshy, organic faces usually have broad, flat noses and thick lips; also characteristic is the tight, domed headdress with earflaps and a strap under the chin. Most of these colossal heads were defaced and buried. Similar sculptures are found at La Venta, a site that flourished from around 900 to 400 B.C., along with monumental public architecture and elaborate tombs containing jade offerings.

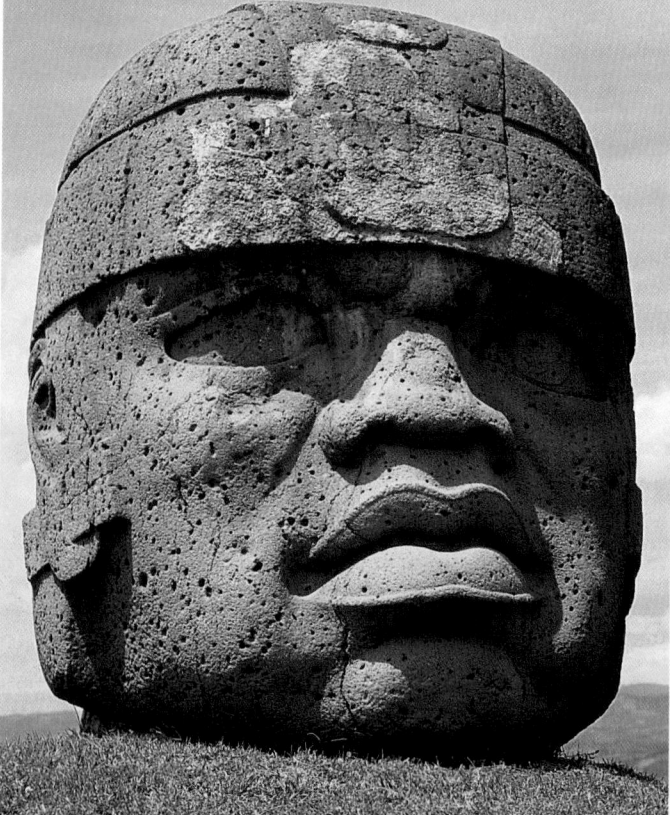

W5.2 Colossal head, from San Lorenzo, Veracruz, Mexico, Olmec, c. 1000 B.C. Basalt; 70⅞ in. (180.0 cm) high. Museo Regional de Veracruz, Jalapa, Mexico.

Teotihuacán

(flourished c. 350–650)

By A.D. 200, Teotihuacán had become a commercial city-state specializing in the manufacture of stone tools (especially of obsidian) and pottery. Between about 350 and 650, Teotihuacán was the biggest and most influential city anywhere in the Americas. It spread over an area of 8 square miles (20.7 sq km) and supported a population of as many as 200,000. The later Aztec culture dominated the region at the time of the Spanish conquest and attached mythical importance to the great ruins of Teotihuacán (an Aztec name, as are the names of many of the gods).

The most significant architecture at Teotihuacán was the ceremonial complex (figs. **W5.3** and **W5.4**) aligned with the Avenue of the Dead, which was 3 miles (4.8 km) long. The largest structure, called the Pyramid of the Sun by the Aztecs, was to the east of the avenue, near its center (see fig. W5.3). A stairway on the west side led to a platform at the top. This supported a two-room temple that has since disappeared. The slightly smaller Pyramid of the Moon was located at the north end of the avenue. Toward the southern

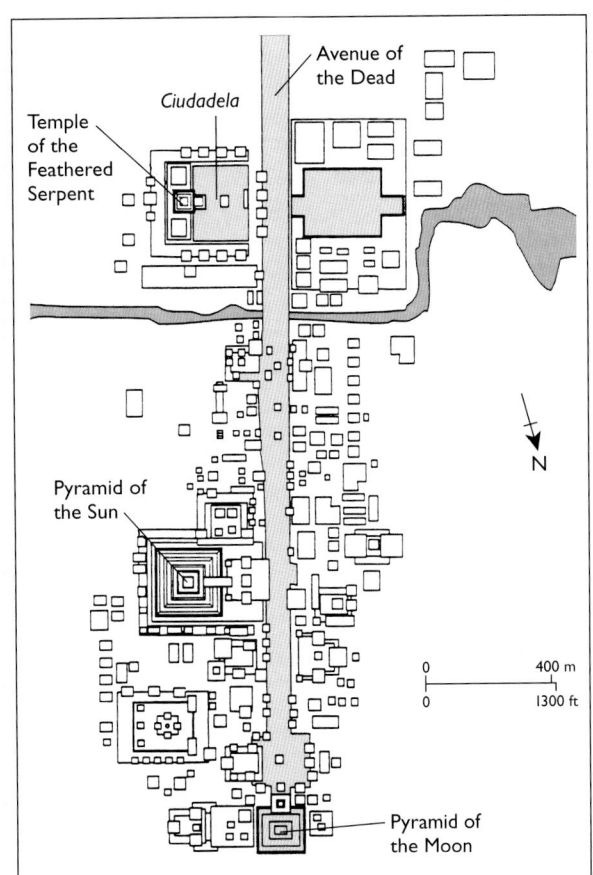

W5.4 Plan of Teotihuacán, c. 350–650.

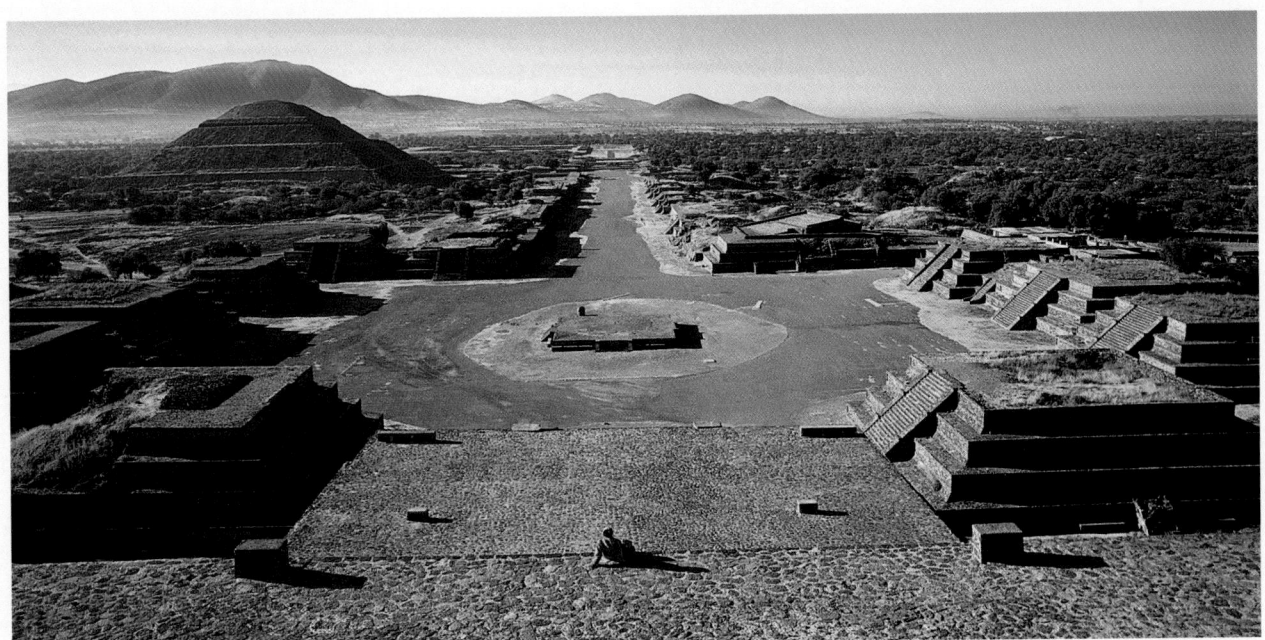

W5.3 View of Teotihuacán, c. 350–650. The Pyramid of the Sun as seen from the Pyramid of the Moon, Teotihuacán c. 350–650. Square base over 700 ft. (213.4 m) per side; over 210 ft. (64.0 m) high; 1,700,400 cubic yards (1.3 million m³) volume. The Moon Pyramid is somewhat smaller with a height of 130 ft. (39.62 m) and a base of 400 × 500 ft. (121.92 × 152.40 m).

end was the *Ciudadela,* or citadel, a square large enough for crowds of 60,000 functioning as the religious and political center of Teotihuacán.

Surrounding the *Ciudadela* were temple platforms constructed in **talud-tablero** style (fig. **W5.5**). This style is typical of Teotihuacán architecture: the *tablero* is the framed vertical element built above a sloping base (the *talud*). The platform façades were faced with painted stucco, and their cores were reinforced with stone piers and filled with rubble embedded in clay.

Excavations at the *Ciudadela* have revealed dramatic monumental painted reliefs on the façade of a temple platform dedicated to the Feathered Serpent (called Quetzalcoatl by the Aztecs). The detail in figure **W5.6** shows massive, blocklike serpent heads with bared fangs, surrounded by a circle of feathers. They alternate with heads of Tlaloc, the rain god. Both are carved frontally, and their fixed gazes are reinforced by their wide, round eyes. The stylized geometry of these figures is characteristic of figural imagery at Teo-

tihuacán, but the exact meaning of their iconography is not known.

That Tlaloc may have served an apotropaic function is suggested by his role—like that of the Gorgoneion—as a shield device. As such, he appears on a stele found at the Classic Maya site of Tikal and carved with the representation of a warrior in Teotihuacán costume (fig. **W5.7**), which may indicate the widespread influence of Teotihuacán. Dressed in full regalia with an elaborate feathered helmet and a shell necklace, he carries a shield decorated with the

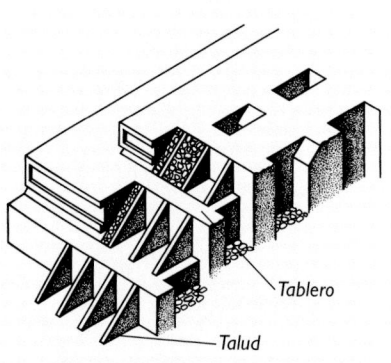
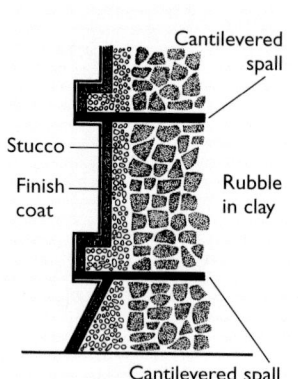

W5.5 Diagrams of a *talud-tablero* platform.

W5.6 (left) Detail of heads from the façade of the Temple of Quetzalcoatl, Teotihuacán, before 300. Painted relief. Skeletons of eighty men dressed as soldiers were found beneath this temple, possibly further evidence of human sacrifice in Mesoamerica.

W5.7 Detail of a warrior in Teotihuacán costume, from the side of stele 31, Tikal, Guatemala, Maya. University Museum, Philadelphia.

face of Tlaloc. The warrior is depicted with his head in profile and his torso slightly turned. But his shield is frontal, like the gods on the temple of Quetzal-coatl in the *Ciudadela*. The image of Tlaloc thus confronts viewers with a direct, and symbolically protective, gaze.

Around 650 to 750, the architectural complex along the Avenue of the Dead was burned, possibly by invaders, and the thriving city of Teotihuacán fell into decline. Its culture was kept alive, however, particularly through Aztec legends, and continued to influence the art and architecture of Mesoamerica for centuries.

Maya
(c. 1100 B.C.–A.D. 1500)

Maya civilization originated in the southern part of Mesoamerica and lasted until its destruction in the sixteenth century. It occupied eastern Mexico (particularly the Yucatán, Tabasco, and Chiapas), Belize, Guate-

mala, and the west of Honduras and El Salvador.

Maya culture developed not only the most complex writing system in Mesoamerica, but a sophisticated knowledge of mathematics and methods of observing celestial phenomena, recorded in books made from strips of bark paper (see box). The Maya created many important political and religious centers, each populated by an elite class of rulers, priests, and nobles, supported by a far more numerous class of farmers and artisans.

Hereditary rulers were theocratic—that is, their claim to power rested on establishing a connection with the gods (see box). A wood carving from Tabasco of a *Maya Lord* (fig. **W5.9**), wearing a

W5.9 (right) *Maya Lord,* from Tabasco, Mexico, 6th century. Wood with hematite pigment; 14 in. (35.5 cm) high. Metropolitan Museum of Art, New York. Michael C. Rockefeller Memorial Collection. Bequest of Nelson A. Rockefeller, 1979 (1979.206.1063). Photograph © 1980 Metropolitan Museum of Art.

The Maya Calendar

Several calendrical systems were developed by the Maya, all of them intimately related to seasonal change and astronomical phenomena. They were used in the service of religious rituals, ceremonies, and festivals. One of the most intriguing creations is the calendar round of fifty-two years, which developed in the Late Preclassic period (300 B.C.–A.D. 250).

Two time cycles within the calendar round have been identified. The 260-day count, which is still used by some contemporary Maya, is based on a sequence of thirteen periods, each of twenty days. Each day has specific omens that prophesy future events. The other cycle is based on a 365-day year consisting of eighteen months, each twenty days long. Five unlucky days are added at the end to round out the total.

The so-called "long count," which dates time from August 13, 3114 B.C., was developed after the calendar round, although precisely when is not known. It was used by the Olmecs and the Maya. The long count differed from the calendar round in being based on a 360-day year. Time, according to recent scholarship, was recorded in units of 400 years, 20 years, 20 days, and individual days.

The jade plaque known as the Leiden Plate (fig. **W5.8**) shows, on the front, an Early Classic Maya ruler from Tikal as he steps on the back of a defeated enemy, a typical iconographic motif in Maya stelae. The reverse shows glyphs indicating a long count date in the year 320, probably the day on which this particular ruler assumed power.

W5.8 The Leiden Plate. Jade; 8½ in. (21.6 cm) high. Rijksmuseum voor Volkenkunde, Leiden.

Maya Religion

The Maya believed in cycles of creation and destruction, ages of development, and an apocalyptic end of the world. They conceived of the universe as having three tiers: sky, earth, and underworld. The earth was a square or rectangle resting on the back of a crocodile. The four corners of the world were oriented to the cardinal directions and associated with specific colors. East was red like the sunrise, and west, where the sun sets, was black. North was white, and south was yellow. Supporting the Maya sky—conceived of as a two-headed serpent—was the great Tree of Life at the center of the world. When Maya died, they went to the underworld, or "place of night" (*Xibalba*), which had nine levels.

The *Popol Vuh*, a Late Postclassic epic history of the Quiche Maya (an important nation that flourished just before the Spanish conquest), relates the story of Hero Twins who defeat the Xibalbans in a ball game. The heroes ascend to heaven and become the sun and the planet Venus. In so doing, they are a model for Maya rulers who likewise hope to escape eternal night. The epic is known from a manuscript discovered in the nineteenth century.

Maya religion was polytheistic, and each god had multiple aspects. Hunabku was the omnipotent god who controlled the universe. The chief god Itzamna ("Lizard House") was depicted as an old man who invented writing; he was the god of science and knowledge. His wife, Ix Chel ("Lady Rainbow"), was the goddess of weaving, medicine, childbirth, and the moon. Together, Itzamna and Ix Chel produced all the other gods in the Maya pantheon.

skirt and an elaborate necklace, kneels in a ritual pose. The Maya shared the pervasive Mesoamerican belief that the gods had given people their own blood when they created them. The gods thus had to be repaid in kind with human blood, and elaborate rites were performed in which rulers let their own blood—but only slightly—as a sign of their identification with the gods. The fate of their captives, however, was not so benign. Typically, four men would each hold a limb of the captive, while a fifth cut out the heart.

Classic Maya

Copán (early 5th century–c. 820) One of the best-preserved Classic Maya sites is Copán, in western Honduras. The reconstruction drawing (fig. **W5.10**) is based on the Late Classic period. It shows the temple pyramids with their stairways on the acropolis at the right, and the plaza with monumental carved stelae at the left. Copán artists used durable green volcanic tufa for architectural monuments and their sculptural decorations, which included elaborate portraits of Maya kings. The ball court

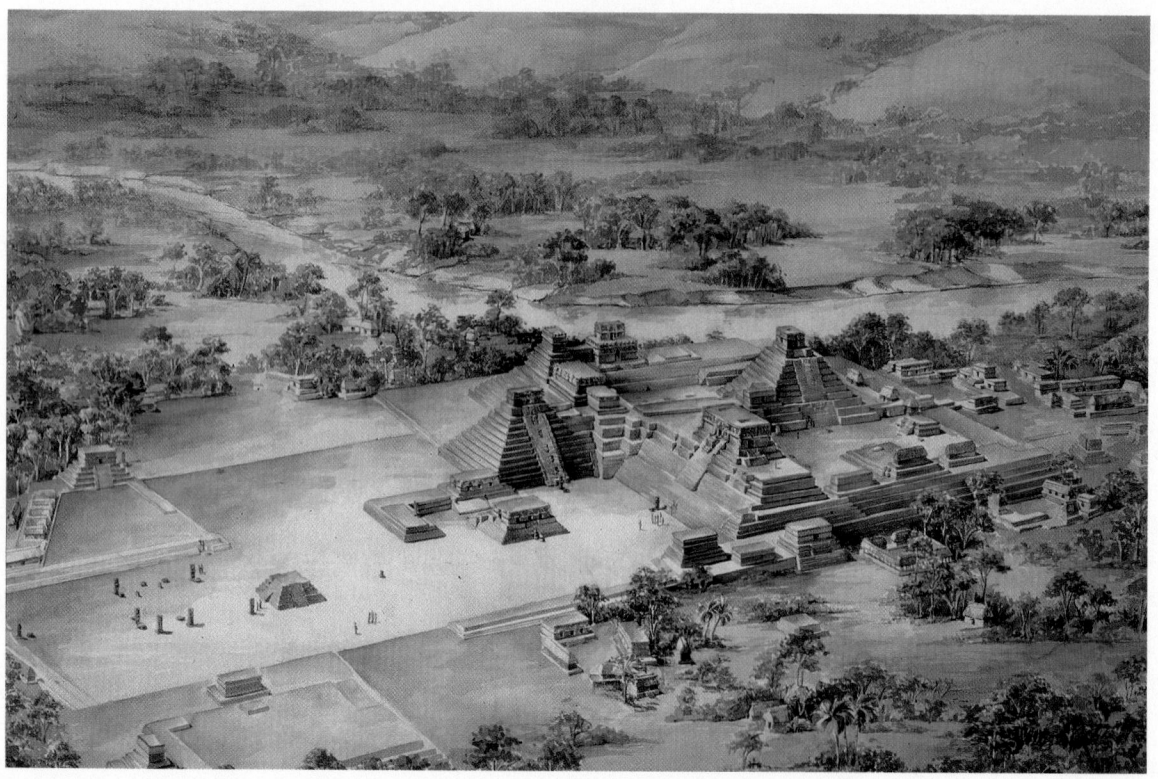

W5.10 Tatiana Proskouriakoff, reconstruction drawing of the site of Copán, Honduras, Maya, Late Classic.

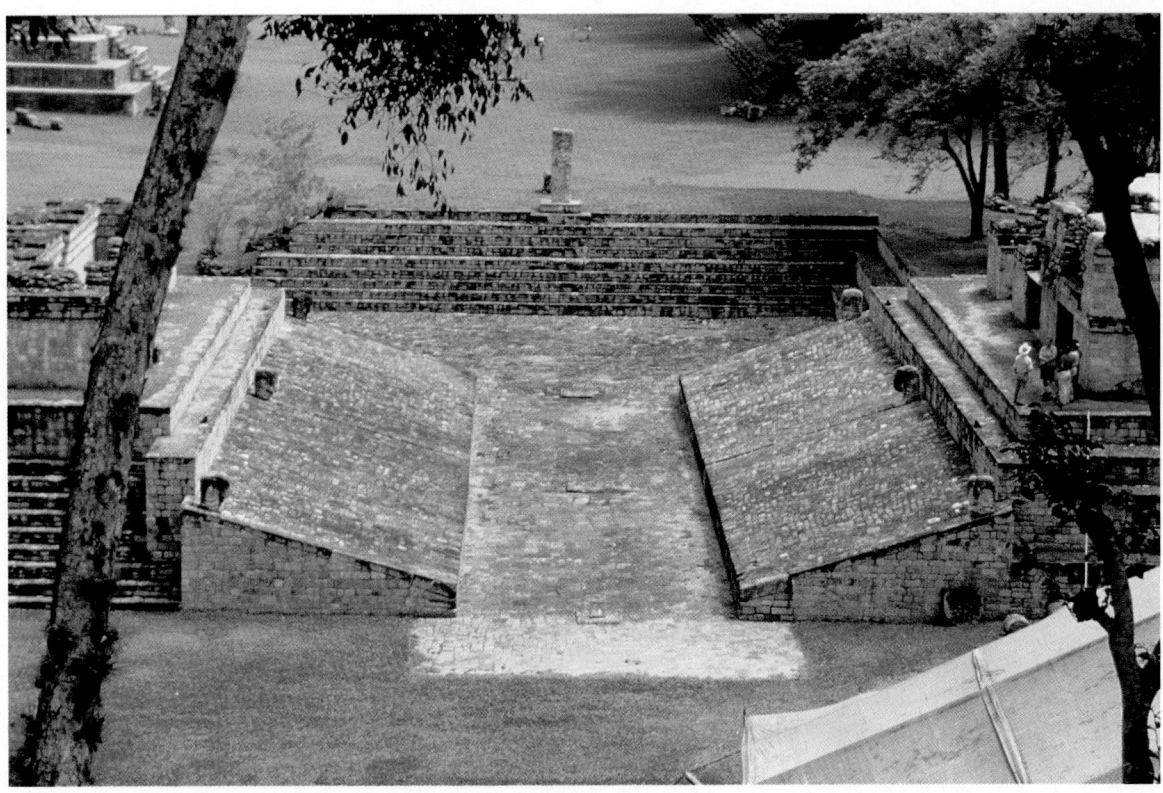

W5.11 Ball court, Copán, Honduras, Maya, Late Classic, c. 800.

at Copán (fig. **W5.11**) is one of the fin-est surviving examples of Classic archi-tecture. It was dedicated in A.D. 738 by a king known as Eighteen Rabbit, who also presided over the construction of a large palace.

Also at Copán, archaeologists have discovered a scribal palace of the Clas-sic period decorated with sculptures of the monkey-man god represented as a scribe (fig. **W5.12**). Scribes were members of the elite. The example il-lustrated here shows a scribe sitting cross-legged, like the Egyptian scribe (cf. fig. 3.20), and listening attentively. His necklace is similar to that worn by the *Maya Lord* (fig. W5.9), and his com-bination of human and animal features is reminiscent of the Olmec *Seated Jag-uar* (fig. W5.1).

Maya scribes wrote with brush or feather pens, which they dipped into small pots made from conch shells. The writing liquid itself was either black or red pigment.

See figure 3.20. Seated scribe, from Saqqara, c. 2551–2528.

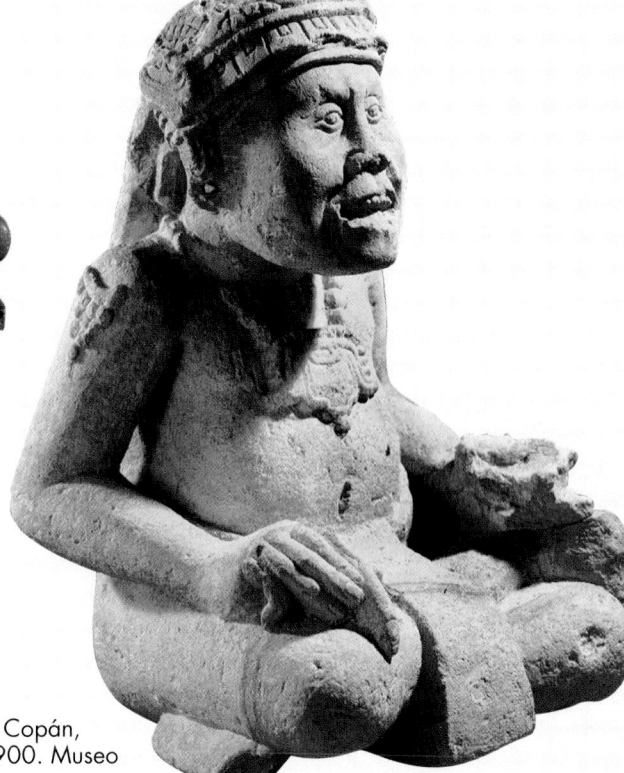

W5.12 Monkey-man scribal god, from Copán, Honduras, Maya, Late Classic, c. 600–900. Museo Municipal, Copán, Honduras.

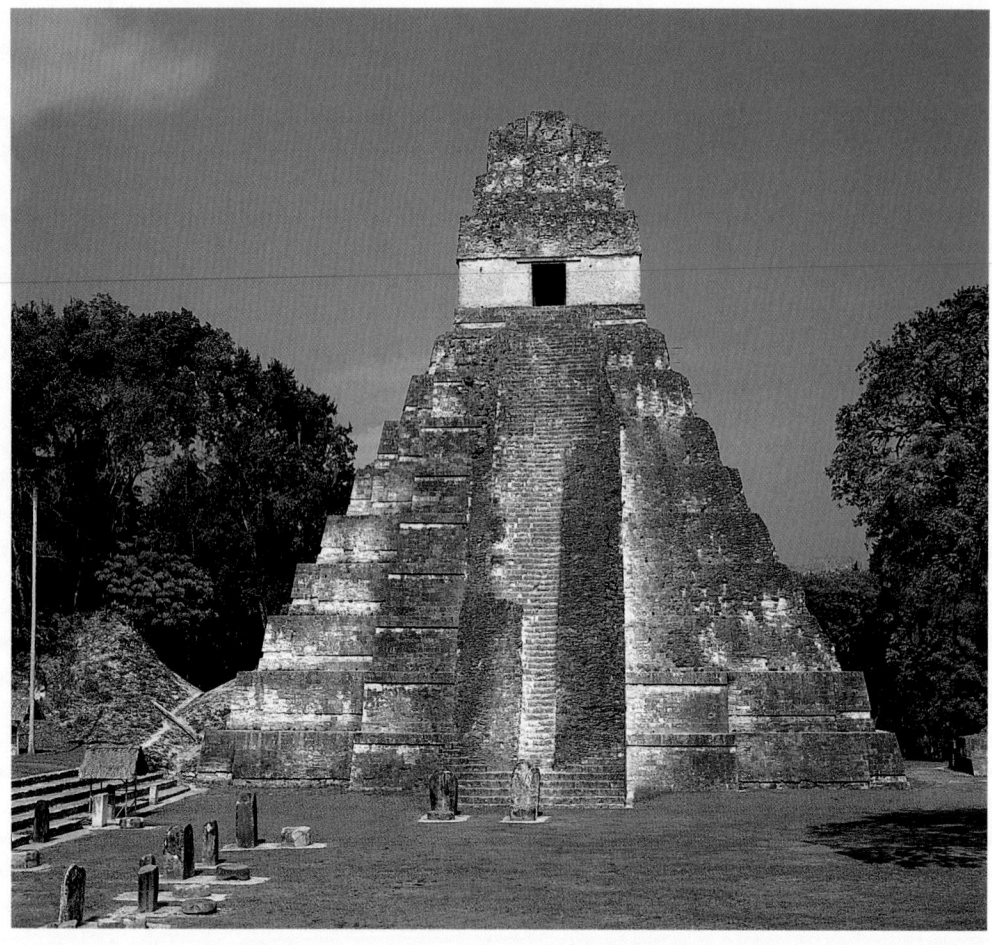

W5.13 Temple I, Tikal, Guatemala, Maya, before 800. Approx. 157 ft. (47.85 m) high.

Tikal: Temple I At Tikal, in the Petén region of modern-day Guatemala, Temple I (the Temple of the Jaguar) is one of six structures that reflect the increasing height of Maya temple pyramids (fig. **W5.13**). In its heyday, Tikal was one of the largest Classic Maya city-states. It had an elevated ceremonial complex consisting of rulers' tombs surmounted by temples, open squares, and ball courts. Temple I has nine layers supporting a temple, accessible by a staircase on the long side, and faces Temple II on the other side of an open square. The temple has two rooms with corbeled vaults and is crowned by a **roof comb** (the crestlike feature, originally decorated with painted sculpture). Beneath Temple I, archaeologists found the tomb of a ruler nicknamed "Au Cacao," which means "Lord Chocolate" (ruled c. 682–727); he was buried with jewelry, food and drink, and bone tubes incised with representations of the gods.

Bonampak: Mural Painting In 1946, at the Classic Maya site of Bonampak (in Chiapas, Mexico), a remarkable group of murals dating to the late eighth century was discovered. These depict narratives of battles, victory celebrations, and the torture and sacrifice of prisoners. The recopied mural in figure **W5.14** illustrates the Mayan treatment of captured prisoners. The scene is set on a stepped pyramid with King Chaanmuan at the center of the top step. He wears a jaguar-skin jacket and is flanked by masked and costumed members of the nobility. Standing at the right is his principal wife wearing a white robe and holding a fan. Between the top step and the attendants at the bottom are nearly nude captives awaiting death. Some stare in shock at their hands, which drip blood. A dead captive lies below the ruler's staff, while a decapitated trophy head is beside his right foot.

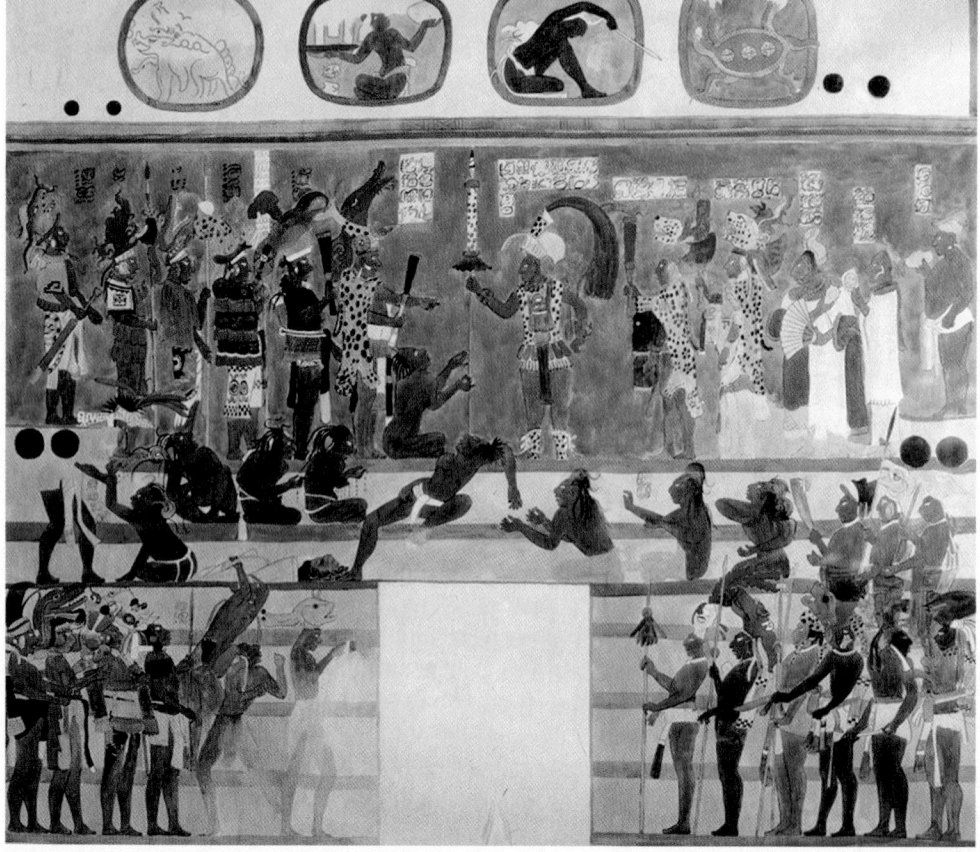

W5.14 Reconstruction of a mural painting from Bonampak, Chiapas, Mexico, Maya, Classic, c. 790. Peabody Museum of Archaeology and Ethnology, Harvard University.

Postclassic Maya: Chichén Itzá
(flourished 9th–13th centuries)

A Postclassic Maya people, the Itzá, flourished in northern Mexico. In their central city of Chichén Itzá (fig. **W5.15**), a more cosmopolitan Maya style assimilated forms from the Toltecs of central Mexico, as did Maya social and religious institutions. The many frescoes at Chichén Itzá—on the walls of the ball court and in the Temples of the Jaguars and the Warriors—are unfortunately in very poor condition. But the architecture at the site clearly reflects the continuing development of new forms. The view in figure **W5.16** shows the *Caracol*, a circular temple, in the foreground, and in the distance the Temple of Kukulcan (called the *Castillo*) at the left and the Temple of the Warriors farther away at the right. Kukulcan—literally the Feathered (*kukul*) Serpent (*can*)—is mentioned in Maya records as the founder of Chichén Itzá's capital. The Temple of Kukulcan has corbeled vaulting, as at Temple I at Tikal, but unlike most Classic Maya temples it has multiple doorways and larger rooms. An earlier stage of the temple is encased by the terraced platform.

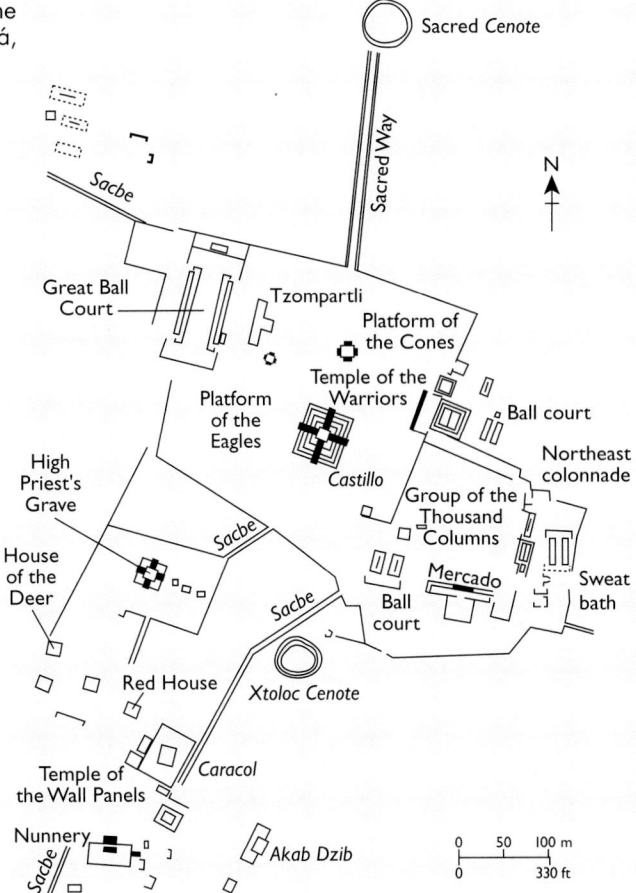

W5.15 Plan of the site of Chichén Itzá, Mexico.

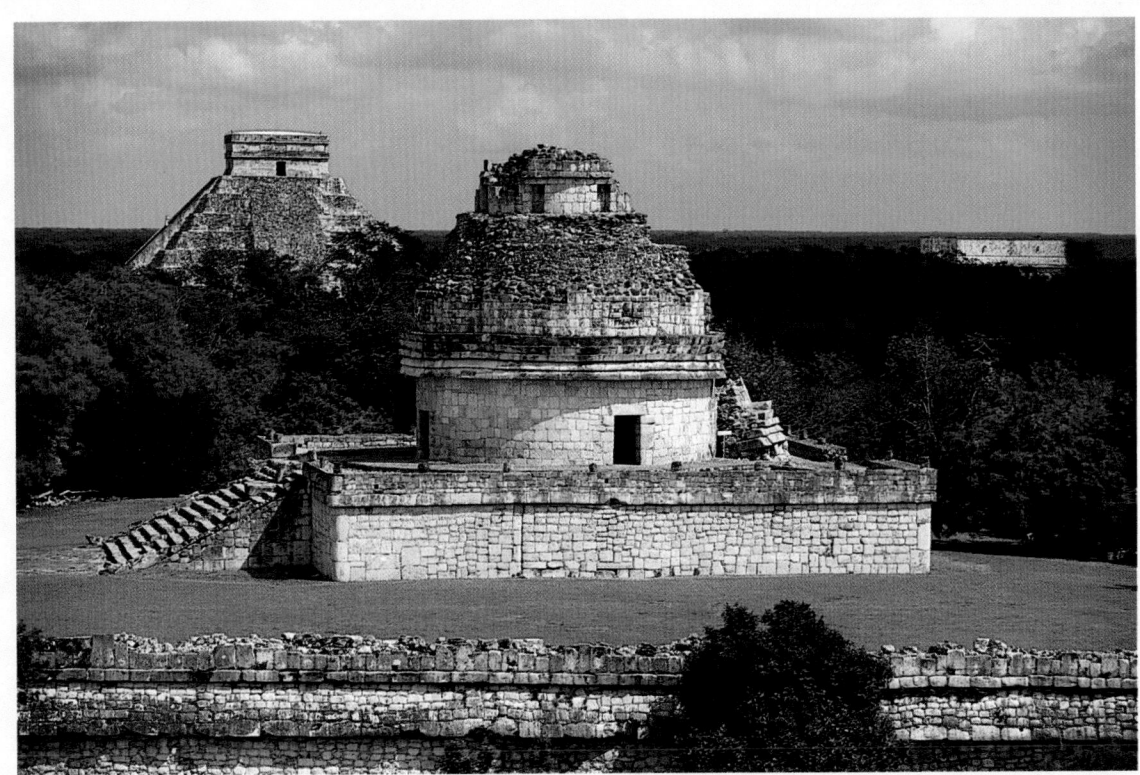

W5.16 View of Chichén Itzá showing the *Caracol* with the *Castillo* (left) and the Temple of the Warriors (right) in the distance, c. 800–1000.

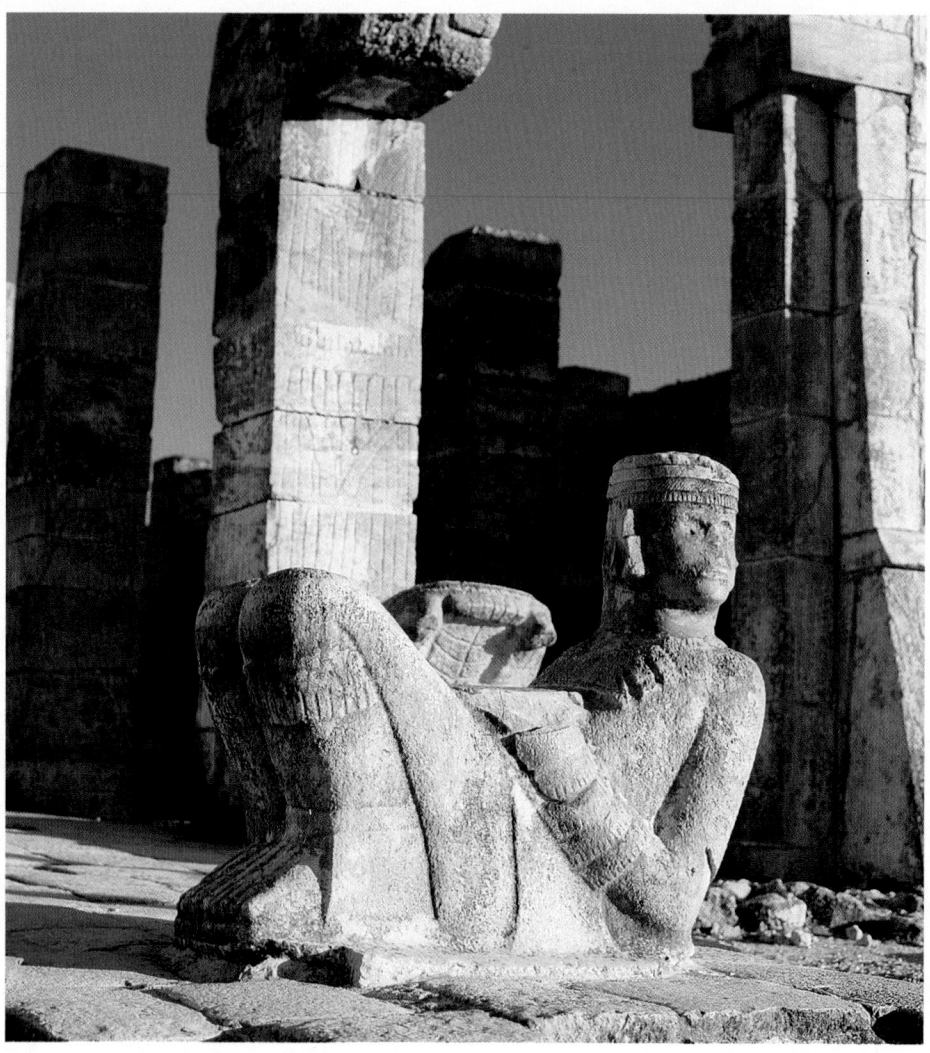

W5.17 *Chacmool,* Chichén Itzá, Mexico. 3 ft. 6 in. (1.07 m) high.

Inside this buried temple, there is a room containing a red throne in the shape of a jaguar, with jade eyes and shell fangs.

The so-called *Chacmool,* meaning "Jaguar King" or "Red Jaguar" (fig. **W5.17**), reclines at the top of the steps leading to the Temple of the Warriors. It turns its head abruptly, as if to stare toward the main open square. The *Chacmool* is a representation of a fallen warrior holding a plate believed to have been for sacrificial offerings.

Chichén Itzá declined in the thirteenth century, and the center of Maya civilization in the north shifted to a new capital at Mayapán. Today, despite the Spanish conquest in the sixteenth century, aspects of traditional Maya culture survive in Mesoamerica.

The Aztec Empire
(c. 1300–1525)

From around 1300, the Aztecs rose to dominance in the Valley of Mexico. They called themselves the Mexica, from which the name Mexico is derived, but their own name is from the legendary Lake Aztlán. Aztec tradition identifies the lake as the original site where they first settled into a recognizable cultural group. In the thirteenth century, according to Aztec tradition, their patron god (Huitzilopochtli), son of Mother Earth and god of the sun and of war, instructed them to leave the region of the lake. After a period of nomadic wandering, the Aztecs arrived at Lake Texcoco, also in the Valley of Mexico. They named the spot Tenochtitlán, and they eventually became the most powerful culture in the

area. By the fifteenth century, the Aztec Empire was vast, its wealth was legendary, and its works of art of remarkable quality.

When Hernán Cortés, the Spanish conqueror, arrived in 1519 in what is today Mexico City, he found the dazzling capital of the Aztec Empire. It was built on a series of islands in the valley. The stone walls, towers, and temples of Tenochtitlán impressed the invaders, who joined forces with the enemies of the Aztecs and conquered them. Cortés destroyed the city and sent enormous quantities of plundered objects, most of gold and silver, to the queen of Spain. Although the spoils were subsequently melted down for the intrinsic value of their materials, caches of Aztec objects continue to be unearthed by archaeologists.

Aztec society was a warrior culture comprised of farmers and workers,

merchants, and a ruling elite. Teotihuacán (see p. 349), which had flourished centuries earlier, became a religious center—the site of the creation of the sun and moon—for the Aztecs. They assimilated the earlier gods into their own belief system, continuing the practice of bloodletting rituals and human sacrifice.

The fifteenth-century relief sculpture in figure **W5.18** shows the dismembered moon goddess Coyolxauhqui, sister of Huitzilopochtli. It was found at the base of the Templo Mayor in the capital city of Tenochtitlán with the head facing the stairway. Coyolxauhqui's head, at a right angle to her neck, is feathered, and her face is decorated with bells. Her belt consists of a two-headed snake with a knot at one end and a human skull at the other. Her arms and legs, adorned with jewelry, are severed from her body, and fanged

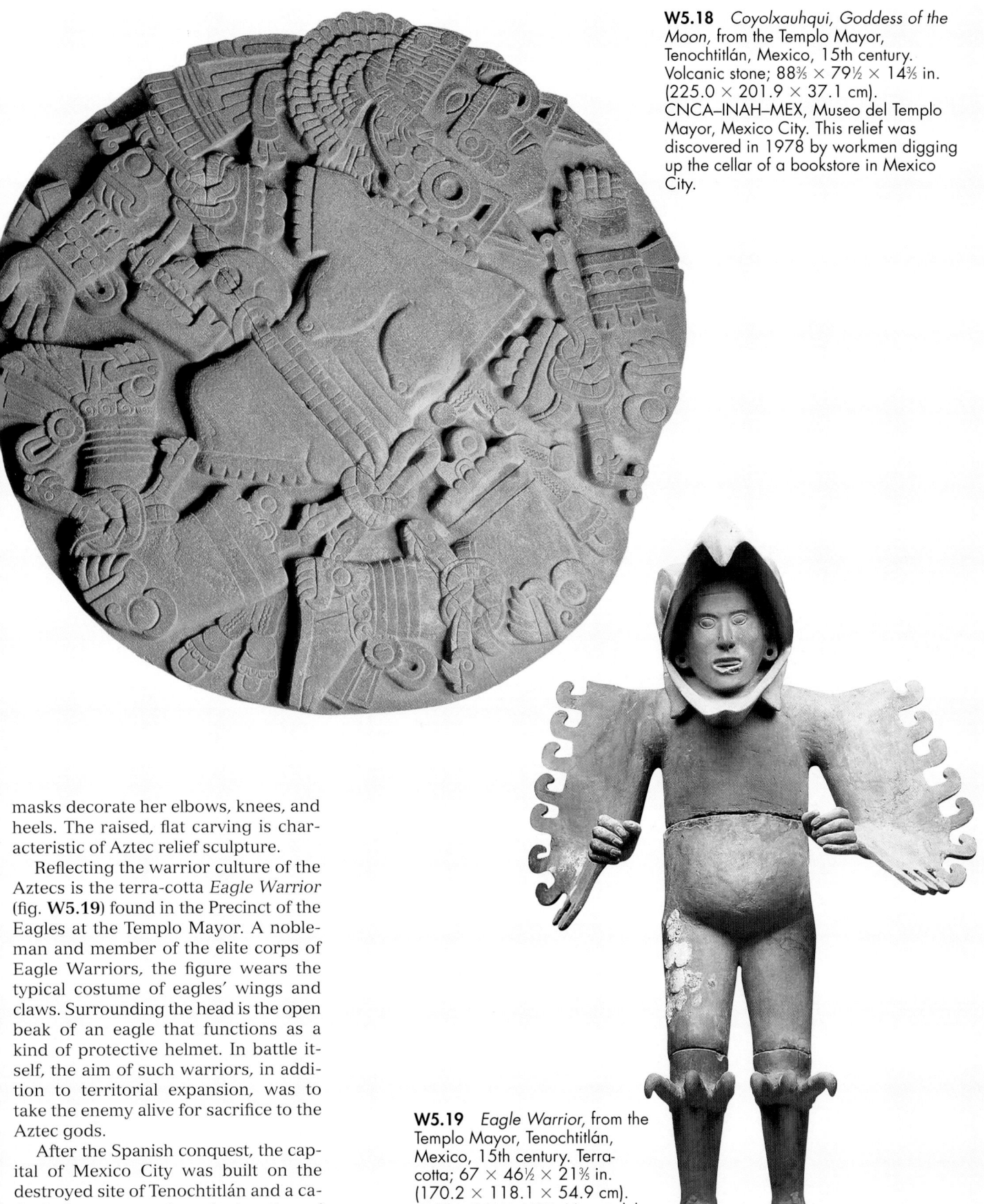

W5.18 *Coyolxauhqui, Goddess of the Moon,* from the Templo Mayor, Tenochtitlán, Mexico, 15th century. Volcanic stone; 88⅗ × 79½ × 14⅗ in. (225.0 × 201.9 × 37.1 cm). CNCA–INAH–MEX, Museo del Templo Mayor, Mexico City. This relief was discovered in 1978 by workmen digging up the cellar of a bookstore in Mexico City.

masks decorate her elbows, knees, and heels. The raised, flat carving is characteristic of Aztec relief sculpture.

Reflecting the warrior culture of the Aztecs is the terra-cotta *Eagle Warrior* (fig. **W5.19**) found in the Precinct of the Eagles at the Templo Mayor. A nobleman and member of the elite corps of Eagle Warriors, the figure wears the typical costume of eagles' wings and claws. Surrounding the head is the open beak of an eagle that functions as a kind of protective helmet. In battle itself, the aim of such warriors, in addition to territorial expansion, was to take the enemy alive for sacrifice to the Aztec gods.

After the Spanish conquest, the capital of Mexico City was built on the destroyed site of Tenochtitlán and a cathedral was erected on the location of the sacred precinct.

W5.19 *Eagle Warrior,* from the Templo Mayor, Tenochtitlán, Mexico, 15th century. Terracotta; 67 × 46½ × 21⅗ in. (170.2 × 118.1 × 54.9 cm). CNCA–INAH–MEX, Museo del Templo Mayor, Mexico City.

Art of the Andes

The Andes is the world's longest mountain range, which includes parts of modern Colombia, Ecuador, Peru, Bolivia, Argentina, and Chile; it also identifies one of the handful of world cultures that evolved as a pristine civilization (see map). Andean culture is often equated with that of the Inkas, who ruled for only a brief time before the arrival of the Spanish in the sixteenth century.

Predating the Inkas, however, was a long and rich cultural tradition with defined artistic periods beginning about 2500 B.C., roughly 12,000 years after people are thought to have crossed the Bering Strait.

Andean art and architecture are remarkably complex, especially when one considers that the wheel, iron, and a clearly defined writing system were little used. The complexity is dependent on a system of duality pervading many abstract ideological concepts as well as many of the visible physical attributes of the society. Fabrication of fine textiles embodying hierarchical and cultural messages is found in each phase of Andean artistic development. Textiles attained the highest level of technology, encompassed the longest-known continuous tradition of fiber art, and were among the most revered objects of Andean culture.

The dramatic and often inhospitable landscape of the Andes influenced its art and contributed to a worldview based on the concept of duality. The dry coastal areas of Peru, which include deserts where only one inch of rain falls annually, are rich in seafood and its nutrients. Highlands and mountains paralleling the coast, on the other hand, provide a contrasting environment where potatoes are often the only crop and conditions are optimal for llamas, alpacas, and other Camelidae that are important sources of fiber and fuel. Trade and reciprocity between these two regions, dating to the preceramic era (3000–1800 B.C.), have been documented. But the lowlands, or tropical jungle, a third geographic area, has not been fully documented because the climate does not permit preservation of cultural remains. Some evidence of interaction, however, particularly as regards imagery, does exist.

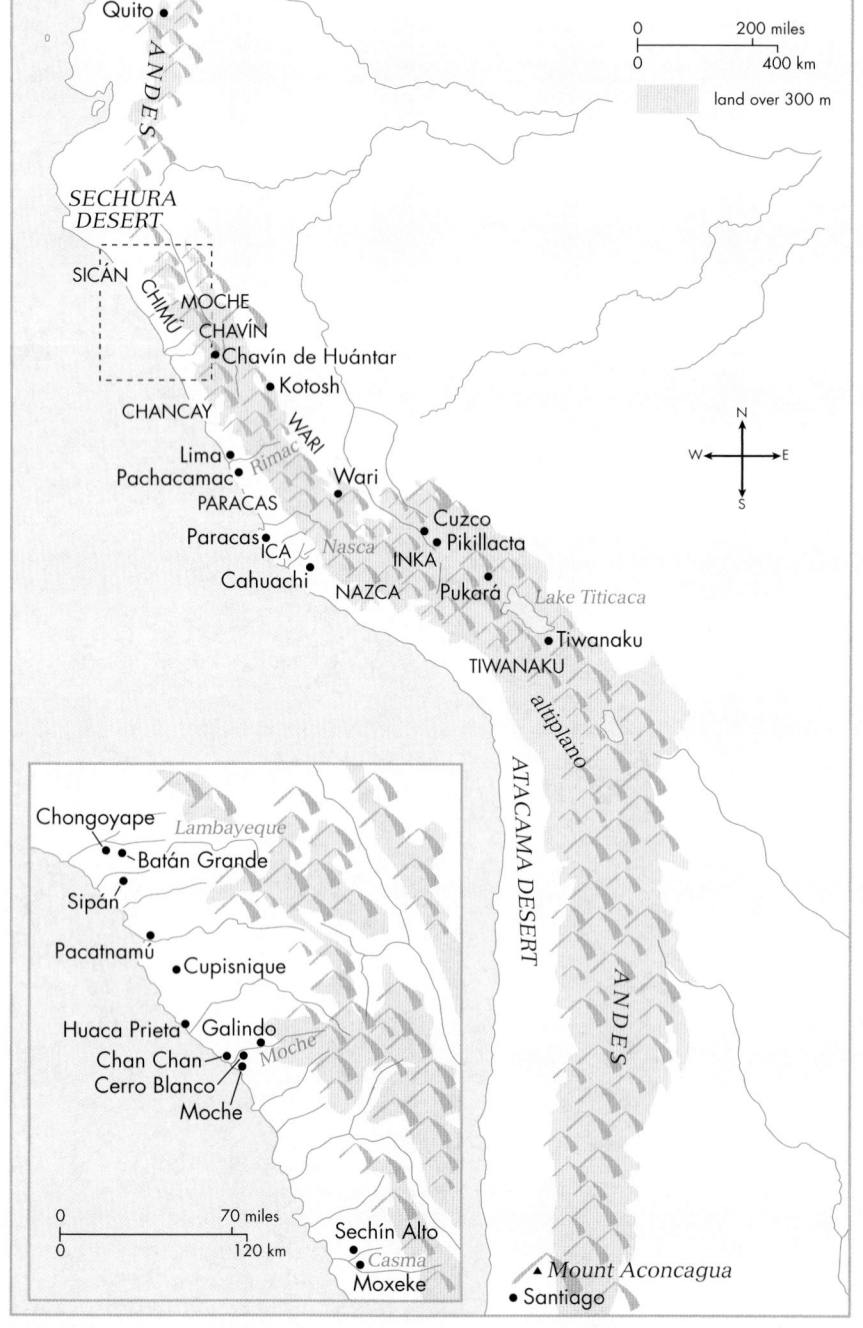

The central Andes.

Chavín: The Beginning

The earliest widespread style began in 900 B.C., the Late Initial period at Chavín—a ceremonial site located at what appears to have been a strategic position halfway between coast and jungle, in the center of two mountain ranges, and near the confluence of the Huachecsa and Mosna rivers. Chavín was well positioned for trading with the lowlands to the east, the surrounding highlands, and the coast. The complex at Chavín de Huántar is made up of two principal temples: the Old, dating from the Late Initial period (c. 900–500 B.C.), and the New, dating from the Early Horizon period (500–200 B.C.) (fig. W5.20). It was at Chavín that U-shaped pyramids facing a large plaza in the tradition of the coast, sunken circular courts in the tradition of the highlands, and various portrayals of snakes, raptors, and the jaguar were unified cohesively. The complex was constructed with large slabs of stone, a highland tradition that culminated in the spectacular architectural accomplishments of the Inkas over two thousand years later.

The Old Temple at Chavín, more than 300 feet in length, faced the sunrise and was approached from the west. Embedded in the walls of the temple were a series of larger-than-life heads, which may have represented the shamanic transformation of a priest into a feline or other animal. Staircases lead to a circular plaza lined with a carved stone frieze showing idealized figures and felines. Beneath the temple, a series of narrow passageways lead to the *axis mundi* ("world axis") of the anthropo-

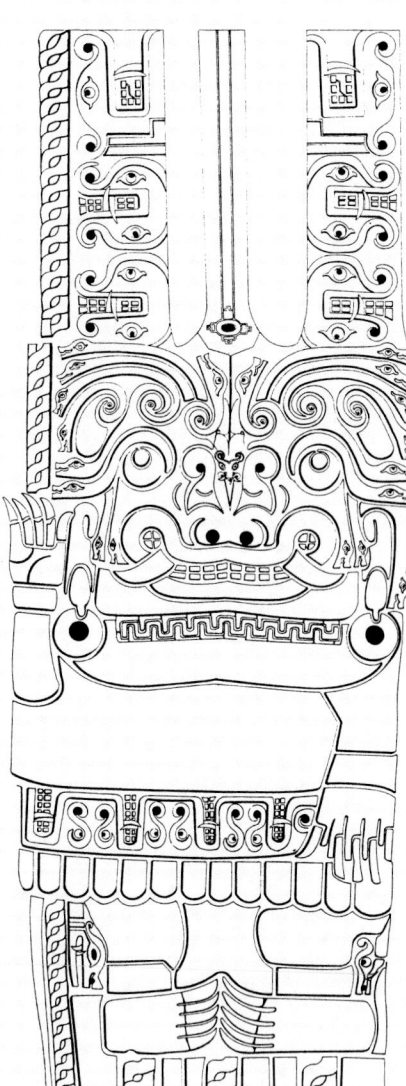

W5.21 Roll-out drawing of the Lanzón, from the Old Temple at Chavín de Huántar, Late Initial period, c. 900–500 B.C. The iconography of the Lanzón, clearly seen here, offers one of the oldest and most eloquent representations of Chavín de Huántar's supreme deity.

morphic Lanzón idol (fig. W5.21), a carved shaftlike piece of granite that extends above the chamber in which it is placed and represents the supreme deity, possibly an oracle. The iconography of the Lanzón embodies all the elements of the Chavín belief system, including a fanged mouth, a flat nose with flared nostrils, talons, and visual metaphors such as snake-like hair that are typical of Andean sculpture.

Evidence of portable Chavín objects such as carved stone bowls, gold repoussé crowns, and textiles have been found as far away as the south coast of Peru, a distance of some 300 miles, indicating the importance of this early cult oracle and its lasting influence on the art of the Andes.

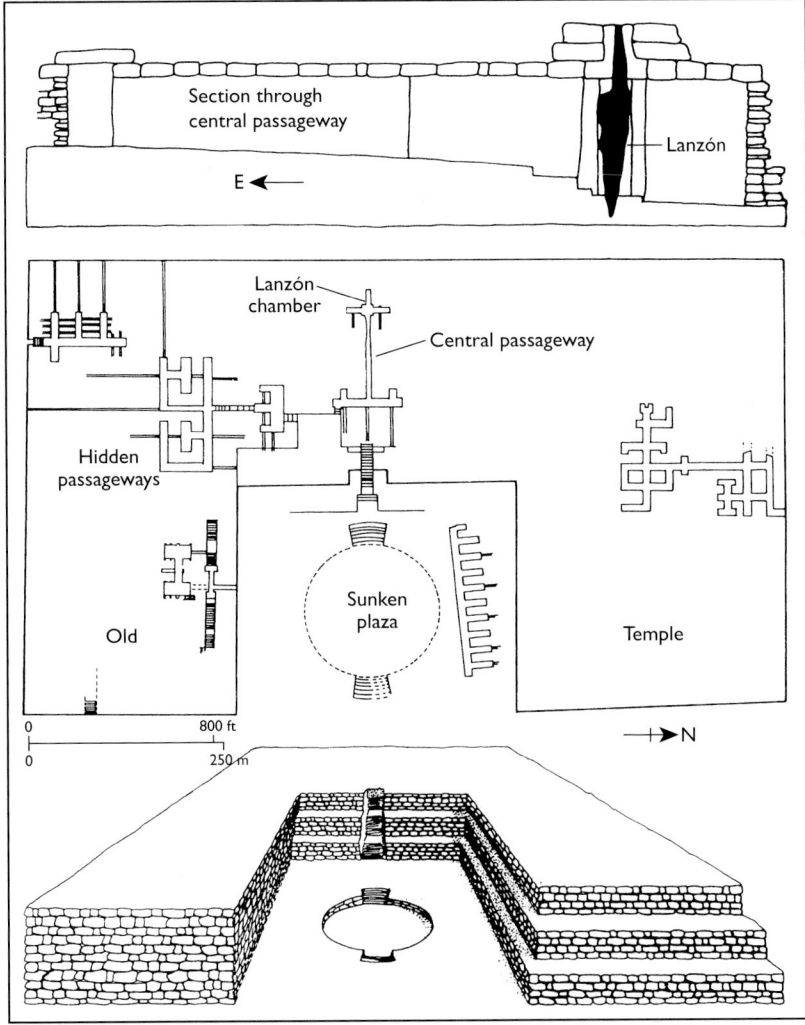

W5.20 Chavín de Huántar: (*top*) cross section, showing the location of the Lanzón at the end of a gallery; (*center*) plan, showing some of the galleries hidden within the temple; (*below*) the Old Temple and its sunken circular courtyard, Late Initial period, c. 900–500 B.C.

Coastal Cultures and the Cult of Irrigation

Although Chavín was one of the defining influences on the Paracas (1000–200 B.C.) and Nazca (200 B.C.–A.D. 600) cultures from the south coast of Peru, the latter evolved a different type of imagery. Designs were based in part on the surrounding coastal desert, where subsistence was dependent on irrigation that harnessed resources from the nearby mountains. In 1927, over 400 graves containing well-preserved mummy bundles wrapped in textiles were discovered at the Paracas site of the necropolis of Wari Kayan. The numerous finds notwithstanding, the iconography portrayed on the graphic textiles is still debated.

It is in textiles that the Paracas culture was preeminent. Finely woven examples were reserved for the elite, and gifts of textiles were made to the gods. Beginning with Paracas, textiles were created with two complementary elements. Cotton, a stronger material used as the supporting warp threads or as a background, was grown on the coast. Wool, which absorbs dye more readily than cotton and can be spun into an extremely fine yarn, was supplied by highland Camelidae. The use of these media is another example of reciprocity or duality in the Andes, for the very structure of weaving reflects duality in the intertwining created by the intersection of the warp and weft threads. Many Paracas textiles were executed using embroidery, a technique that permits greater expressive range than the strictly geometric structure of weaving.

Textiles were used as clothing as well as grave offerings, and family members invested thousands of hours in making the offerings, often entire sets of clothes from turban to mantle. If not completed at the time of death, textiles were placed in the tomb in their unfinished state. Other grave offerings found in the mummy bundles were food, gold, and precious objects, including spondylus shells. These shells of the spiny oyster were traded with Ecuador throughout the pre-Columbian era and symbolized water.

Paracas textiles divide into two styles, Linear and Block, terms that describe the arrangement of the inherent design patterns. Both styles contain a multitude of images, the meaning

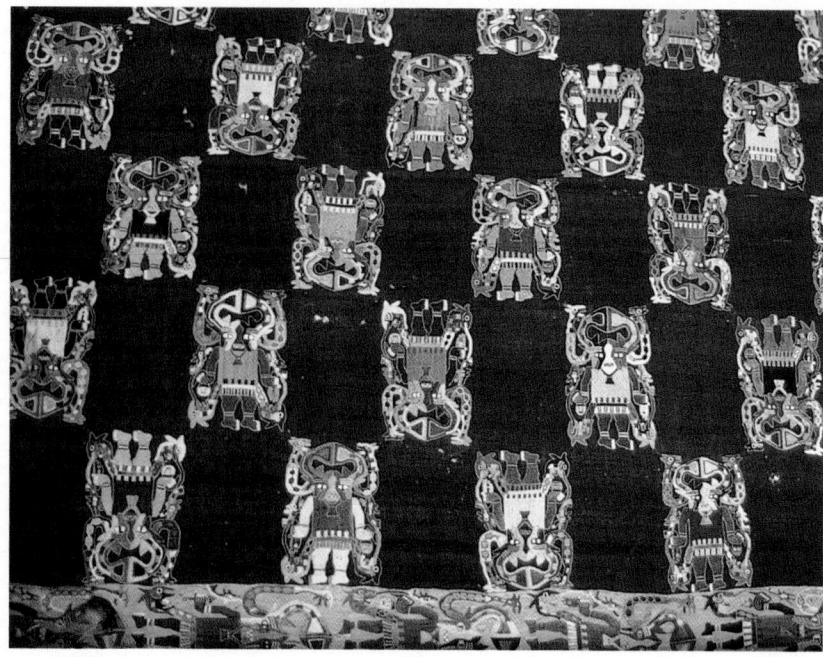

W5.22 Textile with "impersonator" figures, Paracus, Peru, Early Intermediate, c. 100–200. Plain weave with stem-stitch embroidery.

of which is still debated by scholars. Warrior figures wielding knives and hatchets are often seen; "impersonator" figures appear to be wearing face masks and nose ornaments (fig. **W5.22**). From the imagery found on the textiles as well as the archaeological record, it is possible to conclude that the Paracas state was more concerned with the immediate world than the earlier highland culture of Chavín had been. Realism and a sense of urgency are apparent in the design. Although the supernatural is still a factor, it is not the defining ideology that it had been during the Chavín era. Earlier Linear designs tended to concentrate on the supernatural while the slightly later, Block designs portray natural flora and fauna along with figures resplendent in ritual paraphernalia who are often anthropomorphized with simian feet. One scholar has proposed that these human impersonators are part of a conceptual structure of the universe and are wearing ritual symbolic costumes probably used in a ceremonial context related to celestial or agricultural phenomena.

Just south of Paracas, the Nazca culture (200 B.C.–A.D. 600) came to prominence along the coast. Most recognized for the monumental Nazca Lines carved in the desert, the art tends to be more naturalistic than earlier styles, with an emphasis on large-scale depictions not only in the earthworks still visible in the dark sands, but in ceramics and textiles as well. Nazca pottery is characterized

by the introduction of a slip-painted surface in which mineral pigments are mixed with clay to make a pliable medium for design. The pictorial elements are outlined in black, giving them an even stronger presence. Common themes are a heightened interest in crops through portrayal of fruits and vegetables, narrative scenes from everyday life, and ceremonial figures. The vessel illustrated here (fig. **W5.23**) shows the Andean taste for merging natural forms—of a fish, a feline, and a human—as well as for the lively animation of surfaces. This is a moment in Andean art when secular and religious imagery coexist.

While the Nazca flourished on the south coast of Peru, the Moche state (A.D. 100–700) was establishing itself on the north coast. Of the three coastal cultures, the Moche was the most distinctive. Notable in their artistic output are ceramic vessels, metalwork, and monumental architecture, in which the Moche were innovators, developing new techniques that led to increased production. This artistic expansion may have been the result of the fact that the Moche kingdom was the first true centralized state in the Andes. In order for this state to function, corporate labor was required to produce enough objects to disseminate and maintain an ideological hold over a large area. Both the realistic and ritual scenes on Moche pottery indicate the necessity of warfare in extending the power and territory of the Moche.

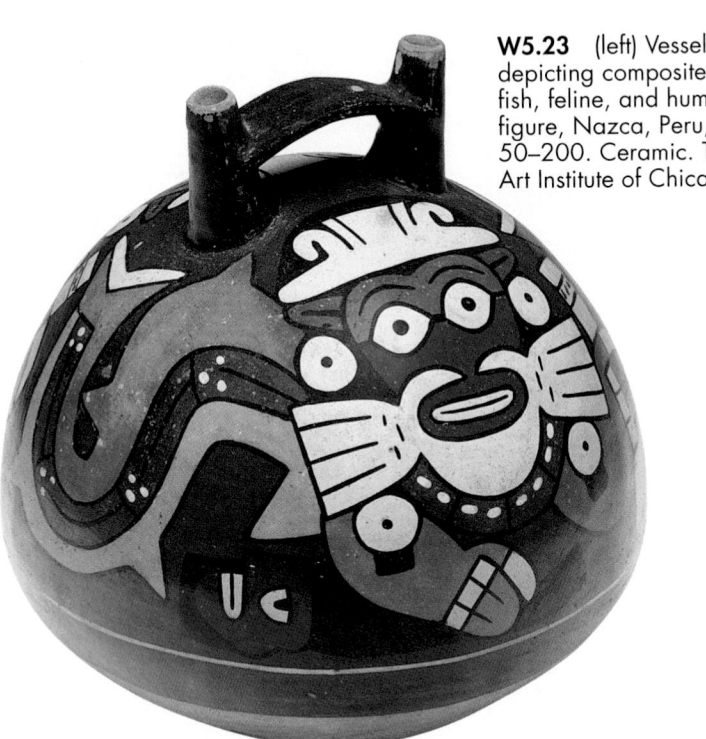

W5.23 (left) Vessel depicting composite fish, feline, and human figure, Nazca, Peru, 50–200. Ceramic. The Art Institute of Chicago.

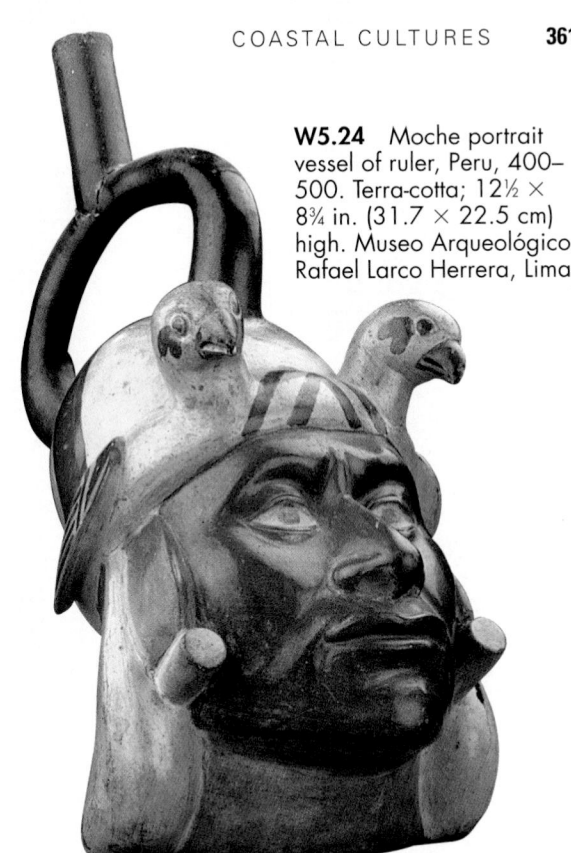

W5.24 Moche portrait vessel of ruler, Peru, 400–500. Terra-cotta; 12½ × 8¾ in. (31.7 × 22.5 cm) high. Museo Arqueológico Rafael Larco Herrera, Lima.

Moche pottery is divided into various styles, including narrative scenes and portrait heads molded in the round, vessels on which fine line painting illustrates a ceremonial ritual, and sexually explicit subjects that probably had a function relating to fertility. For the first time in Andean culture, mold-making techniques were developed to satisfy the need for increased production.

Moche portrait heads are unparalleled in Andean art. Researchers have identified portraits of approximately fifty subjects depicted at various stages of life. In its sense of humor and emphasis on personal themes, Moche pottery is distinctive. The portrait vessel of a ruler (fig. **W5.24**) reflects the organic naturalism characteristic of Moche heads.

The largest adobe structure in the Americas was built by the Moche at their capital, Cerro Blanco. The Huaca del Sol (Pyramid of the Sun), the main temple (originally over 165 feet tall), faces the somewhat smaller palace, the Huaca del Luna (Pyramid of the Moon), across an open plaza. It is estimated that over 100 million bricks were used in the layered construction of the larger pyramid. Most bricks were inscribed with their maker's mark. The stepped pyramids, decorated with murals and containing elite burials, would have been impressive monuments of a grandiloquent civilization. The massive ca-

nal system constructed by the Moche permitted a food supply, adequate for a ceremonial center of this size.

Contemporaneous metalwork is best known from the spectacular finds at Sipán in the late 1980s. Gilding, alloying, and soldering techniques were used by the Moche. Much of the ceremonial ornamentation was made of *tumbaga,* an alloy of gold, silver, and copper. The gold and turquoise ear-

spool (fig. **W5.25**) from the Tomb of the Warrior Priest at Sipán depicts an elaborately attired warrior carrying a shield and sword. Predominantly gold, he is contrasted with the figures flanking him, who are shown to be attendants by their smaller scale. The sense of unified artistic organization in this piece is striking in the repeated formal rhythms and interlocking of the gold and turquoise.

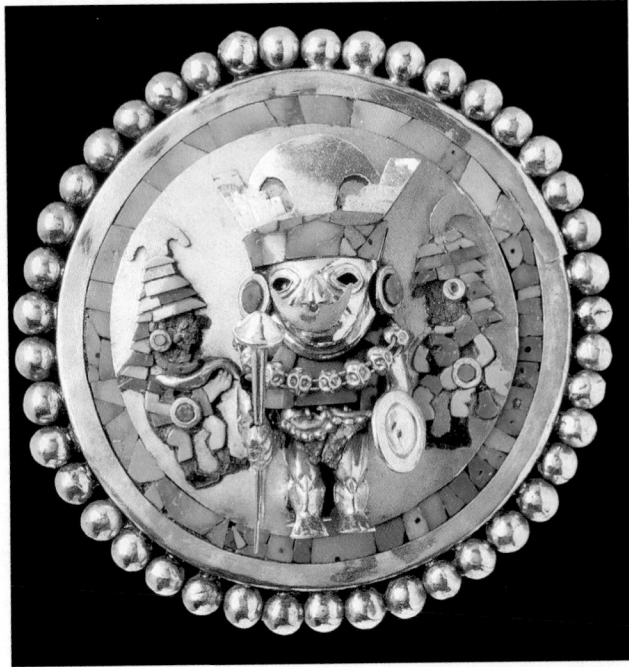

W5.25 Earspool, from the Tomb of the Warrior Priest, Sipán, c. 300. Gold, turquoise, quartz, and shell; diameter 3½ in. (9.4 cm). Archeological Museum, Lambayeque, Peru.

The Highland Empires of Tiwanaku and Wari

The ceremonial center of Tiwanaku is situated in modern-day Bolivia near the southern border of Lake Titicaca, the highest inland lake in the world. It is located strategically between the lowlands to the east and the high plateau to the west. One of a few sites in the Andes with massive stone architecture, its buildings were aligned cosmically with the sunrise and sunset. An artificial moat surrounding the core temples signified the sacred nature of these structures and related the complex to an island in Lake Titicaca. Thus, it is thought that the site of Tiwanaku (600–1000) was conceived as the *axis mundi* in much the same fashion as the Lanzón at Chavín.

The iconography of the monuments, either colossal freestanding godlike figures or mythical carvings of a variety of human and animal composite deities, is emblematic of the power and cosmic symbolism of the city. With a population of over 60,000, Tiwanaku was the capital of an expansionist empire that ranged from the lowlands of Bolivia through Peru and Chile to northern Argentina.

Construction of ceremonial buildings consisted of blocks of ashlar (a carved, square stone), sandstone, and andesite finely worked and fitted much like later Inka structures. In the tradition of the architecture at Chavín, there is a sunken plaza, a wall with tenon heads, and a monumental entrance—the Gateway of the Sun (fig. **W5.26**). It is the most recognizable monument at Tiwanaku, with a carved frieze on the portal depicting a central figure carrying a staff in each hand. The visage is metamorphosed into the sun, and rays emanating from the head are transformed into heads of mythical felines and other forms. This central deity is attended by composites of winged kneeling figures carrying spears. His frontality accentuates authority; his image is repeated in every medium used by the Tiwanaku.

The placement of the figures on the portal is symbolic of the apparent taste for order, which was important to the Tiwanaku and Wari. Design patterns are regulated and based on a set standard of hierarchical figures, an aesthetic reflected in the strict grids of certain Wari cities.

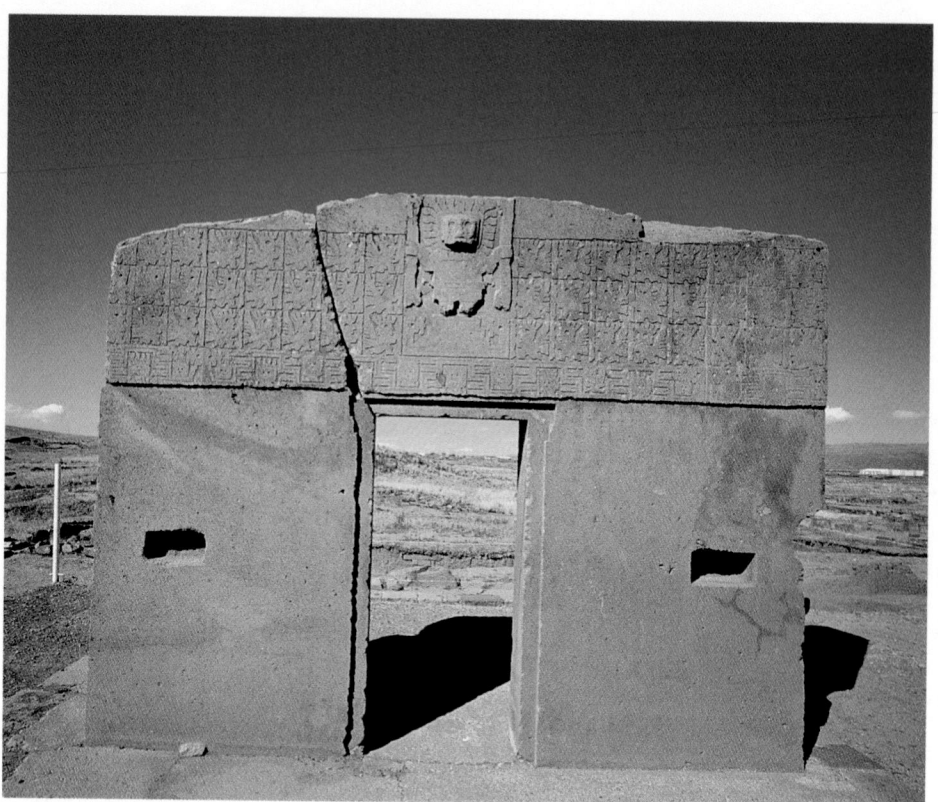

W5.26 The Gateway of the Sun, Tiwanaku, Bolivia, 500–700. Stone; 9 ft. 10 in. (2.99 m) high.

The Wari Empire (500–750) did not produce a site with architecture as spectacular as that of Tiwanaku, but in fiber arts the ideology of this culture unfolds its own permutations on the Gateway of the Sun theme. The way in which textiles are woven, with intersecting warps and wefts, provides a grid for Wari designs (fig. **W5.27**). Variations on both the ideological ideal and the changes in the way this message can be transmitted according to the arrange-

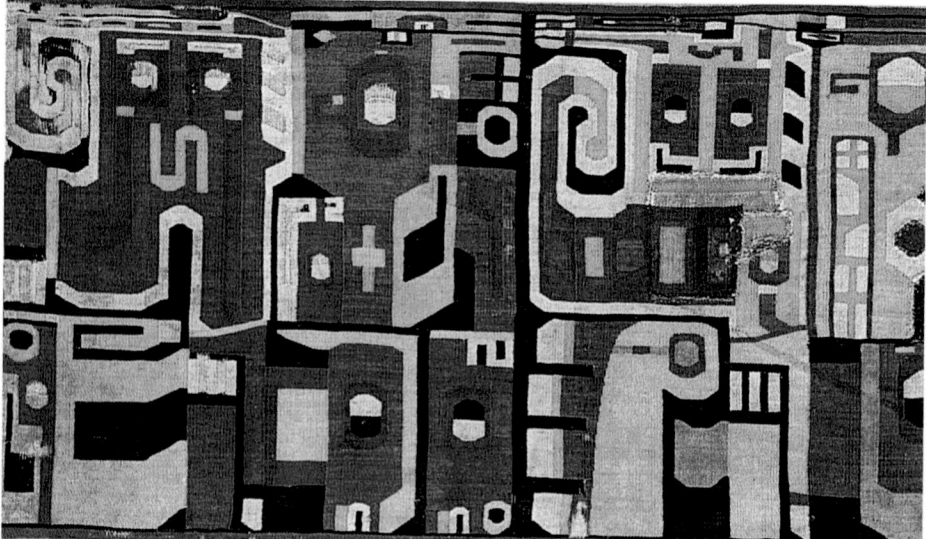

W5.27 Detail of a Wari tunic, from Peru, 600–1000. Cotton and camelid wool tapestry; whole textile 40¾ × 20 in. (103.5 × 50.5 cm). Metropolitan Museum of Art, New York.

ment of the threads are the supreme expression of these textiles. Although the imagery was limited and was directly influenced by the Tiwanaku canon, Wari weavers abstracted the images through compression and expansion combined with alternation (in four directions—back and forth, up and down), making the encoded message harder to decipher. Perhaps the imagery was reduced to a shorthand that was perfectly legible to those familiar with its meaning. Because few Wari textiles survived the humidity of the highlands, most have been found in the dry coastal outposts of the empire, probably taken there to spread the encoded ideological message. Innovative terraced fields and widespread canalization gave this empire an agricultural advantage; but because of its dependence on nature, the supernatural elements required constant appeasement through representation and veneration. The relationship between the Tiwanaku and Wari empires remains one of the major unanswered questions among pre-Columbian scholars.

W5.28 Machu Picchu, Inka culture, near Cuzco, Peru, 15th–16th centuries.

The Inka Empire: The End of an Era
(c. 1438–1532)

Nearly contemporary with the Aztecs and following the decline of the Tiwanaku and Wari cultures, another coastal kingdom, Chimor, rose to power in roughly the same area as the Moche. At the height of its influence in about 1400, the Chimú people of Chimor controlled two-thirds of the entire coast from the administrative center at Chan Chan. Shortly thereafter, another kingdom arose that would rival the Chimú. Its successors, the Inkas, are said to have come into power in 1438, at about the same time, and in much the same way, as the Aztecs in Mexico, having coalesced from a group of unexceptional tribes. The southern highland city of Cuzco, considered to be at the center of the world, was the Inka capital, and the Inka king was known as *the* Inka. For the Inkas, architecture was the highest expression of their art and political power. The iconographic message was not supplication to the gods, as it had been in the past, but projected an image of the Inkas as the true kings.

A highly organized political entity, the Inka Empire, which assimilated various cultural groups, contained over 20,000 miles of roads called Tawantin-suyo, or the Four Quarters, connecting the far reaches of its domain, stretching nearly 3,500 miles from Ecuador to Chile. Local governors controlled each quarter, where they collected taxes in amounts determined by an accurate census and computed on a knotted string, or *quipu*. In less than a century, the Inkas were ruled by a succession of thirteen kings, the first three of which are legendary.

The rapidity with which the Inkas consolidated power can be attributed in part to their shrewd management of the supernatural combined with myth and genealogy. Each king was venerated, and, after his death, his mummy was paraded publicly on a litter. To sustain their relationship with the gods, the Inkas sacrificed llamas, which were associated with the sun, and burned cloth as an offering of the highest status. On occasion, they took young children to the top of a mountain, killing them and offering them in service to the gods.

In the Cuzco region, there are many architectural monuments made of tremendous coursed ashlar blocks laid one on the other without mortar. The most famous Inka monument, Machu Picchu, is located at the northwest end of the Urubamba Valley, a short distance from Cuzco (fig. **W5.28**). This majestic site, built on a mountaintop

some 9,000 feet above sea level, relates architecturally to the distant mountains, the Urubamba River raging below, and the surrounding jungle. A number of large stones echoes the shapes of the mountains, and windows frame spectacular views. At the beginning of the twentieth century, Machu Picchu was thought to have been the last stronghold of the Inkas and the site of a hidden treasure trove of gold, but now the site is identified as the royal estate of an Inka king.

Inka textiles and ceramics are standardized, typically decorated with nonfigurative geometric designs. More original was the metalwork, much of it executed in gold, which was melted down by the conquistadors and taken to Spain.

The Inka Empire came to an end shortly after the arrival of the Spanish conquistador Francisco Pizarro in 1532.

	Style/Period	Works of Art	Cultural/Historical Developments
1200 B.C.	MESOAMERICA OLMEC c. 1200–900 B.C.	*Seated Jaguar* (**W5.1**), San Lorenzo Colossal head (**W5.2**), San Lorenzo	Greek Geometric period (c. 1000–700 B.C.)
	TEOTIHUACÁN c. A.D. 350–650	Temple of Quetzalcoatl (**W5.6**), Teotihuacán Warrior in Teotihuacán costume (**W5.7**), Tikal The Leiden Plate (**W5.8**) Teotihuacán (**W5.3**)	Sack of Rome by the Visigoths (410) Reign of Justinian (6th century)
	MAYA c. 1100 B.C.–A.D. 1500	*Maya Lord* (**W5.9**), Tabasco Monkey-man scribal god (**W5.12**), Copán Copán (**W5.10**) Ball court (**W5.11**), Copán Temple I (**W5.13**), Tikal Mural painting (**W5.14**), Bonampak Chichén Itzá (**W5.15–W5.16**) *Chacmool* (**W5.17**), Chichén Itzá	Julius Caesar becomes dictator (49 B.C.) Death of Jesus (c. A.D. 33) Beginning of Gothic style in France (12th century)
	AZTEC c. 1300–1525	*Coyolxauhqui* (**W5.18**), Tenochtitlán *Eagle Warrior* (**W5.19**), Tenochtitlán	The Renaissance in Italy and northern Europe (1300–1550) Columbus sets sail for India (1492)
	THE ANDES CHAVÍN c. 900–200 B.C.	Lanzón (**W5.20–W5.21**), Chavín de Huántar	Classical Greece (450–400 B.C.) Death of Alexander the Great (323 B.C.)
	PARACAS c. 1000–200 B.C.	"Impersonator" textile (**W5.22**), Peru	
	NAZCA c. 200 B.C.–A.D. 600	Fish/feline/human vessel (**W5.23**), Peru	
	MOCHE 100–700	Earspool (**W5.25**), Peru Portrait vessel (**W5.24**), Peru	Death of Muhammad (632)
	TIWANAKU 600–1000	Gateway of the Sun (**W5.26**), Bolivia	Charlemagne crowned Holy Roman Emperor (800)
	WARI 500–750	Tunic (**W5.27**), Peru	Ottomans capture Constantinople (1453)
A.D. 1500	INKA c. 1438–1532	Machu Picchu (**W5.28**), Peru	Pope Julius II begins the new Saint Peter's in Rome (1502) The Protestant Reformation begins (1517)

Colossal head

Seated Jaguar

Monkey man

Mural painting

Coyolxauhqui

Eagle Warrior

Fish/feline/human vessel

Gateway of the Sun

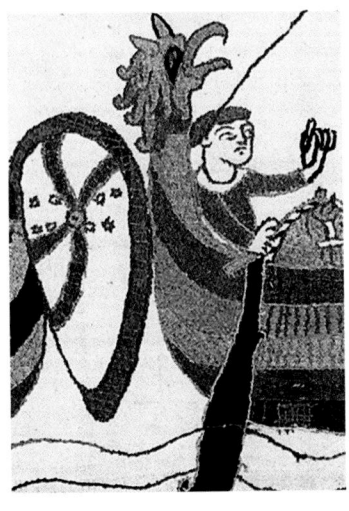

10

Romanesque Art

The term *Romanesque* ("Romanlike") refers to a broad range of styles, embracing many regional variants, that flourished in western Europe in the eleventh and twelfth centuries. It is a stylistic rather than a historical term, intended to describe medieval art that shares certain characteristics with ancient Roman architectural style. Similar features include round arches, stone vaults, thick walls, and exterior relief sculpture. In addition to adapting architectural elements from Rome, the Romanesque style reflects the taste for linear patterns of Hiberno-Saxon art, as well as influences from the Byzantine and Islamic traditions. Since Europe at this time was a patchwork of regions rather than of nations with centralized political administrations, scholars tend to identify the various styles by the name of the relevant geographical area—for example, Norman (from Normandy, in northwest France) or Burgundian, from Burgundy, in central France.

Reflecting the relative stability and prosperity of the Christian Church, there was an enormous surge in building activity, especially of cathedrals, churches, and monasteries. Monasteries owned significant tracts of land, which enhanced their political and economic power in Romanesque Europe. This contributed to the widespread revival of architectural sculpture and the ornamentation of Christian buildings. Since the most innovative Romanesque works were created in France, most of the buildings and works of art discussed in this chapter are French, with a few representative examples from Italy, Spain, and Norway.

Economic and Political Developments

During the late ninth century A.D., the Muslims continued their expansion in the south, and from the east the Magyars (an eastern European tribe whose language is related to Finnish) advanced in search of a permanent home. From the north came the Vikings, who occupied Normandy. By the second half of the eleventh century, the threat of invasion had decreased, largely because many pagans had been assimilated and converted to Christianity. The Magyars had settled in present-day Hungary. The Vikings had also become Christians, and their leaders were recognized as dukes by the French king. In 1066, Duke William II of Normandy invaded England, becoming its first Norman king—William I the Conqueror—and establishing feudalism as the prevailing social system in England (see box). In the early twelfth century, the Normans,

Feudalism

Feudalism (from the Latin word *foedus,* meaning "oath") was the prevailing, but loosely constructed, socioeconomic system of the Middle Ages. Under the feudal system, the nobility had hereditary tenure of the land. In theory, all land belonged to the emperor, who granted the use of certain portions of it to a king in return for an oath of loyalty and other obligations. The king, in turn, granted the use of land (including the right to levy taxes and administer justice locally) to a nobleman. He granted an even smaller portion to a local lord, for whom unpaid serfs, or peasants, worked the land. At each level of dependency, the vassal owed his loyalty to his lord and had to render military service on demand. In practice, however, these obligations were fulfilled only when the king or lord had the power to enforce them. The principal unit of feudalism was the manor. In exchange for their services, the serfs were allowed to cultivate a part of the lord's land for their own benefit.

Feudalism and serfdom declined from the thirteenth century onward, partly because of a growing cash economy and partly because of peasant revolts. In France, however, these social systems lingered on until the revolution of 1789. In Russia and certain other European countries, feudalism continued well into the nineteenth century.

who were descended from the Vikings, expelled the Arabs from Sicily, and wrested control of much of southern Italy from the Byzantines. Muslim dominance of Spain had declined, and the Christians, maintaining their resistance from the mountains in the north, were poised to recapture most of the Iberian peninsula (modern Spain and Portugal).

The social structure of western Europe was based on the feudal system, with the economic and political core centered in manorial estates. Kings, dukes, and counts, to whom lesser barons and lords owed their allegiance, ruled these manors. But there was no centralized political order, and the main unifying authority remained with the pope in Rome. The Church played a vital role in the social and economic structures of secular life, owning a large amount of landed property—close to a third in France—and claiming the same temporal authority as the kings and nobles.

Despite conflicts between social classes engendered by feudalism and the manorial system, however, a degree of military and political equilibrium was achieved. This led to economic growth, especially in Italy, where Mediterranean trade routes were opened and several seaports (such as Naples, Pisa, Genoa, and Venice) became centers of renewed commercial activity. Manufacturing and banking flourished, and new groups of craftsmen and merchants arose. Cities and towns that had declined during the Early Middle Ages revived, and new ones were founded. Gradually, towns began to assert their independence from their lords and the Church. They demanded, and received, charters setting out their legal rights and obligations. Some even established republican governments.

Pilgrimage Roads

By the first half of the eleventh century, Christianity was in the ascendant in western Europe. The spirit of religious vitality affected almost all aspects of life and manifested itself particularly in the Crusades—a series of military campaigns, undertaken from 1095 and lasting into the fifteenth century, the primary purpose of which was to recover the Holy Land from the Muslims (see box).

Earlier in the Middle Ages, it was only penitent Christians who made pilgrimages to atone for their sins (see map, p. 367). From the eleventh century, however, it became customary for devout Christians generally to make pilgrimages, particularly to churches with sacred **relics.** These might be the physical remains of saints, remnants of their clothing, or other objects associated with them. Relics were often housed in a **reliquary**—a container for relics —of the type illustrated in figure 10.1 (see box, p. 368).

The two most sacred pilgrimage sites were Jerusalem and Rome. Jerusalem had been the site of Solomon's Temple and the Holy Sepulcher (see box, p. 369), of Jesus's Entry and Last Supper, of the events leading to his death, and of some of the miracles that followed. Rome was the center of Christendom in the West. It contained the papal residence and the tombs of Saints Peter and Paul. But journeys to these cities, especially Jerusalem, could be dangerous. A third choice, which became popular in the eleventh century, was the shrine of Saint James (Santiago in Spanish) at Compostela, in Galicia (a region of northwest Spain) (see box, p. 369).

The Crusades

The Crusades were a series of military expeditions from western Christendom, originally undertaken in the name of the Cross (*crux* in Latin), to recapture the holy places in Syria and Palestine from the Muslims.

The First Crusade began in 1095 and ended with the capture of Jerusalem in 1099. The Second (1147–1149), Third (1189–1192), and Fourth (1202–1204) Crusades met with varying degrees of success. Many rulers and nationalities participated in these early crusades, including the kings of England and France and the emperor of Germany. Several other expeditions to the Near East took place in the thirteenth century, but in 1291 Acre (near Haifa in modern Israel), the last Frankish foothold in the Near East, fell to the Muslims, and the original impetus behind the Crusades waned. Later Crusades were launched in other regions against non-Christians (for example, the Moors in Spain and the Slavs), heretics, and excommunicated Christian rulers. In 1464, Pope Pius II failed to win support for a last attempt at a Crusade to the Near East.

An assortment of spiritual benefits and material motives encouraged men (and in one case children—in the Children's Crusade of 1212) to undertake these long and arduous journeys. Spiritual benefits included the remission of time that one's soul would spend in purgatory and the promise of becoming a martyr if one were killed. Material motives included the territorial ambitions of feudal princes, the first stirrings of Western colonialism, and the desire of Italian cities (especially Venice) to secure trading bases in the Levant.

The territorial gains of the early Crusades soon disappeared. More lasting results were seen in a widening division between western and eastern Christendom and the formation of orders of knighthood (notably the Knights of Saint John of Jerusalem and the Knights Templar), consisting of soldiers who took monastic vows and devoted themselves to military service against non-Christians.

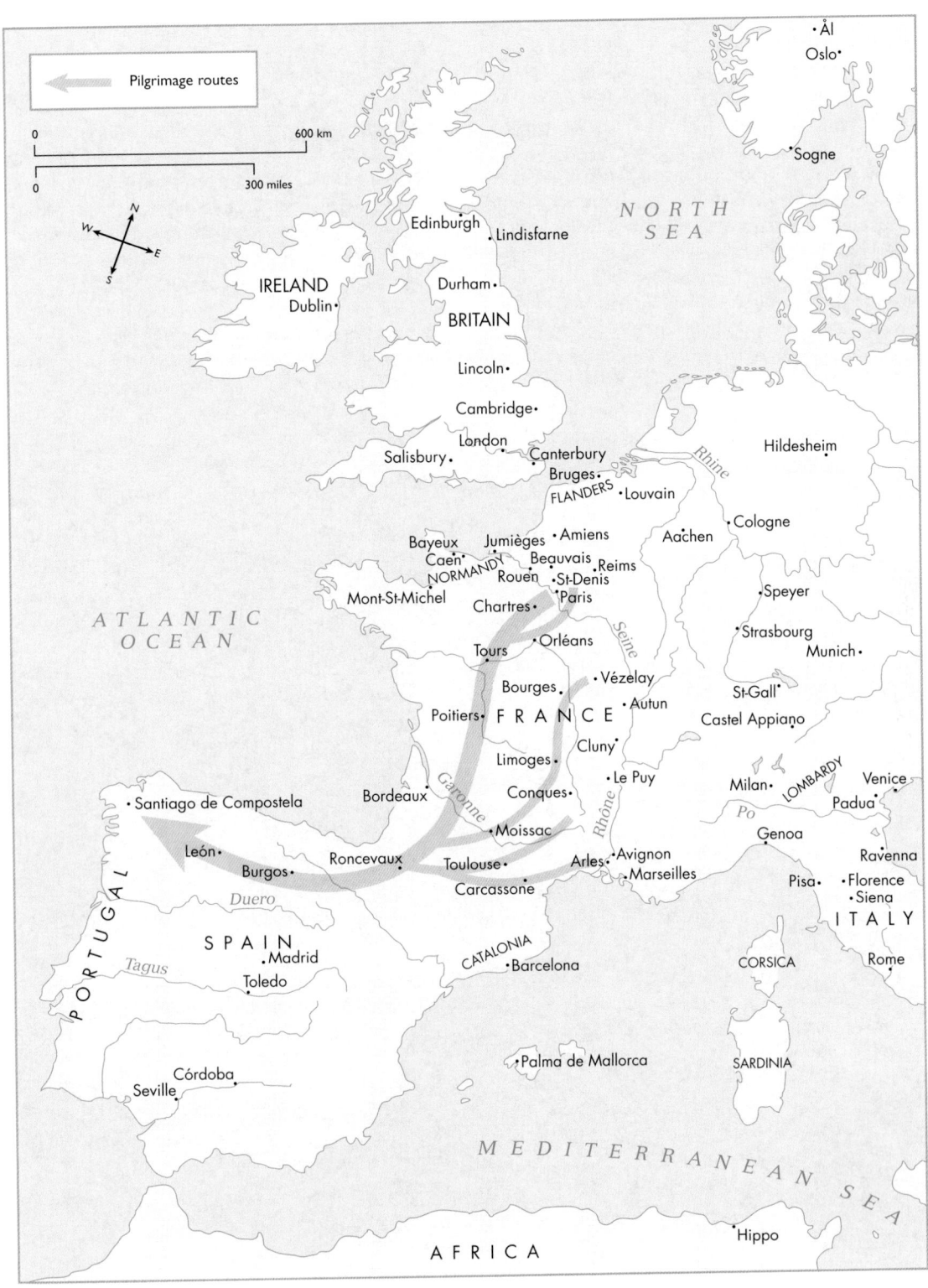

Romanesque and Gothic sites in western Europe, including pilgrimage routes to Santiago de Compostela.

One of the best examples of a Romanesque reliquary is the Stavelot Triptych (figs. **10.1** and **10.2**). It was probably commissioned in the twelfth century by Abbot Wibald of the imperial Benedictine abbey at Stavelot, in the region of the Meuse River in Belgium. The Stavelot reliquary contained relics believed to be of Christ's Cross—referred to as the True Cross to distinguish it from the crosses on which the two thieves were crucified.

It is the earliest known reliquary illustrating scenes from the popular medieval Legend of the True Cross. Each scene is composed of enamel on gold and is set in a circular frame. There are six scenes, three on each wing of the triptych. The wings are framed by Corinthian columns supporting round arches. In the central panel are two additional triptychs. The larger depicts the Cross with standing figures of Constantine and his mother, Saint Helena, who went to search for the True Cross. Two archangels occupy the space above the arms of

the Cross. On the inside of the open wings are four Byzantine saints: Theodore and Demetrius at the right, and George and Procopius at the left. When closed (not illustrated here), the four Evangelists are visible on the exterior of the wings.

The smaller triptych shows an *Annunciation* when closed, but here we see a *Crucifixion* flanked by the Virgin and the apostle John. The sun and moon fill the spaces over the Cross. A recess inside the Crucifixion enamel contained a Byzantine parchment. On it was an inscription identifying the contents of a small silk pouch as fragments of the True Cross, the Holy Sepulcher, and the Virgin's dress. The pouch also contained the head of a nail, which was believed to have been a relic of one of the nails used in the Crucifixion.

The six scenes on the wings are divided into three Constantine scenes (on the left) and three Helena scenes (on the right). They focus on that part of the legend dealing with Constantine's conversion to Christianity and with Helena's discovery

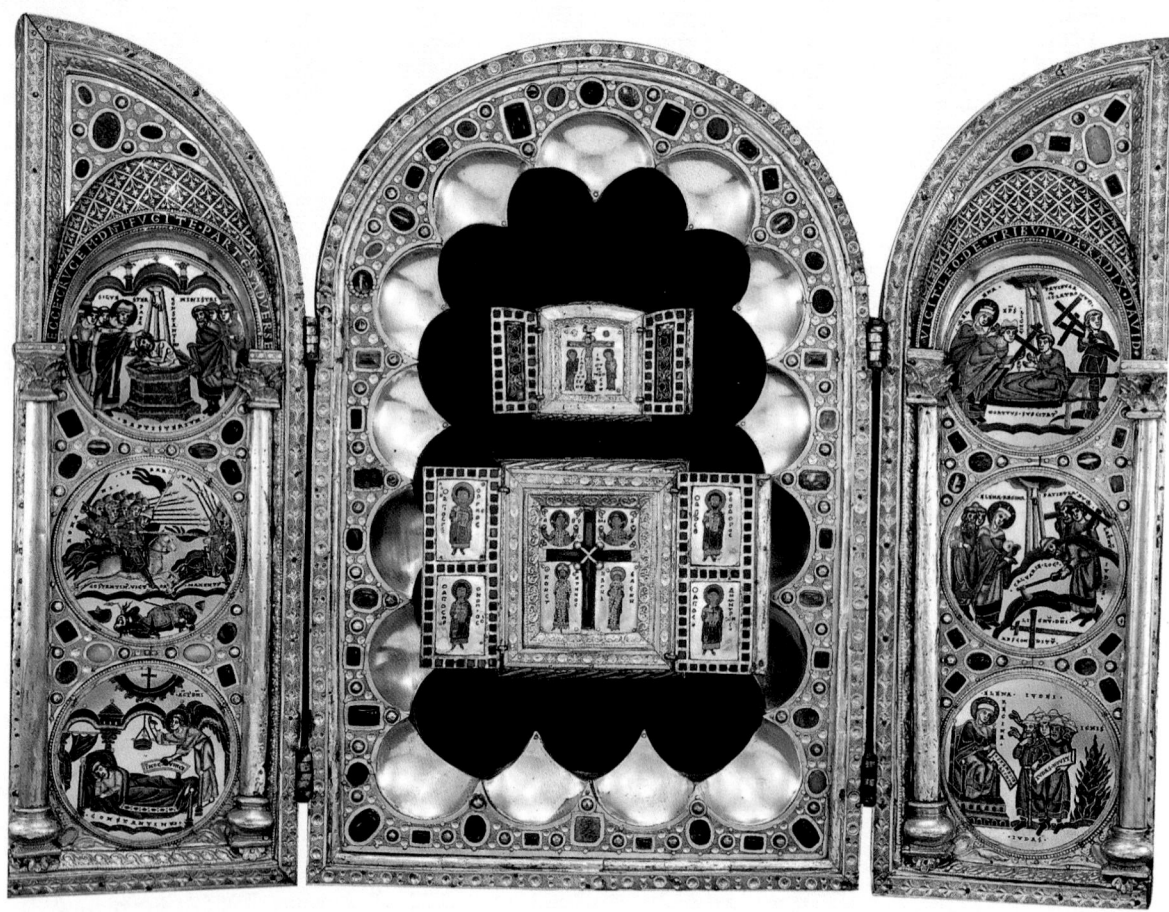

10.1 The Stavelot Triptych, open, Mosan, c. 1156–1158. Gold, *cloisonné* enamel; 19⁹⁄₁₆ in. (48.4 cm) high, 26 in. (66.0 cm) wide, when open. The Pierpont Morgan Library, New York.

The shrine of Santiago also became associated with Charlemagne and therefore had a particular attraction for the French. Two generations earlier, Charlemagne's grandfather, Charles Martel, had ended the Muslim invasion of France at the Battle of Poitiers in 732. This association took on mythic proportions and was based on

Charlemagne's military campaign against the Muslims in Spain. According to tradition, Charlemagne dreamed of a star-filled road in the sky (the Milky Way). Saint James appeared in the dream, explaining that the stars pointed the way to his tomb and telling Charlemagne to follow them. In the popular French imagination, Charlemagne was the

10.2 *Vision of Constantine* (detail of fig. 10.1, left wing).

of the True Cross. On the left, reading from the bottom, is the *Vision of Constantine* (fig. 10.2), his *Victory over Maxentius*, and his *Baptism*. On the right, the lowest scene shows Helena in Jerusalem, searching for the Cross. (According to the legend, Constantine was so impressed with the power of the Cross that he sent his mother to Jerusalem to find it.) Here Helena questions the Jews about the location of the Cross. In the middle scene, she is on Calvary as three crosses are excavated from the ground. At the top, the miracle of the True Cross is enacted. To discover which of the three crosses was Christ's, Helena had each in turn held over the body of a dead boy, whose funeral procession happened by. Only the True Cross restored him to life.

Taken as a whole, the message of these scenes to the medieval pilgrim was the power of the Cross and its role in establishing Christianity as the official religion of Rome. The *Vision of Constantine*, here represented as a dream, was the miracle that set in motion this sequence of events. An angel leans over Constantine's bed, points to a cross in the sky, and carries the inscription "In this sign you conquer."

The pairing of the Constantine and Helena episodes also pairs Rome (on the left) with Jerusalem (on the right). In so doing, the artist evokes the two most important pilgrimage sites and identifies Stavelot with them. When pilgrims traveled to Stavelot, they reinforced its identification with these sites. The pilgrims would also have associated Constantine with Charlemagne and known of the typological relationships of these two emperors with Christ and of Saint Helena with the Virgin.

first pilgrim to go to Compostela. Further enhancing the significance of Charlemagne's dream was its connection with important Christian events: the Vision of Constantine (see box), the angels' instruction to the shepherds that they would find the Christ child in a manger, and the Magi who followed a star.

Pilgrims, Relics, and the *Liber Sancti Jacobi* (Book of Saint James)

In the sense applied by the Church, the term *relic* refers to a personal memorial of a holy person. Often, relics were parts of the person—such as hair, bones, and fingernails—or objects associated with them—such as the nails used to crucify Jesus. Relics are believed to have miraculous powers, including that of healing. But in order to benefit from the relic, one had to travel to it—that is, make a pilgrimage. The pilgrim then had to see the relic and, ideally, to touch it. If the relic could not be touched because of its fragility, then the reliquary could act as a substitute. In some cases, as at the Church of Sainte-Foy, pilgrims viewed the reliquary through an elaborate choir screen, which separated the ordinary worshiper from the most sacred space. Having absorbed the sacred into his own being, the pilgrim returned home.

In A.D. 42, James was beheaded by King Herod, becoming the first of Christ's apostles to be martyred. His remains were believed to have been "translated" (miraculously relocated) from Herod's Judaea to Spain. This miracle is celebrated on December 30 in the liturgical calendar of the Roman Church.

The *Liber Sancti Jacobi* was a twelfth-century guide in five books for pilgrims to the shrine of Santiago de Compostela. Book I contains hymns and liturgical texts related to Saint James. Book II describes his miracles. Book III glorifies his cult. Book IV purports to be a history of the events celebrated in the *Song of Roland*. The actual guide, Book V, describes the pilgrimage roads and the regions they traverse. For those who travel via Le Puy, a visit to Conques is regarded as essential. At the church, according to the guide, "many benefits have been granted there to the healthy no less than to the sick. In front of the portals of the basilica there is an excellent stream, more marvelous than what one is able to tell."[1]

Once in Compostela, the pilgrims are introduced to the town and its cathedral, told how to behave and how they should be welcomed. The final destination of every pilgrim to Compostela is, of course, the richly decorated reliquary of Saint James.

Inspired by these stories as well as by the need to see and touch the relics, pilgrims traveled to Compostela. They followed four main routes across France, through the Pyrenees, and then westward. Along these roads, an extensive network of churches, hospices (or lodging places), and monasteries was constructed. The design and location of such buildings were a direct response to the ever-growing crowds of pilgrims. As we saw in the description of Saint Gall (see p. 341), monasteries were organized to accommodate the Rules of their founders and of the subsequent Orders that were established. Similarly, church plans were designed so that worshipers (especially the monks) could follow the strict routines of the relevant Order.

Solomon's Temple and the Holy Sepulcher

Solomon, the son of David and Bathsheba, was king of Israel from around 970 to 930 B.C. He was known for his great wisdom and his political centralization of Israel. The temple traditionally associated with him was originally located on the present site of the Dome of the Rock in Jerusalem (cf. fig. 9.1). It was seen as an expression of his own power and of Israel's international status. According to Josephus (see Chapter 7), Solomon and Herod enlarged an existing temple whose plan resembled that of the Tabernacle. This was a portable sanctuary some 105 by 75 feet (32 × 23 m), which had been built by Moses and was designed to be taken apart and reassembled as travel required.

The plan also had elements in common with temples built in other Mediterranean cultures. Solomon's Temple had an open courtyard, an interior holy area, and an inner sanctuary (the "holy of holies"). The inner sanctuary contained the Ark of the Covenant, a rectangular wooden chest covered with gold. It signified the presence of God to the Hebrews and was thus their most holy symbol. One entered the Temple through an eastern portico flanked by two hollow bronze columns.

Reflecting the political sway of King Solomon and the relative peace and prosperity of his reign was the international character of the skilled laborers sent by King Hiram of Tyre, in Phoenicia, and the opulent imported materials they used to construct the Temple. The walls were lined with Lebanese cedar. Gold lined the inner sanctuary and covered the olive-wood doors separating the sanctuary from the nave and the nave from the portico. The altar in the nave was also gold, whereas that in the courtyard was bronze, a reflection of the more sacred status accorded the inner altar. In 587/6 B.C., Jerusalem fell, and Solomon's Temple was destroyed by Nebuchadnezzar (see Chapter 2), king of Babylon. The Ark of the Covenant disappeared and was never recovered.

The Holy Sepulcher refers to the rock cave in Jerusalem believed to have been the location of Christ's burial and resurrection. According to the Legend of the True Cross (see p. 368), Saint Helena found the tomb and had a church built on the site in the fourth century. In 614, this was destroyed by the Persians. A second church constructed in 626 was also destroyed, followed by a third structure around 1050. The Crusaders built a large church around 1130 that covered other sacred Christian sites, including Calvary. The present church dates to the nineteenth century.

In the typological system of reading history, the Christians paired both David and Solomon with Christ as exemplars of wise kingship, and Saint Helena with Mary. The Temple and the Holy Sepulcher were typologically paired with church buildings and Jerusalem with Christian cities throughout Christendom.

Architecture

In addition to accommodating the Rule of an Order, Romanesque architects had to construct churches big enough for the influx of pilgrims. At the same time, churches had to be structurally sound and adequately illuminated. The availability of materials often presented problems because of the great increase in building activity. More subjective considerations such as aesthetic appeal also had to be taken into account. These might be influenced by the wishes of a local religious order or a wealthy patron.

Sainte-Foy at Conques

Communication along the pilgrimage routes must have been constant, with pilgrims, masons, and other craftsmen continually traveling back and forth. It is thus not surprising that many Romanesque churches had similar features. The earliest surviving example of a pilgrimage church (fig. **10.3**) is dedicated to Sainte Foy, a third-century virgin martyr known in English as Saint Faith. She was martyred in 303 while still a child because she refused to worship pagan gods. In the ninth century, her relics were transported to Conques. The Church of Sainte-Foy, which belonged to the Benedictine order (see Chapter 9), was erected over her tomb and stands today in Conques, a remote village on the pilgrimage route from Le Puy in southeastern France.

The single most important attraction for pilgrims to this church was the saint's relics. They were contained in an elaborate gold reliquary statue (fig. **10.4**), the head of which is believed to have been formed around the saint's skull. Its large size—it is a late antique mask that has been reused—accentuates the impression of aloof power conveyed by the statue. The figure is made of gold repoussé, with several sheets of gold placed over a wooden core for stability. The saint sits frontally as if enthroned, wearing a martyr's crown and a rich, gold robe covered with gems and Roman cameos.

The builders of Sainte-Foy, and of all pilgrimage churches, had to accommodate large crowds without interfering with the duties of the clergy. The plan in figure **10.5** shows how the traditional Latin-cross basilica was modified by extending the side aisles around the transept and the apse to form an ambulatory. This permitted the lay visitors to circulate freely, leaving the monks undisturbed access to the main altar in the choir. Three smaller apses, or **radiating chapels,** protrude from the main apse, and two chapels of unequal size have been added at the east side of the transept arms. Essentially, such architectural arrangements accommodated two social and temporal systems. One was based on the social world of the laity, while the other provided an architectural space for those whose daily lives followed another "order" of business and a liturgical calendar.

A new architectural development in Romanesque churches was the replacement of wooden roofs by stone

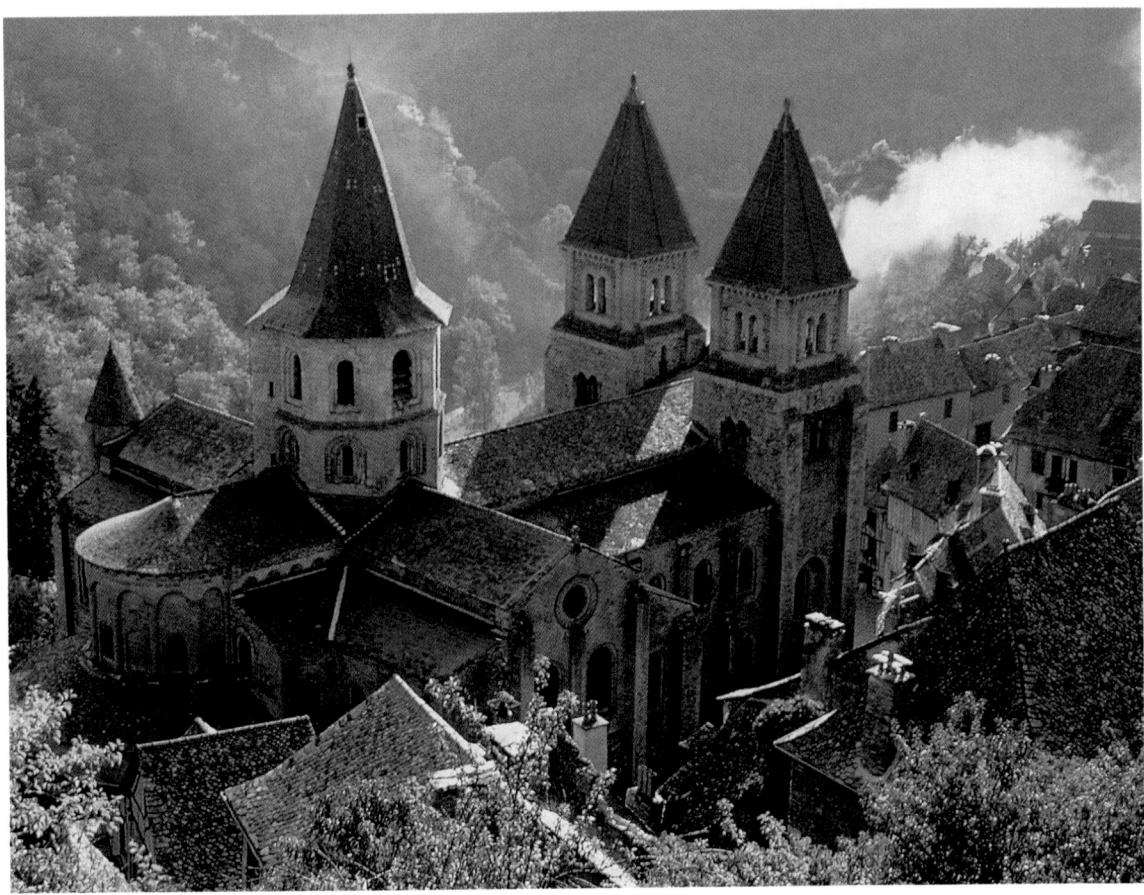

10.3 Aerial view of Sainte-Foy, Conques, Auvergne, France, c. 1050–1120. Apart from two 19th-century towers on the west façade, Sainte-Foy stands today as it did in the 12th century. It has a relatively short nave, side aisles built to the full height of the nave (so that there is no clerestory lighting), and a transept. The belfry, or bell tower, rises above the roof of the **crossing.**

10.4 Reliquary statue of Sainte-Foy, Conques, late 10th–11th century. Gold and gemstones over a wooden core; 33½ in. (85.1 cm) high.

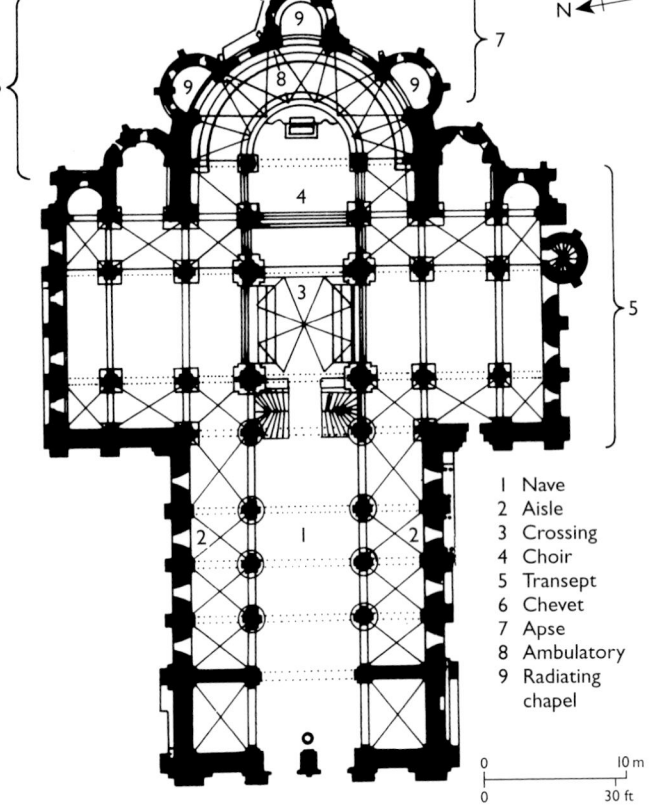

1 Nave
2 Aisle
3 Crossing
4 Choir
5 Transept
6 Chevet
7 Apse
8 Ambulatory
9 Radiating chapel

10.5 Plan of Sainte-Foy, Conques, c. 1050–1120.

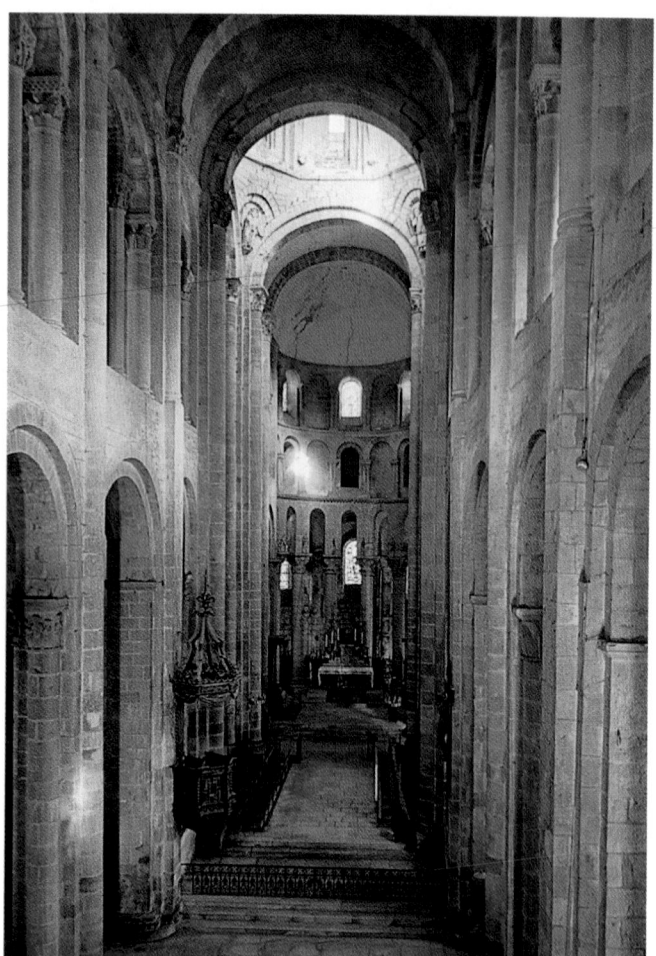

10.6 Tribune and nave vaults, Sainte-Foy, Conques, c. 1050–1120. Romanesque builders solved the problem of supporting the extra weight of the stone by constructing a second-story gallery, or tribune, over the side aisles as an **abutment.** Structurally, the gallery diverted the thrust from the side walls back onto the piers of the nave. It also provided an extra interior space for the pilgrims.

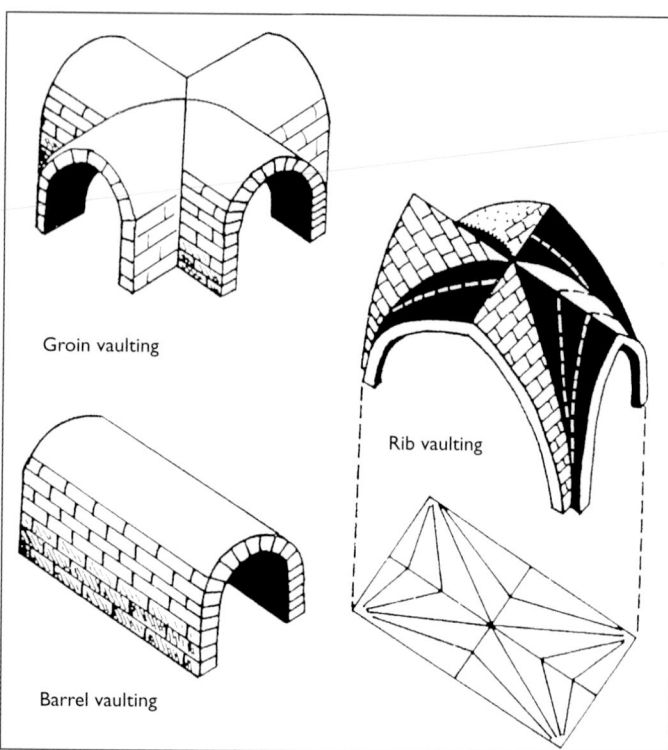

10.7 Diagram of the three main Romanesque vaulting systems: barrel vaulting, groin vaulting, and rib vaulting.

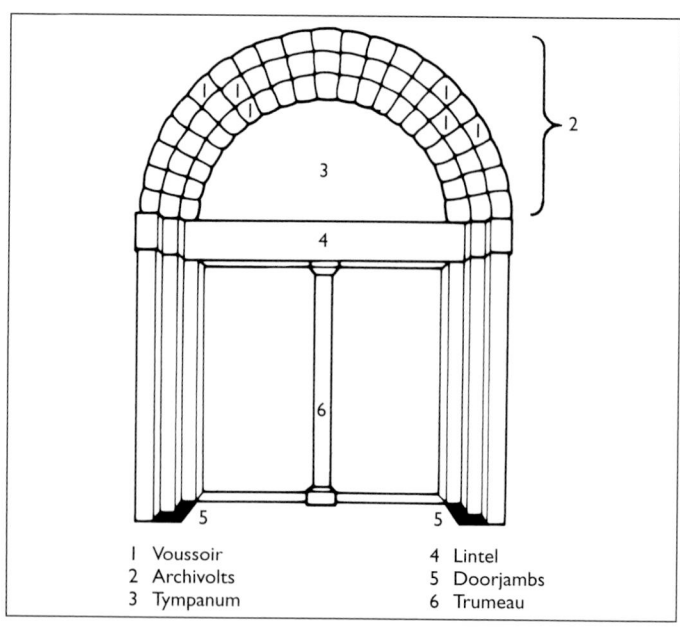

1 Voussoir	4 Lintel
2 Archivolts	5 Doorjambs
3 Tympanum	6 Trumeau

10.8 Diagram of a Romanesque portal.

barrel vaults (fig. **10.6**), which lessened the risk of fire and improved the acoustics (music, particularly Gregorian chant, was an integral feature of the Christian liturgy). The stone vaults (fig. **10.7**) required extra support, or buttressing, to counteract the lateral thrust (sideways force) they exerted against the walls. At Sainte-Foy, **transverse ribs** cross the underside of the **quadrant**—i.e., the half-barrel vaults of the nave. They are supported by **cluster piers**, each of which is reinforced by four engaged half-columns. The piers accent the corners of the groin-vaulted wall sections, or **bays,** of the side aisles.

Romanesque churches were decorated with sculpture, painting, and wall hangings through which an illiterate general population could "read" the images. Tapestries, most of which are now lost, often hung along the aisles, adding color and warmth to the church interiors.

An important Romanesque development was the use of architectural sculpture, animating surfaces and illustrating Bible stories and saints' lives. Most pilgrimage churches had images carved in relief at the main entrance. The area immediately around the doorways, or **portals,** would have contained the first images encountered, and the reliefs were

therefore intended to attract the attention of the worshiper approaching the church. The general layout of medieval church portals is fairly consistent (fig. **10.8**); what varies from building to building is the program—the arrangement and meaning of the subjects depicted on each section.

At Conques, the relief sculpture on the western portal (figs. **10.9** and **10.10**) is confined to the **tympanum** and the lintel. The most usual scenes on Romanesque tympanums depicted Christ in Majesty or, as at Sainte-Foy, the *Last Judgment* (fig. **10.11**). It conforms to iconographic convention

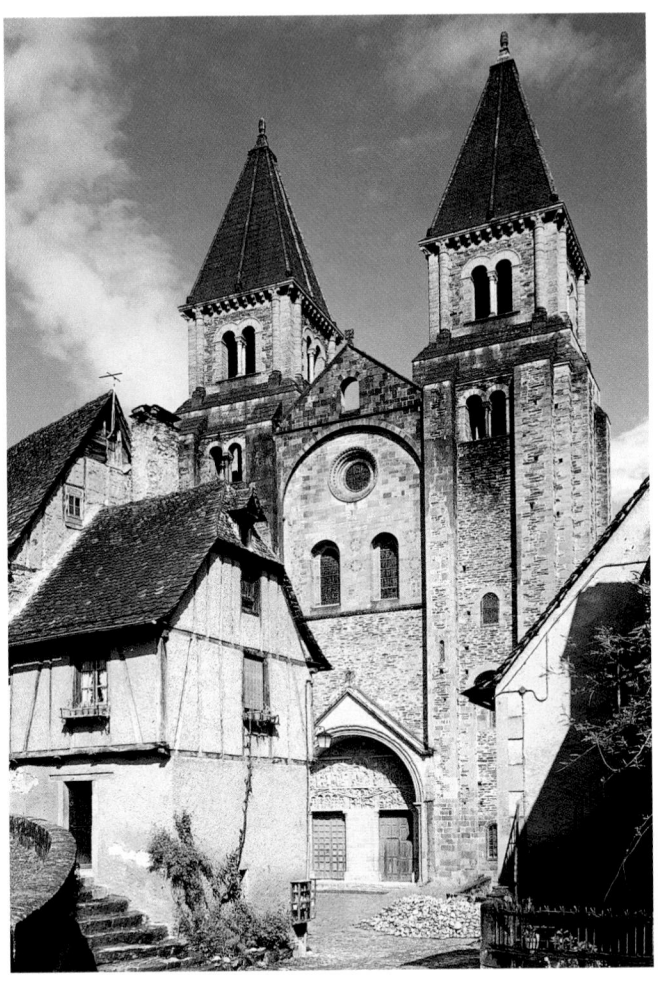

10.9 West entrance wall, Sainte-Foy, Conques, c. 1130.

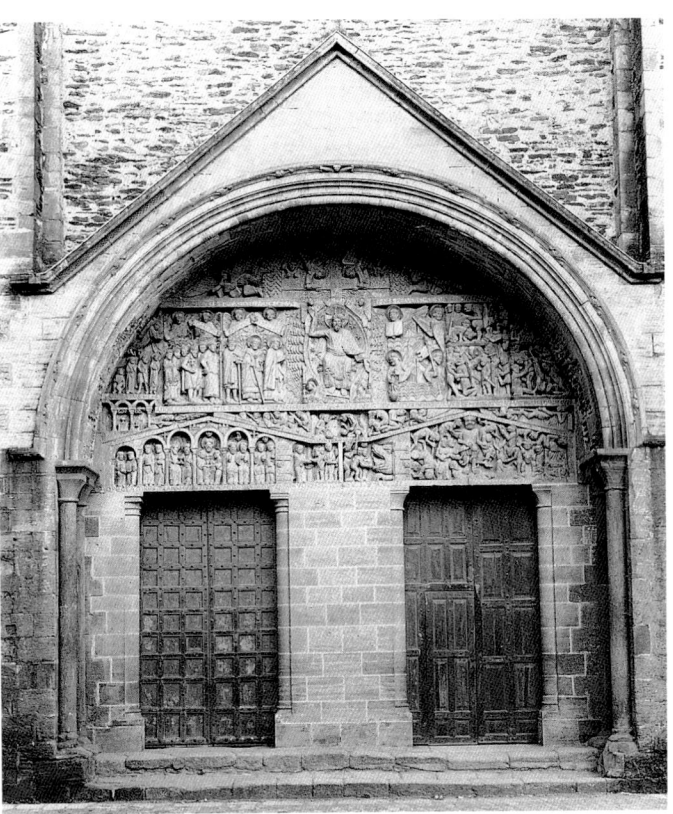

10.10 West portal with tympanum, Sainte-Foy, Conques, c. 1130. Stone; approximately 12 × 22 ft. (3.66 × 6.71 m).

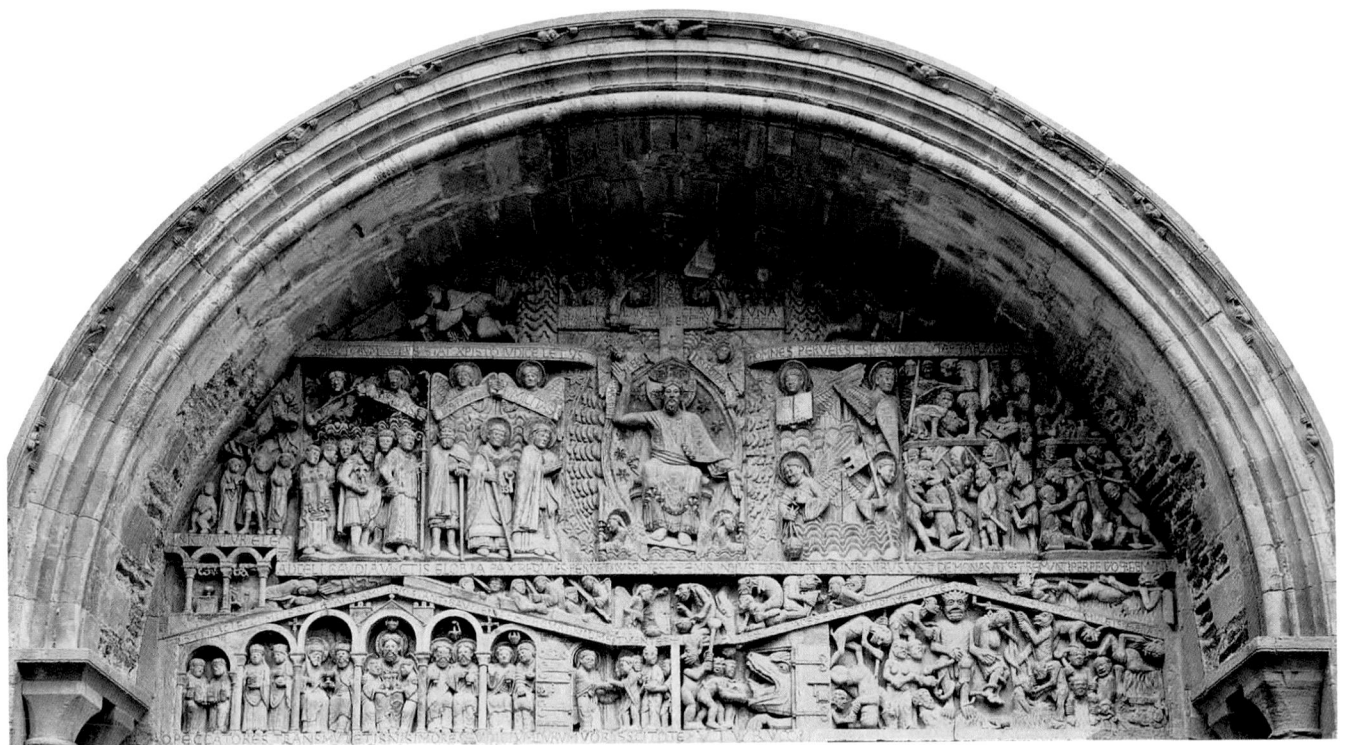

10.11 *Last Judgment*, tympanum of the west portal, Sainte-Foy, Conques, c. 1130. Jesus is both the central and largest figure. He is surrounded by a mandorla, an oval of light (an Eastern motif), and his halo contains the Cross. He raises his right hand, reminding the viewer that the souls on his right will be received in heaven—a visual rendition of the advantages of being "on the right hand of God."

in its overall arrangement. The figures on Christ's right (the viewer's left) and on his level are saints and churchmen. Above them, angels hold scrolls that form arches. Below, also on Christ's right, are figures framed by semicircular arches. A figure of Sainte Foy is shown prostrated before the hand of God. Christ's left hand is lowered toward hell. His gesture directs the viewer's attention to the damned souls falling and being tortured by devils. In the center of hell, on the viewer's right, is the crowned frontal figure of Satan. The punishments in hell are designed to fit the earthly crimes of the damned. Thus, at the far left, a prideful knight tumbles from his horse as a devil spears him with a pitchfork. Next on the (viewer's) right, a lustful woman is yoked to her lover by the neck. On the other side of Satan, reading from right to left, a devil forces molten metal down the throat of a forger; two devils roast a poacher with the head of a rabbit; and a man guilty of greed hangs with a purse (also hanging) around his neck. Note that the saved souls on Christ's right are neatly arranged under framing devices, whereas the damned, on Christ's left, appear jumbled and disordered.

At the center of the lintel, directly below Christ, the traditional right–left Christian symbolism is maintained. Two individual scenes are divided by a vertical. On Christ's right, angels welcome saved souls into heaven. On his left, a grotesque devil with spiked hair and a long nose brandishes a club at a damned soul. The latter bends over as if to enter the gaping jaws of a monster, which pokes its head through a doorway. This iconography conflates the Christian metaphors of the "gate of hell" and the "jaws of death."

Images of heaven and hell vary as Christian art develops. The basic arrangement of the *Last Judgment,* however, is fairly constant. It is a reminder of the passage of time and of the belief that the unrighteous will be condemned to "everlasting punishment: but the righteous [will enter] into life eternal" (Matthew 25:46).

Saint-Pierre at Moissac

To the southwest of Conques, on the route to Santiago de Compostela, the medieval pilgrim would probably pause at Moissac (figs. **10.12–10.15**). Figure 10.13 shows the plan of the abbey and church of Saint-Pierre, which were founded in the seventh century but destroyed and rebuilt

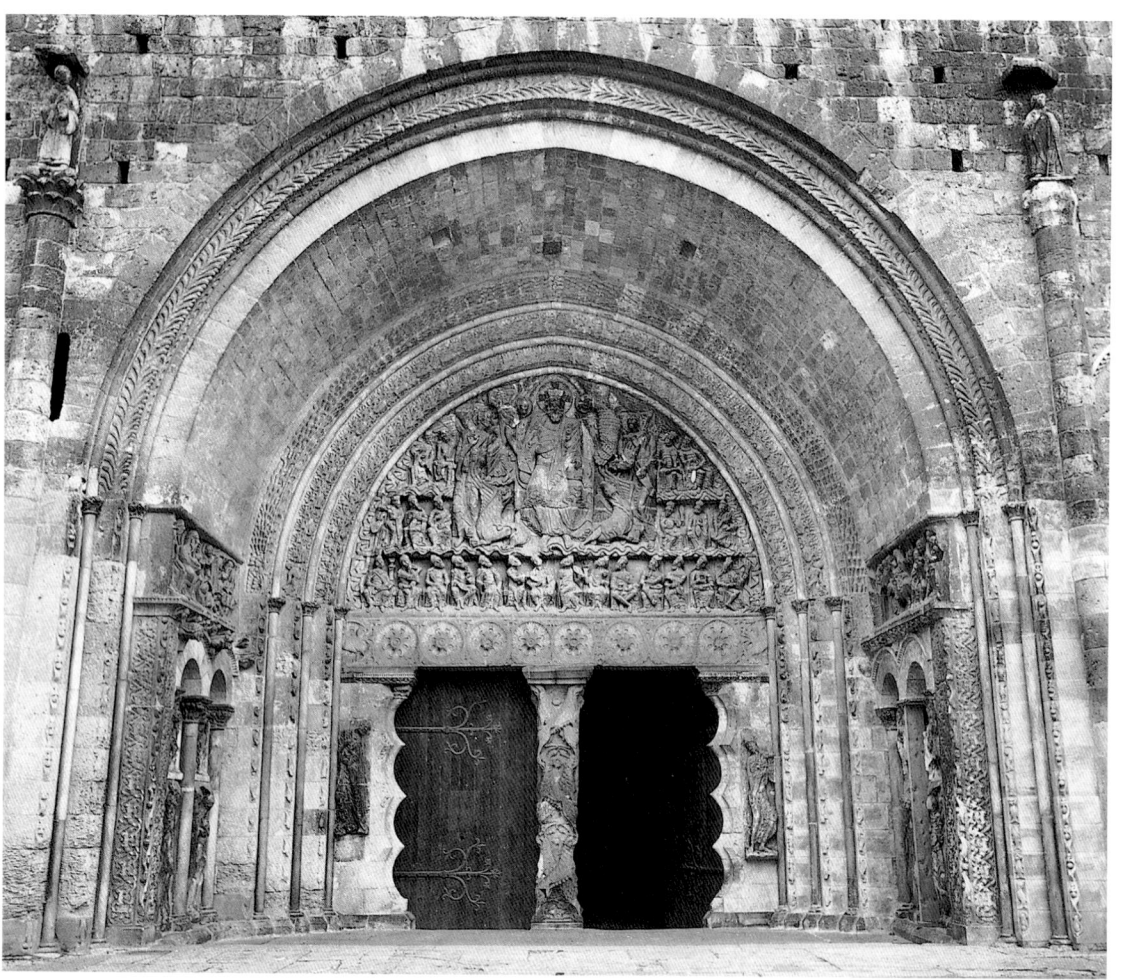

10.12 South porch, Saint-Pierre, Moissac, c. 1115–1135. 16 ft. 6 in. (5.03 m) diameter. According to local tradition, a dream sent by God inspired Clovis, king of the Franks, to found the abbey at Moissac. This is consistent with the visionary character of the tympanum's iconography.

N ◄┼─

I	15th-century church with Romanesque walls
2	Romanesque narthex
3	South porch
4	Tympanum
5	Cloister
6	Lavatorium
7	Chapel and dormitory (destroyed)
8	Refectory
9	Kitchen
10	Gothic chapel house
11	Sacristy

10.13 Plan of the abbey and church of Saint-Pierre, Moissac, France.

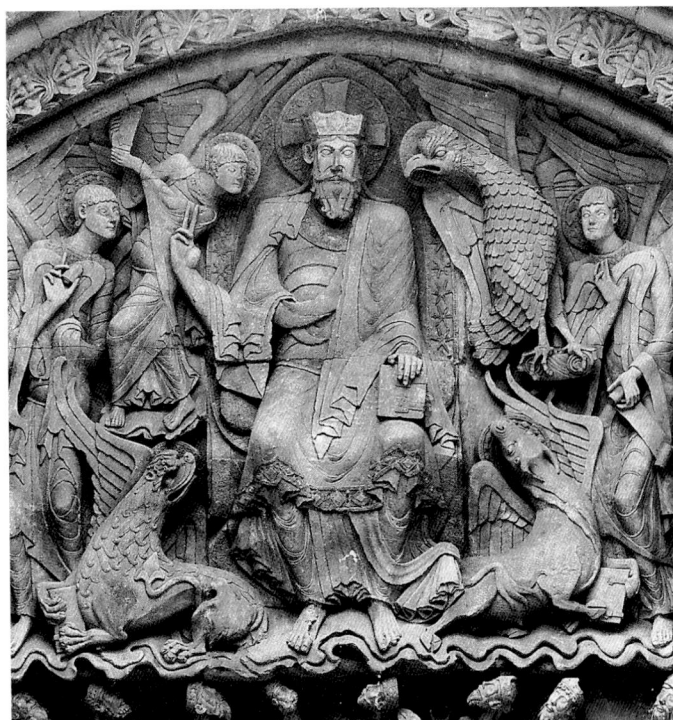

10.15 *Christ,* tympanum of the south porch (detail of fig. 10.12), Saint-Pierre, Moissac, c. 1115–1135.

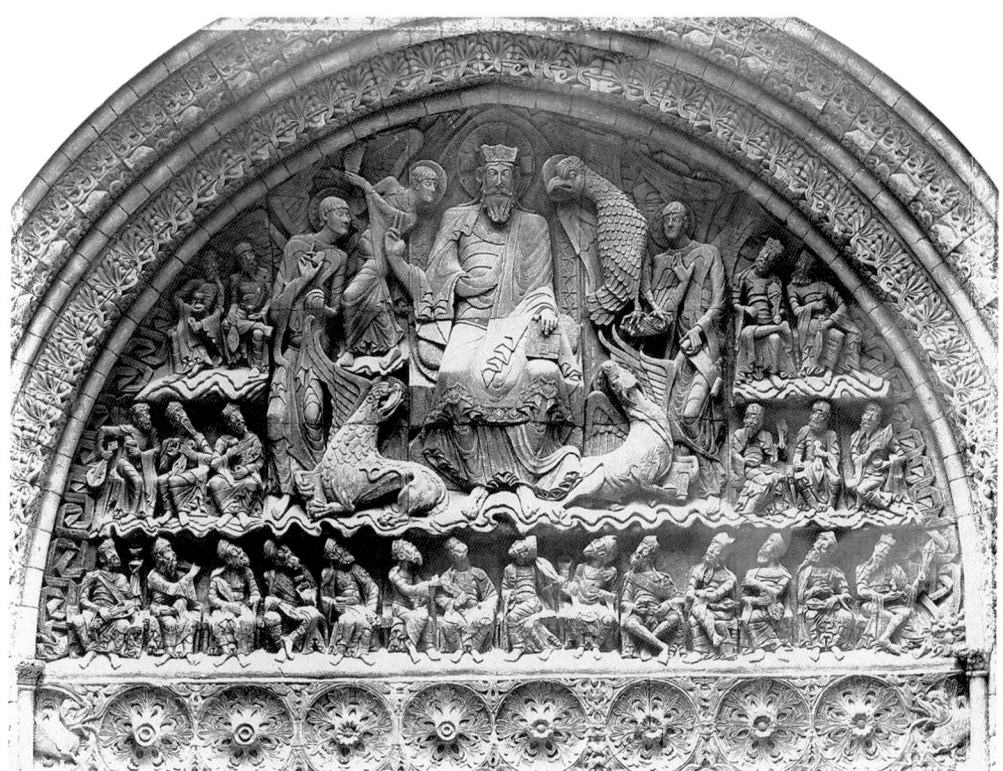

10.14 Tympanum of the south porch, Saint-Pierre, Moissac, c. 1115–1135. The imagery carved here is from the book of Revelation 4:2–7: "And behold, a throne was set in heaven, and one sat on the throne. . . . And round about the throne were four and twenty seats: and upon the seats I saw four and twenty elders sitting, clothed in white raiment; and they had on their heads crowns of gold. . . . And before the throne there was a sea [the wavy lines] of glass like unto crystal: and in the midst of the throne, and round about the throne, were four beasts full of eyes before and behind. And the first beast was like a lion, and the second beast like a calf, and the third beast had a face as a man, and the fourth beast was like a flying eagle."

several times. The Romanesque sections that survive are the cloister, the remains of the lower walls of the church, the south porch, and a tower. The most important Romanesque sculptures are on the south-porch entrance (fig. 10.12 and number 3 on the plan) and in the cloister (number 5 on the plan).

The tympanum over the south portal is filled with reliefs depicting the *Second Coming of Christ* (fig. 10.14), based on Revelation (see p. 339). The artist has eliminated the theological connection between the Second Coming and the Last Judgment—hence there is no representation of the damned and the saved, as at Conques. Instead, Christ is shown in Glory, surrounded by images derived from Saint John's apocalyptic vision (see caption). The tympanum is framed by floral motifs on the **archivolts** and by ten **rosettes** in the lintel.

The figure of Christ at Moissac (fig. 10.15) is proportionally larger than that at Sainte-Foy. He is rendered frontally, his presence commanding the scene, and in this respect the figure can be compared with the manuscript page depicting Christ in Majesty from the Stavelot Bible (fig. **10.16**) (see box, p. 368), in which the monumental proportions of Christ are barely contained within the frame. His mandorla overlaps the inner edges of the illusionistic meander pattern. The four tondos at the corners of the page contain representations of the Evangelists' symbols. The two lower ones—the lion of Saint Mark and the bull of Saint Luke—gaze at each other and hold a Gospel book, referring to their roles as biographers of Christ. The angel and eagle (Saints Matthew and John, respectively) above Christ carry scrolls of prophecy.

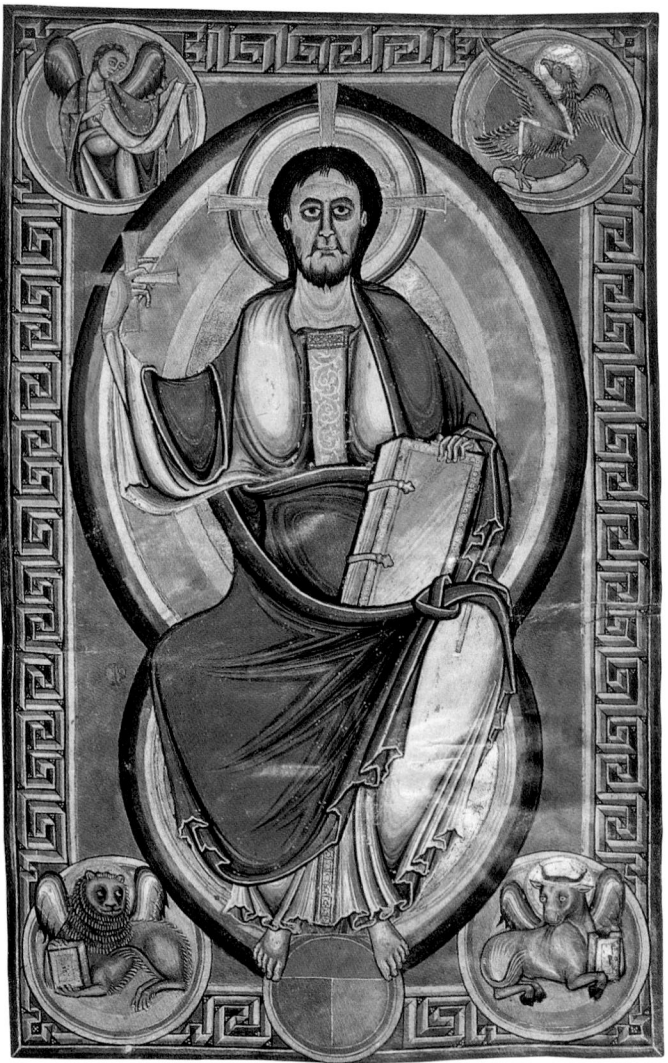

10.16 *Christ in Majesty,* from the Stavelot Bible, 1093–1097. Parchment; 22½ × 14½ in. (57.5 × 36.8 cm). British Library, London.

10.17 The elders, tympanum of the south porch (detail of fig. 10.14), Saint-Pierre, Moissac, c. 1115–1135.

In the tympanum at Moissac, the four symbols of the Evangelists and the twenty-four elders (fig. **10.17**) focus their gaze on Christ. In the Stavelot illumination, on the other hand, the bull and lion seem to cower beneath Christ, while the eagle gazes upward, away from Christ, as does the lion, with a wistful, slightly apprehensive air. Only the angel looks directly at Christ, drawing the viewer's attention directly to him. At Moissac, this effect is multiplied through the tympanum figures, all of whom twist themselves and tilt their heads in order to see Christ, as if riveted by his power. The detail of the elder (fig. **10.18**) shows not only the tilted head, but also the taste for elongated proportions and flat patterns in the Romanesque sculptural style. The beard is rendered as layers of very slightly curved, parallel lines, which are crossed by a diagonal layer of mustache. This pattern is repeated in the long strands of hair and short curls emerging from below the crown.

Another new surface on which Romanesque artists carved sculptures was the **trumeau.** At Moissac, the trumeau figures are even more elongated than the elders, necessitated by the thin, vertical architectural rectangle in which they are located. The relief of *Saint*

10.18 An elder, tympanum of the south porch (detail of fig. 10.14), Saint-Pierre, Moissac, c. 1115–1135.

Paul (fig. **10.19**) is lengthened from the waist down, creating an unexpected shift in proportion. The flat drapery folds, despite suggesting the forms of the legs, do not really flow in relation to the body. The diagonal feet, like those in the mosaics of Justinian and Theodora at Ravenna (see Chapter 8), reinforce the illogical quality of the figure's support. In this case, the saint resembles a wooden puppet, hanging as if attached to the trumeau from behind.

The cloister, which was an important part of monastic life, is a prominent feature of Saint-Pierre. It was not only a place of relaxation and meditation for the monks, but also an earthly prefiguration of the peacefulness of heaven. At Moissac, the cloister contains many sculptures on its architectural surfaces.

The figure of Abbot Durand (fig. **10.20**) on the cloister pier is carved in even flatter relief than the *Saint Paul*. The figure is symmetrical and tightly enclosed by the arch and

10.20 Cloister pier with a relief of Abbot Durand, Saint-Pierre, Moissac, 1047–1072. Durand was bishop of Toulouse and abbot of Saint-Pierre, which prospered under his administration. He consecrated a church in the abbey complex in 1063 and commissioned several churches throughout the region under his authority. He is identified by a Latin inscription on the round arch.

10.19 *Saint Paul,* trumeau of Saint-Pierre, Moissac.

10.21 Initial *L* and *Saint Matthew,* region of Agen-Moissac, c. 1100. 7½ × 4 in. (19.0 × 10.2 cm). Ms. Lat. 254, fol.10. Bibliothèque Nationale, Paris.

its colonnettes. Abbot Durand is perfectly unified with his frame—his halo, hat, and the curve of his crook echo the round arch, and the crook's staff and the edge of his drapery conform to the outlines of the pier. His head sinks into his shoulders, thereby eliminating his neck and flattening the space. Reinforcing this two-dimensional effect is the frontality of the abbot and the verticality of his feet, which make no pretense of naturally supporting him.

A similar flattened treatment of space characterizes Romanesque manuscript illumination. The *Saint Matthew* in figure **10.21** resembles the relief of Abbot Durand in its frontality, relative symmetry, and setting. Matthew's feet are flat and contained in a patterned semicircle that echoes his halo and the round arch above it. The intertwined human, animal, and floral forms on the initial *L* are typical Romanesque manuscript motifs. Also typical is the contrast between the animation inherent in the initial and the more static, iconic quality of the saint. The interlaced forms are reminiscent of Viking and Anglo-Saxon metalwork, and possibly also of Islamic patterns.

The design on a capital from the Moissac cloister (fig. **10.22**) resembles the tight weave found in Islamic mosque decoration and carpets. Capitals decorated with geometric designs had been in use from the Early Christian period. They assimilated Islamic and Anglo-Saxon motifs into nonfigural sculpture decoration in churches—a lasting effect of the Iconoclastic Controversy. But during the revival of monumental figurative sculpture in Romanesque churches, capitals offered artists a new surface for narrative scenes and individual figures as well as for geometric patterns.

10.22 Capital, north gallery of the cloister, Saint-Pierre, Moissac, c. 1100.

A particularly exuberant Romanesque interlace related to that carved on the capital appears in an eleventh-century manuscript page illuminating the initial *T* (fig. **10.23**). Its energy is conveyed by the dynamic movement of intertwined forms. And because of their dynamism, they have an organic character that borders on the figural, despite being geometric. The transition between nature and abstraction is enhanced by the interlaces flanking the *T*, which emerge from the mouths of birds.

10.23 Initial *T*, from the sacramentary of Saint-Saveur de Figeac, 11th century. Ms. Lat. 2293, fol. 19v. Bibliothèque Nationale, Paris.

Autun

An example of a capital decorated with a narrative scene can be seen in the *Flight into Egypt* (fig. **10.24**) at Autun Cathedral in Burgundy. Autun's sculptures were carved by Gislebertus, who signed his name on the tympanum. The capital shows the Holy Family fleeing the edict of King Herod, which decreed the death of all male children under the age of two. Joseph leads a lively, high-stepping donkey carrying Mary and Jesus out of Bethlehem into Egypt. The capital reflects the taste for elegant surface design characteristic of Romanesque sculpture. Decorative foliage is relegated to the background, and design-filled circles support the figures. Open and closed circle designs are repeated in the borders of the draperies, on Joseph's hat, on the halos, and in the donkey's trappings. Also typical are the repeated curves representing folds, which are carved into the draperies more for their patterned effect than to define organic quality. On Joseph's tunic, the surface curves enhance the impression of backward motion, as if the cloth had been blown by a sudden gust of wind. The Romanesque artist's disregard of gravity is evident in the figure of Jesus. He faces front, with his right hand resting on a sphere held by Mary. He is suspended between her knees, with no indication of support for his weight.

A similar taste for flat patterns and weightlessness characterizes the monumental tympanum at Autun (fig. **10.25**). It depicts a large, imposing, and timeless figure of

10.24 Gislebertus, capital depicting the *Flight into Egypt*, Cathedral of Saint-Lazare, Autun, Burgundy, France, c. 1130.

10.25 Gislebertus, *Last Judgment*, tympanum of the west portal, Cathedral of Saint-Lazare, Autun, Burgundy, c. 1120–1135.

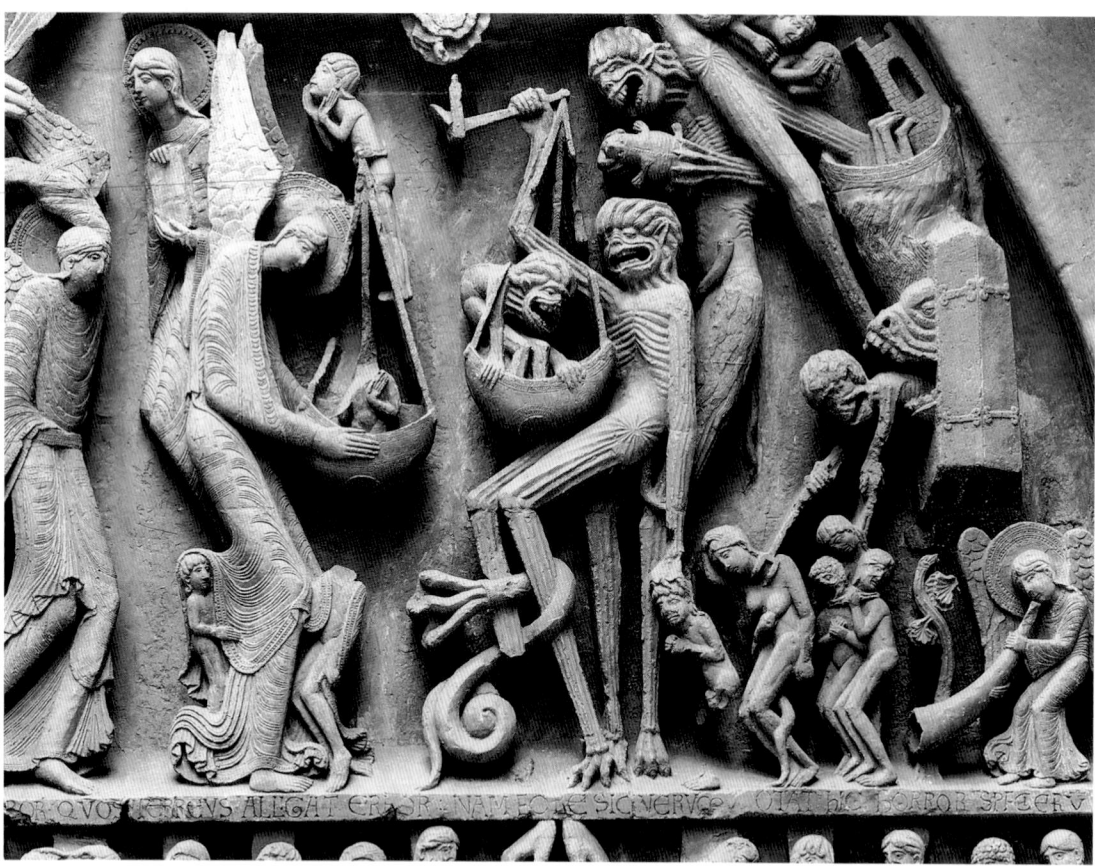

10.26 Gislebertus, *Last Judgment* (detail of fig. 10.25, showing the weighing of souls). Originally, the effect of scenes such as this was accentuated by colors, for most Romanesque architectural sculptures were brightly painted.

Christ appearing in majestic light at the Last Judgment. Surrounded by a mandorla supported by four angels, Christ sits frontally on a throne and spreads out his arms in a broad gesture proclaiming his divine presence. His drapery forms a pattern of flattened curves that correspond to the curved arms. Zigzags repeat the animated poses of the other figures as well as the diagonals of Christ's legs. On either side of Christ are two tiers of angels and souls—the saved at his right and the damned at his left. Christ's left hand indicates the weighing of the souls on the lower tier (fig. **10.26**). The archangel Michael bends at the left of the scale and weighs a soul in human form, while two little souls huddle under his robe for protection. To the right of the scale, two grotesque devils weigh a tiny monstrous demon, who is trying to lower the scale in order to damn the saved soul. At the extreme right, several more damned souls fall downward, denoting their future in hell. In this detail, Gislebertus plays on the theme of physical weight and weightlessness as a metaphor for spirituality and salvation. The irony of his image is that the saved human soul seems to weigh more, for he pulls down the scale, and the damned soul weighs less. Since the damned are destined to "go down," their lesser "substance" is shown by the scale. The saved, on the other hand, "go up," but actually weigh more because of their greater spiritual substance. Just below the devil's side of the scale are small souls being tortured by a devil grasping their necks with tongs. At the far lower left of the tympanum, on the other hand, are two pilgrims (fig. **10.27**), iden-

tifiable from their traveling bags and scallop shells. The latter were signs of pilgrimage and resurrection. Here, represented on the tympanum of a church on the pilgrimage road, the shells refer to the belief that pilgrimage is a route to salvation.

On the horizontal strip of stone above these figures, Gislebertus inscribed a verbal warning to accompany his imagery. He asserts that his images are an accurate portrayal of the future that awaits sinners.

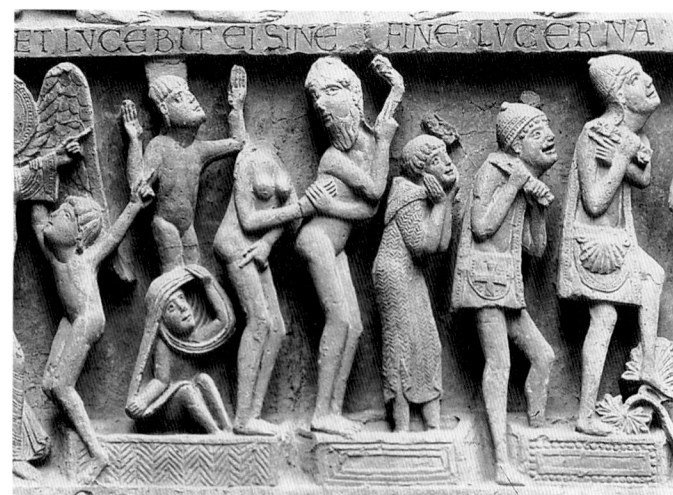

10.27 Gislebertus, *Last Judgment* (detail of fig. 10.25, showing two pilgrims).

The Stave Church of Norway and Stone Interlace

In Norway, the translation of early medieval manuscript interlace into monumental stone relief sculpture became characteristic of later Romanesque churches. A good example is on the twelfth-century west portal of Ål Cathedral (fig. **10.28**), where several elements of early medieval manuscript art are combined. The elaborate curvilinear interlace merges into floral and leaf designs, and is also transformed into animal forms. But rather than being relegated to capital and border designs, this assumes a conspicuous position on the doorjamb.

The derivation of such interlace from wood carving is evident in the headpost from the Oseberg ship burial (see p. 329). In Norway, the custom of building wooden churches (while stone was being adopted elsewhere) persisted into the thirteenth century. A few such stave churches survive—for example, that at Borgund (fig. **10.29**). The walls are supported by a timber frame on a foundation of boulders. The frame supports a tall structure containing the nave and occasionally an apse. Projecting from the sides are sloping gables, whose surfaces resemble thatching. The points of the gables, like the prows of Viking ships, were decorated with animal heads, usually dragons. Above each door stood a cross, and at the top of the building was a turret and a spire. The elaborate wood carvings around the portals were similar to stone examples (cf. fig. 10.28).

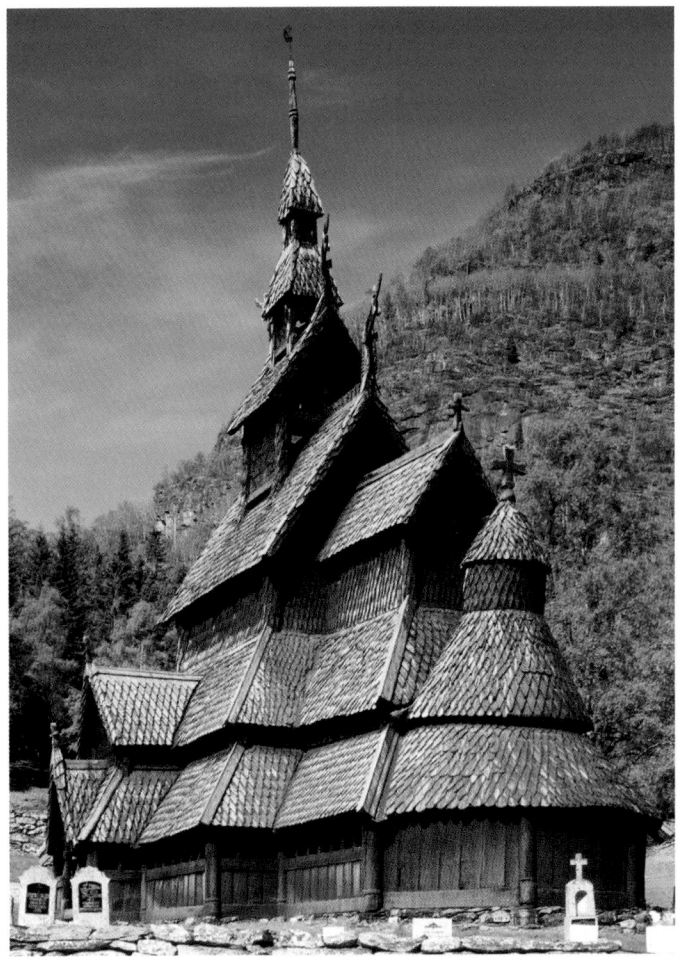

10.29 Borgund stave church, Sogne, Norway, second half of the 12th century.

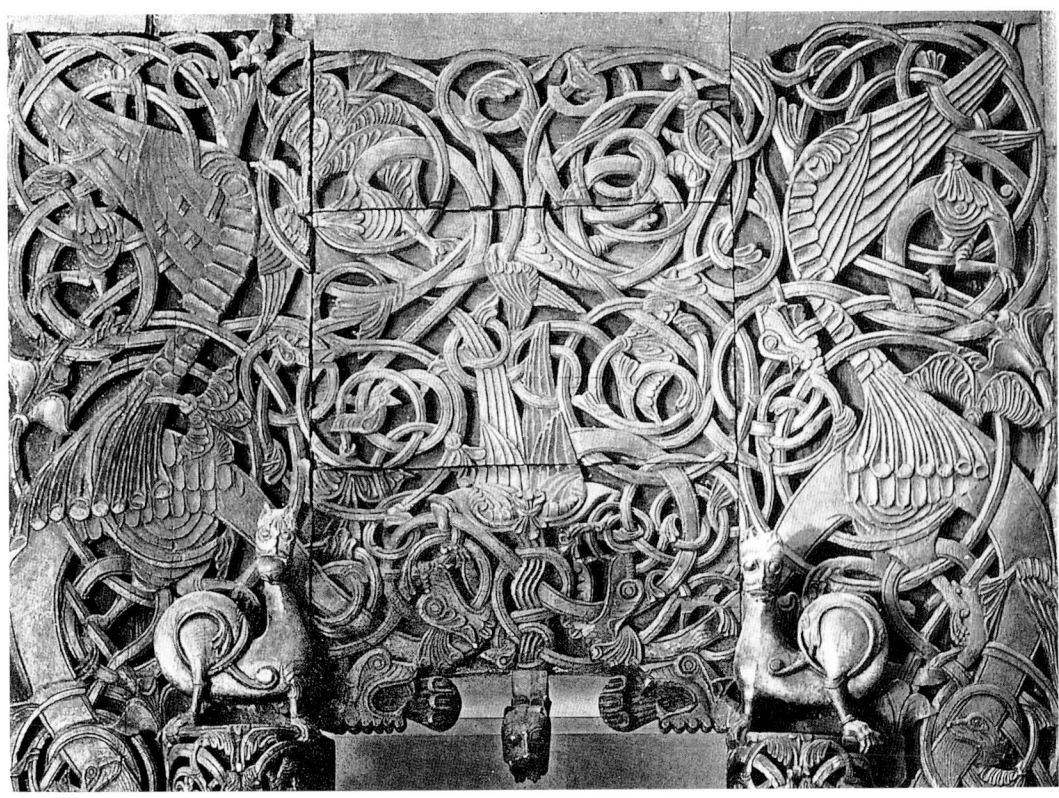

10.28 Decorative detail of interlace sculpture, right jamb of the west portal, Ål Cathedral, Norway, 12th century.

The Italian Romanesque Cathedral Complex at Pisa

The diversity of Romanesque architecture is evident not only in the contrasts between the stave churches of the north and French pilgrimage churches, but also in those of Italy, where Romanesque buildings were influenced by the Classical tradition. These rarely had façade towers or westwork, which were common in France and Germany. The paradigm for Italian Romanesque churches was the Early Christian basilica.

In 1062, the Republic of Pisa, a port on the west coast of Tuscany, defeated the Muslim naval force of Sicily, an island south of Italy. To celebrate their victory, the Pisans used the booty taken from enemy boats to raise funds for a new cathedral. Dedicated to the Virgin, the cathedral was begun the following year, consecrated in 1118, and eventually completed in 1272. In 1153, Pisa celebrated another victory at sea—this time against the Christian Republic of Amalfi, also in the south—by starting the construction of a baptistery opposite the cathedral façade. These two buildings are part of an extraordinary architectural complex that includes the famous "leaning tower" (built 1174–1271) and a thirteenth-century burial ground (the Campo Santo; fig. **10.30**). The baptistery's rotunda-like appearance was derived from the Holy Sepulcher in Jerusalem (see box, p. 370), reflecting Pisa's trade with the East.

The cathedral itself (fig. **10.31**) is an amalgam of diverse influences. The entire exterior is of white marble, the

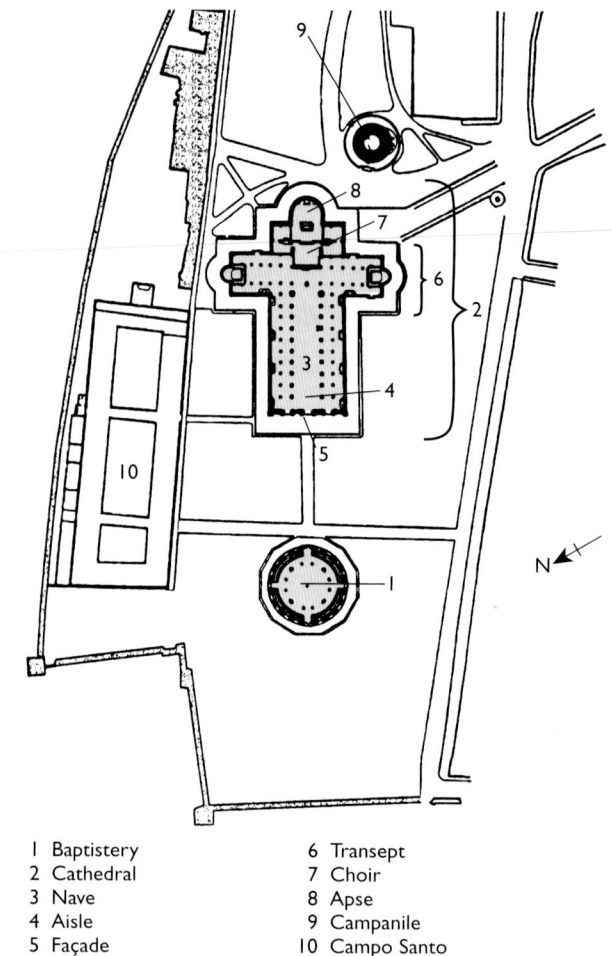

1	Baptistery	6	Transept
2	Cathedral	7	Choir
3	Nave	8	Apse
4	Aisle	9	Campanile
5	Façade	10	Campo Santo

10.30 Plan of Pisa Cathedral and the surrounding complex.

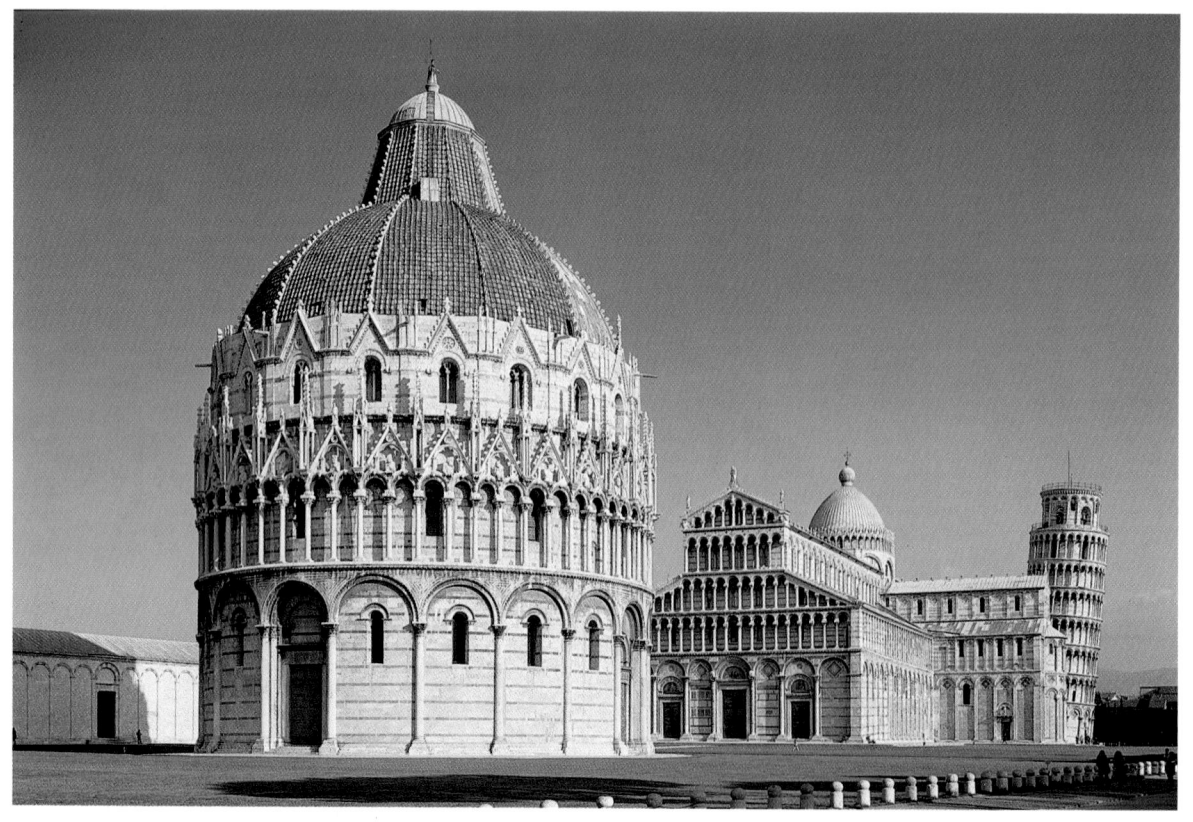

10.31 View of the baptistery, cathedral, and campanile, Pisa, 1053–1272.

material favored in ancient Rome. The cruciform plan (see fig. 10.30) is based on that of the Early Christian basilica with transept arms—each containing an apse at the end—double side aisles, and a flat wooden roof. Arcades separating the nave from the aisles are formed of round arches resting on columns with Corinthian and Byzantine capitals (fig. **10.32**). The apse mosaic is also in the Byzantine style. Islamic features occur in the elliptical dome over the crossing, the interior arch at the end of the nave, and the bronze griffin (now lost), which was looted by the Crusaders and adorned the pinnacle of the façade.

The façade differs from many French examples in the absence of a tympanum illustrating the Last Judgment. Instead, it has three entrances, each of which is flanked by a blind round arch, and is surmounted by four stories of freestanding columns forming arcaded galleries. The arcades continue around the building and create a dynamic surface pattern that unifies the whole. Similar arcades encircle the lower level of the baptistery wall; the upper stories and round dome are later.

Six stories of arcaded galleries are repeated on the cylindrical "leaning tower"—the **campanile** (bell tower) of the cathedral (fig. **10.33**). This was characteristic of Italian churches influenced by Byzantine tradition, in contrast to

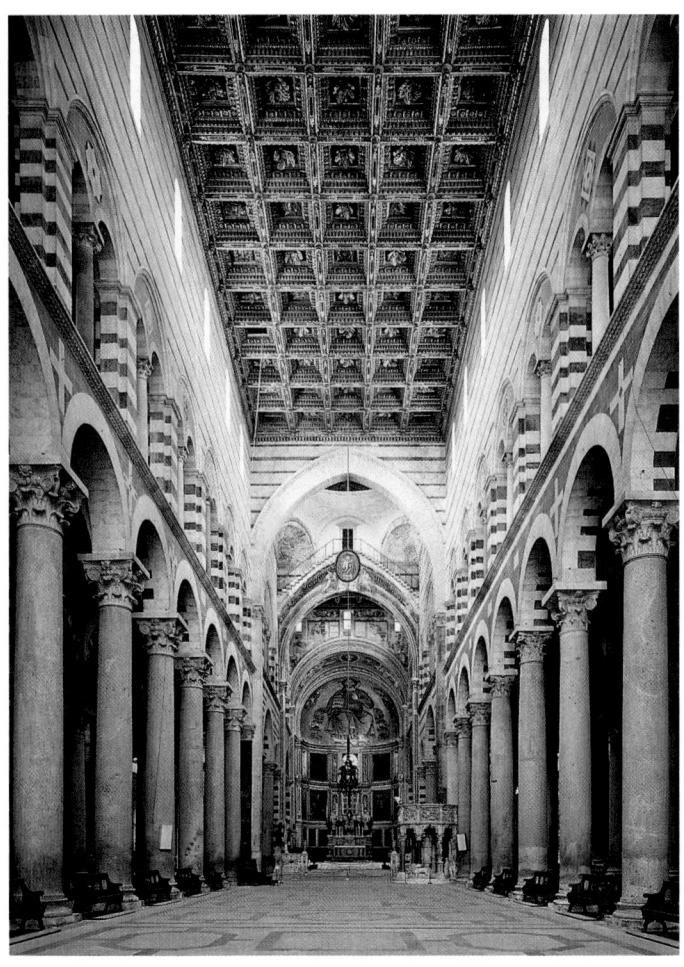

10.32 Nave of Pisa Cathedral, 12th century.

10.33 Campanile of Pisa Cathedral, 1174–1271.

northern Romanesque churches, where westwork was preferred. At Pisa, as elsewhere, the round arches are of Roman inspiration, and their repetition contributes to the sense of unity that pervades the entire complex. The tower leans because it was originally built on a soft foundation; efforts to compensate for the tilt have so far proved unsuccessful. It is now some 13 feet (3.96 m) out of plumb (or off its vertical axis). Recently, a new and firmer foundation has halted the gradual movement, which would eventually have caused the campanile to topple over.

The Romanesque style of architecture at Pisa spread south from northern Italy and the former Yugoslavia to Sardinia. In Tuscany, elements of the style—especially the interior and exterior surface patterns formed by alternating green and white marble—would remain characteristic for several centuries.

Mural Painting

In contrast to those of the Early Middle Ages, Romanesque churches and chapels contain some well-preserved monumental mural paintings. These had both a decorative and a didactic function. Usually, several painters would work on a particular series of murals. The program was generally planned by the principal artist, often in conjunction with a member of the clergy or other patron. A preliminary drawing, in *buon fresco,* was made to prepare outlines and certain details, and compasses were used for repeated curvilinear designs. The painting itself was usually *fresco secco,* possibly redampened so that the plaster would absorb the paint. Sometimes, however, tempera was applied as well. Generally the darker areas were painted before the highlights. In the final stage, the forms would be outlined in black or brown. As in Byzantine mosaics, this technique emphasized the figures rather than creating an illusion of three-dimensional space.

The frescoes in the chapel of Castel Appiano in northern Italy (fig. **10.34**), although damaged, are characteristic in their use of rich colors—blues, greens, browns, and yellows. In the semidome of the central apse, Mary and Christ are enthroned between two angels (fig. **10.35**). The scene is framed by a floral border, interrupted by the base of the throne, whose jeweled golden surface suggests Byzantine influence. A formal unity is created, as the background green repeats the shape of the border, while the blue

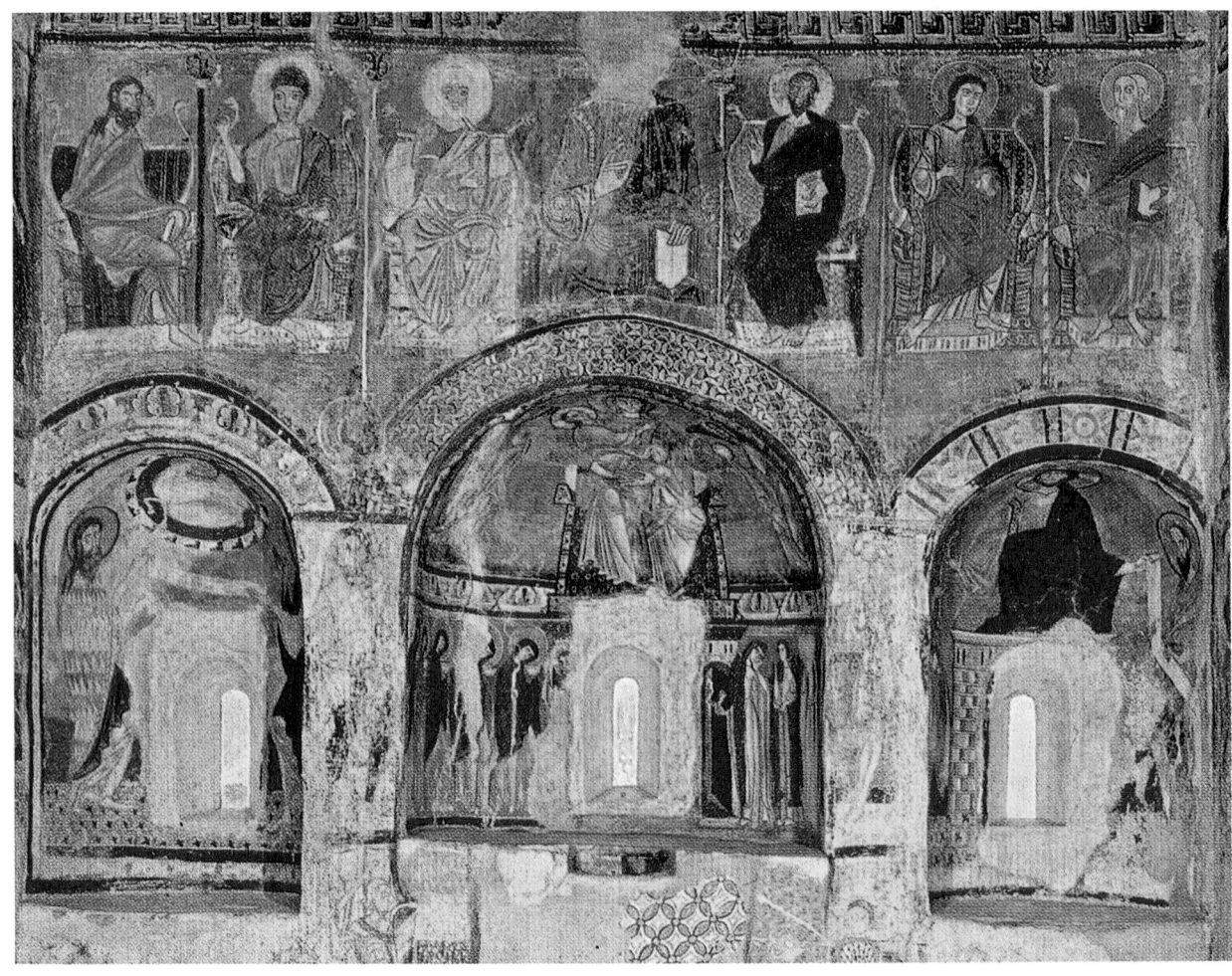

10.34 Apse of the chapel of Castel Appiano, Italy, c. 1200.

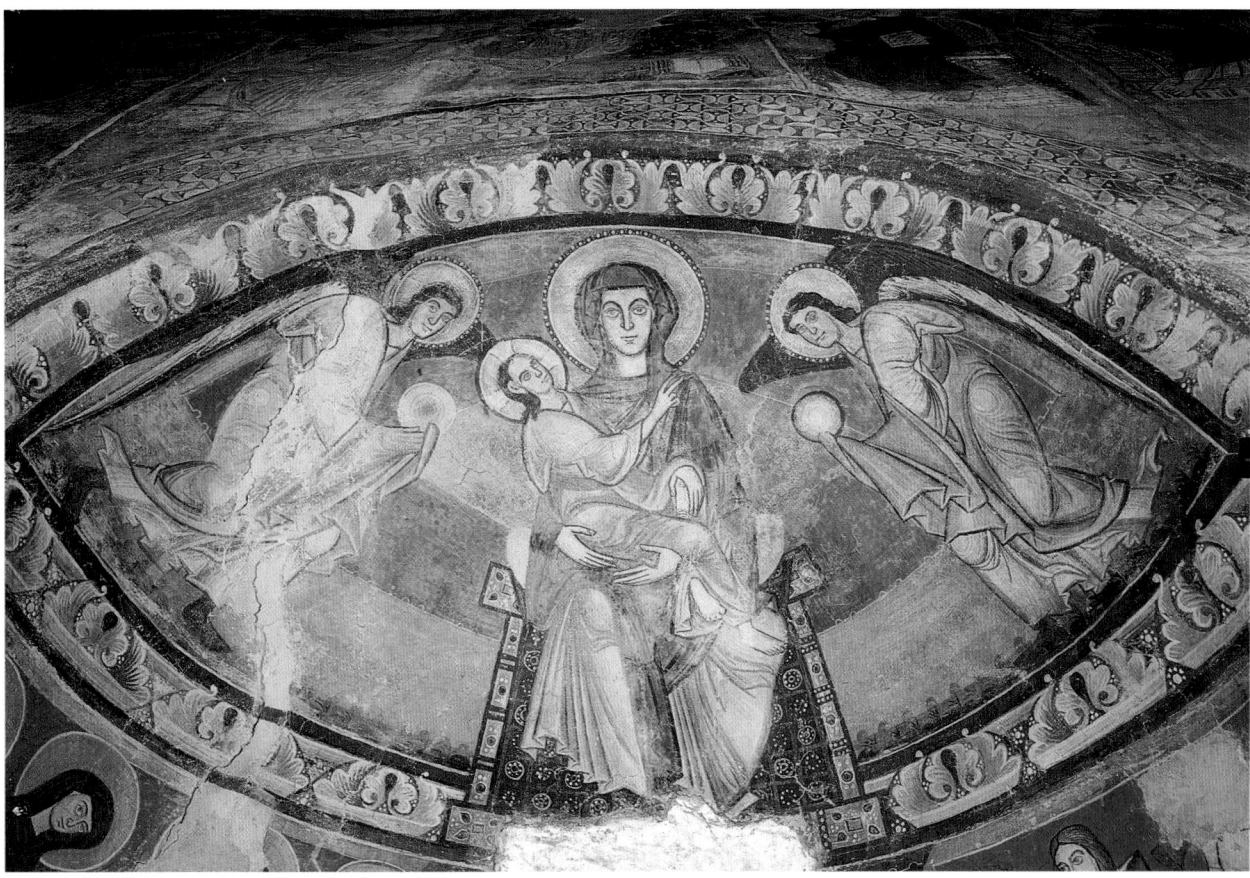

10.35 *Mary and Christ with Two Angels* (detail of fig. 10.34). Fresco.

repeats the pointed oval of the apse itself. Mary is frontal, staring directly at the viewer. Her draperies echo the background blue and green, and her flat halo repeats the color and beaded designs of the throne. This painting shares certain stylistic features with the capital shown in figure 10.24: although differing in proportions, Christ is a small man held in Mary's lap. His right hand extends upward in a gesture of benediction, and the draperies reflect a taste for elegant, curvilinear surface patterns.

The Bayeux "Tapestry"

One of the most intriguing Romanesque works of art is the so-called Bayeux "Tapestry," which depicts the Norman invasion of England in 1066 (figs. **10.36, 10.37,** and **10.38**). It is nearly 230 feet (70.10 m) long and contains 626 human figures, 731 animals, 376 boats, and 70 buildings and trees. Such an undertaking probably involved several artists, technicians, and a general designer working together with a historian. Although invariably called a tapestry, the work is actually an embroidery, made by stitching eight colors

of wool onto bleached linen. We have no records of who the artists were, but most medieval embroidery was done by women, especially at the courts.

The "tapestry" may have been created for the cathedral of Bayeux in Normandy, near the northern coast of France. It is not recorded as being in the cathedral until the fifteenth century, and scholars disagree about its original location. The "tapestry" was probably commissioned by Bishop Odo of Bayeux, half-brother of William the Conqueror; the events depicted on it unfold from left to right and are accompanied by Latin inscriptions. The detail in figure 10.36 shows William the Conqueror leading a group of Norman nobles, including Odo, on a charge against the English. This scene takes place on Saturday morning, October 14, 1066, when William's army departed from Hastings to fight Harold, the Saxon king of England.

All the riders are helmeted and armed. Their chain mail is indicated by circular patterns within the outlines of the armor. Odo holds a mace, while the nobles carry banners, shields, and lances. The weapons, held on a diagonal, increase the illusion of forward movement, as Odo clashes with the enemy. The ground is indicated by a wavy line on a horizontal plane, but, aside from the overlapping of

10.36 Detail of a battle scene showing Bishop Odo brandishing a mace, from the Bayeux "Tapestry," c. 1070–1080. Wool embroidery on linen, 20 in. (50.8 cm) high. Musée de l'Évêché, Bayeux. Note how the smooth texture of the linen contrasts with the rough texture of the raised woolen threads. Single threads were used for waves, ropes, strands of hair on the horses' foreheads, and the outlines of each section of color.

10.37 Detail of Viking ships from the Bayeux "Tapestry." *MARE* is Latin for "sea."

10.38 Detail of craftsmen from the Bayeux "Tapestry." (Figs. 10.36–10.38 by special permission of the city of Bayeux.)

certain groups of figures, there is little attempt to depict three-dimensional space. Above and below the narrative events are borders containing human figures (note the decapitated figure below), natural and fantastic animals, and stylized plant forms.

The Viking longboats from William's fleet (fig. 10.37) reflect the Scandinavian origins of the Normans. Ready to set sail for England, they are propelled by oars and a sail. The man at the far left steers the boat by means of the fixed, rotating rudder characteristic of Viking ships. The prows are decorated with carved dragon heads. Two shields are attached to the bow, and these are believed to have been antiramming devices.

Figure 10.38 shows several craftsmen putting finishing touches on the boats. Above, the figure on the left holds an adze, and the one on the right drills holes into which the oars will be inserted. The two figures below are using axes of the type illustrated in figure 9.18. Note that their feet are visible beneath the ship, a rudimentary attempt to create a sense of three-dimensional space.

Unlike the other Romanesque works of art discussed in this chapter, the Bayeux "Tapestry" is secular in subject. The events depicted in it are primarily historical, although they are shown from the Norman point of view. While the Latin text helps to explain the images, much of the narrative is transmitted through the pictures themselves, and many of the details remain puzzling.

Romanesque Precursors of Gothic: Caen and Durham

Beginning in the twelfth century, new developments would arise in the architecture of western Europe. The scale of cathedrals would be expanded by Gothic (see Chapter 11) architects, and new trends in naturalism would emerge in sculptural and pictorial styles. But Gothic architecture did not emerge suddenly or without precedent, and for a while it overlapped building in the Romanesque style.

Precursors of Gothic are seen in the abbey church of Saint-Étienne at Caen, in Normandy (figs. **10.39**, **10.40**, and **10.41**) and at Durham Cathedral (figs. **10.42**, **10.43**, and **10.44**) in northeastern England. Saint-Étienne was begun in 1067 at the behest of William the Conqueror, who was determined to impose Norman architecture in England as well as in northern France. The nave of Saint-Étienne was completed in 1087, with a flat wooden roof, followed by the façade (see fig. 10.39) around 1096 to 1100. The latter is organized into three distinct vertical sections —a central rectangle surmounted by a gable and flanked by towers—that accentuate its upward thrust. The three horizontal sections divided by thin stone **stringcourses** reflect the three stories of the interior. This type of façade would evolve into characteristic Gothic forms designed to emphasize the verticality of the wall as indicated by the height of the spires, which are a later Gothic addition.

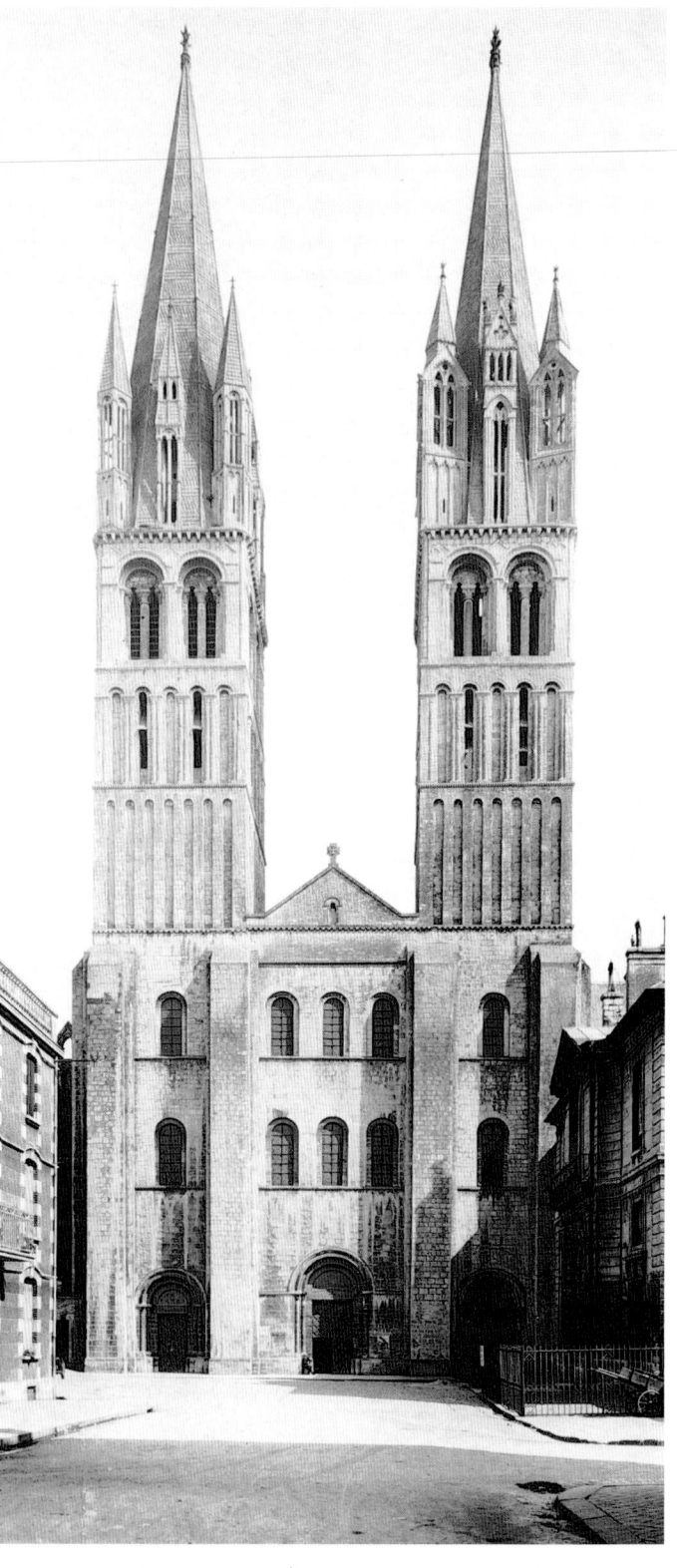

10.39 West façade, Saint-Étienne, Caen, Normandy, France, 1067–1087.

10.40 Plan of Saint-Étienne, Caen.

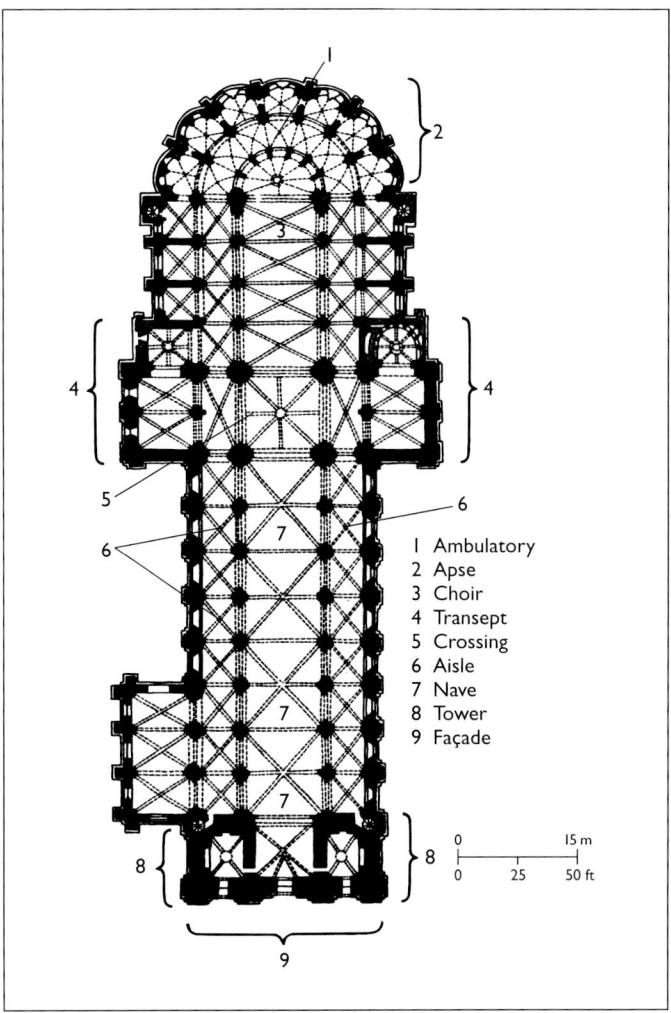

1 Ambulatory
2 Apse
3 Choir
4 Transept
5 Crossing
6 Aisle
7 Nave
8 Tower
9 Façade

A few years after the completion of Saint-Étienne's nave, the French bishop of Durham, William of Calais, supervised the first European cathedral with rib vaults and pointed arches (see diagrams of arches, fig. 10.5). Durham had been an important religious center for centuries because it contained the relics of Saint Cuthbert, bishop of Lindisfarne in the seventh century. But William decided to erect a Norman cathedral (see figs. 10.42 and 10.43) in place of the existing Saxon church.

The vaults of the choir were finished by 1104, and the nave, finished in 1133, shows some of the advantages of combining the pointed arch with a second transverse rib (fig. 10.44). This divided the vault into seven sections and allowed for increased height, while relieving the massiveness of the Romanesque walls. It also made larger clerestory windows possible, which opened up the wall space and admitted more light. Surface decoration on the piers,

consisting of chevron and other patterns, and the interlaces of the nave arches contribute to the impression of lightness. They also reflect the continuing influence of Viking and Hiberno-Saxon design.

The success of Durham's vaulting inspired the builders of Saint-Étienne to change the original flat, wooden roof of the nave into sexpartite (six-part) stone vaulting (see fig. 10.41), a project that was completed in 1120. This, like the three-part façade, influenced the development of Early Gothic architecture, which is the subject of the next chapter.

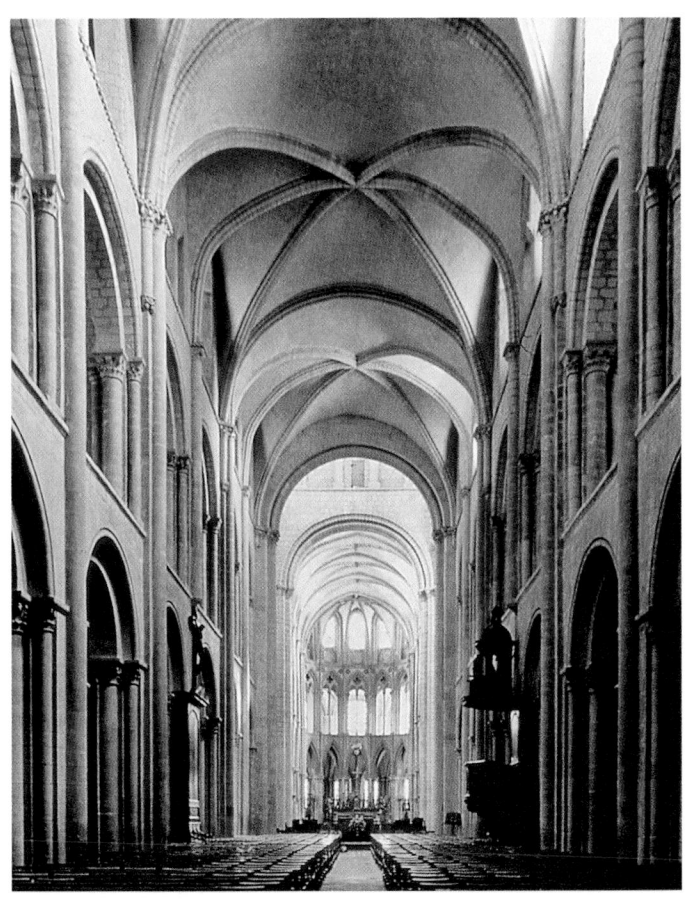

10.41 Nave, Saint-Étienne, Caen, 1067–1087. The vaults date from 1115–1120.

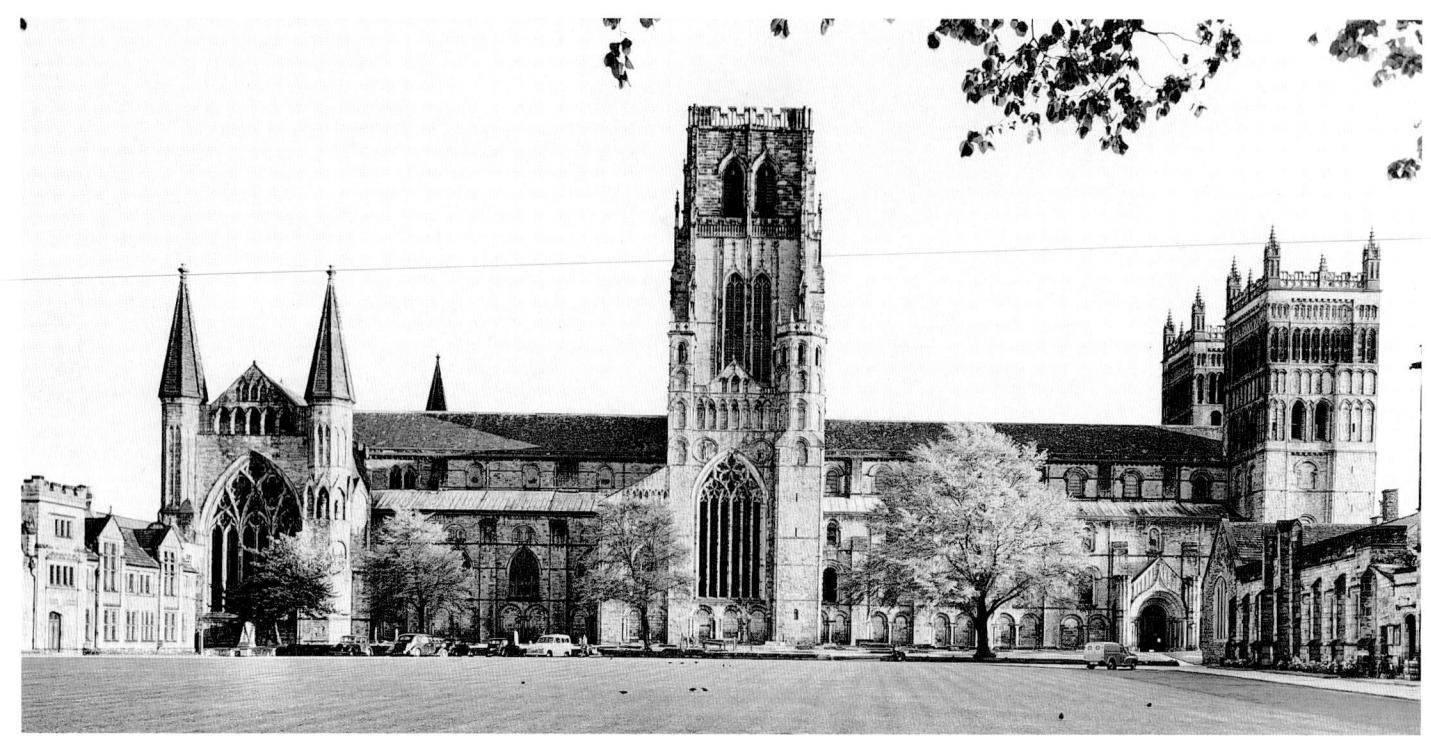

10.42 Exterior of Durham Cathedral, England, begun 1093.

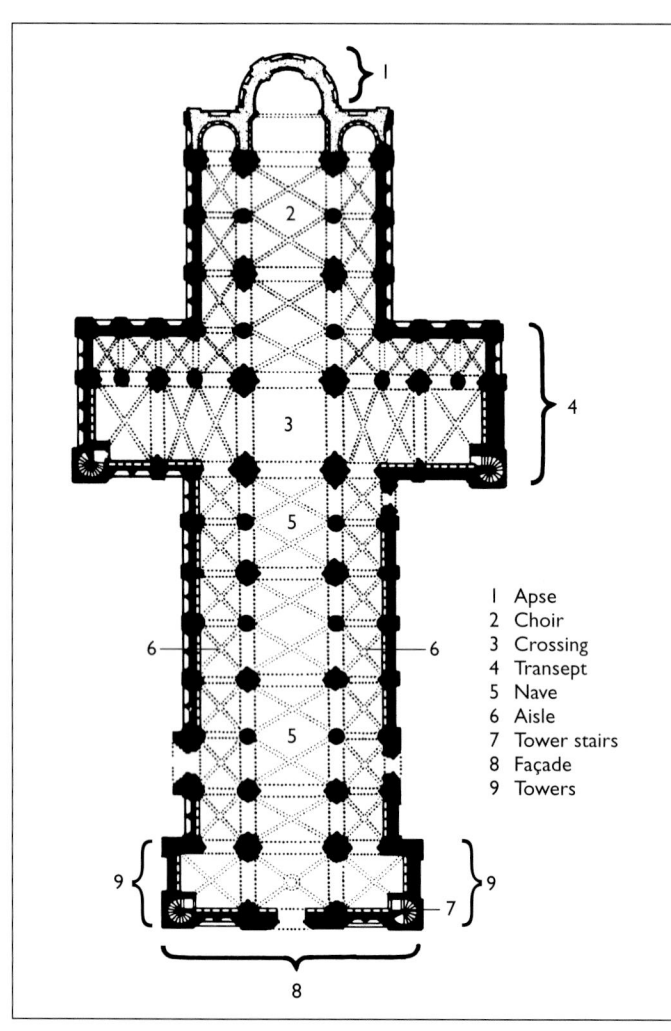

1 Apse
2 Choir
3 Crossing
4 Transept
5 Nave
6 Aisle
7 Tower stairs
8 Façade
9 Towers

10.43 Plan of Durham Cathedral.

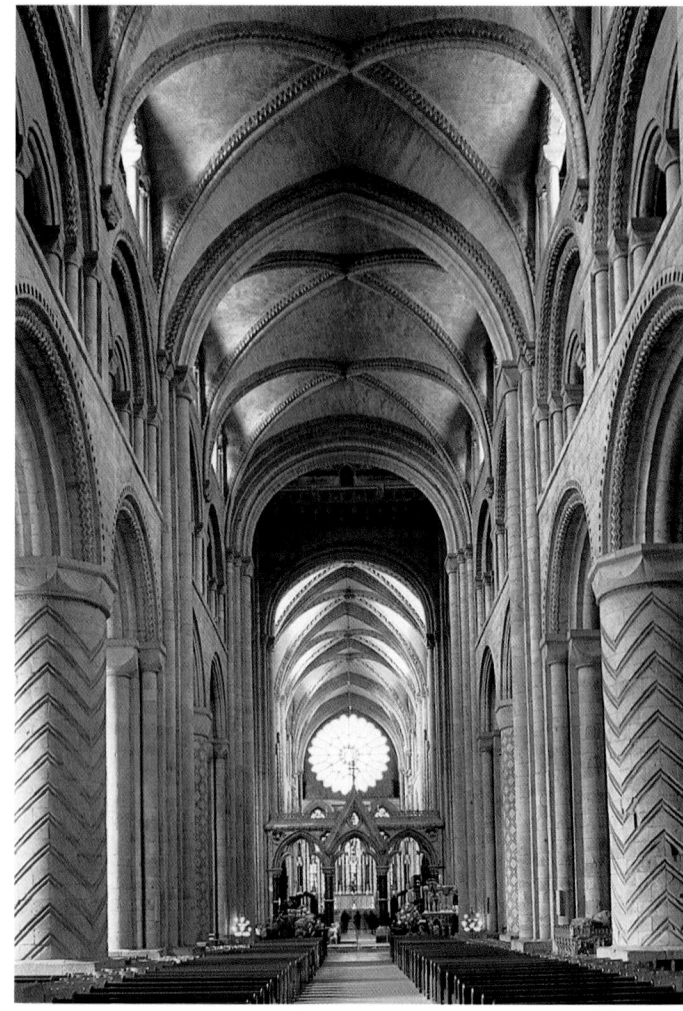

10.44 Nave, Durham Cathedral.

Style/Period	Works of Art	Cultural/Historical Developments
ROMANESQUE 10th century		First canonization of saints (993)
ROMANESQUE 11th century	Sacramentary, Saint-Sauveur de Figeac (**10.23**) Church of Sainte-Foy (**10.3–10.4, 10.6, 10.9–10.11**), Conques Pisa Cathedral (**10.31–10.33**) Bayeux "Tapestry" (**10.36–10.38**) Stavelot Bible (**10.16**)	Leif Ericsson reported to have discovered America (Nova Scotia and New England) (1000) Chinese make gunpowder (1000) Normans under William the Conqueror invade England (1066) Appearance of Halley's comet (1066) Excommunication of married priests (1074) Building of the Church of Santiago de Compostela, Spain, begins (1075) Building of the Tower of London begins (1078) Peter Abelard, French theologian and philosopher, born 1079 (d. 1142) Church of San Marco, Venice, completed (1094) First Crusade; Crusaders take Jerusalem (1095–1099)

Sacramentary, Saint-Sauveur de Figeac

Bayeux "Tapestry"

Sainte-Foy

ROMANESQUE 12th century	New Testament initial *L* and *Saint Matthew* (**10.21**), Agen-Moissac Church of Saint-Pierre (**10.12, 10.14–10.15, 10.17–10.20, 10.22**), Moissac Interlace sculpture (**10.28**), Ål Cathedral, Norway Gislebertus, *Last Judgment* (**10.25–10.27**), Cathedral of Saint-Lazare, Autun Gislebertus, *Flight into Egypt* (**10.24**), Cathedral of Saint-Lazare, Autun Stavelot Triptych (**10.1–10.2**) Abbey church of Saint-Étienne (**10.39, 10.41**), Caen Pisa Cathedral campanile (**10.33**) Borgund stave church (**10.29**), Sogne Durham Cathedral (**10.42, 10.44**)	*Song of Roland,* French heroic poem, written (c. 1100) First appearance of Gothic architecture (mid-1100s) Carmelite Order founded (second half of 12th century) Building of Nôtre-Dame, Paris (1163–1235) Founding of Oxford University (1167) Murder of Thomas à Becket at Canterbury (1170) Construction of Chartres Cathedral begins (1194)

Gislebertus, *Flight into Egypt*

Pisa Cathedral complex

ROMANESQUE 13th century	Chapel of Castel Appiano (**10.34–10.35**)	Founding of the University of Paris (the Sorbonne) (1200) Francis of Assisi founds the Franciscan Order (1209) King John signs the Magna Carta, limiting the absolute powers of the monarchy (1215) First Lateran Council of bishops establishes confession, relic worship, and transubstantiation as Catholic doctrines (1215) Genghis Khan, Mongol ruler, crosses Asia and Russia and threatens Europe (1206–1223) Founding of the Dominican Order (1216)

Castel Appiano

Gislebertus, *Last Judgment*

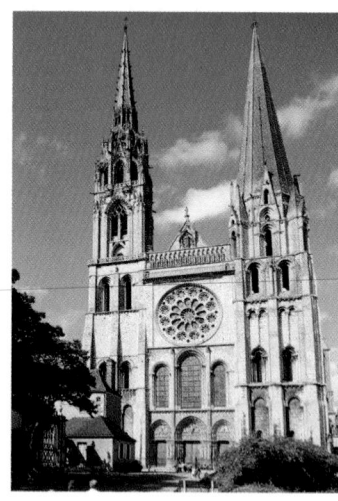

11

Gothic Art

Gothic cathedrals are among the greatest and most elaborate monuments in stone. The term *Gothic* is applied primarily to the architecture, and also to the painting and sculpture, produced in western Europe from about the middle of the twelfth century in France to the sixteenth century in some parts of Europe. The term was first used by Italians in the sixteenth century to denigrate the art preceding their own Renaissance style. Literally, *Gothic* refers to the Germanic tribes who invaded Greece and Italy, and sacked Rome in A.D. 410. The Goths were blamed for destroying what remained of the Classical style. In fact, however, the origins of Gothic art had nothing to do with what had happened several hundred years earlier. By the nineteenth century, when scholars realized the source of the confusion, it was too late. Gothic remains the accepted name of the style discussed in this chapter.

The Origins of the Gothic Style in France

The time and place in which the Gothic style emerged can be identified with unusual precision. It dates from 1137–1144, and it originated in the Île-de-France, the region in northern France that was the personal domain of the French royal family. The credit for its invention goes to one remarkable man, Abbot Suger of the French royal monastery at Saint-Denis, which is about 6 miles (10 km) north of Paris.

Suger was born in 1084 and educated in the monastery school of Saint-Denis along with the future French king, Louis VI. Suger later became a close political and religious adviser to both Louis VI and Louis VII, and remained a successful mediator between the Church and the royal family. While Louis VII was away on the Second Crusade (1147–1149), Suger was appointed regent of France.

In 1122, Suger was named abbot of Saint-Denis, which had a special place in French history. Not only was Denis, the first bishop of Paris and the patron saint of France, buried there, but it was also the burial place of the French royal family. Suger conceived a plan to rebuild and enlarge the eighth-century Carolingian church of Saint-Denis. He intended to make it the spiritual center of France and searched for a new kind of architecture to reinforce the divine right of the king's authority and enhance the spirituality of his church. The rebuilding program did not start until 1137, and in the meantime Suger made extensive preparations. He studied the biblical account of the construction of Solomon's Temple and immersed himself in what he thought were the writings of Saint Denis. (Scholars now believe that Suger was reading the works of Dionysius, a sixth-century mystic theologian.)

Suger was inspired by the author's emphasis on the mathematical harmony that should exist between the parts of a building and the miraculous, even mystical, effect of light. This was elaborated into a theory based on musical ratios; the result was a system that expressed complex symbolism based on mathematical ratios. The fact that these theories about light and the mathematical symbolism of architecture could be attributed to Saint Denis made them all the more appealing to Abbot Suger. In his preoccupation with light, Suger was thinking in a traditional Christian framework, for the formal qualities of light had been associated with Christ and divinity since the Early Christian period. In his reconstruction of the church, Suger rearranged the elements of medieval architecture to express the relationship between light and God's presence in a distinctive way. None of the individual architectural devices that Suger and his builders used was new; it was the way in which he synthesized elements of existing styles that was revolutionary. Alone among great art patrons of this time, Suger wrote an extensive memoir of the work he commissioned and his reasons for commissioning it. *The Book of Suger, Abbot of Saint-Denis* describes the beginning of work on Saint-Denis as follows:

> The first work on this church which we began under the inspiration of God [was this]: because of the age of the old walls and their impending ruin in some places, we

summoned the best painters I could find from different regions, and reverently caused these [walls] to be repaired and becomingly painted with gold and precious colors. I completed this all the more gladly because I had wished to do it, if ever I should have an opportunity, even while I was a pupil in school.[1]

Early Gothic Architecture: Saint-Denis

Suger's additions to Saint-Denis consisted of a new narthex and west façade with twin towers and three portals (fig. **11.1**). Most of the original sculptural decoration on the portals has since been lost. On the interior, Suger retained the basic elements of the Romanesque pilgrimage choir that had made it possible for large crowds of pilgrims to visit the church without disturbing the clergy. A semicircular ambulatory in the apse permitted the lay public to circulate freely, while the clergy remained in the radiating chapels. But Suger combined these elements in an original way (figs. **11.2** and **11.3**).

Under Suger's revision, the arrangement of the chapels is a formal echo of the ambulatory, which creates a new sense of architectural unity. Suger's **chevet** (the east end of the church, comprising the choir, ambulatory, and apse) also emphasized the integration of light with lightness because the entire area was covered with **ribbed vaults**

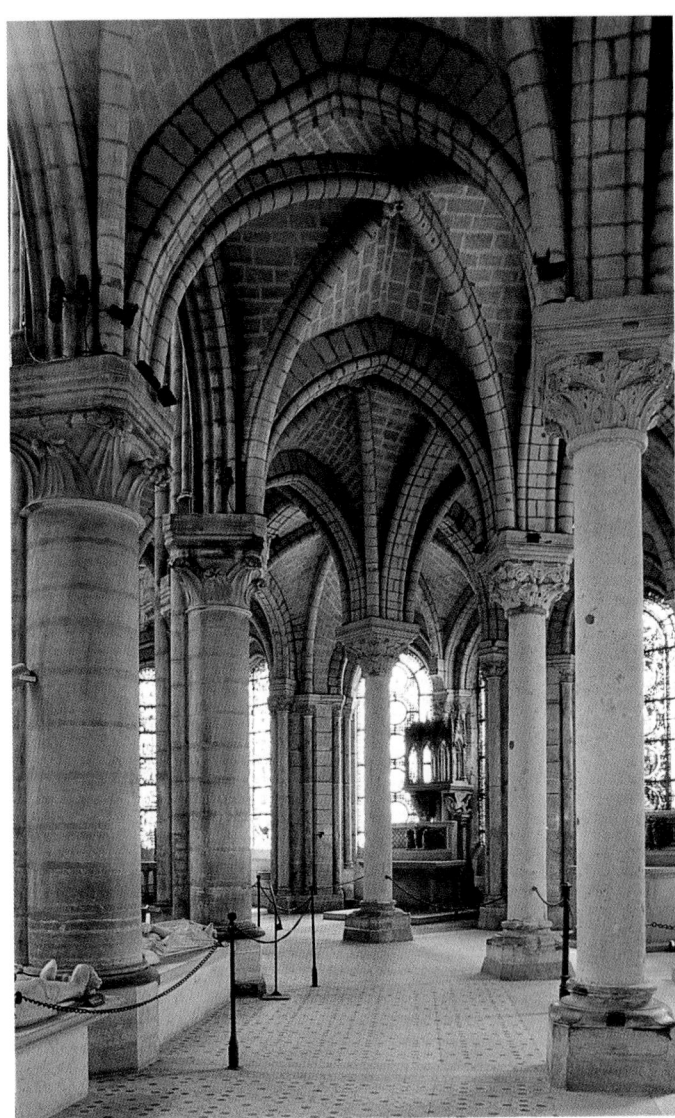

11.1 West façade, Saint-Denis, near Paris, dedicated 1140. After an engraving by A. and E. Rourgue, before the 19th-century restoration.

11.2 Interior of Saint-Denis. Each chapel bay has a pair of large stained-glass windows, delicate columns, and pointed vaults. The ambulatory and chapels have become a series of large windows supported by a masonry frame. Suger described the new effect as "a circular string of chapels, by virtue of which the whole [sanctuary] would shine with the miraculous and uninterrupted light of the most luminous windows."

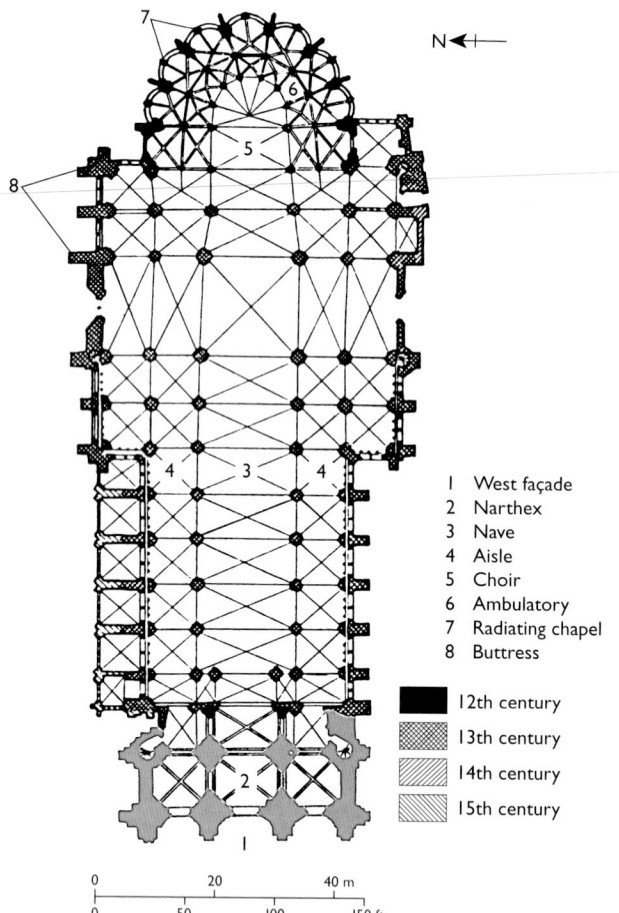

N◄—|——

I	West façade
2	Narthex
3	Nave
4	Aisle
5	Choir
6	Ambulatory
7	Radiating chapel
8	Buttress

███	12th century
▨	13th century
▨	14th century
▨	15th century

```
0          20          40 m
0       50       100      150 ft
```

11.3 Plan of Saint-Denis, 1140–1144. The chapels are connected shallow bays, which form a second ambulatory parallel to the first. This arrangement creates seven wedge-shaped compartments radiating out from the apse. Each wedge is a trapezoidal unit (in the area of the traditional ambulatory) and a pentagonal unit (in the radiating chapel). The old nave and the choir were rebuilt in the High Gothic style between 1231 and 1281.

(fig. **11.4**) supported by pointed arches. The Romanesque builders, in contrast, had restricted the lighter vaulting to the ambulatory. The arches, in turn, were supported by slender columns, which further enhanced the impression of lightness. On the exterior, thin buttresses were placed between the chapels (fig. 11.3) to strengthen the walls. Suger's new architectural approach attracted immediate attention because the effect was so different from the dark interiors and thick, massive walls of Romanesque architecture. He describes the effect of his changes on the interior light in the verses of the consecration inscription:

Once the new rear part is joined to the part in front,
The church shines with its middle part brightened.
For bright is that which is brightly coupled with
 the bright,
And bright is the noble edifice which is pervaded
 by the new light;

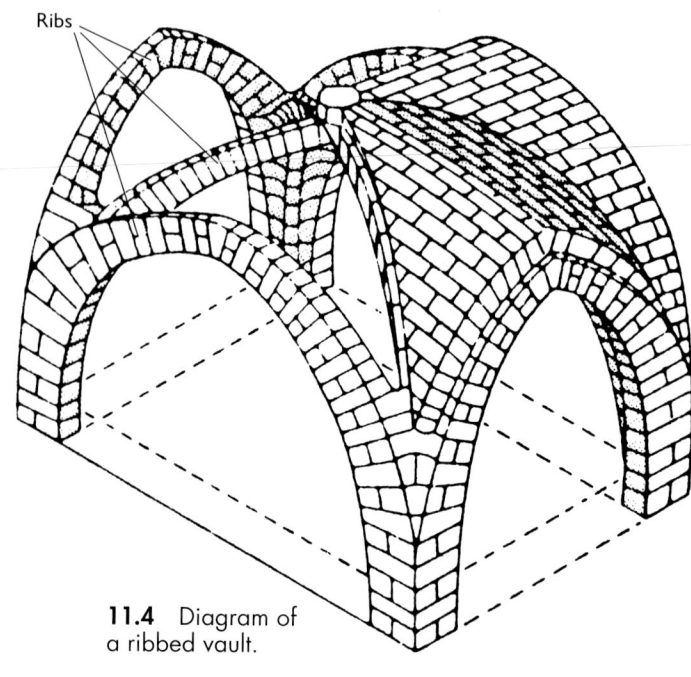

Ribs

11.4 Diagram of a ribbed vault.

Which stands enlarged in our time,
I, who was Suger, being the leader while it was
 being accomplished.[2]

The new style was particularly popular in northern and central France, where royal influence was strongest. From the 1230s to 1250, French architects designed over eighty cathedrals. Notwithstanding the close association of Gothic with France (it was soon dubbed *opus francigenum*, or "French work"), the style migrated north to England, south to Spain, and east to Germany. There was also an Italian Gothic period, although Italy was the region that welcomed the style least and rejected it soonest.

Elements of Gothic Architecture

Ribbed Vaults

In Gothic architecture, the ribbed vault (fig. 11.4) supersedes the earlier barrel vaults typical of Romanesque. The advantage of the ribbed vault is that it requires less buttressing, whereas the barrel vault exerts pressure along its entire length and thus needs strong buttressing. Since the weight of the ribbed vault is concentrated only at the corners of the bay, the structure can be buttressed at intervals, freeing up more space for windows. The ribs could be built before the intervening space (usually triangular or rectangular) was filled in. Adding ribs also enabled Gothic builders to reinforce the vaults and to distribute their weight more efficiently. Because of the weight-bearing capacity of the ribs, the vault's surfaces (the **web**, or infilling) could be made of lighter material.

Piers

As the vaults became more complex, so did their supports. One such support is the cluster, or **compound, pier** (fig. **11.5**). Although compound piers had been used in some Romanesque buildings, they became a standard Gothic feature. The ribs of the vaults formed a series of lines which were continued down to the floor by colonnettes resting on compound piers.

With this system of support, the Gothic builders created a vertical unity leading the observer's gaze to the clerestory windows, the architectural source of interior light. The pier supports, with their attached colonnettes branch-

ing off into arches and vaults, have been likened to the upward growth of a tree.

Flying Buttresses

In Romanesque architecture, thick walls performed the function of buttressing. This decreased the amount of available window space, limiting the interior light. In the Gothic period, builders developed the flying buttress, an exterior structure composed of thin half arches, or flyers. This supported the wall at the point where the thrust of an interior arch or vault was greatest (fig. **11.6**).

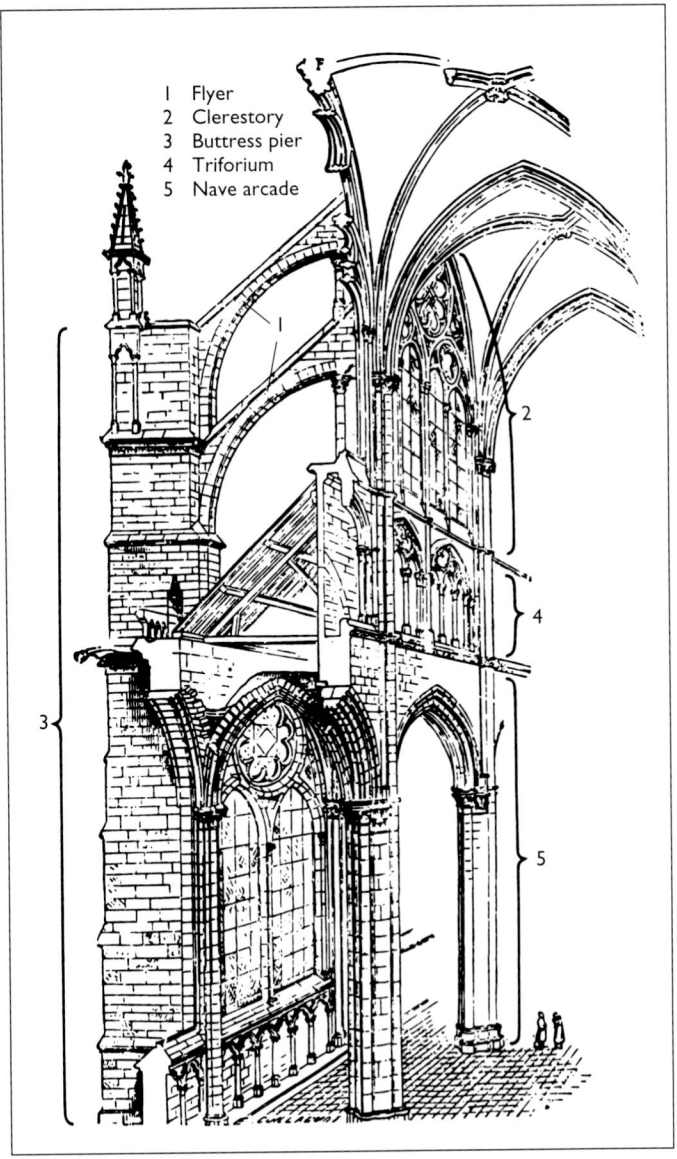

11.6 Section diagram of a Gothic cathedral (after E. Viollet-le-Duc). The **elevation** of the Gothic cathedral illustrates the flyers, which transfer interior thrusts to a pier of the exterior buttress. Since the wall spaces between the buttresses were no longer necessary for structural support, they could be pierced by large windows to increase the light.

11.5 View of piers in the nave arcade, Chartres Cathedral, France, 13th century. The compound piers along the two sides of the nave are massive columnar supports to which clusters of colonnettes, or pilaster shafts, are attached. The clusters usually correspond to arches or vault ribs above them.

Pointed Arches

The pointed arch, which is a characteristic and essential feature of Gothic architecture, can be thought of as the intersection of two arcs of nonconcentric circles. Examples are found in Romanesque buildings but in a much more tentative form. The piers channel the thrust of the pointed arch downward, minimizing the lateral, or sideways, thrust against the wall. Unlike round arches, pointed arches can theoretically be raised to any height regardless of the distance between their supports. The pointed arch is thus a more flexible building element with more potential for increased height. Dynamically and visually, the thrust is far more vertical than that of a round arch.

Stained-Glass Windows

Finally, the light that had so inspired Abbot Suger required an architectural solution. That solution was Suger's special use of the stained-glass window. Suger was not seeking natural daylight, but rather light that had been filtered through colored fragments of glass. Light and color were diffused throughout the interior of the cathedral, producing a different kind of radiance than had been achieved in Early Christian and Byzantine buildings. The predominant colors of Gothic stained glass tend to be blue and red in contrast to the golds that characterize most Byzantine mosaics.

Stained glass is translucent colored glass cut to form a window design. Compositions are made from pieces of colored glass formed by mixing metallic oxides with molten glass or fusing colored glass with clear glass. The artist cuts the individual pieces as closely as possible to the shape of the face or other individual feature to be represented. The pieces are then fitted to a model drawn on wood or paper, and details are added in black enamel.

The dark pigments are hardened and fused with the glass through firing (baking in a kiln). The pieces of fired glass are then arranged on the model and joined by strips of lead. Figure **11.7** shows a detail of a stained-glass window from Chartres Cathedral. Jeroboam, an Old Testament king, is shown praying before two golden calves. The red background is broken up, seemingly at random, into numerous sections. In the figures, however, the lead is arranged to conform either to an outline or to a logical location within the forms. Lead strips frame the head of the first calf and outline Jeroboam's crown. Once the pieces of stained glass are joined together, the units are framed by an iron armature and fastened within the tracery, or ornamental stonework, of the window.

Stained-glass windows were made occasionally for Early Christian and Byzantine churches and more often in the Romanesque period. In the Gothic period, stained glass became an integral part of religious architecture and a more prominent artistic medium.

11.7 *Jeroboam Worshiping Golden Calves,* detail of a **lancet** under the north **rose window** (see fig. 11.25), Chartres Cathedral, early 13th century.

The Age of Cathedrals

Chartres

By the time that the choir and west façade of Saint-Denis were completed, in about 1144, and even before Abbot Suger turned his attention to the rest of the church, other towns in northern France had been competing to build cathedrals in the new Gothic style. A cathedral is, by definition, the seat of a bishop (from the Greek word *kathedra,* meaning "seat" or "throne") and belongs to the city or town in which it is located. In contrast to churches such as Sainte-Foy (see Chapter 10), which were often built in rural areas, cathedrals required a more urban setting. Also consistent with increased urbanization in the twelfth century was the development of cathedral schools and universities. Their growing educational importance encroached on the relatively isolated monasteries that had proliferated in the earlier Middle Ages.

The construction of a cathedral was the largest economic enterprise of the Gothic era. It had a significant effect on neighboring communities as well as on the city or town itself. Jobs were created for hundreds of masons, carpenters, sculptors, stonecutters, and other craftsmen. When a cathedral was finished, it attracted thousands of pilgrims and other visitors, and this continual traffic stimulated the local economy. Cathedrals also provided a focus for community activities, secular as well as religious. Above all, they generated an enormous sense of civic pride among the townspeople.

Guilds

Medieval **guilds,** or gilds, were associations formed for the aid and protection of their members and the pursuit of common religious or economic goals. The earliest form of economic guild was the Guild Merchant, which was responsible for organizing and supervising trade in the towns. Efforts by merchants to exclude craftsmen from the guilds led in the twelfth and thirteenth centuries to the formation of the craft guilds. These comprised all practitioners of a single craft or profession in a town. Craftsmen had to be members of the guild before they could ply their trade.

The functions of the craft guilds included regulating wages and prices, overseeing working conditions, and maintaining high standards of workmanship. Their effect, especially early on, was to ensure an adequate supply of trained workers and to enhance the status of craftsmen. They also provided charity to members in need and pensions to their widows.

The guilds had three grades of membership—masters, journeymen (paid assistants, *compagnons* in French), and apprentices. A precise set of rules governed the terms of apprenticeship and advancement to other grades. For promotion to the rank of master, a craftsman had to present to his guild a piece of work to be judged by masters. This is the origin of the term *masterpiece.*

The cult of the Virgin Mary expanded during the Gothic period. Most of the great French cathedrals were dedicated to "Notre Dame"—that is, "Our Lady," or the Virgin. To avoid confusion, therefore, it is customary to refer to the cathedrals by the towns in which they are located. At Chartres, the Virgin Mary played a particularly significant role as the embodiment of the church building and the Bride of Christ. Her strong link to Chartres reflected the tradition that a pagan statue of a virgin and child worshiped in a nearby cave had prefigured the coming of Christ and the Virgin Birth. One effect of this legend was the preeminence of Chartres in Mary's cult.

The town of Chartres is approximately 40 miles (64 km) southwest of Paris. Its cathedral (cf. fig. 11.11) combines the best preserved early Gothic architecture with High Gothic, as well as demonstrating the transitional developments in between. For a town like Chartres, with only about 10,000 inhabitants in the thirteenth century, the building of a cathedral dominated the economy just as the structure itself dominated the landscape. At Chartres, the construction continued off and on from around 1134 to 1220. The most intensive work, however, followed a fire in 1194, when the nave and choir had to be rebuilt.

The bishop and chapter (governing body) of the cathedral were in charge of contracting out the work. The funds, however, came from a much broader cross section of medieval French society. The church itself usually contributed by setting aside revenues from its estates. At Chartres, the canons (resident clergy) agreed in 1194 to give up their stipends (salaries) for three years so that the rebuilding program could begin. When the royal family or members of the nobility had a connection with a particular project, they also helped. At Chartres, Blanche, the mother of Louis IX, donated funds for the entire north transept façade, including the sculptures and windows. The duke of Brittany contributed to the southern transept. Other wealthy families of the region gave windows, and their donations were recorded by depicting their coats of arms in the stained glass.

Guilds (see box) representing specific groups of craftsmen and tradesmen donated windows illustrating their professional activities (fig. **11.8**). Pilgrims and less wealthy local inhabitants gave money in proportion to their means, often by buying relics or in gratitude for answers to prayers. These donations went toward general costs rather than to a designated use. There were thus economic and social distinctions not only in the size and nature of the contributions, but also in the degree to which they were publicly recognized.

11.8 Carpenters' Guild signature window, detail of a stained-glass window, Chartres Cathedral, early 13th century. This signature scene depicts two carpenters at work on a plank of wood lying across three sawhorses.

Workers and Master Builders

Chartres was one of the over eighty cathedrals and large abbeys constructed in the region around Paris in the thirteenth century. Each one was an enormous undertaking fraught with problems, including fires and poor weather. To make matters worse, funds often ran out in the course of a building project, which meant that work came to a halt. Without banks, there was no system for building up capital or long-term financial planning. It also took three to six months for mortar to set, depending on the weather. And whenever work stoppages did occur, the workers were dismissed and moved on to other cathedrals that would hire them. As a result, the workforce often lacked continuity, which is reflected in stylistic variations of the finished building.

Supervising the construction of every cathedral was the master builder, usually a literate, well-traveled man who had been to school and apprenticed to an older master at the age of thirteen. Typically, he would be well paid and acquainted with both the clergy and the nobles helping to finance the project. He would also understand the iconographic significance of the artistic program. A sign of the high status of the master builder was the custom of inscribing his name in the labyrinth design on the cathedral floor. In some cases, he was even buried along with royal patrons and bishops in a cathedral he had built. The social position of the master builder was sufficiently high that it became a convention to criticize his vanity, for he was conceived of as building the City of God on earth (see box). We have seen from the story of the Tower of Babel (see fig. I.7) that the theme of architectural vanity is an ancient one; it is also explored in the classic play *The Master Builder,* by the nineteenth-century Norwegian writer, Henrik Ibsen (1828–1906).

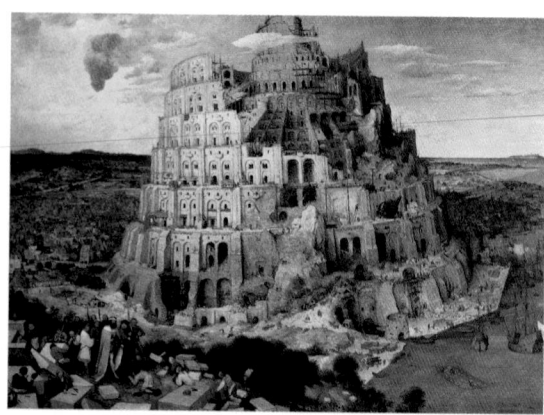

See figure I.7. Bruegel the Elder, *The Tower of Babel,* 1563.

In the Gothic period, master builders worked from templates, which were birchwood replicas of numbered stones. Corresponding numbers were marked on the vaults and elevations to indicate the location of each stone. Each master builder designed his own template, which he took with him if he had to stop work on one cathedral and move on to another. The next master could then continue the work from his predecessor's drawings.

Stones were cut at a quarry and brought by a carter to the building site. There, a foreman sorted the stones according to size and shape, and assigned them to groups of eight to twelve workers. At Chartres, there were over four hundred workers to be supervised, and hundreds of stones were carted from a quarry 7½ miles (12 km) away from the site. Since there were no power tools, stones had to be individually cut and dressed. They were raised up by huge

Saint Augustine's *City of God*

Saint Augustine (354–430), bishop of Hippo in North Africa and later a doctor of the Church, had an immense impact on the development of Christian thought. His mother was a Christian and his father a pagan, and he himself embraced several philosophies before his baptism as a Christian in 387. He fought heresy and wrote prodigiously; his two best-known works are the *Confessions,* an autobiographical account up to the time of his conversion, and *The City of God (De civitate Dei)* (in 22 books), written between 413 and 426. The latter opens with a reply to the pagans, who sacked Rome under the leadership of Alaric the Goth in 410.

One of Augustine's main historical themes is the opposition of the Christian world to the non-Christian world. He contrasted the City of God, the Heavenly City, with the Earthly City, and transience with permanence:

Most glorious is and will be the City of God, both in this fleeting age of ours, wherein she lives by faith, a stranger among infidels, and in the days when she shall be established in her eternal home.[3]

It is likely that Augustine had been influenced by Plato's *Republic* (see Chapter 5) and the work of other Classical philosophers as well as by Old Testament references to the city of Jerusalem. These are essentially architectural metaphors that extend through Christianity from its very beginnings. In a sense, every Christian church—especially the cathedral—was seen as a typological parallel to Solomon's Temple and as a metaphor for the city of Jerusalem and the Heavenly City of God.

11.9 Geometric architectural diagrams from the sketchbook of Villard de Honnecourt, c. 1225, from R. Willis. Bibliothèque Nationale, Paris.

11.10 Geometric analysis of human and animal figures from the sketchbook of Villard de Honnecourt, c. 1225, from R. Willis. Bibliothèque Nationale, Paris.

cranes (of which there were four at Chartres) and by small cranes, or winches, which were powered by the workers themselves. At Chartres, some 45 tons of stone were raised in an average day. Scaffolds also had to be built because of the great heights involved, and workers had to learn how to protect themselves from accidents.

Since technology was limited, precision on the part of the master builder was crucial. His instruments were rudimentary; they consisted of a compass, a square, straightedges (rules), measuring rods, and proportional dividers. His template was organized according to geometric principles, which accounts for the overall formal unity of the cathedrals. Geometry was easy to replicate, so that even if several master builders worked at a particular cathedral, the completed building was a unified structure. Figures **11.9** and **11.10** illustrate pages from the only surviving sketchbook made around 1225 by a master builder known as Villard de Honnecourt. They show the geometric basis by which both architecture and human and animal forms were conceived and designed.

The Exterior Architecture of Chartres

Chartres (fig. **11.11**) was constructed on an elevated site to enhance its visibility. The vertical plane of its towers seems to reach toward the sky, while the horizontal of the side walls (fig. **11.12**) carries one's gaze east toward the apse (fig. **11.13**). Figure 11.11 shows the west façade, whose towers illustrate the dynamic, changing nature of Gothic style. The southern tower, on the right, dates from before 1194 and reflects the transition from Late Romanesque to Early Gothic. The northern tower, begun in 1507, which is taller, thinner, and more elaborate than the southern tower, is Late Gothic. Its greater height reflects advances in structural technology as well as Suger's theological emphasis on verticality and light as expressions of God's presence.

The tripartite organization of Chartres' west façade is characteristic of most Gothic cathedrals. Like the Romanesque church of Saint-Étienne at Caen (see fig. 10.39), it is divided into three sections. Towers with a belfry flank

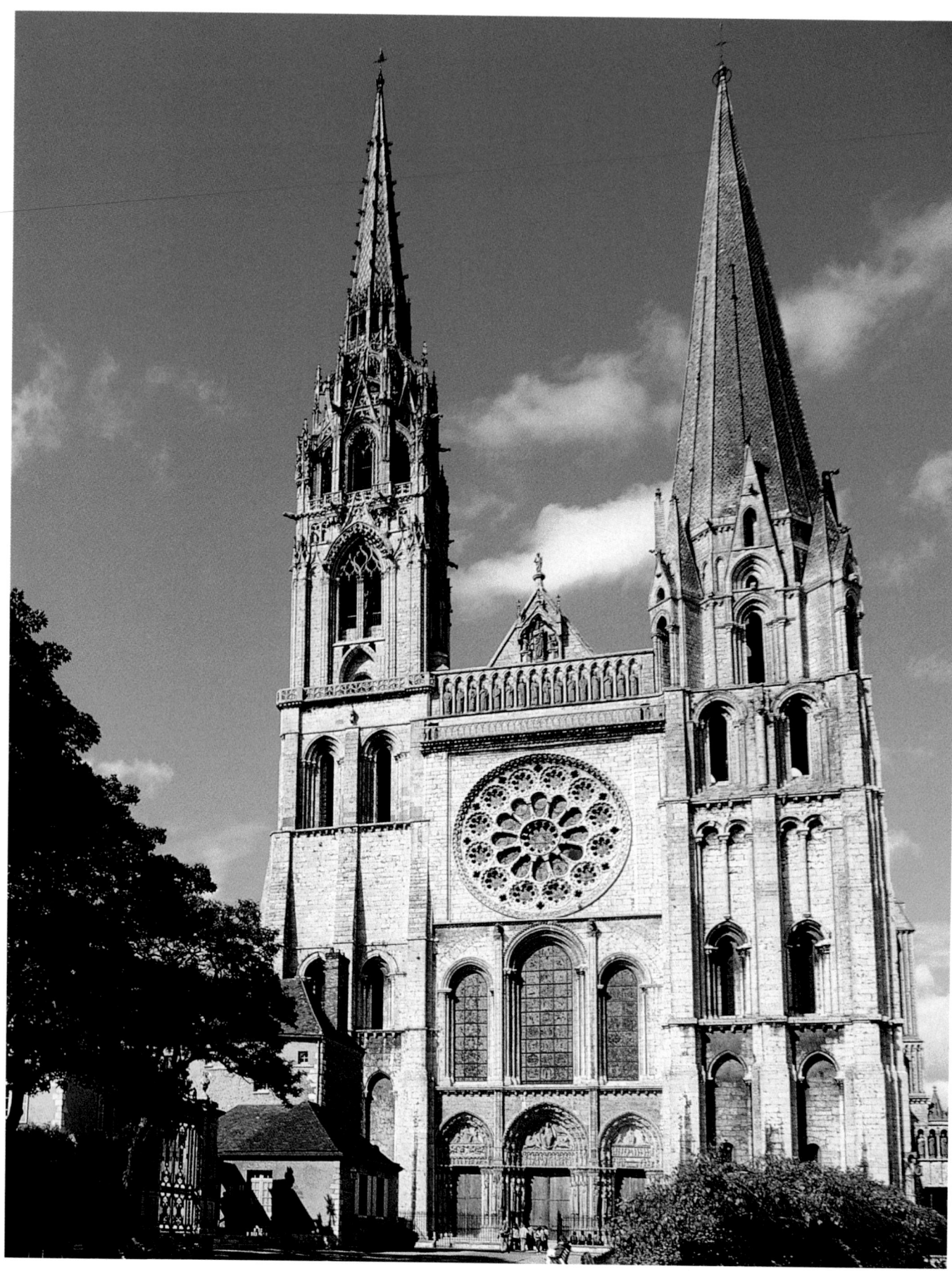

11.11 West façade of Chartres Cathedral, c. 1140–1150. Symmetry in the Classical sense was not a requirement of the Gothic designers. Gothic cathedrals are structurally, but not formally, symmetrical—that is, a tower is opposite a tower, but the towers need not be identical in size or shape.

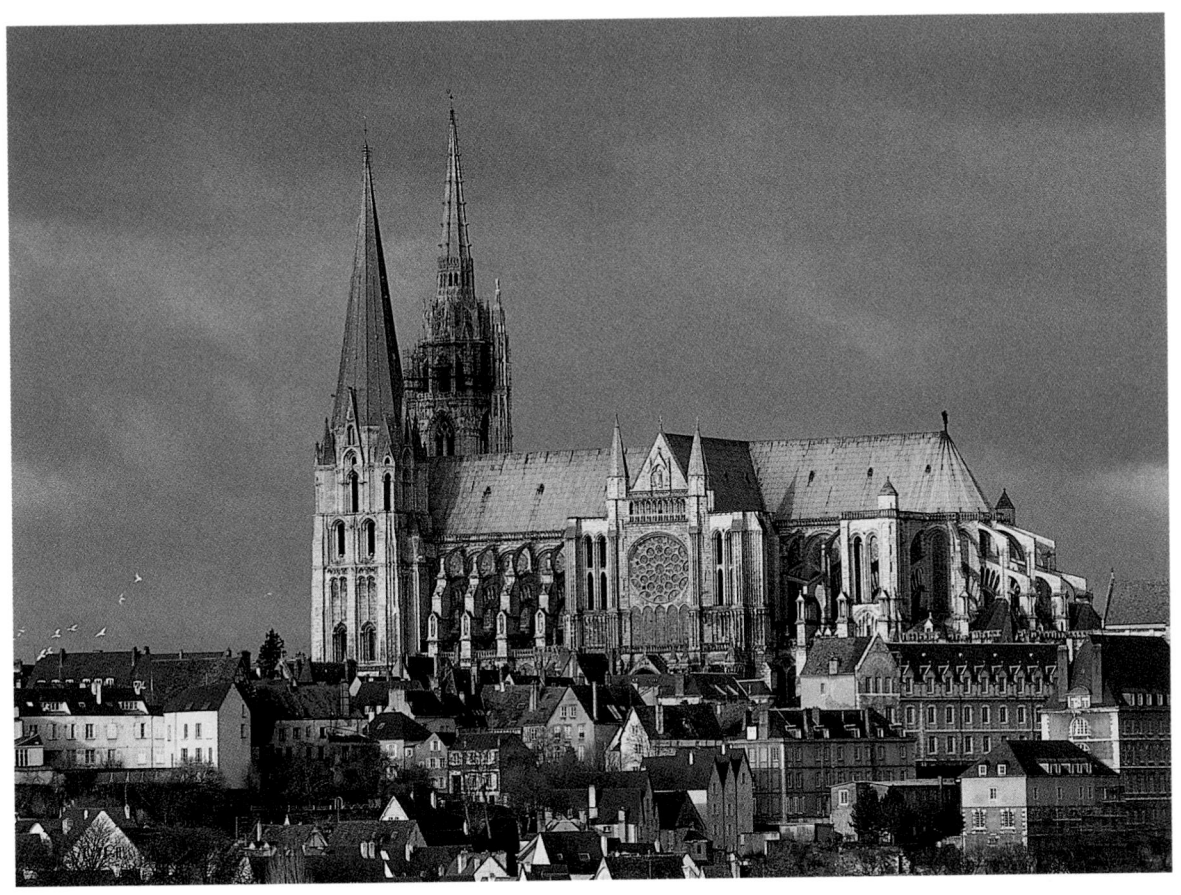

11.12 South wall of Chartres Cathedral, 13th century.

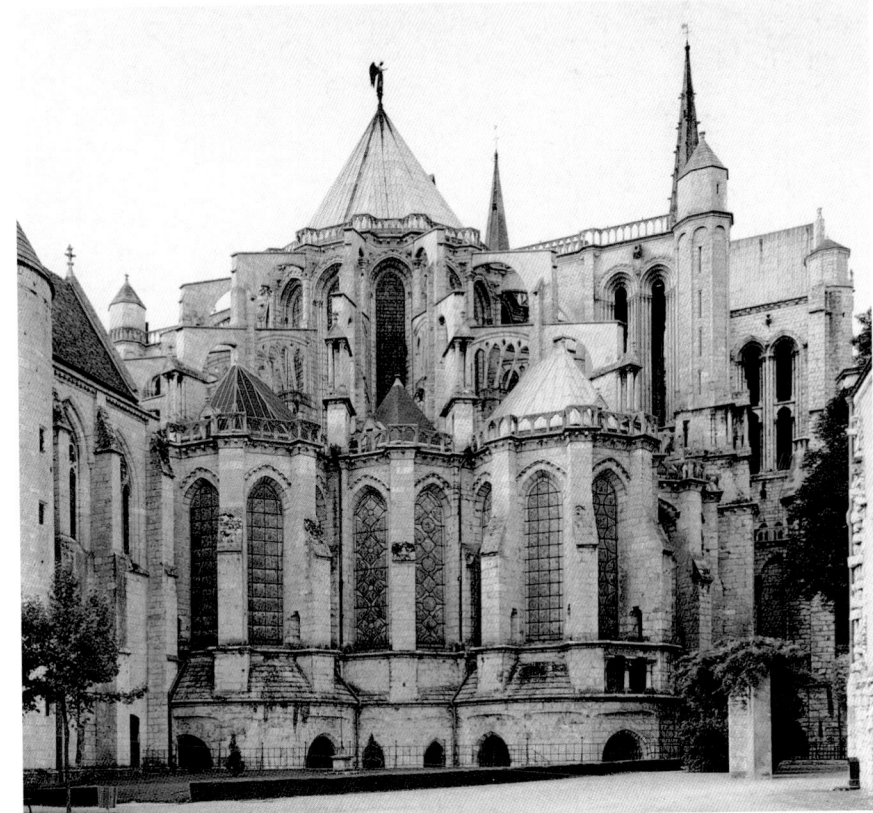

11.13 Apse of Chartres Cathedral, with radiating chapels and flying buttresses, 13th century. Visible in this view are three projecting, semicircular radiating chapels, the flying buttresses above them, and, at the top, the curved end of the roof.

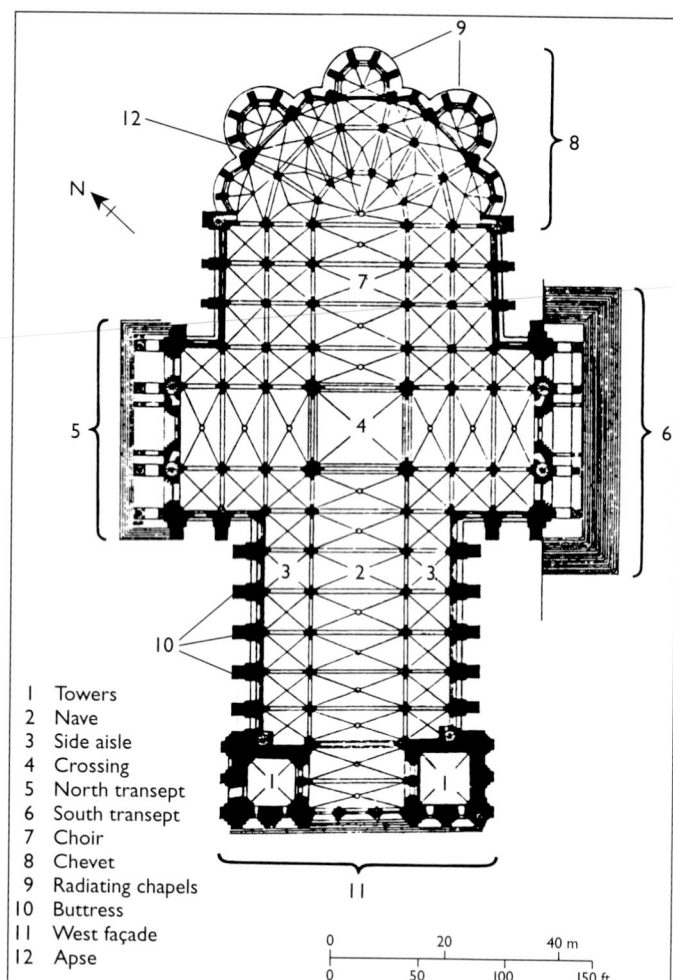

| 0 | | 20 | | 40 m |
| 0 | 50 | | 100 | 150 ft |

11.14 Plan of Chartres Cathedral. Although the plan is quite symmetrical, the number of steps leading to each of the three entrances increases from west to north and from north to south. This increase parallels the building sequence, for Gothic architecture became more detailed and complex as the style developed.

the central rectangle, which is further subdivided. The three portals consist of the same elements as the Romanesque abbey church at Conques (see fig. 10.8); above each portal is a tall, arched, stained-glass lancet window. Inscribed in the rectangle over the lancets is the round rose window, a feature of almost all Gothic cathedral entrance walls. Above the rose window, a gallery of niche figures representing Old Testament kings stretches between the two towers. Finally, the gallery is surmounted by a triangular gable with a niche containing a statue of the Virgin with the infant Christ. The repetition of triple elements—portals, lancets, three horizontal divisions, and the triangular gable—suggests a numerical association with the Trinity (the Father, Son, and Holy Ghost).

In the rose window, too, there is a symbolic Christian significance in the arrangement of the geometric shapes. Three groups of twelve elements surround the small central circle. These refer to Christ's twelve apostles. The very fact that the rose window is a circle could symbolize Christ, God, and the universal aspect of the Church itself.

Proceeding counterclockwise around the southern tower, the visitor confronts the view in figure 11.12. This is one of two long, horizontal sides of the cathedral, parts of which are labeled in figure **11.14**. Visible in the photograph are the roof (**10** in fig. **11.15**), the buttresses (**8**) between the tower and the transept entrance, and the flying buttresses, or flyers (**9**), over the buttresses and, at the east end, behind the apse. This transept, which is on the south, has five lancet windows, a larger rose window than that of the west façade, and a similar gallery and triangular gable with niche statues.

Continuing east to the end of the cathedral, turning around, and facing west, the visitor sees the view of the apse in figure 11.13.

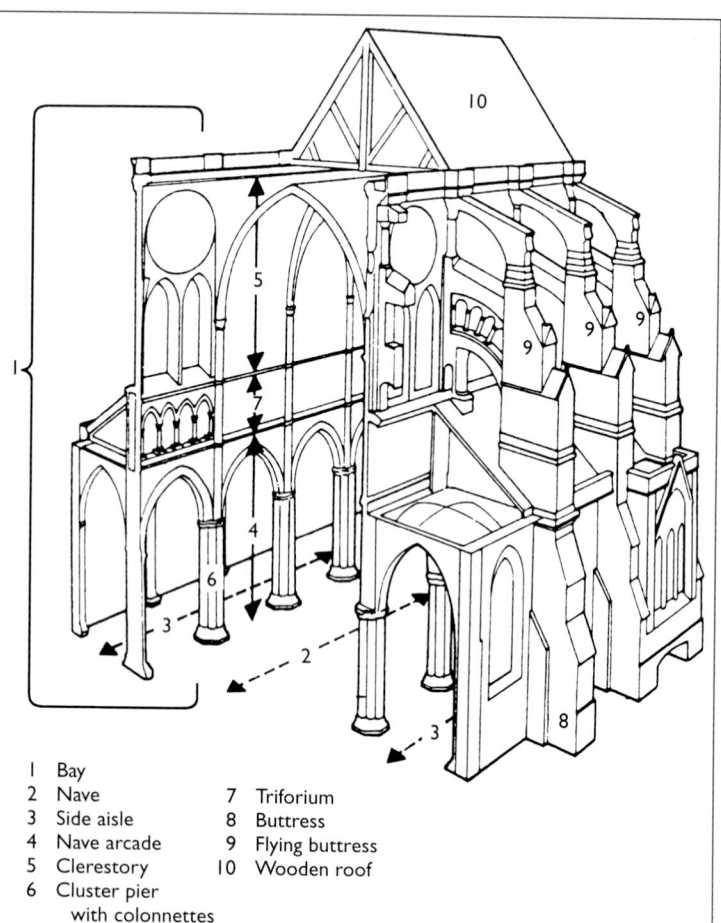

CONNECTIONS

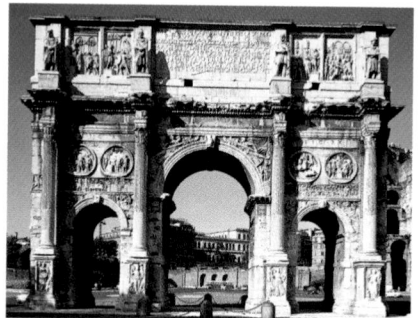

See figure 7.40.
Arch of Constantine, Rome, A.D. 81.

11.15 Perspective diagram and cross section of Chartres Cathedral.

The Exterior Sculpture of Chartres

On the exterior of Chartres there are so many sculptural details that it would take several volumes to consider them thoroughly. We shall therefore concentrate on a few of the most characteristic examples on the west and south sides of the cathedral.

Royal Portal (West Façade) As in Romanesque churches, Gothic church entrances, or portals (fig. **11.16**), are composed of certain standard elements. On the western entrance of Chartres (fig. **11.17**), there are three portals, together known as the Royal Portal. The central portal is slightly larger than the other two, an arrangement derived from the Roman triumphal arch (see fig. 7.40), which marked an entryway into a city. The derivation of the cathedral portal from the Roman arch highlights the symbolic parallel between the interior of the church and the Heavenly City of Jerusalem. Throughout the Middle Ages, entering a church was thought of as an earthly prefiguration of one's ultimate entry into heaven.

The sculptural decorations at Chartres, like those on Romanesque churches and cathedrals, had a didactic function. They were part of an iconographic program intended

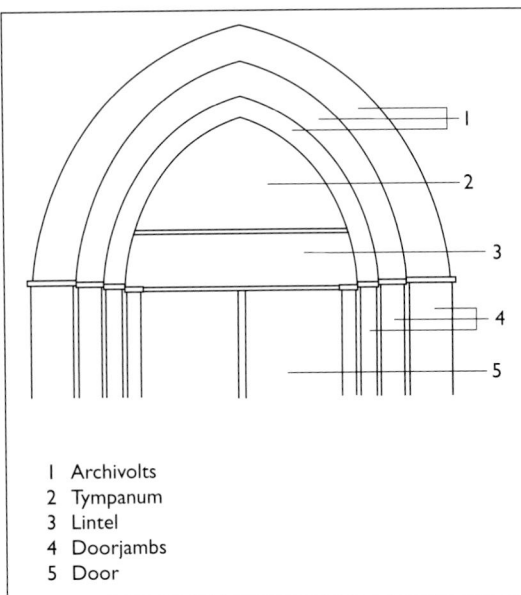

11.16
Generic diagram of a Gothic portal.

1 Archivolts
2 Tympanum
3 Lintel
4 Doorjambs
5 Door

to convey particular messages. It is not known who the author of the program was, but it is possible that theologians at Chartres' cathedral school were involved in planning it.

In the most general sense, these portals remind the observer of the typological view of history, which was

11.17 The three portals of the west façade of Chartres Cathedral, c. 1140–1150. The doorjamb sculptures are slender, columnar figures of Old Testament kings and queens—hence the name "Royal Portal."

Labels on image: St. Matthew, St. Mark, Jesus, St. John, Elders of the Apocalypse, St. Luke, Angel, Prophet, Apostles

11.18 Tympanum, lintel, and archivolts of the central portal, west façade, Chartres Cathedral, c. 1145–1170. The scene on the tympanum represents the *Second Coming of Christ,* with the four apocalyptic symbols of the Evangelists: the eagle stands for John, the angel for Matthew, the lion for Mark, and the bull for Luke. The surface patterns on all of the tympanum figures are stylized—for example, Christ's drapery folds and the wings, the drapery, and the feathers and fur of the Evangelists' symbols. Christ is frontal, directly facing the visitors to the cathedral, as if reminding them of their destiny.

characteristic of Christian thought from its beginnings. The right, or southern, portal contains scenes of Christ's Nativity and childhood on a double lintel. An enthroned Virgin holding the Christ child occupies the tympanum, which is surrounded by the Seven Liberal Arts in the archivolts. The Liberal Arts as depicted here correspond to the *trivium* (Grammar, Rhetoric, and Dialectic) and the *quadrivium* (Arithmetic, Geometry, Astronomy, and Music) adopted from Donatus by Alcuin of York under Charlemagne (see Chapter 9). This curriculum reflects the importance of learning and the high status of the cathedral school as well as Mary's designation as one who "perfectly possessed" the Liberal Arts. On the left, or northern, tympanum and lintel are scenes of the Ascension. The archivolts contain the signs of the zodiac and symbols of the seasonal labors of the twelve calendar months.

The central portal juxtaposes Old Testament kings and queens on the doorjambs with the apocalyptic vision of Saint John the Divine above the door. The doorjamb statues, dating to around 1140–1150, are the oldest surviving examples of Early Gothic sculptural style. Each figure is slim and vertical, reflecting the shape of the colonnette behind. Separating each statue and each colonnette is a space decorated with floral relief patterns, which acts as a framing device.

As in Byzantine mosaics of the Early Christian period, the Old Testament kings and queens are frontal. Their arms are contained within their vertical planes, and their halos are flat. Their feet slant downward on a diagonal, indicating that they are not naturally supported. As in the trumeau figure of *Saint Paul* at Moissac (see fig. 10.19), the drapery folds reveal the artist's delight in surface patterns. The repeated zigzags along the hems and circles at the elbows, along with the hair and beards, are stylizations. Compared with the Romanesque figures at Moissac, however, the kings and queens on the doorjambs at Chartres are more independent of their columns. Figures and columns are vertically aligned, but they are no longer merged in a manner reminiscent of early medieval interlace. Instead, they project forward from the column.

See figure 10.19. *Saint Paul,* trumeau of Saint-Pierre, Moissac, c. 1115–1135.

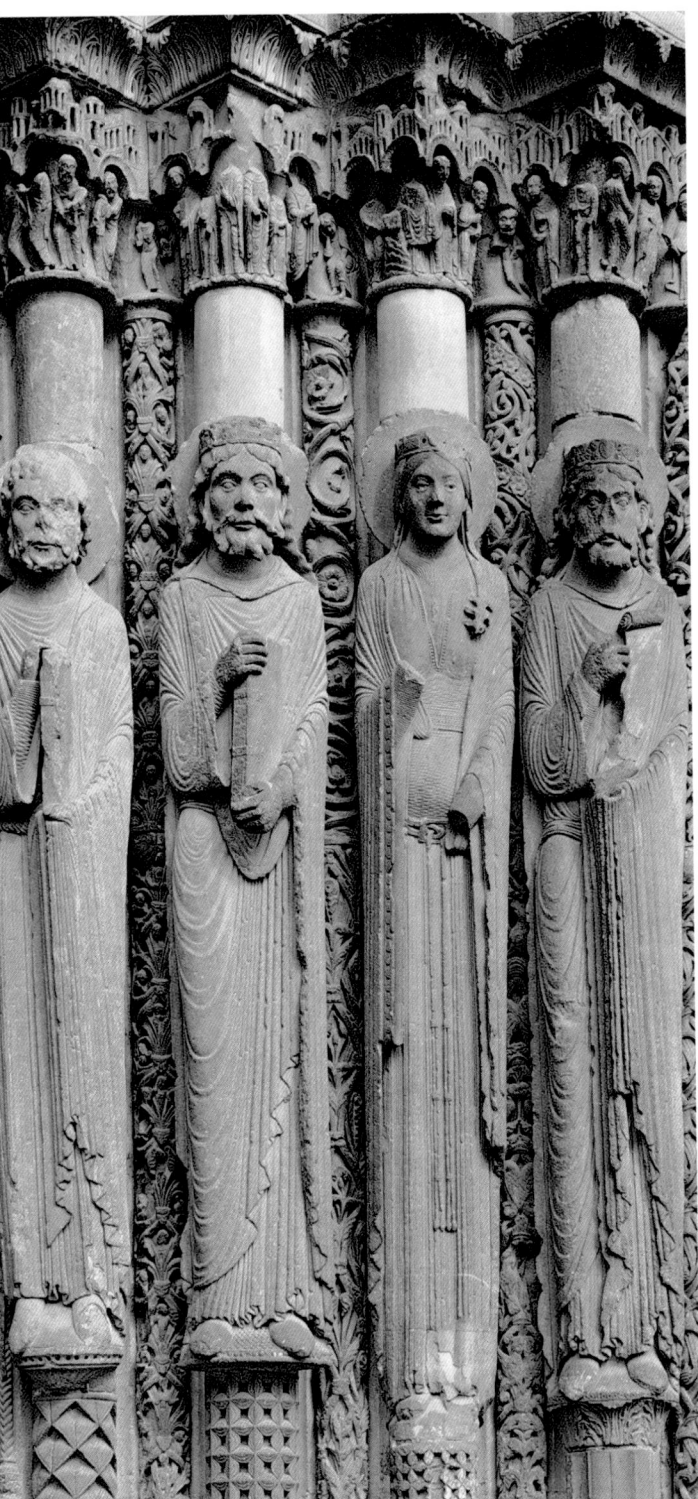

prophet, holding a scroll. Of the three archivolts, the outer two contain the twenty-four elders of the Apocalypse described by John the Divine. The inner archivolt contains twelve angels; the two in the center hold a crown over Christ's head, proclaiming his role as King of Heaven.

In contrast to the treatment of the same subject on the tympanum at the church of Saint-Pierre at Moissac (see fig. 10.14), the program at Chartres separates each group of figures into a discrete architectural element. This creates a greater sense of order and logic, and reduces the sense of crowding. It is thus easier to read this tympanum than its Romanesque predecessor. The resulting clarity is enhanced by the deeper relief and the minimal floral designs —here framing the outer archivolt. By now the influence of Islamic patterning, as well as of interlace, on monumental stone buildings in France has virtually disappeared.

Considered as an iconographic totality, the Royal Portal of Chartres offers the visitor a Christian view of history. The beginning and end of Christ's earthly life are placed over the right and left doors, respectively. The Old Testament kings and queens on the doorjambs are typological precursors of Christ and Mary, while the *Second Coming of Christ*, as envisioned by Saint John, dominates the central portal.

A comparison of the doorjamb statues from the Royal Portal (figs. **11.19** and **11.20**) with those on the south doorjambs reveals the stylistic changes that occurred from Early Gothic to the beginning of High Gothic.

11.19 Doorjamb statues, west façade, Chartres Cathedral, c. 1145–1170.

The New Testament event represented over the central door (fig. **11.18**) is the *Second Coming of Christ* as described by John the Divine in the book of Revelation. On the tympanum, a seated Christ is surrounded by an oval mandorla and the four apocalyptic symbols of the Evangelists. Beneath the tympanum on the lintel, the twelve apostles are arranged in four groups of three. Each group is separated by a colonnette supporting round arches that resemble halos. At either end of the lintel stands a single

11.20 Stylized drapery (detail of fig. 11.19).

The South Façade The saints on the left portal of the south transept (fig. **11.21**) conform less strictly than the figures on the Royal Portal to their colonnettes, and their feet rest naturally on a horizontal plane. They are no longer strictly frontal. They have facial expressions and are of different heights. The heads turn slightly, and there is more variety in their poses, gestures, and costumes. In the figure of *Saint Theodore* at the far left, for example, the right hip swings out slightly in response to the relaxation of the stance. The diagonal of the belt, apparently weighed down at the saint's left by a heavy sword, conveys a slight suggestion of movement in three-dimensional space.

This general increase in the sense of depth is enhanced by the more deeply carved folds and facial features, as well as by the projecting, crownlike architectural elements over the figures' heads. The proportions of the figures have also changed in comparison to those on the west doorjambs and are no longer as tall and thin. Instead, they are wider and seem as if they might step down from their supports into the real world of the observer. Such changes from Early to High Gothic reflect a new, though fledgling, interest in human form and emotion that would continue to develop into Late Gothic.

Between the two doors of the central portal is the trumeau, also a feature of Romanesque cathedrals. It is decorated with a statue of the *Teaching Christ* (fig. **11.22**). He

11.21 *Saints Theodore, Stephen, Clement,* and *Lawrence,* doorjamb statues, south transept, Chartres Cathedral, 13th century.

stands on a lion and a dragon, associated with the beasts and monsters of the Apocalypse, which denote Satan and the Antichrist. Still frontal and strictly vertical, Christ's pose makes him seem more aloof than the doorjamb saints. At the same time, however, he is shown teaching rather than judging and is thus more emotionally accessible to the viewer.

11.22 *Teaching Christ*, trumeau, south transept, Chartres Cathedral, 13th century. Christ's earthly role as a teacher is reflected by the book in his left hand, and his divinity by his gesture of blessing. The act of standing on symbols of Satan and the Antichrist signifies Christ's triumph over the forces of evil.

Antichrist

The notion of the Antichrist, mentioned in the First Epistle of Saint John (2:18 and 2:22), is about the end of time and is apocalyptic in nature. It developed in Europe along with the spread of Christianity and became a powerful force in the Western imagination. The Antichrist is not Satan, but an incarnation of evil, a "Final Enemy," and a "Last Emperor," who takes over from Satan at the end of the world and presides over killing, torture, and universal destruction. Many traditional myths and legends were absorbed into the notion of the Antichrist, who was used for political as well as for religious purposes.

The image of the Antichrist appealed to visionary writers and was frequently illustrated in Christian art. Antichrist iconography was derived from the apocalyptic beasts and monsters described in the book of Revelation. Early Christian allusions to his appearance mention huge stature, bloodshot eyes, white eyelashes, pointed hair, gigantic teeth, sickle-shaped fingers, and a double skull. When he walked, according to one account, he left green footprints.

Around 950, one Brother Adso wrote a biography of the Antichrist, which attracted an enormous popular following. In Adso's version, the Antichrist was born in Babylon, educated in magic, and capable of performing miracles. He rebuilt the Temple of Jerusalem, circumcised himself, and claimed to be the son of God. The twelfth-century liturgical *Play of Antichrist* portrayed the fate of Christianity as depending on the German emperor and warned against the weakness of the French. Various reform movements within the Church similarly took advantage of Antichrist propaganda.

The first woman mystic who significantly influenced Antichrist imagery was the German abbess Hildegard of Bingen (1098–1179). Among her writings is the *Liber scivias* (*The Book of Knowing the Ways of Light*), in which she detailed twenty-six visions, including an account of the Antichrist's birth from Mother Church and his subsequent destruction. She writes that he was born of a licentious woman and emerged from her body with a black head covered with dung. He had fiery eyes, donkey's ears, a lion's mouth and nostrils, and gnashing teeth. When he tried to climb to heaven, a clap of thunder forced him to his death.

In the thirteenth century, the Antichrist was often represented as a three-headed tyrant (fig. **11.23**), which was a reference to his claim to be God and the Trinity. In 1242, a widely quoted verse reflected fears of a Mongol invasion: "When twelve hundred years and fifty After the birth from the dear Virgin are completed, Then will be born demon-filled Antichrist."[4]

11.23 *Antichrist as a Three-headed Tyrant*, from the Harley Manuscript, fol. 127r, 1527. British Library, London.

The Interior of Chartres

The overwhelming sensation on entering Chartres Cathedral from the western entrance is one of height. Its nave is the earliest example of High Gothic architectural style. The view in figure **11.24** shows the nave from the Royal Portal entrance, looking east toward the curved apse. The ceiling vaults of the nave rise nearly 120 feet (37.58 m) and are only about 45 feet (13.72 m) wide.

The new height achieved by Gothic builders was made possible by the buttressing system, the effect of which can be seen in the clerestory (see fig. 11.15). The latter is supported at two points by flyers, allowing more space for windows. In each bay, the clerestory windows consist of two lancets under a small round window. At the far end, in the apse, the clerestory lancets are taller, but there are no round windows.

Proceeding down the nave, from west to east, one arrives at the crossing (see fig. 11.24) and the two transept entrances. Figure **11.25** shows the north rose window illuminated by outside light filtering through the stained glass. Dominating the interior entrance walls, these window arrangements are like colossal paintings in light. Their intensity varies according to weather conditions and times of day. At the center of the rose window, a small circle contains an image of Mary and the infant Jesus surrounded by twelve even smaller circles.

Each series of geometric shapes around the center of the rose window numbers twelve—an implicit reference to the twelve apostles. The first series after the tiny circles contains four doves and eight angels. Twelve Old Testament kings, typological precursors of Christ, occupy the squares. The twelve quatrefoils contain gold lilies on a blue field, symbols of the French kings. The outer semicircles represent twelve Old Testament prophets, who are types for the New Testament apostles.

The central lancet depicts Saint Anne with the infant Virgin Mary. At the left are the high priest Melchizedek and King David, and on the right are King Solomon and the priest Aaron—all Old Testament figures. In these windows, as in the west façade sculptures, the lower images act as visual and symbolic supports for the upper images: the New Dispensation is built on the Old. Here, the additional genealogical link between Christ and Saint Anne is arranged vertically, with Mary as an infant in the lancet below and as the Virgin Mother above, at the center of the rose window.

Wherever possible and appropriate, Gothic artists integrated Christian dogma into the cathedrals. Such buildings were designed as supreme monuments to the glory of God. They were also unified expressions of the skills of the architects, sculptors, artists, and other craftsmen who contributed to them.

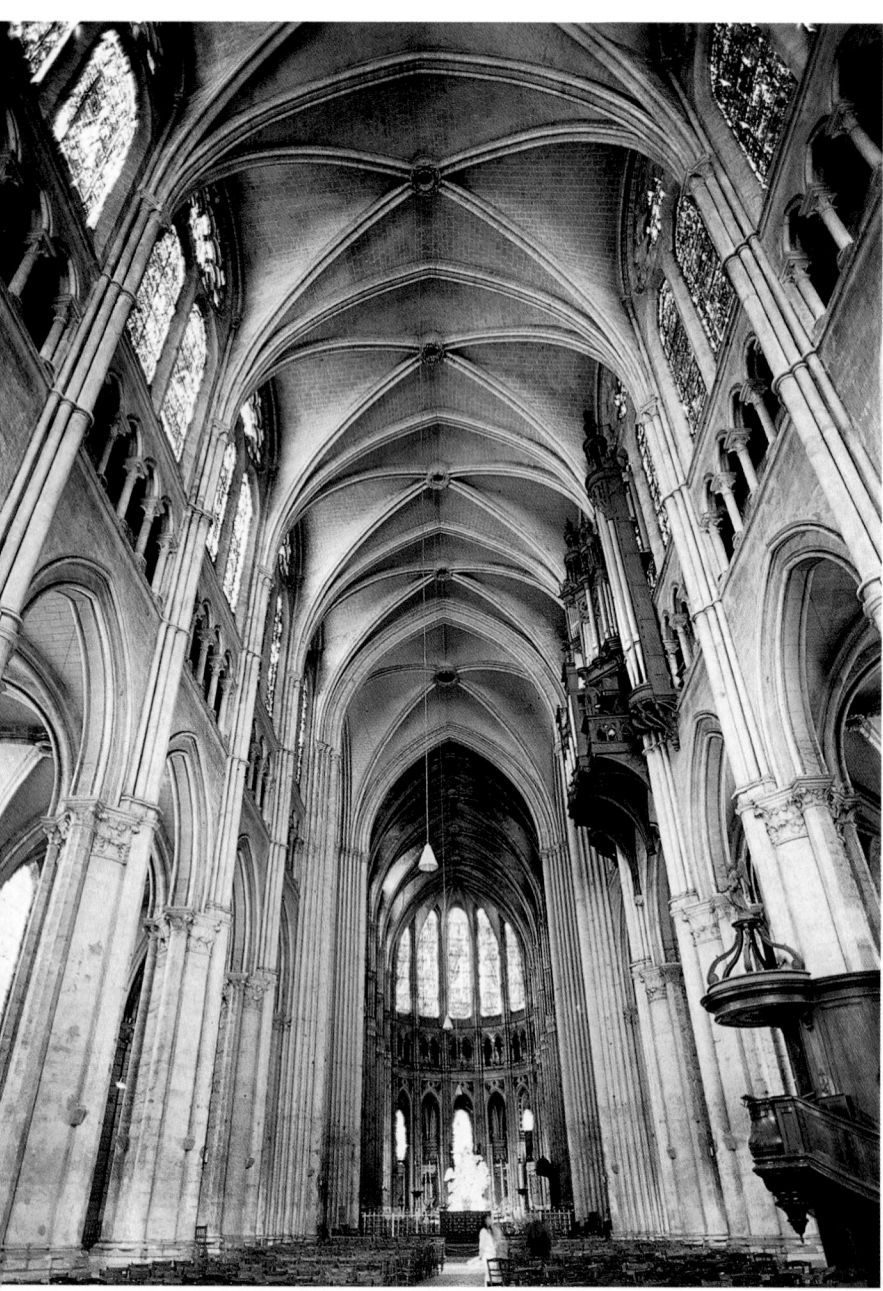

11.24 Nave, Chartres Cathedral, looking east. The three stories of Gothic elevation rise on either side of the nave. The lowest story, or nave arcade, is defined by a series of large arches on heavy piers. These separate the nave from the side aisles. The second story, or **triforium,** is a narrow passageway above the side aisle. At the top is the clerestory, whose windows are the main source of light in the nave.

11.25 Rose window and lancets, north transept, Chartres Cathedral, 13th century. Note that the north windows are larger and more elaborate than the earlier west-façade windows. The north lancets are taller and thinner than those on the west. The north rose window is larger and has a greater variety of geometric shapes within it. Additional windows have also been inserted between the lancets and rose window. The rose window measures over 42 feet (12.80 m) in diameter. The windows between the rose window and lancets are decorated with royal coats of arms, which proclaim the divine right of French kings. They also serve as a signature recording the donation of the north transept by Blanche, the queen mother.

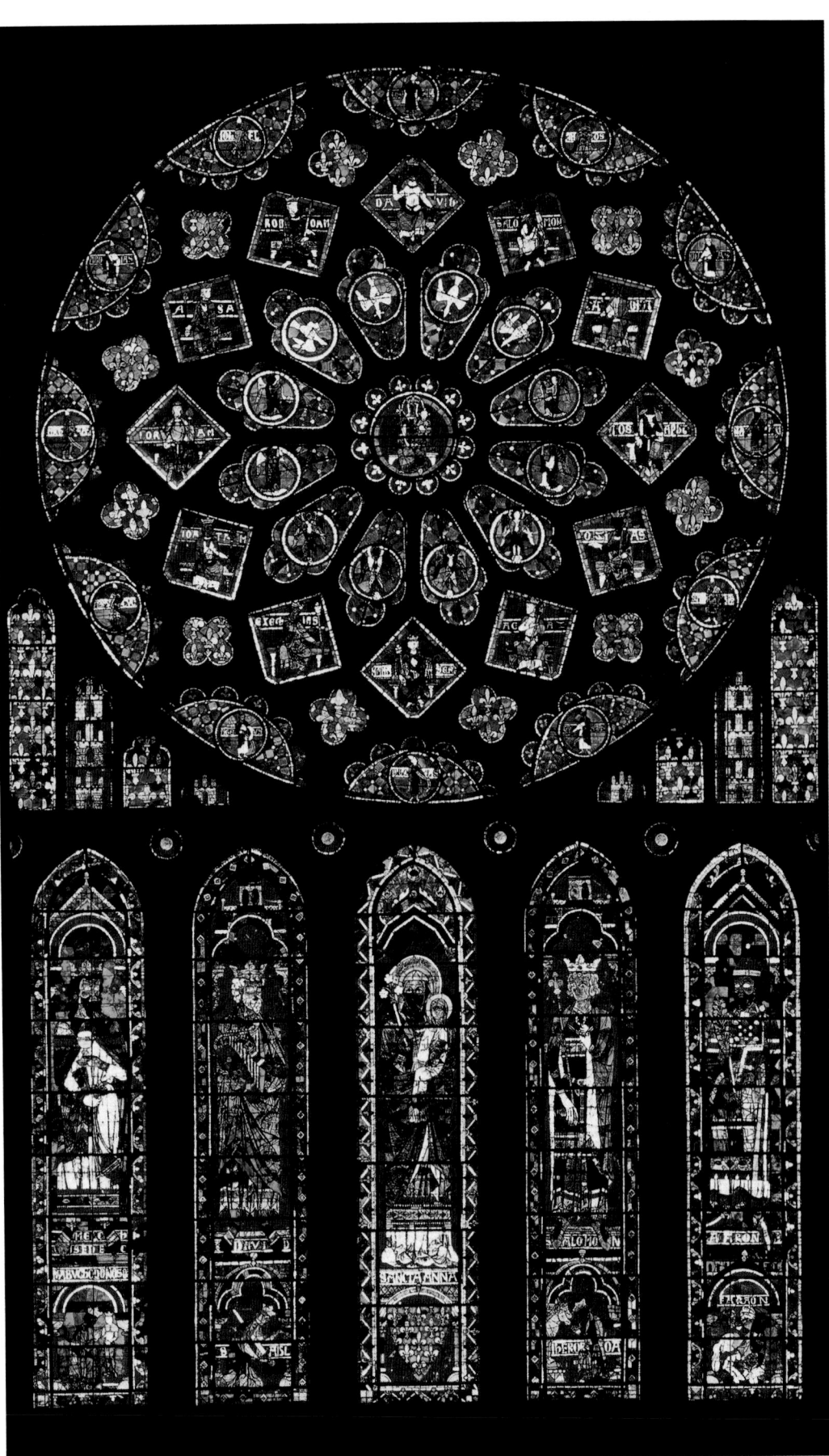

Later Developments of the French Gothic Style

Chartres, completed in 1220, set the standard for other great French cathedrals built in the High Gothic style. Height and luminosity were the criteria by which they were measured. The cathedral at Reims, northeast of Paris, was the next to be built, from 1211 to about 1290. Its nave was 125 feet (38.10 m) high. Amiens, also to the north, was begun in 1220, and its nave reached a height of 144 feet (43.89 m). Each nave was wider than the last, but the ratio of height to width continued to increase.

Amiens

The High Gothic cathedral at Amiens (figs. **11.26–11.31**), like Chartres, was built on the site of a church that had burned down. Because it was conceived from the start as a Gothic structure, the plan (fig. **11.26**) is more unified than that of Chartres. Transept entrances and the towers, for example, are symmetrical. There is also a new integration of parts with the whole in the construction of the nave (fig. **11.27**). Each feature is now in the service of height, and the elements of the wall work together to carry one's gaze upward in a soaring thrust toward the vaults and the source of light through the clerestory

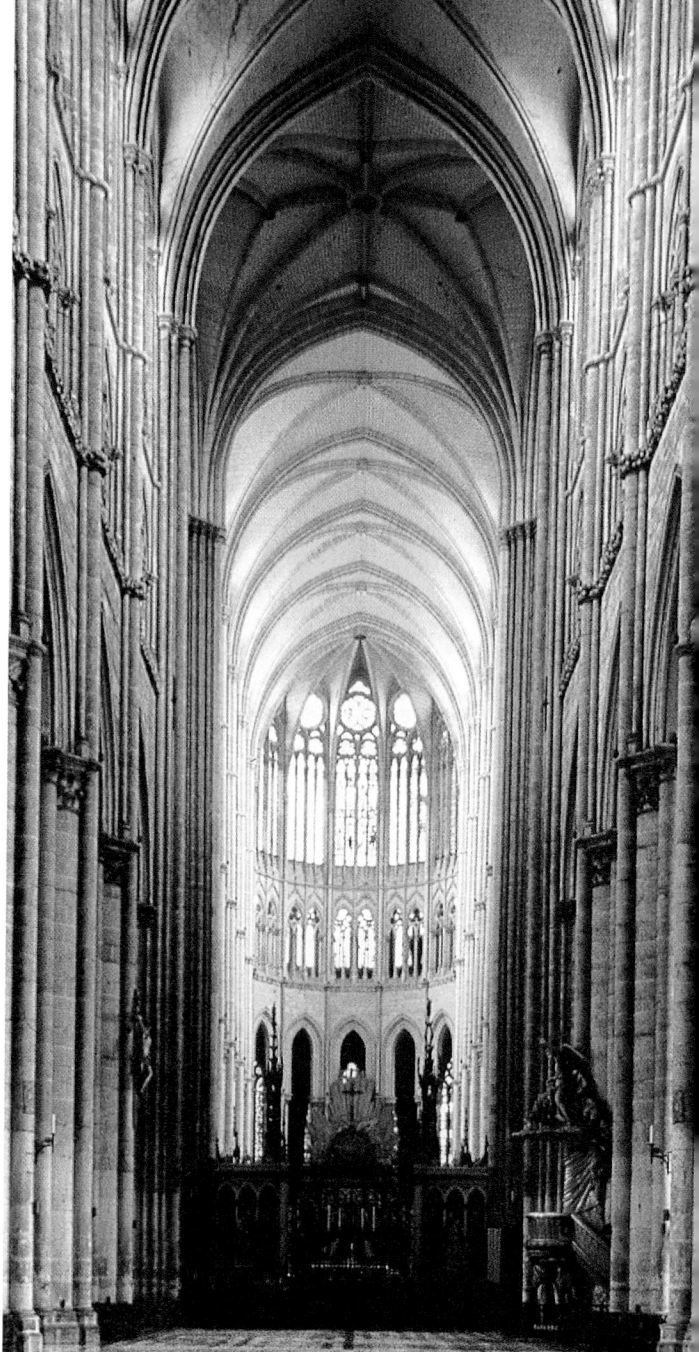

I	Chevet
2	Choir
3	Transept
4	Nave
5	Aisle
6	Façade
7	Crossing
8	Buttress
9	Ambulatory
10	Radiating chapel
11	Lady chapel
12	Apse

11.26 Plan of Amiens Cathedral.

11.27 Nave vaults, Amiens Cathedral, 1220–1269.

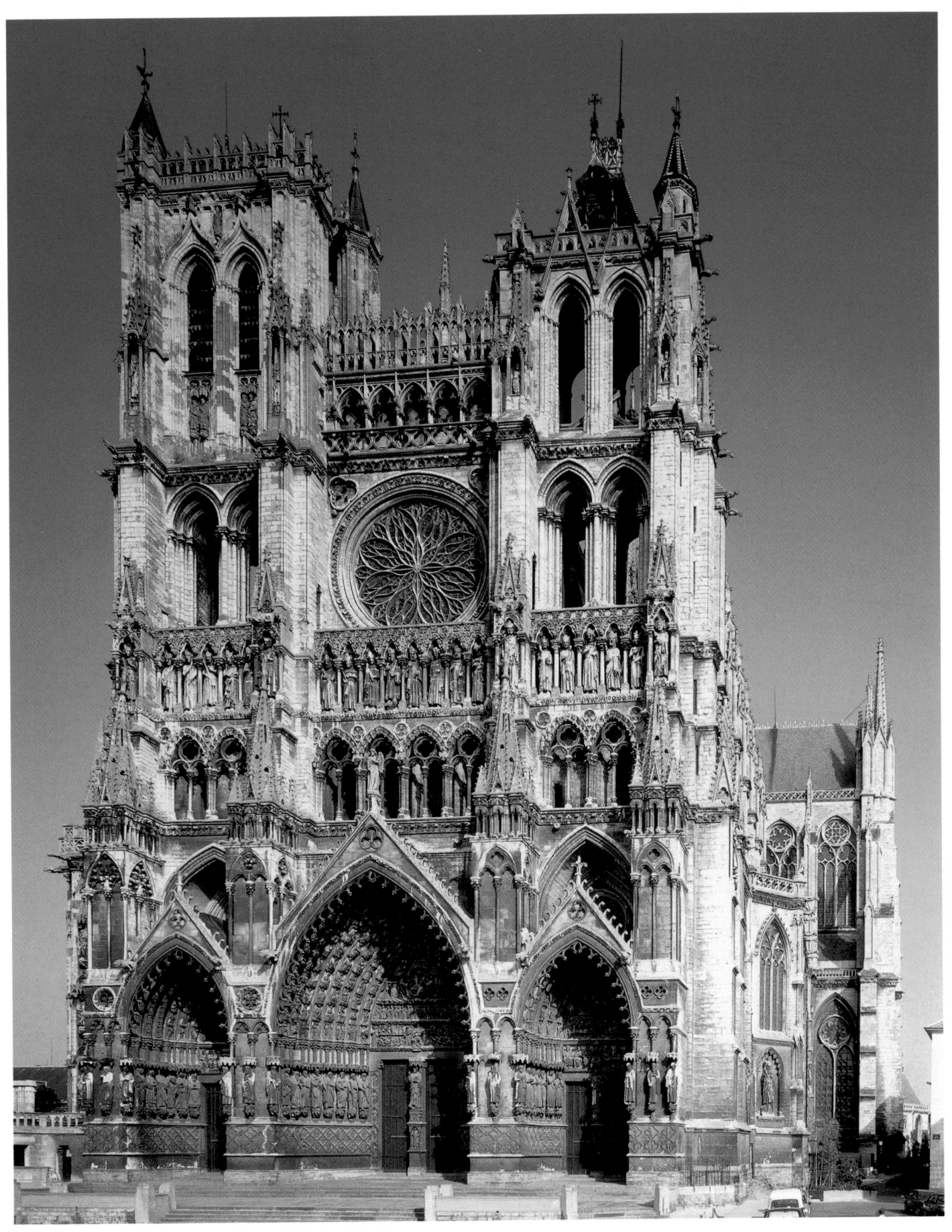

11.28 West façade, Amiens Cathedral, France, 1220–1269. Three architects worked on this cathedral: Robert de Luzarches, Thomas de Cormont, and Regnault de Cormont.

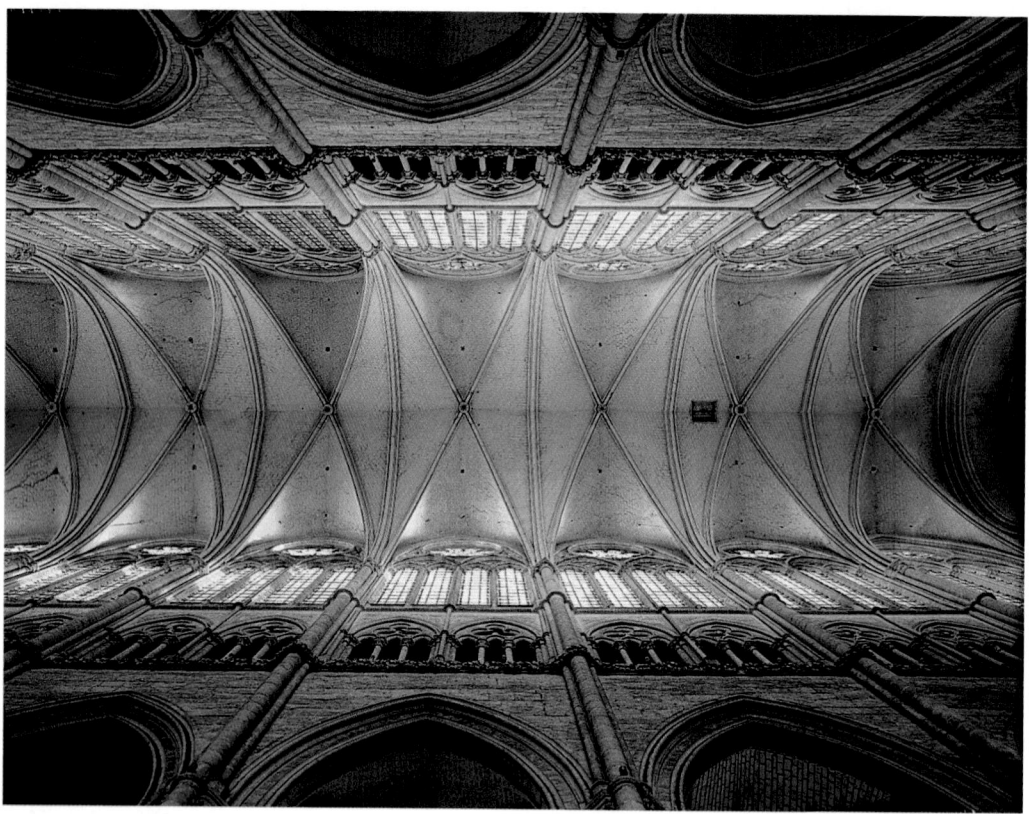

11.29 Nave vaults, Amiens Cathedral, 1220–1269.

windows. The view of the choir vaults in figure **11.29** shows the "uplifting" effect of light and lightness on the delicate upper-story colonnettes and on the webbing of the vaults.

Two trumeau statues at Amiens exemplify certain developments in Gothic sculptural decoration: the *Beau Dieu* ("Beautiful God," fig. **11.30**) and the *Vierge dorée* ("Gilded Virgin," fig. **11.31**). The *Beau Dieu* is carved in deeper relief than the *Teaching Christ* from Chartres (see fig. 11.22), and the right arm is more extended. The hemline is no longer horizontal, but appears to rise up in the middle, which creates more open space and fluid drapery movement. As at Chartres, Christ stands on apocalyptic monsters—here, a lion and a basilisk (a legendary serpent having a deadly glance and poisonous breath), again denoting Satan and Antichrist.

The *Vierge dorée* was carved about twenty years after the *Beau Dieu* and seems even more independent of its architectural background. Whereas the trumeau figures of Christ have an iconic character, the Virgin is represented in more human terms. Although she is the Queen of Heaven by virtue of her crown, she turns to gaze not at the viewer, but at her infant. She holds him on her left arm, while the diagonal drapery folds convey the impression that a shift in her stance helps support his weight. The statue is unusual in combining monumental form on the exterior of a cathedral with an intimate depiction of the mother–child relationship.

11.30 *Beau Dieu,* central portal, west façade, Amiens Cathedral, c. 1225–1230.

11.31 *Vierge dorée,* south portal, Amiens Cathedral, c. 1250. Note the implicit references to the Crucifixion (the arrangement of the angels holding the halo) and to the doctrine of the Trinity (the number of angels).

Reims

At Reims, the west façade (fig. **11.32**) and interior view of the nave (fig. **11.33**) show the extent to which cathedral designs were becoming progressively elongated, with an increasingly vertical thrust. The proportions of the arches at Reims are taller and thinner than those at Chartres, and the plan (fig. **11.34**, p. 418) is longer and thinner. The radiating chapels are deeper than at Chartres, and the transepts are somewhat stubby, appearing to merge into the choir with little or no break. Because Amiens was designed slightly later than Reims, however, its height is

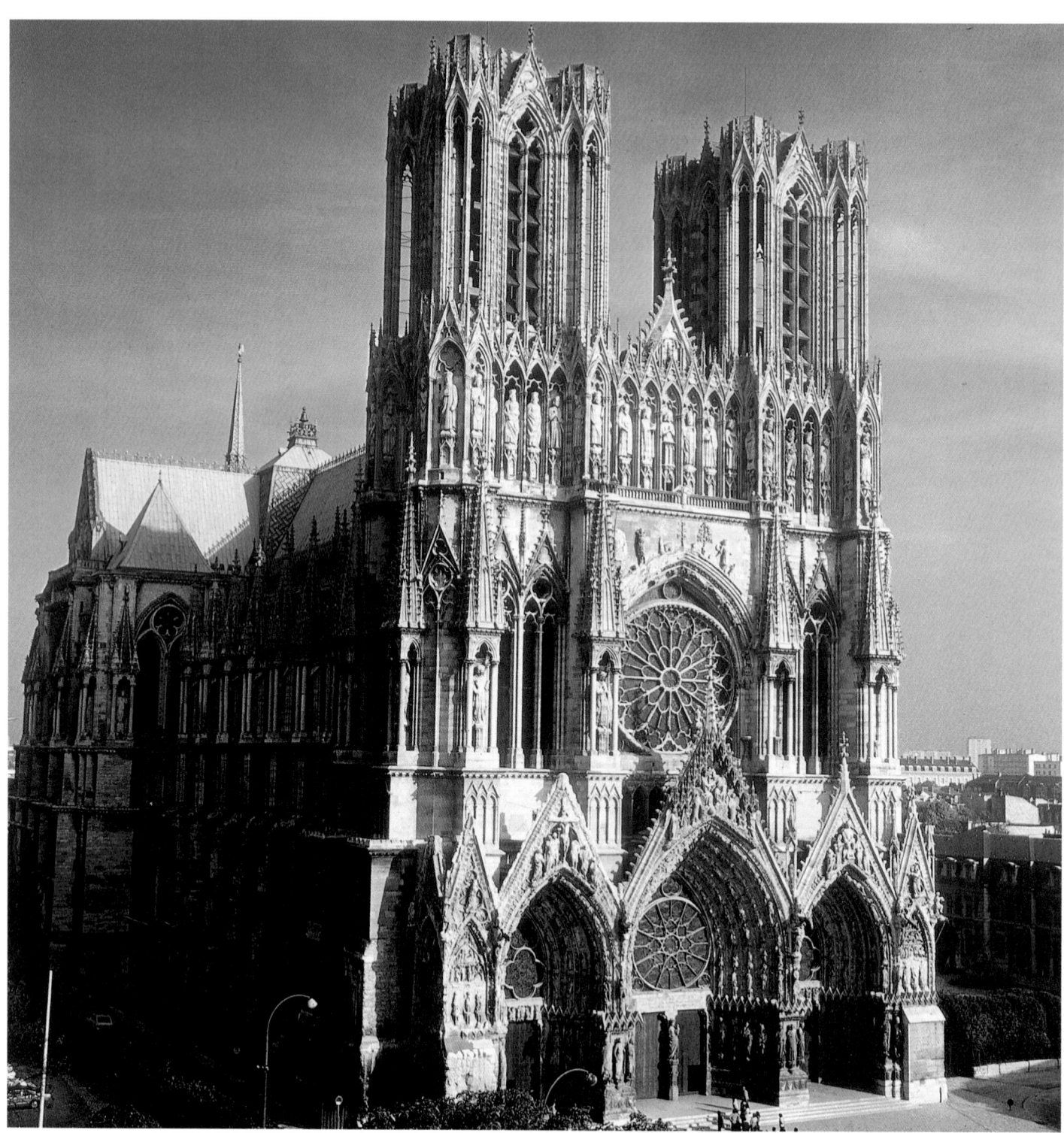

11.32 West façade, Reims Cathedral, France, begun 1211. The window space has been dramatically increased at Reims as a result of continual improvements in the buttressing system. The tympanums on the façade, for example, are filled with glass rather than stone. At Reims, the portals are no longer recessed into the façade, but are built outward from it.

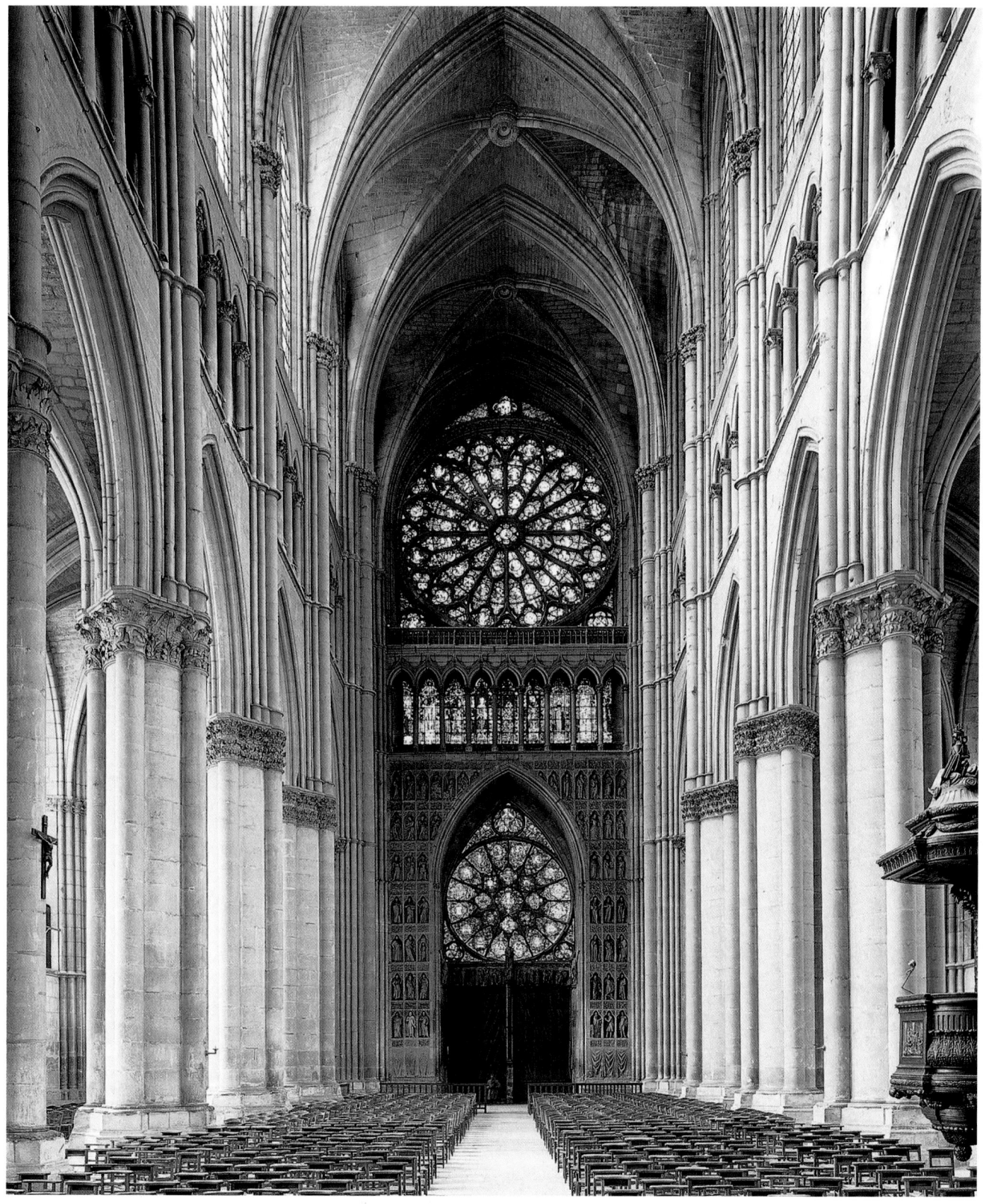

11.33 Nave, Reims Cathedral, 1211–c. 1290. 125 ft. (38.10 m) high.

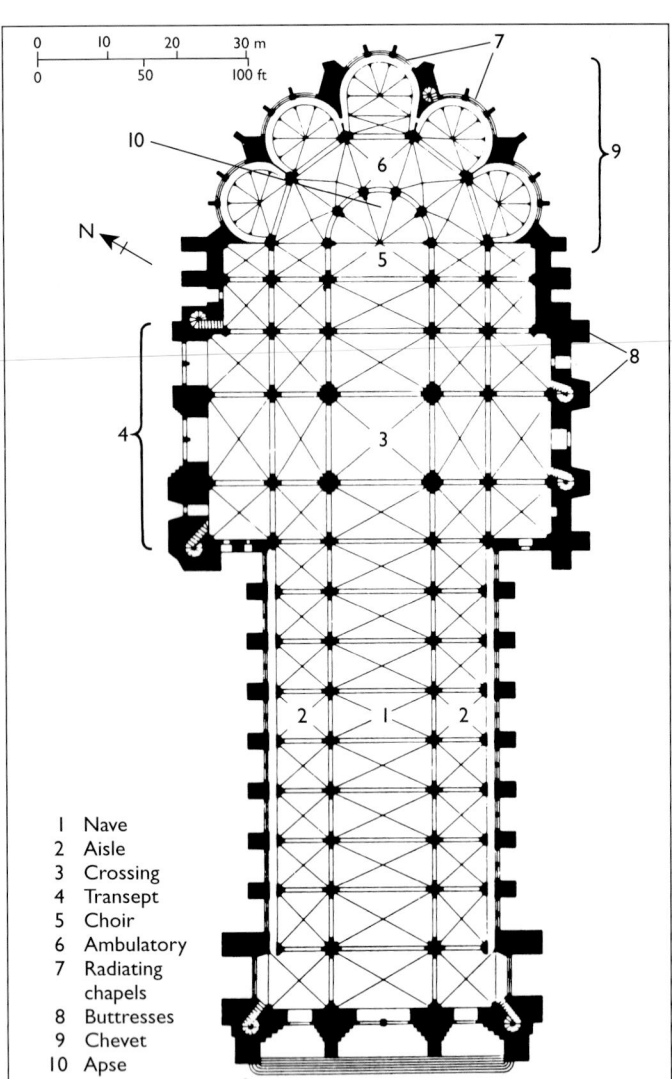

11.34 Plan of Reims Cathedral (after W. Blaser).

both absolutely and proportionately greater, and its nave proportionately narrower than at Reims.

The exterior surfaces at Reims are filled with greater numbers of sculptures than at either Chartres or Amiens. In contrast to the increased verticality of the architecture, the sculptures have become more naturalistic, as can be seen in the doorjamb statues on the west façade at Reims (fig. **11.35**). Rather than being vertically aligned and facing the viewer as at Chartres, the Reims figures turn to face each other, interacting in a dramatic narrative and engaging the spaces between them. The drapery folds reflect human anatomy, poses, and gestures in a more pronounced way than even at the south transept of Chartres. This is one of the earliest examples in the monumental Christian art of western Europe of an interest in the relationship between drapery and the human form it covers.

The two left-doorjamb figures represent the angel Gabriel and Mary. They enact the scene of the Annunciation, in which Gabriel announces the birth of Jesus to Mary. On the right, in the Visitation scene, Mary visits her cousin Elizabeth and tells her that she is three months pregnant. Elizabeth informs Mary that she herself is six months pregnant. Her son will be John the Baptist, Jesus's second cousin and childhood playmate.

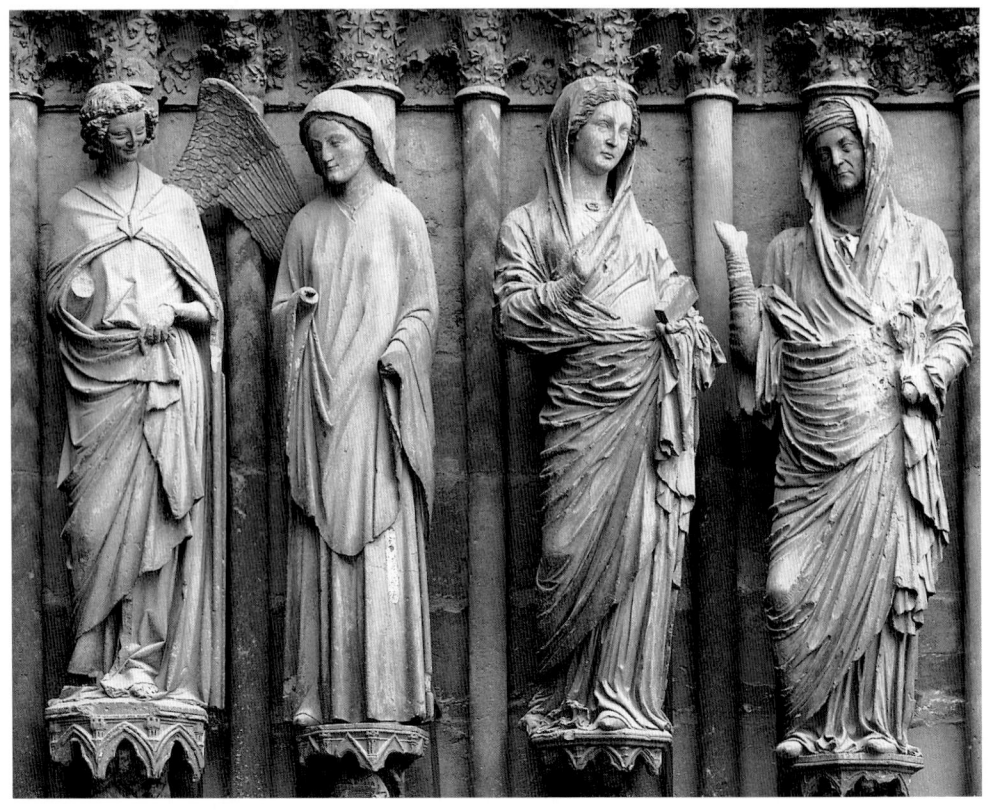

11.35 *Annunciation* and *Visitation*, doorjamb statues, Reims Cathedral, c. 1225–1245.

Gothic Architecture and Scholasticism

This heading was the title of a small book published in 1951 by the art historian Erwin Panofsky. He showed the way in which Scholasticism influenced the Gothic style in terms of its clear, hierarchical systems. Among the examples he used to show this connection was an illustration from a thirteenth-century manuscript (fig. **11.36**). At the upper left, the king sits on a throne and is enclosed by a tripartite Gothic arch. He is the largest figure on the page, and his frame is the most elaborate architectural element. His greater verticality and his higher placement are consistent with his position as ruler. Interior is separated from exterior, which appears in the buildings to the right. Other figures, including members of the clergy, are arranged in three horizontal rows.

The same organizing principle can be seen in an illustration from the early fourteenth-century manuscript of the *Life of Saint Denis* (fig. **11.37**). Its elaborate frame is Late Gothic, and the vines make it a metaphor of the Church itself by reference to Christ's "I am the vine" (see Chapter 8). At the top, Saint Denis, the largest figure, sits on a lion throne, which connects him typologically with King Solomon, and his Church with Solomon's Temple. The abbreviated cathedral entrance over the saint's head emphasizes his position as archbishop of France. His scroll winds around and forms a lintel-like horizontal under the clerestory windows.

11.36 *Philip I of France Granting Privileges to the Priory of Saint-Martin-des-Champs*, France. c. 1250. Book illumination, ms. 1359, fol. 6. Bibliothèque Nationale, Paris.

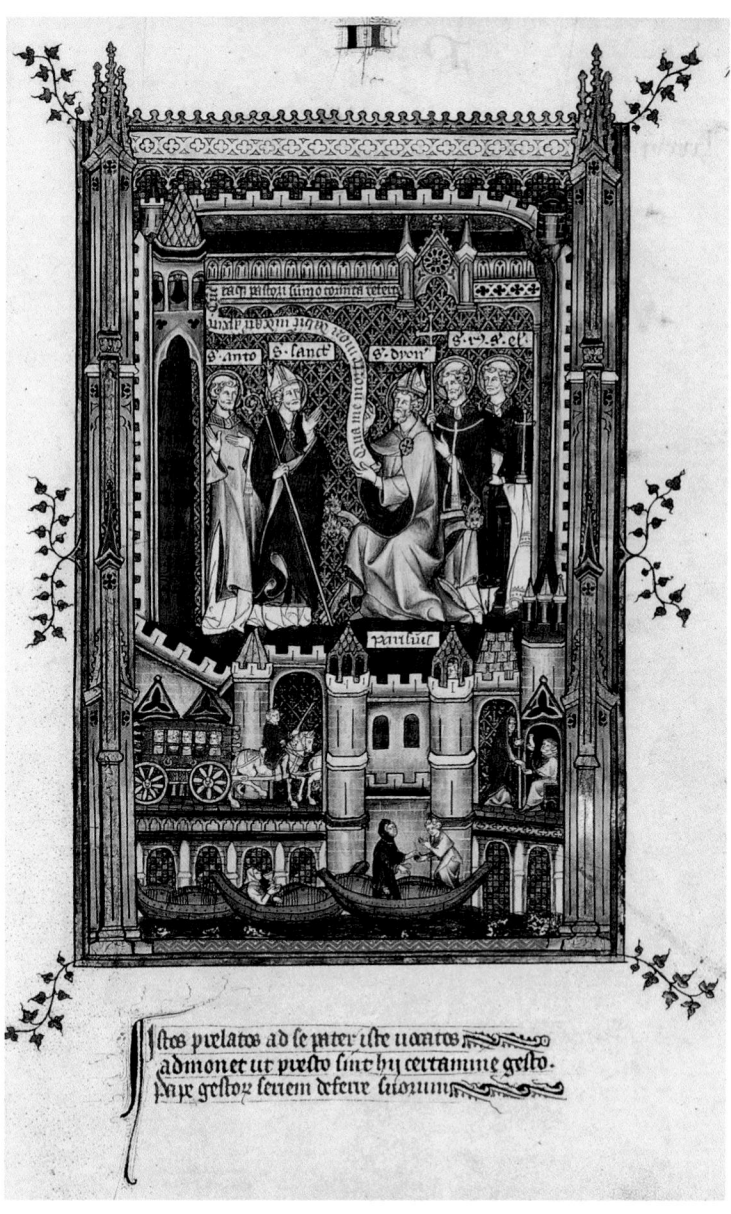

11.37 Scene from the *Life of Saint Denis*, completed 1317. Book illumination, ms. fr. 2091, vol. II, fol. 125. Bibliothèque Nationale, Paris. This manuscript was commissioned during the reign of Philip IV (the Fair). It contains twenty-seven illuminations of the life of Saint Denis. In this scene, the saint asks two others (Saints Antonin and Saintin) to write his biography.

The scene below depicts the everyday life of the Earthly City—in this case fourteenth-century Paris. A coach enters the city gate on the upper left, a doctor checks his patient's urine sample on the right, and in the boats a wine taster and two men complete a commercial transaction. Travel, medicine, and trade are among the transient activities of daily life, while the saints above are engaged in the loftier pursuit of preserving the name and memory of Saint Denis through his image and biography.

Scholasticism was a philosophical method combined with theology. It explained spiritual truth by a kind of inquiry based on analogy and was designed to reconcile faith and reason. The foundations of Scholasticism were laid by Saint Augustine's juxtaposition of the Earthly and Heavenly Cities of Jerusalem (see p. 400). Augustine argued that, although understanding can precede faith, faith leads to understanding. His aesthetic argument, that beauty is symmetry and that there should be a harmonious relation of parts to the whole, is consistent with the visual and structural order of Gothic style.

At the end of the eleventh century, Anselm (c. 1033–1109), the archbishop of Canterbury (see below), established a program based on Augustine's ideas. In the 1130s, the theologian Peter Abelard (1079–1142) published *Yes and No,* a treatise applying the dialectic method to theology, arguing from reason (*ratio*) on the one hand, and for and against an issue (*quaestio*) on the other. About this time, the writings of Aristotle were revived in western Europe. By the thirteenth century, his logical system had been absorbed into Scholasticism.

The work that summed up Scholasticism at its peak was the *Summa theologiae* of Thomas Aquinas (c. 1225–1274). Influenced by Aristotelian logic, Aquinas discussed doctrine according to a system of argument, counterargument, and solution. This system established the relationship between faith and reason, and concluded that, far from being at odds, the one actually complements the other.

The architectural solutions that became typical of the Gothic cathedral are, in a sense, parallel to Scholastic logic. The sculptures and stained glass constitute an illustrated Bible. According to Panofsky, the Scholastic clarification of faith by intellectual demonstration parallels the articulation of the cathedral. For him, Amiens best illustrates a "final" resolution in creating a uniformity of divergent features.

What began with Suger's desire for transparency in architecture led to the philosophical pursuit of a new totality. At Amiens, the three-part nave (counting its two side aisles) corresponds to the three-part transept (the two entrances and the section crossing the nave). The expansion of the nave into the five-part choir creates a logical transition to the semicircular ambulatory in the apse. And the curve of the ambulatory leads one naturally into the radiating chapels. The symmetrical towers repeat the symmetry of the transepts farther east and stand as equals on either side of the western entrance. Here, therefore, by the process of philosophical debate (*disputatio*), the Gothic architects finally arrived at *concordantia* (the harmonious reconciliation of seemingly contradictory elements).

Applying Scholasticism to architecture, Panofsky cites the example of the rose window. At Saint-Denis (fig. 11.1), he argues, the window is too small; at Amiens (fig. 11.28), it is crowded by the surrounding elements. But at Reims (fig. 11.32), a solution has been found. There the architect has opened up the west façade wall and set the rose window inside the pointed arch of another huge window. As a result, the rose window is more logically connected to the west wall. Instead of being a round window in a rectangular wall as at Saint-Denis, Chartres, and Amiens, it is now a window in a window in a wall.

The new window—with the pointed arch—serves a transitional purpose because it shares a structure with the wall and colored glass with the rose window. Whether viewed from the exterior (fig. 11.32) or from the interior (fig. 11.33), the aesthetic effect is striking in the grand vertical sweep of the wall. This is then unified by the repeated rose window inscribed in the pointed arch window over the door. (Note that in the exterior view, the rose window is repeated in each of the three tympanums.) The east-to-west view of the nave (fig. 11.33) accentuates the larger size of the upper rose window compared with the lower. Although such an arrangement would appear to defy structural logic, it works because the eye is immediately drawn upward. This effect has a theological, as well as an architectural, purpose. It synthesizes the traditional association of height and greatness with the belief that spiritual perfection is attained in the light of the Heavenly City.

Sainte-Chapelle

The transcendent quality of Gothic light is nowhere more evident than in the reliquary chapel of Sainte-Chapelle in Paris (fig. **11.38**). It was commissioned by King Louis IX (who was canonized in 1297) and epitomizes the *rayonnant* style. Here the walls literally become glass, as the stone supports diminish. There is no transept, which allows the tall, thin colonnettes to rise uninterruptedly from a short, dimly lit first story. This clear distinction between the lower darkness and the upper light is an architectural mirror of traditional Christian juxtapositions associating darkness with the lower regions of hell, the Earthly City, and the pre-Christian era of the Old Testament. Light, in this context, signifies the Heavenly City and the enlightened teachings of the New Testament. The same parallelism between Old and New Testaments determined the iconography of the scenes represented in the stained-glass windows. These metaphors are reinforced by the ceiling vaults, which are painted blue and decorated with gold stars in the form of fleurs-de-lis—the emblem of the French kings.

The original impetus behind the construction of Sainte-Chapelle is also based in tradition. From Byzantium, Louis IX obtained crucifixion relics believed to be fragments of the True Cross, the Crown of Thorns, the lance, sponge, and a nail. At the time of their arrival, Louis went to the gates of Paris to receive them. (This was in imitation of the last event in the Legend of the True Cross—see Chapter 10—when the Cross is restored to Jerusalem and the townspeople welcome it at the city gate.) The relics were placed in the large, Gothic-style gold and glass reliquary in the apse.

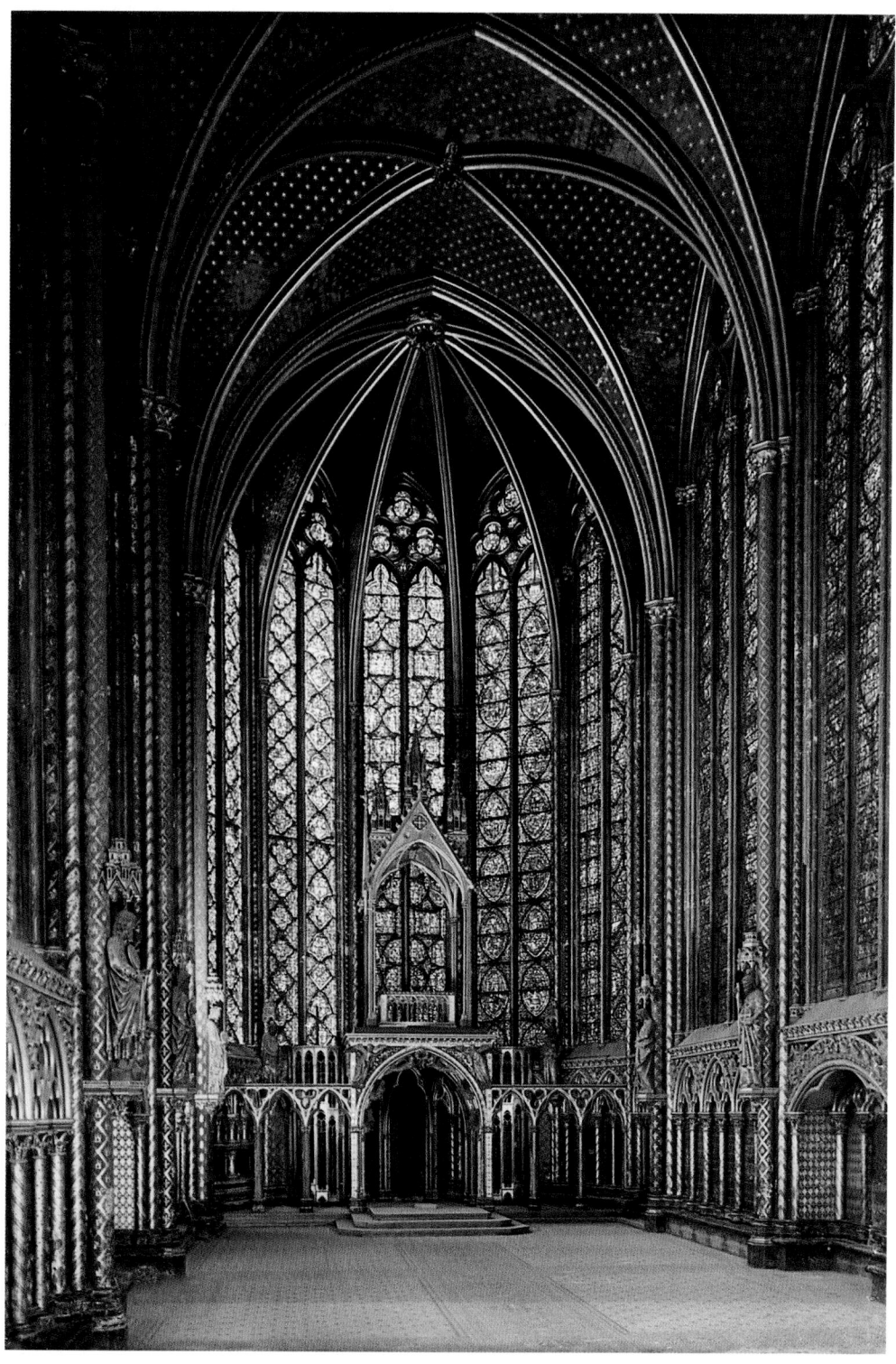

11.38 Nave, Sainte-Chapelle, Paris, 1243–1248. 32.0 × 99.5 ft. (9.75 × 30.33 m).
Thomas de Cormont, who also worked on Amiens Cathedral, designed Sainte-Chapelle.
It was the chapel of the French kings, located on the Île de la Cité and attached to the palace.

English Gothic

Within a generation of the new choir at Saint-Denis, the Gothic style had spread beyond France to other countries. Among the first to adopt the new style was England. Since its defeat by the Normans in 1066, there had been commercial, cultural, and political contacts between the two countries.

Canterbury Cathedral

The Gothic style in England begins with the choir of Canterbury Cathedral (figs. **11.39–11.44**), in the southeastern county of Kent. It was originally built in the Norman style, which developed in England after the Norman conquest. In 1174, a fire destroyed the choir, and architects were summoned from France and England to advise on reconstruction. The French architect William of Sens began the new work with stone imported from Caen; five years into the project, he died of a 50-foot fall from the scaffolding, and an English architect, also named William, took over.

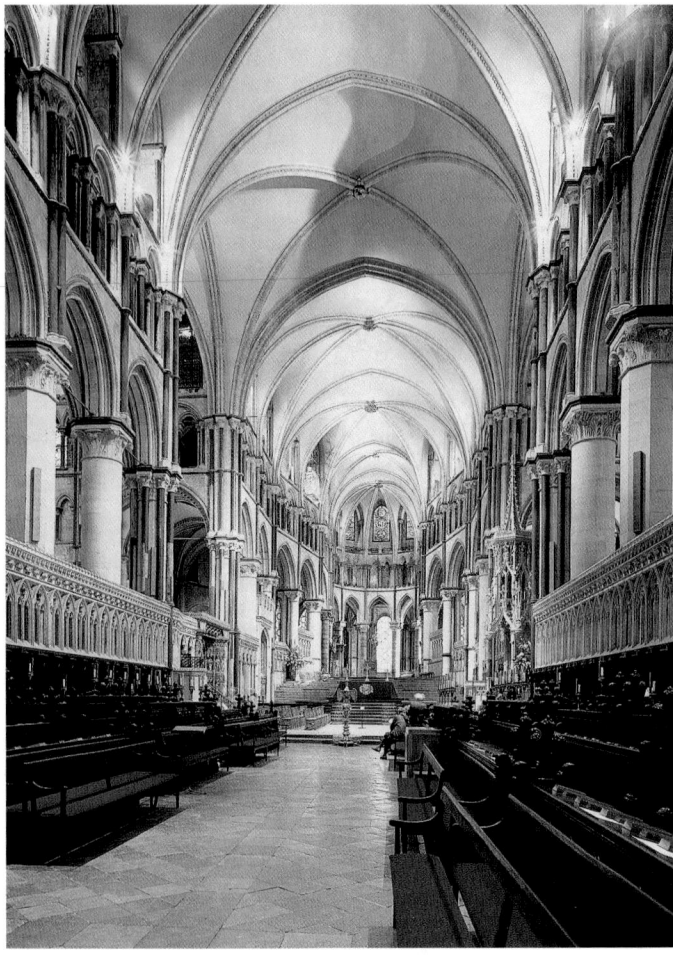

11.39 Choir, Canterbury Cathedral, 1174–1184.

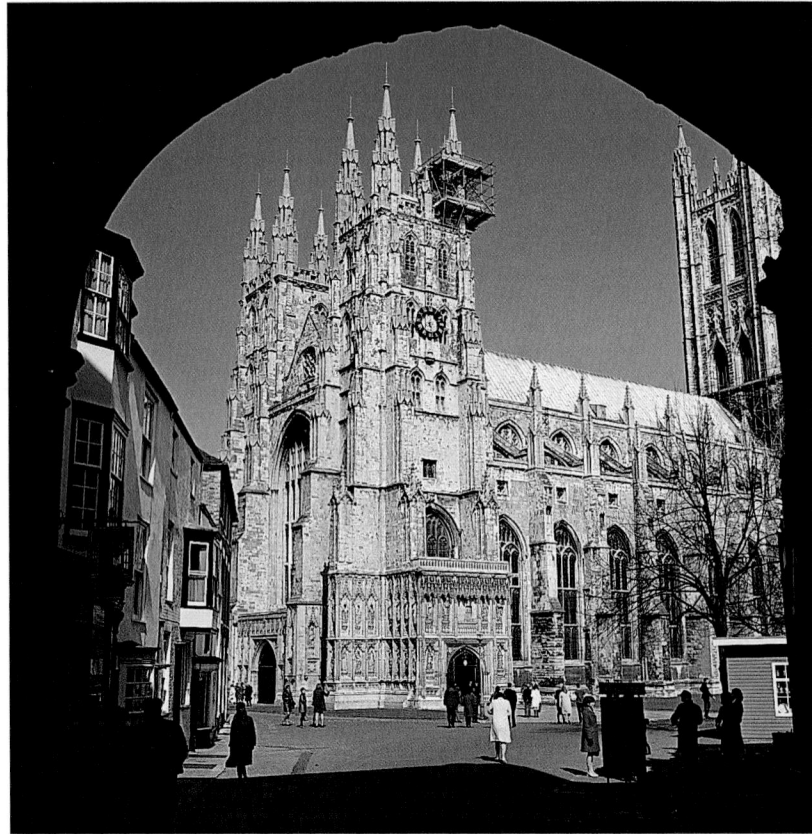

11.40 View of Canterbury Cathedral.

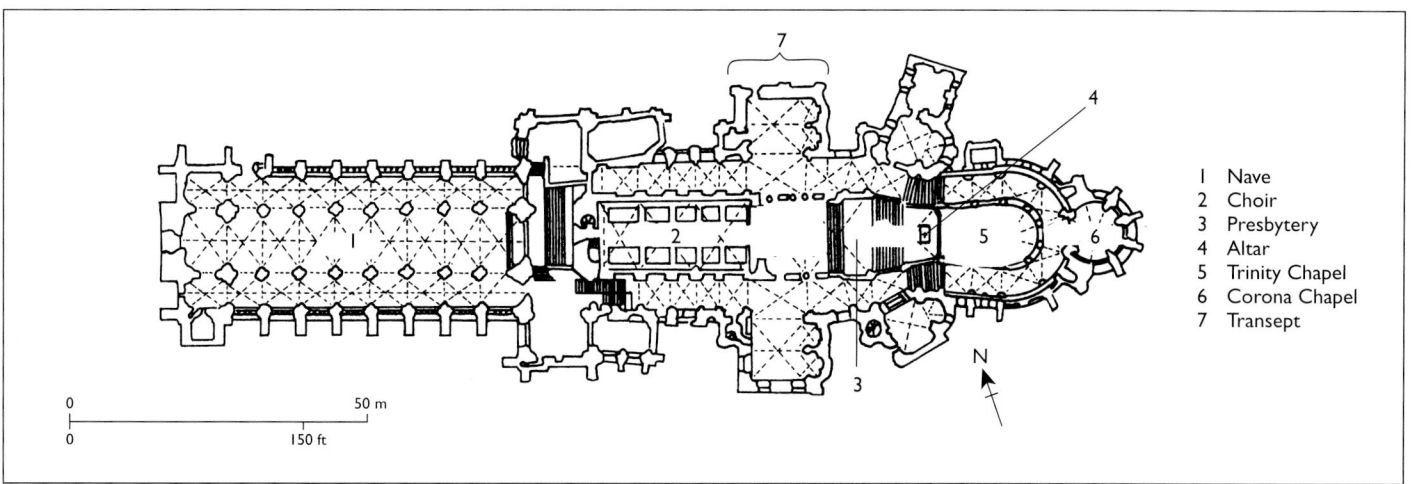

11.41 Plan of Canterbury Cathedral.

1 Nave
2 Choir
3 Presbytery
4 Altar
5 Trinity Chapel
6 Corona Chapel
7 Transept

In the reconstruction of the choir, a Gothic superstructure was erected over the crypt, which was inside the remaining Norman walls. A monk of Canterbury, one Gervase, described the new Gothic elements and their effect. He noted that the number of piers had increased (by six), as had their length (by nearly 12 feet [3.66 m]), drawing attention also to the more elaborately carved capitals, the use of marble and different-colored stone, and the sexpartite arched-rib vaulting held in place by a keystone. The decorations observed by Gervase remained typical of English Gothic and were derived from the taste for Anglo-Saxon interlace (cf. the lower arches in fig. 11.42).

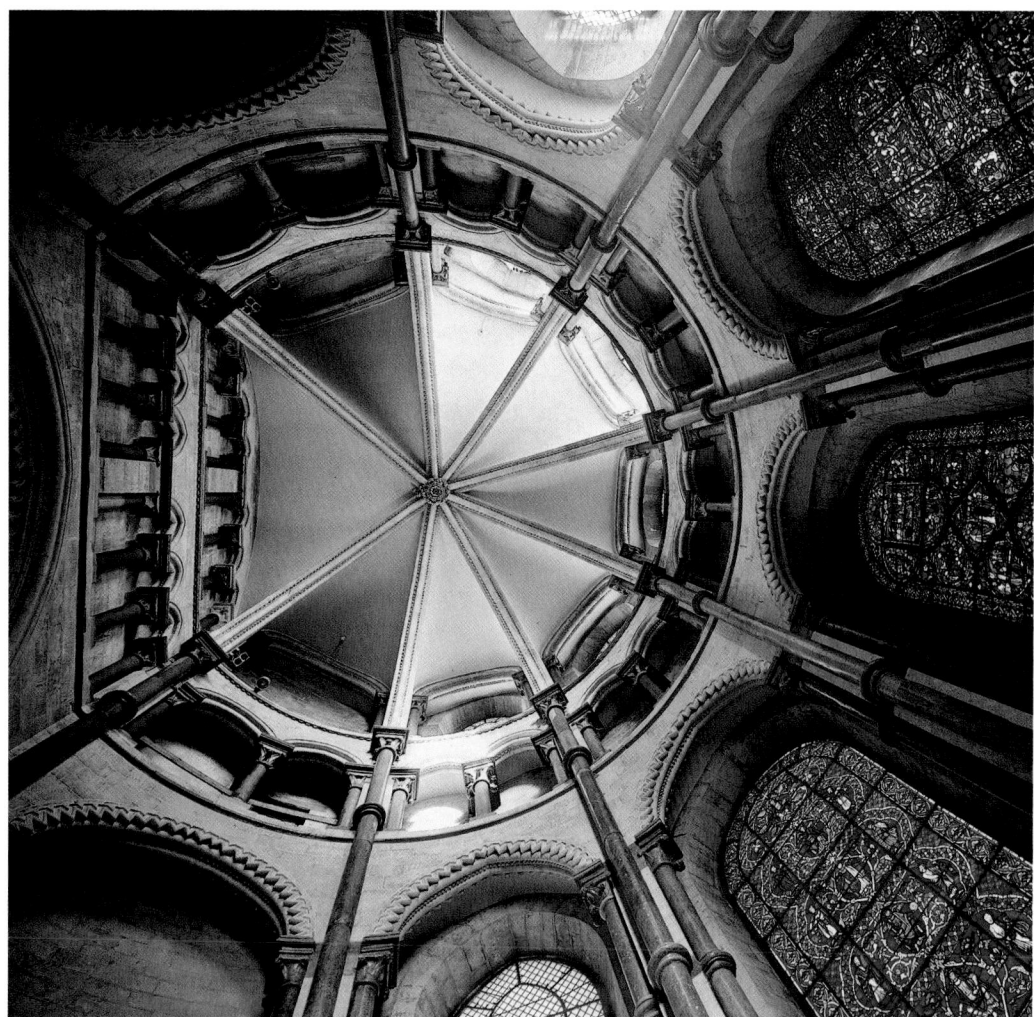

11.42 Vault, Corona Chapel, Canterbury Cathedral.

11.43 *Return of the Messengers from the Promised Land,* detail of window, Corona Chapel, Canterbury Cathedral, 13th century.

Thomas à Becket

Thomas à Becket (c. 1118–1170) was a close friend of King Henry II of England. He was appointed chancellor in 1155 and allied himself with Henry against the Church. Once elected archbishop of Canterbury (in 1162), however, Becket changed his allegiance, now siding with the Church in matters of taxation and legal jurisdiction. The conflict between the secular and ecclesiastical courts escalated and enraged the king. Henry is recorded as having declared in a fit of anger: "Is there no one who will rid me of this low-born priest?"

Four knights obliged. They rode to Canterbury and found the archbishop praying before the altar in the west transept of the cathedral. They killed him, and afterward Henry reportedly did penance for the murder. In 1173, Becket was canonized and became the object of a pilgrimage cult. The Corona Chapel (fig. 11.42) was built as a reliquary to house his scalp, which was severed from his head by the assassin's blow. In 1220, Saint Thomas's remains were transferred to the Trinity Chapel.

William the Englishman added two shrines—the Trinity and Corona Chapels—for Thomas à Becket (see box), whose cult attracted pilgrims to Canterbury (see box, p. 425). These additions made the plan more elongated and more complex than French Gothic cathedrals (fig. 11.41). The view of the ceiling of the Corona Chapel (fig. 11.42) shows the crownlike, octagonal organization of the vaults and the variations in the supports. Also distinguishing Canterbury from French Gothic and increasing its complexity is the combination of round and pointed arches in the same structure.

The stained glass in Canterbury Cathedral, on the other hand, is similar in style to French examples. Figures are elongated, outlined in black, and occupy a relatively flat space. The details illustrated here have typological content and also refer to the theme of pilgrimage. In *Return of the Messengers from the Promised Land* (fig. 11.43), two men shoulder a huge bunch of grapes and walk with a pilgrim's stick. The weight, centrality, and slightly cruciform shape allude to the Crucifixion, whereas the grapes refer to the Eucharist.

Solomon and the Queen of Sheba (fig. 11.44) was an iconographic type for the Adoration of the Magi. Both Sheba and the three kings travel from east to west, Sheba to visit Solomon and the Magi to see Jesus. This journey is symbolically replicated when one enters the cathedral and proceeds along the nave to the main altar supporting a crucifix. Solomon was a type for Jesus, who calls himself "the new Solomon" in the Gospel of Matthew. When the pilgrim traveled to Canterbury, it was to venerate the relics of Thomas à Becket as Sheba had bowed before Solomon and the Magi had knelt before Jesus.

11.44 *Solomon and the Queen of Sheba,* detail of window, Canterbury Cathedral, late 12th century.

Chaucer's *Canterbury Tales* (c. 1387)

The pilgrimage to Canterbury became the subject of one of the canonical works of English literature: Geoffrey Chaucer's *Canterbury Tales.* Chaucer (c. 1340–1400) held several offices at the English court and in April 1388 decided to make a pilgrimage to Saint Thomas à Becket's shrine. The *Canterbury Tales* is a work of some 17,000 lines in prose and verse, predominantly rhyming couplets. The General Prologue describes thirty-one pilgrims, including Chaucer, gathered at the Tabard Inn at Southwark, the main entry to London from the south. The innkeeper, who is joining them, offers a free meal to whoever tells the best tale. If each person tells two tales, he proposes, the way will seem shorter. They take him up on his offer and recount tales ranging from versions of myths and fables to popular stories of the time. Several tales are harshly satirical and criticize the corruption of both the Church and society.

The Prologue offers a vivid description of contemporary life. This is reflected in the broad spectrum of society represented by the pilgrims. They include a knight and a reeve (a bailiff or steward of a manor), a cook and a carpenter, a prioress and a pardoner (seller of indulgences). The most colorful character is the Wife of Bath, who extols the pleasures of the flesh, condemns celibacy, and enjoys her good fortune in having survived five husbands. Her tale, which is based on a medieval romance, reflects her philosophy. A convicted rapist is given one year to discover what women most want. An old hag offers him the answer in exchange for granting her one wish. He agrees, and she demands that he marry her. When they are in bed, she asks if he prefers her ugly and faithful, or beautiful and unfaithful. He leaves the decision to her, and she rewards him by becoming both beautiful and faithful.

Salisbury Cathedral

English Gothic, as in the different-colored stone and elongated plan at Canterbury, was typically more varied than French Gothic. Salisbury Cathedral (figs. **11.45** and **11.46**) was built from 1220 onward in a relatively homogeneous style. It has a cloister (**7** in fig. 11.45), a feature of monastic communities that the English adopted as part of their cathedral plans. In contrast to French cathedrals, Salisbury has a double transept and a square apse. Its chapter house (**8** in fig. 11.45) is octagonal, which also distinguishes English from French Gothic. The large square is a cloister attached to the south side of the cathedral. Apart from the cloister and a small porch on the north side of the nave, the plan is relatively symmetrical. The double transept and the square apse differ from the corresponding parts of a typical French Gothic cathedral.

Characteristic of English cathedrals, Salisbury is set in a cathedral close, a precinct of lawns and trees. Whereas French cathedrals usually rise directly from the streets and squares of a town, emphasizing their verticality, Salisbury is integrated into the natural landscape, with horizontal planar thrusts. It has fewer stained-glass windows and, therefore, less need for exterior buttressing. The view of the chapter-house ceiling (fig. **11.47**) shows the fanning out of the central pier into a vault that reverses the shape of the fan. The fan ribs join those of the vault and resemble the spokes of an inverted umbrella.

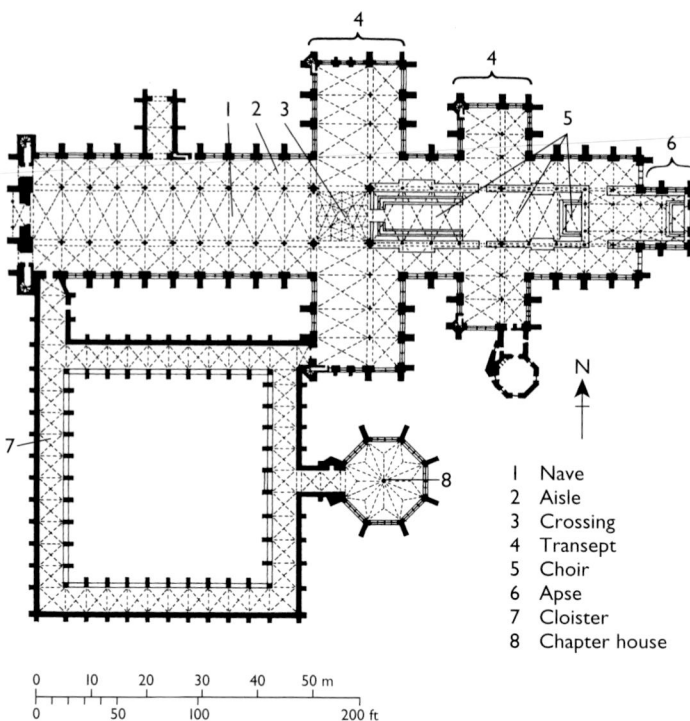

1	Nave
2	Aisle
3	Crossing
4	Transept
5	Choir
6	Apse
7	Cloister
8	Chapter house

11.45 Plan of Salisbury Cathedral.

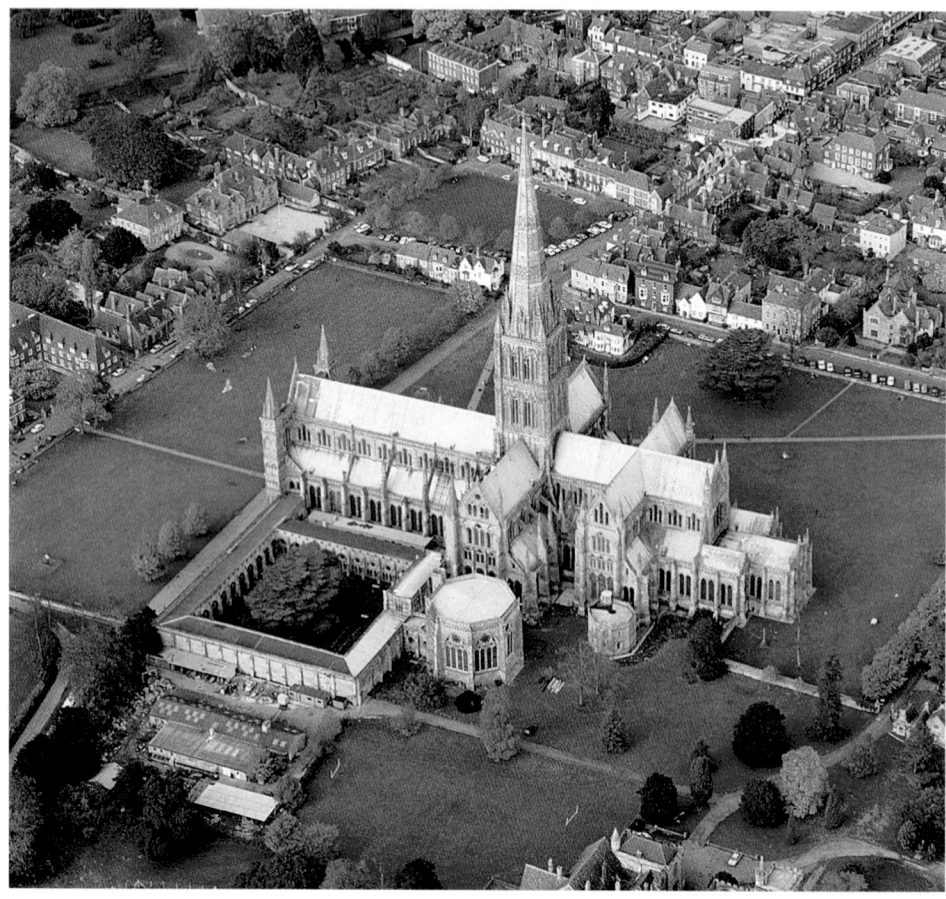

11.46 Salisbury Cathedral, England, begun 1220. The magnificent tower and spire were added in the 14th century.

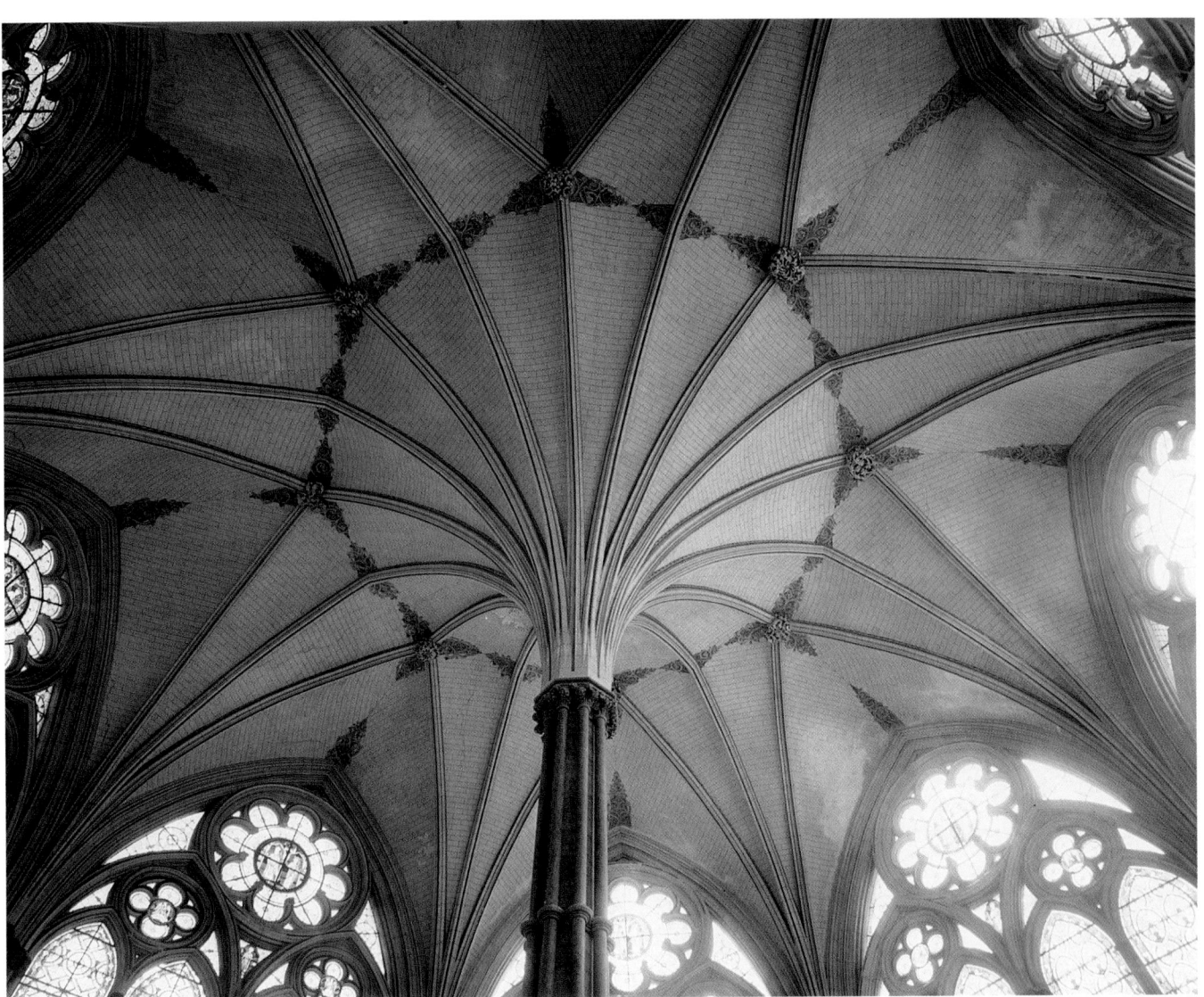

11.47 Vault, chapter house, Salisbury Cathedral, 1263–1284.

King's College Chapel, Cambridge

Fan vaulting became characteristic of English Gothic, one of the most spectacular examples being the chapel at King's College, Cambridge (fig. **11.48**). Its tall, unbroken supports exemplify the late Perpendicular style. The college was founded by Henry VI in 1440, and he was probably in-volved in the plan of the chapel, assisted by the resident master mason, Reginald Ely. As at Sainte-Chapelle, the weight of the walls is supported by external buttresses, which are masked by chapels on either side. William Words-worth's sonnet "Tax not the royal Saint with vain expense," written in 1822, was inspired by King's College Chapel and refers to the elegance and cost of such work.

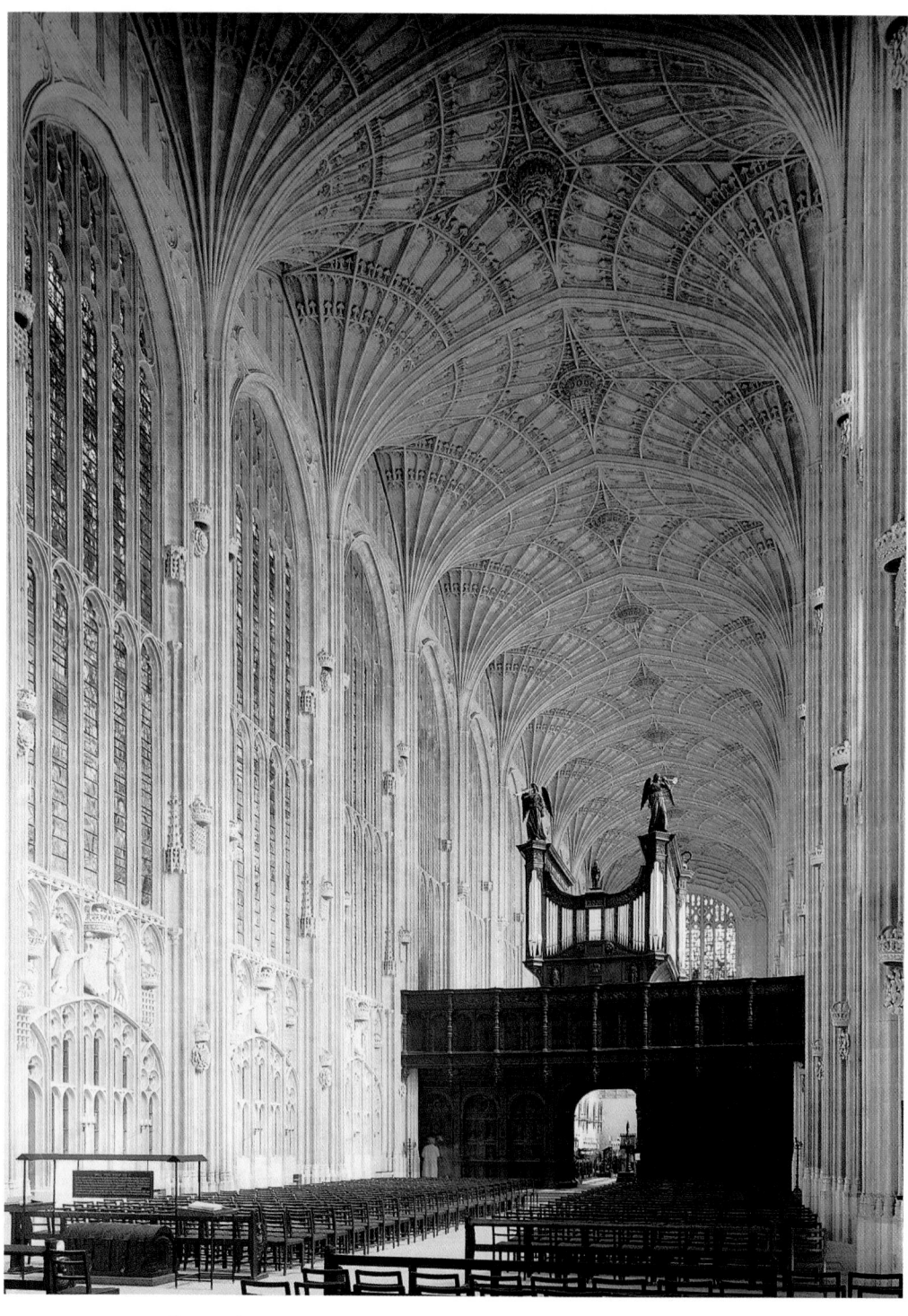

11.48 King's College Chapel, Cambridge, England. The chapel was founded in 1441, and its vaulting was designed by John Wastrell in 1508–1515.

The Spread of Gothic

In Italy, the Gothic style was a continuation of Italian Romanesque, but it was also influenced by French Gothic. A good example of early Italian Gothic is the façade of Siena Cathedral, which dates to around 1284–1299 (fig. **11.49**). It was designed by Giovanni Pisano (active c. 1265–1314), whose father, Nicola, is discussed in the next chapter. Although retaining the dark marble stripes of Italian Romanesque (see Chapter 10), the general organization of the façade is Gothic. There are three portals surmounted by sharply pointed arches, which recur in the triangular gables. A rose window dominates the center of the façade. In contrast to the French examples, however, most of the relief sculpture is on the tympanums. Other sculptures, on the gables and around the doors, are free-standing.

The largest Italian Gothic cathedral is in the northern city of Milan (fig. **11.50**). Begun in 1386, it is also one of the later examples of the style: the choir and transepts were not completed until 1450. The huge, imposing form looms over the square, combining massive size with delicate surface patterns. It is likely that the final structure reflects the debates between local Milanese architects and experts from France and Germany who advised on the project. The lacy effect of traceries, multiple windows, and thin, vertical spires is far more elaborate than the façade of the earlier, and more purely Italian, Siena Cathedral.

11.49 Siena Cathedral, Tuscany, Italy, 1284–1299.

11.50 Milan Cathedral, Milan, Italy, begun 1386.

11.51 Southeast view of Palma de Mallorca Cathedral, island of Mallorca, begun 1306.

In 1306, the enormous cathedral of Palma on the Spanish island of Mallorca was begun (fig. **11.51**). Here it is shown from the southeast, where it towers over the edge of the sea. It is one of many buildings inspired by the ouster of Muslims from major cities in southern Europe just before the middle of the thirteenth century. The cathedral is noteworthy for its huge buttresses as well as for the Islamic influence evident on the entrance arch.

Among the most notable examples of the Gothic style in central Europe is Prague Cathedral, commissioned in 1344 by Emperor Charles IV. The original designs were made by a Frenchman who died in 1356, and work was resumed by Peter Parler (1333–1399), a member of a family of master masons active in southern Germany. The view illustrated here (fig. **11.52**) shows the vertical emphasis of the pinnacled buttresses around the apse and the radiating chapels.

11.52 Apse, Prague Cathedral, Czech Republic.

In terms of secular architecture, the Doges' (Senators') Palace on the Piazza San Marco is characteristic of Venetian Gothic (fig. **11.53**). The first two stories of the façade consist of a lower portico surmounted by an open loggia. These create a striking pattern of light and dark formed by the slightly pointed arches and the lobed openings. The upper-story façade is a more solid wall, faced with a pink and white surface pattern that lightens its effect. Above

this is a row of slender pinnacles that repeat the intricate, curvilinear patterns of the lower levels. Because Venice had been for centuries an important seaport on the east coast of Italy, its architecture reflects the cosmopolitan character of the city.

Belgium, which was in the diocese of Cologne, in Germany, was well known for its town halls and guild halls. These reflected the commercial successes, especially of the

11.53 Doges' Palace, Venice, Italy. The façade dates from the 1420s.

cloth industry, in the fifteenth century. The town hall at Louvain (known in Flemish as Leuven), which dates to 1448, is another example of secular Gothic architecture. It has an elaborate façade with three towers, one at each side and a third over the central gable (fig. **11.54**).

In the nineteenth-century Neo-Gothic style (see Chapter 20), aspects of Gothic were revived, especially in England and America. Figure **11.55** is an aerial view of Saint Patrick's Cathedral in New York City, designed by James Renwick and William Bodrigue. It was built from 1858 to 1879, and the spires were completed in 1888. The basic elements of Gothic—a cruciform plan, a west–east orientation, pointed arches, and architectural layout—are retained. Nor has its imposing verticality been overshadowed by the much taller skyscrapers that were built subsequently.

11.54 Town hall, Louvain, Belgium, 1448.

11.55 Aerial view of Saint Patrick's Cathedral, New York, 1858–1879; spires, 1888.

Style/Period	Works of Art	Cultural/Historical Developments

1100

GOTHIC
12th century

Sainte-Chapelle

Saint-Denis (**11.1–11.2**), Paris
Canterbury Cathedral
(**11.39–11.40,
11.42–11.44**)

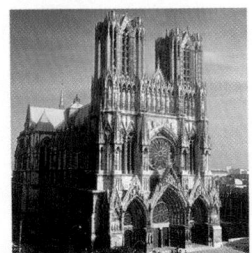

Reims Cathedral

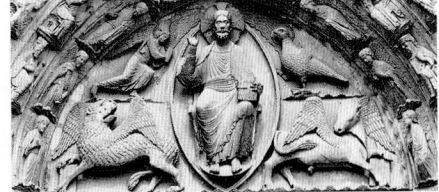

*Virgin of the
Annunciation*

Suger named abbot of Saint-Denis (1122)
Birth of Moses Maimonides, Jewish religious
 philosopher, 1134 (d. 1204)
Game of chess introduced into England (c. 1150)
University of Paris founded (1150)
First silver florins minted at Florence (1189)

Second Coming of Christ

1200

GOTHIC
13th century

Chartres Cathedral

Chartres Cathedral (**11.5, 11.11–11.13,
 11.17–11.22, 11.24–11.25**)
Reims Cathedral (**11.32–11.33, 11.35**)
Amiens Cathedral (**11.27–11.31**)
Salisbury Cathedral (**11.46, 11.47**)
Carpenters' Guild signature window (**11.8**),
 Chartres
Jeroboam Worshiping Golden Calves (**11.7**),
 Chartres
Sketchbook of Villard de Honnecourt
 (**11.9–11.10**)
Sainte-Chapelle (**11.38**), Paris
*Philip I Granting Privileges to Saint-Martin-des-
 Champs* (**11.36**)
Giovanni Pisano, Siena Cathedral (**11.49**)

King John signs Magna Carta (1215)
Dominican Order founded (1216)
Death of Francis of Assisi (1226)
Kublai Khan ruler of the Mongols (1260–1294)
Arabic numerals introduced into Europe (late 1200s)
Dante Alighieri, Italian poet, author of *The Divine
 Comedy* (1265–1321)
Jacopo da Voragine (c. 1228–1298) publishes *The
 Golden Legend*, a collection of apocryphal
 religious stories (1266–1283)
Marco Polo travels from Venice to China
 (1271–1295)
Thomas Aquinas writes *Summa Theologiae* (1273)
Rise of Florence as a leading commercial center
 (1280s)
Fall of Acre; end of Christian rule in the East (1291)

1300

GOTHIC
14th century

Reims Cathedral

Palma de Mallorca Cathedral (**11.51**)
Scene from the *Life of Saint Denis* (**11.37**)
Prague Cathedral (**11.52**)
Milan Cathedral (**11.50**)

Life of Saint Denis

Doges' Palace

Milan Cathedral

Carpenters' Guild window

1400 1500 1800

GOTHIC
15th century

Doges' Palace (**11.53**), Venice
King's College Chapel (**11.48**), Cambridge
Town hall (**11.54**), Louvain

Antichrist as a Three-Headed Tyrant (**11.23**)

NEO-GOTHIC
19th century

Saint Patrick's Cathedral (**11.55**), New York

Buddhist and Hindu Developments in East Asia and South Asia
(6th–13th centuries)

In 1210, the Mongols, central Asian nomads who were feared in Europe as the Antichrist, began their conquest of China (see map, p. 436). Leading the so-called Mongol hordes was Genghis Khan. Fifty years later, his sons ruled a vast territory. By 1279, his grandson Kublai Khan had founded the Yuan dynasty and become its first emperor. This conquest resulted in a unification of China, which would be ruled by khans until 1368. Under Mongol control, China continued to trade with western Europe, exporting silk cloth, ceramics, and carpets. These relatively transportable items exposed Europeans to Far Eastern art forms and motifs, some of which occasionally appear in Western art.

The Venetian merchant Marco Polo (c. 1254–1324) wrote an account of his travels in Asia; although its authenticity has been doubted, the Western image of the Far East during the thirteenth century was long based on this source.

Buddhist Paradise Sects

The Buddhist Paradise sects responsible for the change in the representation of the Buddha between the period of the Yungang caves and those at Longmen (see Window Four) fostered a new imagery in painting. Spectacular examples of paradise iconography from the eighth century have been found in caves at Dunhuang. Nearly 1,000 miles (1,609 km) west of Yungang, the Dunhuang oasis was the easternmost stop on the Silk Route in central Asia.

Buddha Preaching the Law (fig. **W6.1**) from Cave 17 at Dunhuang shows the rich, bright colors used to express the wealth of Amitabha's Great Western Paradise. The Buddha sits cross-legged under an elaborate

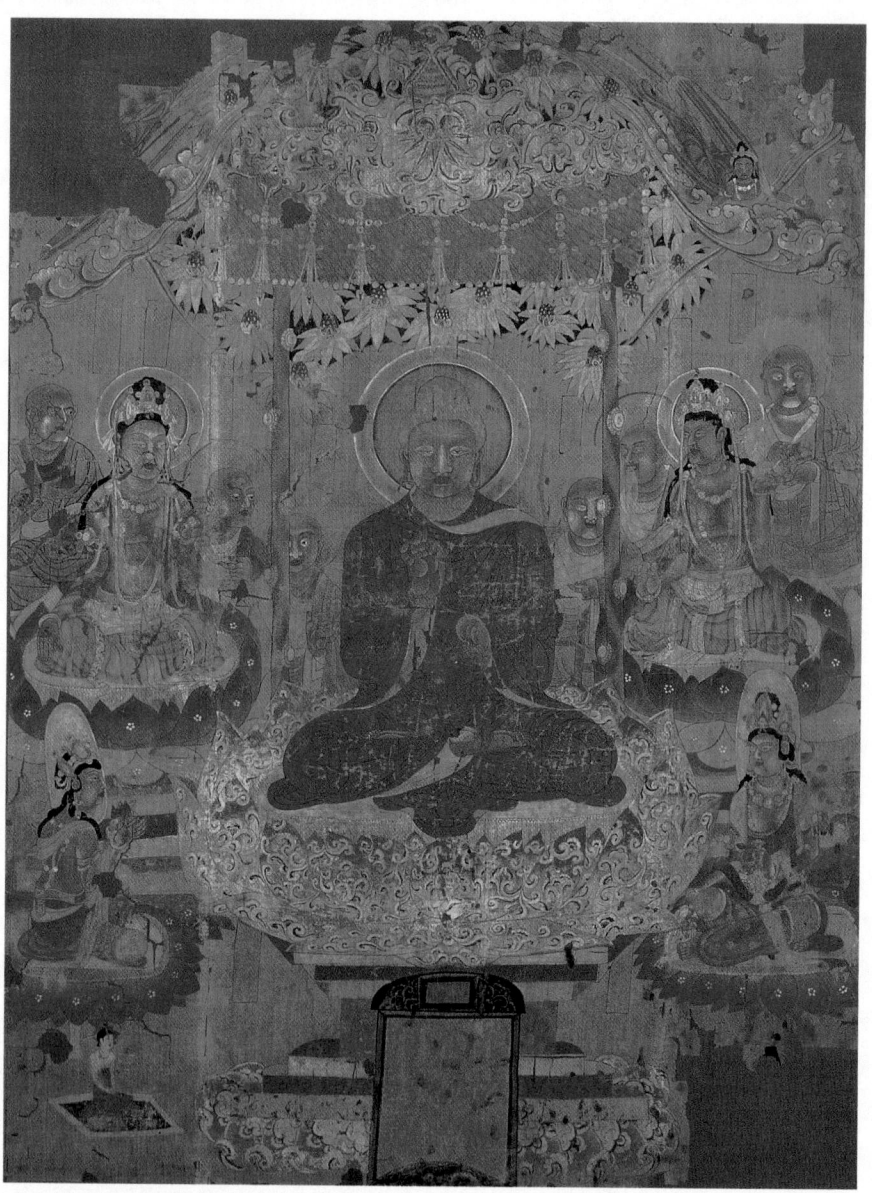

W6.1 *Buddha (Shakyamuni or Amitabha) Preaching the Law*, Cave 17, Dunhuang Province, China, early 8th century. Ink and colors on silk; 11 ft. 6 in. (3.50 m) high. British Museum, London. Both this Buddha image and the one in figure W6.2 were part of an important cache of manuscripts and art hidden by the monks of Dunhuang in the 11th century. It was discovered in 1907–1908 by Sir Aurel Stein, an English archaeologist, who sent as much of the hoard as he could to the British Museum in London. Many such banners were apparently produced in monastery workshops. They were sold to pilgrims as offerings to be laid in Dunhuang's famous Caves of the Thousand Buddhas. The blank space at the bottom of each image was intended for its donor's customized dedication inscription.

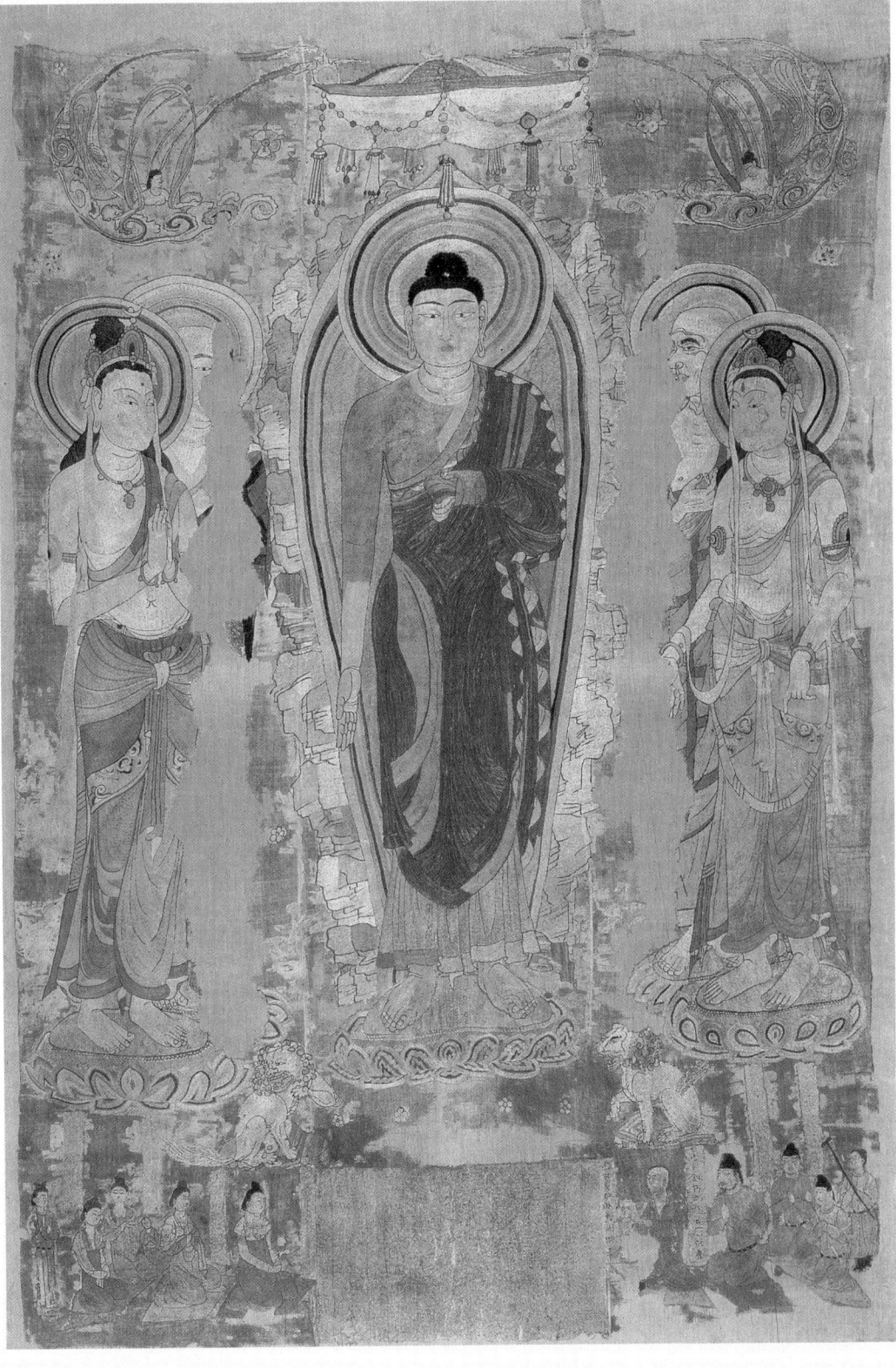

W6.2 *Shakyamuni Buddha Preaching on Vulture Peak,* Cave 17, Dunhuang Province, China, 8th century. Silk embroidery; 20 ft. (6.09 m) high. British Museum, London. This large image, created entirely of fine stitches in silk thread, demonstrates the high level of skill attained by Chinese embroiderers in rendering three-dimensional forms.

canopy on a lotus throne, which symbolizes *nirvana,* his blue hair contrasting sharply with the bright orange of his robe. Four elegantly attired bodhisattvas sit at the corners of his throne. Behind the Buddha, to the left and right, are two sets of three monks who appear to turn in space. Their small size indicates their lesser status, and four of the six reinforce the Buddha's central position and iconic quality by focusing their gaze on him. The tiny female donor in the lower left corner had a male counterpart on the right, but all that remains is his hat.

Among the doctrines related to the Paradise sects was Tiantai, according to which everyone could achieve buddhahood. This belief derived from the Lotus Sutra's doctrine that faith, rather than deeds, could lead to salvation. The silk embroidery of *Shakyamuni Buddha Preaching on Vulture Peak* (fig. **W6.2**) depicts the Buddha propounding the Tiantai Law, as described in the Lotus Sutra. He stands under a canopy on a small lotus throne, surrounded by a mandorla, against a backdrop of rocks representing the Vulture Peak. Two bodhisattvas stand on either side of him, with a pair of small lion guardians below. At the bottom of the image are tiny figures of donors.

The Pagoda

The interiors of many of the Yungang and Dunhuang caves contained multistoried towers. These became the characteristic Buddhist structure of the Far East (China, Korea, and Japan; also known as east Asia). Beginning in the seventh century, **pagodas**—as they were called by the Portuguese living in India—were a synthesis of Indian stupas and Chinese military watchtowers. Like stupas, pagodas have a reliquary function and a setting that leaves enough space for worshipers to circumambulate them, although later Far Eastern pagodas can actually be entered. The pagoda was conceived in sections that were stacked one on top of the other and tapered toward the top. Each section had an eavelike cornice projecting over it. A pyramidal form at the top was surmounted by a vertical element symbolizing the axis pillar of the World Mountain. Inside the caves, these spires merged into the roof.

The pagoda developed from an interior towerlike structure into an exterior, freestanding one made of wood, brick, or stone in several variations on the basic form. Some types were extremely elaborate. The individual tiers ranged from two to fifteen in number, although seven was standard. An early eighth-century pagoda with nine tiers

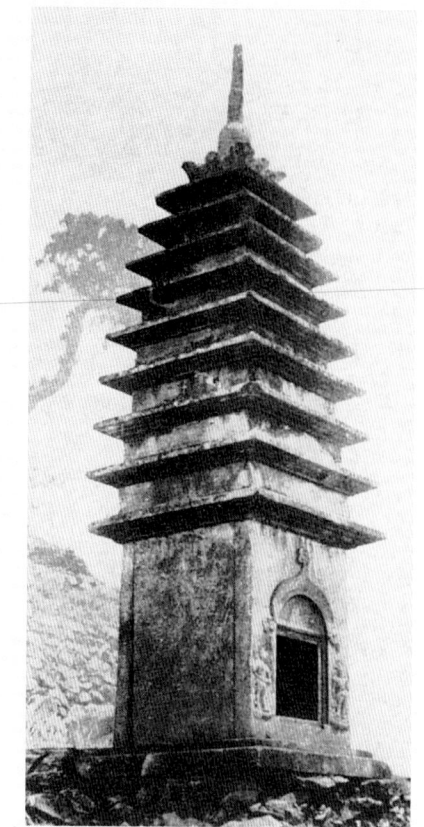

W6.3 Pagoda, Yunshusu, Mount Fang, Hopei (Hebei) Province, China, early 8th century.

is illustrated in figure **W6.3,** while the mid-eleventh-century example in figure **W6.4** has thirteen.

Very little early Chinese architecture survives, but its descendants are

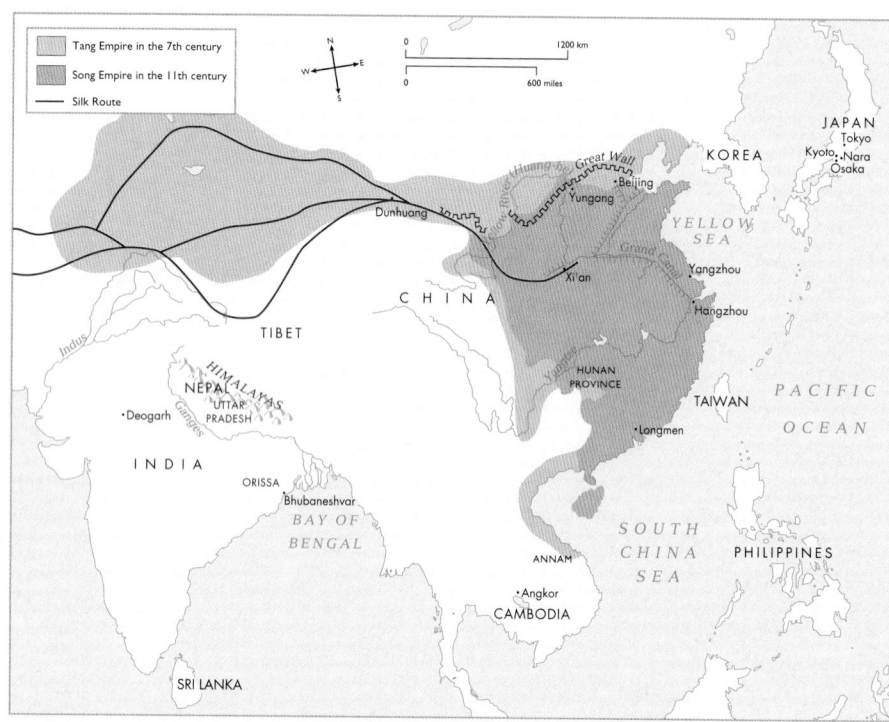

East Asia.

W6.4 Pagoda, Kaifeng, Hunan Province, China, mid-11th century.

found elsewhere in the Far East. From early on, the pagoda was assimilated throughout east Asia into Buddhist architectural complexes, especially monasteries. Besides signifying the spiritual force of Buddhism, the pagoda was believed to represent the passage of time. Relics embodied the past, the structure itself the present, and its height the future aspirations of faith. Like the towers of Gothic cathedrals, pagodas were the tallest part of Buddhist monasteries and were thus visible from afar. In each case, the vertical plane functions as a visual statement of presence, power, and piety.

The Buddhist Monastery: Horyu-ji

Buddhism reached Japan from China through images and sutras sent by the Korean kingdom of Paekche in the middle of the sixth century. Chinese culture was of great interest to Japan at the time. The imported religion flourished under the patronage of Japan's first great leader, Prince Shotoku (574–622). He founded what became the monastery of Horyu-ji (*ji* meaning "temple") in Nara (which from 710 to 784 was the capital of Japan), 25 miles (40 km) east of Osaka.

Horyu-ji's five-tiered pagoda (*Goju-no-to*), dating from the late seventh century, is a good example of a pagoda in a monastic community (fig. **W6.5**). The gently sloping hills on the outskirts of Nara provide a natural enclosure for the monastery complex (fig. **W6.6**), which not only is the earliest surviving Buddhist architectural group in Japan, but also includes the oldest wooden temple in the world. In addition to the pagoda, the small complex consisted of a **kondō** (the Golden Hall; fig. **W6.7**), a cloister, temples, living quarters for the monks, and a gate. The complex was arranged on an east–west axis that ran from the gate, between the *kondō* and the pagoda, to a refectory (now destroyed). The pagoda faces the *kondō,* creating a balance of asymmetrical structures.

The *kondō* (fig. W6.7), also derived from a Chinese building type, is supported by a stone plinth oriented to the cardinal points of the compass. Stairs at the center of each side lead to double doors. The basic elevation is post-and-lintel, with the lintel inserted into the upper part of the post (figs. **W6.8** and **W6.9**). The points where the post and lintel join are reinforced by brackets decorated with carvings. Such brackets channeled the thrust of the tile roof through the wooden posts and into the main foundation supports, and remained a strong design element in later Japanese architecture. By making the inner posts taller than those at the ends, it was possible to create a curved roof supported by the extended, projecting (**cantilevered**) lintels.

W6.5 Five-storied pagoda (*Goju-no-to*), monastery of Horyu-ji, Nara, Japan, late 7th century.

W6.6 View of the monastery of Horyu-ji, Nara, Japan, late 7th century. Prince Shotoku's original temple complex was burned in 670 and rebuilt nearby as the monastery of Horyu-ji.

W6.7 *Kondō* (Golden Hall), Horyu-ji, Nara, Japan, late 7th century.

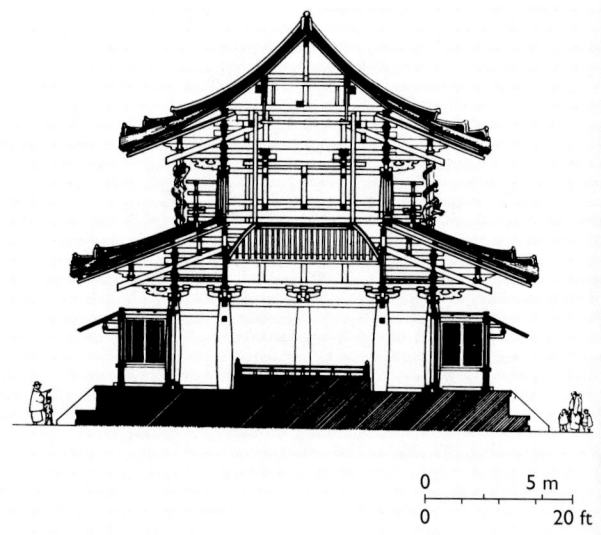

W6.8 Diagram section of the Horyu-ji *kondō*.

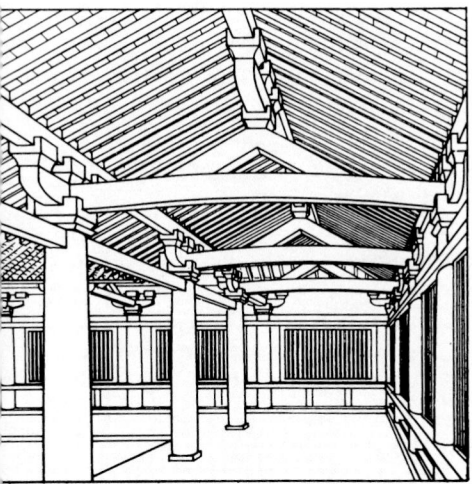

W6.9 Drawing of part of the Horyu-ji *kondō;* gallery, showing post-and-lintel construction.

Hinduism

Hinduism is the only major religion without a founder, being based on an accumulation of sacred and devotional texts, myths, rituals, and practices. Its origins lie somewhere in the second millennium B.C., following the Aryan invasion of the Indian subcontinent. Hindus conceive of the universe as cyclical, destroyed by fire, and dissolving into the ocean at the end of each cosmic age, to be reborn again and again. This universe is conceived of as an egg, separated into three regions where gods, humans, and demons—the forces of order on the one hand and of chaos on the other—battle for control. Hinduism recognizes this cosmic struggle as a necessary, even desirable, search for balance between opposing forces.

The Hindu gods appear in many manifestations, and in art the varied iconography of a single deity represents its different aspects. Often, like Vishnu (see fig. W6.12), the gods are represented with multiple limbs and heads as a sign of their superhuman powers. Each deity is believed to embody a truth that transcends its physical guise, and images are a conduit for bringing the divine world into contact with the human world. By making sculptures of the gods beautiful—following certain canons of proportion and form, clothing and anointing the figures, and so forth—deities can be induced to inhabit their representations. Priests chant in Sanskrit, the sacred language of Hinduism, pray, and make offerings to attract the gods.

The Hindu pantheon is vast and includes deities assimilated from indigenous nature cults (such as *yakshas* and *yakshīs*), as well as from early Aryan religion. The abode of the gods is Mount Meru, the mythical World Mountain whose axis links earth to heaven. A trio of male gods is responsible for the great cycles of cosmic time: Brahma (the Creator), Vishnu (the Preserver), and Shiva (the Destroyer). Each has a powerful female energy, his *shakti.* While Hindus identify themselves as either Vaishnavite or Shaivite (devotees of Vishnu or Shiva, respectively), they honor multiple deities.

Embodying the multiplicity characteristic of Hinduism, Shiva is both destructive and creative. He is associated with male sexual energy and procreation (worshiped in the form of a *lingam,* or phallus, or in anthropomorphic guise astride his bull, Nandi), as well as with asceticism and sacred texts (in the form of a meditating yogi with matted hair, clad in an animal skin). He is the three-eyed lord of the beasts and of the battlefield (symbolized by his trident), and patron god of the arts. His consort is Uma, daughter of the Himalaya Mountains. Their elephant-headed, pot-bellied son Ganesh is popularly worshiped as the remover of obstacles.

Vishnu keeps the universe in equilibrium. According to the creation myth illustrated in figure W6.12, he dreams the plan of the universe at the beginning of each cycle of existence—hence, we are living Vishnu's dream, and what we perceive as reality is actually illusion. Vishnu has ten *avatars,* or manifestations, among them a fish, tortoise, boar, man-lion, a dwarf who encompasses the universe in three strides, and Rama, the hero of the *Ramayana* epic. (Hanuman, a monkey-general who helps Rama, is a popular god.) Vishnu's best-loved *avatar* is Krishna, the blue-skinned, flute-playing erotic trickster god. In each of these forms, Vishnu saves the world from destruction by demons. To upstage Buddhism, its younger rival, Hinduism, incorporated the Buddha as another *avatar* of Vishnu.

Among Hinduism's many important female deities are Sarasvati (goddess of learning) and Lakshmi (goddess of fortune). The holy rivers Ganga (Ganges) and Yamuna (Jumna) are worshiped as fertility goddesses. Collectively, Hindu goddesses may be thought of as embodying aspects of Devi, the Great Mother. Like Shiva, Devi is both creative and destructive: she is a voluptuous, maternal nurturer, and she is also Kali, the skeletal, bloodthirsty hag who eats children; she is both a subservient consort of a male god and Durga, the superwarrior whose strength combines that of the male gods to defeat an otherwise invincible Buffalo Demon. Devi is also worshiped in the ancient form of the Sapta Matrikas, the Seven Mothers. She is closely associated with nature and fertility, and is sometimes represented as a *yoni* (female sex organ) encircling a *lingam,* thus symbolizing the conjunction of female and male energies. Outside mainstream Hinduism, goddess worship is a powerful force in esoteric Tantric sects (Buddhist as well as Hindu), whose practices may include ritual sexual intercourse and offering sacrificial animal blood to the goddess.

One of the central Hindu beliefs is reincarnation leading to *nirvana,* the ultimate release from the cycle of rebirth, when the soul unites with the cosmos. Each incarnation is a stage in the long journey toward liberation from this illusory world, and progress toward nirvana depends on *karma,* the quality of behavior in a current or previous life. While in the world, everyone is ruled by *Dharma,* the Law, in addition to which each hereditary social class (*varnas,* or caste) has its own code of conduct. Society is divided into an elite, ritually pure Brahmin caste, whose men are traditionally priests; a warrior and ruler Kshatriya caste; an artisan and merchant Vaishya caste; and a peasant Shudra caste. Those beneath caste, considered ritually polluted, were known as Untouchables until they were renamed Harijans (Children of God) by Mahatma Gandhi (1869–1948) in an attempt to improve their social status. While hereditary caste is no longer all-important in the lives of Hindus, one must still be born Hindu in order to be Hindu.

For Hindus, art is an expression that transcends the individual artist. The creation of religious art is a hereditary vocation and an act of devotion, an offering to the gods. Hindu artistic activity centers around temples, much as the cathedral towns of medieval Europe were a focus of Christian artistic production. Some Hindu artists were organized into guilds, which tended to be composed of family groups and within which skills were passed from one generation to the next. The guilds set ethical and artistic standards as well as rules regulating the lives of their members. They set prices and arranged contracts. Duties were strictly divided by rank, including those of the chief architect (*sutradhara*), the general overseer, the head stonemason, and head image maker (sculptor). Each supervised a particular group of workers. Brahmins, who were expert in art theory and iconography, were in charge of quality and content. The Vaishyas under them were regarded as skilled laborers.

Artists and their families who lived and worked at temple sites were so numerous that thriving communities grew up around them. Since temples were the intellectual as well as spiritual centers of their communities, schools were established, and festivals were held in their vicinity.

The financing of Hindu temple construction was primarily in the hands of royal patrons. It was supported by donations of money, cattle (sacred to Hindus), objects of value, land grants, and services from others. Contributions to temples were partly motivated by the donor's hope of accumulating good *karma* and of receiving divine assistance. Since Hindu temples amassed considerable wealth, which included land, they became major employers and landlords. In southern India, there are vast temple complexes that were once cities within cities, employing hundreds of specialized artists.

The Hindu Temple

The roots of Hinduism predated Buddhism in south Asia by some fifteen hundred years, and the newer faith borrowed many ideas and artistic motifs from the older one. Hinduism also spread to other regions, particularly to southeast Asia, although to a lesser degree than Buddhism.

The earliest sacred structures on the Indian subcontinent may have been *vedikās* (railings) that surrounded trees and stones to mark places of spiritual significance. As Vedic religion developed, Brahmin priests constructed temporary, open-air fire altars according to a strict geometric system. Hindu temple architecture evolved from these two traditions. (Although fire altars are rarely built today, the ancient practice of worshiping at very simple outdoor shrines continues.)

The sophisticated mathematics of Hindu temples was codified in texts called *Shilpa shastras,* in which temples were conceptualized as both anthropomorphic forms and as mandalas (cosmic diagrams connecting the human world with the celestial). The temples are believed to concentrate divine energy and anchor sacred space along a world axis.

Basically, Hindu temples, like Greek temples, are houses for deities. Images abound, and worship takes place throughout temple precincts. A temple's main cult image is contained within its inner sanctuary, or *garbha griha* ("womb chamber"), which is a small, windowless, cube-shaped *cella*. This dark, intimate space is typically perfumed with incense and lit by the glow of oil lamps. Priests and worshipers perform *puja*—devotions. The protective, womblike function of the Hindu temple is reflected by the thickness of the ceiling and the *cella* walls.

Hindu worship is not congregational in the Western sense. Instead, priests perform elaborate sacred rites on behalf of their communities. *Puja* at a temple begins with sunrise, when a priest opens the chamber of the "womb" and salutes the door guardians. In a ritual involving all the senses, he sounds a bell and claps to expel negative spirits, arouse the deity or deities, and announce his presence. He then chants hymns and *mantras* (ritual sacred formulas), accompanied by *mudrās* (symbolic hand gestures). Vessels are readied for the cleansing and dressing of images, which are anointed, draped with garlands, and offered specially prepared food. When the priest has completed his ceremonial duties, he circumambulates the statue clockwise, bows, and leaves the sanctuary.

For Hindus, the temple was one stop on a long metaphorical journey in the quest for spiritual perfection. In the course of this journey, worshipers progress from a large to a small space, from natural light to a dark interior, and from the illusory complexities of the material world to spiritual simplicity.

These beliefs are reflected in the concepts underlying temple construction. First, a sacred site is chosen—a grove for its links to early tree cults, a river for its life-giving water, or a mountain by association with Mount Meru. Several years are then dedicated to purifying the ground and ridding it of evil and impure spirits. Sacred cows graze on the site in order to enhance its fertility. The ground plan is thought of as a mandala, which maps divine space. This is a geometric "picture" of the pantheon and a miniature manifestation of the cosmos in which the temple represents Mount Meru. After its plan has been laid out, a temple's proportions are arranged according to a unit of measurement deemed to be in alignment with cosmic harmony. Finally, foundation stones are placed in the ground, and construction begins (see box).

The materials of which Hindu temples are built, like the Hindu social structure, were conceived of hierarchically in the early *Shilpa shastras*. Some recommended stone and wood for the higher classes of society, while others related materials to gender. Generally, however, most Hindu temples were of stone, and the color of the stone was associated with a particular caste—white being reserved for Brahmins. Either stone was quarried and bricks baked near a building site, or the materials were floated to the site on barges or brought on wood rollers by elephants. Stone blocks were shaped by masons and hauled up onto the structure by a pulley system. They were then held in place with iron clamps. In what remained basically a post-and-lintel elevation system, Hindu temples had projecting lintels made possible by the strength of the clamps. The main supporting elements were stone columns, and doors were of wood. Window bars were stone copies of wooden prototypes. Hindu temple

architecture is characterized by a wealth of regional variations on two general temple types—the northern and southern—differing primarily in the forms of their towers.

The Vishnu Temple
(6th century)

The early sixth-century Temple of Vishnu at Deogarh, in Uttar Pradesh (figs. **W6.10** and **W6.11**), exemplifies early northern-style Hindu temples. This relatively simple, one-chambered structure was crowned by a *shikhara* (northern-style tower), most of which is now in ruins. Its cubic *garbha griha* stood on a raised plinth and was accessible by a stairway on each side. The dark corner rectangles on the plan mark lesser shrines dedicated to different gods. The temple's relief sculpture, with its rounded, rhythmically swaying forms, embodies the classic Gupta style. In the

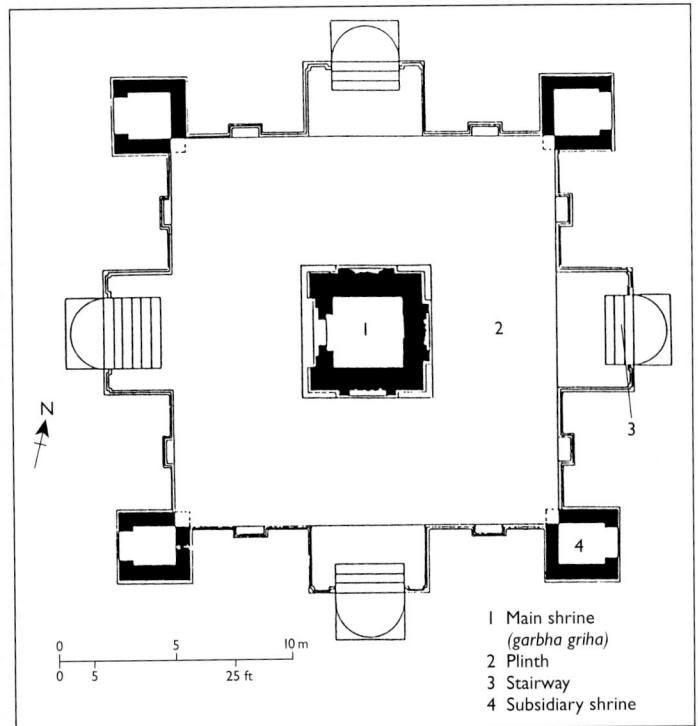

1 Main shrine
 (garbha griha)
2 Plinth
3 Stairway
4 Subsidiary shrine

W6.11 Plan of the Temple of Vishnu, Deogarh, Uttar Pradesh, India, early 6th century.

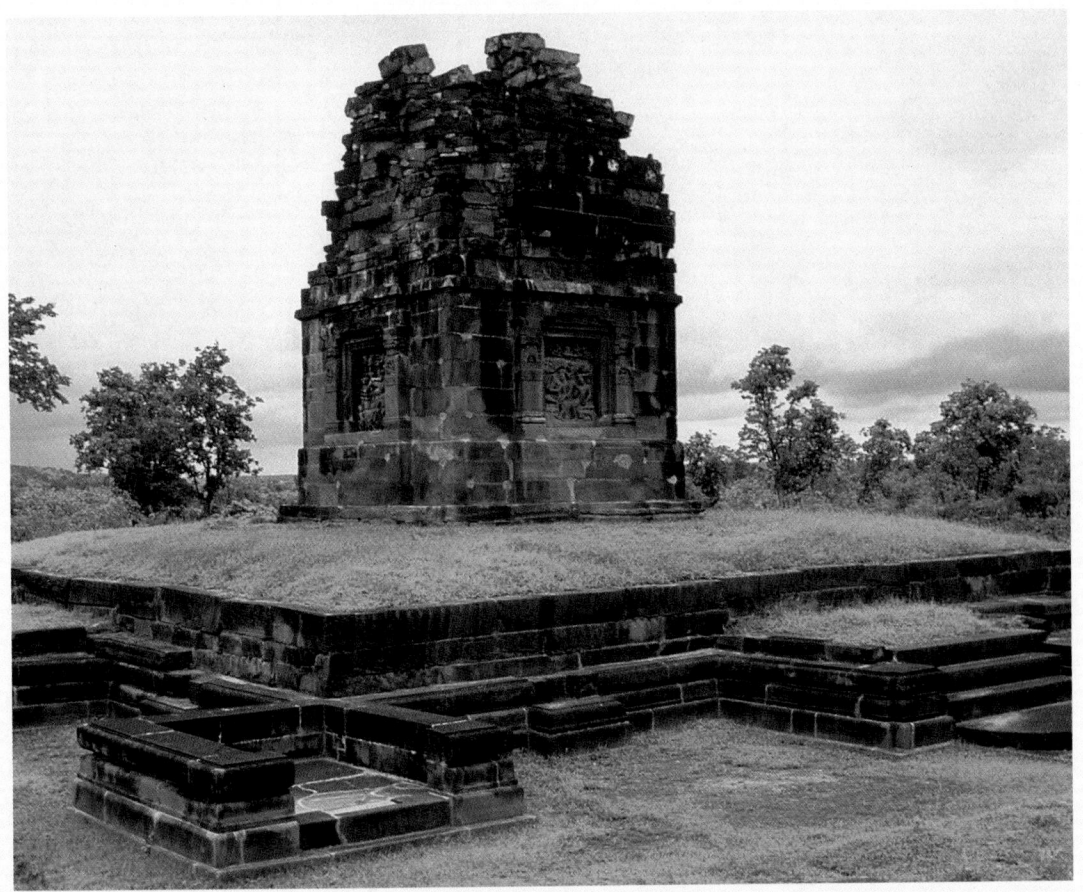

W6.10 Temple of Vishnu, Deogarh, Uttar Pradesh, India, early 6th century.

view shown here, one of the framed panels containing reliefs is visible.

The relief panel of *Vishnu Sleeping on Ananta* (fig. **W6.12**), on the south side, depicts the origin of the universe and the forces of evil within it. The large reclining figure of Vishnu, whose four arms reflect his powers, dominates the image. Crowned and jeweled, he dreams the universe into existence as he sleeps on Ananta, the Endless Serpent encircling the world, whose cobra hood frames the god's head. Holding Vishnu's foot is his wife, Lakshmi, the goddess of fortune. As his *shakti,* she represents his female nature, which energizes his male self to conceive of, and give birth to, the universe. Time is set in motion when a lotus flower emerges from Vishnu's navel. Among the gods at the top of the relief, the first deity, the four-headed Brahma, sits on the lotus. Holding the tools of a builder, he will construct the world. The four figures below Vishnu to the right represent the god's weapons and prepare to do battle against two demons, Madhu and Kaitabha, at the left. The demons were born from Vishnu's ear, and tried to destroy Brahma, but Vishnu killed them instead.

The doorway at the west of the temple that leads to the *garbha griha* (fig. **W6.13**) is framed by a series of elements. The lintels and doorjambs are decorated with reliefs of foliage and various theological guardians. Within the upper corners, the river goddesses Ganga and Yamuna bless the sanctuary by pouring their waters over the threshold. Set in a square panel over the doorway is Vishnu enthroned on Ananta's coils. Here, as in the large relief on the south, Lakshmi strokes his foot to stimulate his cosmic dream.

The Orissan Temple
(8th–13th centuries)

By the eighth century, Hindu temples had become extremely complex structures. They varied according to period, region, patronage, and cult affiliation. From the eighth to the thirteenth centuries, Orissa, in eastern India, was a center of architectural development with a relatively consistent evolution of style. Figure **W6.14** is a diagram of the elevation of a typical Orissan temple, which shows the extent to which architectural style had become elaborated.

The mid-tenth-century Mukteshvar Temple of Shiva at Bhubaneshvar (figs. **W6.15** and **W6.16**) illustrates the Orissan version of northern-style temple architecture. This is the only one of India's famed "temple-cities" to survive. It originally had some seven thousand temples, of which about five hundred still exist, as do some of the *Shilpa shastras* on which they were

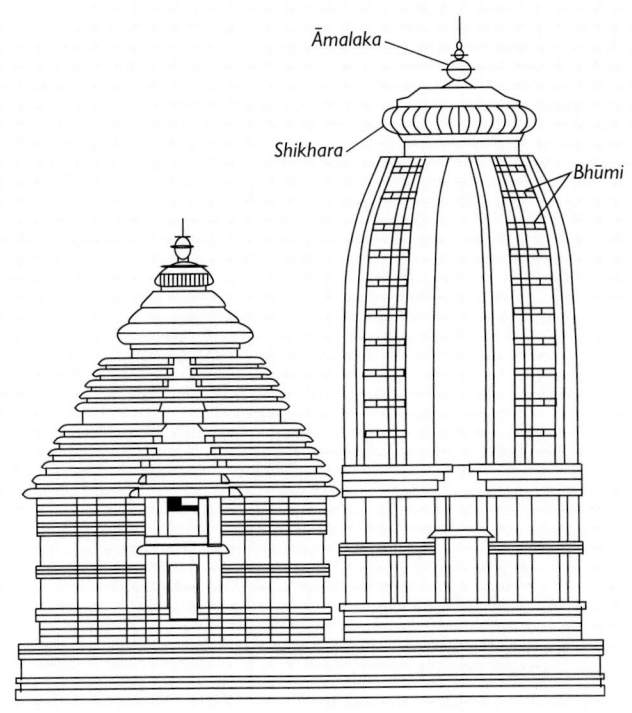

W6.15 Elevation of a typical Orissan temple.

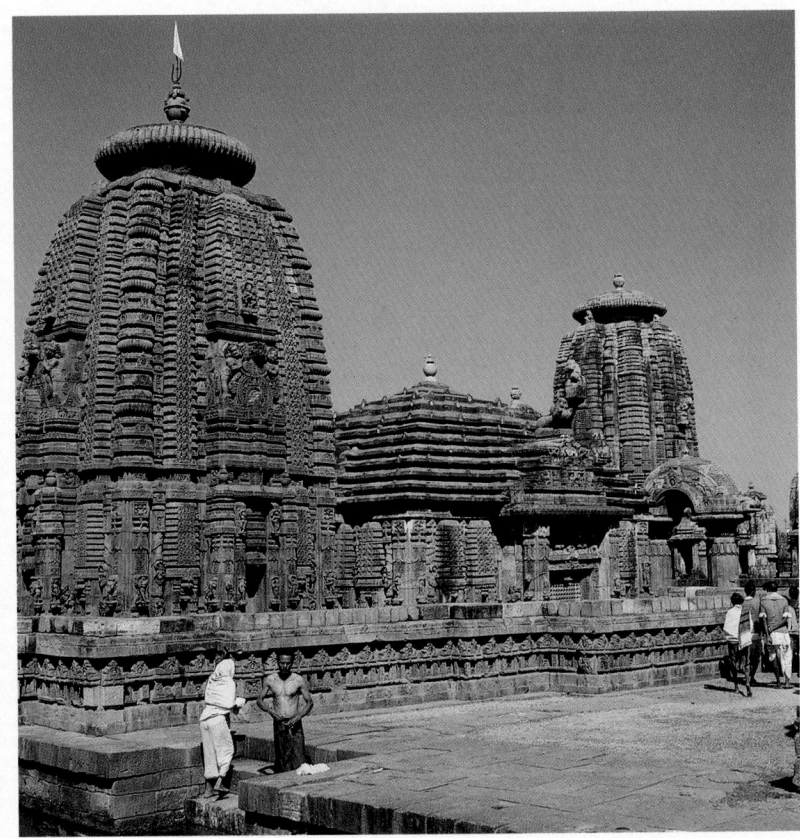

W6.14 Mukteshvar Temple of Shiva, Bhubaneshvar, Orissa, India, c. 950. Sandstone. The temple compound is entered through a *torana* (gateway) on the right. Inside the *garbha griha* at the heart of the temple, the focus of worship is a Shiva *lingam* inside a *yoni*. At the far left is a sacred water tank used for ritual bathing.

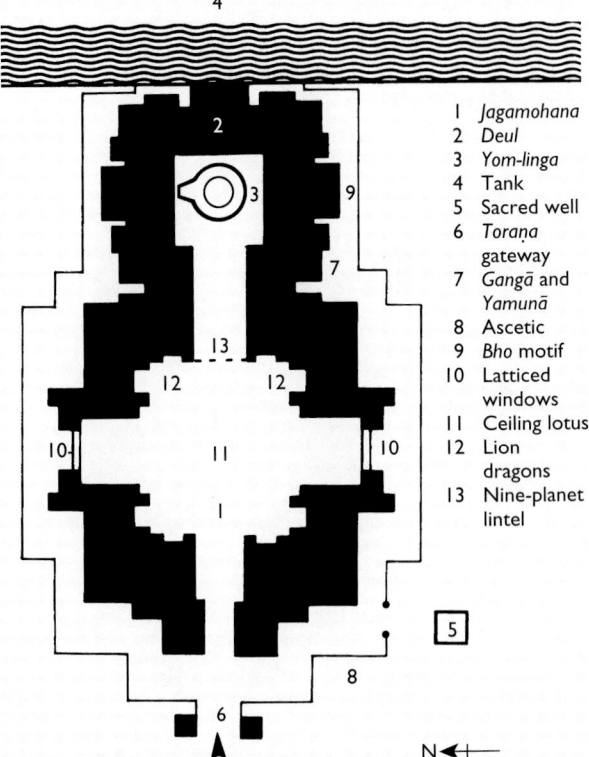

1 *Jagamohana*
2 *Deul*
3 *Yom-linga*
4 Tank
5 Sacred well
6 *Torana* gateway
7 *Gangā* and *Yamunā*
8 Ascetic
9 *Bho* motif
10 Latticed windows
11 Ceiling lotus
12 Lion dragons
13 Nine-planet lintel

W6.16 Plan of Mukteshvar Temple of Shiva, Bhubaneshvar, Orissa, India, c. 950.

based. This view of the exterior shows the towering superstructure that rises over the *garbha griha*. The tower consists of a lobed *shikhara,* surmounted by an *āmalaka* (finial in the shape of a notched ring). An assembly hall (**mandapa**) has also been added. The projecting veranda was used for meditation and reading as well as for dancing and ceremonies. The slightly convex outline of the exterior, which has been referred to as "expanding form," is an architectural expression of *prana.* This small temple's vertical and horizontal planes are unified by the carved detail covering its surface. The repetition of stacked ridges (**bhūmi**) on the superstructure is complemented by a rich variety of organic and abstract forms designed to welcome Shiva.

The meaning of these forms is associated with the Hindu concept of the temple as a manifestation of Mount Meru; the very term for the towers, *shikhara,* means "mountain peak." The term *bhūmi,* meaning "earth" (in the sense of "soil"), has similar symbolic connections with landscape. The crowning *āmalaka* symbolizes the spiritual heights achieved when one transcends the reincarnation cycle. As an elaboration of the ancient Indian axis pillar, this finial was placed directly over the *garbha griha* so that the most sacred and highest points of the temple were in alignment.

Synthesis of Buddhism and Hinduism at Angkor

Hinduism and Buddhism spread from India to southeast Asia and were assimilated into the local belief systems. Under the Khmer Empire (sixth to thirteenth centuries) in Cambodia, the main local contribution to the imported religions was the cult of the Devaraja (god king), in which Hinduism and Buddhism merged. The royal Khmer capital was the city of Angkor, founded by the late ninth-century king, Indravarman. His rule was notable for the development of an irrigation system that made rice the economic backbone of Cambodia during the Khmer period. Under the patronage of Indravarman, characteristic Khmer architectural features were first established. These included temple complexes consisting of several buildings united in an axial plan. Relatively modest at first, these royal temple complexes grew in size and splendor as each Devaraja sought to outdo his predecessor.

Angkor Wat (12th century)

In the twelfth century, Khmer architecture culminated in the massive complex of interconnected waterways, roadways, terraces, monastic buildings, and shrines called Angkor Wat (*wat* meaning "temple"). These were built in gray-black sandstone, under the patronage of Suryavarman II (ruled c. 1113–1150), and dedicated to Vishnu. The temple's central icon depicted Suryavarman in the guise of Vishnu. The plan of the central complex (fig. **W6.17**) shows the characteristic rectangle arranged in an east–west orientation and

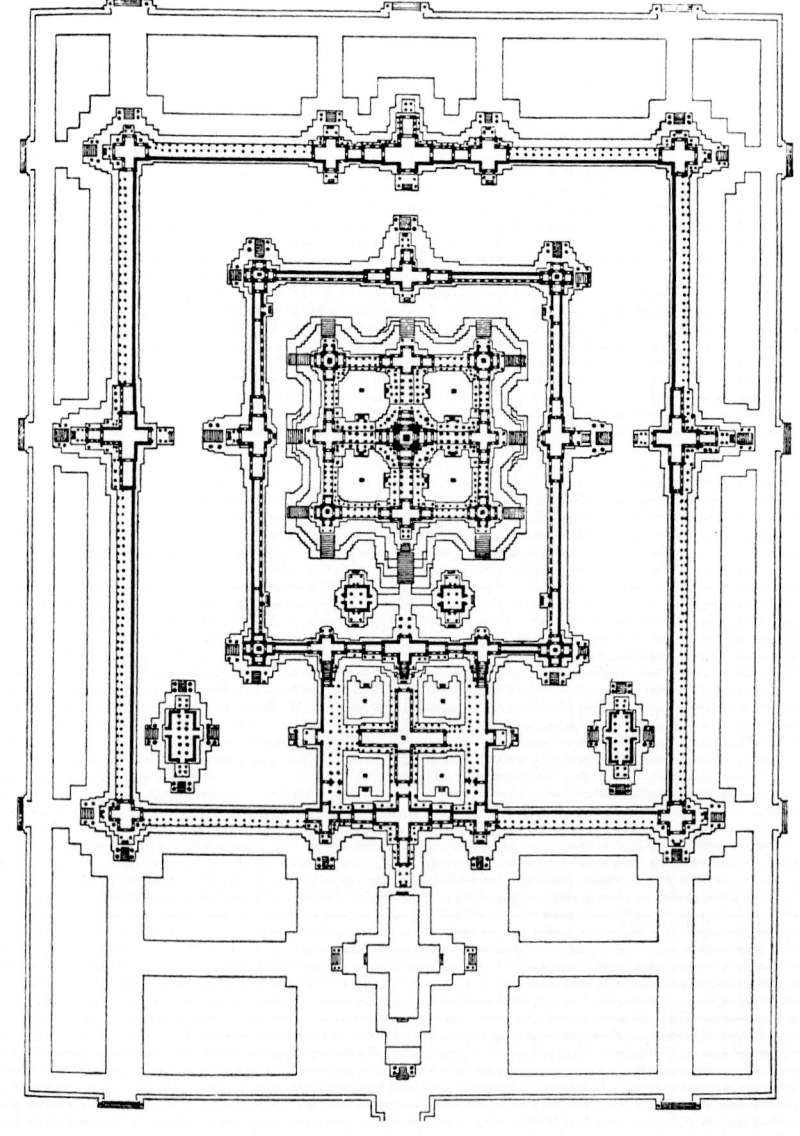

W6.17 Plan of the central complex at Angkor Wat, Cambodia, c. 1113–1150.

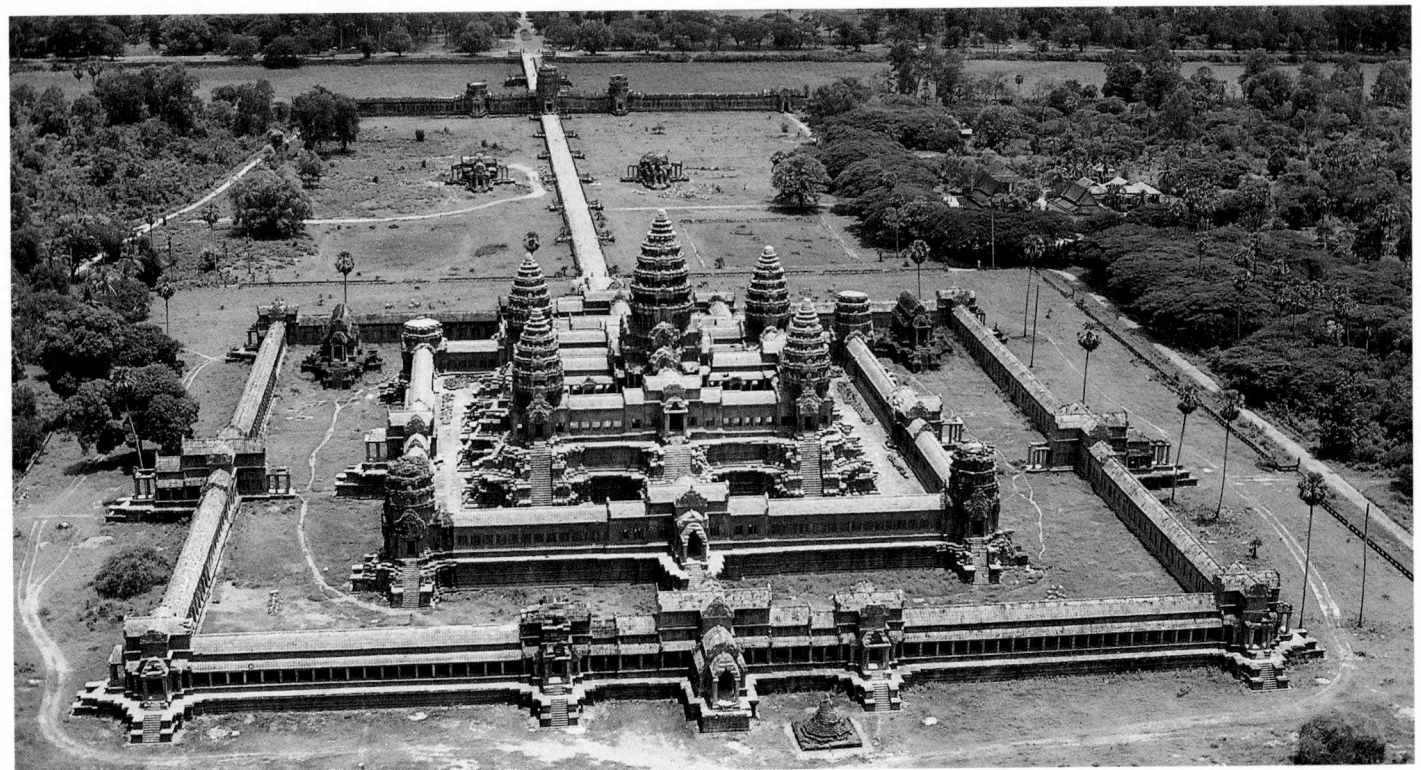

W6.18 Aerial view of Angkor Wat, Cambodia.

concentric colonnaded galleries. An inner rectangle (fig. **W6.18**), three stories high, has five towered shrines and connecting colonnades accessible by stairways. At the focal point of this complex is the central temple, which stands for Mount Meru. Thus the entire conception is a two- and three-dimensional mandala of the cosmos. At the same time, the temple had a mortuary significance and was designed as a memorial to its patron. This is reflected in the frequent representations of the death god Yama in the relief sculptures covering the walls. In addition, the temple's unconventional orientation toward the west reinforces its association with death.

The main roadway leading to Angkor Wat (fig. **W6.19**) is flanked by balustrades in the shape of giant water serpents, which are cosmic fertility symbols. There is elaborate surface decoration on the tall towers, with their flamelike motifs, and the supporting

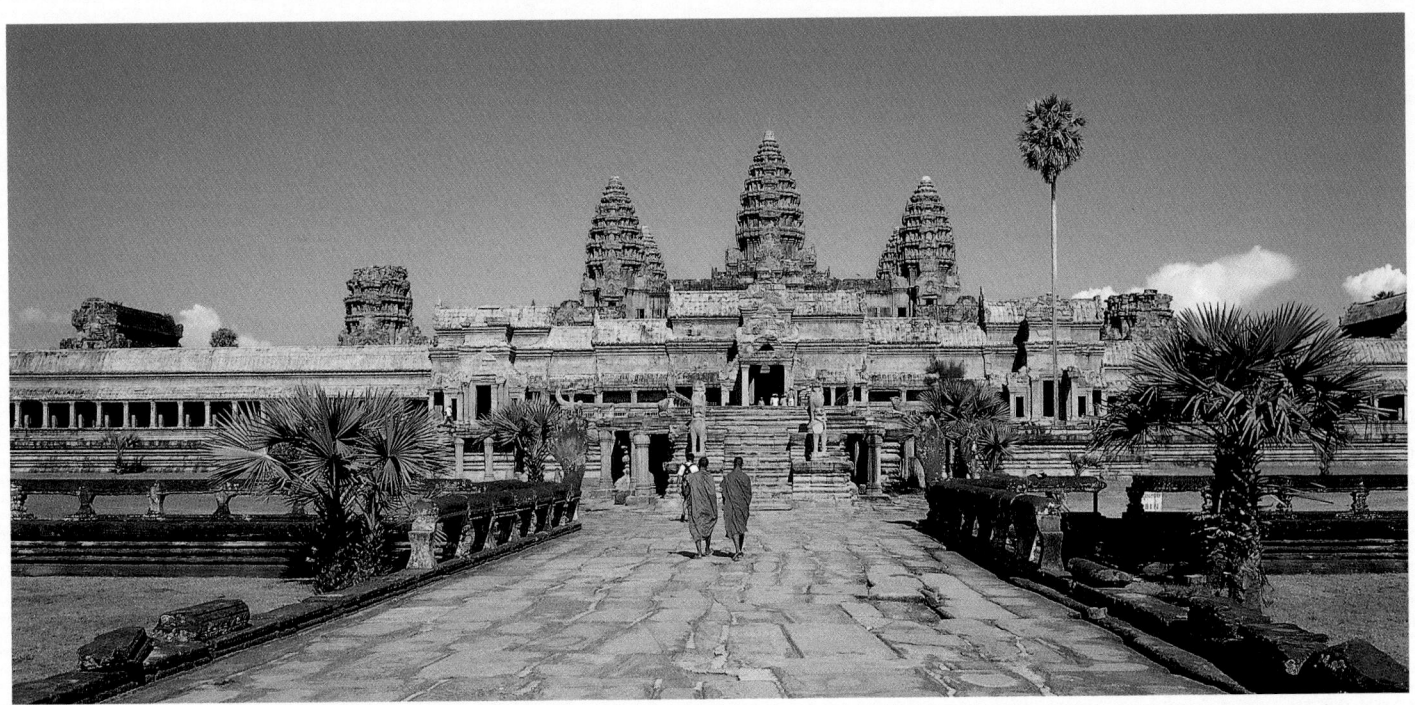

W6.19 Roadway approaching Angkor Wat, Cambodia.

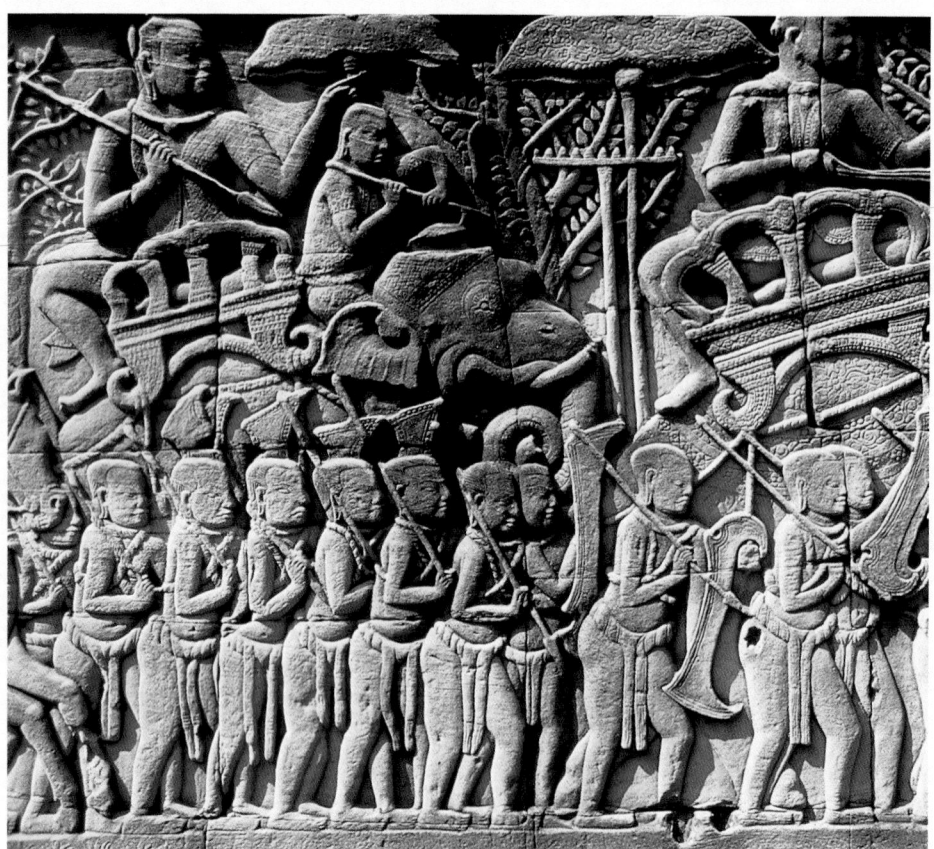

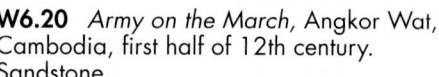

W6.20 *Army on the March*, Angkor Wat, Cambodia, first half of 12th century. Sandstone.

stone columns. As in Hindu temples, the towers at Angkor are tiered, overlaying a basic vertical plane with repeated horizontal bands. This repetition is broken only at the peaks, which, as in India, stand for the highest spiritual state of being.

Angkor Wat is covered with nearly 13,000 square feet (1,208 m²) of intricate relief sculpture. As on the towers, the low relief depicting an *Army on the March* (fig. **W6.20**) is characterized by repetitive detail, which can be hypnotic in effect. The elephant-drawn chariot creates a formal counterpoint, its curves and diagonals combined with expansive forms.

An isocephalic frieze of celestial *Apsaras* (fig. **W6.21**)—courtesans and dancers, probably water nymphs— adorns the exterior wall of a gallery. They provide a visual transition from the carved moldings to the plain wall and thus are integrated with the architecture. The *Apsaras* are portrayed dancing on short horizontal platforms that repeat the projections of the molding. Each figure faces outward and appears to sway with the music. They seem to greet visitors with seductive grace, while also referring to the spiritual heights symbolized by the peaks of the towers. This synthesis of the spiritual with the erotic is characteristic of much Hindu sculpture, particularly at transition points. The detail of the frieze (fig. **W6.22**) shows one of the dancers, whose jewelry is carved in low-relief patterns that contrast with her voluptuous breasts and ample proportions. Echoing her S-shape pose are the framing arch and her belt. The combination of physical sensuousness with an otherworldly inward gaze is typical of Hindu aesthetics.

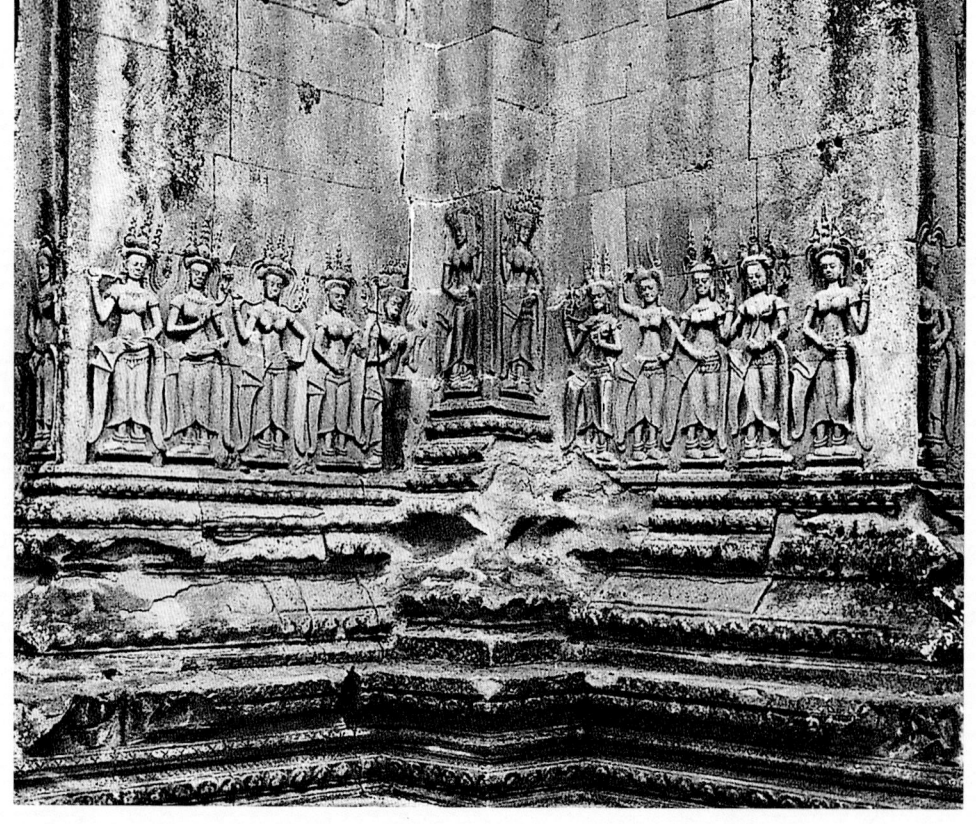

W6.21 *Apsaras*, exterior wall of a gallery, Angkor Wat, Cambodia.

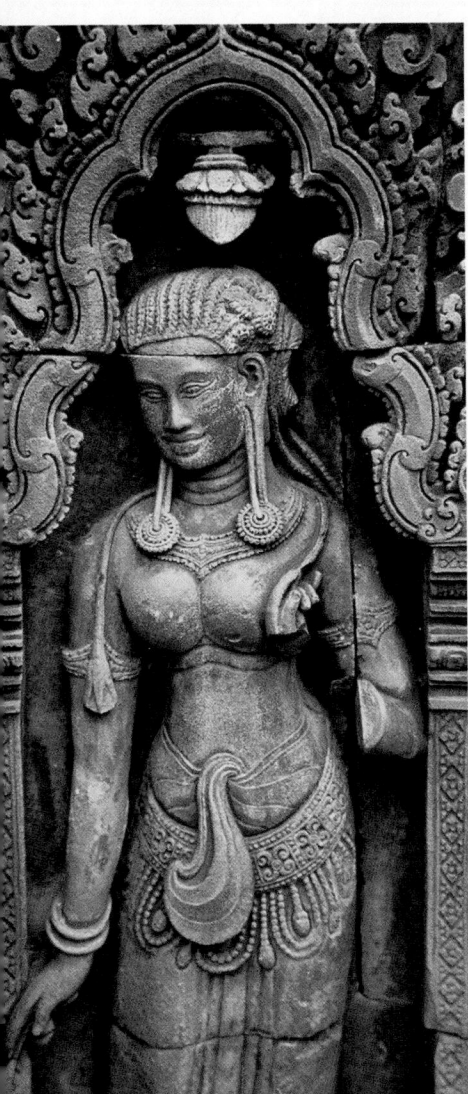

W6.22 *"Water Nymph,"* detail of a frieze, Angkor Wat, Cambodia. © photo: Daniel Entwistle.

Angkor Thom
(13th century)

Angkor was abandoned after being sacked by a neighboring ruler. By the beginning of the thirteenth century, the Buddhist Khmer king, Jayavarman VII (ruled 1181–1218), had planned a new capital and sacred precinct at the nearby Angkor Thom, meaning "Great Angkor" (fig. **W6.23**). There, the city walls have huge gateways with towers on which monumental images of the Devaraja's face are carved (fig. **W6.24**). The most important temple at Angkor Thom, the Bayon, was Buddhist and also incorporates local ancestor cults. As at Angkor Wat, the Angkor Thom temple was intended to replicate the cosmic center and to identify it as the king's power base. The height of the large central tower (see fig. W6.23) is equal to its depth below ground, uniting the subterranean realm with earth and sky. Similarly, the wide moat around the complex was identified with the cosmic ocean. Jayavarman VII's huge face over the entrance proclaims his union with the mountain and his symbolic role as "King of the Mountain"—specifically, the King of Mount Meru.

The Buddhist era at Angkor was short-lived. With the death of Jayavarman VII and the subsequent decline of Angkor's importance, Hinduism was revived in Cambodia.

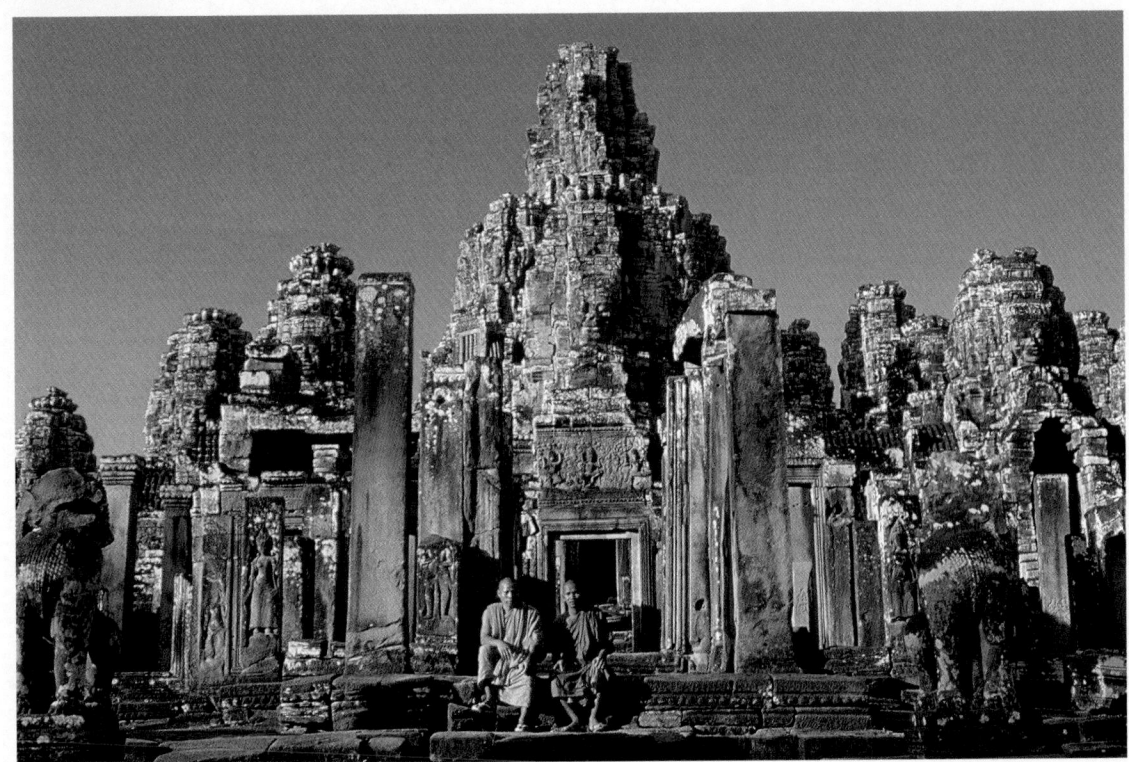

W6.23 Bayon temple, Angkor Thom, Cambodia, c. 1200.

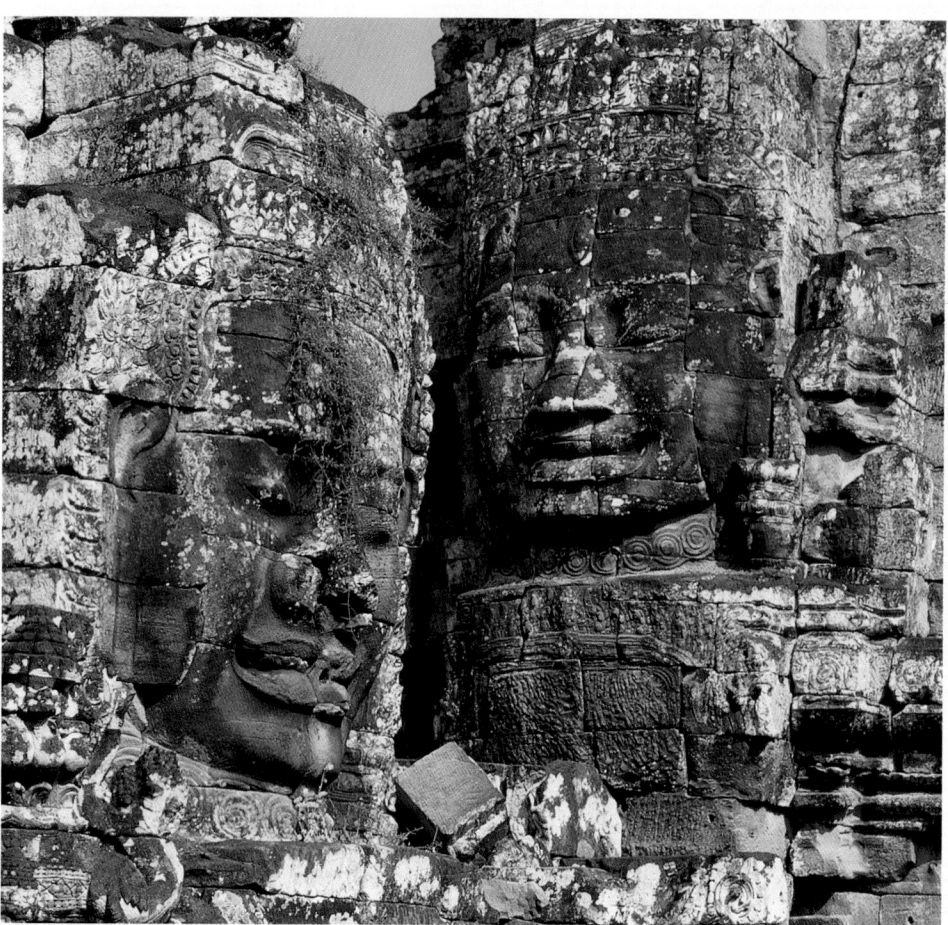

W6.24 Towers with monumental faces of the Devaraja, Bayon, Angkor Thom, Cambodia.

	Style/Period	Works of Art		Cultural/Historical Developments	
600	BUDDHISM 7th century	**Pagoda, Horyu-ji, Nara**	Monastery (**W6.6**), Horyu-ji, Nara Pagoda (**W6.5**), Horyu-ji, Nara *Kondō* (**W6.7**), Horyu-ji, Nara	Khmer Empire, Cambodia (6th–13th centuries) Block printing of books developed in China (c. 600) Death of Prince Shotoku, "founder" of Buddhism in Japan (c. 622)	***"Water Nymph,"*** **Angkor Wat**
	8th century		*Buddha Preaching the Law* (**W6.1**), Dunhuang Province Pagoda (**W6.3**), Hopei Province *Shakyamuni Buddha Preaching on Vulture Peak* (**W6.2**), Dunhuang Province	***Shakyamuni Buddha Preaching on Vulture Peak,* Dunhuang Province**	Death of Muhammad (632) Development of the pagoda (7th–11th centuries) Japan's capital moves from Nara to Kyoto (794) Charlemagne crowned Holy Roman emperor (800)
	9th–11th centuries		Pagoda (**W6.4**), Kaifeng, Hunan Province	Chinese porcelain introduced to central Asia via Silk Road (9th century) Chinese emperor persecutes Buddhism (845) First book printed in China (868)	
	HINDUISM 6th century	***Vishnu Sleeping on Ananta,* Deogarh, Uttar Pradesh**	Temple of Vishnu (**W6.11–W6.13**), Deogarh, Uttar Pradesh	Completion of Koran (935) Chinese discover gunpowder (1000) Muslim dominance of India (c. 1000–1750) Chinese use movable type (1041)	
	8th–13th centuries		Mukteshvar Temple of Shiva, Bhubaneshvar, Orissa (**W6.15**)	Suryavarman II rules Khmer Empire, Cambodia (1113–1150)	**Towers with monumental faces of the Devaraja, Angkor Thom**
	BUDDHISM/HINDUISM SYNTHESIS 12th century		Angkor Wat (**W6.18–W6.19**) *Army on the March* (**W6.20**), Angkor Wat *Apsaras* (**W6.21**), Angkor Wat "Water Nymph" (**W6.22**), Angkor Wat	Mongols begin conquest of China (1210) Signing of the Magna Carta (1215) Kublai Khan rules the Mongols (1260–1294)	
1300	13th century		Angkor Thom (**W6.23–W6.24**)	Marco Polo travels from Venice to China (1271–1295)	

12

Precursors of the Renaissance

Thirteenth-Century Italy

During the eleventh and twelfth centuries, Italy continued to be accessible to Byzantine influences, particularly through its eastern port cities of Venice and Ravenna. Around the turn of the thirteenth century, however, momentous developments in Italy, inspired by imperial Roman traditions, laid the foundations for a major shift in western European art and culture.

The name given to the period of Italian history from the thirteenth through the sixteenth centuries is the *Renaissance*—the French word for "rebirth" (*rinascimento* in Italian). Dating the beginning of Renaissance style remains an issue of debate, and some would consider the works in this chapter to be late Gothic. But the term *Renaissance* denotes a self-conscious revival of interest in ancient Greek and Roman texts and culture that is reflected in the work of most of the artists discussed here. Italy was the logical place for such a revival since the model of imperial Rome was part of its own history and territory (see map, p. 451).

Nicola Pisano

Around 1260, Nicola Pisano (active c. 1258–before 1284) carved the marble pulpit (fig. **12.1**) for the Baptistery in Pisa. The relief of the *Nativity* (fig. **12.2**) provides a good example of the Roman heritage in Italian medieval art. It is crowded with figures, including, from left to right at the bottom, a bearded Joseph, two midwives washing the infant Jesus in a basin, and sheep and goats. The largest figure, showing the influence of Etruscan and Roman tomb effigies, is Mary, whose monumentality and central position evoke her connections with the earth goddesses of antiquity. Despite the Christian subject, the forms are

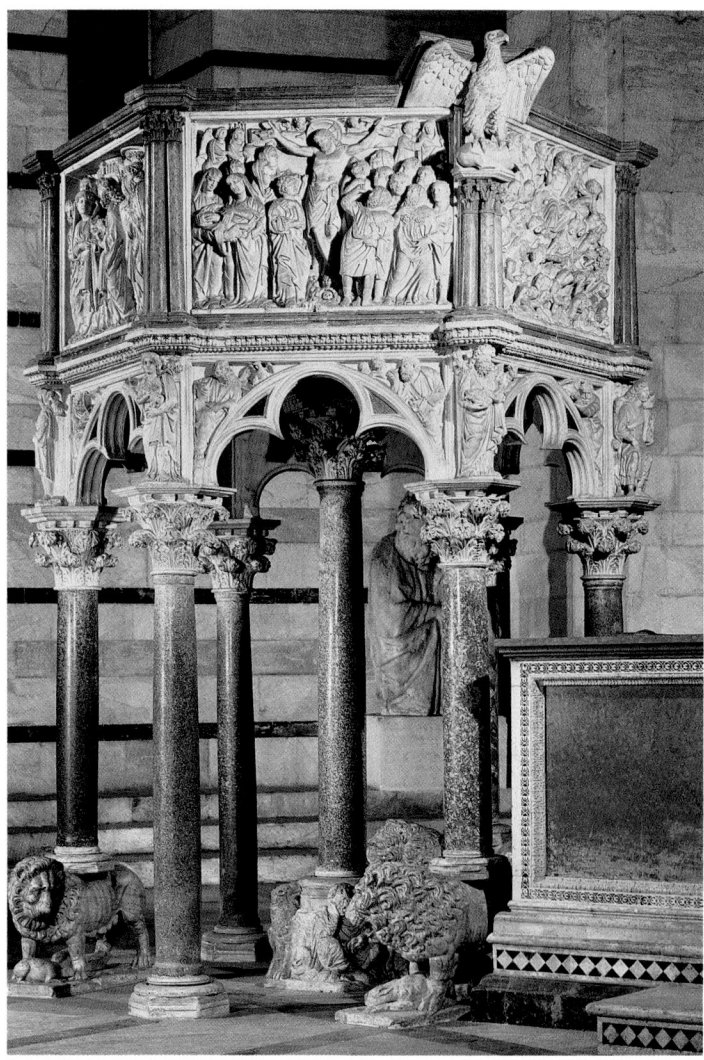

12.1 Nicola Pisano, pulpit, Pisa Baptistery, 1259–1260. Marble; 15 ft. (4.57 m) high. Nicola probably came from southern Italy and trained at the court of Frederick II. When Frederick died in 1250, Nicola went north to Tuscany. He and his son Giovanni settled in Pisa, where they worked mainly in marble.

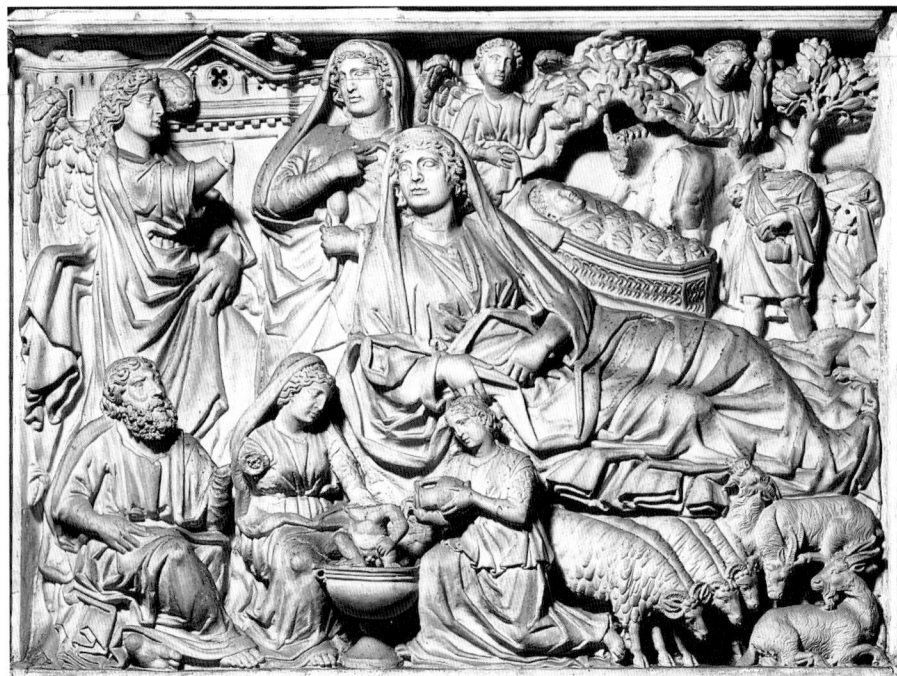

12.2 Nicola Pisano, relief of the *Nativity*, also showing the *Annunciation* (upper left), the *Annunciation to the Shepherds* (upper right), and the *Washing of the Infant Jesus* (lower center), pulpit, Pisa Baptistery, 1259–1260. Marble; approx. 34 in. (86.4 cm) high.

reminiscent of imperial Roman reliefs. Most clearly related to the Roman past is the artist's rendition of draperies, which identify the organic, three-dimensional movements of figures in space.

Furthermore, the pulpit as a whole shows a fusion of Gothic arrangement (the combination of columns with Corinthian capitals and trilobed arches) with the round arches of the Roman (and Romanesque) styles. Every other column rests on a lion, which recalls typological parallels between the Old and New Testaments. In that context, the lions refer to Solomon's throne and here denote the foundation of the teachings of Jesus.

Both the conception and execution of the pulpit reflect the cultural and stylistic crosscurrents to which Nicola Pisano had been exposed at the court of the Holy Roman emperor, Frederick II, as well as to Roman sculpture in Pisa. During the first half of the thirteenth century, Frederick controlled territories in southern Italy, and his patronage brought French and German artists as well as Italians to his court at Capua, just north of Naples. There, imported and local elements were combined with Frederick's personal taste for ancient Roman styles. Like many

rulers before and after him, Frederick used the revival of Classical antiquity for political purposes, relating his accomplishments to those of imperial Rome.

Training an Artist

In the Middle Ages and Renaissance, artists learned their trade by undertaking a prolonged period of technical training in the shop of a master artist. Young men became apprentices in their early teens either because they had already shown talent or because their families wanted them to be artists. Artists usually came from the middle class, often from families of artists. Quite a few married into such families and went into business with their in-laws.

The term of apprenticeship varied, but apprentices began learning their trade at the most menial level. They mixed paints, prepared pigments and painting surfaces, and occasionally worked on less important border areas or painted the minor figures of a master's composition. By the time an apprentice was ready to start his own shop, he had a thorough grounding in techniques and media. He would

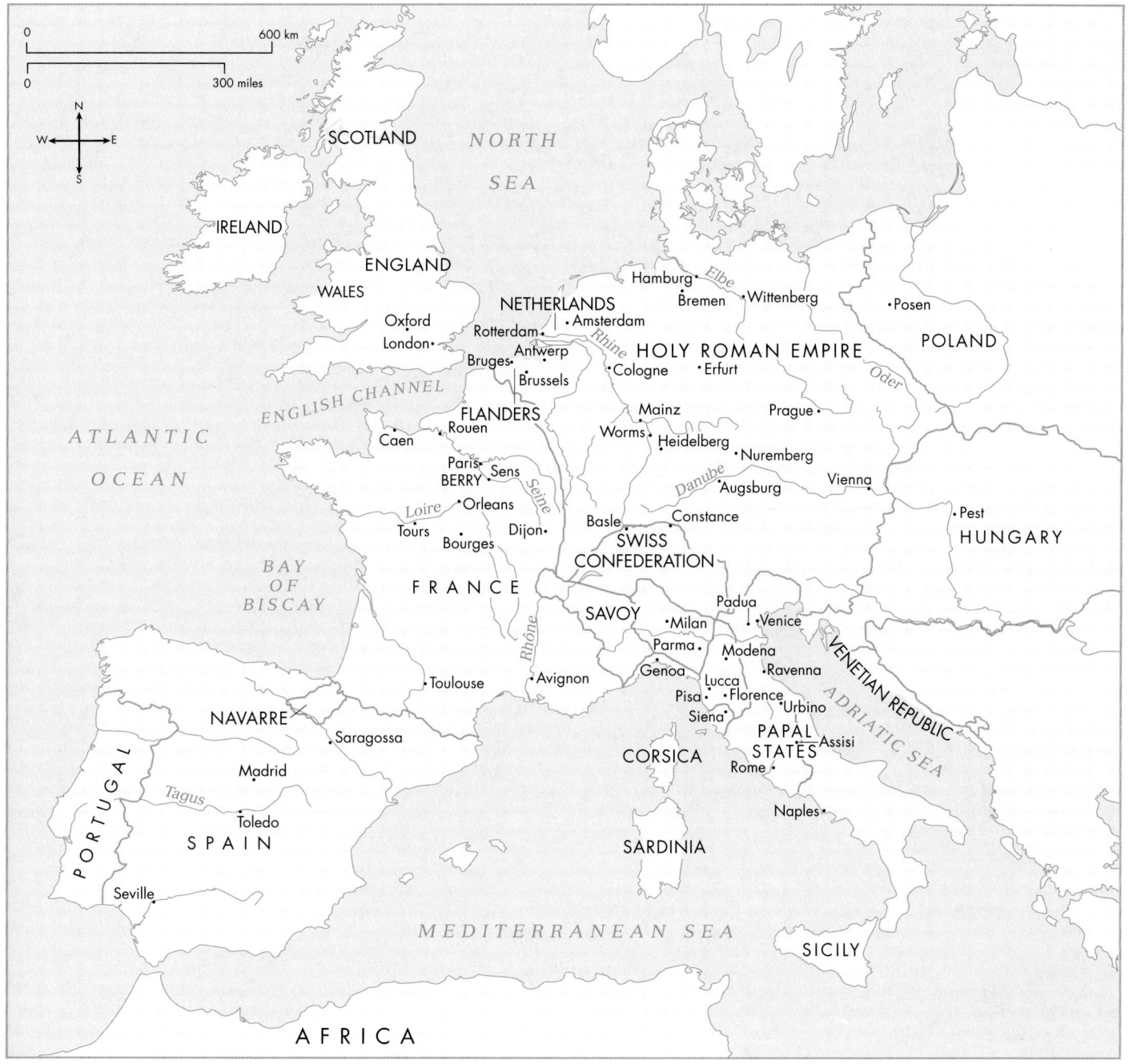

Leading art centers during the Renaissance in western Europe.

probably also have assimilated elements of his master's style.

Renaissance artists were an influential professional group, and the increased demand for art was the result of growth in the sources of patronage. During the Middle Ages, most of the patronage had been ecclesiastic (i.e., from Church authorities). In the Renaissance, more art was also commissioned by civic or corporate groups and by wealthy individuals. The commissions were generally sealed by legal contract between artist and patron, and these contracts have become important documentary sources for modern art historians.

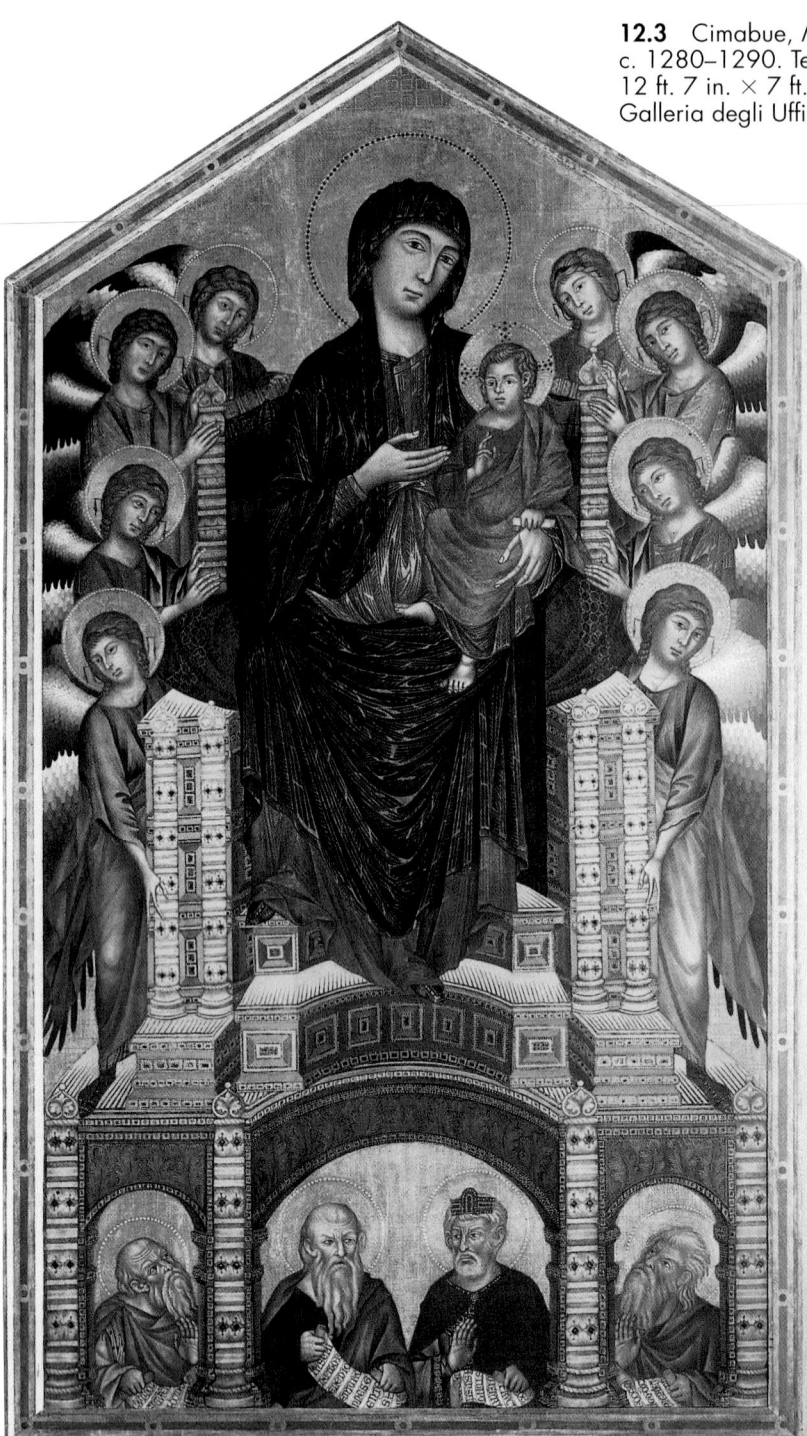

12.3 Cimabue, *Madonna Enthroned*, c. 1280–1290. Tempera on wood; 12 ft. 7 in. × 7 ft. 4 in. (3.84 × 2.24 m). Galleria degli Uffizi, Florence.

Cimabue

Byzantine influence remained strong in Italy, as can be seen in the monumental *Madonna Enthroned* (fig. **12.3**) by Cimabue (active 1272–1302). The gold background, the lines of gold in Mary's drapery, and the long, thin proportions are characteristic of Byzantine style. The elaborate throne has no visible support at the back but seems instead to rise upward, denying the material real-ity of its weight. As in Byzantine and medieval art, the Christ child is depicted with the pro-portions and gestures of a man. The four prophets at the foot of the throne embody the Old Dispensation as the foundation of the New.

Fourteenth-Century Italy

Cimabue is generally thought of as the last great painter working in the Byzantine tradi-tion. The rise of humanism—a movement in-spired by the revival of classical texts—in the fourteenth century reflected, but also signifi-cantly extended, the High Gothic interest in nature. Humanists began to collect ancient texts, establishing major libraries of Greek and Roman authors. Artists began to study the forms of antiquity by observing Roman ruins. And gradually a new synthesis emerged in which nature—including human character and human form—became the ideal pursued dur-ing the Renaissance. Awareness of the Classi-cal revival began to be reflected in the works of Italian authors such as Dante, Petrarch, and Boccaccio, who discussed art and artists in a new, psychological way.

Literacy among the general population increased, and works of literature dealt more and more with art and artists, bringing their achievements to a wider public. Another important feature of the Renaissance in Italy was a new attitude to individual fame. While most medieval artists remained anonymous, those of the Renaissance frequently signed their works. The very fact that the names of many more Italian artists of the thirteenth and fourteenth centuries are documented than in the Early Christian and medieval periods in Europe attests to the artists' wish to record their identity and to preserve it for posterity.

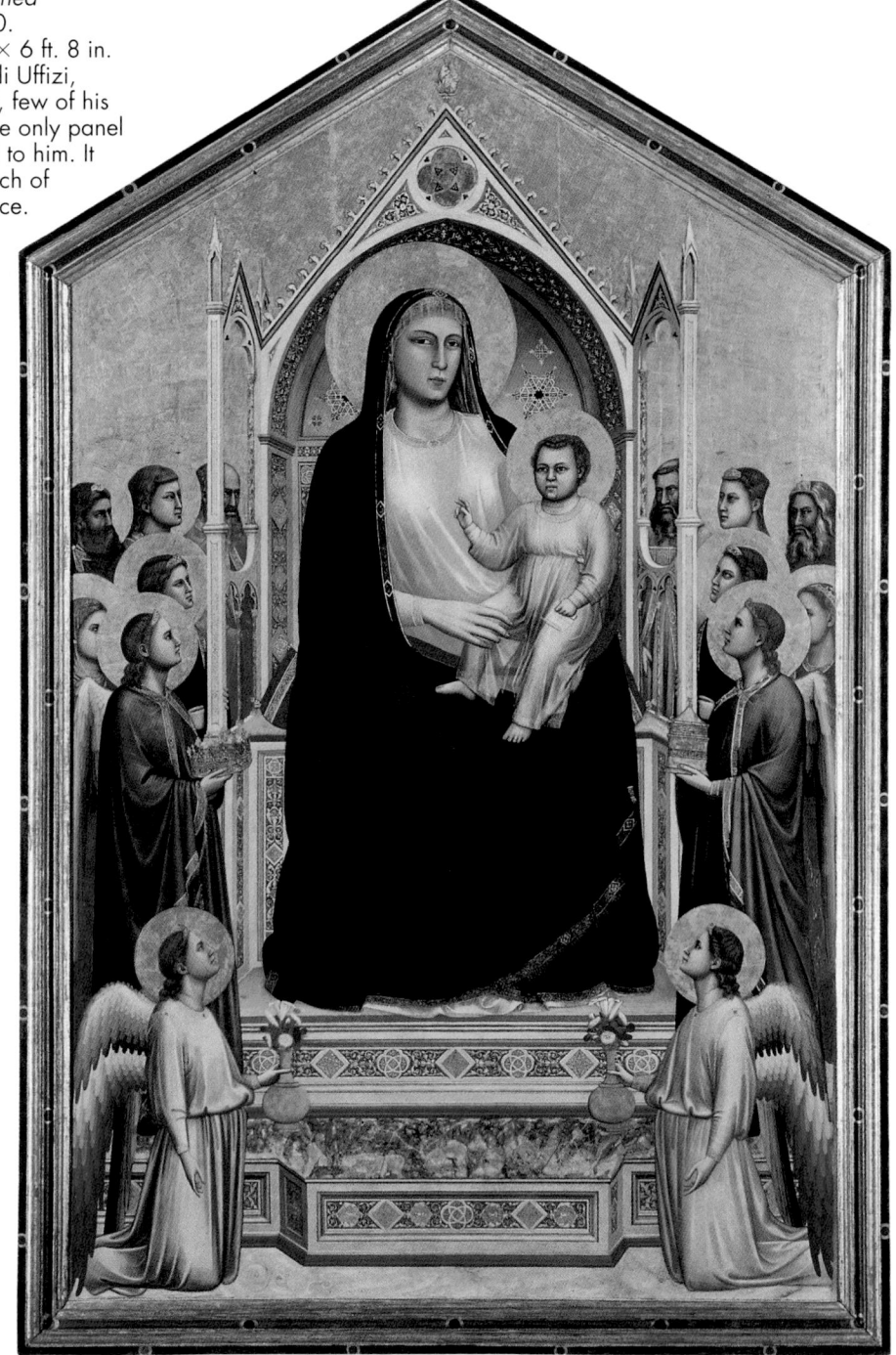

12.4 Giotto, *Madonna Enthroned* (Ognissanti Madonna), c. 1310. Tempera on wood; 10 ft. 8 in. × 6 ft. 8 in. (3.25 × 2.03 m). Galleria degli Uffizi, Florence. Despite Giotto's fame, few of his works are undisputed. This is the only panel painting unanimously attributed to him. It was commissioned for the Church of Ognissanti (All Saints) in Florence.

Giotto

The artist who most exemplified, and in large part created, the new developments in painting was Giotto di Bondone (c. 1267–1337). He was born in the Mugello Valley near Florence and lived mainly in that city, which was the center of the new Renaissance culture. His fame was such that he was summoned all over Italy, and possibly also to France, on various commissions.

Boccaccio, an ardent admirer of ancient Rome, described Giotto as having brought the art of painting out of medieval darkness into daylight. He compared Giotto with the Greek Classical painter Apelles as a master of clarity and illusionism. Petrarch, who was an avid collector of Classical texts and had written extensively about the benefits of nature, owned a painting by Giotto. In his will, he bequeathed the work to his lord. "The beauty of this painting," wrote Petrarch around 1361, "the ignorant cannot comprehend, but masters of the art marvel at it."[1] Petrarch thus shared Boccaccio's view that Giotto appealed to the intellectually and artistically enlightened. Ignorance, by implication, was associated with the "darkness" of the Middle Ages.

Giotto became the subject of a growing number of anecdotes about artists that became popular from the fourteenth century onward. The anecdotal tradition is itself indicative of the Classical revival and derives from accounts of Classical Greek painters who were renowned for their illusionistic skill.

In Dante's *Purgatory* (see box, p. 454), Giotto and Cimabue are juxtaposed as a lesson in the transience of earthly fame:

O empty glory of human powers! How short the time its green endures at its peak, if it be not overtaken by crude ages! Cimabue thought to hold the field in painting, and now Giotto has the cry, so that the fame of the former is obscured.[2]

A comparison of Giotto's *Madonna Enthroned* (fig. **12.4**) of about 1310 with Cimabue's (see fig. 12.3) illustrates their different approaches to space and to the relationship between space and form. Both pictures are

Dante's *Divine Comedy*

The Florentine poet Dante Alighieri (1265–1321) wrote *The Divine Comedy,* a long poem divided into three parts: *Inferno* (Hell), *Purgatorio* (Purgatory), and *Paradiso* (Paradise). Dante describes a week's journey in the year 1300 down through the circles of hell to Satan's realm. From there, he climbs up the mountain of purgatory, with its seven terraces, and finally ascends the spheres of heaven.

The Roman poet Virgil, author of the *Aeneid,* guides Dante through hell and purgatory. The very fact that Dante chooses Virgil as his guide is evidence of the growing interest in Ro-

man antiquity. According to Dante, because Virgil lived in a pre-Christian era, he cannot continue past purgatory into paradise. Instead, it is Beatrice, Dante's deceased beloved, who guides him through heaven and presents him to the Virgin Mary.

Long valued for its literary and spiritual qualities, Dante's poem is equally important for its insights into medieval and early Renaissance history. In the course of his journey, Dante encounters many historical figures to whom he metes out various punishments or rewards, according to his opinion of them.

Tempera: Painstaking Preparation and Delicate Detail

Examples of the use of tempera are found in ancient Egypt. From the medieval period through the fifteenth century, however, it was the preferred medium for wooden panel paintings, especially in Italy, lending itself to precise details and clear edges.

For large panels, such as those illustrated in figures 12.3 and 12.4, elaborate preparations were required before painting could begin. Generally, a carpenter made the panel from poplar, which was glued and braced on the back with strips of wood. He also made and attached the frame. Apprentices then prepared the panel, under the artist's supervision, by sanding the wood until it was smooth. They sealed it with several layers of size, a glutinous material used to fill in the pores of the panel and to make a stable surface for later layers. Strips of linen reinforced the wood to prevent warping. The last step in the preparation of the panel was the addition of several layers of **gesso,** a water-based paint thickened with chalk and size. Once each layer of gesso had dried, the surface was again sanded, smoothed, and scraped. The gesso thus became the support for the artwork.

At this point, painting could begin. Using a brush, the artist lightly outlined the figures and forms in charcoal before reinforcing the outline in ink or incising it with a stylus. The decorative gold designs, halos, and gold background were applied next and were polished so that they would glow in the dark churches.

Apprentices made the paint by grinding pigments from mineral or vegetable extracts to a paste and suspending them in a mixture of water and egg. The artist then applied the paint with small brushes made of animal hair. Once the artist had completed the finishing touches, the painting was left to dry—a year was the recommended time—and then it was varnished.

tempera on panel (see box) and were intended as altarpieces (see box, p. 455). Both have elaborate thrones (Giotto's with Gothic pointed arches), Byzantine gold backgrounds, and flat, round halos that do not turn illusionistically with the heads. Whereas Cimabue's throne rises in an irrational, unknown space (there is no floor), Giotto's is on a horizontal support approached by steps. In contrast to Cimabue's long, thin, elegant figures, Giotto's are bulky, with draperies that correspond convincingly to organic form and obey the law of gravity. Giotto has thus created an illusion of three-dimensional space—his figures seem to turn and move as in nature.

Whereas Cimabue uses lines of gold to emphasize Mary's drapery folds, Giotto's folds are rendered by shading. Giotto's V-shaped folds between Mary's knees identify both their solidity and the void between them, while the curving folds above the waist indicate a slight spatial turn and direct the viewer's attention to Jesus.

A comparison of the two figures of Jesus reveals at once that Giotto was more interested in the reality of childhood than Cimabue. Cimabue's infant retains aspects of the medieval homunculus. He has a small head and thin proportions, and he is not logically supported on Mary's lap. Giotto's Jesus, on the other hand, has chubby proportions and rolls of baby fat around his neck and wrists; he sits firmly on the horizontal surface of Mary's leg. Although Giotto's Jesus is depicted in a regal pose, his right hand raised in a gesture of blessing, his proportions are more natural than those of Cimabue.

It was precisely in the rendition of nature that Giotto seemed to his contemporaries to have surpassed Cimabue and to have revived the forms of antiquity, heralding the emergence of a new generation of artists.

The Arena Chapel

The best-preserved examples of Giotto's work are the paintings in the Arena Chapel in Padua, a town about 25 miles (40 km) southwest of Venice. In the second half of the thirteenth century, under a republican form of government, a group of Paduan lawyers developed an interest in

Altarpieces

An altarpiece is a devotional panel painting (usually tempera on wood) (see fig. **12.5**). After the church's Lateran Council of 1215, the priest was moved to the front of the altar in order to engage worshipers in the sacred drama of the Mass. This freed up the back of the altar for an image. From the thirteenth century onward, altarpieces became more common and increasingly elaborate. They typically had a fixed base (the **predella**), surmounted by one or more large panel paintings. In most cases, the large panels contain the more iconic images—such as an enthroned Virgin and Jesus, or individual saints—and the predella panels contain narrative scenes related to the larger figures.

Taking as examples the illustrations in this chapter, figures 12.3 and 12.4 would have been altarpiece panels. Figure 12.15a is a reconstruction of the front of Duccio's *Maestà*, the original of which replaced a small, undistinguished early thirteenth-century panel painting. Duccio's large panel of the *Enthroned Virgin and Christ* surrounded by saints and angels rests on a predella with scenes of Jesus's early life—from the *Annunciation* at the left to *Jesus among the Doctors* at the right, and individual figures between the narrative scenes. Above is a row of saints under round arches surmounted by pinnacles with scenes from Mary's later life—starting with the *Annunciation* of her death and ending with her *Burial*. Most of the upper sections of the pinnacles are lost.

Simone Martini's Saint Louis Altarpiece (see fig. 12.24) shows the saint crowning his brother Robert in the larger panel. Small scenes on the predella depict events from the saint's life.

In Italy, wings (side panels) would occasionally have been attached with hinges. These wings would then "close" the altarpiece when it was not on display or being used for a service. In the North, hinged wings were the norm. The Ghent Altarpiece (see Chapter 13), for example, is particularly elaborate; figure 13.65 shows the altarpiece closed so that the paintings on the outside of the wings are visible.

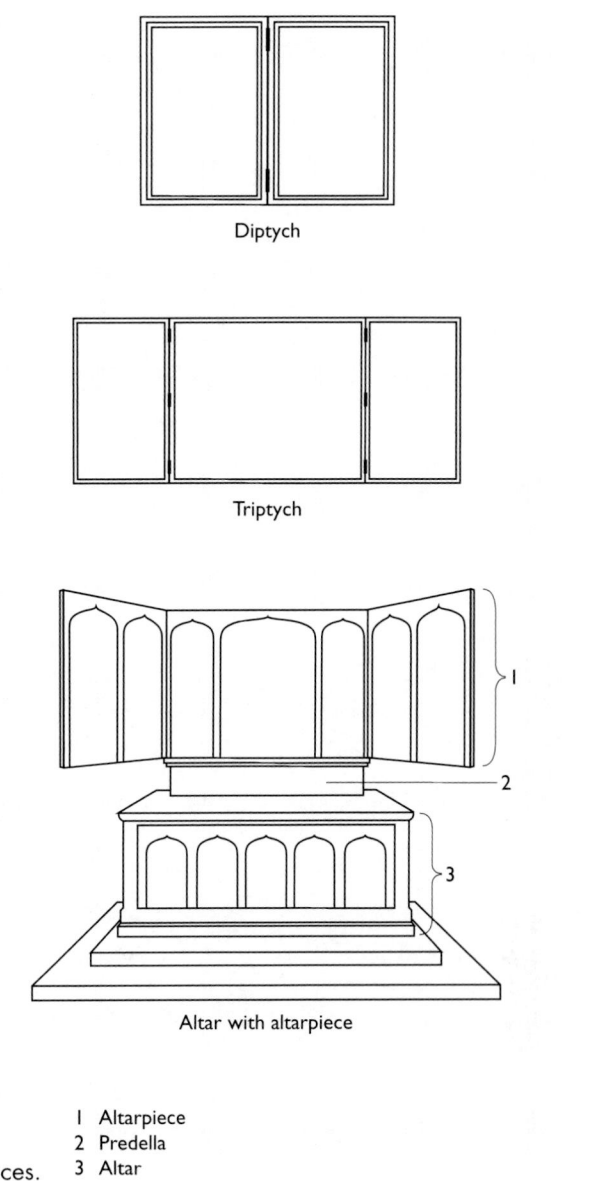

Diptych

Triptych

Altar with altarpiece

1 Altarpiece
2 Predella
3 Altar

12.5 Diagram of an altar and altarpieces.

Roman law, which led to an enthusiasm for Classical thought and literature. Roman theater was revived, along with Classical poetry and rhetoric. As the site of an old and distinguished university, Padua was a natural center for a humanist revival, which acknowledged the primacy of individual intellect, character, and talent. Giotto, more than any other artist, transformed these qualities into painting.

The Arena Chapel (named after the old Roman arena adjacent to it) was founded by Enrico Scrovegni, Padua's wealthiest citizen—hence its designation as the Scrovegni Chapel. Having inherited a fortune from his father, Reginaldo Scrovegni, whom Dante had consigned to the sev-

enth circle of hell for usury (moneylending), Enrico commissioned the chapel and its decoration as an act of atonement. The building is a simple, barrel-vaulted, rectangular structure, faced on the exterior with brick and pilaster strips. The interior is decorated with one of the most remarkable and best-preserved fresco cycles in Western art (fig. **12.6**). Architectural elements are kept to a minimum: the south wall has six windows while the north wall is solid, making it an ideal surface for fresco painting (see box, p. 457). The west wall, which has one window divided into three lancets, is covered with an enormous *Last Judgment* (see fig. 12.10).

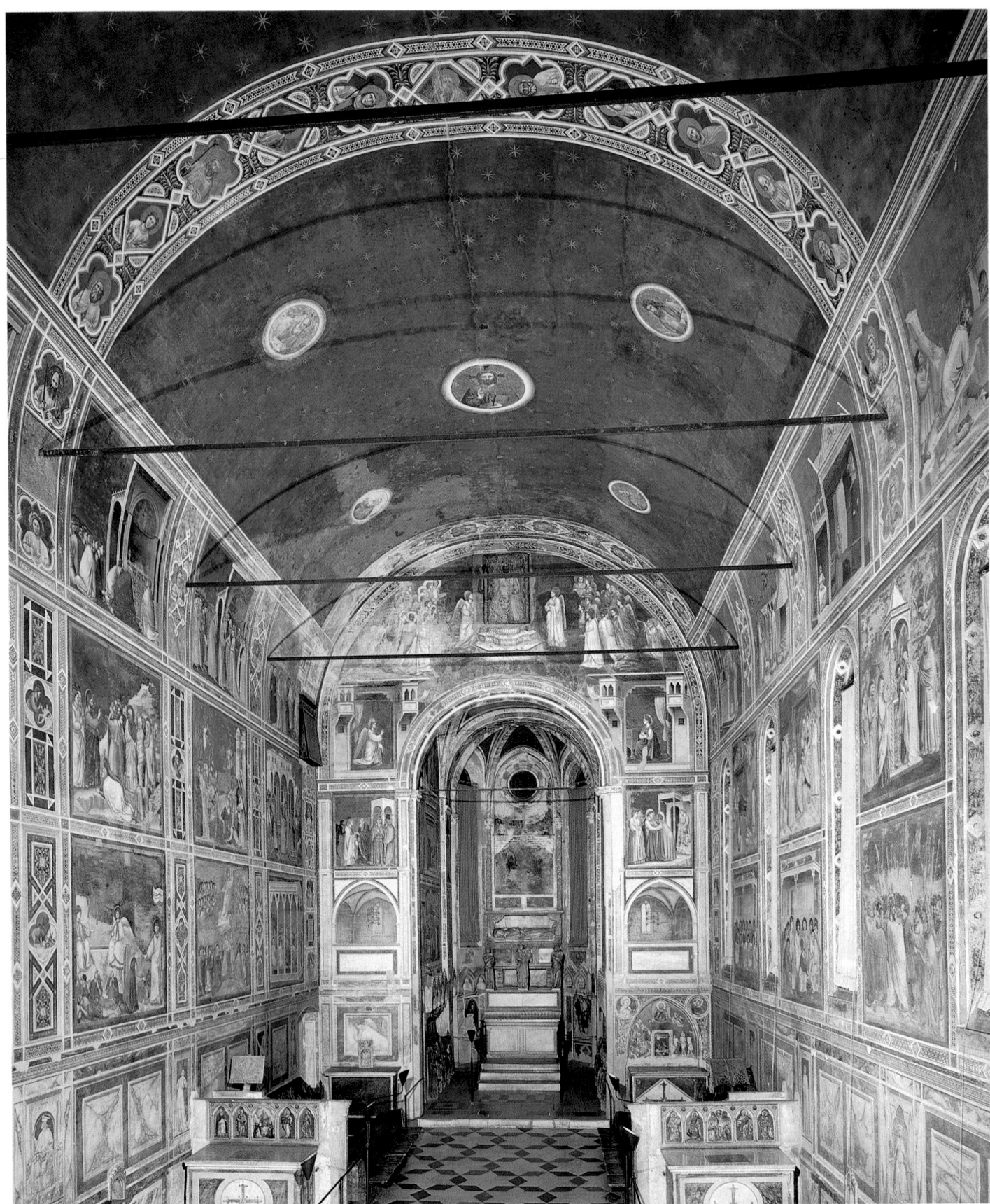

12.6 Interior view, looking east, Arena Chapel, Padua, c. 1305. At the top of the round chancel arch, which is reminiscent of Roman triumphal arches, there is a tempera panel set into the plaster wall, depicting God the Father enthroned. He summons the angel Gabriel and entrusts him with the Annunciation of Jesus's birth to Mary.

Fresco: A Medium for Speed and Confidence

From the thirteenth to the sixteenth centuries, there was a significant increase in the number of monumental fresco cycles, especially in Italy.

Fresco cycles were typically located on plaster walls in churches, public buildings, or private palaces, and large scaffolds were erected for such projects. First, the wall was covered with a layer of coarse plaster, called the **arriccio,** which was rough enough to hold the final layer of plaster. When the first layer had dried, the artist found his bearings by establishing the exact center of the surface to be painted and by locating the vertical and horizontal axes. He blocked out the composition with charcoal and made a brush drawing in red ocher pigment mixed with water. These drawings are called *sinopie* (*sinopia* in the singular) after Sinope, a town on the Black Sea known for the red color of its earth.

Once the artist completed the *sinopia,* he added the final layer of smooth plaster (*intonaco*) to the walls one patch at a time. The artist applied the colors to the *intonaco* while it was still damp and able to absorb them. Thus, when the plaster dried and hardened, the colors became integrated with it. Each patch was what the artist planned to paint in a single day—hence the term *giornata,* the Italian word for a day's work. Because each *giornata* had to be painted in a day, fresco technique encouraged advance planning, speed of execution, broad brushstrokes, and monumental forms. Sometimes small details were added in tempera, and certain colors, such as blue, were applied *secco* (dry). These have been largely lost or turned black by chemical reaction.

On the north and south walls, three levels of rectangular scenes illustrate the lives of Mary, her parents Anna and Joachim, and Jesus. Below the narrative scenes on the north and south walls are Virtues and Vices (see box), disposed according to traditional left–right symbolism. As the viewer enters the chapel, the Virtues are on the right and the Vices on the left. Facing the observer is the chancel arch, containing *Gabriel's Mission* at the top, two other events from Jesus's life (the *Betrayal of Judas* on the left and the *Visitation* on the right), and two illusionistic chapels.

Immediately below *Gabriel's Mission,* separated into two sections on either side of the arch, is the *Annunciation* (fig. **12.7**). The setting is a rectangular architectural space with balconies that seem to project outward. Equally illusionistic are the pieces of cloth that appear to hang on poles attached to the balconies.

Illusion is an important aspect of theater, and in the Arena Chapel the space in which the sacred drama unfolds

Virtues and Deadly Sins

The seven Christian Virtues and Vices, or Deadly Sins, are commonly personified in Christian art. The seven Virtues are divided into four Cardinal Virtues—Prudence, Temperance, Fortitude, and Justice—and three Theological Virtues—Faith, Hope, and Charity.

The seven Vices vary slightly but generally consist of Pride, Covetousness, Lust, Envy, Gluttony, Anger, and Sloth.

12.7 Giotto, *Annunciation*, Arena Chapel, Padua, c. 1305. Fresco.

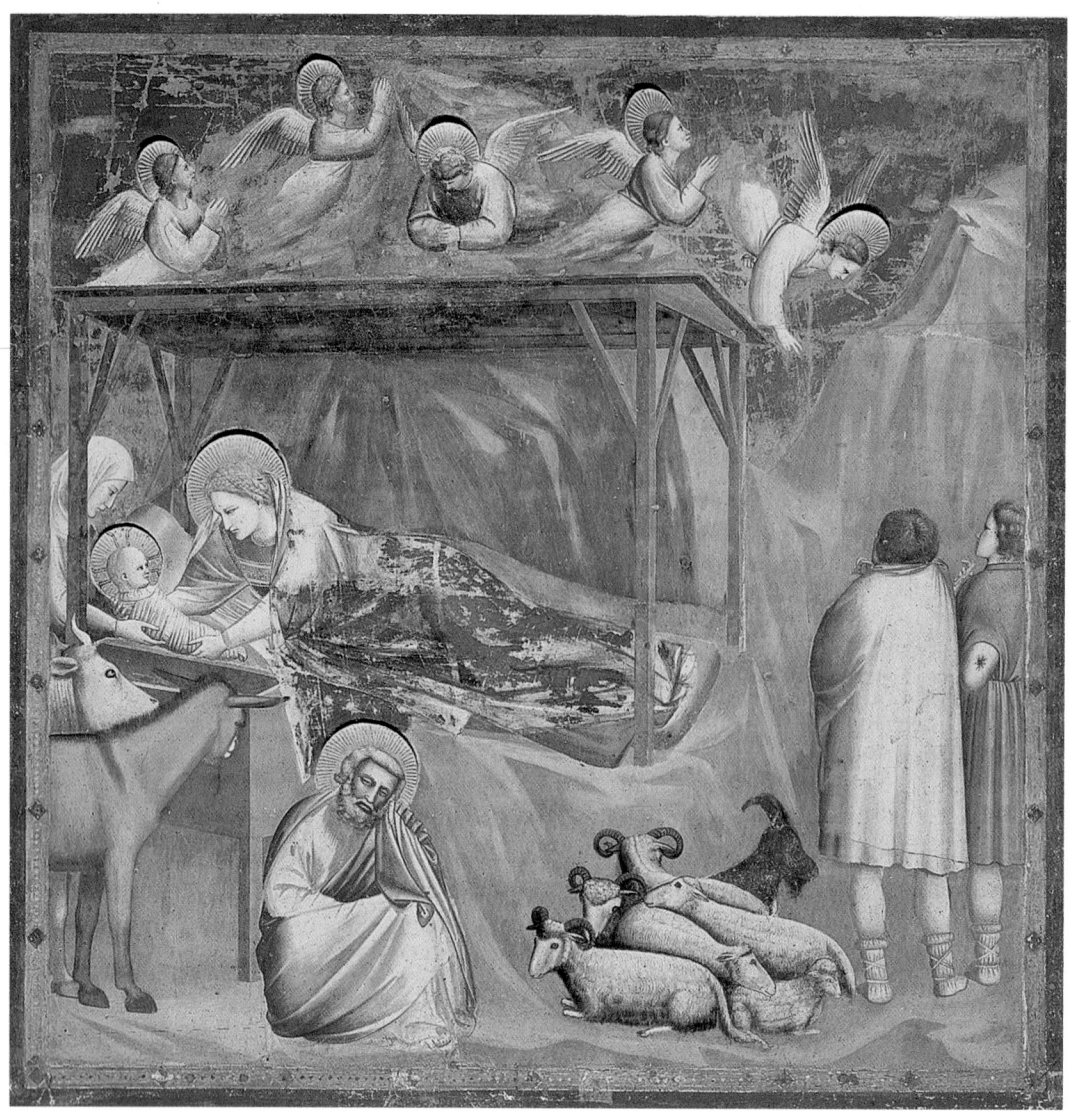

12.8 Giotto, *Nativity*, Arena Chapel, Padua, c. 1305. Fresco.

has been compared with a stage. In the *Annunciation,* for example, the painted space is three-dimensional but narrow, and the architecture—like a stage set—is small in relation to the figures. Gabriel and Mary face each other across the span of the actual arch, while the viewer observes them as if through the "fourth wall" of a stage.

The combination of Classical restraint and psychological insight in Giotto's frescoes may be related to the contemporary revival of Roman theater in Padua. Although there is no documentary evidence for it, the pictures suggest that, in creating the most dramatic fresco cycles of his generation, Giotto was influenced by this revival as well as by the traditional Christian mystery plays performed in front of churches. This combination of influences may also explain Giotto's dramatic depictions of pose and gesture.

In the *Annunciation,* both Mary and Gabriel are rendered as solid, sculpturesque figures, their poses identified mainly by their drapery folds. Gabriel raises his right hand in a gesture of greeting. Mary holds a book, signifying that Gabriel has interrupted her reading, a conventional detail in Annunciation scenes that is taken from the Apocrypha. As Gabriel makes his announcement, diagonal rays of light enter Mary's room. The lack of a logical or natural source for this

light emphasizes that it is divine light, emanating from heaven. As such, it is prophetic of the symbolic light, or *enlightenment,* that Christ will bring to the world. Equally prophetic is Mary's gesture, for her crossed arms refer forward in time to the Crucifixion. According to Christian doctrine, this is the means by which salvation is achieved.

A comparison of the Arena Chapel *Nativity* (fig. **12.8**) with Nicola Pisano's *Nativity* on the Pisa pulpit (see fig. 12.2) illustrates Giotto's reduction of form and content to its dramatic essence. In Giotto's fresco, as in Nicola's sculpture, more than one event is shown within a single space. Nicola combines the *Nativity* with the *Washing of the Infant Jesus* and the *Annunciation to the Shepherds* at the upper right. Giotto combines the *Annunciation to the Shepherds* at the right with the *Nativity* at the left. Both artists use simple, massive draperies that naturally outline human form and monumentalize the figures. But Nicola's composition is more crowded, and the dramatic relationships between figures do not have the power of Giotto's version.

Giotto's shepherds are rendered in back view and stand riveted by the angel's announcement. In the *Nativity,* the human figures are reduced to four: Mary, Jesus, Joseph, and a midwife. A single foreshortened angel above the shed

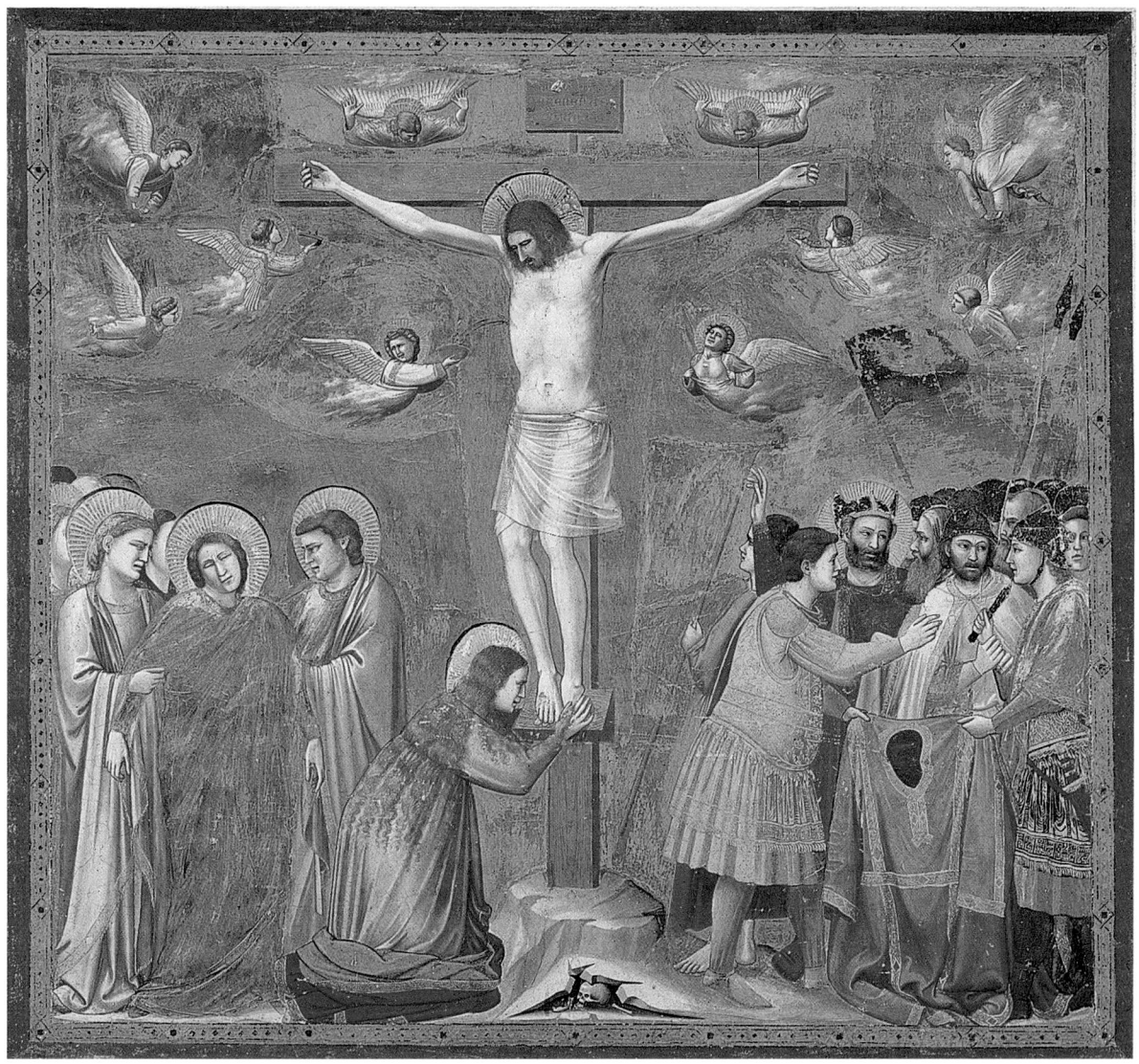

12.9 Giotto, *Crucifixion*, Arena Chapel, Padua, c. 1305. Fresco. The raised ground beneath the Cross represents the Hill of Calvary (from the Latin *calvaria*, meaning "skull"). According to tradition, Jesus was crucified on the Hill, or Place, of the Skull outside Jerusalem. The skull that appears in the opening of the rock is Adam's—a reminder of the tradition that Jesus was crucified on the site of Adam's burial. Both that tradition and its visual reference here are typological in character, for Jesus was considered the new Adam and the redeemer of Adam's sins.

gazes down at the scene, interrupting the left-to-right flow of the other angels toward the shepherds and focusing the viewer's attention onto the Nativity.

A sculpturesque Joseph dozes in the foreground, withdrawing from the intimate relationship between mother and infant. Giotto accentuates this by the power of a gaze that excludes a third party. Nicola's Mary, on the other hand, stares forward while Jesus lies in the manger behind her. Rather than emphasize the dramatic impact of the mother's first view of her son, Nicola monumentalizes Mary as an individual maternal image and, in the *Nativity,* relegates Jesus to the background. In the *Washing of Jesus,* the same Mary towers over her infant but does not make eye contact with him.

Giotto reinforces his perception of the mother–child relationship in the depiction of the animals. Among the sheep, he repeats the theme of protection and physical closeness. In the ox and ass at the manger, he plays on the Christian meaning of their glances and merges it with the emotional

significance of the gaze. The ass looks down and fails to see the importance of the event before him. He thus becomes a symbol of ignorance and sin. The ox, however, stares at the gaze of Mary and Jesus, recognizing its importance in Christian terms and also replicating the role of the outsider looking in, like the viewer, on a dramatic confrontation.

In contrast to the *Annunciation,* the *Crucifixion* (fig. **12.9**) takes place outdoors, on a narrow, rocky, horizontal ground. Jesus hangs heavily from the Cross, his neck and shoulders forced below the level of his hands. His arms are elongated, his muscles are stretched, and his rib cage is visible beneath his flesh. Transparent drapery reveals the form of his body. Family and friends are gathered to the right of the Cross. Mary, dressed in blue, slumps in a faint, her weight supported by Saint John and an unidentified woman. Forming a diagonal bridge from Mary and John to the Cross is the kneeling figure of Mary Magdalen, traditionally understood to have been a prostitute before she became one of Jesus's most devoted followers. In this

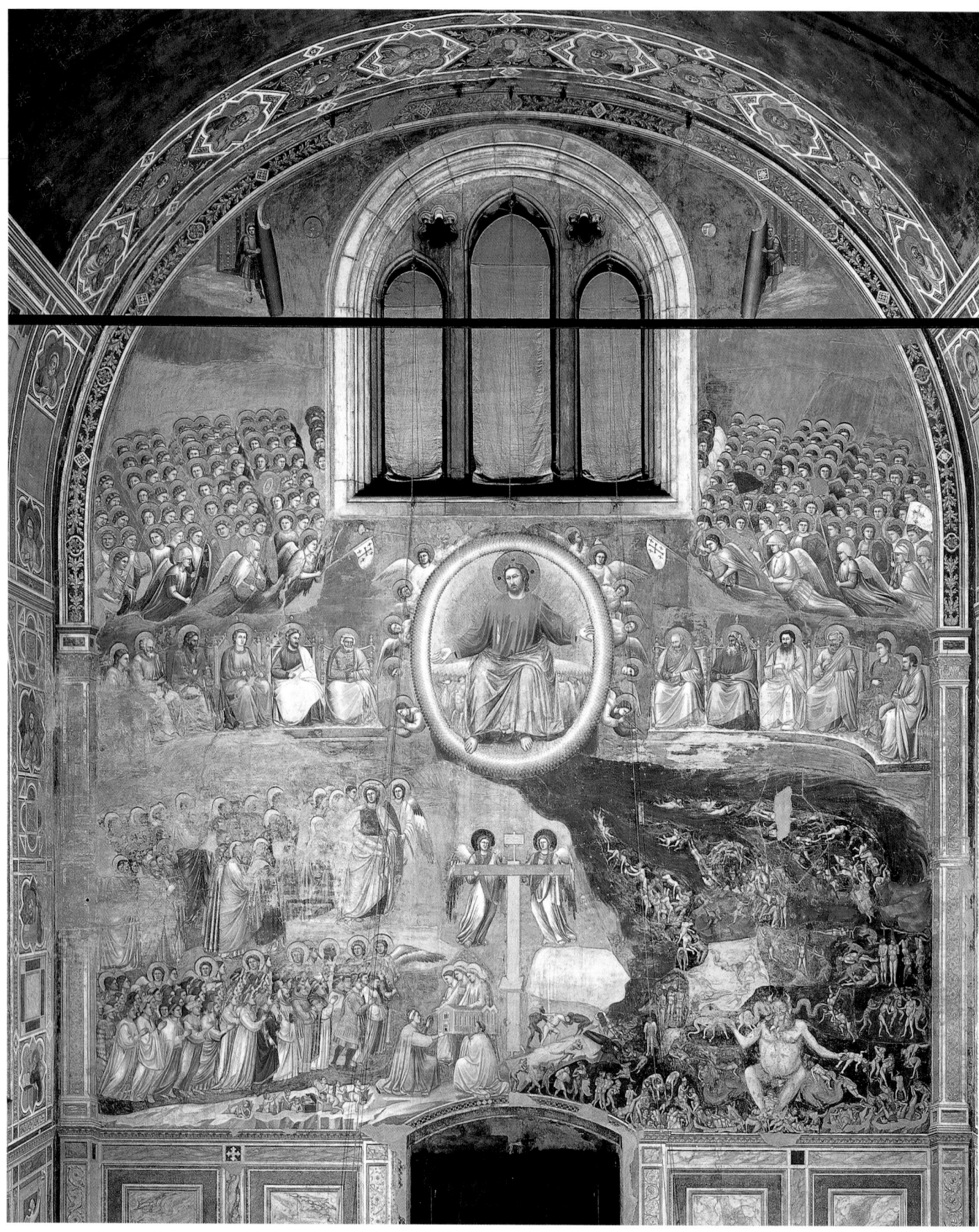

12.10 Giotto, *Last Judgment,* Arena Chapel, Padua, c. 1305. Fresco; approx. 33 ft. × 27 ft. ¾ in. (10.06 × 8.38 m).

painting, she wears her hair long, an iconographic convention denoting her penance.

In contrast to the formal and psychological link between Jesus and his followers on his right (our left), there is a void immediately to the left of the Cross. The symbolic distance between Jesus and his executioners is reinforced by the diagonal bulk of the Roman soldier leaning to the right. The group of soldiers haggles over Jesus's cloak, which one soldier prepares to divide up with a knife. (See Matthew 27:35: "they . . . parted his garments, casting lots.") Framing the head of a Roman soldier in the background is a halo, which sets him apart from the others and identifies him as Longinus, who converted to Christianity and became a martyr.

The sky is filled with two symmetrical groups of mourning angels. Like a Greek chorus, they echo and enhance the human emotions of Jesus's followers. The spatial positions of the angels are indicated by varying degrees of foreshortening, the two above the arms of the Cross being the most radically foreshortened. Two angels extend cups to catch the blood flowing from the **stigmata**—the wounds of Jesus. The greater formal activity and melodrama of the angels act as a foil to the restraint of the human figures.

Chronologically, the last scene in the chapel is the *Last Judgment* (fig. **12.10**), which fulfills the Christian prophecy of Christ's Second Coming. The finality of that event corresponds to its location on the west wall of the Arena Chapel, where it is the last image to confront viewers on their way out. The fresco occupies the entire wall; the host of heaven, consisting of military angels, is assembled on either side of the window. Above the angels, two figures roll up the sky, to reveal the golden vaults of heaven.

Below the window, Christ is enthroned in a circle of light, surrounded by angels. Seated on a curved horizontal platform on either side of Christ are the twelve apostles. Christ's right hand summons the saved souls, while his left rejects the damned. He inclines his head to the lower left of the fresco (his right), where two levels of saved souls rise upward. At the head of the upper group stands the Virgin Mary, who appears in her role as intercessor with Christ on behalf of humanity.

Giotto's hell, conventionally placed below heaven and on Christ's left, is the most medieval of the Arena Chapel frescoes. It is surrounded by flames emanating from the circle around Christ. In contrast to the orderly rows of saved souls, those in hell are disordered—as in the Romanesque example from Conques (see fig. 10.11). The elaborate visual descriptions of the tortures inflicted on the damned by the blue and red devils, and their contorted poses, are reminiscent of medieval border figures, whether on manuscripts or church sculptures.

The large, blue-gray Satan in the depths of hell is typical of the medieval taste for monstrous forms merging with each other. Satan swallows one soul while the serpentine creatures who emerge from his ears bite into other souls, an image of oral aggression that appears in many medieval manuscripts. Dragons on either side of Satan's rear also swallow souls, and from the ear of one of the dragons rises a ratlike creature biting into a soul, who falls back in despair. The falling and tumbling figures emphasize the

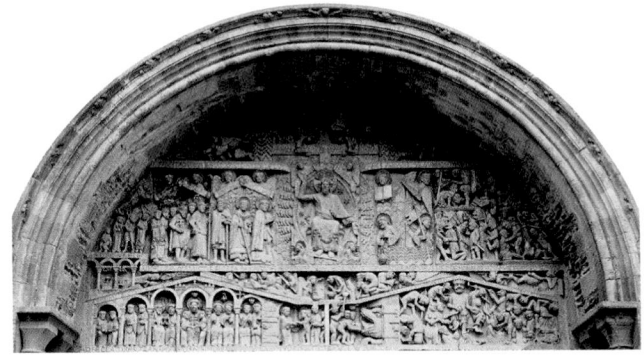

See figure 10.11. *Last Judgment*, Sainte-Foy, Conques, c. 1130.

Christian conception of hell as disordered, violent, and located among the lowest realms of the universe.

Directly below Christ, two angels hold the Cross, which divides the lower section of the fresco into the areas populated by the saved and the damned. Giotto's reputation for humor is exemplified in the little soul behind the Cross who is trying to sneak over to the side of the saved. Toward the bottom of hell, a mitered bishop is approached by a damned soul holding a bag of money, possibly hoping to buy an indulgence. Besides being a criticism of corruption in the Church, this detail may be an implied reference to Reginaldo Scrovegni's financial sin, for which his son tried to atone through his patronage of the Arena Chapel. Not surprisingly, Enrico is placed on the side of the saved (fig. **12.11**). As he kneels, his drapery falls on the ground in soft

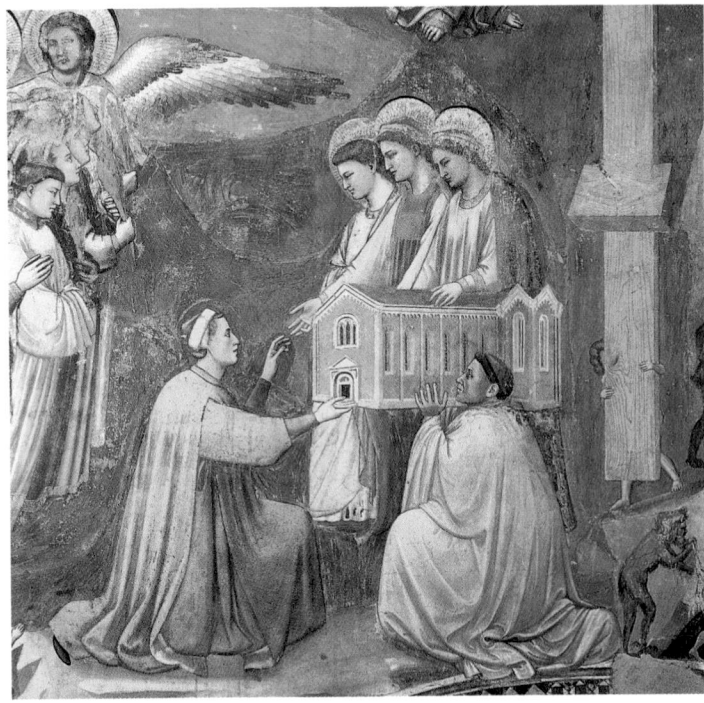

12.11 Giotto, *Last Judgment* (detail of fig. 12.10), Arena Chapel, Padua, c. 1305. Enrico Scrovegni, assisted by a monk, lifts up a model of the Arena Chapel and presents it to Mary and two other figures. Scrovegni holds the model and faces the exterior of the entrance wall, the interior of which contains the *Last Judgment*. The monk's cloak looks as if it is falling out of the picture plane over the doorway arch, an illustration of Giotto's taste for illusionism as well as of his sense of humor.

12.12 Giotto, *Justice*, Arena Chapel, Padua, c. 1305. Fresco.

12.13 Giotto, *Injustice*, Arena Chapel, Padua, c. 1305. Fresco.

folds, suggesting the weight of the fabric. Such portrayal of the donor within a work of art was to become characteristic of the Renaissance.

Before leaving the Arena Chapel, we consider the Virtue of *Justice* (fig. **12.12**) and the Vice of *Injustice* (fig. **12.13**), which illustrate the contemporary Italian concern with government. Two forms of government prevailed in Italy as the Renaissance dawned. Popes and princes ruled the relatively authoritarian states, while republics and communes were more democratic. Although the latter were, in practice, more often oligarchies (governments controlled by a few aristocrats) than democracies in the modern sense, the concept of a republican government was based on the Classical ideal.

Justice is personified as an enthroned queen in a Gothic architectural setting. She holds a Nike in her right hand, as did Phidias's Athena in the Parthenon *naos* (see fig. 5.57), indicating that justice brings victory. Justice also leads to good government and a well-run state, with all the benefits that this implies. Painted as an imitation relief in the rectangle at the bottom of the picture are images of dancing, travel (men on horseback), and agriculture.

The Vice of *Injustice* (fig. 12.13), in contrast, shows a tyrant enclosed inside a crenellated castle and separated from both the viewer and his subjects by a row of trees. Cracks in the walls denote the stress and instability of unjust government. And at the bottom of the fresco, we see the results of tyranny—pillage, rape, and war.

Giotto's *Saint Francis*

Although Giotto's acknowledged masterpiece is the Arena Chapel in Padua, he himself was a citizen of Florence. In that city, he later decorated two surviving chapels in the Gothic Franciscan church of Santa Croce. These were the family chapels of two leading banking families, the Bardi and the Peruzzi. In the Bardi Chapel, Giotto painted scenes from the life of Saint Francis (see box, p. 463), whose cult was one of the most prominent in Italy. Because of Saint Francis's insistence on poverty, the issue of decorating Franciscan churches became controversial. Likewise, the role of rich patrons in commissioning works of art depicting the lives of saints highlighted the contrast between wealthy patrons and the message of the works they commissioned.

Saint Francis pursued poverty in imitation of Christ, with whom he identified, particularly in receiving the stigmata. Giotto depicted the *Stigmatization of Saint Francis* (fig. **12.14**) in a fresco on the outer wall of the Bardi Chapel. The scene takes place in a rocky, mountainous landscape dotted with a few trees. A church stands at the right. As in the Arena Chapel, landscape and architecture are subordinate to the human figures and reinforce them. The cubic mass of Saint Francis from the waist down is mirrored in the building and the base of the mountain. The diagonal of the torso repeats the slanting triangle of the mountaintop in reverse.

12.14 Giotto, *Stigmatization of Saint Francis*, exterior of the Bardi Chapel, Santa Croce, Florence, after 1317. Fresco.

Despite the mystical content of the event, Giotto represents Saint Francis as a solid, three-dimensional figure and conveys a sense of physical reaction to the experience of religious transport. Francis is shown as if "taken aback" by the force of light rays emanating from his vision.

By virtue of the fresco's location on the chapel's exterior wall, the scene is the first to be encountered by visitors. Its purpose must have been at least partly to proclaim the spiritual sentiments of the Bardi family, whose commercial acumen and wealth were widely known.

Saint Francis of Assisi (1181/2–1226)

Saint Francis was the son of a rich merchant in the Umbrian town of Assisi. As a young man, Francis made a pilgrimage to Rome, where he felt a sudden sense of identification with a beggar and traded clothes with him. For the first time in his life of privilege, Francis experienced poverty and realized its spiritual potential. He then renounced his father's wealth and dedicated his life to poverty. In 1224, while he was praying and meditating on the mountain of La Verna, he looked into the rising sun and saw a vision of Jesus on the Cross. Jesus's arms were the outstretched wings of a seraph (a type of angel). Scars corresponding to the wounds of the crucified Christ are then believed to have appeared on Saint Francis's body (a phenomenon known as "stigmatization"). In 1209, Francis received the pope's permission to found an Order of friars, the Franciscan Order. He established a strict, simple Rule, insisting that his followers—the Friars Minor—live by the work of their own hands or by begging. They were forbidden to accept money or property in exchange for services. Pope Innocent III approved the Rule in 1209–1210, and Francis traveled to Spain, eastern Europe, and Egypt to spread his message.

Around 1212, a noblewoman of Assisi, Clare, decided to follow the Rule of Saint Francis. When other women joined her, Francis established a separate community with Clare as its abbess. Her followers became known as the Poor Clares. The power of the Franciscan movement attests to its wide appeal, and, in the course of the thirteenth century, Franciscan churches proliferated. So-called "daughter houses," established by the Poor Clares, also sprang up throughout Europe.

Partly because of the large number of Saint Francis's followers and partly because of conflict over the rigors of his Rule, the Franciscans split into two factions. The Spiritualists adhered to strict interpretation of the Rule, whereas the Conventualists took a more flexible position.

After Saint Francis received the stigmata, he wrote his most famous work, *The Canticle of Brother Sun*. It is a long hymn in praise of the divine presence he believed resided in nature:

> Praised be You, my Lord, with all your creatures,
> especially Sir Brother Sun,
> Who is the day and through whom You give us
> light.
> And he is beautiful and radiant with great splendor; and bears a likeness of You, Most High
> One.
> Praised be You, my Lord, through Sister Moon
> and the stars,
> In heaven You formed them clear and precious
> and beautiful.[3]

This hymn reflects the role of Saint Francis in the new emphasis on nature that developed in the later Gothic period and that would characterize much of the Renaissance. Saint Francis's Rule heralded a shift from monastic isolation to greater involvement—largely through preaching—with urban populations, especially the poor.

On July 6, 1228, two years after his death, Francis was canonized by Pope Gregory IX. His remains are in the thirteenth-century basilica of San Francesco in Assisi, which is the center of his cult.

Duccio's *Maestà*

The leading early fourteenth-century artists in Siena, Florence's rival city, worked in a style that was influenced by Byzantine tradition. Siena was ruled by a group known as the Nine, which was in charge of public commissions. The Nine were particularly devoted to the Virgin, for they believed her intercession had been responsible for a major thirteenth-century military victory over Florence. Her cult was a significant feature of Sienese culture, and she was the city's patron saint. Siena called itself "the Virgin's ancient city" (*vetusta civitas virginis*).

In 1308, the prominent Sienese painter Duccio di Buoninsegna (active 1278–1318) was commissioned to produce a new altarpiece for the high altar of the cathedral. It was to honor the Virgin, whose image is the largest in the entire work. The completed altarpiece was two-sided and originally consisted of over fifty panels, several of which have been lost; some of the dismantled panels are now in museums elsewhere. In its original state, Duccio's *Maestà*

was about as high as the monumental altarpieces by Cimabue and Giotto discussed above but was considerably wider (about 13 feet, or 4 m). Its former appearance has been reconstructed in photo montage by the art historian John White. The front (fig. **12.15**) exalts the Virgin as Queen of Heaven—*maestà* means "majesty." She occupies the large horizontal panel, the sides of her throne opening up as if to welcome the viewer. In the crowd surrounding her are two of the apostles, John the Evangelist and Peter. The other ten apostles appear under the small round arches above. The lower sections of the pinnacles contain scenes of Mary's last days, beginning on the left with the *Annunciation of the Death of the Virgin* and ending with the *Burial of the Virgin* on the right. At the bottom are predella panels with scenes of Jesus's early life, from left to right: the *Annunciation* of his birth, the *Nativity, Adoration of the Magi, Presentation in the Temple, Massacre of the Innocents, Flight into Egypt,* and *Jesus among the Doctors.* Standing by each of these events is the Old Testament prophet interpreted as having foretold it.

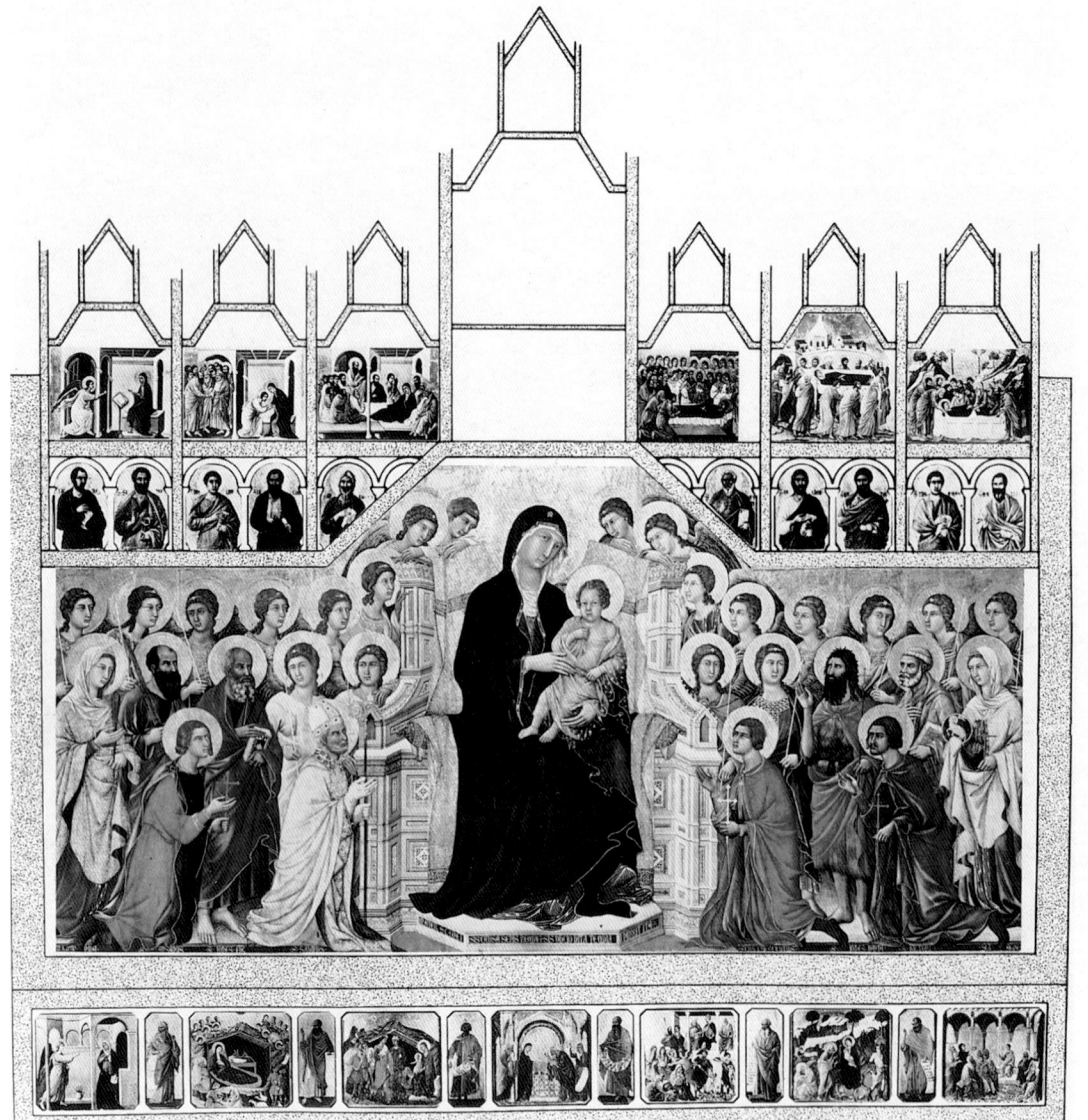

12.15a John White, photo montage of Duccio's *Maestà* (front), 1308–1311. This is Duccio's only signed work (signed on the base of the throne). According to the commission contract, which was signed October 9, 1308, Duccio was paid for every day that he worked on the altarpiece. For those days that he did not work, his pay was docked.

12.15b Duccio, *Maestà,* from Siena Cathedral, 1308–1311. Tempera and gold on panel; 7 ft. × 13 ft. 6¼ in. (2.13 × 4.12 m). Museo dell'Opera del Duomo, Siena.

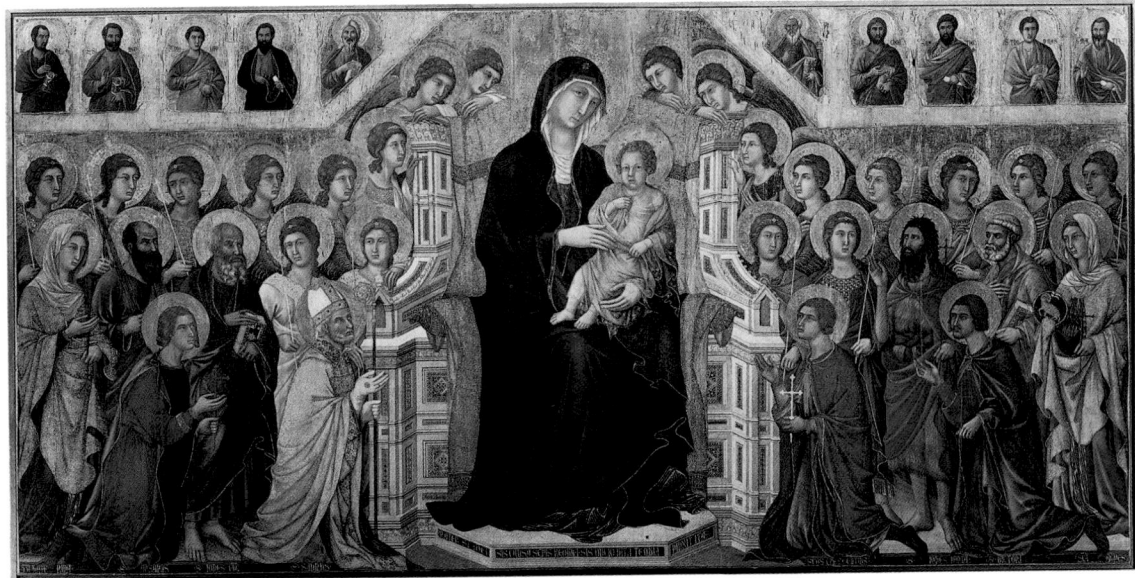

The four registers on the reconstructed back of the *Maestà* (fig. **12.16**) depict the Passion in twenty-six scenes. The largest, at the center, is the *Crucifixion.* The six pinnacle scenes illustrate Christ's miraculous appearances after his death, and on the predellas are scenes of his ministry.

The iconography of the altarpiece covers the full range of the Virgin's majesty and of her maternity. In 1311, when Duccio completed the *Maestà,* it was carried in a triumphal procession, accompanied by pipes and drums, from his studio to the cathedral.

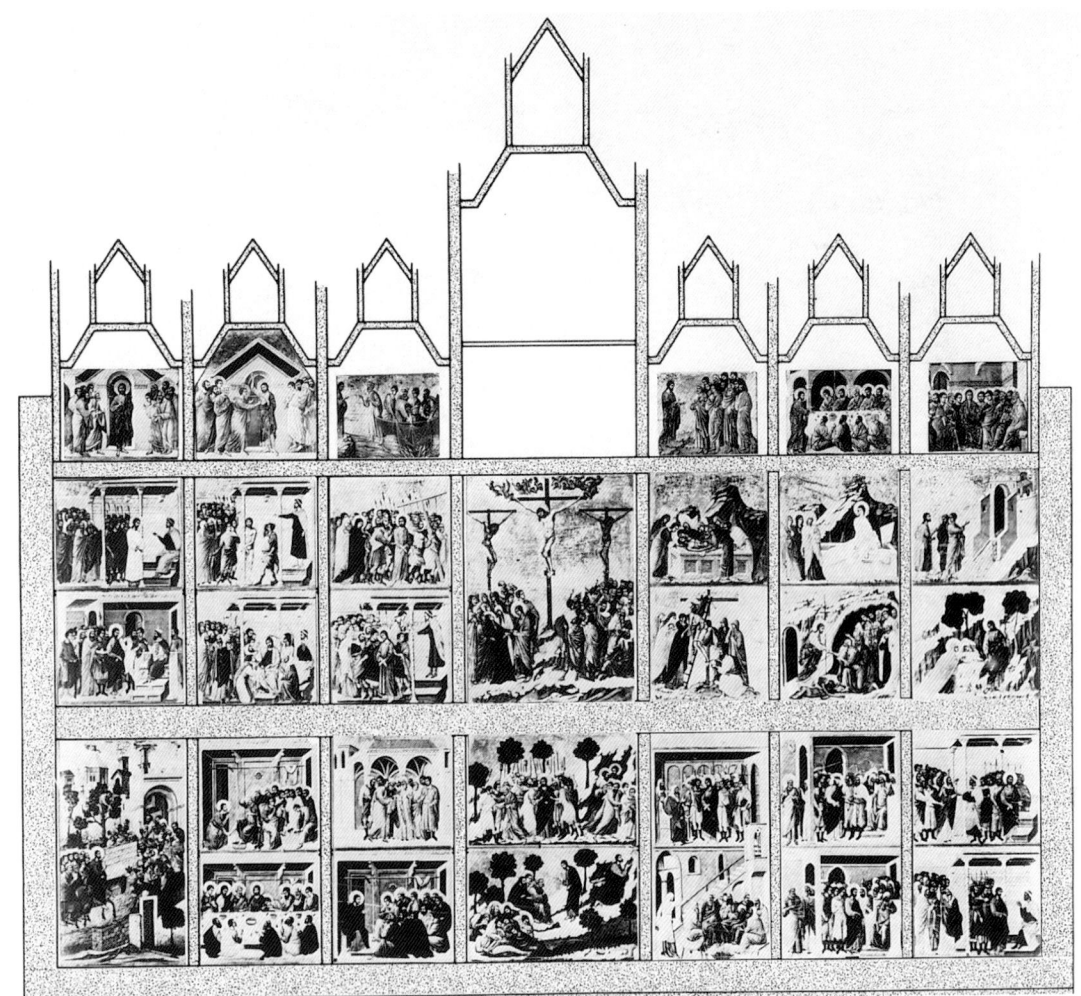

12.16 John White, photo montage of Duccio's *Maestà* (back), 1308–1311.

The *Kiss of Judas*

Duccio and Giotto exemplify two major currents in early fourteenth-century Italian painting. Duccio was more closely tied to the Byzantine tradition, whereas Giotto was steeped in the humanist revival of Classical antiquity. These relationships can be clarified by comparing three examples of the *Kiss of Judas:* a Byzantine mosaic (fig. **12.17**), Duccio's panel below the Crucifixion in the *Maestà* (fig. **12.18**), and the Arena Chapel fresco (fig. **12.19**). All three represent the moment when Judas identifies Jesus to the Romans with a kiss. In the mosaic and in Duccio's panel, Jesus is nearly frontal, and Judas leans over in a sweeping curved plane to embrace him. Their heads connect, but in neither case do Judas's lips actually touch Jesus's face. Both scenes take place outdoors, against a gold sky. The figures in the mosaic face the viewer and are only minimally engaged with each other. They are outlined in black, and their diagonal feet accentuate the two-dimensionality of their space. As the largest figure, Jesus stands out as the most significant; he has a jeweled halo and wears the purple robe of royalty, denoting his future role as King of Heaven.

Duccio's panel is more densely packed with figures than the mosaic is. This, together with the landscape background, conveys an illusion of greater depth. The more subtle shading of the drapery folds also gives the figures a greater sense of three-dimensional form. In the mosaic, the apostles at the right wear Roman-style togas and stand in vertical planes. The only sign of emotion at the arrest of their leader is the slight agitation of their tilted heads. In the Duccio, however, the apostles break away from the central crowd and rush off to the right. Their long, curvilinear planes have the quality of a graceful dance movement performed in unison. At the left, Saint Peter also turns from Jesus, but, in a rage, he cuts off the ear of Malchus, the servant of the high priest.

Giotto's version of the *Kiss of Judas* (fig. 12.19) lives up to his reputation among humanist authors for having reintroduced naturalism to painting. The fresco is virtually devoid of landscape forms that might distract viewers from the central event. Nor do any of Giotto's figures face the picture plane. Most are focused on the dramatic confrontation between Jesus and Judas. These two, in turn, are locked in each other's gaze, surrounded ominously by

12.17 *Kiss of Judas*, Sant'Apollinare Nuovo, Ravenna, early 6th century. Mosaic.

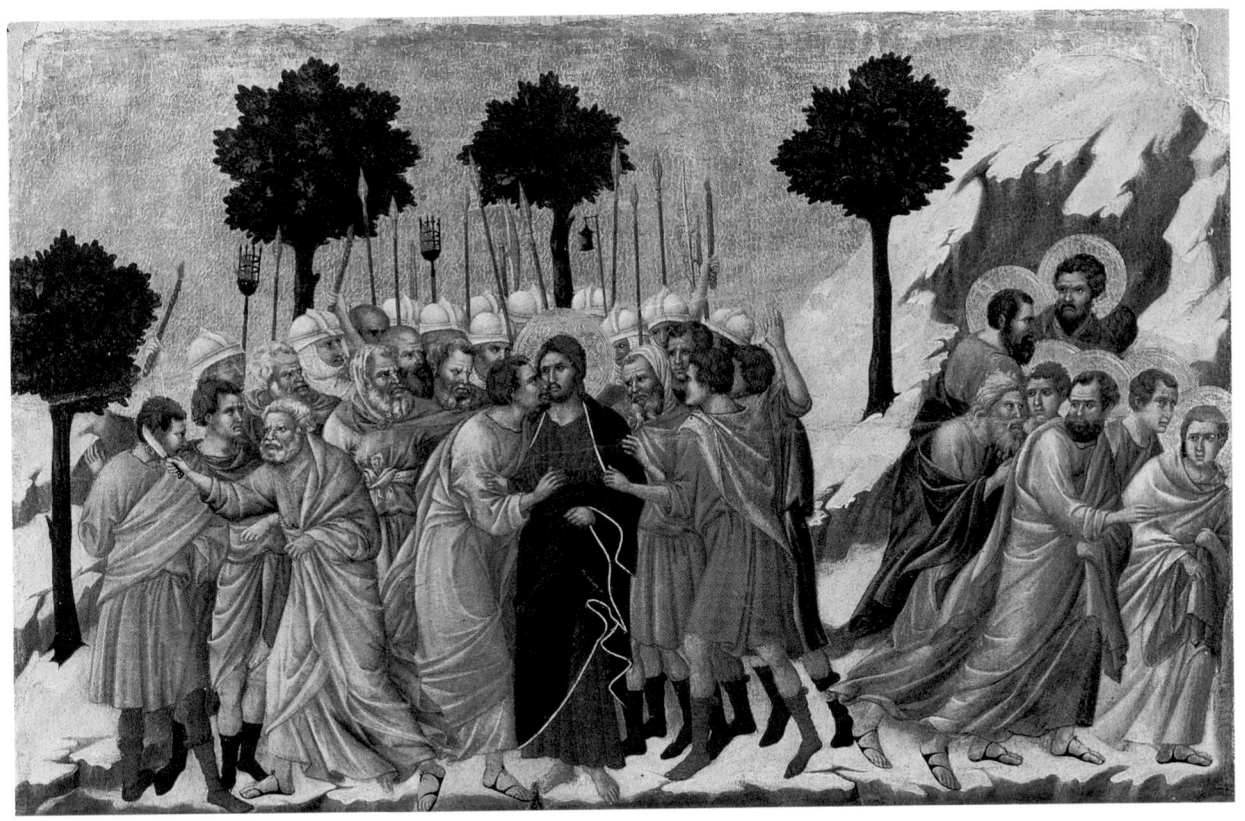

12.18 Duccio, *Kiss of Judas,* from the *Maestà,* from Siena Cathedral, 1308–1311. Tempera on panel. Museo dell'Opera del Duomo, Siena.

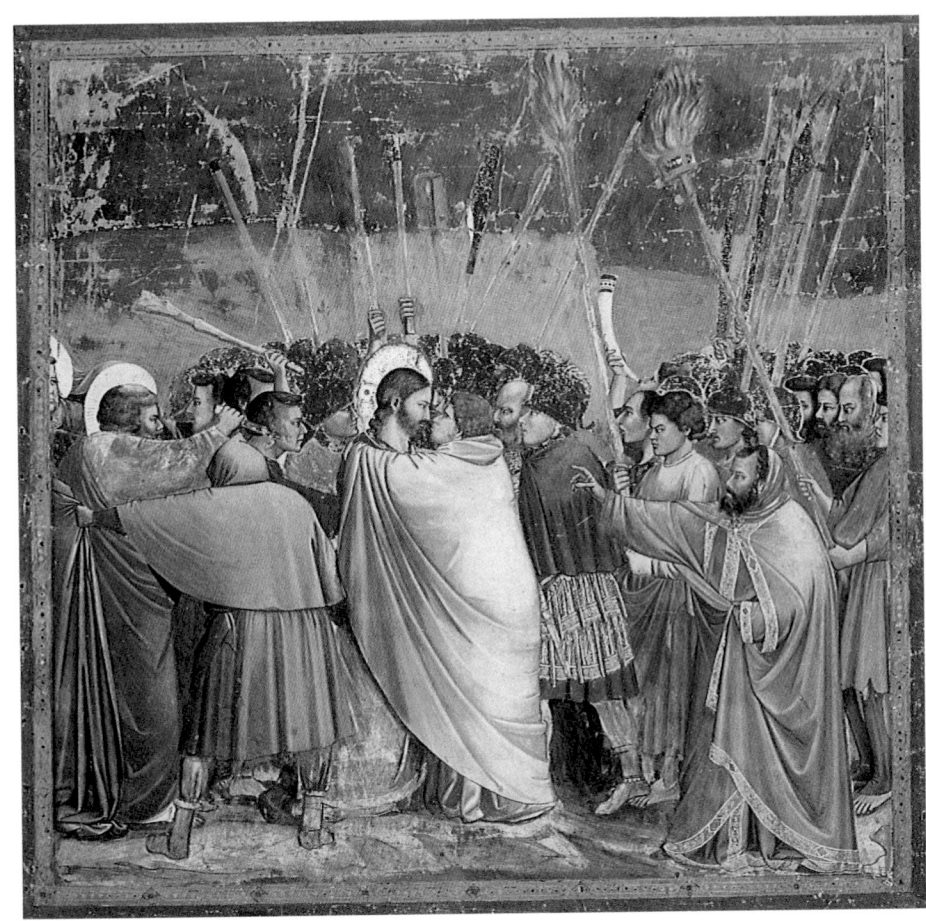

12.19 Giotto, *Kiss of Judas,* Arena Chapel, Padua, c. 1305. Fresco.

the helmets framing their heads. Over Jesus's head, the two hands holding stakes accentuate the rage of the mob against him; none of the stakes is vertical, as in the Duccio, those behind Jesus seeming to radiate from an unseen point. In this convergence of forms, therefore, Giotto signals the violence of Jesus's death and also his ultimate triumph.

Giotto is the first Western artist since ancient Rome to have depicted figures in back view. In the *Kiss of Judas,* he places three figures as if in different stages of a turn: the pointing man at the right is in three-quarter view; Judas turns farther to the right as his yellow cloak envelops Jesus; and the hooded man in gray is seen directly from the rear. Together, these three create a sense of movement from right to left across the picture plane, counteracting the left–right flow of the narrative. Another countermotion can be seen in the figure of Saint Peter, who raises his hand behind the head of the hooded man and vigorously cuts off the ear of Malchus. Saint Peter does not, as in Duccio's scene, turn away from Christ. The thrust of his blow interacts with the gesture of the hooded figure, whose very presence conveys an air of foreboding. His facelessness, characteristic of the executioner, may allude to Jesus's imminent death on the Cross.

Ambrogio Lorenzetti and the *Effects of Good Government*

Twenty-seven years after the triumphal procession for Duccio's *Maestà,* the innovative Sienese artist Ambrogio Lorenzetti (active 1319–1347) painted *Allegories of Good and Bad Government* for the Palazzo Pubblico (Town Hall) of Siena. Figure **12.20,** like Giotto's *Justice* (fig. 12.12), illustrates the effects of good government on a city—in this case, Siena. In contrast to the *Maestà,* Ambrogio's *Allegory* is secular and reflects the new humanist interest in republican government. He depicts a broad civic panorama with remarkable realism. In the foreground (from left to right), women wearing the latest fashions dance and sing in celebration of the joys of good government; people ride on horseback among the buildings, whose open archways reveal a school, a cobbler's shop, and a tavern; farmers are shown entering the city to sell their produce. On top of a building in the background, one worker carries a basket and another a slab; they seem to be laying bricks. In this imagery, Lorenzetti suggests that both agricultural prosperity and architectural construction are among the advantages of good government.

12.20 Ambrogio Lorenzetti, *Effects of Good Government in the City and the Country,* from the *Allegory of Good Government,* Sala della Pace, Palazzo Pubblico, Siena, 1338–1339. Fresco; entire wall 46 ft. (14.02 m) long. Ambrogio was one of two artist brothers who were active in the first half of the fourteenth century. Both were born and worked in Siena, and they are believed to have died in the Black Death since nothing is heard of them after 1347. Ambrogio also worked in Florence, where he was exposed to Giotto's style. The *Allegory of Good Government,* which has considerable documentary value as well as artistic merit, is considered his greatest surviving work.

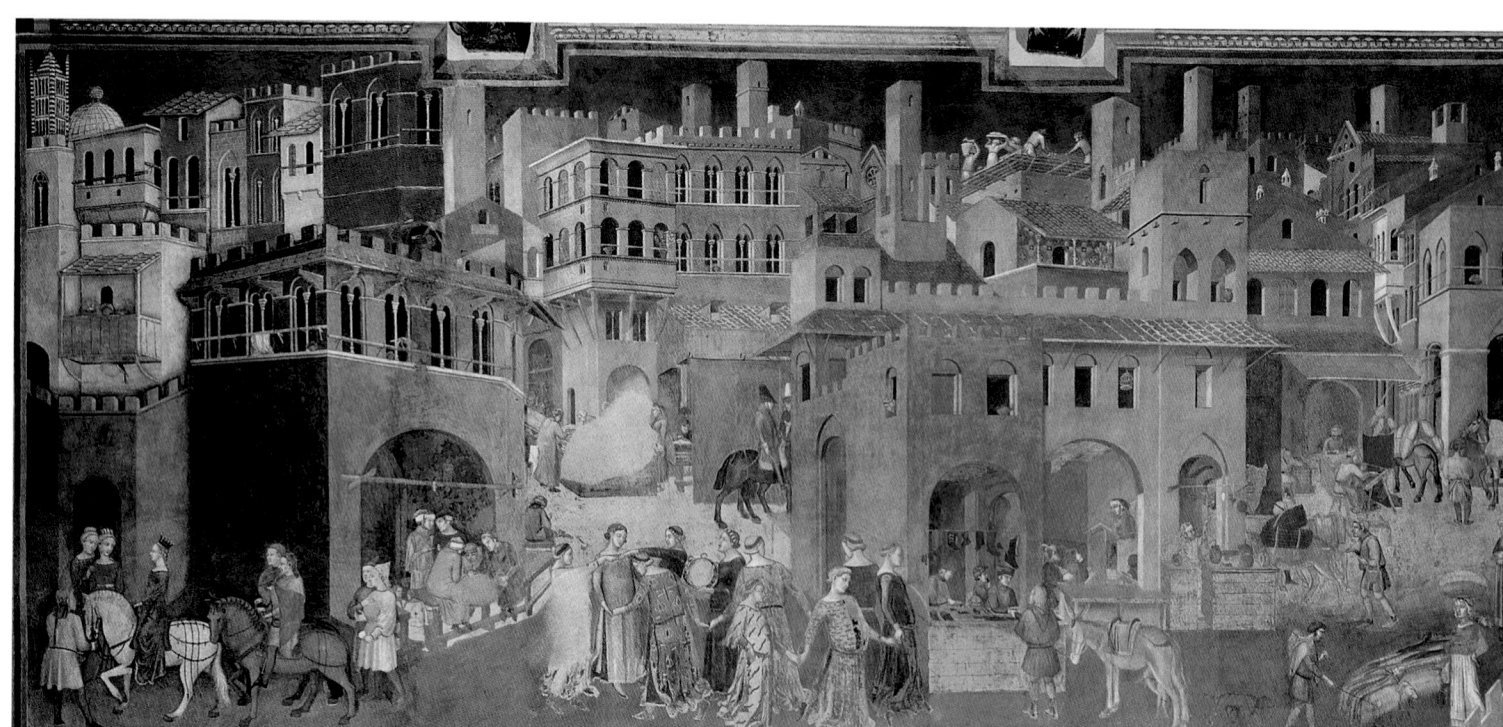

Just outside the city walls, people ride off to the country. Below, a group of peasants tills the soil, and the cultivated landscape visible in the distance draws the viewer into an almost unprecedented degree of spatial depth. Floating above this tranquil scene, an allegorical figure of Security holds a scroll with an inscription reminding viewers that peace reigns under her aegis. And should one fail to read the inscription, she provides a pictorial message in the form of a gallows. Swinging from the rope is a criminal executed for violating the laws of good government. Accompanying Ambrogio's vision of prosperity and tranquillity, therefore, is a clear warning of the consequences of social disruption.

Just behind the left foot of Security, Ambrogio has included the statue of the legendary she-wolf who nursed

Romulus and Remus. Projecting from the city's wall, she seems to survey the surrounding countryside. At the same time, the wolf makes explicit the link between ancient Rome and Siena (see fig. 6.2).

Stylistically, Ambrogio's *Allegories* fall between Giotto and Duccio. Although the *Allegory of Bad Government* is severely damaged, certain details are clear. The detail in figure **12.21** shows two soldiers attacking a woman, rendered in a graceful S-curve. Above are the feet of two hanged criminals, echoing the exemplary gallows of Security. Despite its violence, the scene lacks the

See figure 6.2. *Capitoline Wolf*, Rome, c. 500 B.C.

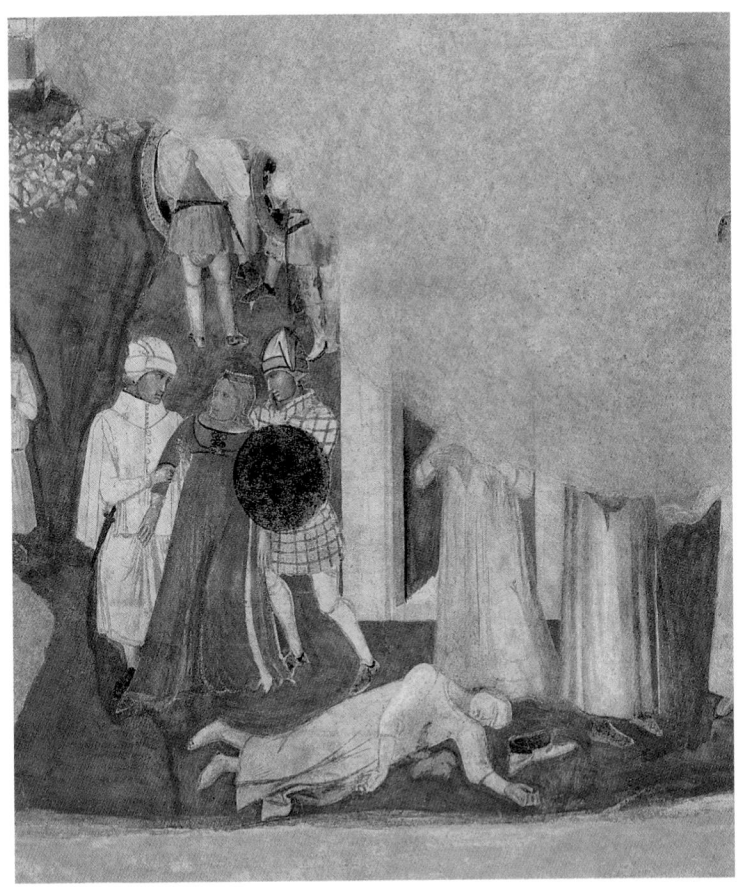

12.21 Ambrogio Lorenzetti, detail showing soldiers attacking a woman, from the *Allegory of Bad Government*, Palazzo Pubblico, Siena, 1338–1339. Fresco.

Boccaccio on the Black Death

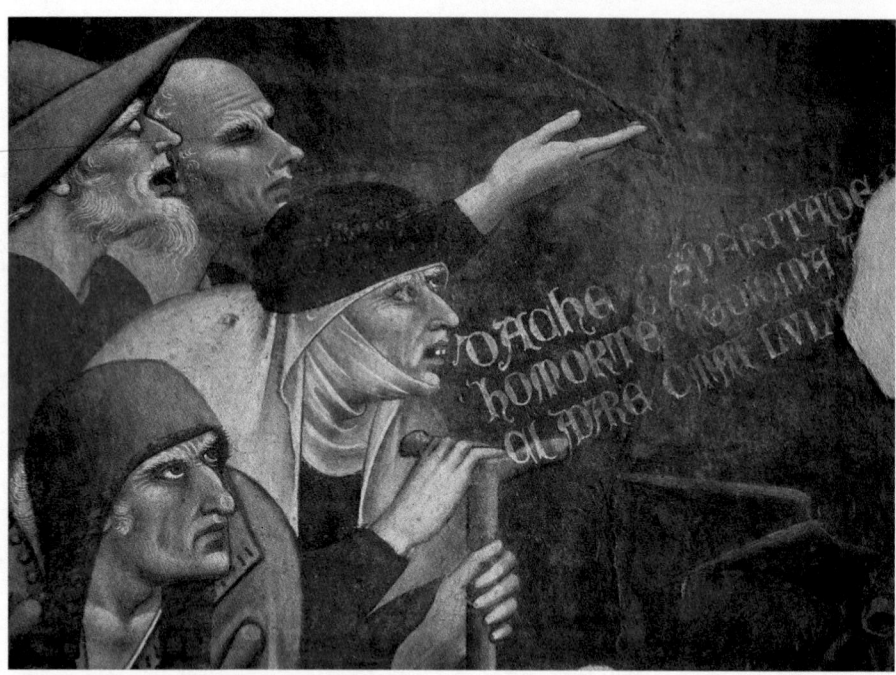

12.22 Andrea Orcagna, detail showing figures invoking Death, from the *Triumph of Death,* 1360s. Fresco. Museo dell'Opera di Santa Croce, Florence.

As a result of the disasters that swept through Europe during the first half of the fourteenth century, artists became drawn to such subjects as the Triumph of Death. Andrea di Cione—known as Orcagna (active c. 1343–1368)—painted a monumental fresco in the church of Santa Croce in Florence in which he combined the theme with depictions of hell and the Last Judgment. Although the work survives only in fragments, its message of impending doom remains clear.

The detail in figure **12.22** shows two cripples and two blind men invoking Death. The anxious gesture of one of the sightless men contrasts with the wide-eyed stares of the cripples. The inscription reads: "Since prosperity has departed, O Death, the medicine of all pain, come and give us our last supper." In another fragment of Orcagna's *Triumph of Death* (fig. **12.23**), two men gaze at an eclipse of the sun. Since contemporary documents related the eclipse of 1333 to subsequent flooding, it is likely that this detail associates those events with both the Old Testament Flood and the apocalyptic "day of . . . wrath" (Revelation 6:12–17).

The bubonic plague of 1348 killed some 25 million people. It was carried by a bacterium in fleas that lodged in the fur of common rodents. The effects of the Black Death were described by Boccaccio in the preface of the *Decameron,* a collection of 100 stories set in fourteenth-century Italy:

> 1348. The mortal pestilence then arrived in the excellent city of Florence. . . . It carried off uncounted numbers of inhabitants, and kept moving . . . in its early stages both men, and women too, acquired certain swellings, either in the groin or under the armpits. Some of these swellings reached the size of a common apple . . . people called them plague-boils . . . the deadly swellings began to reach . . . every part of the body. Then . . . began to change into black or livid blotches . . . almost everyone died within the third day . . . even to handle the clothing or other things touched by the sick seemed to carry with it that same disease. . . .
>
> Some persons advised that a moderate manner of living, and the avoidance of all excesses, greatly strengthened resistance to this danger. . . . Others . . . affirmed that heavy drinking and enjoyment . . . were the most effective medicine for this great evil. . . .
>
> The city was full of corpses . . . there was not enough blessed burial ground . . . they made huge trenches in every churchyard, in which they stacked hundreds of bodies in layers like goods stowed in the hold of a ship, covering them with a bit of earth until the bodies reached the very top.[4]

There was, as Boccaccio observed, a general air of penance on the one hand and a "seize the day" mentality on the other.

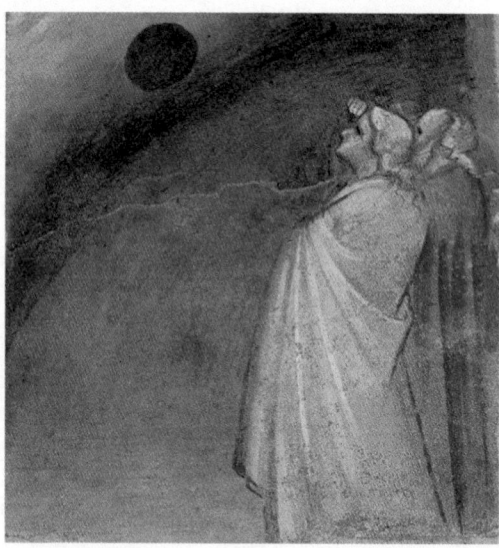

12.23 Andrea Orcagna, detail showing two men watching an eclipse of the sun, from the *Triumph of Death,* 1360s. Fresco. Museo dell'Opera di Santa Croce, Florence.

dramatic power that characterizes Giotto's work. But Ambrogio's figures are closer to Giotto's than to Duccio's in their sense of mass and volume. Nor are their draperies trimmed with gold, as Duccio's often are.

Ambrogio Lorenzetti's monumental secular paintings were the first of their kind in Western art since Christianity had become the official religion of Rome. They reflected the shift that had occurred in patronage, which was no longer exclusively tied to the Church—even in Siena, where the Virgin's cult was at its strongest. As Lorenzetti's work reveals, the new cultural and intellectual concerns of the early fourteenth century had resulted in a revolutionary development in style. Giotto had created a new approach to painted space, influenced as he was by the sculpture of Nicola Pisano and his son Giovanni, by Roman ruins, and by discoveries of Classical texts. For the first time since Greco-Roman antiquity, human figures occupy three-dimensional settings. Backgrounds are no longer gold, but rather defined by natural blue skies or landscape. Architecture is set at an oblique angle to the picture plane, creating an illusion of spatial recession.

A series of disasters in western Europe disrupted the activities of the next generations of fourteenth-century artists. In 1329 there was famine, an eclipse followed by a flood in 1333, and a smallpox epidemic in 1335 that killed thousands of children. In the early 1340s, both the Bardi and Peruzzi banks failed, and in 1348 the bubonic plague—called the Black Death—devastated Europe (see box, p. 470). In Florence and Siena, between 50 and 70 percent of the residents died, resulting in population shifts, economic depression, and radical changes in artistic patronage and style.

Contemporary sermons document the resurgence of religious fervor following the Black Death. In the visual arts, there was a revival of certain aspects of the Byzantine style. The increasingly humanist style of the first half of the century yielded to a more pessimistic view of the world, with greater emphasis on death and damnation. The innovations of Giotto and other early fourteenth-century artists remained in abeyance and were revived by the first generation of Italian painters, sculptors, and architects of the fifteenth century.

The International Gothic Style

An entirely different mood characterized works commissioned by the courts in fourteenth-century Italy and France. Their wealth made it possible to import artists from different regions and to pay them well. The resulting convergence of styles, generally known as International Gothic, continued into the fifteenth century; the best fourteenth-century examples were executed under French patronage.

Simone Martini

In the Angevin court at Naples, French taste predominated, even in the work of Italian artists. King Robert of Anjou was the younger brother of Louis of Toulouse, who had joined the Franciscan Order of the Friars Minor. When elected to the rank of bishop in 1296, Louis renounced the throne in favor of Robert and died a year later. Amid rumors that he had usurped the throne, Robert commissioned the Sienese artist Simone Martini to paint the altarpiece illustrated in figure **12.24**. The date of the commission, 1317, coincided with Louis's canonization.

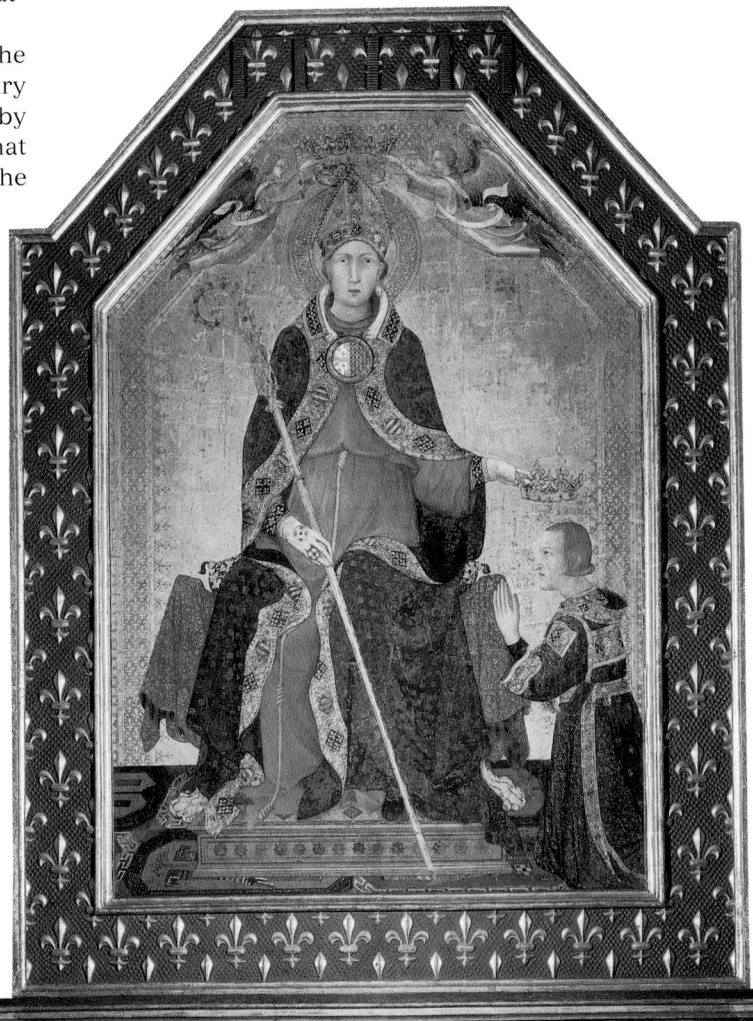

12.24 Simone Martini, Saint Louis Altarpiece, c. 1317. Tempera on panel; main panel 78¾ × 54¼ in. (200.0 × 137.8 cm). Galleria Nazionale, Naples. The predella panels contain scenes from the life of Saint Louis. The altarpiece is signed: "Symon de Senis me pinxit" (Simon of Siena painted me).

The enthroned Franciscan saint is dressed in embroidered velvet robes and wears a bishop's miter. He is placed against a rich gold background with a raised gold halo and border inside the frame. In keeping with courtly taste, especially that of Naples, the drapery was originally decorated with real jewels embedded in the panel. Simone Martini's attraction to such taste is further evident in the fluid, curvilinear robes, the jeweled crozier (bishop's staff) and crowns, the long, thin hands, and pale, delicate faces of his figures. Two angels crown Saint Louis as he bestows the earthly crown on his brother. Through his large size, central position, and frontality, Louis is endowed with an imposing, iconic presence, whereas Robert is portrayed in miniature and in profile. It is clear that Simone (and presumably his patron) intended the viewer to perceive the saint as the more important figure and his ecclesiastic office as more powerful than that of the earthly ruler. The gold fleurs-de-lis on the blue background of the frame identify the scene with the French royal family, which reinforced the legitimacy of Robert's claim to the throne.

Simone's *Annunciation* (fig. **12.25**), painted in 1333 after the artist left Naples, shows the International Gothic taste for elongated forms and delicate detail. The elegant S-shape of Mary's pose, the angel Gabriel's fluttering cloak, and the abundance of gold are typical of courtly International Gothic style. Compared with Giotto's *Annunciation* (see fig. 12.7) in the Arena Chapel, Simone's is filled with a wealth of elaborate features. Mary holds the traditional book, showing that Gabriel has interrupted her reading, and she seems startled. The lilies symbolize Mary's purity, while the palm branch carried by Gabriel is a sign of death and alludes to the Crucifixion of Jesus. Note also that the prophets in the small tondos hold scrolls that refer to prophecies believed by Christians to have foretold the coming of a savior.

A striking feature of Simone's *Annunciation*, and one that also occurs in northern art, is the raised lettering of the angel's announcement—"Hail, Mary, full of grace, God is with you." His words extend from his mouth to Mary's ear, connoting her receptivity to God's Word and illustrating the medieval tradition that she was impregnated through her ear. Jesus thus becomes "the Word . . . made flesh," as written in the Gospel of John (1:14).

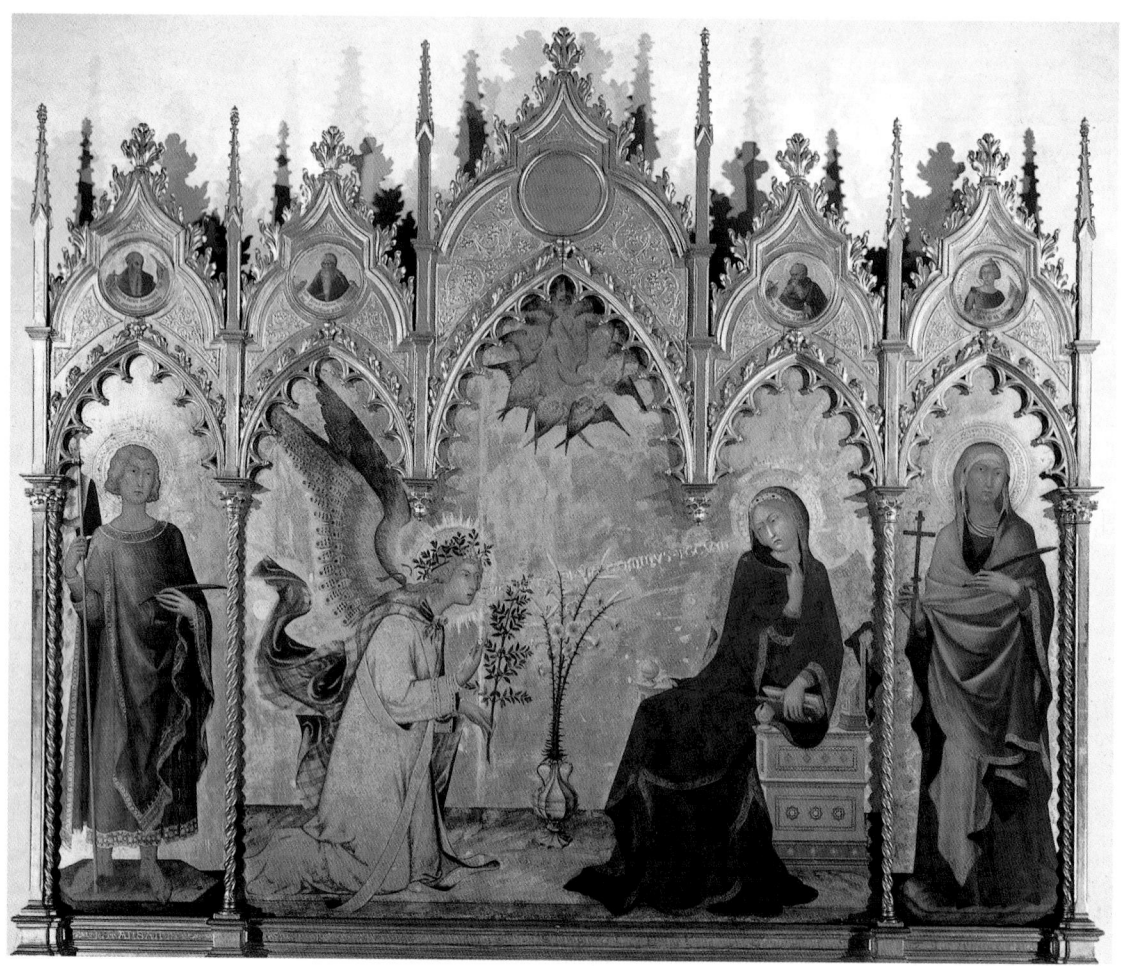

12.25 Simone Martini, *Annunciation*, 1333. Tempera and gold leaf on panel; 42½ × 43½ in. (108.0 × 110.5 cm). Galleria degli Uffizi, Florence. Parts of the altarpiece were apparently painted by Simone's brother-in-law, for both artists signed the painting.

Claus Sluter

Toward the end of the fourteenth century, France was ruled by Charles V. Two of his brothers—Philip the Bold (1342–1404) and Jean, Duc de Berry (1340–1416)—presided over lavish courts, which were enriched by their ambitious patronage. The sumptuousness of the works produced for them shows the degree to which the courts were removed from the real world. France and other areas of Europe were, at the time, suffering continual upheaval from the ravages of the Hundred Years' War.

Philip's court was located at Dijon, in the Burgundy region of central France. His wife, Margaret of Flanders (parts of Belgium and northern France), provided a link with the North. Reflecting the international character of his court and his patronage, Philip commissioned an architect from Paris and a sculptor from the Netherlands to design a Carthusian monastery—the Chartreuse de Champmol—near his Dijon palace. This building was to house the family tombs. Philip's competition with the king is suggested by the fact that his architect had worked for Charles in Paris and that the monastery's portal followed Charles's lead in placing portrait sculptures of living people on the doorjambs—a site formerly reserved for Old Testament kings, queens, and prophets, and for Christian saints.

Philip's sculptor, Claus Sluter (active 1379–1406), placed a figure of the Virgin Mary on the trumeau of the portal (figs. **12.26** and **12.27**). She is crowned, but her character is primarily maternal. Although the architectural feature above her is entirely Gothic and Sluter worked in an essentially Gothic tradition, a comparison of his *Virgin* with the thirteenth-century *Vierge dorée* at Amiens (see fig. 11.31) shows the degree to which he has transformed the

CONNECTIONS

See figure 11.31.
Vierge dorée,
c. 1250.

12.26 Claus Sluter, portal, Chartreuse de Champmol, Dijon, 1385–1393. The sculptor Claus Sluter was born in Haarlem, the Netherlands. After he went to the court of Philip the Bold, he was quickly promoted to the position of *imagier* and *valet de chambre.*

12.27 Claus Sluter, *Virgin Mary and Christ,* central trumeau of portal, Chartreuse de Champmol, Dijon, 1385–1393. (Detail of 12.26.)

12.28 Claus Sluter, Well of Moses, Chartreuse de Champmol, Dijon, begun 1395. Painted stone; interior diameter of basin 23 ft. 6 in. × 23 ft. 7 in. (7.16 × 7.19 m).

elegant drapery curves with the fixed, arrested concentration of the doorjamb figures on Mary and Jesus (see fig. 12.26).

Two years after completing the portal, Sluter set to work on the Well of Moses, a monumental fountain for the Chartreuse (fig. **12.28**). It stands on a hexagonal base with an Old Testament figure on each side. Six small angels on colonnettes between the life-sized figures lean over in the compressed space under the edge of the basin. They spread their wings to form an arch over each figure. Their crossed arms allude to the Crucifixion, originally represented by a great Cross (now lost), which was set in stone carved in imitation of Golgotha. This was supported by the "well," just as the Old Testament was seen as the foundation of the New. Christ was thus the "fountain of life"— the *fons vitae*.

The figure of Moses is a powerful, thoughtful patriarch. His lined face, strong nose, and slight frown give the sculpture a portraitlike quality. But the features are overwhelmed by the swirling energy of the beard and by the stunted horns emerging from his head. These became an iconographic convention in representations of Moses, whose radiance on descending from Mount Sinai with the Tables of the Law was mistranslated as "horned." The Ten Commandments were interpreted as a prefiguration of the new Christian order signified in the great Crucifix over the fountain. And it is to this event that the inscription of Moses's scroll refers: "The whole assembly of the congregation of Israel shall kill it [the lamb] in the evening" (Exodus 12:6).

representation of human figures. Sluter's *Virgin* turns more freely in space and gazes on a Jesus who is more childlike than his Gothic predecessors. Jesus's floppy head and chubby proportions, articulated by the drapery folds, indicate that Sluter was a careful observer of children. He has represented the physical and psychological character of this infant Jesus with a new, naturalistic accuracy, while Mary is animated by the sweep of her billowing draperies. The arrangement of the folds emphasizes her spatial flexibility and creates a sense of dynamic energy.

Mary's gaze, focused as it is on Jesus, is repeated by the doorjamb figures. Philip (on the left) and Margaret (on the right) are represented kneeling in prayer and facing the Virgin. They adore the Queen of Heaven as she adores the Child. Leaning over the noble pair and interceding on their behalf are saints, John the Baptist and Catherine. Sluter contrasts the rhythmic orchestration of deeply carved,

The Limbourg Brothers

In northern Europe, manuscript illumination was the primary medium of painting at the turn of the century. The illuminated manuscripts of the Limbourg brothers were among the most impressive works of art produced at the court of Jean, Duc de Berry. Jean, an ardent patron, collected jewels and books, tapestries and goldwork, and led a life of immense luxury. The three Limbourg brothers—Paul, Herman, and Jean—came from the Netherlands, first to the Burgundy court and then to Berry. They made Books of Hours, which are prayer books organized according to the liturgical calendar. The most famous of these is the *Très Riches Heures du Duc de Berry* (the *Very Rich Hours of the Duke of Berry*).

Books of Hours were illuminated manuscripts made for lay people, and most were commissioned by the aristocracy and upper middle class. They were expensive heirlooms, prized by their owners and passed down from one generation to the next, and were sources of learning and aesthetic pleasure. Their contents vary but generally include the prayers to be said at the eight canonical hours of the day. By the fourteenth century, Books of Hours had become best-sellers, and, for the first time in the Christian era, they were even more popular outside clerical circles than the Bible. Most were produced in France, England, and the Netherlands, while Italy, Spain, and Germany were more likely to import them. Their significance for the rise of literacy in the fourteenth century is problematic, although it is clear that literacy did increase in the later Middle Ages. Strictly speaking, one did not have to be able to read to enjoy Books of Hours: merely gazing on their illuminations was considered a form of prayer, and, in any case, their owners would have known the contents by heart. The primary function of these images was to evoke identification through prayer as a route to salvation.

The manuscript page of the *Annunciation* from the *Très Riches Heures* (fig. **12.29**) shows Mary interrupted at her *prie-dieu* (a type of prayer desk) by Gabriel's arrival. He

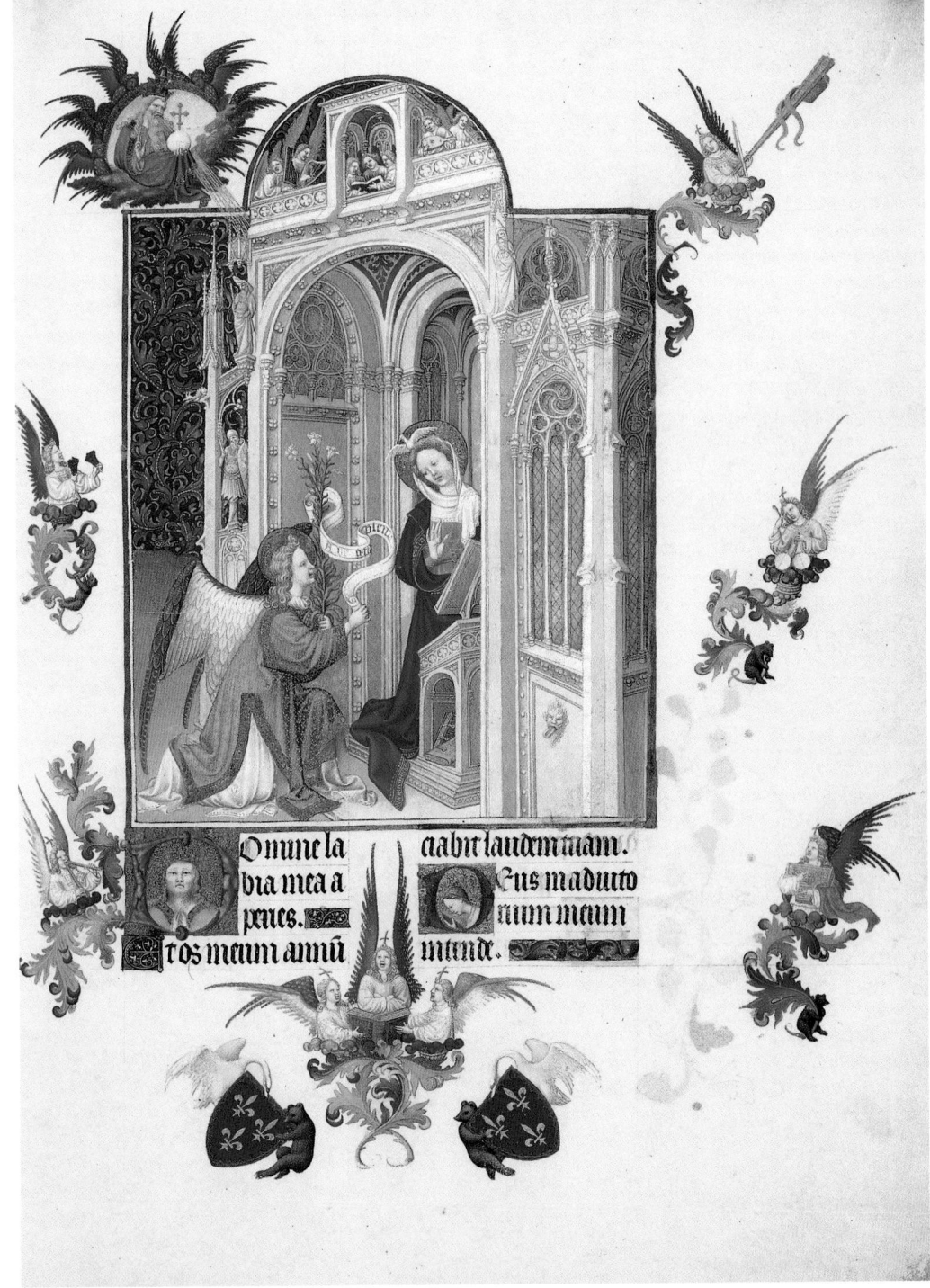

12.29 Limbourg brothers, *Annunciation,* from the *Très Riches Heures du Duc de Berry,* 1413–1416. Illumination, 8¾ × 5⁵⁄₁₆ in. (22.2 × 13.5 cm). Musée Condé, Chantilly, France.

carries three lilies, signifying the purity of the Virgin, and a scroll with the inscription *"Ave gratia plena"* ("Hail [Mary] full of grace"). The scene takes place in a Gothic chapel (despite the round arch) decorated with delicate stone tracery offset by a sumptuous blue-brocade backdrop. An angelic choir makes music on the chapel roof, and at the left are statues of two prophets. In the upper left, outside the frame, God the Father appears in a winged circle of light. He holds an orb with a cross and sends down to

Mary the impregnating rays of his light. Decorating the rest of the border are musician angels (those beneath the text are singing angels) intertwined with elegant, curvilinear foliate forms. Jean de Berry's two coats of arms are held by his emblems, the swan and the bear, and serve as the signature of his patronage.

The manuscript page illustrating the month of January (fig. **12.30**) shows the day on which gifts were exchanged at the court of Berry. The depiction of precise details is

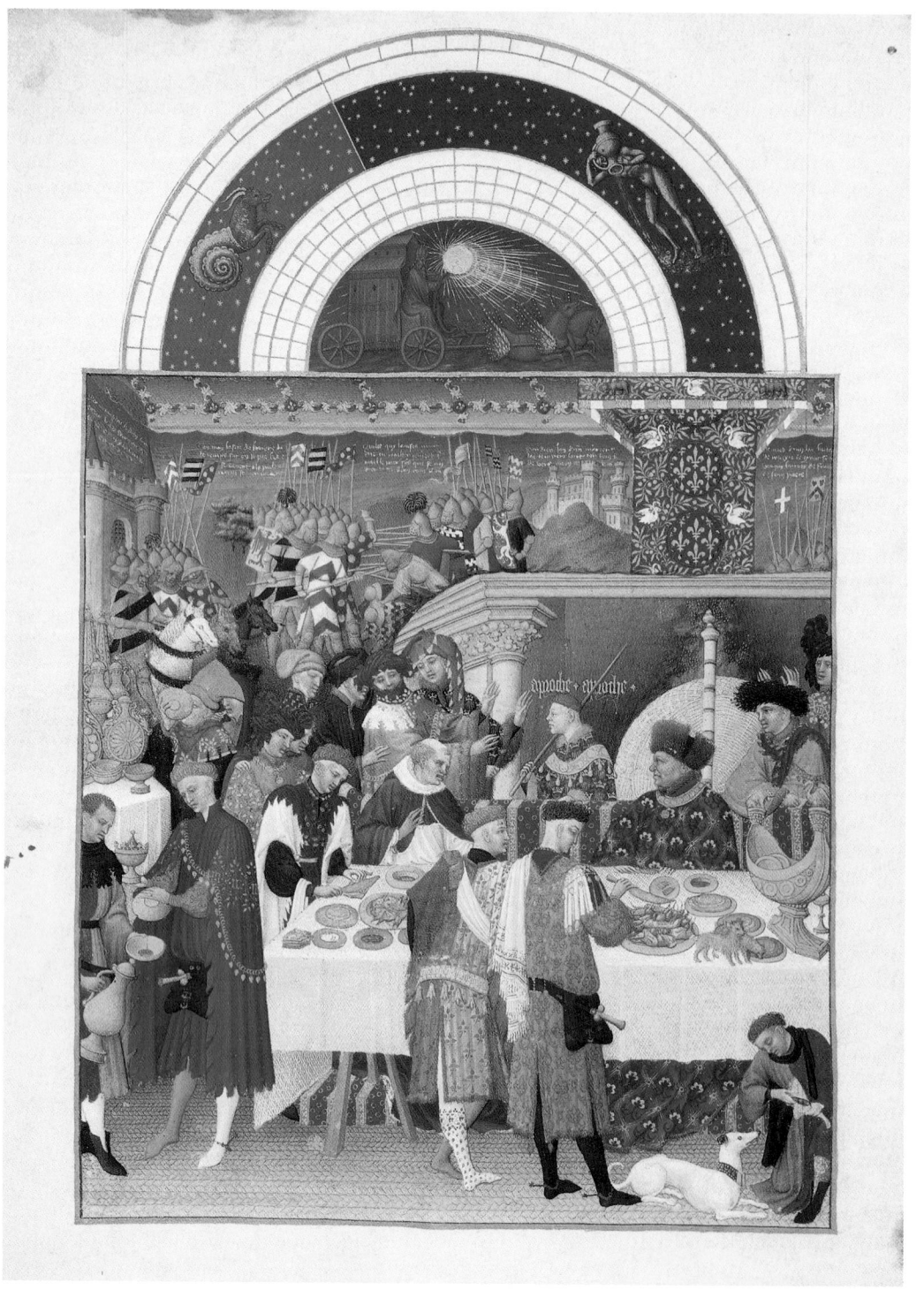

12.30 Limbourg brothers, *January,* from the *Très Riches Heures du Duc de Berry,* 1413–1416. Illumination, 8¾ × 5⁵⁄₁₆ in. (22.2 × 13.5 cm). Musée Condé, Chantilly, France.

typical of the Limbourg brothers, here concentrating on rich material textures. The duke is seated at a table filled with plates of food, a gold saltcellar at the far right, and a pair of dogs nibbling from the dishes. Jean wears a fur cap and an elaborate blue-and-gold brocade robe. Behind him is a golden wicker fire screen, and the man in red on the duke's right is inviting visitors to enter. The words "approach, approach" are lettered in gold above his head. On the background tapestry, a battle from the Trojan War is fought by soldiers in medieval armor. The identity of the battle is indicated by lines of verse written across the sky. In the foreground, various courtiers in patterned robes partake of the feast, while a white dog waits eagerly for a morsel of food at the lower right corner. Perhaps the rich-

est area of the page is the red canopy over the fireplace. It contains blue circles decorated with the *fleurs-de-lis* of French royalty, golden foliage, white swans, and two brown bears. Swans and bears were the duke's heraldic devices, and a gold statuette of each surmounts the tips of the saltcellar on the table. In the semicircle above are the zodiac signs that correspond to January.

Such representation of observed detail entered the vocabulary of painting in the course of the fourteenth century. The art of the courts seems to have ignored the effects of the disasters that swept western Europe in the first half of the century. The International Gothic style persisted into the fifteenth century, but the major innovations in art from 1400 resume the developments introduced by Giotto.

Style/Period	Works of Art	Cultural/Historical Developments
1250 **PRECURSORS OF THE RENAISSANCE** Mid-13th–14th centuries **Martini, Saint Louis Altarpiece** **Sluter, Chartreuse de Champmol portal**	*Kiss of Judas* (**12.17**), Sant'Apollinare Nuovo Pisano, pulpit (**12.1–12.2**), Pisa Baptistery Cimabue, *Madonna Enthroned* (**12.3**) Giotto, *Kiss of Judas* (**12.19**), Arena Chapel Giotto, frescoes (**12.6–12.13**), Arena Chapel Duccio, *Kiss of Judas* (**12.18**), *Maestà* altarpiece Giotto, *Madonna Enthroned* (**12.4**) Martini, Saint Louis Altarpiece (**12.24**) Giotto, *Stigmatization of Saint Francis* (**12.14**), Bardi Chapel Martini, *Annunciation* (**12.25**) Lorenzetti, *Allegory of Good Government* (**12.20**), Palazzo Pubblico, Siena Lorenzetti, *Allegory of Bad Government* (**12.21**), Palazzo Pubblico, Siena Orcagna, *Triumph of Death* (**12.22–12.23**) Sluter, Chartreuse de Champmol portal (**12.26–12.27**), Dijon Sluter, Well of Moses (**12.28**), Chartreuse de Champmol, Dijon **Duccio, *Kiss of Judas***	**Kiss of Judas mosaic** Invention of the glass mirror (1278) Rise of Florence as a leading commercial center (1280s) The "Pied Piper of Hamelin" (1284) End of the Crusades; Knights of Saint John of Jerusalem settle in Malta (1291) Building of Palazzo Vecchio, Florence (1299–1301) Birth of Italian poet Petrarch 1304 (d. 1374) Dante writes the *Divine Comedy* (1307–1321) Papal seat moves to Avignon (1309) Birth of John Wycliffe, English church reformer (c. 1328) Bankruptcy of Bardi and Peruzzi banking houses of Florence (1343–1345) The Black Death ravages Europe (1348) Giovanni Boccaccio writes the *Decameron* (1348–1353?) The Aztecs build their capital at Tenochtitlán, Mexico (1364) Development of the steel crossbow (c. 1370) Peasants' Revolt in England (1381) Chaucer writes the *Canterbury Tales* (c. 1387) Birth of Johann Gutenberg, inventor of printing in Europe (c. 1396)
1400 **EARLY RENAISSANCE** 15th century **Lorenzetti, *Allegory of Bad Government***	Limbourg brothers, *Très Riches Heures du Duc de Berry* (**12.29–12.30**)	The invention of scientific perspective (c. 1400) Rise to power of the Medici in Florence (1400) The English defeat the French at Agincourt (1415) **Giotto, *Kiss of Judas***

CHAPTER PREVIEWS

THE EARLY RENAISSANCE, 15th CENTURY

Florence in the age of Humanism
Competition for the Baptistery doors (1401)
Italian artists: Brunelleschi; Ghiberti; Pisanello; Masaccio; Donatello;
 Rossellino; Gentile da Fabriano; Alberti; Uccello; Castagno;
 Verrocchio; Fra Angelico; Piero della Francesca; Mantegna; Fra
 Filippo Lippi; Botticelli; Ghirlandaio
 Leonardo Bruni's humanist tomb
Patronage: Isabella d'Este
Art theory: Alberti, *On Painting* (c. 1435)
History: Bruni, *Praise of the City of Florence* and *History of the
 Florentine People*
The *condottiere* and fame; the Platonic Academy
Northern painters: Campin; van Eyck; van der Weyden; Memling;
 van der Goes

Perspective in Asian Painting
 China; Persia

THE HIGH RENAISSANCE IN ITALY, c. 1500–c. 1550

Columbus sails in search of a new route to India (1492)
The ideal of the circle: *Vitruvian Man*
Bramante: the Tempietto
Leonardo: *Mona Lisa; Last Supper*
Papal patronage
 Julius II (pope 1503–1513)
 New Saint Peter's; Sistine Ceiling (Michelangelo)
 Stanza della Segnatura (Raphael)
 Leo X (pope 1513–1521)
 Pope Paul III: Michelangelo's *Last Judgment*
Michelangelo in Florence: The Laurentian Library
The myth of Venice
Venetian painters: the Bellini; Giorgione; Titian
Controversy: painting versus sculpture; color versus drawing
Charles V invades Italy (1527)

MANNERISM AND THE LATER 16th CENTURY IN ITALY

The Reformation: Martin Luther; Henry VIII
Counter-Reformation
 Council of Trent (1545–1563)
 Veronese and the Inquisition
Vasari, *Lives* (1550, 1568)
Cellini, *Autobiography*
Saint Teresa, *The Way of Perfection*
Saint Ignatius Loyola, *Spiritual Exercises*
Painters: Pontormo; Parmigianino; Bronzino; Veronese; Romano;
 Anguissola; Tintoretto; El Greco
Sculptors: Cellini; Giambologna; Properzia dé Rossi
Architects: Romano; Palladio; Vignola (Il Gesù)

16th-CENTURY PAINTING AND PRINTMAKING IN NORTHERN EUROPE

Martin Luther's *95 Theses* (1517)
Satire and proverbs: Erasmus (*Praise of Folly* and *Adages*);
Printmaking; alchemy; the myth of the mad artist
Netherlandish artists: Bosch; Bruegel the Elder
German artists: Dürer; Grünewald; von Hagenau; Cranach the Elder;
 Hans Holbein the Younger at the court of Henry VIII
Van Mander: *Het Schilderboeck (The Painter's Book)* (1604)

The fifteenth and sixteenth centuries in western Europe were a period of political turmoil, geographic exploration, and enormous artistic production. The discovery of the Americas and trade with Byzantium and the Far East enriched the cultural base of the West. In fifteenth-century Italy, artists pursued humanism, cultivated fame, and wrote treatises on art theory. Biographies and autobiographies of artists and social and moral satires were written, and science became increasingly empirical, all of which reflected an interest in human nature and human behavior. Linear perspective, in contrast to Far Eastern perspective systems and to previous Western systems, was designed to make a painting or a relief resemble a window. Through this fictive "window," viewers could observe nature represented mathematically.

In Rome, popes financed the arts, especially the New Saint Peter's, and largely determined the course of High Renaissance patronage. In northern Europe, objections to Church corruption launched the Reformation, which led to the establishment of the Protestant Church. Within the Catholic Church, calls for reform led to the Counter-Reformation, which demanded a new emphasis on spirituality and mysticism in all the arts. The development of printmaking and the perfection of movable type made images and texts more widely available than ever before.

13

The Early Renaissance

Italy in the Fifteenth Century

For most of the quattrocento (or 1400s), the city of Florence, in Tuscany, was the intellectual, financial, and artistic center of Renaissance Italy (see map). Florence followed the lead of the fourteenth-century poet Petrarch in the pursuit of humanism (see box) and the revival of Classical texts. Fifteenth-century writers, such as Leonardo Bruni (see fig. 13.1), extolled Florence as a new Athens and the heir of ancient Roman republicanism. A chair of Greek studies had been established at the University of Florence in the 1390s, and

in the next few decades translations of Plato and other Greek authors would become available.

Renaissance Humanism

The Medici, the dominant Florentine banking family in the fifteenth century and the de facto rulers of Florence, were among the leading supporters of humanism. They encouraged the study of Plato and Neoplatonism, one goal of which was to reconcile Christianity with Platonic philosophy. They collected ancient Greek and Roman sculpture and gave contemporary artists access to it.

The humanist interest in individual fame that had developed in the fourteenth century was associated not only with territorial, financial, and political power, but also with the arts. Renaissance rulers understood the power of im-

The Humanist Movement

The Renaissance is sometimes called the great age of humanism because it revived the ideals embodied in the ancient Greek maxim "Man is the measure of all things." Renaissance humanism, which flourished from about 1300 to 1600, was many-faceted. There was a movement away from the medieval, and specifically the Scholastic, use of Aristotelian logic toward the study of original Greek and Roman texts. Beginning with Petrarch in the fourteenth century, educational reforms approached Classical studies independently, rather than linking them with Christianity. Scholars no longer used Gothic script or pursued intellectual inquiry in the service of the Church, but rather preferred the clarity of the Latin alphabet, standardized spelling and grammar, and skill in the art of rhetoric. Classical texts were translated, and history, literature, and mythology were studied along with Christian subjects. Professorships in Greek were established, humanist schools and libraries were founded, and art collectors sought out original Greek and Latin works. There was a new awareness of history and a fledgling interest in archaeology as a means of uncovering ancient objects and resuming contact with the Classical past.

The pursuit of the literature of antiquity had a parallel in the visual arts. Now artists wanted to bypass the Middle Ages and recover Greek and Roman forms. Sometimes, because of faulty historical information, Renaissance artists mistook Romanesque for Roman, just as scholars believed the Carolingian script to be Latin. In literature, the anecdotal tradition led to full-length biography and autobiography, especially of artists; fewer lives of saints were written. Above all, the philosophical idea that man was rational and capable of achieving dignity, intellectual excellence, and high ethical standards by means of a Classical education determined the character of Renaissance humanism. (Women were generally omitted from such characterization.) Several humanist authors wrote on the dignity of man. Gianozzo Manetti (1396–1459), for example, wrote, "How great and wonderful is the dignity of the human body; secondly, how lofty and sublime the human soul, and finally, how great and illustrious is the excellence of man himself made up of these two parts."[1]

Leading art centers in Renaissance Italy.

agery and used it to extend their fame and influence beyond the borders of their own states.

Courts throughout Italy were thriving centers of artistic activity and vied with each other for prominent humanist scientists, writers, architects, painters, and sculptors. They established libraries as collections of Classical and Christian manuscripts expanded. In Mantua, the Gonzaga court founded an innovative school, La Gioiosa, where promising students from less wealthy families were educated alongside the children of the nobility. In the most enlightened families, girls were taught together with boys, and both learned Latin and Greek as well as other humanist subjects. Such humanist schools also stressed physical education and discipline. Girls and boys learned sports, including swimming, ball games, and horse riding, but boys were more likely than girls to study the martial arts.

By the time these students became princes, dukes, and duchesses themselves, they were skilled in politics, diplomacy, and rhetoric, and were knowledgeable in the Classics. In some cases, women were sufficiently well educated to run the state while their husbands were away—either fighting as *condottieri* (see box) or engaged in diplomatic missions abroad. A few women became important patrons of the arts. Painters and sculptors made portraits of the patrons or, as in the Arena Chapel (see figs. 12.9 and 12.10), included their portraits in monumental fresco cycles. The humanist writers praised their patrons in works of literature, which were generally based on ancient Greek and Roman models.

Artists gained stature as they absorbed the culture of Classical antiquity. Leon Battista Alberti, for example (see p. 504), recommended a humanist education for all artists and advised them to befriend poets, orators, and princes. The writing and sculpture of Lorenzo Ghiberti, the goldsmith whose *Commentarii* of around 1450 combined art theory with history, biography, and autobiography, reflected the new interest in Classical texts. Even though Ghiberti himself had not received a formal humanist education, he advocated it as a foundation for artistic training.

Artists and others who admired antiquity traveled to Rome to draw ancient ruins, while antiquarians went to Constantinople and to Greece to collect Classical texts and Greek statuary. This search for the Classical past was combined during the Renaissance with an interest in empirical experience and a taste for intellectual and geographical discovery. In the second half of the fifteenth century, Leonardo da Vinci pursued science as well as art, dissecting bodies and producing detailed anatomical drawings (see fig. 14.11). The invention of printing and the use of movable type in the fifteenth century made books more available to the general population. In the last decade of the century, financed by the Spanish monarchs Ferdinand and Isabella, Columbus sailed to America in ships owned by the Medici, thereby heralding the great age of world exploration in the sixteenth century.

One of the energizing features of the Renaissance was its interdisciplinary nature. The most influential synthesis derived from the integration of antiquity, especially ancient history and art, with the ideas and attitudes of the quattrocento. Whereas the medieval Scholastic tradition had integrated Aristotelian thought with Christianity, the Renaissance encouraged the study of Plato and the revival of Platonic ideas. Far from treating this pagan influence as a threat, the most enlightened Renaissance popes encouraged the humanist assimilation of ancient Greek and Roman philosophies into Christianity.

Leonardo Bruni and the Humanist Tomb

The life and work of Leonardo Bruni (1369–1444)—chancellor of Florence, an apostolic secretary, and a historian—exemplify the humanist ideal. Around 1403, he wrote the *Laudatio [Praise] of the City of Florence,* linking Florence with Classical antiquity and praising the city as a center of liberty and justice. As in ancient Athens and republican Rome, Florentine citizens participated in their government. According to Bruni, the political and social organization of Florence conformed to the Classical ideal of harmonious order. Each civic institution was both an independent entity and integrated into the whole structure of the city. Later, from 1415 to 1429, Bruni wrote a *History of the Florentine People,* in which he argued that classically educated citizens produced the best kind of government.

When he died, the republic of Florence commissioned the sculptor Bernardo Rossellino (1409–1464) to create a monumental wall tomb for his sarcophagus (fig. **13.1**). Its design became the prototype of Renaissance wall tombs. In effigy, Bruni lies with his head resting on a pillow, as if asleep, and holds a book. Two eagles—a reference to the emblem of the Roman legions—support his bier. On the side of the sarcophagus itself, two Nikes (winged Victories) carry a Latin inscription proclaiming that the Greek and Roman Muses mourn Leonardo's death, that history grieves, and that the art of eloquent speech has been silenced. Framing the effigy and the sarcophagus is a classicizing **niche.** Corinthian pilasters support a round arch carved with a laurel-wreath design. In the **lunette,** a tondo flanked by praying angels depicts the Virgin and Child. Over the arch, two winged *putti* hold a wreath, which frames a Marzocco (the lion symbol of Florence). Note that the presence of the lion is also an allusion to the "Leo" in Bruni's name.

The humanist character of Bruni's tomb resides in the exaltation of an individual for his achievements as well as in the details of its iconography. The book, for example, refers to Bruni as a classically educated man of letters and to his own history of Florence. He used his education and talents in the service of the state—hence the Marzocco at the apex of the structure. The combination of Classical with Christian motifs and the specific links to antiquity echo Bruni's own writing. In honoring Bruni with a monumental tomb of this type, therefore, the republic of Florence was also honoring its own Classical heritage.

13.1 Bernardo Rossellino, tomb of Leonardo Bruni, Santa Croce, Florence, 1444. Marble; 20 ft. (6.10 m) high.

13.2 Filippo Brunelleschi, *Sacrifice of Isaac,* competition panel for the east doors of the Florence Baptistery, 1401–1402. Gilded bronze relief; 21 × 17 in. (53.3 × 43.2 cm). Museo Nazionale del Bargello, Florence.

13.3 Lorenzo Ghiberti, *Sacrifice of Isaac,* competition panel for the east doors of the Florence Baptistery, 1401–1402. Gilded bronze relief; 21 × 17 in. (53.3 × 43.2 cm). Museo Nazionale del Bargello, Florence.

The Competition for the Florence Baptistery Doors

A good example of the increase in the range of patronage during the Renaissance was the competition of 1401 to design a set of doors for the east side of the Florence Baptistery. (This was subsequently changed to the north side.) A fourteenth-century pair of doors was already in place, but two more were needed, each to be decorated with gilded bronze reliefs illustrating Old and New Testament scenes. Members of the wool refiners' guild supervised the contest. The familiar subject chosen for the competition was the Sacrifice of Isaac. According to the Old Testament (Genesis 22), Isaac's father, Abraham, obeys God's command to sacrifice his only son as an act of faith. At the last moment, as Abraham is about to kill Isaac, an angel intervenes and Abraham, having proved his obedience to God, is instructed to substitute a ram for Isaac.

Of the seven contestants for the baptistery doors, the most important were two young artists in their twenties: Filippo Brunelleschi (1377–1446) and Lorenzo Ghiberti (c. 1381–1455). Ghiberti won the competition despite, or perhaps because of, his less monumental, more graceful style. Brunelleschi's figures (fig. **13.2**) are more direct and forceful than those of Ghiberti. His Abraham grasps Isaac by the throat and is physically restrained by the angel. The thrust of Brunelleschi's Abraham, emphasized by his drapery folds, is also more energetic than Ghiberti's (fig. **13.3**). The ambivalence of Ghiberti's figure is implicit in its pose; Abraham simultaneously leans toward Isaac and pulls away from him.

Another reason for Ghiberti's victory may have been the technical differences between the reliefs. Brunelleschi cast his panel in several pieces, whereas Ghiberti cast his in two. Ghiberti also required less bronze, which would have made his door considerably less costly to produce than Brunelleschi's.

There are no surviving records of the judges' deliberations to explain their decision. From the perspective of historical hindsight, however, it is clear that both reliefs are indebted to the new synthesis of Classical and Christian thought. Ghiberti's Isaac, in particular, is a Classical nude that attests the artist's awareness of Greek and Roman statues. Brunelleschi also alludes to ancient sculpture in the seated figure at the lower left, which repeats the pose of the well-known Hellenistic statue of the *Thorn Puller,* a youth removing a thorn from his foot.

Thorn Puller (Spinario), c. 1st century B.C. Bronze; life-sized. Palazzo dei Conservatori, Rome.

Both Brunelleschi and Ghiberti were born in or near Florence. Brunelleschi, the son of a lawyer, trained as a gold- and silversmith, and Ghiberti was the stepson of a goldsmith. The scenes are framed by a **quatrefoil** and depict the moment when the angel appears just in time to prevent Abraham from cutting his son's throat. The depiction of nature in both reliefs continues in the tradition of Giotto. Landscape forms provide a narrow, but convincing, three-dimensional space in which the surfaces rationally support the figures and the architecture. The cubic altars on which both Isaacs kneel are set at oblique angles to the background plane of the relief so that, as in the case of Giotto's architecture, their sides imply recession in space. Examples of radical foreshortening in certain figures, such as Ghiberti's angel and the man leaning forward at the lower right of the Brunelleschi, also enhance the impression of three-dimensional space.

The competition reverberated with political and civic levels of meaning. Florence had recently been ravaged by a plague that had killed at least 12,000 citizens, and the survivors probably identified with Isaac. Danger had also come from the powerful and tyrannical duke of Milan, who threatened the Florentine republic. With the duke's death in 1402, Florence must have felt that it, like Isaac, had been granted a reprieve.

Brunelleschi and Architecture

After losing the baptistery competition to Ghiberti, Brunelleschi was said to have given up sculpture, only to become the seminal figure in Renaissance architecture. He moved for a few years to Rome, where he studied ancient buildings and monuments. The effect of Rome on Brunelleschi was recorded by the sixteenth-century biographer of the artists, Giorgio Vasari (see box):

> Through the studies and diligence of Filippo Brunelleschi, architecture rediscovered the proportions and measurements of the antique. . . . Then it carefully distinguished the various orders, leaving no doubt about the difference between them; care was taken to follow the Classical rules and orders and the correct architectural proportions.[2]

The roots of Brunelleschi's early architecture can be traced to Classical precedents. Compared with the complexity of Abbot Suger's search for perfect mathematical ratios based on musical harmonies (see Chapter 11), Brunelleschi's concept of architectural beauty lay in simpler ratios and shapes. He also preferred simple to irrational numbers and ratios of 1:2 and 1:3. Shapes such as the circle and square formed the basis of his building plans, and he constructed round, rather than pointed, arches, which were supported by Classical columns instead of Gothic piers.

The Dome of Florence Cathedral On returning to Florence around 1410, Brunelleschi became actively involved in constructing a dome for the cathedral (figs. **13.4–13.6**). This undertaking was to last until 1436, but Brunelleschi died in 1446 before the **lantern**, which he also designed, could be completed. The dome had been a perennial problem for the city. As early as 1294, Florence had decided to rebuild the old cathedral, and, in the course of the fourteenth century, the original design was enlarged. By the fifteenth century, the cathedral required a dome to surmount an octagonal drum (already in place) measuring 138 feet (42.06 m) across.

In Rome, Brunelleschi had learned from the example of the Pantheon—which had a hemispherical dome 142 feet (43.28 m) in diameter—that it was theoretically possible to span an opening of this width. However, the structure of Florence Cathedral did not lend itself to Roman building techniques. The octagonal drum was too weak to support a heavy dome, and it was also too wide to be built with the wooden centering used in the Middle Ages.

In 1417, Brunelleschi proposed a solution to this problem, which he illustrated with a model on a 1:12 scale. He followed a horizontal construction plan based on a system of vertical **ribs**. Primary ribs were placed at each of the eight corners of the octagonal drum (fig. 13.6). At their base, they were approximately 11 feet by 7 feet (3.35 × 2.13 m), tapering toward their apex and visible to the viewer from the outside. Between each primary rib were two secondary vertical ribs, not visible from the outside, making a total of twenty-four ribs. Around these ribs Brunelleschi constructed, in horizontal sections, two shells comprising a single dome and connected by horizontal ties placed at intervals. Building two thin shells instead of a single thicker one lessened the weight of the dome. Its **thrust** was further reduced by building the walls of the dome at a steep angle—they rose a full 58 feet (17.68 m) before needing support from below. As a result, the dome was slightly pointed rather than perfectly hemispherical.

Vasari's *Lives*

Giorgio Vasari (1511–1574) was a Mannerist architect and painter. Born in Arezzo, he lived and worked in Florence for the Medici family. Cosimo I commissioned him to design the Uffizi Palace in Florence, which was originally a building for the government and judiciary but is now one of the most important art museums in the world.

Vasari's architecture and painting are overshadowed by his writings. His major work, *The Lives of the Most Excellent Painters, Sculptors, and Architects*, is the earliest full account of Renaissance art. The first edition of 1550 began with Cimabue and ended with Michelangelo, a friend and contemporary of Vasari. A second edition gave more prominence to painting and included Vasari's autobiography. Although Vasari's facts are not always accurate, he is a major source of information about art and artists in the fourteenth, fifteenth, and sixteenth centuries. Vasari believed that medieval art was an inferior product of the Dark Ages, which were no more than an unfortunate interlude between Classical antiquity and the Italian Renaissance.

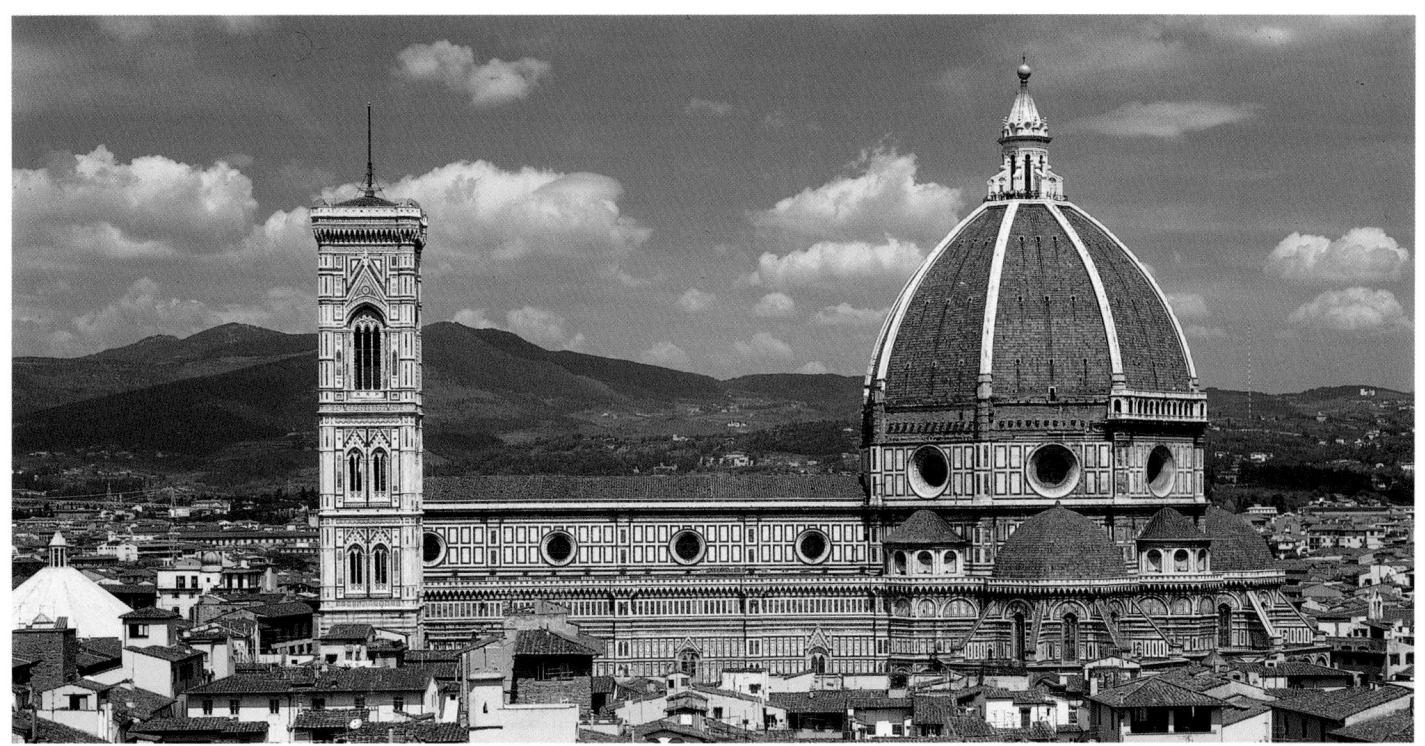

13.4 Exterior of Florence Cathedral, begun late 13th century. According to Vasari, Brunelleschi's rivalry with Ghiberti did not end with the baptistery doors. Ghiberti's political connections won him a commission to work with Brunelleschi on the dome of Florence Cathedral for equal credit and equal pay. Brunelleschi found fault with Ghiberti's work and ideas, but his protests fell on deaf ears. It was not until he took to his bed, feigning illness and refusing to advise on the project, that Ghiberti was removed—although he was allowed to keep his salary.

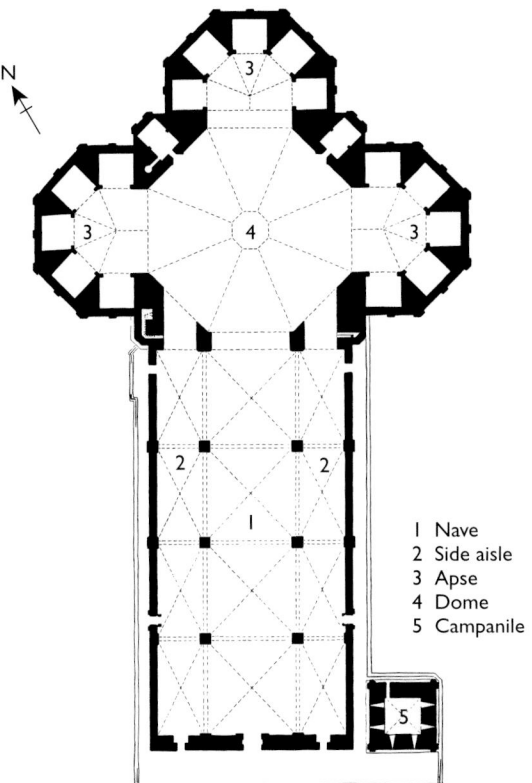

1 Nave
2 Side aisle
3 Apse
4 Dome
5 Campanile

13.5 Plan of Florence Cathedral (after W. Blaser).

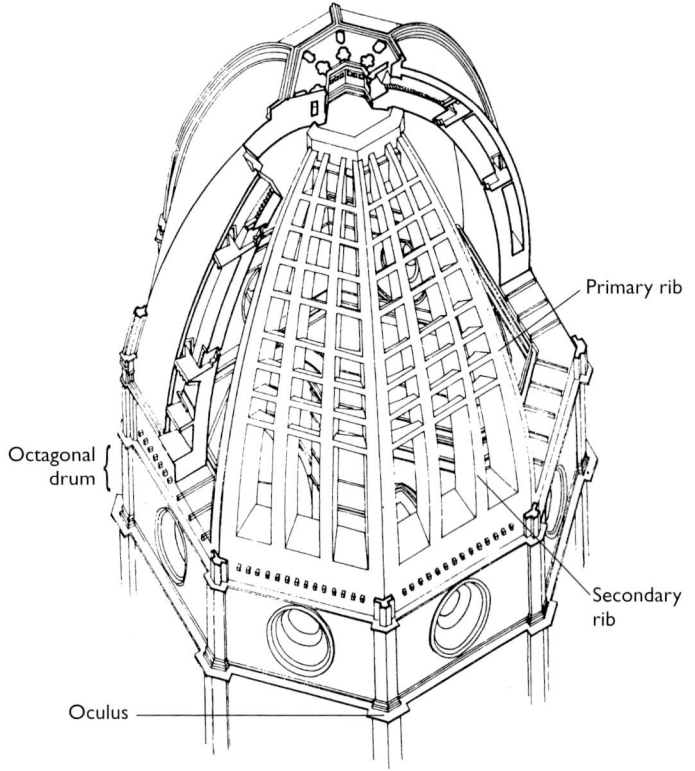

13.6 Axonometric section of the dome of Florence Cathedral. The overall height of the dome is slightly over 100 feet (30.48 m), diameter 138 ft. (42.06 m). © Electa Archive, Milan.

Hospital of the Innocents Brunelleschi's work on the dome, which lasted eighteen years, did not prevent him from undertaking other projects. One of the first of these was the Ospedale degli Innocenti (Hospital of the Innocents) in Florence (fig. **13.7**). It was commissioned in 1419 by the silk guild to shelter orphans and foundlings, and was largely financed by Giovanni di Bicci de Medici, who had established the Medici fortune.

The hospital, often regarded as the first true Renaissance building, is a long, low, graceful, symmetrical structure, dominated by a continuous façade. Renaissance architects preferred arcades to be composed of round arches because of their ability to lead the viewer's eye across the building surface rather than upward, as in Gothic—an effect that Brunelleschi would have seen in the Colosseum in Rome. The **loggia** of Brunelleschi's hospital is divided into bays, and the transverse arch between each bay rests on a corbel (attached to the wall) and a column of the colonnade. Above each second-floor window is a small blank pediment, which derives from Greek and Roman temple architecture.

The overall design of the loggia is based on a unified system of cubes and squares. Distances from column to column are equal to the distance from each column to the wall of the main structure and also to the distance from the foot of each column to the point where the arches appear to meet. The surface decoration of the façade is simple and limited to the Corinthian capitals at the top of each column and to tondos in the triangular spaces between the arches. Inside the tondos are reliefs of swaddled infants by Andrea Della Robbia (in 1487), which are reminders of the hospital's function.

13.7 Filippo Brunelleschi, Hospital of the Innocents, Piazza di Santissima Annunziata, Florence, begun 1419.

Santo Spirito, Florence In his church architecture, Brunelleschi rejected Gothic style, preferring the relative simplicity of the Early Christian basilica. The church of Santo Spirito, planned in 1434, illustrates the basic principles of his architecture—simplicity, **proportion**, and symmetry. Spatial units are based on the square **module** formed by each bay of the aisles, and the whole geometry of the structure is based on a series of interrelated circles and squares.

Each double bay of the nave forms a large square equivalent to four modular squares. The larger square is repeated in the crossing bays, the transept arms, and the choir. The semicircle of each chapel is one half the size of a circle that would fit exactly into the square module. If the larger squares were cubed and placed one on top of another, they would exactly match the height of the nave. The height of the side aisle is exactly half that of the nave.

The plan (fig. **13.8**) is a basic **Latin cross**. The depths of the **choir** and of the transept arms are the same. The perimeter forms a continuous ambulatory and, apart from the southern end (the entrance wall), is ringed with forty semicircular chapels. Round arches in the nave and the aisles are supported by Corinthian columns (fig. **13.9**) and reduce the size and height of the church to human scale. The interior is illuminated by natural light, in contrast to the stained-glass windows preferred by Gothic builders.

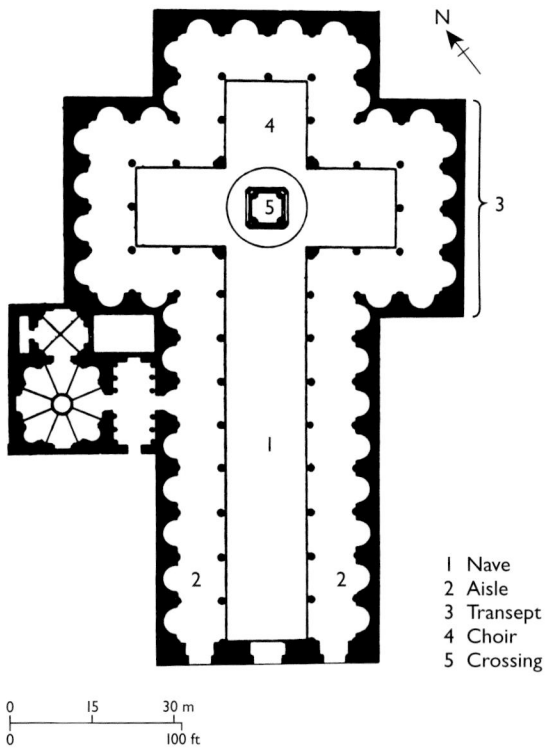

1	Nave
2	Aisle
3	Transept
4	Choir
5	Crossing

13.8 Filippo Brunelleschi, plan of Santo Spirito, Florence (after R. Sturgis).

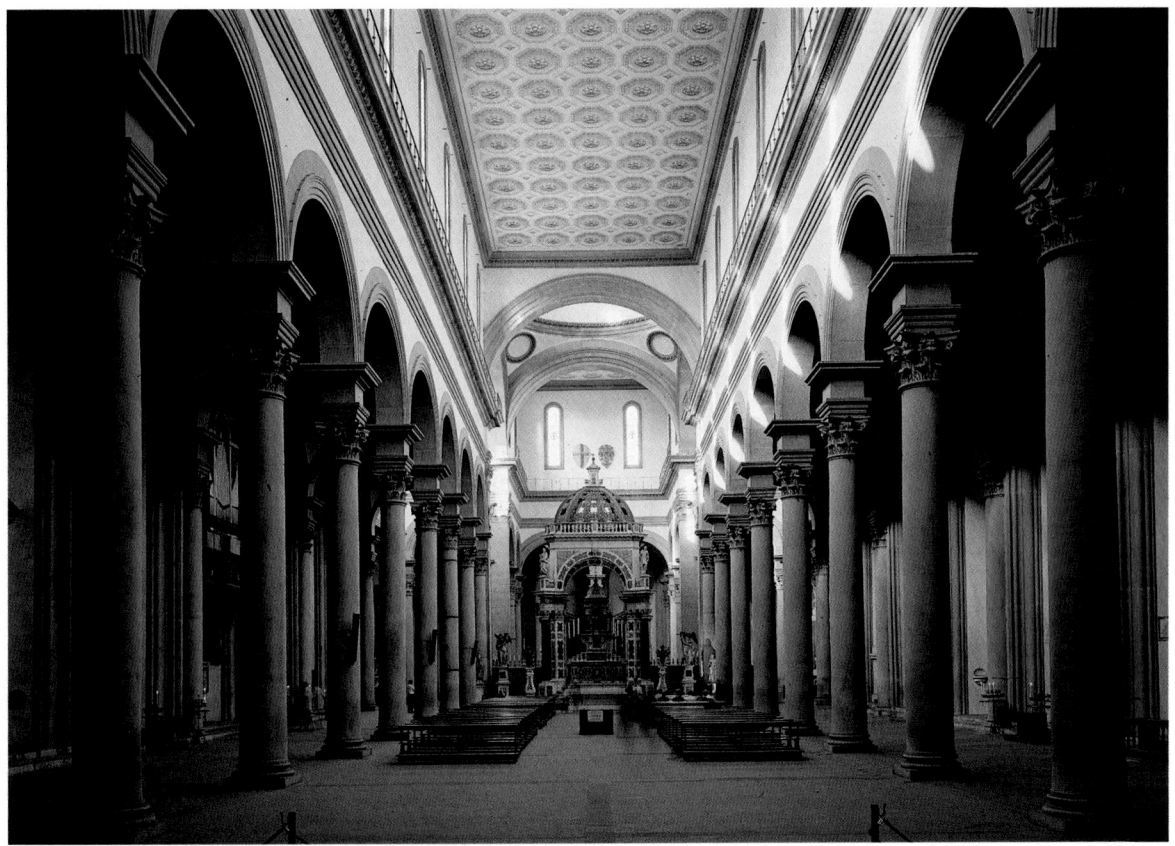

13.9 Filippo Brunelleschi, interior of Santo Spirito, Florence, planned 1434.

13.10 Lorenzo Ghiberti, *Meeting of Solomon and Sheba*, east door of the Florence Baptistery (single panel of fig. 13.12), showing perspective lines, 1450–1452. Gilded bronze relief; 31½ × 31½ in. (80.0 × 80.0 cm).

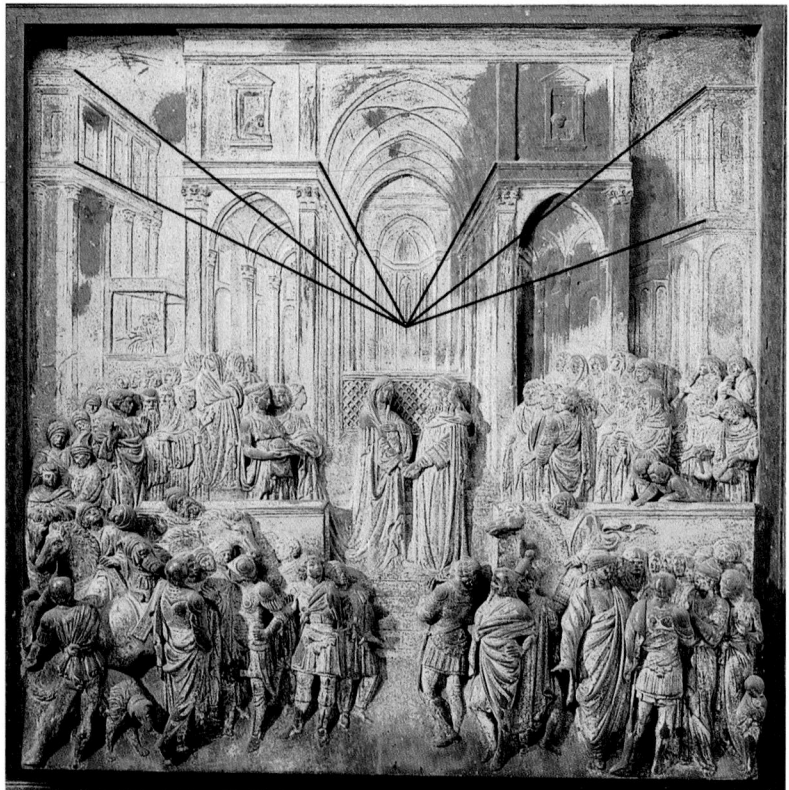

Ghiberti's East Doors for the Baptistery

A good example of the one-point perspective system (in which there is a single vanishing point) occurs in Ghiberti's relief of *The Meeting of Solomon and Sheba* on the east door of the Florence Baptistery (fig. **13.10**). As had been true of the competition reliefs, the *Solomon and Sheba* has political as well as Christian implications, for it illustrates the extension of traditional typology (the pairing of Old and New Testament events and personages) to include contemporary politics. Typologically, the Meeting was paired with the Adoration of the Magi; in both cases, eastern personages (the Queen of Sheba and the Magi, respectively) traveled westward to honor a king (Solomon and Jesus). Politically, the biblical meeting of East and West was related to efforts in the fifteenth century to unite the Eastern (Byzantine) branch of the Church with the Western branch in Rome.

Ghiberti has eliminated the medieval quatrefoil frame and uses the square, which is more suited to the new perspective system. The door is divided into two sets of five Old Testament scenes, which were modeled in wax, cast in bronze, and faced with gold. The east door was nicknamed the *Gates of Paradise* because the space between a cathedral and its baptistery is called a *paradiso*. According to another tradition recorded by Vasari, Michelangelo said that the doors were beautiful enough to grace the entrance of paradise.

Ghiberti's relief illustrates two techniques used by the artist to create the illusion of depth. One is Brunelleschi's system of one-point perspective. The other combines the diminishing size of figures and objects with a decrease in the degree of relief. What is in lower relief appears more distant than what is in higher relief (see pp. 490–492).

Before leaving Ghiberti's *Gates of Paradise* (fig. **13.12**), we should note that he has included his self-portrait at the lower right corner of the *Jacob and Esau*, the middle panel on the left (fig. **13.11**). The face is clearly a likeness and has an expression of slight puzzlement. The bald, dome-shaped head repeats the circular frame and also echoes Brunelleschi's architectural dome across the way. It has been suggested that Ghiberti's self-image was a visual comment on his rival's more monumental dome crowning the cathedral.

13.11 Lorenzo Ghiberti, *Self-Portrait*, from the east door of the Florence Baptistery, (single panel of fig. 13.12), 1424–1452. Gilded bronze; approx. 36 in. (91.4 cm) high.

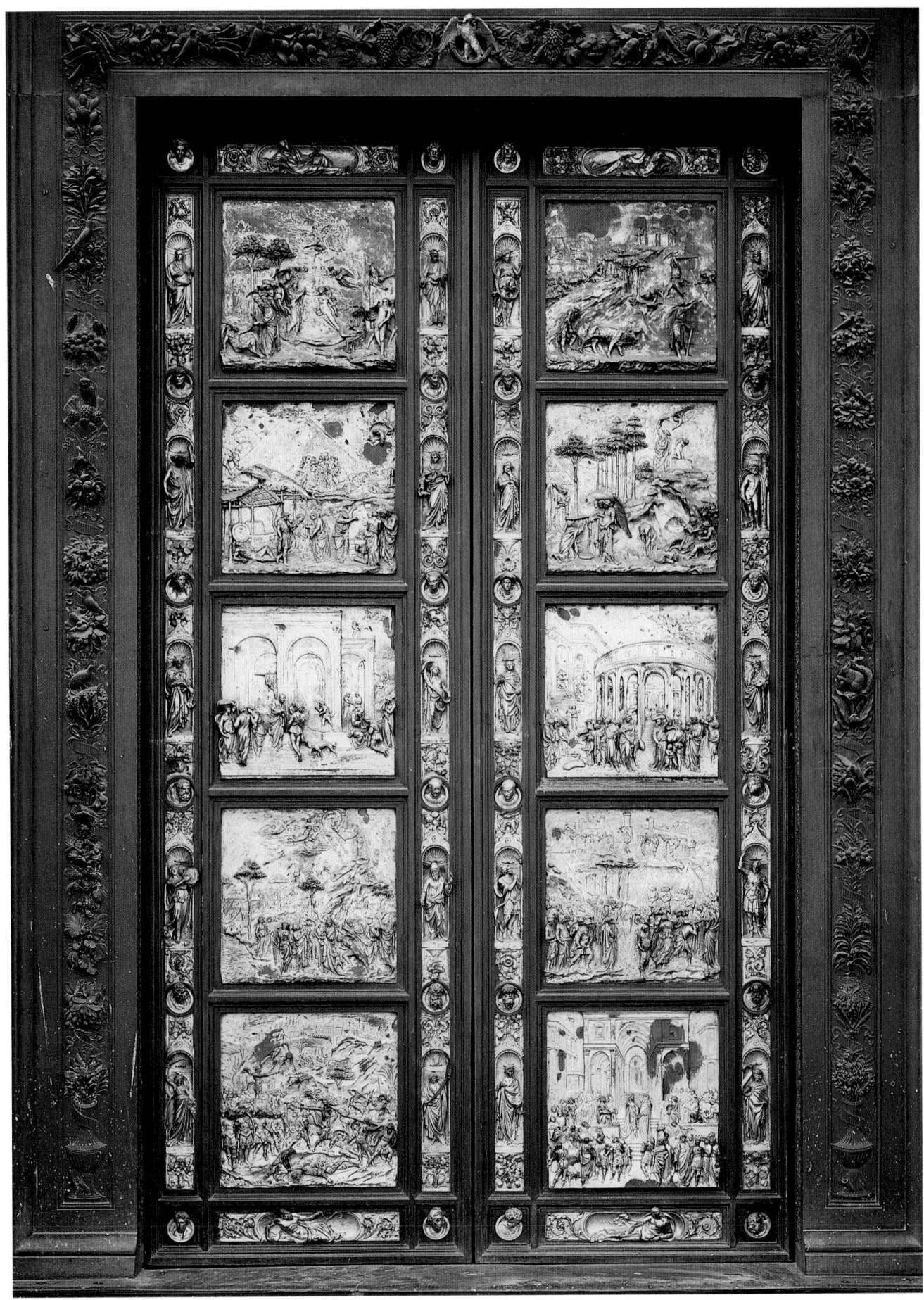

13.12 Lorenzo Ghiberti, *Gates of Paradise*, east door, Florence Baptistery, 1424–1452. Gilded bronze relief; approx. 17 ft. (5.18 m) high.

Linear Perspective

Giotto and other fourteenth-century paint-
ers had used oblique views of architecture
and natural settings to create an illusion of
spatial recession on a flat surface. But their
empirical system had not provided an
objective way to determine the relative sizes
of figures and objects on a picture plane or
the surface of a relief.

In addition to establishing the basis for
Renaissance architecture, Filippo Brunelle-
schi is credited with the invention of **linear
perspective.** This system is based on the
observed fact that distant objects seem
smaller than closer ones and that the far
edges of uniformly shaped objects appear
shorter than the near edges.

Brunelleschi conceived of the picture
plane—the surface of a painting or relief
sculpture—as a window and the frame of
the painting as the window frame. Through
this "window," the viewer sees the depicted
scene. The edges of architectural objects
such as roofs and walls are extended along
imaginary lines, known as **orthogonals,** to converge at a
single point, the **vanishing point.** A good example of this
use of one-point perspective is Masaccio's *Holy Trinity* (see
figs. 13.20 and 13.21), painted around 1425.

In his *De Pictura* (*On Painting*), written in 1435, Leon
Battista Alberti refined Brunelleschi's system, although it
is not clear to what extent he was proposing a new theory
or merely describing current artistic practice. He pro-
posed a method of establishing relative proportions for
every figure and object within a picture and of transposing
them onto a grid consisting of orthogonals and transverse
lines parallel to the baseline.

The paintings of Piero della Francesca (c. 1420–1492)
are notable for their architectural content and geometric
rigor. Nowhere is this more evident than in his *Flagellation*
of c. 1460 (fig. **13.13**), which portrays two distinct groups
of figures: in the right **foreground** three men converse,
while in the middle distance Jesus, bound to a freestand-
ing column, is whipped in the presence of Pontius Pilate
(seated) and another man. Piero has left a number of
clues—in the form of regularly arranged tiles and other
pavement decoration, the interplay of light and shadow,
and clear views between the figures—which make it possi-
ble to reconstruct a floor plan (fig. **13.14**). A work of this
complexity required meticulous planning and detailed per-
spective studies.

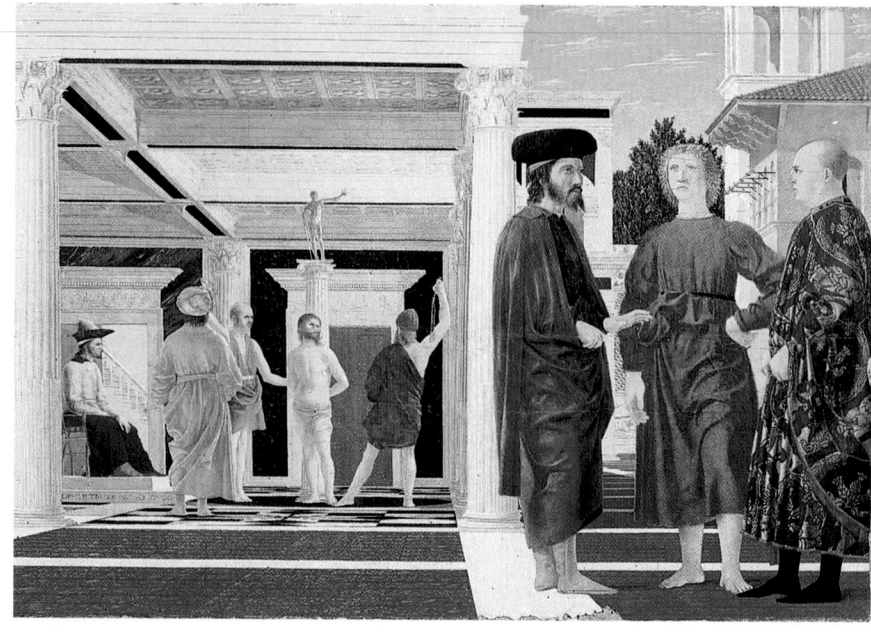

13.13 Piero della Francesca, *Flagellation*, c. 1460. Tempera on panel;
22⅞ × 32 in. (58.4 × 81.4 cm). Ducal Palace, Urbino.

Intersection

Eye

13.14 Reconstructed plan of Piero della
Francesca's *Flagellation*. Drawing by Thomas
Czarnowski.

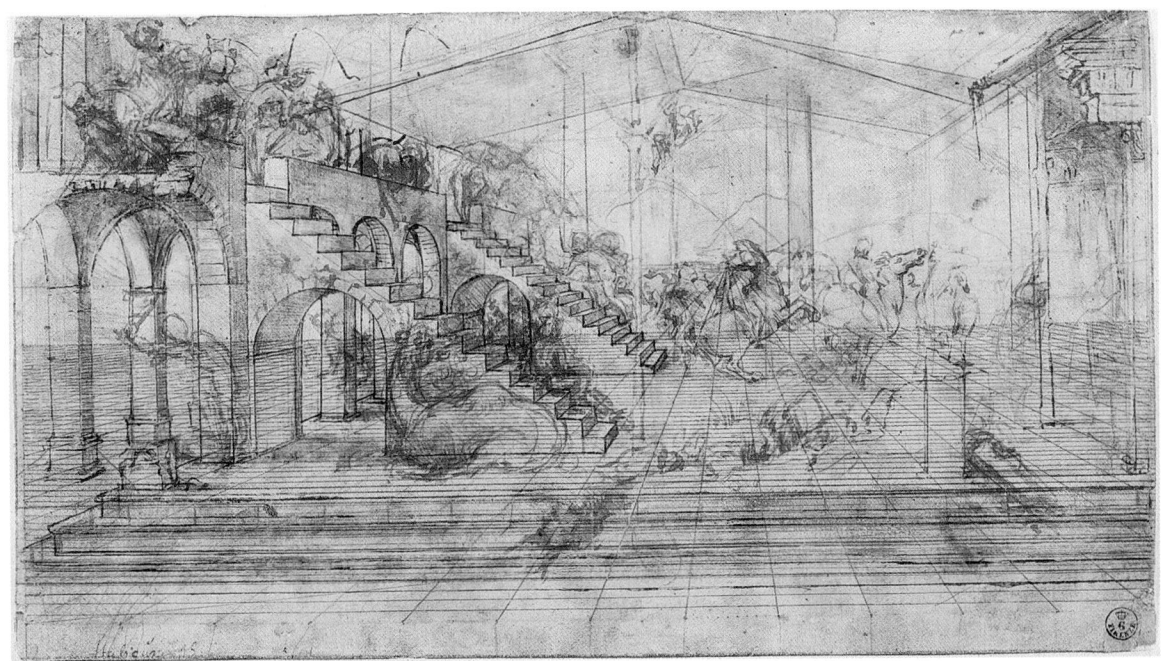

13.15 Leonardo da Vinci, perspective study for the *Adoration of the Magi,* c. 1481. Pen, **bister,** and wash; 6½ × 11½ in. (16.5 × 29.2 cm). Gabinetto dei Disegni e delle Stampe, Galleria degli Uffizi, Florence. Leonardo created a perspective grid by drawing a series of horizontal lines parallel to the picture plane. Then he drew a series of lines perpendicular to the horizontals that converge at the vanishing point, which is just to the left of the figure on a rearing horse. All architectural forms in the study are aligned with the grid, so that the sides of the buildings are either parallel or perpendicular to the picture plane.

In addition to Piero, many artists using linear perspective made preliminary studies in the planning stages of their work. Most were on paper and are now lost. One that survives is Leonardo da Vinci's study for the *Adoration of the Magi* (fig. **13.15**), which allows us a rare look at an artist's working plans laid out in a schematic form.

Linear perspective permitted Renaissance artists to fulfill their ideal of creating the illusion of nature on a flat surface. One fifteenth-century painter who delighted in solving problems of perspective was Paolo Uccello (1397–1475). In his drawing of a chalice in figure **13.16**, Uccello uses geometric shapes, mainly trapezoids, to create the illusion of spinning motion in a rounded, transparent object.

13.16 Paolo Uccello, perspective drawing of a chalice, c. 1430–1440. Pen and ink on paper; 13⅜ × 9½ in. (34.0 × 24.1 cm). Gabinetto dei Disegni e delle Stampe, Galleria degli Uffizi, Florence. Vasari criticized Uccello for his obsession with mathematics and perspective, which, he said, interfered with his art. According to a popular anecdote, they also interfered with his marital life. On being called to bed by his wife, Uccello allegedly extolled the beauty of *la prospettiva* (perspective)— a feminine noun in Italian.

Vanishing point

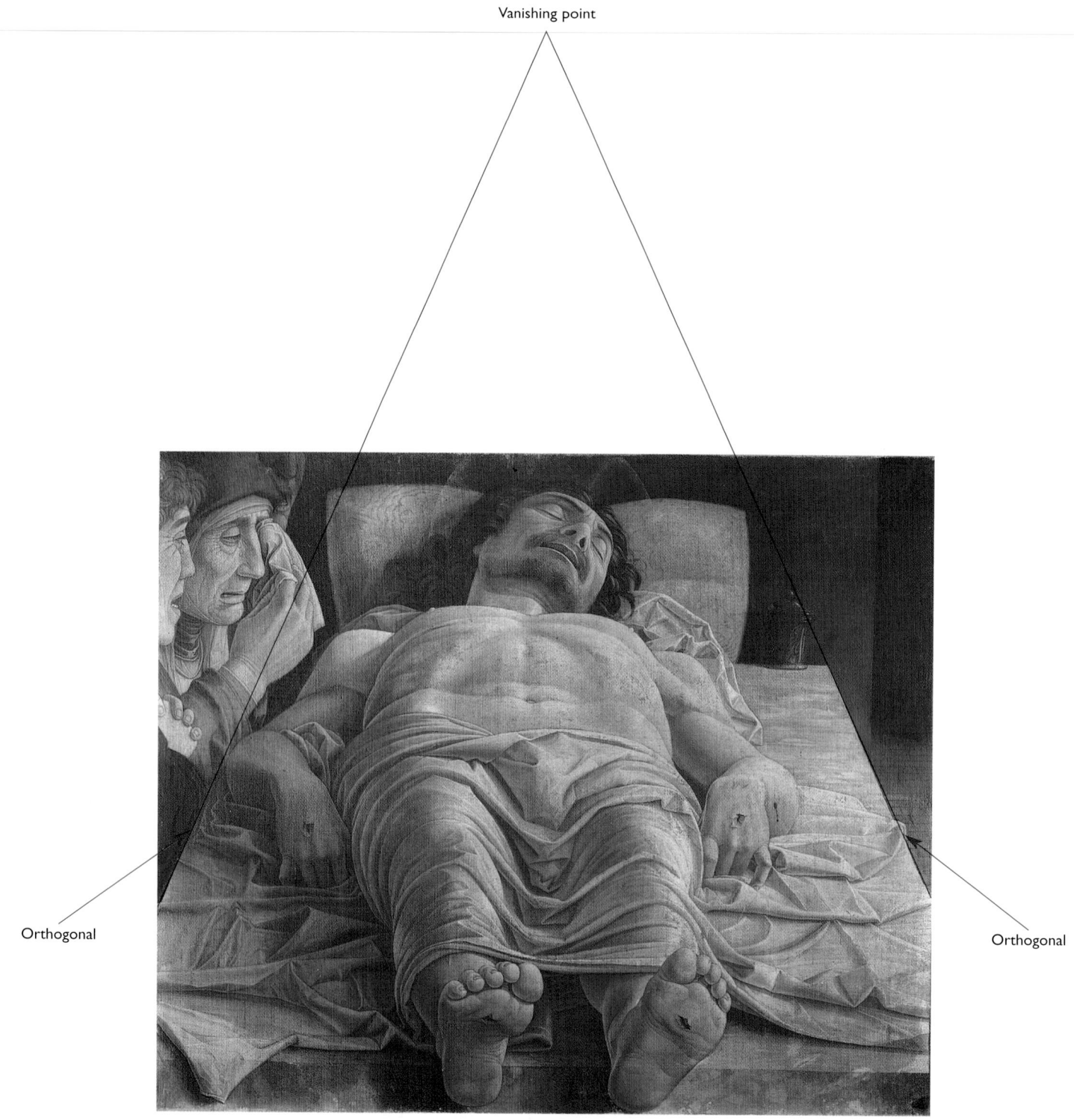

Orthogonal

Orthogonal

13.17 Andrea Mantegna, *Dead Christ,* c. 1500. Tempera on canvas; 26¾ × 31⅞ in. (67.9 × 81.0 cm). Pinacoteca di Brera, Milan.

Some sixty years later, Andrea Mantegna (c. 1430–1506) used perspectival theory to achieve radical foreshortening in the *Dead Christ* (fig. **13.17**). The body is shown feet foremost, with the wounds of the Crucifixion clearly visible and the head slightly tilted forward by a pillow. Man-

tegna's idealization of the body and mastery of perspective create a haunting psychological effect. The superimposed orthogonals show the location of the vanishing point—above the picture plane.

The Renaissance Medal: Pisanello

An important development in fifteenth-century Italy was the casting of bronze medals. Small, easily portable, and less expensive than paintings and sculptures, medals were usually commissioned by rulers wishing to project and disseminate a particular political image of themselves. The typical Renaissance medal shows the ruler on the **obverse** (front) and an emblematic image on the **reverse** (back).

The leading medalist, also a painter and widely praised as a humanist, was Antonio Pisano, known as Pisanello (c. 1395–1455). His interest in ancient Greek and Roman coins inspired the imagery on many of his medals. In 1438/1439, Pisanello cast a large bronze medal of the Byzantine emperor John VIII Palaeologus (figs. **13.18** and **13.19**). The emperor had traveled to Italy in 1438 for the Council of Churches to discuss unifying the Eastern and Western branches of the Church. Ferrara had been chosen as the venue for the council where John VIII and the papal court would meet. But an outbreak of plague sent both sides to Florence, where the council was hosted by the Medici family.

While in Italy, the Byzantine emperor and his retinue impressed the Florentines with their exotic attire, an example of which can be seen in John VIII's large headdress. The obverse shows his bust in profile and bears a Greek inscription around the edge that reads: "John Palaeologus Emperor and Autocrat of the Romans." On the reverse, the emperor is mounted on horseback approaching a crucifix at the right as his page rides off to the left. Note the radical foreshortening of the page's horse compared to the side view of the emperor's horse and the interest in landscape shown by the rocky setting. At the top of the medal, an inscription identifies the work as that of the painter Pisanello. The same inscription is repeated below in Greek. This juxtaposition of Latin and Greek alludes to the efforts to unite the Eastern (Greek/Byzantine) Church with the (Latin) Church of Rome.

13.18 Pisanello, medal of John VIII Palaeologus (obverse), 1438–1439. British Museum, London.

13.19 Pisanello, medal of John VIII Palaeologus (reverse), 1438–1439. British Museum, London.

Early Fifteenth-Century Painting

Masaccio

Of the first generation of fifteenth-century painters, it was Masaccio (1401–1428) who most thoroughly assimilated the innovations of Giotto and developed them into an increasingly monumental style.

The *Holy Trinity* Masaccio's *Holy Trinity* (figs. **13.20** and **13.21**) in the church of Santa Maria Novella in Florence uses not only the new perspective system, but also the new architectural forms established by Brunelleschi. A single vanishing point is located at the center of the step, corresponding to the eye level of the observer standing in the church. Orthogonals, provided by the receding lines of the barrel-vaulted, coffered ceiling, create the illusion of

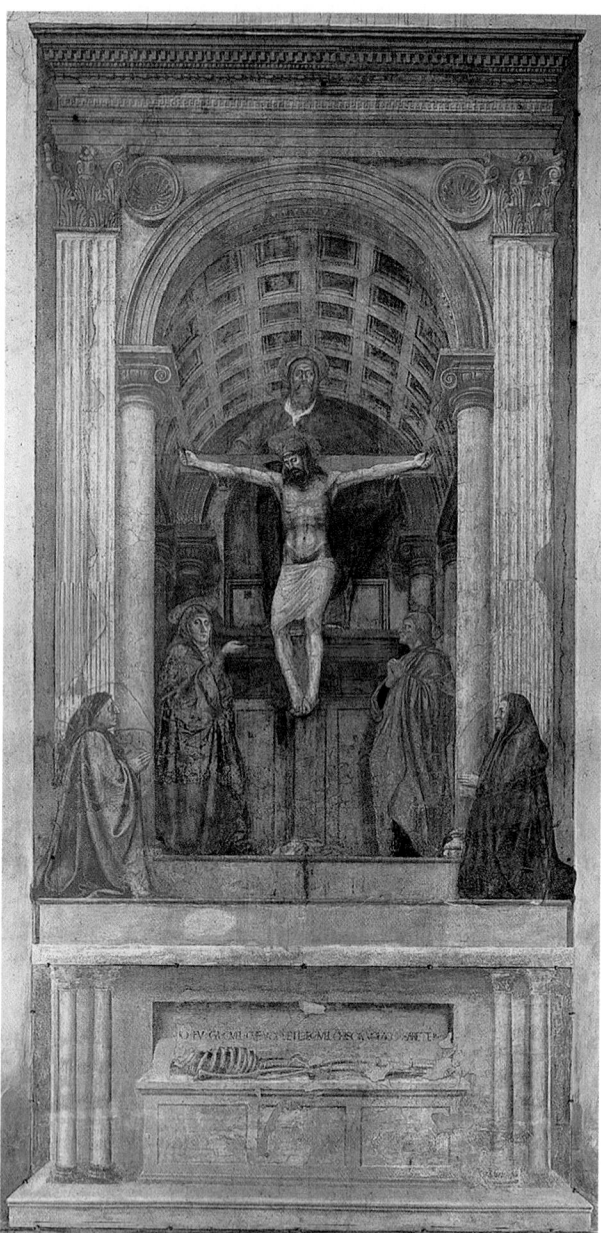

13.20 Masaccio, *Holy Trinity*, c. 1425. Fresco; 21 ft. 9 in. × 9 ft. 4 in. (6.63 × 2.85 m). Santa Maria Novella, Florence. Tommaso di Ser Giovanni di Mone (1401–1428) was nicknamed Masaccio ("Sloppy Tom") because, according to Vasari, he seemed to neglect everything, including his own appearance, in favor of his art. In 1422, he enrolled in the painters' guild of Florence and in 1424 joined the Company of Saint Luke, a lay confraternity of painters. By his death at age twenty-six or twenty-seven, Masaccio had become the most powerful and innovative painter of his generation.

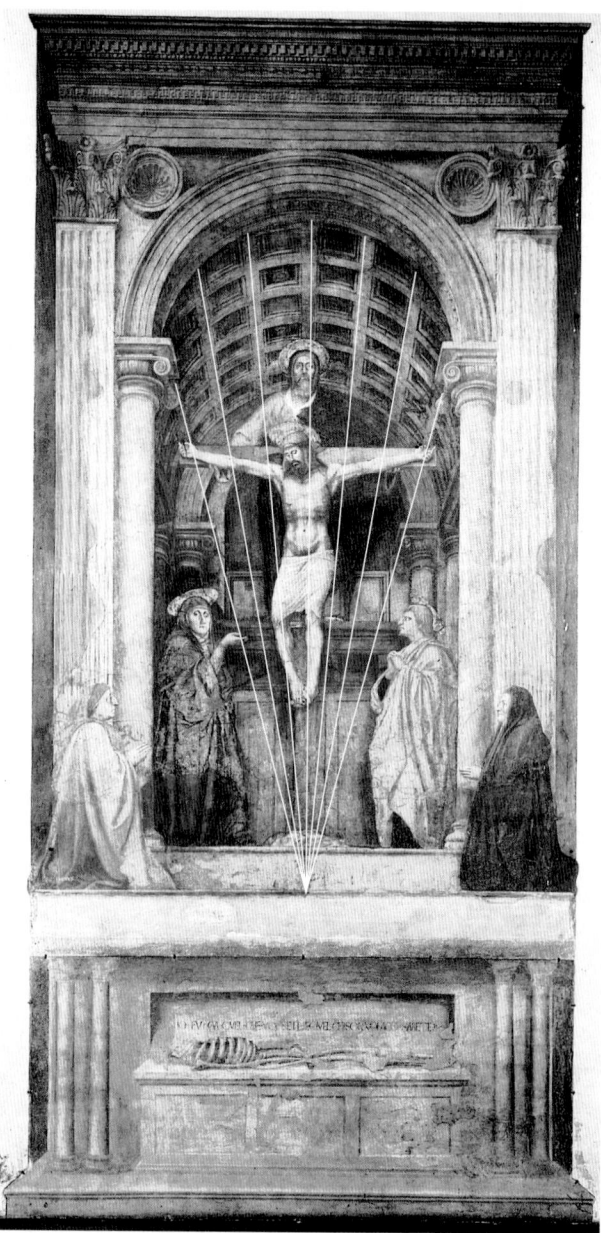

13.21 Masaccio, *Holy Trinity*, showing perspective lines, c. 1425. Fresco; 21 ft. 9 in. × 9 ft. 4 in. (6.63 × 2.85 m). Santa Maria Novella, Florence.

an actual space extending beyond the nave wall. This pictorial space is defined on the outside by two Corinthian pilasters supporting an architrave, above which is a projecting cornice. The pilasters frame a round arch supported by composite columns.

The interior is a rectangular room with a barrel-vaulted ceiling and a ledge on the back wall. Below the illusionistic interior, a projecting step surmounts a ledge supported by Corinthian columns. Framed by the columns, a skeleton lies on a sarcophagus. The inscription above reads: "I was once what you are. And what I am you too will be." This kind of warning to the living from the dead, called a *memento mori* ("reminder of death") had been popular in the Middle Ages and continued as a motif in the Renaissance. One purpose of the warning was to remind viewers that their time on earth was finite and that belief in Christ was the route to eternal salvation.

The spatial arrangement of the figures in the *Holy Trinity* is pyramidal, so that the geometric organization of the image reflects its meaning. The three persons of the Trinity—Father, Son, and Holy Spirit—occupy the higher space. God stands on the foreshortened ledge, his head corresponding to the top of the pyramid. He faces the observer and stretches out his hands to support the arms of the Cross. Between God's head and that of Christ floats the dove, symbol of the Holy Spirit. Masaccio has emphasized the pull of gravity on Christ's arms, which are stretched by the weight of his torso, causing his head to slump forward. His body is rendered organically, and his nearly transparent drapery defines his form.

Inside the sacred space are Mary—who looks out and gestures toward Christ—and Saint John, in an attitude of grief. Outside, on the illusionistic step, kneel two donors, probably members of the politically influential Lenzi family, who commissioned the fresco. They form the base of the figural pyramid.

The Renaissance convention of including donors in Christian scenes served a twofold purpose. In paying for the work, the donors hoped for prayers of intercession with God or Christ to be made on their behalf. Their presence was the visual sign of their donation and of their wish to be associated with holy figures in a sacred space. The donors of the *Holy Trinity* occupy a transitional space between the natural, historical world of the observer and the spiritual, timeless space of the painted room.

The Brancacci Chapel Masaccio's other major commission in Florence was the fresco cycle in the Brancacci Chapel, in the church of Santa Maria del Carmine, illustrating events from the life of Saint Peter (figs. **13.22** and **13.23**). Masaccio, like Giotto, used ***chiaroscuro*** (from the Italian words *chiaro,* meaning "light," and *scuro,* meaning

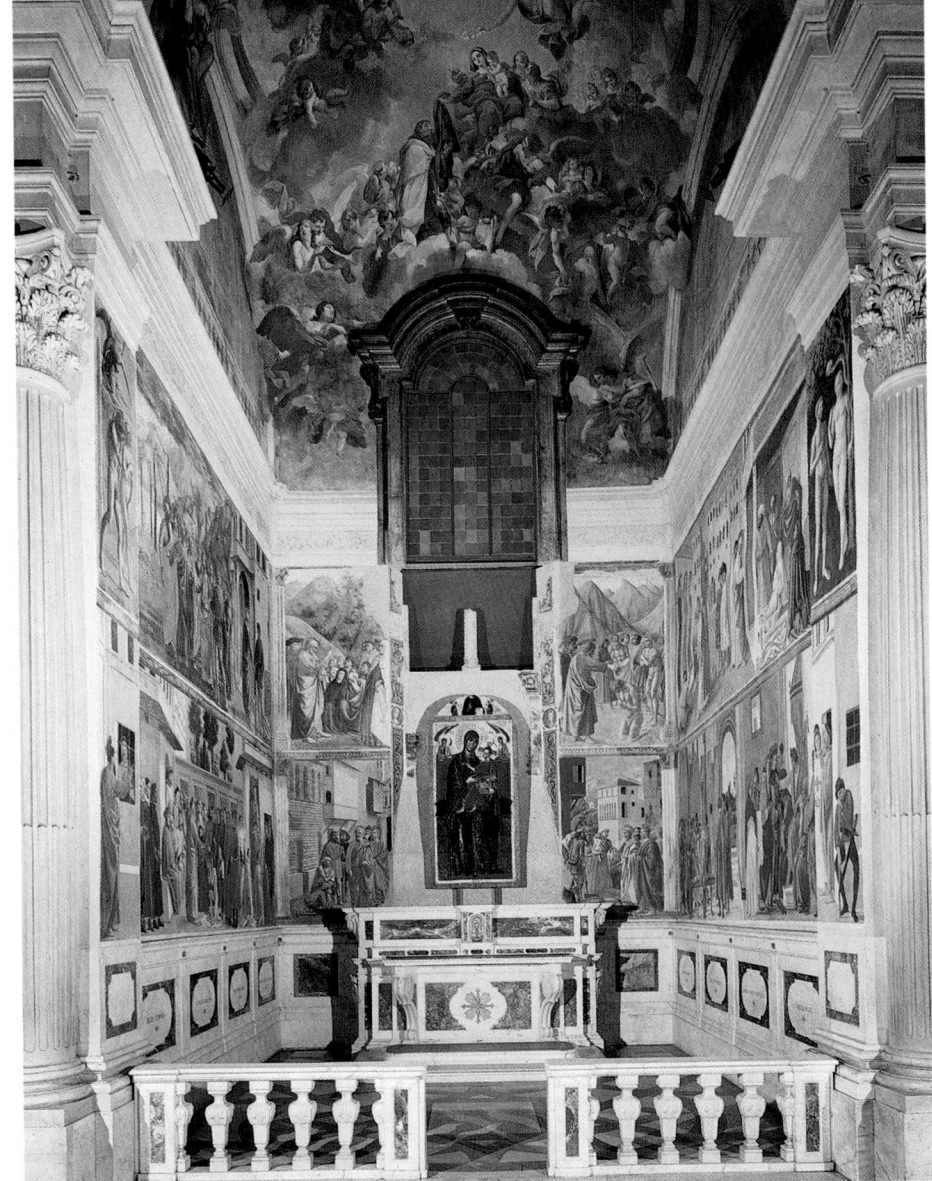

13.22 View of the Brancacci Chapel (after restoration), view toward the altar, Santa Maria del Carmine, Florence. Masaccio worked on the Brancacci Chapel in the 1420s. He shared the commission with the older artist Masolino, whose *Temptation of Adam and Eve* is on the right pilaster. When Masolino left Italy to work in Hungary, Masaccio continued on his own. After Masaccio's untimely death, the frescoes were completed by a third artist, Filippino Lippi, in the 1480s. Lippi completed all of *Saint Peter in Prison*, about half the large lower fresco on the left wall (see fig. 13.23), and everything else on the lower wall.

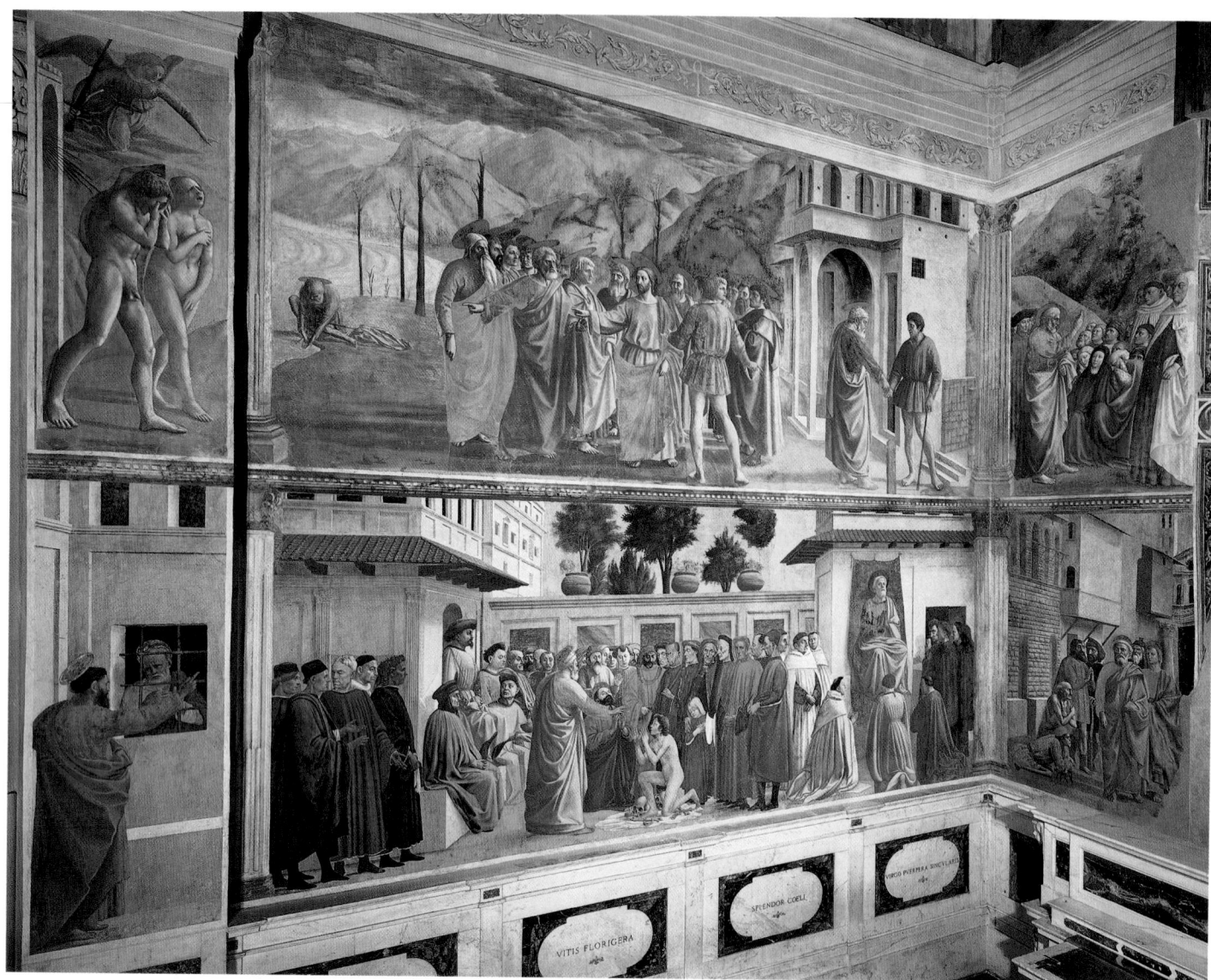

13.23 Left side of the Brancacci Chapel (after restoration, 1989), Santa Maria del Carmine, Florence. The scene on the upper left of the pilaster is the *Expulsion from Eden* (c. 1425), and below is *Saint Peter in Prison*. The large scene to the right of the *Expulsion* is from the New Testament Gospel of Matthew (17:24–27), in which Jesus arrives at the Roman colony of Capernaum, in modern Israel, with his twelve apostles. A Roman tax collector asks Jesus to pay a tribute to Rome. This biblical event was topical in Florence in the 1420s because taxation was being considered as a way of financing the struggle against the imperialistic dukes of Milan. Below, Saint Peter preaches and raises a boy from the dead, and on the right Peter is enthroned *in cathedra*. The two scenes on the altar wall (far right) show *Saint Peter Preaching* (above) and *Saint Peter Curing by the Fall of His Shadow* (below). The latter is by Masaccio and takes place in a contemporary Florentine street. In it, Saint Peter purposefully keeps his right arm at his side and gazes straight ahead to emphasize that it is his shadow alone that has curative power. As he passes and his shadow falls on the cripples to his right, they are miraculously cured and stand upright. The figure with crossed arms is in the process of rising, while the kneeling figure has not yet benefited from Saint Peter's passage. All the frescoes are illuminated as if from the window behind the altar. As a result, the light consistently hits the forms from the right, gradually increasing the shading toward the left. So monumental were the forms created by Masaccio in these frescoes that Michelangelo practiced drawing them in order to learn the style of his great Florentine predecessor.

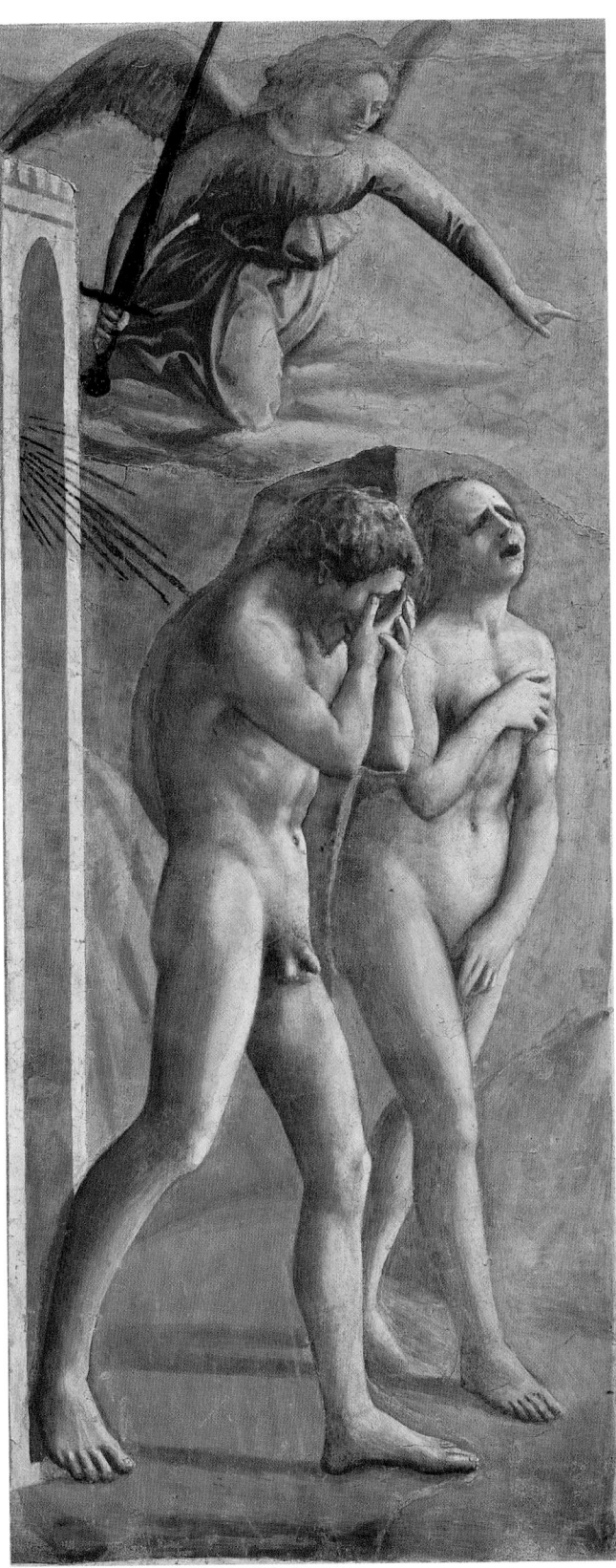

"dark"). This is a more natural use of light and shade than line because it allows artists to model forms and create the illusion of mass and volume.

Masaccio's Adam and Eve (fig. **13.24**) in the scene of the *Expulsion from Eden* are the two most powerful painted nudes since antiquity. Eve's pose is derived from the type of Greek Venus illustrated in figure **13.25,** which is first documented in the Medici collection in the seventeenth century. The artist has transformed the figure of the modest goddess after her bath into a wailing Eve who realizes what she has lost and covers her nakedness in shame. Adam hunches forward and covers his face as if reluctant to face his future. Adam and Eve leave the gateway to paradise behind them at the command of the foreshortened, swordbearing angel.

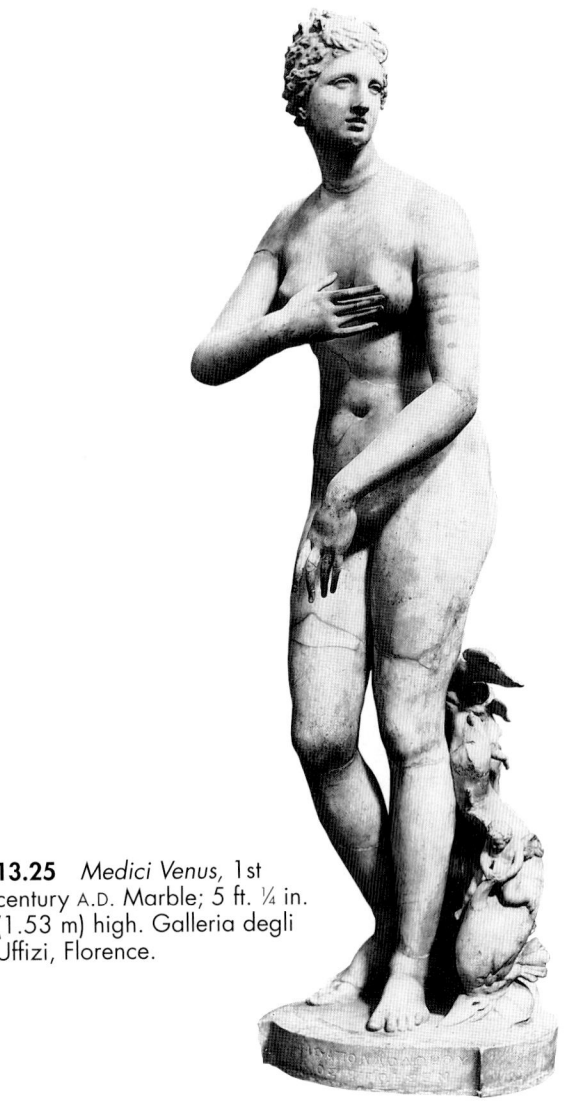

13.25 *Medici Venus,* 1st century A.D. Marble; 5 ft. ¼ in. (1.53 m) high. Galleria degli Uffizi, Florence.

13.24 Masaccio, *Expulsion from Eden* (detail of fig. 13.23, left pilaster of the Brancacci Chapel). Note that the *giornata* outline is visible around Adam's head and torso and above Eve.

Masaccio's characteristic use of massive draperies can be seen in the large horizontal fresco of the *Tribute Money* (see fig. 13.23) immediately to the right of the *Expulsion*. The fresco is divided into three scenes corresponding to three separate events. Occupying the largest, central section is Jesus. He faces the viewer, surrounded by a semicircle of apostles. They wear simple, heavy drapery, whose folds and surface gradations are rendered in *chiaroscuro*. Seen from the back, wearing a short tunic and formally continuing the circular group around Jesus, is the Roman tax collector. Horizontal unity in this central group is maintained by strict isocephaly. The foreshortened halos conform to the geometric harmony of Jesus and his circle of followers by repeating the circular arrangement of figures and matching their convincing three-dimensional quality.

The psychology of this scene is as convincing as its forms. Jesus has no money with which to pay the tax. He tells Saint Peter (the elderly bearded apostle in yellow and blue on his right, fig. **13.26**)—through both word and gesture—to go to the Sea of Galilee, where he will find the money in the mouth of a fish. Saint Peter's not unreasonable skepticism is masterfully conveyed by his angry expression and conflicted gesture. With his right hand, he echoes Jesus's outstretched arm and pointing finger, and withdraws his left hand in protest.

At the far left, separated from the central group, is a foreshortened Saint Peter retrieving a coin from the fish. At the right, Peter, framed by an arch, pays the tax collector. Masaccio has thus organized the narrative so that the point of greatest dramatic conflict—between Jesus and his apostle—occupies the largest and most central space, while the dénouement takes place on either side.

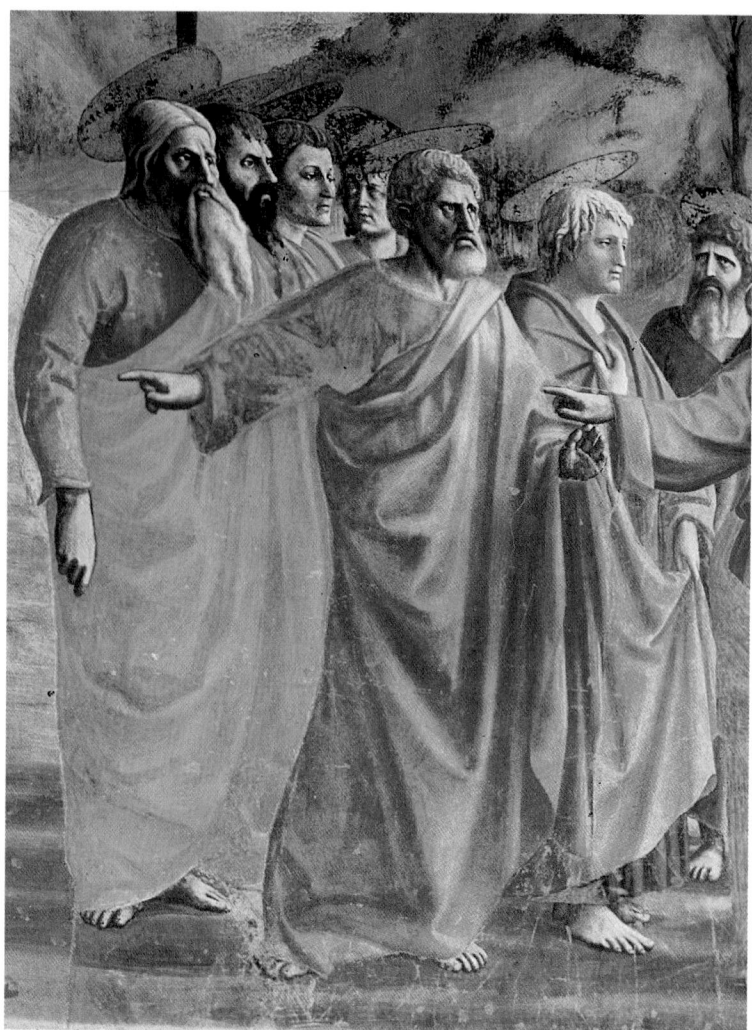

13.26 Masaccio, *Saint Peter* (detail of the *Tribute Money*—see fig. 13.23, left side of the Brancacci Chapel).

Aerial Perspective

Aerial, or atmospheric, perspective is a painting technique based on the fact that objects in the distance appear to be less distinct and vivid than nearby objects. This is because of the presence of dust, moisture, and other impurities in the atmosphere. The artist may, therefore, use fainter, thinner lines and less detail for distant objects, while depicting foreground objects with bolder, darker lines and in greater detail. The artist may also create the illusion of distance by subduing the colors in order to imitate the bluish haze that tends to infuse distant views. In his advice to painters, Leonardo da Vinci recommended that all horizons be blue, as his were. Atmospheric perspective was also employed by Masaccio. In the *Tribute Money* (see fig. 13.23), for example, although the distant mountains are larger than the figures, they are less clearly defined.

Masaccio uses both linear and **aerial**, or **atmospheric, perspective** (see box) in the Brancacci Chapel frescoes. That he has set his figures in a boxlike, cubic space is clear from the horizontal ground and the architecture to the right of the *Tribute Money*. To find the vanishing point of the painting, extend the orthogonals at the right and the receding line of the entrance to paradise in the *Expulsion*. The orthogonals meet at the head of Jesus, who is also at the mathematical center of the combined scenes. Rather than provide the vanishing point within a single frame, as he had done in the *Holy Trinity*, in the Brancacci Chapel Masaccio has unified several scenes through a shared-perspective construction. The diminished figure of Saint Peter at the left of the *Tribute Money* and the gradually decreasing size of the trees also indicate the use of linear perspective, in this case to create the illusion of a spatial recession far into the distance, beyond the Sea of Galilee. The shaded **contours** and slightly blurred mountains and clouds exemplify Masaccio's use of aerial perspective to suggest their distance in relation to the monumental figures in the foreground.

Perspective in Asian Painting

Although aerial perspective is used in Western art, it is much more usual in Asia. The *Pleasures of Fishing* (fig. **W7.1**) of about 1490 by the Chinese painter Wu Wei (1459–1508) shows the use of aerial perspective to create an atmospheric landscape. Unlike most Western landscapes, there is no single vanishing point or set of points. The observer's viewpoint is elevated so that the landscape is seen as if from above. The forms that are meant to be closest to the picture plane are more clearly delineated and more thickly painted. Thus, the trees and rocks at the lower right have darker edges, pronounced knots in the trunks, and visible roots, in contrast to the distant trees. The background mountains are washed out and fade into the sky, compared with those at the right. And the fishermen who are detailed in the foreground become horizontal brushstrokes as they recede into the distance.

W7.1 Wu Wei, *Pleasures of Fishing*, c. 1490. Hanging scroll, ink and color on paper; 8 ft. 10 in. × 5 ft. 7 in. (2.71 × 1.74 m). The Palace Museum, Beijing. Wu Wei was born in 1459 in Hubei Province to a family of government functionaries. His father, who was also an artist, became obsessed with alchemy and died in poverty. Wu was then taken in by Qian Xin and studied with his sons. Wu started to use his calligraphy brush to make pictures on the floor. Qian asked him if he wished to be a painting master, and he then arranged for his training. Wu became a successful artist and worked for the imperial court.

Another Asian approach to perspective can be seen in Persian miniature painting of the fifteenth century. This consisted primarily of manuscript illumination, which departed from the usual conventions of Islamic art (see Chapter 9) in depicting the human figure. Persian perspective can be both two- and three-dimensional within a single frame or scene. The artists preferred harmony of design to illusionistic representations of the natural environment. As a result, they create a world rich in color, pattern, and variations in proportion and in spatial arrangement.

The bright, rich colors of Persian miniatures come from the abundant use of gold, silver, and lapis lazuli. Bright vermilion was made by grinding cinnabar, and green came from malachite. Many illuminations were commissioned by royal patrons, but there was also a demand for commercially produced illustrated manuscripts.

A page from a commercial manuscript is illustrated in figure **W7.2**, and shows the shifting perspective typical of Persian miniatures. It depicts the enthronement of Kuyuk the Great Khan (ruled 1246–1248; grandson of Genghis Khan) at his camp near Qaraqorum, in Iran. At the right, Kuyuk sits in a three-dimensional pose on his throne but occupies a two-dimensional, unmodulated orange space. The table in front of him, on the other hand, is three-dimensional but is seen from above. At the left, two figures kneel on a carpet, which tilts up as if suspended over the ground. A blue and white cloud overlaps the tree and alters the natural relation between landscape and sky. The irrational character of such spatial shifts, however, is subsumed by the brilliant color and intricate patterns of the image.

W7.2 *Kuyuk the Great Khan,* from a Ta'rikh-i Jahan-gusha of 'Ata Malik ibn Muhammad Juvayni, Timurid, Shiraz, 1438. 10⅓ × 6⅔ in. (26.5 × 17.2 cm). British Museum, London.

International Style in Italy: Gentile da Fabriano

Masaccio's originality as a painter can be seen by comparing his work with that of an older contemporary, Gentile da Fabriano (c. 1370–1427). Gentile's greatest extant work is the large altarpiece in figure **13.27,** in which the *Adoration of the Magi* occupies the main panel.

Gentile was born in Fabriano, in the Marches (a region of central Italy bordering on the Adriatic coast). He is first documented in Venice in 1408, and he established himself as a leading painter of the International Gothic style in northern Italy. The *Adoration of the Magi* was commissioned in

13.27 Gentile da Fabriano, *Adoration of the Magi,* altarpiece, 1423. Tempera on wood panel; approx. 9 ft. 11 in. × 9 ft. 3 in. (3.02 × 2.82 m). Galleria degli Uffizi, Florence.

1423 by Florence's richest merchant, Palla Strozzi, to decorate his family chapel in the sacristy of Santa Trinità, thereby reflecting his wealth in the panel's rich materials and abundance of gold.

In contrast to Masaccio's taste for simplicity, Gentile's frame is elaborately Gothic, and his gold sky continues Byzantine convention. Gentile's crowds wind their way from distant fortified hill towns down to the foreground where the three Magi worship Jesus. The crowded composition, elaborate gold drapery patterns, and exotic animals—the birds and monkeys, for example—are typical features of International Gothic. In the foreground, though Gentile's use of linear perspective is not consistent, he has foreshortened the horses and the kneeling page removing the spurs from the youngest Magus.

Early Fifteenth-Century Sculpture: Donatello

The most important sculptor of early fifteenth-century Florence was Donatello (1386–1466). He outlived Masaccio by nearly forty years, continuing to develop his style well into the next generation.

Saint Mark

In his early marble statue of Saint Mark of around 1411–1415, Donatello fulfilled a commission from the Guild of Linen Weavers and Peddlers for their niche in the church of Or San Michele (fig. **13.28**). The Florentine guilds had been obliged to provide sculptures for the exterior niches of the church since the middle of the fourteenth century. This integration of the civic and the religious in the commission and display of works of art was an important development in the transition from the Middle Ages to the Renaissance.

The statue of Saint Mark illustrates the revolutionary method of rendering organic form and drapery that distinguishes the Renaissance from the Middle Ages. The drapery folds identify the saint's bent left knee and the *contrapposto* at the waist. The vertical folds of the supporting right leg recall the fluted columnar draperies of the Classical Erechtheum caryatids (see Chapter 5). Saint Mark's relaxed, slightly languid pose is reminiscent of the *Spear Bearer* by Polykleitos (see fig. 5.27), except that the saint is clothed. However, whereas in Classical sculpture the subjects tend to have no distinctive personalities, Saint Mark is represented here as a mature and thoughtful man, carrying the Gospel that he wrote.

13.28 Donatello, *Saint Mark*, shown in its original Gothic niche on the outside wall of Or San Michele, Florence, with a teaching Christ above and the Evangelist's lion symbol below, 1411–1415. Marble.

The Bronze *David*

Donatello's bronze *David* (fig. **13.29**), probably commissioned by the Medici family for a pedestal in their palace courtyard, is a revolutionary depiction of the nude. Its pose, like that of the *Saint Mark,* recalls that of Polykleitos's *Spear Bearer*. The *David* is the first large, naturalistic nude sculpture that we know of since antiquity. By 1430 to 1440, fragments of original Greek statues had been added to the collections of wealthy Florentine humanists, particularly the Medici. Like Masaccio and Brunelleschi, Donatello studied those works and also went to Rome to study ancient ruins. The pose of his *David* was influenced by Classical statues.

David stands over Goliath's head, which he has severed with the giant's own sword. In his left hand, David holds the stone thrown from his sling. He wears a shepherd's hat ringed with laurel, the ancient Greek and Roman symbol of victory, and boots. His facial expression is one of complacency at having conquered so formidable an enemy.

The genius of this statue lies not only in its revival of antique forms, but also in its enigmatic character and complex meaning. David and Goliath, whose encounter is described in the Old Testament (1 Samuel 17:28–51), were traditional Christian types for Jesus and Satan, respectively, and David's victory over Goliath was paired with the moral triumph of Jesus over the devil. David was also an important symbol for the Florentine republic in its resistance against tyranny, for he represented the success of the apparent underdog against a more powerful aggressor. The polished bronze increases the statue's elegance, along with its adolescent form.

─────── **CONNECTIONS** ───────

See figure 5.27. Polykleitos, *Doryphoros (Spear Bearer),* c. 440 B.C.

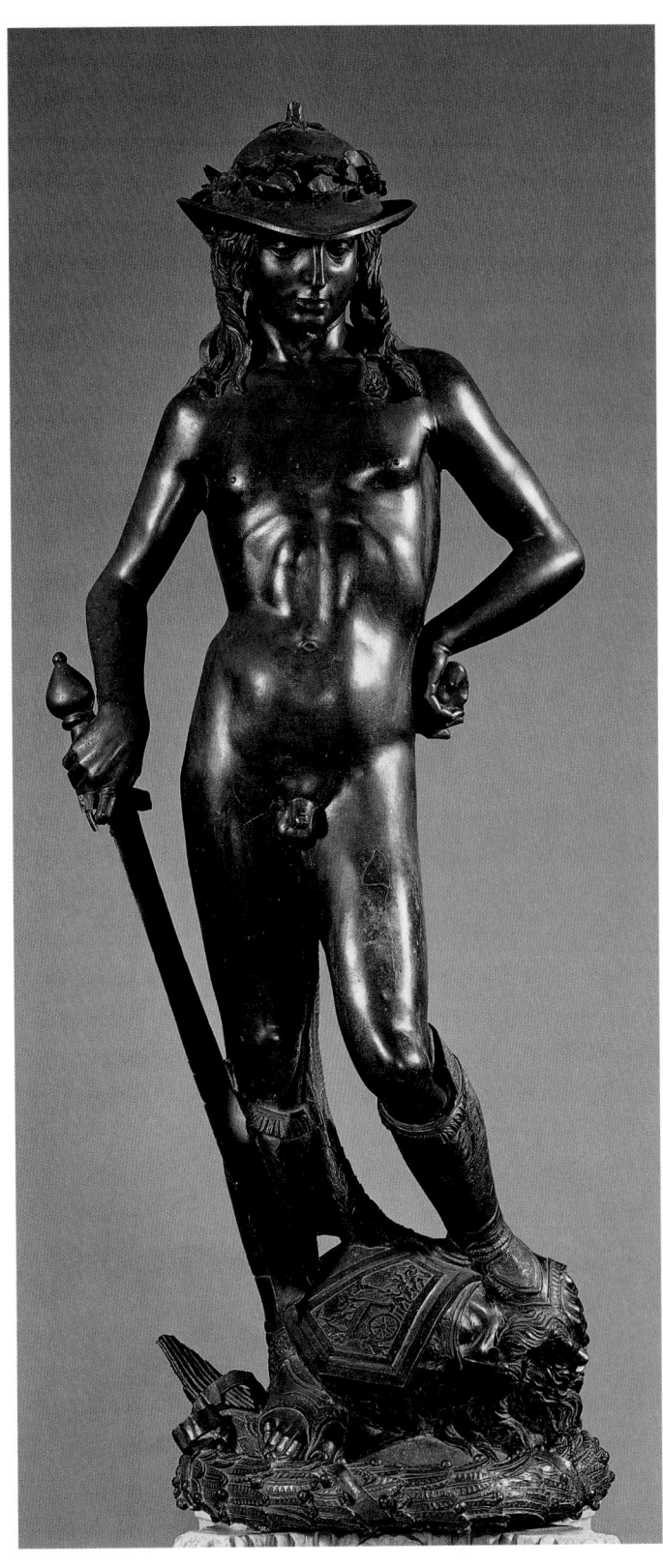

13.29 Donatello, *David,* c. 1430–1440. Bronze; 5 ft. 2½ in. (1.58 m) high. Museo Nazionale del Bargello, Florence.

Second-Generation Developments

Once Donatello, Masaccio, and Brunelleschi had established the foundations of the new Renaissance style, subsequent generations of fifteenth-century artists developed and elaborated their innovations.

Leon Battista Alberti

In his treatise *On Painting,* Leon Battista Alberti (1404–1472) summed up the contributions of Brunelleschi, Masaccio, Ghiberti, and Donatello to the visual arts. But *On Painting* was more than a summation of what had already been done; it was the first Renaissance text of art theory. Alberti was a versatile, prolific humanist writer on many different subjects in both Latin and the vernacular. In addition to art theory, he wrote plays, satirical stories, a Tuscan grammar, a book on dogs, an autobiography, and a book in the form of a dialogue on the family in Renaissance Florence. The latter was his most popular work, and its precepts influenced child rearing in fifteenth-century humanist families. In particular, he advocated a father's watchfulness in raising his sons and, contrary to the general practice of entrusting infants to the care of wet nurses, he recommended that they be breast-fed by their own mothers. At the same time, however, Alberti's virulent misogyny led him to insist that girls be separated from boys lest they infect them with their inferior moral character. From the 1440s onward, Alberti worked as an architect. His influential treatise *De re aedificatoria* (*On Architecture*) was based on the Roman architectural treatise of Vitruvius (see Chapter 6). In contrast to the more technical preoccupations of Brunelleschi, Alberti emphasized the aesthetic importance of harmonious proportions.

The Rucellai Palace From about 1446 to 1450, Alberti designed the Rucellai Palace in Florence (fig. **13.30**). It belonged to the wealthy merchant Giovanni Rucellai, who had made a fortune manufacturing red dye. The façade, which is symmetrical and composed of Classical details, illustrates Alberti's interest in harmonious surface design. The second- and third-story windows, for example, contain round arches subdivided by two smaller arches on either side of a colonnette. Alberti has blended the large window arches with the rest of the wall by leaving visible the stone wedges of which they are composed. In so doing, he retains the surface pattern of the individual stones, setting them in curves around the windows and in horizontals elsewhere. In contrast, the pilasters framing

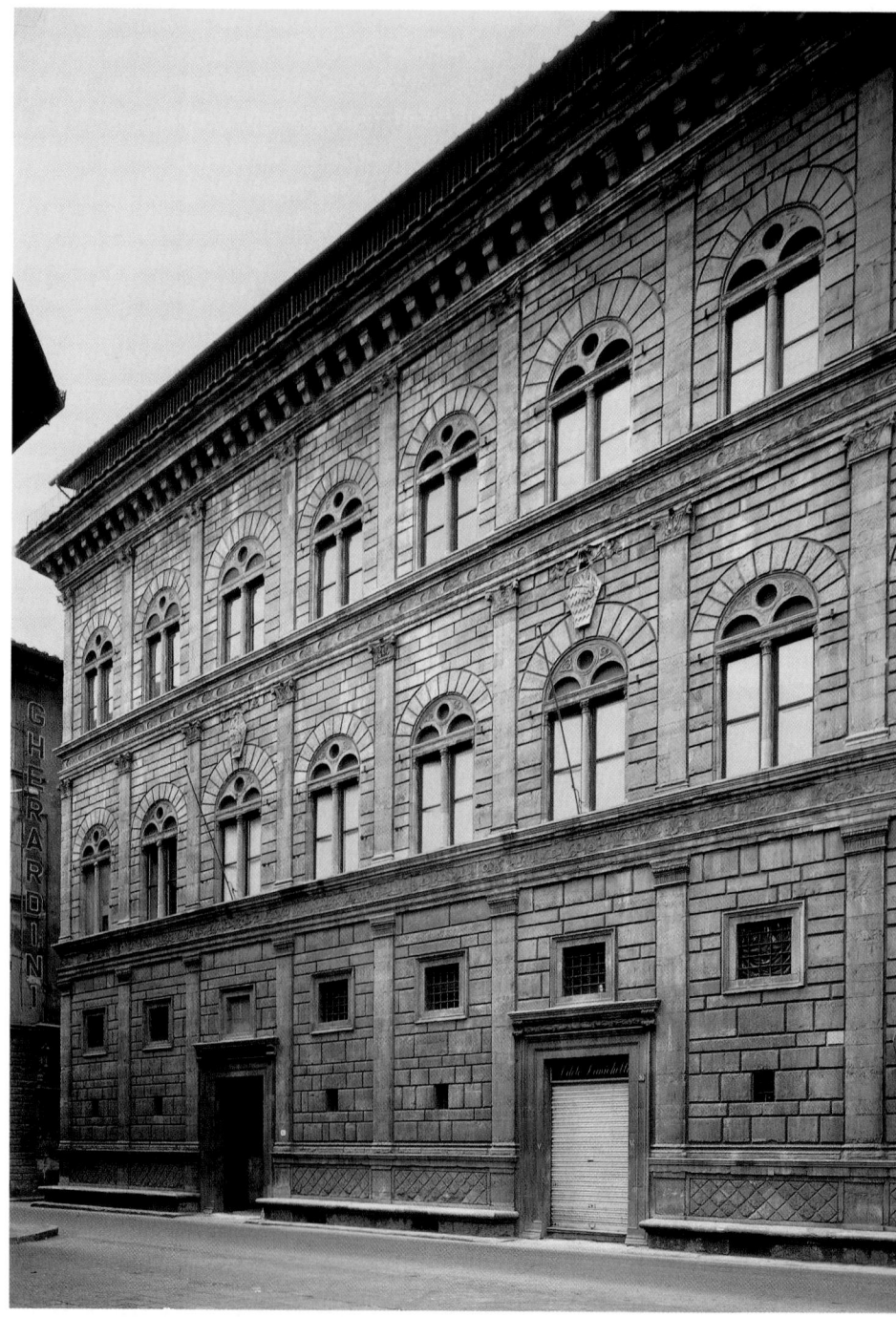

13.30 Leon Battista Alberti, Rucellai Palace, Florence, c. 1446–1450. By way of a family signature, the Rucellai coat of arms appears above each second-story window that is over a ground-floor door. An upward glance from either of the main entrances would therefore have identified the owner of the palace.

each bay on all three stories (the Tuscan Order for the first story, modified Ionic for the second, and Corinthian for the third) have a smooth surface and serve as vertical accents. The vertical progression follows the order of the Colosseum in Rome (see fig. 7.19). Crowning the third story is a projecting cornice, which echoes the horizontal courses separating the lower stories and reinforces the unity of the façade.

The Tempio Malatestiano Alberti's most intriguing commission—which was also his first church—followed soon after the Rucellai Palace. Sigismondo Malatesta, the humanist ruler of Rimini on the Adriatic coast of Italy, hired Alberti to advise on the reconstruction of the Church of San Francesco. Sigismondo, reputed to have been one of the most perverse tyrants of fifteenth-century Italy and a pagan at heart, wanted the church converted to a pagan temple. Its purpose was to glorify him and his young mistress, Isotta degli Atti. Sigismondo's eventual disgrace—in 1462 Pope Pius II consigned him to hell for perversion, rape, murder, and heresy—and his financial setbacks prevented the completion of the Tempio. Nevertheless, what remains is a good example of Alberti's plan to harmonize the Christian church with the forms of antiquity.

The Tempio façade (fig. **13.31**) shows Alberti's use of the triple Roman triumphal arch. The two side arches are blind arches, originally intended for the tombs of Sigismondo and Isotta. All three arches are framed by four **fluted engaged** columns with Corinthian capitals. The transition from the façade to the long sides was effected by a rectangular pier. On each side is an arcade consisting of seven round arches supported by piers. Each niche of the arcade contained the sarcophagus of a humanist admired by Sigismondo. Visually uniting the long sides with the façade are the lower frieze (around the base), the upper cornice, and the circles on either side of each arch, all of which wrap around the building.

13.32 Matteo de' Pasti, foundation medal of the Tempio Malatestiano, Rimini, 1450. National Gallery of Art (Kress Collection), Washington, D.C.

In 1450, the medalist Matteo de' Pasti, who worked for Sigismondo, cast the Tempio's foundation medal (fig. **13.32**), which documents Alberti's unrealized intentions for the completion of the building. He planned to add a central arch flanked by arcs to the second story of the façade,

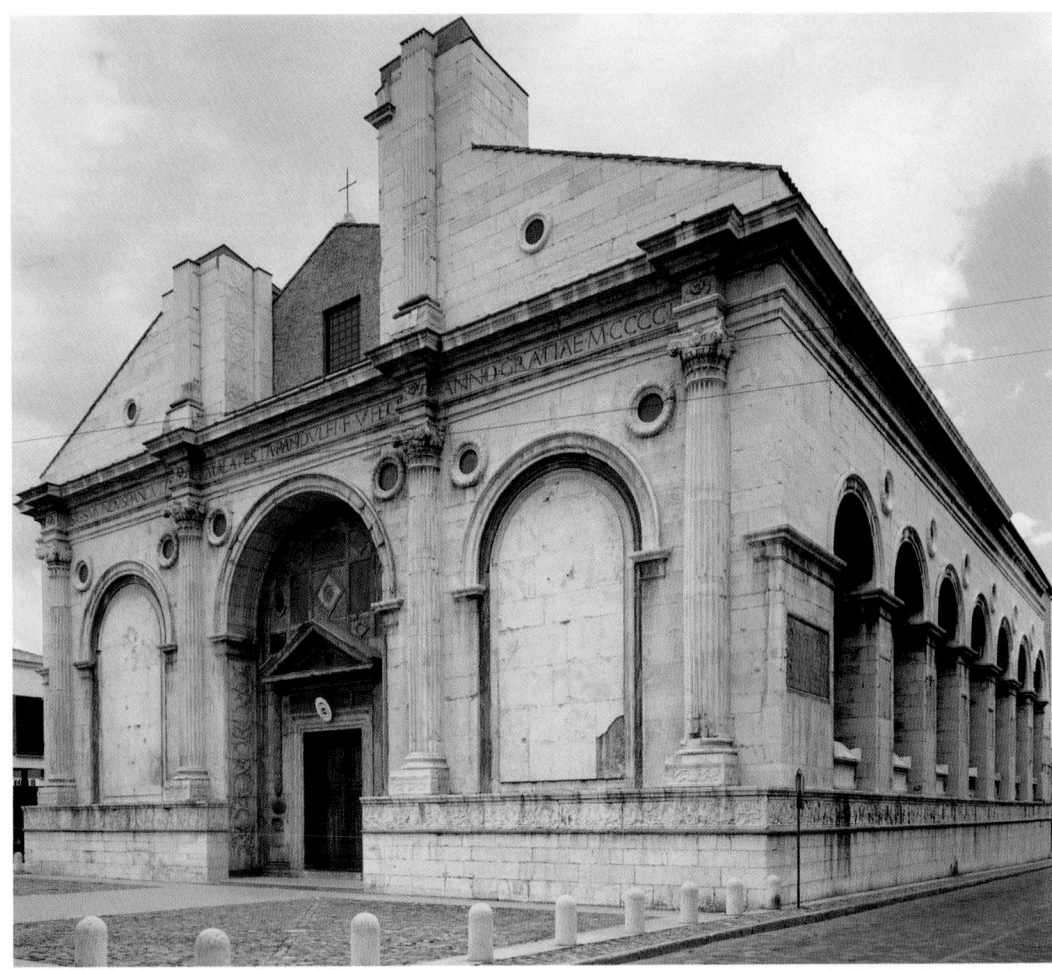

13.31 Leon Battista Alberti, exterior of the Tempio Malatestiano, Rimini, designed 1450.

which would correspond to the nave and the side chapels, respectively. Most significantly, Alberti planned a huge hemispherical dome supported by a cylindrical drum, as in the Roman Pantheon, but with ribs reminiscent of Brunelleschi's dome of Florence Cathedral. Because he had to respect the existing longitudinal structure, however, Alberti was unable to create his ideal temple, which would have been centrally planned. Alberti's ideal of the circular form in architecture, especially for religious buildings, had been inspired by the example of the Pantheon, and it became the ideal architectural form of the Renaissance.

Sant'Andrea in Mantua Twenty years later, Alberti was commissioned by Lodovico Gonzaga, marquis of Mantua (see p. 524), to design the church of Sant'Andrea (figs. **13.33–13.35**). Here again he had to accommodate an existing structure, but the façade achieves the solution left unfinished in the Tempio. Although not completed until some twenty-one years after his death in 1472, Sant'Andrea conforms to Alberti's plan. On the outside, he combined the Classical temple portico (pilasters supporting an architrave surmounted by a pediment) with the Roman triumphal arch. This huge central arch and its

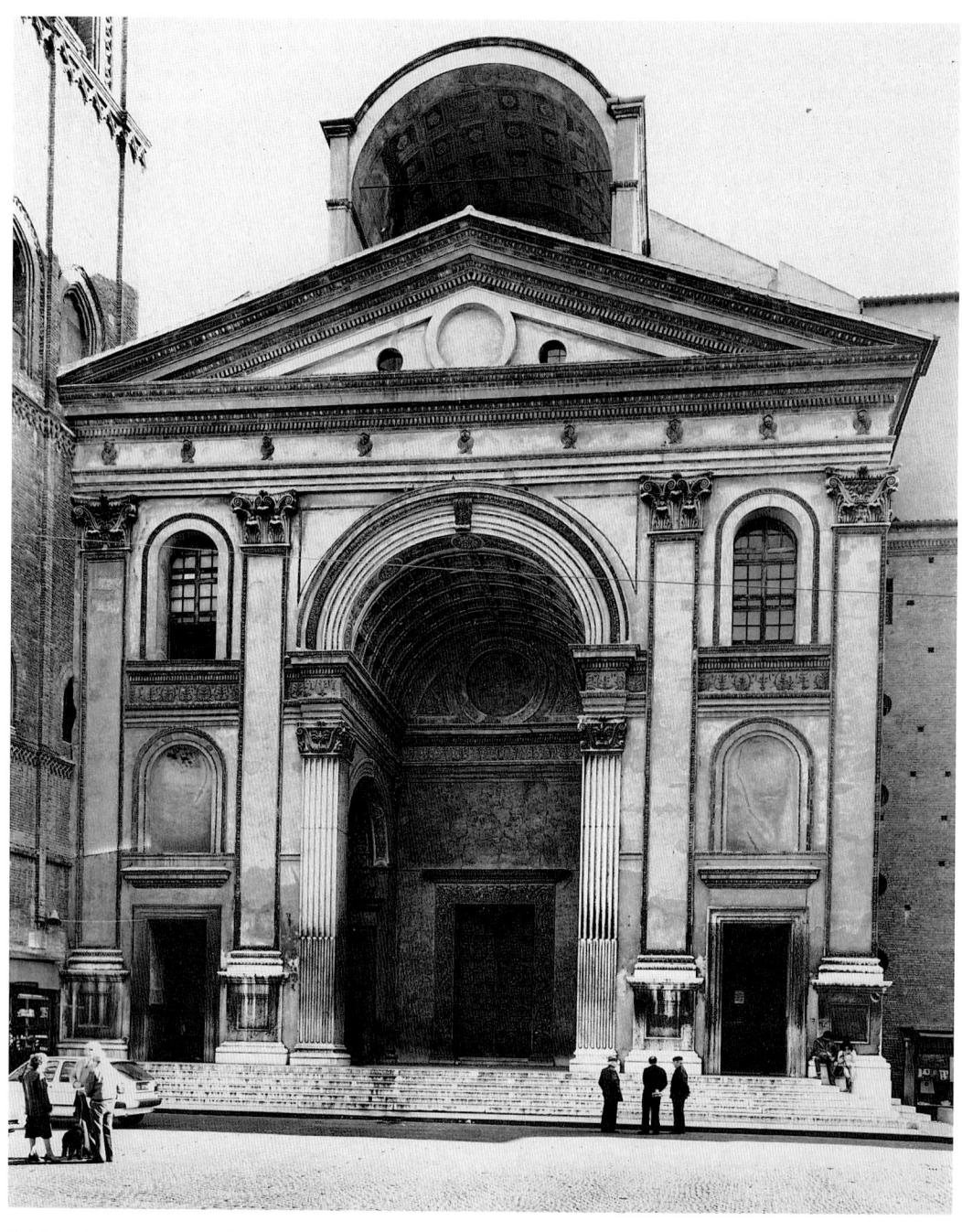

13.33 Leon Battista Alberti, Sant'Andrea, Mantua, 1470–1493.

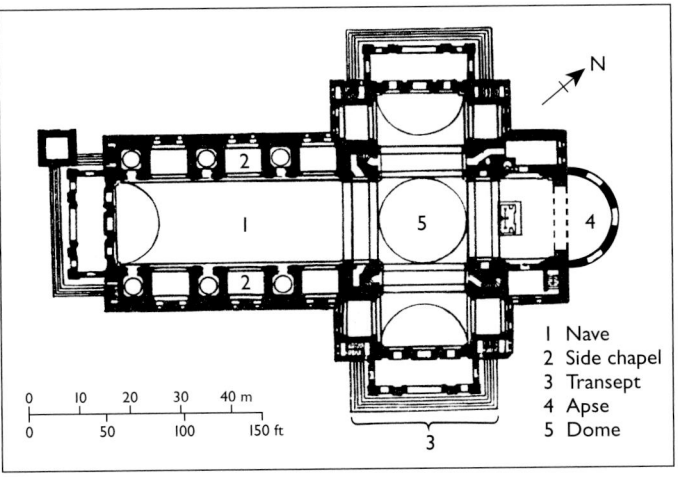

13.34 Plan of Sant'Andrea, Mantua.

1 Nave
2 Side chapel
3 Transept
4 Apse
5 Dome

0 10 20 30 40 m
0 50 100 150 ft

CONNECTIONS

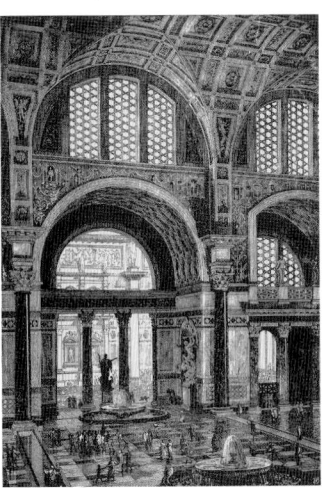

See figure 7.18. Baths of Caracalla (restoration drawing), A.D. 211–217.

barrel-vaulted space in front of the door are reminiscent of ancient Roman basilicas and baths (see fig. 7.18). The view of the nave (fig. 13.35) also shows the influence of the Roman vaulting system and the use of deeply recessed coffers found in the buildings of ancient Rome. Alberti's

concern for symmetry is evident in the organization of the façade, as is his insistence on unity in the way that each section of the façade matches the interior nave and side chapels. His interest in geometry is reflected in the proportions of the façade, which fits into a perfect square.

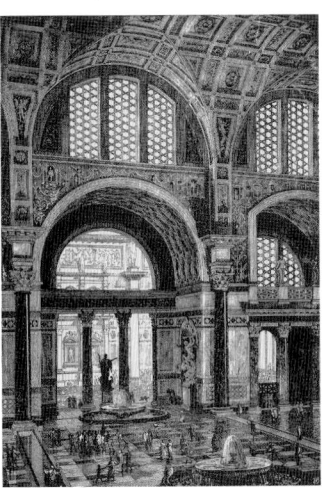

13.35 Nave of Sant'Andrea, Mantua, 1470–1493.

The Theme of David and Goliath

Because of David's role as a symbol of Florence, the theme of David and Goliath continued to preoccupy Italian artists —especially in Florence—throughout the Renaissance. One example is the *Youthful David* (fig. **13.36**) of Castagno (c. 1417/19–1457), which is painted on the curved surface of a leather shield. The shield itself was probably ceremonial, perhaps carried in civic processions. Castagno's sculpturesque style is evident in the figure of David as well as in the rocky terrain. David is depicted in vigorous motion, with the wind blowing his hair and drapery to the right. He raises his foreshortened left arm and fixes his stare as if sighting Goliath. Whereas Donatello's *David* (fig. 13.29) is relaxed, Castagno's participates in a narrative

moment that requires action. The resulting tension of Castagno's *David* is indicated by the taut leg muscles and bulging veins of the arms. David draws back his right arm, preparing to shoot the stone from his sling.

In a striking condensation of time, Castagno has simultaneously depicted two separate moments in the narrative. For although David is about to slay Goliath, the giant's decapitated head lies on the ground between his feet. The same stone that David launches from his sling is embedded in Goliath's head. Temporal condensation of this kind speeds up our vision and our grasp of the narrative so that we see the middle and end of the episode at the same time.

Andrea del Verrocchio (1435–1488), the leading sculptor of the second half of the fifteenth century, cast a bronze *David* (fig. **13.37**), commissioned sometime in the early

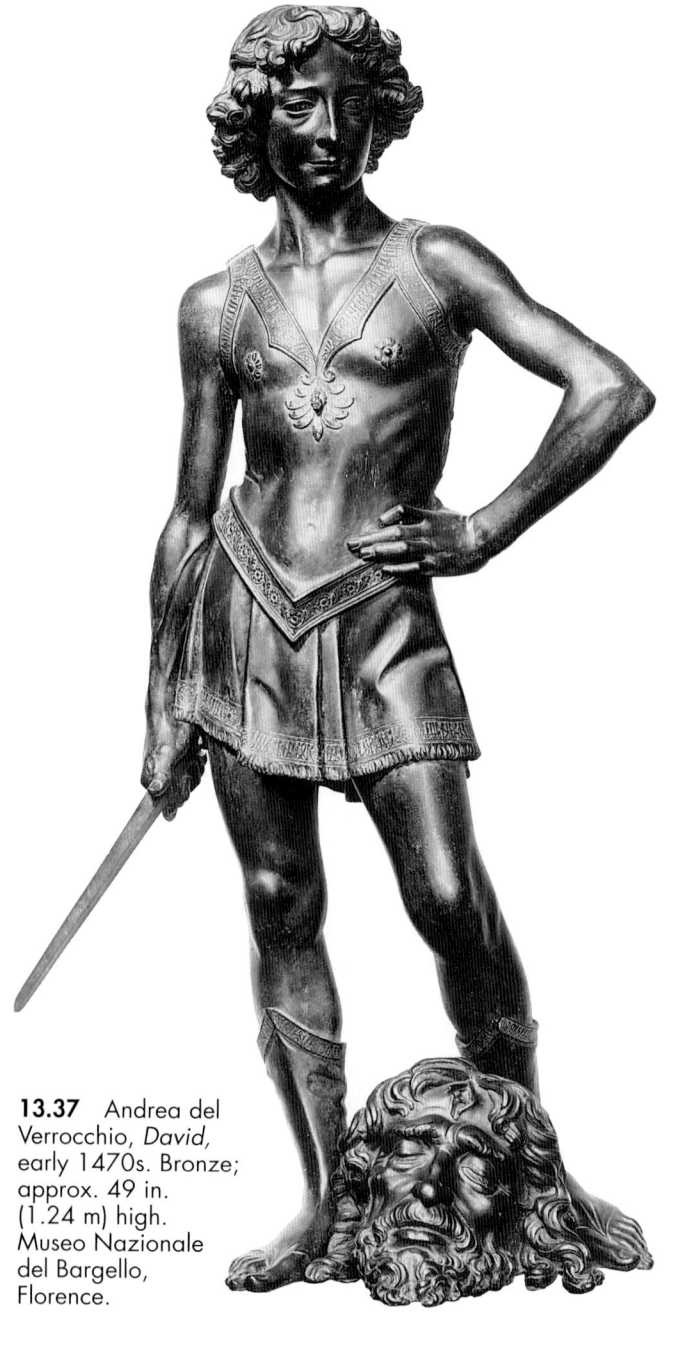

13.36 Andrea del Castagno, *Youthful David*, c. 1450. Tempera on leather mounted on wood; 45½ × 30¼ in. (115.6 × 76.9 cm); lower end 16⅛ in. (41.0 cm) wide. National Gallery of Art (Widener Collection), Washington, D.C. Vasari relates the story of Castagno's decision to become a painter as follows: Caught in a sudden rainstorm, Castagno took shelter in a nearby country house where a painter was working. Castagno was inspired and began drawing on local walls. He was soon discovered by one of the Medici, who was so impressed with Castagno's technique that he provided Castagno with formal training in Florence.

13.37 Andrea del Verrocchio, *David*, early 1470s. Bronze; approx. 49 in. (1.24 m) high. Museo Nazionale del Bargello, Florence.

1470s by Lorenzo de' Medici, known as *Il Magnifico* ("the Magnificent"). The work is at once more straightforward than Donatello's and a comment on it. Verrocchio has transformed the graceful curves and soft flesh of Donatello's effeminate *David* into a sinewy, angular adolescent. The rib cage, molded into the leather cuirass, and the bony arms of the later *David* express a different facet of adolescent arrogance. Here, Goliath's head lies at David's feet, and, instead of a giant sword closing the space and enhancing David's self-absorption, as in Donatello's version, Verrocchio's *David* carries a short sword. He also gazes out into space, rather than down onto his victim. The general effect of the Verrocchio is that of a slightly gawky, outgoing, and energetic boy.

Castagno's *Famous Men and Women*

One aspect of the biblical David that appealed to Renaissance taste was his fame. Since the revival of antiquity in the fourteenth century, fame had been an important preoccupation of Renaissance culture. It was reflected in the comparisons between Cimabue and Giotto, and particu-

larly in Dante's verse on the transience of earthly fame (p. 453).

In 1448, Castagno was commissioned to paint a series of frescoes depicting famous men and women for the loggia of the Villa Carducci at Legnaia, outside Florence. These consisted of nine figures: three Florentine soldiers, three poets (Dante, Petrarch, and Boccaccio), and three women (the Old Testament queen Esther, the Tartar queen Tomyris, and the Cumaean Sibyl). Figure **13.38** shows all nine as they were originally arranged. The three women are flanked by two sets of three men—Queen Esther is the half-length figure over the door. A painted frieze of dancing *putti* with garlands is a reminder of the humanist character of this theme. And the prominence accorded to women (even though they are historical or biblical rather than contemporary) is humanist, for Boccaccio had begun the discussion of famous women, as well as men, in the fourteenth century.

The men and women chosen for this particular commission reflect the humanist interest in freedom and the primacy of intellect. The soldiers were heroic fighters, while Esther and Tomyris defended the liberty of their people. The Sibyl represents wisdom, for she understood and interpreted the future. In the original layout of the

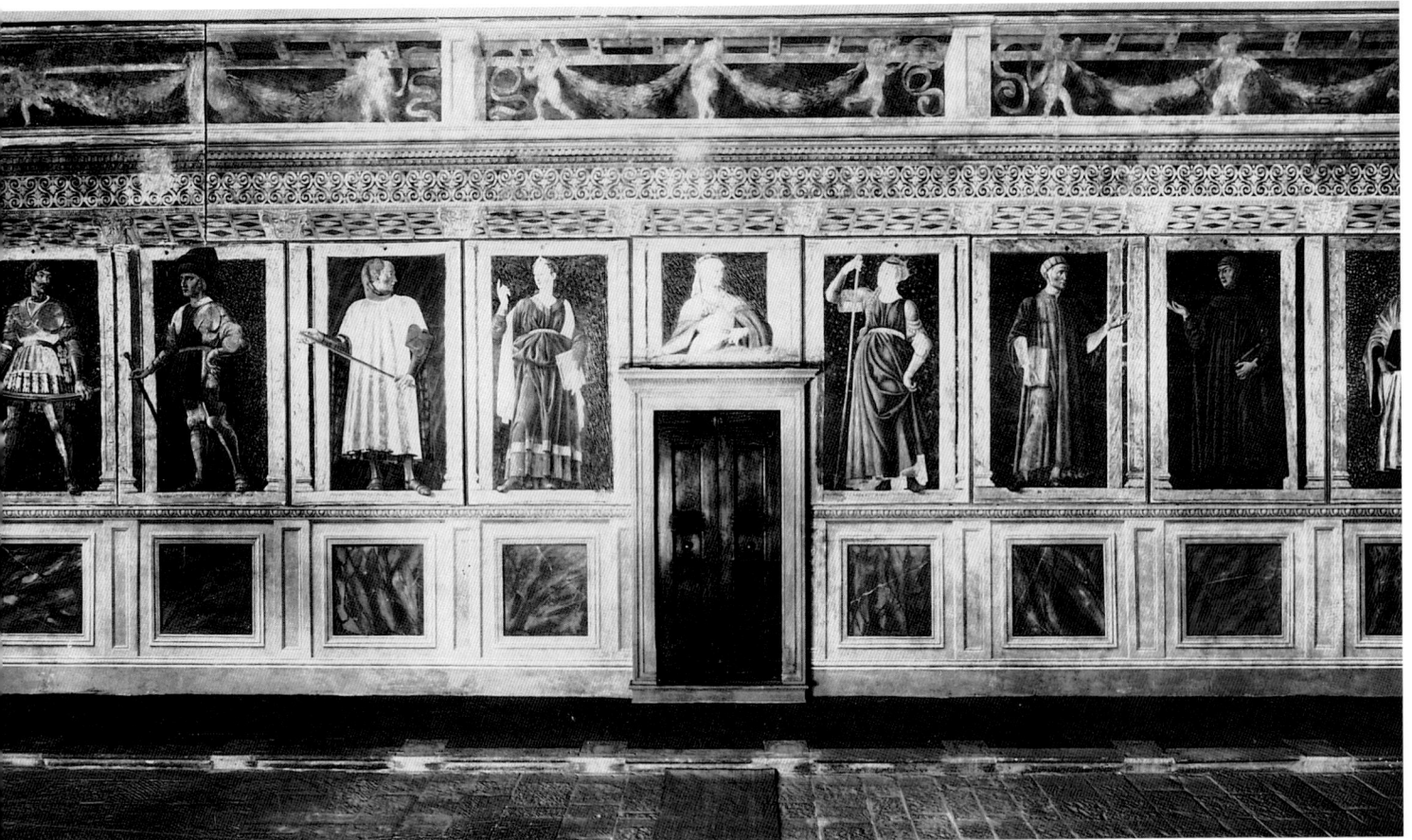

13.38 Andrea del Castagno, *Famous Men and Women*, from the Villa Carducci at Legnaia, 1450. Frescoes transferred to plaster; entire width 50 ft. 10 in. (15.50 m); each panel 8 ft. × 5 ft. 5 in. (2.45 × 1.65 m). The frescoes have since been separated and are now displayed individually in the Uffizi in Florence.

frescoes, the Sibyl was portrayed as turning to what is now a badly damaged fresco of the Virgin on the loggia's short wall—a reference to her foreknowledge of Christ. Large images of Adam and Eve, also on the short wall, reveal the typological meaning of Castagno's program. The three poets were included in the humanist school curriculum of fifteenth-century Italy, and it was their writing that helped spark the Renaissance.

Each figure dominates its niche and seems to step out of its frame. Their dignified self-confidence conforms to the humanist emphasis on individual achievement and talent. The figure of Dante (fig. **13.39**), for example, whose *Divine Comedy* was itself populated with famous men and women, stands in a relaxed, self-assured pose. He carries a book and raises his left hand in a gesture of casual conversation. His scholar's robe falls in sculpturesque folds, except where it defines the bend of his right leg. His foot overlaps the lower frame—inscribed "DANTE ALIGHIERI THE FLORENTINE"—and continues the illusionistic trend begun by Giotto over a century earlier.

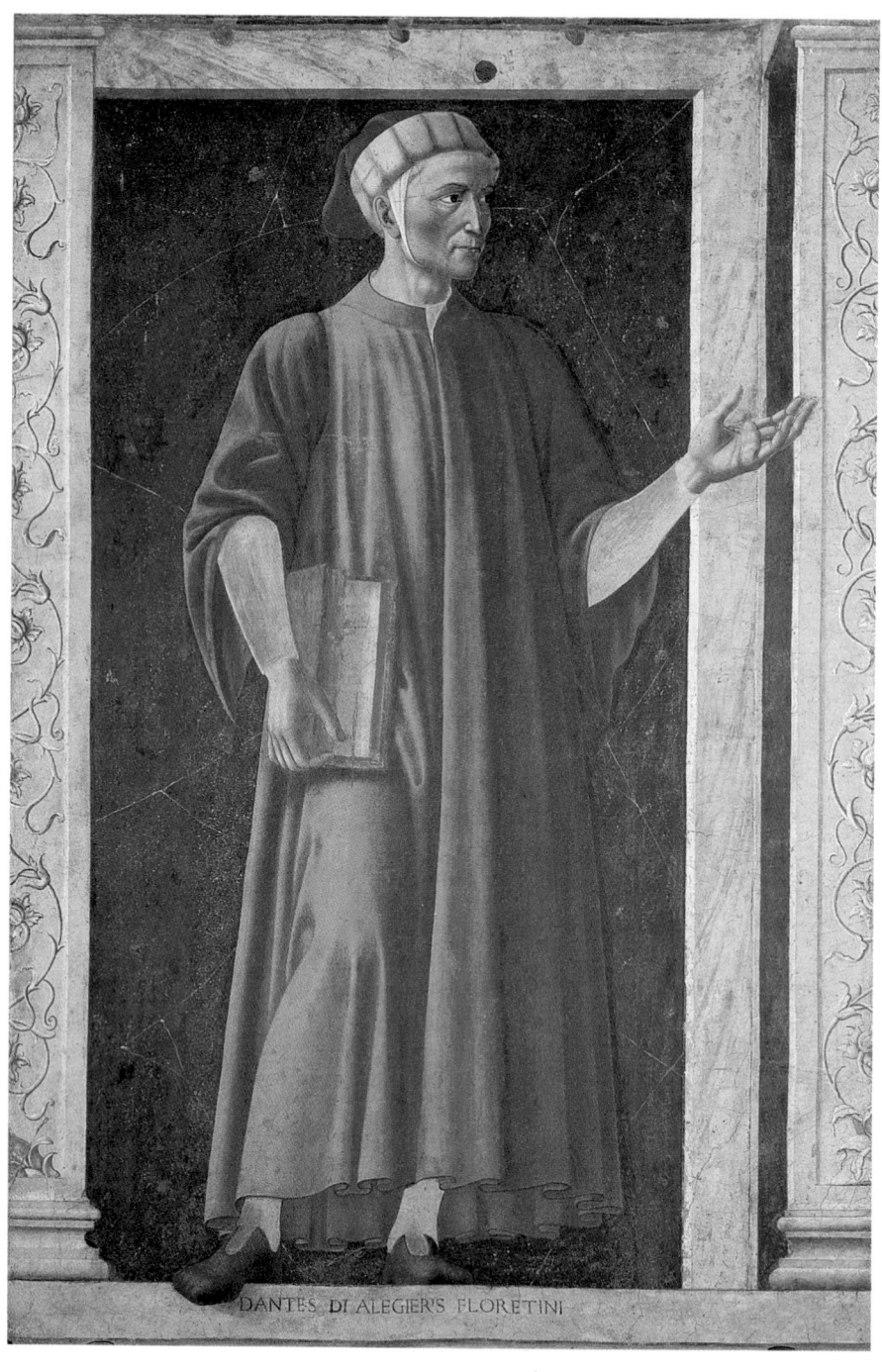

13.39 Andrea del Castagno, *Dante* (detail of fig. 13.38).

The Equestrian Portrait

Another type of image that became increasingly popular in fifteenth-century Italy was the equestrian portrait, typically commissioned to honor a *condottiere*. This, too, can be related to the notion of fame and the wish to preserve one's features in the cultural memory.

Paolo Uccello In 1436, the Florentine artist Paolo Uccello (1397–1475) painted an enormous fresco on the north wall of the cathedral (fig. **13.40**). It was to honor Sir John Hawkwood, an English soldier of fortune who had led the Florentine army in the fourteenth century. Both the Latin inscription on the pedestal and two shields bearing Hawkwood's coat of arms were a means of securing his fame for posterity. Uccello's memory is preserved in the signature at the top of the base. Consistent with the new Renaissance synthesis of secular and sacred is the very location of an image memorializing a military hero on the wall of a cathedral.

Uccello's interest in geometry is evident in the spherical balls on the horse trappings, in Hawkwood's medieval armor, and in his hat. Although the horse's forms are rendered organically, they have a wooden, toylike character created by crisp edges separating light and dark.

Uccello has constructed a double-perspective system in the Hawkwood fresco in order to accommodate the observer. The base and pedestal are rendered as if from the eye level of a viewer standing below the lower edge of the fresco. As a result, the underside of the top ledge is visible, but the sides of both base and pedestal are foreshortened. The horse and rider are painted as if the viewer were higher up or the horse were lower down. This shift permits us to see the soldier and his horse in profile and the pedestal from below. Uccello thus condenses space by portraying a double viewpoint, whereas Castagno, in his *David*, condenses two narrative moments into a single image.

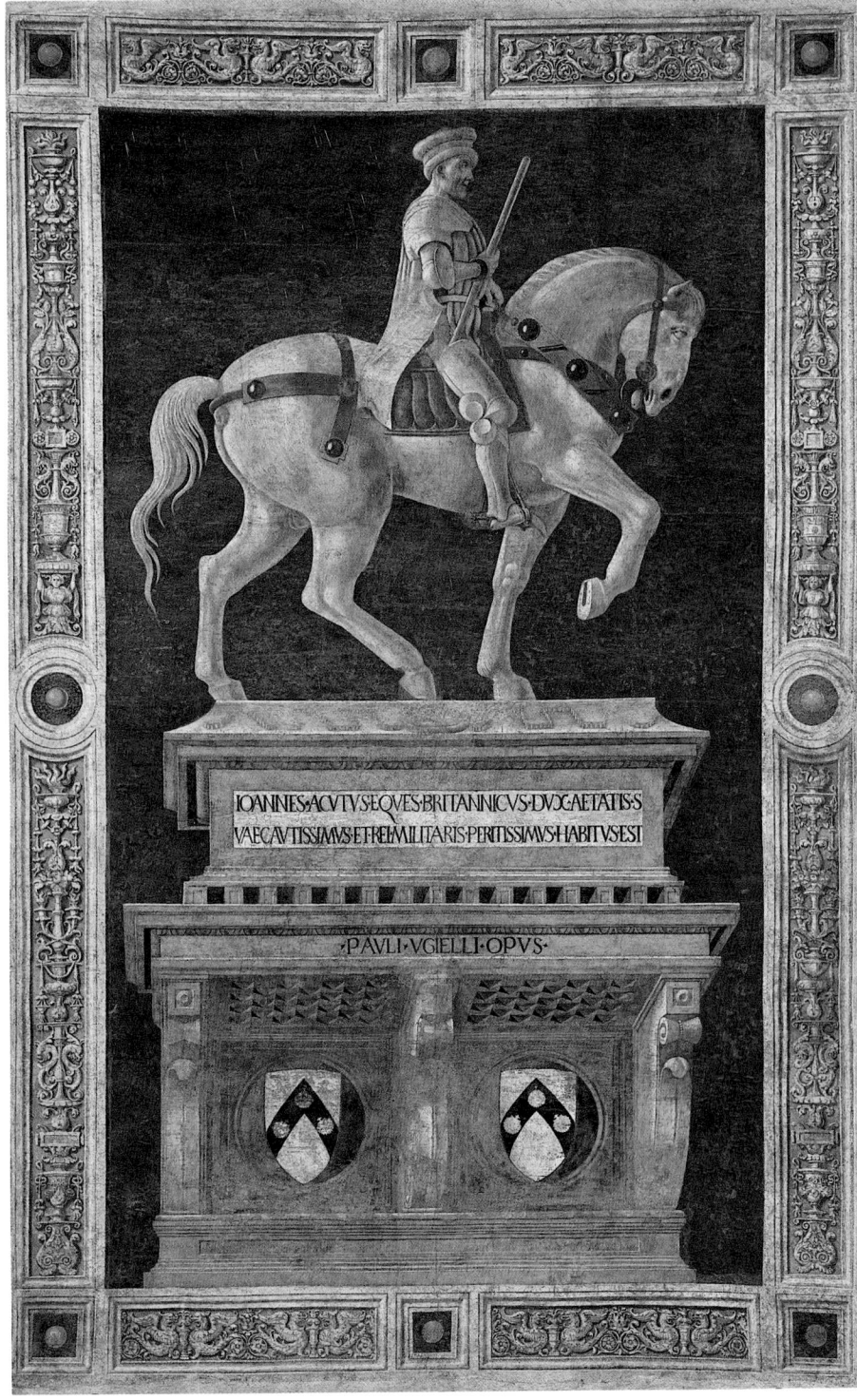

13.40 Paolo Uccello, *Sir John Hawkwood*, Florence Cathedral, 1436. Fresco transferred to canvas; 26 ft. 11 in. × 16 ft. 11 in. (8.20 × 5.16 m).

Andrea del Castagno Paired with Uccello's fresco on the north wall of Florence Cathedral, but commissioned two decades later, is a monumental fresco by Castagno (fig. **13.41**). This work honored the *condottiere* Niccolò da Tolentino, who had defeated Siena in 1432. It is painted to resemble a marble tomb with the mounted figure of the deceased on the lid. This work is more powerful than Uccello's, for the horse has greater mass and turns toward the picture plane. The resulting foreshortening of the neck and head compresses space and monumentalizes the image. Castagno's rider is also heavier than Uccello's, and his assertive character conveys an increased tension compared with Sir John Hawkwood. Here, again, the coats of arms—a gold lion on the left and a knot on the right—proclaim Niccolò's noble heritage. The large scallop shell connotes resurrection and rebirth.

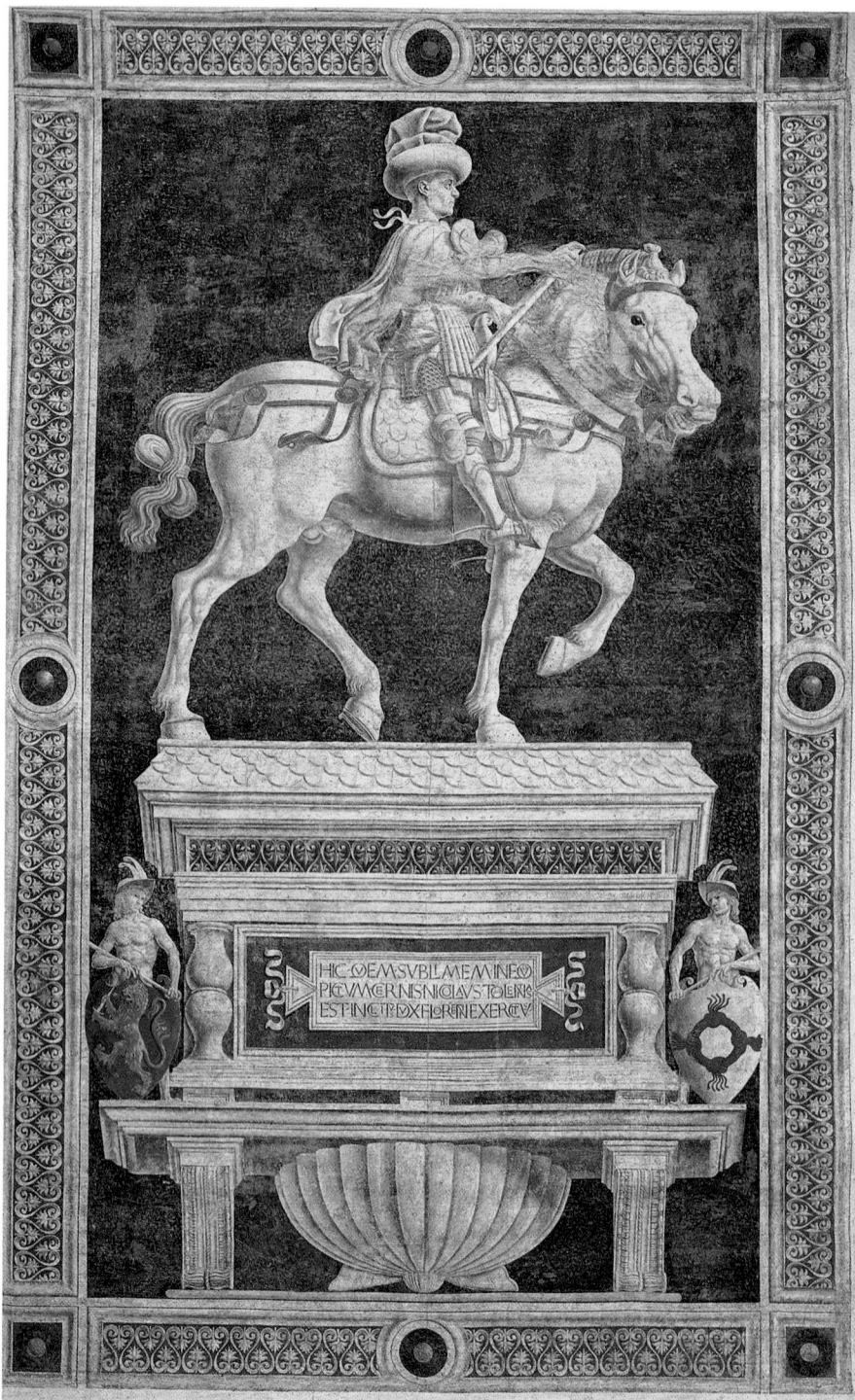

13.41 Andrea del Castagno, *Niccolò da Tolentino,* Florence Cathedral, 1455–1456. Fresco transferred to canvas; 27 ft. 3 in. × 16 ft. 7 in. (8.33 × 5.12 m). Niccolò da Tolentino defeated Siena in 1432 in the Battle of San Romano but was himself defeated in the war between Florence and Milan. He died in prison in 1435 and was buried in Florence Cathedral. The inscription on the sarcophagus reads: *"HIC QUEM SUBLIMEM IN EQUO PICTUM CERNIS NICOLAUS TOLENTINAS EST INCLITUS DUX FLORENTINI EXERCITUS"* (Here Nicholas Tolentinas whom you see mounted on a horse was appointed leader of the Florentine army).

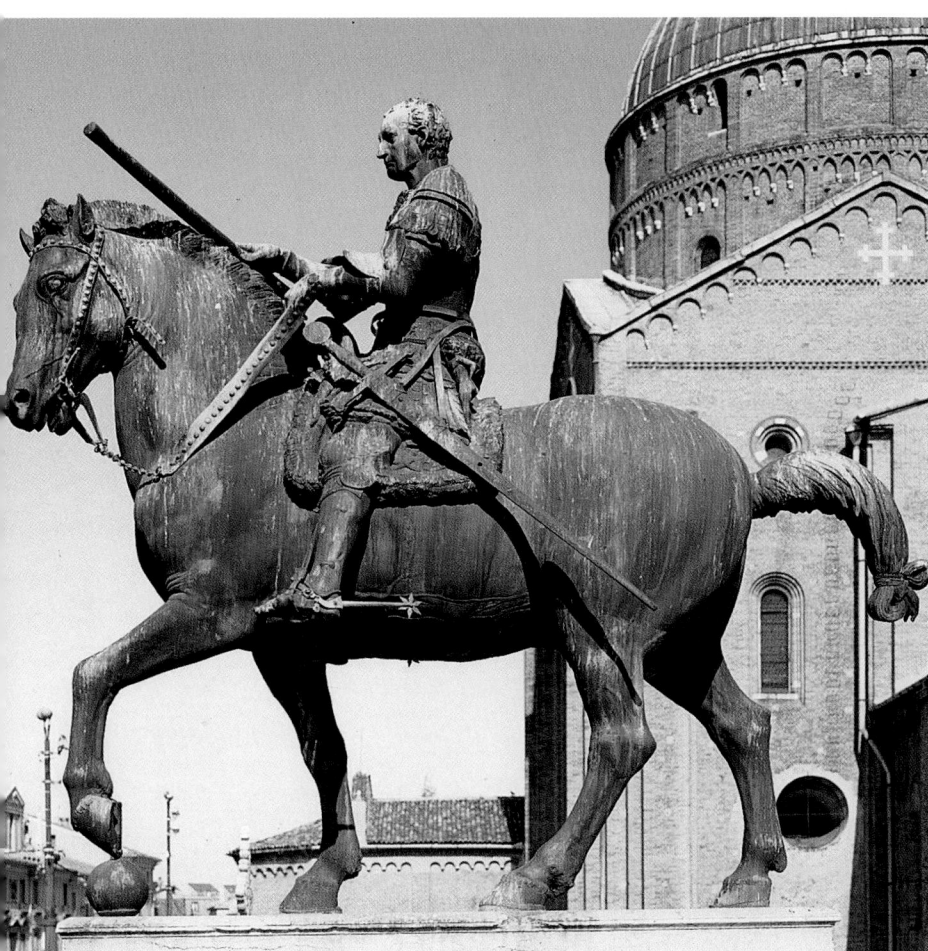

13.42 Donatello, *Gattamelata,* 1445– 1450. Bronze; approx. 11 × 13 ft. (3.35 × 3.96 m). Piazza del Santo, Padua.

Donatello Donatello's monumental bronze equestrian portrait of Gattamelata stands on a high pedestal in front of the Church of Sant'Antonio in Padua (fig. **13.42**). *Gattamelata,* meaning "honeyed cat," was the nickname of the *condottiere* Erasmo da Narni. He had led the army of Venice, which at that time controlled Padua. Even though the *condottiere's* family had, according to the terms of his will, financed the sculpture, its prominent location would have needed approval from the Venetian government.

The statue was inspired by the *Marcus Aurelius* (see fig. 7.50), which Donatello had

— **CONNECTIONS** —

See figure 7.50. *Marcus Aurelius,* A.D. 164–166.

seen in Rome. Both horses raise one foreleg, and their massive forms are rendered with a sense of weight and power. Donatello's rider, like Marcus Aurelius, is assertive, extending his baton in the conventional gesture of command. Gattamelata's armor is also inspired by ancient Roman models and is decorated with figures from Greek and Roman mythology. On his breastplate, a ferocious winged Medusa head symbolically wards off and "petrifies" his enemies (fig. **13.43**).

13.43 Detail of figure 13.42.

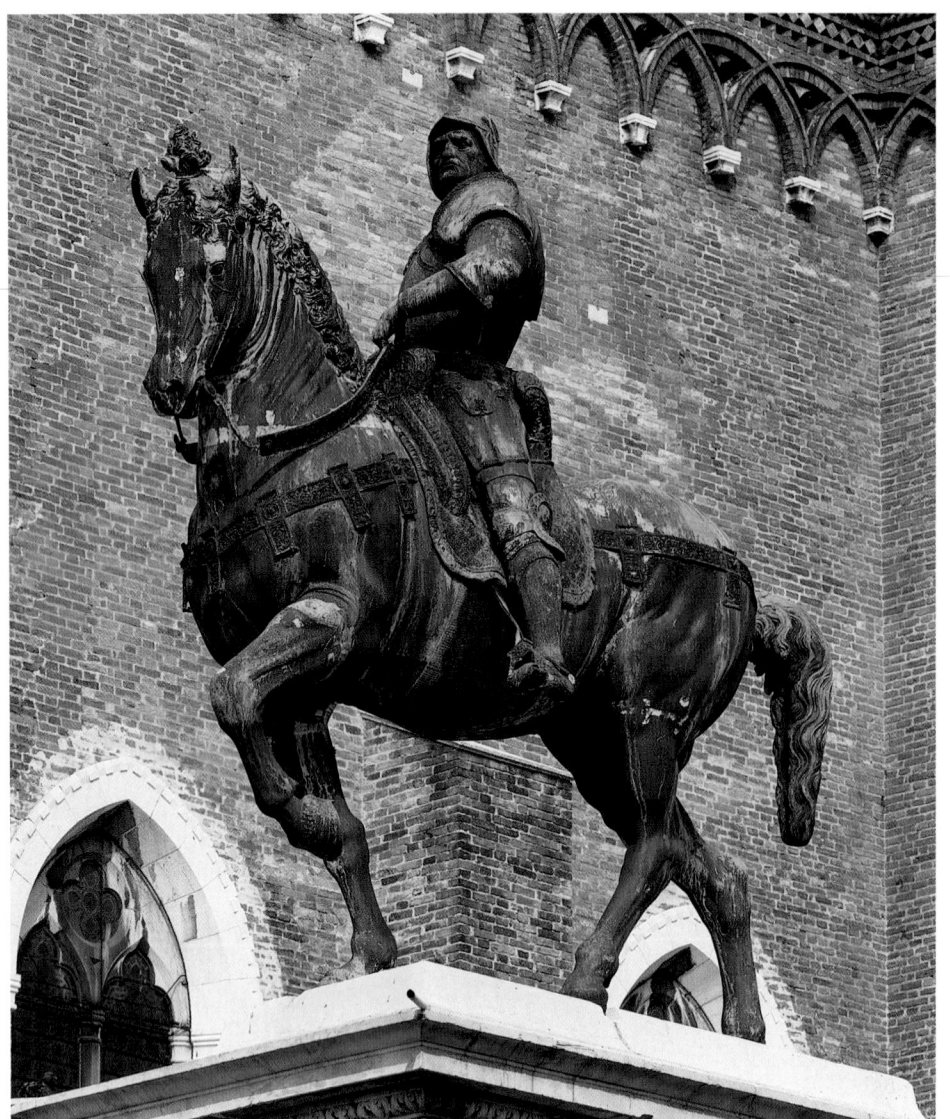

13.44a Andrea del Verrocchio, *Colleone*, c. 1481–1496. Bronze; approx. 13 ft. (3.96 m) high. Campo Santi Giovanni e Paolo, Venice.

Verrocchio In 1480, Verrocchio won the commission for a monumental bronze equestrian statue in Venice (fig. **13.44a**). He produced the model for the work, a portrait of the *condottiere* Bartolommeo Colleone from Bergamo. Although the sculpture was not cast until after the artist's death in 1488, it faithfully followed his model. Verrocchio shows a powerful soldier mounted on a dynamic warhorse, impatient to enter the fray of battle. In contrast to Gattamelata, Colleone wears contemporary armor and appears, like his horse, tense and eager to advance.

The detail in figure **13.44b**, which shows the fierce, piercing gaze of Colleone, reveals his aggressive character. He turns sharply, as if focusing on a hostile enemy. The folds of flesh in his neck, the frown lines on his forehead, and his powerful torso create the impression of a formidable warrior.

According to Vasari, when the republic of Venice decided that another artist would cast the figure—and that Verrocchio would cast only the horse—Verrocchio was so angry that he smashed the head and legs of his model. Venice then threatened to behead the artist, who retorted that a man's head could not be replaced but that an artist of his stature could replace the horse's head. Impressed with Verrocchio's response, Venice recalled him and doubled his salary.

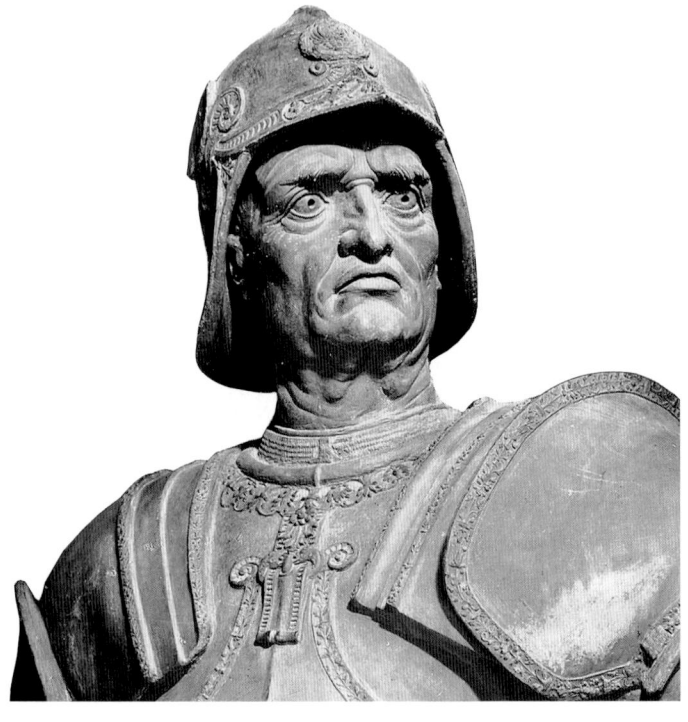

13.44b Andrea del Verrocchio, *Colleone* (detail of fig. 13.44a).

<div style="border:1px solid black">

Oil Painting

In oil painting, pigments are ground to a powder and mixed to a paste with oil, usually linseed or walnut. In Italy, oil first came into use as part of tempera paintings and was applied to panels coated with a gesso support. Although oil had been known and occasionally used in Italy since the fourteenth century, it was not prevalent before about 1500. In northern Europe, on the other hand, oil was the most popular medium for painters from the early 1400s.

There are several advantages to using oil paint. It can be applied more thickly than fresco or tempera because the brush will hold more paint. Oil dries very slowly, which allows artists time to revise their work as they proceed. Oil also increases the possibilities for blending and mixing colors, opening up a much wider color range. Modeling in light and dark became easier because oil enabled artists to blend their shades more subtly. Since oil paint tended to retain the marks made by the brush, artists began to emphasize their brushstrokes so that they became a kind of personal signature. Tempera, a brittle medium, required a rigid support. But oil was flexible, so canvas became popular as a painting surface. This meant that artists did not have to worry as much about warping. The woven texture of canvas also held the paint better than wood.

</div>

State Portraits

The official, or state, portrait of an individual ruler also became popular in fifteenth-century Italy. Portrait busts, a revival of an ancient Roman sculptural type, had been commissioned from the earliest years of the Renaissance, and Donatello was reputed to have cast portraits from death masks, just as the Romans had done.

The Umbrian artist Piero della Francesca painted a double portrait of Federico da Montefeltro and Battista Sforza of Urbino (fig. **13.45**) in **oil** and tempera on wood panels (see box), with images of their triumphs on the back of each. The iconography is inspired by imperial Roman portraits, particularly by profile busts on ancient coins.

The figures are in strict profile (concealing the loss in a tournament of Federico's right eye). The pallor of Battista's complexion, in contrast to that of Federico, probably indicates that she had died by the time Piero painted the diptych. Nevertheless, both Federico and Battista dominate the landscape backgrounds and are also formally connected to them. Figures and landscapes are bathed in the white light characteristic of Piero's style. Battista Sforza's pearls repeat the diagonal of the white buildings in the distance, while the diamond shapes in her necklace and

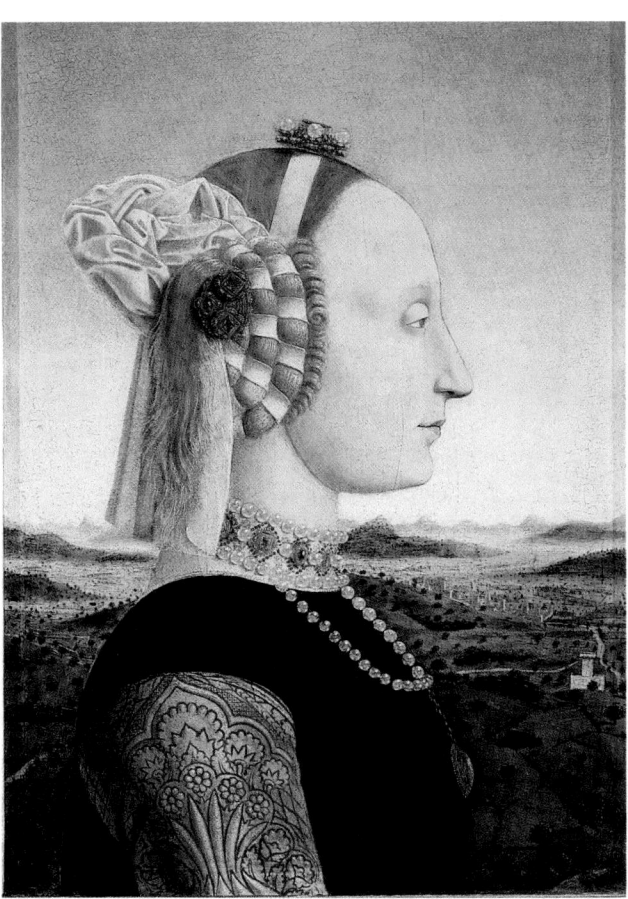 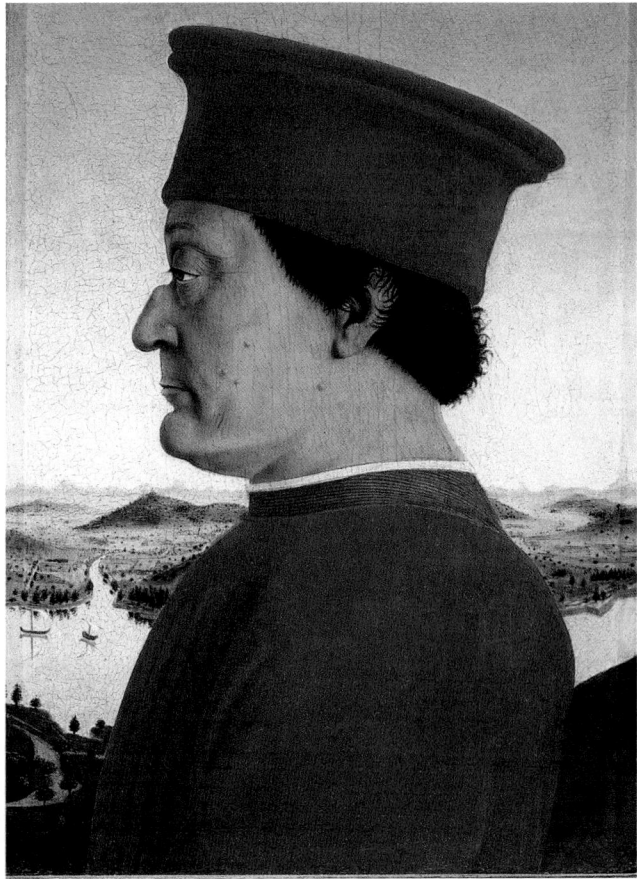

13.45 Piero della Francesca, *Battista Sforza and Federico da Montefeltro, Duke of Urbino* (after cleaning), after 1475. Oil and tempera on panel; each 18½ × 13 in. (47.0 × 33.0 cm). Galleria degli Uffizi, Florence. Federico da Montefeltro, a successful *condottiere,* and his wife were leading patrons of the arts and presided over one of the most enlightened humanist courts in 15th-century Italy. Artists, scientists, and writers (including Alberti) came from various parts of Europe to work for Federico. The fact that Piero used oil in his painting was probably a result of his contacts with Flemish painters working at the court of Urbino.

her brocade sleeve echo the rolling hills and distant mountains. The moles on Federico's face and the curls overlapping his ear create patterns of dark on light, just as the trees do against the landscape. The triangle of his neck and under his chin repeat the triangular mountains. Such formal parallels between rulers and landscape signified the relationship between them and their territory. Piero's perspective construction, which makes the background forms radically smaller than the figures, implies the greatness of the rulers and the expanse of their territory.

Monumentality versus Spirituality in Fifteenth-Century Painting: Fra Angelico and Piero della Francesca

Piero della Francesca was interested in the mathematical and geometric possibilities of painting (note Federico's perfectly round, foreshortened hat in figure 13.45), and wrote two books, one on geometry and one on perspective, in Latin. A comparison of Piero's *Annunciation* (fig. **13.46**) with a painting of the same subject by Fra Angelico (c. 1400–1455) (fig. **13.47**) illustrates two of the leading stylistic trends in mid-fifteenth-century Italian Renaissance painting.

Both pictures must be understood within a specific context. Piero's picture is part of a fresco cycle in the Church of San Francesco in Arezzo (see p. 519), whereas Fra Angelico's is one of many pictures in the Dominican convent of San Marco (Saint Mark) in Florence. In addition to different contexts, the paintings were commissioned by patrons—Franciscans and Dominicans—with differing attitudes to Christian imagery and church decoration.

The Dominican Order, to which Fra Angelico belonged, had been founded by Saint Dominic (1170–1221), who was born in Old Castile in Spain, and its mission was to defend the Church and convert heretics. Since Dominicans wore black mantles, they were also known as the Black Friars. In their choice of church decoration, the Dominicans emphasized the spiritual qualities of Christian subject matter. But humanist artists such as Piero della Francesca, who worked in the tradition of Giotto, tended to attract Franciscan patronage. Piero's *Annunciation* is a good example of the artist's combination of Christian iconography with geometry and the Classical revival. The scene takes place in a white marble Classical building with composite Corinthian and Ionic columns. Mary holds a book, Gabriel enters from the left, and God the Father hovers over a cloud at the upper left. Mary is related to the Classical architecture as both a form and a symbol. She fills the space of the portico, evoking the Christian convention equating Mary's monumental proportions with the Church building. The column swells slightly, even though it is not Doric and should not exhibit such marked *entasis* (see Chapter 5). It is thus an architectural metaphor for Mary's pregnancy through the miraculous Incarnation of

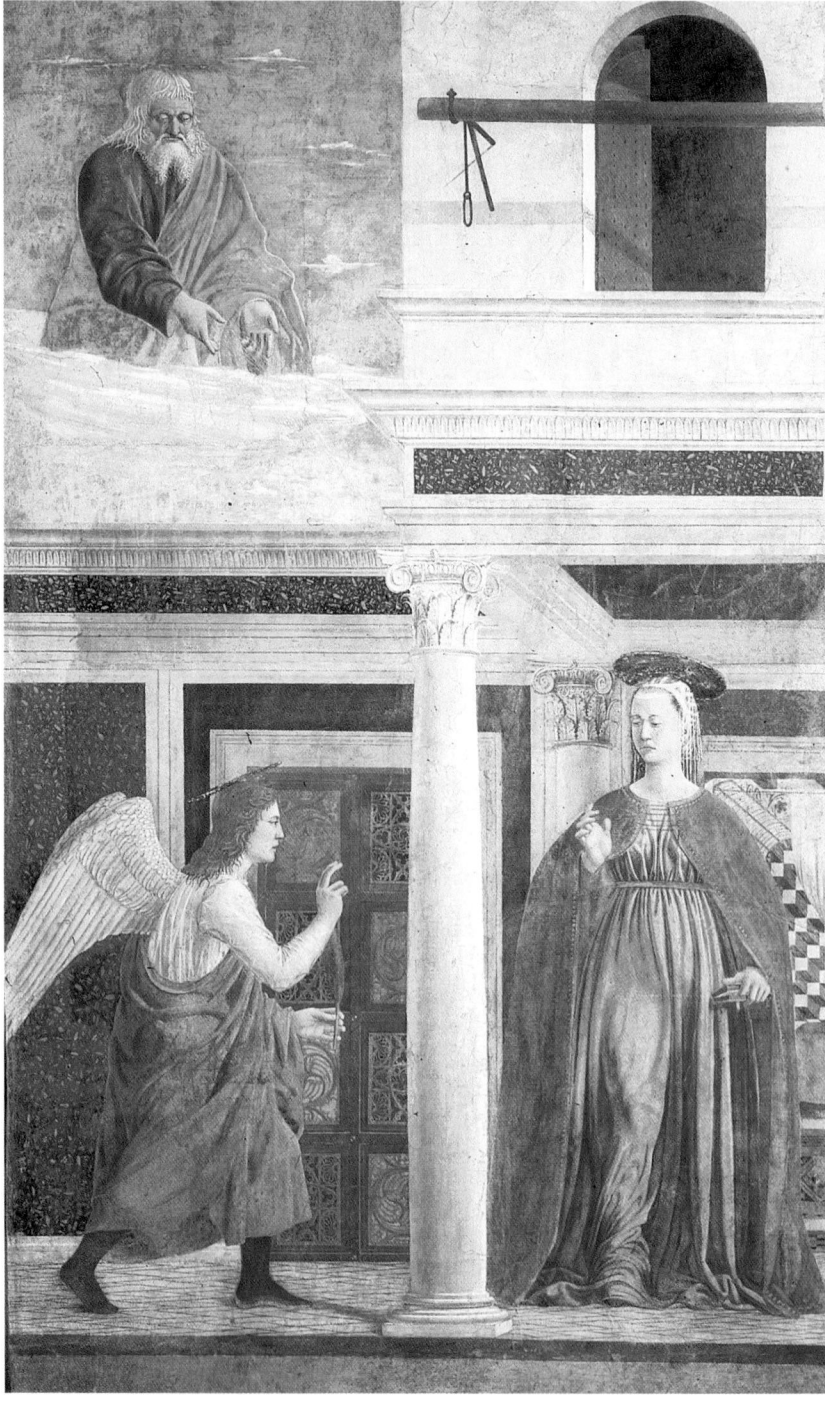

13.46 Piero della Francesca, *Annunciation* (after cleaning), c. 1450. Fresco; 10 ft. 9½ in. × 6 ft. 4 in. (3.29 × 1.93 m). San Francesco, Arezzo.

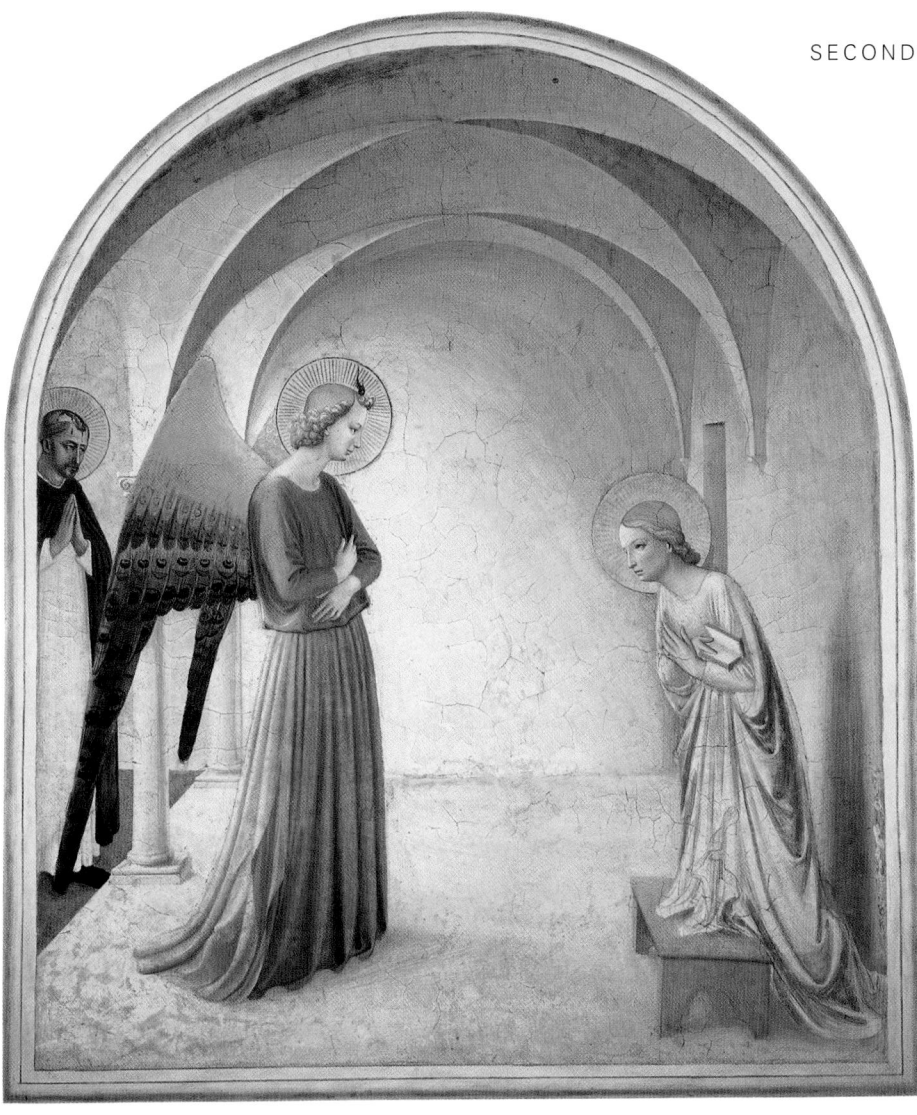

13.47 Fra Angelico, *Annunciation*, c. 1440. Fresco; 6 ft. 1½ in. × 5 ft. 1½ in. (1.87 × 1.56 m). San Marco, Florence. The purpose of Fra Angelico's *Annunciation* is related to its location—in the cell of a Dominican friar in the convent of San Marco. On the far left, just outside the sacred space of the Annunciation, stands the 13th-century Dominican saint Peter Martyr, who devoted his life to converting heretics to orthodox Christianity. A member of the Dominican Order who had evoked visions of the Annunciation through prayer and meditation, he was a daily inspiration to the monks of San Marco.

Christ. Mary's formal relationship with the architecture confirms her symbolic role as the "House of God."

Piero's *Annunciation* contains several allusions to the miraculous nature of Mary's impregnation. In the liturgy, Mary is the "closed door," or *porta clausa,* because she is a virgin. This is the connotation of the closed door behind Gabriel. But she also stands before an open door, which represents Mary herself, because she is receptive, or "open," to God's word. The rays of light that God transmits toward Mary signify Christ, who refers to himself in the Bible as "the light of the world."

The opposite of light—in nature, in painting, and in metaphor—is shadow. Piero uses shadow to create another allusion to impregnation in the *Annunciation.* The horizontal wooden bar that crosses the upper-story window casts a shadow that seems to pierce the metal ring hanging from it, turn the corner, and enter the window. Because in the West we read pictures from left to right, the shadow, like the light, may be read as coming from God. Both shadow and light enter the building and, in a metaphor for conception, symbolically enter Mary. The maternal significance of these images is implicit in the figure of Mary. Her monumental presence allies her with Piero's classicizing architecture, with Christian liturgy, and with the mother goddesses of antiquity.

Fra Angelico's fresco of the Annunciation (fig. 13.47), of about 1440, offers an instructive contrast to Piero's. Although Fra Angelico (c. 1400–1455) was a Dominican friar who painted Christian subjects exclusively, his style reflects the new fifteenth-century painting techniques. His *Annunciation* takes place in a cubic space, and orthogonals indicate the presence of a vanishing point. However, compared with those in Piero's *Annunciation,* Fra Angelico's figures are thin and delicate. Their gently curving draperies echo the curve of the ceiling vaults above them. The halos, rather than being foreshortened as on Piero's God the Father, are flat circles placed on the far sides of the heads. The patterned rays in Gabriel's halo and the design on his wings reveal a taste for surface decoration more compatible with International Gothic than with the monumental artistic trends of fifteenth-century Florence.

Fra Angelico uses light to convey a sense of spirituality. Like Gabriel himself, the light enters from the left and falls on Mary's bowed form. More striking is the fact that the vanishing point lies on the plain back wall of the porch, where the white light is at its most intense. In contemplating this event, therefore, one's line of sight is directed to pure light, which, in the context of the Annunciation, signifies the miraculous presence of Christ.

13.48 Filippo Lippi, *Madonna and Child with Scenes from the Life of Saint Anne* (*Pitti Tondo*), 1450. Diameter 4 ft. 5 in. (134.6 cm). Pitti Palace, Florence. Filippo was notorious for having several nuns living in his household. When one of them—Lucrezia Buti—became pregnant, she was permitted to leave her Order and marry Filippo. He, too, was released from his vows and, thanks to Medici influence, had his son legitimized by the humanist pope Pius II. It has often been suggested that his delicate Madonnas were inspired by the features of Lucrezia. The son of Filippo and Lucrezia, Filippino Lippi, became a painter and later completed the frescoes in the Brancacci Chapel (see fig. 13.22).

Filippo Lippi

An artist who combined spirituality with the monumentality of Masaccio in a new way was Fra Filippo Lippi (c. 1406–1469). Filippo was orphaned in 1421 and placed in the Carmelite convent in Florence. There he studied Masaccio's Brancacci Chapel frescoes, which impressed him enormously. His tondo of the *Madonna and Child with Scenes from the Life of Saint Anne* (fig. **13.48**) shows his taste for Masacciesque blond figure types and weighty forms. The chubby infant Jesus eats a pomegranate, an allusion to the Resurrection. Time is condensed in the image, as the scenes from Saint Anne's life—her meeting with Joachim on the right and the birth of the Virgin on the left—are depicted in the background. Here the past is rendered as literally "behind" Mary and Jesus, while the future, denoted by the pomegranate and Mary's wistful gaze, is in the foreground.

References to antique forms are evident, particularly in the woman carrying a basket to the right of Jesus. Her pose and flowing drapery seem derived from Classical sculpture. The grid patterns of the floor tiles and ceiling beams reflect the artist's study of Brunelleschian perspective. Combined with Filippo's assimilation of monumental form, perspective, and the Classical revival is a taste for delicate, curvilinear draperies, transparent halos that filter light through gold, and rich textures. His fusion of spirituality, grace, and monumentality appealed to contemporary patrons—especially the Medici, who commissioned several of his most important works.

In the drawing study (fig. **13.49**) for the *Madonna and Child,* Filippo's use of light to create form is particularly evident. Whites are the source of the light, which is shown, as in the painting, entering from the left. Here, the artist's linear aesthetic enhances the delicacy of the features as well as the graceful curves of the cloth. The whites in the drawing become light in the painting.

13.49 Filippo Lippi, *Head of a Woman*, drawing study for fig. 13.48, c. 1449–1450. Gabinetto dei Disegni e delle Stampe, Galleria degli Uffizi, Florence.

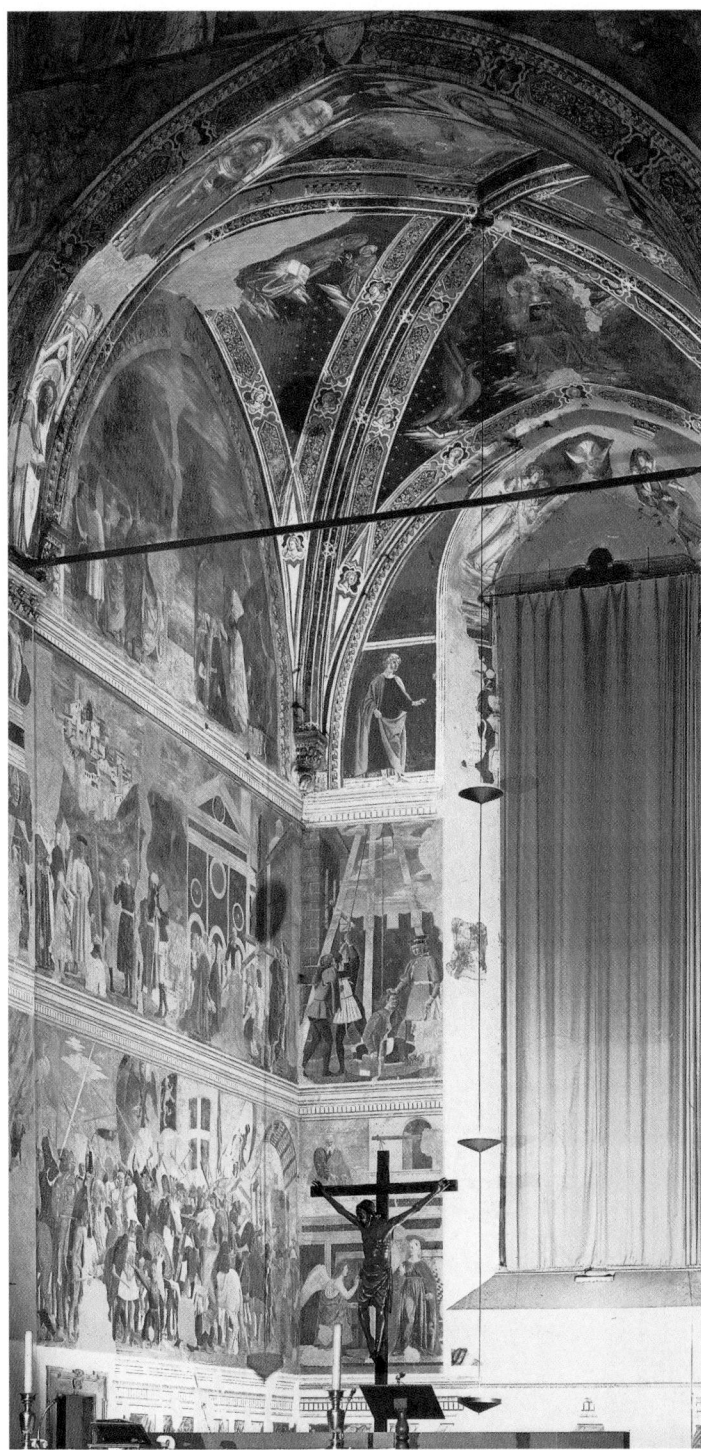

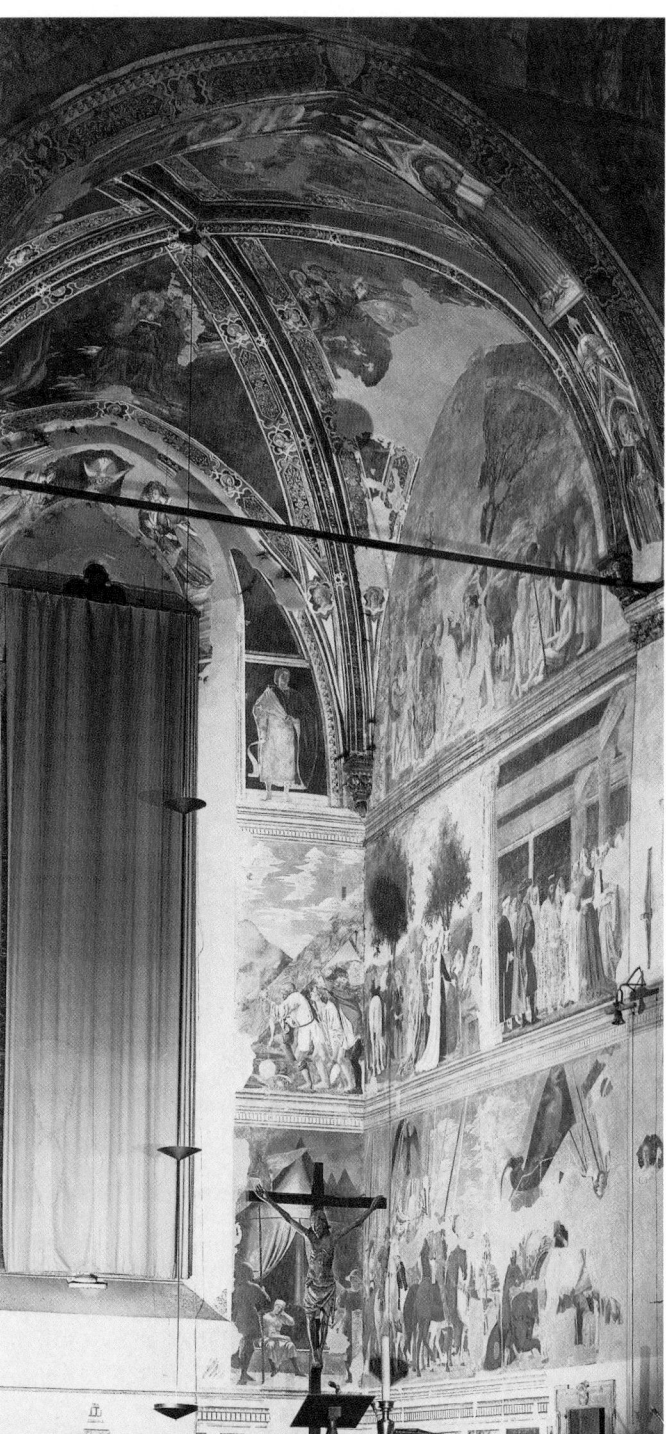

13.50 Piero della Francesca, left wall of the Bacci Chapel (before restoration), San Francesco, Arezzo, 1450s.

13.51 Piero della Francesca, right wall of the Bacci Chapel (before restoration), San Francesco, Arezzo, 1450s.

Piero della Francesca's
Legend of the True Cross

In 1452, the Bacci of Arezzo hired Piero to complete the fresco cycle in their family chapel, in the church of San Francesco. It had been barely started by an artist of lesser reputation who had died. The subject was the Legend of the True Cross (see Chapter 10), which was depicted in ten scenes symmetrically arranged on either side of the chapel and separated by the window (figs. **13.50** and **13.51**). Saints, an angel, and a Cupid are represented on the side

pilasters, and two prophets flank the window in the lunette of the altar wall. Piero's *Annunciation* is illustrated in context in figure 13.50.

Piero's rendition of this popular medieval legend reveals both formal and iconographic complexity. His scenes do not follow in chronological sequence, but are arranged according to a system of visual, typological, and liturgical parallels. At the top, the two lunettes contain the beginning and the end of the legend: the *Death of Adam* on the right and the *Exaltation of the Cross* (in which the True Cross is restored to Jerusalem) on the left. In the middle register,

the two large scenes parallel the women most involved in the legend: *The Queen of Sheba Visits Solomon and Recognizes the Holy Wood* on the right and *Saint Helena Discovers and Proves the True Cross* on the left. The small scenes next to these show *The Burial of the Wood* (right) and *The Torture of the Jew* (left). The two large scenes below are of battles in the name of the Cross: *Constantine Routs Maxentius* (right) and *Heraclius Recovers the Stolen Cross from the Persian Infidel Chosroes* (left).

On either side of the window, on the lowest level, are the *Annunciation* (fig. 13.46) and the *Dream of Constantine* (fig. **13.52**). The parallelism of these two scenes conveys some idea of Piero's complex layers of meaning. They also reflect the mathematical character of the most monumental Renaissance art and in particular of Piero's individual style. Both are scenes of revelation that initiate a new historical order. The Annunciation brought about the New Dispensation and all the events from the New Testament onward. Constantine's dream revealed the power of the Cross and led to his legal sanction of Christianity. Light is the form by which the revelations are made and from which en*light*enment results. As in the Brancacci Chapel, each fresco here is illuminated as if from the window, so that the *Annunciation* is lit from the right and the *Dream* from the left.

In both scenes, revelation comes from the left—in the *Dream* from the angel, in the *Annunciation* from God and Gabriel. The unity of light is reinforced by the structural relationship between the *Annunciation* and the *Dream*. Despite the opposition of day and night, both scenes are divided by a prominent cylindrical form—the column and the tent post, respectively—accentuating their geometric character. The *Annunciation* is divided into strict rectangles, the only variation being the column's *entasis* and the round arch of the window. The *Dream* is divided into triangles by the top of the tent and its open flaps.

Piero's genius for merging complex levels of meaning makes this fresco cycle one of the masterpieces of the fifteenth century, in which geometry coincides with history, liturgy, formal considerations, and typology. Mary was typed with Saint Helena, Constantine's mother, who found and proved the True Cross, and Constantine was typed with Jesus. Piero parallels Jesus's conception with Constantine's rebirth into the Christian faith. In a sense, the *Dream*, like the *Annunciation*, is about birth; the birth of an idea is juxtaposed with a miraculous conception. In that *context*, the architectural implications of Mary as the House of God are echoed in the tent that both encloses and reveals the sleeping figure of Constantine.

13.52 Piero della Francesca, *Dream of Constantine* (after cleaning), Bacci Chapel, San Francesco, Arezzo, 1450s.

Andrea Mantegna's Illusionism

In northern Italy, the leading painter from the middle of the quattrocento was Andrea Mantegna (c. 1430–1506). From 1460 onward, Mantegna worked for Lodovico Gonzaga, marquis of Mantua, who, like Federico da Montefeltro, ruled a humanist court. Mantegna decorated the audience chamber of the Ducal Palace in Mantua, using the new perspective techniques to create an illusionistic environment (fig. **13.53**). Two walls are covered with frescoes depicting members of the Gonzaga family, their court, horses, and dogs, together with decorative motifs and a distant landscape. The landscape view to the left of the door exemplifies the Renaissance idea of a painting as a window.

In the painted wall above the fireplace, the room seems to open onto a balcony where the family sits with children, courtiers, household servants, and a dwarf. Lodovico has just been given a letter by a messenger. An illusionistic curtain flutters out of the picture plane, over Lodovico's head, and overlaps the pilaster on the left. To the right, figures come and go, as painted and real architecture merge.

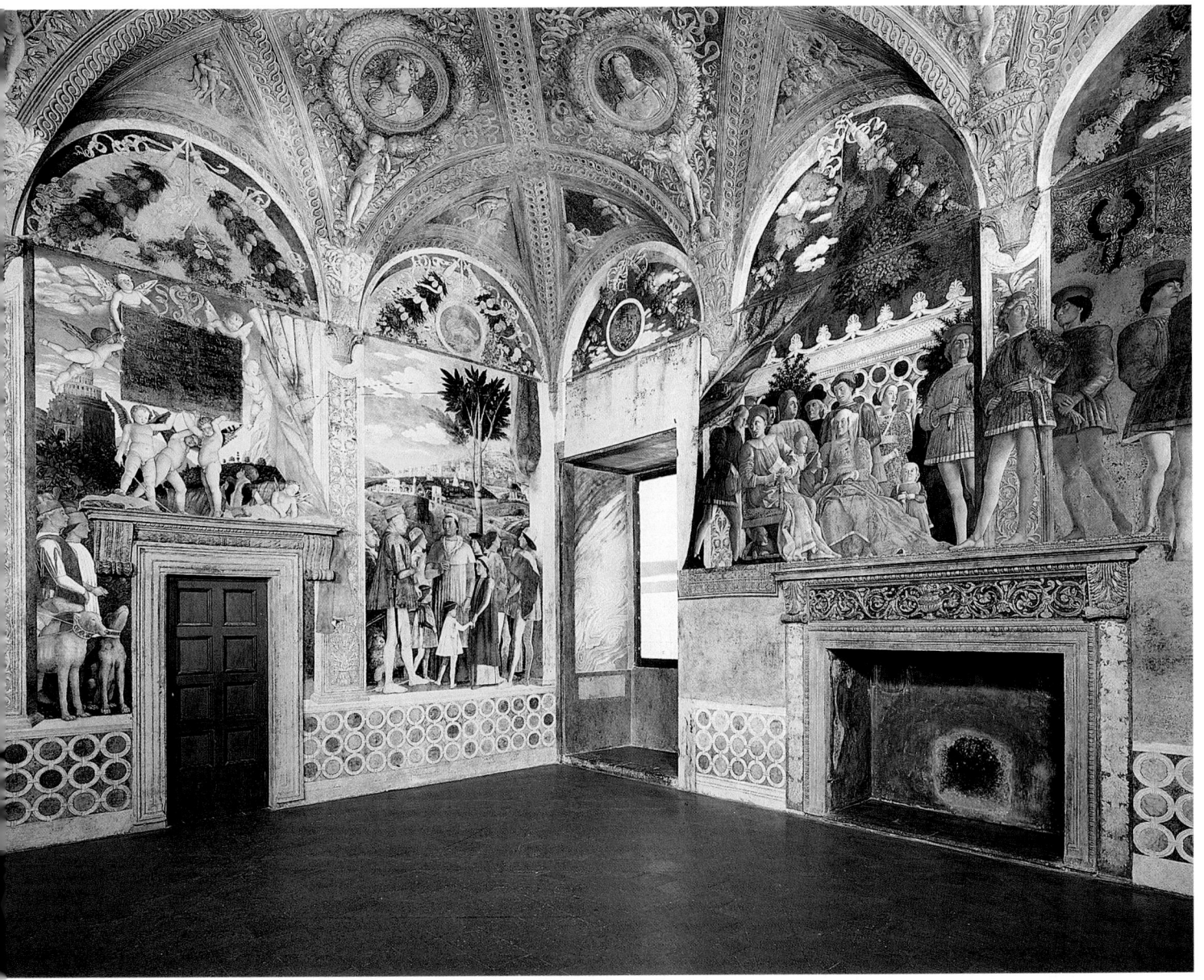

13.53 Andrea Mantegna, Camera Picta (also known as the Camera degli Sposi), Ducal Palace, Mantua, finished 1474. Room approx. 26 ft. 6 in. × 26 ft. 6 in. (8.08 × 8.08 m).

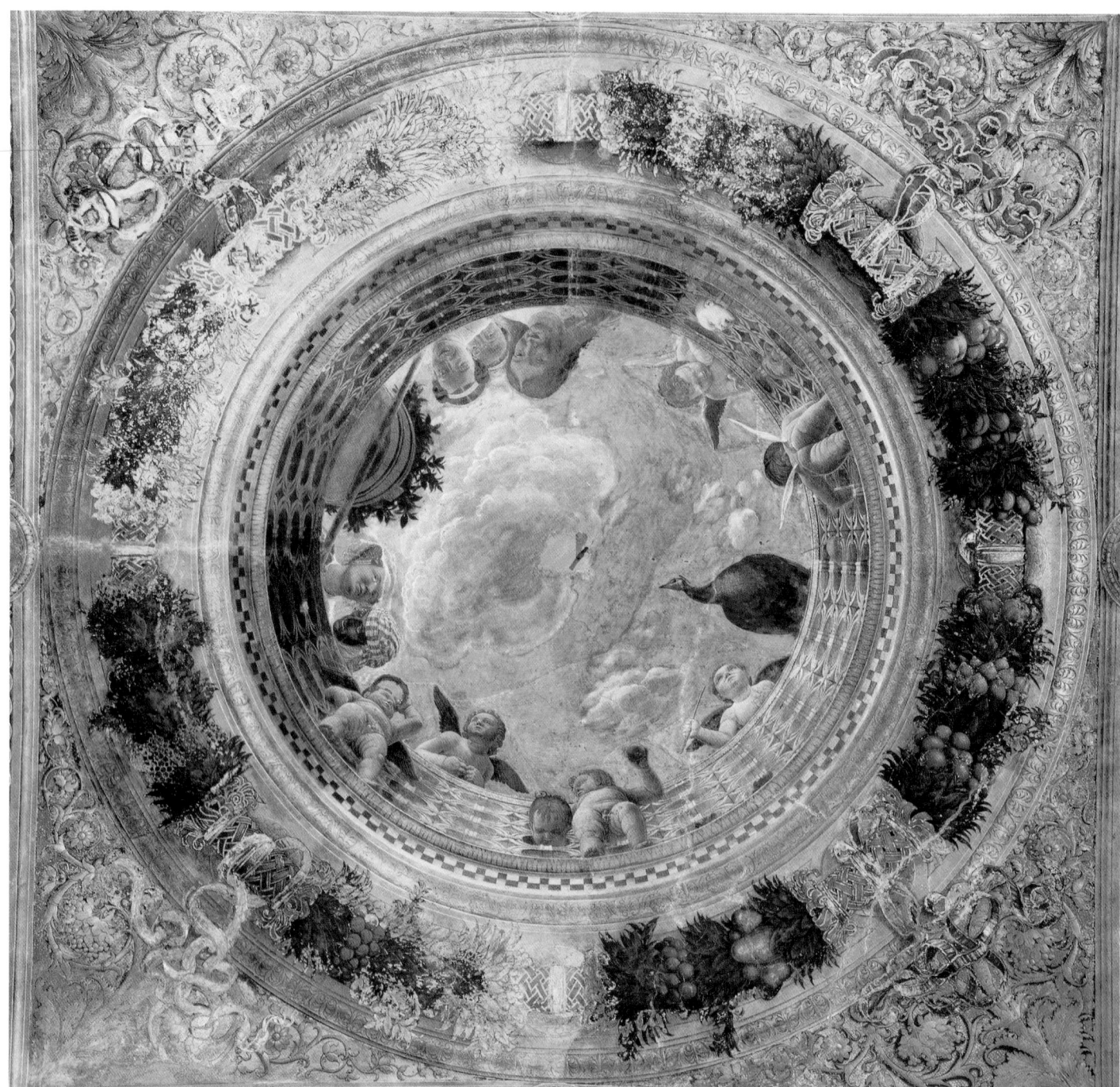

13.54 Andrea Mantegna, ceiling *oculus* of the Camera Picta, Ducal Palace, Mantua, finished 1474. Fresco; diameter of balcony 5 ft. (1.52 m). Mantegna's humor is given full rein in this *oculus*. A potted plant balances precariously on the edge of the wall. Three leering women lean over and stare, while two more engage in conversation. A group of playful *putti* is up to various pranks: one prepares to drop an apple, but three others have got their heads stuck in the round spaces of the parapet. In this scene of surreptitious looking, Mantegna plays upon the dangers that await the observers as well as the observed.

The most dramatic instance of Mantegna's illusionism in the Ducal Palace is the fictive *oculus* (fig. **13.54**). Visually, it is integrated with the ceiling, so that it is difficult for the casual observer to identify the borders between reality and illusion. The portrait busts of Roman rulers on the ceiling (visible in fig. 13.53) simulate relief sculpture and associate the marquis of Mantua with imperial Rome. The tondo seems to open onto a cloudy sky above a round parapet,

with figures peering down into the real space of the room. Mantegna's taste for foreshortening, also evident in the *Dead Christ* (see fig. 13.17), can be seen here in the spatial compression of the parapet and the point of view from which the figures—particularly the *putti*—are depicted. Such illusionistic painted environments, which elaborate the fourteenth-century spatial innovations of Giotto, could not have developed without the invention of perspective.

Mantegna and the *Studiolo* of Isabella d'Este

In the last decade of his life, Mantegna worked for Isabella d'Este (1474–1539), marchesa of Mantua (see box). She commissioned seven large paintings and two small ones from different artists for her *studiolo* (private study) in the Ducal Palace. Together they constituted a cycle of allegorical mythologies based mainly on the romances of the gods. The primary text was Ovid's *Metamorphoses* (see p. 212), and throughout the project Isabella personally supervised the content and arrangement of the pictures.

Two of these pictures were by Mantegna: a *Parnassus* (fig. **13.55**) paired with a *Minerva Expelling the Vices from the Garden of Virtue*. The *Parnassus* (now in the Louvre) is enigmatic, but it is certainly concerned with the arts and the triumph of love. Presiding over the scene from the top of a landscape arch are the illicit lovers, Mars and Venus. At the left, waving angrily from his cave, is Venus's husband, the blacksmith god Vulcan. Making light of Vulcan's

cuckolded state is Cupid, who blows a dart at his genitals. In Ovid's account of the myth, Vulcan ensnares the lovers in a finely woven bronze net, to which the yellow threads hanging from the cave's entrance probably refer.

The physical beauty of Mars and Venus and the calm triumph of their love (implied in the arch) are contrasted with the frantic gestures, agitated pose, and bright red cloak of Vulcan. Nevertheless, Vulcan is a crafts god and, despite being lame (Hera threw him from Olympus when he was born because he was unattractive), a creator of beautiful things. At the right, Mercury, identified by his winged hat, boots, and caduceus, stands with the winged horse Pegasus. Both listen to Apollo's music, which he plays on the lyre at the left. Dancing across the center of the picture plane are the nine Muses, who stand for inspiration in poetry, art, history, and music. Music is related to Mars and Venus by virtue of its harmony, for the daughter of their union was Harmonia.

The likely location of this scene is Mount Helikon, which was frequented by Apollo and the Muses in Greek

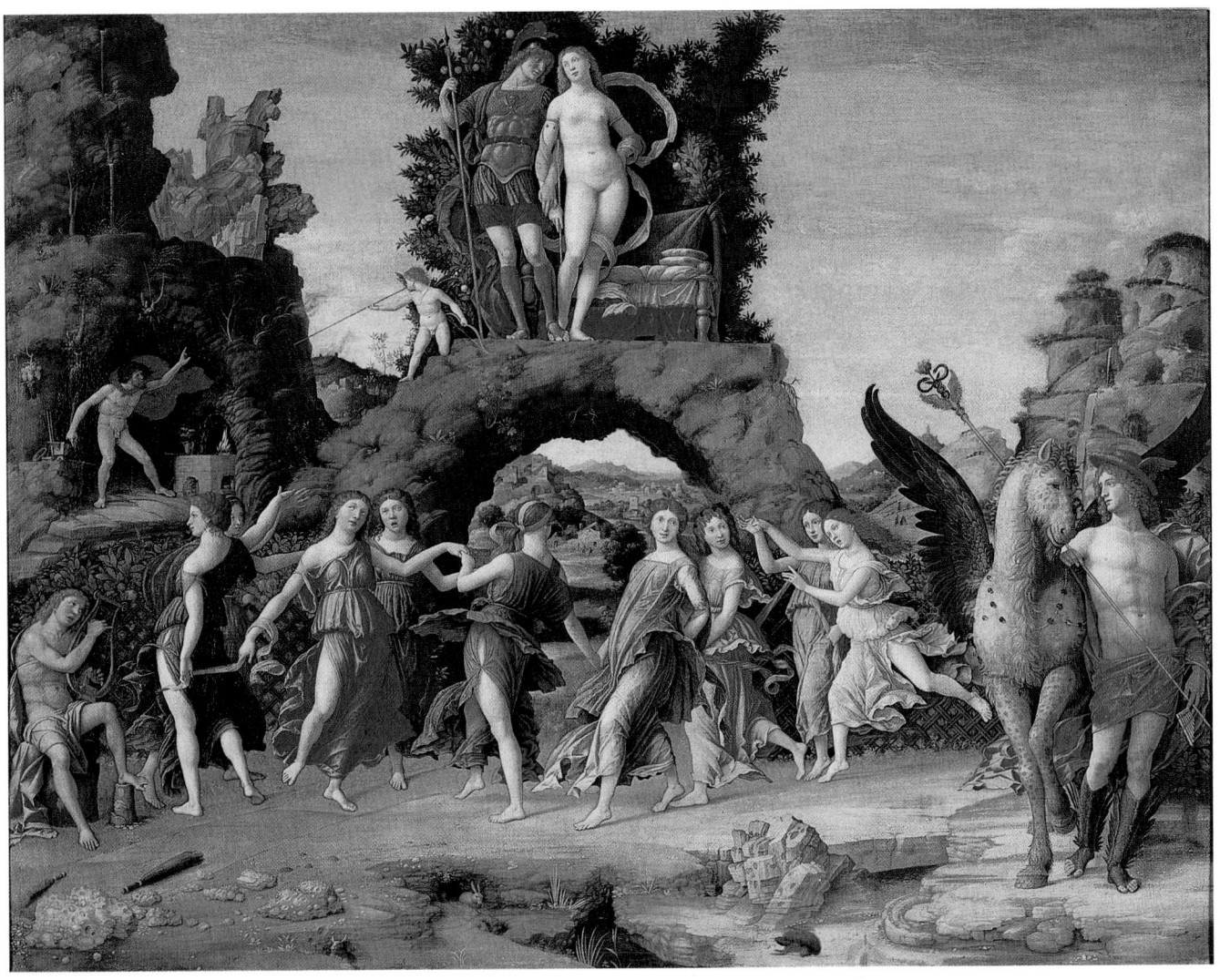

13.55 Andrea Mantegna, *Parnassus*, c. 1497. Tempera on canvas; 5 ft. 3 in. × 6 ft. 4 in. (1.60 × 1.93 m). Louvre, Paris.

Isabella d'Este

Isabella d'Este was raised at the Este court in Ferrara. She received a humanist education and read Classical Latin authors in the original; she could recite Virgil's *Eclogues* by heart. At the age of sixteen, she married Francesco II Gonzaga, marquis of Mantua and grandson of Lodovico, Mantegna's previous patron. Isabella was instrumental in making the Mantuan court a leading center of humanism and became a shrewd patron of the arts and a bibliophile. She also continued her studies and hired tutors to instruct her.

Isabella exemplified the success of certain Renaissance women—usually of noble birth—who married important rulers and governed the state in their absence. She followed the contemporary fashion for designing intimate, private studies (*studioli*), which, before Isabella, had been reserved for men. It was Isabella's uncle, Leonello d'Este, who had created the first known Renaissance *studiolo* in Ferrara. A more famous *studiolo* was built for Federico da Montefeltro in the Ducal Palace of Urbino, and a smaller version was commissioned for his palace in Gubbio. Isabella, in creating her own *studiolo* as well as hiring important artists to decorate it, was self-consciously projecting the image of herself as the intellectual equal of humanist princes.

mythology. According to Greek myth, when Pegasus stamped on the ground of Helikon, the fountain of Hippokrene appeared and became a source of inspiration to poets. Helikon was a retreat of the gods and therefore a metaphor for the *studiolo,* to which Isabella retreated. Like Apollo, Isabella was devoted to music, and she enjoyed singing before small audiences. Her love of art and music, together with her humanist education, achieved full expression in the paintings she commissioned for her private, fifteenth-century Helikon.

Botticelli's Mythological Subject Matter

Sandro Botticelli's (1445–1510) version of *Mars and Venus* (fig. **13.56**) predates Mantegna's by some twenty years and shows the two lovers in a different relation to each other. Venus sits up; she is awake and clothed. Mars is nearly nude and reclines in sleep. This iconography expresses the theme of the dangers to men who fall in love with women. The helpless, sleeping state of Mars, exhausted by his amorous pursuits, makes him the butt of the satyrs' joke. Two of them playfully make off with the war god's lance and helmet; a third blows a trumpet shell in Mars's ear, but fails to awaken him. At the lower right corner, a fourth satyr crawls through the breastplate and sticks out his tongue. All four literally *satirize* Mars—a god of war weakened by a woman. The elongation of the figures and the linear quality of Venus's drapery are characteristic of Botticelli. Their elegance distinguishes them from the classically inspired, sculpturesque forms of Mantegna, despite their mythological content.

Botticelli's *Birth of Venus* (fig. **13.57**) of around 1480 was made for a member of the Medici family. It reflects the Medici interest in Classical themes and the revival of Plato's philosophy that had led to the founding of the

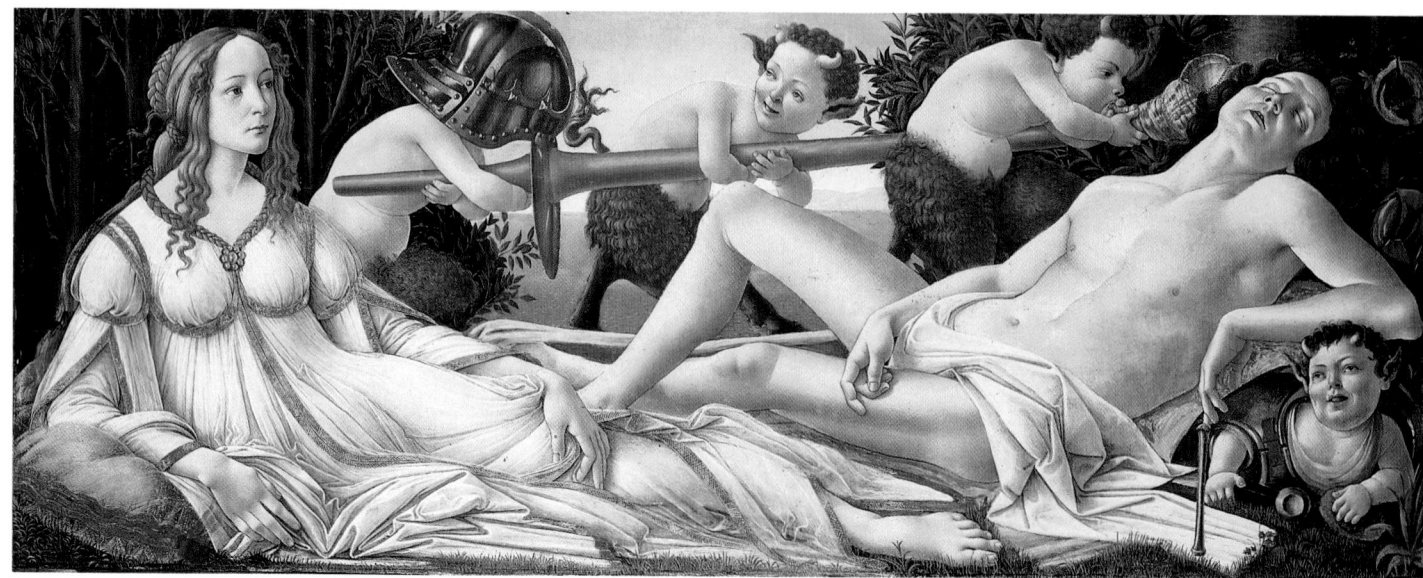

13.56 Sandro Botticelli, *Mars and Venus*, c. 1475. Tempera on panel; 27¼ × 68¼ in. (69.2 × 173.3 cm). National Gallery, London.

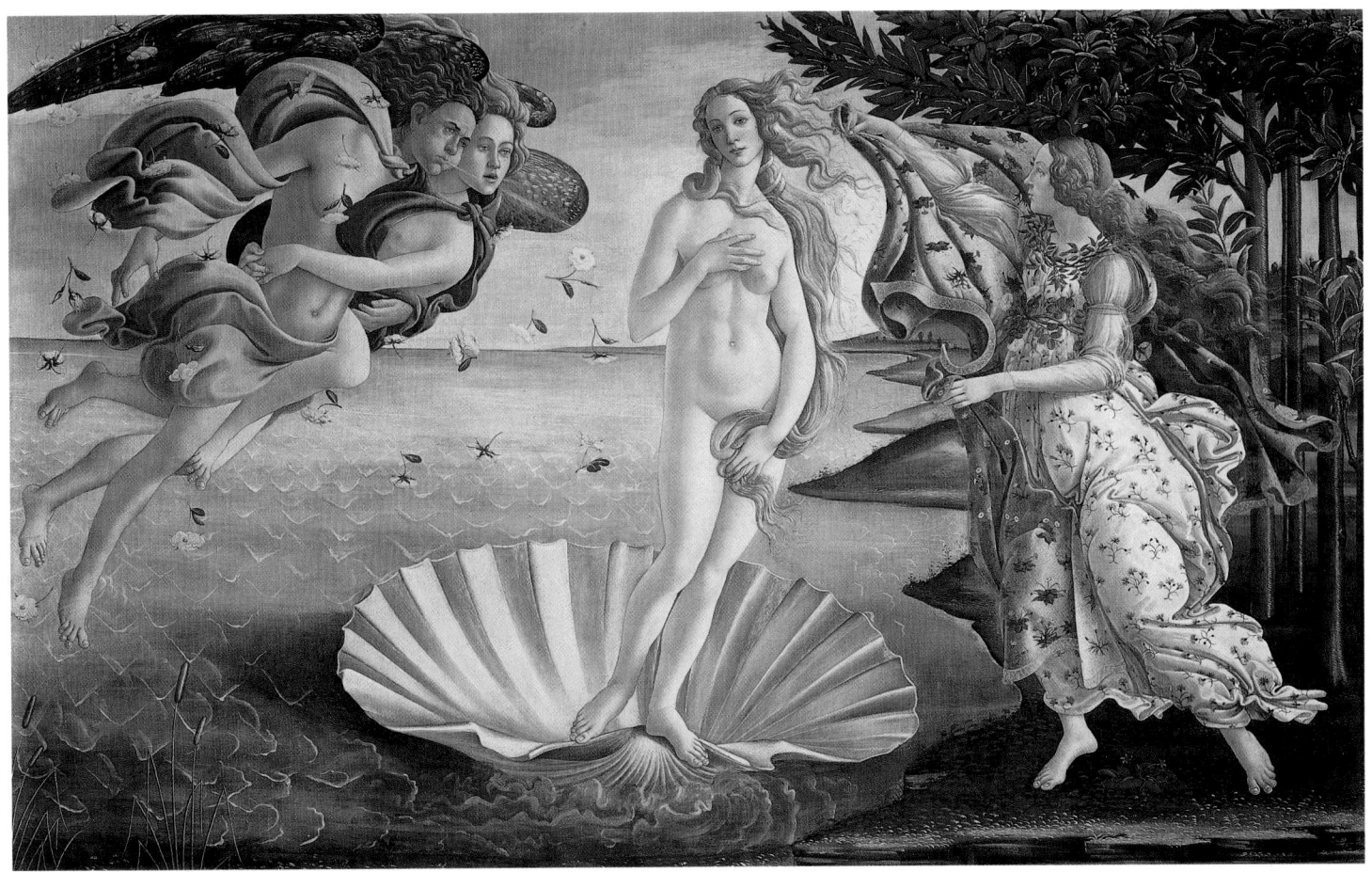

13.57 Sandro Botticelli, *Birth of Venus,* c. 1480. Tempera on canvas; approx. 5 ft. 8 in. × 9 ft. 1 in. (1.73 × 2.77 m). Galleria degli Uffizi, Florence.

Platonic Academy in Florence in 1469 (see box). Botticelli's nude Venus, like Masaccio's Eve (see fig. 13.24), is derived from the type of the *Medici Venus* (see fig. 13.25). Her languid pose, however, conveys the impression that she is just waking up. Her flowing hair, echoing the elegant drapery curves and translucent waves, has the same linear quality as the *Mars and Venus.*

According to Classical myth, Venus was born when the severed genitals of Uranus were cast into the sea. Botticelli's Venus floats ashore on a scallop shell, gently blown by the wind god Zephyr (also the English word for a light breeze). He is clad in blue drapery, suggesting a cool wind, and is embraced by a female breeze. Note that the puff of air emanating from her mouth is lighter than that of the male. On the right, a female, perhaps a personification of Spring, rushes to cover Venus with a pink floral cloak. As a goddess of love and fertility, Venus is appropriately surrounded by flowers.

The Platonic Academy

Cosimo de' Medici was an enthusiastic patron of humanism. From the 1460s, humanists met informally at the Medici villa in Careggi, outside Florence. Their discussions were based on Plato's school of philosophy, which was established in Athens in 387 B.C. There, in a public garden, philosophical interchanges became the basis of Plato's *Dialogues,* a literary form revived in the Renaissance. After Cosimo's death, his grandson Lorenzo (1449–1492) continued to support the humanists and founded the Platonic Academy of Florence in 1469.

The philosophy of Neoplatonism, a combination of Plato's philosophy with Christianity, prevailed at Lorenzo's academy. It was led by Marsilio Ficino, who lived at the villa, where philosophical discussion provided regular dinner-table entertainment. Artists as well as authors participated in these humanist gatherings, along with members of the Medici family.

Ficino translated all of Plato's *Dialogues* and other Greek works into Latin. In his *Commentary on Plato's Symposium,* Ficino notes the twofold nature of Venus—one divine, the other vulgar. The divine Venus is Mind and Intelligence, and loves spiritual beauty. The other Venus is procreative energy, fueled by the impulse to transform spiritual beauty into physical beauty. "On both sides, therefore," according to Ficino, "there is a love: there a desire to contemplate beauty, here a desire to propagate it. Each love is virtuous and praiseworthy, for each follows a divine image."[3]

The Question of Old-Age Style: Donatello and Botticelli

The question of old-age style has become a topic of discussion among art historians. Although most artists develop according to their talents and their energies, and "old age" is a variable, often subjective time, some artists make radical changes at certain periods in their lives. This appears to have been true of both Donatello and Botticelli. In their youth and maturity, they were proponents of the Classical revival. Their subject matter was wide-ranging and included Christian iconography, portraits, and mythological themes that reflected the new interest in Neoplatonic philosophy. Both Donatello and Botticelli portrayed nudes in Classical poses, and both were influenced by Classical texts.

In their fifties, however, these artists changed the emotional tone of their work, renouncing pagan content and displaying an undeniable anxiety and a new sense of spiritual concern. If, for example, we compare Donatello's painted wood statue of *Mary Magdalen* of around 1455 (fig. **13.58**) with his bronze *David* (see fig. 13.29), a change in the artist's outlook is readily apparent. The *Mary Magdalen* is devoid of Classical allusions, and, in contrast to the self-confident, assertive pose of Donatello's *Saint Mark* (see fig. 13.28), the *Magdalen's* despair is consistent with its function as a devotional work. Her long, thin proportions, skeletal appearance, sunken cheeks, and missing teeth reflect the ravages of time. Donatello has clothed the figure in her own hair, grown long as a conventional sign of penance.

Botticelli's *Mystical Nativity* (fig. **13.59**), dated 1500 or 1501, has an agitated quality that differs sharply from the languid atmosphere of his mythological pictures. As in Donatello's *Magdalen,* Botticelli's proportions have become longer and thinner, and there is an increase in formal movement, particularly in repeated curves. The picture is divided into three horizontal sections. In the middle, an Adoration of Christ takes place at the entrance to a rocky cavern. The alignment and lighting of the trees visible behind Mary suggest stained-glass windows. On the roof of the wooden shed are three angels. Above, a group of dancing angels circles around in a gold light. In the scene below, angels grasp the souls who have escaped the clutches of the devils (at the corners) and entered heaven. The sharp color and light/dark contrasts enhance the sense of ecstatic emotionalism that pervades the painting. Since this was not a commissioned work, one can assume that it reflects Botticelli's state of mind at the turn of the

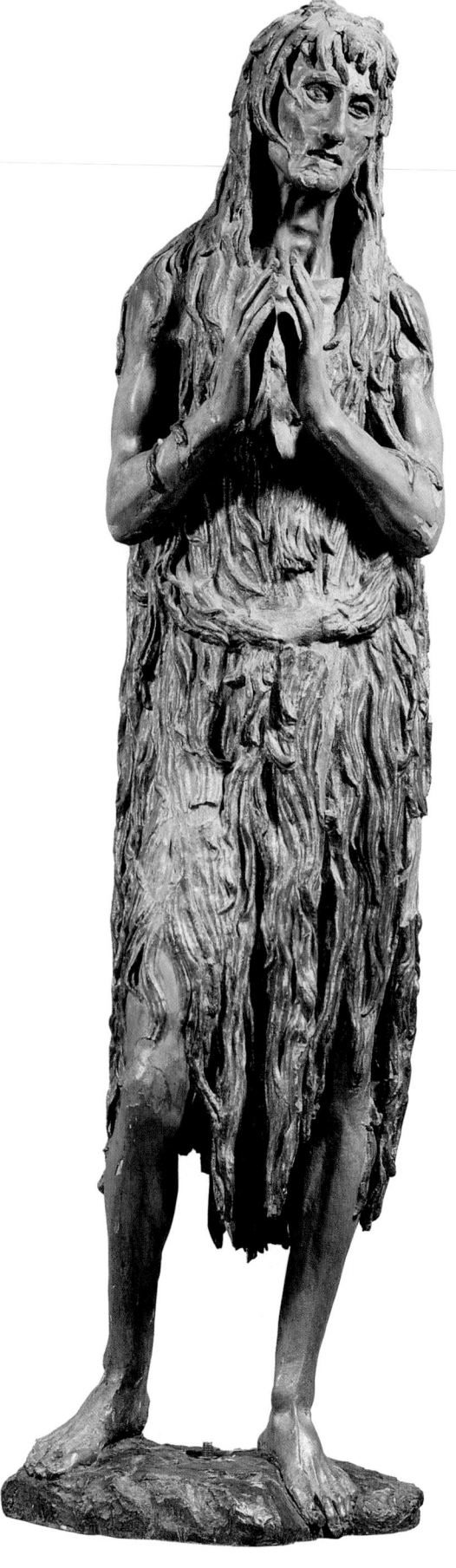

13.58 Donatello, *Mary Magdalen,* c. 1455. Painted wood; 6 ft. 2 in. (1.88 m) high. Museo dell'Opera del Duomo, Florence.

13.59 Sandro Botticelli, *Mystical Nativity*, 1500 or 1501. Oil on canvas; 42¾ × 29½ in. (108.6 × 74.9 cm). National Gallery, London.

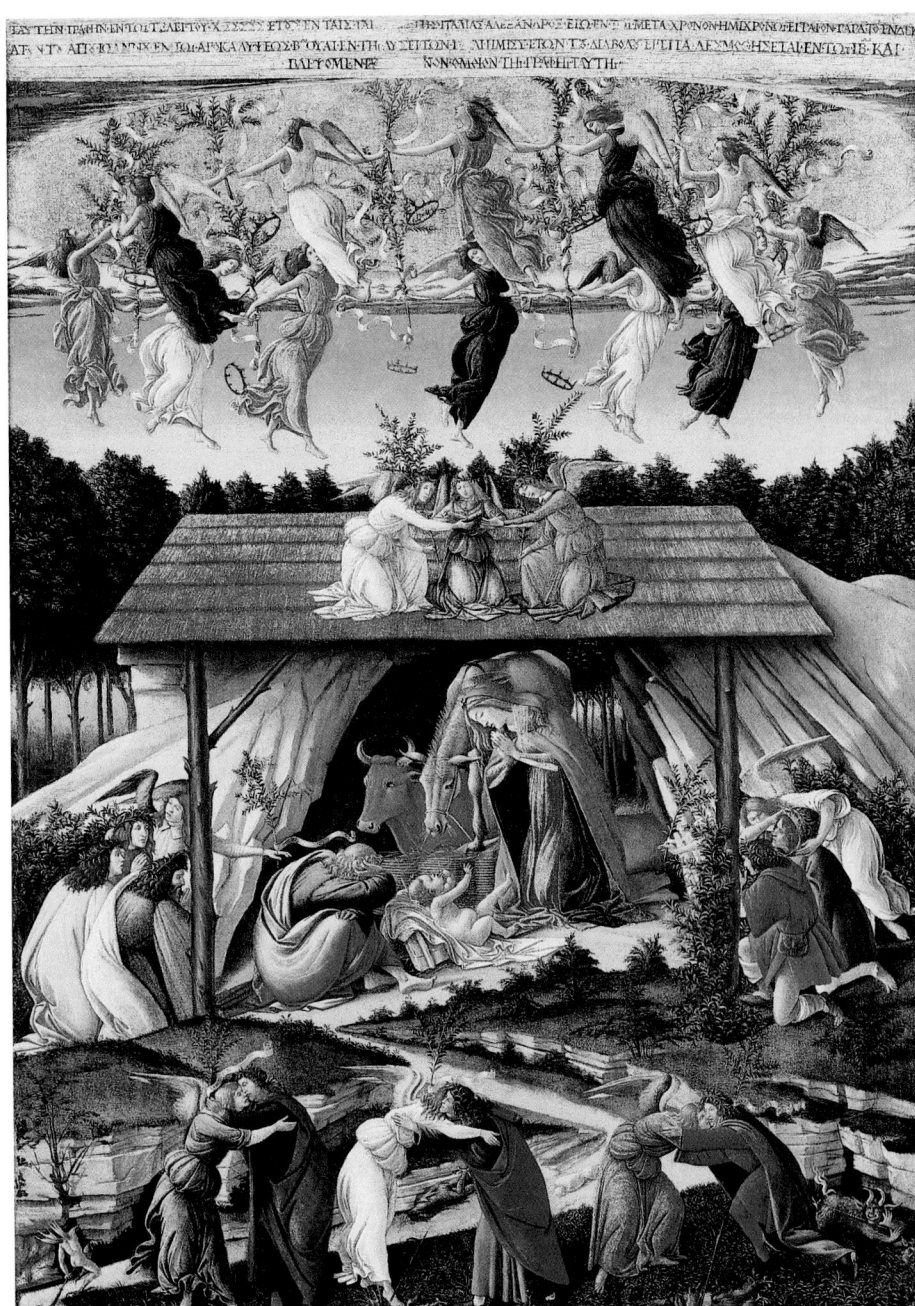

century and that the iconographic choices are his own rather than those of a patron.

Neither artist recorded an explanation for his radical shift in style and iconography. But it is possible that Botticelli was responding to contemporary turbulence in politics and religion. During the 1490s, his most powerful patrons, the Medici, were having difficulty with opposing political factions. As economic tensions increased, the Medici banks declined and finally closed down. Religious pressures also mounted in a reaction against the liberalism of the humanists and the Neoplatonists.

Two influential Dominicans, first Saint Antoninus (1389–1459) and later Girolamo Savonarola (1452–1498), railed against nudity in art and pagan subject matter. In 1450, Antoninus participated in the burning of a heretic at the entrance to the Florence Cathedral. He cited Augustine (see p. 400) on the nature of Mary Magdalen as a "body, mass of corruption." Such sentiments may have affected Donatello's depiction of the Magdalen as a repentant, decaying figure. His subsequent works have more in common with the *Mary Magdalen* than with the fresh, vibrant, youthful optimism of the bronze *David* and of other works before 1455.

Savonarola, the Dominican abbot of San Marco, vigorously opposed Medici support of humanism. In 1494, in the wake of the death of Lorenzo the Magnificent and the exile of the Medici, he gained control of Florence, and preached fire and brimstone. In 1498, he presided over the so-called "Bonfires of the Vanities," in which Florentines burned their elegant clothing, books, and works of art that offended him. Later that same year, public and papal sentiment turned against Savonarola. He was hanged; but before he died, he was cut down and burned as a heretic; his ashes were scattered in the Arno. A Greek inscription at the top of Botticelli's *Mystic Nativity* suggests that it was inspired by Savonarola's sermon warning of the end of the world and proclaiming the eternal damnation of sinners.

Fifteenth-Century Painting in the Netherlands

In the Netherlands (see map), economic changes similar to those in Italy began to occur in the early fifteenth century. Medieval feudalism and court patronage gradually gave way to a more bourgeois society and a merchant economy based mainly on wool trading and banking. By the fifteenth century, commercial ties between Italy and the Netherlands were close and business travel quite common. Northern artists worked in Italian courts, and Italian princes and wealthy businessmen commissioned works of art from the Netherlands.

For the most part, Northern artists of the Renaissance were more innovative in painting than in sculpture or architecture. Whereas in Italy panel paintings were mainly executed in tempera until the sixteenth century, Netherlandish painters preferred oil paint and refined the technique for altarpieces. The use of oil paint satisfied the interest in meticulous, decorative, and naturalistic surface detail that characterizes much fifteenth-century Northern painting.

Although artists in the North of Europe shared the Italian preference for the representation of three-dimensional space and lifelike figures, they were less directly affected by the Classical revival than the Italians. Artists in the North continued to work in a Gothic tradition, which they nevertheless integrated with the new Renaissance style.

Campin's Mérode Altarpiece

A good example of a Northern altarpiece used for private devotions in a home rather than in a church is the **triptych** (fig. **13.60**) by Robert Campin, also called the Master of Flémalle (c. 1375–1444). The central panel depicts the Annunciation. In the right wing, Joseph makes mousetraps in his carpentry workshop; in the left, two donors kneel by an open door. As in contemporary Italian painting, Campin's figures occupy three-dimensional space and are modeled in light and dark. The light source is consistent and unified.

In contrast to contemporary Italian art, however, the Netherlandish painters preferred sharp, precise details, some of which are so small that magnification is necessary to see them clearly. Campin does not use one-point perspective to unify all three panels of the triptych. Instead, each panel is seen from a different viewpoint. The *Annunciation* takes place entirely indoors, whereas in the side panels a distant medieval town is visible. Unlike floors in Italian perspective constructions, Campin's floor appears to rise slightly, even though the ceilings are nearly horizontal. The gradual upward movement of the painted space, together with the attention to minute detail, has been attributed by some scholars to late Gothic influence. Elongated, angular draperies also reflect the Gothic taste for elegant surface design with the new Renaissance understanding of organic form. Note, for example, that the knees of Mary and Joseph are modeled by the shading and highlights of the drapery.

This altarpiece contains a wealth of complex Christian symbols. In contrast to Italian *Annunciations,* Campin's takes place in a bourgeois home, whose everyday, secular objects are endowed with Christian meaning. The lilies represent the purity of the Virgin, and the fact that there are three of them refers to the Trinity. The brass basin and the towel are household objects but may also refer to Christ cleansing the sins of the world. At the same time, the niche corresponds to an altar niche, where the priest washed his hands, symbolically purifying himself before Mass.

Gabriel's garment, the white robe worn by priests at Mass, and other priestly accoutrements endow the central space with liturgical meaning. The candle, which on a naturalistic level has been blown out by the draft from the open door in the left panel, can also represent Jesus's Incarnation. Entering the room from the round window on the left wall, a tiny Jesus carrying his Cross slides down rays of light (fig. **13.61**). Mary sits on the floor reading, her lowered position an allusion to her humility.

In the right panel, the attention to detail and the convincing variety of surface textures—for example, the wood, the metal

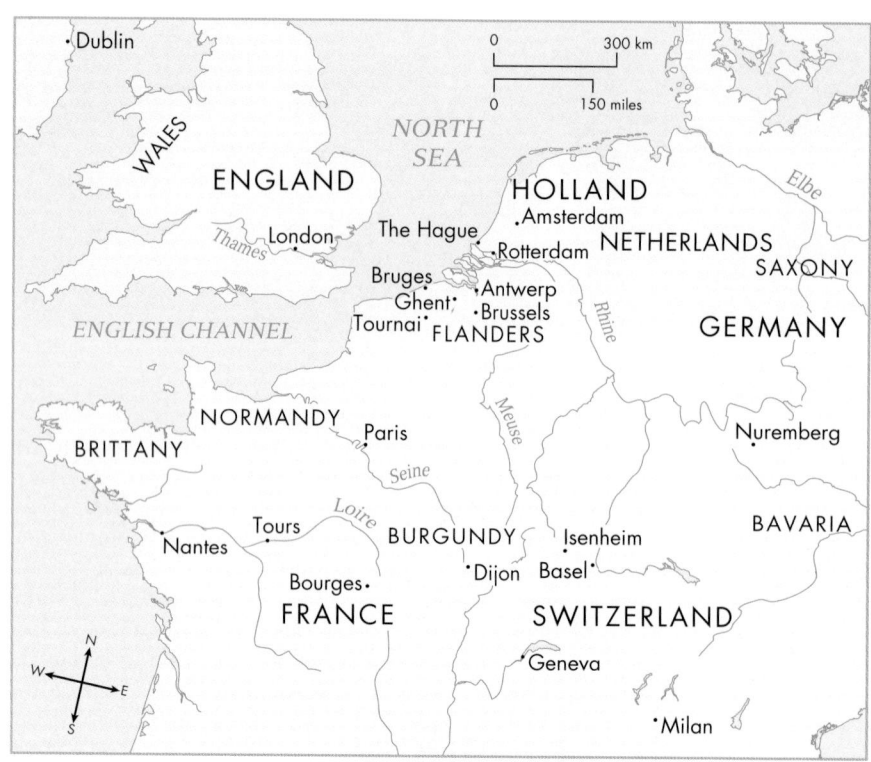

Northern and central Europe in the Renaissance.

13.60 Robert Campin (Master of Flémalle), Mérode Altarpiece (open), c. 1425–1430. Tempera and oil on wood; central panel 25 × 25 in. (63.5 × 63.5 cm), each wing 25 × 10¾ in. (63.5 × 27.3 cm). Metropolitan Museum of Art, New York (Cloisters Collection, purchase). Campin was a master painter in the painters' guild in Tournai from 1406, as well as being active in local government. A married man, he was convicted of living openly with a mistress and was banished from Tournai, though his punishment was later commuted to a fine. This triptych is called the Mérode Altarpiece after the 19th-century family that owned it.

tools, Joseph's fluffy beard, and his heavy, simple drapery—reflect Campin's study of the natural world. The image of Joseph and the mousetraps signifies his symbolic role as a trap for the devil: his marriage to Mary was interpreted as a divine plan to fool Satan into believing that Jesus's father was mortal. Joseph thus protects Mary and Jesus, and so guards the sanctity of the central panel. In working alone, isolated from the miraculous Annunciation, Joseph is both part of, and separate from, the central drama. His inclusion in *Annunciation* scenes was unusual and has been linked by some scholars to a growing cult of Saint Joseph in the North. Joseph is depicted as a family man, reflecting the bourgeois social context of the Netherlands.

The donor (in the left panel) has been identified by the coat of arms at the top of the back-wall window of the *Annunciation* as belonging to the Ingelbrechts family from Mechelen. His wife, a figure thought to have been added after their marriage, kneels behind him and holds a string of rosary beads. Husband and wife are privileged to witness the moment of the Incarnation through the slightly open door, but they remain outside the sacred space. Their presence reinforces the private, devotional function of Campin's triptych. The small figure in the background has been variously identified—from the artist himself, to the donor's patron saint, to Isaiah, whose Old Testament prophecies are the source of several iconographic conventions used in *Annunciation* scenes.

13.61 Detail of figure 13.60. Here Jesus enters the sacred, though domestic, space of the Annunciation. He carries a small Cross, referring forward in time to his Crucifixion. Jesus and the Cross leave the glass intact, illustrating the popular Christian metaphor that equates the entry of light through a window with the Virgin conception and birth.

Jan van Eyck

The most prominent painter of the early fifteenth century in the North was Jan van Eyck (c. 1390–1441), whose work combines Netherlandish interest in natural detail and tactile sensibility with Christian symbolism. He was a successful artist who worked for private patrons and, from 1425, for the Burgundian court of Philip the Good, where he was employed for the last sixteen years of his life. In 1430, he married and bought a house in Bruges (in modern Belgium).

The Ghent Altarpiece Van Eyck's most elaborate and complex work is the *Altarpiece of the Lamb,* also called the Ghent Altarpiece because it is in the cathedral of Saint Bavon in the Belgian city of Ghent (figs. **13.62–13.65**). Jan worked on the altarpiece with his brother Hubert, who

died in 1426. Six years later, Jan completed the altarpiece on his own. Although it is not entirely clear which brother was responsible for which parts, Jan may be credited with the final product. The altarpiece is a **polyptych** (many-paneled painting), its sections held together by hinges. There are twenty-four panels in all, twelve inside (visible when open) and twelve outside (visible when closed).

Van Eyck refined the medieval technique of oil painting to such a degree that the brilliant glow of his light and color took on a symbolic character. He mixed pigment with linseed oil, which he built up through several layers into a rich, but translucent, paint surface. By using tiny brushes, he was able to apply minute dabs of paint that seem to replicate details of the material world. Medium and content thus merge with technique.

Figure 13.62 shows the Ghent Altarpiece opened. The *Adoration of the Lamb by All Saints,* the lower central

13.62 Jan van Eyck, Ghent Altarpiece (open), completed 1432. Oil on panel; approx. 11 ft. 6 in. × 14 ft. 5 in. (3.51 × 4.39 m). Cathedral of Saint Bavon, Ghent, Belgium.

13.63 Jan van Eyck, Ghent Altarpiece (detail of the Cathedral of Saint Bavon in fig. 13.62).

scene, occupies the largest panel. Its literary source is a passage from the book of Revelation, which was read on All Saints' Day (November 1). The Lamb, which is the symbol of Christ's sacrifice, stands on an altar, its blood dripping into a gold chalice. The *fons vitae* (fountain of life) stands before the altar. Water pours forth from the font, symbolically washing away the sins of the worshiper attending Mass before the altar in Saint Bavon.

Above the altar, rays of light emanate from the semicircle around the Holy Spirit and extend toward the crowds of worshipers. At the right are the twelve apostles and a group of martyrs in red robes, and at the left are Old Testament and pagan figures considered by the Church to have merited salvation. In the background, a group of confessors wearing blue robes congregates at the left, with virgin martyrs at the right. They carry palms, signifying the triumph of martyrdom over death. The far distance glows with minute landscape details and the skyline of a city (including a view of Saint Bavon Cathedral—fig. 13.63), evoking the Heavenly Jerusalem.

On the side panels, worshipers are shown traveling to the site of the altar. Just judges (representing the power of Christendom) and knights approach on horseback at the left, and holy hermits and pilgrims on foot at the right. The Altar of the Lamb is both the formal focus of the altarpiece and the destination of the travelers. When they arrive at the open field, they stop. When they reach the altar and the fountain, they kneel in adoration, their movement arrested by the holy sight.

The upper register contains seven additional panels. God the Father, merged with the Christ of the Last Judgment

13.64 Jan van Eyck, Ghent Altarpiece (detail of God's crown in fig. 13.62).

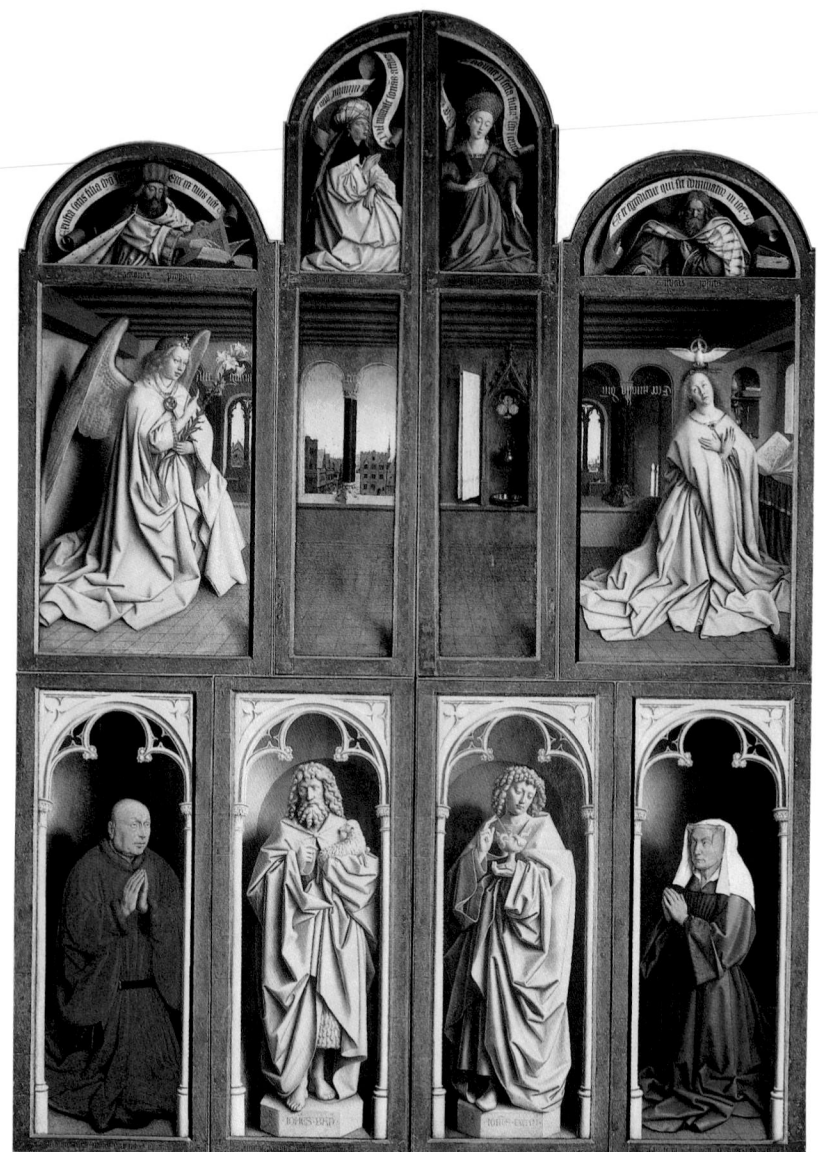

13.65 Jan van Eyck, Ghent Altarpiece (closed). Oil on panel; approx. 11 ft. 6 in. × 7 ft. 7 in. (3.51 × 2.33 m).

and the *Deësis,* occupies the largest space on this level. He sits in a frontal pose and raises his right hand in the manner of Judgment, but is flanked by the Virgin and John the Baptist as in the *Deësis.* The Virgin is crowned Queen of Heaven, and Saint John wears a green robe over his hair shirt. On either side of these figures are music-making angels in elaborate brocade cloaks juxtaposed with the nudity of Adam and Eve.

The figure of God/Christ is depicted in hieratic scale. His importance is indicated by his central position, his height, his frontality, and his regal gestures and accoutrements. The elaborate crown at his feet links him with the semicircle of light in the *Adoration of the Lamb.* Figure 13.64 shows the detail of the crown and the exquisite embroidery on the cloak. The minute depiction of jewels in the crown and its gold tracery is characteristic of Northern taste. Here, however, the rich materials also have

symbolic meaning, for they belong to the personage who embodies the power of the Christian universe. Despite the frontality of the God/Christ figure, he occupies three-dimensional space. The grid pattern in the floor, like that in the panels of the Virgin and John the Baptist, is composed of orthogonals, although van Eyck's perspective is never as mathematically precise as in Italian paintings.

Adam and Eve stand in the narrow end panels, depicted illusionistically as stone niches. Above Adam and Eve are painted imitation sculptures (representing Cain's Offering and the Murder of Abel). Van Eyck's Adam and Eve provide an instructive contrast to those by Masaccio (see fig. 13.24) in the Brancacci Chapel. The latter are derived from the generalized ideal of Classical antiquity, whereas van Eyck's are more specific, as if painted from live models, and more Gothic. They are somewhat elongated, and their physiognomy is portraitlike.

Figure 13.65 shows the Ghent Altarpiece closed. The central lower panels represent John the Baptist holding a lamb (left) and John the Evangelist holding a chalice (right). Both, like the Cain and Abel, are painted in **grisaille** (imitation sculpture). Their prominence is directly related to the commission and iconography of the altarpiece. Saint Bavon Cathedral was originally the church of Saint John, dedicated to John the Baptist, and remained so in the fifteenth century. John the Evangelist was the author of the visionary book of Revelation and hence wrote the text celebrated in the interior scenes. Kneeling on either side of the saints are the donors, Jodocus Vijd, an official of Ghent, and his wife Isabel Borluut, who commissioned the altarpiece for their private chapel. Jodocus is identified by an inscription on the frame.

In the upper panels, the floor tiles and the distant cityscape reveal van Eyck's knowledge of linear perspective. But the pointed arch of the niche containing the wash basin betrays Gothic taste. In the *Annunciation*, Gabriel arrives carrying lilies, and his words are painted in gold. They extend across the picture plane from his mouth to Mary's ear, illustrating the medieval tradition that Mary was impregnated through her ear by the Word of God. Her crossed arms and the cruciform shape of the Holy Spirit remind viewers of the Crucifixion.

The figures in the small panels at the top have typological meaning. At the ends are two Old Testament prophets and, in the center, two sibyls, the female seers of Classical antiquity. As a whole, the iconography of the Ghent Altarpiece encompasses a vast time span. On the exterior, we are reminded that both the Old Testament prophets and the pagan seers were interpreted as having foretold the coming of Christ. The Annunciation marks the New Dispensation, while the two Saints John frame Christ's earthly mission—John the Baptist, who identified Christ to the multitudes and baptized him, and John the Evangelist, the author of the Gospel. The presence of the donors situates the time and place of the altarpiece itself in fifteenth-century Northern Europe.

Inside the altarpiece, the scenes encompass an even greater time span. Adam and Eve refer to the beginning of human time. Mary and John the Baptist mark the life of Christ, which is celebrated by the music-making angels. The lower scenes take Christ's temporal life into the realm of ritual—his sacrifice and rebirth—and, therefore, into timelessness. Although Christ himself never actually appears, except merged with the figure of God, every aspect of the iconography alludes to his presence. Even the little scenes of Cain and Abel refer to Christ's death, for Abel was the first biblical victim and thus typologically paired with Christ.

Man in a Red Turban A year after van Eyck completed the Ghent Altarpiece, he painted the *Man in a Red Turban* (fig. **13.66**). It is widely believed to represent himself, which would make it one of the first self-portraits of the Renaissance. The depiction of the turban, which is actually a fashionable contemporary headdress called a chaperone, reveals the artist's delight in the angular folds and their rich red color. In contrast to the expansive flourishes of the headdress, van Eyck's features are meticulously defined. His lips are thin and drawn, while the corners of his piercing eyes are covered with slight wrinkles. At the top is a text in semi-Greek letters, painted to look as if carved into the picture frame. It reads "Als Ich Kan," which are the first words of a proverb meaning "As I can, but not as I would." Both the signature and the inscription indicate the importance the painting held for van Eyck and would seem to reinforce its reading as his self-portrait. Another element that suggests this is the nature of the cloth he wears, whose flaps have been wrapped around the sitter's head. This arrangement has been explained as something an artist might do to observe his face in a mirror.

13.66 Jan van Eyck, *Man in a Red Turban* (*Self-Portrait?*), 1433. Tempera and oil on wood; approx. 13⅛ × 10⅛ in. (33.3 × 25.8 cm). National Gallery, London. Van Eyck worked in The Hague as painter to John of Bavaria, and in Bruges for Philip the Good, duke of Burgundy, but also received commissions from private individuals. Jan was a master of the oil medium. He used alternating layers of transparent glaze and opaque tempera to produce his characteristic effects of light and shade.

The *Arnolfini Portrait* Jan van Eyck's *Arnolfini Portrait* of 1434 (fig. **13.67**) is a unique subject in western European art. A great deal has been written about this picture, and scholars have proposed numerous interpretations of it (see box). There is, however, general agreement about the basic elements of the painting, if not about the overall intentions of the patron and artist.

The couple stands in a bedroom, holding hands, in formalized poses. Each individual fabric and texture of their dress—for example, the fur, the lace, the gold and leather belt—is convincingly portrayed. The scene contains several references to the woman's potential fertility. She holds her drapery in a way that suggests pregnancy. The seemingly casual positioning of pieces of fruit on the chest and windowsill denote natural abundance; and the little wooden statue on the chair back against the wall represents Saint Margaret, patron of women in childbirth. The dog, whose prominence in the foreground is surely meaningful, signifies fidelity, although it can also have erotic associations.

As in Campin's *Annunciation,* almost every household detail in the *Arnolfini Portrait* has Christian significance. The single candle burning in the chandelier, for example, can refer to Christ's divine presence and also stands for the traditional marriage candle that brides brought to the bridal chamber. Once a marriage was consummated, the flame was snuffed. The most intriguing detail in this painting is the convex mirror on the back wall (fig. **13.68**). It is surrounded by ten small circles, each of which contains a scene of Jesus's Passion. Reflected in the mirror are figures observing the ceremony from a door in front of the couple—the human witnesses. One of the figures may be Jan van Eyck, in which case he has documented his own presence twice, both as a reflection and by his signature. Above the mirror, he has written on the wall in Latin, in an elaborate script, "Johannes de eyck fuit hic," or "Jan van Eyck was here," and added the date, 1434. Van Eyck's presence as both witness and artist recalls the traditional parallel between God, as Creator of the universe, and the mortal artist, who imitates God's creations in making works of art.

13.67 Jan van Eyck, *Arnolfini Portrait*, 1434. Oil on wood; 32¼ × 23½ in. (81.9 × 59.7 cm). National Gallery, London. Commissioned by a member of the Arnolfini family from Lucca, this work reflects the economic ties between the Netherlands and Italy in the 15th century.

13.68 Detail of the mirror in figure 13.67. Convex mirrors were popular in homes before the development of full-length mirrors in Europe around 1500. Because they reflect a large area, they were used by shopkeepers (as they still are today) to detect pilfering. As such, they were the "eyes" of owners who wanted to guard their possessions. Van Eyck's mirror has therefore been interpreted, in Christian terms, as God's eye.

METHODS OF INTERPRETATION

Van Eyck's Arnolfini Portrait

Since van Eyck's picture has been interpreted in so many ways, it provides a good example of the potential for applying different methodological approaches to a single work. In 1934, the German scholar Erwin Panofsky read the painting as a marriage certificate and its signature as proof that the artist was a witness to the wedding. This reading identifies the tiny figure wearing red and blue reflected in the mirror as the artist's self-portrait. Panofsky's methodology also includes the iconographic method, for it explicates the underlying symbolic "text" of individual motifs.

Later historians have considered the social and economic context of the painting, questioning whether it represents a wedding at all. One argues that van Eyck signed the picture as a notary would sign a legal document. Another consideration is the picture's relation to the position of women as pawns in arranged marriages and its function as part of a contract. As it happens, the feminist aspect of such a reading is reinforced by a formal analysis. The bride is shorter than her husband and bows her head before him. He is more upright, literally an "upstanding" character whose verticality is accentuated by the gesture of his right hand. With his left, he "takes" the woman, whose open right hand is a sign of her receptivity.

The painting invites additional approaches. One could consider a poststructuralist reading based on Roland Barthes' *Camera lucida* and his notion that photographs appear to capture an actual moment in time, in contrast to a painted fiction. Aside from the issue of whether van Eyck's self-portrait appears in the mirror is the fact of his signature *over* the mirror, *as if* he were there, stating that he was actually there. The same problem arises in regard to the couple. If we were to see a photograph of them standing in the same room, we would know (or think we know) that the camera had recorded an actual "being there." But van Eyck could have painted the couple from memory or from sketches and then placed them in the room for purposes of the painting, having nothing to do with the outside world.

Enter the Deconstruction of Jacques Derrida, and the opening up of closed systems, to ask "How do we *know* van Eyck was there at the wedding?" He could have lied, like the author who writes a preface after he has finished the book but locates it structurally as if it had preceded the writing of the text.

A psychoanalytic reading of the *Arnolfini Portrait* might consider the image as a primal scene, which is the child's view (seen or imagined) of how adults create children. The picture is, after all, set in a bedroom, complete with a man and a woman, a bed, and allusions to childbirth (Saint Margaret), fertility (the fruit), and pregnancy (the position of the bride's dress). One reference to the gaze of the curious child is the mirror—sometimes read as the eye of God—which draws the viewer's gaze into a depth beyond the wall. The ambivalence of the mirror in that context—simultaneously looking *out* at us, extending our vision, and also recording the space from which we "as witnesses" view the painting—corresponds to the ambivalence of the child witnessing the forbidden primal scene.

A psychoanalytic reading would also add a level of meaning to the dog—traditionally a sign of lust, or fidelity, or both—which can represent the child's identification with animals that has enriched many a toy manufacturer. In van Eyck's painting, the dog is a reversal—that is, instead of looking *at* the couple and/or the bed, he looks at *us* looking at them. His riveted gaze is displaced from the primal scene to its audience and also replicates that of the child who confronts the act by which he himself is created.

Research on this painting published by Lorne Campbell in 1998 identifies it as a double portrait rather than a wedding picture. The figures, in his view, are Giovanni di Niccole Arnolfini, a merchant from Lucca who lived in Bruges, and his second wife, whose name is not known. The wedding identified by Panofsky, according to Campbell, actually took place in 1447 and thus could not be the subject of a painting signed and dated 1434.

Van der Weyden

The third great Netherlandish painter of the first half of the fifteenth century was Rogier van der Weyden (c. 1399–1463), the official painter of Brussels, who had been trained in the Tournai workshop of Robert Campin. His figures are typically larger in relation to their spatial setting than van Eyck's. They seem to enact monumental dramas as if on a narrow stage that brings them close to the actual picture surface.

The *Descent from the Cross* Rogier's *Descent from the Cross* (fig. **13.69**) of around 1435 to 1438 illustrates a theme imbued with emotional content that became popular in fifteenth-century Netherlandish art. The event takes place in a tight space, containing ten harshly illuminated figures. The heavy, angular draperies of the fainting Virgin and Mary Magdalen (at Jesus's feet) and of Saint John (in red) are somewhat relieved by the brocade robe of the man holding Jesus's legs and the red stockings worn by Joseph of Arimathea (the patron saint of embalmers and gravediggers), who is directly behind Jesus. A series of long, flowing curves unites the figures within the compressed setting. Jesus's horizontal S-shaped form echoes the Virgin's. Both are supported by figures in countervailing S-shapes, which are arranged in vertical planes. The

13.69 Rogier van der Weyden, *Descent from the Cross*, c. 1435–1438. Oil on wood; 7 ft. 2⅝ in. × 8 ft. 7⅛ in. (2.19 × 2.65 m). Museo del Prado, Madrid.

diagonal pull from Jesus's bowed head to Mary's limp right arm is anchored between Saint John's bare foot and Adam's skull—the latter a reminder that the Crucifixion took place over his grave.

Mary's pose echoes Jesus's, indicating her emotional and physical identification with his suffering and death. Her empathic response reflects the power of contemporary religious movements, especially prominent in Northern Europe, that strove for mystical communion with the simplicity of Jesus's life and message. The most influential spokesman for this sentiment in the early fifteenth century was the German cleric Thomas à Kempis (1380–1471). He is credited as being the author of *The Imitation of Christ*, written around 1420, which advocates spiritual merger with Jesus through self-denial and prayer.

Saint Luke Depicting the Virgin

Rogier creates an altogether different mood in *Saint Luke Depicting the Virgin* (fig. **13.70**). Through the open wall of the room, the observer joins the two figures seen in back view, in looking beyond the distant city toward the horizon. Figures,

landscape, and architecture diminish abruptly in size, creating the illusion of great distance. At the same time, the elaborate patterns continue the tradition of International Gothic in the North.

Mary and Jesus, whose proportions depart more from the Classical ideal than their Italian counterparts, constitute an insightful psychological depiction of the mother–child relationship. Jesus is contained within Mary's voluminous form and framed by the white cloth. Mary looks down at Jesus, who gazes up at her, his pleasure in breastfeeding indicated by his upturned toes and extended fingers.

The specific physiognomy of Saint Luke has led to the suggestion that he is a self-portrait of Rogier. His slightly wrinkled forehead, intense gaze, poised stylus, and posture reveal a physical tension that could well be autobiographical. There are no records of this painting's commission. However, it may have been painted for an artists' guild, since Saint Luke was the patron saint of artists and tradition had it that he had drawn the Virgin during her lifetime. The identification of himself with the patron saint of his own profession would have been a logical one for Rogier to make.

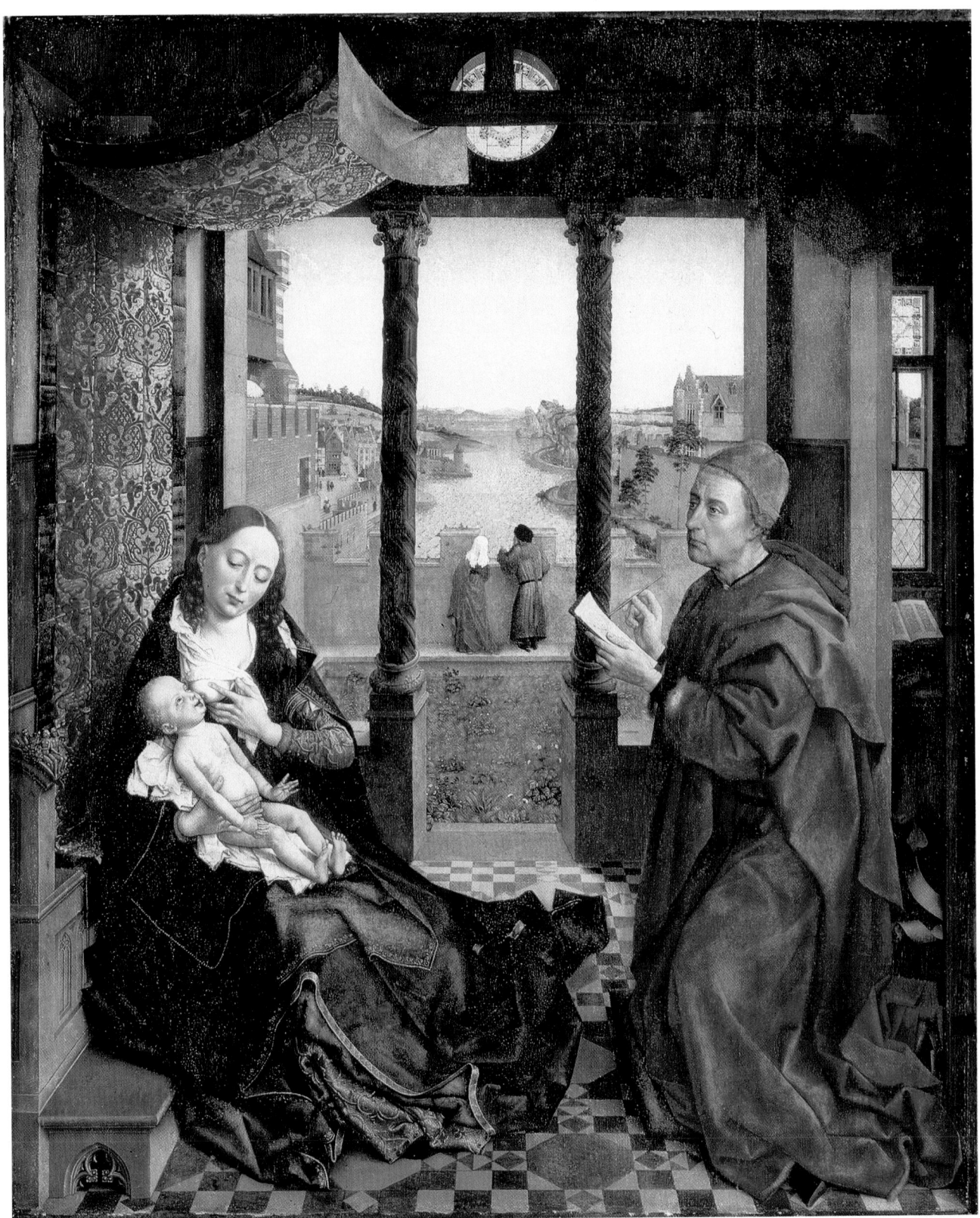

13.70 Rogier van der Weyden, *Saint Luke Depicting the Virgin*, c. 1435–1440. Oil and tempera on panel; panel 4 ft. 6⅛ in. × 3 ft. 7⅝ in. (1.38 × 1.11 m). Courtesy of the Museum of Fine Arts, Boston. Gift of Mr. and Mrs. Henry Lee Higginson.

Later Developments

Hans Memling's Portraits of Tommaso and Maria Portinari In 1470, Tommaso Portinari, the Italian merchant who managed the Medici bank in Bruges, married Maria Baroncelli, a member of another Florentine banking family. She was fourteen, he thirty-eight. It is believed that Tommaso commissioned portraits of himself and his wife from Hans Memling (active 1465–1494) on the occasion of their wedding (figs. **13.71a** and **13.71b**). Born in Germany, Memling moved to Bruges, where he became a citizen in 1465. In his Christian scenes, he was influenced by Rogier; his most original work was portraiture, and some of his most important patrons were Italians living in Bruges.

The Portinari portraits, in contrast to Piero della Francesca's *Battista Sforza and Federico da Montefeltro* (see fig. 13.45), are in three-quarter view against a dark background. Memling emphasizes the surface textures of the figures—of their clothing and jewelry—and endows them with a convincing flesh-and-blood quality. Tommaso's chis-eled physiognomy, detailed by delicate shifts in light and dark, is juxtaposed with the softer features of his young wife. Both are in an attitude of prayer and seem to concentrate intently on the lost central panel between them (see caption). Whereas Piero's figures are united in their devotion to each other—an impression enhanced by the profile view, the mutual gaze, and the depiction of the territory they ruled—Memling's are united in devotion to the Virgin and Christ.

--- **CONNECTIONS** ---

See figure 13.45.
Piero della Francesca, *Battista Sforza and Federico da Montefeltro, Duke of Urbino,* after 1475.

13.71a Hans Memling, *Tommaso Portinari,* c. 1470. Oil on wood; 17⅜ × 13¼ in. (44.1 × 33.7 cm). Metropolitan Museum of Art, New York. Bequest of Benjamin Altman, 1913 (14.40.626). Tommaso managed the Medici bank from 1465 to 1478 and was also the Medici emissary to the Burgundian court of Duke Charles the Bold. The Medici bank in Bruges closed in 1477, three years after Charles's death, because of a bad loan it made to him.

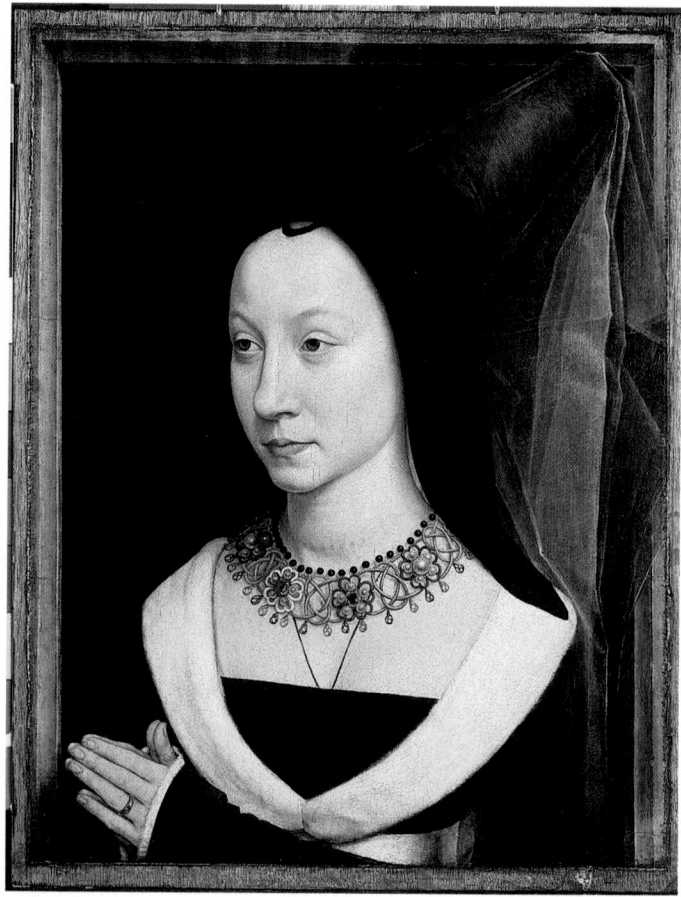

13.71b Hans Memling, *Maria Baroncelli Portinari,* c. 1470. Oil on wood; 17⅜ × 13¼ in. (44.1 × 33.7 cm). Metropolitan Museum of Art, New York. Bequest of Benjamin Altman, 1913 (14.40.627). It is generally assumed that this pair of portraits originally were wings of a devotional triptych and that they flanked a central panel of the Virgin and Christ.

Hugo van der Goes: The Portinari Altarpiece The Portinari triptych (fig. **13.72**) of about 1476 by Hugo van der Goes was another of Tommaso's Northern commissions, this one for the Florentine church of Egidio. The central panel represents Mary, Joseph, shepherds, and angels adoring the newborn Jesus, who lies on the ground surrounded by a glow of light. In the distance, at the upper right, an angel announces Jesus's birth to the shepherds.

Hugo's colors are deeper and richer than those of van Eyck. Certain details, such as the vases of flowers in the foreground, express the typical Netherlandish taste for endowing everyday objects with Christian meaning. The vase at the left, for example, contains flowers that denote Jesus's royal nature as well as his purity and passion. The grapes and vinescrolls on the surface of the vase allude to the wine of the Eucharist and to Jesus as the Church (cf. "I am the vine"). Behind the vases is a sheaf of wheat, the placement of which nearly parallels that of the infant. This refers to his institution of the Eucharist at the Last Supper, when Jesus proclaimed the wine his blood and the bread his body.

The glass container at the right is penetrated by light as Mary was impregnated by God's divine light and became the vessel of Jesus. It holds two types of flowers: red carnations (symbolizing pure love) were called "nail flowers" in Dutch, possibly alluding to the three nails of the Cross), and the columbines symbolize Mary's suffering and humility, as do the violets strewn on the ground. The particular arrangement and iconography of the vases, wheat, and flowers, and their formal relationship to Jesus, reveal the liturgical implications of Hugo's image and its relation to the enactment of the Eucharist in its actual setting in a church.

In the background, David's harp on his palace refers to Jesus's descent from the "House of David." In the shed, the ox looks up and observes the event taking place before him, while the ass keeps on munching. This indifference to the birth of Jesus on the part of the ass became associated with heretics and nonbelievers who failed to recognize Jesus as the Savior. Just to the right of the ox and ass, gazing out from the shadows, is a demon whose presence has been identified as connoting the Incarnation as a means of foiling Satan's plans for the world.

Hugo endows some of his figures with tension and anxiety. This is particularly true of the shepherds at the right of the central panel, whose grimacing faces and frantic gestures reflect their eagerness and wonder before their savior. They form part of a circle of figures whose excitement is revealed by the variety of praying gestures and angular, animated draperies. The tension is somewhat muted in the side panels, where the donors and three of their seven children kneel in front of their patron saints. The children are the first in Netherlandish art to have facial features suitable for their age. By depicting the family members as so much smaller in scale than the saints, however, Hugo creates a hieratic juxtaposition.

Whether the tensions in this painting are a result of the artist's personal conflicts or a reflection of contemporary stylistic developments is difficult to determine. Most likely, a combination of factors was at work. In any case, it is Hugo's greatest surviving work. In 1483, it was sent to Florence, where it was greatly admired, and its influence on Italian artists during the latter part of the fifteenth century was considerable.

13.72 Hugo van der Goes, Portinari Altarpiece (open), 1470s. Oil on wood; central panel 8 ft. 3½ in. × 10 ft. (2.53 × 3.05 m). Galleria degli Uffizi, Florence. In 1475, Hugo entered the monastery of the Red Cloister near Brussels as a lay brother. But his fellow monks accused him of being too worldly because of his artistic success. He suffered several episodes of depression and in 1481 tried to commit suicide. Contemporary rumor attributed his depression to disappointment because he had failed to produce works as good as van Eyck's Ghent Altarpiece.

Ghirlandaio's *Adoration of the Shepherds* Most of all, the Portinari Altarpiece impressed Domenico Ghirlandaio (1449–1494), who was one of the leading Florentine painters at the end of the fifteenth century. His most important commissions were for the Tornabuoni (in-laws of the Medici) and Sassetti families, both wealthy bankers. The two fresco cycles he painted for them are unique in the large numbers of family members represented as taking part in the sacred events. His *Adoration of the Shepherds* (fig. **13.73**) was painted for the altar in the Sassetti Chapel, in Santa Trinità, which was decorated with scenes from the life of Saint Francis, the name saint of Francesco Sassetti.

Ghirlandaio's *Adoration* is clearly related to Hugo's and would attest the commercial and artistic ties between Italy and Northern Europe, even if they were not independently documented. Nevertheless, Ghirlandaio's mood is different from that of his northern inspiration, and his proportions are more Classical. The shepherds at the right are rustic individuals with craggy physiognomies like those in the Portinari Altarpiece, but they do not exhibit the signs of tense agitation suggested by those of Hugo van der Goes. Their nature corresponds to the relaxed atmosphere of the picture as a whole and also to its naturalism. Both the ox and ass gaze in a friendly manner at Jesus. One of the shepherds points to Jesus while turning to talk with the man praying.

In contrast to the tension exhibited in the Portinari Altarpiece, Ghirlandaio's painting is relaxed and seemingly casual. Joseph, for example, turns as if to watch the angel appearing to the shepherds at the upper left and announcing Jesus's birth. There is also, in the Ghirlandaio, an emphasis on physical, tactile warmth that is lacking in the van der Goes. This can be seen in the way the lamb appears to touch the shepherd's head, the ox's horn to caress the ass's forehead, and Joseph's left hand to rest on the rim of the sarcophagus. Whereas the Portinari Jesus lies flat on the ground, isolated and separated from human contact, Ghirlandaio's Jesus sucks his thumb and lies on his mother's extended drapery. The little goldfinch below Jesus in the foreground is a symbol of his earthly mission to die on the Cross.

This painting is both a summation of certain fifteenth-century humanist concerns and a synthesis of the Classical revival. Ghirlandaio's attention to the details of landscape, the distant town, and the elegantly attired crowd traveling to adore Jesus all appealed to popular taste. The rules of linear perspective are strictly followed in the diminishing size of figures and landscape. Finally, Ghirlandaio has incorporated a Classical sarcophagus and Classical architecture into the Christian scene. Two Corinthian pilasters stand behind the Adoration; the one on the left is inscribed with the date of the painting, 1485. The inscription on the sarcophagus identifies as its occupant a fictitious soothsayer, who died when the Roman general Pompey besieged Jerusalem. The soothsayer predicts that his tomb will become the crib of a new deity (Christ). The Roman arch names Pompey as conqueror of Jerusalem and ironically alludes to the triumph of Christianity over pagan Rome.

13.73 Domenico del Ghirlandaio, *Adoration of the Shepherds*, 1485. Panel; 65¼ in. (1.66 m) square. Sassetti Chapel, Santa Trinità, Florence.

1400

THE EARLY RENAISSANCE
1400–1410

Brunelleschi, *Sacrifice of Isaac* (**13.2**)
Ghiberti, *Sacrifice of Isaac* (**13.3**)

1410–1420

Donatello, Saint Mark

Donatello, *Saint Mark* (**13.28**)
Brunelleschi, Hospital of the Innocents (**13.7**), Florence

Founding of Saint Andrews University, Scotland (1411)
Thomas à Kempis, *Imitatio Christi* (1414)
England under Henry V defeats France at Agincourt (1415)

1420–1430

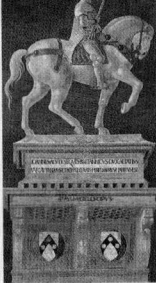

Masaccio, Tribute Money

Gentile da Fabriano, *Adoration of the Magi* (**13.27**)
Ghiberti, *Gates of Paradise* (**13.10–13.12**)
Masaccio, *Holy Trinity* (**13.20–13.21**)
Masaccio, Brancacci Chapel frescoes (**13.22–13.24, 13.26**)
Campin, *Mérode Altarpiece* (**13.60–13.61**)

Invention of scientific perspective (c. 1420)
Itzcoatl, king of the Aztecs, enlarges his empire (1427)

Gentile da Fabriano, Adoration of the Magi

1430–1440

Uccello, Sir John Hawkwood

Uccello, chalice (**13.16**)
Donatello, *David* (**13.29**)
van Eyck, Ghent Altarpiece (**13.62–13.65**)
van Eyck, *Man in a Red Turban* (**13.66**)
van Eyck, *Arnolfini Portrait* (**13.67–13.68**)
van der Weyden, *Saint Luke Depicting the Virgin* (**13.70**)
van der Weyden, *Descent from the Cross* (**13.69**)
Uccello, *Sir John Hawkwood* (**13.40**)
Brunelleschi, Florence Cathedral dome (**13.4**)
Pisanello, Palaeologus medal (**13.18–13.19**)
Juvayni, *Kuyuk the Great Khan* (**W7.2**)

Joan of Arc burned at the stake (1431)
Cosimo de' Medici becomes ruler of Florence (1434)
Leon Battista Alberti, *On Painting* (1435)

van Eyck, Man in a Red Turban

1440–1450

Alberti, Rucellai Palace

Brunelleschi, Santo Spirito (**13.9**), Florence
Fra Angelico, *Annunciation* (**13.47**)
Rossellino, tomb of Leonardo Bruni (**13.1**)
Donatello, *Gattamelata* (**13.42–13.43**)
Alberti, Rucellai Palace (**13.30**), Florence

First record of the suction pump (1440)
Eton College and King's College, Cambridge, founded (1441)

1450

1450–1460

Lippi, Pitti Tondo

Filippo Lippi, *Pitti Tondo* (**13.48**)
Castagno, *Famous Men and Women* (**13.38–13.39**)
Castagno, *Youthful David* (**13.36**)
Alberti, Tempio Malatestiano (**13.31**), Rimini
de' Pasti, Tempio Malatestiano medal (**13.32**)
Piero della Francesca, Arezzo frescoes (**13.46, 13.50–13.52**)
Donatello, *Mary Magdalen* (**13.58**)
Castagno, *Niccolò da Tolentino* (**13.41**)

Vatican Library founded (1450)
Leon Battista Alberti, *On Architecture* (1452)
Gutenberg prints Bible at Mainz (1453–1455)
Turks capture Constantinople; end of Byzantine Empire (1453)
End of Hundred Years' War between England and France (1453)
Turks conquer Athens (1456)

1460–1480

Piero della Francesca, Flagellation

Piero della Francesca, *Flagellation* (**13.13**)
Alberti, Sant'Andrea (**13.33**), Mantua
Memling, Portinari portraits (**13.71**)
Verrocchio, *David* (**13.37**)
van der Goes, Portinari Altarpiece (**13.72**)
Mantegna, Camera Picta frescoes (**13.53–13.54**)
Botticelli, *Mars and Venus* (**13.56**)
Piero della Francesca, *Battista Sforza and Federico da Montefeltro* (**13.45**)

Erasmus of Rotterdam, humanist (1465–1536)
First printed music (1465)
Lorenzo de' Medici, "the Magnificent," rules Florence (1469–1492)
Nicolaus Copernicus, European astronomer (1473–1543)
William Caxton prints first book in English (1474)
Revival of Inquisition in Spain (1478)
Union of Aragon and Castile under Ferdinand and Isabella; birth of the Spanish state (1479)

1480–1500

Botticelli, Birth of Venus

Leonardo, *Adoration of the Magi* study (**13.15**)
Verrocchio, *Colleone* (**13.44**)
Botticelli, *Birth of Venus* (**13.57**)
Ghirlandaio, *Adoration of the Shepherds* (**13.73**)
Wu Wei, *Pleasures of Fishing* (**W7.1**)
Mantegna, *Parnassus* (**13.55**)
Mantegna, *Dead Christ* (**13.17**)
Botticelli, *Mystical Nativity* (**13.59**)

Richard of Gloucester claims English throne as Richard III (1483)
Dias rounds Cape of Good Hope (1486)
Spain finances voyage of Columbus to New World (1492)
Muslims lose Granada, their last stronghold in Spain (1492)
Charles VIII of France invades Italy (1494–1498)
François Rabelais, French author (1494–1553)
Imperial Diet opens in Worms (1495)
Cabot reaches east coast of North America (1497)
Severe famine in Florence (1497)
Savonarola burned at the stake in Florence (1498)
Vasco da Gama discovers sea route to India (1498)

1500

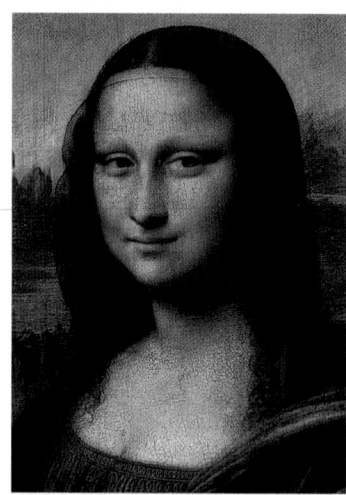

14

The High Renaissance in Italy

The High Renaissance in Italy was an age of great accomplishments in Western art that occurred in the late fifteenth century and the first half of the sixteenth (see map). The term *High* that is used to designate this period reflects the esteem in which it is generally held.

Politically, the High Renaissance was a period of tension and turbulence. Foreign invasions and internal conflicts produced upheaval and instability. The French invaded northern Italy and sacked Milan. The Medici were expelled from Florence in 1494, and the fanatical Dominican friar, Savonarola, was executed only four years later. Although the Medici were reinstated in 1512, their political style had become autocratic. Eighteen years later Florence would come under the sway of the Hapsburg dynasty.

Florence remained an important artistic center, but it no longer provided the primary impetus for creative activity. Rome, meanwhile, under the control of ambitious popes, succeeded Florence as the artistic center of Italy. Pope Julius II (papacy 1503–1513), determined to expand his political and military power, was also an enlightened humanist. In his patronage of the arts, Julius made perhaps the greatest contributions to the High Renaissance. His successor, Leo X (papacy 1513–1521), continued the patronage of major painters, sculptors, and architects, but the artistic achievements of the period were not matched by political success. In 1527, the Holy Roman emperor, Charles V, invaded Italy and sacked Rome.

Although many important artists helped to lay the foundations of the High Renaissance in the first three-quarters of the fifteenth century, the period itself is dominated by a relatively small number of powerful artistic personalities. Those considered in this chapter are Leonardo da Vinci, Bramante, Michelangelo, Raphael, Giorgione, and Titian. In the section on Venice, the Bellini family of painters is discussed as precursors of the High Renaissance.

Leonardo (1452–1519) succeeded Alberti as the embodiment of the "universal Renaissance man," or *uomo universale*. He painted only a small number of pictures but worked as a sculptor and architect, and wrote on nearly every aspect of human endeavor, including the arts and sciences. Bramante (c. 1444–1514), Raphael (1483–1520), and Michelangelo (1475–1564), all of whom were influenced by Leonardo, received their training in Milan, Umbria, and Florence, respectively, but achieved their greatest success in Rome. In Venice, the High Renaissance was dominated by Giorgione (c. 1477–1510) and above all by Titian (c. 1485–1576), whose life was long and productive. Of these six, only Titian and Michelangelo lived beyond the year 1520, when new artistic styles began to emerge and the short period of the High Renaissance came to an end.

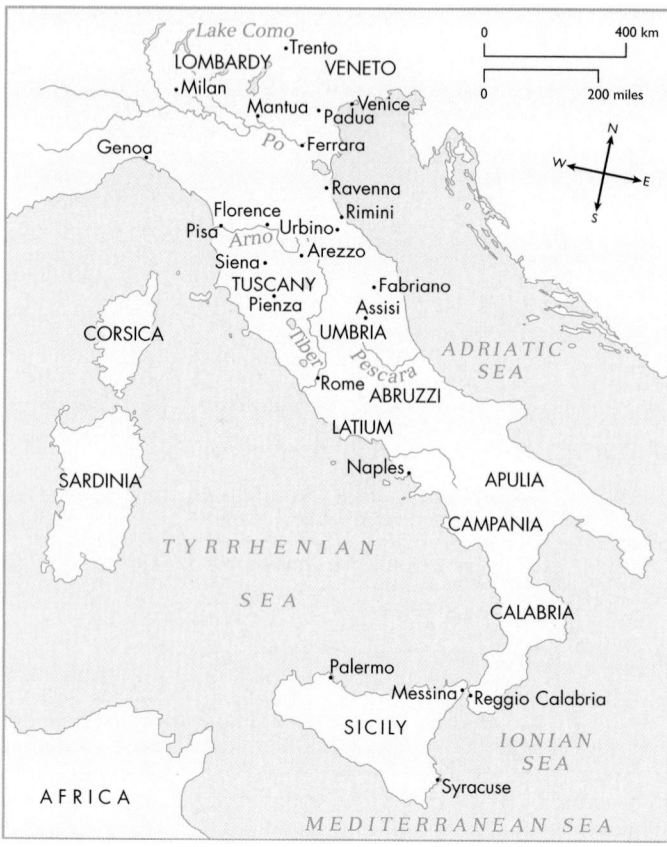

Art centers in Renaissance Italy.

Architecture

The Ideal of the Circle and Centrally Planned Churches

An important architectural ideal that preoccupied many artists and writers on art from the fifteenth century through the High Renaissance was the centrally planned church building. It was based on the ancient notion that the circle is the ideal shape. Plato considered the circle to be the perfect geometric form, associating it with divinity. In Near Eastern cultures and Byzantium, belief in the divine property of the circle was reflected in churches and mosques, the domed ceilings of which symbolized heaven. Churches whose plans are based on the Greek cross are also centralized, in contrast to the longitudinal design of the Latin cross and the basilican plan of the Early Christian church. The divine associations of the circle persisted through the European Middle Ages, recurring, for example, in the huge rose windows of the Gothic cathedrals.

In fifteenth-century Italy, the circular ideal was an aspect of the humanist synthesis of Classical with Christian thought. It was also related to the new interest in the direct observation of nature. Alberti noted that in antiquity temples dedicated to certain gods were round, and he connected the divinity of the circle with round structures in nature. He wrote in his treatise on architecture that "Nature delights primarily in the circle" as well as in other centrally planned shapes such as the hexagon. In support of this view, Alberti observed that all insects create their living quarters in centralized, hexagonal shapes (the cells of bees, for example). Further, Alberti and other fifteenth-century architects followed Vitruvius in relating architectural harmony to human symmetry. Temples, according to Vitruvius, required symmetry and proportion in order to achieve the proper relation between parts that is found in a well-shaped man (fig. **14.1**).

Leonardo da Vinci followed these principles when devising his own projects for churches. From the 1480s, during his stay in Milan, Leonardo designed domed, centrally planned churches (fig. **14.2**). Although these designs were never executed, Leonardo influenced the older architect Donato Bramante, who moved from Milan to Rome when the French invaded Milan in 1499. Bramante's Tempietto,

14.1 Leonardo da Vinci, *Vitruvian Man*, c. 1485–1490. Pen and ink; 13½ × 9⅝ in. (34.3 × 24.5 cm). Galleria dell'Accademia, Venice. This drawing illustrates the observation made by Vitruvius that, if a man extends his four limbs so that his hands and feet touch the circumference of a circle, his navel will correspond to the center of that circle. Vitruvius also drew a square whose sides were touched by the head, feet, and outstretched arms of a man.

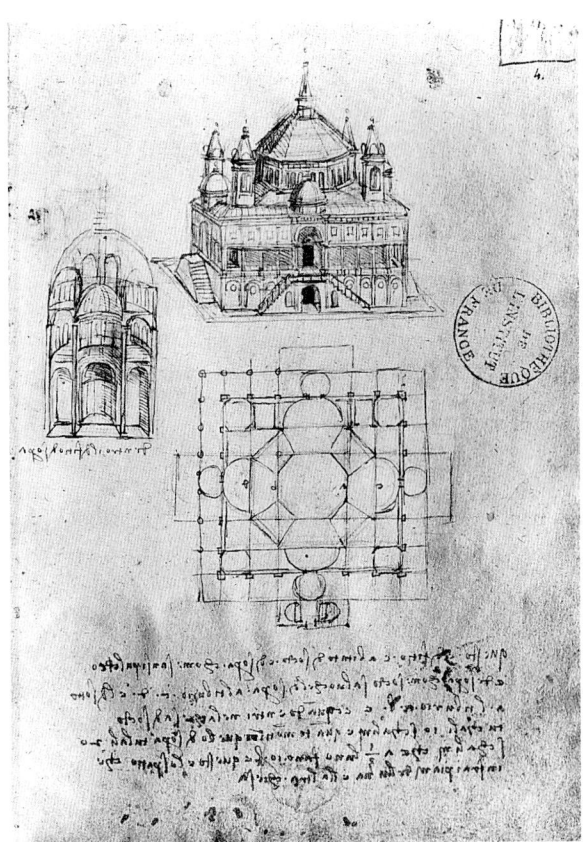

14.2 Leonardo da Vinci, church resembling the Holy Sepulcher in Milan, Ms. 2184 fol. 4r. Pen and ink. Institut de France, Paris. The octagonal plan in this drawing is composed of eight geometric shapes arranged in a circle. Leonardo left thousands of notebook pages with such drawings accompanied by explanatory text.

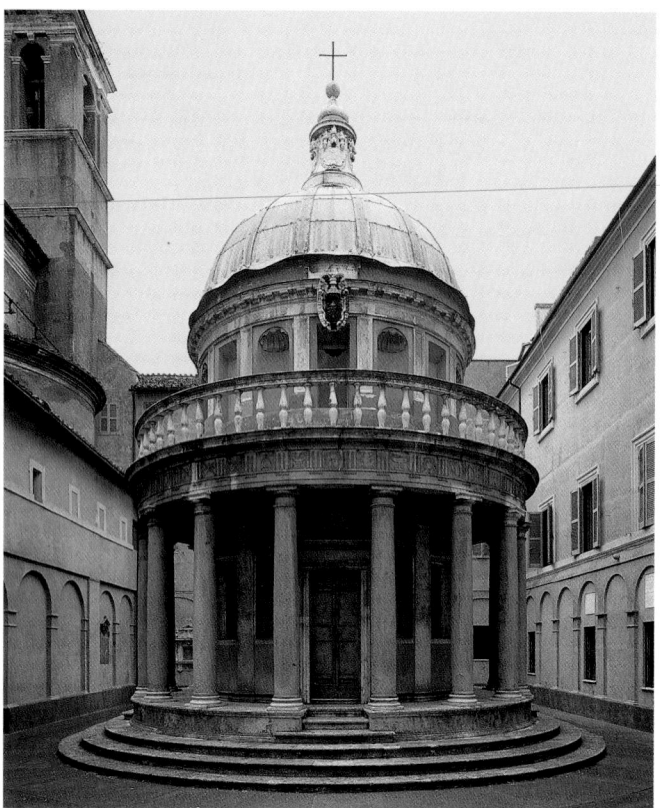

14.3 Donato Bramante, Tempietto, c. 1502–1503. San Pietro in Montorio, Rome. The Tempietto ("Little Temple" in Italian) was a small martyrium commissioned by King Ferdinand and Queen Isabella of Spain and erected in Rome shortly after 1500. The hole in which Saint Peter's cross supposedly stood marked the center of a chamber below the round *cella*. In the *cella* itself, just above the hole, stood a single altar.

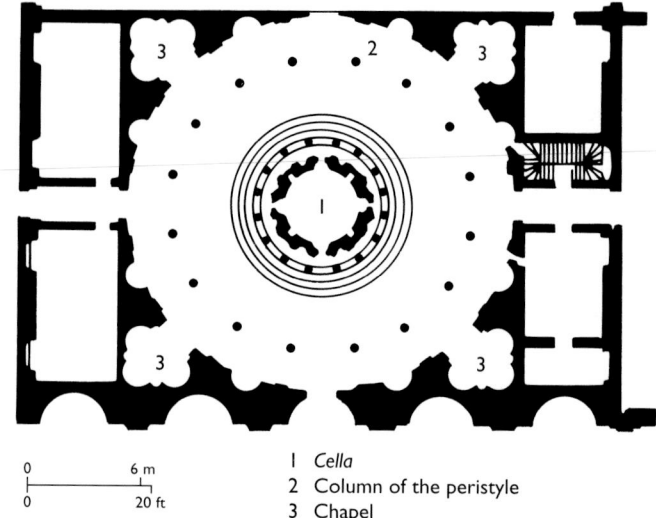

0 6 m
0 20 ft

1 *Cella*
2 Column of the peristyle
3 Chapel

14.4 Donato Bramante, plan of the Tempietto with a projected courtyard, after a 16th-century engraving by Sebastiano Serlio. From the geometrical center of the *cella*, equidistant lines can be drawn to each column of the peristyle, just as they can from the navel of Leonardo's *Vitruvian Man*, which lies at the center of a circle.

situated on the traditional site of Saint Peter's crucifixion, fulfills the ideal of the round building (fig. **14.3**). The exterior, sixteen-column Doric peristyle supports a Doric frieze and a balustrade. Above the peristyle is a drum surmounted by a ribbed, hemispherical dome. In selecting Doric columns and a Doric frieze, Bramante conformed to Vitruvius's view that an architectural Order should correspond to the god to whom the temple was dedicated. Doric, according to Vitruvius, was suitable for the active male gods —a category consistent with Saint Peter's hot-tempered

nature. Finally, Bramante adopted the practice, also dating back to antiquity, of treating a building as one massive block of stone with openings and spaces carved out of it. This has been referred to as the **sculptured-wall motif.**

The relatively small interior of the Tempietto meant that very few people could enter it at once, so it was probably intended to be appreciated more from the outside. It now stands in a rather constricted space, but Bramante's original ground plan, as recorded in a sixteenth-century engraving (fig. **14.4**), placed it in the middle of a circular, colonnaded enclosure. The enclosure was itself inscribed in a square with a tiny chapel in each corner.

Centrally planned buildings were clearly regarded as key elements in Renaissance urban architecture, as can be seen in the painting *An Ideal City* (fig. **14.5**). A circular building occupies the center of the composition, and, by implication, it is the navel of the ideal city. The rectangular buildings surrounding it differ in size and type, but all have the symmetrical, geometrical quality that characterizes Renaissance architecture.

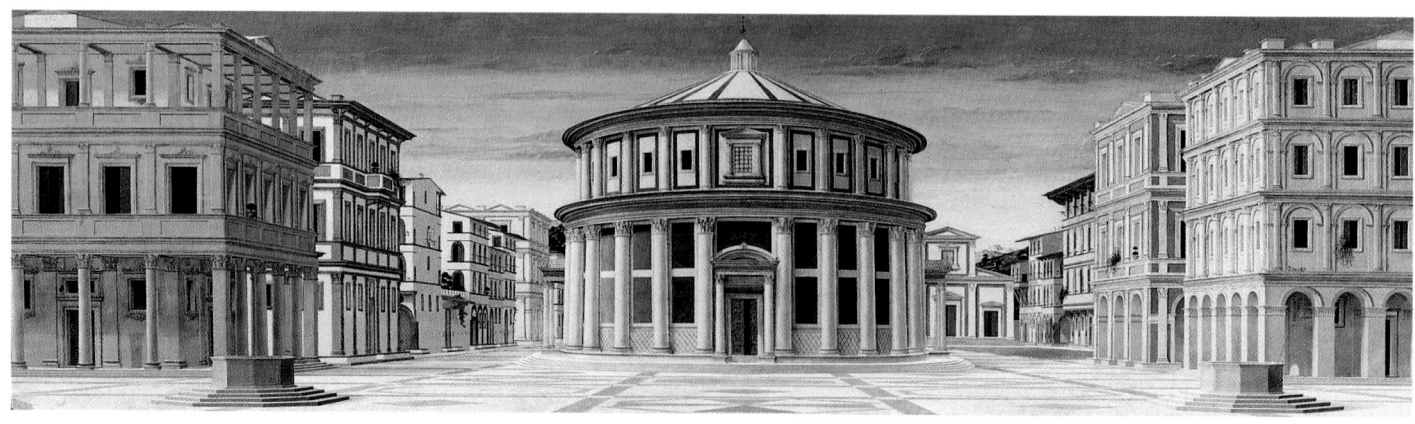

14.5 Anonymous, *An Ideal City*, mid-15th century. Panel painting; 79 × 23½ in. (200.7 × 59.7 cm). Palazzo Ducale, Urbino.

Saint Peter's and the Central Plan

Bramante and Raphael arrived in Rome within a few years of each other. The Tempietto established Bramante as Rome's leading architect, a position from which he acted as Raphael's mentor. In 1503, Julius II (see box) became pope and immediately set about re-creating the ancient glory of imperial Rome. As part of his plan, Julius decided that the basilica of Saint Peter's, by then over a thousand years old and in poor condition, would have to be rebuilt. He gave the commission to Bramante, who, by 1506, had designed a complex plan (fig. **14.6**). Bramante's design for the New Saint Peter's was notable for its size. It was 550 feet (167.64 m) long, making it the largest church in history; in fact, a sizable church could be accommodated in each of its four wings. Bramante also envisaged a large semicircular stepped dome above a relatively shallow drum. This conception was recorded in a medal of 1506 (fig. **14.7**), which shows the smaller domes surmounting one of the apses and two of the chapels. From the front, the viewer would have seen the two towers flanking the massive, symmetrical façade. The central portion would have been a unified alternation of domes and porticoes that was inspired by the design of the Pantheon. It is also likely that, as in the Pantheon, Bramante's large drum would have been of concrete.

In 1506, the foundation stone of the New Saint Peter's was laid, and seven years later Pope Julius II died. Bramante himself died in 1514 but had arranged for Raphael

> ### Julius II: Humanist Pope
>
> Julius II, one of the greatest humanist popes (1503–1513), was born Giuliano Della Rovere in 1443, the nephew of Sixtus IV. His patronage of the arts endorsed mythological as well as Christian subject matter and encouraged their Neoplatonic synthesis. He added to the manuscripts in the Vatican Library and launched the papal collection of Greek and Roman sculpture. The artists he employed—Bramante, Raphael, Michelangelo—were, without question, the geniuses of their age. Julius was also a man of secular ambition, and for this he was admired by Machiavelli. He restored the power and influence of the Papal States, successfully administered the papal finances, maneuvered legal and financial reforms for papal advantage, and advocated missionary activity in the newly discovered Americas.

to succeed him as the new architect of Saint Peter's. By the time of Raphael's death in 1520, little had been achieved beyond the demolition of the old basilica and the construction of the four great piers at the crossing.

In 1546, the task was entrusted to Michelangelo, then aged seventy-one. He retained the underlying concept of a huge dome resting on four piers but simplified Bramante's complex spatial arrangements (fig. **14.8**). As a result of Michelangelo's changes, work proceeded quickly, and at his death in 1564 Saint Peter's was nearly finished except for the dome. Despite the succession of architects who contributed to the New Saint Peter's, the final result (figs. **14.9** and **14.10**) retained the original central Greek-cross plan, with the addition of a nave to form a Latin cross. The dome's profile is slightly pointed, and small double columns soften the projection of the buttresses. Vertical ribs and a high lantern create a greater degree of verticality than in Bramante's original design.

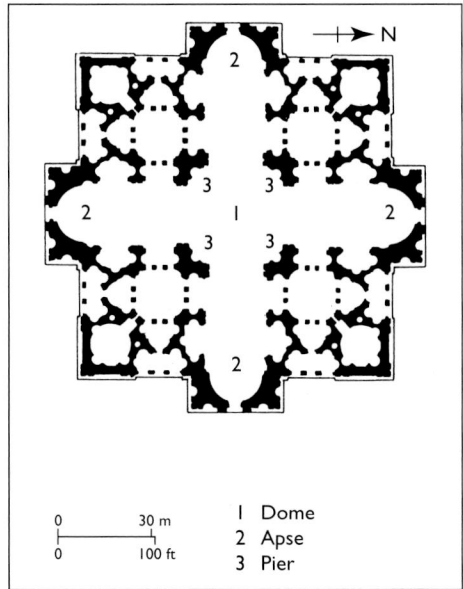

14.6 Donato Bramante, plan for the New Saint Peter's, Vatican, Rome, c. 1505. Bramante's plan is centrally planned, with four arms of a Greek cross ending in semicircular apses. A central, semicircular dome, larger than that of the Pantheon, would cover the central crossing. Between the arms of the cross would be four smaller, cross-shaped units, surmounted by smaller domes, and four tall towers. This plan is strictly symmetrical and follows the "sculptured wall" concept.

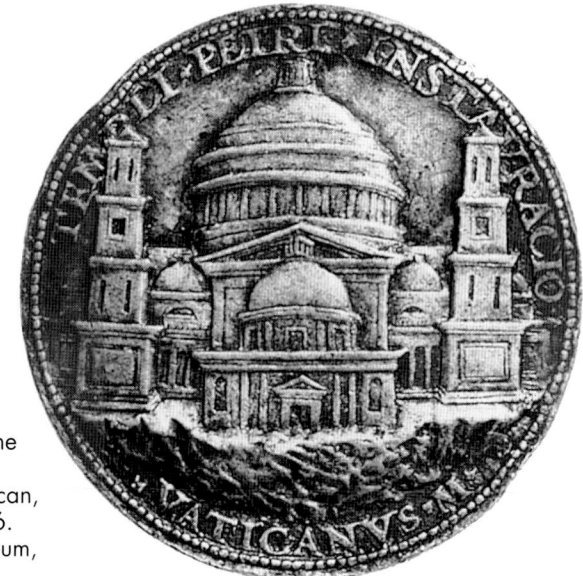

14.7 Cristoforo Caradosso Foppa, medal showing Bramante's design for the New Saint Peter's, Vatican, Rome, 1506. British Museum, London.

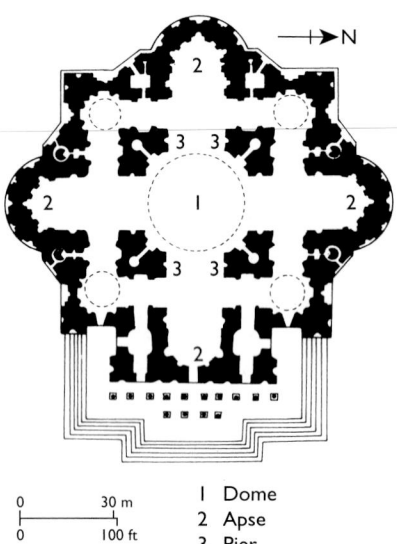

14.8 (left) Michelangelo, plan for the New Saint Peter's, Vatican, Rome, c. 1546. Michelangelo reduced the area of the floor by eliminating the smaller cruciform units (except for their domes) and the corner towers. He also simplified Bramante's proposed exterior by introducing a colossal order of pilasters topped by an entablature and an attic high enough to conceal the smaller interior cupolas.

1 Dome
2 Apse
3 Pier

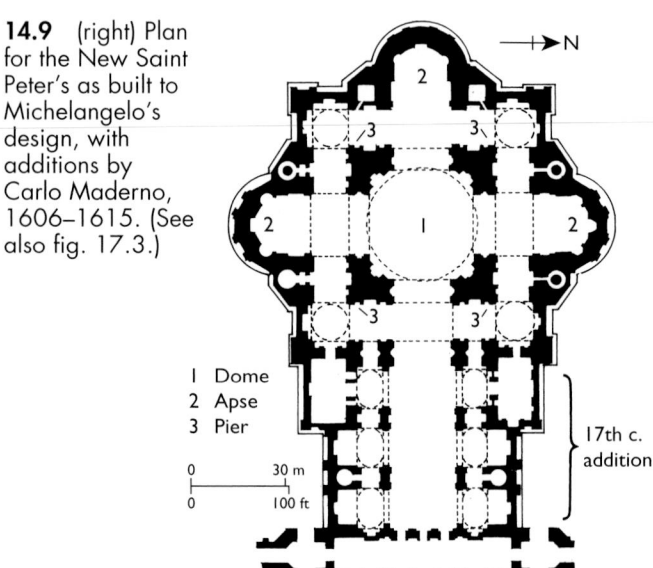

14.9 (right) Plan for the New Saint Peter's as built to Michelangelo's design, with additions by Carlo Maderno, 1606–1615. (See also fig. 17.3.)

1 Dome
2 Apse
3 Pier

17th c. addition

14.10 New Saint Peter's, Vatican, Rome.

Painting and Sculpture

Leonardo da Vinci

Scientific Drawings Leonardo's numerous anatomical drawings illustrate the Renaissance synthesis of art and science. Among the most intriguing are his studies of fetuses in the womb (fig. **14.11**). In the main image, Leonardo depicts an opened uterus, a fetus in the breech position, and the umbilical cord. A smaller drawing to the right depicts the fetus as if seen through the amniotic membrane. Other drawings illustrate the systems by which the fetus is linked to the mother's blood supply.

Such drawings, apart from demonstrating his superb draftsmanship, reflect Leonardo's obsessive interest in the origins of life and in discovering scientific explanations for natural phenomena. The thousands of studies, covering virtually every aspect of scientific and artistic endeavor, contrast strikingly with the small number of finished paintings by his hand. Leonardo's artistic nature may thus be characterized as investigative, preliminary, and experimental. Only rarely did he complete a work and deliver it to a patron.

14.11 Leonardo da Vinci, *Embryo in the Womb*, c. 1510. Pen and brown ink; 11¾ × 8½ in. (29.8 × 21.6 cm). Royal Collection, Windsor Castle, Royal Library, © 2006 Her Majesty Queen Elizabeth II. Many Renaissance artists studied human anatomy, but Leonardo went far beyond the usual artistic concern with musculature and studied the digestive, reproductive, and respiratory systems. He apparently intended to collect his anatomical drawings into a treatise but never completed the project. His script runs from right to left and must be read in a mirror. To date, there is no generally accepted explanation for this curious "mirror writing."

Paintings Leonardo's earliest known painting is the angel at the far left of Verrocchio's *Baptism of Christ* (fig. **14.12**). Verrocchio was a prominent sculptor (see Chapter 13), but he ran a workshop in Florence that produced paintings as well. Leonardo entered Verrocchio's workshop as an apprentice when he was in his teens. The presence of his angel in the master's painting conforms to the practice of allowing pupils to work on peripheral figures. Even at this early stage of Leonardo's career, however, his remarkable talent is apparent. His angel is rendered in three-quarter view from the back and shows Leonardo's command of convincing, sculpturesque drapery. In contrast to the craggy forms of Jesus and John the Baptist, Leonardo has given his angel smooth features bathed in a golden light. Compared with Verrocchio's angel, Leonardo's is suffused with a distinctive softness. In particular, the blond curls have a fluffy quality, rather than the precisely delineated curls of Verrocchio's angel.

14.12 Andrea Verrocchio, *Baptism of Christ*, c. 1470. Oil on panel; 69½ × 59½ in. (1.77 × 1.51 m). Galleria degli Uffizi, Florence. A popular anecdote related that when Verrocchio saw the genius of Leonardo's angel, he realized that he could never emulate it. As a result, he renounced painting and devoted himself entirely to sculpture.

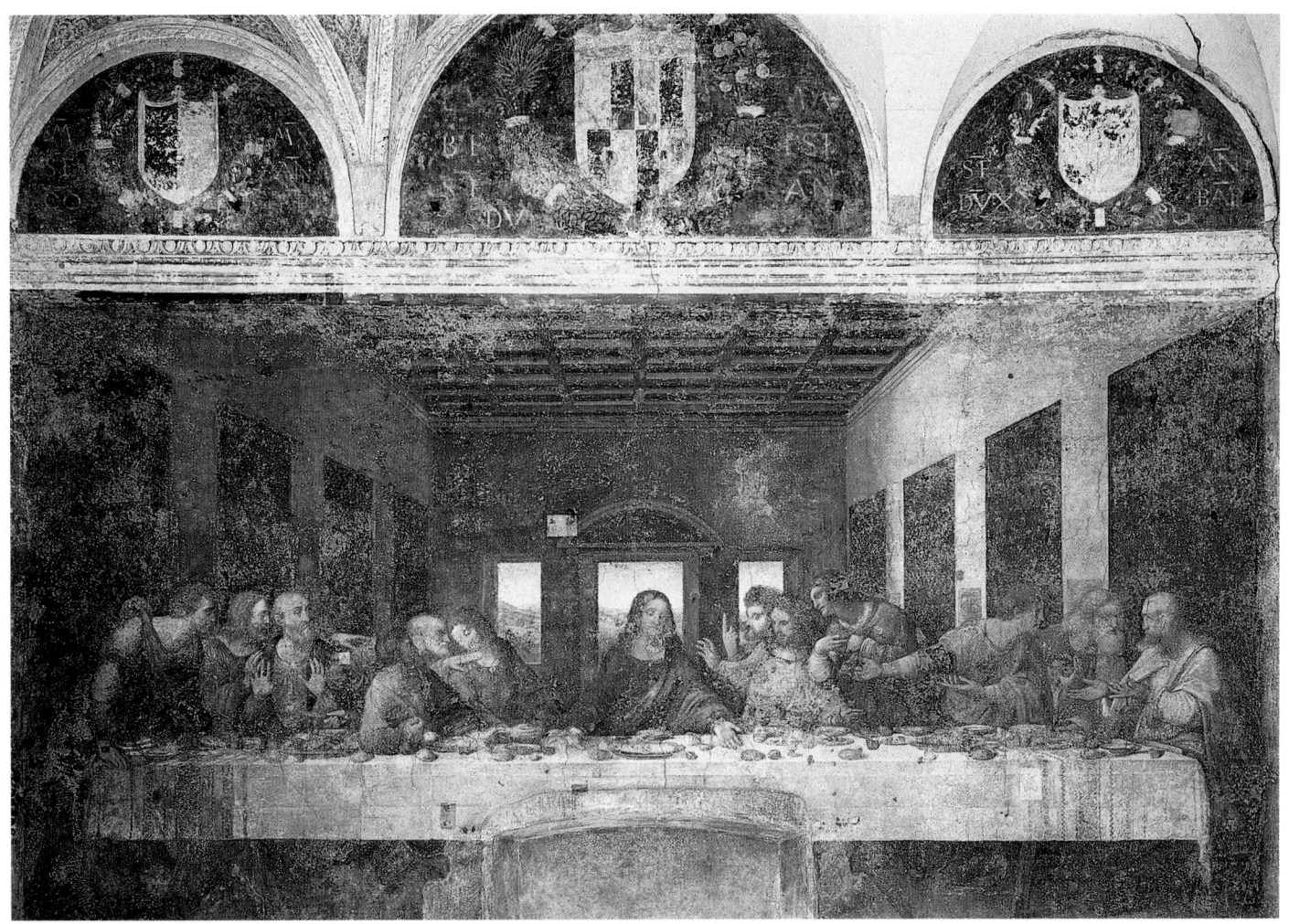

14.13 Leonardo da Vinci, *Last Supper*, refectory of Santa Maria delle Grazie, Milan, c. 1495–1498. Fresco (oil and tempera on plaster); 15 ft. 1⅛ in. × 28 ft. 10½ in. (4.60 × 8.56 m). Leonardo's experimentation had negative as well as positive results. Because of his slow, deliberate working methods, he could not keep pace with the speed required by the *buon fresco* technique. He seems to have applied a mixture of oil and tempera to the dry plaster. Unfortunately, the fusion between pigment and plaster was imperfect, and the paint soon began to flake off the wall. What remained was a badly damaged painting, which has undergone several stages of restoration since Leonardo painted it. The lunettes above the *Last Supper* represent the arms of Lodovico Sforza and his fifteen-year-old bride, Beatrice d'Este, who were married in 1491. Beatrice died at the age of twenty-one before the fresco was finished.

Leonardo's single most important mature work is his great mural of the *Last Supper* (fig. **14.13**) of around 1495 to 1498. Despite its poor condition, the *Last Supper* has become an icon of Christian painting and one of the most widely recognized images in Western art. Its success comes from Leonardo's genius in conveying character and dramatic tension, and integrating these qualities with an imposing and unified architectural setting.

The *Last Supper* was commissioned by Duke Lodovico Sforza for the refectory (dining room) of Santa Maria delle Grazie in Milan. The opposite wall had previously been decorated with a fresco of the Crucifixion to remind the friars of the connection between the Eucharist and the Passion. Like Masaccio's *Holy Trinity* (see fig. 13.20), Leonardo's *Last Supper* occupies an illusionistic room reced-

ing beyond the space of the existing wall. But the *Last Supper* is above the viewer's eye level.

Leonardo has represented a series of moments following Jesus's announcement that one of his apostles will betray him. Each reacts according to his biblical personality. Saint Peter, whose head is fifth from the left, angrily grasps the knife with which he will later cut off the ear of Malchus, the servant of the high priest. John, the youngest apostle, slumps toward Saint Peter in a faint. Thomas, the doubter, on Jesus's left, points upward, his gesture highlighted by the dark wall behind his hand. Judas, to the left of Peter, is the villain of the piece. He leans back, forming the most vigorous diagonal away from Jesus. In placing Judas on the same side of the table as Jesus and the other apostles, Leonardo departs from convention, which distinguishes

14.14 Leonardo da Vinci, *Last Supper* (after latest restoration).

In Leonardo's unfinished *Madonna and Child with Saint Anne* (fig. **14.15**), the underpainting of which remains visible in parts, the figures form a pyramid set in a landscape. Three generations, represented by Anne (Mary's mother), Mary, and Jesus, correspond to the triangulation of their formal organization. The triple aspect of time—past, present, and future—is also a feature of Leonardo's integration of geometry with landscape and narrative. In this painting, past combines with future to form the present image: the lamb and the tree refer forward in time to Jesus's sacrificial death on the Cross.

Leonardo's original handling of *chiaroscuro* is more evident in the *Saint Anne* than in the badly damaged and overrestored *Last Supper*. The soft, yellowish light bathing the figures and the gradual shading characteristic of Leonardo's style endow both flesh and drapery with a degree of softness unprecedented in Christian art. The landscape

Judas by location rather than by pose and gesture. Here Judas is the only apostle whose face is in darkness—a symbol of the evil that comes from ignorance and sin.

The figures also play their part in the geometry of the composition. The twelve apostles are arranged in four groups of three, echoing the four wall hangings on each side of the room and the three windows on the wall behind Jesus. Jesus forms a triangle, as he extends his arms forward. His triangular form corresponds to the triple windows, and both allude to the three persons of the Trinity. The curved pediment over the central window functions as an architectural halo. Combined with the light background behind Jesus's head, it acts as a formal reminder that Jesus is the "light of the world." This aspect of Jesus is reinforced in the perspective construction. The orthogonals radiate outward from his head, so Jesus becomes the sun, or literal "light of the world," as if extending his "rays" to the world outside the picture.

Figure **14.14** shows Leonardo's *Last Supper* after the most recent restoration, which took many years. The aim of the restorers was to remove everything that was not originally painted by Leonardo; when they had finished, very little of the image remained. As a result, several of the figures were nearly blank and had to be repainted. The present appearance of the *Last Supper* is thus rather bland compared to its precleaned state. Its colors are more pastel, and much of the shading has been lost, giving the figures a flattened appearance.

14.15 Leonardo da Vinci, *Madonna and Child with Saint Anne*, c. 1503–1506. Oil on wood; 5 ft. 6⅛ in. × 3 ft. 8 in. (1.68 × 1.12 m). Louvre, Paris.

14.16 Leonardo da Vinci, *Mona Lisa,* c. 1503–1505. Oil on wood; 30¼ × 21 in. (76.8 × 53.3 cm). Louvre, Paris.

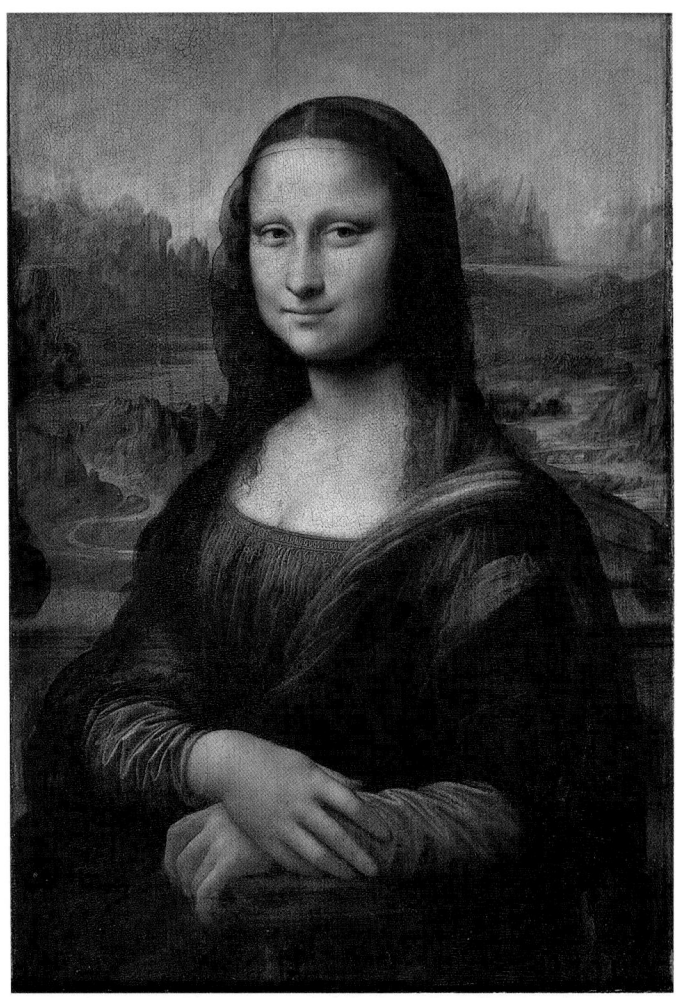

is also softened by the mists of Leonardo's *sfumato* (see box), which filter through the atmosphere. Furthermore, just as the figures in the *Last Supper* echo the architectural composition, so in the *Saint Anne* are figures and landscape interrelated. In particular, the atmospheric mist in the background filters through the veil covering Anne's head. The angles of her veil and the strong zigzag thrust of her left arm repeat the rocky background. In this way, Leonardo depicts Anne as a metaphor of the landscape and perhaps also as the symbolic architectural foundation of Mary and Jesus.

The painting that epitomizes Leonardo's synthesis of nature, architecture, human form, geometry, and character is the *Mona Lisa* (fig. **14.16**). Vasari says that the portrait depicts the wife of Francesco del Giocondo (hence its nickname, *La Gioconda,* meaning "the cheerful one"). The figure forms a pyramidal shape in three-quarter view, set within the cubic space of a loggia. In trimming the panel (see below), parts of columns were cut away; these would have enhanced the sense of a cubic space. The observer's point of view is made to shift from figure to landscape, and although the figure of Mona Lisa is seen from the same level as the observer, the viewpoint shifts upward in the landscape. The light also shifts, bathing the figure in subdued, dark yellow tones and the landscape in a blue-gray *sfumato.* Compared to the landscape in Verrocchio's *Baptism,* the rocky background of the *Mona Lisa,* which is imaginary, has a hazier and more mysterious atmosphere.

The contrasts of viewpoint and light distinguish the landscape from the figure. At the same time, however, Leonardo has created formal parallels between figure and landscape. For example, the form of Mona Lisa repeats the triangular mountains, and her transparent veil echoes the filtered light of the mists. The curved aqueduct continues into the highlighted drapery fold over her left shoulder, and the spiral road on her right is repeated in the short curves on her sleeves. These, in turn, correspond to the line of her fingers.

Such formal parallels do not explain the mystery of the figure, whose expression has been the subject of songs, stories, poems, jokes, and other works of art (e.g., fig. 26.1). They do, however, illustrate Leonardo's own description, found in his notebooks, of the human body as a metaphor for the earth. He compares flesh to soil, bones to rocks, and blood to waterways. This metaphorical style of thinking, which recurs in visual form throughout his paintings and drawings, is characteristic of Leonardo's genius.

The enigmatic smile of Mona Lisa is the subject of volumes of scholarly interpretation. Vasari says that Leonardo hired singers and jesters to keep the smile on her face while he painted. Once he had completed the painting, Leonardo was unwilling to part with it and took it with him to the court of Francis I of France, where he died in 1519. It then became part of the French royal collection and was later trimmed by about an inch on either side.

Sfumato

Sfumato, an Italian word meaning "toned down" or "vanished in smoke," is a technique —used with particular success by Leonardo— for defining form by delicate gradations of light and shade. It is achieved in oil painting through the use of glazes and produces a misty, dreamlike effect.

Michelangelo Buonarroti

Michelangelo, born near Arezzo, lived to be eighty-nine; his life is documented in contemporary biographies, comments on his personality and work, and his own letters and sonnets. Like Leonardo, Michelangelo was an architect, painter, and writer, although he thought of himself primarily as a sculptor and considered sculpture a higher art form than painting.

Michelangelo's father opposed his wish to become a sculptor but, when his son was thirteen, apprenticed him to Domenico Ghirlandaio (see Chapter 13). Before Michelangelo was sixteen, he was recognized by Lorenzo de' Medici, under whose patronage he studied sculpture and was exposed to Classical art and humanist thought. His style was formed in Florence well before he went to Rome to work for Julius II. Michelangelo's attraction to the most monumental of his Florentine predecessors is evident from his habit of visiting the Brancacci Chapel and drawing Masaccio's frescoes. Figure **14.17** shows Michelangelo's copy of Masaccio's Saint Peter paying the tax (see fig. 13.23). Michelangelo has concentrated on the heavy draperies, which he darkens by dense cross-hatching. The jutting chin and strong gesture of Saint Peter emphasize his anger at having to pay a tax.

According to Vasari and other contemporary accounts, Michelangelo regularly drew Masaccio's frescoes in the Brancacci Chapel. At one point, Michelangelo was sarcastic about a drawing by his fellow art student Torrigiano. In retaliation, Torrigiano punched Michelangelo, breaking and permanently flattening his nose.

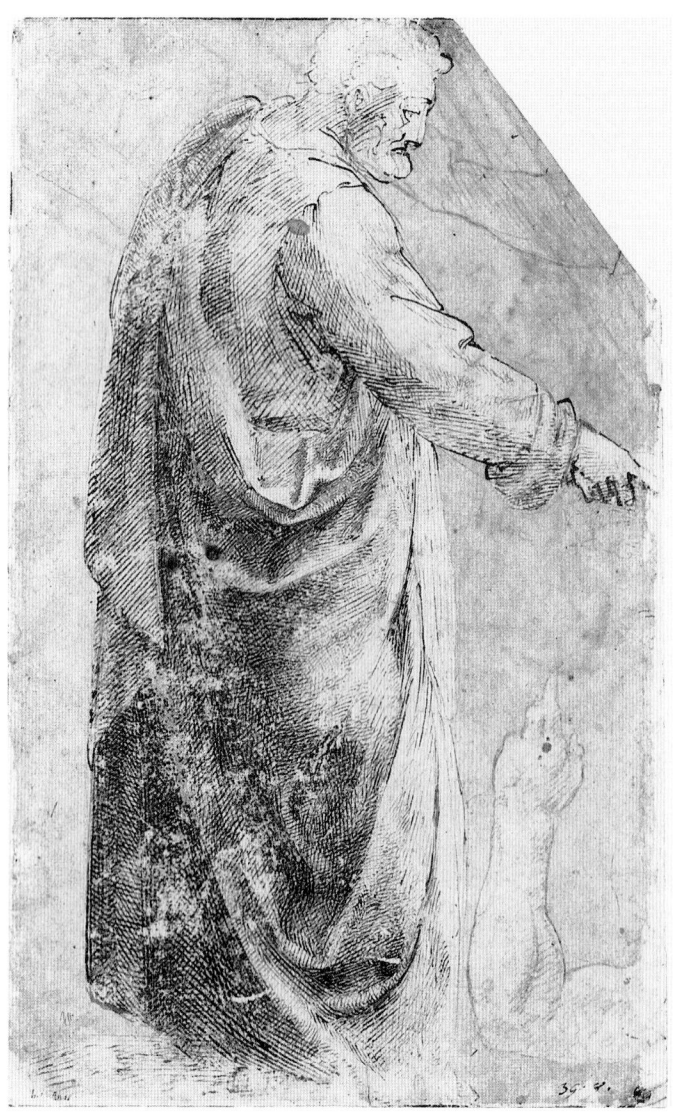

14.17 Michelangelo, copy of Masaccio's Saint Peter in the *Tribute Money* (see fig. 13.23), 1489–1490. Pen drawing; 12½ × 7¾ in. (31.7 × 19.7 cm). Graphische Sammlung, Munich.

─── **CONNECTIONS** ───

See figure 13.23. Masaccio, *Saint Peter*, 1420s.

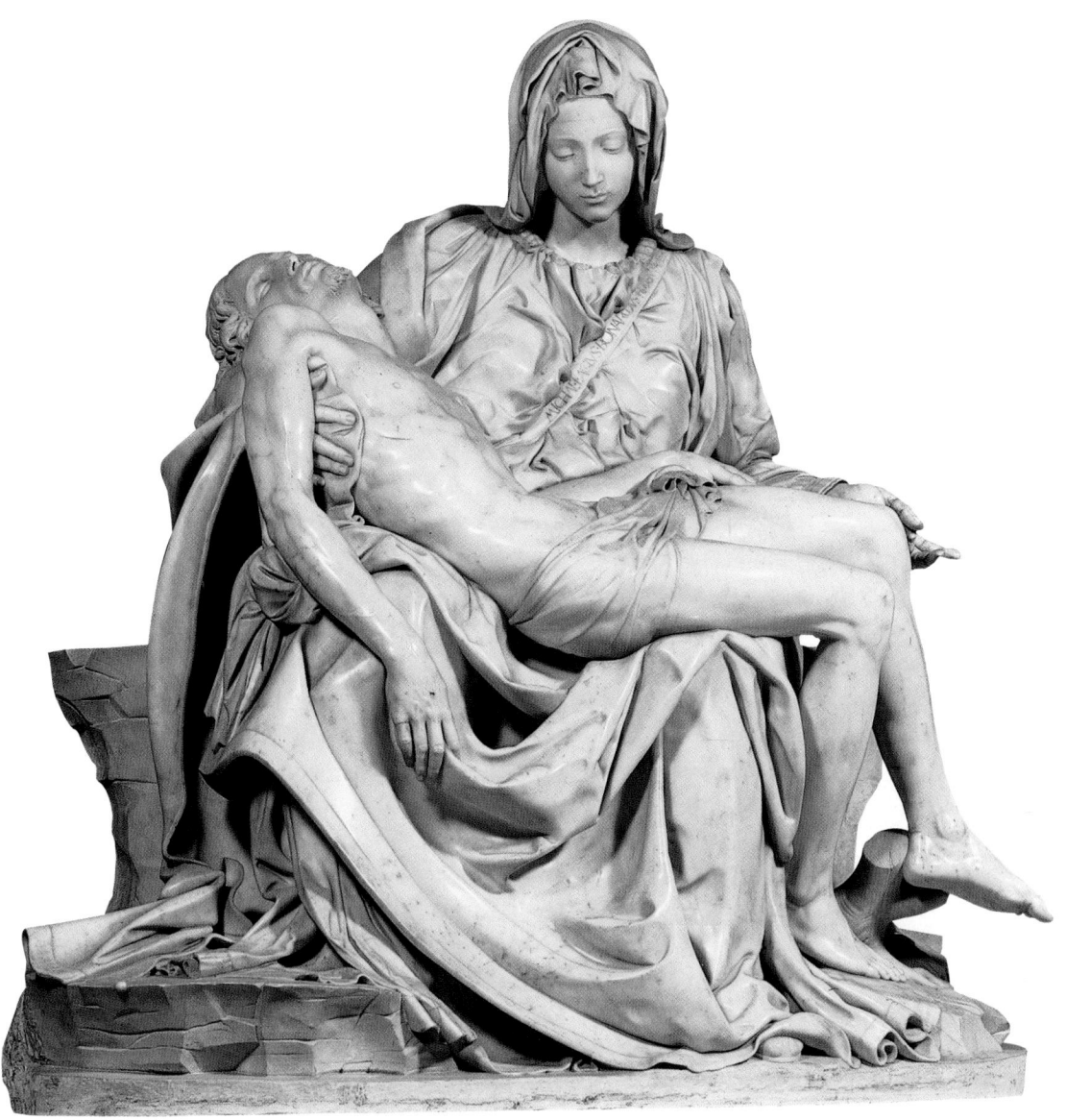

14.18 Michelangelo, *Pietà*, 1498/9–1500. Marble; 5 ft. 8½ in. (1.74 m) high. Saint Peter's, Vatican, Rome.

Early Sculpture Michelangelo's first great work of sculpture is the marble *Pietà* of 1498–1500 (fig. **14.18**), now in Saint Peter's, which he carved in Rome for the tomb chapel of a French cardinal. A youthful Mary mourns the dead Christ, and both are contained within a pyramidal space on an oval base.

Mary and Christ are formally and psychologically interrelated so that one hardly notices Christ's relatively small size compared with Mary's massive form. The zigzag of Christ's body blends harmoniously with Mary's legs and voluminous drapery folds. Mary's left hand repeats the movement of Christ's left leg. She inclines her head forward as Christ's tilts back, and the slow curve of her drapery on the left is repeated by Christ's limp right arm. His right hand falls so that his fingers enclose and continue the prominent drapery curve between Mary's

legs. In addition to the formal rhythms uniting Mary and Christ, Michelangelo makes them appear to be about the same age. He thus creates a powerful emotional and formal bond between mother and son, who, though separated by death, will eventually be reunited, in Christian tradition, as King and Queen of Heaven. According to one report, when Michelangelo was asked about the age of the Virgin, he replied that her youthfulness was the result of her chaste character.

Michelangelo's favorite material was marble, and he spent much time in the quarries selecting the right stone for his sculptures. The *Pietà* is his only signed work. Its signature, carved in the band across Mary's chest, may be related to Michelangelo's comment—cited by Vasari—that he imbibed the hammer and chisels of his trade with the milk of his wet nurse (the wife of a stonecutter).

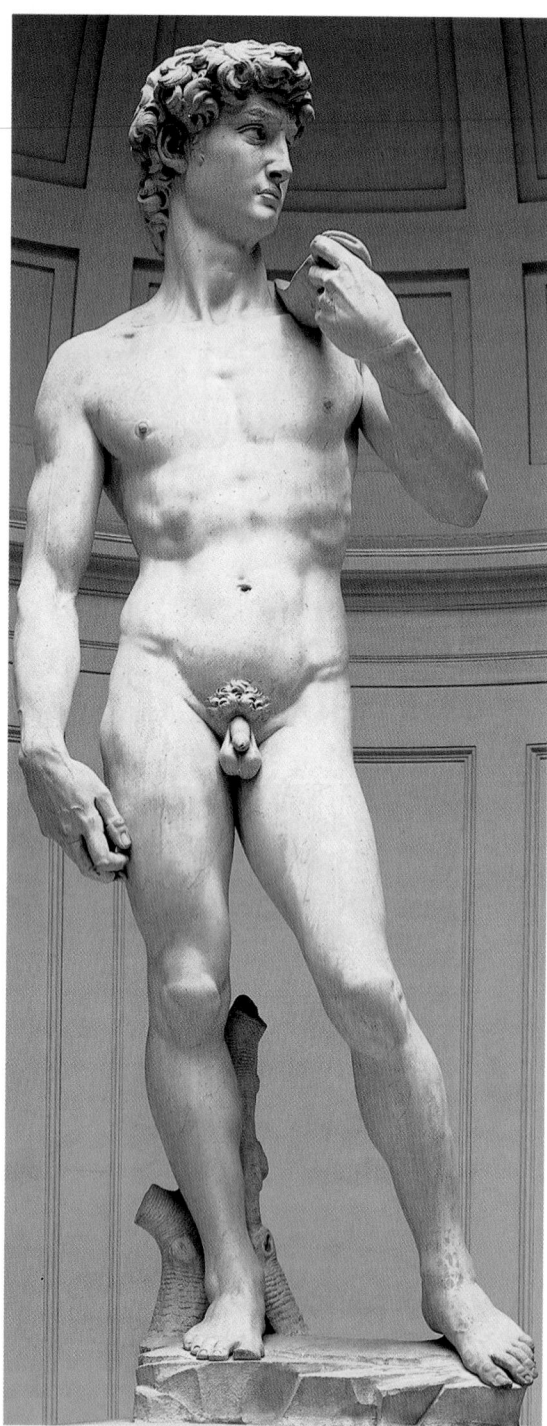

14.19 Michelangelo, *David*, 1501–1504. Marble; approx. 14 ft. (4.27 m) high. Galleria dell'Accademia, Florence.

In 1501, Florence commissioned a marble statue of David (fig. **14.19**), the symbol of Florentine republicanism. For three years Michelangelo worked secretly on a huge and difficult block of marble over 14 feet (4.27 m) high. Originally destined for the exterior of the cathedral, the *David* was placed in 1504 in front of the Palazzo Vecchio (the gov-

─────────── **CONNECTIONS** ───────────

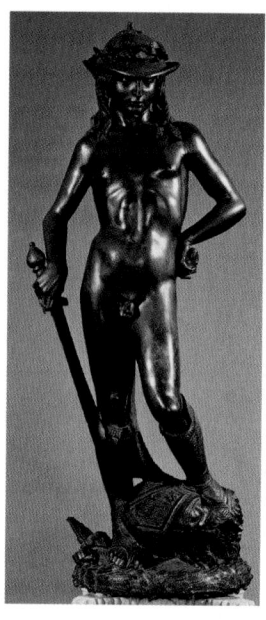

See figure 13.29. Donatello, *David*, c. 1430–1440.

ernment seat of Florence)—a more suitable location for a political sculpture. In 1873, the original was removed to the Accademia and a copy was put in its earlier place.

The little tree trunk supporting the *David* is a reminder of the ancient Roman copies of Greek statuary and evokes the Classical past. Although both Michelangelo's *David* and Donatello's (see fig. 13.29) assume a *contrapposto* pose, the latter is relaxed whereas Michelangelo's is tense and watchful. He is represented at a moment before the battle and so does not stand on the head of the slain Goliath. His creased forehead and strained neck and torso muscles betray apprehension as he sights his adversary. Michelangelo's *David* was the most monumental marble nude since antiquity, its proportions corresponding more to Hellenistic than to Classical style. David's hands, in particular, are large in relation to his overall size, and his veins and muscles seem to bulge from beneath his skin.

Sistine Chapel Frescoes About four years after Michelangelo completed the *David,* he was commissioned by Pope Julius II to paint the ceiling of the Sistine Chapel in the Vatican (fig. **14.20**). The side walls had already been painted by fifteenth-century artists according to typological pairing, with Old and New Testament scenes on the

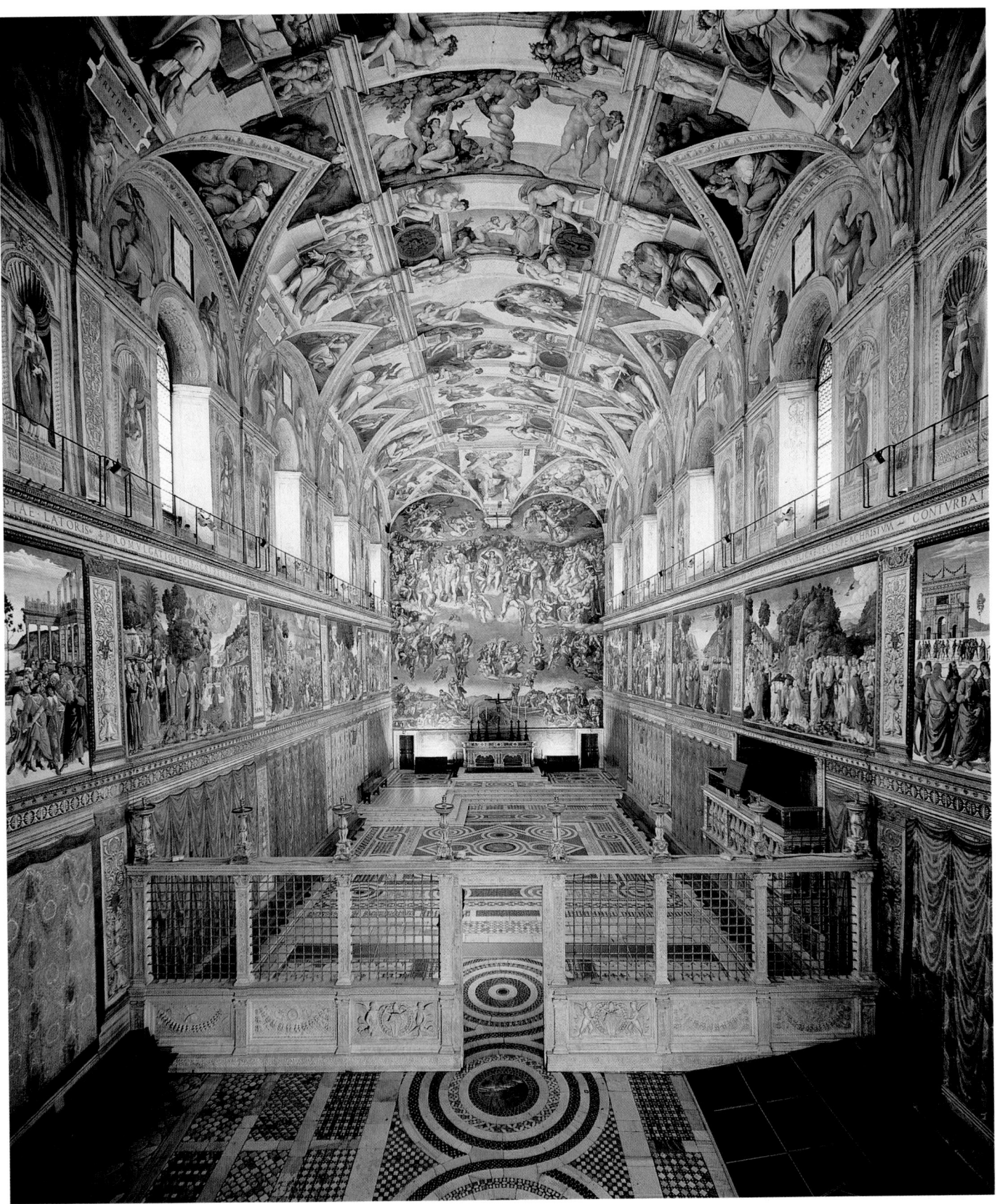

14.20 Michelangelo, Sistine Chapel, Vatican, Rome, 1508–1512. This was the pope's personal chapel and the site of the conclave that elects new popes. Its proportions are exactly those of the Temple of Solomon as they are described in the Bible—twice as long as it is high and three times as long as it is wide. It was built in the 1470s by Pope Sixtus IV, after whom it is named. Sixtus was the uncle of Julius II, both members of the Della Rovere family. Vasari believed that giving Michelangelo this commission was a plot engineered by Bramante to divert him from sculpture. Michelangelo accused Bramante of having let his rival, Raphael, into the chapel before the frescoes were finished. The purpose, according to Michelangelo, was so that Raphael could steal his style.

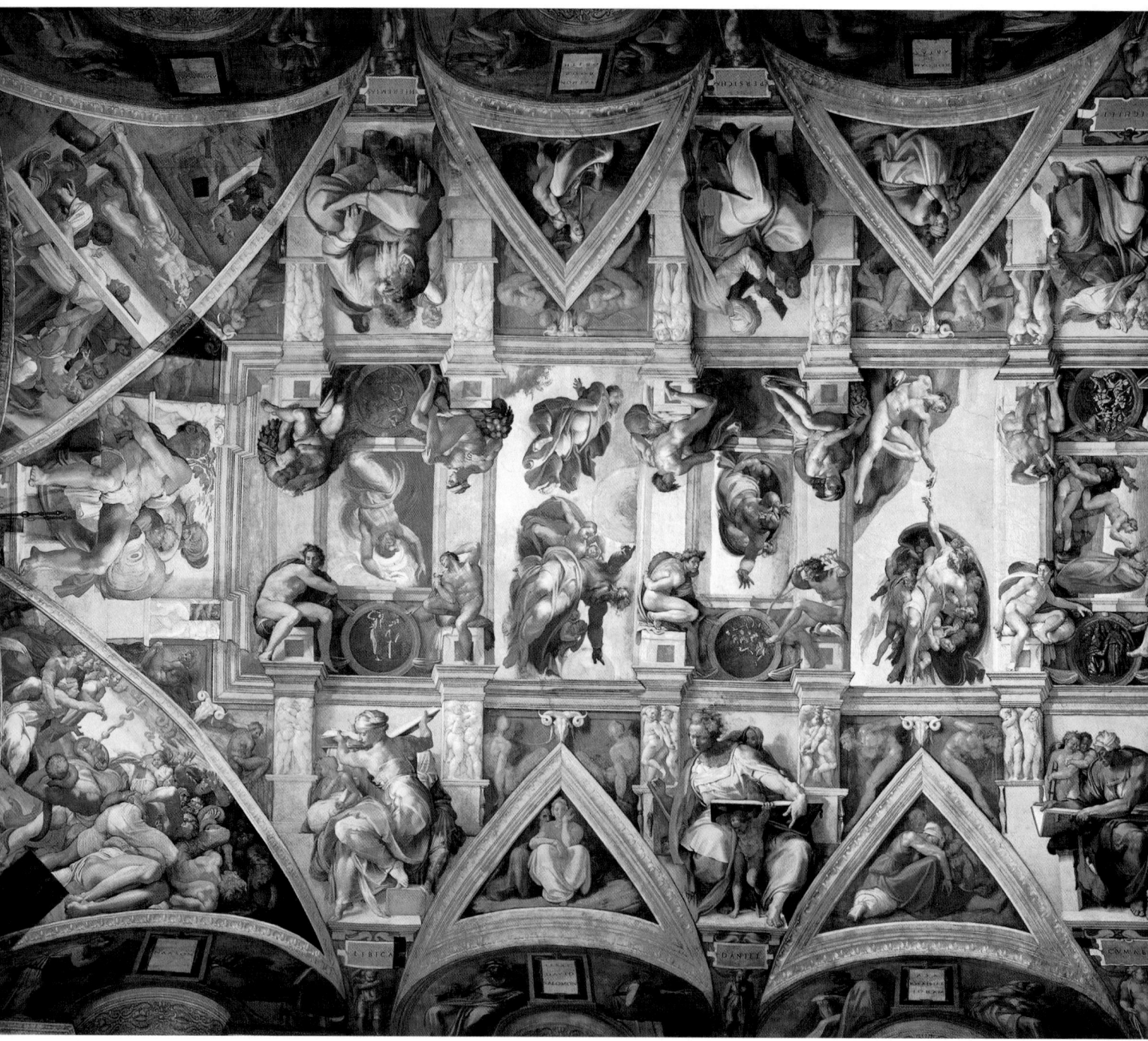

14.21 Michelangelo, ceiling of the Sistine Chapel, Vatican, Rome (after cleaning), 1508–1512. Fresco; 5,800 sq. ft. (538.84 m²).

left and right, respectively. Michelangelo was initially reluctant to undertake the project. He finally agreed, however, designed the scaffold himself, and worked on the ceiling and the window lunettes from 1508 to 1512. Michelangelo's description of the work dwells on the physical discomfort of having to contort his body in order to paint the ceiling. Over twenty years later, from 1536 to 1541, he painted the *Last Judgment* on the altar wall (see fig. 14.27).

Figure **14.21** is a view of the frescoed ceiling from below. The nine main narrative scenes occupy the center of the vault. The first three scenes represent God's creation of the universe; the second three, Adam and Eve; and the last

three, Noah and the Flood. Each small scene is surrounded by four nudes (called *ignudi*) in a variety of poses. In each corner of the ceiling, the **spandrels** (curved triangular sections) contain an additional Old Testament scene. The spandrels and lunettes above the windows depict the ancestors of Christ. Alternating with the lunettes are Old Testament prophets and sibyls.

Michelangelo painted the scenes in reverse chronological order, ending with the three creation scenes, in which God designs the universe. The Adam and Eve scenes depict the Creation and Fall of Man, while the Noah scenes show both God's destructive power and his willingness to save humanity from total annihilation. When viewers stand

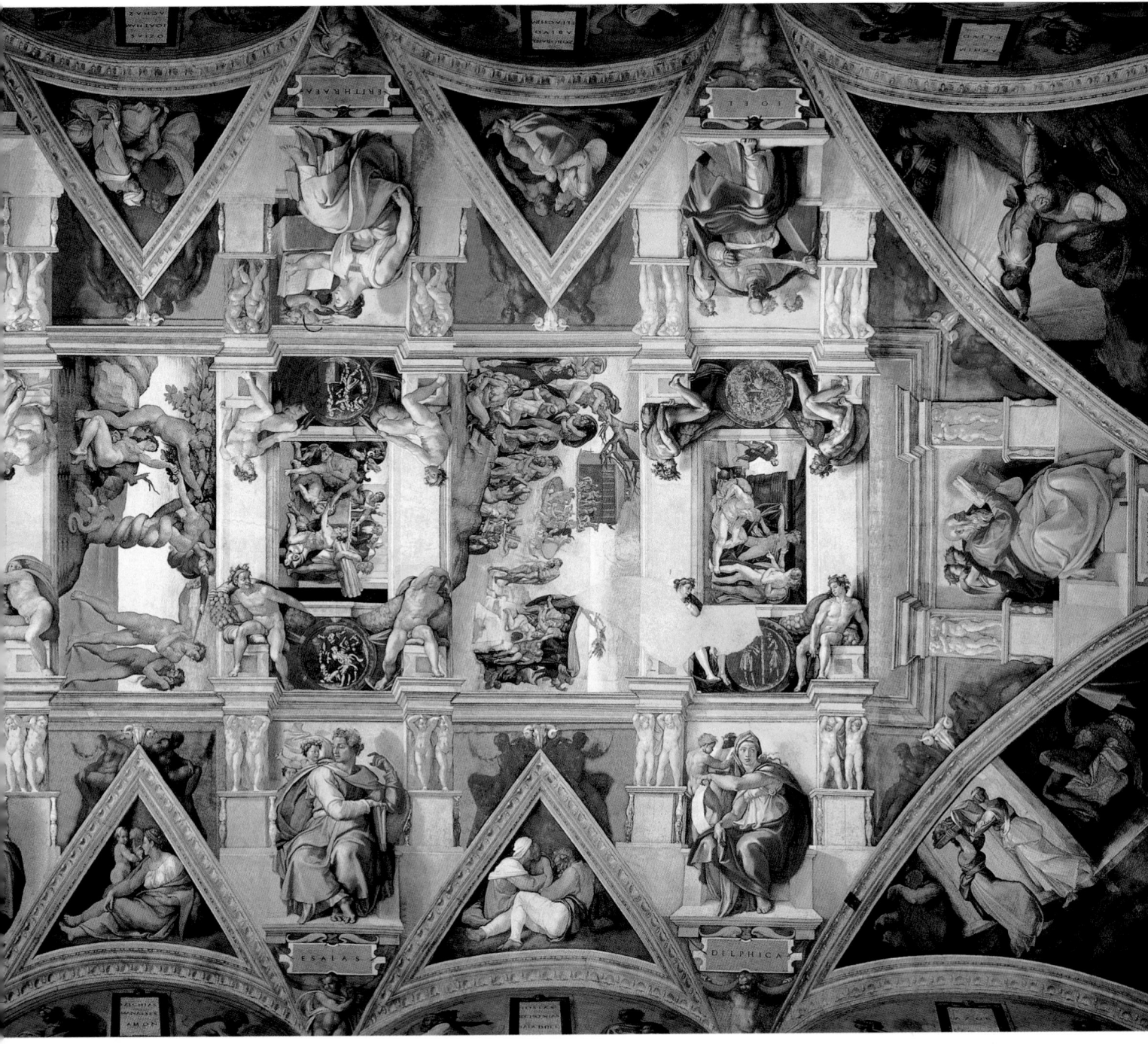

at the entrance opposite the altar wall, the ceiling scenes appear right side up and are read beginning with the earliest creation scene at the greatest distance.

Although none of the figures or scenes on the Sistine ceiling is from the New Testament, they nevertheless have a typological intent, all referring in some way to the Christian future. The Old Testament prophets and the sibyls of antiquity, who are portrayed between the window spandrels, were viewed as having foretold the coming of Christ. The inclusion of Christ's ancestors in the spandrels and lunettes above the windows alludes to the divine plan, in which Christ and Mary redeem the sins of Adam and Eve.

In the *Creation of Adam* (figs. 14.22 and 14.23; see box),

a monumental, patriarchal God extends dramatically across the picture plane. He is framed by a sweeping dark-red cloak containing a crowd of nude figures, including a woman (identified by some scholars as Eve), who looks expectantly over his left shoulder. In contrast to the vibrant energy of God, Adam reclines languidly on the newly created earth, for he has not yet received the spark of life from God's touch. Michelangelo's interest in landscape was minimal compared to his emphasis on the power inherent in the human body, especially the torso. Whether clothed or nude, Michelangelo's muscular figures, rendered in exaggerated *contrapposto,* are among the most monumental images in Western art.

The Restoration Controversy

In 1980, a controversial restoration of the Sistine Chapel frescoes was begun. The results have stirred up a vigorous debate among scholars about the practice of restoration in general and the effects on the Sistine ceiling in particular. The cleaning has revealed a range of **pastel** colors that have been described by its supporters as radiant and dazzling. Other scholars and even some restorers contend that the cleaning was too radical, that a layer of size applied by Michelangelo was removed, that untried solvents were used, and that the treated frescoes will prove to have been damaged beyond repair. The juxtaposition of the two versions shows the difference between the *Creation of Adam* before (fig. **14.22**) and after (fig. **14.23**) restoration.

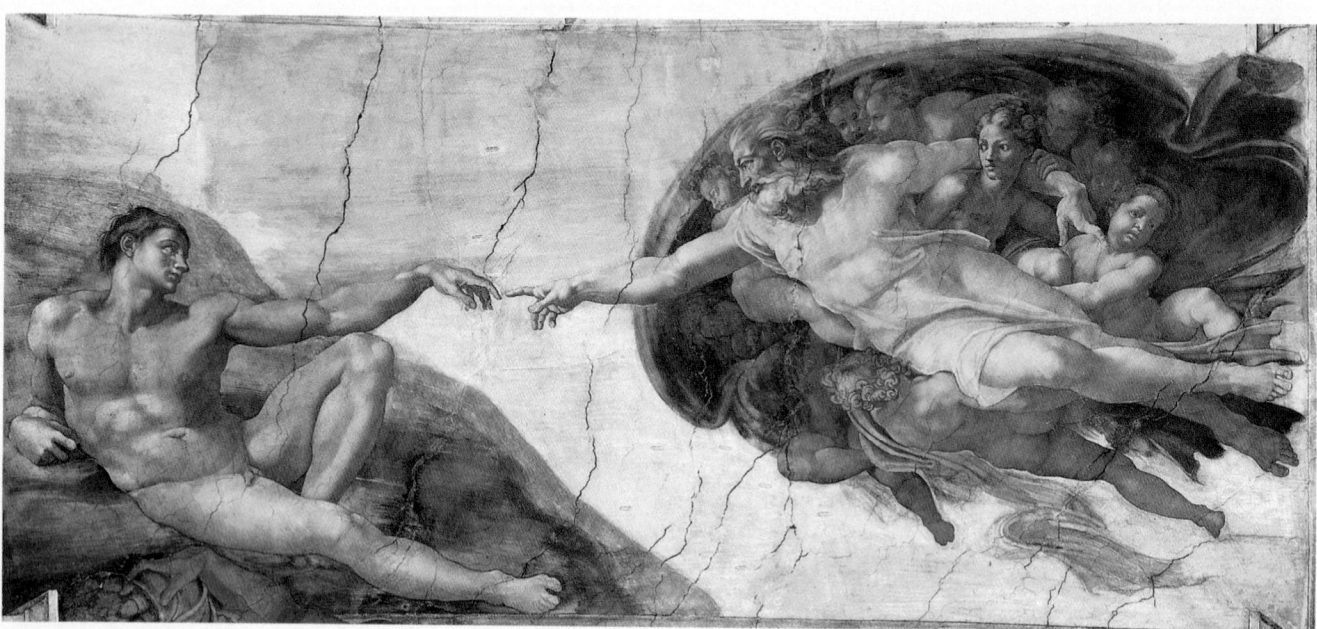

14.22 Michelangelo, *Creation of Adam* (before cleaning, detail of fig. 14.21), c. 1510.

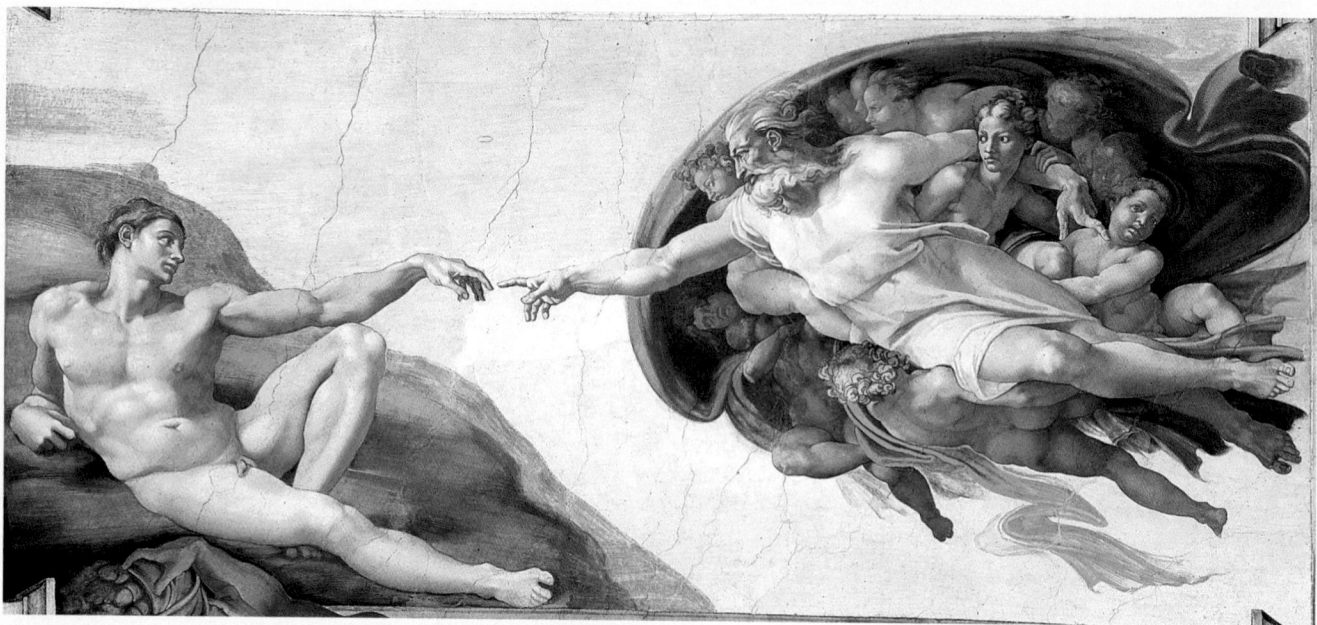

14.23 Michelangelo, *Creation of Adam* (after cleaning, 1989).

The *Fall of Man* (fig. **14.24**), which combines the *Temptation* on the left with the *Expulsion* on the right, is clearly influenced by Masaccio, in particular by his *Expulsion from Eden* in the Brancacci Chapel (see fig. 13.24). Michelangelo follows Masaccio in painting the primal couple as powerful nudes, although with less Classical restraint. In the *Temptation,* Michelangelo represents Eve twisting around to take the forbidden fruit from a coiled, human-torsoed serpent. Adam's massive form looms over Eve as he reaches up in an ambivalent gesture that simultaneously echoes and opposes the outstretched arm of the serpent. To the right of the tree, in the *Expulsion,* an angry, foreshortened angel stabs at the back of Adam's neck as he expels the sinners from paradise. Adam protests, a pained expression on his face, as he tries to repel the attack. Eve cowers at the far right, slinking away from the avenging angel and turning back, as if to avoid facing her future.

The centrality of the tree in this fresco is both a formal division between the scenes and a symbolic reference to the Crucifixion of Jesus. Formally, the long, curved branch on the viewer's left is paralleled by the curve of the angel's extended arm. The tree is a fig tree, associated in antiquity with fertility. But the leaves that we see above the angel's arm are oak leaves, which were emblems of the Della Rovere family. In that motif, Michelangelo reminds views that his patron, Julius II, was a Della Rovere pope.

CONNECTIONS

See figure 13.24. Masaccio, *Expulsion from Eden,* 1420s.

In the brooding figure of the prophet Jeremiah (fig. **14.25**), Michelangelo has created one of the most powerful images of inner absorption and melancholy in Western painting. Jeremiah's massive form hunches over, his chin resting on his hand, and he barely seems contained within the painted space. Located beneath the first creation scene, Jeremiah occupies an illusionistic marble bench between two pairs of caryatids in the form of *putti.*

14.24 Michelangelo, *Fall of Man* (detail of fig. 14.21), 1510.

14.25 Michelangelo, *Jeremiah* (detail of fig. 14.21). Jeremiah was a 7th-century-B.C. Hebrew prophet known for his pessimistic despair over the fortunes of the kingdom of Judah. The word *jeremiad*, meaning a "lamentation" or "doleful complaint," comes from his name. Here Jeremiah laments the destruction of Jerusalem. When Michelangelo painted the ceiling, the Old Testament book of Lamentations was attributed to Jeremiah, although now there are doubts about his authorship.

Late Style When Michelangelo had completed the Sistine ceiling, he returned to Florence and worked for the Medici family. One of his most original architectural designs executed in Florence was the 35-foot (10.67 m) square vestibule of the Laurentian Library (fig. **14.26**), which he began in 1524. The library contained the Medici manuscript collection, which the Medici pope Clement VII wished to make available to the public. The view shown here gives some indication of Michelangelo's dramatic departure from Classical forms in creating a new, sculptural approach to architecture.

The curved steps of the triple staircase seem to tumble from the doorway in two stages. The top steps break suddenly, and the banister curves outward into a broad scroll shape. Then the steps continue downward, ending in large oval platforms. Thick balusters separate the curved central steps from the rectangular steps on either side of them. The latter are open, having no framing banister, and thus add to the sense of dynamic spatial movement.

In the walls, Michelangelo has avoided the impression of logical supporting elements that characterized the buildings

14.26 Michelangelo, view of the Laurentian library vestibule and staircase, 1524–1559. San Lorenzo, Florence.

of Alberti and other fifteenth-century architects. Michelangelo uses different colored stone to accent architectural spaces and divides the wall into two levels. Thick Doric columns on the upper level frame niches crowned with round and triangular pediments. Note that the pediment over the door is broken at the base (called a **broken pediment**), which later became a feature of Baroque architecture (see Chapter 17). At the bottom of each niche, brackets project downward from the pilasters; similarly, large scrolls are suspended below the Doric columns. These "hanging" elements do not create an impression of structural logic, but instead animate the space and seem related to the Mannerist style evolving at the time (see Chapter 15).

In 1534, on the order of Pope Paul III, Michelangelo again went to Rome and began the *Last Judgment,* on the altar wall of the Sistine Chapel (fig. **14.27**). There has been a great deal of discussion about Michelangelo's late style. Some scholars consider it to mark the close of the Renaissance, while others prefer to see it as part of new Mannerist developments. Both views contain some truth since Mannerist trends, which reflect certain characteristics of Michelangelo's late style, were well under way by the mid-sixteenth century. Nevertheless, the *Last Judgment* is considered here within the context of Michelangelo's style as it developed beyond the High Renaissance.

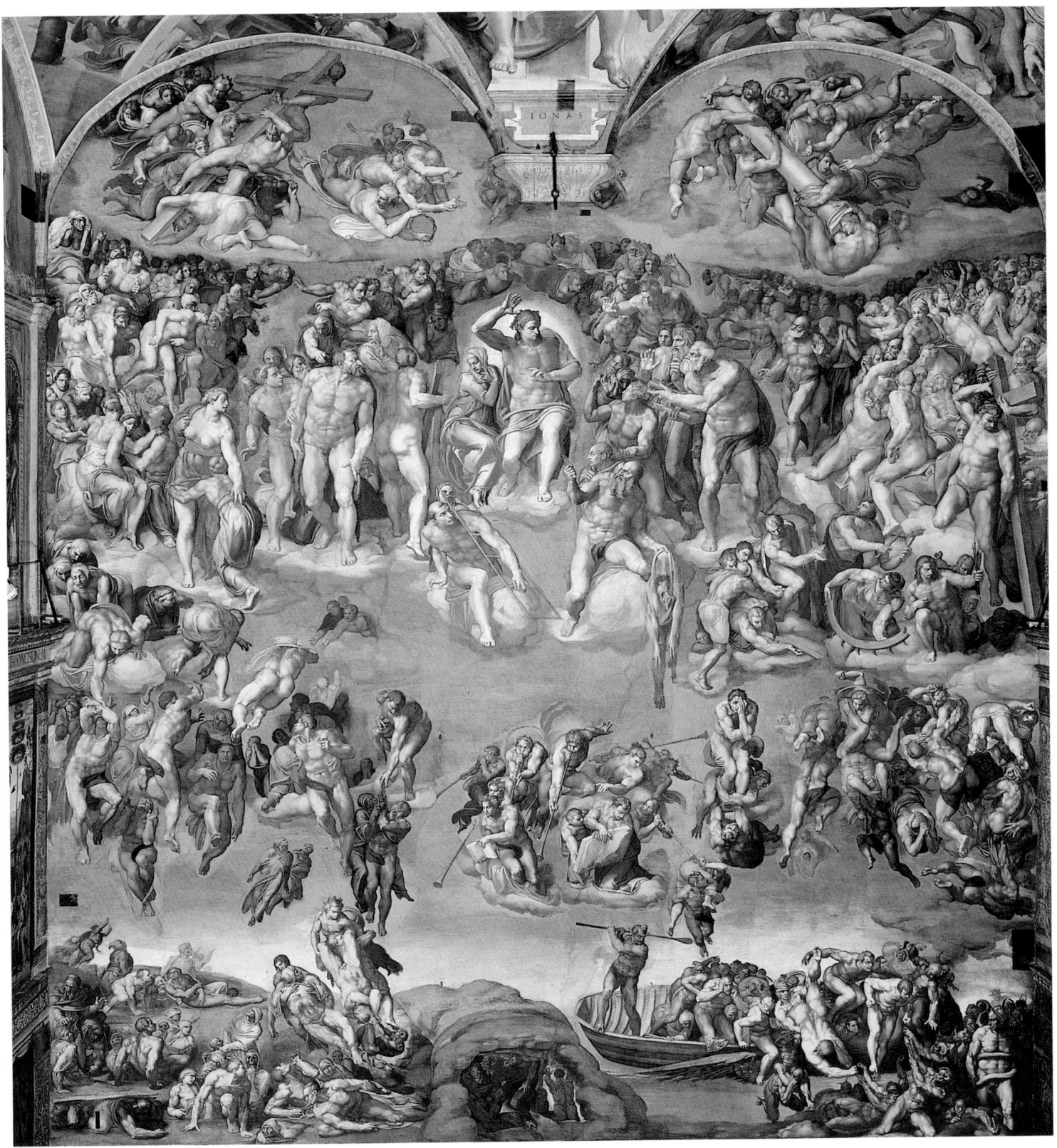

14.27 Michelangelo, *Last Judgment* (after cleaning), fresco on the altar wall of the Sistine Chapel, Vatican, Rome, 1534–1541. Commissioned in 1534, the *Last Judgment* was completed in 1541, when Michelangelo was sixty-six. The effect on contemporary viewers was strong—and not always favorable. During Michelangelo's lifetime, Pope Paul IV wanted to erase it, and, after Michelangelo's death, loincloths and draperies were painted over the nude figures. Many of these have been removed in the recent cleaning.

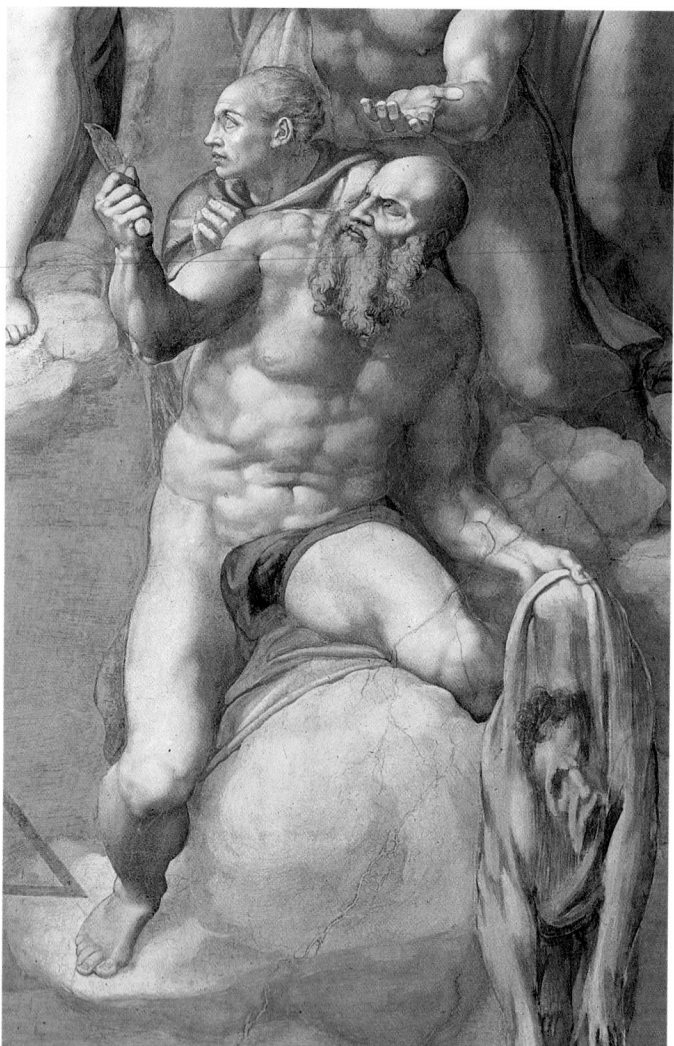

14.28 Michelangelo, *Saint Bartholomew with flayed skin* (detail of fig. 14.27).

Judgment, which, except for hell, is orderly, restrained, and clear, Michelangelo's is filled with overlapping figures whose twisted poses, radical *contrapposto,* and sharp foreshortening energize the surface of the wall. In Giotto's conception, actual tortures are confined to hell. In Michelangelo's, tortuous movement pervades the whole work. That this mood reflects the artist himself, as well as the troubled times, is evident in the detail of Saint Bartholomew (fig. **14.28**), the Christian martyr who was flayed alive. He brandishes a knife and displays a flayed skin containing Michelangelo's self-portrait.

Michelangelo's tension is also evident in the unfinished *Rondanini Pietà* (fig. **14.29**) in Milan. Michelangelo worked on this sculpture until six days before his death. The long, thin forms are strikingly distinct from the powerful, muscular, and energetic figures of his earlier style. These figures have lost their boundaries—their merger is psychological as well as formal. Michelangelo's anxiety about completing this sculpture is revealed in his working and reworking, and in leaving the figures of Mary and Jesus unfinished. The *Pietà* seems to have reflected Michelangelo's sense of his approaching death and his identification with the suffering of Jesus. It also seems likely that, as with Donatello and Botticelli, Michelangelo's late style shows a different attitude toward the content of his works than that seen earlier in his career.

14.29
Michelangelo,
Rondanini Pietà,
c. 1555–1564.
Marble; 6 ft. 5½ in.
(1.97 m) high.
Castello Sforzesco,
Milan.

The picture is divided horizontally into three levels, which correspond roughly to three planes of existence. At the top is heaven; in the lunettes, angels carry the instruments of the Passion—the crown of thorns, the column of the Flagellation, and the Cross. In the center, below the lunettes, Christ is surrounded by a glow of light. He raises his hand and turns toward the damned. Mary crouches beneath his upraised right arm, and crowds of saints and martyrs twist and turn in space, exhibiting the instruments of their martyrdom. In the middle level, at the sound of the Last Trump (blown by angels in the lower center), saved souls ascend toward heaven on Christ's right (our left), while the damned descend into hell on Christ's left. At the lowest level, the saved climb from their graves and are separated from the scene of hell on the lower right by a rocky river bank.

Michelangelo's hell is a new conception in Christian art. Unlike the medieval hell of Giotto's Arena Chapel (see fig. 12.10), Michelangelo's draws on Classical imagery. The boatman of Greek mythology, Charon, ferries the damned across the River Styx into Hades. At the far right corner, a monstrous figure of Minos has replaced Satan and is entwined by a giant serpent. In contrast to Giotto's *Last*

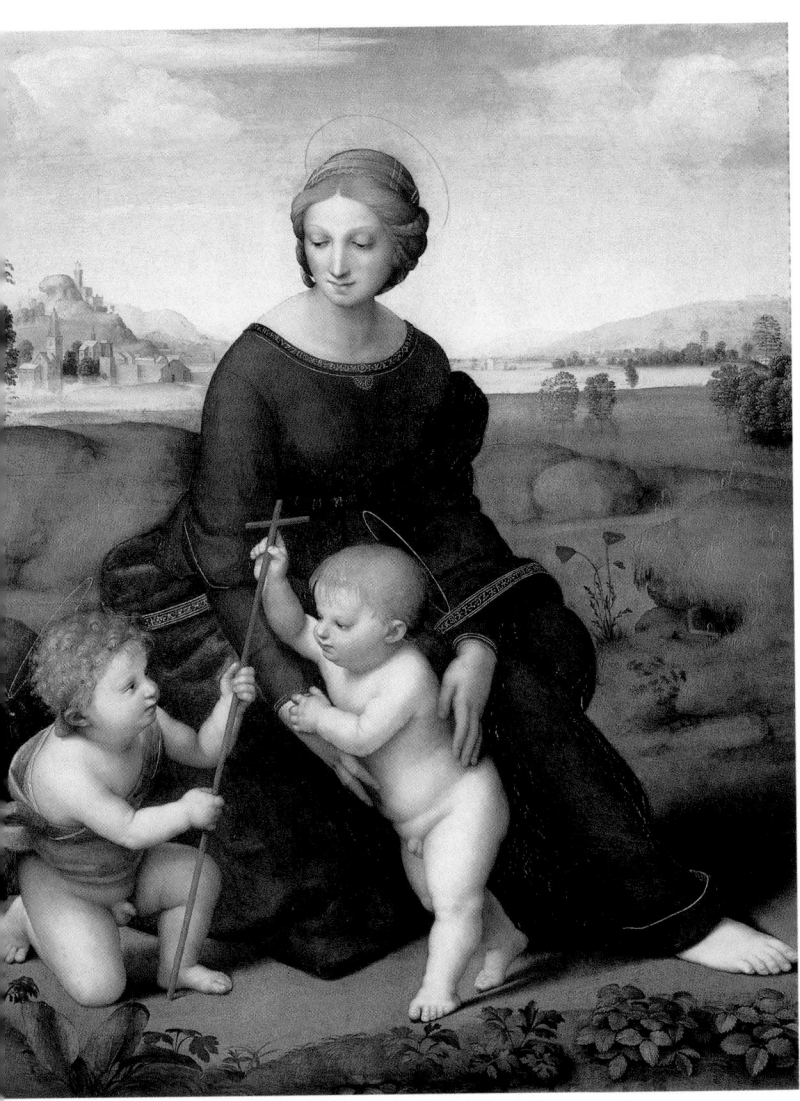

14.30 Raphael, *Madonna of the Meadow*, 1505. Oil on panel; 3 ft. 8½ in. × 2 ft. 10¼ in. (1.13 × 0.87 m). Kunsthistorisches Museum, Vienna.

sacrifice of her son. In contrast to the ambiguities of Leonardo's iconography and the contorted, anxious figures of Michelangelo, Raphael's style is calm, harmonious, and restrained.

At the age of twenty-four or twenty-five, Raphael went to Rome, where, in addition to religious works, he painted portraits and mythological pictures. His patrons were among the political, social, and financial leaders of the High Renaissance. Around 1511–1512, he painted a portrait of Julius II (fig. **14.31**). He conveys the pope's personality, emphasizing the dark eye sockets and the right cheek, which appear recessed. The forehead is highlighted, and the texture of the cap resembles dark-red felt. The result shows a man of about seventy, dressed in everyday (rather than ceremonial) official garb. Raphael has captured a sense of Julius II's intellect and his capacity for deep introspection. The pope's portrait is a psychological portrayal rather than a conventional icon of power. Its oblique position and three-quarter-length view became typical of portraiture throughout the High Renaissance.

Raphael

Raphael (Raffaello Sanzio) was born eight years after Michelangelo but died forty-four years before him. During his short life, he came to embody the Classical character of High Renaissance style. He assimilated the forms and philosophy of Classical antiquity and hired scholars to translate Greek and Roman texts. Prolific and influential, he was primarily a painter, although it is clear from his appointment as overseer of the New Saint Peter's that his skills included architecture.

Raphael grew up at the humanist Urbino court, where his father, Giovanni Santi, was the official court poet and painter. At the age of eleven or later, he was apprenticed to Perugino, then the leading painter in Umbria. At the beginning of his independent career, Raphael worked in Florence, where he painted many versions of the Virgin and Child. The *Madonna of the Meadow* of 1505 (fig. **14.30**) is a good example of his clear, straightforward, classicizing style. Figures are arranged in the pyramidal form favored by Leonardo, though the landscape lacks the *sfumato* of Leonardo's mysterious backgrounds. Jesus stands in the security of Mary's embrace, while John the Baptist, his second cousin and playmate, hands Jesus the symbol of his earthly mission. Mary observes this exchange from above, recognizing that it means the future

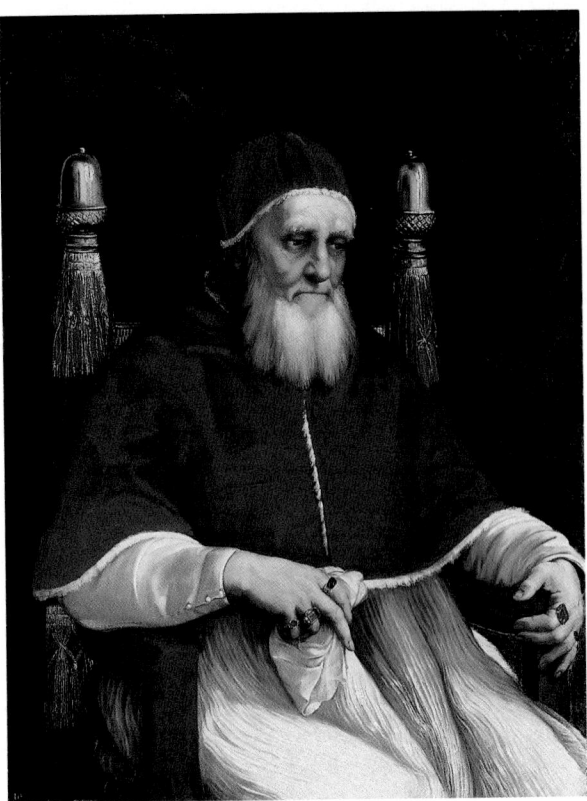

14.31 Raphael, *Pope Julius II*, 1511–1512. Oil on panel; 3 ft. 6½ in. × 2 ft. 7½ in. (1.08 × 0.80 m). Galleria degli Uffizi, Florence.

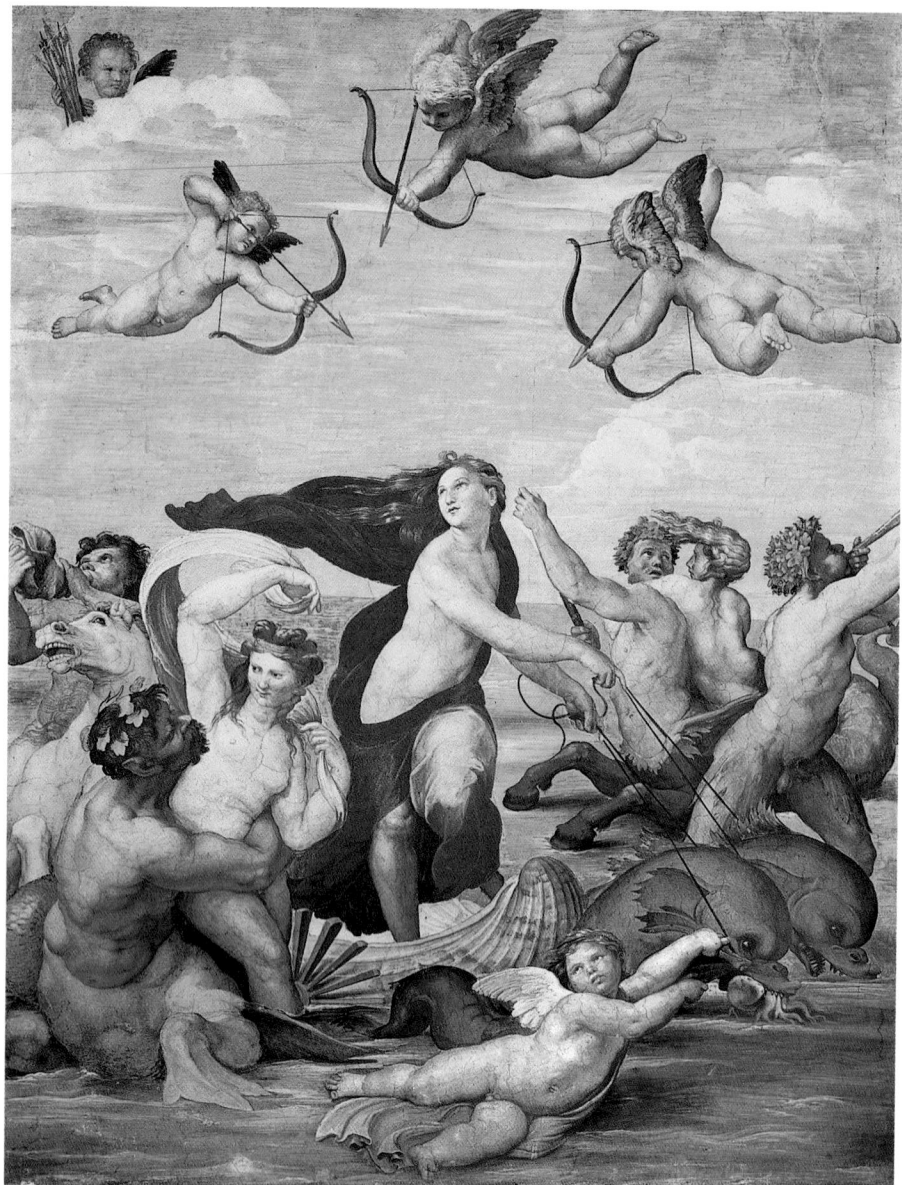

14.32 Raphael, *Galatea*, Villa Farnesina, Rome, c. 1512. Fresco; 9 ft. 8½ in. × 7 ft. 4 in. (2.96 × 2.24 m). After starting work on the *Galatea*, Raphael reportedly requested an additional payment beyond what had been agreed upon. When Chigi's accountants protested, Raphael produced Michelangelo as an expert witness on his behalf. Michelangelo said that *he* would charge 100 scudi per head. Chigi advised his accountants to pay, saying: "Be polite and keep him happy, because we'd be ruined if he made us pay for the draperies."

14.33 *Galatea* in situ, Grand Salon, Villa Farnesina, Rome. In 1514, Baldassare Castiglione, author of *The Courtier*, complimented Raphael on the *Galatea*. Raphael replied that "to paint a beautiful woman, I would need to see many. . . . [Without them] I use an idea." By "idea," Raphael meant the Platonic "idea," in the sense of an ideal, or perfect, model. He thus combined the Renaissance study of nature with the Neoplatonic ideal relating physical beauty to a corresponding state of the soul.

Julius II (1443–1513) was a forceful ruler and the greatest patron of his age. As pope, he restored the Papal States to a leading power in Italy. A fearless military leader, he drove out the French forces of Louis XII. He led a worldly life (he was the father of three illegitimate daughters) and had a reputation for being hot-tempered and *terribile* (awe-inspiring). The acorn motif on the pope's chair was an emblem of his family, the Della Rovere. Rings on six of his fingers confirm reports that Julius liked to spend money on jewels.

One of Raphael's most impressive mythological works is the fresco of *Galatea* (fig. **14.32**), commissioned by the banker Agostino Chigi for the grand salon of his villa, the Villa Farnesina, in Rome. Figure **14.33** shows the location of the work on the long wall of the salon, known as the Sala di Galatea. Unlike the calm Madonnas of his early

period and the introspection of the *Julius II,* Raphael's *Galatea* represents a pagan, amorous chase. Galatea flees from the Cyclops Polyphemos, who is depicted to the left on the same wall. The one-eyed giant of Greek myth has killed Galatea's lover, Acis, and now has designs on her. Galatea escapes in a seashell-chariot pulled by a pair of dolphins, one of whom bites a small octopus. Note that the octopus is a blue-gray color; this is based on a description by the classical author Aelian, who wrote *On Animals* around A.D. 200. Raphael's use of blue-gray to show that the octopus is dying indicates his familiarity with ancient Greek texts.

Galatea herself is in a state of panic as she turns and stares back at Polyphemos. Surrounding her are sea creatures engaged in erotic pursuits or blowing trumpets. Above, three Cupids aim their arrows at Galatea, while a fourth gazes down from a cloud in the upper left corner. Below, another Cupid desperately clings to one of the speeding dolphins. Although this is a classically balanced picture, with Galatea centrally positioned, the variety of poses, the strong diagonal planes, and the twisting, overlapping figures impart a sense of erotic excitement that reflects the narrative of the myth.

In 1508, the year of the contract for the Sistine Chapel ceiling, Julius II commissioned Raphael to decorate the Stanza della Segnatura, a room that was originally the pope's private library. Raphael's program was a monumental synthesis of the Christian world and its thought with Classical antiquity and its philosophy. The ceiling contained four tondos of allegories represented as females: *Theology, Poetry, Philosophy,* and *Jurisprudence.* On either side of the tondos, in each of the four corners, is a scene in a rectangular frame: the *Judgment of Solomon,* the *Temptation of Adam and Eve,* the *Mythical Musical Contest between Apollo and the Satyr Marsyas,* and the *Muse of Astronomy* (*Urania*) *Leaning over the Sphere of Universal Harmony.* Below each of the four allegories is a corresponding large, lunette-shaped fresco filled with life-sized figures: *Parnassus* under *Poetry,* the *Disputation over the Sacrament* under *Theology,* the *School of Athens* under *Philosophy,* and personifications of those Virtues necessary for the administration of justice under *Jurisprudence.*

We will consider two of the lunettes—the *Disputation over the Sacrament,* known as the *Disputa* (fig. **14.34**), and the *School of Athens* (fig. **14.35**). The *Disputa* is a thoroughly Christian painting that represents theologians discoursing

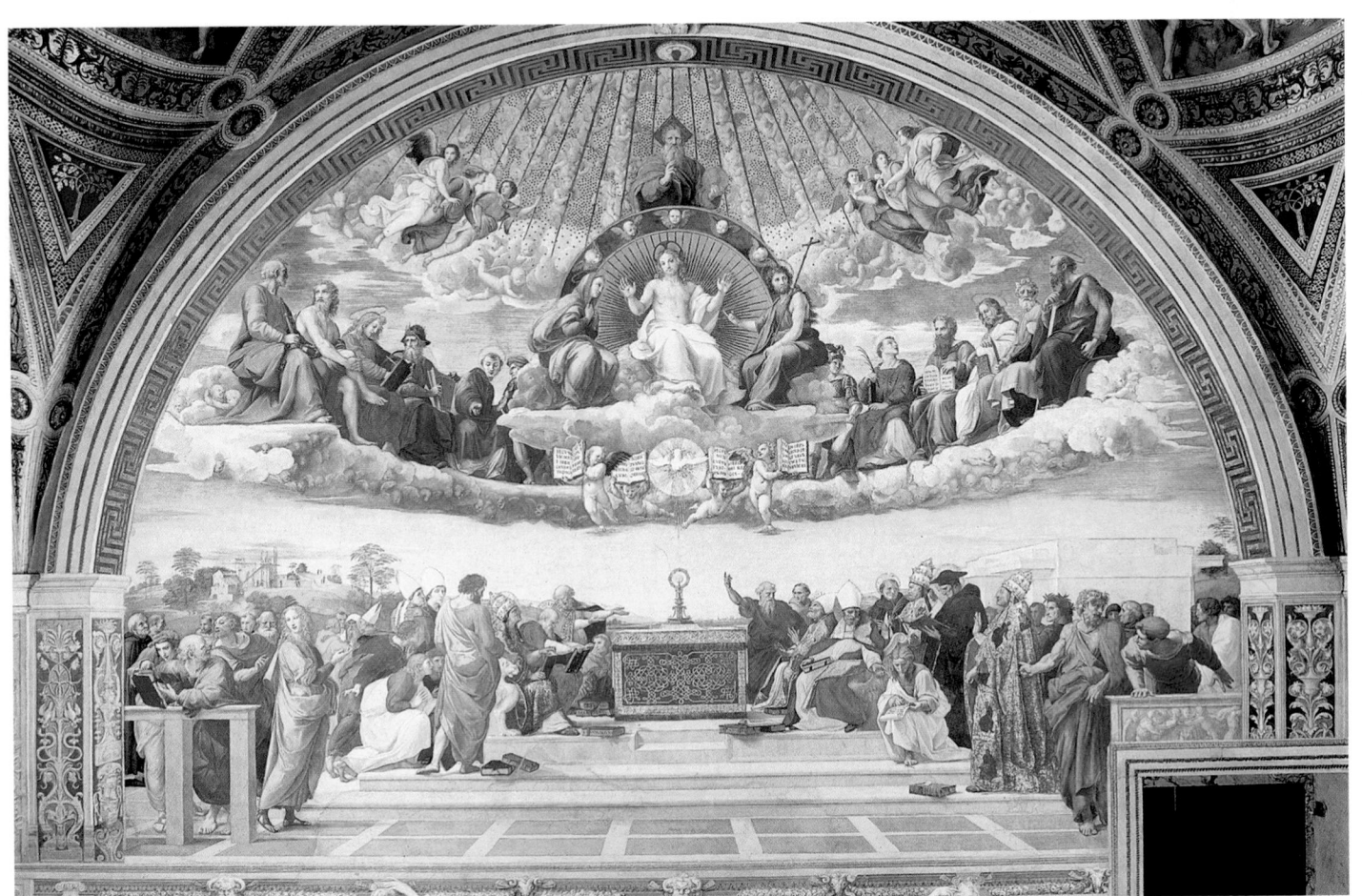

14.34 Raphael, *Disputation over the Sacrament,* Stanza della Segnatura, Vatican, Rome, 1509–1511. Fresco; 26 × 18 ft. (7.92 × 5.49 m).

on the validity of Transubstantiation (the literal transformation of the wine and wafer into the blood and body of Christ) celebrated in the Eucharist. In Raphael's fresco, the wafer in which Christ is believed to be embodied is enclosed by the ring of a monstrance (the vessel containing the host, or wafer). The monstrance, which is the location of the vanishing point, stands on the altar at the center of the picture. The Eucharist is thus its formal and theological center, suggesting that Julius II was especially devoted to the Eucharist. Further, in providing a visual link between the earthly and heavenly planes of existence, the image of the monstrance is a metaphor for its function in the liturgy of the Eucharist, which is to merge the worshiper with Christ.

As depicted by Raphael, the material world is the world of perspective, distant landscape and architecture, and figures that obey the laws of gravity. Saints Jerome and Gregory the Great are to the left of the altar, and to the right are Saints Ambrose and Augustine. Together with these four doctors of the Church are other saints and popes, including Pope Sixtus IV (the uncle of Julius II), who stands at the right, wearing a gold robe and papal tiara. Dante, with a laurel wreath, is just behind him. Leaning on the railing at the left is Bramante, Raphael's mentor, who was still alive at the time the fresco was painted.

The heavenly host occupies the upper half of the lunette. Old Testament figures alternating with saints are seated on a semicircular cloud formation, and angels are suspended in midair. At the center sits Christ, flanked by Mary and John the Baptist (the *Deësis*). God appears above Christ, and the Holy Spirit is below him.

Raphael's geometric unity in the *Disputa* is tightly organized, and this contributes to its clarity. On the earthly level, the rectangular altar echoes the grid pattern of the floor. The alignment of the figures, despite considerable variety of pose, conforms to the planes of the orthogonals, and the horizontal floor plan conforms to the lower frame. The upper, heavenly portion of the fresco is governed by curves and circles (divine shapes). Below, only the gold ring of the monstrance and wafer within it form perfect circles. Echoing these are the gold circles surrounding the Holy Spirit and Christ. Two concentric semicircles of clouds cut through the curve of the lunette in a reverse direction, one supporting the seated figures, the other framing the lower section of heavenly light surrounding God the Father. The Eucharist is the smaller, earthly part of a vertically aligned hierarchy of circles; at the top is the heavenly circle of gold light.

Directly across the Stanza from the *Disputa* is Raphael's monumental *School of Athens* (fig. 14.35), which epito-

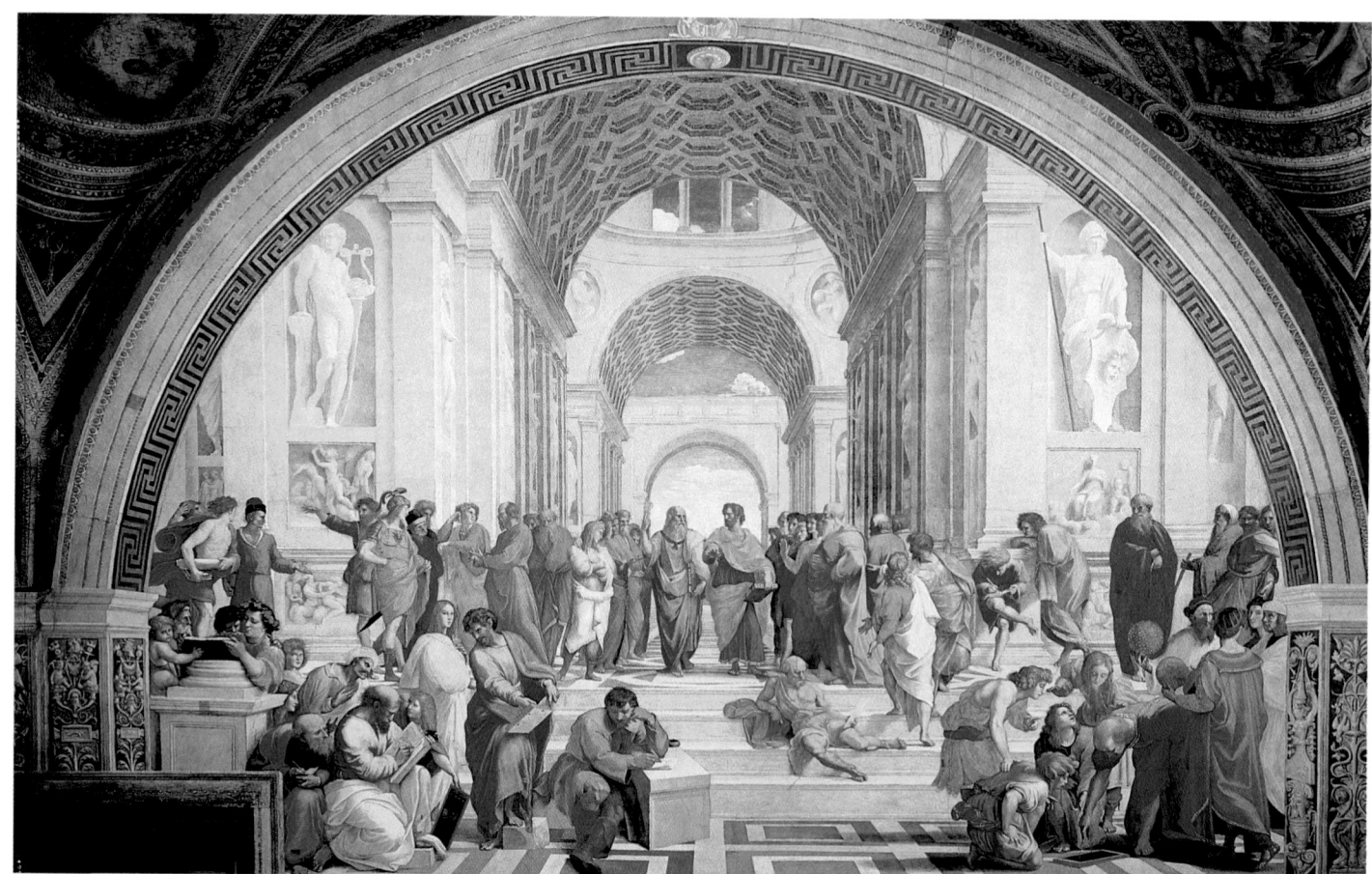

14.35 Raphael, *School of Athens*, Stanza della Segnatura, Vatican, Rome, 1509–1511. Fresco; 26 × 18 ft. (7.92 × 5.49 m). This fresco covered one entire wall of the private library of Julius II. The room was known as the Stanza della Segnatura because it used to be the place where the Signatura Curiae, a division of the supreme papal tribunal, met. Raphael was commissioned by Julius II to decorate this room with frescoes of Classical and Christian subjects.

mizes the Classical harmony of his style. Philosophers representing the leading schools of ancient Greek philosophy are assembled in a single, unified compositional space. The figures at the top of the steps occupy a horizontal plane, with distinct groups on either side; additional groups are placed at the bottom of the steps. On the left, Pythagoras demonstrates his system of proportions to students. Diogenes the Cynic, who proverbially carried a lantern through the streets of ancient Athens in search of an honest man, sprawls across the steps slightly to the right of center. On the right, the Greek mathematician Euclid draws a geometric figure with the aid of a compass. At the center of the top step, framed by the round arches, are the two most famous Greek philosophers (fig. **14.36**). At the left, Plato carries his *Timaeus,* and at the right is Aristotle with his *Ethics.* A point between the shoulders of these two giants of Western thought corresponds to the vanishing point of the painting. At Plato's left is Socrates, whose features were known from an ancient marble portrait bust (see fig. 5.3).

Not only has Raphael integrated different philosophical schools, but he has also included portraits of his contemporaries among the philosophers. Plato (fig. 14.36) is an idealized portrait of Leonardo, whose physiognomy corresponds closely to his *Self-Portrait* drawing (fig. **14.37**). The upward pointing finger of Plato is also a characteristic gesture in Leonardo's own pictures—for example, the doubting Thomas in the *Last Supper* (see fig. 14.14). Raphael thus pays tribute to Leonardo's central role as a thinker and artist in establishing the High Renaissance style. Plato

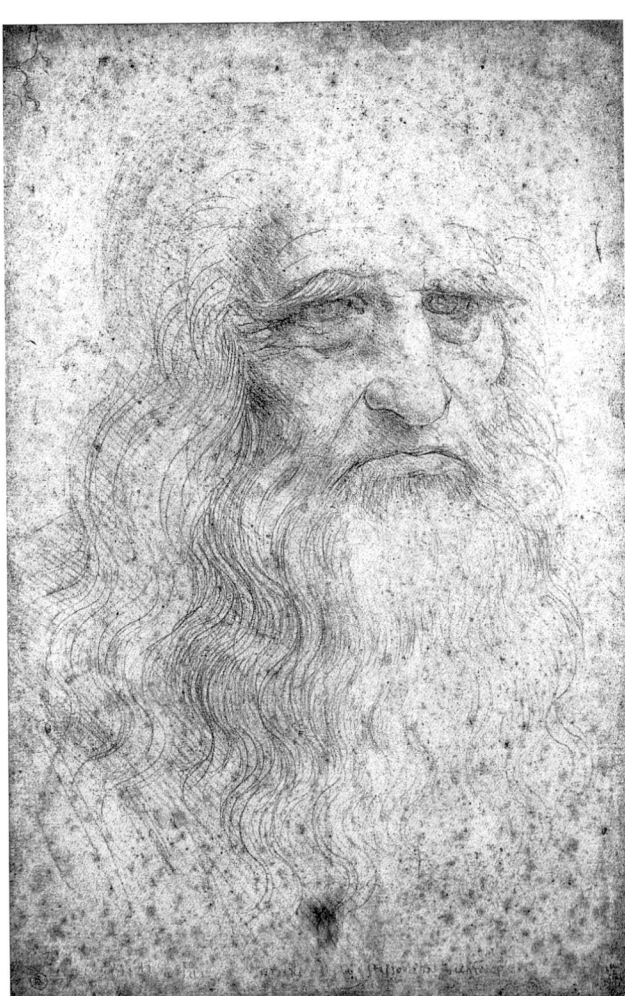

14.37 Leonardo da Vinci, *Self-Portrait,* after 1500. Pen and ink. National Library, Turin.

points upward also as a reference to the Platonic ideal and the notion of a realm of ideas, while Aristotle the empiricist points toward the earthly space of the viewer. The brooding foreground figure to left of center, presumed to be the philosopher Heraklitos, is a portrait of Michelangelo, who was working on the Sistine Chapel ceiling while Raphael was painting the Stanza della Segnatura. Michelangelo's massive, sculpturesque form and his meditative pose are similar to that of his *Jeremiah* (see fig. 14.25) in the Sistine Chapel. Both figures hunch forward and ponder weighty issues.

On the far right is a self-portrait of Raphael (fig. **14.38**), looking out of the picture. He wears a black hat and stands to the right of the figure in white. The latter has been variously identified as the painter Sodoma or as Perugino, to whom Raphael was apprenticed. Euclid is a portrait of Bramante. His prominent, domed bald head is repeated in the globes and in the unseen dome crowning the painted architectural setting. The architecture of the painting, which is a tribute by Raphael to his mentor, is itself based on Bramante's ideas. The figure holding up the celestial globe is Zoroaster, the Persian astronomer, and standing

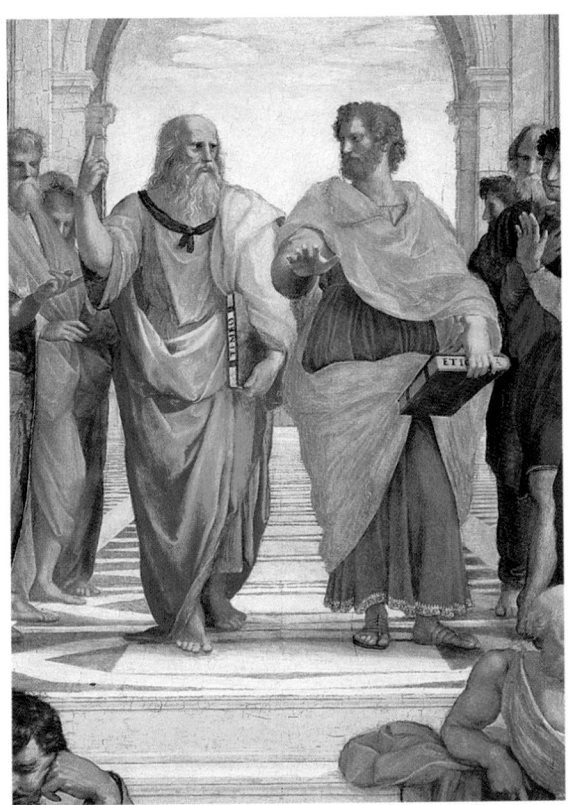

14.36 Plato and Aristotle (detail of fig. 14.35).

14.38 Raphael's self-portrait (second from right) (detail of fig. 14.35). The proverbial contrast between Raphael's sociability and Michelangelo's brooding isolation is captured by a 16th-century anecdote. The two artists run into each other on a street in Rome. Michelangelo, noting the crowd around Raphael, asks: "Where are you going, surrounded like a provost?" Raphael replies: "And you? Alone like the executioner?"

with his back to the viewer is Ptolemy, the Egyptian geographer from Alexandria, holding up a terrestrial globe.

Raphael has portrayed Michelangelo and himself according to their respective personalities and styles. Michelangelo is brooding, isolated, and muscular. Raphael, who was known for his easy, gregarious manner, relates freely to his companions and to the observer, and is painted in the soft, restrained style of his early works. Raphael sets Leonardo apart at the top of the steps, as if to show that his predecessor is above the competitive rivalry between Michelangelo and himself.

Raphael's style became more complex after the *School of Athens,* expanding in scale, in the range of movement, and in the use of light and dark. He, more than any other High Renaissance artist, combined Classical purity with the Christian tradition in painting. He was also a fast and efficient worker, in contrast to Leonardo, who left a number of major works unfinished. Michelangelo's difficult personality often interfered with his relationships with patrons and affected his ability to complete and deliver certain sculptures. Raphael, on the other hand, was sociable and a skilled diplomat.

In 1520, his early death cut short a remarkable career. As a final tribute to the Classical past and its relevance to present and future, Raphael was, at his own request, buried in the Pantheon.

Developments in Venice

Venice was a port city and an international center of trade throughout the Middle Ages and Renaissance. Because it was built on water, it had a different effect on painters than other Italian cities. Its soft, yellow light, at once muted and reflected by its waterways, has influenced painters up to the present day. During the Renaissance, Venice was a republic, which remained invulnerable to foreign attack. The Venetian constitution had lasted since the late thirteenth century, fostering relative political continuity despite upheaval in other Italian states. By 1500, the city had been free of foreign domination for about one thousand years, a fact that contributed to the so-called "myth of Venice." Venice considered itself a harmonious blend of the best qualities of different types of government—the freedom of democracy, the elegant, aristocratic style of oligarchy, and the stability of monarchy. Under its constitution, Venice was ruled by patrician senators who formed the Great Council, which emphasized the rule of law over individual expression. This led to greater stability, as well as to greater political repression, than in Florence.

In the early fifteenth century, the visual arts in Venice were somewhat more conservative than in Florence. They were rooted in Byzantine and Gothic tradition, and Venetian taste was more in tune with the rich colors and elabo-

rate patterns of the International Style. More so than in Florence and Rome, Venetian artists tended to receive their training in family-run workshops maintained for several generations. A major reason for the durability of this tradition was the fact that visual art was still considered a manual craft in Venice—the profession of painting was closely controlled by the Painters' Guild, the Arte dei Dipentori. In Florence, on the other hand, painting had attained the status of a Liberal Art.

The Bellini: A Family of Painters

One of the most successful examples of the family-workshop tradition in Venice is the Bellini family. The workshop of Jacopo Bellini (c. 1400–1470) included himself and his two sons, Gentile (c. 1429–1507) and Giovanni (c. 1432–1516). Jacopo's daughter married Andrea Mantegna, whose interest in Classical antiquity was shared by his in-laws.

Jacopo Bellini Jacopo Bellini was born in Venice and studied with Gentile da Fabriano. Around 1420, he went to Florence with Gentile and must have met the first-generation innovators of Renaissance style. Their knowledge of perspective interested Jacopo, who incorporated it into his own work. Unfortunately, very few of his paintings survive, but those that do reflect the Gothic taste for elegant patterns and decorative detail. Jacopo is best known today for his drawings, most of which are preserved in two sketchbooks, one in the Louvre and one in the British Museum. These indicate a command of perspective, foreshortening, and shading, and an attraction to Classical motifs.

Folio 35 of the Louvre sketchbook is a scene of Jesus before Pilate (fig. **14.39**), which shows Jacopo's combination of Classical and Venetian architecture. The Roman arch rises above a palace with typical Venetian windows and balconies on the back wall. An Ionic frieze is prominently displayed on the entablature of the front wall. The arch itself is flanked by pairs of huge Composite columns, the bases and capitals of which are rather fancifully carved.

14.39 Jacopo Bellini, *Christ before Pilate,* Louvre sketchbook, folio 35, Louvre inv. R. F., 1503. Drawing on parchment.

Between the columns and the arch are representations of Classical winged Victories in relief. The nude male figure at the center of the arch holds up a flaming torch, a motif signifying rebirth and eternal life on Roman sarcophagi. In the context of Jesus brought before Pilate, the motif also refers to the triumph of Christianity and the Resurrection.

Jacopo's perspective is calculated to juxtapose the enormity of Pilate's palace with the small scale of humanity. Pilate occupies the Gothic throne at the center of the picture. The viewer's line of sight is guided by the orthogonals of the floor tiles to the vanishing point at Pilate's feet and carried upward by the spire of his throne to the image of the nude over the arch. In addition to integrating Venetian with ancient architecture, therefore, Jacopo also reflects the influence of Neoplatonism by reinforcing the meaning of a Christian scene with pagan iconography.

Venice and the Ottoman Empire

After concluding a celebrated peace treaty with Venice, Sultan Mehmet II requested that a Venetian portrait painter be sent to his court. On September 3, 1479, Gentile Bellini left Venice for a year in Constantinople, bringing with him a book —later the Louvre sketchbook—of Jacopo's drawings for his host. The greatful sultan made Gentile a Knight of the Ottoman Empire. While he was away, Gentile's brother Giovanni took over the work for the Great Council Hall in Venice.

Gentile's portrait of the sultan (fig. **14.40**) shows his taste for textures created by gradual shading and for the illusion of distinctive materials. Mehmet II is framed by a decorative, round arch, and a rich fabric with Islamic designs is draped over the balustrade in front of him. His heavy robe, beard, turban, and long pointed nose seem to weigh him down and accentuate his serious, thoughtful character. Shortly after returning to Venice in 1480, Gentile cast a medal with the sultan's portrait on the obverse and three crowns on the reverse (fig. **14.41**).

14.40 Gentile Bellini, *Sultan Mehmet II*, c. 1480. Oil on canvas; 27¾ × 20⅝ in. (70.5 × 52.4 cm). National Gallery, London.

14.41 Gentile Bellini, *Sultan Mehmet II*, medal (obverse left, reverse right), c. 1480. National Gallery of Art (Samuel Kress Collection), Washington, D.C.

14.42 Gentile Bellini, *Procession of the Reliquary of the Cross in Piazza San Marco*, 1496. Oil on canvas; 12 ft. ½ in. × 24 ft. 5¼ in. (3.67 × 7.45 m). Galleria dell'Accademia, Venice. Gentile was appointed the official painter of the Venetian Republic and knighted by Frederick III. This work was one of a cycle on canvas for Saint John the Evangelist.

Gentile Bellini Gentile's early style is unknown, possibly because he was in his father's workshop, where he and Giovanni remained until 1460. From 1474, he worked on frescoes for the Great Council Hall of Venice, and his reputation as a portraitist won him many official commissions. Most of these are lost, but his portrait of Sultan Mehmet II (fig. 14.40) survives (see box).

Gentile's *Procession of the Reliquary of the Cross in Piazza San Marco* (fig. **14.42**) of 1496 combines a taste for pageantry with Renaissance perspective. It is a monumental historical painting that shows a panoramic view of the Venetian piazza and the domed Byzantine basilica of San Marco in the background. The receding orthogonals formed by the buildings on either side, which are aligned with participants in the procession, meet at a vanishing point in the basilica's central lunette. At the front of the picture, the Confraternity of San Giovanni Evangelista proceeds parallel to San Marco. Its members carry a relic of the True Cross, encased in the gold reliquary under the canopy. The detailed patterns of Gentile's painting are combined with perspectival control and a large, three-dimensional space. These relieve the sense of crowding and set a stage with the architectural splendor of Venice as a backdrop.

The procession includes an actual event witnessed by the artist. Every year on April 25, Venice celebrated the feast of its patron saint, Mark. In this instance a merchant from Brescia (the man in red kneeling to the right of the canopy) stopped to pray for his son, who was dying of a fractured skull. On returning home the following day, the merchant found his son completely cured. A miraculous event is thus juxtaposed with the secular image of an orderly, opulent, timeless city dominated architecturally by its principal church, ruled by its senators, where members of different social strata peacefully coexist. The latter, including aristocrats, merchants, children, and foreigners, are gathered in Piazza San Marco to view the procession.

Giovanni Bellini Giovanni Bellini, who was active for over sixty years, was the artist most instrumental in bringing the Renaissance style to Venice. His subjects are mainly Christian, although he produced many portraits and a few mythological pictures. His monumental San Giobbe Altarpiece (fig. **14.43**) is the first surviving example in Venetian art of the type known as a *sacra conversazione*. The painted space ends in a fictive apse, which is suffused with a rich, yellow light. This is consistent with the Byzantine flavor of the gold mosaic in the half dome behind Mary and Jesus. At the same time, the classicizing pilasters and the relative precision of their surface carving are reminiscent of Mantegna. Enthroned in front of the apse, Mary and Jesus are the focal point of the painting, even though the viewer's eye level is at the center of the lower frame. As a result, we look up at Mary and Jesus, whose central importance is both literal (in their placement) and symbolic (in their significance).

Mary and Jesus gaze out of the picture, but they are not as iconic as their more static, frontal counterparts in Byzantine art. Saint Francis stands at the left, his head tilted on an angle parallel to the cross of John the Baptist. Francis gestures toward the viewer and, in displaying the stigmata, invites us to participate, as he does, in Jesus's sacrifice. Reading from left to right, we follow Saint Francis's left elbow to the right arm of Saint Job. His gesture of prayer, in turn, leads diagonally up toward Jesus's lowered right arm. At this point, we realize that the gesture of Jesus's right hand is an echo of Saint Francis's gesture and therefore also alludes to the Crucifixion.

Mary's raised left arm recedes toward the upward diagonal of Saint Dominic's book, which repeats the red of her garment. From here, we are led to Saint Sebastian, whose arrows link him with Jesus through martyrdom, with Saint Francis through his wounds, and with Job through his nudity. At the same time, Sebastian's arms, crossed behind his back, lead to the young Saint Louis of Toulouse in his characteristically elaborate robe. The three music-making angels at the foot of the throne are at once a reference to the Trinity and a formal echo of the Cross at the back of the throne.

In this altarpiece, Giovanni Bellini lays the groundwork for future developments in High Renaissance Venetian painting. The soft, yellow light playing over the nudes and the *chiaroscuro* create sensual flesh tones that recur in the work of Giorgione and Titian (see below). Intense colors—especially reds—and textural variations also develop as oil paint becomes the primary medium in Venice. The climate of Venice was not conducive to fresco because of dampness and salt air from the sea. Oil on stretched canvas proved more durable and also allowed for richer, more **painterly** effects.

The same taste for rich textures and subtle shading is evident in Giovanni's portrait of Doge Leonardo Loredan (fig. **14.44**) (1438–1521), a member of an influential Venetian family. He was doge from 1501, during a period of political defeat for Venice. The doges were chairmen of the ruling committees of Venice, and their position was permanent even though committee members often changed.

Each gold thread of the buttons is visible. The gold em-

14.43 Giovanni Bellini, San Giobbe Altarpiece, 1480s. Oil on wood; 15 ft. 4 in. × 8 ft. 4 in. (4.67 × 2.54 m). Galleria dell'Accademia, Venice.

broidery of the cloak and the hat band reflects the influence of Netherlandish painting. Giovanni delineates Doge Loredan's expression by the play of light and dark across his features. His upright posture and precise physiognomy convey the impression of a stern but slightly pensive character. In the clarity of forms—the cubic space and the single, unified source of light—Giovanni Bellini is in the forefront of Renaissance innovation.

14.44 Giovanni Bellini, *Doge Leonardo Loredan*, soon after 1501. Oil on wood; 24¼ × 17¾ in. (61.5 × 45.1 cm). National Gallery, London.

His unusual painting known as *Saint Francis in Ecstasy* (fig. **14.45**) shows the influence of Netherlandish attention to detail. Saint Francis is enveloped by landscape, which can be associated with his devotion to nature and his belief that God's presence resides in nature. This is reinforced by the peaceful animals, who allude to the saint's reputation for communicating with birds and other wildlife. The craggy, linear depiction of the rock formations, the specificity of the leaves, and the accoutrements of the saint's rustic abode all reflect Netherlandish taste. The distant landscape, with its medieval walls and towers, and the horizontal disposition of the clouds show the influence of Giovanni's brother-in-law, Andrea Mantegna. Bellini has signed both the *Saint Francis* and the *Doge* on a simulated piece of paper—at the lower left of the former and on the wooden ledge of the latter.

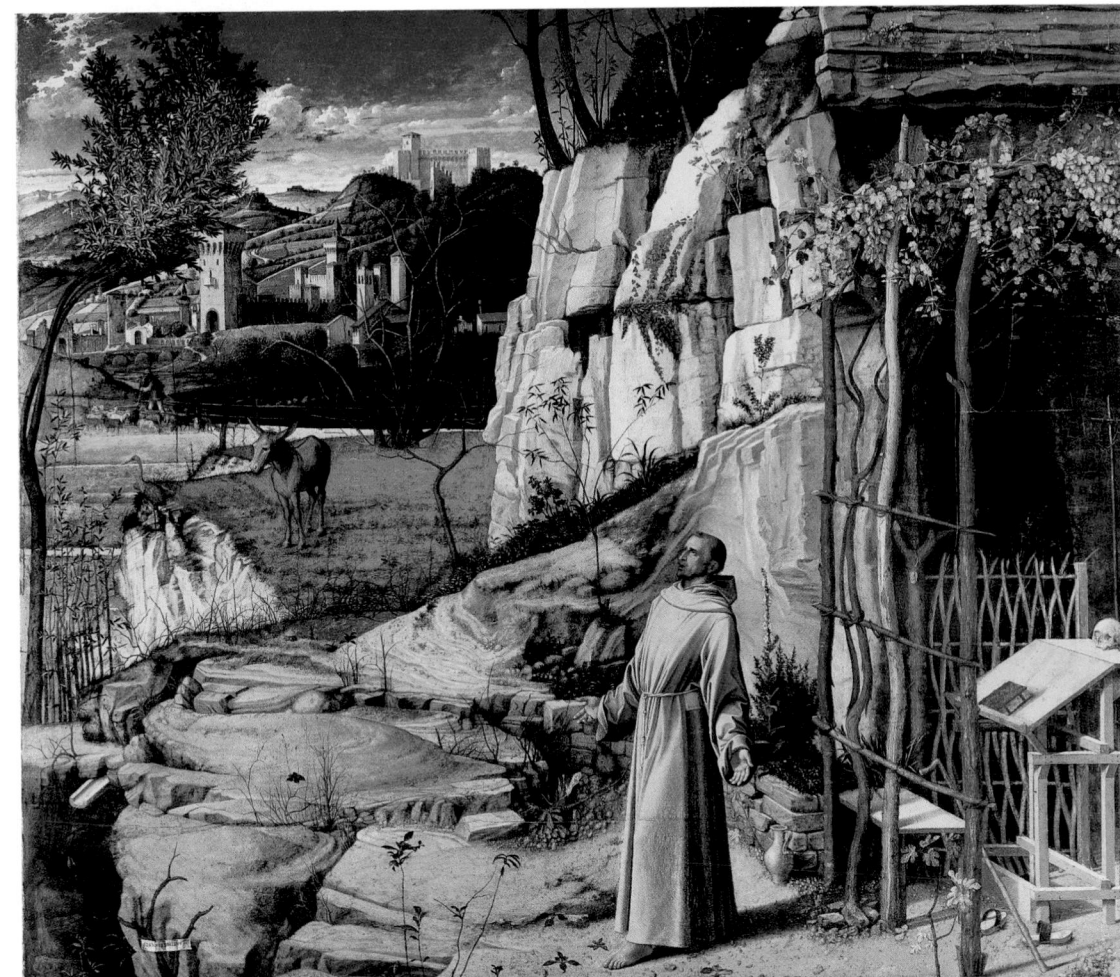

14.45 Giovanni Bellini, *Saint Francis in Ecstasy*, c. 1485. Panel; 48½ × 55 in. (123.2 × 139.7 cm). The Frick Collection, New York.

Giorgione

The Venetian love of landscape, especially when softened by muted lighting, became an important feature in the work of Giorgio da Castelfranco, known as Giorgione (see box). Very little of his life is documented, although he is believed to have studied with Giovanni Bellini. Giorgione lived only to the age of thirty-two or thirty-three, and few of his paintings survive. Because none was either signed or dated, and because Giorgione died in the formative stage of his artistic development, there have been continual problems of attribution. Nevertheless, he emerges as a distinct personality, one who creates a clear stylistic link between Giovanni Bellini and Titian (see below). His so-called *Tempesta* (*Tempest*) (fig. **14.46**) of around 1505–1510 shares with Bellini's *Saint Francis* the subordination of human figures to landscape. As in the *Saint Francis,* the viewer has the impression that there is an intimate relationship between landscape and figures, but scholars disagree on the precise meaning of Giorgione's picture.

The *Tempesta* is one of the persistent mysteries of Renaissance iconography. At the right, a nearly nude woman nurses a baby, and, at the left, a soldier seems to watch over them. Together they create a "dialogue" of glances—the soldier gazes at the woman, she gazes at us, and the infant focuses on her breast. The figures are connected but distanced from each other. This ambivalent relationship is reflected in the background landscape and architecture.

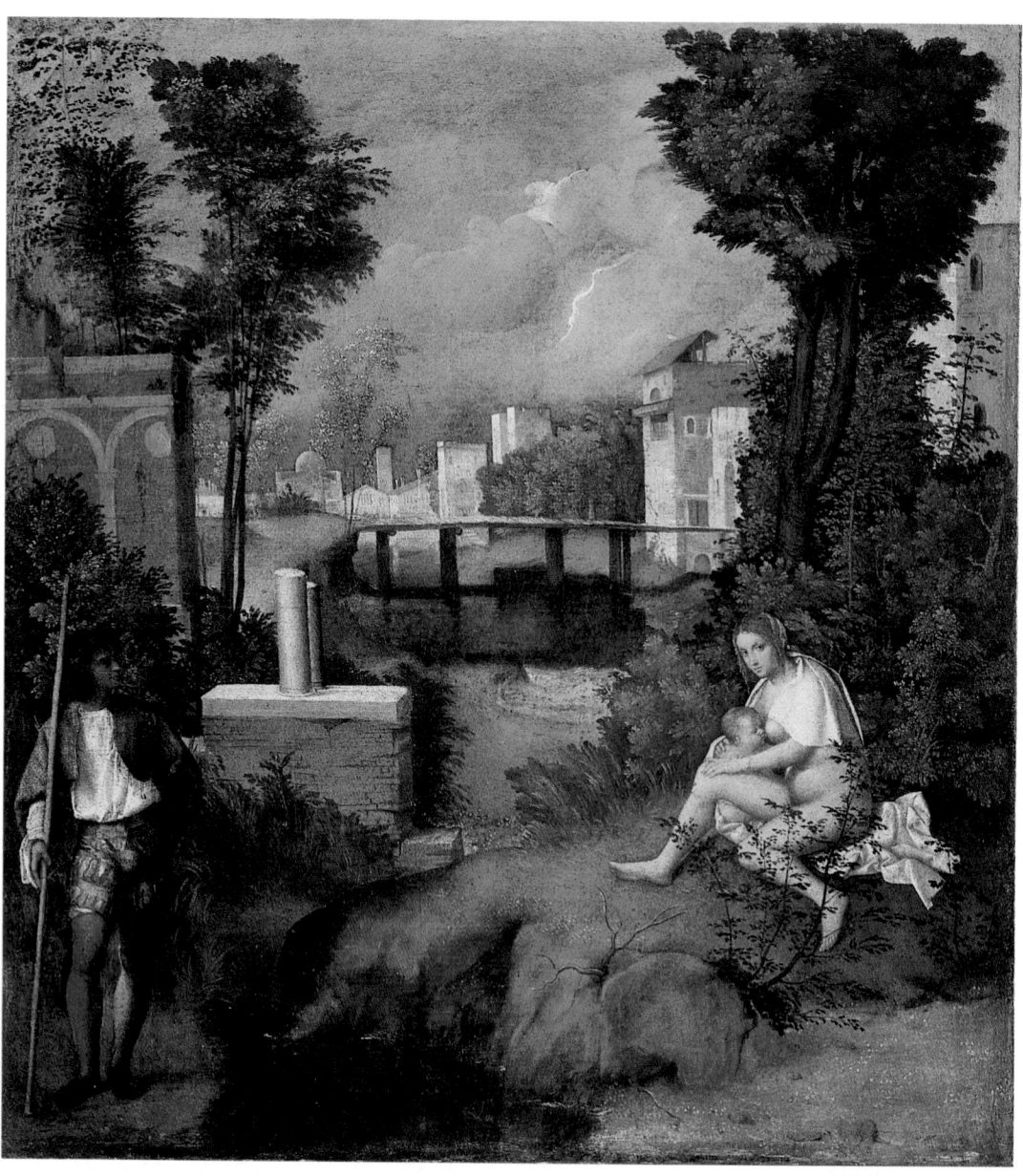

14.46 Giorgione, *Tempest,* c. 1505–1510. Oil on canvas; 31¼ × 28¾ in. (79.4 × 73.0 cm). Galleria dell'Accademia, Venice.

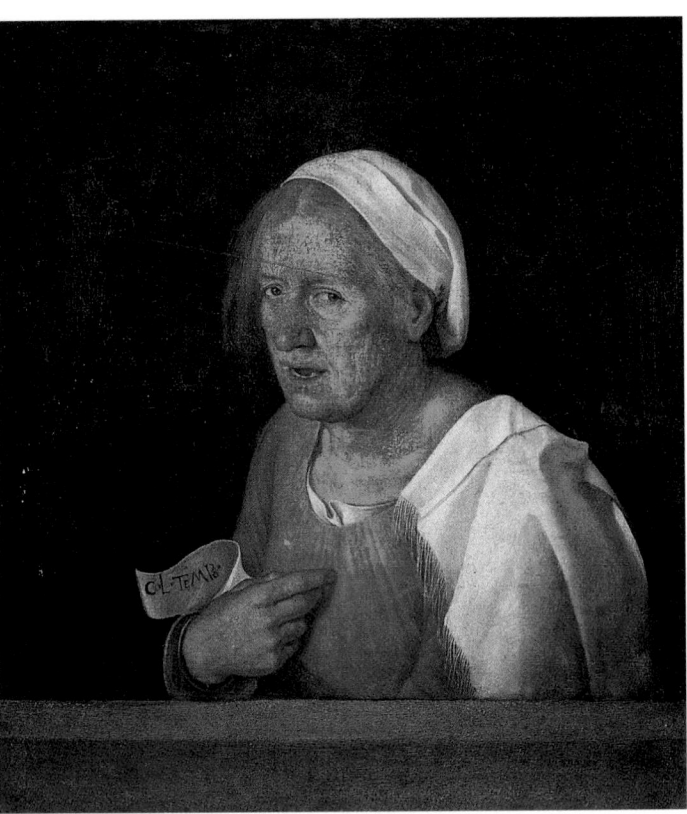

14.47 Giorgione, *Old Woman (Col Tempo)*, early 16th century. Oil on canvas; 26¾ × 23¼ in. (67.9 × 59.1 cm). Galleria dell'Accademia, Venice.

The woman and child are distinguished from the soldier by their nudity and physically by the space between them. Their separation, bridged as it is by the soldier's gaze, is accentuated by open space. They are likewise connected by the painted bridge in the background. The woman and child are surrounded by the knoll on which they sit, and by foliage, while the vertical plane of the soldier recurs in the lance, the trees on the left, and the truncated columns.

Giorgione enhances the figures' tension with the threat of an oncoming storm. A flash of lightning cuts through a darkened sky made turbulent by rolling clouds. Atmo-spheric effects are accentuated by the artist's use of layers of **glaze** and the visible texture of the brushstrokes. Whatever the real meaning of this picture is, Giorgione had become an undisputed master of technique and psychology, which he expressed in the most advanced style of his time.

In his *Old Woman* (fig. **14.47**), Giorgione's mastery of physiognomy enhances the psychological portrayal. It is a study of the ravages of time and its emotional impact. The figure looks out at the viewer—like Giovanni Bellini's doge—from behind a narrow sill. Her dress is simple, her hair slightly disheveled, and her wrinkled skin a formal echo of the creases in her drapery. The gaps in her teeth are revealed by her open mouth. She seems to be speaking to us, but her message is mute. Instead, it is manifest in her image and written on the piece of paper that she holds while pointing to herself—"Col Tempo" (With Time).

An entirely different conception of woman is presented in Giorgione's *Sleeping Venus* (fig. **14.48**) of around 1509. It was unfinished at his death and completed by Titian, but the basic style is Giorgione's. He shows the woman as a metaphor of landscape, which is a recurring theme in Western iconography. The long, slow curve of the left leg repeats the contour of the hill above, while the shorter curves formed by the outlines of the left arm, breast, and shoulder echo the landscape as it approaches the horizon.

The enigmatic *Fête Champêtre,* or *Pastoral Concert* (fig. **14.49**), has been attributed to both Giorgione and Titian. It is, like the *Sleeping Venus,* pastoral in its setting and mood, but the meaning of its iconography has proved elusive. Two clothed musicians are seated opposite a nude woman, and all three seem about to play. At the left, a second nude pours water into a well, and in the background a shepherd tends his flock. The work is related to the *Tempest* in the fleshy character of the women and in the calm of the figures contrasted with the charged atmosphere of the landscape.

Because of their collaboration and stylistic affinities, the transition from Giorgione to Titian seems to have been a natural development. In contrast to Giorgione, who died of plague in 1510, Titian had a long, productive life and became the undisputed master of the High Renaissance in Venice.

Vasari on Painting versus Sculpture

Competition between the arts has a long history in the West. In his *Life of Giorgione*, Vasari takes up the dispute over the virtues of painting, which is seen from a single vantage point, versus sculpture, which is three-dimensional. Giorgione, according to Vasari, set out to prove that "there could be shown in a painted scene, without any necessity for walking round, at one single glance, all the various aspects that a man can present in many gestures—a thing which sculpture cannot do without a change of position and point of view, so that in her [sculpture's] case the points of view are many, and not one."[1]

Giorgione demonstrated this by painting a nude man from the back. In a pool of water at the man's feet, Giorgione painted the reflection of his front. On the man's left was a shiny cuirass that reflected his left side, and on his right, a mirror reflected his right side. This, says Vasari, "was a thing of most beautiful and bizarre fancy," which proved that painting does "with more excellence, labor, and effect, achieve more at one single view of a living figure than does sculpture."[2] Unfortunately, Giorgione's painting is lost, so Vasari's effusive praise cannot be confirmed.

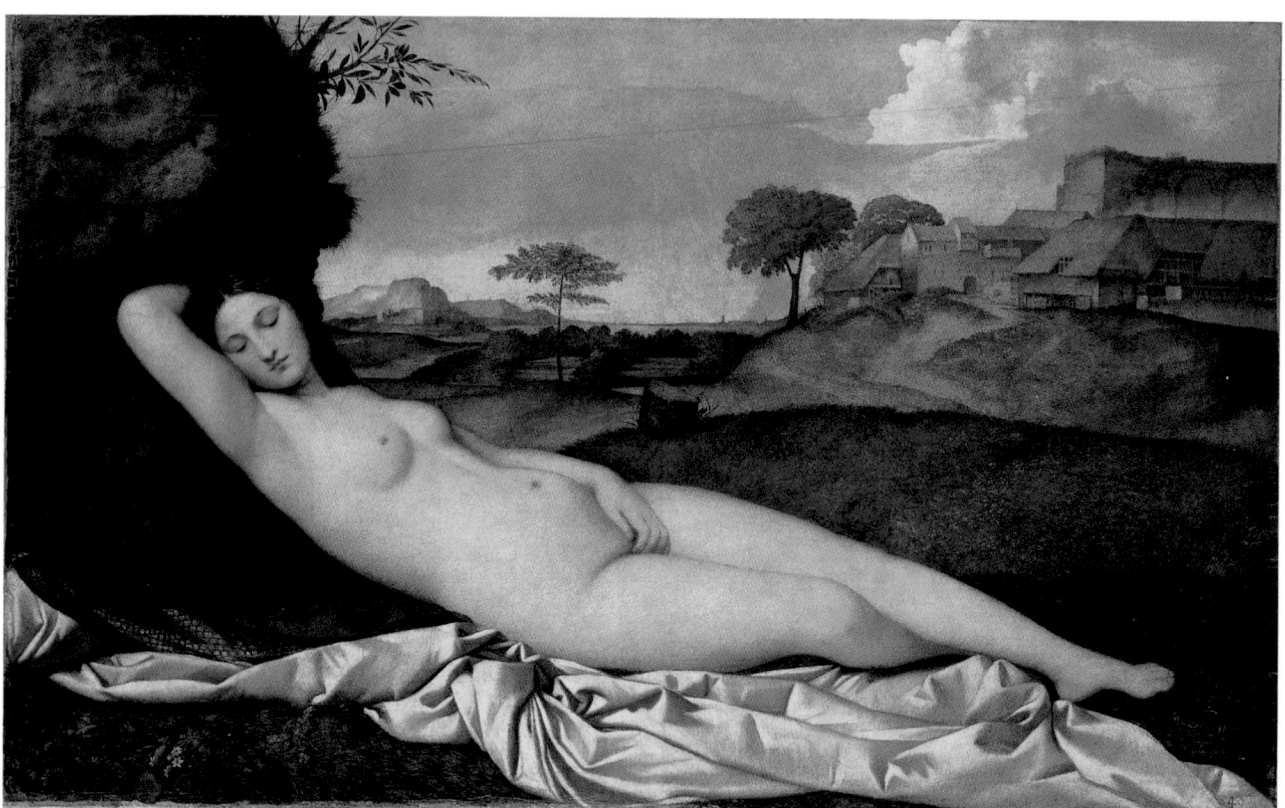

14.48 Giorgione, *Sleeping Venus*, c. 1509. Oil on canvas; 3 ft. 6¾ in. × 5 ft. 9 in. (1.08 × 1.75 m). Staatliche Kunstsammlungen, Dresden, Gemäldegalerie Alte Meister. The woman is identified as Venus by the presence of a Cupid at her feet. Cupid was later painted out, but is visible with X-ray analysis.

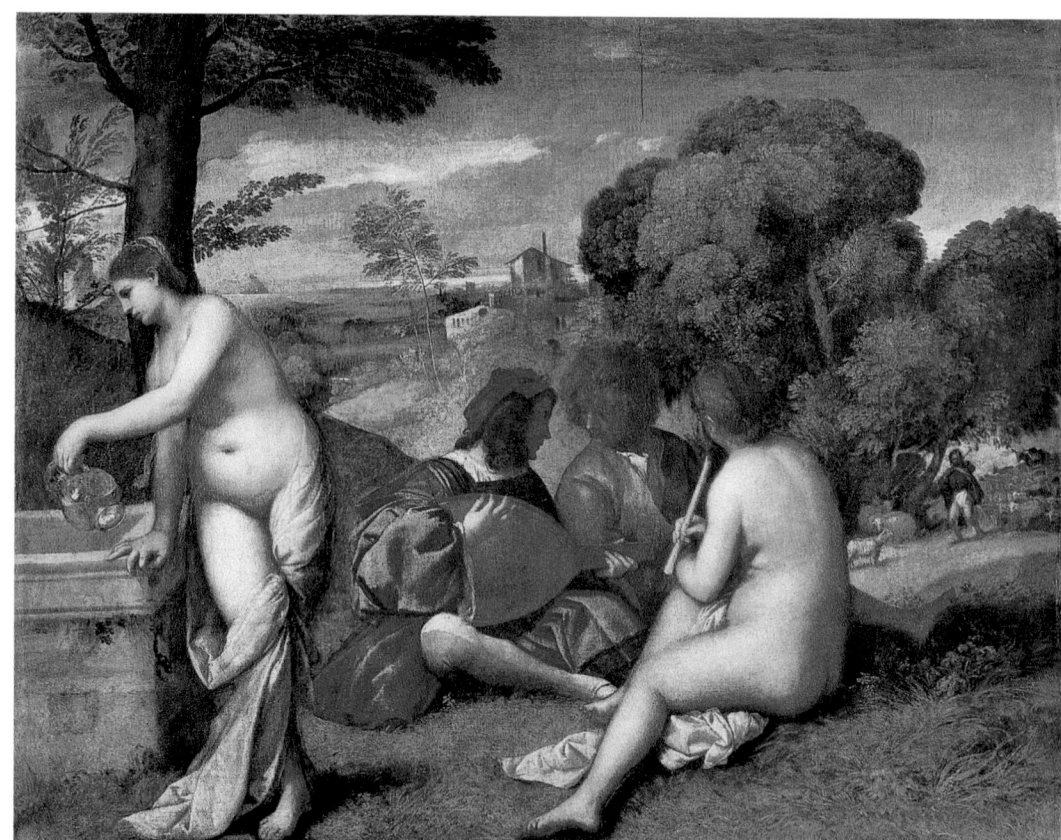

14.49 Giorgione, *Fête Champêtre*, c. 1510. Oil on canvas; 43¼ × 54⅜ in. (1.10 × 1.38 m). Louvre, Paris.

Titian

The paintings of Tiziano Vecellio (Titian, in English) cover a wide range of subject matter, including portraits and religious, mythological, and allegorical scenes. Particularly impressive are his warm colors, deepened by many layers of glaze, his insight into the character of his figures, and his daring compositional arrangements. Compared with the paintings of his Roman and Florentine contemporaries, Titian's are soft, textured, and richly material. These qualities appealed to the critic Pietro Aretino, who became involved in one of the major aesthetic quarrels of the time —namely, the virtues of color (*colorito*) versus drawing (*disegno*) (see box).

On May 19, 1518, Titian's enormous *Assumption of the Virgin* (fig. **14.50**) was unveiled in the Venetian church of Santa Maria Gloriosa dei Frari. It was consecrated the next day, which was the Feast of Saint Bernardino of Siena, who was a patron of Venice. The mystical and passionate character of his sermons is reflected in Titian's use of light and dark. Landscape is virtually eliminated, and we see instead a sharp contrast between the darkened area occupied by the awed apostles and the intense illumination of the heavens. The Virgin gazes toward God, who spreads his arms to receive her. She rises in a glow of yellow light surrounded by clouds and angels. The viewer, like the apostles, is presented with the miracle of Mary's Assumption as a prelude to the possibility of salvation.

In another important early picture, the *Pesaro Madonna* (fig. **14.51**), also in Santa Maria Gloriosa dei Frari, Titian modified the pyramidal composition of Giovanni Bellini's San Giobbe Altarpiece. In contrast to the Bellini, Titian's Mary and Jesus are off-center, high up on the base of a column, and the asymmetrical architecture is positioned at an oblique angle. The painting was commissioned by Jacopo Pesaro, whose family acquired the chapel in 1518, the same year that the *Assumption* was completed. Jacopo was bishop of Paphos, in Cyprus, and had been named commander of the papal fleet by the Borgia pope, Alexander VI. Titian shows his patron in a devotional pose, kneeling before the Virgin and presented to her by Saint Peter. Prominently displayed on the step is Saint Peter's key; its diagonal plane, leading toward the Virgin, parallels that of Jacopo. The Virgin's position at the top of the steps alludes to her celestial role as Madonna della Scala (Madonna of the Stairs) and as the Stairway to Heaven.

The large red banner at the far left prominently displays the papal arms in the center and those of Jacopo below. An unidentified knight has two prisoners in tow, a turbaned Turk and a Moor, probably a reference to Jacopo's victory over the Turks in 1502. At the right, Saint Francis links the five kneeling Pesaro family members to Jesus, suggesting that through identification with Christ salvation can be achieved. Just behind Saint Francis is Saint Anthony of Padua—both, like Saint Bernardino, are Franciscans, as is the church of Santa Maria Gloriosa dei Frari.

The members of the donor's family are motionless. All the other figures gesture energetically and occupy diagonal planes. The steps, surmounted by large columns cut off at the top, are thrust diagonally back into space. Infant angels appear on the cloud above. One, seen in rear view, holds the Cross. The back of this angel is juxtaposed with the infant Jesus, who turns playfully on Mary's lap and looks down at Saint Francis, who returns his gaze. The fabrics are characteristically rich and textured, particularly the flag and costumes. This attention to material textures is further enhanced by the variation of bright lights and dark accents in the sky. The light of Venice, sparkling in its waterways, in contrast to the darkened setting of the Bellini, seems to illuminate this painting.

Pietro Aretino on Color versus Drawing

Pietro Aretino (1492–1556) was a flamboyant Venetian personality, an author writing in the vernacular, and a scathing social critic. For this latter activity, he was dubbed the "Scourge of Princes." His *Dialogues* (1534–1535) reflect his own variable sexual mores and comment pessimistically on those around him. The main character is Nanna, who converses in Volume 1 with a friend about the lives of nuns, married women, and courtesans. In Volume 2, she instructs her daughter on how to succeed as a prostitute.

Pietro's passionate sensibilities led him to take sides in the competition between Michelangelo and Titian, which embodied, among other things, the aesthetic quarrel between *disegno* and *colorito*. Aretino came squarely down on the side of color. He championed the poetic effects of the oil medium applied directly to the canvas without preliminary drawing, in contrast to the more linear styles preferred in Florence and Rome. In particular, he responded to Titian's sensual use of paint, which enhanced the erotic character of his figures. He much preferred Titian's *chiaroscuro* and rich color to the sculpturesque figures of Michelangelo, which he believed failed to differentiate adequately among men, women, and children. Aretino's critical pen was aimed against Michelangelo, in defense of Titian, just as it was directed at the social and political corruption of his time.

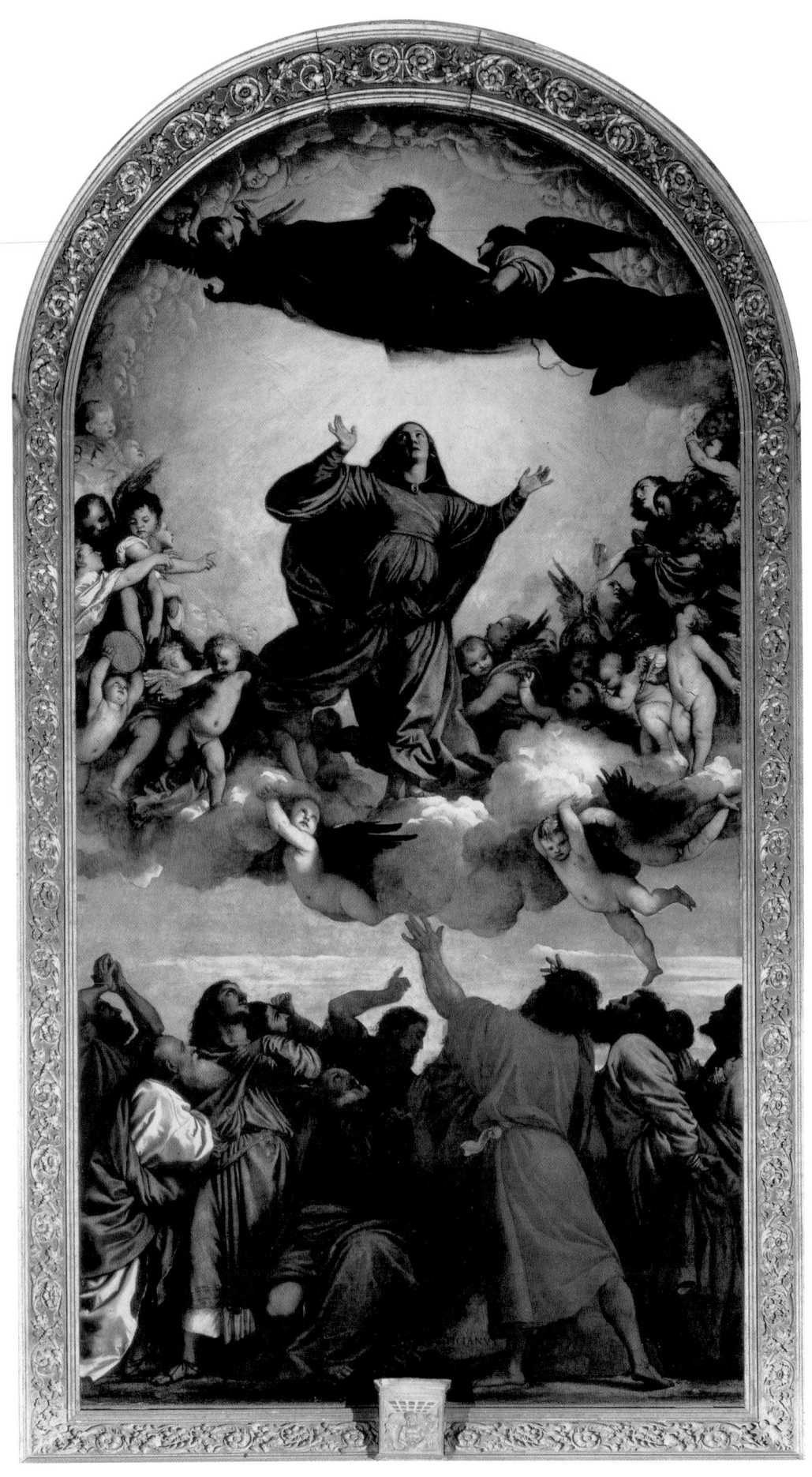

14.50 Titian, *Assumption of the Virgin*, 1516–1518. Oil on panel; 22 ft. 7½ in. × 11 ft. 9¾ in. (6.90 × 3.60 m). Santa Maria Gloriosa dei Frari, Venice.

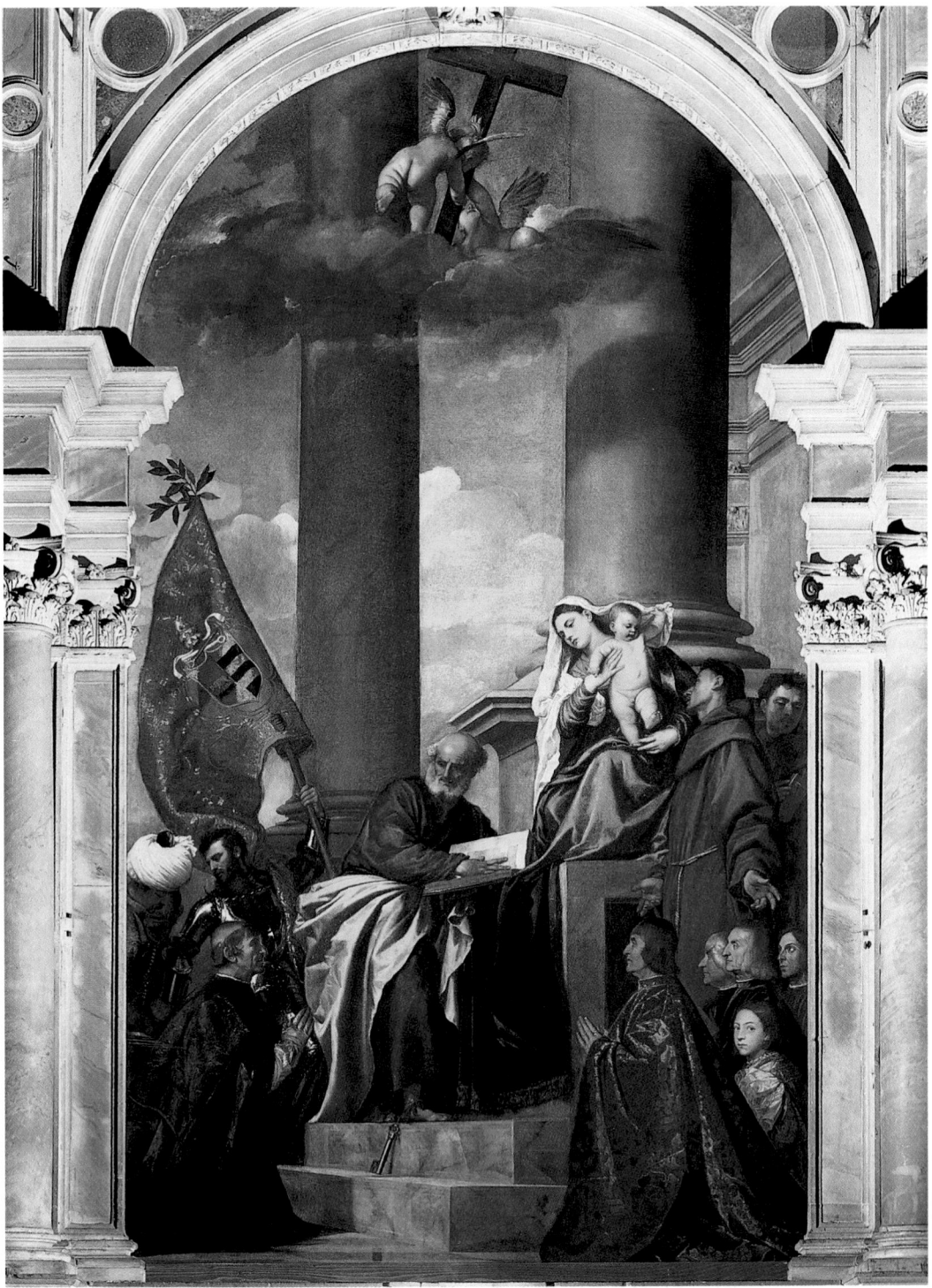

14.51 Titian, *Pesaro Madonna,* 1519–1526. Oil on canvas; 16 ft. × 8 ft. 10 in. (4.88 × 2.69 m). Santa Maria Gloriosa dei Frari, Venice. Titian became the official painter of the Venetian republic in 1516 and raised the social position of the artist in Venice to the level achieved by Michelangelo and Raphael in Rome.

In the *Venus of Urbino* (fig. **14.52**) of c. 1538, Titian's debt to Giorgione is clear. But Titian's nude is awake, consciously observing and being observed. The relation of the figure to the drapery has also been reversed—here the drapery is arranged in easy rhythms, but Venus is a more active participant in the "seduction" of the observer than Giorgione's sleeping figure. Titian's Venus reclines in a contemporary Venetian interior on a bed parallel to the picture plane. A relatively symmetrical, rectangular room occupies the background, where two maids remove garments from a chest. Titian's Venus is clearly descended from the Giorgione; and, as we shall see, variations on the pose recur in Western art up to the present.

The rich red of Venus's long flowing hair is characteristic of Titian, as are the yellow light and gradual shading that enhance the fleshy texture of her body. The roses, which languidly drop from her hand, and the myrtle in the flower pot on the window sill are attributes of the goddess. The dog, as in the *Arnolfini Portrait* (see fig. 13.67), signifies both fidelity and erotic desire.

A late painting, the *Rape of Europa* (fig. **14.53**), reflects Titian's mythological interests. We have already encountered this subject in the red-figure Greek vase by the fifth-century-B.C. Berlin Painter (see fig. 5.10). But Titian portrays the event in the idiom of sixteenth-century Venice, delighting in the deeply glazed colors and the background mists of purple and gold. He endows the scene with erotic excitement by virtue of pose, gesture, and energetic curves and diagonals. Jupiter, in the guise of a white bull, plows the sea with Europa on his back. She, in turn, combines the receptive pose of the reclining nude with gestures of excited protest, accompanied by fluttering drapery. Like the Europa on the red-figure vase, Titian's Europa grabs on to the horn of the bull. Two Cupids in the sky echo Europa's excitement, while a third rides a large fish swimming after the bull. This Cupid gazes at the abduction like a child riveted by the erotic activity of adults. The fish echoes the child's gaze by staring back at the viewer out of one very prominent eye. In the distant background, Europa's companions wave helplessly from the shore.

Titian's long career, like Michelangelo's, chronologically overlapped the Mannerist style, which developed after the High Renaissance. The late styles of both artists went beyond the High Renaissance classicism of Raphael—Titian in his loose brushwork and Michelangelo in his elongated forms. This demonstrates the difficulty of confining dynamic artists to specific stylistic categories. Nevertheless, by virtue of their training and their impact on the history of art, both Titian and Michelangelo are considered to epitomize the High Renaissance.

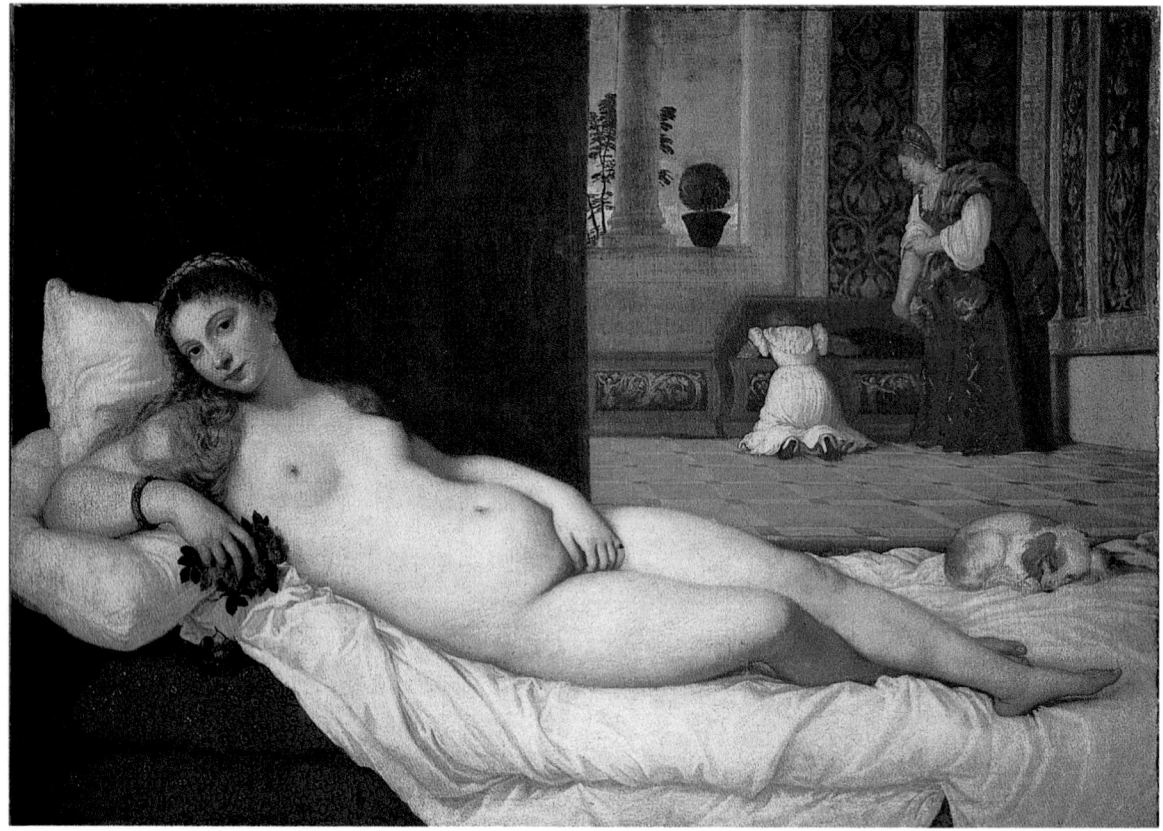

14.52 Titian, *Venus of Urbino*, c. 1538. Oil on canvas; 3 ft. 11 in. × 5 ft. 5 in. (1.19 × 1.65 m). Galleria degli Uffizi, Florence. The meaning of this painting has been the subject of much discussion. Some scholars claim that the reclining woman is a Venetian courtesan and that the theme of the work is illicit love. Others, while admitting its sensuality, see it as representing marital love and fidelity.

—————— CONNECTIONS ——————

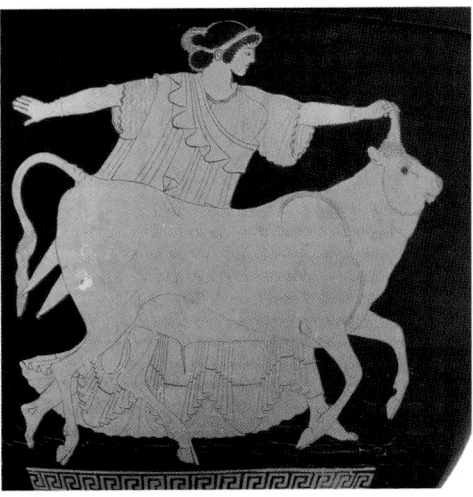

See figure 5.10. Berlin Painter, bell *krater* showing the *Abduction of Europa*, c. 490 B.C.

14.53 Titian, *Rape of Europa*, 1559–1562. Oil on canvas; 73 × 81 in. (1.85 × 2.06 m). Isabella Stewart Gardner Museum, Boston. This is one of a series of mythological scenes, known as *poesie*, that Titian painted from 1550 to 1562 for Philip II of Spain. Titian would have known the description of the episode in Ovid's *Metamorphoses* (II. 843–875), and possibly also in the 2nd-century-A.D. novel by Achilles Tatius, who includes certain details depicted here.

1480

Anonymous, *An Ideal City* (**14.5**)
Verrocchio, *Baptism of Christ* (**14.12**)

THE HIGH RENAISSANCE
c. 1480–1550

Gentile Bellini, *Sultan Mehmet II*

Gentile Bellini, *Sultan Mehmet II* (**14.40**)
Leonardo, church-plan drawing (**14.2**)
Giovanni Bellini, *Saint Francis in Ecstasy* (**14.45**)
Leonardo, *Vitruvian Man* (**14.1**)
Giovanni Bellini, San Giobbe Altarpiece (**14.43**)
Michelangelo, drawing copy of Masaccio's Saint Peter (**14.17**)
Leonardo, *Last Supper* (**14.13–14.14**)
Gentile Bellini, *Procession of the Reliquary of the Cross in Piazza San Marco* (**14.42**)
Michelangelo, *Pietà* (**14.18**)

Spain finances voyage of Columbus to the New World (1492)
François Rabelais, French author (1494–1553)
Imperial Diet opens in Worms (1495)
Severe famine in Florence (1497)
Savonarola burned at the stake in Florence (1498)
Vasco da Gama discovers sea route to India (1498)

1500

1500–1510

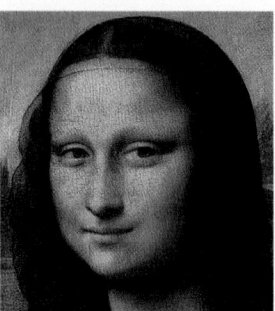

Leonardo, *Mona Lisa*

Leonardo, *Self-Portrait* (**14.37**)
Giovanni Bellini, *Doge Leonardo Loredan* (**14.44**)
Michelangelo, *David* (**14.19**)
Giorgione, *Old Woman* (**14.47**)
Bramante, Tempietto (**14.3**), Rome
Leonardo, *Madonna and Child with Saint Anne* (**14.15**)
Jacopo Bellini, *Christ before Pilate* (**14.39**)
Leonardo, *Mona Lisa* (**14.16**)
Raphael, *Madonna of the Meadow* (**14.30**)
Giorgione, *Tempest* (**14.46**)
Bramante, New Saint Peter's (**14.10**), Rome
Caradosso, medal of New Saint Peter's (**14.7**)
Giorgione, *Sleeping Venus* (**14.48**)

Beginnings of African slave trade (c. 1500)
First manufacture of faïence (Faenza) and majolica (Majorca) (1500)
Giuliano Della Rovere is pope Julius II (1503–1513)
Term *America* used to denote the New World (1507)
Leonardo da Vinci discovers principle of the water turbine (1510)

Michelangelo, *David*

1510–1530

Leonardo, *Embryo*

Michelangelo, Sistine ceiling frescoes (**14.20–14.25**)
Raphael, Stanza della Segnatura frescoes (**14.34–14.36, 14.38**)
Giorgione, *Fête Champêtre* (**14.49**)
Leonardo, *Embryo in the Womb* (**14.11**)
Raphael, *Pope Julius II* (**14.31**)
Raphael, *Galatea* (**14.32–14.33**)
Titian, *Assumption of the Virgin* (**14.50**)
Titian, *Pesaro Madonna* (**14.51**)
Michelangelo, Laurentian Library vestibule and staircase (**14.26**), Florence

Raphael, *Galatea*

Immortality of the soul is pronounced church dogma (1512)
Copernicus states that Earth and other planets revolve around sun (1512)
Ponce de León establishes Spanish claim to Florida (1513)
Sir Thomas More, *Utopia* (1516)
Martin Luther's *Ninety-five Theses;* beginning of the Reformation (1517)
Coffee introduced into Europe (1517)
Niccolò Machiavelli, *The Prince* (1517)
Charles V crowned Holy Roman emperor (1520)
Sultan Suleyman I rules Ottoman Empire (1520–1566)
Magellan embarks on circumnavigation of the globe (1520)
Cortés conquers Aztecs, makes Mexico a Spanish colony (1521)
Castiglione, *Book of the Courtier* (1527)
Sack of Rome by troops of Charles V (1527)

1530

1530–1570

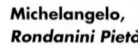

Michelangelo, *Rondanini Pietà*

Michelangelo, *Last Judgment* (**14.27–14.28**)
Titian, *Venus of Urbino* (**14.52**)
Michelangelo, *Rondanini Pietà* (**14.29**)
Titian, *Rape of Europa* (**14.53**)

Titian, *Rape of Europa*

Great ("Halley's") Comet provokes wave of superstition (1531)
Henry VIII rejects papal authority, founds Anglican Church (1534)
Founding of Jesuit Order by Ignatius Loyola (1534)
Thomas More refuses oath of the king's supremacy and is executed (1535)
John Calvin, *Institutes of the Christian Religion* (1536)
Beheading of Anne Boleyn (1536)
First Protestants burned at stake by the Spanish Inquisition (1543)
Andreas Vesalius produces atlas of human anatomy (1543)
Council of Trent introduces Counter-Reformation policies (1545–1563)
Ivan the Terrible rules Russia as tsar (1547–1584)
Giorgio Vasari, *Lives . . .* (1550)
Peace of Augsburg (1555)
Tobacco introduced into Spain from America (1555)
Charles V of Spain abdicates in favor of Philip II (1556)
Elizabeth I queen of England (1558–1603)
Protestant Netherlands rebels against Catholic Spain (1568)

1570

15

Mannerism and the
Later Sixteenth Century in Italy

The sixteenth century was a period of intense political and military turmoil from which no Italian artist could remain completely insulated. Charles I of Spain (also Charles V, the Holy Roman emperor) extended his empire to Austria, Germany, the Low Countries, and, finally, Italy. His aggressive tactics culminated in the sack of Rome in 1527. The 1500s were also a period of fundamental religious change. The power of the Catholic Church was challenged, and finally fractured, by the Protestant Reformation (see box).

The counterchallenge, or Counter-Reformation, went far in the opposite direction, and religious orthodoxy was strictly enforced by the Inquisition. Established in 1232 by the emperor Frederick II, the Inquisition was a group of state officials dedicated to identifying, converting, and punishing heretics. Pope Gregory IX (died 1241) appropriated the Inquisition and instituted papal Inquisitors for the same purposes. Their power was increased by Pope Innocent IV (died 1254), who permitted the use of torture to force confessions from the accused.

During the sixteenth century, in the climate of upheaval within the Church and the Protestant challenges to its authority, humanism seemed to pose a greater threat than it had in the fifteenth century. Notions of the primacy of man

The Reformation

By the second decade of the sixteenth century, after more than a thousand years of religious unity under the Roman Catholic Church, western Christendom underwent a revolution known as the Reformation. This led to the emergence in large parts of Europe of the Protestant Church.

During the fifteenth century, the Catholic Church had become increasingly materialistic and corrupt. Particularly offensive was the selling of "indulgences" (a kind of credit against one's sins), which allegedly enabled sinners to buy their way into heaven. In 1517, the German Augustinian monk Martin Luther protested. He nailed to a church door in Wittenberg, Saxony, a manifesto listing ninety-five arguments against indulgences. Luther criticized the basic tenets of the Roman Church. He advocated abolition of the monasteries and restoration of the Bible as the sole source of Christian truth. Luther believed that human salvation depended on individual faith and not on the mediation of the clergy. In 1520, he was excommunicated.

In 1529, the Holy Roman emperor Charles V tried to stamp out dissension among German Catholics. Those who protested were called Protestants. In the course of the next several years, most of north and west Germany became Protestant. England, Scotland, Denmark, Norway, Sweden, the Nether-

lands, and Switzerland also espoused Protestantism. For the most part, France, Italy, and Spain remained Catholic. By the end of the sixteenth century, about one-fourth of western Europe was Protestant.

King Henry VIII of England had been a steadfast Catholic, but his wish for a male heir led him to ask the pope to annul his marriage to Catherine of Aragon, the first of his six wives. The pope refused, and Henry broke with the pope. In 1534, the Act of Supremacy made Henry, and all future English monarchs, head of the Church of England. In 1536, the fundamental doctrines of Protestantism were codified in John Calvin's *Institutes of the Christian Religion*. His teachings became the basis of Presbyterianism.

The Reformation dealt a decisive blow to the authority of the Roman Catholic Church, and the balance of power in western Europe shifted from religious to secular authorities. As a result, the cultural and educational dominance of the Church waned, particularly in the sciences. In the visual arts, the Reformation had a far greater impact in northern Europe than in Italy or Spain, where the Counter-Reformation had an immense influence on the visual arts. Throughout Europe, however, the Reformation marked the beginning of a progressive decline in Christian imagery in Protestant churches.

were replaced by a harsh view of nature. More emphasis was placed on God's role as judge and on the penalties of sin rather than on the possibility of redemption. Besides splitting Europe into two religious camps, the Reformation and Counter-Reformation (also called the Catholic Reformation) had fundamental effects on art, artists, and patrons.

Mannerism

After the death of Raphael in 1520, new artistic trends began to emerge in Italy. The most significant of these has been called Mannerism. It coexisted with the later styles of Michelangelo and Titian, and remained influential until the end of the sixteenth century.

The term *Mannerism* is ambiguous and has potentially conflicting meanings. Among the several derivations that have been proposed for Mannerism are the Latin word *manus* (meaning "hand"), the French term *manière* (meaning a style or way of doing things), and the Italian *maniera* (an elegant, stylish refinement). In English, too, the term is fraught with possible interpretations. We speak of being "well-mannered" or "mannerly," when we mean that someone behaves according to social convention. "To the manner born" denotes that one is suited by birth to a certain social status. Being "mannered," on the other hand, suggests a stilted, unnatural style of behavior. "Mannerisms," or seemingly uncontrolled gestures, are considered exaggerated or affected. The nature of Mannerism also inspired the term *manneristic*, used in clinical psychology, which means exhibiting bizarre, stylized behavior of an individual nature.

All of these terms apply in some way to the sixteenth-century style called Mannerism. In contrast to the Renaissance interest in studying, imitating, and idealizing nature, Mannerist artists typically took as their models other works of art. The main subject of Mannerism is the human body, which is often elongated, exaggerated, elegant, and arranged in complex, twisted poses. Classical Renaissance symmetry does not apply in Mannerism, which creates a sense of instability in figures and objects. Spaces tend to be compressed and crowded with figures in unlikely or provocative positions, and colors are sometimes jarring. Finally, Classical proportions are rejected, and odd juxtapositions of scale and space often occur.

In contrast to the dominance of papal patronage in the High Renaissance, Mannerism was a style of the courts. It appealed to an elite, sophisticated audience. Mannerist subjects are often difficult to decipher, and their iconography can be highly complex and obscure, except to the initiated. They may also be self-consciously erotic.

Mannerist Painting

Pontormo The sometimes disturbing quality of Mannerism is evident in the work of Jacopo da Pontormo (1494–1557). His *Entombment* of 1525–1528 (fig. **15.1**) was painted for the Church of Santa Felicità in Florence: Jesus has

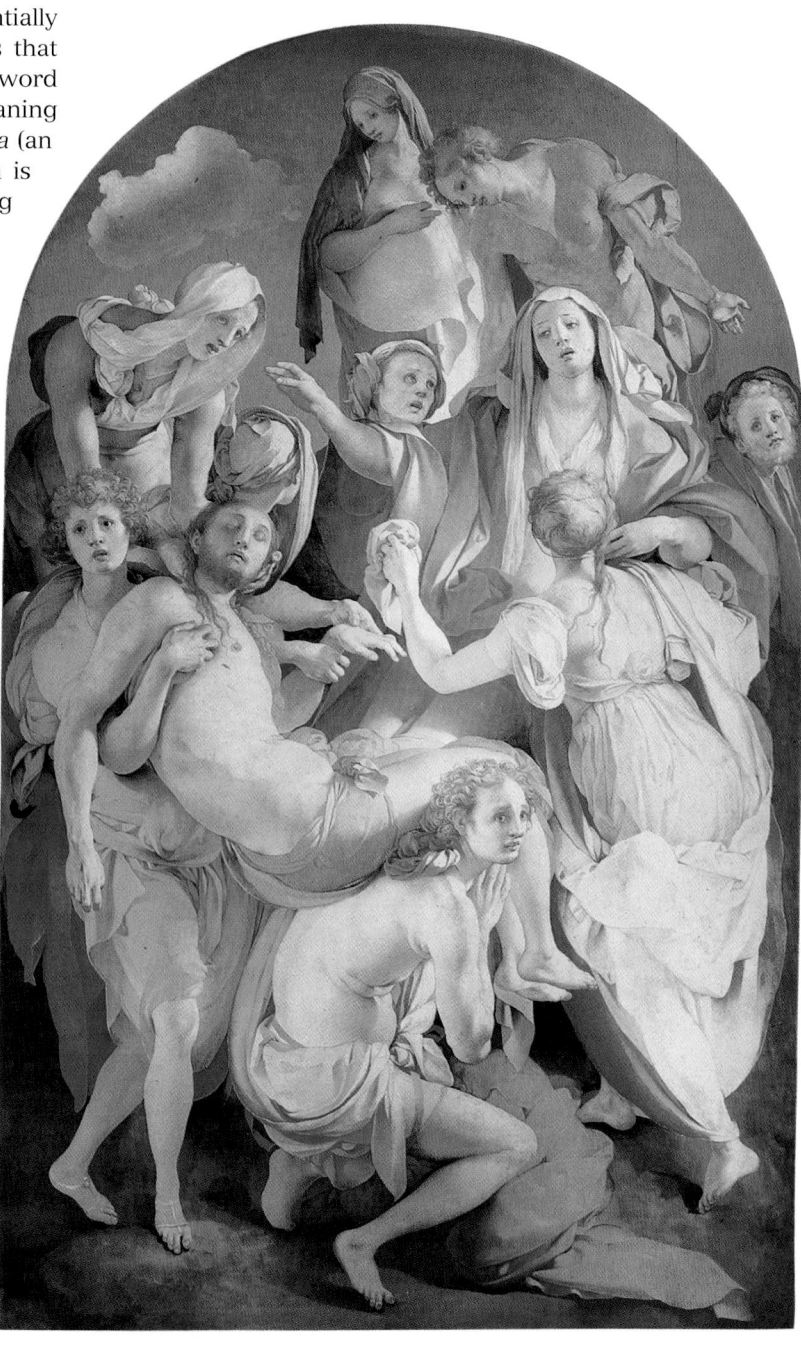

15.1 Jacopo da Pontormo, *Entombment*, Capponi Chapel, Santa Felicità, Florence, 1525–1528. Oil on panel; 10 ft. 3 in. × 6 ft. 4 in. (3.12 × 1.93 m). The painting was commissioned for the altar, with an *Annunciation* on an adjacent wall. This pairs Christ's Incarnation and Death—the former event heralding his birth and the latter his rebirth. The image of the Entombment on an altar was also a visual reminder of the Eucharist.

been taken down from the Cross, and his contorted body, with gray areas denoting the pallor of death, is being carried to his tomb. Michelangelo's influence can be seen in the sculptural, carved appearance of the drapery—especially that worn by the figure seen from the back at the right—as well as in Jesus's pose (see fig. 14.18). But the ambiguous space, the pink-and-blue palette, and the stony rather than fleshy forms create an entirely different effect.

In an uncanny juxtaposition, the activated forms and agitated poses contrast sharply with the fixed, terror-stricken gazes of the two youths carrying Jesus. Several gazes focus on the more languid figure of Mary (in blue), who seems withdrawn into herself, her relaxed, semiconscious state at odds with the dynamic pose of the woman in front of her. Mary's characterization corresponds to that of her dead son—both are removed from the frenzy of the moment. Likewise, the gray-black sky alludes to the tradition that the sky darkened at Jesus's death. Another uncanny juxtaposition is thus the contrast between the gloomy chromatic setting and the pastel colors of the draperies.

Parmigianino Mannerist virtuosity and artifice is exemplified by the *Self-Portrait in a Convex Mirror* (fig. **15.2**) of Parmigianino (1503–1540). He painted it in 1524 at the age of twenty-one with the intention of dazzling the pope, Clement VII, with his skill. According to Vasari, the artist

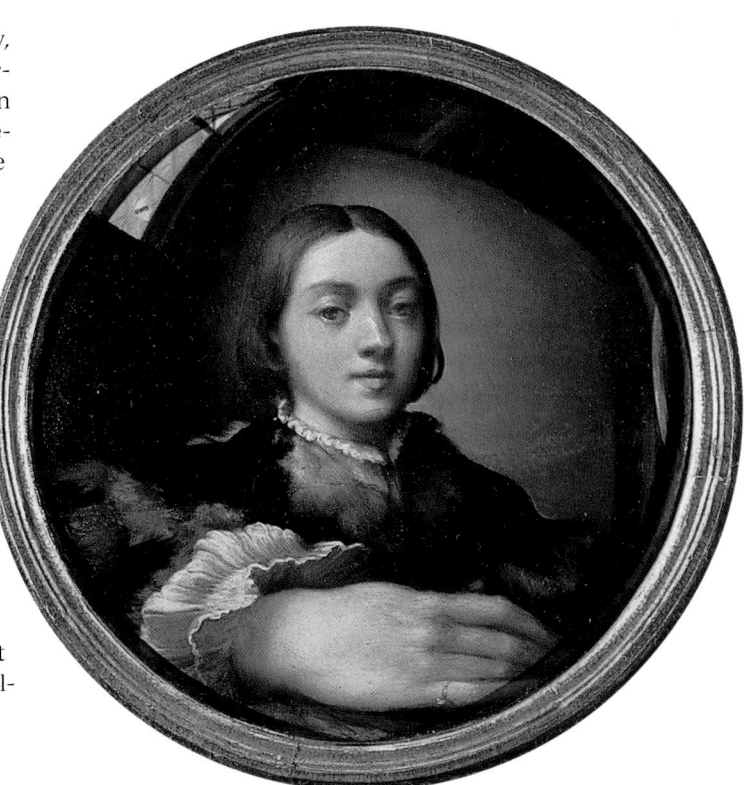

15.2 Parmigianino, *Self-Portrait in a Convex Mirror*, 1524. Oil on wood; diameter 9⅝ in. (24.4 cm). Kunsthistorisches Museum, Vienna. Il Parmigianino ("The Little Fellow from Parma") was the nickname of Francesco Mazzola, who worked in Parma, Rome, and Bologna. His career was fraught with conflicts and lawsuits, and his interest in pictorial illusionism can be related to his preoccupation with counterfeiting. He was obsessed with alchemy (the science of converting base metal to gold), and eventually he abandoned painting altogether.

John Ashbery on Parmigianino

The artifice of Parmigianino's *Self-Portrait in a Convex Mirror*, and the mirror as a metaphor for self-portraiture and self-revelation, appealed to the imagination of the twentieth-century American poet John Ashbery. The following are excerpts from his poem "Self-Portrait in a Convex Mirror":

> As Parmigianino did it, the right hand
> Bigger than the head, thrust at the viewer
> And swerving easily away, as though to protect
> What it advertises . . .
> In a movement supporting the face, which swims
> Toward and away like the hand
> Except that it is in repose. It is what is
> Sequestered . . .
> Chiefly his reflection, of which the portrait
> Is the reflection once removed.
> The glass chose to reflect only what he saw
> Which was enough for his purpose: his image
> Glazed, embalmed, projected at a 180-degree
> angle . . .[1]

got the idea from seeing his reflection in a barber shop and decided to "counterfeit everything." The painting does indeed replicate the image in a convex mirror and is, in reality, convex. In the background, Parmigianino's studio appears curved by the mirror's surface. The face is not distorted because of its relation to the picture surface, whereas the hand, which is closer, is enlarged. In these spatial arrangements, Parmigianino has emphasized the hand, making it as important a part of the image as the face. The role of the artist's hand in the artifice is thus an integral part of the picture's iconography (see box).

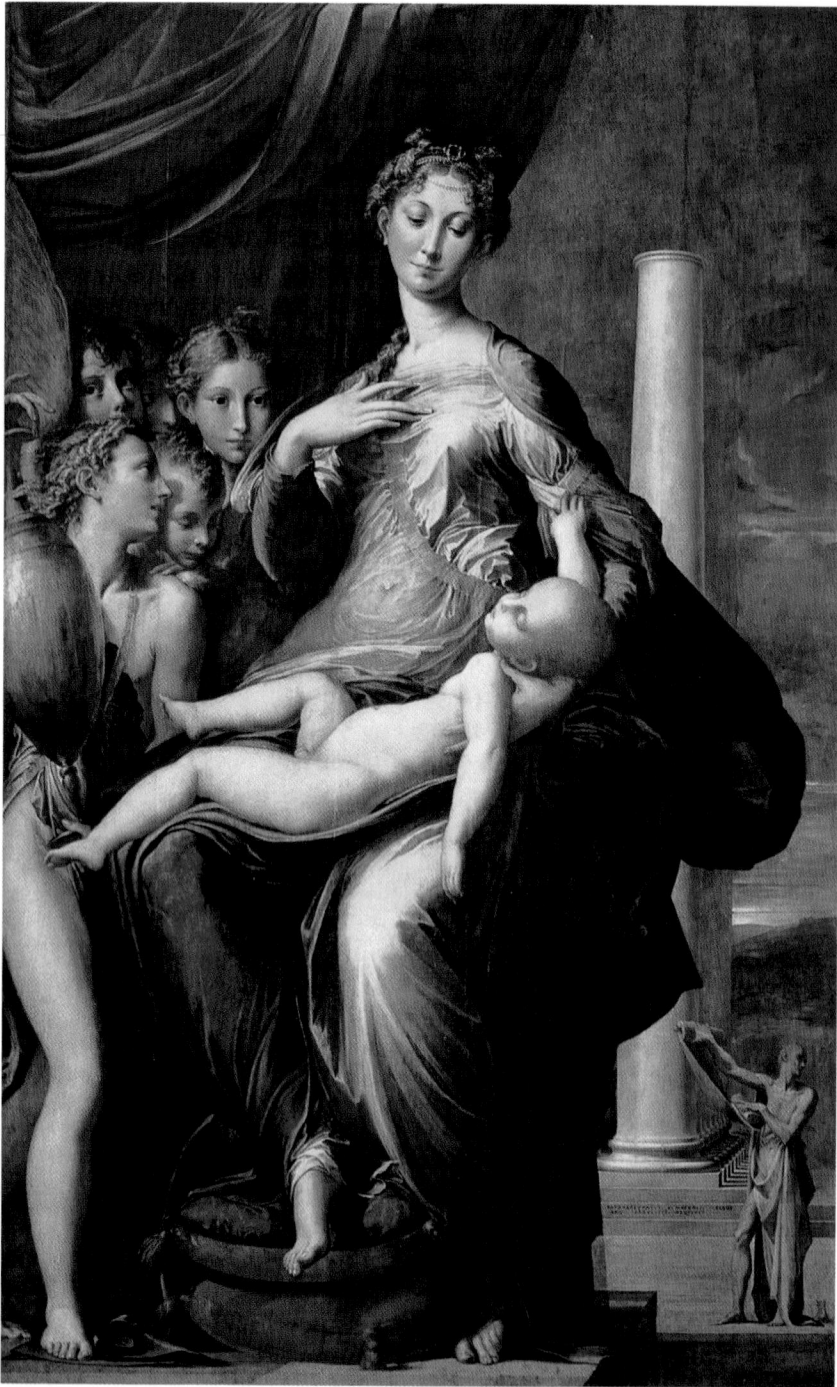

15.3 Parmigianino, *Madonna and Child with Angels (Madonna of the Long Neck)*, c. 1535. Oil on panel; approx. 7 ft. 1 in. × 4 ft. 4 in. (2.16 × 1.32 m). Galleria degli Uffizi, Florence. Parmigianino's perverse nature is evident in this painting. Its undercurrent of sinister, lascivious eroticism is also consistent with Mannerist tastes. Vasari described him as "unkempt . . . melancholy, and eccentric" at the time of his early death and related that he was, at his own request, buried naked with a cypress cross standing upright on his breast—apparently an expression of his psychotic identification with Christ.

Parmigianino's *Madonna and Child with Angels* (fig. **15.3**), also called the *Madonna of the Long Neck,* illustrates odd spatial juxtapositions and non-Classical proportions typical of Mannerism. The foreground figures are short from the waist up and long from the waist down. The Madonna, in particular, has an elongated neck and tilted head; their movement flows into the spatial twist of the torso and legs, creating a typically Mannerist **figura serpentinata.** Mary's dress, in contrast to the usual blue and red of earlier periods, is a cool metallic color. The man in the distance unrolling a scroll could be an Old Testament prophet. His position between the Madonna and the unfinished rows of columns is a logical visual link between pagan antiquity and the Christian era. His improbably small size in relation to both the columns and the Madonna, however, is illogical. The visual juxtaposition of Mary's neck with the column may allude to traditional associations between her and a column—both being conceived of as architectural supports. In a Christian context, Mary was seen as both the church building and its structural support.

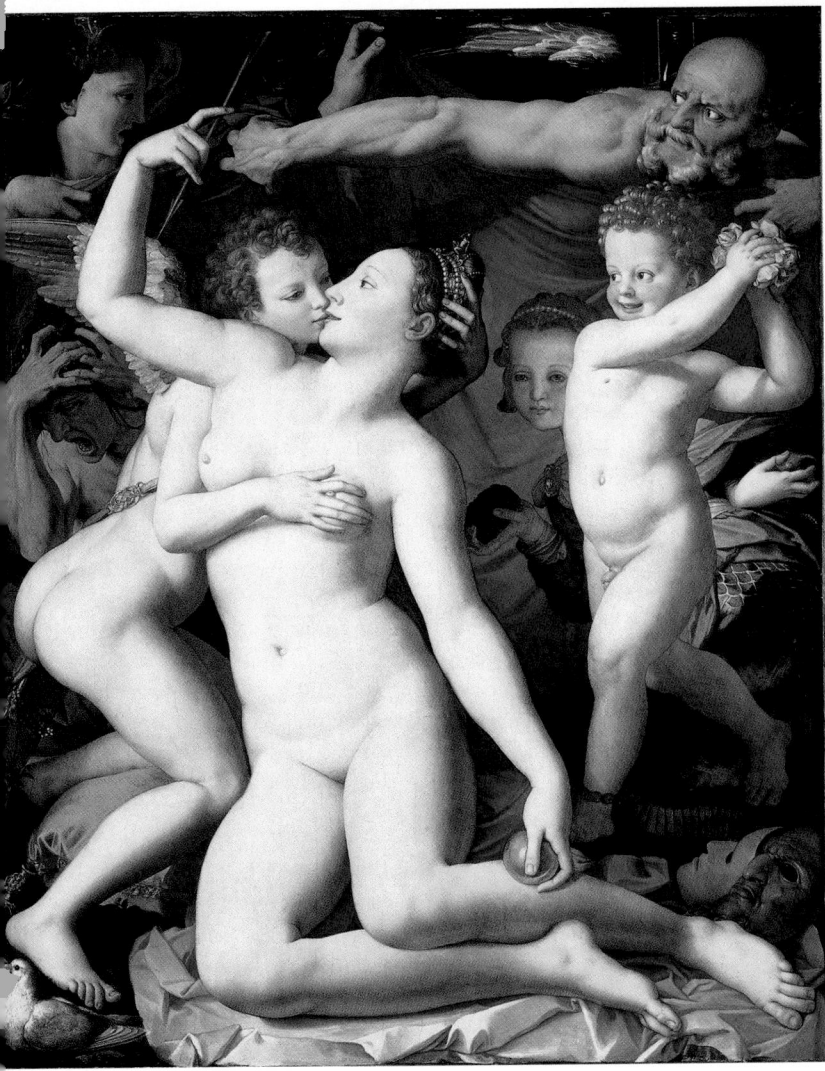

15.4 Agnolo Bronzino, allegory called *Venus, Cupid, Folly, and Time,* c. 1545. Oil on wood; 5 ft. 1 in. × 4 ft. 8¾ in. (1.55 × 1.44 m). National Gallery, London.

aside a curtain to reveal the incestuous transgressions of Venus and Cupid. The identity of the remaining figures is less certain. The hag tearing her own hair has been called Envy, and the creature behind the *putto,* with a serpent's tail, reversed right and left hands, and the rear legs of a lion, Fraud.

A more sedate type of Mannerist painting can be seen in Bronzino's portrait of *Eleonora of Toledo and Her Son Don Giovanni* (fig. **15.5**). In contrast to the nudity of the *Venus, Cupid, Folly, and Time,* these figures are very much attired. Indeed, the portrait is as much about clothing and its significance as about the figures wearing them. Bronzino delights in the carefully ordered patterns of velvet and brocade, and the regularity of Eleonora's curved tiara, which is echoed in the double strands of her pearl necklace. The porcelain skin textures of the Venus and Cupid are translated here to the aloof stares of the sitters. Gazing coldly on the world from a lofty social position, Eleonora and her son exemplify the elite sophistication of the court. Whereas the allegorical painting is about revelation and the exposure of perversion, the portrait depicts figures who are restrained and formal.

Agnolo Bronzino The allegorical painting of about 1545 by Bronzino (1503–1572), traditionally called *Venus, Cupid, Folly, and Time* (fig. **15.4**), illustrates the Mannerist taste for enigmatic imagery with erotic overtones. The attention paid to silky textures, jewels, and masks is consistent with Bronzino's courtly, aristocratic patronage. There is no consensus on the identification of every figure or even on the overall meaning of this painting. It was apparently commissioned by Cosimo I de' Medici as a gift for Francis I of France. Despite the strictures of the Counter-Reformation as codified by the Council of Trent (see box, p. 588), court patronage clearly delighted in playful and erotic, if somewhat obscure, iconography.

Venus and her son Cupid are easily recognizable as the two figures in the left foreground. Both are nude and bathed in a white light that creates a porcelain skin texture. Cupid fondles his mother's breast and kisses her lips. To the right, a nude *putto* with a lascivious expression on his face dances forward and scatters flowers. All three twist in the Mannerist *serpentinata* pose. But only the *putto's* pose seems consistent with his action. The undulating forms of Venus and Cupid are rendered for their own sakes rather than to serve the logic of the narrative. A more purposeful gesture is that of Time, the old man who angrily draws

15.5 Agnolo Bronzino, *Eleonora of Toledo and Her Son Don Giovanni,* 1545–1546. Oil on wood; 3 ft. 8 in. × 3 ft. 1 in. (1.11 × 0.93 m). Galleria degli Uffizi, Florence.

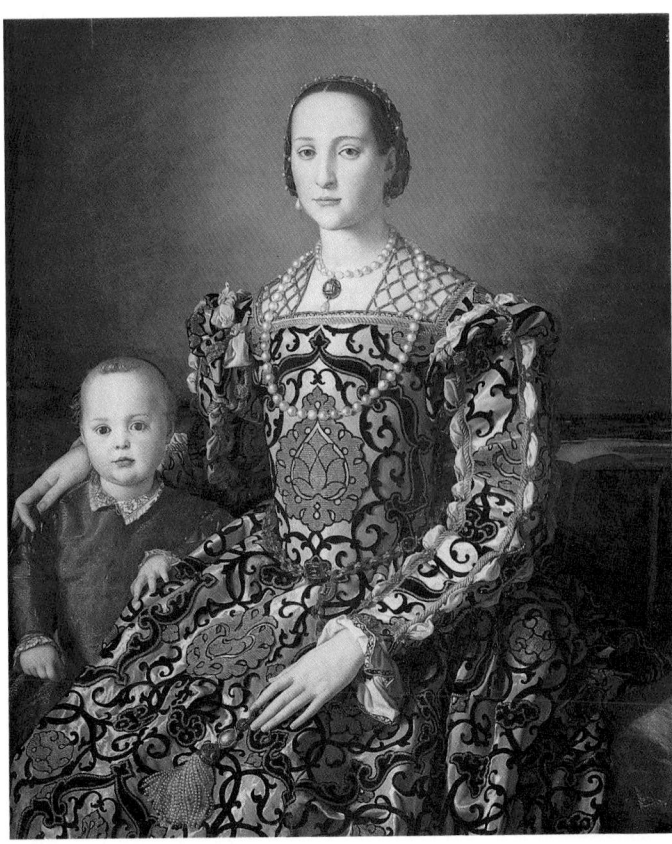

In response to the Reformation, the Roman Catholic Church mounted the Counter-Reformation and tried to eliminate internal corruption. From 1545 to 1563, the Council of Trent was convened at Trento (Trent, in English) in northern Italy. It denounced Lutheranism and reaffirmed Catholic doctrine. Measures were initiated to improve the education of priests and reassert papal authority beyond Italy. The council established an Inquisition in Rome to identify heretics and bring them to trial.

In its final session, the Council of Trent restated the Roman Church's view that art should be didactic, ethically correct, decent, and accurate in its treatment of religious subjects. Parallels between the Old and New Testaments were to be emphasized, rather than Classical events. The council directed that art should appeal to emotion rather than reason—an implicitly anti-humanist stance, which resulted in an increase of miraculous themes. The Roman Inquisition was granted the power to censor works of art that failed to meet the requirements of the council.

In 1573, the Venetian painter Paolo Veronese (1528–1586) was summoned to appear before the Holy Tribunal to defend his monumental painting of the *Last Supper* (fig. **15.6**). The trial transcript, which has been preserved, makes it clear that the Inquisition objected to Veronese's naturalism. The Inquisitors asked Veronese to identify his profession and describe his painting.

"In this Supper," the prosecutor asked, ". . . what is the significance of the man whose nose is bleeding?"

"I intended to represent a servant whose nose was bleeding because of some accident," the artist replied.

The Inquisitor asked about one of the apostles. "He has a toothpick and cleans his teeth," said Veronese.

The Inquisitor also objected to German soldiers eating and drinking on the stairs, and to the jesters and other figures in the picture. Germany, he declared, no doubt thinking of Martin Luther, was "infected with heresy." Veronese was contrite, admitting he had used artistic license. He said that Christ's Last Supper had taken place in the house of a rich man who might be expected to have visitors, servants, and entertainment. The Inquisitor was not impressed.

"Does it seem fitting at the Last Supper of the Lord to paint buffoons, drunkards, Germans, dwarfs, and similar vulgarities?"

"No, milords."[2]

Veronese was given three months to alter his picture. He merely changed its title to *Christ in the House of Levi*.

In Catholic countries, the zeal of the Counter-Reformation led to intolerance, moralizing, and a taste for exaggerated religiosity. Michelangelo came under particular attack. In 1549, a copy of his *Pietà* (see fig. 14.18) was unveiled in Florence. Because of Mary's depiction as an attractive figure, scarcely older than Christ himself, Michelangelo was called an "inventor of filth." In 1545, Pietro Aretino wrote to Michelangelo, criticizing his *Last Judgment* (see fig. 14.27) as suitable for a bath house (*un bagno*) but not for a chapel.

It was against this background of political and religious turmoil that sixteenth-century art developed after 1520. One cannot prove that this directly affected the development of Mannerism. Nevertheless, there is, in that style, an undercurrent of anxiety and tension—beneath the refinement and elegance—that is not inconsistent with the times.

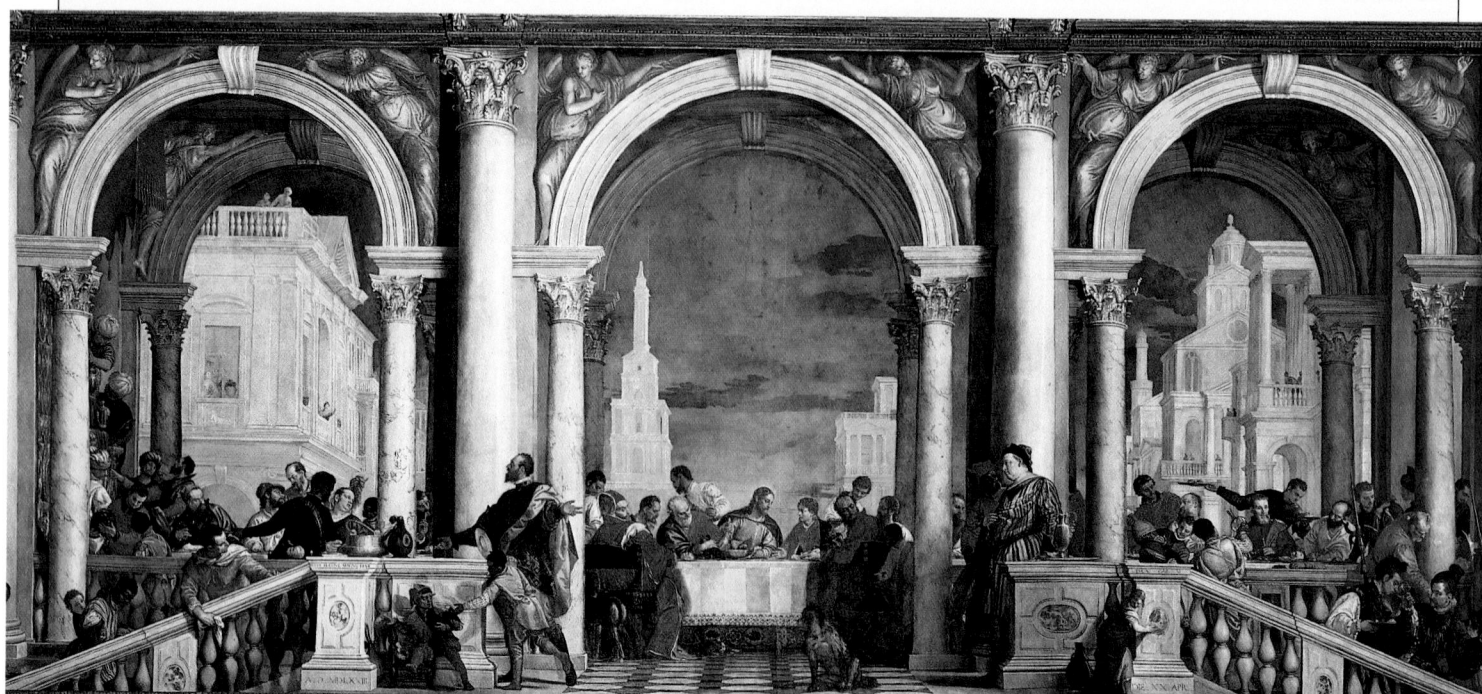

15.6 Paolo Veronese, *Last Supper,* renamed *Christ in the House of Levi,* 1573. Oil on canvas; 18 ft. 3 in. × 42 ft. (5.56 × 12.80 m). Galleria dell'Accademia, Venice. Paolo Caliari was born in Verona, hence his name, Il Veronese. In 1553, he moved to Venice, where, with Titian and Tintoretto, he dominated 16th-century Venetian painting. Although Veronese liked to dress luxuriously—in keeping with the taste for pageantry evident in his paintings—he was known for his piety and financial acumen.

Mannerist Sculpture

Cellini Benvenuto Cellini's elaborate gold and enamel saltcellar (fig. **15.7**) illustrates the iconographic complexity and taste for mythological subject matter that appealed to Mannerist artists and their patrons. Cellini himself gave conflicting accounts of the object's meaning. Perhaps he simply forgot—but the ambiguity is nevertheless consistent with Cellini's ambivalent lifestyle (see box). What is clear is that the two main nude figures represent the bearded Neptune, holding a trident and surrounded by seahorses, next to a ship, and the Earth goddess next to an Ionic triumphal arch. According to Cellini's description of the saltcellar, Neptune's ship was designed to contain the salt, and Earth's arch the pepper. Other figures include personifications of times of day and wind gods. The style and poses of the figures are clearly Mannerist, some appropriated from sculptures by Michelangelo. They are elegantly proportioned and arranged to form spatial twists that result in impossible poses. Both Neptune and Earth lean so far back that in reality they would topple over. The absence of any visible means of support reinforces their uneasy equilibrium, and the movement inherent in their poses and surface patterns is enhanced by the high polish of the gold itself.

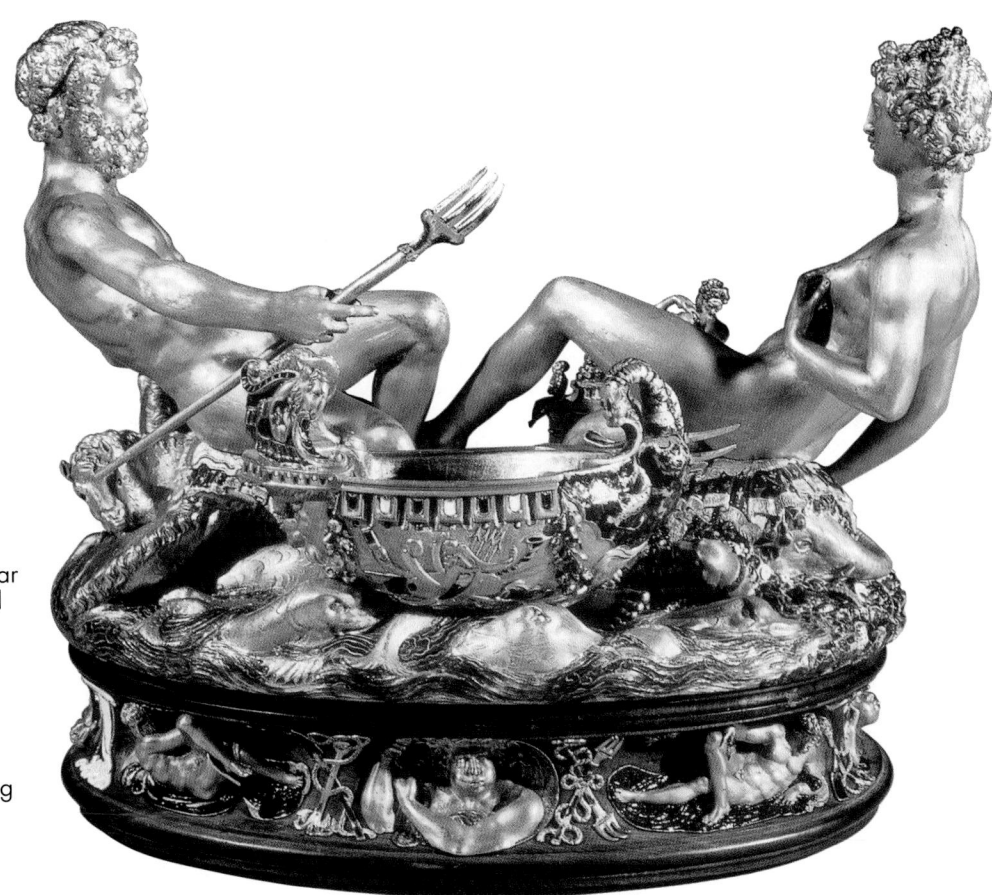

15.7 Benvenuto Cellini, saltcellar of Francis I, finished 1543. Gold and enamel; 10¼ × 13⅛ in. (26.0 × 33.3 cm). Formerly in the Kunsthistorisches Museum, Vienna. Benvenuto Cellini (1500–1571), a versatile Mannerist artist, made this elaborate saltcellar while working in France as Francis I's court goldsmith. This work was stolen from the museum and, as of this writing, is still missing.

Giambologna Although Mannerism was primarily an Italian style, Jean de Boulogne (1529–1608)—known as Giovanni Bologna, or Giambologna in Italy—was born in Flanders and became a leading Mannerist sculptor. His bronze *Mercury* (fig. **15.8**) of around 1576 shows the increasing importance of open space in Mannerism. The god flies forward, his left foot on a breath of air blown by a wind god beneath it. Mercury stretches upward, opening a variety of spaces bounded by curves and diagonals that enhance the sense of motion. The forms are thin and elongated, and the rippled surface of the bronze creates a pattern of reflected light.

Compared with the bronze *David*s of Donatello and Verrocchio (see figs. 13.29 and 13.37), the *Mercury* offers multiple viewpoints, for the difference between the front view and the side view is considerable. Not only do we see another aspect of the figure itself, but the spaces around it change. The bronze *David*s are more of a consistent piece—enclosing rather than opening space, and exhibiting smooth, fleshy surfaces. The content also contributes to the differences between the figures. Whereas the *David*s are self-satisfied and relaxed after victory, the *Mercury*'s winged cap, sandals, and caduceus identify him as the god of speed. Giambologna has used the expanded formal movement and taste for virtuosity that are characteristic of Mannerism to convey the impression of swiftness and flight.

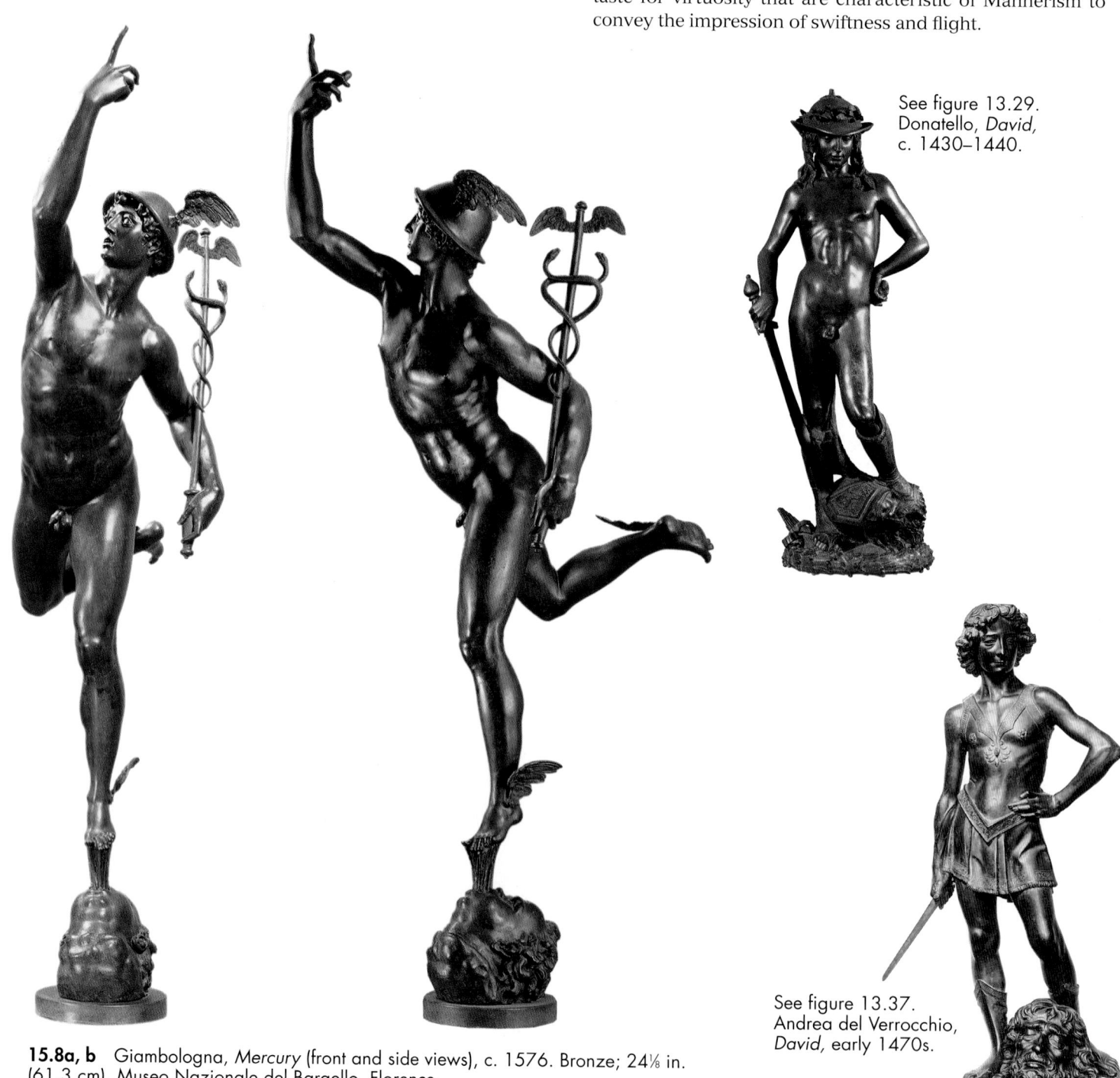

See figure 13.29.
Donatello, *David*,
c. 1430–1440.

See figure 13.37.
Andrea del Verrocchio,
David, early 1470s.

15.8a, b Giambologna, *Mercury* (front and side views), c. 1576. Bronze; 24⅛ in. (61.3 cm). Museo Nazionale del Bargello, Florence.

Vasari on Women Artists

In his view of women artists, Vasari was something of a humanist. He included the biography of Madonna Properzia de' Rossi (c. 1490–1530) in his *Lives*, where he has a lot to say about the excellence of women in antiquity. He also names the women of his own day who achieved fame in letters but elaborates further on the women artists.

Properzia de' Rossi was born in Bologna, where she studied drawing. She received a few public commissions and did several marble portrait busts. Payment for sculptures on the façade of San Petronio in Bologna is documented, but it is not certain which are by her hand. Vasari describes a panel of *Joseph and Potiphar's Wife*, which has been attributed to Properzia. He relates the subject directly to the artist's life—for she, like Potiphar's wife, conceived an unrequited passion for a young man.

The scene itself (fig. **15.9**) is quite complex. Potiphar's wife turns to grab Joseph's cloak, and Joseph, who turns to leave, seems to rush from the plane of the relief. Properzia has conveyed the erotic passion of Potiphar's wife—and Joseph's flight from it—by the agitated swirls of drapery and the open, inviting flaps of the tent. The technical skill of this panel is consistent with Vasari's admiration of Properzia's carvings made from peach stones: "They were singular and marvellous to behold."[3]

15.10 Sofonisba Anguissola, *The Artist's Sister Minerva,* c. 1559. Oil on canvas; 33½ × 26 in. (85.1 × 66.0 cm). Milwaukee Art Museum. Gift of the family of Mrs. Fred Vogel, Jr.

According to Vasari, there were many other women whose talent in drawing and painting equaled Properzia's in carving. Among these was Sofonisba Anguissola (1532/5–1625). Her success brought her to the attention of Philip II of Spain, at whose court she spent many years. She had five sisters who were also artists and was married twice—first to a Sicilian lord and then to a ship's captain.

Sofonisba was an accomplished portrait painter. Her portrait of her sister Minerva (fig. **15.10**) captures a rather wistful expression and emphasizes the textured variation of the dress. She wears coral and gold jewelry, lace, and fur, which, like her features, are delicately rendered. Her pendant depicts the Roman Minerva, goddess of the art of weaving as well as of war and wisdom.

The style of Properzia's relief is well within Renaissance tradition, although there is a Mannerist flavor in the draperies and in the slightly contorted pose of Potiphar's wife. Sofonisba's *Minerva*, however, has affinities with Bronzino's *Eleonora of Toledo* (see fig. 15.5).

15.9 Properzia de' Rossi (attrib.), *Joseph and Potiphar's Wife,* c. 1520. Marble relief panel; 19 ft. ¼ in. × 18 ft. ⅛ in. (5.86 × 5.55 m). Museo di San Petronio, Bologna.

Giulio Romano: The Palazzo del Tè

Giulio Romano (1492/9–1546) created in the Palazzo del Tè, in Mantua, a Mannerist environment that combined architectural humor with painted illusionism. He had been Raphael's chief assistant on the Vatican *stanze,* and when Raphael died in 1520, Giulio completed many of his unfinished works. Four years later, Federigo Gonzaga commissioned a villa for a weekend getaway, a place of entertainment and festivity, and a horse farm. From 1525 to 1535, Giulio Romano worked on the project. The plan illustrated in figure **15.11** shows the square courtyard.

In the design of the courtyard façades (fig. **15.12**), Giulio subverted the classical forms recommended by Alberti. The effect is a more animated surface and a disruption of Classical proportions. The **rustication** is heavier, and the bulky Tuscan Doric columns support an architrave that seems too thin for the frieze above it. The central triglyphs push down a section of the architrave, and both drop below their usual level. The bases of the pediments over the blind windows are missing, leaving them unsupported except for stone brackets at the corners. Keystones, the structural function of which is to lock in the voussoirs, seem to pop forward, as if being pushed from behind. In these variations on Classical Orders, Giulio Romano mocks traditional forms of Western architecture—which he nevertheless retains—by slight alterations in placement and proportion.

15.11 Giulio Romano, plan of the Palazzo del Tè, Mantua, 1525–1535.

15.12 Giulio Romano, courtyard façade of the Palazzo del Tè, Mantua, 1525–1535.

The most spectacular interior decorations in the Palazzo del Tè are the frescoes in the Sala dei Giganti (Room of the Giants). The ceiling and walls (figs. **15.13** and **15.14**) depict the cataclysmic battle between the Olympian gods and the Titans. The ceiling is a Mannerist version of Mantegna's *oculus* (see fig. 13.54), which was also painted in Mantua under Gonzaga patronage. It is covered with a large scene depicting Jupiter's temple, swirling cloud formations, and monumental, twisting figures. The gods surround Jupiter as he hurls thunderbolts at the Titans laying siege to Mount Olympos. Below, the world itself seems to crumble before Jupiter's fury.

On the walls, colossal Titans cower under collapsing buildings or grasp in vain as columns crack in their arms. As in Mantegna's Camera Picta (see fig. 13.53), the viewer is thrown off balance by the illusionistic blend of real and fictive forms. In the Mannerist conception, however,

See figure 13.54. Mantegna, ceiling *oculus* of the Camera Picta, Mantua, finished 1474.

15.13 Giulio Romano, Sala dei Giganti ceiling, Palazzo del Tè, Mantua, 1530–1532.

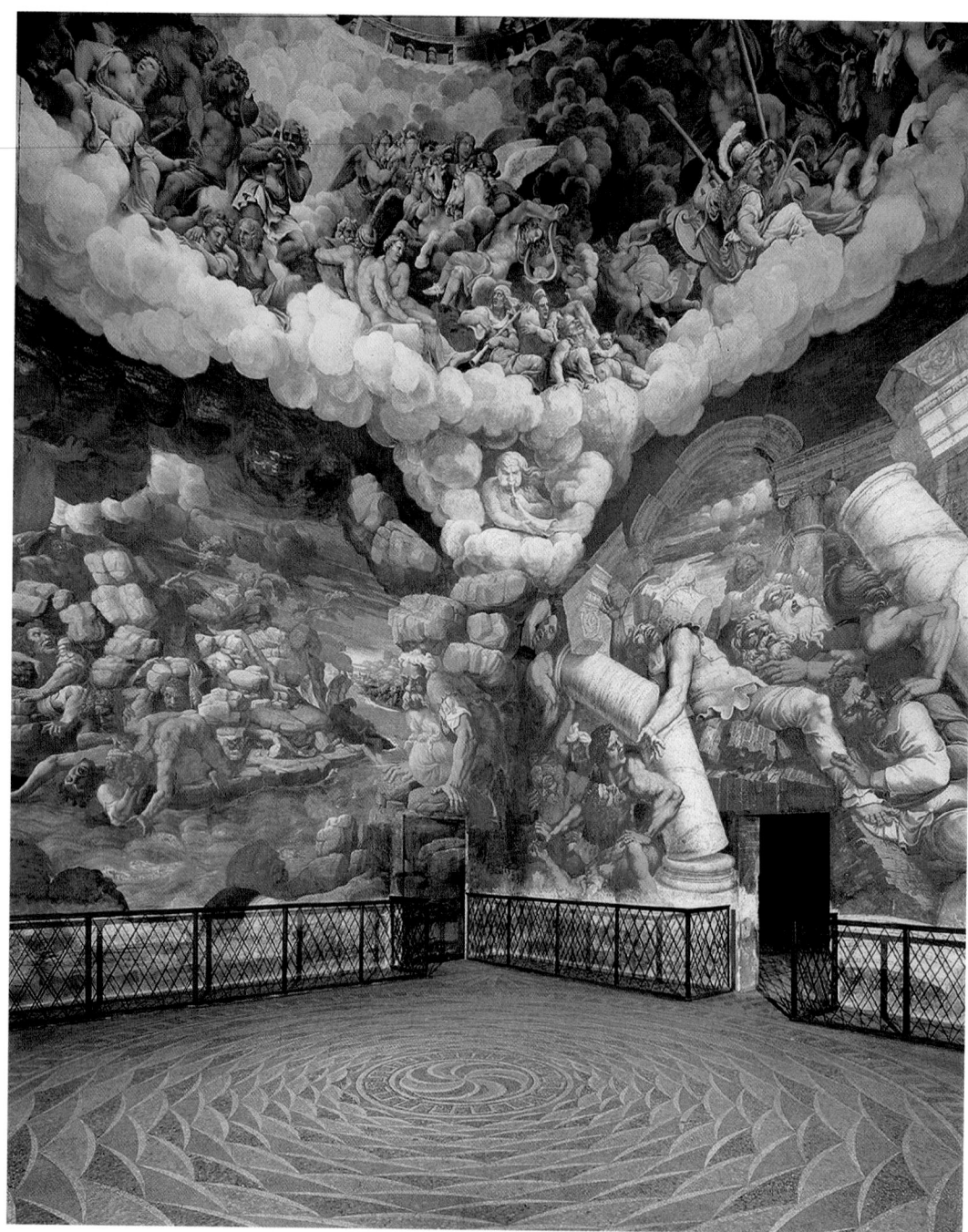

15.14 Giulio Romano, Sala dei Giganti wall view showing the *Fall of the Giants*, Palazzo del Tè, Mantua, 1530–1532.

there is an increased turbulence that animates the surface and deepens the space. The humor in all this is contained in the implicit relationship between the meaning of the Titanic mythological battle and Giulio Romano's architectural disruptions on the courtyard façades. Both represent a rebellion against the rules of a previous era and the establishment of a new order. In the myth it is a social and religious order, and in the building an architectural Order. It is no accident, therefore, that Giulio depicts the Titans' fall in architectural terms and that the crumbling structures are Classical.

Counter-Reformation Painting

Tintoretto

The impact of the Council of Trent and the Counter-Reformation on the visual arts is most evident from the second half of the sixteenth century. Tintoretto (1518–1594), for example, a leading Venetian painter and a contemporary of Veronese, painted a *Last Supper* (fig. **15.15**) in 1592–1594 that conformed well to Counter-Reformation requirements. The choice of the moment represented,

15.15 Jacopo Tintoretto, *Last Supper*, 1592–1594. Oil on canvas; 12 ft. × 18 ft. 8 in. (3.66 × 5.69 m). Choir, San Giorgio Maggiore, Venice. Jacopo Robusti (1518–1594) was nicknamed Tintoretto ("Little Dyer" in Italian) because of his father's profession as a wool dyer. He worked for most of his life in Venice and succeeded Titian as official painter to the republic. He was very prolific and employed many assistants, including two sons and a daughter, Marietta (see box).

The Painter's Daughter

In the seventeenth-century biography of Tintoretto by Carlo Ridolfi, the author includes an account of two of the artist's children, Domenico and Marietta, who were also painters. Both children assisted their father in completing commissions and were well thought of by their contemporaries. Ridolfi reports that Tintoretto trained Marietta and had her instructed in music. She accompanied her father everywhere and dressed as a boy. Because Tintoretto was so attached to her, he arranged for her to marry a local jeweler rather than leave Venice. Her special talent, according to Ridolfi, was portraiture, although he notes that her works have disappeared. Marietta died at age thirty.

Particularly striking, in the light of modern feminist approaches to art history, is Ridolfi's vigorous defense of women artists. Like Vasari, he cites examples of famous women in antiquity as well as in his own day. He condemns the discrimination that kept women untrained and at home. Ridolfi concludes, however, that women will triumph because, in addition to natural talents, they are also armed with beauty.

when Christ demonstrates the symbolic meaning of the bread as his body and the wine as his blood, lends itself to mystical interpretation.

In Tintoretto's *Last Supper*, in contrast to those by Veronese (fig. 15.6) and Leonardo (see fig. 14.13), the picture space is divided diagonally. The table is no longer parallel to the picture plane but recedes into the background, and the figures are not evenly lit from a single direction. The humanist interest in psychology and observation of

CONNECTIONS

See figure 14.13. Leonardo da Vinci, *Last Supper*, c. 1495–1498.

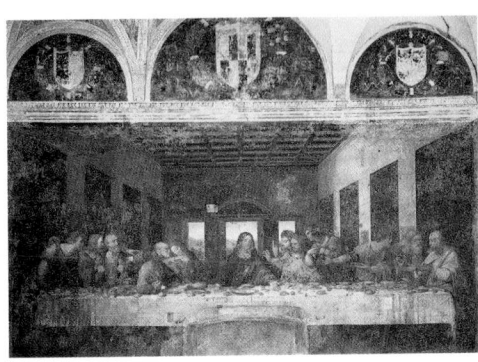

Saint Ignatius Loyola (1491/5–1556) was born to a noble Spanish family and entered military service as a young man. He was wounded and during his convalescence decided to become a Christian soldier. He renounced the material world, lived the life of a beggar, and underwent numerous mystical experiences. In response to Martin Luther and the Protestant Reformation, Ignatius decided to reform the Church from within. He founded the Society of Jesus, which Pope Paul III sanctioned in 1540, and wrote the *Spiritual Exercises* to instruct his followers in meditation.

Loyola's system was calculated to conquer fears and passions by a form of empathetic identification practiced in advance of an experience. For example, in the meditation on the "Agony of Death," he recommends contemplating four things: (1) the dim light and familiar objects in the death room; (2) the

people you leave behind; (3) the disintegration of your own body as death approaches; and (4) devils and angels fighting for your soul. His technique was for potential sufferers to create a mental picture, through which trauma would be experienced in advance, and to prepare themselves for the worst. Contemplate, he writes, the "sound of the clock which measures your last hours . . . your painful labored breathing . . . your face . . . covered with cold sweat."[4] And after death has come, imagine yourself "enclosed in a coffin" and the "open grave where they are laying your body." Contemplate your tombstone, months later, "blackened by time . . . the worms [that] devour the remains of putrid flesh . . . this mass of corruption." And finally, "ask yourself what are health, fortune, friendship of the world, pleasures of the senses, life itself: 'vanity of vanities, all is vanity' (Eccles. 1:2)."

nature has been subordinated to mystical melodrama. To the right of the table, in deep shadow, are servants going about their business, apparently unaware of the significant event taking place. On the left of the table are the apostles, some in exaggerated poses, illuminated by a mystical light that is consistent with official Counter-Reformation requirements. Toward the center of the table, Jesus distributes bread to the apostles. Light radiates from his head so that he is depicted literally as "the light of the world." On the other side of the table, brooding, isolated, and in relative darkness, sits Judas. At the upper right, outlined in glowing light, is a choir of angels.

El Greco

El Greco (Domenikos Theotokopoulos, 1541–1614) was even more directly a painter of the Counter-Reformation. He worked in Spain from 1577 onward, when Counter-Reformation influence was at its strongest. In his paintings virtually all traces of High Renaissance style and Classical subject matter have disappeared. Although he spent time in Titian's workshop, El Greco's style was more affected by the Byzantine influence prevalent in his native Crete and in Venice, to which he moved, than by Titian's humanism. He was more in tune with the mystical fervor and religious zeal that predominated in Catholic Spain (see box).

While still in Italy, El Greco painted *Christ Healing the Blind* (fig. **15.16**), in which Tintoretto's influence is evident in the strong diagonal thrust of the space. As in Tintoretto's *Last Supper,* El

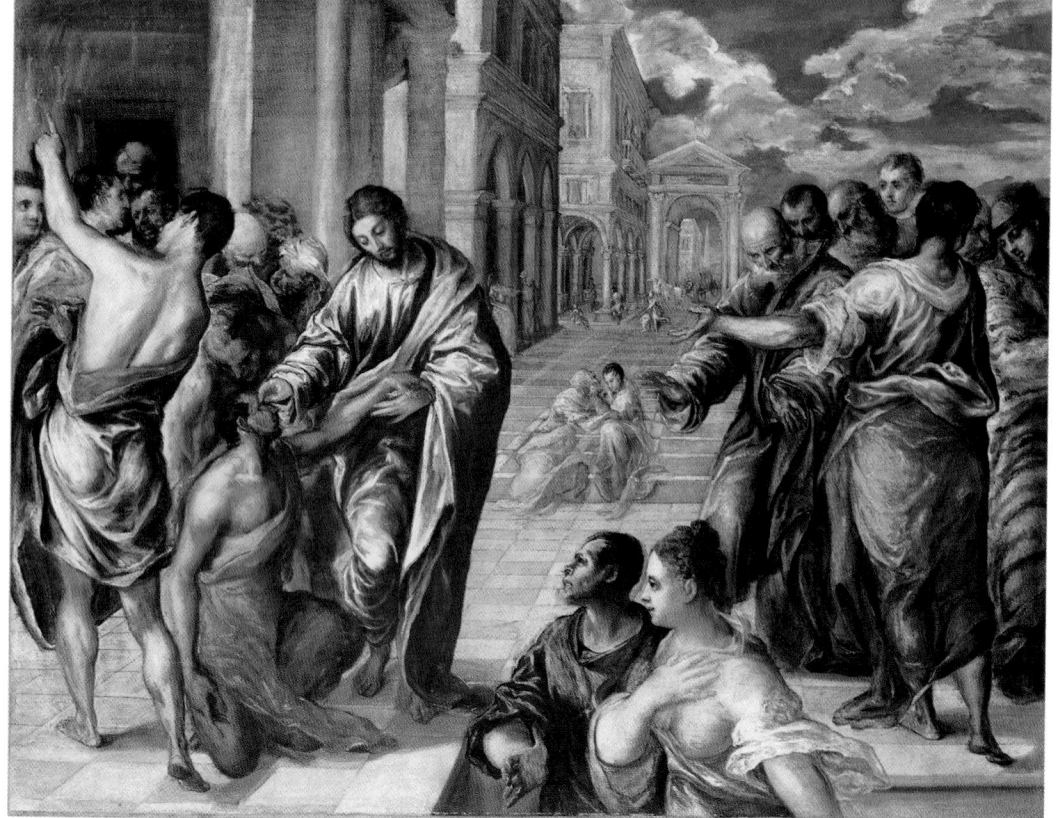

15.16 El Greco, *Christ Healing the Blind,* c. 1577. Oil on canvas; 47¼ × 57½ in. (120.0 × 146.1 cm). Metropolitan Museum of Art, New York. Domenikos Theotokopoulos was born in Crete and was subsequently nicknamed El Greco (Spanish for "The Greek"). Most of his work was executed for the Church rather than the court and has a strongly spiritual quality. Of the leading Mannerist painters, El Greco was the most mystical and was therefore well suited to the fervent religious atmosphere of Counter-Reformation Spain.

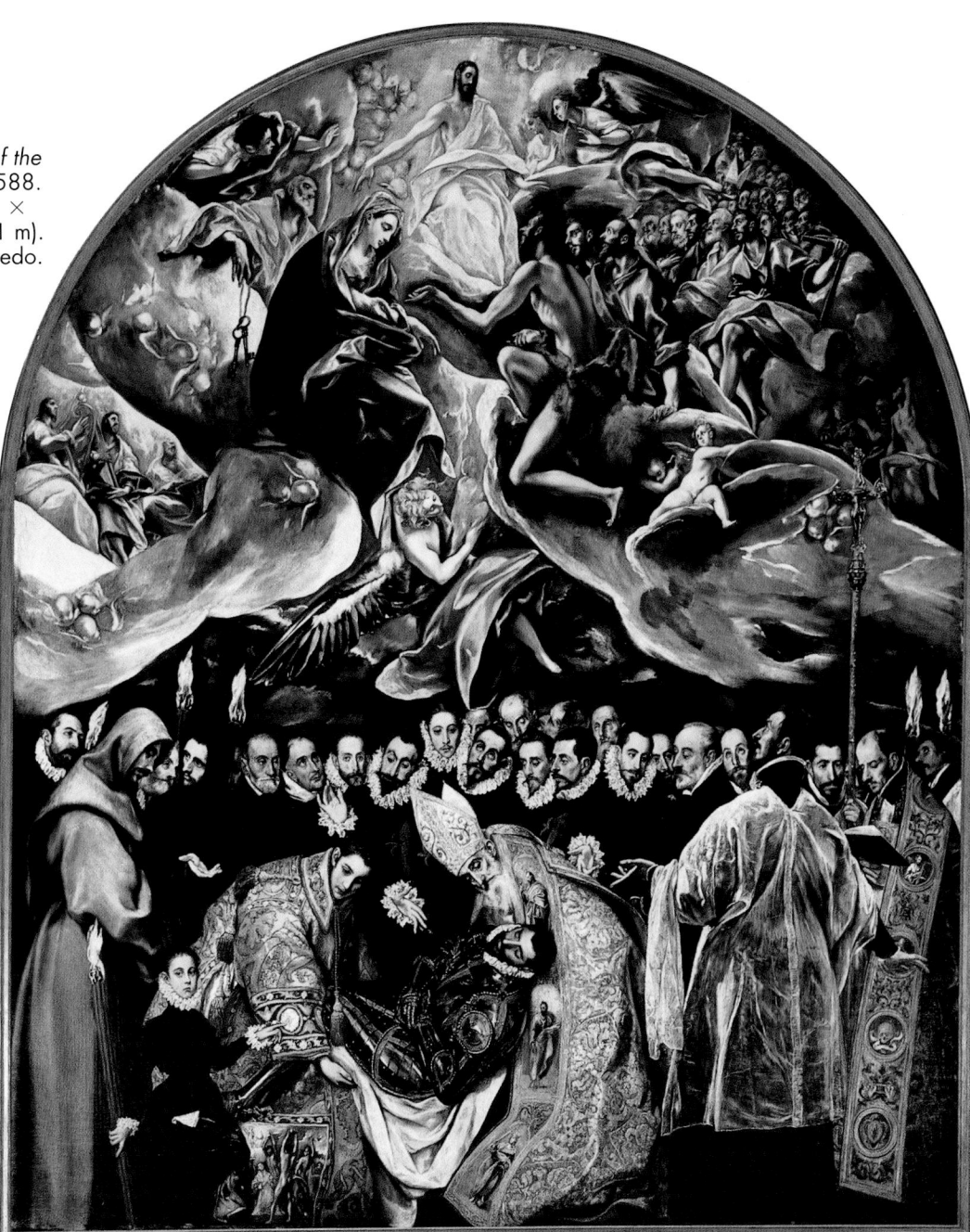

15.17 El Greco, *Burial of the Count of Orgaz*, 1586–1588. Oil on canvas; 15 ft. 9 in. × 11 ft. 10 in. (4.80 × 3.61 m). Church of Santo Tomé, Toledo.

Greco's figures are elongated and occupy somewhat exaggerated poses. The intensity of their gestures reinforces the miracle of Christ restoring sight to a blind man. El Greco's characteristic shimmering silver light creates a mystical aura consistent with Counter-Reformation taste. At the same time, however, the classicizing architecture reflects the continuing impact of the Renaissance revival of antiquity.

Once El Greco had settled in Spain, he spent most of his life in the small town of Toledo. There he painted his famous work in the Church of Santo Tomé for the burial chapel of Gonzalo Ruiz, count of Orgaz (fig. **15.17**). The painting, which is over 15 feet high, is divided into two levels—the earthly and the heavenly. Local tradition had it that the count of Orgaz was rewarded for his good works by the appearance of Saints Stephen and Augustine at his funeral. Here, the elderly Bishop Augustine (on our right) and the youthful Saint Stephen (on our left) lift the count into his grave. Lined up behind the burial scene are citizens of Toledo wearing black costumes and somber expressions. A small boy at the lower left, thought to be the artist's son, points us toward the miracle. At the right, the only figure seen in back view wears a luminous white robe and leads us heavenward with his upward gaze.

The scene taking place in heaven shows the count's nearly naked soul before Christ. The Virgin Mary, opposite the count, is clad in her traditional red and blue robes and acts as intercessor—her traditional role. Just behind the Virgin, Saint Peter dangles the keys to the gate of heaven. Receding upward and into the background, the heavenly host seems to swirl weightlessly, illuminated by variations of mystical, translucent light.

Mystic Saints

Saint Teresa of Ávila (1515–1582) and Saint John of the Cross (1542–1591) were full-fledged mystics caught up in Spanish Counter-Reformation zeal. In 1555, at the age of thirty-nine, Teresa converted to the spiritual life while praying to an image of the flagellated Christ. She established the Discalced ("barefoot") communities of Carmelites. In addition to Spain, Teresa had missions in the Middle East and Africa. She was aided in her efforts at spiritual reform by Saint John of the Cross. He, too, joined the Carmelites and wrote poems and a treatise on the journey of the soul from the world of the senses to God.

Saint Teresa wrote *The Way of Perfection* to instruct her nuns and an autobiography, which recounts her visions and mystical experiences.

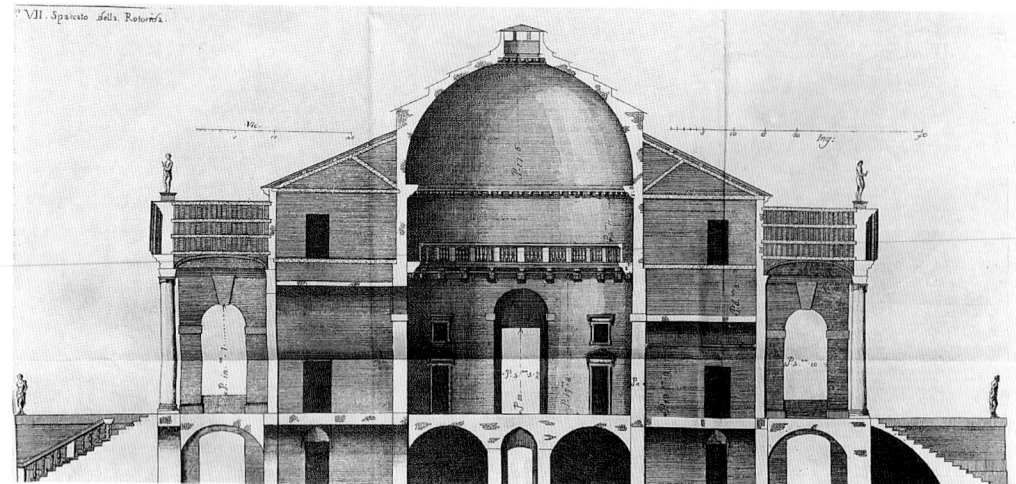

15.18 Section of the Villa Rotonda, Vicenza (from the *I quattro libri dell'architettura*, 1570), 18th-century engraving, Bibliothèque de l'Arsenal, Paris.

Late Sixteenth-Century Architecture

Andrea Palladio

The greatest architect of late sixteenth-century Italy was Andrea Palladio (1508–1580), who synthesized elements of Mannerism with High Renaissance ideals. His use of ancient sources, particularly Vitruvius, was inspired by a humanist education (see box, p. 600).

From 1567 to 1570, Palladio built the Villa Rotonda (figs. **15.18**, **15.19**, and **15.20**), near the northern Italian city of Vicenza, for a Venetian cleric. The façade replicates the Classical temple portico—Ionic columns supporting an entablature crowned by a pediment—in the context of domestic architecture. There are four porticos, all in the same style and one on each side of the square plan. In Palladio's view, the Classical entrance endowed the building with an air of dignity and grandeur. The strict symmetry

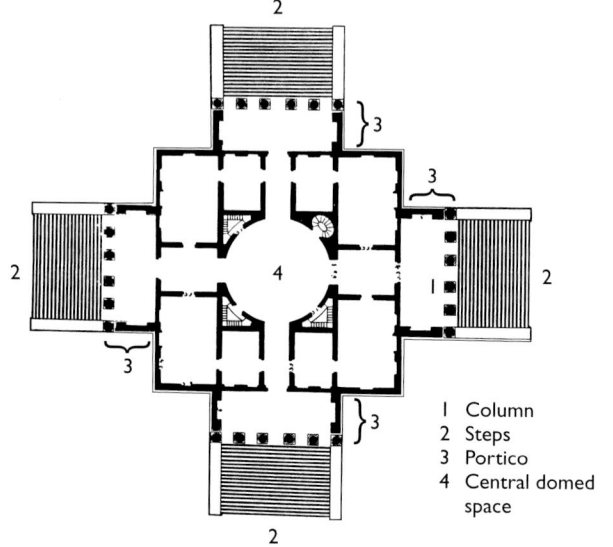

1 Column
2 Steps
3 Portico
4 Central domed space

15.19 Plan of the Villa Rotonda, Vicenza.

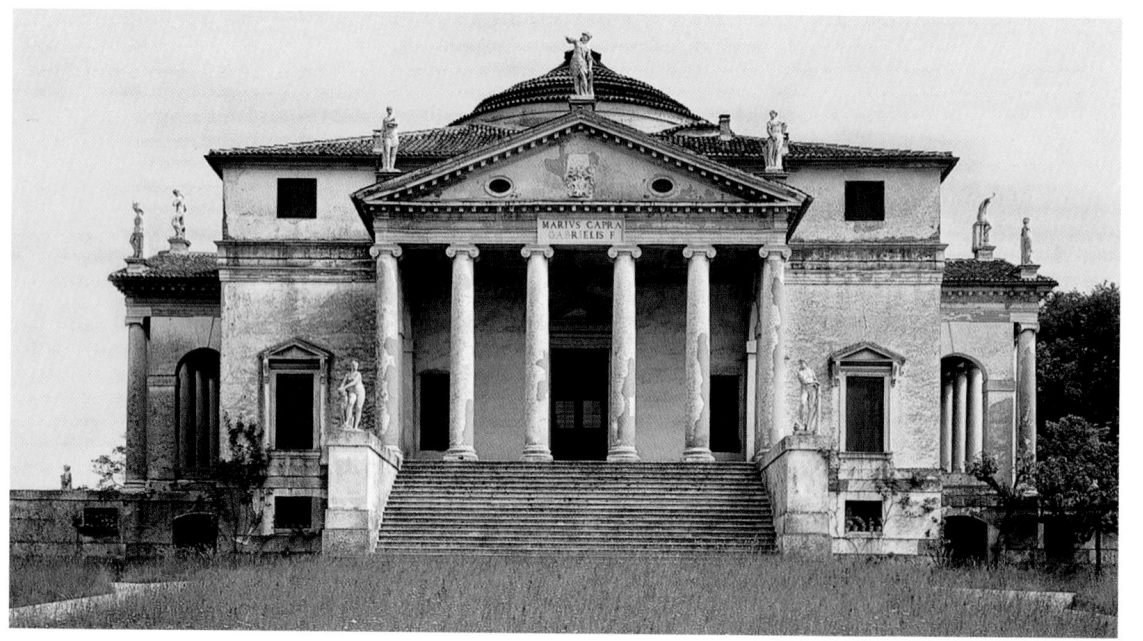

15.20 Andrea Palladio, Villa Rotonda, Vicenza, begun 1567–1569. Andrea di Pietro della Gondola was renamed Palladio (after Pallas Athena) by Count Trissino, a humanist scholar and poet who supervised his education and career. Palladio is known to have been involved in over 140 building projects, of which no more than about 35 survive. He also published *L'antichità di Roma*, one of the first Italian guidebooks, in 1554.

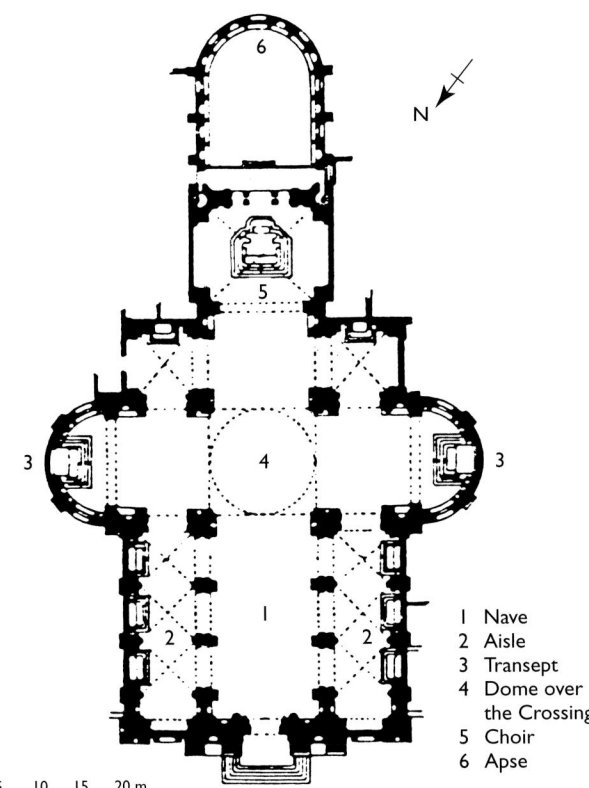

15.21 Andrea Palladio, San Giorgio Maggiore, Venice, begun 1565.

1 Nave
2 Aisle
3 Transept
4 Dome over the Crossing
5 Choir
6 Apse

0 5 10 15 20 m
0 25 50 75 ft

was both a Classical and a Renaissance characteristic. Such features recalled ancient Rome, where the villa had originated as an architectural type.

The square plan of the Villa Rotonda is typical of Palladio's villas. Passages radiate from a domed central chamber to each of the four exterior porticos. They, in turn, offer views of the surrounding landscape in four different directions. At the sides, each portico is enclosed by a wall pierced by an arch, thereby providing shelter as well as ventilation.

In figure 15.20, some of the classically inspired statues at each angle of the pediments are visible. Others decorate the projecting walls flanking each side of the steps. Since the Villa Rotonda was a purely recreational building, used exclusively for entertaining, it did not have the functional additions found in Palladio's other villas.

From 1570, Palladio worked mainly in Venice, particularly on church design. His Church of San Giorgio Maggiore (figs. **15.21** and **15.22**), begun in 1565 but not completed until 1592, stands on a small island off the Grand Canal. In this building, Palladio solved the problem of relating the façade to an interior with a high central nave and lower side aisles—a problem similar to the one

15.22 Plan of San Giorgio Maggiore, Venice.

or interrupts, one pediment in imposing another over it. This feature, called a broken pediment, which Michelangelo used in the Laurentian Library vestibule (see fig. 14.26), became a characteristic aspect of Baroque architecture in the seventeenth century (see Chapter 17). In superimposing larger and smaller façades, as in San Giorgio Maggiore, and in combining a temple portico with a domestic villa, Palladio recalls certain unexpected juxtapositions and combinations found in Mannerist painting.

Palladio was the single most important architect of his generation, and his influence on subsequent generations of Western architects was extensive. His style was revived in England and America in the eighteenth century, and his palaces and villas are still imitated today.

Vignola and Il Gesù

There developed in the late sixteenth century a new conception of church design that would exert a profound influence on the Baroque architecture of the seventeenth century. This was brought about when the Jesuit Order founded by Saint Ignatius decided to build a new mother church, the Church of Il Gesù, for its headquarters in Rome. The powerful Roman cardinal Alessandro Farnese became the patron of the Jesuits in 1565, and he eventually gave the commission for the construction of the church to Giacomo da Vignola (1507–1573). In contrast to the classicizing architecture of Palladio, Vignola's design was intended to reflect Counter-Reformation concerns and to satisfy the requirements of the Council of Trent.

Figure **15.23** shows the plan of the Gesù, based on a Latin cross to accommodate large congregations rather than on the centralized Greek cross preferred in the Renaissance. The transepts are short, and, instead of side

that Alberti had confronted in the Tempio Malatestiano and Sant'Andrea in Mantua (see figs. 13.31 and 13.33). He did so by superimposing a tall Classical façade with engaged Corinthian columns and a high pediment on a shorter, wider façade with shorter pilasters and a low pediment. The former corresponded to the elevation of the nave and the latter to that of the side aisles. This relationship between the façade and the nave and side aisles unified the exterior and interior of the church in a new way (although Alberti had achieved a similar solution in the later fifteenth century in Florence). They are further unified by the repetition of Corinthian columns along the nave and of the shorter pilasters on the side aisles.

In these solutions, Palladio incorporates Classical elements into religious as well as domestic architecture. Nevertheless, the order and the relationship of the elements are not strictly Classical. It would be difficult to demonstrate that his works are Mannerist, but they share with Mannerism the tendency to juxtapose form and space in a way that is inconsistent with Classical arrangements. For example, Palladio breaks,

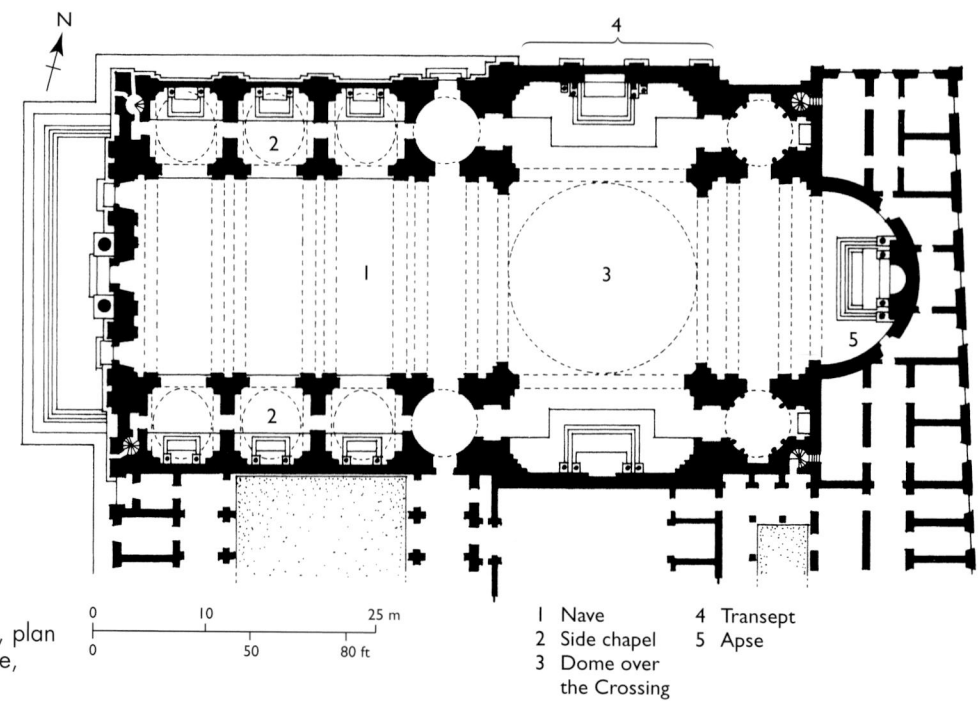

15.23 Giacomo da Vignola, plan of the Church of Il Gesù, Rome, 1565–1573.

1 Nave
2 Side chapel
3 Dome over the Crossing
4 Transept
5 Apse

aisles to permit circulation around the nave, Vignola designed side chapels for individual prayer. Most of the worshipers were thus channeled into the large, barrel-vaulted nave, and their attention was focused on the priest and the altar. At the same time, the choir was separated from the nave to accentuate the hierarchical distinction between the clergy and the public. Also emphasizing this distinction was the lengthened route from the sacristy, where the priest prepares for Mass, to the altar, where he performs it. This increased the time it took the priest to reach the altar and heightened worshipers' sense of anticipation before the Mass began. Most of the interior light came from the windows of the dome and was thus concentrated on the crossing below, creating a mystical effect of the sort encouraged by the Council of Trent.

Vignola died before completing the Gesù, and the dome and façade were finished by Giacomo della Porta (1532/3–1602) in 1573. Figure **15.24** shows the façade as Vignola

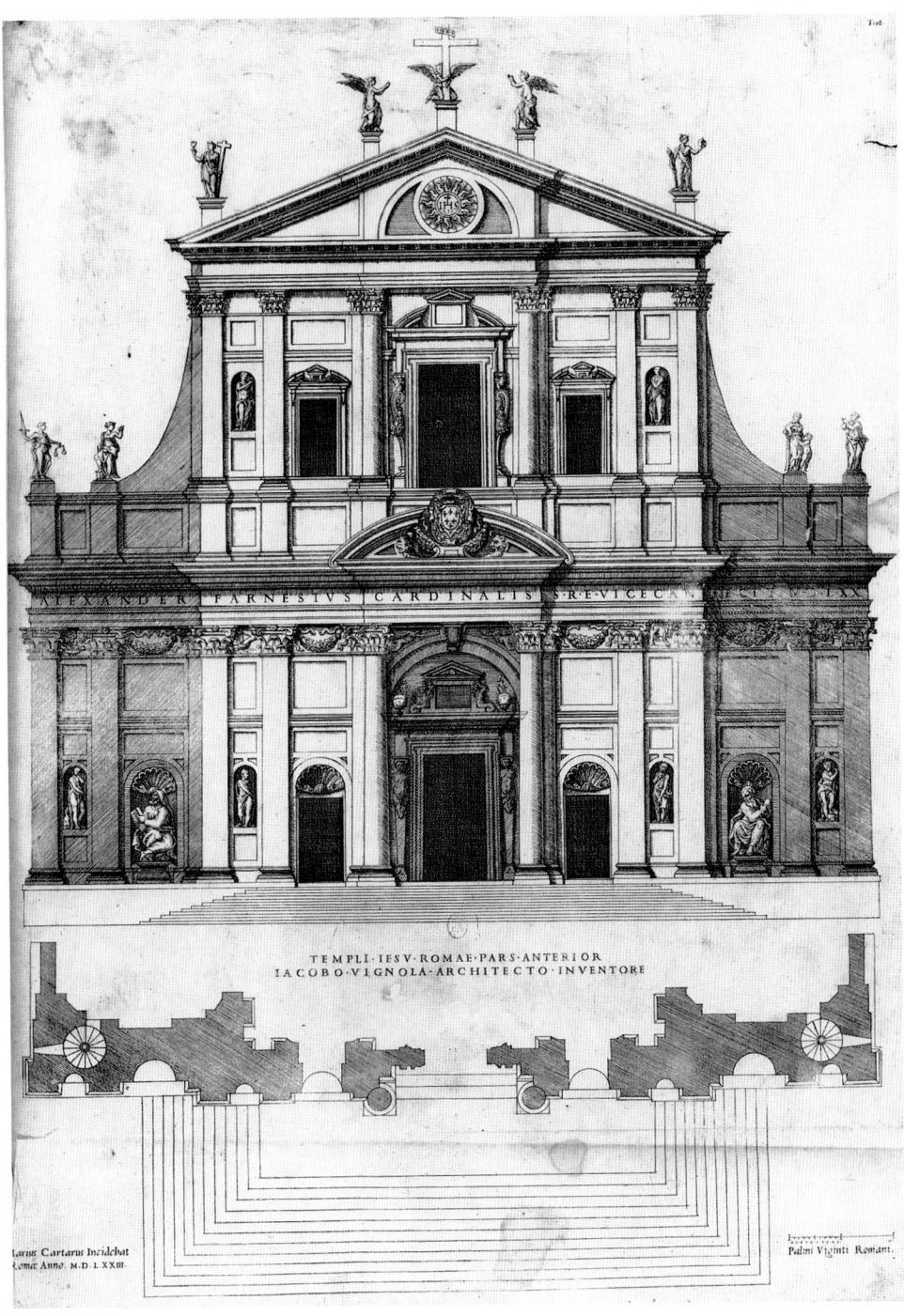

15.24 Engraving of Vignola's design for the façade of the Church of Il Gesù, Rome, late 16th century.

designed it, preserved in a sixteenth-century engraving, and figure **15.25** is the existing façade by della Porta. The façade as conceived by Vignola was influenced by Alberti's architecture and has some similarities to that of Palladio's San Giorgio Maggiore, but the superimposed Greek portico of San Giorgio has been eliminated. Instead of a colossal Order of engaged half columns supported on a large base that overlaps the ground floor and its pediment, the Gesù has two sets of double columns, one on each story. As a result, the Gesù appears to be more imposing and taller than San Giorgio, which was a quality that appealed to the Jesuits.

Vignola originally planned the interior with simplicity in mind, which would have conformed to the style of other early Jesuit churches. But della Porta increased its complexity, integrating sculpture into the wall surface of the façade and adding volutes. He also used two sets of half columns, one set on each level, as well as several pairs of pilasters. The final product was more complex, and had more surface movement and formal animation, than most Renaissance churches. The Gesù was enormously influential. Its complexity would be taken up by Baroque architects and carried by Jesuit missionaries throughout the world.

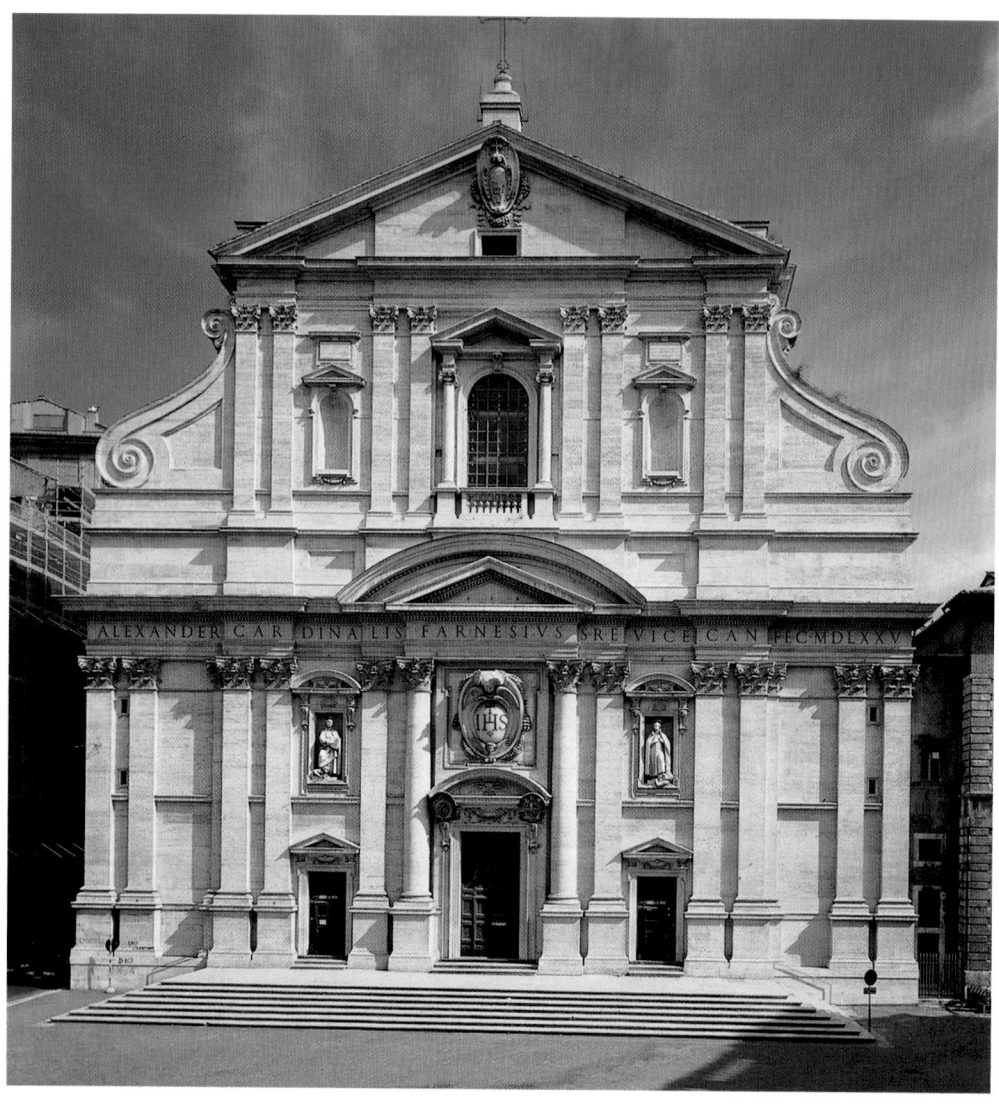

15.25 Giacomo da Vignola and Giacomo della Porta, façade of the Church of Il Gesù, Rome, c. 1575–1584.

Style/Period	Works of Art	Cultural/Historical Developments
1520 MANNERISM AND LATE 16TH-CENTURY ITALY 1520–1540	de' Rossi (attrib.), *Joseph and Potiphar's Wife* (**15.9**) Parmigianino, *Self-Portrait in a Convex Mirror* (**15.2**) Pontormo, *Entombment* (**15.1**) Romano, *Palazzo del Tè* (**15.12–15.14**), Mantua Parmigianino, *Madonna and Child with Angels* (**15.3**)	**Parmigianino, Self-Portrait**
1540–1550	Cellini, saltcellar of Francis I (**15.7**) Bronzino, *Venus, Cupid, Folly, and Time* (**15.4**) Bronzino, *Eleonora of Toledo and Her Son Don Giovanni* (**15.5**) **Cellini, saltcellar**	Council of Trent introduces Counter-Reformation policies (1545–1563) **El Greco, Burial of the Count of Orgaz** **Bronzino, Eleonora of Toledo and Her Son Don Giovanni**
1550 1550–1570 **Palladio, San Giorgio Maggiore**	Anguissola, *The Artist's Sister Minerva* (**15.10**) Palladio, San Giorgio Maggiore (**15.21**), Venice Palladio, Villa Rotonda (**15.18, 15.20**), Vicenza	Sir Philip Sidney, English poet and soldier (1554–1586) Francis Bacon, English philosopher and statesman (1561–1626) Pierre de Ronsard, *Elegies* (1565) Vasari, *Lives . . .* (1550, 1568)
1570–1600 **1600** **Giambologna, Mercury**	Veronese, *Christ in the House of Levi* (**15.6**) Vignola and della Porta, Church of Il Gesù (**15.24–15.25**), Rome Giambologna, *Mercury* (**15.8**) Tintoretto, *Last Supper* (**15.15**) El Greco, *Christ Healing the Blind* (**15.16**) El Greco, *Burial of the Count of Orgaz* (**15.17**)	Turkish fleet defeated at Lepanto (1571) Francis Drake starts circumnavigation of world via Cape Horn (1577) Catacombs discovered in Rome (1578) Mary, Queen of Scots, executed (1587) Monteverdi's first book of madrigals (1587) Christopher Marlowe, *Dr. Faustus* (1588) English fleet defeats Spanish Armada (1588) Galileo Galilei, *De Motu*, describing experiments on falling bodies (1590) Edict of Nantes establishes religious toleration (1598) William Shakespeare, *Hamlet* (1600) **Veronese, Christ in the House of Levi**

16

Sixteenth-Century Painting and Printmaking in Northern Europe

As in the fifteenth century, northern Europe in the sixteenth century underwent many of the same developments as the South did (see map). The most important northern artists were the painters from Germany and the Netherlands, several of whom traveled to Italy and were influenced by Renaissance humanism. Nevertheless, the North was always less comfortable with Classical forms in art than was Italy. The elegant linear qualities, rich colors, and crisp edges of International Gothic forms persist in Netherlandish and German painting. Northern artists were also less interested than the Italians in the subtleties of *chiaroscuro* and modeling, and the textured, painterly qualities of the late Venetian Renaissance do not often appear in the North.

The North produced some of Europe's most distinguished humanists, including the prolific writer and scholar Erasmus of Rotterdam (see box, p. 622, and fig. 16.21). Germany was the home of Martin Luther (see box, p. 605, and fig. 16.20), whose views launched the Protestant Reformation. Humanism, as well as Protestantism, clashed with the Inquisition, and religious strife continued to intensify from the late fifteenth century. The opposition of the Church to both the humanists and the Protestants was often virulent and excessive. One striking expression of the work of the Inquisition was its opposition to alleged witchcraft. In 1487, two German Inquisitors—Heinrich Kramer (d. 1500) and James Sprenger (d. 1494), both of whom were members of the Dominican order—had published *The Witches' Hammer*. In it, they described the characteristics of witches and recommended methods of torture for extracting confessions from them.

In a more humanist vein, northern Europe, like Italy, displayed an interest in artists' biography, which was revived as part of the Classical tradition and was consistent with the rise in the social status of the artist. In 1604, Karel van Mander (1548–1606) of Haarlem, Holland, published *Het Schilderboeck* (*The Painter's Book*), describing the lives of Northern artists. Like Vasari's *Lives,* it has become an important source for the history of Renaissance art.

One of the most prevalent humanist expressions in the North was the proverb. Humanists such as Erasmus collected proverbs, many of which were Classical in origin, as a way of educating people and arousing interest in antiquity. They explained the proverbs, placing them in their historical context, and also showed their relevance to contemporary life. This development was consistent with the Northern tradition of depicting bourgeois **genre** scenes (scenes of everyday life).

Northern and central Europe in the Renaissance.

Luther

Martin Luther (1483–1546), as we have seen, initiated the Protestant Reformation, which divided Europe and broke the monopoly of the Catholic Church. He objected to the practice of selling indulgences and particularly to Johann Tetzel (c. 1465–1519), the Dominican "pardoner." Luther saw Tetzel and the papacy as profiting from the fear and ignorance of his German compatriots. This view was confirmed by Tetzel's "Sermon on Indulgences," in which he compared indulgences to "letters of safe conduct" into heaven and pointed out that each mortal sin was punished by seven years of purgatory. Since people repeatedly commit mortal sins, Tetzel argued, they could save themselves many years of torture by buying indulgences.

Luther's *Ninety-five Theses* included scathing attacks on the principle of buying one's way into heaven. Referring to the financial motives of the Church, thesis number 28 stated, "It is certain that, when the money rattles in the chest, avarice and gain may be increased, but the effect of the intercession of the Church depends on the will of God alone." Number 43 declares, "He who gives to the poor man, or lends to a needy man, does better than if he bought pardons." And number 50, "If the pope were acquainted with the exactions of the preachers of pardons, he would prefer that the basilica of Saint Peter [then being rebuilt] should be burnt to ashes rather than that it should be built up with the skin, flesh, and bones of his sheep."[1]

In these sentiments, Luther essentially refuted the pope's right to speak for God. His zeal for ecclesiastic reform spilled over into the socioeconomic arena. In 1524, following Luther's example, the peasants of southwest Germany rebelled against the increasing demands of the nobility. This time, however, Luther did not sanction the revolt. He published virulent attacks against the peasants on the grounds that the Bible encourages suffering as a means to salvation. According to Luther, the rebels "cause uproar and sacrilegiously rob and pillage monasteries and castles that do not belong to them, for which, like public highwaymen and murderers, they deserve the twofold death of body and soul."[2]

The Netherlands

Hieronymus Bosch

The most important Netherlandish artist at the turn of the sixteenth century was Hieronymus Bosch (c. 1450–1516). Little is known of his artistic development, but he created some of the most original and puzzling imagery in Western art.

The Seven Deadly Sins and the Four Last Things

Corruption in the Catholic Church, which led to the Reformation, and the follies of humanity became popular subjects in the North. Religious and social satire inspired writers and artists, especially in the Netherlands and Germany. In the visual arts, this provided the impetus for iconographic themes containing moral messages. A satirical, moralizing tone is evident in Bosch's *Seven Deadly Sins and the Four Last Things* (fig. **16.1**), which has been dated early in Bosch's career by some scholars and late by others. Some question the attribution to Bosch, but it is generally accepted as either his work or his conception. Painted on a tabletop, it expresses the medieval view that life on earth is a mere reflection, or mirror, of heavenly perfection. God, according to this view, is both the creator and the "eye." He watches, remembers, and in the end punishes or rewards, according to one's merits while on earth.

The large central circle of the painting is a metaphor in which the eye is a mirror. It is a variation on the convex mirror in van Eyck's *Arnolfini Portrait* (see fig. 13.67), which, according to one iconographic reading, reflects the artist and also symbolizes God's presence. In the *Seven Deadly Sins,* the resurrected Christ occupies the center of a dark circle, with rays of light extending from it—a visual metaphor for the pupil in an eye. Inscribed in Latin in Gothic script under the figure of Christ is *Cave cave Dus* [an abbreviation of *Dominus*] *videt* ("Beware beware, the Lord sees").

On the outermost ring of the circle are seven scenes of daily life illustrating the Seven Deadly Sins. They are no longer represented as medieval personifications, but instead are integrated into everyday activities. Superbia (Pride, fig. **16.2**) is represented as a vain, bourgeois woman admiring herself in a mirror. A box of jewels, symbolizing vanity, lies open on the floor. The figure occupies an orderly, middle-class room, decorated with elegant jugs and vases, that reveals pride in her house. Reaching around from behind the chest and holding up the mirror is a devil—a moral warning against self-love and the vanity of appearances.

To the left of Pride is Ira (Anger), shown as a street fight between neighbors, and Invidia (Envy), the next scene to the left, is a verbal quarrel, the acrimony of which is enhanced by barking dogs with bared teeth. The dog on the left gazes at a large bone, while the other glares enviously at him. Neither dog seems interested in the two available bones between them on the ground. Like envious people, the dogs are never satisfied with what they have but only want what the other one has. Avaritia (Avarice) is represented as a rich man taking money from a poor man while bribing a judge. The remaining scenes represent Gula (Gluttony), Accidia (Sloth), and Luxuria (Lust). This combination of Christian moralizing with scenes of daily life infused with humor is characteristic of late Renaissance painting in the Netherlands.

The four corners of the tabletop illustrate the Four Last Things, a reminder of mortality and the rewards or

16.1 Attributed to Hieronymus Bosch, *Seven Deadly Sins and the Four Last Things,* painted tabletop. Oil on wood; 3 ft. 11¼ in. × 4 ft. 11 in. (1.20 × 1.50 m). Museo del Prado, Madrid. None of Bosch's pictures has a documented date. This painting is variously regarded as an early (c. 1475) or a late (1505–1515) work. All that is known of Bosch is that he lived in the small Dutch town of 's-Hertogenbosch (from which his name is derived) and was a member of a religious fraternity, the Brotherhood of Our Lady. He believed in the pervasiveness of sin, usually of a sensual nature, and his works illustrate the torments of hell in vivid detail.

punishments that follow. In the deathbed scene at the upper left, a dying man receives last rites. The angel and devil at the head of the bed wait to see which will take his soul. In the corner, members of his family carry on with their lives, more engaged in the game they are playing than in the deathbed scene. At the upper right, Christ pre-

sides over the Last Judgment, and the dead rise from their graves. In the lower right and left, respectively, are heaven, where Saint Peter greets the saved, and a fiery hell. Heaven is an orderly, harmonious court illuminated by divine light. Hell is dark, disordered, and fraught with torture and destruction.

16.2 Attributed to Hieronymus Bosch, *Superbia* (detail of fig. 16.1).

Garden of Earthly Delights The meaning of Bosch's huge, complex, and controversial triptych known as the *Garden of Earthly Delights* (fig. **16.3**), now generally dated about 1510–1515, is more obscure than the images on the painted tabletop. Documents suggest that the *Garden* was a secular commission for the stateroom of the House of Nassau in Brussels, although this is debated by scholars. The work has been interpreted in a number of ways: as a satire on lust, as an alchemical vision, and as a dream-world revealing unconscious impulses. But there are also a number of traditional Christian features in the triptych, which argues for a religious commission, and some scholars identify the primary source of the iconography as the Bible. The Garden of Eden is represented in the left panel. In the foreground, God presents the newly created Eve to a seated Adam. The prickly tree behind Adam is the Tree of Life. In the middle ground, a curious *fons vitae* (fountain of life) stands in a pool of water, and in the background wild animals exist in a state of apparent tameness.

Even in paradise, however, Bosch's taste for biting satire is evident in certain details that prefigure the Fall. In the foreground, for example, a self-satisfied cat strolls off with a dead mouse in its mouth. At the upper right, a lion eats a deer, while a boar pursues a fantastic animal. Ravens, which can symbolize death, perch on the fountain of life, and the owl in the opening of the fountain could denote the nocturnal activities of witches and devils. Eve's role as the primal seductress is clear from Adam's response to her. He is not the traditional languid or sleeping figure of Michelangelo (see fig. 14.23), but is alert and wide awake. He literally "sits up and takes notice" of the creature to whom he is being introduced.

The human figures in the central panel seem engaged in sexual pursuits. The amorous couple enclosed in a transparent globe, a reference to the transience of lust (fig. **16.4**, p. 610), illustrates the proverb "Happiness and glass, how soon they pass." The upper regions of the central panel depict what is sometimes identified as a Tower of Adultresses in a Pool of Lust. It is decorated with horns and filled with cuckolded husbands. Four so-called castles of vanity stand at the pool's edge. In the middle ground, a procession of frenzied human figures mounted on animals endlessly circles a Pool of Youth. The human figures are small in relation to the strange plant and animal forms that populate the picture. Some are enclosed in transparent globular shapes that suggest alchemical vessels. The illogical juxtapositions of scale, together with the strange symbolic details, such as the enlarged strawberries, have led some scholars to think that Bosch is depicting an inner, dreamlike world. Consistent with Christian tradition, however, is the conventional opposition of the era before the Fall on the left and hell on the right. The sinister aura of the central panels suggests moralizing on the artist's part, which may refer to the decadence of humanity that led God to unleash the Flood.

In hell, buildings burn in the distance. The scene is filled with elaborate tortures and dismembered body parts taking on a life of their own. Musical instruments that cause pain rather than pleasure reflect the medieval notion that music is the work of Satan. One figure is crucified on the strings of a harp, and another is tied to a long flute. A seated monster, probably Satan himself, swallows one soul and simultaneously expels another through a transparent globe. Two ears with no head are pierced by an arrow.

16.3 Hieronymus Bosch, *Garden of Earthly Delights*, c. 1510–1515. Triptych: left panel, *Garden of Eden;* center panel, *World before the Flood;* right panel, *Hell.* Oil on wood; left and right panels 7 ft. 2 in. × 3 ft. (2.18 × 0.91 m), center panel 7 ft. 2 in. × 6 ft. 4 in. (2.18 × 1.93 m). Museo del Prado, Madrid.

16.4 Hieronymus Bosch, couple in a transparent globe (detail of fig. 16.3).

16.5 Hieronymus Bosch, monster with an egglike body (detail of fig. 16.3).

At the center of this vision of hell is a monster whose body resembles a broken egg (fig. **16.5**). This might refer to the alchemical egg, which was believed by alchemists, who strove to transmute base metal into gold and silver, to be the source of spiritual rebirth (see box, p. 612). He is supported by tree-trunk legs, each of which stands in a boat. His egglike body is cracked open to reveal a crone by a wine keg and a table of sinners. On his head, the egg man balances a disk with a bagpipe, which is a traditional symbol of lust in Western art. Peering out from under the disk, and seemingly weighed down by it, is an individualized face. Its self-conscious appeal to the observer is a convention of artists' self-portraits. Like the fantastic complexity and tantalizing obscurity of Bosch's images in this work, however, the meaning of the face remains unexplained.

Pieter Bruegel the Elder

The foremost sixteenth-century painter of the Netherlands was Pieter Bruegel the Elder (c. 1525–1569), a follower of Bosch. Early in his career, Bruegel worked in the port city of Antwerp, in modern Belgium, an international center of commerce and finance. Bruegel trained in a printing concern, which accounts for his prolific graphic output. In 1551, he became a master in the painters' guild and the following year departed for Italy. His trip influenced his work considerably, in particular his taste for landscape. While in Italy, he made many drawings of the landscape, especially the Alps and the southern seacoast, but he made no

known sketches of the Roman sculpture and architecture that appealed to Italian Renaissance artists. Bruegel's passion for landscape reflects his belief that nature is the source of all life, a notion that can be related to contemporary explorations of the globe and is also derived from Petrarch's humanism.

In his *Landscape with the Fall of Icarus* (fig. **16.6**), Bruegel expresses his love of landscape for its own sake, for much of the picture is dominated by a seascape. Bruegel's vision of humanity in nature is shown by the intense relationship between the peasant pushing his plowshare and the land. The folds of the peasant's tunic repeat the furrows of the plowed earth beneath him, formally uniting him with the land. Below the peasant, a shepherd tends his flock, and a peasant sits by the edge of the sea. The shepherd rests on his crook and gazes up at the sky. In the context of the myth (see caption), it is likely that he is watching the flight of Daedalos, but he does not notice the drowning Icarus. The other two figures are so absorbed in their tasks that they fail to observe the mythical event taking place. Bruegel's philosophy as expressed in this painting conforms to the proverb "No plow stops for a dying man."

To the humanist integration of antiquity with contemporary concerns, Bruegel adds the Christian moralizing tradition of northern Europe. The *Fall of Icarus* demonstrates that it is wiser to till the land than to brave the skies, which was also the message of his *Tower of Babel* (see fig. I.7). There, too, though in a biblical setting, Bruegel depicts the dangers of unrealistic ambition, as the tower seems to crumble and fall like Icarus. For Bruegel, therefore, what the Greeks called *hubris* (a combination of pride and unrealistic ambition) corresponds to the Netherlandish notion of human folly. Folly, in Bruegel's view, turns things upside down, just as Icarus has landed head first with his feet flailing in the air. To avoid such a fall, according to Bruegel's imagery, one is advised to concentrate on work. Even in our own age of air travel and space programs, popular wisdom considers it a virtue and a sign of mental stability to "have one's feet planted firmly on the ground." People who "fly too high" are considered overly ambitious and destined for a fall.

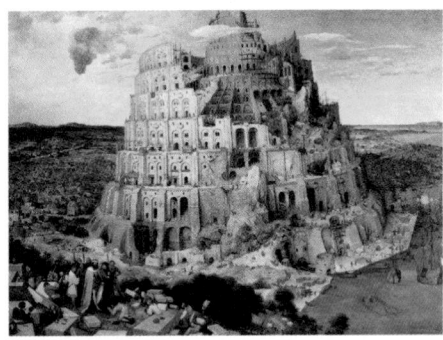

See figure I.7. Pieter Bruegel the Elder, *The Tower of Babel*, 1563.

16.6 Pieter Bruegel the Elder, *Landscape with the Fall of Icarus*, c. 1554–1555. Oil on panel (transferred to canvas); 2 ft. 5 in. × 3 ft. 8⅛ in. (0.74 × 1.12 m). Musées Royaux des Beaux-Arts de Belgique, Brussels. Although famous for his peasant scenes and known as "Peasant Bruegel," Bruegel was a townsman and a humanist. Here he combines the theme of man's unity with landscape with the Classical myth of Icarus. Daedalos, the father of Icarus, fashioned a pair of wings out of feathers held together by wax and warned his son not to fly too near the sun. Icarus disobeyed, the sun melted his wings, and he drowned in the Aegean Sea. In the painting, Icarus can be seen flailing in the water just below the large ship on the right.

Alchemy

Alchemy is the process by which base metals are believed capable of being changed into gold, and it was practiced by several well-known historical figures, including Leonardo da Vinci. The practice of alchemy in both Eastern and Western cultures had symbolic, as well as financial, meanings that are complex and elusive. (The unreal and obsessive qualities of alchemy were satirized by moralists such as Bruegel—see *The Alchemist*, fig. 16.7). Alchemy could symbolize the cosmos and the quest for immortality, the spiritual evolution of the individual, and the recovery of a state of perfection that existed before the Fall of Man. Of the numerous symbolic constructs in alchemy, two of the most prominent are the philosopher's stone and the philosopher's egg. The former makes possible regeneration and spiritual fulfilment, while the latter embodies the source of birth and, therefore, of spiritual rebirth.

Bruegel's 1558 drawing of *The Alchemist* (fig. **16.7**) is another visual parable about the folly of irrational ambition. The alchemist spurns real work and, instead of earning money for his family, tries to make gold from a spurious formula. Bruegel indicates the obsessive nature of alchemy by the alchemist's intense concentration and the lab equipment filling his home. The results of his obsession are evident as his wife and children leave the house to beg. The irony of the family going begging while the father pursues a fantasy of gold contributes to the biting satire of Bruegel's drawing.

In 1559, Bruegel painted *Netherlandish Proverbs* (fig. **16.8**), which is the visual equivalent of Erasmus's *Adagia* (see box, p. 622). It is an outdoor scene filled with about one hundred figures, each of whose activities exemplify a moral principle. But every instance fulfills the proverb in the negative, creating the "world upside down" that stood for Bruegel's view of human folly. The predominant colors are yellows and browns, which are accented throughout by blues and reds—blue denoting cheating and foolishness, and red, sin and arrogance. The painting is also called the *Blue Cloak* from the detail in which a woman in a sinful red dress puts a blue cloak on her foolish husband. The pointed hood is an allusion to the horns of the cuckold.

16.7 Pieter Bruegel the Elder, *The Alchemist*, 1558. Drawing; 12 × 17¾ in. (30.5 × 45.1 cm). Kupferstich-kabinett, Staatliche Museen, Berlin. After 1563, according to Karel van Mander's biography of him, Bruegel's mother-in-law insisted he move to Brussels and end the relationship with his mistress in Antwerp. While in Brussels, he received commissions from the city council as well as from private patrons.

The large number of scenes in this painting makes it difficult to discern the individual proverbs in a small reproduction, but we can identify a few of them. At the lower left, a woman carries a bucket of water and a burning fire poker ("to hold fire in one hand and water in the other"). Above her, a man sits on the ground between two stools ("to fall between two stools in the ashes"). In the lower center, a man whose calf has already drowned is filling the well ("to fill the pothole after the calf has drowned"), and roses are scattered around a pig ("to cast roses before swine"). Gossip is represented as two women, one spinning and the other holding the distaff (they literally "spin tales"). Other proverbs illustrated in the picture include "to hold an eel by the tail" (the man at the hut on the water is holding a large eel), "big fish eat little fish" (in the water), "jumping from ox to ass," or "from the frying pan into the fire" (the man by the door of the castle tower), and at the lower left another man "beats his head against a brick wall."

W. H. Auden on Bruegel's *Icarus*

The twentieth-century poet W. H. Auden included a description of Bruegel's *Icarus* in his 1938 poem "Musée des Beaux-Arts" (Museum of Fine Arts):

> In Bruegel's *Icarus*, for instance: how every-
> thing turns away
> Quite leisurely from the disaster; the plough-
> man may
> Have heard the splash, the forsaken cry,
> But for him it was not an important failure; the
> sun shone
> As it had to on the white legs disappearing
> into the green
> Water; and the expensive delicate ship that
> must have seen
> Something amazing, a boy falling out of the
> sky,
> Had somewhere to get to and sailed calmly
> on.[3]

16.8 Pieter Bruegel the Elder, *Netherlandish Proverbs*, 1559. Panel; 3 ft. 10 in. × 5 ft. 4½ in. (1.17 × 1.63 m). Staatliche Museen, Berlin.

16.9 Pieter Bruegel the Elder, *Peasant Dance,* c. 1567. Oil on wood; approx. 3 ft. 9 in. × 5 ft. 5 in. (1.14 × 1.65 m). Kunsthistorisches Museum, Vienna. After 1563, according to Karel van Mander's biography of him, Bruegel's mother-in-law insisted he move to Brussels and end the relationship with his mistress in Antwerp. While in Brussels, he received commissions from the city council as well as from private patrons.

Entirely different in mood, but nevertheless moralizing, is Bruegel's *Peasant Dance* (fig. **16.9**) of about 1567, which represents the celebration of a feast day of the church. In contrast to the workaday peasants in the *Fall of Icarus,* these indulge in the enjoyments of dancing, eating, drinking, music-making, and lust. On the right, two peasants "kicking up their heels" seem to dance their way into the picture. The dancers in the background give way to even greater abandon. On the left, the bagpipe is a formal echo of the rotund figures. The slow, deliberate peasants who occupied the landscape near Icarus's fall have become energetic, filled with vitality and rhythm. Their folly, according to Bruegel's iconography, is that they ignore the distant church and the image of the Virgin and Child attached to the tree at the right.

Bruegel lived during the tense years of the Reformation and the Counter-Reformation, which coincided with Spanish rule of the Netherlands. Nothing is known for certain of his political views, but it is clear that he was a humanist. In his art, Bruegel creates a synthesis of Christian genre and Classical imagery, which is at once moralizing and satirical.

Germany

Albrecht Dürer

The German taste for linear quality in painting is especially striking in the work of Albrecht Dürer (1471–1528). He was first apprenticed to his father, who ran a goldsmith's shop. Then he worked under a painter in Nuremberg, which was a center of humanism, and in 1494 and 1505 he traveled to Italy. He absorbed the revival of Classical form and copied Italian Renaissance prints, which he translated into a more rugged, linear Northern style. He also drew the Italian landscape, studied Italian theories of proportion, and read Alberti. Like Piero della Francesca and Leonardo, Dürer wrote a book of advice to artists: the *Four Books of Human Proportion* (*Vier Bücher von menschlichen Proportion*).

Self-Portraits The *Self-Portrait* of 1498 (fig. **16.10**) reveals the influence of Leonardo (see fig. 14.16), whom Dürer greatly admired, in the figure's three-quarter view and the distant landscape. Although set in a three-dimensional cubic space according to the laws of fifteenth-century

16.10 Albrecht Dürer, *Self-Portrait*, 1498. Oil on panel; 20½ × 16 in. (52.1 × 40.6 cm). Museo del Prado, Madrid. Dürer was born in Nuremberg, Germany, to a family of goldsmiths. He was trained as a metalworker and painter, and in his twenties traveled in Italy. Young German artists traditionally spent a *Wanderjahr,* or year of travel, visiting different parts of Europe and studying art. From 1512, as court painter to the Holy Roman emperor, Dürer became the most important figure in the transition from late Gothic to Renaissance style in northern Europe.

--- **CONNECTIONS** ---

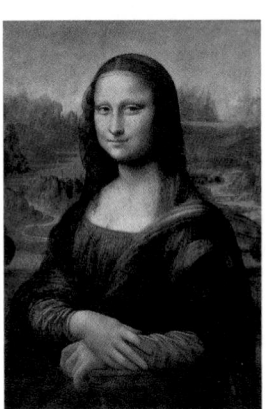

See figure 14.16.
Leonardo da Vinci,
Mona Lisa,
c. 1503–1505.

The Development of Printmaking

Printmaking is the generic term for a number of processes, of which **engraving** and woodcut are two prime examples. **Prints** are made by pressing a sheet of paper (or other material) against an image-bearing surface (the **print matrix**) to which ink has been applied. When the paper is removed, the image adheres to it but in reverse.

The woodcut had been used in China from the fifth century A.D. for applying patterns to textiles, but was not introduced into Europe until the fourteenth century. First it was used for textile decoration and then for printing on paper. Woodcuts are created by a relief process. First, the artist takes a block of wood sawed parallel to the grain, covers it with a white ground, and draws the image in ink. The background is then carved away, leaving the design area slightly raised. The woodblock is inked, and the ink adheres to the raised image. It is then transferred to damp paper either by hand or with a printing press.

Engraving, which grew out of the goldsmith's art, originated in Germany and northern Italy in the middle of the fifteenth century. It is an intaglio process (from the Italian *intagliare,* "to carve"). The image is incised into a highly pol-ished metal **plate,** usually of copper, with a cutting instrument, or **burin.** The artist then inks the plate and wipes it clean so that ink remains only in the incised grooves. An impression is made on damp paper in a printing press, with sufficient pressure being applied so that the paper picks up the ink.

Both woodcut and engraving have distinctive characteristics. Dürer's engraving in figure 16.13, for example, shows how this technique lends itself to subtle modeling and shading through the use of fine lines. Hatching and crosshatching determine the degree of light and shade in a print. Woodcuts, as in figure 16.12, tend to be more linear, with sharper contrasts between light and dark, and hence more vigorous.

Printmaking is well suited to the production of multiple images. A set of multiples is called an **edition.** Both methods described here can yield several hundred good-quality prints before the original block or plate begins to show signs of wear. Mass production of prints in the sixteenth century made images available, at a lower cost, to a much broader public than before. Printmaking played a vital role in Northern Renaissance culture, particularly in disseminating knowledge, in expanding social consciousness, and in transmitting artistic styles.

perspective and consistently illuminated from the left edge, Dürer's figure is painted with crisp contours that would be unusual in Italy. The attention to patterning in the long curls and in the details of costume also reveal Dürer's interest in line for its own sake. Particularly prominent in this and other works by the artist is his signature monogram—a *D* within an *A*—which is accompanied by an inscription—the artist's statement of his own role in creating the image. Dürer's confident sense of himself is conveyed by his upright posture, firmly clasped hands, and elegant costume; it is also a reflection of the social status he had achieved—or hoped to achieve—in Nuremberg.

In 1500, Dürer painted his most famous self-portrait (fig. **16.11**). He shows himself in a manner reminiscent of the frontal images of Christ and saints in Byzantine icons (see Chapter 8). Dürer has placed himself against a dark background and is depicted with more softened, idealized features than in the earlier example. By eliminating the window and landscape vista, Dürer pushes his figure forward, increasing its direct impact on the viewer. The gesture of the right hand, which seems to be touching the fur lining of the cloak, is a reference both to traditional images of Christ blessing the world and to the notion of the artist's divine creative hand.

Prints Dürer's interest in line is most apparent in his work as a **woodcut** artist and engraver (see box, p. 615).

Around the time of the 1498 *Self-Portrait,* Dürer produced the *Apocalypse,* the first book to be designed and published by a single artist. In it, Dürer included the full text of the book of Revelation in Latin and German editions, which he illustrated. In the *Four Horsemen of the Apocalypse* (fig. **16.12**), the aged and withered figure of Death rides a skeletal horse, trampling a bishop whose head is in the jaws of a monster. Cowering before the horse are figures awaiting destruction. Next to Death, and the most prominent of the four, rides Famine, carrying a scale. War brandishes a sword, which is parallel to the angel above. Plague, riding the background horse, draws his bow (arrow wounds were associated with the sores caused by the plague). Finally, the presence of God as the ultimate motivating force behind the four horsemen is implied by rays of light entering the picture from the upper left corner.

In this image, Dürer took evident delight in the graphic and psychological expressiveness of line. The powerful left to right motion of the horses and their riders is created by

16.11 Albrecht Dürer, *Self-Portrait,* 1500. Oil on panel; 26¼ × 19¼ in. (66.7 × 48.9 cm). Alte Pinakothek, Munich. Note the "AD" monogram and the date "1500" to the left of the figure.

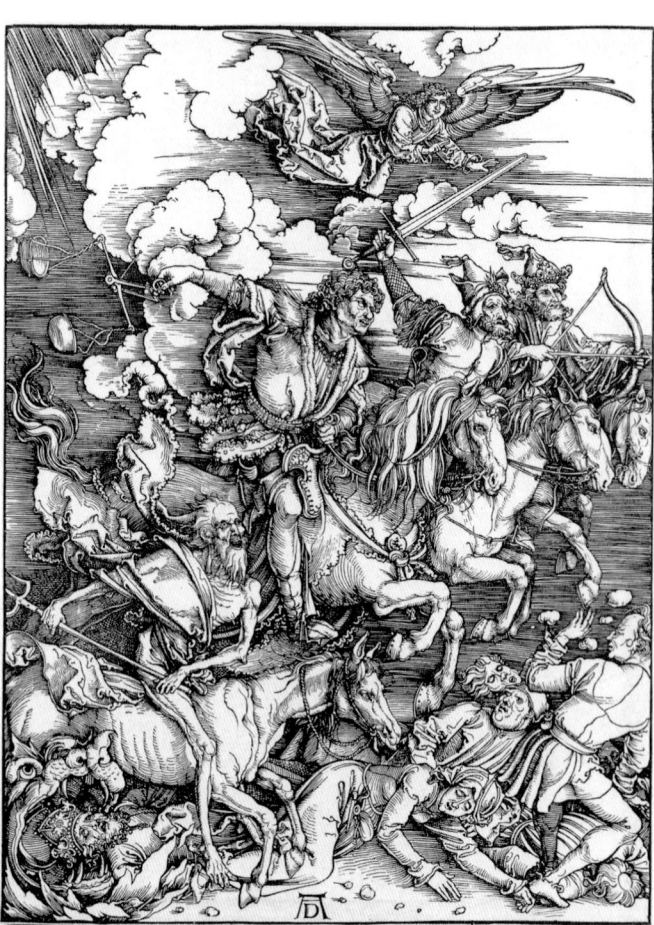

16.12 Albrecht Dürer, *Four Horsemen of the Apocalypse,* c. 1497–1498. Woodcut; 15⅖ × 11 in. (39.2 × 27.9 cm). Metropolitan Museum of Art, New York. Gift of Junius S. Morgan, 1919. This is one of a series of fifteen woodcuts from the late 1490s illustrating the Apocalypse.

Artists, particularly melancholic artists, have traditionally been considered "different" (from the general population) to the point of madness. Aristotle made the first known connection between melancholy—derived from the Greek words *melas*, meaning "black," and *cholos*, meaning "bile" or "wrath"—and genius. Melancholics were thought to have an excess of black bile (one of the four bodily humors) in their systems, an idea revived in the Renaissance.

Marsilio Ficino believed that melancholics were born under the astrological sign of Saturn, an ancient Roman god known for his moody temperament, and hence shared this particular aspect of Saturn's personality. Consistent with his Neoplatonic philosophy, Ficino combined his astrological theories with Plato's notion that artistic genius is a gift of the gods, who inspire artists with a creative *mania* (Greek for "madness" or "frenzy"). Thus, from the Renaissance onward, artists and other creative people have been thought to be saturnine (in the sense of temperamental), melancholic, and eccentric.

Saturn, who was also identified with Kronos, one of the Greek Titans, was a god of agriculture, which was associated with geometry ("measurement of the earth"). Artists, farmers, and geometricians alike used measuring instruments in their work, as seen in the compass in the hand of Dürer's Melancholy (see fig. 16.13).

The pose of Dürer's uninspired genius echoes those of Raphael's Heraklitos/Michelangelo in the *School of Athens* (see fig. 14.35) and of Michelangelo's *Jeremiah* (see fig. 14.25) on the Sistine Chapel ceiling. But Dürer's engraving is the earliest representation of the *idea* of melancholy as an artistic image in its own right. It influenced the view of the artist as a divinely inspired, melancholic genius who suffers bouts of creative frenzy and gloomy idleness. Both Dürer and Michelangelo identified with that image, which declined in popularity in the seventeenth century but was revived by the nineteenth-century Romantics (see Chapter 20).

their diagonal sweep across the width of the picture. The less forceful, zigzag lines of the cowering figures reveal their panic in the face of the relenting and inevitable advance of the horsemen.

Dürer's copper engraving of *Melencolia* (fig. **16.13**), or Melancholy, signed and dated 1514, is an early example of the tradition of portraying artists as having saturnine, melancholic personalities (see box). The female winged

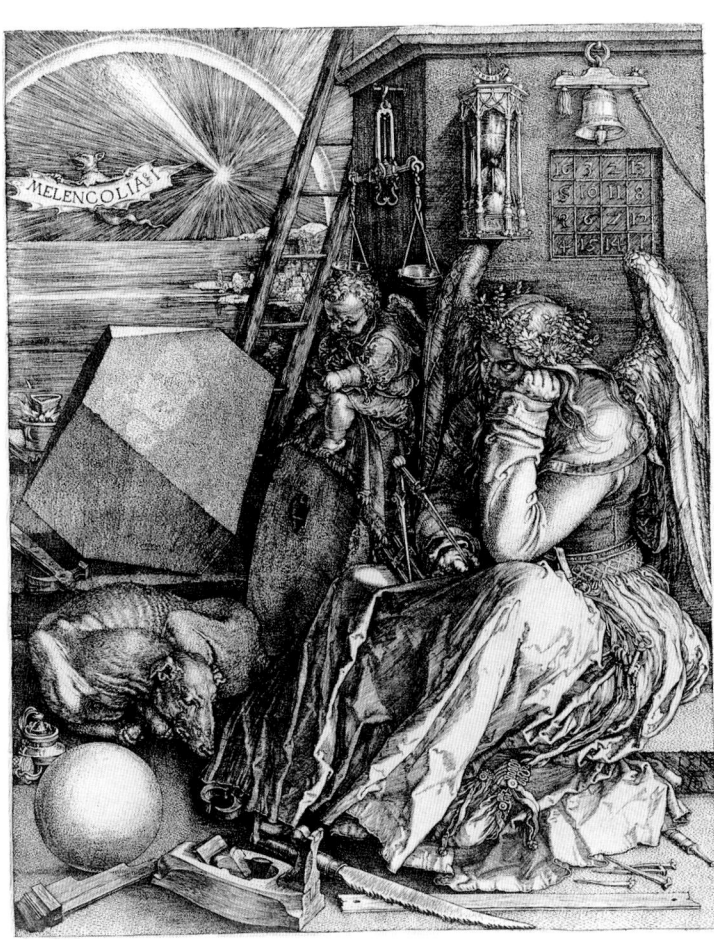

16.13 Albrecht Dürer, *Melencolia I*, 1514. Engraving; 9½ × 7⁵⁄₁₆ in. (24.3 × 18.6 cm). Metropolitan Museum of Art, New York. Harris Brisbane Dick Fund, 1943.

— **CONNECTIONS** —

See figure 14.25.
Michelangelo, *Jeremiah*, 1508–1512.

See figure 14.35.
Raphael, *Heraklitos/ Michelangelo*, 1509–1511.

genius may represent Dürer, as is suggested by the location of his monogram underneath her bench. She leans on her elbow in the pose of melancholy that had been conventional since antiquity.

Dürer's Melancholy is an idle creator, an unemployed "genius" looking inward for inspiration and not finding it. She is in the grip of obsessive thinking and, therefore, cannot act. Idle tools, including a bell that does not ring, empty scales, and a ladder leading nowhere seem to reflect her state of mind. The winged child conveys a sense of anxiety that could mirror the anxiety felt by the uninspired artist. Other details, such as the hourglass above the genius, refer to the passing of time. In the upper left, a squeaking bat displays a banner with "MELENCOLIA I" written on it. The bat, associated with melancholy because of its isolation in dark places, comes out only at night. By combining the bat with the darkened sky pierced by rays of light, Dürer seems to be making a visual play on the contrasting mental states of black melancholy and the light of inspiration.

Matthias Grünewald

Contemporary with Dürer's engraving of Melancholy is the Isenheim Altarpiece (figs. **16.14** and **16.15**), a monumental polyptych by the German artist Matthias Grünewald (d. 1528). It was commissioned for the hospital chapel of the monastery of Saint Anthony in Isenheim. The hospital specialized in the treatment of skin diseases, particularly ergotism, known as "Saint Anthony's fire." The

altarpiece was a form popular in Germany between 1450 and 1525. It typically consisted of a central corpus, or body, containing sculpted figures and was enclosed by doors (wings) painted on the outside and carved in low relief inside. In the Isenheim Altarpiece, it is the base, not the corpus, that contains the sculptures; but sculptured figures of Saints Anthony, Jerome, and Augustine are located in the central corpus behind the *Virgin and Child with Angels*—they are revealed when the two panels of this scene are opened (fig. **16.16**).

The exterior of the doors depicts the *Crucifixion;* its emphasis on physical suffering and the wounds of Jesus was related to healing. This is enhanced by Grünewald's color—the greenish flesh (suggesting gangrene), the gray-black sky, and the rich reds of the drapery that echo the red of Jesus's blood—to accentuate the overwhelming effect of the scene. The Cross is made of two logs tied and nailed together, its arms bowed from Jesus's weight. The Crown of Thorns, a visual echo of the contorted fingers, causes blood to drip from Jesus's scalp, and his loincloth is torn and ragged.

Grünewald's depiction of Jesus has been related to some fourteenth-century mystical writings, notably the *Revelations* of the Swedish saint Bridget. "The crown of thorns," she wrote, "was impressed on his head; it was firmly pushed down covering half his forehead, the blood, gushing forth from the prickling of thorns. . . . The color of death spread through his flesh. . . . His knees . . . contracted. . . . His feet were cramped and twisted. . . . The cramped fingers and arms were stretched out painfully."[4]

16.14 Matthias Grünewald, *Crucifixion with Saint Sebastian* (left) *and Saint Anthony* (right), and *Lamentation* (below), the Isenheim Altarpiece, closed, c. 1510–1515. Oil on panel (with frame); side panels 8 ft. 2½ in. × 3 ft. ½ in. (2.50 × 0.93 m), central panel 9 ft. 9½ in. × 10 ft. 9 in. (2.98 × 3.28 m) base 2 ft. 5½ in. × 11 ft. 2 in. (0.75 × 3.40 m) Musée d'Unterlinden, Colmar, France.

16.15 Matthias Grünewald, *Annunciation, Virgin and Child with Angels,* and *Resurrection,* the Isenheim Altarpiece, opened, c. 1510–1515.

16.16 Nicholas von Hagenau, central corpus and base of the Isenheim Altarpiece, early 16th century. Polychrome wood sculpture. The corpus sculptures depict Saints Augustine at the left, Jerome at the right with his lion attribute, and Anthony, enthroned in the center. Represented on the base are Jesus and the twelve apostles. Two side panels by Grünewald depicting scenes from Saint Anthony's life are not illustrated.

16.17 Lucas Cranach the Elder, *Judgment of Paris*, 1530. Panel; 13½ × 8¾ in. (34.4 × 22.2 cm). Staatliche Kunsthalle, Karlsruhe, Germany. According to Greek myth, the Trojan prince Paris judged a beauty contest among the goddesses Athena, Hera, and Aphrodite. He awarded the prize of a golden apple to Aphrodite, who had promised him the most beautiful woman in the world (Helen of Troy).

John the Baptist, on our right, points to Jesus. The Latin inscription, written in blood red, which John seems to be speaking, reads: "He must increase and I must decrease." At John's feet, holding a small cross, is the sacrificial Lamb, whose blood drips into a chalice that prefigures the Eucharist. On Jesus's right, Mary Magdalen wrings her hands in anguish. The curve of her arms continues backward toward the swooning Virgin and John the Evangelist supporting her. The darkening sky recalls the biblical account of the sun's eclipse and nature's death at the time of the Crucifixion. On the base of the closed altarpiece, Grünewald has depicted the *Lamentation* against a snowy, alpine background with barren trees, both being natural metaphors of Jesus's death.

The wings of the closed altarpiece depict Saint Anthony, who was associated with healing the sick, on the right; and Saint Sebastian, known as a plague saint because his sores from being shot through with arrows were likened to those of the bubonic plague, on the left. The altarpiece was generally kept in the closed position. Patients prayed before it to atone for their sins and to effect a cure. On Sundays and feast days, however, the altarpiece was opened to reveal an interior transformed by bright colors (see fig. 16.15). In the right panel, Jesus, who has become Christ, attains a new, spiritual plane of existence beyond the pull of gravity. His body, defined by curvilinear forms, floats upward into a fiery orb. Christ as Sun is juxtaposed with the Roman soldiers, whose sinful ignorance causes them to stumble in a rock-filled darkness.

Lucas Cranach the Elder

The German artist Lucas Cranach the Elder (1472–1553) was an admirer of Martin Luther. In his early work, he primarily depicted landscapes, an interest that continued in some of his later mythological pictures. In the *Judgment of Paris* (fig. **16.17**), Cranach sets the Greek myth (see caption) in sixteenth-century Germany, with a Saxon castle on a distant hill. An aged, bearded Hermes presents the three goddesses to Paris. Both male figures wear the armor of Saxon knights. The women pose coquettishly, in a way that is reminiscent of the conventional arrangement of the three Classical Graces—the one in the center is seen from the back, and the others, one on each side, from the front. A comparison of the *Judgment of Paris* with the first-century-A.D. Roman fresco of the *Three Graces* (fig. **16.18**) illustrates the extent to which Cranach has altered the character of the women to suit his patrons at the court of Saxony. The horse to the left of the tree adds a touch of humor, for its gaze is riveted by the unexpected sight of

16.18 *Three Graces*, from Pompeii, 1st century A.D. Fresco. National Archaeological Museum, Naples.

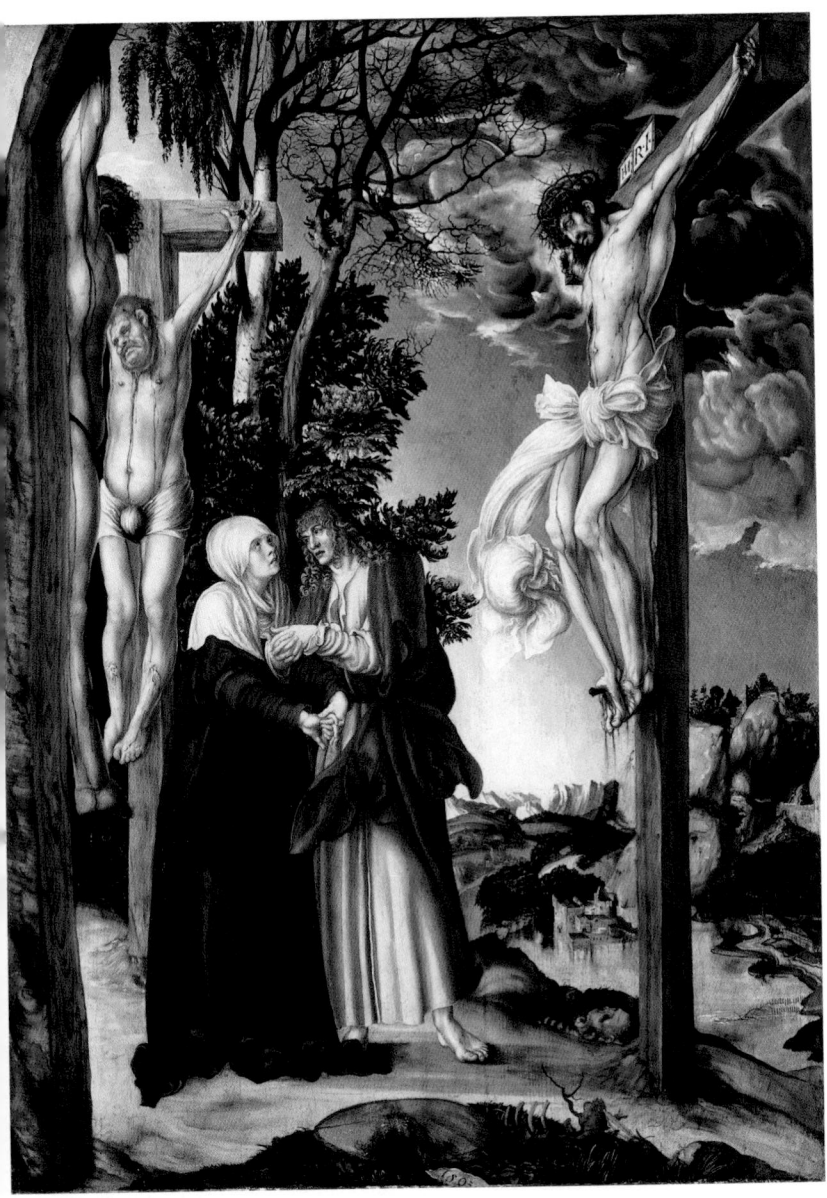

16.19 Lucas Cranach the Elder, *Crucifixion*, 1503. Oil on panel; 54½ × 43 in. (138.4 × 109.2 cm). Alte Pinakothek, Munich.

16.20 Lucas Cranach the Elder, *Martin Luther*, 1533. Panel; 8 × 5¾ in. (20.5 × 14.5 cm). City of Bristol Museum and Art Gallery, England.

the nudes. The horse's raised leg reveals his erotic excitement and contrasts with the relaxed, indifferent pose of Paris, who casually converses with Hermes.

One of Cranach's most important Christian paintings is the large *Crucifixion* of 1503 (fig. **16.19**). As in the *Judgment of Paris,* landscape plays a role in the image and reflects the artist's humanist interest in nature. In both works, the emphasis on linear quality is characteristic of sixteenth-century German painting and shows the influence of Dürer.

Cranach creates the effect of towering figures by showing us the event as if we are looking up at it from below. At the left are the two thieves, one partly hidden from view and the other grotesque in appearance. A more idealized Jesus hangs from the Cross at the right. Mary and John are united in mourning, their agitated gestures repeating Jesus's windblown loincloth and the turbulent sky. Behind them, a dead tree rises, pushing through the green tree

and denoting the death of God's son. The responsiveness of nature to human events is both part of Christian tradition—that the sky turned black when Jesus died—and a reflection of Cranach's humanism.

Cranach was best known for his portraits. His portrait of Martin Luther (fig. **16.20**), who was a close friend, is as austere as the *Judgment of Paris* is delicate and decorative. The figure is set against a solid green background, eliminating the sense of a natural context. Luther's dark robe is also unmodulated so that the only three-dimensional form is the head. In the emphasis on the stubble of Luther's beard, Cranach makes his subject seem above the concerns of daily grooming. He is rendered as a man of vision, staring out of the picture with an air of inner resolution.

Hans Holbein the Younger

The last great German painter of the High Renaissance was Hans Holbein the Younger (c. 1497–1543). He combined German linear technique with the fifteenth-century Northern taste for elaborately detailed surface textures and rich color patterns. Perhaps his greatest achievements were his portraits.

Holbein's family came from the southern German city of Augsburg, which, like Antwerp, was a center of

Desiderius Erasmus of Rotterdam (c. 1466–1536) was a Roman Catholic reformer and one of the greatest Renaissance humanists in northern Europe. The illegitimate son of a priest, Erasmus was ordained in 1492 and then studied Classics in Paris. Among his most important works is *Encomium moriae* (The Praise of Folly) of 1514, in which he satirizes greed, superstition, and the corruption and ignorance of the clergy. He argues that piety depends on spiritual substance rather than on the observance of religious ceremony.

Erasmus's satirical inclinations were well suited to the northern interest in proverbs as a way of revealing human folly. His *Adagia* (Adages), published in 1500, is a compendium of sayings that contain hidden or double meanings. In 1513, he published a satire on Julius II in which the pope is excluded from heaven. Julius announces himself to Saint Peter as "P.M."

(meaning *Pontifex Maximus,* or "Highest Priest"), but Saint Peter takes "P.M." to mean *Pestis Maxima*—"the Biggest Plague." Through the personage of Saint Peter, Erasmus objects to Julius II as an arrogant lush tainted by political and military ambition.

Erasmus's knowledge of Classical languages is evident in his publication of the first edition of the New Testament in Greek (1516); he also published a Latin translation of it. He believed that Latin would bridge the gap between divergent cultures and thus be a force for unification.

Erasmus was a moderate in an age of extremism. But his tolerance and reason limited his influence as compared with that of Martin Luther. He opposed the Reformation, fearing the destructive effects of partisan religious strife. Attacked by Catholics and Protestants alike, Erasmus remained committed to reconciliation and unity.

international trade. At the age of eighteen, Holbein traveled to Basel, where he met Erasmus (see box) and painted his portrait (fig. **16.21**). In contrast to the assertive and slightly unkempt character of Cranach's Luther, Holbein's Erasmus is a scholarly gentleman. He is well groomed, neat, and wears a fur-lined coat. Holbein's painting places the figure in a three-dimensional room. Erasmus rests his hands on a book with the Greek inscription "The Labors of Herakles." Erasmus is thus depicted as a man of his own era whose thought was formed by the Renaissance synthesis of Christianity with Classical antiquity. The pilaster with its Classical motifs shows the influence of artists such as Giovanni Bellini and Mantegna.

Holbein left Basel in 1526 and, on the recommendation of Erasmus, sought the patronage of the humanist Sir Thomas More in England. On a second trip in 1532, Holbein became the court painter to Henry VIII. Holbein's *Henry VIII* (fig. **16.22**) of about 1540 portrays the overpowering force of the king's personality. Henry's proverbial bulk dominates the picture as he stares directly out at the observer. In contrast to the *Erasmus,* Henry's forceful character is unrelieved by a three-dimensional background or by objects in the surrounding space. But the fine textures and minute patterns of his costume create a surface luster that is reminiscent of van Eyck; they also appear in areas of the *Erasmus.* Henry's bent right arm is posed so that the elbow is thrust forward,

16.21 Hans Holbein the Younger, *Erasmus of Rotterdam,* c. 1523. Panel; 30 × 20¼ in. (76.2 × 51.4 cm). National Gallery, London.

16.22 Hans Holbein the Younger, *Henry VIII,* c. 1540. Oil on panel; 34¾ × 29½ in. (88.3 × 74.9 cm). Galleria Nazionale d'Arte Antica, Rome.

emphasizing the elaborate sleeves. From the neck down, the king's body forms a rectangle filling the lower two-thirds of the picture. His head seems directly placed on his shoulders, creating a small, almost cubic shape. The hat, by contrast, forms a slightly curved diagonal, echoing the chain across his chest and also softening the monumental force of Henry's body and gesture.

The main source of variety in this picture is in the material quality of the surface patterns. Their richness is calculated to remind viewers of Henry's wealth, just as his pose exudes power, self-confidence, and determination, while his face

reflects his intelligence and political acumen. In this image, therefore, Holbein has fused formal character with a specific personality, creating a Henry VIII who is "every inch a king."

After Holbein's death, no major artists emerged in Germany during the sixteenth century. By 1600, the conflicts between Protestant and Catholic, Reformation and Counter-Reformation, mysticism and humanism, though hardly at an end, had at least become familiar. Their effects on art would continue, though to a lesser degree, into the seventeenth century.

Style/Period	Works of Art	Cultural/Historical Developments
1490 NORTHERN EUROPE 16th century 1490–1500 **Bosch, Seven Deadly Sins and the Four Last Things**	Pompeii fresco (*Three Graces*) (**16.18**), 1st century A.D. Bosch (attrib.), *Seven Deadly Sins and the Four Last Things* (**16.1–16.2**) Dürer, *Four Horsemen of the Apocalypse* (**16.12**) Dürer, *Self-Portrait* (**16.10**), 1498 Dürer, *Self-Portrait* (**16.11**), 1500	Heinrich Kramer and James Sprenger, *The Witches' Hammer* (1487) Sebastian Brant, *Das Narrenschiff* (*The Ship of Fools*) (1494) 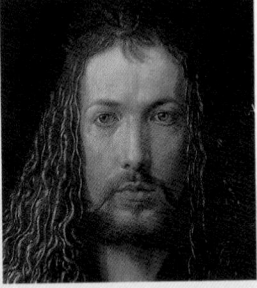 **Dürer, Self-Portrait, 1498** **Dürer, Self-Portrait, 1500**
1520 1500–1530 **Bosch, Garden of Earthly Delights**	Cranach the Elder, *Crucifixion* (**16.19**) Bosch, *Garden of Earthly Delights* (**16.3–16.5**) Grünewald, *Isenheim Altarpiece* (**16.14–16.15**) von Hagenau, corpus and base of the *Isenheim Altarpiece* (**16.16**) Dürer, *Melencolia I* (**16.13**) Holbein the Younger, *Erasmus of Rotterdam* (**16.21**)	Erasmus of Rotterdam, *The Praise of Folly* (1514) Martin Luther's *Ninety-five Theses*; beginning of the Reformation (1517) Martin Luther excommunicated (1521) Peasants' Revolt in Germany (1524–1525)
1570 1530–1570 **Holbein the Younger, Henry VIII** **Bruegel the Elder, Netherlandish Proverbs**	Cranach the Elder, *Judgment of Paris* (**16.17**) Cranach the Elder, *Martin Luther* (**16.20**) Holbein the Younger, *Henry VIII* (**16.22**) Bruegel the Elder, *Landscape with the Fall of Icarus* (**16.6**) **Bruegel, Landscape with the Fall of Icarus** Bruegel the Elder, *The Alchemist* (**16.7**) Bruegel the Elder, *Netherlandish Proverbs* (**16.8**) Bruegel the Elder, *Peasant Dance* (**16.9**)	Hans Holbein the Younger becomes court painter to Henry VIII (1532) Henry VIII rejects papal authority, founds Anglican Church (1534) John Calvin, *Institutes of the Christian Religion* (1536) Council of Trent introduces Counter-Reformation policies (1545–1563) Wars of Lutheran versus Catholic princes in Germany; Peace of Augsburg (1555) Elizabeth I queen of England (1558–1603) John Knox founds Presbyterian Church (1560) Protestant Netherlands rebel against Catholic Spain (1568) Karel van Mander, *Het Schilderboeck* (*The Painter's Book*) (1604) **Cranach the Elder, Judgment of Paris**

17 The Baroque Style in Western Europe

Window on the World Eight:
Mughal Art and the Baroque

18 Rococo and the Eighteenth Century

CHAPTER PREVIEWS

THE BAROQUE STYLE IN WESTERN EUROPE, 17th CENTURY

Age of Absolutism: Louis XIV of France; Philip IV of Spain; Charles I of England
Heliocentrism and advances in science: Kepler; Copernicus; Galileo; Newton
Thirty Years' War (1618–1648)
Treaty of Westphalia (1648)
Dutch East India Company; the rise of capitalism
Charles I of England executed (1649)
Oliver Cromwell (1599–1658)
Witch craze in Europe and New England
Lives of the Artists: Bellori; van Mander, *The Painter's Book*
New Saint Peter's completed
Great Fire of London (1666)
Wren builds Saint Paul's, the first Protestant cathedral, in London
Urban VIII (papacy 1623–1644)
New genres in painting: landscape; *vanitas*; still life
Italian artists: Bernini; Borromini; Caravaggio; Gentileschi; the Carracci; Pietro da Cortona; Gaulli
Flanders: Rubens; van Dyck
Holland: Rembrandt; Hals; Leyster; Vermeer; Ruisdael; Oosterwyck; Etching and drypoint
France: The Louvre
 The Court of Versailles: LeBrun; Tuby; Le Vau; Perrault; Le Nôtre, Hardouin-Mansart
 French Academy founded (1648)
 Poussin: theory of artistic modes
Spain: Velázquez

Mughal Art and the Baroque

ROCOCO AND THE 18th CENTURY

Age of Enlightenment
Science: Priestley; Halley; Leibniz
Music: Vivaldi; Bach; Haydn; Mozart
Literary satire: Voltaire; Swift
Sturm und Drang in Germany: Goethe
The *encyclopédistes*: Diderot
Political philosophers: Locke; Rousseau
Seven Years' War (1756–1763)
American Revolution (1776)
 The U.S. Constitution and the Bill of Rights
French Revolution (1789)
Louis XVI and Marie Antoinette guillotined (1793)
Art patronage moves from Versailles to the Paris salon
Revival styles: Chinoiserie; discovery of Pompeii and Herculaneum
Winckelmann and the beginning of art history
Painters in France: Watteau; Boucher; Fragonard; Rigaud; Vigée-Lebrun; Chardin; Carriera
Painters in England: Wright of Derby; Gainsborough; Hogarth; Kauffmann
Painters in America: Copley; West
German architects: Neumann; Pöppelmann; Zimmermann
Tiepolo in the Kaisersaal
Architects in England: Lord Burlington; Adam; Walpole
Art Theory: Winckelmann; Kant; Hegel

The seventeenth century in western Europe is sometimes called the Age of Absolutism because rulers wanted complete control of their subjects. The most important of these monarchs—Louis XIV of France, Philip IV of Spain, and Charles I of England—used the arts in the service of their political agenda. With Europe now split into Catholic and Protestant countries, the prevailing Baroque style varied according to national tastes. In Protestant Holland, art tended to be more secular than in Catholic countries. New art genres—notably, landscape and still life—evolved in Holland and elsewhere. Trade with India produced cross-cultural motifs, especially under the Mughal dynasty, which, contrary to Islamic tradition, encouraged figurative painting.

The eighteenth century, called both the Age of Reason and the Enlightenment, boasted new discoveries in science, a wealth of musicians—including Bach, Haydn, and Mozart—and political philosophers who challenged the divine right of kings. With the death of Louis XIV, the center of French patronage moved from the court at Versailles to Paris, and the predominant art style became Rococo—a fussy, frivolous version of Baroque with occasional undercurrents of serious satire. The so-called Bourgeois Realism of Chardin emphasized the virtues of everyday hard work. At the end of the eighteenth century, two great revolutions—the American Revolution in 1776 and the French Revolution in 1789—shattered the age-old notion that kings rule by divine right.

17

The Baroque Style in Western Europe

The Baroque style corresponds roughly to the closing years of the sixteenth century, overlapping Mannerism and lasting, in some areas, as late as 1750. Politically, the seventeenth century was a period of crisis and conflict. Religious tensions continued to escalate, while great strides were being made in science. These developments are reflected in the painting, sculpture, and architecture of the time.

Developments in Politics and Science

Although Europe (see map) had rarely been free of war in the sixteenth century, in 1618 the smoldering hostilities between Catholics and Protestants erupted into the Thirty Years War (1618–1648). This was one of the most devastating conflicts in European history. Beginning with a revolt of the Bohemians against Austrian rule, the war spread throughout the entire Continent, involving France, Spain, and many small principalities that were part of the Holy Roman Empire. Aided by the French, the northern Netherlands rebelled against the Catholic domination of Philip II and Philip IV of Spain (both Hapsburg monarchs) and ended forty years of Spanish rule.

When the Treaty of Westphalia was signed in 1648, the war was officially over, although none of the religious differences had been settled. Nevertheless, the principle of national sovereignty was established, and each country controlled its lands and population. A general redistribution of territory also took place, with France receiving most of Alsace, and Sweden annexing provinces on the Baltic Sea. The Netherlands split into Protestant Holland and Catholic Flanders (roughly equivalent to modern Belgium). The authority of the Holy Roman emperor over Germany was severely weakened, and Germany itself was ravaged by mercenaries.

Politically, the seventeenth century is known as the Age of Absolutism because of certain rulers who tried to exercise absolute power over their countries. According to the principle of divine right of kings, rulers derived their authority directly from God. The embodiment of absolute monarchy, Louis XIV of France (reigned 1643–1715), centralized all national authority into his own hands and ruled for fifty-four years.

In England, another absolute monarch, Charles I (reigned 1625–1649), succeeded his father, the first Stuart king, James I. Charles's persecutions of the Puritans (English Calvinists who favored substituting a presbyterian form of church government for the episcopal system) drove them to join with other antiroyalist factions; the English Civil War led to the execution of the king. For eleven years after the death of Charles I, England was a Free Commonwealth under Oliver Cromwell (1599–1658) as Lord Protector. In 1660, Charles's son, Charles II, was restored to the throne.

A reaction to absolutism emerged in the course of the seventeenth century in the first serious study since Plato of the rights of citizens. Political philosophers, notably Thomas Hobbes (1588–1679) and John Locke (1632–1704), argued that government is based on a social contract. Hobbes believed that ultimate power rested with the monarch, whereas Locke maintained that governments derive their authority from the consent of the governed, who may overthrow any ruler threatening their fundamental rights.

The geographic discoveries of the fifteenth century had been spearheaded by navigators from Spain and Portugal. In 1494, these two countries signed the Treaty of Tordesillas, in which they divided up the non-European world between them. Their confidence, however, was misplaced, and by the beginning of the seventeenth century the commercial map of Europe had been redrawn. Venice had declined to the status of a regional market, and the Dutch had overtaken the Hanseatic League (a confederation of north German cities) to become the leading trading nation

Europe during the Baroque period.

of the Western world. For most of the 1600s, Amsterdam was the financial and trade center of Europe, although Seville, in Spain, was also an important port. The English, who had begun to erode the Spanish Empire in the Americas, presented the only serious challenge to the Dutch, for England had the advantage of surplus citizens with which to populate overseas settlements. By the early 1700s, the Dutch had yielded naval superiority to the English, who, together with the French, emerged as the leading colonial and commercial power of Europe.

The period 1600 to 1750 was a time of enormous progress in scientific experimentation and observation. Although religious tensions ran high, with fundamentalism and superstition increasing and executions for heresy and witchcraft multiplying, scientists began to view the universe as a system with natural and predictable laws.

In 1543, Nicolaus Copernicus (1473–1543), a Polish physician and astronomer, had published *De revolutionibus orbium coelestium* (*On the Revolutions of the Heavenly Spheres*), in which he hypothesized that the sun, rather than the earth, was the center of the universe and that the planets revolved around it. This heliocentric theory was confirmed by Johan Kepler (1571–1630), a German mathe-

matician who measured the movement of the five known planets and showed that they orbited the sun in elliptical paths. The Italian astronomer Galileo Galilei (1564–1642) proved that bodies of unequal weight fall with the same speed, impelled by gravity. Galileo also improved the recently invented telescope, which permitted him to see the satellites of the planets and led him to accept the system of Copernicus.

These discoveries flew in the face of Catholic doctrine, which held that the universe was an extension of God's will, that the earth was the center of the universe, and that mankind was central to that system. In 1616 Copernicus's writings were banned by the Church, and in 1633 Galileo was forced by the Inquisition to recant his views. These setbacks notwithstanding, scientific progress was an important feature of the Baroque period. The empirical method, with its emphasis on the direct experience, measurement, and analysis of natural phenomena, culminated in the work of the English natural philosopher Isaac Newton (1642–1727). Newton's laws of motion and theory of gravity (which held that every object in the universe exerts its own gravitational pull) formed the basis of physics until the end of the nineteenth century.

Baroque Style

The term *Baroque* is applied to diverse styles, a fact that highlights the approximate character of art-historical categories. Like Gothic, Baroque was originally a pejorative term. It is a French variant of the Portuguese *barroco*, meaning an irregular, imperfect pearl. The Italians used *barocco* to describe an academic and convoluted medieval style of logic. Although Classical themes and subject matter continued to appeal to artists and their patrons, Baroque painting and sculpture tended to be relatively unrestrained, overtly emotional, and more energetic than earlier styles.

Baroque artists rejected aspects of Mannerist virtuosity and stylization, while absorbing its taste for *chiaroscuro* and theatrical effects. They were more likely than Mannerists to pursue the study of nature directly. As a result, Baroque art achieves a new kind of naturalism that reflects some of the scientific advances of the period. There is also a new taste for dramatic action and violent narratives, and the representation of emotion is given a wide range of expression—a departure from the Renaissance adherence to Classical restraint. Baroque color and light are dramatically contrasted, and surfaces are richly textured. Baroque space is usually asymmetrical and lacks the appearance of controlled linear perspective; sharply diagonal planes generally replace the predominant verticals and horizontals of Renaissance compositions. Landscape, genre, and still life, which had originated as separate, but minor, categories of painting in the sixteenth century, gained new status in the seventeenth. Allegory also takes on a new significance in Baroque art and is no longer found primarily in a biblical context. Portraiture, too, develops in new directions as artists depict character and psychology along with the physical presence of their subjects.

The considerable variety within the Baroque style is partly a function of national and cultural distinctions. Baroque art began in Italy, particularly Rome, whose position as the center of western European art had been established during the High Renaissance by papal patronage and Rome's links with antiquity. At the end of the Baroque period, Paris would emerge as the artistic center of Europe, a position it retained until World War II. Two major Baroque architectural achievements—the completion of Saint Peter's in Rome and the sumptuous court of the French monarch Louis XIV at Versailles—reflect the enormous resources that were devoted to the arts in seventeenth-century Europe.

In Italy, Spain, and Catholic Flanders, the influence of the Counter-Reformation remained strong. In France, the Baroque style had its greatest expression at the court of Versailles. Court patronage also prevailed in Spain and England, whereas in capitalist Holland the art market was primarily, though not entirely, secular.

Architecture

Italy

The rebuilding of Saint Peter's Basilica, which began when Julius II became pope in 1503, was finally completed during the Baroque period. Its interior decoration and spatial design, however, still required attention. Pope Urban VIII (papacy 1623–1644) appointed Gianlorenzo Bernini (1598–1680) to the task, and he remained the official architect of Saint Peter's until his death. One of Bernini's objectives was to reduce the space at the crossing so that worshipers would be drawn to the altar. He achieved this by erecting the bronze **baldacchino** (canopy) (fig. **17.1**) over the high altar above Saint Peter's tomb.

The baldacchino's height is about one-third the distance from the floor of Saint Peter's to the base of its lantern. Although small in relation to the dome, it is the size of a modern nine-story building, and its foundations reach deep into the floor of the old Constantinian basilica.

Four twisted columns, decorated with acanthus scrolls and surmounted by angels, support a bronze valance resembling the tasseled cloth canopy used in religious processions. At the top, a gilded cross stands on an orb. The twisted-column motif did not originate with Bernini. In the fourth century, Constantine was thought to have used spiral columns originally from Solomon's Temple in Jerusalem at Old Saint Peter's. Eight of these columns were incorporated into the pier niches of New Saint Peter's. They are decorated with laurel branches and bees, both of which are devices of the Barberini family, of which Urban VIII was a member. Bernini's columns seem to pulsate as if in response to some internal pressure or tension. The dark bronze, accented with gilt, stands out against the lighter marble of the nave and apse. Such contrasts of light and dark, like the organic quality of the undulating columns, are characteristic of Baroque style.

Visible beyond the baldacchino is the *Cathedra Petri* (Throne of Saint Peter) in the western apse. It is actually a reliquary surrounded at its base by bronze figures of the four doctors of the Church—Saints Augustine and Ambrose (the doctors of the Western Church), and Saints Athanasius and John Chrysostom (the doctors of the Eastern Church). Representatives of Western and Eastern Christendom thus combine to support the Roman pope. Although they appear to be holding up the throne, it is actually cantilevered out from the wall. The illusory support is a metaphor for upholding the spiritual doctrine of faith in the early days of Christianity. Above the throne (actually an early medieval work) the Holy Spirit is framed by a stained-glass window. Because the building is oriented to the west, the window catches the afternoon sun, which reflects from the gilded rods, representing divine light.

In 1656, Bernini began work on the exterior of Saint Peter's. His goal was to provide an impressive approach to the church and, in so doing, to define the Piazza San Pietro.

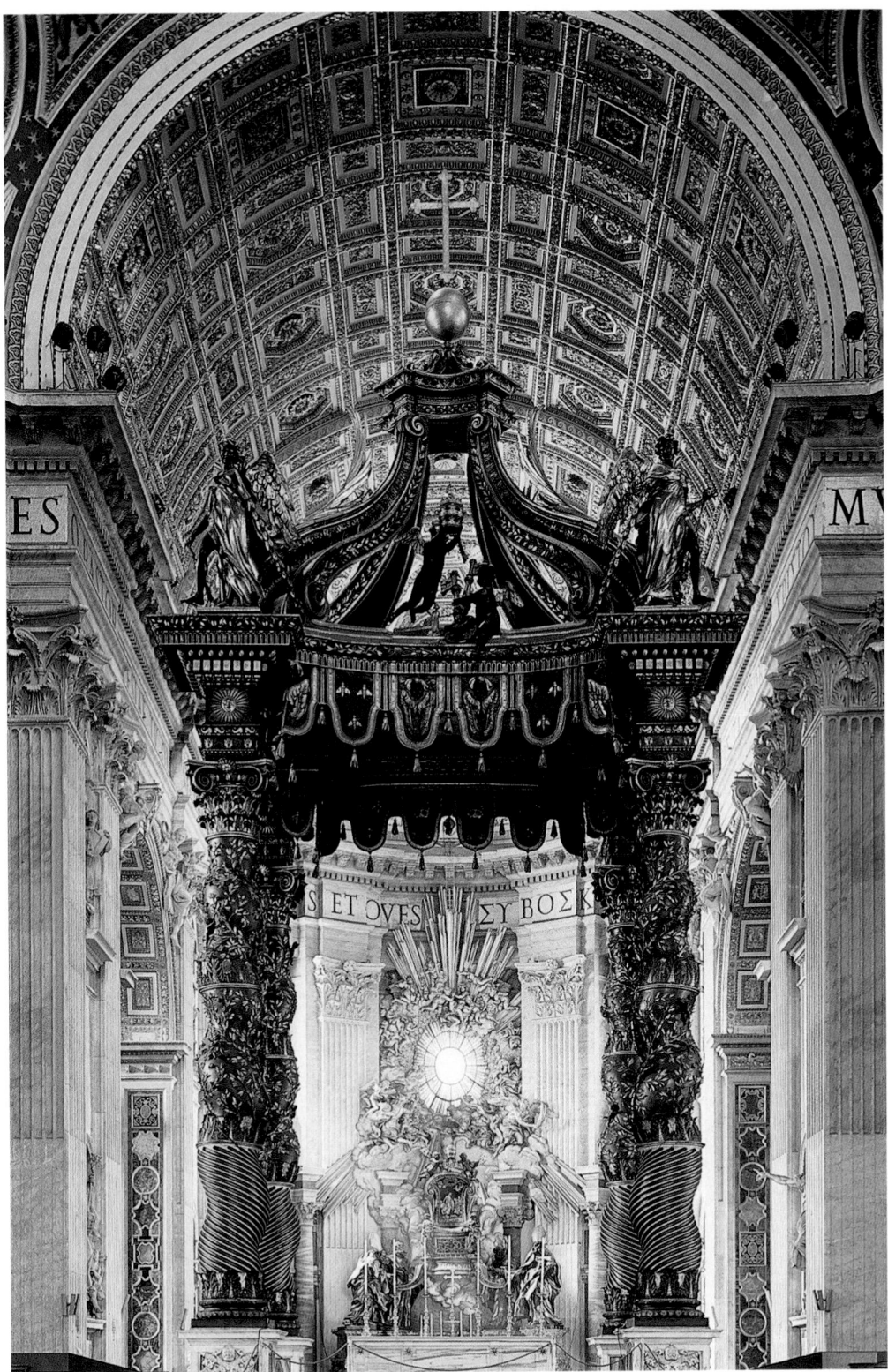

17.1 Gianlorenzo Bernini, baldacchino, Saint Peter's, Rome, 1624–1633. Gilded bronze; approx. 95 ft. (28.96 m) high. The baldacchino's height is about one-third the distance from the floor of Saint Peter's to the base of its lantern. Although small in relation to the dome, it is the size of a modern nine-story building, and its foundations reach deep into the floor of the old Constantinian basilica.

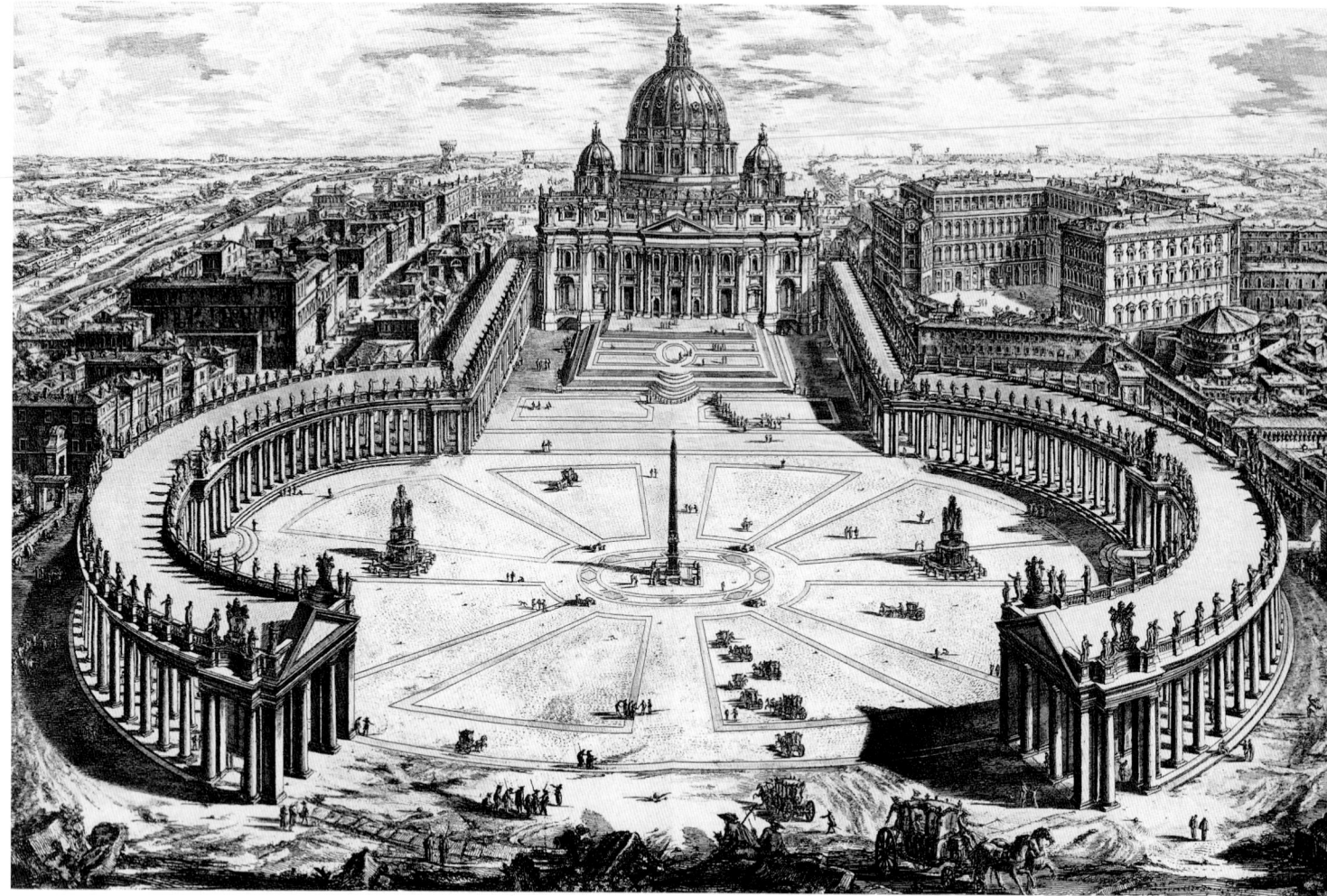

17.2 Gianlorenzo Bernini, aerial view of the colonnade and piazza of Saint Peter's, Rome, begun 1656. Travertine; longitudinal axis approx. 800 ft. (243.84 m). Copper engraving by Giovanni Piranesi, 1750. Kunstbibliothek, Berlin. The enormous piazza in front of the east façade of Saint Peter's can accommodate over 250,000 people.

The piazza, or public square (fig. **17.2**), is the place where the faithful gather on Christian festivals to hear the pope's message and receive his blessing. Bernini conceived of the piazza as a large open space organized into elliptical and trapezoidal shapes (in contrast to the Renaissance circle and square). He used Classical Orders and combined them with statues of Christian saints.

He divided the piazza into two parts (fig. **17.3**). The first section has the approximate shape of an oval or ellipse, and at its center is an obelisk 83 feet (25.30 m) high, imported from Egypt during the Roman Empire.

A radial pattern converges at the obelisk. The shape and width of the oval—approximately 800 feet (243.84 m)—and the location of a fountain within each of its semicircular sections help to establish a stronger north–south axis. That axis is perpendicular to the direction in which most visitors move—namely, along the east–west axis of the nave and dome.

Around the curved sides of the oval, Bernini designed two colonnades, consisting of 284 travertine columns in the Tuscan Order, each one 39 feet (11.89 m) high. The columns are four deep, and the colonnades end in temple fronts on either side of a large opening. Crowds can thus convene and disperse easily; they are enclosed, but not confined. Bernini wrote that the curved colonnades were like the arms of Mother Church, spread out to embrace the faithful.

The second part of the piazza is a trapezoidal area connecting the oval with the church façade. The trapezoid lies on an upward gradient, and the visitor approaches the portals of Saint Peter's by a series of steps. As a result, the walls defining the north and south sides of the trapezoid become shorter toward the façade. This enhances the verticality of the façade and offsets the horizontal emphasis produced by the incomplete flanking towers. The two sections of the piazza are tied together by an Ionic entablature that extends all the way around the sides of both the oval and the trapezoid, and the entablature is crowned by a balustrade with marble statues of saints. The integration of the architecture with the participating crowds reflects

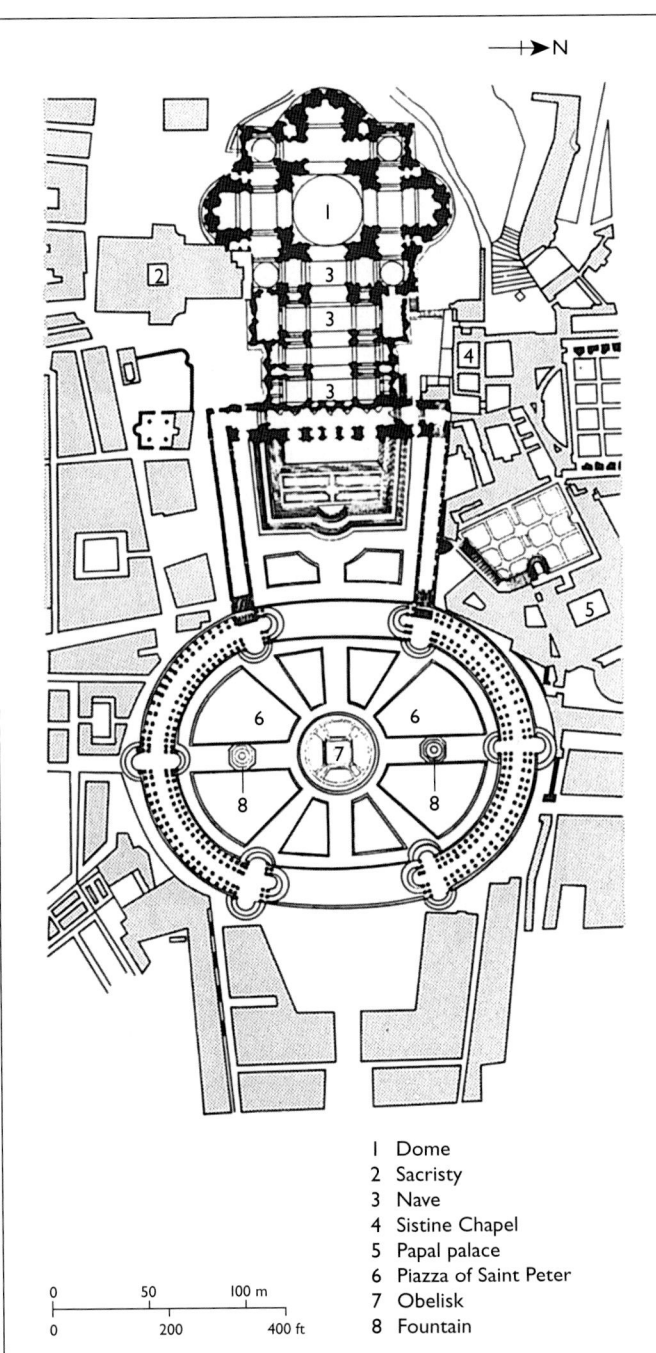

I	Dome
2	Sacristy
3	Nave
4	Sistine Chapel
5	Papal palace
6	Piazza of Saint Peter
7	Obelisk
8	Fountain

17.3 Plan of Saint Peter's and the piazza, Rome. In the center of the oval, a radial pattern converges at the obelisk. The shape and width of the oval—approx. 800 ft. (244 m)—and the location of a fountain within each of its semicircular sections help to establish a stronger north–south axis. That axis is perpendicular to the direction in which most visitors move: along the east–west axis of the nave and dome.

the theatrical Baroque taste for involving audiences in a created space, in particular a processional space leading to the high altar.

Bernini's greatest professional rival in Rome was Francesco Borromini (1599–1667). They collaborated on the baldacchino, but their interests diverged immediately after-

ward. Born in Lombardy, Borromini was the son of an architect. In 1621, he moved to Rome and worked under both Maderno and Bernini. Borromini and Bernini were intense rivals of very different temperaments, and Borromini resented living and working in Bernini's shadow. Moody and constantly dissatisfied, he eventually committed suicide. From about 1634 until his death, Borromini worked on the Trinitarian monastery of San Carlo alle Quattro Fontane (Saint Charles of the Four Fountains) in Rome (figs. **17.4, 17.5, 17.6,** and **17.7**), named after the fountains at the four corners of the street intersection. The small monastery church is Borromini's best-known building, and it established his reputation for daring architectural innovation.

The alternation of convexity and concavity in the façade of San Carlo is repeated with variations in the walls. The plan is shaped like a pinched and distended oval. Its main altar and entrance are opposite each other on the short sides of the oval. Side chapels, which seem to be parts of

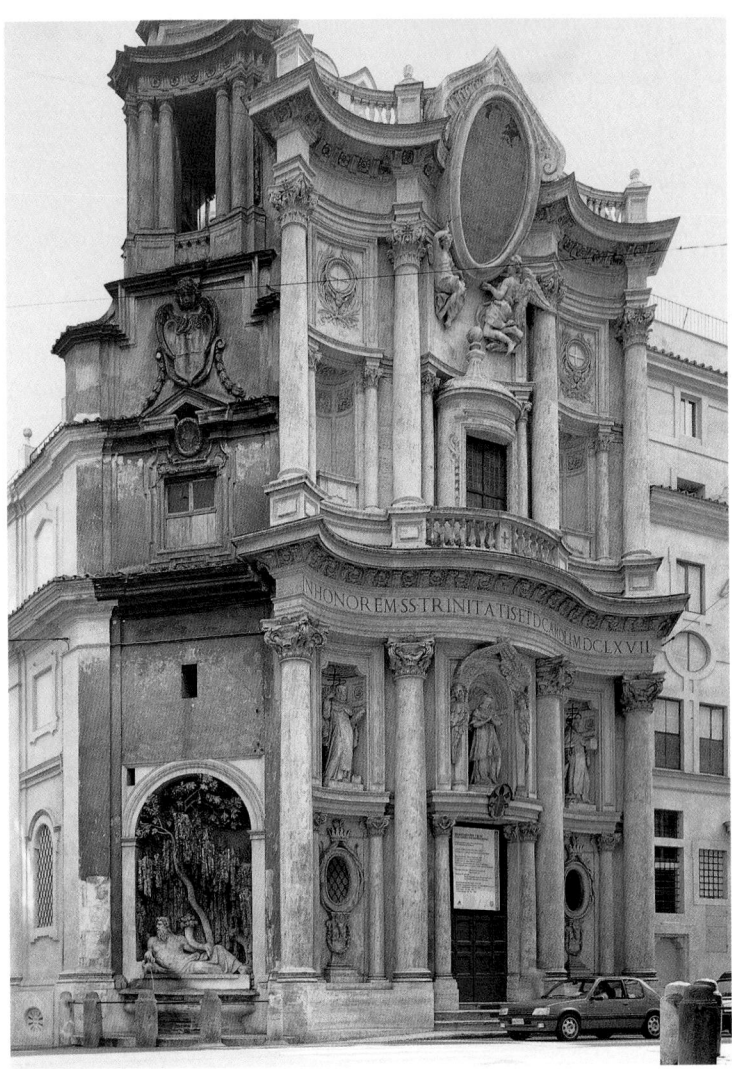

17.4 Francesco Borromini, San Carlo alle Quattro Fontane, Rome, 1665–1667.

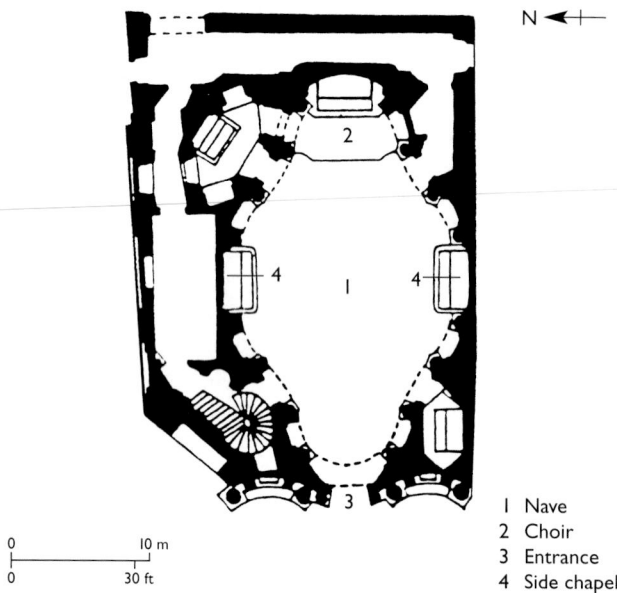

N ◄─┼─

```
0          10 m
├──────────┤
0          30 ft
```

I Nave
2 Choir
3 Entrance
4 Side chapel

17.5 Francesco Borromini, plan of San Carlo alle Quattro Fontane, Rome, 1638–1641. The plan is shaped like a pinched and distended oval. Its main altar and entrance are opposite each other on the short sides of the oval, and the walls are a series of convexities and concavities. Side chapels, which seem to be parts of smaller ovals, bulge out from the walls.

17.6 Francesco Borromini, view toward the high altar, San Carlo alle Quattro Fontane, Rome, 1638–1641.

smaller ovals, bulge out from the walls. At ground level, there are three bays—alternately concave, convex, and concave. At the upper level, the bays are all concave, although a small **aedicule** (niche) and a balustrade fill the central bay, echoing the convex shape of the level below. Borromini's undulating walls, like the twisted columns of Bernini's baldacchino, are characteristic of the plasticity of Italian Baroque architecture.

Above the door of the church, a statue of Saint Charles stands in a niche, surmounted by a pointed gable. A large painted medallion of the saint, crowned with a gable that echoes the lower one, has been placed above the top level, in alignment with the statue. The corner of the building is beveled and contains one of the four fountains referred to in the name of the church. Above the entablature are pendentives supporting an oval ring at the base of the dome.

The interior view (fig. 17.6) toward the high altar shows the use of large, smooth-shafted Corinthian columns to create a plastic effect in the walls. This is enhanced by the undulating character of the walls as they approach the apse. Surmounting the relatively sharp curve of the apse's entablature is a pediment that seems to be stretching its lower corners outward.

In figure 17.7, we are looking up at the interior of the dome, which expresses the Baroque concern for lightening

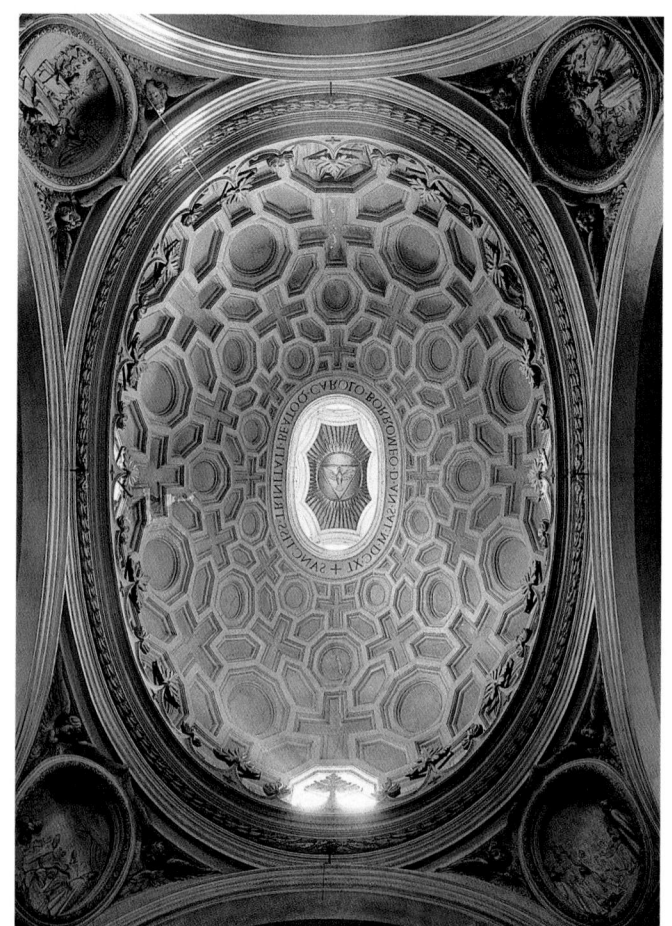

17.7 Francesco Borromini, interior dome of San Carlo alle Quattro Fontane, Rome, 1665–1667.

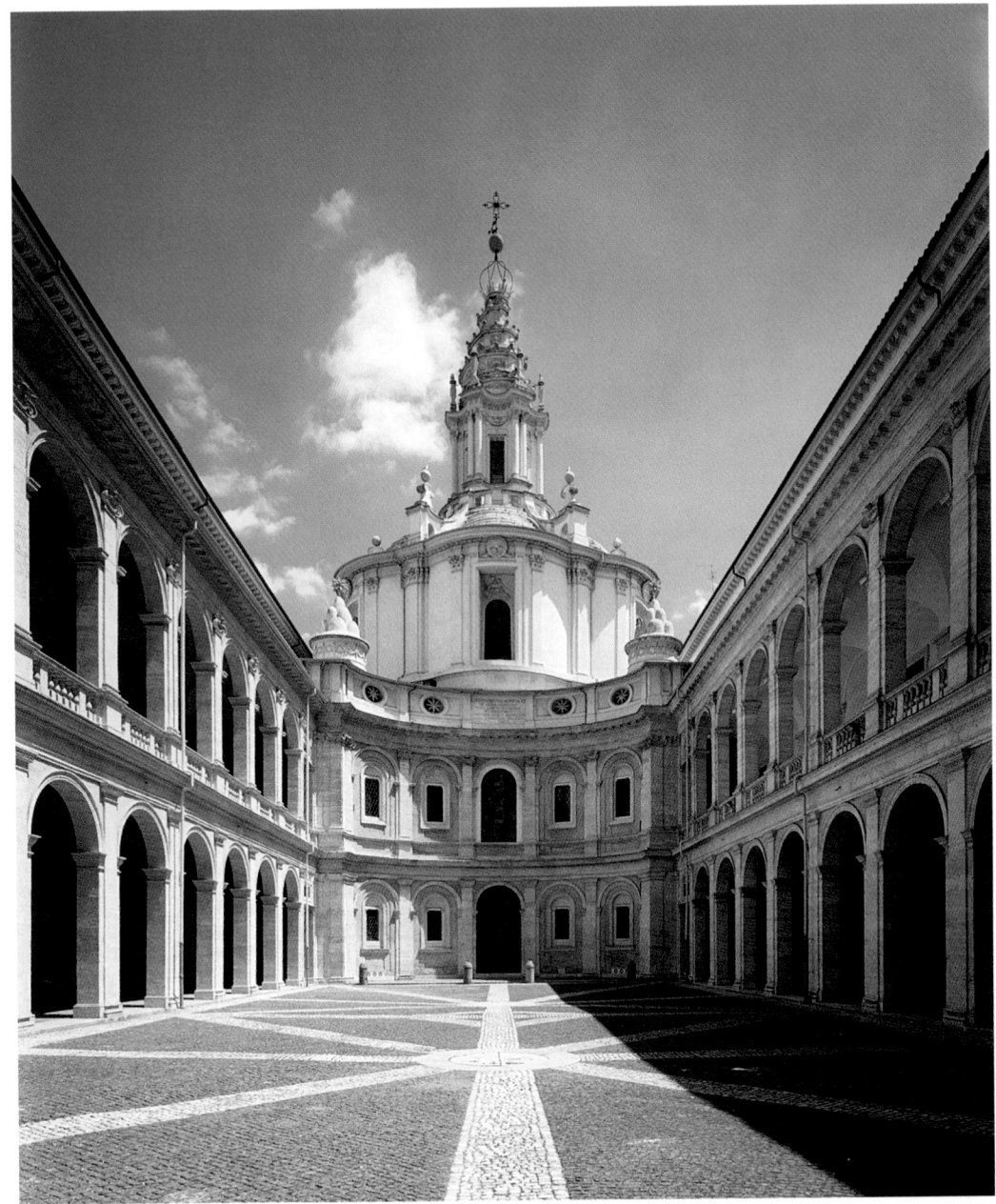

17.8 Francesco Borromini, Collegiate Church of Sant'Ivo della Sapienza, Rome, 1642–1660. In 1632, Borromini was appointed the official architect of Rome University by Pope Urban VIII.

architectural volume. The dome is illuminated on the interior by windows at its base, and contains coffers in the shape of hexagons, octagons, and crosses. At the center of the dome, an oval *oculus* contains a triangle, a geometric symbol of the Trinity and emblem of the Trinitarian Order that commissioned the church. The appearance of increased height, and of actual upward motion, is enhanced by coffers that decrease in size as they approach the center of the dome.

From 1642 to 1660, Borromini worked on the church of Sant'Ivo della Sapienza, which is another product of his original architectural imagination. Its concave façade (fig. **17.8**) blends into the surrounding buildings of Rome University, known at the time as the Sapienza (Wisdom). The crowning features of this church are particularly innovative—for example, the stepped, pyramidal form supporting the lantern, which is surmounted by a spiral ramp leading to a stone laurel wreath. This is decorated with carved flames and supports an iron cage upholding an orb with a cross. The sources of these motifs and their unusual combinations are difficult to identify, but they appear to have been inspired by the ancient Near Eastern ziggurat.

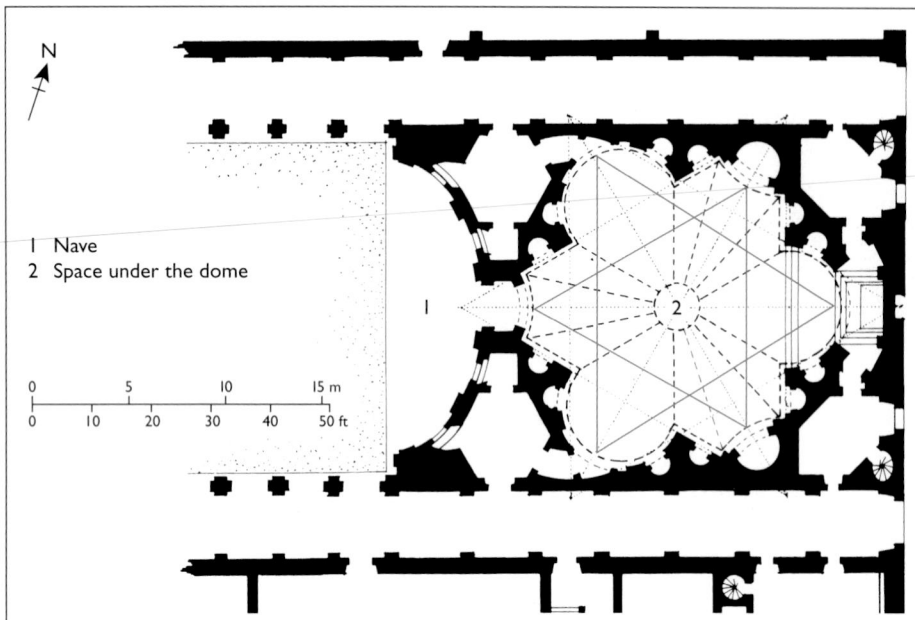

17.9 Francesco Borromini, plan of the Collegiate Church of Sant'Ivo della Sapienza, Rome.

1 Nave
2 Space under the dome

17.10 Francesco Borromini, interior of dome, Collegiate Church of Sant'Ivo della Sapienza, Rome, 1642–1660.

The plan of Sant'Ivo (fig. **17.9**) is formed by two equilateral triangles superimposed to form the shape of a six-pointed star. The center is hexagonal, with a bay at each side. Three of the angles end in semicircular apses, and three in pointed apses. The walls of the latter are convex and seem to push in toward the center of the plan. As a result, there is an organic quality in Borromini's conception that is enhanced by continual tension in the relationship of the walls to the space.

A comparison of the interior view of Sant'Ivo's dome (fig. **17.10**) with that of San Carlo (fig. 17.7) shows the greater complexity of the former. Here the alternation of curves over the semicircular apses with the convex apse walls is clear. The effect is to increase the variation of shapes and spaces, which seem to radiate from the central circle. At San Carlo, on the other hand, the sides of the dome appear to have been pushed inward toward the center to create its oval form. The interior illumination of Sant'Ivo's dome enhances the impression of a large architectural star, which evokes the celestial associations of domed buildings in a new and original way. Being in the form of a Star of David, the dome refers to the typological tradition relating Old Testament kings with Christ, and specifically to Christ's descent from the House of David.

France

French seventeenth-century architecture is elegant, ordered, rational, and restrained, recalling the Classical aesthetic. France rejected the exuberance of Italian Baroque, preferring a strictly **rectilinear** approach to Borromini's curving walls or the open, activated spaces of Bernini. Geometric regularity was also more in keeping with the French political system—absolute monarchy personified by Louis XIV.

Louis ascended the throne in 1643 at the age of five and ruled from 1661, when he came of age, until his death in 1715. His shrewd policies and talented ministers made France the most powerful, and most populous, nation in Europe. His chief minister, Jean-Baptiste Colbert, organized the arts in the service of the monarchy. Their purpose was to glorify Louis's achievements and enhance his power and splendor in the eyes of the world. To this end, the building industry and the crafts guilds were subjected to a central authority. An Academy was established to create a national style that would reflect the glory of France and its king (see box, p. 636).

The first task of Louis and Colbert was to complete the rebuilding of the Louvre (fig. **17.11**) in Paris. Now the city's principal art museum, the Louvre was then a royal palace. Bernini submitted a series of proposals and was summoned to work on the Louvre project. His final proposal was rejected, however, on the grounds that it did not match the existing structure or conform to French taste. The eventual design for the east façade was the work of three men: the painter Charles Le Brun (director of the French Academy), the architect Louis Le Vau, and Claude Perrault, a physician. The restrained, classicizing symmetry of the façade, in contrast to Bernini's plan for a curved wall, occupies a long horizontal plane; it set the style for seventeenth-century French architecture. Paired, two-story columns separate the windows and are linked by a continuous entablature. The flat roof is hidden by a surrounding balustrade, which accents the horizontality of the building. The central pavilion, resembling a Roman temple front, is crowned by a pediment, which is echoed by the small individual pediments above the windows. The main floor rests on a ground floor presented as a **podium.** Its masonry blocks have roughened surfaces and sunken joints.

In 1667, Louis XIV decided to move his court to Versailles, a small town about 15 miles (24 km) southwest of Paris. This involved moving not only the vast royal household, but also the whole apparatus of government. Versailles was the site of a hunting lodge built in 1624 by Louis's father, Louis XIII, and enlarged from 1631 to 1636. His son had visited this modest twenty-room **château** as a child. The lodge was at the center of a radiating landscape design and formed the nucleus of the new palace, which

17.11 Claude Perrault, Louis Le Vau, and Charles Le Brun, east façade of the Louvre, Paris, 1667–1670.

17.12 Aerial view of the park and palace of Versailles, after a 17th-century engraving by G. Pérelle. Versailles was the epitome of the French château (meaning "castle," "mansion," or "country house"), which had been established in the 16th century as the centerpiece of lavish country estates. A small town grew up at the eastern end of the palace, planned in grid formation around three broad boulevards. These radiated out from the palace and funneled visitors into the courtyard, or Court of Honor.

was built under Louis XIV (fig. **17.12**). From 1661 to 1708 the building underwent a series of enlargements, the earlier ones under the direction of Le Brun and Le Vau. The landscape architect André Le Nôtre (1613–1700) designed the elaborate gardens with pools and fountains—typical Baroque features. By 1678, the new palace was large enough for the court to move to Versailles, which then became the seat of government, including the treasury and the diplomatic corps. The palace contained hundreds of rooms and accommodated over 20,000 people. Four thousand servants lived inside the palace and 9,000 soldiers were billeted nearby.

The French Academy (Académie Royale de Peinture et de Sculpture)

Louis XIV extended his notion of the monarch's absolute power to the arts. In 1648, his minister, Jean-Baptiste Colbert, founded the Royal Academy of Painting and Sculpture with a view to manipulating imagery for political advantage. The philosophy and organization of the Academy were as hierarchical as Louis's state. Artists were trained according to the principle that tradition and convention had to be studied and understood. Art students drew from plaster casts and copied the old masters. They were steeped in the history of art and of French culture.

Another issue of philosophical importance to the Academy was the role of nature in the concept of the "ideal." Artists, if properly trained, should be able to produce the ideal in their work. The representation of emotion through physiognomy, expression, and gesture was also discussed at length by Charles Le Brun, who headed the Academy for twenty years. All such considerations were subject to a system of rules, which was derived partly from Platonic and Renaissance theory and partly from the French interest in the creation of an aesthetic order.

The subject matter of art was also organized according to a hierarchy. At the top were the Christian Sacraments, followed by history painting. In these two categories, the philosophy of the Academy supported the religious and political hierarchy imposed by Louis XIV. Next in line were portraiture, genre (scenes of daily life), landscape (with or without animals), and, lowest on the scale, still life.

With all the Academy's emphasis on systems and rules, a number of artistic "quarrels" were prevalent in the seventeenth century. The High Renaissance arguments over the merits of line and color (*disegno* and *colorito*) continued in the Baroque period, now exemplified by Poussin and Rubens. The *Rubénistes* championed color, whereas the *Poussinistes* preferred line. A parallel quarrel between the "Ancients" and "Moderns" arose: this concerned the question of which was the best authority for artists to follow. The Ancients were more traditional and tended to be allied with the proponents of *disegno* and Poussin. Line was considered rational, controlled, and Apollonian. Color, which was allied with Rubens and the Moderns, was emotional, exuberant, and related to Dionysiac expression.

17.13 Charles Le Brun and Jean-Baptiste Tuby, Fountain of Apollo, Versailles, 1668–1670. Gilded metal.

Unprecedented in scale and grandeur, the palace at Versailles was intended to glorify the power of the French monarch—and so was its iconography. The latter was supervised by Le Brun, who portrayed Louis as *Le Roi Soleil* (the Sun King), an appellation designed to bolster his divine right to rule. The unrivaled splendor and life-giving force of the king was proclaimed throughout the lavish interior of the palace.

Located in the pool at one end of the east–west axis of the vast park was an elaborate gilded fountain representing Apollo with his chariot drawn by four horses (fig. **17.13**). Jets of water spraying up from the statues enliven the ensemble and create the impression that the horses are leaping from the pool at dawn to begin their daily course across the sky. On either side of the chariot, four Tritons (sea gods) blow their conches to announce the new day. The four dolphins swimming away from the fountain appear to have been startled by Apollo's sudden emergence from the pool. This is only one of several fountains identifying Louis XIV with the sun god through the use of solar iconography.

A second stage in the construction of Versailles lasted from 1678 to 1688 and included the great Galerie des Glaces (Hall of Mirrors) (fig. **17.14**), which

17.14 Jules Hardouin-Mansart and Charles Le Brun, *Galerie des Glaces* (Hall of Mirrors), palace of Versailles, c. 1680.

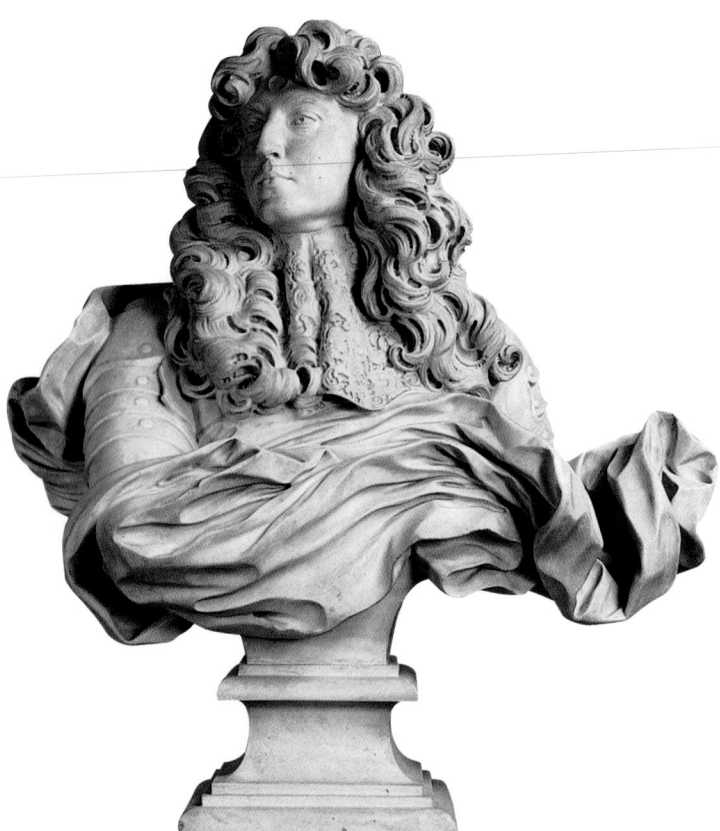

17.15 Gianlorenzo Bernini, *Louis XIV*, 1665. Marble; life-sized. Versailles.

CONNECTIONS

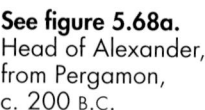

See figure 5.68a.
Head of Alexander, from Pergamon, c. 200 B.C.

and his wide-eyed, energetic gaze, the bust is also reminiscent of the Hellenistic type of Alexander the Great (see fig. 5.68) and other royal figures. Bernini creates the impression that Louis is both of this world—as a king and warrior, a worthy successor to Alexander the Great—and destined for apotheosis.

England

Baroque was also the architectural style of seventeenth-century England. Its greatest exponent was Sir Christopher Wren (1632–1723). Following the Great Fire (1666), which destroyed over two-thirds of the old walled city of London, Wren was appointed the King's Surveyor of Works. From 1670 to 1700, he took part in redesigning fifty-one of the churches that had burned down. Wren's priority during this period, however, was Saint Paul's, the first cathedral to be built for the Protestant Church of England.

The longitudinal plan and section (fig. **17.16**) blended elements from several styles. The formal arrangement (although not the style) of the nave, side aisles, and clerestory is based on the Early Christian basilica. The western façade (fig. **17.17**), with its paired columns and central pediment, is reminiscent of the Louvre. Two flanking towers, although similar in conception to Gothic cathedral towers, are more Baroque in their execution. They include round arches and triangular pediments on the two lower stories, while curved walls appear at the bases of the spires. On the two stories of the façade between the towers, like the façade of the Louvre, paired Corinthian columns support an entablature. Both are also crowned by a triangular pediment. The dome, which rises over the crossing and spans both the nave and the aisles, was originally a Renaissance feature.

It took forty years to complete Saint Paul's under Wren's supervision. The result is a successful synthesis of French and Italian Baroque, with elements of Renaissance and Gothic style.

was added by Jules Hardouin-Mansart. The Galerie has seventeen large arched mirrors, which form a literal wall of glass. They multiplied the sunlight entering the windows opposite and reflected the glittering splendor of Louis and his court. At each end of the Hall of Mirrors are the Salons of War and Peace, decorated with the relevant symbols. Foreign ambassadors were received in the appropriate salon to learn Louis's political intentions.

The reflected sunlight in the Hall of Mirrors was only one of the many solar allusions at Versailles. The Salon d'Apollon, named after Apollo, the sun god, was the throne room. The gardens are laid out along axes that radiate like the sun's rays from a central hub. They are adorned with sculptures, such as those illustrated in figure 17.13, illustrating Apollonian myths.

Above the main entrance, at the center of the palace, was the king's bedroom. Here, Louis enacted his daily ceremonies of *lever* (rising) and *coucher* (going to bed), which, like the garden fountains, identified him directly with the rising and setting sun. Bernini's life-sized marble bust of Louis XIV (fig. **17.15**), which is still in the king's bedroom, contains more subtle allusions to Louis's role as the Sun King. The smooth surface of the face, in contrast to the luxurious curls framing it, suggests the sun radiating as a central force through the clouds. With the sharp turn of Louis's head, as if something has suddenly caught his attention,

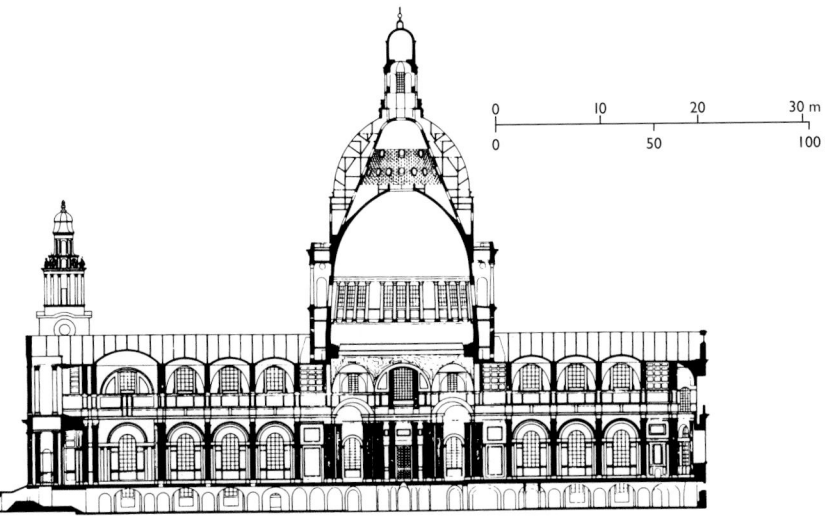

17.16 Longitudinal **section** and plan of Saint Paul's Cathedral, London. An invisible conical brick structure supports the lantern and the lead-faced, wooden framework of the outer dome. Extra support is supplied by flying buttresses, which are masked by the upper parts of the side aisle walls.

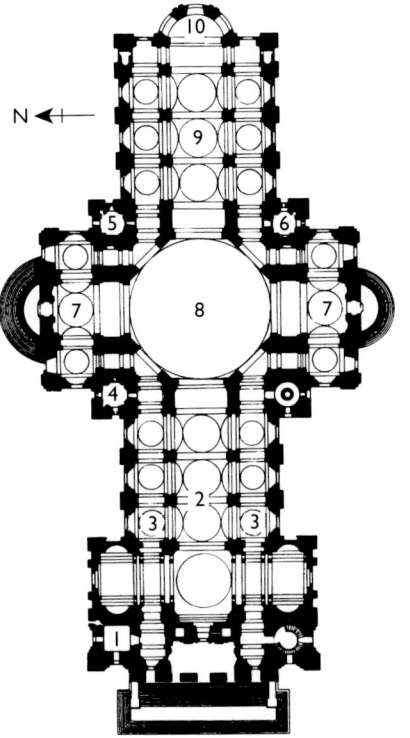

1 Bell tower
2 Nave
3 Aisle
4 Lord Mayor's vestry
5 Minor canons' vestry
6 Dean's vestry
7 Transept
8 Crossing under the dome
9 Choir
10 Jesus Chapel

17.17 Christopher Wren, western façade of Saint Paul's Cathedral, London, 1675–1710. The dome of Saint Paul's is 112 ft. (34.14 m) in diameter and 300 ft. (91.44 m) high, second in size only to Saint Peter's in Rome. Today, the dome continues to dominate the London skyline, but the lower façade is visible only from nearby.

Sculpture: Gianlorenzo Bernini

The most important Baroque sculptor in Rome was Gianlorenzo Bernini. His over-life-sized sculpture *Pluto and Proserpina* (fig. **17.18**) represents the most violent moment in the Greek myth designed to explain the change in seasons—namely, the abduction of Proserpina, daughter of Ceres, the goddess of agriculture. A muscular Pluto, the Roman god of the underworld who wants Proserpina for his wife, grabs hold of her, his fingers convincingly digging into her flesh. She, in turn, pushes Pluto's head away from her as she assumes a version of the Mannerist *figura serpentinata* and squirms to escape his grasp. Here, how-

ever, the pose is in the service of a violent narrative moment rather than being a virtuoso Mannerist exercise. Both figures are in strong *contrapposto,* leaning sharply backward at the waist. The flowing hair and beard echo the rippling motion of the body surfaces and reinforce the sense of action. Seated next to Pluto is Cerberus, the three-headed dog who guards the underworld. One head eyes the abduction intently, while another howls behind Proserpina's foot.

Bernini creates erotic tension between Pluto and Proserpina by a combination of pose and gesture characteristic of Baroque style. Although Proserpina struggles against Pluto, she also turns toward him. In pushing away Pluto's head, her fingers curl around a peak of his crown, as he in turn leers amorously at her. The exuberant back-and-forth

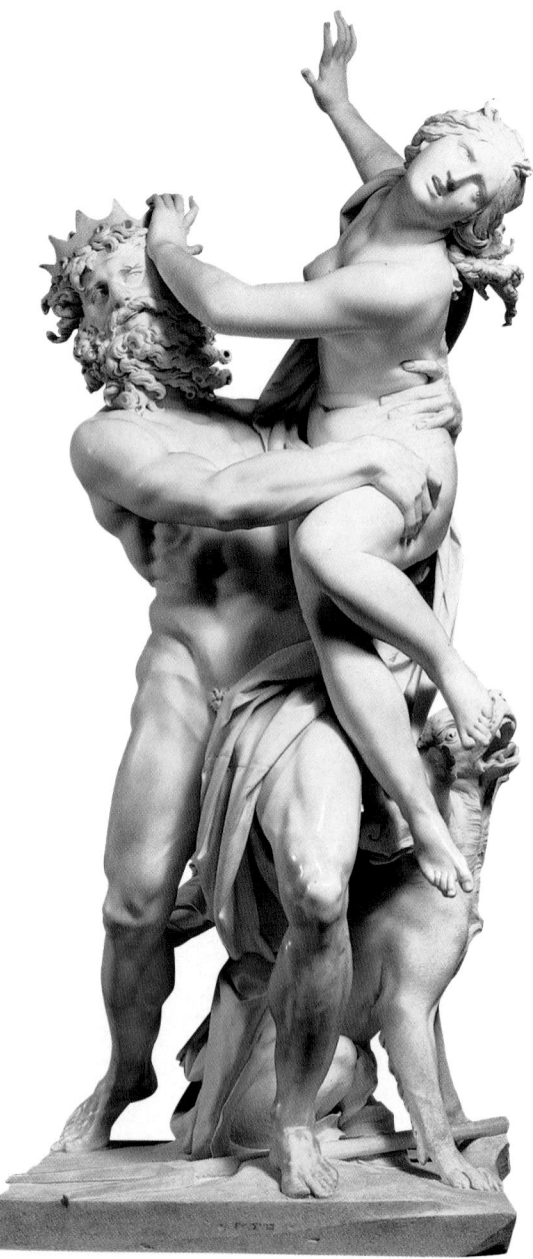

17.18a Gianlorenzo Bernini, *Pluto and Proserpina (Rape of Persephone)* (after restoration), front view, 1622. Marble. Galleria Borghese, Rome.

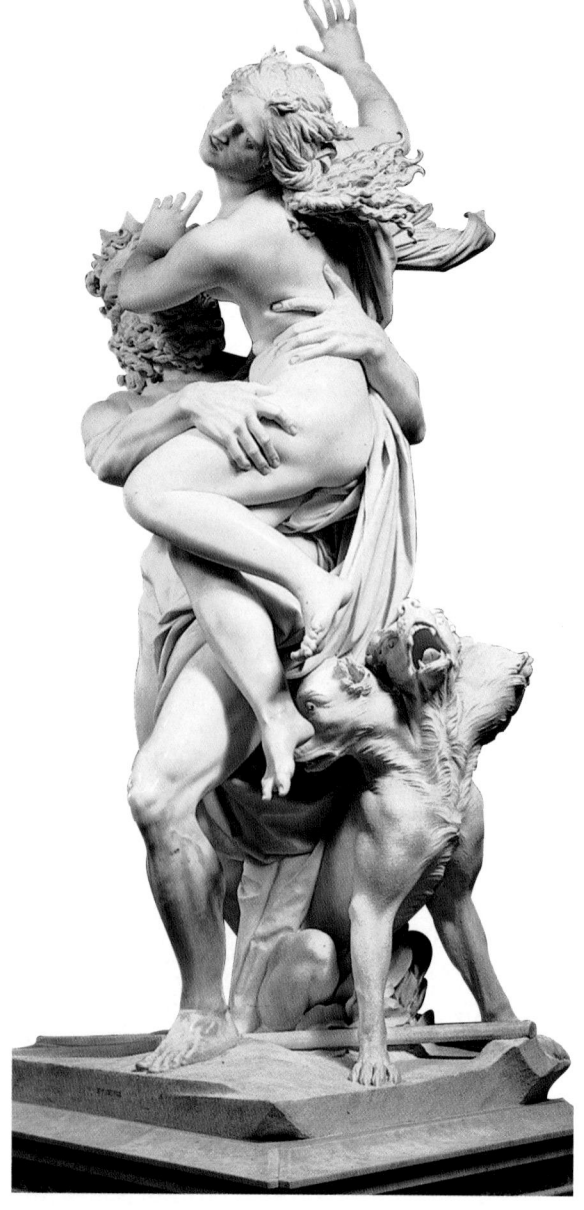

17.18b Gianlorenzo Bernini, *Pluto and Proserpina (Rape of Persephone),* side view.

motion of the figures echoes the movement of Cerberus's two visible heads. The rhythm of the struggle can be related to the myth itself, for Proserpina is committed to Pluto for one-half of the year (corresponding to fall and winter) and returns to her mother for the other half (spring and summer).

In the Roman myth borrowed from Greece, Pluto's abduction of Proserpina (Persephone in Greek) explained the seasonal changes. When Proserpina's mother, Ceres, went in search of her daughter, vegetation ceased to grow and winter fell. Ceres found Proserpina in Pluto's underworld. Because her daughter had eaten six seeds from Pluto's pomegranate, she was doomed to spend half the year in his domain. During the six months of fall and winter, Ceres mourns and nature dies. Spring and summer return when Proserpina rejoins her mother.

In the life-sized marble sculpture of *David* of 1623 (fig. **17.19**), all trace of Mannerism has disappeared. Once again Bernini has chosen to represent a narrative moment requiring action. David leans to his right and stretches the sling, while turning his head to look over his shoulder at Goliath. In contrast to Donatello's relaxed and self-satisfied bronze *David* (see fig. 13.29), who has already killed Goliath, and Michelangelo's (see fig. 14.19), who tensely sights his adversary, Bernini's is in the throes of the action.

The vertical plane of the Renaissance *Davids* has become, in the Baroque style, a dynamic diagonal extending from the head to the left foot. That diagonal is countered by the left arm, the twist of the head, and the drapery. In contrast to the *Pluto and Proserpina,* Bernini's *David* is a single figure. Nevertheless, his portrayal assumes the presence of Goliath, thereby expanding the space—psychologically as well as formally—beyond the immediate boundaries of the sculpture. Such spatial extensions are a characteristic, dramatic Baroque technique for involving the spectator in the work.

CONNECTIONS

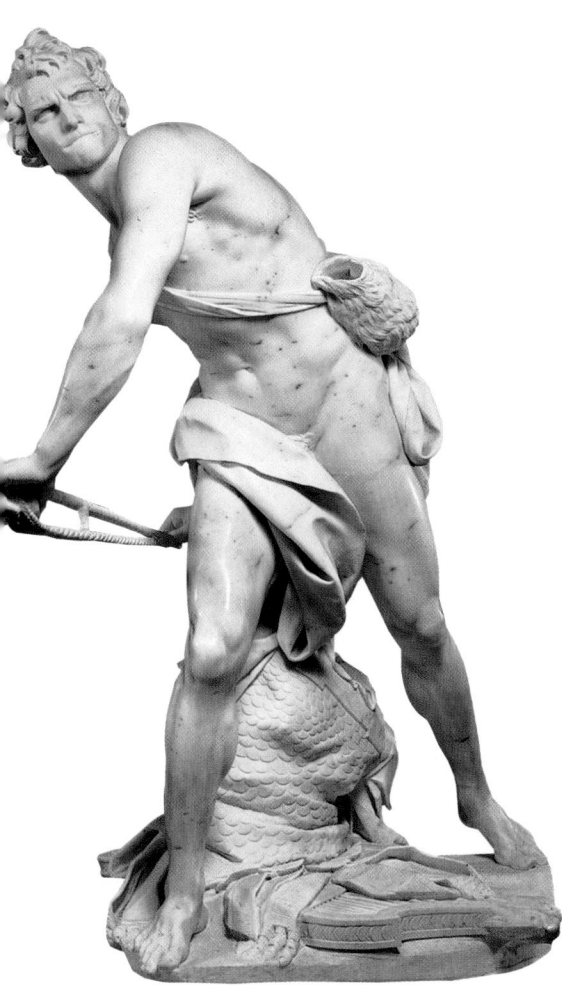

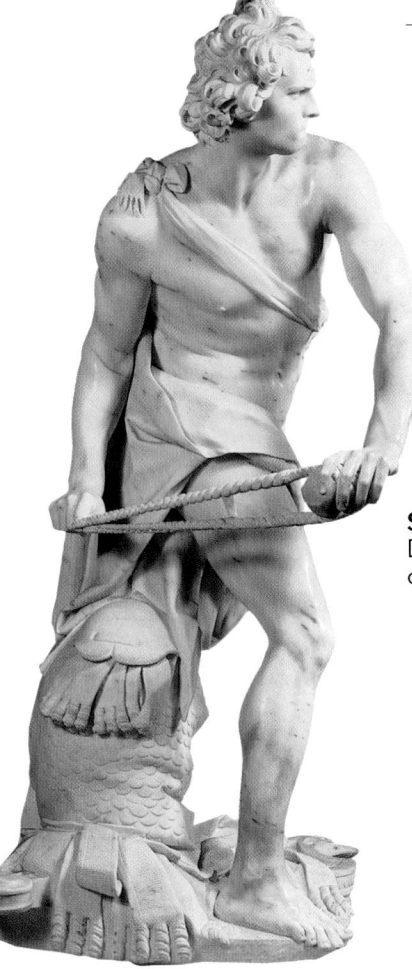

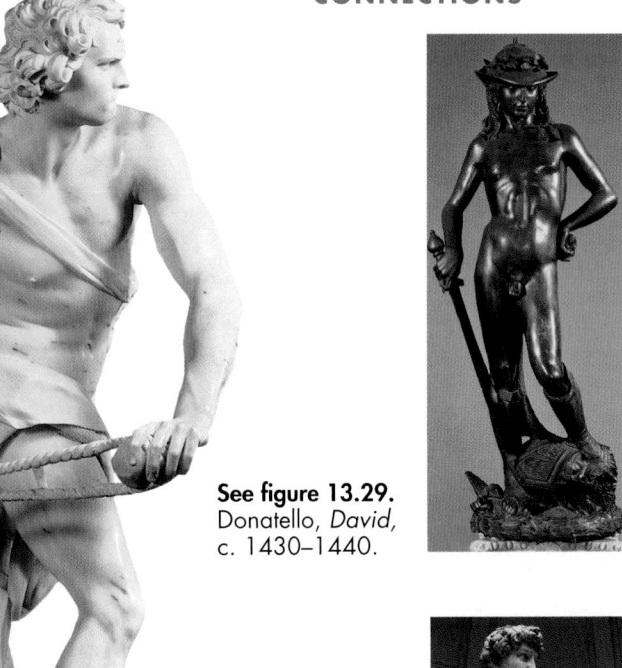

See figure 13.29.
Donatello, *David,*
c. 1430–1440.

17.19a Gianlorenzo Bernini, *David,* 1623. Marble; life-sized. Galleria Borghese, Rome. According to Bernini's biographers, Cardinal Maffeo Barberini (elected pope in 1623) held up a mirror so that Bernini could carve the *David*'s face as a self-portrait. Whether true or not, the story is consistent with Bernini's habit of studying his mirror reflection for the purpose of self-portraiture.

17.19b Gianlorenzo Bernini, *David,* side view (after cleaning).

See figure 14.19.
Michelangelo,
David,
1501–1504.

17.20 Gianlorenzo Bernini, Cornaro Chapel, Santa Maria della Vittoria, Rome, 1640s. The Cornaro Chapel illustrates Bernini's skill in integrating the arts in a single project. Here he uses the chapel as if it were a little theater. Directly opposite the worshiper, the altar wall opens onto the dramatic encounter of Saint Teresa and the angel. Joining the worshiper in witnessing the miracle are members of the Cornaro family, who are sculptured in illusionistic balconies on the side walls.

representing the visionary world of the mystic saint. Life-sized figures occupy a Baroque niche with paired Corinthian columns and a broken pediment over a curved entablature. As in the *David* and *Pluto and Proserpina,* Bernini represents a moment of heightened emotion—in this case the transport of ecstasy. The angel has just pierced Saint Teresa's breast with a spear as he gently pulls aside her drapery. Although Teresa appears elevated from the ground, she is actually supported by a formation of billowing clouds. Leaning back in a long, slowly curving diagonal plane, she closes her eyes and opens her mouth slightly, as if in a trance. Her inner excitement contrasts with the relaxed state of her body and is displaced onto the elaborate, energetic drapery folds, which blend with the clouds. Behind Saint Teresa and the angel are gilded rods, representing rays of divine light. They seem to descend from the infinite realm of heaven and enter the niche behind the altar.

This scene synthesizes the Baroque taste for inner emotion with Counter-Reformation mysticism. Only a sculptor as great as Bernini could combine the powerful religious content of this scene with its erotic implications in a way that would satisfy the Church. Also characteristic of the Baroque style is Bernini's ability to draw the observer into the event, which is reinforced by the theatrical arrange-

Even more theatrical in character is Bernini's "environmental" approach to the chapel of the Cornaro family (fig. **17.20**) in the church of Santa Maria della Vittoria. This was the funerary chapel of Cardinal Federico Cornaro, who came to Rome from Venice in 1644. The event taking place behind the altar is the *Ecstasy of Saint Teresa* (fig. **17.21**),

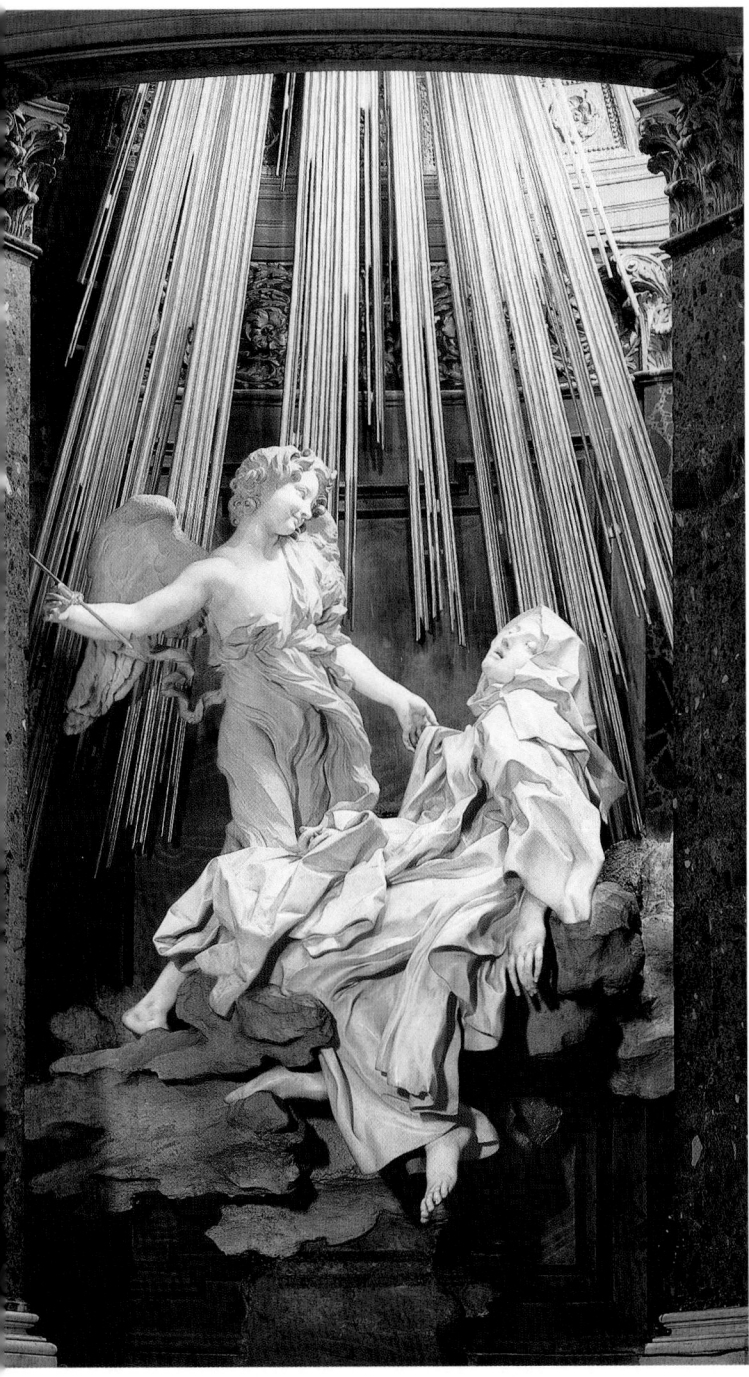

17.21 Gianlorenzo Bernini, *Ecstasy of Saint Teresa*, Cornaro Chapel, Santa Maria della Vittoria, Rome, 1645–1652. Marble; 11 ft. 6 in. (3.51 m) high. Saint Teresa was born in Ávila, Spain, in 1515. She was a Carmelite nun who, in her *Life*, described the mystical experience depicted here: "He was not tall, but short, and very beautiful, his face so aflame that he appeared to be one of the highest types of angel who seem to be all afire . . . they do not tell me their names. . . . In his hands I saw a long golden spear and at the end of the iron tip I seemed to see a point of fire. With this he seemed to pierce my heart several times. . . . When he drew it out . . . he left me completely afire with a great love for God . . . so excessive was the sweetness caused me by this intense pain that one can never wish to lose it."[1] Teresa was canonized in 1622.

Italian Baroque Painting

The two leading painters in Rome at the start of the seventeenth century were Annibale Carracci (1560–1609) and Michelangelo Merisi da Caravaggio (1571–1610). Both had the Church and the nobility as patrons. Carracci turned the late sixteenth-century Mannerist trends back to classicism, while infusing his images with exuberant Baroque drama. Caravaggio pursued a new kind of realism.

Ceiling frescoes in churches and palaces became particularly elaborate in this period, using illusionism to glorify the message of the Catholic Church. Two of the most impressive creators of these were Pietro da Cortona (1596–1669), who painted the ceiling of the Barberini Palace, and Giovanni Battista Gaulli, called Baciccio (1639–1709), who decorated the ceiling of Il Gesù (see figs. 15.23–15.25), both in the grand Baroque manner.

Annibale Carracci

Annibale was the most important member of the Carracci family of artists from the northern Italian city of Bologna (see box, p. 645). In 1597, Cardinal Odoardo Farnese commissioned him to decorate the Grand Gallery of his Roman palace in celebration of the marriage of a Farnese duke. The subject of the frescoes, the loves of the gods (fig. **17.22**), was in keeping with the wedding of an aristocratic Roman family. It also reflects Annibale's attraction to Classical iconography, which he infused with the formal elements of Baroque.

The ceiling is a curved vault, on which Annibale painted monumental imitation caryatid reliefs with picture frames dividing the narrative scenes. The colors are lively and reflect the amorous exuberance of the content. Although the subject matter is mythological, certain motifs such as the male figures seated in strong *contrapposto* are inspired by those in the Sistine ceiling. Implicit in the

ment of the chapel itself. Sculptures of the Cornaro family on the side walls occupy an illusionistic architectural space in low relief. Broken pediments and convincing barrel vaults are supported by Ionic columns. Some of the onlookers witness and discuss Saint Teresa's mystical experience like theatergoers watching a play. All except the cardinal were, in fact, deceased at the time of the commission. They represent the earthly, material world of the donor and his family, while two skeletons inlaid on the marble floor (not visible in the illustration) occupy purgatory—one prays for redemption, and the other raises his hands in despair.

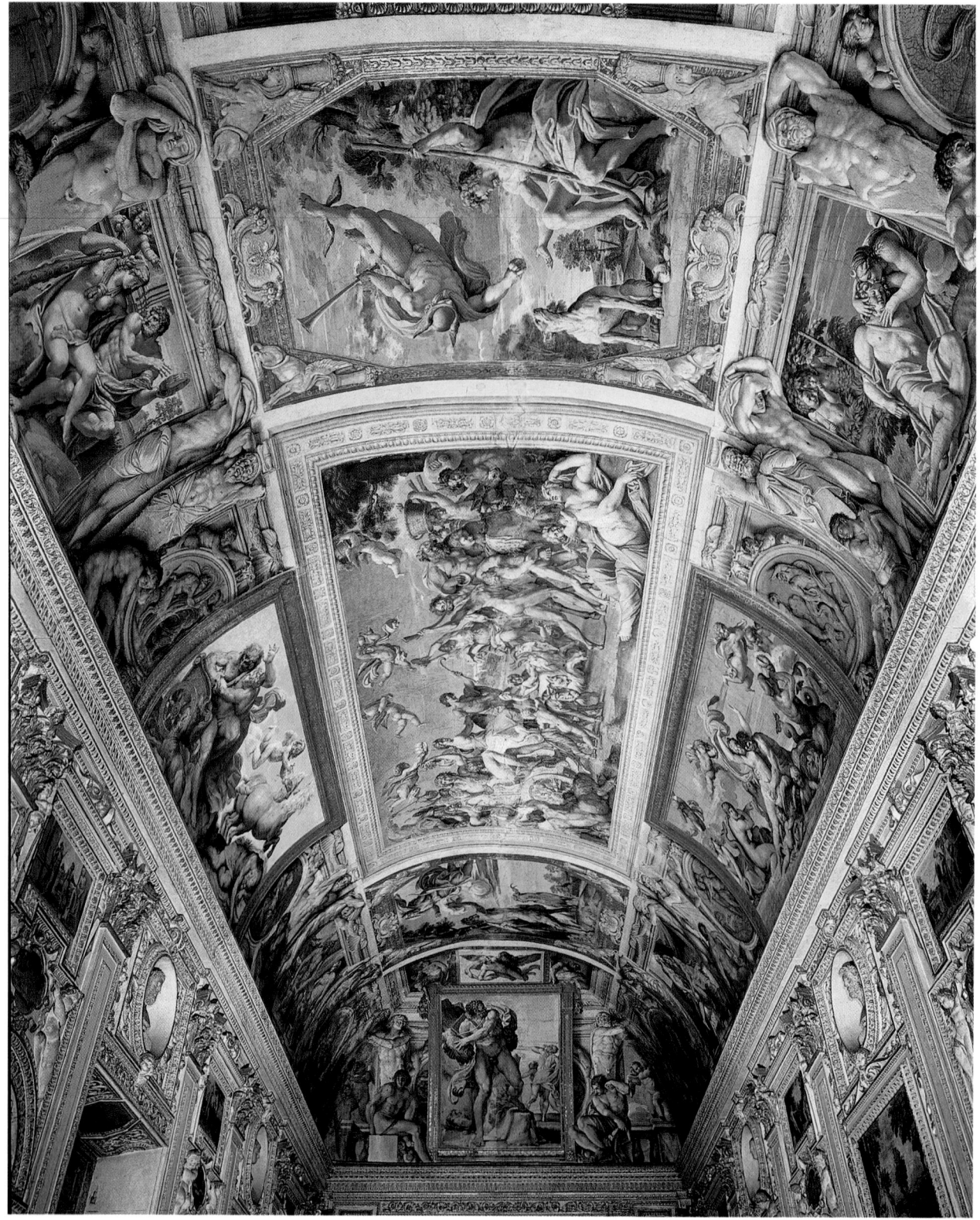

17.22 Annibale Carracci, ceiling frescoes in the Grand Gallery, Farnese Palace, Rome, 1597–1601. Altogether there are eleven scenes. Clearly visible in this view is *Polyphemos* in the far lunette and the large ceiling panel of the *Triumph of Bacchus*. The ceiling panel next to this shows an airborne Mercury approaching Paris.

theme of the gods' loves is also a Christian subtext in which divine love is moralized as a unifying force that leads to salvation. Another theme can be seen in the fresco to the left of the one-eyed Cyclops Polyphemos, which represents Venus and her mortal lover Anchises (fig. **17.23**). As the parents of Aeneas, Venus and Anchises refer to the founding of Rome and, by implication, to the antiquity of the Farnese family. They thus link the Farnese Palace and its ecclesiastical patron with the mythological past.

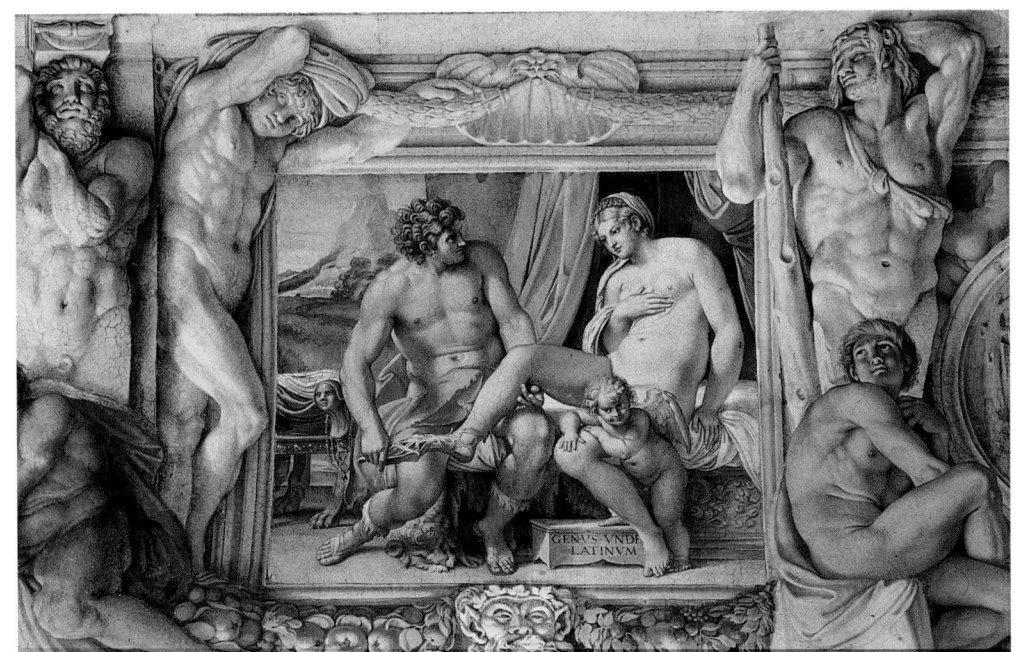

Pietro da Cortona

Pietro da Cortona's *Glorification of the Reign of Urban VIII* of 1633–1639 on the ceiling of the great hall of the Palazzo Barberini also links moralized allegories using mythological figures with the exaltation of the Catholic Church (fig. **17.24**). Vigorous spatial shifts, illusionistic architecture, and variations of pose, color, and light animate and dissolve the surface of the walls and ceiling. The central field of the painted ceiling, in keeping with the traditional association of church ceilings and the heavens, is depicted as the sky. It is defined by an illusionistic, rectangular frame, with corner octagons containing fictive bronze reliefs and simulated sculptures below each corner. The curvilinear billows of the clouds are formal echoes of the twisted, dynamic poses of the figures.

The iconography incorporates the family and achievements of Maffeo Barberini (1568–1644), who was elected Pope Urban VIII. He was a zealous church reformer (Galileo's second condemnation occurred during his papacy), a classicist who published poems in Latin, and Bernini's most powerful patron. At the lower section of the center rectangle (from the point of view illustrated here), the figure in orange draperies holding a scepter personifies Divine Providence. This is reflected in the fact that the whitest light surrounds her head. Her upraised right hand directs the viewer to the figure of Immortality carrying a crown of stars upward toward the Barberini arms.

Above Immortality are three huge bees encircled by a laurel wreath, which is held aloft by Faith, Hope, and Charity. The three bees are Barberini devices that Bernini would later depict in relief on Urban VIII's tomb. There they refer to the sweet odor of sanctity believed to have emanated from his body after death. Their juxtaposition with laurel on the Barberini ceiling links the pope with the grandeur of ancient Rome, while the little *putto* underneath the laurel refers to Urban as a poet. Surmounting the laurel are personifications of Religion with the keys to the Church and the papal tiara.

At the sides of the heavenly realm, but depicted as below it, are mythological subjects connected in some way with the overall themes of the fresco. The side figures are consistently shown in relative darkness, emphasizing their role as precursors, or forerunners, of the Christian faith. Athena, for example, battles the pre-Greek Giants, a scene that was read in the seventeenth century as an allusion to Urban VIII's efforts to eradicate heresy. Below Divine Providence are the three Fates and Saturn (the Roman counterpart of Kronos) devouring his children. This juxtaposition of mythological figures associated with time—the Fates who control the life span of mortals—alludes, by contrast, to the Christian concept of future eternity at the end of time.

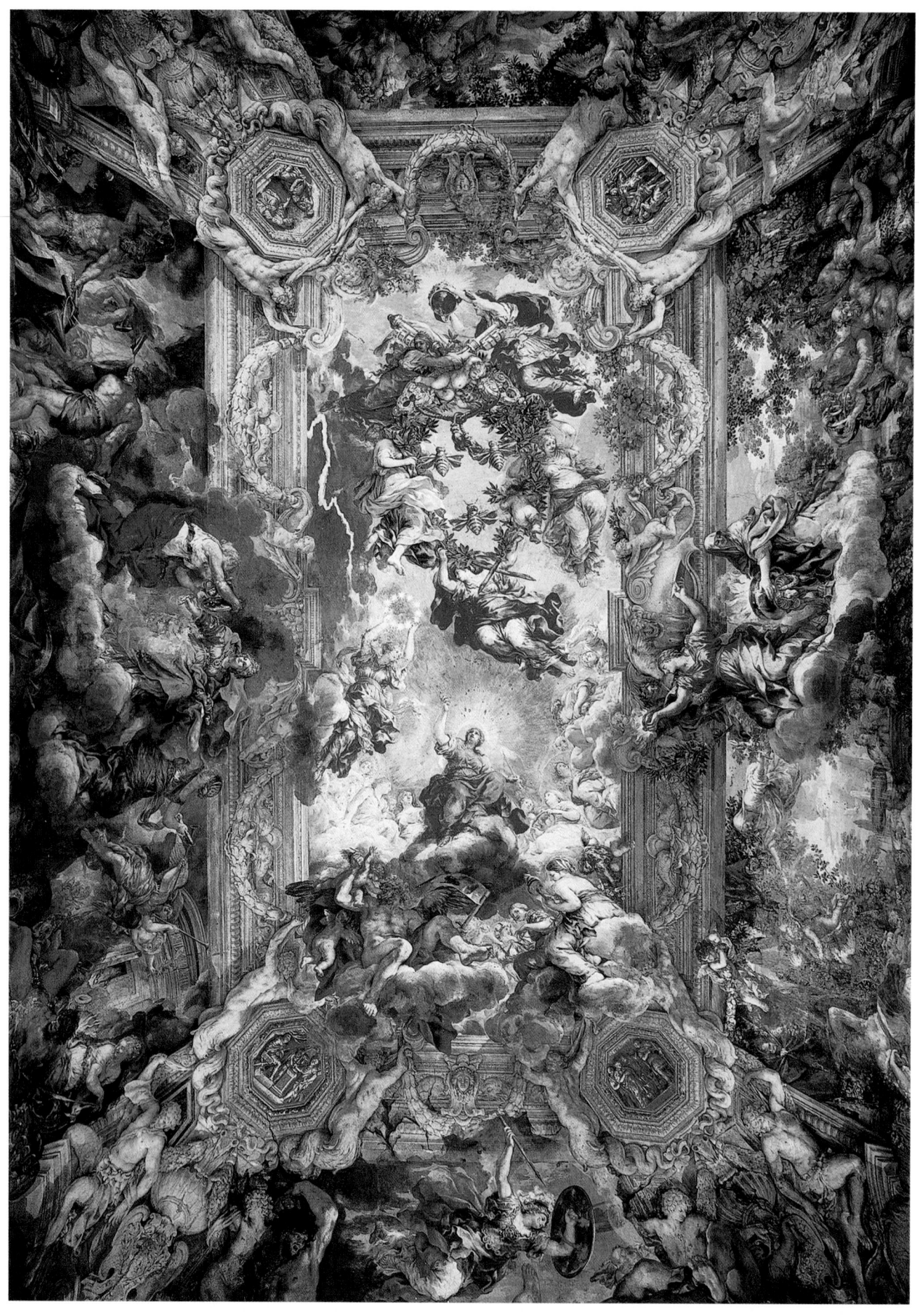

17.24 Pietro da Cortona, *Glorification of the Reign of Urban VIII*, 1633–1639. Ceiling fresco. Palazzo Barberini, Rome.

Giovanni Battista Gaulli

One of the most spectacular of the seventeenth-century ceiling paintings in Rome is Giovanni Battista Gaulli's fresco of the *Triumph of the Name of Jesus* in the barrel vault of Il Gesù (fig. **17.25**). The artist had worked with the devoutly Catholic Bernini in Rome and eventually surpassed him in illusionistic effects. Despite Vignola's plan for a simple interior of the Gesù (see fig. 15.23), a new general of the Jesuit order, Padre Giovanni Paolo Oliva, elected in 1664, had a more elaborate program in mind.

In a large oval space framed by architectural features and writhing figures, Gaulli painted the IHS, the first three letters of "Jesus" in Greek, as a dramatic source of formal and spiritual light. The scene resembles a Last Judgment, with the saved rising toward the light of Jesus's name, and the damned, depicted in shadow, plummeting toward the nave below. Worshipers thus appear to be on the same material plane as the sinners, whereas the vault of heaven and of the mother church of the Jesuit Order merge in a blaze of light.

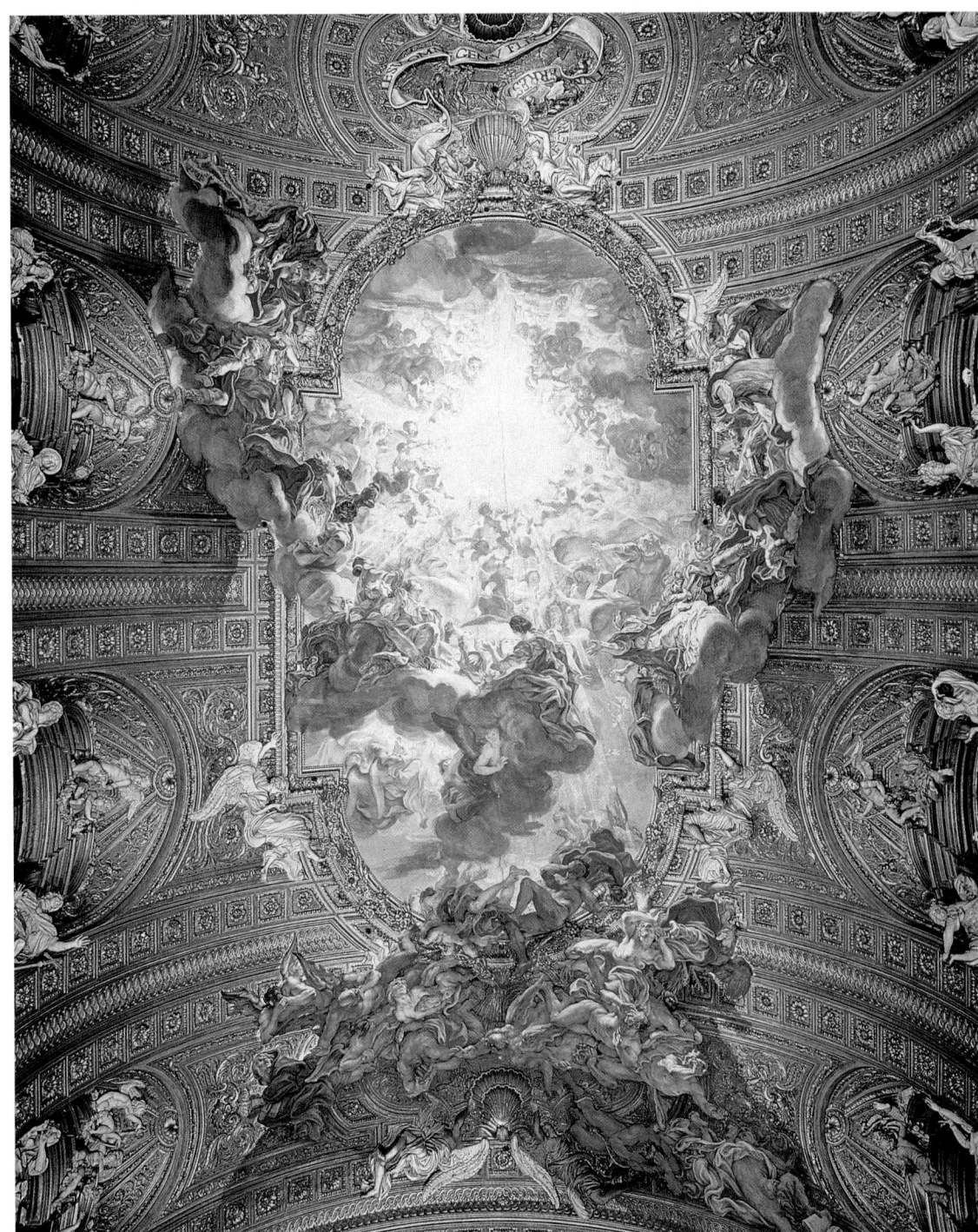

17.25 Giovanni Battista Gaulli, *Triumph of the Name of Jesus*, 1676–1679. Ceiling fresco with stucco figures on the vault of the Church of Il Gesù, Rome.

Michelangelo Merisi da Caravaggio

Michelangelo Merisi was born in the small northern Italian town of Caravaggio, the name by which he is known. When he was thirteen, his father apprenticed him to a painter in Milan. In 1592, Caravaggio moved to Rome, where his propensity for violence repeatedly landed him in trouble. During his relatively short life, and despite the interruptions to his career caused by brushes with the law, Caravaggio worked in an innovative style and used new techniques that influenced painters in Italy, Spain, and northern Europe. In contrast to Annibale Carracci, Caravaggio painted in oil directly on the canvas and made no preliminary drawings. Although Carracci worked in the faster medium of fresco, he did many drawing studies and thus appeared to his contemporaries to be a more deliberate, restrained artist than the flamboyant Caravaggio.

In 1604, Karel van Mander (1548–1606) published *The Painter's Book,* a biography of artists inspired by Vasari (see Chapter 14). He was the first art theoretician in the Netherlands, and he wrote perceptively about Caravaggio. Van Mander admired the artist for his talent and for the fact that he had risen to fame from humble beginnings. His view that Caravaggio studied nature closely and painted realistically reflected the artist's general reputation. Van Mander also shared the theoretical bias—influenced by Neoplatonism—of Giovanni Bellori and the French Academy when he wrote that "one should distinguish the most beautiful of life's beauties and select it." But van Mander also understood the effect of Caravaggio's self-destructive lifestyle on his art:

> He does not study his art constantly, so that after two weeks of work he will sally forth for two months together with his rapier at his side and his servant-boy after him, going from one tennis court to another, always ready to argue or fight, so that he is impossible to get along with. This is totally foreign to art; for Mars and Minerva have never been good friends.[3]

Van Mander's comments are consistent with Caravaggio's artistic style and iconography as well as with his lifestyle. His attention to realism can be seen in his early painting *Boy with a Basket of Fruit* (fig. **17.26**). The convincing rendition of the fruit confirms Caravaggio's close study of nature. Details such as the points of light on the grapes and the veins in the leaves contribute to the realistic effect. The boy stands out against a plain background, which is divided by irregular Baroque illumination. He may be a fruit vendor, but he offers himself as well as the fruit to the observer.

In contrast to the Renaissance view of painting as the natural world made visible through the window of the picture plane, Baroque artists draw the observer into the picture by means other than Brunelleschian linear perspective. In this painting, Caravaggio attracts us through the diagonal planes of the boy's right arm and the tilt of his head. His seductive nature is reinforced by the theatrical quality of his illumination. The fruit, which traditionally has erotic

17.26 Caravaggio (Michelangelo Merisi), *Boy with a Basket of Fruit,* c. 1594. Oil on canvas; 27½ × 26⅓ in. (69.9 × 66.9 cm). Galleria Borghese, Rome.

connotations, creates another transition between the observer and the boy. For example, the bright red and yellow peach at the front of the basket is a visual echo of the bare shoulder. Both have a slight cleft, repeated in the boy's chin, as if to suggest that the boy is as edible as the fruit. The wilting leaf at the right, which droops from the basket, is a reference to time. Together with the yellow piece of fruit turning brown at the center of the basket, the leaf calls on the viewer to enjoy life's pleasures—of the palate as well as of the flesh—before they become rotten with age.

Caravaggio's *Medusa* (fig. **17.27**) has the opposite effect: it repels rather than attracts. Painted on a tournament shield, the head exemplifies the artist's fascination with violence and decapitation. With its snaky hair, the head is highlighted against a dark background. Caravaggio thus focuses our attention on the very source of repulsion. The writhing snakes, whose skins reflect light, seem to squirm anxiously in response to the dangers of beheading. Likewise, the face itself looks down, as if at its own severed body, and cries out in horror as fresh blood spurts from the neck.

According to a contemporary source, Caravaggio, like Bernini, studied his own grimacing reflection in a mirror. It was also rumored that he used his own features for Medusa's face. If so, then Caravaggio represented himself as an androgynous, monstrous, mythological female who is simultaneously dead and alive. The transitional state between life and death recurs in some of the artist's other decapitated heads and is also implied in the rotting fruit and wilting leaf of the *Boy with a Basket of Fruit.* In this unusual

17.27 Caravaggio, *Medusa*, c. 1597. Oil on canvas on a wooden shield. Galleria degli Uffizi, Florence. According to a contemporary source, the *Medusa* was commissioned by Cardinal del Monte as a wedding present for the grand duke of Tuscany. It is a play on the Western tradition of putting the *gorgoneion* (the representation of Medusa's head) on shields and armor, recalling the similar decoration on the aegis of the goddess Athena.

iconography, Caravaggio expresses his personal ambivalence, oscillating between male and female, self-destructive criminal and creative artist, life and death, and, as van Mander noted, between the warlike Mars and the wise, creative goddess Minerva.

The oppositions that are characteristic of Caravaggio's iconographic choices—and their relation to the nature of his patronage—can be seen by comparing his *Calling of Saint Matthew* (fig. **17.28**), which was an ecclesiastical commission, with the *Boy with a Basket of Fruit* (fig. 17.26). The *Calling of Saint Matthew* is a good example of Caravaggio's innovative approach to Christian subjects. Following the account in the Gospel, Jesus and an apostle approach a group of older men and youths who are counting money. Among them is Matthew, the tax collector. Jesus points to him with a gesture that is a visual quotation of Michelangelo's *Creation of Adam* (see fig. 14.23) as if to

CONNECTIONS

See Michelangelo,
Hand of God (detail
of fig. 14.23,
Creation of Adam,
c. 1510).

17.28 Caravaggio, *Calling of Saint Matthew,* Contarelli Chapel, San Luigi dei Francesi, Rome, 1599–1600. Oil on canvas; 10 ft. 6¾ in. × 11 ft. 1⅞ in. (3.22 × 3.40 m). Caravaggio's criminal behavior and his acquaintance with Roman street life contributed to the character of this picture. In 1606, Caravaggio fled Rome after killing a man in a dispute over a tennis match. He died in 1610 before news of the pope's pardon reached him.

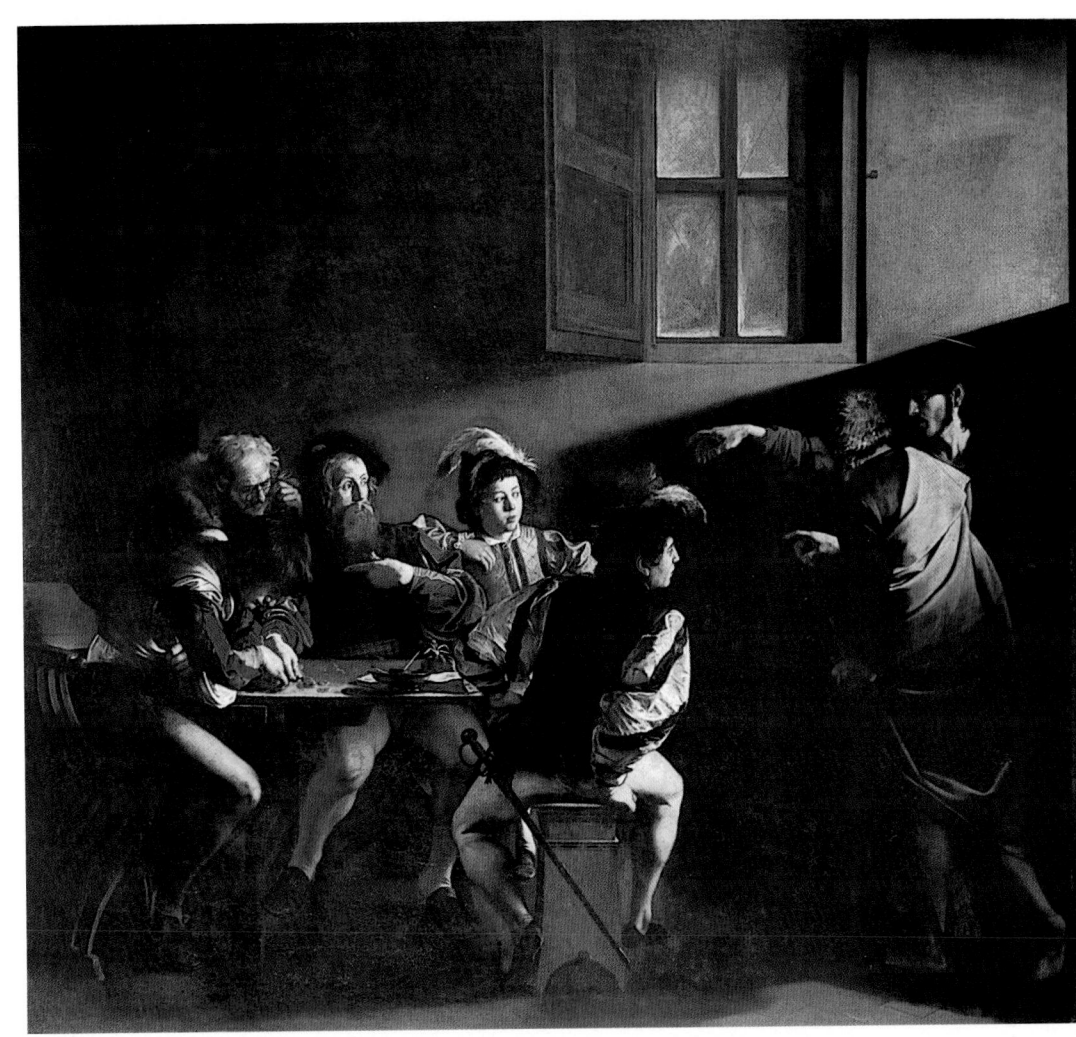

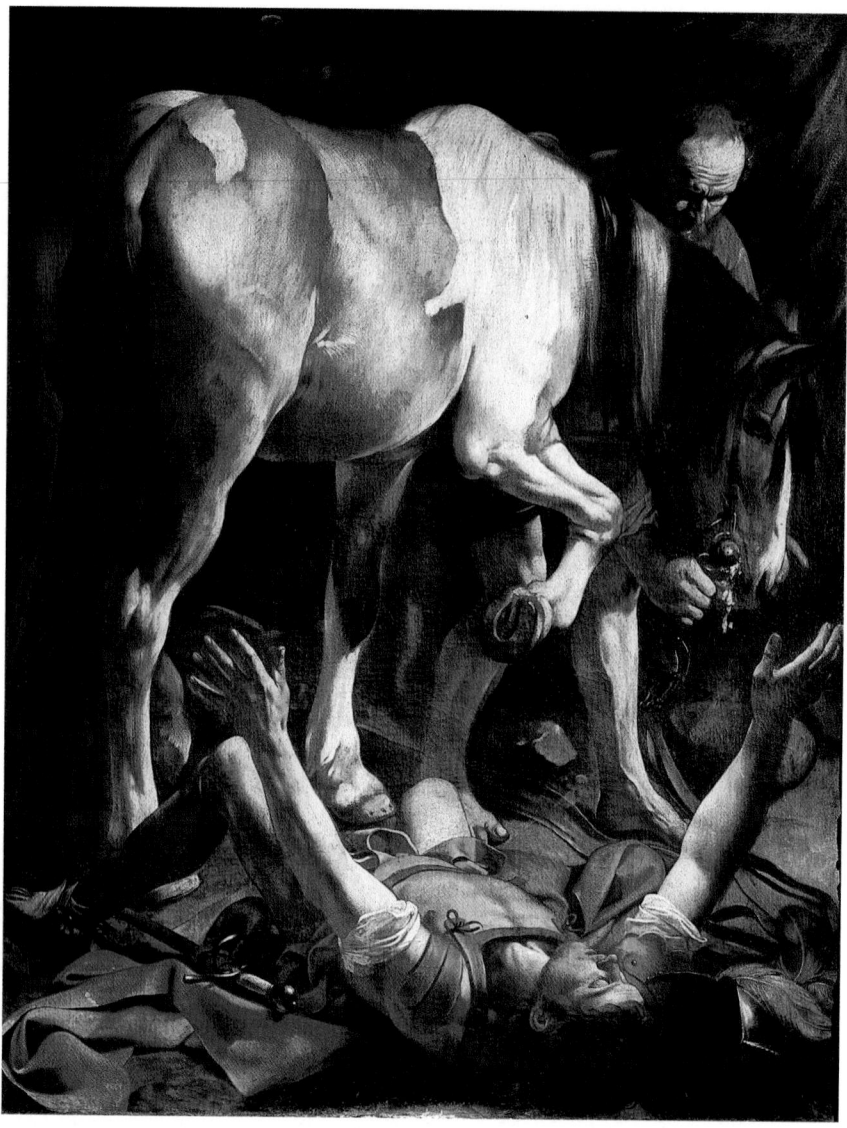

17.29 Caravaggio, *Conversion of Saint Paul,* 1601. Oil on canvas; 90⅝ in. × 68⅞ in. (2.30 × 1.75 m). Cerasi Chapel, Santa Maria del Popolo, Rome.

say, "Follow me." This parallels Adam's original creation with Matthew's re-creation through Jesus. The coin in Matthew's hatband underlines his preoccupation with money. His own gesture echoes that of Jesus, however, and indicates that his future will be dedicated to Jesus's service.

In the *Calling of Saint Matthew,* Caravaggio's **tenebrism** —the use of sharply contrasting light and dark—enhances the Christian message. Jesus enters the picture from the right, along with a shaft of light penetrating the darkness. Light is ironically juxtaposed with sight in the two figures on the far left. The young man who does not see the savior because he is focusing intently on money is covered in shadow. The old man leaning over him peers through his spectacles. But, in his myopia, he sees only the money and remains oblivious to the significance of the event taking place right beside him.

The significance of light as insight also characterizes Caravaggio's *Conversion of Saint Paul* (fig. **17.29**), commissioned by Pope Clement VIII's treasurer general for his funerary chapel in Santa Maria del Popolo. It depicts the moment described in Acts 9:3–9, when Saul of Tarsus, a Roman Jew who persecuted Christians, fell from his horse on the way to Damascus. A bright light illuminated the sky, blinding Saul. The voice of Christ asked why Saul was persecuting him and instructed him to proceed to Damascus. Saul was blind for three days, when an apostle restored his sight. He then converted to Christianity and became the apostle Paul.

In the painting, Saul has fallen abruptly toward the picture plane, his arms outstretched in an echo of the Crucifixion. Sudden shifts from light to dark enhance the drama of the event as the horse and page stand by without understanding the significance of what is happening.

Artemisia Gentileschi

Caravaggio's unstable lifestyle did not lend itself to maintaining a workshop or employing apprentices. Nevertheless, he had a major influence on Western art. Among his followers, known as the *Caravaggisti,* was Artemisia Gentileschi (1593–1652/3), one of the first women artists in Europe to emerge as a significant personality (see box).

Artemisia's *Judith Slaying Holofernes* (fig. **17.30**), which exhibits the Baroque taste for violence, illustrates an event from the book of Judith in the Old Testament Apocrypha. The Assyrian ruler Nebuchadnezzar has sent his general Holofernes to lay waste the land of Judah. A Hebrew widow of Bethulia, Judith, pretending to be a deserter, goes with her maidservant Abra to the camp of Holofernes and flirts with him. Arranging to spend the evening alone with him, Judith plies him with liquor until he falls into a stupor, and she uses his own sword to cut off his head. She places the head in a bag and returns home; the head is exhibited from the city walls, and the Assyrians disperse. Artemisia depicts the moment at which Judith plunges the blade through Holofernes' neck. The violence of the scene is enhanced by the dramatic, Caravaggesque shifts of light and dark and by the energetic draperies.

With *Judith and Her Maidservant with the Head of Holofernes* (fig. **17.31**), Artemisia continues the apocryphal story. The aftermath of the beheading is calmer but no less fraught with tension. The two women watch intently to make certain that no one has observed them. Artemisia creates a chromatic unity—from the red curtain to Abra's blue and lavender dress to the green pallor of Holofernes' head and Judith's rich yellow—that echoes the women's unity of purpose. A series of curves, in Judith's arms, sword, and the curtain, involves the viewer in the rhythms of the picture. In addition, the intensity of light and color against the darkened background throws the figures into relief and conveys a sense of immediacy that is both formal and a feature of the narrative text.

Women Artists: From Antiquity to the Seventeenth Century

Over the past quarter century, art historians have researched and reevaluated the role of women artists in the West. As a result, women's achievements in the visual arts, and the obstacles they have had to overcome, are much better understood.

Pliny's *Natural History* names five women artists in ancient Greece and Rome, together with their works, although nothing else is known of them. From the Roman period through the end of the fourteenth century, there are relatively few records of any individual artists, men or women. During the Middle Ages, women played a role in the production of embroidery and tapestry—more so in northern Europe than in Italy. They were also active in the illumination of manuscripts, although this was largely confined to the daughters of wealthier families. Until the late thirteenth century, illumination was done by nuns, and a woman needed a dowry to enter a convent.

The bylaws of the Company of Saint Luke, a confraternity of artists in Florence founded in 1361, mention dues to be paid by women members. However, no women's names are found in the Company records. From the fifteenth century onward, beginning in Italy, women artists emerge from obscurity. There is evidence, for example, that a woman submitted a model for the lantern of Brunelleschi's dome over Florence Cathedral, but her name is unknown. Previously, women artists in Italy had usually been nuns, women of education and talent but whose work had been limited through their isolation from the wider artistic community. An exception was Sofonisba Anguissola, who worked for Philip II of Spain. Artemisia Gentileschi was the first woman to join the Company's successor, the Accademia del Disegno (Academy of Design), in 1616.

The elevated status of the artist in the Renaissance was largely the result of a new humanist educational curriculum. For the first time, artists mixed socially with the princes of the Church and the nobility as intellectual equals rather than as artisans and craftsmen. Gradually, the new educational standards were extended, especially among the ruling classes, to women, who were encouraged to engage in a wider range of activities, including poetry, music, and art (in that order). By the sixteenth century, it was generally agreed that the daughters of the middle classes should be educated. Women who wanted to become artists had to be trained in the workshops of established masters; many were daughters, sisters, or wives of artists. The courts of fifteenth- and sixteenth-century Italy produced women who were outstanding cultural patrons, as well as having significant artistic accomplishments in their own right. Nevertheless, attributions are always a problem with women, for works by women were likely to have been delivered under the name of the male head of the workshop.

Despite the advances made by women in the Renaissance, however, practical obstacles remained. Marriage, usually followed by continuous childbearing, interfered with some promising careers. Nevertheless, Artemisia Gentileschi did marry and have children. Women were also barred from drawing from live models, which prevented competition on equal terms with men. Artemisia drew from female models, but familiarity with the male nude was important for monumental works. It is thus no accident that, until recently, women's artistic achievements were generally confined to portraiture and still life.

17.30 Artemisia Gentileschi, *Judith Slaying Holofernes*, c. 1614–1620. Oil on canvas; 6 ft. 6⅓ in. × 5 ft. 4 in. (1.99 × 1.63 m). Galleria degli Uffizi, Florence. Artemisia learned painting from her father, Orazio. In 1611, Orazio hired Agostino Tassi to teach her drawing and perspective. Tassi raped Artemisia and then refused to marry her. When Orazio sued Tassi, Artemisia was tortured with thumbscrews to test her veracity before Tassi was convicted. Undoubtedly affected by this experience, Artemisia is known for her pictures of heroic women and of violent scenes.

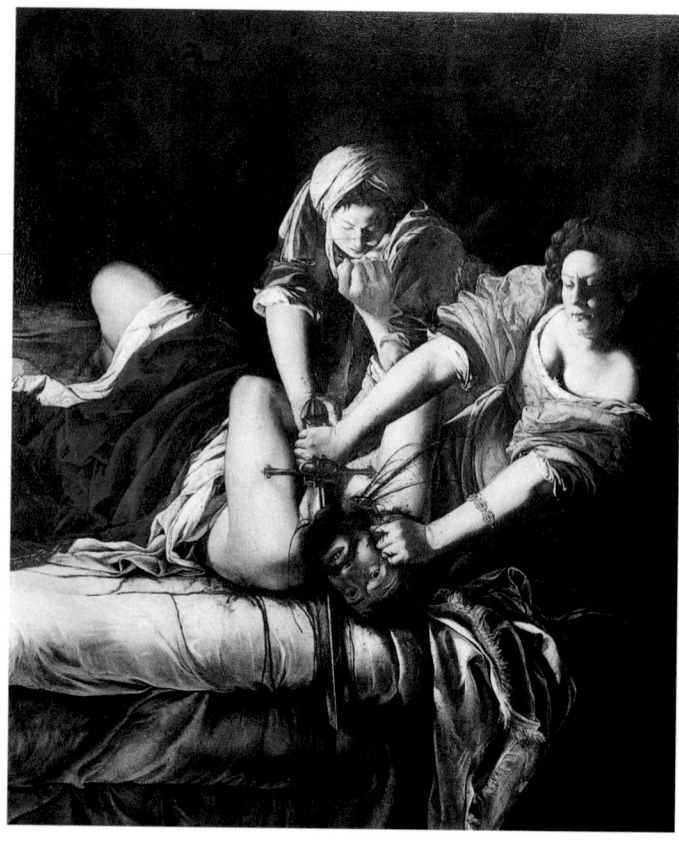

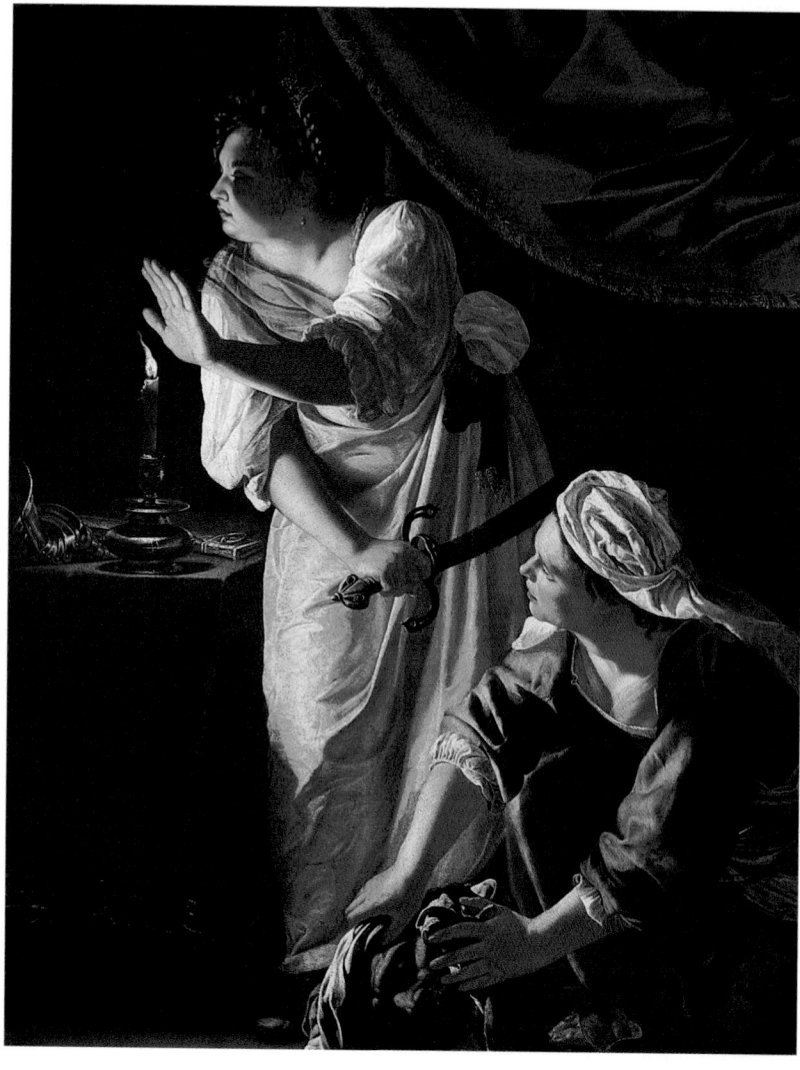

17.31 Artemisia Gentileschi, *Judith and Her Maidservant with the Head of Holofernes*, c. 1625. Oil on canvas; 72½ in. × 55¾ in. (1.84 × 1.42 m). Detroit Institute of Arts. Gift of Leslie H. Green.

Baroque Painting in Northern Europe

In Flanders, the Catholic Church was the primary patron of the arts. In Protestant Holland, on the other hand, the development of a bourgeois economy and a free commercial art market resulted in a significant change in the kind of art produced. For the first time, artists were able to support themselves by specializing in a particular category such as portraiture, still life, genre, or landscape. Art dealers sold works to middle-class citizens, who often purchased as much for investment and resale as for aesthetic pleasure.

Peter Paul Rubens

The Flemish artist Peter Paul Rubens (1577–1640) was extremely prolific. He worked for the Church, the nobility, private citizens, and himself. Rubens ran a successful workshop with many apprentices and assistants, and dealt shrewdly in the art market. He undertook important diplomatic missions for the Spanish Netherlands and was also the court painter to the Spanish governors. In the late 1620s, Rubens spent several months in Spain at the court of Philip IV, where he influenced Velázquez (see p. 669).

Rubens's mythological paintings, such as *Venus and Adonis* (fig. **17.32**), celebrate the sensual side of life and seem unaffected by the Counter-Reformation. They also reflect Rubens's Classical education. In this work, Venus tries to prevent her handsome mortal lover Adonis from departing. His hunting dogs wait impatiently as he tries to disengage from the goddess and her son Cupid, who has placed his bow and arrow on the ground and tugs at Adonis's leg. Venus clings to his arm, as he turns to leave. The ambivalence of Adonis's pose, forming a long diagonal, reveals his inner struggle between staying and leaving.

Venus herself forms a counterdiagonal, her fleshy, highlighted body a variation on the traditional reclining nude. In contrast to Classical and Renaissance reclining nudes, Rubens's figure is actively, rather than passively, seductive. Venus's more active role in this scene is consistent both with the particular myth and with the moment represented, in which she attempts to control and dominate her lover. Her proportions have also ventured some distance from those of Classical antiquity, for Rubens has emphasized her generous breasts and rippling, dimpled flesh in a way that is frankly sensuous. It is likely that, for Rubens, such full figures reflected, among other things, the Flemish equation of fleshiness with prosperity.

In the *Straw Hat* (fig. **17.33**), Rubens conveys his taste for lusty women. The figure is Susanna Fourment, the

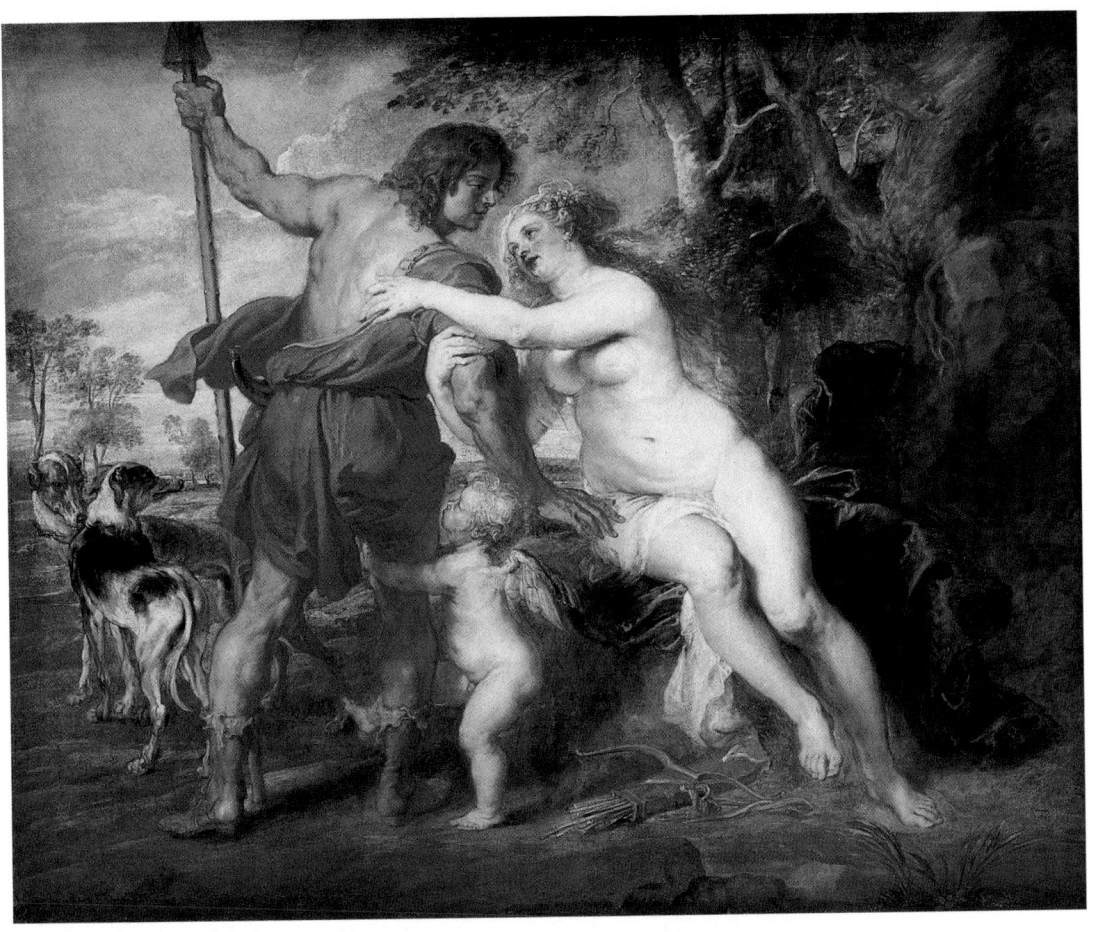

17.32 Peter Paul Rubens, *Venus and Adonis*, c. 1635. Oil on canvas; 6 ft. 5½ in. × 7 ft. 11¼ in. (1.97 × 2.42 m). Metropolitan Museum of Art, New York. Gift of Harry Payne Bingham, 1937.

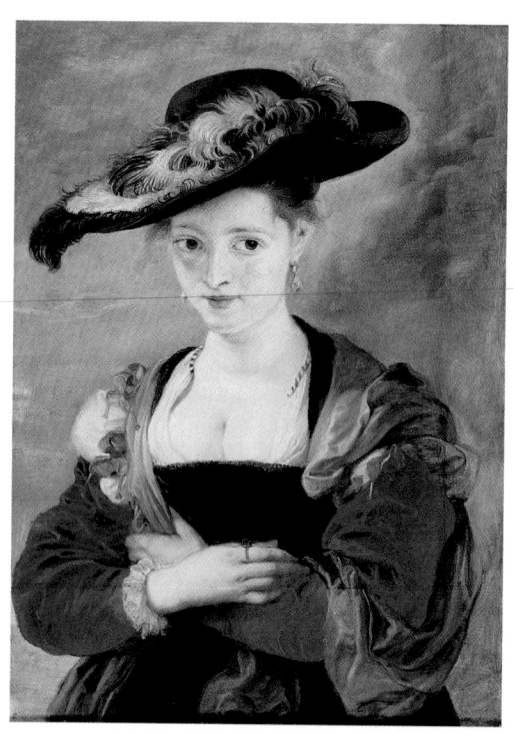

17.33 Peter Paul Rubens, *Straw Hat* (Susanna Fourment), c. 1620–1625. Oil on wood; 31⅛ in. × 21½ in. (79.1 × 54.6 cm). National Gallery, London.

The composition is based on the sharp diagonal of Jesus and the Cross, their weight accentuated by the muscular figures struggling to elevate them into an upright position. A touch of realism is introduced in the dog barking excitedly at the lower left—Rubens has meticulously depicted the texture of its curly coat.

The image juxtaposes the brute force of the executioners with Jesus's enlightened spirituality. In contrast to the pushing and pulling necessary to raise the Cross, Jesus seems to soar toward heaven, despite the suffering caused by the nails and the Crown of Thorns. His form is the most extended highlight in the painting, which is a reminder of his role as the Light of the World. Fluttering weightlessly over his head are inscriptions in Latin, Greek, and Hebrew proclaiming Jesus "King of the Jews."

artist's future sister-in-law. She peers at the observer from beneath a hat set on a diagonal and adorned with feathers. Her proportions are voluptuous: the snug fit of her dress pushes her breasts upward, and her ring squeezes the flesh of her forefinger. The strong contrasts of white light and rich blacks accentuate the textural differences between the soft flesh and the silky sleeves. Their swirling folds and bulky proportions echo the voluminous clouds, and their blackness is repeated in the dress, eyes, and hat. Such striking shifts of light and dark emphasize the increased planar movement of Baroque painting in comparison with Renaissance style.

In contrast to the *Venus and Adonis*, the central panel of the monumental triptych in Antwerp Cathedral depicting the *Raising of the Cross* (fig. **17.34**) is very much affected by Counter-Reformation concerns. Formally and emotionally, viewers are drawn into the picture, and their identification with Jesus's suffering is powerfully evoked.

17.34 Peter Paul Rubens, *Raising of the Cross,* originally for the Church of Saint Walburgis and now in Antwerp Cathedral, 1609. Oil on wood; 15 ft. 1⅞ in. × 11 ft. 1½ in. (4.62 × 3.39 m).

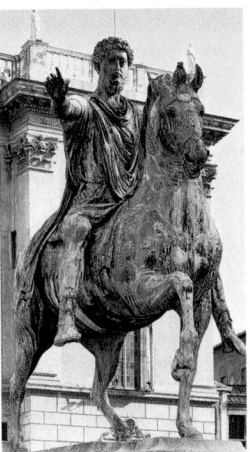

See figure 7.50.
Equestrian statue of
Marcus Aurelius,
A.D. 164–166.

His portrait of Charles I on horseback (fig. **17.35**) memorializes the ten years when Charles ruled England as an absolute monarch—called the Period of Personal Rule—after he dissolved Parliament in 1629.

Van Dyck depicts Charles in the tradition of equestrian portraiture, exemplified by the bronze *Marcus Aurelius* in Rome (see fig. 7.50). The monumental horse, Charles's shiny armor and baton of rule, and the king surveying the landscape create an image of imperial power. Like Rubens, van Dyck conveys a sense of painterly texture in rendering materials and creates an atmospheric sky. Behind the horse is a page in rich red silk who holds the king's helmet. Charles's melancholy, watery-eyed expression is characteristic of van Dyck's portraits and would later be related to the king's tragic end. Otherwise, there is nothing in the painting to suggest the reality of the political situation in England at the time. The inscription on the plaque attached to the tree reads "Charles I, King of Great Britain." Like the painting itself, the inscription reflects the degree to which Charles was out of touch with the dissatisfied and rebellious mood of his subjects.

17.35 Anthony van Dyck, *Charles I on Horseback,* c. 1638. Oil on canvas; 12 ft. × 9 ft. 7 in. (3.66 × 2.92 m). National Gallery, London.

Anthony van Dyck

Rubens's assistant, Anthony van Dyck (1599–1641), was born in Antwerp but reached the height of his career as the court portrait painter to the Stuart king Charles I of England. As such, van Dyck set a standard for portraiture that influenced successive generations of English painters.

Rembrandt van Rijn

Rembrandt van Rijn (1606–1669) was born in Leiden, in Protestant Holland. He quickly became successful and moved to Amsterdam. Unlike Rubens, Rembrandt worked largely for Protestant patrons. However, he ran his own commercial enterprise as free as possible from the influence of patronage, preferring that his works be valued as "Rembrandts" rather than as the products of a contractual agreement. He thus reflected the seventeenth-century rise in Dutch capitalism, which, through the East India Company, had become international in scope (see box, p. 665).

The subject matter of Rembrandt's paintings includes biblical and mythological scenes, landscapes, and portraits. Like Caravaggio, Rembrandt was attracted to the dramatic effects of light and dark, but he used them as much to create the character of his figures as their back-grounds. His *Blinding of Samson* (fig. **17.36**) shows the most dramatic moment in the story told in the book of Judges (16:20–21). The Philistines have pinned down Samson and are chaining his hand as he struggles fiercely. Rembrandt draws the viewer into the picture through the strong, silhouetted diagonals of the man in red who directs his lance at Samson. Leaning over Samson is the armored soldier plunging a dagger into his eye. Delilah, who is thought to be a portrait of Rembrandt's wife Saskia (see fig. 17.40), runs away, carrying the hair that was the source of Samson's strength and the scissors she used to cut it. At the upper right is a figure with a raised sword, who is nevertheless appalled at the blinding, a theme that had enormous significance for Rembrandt. It recurs throughout his work, but this is its most violent expression. As a painter, Rembrandt would have identified with the horror of a man blinded and his right hand immobi-

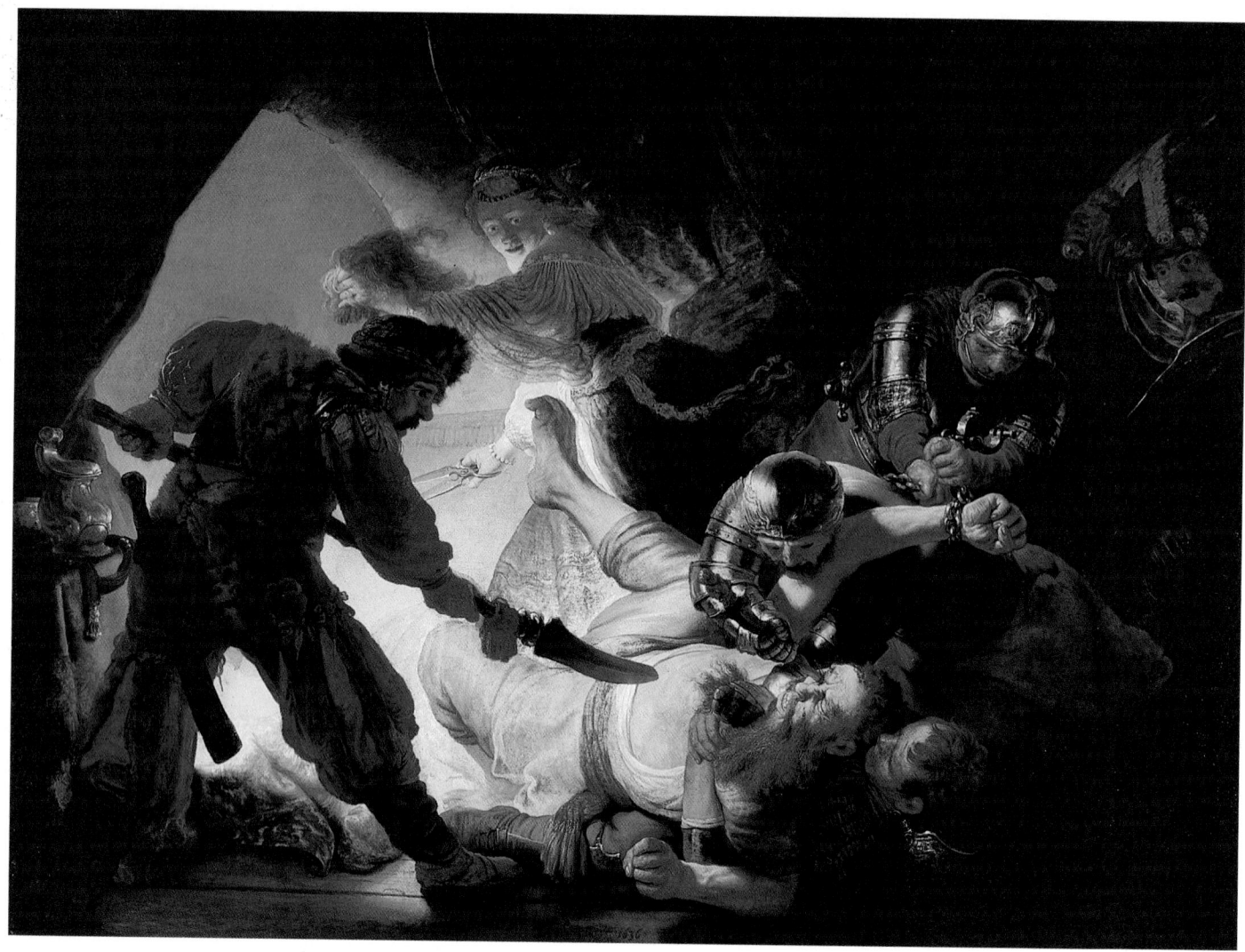

17.36 Rembrandt van Rijn, *Blinding of Samson* (*Triumph of Delilah*), 1636. Oil on canvas; 6 ft. 8¾ in. × 8 ft. 11 in. (2.05 × 2.72 m). Städelsches Kunstinstitut, Frankfurt.

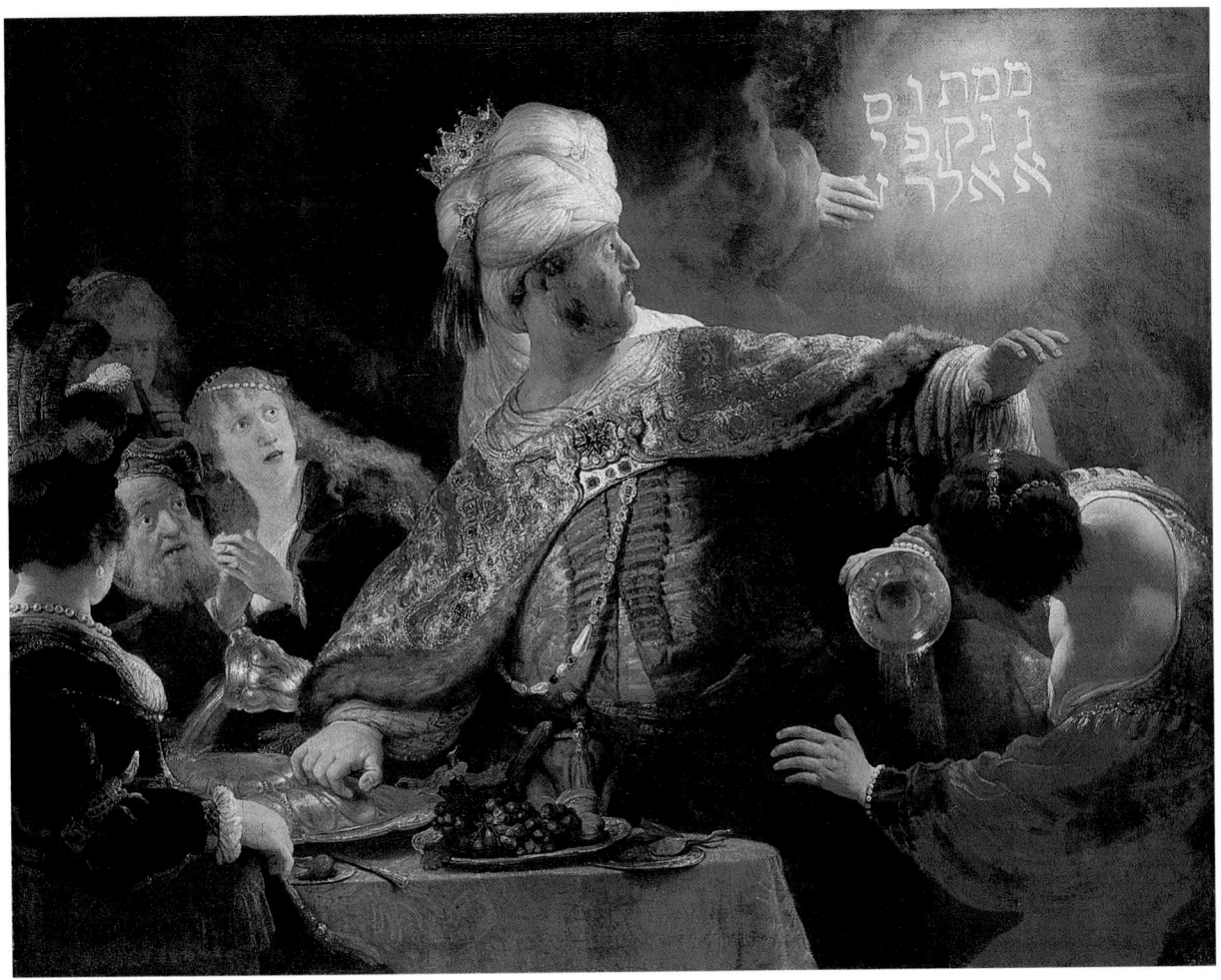

17.37 Rembrandt van Rijn, *Belshazzar's Feast*, c. 1635. Oil on canvas; 5 ft. 5¾ in. × 6 ft. 9½ in. (1.67 × 2.07 m). National Gallery, London. Rembrandt shared the Baroque interest in naturalism. For his Old Testament scenes, he liked to frequent the Jewish quarter of Amsterdam for inspiration and models.

lized. Here, the sharp contrasts of light and dark emphasize the effect of blindness, and the violence is accentuated by the force of diagonal thrusts that are typically Baroque.

In the Old Testament scene of *Belshazzar's Feast* (fig. **17.37**), Rembrandt emphasizes the mystical light required by the text. Belshazzar, the son of the regent of Babylon in the sixth century B.C., sees a great light on the wall during a feast. Beside the light a hand appears with a cryptic message, which Daniel interprets as "You have been weighed in the balance and found wanting." The same night, Belshazzar is killed, fulfilling the sense of menace that is still popularly associated with "handwriting on the wall."

In Rembrandt's image, Belshazzar rises from the table and turns to face the mysterious light. He spreads out his arms in a sweeping diagonal, displaying the elaborate gold embroidery of his cloak. Light is also concentrated on his face, jewelry, turban, and crown, contrasting these reflections of his material wealth with the illumination of inner fear and awe in the faces of the two figures on Belshazzar's right (our left) and with the light from heaven appearing on the wall. This painting is primarily rendered in warm brown tones, with a prominent color shift in the red-orange of the woman at the lower right corner. She withdraws in fear from the light and spills her drink. In so doing, she helps to draw the observer

17.42 Rembrandt van Rijn, *Self-Portrait in a Cap, Openmouthed and Staring*, 1630. Etching; 2 × 1⅞ in. (5.1 × 4.6 cm). Rijksmuseum, Amsterdam.

17.43 Rembrandt van Rijn, *Self-Portrait, Grimacing*, 1630. Etching; 3¼ × 2⅞ in. (8.3 × 7.2 cm). Kupferstich-kabinett, Staatliche Museen, Berlin.

The medium of etching (see box) was suited to Rembrandt's genius for manipulating light and dark. Although etching had been invented in the sixteenth century, it was Rembrandt who perfected the technique during the seventeenth century. The three little self-portrait etchings reproduced here illustrate his use of black and white, or pure dark and pure light, to convey character.

The earliest figure (fig. **17.42**) is the twenty-four-year-old Rembrandt in a cap. His youthful vigor is indicated by the short, wavy lines of hair and the sharp twist of the head. Something seems suddenly to have caught his attention, for his eyes are round with wonder and his mouth is slightly open as if he is about to speak. Figure **17.43**, in which the artist is the same age, shows him grimacing. Like Caravaggio and Bernini, Rembrandt studied his own facial expressions in a mirror, which he used in self-portraits and biblical scenes. The third etching (fig. **17.44**) was executed in 1639, not long before the painted self-portrait in figure 17.39, to which it is related. A well-dressed Rembrandt, his hat perched rakishly on his head, exudes the self-confidence of success. His inner artistic energy seems to shine forth from the illumination of his face.

Etching

Etching, like engraving, is an intaglio method of producing multiple images from a metal (usually copper) plate. In etching, the artist covers the plate with a resinous, acid-resistant substance (the **etching ground**). A pointed metal instrument, or stylus, is then used to scratch through the ground and create an image on the plate. When the plate is dipped in acid, or some other corrosive chemical, the acid eats away the exposed metal. In so doing, it creates grooves where the ground was scratched through by the stylus. The ground is then wiped off, the plate inked, and impressions taken just as in engraving. The result, however, is different. Whereas in engraving the artist pushes the burin to cut into the metal surface, the etching stylus moves more easily through the ground, allowing for more delicate marks and greater freedom of action. The result is a more convincing sense of spontaneity in the image and a blurred, atmospheric quality (see, for example, the sleeves in fig. 17.44).

Rembrandt also used the intaglio **drypoint** method, in which the image is scratched directly on to the plate. "Dry" signifies that acid is not used. The incisions on the plate make metal grooves with raised edges, called the **burr.** When the drypoint plate is inked, the burr collects the ink and produces a soft, rich quality in the darker areas of the image.

In both etching and drypoint, the burin can also be used for emphasis. It is possible to combine the two techniques in one image, as Rembrandt did. It is also possible to make alterations to an etched or engraved plate and then produce additional prints. One can see the artist's changes by studying in order the different **states,** or subsequent versions, of the same image.

17.44 Rembrandt van Rijn, *Self-Portrait, Leaning on a Stone Sill,* 1639. Etching and drypoint, state 2; 8⅛ × 6½ in. (20.5 × 16.4 cm). Rembrandt House Museum, Amsterdam.

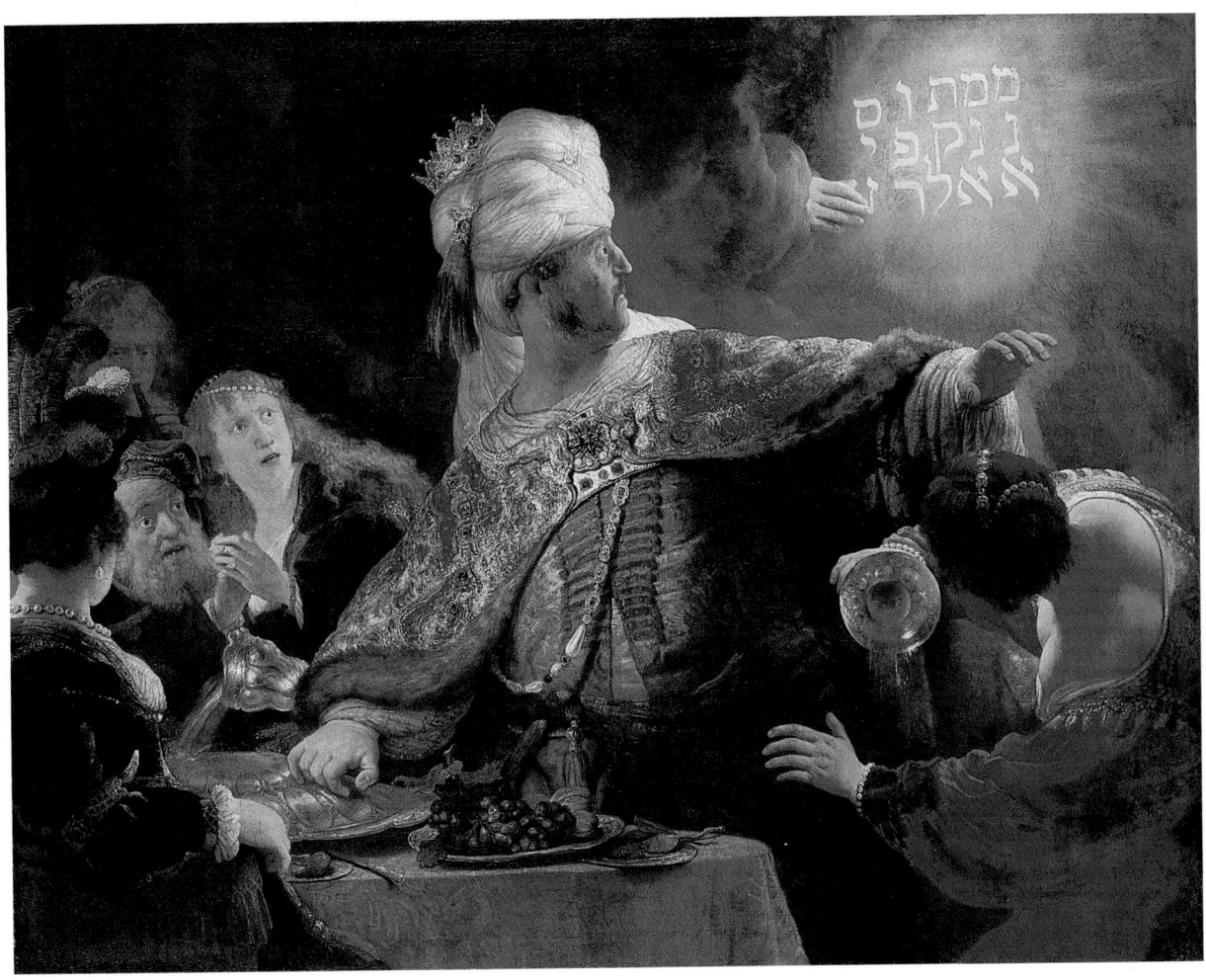

17.37 Rembrandt van Rijn, *Belshazzar's Feast*, c. 1635. Oil on canvas; 5 ft. 5¾ in. × 6 ft. 9½ in. (1.67 × 2.07 m). National Gallery, London. Rembrandt shared the Baroque interest in naturalism. For his Old Testament scenes, he liked to frequent the Jewish quarter of Amsterdam for inspiration and models.

lized. Here, the sharp contrasts of light and dark emphasize the effect of blindness, and the violence is accentuated by the force of diagonal thrusts that are typically Baroque.

In the Old Testament scene of *Belshazzar's Feast* (fig. **17.37**), Rembrandt emphasizes the mystical light required by the text. Belshazzar, the son of the regent of Babylon in the sixth century B.C., sees a great light on the wall during a feast. Beside the light a hand appears with a cryptic message, which Daniel interprets as "You have been weighed in the balance and found wanting." The same night, Belshazzar is killed, fulfilling the sense of menace that is still popularly associated with "handwriting on the wall."

In Rembrandt's image, Belshazzar rises from the table and turns to face the mysterious light. He spreads out his arms in a sweeping diagonal, displaying the elaborate gold embroidery of his cloak. Light is also concentrated on his face, jewelry, turban, and crown, contrasting these reflections of his material wealth with the illumination of inner fear and awe in the faces of the two figures on Belshazzar's right (our left) and with the light from heaven appearing on the wall. This painting is primarily rendered in warm brown tones, with a prominent color shift in the red-orange of the woman at the lower right corner. She withdraws in fear from the light and spills her drink. In so doing, she helps to draw the observer

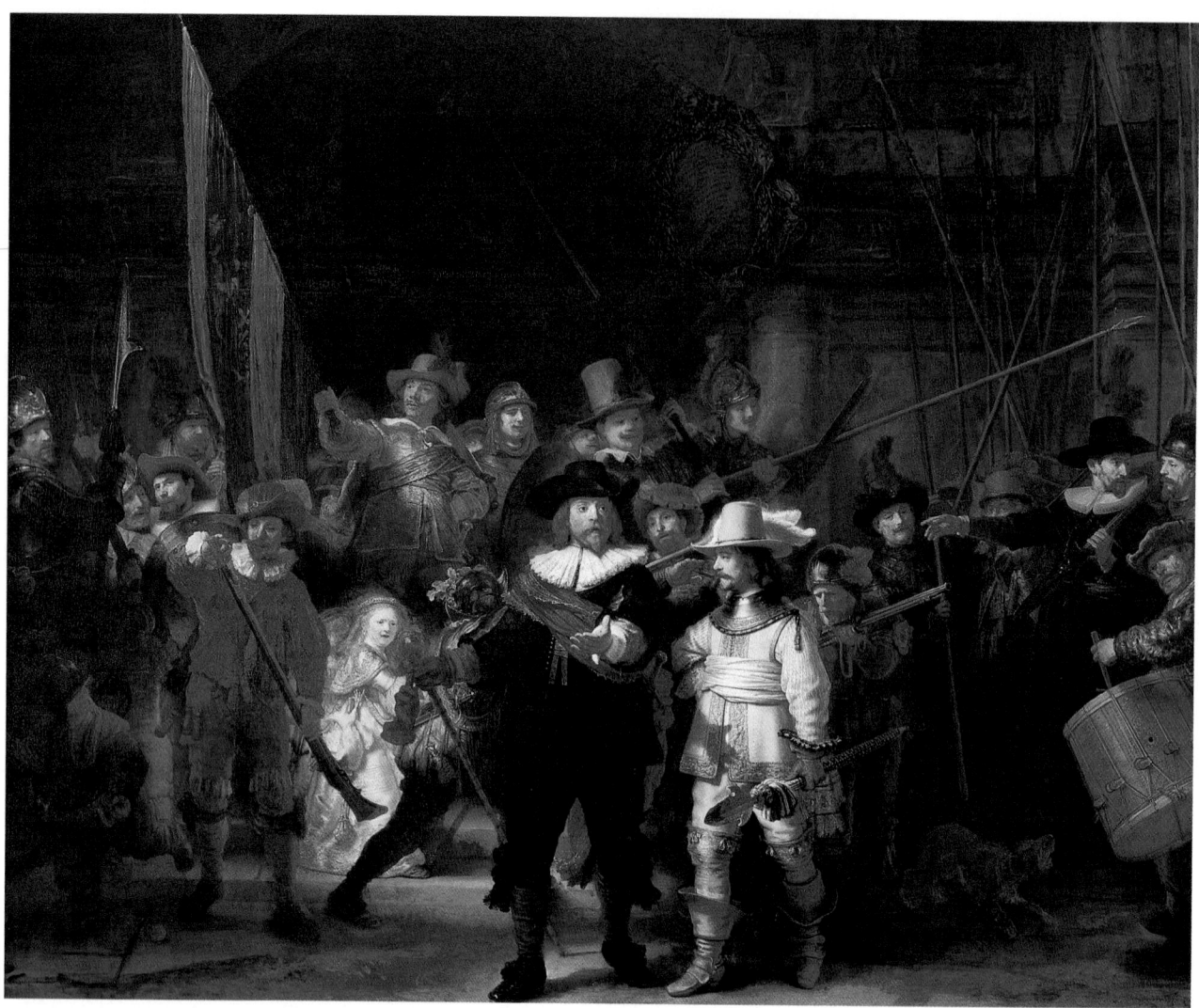

17.38 Rembrandt van Rijn, *Militia Company of Captain Frans Banning Cocq* (known as the *Night Watch*), 1642. Oil on canvas; 12 ft. 2 in. × 14 ft. 4 in. (3.71 × 4.37 m). Rijksmuseum, Amsterdam. This was originally located in the headquarters of the Amsterdam Civic Guard. In 1975, a cook who had been fired from the Dutch navy slashed the *Night Watch*. This painting is so identified with the Dutch nation that the sailor believed he was taking revenge on Holland itself.

into the picture plane by virtue of her forceful diagonal movement.

By mid-career, Rembrandt was Amsterdam's most esteemed portrait painter. His *Night Watch* (fig. **17.38**) is a group portrait that depicts a militia company, led by Captain Banning Cocq. The city wall, pierced by an arch in the background, evokes the triumphal arches of ancient Rome; it also reminded viewers that the Dutch had overthrown their Spanish conquerors and were now a free people.

The two men striding into the foreground form a diagonal link between the observer and the company. The captain extends his left hand as if to invite us into the scene. Light falls on to his hand from above and casts a shadow across the yellow jacket of his companion. As a result, the shadow continues the line of the captain's red sash, creating a typical Baroque interplay of light, dark, and color.

The facial features are defined by gradations of light and dark. Each figure is a portrait, mainly of the company members. Included in the crowd is a young woman highlighted in yellow; hanging from her belt is a bird, whose

claws were the emblem of the militia. Peering out over the shoulder of the flag bearer is Rembrandt's own face—possibly his most unassuming self-portrait.

Rembrandt painted many portraits and more self-portraits than any other artist before the seventeenth century. Including paintings, etchings, and drawings, he produced at least seventy-five self-portraits, which constitute a visual autobiography. They chronicle Rembrandt's changing fortunes and moods and, above all, his journey through life from youth to old age.

In figure **17.39**, at age thirty-four, Rembrandt is dressed in velvet and fur, resting his arm on a windowsill in the manner of portraits by Raphael and Titian. He looks optimistically out on the world. In the facial shading, Rembrandt creates a sense of inner character visible through the "window" of the eyes, just as the picture itself is a "window" on the figure.

Eight years before the 1640 self-portrait, Rembrandt married the young and wealthy Saskia, whom he adored. Around 1634, he painted her portrait in an impressive large, red feathered hat (fig. **17.40**). Both the hat and the

17.39 Rembrandt van Rijn, *Self-Portrait, Leaning on a Sill* (aged thirty-four), 1640. Oil on canvas; 3 ft. 4⅛ in. × 2 ft. 7½ in. (1.02 × 0.80 m). National Gallery, London.

17.40 Rembrandt van Rijn, *Saskia,* 1634. Oil on panel; 3 ft. 4 in. × 2 ft. 7 in. (99.5 × 78.8 cm). Staatliche Museen Kassel, Gemäldegalerie Alte Meister.

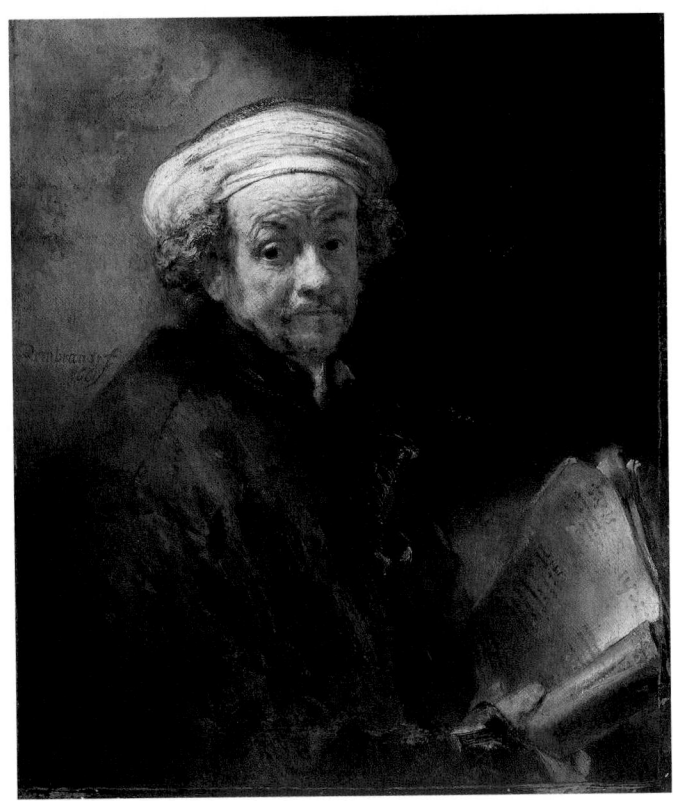

17.41 Rembrandt van Rijn, *Self-Portrait as Saint Paul* (aged fifty-five), 1661. Oil on canvas; 35⅞ × 30⅜ in. (91.1 × 77.2 cm). Rijksmuseum, Amsterdam.

feather form sharp Baroque diagonals, which are repeated in the position of the torso. Rembrandt's taste for rich materials of costume—velvet, brocade, fur, lace, gold, and pearls—is conveyed with an exuberance mitigated only by Saskia's proper demeanor. In this case, the artist's attention to tactile variety, to red tones, and to the subtle lighting playing over surface textures expresses the intensity of his passion for Saskia.

By 1661, after several personal tragedies, including the death of Saskia, Rembrandt is an older and more sorrowful figure (fig. **17.41**). He is no longer the prosperous, bourgeois artist, confident of his future. Now he is a "Saint Paul," humbled and saddened; his pose is less assertive, and he seems weighed down by his own body. Barely visible is the sword, which is Saint Paul's traditional attribute; it emerges in flecks of gold from under his left arm. Rather than endow the saint with a conventional halo, Rembrandt weaves a yellow band into the cloth of his hat, merging light, color, and the paint itself with content in a unique way. The figure looks up from the rather worn pages of an open book, as if shrugging his shoulders at the twists of fate. (Traditionally, Saint Paul is depicted carrying a book.) The slight tilt of the artist's head and the loose brushwork emphasize the sagging cheeks. The raised eyebrows create a pattern of wrinkles on Rembrandt's forehead, and his hair has turned gray. As in the earlier pictures, Rembrandt highlights the face and hand, leaving a darkened surrounding space from which the figure seems to emerge.

17.42 Rembrandt van Rijn, *Self-Portrait in a Cap, Openmouthed and Staring*, 1630. Etching; 2 × 1⅞ in. (5.1 × 4.6 cm). Rijksmuseum, Amsterdam.

17.43 Rembrandt van Rijn, *Self-Portrait, Grimacing*, 1630. Etching; 3¼ × 2⅞ in. (8.3 × 7.2 cm). Kupferstich-kabinett, Staatliche Museen, Berlin.

The medium of etching (see box) was suited to Rembrandt's genius for manipulating light and dark. Although etching had been invented in the sixteenth century, it was Rembrandt who perfected the technique during the seventeenth century. The three little self-portrait etchings reproduced here illustrate his use of black and white, or pure dark and pure light, to convey character.

The earliest figure (fig. **17.42**) is the twenty-four-year-old Rembrandt in a cap. His youthful vigor is indicated by the short, wavy lines of hair and the sharp twist of the head. Something seems suddenly to have caught his attention, for his eyes are round with wonder and his mouth is

slightly open as if he is about to speak. Figure **17.43**, in which the artist is the same age, shows him grimacing. Like Caravaggio and Bernini, Rembrandt studied his own facial expressions in a mirror, which he used in self-portraits and biblical scenes. The third etching (fig. **17.44**) was executed in 1639, not long before the painted self-portrait in figure 17.39, to which it is related. A well-dressed Rembrandt, his hat perched rakishly on his head, exudes the self-confidence of success. His inner artistic energy seems to shine forth from the illumination of his face.

Etching

Etching, like engraving, is an intaglio method of producing multiple images from a metal (usually copper) plate. In etching, the artist covers the plate with a resinous, acid-resistant substance (the **etching ground**). A pointed metal instrument, or stylus, is then used to scratch through the ground and create an image on the plate. When the plate is dipped in acid, or some other corrosive chemical, the acid eats away the exposed metal. In so doing, it creates grooves where the ground was scratched through by the stylus. The ground is then wiped off, the plate inked, and impressions taken just as in engraving. The result, however, is different. Whereas in engraving the artist pushes the burin to cut into the metal surface, the etching stylus moves more easily through the ground, allowing for more delicate marks and greater freedom of action. The result is a more convincing sense of spontaneity in the image and a blurred, atmospheric quality (see, for example, the sleeves in fig. 17.44).

Rembrandt also used the intaglio **drypoint** method, in which the image is scratched directly on to the plate. "Dry" signifies that acid is not used. The incisions on the plate make metal grooves with raised edges, called the **burr.** When the drypoint plate is inked, the burr collects the ink and produces a soft, rich quality in the darker areas of the image.

In both etching and drypoint, the burin can also be used for emphasis. It is possible to combine the two techniques in one image, as Rembrandt did. It is also possible to make alterations to an etched or engraved plate and then produce additional prints. One can see the artist's changes by studying in order the different **states,** or subsequent versions, of the same image.

17.44 Rembrandt van Rijn, *Self-Portrait, Leaning on a Stone Sill,* 1639. Etching and drypoint, state 2; 8⅛ × 6½ in. (20.5 × 16.4 cm). Rembrandt House Museum, Amsterdam.

Frans Hals

Frans Hals (c. 1581–1666) worked mainly in the Dutch town of Haarlem. Known primarily for his individual and group portraits, he did not have as wide a range of subject matter as Rembrandt. His portraits, such as the *Laughing Cavalier* (fig. **17.45**), convey a sense of exuberance and immediacy, which is enhanced by the sitter's pose, character, and proximity to the picture plane. The cavalier, a courtly soldier, is set at an oblique angle. His left arm forms two diagonals simultaneously leading in and out of the picture space, which are repeated in the torso and the tilted hat. He does not actually laugh, but the upturned curves of his mustache and his direct gaze create that impression. Hals's evident delight in the textural variations of the portrait add to its cheerful effect. The hat is virtually flat in contrast to the ruddy complexion and slightly fleshy face. The intricate lace and embroidery of the costume is interrupted, and relieved, by the broad brushstrokes defining the black silk sash.

Judith Leyster

Judith Leyster (1609–1690) also worked in Haarlem, where she was the only woman elected to the painters' Guild. Her figures, like Hals's *Laughing Cavalier,* are vital and energetic. Her genre painting *The Last Drop* (formerly known as the *Gay Cavalier*) (fig. **17.46**) provides an instructive contrast to the Hals and shows the influence of Caravaggio's tenebrism. In *The Last Drop,* exuberance is created, as in the Hals, by broad, hearty gestures and strong diagonals. This is accentuated by Leyster's dramatic contrasts of light and dark, the flickering candle, and the rich red costume. Whereas Hals's figure is right up against the picture plane, Leyster's two youths are farther back in space. They are less monumental in their impact and do not confront the viewer directly. Instead, the drinker engages us by his absorption in the wine cask, and the smoker by his graceful, dancelike motion. The skeleton and hourglass allude to the passage of time, which was a popular theme in seventeenth-century Dutch art.

17.45 Frans Hals, *Laughing Cavalier,* 1624. Oil on canvas; 33¾ × 27 in. (85.7 × 68.6 cm). Reproduced by permission of the Trustees, The Wallace Collection, London.

17.46 Judith Leyster, *The Last Drop* (*Gay Cavalier*) (after restoration), c. 1628–1629. Oil on canvas; 35⅛ × 29 in. (89.3 × 73.7 cm). Philadelphia Museum of Art (The John G. Johnson Collection). Leyster was the daughter of a brewer in Haarlem. She married a painter of genre scenes and had five children. In 1635, she successfully sued Frans Hals for taking one of her students as his apprentice.

Jan Vermeer

Jan Vermeer (1632–1675) left a very small number of pictures—no more than thirty-five in all. Like Rembrandt, he was a master of light, though in a completely different way. Most of his paintings are interior genre scenes, many with allegorical meanings. His canvases are generally small, and his subjects, as well as their treatment, are intimate.

Vermeer's *Geographer* (fig. **17.47**) reflects both the Dutch interest in exploration and science, and the artist's meticulous depiction of interiors. It shows a scholarly geographer surrounded by maps and charts. The globe above him refers to the exterior world, which is contrasted with the enclosed space of the room. Reinforcing the sense of a vast world are the cropped map on the wall and the gaze of the geographer. He looks toward the window, whose light brightly illuminates his desk. Clearly preoccupied with the outside world, he holds a pair of calipers and rests his hand on a book. His intellectual energy is conveyed by his alertness and the sense that a sudden thought has arrested his movement.

Vermeer's characteristic use of light and color to convey texture is particularly evident in the wooden chest and rumpled tapestry. The areas of glistening, pearl-like light are typical of Vermeer and reflect contemporary advances in microscopic research. (The anatomist and microscopist Anton van Leeuwenhoek was appointed executor of Vermeer's estate.)

17.48 Jan Vermeer, *Lacemaker*, c. 1669–1670. Oil on canvas laid down on wood, 9⅝ × 8¼ in. (24.5 × 21.0 cm). Louvre, Paris.

In the *Lacemaker* (fig. **17.48**) of around 1669–1670, which is typical of his small-scale, intimate interiors, Vermeer depicts a figure totally absorbed in concentrated work. The view of the girl and her threads is a close-up, creating the impression that we share her space. We follow her gaze to the needles and bobbins as her hands work them with determined focus. At the left, the unformed, textured threads hang limply as they wait to be made into lace. Vermeer's characteristic pinpoints of light play over the surfaces, and we can imagine his own intense focus on each dab of paint, just as the lacemaker pores over her threads.

17.47 Jan Vermeer, *Geographer*, c. 1668. Oil on canvas; 20⅞ × 18¼ in. (53.0 × 46.4 cm). Städelsches Kunstinstitut, Frankfurt. Vermeer lived and worked in Delft, Holland. Little is known of his life and career, but it appears that he earned a good income from his paintings. After his death, his works were neglected by critics and collectors until the late 19th century. Today they are among the most highly valued in the world. The signature and date at the upper right are not original.

17.49 Jan Vermeer, *View of Delft* (after restoration), c. 1660–1661. Oil on canvas; 3 ft. 2 in. × 3 ft. 9½ in. (0.97 × 1.16 m). Mauritshuis, The Hague.

The juxtaposition of expansive space and minute detail characterizes Vermeer's *View of Delft* (fig. **17.49**). It is a particularly striking example of the Dutch taste for landscape, and it is unique among his known works. Vermeer has combined an atmospheric sky with houses and water in a way that illustrates his genius for conveying jewel-like areas of light. Despite the large size of the canvas, Vermeer's attention to meticulous detail creates a feeling of intimacy.

The shifting lights and darks of the clouds and the delicately colored buildings are reflected in the water. Standing on the shore in the foreground are a few small human figures, who seem insignificant compared with the vast sky and the implied continuation of the scene beyond the picture's frame. Their staunch verticals anchor the church spires, the towers of the drawbridge, and their reflections. Silvers, blues, and grays alternate in the sky, as yellow sunlight filters through the clouds. The sparkle of the sunlight, as it catches details of the houses or glimmers on the water, shows Vermeer's concern for naturalistic effects and creates a glowing, textured surface motion that was entirely new in Western European art.

17.50 Jacob van Ruisdael, *Extensive Landscape with Ruins*, c. 1670. Oil on canvas; 13⅓ × 15¾ in. (33.9 × 40.0 cm). National Gallery, London.

Jacob van Ruisdael

The landscapes of Jacob van Ruisdael (c. 1628–1682) extend the vistas farther toward the horizon than Vermeer does in the *View of Delft*. Much of Holland's landscape was artificially created by the dikes that hold back the sea. Ruisdael's subjects, therefore, resonate with the very survival of Holland and its economy. His panoramic view in *Extensive Landscape with Ruins* (fig. **17.50**), for example, seems to encompass a vast space, which is expanded by the broad, horizontal sweep of earth, water, and sky. Together, these natural features produce a sense of atmospheric intensity enhanced by the rumbling clouds that menace the calm water and land.

The strong vertical accent provided by the church tower serves to anchor the painting and to emphasize the flatness of the surrounding landscape. It also proclaims the transitional character of religious architecture as it mediates between earth and sky. Painterly atmospheric effects and imagery that shows the smallness of human creations (the church) in relation to the vastness of nature took on a moralizing quality in seventeenth-century Holland. The ruins show the deterioration over time of man-made works, in contrast to the seasonal renewal of nature. In the nineteenth century, these themes are integrated into the Romantic aesthetic (see Chapter 20).

Maria van Oosterwyck

The moralizing trends in Dutch art are perhaps clearest in Baroque **vanitas** still lifes. In contrast to the macrocosmic views of Dutch landscape, the still lifes reflect the microcosm. Both illustrate the scientific concerns of northern Europe.

In the *Vanitas Still Life* of Maria van Oosterwyck (fig. **17.51**), each element contains a warning against folly. As such, it is well within the Northern tradition of Erasmus's *Adagia* (see p. 622). Flowers are transient and die —the tulip refers to the economic folly of the Dutch tulip craze, which collapsed in 1637. The skull, the stalk being eaten by a mouse, and the ear of corn are images of transience and decay. An hourglass marks the passage of time, and the astrological globe contrasts the vastness of the universe and the notion that humanity is ruled by the stars with minute creatures such as flies and butterflies. Written texts accompanying the images reinforce their message: *Rekeningh* ("reckoning") alludes to the final accounting at the end of time, and *Self-Stryt* ("self-struggle") to the moral conflicts of the human soul. Visible in the carafe at the left are a window and the artist herself, continuing the Northern interest in reflective surfaces and in asserting the artist's presence in the work.

17.51 Maria van Oosterwyck, *Vanitas Still Life,* 1668. Oil on canvas; 29 × 35 in. (73.7 × 88.9 cm). Kunsthistorisches Museum, Vienna.

The Dutch East India Company: Seventeenth-Century Capitalism

Holland was a small country, not blessed with natural resources and constantly on the defensive against the North Sea. Among its more important industries were commercial fisheries (mainly herring) and the production of linen and other cloths. During the seventeenth century, Dutch fortunes benefited from an expansion in world trade. The East India Company, established in 1602 by a group of Dutch merchants and sea captains, exemplified the capitalist trends of the period.

The purpose of the company was to corner the market in products imported from India. Fleets of Dutch ships brought commodities such as spices, silks, and metals from India to the company's headquarters in the Netherlands. Competitors, principally the English and the Portuguese, were driven out of the market by various stratagems, including setting prices below actual cost. By keeping large stores of goods in warehouses,

the Dutch maintained a continuous stock of merchandise and could raise prices when their competitors ran out of supplies. Surplus cargo was occasionally destroyed but, more often, was used to undersell the competition and put rivals out of business. Production was in the hands of Dutch settlers in India, who relied on slave labor. The profits from these enterprises, which were distributed to the shareholders of the company, could be enormous and helped to swell the prosperity of the Dutch merchant class.

By combining their resources and channeling their efforts through the company, the Dutch had secured a monopoly of the spice market (cinnamon, cloves, nutmeg, pepper) by the second half of the seventeenth century as well as a strong position in cotton, porcelain, and silk.

Mughal Art and the Baroque

The sixteenth-century age of exploration led to colonization, missionary activity, and trade with the Americas and the Far East. In Holland, many Chinese and Japanese objects were imported through the Dutch East India Company. Although by and large any real understanding of these distant regions on the part of Europeans was minimal, Eastern motifs began to influence furniture design, and a general taste for the exotic emerged in Europe. These cultural exchanges were most meaningful in contacts with Mughal painters of seventeenth-century India (see map). Rembrandt copied Mughal miniatures, and Rubens drew figures from the Mughal court.

The Mughal school of painting in India was known in Europe largely through the enlightened patronage of three emperors: Akbar (reigned 1555–1603), Jahangir (reigned 1603–1627), and Shah Jehan (reigned 1627–1658). Descended from Genghis Khan, Akbar's Persian grandfather founded the Mughal dynasty in India. He brought with him Persian artists, with whom Akbar studied as a child. Although raised as a Muslim, Akbar did not subscribe to the Islamic prohibition against figurative art. He therefore had Hindu artists working at his court, and they painted in a naturalistic tradition.

Akbar wished to unite Hinduism with Islam and to synthesize both with Christianity. He endorsed the progressive notion that the divine status of a ruler depended on a just and fair administration. His advanced religious views and desire for political unity inspired him to collect European art.

Akbar's European collection influenced Mughal artists, who began to introduce Western perspective into their own work. The **miniature** of *Akbar Viewing a Wild Elephant Captured near Malwa* (fig. **W8.1**) combines Hindu shading, which forms the elephant's bulk, Islamic patterning, and elements of Western perspective. For example, the oblique angle of the castle's middle wall creates a three-dimensional effect. Reinforcing this is the depiction of the ground as convincingly supporting elephants, riders, and trees.

Although orthodox Muslims in India objected to Akbar's patronage of figurative art, his son Jahangir continued to encourage artists to study nature and European painting. In the *Allegorical Representation of the Emperor Jahangir Seated on an Hourglass Throne* (fig. **W8.2**, p. 668), the Baroque interest in the *vanitas* theme of time (the hourglass) is incorporated into an Islamic setting. The border designs, calligraphic

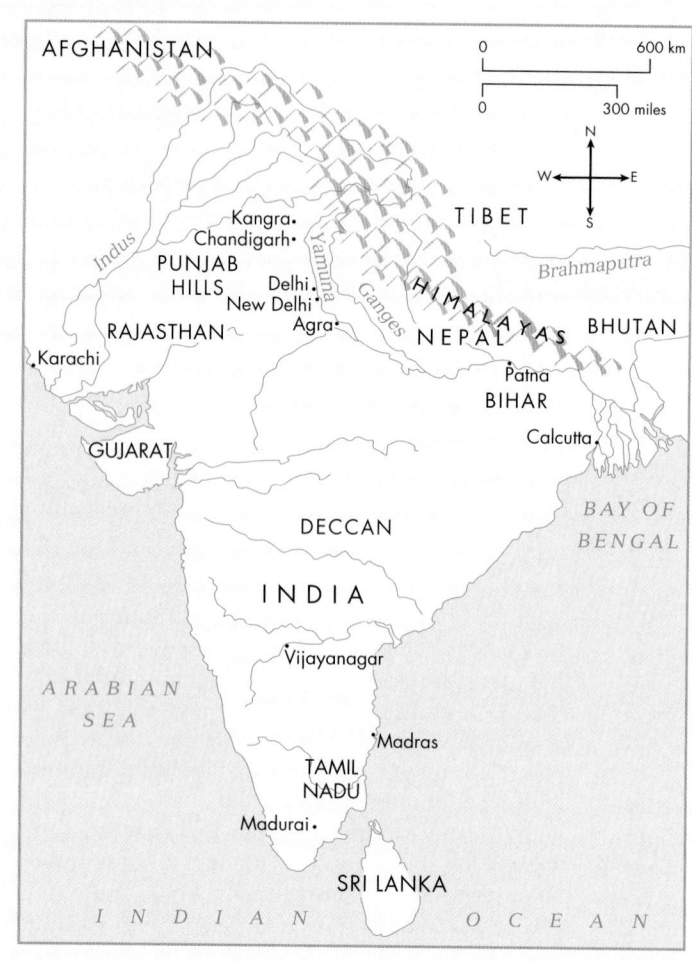

India in the 17th century.

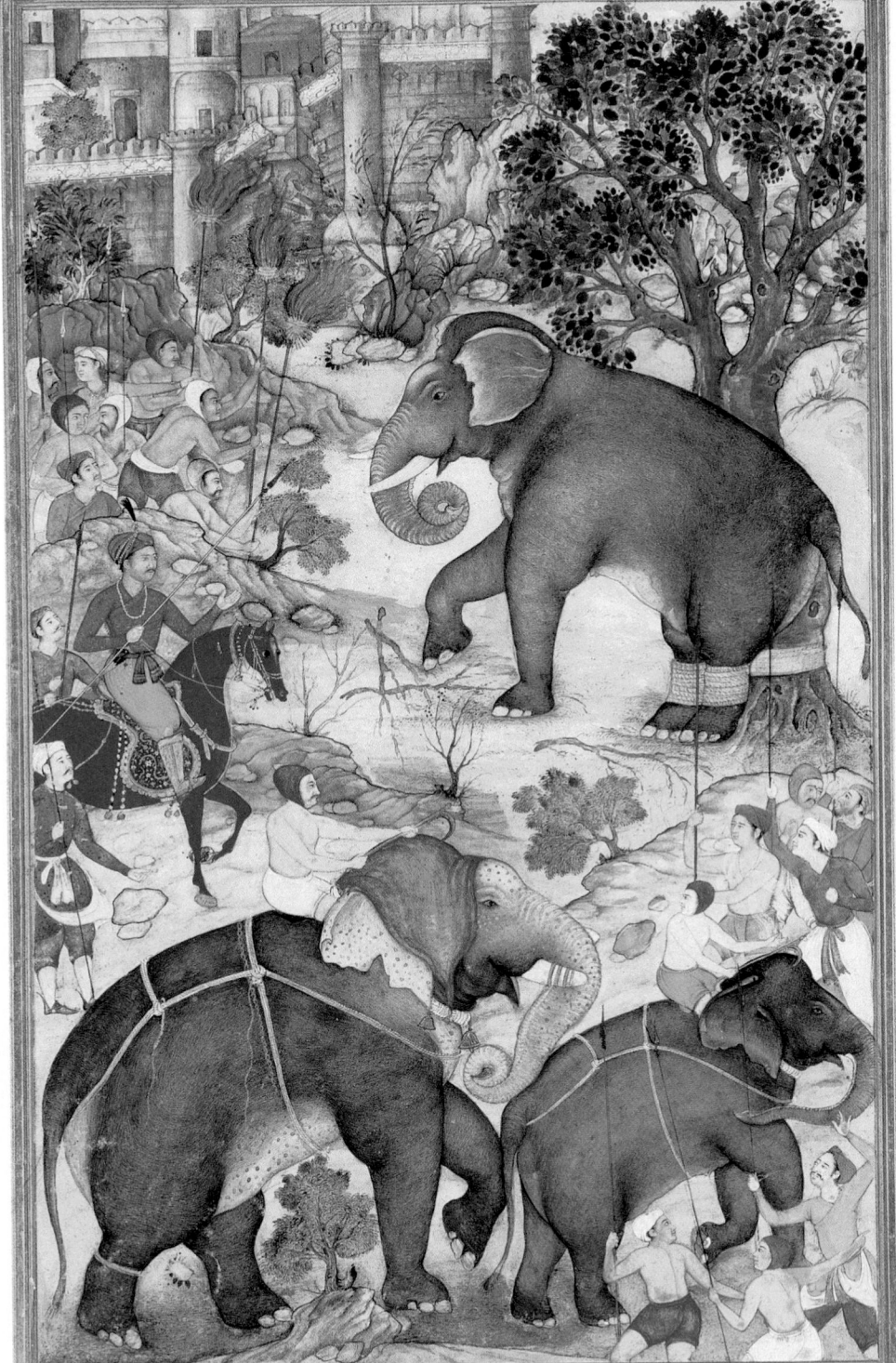

W8.1 Lal and Sanwah, *Akbar Viewing a Wild Elephant Captured near Malwa*, 1600. Gouache on paper; 13⅛ in. (33.4 cm) high. Victoria and Albert Museum, London.

lettering, and elaborate carpet that flattens the space are the result of Persian influence. The figures and hourglass, on the other hand, are rendered three-dimensionally and are shaded. Jahangir, surrounded by a double sun and moon halo, greets four personages, who reveal his international outlook: a Muslim divine with a long white beard, a Muslim prince with a black beard, a European delegate in Western dress, and an artist holding up a picture. Two little angels, copied from a European painting, play by the hourglass. Above and to the left, a Cupid carries a bow and arrow. To the right is another Cupid who covers his eyes—an allusion to the Western notion of blind love.

The masterpiece of Mughal architecture combines Hindu and Islamic features. The Taj Mahal (literally, "Crown of Buildings"; fig. **W8.3**) was commissioned by Jahangir's son, Shah Jehan, as a memorial to his wife, Mumtaz Mahal, who died in 1631. The jewel-like building is located in a garden and approached by four waterways, its ensemble signifying paradise and its four rivers. The mausoleum has a large cusped arch over a deep recess and stands on a podium with four domed minarets, one at each corner. On either side of the mausoleum are two identical structures—a mosque and a secular building. Balancing the large central onion dome, which is a characteristic feature of Mughal architecture, are two smaller *chattris*—the parasol-shaped elements that are derived from the *chattras* on early stupas (see fig. W3.10). The entire structure is perfectly symmetrical, which contributes to its calm, imposing impression. Elaborate curvilinear designs of inlaid semiprecious stones enhance the marble surface of the Taj Mahal.

W8.2 Bichtir, *Allegorical Representation of the Emperor Jahangir Seated on an Hourglass Throne*, early 17th century. Color and gold on paper; 10⅞ in. (27.6 cm) high. Freer Gallery of Art and Arthur M. Sackler Gallery, Smithsonian Institution, Washington, D.C. (42.15V).

CONNECTIONS

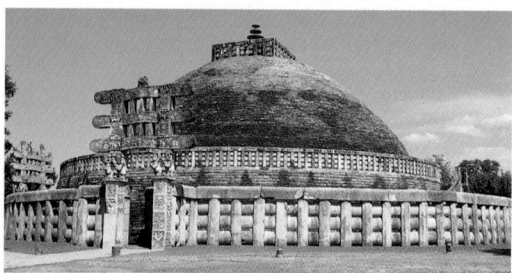

See figure W3.10. Great Stupa at Sanchi, India, 3rd century B.C.

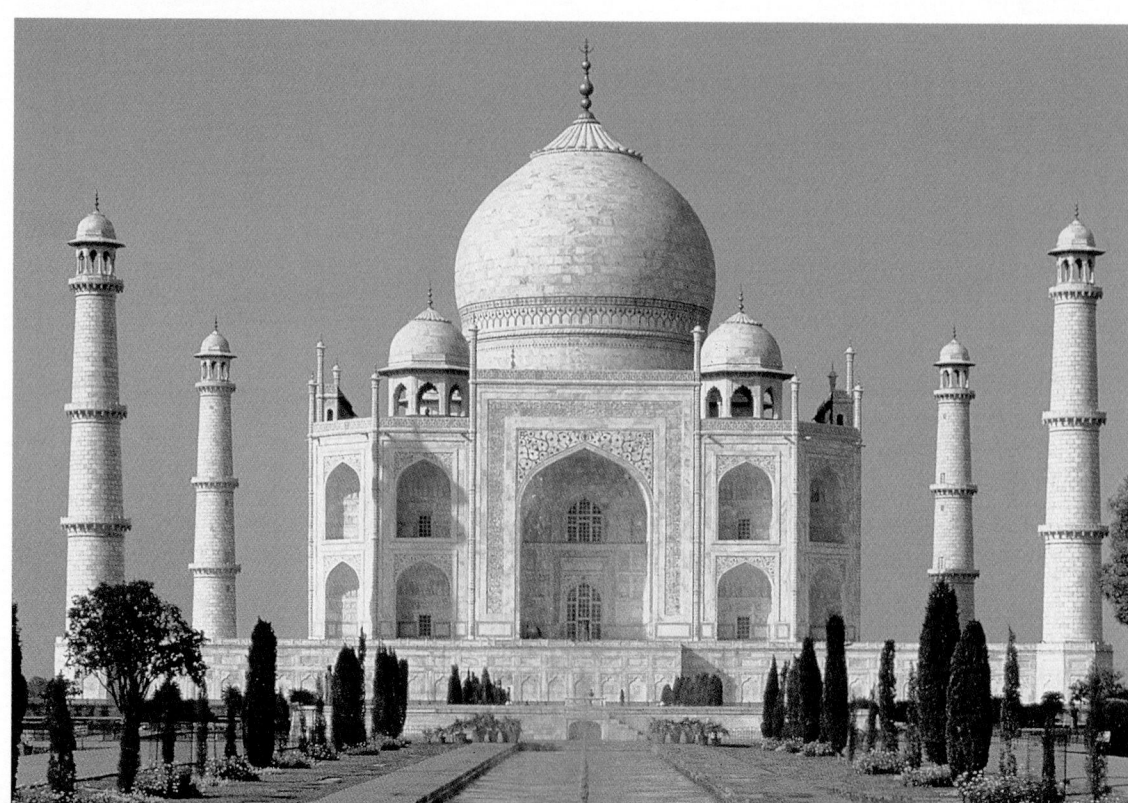

W8.3 Taj Mahal, Agra, India, 1634.

Spanish Baroque Painting: Diego Velázquez

The paintings of the leading Baroque artist in seventeenth-century Counter-Reformation Spain, Diego Velázquez (1599–1660), covered a broad spectrum of subject matter. His genius was nurtured by his Classical education, stimulated by his admiration for Titian, and spurred by his competition with Rubens.

Velázquez's *Crucifixion* (fig. **17.52**), probably painted in the 1630s, is thought to have been commissioned for a Benedictine Order of nuns in Madrid. The work would have satisfied the Counter-Reformation view that observers should identify with Jesus's Passion. His illuminated body stands out against a darkened background, which may refer to the tradition that the sky went black at the time of the Crucifixion. The softly textured hair falls forward over Jesus's face, and the curved glow of light surrounding his head is reflected in the crown of thorns. Velázquez's taste for realistic detail is indicated by the blood dripping from Jesus's wounds and the grain and knots of the Cross's

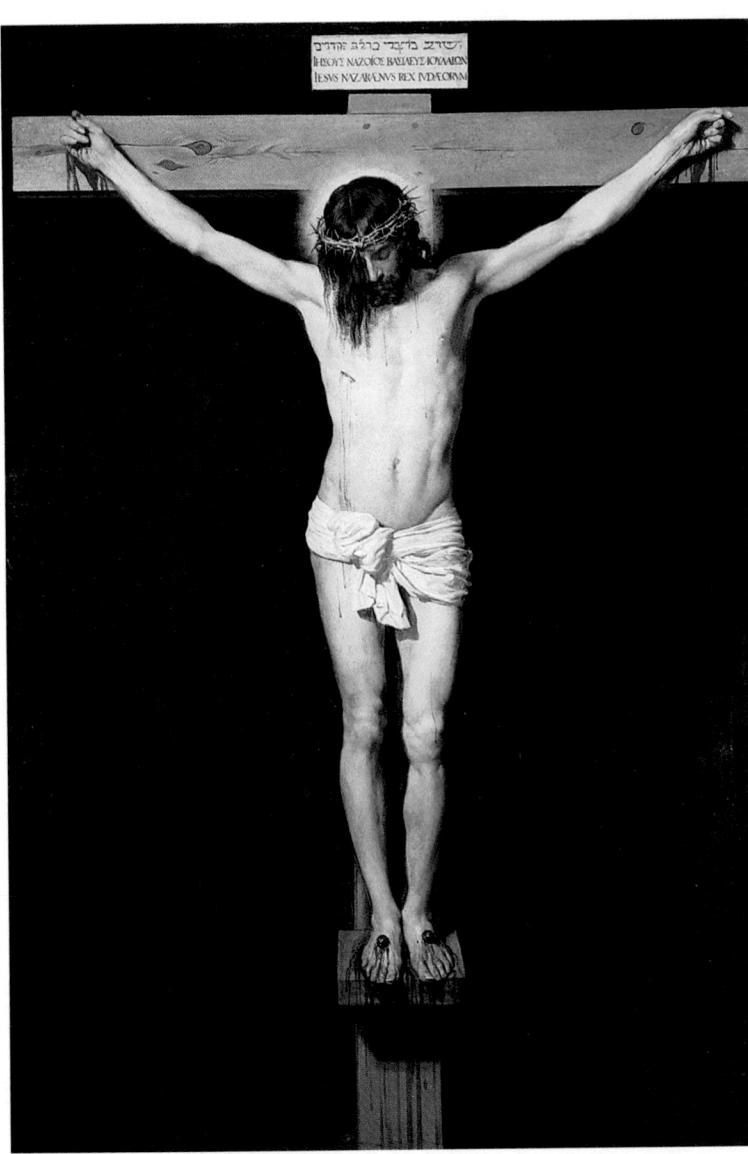

wood. The precision of such details recurs in the lettering on the plaque at the top of the Cross. Clearly written in Greek, Hebrew, and Latin is "Jesus of Nazareth, King of the Jews." (See also fig. 17.34, Rubens's *Raising of the Cross*.)

Despite the mystical quality of the light, Jesus is actually supported by the platform beneath his feet. The slight *contrapposto* that results from the weight-bearing right leg and the bent left knee resembles the relaxed Classical pose of Polykleitos's *Spear Bearer* (see fig. 5.27). In thus combining the formal elements of Baroque style with a Classical pose, Velázquez conforms to Counter-Reformation ideology, according to which physical suffering leads to moral repose.

For Philip IV, his most constant patron, Velázquez painted numerous pictures. The equestrian portrait *Philip IV on Horseback* (fig. **17.53**) was commissioned for the Hall of Realms in Philip's Buen Retiro Palace. It was one of several equestrian portraits of Philip and members of his family, which, like van Dyck's *Charles I on Horseback* (see fig. 17.35), served a dynastic as well as a political purpose. Philip's exalted pose is a Baroque version of the mounted Roman emperor, which implicitly connects him to the glory of ancient Rome (see fig. 7.50). Philip controls the horse with apparent ease as he executes a *levade*—a difficult Spanish Riding School maneuver in which the rider uses one hand to control a rearing horse. Despite the skill required for this exercise, Philip remains calm and in control. His upright posture contrasts with the diagonal plane of the horse, the slanting ground below, and the horizontal expanse of the sky. The blues and yellows spreading across the sky, the metal sheen of Philip's armor, and the rendering of the horse are all testimony to Velázquez's remarkable command of color and texture.

In addition to equestrian portraits, Philip's Hall of Realms was decorated with battle scenes intended to project an image of Spain's military superiority. But in the *Surrender of Breda* (fig. **17.54**), Velázquez also depicted Spanish moral superiority by departing from the traditional approach—portraying the domination of the vanquished by the victor. Rather than show Spinola, the victorious general, on horseback, Velázquez places him on the ground and to the right. He is therefore on an equal footing—although his head is higher—with Nassau, the defeated Dutch commander, to the left. In a gesture of friendship and compassion, Spinola restrains Nassau from kneeling. Nevertheless, Velázquez makes clear that the Spaniards are militarily as well as morally superior. The greater number of lances on the Spanish side —the right side—signify military superiority. They are aligned in an orderly formation, and the well-groomed soldiers are elegantly costumed. The Dutch,

17.52 Diego Velázquez, *Crucifixion*, 1630s. Oil on canvas; 8 ft. ⅛ in. × 5 ft. 5 in. (2.48 × 1.69 m). Museo del Prado, Madrid.

17.53 Diego Velázquez, *Philip IV on Horseback*, 1629–1630. Oil on canvas; 9 ft. 10½ in. × 10 ft. 5¼ in. (3.01 × 3.18 m). Museo del Prado, Madrid.

17.54 Diego Velázquez, *Surrender of Breda*, c. 1635. Oil on canvas; 10 ft. × 12 ft. ⅛ in. (3.07 × 3.66 m). Museo del Prado, Madrid. From 1624 to 1625, Spanish troops led by General Ambrogio Spinola laid siege to the city of Breda, in Holland. Spain allowed the Dutch to surrender and withdraw gracefully, which they did. Here the Dutch leader, Justin of Nassau, hands over the keys to his fortress to Spinola—an event that did not actually occur. Two years later, the Dutch retook Breda from Spain.

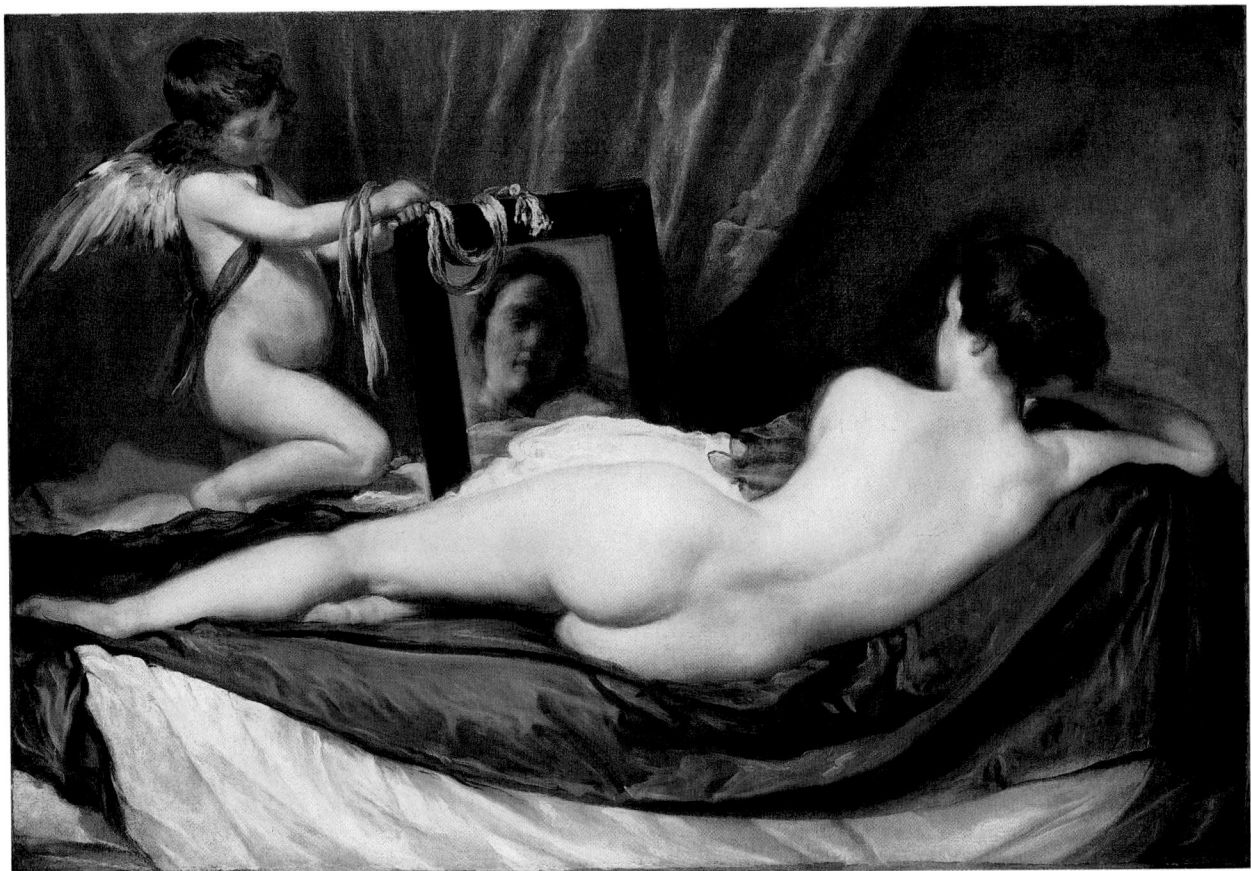

17.55 Diego Velázquez, *Venus with a Mirror* (*Rokeby Venus*), c. 1648. Oil on canvas; 4 ft. ⅜ in. × 5 ft. 9⅝ in. (1.23 × 1.77 m). National Gallery, London. The existence of this painting demonstrates that it was acceptable, even in Counter-Reformation Spain, to paint the female nude—provided it was for a private patron. Even so, Velázquez has erred on the side of modesty by showing only the face of the model in the mirror. A stricter application of the laws of physics might have shown another part of her body.

CONNECTIONS

in contrast, are disheveled, and their clothing is torn. Behind their weapons, smoke and fire indicate the aftereffects of battle, whereas the landscape beyond the Spanish side is peaceful. Also conveying Spanish power is the monumental form of the partly foreshortened horse from which Spinola has dismounted, and the clean diagonal of the checkered flag.

In contrast to his political pictures, the *Venus with a Mirror* (fig. **17.55**), known as the *Rokeby Venus* after the nineteenth-century family that owned it, was designed for a private patron, probably the marquis of Eliche, who was well known as both a libertine and a collector of Velázquez's works. The painting obscures the identity of the model by turning her away from the viewer and blurring her features in the mirror. Cupid's presence hints at, but does not specifically identify, the amorous content of the scene, which is enhanced by the painterly textures and rich colors. Seen in rear view, the nude is a long series of curves, which are repeated in the grand sweep of the silky curtain. The rarity of the female nude in seventeenth-century Spain makes this painting all the more unusual. It reflects the influence of reclining Venuses by Giorgione (see fig. 14.48) and Titian (see fig. 14.52), which Velázquez probably studied during his two trips to Italy.

Velázquez's unqualified masterpiece is the monumental *Las Meninas* of 1656 (fig. **17.56**). This work is not only a

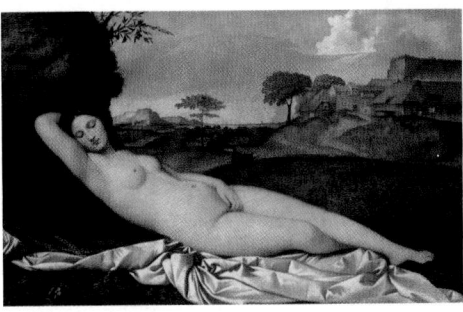

See figure 14.48. Giorgione, *Sleeping Venus*, c. 1509.

See figure 14.52. Titian, *Venus of Urbino*, c. 1538.

671

17.56 Diego Velázquez, *Las Meninas* (after cleaning), 1656. Oil on canvas; 10 ft. 7 in. × 9 ft. ½ in. (3.23 × 2.76 m). Museo del Prado, Madrid. Velázquez's personal pride in his own status—as a "divine" artist and member of the royal circle—is evident in his self-confident stance and raised paintbrush. The red cross on his black tunic is the emblem of the Order of Santiago, of which Velázquez became a knight in 1659. Since the painting was completed in 1656, the cross must have been a later addition. Velázquez became court painter to Philip IV early in his career. He followed the humanist leanings of his teacher, Francisco Pacheco, who later became his father-in-law. Like Titian, Velázquez worked for the elevation of painting to the status of a Liberal Art, alongside music and astronomy. In Spain, painting and sculpture were still considered mere crafts because artists worked with their hands.

tribute to the artist's genius as a painter, but it is about the very art of painting. The setting is a vast room in Philip's palace, and the five-year-old infanta, or princess, Margharita, is the focus of the picture. She is attended by her maids (*meninas*) and accompanied by a midget, a dwarf, and a dog. The elaborate costumes of the Spanish court are painted in such a way that the brushstrokes highlight the textures.

Certain forms, such as the infanta and the doorway, are emphasized by light. Other areas of the picture—the paintings on the side wall, for example—are unclear. Most obscure of all is the huge canvas at the left on which Velázquez himself is working. It is seen, like the *Venus with a Mirror*, from the back.

Below the mythological pictures on the back wall, depicting contests between gods and mortals (inevitably won by the gods), is a mirror, which has been the subject of extensive scholarly discussion. King Philip IV and Queen Mariana, the parents of the infanta, are visible in the mirror. Does their image mean that they are actually standing in front of their daughter, that they are the subjects of Velázquez's canvas? Or is this perhaps not a reflection at all, but rather a painted portrait? These are among the questions most often posed about the unusual iconography. We have seen that mirror images occur in paintings for a variety of reasons (see figs. 13.68 and 15.2). The mirror in *Las Meninas* may be intentionally ambiguous, which would be consistent with Baroque taste.

Another issue to which Velázquez almost certainly refers in *Las Meninas* is the status of the art of painting in seventeenth-century Spain. It was not considered a Liberal Art as it was in Italy, but rather a handicraft. By placing himself in royal company, it is likely that Velázquez was arguing for elevating the status of painting as well as that of the artist (see caption).

17.57 Nicolas Poussin, *Assumption of the Virgin*, c. 1626. Oil on canvas; 4 ft. 4⅞ in. × 3 ft. 2⅜ in. (1.34 × 0.98 m). National Gallery, Washington, D.C. Ailsa Mellon Bruce Fund.

French Baroque Painting: Nicolas Poussin

Although Nicolas Poussin (1594–1665) was a French painter, born in Normandy, he lived most of his adult life in Rome. He studied the Italian Renaissance and was drawn to Classical as well as biblical subjects. In his later works, Poussin represents the most Classical phase of the Baroque style, particularly in scenes with ancient Greek and Roman subject matter. By 1624, Poussin was in Rome, working for influential patrons. Ironically, his reputation was at its highest with the French Academy, but he preferred to live in Rome, where his restrained classicizing style was out of tune with the more exuberant Roman Baroque.

In his *Assumption of the Virgin* (fig. **17.57**), Poussin's attraction to antique forms is apparent. Large fluted columns frame the scene asymmetrically, and cherubs drop flowers into a sarcophagus. The Virgin rises in an exuberant swirl of blue drapery, which echoes the cloud formations, as excited cherubs celebrate their joy at her ascent to heaven. The contrast of the carefully arranged white drapery with the dark stone of the sarcophagus continues the zigzag motion of the dark clouds right down to the lower edge of the picture. At the ground, the short diagonal of the drapery invites us into the scene and sends our vision soaring upward with the Virgin.

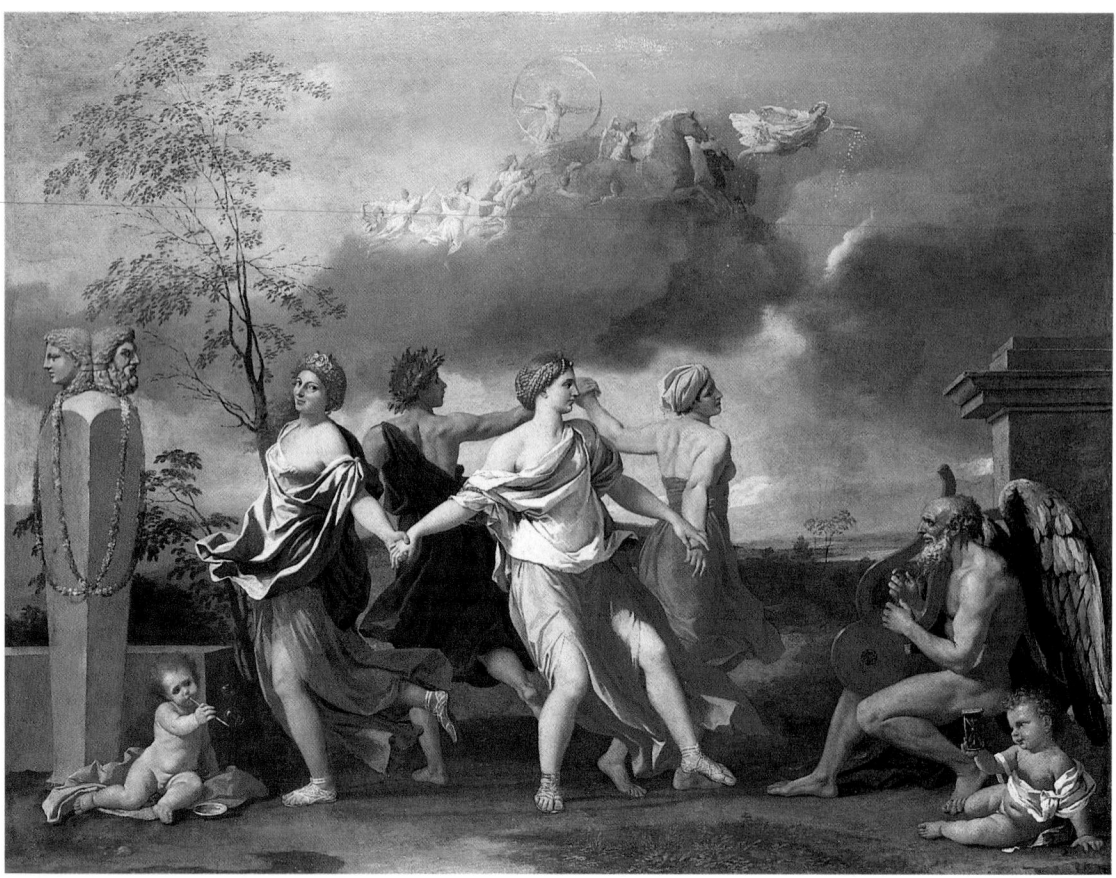

17.58 Nicolas Poussin, *Dance of Human Life,* c. 1638–1640. Oil on canvas; 2 ft. 8⅝ in. × 3 ft. 8⅝ in. (0.83 × 1.05 m). The Wallace Collection, London.

Poussin's Theory of Artistic Modes

This was one expression of the seventeenth-century French pursuit of an ordered system for conveying emotions in art. It was based on ancient Greek musical theory and Greek modes, from which the modern "keys" of music are derived. Modes were associated with different emotions. The Dorian mode, which was steady, solemn, and severe, corresponded to intellectual gravity and wisdom. The subtle modulations of the Phrygian mode made possible strong and violent effects. The Lydian mode was elegiac, the Hypolydian evoked sweetness and divinity, and the Ionian was cheerful and joyous.

Each mode was considered suited to a particular category of subject. Dorian was for Classical histories, Phrygian for representations of war, Lydian for funerals, Hypolydian for scenes of Paradise, and Ionian for celebrations, dancing, and feasting. Of Poussin's three paintings illustrated in this chapter, the *Assumption* is in the Hypolydian mode, the *Ashes of Phokion* corresponds to the Dorian mode, and the *Dance of Human Life* to the Ionian.

The *Dance of Human Life,* also called *Dance to the Music of Time* (fig. **17.58**), was made for Pope Clement IX (then still a cardinal), who suggested the subject to Poussin. In this painting, Poussin uses mythology in the service of Christian allegory and *vanitas.* Three women and one man in Classical dress join hands and dance in a circle. They represent Luxury, Wealth, Poverty, and Industry—four states of human existence—locked in never-ending circular movement. Time, the old winged man at the right, is the musician. Apollo drives his chariot across the sky, symbolizing the passage from day to night. Leading the chariot is Aurora, the dawn goddess, and following behind are the Horai (the four seasons). The twin heads of Janus—the god of gateways who sees the past and future simultaneously—adorn the top of an antique stele. Two children, one with an hourglass and the other blowing bubbles, are reminders that life is fleeting and insubstantial.

Entirely different in its somber, stoic, and elegiac mood is Poussin's *Ashes of Phokion* (fig. **17.59**). Phokion was a fourth-century-B.C. Athenian politician. Although elected general forty-five times, he consistently opposed the war against Macedon because he believed that Athenian military supremacy had come to an end. As a result, he was

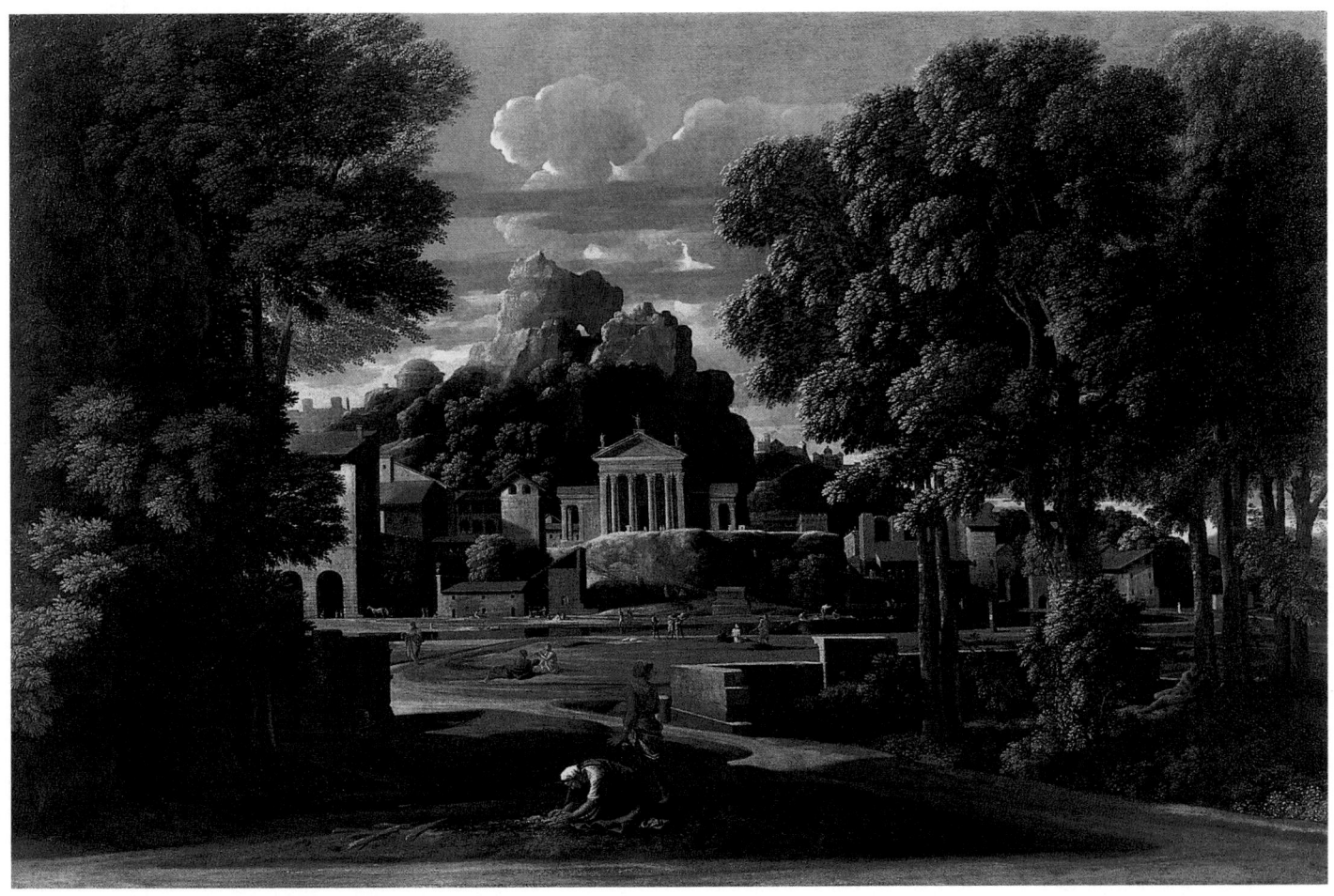

17.59 Nicolas Poussin, *Ashes of Phokion*, 1648. Oil on canvas; 3 ft. 9¾ in. × 5 ft. 9¼ in. (1.16 × 1.76 m). Walker Art Gallery, National Museums Liverpool.

convicted of treason and executed, and his ashes were buried outside the city limits. The Greek author Plutarch included Phokion in his *Lives* as a model of Stoic virtue. Despite Baroque lighting, everything seems ordered and rational, in keeping with the Classical restraint of Poussin's later style. The Classical temple façade is set off by the dark landscape forms, and tiny figures stroll calmly in the clearing between foreground and background. Closest to

the picture plane and highlighted by a white headscarf and sleeve is Phokion's widow. Ignored by the other figures, she collects her husband's ashes, evoking the *vanitas* theme of "ashes to ashes, and dust to dust." A related theme is evident in Poussin's combination of buildings from different historical periods. Buildings and nature, he suggests, may last; human beings do not.

Style/Period	Works of Art	Cultural/Historical Developments
1580 BAROQUE WESTERN EUROPE 1580–1600 **Caravaggio, Boy with a Basket of Fruit**	Caravaggio, *Boy with a Basket of Fruit* (**17.26**) Caravaggio, *Medusa* (**17.27**) Annibale Carracci, Farnese ceiling frescoes (**17.22–17.23**) Caravaggio, *Calling of Saint Matthew* (**17.28**)	Death of Saint Teresa of Ávila (1582) English East India Company founded (1600) **Caravaggio, Calling of Saint Matthew**
1600 1600–1630 **Bernini, David**	Lal and Sanwah, *Akbar Viewing a Wild Elephant Captured near Malwa* (**W8.1**) Caravaggio, *Conversion of Saint Paul* (**17.29**) Bichtir, *Allegorical Representation of the Emperor Jahangir Seated on an Hourglass Throne* (**W8.2**) Rubens, *Raising of the Cross* (**17.34**) Gentileschi, *Judith Slaying Holofernes* (**17.30**) Rubens, *Straw Hat* (**17.33**) Bernini, *Pluto and Proserpina* (**17.18**) Bernini, *David* (**17.19**) Hals, *Laughing Cavalier* (**17.45**) Bernini, baldacchino, Saint Peter's (**17.1**), Rome Gentileschi, *Judith and Her Maidservant with the Head of Holofernes* (**17.31**) Poussin, *Assumption of the Virgin* (**17.57**) Leyster, *The Last Drop* (**17.46**) Velázquez, *Philip IV on Horseback* (**17.53**)	Dutch East India Company founded (1602) Bodleian Library, Oxford, opened (1602) Cervantes, *Don Quixote* (1605) William Shakespeare, *King Lear* (1605) First permanent English settlement at Jamestown, Virginia (1607) Johan Kepler postulates planetary system (1609) Publication of King James Bible (1611) First use of Manhattan by the Dutch as a fur-trading center (1612) Thirty Years War (1618–1648) Puritans reach New England (1620) Molière (Jean-Baptiste Poquelin), French dramatist (1622–1673) Cardinal Richelieu adviser to Louis XIII of France (1624–1642) William Harvey describes circulation of the blood (1628) Great migration to America begins (1630)
1630 1630–1640 **Rubens, Raising of the Cross**	Rembrandt, *Self-Portrait in a Cap* (**17.42**) Rembrandt, *Self-Portrait, Grimacing* (**17.43**) Velázquez, *Crucifixion* (**17.52**) da Cortona, *Glorification of the Reign of Urban VIII* (**17.24**) Rembrandt, *Saskia* (**17.40**) Taj Mahal (**W8.3**), Agra Velázquez, *Surrender of Breda* (**17.54**) Rubens, *Venus and Adonis* (**17.32**) Rembrandt, *Belshazzar's Feast* (**17.37**) Rembrandt, *Blinding of Samson* (**17.36**) van Dyck, *Charles I on Horseback* (**17.35**) Poussin, *Dance of Human Life* (**17.58**) Borromini, San Carlo alle Quattro Fontane (**17.4–17.7**), Rome Rembrandt, *Self-Portrait, Leaning on a Stone Sill* (**17.44**)	Galileo forced to recant by the Inquisition (1633) John Donne, *Poems* (1633) Harvard College founded (1636) René Descartes, *Discourse on Method* (1637) Collapse of Dutch tulip market (1637) **Velázquez, Surrender of Breda**
1640 1640–1650 **Rembrandt, Self-Portrait**	Rembrandt, *Self-Portrait, Leaning on a Sill* (**17.39**) Rembrandt, *Night Watch* (**17.38**) Borromini, Sant'Ivo della Sapienza (**17.8, 17.10**), Rome Bernini, Cornaro Chapel (**17.20–17.21**), Rome Velázquez, *Venus with a Mirror* (**17.55**) Poussin, *Ashes of Phokion* (**17.59**)	Louis XIV succeeds to French throne (1643) Battle of Rocroi ends Spanish ascendancy in Europe (1643) Treaty of Westphalia ends Thirty Years War (1648) French Royal Academy founded, Paris (1648) Charles I beheaded; England declared a Commonwealth (1649)
1650 1650–1710 **Vermeer, View of Delft** **1710**	Velázquez, *Las Meninas* (**17.56**) Bernini, piazza of Saint Peter's (**17.2**), Rome Rembrandt, *Self-Portrait as Saint Paul* (**17.41**) Bernini, *Louis XIV* (**17.15**) Vermeer, *View of Delft* (**17.49**) Perrault, Le Vau, and Le Brun, east façade of the Louvre (**17.11**), Paris Le Brun, Le Vau, and Le Nôtre, Versailles (**17.12**) Le Brun and Tuby, Fountain of Apollo (**17.13**), Versailles Oosterwyck, *Vanitas Still Life* (**17.51**) Vermeer, *Geographer* (**17.47**) Vermeer, *Lacemaker* (**17.48**) van Ruisdael, *Extensive Landscape with Ruins* (**17.50**) Wren, Saint Paul's Cathedral (**17.17**), London Gaulli, *Triumph of the Name of Jesus* (**17.25**) Hardouin-Mansart and Le Brun, Hall of Mirrors (**17.14**), Versailles	Thomas Hobbes, *Leviathan*, a defense of absolute monarchy (1651) Oliver Cromwell becomes Lord Protector of England (1653) Restoration of Stuart monarchy in England under Charles II (1662) Plague in London (1665) Great Fire of London (1666) John Milton, *Paradise Lost* (1667) Antonio Vivaldi, Italian composer (1675–1741) Jean Racine, *Phèdre* (1677) John Bunyan, *Pilgrim's Progress* (1678) Versailles becomes residence of French kings (1682) Isaac Newton, *Philosophiae naturalis principia mathematica* (1687) John Locke, *An Essay Concerning Human Understanding* (1690) Witchcraft trials in Salem, Massachusetts (1692)

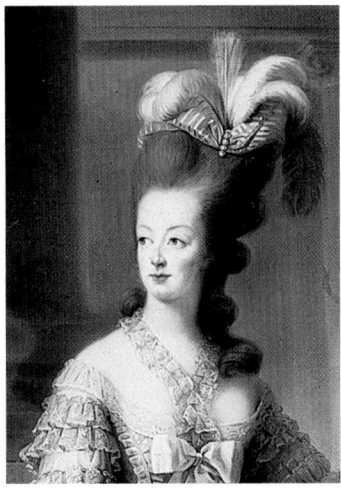

18

Rococo and the Eighteenth Century

The eighteenth century (see map), particularly its latter half, was a complex patchwork of several different artistic trends. Two of these, the Neoclassical and the Romantic, overlap each other in time and often converge in a single work. They continue into the nineteenth century and are covered more completely in Chapters 19 and 20. The most distinctive eighteenth-century style, which flourished from about 1700 to 1775, is called *Rococo,* a term apparently coined from the French words *rocaille* and *coquille* (meaning, respectively, "rock" and "shell"—formations used to decorate Baroque gardens). Scholars are divided over whether Rococo was an independent style or a refinement of Baroque.

Rococo style is above all an expression of wit and frivolity, although at its best there are more serious, somber, and satirical undercurrents. On the surface, the typical Rococo picture depicts members of the aristocracy gathered in parks and gardens, as Cupids frolic among would-be lovers. Classical gods and goddesses engage in amorous pursuits. The world of Rococo is a world of fantasy and grace, which also includes a taste for the exotic and for satire. One expression of this taste in the eighteenth century was the fad for **chinoiserie.** From about 1720, an interest in Chinese imagery developed in France and England. This included garden design, architectural follies, costumes, and decorative motifs in general. In 1761, Sir William Chambers built a pagoda in Kew Gardens, on the outskirts of London (fig. **18.1**). The fanciful, unlikely appearance of a Chinese pagoda in an English garden appealed to the Rococo aesthetic.

18.1 Sir William Chambers, Pagoda, Kew Gardens, England, 1761. Engraving by William Woollett after J. Kirby, hand-colored by Heath. Victoria and Albert Museum, London.

After the death of Louis XIV in 1715 and a subsequent decline in royal patronage, the center of French taste shifted from the court to the Paris *hôtel* (elegant townhouse) and to the salon (see box). The source of patronage also shifted from being the exclusive province of the French aristocracy to include the upper middle class and the bourgeoisie. In other capitals of Europe, especially in Germany, the Rococo style was quickly taken up by rulers and their courts.

Exemplifying the ornate Rococo interior typical of the Paris *hôtel* is the Salon de la Princesse in the Hôtel de Soubise (fig. **18.2**). Animating the lightly colored walls are elaborate gilded relief patterns of floral and plant designs framing blank spaces and mirrors. At the top of each section of the wall, Cupids perch precariously at the edges of the gilded arches. The lively energy of such interiors and their airy, reflective character provided appropriate settings for the witty social interaction of the eighteenth-century salon.

Although Rococo was the primary artistic style of the eighteenth century, Classicism remained a potent force. Excitement over the discovery of the buried Roman cities of Herculaneum (in 1709) and Pompeii (in 1748) fueled the interest in antiquity. The German scholar Johann Winckelmann introduced a historical approach to the study of ancient Greek and Roman art (see box, p. 681). At the same time, Neo-Gothic and Palladian styles developed—the former especially in England, the latter in both England and America. Toward the end of the century, Romanticism arose in opposition to the Classical aesthetic of the European "Academies."

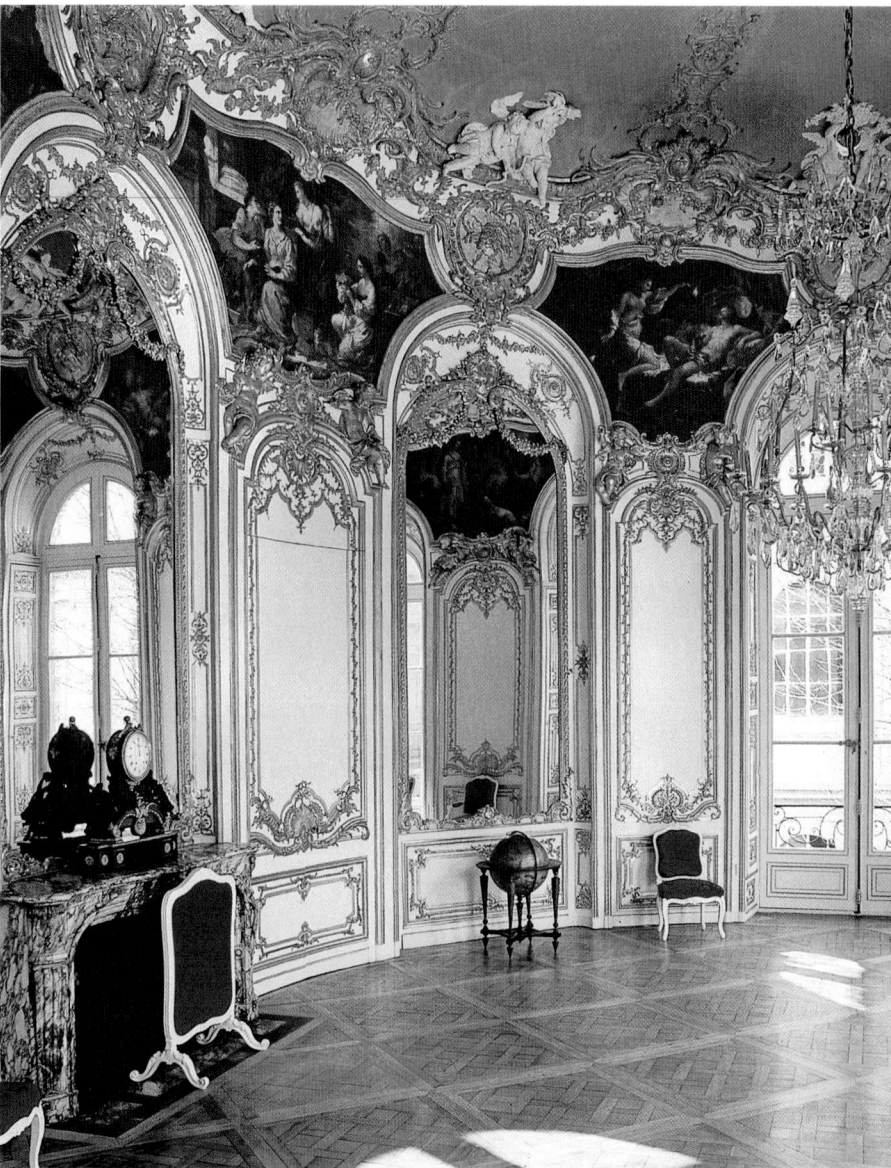

18.2 Germain Boffrand, Salon de la Princesse, Hôtel de Soubise, Paris, c. 1740.

Salons and *Salonnières*

In the eighteenth century, the salon became the center of Parisian society and taste. The typical salon was the creation of a charming, financially comfortable, well-educated, and witty hostess (the *salonnière*) typically in her forties. She provided good food, a well-set table, and music for people of achievement in different fields who visited her *hôtel*. The guests engaged in the art of conversation and in social and intellectual interchange.

In the seventeenth century, the most important salon had been that of Madame de Rambouillet, who wished to exert a "civilizing" influence on society. By the next century, the salon was a fact of Paris social life, and one in which women played the dominant role. Among the *salonnières* were women of significant accomplishments in addition to hostessing. These included writers (Mesdames de La Fayette, de Sévigné, and de Staël, and Mademoiselle de Scudéry), a scientist (Madame du Châtelet), and the painter Élisabeth Vigée-Lebrun.

Political and Cultural Background

In contrast to the apparent frivolity of Rococo, serious advances were taking place in other fields. The world of music could boast Antonio Vivaldi, Johann Sebastian Bach, Franz Joseph Haydn, and Wolfgang Amadeus Mozart. In science, Gottfried Wilhelm Leibniz developed calculus, Joseph Priestley discovered oxygen, and Edmund Halley identified the comet that bears his name. Technological developments, such as mechanized spinning and James Watt's steam engine, laid the foundations for the industrial revolution. Satire, which is a feature of certain Rococo artists, had as its leading literary exponents Jonathan Swift in Ireland and François-Marie Arouet (Voltaire) in France.

Important political changes also occurred in eighteenth-century Europe. Frederick the Great turned Prussia into an aggressive military power, and France and Austria united against him. This new alignment resulted in the Seven Years' War (1756–1763), which was won by the Prussians. England, whose international influence was based largely on the strength of its navy, consolidated its position in the eighteenth century and took the lead in European industrialization. England's position of economic and naval primacy extended to the New World and to India.

Developments in America mirrored the shifts in European power. The North American colonies belonged mainly to England. The exceptions were in the South, in the Louisiana Territory, and in Canada, where the English did not dislodge the French until 1763. Spain controlled the whole of Central and South America (with the exception of Brazil), Mexico, Texas, parts of California, and most of Florida (which it ceded to England in 1763).

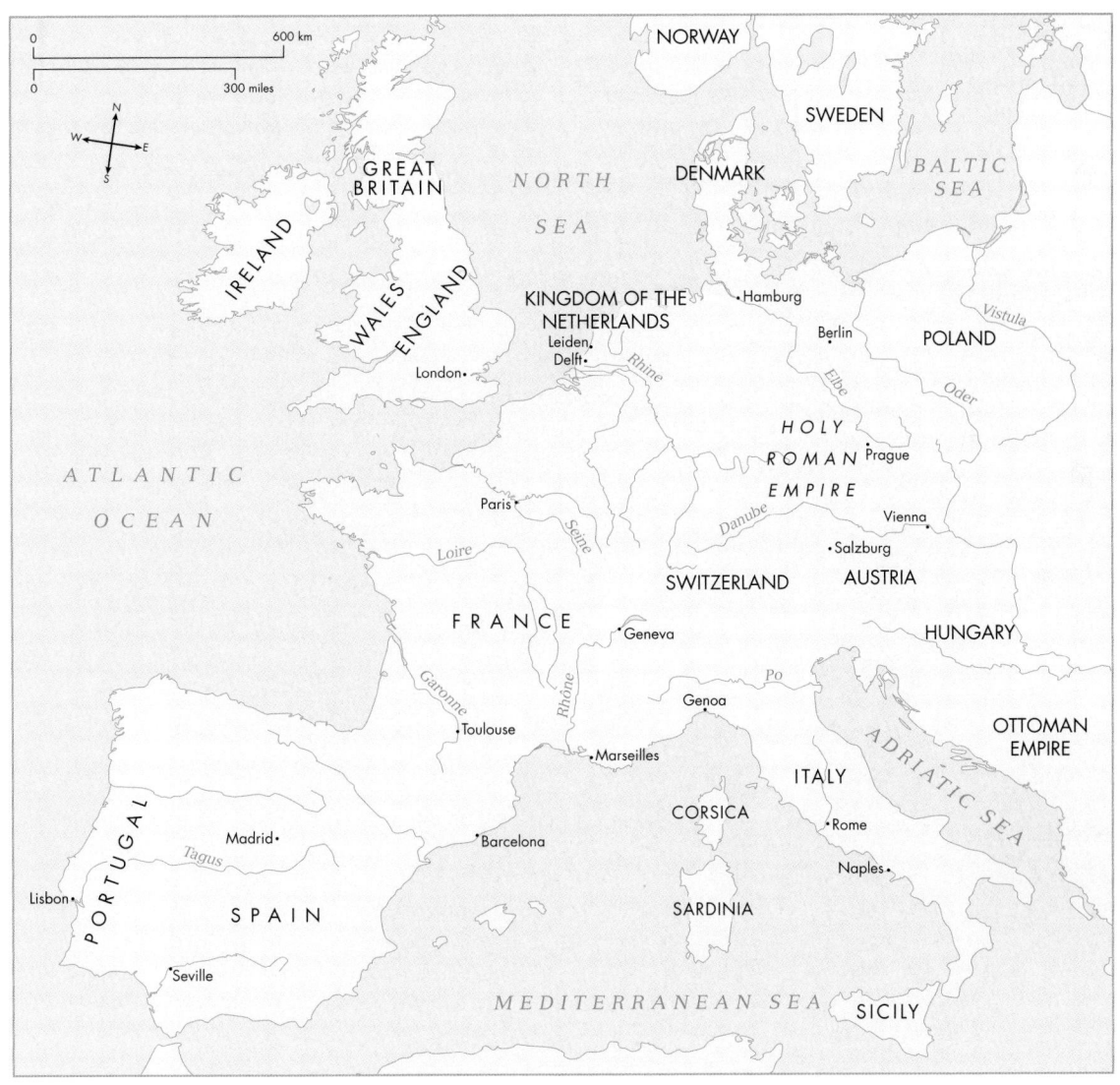

Western Europe, c. 1740.

The Age of Enlightenment

The eighteenth century has been called the Age of Enlightenment. This complex concept derives from certain philosophical ideas that were translated into political movements. The rationalism of the French philosopher René Descartes —"Cogito, ergo sum" (I think, therefore I am)—in the previous century continued to appeal to European and American thinkers. In England, John Locke advanced the notion of "empiricism," the belief that all knowledge of matters of fact derives from experience. This became the basis of the scientific method (see box, below). Seventeenth-century improvements in microscopes and telescopes lent credence to Locke's ideas. And in France, Denis Diderot and other *encyclopédistes* classified the various branches of knowledge on a scientific basis. Diderot's pursuit of scientific

Scientific Experiments in the Enlightenment

Joseph Wright (1734–1797) painted two scenes of scientific experimentation. These placed him firmly in the tradition of the Enlightenment and its interest in empirical reasoning. In addition, he was particularly intrigued by the dramatic effects of artificial light, and this led him into industrial workshops and other settings where he could study figures silhouetted against the glow of forges.

In 1768, Wright exhibited *An Experiment on a Bird in the Air Pump* (fig. **18.3**). The experiment in this picture consisted of putting an animal or bird into a glass container that was connected to a pump. The demonstrator then pumped out the air in order to show the effect on the creature. Here the victim is a white cockatoo, which in reality was too valuable a bird to risk; it was probably chosen for its dramatic effect. In the picture, the air has already been pumped out and the bird has fallen to the bottom of the container. The left hand of the demonstrator is raised to the valve of the pump, which, if turned in time, will restore the air flow and save the bird.

On the table stands a large glass jar containing an opaque liquid and what appears to be a skull, silhouetted by a candle standing behind the jar. Both candle and skull are traditional components of a *vanitas* scene—the candle signifying the passage of time, the skull its inevitable result. The man seated in profile to the left of the pump holds a watch, ostensibly to clock the experiment but also as a further reminder that time is passing.

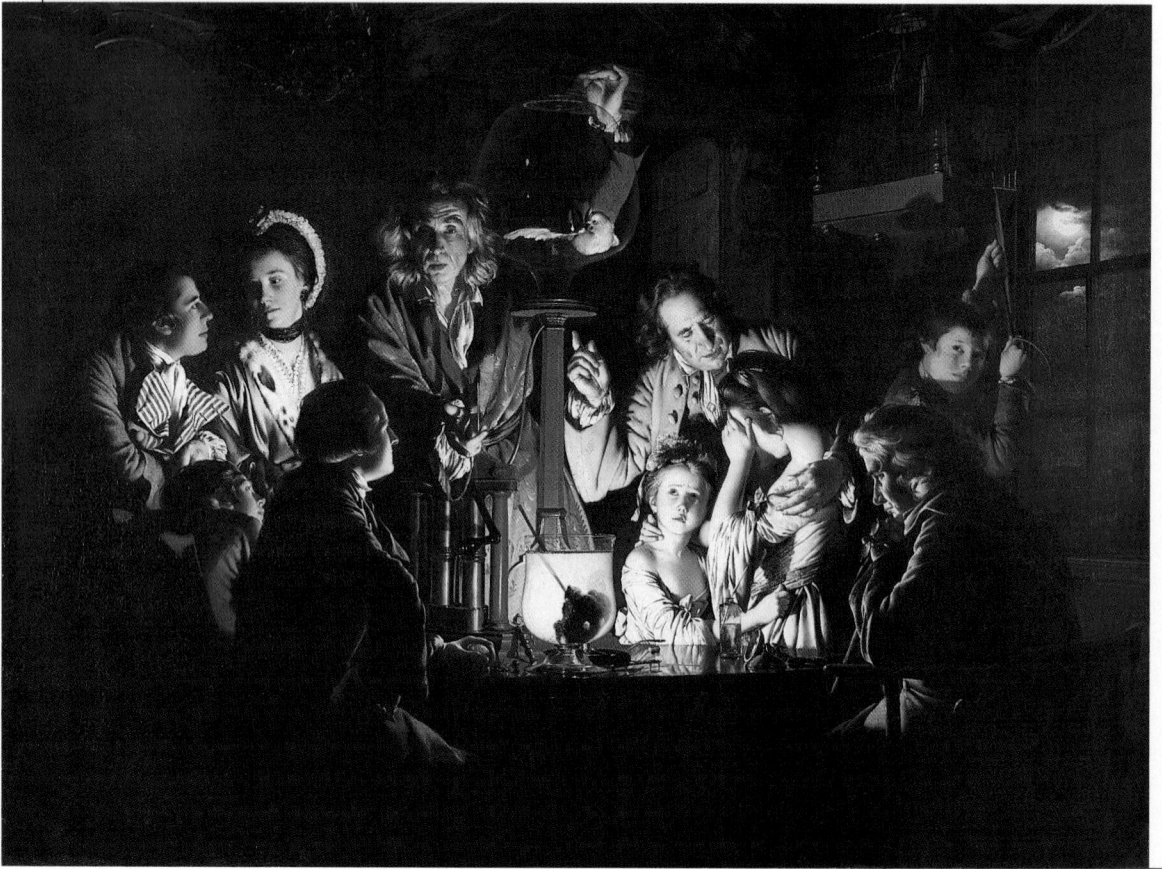

18.3 Joseph Wright, *An Experiment on a Bird in the Air Pump*, 1768. Oil on canvas; 28⅓ × 37¾ in. (72.0 × 95.9 cm). National Gallery, London. Wright was a British portraitist and landscape painter who spent most of his life in Derby, in the heartland of England. He became known as Wright of Derby to distinguish him from other contemporary artists of the same name.

observation carried over into his views on artistic training. In contrast to the study of tradition advocated by the French Academy, Diderot advised art students to leave the studio and observe real life.

In political philosophy, the concept of a secular "social contract" developed. Locke's *Two Treatises on Government,* published in 1690, argued against the divine right of kings. In Locke's view, government was based on a contract between the ruler and the ruled, who have a right to rebel when their freedom is threatened. In 1762, Jean-Jacques Rousseau went a step further in his *Social Contract.* For him, the "contract" was not between people and government, but among the people themselves. The practical and ultimate effect of such reasoning can be seen in Thomas Jefferson's Bill of Rights and the American Constitution. The American Revolution (1775–1783) ended the oppression of the colonies by the British king George III and was followed a few years later by the French Revolution (1789–1799). These two revolutions essentially shattered the time-honored belief throughout most of western Europe in the divine right of kings.

Traditionally, the image of light, associated with the power of the sun, had been used for political ends. In ancient Egypt, the pharaoh was thought of as the sun god Ra on earth, while the entire court of Louis XIV revolved around his self-image as the Sun King. Likewise, through-

out the history of Christian art, Christ is paralleled with the sun as the "Light of the World." With the inroads made by non-Christian philosophies and the decline in the influence of the Church following the Reformation, the notion of "light" became increasingly secular. In the eighteenth century, it became associated with a "rational," empirical outlook. The light in En*light*enment referred to the primacy of reason and intellect, in contrast to the unquestioning acceptance of divine power. This bias was profoundly optimistic because it encouraged a spirit of inquiry and a belief in progress and in the human ability to control nature.

While these were the most dominant eighteenth-century views, countercurrents persisted. The prevalence of irony and satire, for example, implied an awareness that darker forces underlay the optimistic view of nature and the surface levity of Rococo. In Germany, the reaction was even more pronounced, particularly in the aesthetic of the so-called *Sturm und Drang* (storm and stress) movement, which was a manifestation of early Romanticism. According to that more pessimistic outlook, nature had ultimate power over reason. As in Johann Wolfgang von Goethe's play *Faust,* human life was seen as a constant—and losing—battle for control over the evil forces of nature.

Art Theory and the Beginnings of Art History

The eighteenth century, particularly the latter half, saw the beginning of modern art theory and art history. The very term *aesthetic* is an eighteenth-century invention.

Johann Joachim Winckelmann (1717–1768) was born in Berlin and became a librarian near Dresden. There he met artists and visited museums. In the 1760s, he moved to Rome, where he was appointed superintendent of antiquities and oversaw excavations at Herculaneum and Pompeii. Based on his publication in 1764 of *The History of Ancient Art,* Winckelmann has been called the father of art history because he believed that style was determined by culture. He thus expanded the study of art beyond the more biographical approach of Vasari and the Classical tradition, and beyond the philosophical views of Plato and Aristotle. Beauty, for Winckelmann, was a matter of intuition and spirit, and the height of aesthetic beauty had been attained by Greece in the fifth and fourth centuries B.C. Roman art, he said, was derivative of Greek art, which was noble, restrained, and ideal. The Renaissance, in his view, was a revival not of Roman, but of Greek, art. Winckelmann classified ancient art into four phases: Archaic, Phidian, the fourth century B.C., and the period from the third century B.C. through the fall of the Roman Empire. These categories became a model for later art-historical divisions.

A different approach to art theory was espoused by the German philosopher Immanuel Kant (1724–1804). In 1790, he published his *Critique of Judgment,* in which he advanced the notion of aesthetic assessment of, and response to, both nature and art. Beauty, for Kant, resided in the interplay between the viewer and what was viewed. Kant thus accorded to the aesthetic response a significant and independent role in human experience.

In the early decades of the nineteenth century, G. W. F. Hegel (1770–1831) combined elements of Winckelmann and Kant in his theoretical lectures. He addressed the spiritual connection between art and religion, and also identified the historical evolution of style. This evolution, according to Hegel, was inevitable and could be perceived and understood in retrospect. Artistic expression for Hegel symbolized an idea and therefore had a more rational underpinning than in Kant's system. Hegel's belief that art revealed its culture and was a historical artifact conformed to Winckelmann's ideas, but Hegel's historical stages differed. The first, Symbolic, stage was pre-Classical and included ancient Egypt. In the second stage, the fifth- and fourth-century-B.C. Greeks produced the Classical ideal, in which the soul is revealed by the formal perfection of the body. The third and last stage was Hegel's own Romantic period, in which the spiritual and the religious converged.

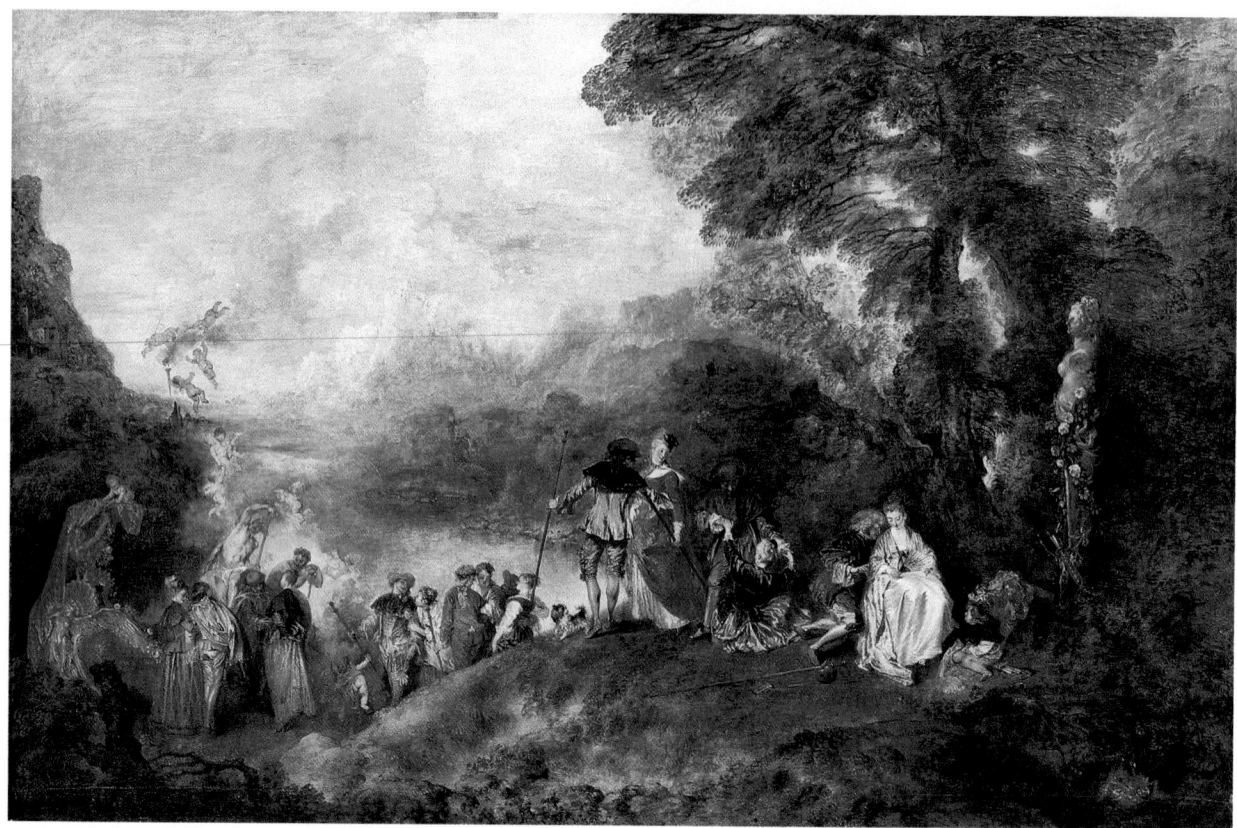

18.4 Antoine Watteau, *Pilgrimage to Cythera*, 1717. Oil on canvas; 4 ft. 3 in. × 6 ft. 4¼ in. (1.30 × 1.94 m). Louvre, Paris. This was Watteau's presentation painting for admission to the French Academy. Not only was he accepted, but the Academy added the category *fêtes galantes* to its hierarchy of genres. Watteau died of tuberculosis at age thirty-seven.

Rococo Painting

Antoine Watteau

The leading Rococo painter, Antoine Watteau (1684–1721), was born in Flanders but spent most of his professional life in France. He worked in the painterly, colorist tradition of his compatriot Rubens, whose interest in voluptuous nudes and richly textured materials he shared. Nevertheless, the thin, graceful proportions of Watteau's figures as well as his subject matter are more consistent with Rococo style. He is best known for his *fêtes galantes,* paintings of festive gatherings in which elegant aristocrats relax in outdoor settings.

The best known of Watteau's works is the *Pilgrimage to Cythera* (fig. **18.4**), depicting a group of amorous couples who have journeyed to the island of Venus. At the right, her statue is draped with flowers, denoting love and fertility. Her presence in stone marks the enduring character of the Classical tradition, in contrast to the frivolity and transience of the trysting lovers. The emphasis on silk textures that reflect light and the powder-pink Cupids frolicking in the sky are typical of Rococo. As the lovers prepare to depart the magical island, they descend toward the scallopshell boat at the left; the colors of their costumes become dulled as they begin their return to the world of reality.

The more wistful side of Watteau can be seen in his undated *Gilles* (fig. **18.5**), the sad Harlequin. The actor, in this case a comic lover, wears his costume but does not perform. His pose is frontal, and his arms hang limply at his sides. His melancholy expression betrays his mood, which is at odds with the silk costume and pink ribbons on his

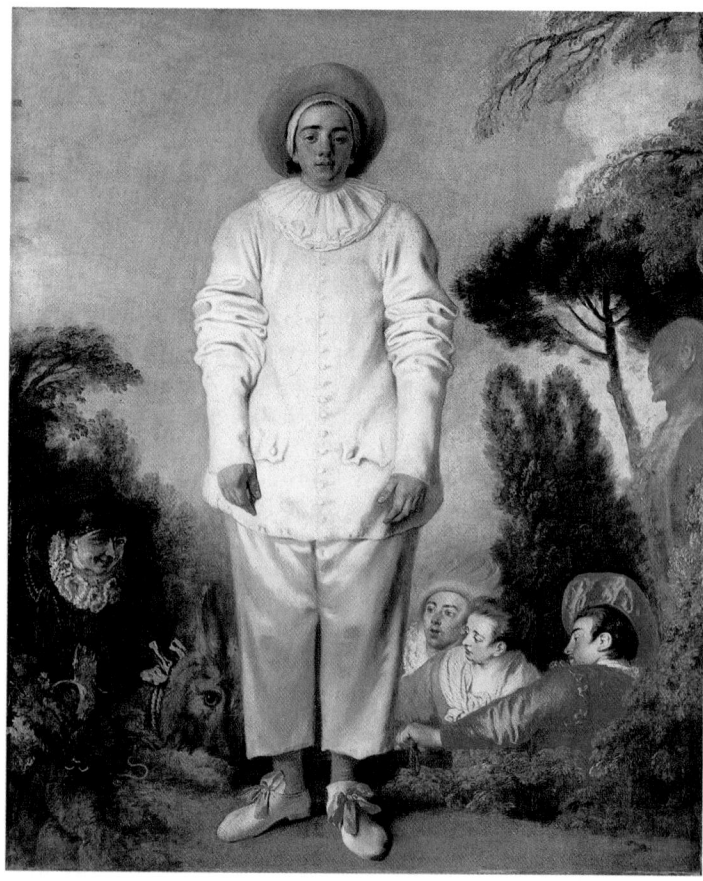

18.5 Antoine Watteau, *Gilles*, undated. Oil on canvas; 6 ft. ⅝ in. × 4 ft. 10¾ in. (1.84 × 1.49 m). Louvre, Paris.

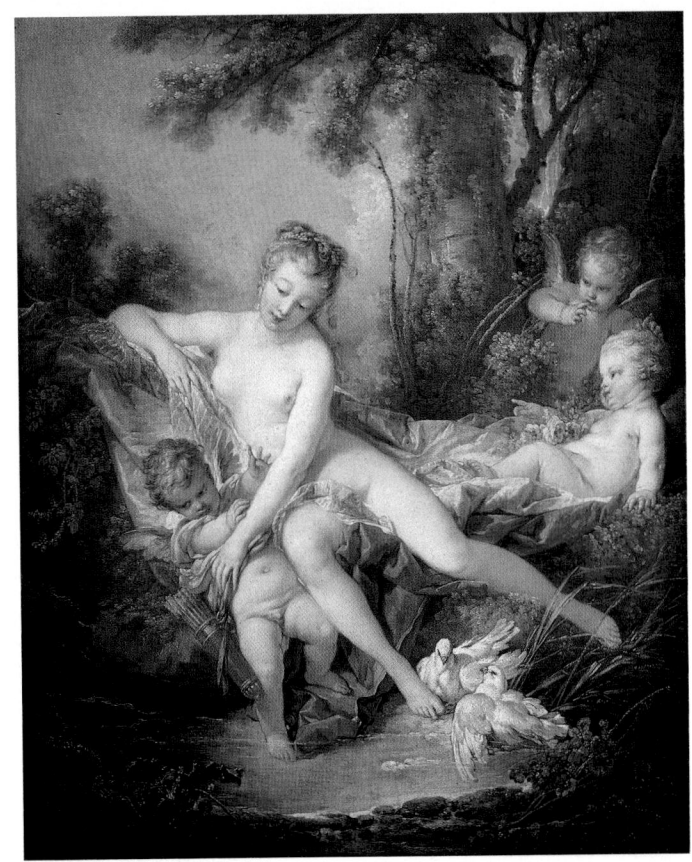

18.6 François Boucher, *Venus Consoling Love,* 1751. Oil on canvas; 3 ft. 6⅛ in. × 2 ft. 9⅜ in. (1.07 × 0.85 m). National Gallery, Washington, D.C. (Chester Dale Collection). It was also during 1751 that Madame de Pompadour, Louis XV's mistress, moved to the north wing of Versailles and lived there until her death. Throughout her tenure at court, Boucher was her favorite artist.

shoes. Presently between roles, this actor is "all dressed up with nowhere to go." The blue-gray sky echoes the figure's mood, as do the sunset-colored clouds. End of day, which is indicated by the sunset, corresponds to the sense that Gilles is at a loss about what to do next. His lonely isolation is accentuated by the four figures around him, who seem engaged in animated conversation.

François Boucher

François Boucher's (1703–1770) "Rubenist" brand of Rococo is evident in the playful *Venus Consoling Love* (fig. **18.6**), which is devoid of Watteau's undercurrent of irony and melancholy. A powder-pink Venus, in a lightly erotic pose, tries to console a pouting, flustered Cupid, whose arrow-filled quiver hangs from his shoulder. Reclining on Venus's couch and watching from the trees are two more Cupids, whose intent gazes draw the viewer toward the central characters. The two white doves—"love birds"—echo the amorous text of this scene. The predominance of pinks, the curly blond heads of the Cupids, and the silky, feathery textures contribute to the cheerful, material richness of Boucher's work.

Jean-Honoré Fragonard

The last significant Rococo painter was Jean-Honoré Fragonard (1732–1806). In *The Swing* (fig. **18.7**), he enlivens nearly the entire picture plane with frilly patterns. The lacy ruffles in the dress of the girl swinging are repeated in the illuminated leaves, the twisting branches, and the scalloped edges of the fluffy clouds.

At the right of the painting, an elderly cleric pushes the swing, while a voyeuristic suitor hides in the bushes and peers under the girl's skirt. His hat and her shoe are sexual references in this context—the former a phallic symbol and the latter a

18.7 Jean-Honoré Fragonard, *The Swing,* 1766. Oil on canvas; 35 × 32 in. (88.9 × 81.3 cm). Wallace Collection, London. *The Swing* was commissioned by the Baron de Saint-Julien, who specified that Fragonard should paint his (the baron's) mistress on the swing, with himself as her observer. Fragonard emphasizes the erotic associations of "swinging" by highlighting the shimmering texture and swirling curves of the dress. Swinging has some of the same connotations today—compare the "swinging sixties."

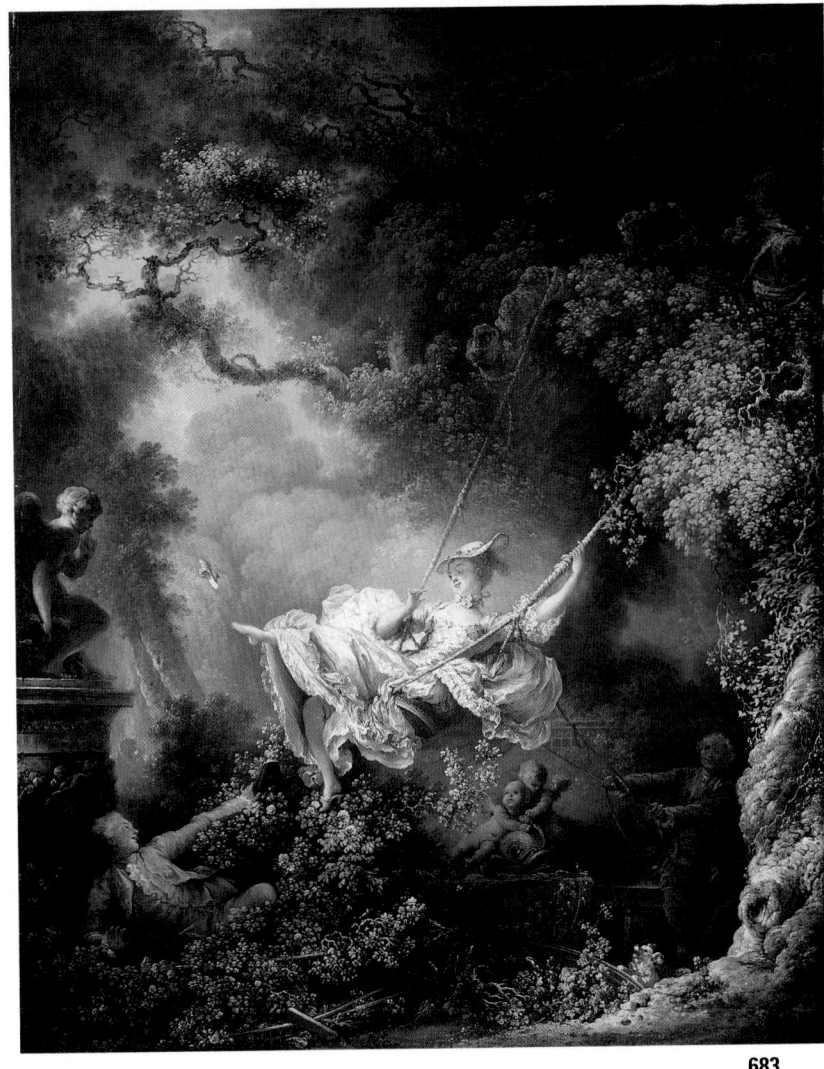

vaginal one. They complement the setting: an enclosed yet open garden, where amorous games are played. The stone statues also deepen the erotic implications of the scene. On the left, Cupid calls for secrecy and silence by putting his finger to his lips. Between the swing and the old man, two additional Cupids cling to a dolphin. Like Watteau, Fragonard uses Classical imagery to provide a serious underpinning of frivolous erotic themes.

Royal Portraiture

Hyacinthe Rigaud A comparison of the late Baroque, large-scale portrait of *Louis XIV* (fig. **18.8**) by the French artist Hyacinthe Rigaud (1659–1743) with two other royal portraits of the later eighteenth century reflects different artistic trends. Rigaud's Louis XIV stands majestically in an elaborate costume of ermine and blue velvet with gold fleurs-de-lis signifying French royalty. Louis's silk stockings show off his shapely legs, while his high-heeled shoes (which he designed himself) compensate for his short stature. He is framed by the folds of a rich red silk curtain and surrounded by the accoutrements of kingship and power—a scepter and sword. The column, with the classicizing relief on its podium, is an echo of Louis himself and associates his personal iconography with the Classical past. It is also an architectural metaphor for Louis's role as the structure and support of France itself. Rigaud's figure is very much a king, not surprisingly the monarch who declared "L'état, c'est moi" ("I am the state"), thus merging his personal identity with that of France.

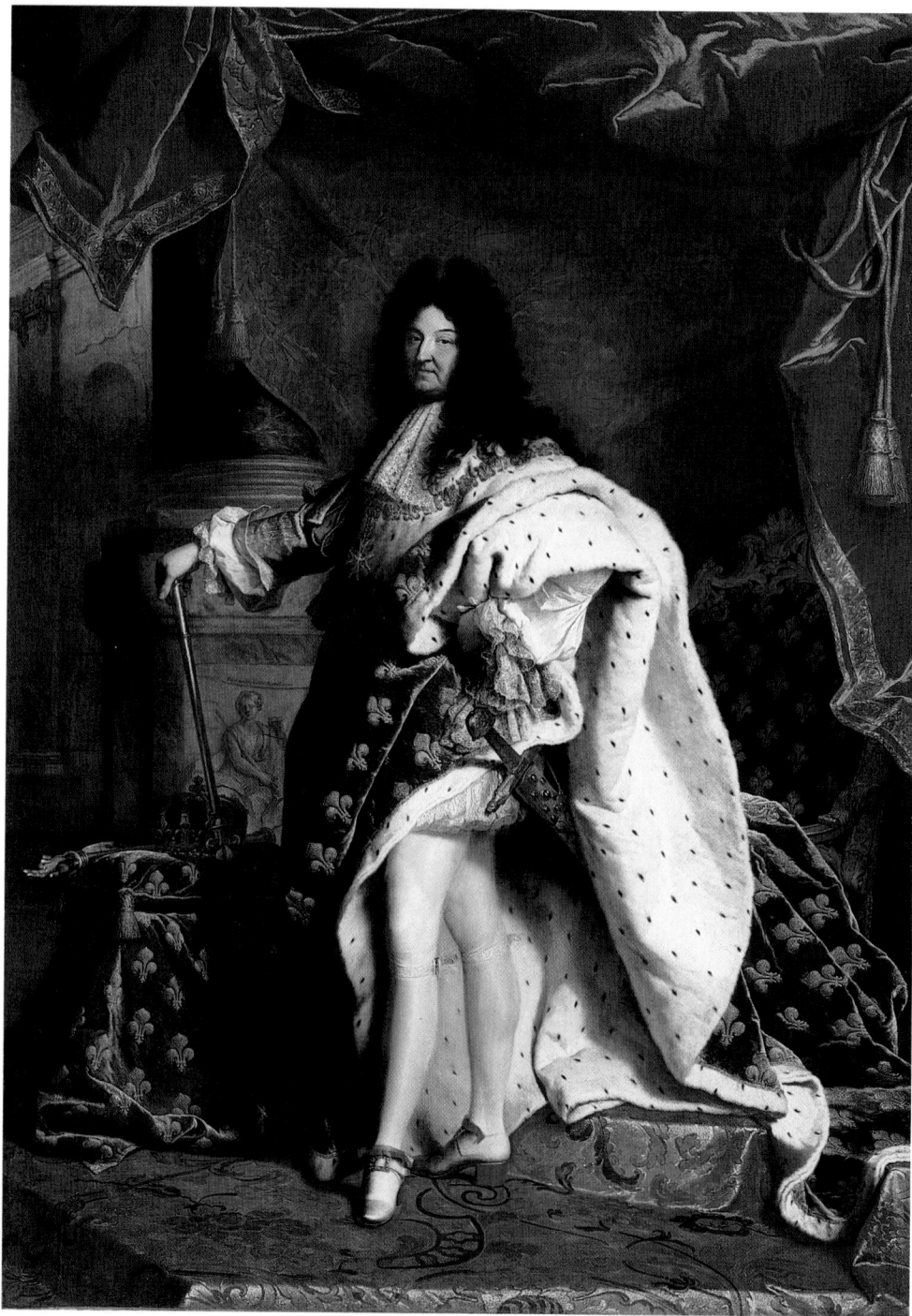

18.8 Hyacinthe Rigaud, *Louis XIV*, 1701. Oil on canvas; 9 ft. 2 in. × 7 ft. 10¾ in. (2.79 × 2.41 m). Louvre, Paris.

18.9 Rosalba Carriera, *Louis XV*, 1721. Pastel on paper; 18½ × 15¾ in. (47.0 × 40.0 cm). Museum of Fine Arts, Boston. Rosalba's father was a government official, her mother worked as a lacemaker, and her grandfather was a painter. She never married and devoted herself to her two sisters, to whom she taught art. Rosalba was enormously successful as a portrait painter to 18th-century European royalty.

Rosalba Carriera Rosalba Carriera (1675–1757) was born in Venice and worked mainly in Italy and France as a portraitist. Her success won her election to the French Academy. In 1721, she painted a portrait of the ten-year-old King Louis XV, son of Louis XIV (fig. **18.9**). By this time, the Sun King had been dead for six years, a regency had been established, and the court had moved to Paris. There, Rosalba's reputation for quick, flattering portraits earned her extensive aristocratic patronage. In the portrait of Louis XV, the shimmering pastel (see box) quality of the costume, with

its prominent gold medal, matches the soft curls of the powdered wig. Compared to the stately portrait of his father, Louis XV seems vapid and devoid of a distinctive personality. This impression is probably a combination of Rosalba's efforts to flatter and Louis XV's own ineffectual character.

Élisabeth Vigée-Lebrun The other major eighteenth-century portrait painter to the aristocracy in France was Élisabeth Vigée-Lebrun (1755–1842). She painted several portraits of Marie Antoinette, the Austrian-born queen of Louis XVI. Like Rosalba Carriera, Vigée-Lebrun befriended monarchs and their families, and benefited from their patronage. In figure **18.10**, Vigée-Lebrun depicts Marie Antoinette wearing an elaborate ruffled silk gown, an ostrich-feathered headdress, and a powdered wig. Her reputation for aloofness is suggested by her gaze, which is directed to the left, away from the viewer. She seems oblivious to the social, political, and economic unrest among her subjects that would erupt the following year, culminating in the French Revolution (see box).

Surrounding the queen are accoutrements of French royalty. A huge column at the left alludes to the state, and the bust of Louis XVI on the ledge at the right is a reminder of his power. Like the queen, he appears aloof, literally elevated and thus of higher status than she. The room itself is filled with signs of wealth—the red velvet chair with a gilded frame, and the vase of roses and jeweled crown on the table.

18.10 Élisabeth Vigée-Lebrun, *Marie Antoinette*, 1778–1779. Oil on canvas; 9 ft. × 6 ft. 4 in. (2.73 × 1.94 m). Kunsthistorisches Museum, Vienna. The large scale of the painting is typical of the portraits of Marie Antoinette and reflects the power of her position as queen of France.

18.11 Thomas Gainsborough, *Mrs. Richard Brinsley Sheridan,* 1785–1787. Oil on canvas; 7 ft. 2½ in. × 5 ft. ½ in. (2.20 × 1.54 m). National Gallery of Art, Washington, D.C. (Andrew W. Mellon Collection). Gainsborough's patrons included the British royalty and aristocracy, but he also painted portraits of his musical and theatrical friends and their families. Mrs. Sheridan was the wife of Richard Brinsley Sheridan, author of the satirical comedies *The Rivals* and *School for Scandal.*

Thomas Gainsborough

Nature and portraiture, which predominated in French Rococo, were also an important aspect of the style in England. Thomas Gainsborough (1727–1788), who was influenced by van Dyck and best known for his full-length portraits, liked to set his figures in landscape. In his *Mrs. Richard Brinsley Sheridan* (fig. **18.11**), for example, the sitter assumes a slightly self-conscious, prim pose and gazes out of the picture. The shiny, silky textures of her dress and the light filtering through the background trees recall the materials and garden settings of French Rococo. Here, however, the amorous frivolity has been subdued. Mrs. Sheridan is at once enclosed by nature and distinct from it. She is sedate, aristocratic, and surrounded by a landscape as apparently controlled as she is.

William Hogarth

A different expression of British Rococo is found in the witty satire of William Hogarth (1697–1764). Influenced in part by Flemish and Dutch genre paintings, he satirized contemporary manners and social conventions. His series of six paintings entitled *Marriage à la Mode* from the 1740s pokes fun at hypocritical commitments to the marriage contract. The second scene of the series (fig. **18.12**) is illustrated here. The husband, a young aristocrat, has returned home exhausted from carousing. An excited dog sniffs the woman's hat still in the husband's pocket, drawing the viewer's attention to his master's sexual exploits. A black mark on the side of the man's neck indicates that he has already contracted syphilis.

18.12 William Hogarth, *Marriage à la Mode II,* c. 1743. Oil on canvas. National Gallery, London.

The wife, meanwhile, seems to have indulged in some impropriety of her own. As she leans back, a fallen chair in the foreground suggests that someone, perhaps her music teacher, has just made a speedy exit. The architecture reflects the Neoclassical Palladian style of eighteenth-century England, but Rococo details fill the interior. The frills on the clothing, for example, echo the French version of the style. The elaborate chandelier and the wall designs are characteristic of Rococo fussiness. On the mantelpiece, the bric-a-brac of chinoiserie reflects the eighteenth-century interest in Far Eastern exotic objects, as well as referring to a frivolous lifestyle. They are contrasted with the august pictures of saints in the next room.

The device of paintings within paintings performs the same function as the stone statues in the Watteau and Fragonard discussed above. Paintings of saints line a wall of the background room, isolated from the living, who ignore them. Cupid, on the other hand, blows the bagpipes, which, as in Bruegel's *Peasant Dance* (see fig. 16.9), signify lust.

The dangers of sexual excess are underscored in the Hogarth by placing Cupid among ruins, foreshadowing the inevitable ruin of the marriage. As in French Rococo, Hogarth uses traditional figures from Classical antiquity for the purpose of playful, but telling, satirical warnings. Also like French Rococo, which typically represents aristocrats, Hogarth's pictures deal with identifiable social and professional classes. But they lack the air of theatrical fantasy that pervades French examples of the style.

Hogarth's satirical imagery included comments on taste and fraud in the art world. In 1761, he produced the etching *Time Smoking a Picture* (fig. **18.13**), in which the motif of a picture within a picture plays a central role. An aged Father Time literally "smokes" a picture in order to make it seem older than it is. He sits on a broken plaster cast, which denotes Hogarth's preference for modern art rather than for old-master paintings (see caption). Time's scythe cuts through the canvas, the top frame of which is inscribed in Greek: "Time is not a clever craftsman, for he makes everything more obscure." At the left, the jar marked "Varnish" refers to the technique of varnishing pictures to age them artificially. The purpose of Time's activity is to increase the value of the painting, as is indicated by the phrase at the lower right: "As Statues moulder into Worth." Hogarth depicts Time as a fraudulent art dealer, more interested in profit than in paintings and willing to destroy art in order to make money.

18.13 William Hogarth, *Time Smoking a Picture*, 1761. Etching and mezzotint; 8 × 6¹¹⁄₁₆ in. (20.3 × 17.3 cm). Guildhall Art Gallery, London. Hogarth's father was a teacher, from whom his son learned Latin and Greek. He also opened a Latin-speaking coffeehouse that went bankrupt. As a result, he spent three years in debtor's prison until Parliament passed an act freeing all debtors. This experience contributed to the artist's fierce opposition to social injustice and hypocrisy. In 1752, Hogarth published his views on art in *Analysis of Beauty*, which, like the etching, states his anti-Academic position. In the couplet at the bottom of the print, he urges people to look at nature and to themselves, rather than to the plaster casts of traditional art schools, for "what to feel."

Rococo Architecture

Several divergent architectural trends can be identified in the eighteenth century, but the most original new style was Rococo. In architecture, as in painting, Rococo emerged from late Baroque Classicism, which it both elaborated and refined. In northern Italy and central Europe, Baroque had been the preferred style for palaces and hunting lodges. Particularly in the countries along the Danube—Austria, Bohemia, and southern Germany—a distinct regional style developed, which was a blend of Italian Baroque and French Rococo.

Balthasar Neumann

A leading exponent of this movement was the German architect Balthasar Neumann (1687–1753). He created one of the most ornate Rococo buildings, the Residenz (fig. **18.14**), or Episcopal Palace, in Würzburg, Bavaria, in southwest Germany. Begun in 1719 and completed in 1753, the Residenz was an enormous edifice built for the hereditary prince-bishops of the Schönborn family. It was designed around a large entrance court, and the side wings, reminiscent of the plan at Versailles, had interior courtyards of their own. Although elements of the Classical Orders remain in the columns and pilasters on the façade of the Würzburg Residenz, the spaces in the pediments are largely filled with elaborate curvilinear designs.

The main feature of the interior of the Residenz is its magnificent staircase, which ascends to a first landing. It then divides, reverses direction, and rises to the upper level (fig. **18.15**). The hall containing the staircase is the largest room—nearly 100 by 60 feet (30.48 by 18.29 meters) —in the Residenz. The banister and balustrade are decorated with statues and stone *kraters,* while Cupids lounge on the entablatures over the doorways. Each door is framed by large, triple Corinthian pilasters, which support another entablature that continues around the entire room. The

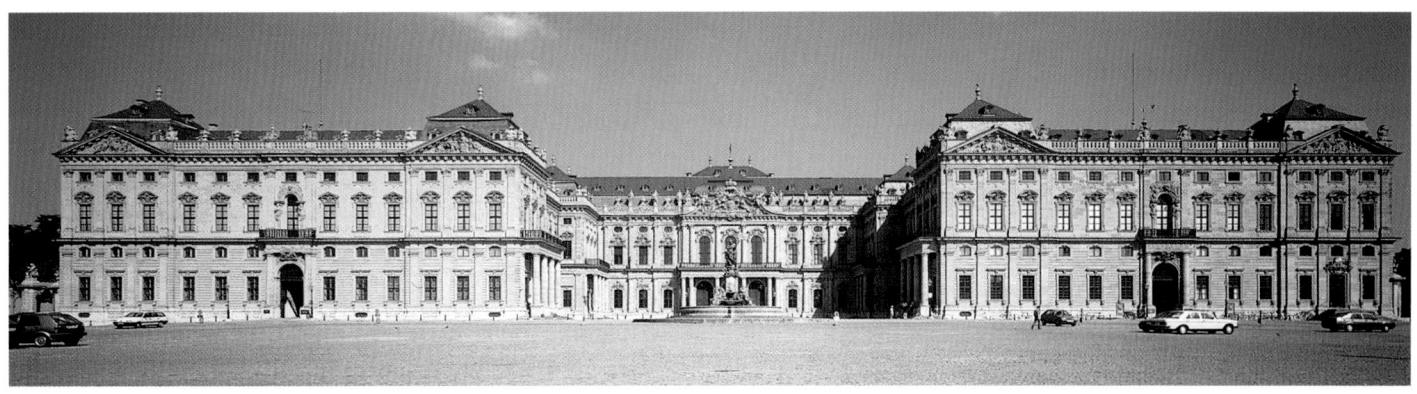

18.14 Balthasar Neumann, the Residenz, Würzburg, Germany, 1719–1753.

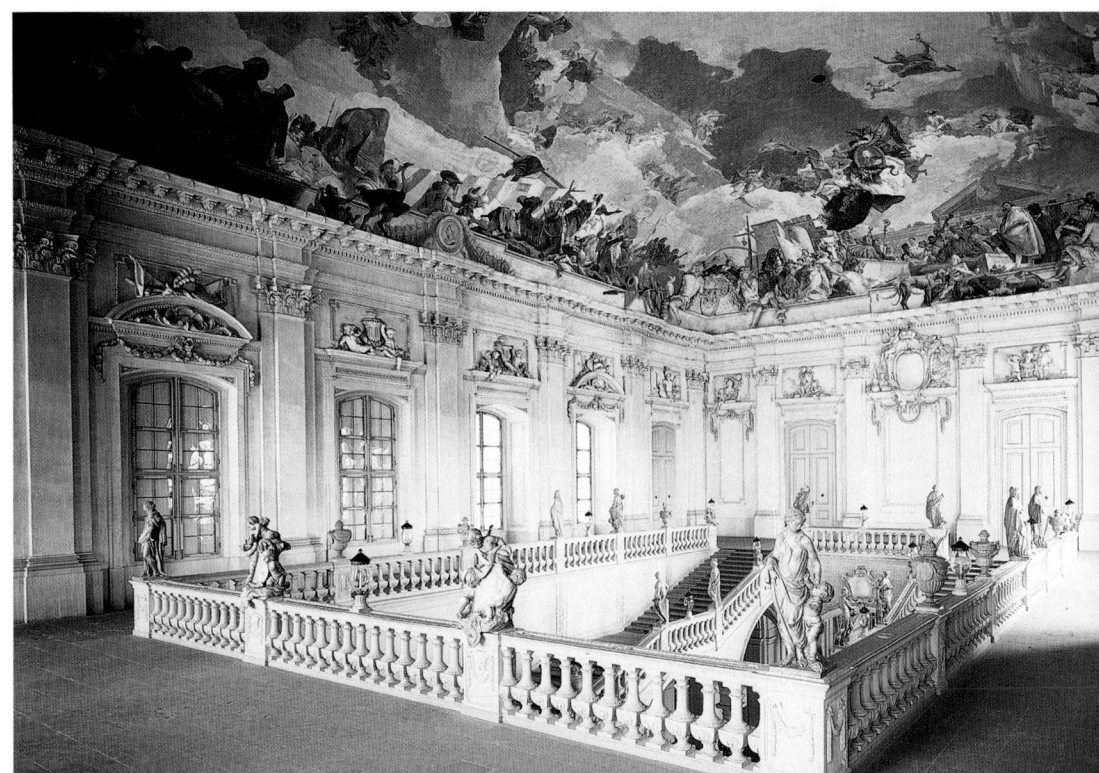

18.15 Staircase of the Residenz showing the ceiling fresco of Giovanni Battista Tiepolo, Würzburg, Germany, 1752–1753.

ceiling fresco was painted by the Italian Rococo artist Giovanni Battista Tiepolo (1696–1770) and is believed to be the largest in the world. Its portrayal of Apollo and the prince-bishop, the seasons, the zodiac, and the continents of Africa, America, Asia, and Europe is a grand statement of the far-reaching influence of the Schönborns.

The Kaisersaal (Imperial Room) of the Residenz is a two-story octagonal chamber. Painted in white, gold, and pastel colors, it rises to a vaulted oval ceiling pierced by oval windows. The frescoes are by Tiepolo. Engaged Corinthian columns with gilt capitals and bases and the entablature above them are made of **stucco** (fine plaster) painted to resemble marble. The edges of the windows and other architectural features are traced with delicate, thin **moldings,** like designs made of spun sugar. The white surfaces of the vault are covered with ornament. Most striking of all are the giant, illusionistic gilded curtains that are drawn apart by a pair of white Cupids to reveal the *Investiture of Bishop Harold* (fig. **18.16**). Other *trompe l'oeil* devices blur the boundary between the actual ceiling and the exterior space. A dog sits on top of a column, and other figures appear to be half in and half out of the picture frame. Such playful illusions, combined with ornate decoration, are characteristic of Rococo painted spaces.

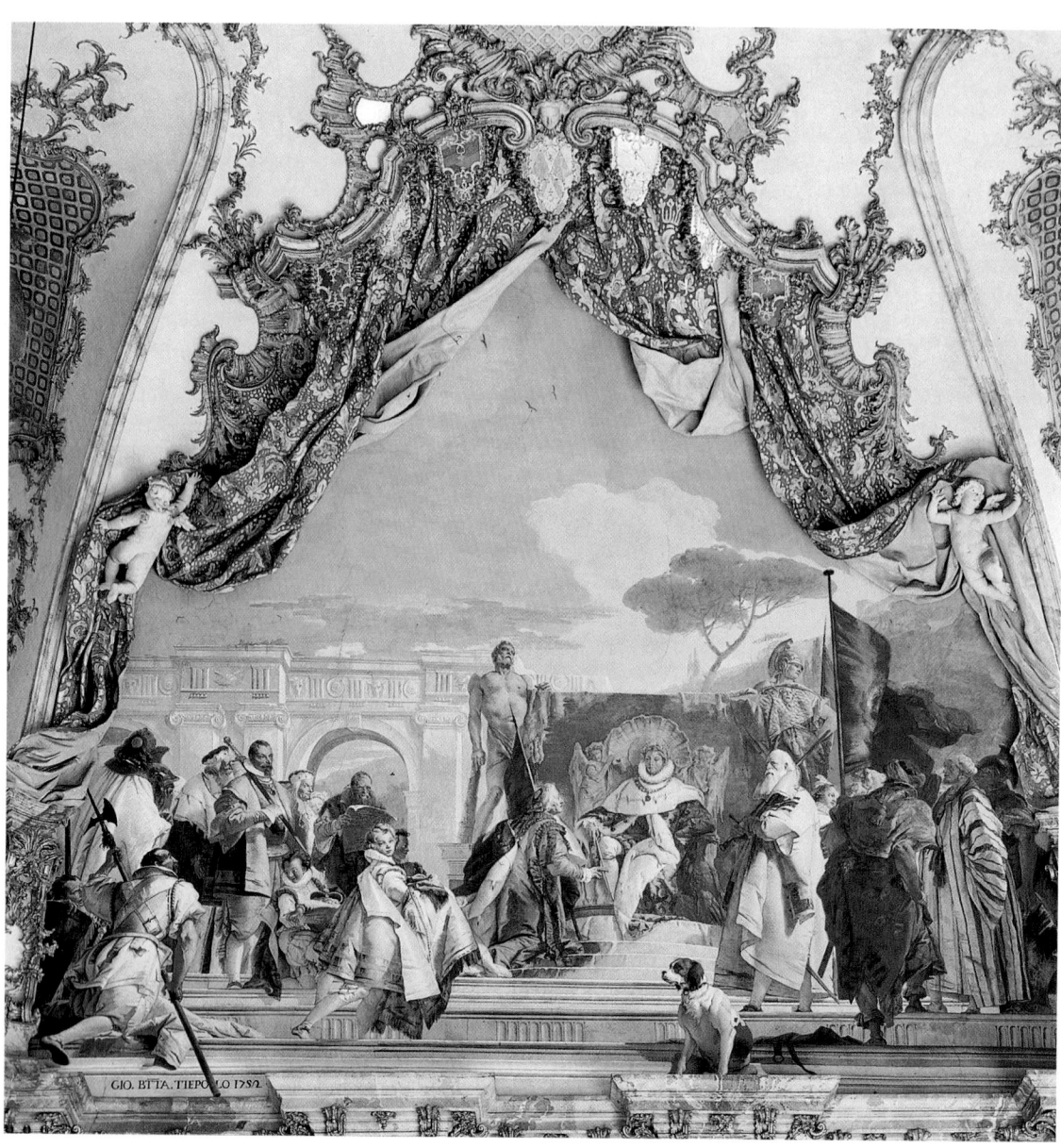

18.16 Giovanni Battista Tiepolo, *Investiture of Bishop Harold*, detail of the ceiling frescoes in the Kaisersaal, the Residenz, Würzburg, Germany, 1751–1752. Born and trained in Venice, by the 1730s Tiepolo had established himself throughout northern Italy as a master of monumental fresco decoration. He was known for his technical skill, command of perspective, and fondness for illusionistic architecture. He spent three years in Würzburg decorating the Residenz, and in 1762 he was invited to Spain by Charles II to work on the royal palace.

Matthäus Daniel Pöppelmann

One of the best examples of German Rococo architecture is the Zwinger, built in Dresden in 1711–1722 (fig. **18.17**). The Zwinger (German for "enclosure," or "courtyard") is a series of galleries and pavilions commissioned by Augustus the Strong, king of Poland and elector of Saxony. Arranged around an enclosed courtyard, it serves as an open-air theater for tournaments and other spectacles. The section illustrated here is the Wallpavillon, one of the pavilions situated at the corners of the courtyard, to which it is connected by glass-covered arcades. All of these structures were designed to provide shelter for the spectators. The architect, Matthäus Daniel Pöppelmann (1662–1736), claimed that his design was based on Vitruvian proportions. He even included elements that are Classical in origin, such as the statue of Hercules with the world on his shoulders—a reference to Augustus—at the top, and satyrs emerging from the bunched pilasters. But the Classical elements are freely rearranged so that the overall intricate effect is far from Classical in spirit. So elaborate, in fact, is the surface decoration that the wall seems to dissolve into ornate detail.

18.17 Matthäus Daniel Pöppelmann, Wallpavillon, the Zwinger, Dresden, Germany, 1711–1722. Pöppelmann was trained as a sculptor but became court architect to Augustus the Strong, elector of Saxony and king of Poland. Augustus sent Pöppelmann to Rome, Vienna, Paris, and Versailles (the capitals of Rococo taste) to gather ideas for his palace in Dresden. Finally, only the Zwinger was built. It was gutted during World War II but has been accurately reconstructed.

Dominikus Zimmermann

Rococo church architecture is illustrated by Dominikus Zimmermann's Wieskirche, or "Church of the Meadow" (figs. **18.18** and **18.19**). It is a pilgrimage church near Oberammergau in the foothills of the Bavarian Alps. From the plan, it is clear that Zimmermann was influenced by Borromini's elliptical architectural shapes. The exterior is relatively plain, but the interior is typical of German Rococo church interiors, which were designed to give visitors a sense of spiritual loftiness and a glimpse of heaven. The nave is mainly white, and the decoration (including the elaborate pulpit at the left) is largely gold, though there are accents of pink throughout. As one approaches the **chancel**, the colors deepen. Gilt and brown predominate, but the columns flanking the altar are of pink marble, whereas the statues and other decorations are white. The decoration of the ceiling is entirely Rococo in that it merges the painted surfaces with the architecture through ornate illusionism.

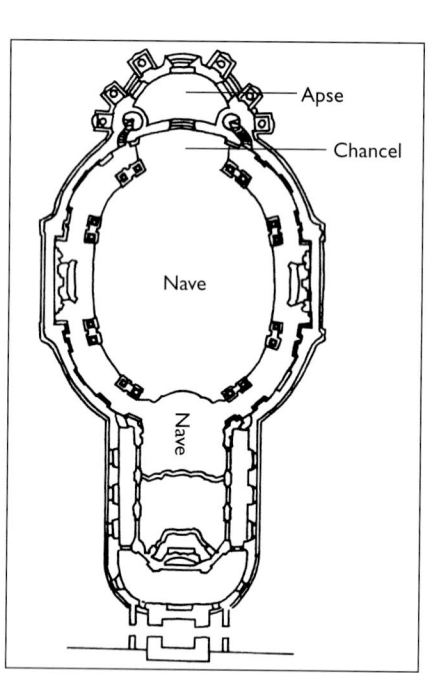

18.18 Plan of the Wieskirche.

18.19 Dominikus Zimmermann, Wieskirche, Bavaria, 1745–1754. The nave is a Rococo development of Borromini's oval church plans in Baroque Rome. The Wieskirche's longitudinal axis is emphasized by the deep, oblong chancel. Eight freestanding pairs of columns with shadow edges (square corners or ridges that accentuate light and shadow) support the ceiling. The ambulatory, which continues the side aisles, lies outside the columns.

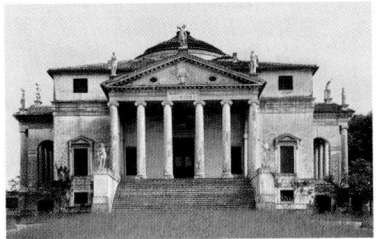

See figure 15.20. Andrea Palladio, Villa Rotonda, begun 1567–1569.

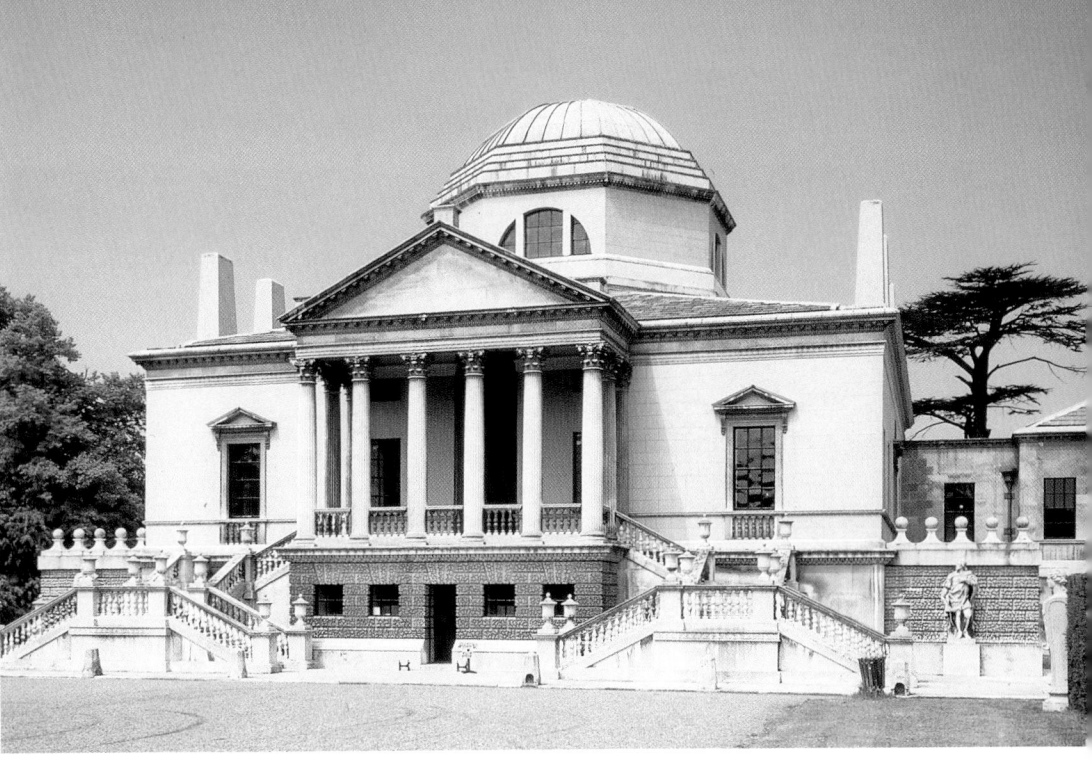

18.20 Richard Boyle (Earl of Burlington), Chiswick House, near London, begun 1725. Lord Burlington was one of a powerful coterie of Whigs and supporters of the House of Hanover (George I and his family). He took a grand tour of Europe in 1714 to 1715 and returned to Italy in 1719 to revisit Palladio's buildings. On his return to England, he became an accomplished architect in the tradition of Palladio.

Architectural Revivals

Palladian Style: Lord Burlington and Robert Adam

In England, the Baroque style—and especially Rococo, with all its frills—was rejected in the eighteenth century in favor of renewed interest in the ordered, classicizing appearance of Palladian architecture. Palladio's *Four Books of Architecture* (see Chapter 15) was published in an English translation in 1715 and exerted widespread influence. An early example of English Palladian style is Chiswick House (figs. **18.20** and **18.21**) on the southwestern outskirts of London, which Lord Burlington (1695–1753) began in 1725 as a library and place of entertainment.

Burlington based Chiswick House loosely on Palladio's Villa Rotonda (see fig. 15.20), although it is on a smaller scale and there are some significant differences in the plans (figs. 18.21 and 15.19). Unlike the Villa Rotonda, Chiswick House did not need four porticos. Instead, it has

Central octagon

Portico

18.21 Plan of Chiswick House.

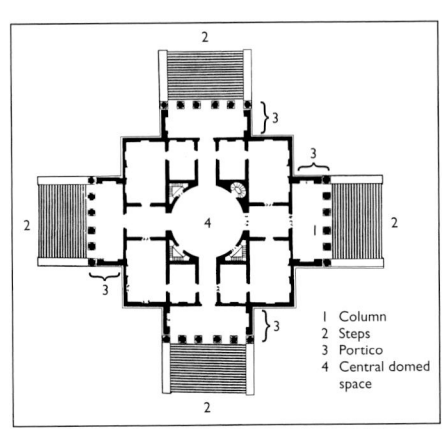

See figure 15.19. Plan of the Villa Rotonda.

1 Column
2 Steps
3 Portico
4 Central domed space

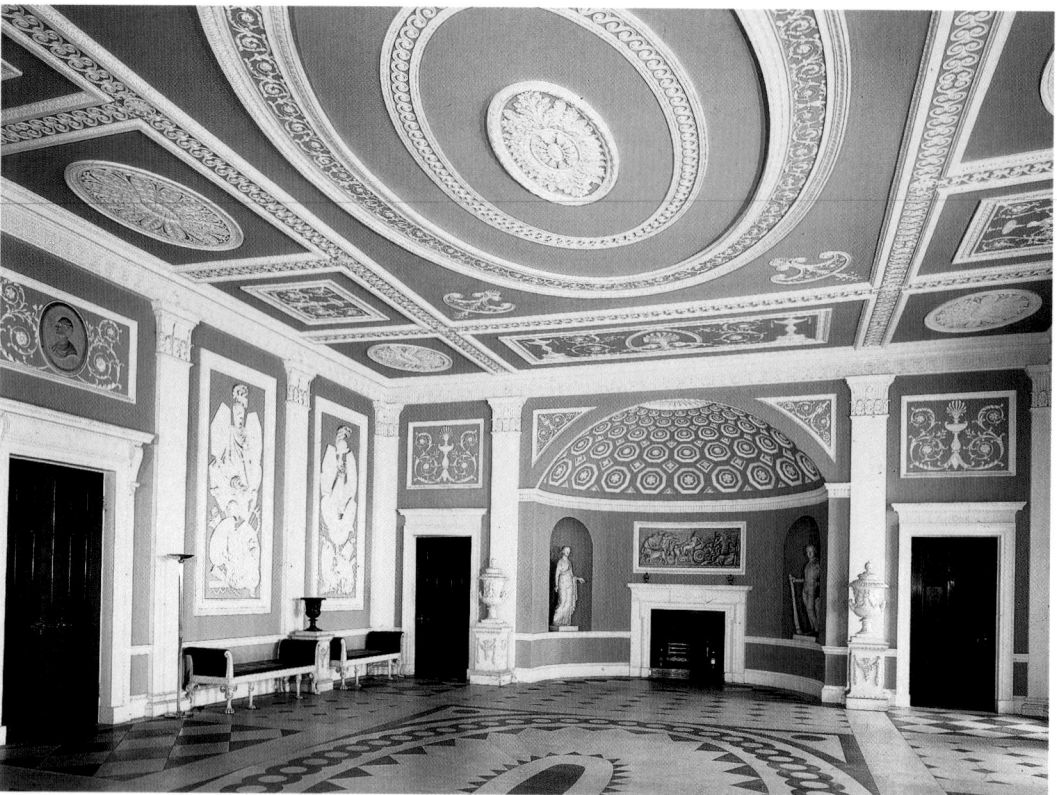

18.22 Robert Adam, fireplace niche, Osterley Park House, Middlesex, England, begun 1761. The ornamentation—including pilasters, entablature, moldings, relief over the fireplace, coffered semidome, and sculptures in the smaller niches—was all based on Classical precedents.

one, which is approached by lateral double staircases on each side. The arrangement of the rooms around a central octagon rather than a circle is also different, and the columns are Corinthian rather than Ionic, as in the Villa Rotonda. There are no gable sculptures, and the roof is decorated on each side by a row of obelisks, which function as chimney flues. The dome is shallower than that of the Villa Rotonda and rests on an octagonal drum, allowing more light into the central chamber. Despite such differences, however, the proportions and spirit of Chiswick are unmistakably Palladian.

Another leader of the Classical revival in Britain, particularly in the field of interior design, was Robert Adam (1728–1792). Interest in Classical antiquity had been heightened by the excavations at Herculaneum and Pompeii. Discoveries from these sites provided the first concrete examples of imperial Roman domestic architecture since the eruption of Mount Vesuvius in A.D. 79. Publications on Classical archaeology followed. Not only was Adam influenced by these, but he was himself an enthusiastic amateur archaeologist. He had traveled to Rome and made drawings of the ruins, which informed much of his own work. In a fireplace niche in the entrance hall of Osterley Park House near London (fig. **18.22**), which Adam began to remodel in 1761, he re-created the atmosphere of a Roman villa. Although there is still an element of Rococo delicacy, especially in the pastel color schemes of certain rooms, it is now a much more austere setting. The principal characteristics of this later style are axial symmetry and geometrical regularity, both of which reflect the Classical revival.

Gothic Revival: Horace Walpole

Contemporary with German Rococo architecture and the Palladian movement was a renewed interest in Gothic style. The revival of Gothic—which never completely died out in England—began around 1750. It must be seen in relation to the late eighteenth-century Romantic movement, which is discussed in Chapter 20.

In its most general form, Romanticism rejected established beliefs, styles, and tastes—particularly the Classical ideals of clarity and perfection of form. It fostered the dominance of imagination over reason. At the same time, however, to the extent that it evoked the Classical past, Romanticism shared certain aspects of the Neoclassical style.

One of the earliest non-Classical manifestations of Romanticism in England was the use (from the 1740s) of imitation Gothic ruins and other medievally inspired objects in garden design. This was followed by the more radical activity of Horace Walpole (1717–1797), a prominent figure in politics and the arts. Walpole and a group of friends spent over twenty-five years enlarging and "gothicizing" a small villa in Twickenham, just outside London. The result, renamed Strawberry Hill (fig. **18.23**), was widely admired at the time. It is a large, sprawling structure, without the the soaring grandeur of traditional Gothic buildings. Nevertheless, Strawberry Hill is an interesting combination of Gothic features, including battlements, buttresses, and tracery. There are turrets on the outside and vaulting in the interior. Strawberry Hill also reflected the serious nostalgia with which the British viewed the Middle Ages, associated with a lost sense of community.

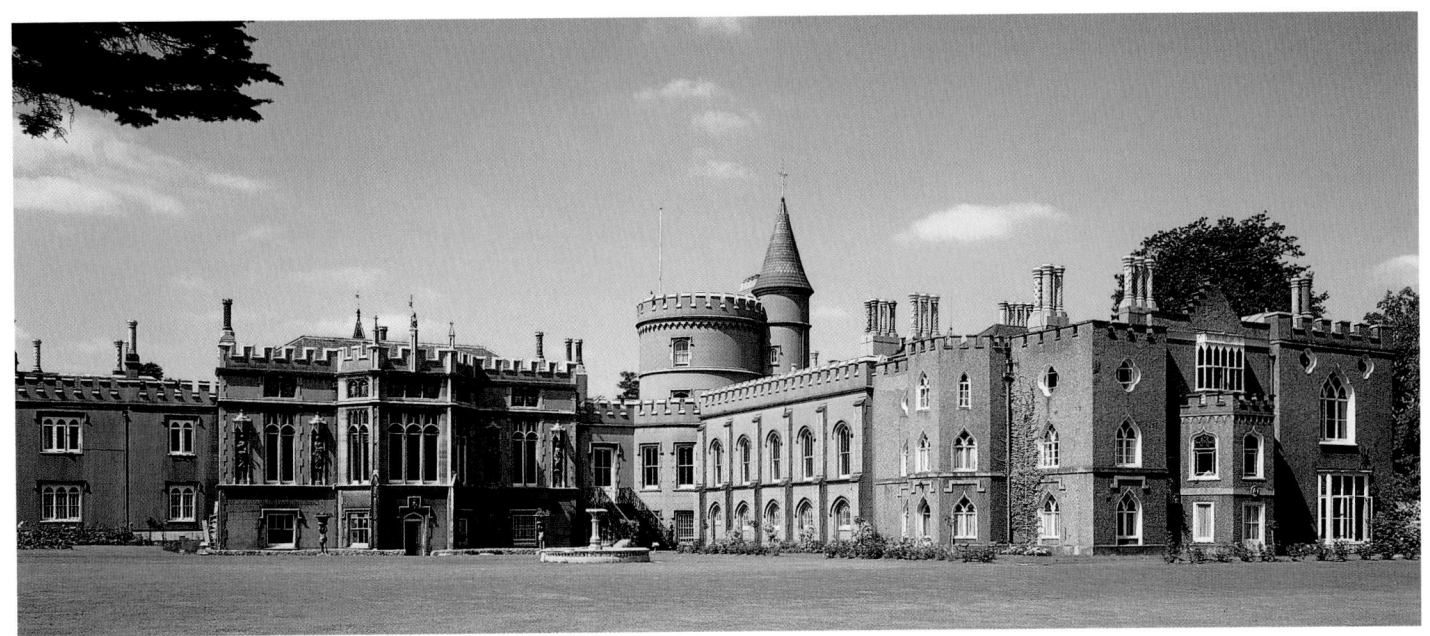

18.23 Horace Walpole, Strawberry Hill, Twickenham, near London, 1749–1777. Like his father, Sir Robert Walpole, a Whig prime minister of England, Horace Walpole also sat in Parliament as a Whig. His novel *The Castle of Otranto* started a fashion for Gothic tales of terror. Walpole's prolific correspondence is a valuable record of 18th-century manners and tastes, and, through it, he elevated letter writing to an art form.

European Painting

Bourgeois Realism: Jean-Baptiste-Siméon Chardin

The *encyclopédiste* Diderot praised Jean-Baptiste-Siméon Chardin (1699–1779) as a realist painter. In contrast to the fashionable, aristocratic elegance of his Rococo contemporaries, Chardin's subjects, especially still life and genre, are influenced by Netherlandish painting.

La Fontaine (fig. **18.24**) illustrates the artist's interest in household work. Simple tasks are raised above the level of the ordinary by the conviction and intense concentration of the figures. Work, rather than play—as in Rococo—is Chardin's subject. In the very application of paint to canvas, Chardin conveys his own focus and intensity. The large copper vat at the center of *La Fontaine,* for example, is painted with thick, almost **impasto,** brushstrokes, creating the impression of a shiny metal surface. The wooden bucket, the tiled floor, and the draperies hanging at the left reflect Chardin's attention to the rustic textures of country kitchens. The woman in the foreground carries out her chores with determination and wears plain household attire, in contrast to Rococo silks and laces. In the background, another woman talks to a little girl, as if to instill in her the "bourgeois" values of work. These figures gaze neither at one another nor at the observer. Unlike the flirtatious character and fanciful settings of Rococo, in which time is spent primarily in leisure pursuits, Chardin's scenes extol the moral virtues of work and study in everyday surroundings.

18.24 Jean-Baptiste-Siméon Chardin, *La Fontaine,* first exhibited 1733. Oil on canvas; 15 × 16½ in. (38.1 × 41.9 cm). National Museum, Stockholm.

18.25 Jean-Baptiste-Siméon Chardin, *Pipe and Jug,* undated. Oil on canvas; 12½ × 16½ in. (31.7 × 41.9 cm). Louvre, Paris.

Chardin's still lifes, such as *Pipe and Jug* (fig. **18.25**), eliminate human figures, while assuring the observer of their presence. Chardin also endows his objects with distinctive shapes and textures. The objects seem to have been arranged by an absent person who might return at any moment. The box is a sturdy container, solid and reliable like the woman in *La Fontaine.* It seems as if it has just been opened and the pipe casually propped against it until its owner comes back. A prominent white jug, illuminated from the window at the left, presides over the smaller objects. It dominates the space—like a woman with her hand on her hip. The thick impasto of the jug contrasts with the shiny surfaces of the smaller, more delicate, and less imposing objects. As in *La Fontaine,* Chardin's focused attention and the visible care lavished on the application of the paint herald the nineteenth-century still lifes of Manet and Cézanne (see Chapters 22 and 23).

Neoclassicism: Angelica Kauffmann

Angelica Kauffmann (1741–1807) was a child prodigy who became one of the most important and prolific Neoclassical painters. Her *Cornelia Pointing to Her Children as Her Treasures* (fig. **18.26**) illustrates the late eighteenth-century interest in Classical form and content as well as the degree to which different styles can overlap each other within the same period. Although the content is Classical, the mood is Romantic.

Cornelia was the daughter of the Republican-minded Roman leader Scipio Africanus. Her husband, Tiberius Sempronius Gracchus, was a distinguished Roman official known for his fairness. In this painting, Kauffmann depicts an event that took place in second-century-B.C. Rome, when Cornelia received a visit from a friend. Her friend is shown with an open jewelry box on her lap, displaying a necklace. When she asks to see Cornelia's jewels, her hostess points to her sons—the Gracchi (sons of Gracchus). They, in turn, grew up to be respected politicians, a reflection of their honorable parents. In the first century A.D., the Gracchi became the subject of a well-known biography by the moral philosopher Plutarch, according to whom the Romans honored Cornelia with a statue inscribed "Cornelia, mother of the Gracchi."

Kauffmann's painting is Neoclassical in subject, the figures wear costumes inspired by ancient Rome, and the profiles are reminiscent of Classical busts. But the pronounced gestures and the textured lighting that leaves areas hidden in shadow have a Romantic flavor. At the same time, such details as the jewels and the way they are handled reveal a taste for Rococo fussiness.

18.26 Angelica Kauffmann, *Cornelia Pointing to Her Children as Her Treasures,* 1785. Oil on canvas; 80 × 50 in. (203.2 × 127.0 cm). Virginia Museum of Fine Arts, Richmond. The Adolph D. and Wilkins C. Williams Fund. Kauffmann was born in Switzerland and studied art in Italy. Although a member of the Accademia di San Luca in Rome from 1765, as a woman she was barred from figure drawing. She also worked in England, where she was influenced by Reynolds, and became a founding member of the Royal Academy of Art. She married a man who pretended to be a Swedish count but turned out to be a bigamist. In 1781, she married a Venetian artist and returned to Italy, where her career continued to prosper.

American Painting

John Singleton Copley

In North America (see map), artists of the late eighteenth century were affected by European styles. John Singleton Copley (1738–1815) was a leading painter of the Colonial period. He did not sympathize with the American Revolution and in 1775 emigrated to England, where, under the influence of European Rococo, his work became more ornate.

Before his departure, Copley painted a portrait of Paul Revere (fig. **18.27**), which is typical of his earlier, more realist style. Despite the apparent simplicity of the picture, however, there are elements of Baroque and Rococo. The figure looks directly out of the picture, inviting the viewer into his space, as Baroque figures do. The way in which the sharply focused, illuminated figure is set against a dark background is reminiscent of Baroque portraiture and the tenebrism of Caravaggio. Likewise, the attention to surface shine (the silver teapot and highly polished tabletop with engraving tools) occurs frequently in both Baroque and Rococo. In contrast to those styles, however—and particularly to the latter—Copley's Paul Revere is not idealized; he wears a simple shirt and a plain vest. His solid, squarish bulk is emphasized, and the weight of his head is indicated by his stern expression and the thumb pushing up against his jaw.

18.27 John Singleton Copley, *Paul Revere*, c. 1768–1770. Oil on canvas; 35 × 28½ in. (88.9 × 72.3 cm). Courtesy, Museum of Fine Arts, Boston (Gift of Joseph W., William B., and Edward H. R. Revere). Copley grew up in Boston, the son of Irish emigrants. He was trained by his stepfather, an engraver of mezzotint portraits, and then became a portrait painter.

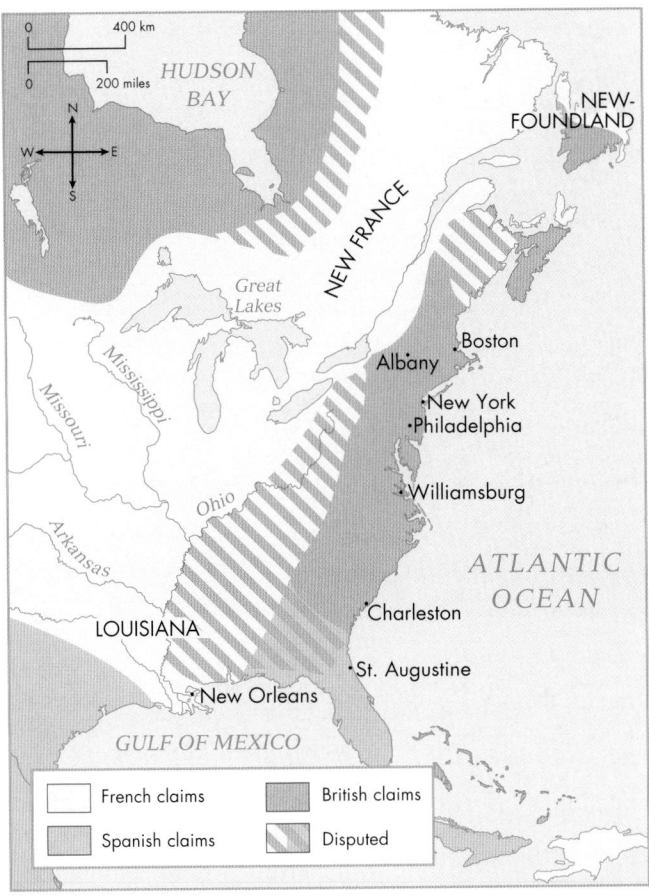

North American settlements in the 18th century.

Benjamin West

Benjamin West (1738–1820), another important late-eighteenth-century American artist, came from a Pennsylvania Quaker family and began painting at the age of six. Like Copley, West settled in England, where he became known for his pictures of Classical and historical subjects. In 1772, he was appointed history painter to King George III and was president of the Royal Academy from 1792 to 1805 and from 1807 to 1820. Many young American artists visiting London, including Copley, trained at his studio.

In the *Death of General Wolfe* (fig. **18.28**), West caused consternation among conservatives by his choice of contemporary, rather than Neoclassical, dress. King George III was not alone in feeling that modern dress was vulgar. It was generally thought that West's figures should have worn togas so that the picture would convey a universal message. But despite such criticism, the work was enormously popular. Its nostalgic appeal to the past became characteristic of nineteenth-century Romanticism. Although West rejected Classical costume, his training in the Classical tradition is evident. The American Indian in the foreground assumes the traditional pose of mourning. At the same time, however, the use of light and the melodramatic gestures are reminiscent of the Baroque style.

In eighteenth-century America, as in Europe, different trends in artistic style persisted alongside the Palladian movement, the Gothic Revival, and the beginnings of Romantic and Realist developments. By the end of the eighteenth century, Rococo was a style of the past. The Neoclassical, Romantic, and Realist movements would at various times emerge to dominate nineteenth-century taste.

18.28 Benjamin West, *Death of General Wolfe*, c. 1770. Oil on canvas; 4 ft. 11½ in. × 7 ft. ¼ in. (1.51 × 2.13 m). National Gallery of Canada, Ottawa (Gift of the 2nd Duke of Westminster, 1918). James Wolfe, the subject of this painting, was the young general who led the British troops to victory over a much larger French force in Quebec in 1759. His success obliged France to concede Canada to England. At the decisive moment of battle, Wolfe was wounded and died in the arms of his officers.

Style/Period	Works of Art	Cultural/Historical Developments

1700

ROCOCO AND THE 18TH CENTURY 1700–1740

Watteau, Gilles

Rigaud, *Louis XIV* (**18.8**)
Pöppelmann, the Zwinger (**18.17**), Dresden
Watteau, *Pilgrimage to Cythera* (**18.4**)
Watteau, *Gilles* (**18.5**)
Neumann, Residenz (**18.14**), Würzburg
Boyle, Chiswick House (**18.20**), near London
Chardin, *La Fontaine* (**18.24**)
Chardin, *Pipe and Jug* (**18.25**)

Chardin, Pipe and Jug

Peter the Great founds Saint Petersburg (1703)
Union of England and Scotland as Great Britain (1707)
Alexander Pope, *Rape of the Lock* (1712)
Death of Louis XIV of France (1715)
Daniel Defoe, *Robinson Crusoe* (1719)
Spain occupies Texas (1720–1722)
South Sea Bubble (English speculative craze) bursts (1720)
Johann Sebastian Bach, Brandenburg Concertos (1721)
Establishment of cabinet government in England; Robert Walpole first prime minister (1721)
Regular postal service established between London and New York (1721)
Jonathan Swift, *Gulliver's Travels* (1726)
John Gay, *The Beggar's Opera* (1728)
Methodist movement founded by John and Charles Wesley (1730)
Discovery of Herculaneum and Pompeii (1738–1748)
David Hume, *A Treatise of Human Nature* (1739)

1740

1740–1760

Hôtel de Soubise

Hôtel de Soubise (**18.2**), Paris
Hogarth, *Marriage à la Mode II* (**18.12**)
Zimmermann, Wieskirche (**18.19**), Bavaria
Walpole, Strawberry Hill (**18.23**), Twickenham
Boucher, *Venus Consoling Love* (**18.6**)
Carriera, *Louis XV* (**18.9**)
Tiepolo, Residenz frescoes (**18.15–18.16**)

Hogarth, Marriage à la Mode II

George Frederick Handel, *Messiah* (1741)

Benjamin Franklin invents the lightning conductor (1752)
Samuel Johnson begins *Dictionary of the English Language* (1755)
Voltaire, *Candide* (1759)

1760

1760–1770

Copley, Paul Revere

Adam, Osterley Park House (**18.22**), Middlesex
Hogarth, *Time Smoking a Picture* (**18.13**)
Chambers, *Pagoda* (**18.1**), Kew Gardens
Fragonard, *The Swing* (**18.7**)
Wright, *An Experiment on a Bird in the Air Pump* (**18.3**)
Copley, *Paul Revere* (**18.27**)
West, *Death of General Wolfe* (**18.28**)

Walpole, Strawberry Hill

Jean-Jacques Rousseau, *Social Contract* (1762)
Spain cedes Florida to England (1763)
England defeats France at the Battle of Quebec and gains control of Canada (1763)
Wolfgang Amadeus Mozart writes his first symphony (1764)
Johann Winckelmann, *The History of Ancient Art* (1764)
James Watt invents the steam engine (1769)
Captain James Cook lands at Botany Bay, Australia (1770)

Boyle, Chiswick House

1770

1770–1800

Vigée-Lebrun, Marie Antoinette

Vigée-Lebrun, *Marie Antoinette* (**18.10**)
Kauffmann, *Cornelia Pointing to Her Children as Her Treasures* (**18.26**)
Gainsborough, *Mrs. Richard Brinsley Sheridan* (**18.11**)

Denis Diderot completes his encyclopedia (1772)
Boston Tea Party in protest against tea duty (1773)
American Declaration of Independence (1776)
Adam Smith, *Wealth of Nations* (1776)
Lavoisier proves that air is composed mainly of oxygen and nitrogen (1777)
Richard Brinsley Sheridan, *The School for Scandal* (1777)
Immanuel Kant, *Critique of Pure Reason* (1781)
Beginning of the French Revolution (1789)
William Blake, *Songs of Innocence* (1789)
Execution of Louis XVI and Marie Antoinette (1793)
Eli Whitney invents the cotton gin (1793)
Edward Jenner introduces vaccination against smallpox (1796)
Napoleon Bonaparte appointed first consul of France (1799)

Kauffmann, Cornelia Pointing to Her Children as Her Treasures

1800

CHAPTER PREVIEWS

NEOCLASSICISM: THE LATE 18th AND EARLY 19th CENTURIES

Revolutionary fervor in France
Napoleon becomes emperor of France (1804)
 Imperial patronage: Arc de Triomphe; Vendôme column
Battle of Waterloo (1815)
Painters in France: David; Benoist; Ingres
Sculptors in France: Canova; Houdon
United States Constitution (1787)
American artists: Trumbull; Greenough
 Thomas Jefferson (architect and statesman): Third U.S. president
 Federal style: Richmond, Virginia, Capitol building; Monticello;
 University of Virginia

ROMANTICISM: THE LATE 18th AND EARLY 19th CENTURIES

Music and poetry; architectural revival styles
Burke on the Sublime (1757)
Artists
 England: Blake; Constable; Turner
 France: Rude; Géricault; Delacroix
 Germany: Friedrich
 Spain: Goya
American Transcendentalism: Emerson; Thoreau
Painters in the United States: Cole; Bingham; Bierstadt; Catlin; Hicks

19th-CENTURY REALISM

Industrial Revolution
Communist Manifesto (1848)
Authors: Dickens; Balzac; Flaubert; Zola
American Civil War (1861–1865)
Emancipation Proclamation (1863)
Development of photography: Daguerre; Niepce; Talbot; Nadar;
 Cameron; Brady
Expansion of lithography
Painters
 France: Millet; Bonheur; Courbet; Daumier; Manet
 Pre-Raphaelites in England: Rossetti; Millais
 United States: Eakins; Tanner
Architecture: Crystal Palace; Brooklyn Bridge; Eiffel Tower; Statue of
 Liberty; skyscrapers

19th-CENTURY IMPRESSIONISM

Second Empire in France; urban renewal of Paris
Cult of Bohemia; Paris Opera; optical realism
French artists: Manet; Renoir; Degas; Morisot; Monet; Pissarro; Rodin
Artists quote art: Delaney on Rodin's *Balzac*
American artists: Cassatt; Muybridge; Homer; Sargent; Whistler

Japanese Woodblock Prints of the Edo Period

POST-IMPRESSIONISM AND THE LATE 19th CENTURY

Posters, advertisements; Toulouse-Lautrec
Cézanne's "constructive brushstroke"
Seurat's Pointillism
van Gogh; Gauguin
The Symbolist movement: Moreau; Munch
Aestheticism: Wilde; Beardsley
Art Nouveau: Horta; Guimard
Vienna Secession: Klimt
Freud, *The Interpretation of Dreams* (1899)
Rousseau, *The Dream* (1910)

Gauguin and Oceania

The arts in nineteenth-century Europe and America are characterized by a parade of styles that reflect the context of their time. Paris, still the center of the Western art world, was the origin of the major nineteenth-century styles. Neoclassicism, because of its associations to the Greek and Roman republics, had been a style of revolution in the late eighteenth century. But under Napoleon, who crowned himself emperor of France in 1804, it became an imperial style. In the United States, Neoclassicism was called the Federal style, notably in the architecture of Thomas Jefferson.

The Romantics fought tyranny and colonialism, longed for past and exotic locales, and were fired by poetic imagination—all of which is expressed in their art. Realists strove to represent everyday life and to depict the broad panorama of society. Impressionists and Post-Impressionists, on the other hand, focused on the material of art, using prominent brushstrokes to convey the way we actually see—which they called "optical realism." They shared with the artists of Japanese woodblock prints of the Edo period a taste for scenes of entertainment and leisure, and a formal interest in patterns, silhouettes, and cropped viewpoints. Exhibitions of non-Western art in Europe inspired artists to study works from the Far East and Oceania. At the end of the century, the Symbolist movement in art, music, and theater reflected the late nineteenth-century interest in psychology, dreams, and the unconscious mind.

19

Neoclassicism: The Late Eighteenth and Early Nineteenth Centuries

During the late eighteenth and early nineteenth centuries in western Europe, several styles competed for primacy. Paris had become the undisputed center of the Western art world, but Rome was still a significant artistic force. In France, the "True Style," later called the Neoclassical style, was a reaction against the levity of Rococo. French Baroque, especially under Louis XIV, had had a pronounced Classical flavor; from it evolved the Neoclassical style, which was adopted by the leaders of the French Revolution. Neoclassical then became the style most closely associated with the revolutionary movements of the period (see box). But with Napoleon's rise to power, Neoclassicism became an imperial style.

The Neoclassical Style in France

The contrast between Rococo and Neoclassical style can be illustrated by comparing two sculptures depicting an embrace, both derived from Classical mythology. The terracotta *Nymph and Satyr Carousing* (fig. **19.1**) by Clodion (1738–1814) exemplifies the amorous frivolity of Rococo, whereas the *Cupid and Psyche* (fig. **19.2**) of Antonio Canova (1757–1822) displays the sweeping grandeur of Neoclassical.

In the Clodion, a lusty satyr (see box, p. 703) leans backward, drawing a nude bacchante toward him. She pours wine into his mouth while embracing him and straddling his thigh. The satyr's excitement is revealed by his raised right leg, which echoes the bacchante's left leg. The figures seem prevented from toppling over only by the satyr's hand resting on the rock. Twisted poses and diagonal planes animate and open the space, pointing outward from the core of the statue. The surface motion created by the satyr's rippling muscles and the rough textures of his shaggy hair underline the orgiastic nature of the encounter.

19.1 Clodion (Claude Michel), *Nymph and Satyr Carousing*, c. 1780–90. Terra-cotta; 23¼ in. (59.1 cm) high. Metropolitan Museum of Art, New York, Bequest of Benjamin Altman, 1913 (14.40.687).

Satyrs and Bacchantes

In Greek mythology, satyrs are woodland creatures, part man and part goat, that symbolize male lust. Satyr plays, in which satyrs made fun of human tragedies, were performed in Classical Greece and became the basis of satire in Western literature. The bacchantes were priestesses of Dionysos, the Greek god of wine. The term *bacchante* is related to the Roman wine god, Bacchus, and a *bacchanal* is an orgiastic, drunken party.

19.2 Antonio Canova, *Cupid and Psyche,* 1787–1793. Marble; 5 ft. 1 in. (1.55 m) high. Louvre, Paris. The tragic character of the myth of Cupid and Psyche is more suited than satyrs and bacchantes to the Neoclassical aesthetic. Their romance was fated to end if Psyche should see Cupid. Unable to restrain her curiosity, Psyche did look at her lover and so lost him.

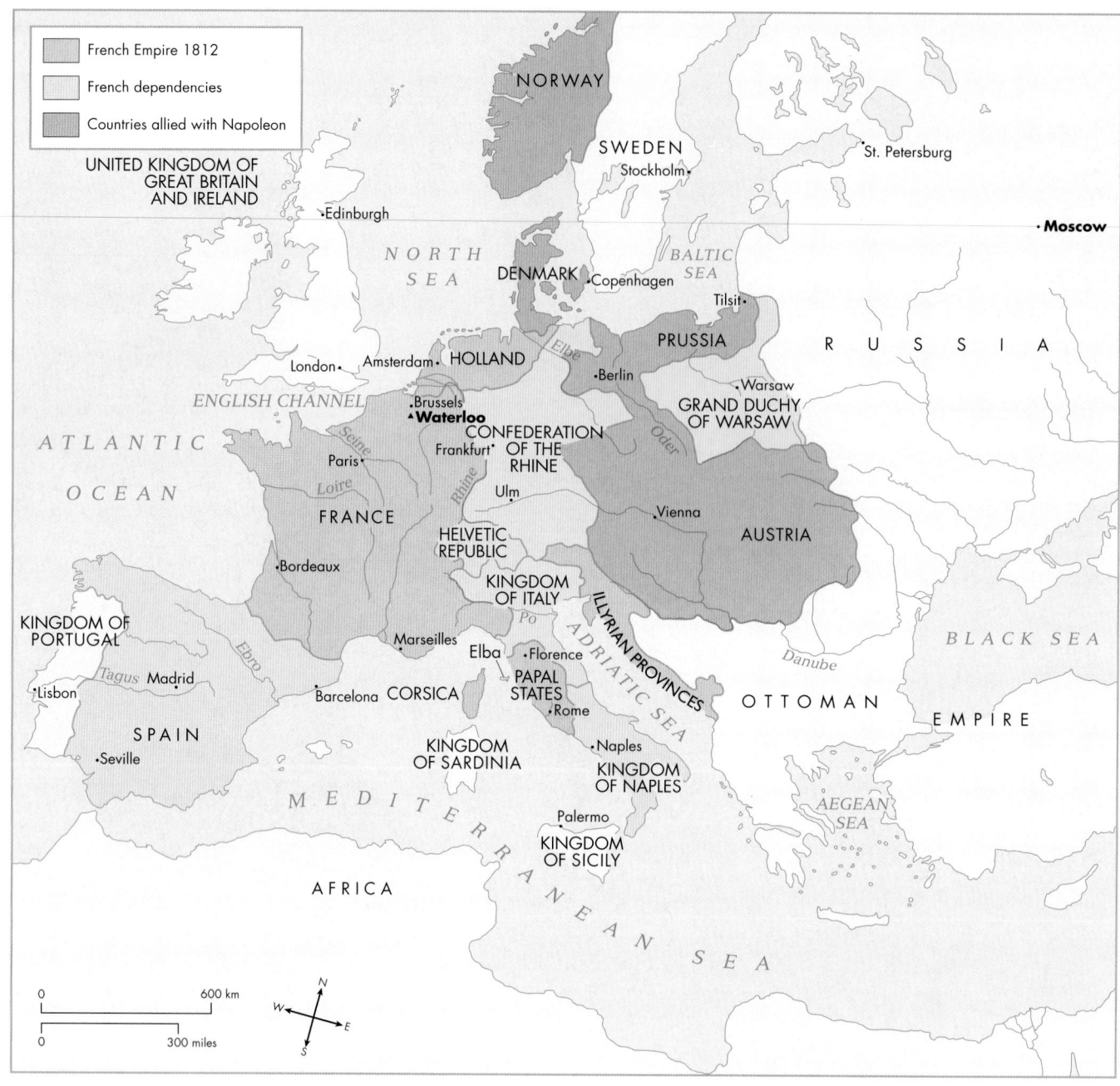

The Napoleonic empire, 1812.

Canova's *Cupid and Psyche* portrays an embrace of another kind. Its subject is the ill-fated romance between Cupid and Psyche. It is a tale that contains the seeds of tragedy, and so this sculpture rises above the frivolous anonymity of the Clodion. The Canova is reminiscent of Classical ballet, with its smooth surfaces, broad poses, and gestures encompassing and enclosing a space beyond the embrace itself. Cupid leans over, his wings spreading out in an eloquent V-shape. Their formal upward motion suggests the rising of the soul and the lofty nature of true love. Psyche lies back in a pose that recalls the traditional reclining nude, and curves her arms about Cupid's head in a gesture that is at once open and closed. It is the tragic grandeur of Canova's sculpture that allies it with the Neoclassical style, in contrast to the "satirical" Rococo revelry of Clodion.

Art in the Service of the State: Jacques-Louis David

The political aspects of the Neoclassical style derived from its associations with heroic subject matter, formal clarity, and the impression of stability and solidity. It also contained implicit references to Athenian democracy and the Roman Republic. In artistic terms, the Neoclassical style was a reaction against Rococo. However, the political preoccupations of the Neoclassical style arose directly from the questioning stance that had characterized eighteenth-century Enlightenment thought. Increasing popular resentment of the abuses of the monarchy was a logical development of the Enlightenment, which championed the rights of the individual. After the French Revolution, Napoleon Bonaparte adopted the Neoclassical style to sustain

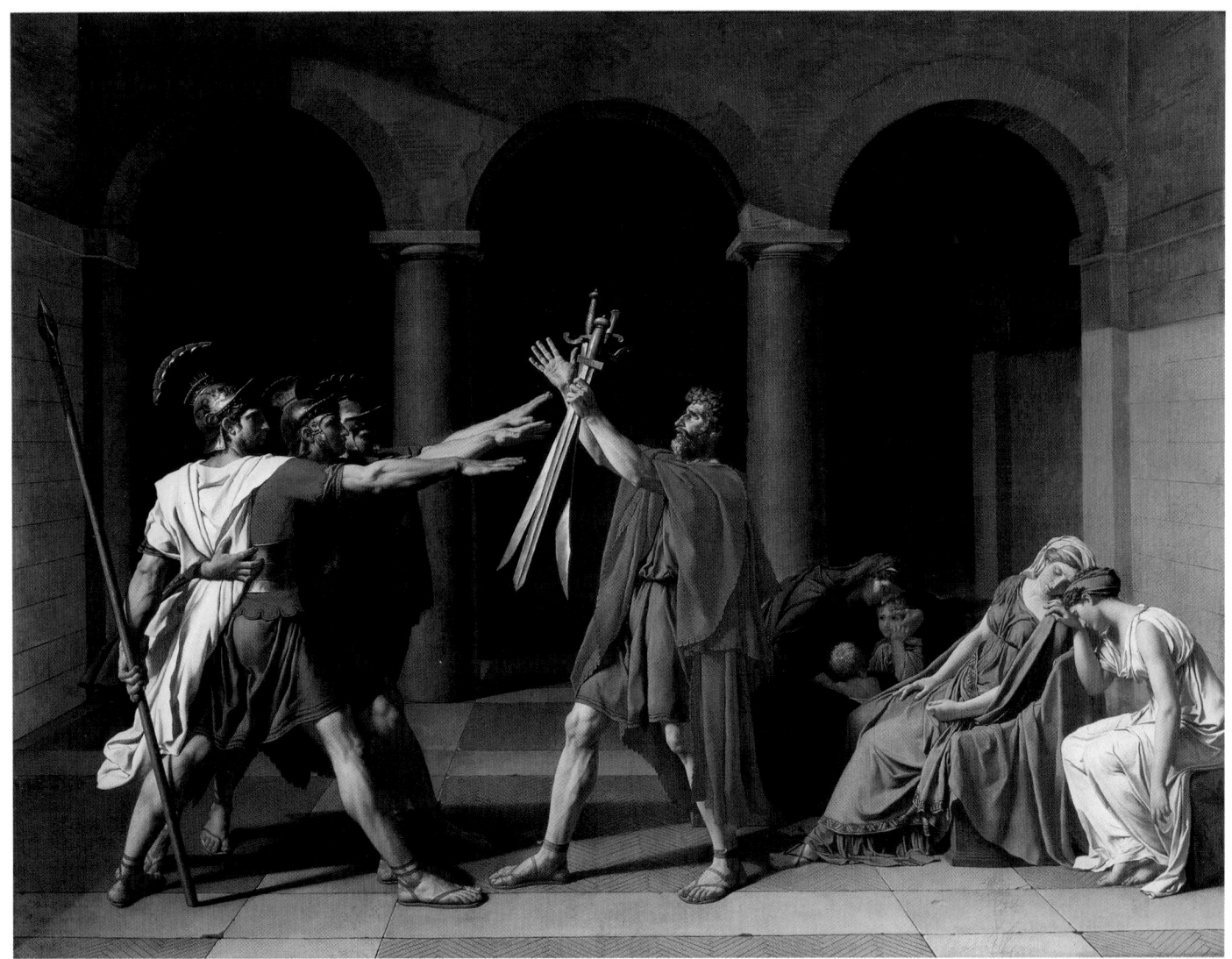

19.3 Jacques-Louis David, *Oath of the Horatii*, 1784–1785. Oil on canvas; approx. 11 ft. × 14 ft. (3.35 × 4.27 m). Louvre, Paris. Although the event is not described in Classical sources, the story of the Horatii was known from a tragedy by Pierre Corneille, the 17th-century French dramatist. Rome and Alba Longa had agreed to settle their differences by "triple" combat between two sets of triplets—the Horatii of Rome and the Curiatii of Alba—rather than by all-out war.

his political image—first as general and consul, and later as emperor.

The leading Neoclassical painter, Jacques-Louis David (1748–1825), appealed to the republican sentiments associated with Classical antiquity. His *Oath of the Horatii* (fig. **19.3**), first exhibited in 1785, illustrates an event from Roman tradition in which honor and self-sacrifice prevailed (see caption). The figures wear Roman dress, and the scene takes place in a Roman architectural setting, before three round arches resting on a type of Doric column. Framed by the center arch, Horatius raises his sons' three swords, on which they swear an oath of allegiance to Rome. Within a rectangular space composed of clear verticals and horizontals, and subdued by muted color, the gestures of the soldiers are vigorous, determined, and somewhat theatrical. They express a fervor that links Roman patriotism of the past to the contemporary passions of the French—first for reform and later for revolution. The women and children, in contrast, collapse at the right in a series of fluid, rhythmic curves, which reflect the view that they are more

emotional. They include the sisters of the Horatii, one of whom is engaged to an enemy combatant and is overcome by her tragic destiny. In the shadows, the wife of Horatius comforts her grandchildren.

The painting was commissioned by Louis XVI as part of a program aimed at the moral improvement of France. Although the modern viewer tends to see it as a piece of overtly revolutionary propaganda, the ideals embodied in Neoclassical painting were in fact appealing to both the royalist supporters of the king and their republican opponents. The irony of the political subtext was apparently lost on Louis's minister for the arts, who approved the painting.

In the *Death of Socrates* (fig. **19.4**), painted in 1787, David used a subject from Greek history to exemplify individual heroism and self-sacrifice in the service of intellectual freedom. The Athenians objected to Socrates' teaching and condemned him for corrupting the youth. He was offered a choice of exile or death but, as recorded by Plato in *The Apology*, refused to abandon his principles and chose to die. David portrays the last moments of Socrates, who

— CONNECTIOI

See figure 14.37
Plato, detail of
Raphael, *School
of Athens*, 1509
1511.

19.4 Jacques-Louis David, *Death of Socrates*, 1787. Oil on canvas; 4 ft. 3 in. × 6 ft. 5¼ in. (1.29 × 1.96 m). Metropolitan Museum of Art, New York (Wolfe Fund, 1931, Catherine Lorillard Wolfe Collection).

continues teaching to the very end. One disciple turns away as he hands him the goblet of poison hemlock. Others, wearing Classical dress, gather at the right and listen intently to Socrates' words.

The architecture of the prison, with its round arch, is depicted with the same clarity and boxlike construction as the *Oath of the Horatii*. Not only is the subject drawn from antiquity, but the specific gesture of Socrates—his hand raised and his finger pointing upward as if toward a higher truth—is a visual quotation from Raphael's Plato in the *School of Athens* (see fig. 14.35). The high moral tone of David's *Oath of the Horatii* and the *Death of Socrates,* the former patriotic and the latter intellectual, made them exemplary images for a France on the verge of revolution. In 1789, two years after David painted the *Death of Socrates,* angry mobs in Paris stormed the Bastille and ignited the Revolution.

In the *Death of Marat* (fig. **19.5**), commissioned during the Reign of Terror, David used the principles of the Neoclassical style in the service of contemporary political events (see caption). Both David and Marat were members of the Jacobin

19.5 Jacques-Louis David, *Death of Marat,* 1793. Oil on canvas; approx. 5 ft. 3 in. × 4 ft. 1 in. (1.60 × 1.25 m). Musées Royaux des Beaux-Arts de Belgique, Brussels. On July 13, 1793, Marat was stabbed in his bathtub by Charlotte Corday, a supporter of the conservative Girondin group. Inscribed on the crate supporting Marat's inkwell, pen, and papers is a combined personal and political message. David dedicated the painting "À Marat, David" (To Marat, from David) and dated it "L'An Deux" (The Year Two), the second year of the French revolutionary calendar.

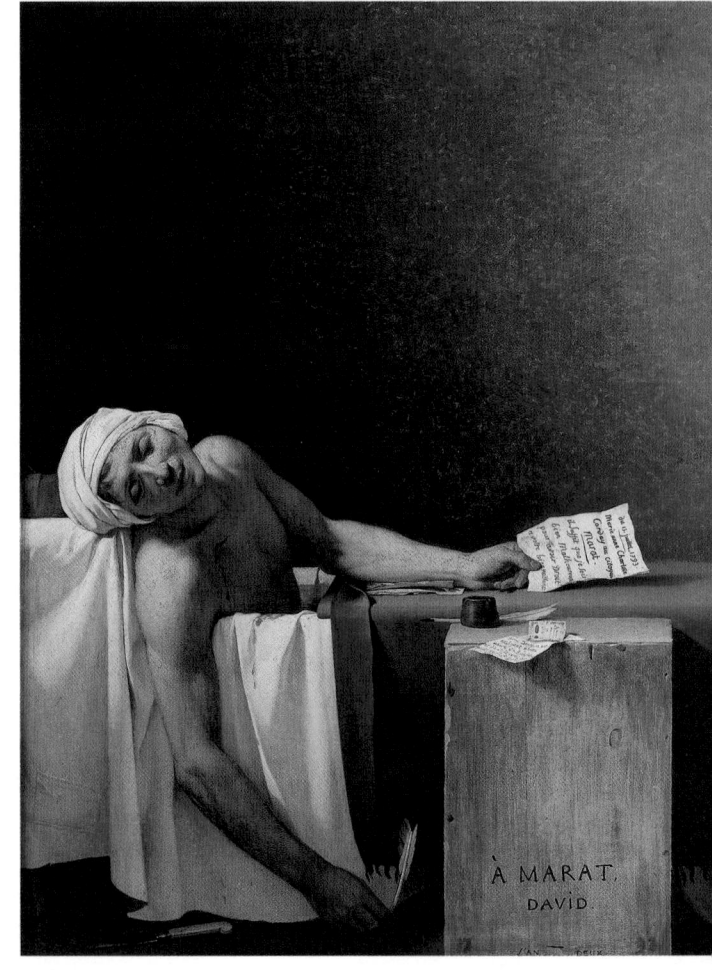

movement, a group of revolutionary extremists and the patrons of David's painting. David himself was elected to the National Convention and voted to send Louis XVI to the guillotine. When Robespierre, the minister who presided over the Reign of Terror, fell, David was imprisoned twice. But he regained favor under Napoleon, who appointed him his imperial painter and granted him a barony. After Napoleon's exile, David left France and died in Brussels in 1825.

The painting, which is set in a clear cubic space, like the *Horatii* and the *Socrates,* depicts a recent, rather than a Classical, event. David's *Marat* has affinities with Christian images of the dead Christ, which emphasizes Marat's role as a political martyr. The influence of Caravaggio's tenebrism can be seen in the darkened background, from which the figure of Marat emerges into light. In both form and content, therefore, David's *Marat* represents intellectual and political enlightenment.

David has idealized Marat in Classical fashion, for his body was in fact ravaged by a skin disease. He found relief from this by soaking in the bath. At the same time, however, the stab wound is visible, and the red bath water has stained the sheet. Marat has placed a writing surface over the tub, and he holds the letter sent by his killer, which reads: *"Il suffit que je sois bien malheureuse pour avoir droit à votre bienveillance,"* meaning "I just have to be unhappy to merit your goodwill."

Marat was the victim of a deceitful woman, and David displays her deceit for all the world to see as political propaganda. The knife that Charlotte Corday has dropped on the floor beside the tub is contrasted ironically with the quill pen still in Marat's limp hand. The instrument of violence and death is thus opposed to the pen, which is associated in this picture with revolutionary political writing. That Marat the revolutionary was stabbed by a member of a more conservative party enhances the tragic irony of David's picture.

Napoleon and the Arts

From 1799, David created images for his new patron, Napoleon Bonaparte, who was first consul of France (see map). His *Napoleon at Saint Bernard Pass* of 1800 (fig. **19.6**), which depicts Napoleon crossing the Alps, is clearly in the tradition of Roman equestrian portraits. Napoleon wears full military regalia and sits proudly astride a splendid rearing white charger. The textures of his uniform and the horse trappings are rendered in precise detail. The wind blows at their backs, whipping forward the horse's tail and mane. Napoleon points ahead, toward the peak of the mountain, and simultaneously looks down at the viewer. His dramatic gesture and the horse's pose are intimations of early Romanticism. David's glorification of his patron is evident from the fact that on this occasion Napoleon actually rode a mule.

David's Neoclassicism is used here in the interests of the new political regime in France. Napoleon's charger

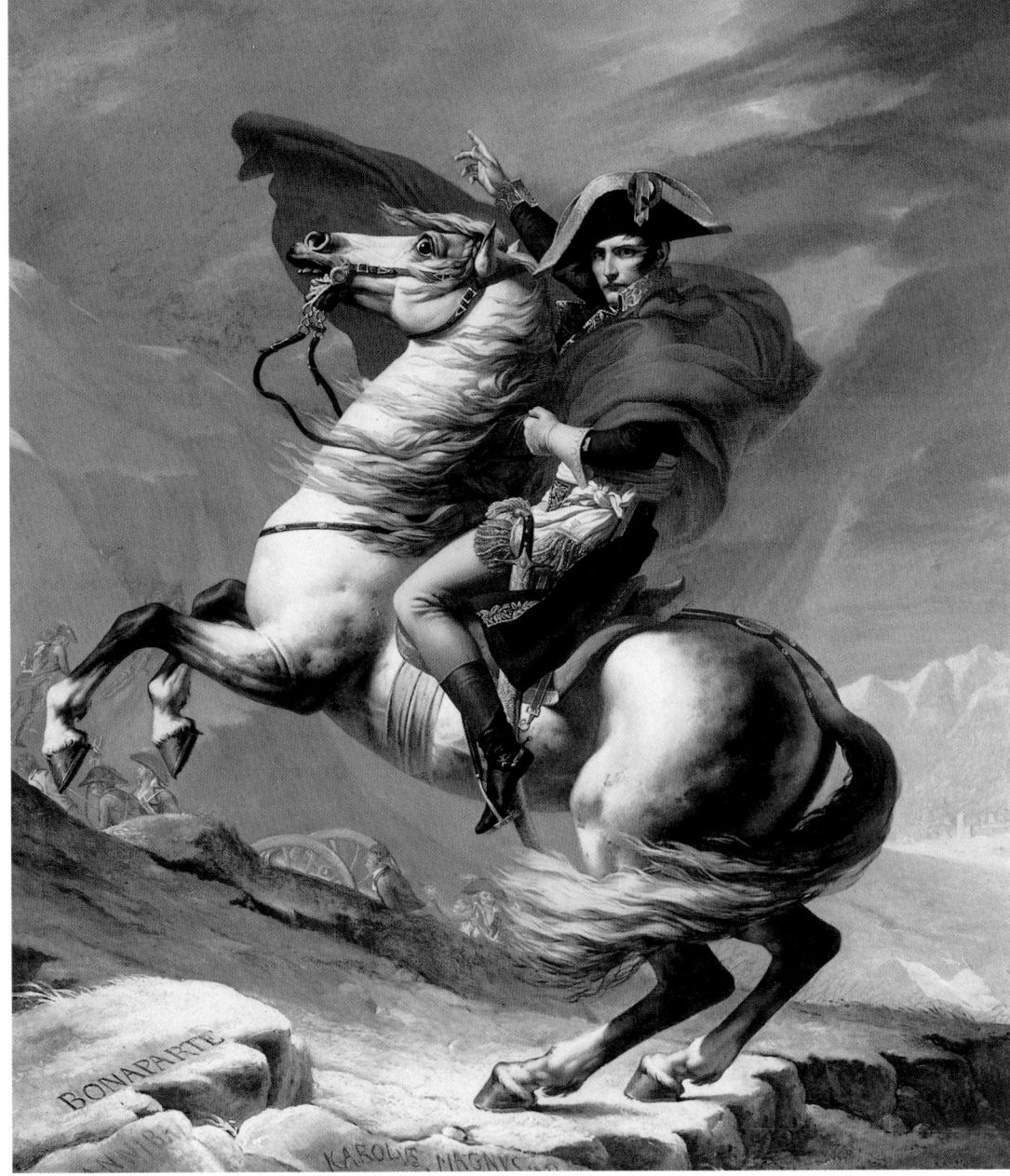

19.6 Jacques-Louis David, *Napoleon at Saint Bernard Pass*, 1800. Oil on canvas; 8 ft. × 7 ft. 7 in. (2.44 × 2.31 m). Musée National du Château de Versailles.

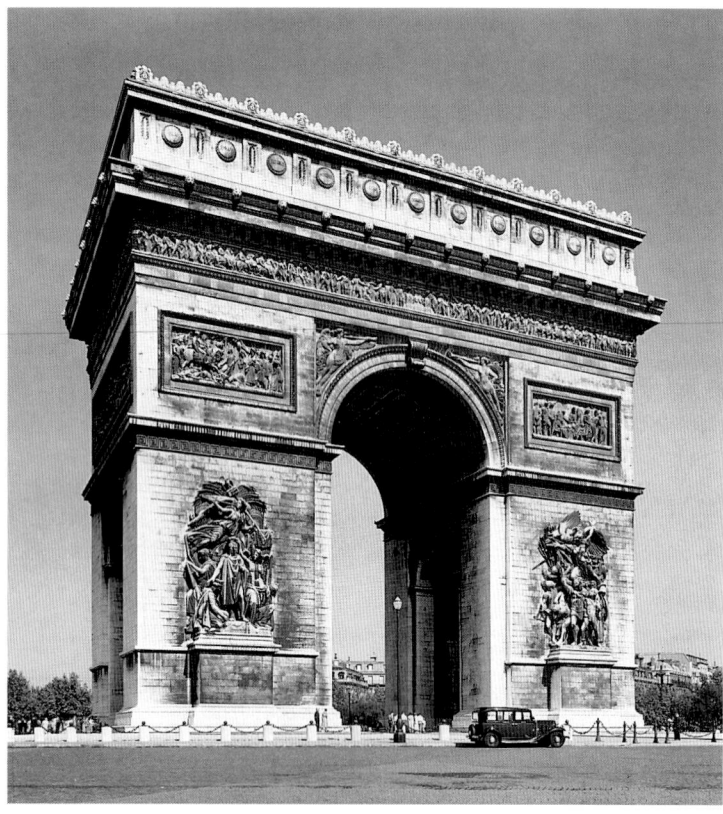

19.7 Jean-François-Thérèse Chalgrin et al., Arc de Triomphe, Paris, 1806–1836. 164 ft. (49.99 m) high.

CONNECTIONS

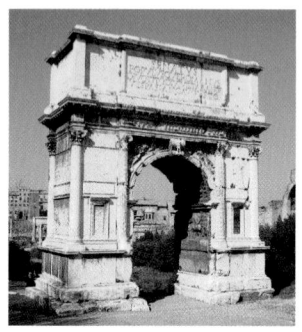

See figure **7.38.** Arch of Titus, A.D. 81.

looms up and dominates the picture, in contrast to the distant soldiers, who struggle with their cannons and are obscured by the misty sky. David relates Napoleon to his illustrious imperial predecessors by the inscriptions "KAROLUS MAGNUS" (Charlemagne) and "ANNIBAL" (Hannibal) carved in stone under "BONAPARTE" in the left foreground.

When Napoleon was crowned emperor in 1804, he set about commissioning monuments throughout Paris with a view to re-creating the grandeur of imperial Rome. To commemorate his military successes, he conceived the idea of constructing an Arc de Triomphe (Arch of Triumph) (fig. **19.7**) that would be based on the triumphal arches of ancient Rome. From these, the architect adopted the relief sculptures on the upper piers, the decorative cornices, and the row of metopes and triglyphs below the upper cornice. There were no columns or pilasters on the Arc de Triomphe, and the design was elaborated later by adding sculptures to the lower parts of the piers. The arch was commissioned in 1806 but only completed in 1836, twenty-one years after Napoleon's defeat at Waterloo in 1815 (he was exiled to the island of Saint Helena the following year). At 164 feet (49.99 m) high, it was the largest arch ever built; it stands at a busy intersection in the Place Charles de Gaulle (formerly named the Place de l'Étoile).

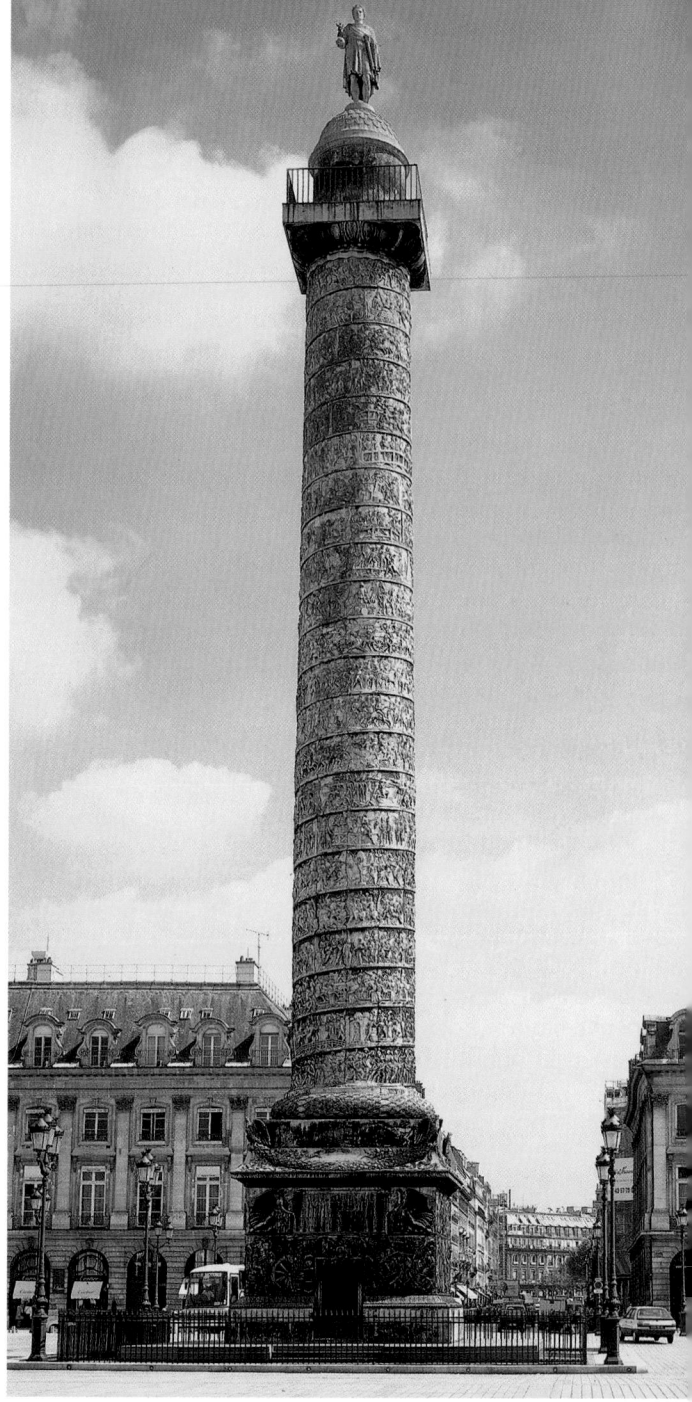

19.8 Charles Percier and Pierre F. L. Fontaine, Place Vendôme column, Paris, 1810. Marble with bronze spiral frieze.

Napoleon also commissioned a monumental freestanding Doric column of marble, surmounted by a statue of himself, for the Place Vendôme in Paris (fig. **19.8**). Decorated with spiral reliefs depicting events from his campaign of 1805, it was directly inspired by Trajan's Column in Rome (see fig. 7.34). The bronze from which the frieze was made had been melted down from the captured artillery of the Austrian and Prussian armies. In the column, as in the Arc de Triomphe, Napoleon expressed his view that architecture and sculpture inspired by ancient Rome would

enhance both his claim to the throne of France and his image as heir of the Roman emperors.

With a similar purpose in mind, Napoleon brought the sculptor Canova to Paris from Rome and in 1808 commissioned him to carve a life-sized marble sculpture of his sister Pauline (fig. **19.9**). Pauline's proportions are Classical, and she is nude from the waist up. Although she lounges on an Empire-style divan, her pose recalls that of the traditional reclining Venus.

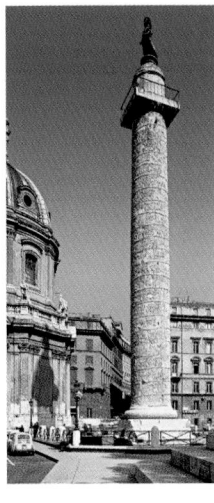

See figure 7.34. Trajan's Column, dedicated A.D. 113.

Marie-Guillemine Benoist Napoleon also enlisted the services of Marie-Guillemine Benoist (1768–1826), who painted several portraits of him. Benoist was the daughter of a government official. She studied with Vigée-Lebrun and began her career as a portraitist in pastel. Later she studied with David and in 1791 exhibited two history paintings. When she married a royalist, her career declined, and she was in constant danger under the Reign of Terror. Napoleon awarded her an annual pension.

David's influence is apparent in Benoist's *Portrait of a Negress* of 1800 (fig. **19.10**). Like Canova's *Pauline,* the fig-

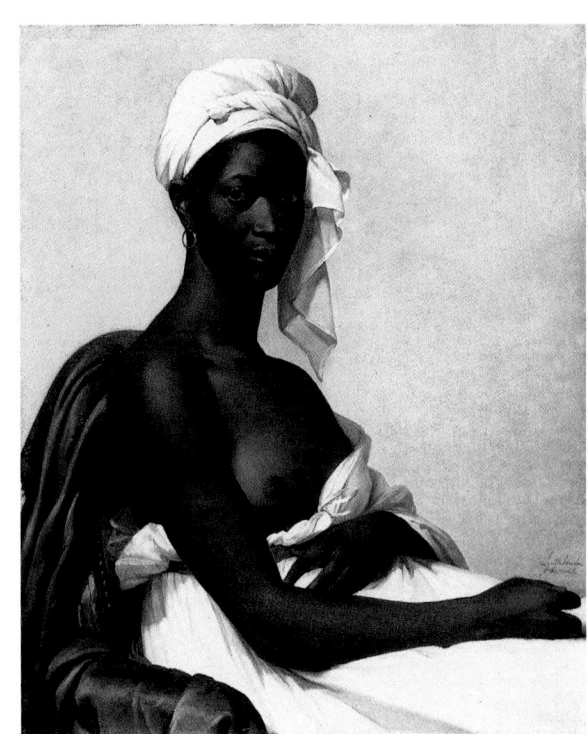

19.10 Marie-Guillemine Benoist, *Portrait of a Negress*, 1800. Oil on canvas; 31⅝ in. × 25⅝ in. (80.3 × 65.1 cm). Louvre, Paris.

ure is partly nude from the waist up and is in the tradition of the reclining nude female. She combines aspects of Classicism and Romanticism, reflecting the overlap of the two styles in the late eighteenth and early nineteenth centuries. The figure stands out against a plain background, and the dark brown skin contrasts sharply with the classicizing white drapery. At the same time, Benoist has increased the figure's exotic, Romantic character by adding the turban and the gold earring. But the clear edges, the smooth texture of the paint, and the Neoclassical drapery accentuate the unexpected impact made by a black woman in a conventional European tradition.

19.9 Antonio Canova, *Maria Paolina Borghese as Venus*, 1808. Marble; 5 ft. 2⅞ in. × 6 ft. 6¾ in. (1.60 × 2.00 m), including divan. Borghese Gallery, Rome.

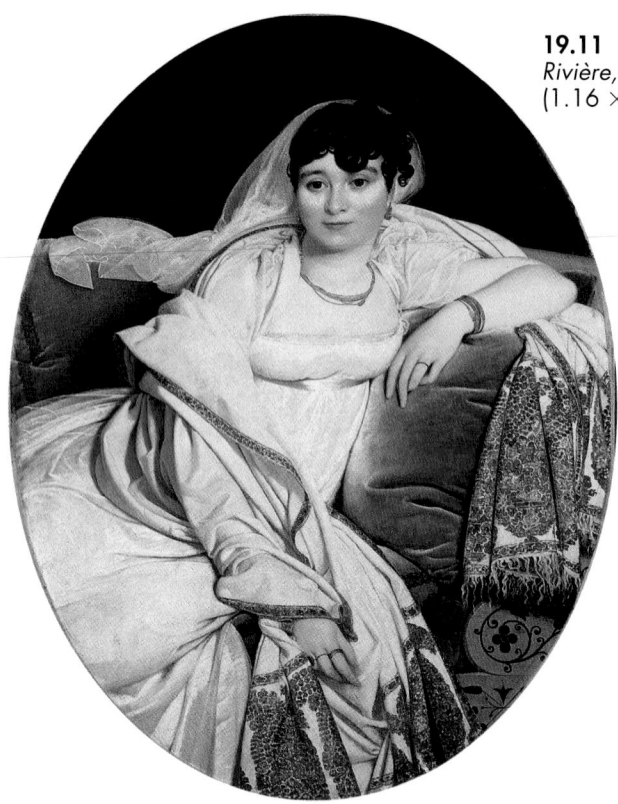

19.11 Jean-Auguste-Dominique Ingres, *Madame Rivière*, 1805. Oil on canvas; 3 ft. 9 in. × 3 ft. (1.16 × 0.90 m). Louvre, Paris.

Jean-Auguste-Dominique Ingres

The career of another of David's students who worked for Napoleon, Jean-Auguste-Dominique Ingres (1780–1867), also embodies the interplay of Neoclassicism and Romanticism. There are already hints of Romantic taste for the exotic in Benoist's *Negress,* but Ingres' work also retains traces of Mannerist elegance. His portrait of *Madame Rivière* (fig. **19.11**), painted in 1805, continues the tradition of formal clarity, interest in rich detail, and smooth texture that he learned in David's studio. Placed in an oval frame, Madame Rivière reclines on velvet cushions, which are draped with an elaborately patterned shawl. Its blues echo the velvet, while a slightly diaphanous white veil flutters from behind her head. Her black, piercing eyes repeat the curls, which are derived from Ingres' study of Greek vase painting. The soft shading of her flesh is consistent with the soft material textures and her relaxed, somewhat languid pose. Despite the Classical allusions of the figure, she is clothed in the garb of early nineteenth-century French aristocracy.

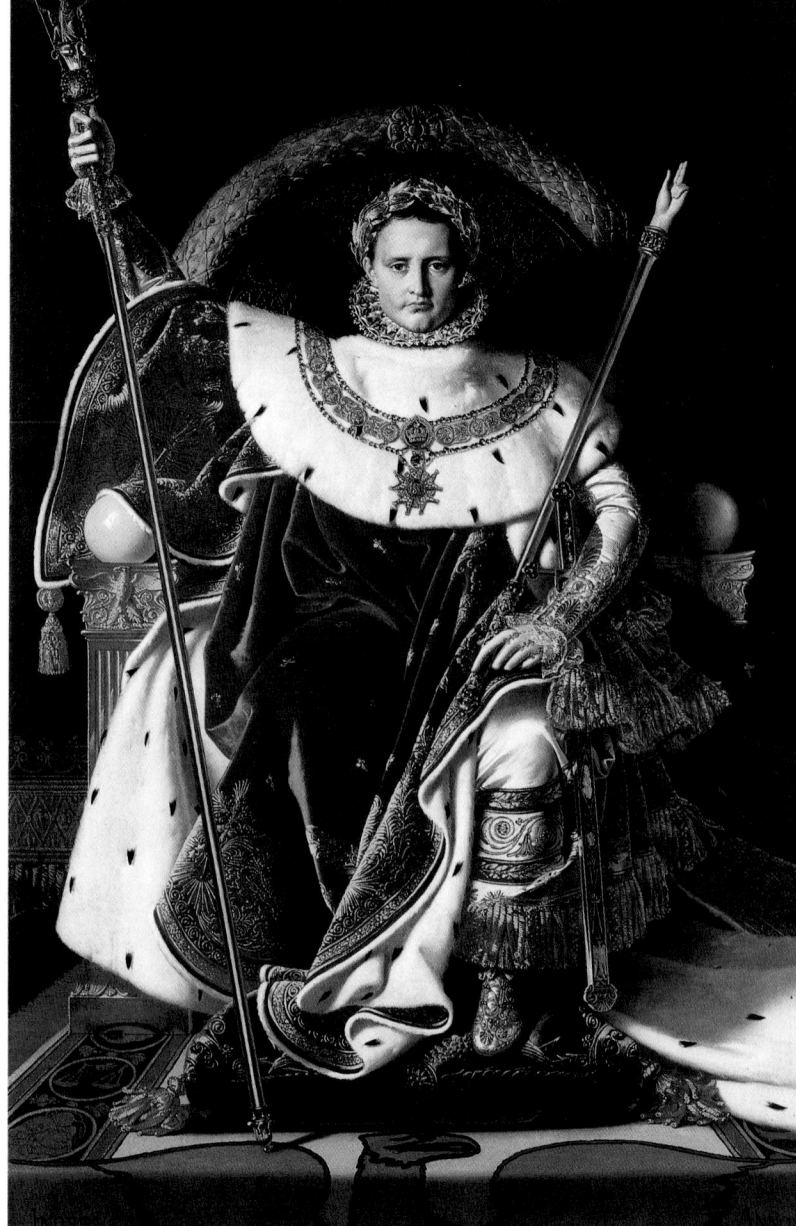

19.12 Jean-Auguste-Dominique Ingres, *Napoleon Enthroned*, 1806. Oil on canvas; 8 ft. 8 in. × 5 ft. 5¼ in. (2.59 × 1.55 m). Musée de l'Armée, Paris.

METHODS OF INTERPRETATION

Napoleon's Political Iconography

In 1804, just fifteen years after the outbreak of the French Revolution, Napoleon Bonaparte declared himself emperor of France. He enacted several important social and educational reforms and agreed with the pope that Catholicism would be the country's official religion. Above all, however, Napoleon wanted France (and especially himself) to dominate the world. By 1810, he controlled the entire west coast of Europe. He also became one of the world's greatest art plunderers. Like the conquering rulers of antiquity, Napoleon looted the national treasures of his defeated enemies and used them to found the Napoleonic Museum. He combined the plundered works with the royal collection already in the Louvre, creating a magnificent display of European art from ancient Greece and Rome to his own era.

Napoleon's military genius notwithstanding, his personal grandiosity destroyed him. He made a number of political misjudgments and military blunders that eventually caused his downfall. Indeed, the name of his last battle, fought in Belgium on June 18, 1815, has become synonymous with defeat—the Battle of Waterloo.

In 1806, two years after Napoleon became emperor, the portrait in figure **19.12**, which was commissioned by the French legislature, was exhibited at the Salon. It depicts Napoleon as a deified Roman emperor in all his imperial splendor, recalling the fussiness of Rococo and the exaggeration of Mannerism. On the other hand, the clarity and precision of the details are characteristic of Neoclassical style. Everywhere, the brushstrokes are submerged to enhance the illusion of texture. Ingres' smooth, highly finished surfaces were characteristic of Academic painting rather than of Romanticism (see Chapter 20), which stressed the material quality of the media. Ingres' fondness for rich textures is expressed in the red velvet (red was the color of Roman emperors), ermine, and gold, all of which finally overwhelm the emperor. Napoleon is shown in a way that is reminiscent of the frontal depiction of Christ and the saints in Byzantine icons, as well as the Roman emperors. Ingres thus characterizes Napoleon as a ruler imbued with the power of imperial Rome and sanctioned by God.

As the "head" of the state body, it is significant that the only visible part of Napoleon's body is the head. For the rest, he is covered in signs of wealth, kingship, and divinity; he is dressed in ermine, red velvet, silk, lace, and gold and silver. A number of iconographic elements allude to antiquity—the laurel crown was awarded to Greek athletes victorious in the Olympic Games and to Renaissance poets in imitation of ancient Roman literary ceremonies. The eagles, which signified the divine status of the Roman emperor and were emblems of the Roman legions, adorn the capitals of the columns on either side of the throne and the carpet beneath the throne. Our gaze, in fact, enters the picture at the lower step and follows the eagle upward to the enthroned Napoleon. We thus literally "look up to" the emperor, signaling his domination over us as viewers as he dominated nineteenth-century Europe. By raising up Napoleon, the artist disguises the ruler's small stature, just as short leading men in Hollywood are filmed at angles or on hidden platforms that make them appear tall.

In addition to Christ and the Roman emperors, Ingres' Napoleon is associated with French kings and with Charlemagne (who also allied himself with the Classical tradition). In his right hand Napoleon extends the scepter of Charlemagne, and his left holds the staff surmounted by the ivory hand of justice, signifying kingship in the French Middle Ages. Formally, the diagonals of the staffs create an asymmetrical, open triangle so that each of the top two angles are accentuated by a hand—Napoleon's own right hand to the viewer's left and the ivory hand that makes the Christian gesture of blessing to the viewer's right. Reinforcing Napoleon's association with Christian divinity is the broad, haloesque curve made by the back of the throne, which frames his head. In this image, therefore, Ingres has combined the political connotations of Roman imperial power with the divine imagery of Christian tradition.

Oedipus

The myth of Oedipus is given its definitive literary form in Sophokles' play *Oidipos Tyrannos* (*Oedipus the King*). Oedipus' father, King Laios of Thebes, had been warned by an oracle that his son would kill him. He therefore drove a stake through his son's foot and left him to die on a mountain. A shepherd couple discovered Oedipus and raised him as their own son. Later, Oedipus learned from the oracle that he was destined to kill his father and marry his mother. To avoid this fate, Oedipus left home. Nearing the city of Thebes, he came to a fork in the road where he encountered a man who refused to let him pass. Oedipus killed the man and continued on his way. He met the Sphinx on the outskirts of Thebes and solved her riddle: "What walks on four legs in the morning, two legs in the afternoon, and three legs in the evening?" The answer: "Man." (As a baby, he crawls on all fours; then he walks on two legs; and finally he walks with a cane.) The prominent foot in the lower left corner of Ingres' painting refers both to the name *Oedipus* (which means "swollen foot" in Greek) and to the riddle's emphasis on walking.

The Thebans rejoiced at the destruction of the Sphinx and gave their widowed queen, Jocasta, to Oedipus in marriage. Years later, as king of Thebes and the father of four children by Jocasta, Oedipus is told that he is the cause of a plague ravaging the city. On learning that he has committed patricide and incest—for Laios was the man at the crossroads and Jocasta his mother—Oedipus blinds himself.

This myth has been taken up in various forms by artists and writers ever since. In the early twentieth century, Sigmund Freud named the Oedipus complex after it, believing it to be the core of child development and the nucleus of every neurosis.

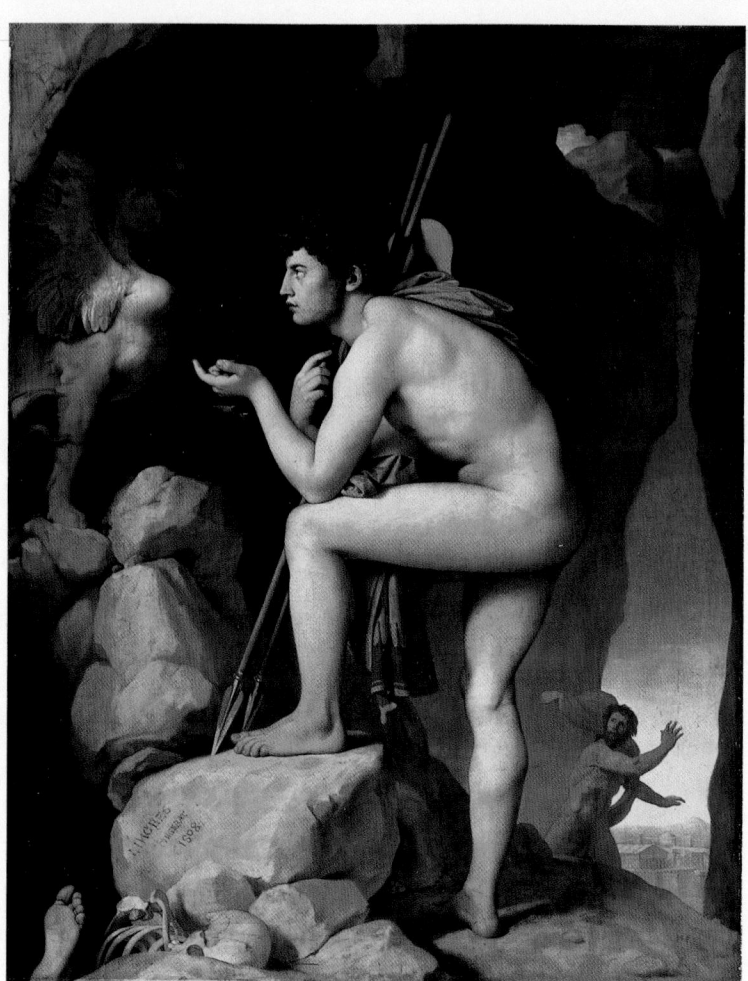

19.13 Jean-Auguste-Dominique Ingres, *Oedipus and the Sphinx*, 1808. Oil on canvas; 6 ft. 2⅜ in. × 4 ft. 8⅜ in. (1.89 × 1.44 m). Louvre, Paris.

Drawing on Greek mythology, Ingres painted an *Oedipus and the Sphinx* (fig. **19.13**) in 1808. Oedipus (see box) is shown solving the riddle of the Sphinx as a frightened Theban rushes off toward the Greek city in the background. Oedipus' head, particularly his profile, recalls Greek statuary, but his muscular torso is a departure from the Classical ideal. The bones and the foot in the lower left corner, which are the remains of the Sphinx's victims, and the Sphinx herself are also unclassical because they impart a disturbing sense of mystery. Ingres thus combines themes and motifs from Classical antiquity with certain characteristics that heralded the nineteenth-century Romantic movement.

It was in his "odalisques" that Ingres achieved his most successful synthesis of Neoclassical clarity, rich, aristocratic textures, and a Romantic taste for the exotic. (An odalisque is a harem girl, from *oda,* meaning a room in a Turkish harem.) Ingres' *Grande Odalisque* (fig. **19.14**), exhibited in 1814 (the year of Napoleon's abdication), is the

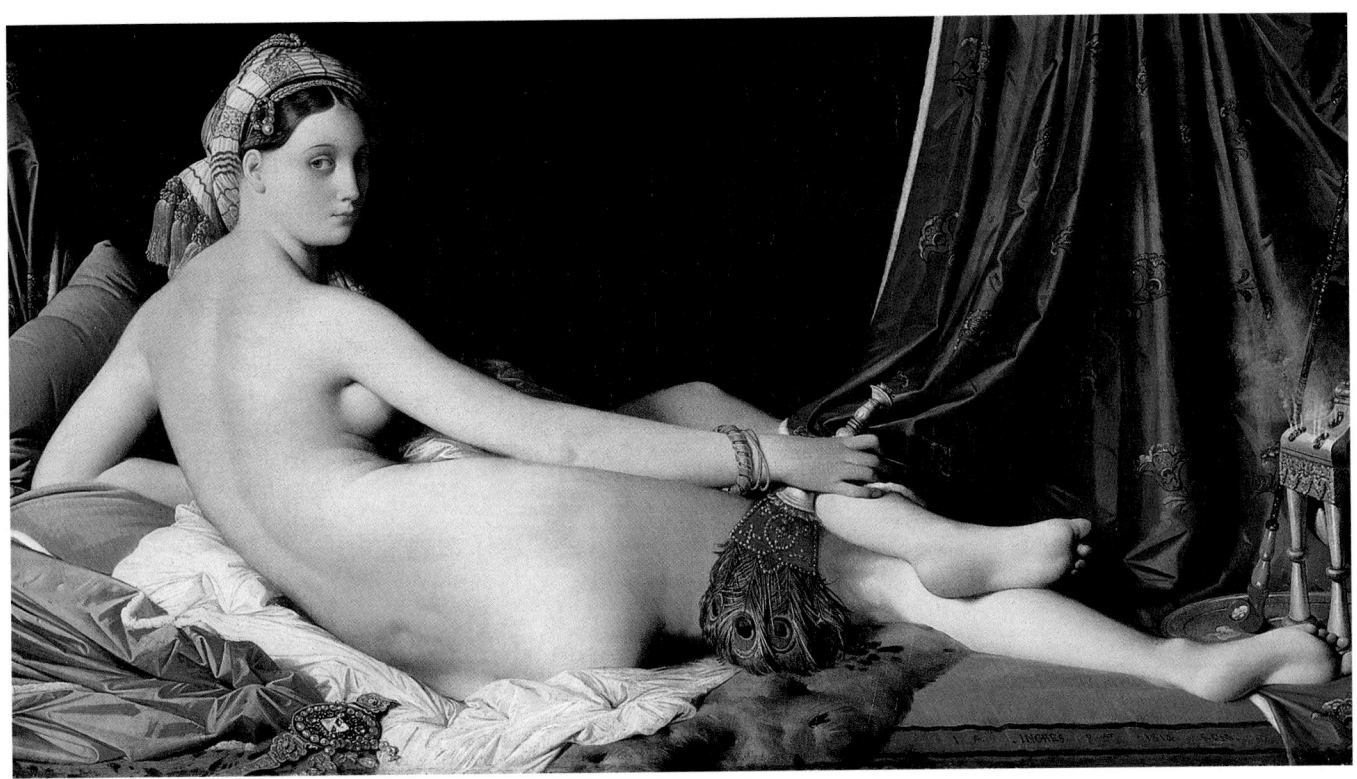

19.14 Jean-Auguste-Dominique Ingres, *Grande Odalisque,* 1814. Oil on canvas; approx. 2 ft. 11¼ in. × 5 ft. 4¾ in. (0.89 × 1.65 m). Louvre, Paris.

─────────── **CONNECTIONS** ───────────

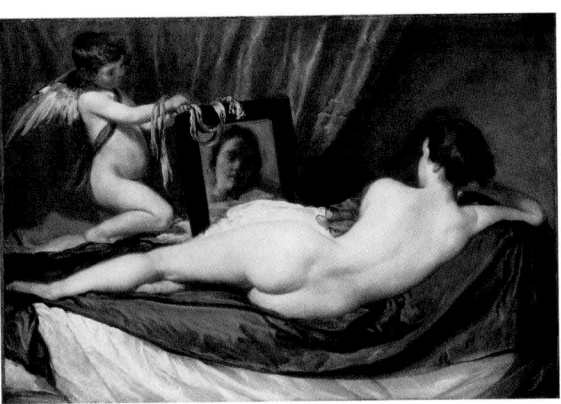

See figure 17.54. Diego Velázquez, *Venus with a Mirror (Rokeby Venus),* c. 1648.

best example. The idealized, reclining nude is seen from the back, as is Velázquez's *Venus with a Mirror* (see fig. 17.55). But here the figure turns to gaze at the observer. In contrast to the painterliness that obscures Velázquez's Venus, Ingres' nude has precise edges and a clear form. At the same time, however, the odalisque remains aloof and somewhat distant by comparison with the Baroque Venus. She is removed from everyday contemporary French experience by an exotic setting filled with illusion-istic textures—the silk curtain and sheets, the peacock feathers of the fan, the fur bed covering, the headdress, and the hookah (a Turkish pipe in which the smoke is cooled by passing through water). The *Grande Odalisque* illustrates Ingres' love of clarity, which he associated with line—hence his Academic motto: "Drawing is the probity of art." Nevertheless, he, more than the purely Neoclassical David, was attracted to the Romantic elements of sensuality and color.

Developments in America

The American Revolution preceded the French Revolution by only a few years. As in France, the intent of the American Revolution was liberation from monarchy. But the additional factor of throwing off the yoke of a foreign ruler made the Revolution in America somewhat different from its French counterpart. Once liberated from the British throne, which was then occupied by King George III, America abandoned monarchy completely. The system designed by Jefferson and the other framers of the Constitution resulted in a smoother transition of power than in France and a more stable form of government.

In America, the Revolution not only signified a political break with its colonial origins, it also marked a departure from the pre-Revolutionary "Colonial Georgian" style, named after the British king. Just as republican Rome was the political model to which the newly independent colonies aspired, so Roman architecture was more closely imitated in the early period of independence. Since this period (c. 1780–1810) coincided with the establishment of many United States government institutions, the style is referred to as the Federal style.

Chronology of the American Campaign for Independence

1776 Declaration of Independence. The colonies declare independence from Britain, marking the beginning of the American Revolution.

1787 The Constitution of the United States is signed.

1789 George Washington is inaugurated as the first president of the United States.

1790 Washington, D.C., is founded as the nation's capital.

1801 Thomas Jefferson is inaugurated as the third president of the United States.

The Architecture of Thomas Jefferson

No single American embodied the principles of Neoclassicism more than Thomas Jefferson (1743–1826). In 1789, the leading French sculptor, Jean-Antoine Houdon (1741–1828), carved a marble portrait bust of Jefferson (fig. **19.15**) during his stay in France as United States minister to that country (1785–1789). Houdon captured an air of kindly self-

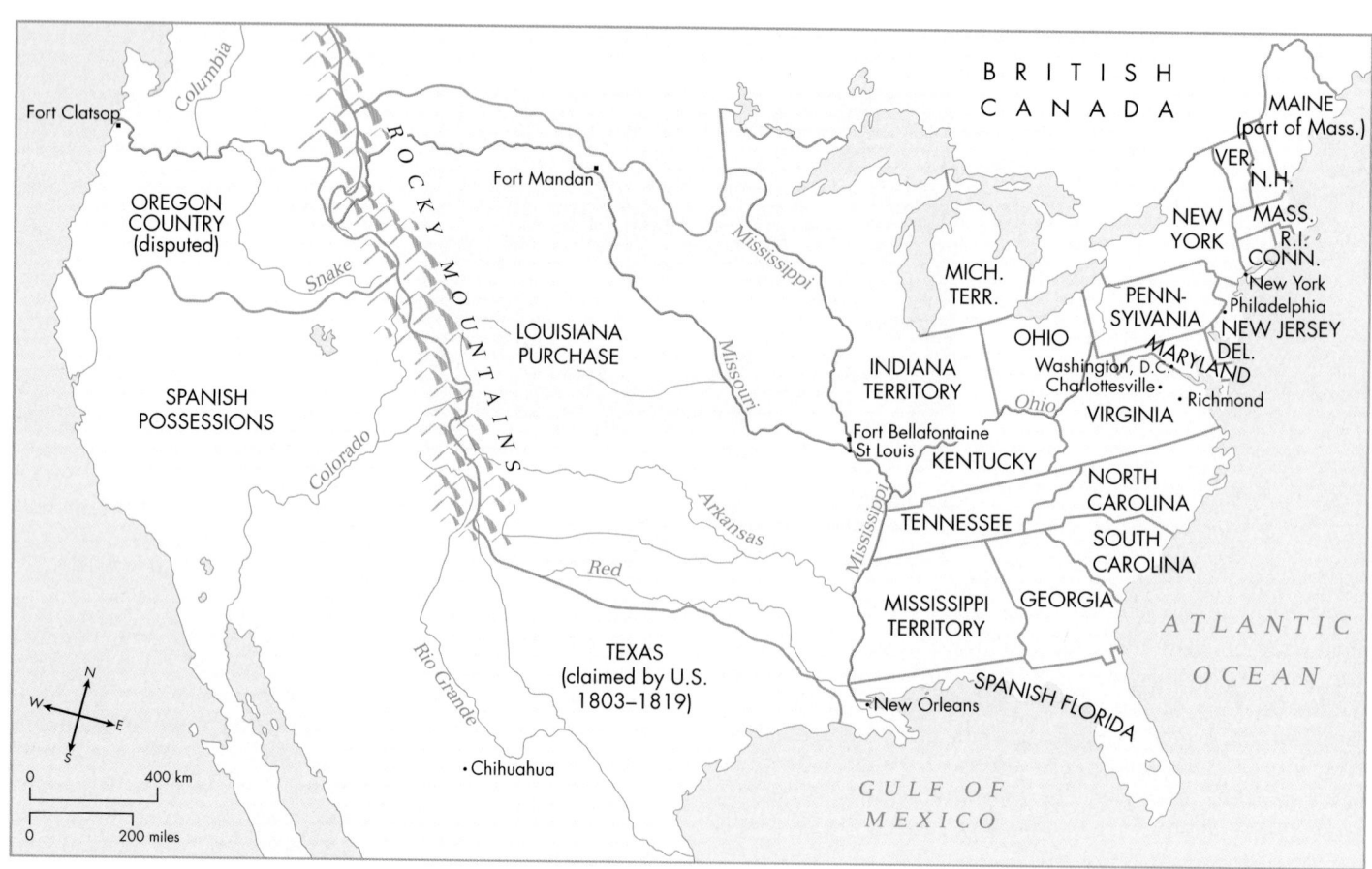

The United States during Jefferson's presidency, c. 1803.

19.15 Jean-Antoine Houdon, *Bust of Thomas Jefferson, frontal view,* 1789. White marble on white marble base; 21½ in. (54.6 cm) high. Museum of Fine Arts, Boston, George Nixon Black Fund (inv. 34.129). Jefferson was a member of the Continental Congress of 1775–1776 and was principally responsible for drafting the Declaration of Independence. He was governor of Virginia 1779–1781, U.S. minister in France 1785–1789, secretary of state under George Washington 1789–1793, vice president 1796–1801, and president 1801–1809.

confidence and suggested his sitter's profound intellect. The indentation by the side of Jefferson's jutting chin, his smile, and the slight furrow of his brow convey the impression of a composed, thoughtful individual. The portrait bust itself was a type derived from ancient Rome and therefore further reflects the Neoclassical tastes of both Houdon and Jefferson.

Jefferson's views on contemporary architecture also reveal his Classical education and humanist outlook. Although Jefferson was a native of Virginia, which was then the wealthiest and most populous of the states (see map), he disliked the houses of Virginia and wrote that they were "very rarely constructed of stone and brick. . . . It is impossible to devise things more ugly, uncomfortable, and happily more perishable." He described the buildings of colonial Williamsburg, which he knew from his student days at the College of William and Mary, as "rude, misshapen piles, which, but that they have roofs, would be taken for brick-kilns."[1] In addition to his other accomplishments, Jefferson studied Classical and Palladian architectural theory, and owned the first copy in America of Palladio's *Four Books on Architecture.* His work as an architect produced three of the finest Neoclassical buildings in America.

Jefferson began the construction of his own home, Monticello (Italian for "Little Mountain"), in 1769 (fig. **19.16**). It is located on a hilltop outside Charlottesville, Virginia. Jefferson designed Monticello himself and, despite frequent absences, supervised its construction over a period of more than forty years. The house was planned and built in two stages. At first (1769–1784) it was designed as a building with a double portico, two stories high. On the east façade, a second-story Ionic Order was to be superimposed on a ground-floor Doric, a concept that Jefferson borrowed from Palladio, but it was never executed.

In 1789, Jefferson returned to America with new plans for enlarging and remodeling Monticello, which he began to put into effect in 1794, soon after his resignation as secretary of state. Since Palladio's most admired designs had a single story, Jefferson decided that he too wanted a house that would appear to be one story. The final result was a building that seemed to have only one high-ceilinged floor. In fact, however, the entablature and balustrade conceal a second and a third floor, both containing bedrooms. The windows for these rooms are near floor level, and on the east façade they look from the outside like the top sashes of the ground-floor windows.

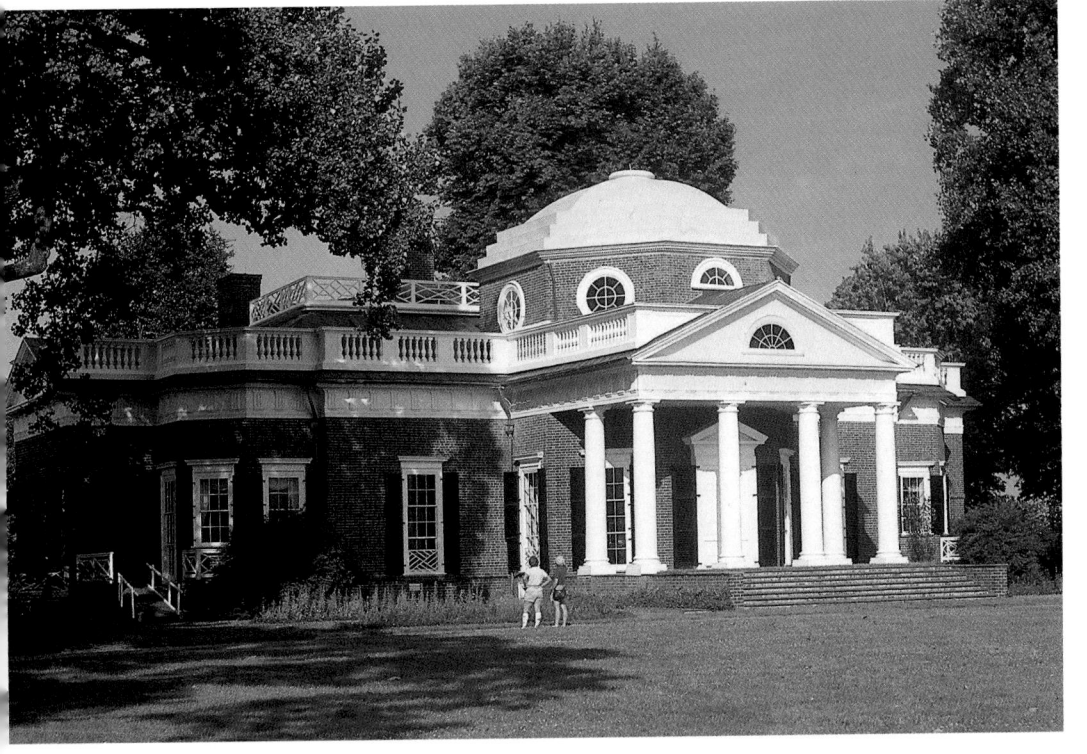

19.16 Thomas Jefferson, Monticello, near Charlottesville, Virginia, 1769–1784 (rebuilt 1794–1809).

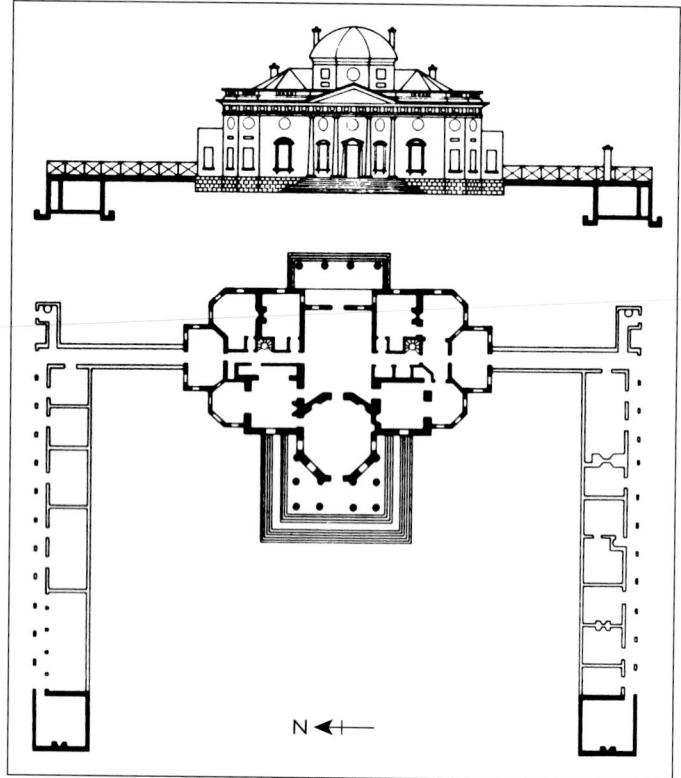

19.17 Plan and elevation of Monticello. (From W. Blaser.)

The remodeling of the ground floor can be seen from the plan (fig. **19.17**), where the shaded areas represent the old floor plan. The new plan, which is more than twice the size of the old, includes a large entrance hall with a gallery, a suite of rooms (bedroom, library, and study) on the south side of the house for Jefferson's personal use, and a corresponding set of public rooms on the north side. The house itself is connected to two small pavilions by a wooden boardwalk. Located underneath the boardwalk and below the level of the lawn were the service areas of the house—the kitchen, cellar, icehouse, stables, and so forth. The symmetry of these side extensions, or "dependencies" as they were called, is another feature that Jefferson borrowed from Palladio's country estates. Jefferson's design for Monticello, in particular the dome and the two entrances, was also influenced by that of Chiswick House (see fig. 18.20).

Monticello's individual rooms, its dome, and central drum are octagons, which was a favorite shape of Jefferson's. The octagon tended to broaden the corners of a building and expand the interior spaces. Roman influence is evident in the dome and east portico, which is colonnaded in the Doric Order. Just as republican Rome represented Jefferson's political ideal, so Monticello fulfilled the Classical ideal that he found lacking in the previous domestic architecture of colonial America.

While in France, Jefferson had become familiar with the elegant Paris *hôtels* and French Neoclassical architecture. He visited the ruins of Roman Gaul and saw the so-called Maison Carrée at Nîmes in southern France. This was a small, well-preserved Roman temple, similar to the Temple of Portunus (see fig. 7.23). Jefferson used it as the model for a new State Capitol of Virginia in Richmond. Figure **19.18** shows the projecting Ionic portico, surmounted by a Classical pediment.

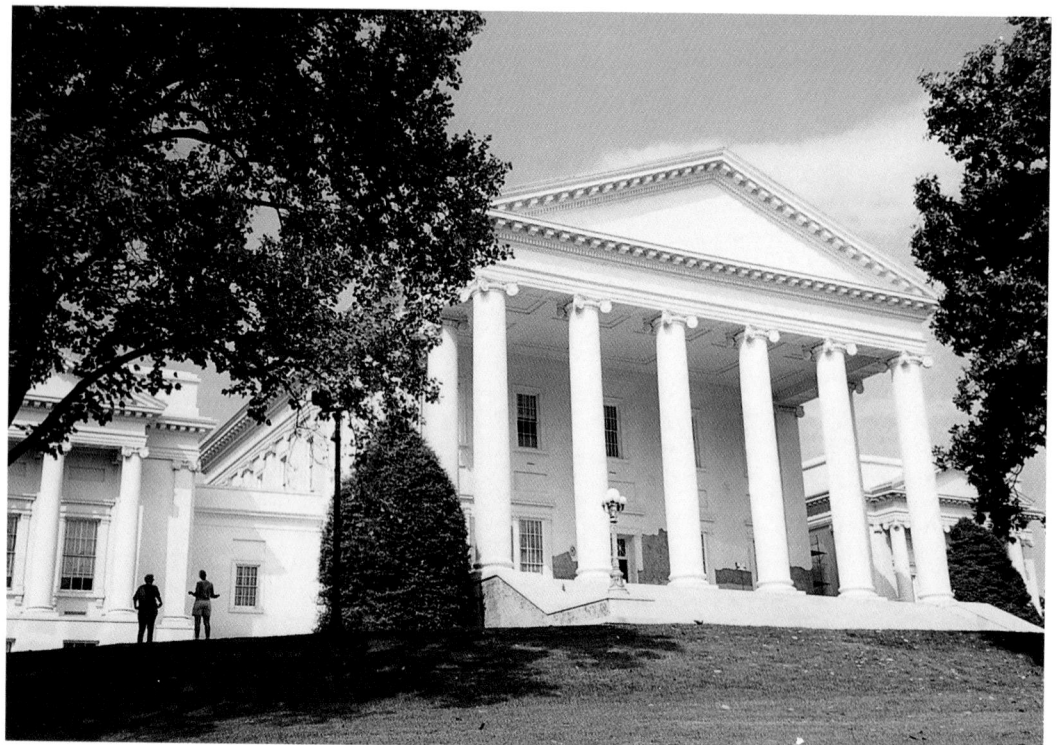

19.18 Thomas Jefferson, State Capitol, Richmond, Virginia, 1785–1789.

— CONNECTIONS —

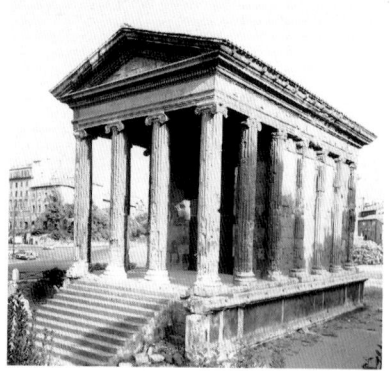

See figure 7.23. Temple of Portunus, late 2nd century B.C.

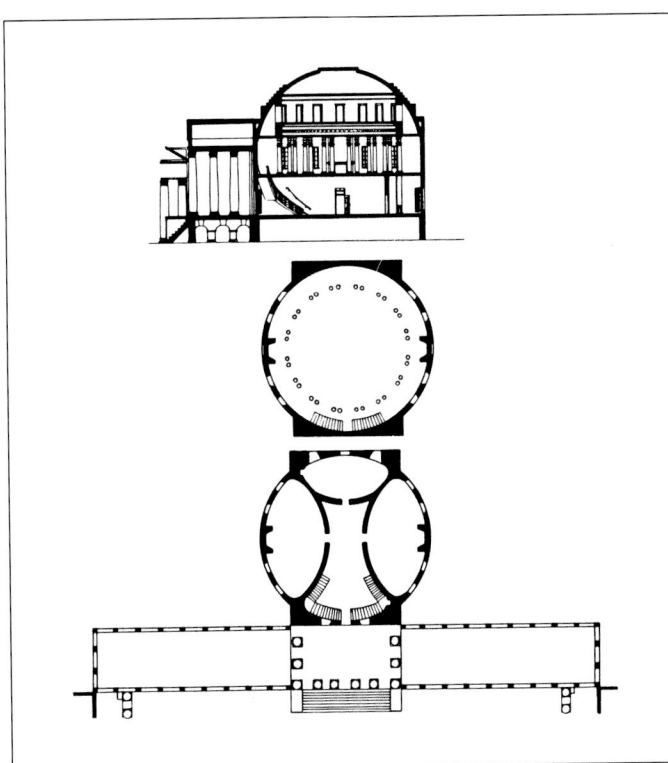

19.19 Thomas Jefferson, plan and section of the Rotunda, University of Virginia, Charlottesville. (From W. Blaser.)

The pride and joy of Jefferson's later years was the University of Virginia, the first state-supported educational establishment, located just a few miles from Monticello. Its centerpiece is the Rotunda (figs. **19.19** and **19.20**), originally the library. Although its proportions are somewhat taller, its inspiration is the Pantheon in Rome (see fig. 7.27). Among the purely Jeffersonian features are an entablature encircling the building and two layers of windows (pedimented on the ground floor, plain on the second).

On either side of the Rotunda, framing the central lawn, are two symmetrical rows of low, colonnaded buildings, which were (and still are) student quarters. These link a series of pavilions, built in the form of Roman temples. Each pavilion faithfully reproduces an architectural order according to a Classical prototype. The pavilions also housed the academic departments, with classrooms on the ground floor and living quarters for the professors on the upper floor.

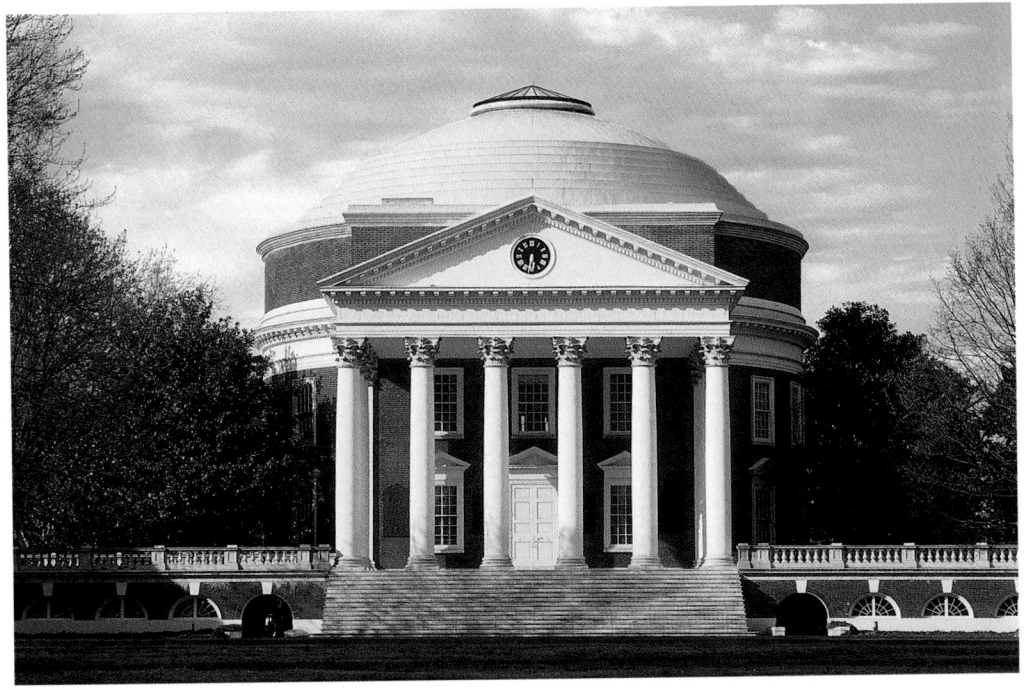

19.20 Thomas Jefferson, Rotunda, University of Virginia, Charlottesville, 1817–1826. Jefferson was the first rector of the university and described himself on his tombstone as "Father of the University." Both the curriculum and the architectural conception were a tribute to Jeffersonian humanist principles. In the quality of its individual parts and the harmony of the whole environment, Jefferson's "academical village," as he called it, is a masterpiece of the Federal style.

CONNECTIONS

See figure 7.27. The Pantheon, A.D. 117–125.

John Trumbull's *Declaration of Independence*

In 1817, President James Madison commissioned John Trumbull to paint four pictures illustrating American independence; they were to hang in the Rotunda of the Capitol building in Washington, D.C. One of these was the *Declaration of Independence* (fig. **19.21**). The Declaration was a product of Enlightenment philosophy and of the belief that reason could impose an intelligent order on human society. According to Trumbull's autobiography, he was given advice on the composition by Jefferson himself.

All the signers are present in the painting, in which the solemn dignity of the occasion is portrayed. Formally, it is a construction of rectangular space, with simple doors and an unadorned Doric frieze. The furniture is austere, and the figures wear plain, contemporary American dress. Contrasting with the overall austerity are the sweeping—and slightly more colorful—diagonals of the flags and the drum on the far wall. These refer to the battles that had made it possible to achieve the aims of the Declaration. Visually, the flags unite the long diagonal of mostly seated figures at the left with the central group in front of the desk and the seated figures at the right. The tallest figure, distinguished by a long red vest, is Jefferson. He hands a copy of the Declaration to John Hancock of Massachusetts. Standing to Jefferson's left is the stocky Benjamin Franklin of Pennsylvania, and at the left in the foreground is John Adams of Massachusetts. Between Adams and Jefferson are Roger Sherman of Connecticut and Robert Livingston of New York.

19.21 John Trumbull, *Declaration of Independence*, 1818. Oil on canvas; 12 × 18 ft. (3.66 × 5.49 m). U.S. Capitol Rotunda, Washington, D.C. Trumbull came from a Calvinist family of Connecticut. He fought in the Revolution and was educated at Harvard. In 1780, he went to London and studied with Benjamin West, who influenced his history paintings. He also painted many portraits.

Greenough's *George Washington*

Shortly after the University of Virginia was completed, the United States Congress decided to erect a statue to commemorate George Washington in a grand manner. In 1832, the commission was given to Horatio Greenough (1805–1852), America's first professional sculptor, then living in Italy. The colossal marble statue that he produced (fig. **19.22**) was inspired by Phidias's Early Classical sculpture of Zeus in the temple at Olympia (see fig. 5.36). Although this work, one of the Seven Wonders of the ancient world, was lost, it was known from ancient descriptions and from representations on coins. Figure **19.23** shows a nineteenth-century illustration based on the original statue of Zeus by Phidias at Olympia.

The imposing presence, monumental scale, and grand gestures of the *Washington* also have a Romantic quality. Nude from the waist up, the figure points upward in the manner of David's Socrates (see fig. 19.4) and Raphael's Plato (see fig. 14.36). The statue embodies the various aspects of Washington—man of action, political philosopher, ruler, and general. A frontal pose and imposing presence, combined with a lion throne, create the impression of a powerful leader. Unfortunately, the statue did not reach America until 1841, by which time tastes had changed. The Neoclassical style was no longer in fashion, and the statue was criticized for its partial nudity. It was placed outside the Capitol building in Washington, D.C., where it began to erode; today it sits unceremoniously inside the rotunda of the National Museum of American Art, part of the Smithsonian Institution.

In the United States, as in western Europe, the purity of Neoclassicism gave way to Romanticism. In its own way, the Romantic movement, like the Neoclassical, had political, cultural, and literary significance, much of which is reflected in the visual arts.

19.22 Horatio Greenough, *George Washington*, 1832–1841. Marble; 11 ft. 4 in. × 8 ft. 6 in. × 6 ft. 10 in. (3.45 × 2.59 × 2.08 m). National Museum of American Art, Smithsonian Institution, Washington, D.C.

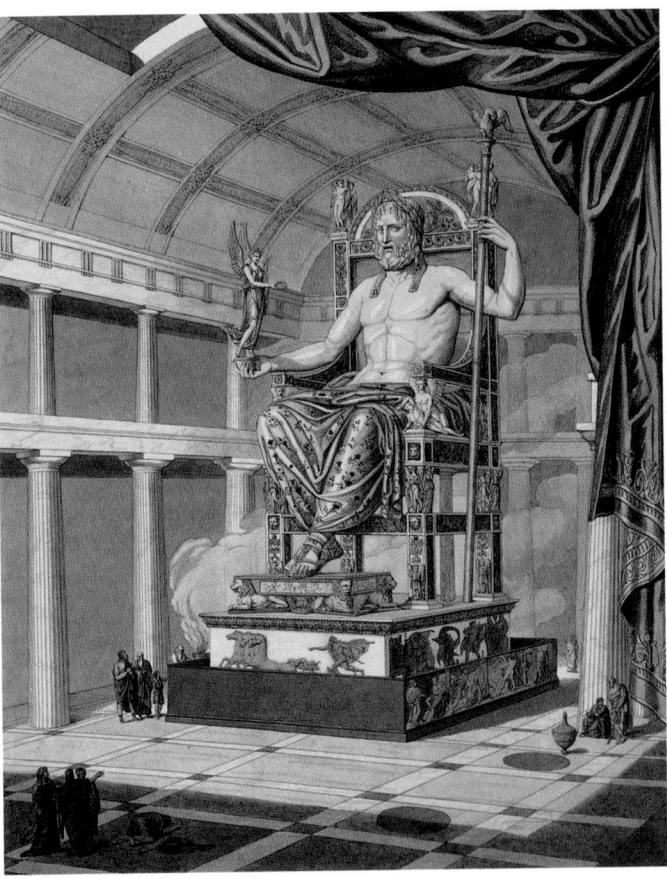

19.23 Antoine Chrysostome Quatremère de Quincy, *Reconstruction of Zeus at Olympia*, frontispiece to *Le Jupiter Olympien*, 1815.

Style/Period	Works of Art	Cultural/Historical Developments

1730

NEOCLASSICAL 1730–1800

Jefferson, Monticello

Jefferson, Monticello (**19.16**), Charlottesville
Clodion, *Intoxication of Wine* (**19.1**)
David, *Oath of the Horatii* (**19.3**)
Jefferson, State Capitol, Richmond (**19.18**)
Canova, *Cupid and Psyche* (**19.2**)
David, *Death of Socrates* (**19.4**)
Houdon, *Thomas Jefferson* (**19.15**)
David, *Death of Marat* (**19.5**)

David, Death of Marat

Lord Burlington promotes Neoclassical architecture in England (1725–1750)
James Watt perfects the steam engine (1775)
American Declaration of Independence (1776)
American Revolutionary War (1776–1784)
Edward Gibbon, *Decline and Fall of the Roman Empire* (1776–1788)
French Revolution begins (1789)
Thomas Paine, *Rights of Man* (1790)
Wolfgang Amadeus Mozart, *Magic Flute* (1790)

Benoist, Portrait of a Negress

1800

1800–1810

David, Napoleon at Saint Bernard Pass

Benoist, *Portrait of a Negress* (**19.10**)
David, *Napoleon at Saint Bernard Pass* (**19.6**)
Ingres, *Madame Rivière* (**19.11**)
Ingres, *Napoleon Enthroned* (**19.12**)
Chalgrin et al., *Arc de Triomphe* (**19.7**), Paris
Canova, *Maria Paolina Borghese as Venus* (**19.9**)
Ingres, *Oedipus and the Sphinx* (**19.13**)
Percier and Fontaine, Place Vendôme column (**19.8**), Paris

Thomas Jefferson negotiates Louisiana Purchase (1803)
Expedition to the Pacific Coast by Lewis and Clark (1803–1806)
Napoleon proclaimed emperor of France (1804)
Ludwig van Beethoven, the Eroica Symphony (1804)
Lord Nelson defeats French fleet at Trafalgar (1805)

Canova, Maria Paolina Borghese as Venus

1810

1810–1840

Jefferson, Rotunda, University of Virginia

Ingres, *Grande Odalisque* (**19.14**)
Quatremère de Quincy, *Reconstruction of Zeus at Olympia* (**19.23**)
Jefferson, Rotunda, University of Virginia (**19.20**), Charlottesville
Trumbull, *Declaration of Independence* (**19.21**)
Greenough, *George Washington* (**19.22**)

Ingres, Grande Odalisque

Johann Wolfgang von Goethe, *Faust* (1808–1832)
Napoleon retreats from Russia (1812)
Lord Elgin brings sculptures from the Parthenon to England (1812)
Jane Austen, *Pride and Prejudice* (1813)
Stephenson's first steam locomotive (1814)
Congress of Vienna (1814–1815)
Napoleon defeated at Waterloo; exiled to Saint Helena (1815)
University of Virginia founded by Thomas Jefferson (1817)
Greece declares independence from Turkey (1822)
James Fenimore Cooper, *Last of the Mohicans* (1826)
Alexandre Dumas, *Three Musketeers* (1828)
July Revolution; Louis-Philippe king of France (1830)
Stendhal, *The Red and the Black* (1830)
Alfred Lord Tennyson, "The Lady of Shalott" (1832)
Honoré de Balzac, *Comédie Humaine* (1832–1850)
Charles Dickens, *Oliver Twist* (1838)

1840

20

Romanticism: The Late Eighteenth and Early Nineteenth Centuries

The Romantic Movement

The Romantic movement, like Neoclassicism, swept through western Europe and the United States. The term *Romantic* is derived from the Romance languages (French, Italian, Spanish, Portuguese, and Romanian) and from the medieval tales of chivalry and adventure written in those languages, such as the *Chanson de Roland* (Song of Roland). Romantic literature shares with the so-called "Gothic" novels and poems by English writers of the late eighteenth and early nineteenth centuries a haunting nostalgia for the past. The Romantic aesthetic of "long ago" and "far away" is conveyed in works with locales and settings that indicate the passage of time, such as ruined buildings and broken sculptures. To the extent that Neoclassicism expresses a nostalgia for antiquity, it too may be said to have a "Romantic" quality.

Whereas Neoclassicism has its roots in antiquity, the origins of Romanticism are found in the eighteenth cen-

Chronology of Events in France

1814 Napoleon abdicates, and the Bourbon monarchy is restored under Louis XVIII (the Restoration).

1824 Charles X becomes king of France.

1830 The July Revolution. The Bourbons are overthrown and Louis-Philippe becomes "citizen-king" with limited powers. More citizens are given the right to vote for the legislature.

1848 The February Revolution. Louis-Philippe is overthrown, and the Second Republic begins. Napoleon's nephew, Louis-Napoleon, is elected president.

1852 Louis-Napoleon is proclaimed emperor (Napoleon III); the Second Empire begins.

1870 Louis-Napoleon abdicates following France's defeat in the Franco-Prussian War; the Third Republic begins.

Rousseau on the Return to Nature

Jean-Jacques Rousseau (1712–1778) was a leading eighteenth-century French philosopher. His writings inspired the French Revolution and also provided the philosophical underpinning of the Romantic movement. The artists and writers who subscribed to Rousseau's views are known as the "Romantics." Rousseau advocated a "return to nature." He believed in the concept of the "noble savage"—that humanity was born to live harmoniously with nature, free from vice, but had been corrupted by civilization and progress. Such ideas led to the political belief that the people themselves should rule. In his literary fiction, Rousseau created elaborate descriptions of natural beauty that were consistent with the Romantic aesthetic.

tury, especially in the work of the French philosopher Jean-Jacques Rousseau (see box). The effect of the Romantic movement on early nineteenth-century culture is evident not only in the visual arts, but also in politics, social philosophy, music, and literature (see box, p. 722).

It is impossible to assign precise dates to the Romantic movement. Historians generally agree, however, that the *Lyrical Ballads* of Wordsworth and Coleridge, which were published in 1798, are a seminal work, that the July Revolution of 1830 in France (see box) marks the high point in Romantic influence on politics, and that by 1848 enthusiasm for Romanticism was in decline.

Romanticism comprised a wide range of subject matter, which offered more thematic possibilities than Neoclassicism. In contrast to the Neoclassical virtues of order and clarity, the Romantics believed in emotional expression and sentiment. Instead of encouraging heroism on behalf of an

The various strains of Romanticism that are evident in the visual arts are also found in nineteenth-century music and poetry. In Romantic music, the expression of mood and feeling takes precedence over form and structure. Its antithesis is classical music, in which classical form and proportion predominate over emotional expression.

Romantic music was often based on literary themes, and literary or geographical references evoked various moods. Some of Hector Berlioz's overtures, for example, are based on Sir Walter Scott's historical novels, which are set in the Middle Ages. Felix Mendelssohn's "Italian" and "Scottish" Symphonies are based on the composer's travels in Italy and Scotland. The Polish mazurkas of Frédéric Chopin and the Hungarian rhapsodies of Franz Liszt reflect the strong nationalistic strains of Romanticism. In opera, the emotional and nationalistic intensity of the Romantic movement found its fullest expression in the works of Richard Wagner.

In English poetry, the leaders of Romanticism were William Wordsworth (1770–1850) and Samuel Taylor Coleridge (1772–1834). In 1798, they jointly published a collection of poems, *Lyrical Ballads*, the introduction to which served as a manifesto for the English Romantics.

Wordsworth's "The Solitary Reaper" conveys a sense of the melancholy oneness of humanity with an all-encompassing nature. The reaper is alone in a vast expanse of land when seen by the poet:

Behold her, single in the field,
Yon solitary Highland Lass!
Reaping and singing by herself;
Stop here, or gently pass!
Alone she cuts and binds the grain,
And sings a melancholy strain;
O listen! for the Vale profound
Is overflowing with the sound. (stanza I)

Other English poets of the Romantic movement included Lord Byron (1788–1824), Percy Bysshe Shelley (1792–1822), and John Keats (1795–1821). Byron's nostalgic yearning for ancient Greece is evident in much of his poetry:

The isles of Greece, the isles of Greece!
 Where burning Sappho loved and sung,

Where grew the arts of war and peace,
 Where Delos rose, and Phoebus sprung!
Eternal summer gilds them yet,
But all, except their sun, is set.
("Don Juan" III, lxxxvi)

Shelley's "Ozymandias" conveys the attraction of exotic locales and explores our ability to communicate with the past through time-worn artifacts:

I met a traveller from an antique land
Who said: "Two vast and trunkless legs of stone
Stand in the desert . . ."
And on the pedestal these words appear:
"My name is Ozymandias, king of kings:
Look on my works, ye Mighty, and despair!"
Nothing beside remains. Round the decay
Of that colossal wreck, boundless and bare,
The lone and level sands stretch far away.
(lines 1–3, 9–14)

In 1819, Shelley visited the Uffizi Gallery in Florence, where he saw a painting of Medusa's head, then attributed to Leonardo da Vinci. The head lies on the ground, crawling with lizards, insects, and snakes. Shelley's poem expresses the Romantic taste for the macabre, the appeal of death, and the theme of the aloof, unattainable woman:

It lieth, gazing on the midnight sky,
 Upon the cloudy mountain-peak supine;
Below, far lands are seen tremblingly;
 Its horror and its beauty are divine.
("On the Medusa of Leonardo da Vinci in the Florentine Gallery," lines 1–4)

The aloof and unattainable woman, seen by the Romantics as cold and deathlike but nevertheless fascinating, is celebrated with a medieval flavor in Keats's "La Belle Dame sans Merci":

I saw pale kings and princes too,
 Pale warriors, death-pale were they all;
They cried—"La Belle Dame sans Merci
 Hath thee in thrall!" (lines 37–40)

abstract ideal in the Neoclassical manner, the Romantics were often partisan supporters of contemporary causes, such as the individual's struggle against the abuses of the state.

In addition to their nostalgia for the past and idealistic participation in current events, the Romantics were interested in the mind as the site of mysterious, unexplained, and possibly dangerous phenomena. For the first time in Western art, dreams and nightmares were depicted as internal events, with their source in the individual imagination, rather than as external, supernatural happenings. States of mind, including insanity, began to interest artists, whose studies anticipated Freud's theories of psychoanalysis at the end of the nineteenth century and the development of modern psychology in the twentieth.

Architecture

In architecture, the Romantic movement was marked by revivals of historical styles. The Gothic Revival had begun in the late eighteenth century with such buildings as Horace Walpole's Strawberry Hill (see fig. 18.23). Likewise, the Neoclassicism of Jefferson was a revival of ancient Greek and Roman forms, which were ideologically appropriate for a newly founded democracy.

The first important nineteenth-century public buildings in the Gothic style were the new Houses of Parliament in London (fig. **20.1**). These were constructed from 1836 to 1870 to replace the old palace of Westminster, which had been destroyed by fire in 1834 (see fig. 20.21). There was

20.1 Sir Charles Barry and Augustus W. N. Pugin, Houses of Parliament, London, 1836–1870.

See figure 11.28. West façade, Amiens Cathedral, 1220–1269.

20.2 Richard Upjohn, Trinity Church, New York, 1841–1852.

considerable debate over whether the new Houses should be in the Classical or the Gothic style. In the end, Gothic prevailed because it was regarded as both the national and the more Christian style. In addition, it would be a reminder that the parliamentary system of government had been established in the Middle Ages.

A competition held for this commission was won by Sir Charles Barry (1795–1860), one of the most established English architects. His collaborator, Augustus Pugin (1812–1852), was responsible for the decoration and details. A Catholic convert and almost a cult figure in early Victorian England, Pugin was the most vocal crusader for the Gothic style; he proclaimed its moral and religious superiority as the "only correct expression of the faith, wants, and climate" of England. In his book *Contrasts,* Pugin discusses architecture as a reflection of society; and in *The True Principles of Pointed or Christian Architecture,* he writes that architecture should be judged by the highest standards of Christian morality.

The new Houses of Parliament have Gothic decoration and fixtures but retain formal symmetry. (The overall result reportedly disappointed Pugin, who thought it too "Greek.") Despite the strong vertical accent of the Victoria Tower in the southwest corner and the clock tower of Big Ben at the north, the Houses of Parliament lack the soaring quality of Gothic cathedrals (see fig. 11.28). Instead, when seen from a distance, they give an impression of low horizontality.

Architects in America as well as Europe were influenced by the Gothic Revival. Richard Upjohn (1802–1878), an English immigrant to America, built over forty Gothic Revival churches. He is best known for Trinity Church, which he built in the pure Perpendicular Gothic style, at the intersection of Wall Street and Broadway in New York City (fig. 20.2). Its vaulting is of plaster, and the rest of the construction is stone. The deep chancel and elevated altar reflected the liturgical views of the High Church Anglican (Episcopalian) movement, to which Upjohn belonged. Trinity Church served a wealthy, urban parish, but Upjohn also designed churches built entirely of timber for poorer, rural

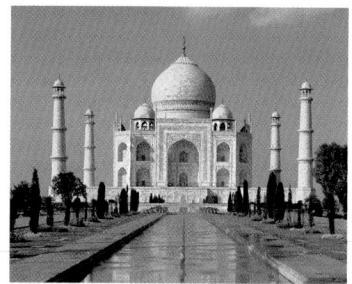

See figure I.3.
Taj Mahal,
1632–1648.

20.3 John Nash, Royal Pavilion, Brighton, England, 1815–1818. Nash had to leave London because of bankruptcy in 1793. By the end of the decade, his affairs were in order, and he returned to become a member of the prince regent's circle. He then made a fortune in real estate, especially from the development of Regent's Park and Regent Street, named after the title of his royal patron.

communities. *Upjohn's Rural Architecture,* published in 1852, was an illustrated handbook for the construction of inexpensive churches, chapels, and houses. These were largely of wood and provided the origin of the term *carpenter's Gothic.*

The Romantic vision of the Far East as a distant, exotic locale also became a source for nineteenth-century architecture. The Royal Pavilion (fig. **20.3**) in Brighton, a fashionable English seaside resort, was constructed for the prince regent by John Nash (1752–1835) in the Indian Gothic style (see fig. I.3). A mixture of minarets and onion domes, borrowed from Islamic architecture, covers a cast-iron framework. The Royal Pavilion echoes the Eastern forms that attracted Coleridge, whose "Kubla Khan" incorporates the exotic sounds of faraway places and suggests the typically Romantic taste for endless time and infinite space:

> In Xanadu did Kubla Khan
> A stately pleasure-dome decree;
> Where Alph, the sacred river, ran
> Through caverns measureless to man
> Down to a sunless sea. (lines 1–5)

Sculpture

Romantic sculptors were generally less prominent than poets, painters, and architects. One sculpture inspired by Romantic ideals is François Rude's (1784–1855) stone relief of 1833–1836 (fig. **20.4**). Originally entitled the *Departure of the Volunteers of 1792,* it is known as *La Marseillaise* and was one of four reliefs added to the Arc de Triomphe in Paris (see fig. 19.7).

The relief shows a group of volunteers answering the call to arms in defense of France against foreign enemies. They seem caught up in the "romance" of their enthusiasm as the rhythmic energy of their motion echoes the imaginary beat of military music (see caption). Rude's soldiers range from youths to old men, who are either nude or equipped with Classical armor. But unlike the stoic imagery of Neoclassical patriotism (see Chapter 19), Rude's volunteers seem carried away by the force of the crowd. Vigorously striding above the volunteers and driving them on is an allegory of Liberty. She is a nineteenth-century revolutionary version of the traditional winged Victory (cf. fig. 5.70).

20.4 François Rude, *Departure of the Volunteers of 1792 (La Marseillaise),* 1833–1836. Limestone; approx. 42 ft. (12.80 m) high. Arc de Triomphe, Paris. The "Marseillaise," the French national anthem, was composed in 1792 by the army officer Claude-Joseph Rouget de Lisle. Volunteers from the port of Marseille, who led the storming of the Tuilleries, brought the song to Paris.

Painting in Europe

William Blake

There was a strong Christian strain in Romanticism. This was associated with the longing for a form of religious mysticism, which, from the Reformation onward, had been on the wane in western Europe. This longing can be seen in the work of the English visionary artist and poet William Blake (1757–1827).

From 1793 to 1796, Blake illuminated a group of *Prophetic Books* dealing with visionary biblical themes. His watercolor and gouache (see box) *God Creating the Universe* (fig. **20.5**), also called the *Ancient of Days,* shows God organizing the world with a compass (cf. fig. I.6).

In this image, Blake's God is almost entirely enclosed in a circle. The light extending from each side of his hand forms the arms of a compass. The precision of the circle and triangle contrasts with the looser painting of clouds and light, and the frenetic quality of God's long, white hair, blown sideways by the wind. Blake's nostalgic combination of medieval iconography and a Michelangelo-style God with a revival of mysticism is characteristic of the Romantic movement. His passionate yearning for a past (and largely imaginary) form of Christianity appears in his poems as well as in his pictures. It is exemplified by the opening lines of his hymn "Jerusalem":

> And did those feet in ancient time
> Walk upon England's mountains green?
> And was the holy Lamb of God
> On England's pleasant pastures seen?

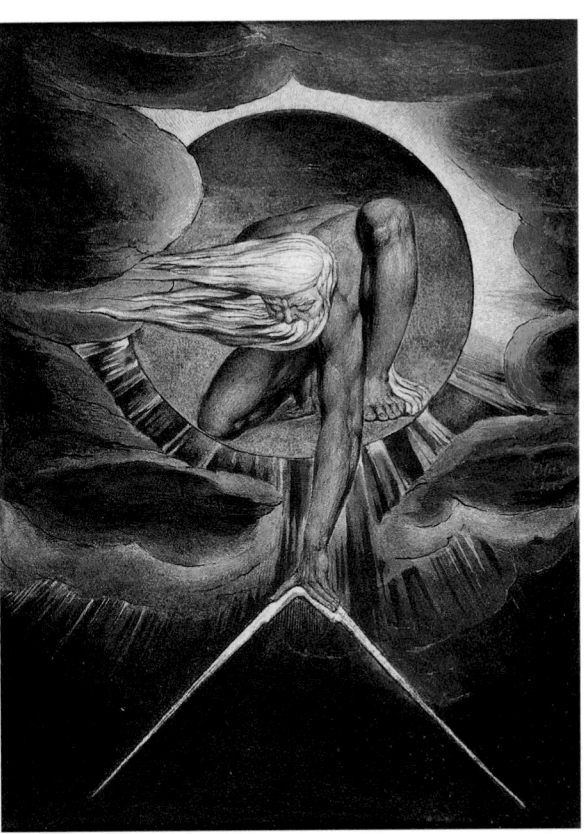

20.5 William Blake, *God Creating the Universe* (*Ancient of Days*), frontispiece of *Europe: A Prophecy*, 1794. Metal relief etching, hand-colored with watercolor and gouache; 12¼ × 9½ in. (31.1 × 24.1 cm). British Museum, London. Blake was an engraver, painter, and poet whose work was little known until about a century after his death.

CONNECTIONS

See figure 5.70. *Winged Nike* (*Winged Victory*), c. 190 B.C.

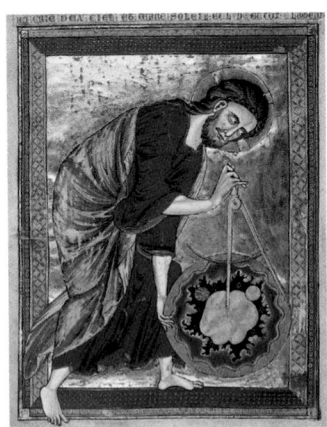

See figure I.6. *God as Architect* (*God Drawing the Universe with a Compass*), mid-13th century.

Watercolor

In **watercolor,** powdered pigments are mixed with water, often with gum arabic used as a binder and drying agent. Watercolor is transparent, and so one color overlaid on another can create a **wash** effect. The most common **ground** for watercolor is paper. Because the medium is transparent, the natural color of the paper also contributes to the image.

Watercolor had been known in China as early as the third century A.D. but was only occasionally used in Europe before the late eighteenth and early nineteenth centuries. At that point, it became popular, particularly with English artists such as Constable and Turner, for landscape paintings on a small scale. In the second half of the nineteenth century, watercolor also became popular among American artists. It was favored by those who preferred to paint directly from nature rather than in a studio and needed a more portable, quickly drying medium.

Gouache is a watercolor paint that, when dry, becomes opaque. It is commonly used on its own or in combination with transparent watercolor.

Théodore Géricault

Although Théodore Géricault (1791–1824) died at the age of thirty-three, his work was crucial to the development of Romantic painting, especially in France. His *Mounted Officer of the Imperial Guard* (fig. **20.6**), painted in 1812, when Géricault was only twenty-one, shows the early expression of his prodigious talent. It is a tour de force illustrating the Romantic theme of man against nature. The officer turns sharply as he tries to control the rearing charger, on which he depends for his life. The turbulent sky and the indications of battle in the distance enhance the dramatic effect of the scene. A comparison of this work with David's *Napoleon at Saint Bernard Pass* (see fig. 19.6), which also glorifies equestrian courage, shows the difference between the idealized clarity of Neoclassicism and the energetic textures of Romanticism.

Géricault's interest in human psychology is evident in his studies of the insane, which he executed from 1822 to 1823. In these works, he captured the mental disturbance of his subjects through pose and physiognomy. In the *Madwoman with a Mania of Envy* (fig. **20.7**), for example,

the figure hunches forward and stares suspiciously off to the left, as if afraid of some potential menace. The raising of one eyebrow and the lowering of the other, combined with the slight shift in the planes of her face, indicate the wariness of paranoia.

Géricault's loose brushstrokes create the textures of the woman's face, which is accentuated by light and framed by the ruffle of her cap. By the conscious organization of light, color, and the visibility of his brushwork, Géricault unifies the composition both formally and psychologically. The sweeping, light brown curve below the collar echoes the more tightly drawn curve of the mouth. Reds around the eyes and mouth are repeated in the collar, and the white of the cap ruffle recurs in the small triangle of the white undergarment. The untied cap laces and the few disheveled strands of her hair are a subtle metaphor for the woman's emotional state, as if she is "coming apart" and "unraveling" physically as well as mentally.

Géricault was a man of paradoxes—a fashionable society figure, but a political and social liberal who was active in exposing injustice. The subject of this portrait, which is also known as *L'Hyène de la Salpêtrière* (*The Hyena of the*

See figure 19.6. Jacques-Louis David, *Napoleon at Saint Bernard Pass*, 1800.

20.6 Théodore Géricault, *Mounted Officer of the Imperial Guard*, 1812. Oil on canvas; 9 ft. 7 in. × 6 ft. 4½ in. (2.92 × 1.94 m). Louvre, Paris. Géricault grew up in Napoleonic France. He admired the soldiers, especially the cavaliers, who fought with Napoleon. He himself was an avid rider; his death in 1824 was due to a fall from his horse.

20.7 Théodore Géricault, *Madwoman with a Mania of Envy*, 1822–1823. Oil on canvas; 28⅜ × 22⅘ in. (72.3 × 58.3 cm). Musée des Beaux-Arts, Lyons.

Salpêtrière), was a child murderess. La Salpêtrière was a mental hospital in Paris where Freud studied under the celebrated neurologist Jean-Martin Charcot and learned that hypnosis could temporarily relieve the symptoms of hysteria.

Géricault's commitment to social justice is reflected in his acknowledged masterpiece, the *Raft of the "Medusa"* (fig. **20.8**), which he began in 1818 and exhibited at the Salon (see box, p. 728) the following year. This picture

20.8 Théodore Géricault, *Raft of the "Medusa,"* 1819. Oil on canvas; 16 ft. × 23 ft. 6 in. (4.88 × 7.16 m). Louvre, Paris.

The Salon

The Salon refers to the official art exhibitions sponsored by the French authorities. The term is derived from the Salon d'Apollon in the Louvre Palace. It was here, in 1667, that Louis XIV sponsored an exhibition of works by members of the Académie Royale de Peinture et de Sculpture (Royal Academy of Painting and Sculpture). From 1737, the Salon was an annual event, and in 1748 selection by jury was introduced. Throughout the eighteenth century, the Salons were the only important exhibitions at which works of art could be shown.

This made acceptance by the Salon jury crucial to an artist's career.

During the eighteenth century, the influence of the Salon was largely beneficial and progressive. By the nineteenth century, however, despite the fact that during the Revolution the Salon was officially opened to all French artists, it was in effect controlled by Academicians, whose conservative taste resisted innovation.

commemorates a contemporary disaster at sea rather than a heroic example of Neoclassical patriotism. On July 2, 1816, the French frigate *Medusa* hit a reef off the west coast of Africa. The captain and senior officers boarded six lifeboats, saving themselves and some of the passengers. The 149 remaining passengers and crew were crammed onto a wooden raft, which the captain cut loose from a lifeboat. During the thirteen-day voyage that followed, the raft became a floating hell of death, disease, mutiny, starvation, and cannibalism. Only 15 people survived.

The episode became a national scandal when it was discovered that the ship's captain owed his appointment to his monarchist sympathies rather than to merit. Furthermore, the French government had tried to cover up the worst details of the incident. It was not until the ship's surgeon, one of the survivors from the raft, published an account of the disaster that the full extent of the tragedy became known. Géricault took up the cause of the victims against social injustice and translated it into a struggle of humanity against the elements.

The writhing forms, which are reminiscent of Michelangelo's Sistine Chapel figures from the *Flood*, echo the turbulence of sea and sky. In the foreground, a father mourns his dead son. Other corpses hang over the edge of the raft, while in the background, to the right, frantic survivors wave hopefully at a distant ship. The raft itself tilts upward on the swell of a wave, and the sail billows in the wind. As a result, the viewer looks down on the raft, directly confronting the corpses. The gaze gradually moves upward, following the diagonals of the central figures, and finally reaches the waving drapery of the man standing upright. In this painting, Géricault incorporates the Romantic taste for adventure and individual freedom into an actual event in which victims of injustice fight to survive the primal forces of nature. The mood of this painting is evoked by lines from "The Rime of the Ancient Mariner" by Coleridge, the English Romantic poet: "I looked upon the rotting deck, and there the dead men lay." To ensure authenticity, Géricault spoke with survivors and made studies of the dead and dying in morgues and hospitals before executing the final painting.

Eugène Delacroix

The most prominent figure in French Romantic painting was Eugène Delacroix (1798–1863), who outlived Géricault by nearly forty years. Delacroix was rumored to be the illegitimate son of the French statesman Charles Talleyrand (whom he resembled physically), but he was brought up in the family of a French government official. His celebrated *Journal,* which reveals his talent for writing, is a useful source of information on the social context of his life as well as on his philosophy of art.

In painting, Delacroix stood for color just as Ingres, his contemporary and rival, championed line. In this theoretical opposition, Delacroix and Ingres transformed the traditional aesthetic quarrel between *colorito* and *disegno,* the Rubenists and the Poussinists, the Moderns and the Ancients, into Romanticism versus Classicism. Delacroix's paintings are characterized by broad sweeps of color, lively patterns, and energetic figural groups. His thick brushstrokes, like Géricault's, contribute to the character of the image as well as to the surface textures of the canvas. They are in direct contrast to the precise edges and smooth surfaces of Neoclassical painting. Just as in literature Delacroix's contemporary, Victor Hugo (see box, p. 729), broke with the classically inspired rules of seventeenth-century French drama, so Delacroix continued and developed Géricault's taste for emotional expression, a wider range of textures, and freer outlines.

In an early work, the *Bark of Dante* (fig. **20.9**), exhibited in 1822, Delacroix reflects the Romantic revival of interest in Dante's *Inferno.* Dante and his guide, Virgil, are in the lake around the infernal city of Dis, the burning towers of which are visible in the background. The bark lists precariously as the damned souls rise up from the turbulent water to grasp hold of its sides. At the left, a terrified soul bites into the wooden rim of the boat. Dante reveals his own terror by raising his right hand in alarm to maintain his balance. In contrast, the figure of Virgil, clad in a heavy robe and a Classical laurel wreath, is calm. Leaning over and rendered in back view is Charon, the boatman of Hades.

20.9 Eugène Delacroix, *Bark of Dante*, 1822. Oil on canvas; 6 ft. 2⅞ in. × 8 ft. ⅞ in. (1.88 × 2.46 m). Louvre, Paris.

Victor Hugo

Victor Hugo (1802–1885), a prolific author of novels, plays, and poems, led the French Romantic movement in literature, especially in the 1820s and 1830s. Since his father was a general in Napoleon's army, his family was on close terms with the emperor. This gave Hugo an overview of French society, which he chronicled in his novels. He equated artistic freedom with political and social freedom, and championed all three. His novel *Les Misérables* deals with social injustice, and his poem "Written after July 1830"—like Delacroix's *Liberty*—supported the July 1830 Revolution:

Too long by tyrant hand restrain'd,
Too long in slavery enchain'd,
Paris awoke—and in his breast,

Each his ideas at once confest:
"Vainly may despots not essay
To lead a mighty race astray;
True to themselves, the French shall bring
Such treason home unto the king."

Hugo also defended the cause of Greek emancipation from Turkey, which is the subject of Delacroix's *Massacre at Chios*. His play *Hernani*, performed in 1830, led to a quarrel between conservative "Classicists," who favored order, rules, and restraint, and the proponents of a more "Romantic" emotional style. Like the other Romantics, Victor Hugo was drawn to subjective expression and to exotic, nostalgic, and melancholic themes.

20.10 Eugène Delacroix, *Massacre at Chios*, 1822–1824. Oil on canvas; 13 ft. 10 in. × 11 ft. 7 in. (4.22 × 3.53 m). Louvre, Paris.

In the *Massacre at Chios* (fig. **20.10**) of 1822–1824, Delacroix satisfied the Romantic interest in distant places and political freedom. In this, he shared the views of Byron (see p. 722), who died in 1824 fighting for Greek independence from Turkey. Delacroix enlists the viewer's sympathy for Greece by showing the suffering and death of its people in the foreground. They are individualized and thus elicit identification with their plight. At the same time, Delacroix has concentrated attention on the details of their exotic dress. Two Turks—one holding a gun and the other on a rearing horse—threaten the Greeks, while scenes of burning villages and massacre are depicted in the distance.

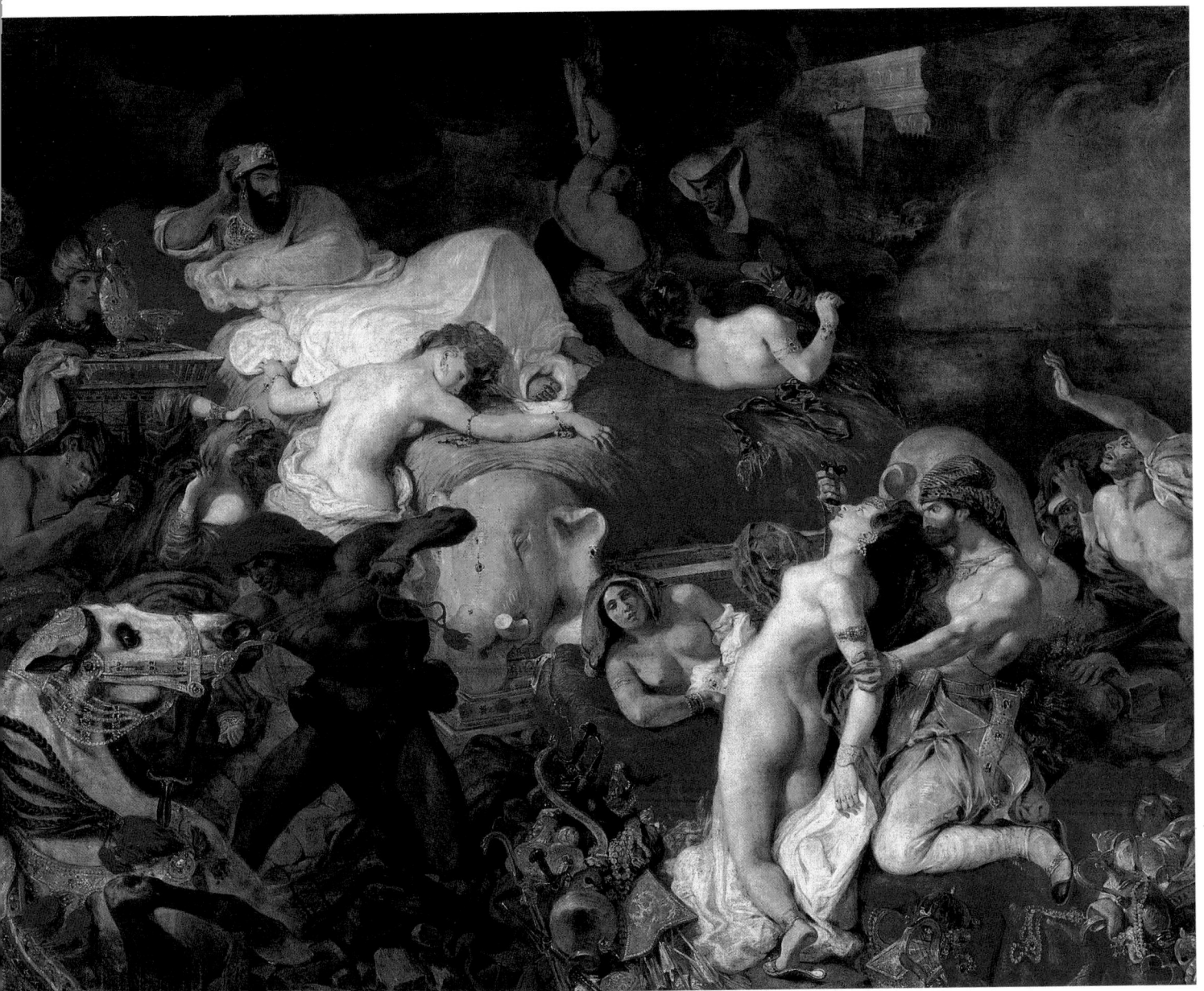

20.11 Eugène Delacroix, *Death of Sardanapalus*, 1827–1828. Oil on canvas; 12 ft. 11½ in. × 16 ft. 3 in. (3.95 × 4.95 m). Louvre, Paris. When the painting was exhibited at the Salon in February 1828, it was widely criticized. Delacroix was unable to sell it until 1845, and then the buyer was an English collector. The Louvre purchased the work in 1921.

The enormous *Death of Sardanapalus* (fig. **20.11**), inspired by Byron's play of the same subject, also reflects Delacroix's affinities with the poet. Both Byron and Delacroix portray the Assyrian king as a meditative figure in the midst of violence and debauchery. In the play, Sardanapalus accepts that his empire has fallen because his officials betrayed him, and he kills himself on a pyre with his favorite Ionian concubine, Myrrha. Delacroix's figure reclines on a large bed with a rich red covering that accentuates the sensuality of the scene and echoes the multiple reds throughout the painting. The opulence associated with the East is shown in the jewels and objects of gold strewn on the floor, and in the exotic costumes. Only Sardanapalus and Myrrha, lying at the king's feet, are calm. They are surrounded by vignettes of murderous rage and helpless victims. At the lower left, a black man pulls a fallen horse decked out in elaborate trappings, and at the upper right the city is engulfed in smoke.

Delacroix's *Liberty Leading the People* (fig. **20.12**), executed in 1830, applies Romantic principles to the revolutionary ideal. In contrast to Rude's *Marseillaise* (see fig. 20.4), whose figures are shown in side view, Delacroix's rebels march directly toward the viewer. Delacroix "romanticizes" the uprising by implying that the populace has spontaneously taken up arms, united in yearning for liberty (see caption). The figures emerge from a haze of smoke—a symbol of France's political emergence from the shackles of tyranny to enlightened republicanism. Visible in the distance is the Paris skyline with the towers of Notre-Dame Cathedral. From here the rebels will fly the tricolor (the red, white, and blue French flag).

As in the *Raft of the "Medusa,"* Delacroix's corpses lie in contorted poses in the foreground. The diagonal of the kneeling boy leads upward to Liberty, whose raised hand, holding the flag aloft, forms the apex of a pyramidal composition. Her Greek profile and bare breasts recall ancient statuary, while her towering form and costume confirm her allegorical role. By incorporating antiquity into his figure of Liberty, Delacroix makes a nostalgic, "Romantic" appeal to republican sentiment. Among Liberty's followers are representatives of different social classes, who are united by their common cause. In their determined march forward, they trample the corpses beneath them. They are willing to die themselves, secure in the knowledge that others will arise to take their place.

A colorist in the tradition of Rubens, Delacroix integrates color with the painting's message. In an image that is primarily composed of brown tones and blacks, the colors that appear most vividly on the flag are repeated with more or less intensity throughout the picture. Whites are more freely distributed. In the sky, reds and blues are muted. Denser blues are repeated in the stocking of the fallen man at the left and the shirt of the kneeling boy. His scarf and belt, like the small ribbon of the corpse at the right, are

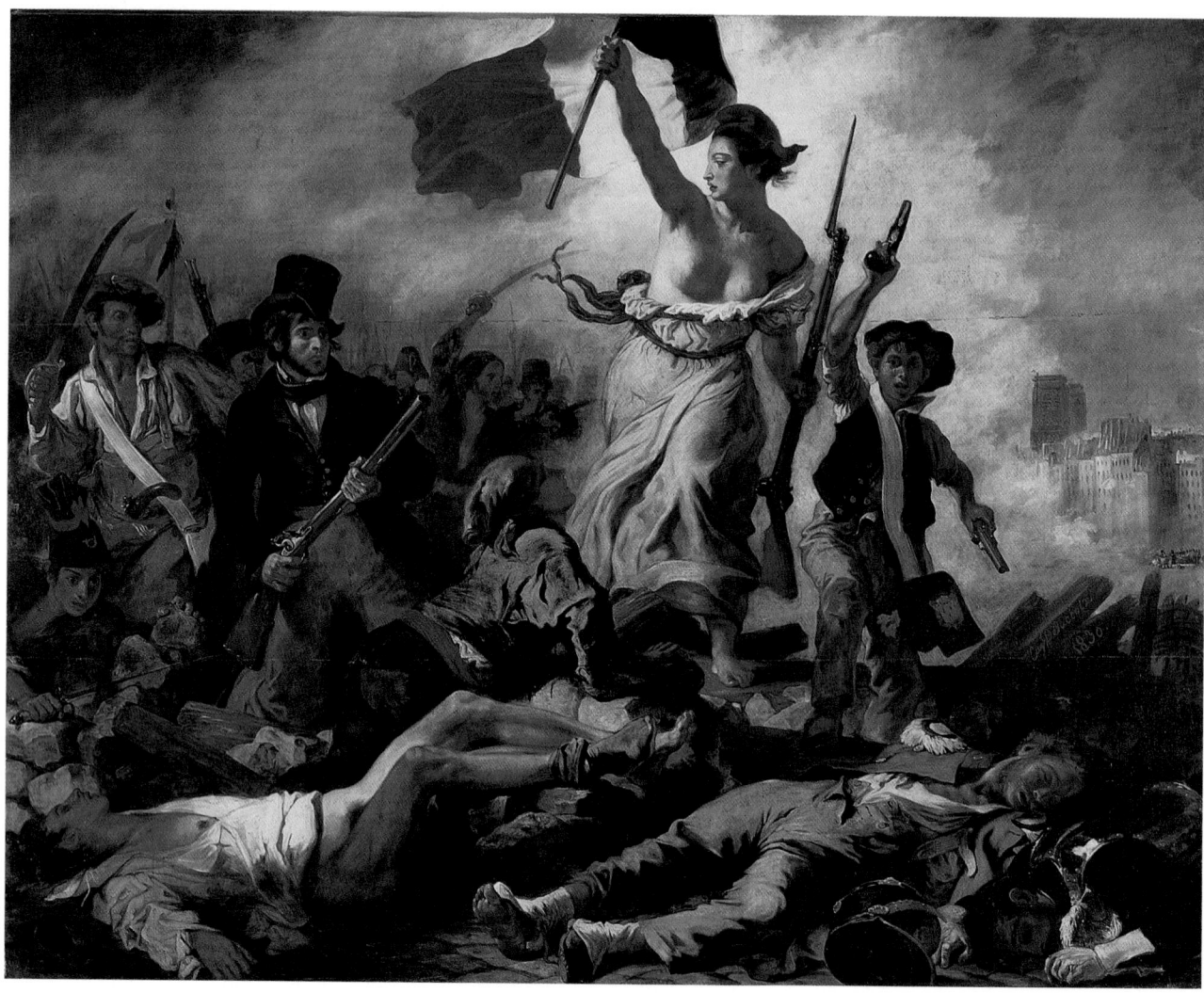

20.12 Eugène Delacroix, *Liberty Leading the People*, 1830. Oil on canvas; 8 ft. 6 in. × 10 ft. 7 in. (2.59 × 3.23 m). Louvre, Paris. This painting refers to the July 1830 uprising against the Bourbon king Charles X, which led to his abdication. Louis-Philippe, the "citizen-king," was installed in his place, though his powers were strictly limited.

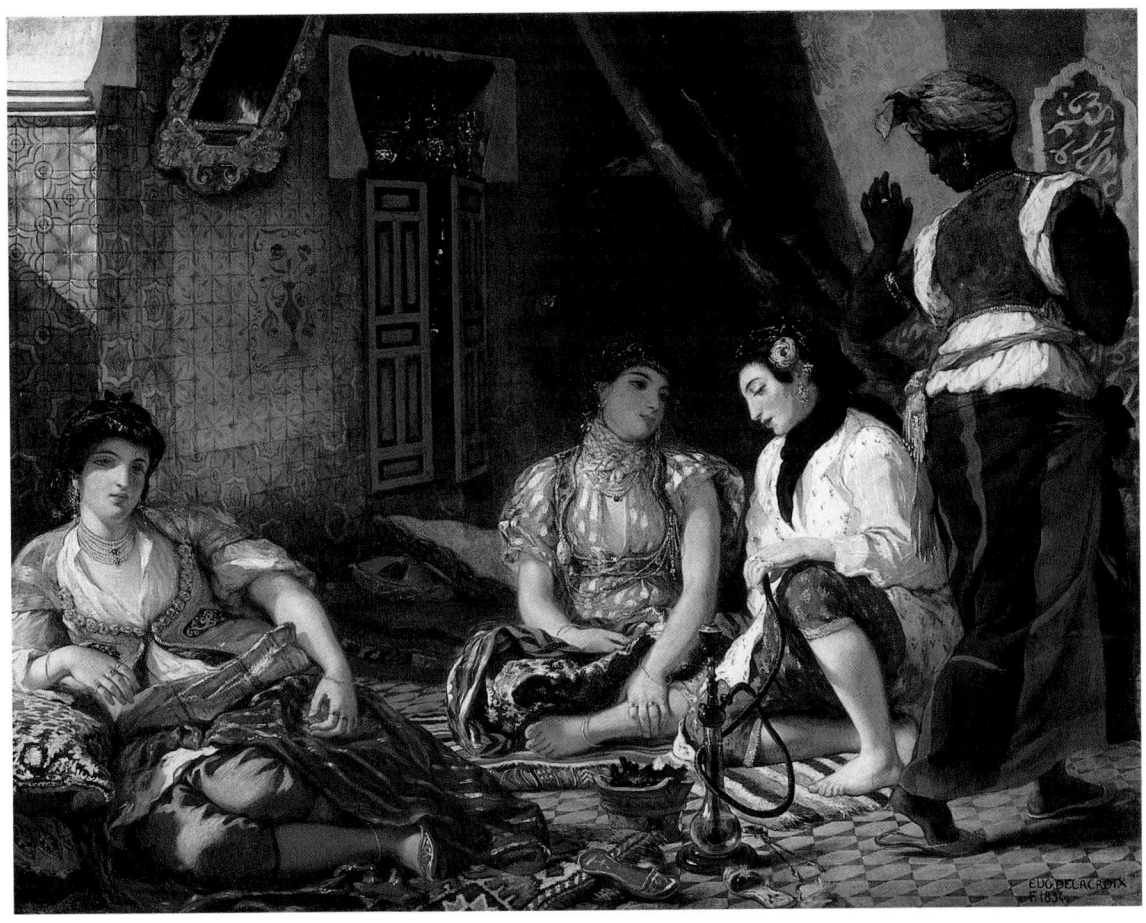

20.13 Eugène Delacroix, *Women of Algiers*, 1834. Oil on canvas; 5 ft. 10⅞ in. × 7 ft. 6⅛ in. (1.80 × 2.29 m). Louvre, Paris.

accents of red. In echoing the colors of the flag, which is at once a symbol of Liberty and of French republicanism, Delacroix paints a political manifesto.

In 1832, Delacroix traveled to North Africa, where he visited a harem and became fascinated by the lively patterns of Moorish costume and interior decor. The exotic, Moorish character of the region appealed to his Romantic taste. Although he continued to paint scenes of violence, including battles and animal hunts, he was also attracted by more tranquil scenes. A comparison of the *Women of Algiers* (fig. **20.13**) of 1834 with Ingres' *Grande Odalisque* (fig. 19.14) highlights Delacroix's rejection of the precise edges and smooth surface texture of Neoclassicism. He combines the relaxed, languorous poses of the harem women with the formal motion of surface design. Throughout the picture plane, the arabesques of Islamic lettering are reflected in pose and gesture, as well as in the designs themselves. The figures are redolent of the exotic, perfumed, and probably drugged harem atmosphere, whereas Ingres' odalisque is alert and clear. In contrast to the three

seated harem girls, the black African woman at the right seems in full possession of her faculties. She turns in a dancelike motion, as if something has caught her attention. The figure at the far left is a Moorish version of the traditional reclining nude, which is at odds with the pictorial principles of Ingres' odalisque.

See figure 19.14. Jean-Auguste-Dominique Ingres, *Grande Odalisque*, 1814.

Francisco de Goya y Lucientes

The leading Spanish painter of the late eighteenth and early nineteenth centuries, Francisco de Goya (1746–1828), was attracted by several Romantic themes. His compelling images reflect his remarkable psychological insights, and many also display his support for the causes of intellectual and political freedom. He studied Rembrandt and Velázquez both for their painterly techniques and for their penetrating character studies. Goya's affinity for Rembrandt's etchings is evident in his own prolific work in that medium.

In 1799, Goya published *Los Caprichos* (The Caprices), a series of etchings combined with the new medium of aquatint (see box). In this series, he depicts psychological phenomena, often juxtaposing them with an educational or social message. In plate 3 (fig. **20.14**), for example, the title of which may be translated as "The Bogeyman Is Coming," Goya illustrates the nighttime fears of childhood. The mother's gaze is riveted on the unseen face of the bogeyman, and her children cringe in fear. Their terrified expressions, contrasted with the anonymity of the apparition, accentuate the uncanny character of the bogeyman. Goya takes full advantage of the dramatic possibilities of the blacks and whites characteristic of the medium. The bogeyman's sharply contrasting light and dark—his "dark

> ### Aquatint
>
> Although etching was not new to the nineteenth century, its use in combination with **aquatint** was. In aquatint, the artist covers the spaces between etched lines with a layer of **rosin** (a form of powdered resin). This partially protects against the effects of the acid bath. Since the rosin is porous, the acid can penetrate to the metal, but the artist controls the acid's effect on the plate by treating the plate with varnish. This technique expands the range of grainy tones in finished prints. Aquatint thus combines the principles of engraving with the effects of a watercolor or wash drawing.

side" turned toward the children, whose white faces and black features accentuate their terror—is a metaphor for his two-sided nature. An inscription on the plate confirms Goya's enlightened view of child development, consistent with the philosophy of Jean-Jacques Rousseau, which was unusual in a country still haunted by the shadow of the Inquisition.

The *Witches' Sabbath* (fig. **20.15**) of 1798–1799 satirizes the irrational belief in witchcraft by exaggerating the primitive quality of such thinking. Goya implicitly attacks the Inquisition, which opposed the principles of the Enlightenment. He depicts the widespread fantasy that witches were old, ugly, deformed women who sucked the blood of children and fed infants to Satan. His witches form a circle around a devil in the guise of a goat, and one witch offers him a bloodless, skeletal infant. The lascivious implications of the goat and the bacchanalian grape leaves on his horns refer to popular notions of the witches' sabbath as an orgiastic, cannibalistic ritual.

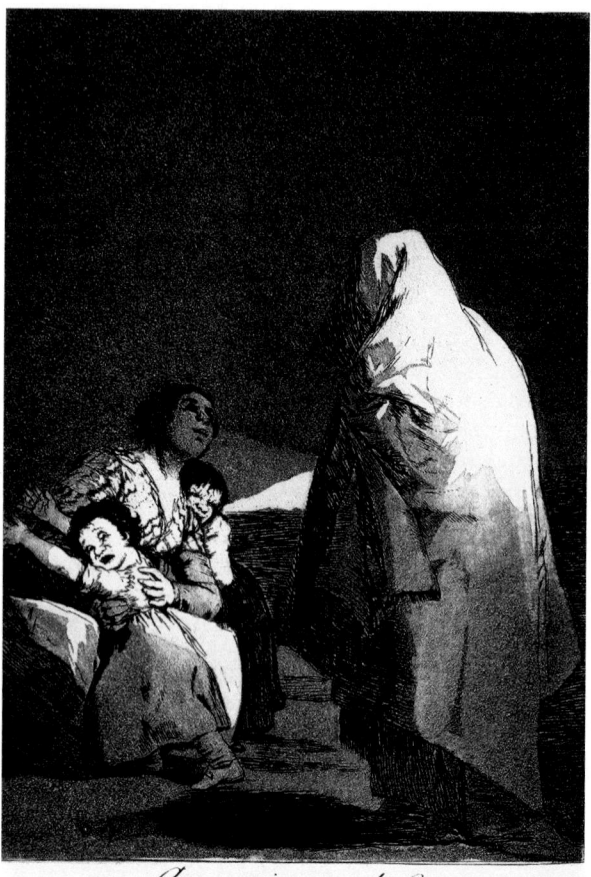

Que viene el Coco.

20.14 Francisco de Goya y Lucientes, *Los Caprichos*, plate 3, published 1799. Etching and aquatint. Inscribed on the plate (but not visible here) is Goya's warning against instilling needless fears into children: "Bad education. To bring up a child to fear a Bogeyman more than his own father is to make him afraid of something that does not exist."

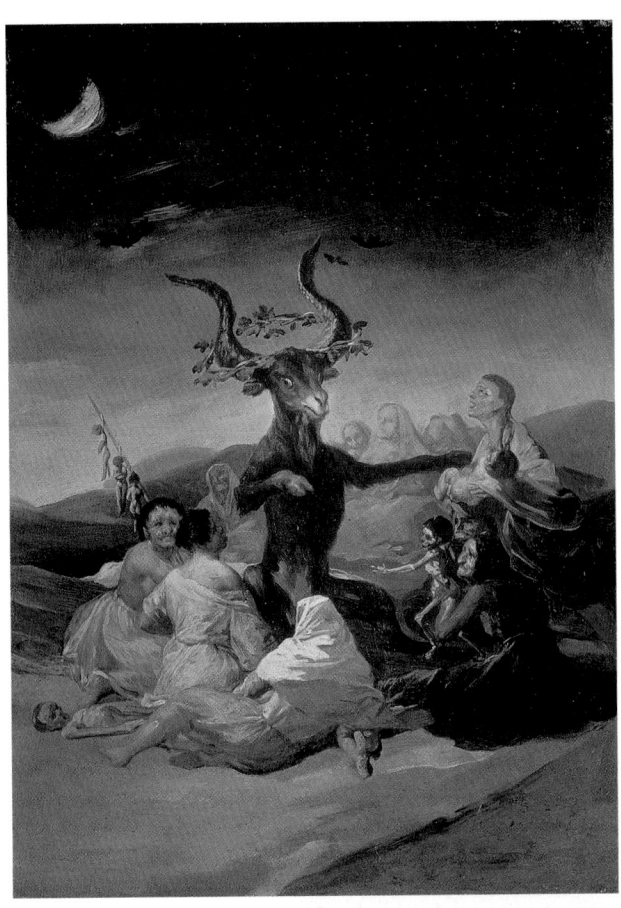

20.15 Francisco de Goya y Lucientes, *Witches' Sabbath*, 1798–1799. Oil on canvas; 17¼ × 12¼ in. (43.8 × 31.1 cm). Museo Lázaro Galdiano, Madrid.

In 1786, Charles III of Spain appointed Goya court painter, and his successor, Charles IV, promoted the artist to the position of principal painter. In his monumental portrait of the *Family of Charles IV* of 1800 (fig. **20.16**), Goya left a record of three generations of Spanish royalty. The pompous poses, glittering costumes, and blank stares highlight the unappealing character of the royal family. Such grandiose self-display conforms to the setting—the palace picture gallery—that had served the political image of Spanish royalty for centuries.

Goya's irony is enhanced by the insertion of his self-portrait at the left. In a quotation from Velázquez's *Las Meninas* (see fig. 17.56), Goya faces a large canvas of which only part of the back is visible to the observer. In contrast to the dynamic poses of Velázquez's picture, however, Goya's are stiff, rather like stuffed dolls. Instead of being drawn into the space of the picture as in *Las Meninas*, Goya's space comes to an abrupt halt in the shallow depth of the hall. The family of Charles IV is arrayed in a horizontal plane and seems to compete for visibility, like a group posing for a photograph. Whereas Velázquez stands proudly among his royal "peers," displaying his palette and brush for all to see, Goya portrays himself as diffidently fading into the background.

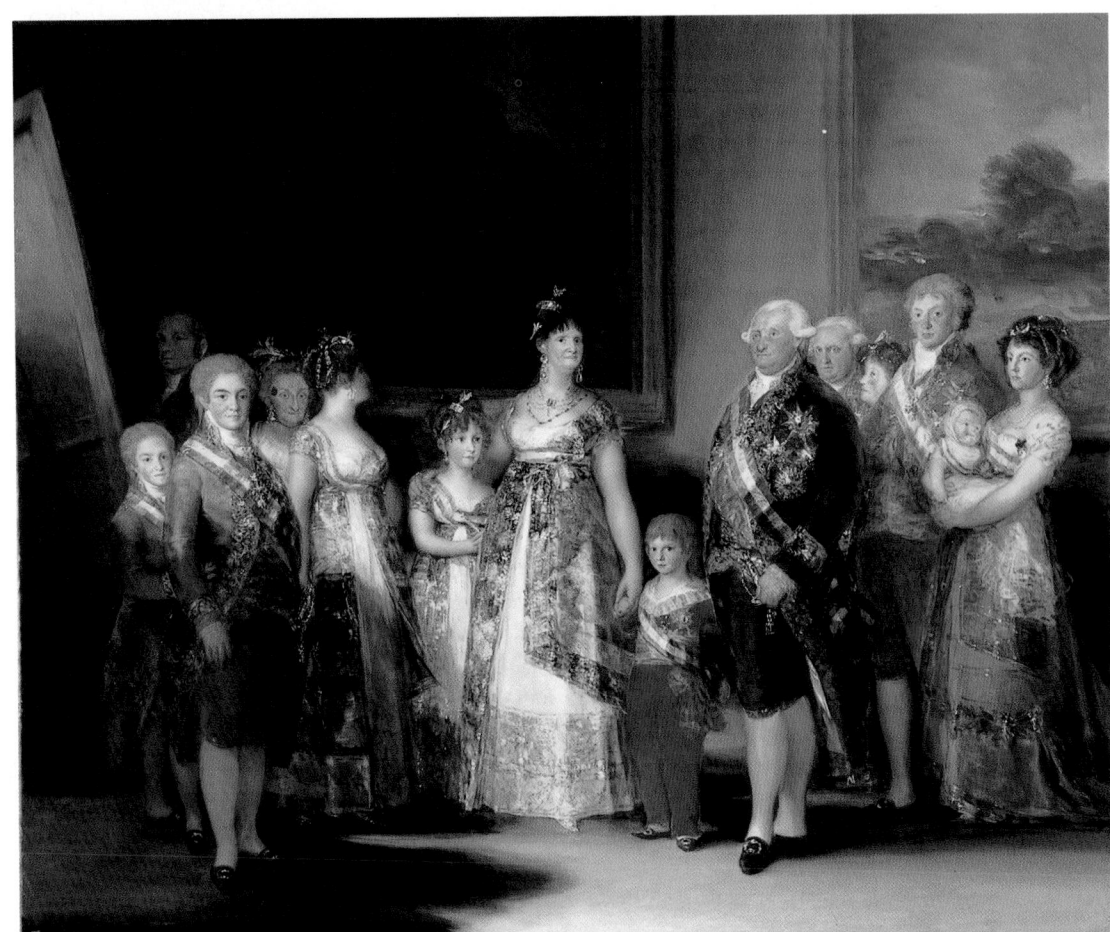

20.16 Francisco de Goya y Lucientes, *Family of Charles IV*, 1800. Oil on canvas; 9 ft. 2 in. × 11 ft. (2.79 × 3.35 m). Prado, Madrid.

In his images of war Goya champions Enlightenment views of individual freedom against political oppression. In the *Executions of the Third of May, 1808* (fig. **20.17**) he dramatically juxtaposes the visible faces of the victims with the covered faces of the executioners. This painting depicts the aftermath of events that occurred on May 2 and 3, 1808. Two Spanish rebels had fired on fifteen French soldiers from Napoleon's army. In response, the French troops rounded up and executed close to a thousand inhabitants of Madrid and other Spanish towns. Six years later, after the French had been ousted, the liberal government of Spain commissioned a pair of paintings, of which this is one, to commemorate the atrocity.

The firing squad is an anonymous, but deadly, force, whose regular, repeated rhythms and dark mass contrast with the highlighted, disorderly victims. The emotional poses and gestures, accentuated by thick brushstrokes, and the stress on individual reactions to the "blind," brute force of the firing squad are characteristic of Goya's Romanticism. The raised arms of the central, illuminated victim about to be shot recall the death of Jesus. His pose and gesture, in turn, are repeated by the foremost corpse. The lessons of Jesus's Crucifixion, Goya seems to be saying, are still unlearned. By mingling reds and browns in this section of the picture, Goya creates the impression that blood is flowing into the earth. Somewhat muted by the night sky, a church rises in the background and towers over the scene.

When he was in his seventies, Goya painted a series of so-called "black paintings." Since they were not commissioned, these late pictures reveal some of the artist's most intimate preoccupations. *Chronos Devouring One of His Children* (fig. **20.18**), of about 1820–1822, is a disturbing indictment of man's bestial nature.

According to Greek mythology, Chronos devoured his children to thwart the prophecy that they would overthrow him. But the children were gods and therefore immortal. They survived to fulfill their destiny and became the twelve Olympians. Goya's Chronos, on the other hand, crushes the child like a flimsy doll and tears away its arms

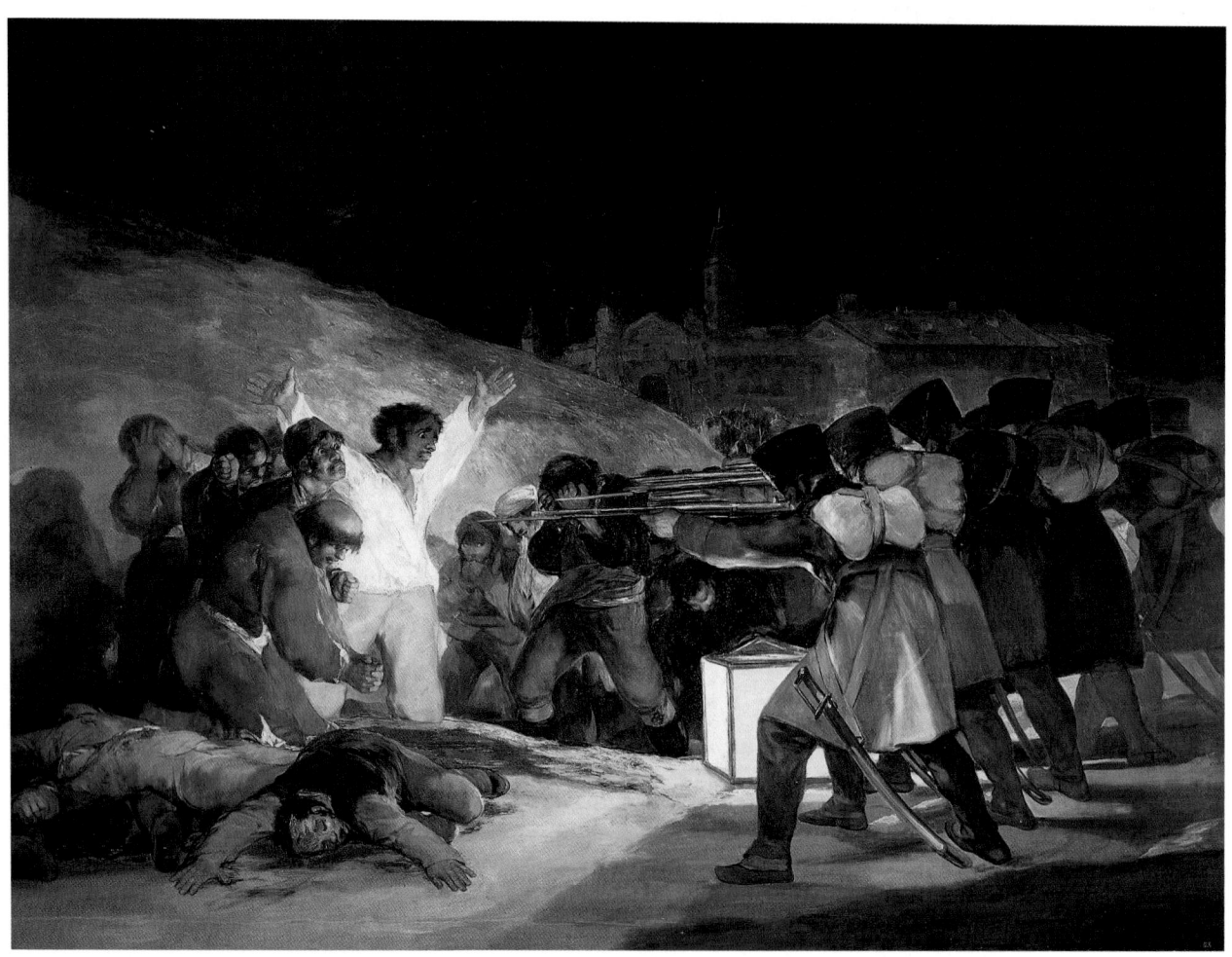

20.17 Francisco de Goya y Lucientes, *Executions of the Third of May, 1808*, 1814. Oil on canvas; 8 ft. 9 in. × 11 ft. 4 in. (2.67 × 3.45 m). Prado, Madrid.

20.18 Francisco de Goya y Lucientes, *Chronos Devouring One of His Children*, c. 1820–1822. Wall painting in oil detached on canvas; 4 ft. 9⅞ in. × 2 ft. 8⅝ in. (1.47 × 0.83 m). Prado, Madrid.

and head. His savagery is accented by the red of the blood outlining the upper torso and flowing across his hands.

Chronos stares wildly out of the picture, his gaping mouth tearing off a piece of the child's body. Goya depicts the Titan as a crazed, wide-eyed cannibal who is barely contained by the picture space. The loose brushstrokes, especially in the long hair and body, reinforce his bestial nature. In this frenzied, un-Classical image of a father devouring his child, Goya combines several themes that preoccupied him throughout his life. In particular, as in the "Bogeyman," he deals with the image of a terrifying father who destroys his vulnerable children, psychologically in the former and physically in the *Chronos*. Goya confronts humanity with an example of its "blackest," most primitive forms of behavior—infanticide and cannibalism. It is ironic that Goya's most anti-Classical image should ultimately project a humanistic message.

Burke on the Aesthetic of the Sublime

In 1757, the British philosopher Edmund Burke (1729–1797) published *A Philosophical Enquiry into the Origin of Our Ideas of the Sublime and Beautiful*. Certain artists and writers of the late eighteenth and early nineteenth centuries took up his views on the sublime, which reflect the ambivalent character of the Romantic aesthetic. According to Burke, the passions and the irrational exert a powerful, awesome force on people. These, he believed, explain the subjective reaction to art. Burke's aesthetic system describes the "irrational" attraction to fear, pain, ugliness, loss, hatred, and death (all of which comprise the notion of the sublime) on the one hand, and to beauty, pleasure, joy, and love on the other. (Some one hundred and fifty years later, Freud would show the co-existence of these oppositions in the unconscious and relate their dynamics to child development. Freud's essay of 1919 entitled "The Uncanny," which is his only work on aesthetics, has affinities with both the writing of Burke and the psychological paintings of Goya.) Pain and danger, according to Burke, "are the most powerful" passions. Life and health, in contrast, make less of an impression on people.

A summation of Burke's aesthetic is reflected in Shelley's "Medusa," whose "horror and . . . beauty are divine." Of the paintings illustrated in this chapter, several can be related to Burke's ideas. Revolutionary zeal that elevates the passions to new heights appears in Rude's *Marseillaise* and Delacroix's *Liberty Leading the People*. Géricault's *Madwoman* and Goya's *Chronos* evoke the terror of being killed or devoured by one's parents. Irrational fears are aroused in Goya's *Los Caprichos*, plate 3, and *Witches' Sabbath*. And nature, as in Friedrich's *Two Men Contemplating the Moon* (see fig. 20.19), has a quality of beauty, but it also threatens to envelop and submerge humanity with its infinite vastness. Friedrich's two men gazing at the moon evoke Burke's view that "terror is in all cases whatsoever, either more openly or latently, the ruling principle of the sublime."[1]

Germany: Caspar David Friedrich

Romantic themes often focused on the longing to return to nature and on the insignificance of the individual in relation to nature's vastness. The varying moods of nature were seen as a reflection of states of mind. Such themes led to an expansion of landscape painting in the nineteenth century. Romantic landscape often evoked a sense of the sublime (see box, p. 737), which included an uncanny quality of terror.

In Germany (see box), the poetic landscapes of Caspar David Friedrich (1774–1840) express these Romantic trends. His *Two Men Contemplating the Moon* (fig. **20.19**) exemplifies the merging of human form and mood with nature. The scene is barren, and the vastness of the landscape is suggested by its implied continuation beyond the borders of the picture. The two men have no identity other than their relationship to the landscape and their medieval dress, which reflects Romantic nostalgia for the past. Their forms are pure silhouettes and provide vertical accents cutting through the horizon line. As a result, they seem transitory and ghostly in contrast to the permanence of nature, which contributes to the sense of awe and the sublime.

20.19 Caspar David Friedrich, *Two Men Contemplating the Moon*, 1819. Oil on canvas; 13¾ × 17½ in. (35.0 × 44.5 cm). Gemäldegalerie Neue Meister, Staatliche Kunstsammlungen, Dresden.

England: John Constable and Joseph Mallord William Turner

In England, the two greatest Romantic landscape painters, John Constable (1776–1837) and Joseph Mallord William Turner (1775–1851), approached their subjects quite differently. Whereas Constable's images are clear and tend to focus on the details of English country life, Turner's are apt to become swept up in the paint.

In Constable's *Salisbury Cathedral from the Bishop's Garden* (fig. **20.20**), for example, cows graze in the foreground, while couples stroll calmly along pathways. The cathedral is framed by trees that repeat the verticality of its spire. Nostalgia for the past is evident in the juxtaposition of the day-to-day activities of the present with the Gothic cathedral. Humanity, like the cathedral, is at one with nature,

and there is no hint of the industrialization that in reality was encroaching on the pastoral landscape of nineteenth-century England. Echoing the atmosphere of this painting are the poems of Wordsworth, who wanted to break away from eighteenth-century literary forms and return to nature, to a "humble and rustic life." In "Tintern Abbey," Wordsworth evokes the Romantic sense of the sublime that is achieved by oneness with nature:

> . . . And I have felt
> A presence that disturbs me with the joy
> Of elevated thoughts; a sense sublime
> Of something far more deeply interfused,
> Whose dwelling is the light of setting suns,
> And the round ocean and the living air,
> And the blue sky, and in the mind of man . . .
>
> (lines 93–99)

20.20 John Constable, *Salisbury Cathedral from the Bishop's Garden*, 1820. Oil on canvas; 2 ft. 10⅝ in. × 3 ft. 8 in. (0.91 × 1.12 m). Metropolitan Museum of Art, New York (Bequest of Mary Stillman Harkness, 1950). (See also figs. 11.45–11.47.)

20.21 Joseph Mallord William Turner, *Burning of the Houses of Lords and Commons, October 16, 1834*, 1835. Oil on canvas; 3 ft. ¼ in. × 4 ft. ½ in. (0.92 × 1.23 m). Cleveland Museum of Art (Bequest of John L. Severance, 42.647).

In contrast to the calm landscapes of Constable, Turner's approach to Romanticism is characterized by dynamic, sweeping brushstrokes and vivid colors that blur the forms. His *Burning of the Houses of Lords and Commons* (fig. **20.21**) is a whirlwind of flame, water, and sky, structured mainly by the dark diagonal pier at the lower right, the bridge, and the barely visible towers of Parliament across the Thames. The painting is based on an actual fire of 1834. Turner spent the entire night sketching the scene. After the fire, the new Houses of Parliament (still standing today) were built in the Gothic Revival style (see fig. 20.1), which was inspired by Romantic nostalgia for a medieval Christian past.

The luminous reds, yellows, and oranges of the fire dominate the sky and are reflected in the water below. In this work, architectural structure is in the process of dissolution, enveloped by the blazing lights and colors of the fire. The forces of nature let loose and their destruction of man-made structures are the primary theme of this painting. In Constable, on the other hand, nature is under control and in harmony with human creations.

Painting in the United States

In the United States as well as Europe, the Romantic movement infiltrated both art and literature (see box). The landscape of different parts of the country inspired artists, individually and in groups, to produce works that were often monumental in size and breathtaking in effect.

Thomas Cole

One such painting is *The Oxbow* (fig. **20.22**) by Thomas Cole (1801–1848), which depicts a bend in the Connecticut River, near Northampton. (*Oxbow* is the term used to describe the crescent-shaped, almost circular, course of a river caused by its meandering.) One is struck by the abrupt contrast between the two sides of the painting. On the left is wilderness, where two blasted trees in the foreground

bear witness to the power of the elements. A thunderstorm, an example of nature's dramatic, changing moods characteristic of the Romantic aesthetic, is passing over. The direction of the rain indicates that the storm is moving away to the left and that it has already passed the farmland at the right, which now lies serene and sunlit. A landscape of neatly arranged fields, dotted with haystacks, sheep, and other signs of cultivation, extends into the distance. Boats ply the river, and plumes of smoke rise from farmhouses. Barely visible in the foreground, just right of center, is a single figure, the artist at work before his easel. On a jutting rock are his umbrella and folding stool and, leaning against them, a portfolio with the name T. Cole on its cover. Both artist and viewer have a panoramic view from the top of the mountain, a feature that became typical of the Hudson River school of painting, of which Cole was the acknowledged leader.

It was Cole's habit to journey on foot through the northeastern states, making pencil sketches of the landscape. He

20.22 Thomas Cole, *View from Mount Holyoke, Northampton, Massachusetts, after a Thunderstorm* (*The Oxbow*), 1836. Oil on canvas; 4 ft. 3½ in. × 6 ft. 4 in. (1.31 × 1.93 m). Metropolitan Museum of Art, New York (Gift of Mrs. Russell Sage, 1908). Cole was born in England and emigrated to America with his family at the age of seventeen. In 1825, his work came to the attention of John Trumbull (see Chapter 19), then president of the American Academy, who is quoted as saying: "This youth has done at once, and without instruction, what I cannot do after fifty years' practice." This story, whether anecdotal or not, places Cole squarely in the tradition of other "boy wonders" such as Giotto and Picasso.

American Romantic Writers

Nineteenth-century America produced many important Romantic works of literature. The historical adventures of James Fenimore Cooper (1789–1851), particularly *The Last of the Mohicans* (1826), extol Native Americans as examples of the "noble savage." The supernatural poems and tales of Edgar Allan Poe (1809–1849) contain uncanny portrayals of death and terror. Likewise, the Gothic novels and short stories of Nathaniel Hawthorne (1804–1864) create a haunted, medieval atmosphere in which supernatural phenomena abound. In *Tales of the Alhambra*, Washington Irving (1783–1859) evokes the mysterious atmosphere and exoticism of Islamic Spain.

A characteristic American Romantic philosophy emerged in the Transcendentalism of Ralph Waldo Emerson (1803–1882) and Henry David Thoreau (1817–1862), a doctrine that stressed the presence of God within the human soul as a source of truth and a moral guide. After a trip to England (where he met Coleridge and Wordsworth), Emerson became a spokesman for Romantic individualism, which he expressed in poems and essays. A more personal form of natural philosophy can be seen in Thoreau's experimental return to nature. He lived alone for two years in a hut at the edge of Walden Pond in Massachusetts and recorded his experience in *Walden; or, Life in the Woods* (1854).

would then develop them into finished paintings during the winter, and this was the case with *The Oxbow*. It is likely that Cole never actually witnessed the storm in the way he depicts it, and that there is a large element of the artist's imagination at work. If so, why did Cole choose this particular image? An untitled poem that he wrote in January 1835, a year before he completed *The Oxbow*, begins as follows:

I sigh not for a stormless clime,
Where drowsy quiet ever dwells,
Where purling waters changeless chime
Through soft and green unwinter'd dells—

For storms bring beauty in their train;
The hills that roar'd beneath the blast,
The woods that welter'd in the rain
Rejoice, whene'er the tempest's past.

Cole's affinity for storms has been interpreted by some scholars as a metaphor for his inner life, symbolic of some unresolved conflict or of inner peace following a period of stress. It is also possible to see the painting as an allegory of civilization (the right) versus savagery (the left), which is certainly consistent with Cole's own outlook. For although he made his reputation primarily as a landscape artist, Cole always aspired to a "higher style of landscape," a mode of painting having moral or religious significance.

George Bingham

In the latter half of the eighteenth century, most rural communities consisted of clusters of largely self-sufficient family-owned farms. Over the next fifty years, population growth and the increasing demand for new land made it hard for this system to survive. The building of canals and railroads commercialized the farm sector and stimulated competition between regions, all vying to sell the same crops to the same markets. Cole's country, the Hudson Valley and the Catskills, faced new competition from the Midwest and the Great Lakes. Agriculture became subject to the laws of the marketplace, vulnerable to changes in prices,

government policies, and credit conditions. Some farmers prospered, while those who were unable to adjust to the changes became marginalized by progress. Many immigrants, who had come to America in search of opportunity, never rose above the bottom rung of the economic ladder.

This darker side of American rural life is illustrated in the *Squatters* (fig. **20.23**) by George Caleb Bingham (1811–1879), who combined a career in Missouri politics with a vocation as a painter. His image of a poor rural family outside a log cabin reminds us that there were many agricultural workers who, unable to compete in a market economy and having perhaps lost their land through overmortgaging, led a hand-to-mouth existence as tenants, wage laborers, or squatters.

20.23 George Caleb Bingham, *Squatters*, 1850. Oil on canvas; 25 × 30 in. (63.5 × 76.2 cm). Museum of Fine Arts, Boston (Bequest of Henry L. Shattuck in memory of Ralph W. Gray).

Albert Bierstadt

The interest in American landscape pushed west from the Hudson River and inspired paintings of panoramic spaces with spectacular views of nature. Variations of light play over mountains, trees, and lakes, the colors softening and changing with the time of day. This emphasis on light led to the term **luminism,** an example of which can be seen in Albert Bierstadt's (1830–1902) *Sunrise, Yosemite Valley* (fig. **20.24**).

Bierstadt was born in Germany but raised in Massachusetts. He combined the German taste for Romanticism with an enthusiasm for the American West. In 1859, Bierstadt traveled west with European landscape painters in mind and an ambition to create a new vision in America. In *Sunrise, Yosemite Valley,* his rich yellow lighting is gradually transformed into muted grays as it moves left. The still lake is a mirror of change as it captures the fleeting sensations of nature. As with Friedrich (see fig. 20.19), Bierstadt emphasizes nature's vastness compared with humanity's smallness.

20.24 Albert Bierstadt, *Sunrise, Yosemite Valley,* n.d. Oil on canvas; 36½ × 52½ in. (92.7 × 133.4 cm). Amon Carter Museum, Fort Worth.

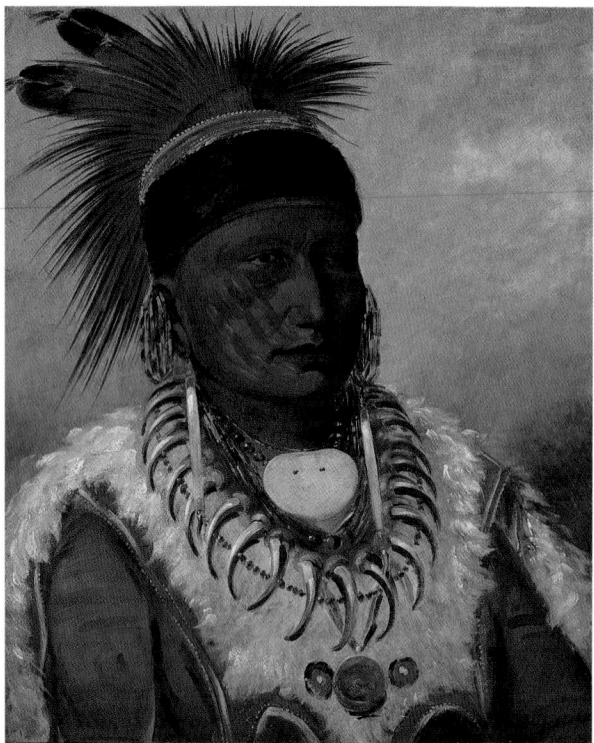

20.25 George Catlin, *The White Cloud, Head Chief of the Iowas*, 1844–1845. Oil on canvas; 28 × 22⅞ in. (71.1 × 58.1 cm). © 1998 Board of Trustees, National Gallery of Art, Washington, D.C., Paul Mellon Collection.

20.26 Edward Hicks, *Peaceable Kingdom*, c. 1834. Oil on canvas; 29⅜ × 35½ in. (74.8 × 90.2 cm). National Gallery of Art, Washington, D.C. (Gift of Edgar William and Bernice Chrysler Garbisch).

George Catlin

Although westward expansion in the nineteenth century caused conflict with the native population, it also led artists and authors to depict Native Americans—often in a Romantic light. The artist and ethnographer George Catlin (1796–1872), for example, created a visual and literary record of Native American life. He observed the Native American sense of oneness with nature, which, as with the European Romantics and American landscape painters, was seen as imbued with powerful spiritual forces.

In figure **20.25**, *The White Cloud, Head Chief of the Iowas,* Catlin shows the chief in full ritual dress, including feathers, war paint, animal skins, and a bear-claw necklace. The upright posture of White Cloud signifies the cultural pride of Native Americans, while his stoic, slightly worried expression suggests concern for his people.

Folk Art: Edward Hicks

Another view of nature in nineteenth-century American painting can be found in folk art. Typically, folk artists are not academically trained; their forms are usually flattened, their proportions are unnatural, and their imagery is without reference to the Classical tradition. As a result, their works tend to have a spontaneous quality that can be refreshing, compared with the more "finished" appearance of works by artists who have had formal training.

One example of this genre that embodies the Romantic ideal of a return to nature is the *Peaceable Kingdom* (fig. **20.26**) by Edward Hicks (1780–1849), who during his lifetime was celebrated more as a Quaker preacher than as an artist. Hicks based this painting on a passage from the book of Isaiah (11:6–9): "The wolf also shall dwell with the lamb, and the leopard shall lie down with the kid; and the calf and the young lion and the fatling together; and a little child shall lead them. . . ." Rather than being drawn into a vast space, the viewer experiences an immediate confrontation with the image, especially the wild cats. Its impact is enhanced by the close-up view of wild animals coexisting peacefully with humans. Their careful, almost staged arrangement and immobile frontality endow them with a static quality. The *Peaceable Kingdom* merges the natural landscape with a utopian ideal related to the notion of a Garden of Eden. The background scene, also utopian, is a visual quotation of a scene in Benjamin West's *Penn's Treaty with the Indians.* In contrast to the capricious, dangerous, and constantly changing eruptions of nature that are captured in the work of Turner, Cole, and Bierstadt, Hicks's image seems frozen in time.

Style/Period	Works of Art	Cultural/Historical Developments
ROMANTICISM **1790–1800**	Blake, *Ancient of Days* (**20.5**) Goya, *Witches' Sabbath* (**20.15**) Goya, *Los Caprichos* (**20.14**)	Samuel Taylor Coleridge, *Kubla Khan* (1797) Wordsworth and Coleridge, *Lyrical Ballads* (1798) Romantic literary movement (1798–1850)
1800–1820 **Friedrich, *Two Men Contemplating the Moon***	Goya, *Family of Charles IV* (**20.16**) Géricault, *Mounted Officer of the Imperial Guard* (**20.6**) Goya, *Executions of the Third of May, 1808* (**20.17**) Nash, *Royal Pavilion* (**20.3**), Brighton Géricault, *Raft of the "Medusa"* (**20.8**) Friedrich, *Two Men Contemplating the Moon* (**20.19**) **Nash, Royal Pavilion**	French army under Napoleon occupies Spain (1808) John Keats, *Endymion* (1818) Lord Byron, *Don Juan* (1819) **Géricault, Mounted Officer of the Imperial Guard**
1820–1830 **Goya, *Chronos Devouring One of His Children***	Goya, *Chronos Devouring One of His Children* (**20.18**) Constable, *Salisbury Cathedral from the Bishop's Garden* (**20.20**) Delacroix, *Bark of Dante* (**20.9**) Géricault, *Madwoman with a Mania of Envy* (**20.7**) Delacroix, *Massacre at Chios* (**20.10**) Delacroix, *Death of Sardanapalus* (**20.11**) **Constable, *Salisbury Cathedral from the Bishop's Garden***	Percy Bysshe Shelley, "Adonais" (1821) Walter Scott, Waverley novels (1821–1825) Ludwig van Beethoven, Choral Symphony (1824) John James Audubon, *Birds of America* (1827) **Delacroix, Death of Sardanapalus**
1830–1840 **Turner, *Burning of the Houses of Lords and Commons***	Delacroix, *Liberty Leading the People* (**20.12**) Rude, *La Marseillaise* (**20.4**) Hicks, *Peaceable Kingdom* (**20.26**) Delacroix, *Women of Algiers* (**20.13**) Turner, *Burning of the Houses of Lords and Commons* (**20.21**) Barry and Pugin, Houses of Parliament (**20.1**), London Cole, *The Oxbow* (**20.22**) **Delacroix, Liberty Leading the People**	Charles Darwin begins *Beagle* voyage (1831) Hector Berlioz, *Symphonie fantastique* (1832) End of slavery in British Empire (1834) William Wordsworth, *Poems* (1835) Victoria, queen of England (1837–1901) **Catlin, The White Cloud, Head Chief of the Iowas**
1840–1850 **Bierstadt, *Sunrise, Yosemite Valley***	Upjohn, *Trinity Church* (**20.2**), New York Catlin, *The White Cloud, Head Chief of the Iowas* (**20.25**) Bingham, *Squatters* (**20.23**) Bierstadt, *Sunrise, Yosemite Valley* (**20.24**)	John Ruskin, *Modern Painters I* (1843) Edgar Allen Poe, *The Raven and Other Poems* (1845) Irish famine leads to mass emigration (1845) Richard Wagner, *Tannhäuser* (1845) Pre-Raphaelite Brotherhood founded in England (1848) California gold rush begins (1848) John Ruskin, *Seven Lamps of Architecture* (1849) Nathaniel Hawthorne, *The Scarlet Letter* (1850)

1790 · 1800 · 1820 · 1830 · 1840 · 1850

21

Nineteenth-Century Realism

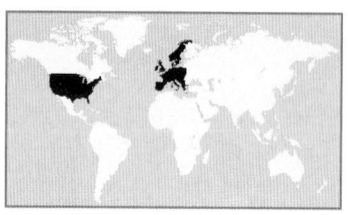

Cultural and Political Context

The nineteenth century was an age of revolutions—economic, social, and political—and these, like contemporary ideas about human rights, can be traced to the eighteenth-century Enlightenment. Resulting conflicts between different classes of society were often implicit in works of art—usually depicted from the viewpoint of those rebelling against political oppression.

A major force in polarizing social classes was the industrial revolution, which began in England, transforming the economies, first of western Europe (see map), then of the United States and other parts of the world, from an agricultural to a primarily industrial base. The process of industrialization continued at breakneck speed. Inventions

such as the steam engine and new materials such as iron and steel made manufacturing possible. The iron industry was transformed by the substitution of coke for charcoal in the smelting process. The greater availability of iron as a building material, in addition to its strength and resistance to fire, made it preferable to wood. By the third quarter of the nineteenth century, new processes led to the manufacture of inexpensive steel (an alloy of low-carbon iron and other metals), which by 1875 had begun to replace iron in the building and industrial sectors.

Factories were established, mainly in urban areas, and people moved to the cities in search of work. New social class divisions arose between factory owners and workers. Demands for individual freedom and citizens' rights were accompanied in many European countries by social and political movements for workers' rights. In 1848 Karl Marx and Friedrich Engels (see box) published the most influential of all political tracts on behalf of workers—the *Communist Manifesto*. The same year, the first convention for women's rights was held in New York.

Marx and Engels: The *Communist Manifesto*

The political theory of communism was set out by Karl Marx (1818–1883) and Friedrich Engels (1820–1895) in the *Communist Manifesto*, published in England in 1848.

Marxism views history as a struggle to master the laws of nature and apply them to humanity. The *Manifesto* outlines the stages of human evolution, from primitive society to feudalism and to capitalism, each phase being superseded by a higher one.

Marxists believed that bourgeois society had reached a period of decline; it was now time for the working class (or "proletariat") to seize power from the capitalist class and organize society in the interests of the majority. The next stage would be socialism under the rule of the working-class majority ("dictatorship of the proletariat"). This, in turn, would be followed by true communism, in which the guiding principle "from each according to his ability, to each according to his needs" would

be realized. Part analysis, part rhetoric, the *Manifesto* ends: "The proletarians have nothing to lose but their chains. They have a world to win. Working men of all countries, unite!"

Marx wrote very little about art, but he did discuss it briefly in his *Introduction to the Critique of Political Economy* (1857–1858). He believed that art is linked to its cultural context and thus should not be regarded in a purely aesthetic light. His primary interest was in the relationship of art production to the proletarian base of society, and its exploitation by the superstructure (the bourgeoisie). For Marx, the arts were part of the superstructure, which comprises the patrons of art, while the artists were "workers." As a result, he argued, artists, like other members of the working class, had become alienated from their own productions. His view of the class struggle has led to various so-called "Marxist" theories of art history in which art is interpreted in an economic context.

Industrialized Europe in the 19th century.

English and French literature of the nineteenth century is imbued with the currents of reform inspired by a new social consciousness. Novelists such as Charles Dickens, Honoré de Balzac, Gustave Flaubert, and Émile Zola described the broad panorama of society as well as the psychological motivations of their characters (see box, p. 749). In science, the observation of nature led to new theories about the human species and its origin. In 1859 the naturalist Charles Darwin (1809–1882) published *On the Origin of Species by Means of Natural Selection,* written after a five-year sea voyage aboard the *Beagle.*

Newspapers and magazines reported scientific discoveries and also carried **cartoons** and **caricatures** satirizing political leaders, the professions, actors, and artists. The proliferation of newspapers reflected the expanding communications technology, and advances in printing and photography made articles and images ever more accessible to a wider public. Inventions such as the telegraph (1837) and telephone (1876) increased the speed with which messages and news could be delivered. Travel was also accel-

erated; the first passenger railroad, powered by steam, went into service in 1830.

Paralleling the more general social changes in the nineteenth century was the change in the social and economic structure of the art world that had begun in the previous century. Crafts were replaced by manufactured goods. Guilds were no longer important to an artist's training, status, or economic well-being. A new figure on the art scene was the critic, whose opinions, published in newspapers and journals, influenced buyers. Patronage became mainly the province of dealers, museums, and private collectors. Both the art gallery and the museum as they exist today originated in the nineteenth century.

In the visual arts, the style that corresponded best to the new social awareness is Realism. The term was coined in 1840, although the style appeared well before that date. The primary concerns of the Realist movement in art were direct observation of society and nature, as well as political and social satire.

French Realism

Jean-François Millet

The *Gleaners* (fig. **21.1**), by Jean-François Millet (1814–1875), illustrates the transition between Romanticism and Realism in painting. The heroic depiction of the three peasants in the foreground and their focus on their tasks recall the Romantic sense of "oneness with nature." Two peasants in particular are monumentalized by their foreshortened forms, which convey a sense of powerful energy. Contrasted with the laborers gleaning the remains of the harvest is the prosperous farm in the background. The emphasis on class distinctions—the hard physical labor of the poor as opposed to the comfortable lifestyle of the wealthy—is characteristic of Realism. In addition to social observation, Millet uses light to highlight economic differences—the farm is illuminated in a golden glow of sunlight, whereas the three foreground figures and the earth from which they glean are in shadow.

Rosa Bonheur

Another approach to nature in which Realism and Romanticism are combined is found in the work of Rosa Bonheur (1822–1899). Her painting *Horse Fair* (fig. **21.2**) shows her close study of the anatomy and movement of horses galloping, rearing, and parading. Consistent with the Realist interest in scientific observation, Bonheur dissected animals from butcher shops and slaughterhouses; she also visited horse fairs such as this one and cattle markets. In addition to the Realist qualities of the *Horse Fair*, the thundering energy of the horses and the efforts of their grooms to keep the animals under control have a Romantic character. Likewise, the turbulent sky echoes the dramatic (and Romantic) dynamism of the struggle between humanity and the untamed forces of nature.

Rosa Bonheur regularly exhibited in the Salons of the 1840s and achieved international renown as an animal painter. In 1894, she was named the first woman artist of the Legion of Honor. Her father was a landscape painter

21.1 Jean-François Millet, *Gleaners*, 1857. Oil on canvas; approx. 2 ft. 9 in. × 3 ft. 8 in. (0.84 × 1.12 m). Musée d'Orsay, Paris. Because of their powerful paintings of rural labor, Millet and his contemporary Courbet were suspected of harboring anarchist views. Both were members of the Barbizon school, a group of French artists who settled in the village of that name in the Fontainebleau Forest. They painted directly from nature, producing landscapes tinged with nostalgia for the countryside, which was receding before the advance of the industrial revolution.

21.2 Rosa Bonheur, *Horse Fair*, 1853. Oil on canvas; 8 ft. ¼ in. × 16 ft. 7½ in. (2.44 × 5.07 m). Metropolitan Museum of Art, New York (Gift of Cornelius Vanderbilt, 1887).

and a Saint-Simon socialist who favored women's rights and believed in a future female Messiah. Bonheur made a point of imitating the dress and behavior of men and lived only with women. In order to wear men's clothes in Paris—they were especially practical when she made sketches in slaughterhouses—she had to have a police permit, which was renewable every six months. The *Horse Fair* toured England and was privately exhibited in Windsor Castle at the behest of Queen Victoria. In 1887, Cornelius Vanderbilt donated it to the Metropolitan Museum of Art. When Buffalo Bill took his Wild West show to France, he brought Bonheur a gift of two mustangs from Wyoming.

Realism in Literature

The current of Realism and its related "-ism," Naturalism, flows through nineteenth-century literature, science, and art. In England, Charles Dickens (1812–1870) described the dismal conditions of lower-class life. He drew on direct observation and personal experience, for as a boy he had worked in a factory while his father was in debtors' prison. In *Hard Times*, published in 1854, Dickens condemns the purely utilitarian emphasis on industry as abusive and lacking in creative imagination.

In France, Honoré de Balzac (1799–1850) wrote eighty novels comprising the *Comédie humaine* (Human Comedy)—a sweeping panorama of nineteenth-century French life. The novelists Gustave Flaubert (1821–1880) and Émile Zola (1840–1902) also focused on society and personality. In 1857, Flaubert published *Madame Bovary*, the story of the unfaithful wife of a French country doctor. The description of her suicide by arsenic poisoning is a classic example of naturalistic observation. Zola's *Thérèse Raquin* (1871) details a particular state of mind—namely, remorse—while his *Nana*, the story of a prostitute, has broader social connotations. Zola not only championed a Realist approach to the arts; he was also a staunch defender of political and social justice.

Charles Baudelaire (1821–1867) published his first book of verse, *Les Fleurs du mal* (The Flowers of Evil), in 1857. Both he and the printer were fined and censored for endangering French morals, a condemnation that was not lifted until 1949. He was obsessed with the beauty of evil and decadence, but he was also a Realist in depicting the specific details of perversion.

Realist theater can be found throughout nineteenth-century Europe. In France, Alexandre Dumas the Younger's (1824–1895) novel *La Dame aux Camélias* (1849) was turned into a play. Its description of Camille's death from tuberculosis has become a classic. In Norway, Henrik Ibsen (1828–1906) carefully detailed the psychological motives of his characters. In England, George Bernard Shaw (1856–1950) portrayed both the inevitability and the absurdity of class distinctions.

Gustave Courbet

The painter most directly associated with Realism was Gustave Courbet (1819–1877), who believed that artists could accurately represent only their own experience. He rejected historical painting and the Romantic depiction of exotic locales and revivals of the past. Although Courbet had studied the history of art, he claimed to have drawn from it only a greater sense of himself and his own experience. In 1861, he wrote that art could not be taught. One needed individual inspiration, he believed, fueled by study and observation. Courbet's Realist approach to his subject matter is expressed in the statement in his manifesto: "Show me an angel and I'll paint one."

In the *Stone Breakers* of 1849 (fig. **21.3**), Courbet reveals the impact of socialist ideas on his iconography. It depicts two workers, one breaking up stones with a hammer and the other lifting a heavy rock. Like Millet's *Gleaners,* these figures evoke the romantic nostalgia for a simple existence but also show the mindless, repetitive character of physical labor born of poverty. The figures in both the *Gleaners* and the *Stone Breakers* are rendered anonymously—their faces are lost in shadow—which allies them with a class of work rather than accentuating their human individuality.

A similar emphasis on repetitive sameness as an aspect of French society can be seen in Courbet's enormous frieze-like *Burial at Ornans* (fig. **21.4**). Turning to his native town of

Ornans, Courbet depicted the local bourgeoisie attending a funeral. At the right, female mourners in black attract the gaze of the dog in the foreground. A circle formed by male relatives, a group of beadles (local officials) in red, and a priest frames the newly dug grave. Churchmen occupy the far left. The long horizontal of figures is interrupted only by the vertical crucifix penetrating the somber sky. The dark colors that predominate are varied only by the red costume of the beadles and the blue stocking on the man by the dog.

This intensely Catholic group, its compact arrangement, and its minimal variety reflect the monotonous reality of life in rural nineteenth-century France. It is also possible that by equalizing his figures through the use of isocephaly, Courbet was making a revolutionary political statement in favor of egalitarianism. When the *Burial* was first exhibited in 1850, critics found it boring. They also objected to monumentalizing such an everyday occurrence.

Courbet's huge and complex *Interior of My Studio: A Real Allegory Summing Up Seven Years of My Life as an Artist from 1848 to 1855* (fig. **21.5**) can be considered a "manifesto" in its own right. The seven-year period in the title begins with the February Revolution of 1848 and the proclamation of the Second Republic. Over this period, Courbet struggled to free himself from the style of his Romantic predecessors. He wanted to embark on a new artistic phase in which his subject matter would reflect the reality of French society.

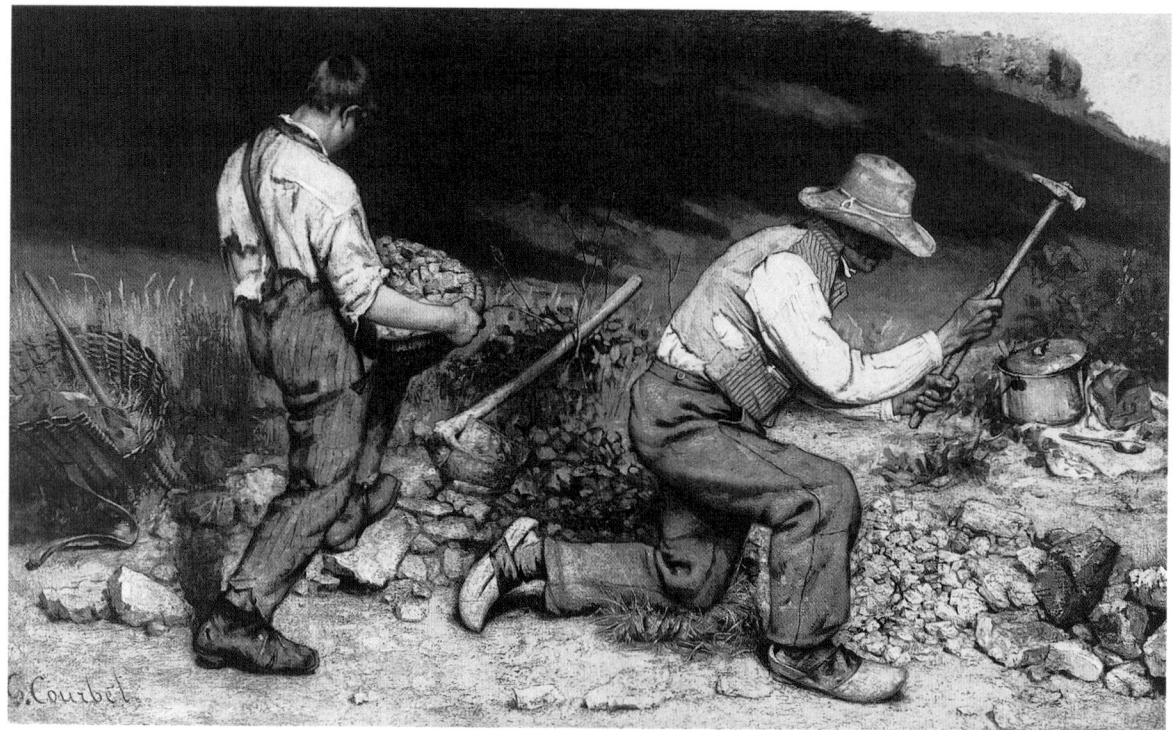

21.3 Gustave Courbet, *Stone Breakers,* 1849. Oil on canvas; 5 ft. 3 in. × 8 ft. 6 in. (1.60 × 2.59 m). Whereabouts unknown since World War II.

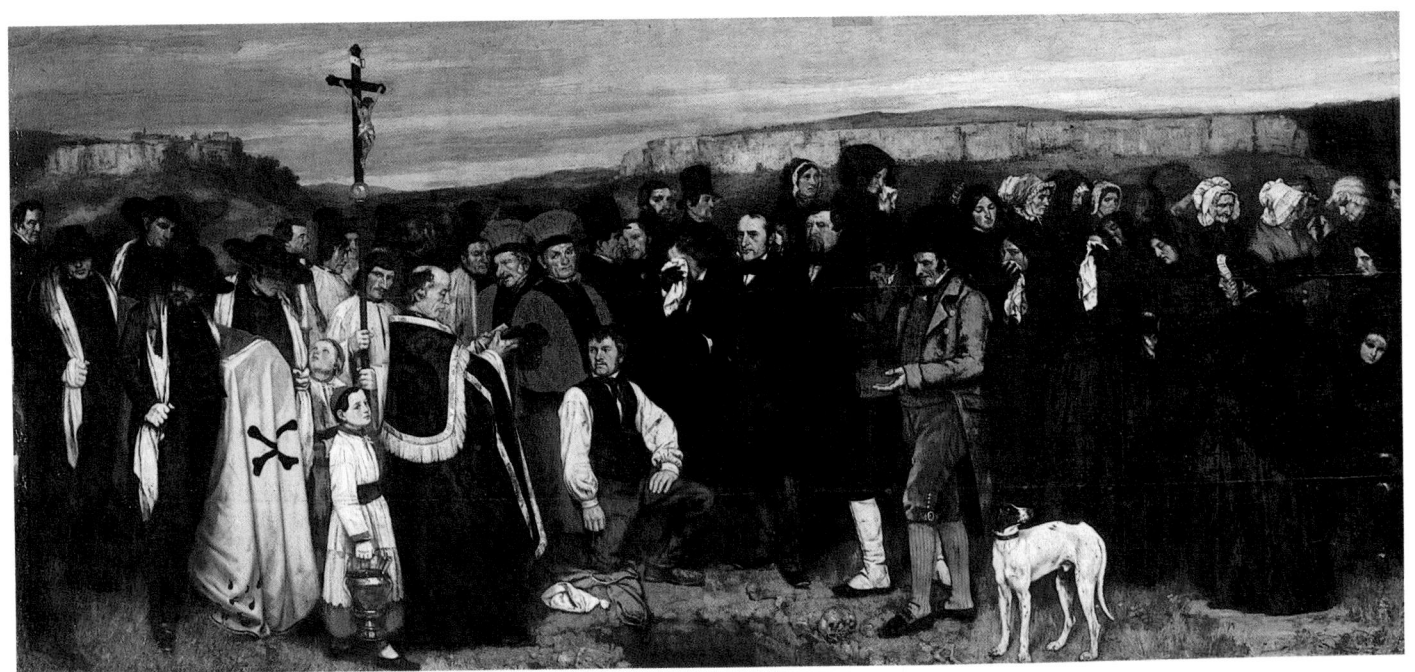

21.4 Gustave Courbet, *Burial at Ornans,* 1849. Oil on canvas; 10 ft. 4 in. × 21 ft. 11 in. (3.15 × 6.68 m). Musée d'Orsay, Paris.

21.5 Gustave Courbet, *Interior of My Studio: A Real Allegory Summing Up Seven Years of My Life as an Artist from 1848 to 1855,* 1855. Oil on canvas; 11 ft. 10 in. × 19 ft. 7¾ in. (3.61 × 5.99 m). Musée d'Orsay, Paris.

The *Studio* depicts Courbet's broad view of society on the one hand and his relationship to the art of painting on the other. In his own words, the painting showed "society at its best, its worse, and its average" ("la société dans son haut, dans son bas, dans son milieu"). While working on the *Studio,* Courbet described the figures on the right as his friends—workers and art collectors.

The thirty figures portrayed cover the spectrum of society, from the intelligentsia to the lower classes. The group on the left are anonymous working-class types. They consist mainly of country folk and include laborers, an old soldier with a begging bag, a Jew, a peddler, a fairground strongman, a clown, and a woman sprawled on the ground, suckling a child. On the floor are the paraphernalia of Romanticism—a dagger, a guitar, a plumed hat. A skull rests on a newspaper, symbolizing the death of journalism. Behind the easel, as if invisible to the artist, is an academic sculpture of a nude male.

On the right, and more brightly illuminated, are portraits of friends, members of Courbet's artistic and literary coterie, an art collector and his fashionable wife, and a pair of lovers. Many of these are recognizable, including Courbet's patron, J. L. Alfred Bruyas, who financed the Realist exhibition (see below). Seated at the far right and reading a book is the poet Charles Baudelaire, who was a champion of Realism at the time. Echoing Baudelaire's absorption in his book is a boy lying on the floor sketching; he has been interpreted as an allusion to Courbet as a child as well as to the ideal of freedom in learning.

The central group illustrates Courbet's conception of himself as an artist and of his place in the history of western European painting. Having come from a provincial background, Courbet identifies the group on the left with his past. Those on the right refer to his present and future role in the sophisticated world of Parisian society. He himself is at work on a rural landscape, characteristically building up the paint with brushes and a **palette knife** in order to create the material textures of "reality." He displays the unformed paint by tilting his **palette** toward the observer, while also extending his arm to place a daub of paint on the landscape. In this gesture, he has appropriated the creative hand of Michelangelo's God in the *Creation of Adam* (see fig. 14.24). As such, Courbet shows himself in the act of observing nature and then re-creating it with his brush and colors. The creative hand of the artist, echoing an ancient tradition, is a metaphor for the creating hand of God.

Courbet also had in mind Velázquez's *Las Meninas* (see fig. 17.56) and Goya's *Family of Charles IV* (see fig. 20.16), in which the artist paints in royal company. Whereas Velázquez and Goya place themselves in the same room as the royal family but off to one side, Courbet places himself at the center of the picture within the spectrum of society, midway between the workers and the intellectual elite. In contrast to his Spanish predecessors, whose canvases are unseen by the viewer, Courbet the artist is "enthroned" before his picture, which we can see.

A nude woman inspires the painter-king. She is a kind of artistic "power behind the throne," or muse. In this role, she fulfills Courbet's stated relationship to earlier art—that is, he studies and absorbs it but then transforms it according to his inspiration in the "real," present world. The further significance in the woman's placement behind Courbet is that the artist "turns his back" on her, rejecting the Academic tradition embodied by the Classical nude.

A small boy stands at Courbet's knee and stares raptly at his work, perhaps personifying the untrained, childlike admiration that Courbet hoped to arouse in his public. The boy has no socks and wears *sabots* (clogs) to indicate his rural origin. To the boy's right is a white cat that seems to be playing with the nude's falling drapery. But it turns its head and looks up at Courbet, recalling the sixteenth-century saying "A cat may look at a king." The adage as represented here is a subtle combination of Courbet's egalitarian "socialism" and his self-portrait as an artist-king.

The *Studio* was offered to the International Exhibition of 1855 but was rejected by the jury. Courbet rented an exhibition space nearby, where he hung forty of his own paintings—the first one-man show in the history of art. The sign over the entrance read "Realism, G. Courbet." The public ignored the show, and most critics derided it. Courbet took the picture back to his studio and exhibited it only twice more. It remained unsold until after his death.

Honoré Daumier

Honoré Daumier (1808–1879), one of the most direct portrayers of social injustice, has been called both a Romantic and a Realist. In this chapter, he is discussed in the context of Realism. A comparison of his *Third-Class Carriage* (fig. **21.6**) with *Interior of a First-Class Carriage* (fig. **21.7**) illustrates his attention to Realist concerns. In both works, Daumier's characteristically dark, sketchy outlines and textured surfaces make the viewer aware of his media. In both, a section of society seems to have been framed unawares. Strong contrasts of light and dark, notably in the silhouetted top hats, create clear edges, in opposition to the looser brushwork elsewhere.

Lower-class figures crowd together in a dark, confined space. The three drably dressed passengers in the foreground slump slightly on a hard, wooden bench. They seem resigned to their station in life and turn inward, as if to retreat from harsh economic reality. Their psychological isolation defends them from the crowded conditions in which they live. The very setting, the interior of a railroad car, exemplifies the new industrial subject matter of nineteenth-century painting.

Four well-dressed and comfortably seated passengers occupy the first-class car. One woman looks out of the window, as if alert to the landscape and not destined for a life of crowded confinement. The elegant dress and upright, neatly arranged poses of all these figures reveal their higher social position, compared with the rough dress and peasant-like proportions of their counterparts in third class.

Although Daumier had painted for much of his life, he was not recognized as a painter before his first one-man

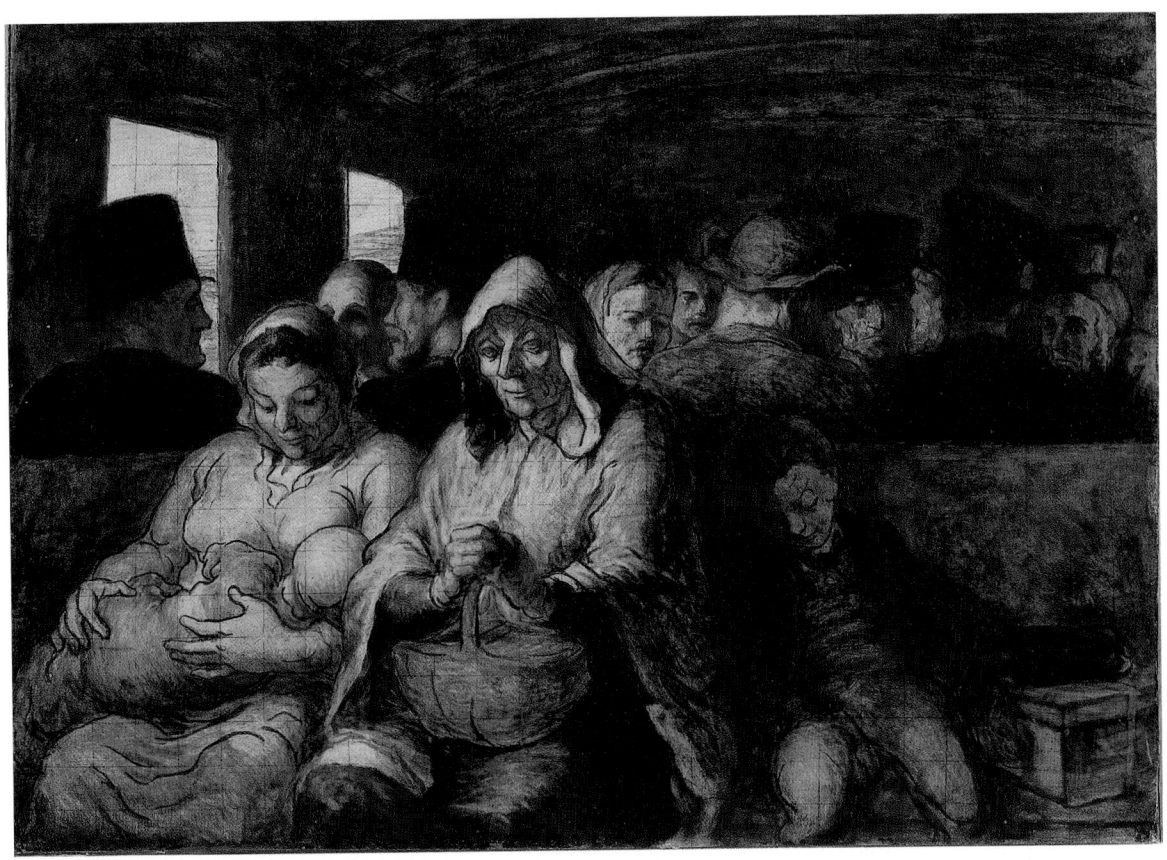

21.6 Honoré Daumier, *Third-Class Carriage*, c. 1862. Oil on canvas; 25¾ × 35½ in. (65.4 × 90.2 cm). Metropolitan Museum of Art, New York (Bequest of Mrs. H. O. Havemeyer, 1929).

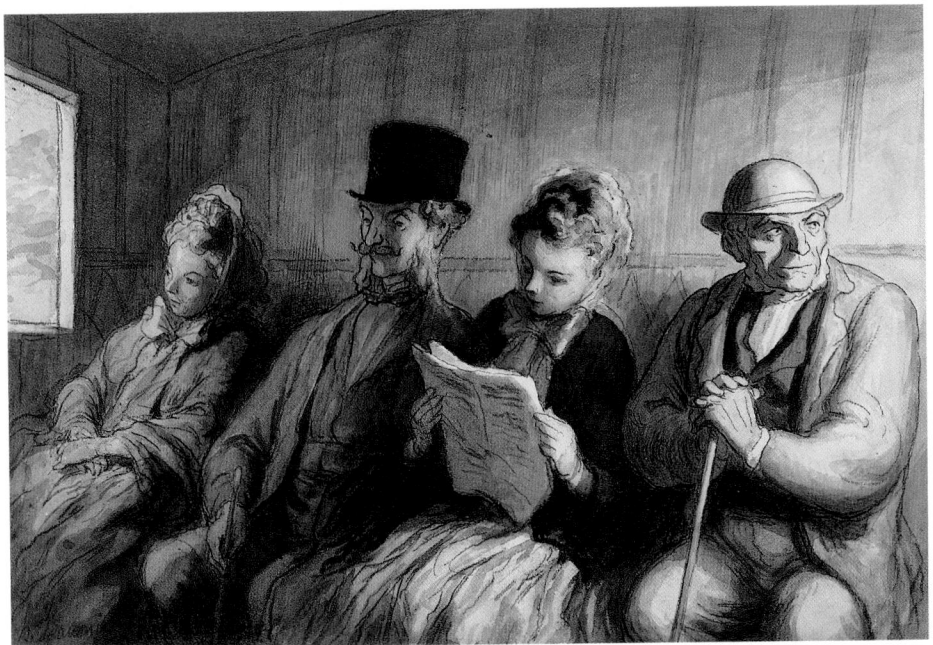

21.7 Honoré Daumier, *Interior of a First-Class Carriage*, 1864. Crayon and watercolor; 8¹⁄₁₆ × 11¾ in. (20.5 × 29.9 cm). Walters Art Museum, Baltimore.

Lithography

A lithograph, literally a "stone (*lith*) writing or drawing (*graph*)," is a print technique first used at the end of the eighteenth century in France. In the nineteenth century, lithography became the most widely used print medium for illustrating books, periodicals, and newspapers, and for reproducing posters.

To create a lithograph (fig. **21.8**), the artist makes a picture with a grease crayon on a limestone surface. Alternatively, a pen or brush is used to apply ink to the stone. Since limestone is porous, it "holds" the image. The artist then adds water, which adheres only to the nongreased areas of the stone because the greasy texture of the image repels the moisture. The entire stone is rolled with a greasy ink that sticks only to the image. When a layer of damp paper is placed over the stone and both are pressed together, the image is transferred from the stone to the paper, thereby creating the lithograph. This original print can then be reproduced relatively cheaply and quickly, making it suitable for mass distribution. Since the stone does not wear out in the printing process, a large number of impressions can be taken from it.

In transfer lithography, a variant used by Daumier, the artist draws the image on paper and fixes it to the stone before printing. This retains the texture of the paper in the print and is more convenient for mass production.

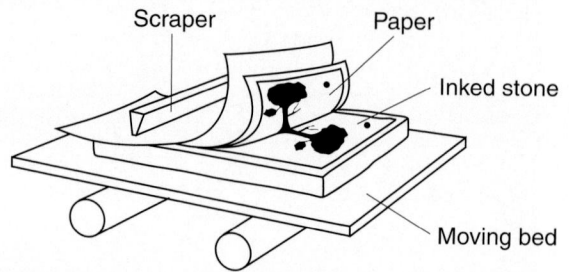

21.8 Creating a lithograph.

show at the age of seventy. He earned his living by selling satirical drawings and cartoons to the Paris press and reproducing them in large numbers by **lithography** (see box). His works usually appeared in *La Caricature,* a weekly paper founded in 1830 and suppressed by the government in 1835, and *La Charivari,* a daily paper started in 1832. Daumier satirized the corruption of political life, the legal system, judges, lawyers, doctors, businessmen, actors, bourgeois hypocrisy, and the king (see box, p. 755).

In 1834, *La Caricature* published Daumier's protest against censorship entitled the *Freedom of the Press: Don't Meddle with It* (fig. **21.9**). The foreground figure in working-class dress is Daumier's hero. He stands firm, with clenched fists and a set, determined jaw. Behind him "Freedom of the Press" is inscribed like raised type on a rocky terrain. He is flanked in the background by two groups of three social and political types, who are the targets of Daumier's caricature. On the left, members of the bourgeoisie feebly brandish an umbrella. On the right, the dethroned and crownless figure of Charles X receives ineffectual aid from two other monarchs in a configuration that recalls West's *Death of General Wolfe* (see fig. 18.28).

So great was the impact of Daumier's caricatures that in 1835 France passed a law limiting freedom of the press to verbal rather than pictorial expression. The French authorities apparently felt that drawings were more apt to incite rebellion than words. Such laws, which are reminiscent of the ninth-century Iconoclastic Controversy (see Chapter 8), are another reflection of the power of images. Clearly, the nineteenth-century French censors felt more threatened by pictures than by the proverbial "thousand words."

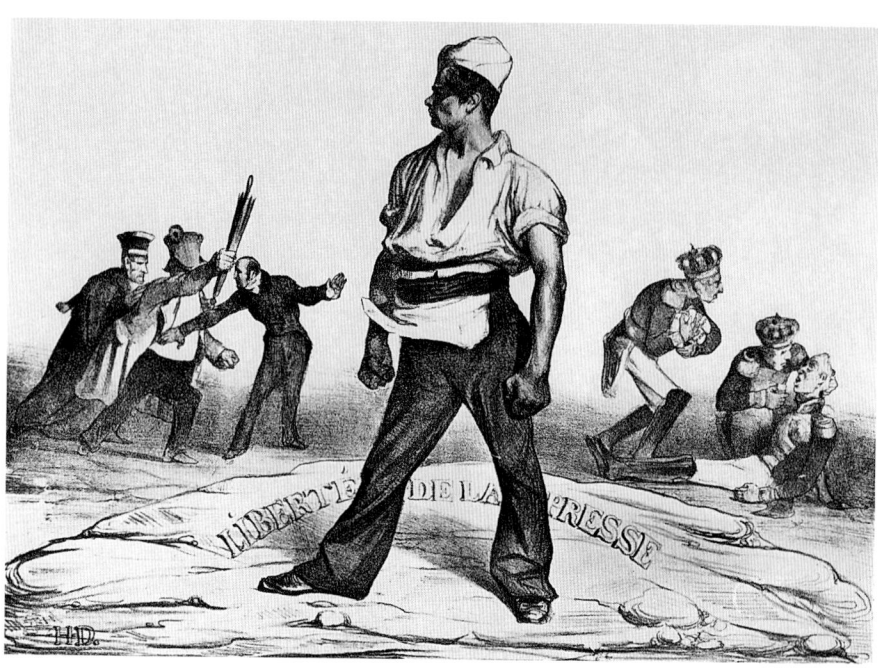

21.9 Honoré Daumier, *Freedom of the Press: Don't Meddle with It (Ne Vous y Frottez Pas),* 1834. Lithograph; 12 × 17 in. (30.5 × 43.2 cm). Private collection, France. The implication of this image is that the power of the press is ultimately greater than that of a king. Daumier's depiction of dress according to class distinctions is characteristic of 19th-century Realist social observation.

Daumier and Satire

Gargantua, a good-natured giant in French folklore, became the main character in the classic work by Rabelais (c. 1494–1553) on monastic and educational reform, *La Vie très horrifique du grand Gargantua* (*The Very Horrific Life of the Great Gargantua*). Rabelais's Gargantua is a gigantic prince with an enormous appetite. (The root word *garg* is related to *gargle* and *gorge*, which is French for "throat." In Greek, the word *gargar* means "a lot" or "heaps," and in English one who loves to eat is sometimes referred to as having a "gargantuan" appetite.)

In Daumier's print (fig. **21.10**), a gigantic Louis-Philippe, the French king (reigned 1830–1848), is seated on a throne before a starving crowd. A poverty-stricken woman tries to feed her infant, while a man in rags is forced to drop his last few coins into a basket. The coins are then carried up a ramp and fed to the king. Underneath the ramp, a crowd of greedy but well-dressed figures grasps at falling coins. A group in front of the Chamber of Deputies, the French parliament, applauds Louis-Philippe. The message of this caricature is clear: a never-satisfied king exploits his subjects and grows fat at their expense. Daumier explicitly identified Louis-Philippe as Gargantua in the title of the print. In 1832, Daumier, along with his publisher and printer, was charged with inciting contempt and hatred for the French government and with insulting the person of the king. He was sentenced to six months in jail and fined one hundred francs.

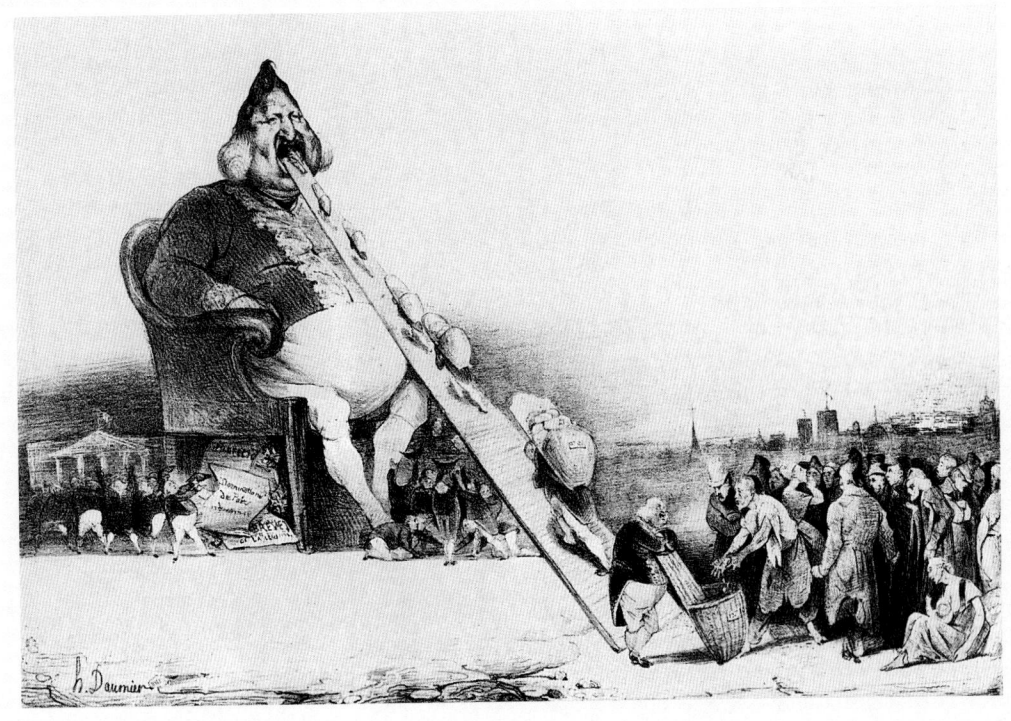

21.10 Honoré Daumier, *Louis-Philippe as Gargantua*, 1831. Lithograph; 8⅜ × 12 in. (21.4 × 30.5 cm). Private collection, Paris.

Photography

Another method of creating multiple images—and one that struggled to become an art form in its own right in the nineteenth century—was photography. It achieved great popularity, and its potential use for both portraiture and journalism was widely recognized. Many painters were also photographers, and, from the nineteenth century to the present, the mutual influence of photography and painting has grown steadily.

At first, photography was primarily a medium of portraiture. As such, it served several purposes. One of its most commercial successes was the *carte de visite* (calling card) bearing the likeness of the sender. Heads of state, such as Queen Victoria and Napoleon III, soon realized the potential of photography for political imagery. Eventually, photography would be used to identify criminals, to capture the physiognomy, gestures, and postures of the insane, to record cultural groups and monuments throughout the world, and to document social conditions of all kinds.

Photography means literally "drawing with light" (from the Greek words *phos,* meaning "light," and *graphe,* meaning "drawing" or "writing"). The basic principles may have been known in China as early as the fifth century B.C.,

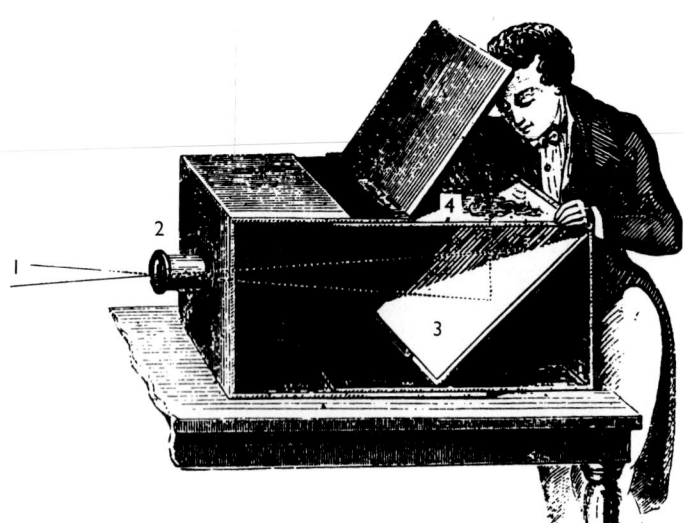

21.11 Diagram of a camera obscura. Here the camera obscura has been reduced to a large box. Light reflected from the object (**1**) enters the camera through the lens (**2**) and is reflected by the mirror (**3**) onto the glass ground (**4**), where it is traced onto paper by the artist/photographer.

but the first recorded account of the **camera obscura** (fig. **21.11**), literally a "dark room," is by Leonardo da Vinci. He described how, when light is admitted through a small hole into a darkened room, an inverted image appears on the opposite wall or on any surface (for example, a piece of paper) interposed between the wall and the opening. In the early seventeenth century, the astronomer Johan Kepler devised a portable camera obscura, resembling a tent. It has since been refined and reduced to create the modern camera, the operation of which matches the principles of the original "dark room."

From the eighteenth century, discoveries in photochemistry accelerated the development of modern photography. It was found that silver salts, for example, were sensitive to light and that an image could, therefore, be made with light on a surface coated with silver. In the 1820s, a Frenchman, Joseph-Nicéphore Niepce (1765–1833), discovered a way to make the image remain on the surface. This process was called **fixing** the image; however, the need for a long exposure time (eight hours) made it impractical. The *View from His Window at Gras* (fig. **21.12**) was made with an eight-hour exposure time and is the only surviving example of Niepce's efforts to fix an image from nature.

In the late 1830s another Frenchman, Louis Daguerre (1789–1851), discovered a procedure that reduced the exposure time to fifteen minutes. He inserted a copper plate coated with silver and chemicals into a camera obscura and focused through a lens onto a subject. The plate was then placed in a chemical solution (or "bath"), which "fixed" the image. Daguerre's photographs, called **daguerreotypes**, could not be reproduced, and each one was, therefore, unique. The final image reversed the real subject, however,

and also contained a glare from the reflected light. In 1839, the French state purchased Daguerre's process and made the technical details public. The daguerreotype in figure **21.13** shows the sense of immediacy that was possible to achieve in portrait photography.

Improvements and refinements quickly followed. Contemporaneously with the development of the daguerreotype, the English photographer William Henry Fox Talbot (1800–1877) invented negative film, which permitted multiple prints. The negative also solved the problem of Daguerre's reversed print image: since the negative was reversed, reprinting the negative onto light-sensitive paper reversed the image back again. By 1858, a shortened exposure time made it possible to capture motion in a still picture.

During the twentieth century, color photography developed. Still photography inspired the invention of "movies," first in black and white and then in color. Today, photography and the cinema have achieved the status of art forms in their own right.

From its inception, photography has influenced artists. Italian Renaissance artists used the camera obscura to study perspective. Later artists, possibly including Vermeer, are thought to have used it to enhance their treatment of light. In the mid-nineteenth century, artists such as Ingres and Delacroix used photographs to reduce the sitting time for portraits. Eakins was an expert photographer who used photographic experiments to clarify the nature of locomotion.

Black-and-white photography has an abstract character quite distinct from painting, which, like nature, usually has color. The black-and-white photograph creates an image with tonal ranges of gray rather than line or color. Certain photographic genres, such as the close-up, the candid shot, and the aerial view, have influenced painting considerably.

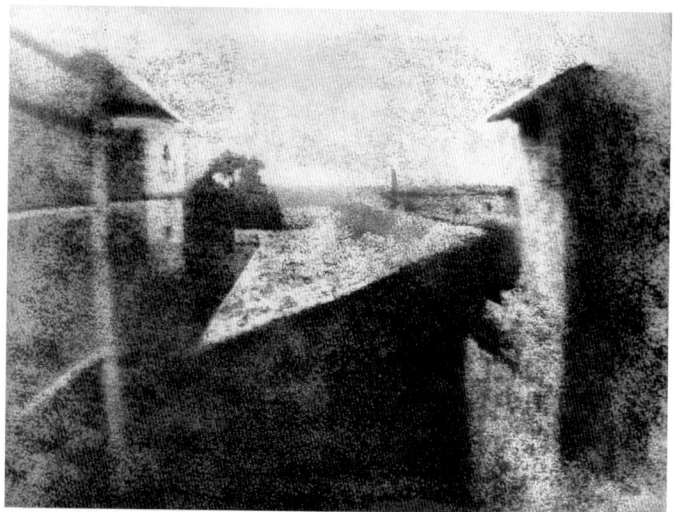

21.12 Joseph-Nicéphore Niepce, *View from His Window at Gras*, 1826. Heliograph. Harry Ransom Humanities Research Center, The University of Texas at Austin, Gernsheim Collection.

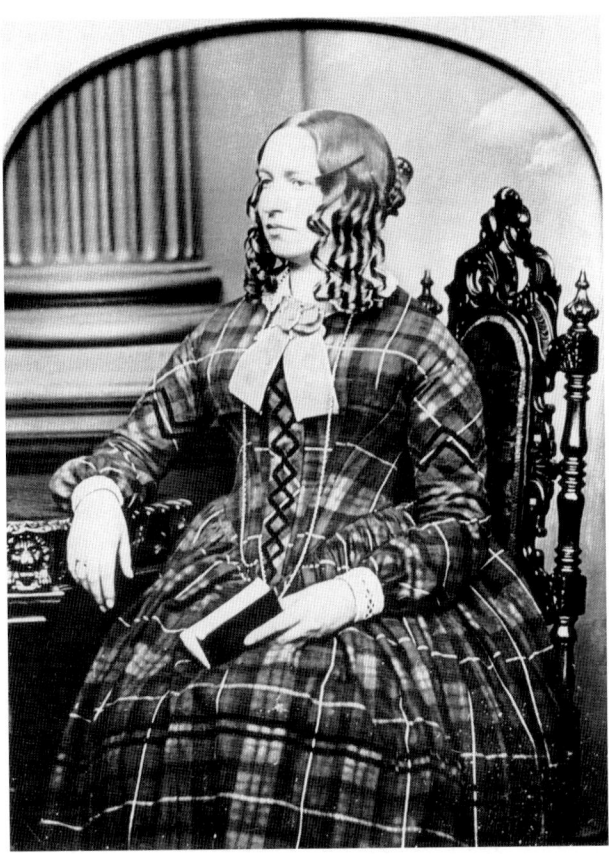

21.13 Unknown photographer, daguerreotype, c. 1845.

France: Nadar

In France, the photographic portraits taken by the novelist and caricaturist Gaspard-Félix Tournachon, known as Nadar (1820–1910), were particularly insightful. In 1853, he opened a studio, which was frequented by the celebrities of his generation. In contrast to most of his contemporaries, Nadar photographed his sitters against a plain, dark backdrop, focusing attention solely on the subjects themselves. His portrait of Sarah Bernhardt (fig. **21.14**), the renowned French actress, illustrates the subtle gradations of light and dark that are possible in black-and-white photography. Nadar has captured Bernhardt in a pensive mood. Her piercing eyes stare at nothing in particular but seem capable of deep penetration.

In addition to portraiture, Nadar was a pioneer of aerial photography. He took the first pictures from a balloon in 1856, which demonstrated the potential of photography for creating panoramic vistas and new viewpoints. Nadar then built his own balloon, one of the largest in the world, which he named *Le Géant* (The Giant). In 1870, when France declared war on Prussia, Nadar helped organize the Paris balloon service for military observation.

From 1850, a new "quarrel" arose in the French art world over the status of photography. "Is it ART?" became a con-

troversial issue, with the "Nays," arguing that its mechanical technology made it an automatic, rather than an artistic, process. Because the artist's hand did not create the image directly, it was not "ART." Many adherents of this point of view, however, approved of using photography for commerce, industry, journalism, and science. The exhibition of photography also became an issue, which was exemplified by the International Exhibition of 1855 in Paris. On the one hand, photography was brought before a wide public, and its advantages were recognized. But on the other hand, because it was not shown in the Palais des Beaux-Arts (Palace of Fine Arts), photography was allied with industry and science rather than with the arts. In 1859, the French Photographic Society negotiated an exhibition scheduled at the same time, and in the same building, as the Salon, but the two exhibitions were held in separate areas of the building.

In the 1860s, several books were published that argued that photography should be accorded artistic status. To

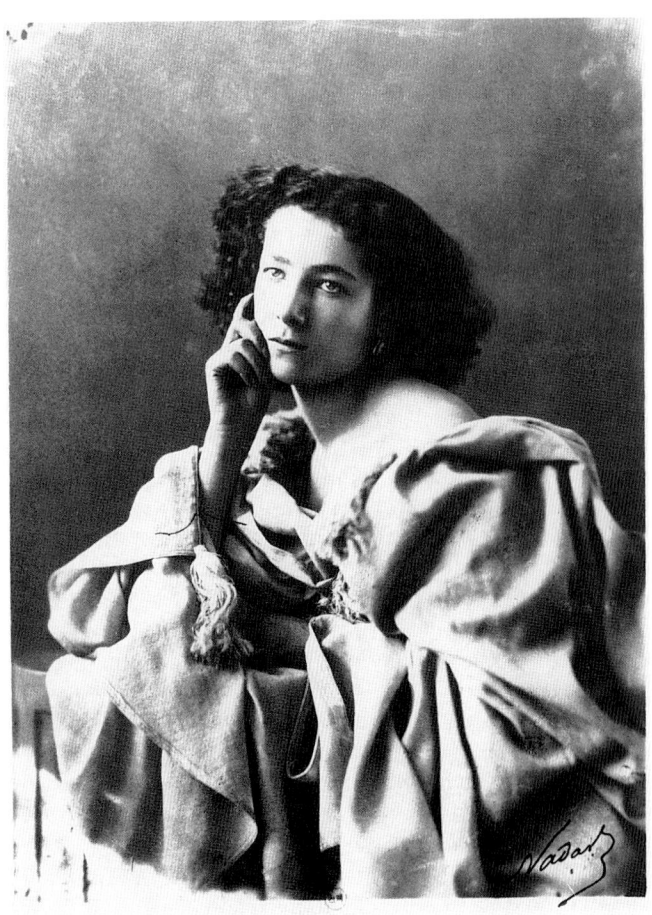

21.14 Gaspard-Félix Tournachon (Nadar), *Sarah Bernhardt*, c. 1864. Photograph from a collodion negative. Bibliothèque Nationale, Paris. In 1854, Nadar published *Le Panthéon Nadar*, a collection of his best works. The portrait of Bernhardt (at age fifteen) emphasizes her delicate features and quiet pose, in contrast to the large, voluminous, tasseled drapery folds.

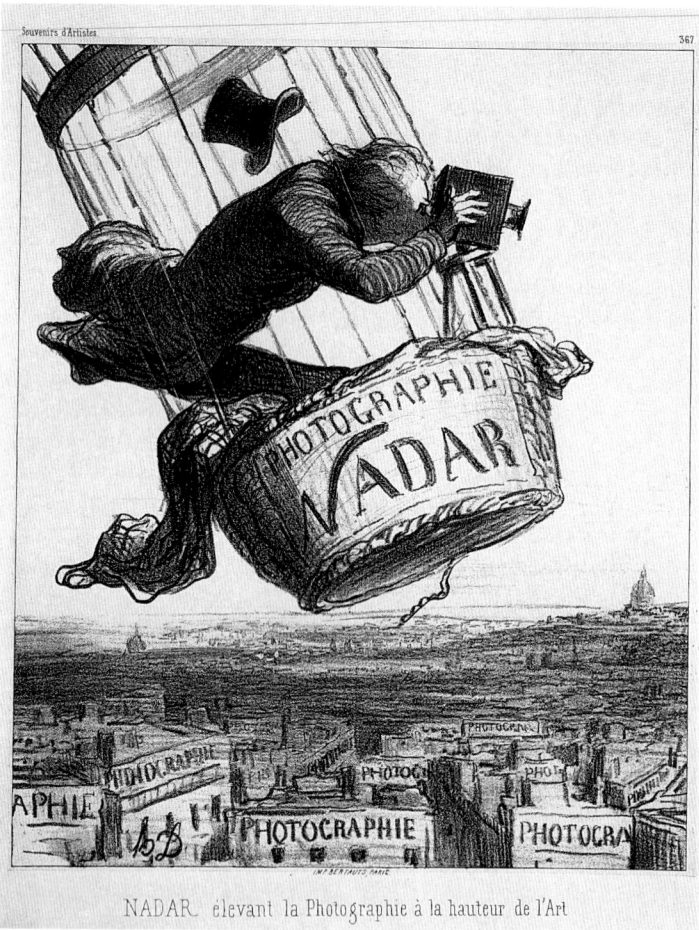

Souvenirs d'Artistes 367

NADAR élevant la Photographie à la hauteur de l'Art

21.15 Honoré Daumier, *Nadar Elevating Photography to the Height of Art*, 1862. Lithograph; 10¾ × 8¾ in. (27.2 × 22.2 cm).

some extent, this debate continues even today. Its irony can be seen in the light of the sixteenth- and seventeenth-century quarrels—in Venice and Spain, respectively—over the status of painting as a Liberal Art. In those instances, because the artist's hand *did* create the work, it was considered a craft and not an art. With photography, the *absence* of the hand is used as an argument against artistic status.

This ongoing quarrel did not escape Daumier's penchant for satire. In 1862, he executed the caricature entitled *Nadar Elevating Photography to the Height of Art* (fig. **21.15**), showing Nadar inside *Le Géant,* photographing the rooftops of Paris. Each roof is inscribed with the word "PHOTOGRAPHIE." Daumier emphasizes Nadar's precarious position by a series of sharp diagonals—from his hat to his camera, which is parallel to his legs, and the line of his back which repeats the basket and rim of the balloon. The force of the wind is indicated by the flying drapery, flowing hair, and hat about to be blown away. Height, in this image, is satirically equated with the lofty aspirations of photography to the status of "ART."

England: Julia Margaret Cameron

In England, the amateur portrait photographer Julia Margaret Cameron (1815–1879) insisted on the aesthetic qualities of her work and avoided the professionalism of studio photography. She manipulated techniques in order to achieve certain effects, preferring blurred edges and a dreamy atmosphere to precise outlines. Her 1867 portrait of Mrs. Herbert Duckworth (fig. **21.16**) illustrates these preferences. The softness of the face and collar, which emerge gradually from the darkness, seem literally "painted in light." Cameron conceived of photography almost with reverence, as a means to elicit the inner character of a talented sitter. She described this in her autobiography, *Annals of My Glass House,* as follows: "When I have had such men before my camera, my whole soul has endeavored to do its duty towards them in recording faithfully the greatness of the inner as well as the features of the outer man. The photograph thus taken has been almost the embodiment of a prayer."[1]

21.16 Julia Margaret Cameron, *Mrs. Herbert Duckworth,* 1867. Photograph. National Museum of Photography, Film and Television/Science and Society Picture Library. Mrs. Duckworth, later Mrs. Leslie Stephen, was the mother of the English author Virginia Woolf. She was also Cameron's niece, reflecting the photographer's preference for using members of her family as subjects.

America: Mathew Brady

In the United States, the photographs of Mathew Brady (c. 1822–1896) combine portraiture with on-the-spot journalistic reportage. His "Cooper Union" portrait of Lincoln (fig. 21.17) was taken February 27, 1860 at the Tenth Street Gallery in New York City. Lincoln had just delivered his Cooper Union Speech to members of the Young Men's Republican Club.

Brady depicts the president as a thoughtful, determined man. Lincoln's straightforward stare, as if gazing firmly down on the viewer, creates a very different impression from the dreamy, introspective characters of Nadar's *Sarah Bernhardt* and Cameron's *Mrs. Herbert Duckworth*. Lincoln stands before a column, which is both a studio "prop" and an architectural allusion. To foster the union of North and South, Lincoln cited the biblical metaphor "A house divided against itself cannot stand." His hand rests on a pile of books, evoking his profound commitment to literature and intellectual truth. Of the one hundred or so known photographs of Lincoln, more than one-third were taken by Brady.

21.18 Mathew B. Brady, *Robert E. Lee*, 1865. Photograph. Library of Congress, Washington, D.C.

21.17 Mathew B. Brady, *Lincoln "Cooper Union" Portrait*, 1860. Photograph. Library of Congress, Washington, D.C.

In April 1865, Brady photographed the Confederate general Robert E. Lee (fig. 21.18). He portrayed the formally dressed and neatly groomed Lee as proud and dignified, despite defeat. Only a few creases in his clothing and under his eyes betray the years of suffering he has witnessed. His house in Richmond, like Lee himself, is shown still standing at the end of the war—he is framed by the rectangle of his back door. The elegant, upholstered chair, half out of the picture plane, is a memento of the passing civilization for which he fought.

21.19 Studio of Mathew B. Brady, *Ruins of Gallego Flour Mills, Richmond,* 1863–1865. Albumen-silver print from a glass negative; 6 × 8³⁄₁₆ in. (15.2 × 20.8 cm). Museum of Modern Art, New York (purchase). When the Civil War broke out in 1861, Brady organized a group of cameramen into a "photographic corps" to record the events of the war. The project was a great artistic and historical success but proved a financial disaster for Brady.

Differing from the varied tones that characterize the Lincoln and Lee portraits are the sharp contrasts of the *Ruins of Gallego Flour Mills, Richmond* (fig. **21.19**). The remains of the flour mills, burned when the Union army drove Confederate troops from Richmond, Virginia, stand—like the portrait of Robert E. Lee—as testimony to a dying civilization. The dark architectural skeleton, arranged as a stark horizontal, is silhouetted against a light sky with only a few intervening grays.

English Realism: The Pre-Raphaelites

An altogether different current of Realism developed in England with the Pre-Raphaelite Brotherhood, founded in 1848. It was the conception of three young London painters —William Holman Hunt (1827–1910), Dante Gabriel Rossetti (1828–1882), and John Everett Millais (1829–1896)— and soon grew to include others. The three founders called themselves Pre-Raphaelites because of their belief that the aim of artists since (and including) Raphael had been to achieve beauty through idealization. They considered this aesthetic artificial and sentimental, rather than natural and sincere. They, therefore, decided that their own inspiration would be drawn from the "truthful" crafts tradition that predated Raphael. In thus looking to the past, the Pre-Raphaelite movement also had a Romantic quality.

Although the Pre-Raphaelites followed Turner's ideal of truth to nature, their pictorial style is quite distinct from his. In contrast to the Impressionistic quality of Turner's work, in which forms often dissolve into the paint, Pre-Raphaelite paintings have clear edges, smooth surfaces, and precise patterns. Whereas Turner's color tended to be pastel, Pre-

Raphaelite color is pure and vivid, and its subject matter is wide-ranging. It includes portraiture and contemporary, mythological, medieval, and Christian themes.

Dante Gabriel Rossetti

Rossetti's *Ecce Ancilla Domini* ("Behold the Handmaid of the Lord"), also called *The Annunciation* (fig. **21.20**), was exhibited in 1850. It infuses youthful emotional tension into the traditional religious scene. The Virgin, who was modeled on the artist's sister, is sullen and withdrawn. She cringes on her bed as a tall, thin, weightless, and somewhat effete Gabriel floats into her room with yellow flames at his feet. Rossetti represents the Virgin according to his idea of her "truth"—that is, as a frightened adolescent in a sexually equivocal situation. He combines her inner disturbance with an oddly mystical atmosphere, accentuated by the conventional lilies, halos, candle, and open window. Rossetti also depicts the nineteenth-century awareness of conflict between external appearance and internal, psychic reality.

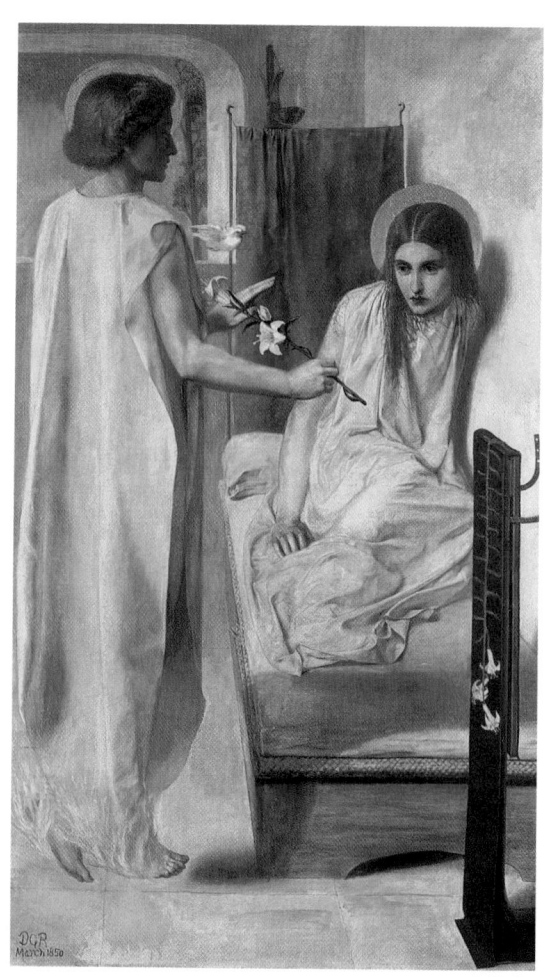

21.20 Dante Gabriel Rossetti, *Ecce Ancilla Domini* (*The Annunciation*), 1850. Oil on canvas; 28½ × 16½ in. (72.4 × 41.9 cm). Tate Gallery, London.

John Everett Millais

One of the most glaring examples of the nineteenth-century conflict between social propriety and hidden emotional turmoil is Millais' portrait of John Ruskin (fig. **21.21**). While the artist was working on the picture in 1854, he fell in love with Ruskin's wife, Euphemia (Effie) Gray. Although Ruskin had been an ardent suitor, he was a disappointment as a husband; in 1855, the Ruskins' marriage was annulled on grounds of nonconsummation. Effie literally escaped from Ruskin, married Millais, and subsequently had six children.

In his five-volume *Modern Painters,* a work of art criticism that he wrote in defense of Turner, Ruskin had advocated truth to nature. Millais' portrait is partly a tribute to Ruskin's vision of nature, which is evident in the landscape. The intricate details of rock formations and leaves reflect Ruskin's passion for geology and botany as well as the Pre-Raphaelite attention to meticulous detail. Ruskin stands calmly, the quintessential picture of a Victorian gentleman in control of himself and his surroundings. His ruddy complexion and pale blue eyes are set against the darker background, while his black clothing contrasts with the light foreground rocks and the whites, yellows, and light blues of the water. He carries a walking stick, which suggests that he had climbed to the edge of the waterfall and stopped to contemplate nature. Ruskin's outward calm, in contrast to the rushing water, is an ironic

and tragic image of England's greatest living art critic. Despite his genius for describing works of art and his extraordinary writings on many other subjects, Ruskin tried to conceal his emotional conflicts and repeated bouts of psychosis throughout his life.

John Ruskin (1819–1900), the son of a wealthy sherry merchant, grew up in a materially pampered but psychologically isolated and abusive home. When he went to Oxford University, his mother went too. The sadistic character of his upbringing is described in his autobiography, *Praeterita* (From the Past). In 1843, at the age of twenty-four, Ruskin published the first volume of *Modern Painters*. In 1849, he published *The Seven Lamps of Architecture* and in 1851 *The Stones of Venice*. These books established his reputation as the leading English art critic of his generation. In the 1860s, he wrote on economic and social matters, defending aesthetic, humanitarian, and environmental values against free-market capitalism. In 1885, because of declining mental health, Ruskin had to resign his Slade Professorship at Oxford and retire to his family home in Coniston, in the Lake District. Throughout his life, he kept detailed diaries, some of which describe his psychotic episodes, including his dreams and hallucinations.

21.21 John Everett Millais, *John Ruskin,* 1854. Oil on canvas; 31 × 26¾ in. (78.7 × 67.9 cm). Collection of Lady Gibson.

American Realist Painting

Thomas Eakins

One of the landmarks of Realist painting in America was the *Gross Clinic* (fig. **21.22**) by Thomas Eakins (1844–1916). It depicts a team of doctors led by Dr. Samuel D. Gross, an eminent surgeon and professor at the Jefferson Medical College in Philadelphia. They are performing an operation dressed in street clothes, as was the custom in the nineteenth century. Dr. Gross holds a scalpel and comments on the operation to the audience in the amphitheater.

Eakins uses atmospheric perspective and highlights the surgical procedure. In his choice of subject as well as his lighting, Eakins echoes Rembrandt, who had painted a well-known scene of a doctor dissecting a cadaver. Here, however, the patient is alive, and a female relative, probably his mother, sits at the left and hides her face. In addition to using light to highlight the surgery, Eakins endows it with symbolic meaning. The illumination on Gross's forehead and hand accentuates his "enlightened" mind and his manual skill.

In the early 1870s, Eakins had painted several scenes of rowing, a sport he greatly enjoyed. *John Biglen in a Single Scull* (fig. **21.23**) is one of a series showing the well-known rower with his oars poised above the water. Eakins's watercolors are deliberately executed and were exhibited as finished pictures. This example juxtaposes the calm, undisturbed water and the rower's tension as he awaits the signal to begin. The contrast is reinforced by the horizontals of the water, the horizon, and the body of the scull set against the diagonals of Biglen's outstretched arms, curved back, bent knees, and the long oar.

21.22 Thomas Cowperthwait Eakins, *Gross Clinic*, 1875–1876. India ink and watercolor on cardboard; 23¾ × 19¼ in. (60.4 × 49.1 cm). Metropolitan Museum of Art, New York (Rogers Fund, 1923). As an art teacher, Eakins emphasized the study of anatomy, dissection, and scientific perspective. He clashed with the authorities of the Pennsylvania Academy over his policy that women art students draw from the nude.

21.23 Thomas Cowperthwait Eakins, *John Biglen in a Single Scull,* 1873. Watercolor on off-white wove paper; 19⁵⁄₁₆ × 24⅞ in. (49.2 × 63.2 cm). Metropolitan Museum of Art, New York (Fletcher Fund, 1924).

Henry Ossawa Tanner

Eakins's student Henry Ossawa Tanner (1859–1937) moved to Paris, where he was the first African American to exhibit at the Paris Salon. Under Eakins's influence, he painted Realist scenes of African-American life in the United States. Later he used his religious faith to express what he believed were the universal emotions—the essential reality—in biblical stories. In that approach, Tanner can be compared with certain of the Pre-Raphaelites. He traveled to the Middle East in January 1897 and absorbed the atmosphere that would provide settings for his biblical pictures.

The next year, Tanner exhibited his *Annunciation* (fig. **21.24**) at the Salon. He shows Mary having just awakened and sitting up in bed. She tilts her head to stare at the appearance of a gold rectangle of light, which signifies a divine presence. The attention to realistic details, such as Mary's dress, the stone floor, and Near Eastern rug, is combined—as in Rossetti's *Ecce Ancilla Domini*—with mystical qualities of light. Tanner shares with Rossetti the depiction of Mary's inner reality as an apprehensive participant in a miraculous event.

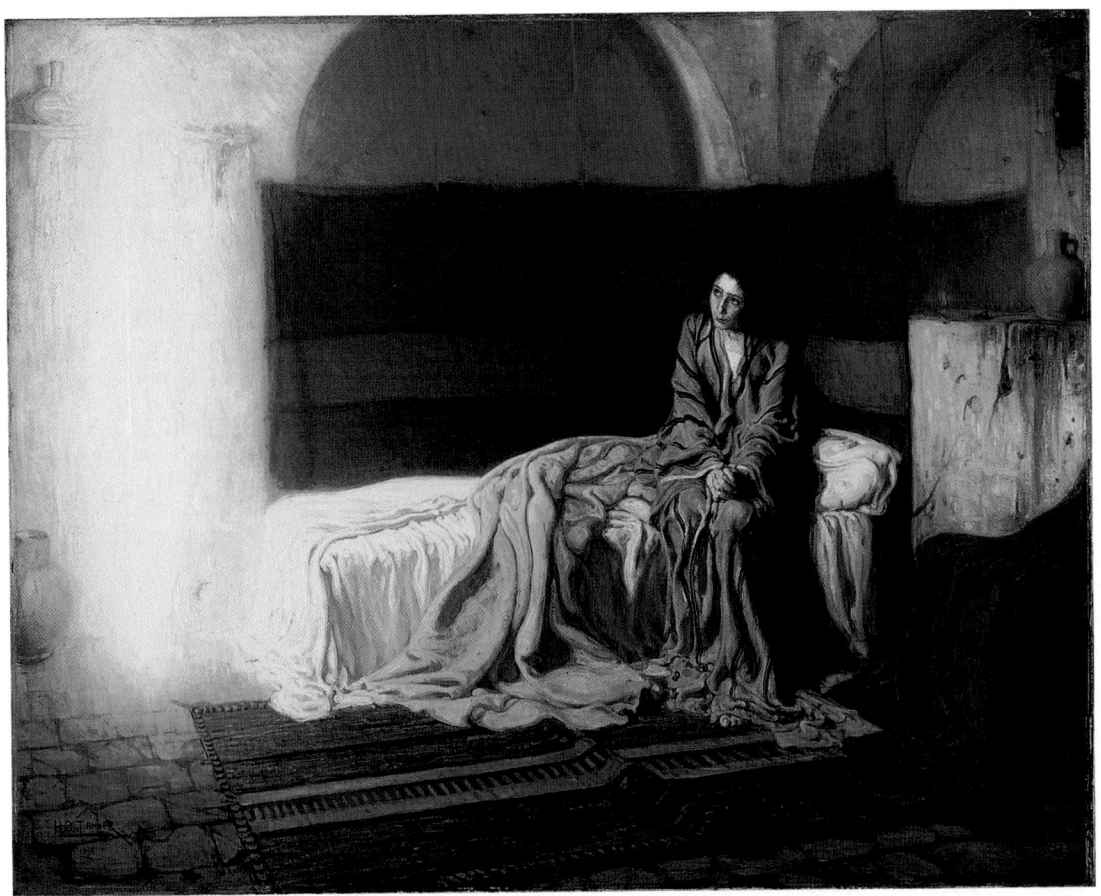

21.24 Henry Ossawa Tanner, *Annunciation*, 1898. Oil on canvas; 4 ft. 9 in. × 5 ft. 11½ in. (1.45 × 1.82 m). Philadelphia Museum of Art (W. P. Wilstach Collection). Tanner's mother was born a slave and remained so until her father was given his freedom. She moved to Pittsburgh, attended school, and eventually married the Reverend Benjamin Tucker Tanner, who became a bishop. Tanner's parents admired the abolitionist John Brown; they gave their son the middle name Ossawa after Osawatomie, Kansas, where John Brown killed several vigilantes who were fighting to preserve slavery.

French Realism in the 1860s

Édouard Manet's *Déjeuner sur l'Herbe*

The work of Édouard Manet (1832–1883) in Paris formed a transition from Realism to Impressionism (which is the subject of the next chapter). By and large, Manet's paintings of the 1860s are consistent with the principles of Realism, whereas in the 1870s and early 1880s he adopted a more Impressionist style.

In 1863, Manet shocked the French public by exhibiting *Le Déjeuner sur l'Herbe* (*Luncheon on the Grass*) (fig. **21.25**). It is not a Realist painting in the social or political sense of Daumier, but it is a statement in favor of the artist's individual freedom and challenges the viewer on several grounds. The shock value of a nude woman casually lunching in public with two fully dressed men, which was an affront to the propriety of the time, was accentuated by the recognizability of the figures. The nude, Manet's model Victorine Meurend, stares directly at the viewer. The two men are Manet's brother Gustave and his future brother-in-law, Ferdinand Leenhoff. In the background, a lightly clad woman wades in a stream.

Although Manet's *Déjeuner* contains several art-historical references to well-known Renaissance pictures, in particular to Giorgione's *Fête Champêtre* (see fig. 14.51), they have been transformed in a way that was unacceptable to the nineteenth-century French public. The figures were not suf-ficiently Classical, or even close enough to their Renaissance prototypes, to pass muster with the prevailing taste. Certain details such as the bottom of Victorine's bare foot and the unidealized rolls of fat around her waist aroused the hostility of the critics. The seemingly cavalier application of paint also annoyed viewers, with one complaining, "I see fingers without bones and heads without skulls. I see sideburns painted like two strips of black cloth glued on the cheeks."

─── **CONNECTIONS** ───

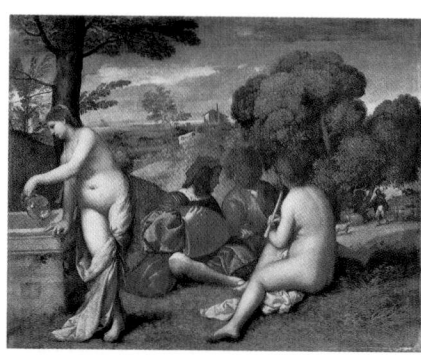

See figure 14.49. Giorgione, *Fête Champêtre*, c. 1510.

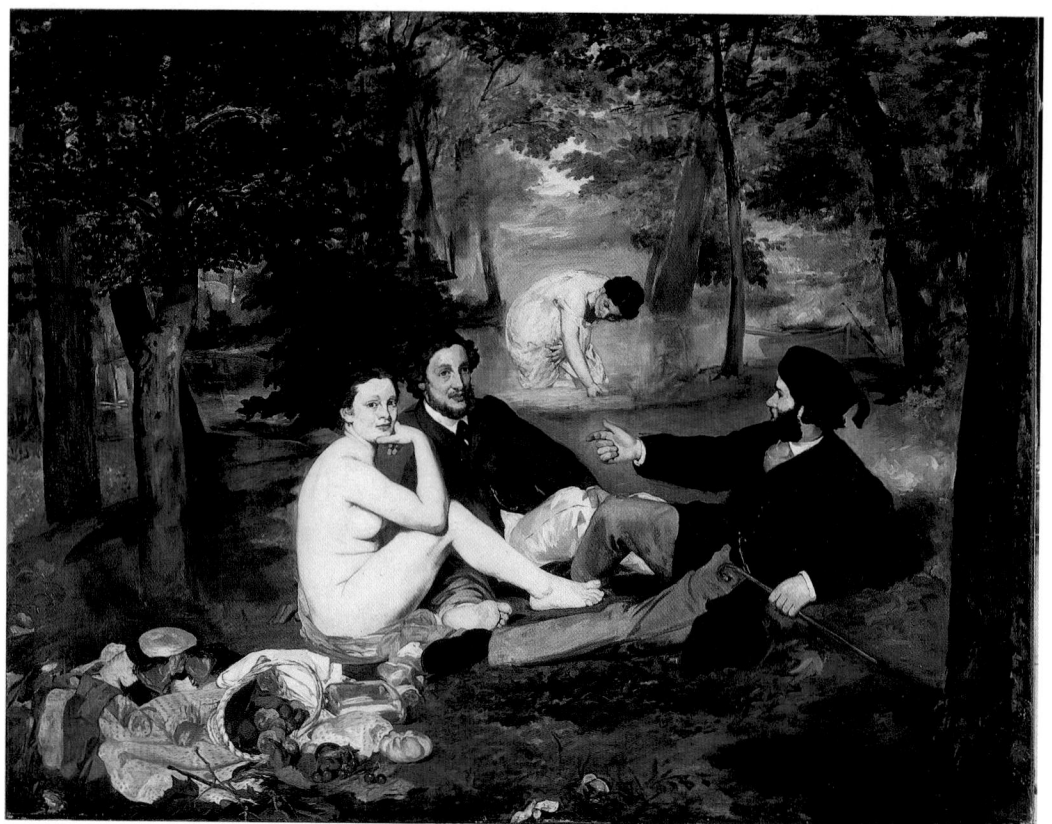

21.25 Édouard Manet, *Le Déjeuner sur l'Herbe*, 1863. Oil on canvas; 7 × 9 ft. (2.13 × 2.69 m). Musée d'Orsay, Paris. The visual impact of the painting is partly the result of the shallow perspective. Rather than creating the illusion of a distant space, Manet, like Courbet and Eakins, builds up areas of color so that the forms seem to advance toward the viewer. The final effect of this technique is a direct confrontation between viewer and image, allowing little of the relief, or "breathing space," that comes with distance.

Manet's *Olympia*

Manet created an even more direct visual impact in the *Olympia* (fig. **21.26**), which also caused a scandal when first exhibited in 1865. Here, again, Manet is inspired by the past—most obviously by Giorgione's *Sleeping Venus* (see fig. 14.48) and Titian's *Venus of Urbino* (see fig. 14.52). But whereas the Italian Renaissance nudes are psychologically "distanced" from the viewer's everyday experience by their designation as Classical deities, Manet's figure (the same Victorine who posed for the *Déjeuner*) was widely assumed to represent a prostitute. As such, she raised the specter of venereal disease, which was rampant in Paris at the time. The reference to "Olympia" in such a context only served to accentuate the contrast between the social "reality" of nineteenth-century Paris and the more comfortably removed Classical ideal. Titian had also relieved the viewer's confrontation with his Venus by spatial recession. In the *Olympia,* however, the back wall of the room approaches the picture plane, separated from it only by the bed and the black servant. Olympia is harshly illuminated, in contrast to the soft light and gradual, sensual shading of Titian's Venus. Furthermore, she shows none of the traditional signs of modesty, but instead stares boldly at the viewer.

In 1863, the Salon rejected the *Déjeuner* but two years later accepted the *Olympia*. It is impossible to overestimate not only the depth of feeling that surrounded the decisions of the Salon juries, but also the hostile criticism that generally greeted **avant-garde** (modernist) works. The subsequent outcry following the rejection of over 4,000 canvases by the Salon jury prompted Napoleon III to authorize a special exhibition, the "Salon des Refusés," for the rejected works. Among the "rejected" were Manet, Camille Pissarro, Paul Cézanne (only one of whose works was ever shown in an official Salon during his lifetime), and James Abbott McNeill Whistler—all of whom subsequently gained international recognition.

Manet's *Olympia* caused dissension even among the ranks of the Realists. It offended Courbet, who pronounced it "as flat as a playing card."

— **CONNECTIONS** —

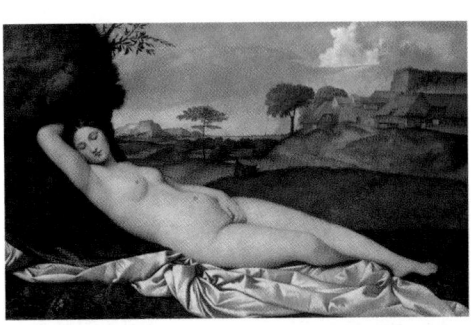

See figure 14.50.
Giorgione, *Sleeping Venus,* c. 1509.

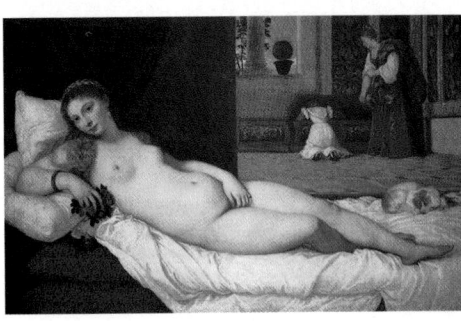

See figure 14.52. Titian, *Venus of Urbino,* c. 1538.

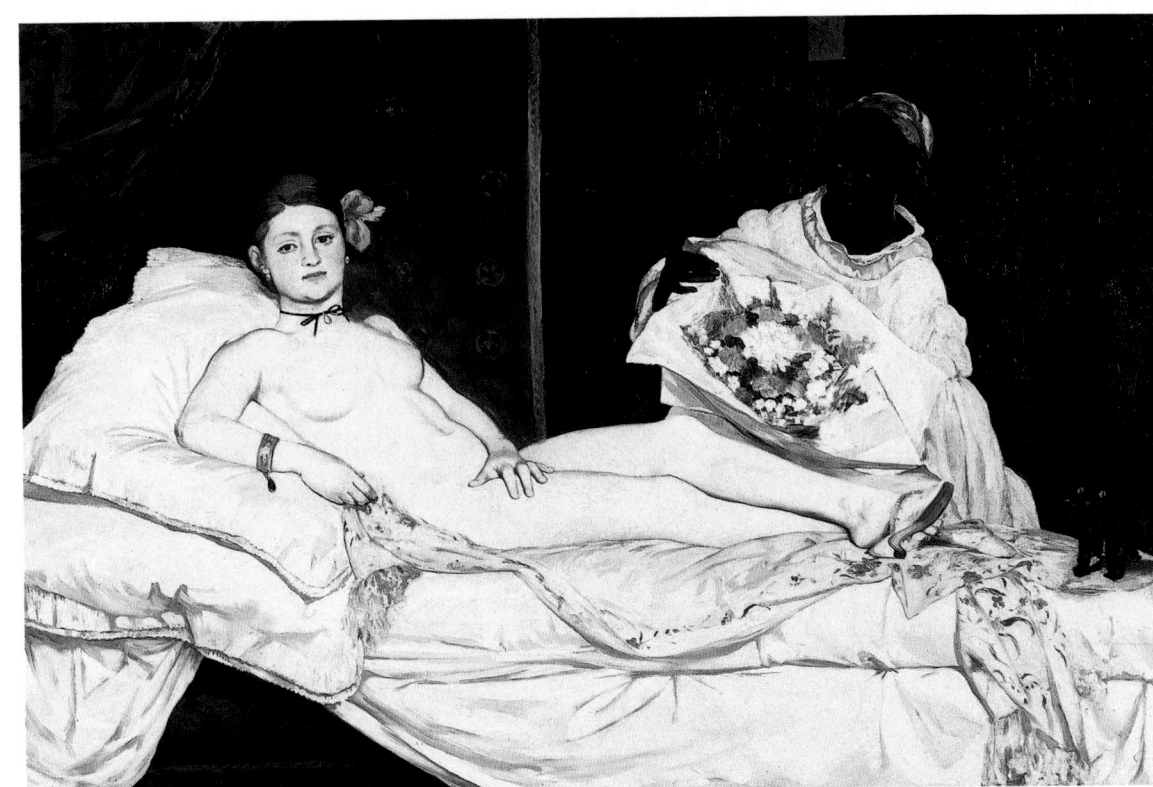

21.26 Édouard Manet, *Olympia,* 1865. Oil on canvas; 4 ft. 3 in. × 6 ft. 3 in. (1.30 × 1.91 m). Musée d'Orsay, Paris. Olympia is naked rather than nude, an impression emphasized by her bony, unclassical proportions. The sheets are slightly rumpled, suggesting sexual activity. The flowers that her maid delivers have clearly been sent by a client. Olympia's shoes may refer to "streetwalking," and the alert black cat is a symbol of sexuality, no doubt because of the popular reputation of the alley cat. The term *cathouse* is commonly used for a brothel.

Architecture and Sculpture

By and large, nineteenth-century architects were not quick to adopt iron and steel, both of which had been recently developed, as building materials. At first, they did not regard them as suitable for such use. The first major project making extensive use of iron was considered a utilitarian structure rather than a work of art.

Joseph Paxton: The Crystal Palace

In 1851, the Great Exhibition of the Works of Industry of All Nations was held in London. This was the first in a series of Universal, or International, Expositions ("Expos") and World's Fairs that continues to this day. Architects were invited to submit designs for a building in Hyde Park to house the exhibition.

When Joseph Paxton submitted his proposal, 245 designs had already been received and rejected. Paxton had started his career as a landscape gardener and had built large conservatories and greenhouses of iron and glass. Not only was his proposal less expensive than the other designs, but it could be completed within the nine-month deadline. The design was subdivided into a limited number of components and subcontracted out. The individual components were thus "prefabricated"—made in advance and assembled on the site. Because of its extensive use of glass, the structure was dubbed the Crystal Palace (fig. **21.27**).

There were many advantages to this construction method. Above all, prefabrication meant that the structure could be treated as a temporary one. After the exhibition had ended, the building was taken apart and reassembled on a site in the south of London. But one alleged advantage of iron and glass—that they were fireproof—proved to be illusory. In 1936, the Crystal Palace was destroyed in a fire, the framework buckling and collapsing in the intense heat.

21.27 Joseph Paxton, Crystal Palace, London, 1850–1851. Cast iron, wrought iron, and glass. Engraving (R. P. Cuff after W. B. Brounger). Victoria and Albert Museum, London. The Crystal Palace was 1,850 feet (563.88 m) long (perhaps an architect's pun on the year in which it was built) and 400 feet (121.92 m) wide. It covered an area of 18 acres (7.3 ha), enclosed 33 million cubic feet (934,000 m³) of space (the largest enclosed space up to that time), and contained more than 10,000 exhibits of technology and handicrafts from all over the world.

Bridges: The Roeblings

The industrializing countries, particularly the United States with its great distances, needed better systems of transportation to keep up with the advances in communication and commerce. Rivers and ravines had to be crossed by roads and railroads, and this led to new developments in nineteenth-century bridge construction. Until the 1850s, bridges had been designed according to the **truss** method of construction, which utilized short components joined together to form a longer, rigid framework. Wooden truss bridges used by the Romans to cross the river Danube, for example, are illustrated on Trajan's Column (see fig. 7.34). By the 1840s, metal began to replace wood as the preferred material for such bridges.

The principle of the **suspension bridge** had been known for centuries, from the bridges of twisted ropes or vines that had been used to cross ravines in Asia and South America. The superior span and height of the suspension bridge were appropriate for deep chasms or wide stretches of navigable water. Modern suspension bridges were built from the early 1800s using iron chains, but by the middle of the century engineers had begun to see the advantages of using flexible cable made of steel wire.

The greatest American bridge builders of the nineteenth century were John A. Roebling (1806–1869) and his son, W. A. Roebling (1837–1926), who were responsible for the Brooklyn Bridge (fig. 21.28). Two massive towers of granite were constructed at either end of the bridge. They were linked by four huge parallel cables, each containing over 5,000 strands of steel wire. The steel, which was spun on the site, supported the roadways and pedestrian walkways. It was the first time that steel had been used for this purpose. Ironically, however, in deference to architectural tradition, the pointed arches in the masonry marked a return to Gothic forms.

21.28 John A. and W. A. Roebling, Brooklyn Bridge, New York, 1869–1883. Stone piers with steel cables; 1,595 ft. (486.16 m) span. This suspension bridge spanned the East River to connect Manhattan (New York City) and Brooklyn. Like the Crystal Palace, the Brooklyn Bridge was regarded as a work of engineering rather than of architecture.

The Statue of Liberty

Shortly after the American Civil War, a French intellectual, Édouard de Laboulaye, thought of presenting the United States with a monument to commemorate French assistance to America in the Revolutionary War. For the next ten years, funds were raised from France by public subscription, and the monument was constructed from 1875 to 1884.

Originally called *Liberty Enlightening the World* but popularly known as the Statue of Liberty, the monument is a massive statue (fig. **21.29**) of a classically clothed woman raising the torch of liberty. In her left hand, she holds a tablet bearing the starting date of the American Revolution, July 4, 1776. She stands in a traditional *contrapposto* pose and looks slightly to her right. The statue's weight (225 tons) and height (151 ft. 6 in. [46.18 m]) and the fact that it was destined for a site where it would be constantly exposed to strong winds required the skills of a sculptor and a structural engineer.

The sculptor was Auguste Bartholdi (1834–1904), who was influenced by colossal Egyptian sculptures and had established himself in France as a sculptor on a massive scale. He fashioned the statue by hammering thin copper sheets into the required shape and then attaching them with iron straps to a supporting framework. The frame (fig. **21.30**) was built of steel and wrought iron by Alexandre-Gustave Eiffel (1832–1923).

In 1885, the completed statue was disassembled and shipped to America. It was reassembled on Bedloe's Island (later renamed Liberty Island), which guards the entrance to New York Harbor. The pedestal on which the statue stands, approximately the same height as the statue, was financed by the American public. The statue's proximity to Ellis Island, the most important entry port to America, made it one of the first sights greeting millions of immigrants. As such, its very conception is consistent with the nineteenth-century theme of struggle for social, political, and artistic freedom. It has become an icon of liberty, symbolizing opportunity for Americans and non-Americans alike.

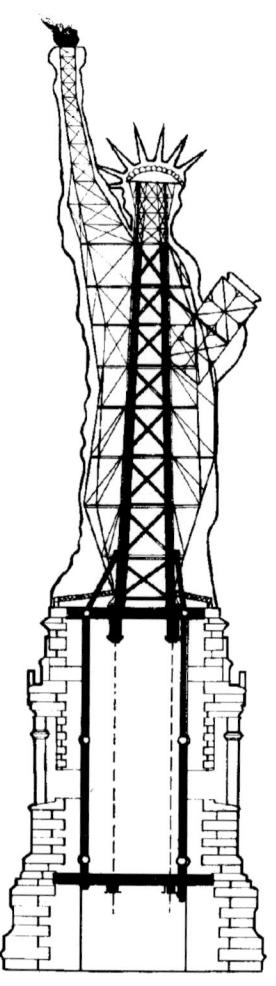

21.29 Auguste Bartholdi and Alexandre-Gustave Eiffel, Statue of Liberty, New York, 1875–1884. Copper plate on a steel and wrought-iron framework; 151 ft. 6 in. (46.18 m) high.

21.30 Alexandre-Gustave Eiffel, diagram of the construction of the Statue of Liberty.

The Eiffel Tower

Like the Crystal Palace, the Eiffel Tower in Paris (fig. **21.31**) was built as a temporary structure. It was designed as a landmark for the Universal Exposition of 1889, celebrating the centenary of the French Revolution. From the third and highest platform of the tower, visitors could enjoy a spectacular panorama of Paris, covering a radius of about 50 miles (80.5 km).

Named for its designer, Alexandre-Gustave Eiffel, the tower was a metal-truss construction on a base of reinforced concrete. Through the curves of the elevation and the four semicircular curves of the base—all executed in open-lattice wrought iron—Eiffel transformed an engineering feat into an elegant architectural monument. An unusual feature of the tower was the design of its elevators (by the American Elisha Otis), which at the lowest level had to ascend in a curve.

The Eiffel Tower was so controversial that a petition demanding its demolition was circulated. When the exposition ended in 1909, the tower was saved because of its value as a radio antenna. Its original height, before the addition of a television mast, was twice that of the dome of Saint Peter's or the Great Pyramid at Giza. Until the Empire State Building was built in New York in 1932, the Eiffel Tower was the highest man-made structure in the world.

21.31 Alexandre-Gustave Eiffel, Eiffel Tower, Paris, 1887–1889. Wrought-iron superstructure on a reinforced concrete base; 984 ft. (299.92 m) high, 1,052 ft. (320.65 m) including television mast.

21.32 Louis Sullivan, Wainwright Building, St. Louis, Missouri, 1890–1891.

Origins of the Skyscraper: Louis Sullivan

By the second half of the nineteenth century, a new type of construction was needed to make more economical use of land. One of the drawbacks of masonry or brick construction is that the higher the building, the thicker the supporting walls have to be at the base. This increases the cost of materials, the overall weight of the structure, and the area that it occupies. The new materials of structural steel and concrete reinforced with steel wire or mesh were stronger than the traditional materials. Their **tensile strength** (abil-

ity to withstand longitudinal stress) was also much greater, allowing flexibility in reaction to wind and other pressures. The power-driven electric elevator was another necessity for high-rise construction. All of the ingredients for the skyscraper were now in place. Skyscrapers could be used as apartment houses, office buildings, multistory factories, department stores, auditoriums, and other facilities for mass entertainment.

The Wainwright Building in St. Louis (fig. **21.32**), a nine-story office building built in 1890–1891, is one of the finest examples of early high-rise building. It is based on the **steel frame** method of construction, in which steel girders are joined horizontally and vertically to form a grid. The framework is strong enough for the outer and inner walls to be suspended from it without themselves performing any supporting function. Architectural features that had been used since Classical antiquity and the Gothic era—post and lintel, arch, vault, buttress—were now functionally superfluous.

The architect, Louis Sullivan (1856–1924), used a Classical motif to stress the verticality of the building and to disguise the fact that it was basically a rectangular block with nine similar horizontals superimposed on one another. He treated the first and second floors as a horizontal base. The next seven floors were punctuated vertically by transforming the wall areas between the windows into slender pilasters (every second one corresponding to a vertical steel beam), extending from the third to the ninth floor. The top floor, which contained the water tanks, elevator plant, and other functional units, was made into an overhanging cornice, with small circular windows blending into the ornamental reliefs. The Renaissance impression of the building is heightened by the brick, red granite, and terra-cotta facing. Although the Wainwright Building is not tall by contemporary standards, Sullivan's use of Classical features makes it seem taller than it actually is.

Sullivan believed that the form of a building should correspond to its purpose—"form follows function." In his view, a "properly designed building" should reflect the reason for which it was built, and this should be obvious to even a casual observer. This philosophy of architecture is embodied in the Wainwright Building.

Style/Period	Works of Art	Cultural/Historical Developments
REALISM **1830–1850** **Brady, Lincoln "Cooper Union" Portrait**	Niepce, *View from His Window at Gras* (**21.12**) Daumier, *Louis-Philippe as Gargantua* (**21.10**) Daumier, *Freedom of the Press* (**21.9**) Anonymous, daguerreotype (**21.13**) Courbet, *Burial at Ornans* (**21.4**) Courbet, *Stone Breakers* (**21.3**) **Daumier, Louis-Philippe as Gargantua**	John Ruskin, first volume of *Modern Painters* (1843) John Stuart Mill, *Principles of Political Economy* (1848) Karl Marx and Friedrich Engels, *Communist Manifesto* (1848) Alexandre Dumas the Younger, *La Dame aux Camélias* (1849)
1850–1860	Rossetti, *The Annunciation* (**21.20**) Paxton, *Crystal Palace* (**21.27**), London Bonheur, *Horse Fair* (**21.2**) Millais, *John Ruskin* (**21.21**) Courbet, *Interior of My Studio* (**21.5**) Millet, *Gleaners* (**21.1**) **Courbet, Interior of My Studio** **Millet, Gleaners**	Herman Melville, *Moby-Dick* (1851) Harriet Beecher Stowe, *Uncle Tom's Cabin* (1851) Crimean War (1853–1856) Haussmann begins reconstruction of Paris boulevards (1853) Henry David Thoreau, *Wolden* (1854) Walt Whitman, *Leaves of Gross* (1855) Gustave Flaubert, *Madame Bovary* (1857) Charles Baudelaire, *Les Fleurs du mal* (1857) First transatlantic cable laid (1858–1866) Charles Darwin, *On the Origin of Species* (1859)
1860–1870 **Manet, Le Déjeuner sur l'Herbe** **Cameron, Mrs. Herbert Duckworth**	Brady, *Lincoln "Cooper Union" Portrait* (**21.17**) Daumier, *Nadar Elevating Photography to the Height of Art* (**21.15**) Daumier, *Third-Class Carriage* (**21.6**) Brady, *Ruins of Gallego Flour Mills, Richmond* (**21.19**) Manet, *Le Déjeuner sur l'Herbe* (**21.25**) Daumier, *Interior of a First-Class Carriage* (**21.7**) Nadar, *Sarah Bernhardt* (**21.14**) Manet, *Olympia* (**21.26**) Brady, *Robert E. Lee* (**21.18**) Cameron, *Mrs. Herbert Duckworth* (**21.16**) Roebling, *Brooklyn Bridge* (**21.28**), New York **Studio of Brady, Ruins of Gallego Flour Mills, Richmond**	William Morris founds Arts and Crafts movement in England (1860s) Charles Dickens, *Great Expectations* (1861) American Civil War (1861–1865) Victor Hugo, *Les Misérables* (1862) Le Salon des Refusés, Paris (1863) Leo Tolstoy, *War and Peace* (1864–1869) Assassination of Abraham Lincoln (1865) Lewis Carroll, *Alice's Adventures in Wonderland* (1865) Gregor Mendel formulates laws of genetics (1865) Fyodor Dostoevsky, *Crime and Punishment* (1866) Russia sells Alaska to the U.S.A. (1867) Louisa M. Alcott, *Little Women* (1868) Opening of Suez Canal (1869) U.S. transcontinental railroad completed (1869)
1870–1900 **Roebling, Brooklyn Bridge**	Eakins, *John Biglen in a Single Scull* (**21.23**) Eakins, *Gross Clinic* (**21.22**) Bartholdi and Eiffel, *Statue of Liberty* (**21.29**), New York Eiffel, *Eiffel Tower* (**21.31**), Paris Sullivan, *Wainwright Building* (**21.32**), St. Louis Tanner, *Annunciation* (**21.24**) **Bartholdi and Eiffel, Statue of Liberty**	Franco-Prussian War; Bismarck becomes chancellor of Germany (1870–1871) Heinrich Schliemann begins excavations at Troy (1870) Émile Zola, *Thérèse Raquin* (1871) Samuel Butler, *Erewhon* (1872) Thomas Hardy, *Far from the Madding Crowd* (1874)

22

Nineteenth-Century Impressionism

The Impressionist style evolved in Paris in the 1860s and continued into the early twentieth century. Unlike Realism, Impressionism rarely responded to political events. The devastating effects of France's defeat in the Franco-Prussian War in 1871, for example, had virtually no impact on Impressionist imagery. Impressionist painters preferred genre subjects, especially scenes of leisure activities, entertainment, and landscape, and Impressionism was more influenced by Japanese prints (see Window 9, pp. 776–781) and new developments in photography than by politics.

Despite the changing focus of its content, Impressionism was in some ways a logical development of Realism. But Impressionists were more concerned with optical than with social realism. In their preoccupation with political commentary, the Realists had emphasized social observation, whereas the Impressionists were interested in the natural properties of light. They studied changes in light and color caused by weather conditions, times of day, and seasons, making shadows and reflections important features of their iconography. Impressionists also studied the effects of interior, artificial lighting, such as theater spotlights and café lanterns. Nevertheless, these formal concerns did not entirely eliminate the interest in observing society and in the changes brought about by growing industrialization; subject matter included canals and barges, factories with smoking chimneys, and railway stations.

Although many Impressionist artists came from bourgeois families, they liked to exchange ideas in more bohemian surroundings, notably the Café Guerbois in the Montmartre district of Paris, where Manet, Degas, and their circle congregated. Because their paintings were initially, and vociferously, rejected by the French Academy as well as by the French public, the Impressionists became a group apart. They mounted eight exhibitions of their own work between 1874 and 1886, the first of which was held at the studio of Nadar. Ironically, despite the contemporary rejection of Impressionism, it had a greater international impact in the long run than previous styles that France readily accepted.

Urban Renewal during the Second Empire

In 1852, after a coup the previous year, Napoleon Bonaparte's nephew, Napoleon III, had himself proclaimed ruler of the Second Empire. For political as well as aesthetic reasons, he decided to modernize Paris. He wanted the city to be the center of European culture, adapting industrial developments to improve the lifestyle of the general population. New housing would eliminate slums, and wide boulevards would replace the old, narrow, medieval streets. Modern amenities such as drainage and sewer systems, clean water supplies, bridges, lamplighting along the streets, outdoor fountains, and public parks would instill renewed civic pride in the Parisians. The emperor believed that these renovations would discourage revolutionary activity and prevent uprisings of the kind that swept Europe in 1848. With this in mind, in 1853 Napoleon III commissioned Baron Georges-Eugène Haussmann (1809–1891) to plan and supervise the new urban design.

Baron Georges-Eugène Haussmann

Haussmann was inspired by the Baroque grandeur of Bernini's square of Saint Peter's (see fig. 17.2) and the layout of Versailles (see fig. 17.12). His plan was to focus on important buildings, on which the boulevards converged (or from which they radiated). Figure 22.1 shows the Place de l'Étoile (Square of the Star) with the Arc de Triomphe (cf. fig. 19.7) at the center of a traffic circle. This design facilitated the movement of vehicles and crowds, while also emphasizing the political significance of the triumphal arch.

22.1 Aerial view of the Place de l'Étoile, Paris, seen from the west. From the Place de l'Étoile, the Avenue des Champs-Élysées leads eastward to the Jardin des Tuileries and, beyond that, to the Louvre.

22.2 Jean-Louis-Charles Garnier, south façade of the Opéra, Paris, 1862–1875.

Jean-Louis-Charles Garnier

One of the architects hired to work on the renovation was Jean-Louis-Charles Garnier (1825–1898). He created the greatest of the new buildings, the Paris Opéra, from 1862 to 1875. The façade (fig. **22.2**) is Baroque in conception, re- flecting the opulence of Second Empire taste as well as the fact that opera itself is a Baroque genre.

The plan (fig. **22.3**) shows Garnier's organization of the entrances, which corresponded to the social rank of the audience. The emperor would have had a private entrance accessible by a ramp, had he not fallen from power before its completion. Everyone else was divided according to whether they arrived by carriage (at the side entrance) or on foot (through the main entrance), and whether they already had tickets or intended to buy them at the box office.

Entrance for those arriving by carriage

N

Entrance for those arriving on foot

Stage

Emperor's entrance

22.3 Plan of the Opéra, Paris.

The interior view of the Grand Staircase (fig. **22.4**) exemplifies the character of this neo-Baroque splendor, with its colossal Ionic columns, the broken pediment at the head of the stairs, the upper-story balustrade surmounted by undulating arches broken by female heads, and the ornate frescoes on the ceiling. Like the Galerie des Glaces at Versailles (see fig. 17.14), mirrors adorned the Opéra walls. This feature, together with the vast open space around the stairway, created a "stage" on which the operagoers circulated. Seeing and being seen, as much as the performance itself, enhanced the excitement of attending the opera.

22.4 Grand Staircase of the Opéra, Paris. Engraving, 1880.

Japanese Woodblock Prints

From 1853 to 1854, Commodore Matthew Perry, a United States naval officer, led an expedition that forced Japan (see map) to end its policy of isolation. This opened up trade with the Far East and set the stage for cultural exchange. In the Paris Universal Exposition of 1867, many Japanese woodblock prints were on view. As a result, *japonisme*, the French term for the Japanese aesthetic, became popular in fashionable Parisian circles. Japanese prints exerted considerable influence on Impressionist painters in France, the United States, and elsewhere.

Woodblock printing had begun in China in the fourth century A.D. In the sixth century, Buddhist missionaries brought the technique to Japan. At first, it was used for printing words, but in the sixteenth century artists began to make woodblock images illustrating texts. Originally the images were black and white, but in the seventeenth century color was introduced. In order to create a woodblock print in color, the artist makes a separate block for each color and prints each block individually. The raised portions differ in each block and correspond to a different color in the final print. It is important, therefore, that the outlines of each block correspond exactly, so that there is no unplanned overlapping or empty space between forms.

The prints that most influenced the Impressionist painters were made during the Edo period (1600–1868). In the seventeenth century, Edo (the former name of Tokyo) became an urban center of feudalism in Japan. It was also the primary residence of the emperor, whose power was nearly absolute. Nevertheless, a merchant class developed that produced the main patrons of literature and the visual arts. Woodblock prints provided multiple images, which could be sold to a wide audience. As a result, publishers commissioned artists to prepare preliminary designs and then supervised the engraving, printing, and sale of the final works.

Japanese art students were apprenticed to master artists, just as in western Europe during the Renaissance. The signatures on the prints reflect this system, for the artist had a chosen name (or *go*) as well as an apprentice name. The former was framed by a cartouche (cf. fig. 3.4), whereas the latter was usually unframed and placed at the bottom of the page. A publisher's mark might also be stamped on the print. At the top of the page are the titles of the individual texts, or series of texts, that are illustrated. If the subject is an actor, his name or role is sometimes added.

From 1790 to 1874, the Japanese government made several unsuccessful attempts to censor certain types of imagery—especially erotica—so there is sometimes an official seal and a date printed on the page. The standard dimensions (*oban*) of a woodblock print were 15 by 10½ inches (38.1 × 26.7 cm). Smaller works were reduced proportionally, and subjects requiring larger sizes or several episodes were printed, like polyptychs, in attached sections.

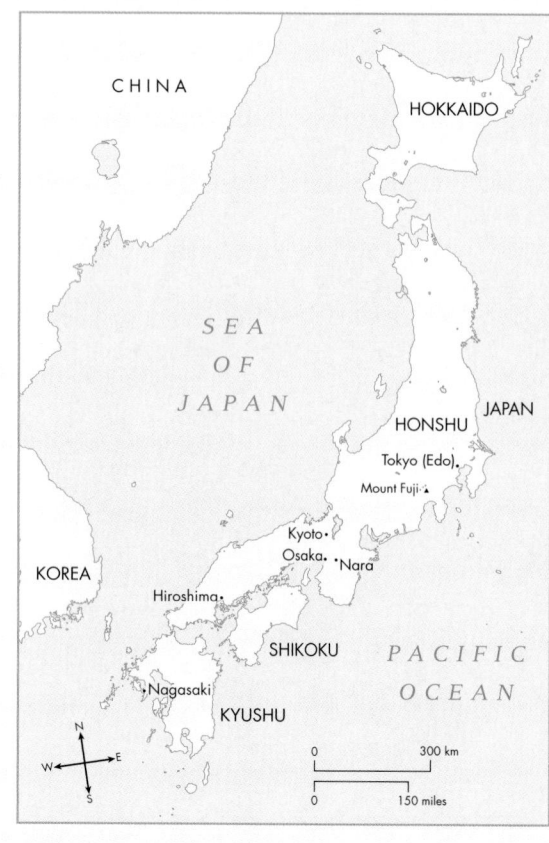

Japan in the 19th century.

Ukiyo-e

The golden age of Japanese woodblock was the Ukiyo-e school of painting, which was founded around the middle of the seventeenth century. It lasted until the end of the Edo period in 1868. The term *ukiyo-e* means "floating world" and refers to the transience of material existence. The most popular subjects were theater, dance, and erotica, ranging from depictions of various kinds of female services to portraits of high-class courtesans. Respectable, middle-class women performing daily tasks were also depicted, but mythological and historical scenes were less popular, and landscape was used only as background until the nineteenth century. Both the stylistic techniques used in woodblock prints and their subject matter—leisure genre scenes, entertainment, courtesans, landscape and cityscape, aerial views, and so forth—have affinities with French Impressionism.

W9.1 Utagawa Kunisada, *The Actor Seki Sanjuro in the Role of Kiogoku Takumi*, 1860. Woodblock print with *gauffrage* (blind printing) and burnishing. Private collection.

Utagawa Kunisada

The actor in figure **W9.1** by Utagawa Kunisada (1786–1865) is shown in a close-up view. The monumental impact of the print is created by the broad forms that seem barely contained by the frame. The actor's stylized expression—its exaggerated, masklike quality—conforms to the stylization of kabuki theater. Kabuki is a type of Japanese theater derived from sixteenth-century songs and dances that were originally performed by women and later exclusively by men. The typical kabuki play lasts many hours and has many parts. There is a great deal of action in the plot, actors change costume on stage, and props are numerous. Costumes are elaborate, poses and gestures are stylized, and the actors' voices are trained according to strictly defined systems of modulation. Music and sound effects are created by a banjo, drums, bells, and clappers. The triptych (fig. **W9.2**) of around 1835 shows an episode from a kabuki play. The figures assume stylized, contorted, *contrapposto* poses that constrict and monumentalize their space. At the same time, the elaborate patterning of the costumes carries the observer's gaze across the picture plane and accentuates the flatness of the surface.

W9.2 Utagawa Kunisada, *Scene from Sukeroku*, c. 1835. Woodblock print; 8½ × 22½ in. (21.6 × 57.2 cm). Victoria and Albert Museum, London.

Utagawa Toyokuni

Utagawa Toyokuni's (1769–1825) actor portrait (fig. **W9.3**) shows Onoe Matsusuke as a villain. Its lively color and expressive character were qualities that contributed to Toyokuni's reputation as the best artist of his generation. In this work, the figure's full body is represented, but the face, despite its small size, is the focus of attention. The picture plane is dominated by the geometry of the costume, from which the villain's face emerges. The downward curve of his mouth and long, pointed nose accentuate his villainous intent. This, in turn, is reinforced by the upward sweep of his sword's sheath, which repeats the curved eyebrows and headdress. Both Kunisada's and Toyokuni's actor portraits convey an intensity of pose, gesture, and grimace that is typical of kabuki.

Kitagawa Utamaro

The Ukiyo-e images of beautiful women (*bijin*) reflect a new expressiveness of mood and personality. The late eighteenth-century example by Kitagawa Utamaro (1753–1806) illustrated here (fig. **W9.4**) is from a series entitled *Ten Facial Types of Women*. It reveals some of the differences between Western and Japanese portraiture. At first glance, the stylization of the *Young Woman with Blackened Teeth Examining Her Features in a Mirror* appears to eliminate the specificity of Western portraits. The depiction of the features recurs in many of Utamaro's female portraits: the brushed eyebrows form two raised curves, thin oval eyes contain a black pupil, the nose is purely linear, and the small lips are slightly parted. A sense of three-dimensional space is created by contours almost entirely without shading. As in Kunisada's *Actor*, it is by the foreshortening of the forms and the arrangement of curved outlines—especially of the drapery folds—that Utamaro conveys the illusion of depth. The flat background was originally coated with powdered mica, most of which has since worn away. Its shine made the figure stand out, enhancing its three-dimensional quality and creating a reflective, mirrorlike surface.

Two aspects of this print can be related to the prevailing concerns of Impressionism. The intimate, close-up view, in which one sees the woman during a private moment of self-absorption, became an Impressionist theme. She is unaware of being observed, for she is locked in the gaze of her own reflection. The flat blackness of the mirror repeats the other blacks—hair, pupils, teeth, and the official stamps and signatures

W9.3 Utagawa Toyokuni, *Portrait of the Actor Onoe Matsusuke as the Villain Kudo Suketsune*, 1800. Woodblock print; 14⅝ × 9⅝ in. (37.2 × 24.6 cm). Victoria and Albert Museum, London.

W9.4 Kitagawa Utamaro, *Young Woman with Blackened Teeth Examining Her Features in a Mirror*, from the series *Ten Facial Types of Women*, c. 1792–1793. Woodblock print; 14⅔ × 9⅔ in. (37.3 × 24.6 cm). British Museum, London.

in the upper right. Silhouettes of this kind appealed to the Impressionist taste for the effects of black-and-white photography. Furthermore, the back of the mirror—its form as well as its black tone —makes us aware of our exclusion from the intimate interchange between the woman and her reflection. This, too, is characteristic of certain Impressionist works. But it is also a device familiar to us from Velázquez's *Las Meninas* (see fig. 17.56) and Goya's *Family of Charles IV* (see fig. 20.16), where, in both cases, we are prevented from seeing the canvases within the paintings.

Keisei Eisen

The print of the *Oiran on Parade* (fig. **W9.5**) by Utamaro's pupil Keisei Eisen (1790–1848) illustrates a different type of *bijin*. This is one of Edo's high-ranking courtesans, and she is decked out in full regalia for public viewing. Her lofty position is reflected by her height, her massive proportions, and the attention to the design of her costume. Two birds embroidered on the kimono echo the woman herself: the bird at the left repeats the kimono's lower curve, and the other echoes her strutting posture. Utamaro's influence is evident in the depiction of the face and the unmodeled, empty background, but not in the abundance of patterning. This feature, the repetition of orange and blue, and the subject itself are related to the chromatic unity of Impressionism. The Prussian blue, which is used here, was a recent import from the West and attests the contacts between the East and Europe even before 1853.

W9.6 Utagawa Kuniyoshi, *Tairano Koremochi Waking Up from a Drunken Sleep,* 1843. Woodblock print. Private collection.

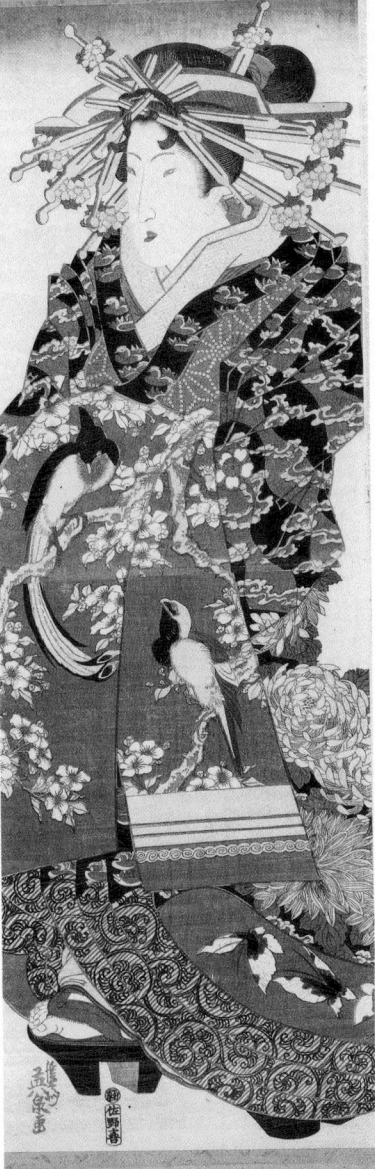

W9.5 Keisei Eisen, *Oiran on Parade,* c. 1830. Woodblock print; 29 × 9¾ in. (73.7 × 24.8 cm). An *oiran* is the highest ranking Japanese courtesan. Victoria and Albert Museum, London.

Utagawa Kuniyoshi

Tairano Koremochi Waking Up from a Drunken Sleep (fig. **W9.6**) by Utagawa Kuniyoshi (1797–1861) illustrates a scene from the *Tale of Genji,* an epic Japanese romance of the eleventh century attributed to the aristocratic Lady Murasaki Shikibu. It chronicles the life of its hero, Genji, and continues into the generation of his grandchildren. In this episode, a man sees a woman reflected in a *sake* cup as a demon. In contrast to the portraits, this print has a sense of place. Scattered leaves and the *sake* cup appear to be on the ground, and the tree branch identifies the outdoor setting. The detailed attention to the layers of patterned drapery corresponds to the elaborate descriptions of sartorial minutiae that characterize the *Tale of Genji.*

W9.7 Katsushika Hokusai, *Great Wave of Kanagawa*, from the series *Thirty-six Views of Mount Fuji*, 1831. Woodblock print; 9⅞ × 14⅝ in. (25.1 × 37.1 cm). Victoria and Albert Museum, London.

Katsushika Hokusai

The two greatest woodblock artists who accorded a prominent role to landscape were Katsushika Hokusai (1760–1849) and Utagawa Hiroshige (1797–1858). Hokusai's *Great Wave of Kanagawa* (fig. **W9.7**) is from a series entitled *Thirty-six Views of Mount Fuji*. Such series of scenes, in particular different views of the same place or similar views of the same place at different times of day and in different seasons, were also taken up by the Impressionists. The use of Prussian blue in this print enhances the wave's naturalism, but it is the dramatic rise of the wave and its nearness to the picture plane that create its impressive effect. It is a convincing portrayal of the rhythmic power of a swelling wave, even though the wave's flat, patternistic quality seems to arrest its movement. In the distance, the sacred Mount Fuji is small and insignificant by comparison. When the Impressionists first saw this print in the late nineteenth century, they were astounded by it. According to Debussy, this image inspired his famous composition *La Mer* (*The Sea*).

Hokusai's *Horsetail Gatherer* (fig. **W9.8**) of about 1840 uses landscape to create an atmosphere of stillness. As in the *Great Wave*, the artist depicts the scene from a bird's-eye view. It is from a Noh play, another type of Japanese

theater. In contrast to Kabuki, Noh plays are austere, usually consisting of one main actor conveying a specific emotion. Hokusai's print shows an old man searching the woods and mountains for his lost child. In the print, the moon moves from behind the distant trees, as if to light the man's way. But although it is nighttime, the landscape is brightly illuminated. Its stillness is broken only by the flowing water under the bridge. The curves of the stream form a sharp contrast to the smooth, glasslike water on which two ducks have settled. Their peacefulness highlights the man's anxious search, which, in turn, is echoed in the rushing stream beneath him.

W9.8 Katsushika Hokusai, *Horsetail Gatherer*, c. 1840. Woodblock print; 19¹/₁₆ × 9 in. (49.8 × 22.9 cm). Musee des Arts Asiatiques-Guimet, Paris.

W9.9 Utagawa Hiroshige, *Travelers in the Snow at Oi*, late 1830s. Woodblock print; 10¼ × 14½ in. (26.0 × 36.8 cm). British Museum, London.

Utagawa Hiroshige

Travel, which became a popular subject in nineteenth-century France—for example, Daumier's *Third-Class* and *First-Class Carriage* (see figs. 21.6 and 21.7)—is also depicted in Japanese woodblock prints. Hiroshige produced several travel series, which established his reputation. *Travelers in the Snow at Oi* (fig. **W9.9**) is from the *Sixty-nine Stations of the Kisokaida* of the late 1830s. Hiroshige, like the Impressionists, Bruegel, and other artists, conveys a sense of the season. The abundance of white, the heads bowed and arms folded to ward off the falling snow, express the coldness of winter. This impression is enhanced by the minimal color, the stark geometric quality of the round hats, and the predominance of flattened forms.

Hiroshige's last series was entitled *One Hundred Views of Edo*. The *Saruwaka-cho Theater* of 1856 (fig. **W9.10**) shows a busy theater street at night. It is rendered in linear perspective, with the moon causing the figures to cast gray shadows. At the left, theater touts are trying to lure customers. The sense of a busy street, seen from an elevated vantage point, appeals to the same aesthetic as Renoir's *Pont-Neuf* (see fig. 22.21) and Pissarro's *Place du Théâtre Français* (see fig. 22.22). It reflects the fact that just as the Impressionists were influenced by Japanese prints, so some of the Japanese artists, notably Hiroshige, were influenced by Western art.

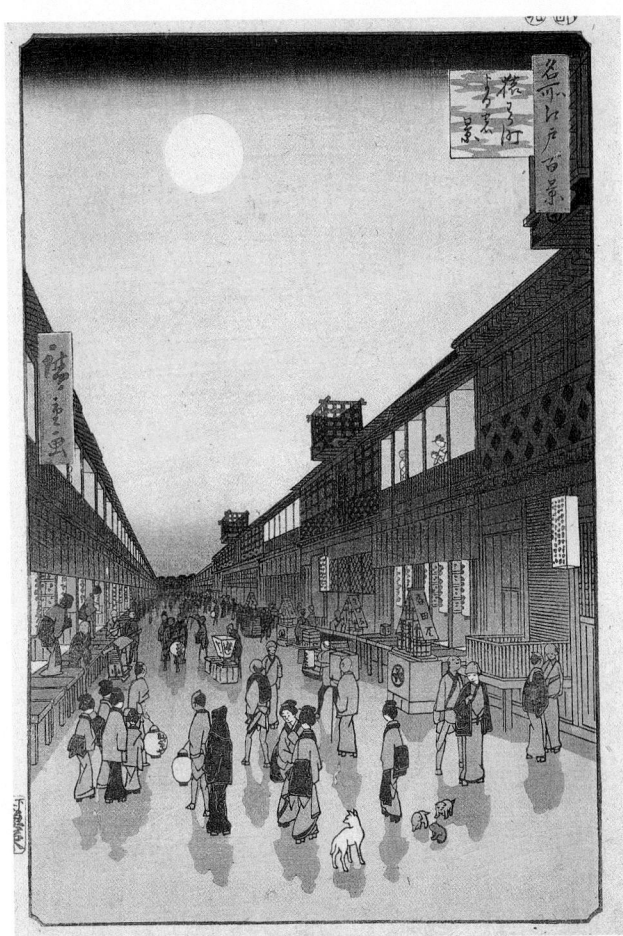

W9.10 Utagawa Hiroshige, *Saruwaka-cho Theater*, 1856. Woodblock print; 14⅛ × 9¾ in. (35.9 × 24.8 cm). Whitworth Art Gallery, University of Manchester.

Painting

Édouard Manet

At first, Manet remained separate from the core of Impressionist painters, who were his contemporaries. He did not adopt their interest in bright color and the study of light until the 1870s. From around 1866, he was championed by the novelist Émile Zola, who wrote art criticism for the Paris weekly *L'Événement*. Zola argued in favor of Manet's challenge to Academic taste on the grounds that artists should be free to pursue their own aesthetic inclinations.

Manet's *Zola* When Manet exhibited his portrait of Zola (fig. 22.5) in 1868, it was not popular. As with the *Olympia* (see fig. 21.26), Manet's figure of Zola occupies a narrow space and is close to the picture plane. Even at this early date, the *Zola* reveals elements that would become characteristic of Impressionism. The figure's studied casualness, for example, and the close-up viewpoint create the impression of an unposed snapshot. Zola's manuscripts are piled in front of his books so that his review of Manet's work is visible. The textured paint, in contrast to Neoclassical clarity of edge and smoothness of surface, shows sympathy with the Impressionist aesthetic. At the left is a Japanese screen; its pattern of white flowers is repeated in the gold upholstery nails on the chair and reflects the influence of *japonisme* on nineteenth-century painting.

In addition to the Japanese screen, Manet uses the device of pictures within pictures as a kind of visual autobiography, showing the sources for Zola's portrait. A reproduction of Manet's *Olympia* overlaps an etching by Goya of Velázquez's *The Drinkers* and a Japanese print of a wrestler. Goya's assimilation of Velázquez reflects Manet's affinity for Spanish art. Velázquez had, at times, painted in strong contrasts of light and dark, while Goya's late series of black paintings appealed to Manet's early interest in black tones. *Olympia*'s placement on top of reproductions of Manet's predecessors accentuates the fact that Manet is the more "modern," in the sense of "recent," artist. The Japanese print is only slightly overlapped by the *Olympia*, indicating its contemporariness. Both the print and the *Olympia* make use of flattened form and areas of dark silhouettes—characteristics that recur in the *Zola*.

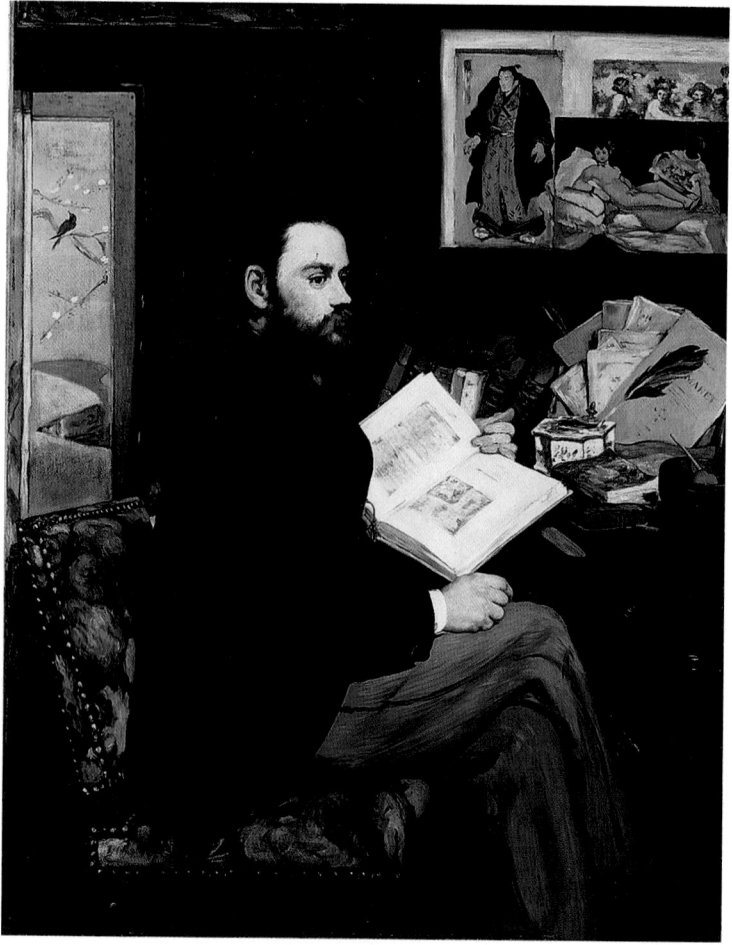

22.5 Édouard Manet, *Zola*, exhibited 1868. Oil on canvas; *57* × *45* in. (144.8 × 114.3 cm). Louvre, Paris.

CONNECTIONS

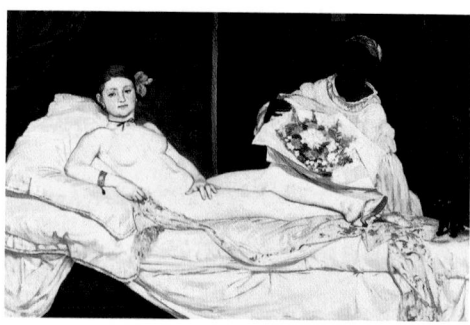

See figure 21.26. Édouard Manet, *Olympia*, 1865.

Manet's *A Bar at the Folies-Bergère* Manet's *A Bar at the Folies-Bergère* (fig. **22.6**) of 1881–1882 depicts the figure close to the picture plane and reveals the artist's adoption of Impressionist color, light, and brushwork. By the device of the mirror, Manet simultaneously maintains a narrow space and also expands it. The mirror reflects the back of the barmaid, her customer, and the interior of the music hall, which is both in front of her and behind the viewer.

The bright oranges in the glass bowl are the strongest color accent in the picture. The bowl, like the green and brown bottles, is a reflective surface. Daubs of white paint on these objects create the impression of sparkling light. In contrast, the round lightbulbs on the reflected pilasters seem flat because there is no tonal variation. Absorbing the light, on the other hand, is the smoke that rises from the audience, blocking out part of the pilaster's edge and obstructing our view. This detail exemplifies the Impressionist observation of the effect of atmospheric pollution—a feature of the industrial era—on light, color, and form.

A third kind of light can be seen in the chandeliers, the blurred outlines of which create a sense of movement. The depiction of blurring is one aspect of Impressionism that can be related to photography as well as to the ways in which we see. When a photographic subject moves, a blur results. In Manet's painting, the figures reflected in the mirror are blurred, indicating that the members of the audience are milling around.

The formal opposite of blurred edges—the silhouette—is also an important feature of Impressionism. In its purest form, a silhouette is a flat, precisely outlined image, black on white or vice versa, as in the black ribbon around the barmaid's neck. Other, more muted silhouettes occur in the contrast of the round lightbulbs and the brown pilasters, the gold champagne foil against the dark green bottles, or the woman with the white blouse and yellow gloves in the audience. Such juxtapositions, whether of pure black and white or of less contrasting lights and darks, also occur in certain Realist pictures, notably those by Daumier. They reflect the contrasts that are possible in black-and-white photography.

The impression that the image is one section of a larger scene—a "slice of life," or cropped view—is another characteristic of Impressionism that is related to photography.

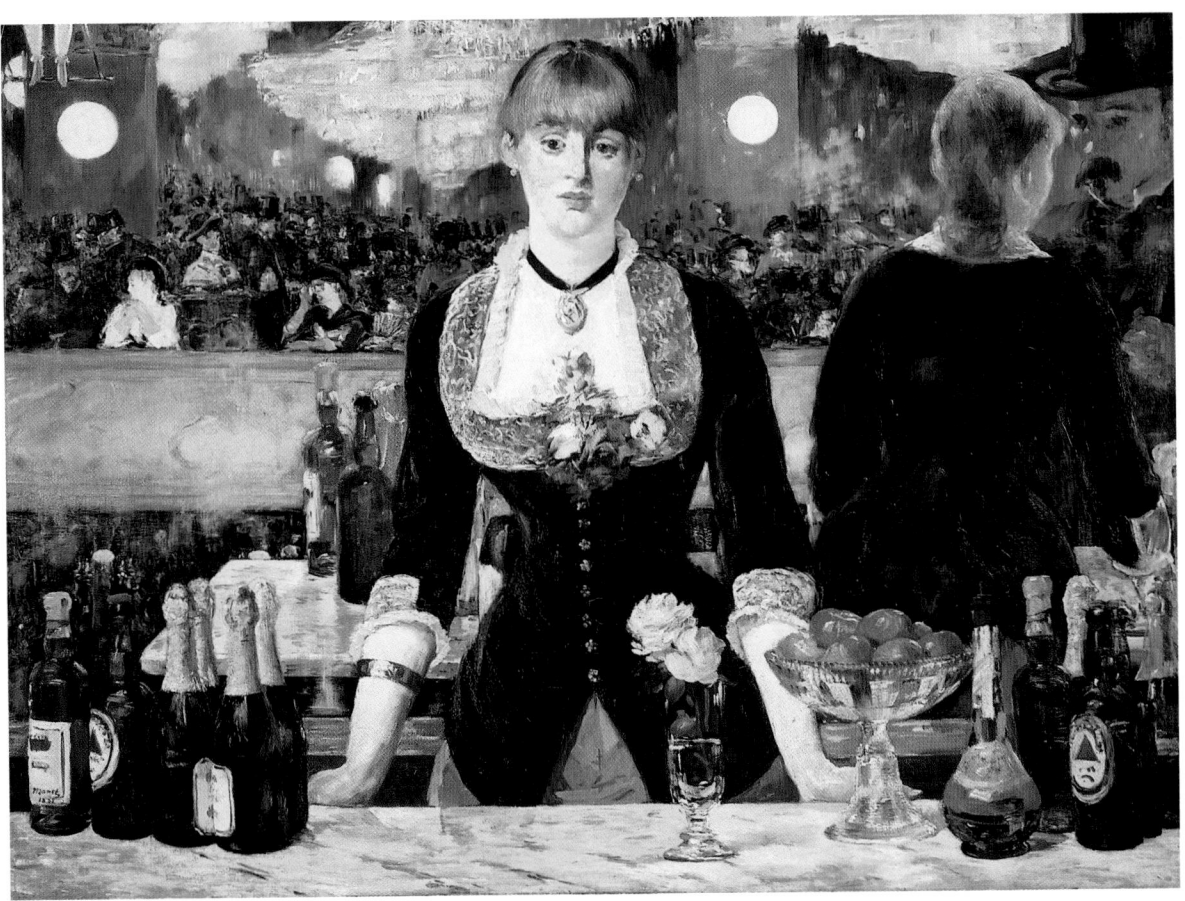

22.6 Édouard Manet, *A Bar at the Folies-Bergère*, 1881–1882. Oil on canvas; 3 ft. 1½ in. × 4 ft. 3 in. (0.95 × 1.30 m). The Samuel Courtauld Trust, Courtauld Institute of Art Gallery, London. The Folies-Bergère is a Paris music hall, which opened in 1869. Today it is a tourist attraction, offering lavish spectacles featuring a great deal of nudity. In Manet's day, its program consisted of light opera, pantomime, and similar forms of entertainment.

METHODS OF INTERPRETATION

Manet's *A Bar at the Folies-Bergère*

Manet's last important painting has been the subject of extensive study and has been analyzed using several different methodological approaches.[1] As a painter of nineteenth-century contemporary life, Manet wanted to capture the fleeting visual impressions of modernity and represent them as we see them. In this work, he achieves that aim, but he also imbues it with many layers of meaning.

If we consider the **formal** structure of the *Bar*, we note that Manet has divided the picture into a series of long horizontals (the bar, the mirror, and the barrier in front of the audience reflected in the mirror) and shorter verticals (the barmaid, the bottles, the piers, the legs of a trapeze artist, and the man at the far right reflected in the mirror). Despite the emphasis on formal structure, however, the picture is not framed in the traditional sense but, rather, seems to be a piece of a scene that continues above, below, and to the sides of the picture. This "piece of a scene" is the artist's view of "modern life" in Paris.

Iconographically, the subject of the picture is relatively clear. Manet shows us a marble bar attended by a seemingly bored barmaid. She is immobile, as are the bar and the objects on it, whereas most of the action takes place in the mirror's reflection. There we see that a man is approaching the barmaid, whose reflection shows that she is leaning forward on a diagonal toward the viewer. We also see the audience, crowds entering at the back, lights, smoke, and the legs of the trapeze artist. On the surface, therefore, this seems to be a straightforward depiction of nineteenth-century entertainment in context.

In any great painting, however, there must be more than mere illustration to meet the eye. **Feminist** art historians have noted that the barmaid has the quality of a commodity—like the drinks she is selling. In addition, the prominent flowers in the glass vase echo those on her lace collar, her gold bracelet repeats the gold foil of the champagne bottles, the marble countertop is painted in the same black and white as her dress, and the ripe orange fruit in the bowl appears ready to eat. To the degree that these objects signify (in the **semiotic** sense), or symbolize (in the **psychoanalytic** sense), the woman, they connote her role as a commodity to be sexually consumed (for money—in the **Marxist** sense), in the fleeting world of entertainment. In any case, the woman's bored expression implies a sense of humdrum repetition, as if all this has happened many times before.

The barmaid is the object of a double gaze, the gaze being a feature of the psychoanalytic method of interpretation. She is being looked at by us as viewers and by the man inside the picture at the right. The question as to whether he is propositioning her or merely ordering a drink is left open by the artist. In the former instance, we would be witnessing a kind of preliminary to a primal scene, which children experience as both fleeting and riveting. This ambivalent reaction of the child is precisely what Manet has captured in the *Bar*, where objects and figures are both static and in flux. Manet also shows this formally by juxtaposing clear edges that stabilize the image and blurred forms created by prominent Impressionist brushstrokes. The brushstrokes, in a semiotic analysis, might be taken as signs that are unrelated to what is represented—just as words are composed of letters that do not correspond to our mental image of what they refer to. Taken as a whole, however, the *Bar* adds up to one of the major works of the late nineteenth century, and its power to evoke various interpretive approaches is a reflection of its visual and conceptual depth.

In Manet's painting, the customer is cut by the frame, as is the trapeze artist, whose legs and feet are visible at the upper left. The marble surface of the bar is also cut and appears to continue indefinitely to the right and left of the observer.

In addition to the many formal innovations of Impressionism in Manet's *Bar*, the iconography of the painting is also significant. Its structural fragmentation corresponds to the mood of the barmaid. In contrast to the visible energy in the audience, the barmaid stares dully into space. Her immobility is accentuated by the clarity and sharp focus of her edges compared with those of the audience. Nor does she seem interested in the male customer approaching at the right. There the viewpoint shifts, and the two figures are seen as if from an angle, whereas the barmaid and the mirror are seen from the front.

This image has evoked art-historical interpretation from several methodological viewpoints. As a social comment, Manet makes a distinction between the monotony of serving at a bar and the bourgeoisie enjoying leisure time. This effect continues the concerns of Courbet and the Realists (see box).

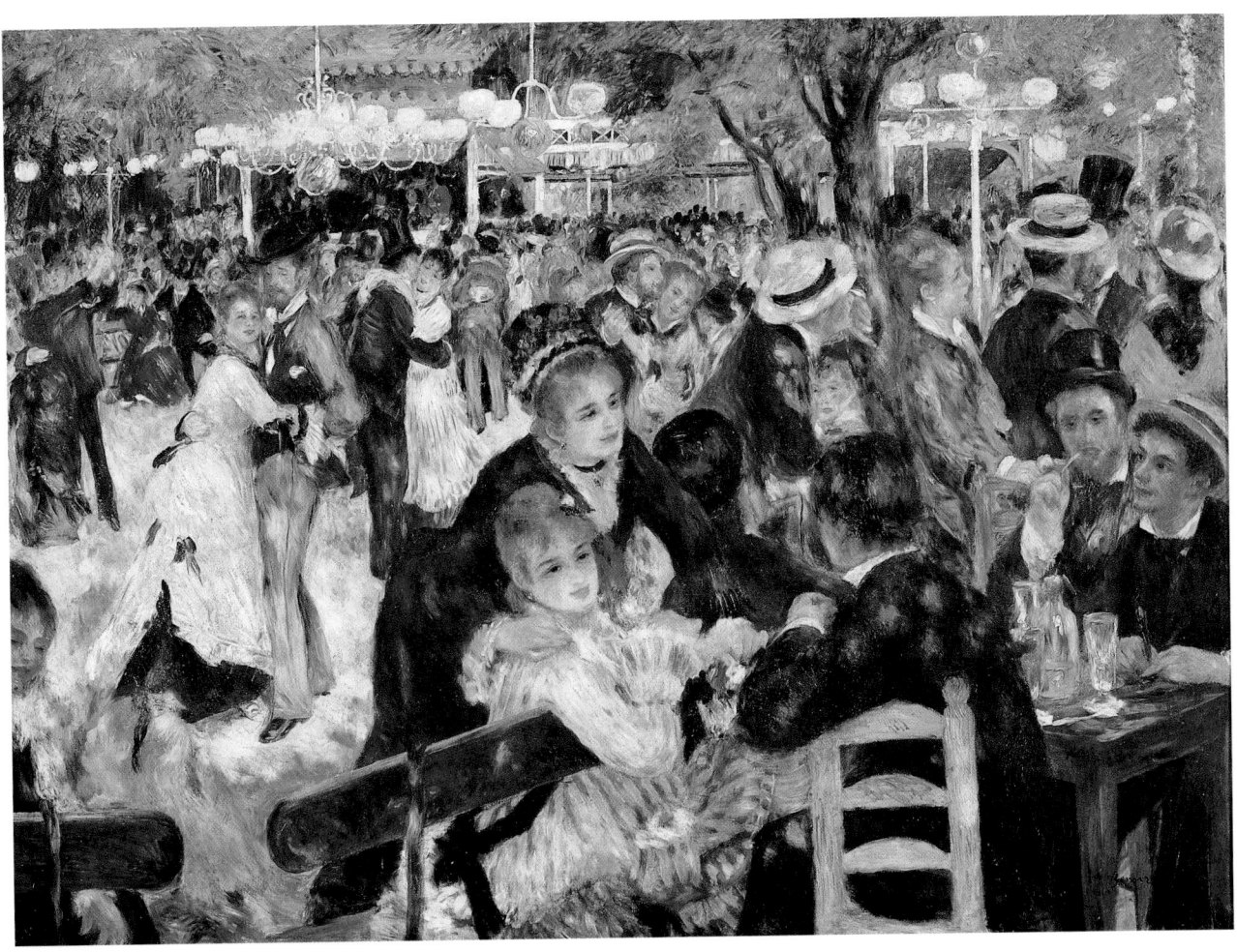

22.7 Pierre-Auguste Renoir, *Moulin de la Galette*, 1876. Oil on canvas; 4 ft. 3½ in. × 5 ft. 9 in. (1.31 × 1.75 m). Musée d'Orsay, Paris.

Pierre-Auguste Renoir

Renoir's *Moulin de la Galette* (fig. **22.7**) depicts a "slice of life," a scene of leisure set outdoors in the courtyard of a Montmartre dance hall. In the foreground, a group of men and women gather around a table where their half-filled glasses reflect light. They are separated from the dancers by the strong diagonal of the bench, which blocks off a triangular space at the lower right. The dancers comprise the background, along with the lamps and the windmill. Animating the scene are shifting shadows that create patterns of lights and darks. Characteristic of Renoir, even in this relatively early picture, is the soft, velvety texture of his brushstrokes.

Hilaire-Germain-Edgar Degas

Absinthe (fig. **22.8**), painted by Hilaire-Germain-Edgar Degas (1834–1917) in 1876, also represents a "slice of life," the boundaries of which are determined by the seemingly arbitrary placement of the frame. The zigzag construction of the composition creates a slanted viewpoint, like that of a candid photograph. It is as if the photographer had taken the picture without aligning the camera with the space being photographed. The two figures are "stoned"—the white liqueur in the woman's glass is absinthe—and, like Manet's barmaid, stare fixedly at nothing in particular. The poses and gestures convey emotional isolation and physical inertia.

Degas depicted another type of immobility in his painting of the American Impressionist Mary Cassatt in the Louvre (fig. **22.9**). As in *Absinthe,* Degas uses the device of a tilted floor to create a candid impression—itself a play on the gaze. Here, it is the sight of a painting that immobilizes the figure, rather than an alcoholic stupor. Both Cassatt and the woman on the right, possibly her sister, are riveted by the sight of an "impressionistic" picture. The seated figure looks up from her open book as her focus is preempted by the image. Finally, Degas draws in the observer, who, in looking at *his* picture, also watches the painted viewers gazing at a painting.

In his ballet pictures, Degas expresses a wide range of movement. His dancers rest, stretch, exercise, and perform. The *Dancing Lesson* (fig. **22.10**) of 1883–1885, which, like *Absinthe,* is set at an oblique angle, shows a series of ballerinas in various poses and stages of motion or rest. Illuminating the interior and backlighting the figures is

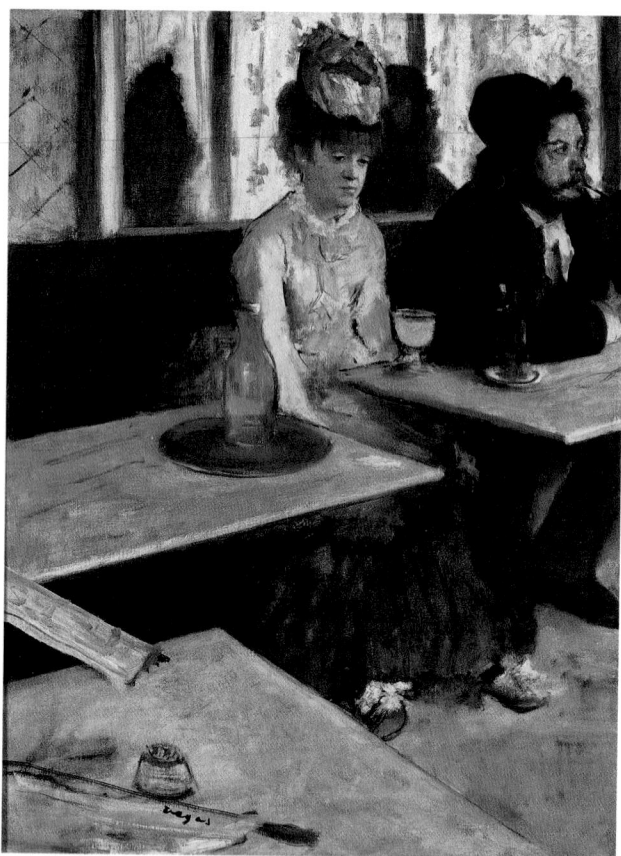

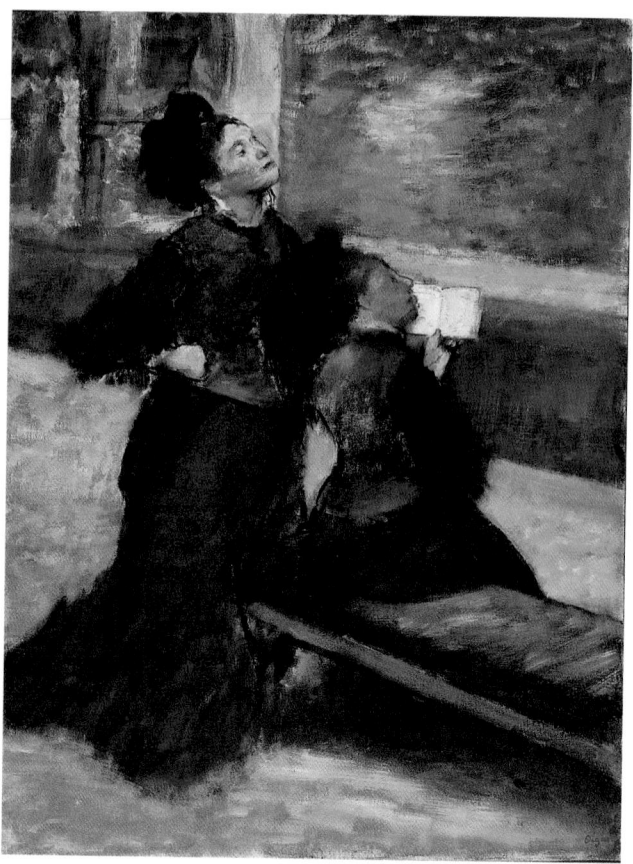

22.8 Hilaire-Germain-Edgar Degas, *Absinthe*, 1876. Oil on canvas; 36¼ × 26¾ in. (92.1 × 67.9 cm). Musée d'Orsay, Paris. Degas, the son of a wealthy Parisian banker, joined the Impressionist circle around 1865 and exhibited in seven of their eight exhibitions between 1874 and 1886.

22.9 Hilaire-Germain-Edgar Degas, *Visit to a Museum*, c. 1885. Oil on canvas; 36⅛ × 26¾ in. (91.8 × 68.0 cm). Gift of Mr. and Mrs. John McAndrew. Courtesy, Museum of Fine Arts, Boston.

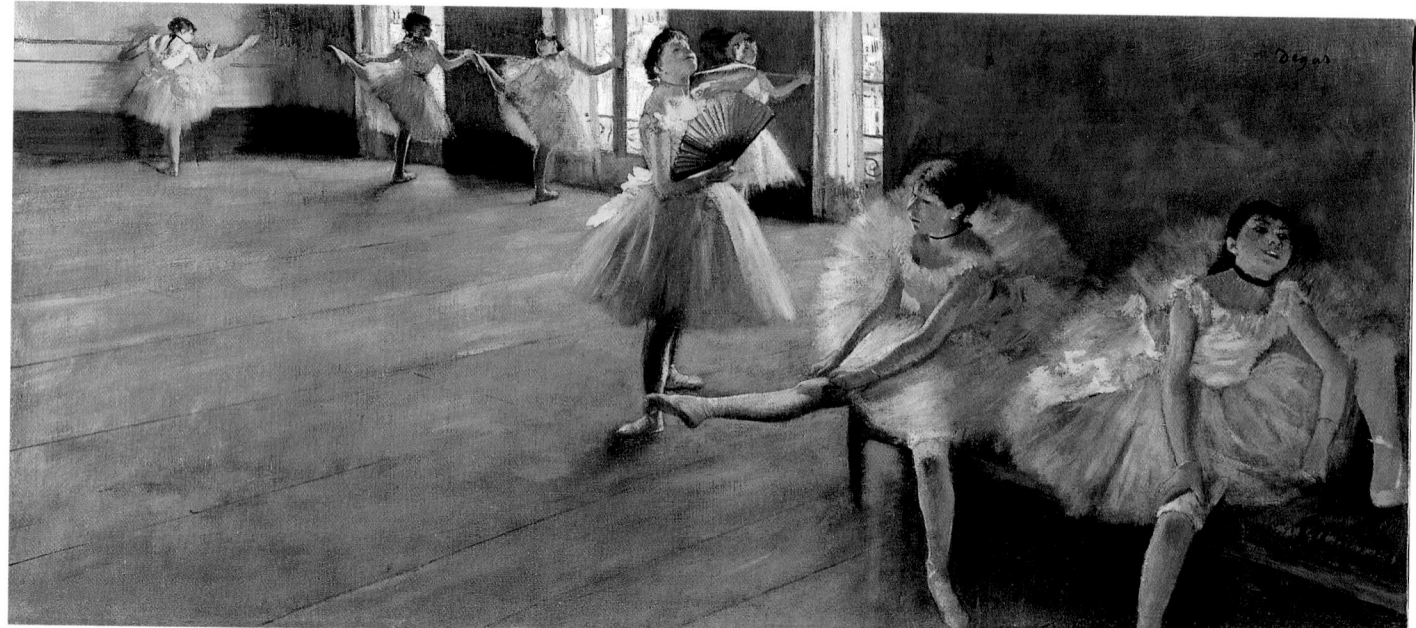

22.10 Hilaire-Germain-Edgar Degas, *Dancing Lesson*, 1883–1885. Oil on canvas; 15½ × 34¾ in. (39.4 × 88.4 cm). Sterling & Francine Clark Art Institute, Williamstown, Massachusetts. Degas is well known for his ballet pictures. He sketched ballerinas from the wings of the theater and in ballet studios such as this one. His interest in depicting forms moving through space led him to paint horseraces, acrobats, and other entertainers.

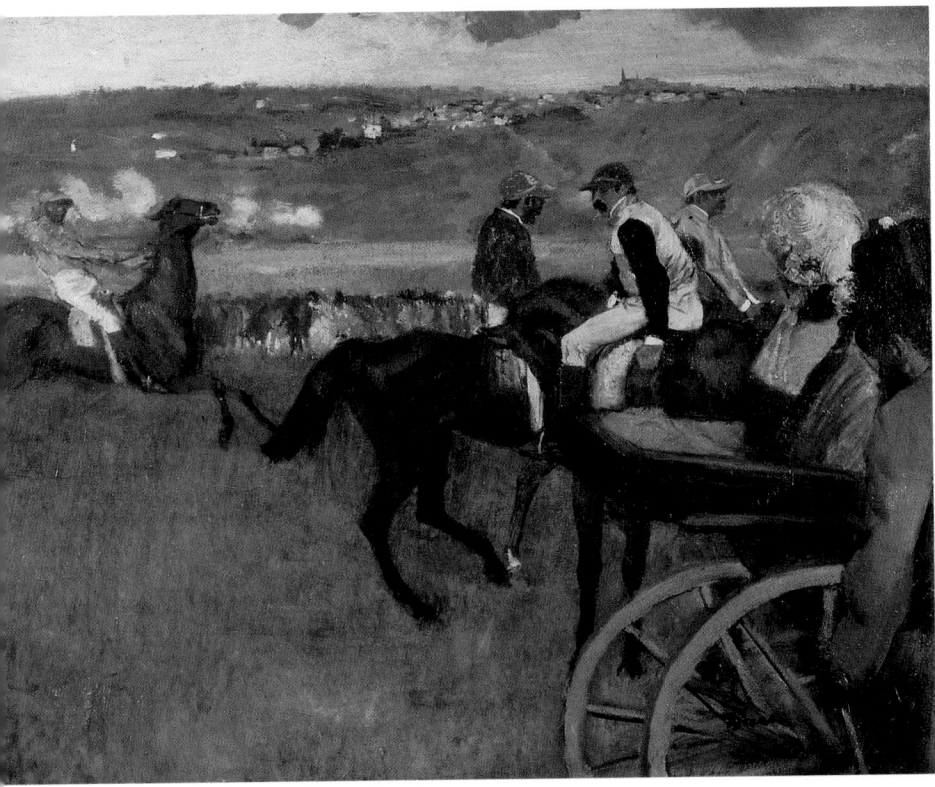

22.11 Hilaire-Germain-Edgar Degas, *At the Races*, 1886–1887. Oil on canvas; 26 × 31⅞ in. (66.0 × 81.0 cm). Musée d'Orsay, Paris.

as if impatient for the race to begin. Patches of color that blur the waiting crowd enhance the sense of restless expectation. The woman in the carriage and the man in the top hat also prepare for the race. At the left, a single horse gallops into the picture plane as his jockey reins him in. The arrested movement of the galloping horse draws attention to the distant train. In this detail, Degas refers to the contrast between mechanized and natural movement and to the changing modes of transportation created by the industrial revolution.

Degas was a devoted amateur photographer, and his passion for depicting forms moving through space can be related to his photographic interests. Other nineteenth-century photographers also explored the nature of motion. In 1878, for example, the British-born American photographer Eadweard Muybridge (1830–1904) recorded for the first time the actual movements of a galloping horse (fig. **22.12**). To do so, he set up along the side of a racetrack twelve cameras, the shutters of which were triggered as the horses passed. Muybridge discovered that all four feet are off the ground only when they are directly underneath the horse (as in the second and third frames), and not when they are stretched out, as in Degas' galloping horses, or in the prehistoric running bulls from Lascaux (see fig. 1.12).

outdoor light, which enters the rehearsal room through three windows. The dancers are unified by the repeated blue of their costumes, each accented by a different color. Blue, yellow, and reddish orange—the three main colors of the costumes—are assembled in the open fan held by the central girl. The repetition of colors throughout the composition creates a chromatic unity that is a characteristic innovation of the Impressionist style. It also reflects the flat color patterns that are typical of Japanese woodblock prints.

In *At the Races* (fig. **22.11**), Degas' figures are in a state of restlessness before the event. At the right, three mounted jockeys wearing shiny silk vests face in different directions

See figure 1.12. Hall of Running Bulls, Lascaux, Dordogne, France, c. 15,000–13,000 B.C.

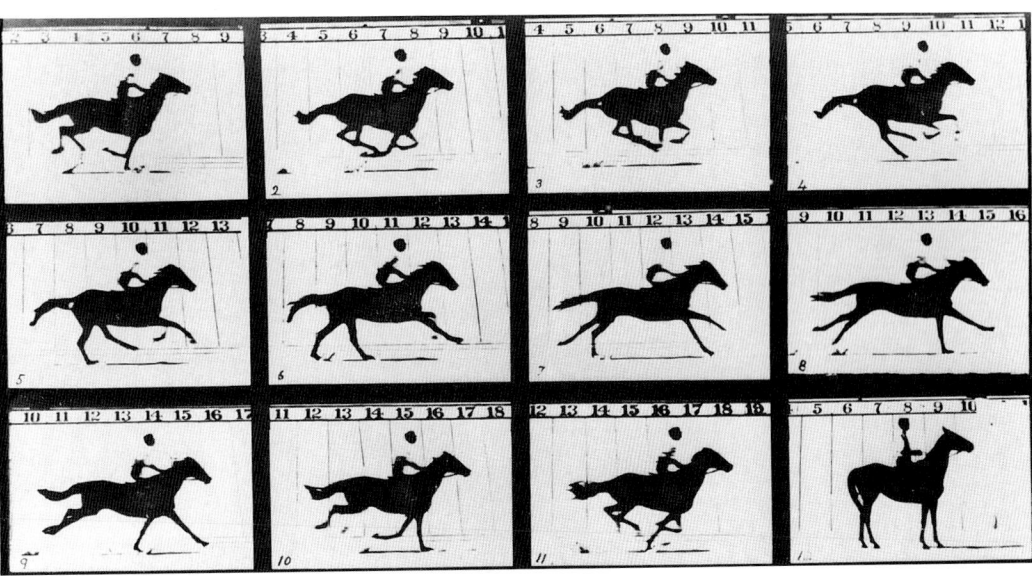

22.12 Eadweard Muybridge, *Galloping Horse*, 1878. Albumen print. Eadweard Muybridge Collection, Kingston Museum, Kingston upon Thames.

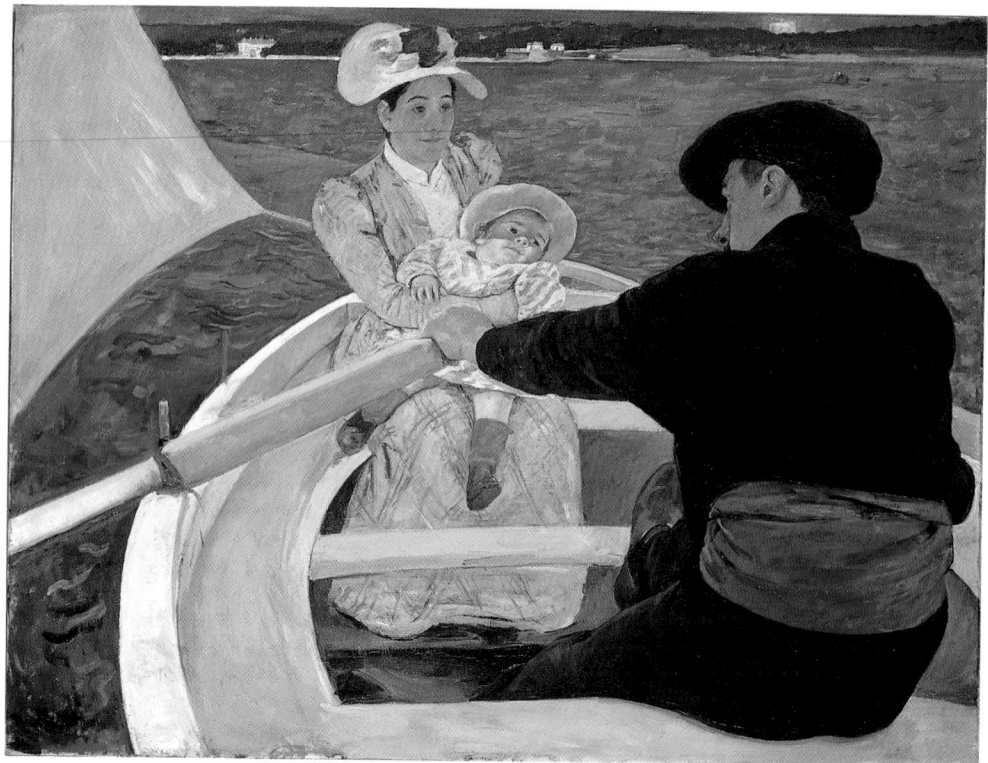

22.13 Mary Cassatt, *Boating Party*, 1893–1894. Oil on canvas; 2 ft. 11½ in. × 3 ft. 10⅛ in. (0.90 × 1.17 m). National Gallery of Art, Washington, D.C. (Chester Dale Collection). Cassatt came from a well-to-do Pennsylvania family. For most of her career, she lived in France, where she exhibited with the Impressionists and was a close friend of Degas. She fostered American interest in the Impressionists by urging her relatives and friends—particularly the Havemeyer family—to buy their paintings at a time when the works were unpopular.

Mary Cassatt

In the *Boating Party* (fig. **22.13**) of 1893–1894, Mary Cassatt (1845–1926) uses the Impressionist "close-up," another pictorial device inspired by photography. She combines it with a slanting viewpoint to emphasize the intimacy between mother and child. The rower, on the other hand, is depicted in back view as a strong silhouette. More individualized are the mother and child, who gaze at the rower and are contrasted with his anonymity. Cassatt intensifies the tension among the three figures by flattening the space and foreshortening both child and rower. The compact forms create an image of powerful monumentality. Cassatt's bold planes of color, sharp outlines, and compressed spaces, as well as the *obi* (wide sash) worn by the rower, exemplify the influence of Japanese woodblocks on the Impressionist painters.

A different kind of intimacy characterizes Cassatt's *Letter* (fig. **22.14**). It contains a single figure, whose relationship to another person is implied by the letter. She hunches forward, concentrating on sealing the envelope and oblivious to being observed. Her apprehensive air is given formal expression in the agitated surface designs. The observer looks in on a private moment, just as when viewing Utamaro's *Young Woman with Blackened Teeth* (see fig. W9.4). Cassatt's skill as a printmaker reinforced her affinity for Japanese woodblocks, the flat patterns of which recur in the *Letter*.

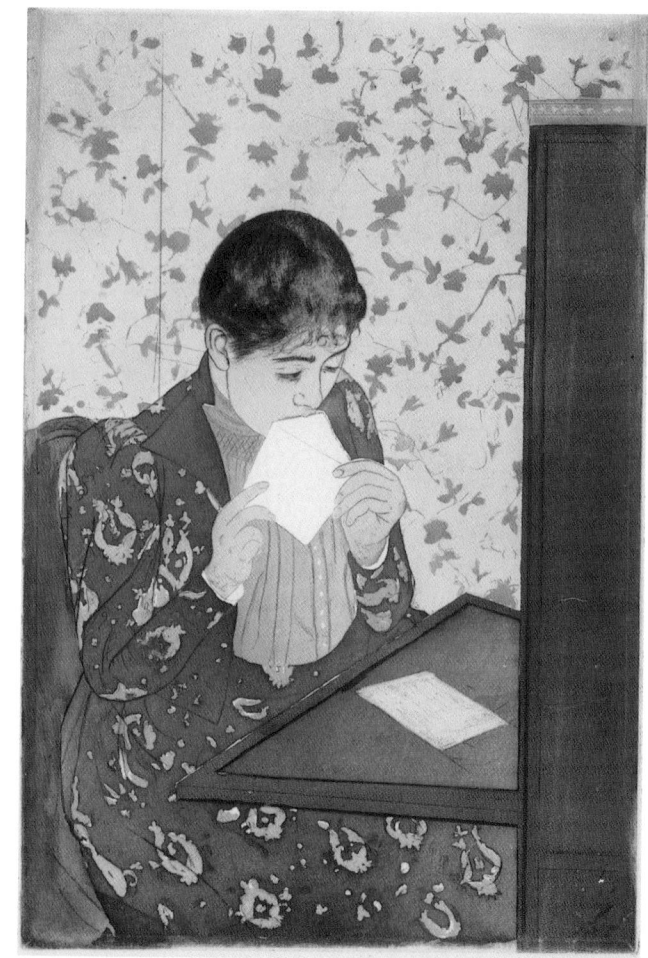

22.14 Mary Cassatt, *Letter*, 1891. Etching and aquatint; 17 × 11⅞ in. (43.2 × 30.2 cm). Philadelphia Museum of Art (Louis E. Stern Collection).

Berthe Morisot

As in the work of Cassatt, Berthe Morisot's (1841–1895) *The Cradle* of 1873 (fig. **22.15**) explores the theme of intimacy through a close-up viewpoint. Morisot does not, however, use oblique spatial shifts. Instead, she sets her figures on a horizontal surface within a rectangular composition. Curves and diagonals reinforce the interaction between mother and child. For example, the mother's left arm connects her face with the baby's arm, which is bent back behind her head. The line of the mother's gaze, intently focused on the baby, is repeated by the diagonal curtain. On the left, the mother's right arm curves toward the picture plane and is counteracted by the slow curve of the cradle-covering from top right to lower left. The baby's left arm also curves, so that the unity of mother and child is here indicated by a series of formal repetitions in which both participate.

The loose brushwork, for which Morisot and her Impressionist colleagues were often criticized, is particularly apparent in the lighter areas of the painting. The translucent muslin invites the viewer to "look through" the material at the infant. Looking is also implied by the window and curtain, although in fact nothing is visible through the window. In these lighter areas, as in the edges of the mother's dress, individual white brushstrokes seem to catch the available light and reflect it. Contrasting with the whites are dark, silhouetted areas such as the wall, chair, and the ribbon around the mother's neck. A transitional area is provided by the mother's dress, which, though dark, contains light highlights that create a shiny surface texture.

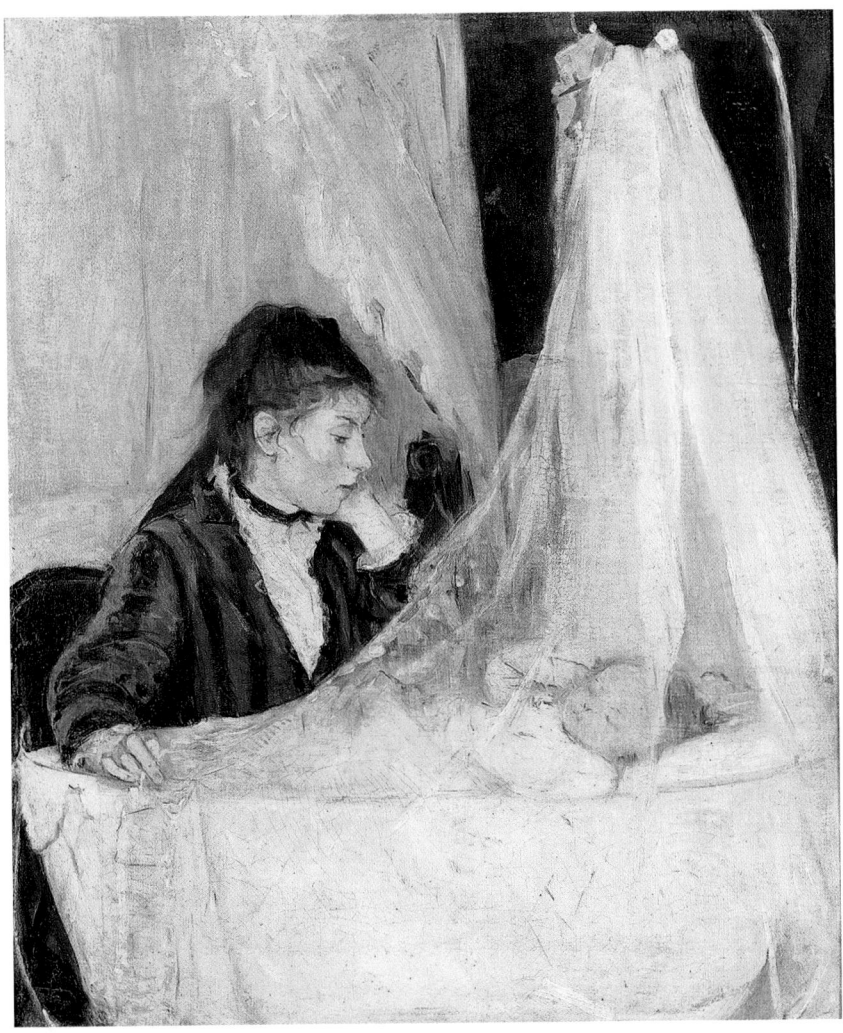

22.15 Berthe Morisot, *The Cradle*, 1873. Oil on canvas; 22½ × 18½ in. (57.2 × 47.0 cm). Louvre, Paris. Morisot was one of five sisters, all of whom learned to paint. She married Eugène Manet, the brother of the artist, and had one daughter, whom she frequently used as a model in her paintings.

Claude Monet

The work of Claude Monet (1840–1926), more than any other nineteenth-century artist, embodied the technical principles of Impressionism. He was above all a painter of landscape who studied light and color with great intensity. In contrast to the Academic artists, Monet did much of his painting outdoors, in the presence of natural landscape, rather than in the studio. As a result, he and the Impressionists were sometimes called *plein air* ("open air") painters.

The term *Impressionism* is derived from one critic's negative view of Monet's *Impression: Sunrise* (fig. **22.16**), which was painted in 1872 and exhibited two years later. The critic declared Monet's picture and others like it "Impressionisms." By that he meant that the paint was sketchily applied and the work unfinished in appearance. In fact, however, Monet was striving for the transient effects of shifts in nature. He used the technique of "broken color" to show that the clear circle of orange sun is separated into individual brushstrokes when reflected in the water. The same is true of the black, silhouetted boat. Both reflections are composed of horizontal daubs of paint to convey the leisurely motion of the water and blurred forms that we would actually see.

From the 1860s, early in his career, Monet worked with a wide range of color. A comparison of an early and a late work by Monet illustrates the development of the Impres-

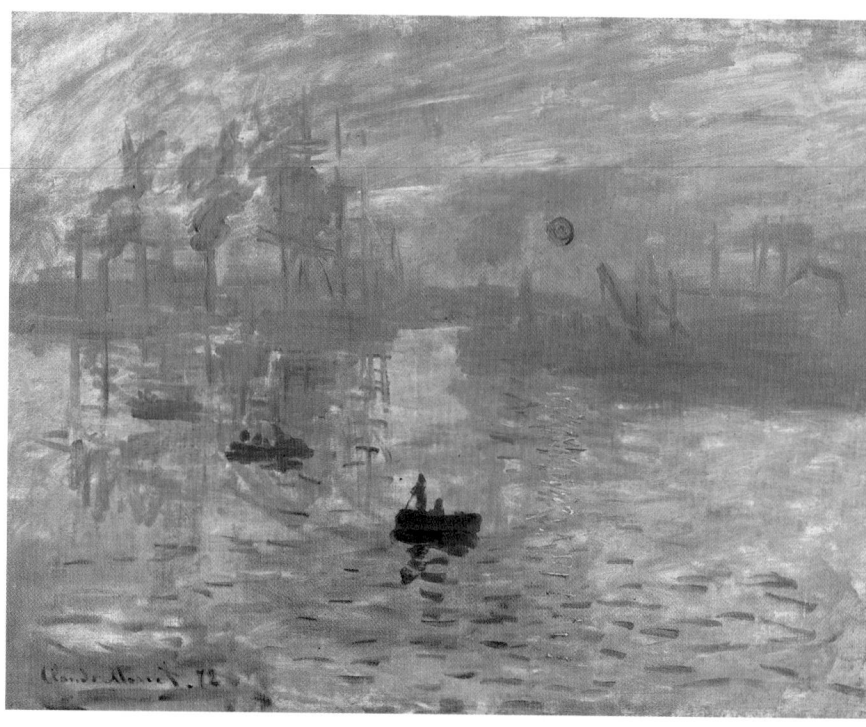

22.16 Claude Monet, *Impression: Sunrise*, 1872. Oil on canvas; 1 ft. 7½ in. × 2 ft. 1½ in. (49.5 × 64.8 cm). Musée Marmottan, Paris.

sionist style. The *Garden at Sainte-Adresse* (fig. **22.17**) of about 1866–1867 is a leisure genre scene. In the distance, sailboats and steamships hint at the industrial revolution and the changing times. The *Bassin des Nymphéas*, or

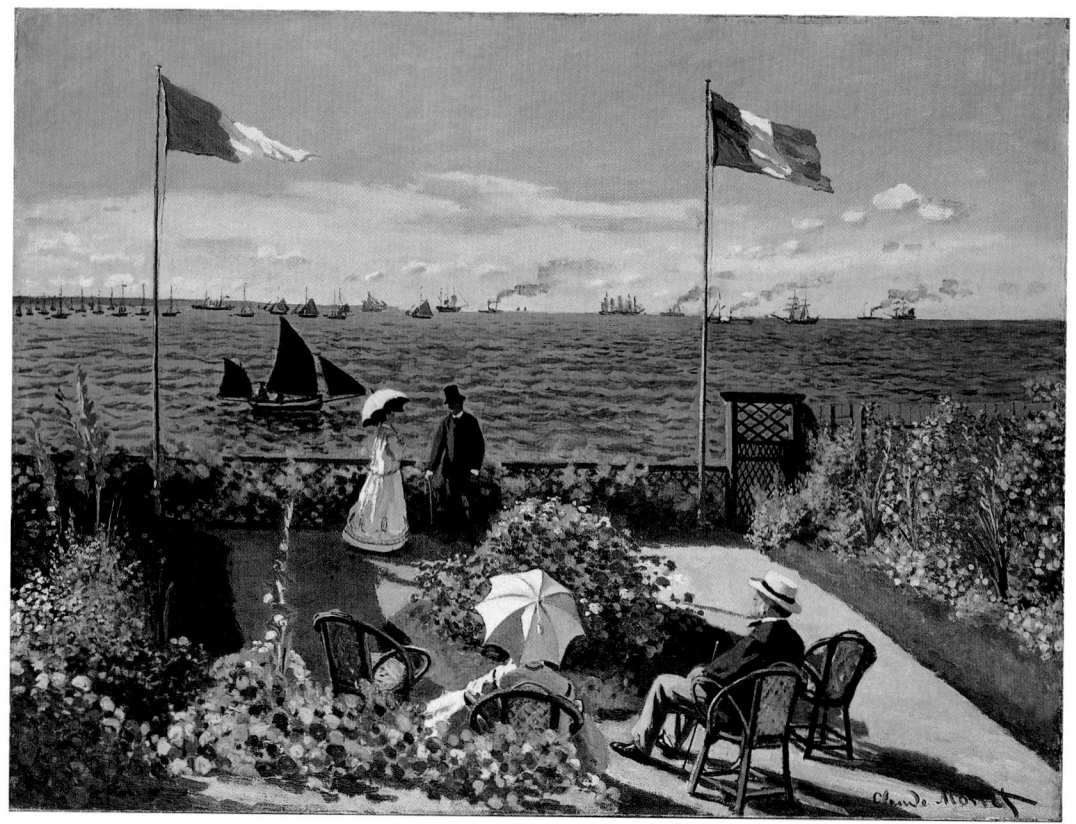

22.17 Claude Monet, *Garden at Sainte-Adresse*, c. 1866–1867. Oil on canvas; 3 ft. 2⅜ in. × 4 ft. 3⅛ in. (0.98 × 1.30 m). Metropolitan Museum of Art, New York. In his youth, Monet lived at Le Havre, a port town on the Normandy coast. It was here that he first became familiar with rapid changes in light and weather. In 1874, he exhibited in the show that launched the Impressionist movement. Until the 1880s, his work was poorly received, and he lived in extreme poverty.

22.18 Claude Monet, *Bassin des Nymphéas (Water-Lily Pond)*, 1904. Oil on canvas; 34½ × 35¾ in. (87.6 × 90.8 cm). Denver Art Museum. In 1883, Monet moved to Giverny, a village about 50 miles (80 km) west of Paris, where he spent his later years. He built a water garden that inspired numerous "waterscape" paintings, including this one and a series of large water-lily murals.

Water-Lily Pond, of 1904 (fig. **22.18**) illustrates Monet's style nearly forty years later.

Both pictures reflect Monet's concern with the direct observation of nature, and both are the result of his habit of painting outdoors with nature itself as his "model." The Impressionist technique of "broken color" breaks up color into light and dark and creates the illusion that the water is moving. In the *Water-Lily Pond,* the lack of motion is indicated by the more vertical arrangement of the broken colors—greens, blues, yellows, and purples—that comprise the water's surface. Monet's method here reflects the way light strikes the eye—in patterns of color rather than in the relatively sharp focus of the *Terrace.* In the *Water-Lily Pond,* the observer's point of view is the same as in the *Terrace,* but the field of vision is much narrower.

These paintings illustrate Monet's fidelity to optical experience through the depiction of colored shadows and reflections. In the *Terrace,* shadows on the pavement are dark

gray, and creases in the flags are darker tones of their actual colors—red, yellow, and blue. Likewise, the reflection in the water of the large dark-gray sailboat is composed of more densely distributed dark-green brushstrokes than the rest of the water. In the *Water-Lily Pond,* the reflected foliage is transformed into relatively formless patches of color. Without the lily pads and the shore, there would be no recognizable objects at all and no way for viewers to orient themselves in relation to the picture's space.

Although even in late Impressionism there is never a complete absence of recognizable content, the comparison of these two pictures indicates a progressive dissolution of painted edges. The brushstrokes and the paint begin to assume an unprecedented prominence. As a result, instead of accepting a canvas as a convincing representation of reality, the viewer is forced to take account of the technique and medium in experiencing the picture. This is consistent with Monet's recommendation that artists focus on

See figure 11.32. West façade, Reims Cathedral, France, begun 1211.

light sections of the façade, while darker blues and purples fall on the shaded areas. A slight yellow glow from the sun pervades the sky and is visible on the tower. Here, as in the *Water-Lily Pond*, viewers are made aware of the medium as much as of the subject matter. They are also reminded that our normal vision lacks sharp focus.

22.19 Claude Monet, *Rouen Cathedral, West Façade, Sunlight*, 1894. Oil on canvas; 39½ × 26 in. (1.00 × 0.66 m). National Gallery of Art, Washington, D.C. (Chester Dale Collection).

the color, form, and light of an object rather than its iconography. Monet emphasized the essence of a painted object as an abstract form and not as a replica of the thing itself. A painted "tree," he said, is not a tree at all, but a vertical accent on a flat surface.

In studying the natural effects of light and color on surfaces, Monet painted several series of pictures representing a single locale under different atmospheric conditions. In 1895, he exhibited eighteen canvases of Rouen Cathedral. A comparison of *Rouen Cathedral, West Façade, Sunlight* of 1894 (fig. **22.19**) with the version in figure **22.20** shows the changes in the façade according to the time of day. In both paintings, the myriad details of a Gothic cathedral (see fig. 11.32) dissolve into light and shadow, which are indicated by individual patches of color. The blue sky in figure 22.19 results in a cream-colored façade, the dark areas of which repeat the sky-blue combined with yellows and oranges. In figure 22.20, on the other hand, the gray, early-morning sky casts a lavender hue on the

22.20 Claude Monet, *Rouen Cathedral, the Portal and the Tower of Albane, the Morning*, 1894. Oil on canvas; 42 × 29 in. (1.07 × 0.74 m). Fondation Beyeler, Riehen/Basel.

Views of Paris: Renoir and Pissarro

In Renoir's *Pont-Neuf* (fig. **22.21**) of 1872, the influence of photography can be seen in the somewhat elevated vantage point. The rhythms of the city, which became a favorite Impressionist subject, are indicated by the variety of human activity. The scene is a "slice" of a city street, but Renoir also presents a condensed panorama of different social classes. Mothers stroll with children, youths lean against the side of the bridge, some people carry bundles and push carts, and others walk their dogs or ride in carriages. Soldiers and policemen are among the crowd. At the far side of the bridge, the familiar buildings of the Left Bank are visible. Because the sky is blue, the forms—like the day—are relatively clear, and figures cast dark shadows on the pavement. Their patterns, as well as the general view of a busy street, are reminiscent of Hiroshige's *Saruwaka-cho Theater* (see fig. W9.10). Hiroshige's print, in turn, reflects the influence of Western one-point perspective.

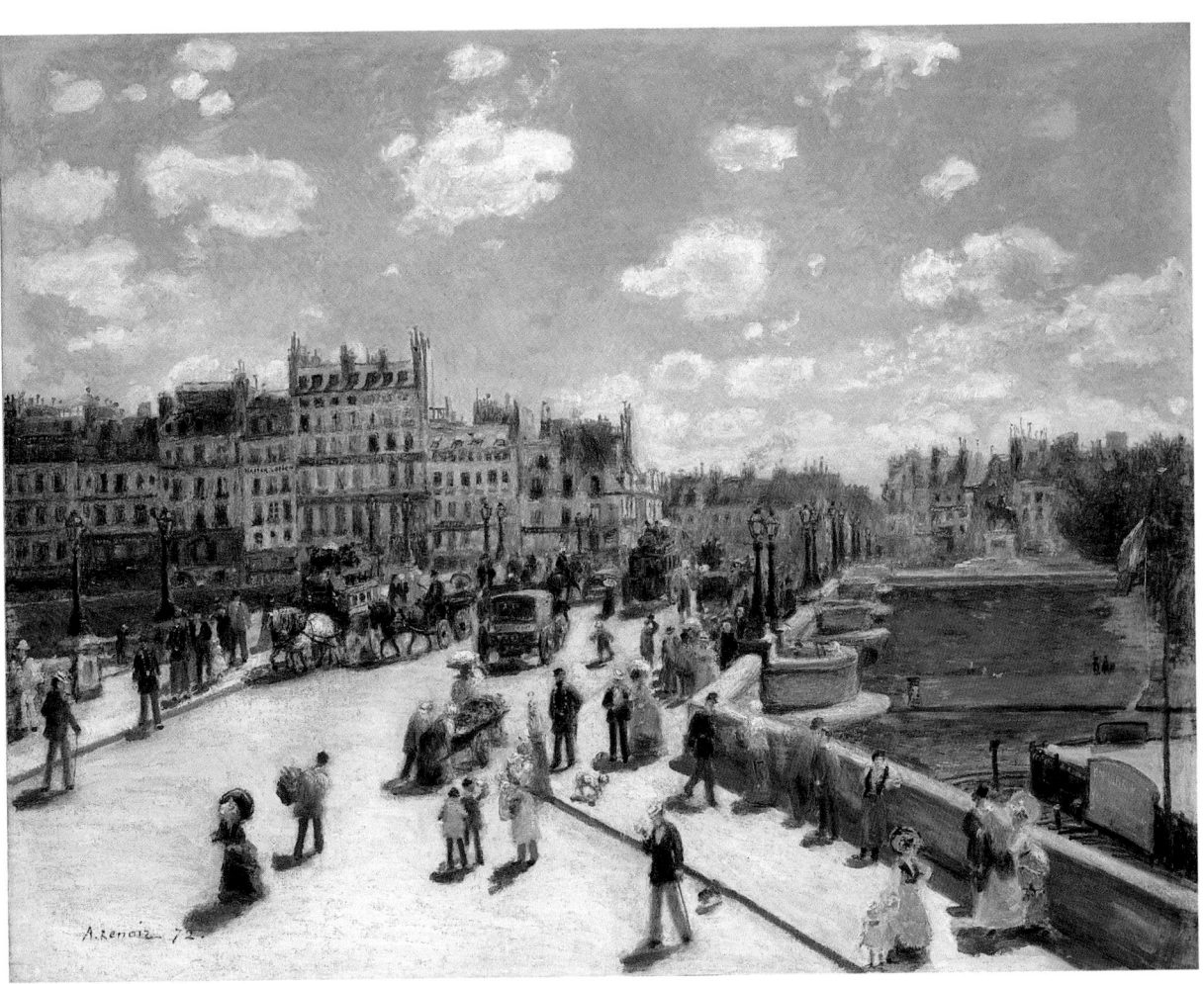

22.21 Pierre-Auguste Renoir, *Pont-Neuf,* 1872. Oil on canvas; 29⅝ × 36⅞ in. (75.2 × 93.7 cm). National Gallery of Art, Washington, D.C. (Ailsa Mellon Bruce Collection).

The viewpoint of Camille Pissarro's (1830–1903) *Place du Théâtre Français* of 1898 (fig. **22.22**) is higher than that of Renoir's *Pont-Neuf*. In contrast to the Renoir, this picture represents a rainy day, and the figures are in softer focus, which blurs their forms. Also blurred is the façade of the Paris Opéra at the end of the long Boulevard de l'Opéra. Both are rendered as patches of color and create dark accents against the lighter pavement. The effect of the gray sky is to drain the color from the street and dull it. At the same time, however, the street's surface is enlivened by visible brushstrokes and reflective shadows. Such Impressionist cityscapes offered artists an opportunity to explore the effects of outdoor light on the color and textures of the city. They also record the momentary and fugitive aspects of Haussmann's boulevards in ways that even photographs could not.

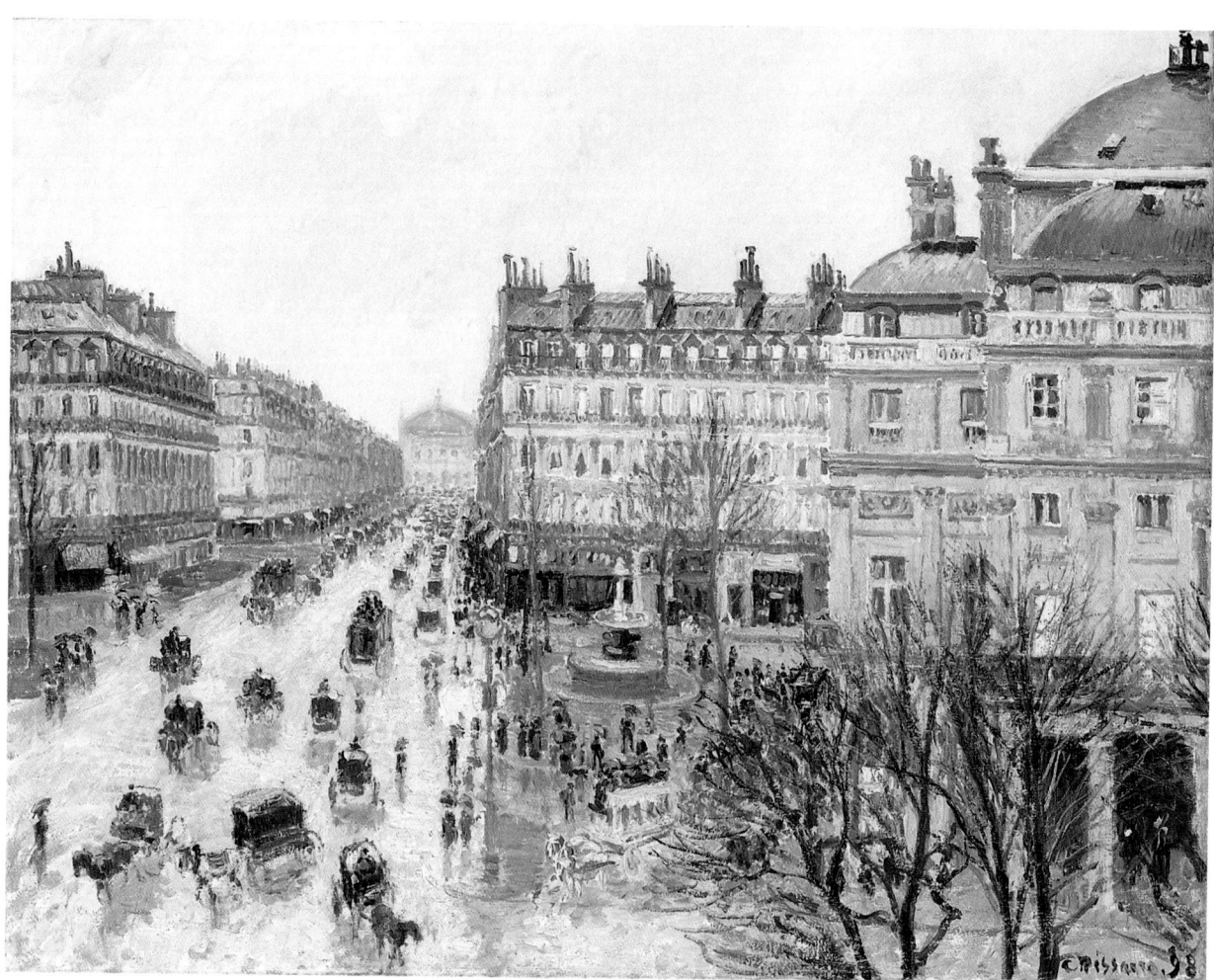

22.22 Camille Pissarro, *Place du Théâtre Français*, 1898. Oil on canvas; 29 × 36 in. (73.7 × 91.4 cm). Minneapolis Institute of Arts (William Hood Dunwoody Fund).

French Sculpture

Hilaire-Germain-Edgar Degas

The term *Impressionism* is more applicable to painting than to sculpture. Degas exhibited only one sculpture in his lifetime, and most remained as wax models until his death. About half of these were cast in bronze in the 1920s. Degas' *Fourth Position Front, on the Left Leg* (fig. **22.23**), which was probably modeled during the 1880s, illustrates his ability to capture motion in space in sculpture as well as in painting. The dancer seems as if she is about to spring up and twist around to her right.

Since Degas apparently did not intend to cast such wax figures, they may be considered as preliminary studies for his paintings. As such, they provide a glimpse into his working methods. The textured surface of this bronze, which retains evidence of the medium, recalls the prominence of Impressionist brushstrokes. The observer is made aware of the dynamic modeling process just as the dancer herself shows the process of "working out" her movements in preparation for the finished performance.

22.23 Hilaire-Germain-Edgar Degas, *Fourth Position Front, on the Left Leg*, c. 1880s. Bronze; 16 in. (40.6 cm) high. Musée d'Orsay, Paris.

Auguste Rodin

The acknowledged giant of nineteenth-century sculpture was Auguste Rodin (1840–1917). His influence on twentieth-century sculpture parallels the impact of the Impressionists on the development of painting. Like Degas, Rodin built up forms in clay or wax before **casting** them. His characteristic medium was bronze, but he also made casts of plaster. *The Thinker* of 1879–1889 (fig. **22.24**) reveals the influence of Italian Renaissance sculpture on Rodin's conception of the monumental human figure. The work actually evolved from Rodin's original plan to represent Dante. Its introspective power and large, muscular body, reminiscent of Michelangelo's *Jeremiah* (see fig. 14.25) and Dürer's *Melencolia* (see fig. 16.13), are created by the figure's formal tension and sense of contained energy. Both the *Jeremiah* and *Melencolia* are meditative figures—Jeremiah the Old Testament prophet who "sees" the future, and the idle melancholic genius of Dürer—who have affinities with Rodin's introspective, immobilized *Thinker*.

In 1891, Zola asked Rodin to take over a commission from the French Society of Men of Letters for a monumental statue of the French novelist Honoré de Balzac. Rodin spent the last seven years of his life on the work, which was not cast until after his death. He called it the sum of his whole life. A comparison of the plaster and bronze versions of Rodin's *Balzac* (figs. **22.25** and **22.26**) demonstrates his interest in conveying the dynamic, experimental *process* of making sculpture, rather than in the finished work. In the plaster statue, the great novelist looms upward like a ghostly specter wrapped in a white robe. The bronze is less spectral, but more reflective. In both versions, the nature of the medium defines the surface texture of the work. The rough, unfinished plaster surface recalls the unpolished and unfinished marble sculptures of Michelangelo. In the bronze, the reflecting light activates the surface and energizes it.

Both statues have the Impressionist quality of revealing the surface texture of an artist's material and also

22.24 Auguste Rodin, *The Thinker*, (¾ view), 1881. Bronze; 23 in. (58 cm) high. Musee Rodin, Paris.

— **CONNECTIONS** —

See figure 14.25. Michelangelo, *Jeremiah*, 1510.

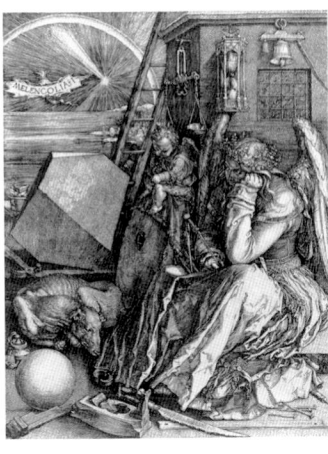

See figure 16.13. Albrecht Dürer, *Melencolia I*, 1514.

convey an impression of raw power and primal thrust that is characteristic of Rodin. Their surface motion creates a blurred effect similar to the prominence of Impressionist brushwork and mirrors Balzac's dynamic spirit. The figure seems to be in an unfinished state—a not-quite-human character in transition between unformed and formed. Since Balzac's literary output was prodigious, his representation as a monumental, creative power is consistent with the timeless energy of his own work.

In 1898, when the plaster version of the *Balzac* was first exhibited, the public disliked it, and so did the Society of Men of Letters that had commissioned it. Rodin never cast the work in bronze, and it is not known whether he ever intended to do so.

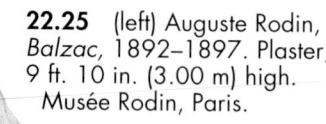

22.25 (left) Auguste Rodin, *Balzac*, 1892–1897. Plaster; 9 ft. 10 in. (3.00 m) high. Musée Rodin, Paris.

22.26 (right) Auguste Rodin, *Monument to Balzac*, 1898 (cast 1954). Bronze; 9 ft. 3 in. × 48¼ in. × 41 in. (281.9 × 122.5 × 104.2 cm). Sculpture Garden, Museum of Modern Art, New York.

22.25, 22.26 Rodin's revolutionary methods of working included the use of nonprofessional models in nontraditional poses. Apart from portrait busts, Rodin was the first major sculptor to create work consisting of less than the whole body—a headless torso, for example.

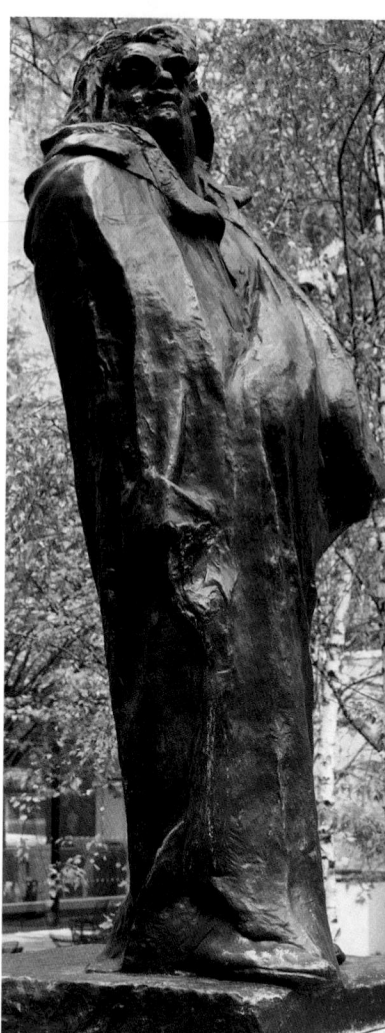

Artists Quote Art: Beauford Delaney on Rodin

In the 1960s, Beauford Delaney (1901–1979), the African-American artist living in Paris, painted a small tribute to Rodin entitled *Balzac by Rodin* (fig. **22.27**), in which he transported the statue from the Boulevard Raspail to an anonymous landscape setting. He has retained the looming, gigantic aspect of Rodin's sculpture, its sense of process, and the green hue of aged bronze. But he has endowed the work with his own unique white light, which, according to the American author James Baldwin, "held the power to illuminate, even to redeem and reconcile and heal."[2] Henry Miller described Delaney's picture as "saturated with color and light."[3] White light fills the areas of the *Balzac* that in reality are darkened, thus reversing the relationship of light and dark on a sculptured surface. The entire sky is white, except for the blue patch over the *Balzac*'s head, a reversal of the expected, for the blue becomes cloud-like and the naturally blue sky is whitened.

22.27 Beauford Delaney, *Balzac by Rodin*, 1960s. Oil on canvas; 24 × 19½ in. (61.0 × 49.5 cm), whereabouts unknown. Beauford Delaney was the son of a minister in Knoxville, Tennessee. He studied art and went to New York in 1929 at the end of the Harlem Renaissance. In 1954, he moved to Paris, where he painted portraits of the French playwright Jean Genet and the American novelists Henry Miller, James Baldwin, and James Jones.

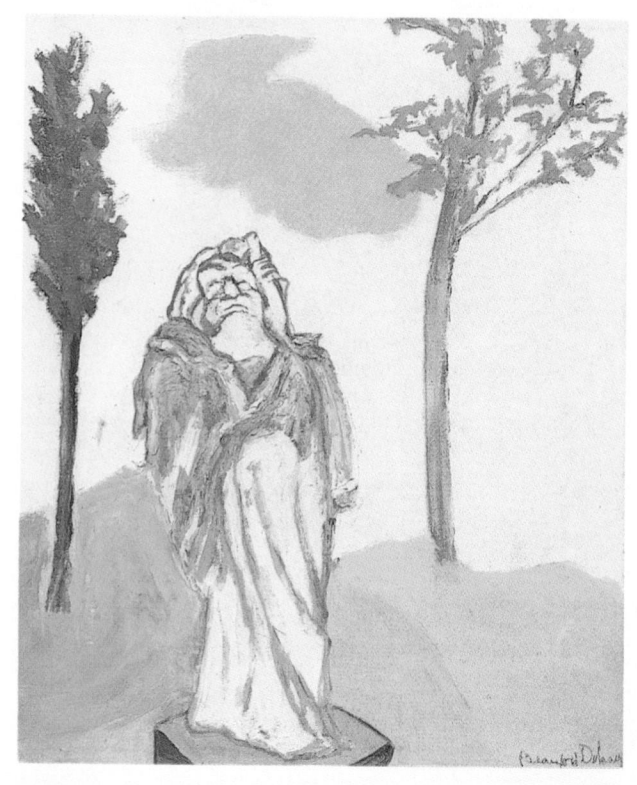

American Painting at the Turn of the Century

Several important late nineteenth-century American artists correspond chronologically to the French Impressionists. Some, such as Cassatt, lived as expatriates in Europe and worked in the Impressionist style. Others stayed in America and continued in a more Realist vein.

Winslow Homer

Winslow Homer (1836–1910) visited Paris before the heyday of Impressionism, and his work can be regarded as transitional between Realism and Impressionism. In *Breezing Up* (fig. **22.28**) of 1873–1876, Homer's interest in the American identity of his subjects and their place in society is evident. At the same time, however, he has clearly been influenced by the Impressionist interest in weather conditions and their effect on light and color. The sea, churned up by the wind, is rendered as broken color with visible brushstrokes. By tilting the boat in the foreground, Homer creates a slanted "floor" that is related to Degas' compositional technique. The interruption of the diagonal sail by the frame, the oblique viewpoint, and the sailors' apparent indifference to the observer suggest a fleeting moment captured by the camera.

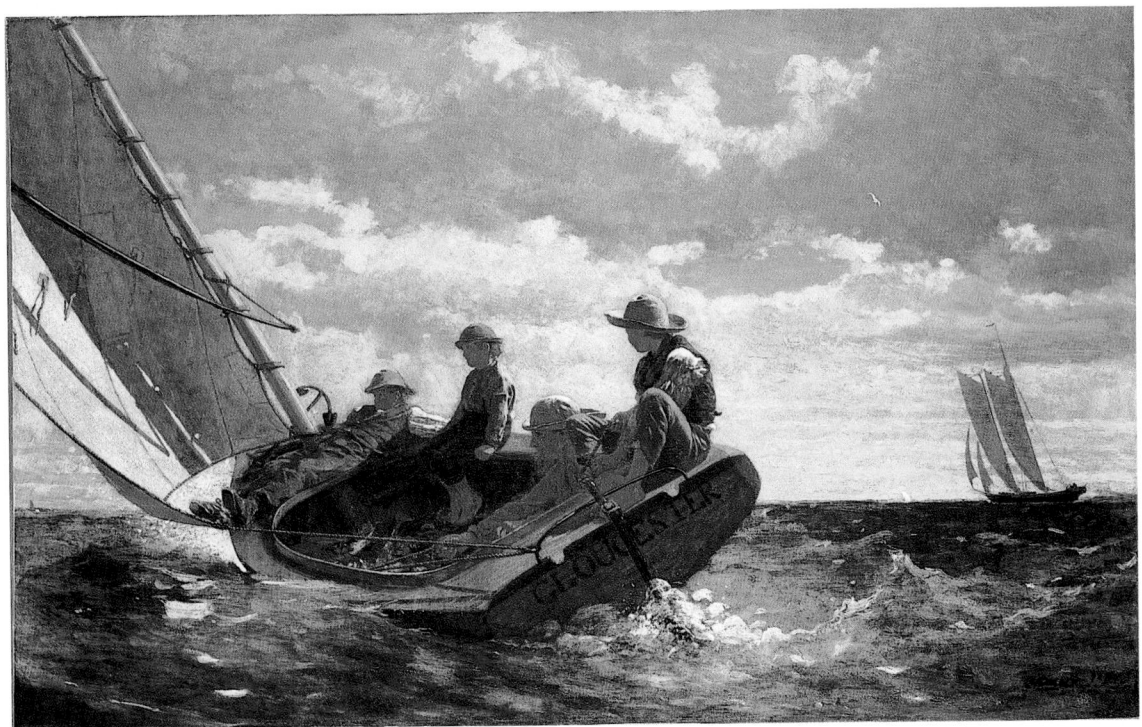

22.28 Winslow Homer, *Breezing Up (A Fair Wind)*, 1873–1876. Oil on canvas; 24⅛ × 38⅛ in. (61.5 × 96.8 cm). National Gallery of Art, Washington, D.C. (Gift of the W. L. and May T. Mellon Foundation). Homer, a largely self-taught artist from Boston, worked as a magazine illustrator. At the outbreak of the Civil War, he was sent by *Harper's Weekly* to do drawings at the front. After the war, he spent a year in France. From 1873, he worked in watercolor, which became as important a medium for him as oil.

John Singer Sargent

John Singer Sargent (1856–1925), who lived in Paris in the early 1880s, espoused Impressionism wholeheartedly. But even though Sargent is sometimes considered an Impressionist, he did not allow form to dissolve into light, as did the French Impressionists. After his death, and with the advent of modernism, Sargent was dismissed as a painter of elegant, superficial portraits that emphasized the rich materials worn by his society patrons. But the *Daughters of Edward Darley Boit* (fig. **22.29**), exhibited in the Salon of 1883, reveals the inner tensions of four young sisters, despite their comfortable lifestyle.

The girls occupy a fashionable room decorated with large Chinese vases and a Chinese rug. The mirror, which recalls Velázquez's *Las Meninas* (see fig. 17.56), complicates the spatial relationships within the picture, while the oblique view locates the figures above the observer. The cropped rug and vase produce a version of the Impressionist "slice of life," and the subjects seem frozen in time. Three gaze at the viewer, and one leans introspectively against a vase. Two are close together and two, echoing the vases, are apart. The spaces separating the figures convey psychological tension and create the impression of an internal subtext. Enhancing the psychological effect of the work is the fact that as the girls become older, they are more in shadow.

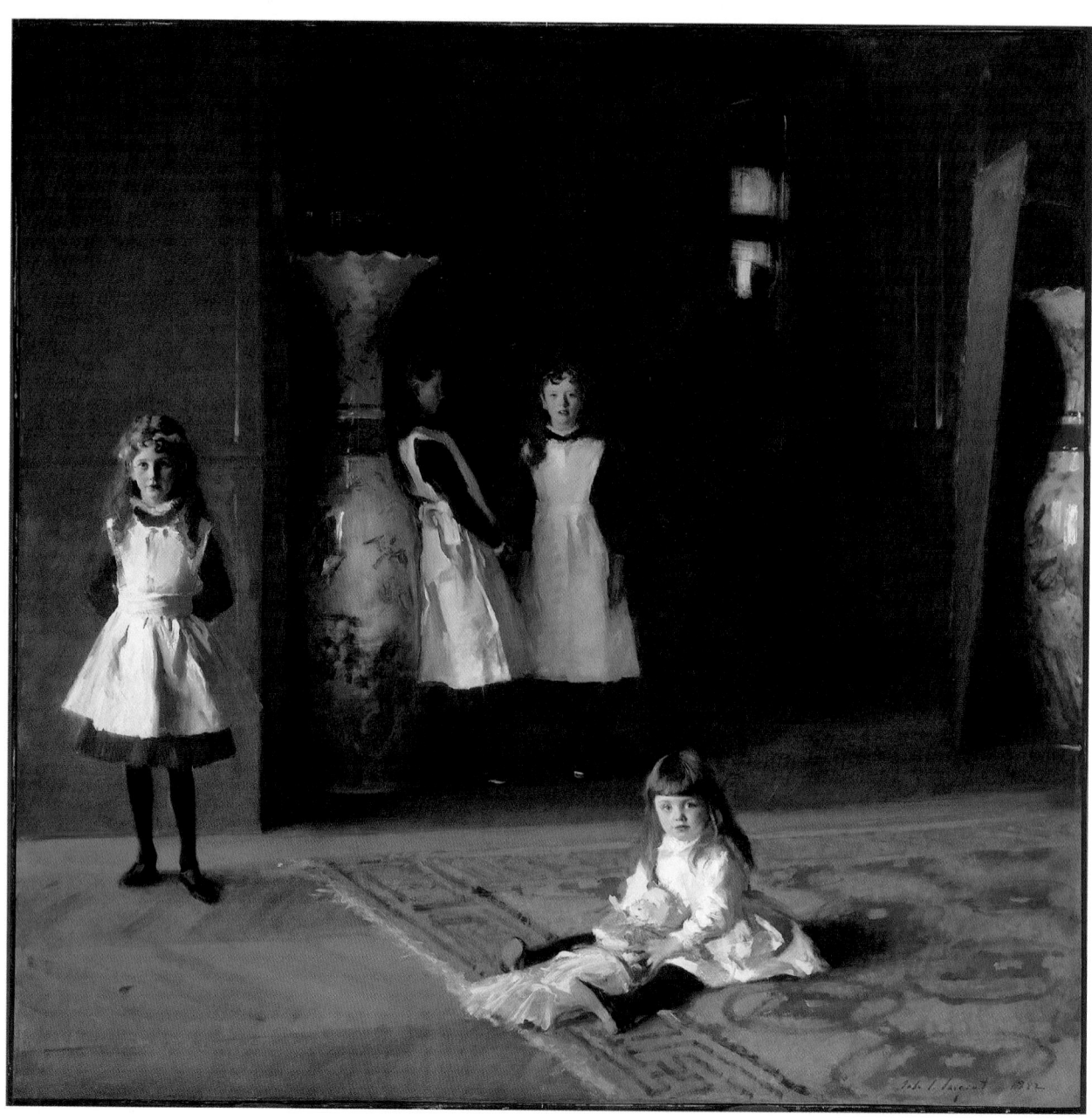

22.29 John Singer Sargent, *Daughters of Edward Darley Boit,* 1882. Oil on canvas; 7 ft. 3 in. × 7 ft. 3 in. (2.21 × 2.21 m). Courtesy Museum of Fine Arts, Boston (Gift of Mary Louisa Boit, Florence D. Boit, Jane Hubbard Boit, and Julia Overing Boit, in memory of their father, Edward Darley Boit).

"Art for Art's Sake"

In Paris, widespread public and critical condemnation made it difficult for the Impressionists to sell their work. In London as well, there were aesthetic quarrels. One of these erupted into the celebrated libel trial between the American painter James Abbott McNeill Whistler (1834–1903) and the English art critic John Ruskin. In 1877, Ruskin published a scathing review of Whistler's *Nocturne in* *Black and Gold (The Falling Rocket)* (fig. **22.30**), painted some two years previously. The picture was on view at London's Grosvenor Gallery, and it threw Ruskin into a rage. He accused Whistler of flinging "a pot of paint . . . in the public's face." Whistler himself, Ruskin added, was a "coxcomb," guilty of "Cockney impudence" and "wilful imposture."

Whistler sued Ruskin for libel, and the case went to trial in November 1878. Ruskin, who was in the throes of a psychotic breakdown, could not appear in court, but his views

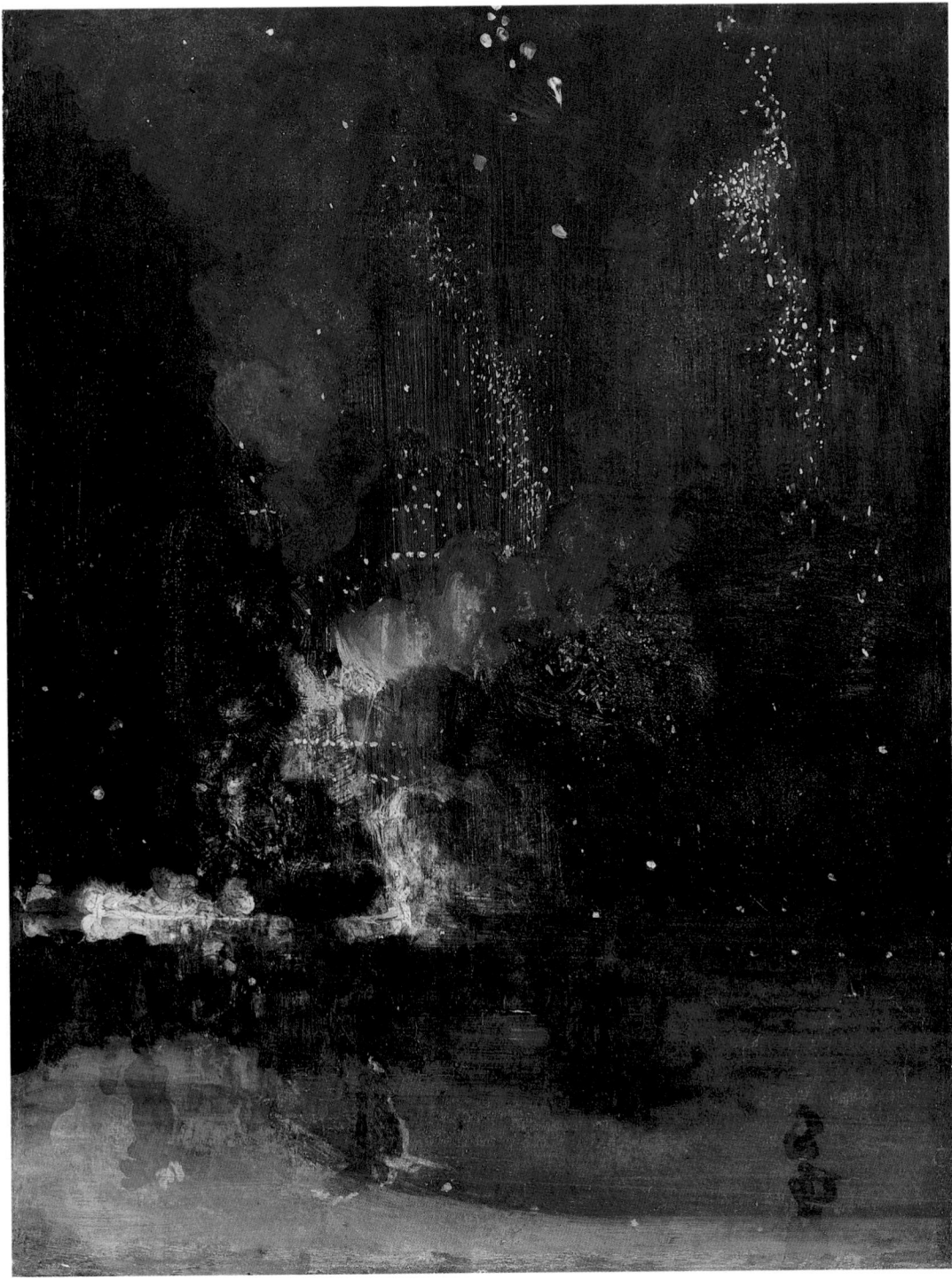

22.30 James Abbott McNeill Whistler, *Nocturne in Black and Gold* (*The Falling Rocket*), c. 1875. Oil on oak panel; 23⅝ × 18½ in. (60.0 × 47.0 cm). Detroit Institute of Arts (Gift of Dexter M. Ferry, Jr.). Whistler, born in Lowell, Massachusetts, moved with his family to Russia, where his father designed the Moscow–Saint Petersburg railroad. He set up art studios in Paris and London, finally settling in Chelsea. The author of *The Gentle Art of Making Enemies*, Whistler was known for his distinctive personality and biting wit. He dressed as a dandy, wearing pink ribbons on his tight, patent-leather shoes and carrying two umbrellas in defiance of the inclement London weather.

were presented by his attorney. According to Ruskin, Whistler's picture was outrageously overpriced at 200 guineas, quickly and sloppily executed, technically "unfinished," and devoid of recognizable form. Several of Whistler's other paintings were introduced as exhibits and declared equally "unfinished." In particular, the defense pointed out, Whistler did not paint like Titian, whose works *were* "finished." Ruskin also objected to Whistler's musical titles (in this case *Nocturne*) as pandering to the contemporary fad for the incomprehensible. The paintings were not, he insisted, serious works of art. In his opening statement, the attorney general, acting for Ruskin, had this to say about musical titles:

> In the present mania for art it had become a kind of fashion among some people to admire the incomprehensible, to look upon the fantastic conceits of an artist like Mr. Whistler, his "nocturnes," "symphonies," "arrangements," and "harmonies," with delight and admiration; but the fact was that such productions were not worthy of the name of great works of art. This was not a mania that should be encouraged; and if that was the view of Mr. Ruskin, he had a right as an art critic to fearlessly express it to the public.

On cross-examination, Whistler was questioned about his subject matter:

> "What is the subject of the *Nocturne in Black and Gold*?"
> "It is a night piece," Whistler replied, "and represents the fireworks at Cremorne."
> "Not a view of Cremorne?"
> "If it were a view of Cremorne, it would certainly bring about nothing but disappointment on the part of the beholders. It is an artistic arrangement. . . . It is as impossible for me to explain to you the beauty of that picture as it would be for a musician to explain to you the beauty of a harmony in a particular piece of music if you have no ear for music."

Ironically, Ruskin had once used his critical genius to further the public reception of Turner, himself a rather "Impressionistic" artist. Equally ironic, Whistler was quite capable of producing clear and precise images, as he did in his etchings as well as in some of his portraits. The famous portrait of Whistler's mother (see fig. I.9), which also has a combined musical and artistic title—*Arrangement in Gray and Black*—is a remarkable psychological portrait and also satisfies Ruskin's requirement that a painting appear "finished." It conveys her dour, puritanical character, reflected in the assertion by one of Whistler's friends that she lived on the top floor of his London house in order to be closer to God.

Whistler's two stylistic tendencies—linear and atmospheric—mirrored his psychological conflicts as well as the traditional quarrels between *disegno* and *colorito,* the *Poussinistes* and the *Rubénistes,* Classical art and modernism. In the Impressionist period, the Academy stood for traditional "clarity" and opposed the atmospheric effects of works by Whistler and Debussy. Whistler internalized these quarrels according to his own struggle between

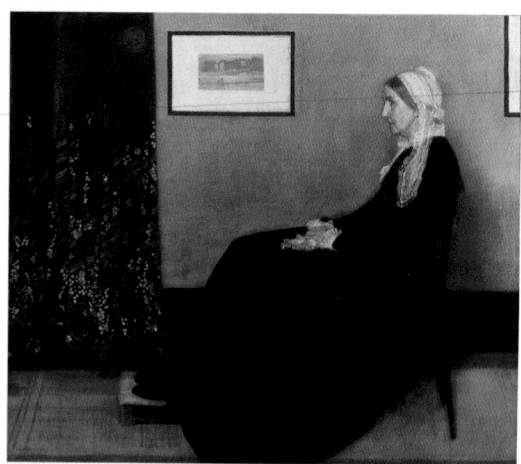

See figure I.9. James Abbott McNeill Whistler, *Arrangement in Black and Gray (Portrait of the Artist's Mother),* 1871.

male and female forces within himself. He wrote that "Color is vice. . . . When controlled by a firm hand, well-guided by her master, Drawing, Color is then like a splendid woman with a mate worthy of her . . . the most magnificent mistress possible. But when united with uncertainty, with a weak drawing . . . , Color becomes a bold whore, makes fun of her little fellow, isn't it so?"[4]

In court, Whistler countered Ruskin's position by stating what was essentially the formalist "art for art's sake" view of art—namely, that art does not necessarily serve a utilitarian purpose. Although designated a painting of fireworks on the Thames, Whistler's *Nocturne* was actually a study in light, color, and form. The atmospheric effects of the cloudy night sky are contrasted with gold spots of light from the exploded rocket. When questioned about the identity of the black patch in the lower right corner, Whistler replied that it was a vertical, placed there for purely formal reasons. In that response, he echoed Monet's view that a painted "tree" is not a tree, but a vertical daub of paint. On the subject of money, Whistler testified that he had spent only a day and a half painting the *Nocturne* but was charging for a lifetime of experience.

The jury followed the judge's instructions and decided in Whistler's favor but awarded him only a farthing in damages. When it was over, the trial was extensively ridiculed in the English and American press. A *New York Times* critic complained (December 15, 1878) that "the world has been much afflicted of late with these slapdash productions of the paint-pot." In his view, musical titles were "exasperating nomenclature," and the "shadowy and unseen presences" of modern art were confusing. "Ordinary men and women in a state of health," he concluded, "prefer to have their pictures made for them." The London *Times* suggested that Whistler might take his "brush" to Ruskin's "pen" and paint a caricature of Ruskin as an "arrangement in black and white." The tragic irony of this notion is that when, at the end of his life, Ruskin descended into his final

madness, he went around muttering "everything black . . . everything white."

The trial was also the subject of the cartoon in figure **22.31**, which appeared in the English humorous magazine *Punch* on December 7, 1878. In it, the judge holds up a giant farthing, which he offers to Whistler, who has a large ear on top of his head—his "ear for musical titles." Whistler stands on flute legs, referring not only to his musical titles, but also to his father, whose nickname was "Pipes" since he was an accomplished amateur flautist. At the right, the balloon over the jury reads: "No symphony [for "sympathy"] with the defendant."

Below the jury, Ruskin is represented as an "Old Pelican in the Art Wilderness," his head bowed as if in shame at having lost the case. The box in front of the judge reads "Damages" and has a slot large enough to accommodate the farthing. Slithering along the floor are two serpents emerging from the bottomless pit of court costs. In fact, Whistler was bankrupted by the trial and was forced to sell his house in Chelsea. A fellow artist called the bankruptcy petition an "arrangement in black and white." Nearly seventy years after the trial, *Art Digest* reported that the Detroit Institute of Arts paid $12,000 for the infamous "pot of paint."

The significance of this absurd trial is its function as a window on aesthetic conflict in the late nineteenth century. It also proves the adage that one cannot legislate taste. Whistler later called the trial a conflict between the "brush" and the "pen." It exemplified the rise of the critic as a potent force in the nineteenth-century art world. Although Ruskin had shown foresight when dealing with his own innovative contemporaries—notably Turner and the Pre-Raphaelites, whose causes he had championed—he did not have the same vision about the younger generation of artists. And he was not alone. The French public also failed to recognize the merits of avant-garde nineteenth-century art, and, as a result, many important French paintings were bought by foreign collectors and are now in collections outside France.

We have seen that the history of Western art is fraught with aesthetic quarrels, but passions rose to new heights during the latter half of the nineteenth century. For the first time, the material of art became a subject of art, and content yielded to style. More than anything else, it was the dissolution of form that seems to have caused the most intense critical outrage. But this was the very trend that would prove to have the most lasting impact on the development of Western art.

AN APPEAL TO THE LAW.

Naughty Critic, to use bad Language! Silly Painter, to go to Law about it!

22.31 *Whistler versus Ruskin: An Appeal to the Law,* from *Punch*, December 7, 1878, p. 254.

Style/Period	Works of Art	Cultural/Historical Developments

Hiroshige, Saruwaka-cho Theater

Utamaro, *Young Woman with Blackened Teeth Examining Her Features in a Mirror* (**W9.4**)
Toyokuni, *Portrait of the Actor Onoe Matsusuke as the Villain Kudo Suketsune* (**W9.3**)
Eisen, *Oiran on Parade* (**W9.5**)
Hokusai, *Great Wave of Kanagawa* (**W9.7**)
Kunisada, *Scene from Sukeroku* (**W9.2**)
Hiroshige, *Travelers in the Snow at Oi* (**W9.9**)
Hokusai, *Horsetail Gatherer* (**W9.8**)
Kuniyoshi, *Tairano Koremochi Waking Up from a Drunken Sleep* (**W9.6**)
Hiroshige, *Saruwaka-cho Theater* (**W9.10**)
Kunisada, *The Actor Seki Sanjuro in the Role of Kiogoku Takumi* (**W9.1**)

Edo period (1600–1868)
Ukiyo-e school of painting
Restoration of Meiji dynasty in Japan (1868)

Manet, A Bar at the Folies-Bergère

Manet, Zola

IMPRESSIONISM
1860–1920

Garnier, Opéra (**22.2–22.4**), Paris
Monet, *Terrace at Sainte-Adresse* (**22.17**)
Manet, *Zola* (**22.5**)

1870–1880

Muybridge, Galloping Horse

Monet, *Impression: Sunrise* (**22.16**)
Renoir, *Pont-Neuf* (**22.21**)
Morisot, *The Cradle* (**22.15**)
Whistler, *Nocturne in Black and Gold* (**22.30**)
Homer, *Breezing Up* (**22.28**)
Degas, *Absinthe* (**22.8**)
Renoir, *Moulin de la Galette* (**22.7**)
Muybridge, *Galloping Horse* (**22.12**)
Whistler versus Ruskin (**22.31**)
Rodin, *The Thinker* (**22.24**)

Richard Wagner, *Die Walküre* (1870)
Giuseppe Verdi, *Aïda* (1871)
First Impressionist art exhibition in Paris (1874)
Mark Twain, *Adventures of Tom Sawyer* (1875)
Georges Bizet, *Carmen* (1875)
Alexander Graham Bell invents the telephone (1876)
Pyotr Ilich Tchaikovsky, *Swan Lake* ballet (1876)
U.S. National Baseball League founded (1876)
First lawn-tennis championship played at Wimbledon (1877)
Henrik Ibsen, *Doll's House* (1879)
Thomas Edison invents the phonograph and electric light bulb (1879–1880)

1880–1890

Hiroshige, Travelers in the Snow at Oi

Degas, At the Races

Degas, *Fourth Position Front, on the Left Leg* (**22.23**)
Manet, *A Bar at the Folies-Bergère* (**22.6**)
Sargent, *Daughters of Edward Darley Boit* (**22.29**)
Degas, *Dancing Lesson* (**22.10**)
Degas, *Visit to a Museum* (**22.9**)
Degas, *At the Races* (**22.11**)

European colonization of Africa begins (1880s)
Louis Pasteur discovers a chicken cholera vaccine (1880)
Andrew Carnegie develops first large steel furnace (1880)
Fyodor Dostoevsky, *Brothers Karamazov* (1880)
Henry James, *Washington Square* (1881)
Johannes Brahms, *Academic Festival Overture* (1881)
Brooklyn Bridge opened to traffic (1883)
Friedrich Wilhelm Nietzsche, *Thus Spake Zarathustra* (1883)
First steam turbine engine invented (1884)
Gilbert and Sullivan, *The Mikado* (1885)
Walter Pater, *Marius the Epicurean* (1885)
American Federation of Labor founded (1886)
Robert Louis Stevenson, *Dr. Jekyll and Mr. Hyde* (1886)
Karl Marx, *Das Kapital* published in English (1886)
Arthur Conan Doyle, *A Study in Scarlet* (1887)
John Dunlop invents the pneumatic tire (1888)
Nicolai Rimsky-Korsakov, *Scheherazade* (1888)
George Eastman develops Kodak box camera (1888)

1890–1900

Monet, Rouen Cathedral

Cassatt, *Letter* (**22.14**)
Rodin, *Balzac* (**22.25–22.26**)
Cassatt, *Boating Party* (**22.13**)
Monet, *Rouen Cathedral, West Façade, Sunlight* (**22.19**)
Monet, *Rouen Cathedral, the Portal and the Tower of Albane, the Morning* (**22.20**)
Pissarro, *Place du Théâtre Français* (**22.22**)

Pissarro, Place du Théâtre Français

James G. Frazer, *Golden Bough* (1890–1915)
Sergei Rachmaninoff, Piano Concerto No. 1 (1891)
George Bernard Shaw, *Mrs. Warren's Profession* (1892)
F. H. Bradley, *Appearance and Reality* (1893)
Antonín Dvořák, *New World Symphony* (1893)
Beginning of the Dreyfus Affair in France (1894)
Jean Sibelius, *Finlandia* (1894)
Rudyard Kipling, *Jungle Books* (1894–1895)
Discovery of X-rays by Wilhelm Roentgen (1895)
Oscar Wilde, *The Importance of Being Ernest* (1895)
H. G. Wells, *The Invisible Man* (1897)
Edmond Rostand, *Cyrano de Bergerac* (1897)
Edward Elgar, *Enigma Variations* (1899)
Ernest Rutherford discovers alpha and beta rays in radioactive atoms (1899)
Boxer Rebellion in China against Western interests (1899–1900)

1900–1920

Monet, *Water-Lily Pond* (**22.18**)

Monet, Water-Lily Pond

23

Post-Impressionism and the Late Nineteenth Century

*P*ost-*Impressionism,* meaning "After Impressionism," is the term used to designate the work of a group of important late nineteenth-century painters. Although their styles are quite diverse, they are united by the fact that nearly all were influenced by Impressionism. Like the Impressionists, the Post-Impressionists were drawn to bright color and visible, distinctive brushstrokes. Despite the prominent brushwork, however, Post-Impressionist forms do not dissolve into the medium as they do in the late works of Monet. The edges in Post-Impressionist works, whether outlined or defined by sharp color separations, are usually relatively clear.

Within Post-Impressionism, two important trends evolved. These are exemplified on the one hand by Cézanne and Seurat, who reassert a strong sense of formal structure and, on the other, by Gauguin and van Gogh, who explore emotional content. Both trends set the stage for the major directions of early twentieth-century art. Certain Post-Impressionist artists were also influenced by the late nineteenth-century Symbolist movement (see p. 818).

Post-Impressionist Painting

Henri de Toulouse-Lautrec

Henri de Toulouse-Lautrec (1864–1901), who was inspired by Degas, based his most characteristic imagery on Parisian nightlife. He frequented dance halls, nightclubs, cafés, and bordellos in search of subject matter. Loose, sketchy brushwork contained within clearly defined color areas contributes to a sense of dynamic motion in his paintings. In the *Quadrille at the Moulin Rouge* (fig. **23.1**), the woman facing the viewer exudes an air of determined, barely contained energy about to erupt in dance. Her stance is the opening position of a quadrille and a challenge to the other figures. Like Degas, Toulouse-Lautrec favored partial, oblique views

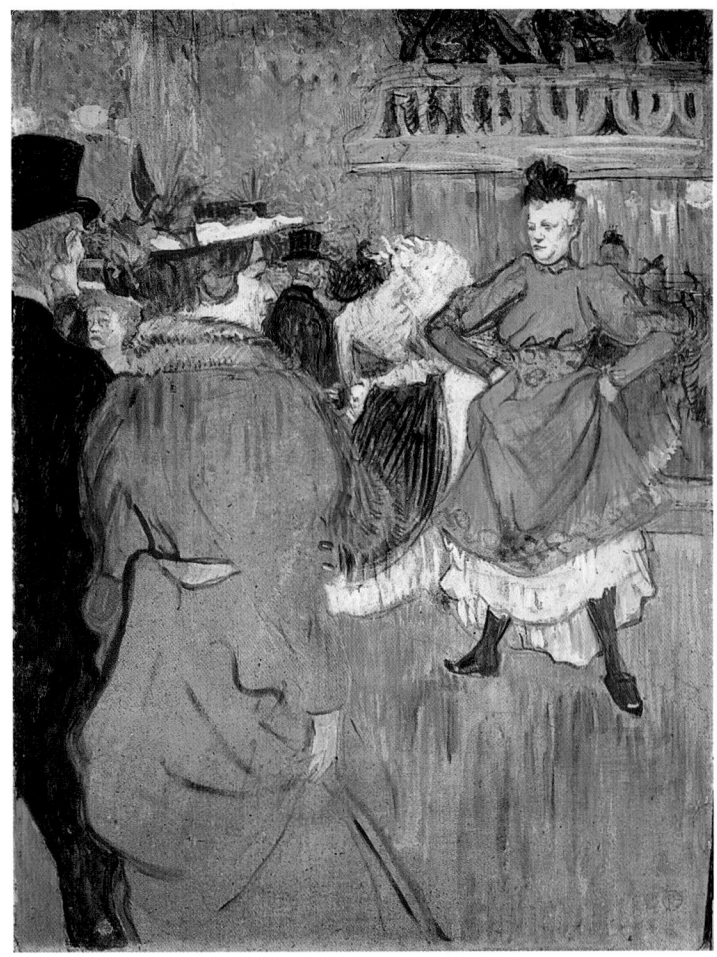

23.1 Henri de Toulouse-Lautrec, *Quadrille at the Moulin Rouge*, 1892. Oil on cardboard; 31⅓ × 31½ in. (79.6 × 80.01 cm). National Gallery of Art, Washington, D.C. (Chester Dale Collection). The Moulin Rouge was (and still is) a popular music hall in Montmartre. It was here, in the artistic and entertainment center of Paris, that Toulouse-Lautrec lived and worked. He was descended from the counts of Toulouse, and, although his family disapproved of his lifestyle, his wealth saved him from the poverty suffered by many artists of his generation. He died at age thirty-seven from the effects of alcoholism.

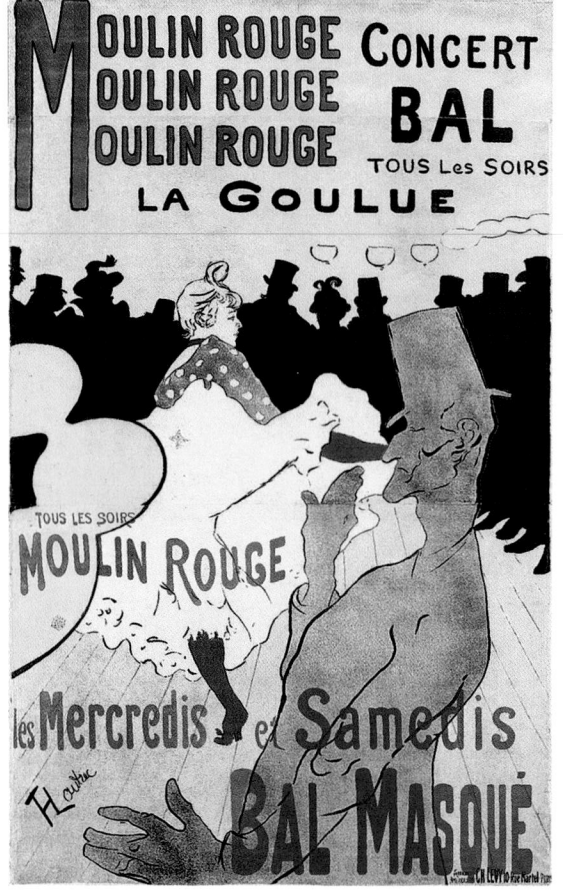

that suggest photographic cropping. He was also, like Degas, influenced by Japanese prints, using strong silhouettes to offset the more textured areas of his painted surfaces.

In contrast to the textured surfaces of his paintings, Toulouse-Lautrec's lithograph posters consist of flat, unmodeled areas of color. The poster—which Lautrec popularized at the end of the nineteenth century—was not only an art form. Like the print techniques used by the Realists for social and political ends, posters such as *La Goulue at the Moulin Rouge* (fig. **23.2**) disseminated information. Because the purpose of a poster is to advertise an event, words convey part of the message. In *La Goulue,* the letters are integrated with the composition by repetition of the lines and colors of the printed text within the image. The blacks of "BAL" (Dance) and "LA GOULUE" recur in the silhouetted background crowd and the stockings of the dancer. The flat red-orange of "MOULIN ROUGE" is echoed in the dress. And the thin, dark lines of "TOUS LES SOIRS" (Every Evening) are repeated in the floorboards and the outlines of the figures.

Paul Cézanne

The Post-Impressionist who was to have the most powerful impact on the development of Western painting was Paul Cézanne (1839–1906). He, more than any artist before him, transformed paint into a visible structure. Cézanne's early pictures were predominantly black and obsessed with erotic or violent themes. The *Temptation of Saint Anthony* (fig. **23.3**) of about 1870 depicts an erotic theme that preoccupied Cézanne for many years. Related to a book of the same title by Zola, whom Cézanne had known since childhood, the painting shows the hermit saint at the

23.2 Henri de Toulouse-Lautrec, *La Goulue at the Moulin Rouge*, 1891. Poster, color lithograph; 6 ft. 3 in. × 3 ft. 10 in. (1.9 × 1.17 m). The Metropolitan Museum of Art, Harris Brisbane Dick Fund. At fifteen, two accidents left Toulouse-Lautrec with permanently stunted legs. Perhaps because of this, dancers had a particular attraction for him. La Goulue was one of the professional dancers who, along with singers, circus performers, and prostitutes, were among his favorite subjects.

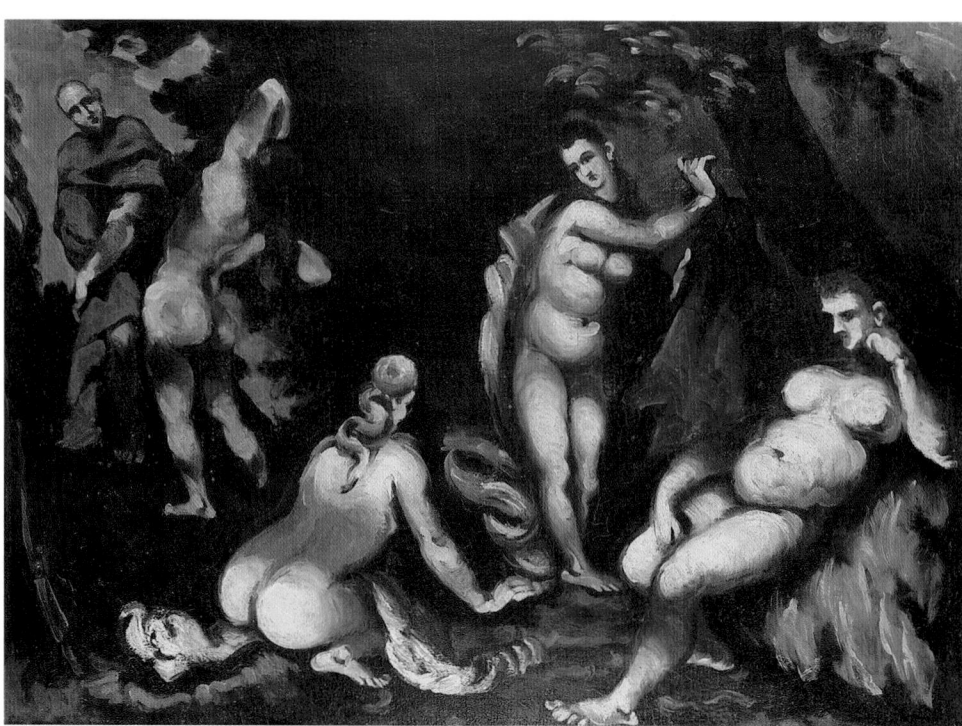

23.3 Paul Cézanne, *Temptation of Saint Anthony*, c. 1870. Oil on canvas; 22⅖ × 30 in. (56.9 × 76.2 cm). The Foundation E. G. Bührle Collection, Zürich.

upper left. He recoils from a nude exposing herself to him. The two figures at the right have an androgynous quality but appear to be male. The seated figure broods in the manner of Dürer's *Melencolia I* (see fig. 16.13), while also reclining in a traditional female pose. The ambivalence of the standing figure lies in the fact that his gaze is riveted to the kneeling woman, while he turns as if to escape the sexual dangers that she represents. The erotic conflicts dramatized in this *Temptation* are Cézanne's own, and they are characteristic of his early imagery.

Cézanne's *Self-Portrait* (fig. **23.4**) of around 1872 depicts a man of intense vitality. Although the colors are dark, the background landscape conveys Impressionist ideas. The thickly applied paint accentuates each brushstroke—short and determined—like the bricks of an architectural structure. The arched eyebrows frame diamond-shaped eye sockets, and the curved brushstrokes of the hair and beard create an impression of wavy, slightly unruly motion.

Cézanne exhibited with the Impressionists in 1873 and 1877, and, under the influence of Pissarro, his palette became brighter and his subject matter more restricted. In *Still Life with Apples* (fig. **23.5**) of c. 1875–1877, painted at the height of his Impressionist period, Cézanne subordinates narrative to form. He condenses the rich thematic associations of the apple in Western imagery with a new, structured abstraction. Cézanne's punning assertion that he wanted to "astonish Paris with an apple" (see box, p. 806) is nowhere more evident than in this work. Seven brightly colored apples are placed on a slightly darker surface. Each is a sphere, outlined in black and built up with patches of color—reds, greens, yellows, and oranges—like the many facets of a crystal. Light and dark, as well as color, are created by the arrangement of the brushstrokes in rectangular shapes. The structural quality of the apples seems to echo Cézanne's assertion that the natural world can be "reduced to a cone, a sphere, and a cylinder."

The apples are endowed with a life of their own. Each seems to be jockeying for position, as if it has not quite settled in relation to its neighbors. The shifting, animated quality of these apples creates dynamic tension, as does the crystalline structure of the brushstrokes. Nor is it entirely clear just what the apples are resting on, for the unidentified surface beneath them also shifts. As a result, the very space of the picture is ambiguous, and the image has an abstract, iconic power.

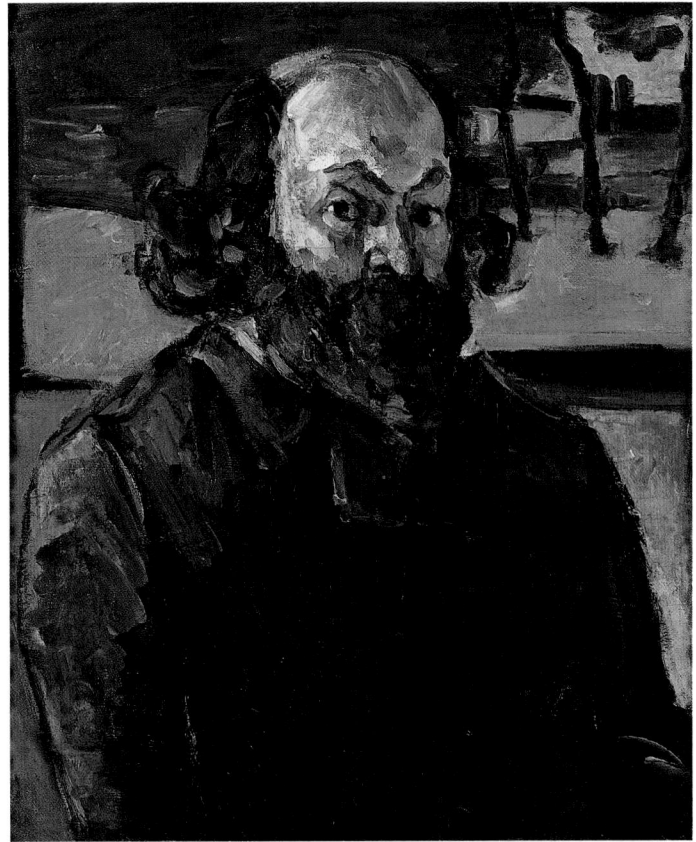

23.4 Paul Cézanne, *Self-Portrait*, c. 1872. Oil on canvas; 25¼ × 20½ in. (64.1 × 52.1 cm). Musée d'Orsay, Paris. Cézanne was born and lived most of his life in Provence, in the south of France. He studied law before becoming a painter. In 1869, he began living with Hortense Fiquet, by whom he had a son in 1872. They married in 1886, the year his father died.

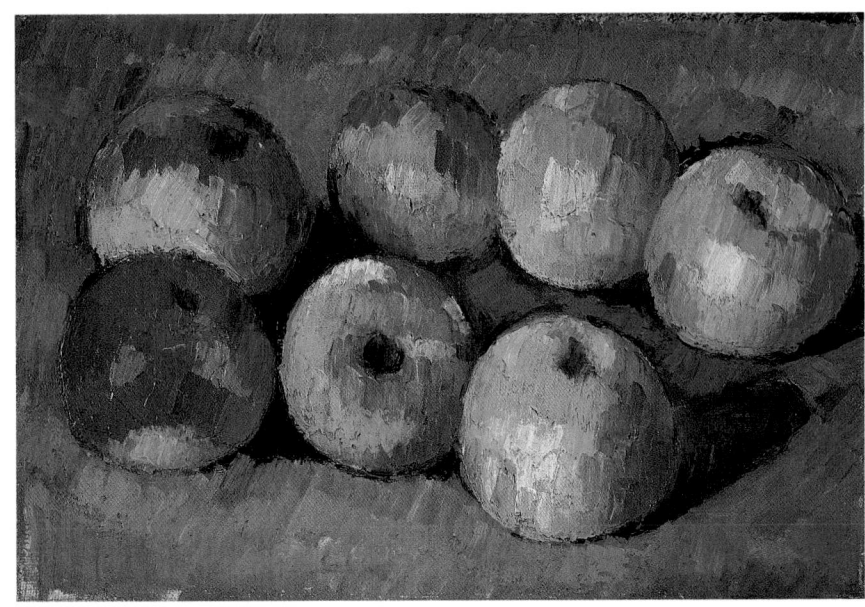

23.5 Paul Cézanne, *Still Life with Apples*, c. 1875–1877. Oil on canvas; 7½ × 10¾ in. (19.1 × 27.3 cm). By kind permission of the Provost and Fellows of King's College, Cambridge, England (Keynes Collection).

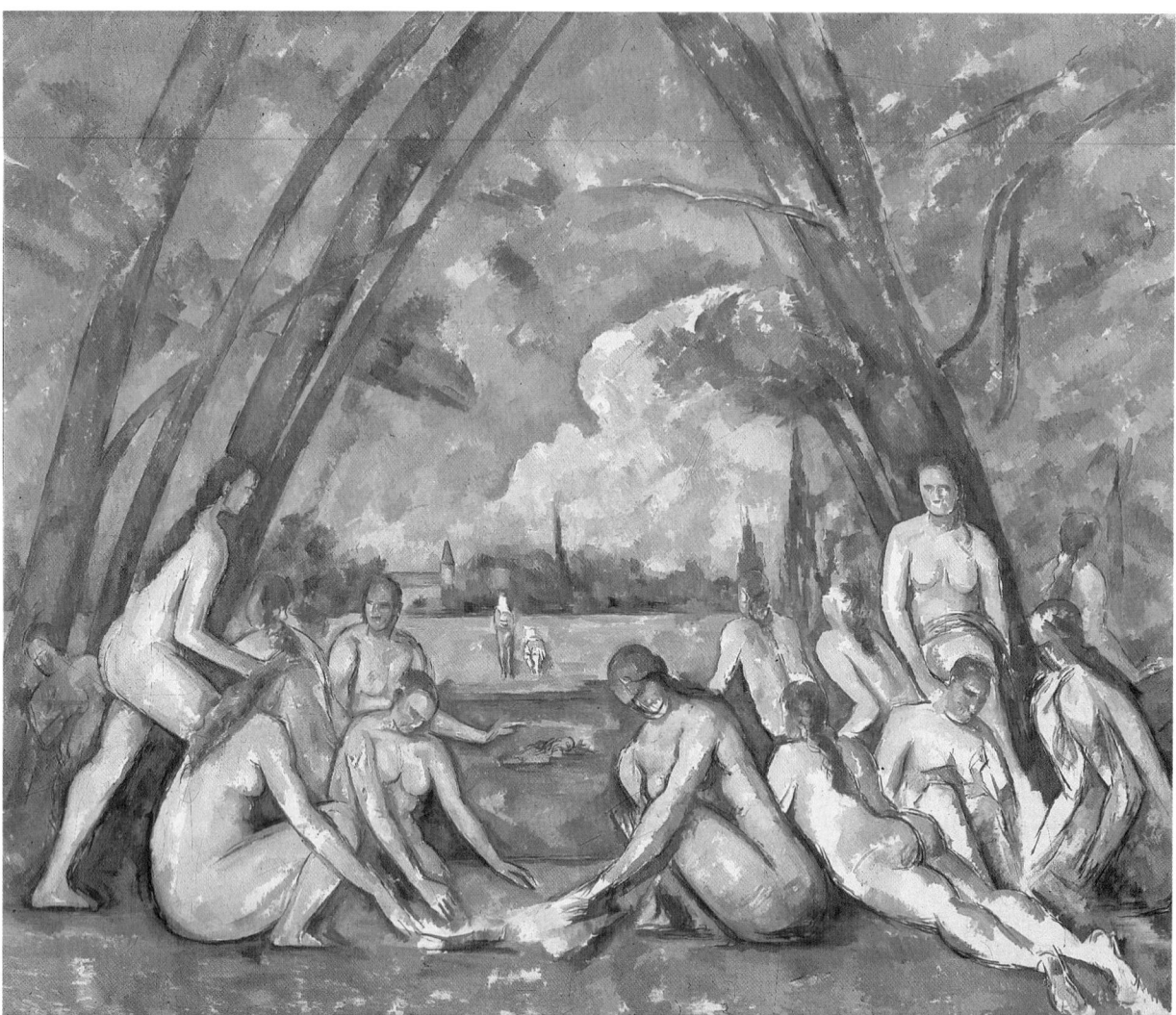

23.6 Paul Cézanne, *Great Bathers*, 1898–1905. Oil on canvas; 6 ft. 10 in. × 8 ft. 3 in. (2.08 × 2.52 m). Philadelphia Museum of Art (W. P. Wilstach Collection).

An Apple a Day . . .

Since its portrayal as the "forbidden fruit" in the Garden of Eden, the apple has had a prominent place in the Western imagination. The traditional associations of the apple with health ("an apple a day keeps the doctor away") and love ("the apple of one's eye") are still apparent in popular expressions. In Greek mythology, one of the Labors of Herakles (the Roman Hercules) required that he steal the golden apples of the Hesperides. The role of the golden apple in the Trojan War was illustrated in the sixteenth century by Cranach, who depicted Paris, the Trojan prince, judging the beauty contest between Hera, Athena, and Aphrodite (see fig. 16.17).

Cézanne's pun condenses the Paris of Greek myth with Paris, the capital city of France. In astonishing "Paris" (in the latter sense), Cézanne wins the beauty contest and becomes a Hercules among painters.

In 1887, Cézanne's active involvement with the Impressionists in Paris ended, and he returned to his native Provence in the south of France. Having integrated Impressionism with his own objectives, he now focused most of his energy on the pursuit of a new pictorial approach. In the *Great Bathers* (fig. **23.6**), painted toward the end of his life, Cézanne achieved a remarkable synthesis of a traditional subject with his innovative technique of spatial construction.

As in *Still Life with Apples,* there is no readily identifiable narrative in the *Great Bathers.* A group of nude women occupies the foreground, blending with the landscape through pose and similarity of construction, rather than through Impressionist dissolution of form. They correspond to the base of a towering pyramidal arrangement, which is carried upward by the arching trees. Two smaller figures visible across a river repeat the distant verticals.

Cézanne's new conception of space is evident in the relationship of the sky and trees. He depicts air and space, as

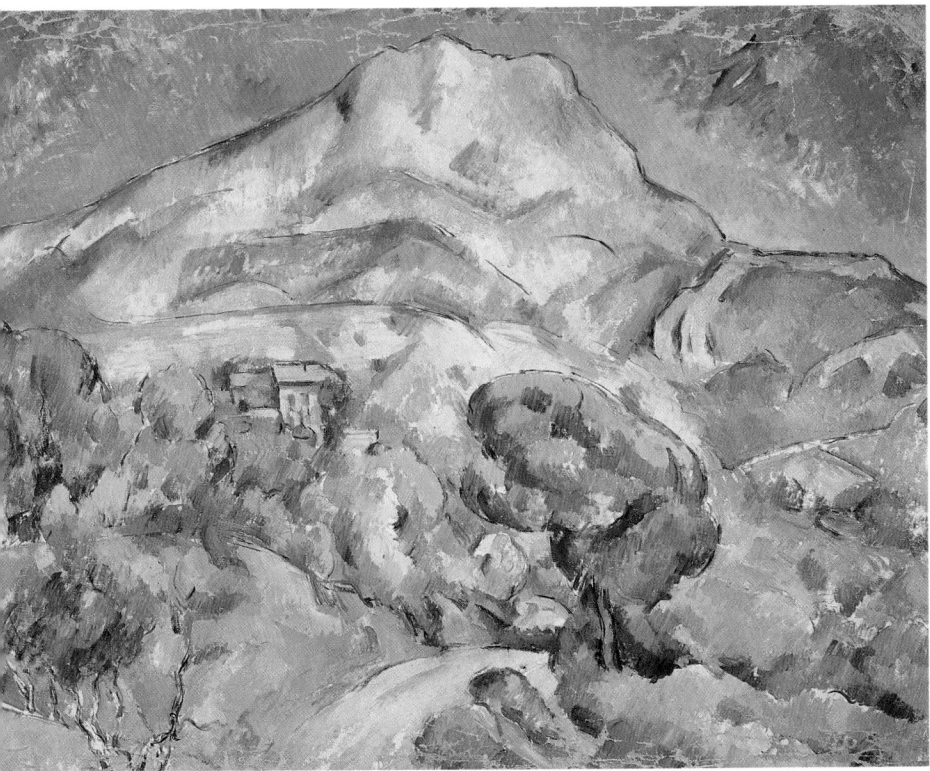

23.7 Paul Cézanne, *Mont Sainte-Victoire*, c. 1900. Oil on canvas; 30¾ × 39 in. (78.1 × 99.1 cm). Hermitage, Saint Petersburg.

well as solid form, as a "construction." Through his technique of organizing the brushstrokes into rectangular shapes, his surfaces, such as the sky, become multifaceted patchworks of shifting color. In certain areas—the tree on the left, for example—patches of sky overlap the solid forms. This results in spatial ambiguity and in the abandonment of the traditional distinctions between foreground and background.

In *Mont Sainte-Victoire* of c. 1900 (fig. **23.7**), Cézanne returned to a subject that had preoccupied him for years. His personal identification with the mountain is indicated by the anthropomorphism of the rich green tree in the right foreground—possibly a self-image. The landscape itself is a multifaceted patchwork of shifting color—greens, oranges, and blues. Geometry pervades the picture, not only in the cubic character of the brushstrokes but also in the trapezoidal mountain, the rectangular house in the middle ground, and the structured curve of the foreground road. Through Cézanne's faceted, crystalline forms, a breakdown and a restructuring of Western spatial conventions are achieved. This was a revolution made possible by the Post-Impressionist synthesis of prominent brushstrokes and clear edges.

Georges Seurat

In his own brand of Post-Impressionism, short-lived though it was, Georges Seurat (1859–1891) combined Cézanne's interest in volume and structure with Impressionist subject matter. His most famous painting, *Sunday Afternoon on the Island of La Grande Jatte* (fig. **23.8**), monumentalizes a scene of leisure by filling the space with solid, rigid, iconic forms. Human figures, animals, and trees are frozen in time and space. Motion is created formally, by contrasts of color, silhouettes, and repetition, rather than by the figures.

Seurat's attention to detail is apparent from the many studies he made in preparation for the final painting. The little monkey, for example, which stands by the woman at the right, was the subject of several studies. The drawing in figure **23.9** shows a monkey in a different pose from that in the painting. It is also quickly drawn rather than being built up with dots. Here the texture of the paper surface contributes to the tactile coat of the animal. It has a light edge and face, with the inner form darkened to show contour. Endowed with a sense of inherent energy, this monkey seems tense and alert.

Seurat has been called a Neo-Impressionist and a Pointillist after his process of building up color through dots, or points, of pure color; Seurat himself called this technique "divisionism." In contrast to Cézanne's outlined forms, Seurat's are separated from each other by the grouping of dots according to their color. In the detail of the girl holding the spray of flowers (fig. **23.10**), the individual dots are quite clear.

Seurat's divisionism was based on two relatively new theories of color. The first was that placing two colors side by side intensified the hues of each. There is in *La Grande Jatte* a shimmering quality in the areas of light and bright color, which tends to support this theory. The other theory, which is only partly confirmed by experience, asserted that the eye causes contiguous dots to merge into their combined color. Blue dots next to yellow dots, according to this theory, would merge and be perceived as vivid green. If the painting is viewed from a distance or through half-closed eyes, this may be true. It is certainly not true if the viewer examines the picture closely, as the illustration of the detail confirms. True or not, such theories are characteristic of the search by nineteenth-century artists for new approaches to light and color, based on scientific analysis.

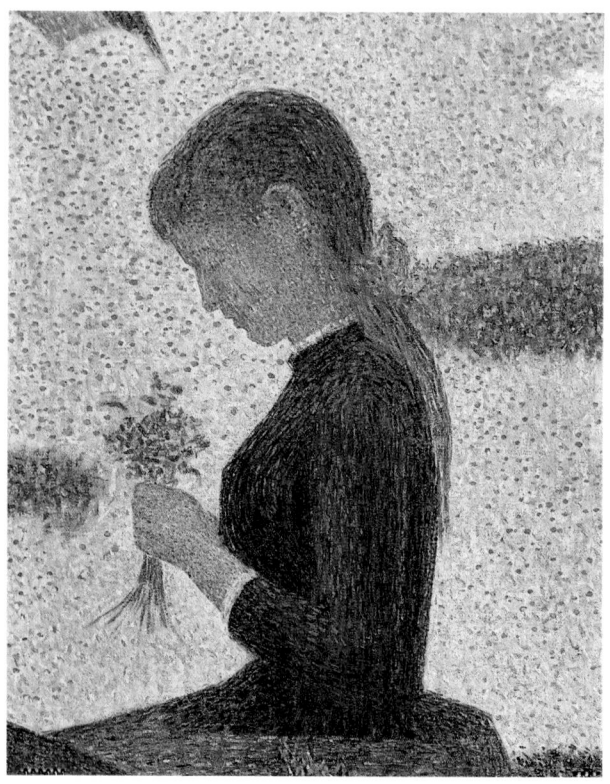

23.8 Georges Seurat, *Sunday Afternoon on the Island of La Grande Jatte*, 1884–1886. Oil on canvas; 6 ft. 9 in. × 10 ft. ⅜ in. (2.08 × 3.08 m). Art Institute of Chicago (Helen Birch Bartlett Memorial Collection). La Grande Jatte is an island in the river Seine that was popular with Parisians for weekend outings. Seurat's painstaking and systematic technique reflected his scientific approach to painting. For two years, he made many small outdoor studies before painting the large final canvas of *La Grande Jatte* in his studio. In 1886, it was unveiled for the last Impressionist Exhibition.

23.9 Georges Seurat, *Monkey*, 1884. Conté crayon; 7 × 9¼ in. (17.7 × 23.7 cm). Metropolitan Museum of Art, New York (Bequest of Miss Adelaide Milton de Groot, 1967).

23.10 Detail of fig. 23.8.

Vincent van Gogh

Vincent van Gogh (1853–1890), the greatest Dutch artist since the Baroque period, devoted only the last ten years of his short life to painting. He began with a dark palette and subjects that reflected a social consciousness reminiscent of nineteenth-century Realism. The *Potato Eaters* (fig. **23.11**) of 1885 exemplifies van Gogh's empathy with the poverty of the coal miners he knew in the Borinage region of southern Belgium. It shows four family members gathered around a crude wooden table; their meal consists only of potatoes and coffee. In the foreground, a girl rendered in back view is silhouetted against the rising steam. The rather heavy, ponderous character of all the figures is enhanced by a thick, impasto paint texture.

More than many artists, van Gogh painted unequivocally autobiographical scenes. His signature, "Vincent," on the back of the chair in the left corner of the *Potato Eaters,* indicates his identification with the young man. Tension created by his personal sense of isolation pervades the painting. Although united by their spatial proximity, none of these figures communicates with anyone. The dark interior is warmed solely by the light above the table, which, given van Gogh's strict religious upbringing, might refer to the presence of God in the miners' humble house.

The following year, 1886, van Gogh moved to Paris, where his brother Theo worked as an art dealer. Under the influence of French Impressionism, van Gogh's paintings became explosions of light and color.

Van Gogh's most penetrating exercise in self-portraiture was his correspondence with his younger brother, Theodorus van Gogh, known as Theo. The letters chronicle Vincent's life of poverty and despair, his efforts to find his life's calling, his tortured relationships with women, and his bouts of madness.

Van Gogh's father was a clergyman in Zundert, Holland. His mother was depressed by the death of her first son, after whom Vincent was named, and who was born on the same day as the second Vincent. Van Gogh grew up with the grave of his older brother, which was located near the family house, a constant presence. At first, he aspired to follow his father as a minister in the Dutch Reformed Church, but his religious zeal alarmed the authorities, and he was not ordained. He also worked in his uncle's art dealership (Goupil) in Brussels and London, and taught school in England. He was a prodigious reader, fluent in English and French as well as in Dutch.

Although van Gogh did not decide to be a painter until about 1884, he had—like most artists—begun drawing as a child. Once he settled on his career, he became dependent on Theo for money and emotional support. Virtually every letter details his expenditures on art supplies and complains about the cost of living. Often he went without food in order to paint. His letters describe his efforts to learn to draw, to capture a likeness, and his views on art and artists, particularly Delacroix.

After two years in Paris, van Gogh moved to Arles, in the south of France. There he hoped to found a society of artists who would live and work communally. Gauguin joined him, but these two difficult personalities were destined not to co-exist for long. When van Gogh cut off his earlobe in a fit of jealous despair and was hospitalized, Gauguin left. Van Gogh then suffered several episodes of mental breakdown, and on July 27, 1890, he shot himself, dying two days later. Six months after Vincent's death Theo also died.

23.11 Vincent van Gogh, *Potato Eaters*, 1885. Oil on canvas; 2 ft. 8¼ in. × 3 ft. 9 in. (0.82 × 1.14 m). Amsterdam, Van Gogh Museum (Vincent van Gogh Foundation).

Van Gogh's clinical diagnosis has never been satisfactorily identified. Theories abound, however, and they range from epilepsy to childhood depression to lead poisoning from paint fumes. Unable to sell his pictures during his lifetime, van Gogh's legacy of paintings went to Theo and then to Theo's son, also named Vincent. The young Vincent bequeathed the bulk of the collection to Holland, and most are now permanently exhibited in the Vincent van Gogh Museum in Amsterdam.

Van Gogh's interest in Japanese woodblock prints was consistent with certain features of Impressionism. While living in Paris, he began to collect such prints, which he had known and admired previously. He wrote to Theo from Antwerp that he had decorated his room with "a number of little Japanese prints." Once in Paris, he encountered the new fashion for *japonisme* and its impact on the Impressionists.

His *Japonaiserie: Bridge in the Rain* (*after Hiroshige*), for example, is a copy of Hiroshige's *Sudden Shower at Ohashi Bridge at Ataka* (figs. **23.12** and **23.13**). Both works

share certain formal and iconographic interests with the French Impressionists. The pictures are divided by strong diagonals—the bridge and the shoreline—into asymmetrical trapezoids. Reminiscent of the candid-camera effect of Degas' *Absinthe* (see fig. 22.8), the resulting tilt is stabilized by the silhouetted verticals of the piers supporting the bridge. Hiroshige's portrayal of rain is echoed in the Impressionist studies of weather conditions—for example, Pissarro's *Place du Théâtre Français* (see fig. 22.22). The darkened sky and the huddled figures, which are small and anonymous, are consistent with van Gogh's frequent bouts of depression. Finally, the people in Hiroshige's print are arranged in two pairs and two single figures. A lone boatman, working against the current, drives his boat up the river. Such contrasts between pairs and solitary figures were a continuous theme in van Gogh's work. It reflected his personal struggle with isolation and his unsuccessful attempts to form a lasting relationship with a woman. It also evoked his close—"paired"—relationship with Theo.

23.12 Vincent van Gogh, *Japonaiserie: Bridge in the Rain* (*after Hiroshige*), 1887. Oil on canvas; 28¾ × 21¼ in. (73.0 × 54.0 cm). Amsterdam, Van Gogh Museum (Vincent van Gogh Foundation).

23.13 Utagawa Hiroshige, *Sudden Shower at Ohashi Bridge at Ataka*, from the series *One Hundred Views of Edo*, 1857. Woodblock print; 14⅛ × 9¾ in. (35.9 × 24.8 cm). The Brooklyn Museum of Art.

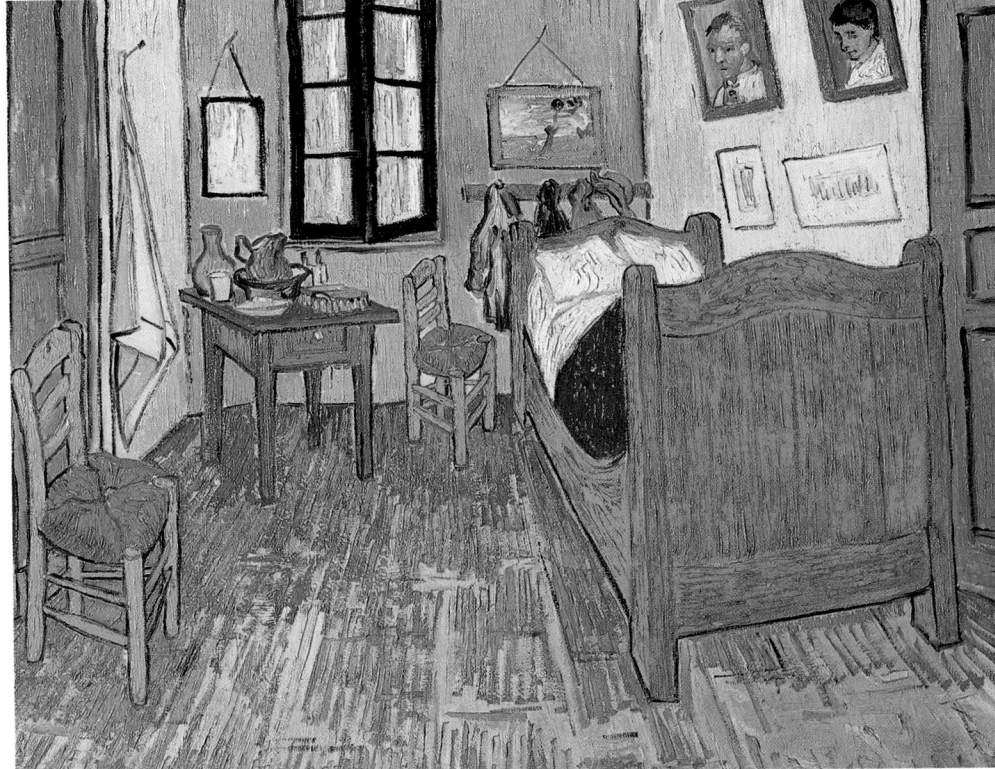

23.14 Vincent van Gogh, *Bedroom at Arles*, 1889. Oil on canvas; 28⅜ × 35⅜ in. (72.1 × 89.9 cm). Musée d'Orsay, Paris.

In 1888, van Gogh moved from Paris to Arles, in the south of France. The following year he painted the famous *Bedroom at Arles* (fig. **23.14**), which is pervaded by isolation and tension. Figures who do not communicate are replaced by an absence of figures. The artist's existence, rather than the artist himself, is indicated by furnishings and clothing. Only the portraits on the wall, one of which is a self-portrait, contain human figures. Like the figures on Hiroshige's bridge, the portraits are arranged as a pair and are juxtaposed with a single landscape over the clothes rack. Likewise, two pillows lie side by side on a single bed. There are two chairs, but they are separated from each other. The same is true of the doors. There are two bottles on the table, and a double window next to a single mirror. Van Gogh's *Bedroom* is thus a psychological self-portrait that records his efforts to achieve a fulfilling relationship with a woman and his failure to do so.

The tension is reinforced by the color, particularly the intense hue of the red coverlet, which is the only pure color in the painting. In October 1888, Vincent sent Theo a sketch of the *Bedroom* (fig. **23.15**) in order to give him an idea of his work:

> I have a new idea in my head and here is a sketch of it. . . . This time it's simply my bedroom, only here color is to do everything, and giving by its simplification a grander style of things, it is to be suggestive here of rest, or of sleep in general. In a word, looking at the picture ought to rest the brain, or rather the imagination.[1]

The sketch was also accompanied by van Gogh's description of the color and mood of the actual painting:

> The walls are pale violet. The floor is of red tiles. The wood of the bed and chairs is the yellow of fresh butter, the sheets and pillows very light greenish citron. The coverlet scarlet. The window green. The toilet table orange, the basin blue. The doors lilac. And that is all—there is nothing in this room with its closed shutters.[2]

23.15 Vincent van Gogh, sketch for *Bedroom at Arles*, 1888. Pen and ink on squared paper; 5¼ × 8⅓ in. (13.3 × 21.1 cm). Amsterdam, Van Gogh Museum (Vincent van Gogh Foundation).

23.16 Vincent van Gogh, *Wheat Field with Reaper*, 1889. Oil on canvas; 29¼ × 36¼ in. (74.3 × 92.1 cm). Amsterdam, Van Gogh Museum (Vincent van Gogh Foundation). Van Gogh described the "all yellow, terribly thickly painted" figure as Death, who reaps humanity like a wheat field. The yellow symbolically derives its power from the sun, which is the painting's source of light. Here it determines the color of the entire picture, and its intensity seems to "heat" the scene.

Van Gogh shared the Impressionist passion for landscape. His *Wheat Field with Reaper* (fig. **23.16**) illustrates his genius for vibrant color. The frenzied curves of wheat —actually formed with individual brushstrokes—repeat the curve of the reaper's scythe. But, despite the impressive power of van Gogh's brushwork, his forms never dissolve completely. The areas of color are maintained as distinct shapes, and the power of the color exceeds that of Impressionism.

In *Starry Night* (fig. **23.17**), van Gogh has depicted an unforgettable image of a nighttime landscape. Here line becomes color in the energetic curves spiraling across the sky. Their movement from left to right is counteracted by hills cascading in the opposite direction. Stabilizing the animated surface are the verticals of the two foreground cypress trees and the church spire. The church itself, as well as the small village, has been identified as van Gogh's memory of Dutch villages, merged here with the French landscape of Provence. Because he painted *Starry Night* while in a mental asylum, it has been seen as the reflection of a disturbed mind. Nothing, however, could be further from the truth, for van Gogh's characteristic control of formal elements, technical skill, and intellectual clarity radiate from every inch of the canvas.

23.17 Vincent van Gogh, *Starry Night*, 1889. Oil on canvas; 28¾ × 36½. (73.0 × 92.7 cm). Museum of Modern Art, New York.

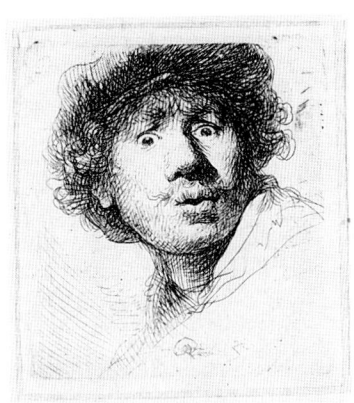

See figure 17.42.
Rembrandt van Rijn,
*Self-Portrait in a Cap,
Openmouthed and Staring,*
1630.

23.18 (right) Vincent van Gogh, studies for *Self-Portrait,* 1889. Pencil and pen drawing; 12⅝ × 9½ in. (32.1 × 24.1 cm). Amsterdam, Van Gogh Museum (Vincent van Gogh Foundation).

Like Rembrandt (see figs. 17.40 and 17.41), whom he studied in his native Holland, van Gogh painted many self-portraits (see fig. I.1). His drawings show that he observed his own features as intensely as he did the world around him. The sheet in figure **23.18** depicts different views of his head, which are related to the *Self-Portrait* in figure **23.19.** The structural quality of the head is emphasized by the firm outlines and gradual shading. Whereas Rembrandt created physiognomy primarily by variations in lightness and darkness, van Gogh did so with color. Aside from the yellows and oranges of the face and hair, the *Self-Portrait* is very nearly monochromatic. The main color is a pale blue-green, varying from light to dark in accordance with the individual brushstrokes. The jacket remains distinct from its background by its darkened color and outline.

Although the figure itself is immobile, like the town and landscape in *Starry Night,* the pronounced spiraling, wavy brushstrokes undulate over the surface of the picture. Yellow—the color associated with death in *Wheat Field with Reaper*—predominates in the depiction of van Gogh's head and is a component of both the orange and the blue-green. The piercing gaze is also achieved through color, for the whites of the eyes are not white at all, but rather the same blue-green as the background. As a result, the viewer has the impression of looking through van Gogh's skull at eyes set far back inside his head.

See figure 17.41.
Rembrandt van Rijn, *Self-Portrait as Saint Paul,* 1661.

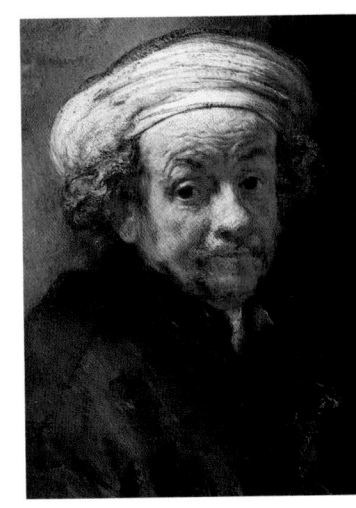

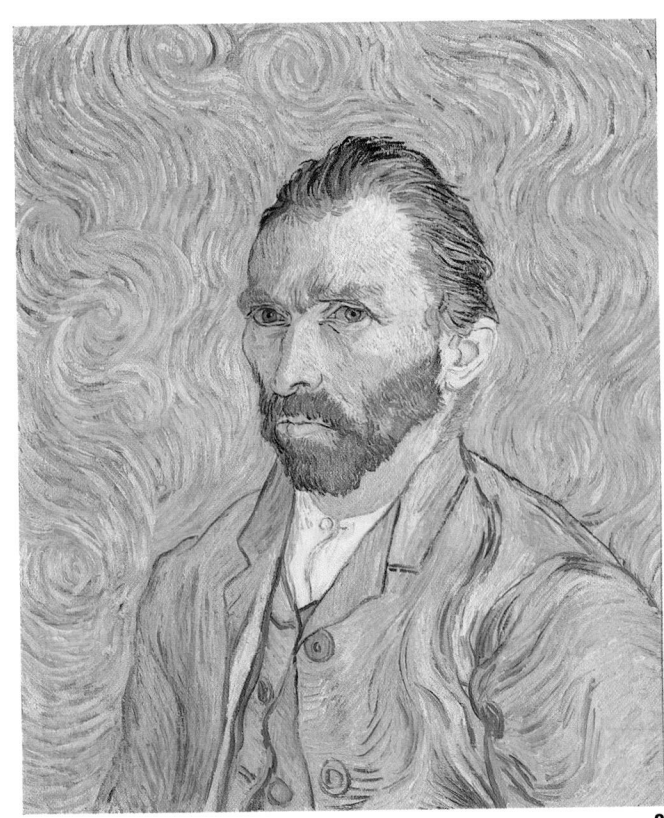

23.19 (right) Vincent van Gogh, *Self-Portrait,* 1889. Oil on canvas; 25½ × 21¼ in. (64.8 × 54.0 cm). Musée d'Orsay, Paris.

Paul Gauguin

Compared to the dynamic character of van Gogh's painted surfaces, Paul Gauguin's (1848–1903) brushstrokes are smooth. Although his colors are bright, they are arranged as flat shapes, usually outlined in black. The surfaces of his pictures seem soft and smooth in contrast to the energetic rhythms of van Gogh's thick brushstrokes.

Gauguin began his career under the aegis of the Impressionists—he exhibited with them from 1879 to 1886—and then went on to explore new approaches to style. In *The Yellow Christ* (fig. 23.20) of 1889, Gauguin identifies with the Symbolist movement and a group of painters referred to as the Nabis, meaning "prophets." He locates the Crucifixion in a Breton landscape and depicts Christ in flattened yellows. Three women in local costume encircle the Cross—a reference to traditional Christian symbolism in which the circle signifies the Church. In fact, the women of Brittany often prayed at large stone crosses in the countryside. The juxtaposition of the Crucifixion with the late nineteenth-century landscape of northern France is a temporal and spatial condensation that is characteristic of the dreamworld depicted by the Symbolists. It is also intended to convey the hallucinatory aspects of prayer, indicating that through meditating on the scene of the Crucifixion the Breton women conjured up an image of the event.

23.21 Paul Gauguin, *Self-Portrait with Halo*, 1889. Oil on wood; 31⅓ × 20¼ in. (79.5 × 51.4 cm). National Gallery of Art, Washington, D.C. (Chester Dale Collection). In 1873, Gauguin married a Danish piano teacher, with whom he led a middle-class life and had five children. In 1882, he became a full-time painter and deserted his family. After a turbulent year with van Gogh in Arles in the south of France, Gauguin returned in 1889 to Brittany, where he was influenced by the Symbolists, and his work assumed a spiritual, self-consciously symbolic quality.

In *Self-Portrait with Halo* (fig. 23.21) of the same year, a pair of apples is suspended behind Gauguin's head. They, like the serpent rising through his hand, allude to the Fall of Man. The flat, curved plant stems in the foreground repeat the motion of the serpent, the outline of Gauguin's lock of hair, and the painting's date and signature. The clear division of the picture plane into red and yellow indicates the artist's divided sense of himself; his head is caught between the two colors, implying that his soul wavers between the polarities of good and evil. Gauguin combines Symbolist color with traditional motifs to convey this struggle. He is at once the tempted and the tempter, a saint and a sinner, an angel and a devil. An important feature of the *Self-Portrait* is Gauguin's contrast between himself as a physical body and the red and yellow areas of the picture plane. His hand and face, as well as the apples, are modeled three-dimensionally, whereas the red and yellow are flat. These methods by which the artist depicted animate and inanimate objects continued to be used throughout his career.

23.20 Paul Gauguin, *The Yellow Christ*, 1889. Oil on canvas; 36¼ × 28⅞ in. (92.1 × 73.3 cm). Albright-Knox Art Gallery, Buffalo, New York.

23.22 Paul Gauguin, *Nevermore*, 1897. Oil on canvas; 1 ft. 11⅞ in. × 3 ft. 9⅝ in. (0.61 × 1.16 m). The Samuel Courtauld Trust, Courtauld Institute of Art Gallery, London. Although Gauguin's style changed little after he left France, Polynesian life and culture became the subjects of his work. Gradually, poverty, alcoholism, and syphilis undermined his health, and he died at age fifty-five after at least one suicide attempt.

In 1891, Gauguin sold thirty paintings to finance a trip to Tahiti. Apart from an eighteen-month stay in France in 1895–1896, he spent the rest of his life in the South Sea Islands. In his Tahitian paintings, Gauguin synthesized the Symbolist taste for dreams and myth with native subjects and traditional Western themes. *Nevermore* (fig. **23.22**), for example, depicts a Tahitian version of the reclining nude. The brightly colored patterns and silhouettes indicate the influence both of Japanese prints and of native designs. They enliven the composition and contrast with the immobility of the figures.

Gauguin has infused the traditional reclining nude with a sense of danger and suspicion. She evidently knows of the danger since she rolls her eyes as if aware of the two women talking in the background. The title of the picture, spelled out in the upper left corner, echoes the refrain of Edgar Allan Poe's "The Raven," which Gauguin knew from Baudelaire's translation:

Once upon a midnight dreary, while I pondered, weak and weary,
Over many a quaint and curious volume of forgotten lore—
While I nodded, nearly napping, suddenly there came a tapping,
As of someone gently rapping, rapping at my chamber door.
"Tis some visitor," I muttered, "tapping at my chamber door—
Only this and nothing more." . . .
"Prophet!" said I, "thing of evil! prophet still, if bird or devil!—
Whether Tempter sent, or whether tempest tossed thee here ashore,
Desolate yet all undaunted, on this desert land enchanted—
On this home by Horror haunted—tell me truly, I implore—
Is there—is there balm in Gilead?—tell me—tell me, I implore!"
Quoth the Raven, "Nevermore."

In Gauguin's painting, the raven stands on a shelf between the title and the whispering women, and stares at the nude. The juxtaposition of the raven, the nude, and the talking women hints at a silent, but sinister, communication. In this combination of Tahitian imagery and Western themes, self-consciously imbued with a psychic dimension, Gauguin merges his personal brand of Post-Impressionism with a Symbolist quality.

Window on the World Ten

Gauguin and Oceania

Following the eighteenth-century Enlightenment, there developed a new interest in Oceania, which includes Polynesia, Melanesia, Micronesia, and New Guinea (see map). The possibility that humans existed there in the utopian state of nature posited by Jean-Jacques Rousseau intrigued western Europe. Between 1768 and 1778, Captain Cook made three voyages to the South Seas. Collectors began to focus on Oceanic objects that had been brought back by explorers.

Descriptions and drawings of the native populations, their artifacts, dwellings, costumes, and even their tattoos achieved a certain popularity in Europe.

In 1872, Sarah Bernhardt was given a drawing of the monumental statues on Easter Island, imposing stone figures with huge heads and blocklike features. They date from the fifth to the seventeenth century A.D. and are the most impressive Oceanic sculptures (fig. **W10.1**). Their frontal poses and impassive gazes

endow them with a fascinating, timeless quality. Some mark burials, but their primary purpose was to embody the divine power of a deceased ruler. As such, they can be related to ancestor cults throughout the world, such as the Cambodian cult of the sun king at Angkor (see Window 6).

By the latter half of the nineteenth century, after the fashion for *japonisme* had been established, ethnology museums became more numerous and

Oceania.

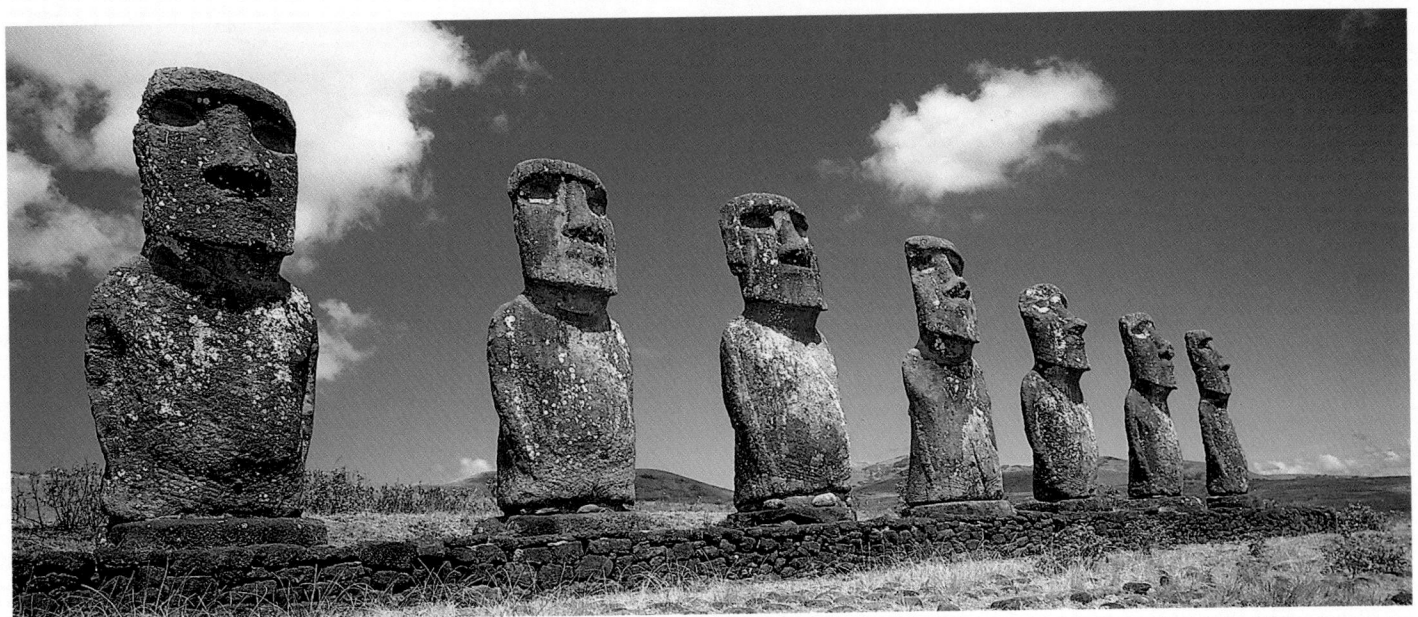

W10.1 Stone heads, Easter Island, 5th–17th centuries.

began to mount exhibits of Oceanic art. This development was encouraged by French colonial expansion in Africa and the Far East (especially Indochina) in the 1880s. In 1882, the Musée d'Ethnographie (Musée de l'Homme) opened in Paris, and the arts of Polynesia were well represented. In an effort to provide "context," the Universal Exposition of 1889 exhibited Oceanic objects in reconstructed village settings.

Gauguin was one of the first major artists to become interested in Oceanic culture and to collect its art and artifacts. The European fantasy of a "noble savage" appealed to him, and in 1891 he gave the following account of his intention to live and work in Tahiti:

> I am leaving in order to have peace and quiet, to be rid of the influence of civilization. I only want to do simple, very simple art, and to be able to do that, I have to immerse myself in virgin nature, see no one but savages, live their life, with no other thought in mind but to render, the way a child would, the concepts formed in my brain and to do this with the aid of nothing but the primitive means of art, the only means that are good and true.[3]

For Gauguin, Tahiti had many complex associations. It was one aspect of the ambivalent self he depicted in the *Self-Portrait* of 1889. He saw Tahiti as a new Eden, an island paradise, where nature took precedence over the corrupt, industrial, "civilized" West, and he described his trip as a return to the "childhood of mankind." The South Seas also fueled the eclectic character of his art. For he never renounced the Western tradition, in which he was deeply immersed. His affinity with late nineteenth-century European abstraction is evident in his

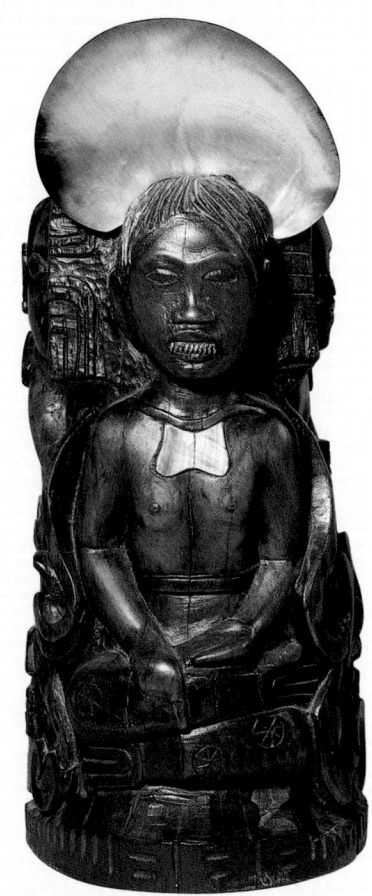

W10.2 Paul Gauguin, *Idol with the Seashell*, c. 1893. Wood; 10⅝ in. (27.0 cm) high. Musée d'Orsay, Paris.

reply to a question about his "red dogs" and "pink skies":

> It's music, if you like! I borrow some subject or other from life or from nature as a pretext, I arrange lines and colors so as to obtain symphonies, harmonies that do not represent a thing that is real, in the vulgar sense of the word, and do not directly express any idea, but are supposed to make you think the way music is supposed to make you think, unaided by ideas or images, simply through the mysterious affinities that exist between our brains and such arrangements of colors and lines.[4]

Gauguin was a prodigious synthesizer of different artistic traditions, including those of western Europe, Japanese woodblock, and the sculpture of Egypt, Oceania, Indonesia, and the Far East. For example, he combined Oceanic mythology with Christian and Buddhist iconography. In the *Idol with the Seashell* (fig. **W10.2**) of about 1893, the figure represents Taaroa, who was worshiped on Easter Island as the divine creative force of the universe. The prominent teeth, made of inlaid bone, carry cannibalistic implications. But the idol occupies a traditional pose of Buddha, and the rounded, polished shell is reminiscent of the Christian halo. In such works as this, Gauguin helped to correct the popular misunderstanding of the tribal arts as primitive in the sense of regressive. For him, the incorporation of various non-Western forms and motifs into Western art expanded intellectual as well as aesthetic experience.

The Symbolist Movement

Symbolism was particularly strong in France and Belgium in the late nineteenth century. It began as a literary movement, emphasizing internal psychological phenomena rather than objective descriptions of nature.

The English word *symbol* comes from the Greek word *sumbolon,* meaning "token." It originally referred to a sign that had been divided in two and could be identified because the two halves fitted together. A symbol thus signifies the matching part or other half. It is something that stands for something else. Symbols derive from myth, folklore, allegory, and dreams. The Symbolists believed that, by focusing on dreams, it was possible to rise above the here and now of a specific time and place, and arrive at what is universal. It is no coincidence that the Symbolist movement in art and literature was contemporary with advances in psychology and psychoanalysis.

In literature, the poets' "Symbolist Manifesto" of 1886 rejected Zola's Naturalism in favor of the Idea and the Self. The French poets Charles Baudelaire, Stéphane Mallarmé, and Paul Verlaine became cult figures for the Symbolists, as did the American author Edgar Allan Poe and the Swedish philosopher Emanuel Swedenborg. Their literature of decadence, disintegration, and the macabre shares many qualities with Symbolist painting. An erotic subtext, often containing perverse overtones, pervades and haunts the imagery.

The Symbolists rejected both the social consciousness of Realism and the Impressionist interest in nature and the outdoors. They were attracted instead by the internal world of the imagination and by images that portrayed the irrational aspects of the human mind. Their interest can be related to Goya's Romantic preoccupation with dream and fantasy and Géricault's studies of the insane. They were drawn to mythological subject matter because of its affinity with dreaming, but their rendition of myth was neither heroic in character nor Classical in style. Rather, it was disturbed and poetic, and contained more than a hint of perversity.

Gustave Moreau

Gustave Moreau (1826–1898) was the leading artist of the Symbolist movement in France. His *Orpheus* (fig. **23.23**) depicts an imaginary scene from the Greek myth of the musician who was killed and torn limb from limb by maenads—frenzied female followers of Dionysos. Here, a young woman dressed in rich fabrics gazes down at the severed head of Orpheus as it lies across his lyre. Both she and the head are somewhat idealized, and there is a sense of languid passivity in their expressions, enhanced by the soft yellow light. The idyllic episode at the top of the craggy mountain on the left together with the peaceful quality of Orpheus and the woman belie the violence that has preceded the present moment.

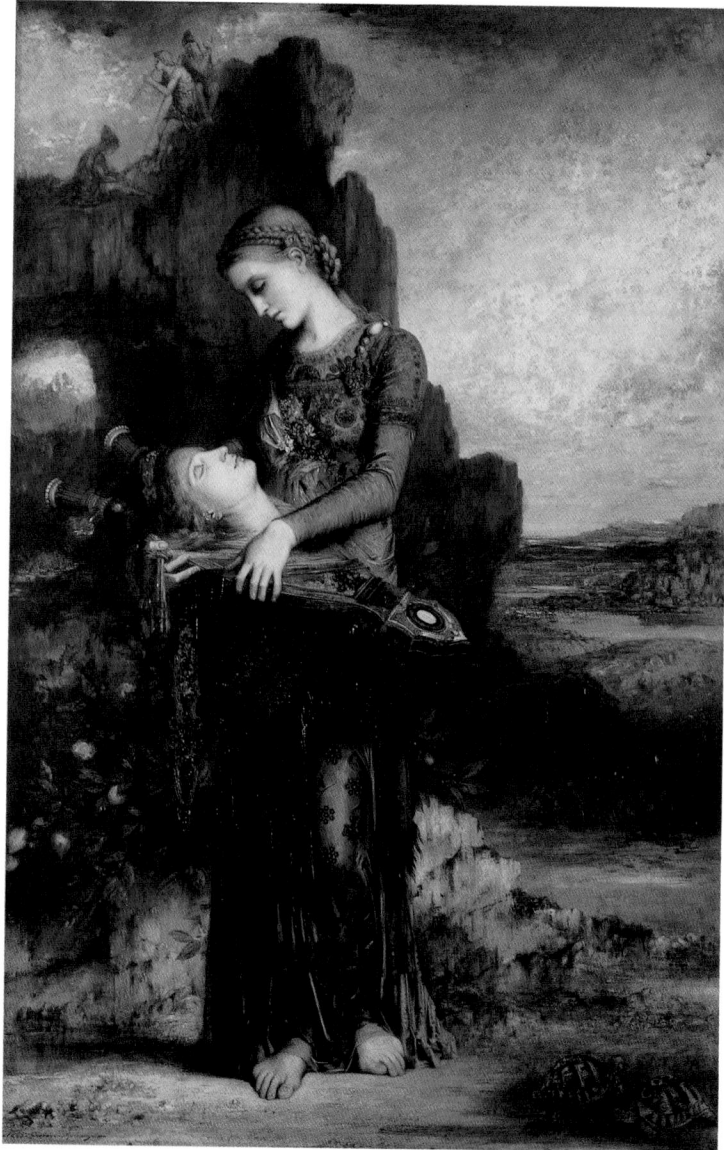

23.23 Gustave Moreau, *Orpheus*, 1865. Oil on canvas; 5 ft. 1 in. × 3 ft. 3½ in. (1.5 × 1.0 m). Musée d'Orsay, Paris. This painting was shown in the Paris Universal Exposition of 1867. The two turtles in the lower right corner, an apparently anomalous feature, may refer to the legend that Orpheus made his lyre by stringing a hollow tortoiseshell. To a public that knew the story of Orpheus, this painting must have seemed macabre indeed.

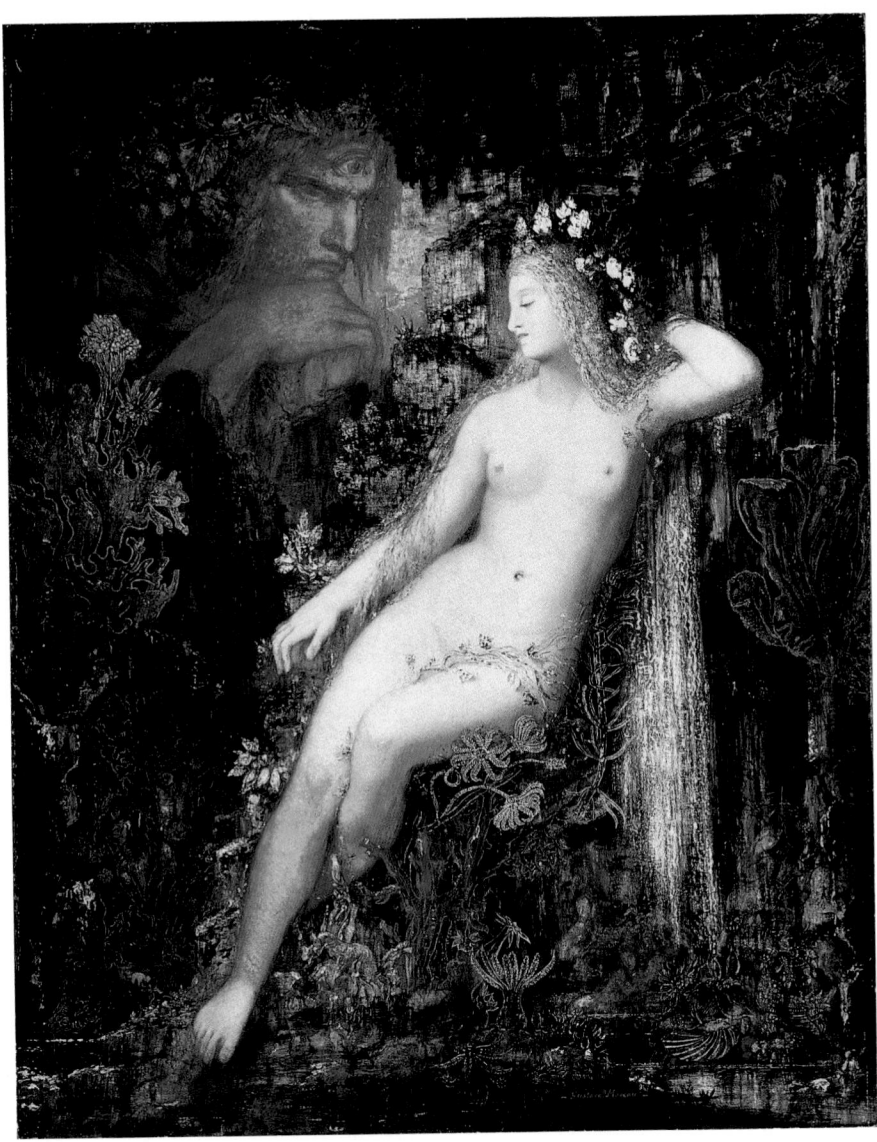

23.24 Gustave Moreau, *Galatea*, 1880–1881. Oil on panel; 33½ × 26⅓ in. (85.1 × 66.9 cm). Musee d'Orsay, Paris.

In *Galatea* (fig. **23.24**), Moreau reverses the relationship of observer to observed. In *Orpheus,* the woman gazes at the severed head of a man, whereas in the *Galatea* the male, who is the Cyclops Polyphemos (see Chapter 4), gazes at the woman—in this case, Galatea—through the large single eye in the middle of his forehead. He holds the stone with which he has killed her human lover, Acis, because of his primitive longing for her. Like the woman in the *Orpheus,* the very idealization of the Cyclops is sinister, for it is at odds with his bestial nature. Both scenes depict tales of unrequited love and passion turned to murder, and both are pervaded by a disturbing calm. As in the *Orpheus,* an eerie, unreal light transports the *Galatea* into the realm of the imagination: the Cyclops is bathed in orange light, and Galatea is illuminated by white light. There is no rational explanation for the discrepant illumination. Galatea reclines on a bed of mysterious, translucent flowers, and her pose recalls the traditional reclining nude, which enhances the impression of her vulnerability.

A comparison of Moreau's *Orpheus* and *Galatea* with other works discussed in this chapter makes it clear that, while the ideas of the Symbolists influenced certain Post-Impressionists, the Symbolist style did not.

Edvard Munch

The Norwegian artist Edvard Munch (1863–1944) went in 1889 to Paris, where he came into contact with Impressionism and Post-Impressionism. The combination of Symbolist content with Post-Impressionism was particularly well suited to Munch's character. His mental suffering, like van Gogh's, was so openly acknowledged in his imagery and statements that it is unavoidable in considering his work. His pictures conform to Symbolist theory in that they depict states of mind, emotions, or ideas rather than observable physical reality. The style in which Munch's mental states are expressed, however, is Post-Impressionist in its expressive distortions of form and its use of nonlocal color.

In his best-known painting, *The Scream* (fig. **23.25**) of 1893, Munch displaces his sense of disintegration onto a figure crossing the bridge over Oslo's Christianafjord. The bright colors—reds, oranges, and yellows—intensify the sunset, with darker blues and pinks defining the water. Both sky and water seem caught up in an endless swirl that echoes the artist's anguish. In contrast to the pedestrians at the far end of the bridge, Munch stops to face the picture plane, simultaneously screaming and holding his ears. The action of blocking out the sound pushes in the sides of his face so that his head resembles a skull and repeats the landscape curves. Munch described the experience depicted in this painting as follows: "I felt as though a scream went through nature—I thought I heard a scream—I painted this picture—painted the clouds like real blood. The colors were screaming."[5] He thus joins the scream of nature as his form echoes the waving motion of the landscape.

In *The Voice* (fig. **23.26**), painted the same year as *The Scream,* Munch's figure merges with the landscape by repeating the vertical tree trunks. In contrast to the fluid curves and warm colors of *The Scream, The Voice* is painted in cool colors, and the forms have sharp edges, varied mainly by the gradual slope of the shoreline, a few details of foliage, and the small white boat visible between the trees. The figure conveys a sense of rigid tension, suggesting that the sound of a voice has terrorized her into immobility. Her form is eerily echoed by the yellow moon and its odd, vertical reflection in the water, which Munch repeated in several compositions.

Munch also evokes the folklore associated with the moon, which, as we saw in Friedrich's *Two Men Contemplating the Moon* (fig. 20.19), is imbued with mysticism and magic. *The Voice* was the first of a series called *Love* that became part of Munch's *Frieze of Life,* a loosely organized frieze composed of his paintings—including *The Scream*—arranged to demonstrate his philosophy that art reflects life.

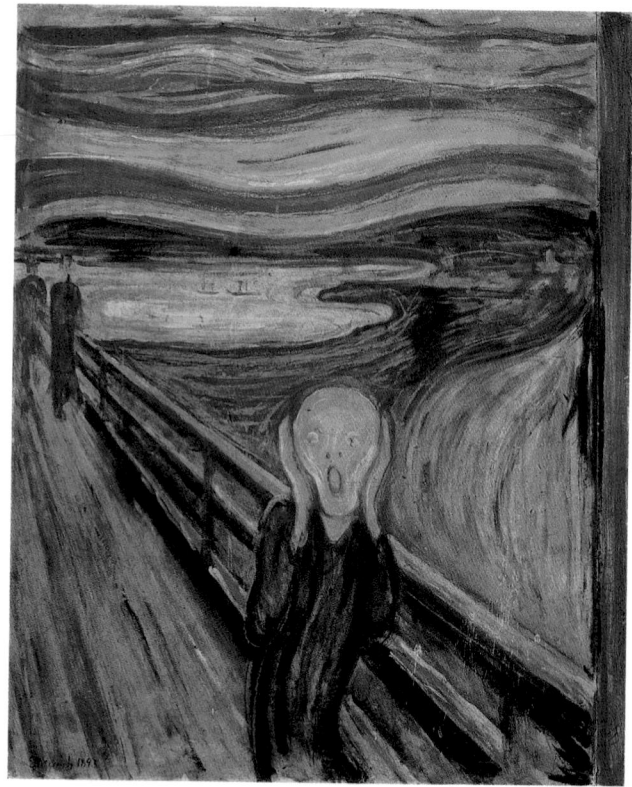

23.25 Edvard Munch, *The Scream*, 1893. Oil, pastel, and casein on cardboard; 35¾ × 29 in. (90.8 × 73.7 cm). National Gallery, Oslo. In 1892, Munch received electric shock treatment for depression and lived thereafter in almost total seclusion. Anxiety is one of Munch's favorite themes, along with death, illness, despair, and other forms of suffering.

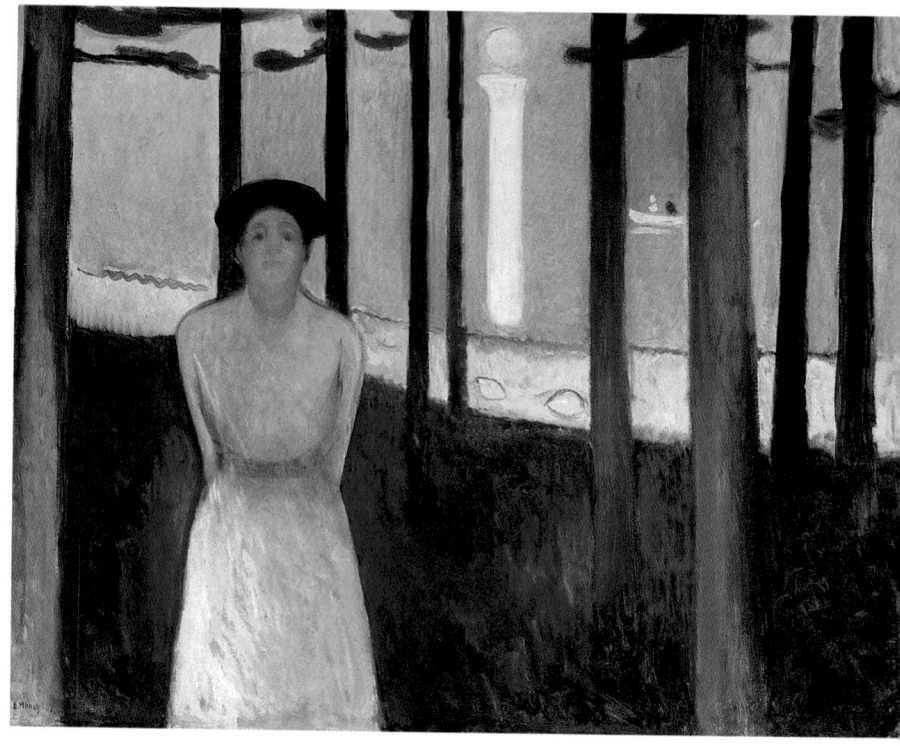

23.26 Edvard Munch, *The Voice*, 1893. Oil on canvas; 34½ × 42½ in. (87.5 × 108 cm). Museum of Fine Arts, Boston.

Fin de Siècle Developments

The last decade of the nineteenth century witnessed the emergence of several related styles. All signaled a reaction against the revival styles of the earlier part of the century. This period, and a few years on either side of it, is referred to as *fin de siècle* ("end of century").

Aestheticism

The principal tenet of Aestheticism was that the sole justification of art is its intrinsic beauty. This notion derived from the philosophy of Immanuel Kant, who believed that aesthetics should be independent of morality and utility. In France, this became the popular *l'art pour art* ("art for art's sake") movement. In England, Whistler had championed this view of art in his lawsuit against Ruskin.

The playwright Oscar Wilde (1854–1900) was also a spokesman for the Aesthetic movement in England. His writings and lifestyle alternately amused and shocked polite society, and in 1895 he was sentenced to prison for homosexual offenses. Aubrey Beardsley (1872–1898), the leading illustrator of the decade, created what he called "embellishments" of Wilde's play *Salomé*. (In the Gospel of Matthew 14:1–12, Salomé's mother, Herodias, persuades her daughter to charm King Herod with her dancing and then to demand the head of John the Baptist as her reward.) Figure **23.27** shows Beardsley's portrayal of Salomé fondling John's severed head. The legend below reads: "J'AI BAISÉ TA BOUCHE IOKANAAN/J'AI BAISÉ TA BOUCHE" (I have kissed your mouth, Jokanaan, I have kissed your mouth). John's Medusa-like hair hangs limply, whereas Salomé's stands on end. Echoing this contrast at the bottom of the drawing is an open, erect flower beside a drooping bud. The blood from John's neck drips into a dark pool.

Beardsley's use of strong blacks, his emphasis on the unnatural and the macabre, and his taste for sexual metaphors with decadent overtones are characteristic of the *fin de siècle* aesthetic. So, too, are the ambiguous features of Salomé and John. Both have an androgynous quality and, were it not clear from the context, it would be difficult to say which was male and which female. This is also a projection of Beardsley himself, for although he was not overtly bisexual, as Wilde was, there is evidence that he engaged in cross-dressing.

Conservative critics denounced Beardsley's work for its decadence. Those who believed that art without morality has no value railed at his thinly disguised eroticism. After the trial and conviction of Oscar Wilde, a general revulsion against Aestheticism set in. Nevertheless, in focusing on the formal, aesthetic qualities of art, the movement was partially successful in establishing the independence of art from ethical considerations.

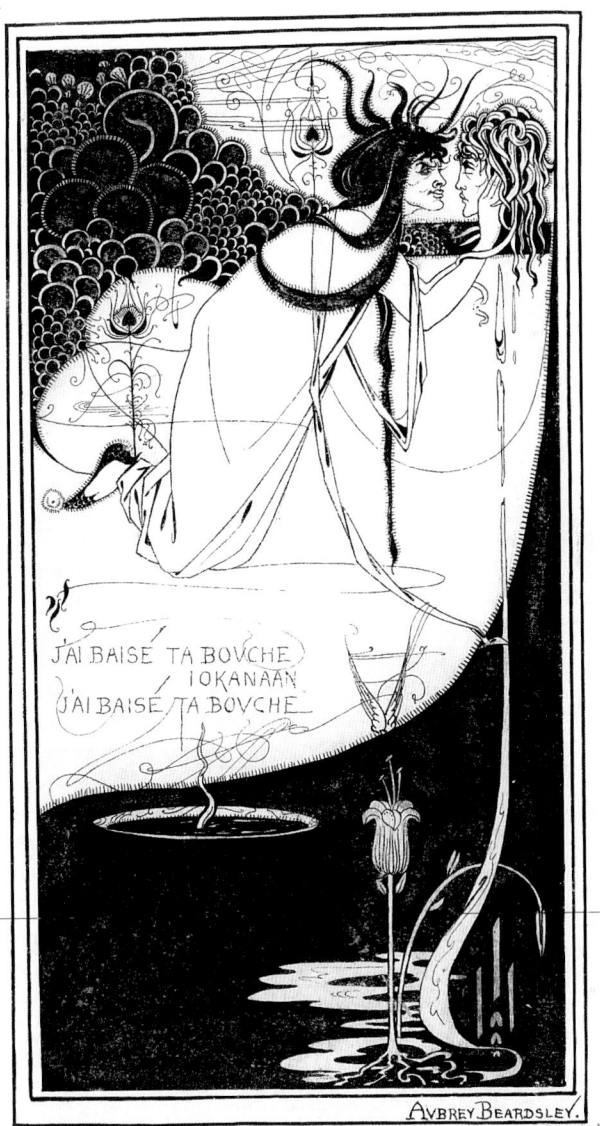

23.27 Aubrey Beardsley, *Salomé with the Head of John the Baptist*, 1893. Pen drawing; 11 × 6 in. (27.9 × 15.2 cm). Princeton University Library.

Art Nouveau

Art Nouveau ("New Art") was an ornamental style composed of curvilinear, organic forms that was a European-wide response against industrialization and the prevalence of the machine. In France it was known as the *Style Moderne,* or "Modern Style," in Germany as the *Jugendstil* ("Youthful Style"), and in Italy as the *Stile Liberty* (after Liberty of London, a store that imported Art Nouveau fabrics). The style is characterized by sinuous, asymmetrical, linear patterns that mainly influenced architecture and the decorative arts—especially glass, furniture, jewelry, and wrought-iron work.

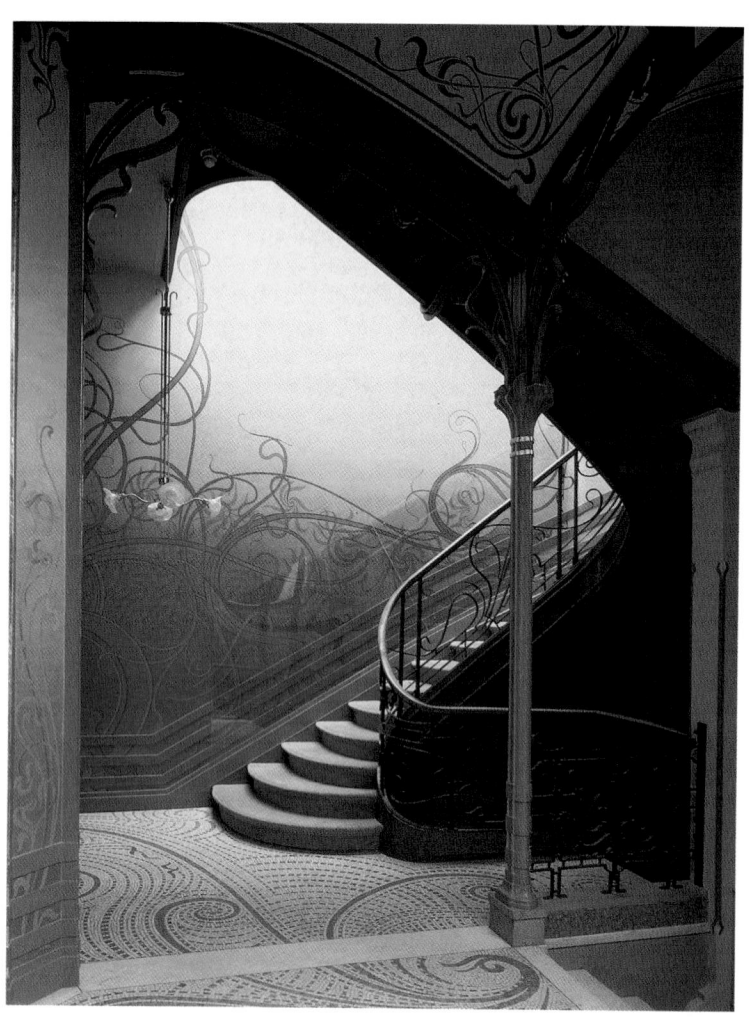

23.28 Victor Horta, staircase of the Maison Tassel, Brussels, 1892.

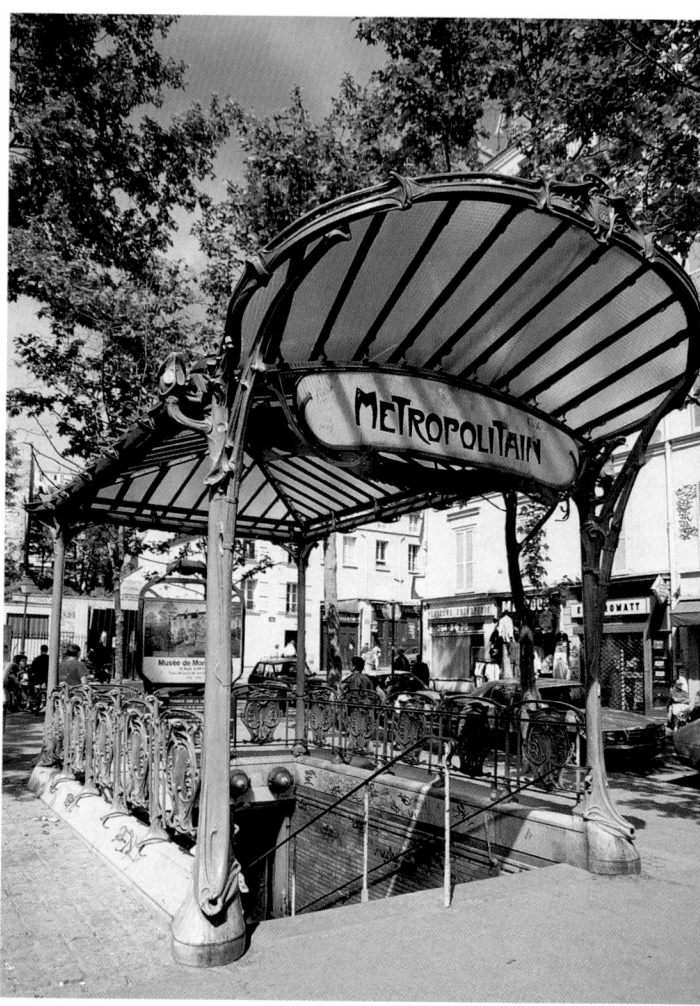

23.29 Hector Guimard, entrance to a Métro station, Paris, 1900.

From 1892 to 1893 the Belgian architect Victor Horta (1861–1947) designed a house for the Tassel family of Brussels. His patron, Professor Tassel, typified the new generation that wanted to express its opposition to the tastes of the older aristocracy. Figure **23.28** shows the staircase of the house, which reflects the undulating, organic lines of Art Nouveau. They resemble the natural forms of plant stalks, tendrils, vinescrolls, insect wings, and peacock tails. Here, the ornamental ironwork corresponds to the designs painted on the adjoining wall.

Figure **23.29** illustrates the entrance to a Métropolitain (Métro) subway station in Paris. It was designed in 1900 by Hector Guimard (1867–1942) from prefabricated glass and metal. The tall, thin, curvilinear lampposts on either side of the entrance recall certain plant stalks and flowers, and seem to stand on tiptoe. Also reminiscent of floral designs is the elegant ironwork railing that surrounds the opening in the sidewalk. Even the lettering of the sign—"METROPOLITAIN"—corresponds to the sinuous, linear style of Art Nouveau.

The Vienna Secession

Fin de siècle Vienna, the capital of the Austro-Hungarian Empire, was a city of contradictions. The Hapsburg monarchy persisted amid the growth of a liberal bourgeoisie. Technology advanced against a backdrop of conservative nationalism. And Sigmund Freud was formulating a theory of the mind that exploded entrenched philosophical and religious traditions of western Europe.

The resistance to change in Viennese society was nowhere more evident than in its attitude to contemporary art. The visual arts were dominated by two institutions—the Akademie der Bildenden Künste and the Künstlerhausgenossenschaft. The former was Vienna's teaching academy, the latter a private society that owned the city's only exhibition space. Both were conservative and in control of all exhibitions in Vienna, as well as of Austrian exhibits abroad.

In 1897, a group of artists broke away and formed the independent Vereinigung Bildender Künstler Österreichs (Secession), known as the "Vienna Secession." This group did not champion any one artistic style, even though the *Jugendstil* was strongly represented. Rather, its purpose was to provide a forum for diverse styles which shared the rejection of Academic naturalism. The leader of the Secession and its first president was Gustav Klimt (1862–1918), an established painter in the Academic tradition.

Within eighteen months of its formation, the Secession held two successful exhibitions and built its own exhibition hall. Klimt designed the poster (fig. **23.30**) and the cover of the catalogue for the first exhibition. The poster shows a scene derived from Greek mythology—a vigorous Theseus about to plunge his sword into the Minotaur. This symbolizes youth (Theseus) heroically destroying the oppressive forces of conservatism (the Minotaur). Athena, armed as if to defend the wisdom of artistic rebellion, stands at the far right. She is rendered in profile, holding up the Gorgon shield which faces the viewer.

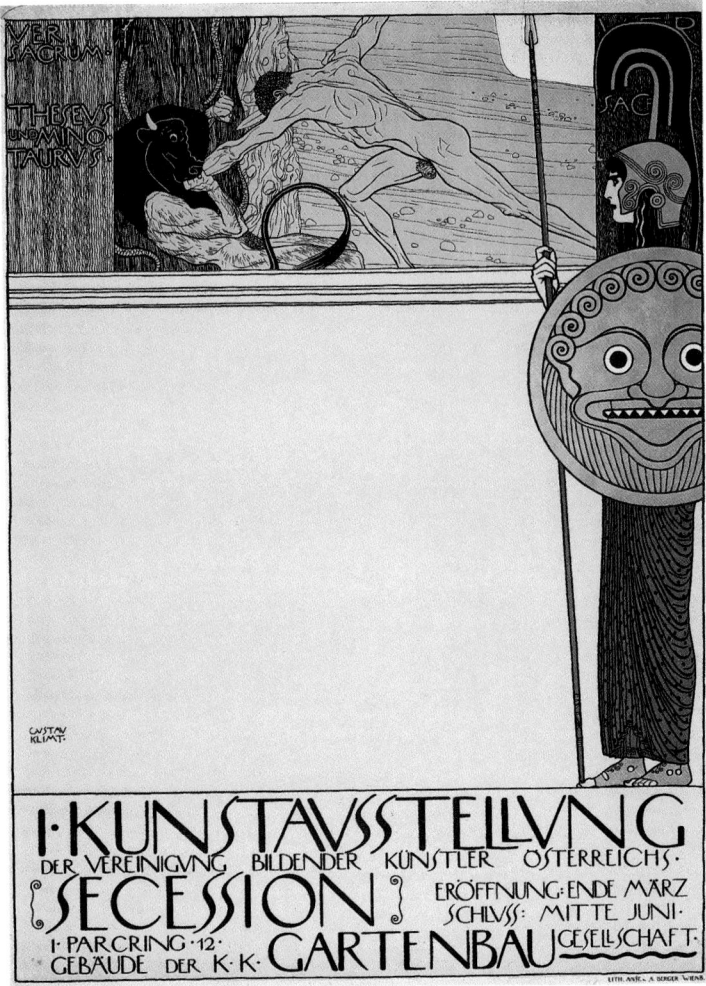

23.30 Gustav Klimt, *Ver Sacrum,* depicting Theseus and the Minotaur, c. 1898. Poster for the first Secession exhibition. Historisches Museum der Stadt, Vienna.

In 1894, Klimt was commissioned to paint a series of allegorical murals for the University of Vienna. Their completion was long delayed, and when Klimt produced the first, full-sized version of one of these, it was clear that his style had radically changed. Because of public criticism, he never completed the project. Klimt's mature style is evident in the *Kiss* (fig. **23.31**) of 1908, in which the kneeling, silhouetted forms of a man and a woman—possibly the artist and his mistress—blend into the design. Aside from their heads and limbs, the figures are submerged by the lively, gold surface patterns.

The remainder of this text surveys the major styles of twentieth-century art, which derive from certain nineteenth-century developments. Realism had introduced a new social consciousness into the visual arts, and Impressionism had made artists and viewers alike aware of the potential, expressive power of the medium. Post-Impressionists explored various ways in which individual brushstrokes could enhance and construct images, even to the point where paint intruded on the subject. At the same time, Symbolism took up the Romantic interest in giving visual form to states of mind. The nineteenth century ended with an artist in whose work both the medium and the imagination were combined as new subjects in Western art.

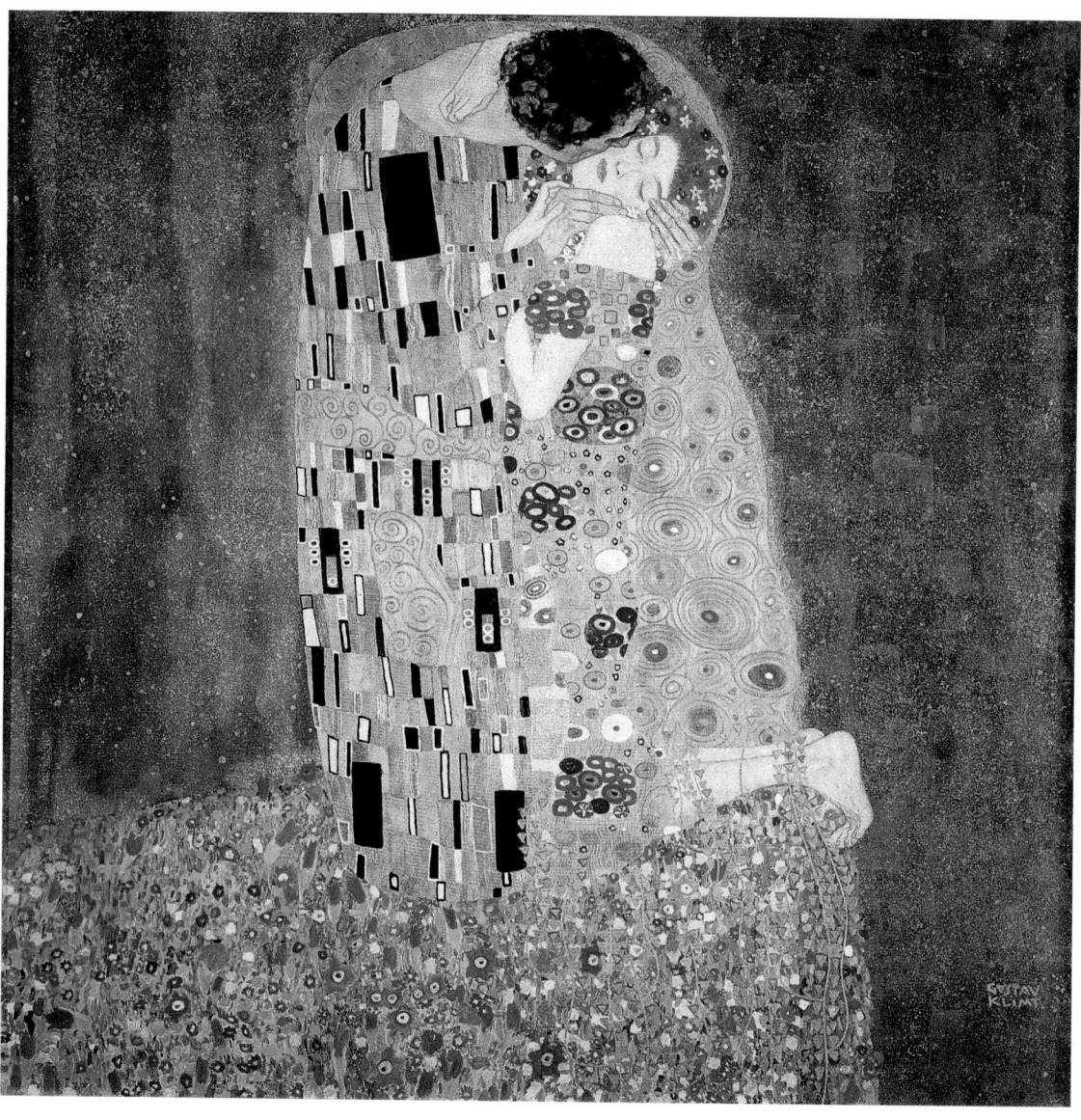

23.31 Gustav Klimt, *Kiss*, 1908. Oil on canvas; 5 ft. 10⅞ in. × 5 ft. 10⅞ in. (1.8 × 1.8 m). Österreichische Galerie, Vienna.

Henri Rousseau

Although Henri Rousseau (1844–1910) worked largely during the latter part of the nineteenth century, his impact on Western art history must be seen in the context of the first half of the twentieth century. He has been called a naive painter because he had no formal training and spent most of his working life as a customs inspector near Paris—hence his nickname "Le Douanier" (Customs Officer). He painted in his spare time, exhibited at the Salon des Indépendants, and in 1885 retired from his job to become a full-time painter. At first mocked by the critics, Rousseau was later much admired. In 1908, Pablo Picasso (see Chapter 24) held a banquet in his honor at his Montmartre studio.

Rousseau's last great work, *The Dream* (fig. **23.32**), was painted in 1910 shortly before his death and eleven years

CONNECTIONS

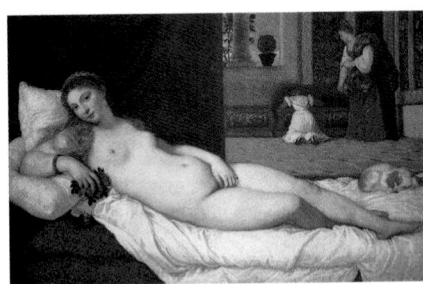

See figure 14.52.
Titian, *Venus of Urbino*, c. 1538.

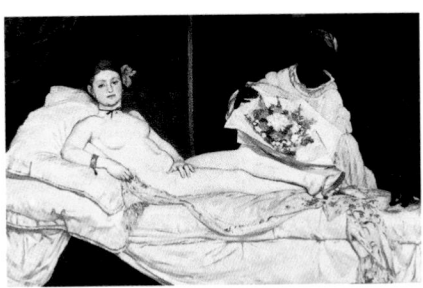

See figure 21.26.
Édouard Manet, *Olympia*, 1865.

23.32 Henri Rousseau, *The Dream*, 1910. Oil on canvas; 6 ft. 8½ in. × 9 ft. 9½ in. (2.05 × 2.99 m). Museum of Modern Art, New York (Gift of Nelson A. Rockefeller).

The Mechanisms of Dreaming

In 1899, Sigmund Freud published *The Interpretation of Dreams*. Although initially only a few copies were sold, its impact on Western thought has been enormous. As defined by Freud, there are four mechanisms of dreaming:

1. *Representability* means that an idea or a feeling can be changed into a picture. The dream picture is an unconscious regression from words to images, whereas works of art are consciously produced.

2. *Condensation* merges two or more elements into a new, disguised form. In Rousseau's *The Dream*, the jungle is condensed with a European sitting room, and day is condensed with night.

3. *Displacement* means moving an element from its usual setting to another place. The dark musician in *The Dream* is an example, for nonhuman features have been displaced onto him. Displacement can result in condensation. Geographical condensation in Rousseau's picture is achieved by displacing the couch into the jungle.

4. *Symbolization* is the process of symbol making. A symbol is something that stands for something else. In *The Dream*, the flowers, fruit, serpent, musician, jungle setting, and nude may be interpreted as symbols of the dreamer's sexual fantasies.

after the publication of Freud's *The Interpretation of Dreams* (see box). The painting shows a nude, reclining but alert, who has been transported on a Victorian couch to a jungle setting, complete with wild animals and abundant flowers and foliage. Emerging from the jungle depths is a dark gray creature, clothed and upright, who is simultaneously animal and human and plays a musical instrument. The bizarre gray of its face and skin contrasts with the bright jungle colors. The daytime sky is at odds with the normal time for dreaming, which is night.

When asked about the unlikely juxtaposition of the couch with the jungle in *The Dream*, Rousseau provided two different answers. In the first, he said that the woman is the dreamer; she is sleeping on the couch, and both have been transported to the jungle. In the second, he said that the couch was there simply because of its red color. The following inscription by Rousseau was posthumously published in the French journal *Soirées de Paris* on January 15, 1914:

In a beautiful dream
Yadwigha gently sleeps
Heard the sounds of a pipe
Played by a sympathetic charmer

While the moon reflects
On the rivers and the verdant trees
The serpents attend
The gay tunes of the instrument.

In one sense, *The Dream* can be regarded as a synthesis of the two main trends in western European art at the turn of the century. For lack of better terminology, these trends may be described as "subjectivity" (one of the primary characteristics of Romanticism and Symbolism) and "objectivity" (the ideal aspired to by the Realists and Impressionists.) In *The Dream*, Rousseau merges the visionary world of dream and imagination with a detailed depiction of reality. To this end, he made a careful study of leaves and flowers, although their very "reality" in this painting has an eerie quality. However, *The Dream* is remarkably consistent with Freud's account of the mechanisms of dreaming and, as such, looks forward to twentieth-century Surrealism (see Chapter 26). Rousseau's image merges the dream (the picture) with the dreamer (the nude). Its precise, clear edges serve to contain the wild character of the jungle, which represents the primitive forces revealed in dreams.

Style/Period	Works of Art	Cultural/Historical Developments

Stone heads, Easter Island (**W10.1**)

Stone heads, Easter Island

1850

POST-IMPRESSIONISM AND THE LATE NINETEENTH CENTURY

1850–1880

Hiroshige, *Sudden Shower at Ohashi Bridge at Ataka* (**23.13**)
Moreau, *Orpheus* (**23.23**)
Cézanne, *Temptation of Saint Anthony* (**23.3**)
Cézanne, *Self-Portrait* (**23.4**)
Cézanne, *Still Life with Apples* (**23.5**)

Cézanne, Still Life with Apples

1880

1880–1890

Moreau, *Galatea* (**23.24**)
Seurat, *Sunday Afternoon on the Island of La Grande Jatte* (**23.8, 23.10**)
Seurat, *Monkey* (**23.9**)
van Gogh, *Potato Eaters* (**23.11**)
van Gogh, *Japonaiserie: Bridge in the Rain* (**23.12**)
van Gogh, *Bedroom at Arles* (**23.14–23.15**)
van Gogh, *Self-Portrait* studies (**23.18**)
van Gogh, *Self-Portrait* (**23.19**)
van Gogh, *Starry Night* (**23.17**)
van Gogh, *Wheat Field with Reaper* (**23.16**)
Gauguin, *The Yellow Christ* (**23.20**)
Gauguin, *Self-Portrait with Halo* (**23.21**)

van Gogh, Self-Portrait

1890

1890–1900

Toulouse-Lautrec, *La Goulue at the Moulin Rouge* (**23.2**)
Toulouse-Lautrec, *Quadrille at the Moulin Rouge* (**23.1**)
Horta, staircase of the Maison Tassel (**23.28**), Brussels
Gauguin, *Idol with the Seashell* (**W10.2**)
Munch, *The Scream* (**23.25**)
Munch, *The Voice* (**23.26**)
Beardsley, *Salomé with the Head of John the Baptist* (**23.27**)
Gauguin, *Nevermore* (**23.22**)
Klimt, *Ver Sacrum* poster (**23.30**)
Cézanne, *Great Bathers* (**23.6**)

Gauguin, Nevermore

Cézanne, Mont Sainte-Victoire

Rudolf Diesel patents internal combustion engine (1892)
Emergence of Art Nouveau in Europe (1893)
Cinematograph invented (1894)
Sino-Japanese War; the Japanese victorious (1894–1895)
Wireless telegraphy invented by Guglielmo Marconi (1895)
Richard Strauss, *Till Eulenspiegel's Merry Pranks* (1895)
Giacomo Puccini, *La Bohème* (1896)
The Curies discover radium (1898)
Boer War; the English defeat the South Africans (1899–1902)
Sigmund Freud, *The Interpretation of Dreams* (1899)

Munch, The Scream

1900

1900–1910

Cézanne, *Mont Sainte-Victoire* (**23.7**)
Guimard, entrance to a Métro Station (**23.29**), Paris
Klimt, *Kiss* (**23.31**)
Rousseau, *The Dream* (**23.32**)

Anton Chekhov, *Uncle Vanya* (1900)
Joseph Conrad, *Lord Jim* (1900)
Theodore Dreiser, *Sister Carrie* (1900)
Max Planck formulates quantum theory (1900)
Discovery of Minoan culture in Crete (1900–1909)
Wright brothers' first flight in a powered airplane (1903)
G. E. Moore, *Principia Ethica* (1903)
Jack London, *The Call of the Wild* (1903)
Anton Chekhov, *The Cherry Orchard* (1904)
James Barrie, *Peter Pan* (1904)
Giacomo Puccini, *Madama Butterfly* (1904)
Edith Wharton, *The House of Mirth* (1905)
Emmeline Pankhurst launches suffragette movement (1906)
William James, *Pragmatism* (1907)
Lord Baden-Powell founds the Boy Scouts (1907)
E. M. Forster, *A Room with a View* (1908)
Ford Motor Company produces first Model T car (1908)

1910

Rousseau, The Dream

Guimard, entrance to a Métro Station

CHAPTER PREVIEWS

TURN OF THE CENTURY

Worringer: *Abstraction and Empathy* (1908); *The Historical Development of Modern Art* (1911)
Wöfflin: *The Principles of Art History* (1915)
Technology advances; Russian Revolution (1917)
Picasso's Blue Period; Matisse's Fauvism
Expressionism in Germany
 The Bridge: Kirchner; Nolde
 The Blue Rider: Kandinsky; Marc
Kollwitz
Matisse after Fauvism; collage

African Art and the European Avant-Garde

CUBISM, FUTURISM, AND RELATED STYLES

Picasso's Rose Period; *Les Demoiselles d'Avignon* (1907)
Analytic Cubism: Picasso; Braque
Collage and assemblage; Synthetic Cubism
Picasso's Surrealism; Futurism (Boccioni)
Artists influenced by Cubism: Léger; Mondrian; Duchamp; Brancusi; Davis; Douglas
The 1913 Armory Show, New York; Harlem Renaissance
Russia: Malevich's Suprematism
Architecture: the Bauhaus (Gropius); International Style (Le Corbusier, van der Rohe); Prairie Style (Frank Lloyd Wright)

DADA, SURREALISM, FANTASY, AND THE UNITED STATES BETWEEN THE WARS

World War I (1914–1918); Dada in Zurich
Duchamp's Ready-Mades; Breton's *Surrealist Manifesto*
European painters: de Chirico; Klee; Dalí; Miró; Magritte; Ernst

Hopi Kachinas
The Hopi pueblo

Sculptors: Giacometti; Moore; Calder (mobiles)
American painters: Wood; Lawrence; Hopper; Dove; O'Keeffe; Pelton; Moses; Pippin
Photographers: Man Ray; Van Der Zee; Evans; Lange; Weston; Stieglitz
Mexico: Rivera; Kahlo

ABSTRACT EXPRESSIONISM

World War II (1939–1945)
Hofmann and Albers
Abstract Expressionism: Gorky; Pollock; de Kooning; Kline; Frankenthaler
Navajo Sand Painting
Color Field: Rothko; Reinhardt; Stella; Kelly
Sculptors: Noguchi; Smith; Nevelson
West Coast Abstraction: Diebenkorn
European Figuration: Dubuffet; Bacon

POP, OP, MINIMALISM, AND CONCEPTUALISM

Happenings (1960s)
Pop Art: Hamilton; Johns; Rauschenberg; Warhol; Lichtenstein; Lindner; Kitaj; Wesselmann; Thiebaud; Oldenburg; Segal; Marisol; de Saint-Phalle; Op Art: Riley
Minimalism: Judd; Flavin; Martin; Hesse; Conceptualism: Kosuth

INNOVATION, CONTINUITY, AND GLOBALIZATION

Controversy in the United States: government funding for the arts; Serrano; Mapplethorpe
Performance : Gilbert and George; Anderson; Nauman
Return to Realism: Close; Hanson; Estes; Mueck
Installation: Holzer; Barney
Fuller (geodesic dome); Breuer (Whitney Museum)
Post-Modern architecture: Moore and Hersey; Graves; Pei; Rogers
Environmental art: Smithson; Holt; the Christos; Goldsworthy
Feminism: Chicago; Smith; Lin; Sherman; Rothenberg
Graffiti-inspired painting: Basquiat
Video: Paik; Viola; Neshat

The twentieth century witnessed a proliferation of styles, resulting in part from rapid global communication. Early in the century, the innovations of Matisse, Kandinsky, and Picasso revolutionized the approach to the picture plane. These three, like many avant-garde artists, sought to break the hold of the Classical tradition on Western consciousness. To this end, they studied the non-Classical forms of African and other non-Western art. But because Europe was shattered by two world wars, many artists by the end of World War II had emigrated to New York, which supplanted Paris as the art center of the Western world.

Newness became an end in itself, leading to such innovative styles as Dada and Surrealism, Cubism and Futurism, Abstract Expressionism and Pop Art, Minimalism and Conceptualism, Photo-Realism and others. Before 1917, Moscow had been a center of the avant-garde, along with Dresden and Munich. But totalitarianism in Russia and Germany considered modernism subversive. In the United States, the influx of European artists, combined with the young generation of Americans, enriched the visual arts. There had also been a rise in the cultural contributions of black artists, writers, and philosophers that formed the Harlem Renaissance. In addition, new media were explored—plastics, manufactured objects, and video—that opened up new artistic possibilities. In the early years of the twenty-first century, these trends continued, and the arts increasingly reflected the cross-cultural character of globalization.

24

Turn of the Century:
Early Picasso, Fauvism,
Expressionism, and Matisse

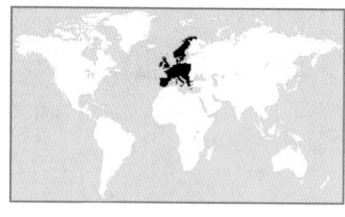

Western history is traditionally divided into centuries, and historians tend to see significance in the "turn of a century." Given the span of human history from the Paleolithic era, in which the first known works of art were produced, a century represents a small, almost infinitesimal, fragment of time. Nevertheless, as we consider historical events that are closer to our own era, their significance seems to increase and time itself to expand. Although we measure the prehistoric era by millennia and later periods by centuries, we tend to measure our own century by decades—or less. Our perception of time depends upon its relation to ourselves.

From the perspective of the end of the twentieth century and the beginning of a new millennium, we can see that rapid changes occurred in many fields. Technological advances set in motion by the industrial revolution speeded up communication and travel to an unprecedented degree. Electric lights have been used from the 1890s, radios from 1895, cars from the early 1900s, televisions and computers from the 1950s, and the Internet from the 1980s. The Wright brothers flew the first airplane at Kitty Hawk in 1903. Sixty-six years later, in 1969, the United States put the first man on the moon. Great strides were made in medicine; Albert Einstein formulated the theory of relativity, and Freud founded the psychoanalytic movement.

In politics, too, major changes took place. Lenin led the Russian Revolution in 1917; by 1991 the Soviet Union was dissolved. World War I (1914–1918) decimated a generation of European men. Following the Great Depression of 1929, Europe witnessed the rise of Hitler and National Socialism, which culminated in World War II (1939–1945). The end of that war ushered in the anxieties of the nuclear age and new concerns about the future of the environment.

In the arts, there were rapid changes in styles, which often merged into one another. For the purposes of this text, the twentieth century is divided by the marker of World War II. Up to that point, Paris had been the undisputed center of the Western art world. As Gertrude Stein

(see p. 850) said, "Paris was where the twentieth century was." Paris exerted a strong pull on artists, who studied in its art schools, and on collectors and critics, who toured its studios, galleries, and museums. After the war, and partly because of it, many artists—indeed, entire schools of artists—were forced to flee Europe .

In 1900, many works by Impressionist and Post-Impressionist artists were shown at the World's Fair—the International Exposition—in Paris. These styles had emphasized the primacy of the medium. Building on this innovation, twentieth-century artists expanded into new areas, influenced in part by non-Western cultures. The nineteenth century had developed a taste for *japonisme* as a result of the influence of Japanese woodblock prints. In the early twentieth century, there was a growing interest in African art, the geometric abstraction of which appealed to artists, collectors, and critics.

Just as the Impressionists expanded subject matter by increasing the range of social classes depicted by Neoclassicism, twentieth-century artists developed a new iconography that included everyday objects. They also began to use new materials, such as plastics, which resulted from advances in technology. New techniques for making art were developed, especially in the second half of the century. Technological developments also encouraged new directions in architecture.

The very idea of "newness" became one of the tenets of modernism. The so-called avant-garde (literally, the "vanguard," who were leaders of artistic change) became a prominent force in Western art. Striving for avant-garde status contributed to the rapidity with which styles changed in the twentieth century.

Picasso's Blue Period

In painting, two figures dominated the first half of the twentieth century: the Spanish artist Pablo Picasso (1881–1973) and the French artist Henri Matisse (1869–1954). Both made sculptures but were primarily painters. In contrast to the experience of the Impressionists and Post-Impressionists, the genius of Picasso and Matisse was recognized rela-

tively early in their careers. Their paths crossed at the Paris apartment of Gertrude Stein, who held regular gatherings of artists and intellectuals from Europe and the United States.

Picasso and Matisse began their careers in the nineteenth century under the influence of Impressionism, Post-Impressionism, and Symbolism. They soon branched out —Picasso earlier than Matisse—and spearheaded the avant-garde, although their styles were quite distinct. Matisse began and ended as a colorist, with important evolutions along the way. Picasso, on the other hand, shifted from one style to another, often working in more than one mode at the same time (see Chapter 25). His first major style was Symbolist; it is referred to as his Blue Period.

Picasso's Blue Period lasted from approximately 1901 to 1904. Consistent with the Symbolist aesthetic, his "Blue" paintings depict a mood or state of mind—in this case, melancholy and pessimism. The predominance of blue as the mood-creating element reflects the liberation of color that had been effected by nineteenth-century Post-Impressionism.

Picasso emphasizes the somber quality of the *Old Guitarist* (fig. **24.1**) by the all-pervasive blue color and the shimmering, silver light (see box). The musician's long, thin, bony form, tattered clothes, and downward curves convey dejection. His inward focus enhances the impression that he is listening intently, absorbed in his music, and also indicates that he is blind. The elongated forms and flickering silver light hark back to the spirituality of El Greco.

24.1 Pablo Picasso, *Old Guitarist*, 1903. Oil on panel; 4 ft. ⅔ in. × 2 ft. 8½ in. (1.23 × 0.83 m). Art Institute of Chicago (Helen Birch Bartlett Memorial Collection). Picasso was born in Málaga on the south coast of Spain. His father, José Ruíz Blasco, was an art teacher devoted to furthering his son's career. (Picasso took his mother's family name.) From 1901 to 1904, Picasso moved among Paris, Barcelona, and Madrid, settling permanently in Paris in 1904. The subjects of Picasso's Blue Period were primarily the poor and unfortunate.

Wallace Stevens: "The Man with the Blue Guitar"

The Symbolist quality of Picasso's *Old Guitarist* appealed to the American poet Wallace Stevens (1879–1955), who wrote "The Man with the Blue Guitar" in 1937 in response to it:[1]

> The man bent over his guitar,
> A shearsman of sorts. The day was green.
>
> They said, "You have a blue guitar,
> You do not play things as they are."
>
> The man replied, "Things as they are
> Are changed upon the blue guitar."
>
> And they said then, "But play, you must,
> A tune beyond us, yet ourselves,
>
> A tune upon the blue guitar
> Of things exactly as they are." [Stanza I]
>
> And the color, the overcast blue
> Of the air, in which the blue guitar
>
> Is a form, described but difficult,
> And I am merely a shadow hunched
>
> Above the arrowy, still strings,
> The maker of a thing yet to be made;
>
> The color like a thought that grows
> Out of a mood, the tragic robe
>
> Of the actor, half his gesture, half
> His speech, the dress of his meaning, silk
>
> Sodden with his melancholy words,
> The weather of his stage, himself. [Stanza IX]
>
> Is this picture of Picasso's, this "hoard
> Of destructions," a picture of ourselves,
>
> Now, an image of our society?
> Do I sit, deformed, a naked egg,
>
> Catching at Good-bye, harvest moon,
> Without seeing the harvest or the moon?
>
> Things as they are have been destroyed.
> Have I? Am I a man that is dead
>
> At a table on which the food is cold?
> Is my thought a memory, not alive?
>
> Is the spot on the floor, there, wine or blood
> And whichever it may be, is it mine? [Stanza XV]

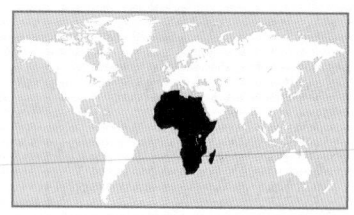

African Art and the European Avant-Garde

With the increasing number of ethnological museums at the end of the nineteenth century, non-Western art was becoming an aesthetic force in Europe. Against the background of nineteenth-century *japonisme*, the influence of Oceanic art, revivals of interest in Egyptian and Iberian art, and the spatial revolution of Cézanne, the early twentieth-century avant-garde was receptive to new formal ideas. One of the major sources for these was the growing interest in African art.

From about 1906, leading European artists began to notice African works in museums and shops, to discuss them with each other, and to collect them. Artists also traveled outside of Europe more than they had in the past. Despite this geographic and intellectual expansion, the early twentieth-century approach to the visual arts led to certain misconceptions about African art. First, Africa is a huge continent (see map), comprising many different cultures, each with its own artistic history. The time span of African art is as vast as that of Europe, ranging from the Stone Age to the present. Second, the understanding of African art is complicated by certain essential differences between it and other non-Western styles. Unlike Far Eastern art, there is virtually no narrative in African art. African artists did not conceive of their objects as set in a time and space in the way that Western artists had. As a result, much African art has a timeless quality, which was one of the sources of its appeal to the West.

The Fang of Gabon, for example, associate large heads with infancy, an age that was believed to be in a state of greater harmony with ancestors. According to the Fang, adults lose contact with the power wielded by deceased ancestors and with their own infantile past. The example illustrated here (fig. **W11.1**) was placed on a reliquary chest.

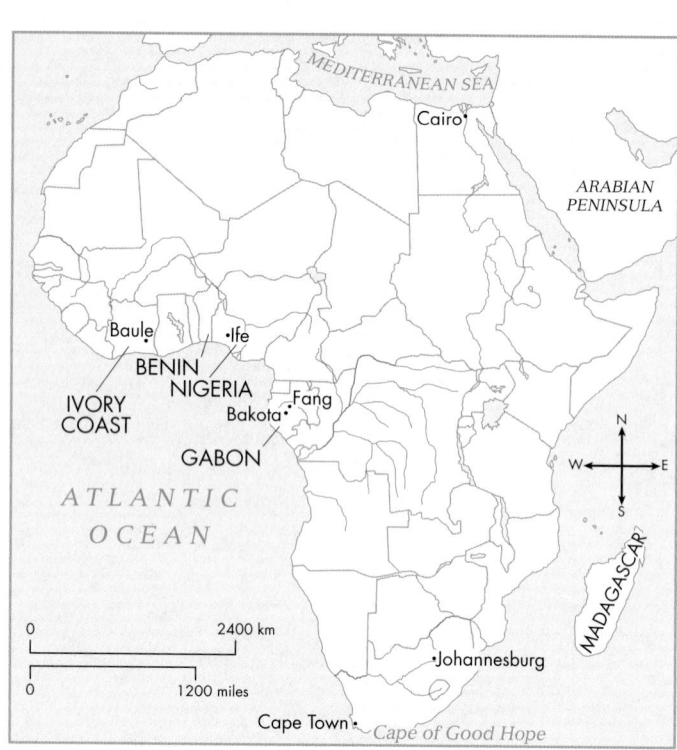

Africa.

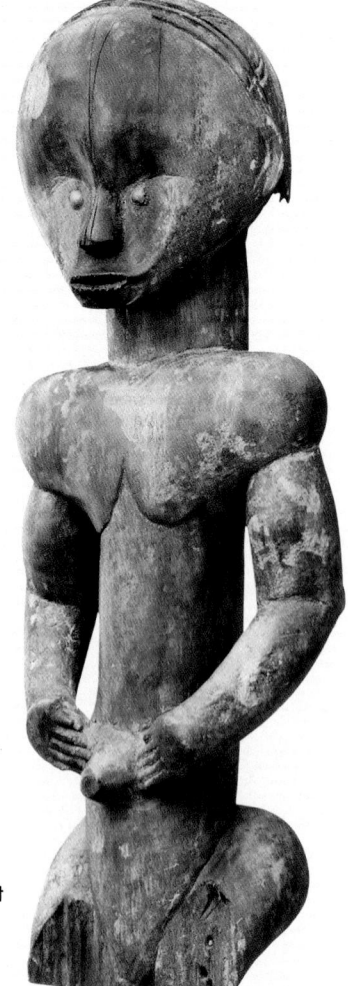

W11.1 Male ancestor statue, eyema-o-byeri, Gabon, northern Fang, Ndoumou substyle. Light brown polished wood; 17¼ in. (43.8 cm) high. Musée Barbier-Mueller, Geneva.

Its legs are broken off, but it was originally in a seated position. Note the combination of a rounded childlike head with the more elongated proportions of an adult.

Another interpretation of such works is that they symbolize the desire for children. Clearly, African sculptures combining childlike with adult features condense time. In so doing, they seem timeless because they are essentially out of the chronological sequence of time as people experience it.

Most surviving African art is sculpture, which can be understood only in its cultural context. The cave paintings and glyptic arts of Africa were little known to nineteenth- and early twentieth-century European artists, who only rarely had contact with African architecture. The range of African sculpture is reflected by the formal, cultural, and iconographic variety of the works illustrated here.

Ife

Figure **W11.2** is from the city of Ife, founded around A.D. 800 to 900 in southwestern Nigeria. Its surviving art dates from the twelfth and thirteenth centuries A.D. and shows currents of naturalism as well as stylization. This copper mask is a convincing likeness, with a sense of soft flesh around the cheeks and lips, a firm bone structure beneath the nose, organic ears, and a broad, curved forehead. The hair, mustache,

and beard were attached through holes, which are still visible. The only significantly stylized feature is the outline around the eye. This work shows the Ife skill in modeling, as well as in metal-casting technology. It is believed to have been used in royal burials and was probably worn during funerary ceremonies. There can be little question, however, that it has the quality of a portrait—possibly of a king.

Baule

The Baule figure from the Ivory Coast (fig. **W11.3**) typifies the African sculptures whose abstraction appealed to the Western avant-garde in the early twentieth century. Some scholars identify this as an ancestor, and others argue that it represents so-called otherworld people who are ideal mates for the Baule. Its surface is smooth and polished, with

relief patterns of scarification on the face, neck, and torso. The hair is made of finely incised parallel lines. A mechanical effect is created by the abrupt, nonorganic planar shifts that contrast with Classical proportions (cf. fig. 5.27). Such objects offered non-Western artists new ways of approaching the human figure. At the same time, however, the proportions of African sculpture have meanings that vary from culture to culture.

See figure 5.27. Polykleitos, *Doryphoros (Spear Bearer)*, c. 440 B.C.

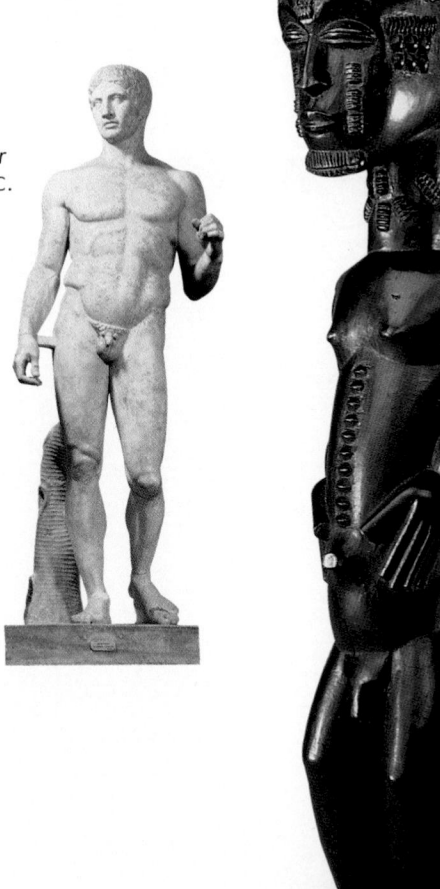

W11.3 Baule ancestor, Ivory Coast. Wood; 20½ in. (52.1 cm) high. British Museum, London.

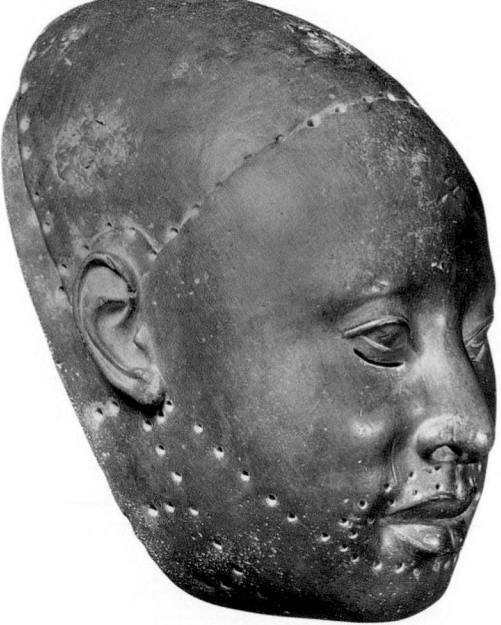

W11.2 Copper mask, Ife, Nigeria, 12th–13th century. 13 in. (33.0 cm) high. Life Museum, Lagos.

Bakota

The Bakota of Gabon made a distinctive type of figure, which was generally of wood covered with metal sheets of brass or copper (fig. **W11.4**). Their flat geometry struck the European avant-garde as particularly expressive. The oval face, identified as such by the lunette-shape eyes and pyramidal nose, is surmounted by a geometric headdress. The neck is cylindrical and the body abstracted to form a diamond shape framing empty space. It is clear that both the Bakota and the Baule figures would have appealed aesthetically to a generation of Western artists on the verge of Cubism. But here, again, the African figure is admired out of context. The actual function of the Bakota statue was to cover a reliquary containing ancestral bones. Ironically, therefore, traditional works within one society (in this case, an African society) became inspirational for artists breaking with tradition in another society (that of western Europe).

Benin

Around the turn of the century, the art of Benin, a small kingdom to the west of modern Nigeria, attracted the art world's attention. Benin culture had been known since the fifteenth century, when the Portuguese infiltrated the area, sending missionaries, fighting as mercenaries in the Benin armies, and introducing guns to the local population. As traders, the Portuguese were interested in cloth, ivory, pepper, gold, and slaves. Their presence on Benin soil is known from contemporary accounts and also from bronze Benin sculptures representing Portuguese soldiers. Two centuries later, the Dutch also began trading in Benin. In 1897, a group of British officials went to Benin City during the annual festival honoring royal ancestors. The officials were killed, and Britain sent in a force known as the "Punitive Expedition," which set the city on fire. The metal and ivory objects that

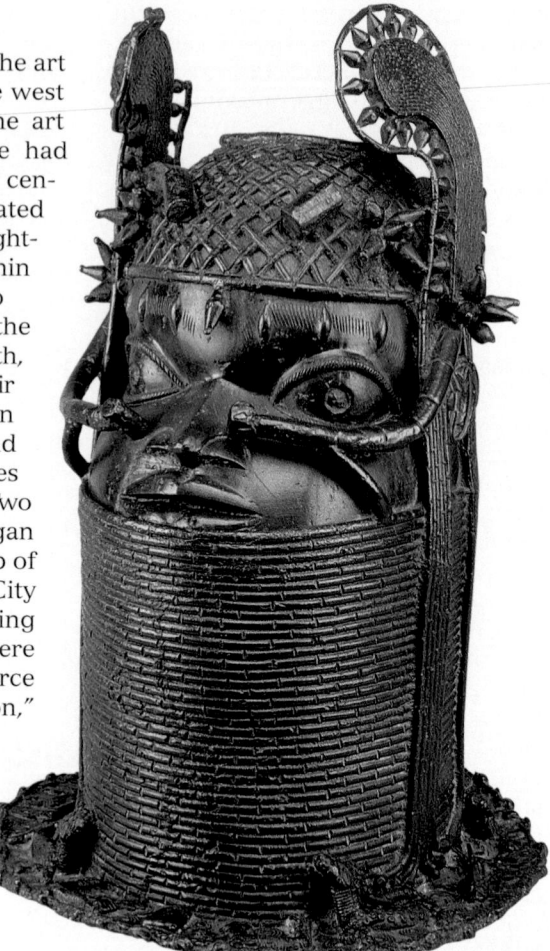

W11.5 Bronze Oba head, Benin, mid-19th century. 20⅛ in. (51.1 cm) high. British Museum, London. In 1927, Picasso acquired one of the Oba heads for his personal collection of African art.

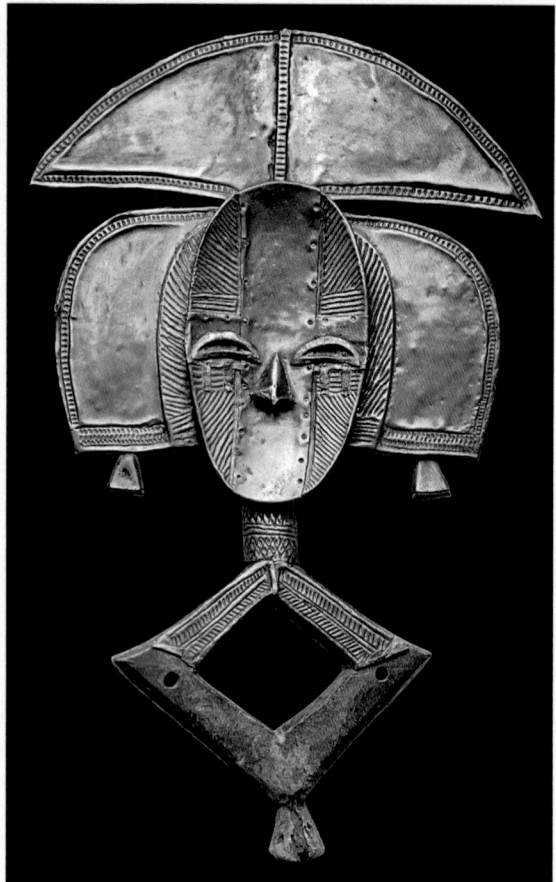

W11.4 Bakota figure, Gabon. Wood covered with brass sheeting; 26 in. (66.0 cm) high. British Museum, London.

survived were taken to England. Some were sold to the British Museum, others to the Berlin Museum of Folk Art. Several ended up in private collections.

The bronze head in figure **W11.5** represents the Oba, or divine king, of Benin. He controls the fate of his subjects through the spiritual power conferred on him by his divine ancestors. According to Benin tradition, which is transmitted orally, the former, celestial kings of Benin had failed their subjects, who sought a new ruler. They turned to the Oni, who ruled the neighboring Ife culture, and he sent his son, Oranmiyan, to Benin. There, Oranmiyan became the father of Eweka I by a local princess. The present Oba is the direct

descendant of Eweka I and the undisputed ruler of Benin. He combines the power of earth and sky, and is both feared and loved by his people.

Heads of kings comprise a major iconographic category in Benin art. They reflect the importance of the Oba as a patron and the fact that most Benin art is connected to the court. The example illustrated here is cast in bronze, a technique introduced in the late 1300s. Multiple strands of coral beads covering the neck and chin are indications of wealth and status. The crown is decorated on either side with curved features, which were introduced in the nineteenth century. Such works were placed on ancestral altars—in this instance as a stand for an ivory tusk.

In the sixteenth century, from the period of Oba Esigie's reign, the Benin queen mother was accorded special status. Esigie's mother, Idia, was honored for her role in helping her son achieve victory in the Tgala war. According to oral tradition, Idia was a skillful military tactician who was able to communicate with the spirit world. Her position is reflected in the production of heads cast in brass for altars in the queen mother's home and in the palace (fig. **W11.6**). The high polish of the brass, the beaded strands around the neck, and the beaded crown adorning the so-called chicken's beak hair style are signs of her importance.

All the African figures described here have ritual, spiritual, or royal significance. Each belongs to a distinctive group of people. They also vary in their degree of stylization, abstraction, and naturalism. But together they illustrate some of the qualities that inspired the Western avant-garde. The following quotations from European artists discussed in this text express the liberating effect of their encounter with African sculpture:

Kirchner (1910) (on the Benin bronzes in the Dresden Ethnology Museum): "A change and a delight."[2]

Nolde (1912): "Why is it that we artists love to see the unsophisticated artifacts of the primitives?"

"It is a sign of our times that every piece of pottery or dress or jewelry, every tool

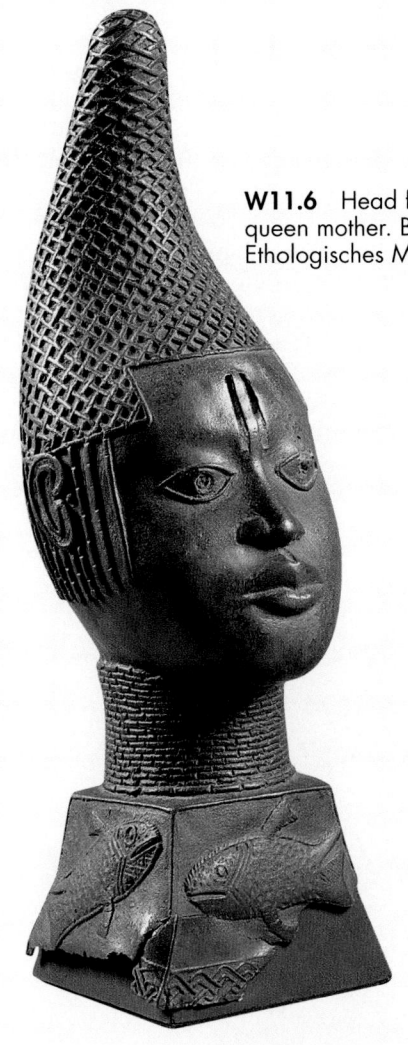

W11.6 Head for an altar dedicated to the Benin queen mother. Bronze; 20 in. (50.8 cm) high. Ethologisches Museum, Staatliche Museen zu Berlin.

for living has to start with a blueprint—Primitive people begin making things with their fingers, with material in their hands. Their work expresses the pleasure of making. What we enjoy, probably, is the intense and often grotesque expression of energy, of life."[3]

Kandinsky (statement published 1930): "the shattering impression made on me by Negro art, which I saw in [1907] in the Ethnographic Museum in Berlin."[4]

Marc (1911): "I was finally caught up, astonished and shocked, by the carvings of the Cameroon people, carvings which can perhaps be surpassed only by the sublime works of the Incas. I find it so self-evident that we should seek the

rebirth of our artistic feeling in this cold dawn of artistic intelligence, rather than in cultures that have already gone through a thousand-year cycle like the Japanese or the Italian Renaissance."[5]

Matisse (on African sculptures in a shop on the rue de Rennes in Paris; interview recorded in 1941): "I was astonished to see how they were conceived from the point of view of sculptural language; how it was close to the Egyptians . . . compared to European sculpture, which always took its point of departure from musculature and started from the description of the object, these Negro statues were made in terms of their material, according to invented planes and proportions."[6]

Picasso (on African masks): "For me the [tribal] masks were not just sculptures, they were magical objects . . . intercessors . . . against everything—against unknown, threatening spirits. . . . They were weapons—to keep people from being ruled by spirits, to help free themselves. . . . If we give a form to these spirits, we become free."[7]

Braque: "Negro masks opened a new horizon for me."[8]

Henri Matisse and Fauvism

In 1905, a new generation of artists exhibited their paintings in Paris at the Salon d'Automne. Bright, vivid colors seemed to burst from their canvases and dominate the exhibition space. Forms were built purely from color, and vigorous patterns and unusual color combinations created startling effects. To a large extent, they were derived from Gauguin's Symbolist use of color. The critic Louis Vauxcelles noticed one traditional work in the room and reportedly exclaimed, "Donatello parmi les fauves!" ("Donatello among the wild beasts!"), because the color and movement of the paintings reminded him of the jungle. His term stuck, and the style of those pictures is still referred to as "Fauve."

Vauxcelles's observation of a single traditional sculpture juxtaposed with the works of the young artists exhibiting in 1905 signaled the latest skirmish in the traditional western European dispute over the primacy of line versus color. Although there was plenty of "line" in Fauve painting, it was the brilliant, nonnaturalistic color and emotional exuberance that struck viewers. In contrast, Classical restraint and harmony, which were associated with line, appeared more controlled and, by implication, more civilized.

The leading artist of the Fauve group in France was Henri Matisse. His *Notre-Dame in the Late Afternoon* of 1902 (fig. **24.2**) depicts urban spaces as flat planes of color. Although the shapes are clearly defined, as in Post-Impressionism, and the paint texture is visible, Matisse has eliminated detail in favor of the predominance of color. Human figures are silhouettes, and the façade of Notre-Dame contains no reference to the Gothic surface variations on the actual building. Whereas the *Rouen Cathedral*s of Monet (see figs. 22.19 and 22.20) had subordinated Gothic detail (see fig. 11.28) to shifts of light and dark, Matisse's cathedral is reduced to a shape of color. But the color—lavender—combines the blues and pinks that are present throughout the picture. As a result, the cathedral assumes a position of power, for not only does it dominate the scene by its imposing height, but it unifies the view of modern Paris through color—just as it had once been the social, economic, religious, and artistic focal point of the medieval town.

─────────── **CONNECTIONS** ───────────

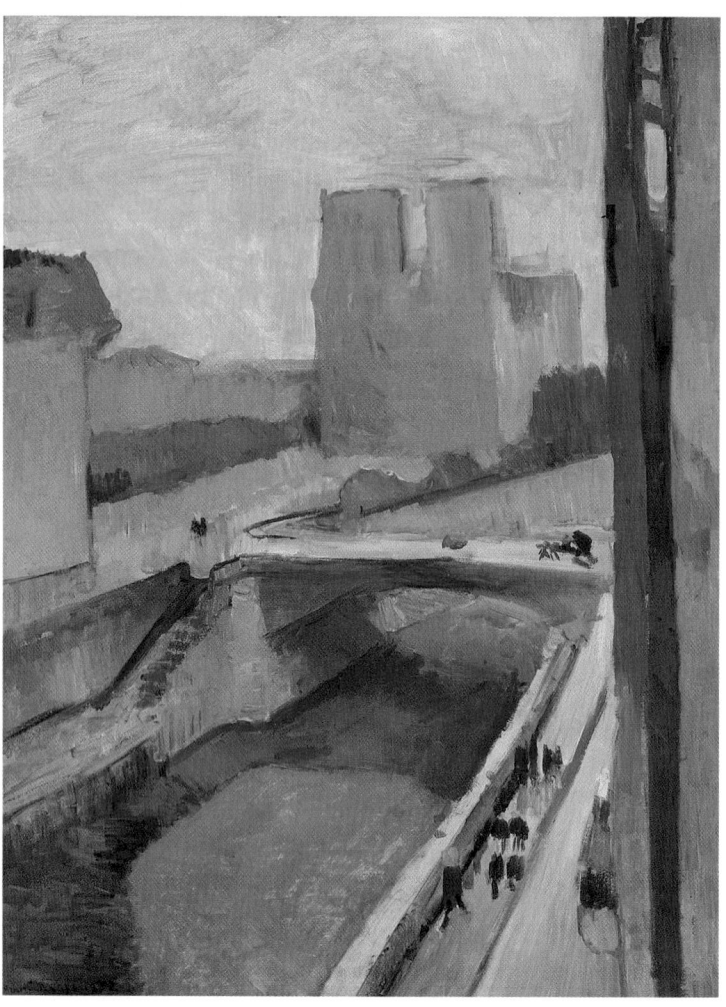

24.2 Henri Matisse, *Notre-Dame in the Late Afternoon*, 1902. Oil on canvas; 28½ × 21½ in. (72.4 × 54.6 cm). Albright-Knox Art Gallery, Buffalo, New York (Gift of Seymour H. Knox).

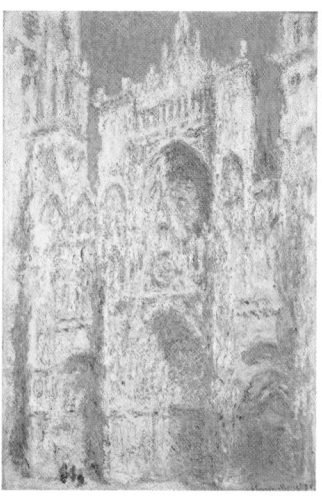

See figure 22.19.
Claude Monet, *Rouen Cathedral, West Façade, Sunlight*, 1894.

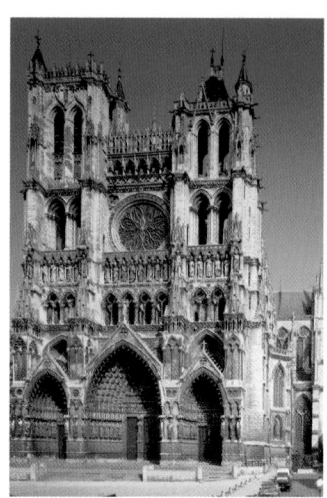

See figure 11.28.
West façade, Amiens Cathedral, 1220–1269.

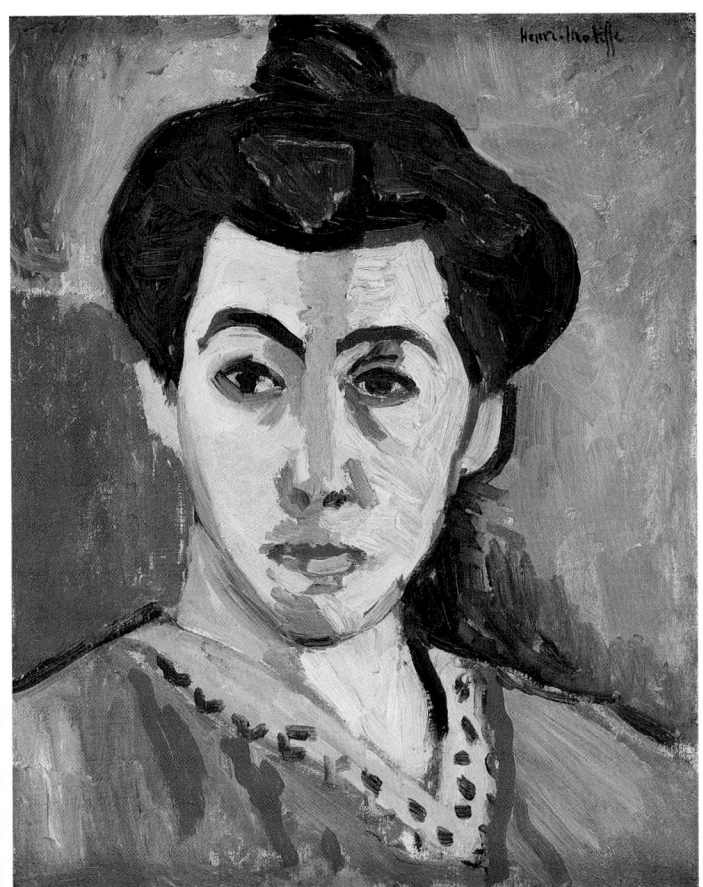

24.3 Henri Matisse, *Madame Matisse* (*The Green Line*), 1905. Oil on canvas; 16 × 12¾ in. (40.6 × 32.4 cm). Statens Museum for Kunst, Copenhagen. Matisse was born in northern France. He reportedly decided to become a painter when his mother gave him a set of **crayons** while he was recuperating from surgery.

Three years later, Matisse painted a portrait of his wife in the new style (fig. **24.3**). Here, Madame Matisse is a construction in color—a concept that Matisse had learned from Cézanne. He subtitled the work *The Green Line,* which refers to the line, beginning at the top of the forehead and continuing down the nose, that divides the face into a subdued ocher on the left and pink on the right. Throughout the picture plane, shading, modeling, and perspective are subordinate to color, which creates the features. The dark blue hair, which lacks organic quality because of its flatness, seems to perch on the head. This inorganic relation of head to hair, like the absence of modeling—for example, in the flat planes of the ears—reveals the influence of African masks on Matisse's style.

The background of *The Green Line* is identified only as color. To the right of Madame Matisse (our left) are two tones of red, clearly separated above her ear. At the oppo-

site side, the background is green. Variations on these reds and greens recur in the face, creating a chromatic unity between figure and background.

In Matisse's *Woman with the Hat* (fig. **24.4**), as in *The Green Line* (fig. 24.3), color has again taken the lead, supported by shading, modeling, and perspective. Again, patches of color identify the background—greens, yellows, blues, and oranges to the left of the figure and mainly green and yellow to the right—variations of which appear in the face, thus unifying the work. The painting caused a scandal in the Paris art world for its unconventional use of color. But when purchased by Michael Stein, Gertrude's brother, the painting's reputation was saved. From that point on, Matisse's prices began to rise.

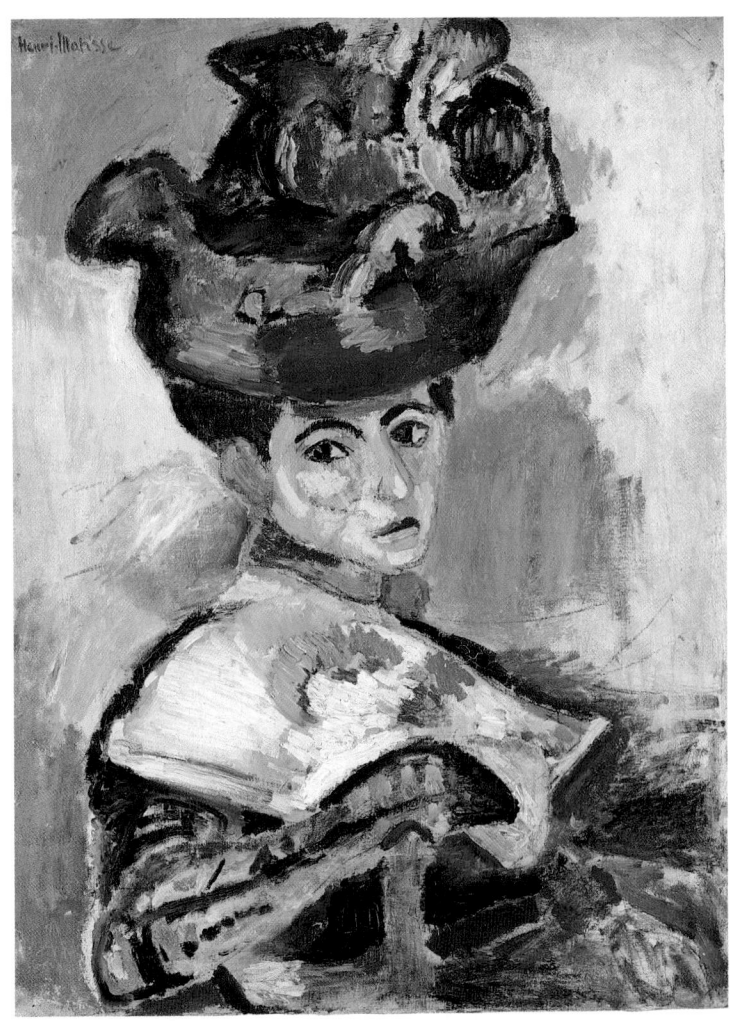

24.4 Henri Matisse, *Woman with the Hat,* 1905. Oil on canvas; 2 ft. 7¾ in. × 1 ft. 11½ in. (80.7 × 60.0 cm). San Francisco Museum of Modern Art, bequest of Elise S. Hass.

Art History and Aesthetics in Early Twentieth-Century Munich

Two important figures in the Munich art world, Heinrich Wölfflin (1864–1945) and Wilhelm Worringer (1881–1965), were particularly influential. Wölfflin lectured on art history, whereas Worringer's aesthetic theories supported the Expressionist movement.

Wölfflin's most important work, which is still read by art students—*The Principles of Art History*—was first published in German in 1915. He devised a system of determining style by an analysis of its formal elements. Renaissance and Classical styles, for example, were distinguished from Baroque by five pairs of opposing characteristics. The classicizing Renaissance style was, according to Wölfflin, linear, whereas Baroque was painterly. Renaissance planes were constructed according to the verticals and horizontals of linear perspective, while Baroque planes receded diagonally. Space tended to be open in Baroque and closed in Renaissance. Elements were multiple and clarity was absolute in the Renaissance style. In Baroque, elements were unified and clarity was relative.

What united Wölfflin with Worringer was a mutual emphasis on the viewer's experience of works of art. But whereas Wölfflin focused on past styles, Worringer championed the avant-garde—notably, the German Expressionists. In 1908, Worringer published his dissertation *Abstraktion und Einfühlung* (*Abstraction and Empathy*); this argued for new forms of expression and was widely read by the young artists of Worringer's generation. Three years later, in *The Historical Development of Modern Art*, Worringer replied to criticism leveled at the Expressionists, defending them against charges reminiscent of those brought against Whistler and the French Impressionists. Expressionist paintings were accused of being decadent, self-indulgent, without form, finish, or depth. Worringer countered by pointing out the limitations of adherence to naturalism. He called for accessibility to new influences as a way of expanding artistic consciousness. Such infusions, particularly from non-European cultures, Worringer believed, would offer a new route to the spiritual core of creativity.

The Blue Rider (*Der Blaue Reiter*)

Another German Expressionist group more drawn to non-figurative abstraction than members of The Bridge was *Der Blaue Reiter* (The Blue Rider), established in Munich in 1911. The name of the group, derived from the visionary language of the book of Revelation (cf. the Four Horsemen of the Apocalypse), was inspired by the millennium and the notion that Moscow would be the new center of the world from 1900—as Rome had once been. *Blue Rider* referred to the emblem of the city of Moscow showing Saint George (the "Rider") killing the dragon.

Vassily Kandinsky The Russian artist Vassily Kandinsky (1866–1944) was among the first to eliminate recognizable objects from his paintings. He identified with the Blue Rider as the artist who would ride into the future of a spiritual nonfigurative and mystical art; for him, the color blue signified the masculine aspect of spirituality (cf. fig. 24.11). At the age of thirty, Kandinsky left Moscow, where he was a law student, and went to Munich to study painting. There he was a founder of the Neue Künstler Vereinigung (New Artists' Association), or NKV, the aim of which was rebellion against tradition. A few artists split from the NKV to form the Blue Rider.

For Kandinsky, art was a matter of using rhythmic lines, colors, and shapes rather than narrative. Like Whistler, Kandinsky gave his works musical titles to express their abstract qualities. By eliminating references to material reality, Kandinsky followed the Blue Rider's avoidance of the mundane in order to communicate the spiritual in art. Titles such as *Improvisation* evoked the dynamic spontaneity of creative activity, while the *Compositions* emphasized the organized abstraction of his lines, shapes, and colors.

In 1912, Kandinsky published *Concerning the Spiritual in Art,* in which he explained his philosophy—he argued that music was intimately related to art. He was by temperament drawn to religious and philosophical thinking imbued with strains of mysticism and the occult, which can be related to a millenarian spirit of the Blue Rider emblem. And he believed that art had a spiritual quality because it was the product of the artist's spirituality. The work of art, in turn, reflected this through the musical harmony of form and color.

Panel for Edwin R. Campbell No. 4 (formerly *Painting No. 201, Winter*) of 1914 (fig. **24.9**) was one of four in a series representing the seasons—this one being winter. In it Kandinsky creates a swirling, curvilinear motion within which there are varied lines and shapes. Lines range from thick to thin, color patches from plain to spotty, and hues from solid to blended. The most striking color is red, which is set off against yellows and softer blues and greens. The strongest accents are blacks, while the sense of winter is suggested primarily by the whites, which occur in pure form and also blend with the colors. Blues become light blues, and reds become pinks, creating an illusion of coldness that is readily associated with winter.

Later, in the 1920s, despite stylistic changes inspired by his association with the Moscow avant-garde, Kandinsky continued to pursue the notion of the spiritual in art. He did so by endowing delicate geometric shapes with a dynamic spatial tension. This is evident in *Several Circles, No. 323* (fig. **24.10**), in which translucent circles float in a swirling space. Some of the circles are isolated, others barely touch the edge of adjacent circles, while a few appear to skim over one another, their geometric purity contrasting with the textured background. Kandinsky's image has an "otherworldly" quality, evoking both the minutiae of the invisible molecular world and the vast distances of a solar system occupied by orbiting moons and planets.

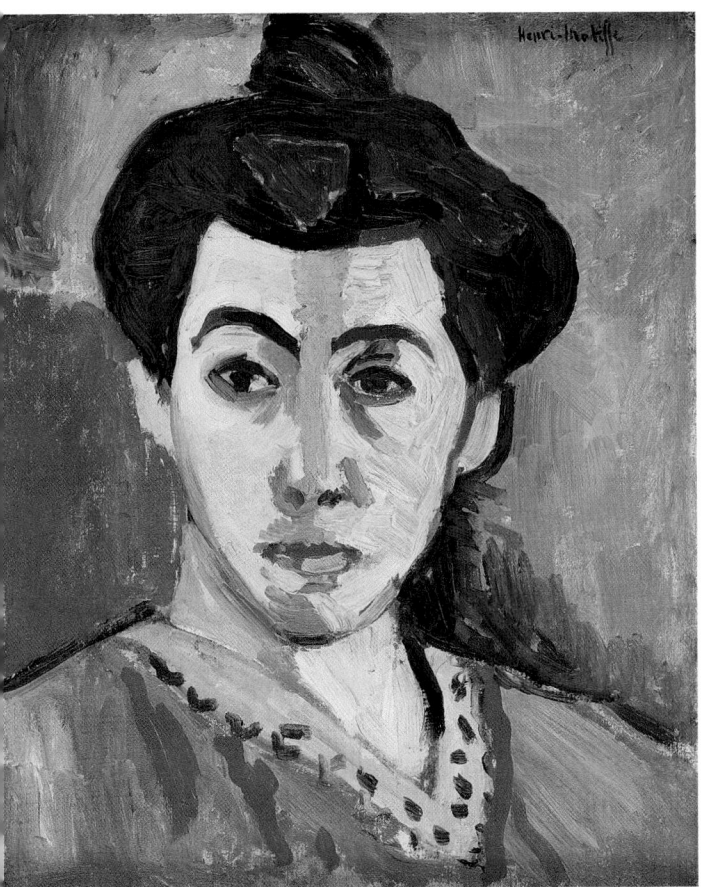

24.3 Henri Matisse, *Madame Matisse* (*The Green Line*), 1905. Oil on canvas; 16 × 12¾ in. (40.6 × 32.4 cm). Statens Museum for Kunst, Copenhagen. Matisse was born in northern France. He reportedly decided to become a painter when his mother gave him a set of **crayons** while he was recuperating from surgery.

Three years later, Matisse painted a portrait of his wife in the new style (fig. **24.3**). Here, Madame Matisse is a construction in color—a concept that Matisse had learned from Cézanne. He subtitled the work *The Green Line,* which refers to the line, beginning at the top of the forehead and continuing down the nose, that divides the face into a subdued ocher on the left and pink on the right. Throughout the picture plane, shading, modeling, and perspective are subordinate to color, which creates the features. The dark blue hair, which lacks organic quality because of its flatness, seems to perch on the head. This inorganic relation of head to hair, like the absence of modeling—for example, in the flat planes of the ears—reveals the influence of African masks on Matisse's style.

The background of *The Green Line* is identified only as color. To the right of Madame Matisse (our left) are two tones of red, clearly separated above her ear. At the oppo-site side, the background is green. Variations on these reds and greens recur in the face, creating a chromatic unity between figure and background.

In Matisse's *Woman with the Hat* (fig. **24.4**), as in *The Green Line* (fig. 24.3), color has again taken the lead, supported by shading, modeling, and perspective. Again, patches of color identify the background—greens, yellows, blues, and oranges to the left of the figure and mainly green and yellow to the right—variations of which appear in the face, thus unifying the work. The painting caused a scandal in the Paris art world for its unconventional use of color. But when purchased by Michael Stein, Gertrude's brother, the painting's reputation was saved. From that point on, Matisse's prices began to rise.

24.4 Henri Matisse, *Woman with the Hat,* 1905. Oil on canvas; 2 ft. 7¾ in. × 1 ft. 11½ in. (80.7 × 60.0 cm). San Francisco Museum of Modern Art, bequest of Elise S. Hass.

Expressionism

In Germany, the artists who, like the Fauves, were most interested in the expressive possibilities of color—as derived from Post-Impressionism—were called Expressionists. They formed groups that outlasted the Fauves in France and styles that persisted until the outbreak of World War I in 1914. Expressionism, like Fauvism, used color to create mood and emotion (see box) but differed from Fauvism in its greater concern with the emotional properties of color. Expressionism was also less concerned than the Fauves with the formal and structural composition of color.

The Bridge (*Die Brücke*)

In 1905, the year of the Fauve exhibition in Paris, four German architecture students in Dresden formed *Die Brücke* (The Bridge). Joined the following year by two others, this group of artists continued to work together until 1913. The name was inspired by the artists' intention to create a "bridge," or link, between their own art and modern revolutionary ideas, and between what was traditional and what was new in art. They modernized both the spiritual abstraction of medieval art and the geometric aesthetic of African and Oceanic art by integrating them with the mechanical forms of the city. Expressionist color was typically brilliant and exuberant and further energized by harsh, angular shapes.

Ernst Ludwig Kirchner The most important founding artist of *Die Brücke* was Ernst Ludwig Kirchner (1880–1938), who had been trained as an architect before becoming a

24.6 Ernst Ludwig Kirchner, *Five Women in the Street*, 1913. Oil on canvas; 3 ft. 10½ in. × 2 ft. 11½ in. (1.18 × 0.90 m). Ludwig Museum, Cologne/Rheinisches Bildarchiv, Cologne.

painter. He had been inspired by the *Jugendstil* of the Vienna Secession as well as by Munch, van Gogh, and non-Western art. *The Street* of 1907 (fig. 24.5), for example, combines Expressionist color with undulating forms reminiscent of Munch. The flat color areas, on the other hand, can be related to Fauvism.

A comparison with a later street scene by Kirchner—*Five Women in the Street* of 1913 (fig. 24.6)—reflects certain stylistic shifts (in this case, toward Cubism) of the period. The dreamlike quality of the earlier picture and its pure, primary hues ally it with nineteenth-century Symbolism and Post-Impressionism. In the later picture, the color is subdued and limited, which shows the influence of Analytic Cubism (see p. 852). The predominance of dulled greens creates a uniformity that accentuates the impersonal character of the women. Kirchner captures the anxious, frenetic pace of urban life through angular, elongated figures occupying a shifting perspective. His training in architecture is evident in the tectonic forms of the women. Their high-heeled shoes, for example, create two-dimensional geometric silhouettes against a lighter space, and their fur ruffs form crescents. The distinctions between light and dark in the dresses are crisply defined, creating a sense of solid, crystalline structure rather than of soft material.

24.5 Ernst Ludwig Kirchner, *The Street*, 1907. Oil on canvas; 4 ft. 11¼ in. × 6 ft. 6⅞ in. (1.51 × 2.00 m). Museum of Modern Art, New York.

Emil Nolde Another artist associated with German Expressionism, Emil Nolde (1867–1956), spent only a year as a member of The Bridge. His early pictures depicted religious themes infused with a visionary mood. After spending the year 1899 to 1900 in Paris, Nolde increased his range of color. In addition to the influence of nineteenth-century French styles, his work shows very clearly that non-Western art provided him with a significant source of inspiration.

His *Still Life with Masks* of 1911 (fig. **24.7**) combines bright color with thickly applied paint to achieve intense, dynamic effects. The upside-down pink mask and the adjacent yellow one were inspired by northern European carnivals. But the red mask at the far left is based on Nolde's own drawing of an Oceanic canoe prow (fig. **24.8**). The yellow skull at the lower right is also derived from non-Western prototypes—in this case, a shrunken head from Brazil, of which Nolde made sketches. African examples probably inspired the green mask at the upper right, but the combination of a green surface with red outlining the features is an Expressionist use of color. Nolde's non-Western imagery served to express qualities that were finally more in tune with Expressionism than with the cultural or artistic intentions of the non-Western art he studied.

24.8 Emil Nolde, drawing of an Oceanic canoe prow, for left-hand mask in fig. 24.7, 1911. Pencil drawing; 11⅞ × 7⅛ in. (30.2 × 18.1 cm). Stiftung Seebüll Ada und Emil Nolde.

24.7 Emil Nolde, *Still Life with Masks,* 1911. Oil on canvas; 28¾ × 30½ in. (73.0 × 77.5 cm). Nelson-Atkins Museum of Art, Kansas City.

Art History and Aesthetics in Early Twentieth-Century Munich

Two important figures in the Munich art world, Heinrich Wölfflin (1864–1945) and Wilhelm Worringer (1881–1965), were particularly influential. Wölfflin lectured on art history, whereas Worringer's aesthetic theories supported the Expressionist movement.

Wölfflin's most important work, which is still read by art students—The Principles of Art History—was first published in German in 1915. He devised a system of determining style by an analysis of its formal elements. Renaissance and Classical styles, for example, were distinguished from Baroque by five pairs of opposing characteristics. The classicizing Renaissance style was, according to Wölfflin, linear, whereas Baroque was painterly. Renaissance planes were constructed according to the verticals and horizontals of linear perspective, while Baroque planes receded diagonally. Space tended to be open in Baroque and closed in Renaissance. Elements were multiple and clarity was absolute in the Renaissance style. In Baroque, elements were unified and clarity was relative.

What united Wölfflin with Worringer was a mutual emphasis on the viewer's experience of works of art. But whereas Wölfflin focused on past styles, Worringer championed the avant-garde—notably, the German Expressionists. In 1908, Worringer published his dissertation Abstraktion und Einfühlung (Abstraction and Empathy); this argued for new forms of expression and was widely read by the young artists of Worringer's generation. Three years later, in The Historical Development of Modern Art, Worringer replied to criticism leveled at the Expressionists, defending them against charges reminiscent of those brought against Whistler and the French Impressionists. Expressionist paintings were accused of being decadent, self-indulgent, without form, finish, or depth. Worringer countered by pointing out the limitations of adherence to naturalism. He called for accessibility to new influences as a way of expanding artistic consciousness. Such infusions, particularly from non-European cultures, Worringer believed, would offer a new route to the spiritual core of creativity.

The Blue Rider (*Der Blaue Reiter*)

Another German Expressionist group more drawn to non-figurative abstraction than members of The Bridge was *Der Blaue Reiter* (The Blue Rider), established in Munich in 1911. The name of the group, derived from the visionary language of the book of Revelation (cf. the Four Horsemen of the Apocalypse), was inspired by the millennium and the notion that Moscow would be the new center of the world from 1900—as Rome had once been. *Blue Rider* referred to the emblem of the city of Moscow showing Saint George (the "Rider") killing the dragon.

Vassily Kandinsky The Russian artist Vassily Kandinsky (1866–1944) was among the first to eliminate recognizable objects from his paintings. He identified with the Blue Rider as the artist who would ride into the future of a spiritual nonfigurative and mystical art; for him, the color blue signified the masculine aspect of spirituality (cf. fig. 24.11). At the age of thirty, Kandinsky left Moscow, where he was a law student, and went to Munich to study painting. There he was a founder of the Neue Künstler Vereinigung (New Artists' Association), or NKV, the aim of which was rebellion against tradition. A few artists split from the NKV to form the Blue Rider.

For Kandinsky, art was a matter of using rhythmic lines, colors, and shapes rather than narrative. Like Whistler, Kandinsky gave his works musical titles to express their abstract qualities. By eliminating references to material reality, Kandinsky followed the Blue Rider's avoidance of the mundane in order to communicate the spiritual in art. Titles such as *Improvisation* evoked the dynamic spontaneity of creative activity, while the *Compositions* emphasized the organized abstraction of his lines, shapes, and colors.

In 1912, Kandinsky published *Concerning the Spiritual in Art,* in which he explained his philosophy—he argued that music was intimately related to art. He was by temperament drawn to religious and philosophical thinking imbued with strains of mysticism and the occult, which can be related to a millenarian spirit of the Blue Rider emblem. And he believed that art had a spiritual quality because it was the product of the artist's spirituality. The work of art, in turn, reflected this through the musical harmony of form and color.

Panel for Edwin R. Campbell No. 4 (formerly *Painting No. 201, Winter*) of 1914 (fig. **24.9**) was one of four in a series representing the seasons—this one being winter. In it Kandinsky creates a swirling, curvilinear motion within which there are varied lines and shapes. Lines range from thick to thin, color patches from plain to spotty, and hues from solid to blended. The most striking color is red, which is set off against yellows and softer blues and greens. The strongest accents are blacks, while the sense of winter is suggested primarily by the whites, which occur in pure form and also blend with the colors. Blues become light blues, and reds become pinks, creating an illusion of coldness that is readily associated with winter.

Later, in the 1920s, despite stylistic changes inspired by his association with the Moscow avant-garde, Kandinsky continued to pursue the notion of the spiritual in art. He did so by endowing delicate geometric shapes with a dynamic spatial tension. This is evident in *Several Circles, No. 323* (fig. **24.10**), in which translucent circles float in a swirling space. Some of the circles are isolated, others barely touch the edge of adjacent circles, while a few appear to skim over one another, their geometric purity contrasting with the textured background. Kandinsky's image has an "otherworldly" quality, evoking both the minutiae of the invisible molecular world and the vast distances of a solar system occupied by orbiting moons and planets.

24.9 Vassily Kandinsky, *Panel for Edwin R. Campbell No. 4* (formerly *Painting No. 201, Winter*), 1914. Oil on canvas; 5 ft. 4¼ in. × 4 ft. ¼ in. (1.63 × 1.24 m). Museum of Modern Art, New York (Nelson A. Rockefeller Fund, by exchange).

24.10 Vassily Kandinsky, *Several Circles, No. 323*, 1926. Oil on canvas; 55⅛ × 55⅛ in. (140.0 × 140.0 cm). Guggenheim Museum, New York.

24.11 Franz Marc, *Large Blue Horses*, 1911. Oil on canvas; 3 ft. 5⅝ in. × 5 ft. 11⁵⁄₁₆ in. (1.06 × 1.81 m). Walker Art Center, Minneapolis (Gift of the T. B. Walker Foundation, Gilbert Walker Fund, 1942). Marc shared Kandinsky's spiritual attitude toward the formal qualities of painting, especially color. He thought of blue as masculine, yellow as having the calm sensuality of a woman, and red as aggressive. Mixed colors were endowed with additional forms of emotional iconography.

Franz Marc The other major Blue Rider artist was Franz Marc (1880–1916), who joined Kandinsky in editing the *Blue Rider Yearbook* of 1912. This contained discussions of Picasso and Matisse, The Bridge, The Blue Rider itself, and the new interest in expanding aesthetic experience through contact with non-Western art. In contrast to Kandinsky, however, Marc did not entirely eliminate recognizable objects from his work, except in preliminary drawings made shortly before his premature death.

Marc's *Large Blue Horses* of 1911 (fig. **24.11**) combines geometry with rich color. As Gauguin described his "red dogs" and "pink skies" (see Chapter 23), Marc's animals and their setting can be considered in the abstract terms of musical composition. They are an arrangement in blue, foreshortened forms, which harmonize with the curvilinear, brightly colored landscape. Marc's use of animals reflects his belief that they are better suited than humans to the expression of cosmological ideas. The two gray curves representing slender tree trunks serve as structural anchors. They also create a sense of confinement, which compresses the space and enhances the monumentality of Marc's horses.

The Blue Rider, in contrast to The Bridge, was international in scope and had a greater influence on Western art. In particular, Kandinsky's nonfigurative imagery, which was among the first of its kind, was part of a revolutionary development that would remain an important current in twentieth-century art. Neither Matisse nor Picasso, despite all their innovations, ever completely renounced references to nature and other recognizable forms.

Käthe Kollwitz

Although Käthe Kollwitz (1867–1945) was not a formal member of any artistic group, her *Whetting the Scythe* of 1905 (fig. 24.12) conveys the direct emotional confrontation characteristic of Expressionism. Her harsh textures and the preponderance of rich blacks enhance her typically depressive themes. The gnarled figure concentrating intently on her task is rendered in close-up, which accentuates the detailed depiction of her wrinkled hands and aged, slightly wary expression. In the background, the cruciform arrangement of blacks reinforces the morbid associations of the image. The presence of the scythe, an attribute of the Grim Reaper, or Death, conforms to the woman's rather sinister quality. She is a version of van Gogh's Post-Impressionist *Wheat Field with Reaper* (see fig. 23.16) and Wordsworth's Romantic "Solitary Reaper."

24.12 Käthe Kollwitz, *Whetting the Scythe*, 1905. Soft-ground eighth-state etching; 11¹¹⁄₁₆ × 11¹¹⁄₁₆ in. (29.7 × 29.7 cm). British Museum, London. Despite being financially comfortable herself, Kollwitz's imagery brings the viewer into contact with the emotional and material struggles of the working classes. This print is from a series published in 1904 to commemorate Germany's 16th-century peasant rebellion.

Matisse after Fauvism

Although Fauvism was short-lived, its impact, like that of Expressionism, was a basis for twentieth-century abstraction. Matisse reportedly said that "Fauvism is not everything, but it is the beginning of everything."

As Matisse developed, he was influenced by abstraction without embracing it completely. His sense of musical rhythm translated into line creates energetic, curvilinear biomorphic form. On the other hand, the shapes and spaces of Matisse that are determined primarily by color and only secondarily by line can be more static and geometric. These two tendencies—fluid line and flat color—create a dynamic tension that persists throughout his career.

Harmony in Red

In *Harmony in Red* of 1908–1909 (fig. **24.13**), Matisse goes beyond the thick, constructive brushstrokes and unusual color juxtapositions of his Fauve period. The subject of the painting, a woman placing a fruit bowl on a table, seems secondary to its formal arrangement. Within the room, the sense of perspective has been minimized because the table and wall are of the same red. The demarcation between them is indicated not by a constructed illusion of space, but by a dark outline and by the bright still-life arrangements on the surface of the table. The perspective is confined to the chair at the left and the window frame behind it. But, despite the flattening of the form by minimal modeling, Matisse endows the woman and the still-life objects with a sense of volume.

The landscape, visible through the open window, relieves the confined quality of the interior view. It is related to the interior by the repetition of energetic black curves, which Matisse referred to as his "arabesques." The inside curves create branchlike forms that animate the table and wall, while those outside form branches and tree trunks. Smaller arabesques define the flower stems and the outline of the woman's hair.

The title *Harmony in Red* reinforces the musical abstraction of Matisse's picture. It refers to the predominant color, the flat planes of which "harmonize" the wall and table into a shared space. Matisse builds a second, more animated "movement" in the fluid arabesques harmonizing interior with exterior. Finally, the bright patches on the woman, the still-life objects, and the floral designs create a more staccato rhythm composed of individual accented forms. Matisse's ability to harmonize these different formal modes within a static pictorial space synthesizes three artistic currents: the Post-Impressionist liberation of color, the Symbolist creation of mood, and the twentieth-century trend toward abstraction.

24.13 Henri Matisse, *Harmony in Red*, 1908–1909. Oil on canvas; 5 ft. 11 in. × 8 ft. 1 in. (1.80 × 2.46 m). State Hermitage Museum, St. Petersburg.

Dance I

In *Dance I* of 1909 (fig. **24.14**), it is the figures, rather than the arabesques, that dance. The black outlines define the dancers, who twist and turn, jump and stretch. Their rhythmic, circular motion has been compared to dancers on the surface of a Greek vase. Although the blue and green background is composed of flat color, Matisse creates a three-dimensional illusion in the dancers. This is enhanced by the warm pinks that make the dancers appear to advance, as the cool background colors recede. Although the individual movements of the dancers vary, together they form a harmonious continuum.

24.14 Henri Matisse, *Dance I*, 1909. Oil on canvas; 8 ft. 6½ in. × 12 ft. 9½ in. (2.60 × 3.90 m). Museum of Modern Art, New York (Gift of Nelson A. Rockefeller in honor of Alfred H. Barr, Jr.).

Piano Lesson

Another painting with a musical subject reflects changes in Matisse's style over the next decade. The *Piano Lesson* of 1916 (fig. **24.15**) has an autobiographical subtext. It is about the conflict between musical discipline and ambition on the one hand and erotic pleasure on the other. In contrast to the earlier paintings, the *Piano Lesson* is constructed geometrically from rectangular and trapezoidal shapes that indicate Matisse's willingness to experiment with Cubist form. The seated woman at the right, for example, who could be the boy's mother or teacher, is a rectangular structure with ovals defining her blank face. She is elevated, as if on a throne, implicitly commanding the boy to practice. The boy stares fixedly at his music. His right eye is blocked out by a gray trapezoid that echoes the shape in the window and the metronome.

To the left of the gray window section is a rich green trapezoid. In the lower left corner, a figurine lounges in a seductive pose reminiscent of Titian's *Venus of Urbino* (see fig. 14.52); it is also a quotation of an earlier sculpture by Matisse. The outlines of the figure echo the arabesques in the music stand and the grillwork in the window. Although the boy is boxed in by the rectangle, which he shares with the "enthroned" woman, he is also related to the figurine through their shared tones of orange-brown. Although prevented from "seeing" her by the gray shape over his right eye, he seems to have her literally "on his mind" by virtue of the color of his hair. The same orange-brown is repeated in the illuminated candle, which is positioned between the boy and the figurine. The candle, which can have erotic implications, also denotes the passage of time.

The opposition of the notion of woman as disciplinarian and as seductress is evident in the formal structure of the painting, as well as in its iconographic details. The rectilinear organization of the space, like the metronome, corresponds to the "lofty" woman in its sense of ordered logic and measured time. (She is based on an earlier portrait of the wife of a Cubist critic and can thus be linked with the geometry of Cubism in content as well as form.)

Inscribed across the center bar of the music stand is the word "PLEYEL" in reverse. This is a reference to the manufacturer of the piano as well as to the Salle Pleyel, the most distinguished concert hall of Paris. It, therefore, combines the present practice of the ambitious young musician with a future that his mother or teacher wishes for him. The *Piano Lesson* can be read as a metaphor for Matisse's relationship to the art of painting. It combines the rules of practice, technique, order, and logic with controlled energy. The role of female inspiration, echoed by the separate implications of metronome and candle, is divided between the two women. In a way, therefore, this picture is to Matisse what the *Studio* (see fig. 21.5) was to Courbet —a psychological "manifesto" of the painter's art.

CONNECTIONS

See figure 14.52. Titian, *Venus of Urbino*, c. 1538.

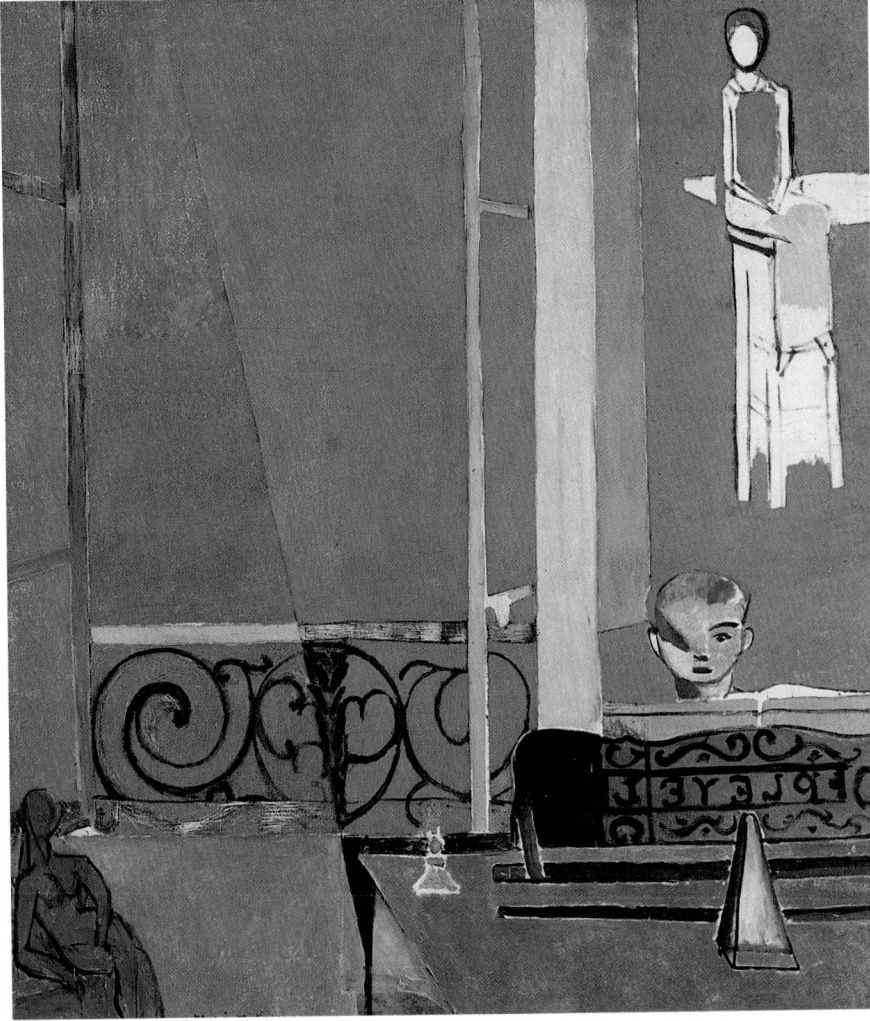

24.15 Henri Matisse, *Piano Lesson*, 1916. Oil on canvas; 8 ft. ½ in. × 6 ft. 11¾ in. (2.45 × 2.13 m). Museum of Modern Art, New York (Mrs. Simon Guggenheim Fund).

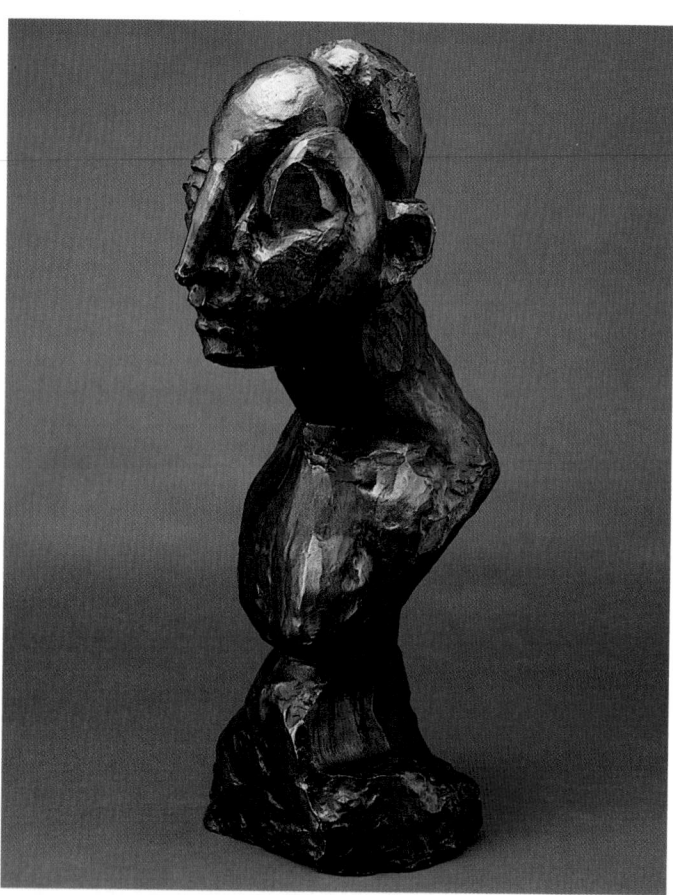

24.16 Henri Matisse, *Jeannette V*, 1916. Bronze; 23 × 7¾ × 11½ in. (58.4 × 19.7 × 29.3 cm). Art Gallery of Ontario, Toronto.

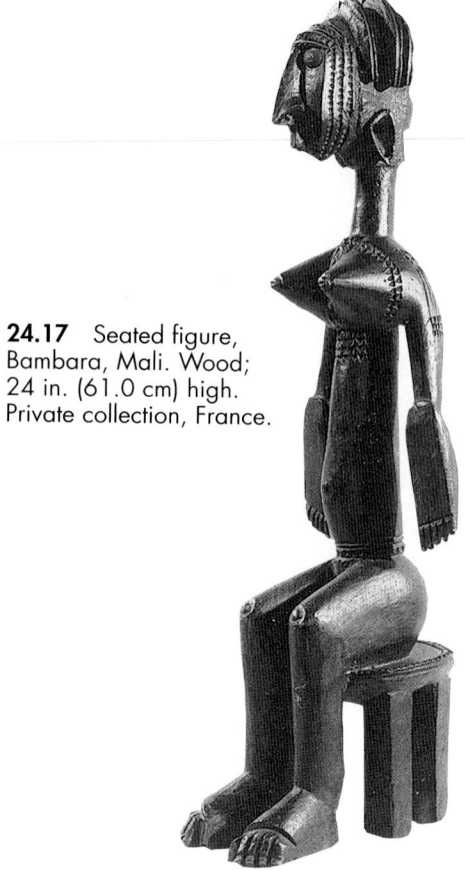

24.17 Seated figure, Bambara, Mali. Wood; 24 in. (61.0 cm) high. Private collection, France.

Jeannette V

The geometric qualities of the *Piano Lesson* recur in a sculpture of the same year that reflects the influence of African art. *Jeannette V* (fig. **24.16**) is a bronze bust organized more according to geometry than to nature; it is the last of a series of heads begun in 1909 that move toward increasingly simplified abstraction. The hair is divided into shifting forms, one of which merges into the long nose, and the neck and body are arranged in three zigzag planes. This work shares an aggressive, angular quality with the seated Bambara figure from Mali (fig. **24.17**) that Matisse owned at the time. In both, there is an emphasis on pointed forms and a vigorous self-assertiveness.

Later Works

Matisse later became interested in the lively, Moorish patterns of North Africa. He traveled to Morocco for the first time in 1906 and painted European models in Moorish settings. In *Decorative Figure in an Oriental Setting* of 1925 (fig. **24.18**), Matisse placed a monumental odalisque in a space crowded with colorful linear energy. The woman, by contrast, is massive and blocklike. She retains some of the geometry of his earlier figures, with her cylindrical neck, circular breasts, triangular side, and rectangular thigh.

The solidity of her form anchors the picture, which is otherwise filled with the motion of elaborate patterns. The curved drapery creates a transition from the still, restful pose of the odalisque to the tilting floor and profusely animated designs of the carpet, wall, and flowerpot. Orange arabesques frame the blue shapes on the wall—a particularly vivid chromatic juxtaposition because blue and orange are opposites on the color wheel (see fig. I.18). The blues are further enlivened by the flowers in their midst, especially by the intense reds. The extent to which Matisse's style has departed from the Classical tradition—while also maintaining its themes—can be seen by comparing his "decorative figure" with the Neoclassical *Grande Odalisque* of Ingres (see fig. 19.14).

During the last decade of his life, Matisse gave up painting, partly because of cancer. Instead, he grappled with the problem of creating a three-dimensional illusion from absolutely flat forms. His medium was *découpage* (cutout),

CONNECTIONS

See figure **19.14.** Jean-Auguste-Dominique Ingres, *Grande Odalisque*, 1814.

creating an image by pasting pieces of colored paper onto a flat surface. An early series of cutouts, entitled *Jazz,* indicates Matisse's continuing interest in synthesizing musical with pictorial elements. His cutout of *Icarus* of 1947 (fig. **24.19**), from the *Jazz* series, combines a subject from Greek mythology with modern style and technique. By curving the edges and expanding or narrowing the forms, Matisse gives the silhouetted Icarus (see Bruegel's *Landscape with the Fall of Icarus,* fig. 16.6) the illusion of volume. His outstretched, winglike arms and tilting head create the impression that, though he is falling through space, he is not plummeting down to the sea, but floating gracefully in slow motion.

Entirely different in character are the zigzagging bright yellow stars that surround Icarus. Their points shoot off in various directions, and their vivid color is far more energetic than the languid figure of Icarus. There are thus two musical "movements" in this cutout—the slower, curvilinear motion of Icarus and the rapid, angular motion of the stars. Adagio and staccato are combined against the deep, resonant blue sky.

The drive toward new techniques and media for image making, which is evident in Matisse's cutouts, will be seen to characterize many of the innovations of twentieth-century art.

24.18 (above) Henri Matisse, *Decorative Figure in an Oriental Setting,* 1925. Oil on canvas; 51⅛ × 38½ in. (129.8 × 97.8 cm). Museum of Modern Art, Paris.

24.19 Henri Matisse, *Icarus,* plate 8 from *Jazz.* Paris, E. Tériade, 1947. Pochoir, printed in color, each double page 16⅝ × 25⅝ in. (42.2 × 65.1 cm). Museum of Modern Art, New York (Louis E. Stern Collection). The *Jazz* series is composed of individual book-size cutouts printed in book form to accompany Matisse's own text.

Style/Period	Works of Art	Cultural/Historical Developments
TURN OF THE CENTURY **Benin Oba head**	Ife copper mask (**W11.2**) Benin Oba head (**W11.5**) Fang reliquary statue (**W11.1**) Baule figure (**W11.3**) Bakota figure (**W11.4**) Bambara seated figure (**24.17**) Benin head for the altar of the queen mother (**W11.6**)	 **Bakota figure** **Benin head**
1900–1910 **Picasso, *Old Guitarist***	Matisse, *Notre-Dame in the Late Afternoon* (**24.2**) Picasso, *Old Guitarist* (**24.1**) Matisse, *Madame Matisse* (**24.3**) Matisse, *Woman with the Hat* (**24.4**) Kollwitz, *Whetting the Scythe* (**24.12**) Kirchner, *The Street* (**24.5**) Matisse, *Harmony in Red* (**24.13**) Matisse, *Dance I* (**24.14**) **Matisse, *Harmony in Red***	Theodore Roosevelt president of the U.S.A. (1901–1909) Foundation of Nobel prizes (1901) August Strindberg, *The Dance of Death* (1901) The hormone adrenalin first isolated (1901) First oil wells drilled in Persia (1901) Maxim Gorky, *Lower Depths* (1902) Anton Chekhov, *Three Sisters* (1902) Aswan Dam opened (1902) Albert Einstein, *Special Theory of Relativity* (1905) Alfred Stieglitz opens the 291 Art Gallery (1905) *Die Brücke* formed in Dresden (1905) Upton Sinclair, *The Jungle* (1906) Ivan Pavlov's study of conditioned reflexes (1907)
1910–1920 **Marc, *Large Blue Horses***	Nolde, *Still Life with Masks* (**24.7**) Nolde, drawing of an Oceanic canoe prow (**24.8**) Marc, *Large Blue Horses* (**24.11**) Kirchner, *Five Women in the Street* (**24.6**) Kandinsky, *Painting No. 201* (**24.9**) Matisse, *Jeannette V* (**24.16**) Matisse, *Piano Lesson* (**24.15**) **Kandinsky, *Painting No. 201***	Igor Stravinsky, *The Firebird* (1910) *Der Blaue Reiter* formed in Munich (1911) Frederick Delius, *On Hearing the First Cuckoo in Spring* (1912) *Titanic* sinks on maiden voyage (1912) Thomas Mann, *Death in Venice* (1913) First World War (1914–1918) W. Somerset Maugham, *Of Human Bondage* (1915) Ford Madox Ford, *The Good Soldier* (1915) Bolshevik Revolution in Russia (1917) League of Nations established (1919) **Kandinsky, *Several Circles, No. 323***
1920–1930 **Matisse, *Icarus***	Matisse, *Decorative Figure in an Oriental Setting* (**24.18**) Kandinsky, *Several Circles, No. 323* (**24.10**) Matisse, *Icarus* (**24.19**)	Roaring Twenties, age of prosperity and cultural innovation in America (1920–1929) The Jazz Age (1920s)

25

Cubism, Futurism, and Related Twentieth-Century Styles

T he most influential style of the early twentieth century was Cubism, which, like Fauvism, developed in Paris. Cubism was essentially a revolution in the artist's approach to space, both on the flat surface of the picture and in sculpture. The nonnaturalistic Fauve can be seen as synthesizing nineteenth-century Impressionism, Post-Impressionism, and Symbolism. Cubism, however, together with the nonfigurative innovations of Expressionism, soon became the wave of the artistic future.

The main European impetus for Cubism came from Cézanne's new spatial organization, in which he built up images from constructions of color. Other decisive currents of influence came from so-called "primitive," or tribal, and Iberian art. These offered European artists unfamiliar, non-Classical ways to represent the human figure.

Cubism

Precursors

Picasso's 1906 portrait of Gertrude Stein (fig. **25.1**; see box, p. 850) is executed in the dark red hues that mark the end of his Rose Period, which followed the Blue Period discussed in Chapter 24. The emphasis on color is consistent with contemporary Fauve interests, but a comparison with the *Old Guitarist* of the Blue Period (see fig. 24.1) indicates that more than color has changed. In the *Gertrude Stein,* new spatial and planar shifts occur that herald the beginning of the development of Cubism.

Gertrude Stein's right arm and hand are organically shaded and contoured. Her left hand, however, is flatter, and her arm looks as if it were constructed of cardboard. Picasso reportedly needed over eighty sittings to finish the picture, the main stumbling block being the face. In the final result, Gertrude Stein stares impassively, as if from

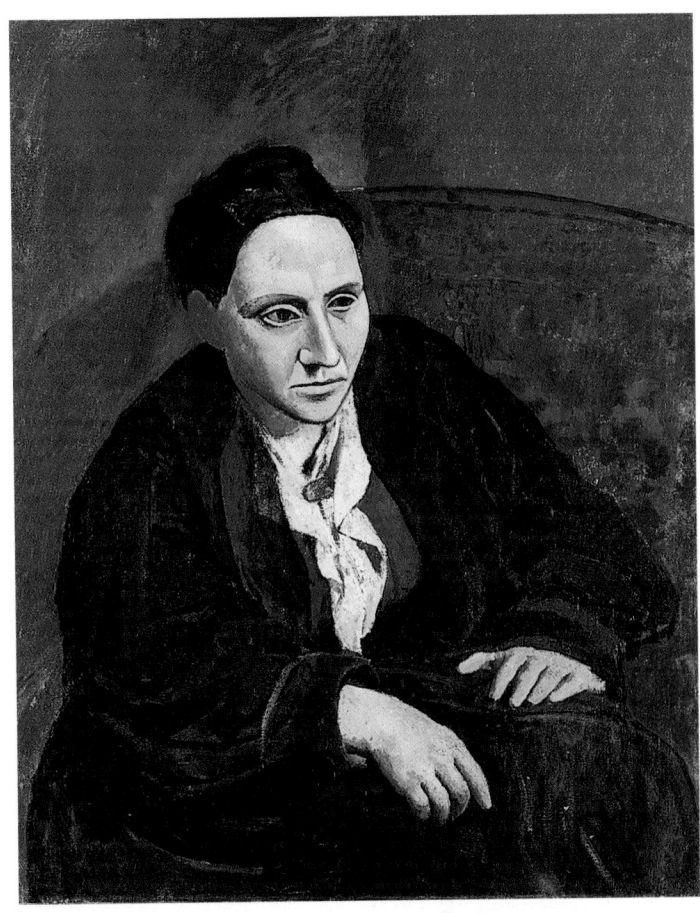

25.1 Pablo Picasso, *Gertrude Stein*, 1906. Oil on canvas; 39⅜ × 32 in. (100.0 × 81.3 cm). Metropolitan Museum of Art, New York (Bequest of Gertrude Stein, 1947). In 1909, Gertrude Stein wrote *Prose Portraits*, the literary parallel of Analytic Cubism. Her unpunctuated cinematic repetition reads like free association. The following is from her *Portrait* of Picasso. "One whom some were certainly following was one working and certain was one bringing something out of himself then and was one who had been all his living had been one having something coming out of him. . . . This one was one who was working."[1]

Gertrude Stein

Gertrude Stein (1874–1946) was an expatriate American art collector and writer. She moved to Paris in 1903, after studying psychology at Radcliffe and medicine at Johns Hopkins. Her Paris apartment became a salon for the leading intellectuals of the post–World War I era, whom she dubbed the "lost generation." Her most popular book, *The Autobiography of Alice B. Toklas* (Stein's companion), is actually her own autobiography.

Stein and her two brothers were among the earliest collectors of paintings by avant-garde artists. History has vindicated her judgment, for she left an art collection worth millions of dollars. Ernest Hemingway, in *A Moveable Feast*, wrote that he had been mistaken not to heed Stein's advice to buy Picassos instead of clothes.

behind a mask. The hair does not grow organically from the scalp, and the ears are flat. The sharp separations between light and dark at the eyebrows, the black outlines around the eyes, and the disparity in the size of the eyes detract from the impression of a flesh-and-blood face.

Even more like masks are the faces in Picasso's pivotal picture *Les Demoiselles d'Avignon* (*The Women of Avignon*) of 1907 (fig. 25.2). With this representation of five nudes and a still life, Picasso launched a spatial revolution. The subject itself was hardly new, and Picasso had adapted traditional poses from earlier periods of Western art. On the far left, for example, the standing figure nearly replicates the pose of ancient Egyptian kings (see Chapter 3). The left leg is forward, the right arm is extended downward, and the fist is clenched. Also borrowed from Egypt is the pictorial convention of rendering the face in profile and the eye in front view. Picasso's two central figures, whose arms stretch behind their heads, are based on traditional poses of Venus. Of all the figures, the faces of the seated and standing nudes on the far right are most obviously based on African prototypes. The wooden mask from the Congo in figure 25.3, for example, shares an elongated, geometric quality with the face of the standing figure at the right. Here, Picasso has abandoned *chiaroscuro* in favor of the Fauve preference for bold strokes of color. The nose resembles the long, curved, solid wedge of the mask's nose.

In the Mbuya (sickness) mask from Zaire (fig. 25.4), the natural facial configuration is disrupted. Similarly, the face of Picasso's seated figure defies nature as well as the Classical ideal. In both faces, the nose curves to one side, while

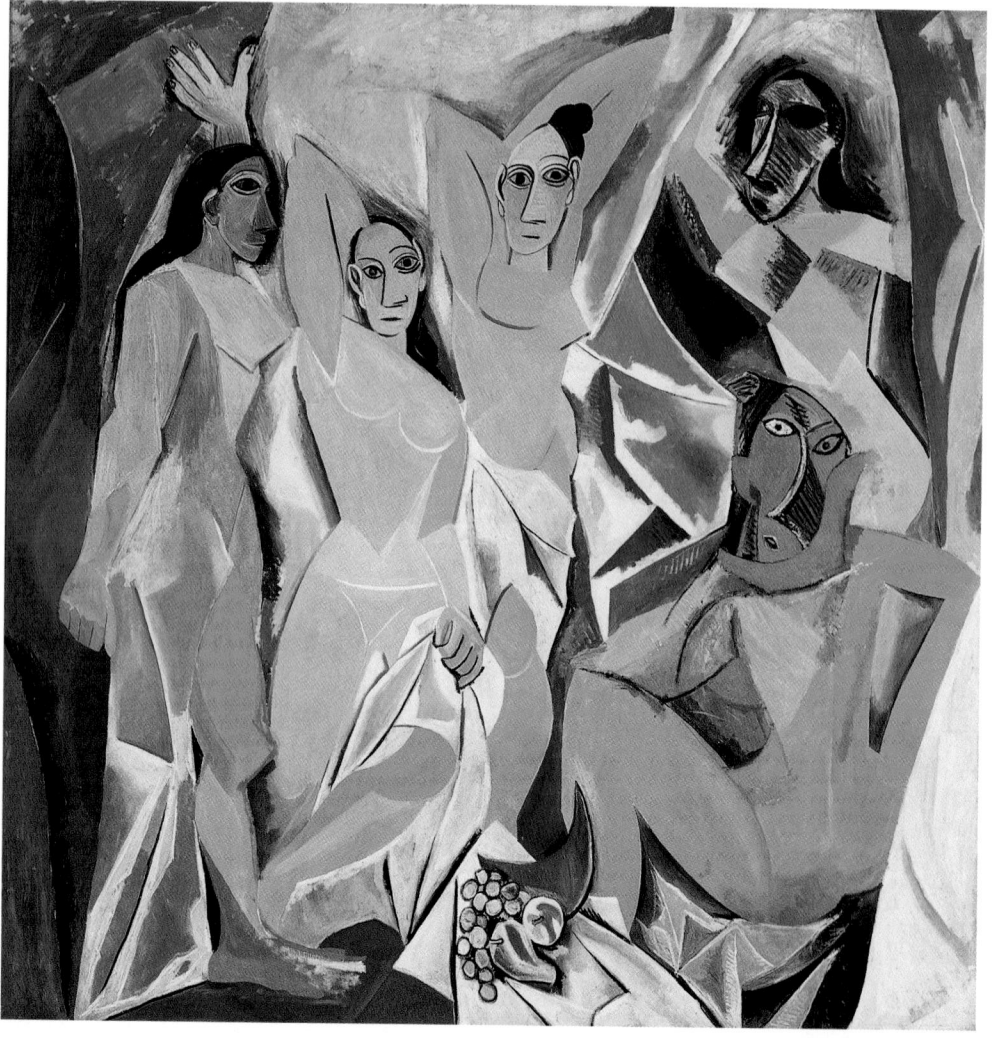

25.2 Pablo Picasso, *Les Demoiselles d'Avignon*, Paris, June–July 1907. Oil on canvas; 8 ft. × 7 ft. 8 in. (2.44 × 2.34 m). Museum of Modern Art, New York (acquired through the Lillie P. Bliss Bequest). This painting was named for a bordello in the Carrer d'Avinyo (Avignon Street), Barcelona's red-light district. Earlier versions contained a seated sailor and a medical student carrying a skull. Both were aspects of Picasso himself. By removing them from the final painting, Picasso shifted from a personal narrative to a more powerful mythic image.

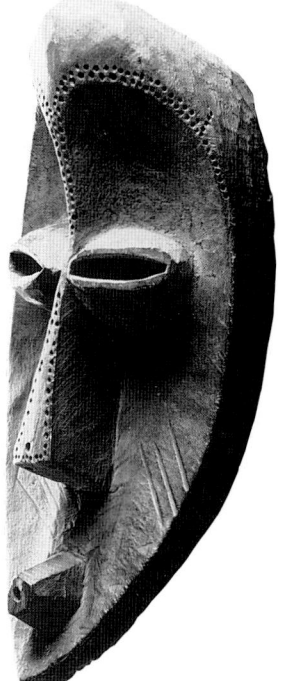

25.3 Mask from the Etoumbi region, People's Republic of the Congo. Wood; 14 in. (35.6 cm) high. Musée Barbier-Müller, Geneva.

25.4 Mbuya (sickness) mask, Pende, Zaire. Painted wood, fiber, and cloth; 10½ in. (26.6 cm) high. Musée Royal de l'Afrique Centrale, Tervuren, Belgium.

the mouth shifts to the other. In the two central nudes as well, the features have been not only simplified, but also distorted, so that one eye is slightly above another, the nose is no longer directly above the mouth, and the ears are asymmetrical. Still more radical is the depiction of the body of the seated figure, the so-called "squatter." She looks toward the picture plane while simultaneously turning her body in the opposite direction so that her face and back are visible at the same time. In this figure, Picasso has broken from tradition by abandoning the single vantage point of the observer in favor of multiple vantage points along the lines pioneered by Cézanne. The so-called simultaneous view was to become an important visual effect of Cubism.

The figures in the *Demoiselles* are fragmented into solid geometric constructions, with sharp edges and angles. They interact spatially with the background shapes, blurring the distinction between foreground and background, as Cézanne had done. Such distortion of the human figure is particularly startling because it assaults our bodily identity. Light as well as form is fragmented into multiple sources so that the observer's point of view is constantly shifting. Because of its revolutionary approach to space and its psychological power, the *Demoiselles* represented the greatest expressive challenge to the traditional Classical ideal of beauty and harmony since the Middle Ages.

25.5 Marie Laurencin, *Group of Artists*, 1908. Oil on canvas; 27½ × 31⅞ in. (64.8 × 81.0 cm). The Baltimore Museum of Art. The Cone Collection, formed by Dr. Claribel Cone and Miss Etta Cone. BMA 1950.215.

Guillaume Apollinaire and Marie Laurencin

Guillaume Apollinaire, the Symbolist poet and critic, was one of the most outspoken advocates of Cubism, particularly that of Picasso. "A man like Picasso," he wrote in 1912, "studies an object as a surgeon dissects a cadaver." According to Apollinaire, modern painters "still look at nature, [but] no longer imitate it. . . . Real resemblance no longer has any importance, since everything is sacrificed by the artist to truth. . . . Thus we are moving towards an entirely new art which will stand . . . as music stands to literature. It will be pure painting, just as music is pure literature."[2]

Figure **25.5** by Marie Laurencin (1885–1956) shows Apollinaire seated with Picasso (on the left) and his dog Frika, Picasso's mistress Fernande Olivier, and the artist herself on the right. Laurencin typically painted in flat planes of pastel blues, pinks, and grays. Here, Picasso's abrupt profile and frontal eye recall his own use of that distortion, which he had found in Egyptian painting. Fernande's face is divided by color into two planes, reminiscent of Cubist construction. Laurencin depicts her self-portrait with the neck characteristically curving sharply into the face, an arrangement that is repeated in the positioning of her left arm and hand.

Laurencin and Apollinaire were inseparable companions for about five years, from 1909 to 1914. She was accused of being a superficial artist and intellectually inferior until Gertrude Stein bought this painting. The affinities of Laurencin's work with Cubism are evident in this picture as well as in some of her designs for stage sets. She also illustrated Poe's "The Raven" (see p. 815), which reveals her admiration for Symbolist poetry. In fact, it was partly through her encouragement that Apollinaire wrote in a Symbolist style.

Analytic Cubism: Pablo Picasso and Georges Braque

In 1907, Picasso met the French painter Georges Braque (1882–1963), who had studied the works of Cézanne and been overwhelmed by the *Demoiselles*. Braque is reported to have declared, when he first saw the *Demoiselles,* that looking at it was like drinking kerosene. For several years, in the Montmartre quarter of Paris, Braque worked so closely with Picasso that it can be difficult to distinguish their Analytic Cubist pictures. Braque's *Violin and Pitcher* of 1909–1910 (fig. **25.6**) is very much like Picasso's works of that time and will serve as an example of the style.

25.6 Georges Braque, *Violin and Pitcher*, 1909–1910. Oil on canvas; 3 ft. 10 in. × 2 ft. 4¾ in. (1.17 × 0.73 m). Öffentliche Kunstsammlung Basel, Kunstmuseum (Gift of Dr. H. C. Raoul La Roche, 1952). Braque was born in Argenteuil, France, and moved to Paris in 1900. There he joined the Fauves and established a collaborative friendship with Picasso. They worked closely together until World War I and were jointly responsible for the development of Cubism. In 1908, on seeing a painting by Braque, Matisse reportedly remarked that it had been painted "with little cubes." This was credited with being the origin of the term *Cubism.*

25.7 Pablo Picasso, *Head of a Woman*, 1909. Bronze (cast); 16³⁄₁₆ × 9⅝ × 10½ in. (41.1 × 24.5 × 26.7 cm). National Gallery of Art, Washington, D.C.

Both the subject matter and the expressive possibilities of color—here limited to dark greens and browns—are subordinated to a geometric exploration of three-dimensional space. The only reminders of natural space and of the objects that occupy it are the violin and pitcher, a brief reference to the horizontal surface of a table, and a vertical architectural support on the right. Most of the picture plane, including parts of these objects, is rendered as a jumble of fragmented cubes and other solid geometric shapes. What in reality would be air space is filled up with multiple lines, planes, and geometric solids. The sense of three-dimensional form is achieved by combining shading with bold strokes of color. Despite the crisp edges of the individual shapes in Analytic Cubist pictures such as this one, the painted images lose parts of their outlines. Whereas in Impressionism edges dissolve into prominent brushstrokes, in Cubism they dissolve into shared geometric shapes. No matter how closely the forms approach dissolution, however, they never dissolve completely.

In 1909, Picasso produced the first Cubist sculpture, the bronze *Head of a Woman* (fig. **25.7**), in which he shifted the natural relationship between head and neck, creating two diagonal planes. The hair, as in Analytic Cubist paintings, is multifaceted, and the facial features are geometric rather than organic.

In 1911, two Cubist exhibitions held in Paris brought the work of avant-garde artists to the attention of the general public. The year 1911 also marked the culmination of Analytic Cubism. Although this phase of Cubism was brief, its impact on Western art was enormous. It stimulated the emergence of new and related styles, along with original techniques of image making.

Collage

Picasso's Cubist *Man with a Hat* of 1912 (fig. **25.8**) is an early example of **collage** (see box), which was a logical outgrowth of Analytic Cubism and marked the beginning of the shift to Synthetic Cubism (see p. 854). Pieces of colored paper and newspaper are pasted onto paper to form geometric representations of a head and neck; the remainder of the image is drawn in charcoal. The use of newspaper, which seems textured because of the newsprint, was a common feature of early collages. Words and letters, which are themselves abstract signs, often formed part of the overall design. Collage, like Cubism, involved disassembling objects—just as one might take apart a machine, break up a piece of writing, or even divide a single word into letters—and then rearranging (or reassembling) the parts to form a new image.

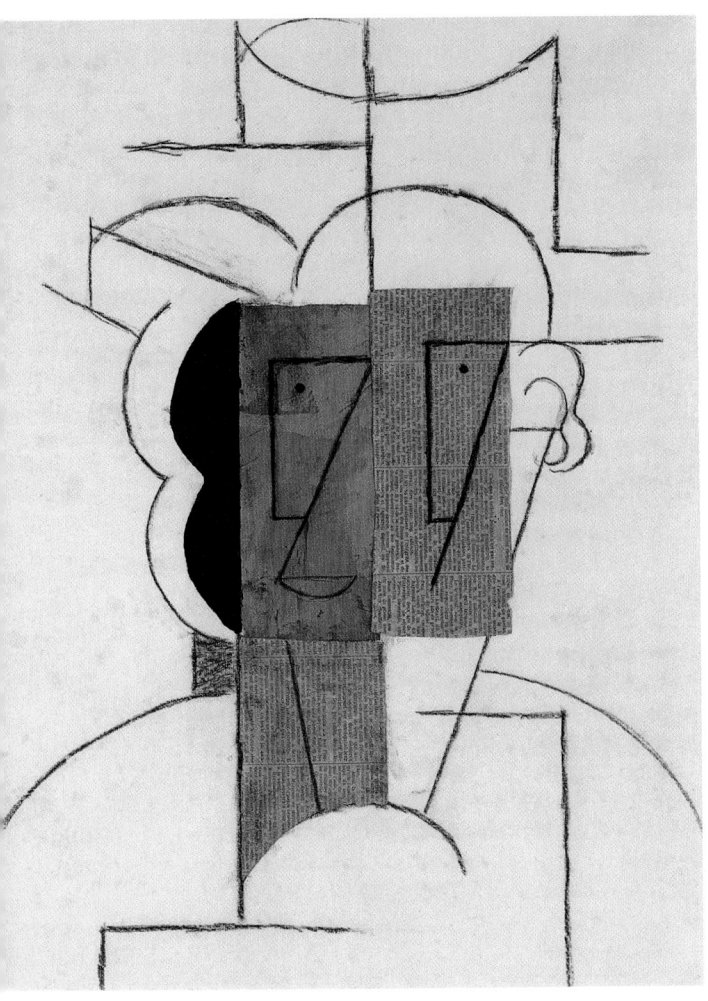

25.8 Pablo Picasso, *Man with a Hat,* after December 3, 1912. Pasted paper, charcoal, and ink; 24½ × 18⅝ in. (62.2 × 47.3 cm). Museum of Modern Art, New York (Purchase).

Collage and Assemblage

Collage (from the French word *coller,* meaning "to paste" or "to glue") developed in France from 1912. It is a technique that involves pasting lightweight materials or objects, such as newspaper and string, onto a flat surface. A technique related to collage, which developed slightly later, is **assemblage.** Heavier objects are brought together and arranged, or assembled, to form a three-dimensional image. Both techniques make use of **"found objects"** (*objets trouvés*), which are taken from everyday sources and incorporated into works of art.

Picasso's witty 1943 assemblage entitled *Bull's Head* (fig. **25.9**) is a remarkable example of his genius for synthesis. He has fused the ancient motif of the bull and the traditional medium of bronze with modern steel and plastic. He has also conflated the bull's head with African masks and effected a new spatial juxtaposition by reversing the direction of the bicycle seat and eliminating the usual space between it and the handlebars. In this work, Picasso simultaneously explores the possibilities of new media, of conflated imagery, and of the spatial shifts introduced by Cubism.

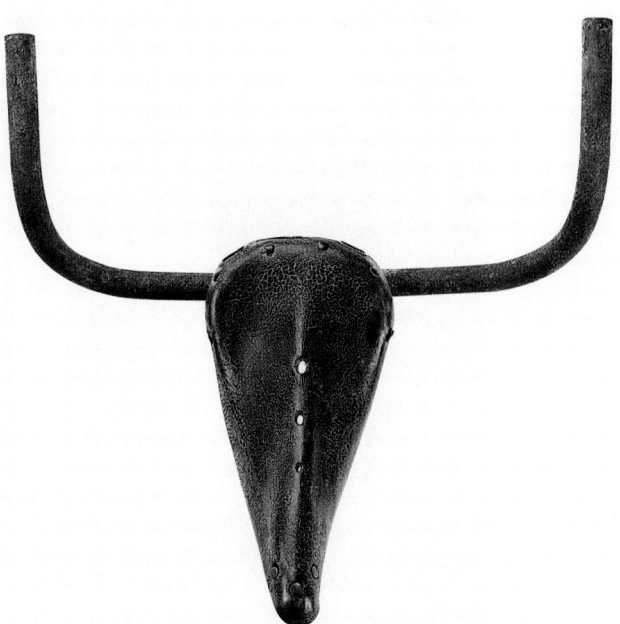

25.9 Pablo Picasso, *Bull's Head,* 1943. Assemblage of bicycle saddle and handlebars; 13¼ × 17⅛ × 7½ in. (33.7 × 43.5 × 19.1 cm). Musée Picasso, Paris. Picasso detached the seat and handlebars of a bicycle, turned the seat around, and attached it to the handlebars. The object was then cast in bronze and hung on a wall.

Synthetic Cubism

Synthetic Cubism marked a return to bright color. Whereas Analytic Cubism fragmented objects into abstract geometric forms, Synthetic Cubism arranged flat shapes of color to form objects. Picasso's *Three Musicians* (fig. **25.10**)—a clarinetist on the left, a Harlequin playing a guitar in the center, and a monk—is built up from unmodeled shapes of color arranged into tilted planes. In addition, the flat shapes—such as the dog under the table—occupy a more traditional space than those of Analytic Cubism, in which air space is filled with solid geometry. The painted shapes resemble the flat paper pasted to form a collage. Simultaneity of viewpoint is preserved—for example, in the sheet of music. It is held by the monk and turned toward the viewer, who sees both the musician and what he is reading.

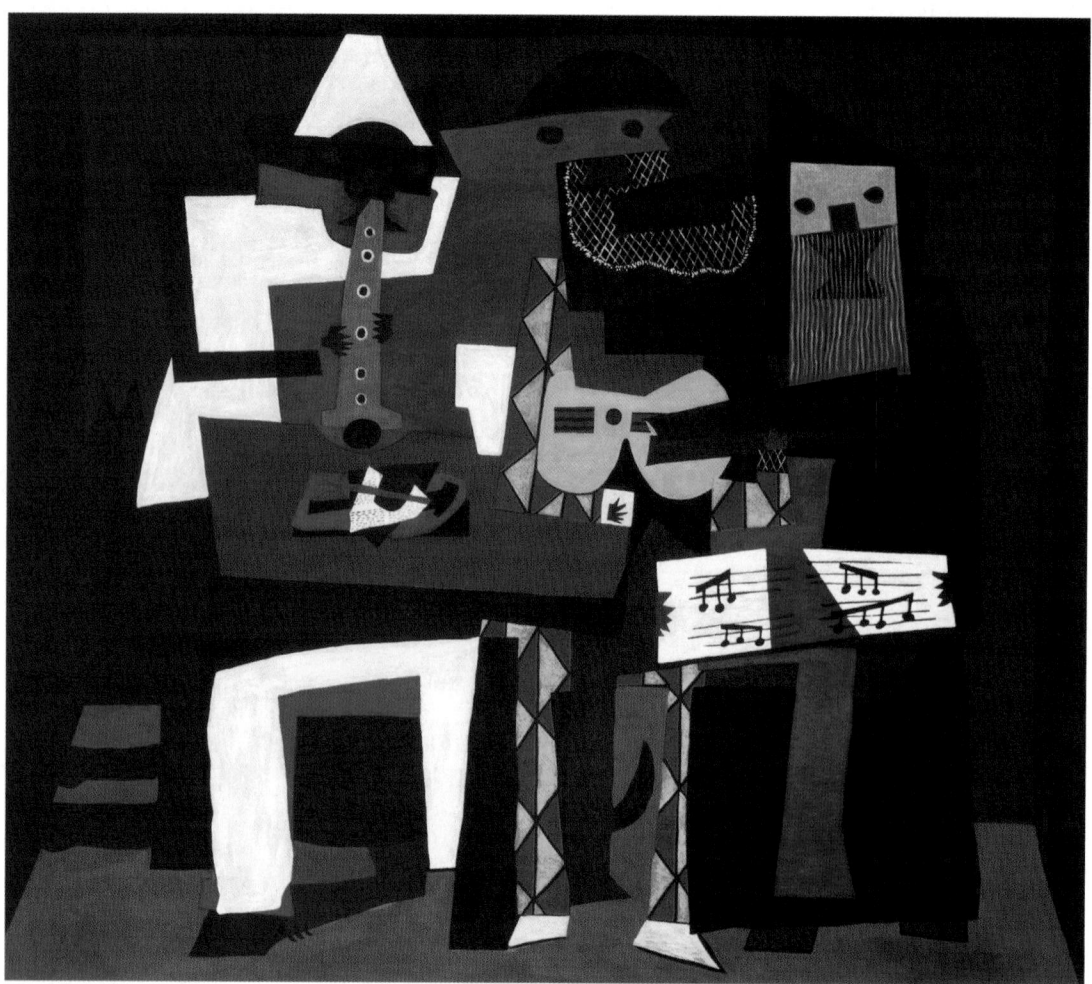

25.10 Pablo Picasso, *Three Musicians*, 1921. Oil on canvas; 6 ft. 7 in. × 7 ft. 3¾ in. (2.01 × 2.23 m). Museum of Modern Art, New York (Mrs. Simon Guggenheim Fund).

Picasso's Surrealism

Another stylistic shift in Picasso's work that was influenced by Cubism has been called Surrealism. This term (see Chapter 26) literally means "above real" and denotes a truer reality than that of the visible world. In the *Girl before a Mirror* of 1932 (fig. **25.11**), Picasso aims at psychological reality. He uses the multiple viewpoint in the service of symbolism, although the precise meaning of this picture has remained elusive and has been the subject of many interpretive discussions. The girl at the left is rendered in a combined frontal and profile view, but her mirror reflection is in profile. It is also darker than the "real" girl outside the mirror, and the torsos do not match.

The device of the mirror to create multiple viewpoints is not new. Picasso was certainly familiar with Manet's *Bar at the Folies-Bergère* (see fig. 22.6) and Velázquez's *Venus with a Mirror* (see fig. 17.55) and *Las Meninas* (see fig. 17.56), all of which use mirrors to expand the viewer's range of vision. Here, however, the formal differences between the girl and her reflection suggest that outer appearances are contrasted with an inner, psychological state. One French term for *mirror* is *psyché,* which means "soul," and this provides a clue to the picture's significance. It reinforces the notion that Picasso transformed the multiple views of Cubism into multiple psychological views, which simultaneously show the girl's interior psychic reality and exterior appearance.

CONNECTIONS

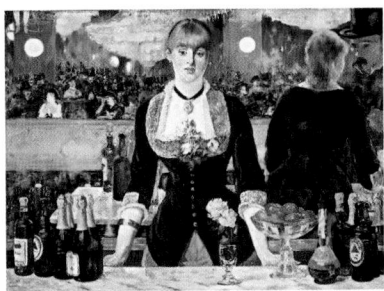

See figure 22.6. Édouard Manet, *A Bar at the Folies-Bergère,* 1881–1882.

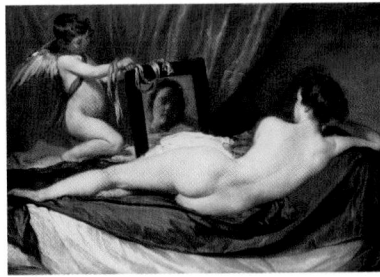

See figure 17.55. Diego Velázquez, *Venus with a Mirror (Rokeby Venus),* c. 1648.

See figure 17.56. Diego Velázquez, *Las Meninas,* 1656.

25.11 Pablo Picasso, *Girl before a Mirror,* 1932. Oil on canvas; 5 ft. 4 in. × 4 ft. 3¼ in. (1.62 × 1.31 m). Museum of Modern Art, New York (Gift of Mrs. Simon Guggenheim).

Picasso's *Guernica*

In his monumental work of 1937, *Guernica* (fig. **25.12**), Picasso combined Analytic and Synthetic Cubist forms with several traditional motifs, juxtaposing them in a new Surrealist way. The combination serves the political message of the painting—namely, Picasso's powerful protest against the brutality of war and tyranny (see caption). Consistent with its theme of death and dying, the painting is nearly devoid of color, although there is considerable tonal variation within the range of black to white. The absence of color enhances the journalistic quality of the painting, relating it to the news accounts of the bombing it protests.

Guernica is divided into three sections—a central triangle with an approximate rectangle on either side. The base of the triangle extends from the arm of the dismembered and decapitated soldier at the left to the foot of the running woman at the right. The dying horse represents the death of civilization, though it may be revived by the woman with a lamp (Liberty) rushing toward it. Another expression of hope, as well as of the light of reason, appears in the motif combining the shape of an eye with the sun's rays and a lightbulb just above the horse's head. On the right, the pose and gesture of a falling woman suggest Christ's Crucifixion. On the left, a woman holds a dead baby on her lap in a pose reminiscent of Mary supporting the dead Christ in the traditional *Pietà* scene (see fig. 14.18). Behind the woman looms the specter of the Minotaur, the monstrous tyrant of ancient Crete, whose only human qualities are the flattened face and eyes. For

CONNECTIONS

See figure 14.18.
Michelangelo, *Pietà*,
1498/9–1500.

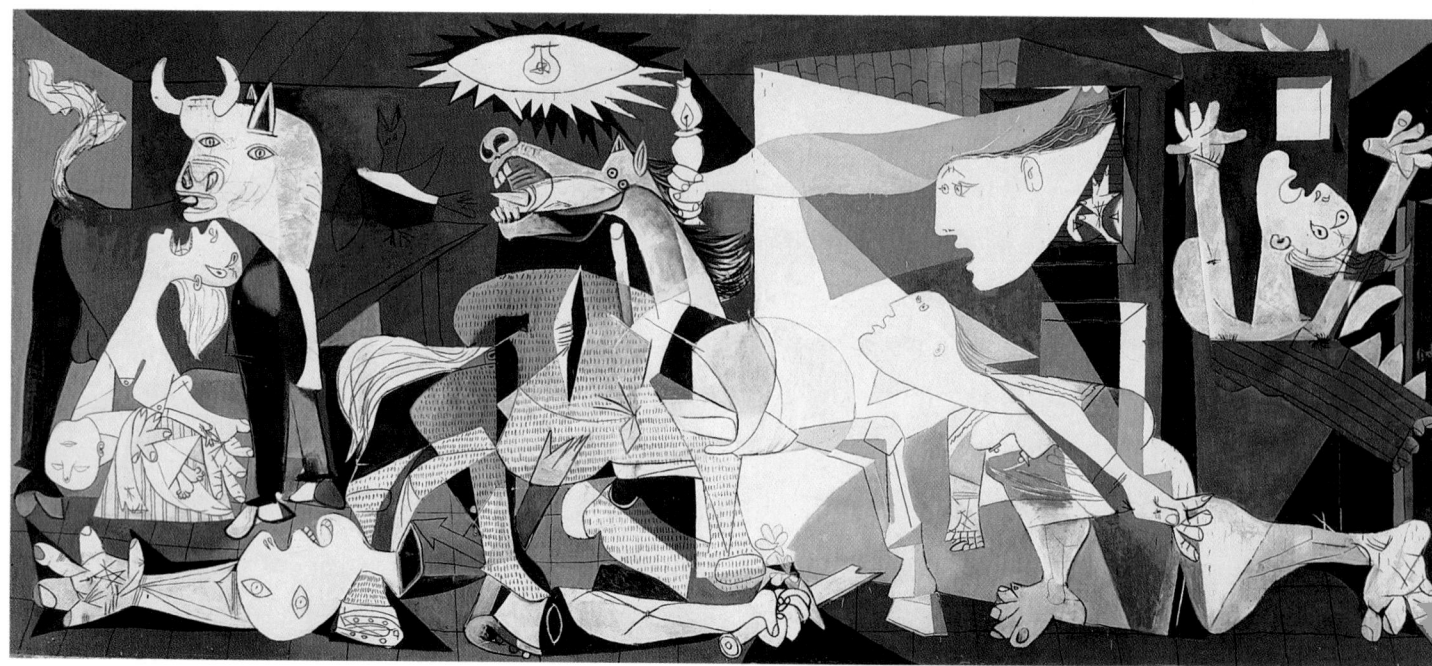

25.12 Pablo Picasso, *Guernica*, 1937. Oil on canvas; 11 ft. 5½ in. × 25 ft. 5¾ in. (3.49 × 7.77 m). Museo Nacional Centro de Arte Reina Sofia, Madrid. From 1936 to 1939, there was a civil war between Spanish Republicans and the Fascist army of General Franco. In April 1937, Franco's Nazi allies carried out saturation bombing over the town of Guernica. Picasso painted *Guernica* to protest this atrocity. He loaned it to New York's Museum of Modern Art, stipulating that it remain there until democracy was restored in Spain. In 1981, *Guernica* was returned to Madrid.

Picasso, the Minotaur came to represent modern tyranny, as embodied by the Spanish dictator General Francisco Franco (1892–1975), who was allied with Adolf Hitler and Benito Mussolini.

These apparently disparate motifs are related by form and gesture, by their shared distortions, and by the power and content of their message. Cubist geometric shapes and sharp angles pervade the painting. Picasso's characteristic distortions of body and face emphasize the physical destruction of war. Eyes are twisted in and out of their sockets, ears and noses are slightly out of place, tongues are shaped like daggers, palms and feet are slashed. Although the integrity of the human form is maintained throughout, it is an object of attack and mutilation.

Picasso did forty-five studies for *Guernica*. The one illustrated here (fig. **25.13**) shows the dying horse and the mother with the dead child. They have been changed in the final painting, although they retain their basic character. The Cubist neck of the horse has a stronger curve in the drawing, and its protruding teeth seem to hang from the mouth. The woman howls in despair as in the painting, but in the drawing she crawls on the ground and the baby flops over like a rag doll. Picasso's spontaneous, dynamic drawing technique is evident in this study, particularly in the horse's mane and the areas of shading. The individualized anguish of the figures in the drawing becomes generalized, and thus—as with the *Demoiselles d'Avignon*—assumes mythic proportions in the final work.

25.13 Pablo Picasso, study for *Guernica*, 1937. Pencil drawing; 9½ × 17⅞ in. (24.1 × 45.4 cm). Museo Nacional Centro de Arte Reina Sofía, Photographic Archive, Madrid, Spain.

Other Early Twentieth-Century Developments

Futurism

Related to Expressionism was the contemporary movement called Futurism, which originated in Italy. The Futurists were inspired by the dynamic energy of industry and the machine age. They argued for a complete break with the past. In February 1909, a Futurist manifesto, written by Filippo Marinetti, the editor of a literary magazine in Milan, appeared on the front page of the French newspaper *Le Figaro.* The manifesto sought to inspire in the general public an enthusiasm for a new artistic language. In all of the arts—the visual arts, music, literature, theater, and film—the old Academic traditions would be abandoned, and creative energy would be focused on the present and future. Speed, travel, technology, and dynamism would be the subjects of Futurist art.

Marinetti's language was apocalyptic in its determination to slash through the "millennial gloom" of the past. "Time and Space died yesterday," he declared. "We already live in the absolute, because we have created eternal, omnipresent speed.... We will destroy

the museums, libraries, academies of every kind, we will fight moralism, feminism, every opportunistic or utilitarian cowardice." And later in the same tract: "We establish *Futurism,* because we want to free this land from its smelly gangrene of professors, archaeologists, . . . and antiquarians." Marinetti equated "admiring an old picture" with "pouring our sensibility into a funerary urn," and he recommended an annual "floral tribute" to the *Mona Lisa,* implying that the artistic past was dead and merited only the briefest remembrance.

Futurism was given plastic form in a 1913 sculpture by Umberto Boccioni (1882–1916) entitled *Unique Forms of Continuity in Space* (fig. **25.14**). It represents a man striding vigorously, as if with a definite goal in mind. The long diagonal from head to foot is thrust forward by the assertive angle of the bent knee. The layered surface planes, related to the fragmented planes of Analytic Cubism, convey the impression of flapping material. Organic flesh and blood are subjugated to a mechanical, robotlike appearance—a vision that corresponds to Boccioni's aims as stated in his *Technical Manifesto of Futurist Sculpture 1912.* Sculpture, he said, must "make objects live by showing their extensions in space" and by revealing the environment as part of the object.

25.14 Umberto Boccioni, *Unique Forms of Continuity in Space,* 1913. Bronze (cast 1931); 43⅞ × 34⅞ × 15¾ in. (111.2 × 88.5 × 40.0 cm). Museum of Modern Art, New York (acquired through the Lillie P. Bliss Bequest). In 1910, Boccioni wrote the *Manifesto of the Futurist Painters,* which encouraged artists to portray the speed and dynamism of contemporary life, as he himself has done in this sculpture. He fought for Italy in World War I and was killed by a fall from a horse in 1916.

25.15 Fernand Léger, *The City*, 1919. Oil on canvas; 7 ft. 7 in. × 14 ft. 9½ in. (2.31 × 4.51 m). Philadelphia Museum of Art (A. E. Gallatin Collection).

Fernand Léger's *The City*

The work of Fernand Léger (1881–1955) is more formally derived from Cubism than Boccioni's sculpture. In *The City* of 1919 (fig. **25.15**), Leger captures the cold steel surfaces of the urban landscape. Harsh forms, especially cubes and cylinders, evoke the metallic textures of industry. The jumbled girders, poles, high walls, and steps, together with the human silhouettes, create a sense of the anonymous, mechanical movement associated with the fast pace of city life. In *The City*, Léger has taken from Analytic Cubism the multiple viewpoint and superimposed solid geometry. His shapes, however, are colorful and recognizable, and there is a greater illusion of distance.

Léger described the kinship between modern art and the city as follows: "The thing that is imaged does not stay as still . . . as it formerly did. . . . A modern man registers a hundred times more sensory impressions than an 18th-century artist. . . . The condensation of the modern picture . . . its breaking up of forms, are the result of all this. It is certain that the evolution of means of locomotion, and their speed, have something to do with the new way of seeing."[3]

Piet Mondrian

In 1911, the year of the two Cubist exhibitions, Piet Mondrian (1872–1944) came to Paris from Holland. He had begun as a painter of nature but under the influence of Cubism gradually transformed his imagery to flat rectangles of color. His delicate *Amaryllis* (fig. **25.16**) exemplifies his sensitivity to nature and attention to the subtleties of surface texture. Mondrian gradually abstracted forms from nature to create flat rectangles bordered by thick, black lines. In these pictures, he plays on the tension, as well as the harmony, between vertical and horizontal. In them, he also rejects curves and diagonals altogether and expresses his belief in the purity of primary colors. According to Mondrian, chromatic purity, like the simplicity of the rectangle, had a universal character. To illustrate this, he wrote that since paintings are made of line and color, they must be liberated from the slavish imitation of nature (see the **installation** photograph in fig. 25.28).

Later, while living in New York in the early 1940s as a refugee from World War II, Mondrian painted *Broadway Boogie Woogie* (fig. **25.17**). This was one of a series of pictures that he executed in small squares and rectangles of color, which replaced the large rectangles outlined in black. The grid pattern of the New York streets, the flashing lights of Broadway, and the vertical and horizontal motion of cars and pedestrians are conveyed as flat, colorful shapes. Rapid shifts of color and their repetition recall the strong, accented rhythm of boogie-woogie, a style of piano blues. In combining musical references with the beat of city life and suggesting these qualities through color and shape, Mondrian synthesized Expressionist exuberance with Cubist order and control.

25.16 Piet Mondrian, *Red Amaryllis with Blue Background.* Watercolor on paper; 18½ × 13½ in. (47.3 × 34.2 cm). Janis Family Collection, New York. Mondrian was an Impressionist and Symbolist painter before helping to found the De Stijl movement in 1917. His spiritual attitude toward art was reflected in his belief that perfect aesthetic harmony and balance in art are derived from ethical purity and world harmony. Photo courtesy of Carroll Janis, New York. © 2006 Mondrian/ Holtzman Trust c/o HCR International, Warrenton, VA, USA.

25.17 Piet Mondrian, *Broadway Boogie Woogie*, 1942–1943. Oil on canvas; 4 ft. 2 in. × 4 ft. 2 in. (1.27 × 1.27 m). The Museum of Modern Art, New York (given anonymously). © 2006 Mondrian/ Holtzman Trust c/o HCR International, Warrenton, VA, USA.

The Armory Show

The burgeoning styles of the early twentieth century in western Europe did not reach the general American public until 1913. In February of that year, the Armory of the Sixty-ninth Regiment, National Guard, on Lexington Avenue between Twenty-fifth and Twenty-sixth Streets in New York, was the site of an international exhibition of modern art. A total of 1,200 exhibits, including works by Post-Impressionists, Fauves, and Cubists, as well as by American artists, filled eighteen rooms. This event marked the first widespread American exposure to the European avant-garde.

The Armory Show caused an uproar. Marcel Duchamp (1887–1968) submitted *Nude Descending a Staircase, No. 2* (fig. **25.18**), which was the most scandalous work of all. It was a humorous attack on Futurist proscriptions against traditional Academic nudity. The image has a kinetic quality consistent with the Futurist interest in speed and motion. At the same time, the figure is a combination of Cubist form and multiple images that indicate the influence of photography. She is shown at different points in her descent, so the painting resembles a series of consecutive movie stills, unframed and superimposed.

Various accounts published at the time ridiculed the *Nude*'s début in the United States. Descriptions by outraged viewers included the following: "disused golf clubs and bags," an "elevated railroad stairway in ruins after an earthquake," "a dynamited suit of Japanese armor," an "orderly heap of broken violins," an "explosion in a shingle factory," and "Rude Descending a Staircase (Rush Hour in the Subway)." Duchamp recorded his own version of the *Nude*'s place in the history of art: "My aim was a static representation of movement—a static composition of indications of various positions taken by a form in movement—with no attempt to give cinema effects through painting."[4]

25.18 Marcel Duchamp, *Nude Descending a Staircase, No. 2*, 1912. Oil on canvas; 4 ft. 10 in. × 2 ft. 11 in. (1.47 × 0.89 m). Philadelphia Museum of Art (Louise and Walter Arensberg Collection).

The influence of Futurism, Cubism, and African sculpture is evident in the style of the Romanian sculptor Constantin Brancusi (1876–1957), who was also represented in the Armory Show. Version I of his *Mademoiselle Pogany* (fig. **25.19**), listed for sale at $540, created a stir of its own. Her reductive, essential form was described as a "hard-boiled egg balanced on a cube of sugar." The last stanza of "Lines to a Lady Egg," which appeared in the *New York Evening Sun,* went as follows:

> Ladies built like a bottle,
> Carrot, beet, or sweet potato—
> Quaint designs that Aristotle
> Idly drew to tickle Plato—
> Ladies sculptured thus, I beg
> You will save your tense emotion;
> I am constant in devotion,
> O my egg!⁵

In the Introduction, we discussed Brancusi's bronze *Bird in Space* (see fig. I.4), which

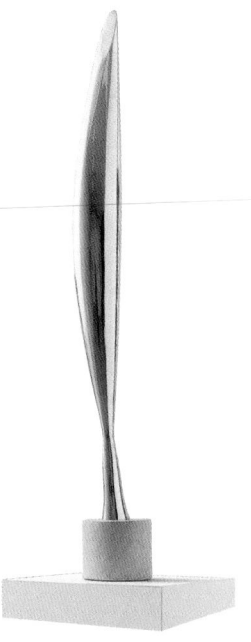

See figure I.4.
Constantin Brancusi,
Bird in Space, 1928.

achieved notoriety in the legal debate over whether it was a work of art or a "lump of manufactured metal." In *Mademoiselle Pogany,* the emphasis on rationalized, or quasigeometrical, form allies the work with Cubism and related styles. Brancusi's high degree of polish conveys the increased prominence of the medium itself as artistic "subject." But the roughness of the unpolished bronze at the top of the head in figure 25.19b contrasts with the polish of the face, creating an impression of hair. In the detachment of the *Mademoiselle Pogany*'s hands and head from her torso, she becomes a partial body image that is characteristic of Brancusi's human figures and reflects the influence of Rodin, with whom Brancusi studied briefly in Paris. The partial aspect of Brancusi's sculptures is related to his search for a truthful, Platonic "essence" of nature, rather than a literal and objective depiction.

25.19a (left) Constantin Brancusi, *Mademoiselle Pogany,* Version I (1913) after a marble of 1912. Polished bronze; 17½ in. (44.5 cm) high. Private collection. Courtesy Acquavella Galleries.

25.19b (right) Constantin Brancusi, *Mademoiselle Pogany,* Version I (1913) after a marble of 1912. Bronze, 17¼ × 8½ × 12½ in. (43.8 × 21.5 × 31.7 cm) on limestone base, 5¾ × 6⅛ × 7⅜ in. (14.6 × 15.6 × 18.7 cm). The Museum of Modern Art, New York. Acquired through the Lillie P. Bliss Bequest.

Stuart Davis

The Armory Show, which traveled to Chicago and Boston, had a lasting impact on American art. The American artist Stuart Davis (1894–1964) had exhibited several watercolors in the Armory Show while still an art student. Later, in 1921, he painted *Lucky Strike* (fig. **25.20**), in which the flattened cigarette box was clearly influenced by collage. The colorful, unmodeled shapes are reminiscent of Synthetic Cubism, while the words and numbers recall early newspaper collages. The subject reflects American consumerism, which advertises a product by its package; the painting was thus an important early forerunner of Pop Art (see Chapter 28).

Davis designed the first abstract postage stamp for the United States in 1964. He gravitated to abstract forms from objects such as eggbeaters and electric fans. As a lifelong smoker, Davis had a particular fondness for the imagery of smoking.

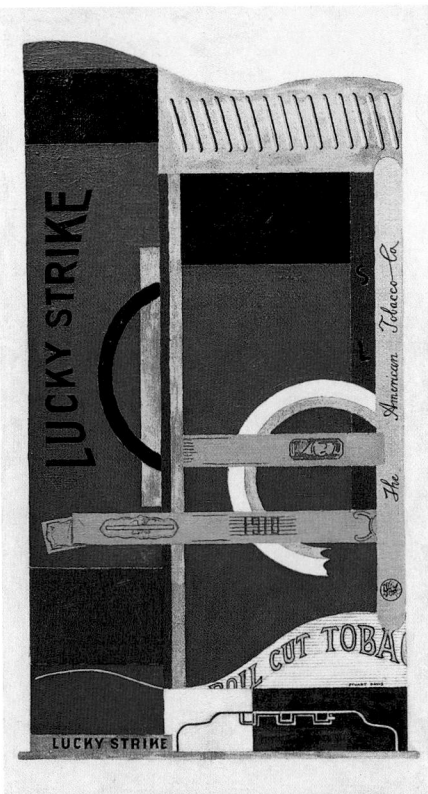

25.20 Stuart Davis, *Lucky Strike*, 1921. Oil on canvas; 33¼ × 18 in. (84.5 × 45.7 cm). Museum of Modern Art, New York (Gift of the American Tobacco Company, Inc.).

Aaron Douglas and the Harlem Renaissance

The African-American painter Aaron Douglas (1898–1979) used the principles of Synthetic Cubism to depict the history of his people. Douglas was a leading figure in the Harlem Renaissance of the 1920s. Centered in Harlem, in New York City, this was a significant black American cultural movement. It was primarily a literary movement but also included philosophers, performers, political activists, and photographers, as well as painters and sculptors. The philosopher Alain Locke (1886–1954) urged artists of African descent to reflect their heritage in their works.

Douglas was born in Kansas and studied art in Paris, where he was exposed to the avant-garde. He became interested in the affinities between Cubism and African art, and combined them with black experience in America. In 1934, Douglas painted four murals entitled *Aspects of Negro Life* for the New York Public Library. The second in the series—*From Slavery through Reconstruction* (fig. **25.21**)—depicts three events following the American Civil War. At the right, there is rejoicing at the news of the Emancipation Proclamation (January 1, 1863), which freed the slaves. The man on the soapbox in the center represents the success of the black man, whose voice is now being heard. In the background, the Union army leaves the South, and Reconstruction with its anti-black backlash follows.

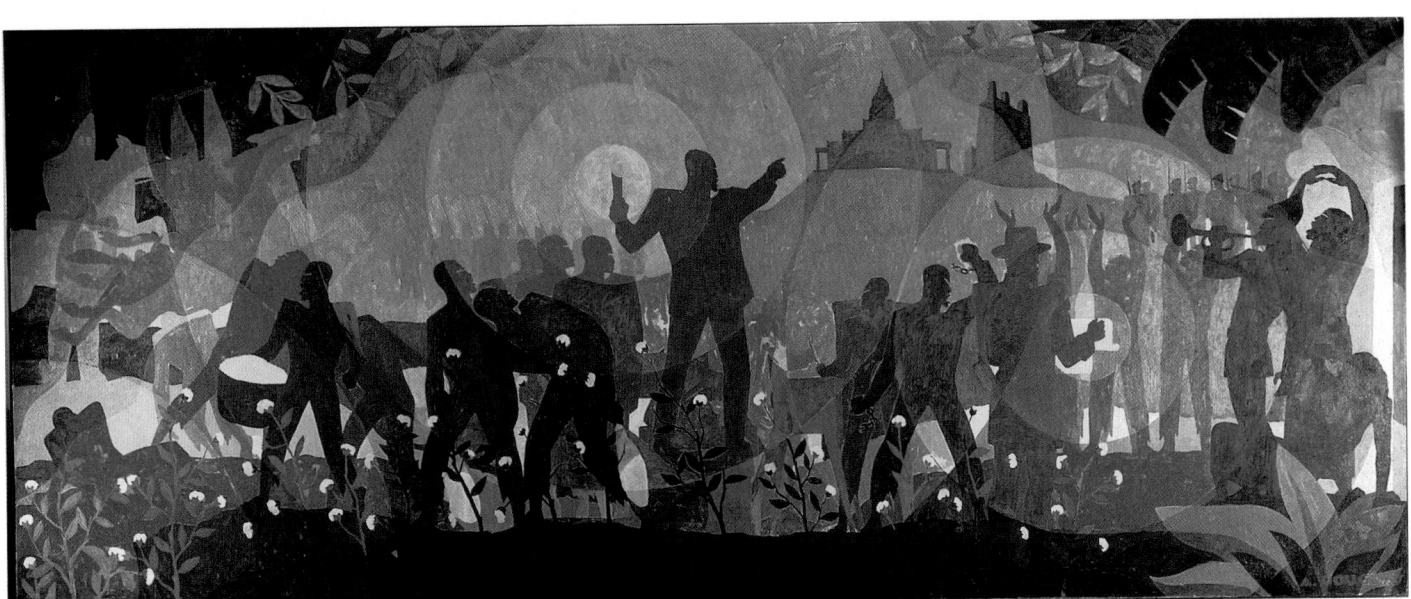

25.21 Aaron Douglas, *From Slavery through Reconstruction* (from the series *Aspects of Negro Life*), 1934. Oil on canvas; 5 ft. × 10 ft. 8 in. (1.52 × 3.25 m). Schomburg Center for Research in Black Culture, New York Public Library, Astor, Lenox and Tilden Foundations.

The exuberance of the figures recalls the dynamic energy of jazz that also appealed to Matisse. Music appears in the subject matter of the mural—the trumpet and the drums—as well as in the rhythms of its design. The main colors are variations on the hue of rose, whereas concentric circles of yellow convey a sense of sound traveling through space. At the same time, the unmodeled character of the color allies the work with Synthetic Cubism. The green and white cotton plants in the foreground refer to the work of slaves in America and create an additional pattern superimposed over the light reds.

Kazimir Malevich and Suprematism

One of the most geometric developments that grew out of Cubism took place in Russia. Kazimir Malevich (1878–1935) was born in Kiev and in 1904 went to Moscow to study art. Although, as a student, he did not travel outside Russia, he was exposed to the European avant-garde through important collections in Moscow, and in 1908 he saw works exhibited by Cézanne, Gauguin, Matisse, and Braque. As a mature artist, Malevich combined Cubism with Futurism. He considered the proto-Cubism of Cézanne to have been rooted in village life, whereas the later development of the style was urban in character. For Malevich, it was Futurism, the more dynamic form of Cubism, that expressed the fast pace of city life.

His *Composition with the Mona Lisa* of 1914 (fig. **25.22**) is a collage composed of pasted bits of newspaper and oil paint on canvas. The structure of the composition is based on Synthetic Cubism, with the cylindrical shapes suggesting engines and other mechanical devices. Malevich literally "crossed out" the *Mona Lisa* because, he said, the new version had more value as "the face of the new art." This sentiment reflected his view that the tradition of naturalistic painting had been superseded by avant-garde abstraction.

Following his Cubist-Futurist phase, Malevich created the style he called Suprematism. His first Suprematist painting, exhibited in 1915, in St. Petersburg, Russia, consisted

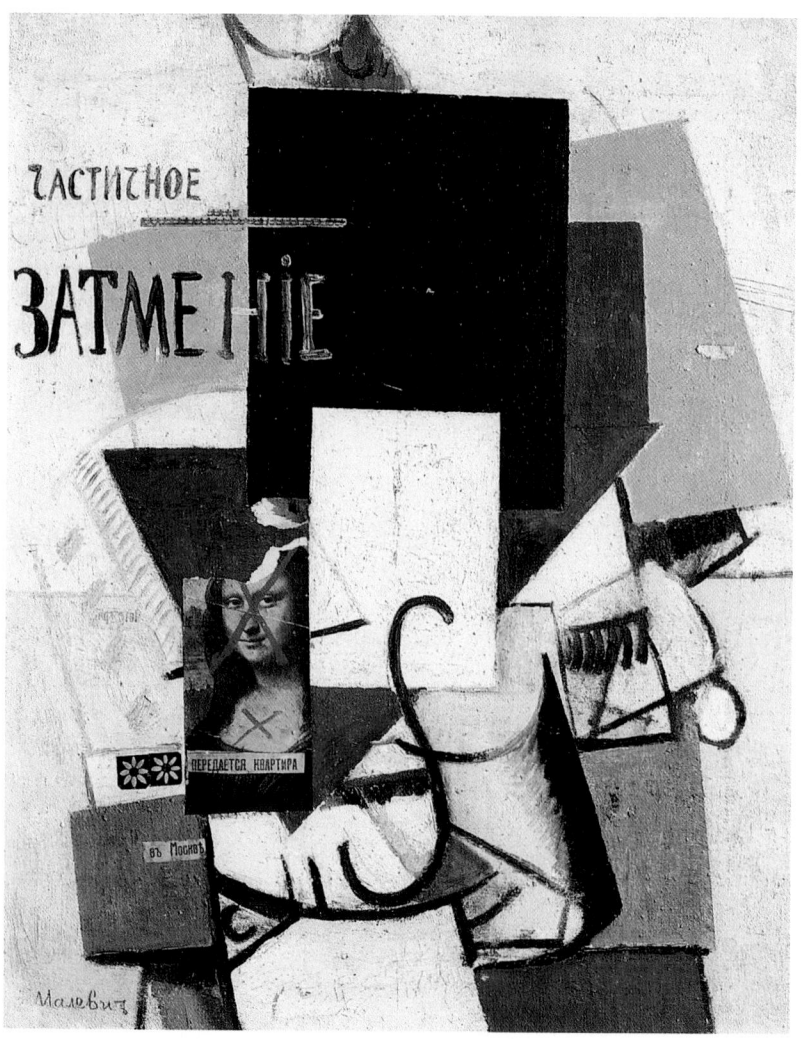

25.22 Kazimir Malevich, *Composition with the Mona Lisa*, 1914. Graphite, oil, and collage on canvas; 24⅜ × 19½ in. (61.9 × 49.5 cm). State Russian Museum, St. Petersburg.

25.23 Kazimir Malevich, *Black Square,* 1929. Oil on canvas; 31¼ × 31¼ in. (79.4 × 79.4 cm). State Tretiakov Gallery, Moscow.

of a black square centered in a white background. The original became damaged, and he subsequently made several additional versions of it (fig. **25.23**). According to Malevich, the black square was an expression of the cosmic, of pure feeling, and the white was the void beyond feeling. His aim was to achieve the mystical through pure form, which embodied pure feeling, instead of depicting what is visible and natural. In his book *The Non-objective World,* Malevich summed up his philosophy of Suprematism as follows:

> Artists have always been partial to the use of the human face in their representations, for they have seen in it (the versatile, mobile, expressive mimic) the best vehicle with which to convey their feelings. The Suprematists have nevertheless abandoned the representation of the human face (and of natural objects in general) and have found new symbols with which to render direct feelings (rather than externalized reflections of feelings), for the *Suprematist does not observe and does not touch—he feels.*[6]

After the Communist Revolution of 1917, Malevich was appointed Commissar for the Preservation of Monuments and Antiquities. By the late 1920s, the Soviet government under Stalin (d. 1953) was suppressing avant-garde art and asserting state control over all the arts. Sensing that further oppression was to come, Malevich traveled in 1927 to Poland and Germany, where the Bauhaus (see p. 873) published his book in German. In 1930, he was arrested by the Soviets for artistic "deviation."

Three years later, Malevich painted his last *Self-Portrait* (fig. **25.24**), which reflects his renunciation of the "deviant" avant-garde and his return to naturalism. Ironically, he represented himself as a "Renaissance man." When he died, his white coffin was decorated with one black circle and one black square, and a white cube with a black square on it marked the place where his ashes were buried. In 1936, the Soviets confiscated his remaining pictures; they were not shown publicly again until 1977.

25.24 Kazimir Malevich, *Self-Portrait,* 1933. Oil on canvas; 28¾ × 26 in. (73.0 × 66.0 cm). State Russian Museum, St. Petersburg.

Brancusi's *Gate of the Kiss* and *Endless Column*

In 1935, the year before the Soviet confiscation of Malevich's abstract pictures, Brancusi accepted a commission for his native town of Tirgu-Jiu, in Romania. He agreed to design a peace memorial dedicated to those who had died in World War I. In its final form, the memorial consisted of three structures—*The Table of Silence, The Gate of the Kiss,* and *The Endless Column*. The central feature, *The Gate of the Kiss* (fig. **25.25**), was derived from a much earlier series of sculptures entitled *The Kiss,* of which the 1912 version is illustrated in figure **25.26**. The Cubist quality of *The Kiss* resides in its blocklike form, which Brancusi used to merge the embracing figures. The arms overlap and, as seen from the front, appear shared equally between the couple. The lips are formed into a little cube connecting the rectangular heads. As with many of Picasso's Cubist faces after 1906, these can be read simultaneously as a profile and a front view. The focal point of the face is the eye, the placement of which creates the multiple viewpoint, for it is both two eyes rendered in profile and a single eye.

In *The Gate of the Kiss,* Brancusi persists in the use of cubic form and also endows it with symbolic meaning. The lintel is decorated with incised, geometric versions of *The Kiss,* and each supporting post is decorated with four large, round "eyes." The ensemble implies that the notion of a kiss embodies love, which therefore "upholds" peace. The eyes, combined with the rectangular opening, also transform *The Gate* into a large face, which, like Janus of the ancient Roman gateways, watches those who come and those who go with equal attention.

25.26 Constantin Brancusi, *The Kiss,* 1912. Stone; 23 in. (58.4 cm) high. Philadelphia Museum of Art (Louise and Walter Arensberg Collection).

25.25 Constantin Brancusi, *The Gate of the Kiss,* 1938. Stone; 17 ft. 3½ in. × 21 ft. 7⅛ in. × 6 ft. 1½ in. (5.27 × 6.58 × 1.84 m). Public Park, Tirgu-Jiu, Romania.

The *Endless Column* (fig. **25.27**) stands alone and, like Trajan's Column (see fig. 7.34), does not function as an architectural support. Instead, it conveys an independent message, which is related to the significance of height. Rather than proclaiming the power of a single leader such as the Roman emperor (compare the column erected under Napoleon in the Place Vendôme in Paris, fig. 19.8), Brancusi's column seems to soar skyward in the manner of his *Bird in Space* (see fig. I.4). It represents the aspiration expressed by Gothic cathedral towers and, ironically, as in *The Gate of the Kiss,* the ambitious hope for peace in a world on the verge of World War II.

See figure 7.34. Trajan's Column, Rome, dedicated A.D. 113.

25.27 Constantin Brancusi, *Endless Column,* 1937. Cast iron; 96 ft. 3⅜ in. (29.35 m) high, 35⅜ in. (0.89 m) wide, 35⅜ in. (0.89 m) deep. (Formerly) Public Park, Tirgu-Jiu, Romania.

Postscript

The installation photograph in figure **25.28** illustrates the main space of the Sidney Janis Gallery in New York in the early 1980s during a landmark exhibition entitled *Brancusi + Mondrian*. Mounted nearly seventy years after the Armory Show and over fifty years after Malevich's detention for so-called "deviant" art, the exhibition conveyed the importance of the avante-garde. It also emphasized the formal and historical relationship between Brancusi and Mondrian. In the left corner, a group of highly polished bronzes by Brancusi includes two versions of *Mademoiselle Pogany*. Flanked by Mondrians are a marble and a bronze version of *Bird in Space*. Brancusi's

"essences," here composed of graceful curves and rounded, volumetric shapes, are contrasted with Mondrian's pure verticals and horizontals on a flat surface. In this juxtaposition, the viewer confronts the work of two major early twentieth-century artists. Despite their apparent differences, these artists have a remarkable affinity in their pusuit of an "idea," which they render in modern, abstract form.

The art critic Sidney Geist wrote of this show that "if the century's Modernist struggle seems to have been called in question by recent developments, 'Brancusi + Mondrian' banished all doubt. . . . We have to do here with two saintly figures—for whom art was a devotion. Their lives and art evolved under the sign of inevitability."[7]

25.28 Installation view, *Brancusi + Mondrian* exhibition, December 1982–January 1983. Painting on left: Piet Mondrian, *Lozenge Composition with 8 Lines and Red/Picture No. III*, 1938. Oil on convas; diagonal measurement 55¼ in. (140 cm). Painting on right: Piet Mondrian, *Lozenge Composition with 2 Lines*, 1931. Oil on canvas; diagonal measurement 44⅛ in. (112 cm). Photo courtesy of Carroll Janis, New York. © 2006 Mondrian/Holtzman Trust c/o HCR International, Warrenton, VA, USA.

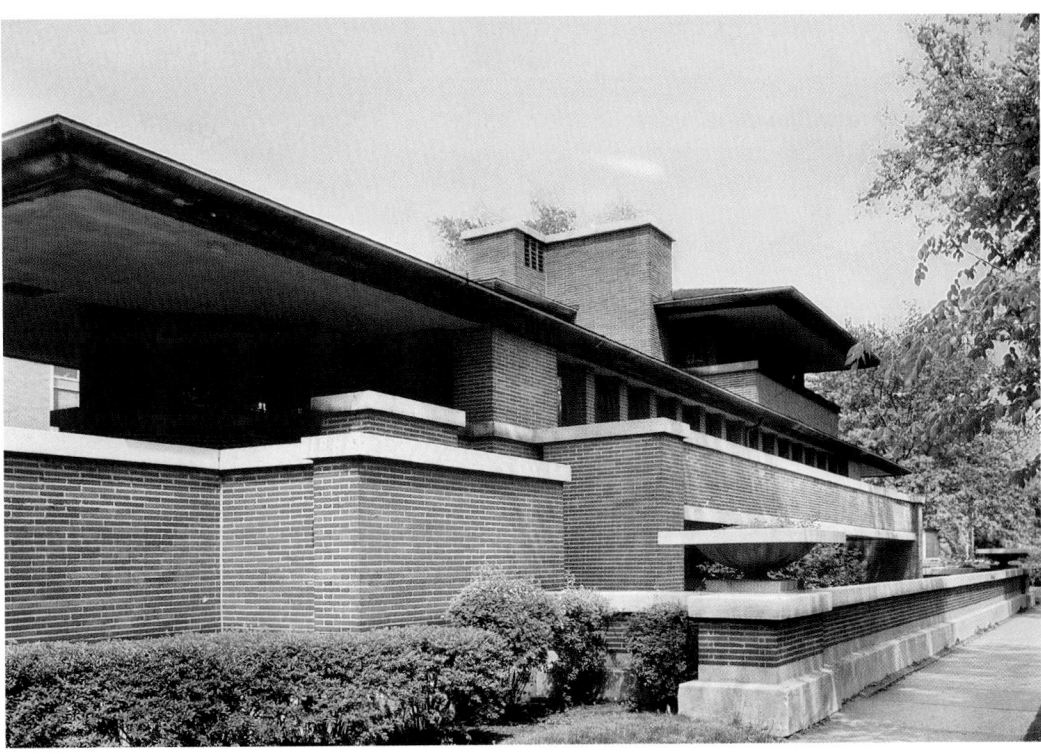

25.29 Frank Lloyd Wright, Robie House, Chicago, 1909. Wright's insistence on creating a total environment inspired him, sometimes against the wishes of his clients, to design the furniture and interior fixtures of his houses. In the case of the Robie House, Wright even designed outfits for Mrs. Robie to wear on formal occasions so that she would blend with his architecture.

Early Twentieth-Century Architecture

In the late nineteenth and early twentieth centuries, the most innovative developments in architecture took place in the United States. Following Louis Sullivan, who developed the skyscraper, the next major American architect was Frank Lloyd Wright (1869–1959). Wright had worked in Chicago as Sullivan's assistant before building private houses, mainly in Illinois, in the 1890s and early 1900s. But, whereas Sullivan's skyscrapers addressed the urban need to provide many offices or apartments on a relatively small area of land, Wright launched the Prairie Style, which sought to integrate architecture with the natural landscape.

Frank Lloyd Wright and the Prairie Style

In 1908, Wright wrote that "the Prairie has a beauty of its own and we should recognize and accentuate this natural beauty, its quiet level. Hence . . . sheltering overhangs, low terraces and out-reaching walls, sequestering private gardens." Wright admired Japanese architecture and its tradition of open internal spaces, which he incorporated into a series of early twentieth-century, Midwestern Prairie Style houses.

The best-known example of Wright's early Prairie Style is the Robie House of 1909 (fig. **25.29**) in south Chicago. Its horizontal emphasis, low-pitched roofs with large overhangs, and low boundary walls are related to the flat prairie landscape of the American West and Middle West. At the same time, the predominance of rectangular shapes and shifting, asymmetrically arranged horizontal planes is reminiscent of Cubism.

The ground floor of the Robie House contained a playroom, garage, and other service areas. The main living area was on the second floor, and the bedrooms were on the third. The second-floor plan (fig. **25.30**) illustrates the massive central core, which doubles as a fireplace and staircase, and is the focal point of the living quarters. Around the central core, the living and dining rooms are arranged in an open plan. Verandas extend from the two main rooms. The huge cantilevered (see box, p. 870) roof on the second floor shields the windows from sunlight.

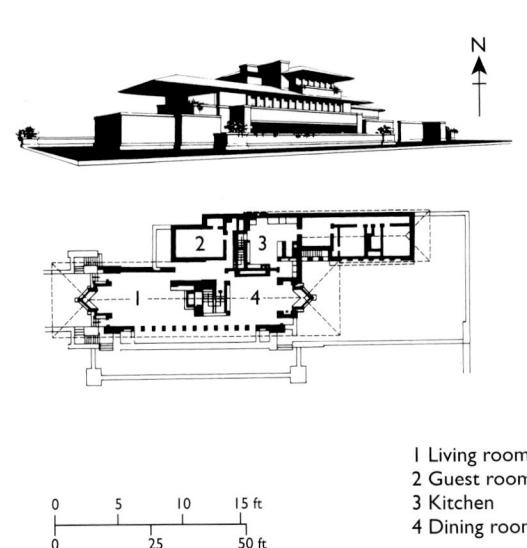

N

1 Living room
2 Guest room
3 Kitchen
4 Dining room

0 5 10 15 ft
0 25 50 ft

25.30 Perspective drawing and plan of the second floor of the Robie House.

The system of **cantilever construction** (fig. **25.31**) is one in which a horizontal architectural element, projected in space, has vertical support at one end only. Equilibrium is maintained by a support and counterbalancing weight inside the building. The cantilever requires materials with considerable tensile strength. Wright pioneered the use of **reinforced concrete** and steel girders for cantilever construction in large buildings. In a small house, wooden beams provide adequate support.

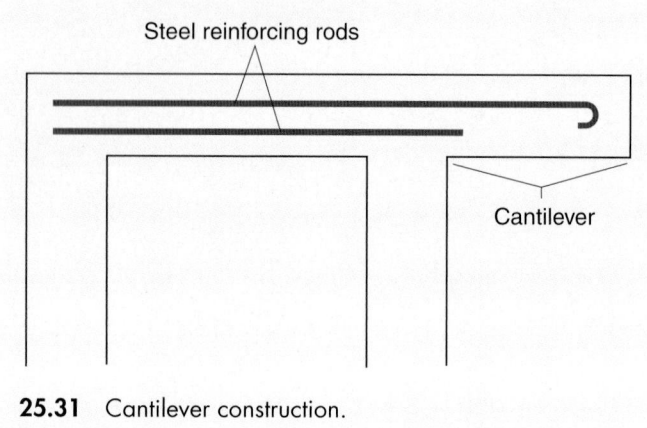

Steel reinforcing rods

Cantilever

25.31 Cantilever construction.

In 1936, on a wooded site at Bear Run, Pennsylvania, Wright built a weekend house (fig. **25.32**) for the Edgar Kaufmann family that combined elements of the International Style (see below) with the Prairie Style. It is called Fallingwater because it is perched over a small waterfall. As in the Robie House, there is a large central core, composed here of local masonry. Fallingwater is surrounded by reinforced concrete terraces, which are related to the International Style. Their beige color attempts to blend with the landscape, and their cantilevered horizontals repeat the horizontals of the rocky ledges below. Although the smooth texture and light hue of the terraces actually contrast with the darker natural colors of the woods, the natural stone of the chimneys resembles the rocks in the surrounding landscape. In keeping with the Prairie Style, parts of the house are integrated with the landscape and seem to "grow" from it. Glass walls, which make nature a constant visible presence inside the house, further reinforce the association of architecture with landscape. To some extent, therefore, Fallingwater fulfills Wright's pursuit of "organic" architecture.

25.32 Frank Lloyd Wright, Fallingwater, Bear Run, Pennsylvania, 1936.

In 1938, Wright began work on his own house and office, Taliesin West (fig. **25.33**), in the Arizona foothills outside of Phoenix. Its main materials were called "desert concrete" by Wright because they consist of concrete embedded with local stones and rocks, redwood beams, and canvas awnings. As in most of his designs for private houses, Wright used squares and rectangles as his primary shapes and right angles for beams and other planar juxtapositions.

25.33 Frank Lloyd Wright, Taliesin West, Arizona, begun 1938.

International Style

From the end of World War I, a new architectural style developed in western Europe. Since it apparently originated in several countries at about the same time, it is known as the International Style.

Holland: *De Stijl* In Holland, the International Style of architecture began as a movement called *De Stijl*, of which Mondrian was a founder. The primary leader, however, was Theo van Doesburg (1883–1931), whose transformation of a cow into abstract geometric shapes is illustrated in figures I.21–I.25. Several Dutch architects, attracted by Frank Lloyd Wright's work (which had been exhibited in Germany in 1910), joined Mondrian and van Doesburg in the movement. They were idealists searching for a universal style that would satisfy human needs through mass pro-duction. The spiritual goal of world peace, they believed, would also be fostered by the "equilibrium of opposites" that was part of *De Stijl*'s credo.

Typical of this new architecture is the Schroeder House in Utrecht (fig. **25.34**), designed by Gerrit Rietveld (1888–1964). The flat roof and cantilevered balconies are similar to those in Wright's private houses. Whereas Wright emphasized horizontals, however, Rietveld preferred opposi-tions of horizontals and verticals derived from Cubism, which he integrated with a **skeletal construction.** There is no surface decoration to interrupt the exterior simplicity of the building. The windows and balconies, with attached rec-tangular panels that seem to float in midair, create a sense of tension paradoxically combined with weightlessness. Composed of predominantly white flat planes and right an-gles, the Schroeder House is the architectural equivalent of Mondrian's classic style (see fig. 25.28).

Piet Mondrian, *Lozenge Composition with 2 Lines,* 1931. Oil on canvas; 44⅛ in. (112 cm). Photo courtesy of Carroll Janis, New York. © 2006 Mondrian/ Holtzman Trust, c/o HCR International, Warrenton, VA, USA.

25.34 Gerrit Rietveld, Schroeder House, Utrecht, the Netherlands, 1923–1924. Alfred Barr, Jr., curator of New York's Museum of Modern Art, defined the International Style as follows: " . . . emphasis upon volume . . . thin planes . . . as opposed to . . . mass and solidity; . . . regularity as opposed to symmetry . . . and . . . dependence upon the intrinsic elegance of materials, perfection, and fine proportions, as opposed to applied ornament." These goals are fulfilled in the Schroeder House.

Germany: The Bauhaus The German version of the International Style centered on the Bauhaus. In the first decade of the twentieth century, the Deutscher Werkbund ("German Craft Association") was formed. Its aim was to improve the aesthetic quality of manufactured goods and industrial architecture, to produce them more cheaply, and to make them more widely available. This produced a number of important architects and designers who had enormous international influence through the 1960s. Many who had worked together in Europe later emigrated to the United States to escape Hitler's persecutions during World War II.

The leader of this community was Walter Gropius (1883–1969), who in 1919 became the first director of the Bauhaus, in Weimar. The Bauhaus (from the German *Bau*, meaning "structure" or "building," and *Haus*, meaning "house") combined an arts-and-crafts college with a school of fine arts. Gropius believed in the integration of art and industry. With that in mind, he set out to create a new institution that would offer courses in design, architecture, and industry.

Vassily Kandinsky was a prominent member of the Bauhaus faculty from 1922, and he remained until 1933, when it was closed by the Nazis. His paintings of that period reflect the geometric angularity he espoused as part of the Russian avant-garde in Moscow at the beginning of World War I. Such forms, which were also characteristic of the Bauhaus aesthetic, can be seen, for example, in *Composition 8* (fig. **25.35**). Compared to the exuberant curvilinear forms of his Expressionist *Painting No. 201* (see fig. 24.9), this is measured, constructed, and dominated by dynamic diagonal planes. While at the Bauhaus, Kandinsky published

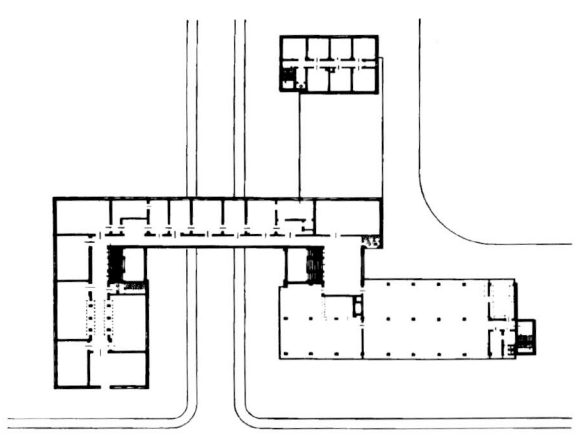

25.36 Walter Gropius, plan of the Bauhaus, Dessau, Germany, 1925–1926.

a textbook on composition entitled *Point and Line to Plane: Contribution to the Analysis of the Pictorial Elements* (1926), in which he combined spirituality and mysticism with strict formal analysis.

In 1926, Gropius relocated the Bauhaus from Weimar to Dessau and planned its new quarters (fig. **25.36**) according to his International Style philosophy. Three blocklike buildings contained living and working areas as well as the schools. They were linked by an elevated bridge containing offices. This differed radically from previous academic institutions, which were monumental, had a clearly marked entrance within a distinctive façade, and were usually Neoclassical in style.

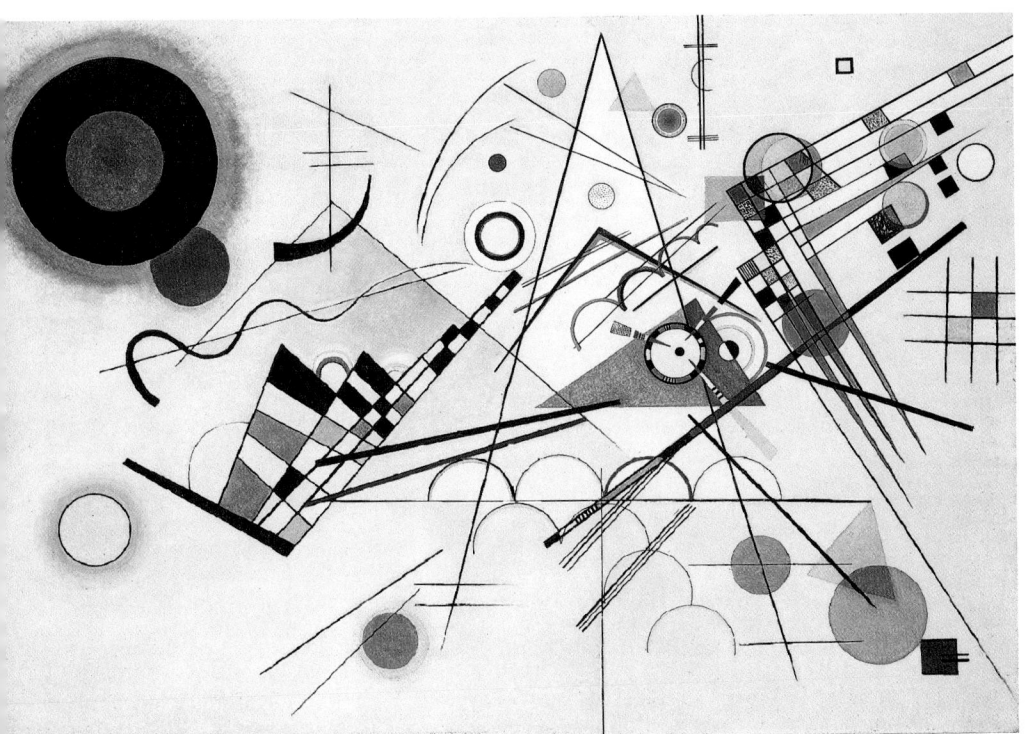

See figure 24.9. Vassily Kandinsky, *Panel for Edwin R. Campbell No. 4*, 1914.

25.35 Vassily Kandinsky, *Composition 8*, 1923. Oil on canvas; 55⅛ in. × 79⅛ in. (140.0 × 201.0 cm). Solomon R. Guggenheim Museum, New York.

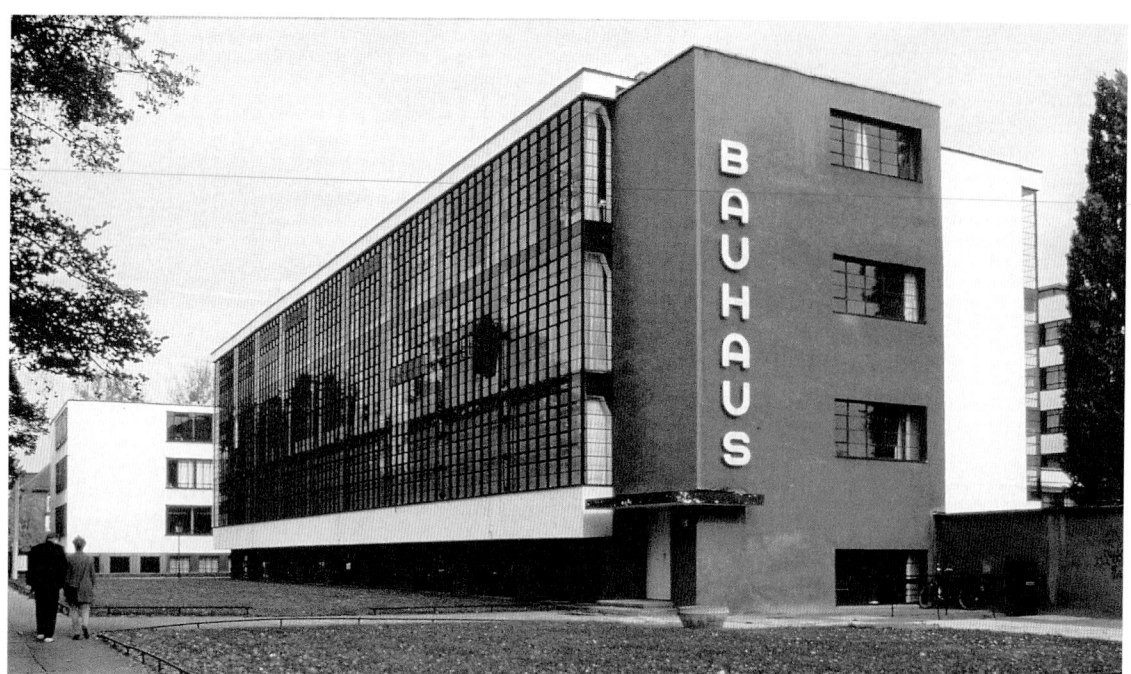

The workshop wing of the Bauhaus (fig. **25.37**) is typical of the International Style. It is entirely rectilinear, with verticals and horizontals meeting at right angles. The primary material is reinforced concrete, but, apart from two thin white bands at the top and bottom, the viewers see only sheet-glass walls from the outside. Structurally, this was a logical extension of the steel-skeleton system of construction, which, as in the Wainwright Building (see fig. 21.32), relieves the outer walls of any support function. Formal affinities with Cubism are inescapable, although Gropius, like the members of *De Stijl,* was motivated primarily by a philosophy of simplicity and harmony intended to integrate art and architecture into society. The Bauhaus exteriors, devoid of any regional identity, were an international concept translated into architectural form.

France: Le Corbusier The best-known exponent of the International Style in France during the 1920s and early 1930s was the Swiss-born architect Charles-Édouard Jeanneret, known as Le Corbusier (1887–1965). The Villa Savoye (fig. **25.38**), a weekend residence built from 1928 to 1930 at Poissy, near Paris, is the last in a series of International

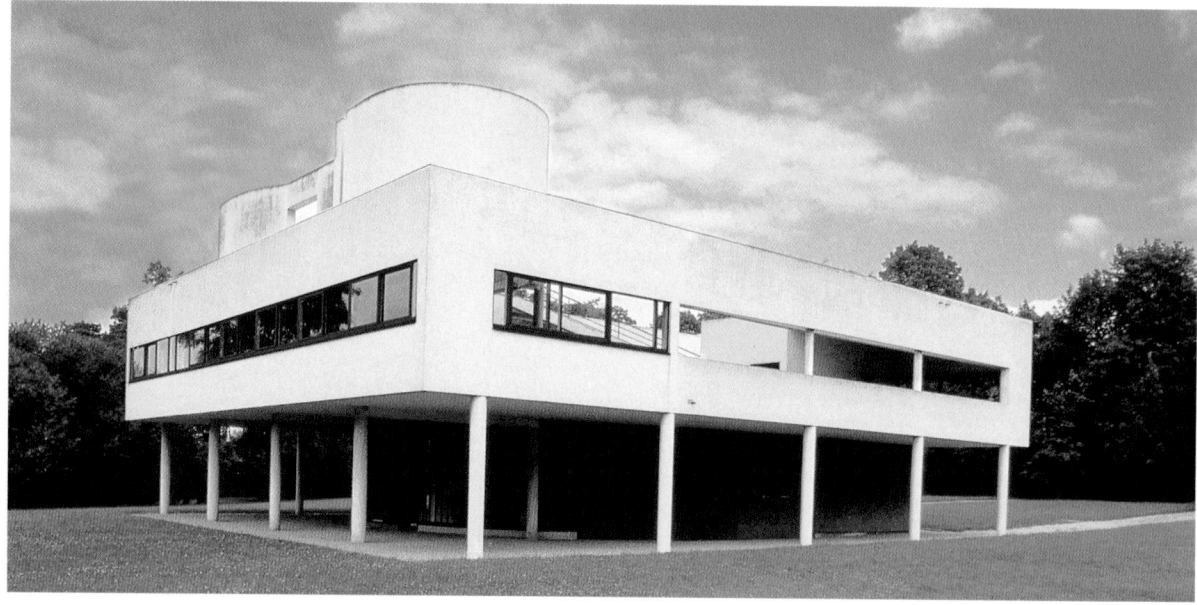

25.38 Le Corbusier, Villa Savoye, Poissy-sur-Seine, France, 1928–1930. Le Corbusier believed that houses should be mass-produced. To this end, he reduced architectural components to simple forms—concrete slabs for floors, concrete pillars for vertical support, stairs linking the floors, and a flat roof. In his *Towards a New Architecture* (1931), Le Corbusier wrote: "If we eliminate from our hearts and minds all dead concepts in regard to houses . . . we shall arrive at the 'House-Machine,' the mass-production house, healthy (and morally so too) and beautiful in the same way that the working tools and instruments which accompany our existence are beautiful."

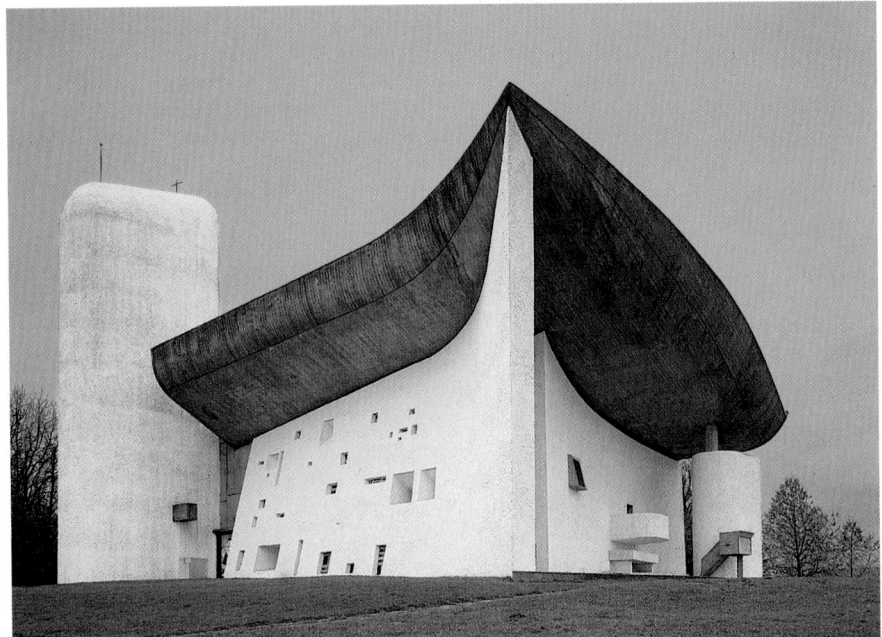

25.39 Le Corbusier, Notre-Dame-du-Haut, Ronchamp, France, 1950–1954.

Style houses by Le Corbusier. It is regarded as his masterpiece.

The Villa Savoye is a grand version of what Le Corbusier described as a "machine for living." It rests on very slender reinforced concrete pillars, which divide the second-floor windows. The second floor contains the main living area, and it is connected to the ground floor and the open terrace on the third floor by a staircase and a ramp. The driveway extends under the house and ends in a three-car carport. This part of the ground floor is deeply recessed under the second-floor overhang and contains an entrance hall and servants' quarters. All four elevations of the house are virtually identical, each having the same ribbon windows running the length of the wall.

Le Corbusier was active into his seventies, and his designs underwent a series of evolutions. In the late 1940s, he worked in a style that has come to be known as the New Brutalism, a reference to his habit of leaving the surface of concrete (still his favorite material) rough and unfinished so that it remained true to its natural texture. He also experimented with the sculptural properties inherent in the material, as in Notre-Dame-du-Haut (fig. **25.39**), a pilgrimage chapel perched on the top of a hill at Ronchamp, in eastern France. The rough concrete walls are painted white, and the roof is a huge mantle of darker concrete curving organically over the eastern wall of the chapel. Piercing the south wall are several unevenly shaped and sized windows, which are inlaid with hand-painted glass. The thickness of the wall and the small size of the windows produce an effect of focused beams of light. Between the roof and the walls is a very thin strip of clear glass, which makes the heavy roof of the chapel appear to float.

The United States The architectural principles of the International Style were brought to the United States by Bauhaus artists who were forced to leave Germany in the late 1930s. Ludwig Mies van der Rohe (1886–1969), the director of the Bauhaus from 1930, designed the glass and steel Lake Shore Drive Apartment Houses in Chicago (fig. **25.40**) with the principles of **functionalism** in mind. The influence of Cubism in their geometric repetitions is inescapable. These vertical, cubic structures, which are reminiscent of Mondrian's late paintings, inspired many similar skyscrapers throughout America's large cities.

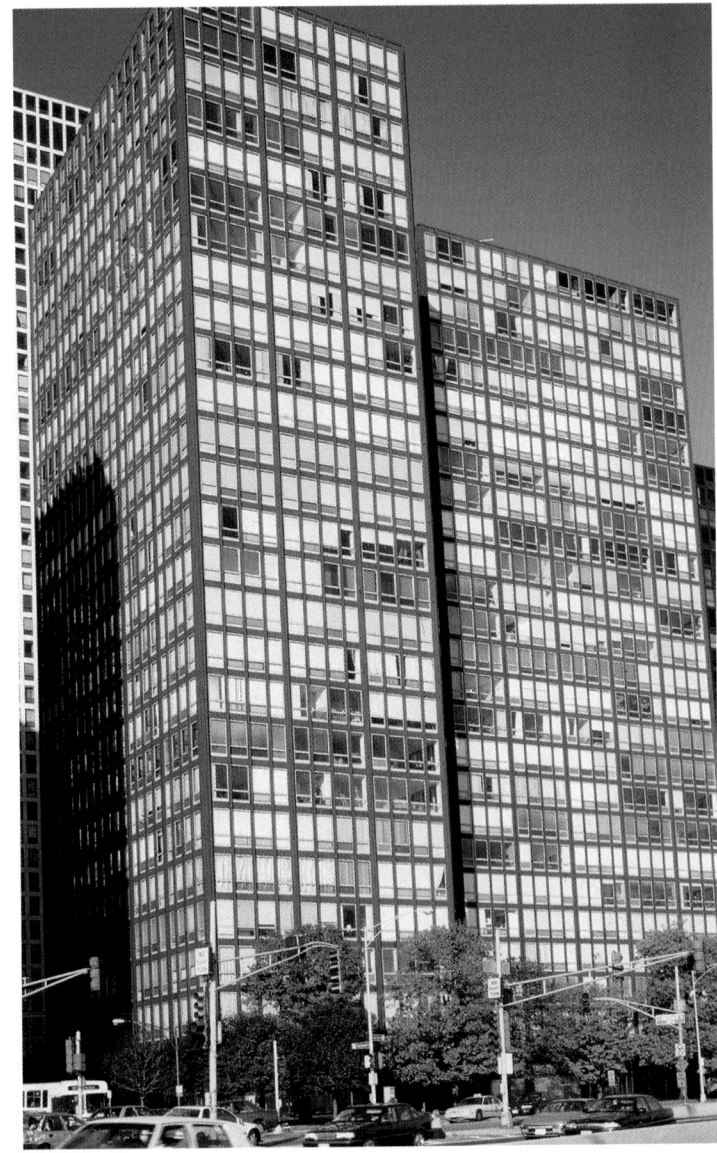

25.40 Ludwig Mies van der Rohe, Lake Shore Drive Apartment Houses, Chicago, 1950–1952.

Style/Period	Works of Art	Cultural/Historical Developments

| | | Pende Mbuya mask (**25.4**)
Etoumbi mask (**25.3**) | |

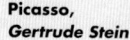

1900

CUBISM, FUTURISM, AND RELATED STYLES

1900–1910

Picasso, *Gertrude Stein* (**25.1**)
Picasso, *Les Demoiselles d'Avignon* (**25.2**)
Laurencin, *Group of Artists* (**25.5**)
Wright, Robie House (**25.29**), Chicago
Braque, *Violin and Pitcher* (**25.6**)
Picasso, *Head of a Woman* (**25.7**)
Mondrian, *Amaryllis* (**25.16**)

Futurist manifesto published in *Le Figaro* (1909)

Picasso, Les Demoiselles d'Avignon

Picasso, Gertrude Stein

1910

1910–1920

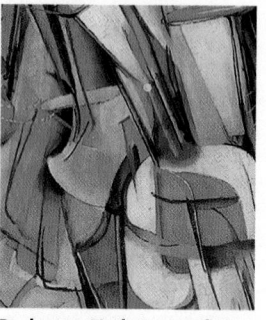

Duchamp, Nude Descending a Staircase, No. 2

Brancusi, *The Kiss* (**25.26**)
Duchamp, *Nude Descending a Staircase, No. 2* (**25.18**)
Brancusi, *Mademoiselle Pogany* (Version I) (**25.19**)
Picasso, *Man with a Hat* (**25.8**)
Boccioni, *Unique Forms of Continuity in Space* (**25.14**)
Malevich, *Composition with the Mona Lisa* (**25.22**)
Léger, *The City* (**25.15**)

Bertrand Russell and Alfred North Whitehead, *Principia Mathematica* (1910–1913)
De Stijl movement founded in the Netherlands (1910–1920)
Two Cubist exhibitions held in Paris (1911)
Gustav Mahler, *Das Lied von der Erde* (1911)
Max Beerbohm, *Zuleika Dobson* (1911)
J. M. Synge, *Playboy of the Western World* (1912)
R. F. Scott reaches the South Pole (1912)
C. G. Jung, *The Theory of Psychoanalysis* (1912)
D. H. Lawrence, *Sons and Lovers* (1913)
Armory Show held in New York (1913)
Marcel Proust, *Remembrance of Things Past* (1913–1927)
First World War (1914–1918)
Margaret Sanger jailed for advocating birth control (1915)
Austria, Czechoslovakia, Germany, Poland become republics (1918)
Lytton Strachey, *Eminent Victorians* (1918)
Willa Cather, *My Antonia* (1918)
Worldwide flu epidemic kills 22 million people (1918–1920)
Versailles Peace Conference (1919)
Walter Gropius establishes Bauhaus in Weimar, Germany (1919)
League of Nations established (1919)
Sinclair Lewis, *Main Street* (1920)

Etoumbi mask, Congo

Brancusi, Mademoiselle Pogany

1920

1920–1930

Rietveld, Schroeder House

Davis, *Lucky Strike* (**25.20**)
Picasso, *Three Musicians* (**25.10**)
Kandinsky, *Composition 8* (**25.35**)
Rietveld, Schroeder House (**25.34**), Utrecht
Gropius, the Bauhaus (**25.37**), Dessau
Le Corbusier, Villa Savoye (**25.38**), Poissy-sur-Seine
Malevich, *Black Square* (**25.23**)

Mussolini forms fascist government in Italy (1922)
T. S. Eliot, *The Waste Land* (1922)
James Joyce, *Ulysses* (1922)
Adolf Hitler, *Mein Kampf* (1924)
F. Scott Fitzgerald, *The Great Gatsby* (1925)
Invention of television (1926)
Vassily Kandinsky, *Point and Line to Plane* (1926)
Berthold Brecht, *Threepenny Opera* (1928)
Margaret Mead, *Coming of Age in Samoa* (1928)
Ernest Hemingway, *A Farewell to Arms* (1929)
Stock market crash on Wall Street; economic depression (1929)
Museum of Modern Art opens in New York (1929)
Virginia Woolf, *A Room of One's Own* (1929)
Erich Maria Remarque, *All Quiet on the Western Front* (1929)

1930

1930–1940

Wright, Fallingwater

Picasso, *Girl before a Mirror* (**25.11**)
Malevich, *Self-Portrait* (**25.24**)
Douglas, *Aspects of Negro Life: From Slavery through Reconstruction* (**25.21**)
Wright, Fallingwater (**25.32**), Pennsylvania
Picasso, *Guernica* (**25.12–25.13**)
Brancusi, *Endless Column* (**25.27**)
Brancusi, *The Gate of the Kiss* (**25.25**)
Wright, Taliesin West (**25.33**), Arizona

Evelyn Waugh, *Vile Bodies* (1930)
Dashiell Hammett, *The Maltese Falcon* (1930)
Robert Frost, *Collected Poems* (1931)
Pearl S. Buck, *The Good Earth* (1931)
Franklin Roosevelt introduces New Deal social and economic measures (1933)
Adolf Hitler appointed German chancellor (1933)
Gertrude Stein, *Autobiography of Alice B. Toklas* (1933)
Development of sulfa drugs (mid-1930s)
Spanish Civil War (1936–1939)
World War II (1939–1945)
Bauhaus artists emigrate to the United States (late 1930s)

1940

1940–1950

Mondrian, *Broadway Boogie Woogie* (**25.17**)
Picasso, *Bull's Head* (**25.9**)

1960

1950–1960

van der Rohe, Lake Shore Drive Apartment Houses (**25.40**), Chicago
Le Corbusier, Notre-Dame-du-Haut (**25.39**), Ronchamp

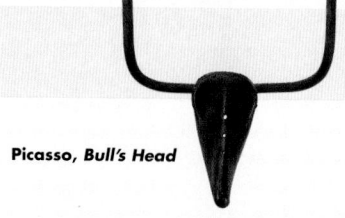

Picasso, Bull's Head

26

Dada, Surrealism, Fantasy, and the United States between the Wars

The devastation of World War I affected the arts as well as other aspects of Western civilization. For the first time in history, armies used trench warfare, barbed wire, machine guns firing along fixed lines, and chemical weapons. After treating the victims of gassing and shell shock in World War I, Freud and other medical researchers published accounts of the long-term psychological traumas of the new warfare. "The lost generation," a phrase coined by Gertrude Stein, captured the overwhelming sense of desolation experienced by the post–World War I intellectuals. In the visual arts the same pessimism and despair emerged as Dada.

Dada

The term *Dada* refers to an international artistic and literary intellectual movement that began during World War I in the relative safety of neutral Switzerland. Artists, writers, and performers gathered at the Cabaret Voltaire, a café in Zurich, for discussion, entertainment, and creative exploration (see box). Dada was thus not an artistic style in the sense of shared formal qualities that are easily recognized. Rather, it was an idea, a kind of "anti-art," predicated on a nihilist (from the Latin word *nihil,* meaning "nothing") philosophy of negation. By 1916, the term *Dada* had appeared in print—a new addition to the parade of aesthetic "manifestos" that developed in the nineteenth century. Dada lasted as a cohesive European movement until about 1920.

The Cabaret Voltaire

In February 1916, the German pacifist actor and author Hugo Ball (1886–1927) placed the following announcement in a Zurich paper:

> Cabaret Voltaire. Under this name a group of young artists and writers has formed with the object of becoming a center for artistic entertainment. The Cabaret Voltaire will be run on the principle of daily meetings where visiting artists will perform their music and poetry. The young artists of Zurich are invited to bring along their ideas and contributions.[1]

Among those who accepted Ball's invitation were Jean (Hans) Arp, the *chanteuse* Emmy Hennings, who later married Ball, and the Romanian poet Tristan Tzara. The cabaret was housed in a bar in a run-down quarter of Zurich, where poems, songs, and stories were recited and performed. Some of these were later published in the cabaret's periodical, entitled *Dada*. The movement stood for the absence of an artistic program and of rules. Dadaists rebelled against bourgeois values, which Ball referred to as "a public execution of false morality." Arp described Dada sentiments as follows:

> Revolted by the butchery of the 1914 World War, we in Zurich devoted ourselves to the arts. While the guns rumbled in the distance, we sang, painted, made collages and wrote poems with all our might. We were seeking an art based on fundamentals, to cure the madness of the age, and a new order of things that would restore the balance between heaven and hell.[2]

A feature of Dada expression was the "abstract phonetic poem," which Ball intended as a literary parallel to abstract painting and sculpture. "The next step," he wrote in his diary on March 5, 1917, "is for poetry to discard language as painting has discarded the object." One example of such poetry follows:

> gadji beri bimba glandridi laula lonni cadori
> gadjama gramma berida bimbala glandri galassassa
> laulitalomini
> Gadjama tuffm i zimzalla binban gligia wowolimai bin
> beri ban
> o katalominal rhinocerossola hopsamen laulitalomini
> hoooo gadjama
> rhinocerossola hopsamen
> bluku terullala blaulala loooo. . . .[3]

It also achieved a foothold in New York, where it flourished from about 1915 to 1923.

There are several accounts of the origin of the term *Dada*. The most widely accepted is that, when the leaders of the movement were trying to think of a name, they came upon a French-German dictionary that was opened at random to the word *Dada*. According to the 1916 manifesto, *Dada* is French for a child's wooden horse. *Da-da* are also the first two syllables spoken by children learning to talk and thus suggest a regression to early childhood. The implication was that artists wished to "start life over." Likewise, Dada's iconoclastic force challenged traditional assumptions about art and had an enormous impact on later twentieth-century **conceptual art** (see Chapter 28). Despite the despair that gave rise to Dada, however, a taste for the playful and the experimental was an important, creative, and ultimately hopeful aspect of the movement. This, in turn, is reflected in the Russian meaning of *da, da,* which is "yes, yes."

Marcel Duchamp

One of the major proponents of Dada was Marcel Duchamp (1887–1968), whose *Nude Descending a Staircase* (see fig. 25.18) had caused a sensation in the 1913 Armory Show. He shared the Dada taste for wordplay and punning, which he combined with visual images. Delighting, as children do, in nonsensical repetition, Duchamp entitled his art magazine *Wrong Rong*. The most famous instance of visual and verbal punning in Duchamp's work is *L.H.O.O.Q.* (fig. **26.1**), whose title is a bilingual pun. Read phonetically in English, the title sounds like "LOOK," which, on one level, is the artist's command to the viewer. If each letter is pronounced according to its individual sound in French, the title reads "Elle (*L*) a ch (*H*) aud (*O*) au (*O*) cul (*Q*)," meaning in English "She has a hot ass." Read backward, on the other hand, "LOOK" spells "KOOL," which counters the forward message.

When viewers do, in fact, look, they see that Duchamp has penciled a beard and mustache onto a reproduction of Leonardo's *Mona Lisa* (see fig. 14.16), turning her into a bearded lady. One might ask whether Duchamp has "defaced" the *Mona Lisa* or merely "touched her up." This question plays with the sometimes fine line between creation and destruction. (The modern expression "You have to break eggs to make an omelet" illustrates the connection between creating and destroying that was made explicit by the Dada movement.)

Duchamp called the kind of work exemplified by *L.H.O.O.Q.* a "Ready-Made-Aided." When he merely added a title to an object, he called the result a "Ready-Made."

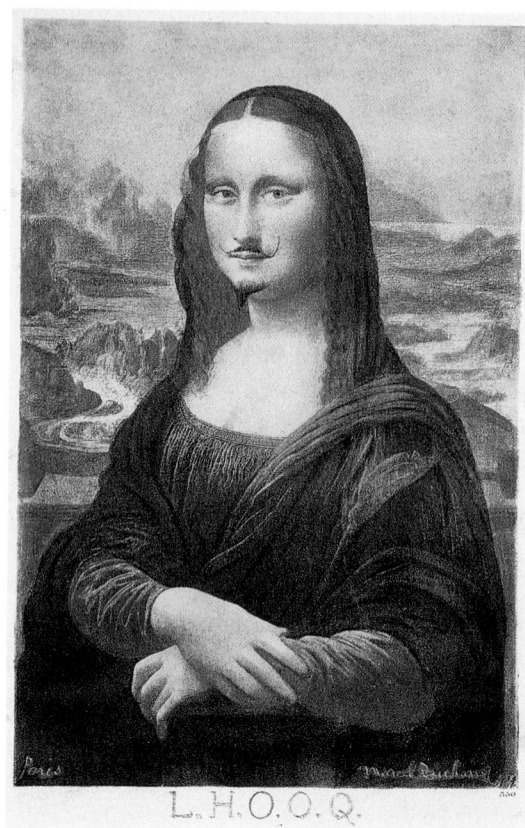

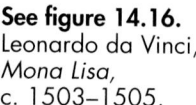 —————— **CONNECTIONS** ——————

See figure 14.16.
Leonardo da Vinci,
Mona Lisa,
c. 1503–1505.

26.1 Marcel Duchamp, replica of *L.H.O.O.Q.*, Paris, 1919, from "Boîte-en-Valise." Color reproduction of the *Mona Lisa* altered with a pencil; 7¾ × 5 in. (19.7 × 12.7 cm). Philadelphia Museum of Art (Louise and Walter Arensberg Collection). Duchamp was born in Blainville, France, the third of three sons who were all artists. In 1915, he moved to New York and in 1955 became an American citizen. After painting only twenty works, Duchamp announced his retirement in 1923 and devoted the rest of his life to chess.

the work of art and its potential for shock in looking and seeing. Whereas Renaissance artists controlled the viewer's direction of sight with linear perspective, Duchamp "instructs" the observer verbally via the title. He also plays with the point of view, making it two-sided, which can be seen as a development of the Cubist simultaneous viewpoint.

The glass surface of *To Be Looked At* cracked while it was being shipped, and the cracks were allowed to remain as part of the design. This accident and Duchamp's decision to let it stand are characteristic of Dada. For the Dada artists, chance became a subject of art, just as the medium had become a subject in the late nineteenth century. In collage and assemblage, too, the medium is as prominent a feature of the image as brushstrokes were for Impressionists and Post-Impressionists. Art based on the "found object" relies on the conscious exploration of chance in finding the medium for the work. Accepting chance and using what it offers also require a degree of flexibility and spontaneity that are necessary aspects of creativity.

26.2 Marcel Duchamp, *Fountain (Urinal)*, 1917. Ready-made, 24 in. (61.0 cm) high. Photo courtesy of Carroll Janis, New York. Duchamp declared that it was the artist's conscious choice that made a "Ready-Made" into a work of art. In 1915, he bought a shovel in a New York hardware store and wrote on it: "In advance of a broken arm." "It was around that time," he said, "that the word 'ready-made' came to my mind. . . . Since the tubes of paint used by an artist are manufactured and ready-made products, we must conclude that all the paintings in the world are ready-made aided."[4]

Duchamp's most outrageous Ready-Made was a urinal (fig. **26.2**) that he submitted as a sculpture to a New York exhibition mounted by the Society of Independent Artists in 1917. He turned the urinal upside down, signed it "R. Mutt," and called it *Fountain*. The work was rejected by the society, and Duchamp resigned his membership.

Despite the iconoclastic qualities of his Ready-Mades and his Ready-Mades-Aided, it must be said that both *L.H.O.O.Q.* and the *Fountain* have a place in the history of art. In the former, the connection with the past is obvious, for the work reproduces a classic icon. It comments on Leonardo's homosexuality and on the sexual ambiguity of the *Mona Lisa* herself. It also reflects Duchamp's interest in creating his own alter ego as a woman, whom he named Rrose Sélavy, a pun on "c'est la vie," meaning "that's life." The *Fountain* connects the idea of a fountain and a urinating male, which in fact has been the subject of actual and painted fountains in many works of Western art.

A good example of Dada principles in a work by Duchamp is *To Be Looked At (from the Other Side of the Glass) with One Eye, Close to, for Almost an Hour* of 1918 (fig. **26.3**). A pyramidal shape (above a balance) painted on a glass surface is tilted slightly by the weight of a circle. As in *L.H.O.O.Q.*, the title is about the viewer's relationship to

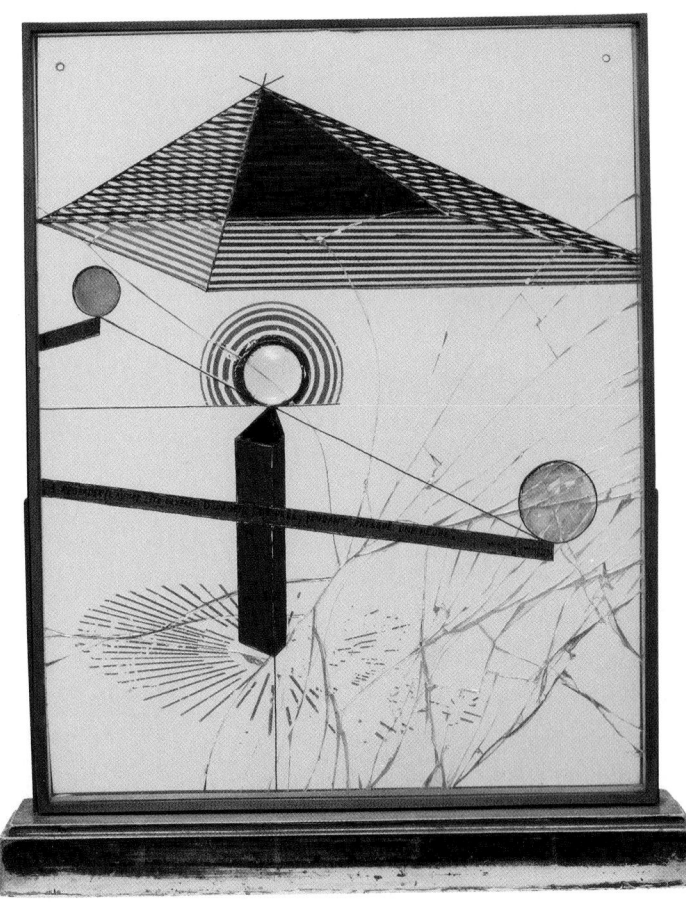

26.3 Marcel Duchamp, *To Be Looked At (from the Other Side of the Glass) with One Eye, Close to, for Almost an Hour*, Buenos Aires, 1918. Oil paint, silver leaf, lead wire, and magnifying lens on glass; overall height 22 in. (55.8 cm). Museum of Modern Art, New York (Katherine S. Dreier Bequest).

Jean (Hans) Arp

A quality of playfulness pervades the work of the Swiss artist Jean Arp (1887–1966), who was one of the founders of European Dada. In 1916–1917, in a famous act of Dada "chance," Arp cut up rectangles of blue, white, and gray paper and dropped them onto a surface. He then pasted them where they fell and called the result *Collage Arranged According to the Laws of Chance* (fig. **26.4**). By tilting the rectangles slightly and leaving the edges ragged, Arp animated the image and created the impression that the shapes are trying to arrange themselves.

In the cord collage *The Dancer* of 1928 (fig. **26.5**), Arp arranged a string on a flat surface. The string is equivalent to the draftsman's "line"—it defines the form and its character. By moving the string to achieve the desired shapes, Arp "played" creatively and arrived at a humorous image

26.5 Jean (Hans) Arp, *The Dancer*, 1928. Cord collage; 20 × 15½ in. (50.8 × 39.4 cm). Photo courtesy of Carroll Janis, New York.

26.4 Jean (Hans) Arp, *Collage Arranged According to the Laws of Chance*, 1916–1917. Torn and pasted paper; 19⅛ × 13⅝ in. (48.6 × 34.6 cm). Museum of Modern Art, New York. Purchase, © 1996 Artists Rights Society (ARS). New York/VG Bild-Kunst, Bonn.

—a small head on a bulky torso with a circle in the center. The figure's slight tilt, the position of the left leg, and the upward curve of the right leg create a convincing impression of forward motion. The dancer literally seems to "kick up her heel," which, together with the flowing hair evoked by a single strand of string, conveys a feeling of movement through space.

In moving the string, Arp also engaged in a form of visual free association, which was part of Dada and appealed to the interest in the spontaneous quality of chance. Dada artists and writers attempted a creative process designed to minimize the overlay of tradition and conscious control. Instead, they emphasized the expression of unconscious material through play, chance, and rapid execution. This approach was used in wordplay as well as in visual punning. The connection of both with unconscious processes had been explicated in Freud's 1911 publication *Jokes and Their Relation to the Unconscious*. Several Dada artists, including Arp, wrote poems intended to illustrate these processes (see box).

Man Ray

The American Dadaist Man Ray (1890–1976) also played with words, images, and objects, parts of which were "ready-made." His *Indestructible Object (or Object to Be Destroyed)* of 1923 (fig. **26.6**), for example, consisted of a "ready-made" metronome. He attached a photograph of a human eye to the pendulum, thereby combining the moving piece of the metronome with the eye that watches it move. The viewer is "looked at" by the metronome, which has been transformed by Man Ray's addition from a purely functional object to a work of art. The transitional state between looking and being looked at, between actual and implied motion, between utility and aesthetics is reflected in the ambivalence of the title. The object is both indestructible and intended to be destroyed. Like the European Dada artists, Man Ray played with the fine line separating creation from destruction and the mundane "found objects" of everyday life from art.

26.6 Man Ray, *Indestructible Object (or Object to Be Destroyed)*, 1964. Replica of the original of 1923. Metronome with cutout photograph of an eye on a pendulum; 8⅞ × 4⅜ × 4⅜ in. (22.5 × 11.1 × 11.1 cm). Museum of Modern Art, New York (James Thrall Soby Fund). The artist's real name was Emanuel Rudnitsky (1890–1976). His choice of the name Man Ray, although derived from his real name, illustrates the fondness for punning and word games that he shared with other Dada artists. He reportedly chose "Man" because he was male and "Ray" because of his interest in light.

Surrealism

Many members of the Dada movement also became interested in the Surrealist style that supplanted it. It was the writer André Breton who bridged the gap between Dada and Surrealism with his first *Surrealist Manifesto* of 1924 (see box). He advocated an art and literature based on Freud's psychoanalytic technique of free association as a means of exploring the imagination and entering the world of myth, fear, fantasy, and dream. The very term *surreal* connotes a higher reality—a state of being, like that depicted in Picasso's *Girl before a Mirror* (see fig. 25.11), that is more real than mere appearance.

Breton had studied medicine and, like Freud, had encountered the traumas experienced by World War I shell-shock victims. This led both Breton and Freud to recognize the power that trauma has over logical, conscious thinking. As a result, Breton wished to gain access to the unconscious mind, where, he believed, the source of creativity lay. He recommended that authors write in a state of free-floating association in order to achieve spontaneous, unedited expression. This "automatic writing" influenced European Abstract Surrealists and later, in the 1940s, had a significant impact on the Abstract Expressionists in New York City (see Chapter 27). The Surrealists' interest in gaining access to unconscious phenomena led to images that seem unreal or unlikely, as dream images often are, and to odd juxtapositions of time, place, and iconography.

See figure 25.11. Pablo Picasso, *Girl before a Mirror*, 1932.

Giorgio de Chirico

Breton cited Giorgio de Chirico (1888–1978), who was born in Greece of Italian parents, as the paradigm of Surrealism. De Chirico had signed the 1916 Dada manifesto and then developed an individual Surrealist style, which he termed *pittura metafisica*—"metaphysical painting." His *Place d'Italie* of 1912 (fig. **26.7**) combines a perspective construction and architectural setting reminiscent of the Italian Renaissance with an unlikely marble reclining figure in the foreground and a train in the background. Diagonal shadows are cast by the buildings, the statue, and a standing couple in the distance. One shadow, entering the picture from the left, belongs to an unseen person.

In this painting, de Chirico combines anachronistic time and place within a deceptively rational space. The reclining figure is derived from Classical sculpture and thus denotes the Greek and Roman past. The moving train, on the other hand, refers to the industrial present and the passage of time. There is an eerie, uncanny quality to this scene, reinforced by the shadows, that is typical of de Chirico. Isolation and a sense of foreboding pervade the picture space, making the viewer uneasy, as if aware of a mystery that can never be solved.

André Breton's First Surrealist Manifesto

The term *Surrealist* was coined by Apollinaire to describe one of his plays. In 1924, André Breton published the first *Surrealist Manifesto*, in which he defined the term as "pure psychic automatism by which it is intended to express, either verbally or in writing, the true function of thought. Thought dictated in the absence of all control exerted by reason, and outside all aesthetic or moral preoccupations."[6]

Surrealist aims followed logically from Dada interest in spontaneous, unconscious expressions of dreams and imagination. For this development, Breton gave full credit to Sigmund Freud's *Interpretation of Dreams*, which had been published in 1899. In dreams, according to both Freud and Breton, the dreamer is not inhibited by the possibility of action and therefore gives freer reign to unconscious thoughts. "Perhaps," wrote Breton in his opening paragraph, "the imagination is on the verge of recovering its rights. If the depths of our minds conceal strange forces capable of augmenting or conquering those on the surface, it is in our greatest interest to capture them . . . and later to submit them, should the occasion arise, to the control of reason."[7]

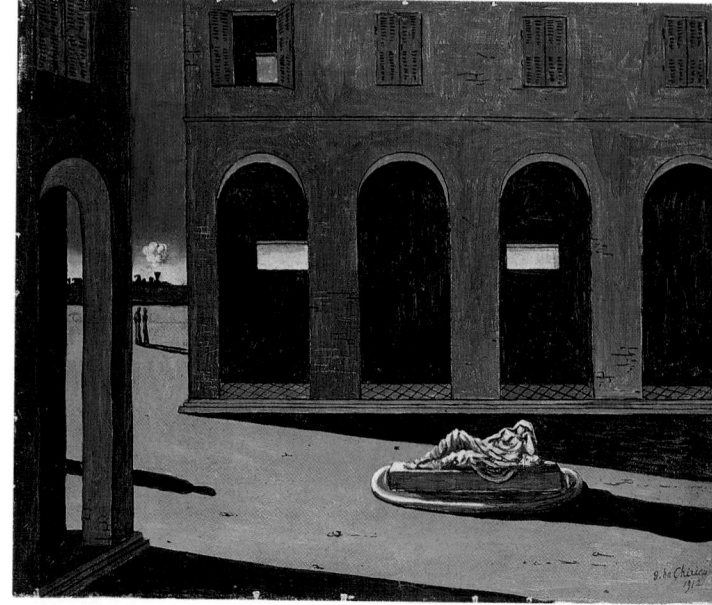

26.7 Giorgio de Chirico, *Place d'Italie*, 1912. Oil on canvas; 18½ × 22½ in. (47.0 × 57.2 cm). Collection, Dr. Emilio Jesi, Milan.

Man Ray

Among the Surrealists who had also been part of the Dada movement was Man Ray. In 1921, he moved to Paris, where he showed his paintings in the first Surrealist exhibition of 1925. He worked as a fashion and portrait photographer and as an avant-garde filmmaker. His experiments with photographic techniques included the **Rayograph,** made without a camera by placing objects on light-sensitive paper. Man Ray's most famous photograph, *Le Violon d'Ingres* (fig. **26.8**), combines Dada wordplay with Surrealist imagery. The nude recalls the odalisques of Ingres (see fig. 19.14), while the title refers to Ingres' hobby—playing the violin (which led to the French phrase *violon d'Ingres,* meaning "hobby"). By adding sound holes, Man Ray puns on the similarity between the nude's back and the shape of a violin. The combination of the nude and the holes exemplifies the dreamlike imagery of Surrealism.

Man Ray defended the art of photography and argued against those unwilling to treat it as an art form. In *Photography Can Be Art,* he wrote:

> When the automobile arrived, there were those that declared the horse to be the most perfect form of locomotion. All these attitudes result from a fear that the one will replace the other. Nothing of the kind has happened. We have simply increased our vocabulary. I see no one trying to abolish the automobile because we have the airplane.[8]

In true Dada fashion, Man Ray also published two books, *Photography Is Not Art* and *Art Is Not Photography.*

CONNECTIONS

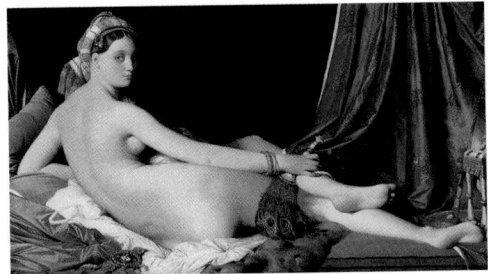

See figure 19.14. Jean-Auguste-Dominique Ingres, *Grande Odalisque,* 1814.

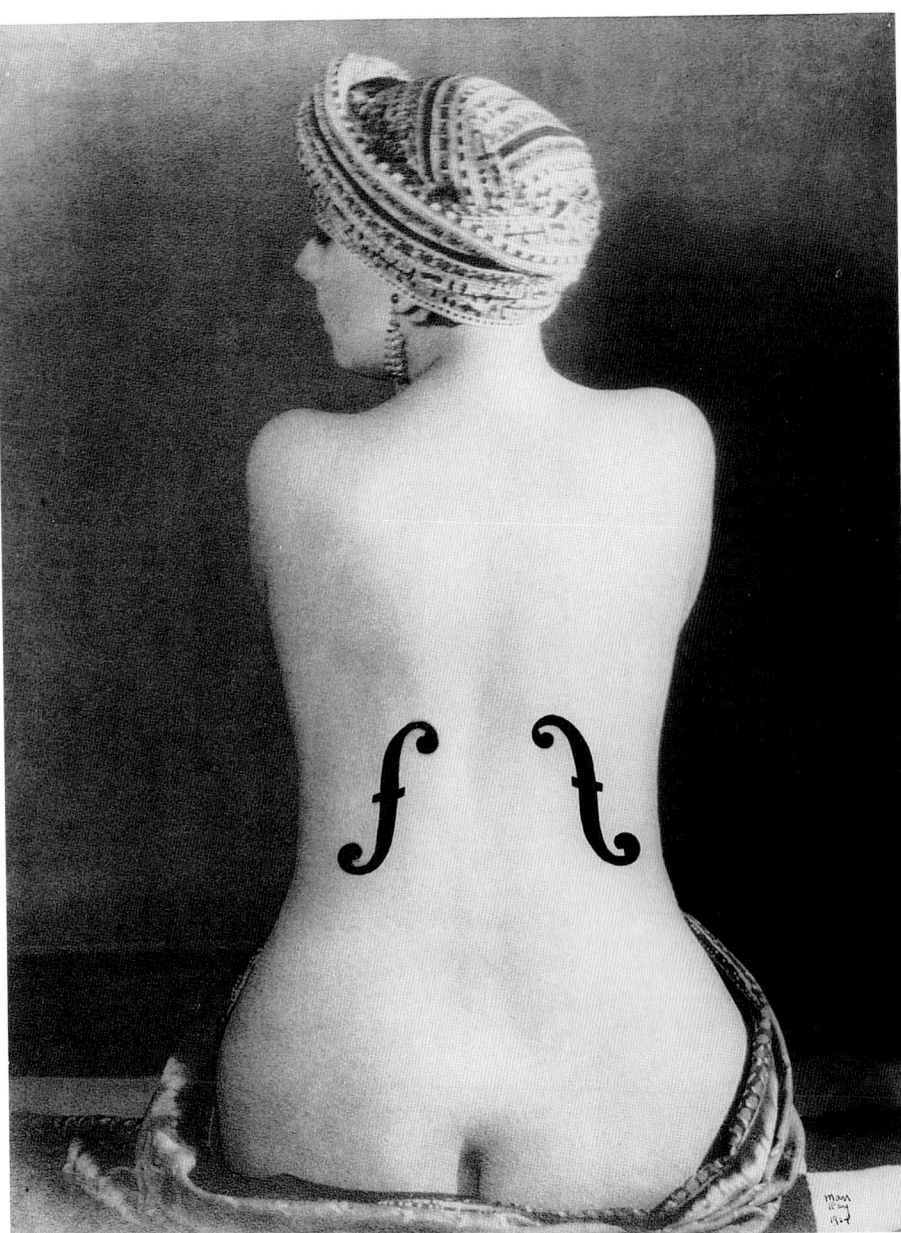

26.8 Man Ray, *Le Violon d'Ingres,* 1924. Photograph. Museé National d'Art Moderne, Centre George Pompidou.

Paul Klee

Fantasy characterizes the Surrealism of the Swiss artist Paul Klee (1879–1940), who had been a member of The Blue Rider (see p. 840). He made many pencil drawings that reveal his attraction to linear, childlike imagery as well as the influence of Surrealist "automatic writing." His *Mask of Fear* of 1932 (fig. **26.9**) reflects all of these qualities, including the recollection of a painted wooden sculpture by the Zuni carvers of the American Southwest (fig. **26.10**). Such allusions exemplify the Surrealists' search for new sources

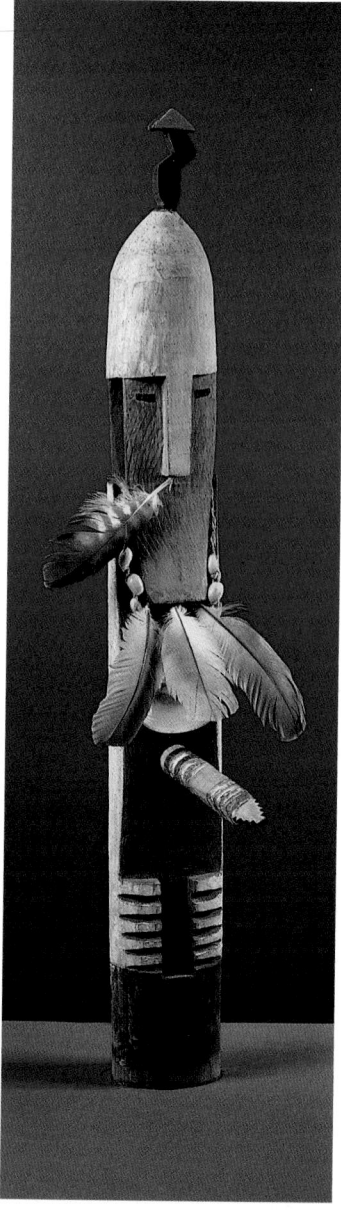

26.10 Zuni war god from Arizona or New Mexico, before 1880. Painted wood and mixed media; 30½ in. (77.5 cm). high. Museum für Volkerkunde, Berlin.

26.9 Paul Klee, *Mask of Fear,* 1932. Oil on burlap; 3 ft. 3½ in. × 1 ft. 10½ in. (1.00 × 0.57 m). Museum of Modern Art, New York (Nelson A. Rockefeller Fund). Klee described the creative process as follows: "Art does not reproduce the visible; rather, it makes visible."[9] Klee himself was enormously productive, recording a total of nearly 9,000 works.

of imagery, especially those with dreamlike and mythological content. As a young man, Klee visited the folk art museum in Berlin, which had acquired the Zuni statue in 1880. In addition to formal correspondences, it is also possible that there are iconographic parallels. For the Zuni figure represents a war god and thus might have been associated in Klee's mind with the rise of the Nazi storm troopers. They, too, wore zigzag insignia reminiscent of lightning, and they aroused fear of the kind suggested by the man hidden behind the mask.

In any event, Klee has transformed the Zuni sculpture into a flat image that plays with the boundaries between two- and three-dimensionality. The horizontal line defining the tip of the mask's nose is also the horizon line of the painting. Two pairs of legs either support the mask, whose size does not correspond naturally to theirs, or walk behind it. As a result, the viewer is startled by unlikely juxtapositions.

26.11 Salvador Dalí, *The Persistence of Memory*, 1931. Oil on canvas; 9½ in. × 13 in. (24.1 × 33.0 cm). Museum of Modern Art, New York (given anonymously).

Salvador Dalí

Salvador Dalí's (1904–1989) famous "melting clocks" in *The Persistence of Memory* (fig. **26.11**) portray the uncanny quality of certain dreams. In a stark, oddly illuminated landscape, a number of elements referring to time—watches, eggs, a dead fish, a dead tree—are juxtaposed with a single living fly and swarming ants. Displaced from an unidentified location onto the eerie landscape are two rectangular platforms at the left. The one in the foreground impossibly supports a tree, just as an impossible system of lighting produces strange color combinations.

Joan Miró

The Surrealist pictures of Joan Miró (1893–1983) are composed of imaginary motifs that are often reminiscent of childhood. His early painting *Dog Barking at the Moon* of 1926 (fig. **26.12**) depicts a colorful, toylike dog standing alone on a hill. The night sky contains a fanciful moon and another shape, which could be a bird. The most surreal form is the unsupported ladder that seems to go nowhere. As the ladder rises, its reach becomes vast, and the space between earth and sky is collapsed.

26.12 Joan Miró, *Dog Barking at the Moon*, 1926. Oil on canvas; 28¾ × 36¼ in. (73.0 × 92.1 cm). Philadelphia Museum of Art (A. E. Gallatin Collection).

Miró's later style retains biomorphic, sexually suggestive abstract forms and primary colors, but there is an increase in linear movement and complex design. The *Spanish Dancer* of 1945 (fig. **26.13**), for example, captures the rapid rhythm of Spanish dancing by juxtaposing thin curves, diagonal planes, and flat shapes that shift abruptly from one color to another. The red-and-green curve on the red-and-black shape at the lower right seems to turn in space like a dancer's torso. Two legs kick energetically to the left, while a hand is poised above the torso. Surrounding the hand is a shape with two curved points—one black, one red—which resemble breasts. At the top, the large head tilts upward as a nose and mouth (two black eyes hang from the nose) project from it to the left. Two eyes—one red, one blue—each with two black circles within it, also occupy the large head. A corresponding eye shape is lodged in the lower leg. The exuberance of Miró's dancing figure and the illusion of speed created by curved lines and shifting planes reflect his interest in Surrealist "automatic writing."

26.13 Joan Miró, *Spanish Dancer*, 1945. Oil on canvas; 4 ft. 9½ in. × 3 ft. 8⅞ in. (1.46 × 1.14 m). Fondation Beyeler, Riehen/Basle.

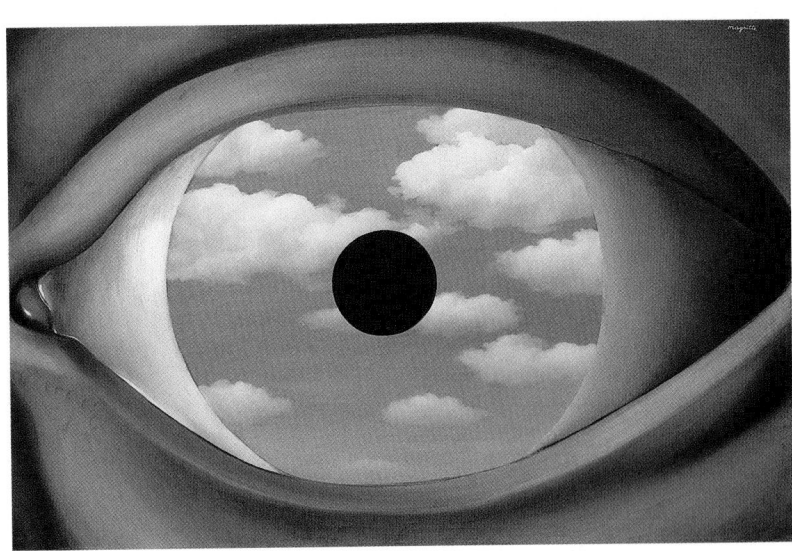

26.14 René Magritte, *The False Mirror*, 1928. Oil on canvas; 21¼ × 31⅞ in. (54.0 × 80.9 cm). Museum of Modern Art, New York.

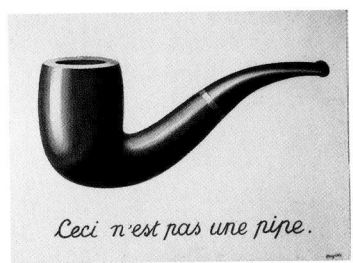

Ceci n'est pas une pipe.

See figure I.5. René Magritte, *The Betrayal of Images*, 1928.

René Magritte

The Belgian artist René Magritte (1898–1967) painted Surrealist images of a more veristic kind. Individually they are realistic, often to the point of creating an illusion. However, their context, size, or their juxtaposition of objects is unrealistic or possible only in a world of dreams. Magritte's *False Mirror* of 1928 (fig. **26.14**) depicts a large eye (from which the familiar CBS logo was derived). The black circle at the center can refer both to the pupil and to an eclipsed sun. The observer is thrown off balance by the unusual close-up view of the "eye" as well as by its unexpected character. We do not know if we are looking into the eye and seeing a reflection of the sky, or if we are inside the eye, looking past the pupil at the sky. The "mirror" is "false" because, like the "pipe" in *The Betrayal of Images* (see fig. I.5), it plays a visual trick. As puns, however, both contain truth. In *The False Mirror*, Magritte applies the simultaneous viewpoint of Cubism to clear, recognizable forms but without the Cubist use of geometric abstraction.

In *Time Transfixed* (*La Durée poignardée* in French) of 1938 (fig. **26.15**), Magritte juxtaposed two familiar objects in order to create an unfamiliar effect. Various motifs in this work are clearly depicted and easily identifiable, but their relation to each other is odd, and they convey an impression of immobility and timelessness. The clock indicates a specific hour, but the candlesticks are empty. The cold, sterile room, composed almost entirely of rectangular forms, is devoid of human figures. A steam engine has burst through the fireplace but without disrupting the wall. The shadow cast by the train is unexplained because there is no light source to account for it. The smoke, which indicates that the train is moving although it looks stationary, disappears up the chimney. *Poignardée* in the French title, literally meaning "stabbed" with a dagger or sword, expresses the "fixed," frozen quality of both the train and the time.

26.15 René Magritte, *Time Transfixed* (*La Durée poignardée*), 1938. Oil on canvas; 4 ft. 9⅝ in. × 3 ft. 2⅜ in. (1.46 × 0.98 m). Art Institute of Chicago (Joseph Winterbotham Collection). Freud's discovery that time does not exist in the unconscious accounts for certain unlikely condensations in dreams. The uncanniness of temporal condensation contributes to the eerie quality of this painting, as does the impossible juxtaposition of realistic objects.

26.16 Max Ernst, *The King Playing with the Queen*, 1944. Bronze (cast 1954, from original plaster); 38½ in. (97.8 cm) high, at the base 18¾ × 20½ in. (47.7 × 52.1 cm). Museum of Modern Art, New York (Gift of D. and J. de Menil).

26.17 (right) Mossi whistle, Upper Volta. Wood; 22⅜ in. (56.8 cm) high.

Sculpture Derived from Surrealism

Surrealism influenced sculptors as well as painters and photographers in Europe and America. The Surrealist interest in the literal depiction of unconscious chance and in dream images contributed to the twentieth-century break with many traditional forms and techniques.

Max Ernst

Max Ernst (1891–1976) began his artistic career as a Dadaist in Germany. He moved to France after World War I and eventually settled in the United States. *The King Playing with the Queen* (fig. **26.16**) of 1944 combines the influence of Surrealism, Cubism, a knowledge of Freud's theories, and the playful qualities of Picasso and Duchamp. A geometric king looms up from a chessboard, which is also a tabletop. His horns are related to the role of the bull as a traditional symbol of male fertility and kingship. He dominates the board by his large size and extended arms. The king is a player sitting at the table as well as a chess piece on the board. He literally "plays" with the queen, who is represented as a smaller geometric construction at the left. On the right, a few chess pieces seem detached from whatever "game" is taking place between the king and queen.

In the 1930s and 1940s, Ernst was the Surrealist most influenced by non-Western art. For example, *The King Playing with the Queen* has obvious affinities with a type of wooden whistle produced in Upper Volta, in Africa (fig. **26.17**). Its geometric head, vertical torso, and zigzag arms enclosing open space are remarkably similar to Ernst's sculpture. In addition to African sculpture, Ernst was influenced by Native American art, especially that of Arizona, where he lived from 1946 to 1953. He collected Kachina carvings made by the Hopi tribe (fig. **26.18**) and identified strongly with its mythology, envisioning himself as a shaman and describing shamanistic hallucinations in his autobiography. For Ernst, the shaman—like the artist—had highly charged sensory experiences that offered new ways of interpreting and rendering ordinary phenomena.

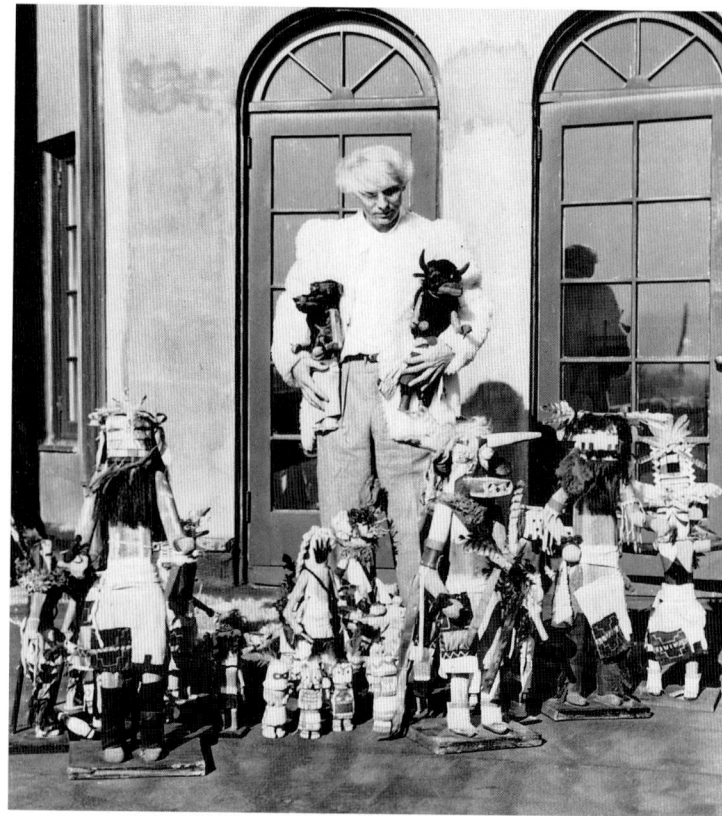

26.18 Max Ernst with his Kachina doll collection, 1942. Photograph by James Thrall Soby. Collection of Elaine Lustig Cohen.

Hopi Kachinas

The Hopi Indians inhabited the American Southwest, especially Arizona, undisturbed until they were relegated to reservations in the late nineteenth century. Theirs is an agricultural society; they live in **pueblos,** which are communal houses divided into individual units made of **adobe** (mud brick). Figure **W12.1** is a diagram of a typical pueblo unit. The thick walls keep the interior cool in summer and prevent freezing in winter. The photograph in figure **W12.2** was taken in about 1929 by Ansel Adams (1902–1984), who was perhaps the leading American photographer of the Southwest. It shows a woman winnowing grain outside the Taos pueblo in New Mexico.

In Hopi villages, an open central space is a ceremonial site in which Kachinas play a major role. According to Hopi mythology, Kachinas are supernatural spirits who dwell in the mountains. They exist in three forms: as unseen spirits, as impersonations by masked men, and as carved, wooden dolls. There are over 200 such Kachinas, some of which are deceased members of the Hopi tribe. Ceremonies involving Kachinas are performed from the winter solstice to mid-July in connection with agriculture, rites of spring, and weather conditions.

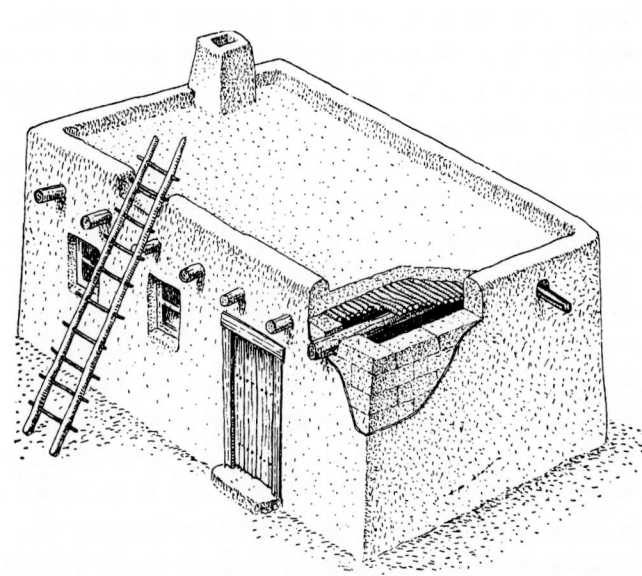

W12.1 Diagram of a typical pueblo adobe unit, American Southwest.

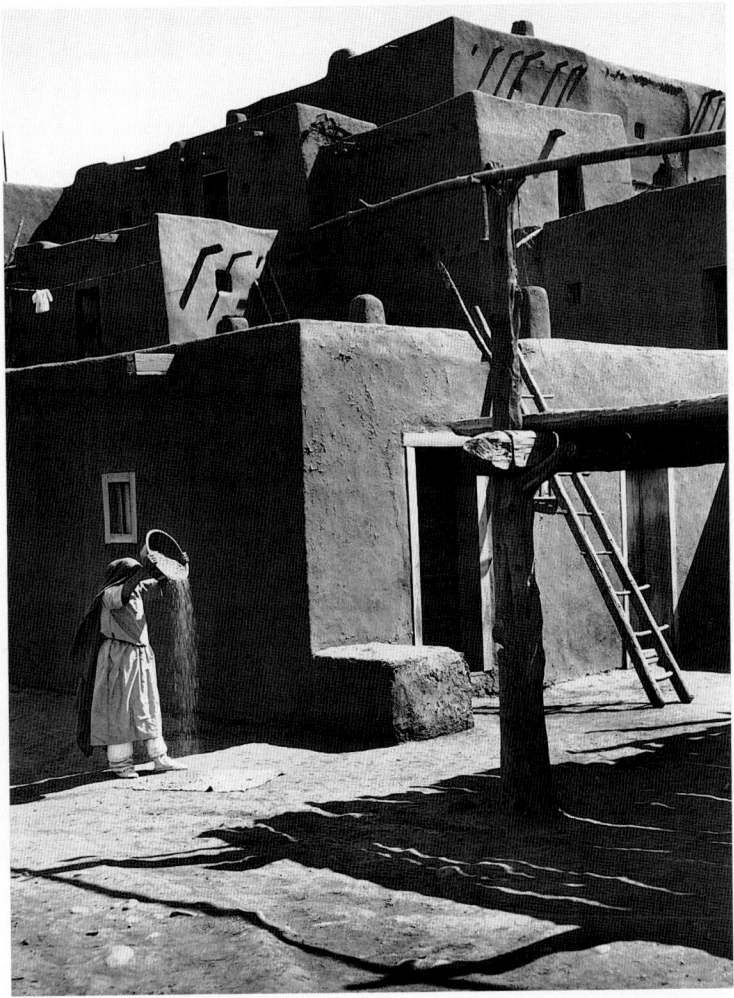

W12.2 Ansel Adams, *Winnowing Grain, Taos Pueblo,* c. 1929. Photograph.

Each type of Kachina serves a particular function. There are runners, for example, who race with men in order to train boys in speed, and ogres, whose function is to frighten children into obedience. Clowns provide comic relief during intermissions between rites, a practice similar to the satyr plays in ancient Greece. Children are given Kachinas as presents to serve an exemplary purpose and to train them to recognize the different classes of Kachina. Although there are female Kachinas, they are always impersonated by men.

The Hopi carve Kachinas by shaping the roots of dead cottonwood trees with a chisel and saw. The finer carving is done with a penknife, and the surface is then smoothed with a rasp and sanded. Facial features are attached with glue or pins. Kachinas are painted, and the colors symbolize geographic directions or spatial orientation—blue and green represent the West or Southwest, red the South or Southeast, white the East or Northeast, black the depths, and all the colors together represent the top. Facial markings are also symbolic. For example, parallel lines under the eye denote a warrior's footprint, an inverted V over the mouth denotes an official, and phallic symbols stand for fertility.

The two Kachinas illustrated here represent Black Ogre (fig. **W12.3**) and Butterfly Maiden (fig. **W12.4**). Black Ogre wears a mask with movable jaws and prominent teeth. He has a blue crow's foot on his forehead, wears a white shirt and trousers, red leggings and moccasins, and holds a hammer and a bow. He is believed to take food from children, whom he swallows whole. Butterfly Maiden is a more benign Kachina. She wears a white mask decorated with triangles and a white robe with geometric designs, and her bare feet are yellow. Her feathered headdress is particularly elaborate. In contrast to Black Ogre, whose crow's foot between his eyes makes him seem to be frowning angrily, her expression is impassive.

W12.3 Black Ogre, Hopi Kachina. Carved cottonwood.

W12.4 Butterfly Maiden, Hopi Kachina. Carved cottonwood.

Alberto Giacometti

In the 1930s Alberto Giacometti (1901–1966) had been involved with the Surrealists in Paris, and from the 1940s he began exploring the paradoxical power of emaciated human form. The tall, thin, anti-Classical proportions of *Large Standing Woman III* (fig. **26.19**), one of his most imposing works, hark back to the rigid, standing royal figures of ancient Egypt (see fig. 3.32), which had exerted a significant influence on Giacometti's development. In figures such as this, whether large or small, Giacometti plays with the

idea of extinction. His obsession with existence and non-existence is evident in the fact that he made these sculptures as thin as they can be without collapsing. Ironically, the thinner they become, the more their presence is felt. By confronting the observer with the potential for disappearance, Giacometti arouses existential anxiety and takes the viewer to the very threshold of being. The sculpture is shown here as installed at the Sidney Janis Gallery in New York. On the wall is Mondrian's *Composition with Red, Yellow, and Blue* of 1935–1942; the juxtaposition shows the relationship of both artists to the avant-garde.

— **CONNECTIONS** —

See figure 3.32.
Statue of Hatshepsut as pharaoh, Eighteenth Dynasty, c. 1473–1458 B.C.

26.19 Alberto Giacometti, *Large Standing Woman III*, 1960, and Piet Mondrian, *Composition with Red, Yellow, and Blue*, 1935–1942. Giacometti: bronze; 7 ft. 8½ in. (2.35 m) high. Mondrian: oil on canvas; 3 ft. 3¼ in. × 1 ft. 8¼ in. (0.99 × 0.51 m). Photo courtesy of Carroll Janis, New York. © 2006 Artists Rights Society (ARS), New York/ADAGP, Paris. © 2006 Mondrian/Holtzman Trust, c/o HCR International, Warrenton, VA, USA. Born in Switzerland, Giacometti spent a formative period in the 1930s as a Surrealist. He met the Futurists in Italy and the Cubists in Paris, and finally developed a distinctive way of representing the human figure that has become his trademark.

Henry Moore

In contrast to Giacometti, the British sculptor Henry Moore (1898–1986) was drawn to massive, biomorphic forms. Moore's habit of collecting the chance objects of nature, such as dried wood, bone, and smooth stones from beaches, recalls the use of "found objects" in collage and assemblage. Unlike Dada and Surrealist artists, however, he used found objects as his inspiration rather than his medium, preferring the more traditional media of stone, wood, and bronze.

The motif of the reclining figure was one of Moore's favorite subjects. He related the image to the Mother Earth theme and to his fascination for the mysterious holes of nature. From the 1930s, he began making sculptures with hollowed-out spaces and openings, thereby playing with the transition between inside and outside, interior and exterior. Many of Moore's reclining figures are intended as outdoor landscape sculptures. As such, their holes permit viewers to see through the work as well as around it and thus to include the surrounding landscape in their experience of the sculpture.

Reclining Figure, in front of the main UNESCO building in Paris (fig. **26.20**), is in an architectural setting. Its curvilinear masses and open spaces contrast with the stark rectangularity of the wall. The white marble, with its pronounced grain, gleams in the natural outdoor light. Moore considered the mountainous quality of the forms and the majestic character of the upright head and torso a fitting metaphor for the noble aims of the United Nations.

In his *Helmet* series of the 1950s, Moore continued to pursue the theme of interior and exterior. *Helmet Head No. 1*

26.21 Henry Moore, *Helmet Head No. 1,* 1950. Bronze; 13 in. (33.0 cm) high. Tate Gallery, London.

(fig. **26.21**) condenses the helmet with the head in a surreal way by the eyelike forms protruding from the helmet. The inside of the helmet is occupied by a cone, leaving open spaces behind it. In this series, Moore included the idea of protective covering, which is the practical function of a helmet. But he also related the theme of protection to another favorite motif—namely, mother and child. For Moore, the helmet head is a metaphor for maternal protection, and the unformed interior figure represents the child.

─── **CONNECTIONS** ───

See figure 14.48. Giorgione, *Sleeping Venus,* c. 1509.

26.20 Henry Moore, *Reclining Figure,* 1957–1958. Roman travertine; 16 ft. 8 in. (5.08 m) long. UNESCO Building, Paris.

Alexander Calder

From the 1930s, the American artist Alexander Calder (1898–1976) developed **mobiles**, hanging sculptures that could be set in motion by air currents. The catalyst for these works came from experiments with kinetic sculpture in Paris in the late 1920s and early 1930s. *Big Red* of 1959 (fig. **26.22**) is made from a series of curved wires arranged in a sequence of horizontal, vertical, and diago-nal planes. Flat red metal shapes are attached to the wires. Because they hang from the ceiling, mobiles chal-lenge the traditional viewpoint of sculpture. Their playful quality and the chance nature of air currents are reminis-cent of Dada and Surrealism, although Calder is more abstract (in the nonfigurative sense) than many Dada and Surrealist artists. Of this mobile, Calder is quoted as hav-ing said, "I love red so much that I almost want to paint everything red."[10]

26.22 Alexander Calder, *Big Red,* 1959. Painted sheet metal and steel wire; 6 ft. 1 in. (1.88 m) high, 9 ft. 6 in. (2.90 m) wide. Whitney Museum of American Art, New York (Purchase). The playfulness of Calder's mobiles has not been lost on the toy industry. Mobiles of various figures, often activated by a wind-up motor attached to a music box, have been suspended over the cribs of generations of babies.

The United States: Regionalism and Social Realism

In spite of the variety of expression produced by the European avant-garde and exhibited in the 1913 Armory Show, art in the United States of the 1920s and 1930s was, above all, affected by economic and political events, particularly the Depression and the rise of Fascism in Europe. Two different types of response to the times, both of which had political overtones of their own, can be seen in the work of American Regionalists and Social Realists.

Painting

American Gothic (fig. **26.23**) by Grant Wood (1892–1942) reflects the Regionalists' interest in provincial America and their isolation from the European avant-garde. Although the influence of Gothic is evident in the vertical planes and the pointed arch of the farmhouse window, the figures and their environment are unmistakably those of the American Middle West. The clapboard style of domestic architecture, developed in the nineteenth century by Richard Upjohn and referred to as "Carpenter's Gothic" (see p. 724), is shown here. Wood's meticulous attention to detail and the linear quality of his forms recall the early fifteenth-century Flemish painters. All such European references, however, are subordinated to a distinctly regional American character.

Wood studied in Europe but returned to his native Iowa to paint the region with which he was most familiar. In this work, the two sober paragons of the American work ethic depicted as Iowa farmers are actually the artist's sister and dentist.

The African-American artist Jacob Lawrence (1917–2000), who was influenced by the Harlem Renaissance, dealt with

26.23 Grant Wood, *American Gothic*, 1930. Oil on beaverboard; 29¼ × 24½ in. (74.3 × 62.4 cm). Art Institute of Chicago (Friends of American Art Collection).

──── **CONNECTIONS** ────

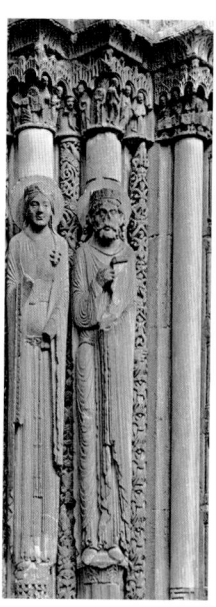

See figure 11.19. Doorjamb statues, west façade, Chartres Cathedral, c. 1145–1170.

26.24 Jacob Lawrence, *Harriet Tubman Series, No. 7*, 1939–1940. **Casein** tempera on hardboard; 17⅛ × 12 in. (43.5 × 30.5 cm). Hampton University Museum, Hampton, Virginia. From the age of ten, Lawrence lived in Harlem; in 1990, he was awarded the National Medal of Arts. This painting is from his 1939–1940 series celebrating Harriet Tubman (c. 1820–1913). She was an active abolitionist and champion of women's rights who helped southern slaves to escape to the North. From 1850 to 1860, as a "conductor" on the "underground railroad," she freed more than 300 slaves.

issues of racial inequality and social injustice. Figure **26.24** reflects the influence of European Expressionist and Cubist trends, although the subject and theme are purely American. Using a combination of flattened planes and abrupt foreshortening, Lawrence creates a powerful image of the abolitionist Harriet Tubman sawing a log. Tubman's single-minded concentration, as she fills the picture and focuses her energies on the task at hand, engages the observer directly in her activity. The geometric abstraction of certain forms, such as her raised right shoulder, contrasts with three-dimensional forms—the shaded sleeve on the right, for example—to produce shifts in tension. The result of such shifts is a formal instability that is stabilized psychologically by Tubman's evident determination.

Edward Hopper (1882–1967), also a painter of the American scene, cannot be identified strictly as either a Regionalist or a Social Realist. His work combines aspects of both styles, to which he adds an atmosphere of isolation and loneliness. His settings, whether urban or rural, are uniquely American, often containing self-absorbed human figures whose interior focus matches the still, timeless quality of their surroundings. In *Gas* of 1940 (fig. **26.25**), a lone figure stands by a gas pump, the form of which echoes his own. The road, for Hopper a symbol of travel and time, seems to continue beyond the frame. Juxtaposed with the road are the figure and station that "go nowhere," as if frozen within the space of the picture.

26.25 Edward Hopper, *Gas*, 1940. Oil on canvas; 2 ft. 2¼ in. × 3 ft. 4¼ in. (0.67 × 1.02 m). Museum of Modern Art, New York (Mrs. Simon Guggenheim Fund).

Photography

Photography served the aims of social documentation in America as well as in Europe. During the period of black intellectual expansion known as the Harlem Renaissance, photographers recorded the life of the black community in New York City. James Van Der Zee's (1886–1983) *Portrait of Couple, Man with Walking Stick* of 1929 (fig. **26.26**) was taken in his Lenox Avenue studio against a landscape backdrop. The couple seems self-consciously well dressed in an urban style that is slightly at odds with the scenery. Their attire places them in the 1920s at the height of the Harlem Renaissance, and their poses convey a sense of self-assurance.

Shoeshine Sign in a Southern Town of 1936 (fig. **26.27**) by Walker Evans (1903–1975) evokes the atmosphere of the Deep South in the 1930s. During the Depression, until 1937, Evans took pictures for the Resettlement Administration—later the Farm Security Administration (FSA). This organization hired photographers to illustrate rural poverty, as is suggested here by the ramshackle wall and the bare lightbulb. The necessity of earning money by shining shoes stands for the larger social picture of American life in the 1930s. At the same time, however, Evans has exploited the abstract qualities of black and white contrast and textured surfaces. The prominence of the word "SHINE" is reminiscent of early collage and reflects Evans's interest in the formal possibilities of billboards, shop signs, and posters that are part of the American landscape.

26.26 James Van Der Zee, *Portrait of Couple, Man with Walking Stick*, 1929. Silver print. James Van Der Zee Collection.

26.27 Walker Evans, *Shoeshine Sign in a Southern Town*, 1936. Gelatin-silver print; 5⅝ × 6⅝ in. (14.4 × 16.8 cm). Museum of Modern Art, New York (Stephen R. Currier Memorial Fund).

Dorothea Lange (1895–1965) also worked for the FSA, but she was less interested in formal abstraction than Evans and more committed to conveying the desired social message. Her *Migratory Cotton Picker* of 1940 (fig. **26.28**) is typical of the way in which she ennobled the poor and the working class. The man is physically attractive, but worn by laboring in the fields and tough-ened by the hot sun. Earth clings to his hands, the lines and veins of which create abstract patterns by virtue of the close-up viewpoint. Arizona's arid climate is por-trayed in the clear, crisp sky and the precise outlines of the worker. In such images, Lange achieved her political goals by evoking sympathy for, and identification with, her subjects.

26.28 Dorothea Lange, *Migratory Cotton Picker, Eloy, Arizona,* 1940. Gelatin-silver print; 10½ × 13½ in. (26.8 × 34.3 cm). Oakland Museum.

Mexico

Diego Rivera

Another approach to social concerns can be seen in the murals of the Mexican artist Diego Rivera (1886–1957). From 1909 to 1921, he lived in Europe, where he painted in a Cubist style. On returning to Mexico, however, he renounced modernism and the avant-garde in favor of Mexican nationalism. The government commissioned him to create a series of large murals for the National Palace in Mexico City, which he used as a vehicle for depicting Mexican history. In this approach, Rivera was influenced by Social Realism.

Figure **26.29** shows the first mural in the series. At the left, the Spanish conquerors fight the native population, who perform ancient ceremonies at the far right. References to Quetzalcoatl, the pre-Columbian feathered serpent god, appear on either side of the sun, which hovers above a Mesoamerican pyramid, an alignment recalling that of the Teotihuacán pyramids of the sun and moon (see p. 349). The seated figure in front of the pyramid resembles Lenin, leaving no doubt about Rivera's political message. Rivera has thus combined a kind of historical imperative with contemporary issues, and even though he has diverged from the avant-garde, there are unmistakable Cubist forms in his imagery.

26.29 Diego Rivera, *Ancient Mexico*, from the *History of Mexico* fresco murals, 1929–1935. National Palace, Mexico City.

Frida Kahlo

Rivera's third wife, Frida Kahlo (1907–1954), shared her husband's Marxist sentiments and his Surrealist style. She joined the Communist party in the 1940s to fight Hitler and befriended Leon Trotsky, the Russian revolutionary exiled to Mexico and later assassinated.

Despite a turbulent marriage, Kahlo remained in love with Diego Rivera until her death. She shared the Surrealist interest in childhood memory and in using imagery to reveal the unconscious mind. Having suffered a serious accident as an adolescent that required repeated surgery and forced her to wear an uncomfortable back brace, Kahlo was in constant pain. This she depicted in many of her paintings, but she also portrayed the mental suffering caused by her relationship to Diego.

In figure **26.30**, Kahlo uses the Surrealist technique of painting thoughts and ideas. She depicts herself against a background of green and yellowing leaves and thorns that seem about to engulf her. The abundance of foliage, juxtaposed with the death's head in the landscape tondo on Kahlo's forehead, alludes to Mexican mythology in which life and death are seen as integral aspects of nature's continuum.

In *Marxism Will Give Health to the Sick* (fig. **26.31**), painted in the last year of her life, she depicts Karl Marx strangling a Surrealist image of Uncle Sam in the body of an eagle. At the same time, Marx is performing a "laying on of hands"—one hand with an eye embedded in the palm—thereby curing Kahlo and dispensing with her need for crutches. Formally, the released crutches create an inverted trapezoid that echoes Kahlo's wide green-and-white dress. The red plain at the right suggests the blood of her suffering, while the white dove of peace spreading its wings over the globe and fertile valleys on the left suggests a semblance of spiritual health and well-being.

26.30 Frida Kahlo, *Thinking about Death*, 1943. Oil on canvas, mounted on masonite; 17½ × 14⅓ in. (44.5 × 36.3 cm). Private collection.

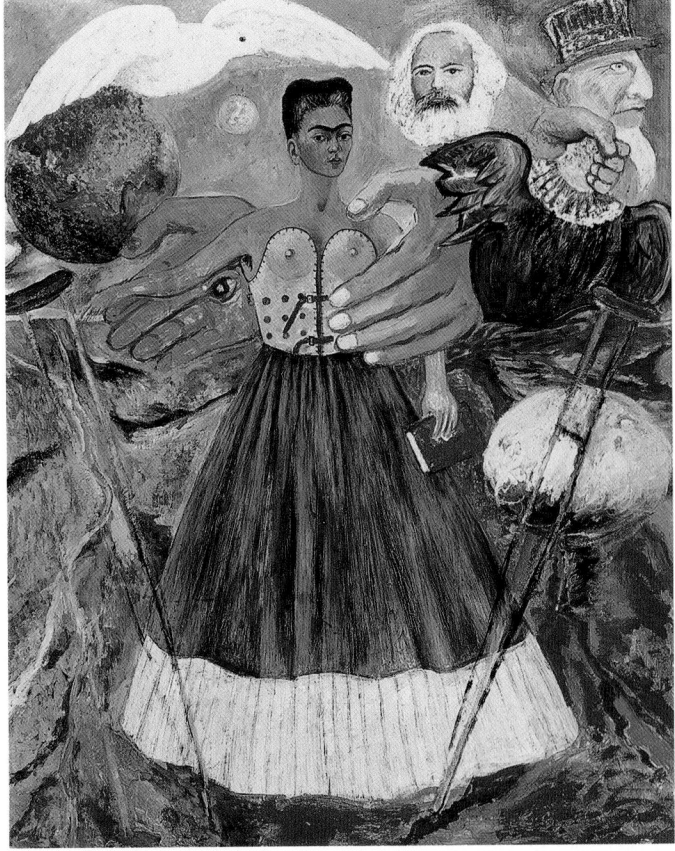

26.31 Frida Kahlo, *Marxism Will Give Health to the Sick*, 1954. © Fundación Dolores Olmedo.

Toward American Abstraction

Countering the Regional and Social Realist currents of Western art between the wars was the influence of the European avant-garde. A few private New York galleries, run by dealers who understood the significance of the new styles, began to exhibit "modern" art. In 1905, the American photographer Alfred Stieglitz (1864–1946) opened the 291 Art Gallery at 291 Fifth Avenue in New York, where he exhibited work by Rodin, Cézanne, the Cubists, and Brancusi along with that by more progressive American artists. The Museum of Modern Art, under the direction of Alfred Barr, Jr., opened in 1929, the year of the stock market crash. In 1930, Stieglitz opened the American Place Gallery to exhibit abstract art. Also during this period, government support for the arts was provided by the Federal Arts Project, which operated under the aegis of Franklin Roosevelt's social programs. The Project provided employment to thousands of artists and, in doing so, granted some measure of official status to abstract art.

Alfred Stieglitz

Stieglitz's photographs straddle the concerns of American Social Realism and avant-garde abstraction. Many of his pictures document contemporary society, while others are formal studies in abstraction. In 1922, he began a series of abstract photographs entitled *Equivalent* (fig. **26.32**), in which cloud formations create various moods and textures. Stieglitz believed in what is called "straight photography," as opposed to unusual visual effects achieved, among other means, by the manipulation of negatives and chemicals.

Edward Weston

The photography of Edward Weston (1886–1958) also transformed "straight" nature pictures into abstraction. His *Two Shells* (fig. **26.33**) of 1927, for example, shows the organic character of a chambered nautilus inside another shell. Of these, Weston wrote:

> One of these two new shells when stood on end is like a magnolia blossom unfolding. The difficulty has been to make it balance on end and not cut off that important end, nor show an irrelevant base. I may have solved the problem by using another shell for the chalice. . . .[11]

By virtue of the arrangement of the two shells, as well as the close-up viewpoint, Weston's image invites free association. The shells become more than shells as a result of the suggestive metaphorical character of their forms. Weston's transformations of natural shapes into associative abstraction—like those of Stieglitz—allied him with the early twentieth-century avant-garde.

26.32 Alfred Stieglitz, *Equivalent*, 1923. Chloride print; 4⅝ × 3⅝ in. (11.8 × 9.2 cm). Art Institute of Chicago (Alfred Stieglitz Collection). Stieglitz was born in Hoboken, New Jersey. He organized the 1902 exhibition that led to Photo-Secession, an informal group that held exhibitions all over the world and whose objective was to gain the status of a fine art for pictorial photography. In 1903, he founded the quarterly journal *Camera Work*, which encouraged modern aesthetic principles in photography.

26.33 Edward Weston, *Two Shells*, 1927. Photograph.

26.34 Arthur Dove, *Goin' Fishin'*, 1925. Mixed-media collage; 19½ × 24 in. (49.5 × 61.0 cm). Phillips Collection, Washington, D.C.

Arthur Dove

Another important figure in early American abstraction was Arthur Dove (1880–1946), who lived in Europe from 1907 to 1909. He had been influenced by Kandinsky's views of the spiritual in nature and exhibited in the 1913 Armory Show. His *Goin' Fishin'* of 1925 (fig. **26.34**) is a construction of fishing poles, pieces of denim, and slabs of bark. The poles are curved, forming an arch around the flatter denim and bark, which creates a structured, architectural image. At the same time, the use of objects that are associated with fishing infuses the work with a sense of the texture of boats, workers, and bamboo. In this work, Dove "Americanizes" the collage technique by his choice of objects and by the colloquial title. He also looks forward to the work of Robert Rauschenberg in the 1950s (see p. 933).

In *Fog Horns* (fig. **26.35**), painted four years later, Dove uses circular biomorphic forms to suggest sound waves traveling through space. The shapes of sound correspond to the round openings of the horns, while their decreasing size indicates temporal distance. The pastel colors and foggy atmosphere create a mood that can be related to the mysterious, poetic quality of certain Symbolist painters. It is typical of Dove that he used the sea to convey such moods, which have a Romantic as well as a Symbolist character.

26.35 Arthur Dove, *Fog Horns*, 1929. Oil on canvas; 18 × 26 in. (45.7 × 66.0 cm). Colorado Springs Fine Arts Center.

Georgia O'Keeffe

Georgia O'Keeffe (1887–1986), who was married to Stieglitz, is difficult to place within a specific stylistic category, but it is clear that she was influenced by photography and early twentieth-century abstraction as well as by the landscape of the American Southwest. She, along with Arthur Dove and other abstractionists, had exhibited at Stieglitz's 291 in the 1920s. Her *Black and White* of 1930 (fig. **26.36**) is an abstract depiction of various textures, motion, and form without any reference to recognizable objects. By eliminating color, O'Keeffe makes use of the same tonal range that is available to the black-and-white photographer.

In her *Cow's Skull with Calico Roses* of 1931 (fig. **26.37**), O'Keeffe depicts one of the desiccated skulls found in the dry deserts of Arizona and New Mexico. The close-up view abstracts the forms. With the accent of the black vertical and the horizontal of the horns, the image evokes the Crucifixion. At the same time, the death content of O'Keeffe's subject is softened by the roses, which are still alive. This juxtaposition of living and dead forms recalls the death and resurrection themes of Christian art, as well as being a feature of the desert. It also has a Surrealist quality.

26.36 Georgia O'Keeffe, *Black and White*, 1930. Oil on canvas; 36 × 24 in. (91.4 × 61.0 cm). Collection, Whitney Museum of American Art, New York (Gift of Mr. and Mrs. R. Crosby Kemper). O'Keeffe was born in Sun Prairie, Wisconsin. In 1917, Stieglitz gave O'Keeffe her first one-woman show at 291. She married Stieglitz in 1924 and after his death in 1946 moved permanently to New Mexico, where desert objects—animal bones, rocks, flowers—became favorite motifs in her work.

26.37 Georgia O'Keeffe, *Cow's Skull with Calico Roses*, 1931. Oil on canvas; 36⁵⁄₁₆ × 24⅛ in. (92.2 × 61.3 cm). Art Institute of Chicago (Gift of Georgia O'Keeffe). In July 1931, O'Keeffe wrote from New Mexico to the art critic Henry McBride: "Attempting to paint landscape—I must think it important or I wouldn't work so hard at it—Then I see that the end of my studio is a large pile of bones—a horse's head—a cow's head—a calf's head—long bones—all sorts of funny little bones and big ones too—a beautiful ram's head has the center of the table—with a stone with a cross on it and an extra curly horn."[12]

26.38 Alfred Stieglitz, *Georgia O'Keeffe: A Portrait: Hands and Bones (15)*, 1930. Silver-gelatin print, negative; 8 × 10 in. (20.3 × 25.4 cm). National Gallery of Art, Washington, D.C. (Alfred Stieglitz Collection).

Similar juxtapositions characterize Stieglitz's *Georgia O'Keeffe: A Portrait: Hands and Bones (15)* of the previous year (fig. **26.38**). In addition to the opposition of living and dead form, Stieglitz contrasts flesh with bone and soft texture with hardness. He made several "portraits" of Georgia O'Keeffe's hands—in this case, identifying them as hers by their connection with the animal skull. The close-up viewpoint, as well as the partial nature of the image, contributes to its abstraction.

Transcendental Painting

From 1938 to 1941, a unique group of avant-garde painters who were dedicated to the principles of abstraction was formed in New Mexico. These artists were inspired by the expanses of the southwestern landscape and by Kandinsky's *Concerning the Spiritual in Art*. In a brochure published by the group, they stated:

> Transcendental has been chosen as a name for this group because it best expresses its aim, which is to carry painting beyond the appearance of the physical world, through new concepts of space, color, light, and design, to imaginative realms that are idealistic and spiritual. The work does not concern itself with political, economic, or other social problems.[13]

The expression of these goals can be seen in the work of Agnes Pelton, who, like Dove, had participated in the Armory Show and exhibited at Stieglitz's gallery in New York. *The Fountains* of 1926 (fig. **26.39**) shows her use of soft color and expanding form to create an impression of otherworldly phenomena. The translucent character of the image and its flowing motion produce a mystical effect related to Transcendental notions of spirituality.

The Transcendental painters, along with Stieglitz, Dove, O'Keeffe, and other abstractionists, were among the most avant-garde artists of the early twentieth century in America. At that time, despite the Armory Show and other inroads made by the new European styles, art in the United States was still primarily conservative. It was not until the 1950s that American art finally emerged as the most innovative on an international scale.

26.39 Agnes Pelton, *The Fountains*, 1926. Oil on canvas; 36 × 31½ in. (91.4 × 80.0 cm). Collection of Georgia Riley de Havenon, New York.

The United States has had a strong ongoing folk-art tradition. In the nineteenth century, folk sculpture included shop signs, carousel horses, weather vanes, ships' figureheads, carved gravestones, and cigar-store Indians. Folk art also includes quilts, embroidery, and painting, which have continued into the twenty-first century.

One of the best-known folk artists is Anna Mary Robertson (Grandma) Moses (1860–1961). She worked mainly in embroidery until she was in her seventies, when she turned to painting. Scenes such as *The Old Checkered House* of 1944 (fig. **26.40**) show the persistent appeal of styles that have not been modified by formal training.

Although Grandma Moses was self-taught, it is clear that the lively designs of embroidery provided her with a training

of their own. Small patterns, particularly in the red and white squares of the house, recall those made by embroidered threads. Here they are flattened, as are the silhouetted horses, creating an impression of naiveté. But there is a convincing sense of three-dimensional space. The hills diminish in clarity as well as in size compared with the foreground forms, indicating a familiarity with both aerial and linear perspective. There is no suggestion here of the momentous international events of the period, no reference to American participation in World War II (then in its third year) or to industrialization. Instead, the scene evokes a past era of rural life, horse-drawn carriages, and soldiers of the American Civil War. The painting thus has a romantic, nostalgic quality.

26.40 Anna Mary Robertson (Grandma) Moses, *The Old Checkered House*, 1944. Oil on pressed wood; 24 × 43 in. (0.61 × 1.09 m). Seiji Togo Memorial Yasuda Kasai Museum of Art, Tokyo, Japan.

26.41 Horace Pippin, *Domino Players*, 1943. Oil on composition board; 12¾ × 22 in. (32.4 × 55.9 cm). Phillips Collection, Washington, D.C. Pippin lived in Pennsylvania. A veteran of World War I, in which he suffered a shoulder wound, he exercised his right arm by decorating cigar boxes with charcoal. In 1928, at the age of forty, he began working in oil paints, although he described himself as having been interested in pictures from his youth.

The self-taught African-American artist Horace Pippin (1888–1946) is best known for his domestic interiors, often evoking memories of his childhood. In *Domino Players* of 1943 (fig. **26.41**), he depicts three figures seated at a table playing dominoes. The two women seem intent on the game, but the boy—Pippin himself—is clearly bored. He gazes directly out of the picture, inviting viewers to identify with a child

stuck in an adult setting. Behind the table, a grandmotherly figure sews a quilt. As in the work of Grandma Moses, Pippin's imagery has the appearance of folk art, emphasizing flat patterns—the dominoes, the polka-dot blouse, and the quilt. Likewise, seemingly casual details, such as the stove and the oil lamp, are reminiscent of another era.

Style/Period	Works of Art	Cultural/Historical Developments
1900 — DADA, SURREALISM, REGIONALISM, SOCIAL REALISM, AND ABSTRACTION	Hopi Black Ogre (**W12.3**) Hopi Butterfly Maiden (**W12.4**) Zuni war god (**26.10**) Mossi whistle (**26.17**)	
1910–1920 	de Chirico, *Place d'Italie* (**26.7**) Arp, *Collage Arranged According to the Laws of Chance* (**26.4**) Duchamp, *Fountain (Urinal)* (**26.2**) Duchamp, *To Be Looked At (from the Other Side of the Glass) with One Eye, Close to, for Almost an Hour* (**26.3**) Duchamp, *L.H.O.O.Q.* (**26.1**) 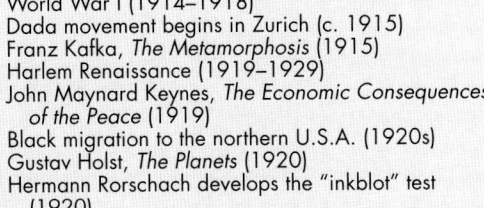 **Duchamp, *Fountain* (Urinal)** **Duchamp, L.H.O.O.Q.**	World War I (1914–1918) Dada movement begins in Zurich (c. 1915) Franz Kafka, *The Metamorphosis* (1915) Harlem Renaissance (1919–1929) John Maynard Keynes, *The Economic Consequences of the Peace* (1919) Black migration to the northern U.S.A. (1920s) Gustav Holst, *The Planets* (1920) Hermann Rorschach develops the "inkblot" test (1920)
1920 — **1920–1930**	Stieglitz, *Equivalent* (**26.32**) Man Ray, *Indestructible Object (or Object to Be Destroyed)* (**26.6**) Man Ray, *Le Violon d'Ingres* (**26.8**) Dove, *Goin' Fishin'* (**26.34**) Miró, *Dog Barking at the Moon* (**26.12**) Pelton, *The Fountains* (**26.39**) Weston, *Two Shells* (**26.33**) Magritte, *The False Mirror* (**26.14**) Arp, *The Dancer* (**26.5**) Dove, *Fog Horns* (**26.35**) Van Der Zee, *Portrait of Couple, Man with Walking Stick* (**26.26**) Adams, *Winnowing Grain, Taos Pueblo* (**W12.2**) Rivera, *Ancient Mexico* (**26.29**) **Man Ray, *Le Violon d'Ingres***	Revival of Ku Klux Klan in the American South (1920s) Nicola Sacco and Bartolomeo Vanzetti convicted of murder (1921) Foundation of British Broadcasting Corporation (1921) Sergei Prokofiev, *The Love for Three Oranges* (1921) John Dos Passos, *Three Soldiers* (1921) Ludwig Wittgenstein, *Tractatus Logico-Philosophicus* (1921) *Readers' Digest* founded (1922) A. E. Housman, *Last Poems* (1922) James Joyce, *Ulysses* (1922) Hermann Hesse, *Siddhartha* (1922) E. E. Cummings, *The Enormous Room* (1923) New Orleans–style jazz grows in popularity (1923) André Breton publishes first *Surrealist Manifesto* (1924) E. M. Forster, *A Passage to India* (1924) Sean O'Casey, *Juno and the Paycock* (1924) First Surrealist exhibition in Paris (1925) First edition of the *New Yorker* appears (1925) Scopes trial over teaching of evolution theory (1925) T. E. Lawrence, *The Seven Pillars of Wisdom* (1926) D. H. Lawrence, *Lady Chatterley's Lover* (1928) Jean Cocteau, *Les Enfants terribles* (1929)
1930 — **1930–1940** **Wood, *American Gothic***	O'Keeffe, *Black and White* (**26.36**) Wood, *American Gothic* (**26.23**) Stieglitz, *A Portrait (15)* (**26.38**) O'Keeffe, *Cow's Skull with Calico Roses* (**26.37**) Dalí, *The Persistence of Memory* (**26.11**) Klee, *Mask of Fear* (**26.9**) Evans, *Shoeshine Sign in a Southern Town* (**26.27**) Magritte, *Time Transfixed (La Durée poignardée)* (**26.15**) Lawrence, *Harriet Tubman Series, No. 7* (**26.24**)	Social Realism in Russian art mandated by Stalin (1930s) Aldous Huxley, *Brave New World* (1932) Henry Miller, *Tropic of Cancer* (1934) George Gershwin, *Porgy and Bess* (1935) A. J. Ayer, *Language, Truth and Logic* (1936) John Steinbeck, *The Grapes of Wrath* (1939) World War II (1939–1945)
1940 — **1940–1950** **Lange, *Migratory Cotton Picker***	Hopper, *Gas* (**26.25**) Lange, *Migratory Cotton Picker* (**26.28**) Pippin, *Domino Players* (**26.41**) Kahlo, *Thinking about Death* (**26.30**) Ernst, *The King Playing with the Queen* (**26.16**) Moses, *The Old Checkered House* (**26.40**) Miró, *Spanish Dancer* (**26.13**)	Eugene O'Neill, *Long Day's Journey into Night* (1940) Hemingway, *For Whom the Bell Tolls* (1940) Pearl Harbor attacked; United States enters war (1941) America drops atomic bombs on Japan (1945) Charles Ives wins Pulitzer Prize for Symphony No. 3 (1947) Founding of the State of Israel (1948) Birth of network television in U.S.A. (1949)
1950 — **1950–1960** **Moore, Helmet Head No. 1**	Moore, *Helmet Head No. 1* (**26.21**) Kahlo, *Marxism Will Give Health to the Sick* (**26.31**) Moore, *Reclining Figure* (**26.20**) Calder, *Big Red* (**26.22**) Giacometti, *Large Standing Woman III*, and Mondrian, *Composition with Red, Yellow, and Blue* (**26.19**)	Senator Joseph McCarthy begins Communist "witch hunt" in United States (1950) Korean War (1950–1953) *Playboy* and *TV Guide* begin publication (1953) J. R. R. Tolkien, *Lord of the Rings* (1955) Vladimir Nabokov, *Lolita* (1955) *Sputnik I* launched (1957) Creation of the European Common Market (1957) Chinua Achebe, *Things Fall Apart* (1958) New York's Guggenheim Museum opens (1959)

27

Abstract Expressionism

B y the middle of the 1930s, the New York avant-garde was identified with abstraction, which paradoxically had emerged from the background of the more conservative Regionalism and Social Realism styles. Equally influential in the development of abstraction and the avant-garde was the influx of artists and intellectuals from overseas. In Europe during the 1930s, totalitarian leaders prevented artists from pursuing modernism on the grounds that it was degenerate and corrupted the moral fiber of the nation (see box). The waves of refugees who fled oppression and war during the last years of that decade, therefore, included many avant-garde architects, artists, musicians, and writers. By 1940, when Paris fell to the Nazis, the center of the art world had shifted to New York, whose cultural life was enriched by the émigré art-ists. Among the dealers and collectors who fled Europe was Peggy Guggenheim; in 1942, she opened the Art of This Century Gallery in New York, which exhibited avant-garde work.

The Teachers: Hans Hofmann and Josef Albers

Two of the most important emigrants from Germany were Hans Hofmann (1880–1966) and Josef Albers (1888–1976). They taught at the Art Students League in New York and at Black Mountain College in North Carolina, respectively, and from 1950 to 1960 Albers chaired the Department of Architecture and Design at Yale. Both Hofmann and Albers influenced a generation of American painters.

Hitler on "Degenerate Art"

On July 19, 1937, Hitler opened the first *Great German Art Exhibition* in Munich. He announced in his inaugural speech that he intended

> to clear out all the claptrap from artistic life in Germany. "Works of art" that are not capable of being understood in themselves but need some pretentious instruction book to justify their existence . . . will never again find their way to the German people. From now on, we are going to wage a merciless war of destruction against the last remaining elements of cultural disintegration.[1]

Hitler's notion of an aesthetic "clearing out" was similar to the Nazi "Final Solution," which was intended to purge Europe of Gypsies, Jews, homosexuals, the mentally sick, and liberal intellectuals. Modern music, architecture, films, and plays were declared subversive. In May 1933, "un-German" books were burned and virtually all avant-garde artists dismissed from their teaching positions. On July 20, 1937, an exhibition of over 650 works by artists such as Ernst, Kandinsky, Kirchner, Klee, and other members of the avant-garde opened, the purpose of which was to make an "example" of "degenerate art." A pamphlet accompanying the exhibition denounced the morals of certain modern artists, who were accused of viewing the world as a brothel inhabited by pimps and prostitutes. In an irony that was lost on the Nazi regime, the exhibition must have been one of the finest shows of avant-garde art that ever took place.

In June 1939, works by Gauguin, van Gogh, Braque, and Picasso were removed from German museums and auctioned to foreigners. Similar tendencies existed in other countries as well as in Germany. In France, non-French (especially Jewish) elements in the arts were eliminated by the pro-Nazi Vichy regime. In Russia, an exhibition held in Moscow in 1937 was aimed at discrediting the avant-garde.

Hofmann's *The Gate* (fig. **27.1**) is an architectural construction in paint. The intense, thickly applied color is arranged in squares and rectangles. It ranges from relatively pure hues, such as the yellow and red, to more muted greens and blues. For Hofmann, as for the Impressionists, it was the color in a picture that created light. In nature, the reverse is true; light makes color visible. In *The Gate,* edges vary from precise to textured. Everywhere, the paint is structured, combining bold, expressive color with the tectonic qualities of Cubism and related styles.

27.2 Josef Albers, *Study for Homage to the Square,* 1968. Oil on masonite; 32 × 32 in. (81.3 × 81.3 cm). Photo courtesy of Carroll Janis, New York.

27.1 Hans Hofmann, *The Gate,* 1959–1960. Oil on canvas; 6 ft. 3⅛ in. × 4 ft. ½ in. (1.91 × 1.23 m). Solomon R. Guggenheim Museum, New York. For Hofmann, nature was the source of inspiration, and the artist's mind transformed nature into a new creation. "To me," he said, "a work is finished when all parts involved communicate themselves, so that they don't need me."[2]

Albers's series of paintings entitled *Homage to the Square* (fig. **27.2**) also explores color and geometry. But his surfaces are smooth, and the medium is subordinate to the color relationships between the squares. In his investigation of light and color perception, Albers concentrated on the square because he believed that it was the shape furthest removed from nature. "Art," he said, "should not represent, but present."[3]

Abstract Expressionism: The New York School

Abstract Expressionism was a term used in 1929 by Alfred Barr, Jr. to refer to the nonfigurative and nonrepresentational paintings of Kandinsky. The style was to put the United States on the map of the international art world. In the 1950s, it was generally used to categorize the New York school of painters, which, despite its name, was actually comprised of artists from many different parts of the United States and Europe.

Nearly all the Abstract Expressionists had passed through a Surrealist phase. From this, they absorbed an interest in myths and dreams and in the effect of the unconscious on creativity. From Expressionism, they inherited an affinity for the expressive qualities of paint. This aspect emerged particularly in the so-called "Action" or "Gesture" painters of Abstract Expressionism.

Arshile Gorky

The Abstract Expressionist painter who was most instrumental in creating a transition from European Abstract Surrealism to American Abstract Expressionism was the Armenian Arshile Gorky (1904–1948). After absorbing several European styles, including Impressionism and Surrealism, he developed his own pictorial "voice" in the 1940s.

Some time between about 1926 and 1936, Gorky painted his famous work *The Artist and His Mother* (fig. **27.3**). The slightly geometric character of the faces suggests the influence of early Cubism. Flattened areas of color—the mother's lap, for example—and visible brushstrokes reveal affinities with Fauvism and Expressionism. To the left stands a rather wistful young Gorky. His more dominant mother recalls enthroned mother goddesses of antiquity (see fig. 6.8).

Gorky's painting was based on an old undated photograph of himself and his mother (fig. **27.4**). The grid (fig. **27.5**) dates to around 1936 and thus must have been made in preparation for the painting. Note that Gorky has eliminated the original pattern of his mother's dress and transformed his own coat and shoes into shapes of pure color.

Entirely different in form, though it shares the nostalgic quality of *The Artist and His Mother,* is *Garden in Sochi* of 1943 (fig. **27.6**). The third of a series depicting childhood recollections, this painting exemplifies Gorky's most characteristic innovations. Paint is applied thinly, and the colorful shapes are bounded by delicate curvilinear outlines, which create a sense of fluid motion. Both the title and the abstract biomorphic shapes suggest references to natural, organic protozoan or vegetable life. Gorky studied nature closely, sketching flowers, leaves, and grass from life before transforming the drawings into abstract forms. The suggestive, elusive identity of Gorky's shapes is reminiscent of Miró, who influenced Gorky's Surrealist phase.

Gorky related this series to a garden at Sochi on the Black Sea. He recalled porcupines and carrots and a blue rock buried in black earth with moss patches resembling fallen clouds. Village women rubbed their breasts on the rock—probably a fertility rite. Long shadows reminded the artist of the lances in the battle scenes of Uccello. Passersby tied colorful strips of clothing to a leafless tree, the fabric blowing in the wind like banners and rustling like leaves.

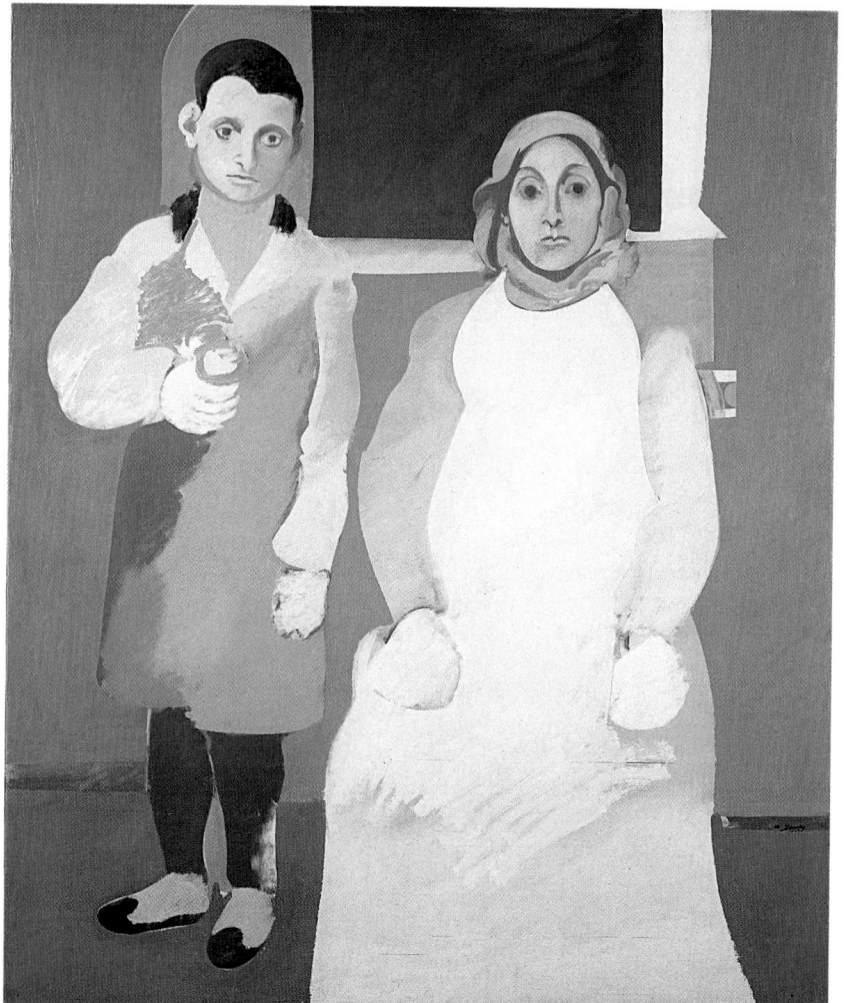

27.3 Arshile Gorky, *The Artist and His Mother,* c. 1926–1936. Oil on canvas; 5 ft. × 4 ft. 2 in. (1.52 × 1.27 m). Collection, Whitney Museum of American Art, New York (Gift of Julien Levy for Maro and Natasha Gorky). Gorky was born Vosdanig Manoog Adoian in Turkish Armenia and emigrated to the United States in 1920. At the height of his career, a series of misfortunes—a fire that burned most of his recent work, a cancer operation, a car crash that fractured his neck—led to his suicide in 1948.

── **CONNECTIONS** ──

See figure 6.8. *Mater Matuta,* from Chianciano, near Chiusi, 460–440 B.C.

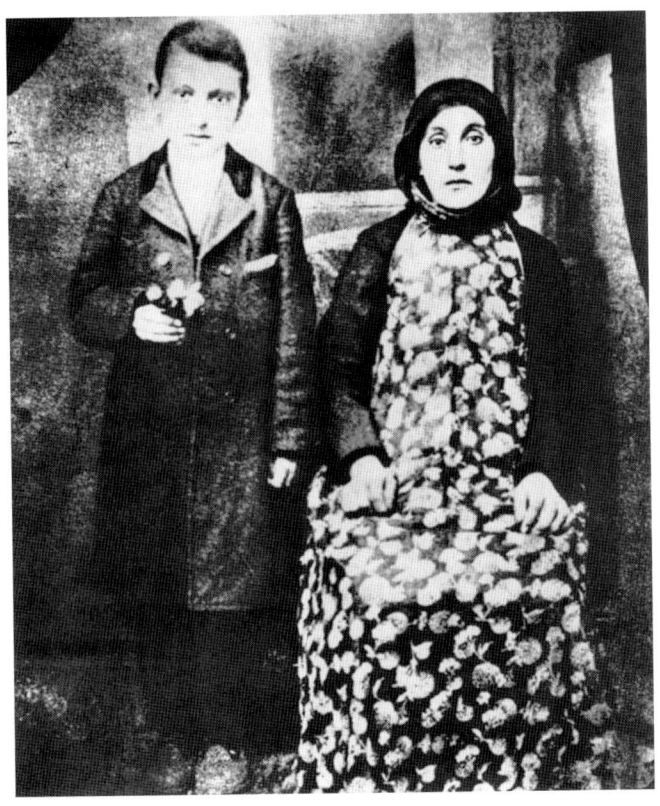

27.4 Photographer unknown, *Arshile Gorky and His Mother*, n.d. Photograph.

27.5 Arshile Gorky, *Portrait of the Artist and His Mother*, 1926/1936. Graphite on squared paper; 24 × 19 in. (61.0 × 48.3 cm). National Gallery of Art, Washington, D.C. Ailsa Mellon Bruce Fund.

27.6 Arshile Gorky, *Garden in Sochi*, c. 1943. Oil on canvas; 31 × 39 in. (78.7 × 99.1 cm). Museum of Modern Art, New York (Acquired through the Lillie P. Bliss Bequest).

Art Critics and the Avant-Garde

Harold Rosenberg (1906–1978) and Clement Greenberg (1909–1994) were the two leading critics most closely associated with American Abstract Expressionism. In 1952, Rosenberg coined the term *Action painting* to describe the new techniques of applying paint. For American artists, he said, the canvas became "an arena in which to act—rather than . . . a space in which to reproduce. . . . What was to go on the canvas was not a picture but an event." Rather than begin a painting with a preconceived image, the Abstract Expressionists approached their canvases with the idea of doing something *to* it. "The image," wrote Rosenberg, "would be the result of this encounter."[4]

Greenberg took issue with Rosenberg's assessment on the grounds that painting thus became a private myth. Because such work did not resonate with a larger cultural audience, according to Greenberg, it could not be considered art. But he was nevertheless a staunch defender of abstraction, noting that subject matter had nothing to do with intrinsic value. "The

explicit comment on a historical event offered in Picasso's *Guernica,*" he wrote in 1961, "does not make it necessarily a better or richer work than an utterly 'non-objective' painting by Mondrian."[5]

Greenberg described the shift in the artists' view of pictorial space as having "lost its 'inside' and become all 'outside.'" He surveyed this shift from the fourteenth century as follows:

From Giotto to Courbet, the painter's first task had been to hollow out an illusion of three-dimensional space on a flat surface. One looked through this surface as through a proscenium into a stage. Modernism has rendered this stage shallower and shallower until now its backdrop has become the same as its curtain, which has now become all that the painter has left to work on.[6]

Action Painting

Just as brushstrokes are a significant aspect of Impressionism and Post-Impressionism, so the action painters developed characteristic methods of applying paint. They dripped, splattered, sprayed, rolled, and threw paint on their canvases, with the result that the final image reflects the artist's activity in the creative process (see box).

Jackson Pollock Of the "Action" or "Gesture" painters who were part of the New York school, the best-known is Jackson Pollock (1912–1956). He began as a Regionalist and

turned to Surrealism in the late 1930s and early 1940s. His first paintings reflect the Regional style of his teacher, Thomas Hart Benton (1889–1975), at the Art Students League in New York. *Going West* (fig. **27.7**), which Pollock painted in the 1930s, is typical of Regionalism in that it can be identified with a specific American region. Settlers traveling in covered wagons and the stark landscape evoke the pioneering spirit of the Old West. The curves in the landscape enclose the figures, who seem to struggle through a cavernous space toward their destination. Curvilinear rhythms dominate the picture and look forward to Pollock's mature abstract style.

27.7 Jackson Pollock, *Going West,* 1934–1935. Oil on gesso ground on composition board; 15⅜ × 20⅞ in. (39.1 × 53.0 cm). Smithsonian Institution, Washington, D.C. Pollock, born in Wyoming, moved to New York in 1929. He worked for the Federal Arts Project and had his first one-man show in 1943 at Peggy Guggenheim's Art of This Century Gallery. In 1956, he died in a car accident in East Hampton, Long Island.

Guardians of the Secret (fig. **27.8**) is from Pollock's period of Surrealist abstraction. A series of thickly painted rectangles enlivened by energetic curves and zigzags recalls the spontaneous character of graffiti. The painting's linear quality is also reminiscent of graffiti and suggests the signs of a hidden and unintelligible language. The apparent spontaneity of Pollock's "signs" can be related to Surrealist automatic writing as a means of gaining access to the unconscious.

From 1947 onward, Pollock used a **drip technique** to produce his most celebrated pictures, in which he engaged his whole body in the act of painting. From cans of commercial housepainter's paint, enamel, and aluminum, Pollock dripped paint from the end of a stick or brush directly onto a canvas spread on the ground. In so doing, he achieved some of the chance effects sought by the Dada and Surrealist artists. At the same time, however, he controlled the placement of the drips and splatters through

27.8 Jackson Pollock, *Guardians of the Secret*, 1943. Oil on canvas; 4 ft. ⅜ in. × 6 ft. 3⅜ in. (1.23 × 1.91 m). San Francisco Museum of Modern Art, California (Albert M. Bender Collection, Albert M. Bender Bequest Fund Purchase). Pollock's interest in Surrealism, unconscious processes, and myth, which is apparent in this painting, led him to undertake Jungian psychoanalysis.

the motion of his arm and body (fig. 27.9a, b). He described this process as follows: "On the floor I am more at ease. I feel nearer, more a part of the painting, since this way I can walk around it, work from the four sides and literally be *in* the painting. This is akin to the Indian sand painters of the West" (see box). Pollock also declared that, when in the process of painting, he was unaware of his actions: "When I am *in* my painting, I'm not aware of what I'm doing . . . because the painting has a life of its own."[7]

27.9a Hans Namuth, *Jackson Pollock Painting*, 1950. Photograph. Center for Creative Photography, University of Arizona.

27.9b Hans Namuth, *Jackson Pollock Painting*, 1950. Color stills from a film strip. Museum of Modern Art, New York.

Navajo Sand Painting

Pollock's "Indian sand painters" were the Navajo, who led a nomadic existence in the American Southwest. They made paintings out of crushed colored rocks, which were ground to the consistency of sand. These were the sacred products of a medicine man, or shaman, who created images in order to exorcise the evil spirits of disease from a sick person. He continued to make the pictures until the patient either died or recovered. Then the image was destroyed, usually at night, and its effect dissipated.

According to Navajo belief, humans had been preceded by Holy People who created sacred images in nature. These images became a medium of communication between the human and spirit worlds. For the Navajo, sand paintings provide a means of summoning the assistance of the Holy People in order to restore the spiritual and physical balance of a sick person. Typically the patient sits inside the painting and faces east, the direction from which the Holy People enter the image. As a result, the Navajo refer to sand paintings as *iikaah,* or "the place to which gods come and from which they go."

Figure **27.10** shows a modern sand painter at work, his image not yet complete. Figure **27.11** is a sand painting of a yei god (a lesser Navajo deity). Its frontal stance, stylized, figurative character, geometric forms, and clear outlines are unlike anything in Pollock's work. Figure 27.10 also differs from Pollock's all-over drips in its flattened perspective and discrete zones of color. His interest was in energetic execution and the artist's movement around the image on the ground. It is also likely that Pollock was drawn to the shamanistic character of the medicine man and that he identified with the notion that images have curative power.

27.10 Navajo man creating a sand painting.

27.11 Yei god, sand painting, 20th century. Navajo Indian Reservation.

Pollock's *White Light* of 1954 (fig. **27.12**) eliminates all reference to recognizable objects. Lines of different widths and textures swirl through the picture space and are slashed diagonally at various points. There is an underlying chromatic organization of yellows and oranges blending with, and crisscrossed by, thick blacks and whites. The white, as indicated by the title, is what predominates, and the intensity of Pollock's light is everywhere present. His habit of trimming his finished canvases enhances their dynamic quality, for the lines appear to move rhythmically in and out of the picture, unbound by either an edge or a frame, as if self-propelled.

27.12 Jackson Pollock, *White Light,* 1954. Oil, enamel, and aluminum paint on canvas; 48¼ × 38¼ in. (122.4 × 96.9 cm). Museum of Modern Art, New York (Sidney and Harriet Janis Collection). Pollock first exhibited paintings such as this in 1948 to a shocked public. A critic for *Time* magazine dubbed him "Jack the Dripper," but avant-garde critics came to his defense. Within a few years of his death, he was the most widely exhibited of all the artists of the New York school.

Franz Kline The dynamic energy of Pollock's monumental drip paintings is virtually unmatched, even among the Abstract Expressionist Action painters. But Franz Kline (1910–1962) achieved dynamic imagery through thick, bold strokes of paint slashing across the picture plane. He had his first one-man show in New York in 1950, by which time he had renounced figuration and begun working on his characteristic black and white canvases. *Mahoning* of 1956 (fig. **27.13**) is a typical example. Strong black diagonals are created by the wide brush of a housepainter and form a kind of "structured" calligraphy. The blacks have an (angular) architectural appearance, but they tilt, like beams about to collapse. Drips and splatters enhance the textured quality of the surface.

27.13 Franz Kline, *Mahoning*, 1956. Oil and paper collage on canvas; 6 ft. 8 in. × 8 ft. 4 in. (2.03 × 2.54 m). Whitney Museum of American Art, New York (Purchase, funds from friends of Whitney Museum of American Art).

27.14 Willem de Kooning, *Woman and Bicycle,* 1952–1953. Oil on canvas; 6 ft. 4½ in. × 4 ft. 1 in. (1.94 × 1.25 m). Collection, Whitney Museum of American Art, New York (Purchase).

Willem de Kooning De Kooning (1904–1997) was born in Rotterdam and emigrated to the United States in 1926, but did not have his first one-man show until 1948. He described his relationship to twentieth-century art as follows: "Of all movements, I like Cubism most. It had that wonderful unsure atmosphere of reflection . . . and then there is that one-man movement: Marcel Duchamp—for me a truly modern movement because it implies that each artist can do what he thinks he ought to—a movement for each person and open for everybody."8

In the work of Willem de Kooning, Action painting is used in the service of explicit aggression and violence. This is particularly true of the series of pictures of women that de Kooning painted in the early 1950s. Unlike Pollock and Kline, de Kooning only partially eliminated recognizable subject matter from his iconography. *Woman and Bicycle* of 1952–1953 (fig. **27.14**), for example, combines the frontal image of a large, frightening woman with aggressive brushstrokes that literally tear through the figure's outline. The anxiety created by the woman's appearance—huge staring eyes, a double set of menacing teeth, and platformlike breasts, which reveal the influence of Cubist geometry—matches the frenzy of the brushstrokes. The assault on the figure, which disintegrates into unformed paint, is also an attack on the idealized Classical image of female beauty.

27.15 Helen Frankenthaler, *The Bay*, 1963. Acrylic on canvas; 6 ft. 8¾ in. × 6 ft. 9¾ in. (2.05 × 2.12 m). Collection, Detroit Institute of Arts (Gift of Dr. and Mrs. Hilbert H. DeLawter).

Helen Frankenthaler Helen Frankenthaler (born 1928), another Action painter, used synthetic media (see box) to "stain" her canvas by pouring paint directly onto it. In 1952, she visited Pollock in his studio in the Springs, on eastern Long Island, with the critic Clement Greenberg. There she saw the effect of Pollock's paint on unprimed canvas, which revealed the staining process—a method that is basic to Color Field painting (see below). *The Bay* of 1963 (fig. **27.15**) is made of thinned paint poured on to the canvas in layers of color, engulfing the picture plane. The colors are delicate and, for the most part, pastel. The blue expands over the canvas, like water filling the recess in the yellow and green areas of color. We seem to be looking down on a body of water in a landscape.

Color Field Painting

At the opposite pole from the Action painters are the artists who applied paint in a more traditional way. This has been variously referred to as *Chromatic Abstraction* and *Color Field painting*. The latter term refers to the preference for expanses of color applied to a flat surface in contrast to the domination of line in Action painting. The imagery of Action painting is more in tune with Picasso

and Expressionism. Color Field painters, by contrast, were influenced by Matisse's broad planes of color. Compared with Action paintings, Color Field imagery is typically calm and inwardly directed and is capable of evoking a meditative, even spiritual, response.

Acrylic

One of the most popular of the modern synthetic media is **acrylic,** a water-based paint. Acrylic comes in bright colors, dries quickly, and does not fade. It can be applied to paper, canvas, and board with either traditional brushes or **airbrushes.** It can be poured, dripped, and splattered. When thick, acrylic approaches the texture of oils. When thinned, it is fluid like water paint. In contrast to water paint, however, which mixes when more than one wet color is applied, acrylic can be applied in layers which do not blend even when wet. It is possible to build up several layers of paint, which retain their individual hues, and thus to create a structure of pure color—as Frankenthaler does in *The Bay* (see fig. 27.15).

Mark Rothko One of the most important Color Field artists, Mark Rothko (1903–1970) had gone through a Surrealist phase and was engaged in the search for universal symbols, which he believed were accessible through myths and dreams. His *Baptismal Scene* of 1945 (fig. **27.16**) conveys the sense of a preverbal, aquatic world. Delicate protozoan forms that elude identification swirl weightlessly in various directions, and the amoeba-like biomorphs seem to exist below the surface of consciousness. By the 1950s, Rothko had developed his most original style. Totally nonfigurative and nonrepresentational, Rothko's paintings are images of large rectangles hovering in fields of color.

In *Number 15* of 1957 (fig. **27.17**), two black-green rectangles occupy an intense, vibrant blue. Above and below the larger rectangle is a thinner bar of green. The blue background appears to be suffused into the greens and blacks, producing a shimmering, textured quality that infiltrates the overall impression of darkness. By muting the colors and blurring the edges of the rectangles, Rothko softens the potential contrast between them. He likewise mutes the observer's attention to the "process" of painting by nearly eliminating the presence of the artist's hand.

In the absence of references to the natural world as well as to the creative process, Rothko attempted to transcend material reality. His pictures seem to have no context in time or space. The weightless quality of his rectangles is enhanced by their blurred edges and thin textures, which

27.16 Mark Rothko, *Baptismal Scene*, 1945. Watercolor; 19⅞ × 14 in. (50.4 × 35.5 cm). Whitney Museum of American Art, New York (Purchase).

27.17 Mark Rothko, *Number 15*, 1957. Oil on canvas; 103 × 116½ in. (2.62 × 2.96 m). Collection of Christopher Rothko. Rothko was born in Latvia. In 1913, his family immigrated to Portland, Oregon, and in 1923 he moved to New York.

allow the underlying blue to filter through them. Whereas Pollock's light moves exuberantly across the picture plane, weaving in and out of the colors in the form of white drips, Rothko's light is luminescent. It flickers at the edges of the rectangles and shifts mysteriously from behind and in front of them.

Rothko suffered from depression and committed suicide in 1970. He expressed his alienation from society as follows: "The unfriendliness of society to his [the artist's] activity is difficult . . . to accept. Yet this very hostility can act as a lever for true liberation. . . . The sense of community and of security depends on the familiar. Free of them, transcendental experiences become possible."[9] Rothko's striving for freedom from the familiar is evident in the absence of recognizable forms in paintings such as this one.

Ad Reinhardt Even more luminous are the late Color Field paintings of Ad (Adolph) Reinhardt (1913–1967). The longer one stares at these pictures, the stronger is the sense of light shimmering and glowing behind the paint. Reinhardt's stated intention was to avoid all association with nature. He wanted the viewer to focus on the painting as an experience in itself—distinct from other, more familiar experiences. In his series of black paintings dating from the 1960s (fig. **27.18**), Reinhardt comes close to his aim. Color is eliminated, and nine squares of dark gray and black fill the picture plane.

27.18 Adolph (Ad) Reinhardt, *Abstract Painting* (*Black*), 1965. Oil on canvas; 5 × 5 ft. (1.52 × 1.52 m). Tate Gallery, London.

27.19 Frank Stella, *Empress of India,* 1965. Metallic powder in polymer emulsion paint on canvas; 6 ft. 5 in. × 18 ft. 8 in. (1.96 × 5.69 m). Museum of Modern Art, New York (Gift of S. I. Newhouse, Jr.).

Frank Stella Frank Stella (born 1936) was trained in art during the heyday of the New York school of Abstract Expressionism, but he paints with a new vision of color and form. His early somber, largely monochrome pictures were indebted to the reductive art of Reinhardt and departed from the traditional square, rectangle, or circle. They are fitted into triangular, star-shaped, zigzag, and open rectangular frames—for example, in his *Empress of India* of 1965 (fig. **27.19**). By varying the shape of the canvas, Stella focused on presenting a picture as an object-in-itself. Within the picture, he painted stripes of flat color, separated from each other and bordered by a precise edge. This technique is sometimes referred to as Hard Edge painting.

Tahkt-i-Sulayman I of 1967 (fig. **27.20**) belongs to Stella's *Protractor Series,* in which arcs intersect as if drawn with a compass. Here, a central circle is divided into two semicircles, which are repeated symmetrically on either side by flanking semicircles. These forms are related by sweeping curves, which interlace with all three sections in a continuous, interlocking motion. The intense, bright color strips in Stella's paintings of the 1960s combine dynamic exuberance with geometric control. Since the 1960s, Stella has continued to expand his repertory of shapes, formats, colors, and textures. He has evolved from early reductive clarity to complex, often very colorful, three-dimensional wall sculptures of varying textures and materials.

27.20 Frank Stella, *Tahkt-i-Sulayman I,* 1967. Polymer and fluorescent paint on canvas; 10 ft. ¼ in. × 20 ft. 2¼ in. (3.05 × 6.15 m). Menil Collection, Houston, Texas. Stella has lived and worked in New York since 1958. The Near Eastern title of this painting indicates his interest in colorful Islamic patterns (which also influenced Matisse). The interlaced color strips reflect his study of Hiberno-Saxon designs.

Ellsworth Kelly Ellsworth Kelly (born 1923) is another leading Hard-Edge Color Field painter who works in the tradition of Josef Albers. His color is generally vibrant and arranged in large, flattened planes that sometimes seem to expand organically. In other instances—as in *Spectrum III* (fig. **27.21**)—bands of color create a sequence of visual movement through the spectrum. By aligning the colors in this way, Kelly produces a tactile effect, despite the absence of modeling. The sequential arrangement of the rich hues causes a buildup of tension that proceeds through a progression of color.

In 1990, the Sidney Janis Gallery in New York mounted an exhibition entitled *Classic Modernism: Six Generations.*

Figure **27.22** is a view of the installation, with Mondrian's *Trafalgar Square* of 1939 on the left and Ellsworth Kelly's *Red, Yellow, Blue* of 1965 on the right. This juxtaposition illustrates the relationship between Kelly's pure primary colors, unframed and juxtaposed with the stark white wall of the gallery, and Mondrian's rectangles of color bounded by firm black verticals and horizontals. Kelly has enlarged the rectangles by comparison with Mondrian and liberated the color from Mondrian's black "frames." By organizing the two paintings in this way, the gallery shows Mondrian's historical role as the link between Cubism and Color Field painting.

27.21 Ellsworth Kelly, *Spectrum III,* 1967. Oil on canvas; in 13 parts; overall 9 ft. ⅝ in. × 2 ft. 9¼ in. (2.76 × 0.84 m). Collection of Anne and John Marion in Fort Worth, Texas.

27.22 Installation view of *Classic Modernism: Six Generations.* On right: Ellsworth Kelly, *Red, Yellow, Blue,* 1965. Oil on canvas; 6 ft. 10 in. × 15 ft. 5 in. (2.08 × 4.70 m). On left: Piet Mondrian, *Trafalgar Square,* 1939–1943. Oil on canvas, 57¼ × 47¼ in. (1.45 × 1.2 m). Exhibition held Nov. 15–Dec. 19, 1990, at the Sidney Janis Gallery, New York. Photo courtesy of Carroll Janis, New York. © Ellsworth Kelly. © 2006 Mondrian/Holtzman Trust c/o HCR International, Warrenton, VA, USA.

West Coast Abstraction: Richard Diebenkorn

An important group of abstract painters also developed on the West Coast. It includes Richard Diebenkorn (1922–1993), whose early landscapes were often based on views of the San Francisco Bay area, and of anonymous, isolated figures reminiscent of Hopper in mysterious, architectural settings. By the end of the 1960s, however, Diebenkorn had replaced figuration with nonfigurative abstraction, building up layers of textured geometric shapes defined by straight lines.

Diebenkorn's monumental *Ocean Park* series (1970s–1980s) suggests the open spaces of the American West and the vast expanse of the Pacific Ocean. Most of his paintings contain a dominant horizontal, suggestive of landscape. The colors of *Ocean Park No. 129* of 1984 (fig. **27.23**), for example, evoke the blue sea, while above the horizon is a narrow strip of abstract patches of color bounded by horizontals and diagonals. Despite the evident influence of Matisse and Cubism on Diebenkorn's vision, the strict geometry of the forms is relieved by the drips and paint texture, which relates his work to Abstract Expressionism.

27.23 Richard Diebenkorn, *Ocean Park No. 129*, 1984. Oil on canvas; 5 ft. 6 in. × 6 ft. 9 in. (1.68 × 2.06 m). Private collection. © Estate of Richard Diebenkorn. Courtesy Greenberg Van Doren Gallery.

Figurative Abstraction in Europe

Jean Dubuffet

During the 1950s, when American Abstract Expressionism was at its height, a more figurative kind of Expressionism developed in Europe. The French artist Jean Dubuffet (1901–1985) was fascinated by the art of non-Western cultures, of children and the insane, as well as by graffiti and the self-taught painters. He amassed a significant collection of such work, which he believed would provide a route to unconscious sources of creativity. The influence of these styles pervades his own paintings. Dubuffet's early canvases are thickly textured, dark, and often built up with granular materials such as sand. They tend to be muddy—composed mainly of browns and blacks—and to convey the rough textures of walls, doors, and pavements.

In the 1960s, Dubuffet's style changed radically, becoming more colorful and composed of lively, linear patterns. *The Reveler* of 1964 (fig. **27.24**) is a typical example of what Dubuffet called *L'Hourloupe*—his "Twenty-third period." It shows his use of animated, biomorphic form, which is generally outlined in pure hues of red and blue. The labyrinthine and doodle-like paths of line impart a quality of frenetic motion to Dubuffet's figure. This feature of his Twenty-third period is reminiscent of certain figures from Papua New Guinea (fig. **27.25**) and shows the influence of the art he collected. Dubuffet's lines also suggest the spontaneous character of Surrealist "automatic writing." Different as this style is from his early work, the scratchy quality of the lines and colored shapes maintains the emphasis on textured surfaces.

27.24 Jean Dubuffet, *The Reveler*, 1964. Oil on base of black acrylic; 6 ft. 4¼ in. × 4 ft. 3¾ in. (1.94 × 1.31 m). Dallas Museum of Art, Texas (Gift of Mr. and Mrs. James H. Clark).

27.25 Spirit figure from Wapo Creek, Papua New Guinea. Painted wood and shell; 25 in. (63.5 cm) high. Friede Collection, New York.

Francis Bacon

In England, the work of Francis Bacon (1909–1992) comprises an entirely different kind of figurative Expressionism. His *Portrait of Isabel Rawsthorne Standing in a Street in Soho* (fig. **27.26**) makes the transformation of figures into paint a subject in itself. This is reflected in Bacon's statement of 1952:

> It is in the search for the technique to trap the object at a given moment. The technique and the object become inseparable. The object is the technique and the technique is the object. Art lies in the continual struggle to come near to the sensory side of objects.[10]

When form becomes unformed color, as in the right shoe, the effect is less disturbing than in the face. There the features swivel into distortion and the mouth seems ripped open. Bacon thus confronts the viewer with a partially flayed head that is nevertheless alive and in motion. His forms simultaneously stretch and contract, are at once clear and blurred, appealing and repulsive. They are uniquely powerful in their manner of seeming to dissolve into, and emerge from, the paint itself—not through the prominent brushstrokes of Impressionism, but by the personal, determined aggression of the artist.

27.26 Francis Bacon, *Portrait of Isabel Rawsthorne Standing in a Street in Soho,* 1967. Oil on canvas; 6 ft. 6 in. × 4 ft. 10 in. (1.98 × 1.47 m). Staatliche Museen, Berlin.

Sculpture

Contemporary with the above developments in American and European painting were several sculptors whose work conveys a dynamic abstraction akin to both Abstract and Figurative Expressionism.

Isamu Noguchi

The *Kouros* (fig. **27.27**), by the Japanese-American Isamu Noguchi (1904–1988) contains biomorphic shapes like those of Miró and Gorky. Flat, protozoan forms are arranged in interlocking horizontal and vertical planes, creating a configuration that, the artist claimed, "defies gravity." Although it conforms to the principles of twentieth-century abstraction, Noguchi's figure shares a vertical stance—softened by curvilinear stylization—with the Archaic Greek *kouros* (see fig. 5.19).

Noguchi was born in Los Angeles in 1904 to an American mother and a Japanese father. He grew up in Japan and was a premedical student at Columbia University (1921–1924). He decided to become a sculptor and worked with Brancusi, whose influences can be seen in the smooth surfaces and elegant forms of the *Kouros*. In addition to sculpture, Noguchi has produced furniture and stage designs, public sculpture gardens, and playgrounds.

CONNECTIONS

See figure 5.19.
New York Kouros,
from Attica,
c. 600 B.C.

27.27 Isamu Noguchi, *Kouros,* 1944–1945. Pink marble, slate base; 9 ft. 9 in. (2.97 m) high. Metropolitan Museum of Art, New York (Fletcher Fund, 1953).

David Smith

Shapes and lines combine with open space in the sculpture of David Smith (1906–1965). Smith welded iron and steel to produce a dynamic form of sculptural abstraction. His last great series of work, entitled *Cubi* (fig. **27.28**), is composed of cylinders, cubes, and solid rectangles. As both the title and the shapes indicate, Smith was influenced by Cubism. The works were intended to be installed outdoors (as in the illustration), their open spaces making it possible to experience the landscape through and around them. The surface, enlivened by variations of texture, contributes to the sense of planar motion in the individual shapes.

27.28 David Smith, *Cubi XXVII*, 1965. Polished stainless steel; 111⅜ × 87¾ × 34 in. Solomon R. Guggenheim Museum. By exchange.

Louise Nelson

Louise Nevelson (1900–1988) made assemblages consisting of "found objects"—especially furniture parts and carpentry tools—placed inside open boxes. The boxes are piled on top of each other and arranged along a wall, much like bookshelves, so that they are seen, like paintings, from only one side. Typical of these works is *Black Wall* of 1959 (fig. **27.29**), in which the framing device of the boxes orders the assembled objects. Although originally utilitarian in nature, the objects become abstractions by virtue of their arrangement. Further abstracting the assemblage from everyday experience is the fact that the work is monochrome. As a result, the variety of shape and line takes precedence over the absence of color.

Many American Abstract Expressionists—some of whom have been illustrated in this chapter—worked beyond the 1950s, when the novelty and excitement of the style was at its height. In painting, Abstract Expressionism can be seen as a logical development of the Impressionist attention to the medium of paint. Brushstrokes became part of the critical vocabulary of Impressionism, Post-Impressionism, Fauvism, and the different forms of Expressionism. With the gestural Abstract Expressionists, paint and the way it behaved sometimes replaced narrative content entirely, emerging finally as the "subject" of painting. In sculpture as well, the texture of the medium became an increasingly significant feature of the work.

27.29 Louise Nevelson, *Black Wall,* 1959. Gilded wood; 9 ft. 4 in. × 7 ft. 1¼ in. (2.64 × 2.17 m). Tate Gallery, London.

	Style/Period	Works of Art	Cultural/Historical Developments
		Yei god, Navajo sand painting (**27.11**) Wapo Creek spirit figure (**27.25**)	
1920	ABSTRACT EXPRESSIONISM AND COLOR FIELD 1920–1940	Gorky, *The Artist and His Mother* (**27.3–27.5**) Pollock, *Going West* (**27.7**) Mondrian, *Trafalgar Square* (**27.22**)	Emigration of Bauhaus artists to the U.S.A. (late 1930s) World War II (1939–1945) *Gone with the Wind* wins Oscar for Best Picture (1939)
1940	1940–1950	Pollock, *Guardians of the Secret* (**27.8**) Gorky, *Garden in Sochi* (**27.6**) Noguchi, *Kouros* (**27.27**) Rothko, *Baptismal Scene* (**27.16**)	Graham Greene, *The Power and the Glory* (1940) Edmund Wilson, *To the Finland Station* (1940) Penicillin developed as an antibiotic (1940) Japan attacks Pearl Harbor; U.S.A. enters war (1941) Albert Camus, *L'Étranger* (1942) Aaron Copland, *Rodeo* (1942) Art of This Century art gallery opens (1942) Rodgers and Hammerstein, *Oklahoma!* (1943) Jean-Paul Sartre, *L'Être et le néant* (1943) Atomic bomb dropped on Hiroshima (1945) Establishment of United Nations (1945) Beginning of the Cold War (1945) Benjamin Britten, *Peter Grimes* (1945) India achieves independence from British rule (1947) Tennessee Williams, *A Streetcar Named Desire* (1947) Nation of Israel established (1948) Alan Paton, *Cry, The Beloved Country* (1948) People's Republic of China established (1949)

Gorky, *The Artist and His Mother*

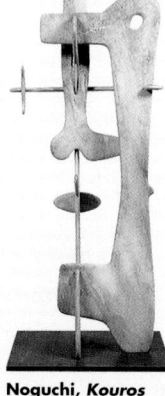

Arshile Gorky and His Mother

Noguchi, *Kouros*

	Style/Period	Works of Art	Cultural/Historical Developments
1950	1950–1960	Namuth, *Jackson Pollock Painting* (**27.9**) de Kooning, *Woman and Bicycle* (**27.14**) Pollock, *White Light* (**27.12**) Kline, *Mahoning* (**27.13**) Rothko, *Number 15* (**27.17**) Nevelson, *Black Wall* (**27.29**) Hofmann, *The Gate* (**27.1**)	Korean War (1950–1953) John Van Druten, *I Am a Camera* (1951) James Jones, *From Here to Eternity* (1951) J. D. Salinger, *Catcher in the Rye* (1951) Samuel Beckett, *Waiting for Godot* (1952) J. D. Watson and F. H. C. Crick describe the double- helix structure of DNA (1953) Arthur Miller, *A View from the Bridge* (1953) Vladimir Nabokov, *Lolita* (1955) Ingmar Bergman, *The Seventh Seal* (1956) Leonard Bernstein, *West Side Story* (1957) Boris Pasternak, *Dr. Zhivago* (1958) Truman Capote, *Breakfast at Tiffany's* (1958) Eugène Ionesco, *Rhinocéros* (1959)

Pollock, *White Light*

de Kooning, *Woman and Bicycle*

Hofmann, *The Gate*

Kelly, *Spectrum III*

**Rothko,
Number 15**

	Style/Period	Works of Art	Cultural/Historical Developments
1960	1960–1990	Frankenthaler, *The Bay* (**27.15**) Dubuffet, *The Reveler* (**27.24**) Kelly, *Red, Yellow, Blue* (**27.22**) Stella, *Empress of India* (**27.19**) Reinhardt, *Abstract Painting* (*Black*) (**27.18**) Smith, *Cubi XXVII* (**27.28**) Stella, *Tahkt-i-Sulayman I* (**27.20**) Kelly, *Spectrum III* (**27.21**) Bacon, *Portrait of Isabel Rawsthorne Standing in a Street in Soho* (**27.26**) Albers, *Study for Homage to the Square* (**27.2**) Diebenkorn, *Ocean Park No. 129* (**27.23**)	Harper Lee, *To Kill a Mockingbird* (1960) Construction of the Berlin Wall (1961) Joseph Heller, *Catch-22* (1961) First U.S. intervention in Vietnam (1962) James Baldwin, *Another Country* (1962) President John F. Kennedy assassinated (1963) The Beatles, "I Want to Hold Your Hand" (1964) Entire genetic code decoded (1966) Harold Pinter, *The Homecoming* (1967) Martin Luther King, Jr., assassinated (1968) James D. Watson, *The Double Helix* (1968) *Apollo II* lands on the moon (1969)
1990			

Stella, *Tahkt-i-Sulayman I*

28

Pop Art, Op Art, Minimalism, and Conceptualism

I n the late 1950s and 1960s, a reaction against the nonfigurative and seemingly egocentric character of Abstract Expressionism took the form of a return to the object. The most prominent style to emerge in the United States in the 1960s was "Pop," although the origins of the style are to be found in England in the 1950s. The popular imagery of Pop Art was derived from commercial sources, the mass media, and everyday life. In contrast to Abstract Expressionist subjectivity—which viewed the work of art as a revelation of the artist's unconscious mind—the Pop artists strove for an "objectivity" embodied by an imagery of objects. What contributed to the special impact of Pop Art was the mundane character of the objects selected. As a result, Pop Art was regarded by many as an assault on accepted conventions and aesthetic standards.

Despite the 1960s emphasis on the objective "here and now," however, the artists of that period were not completely detached from historical influences or psychological expression. The elevation of everyday objects to the status of artistic imagery, for example, can be traced to the early twentieth-century taste for "found objects" and assemblage. Likewise, the widespread incorporation of letters and numbers into the iconography of Pop Art reflects the influence of the newspaper collages produced by Picasso and Braque.

Another artistic expression of the 1960s, the so-called **Happenings,** probably derived from the Dada performances at the Cabaret Voltaire in Zurich during World War I. Happenings, in which many Pop artists participated, were multimedia events that took place in specially created environments. They included painting, assemblage, television, radio, film, and artificial lighting. Improvisation and audience participation encouraged a spontaneous, ahistorical atmosphere that called for self-expression in the "here and now." Happenings were also a response to consumerism and the fact that works of art were valued as commodities. In a Happening, there is no commodity, for nothing about it—unless it is recorded or videotaped—is permanent.

Pop Art in England: Richard Hamilton

The small collage *Just what is it that makes today's homes so different, so appealing?* (fig. **28.1**), by the English artist Richard Hamilton (born 1922), was originally intended for reproduction on a poster. It can be considered a visual manifesto of what was to become the Pop Art movement. First exhibited in London in a 1956 show entitled *This Is Tomorrow,* Hamilton's collage inspired an English critic to coin the term *Pop.*

The muscleman in the middle of the modern living room is a conflation of the Classical *Spear Bearer* (see fig. 5.27) by Polykleitos and the *Medici Venus* (see fig. 13.25). The giant Tootsie Pop directed toward the woman on the couch is at once a sexual, visual, and verbal pun. Advertising references occur in the sign pointing to the vacuum hose, the Ford car emblem, and the label on the tin of ham. Mass-media imagery is explicit in the tape recorder, television set, newspaper, and movie theater. The framed cover of *Young Romance* magazine reflects popular teenage reading of the 1950s.

Despite the iconographic insistence on what was contemporary, however, Hamilton's collage contains traditional historical allusions. The image of a white-gloved Al Jolson on the billboard advertising *The Jazz Singer* recalls an earlier era of American entertainment. The old-fashioned portrait on the wall evokes an artistic past, and the silicone pinup on the couch is a plasticized version of the traditional reclining nude. Hamilton's detailed attention to the depiction of objects, especially those associated with the domestic interior, reveals his respect for fifteenth-century Flemish painters as well as his stated admiration for Duchamp.

As a guide for subsequent Pop artists, Hamilton compiled a checklist of Pop Art subject matter: "Popular (designed for a mass audience), transient (short-term solution), expendable (easily forgotten), low-cost, mass-produced, young (aimed at youth), witty, sexy, gimmicky, glamorous, big business."

See figure 5.27.
Polykleitos, *Doryphoros*
(Spear Bearer),
c. 440 B.C.

See figure 13.25. *Medici*
Venus, 1st century A.D.

28.1 Richard Hamilton, *Just what is it that makes today's homes so different, so appealing?,* 1956. Collage on paper; 10¼ × 9¼ in. (26.0 × 23.5 cm). Kunsthalle, Tübingen (Collection, Professor Dr. Georg Zundel).

28.2 Jasper Johns, *Three Flags,* 1958. Encaustic on canvas; 30⅞ × 45½ × 5 in. (78.4 × 115.6 × 12.7 cm). Collection, Whitney Museum of American Art, New York (Fiftieth Anniversary Gift of Gilman Foundation, Lauder Foundation, A. Alfred Taubman, anonymous donor, purchase).

Pop Art in the United States

Painting

Although Pop Art made its début in London in 1956 and continued in England throughout the 1960s, it reached its fullest development in New York. In 1962, an exhibition of the *New Realists* at the Sidney Janis Gallery gave Pop artists official status in the New York art world. Pop Art, however, was never a homogeneous style, and within this classification are many artists whose imagery and technique differ significantly. The first three artists discussed here—Jasper Johns, Larry Rivers, and Robert Rauschenberg—are actually transitional between Abstract Expressionism and Pop, for they combine textured, painterly brushwork with a return to the object.

Jasper Johns One of the constant themes of Jasper Johns (born 1930) is the boundary between everyday objects and the work of art. In the late 1950s, he chose a number of objects whose representation he explored in different ways, including the map and flag of the United States, targets, and stenciled numbers and words. In *Three Flags* of 1958 (fig. **28.2**), Johns depicts a popular image that is also a national emblem. His flags are built up with superimposed canvas strips covered with wax encaustic—a combination that creates a pronounced sense of surface texture. "Using the design of the American flag," Johns has been quoted as saying, "took care of a great deal for me because I didn't have to design it." The flag is abstract insofar as it consists of pure geometric shapes (stars and rectangles), but it is also an instantly recognizable, familiar object. The American flag has its own history, and the encaustic medium that Johns used to paint it dates back to antiquity

(see Chapter 5). It thus combines the painterly qualities of Abstract Expressionism with the representation of a popular and well-known object. One question raised by Johns's treatment of this subject is "When does the flag cease to be a patriotic sign or symbol and become an artistic image?"

In Johns's painted bronze casts of cans of Ballantine Ale (fig. **28.3**), he retains the painterly texture of the *Three Flags*. As a Pop artist, Johns deals with themes of commercialism and repeated imagery versus the unique work of art. In this case, he draws commercial objects into the realm of art but, in contrast to Duchamp (see Chapter 26), Johns makes the artist's presence visible in the artistic process. In repeating the ale cans, Johns has created an imposing pair of cylinders. The more we look at them, the more we have the impression that they are standing up and looking back at us. Each label thus takes on the quality of a face.

28.3 Jasper Johns, *Painted Bronze (Ale Cans),* 1960. Painted bronze; 5½ × 8 × 4¾ in. (14.0 × 20.3 × 12.1 cm). Museum Ludwig, Cologne.

Larry Rivers Larry Rivers (1923–2002) studied with Hans Hofmann (see Chapter 27) and never lost his sense of painterly texture. His *Portrait of Frank O'Hara* (fig. **28.4**) combines words with the poet's image. The picture is co-signed "Rivers" above "O'Hara" near the figure's shoulder on the right, signifying that the work is a collaborative effort of painter and poet. As such, the portrait recalls Dada combinations of words and pictures, and other forms of multimedia experimentation.

28.4 Larry Rivers, *Portrait of Frank O'Hara*, 1961. Oil on canvas; 36 × 36 in. (91.4 × 91.4 cm). Private collection. Photo Maggie Nimkin. Rivers worked as a professional saxophonist before taking up painting in 1945. His portrait of Frank O'Hara (1926–1966), a post–World War II poet, playwright, and art critic, reveals his interest in diverse expressive media. O'Hara himself worked as a curator at the Museum of Modern Art, New York, and his poems depict mental states of consciousness in a style reminiscent of Abstract Expressionism.

Robert Rauschenberg Robert Rauschenberg (born 1925) was as liberal in his choice of imagery as Johns was frugal. His sculptures and "combines"—descendants of Duchamp's Ready-Mades and Picasso's assemblages—include stuffed animals, quilts, pillows, and rubber tires. His paintings contain images from a wide variety of sources, such as newspapers, television, billboards, and old masters.

The **silkscreen** print of 1964, *Retroactive I* (fig. **28.5**), is an arrangement of cutouts resembling a collage. It illustrates the artist's expressed wish to "unfocus" the mind of the viewer by presenting simultaneous images that are open to multiple interpretations. The newspaper imagery evokes current events, reflecting the contemporary emphasis of Pop Art. A returning astronaut parachutes to earth in the upper left frame, while in the center President Kennedy, who had been assassinated the previous year, extends his finger as if to underline a point. The frame at the lower right reveals a historical thread behind Rauschenberg's "current events" iconography. It contains a blowup of a stroboscopic photograph of a takeoff on Duchamp's *Nude Descending a Staircase* (see fig. 25.18); at the same time, it is strongly reminiscent of Masaccio's *Expulsion of Adam and Eve* of c. 1425 (see fig. 13.24).

Despite the presence of media images in this print, Rauschenberg seems to have covered it with a thin veil of paint. Brushstrokes and drips running down the picture's surface are particularly apparent at the top. The dripping motion of paint parallels the fall of the astronaut: one drip lands humorously in a glass of liquid embedded in the green patch on the right. More hidden, or "veiled," is the iconographic parallel between the falling paint, the astronaut, and the "Fall of Man." Kennedy's "mythic" character is implied by his formal similarity to the Christ of Michelangelo's *Last Judgment* (see fig. 14.27) and to God in his *Creation of Adam* (see fig. 14.23).

CONNECTIONS

See figure 14.27. Michelangelo, *Last Judgment*, detail: figure of Christ, 1534–1541.

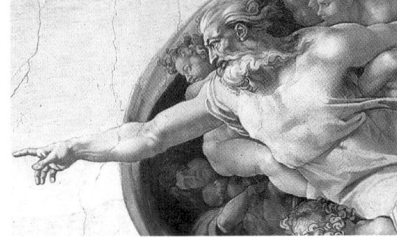

See figure 14.23. Michelangelo, *Creation of Adam*, c. 1510.

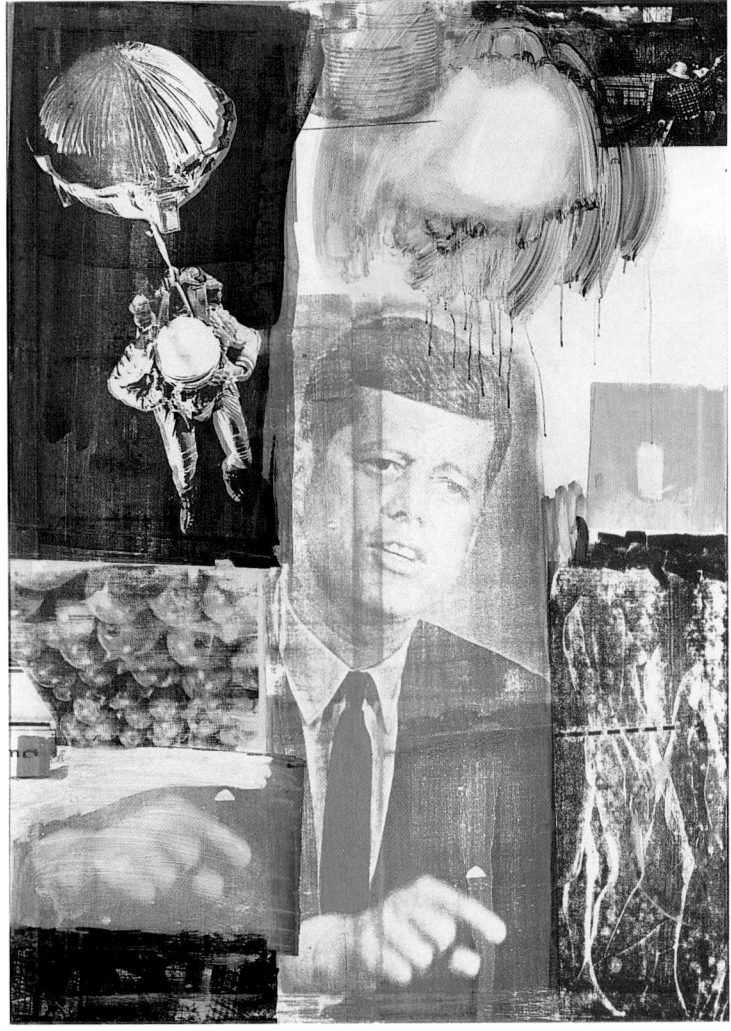

28.5 Robert Rauschenberg, *Retroactive I*, 1964. Silkscreen print with oil on canvas; 7 × 5 ft. (2.13 × 1.52 m). Wadsworth Athenaeum, Hartford, Connecticut (Gift of Susan Morse Hilles).

Andy Warhol Andy Warhol (1928–1987) was the chief example of the Pop Art lifestyle as well as the creator of highly individual works of art. With his flair for multi-media events and self-promotion, Warhol turned himself into a work of Pop Art and became the central figure of a controversial cult. One of his most characteristic works, *Campbell's Soup I* (*Tomato*) of 1968 (fig. **28.6**), illustrates his taste for commercial images. The clear precision of his forms and the absence of any visible reference to paint texture intensify the confrontation with the object represented—with the object as object. Warhol's famous assertion "I want to be a machine" expresses his obsession with mass production and his personal identification with the mechanical, mindless, repetitive qualities of mass consumption.

Warhol's iconography is wide-ranging. In addition to labels advertising products, he created works that monumentalize commercial American icons. These include Coca-Cola bottles, Brillo and Heinz boxes, comic books, matchbook covers, green stamps, dollar bills, and so forth. He also produced portraits of iconic American heroes and heroines—John F. Kennedy, Jackie Kennedy, Marilyn Monroe, Elvis Presley, Elizabeth Taylor, Marlon Brando, and Troy Donahue. Icons have a mythic quality, and Warhol did a myth series that included Superman, Howdy Doody, Mickey Mouse, Uncle Sam, Dracula, and the Wicked Witch of Oz.

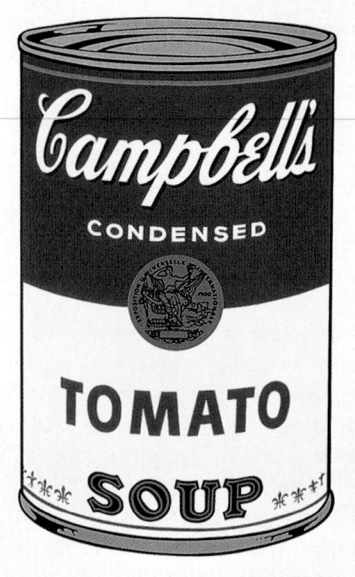

28.6 Andy Warhol, *Campbell's Soup I* (*Tomato*), 1968. One from a portfolio of screenprints on paper; 35 × 23 in. (88.9 × 59.4 cm). The Andy Warhol Foundation, Inc./ Art Resource, NY. © 2006 Andy Warhol Foundation for the Visual Arts/ ARS, NY/TM Licensed by Campbell's Soup Co. All rights reserved.

In *Elvis I and II* (fig. **28.7**), Warhol depicts an icon of American pop culture in the traditional diptych format. He juxtaposes a monochrome pair of images with a colored pair, creating the impression of photographic repetition. Elvis is shown in an aggressive stance with his gun drawn, transforming the conventional cowboy image into that of a pop star.

28.7 Andy Warhol, *Elvis I and II*, 1964. Synthetic polymer paint and silkscreen ink on canvas, aluminum paint and silkscreen on canvas; each panel 82 × 82 in. (2.08 × 2.08 m). Copyright The Andy Warhol Foundation, Inc./Art Resource, New York.

Roy Lichtenstein Popular American reading matter of the 1940s and 1950s included comic books. These provided the source for some of the best-known images of Roy Lichtenstein (1923–1997). He monumentalized the flat, clear comic-book drawings with "balloons" containing dialogue. *Torpedo . . . Los!* (fig. **28.8**) is a blowup inspired by a war comic, illustrating a U-boat captain launching a torpedo. The impression of violence is enhanced by the close-up of the figure's open mouth and scarred cheek. The absence of shading, except for some rudimentary hatching, and the clear, outlined forms replicate the character of comic-book imagery.

In addition to comic books, Lichtenstein became inspired by the work of previous artists—Picasso, Matisse, Mondrian, and others—and he painted versions of their pictures. He also did a series of paintings in which he made "objects" out of brushstrokes (fig. **28.9**), which are implicit comments on the "objectlessness" of many Abstract Expressionist works. As with his comic-book imagery, Lichtenstein enlarges the brushstrokes along with their drips and splatters, indicating in solid black the indentations in the paint made by the bristles of the brush. But the flattening of the paint eliminates the natural texture of such a brushstroke. The background is composed of hundreds of Ben Day dots, which identify the surface of commercially printed paper and render the image static.

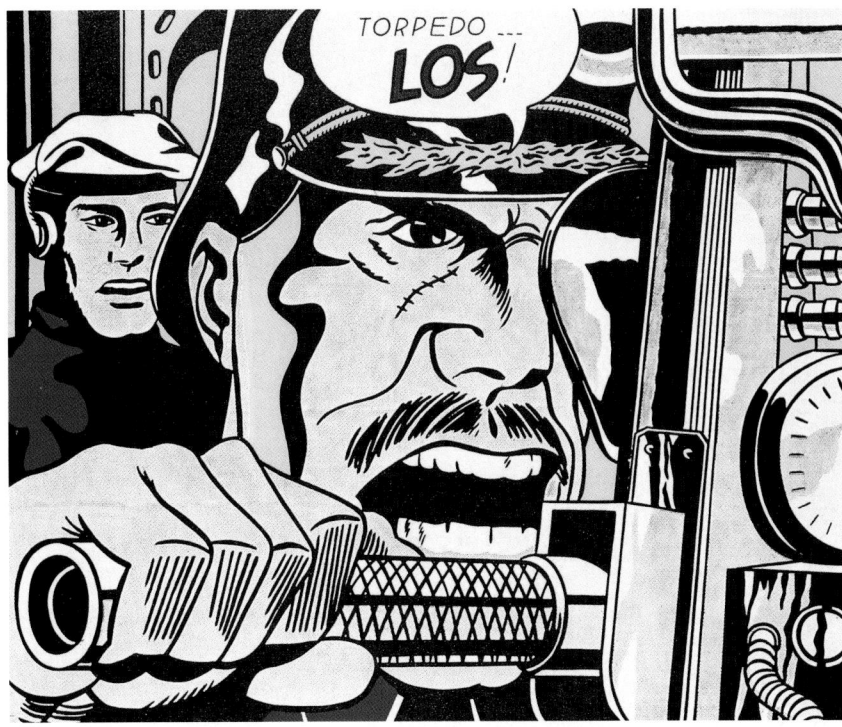

28.8 Roy Lichtenstein, *Torpedo . . . Los!*, 1963. Oil on canvas; 5 ft. 8 in. × 6 ft. 8 in. (1.73 × 2.03 m). Estate of Roy Lichtenstein.

By isolating the brushstroke, Lichtenstein "objectifies" it. At the same time, he retains the dynamic movement and gestural expressiveness of the Action painters. In this combination of techniques, he creates a synthesis of the Pop Art taste for objects with the Abstract Expressionist transformation of medium into content. The title of the painting illustrated here, *Little Big Picture,* refers to the battle of 1876 in which General George Armstrong Custer made his famous "last stand" against the Sioux—the Battle of Little Bighorn. Lichtenstein thus links the cultural struggles that made American history with conflicting styles of American art.

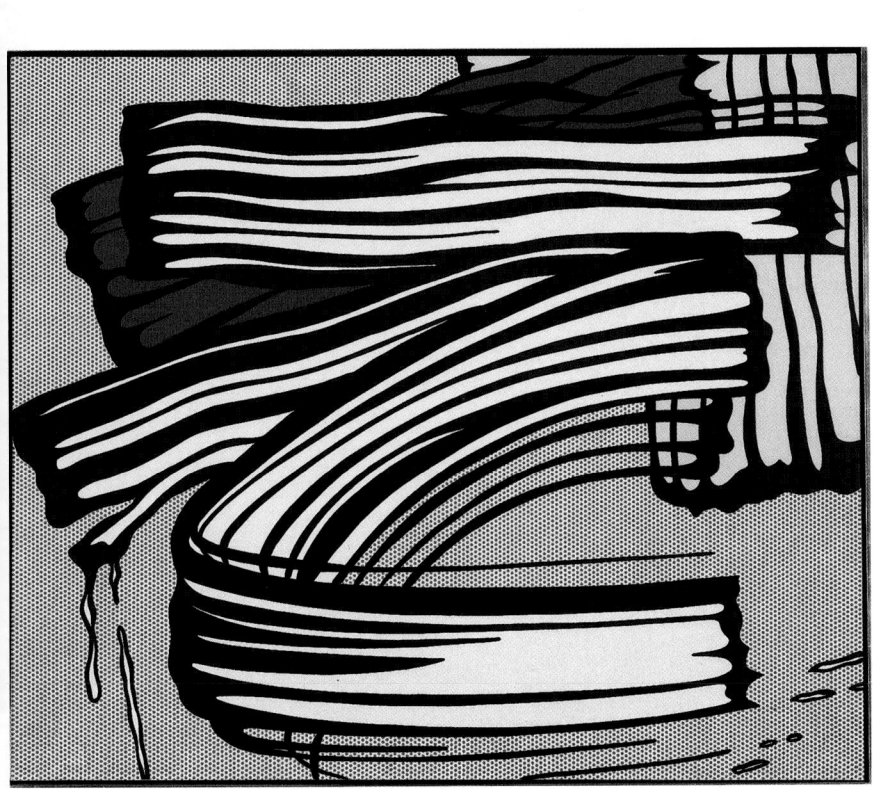

28.9 Roy Lichtenstein, *Little Big Picture*, 1965. Oil and synthetic polymer on canvas; 5 ft. 8 in. × 6 ft. 8 in. (1.73 × 2.03 m). Whitney Museum of American Art, New York (Purchase, Friends of Whitney Museum of American Art).

28.10 Richard Lindner, *Rock-Rock,* 1966–1967. Oil on canvas; 5 ft. 10 in. × 5 ft. (1.78 × 1.52 m). Dallas Museum of Fine Arts (Gift of Mr. and Mrs. James H. Clark).

Richard Lindner Richard Lindner (1901–1978) was born in Hamburg, Germany, and emigrated to the United States in 1941. His mechanical figures are somewhat reminiscent of Léger's volumetric Cubism, but his bright colors and metallic and shiny leather surfaces have affinities with Pop Art. *Rock-Rock* of 1966–1967 (fig. **28.10**) has an electric quality that recalls the blinking lights and tinny sounds of pinball machines as well as the dynamic energy of rock music. It depicts the rock star in a frontal pose, as a cultural icon of ambiguous gender. The dark glasses enhance the anonymity of the figure, while the background diagonals radiate in the manner of a halo. Bisecting the composition is the electric guitar, which has become a hallmark of the rock movement. It is also a formal reminder of Man Ray's Surrealist photograph *Le Violon d'Ingres* (see fig. 26.8), in which the violin is conflated with the back of the nude woman. In *Rock-Rock,* the guitar merges with the torso of the rock star—it curves around the collar, and the holes at the right resemble buttons. The figure seems literally to "wear" the guitar, which, in the end, *is* its identity.

R. B. Kitaj An entirely different atmosphere pervades the Pop Art of R. B. Kitaj (1932–1997), an American artist who lived and worked in London. His *Juan de la Cruz* of

1967 (fig. **28.11**) depicts a black American, Sergeant Cross, as a soldier during the Vietnam War. Through the window to his right, a nude Saint Teresa (see caption) wearing high heels is ordered to walk the plank by two thugs in the guise of Counter-Reformation Inquisitors. Kitaj relates the abuses of the Inquisition to various forms of twentieth-century discrimination by juxtaposing different cultural allusions. For example, the woman's nudity accentuates her victimization by the two men, the black sergeant fights for a country that discriminates against his people, while the Hispanic title of the painting merges another American minority with the Spanish martyr. Formally, too, Kitaj's arrangement of slightly textured patches of color recalls the juxtapositions of collage.

28.11 R. B. Kitaj, *Juan de la Cruz,* 1967. Oil on canvas; 6 ft. × 5 ft. (1.83 × 1.52 m). Astrup Fearnley Collection, Oslo. Kitaj was born in Cleveland, Ohio. After World War II, he became preoccupied with his Jewish heritage and the Holocaust. His interest in Saint Teresa, originally a Jew, and in Saint John of the Cross, who was rumored to have been Jewish, is related to Kitaj's sense of his own cultural identity. Although she became a Christian mystic, Saint Teresa was accused by the Inquisition of having relapsed. Saint John of the Cross was her protégé and a mystic poet.

28.12 (right) Tom Wesselmann, *Great American Nude No. 57*, 1964. Synthetic polymer on composition board; 4 ft. × 5 ft. 5 in. (1.22 × 1.65 m). Whitney Museum of American Art, New York (Purchase).

— CONNECTIONS —

See figure 14.52. Titian, *Venus of Urbino* (detail), c. 1538.

Tom Wesselmann The *Great American Nude* series by Tom Wesselmann (1931–2004) combines Hollywood pinups with the traditional reclining nude. In *No. 57* (fig. **28.12**), the nude is a symbol of American vulgarity. She lies on a leopard skin, and two stars on the back wall evoke the American flag. She is faceless except for her open mouth, and her body bears the suntan traces of a bathing suit. Her pose is related to figures such as Titian's *Venus of Urbino* (see fig. 14.52) and Manet's *Olympia* (see fig. 21.26), but Wesselmann's surfaces are unmodeled, though they appear to have volume. The partly drawn curtain opens onto a distant landscape, and the oranges and flowers refer to the woman's traditional role as a fertile earth goddess. This metaphor is reinforced by the formal parallels between the mouth, nipples, and interior of the flowers. In this work, Wesselmann combines three-dimensional forms with flattened geometric abstractions, the interior bedroom with exterior landscape, and intimacy with universal themes.

Wayne Thiebaud Born in 1920, the West Coast artist Wayne Thiebaud arranges objects in a self-consciously ordered manner. Although identified with Pop Art, he, like Larry Rivers, emphasizes the texture of paint. In the 1960s, Thiebaud focused on cafeteria-style food arrangements, but his content in the following decades includes a wide range of objects, portraits, and atmospheric images of cloud formations and landscape.

His *Thirteen Books* of 1992 (fig. **28.13**) depicts a neat pile of books, which has a constructed, architectural quality that is enhanced by the oblique angle. Each book functions as an individual structural element that contributes to the effect of the whole and creates the impression of a rectangular column. The textured edges of the books and the bright colors of their spines contrast with the stark white background. The titles are blurred and unreadable, thereby suggesting the hidden, secret content of the proverbial "closed book."

To the right of the stack, there is no distinction between the surface supporting the books and the background. This leaves the viewer uncertain of their exact placement in space—they seem to float in a plane of white. At the left, on the other hand, the books cast a gray, trapezoidal shadow edged in orange, which identifies a source of light and confirms the presence of a supporting surface. The predominance of white is characteristic of the artist's paintings of objects. White was of particular interest to Thiebaud as it combines all the colors of the visible spectrum, as well as simultaneously absorbing and reflecting light.

28.13 Wayne Thiebaud, *Thirteen Books*, 1992. Oil on panel; 13 × 10 in. (33.0 × 25.4 cm). Allan Stone Gallery, New York.

937

Sculpture

Generally included among the leading New York Pop artists are the sculptors Claes Oldenburg (born 1929) and George Segal (1924–2000). Although both can be considered Pop artists in the sense that their subject matter is derived from everyday objects and mass media, their work is distinctive in maintaining a sense of the textural reality of their materials.

Claes Oldenburg Oldenburg has produced an enormous, innovative body of imagery, ranging from clothing, light switches, food displays, and furniture sets to tea bags. *Soft Switches* (fig. **28.14**) is one of his "soft" vinyl sculptures, which amuses us because it is unexpected. We expect a light switch to be a hard, solid object which we can flick on or off. Here, however, the switches sag like a pair of shoes poking through a pouch. Oldenburg also creates "ghosts," or ghost versions of his sculptures, which are devoid of color and usually made of canvas (fig. **28.15**). These sculptures are not only startling because of their material, but also because of their size. We expect light switches to be small, almost unnoticeable, and purely func-

tional household fixtures. But these are imposing, and they announce their presence, insisting on being noticed. In so doing, the switches reflect the characteristic Pop Art taste for monumentalizing everyday objects and the style's introduction of a new body of subject matter.

Oldenburg's giant *Clothespin* of 1976 in Philadelphia (fig. **28.16**) is also an enlargement of an everyday household object. The clothespin has an anthropomorphic quality, resembling a tall man standing with his legs apart, as if striding forward. The wire spring suggests an arm, and the curved top with its two circular openings, a head and face. Despite the hard texture of this work, Oldenburg manages to arouse a tactile response by association with actual clothespins. Pressing together the "legs," for example, would cause the spring to open up the spaces at the center of the "head." The tactile urge aroused by the clothespin, together with its anthropomorphic character, reflects Oldenburg's talent for conveying paradox and metaphor. The clothespin thus assumes the quality of a visual pun, which is reminiscent of Picasso's *Bull's Head* (see fig. 25.9) and of the unlikely, surprising juxtapositions of the Surrealist aesthetic that were calculated to raise the consciousness of the viewer.

28.14 Claes Oldenburg, *Soft Switches*, 1964. Vinyl with Dacron and canvas; 47 × 47 × 3¼ in. (119.4 × 119.4 × 8.3 cm). Nelson-Atkins Museum, Kansas City, Missouri (Chapin family in memory of Chapin Buckwalter, 65-29).

28.15 Claes Oldenburg, *Soft Light Switches—Ghost Version*, 1971 version of a 1964 original. Canvas filled with kapok, gesso, and pencil; 47 × 47 × 12 in. (121.9 × 121.9 × 30.5 cm). Collection of Claes Oldenburg and Coosje van Bruggen, New York, on loan to the Museum für Moderne Kunst, Frankfurt.

28.16 Claes Oldenburg, *Clothespin*, Central Square, Philadelphia, 1976. Cor-Ten and stainless steel; 45 ft. × 6 ft. 3¾ in. × 4 ft. ⅓ in. (13.72 × 1.92 × 1.32 m). This is one of several "projects for colossal monuments," based on everyday objects, which Oldenburg proposed for various cities. Others include a giant *Teddy Bear* for New York, a *Drainpipe* for Toronto, and a *Lipstick* for London (presented to Yale University in 1969). Oldenburg says that he has always been "fascinated by the values attached to size."

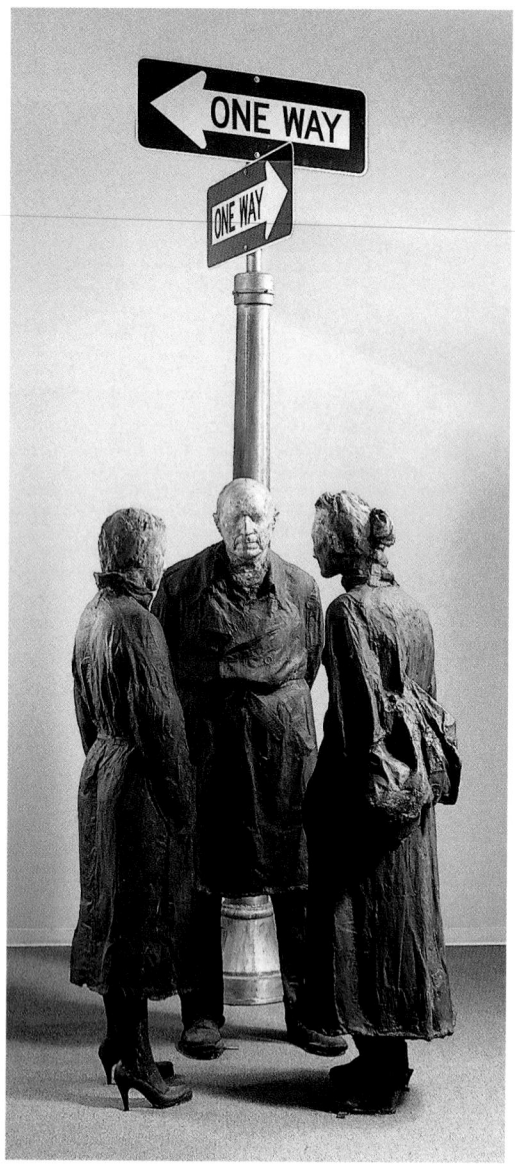

28.17 George Segal, *Chance Meeting*, 1989. Plaster, paint, aluminum post, and metal sign; 10 ft. 3 in. × 3 ft. 5 in. × 4 ft. 7 in. (3.12 × 1.04 × 1.40 m). Photo courtesy of Carroll Janis, New York. Segal wrapped the subject's body in gauze bandages dipped in wet plaster. Once the plaster hardened, he cut it off in sections, which he then reassembled. His effigies, the descendants of Egyptian mummies and Roman death masks, were usually in unpainted white plaster, but sometimes in gray or color. Segal's subjects, however, were alive when the cast was made and were often depicted in the course of some activity.

George Segal The sculptures of George Segal differ from Oldenburg's in that they are literally "figurative." Segal creates environments in which he places figures, singly or in groups, that convey a sense of isolation or self-absorption. In *Chance Meeting* (fig. **28.17**), three life-sized pedestrians encounter each other by a one-way street sign. Their otherworldliness is emphasized by Segal's "mummification" of living figures (see caption) and the impres-

28.18 George Segal, *Cinema*, 1963. Plaster, illuminated Plexiglas, and metal; 118 × 96 × 30 in. (299.7 × 243.8 × 76.2 cm). Albright-Knox Art Gallery, Buffalo (Gift of Seymour H. Knox, 1964).

sion that they do not communicate. Their light, textured surfaces create a paradoxical impression of emotional coldness for, although they have been molded from living people, they seem ghostly and alien.

In *Cinema* (fig. **28.18**), which was Segal's favorite work, he has also created a ghostly figure. In contrast to *Chance Meeting*, this figure is alone, placing an *R* on the neon billboard. His anonymous whiteness is accentuated by the glare of the white light in front of him. The red letters of "CINEMA" reflect the Pop Art use of commercial letters and numbers, and the influence of advertising. By juxtaposing a human form with the electric sign, Segal shows the way in which technology overwhelms humanity as well as its isolating effects.

28.19 Marisol Escobar, *The Last Supper* (installed at the Sidney Janis Gallery), 1982. Wood, brownstone, plaster, paint, and charcoal; 10 ft. 1 in. × 29 ft. 10 in. × 5 ft. 7 in. (3.07 × 9.09 × 1.70 m). Photo courtesy of Carroll Janis, New York.

Marisol Escobar Marisol Escobar's (born 1930) brand of Pop Art combines Cubist-inspired blocks of wood with figuration. In her monumental sculptural installation of *The Last Supper* (fig. **28.19**), she re-creates Leonardo's fresco (see fig. 14.14) in a modern idiom. The architectural setting replicates the Leonardo, with four rectangular panels on either side that recede toward a back wall, a triple window, and a curved pediment. The apostles, like Leonardo's, are arranged in four groups of three, with corresponding poses. An image of Marisol herself sits opposite the scene, playing the role of viewer as well as being the artist. As viewer, Marisol contemplates the past, which she appropriates.

Niki de Saint-Phalle Niki de Saint-Phalle (1930–2002) was born in Paris, grew up in New York, and returned to Paris in 1951. There she began painting and making combinations of reliefs and assemblages, using toys as a primary medium. She was originally part of the French *nouveaux réalistes,* a group of artists that was formed in 1960. In New York, these artists were termed the New Realists, which was also the title of the exhibition held in 1962 at the Sidney Janis Gallery.

De Saint-Phalle's most characteristic works are her so-called *Nanas,* which are polyester sculptures of large women. Generally, as with her *Black Venus* of 1965–1967 (fig. **28.20**), the *Nanas* are painted in bright, unshaded colors that are reminiscent of folk imagery. The torso of this figure looks inflated, ironically even more so than the beach ball, which seems to be losing its air. De Saint-Phalle's *Venus* shares exaggerated breasts and hips with the Paleolithic *Venus of Willendorf* (see fig. 1.1), but the head is small by comparison, a device that has a Mannerist quality. The figure also seems engaged in an energetic dance movement, which, together with its "blackness," allies it with the exuberance and modernism of jazz.

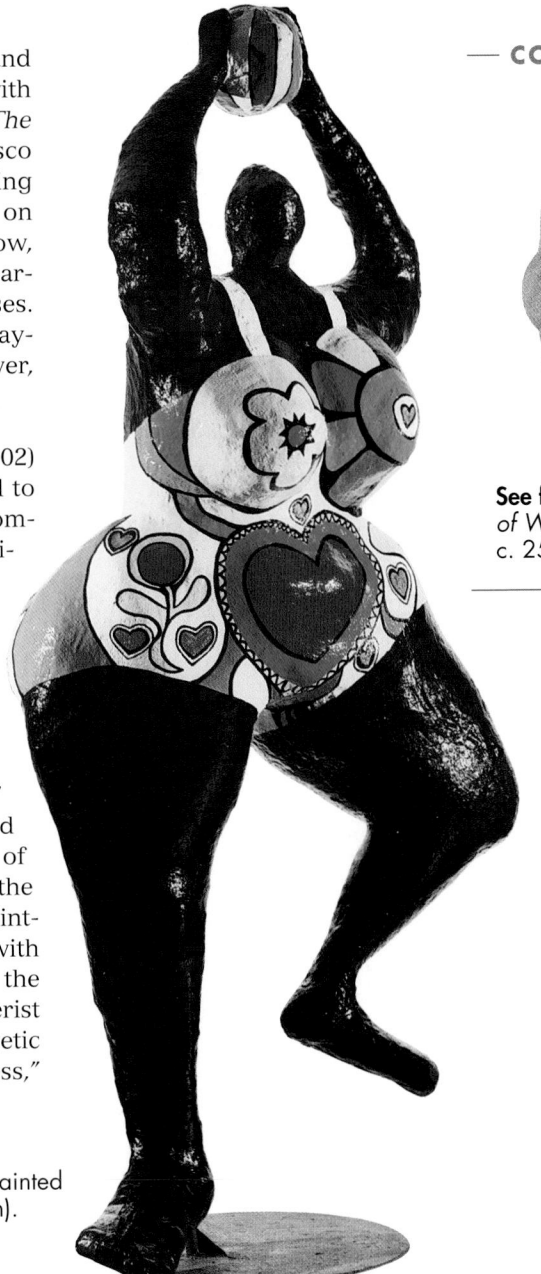

28.20 Niki de Saint-Phalle, *Black Venus*, 1965–1967. Painted polyester; 110 × 35 × 24 in. (279.4 × 88.5 × 61.0 cm). Whitney Museum of American Art, New York (Gift of Howard and Jean Lipman Foundation).

— CONNECTIONS —

See figure 1.1. *Venus of Willendorf,* c. 25,000–21,000 B.C.

28.21 Bridget Riley, *Aubade (Dawn)*, 1975. Acrylic on linen; 6 ft. 10 in. × 8 ft. 11½ in. (2.08 × 2.73 m). Private collection.

Op Art

Another artistic movement that flourished during the 1960s has been called Optical, or Op, Art. In 1965, the Museum of Modern Art contributed to the vogue for the style by including it in an exhibition entitled *The Responsive Eye*. Op Art is akin to Pop Art in rhyme only, for the recognizable object is totally eliminated from Op Art in favor of geometric abstraction, and the experience of it is exclusively retinal. The Op artists produced kinetic effects (that is, illusions of movement), using arrangements of color, lines, and shapes, or some combination of these elements.

In *Aubade (Dawn)* of 1975 (fig. **28.21**), by the British painter Bridget Riley (born 1931), there are evident affinities with Albers and the Color Field painters. Riley has arranged pinks, greens, and blues in undulating vertical curves of varying widths, evoking the vibrancy of dawn itself. The changing width of each line, combined with the changing hues, makes her picture plane seem to pulsate with movement. Riley's work generally relies on two effects—producing a hallucinatory illusion of movement (as here), or encouraging the viewer to focus on a particular area before using secondary shapes and patterns to intrude and disturb the original perception. Riley's early Op Art pictures were in black and white and shades of gray. In the mid-1960s, she turned to color compositions such as this one.

Minimalism

Sculptures of the 1960s "objectless" movement were called "minimal," or "primary," structures because they were direct statements of solid geometric form. In contrast to the personalized process of Abstract Expressionism, Minimal-

ism, like Color Field painting, eliminates all sense of the artist's role in the work, leaving only the medium for viewers to contemplate. There is no reference to narrative or to nature, and little content beyond the medium. The impersonal character of Minimalist sculptures is intended to convey the idea that a work of art is a pure object having only shape and texture in relation to space.

Donald Judd

Untitled (fig. **28.22**) by Donald Judd (1928–1994) is a set of rectangular "boxes" derived from the solid geometric shapes of David Smith's *Cubi* series (see fig. 27.28) and the "minimal" simplicity of Ad Reinhardt (see fig. 27.18). Judd's boxes, however, do not stand on a pedestal. Instead, they

28.22 Donald Judd, *Untitled*, 1967. Green lacquer on galvanized iron; each unit 9 × 40 × 31 in. (22.9 × 101.6 × 78.7 cm). Museum of Modern Art, New York. Helen Achen Bequest and gift of Joseph A. Helman.

hang from the wall, thereby involving the immediate environment in the viewer's experience of them. They are made of galvanized iron and painted with green lacquer, reflecting the Minimalist preference for industrial materials. Judd has arranged the boxes vertically, with each one placed exactly above another at regular intervals, to create a harmonious balance. The shadows cast on the wall, which vary according to the interior lighting, participate in the design. They break the monotony of the repeated modules by forming trapezoids between each box, and between the lowest box and the floor. The shadows also emphasize the vertical character of the boxes' alignment by linking them visually and creating the impression of a modern, nonstructural pilaster.

Dan Flavin

Light was the primary medium of the Minimalist fluorescent sculptures of Dan Flavin (1933–1996). As store-bought objects transformed into "art" by virtue of the artist's in-

tervention, they can be related to Duchamp's Ready-Mades. Flavin defines interior architectural spaces with tubes of fluorescent lights arranged in geometric patterns or shapes. Light spreads from the tubes and infiltrates the environment, creating an installation within an available space. The technological character of the medium and its impersonal geometry is typical of the Minimalist aesthetic. Sometimes, as in *Untitled* (*in Honor of Harold Joachim*) (fig. **28.23**), the color combinations are unexpected. Flavin's merging of light and color, dependent as it is on technology and twentieth-century nonrepresentation, nevertheless has a spiritual quality that ironically allies his work with stained-glass windows and the play of light and color inside Gothic cathedrals (see fig. 11.33).

Flavin described this work as a "corner installation . . . intended to be beautiful, to produce the color mix of a lovely illusion. . . . [He] did not expect the change from the slightly blue daylight tint on the red rose pink near the paired tubes to the light yellow midway between tubes and the wall juncture to yellow amber over the corner itself."[1]

CONNECTIONS

See figure 11.33. Nave, Reims Cathedral, 1211–c. 1290.

28.23 Dan Flavin, *Untitled* (*in Honor of Harold Joachim*), 1977. Fluorescent light fixtures with pink, blue, green, and yellow tubes; 8 ft. (2.44 m) square across the corner. Courtesy, Dia Center for the Arts, New York.

Agnes Martin

The early work of Agnes Martin (1912–2004) was an inspiration to the Minimalists, but she developed in a more painterly direction. She was born in Saskatchewan, Canada, and moved to the United States in the 1930s. Her first one-woman show was held at the Betty Parsons Gallery in New York City. Martin's early allover grid paintings consist of grids penciled by hand that criss-crossed the canvas, which appear, like Minimalist sculpture, to "minimalize" the presence of the artist. In contrast to the Minimalists, however, she fills the picture with glowing color that seems to radiate from an inner mental landscape projected beneath the material surface of the finished work. In so doing, she reveals affinities with the vast—because conceptually vast—pictorial spaces of Ad Reinhardt and Mark Rothko.

From 1967 to 1974, Martin took a "sabbatical" from painting and traveled through Canada and the American West, finally settling into an isolated existence in New Mexico. When she returned to painting in the 1970s, her work had changed, progressing even further beyond the material world—possibly influenced by her interest in Far Eastern philosophy. *Untitled #9* (fig. **28.24**) is an example of her work in 1990. The allover grid has been replaced by gray horizontal bands that potentially extend beyond the confines of the frame. Their geometry and the fact that the grays lighten as they rise present an image that combines the structure of architecture with the changing, cyclical quality of nature.

The following excerpts from Martin's writings were selected to accompany her exhibition of 1992–1993 at the Whitney Museum of American Art in New York:

I didn't paint the plane
I just drew this horizontal line
Then I found out about all the other lines
But I realized what I liked was the horizontal line

Art restimulates inspirations and awakens sensibilities
That's the function of art

Any thing is a mirror.
There are two endless directions. In and out.[2]

28.24 Agnes Martin, *Untitled #9*, 1990. Synthetic polymer and graphite on canvas; 6 × 6 ft. (1.83 × 1.83 m). Whitney Museum of American Art, New York (Gift of the American Art Foundation 92.60).

28.25 Eva Hesse, *Metronomic Irregularity I,* 1966. Painted wood, sculpmetal, and cotton-covered wire; 12 × 18 × 1 in. (30.5 × 45.7 × 2.5 cm). Collection, Robert Smithson, New York. © The Estate of Eva Hesse. Museum Wiesbaden.

Eva Hesse

The American sculptor Eva Hesse (1936–1970) took Minimalism in a new direction by consciously "writing" her autobiography into her work. As a result, she is sometimes referred to as a Post-Minimalist. She was born a Jew in Hamburg, Germany, and was taken to Amsterdam to escape Nazi persecution. After a few traumatic years, she went with her family to New York, where her mother killed herself. Hesse's psychological difficulties and sense of abandonment found expression in an art that was rooted in the forms and materials of Minimalism. She studied at the Yale School of Art, where she came under the influence of Josef Albers, and after graduation returned to Germany. She had her first solo exhibition in Düsseldorf in 1965, and, by the time of her own early death at the age of thirty-four, she had produced an influential body of work.

Hesse's *Metronomic Irregularity I* of 1966 (fig. **28.25**), the first in a series of three, explores the relationship of line to plane in a literal way. The surfaces of the rectangles are inscribed with a grid pattern; there is a small hole in the corner of each square of the grid. White cotton-covered wires are threaded from holes in one rectangle through holes in another. Formally, Hesse has juxtaposed actual, three-dimensional lines (the threads) with the flat planes of the two vertical plaques. The space between them participates in the image, creating a nonrepresentational triptych in which medium and content converge. From an autobiographical point of view, one can read the threads as attachments, binding together the plaques across a space, as a metaphor for Hesse's fear of separation and abandonment, and also as links between her two identities, German and American. Her lifelong sense of anxiety is perhaps reflected in the frantic, though lyrical, quality of the connecting threads.

28.26 Eva Hesse, *Laocoön*, 1966. Acrylic paint, cloth-covered cord, wire, and papier-mâché over plastic plumber's pipe; 120 × 24 × 24 in. (304.8 × 61.0 × 61.0 cm). Allen Memorial Art Museum, Oberlin College, Ohio. Fund for Contemporary Art and gift of the artist and the Fischbach Gallery, 1970.

A similar aesthetic informs Hesse's *Laocoön* of the same year (fig. **28.26**). This work, too, although not part of a series, evolved in stages. A vertical armature of plastic pipes—a combination ladder and scaffold—is wrapped in cloth. Cloth-covered cords are intertwined around the open cubes, animating their spaces.

Hesse's sense of irony and identification with the work is clear from its title, which refers to the second-century-B.C. Hellenistic sculpture *Laocoön and His Two Sons* (see fig. 5.75). Hesse's cords bind her armature just as, in the Greek statue, the snakes bind and connect the figures. But Laocoön's snakes are also the messengers and instruments of his death. Just as the snakes envelop and kill the Trojan seer and his two sons, so the cords seem both to connect and to strangle Hesse's structure. The structure is herself, uncannily prefiguring her own death from a brain tumor four years later. "My life and art," she said, "have not been separated. They have been together."[3]

———— CONNECTIONS ————

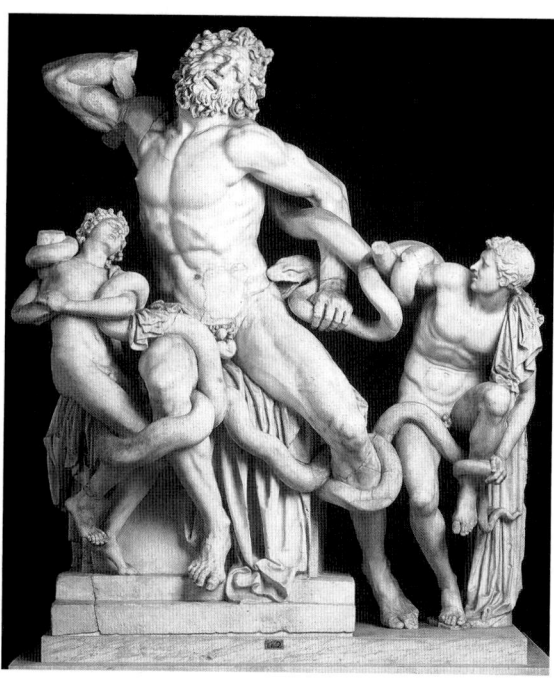

See figure 5.75. *Laocoön and His Two Sons.*

Action Sculpture: Joseph Beuys

The German artist Joseph Beuys (1921–1986), like Eva Hesse, was significantly affected by World War II, although in an entirely different way. He flew a Stuka for the Luftwaffe and was shot down by the Russians in 1943. This led Beuys to construct an autobiographical myth that continually informed his art and has become a staple of art-world mythology. According to Beuys, he was rescued by Tartars (a Mongolian people of central Asia) and wrapped in animal fat and felt, which kept him alive. Beuys viewed this event as a kind of resurrection through which he identified with Christ. Influenced by German Romanticism and Germanic myth, and impelled to atone for the German atrocities in the war, Beuys was drawn to mysticism and spirituality, and projected the self-image of a shaman on an international scale. As such, he set out to cure the social, economic, and political ills of the world. To this purpose he dedicated thousands of drawings, sculptures, and, above all, a series of carefully choreographed so-called "action sculptures" with moving figures and music, conceived of as neither happenings nor performances, but containing elements of both.

Like Marc, Beuys believed in the spirituality of animals and, like Kandinsky, in the spiritual in art (see Chapter 24). As a shaman, he experimented with the boundary between human and animal, just as politically he worked toward peace among nations and cultures by crossing borders and merging boundaries. On July 20, 1964 (the anniversary of the unsuccessful attempt on Hitler's life), for example, Beuys staged a performance in the cathedral at Aachen, where Charlemagne (see Chapter 9) had his court in the ninth century. Disrupted by Neo-Nazi students, Beuys became even more politically engaged, founding several leftist groups, including the predecessor to the Green party.

Individual works of sculpture such as the *Fat Chair* (a chair wrapped in fat) and *Ur-Sled* (composed of an orange box, ribbon, and fat), both of 1964, were inspired by his rescue. Other materials that were relics from his war experiences were batteries and transistors, and these, like the fat, assumed the quality of religious icons for Beuys.

The Pack of 1969 (fig. **28.27**) creates the impression of a sculpture in the process of becoming. It shows twenty sleds emerging from the back of a Volkswagen bus. Each sled carries a felt blanket roll, fat, and a flashlight, all elements Beuys associated with his rescue by the Tartars in a Russian snowstorm. Their nomadic form of transportation is juxtaposed with the vehicle (*wagen*) of the "civilized" German people (*volk*), which is a reference to World War II. The arrangement and forms of the sleds animate them; they resemble enlarged insectlike creatures pouring forth from the bus and rushing to a scene of rescue. Their runners resemble legs, their flashlights, eyes, and their blanket rolls, bodies.

28.27 Joseph Beuys, *The Pack*, 1969. Volkswagen bus with twenty sleds, felt, fat, and flashlights. Neue Gallery, Staatliche Museen, Kassel.

28.28 and **28.29** Joseph Beuys, *Coyote, I Like America and America Likes Me,* two views of a week-long sequence, 1974. Action sculpture. New York.

In 1973, Beuys became seriously ill and once again associated his recovery with Christ's Resurrection. After that, he lectured passionately about art and the state of the world, writing and drawing on a blackboard before audiences. In 1974, Beuys performed one of his most famous action sculptures, *Coyote, I Like America and America Likes Me* (figs. **28.28** and **28.29**). He arrived in New York and was taken, wrapped in felt, by ambulance to the René Block Gallery. For a week, he and a live coyote performed the sculpture on the floor of the gallery, which had a pile of felt for the coyote to sit on. Fifty copies of the *Wall Street Journal* were placed on the floor every day as a sign of the financial values overwhelming modern culture. Beuys himself was wrapped up in a tentlike felt blanket with a Tartar's crook emerging from the top. As he moved, the coyote moved, and vice versa. Tied together by their gazes, at once uniting them and signifying their mutual suspicion, Beuys and the coyote engaged in a dance calculated, shamanlike, to blur the boundaries between man and animal.

Many meanings have been read into this performance, most based on Beuys's autobiographical myth. The Tartar's felt that kept him alive protects him from the wild animal, while the crook has associations with Christ as the Good Shepherd. To celebrate the plane crash and subsequent rescue at the Eurasian border of two continents, Beuys tries to bridge the borders of human and animal, of the Native American worship of the coyote and the white man's fear and hatred of it, and of modern commercial society and the values of a less technological age.

The aesthetic quality of the action sculpture is in the planned and unplanned movements and positions of the two performers, and the lighting and setting as captured by the camera. Figure 28.28 shows the coyote gazing fixedly at the triangular felt "tent," with the crook protruding at the top in the manner of a Native American tepee. Backlit from the window at the left, the coyote and the tent create stark silhouettes against the back wall. Both are static, frozen in space. In figure 28.29, the close-up camera angle captures the simultaneity of movement as both figures now turn in space, and the diagonal of the coyote's head and neck parallels that of the crook. The nature of the relationship, Beuys seems to be saying, moves dynamically from enmity, to suspicious contemplation and mutual assessment, to harmony. Such was his program for the world.

Conceptualism: Joseph Kosuth

For Beuys, thinking about art was creative, and therefore the idea itself was a work of art. In that view, he had affinities with the Conceptual artists of the 1960s, who wanted to extend Minimalism so that even the materials of art would be eliminated, leaving only the idea, or concept, of the art. Like Duchamp and the Dadaists, for the Conceptualists the mental concept takes precedence over the object. This is also related to the Minimalist rejection of the object as a consumer product. Although the term itself was coined in the 1960s, Conceptual art attained official status through the 1970 exhibition at the Museum of Modern Art, New York. The show's title—*Information*—reflected the emphasis of Conceptual art on language and text, rather than on imagery.

Some Conceptual works combine objects with text, and others, such as Joseph Kosuth's (born 1945) *Art as Idea as Idea* of 1966 (fig. **28.30**), consist only of text. The "text" in this instance is composed of five dictionary definitions of the noun *painting*. Definition numbers 4 and 5, which are marked "Obs.," or "obsolete," describe the term in its most painterly ("colors laid on") and pictorial ("vivid image") sense. Their "obsolescence," therefore, is consistent with the takeover by the idea and with the presumed demise of the object. At the same time, however, Kosuth presents the text as a photographic enlargement within a pictorial field. As a result, the text is as much an "object" as it is the expression of an idea.

28.30 Joseph Kosuth, *Art as Idea as Idea*, 1966. Mounted photostat; 4 × 4 ft. (1.22 × 1.22 m).

tual space between words and pictures—children "read" pictures and objects before they read words. And animals, like the ancient Greek horse who neighed at the painted horse of Zeuxis and the birds who tried to eat his painted grapes, read images but not words. Conceptual art makes images of words by arranging ideas conveyed through words on a pictorial surface.

The 1960s was a decade of social and political upheaval both in the United States and in western Europe. It culminated in the Paris riots of May 1968, campus takeovers by college students, and radical changes in educational curricula. The burgeoning women's movement, advances in civil rights—especially in the United States—and, above all, the Vietnam War contributed to the cultural turmoil. In the arts, these currents were expressed in the "here and now" character of the Happenings and other types of artistic performances, in the protests against commercialism implied by some Pop Art, in the withdrawal from figuration by the Minimalists, and in the exaltation of the idea by the Conceptualists.

The contradictory aspect of the 1960s, in which two generations clashed over social and political issues, was reflected in the arts. On the one hand, Pop artists imposed the "object" by making it a central image, and, on the other hand, they protested against the abuses of materialism and the profit motives of industry. Minimalists avoided the "figurative" object in favor of geometric form but used industrial materials to do so. In the next and final chapter, we shall see that it is in the nature of art to evolve dynamically by continually responding to the past, while also "pushing the envelope" into the future.

The dichotomy of words and pictures, which Magritte portrayed in *The Betrayal of Images* (see fig. I.5), is a subtext of Kosuth's *Art as Idea as Idea*. Due to the flat, empty space between Magritte's "pipe" and his written words, the artist "pictures" the developmental and concep-

See figure I.5. René Magritte, *The Betrayal of Images*, 1928.

	Style/Period	Works of Art	Cultural/Historical Developments
1950	POP ART, OP ART, MINIMALISM, AND CONCEPTUALISM 1950–1960	Hamilton, *Just what is it that makes today's homes so different, so appealing?* (**28.1**) Johns, *Three Flags* (**28.2**)	Fidel Castro becomes premier of Cuba (1959) Charles de Gaulle proclaimed president of Fifth Republic (1959)
1960	1960–1970	Johns, *Painted Bronze (Ale Cans)* (**28.3**) Rivers, *Portrait of Frank O'Hara* (**28.4**) Warhol, *Elvis I and II* (**28.7**) Segal, *Cinema* (**28.18**) Lichtenstein, *Torpedo . . . Los!* (**28.8**) Rauschenberg, *Retroactive I* (**28.5**) Wesselmann, *Great American Nude No. 57* (**28.12**) Lichtenstein, *Little Big Picture* (**28.9**) de Saint-Phalle, *Black Venus* (**28.20**) Hesse, *Metronomic Irregularity I* (**28.25**) Hesse, *Laocoön* (**28.26**) Kosuth, *Art as Idea as Idea* (**28.30**) Lindner, *Rock-Rock* (**28.10**) Oldenburg, *Soft Switches* (**28.14**) Judd, *Untitled* (**28.22**) Kitaj, *Juan de la Cruz* (**28.11**) Warhol, *Campbell's Soup I (Tomato)* (**28.6**) Beuys, *The Pack* (**28.27**)	Cuban missile crisis (1962) Rachel Carson, *Silent Spring;* start of environmentalist movement (1962) Edward Albee, *Who's Afraid of Virginia Woolf?* (1962) Mary McCarthy, *The Group* (1963) Betty Friedan's *Feminine Mystique* launches the women's movement (1963) John Le Carré, *The Spy Who Came in from the Cold* (1963) Assassination of President John F. Kennedy (1963) Civil rights bill bans discrimination in voting, jobs, etc. (1964) *Autobiography of Malcolm X* (1964) First rock musical, *Hair* (1967) Assassination of Martin Luther King, Jr. (1968) John Updike, *Couples* (1968) Joe Orton, *Loot* (1968) Philip Roth, *Portnoy's Complaint* (1969) Music festival at Woodstock, New York, attracts half a million people (1969) *Apollo II* lands on the moon (1969) Student riots in United States and Europe (late 1960s) Gay liberation movement begins (late 1960s)
1970	1970–1980	Oldenburg, *Soft Light Switches—Ghost Version* (**28.15**) Beuys, *Coyote* (**28.28–28.29**) Riley, *Aubade (Dawn)* (**28.21**) Oldenburg, *Clothespin* (**28.16**) Flavin, *Untitled* (in Honor of Harold Joachim) (**28.23**)	Sylvia Plath, *The Bell Jar* (1971) *Grease* (Tom Moore, director) (1972) U.S. Supreme Court legalizes abortion (1973) End of Vietnam War (1973) DNA recombined for the first time; birth of genetic engineering (1973) Nixon resigns U.S. presidency after Watergate scandal (1974) Aleksandr Solzhenitsyn, *The Gulag Archipelago* (1974) Saul Bellow, *Humboldt's Gift* (1976) Alex Haley, *Roots* (1976) David Mamet, *American Buffalo* (1977) Woody Allen, *Annie Hall* (1977) Mother Teresa wins Nobel Peace Prize (1979) William Styron, *Sophie's Choice* (1979)
1990	1980–1990	Marisol, *The Last Supper* (**28.19**) Segal, *Chance Meeting* (**28.17**) Martin, *Untitled #9* (**28.24**) Thiebaud, *Thirteen Books* (**28.13**)	

Johns, Three Flags

Lichtenstein, Little Big Picture

Warhol, Cambell's Soup I

Flavin, Untitled

Beuys, Coyote

Thiebaud, Thirteen Books

Warhol, Elvis I and II

29

Innovation, Continuity, and Globalization

A s we respond to contemporary art, our sense of historical perspective inevitably diminishes. The more recent the development or style, the more necessary the passage of time before one can properly evaluate a work of art and assess whether or not it will endure. Accordingly, of all the chapters in this survey, this one is the most subject to revision.

Continuing Controversy: Government Funding of the Arts

The difficulty in assessing the artistic value of a work of one's own time was reflected in the 1927 trial over whether Brancusi's *Bird in Space* (see fig. I.4) was "art." More recently, from 1989 to 1990, controversial works have raised First Amendment issues of censorship in the United States. The work of two photographers, Andres Serrano (born 1950) and Robert Mapplethorpe (1946–1989), provoked heated national debates over the degree to which freedom of speech in the visual arts should be guaranteed by the Constitution. Both Serrano and Mapplethorpe tested the limits of convention and propriety, and challenged traditional taboos—Serrano in regard to religion, Mapplethorpe in regard to sexuality. Since both artists had been funded, directly or indirectly, by the National Endowment for the Arts (NEA), questions were raised about government funding for the arts in general.

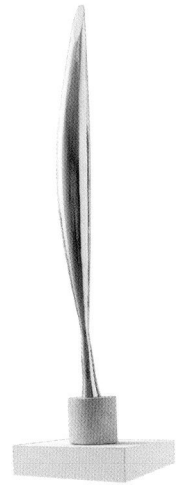

See figure I.4. Constantin Brancusi, *Bird in Space*, 1928.

Andres Serrano

In the 1980s, Serrano (see p. 975) made a series of color photographs (Cibachromes) dealing with Catholic imagery and, in some cases, used body fluids as both subject matter and symbol. For example, he filled with blood a Plexiglas container in the shape of a cross and photographed it against a dazzling sky. He photographed a transparent cross filled with milk, which was immersed in a vat of blood, thereby creating a sharp contrast of red and white. In these images, Serrano evokes traditional Christian iconography, making the "Blood of the Cross" into a concrete form. The reference to milk evokes associations with the Virgin Mary's role as both the mother of Christ and the maternal intercessor for all Christians. More controversial was the artist's photograph of his own semen in the form of an illuminated streak against a dark background. Such content reflects Serrano's interest in the life forces that are normally contained within the body and hidden from view.

The work that ultimately caused a furor and brought Serrano into the limelight was his photograph of a Crucifixion set against a red background and lit up as if by a flash of soft, yellow light. The latter turned out to have been the artist's urine, which he had saved up and into which he had immersed a plastic Crucifix. By calling the work *Piss Christ,* Serrano left viewers in no doubt about the nature of his media.

Piss Christ was included in a group exhibition of 1989—*Awards in the Visual Arts 7*—which had been arranged by the Southeastern Center for Contemporary Art (SECCA), in Winston-Salem, North Carolina. Serrano was one of ten artists chosen from 599 entries and was awarded a $15,000 grant. The show ran in the Los Angeles County Museum and in the Carnegie-Mellon University Art Gallery in Pittsburgh without incident. But after it closed at the Museum of Fine Arts in Richmond, Virginia, a letter of protest was published on Palm Sunday in the *Richmond Dispatch Times.* The author of the letter accused the museum of promoting "hatred and intolerance" and asked whether Christianity had "become fair game in our society for any kind of blasphemy and slander."

Piss Christ then came to the attention of the Reverend Wildmon, who had founded the National Federation of Decency (later renamed the American Family Association). Wildmon objected to Serrano *and* the NEA, and exhorted his supporters to write to Congress and the NEA, which they did by the thousands. Wildmon referred to the work as "hate-filled, bigoted, anti-Christian, and obscene art." In response, factions of the art world organized an Art Emergency Day—August 26, 1989.

Wildmon's vilification of the NEA was endorsed by Senators Alfonse D'Amato (R-NY) and Jesse Helms (R-NC), the evangelist Pat Robertson, and army colonel Oliver North. Of Serrano, Helms declared: "He is not an artist, he is a jerk. Let him be a jerk on his own time and with his own resources. Do not dishonor our Lord."[1]

Robert Mapplethorpe

In 1989, federal funding also went to Mapplethorpe, whose subject matter ranges from flowers, to portraits, to nude studies, to frankly homosexual and sadomasochistic acts. From December 9, 1988, to January 29, 1989, Mapplethorpe exhibited 175 photographs at the Philadelphia Institute of Contemporary Art. Funded by the NEA, the show was entitled *Robert Mapplethorpe: The Perfect Image*. It included three portfolios—the 1978 X-Portfolio depicting some homosexual and sadomasochistic scenes, the 1978 Y-Portfolio depicting flowers, and the 1981 Z-Portfolio of black men, mainly shown in Classical poses. From February 25 to April 9, 1989, the show was held in Chicago, where it was well attended.

Problems for Mapplethorpe began in Washington, D.C., in the midst of the Serrano controversy. Senator Helms cited the Mapplethorpe grant as another example of irresponsible NEA funding, whereupon the exhibition of photographs at the Corcoran Gallery (scheduled to open July 1, 1989) was canceled by the director. The works were shown instead in an alternative space—the Washington Project for the Arts. Subsequent scheduled stops at the Wadsworth Athenaeum, in Hartford, Connecticut, and at the University Art Museum in Berkeley, California, were quite successful.

Meanwhile, a five-year moratorium on funding for the SECCA was proposed by the Senate. NEA funding was cut by $45,000, equivalent to the $15,000 grant to Serrano and the $30,000 grant to Philadelphia for the Mapplethorpe exhibition. Congress also approved a one-year ban on government grants to artists who depict obscene or perverse subjects, or who exploit children for sexual purposes, provided that their work has no "serious literary, artistic, political, or scientific value."

Robert Mapplethorpe: The Perfect Image hit a new and unprecedented snag on the way to Cincinnati, Ohio. Dennis Barrie, director of the Contemporary Arts Center in that city, had decided—over local protests—that the show would go on. It was scheduled to open on April 6 and to run until May 27, 1990. But, bowing to propriety, Barrie planned to segregate the X-Portfolio in a separate room and to exclude visitors under the age of eighteen. In addi-

29.1 Robert Mapplethorpe, *Self-Portrait*, 1980. Unique gelatin silver print; 30 × 30 in. (76.2 × 76.2 cm). Collection, Howard and Suzanne Feldman.

tion, a notice posted outside the X-rated area served as a warning that sexually explicit photographs were on view.

In Washington, the first Bush administration took a stand against censorship and supported the NEA. Performers and arts administrators lobbied Congress on behalf of First Amendment protection for the arts. But in Cincinnati, there was a flurry over "moral values." The Cincinnati Citizens for Community Values mounted vigorous opposition to the show. Editorials and caricatures flooded the press. In the March 24 edition of the *Cincinnati Enquirer,* three medical doctors argued against the show on the grounds that it was an attack on civilized society. Local law-enforcement officials declared Mapplethorpe's pictures "criminally obscene." The chief of police warned, "There are no raving Neanderthals running amok in the streets of Cincinnati."[2] Cincinnati was, after all, the headquarters of the National Coalition against Pornography and was noteworthy for the absence of peep shows, X-rated movies, adult bookstores, and the like.

The city also had its art lovers, for membership in the Contemporary Arts Center rose by 40 percent. A poll published by the *Cincinnati Post* on April 13 indicated that 59 percent of those questioned were in favor of the show, 39 percent were opposed to it, and 3 percent had no opinion. Three days later, *Newsweek* published Mapplethorpe's 1980 *Self-Portrait* (fig. **29.1**) with the caption "Eye of the Storm." Although this photograph is not as graphic as some from the X-Portfolio, it clearly reveals Mapplethorpe's identification with homosexual themes. Here, he represents himself partly as a transvestite, partly as an androgynous, male–female figure. He plays with the boundaries of gender and with the limits of sexual identity. The image itself is beautifully printed, and, as with all his black-and-white photographs, the forms are imbued with a soft, silver glow.

On April 7, an Ohio grand jury indicted the Arts Center and its director on obscenity charges. These focused on five pictures showing homosexual acts and on two pictures of children with their genitals exposed. The following day, a federal district judge ruled that the exhibition could not be shut down, pending the outcome of the trial. The director, Dennis Barrie, pleaded not guilty, and the trial began on September 24 before a jury of four men and four women, none of whom was particularly interested in art.

The art world, including prominent museum directors, came out in force to testify for the defense. The position of the defense resembled that of the modernists in the 1927 Brancusi trial—namely, that works in museums, like works made by artists, are, by definition, ART. And, they further argued, artistic statements made by artists are protected by the First Amendment. At one point, the prosecutor asked the jury to consider whether the offending photographs were "van Goghs," as if that were the ultimate criterion. The irony of that question, rhetorical as it may have been, lies in the fact that van Gogh's paintings were not considered ART by the prevailing taste of his own generation and that van Gogh lived in poverty because no one would buy his pictures. Recourse to the example of van Gogh is thus a risky business when arguing the cause of aesthetic judgment.

After five days of testimony, the judge instructed the jury on the legal test for obscenity: "That the average person applying contemporary community standards would find that the picture, taken as a whole, appeals to prurient interest in sex, that the picture depicts or describes sexual conduct in a patently offensive way and that the picture, taken as a whole, lacks serious literary, artistic, political, or scientific value." The jury deliberated for two hours and on October 5 acquitted both the museum and Barrie. When the jurors were interviewed later, one stated: "We learned that art doesn't have to be pretty."

When the Mapplethorpe show closed in Cincinnati, it traveled to Boston's Institute of Contemporary Art, where it was exhibited without incident.

In 1999, Mayor Giuliani of New York City sued to close the Brooklyn Museum over an exhibit of young British artists entitled *Sensation*. In that case, the mayor had not seen the show, but he professed outrage at a painting of the Virgin with a small lump of dried elephant dung on one breast. Unfortunately, the impulsiveness of the mayor's rush to judgment exposed his own lack of contextual knowledge, for in parts of Africa—where the artist had been raised—elephant dung was endowed with magic properties. Whatever the aesthetic value of the work turns out to be, it was neither pornographic nor an offense in the context of the history of Christian art. In any case, the media attention given to the uproar and the money spent on lawyers show that debates over censorship of the arts, as well as government funding, are likely to continue. The controversies over such works of art, some of which challenge convention, tradition, and even propriety, are evidence of the continuing power of images.

Performance

Gilbert and George

Two English performing artists, Gilbert (Proesch, born 1943) and George (Passmore, born 1942), created a series of performances related to the "happenings" of the 1960s and became their own works of art. Figure **29.2** illustrates a 1969 performance of their much-repeated piece, *Singing Sculptures,* in which they mimed in slow motion to a recording of an old English music-hall song while standing on a low platform. They gilded their faces and hands and wore business suits. Their only props were Gilbert's cane and George's gloves. This and similar performances raised the issue of the boundary between artists and their work. By describing themselves as "living sculptures," Gilbert and George explored the ambiguous transitional space between living and nonliving, and between illusion and reality.

29.2 Gilbert and George, *Singing Sculptures,* 1971.

29.3 Laurie Anderson, *Nerve Bible Tour*, 1995.
Photo: Adriana Friere.

Laurie Anderson

The multimedia performance art of Laurie Anderson (born 1947) uses photography, video, film, and music. Her message, which is typically delivered in spoken narrative, is political and social. Figure **29.3** is a still from the *Nerve Bible Tour* in July 1995 at the Park Theater in Union City, New Jersey. Anderson describes her performances as being "about a collaboration between people and technology." Like Gilbert and George, she participates as an actor in her own work of art. In so doing, she explores the boundary between artist and art, subject and object, and the natural and the technological worlds.

Return to Realism

With the development of photography in the nineteenth century, artists found a new medium for capturing a likeness. Many painters and sculptors used photographs to decrease the posing time of their sitters. In the late 1960s, the popularity of photography, its relationship to Pop Art, and the belief that it permits an objective record of reality led to the development of Super Realism.

Chuck Close

In his 1968 study for *Self-Portrait* (fig. **29.4**), Chuck Close (born 1940) used a grid to convert a photographic image—in this case a black-and-white passport-style close-up of his own head—into a painting. The final picture conveys a sense of rugged monumentality. Because the face is frontal and seen from slightly below the chin, the nose and cigarette are foreshortened. At the same time, there is an interplay between the curvilinear strands of the hair and the textures of the flesh. Up to 1970, it was Close's habit to paint mainly in black and white, as here, and to use an airbrush to create a smooth surface. The result is a work that resembles a photographic enlargement and, in a sense, forms a transition between painting and photography.

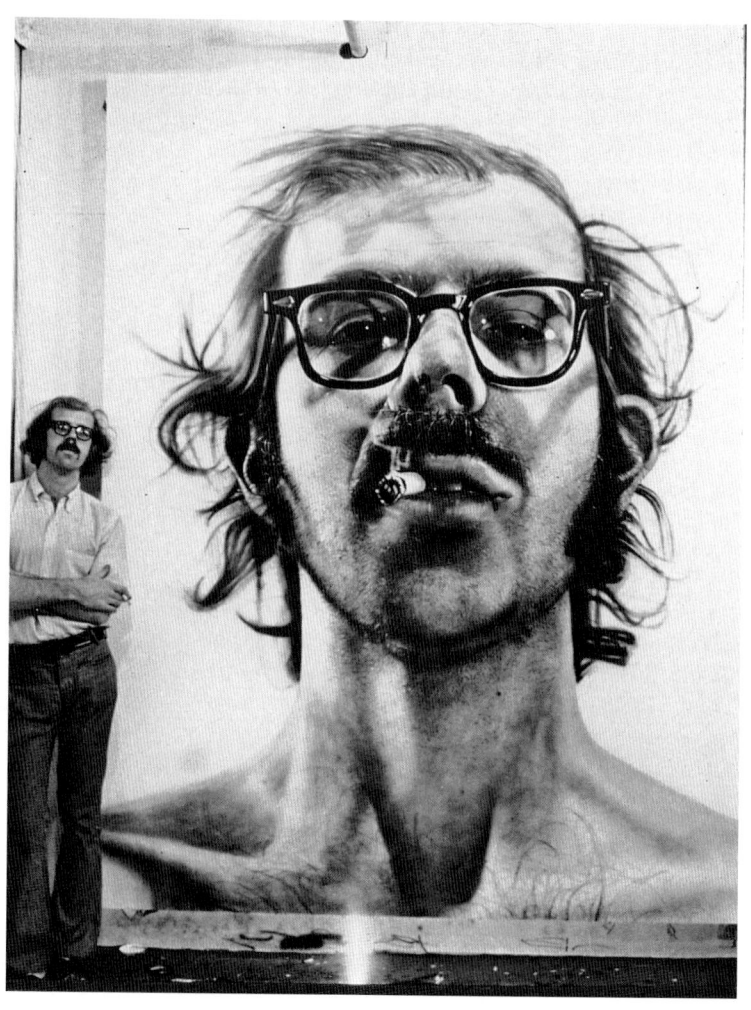

29.4 Chuck Close, *Self-Portrait*, 1968. Acrylic on canvas; 9 × 7 ft. (2.74 × 2.13 m). Photo Kenny Lester, courtesy of the Pace Gallery, New York. The grid used to transfer this image from a photograph to a painting consisted of 567 squares ruled on a piece of paper measuring 14 × 11 inches (35.6 × 27.9 cm). The photographic data in each small square were enlarged to fill squares of approximately 16 square inches (103 cm²).

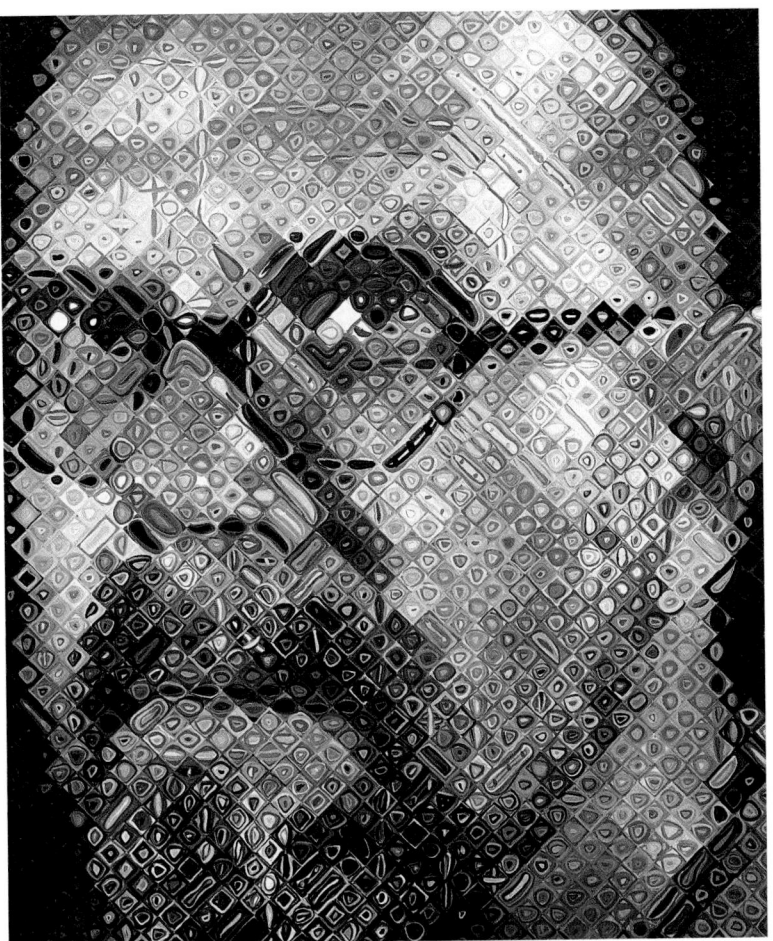

29.5 Chuck Close, *Self-Portrait*, 1997. Oil on canvas; 8 ft. 6 in. × 7 ft. (2.59 × 2.13 m). Pace Wildenstein Gallery, New York.

For the past thirty years, Close has been creating portraits of art-world figures. He is the first artist in the history of art to produce a large body of work consisting of portraits of other artists, appropriating them for a new brand of iconography. Figure **29.5** is an example of his more recent work, his *Self-Portrait* as a close-up, still based in photography but painstakingly painted, colored square by colored square. Combining the crystalline structure of Cubism with the illusion of a computer-derived image, and assembling the building blocks of paint as if each were a mosaic *tessera*, Close creates a head that emerges in a blaze of light and color from the black edge of the picture plane.

Richard Estes

One of the most prominent Super Realist painters is Richard Estes (born 1936). His oil paintings resemble color photographs, although they are on a larger scale and are more crisply defined than a photograph of similar size would be. His *Williamsburg Bridge* of 1987 (fig. **29.6**) combines an urban landscape with the reflections of steel, chrome, and glass. Divided by the strong vertical accent of the red subway car, the painting is an optical play between the interior on the left and the exterior, visible through the window of the car, on the right. The self-absorption of the subway riders contrasts with the moving cars and distant city skyline on the right. As in the Renaissance, Estes's illusionistic effects are enhanced by the use of linear perspective.

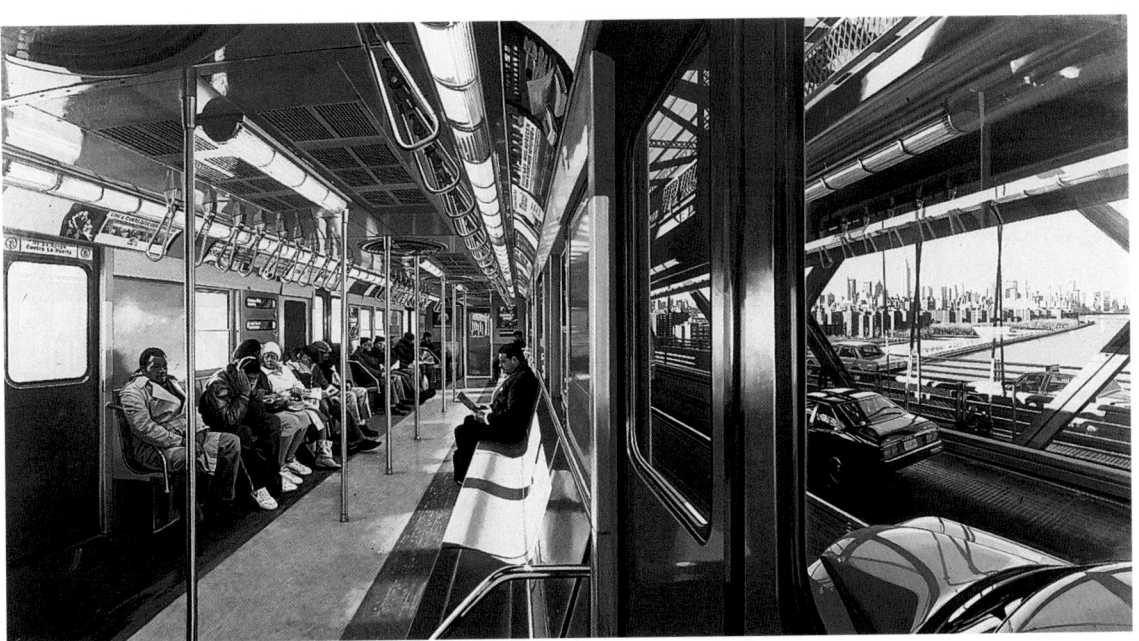

29.6 Richard Estes, *Williamsburg Bridge*, 1987. Oil on canvas; 3 ft. × 5 ft. 6 in. (0.91 × 1.68 m). Courtesy, Allan Stone Gallery, New York. Estes assembles color photographs and re-creates the scene with brushes and oil on canvas. "The incorporation of the photograph into the means of painting," he wrote, "is the direct way in which the media have affected the type of painting. That's what makes New Realism new."[3]

Duane Hanson

The Super Realist sculptures of the American artist Duane Hanson (1925–1996) are striking for their illusionism. Whereas no one would mistake Gilbert and George for actual sculptures or Close's portraits for the figures themselves, Hanson's sculptures are often taken for real people. As in the allover white plaster figures of George Segal, Hanson's sculptures are created directly from the models themselves. His convincing *trompe-l'oeil* illusionism is reminiscent of ancient Greek legends about the artist Daedalos, who reportedly rivaled the gods by making living sculptures. In clothing his figures, Hanson also evokes Ovid's tale of Pygmalion, the sculptor who dressed and attended to his statue of Galatea as if she were a real woman.

Combined with a contemporary aesthetic and dependence on modern materials, Hanson's *The Cowboy* of 1995 (fig. **29.7**) assumes a traditional *contrapposto* pose. Like Donatello's *David* (see fig. 13.29), despite an entirely different characterization, the *Cowboy* is meditative, gazing downward and forming a closed space within the boundaries of the sculpture. He holds a bridle in his right hand—David holds Goliath's sword—and wears the costume of a canonical American cowboy. His hat, checked shirt, suede vest, dungarees, and leather boots identify the type, whereas the "five o'clock shadow" and the chest hair contribute to the illusion that he is also a specific individual.

CONNECTIONS

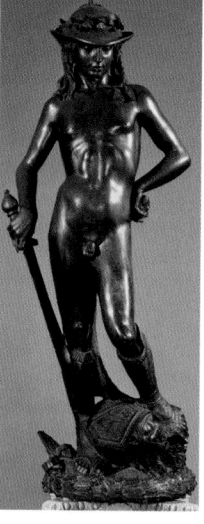

See figure 13.29.
Donatello, *David*,
c. 1430–1440.

29.7 Duane Hanson, *The Cowboy*, 1995. Polyester resin polychromed in oil; life-sized. Hanson molded each section of the model's body and assembled the sections. Flesh-colored polyester resin was then poured in the mold and reinforced with fiberglass. When the mold was broken, the figure was painted and dressed in actual clothing, and real accessories such as hair and glasses were added.

29.8 Ron Mueck, *Mask II*, 2001. Mixed media; 30⅜ × 33½ in. (77.2 × 85.1 cm). Photo courtesy James Cohan Gallery. Mueck began his career working for children's television and then went into advertising and film. He turned from photographing objects to making the object, rather than the photograph, the end product.

Ron Mueck and Constantin Brancusi

More recent examples of Super Realism can be seen in works by the Australian-born Ron Mueck (born 1958), who now lives in London. His intriguing *Mask II* of 2001 (fig. **29.8**), like Hanson's sculptures, is made of modern materials such as fiberglass resin. *Mask II* also seems uncannily alive, despite the absence of a body. The head lies sideways; the eyes are closed, and the lips are parted. The head thus appears to be sleeping, with the slight creases in the forehead suggesting mental activity—as if the figure were dreaming.

In this work, Mueck continues the theme of partial form that characterized the human figures of Rodin and Brancusi (see Chapters 22 and 25). Brancusi produced several versions in bronze and marble of *Sleeping Muse,* which also shows a detached head lying sideways, with closed eyes and an open mouth. But *Sleeping Muse I* (fig. **29.9**) has an abstract, curvilinear quality and a smooth contour that create an impression of elegance. As with *Bird in Space* (see fig. I.4), Brancusi has captured the essence of a figure—in this case, a detached head replicating the detachment of sleep. Mueck's head, in contrast, is very much present by virtue of its "in your face" realism.

29.9 Constantin Brancusi, *Sleeping Muse I*, 1909–1910. Marble; 6¾ × 10⅞ × 8⅜ in. (17.2 × 27.6 × 21.2 cm). Hirshhorn Museum and Sculpture Garden, Smithsonian Institution, Washington, D.C. (Gift of Joseph H. Hirshhorn, 1966, 66.610).

Developments in Architecture

Estes's Super Realist painting of the Guggenheim Museum (fig. **29.10**) illustrates the exterior of Frank Lloyd Wright's impressive building in New York City. Its purpose was to house the Guggenheim collection and to provide space for exhibitions of twentieth-century art.

The Guggenheim Museum, New York

Built between 1956 and 1959, somewhat earlier than the other works in this chapter, the Guggenheim embodies the climax of Wright's interest in curvilinear form. Its most distinctive feature is the large inverted cone, which encloses a six-story ramp coiling around a hollow interior.

Natural light enters through a flat skylight. Viewers inside the Guggenheim Museum look at paintings and sculptures as they walk down the ramp, so that they are always slightly tilted in relation to the works of art.

Despite a design that is frankly inconvenient for viewing art, the Guggenheim is itself a monumental work of art. Unlike Wright's Prairie Style architecture (see Chapter 25), it cannot be said to blend into its surroundings. Located on Fifth Avenue directly across from Central Park, the spiral cone can be conceived of organically as growing upward and outward, toward the sky, like the trees opposite. Most observers, however, experience the museum in relation to the neighboring rectangular buildings, which generally tend to become smaller toward the top. These formal anomalies between the Guggenheim and its architectural environment were, for a while, a source of considerable controversy.

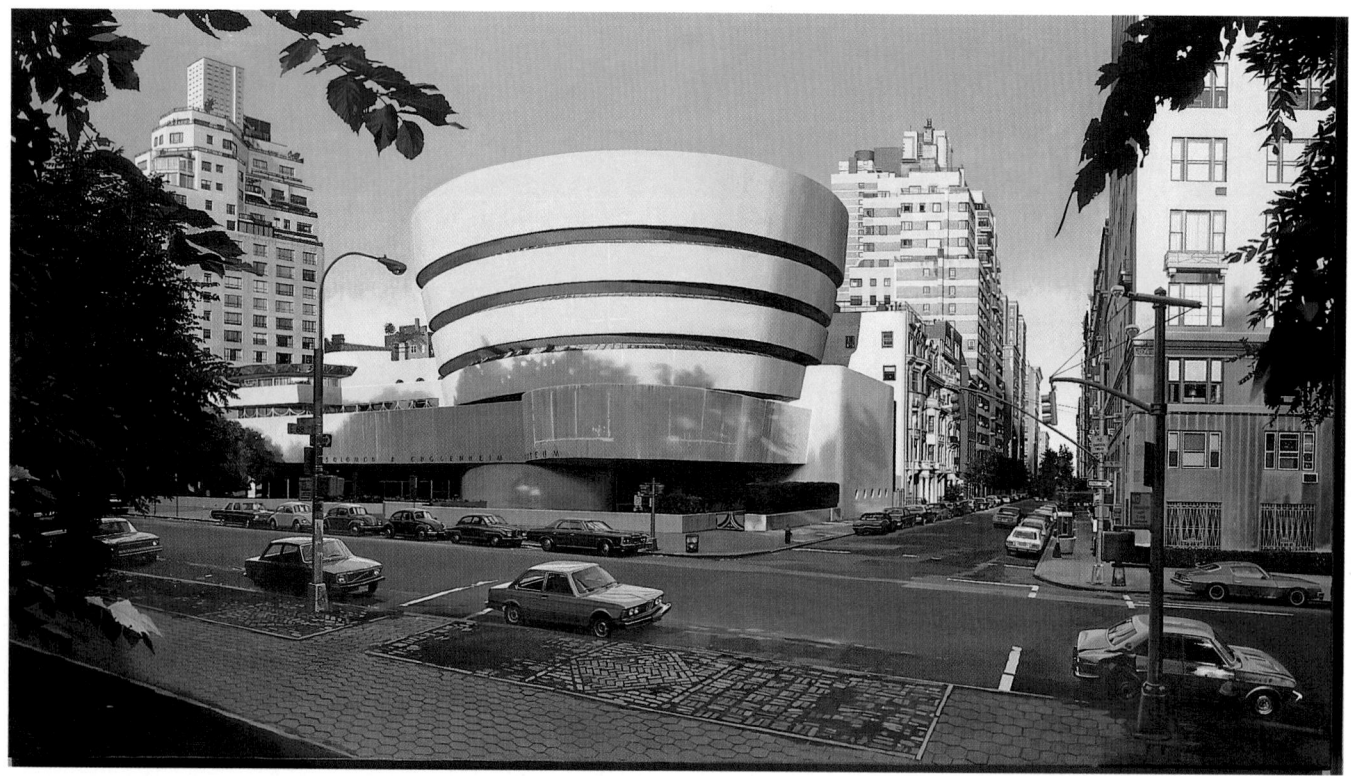

29.10 Richard Estes, *Solomon R. Guggenheim Museum*, 1979. Oil on canvas; 2 ft. 7⅛ in. × 4 ft. 7⅛ in. (0.79 × 1.40 m). Solomon R. Guggenheim Museum, New York.

Guggenheim Museum Installations: Jenny Holzer and Matthew Barney

The interior of the Guggenheim Museum has provided a unique context for many innovative installation exhibitions devoted to a single artist. In 1989, for example, Jenny Holzer (born 1950) installed a program lasting 105 minutes and consisting of some 330 verbal messages conveyed through vivid colored lights (fig. **29.11**). The view shown here looks toward the skylight at the top of the inverted cone.

Holzer is a Conceptual artist who uses the power of words and texts—carved in stone or signed in neon lights—and combines them with impressive visual form.

Among her groups of messages are *Laments, Truisms, Inflammatory Essays, The Living Series,* and *The Survival Series,* all of which were represented in the Guggenheim installation. She used the circular format of the ramp in a unique way, aligning its spiraling plane with the viewer's sequential reading of texts. Below the skylight on the ground floor of the museum, Holzer arranged in a circle seventeen red granite benches inscribed with verbal messages. She thus juxtaposed the age-old tradition of inscribing texts in stone with the more transitory electronic media of the modern era.

In 2003, the Guggenheim Museum became the site of a complex installation by Matthew Barney (born 1967) entitled *The Cremaster Cycle.* This was an elaborate

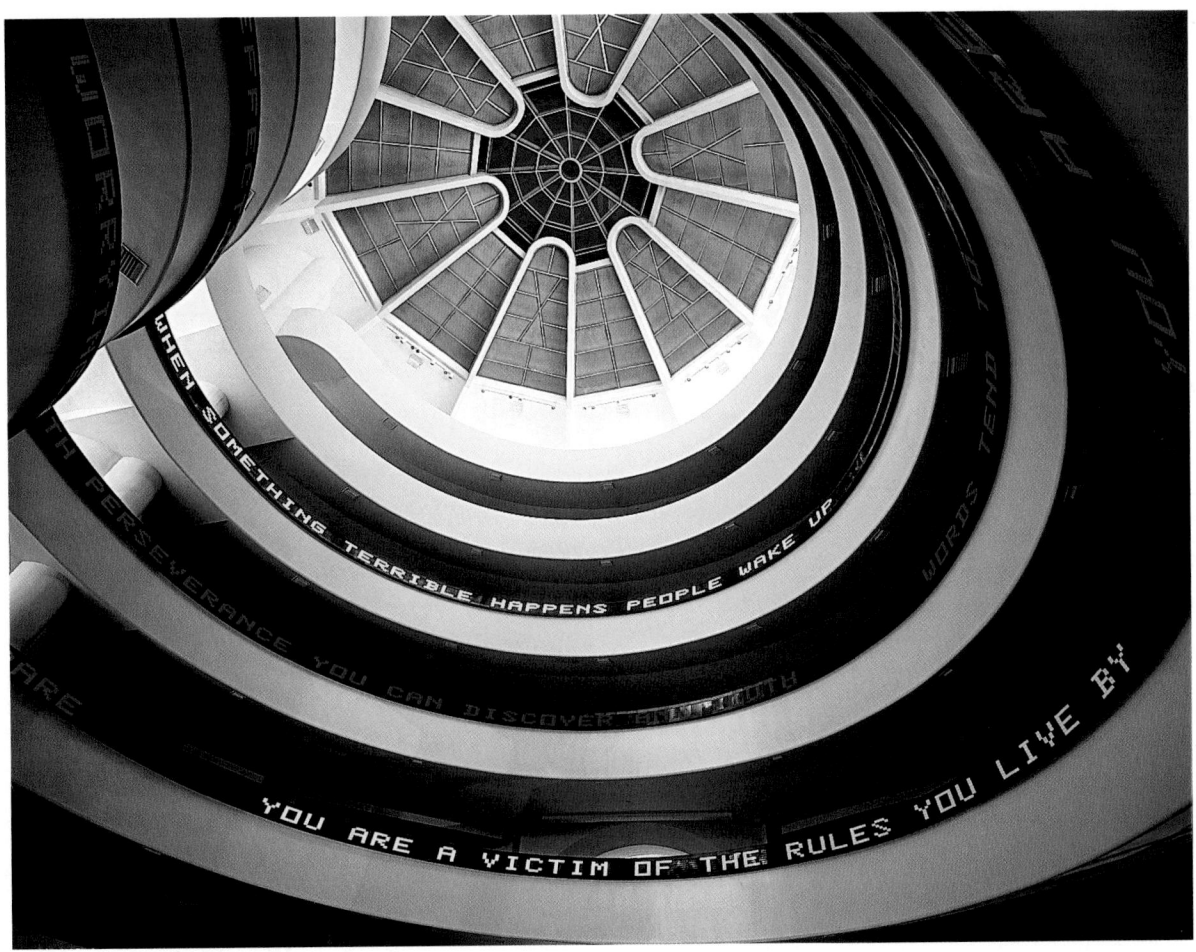

29.11 Jenny Holzer, *Untitled* (selections from *Truisms, Inflammatory Essays, The Living Series, The Survival Series, Under a Rock, Laments,* and *Mother and Child Text*), 1989–1990. Temporary installation with extended helical tricolor LED electronic display signboard. Installed at the Solomon R. Guggenheim Museum, New York. Commissioned by the Guggenheim Museum. Partial gift of the artist, 1989.

29.12 Matthew Barney, *Cremaster 4: The Loughton Candidate*, 1994. Color photograph, 19½ × 17⅝ in. (49.5 × 45.3 cm). © 1994 Matthew Barney. Photo: Michael James O'Brien. Courtesy Gladstone Gallery.

combination of sculptures, drawings, still photographs, videos, and music that drew on a wide range of media and iconographic sources. Media ranged from film to Astroturf, and imagery from myth and surreal fantasy to biogenetics. The term *cremaster* refers to the muscle of the testicles and reflects the artist's preoccupation with sexuality and anatomy. The cycle has five parts, adding up to an epic display of imagery that encompasses the history of the human race.

Barney created a number of sculptures depicting mutating species and shifting genders. Nearly all his work is based in the human figure and is influenced by issues in modern biology. Figure **29.12** is a video still from *Cremaster 4*. A male figure, formally dressed in a white coat, is represented against a blue-plaid background. The head, like certain facial configurations of Picasso, is arresting because it distorts and disrupts our expectations of how a face should look. It attacks our narcissism by challenging Classical idealization and threatens our sense of being human. The pointed ears assume an animal quality, whereas the curls recall old-fashioned hair styles for men. At the same time, the folds of flesh in the forehead and the flattened nose seem in the very process of mutating into some unknown and unknowable future species.

The Whitney Museum

Less than a mile away from the Guggenheim Museum is the Whitney Museum of American Art (fig. **29.13**). This was designed by the German architect Marcel Breuer (1902–1981) in a style inspired by the stark rectangularity of the Bauhaus (see Chapter 25). The floors are cantilevered out toward Madison Avenue like a chest with its drawers pulled out at increasing distances. The only features that interrupt the wall surfaces are the slightly projecting trapezoidal windows. Inside and out, the museum is constructed of concrete and dark gray granite blocks, which correspond to its stark, angular character.

In contrast to the Guggenheim, the Whitney is well conceived for viewing works of art. The floors are horizontal rather than slanted, and the galleries are ample and flexible, with ceilings that can support mobile wall partitions. Both buildings, however, have thick, massive walls, in contrast to the earlier International Style developed at the Bauhaus.

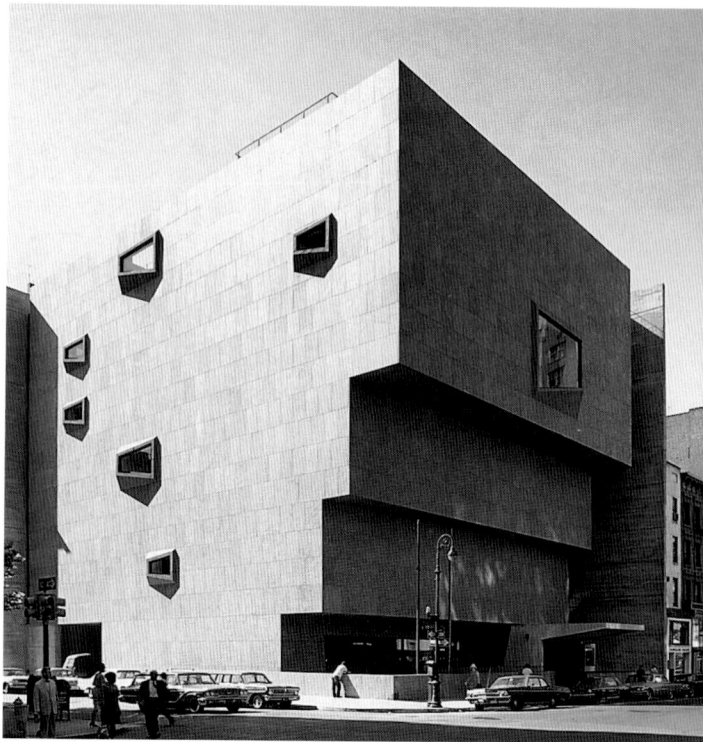

29.13 Marcel Breuer, Whitney Museum of American Art, New York, 1966. Breuer was one of the first graduates of the Bauhaus. He became chairman of its carpentry department and designed his celebrated S-shaped chairs in aluminum, plywood, and steel tubing. In 1936, he emigrated to the United States, where he taught at Harvard under Gropius and established an architectural practice that was responsible for, among other things, the UNESCO building in Paris.

The Geodesic Dome:
R. Buckminster Fuller

One of the more interesting personalities of twentieth-century design, R. Buckminster Fuller (1895–1983), was a philosopher, poet, architect, and engineer, as well as a cult figure among American college students. His architecture expresses his belief that the world's problems can be solved through technology. One of his first designs (1927–1928) was a house that he called Dymaxion, a name conflating "dynamic" and "maximum." These reflect key concepts for Fuller, who wanted to achieve the maximum output with the minimum energy consumption. The Dymaxion house was a prefabricated, factory-assembled structure that hung from a central mast and cost no more than a car to build. A later invention was a three-wheeled Dymaxion car (1933), but, like the house, it was never produced commercially.

Fuller is best known for the principle of structural design that led to the invention of the **geodesic dome.** It is composed of polyhedral units (from the Greek words *poly,* meaning "many," and *hedron,* meaning "side")—usually either tetrahedrons (four-sided figures) or octahedrons (eight-sided figures). The units are assembled in the shape of a sphere.

The geodesic dome offers four main advantages. First, because it is a sphere, it encloses the maximum volume per unit of surface area. Second, the strength of the framework increases logarithmically in proportion to its size. This fulfills Fuller's aim of combining units to create a greater strength than the units have individually. Third, the dome can be constructed of any material at low cost. And fourth, it is easy to build. Apart from purely functional structures like greenhouses and hangars, however, the geodesic dome has been used very little. Fuller's design for the American Pavilion at the Montreal Expo of 1967 (fig. **29.14**) reveals both its utility and its curious aesthetic attraction. (The architectural principle underlying the geodesic dome is shared by a class of carbon molecules, named "fullerenes" after Buckminster Fuller. They were discovered in the late 1980s and possess unique qualities of stability and symmetry.)

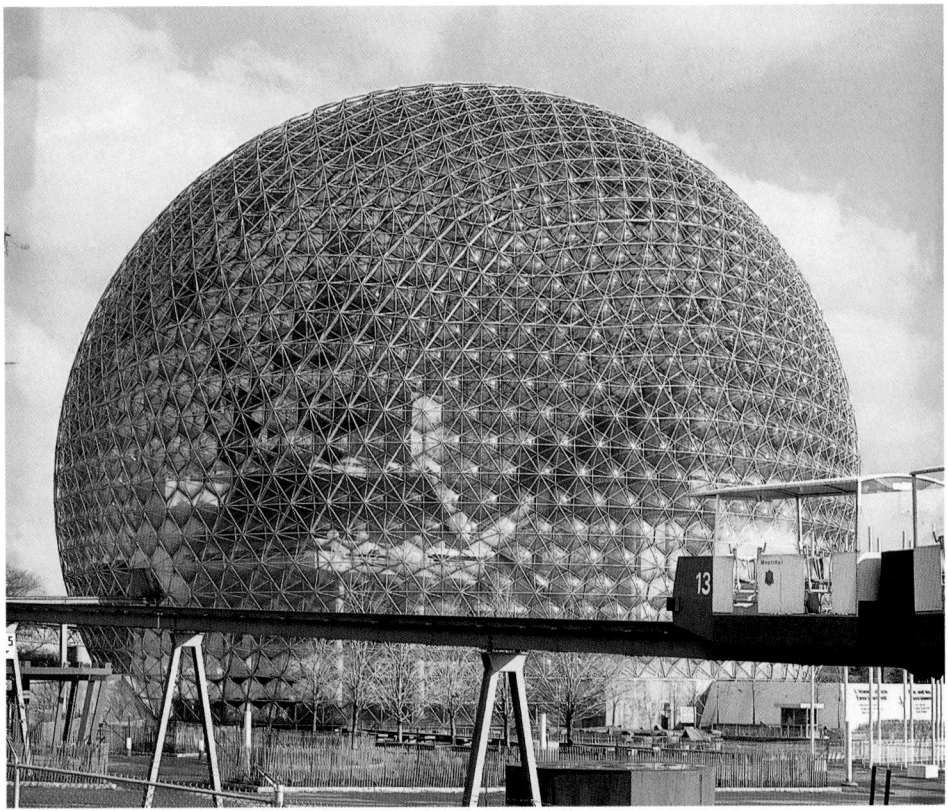

29.14 R. Buckminster Fuller, American Pavilion, Expo '67, Montreal, 1967. Fuller was descended from eight generations of New England lawyers and ministers. He was expelled from Harvard twice, served in the U.S. Navy in World War I, and worked in the construction business. In 1959, he became a professor of design science at Southern Illinois University. Fuller's abiding interest in education is revealed by his belief that all children are born geniuses. "It is my conviction from having watched a great many babies grow up," he said, "that all of humanity is born a genius and then becomes de-geniused very rapidly by unfavourable circumstances and by the frustration of all their extraordinary built-in capabilities."[4]

Post-Modern Architecture

Fuller's architectural ideas remained isolated from the stylistic mainstream of the late twentieth century. Post-Modernism, on the other hand, has developed into a widespread movement. Post-Modern architecture is eclectic. It combines different styles from the past to produce a new vision, which is enhanced, but not determined, by modern technology. Post-Modernism rejects the International Style philosophy that "form follows function" and juxtaposes traditional architectural features without regard for their historical contexts.

Charles Moore A good example of Post-Modernism is Charles Moore's (born 1925) Piazza d'Italia (fig. **29.15**)—Italy Square—in New Orleans. In this illustration, the piazza is shown at night, illuminated by colored neon lights. The lights define space and accentuate architectural form—an effect that relates the piazza to Flavin's sculptures. Color conforms to each particular architectural element; the central entablature and its round arch are green, and the supporting Corinthian columns are red. Curved colonnades on either side are alternately red and yellow, and the inner Corinthian capitals are predominantly blue. The pool of water reflects the lights in broad patches of color.

Piazza d'Italia is a Post-Modern rearrangement of Classical, Renaissance, and Baroque architectural forms, enlivened by the light and color possibilities of twentieth-century technology. Whereas Flavin's light sculptures are designed for interiors and are intimate in scale, those in the Piazza d'Italia contribute to its expansive relationship with the surrounding area.

29.15 Charles W. Moore and William Hersey, *Piazza d'Italia*, New Orleans, 1978–1979. The piazza was built to celebrate the contributions made to New Orleans by Italian immigrants. Its eclecticism is characteristic of the Post-Modern style.

29.16 Michael Graves, Public Services Building, Portland, Oregon, 1980–1982.

Michael Graves The massive, blocklike Post-Modern buildings of Michael Graves (born 1934) assimilate elements of Cubism and Classical architecture. His striking Public Services Building (fig. **29.16**) in Portland, Oregon, built from 1980 to 1982, also uses color as a significant architectural feature. He defined the stepped base in green and the upper cube in a cream color. Planned mainly for offices, the Public Services Building is decorated on the exterior with multiple square windows piercing the wall surfaces. The side most visible in figure 29.16 incorporates two sets of six dark verticals accented like fluted pilasters against a glass rectangle. Capping these are projecting, inverted trapezoidal blocks that are a visual—not structural—equivalent of Classical capitals. Above these is a large, flat, inverted trapezoid enclosing horizontal strips of windows separated by dark cream-colored horizontal sections.

Complaints that the building is not "environmentally correct"—that is, that it does not conform to the surrounding architecture—ignore the fact that it is "color coded" with the blue sky and green trees. It looms upward from a green base, with the cream block framed above and below by green. Since green combines cream with blue, the building is unified with its natural, if not with its architectural, surroundings. Architecturally it is an amalgam of the Mesopotamian ziggurat, the Egyptian pylon, the Greek temple, and the contemporary American office building. In the original model for the building, Graves had planned to add a group of small structures, inspired by Greek temples and Renaissance churches. Their function would have been to enclose the machinery used to run the building, but they were eliminated from the final version.

I. M. Pei: The Louvre Pyramid

Glass and steel form the prevailing aesthetic in I. M. Pei's (born 1917) Louvre Pyramid (fig. **29.17**). In 1983, the French government commissioned Pei to redesign parts of the Louvre in Paris. Completed in 1988, the pyramid includes an underground complex of reception areas, retail stores, conference rooms, information desks, and other facilities, all located below the vast courtyard. To serve as a shelter, skylight, and museum entrance for the underground area, Pei built a large glass pyramid between the wings of the sixteenth-century building.

Paris had not witnessed such architectural controversy since the construction of the Eiffel Tower in 1889. Not only was the architect not a Frenchman, but the imposing façade of the Louvre, former residence of French kings, was to be blocked by a pyramid—and a glass one at that. Pei's Pyramid has an undeniable presence, with transparent glass that allows a fairly clear view of the buildings beyond. Broad expanses of water around the Pyramid create a reflective interplay with the glass, literally mirroring the old in the new. The view shown here illustrates the dramatic possibilities of the Pyramid as a pure geometric form juxtaposed with a Baroque environment.

──────────── **CONNECTIONS** ────────────

See figure 3.12.
Pyramids
at Giza, Egypt,
c. 2551–2472 B.C.

29.17 I. M. Pei, Louvre Pyramid, Paris, 1988. The pyramid is 65 feet (19.81 m) high at its apex and 108 feet (32.92 m) wide; it contains 105 tons (107,000 kg) of glass.

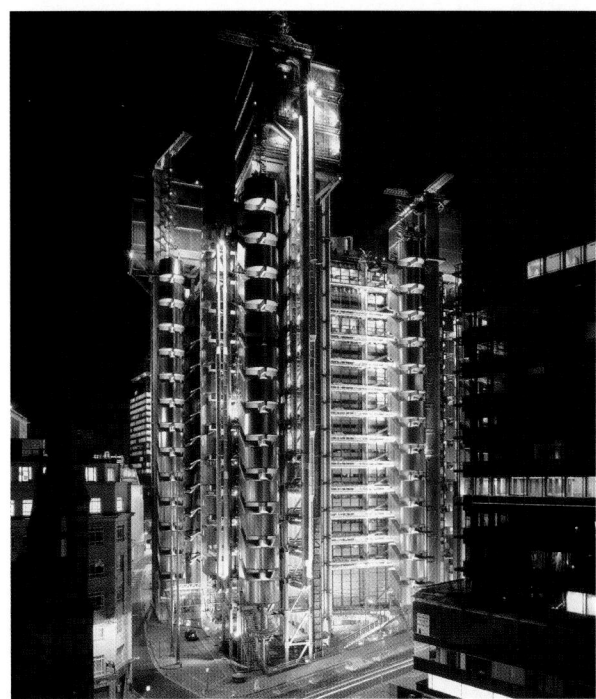

29.18a, b Richard Rogers, Lloyd's Building, London, 1986. Rogers wrote that "esthetically one can do what one likes with technology . . . but we ignore it at our peril. To our practice, its natural functionalism has an intrinsic beauty." In the Lloyd's Building, Rogers has fulfilled his philosophical view of uniting technology with aesthetic appeal.

Richard Rogers: The Lloyd's Building

By 1977, Lloyd's of London, the international insurance market, needed new quarters. In addition to accommodating the more than five thousand people who use the building every day, the new Lloyd's had to adapt to the technological changes, principally in communications, that were revolutionizing the insurance and other financial markets.

Richard Rogers (born 1933), who was given the commission, is an English architect who had been jointly responsible for the Pompidou Centre in Paris in the 1970s. The irregular, triangular space that Rogers had to work with in London was large, but not large enough to accommodate all of the underwriting staff on one floor. Rogers solved the problem in two ways. First, he created an *atrium*—the original central court of Etruscan and Roman houses—and wrapped all the floors around it. The *atrium,* an architectural feature that was widely revived in the 1970s, is a rectangle rising the entire height of the building (twelve floors) and culminating in a barrel-vaulted, glass and steel roof (fig. **29.18**). The three lower floors form galleries around the *atrium.* Together, they make up the approximately 115,000 square feet (10,700 m²) where underwriters sit and negotiate terms with brokers. This solution visually unified the working areas of the building and illuminated them from above.

Second, Rogers left the *atrium* space as flexible and open as possible by housing all the ancillary services—air-conditioning ducts, elevators, staircases, toilet facilities, and so forth—in satellite towers built apart from the main structure. At the top of the towers are boxlike "plant rooms," which dominate distant views of the building. Each room is three stories high and contains elevator motors, tanks, and an air-handling plant. On the roofs, bright yellow cradles for carrying maintenance crews are suspended from blue cranes.

Rogers's system (see fig. **29.19**) has the advantage of ensuring the greatest flexibility of space on each floor. On the ground floor, the only structural elements that interrupt the working space are eight concrete columns supporting the galleries, and the escalator block that links the basement and the underwriting floors. Since the mechanical services are located in the towers, they can be replaced or upgraded without disturbing the main floors.

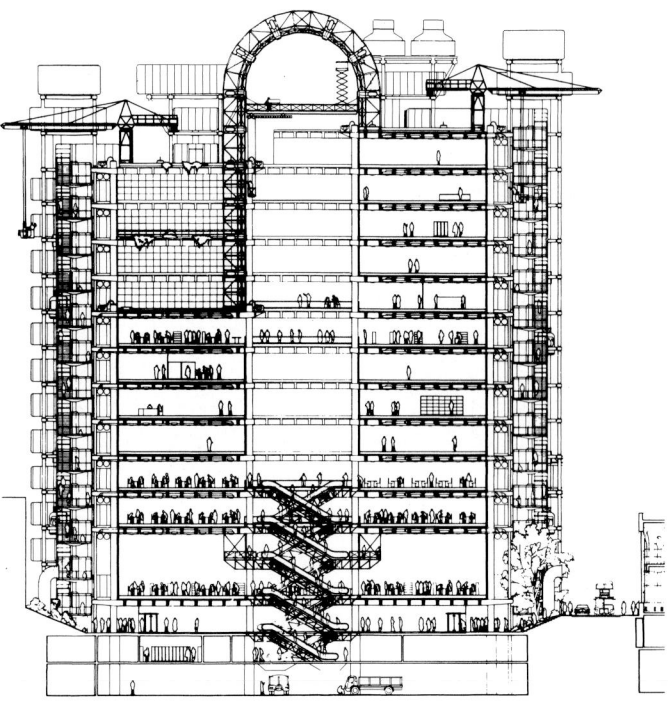

29.19 Schematic section of the Lloyd's Building.

Frank Gehry: The Solomon R. Guggenheim Museum Bilbao

In 1997, the Solomon R. Guggenheim Museum Bilbao opened in Bilbao, on the Bay of Biscay, in Spanish Basque country (fig. **29.20**). The architect, Frank Gehry (born 1929), originally from Toronto, Canada, came to the United States in 1974, living and working mainly in Los Angeles. He is known for his ability to integrate striking new forms into existing spaces. In the 1980s, for example, he assisted in the placement of a giant pair of binoculars by Oldenburg at the entrance to the city of Venice, in California. In 1990, Gehry completed the Frederick R. Weisman Museum in Minneapolis (fig. **29.21**), which shows his interest in merging sculptural with architectural form, animating the building so that it seems to grow and expand upward from its site.

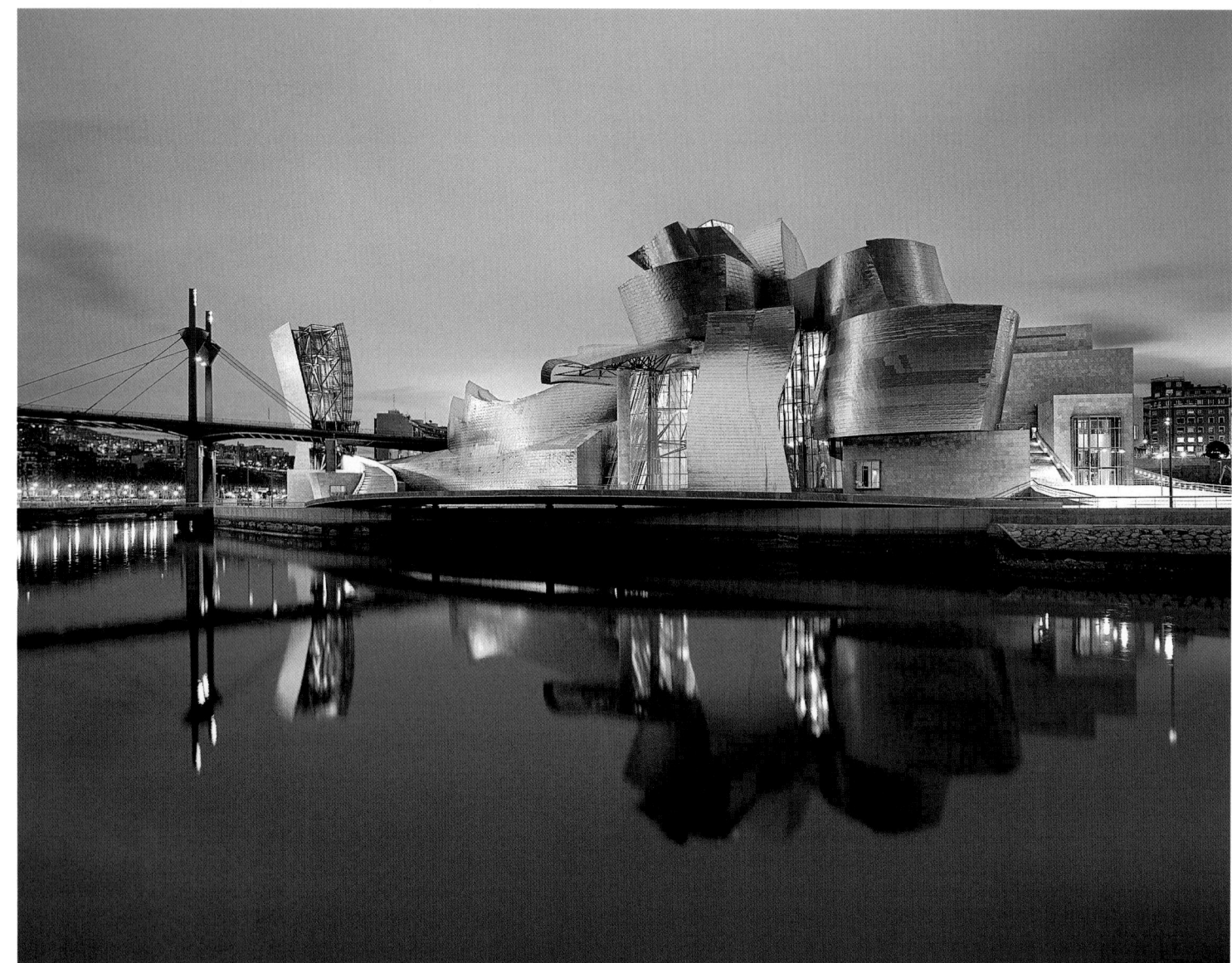

29.20 Frank O. Gehry, Solomon R. Guggenheim Museum Bilbao, Bilbao, Spain, 1993–1997. The museum is 257,000 square feet (24,290 m²), with 112,000 square feet (10,560 m²) of gallery space, and stands on the site of an old factory and parking lot. Its construction was part of an urban renewal project for Bilbao and cost $100 million.

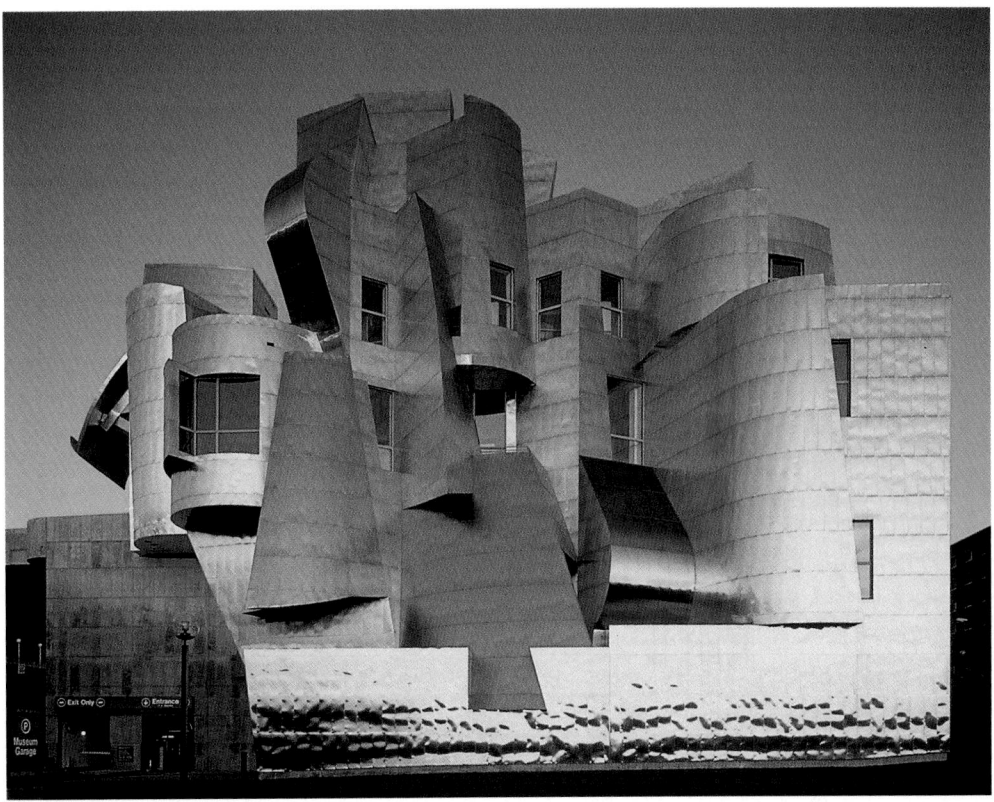

29.21 Frank O. Gehry, Frederick R. Weisman Museum, Minneapolis, Minnesota, finished 1990.

The Bilbao Guggenheim, begun in 1993, is situated by the Nervión River, across from a bridge and a thriving port, and surrounded by a water garden. Its striking curvilinear roof forms, referred to as a "metallic flower," are made of titanium, which is durable in the salty atmosphere of Bilbao, and the main structural elements are of limestone-covered blocks. The complexity of the design and its unusual variety of shapes is clear from the plan in figure **29.22**, which shows the way in which the building seems to transform itself as one viewpoint succeeds another. The otherwise prohibitive cost of such a building was mitigated by a three-dimensional computer program known as

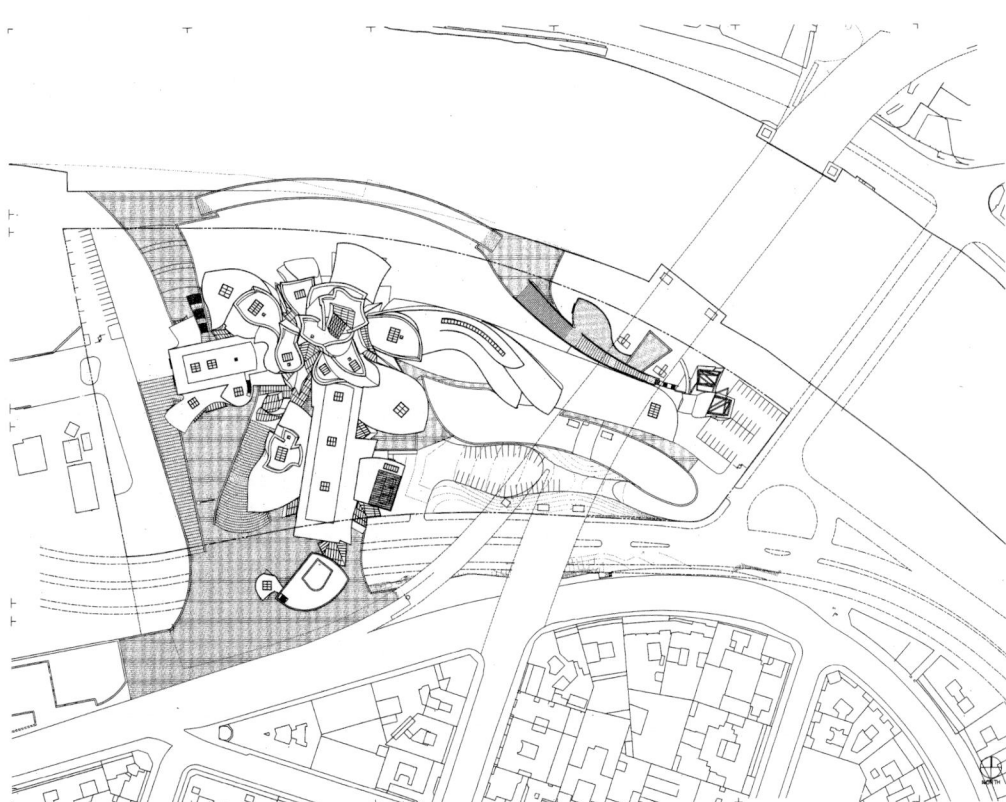

29.22 Frank O. Gehry, plan of the Solomon R. Guggenheim Museum Bilbao, finished 1997.

29.23 Computer-generated Catia image used for the Solomon R. Guggenheim Museum Bilbao, finished 1997.

Catia, designed in France for aerospace projects. Figure **29.23** is a computer image generated by digital mapping of paper and wood models that saved the architect time and reduced expenses by virtually building the museum prior to its actual construction. Gehry described the computer as his "interpreter."

The interior of the museum consists of a large *atrium,* 165 feet (50.29 m) high, which is illuminated by light from windows in the roof. The style of the galleries varies from traditional to boat-shaped (fig. **29.24**), the latter with no columns to interrupt the viewing of installation pieces. All the galleries surround the *atrium* and are accessed by a glass elevator, a system of bridges, and towers containing stairs.

Note the monumental rolled-steel sculpture by the Minimalist Richard Serra (born 1939), which dominates the interior space. The simplified curved planes correspond formally to Gehry's broad, curvilinear architectural spaces. Both the sculpture and the building are united in an expansive, flowing motion. In 2005, Serra installed seven additional sculptures inside the Bilbao Guggenheim, where their curved walls and massive, often claustrophobic interiors also contrast with the open spaces of the building.

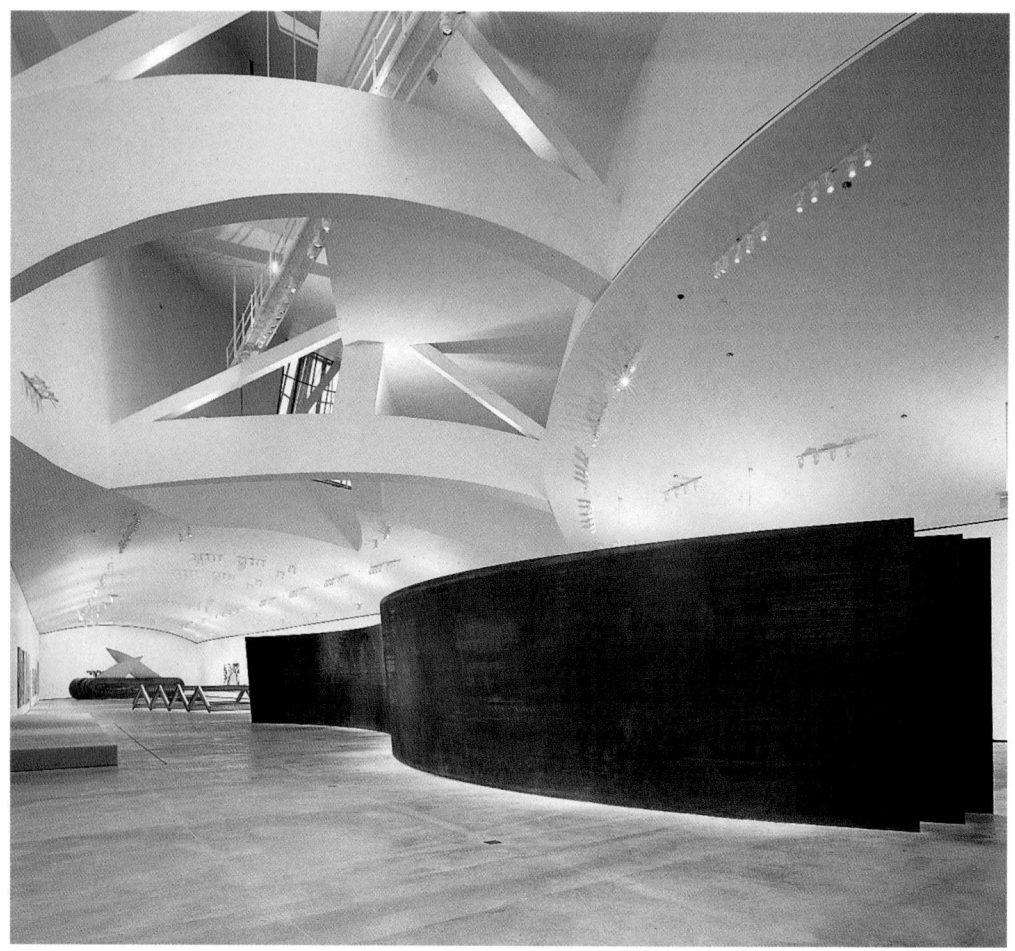

29.24 Interior gallery, Solomon R. Guggenheim Museum Bilbao.

Environmental Art

All works of art affect the environment in some way. In its broadest sense, the environment encompasses any indoor or outdoor space. Today, the term tends to refer more to the outdoors—the rural and urban landscape—than to indoor spaces. Four recent artists whose work has had a startling, though usually temporary, impact on the natural environment are Robert Smithson (1938–1973), the Christos (both born 1935), and Andy Goldsworthy (born 1956). The environmental works of Nancy Holt (born 1938), on the other hand, are intended to be permanent.

Robert Smithson

Robert Smithson's *Spiral Jetty* (fig. **29.25**), a huge, single spiral that jutted 400 yards (366 m) out into the Great Salt Lake of Utah, is his best-known "earthwork." As an isolated form, set against a background—in this case, water—*Spiral Jetty* was rooted in 1960s Minimalism, but its concept and actuality are related to the gesture painting of Abstract Expressionism. The philosophy of Smithson's earthworks, however, which is extensively described in his writings, has many levels of meaning. In some of his gallery exhibits, he placed rocks and earth—reflecting his interest in the natural landscape—in boxes and bins indoors (the "non-site," in Smithson's terminology). Crystals, in particular, appealed to him as examples of the earth's geometry, and he used them, along with earth, as an artistic medium.

Ecology, as one might expect, was one of Smithson's primary concerns. *Spiral Jetty* and his other earthworks are all degradable and will eventually succumb to the natural elements. Smithson's interest in the earth has a primeval character. He was inspired by the Neolithic stone structures of Great Britain and their mythic association with the land. Although he created his own earthworks with modern construction equipment, his affinity for the prehistoric earth mounds of the United States and Mexico also influenced the shape of his monuments and their integration with the landscape.

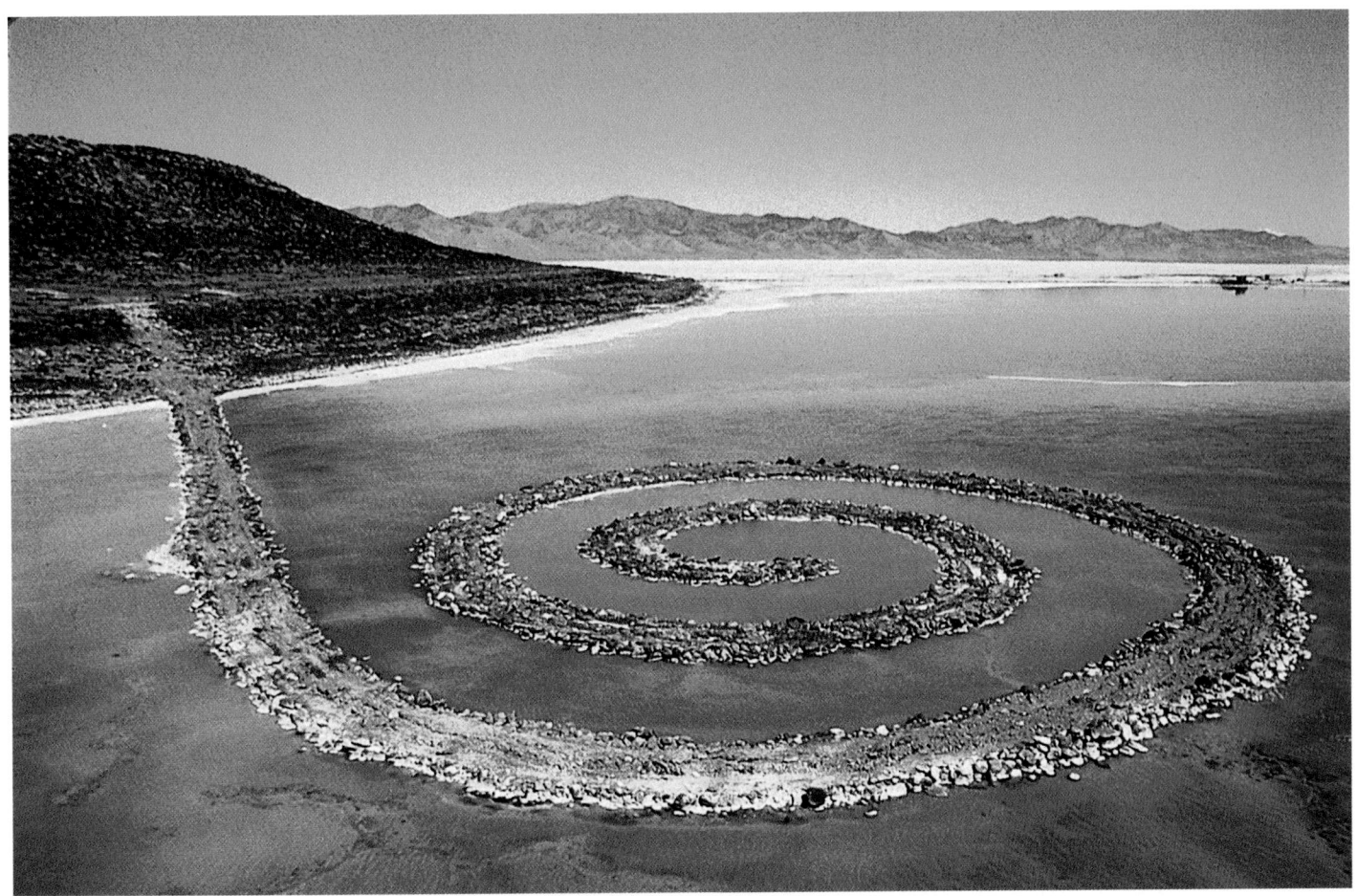

29.25 Robert Smithson, *Spiral Jetty*, Great Salt Lake, Utah, 1970. Rock, salt crystals, earth, and algae; coil 1,500 ft. (457.20 m) long, approx. 15 ft. (4.57 m) wide. Financed by two art galleries, Smithson took a twenty-year lease on 10 acres (4 ha) of land. He hired a contractor to bulldoze some 6,000 tons of earth. The resulting spiral consists of black rock, earth, and salt crystals. The algae inside the spiral change the water's color to red. Smithson wrote an essay on this work, and photographed and filmed it from a helicopter. The Jetty was, for a time, under water but is now becoming visible again.

Nancy Holt

Architectural and sculptural ideas merge in Nancy Holt's approach to environmental art. She was introduced to the subject by her late husband, Robert Smithson, and, after his death, continued to pursue an independent career. Her *Stone Enclosure: Rock Rings* of 1977–1978 (fig. **29.26**) is located in the landscape of Western Washington University (Bellingham, Washington). It is constructed of two concentric rings of stone, which are pierced by arches and twelve circular openings at eye level. Like Stonehenge (see figs. 1.22 and 1.26), *Stone Enclosure* rises abruptly from a green expanse and is related to the sky—what Holt calls the "dead center of the universe." The round holes are connected diagonally by lines of sight corresponding to the directions of the compass. The plane of the structure evokes the antiquity of ideas connecting the circle with divine form. By virtue of the formal association to Stonehenge and other Neolithic cromlechs, and to the later development of arch construction, *Stone Enclosure* embodies the continued existence of the past in the present.

── **CONNECTIONS** ──

See figure 1.26. The inside ring of Stonehenge.

29.26 Nancy Holt, *Stone Enclosure: Rock Rings*, Western Washington University, 1977–1978. Brown Mountain stone; outer ring 40 ft. (12.19 m) diameter, inner ring 20 ft. (6.10 m) diameter, height of ring walls 10 ft. (3.05 m).

Andy Goldsworthy

For the British artist Andy Goldsworthy (born 1956), nature is the primary medium. He creates dazzling works by arranging foliage, stones, and twigs on the earth's surface. He also forms snow and ice into temporary sculptures, which he photographs in their natural setting before they disappear. He has had exhibitions in Europe and Japan, and is scheduled to have a one-man show at the National Gallery in Washington, D.C. Goldsworthy's main themes involve the changing character of nature, its sense of process and energy. In the sculpture illustrated in figure **29.27**, he has created a starlike burst of icicles radiating from a central point and balanced on natural rock. The variations in the icicles emit different degrees of translucency. This was created in Scotland and photographed in January 1987.

29.27
Andy Goldsworthy,
Icicles
thick ends dipped in snow then water
held until frozen to the work
pouring on water until solid
occasionally using forked sticks as support until stuck
a tense moment when taking them away
breathing on the stick first to release it
sun catching the work for a dangerous half hour
but always intensely cold.
1987. © Andy Goldsworthy.
Courtesy Galerie Lelong, New York.

Christo and Jeanne-Claude

Another approach to shaping the environment can be seen in the work of Christo and Jeanne-Claude. They create a sense of mystery by "wrapping up" buildings or sections of landscape, paradoxically covering something from view while accentuating its external contour. Among the structures they have "wrapped" are the Kunsthalle in Berne (1968) and the Pont-Neuf, the oldest bridge in Paris (1985). They have surrounded eleven islands in Biscayne Bay, Florida, with over 6 million square feet (560,000 m²) of pink fabric (*Surrounded Islands*) and have run a white fabric fence (*Running Fence*) 24½ miles (39 km) long and 18 feet (5.49 m) high through two California counties.

Christo and Jeanne-Claude's work is sometimes referred to as Conceptual art, which emphasizes its relation to an idea or a concept. This is not, however, the case because the artists actually realize the concept. Unlike artists who intend their works to last, Christo and Jeanne-Claude always remove their projects from their sites, leaving the environment intact. The temporary nature of their large-scale works is part of their aesthetic identity. The continued existence of the work depends on film, photographs, drawings, and models. It endures as a series of visual concepts, temporarily realized on a monumental scale. Another feature distinguishes Christo and Jeanne-Claude from many artists—a unique view of patronage. They accept no financial sponsorship or commissions for large-scale projects and personally provide the funding for construction. Money is raised by selling drawings, collages, and scale models for the projects, as well as early work from the 1950s and 1960s.

Figures **29.28** and **29.29** illustrate sections of the blue and yellow *Umbrellas* in Japan and California, respectively. Their placement is related to their environment. The blue umbrellas are close together, reflecting the limited space of Japan, and the yellow umbrellas are farther apart, whimsically spread out in harmony with the vast California landscape. Blue is consistent with the water that fertilizes the Japanese rice fields, while the yellow echoes the blond grass and brown hills of the dry valley in which the California umbrellas were located. As freestanding, dynamic forms, the umbrellas have a sculptural quality. They define space and interact with it, casting shadows and swaying with the wind. Each umbrella was the size of a small studio apartment.

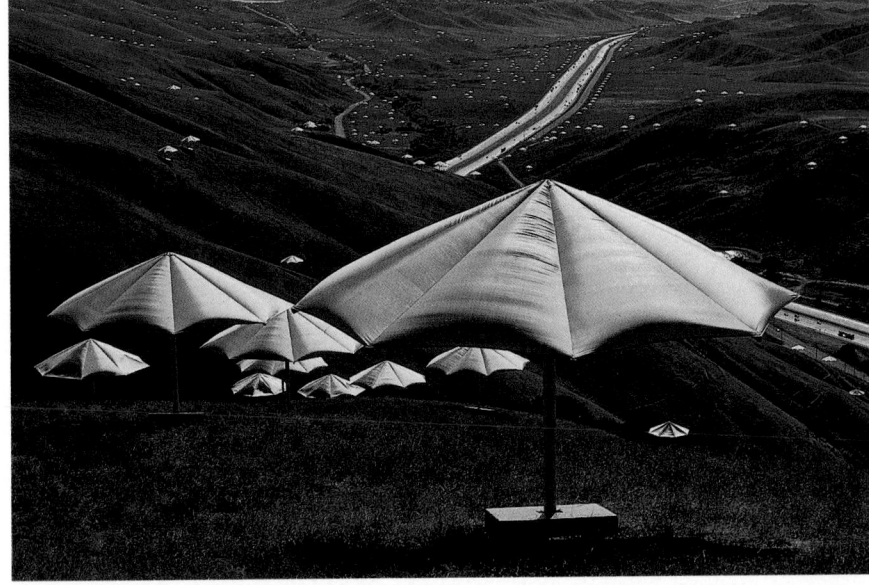

29.28 and **29.29** Christo and Jeanne-Claude, *The Umbrellas*, Japan–U.S.A., 1984–1991. Nylon and aluminum. Photos Wolfgang Volz, Christo. **29.28:** detail of 1,340 blue umbrellas in Ibraki, Japan. **29.29:** detail of 1,760 yellow umbrellas in California, U.S.A. *Umbrellas* ran 12 miles (19 km) in length in Japan and 18 miles (29 km) in California. Height of each umbrella, including the base, was 19 feet 8¼ inches (6.00 m), diameter was 28 feet 5 inches (8.66 m), weight without base was 448 pounds (203 kg). The fabric area was about 638 square feet (59.27 m²). At sunrise on October 9, 1991, 1,880 workers opened 3,100 umbrellas in Ibraki, Japan, and in California. The project, which cost the artists $20 million, was dismantled eighteen days after the umbrellas were opened, and the aluminum was recycled. Christo was born in communist Bulgaria but escaped and settled in Paris in 1958, where he met Jeanne-Claude. They moved to New York in 1964 and have lived there ever since, although their projects have taken them around the world.

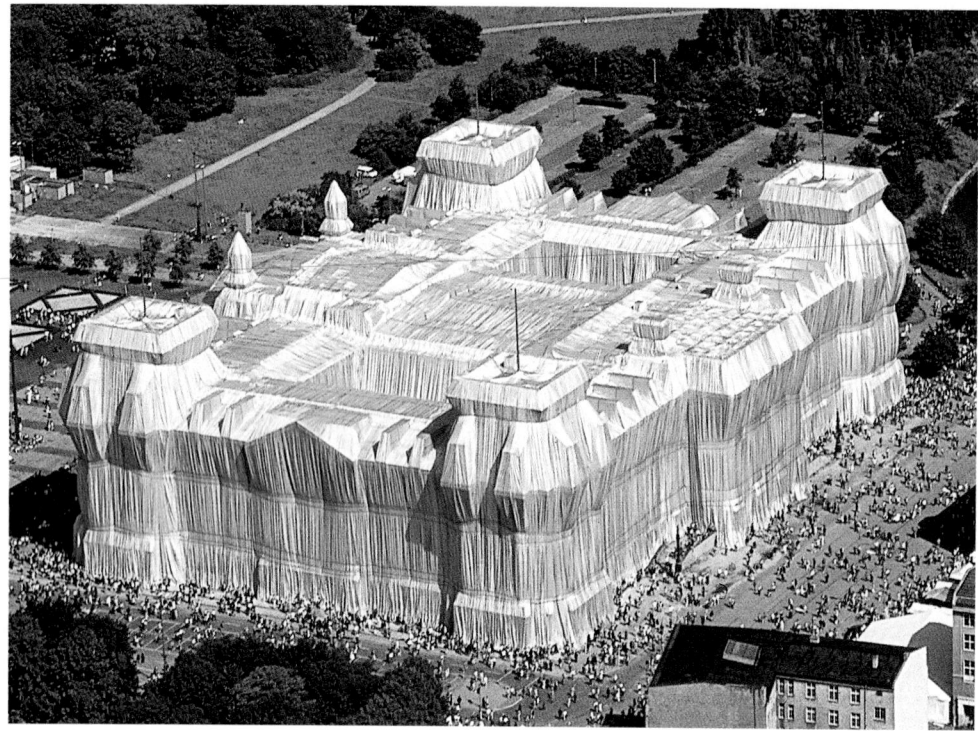

29.30 Christo and Jeanne-Claude, *Wrapped Reichstag,* Berlin, 1971–1995. Photos Wolfgang Volz, Christo. The wrapping was carried out in 1995 by 90 climbers and 120 installation workers, and 10 German companies manufactured the equipment. The wrapping material consisted of 1,076,000 square feet (99,963.67 m²) of woven polypropylene fabric with an aluminum surface and 51,181 feet (15,599.97 m) of blue polypropylene rope, 1¼ inches (3.18 cm) thick.

On June 24, 1995, Christo and Jeanne-Claude completed the wrapping of the Reichstag in Berlin (fig. **29.30**). They had spent twenty-four years and made fifty-four trips to Germany in their efforts to obtain permission for the project, which was denied three times—in 1977, 1981, and 1987. The building itself was originally designed in 1894. In 1933, soon after Hitler became chancellor, it was set on fire. The Reichstag was destroyed again in 1945, during the Battle of Berlin, and later restored. In 1990, following the reunification of Germany, the seat of German government moved from Bonn to Berlin, and the Reichstag was occupied by the Bundestag, the lower house of the German parliament. Permission for the "wrapping" was finally granted in February 1994, after members of the Bundestag debated

the issue and voted 292 in favor, 223 against, with 9 abstentions.

The *Wrapped Reichstag* was a silver-gray architectural specter, which is shown here surrounded by crowds of visitors. The vertical folds of the silvery fabric are reminiscent of Classical draperies. The fabric is held against the building with blue ropes, which accent the Reichstag's structural elements and create a sense of expanding, organic form. Two weeks from the day of its completion, on July 7, the "wrapped" Reichstag was unwrapped, and the aluminum and steel were recycled.

In 1980, Christo and Jeanne-Claude proposed a two-week project entitled *The Gates, Project for Central Park, New York City* (fig. **29.31**). As is often the case, the project

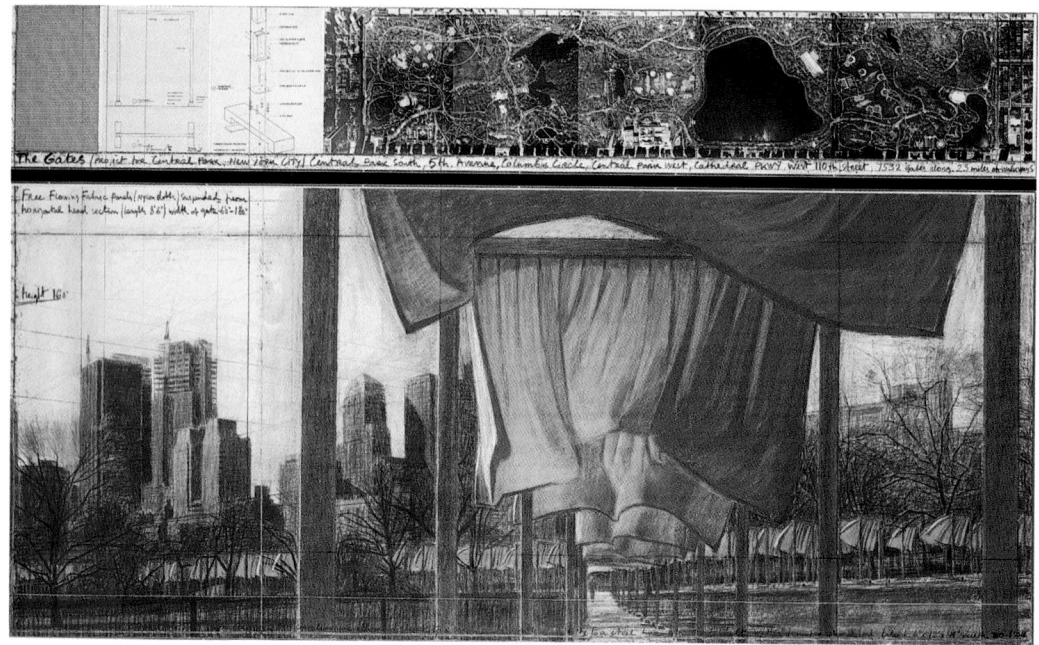

29.31 Christo, *The Gates, Project for Central Park, New York City,* 2003 (in two parts). Pencil, pastel, wax crayon, technical data, fabric sample, and aerial photograph; 15 × 96 in. (0.38 × 2.44 m) and 42 × 96 in. (1.07 × 2.44 m).

initially met with vigorous local resistance. A 185-page report by the Parks Department rejected the idea. Eventually, however, New York's Mayor Bloomberg supported the project, which became a reality in February 2005.

Christo and Jeanne-Claude envisioned steel gates with rectangles of saffron fabric extending from the top of each gate to some 6 feet over the ground. In 1979, the first drawing was entitled *Ten Thousand Gates*; in 2005, there were 7,500 gates. The gates were 12 feet tall in 1979; they were 16 feet tall in 2005. In 1979, the thin steel poles were considered only as a means of suspending fabric panels, while in 2005 the poles were made of a thick saffron-colored vinyl and had a commanding profile, 5 inches × 5 inches. They were no longer simply structural, but an important part of the sculpture. The top of the fabric panel in 1979 was attached by loops to a horizontal steel cable; in 2005, the upper parts of the fabric panels were secured inside the bottom part of the horizontal pole in a "sail tunnel."

The view in figure **29.32** shows the *Gates* as it was realized in Central Park for a two-week period. The wind is blowing, creating a variety of shapes and rhythms in the flowing fabric. There is also variety in the color—ranging from orange and saffron to yellow, depending on the light. The movement of the *Gates* is repeated in the visitors strolling through the walkways, whereas the skyscrapers surrounding the park create a backdrop of patterned, static vertical stone.

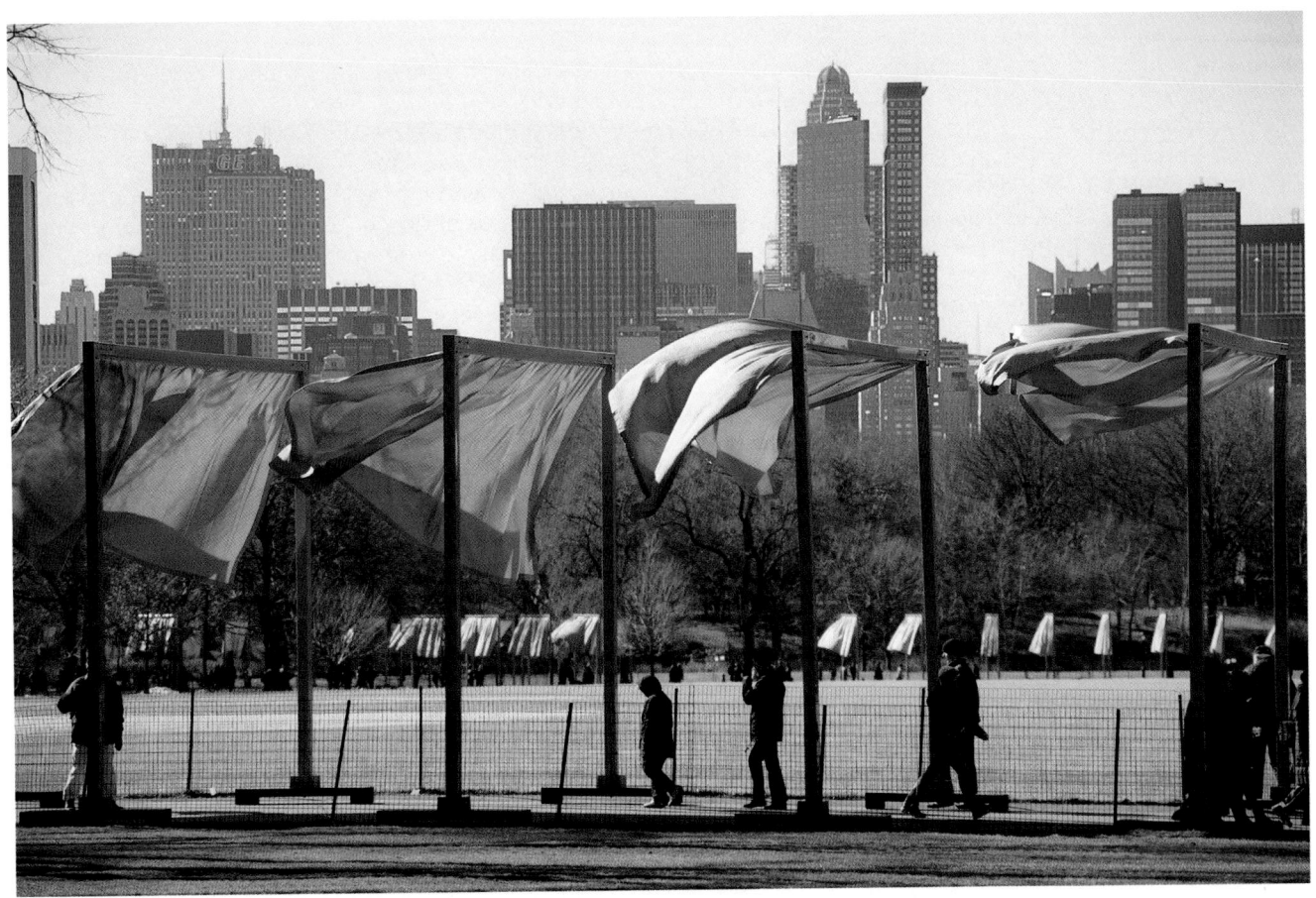

29.32 Christo and Jeanne-Claude, *The Gates*, Central Park, New York City, 1979–2005. © Christo 2005. Photo: Wolfgang Volz.

29.33 Valerie Jaudon, *Long Division*, 23rd Street Station, IRT Subway Line, New York, 1988. Painted steel; 12 × 60 ft. (3.66 × 18.29 m). Photo courtesy of Carroll Janis, New York.

Urban Environment

The urban environment has also been influenced by artistic "projects." *Long Division* of 1988 (fig. **29.33**) by Valerie Jaudon (born 1945) is a painted steel barrier commissioned by the Metropolitan Transportation Authority in New York City. Located in the 23rd Street subway station, *Long Division* is an "open wall" enlivened by curves and diagonals that seem to dance across the vertical bars. The surrounding neon lights and broad areas of color create a sharp contrast to the dark accents of the barrier.

A recent development in painting that has been inspired by an aspect of the modern urban environment are works with imagery derived from graffiti. Graffiti—which are visual statements and often a personal affirmation—and public reactions to them call into question the boundary between the creative and destructive impulses.

CARBON/OXYGEN of 1984 (fig. **29.34**) by Jean-Michel Basquiat (1960–1988) conveys the frenetic pace and mortal dangers of the city in a harsh, linear style derived from graffiti. The child-like drawing of the buildings is ironically contrasted with scenes of explosion and death. Various methods of transportation—cars, planes, and rocket ships—create a sense of speed and of the technology that pollutes the environment. The black face at the center of the picture stares blankly at the viewer as if warning of threatened destruction. The title implicitly poses the question whether we are going to poison the air we breathe or ensure that it remains clean.

29.34 Jean-Michel Basquiat, *CARBON/OXYGEN*, 1984. Acrylic, oilstick, and silkscreen on canvas; 66 × 60 in. (167.6 × 152.4 cm). Private collection, Switzerland. Courtesy, Robert Miller Gallery, New York.

Another modern expression of the urban environment in works of art is reflected in Andres Serrano's (born 1950) series of thirty photographs entitled *Nomads*. These large Cibachromes represent the homeless of America's cities. Although the title of the series refers to the figures of nomads who wander the city streets, the photographs do not show the suffering, poverty, or anonymity of the figures. Instead, as in *Sir Leonard* (fig. 29.35), Serrano disrupts expectations by ennobling and individualizing his subjects. He also monumentalizes them by combining a close-up viewpoint with an enlarged scale. Sir Leonard, for example, is relatively well groomed. His beard and mustache are neatly trimmed, and he wears a felt hat, a jacket, and woolen gloves. The only suggestions of his homelessness (contradicted by the epithet "Sir") are the torn fabric by his white scarf and the fact that he wears two jackets and two scarves.

He also displays a belt buckle as if it were a medal; it appears to have been taken from a pair of jeans, for it is inscribed "IN DENIM WE TRUST" and "QUALITY GARMENTS FOR QUALITY PEOPLE." The former is a pun on the United States currency inscription "IN GOD WE TRUST," an ironic allusion to Sir Leonard's indigence. At the same time, the central image on the buckle is a relief of the famous fourth-century-B.C. Etruscan bronze statue *Wounded Chimera* (see fig. 6.3), a creature having the body of a lion and a serpent's tail. A goat's head emerges from the Chimera's back. In the detail on the belt buckle, Serrano associates Sir Leonard with the mythic Greek hero Bellerophon, who rode the winged horse Pegasus and slew the Chimera.

CONNECTIONS

See figure 6.3. *Wounded Chimera*, Arezzo, second quarter of the 4th century B.C.

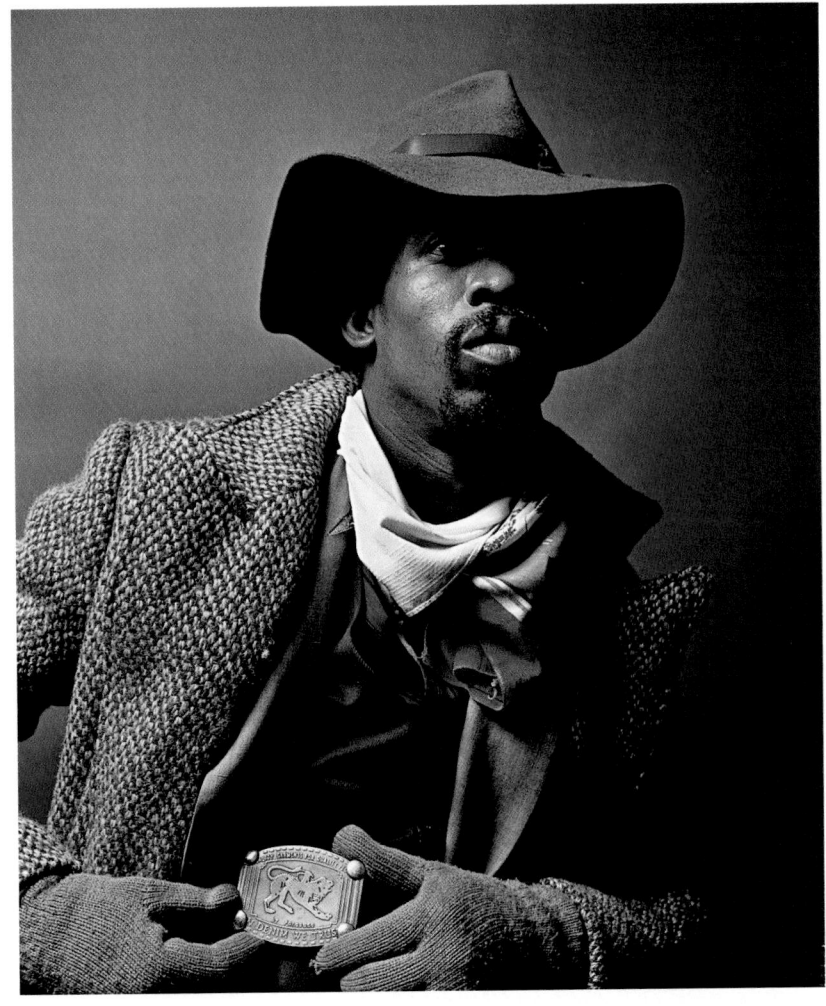

29.35 Andres Serrano, *Nomads (Sir Leonard)*, 1990. Cibachrome print, edition of four; 60 × 49½ in. (1.52 × 1.26 m).

Feminist Art

Although women artists for centuries have made significant contributions to the history of Western art, the iconography of feminism per se is a phenomenon of the twentieth and twenty-first centuries.

Judy Chicago: *The Dinner Party*

In 1979, Judy Chicago (née Cohen; born 1939) created her monumental installation *The Dinner Party* (fig. **29.36**) with the assistance of hundreds of female coworkers. The result is a triangular feminist version of *The Last Supper* (see fig. 14.14) with strong diagonals that are reminiscent of Tintoretto's *Last Supper* (see fig. 15.15). We saw in Marisol's *Last Supper* (see fig. 28.19) that the artist introduced herself as both viewer and participant in the work. Here, on the other hand, Jesus and his apostles have been replaced by the place settings of thirty-nine distinguished women such as Queen Hatshepsut of Egypt, the American painter Georgia O'Keeffe, and the British author Virginia Woolf. The settings are designed to commemorate the achievements of such women even though the women themselves are not actually represented. The plates are decorated with designs that are intentionally vaginal because, according to the artist, that was the one feature all the women at the table had in common.

Thirty-nine is three times the number of Jesus plus his twelve apostles. The tiled floor contains 999 names of famous women not referred to in the place settings. Traditional female crafts, such as embroidery, appliqué, needlepoint, painting on china, and so forth, are used for details. In part, this is to emphasize the value of these skills, which feminists believe to have been undervalued by a male-dominated society.

The artist established a foundation to send *The Dinner Party* on tour and later published a monograph on it that included the biographies of the women it celebrated. Despite the originality of Chicago's conception and the new iconographic content of her piece, the work would have less impact without its historical relevance. For although the triangle can be read as a female symbol, it also refers to the Trinity and is thus rooted in Christian art and culture. Likewise, the numerical regularity and symmetry of the design links the formal arrangement of *The Dinner Party* with Leonardo's *Last Supper*.

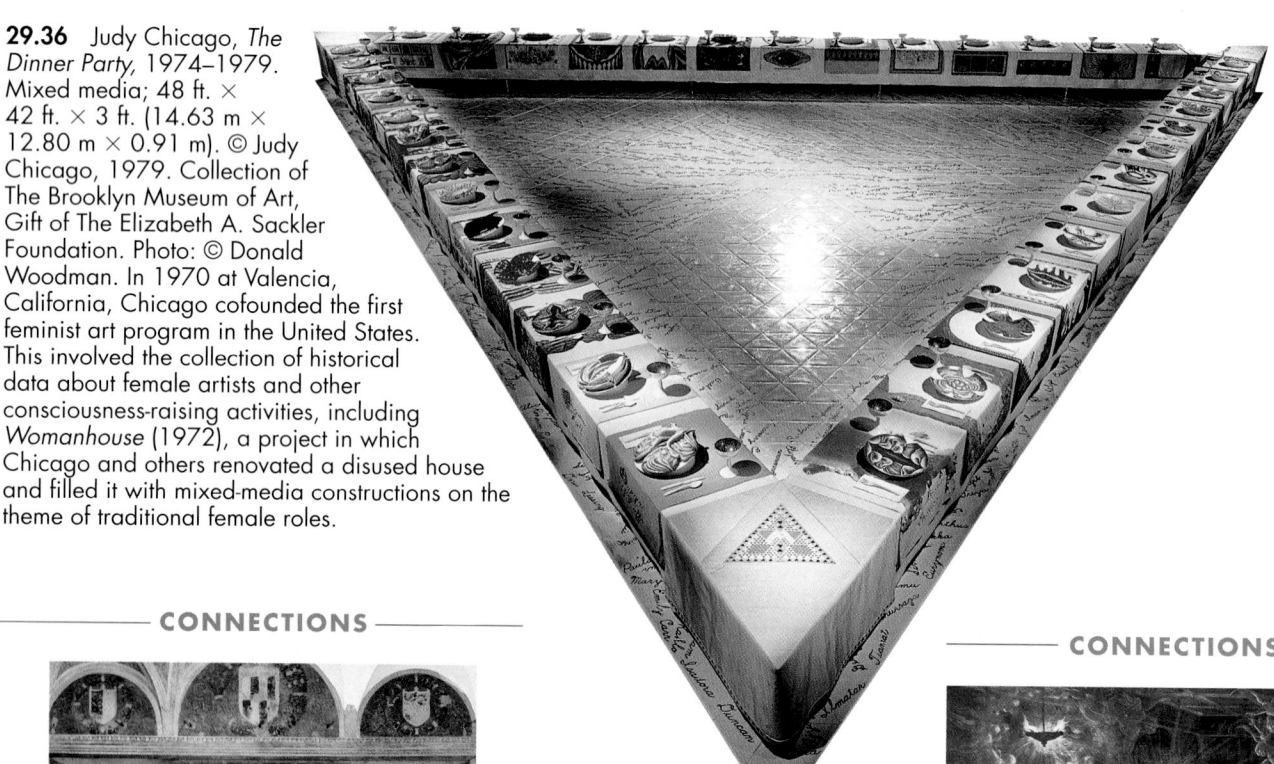

29.36 Judy Chicago, *The Dinner Party*, 1974–1979. Mixed media; 48 ft. × 42 ft. × 3 ft. (14.63 m × 12.80 m × 0.91 m). © Judy Chicago, 1979. Collection of The Brooklyn Museum of Art, Gift of The Elizabeth A. Sackler Foundation. Photo: © Donald Woodman. In 1970 at Valencia, California, Chicago cofounded the first feminist art program in the United States. This involved the collection of historical data about female artists and other consciousness-raising activities, including *Womanhouse* (1972), a project in which Chicago and others renovated a disused house and filled it with mixed-media constructions on the theme of traditional female roles.

— CONNECTIONS —

See figure 14.14. Leonardo da Vinci, *Last Supper*, c. 1495–1498.

— CONNECTIONS —

See figure 15.15. Jacopo Tintoretto, *Last Supper*, 1592–1594.

Body Art: Kiki Smith

A recent development, particularly in sculpture, that is derived from the feminist movement is so-called Body Art. In general, Body Art signals a return to the interest in the human form, which in some artists focuses primarily on the female body.

The Body Art of Kiki Smith (born 1954) challenges viewers by refusing to be "pretty." Smith has developed an iconography of body parts, in particular those that reveal the interior functions of the female. There is a political significance for Smith in the metaphor of the body and the "body politic," with the hidden body systems as signs of hidden social issues. She has been engaged with contemporary controversies over AIDS, gender, race, and battered women.

Smith was born in Germany to American parents; her father and sister were artists. When her parents died, she made death masks of them, as well as of her grandmother when she died. In 1976, Smith came to New York, studied *Gray's Anatomy* in 1979, and in 1985 trained as an emergency medical technician. Among her works are her mother's feet cast in glass, a bronze womb, hanging heads and hands, and veins, arteries, and body fluids preserved in jars. In these subjects, Smith evokes both the embalming practices of ancient Egypt and the severed body parts of Brancusi.

Smith's *Mary Magdalene* of 1994 (fig. **29.37**) is a traditional Christian subject rendered in a new light. The bronze body is covered with incised lines, except for the smooth breasts and navel area. The lines are reminiscent of the Magdalene's hair, grown long after the Crucifixion as penance for her sins. As such, the figure represents the penitent Magdalene, like that depicted by Donatello (see fig. 13.58) and other Renaissance artists. The long hair, combined with the ankle chain, endows the figure with a subhuman quality, which places her at the borderline between human and animal, saint and sinner, chastity and lust.

Smith has related this sculpture to French folktales about the Magdalene's life after Jesus's death. According to these stories, Mary Magdalene lived in the wilderness for seven years. When, on one occasion, she happened to catch sight of her reflection in a pool, she was punished for her narcissism and condemned to do further penance. Her flowing tears created the seven rivers of Provence, in the south of France.

CONNECTIONS

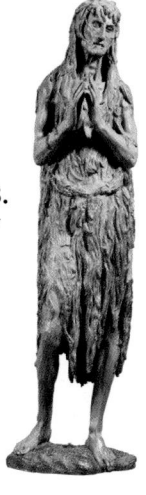

See figure 13.58.
Donatello, *Mary Magdalen,* c. 1455.

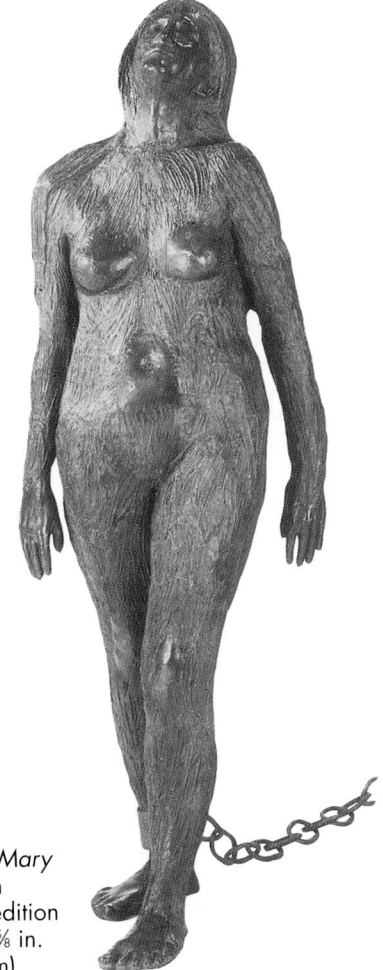

29.37 (right) Kiki Smith, *Mary Magdalene,* 1994. Silicon bronze and forged steel, edition 2 of 3; 59⅞ × 20½ × 21⅝ in. (152.1 × 52.1 × 54.9 cm).

Maya Ying Lin: *The Women's Table*

On October 1, 1993, Yale University dedicated *The Women's Table* (fig. **29.38**) by Maya Ying Lin (born 1959). Juxtaposed here with the more traditional campus architecture, the *Table* memorializes Yale's decision to admit women. Designed as a place for students to meet, talk, and read, the *Table* is also a "fountain." A smooth swirl of water slides across the tabletop and echoes the curvilinear shape of the green granite spiral. This, in turn, is supported by an irregular triangular base made of black granite, on which students can sit. The smooth texture of the granite and its sleek, elegant forms are reminiscent of the high polish and "essential" forms achieved by Brancusi. Lin also has affinities with the outdoor sculptures and taste for varieties of stone that are characteristic of Noguchi's work.

Carved into the top of the *Table* is a spiral, which records the numbers of females attending Yale (fig. **29.39**). At the center of the spiral are about three rings of zeros. The last zero is followed by the number 13, which corresponds to the year 1873, when thirteen women were enrolled in the School of Fine Arts. Carved to the side of the spiral are the decades from 1870 to 1990, indicating the number of female students in any single year. As the spiral expands, the number of women increases, and its open-ended design looks forward to the growing future of women on the Yale campus.

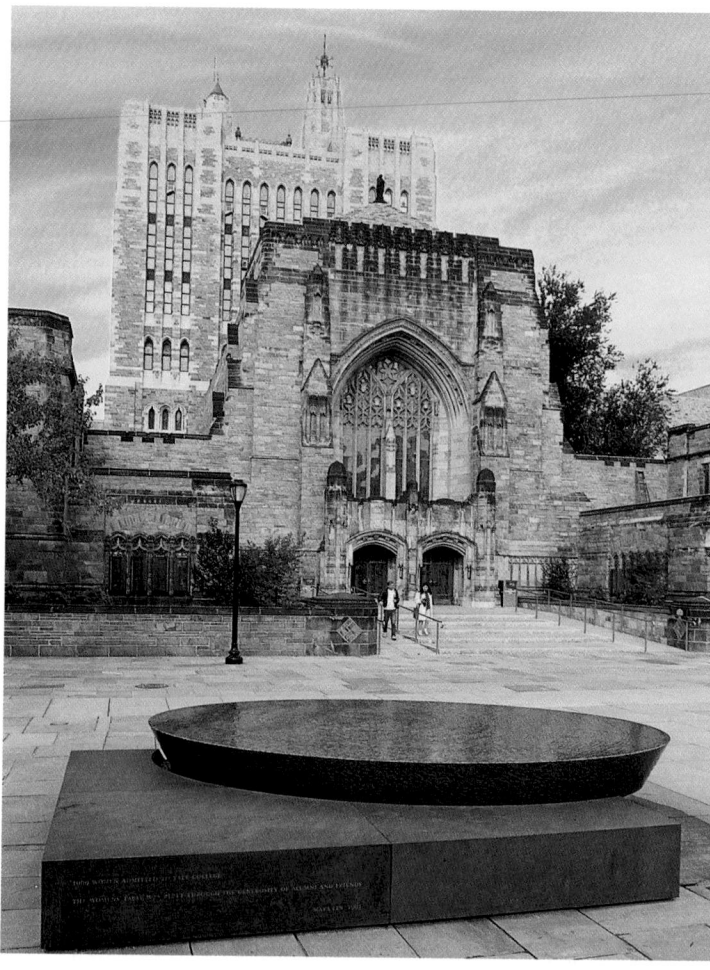

29.38 Maya Ying Lin, *The Women's Table*, Yale University, New Haven, Connecticut, 1993. Green granite on black granite base; 30 in. (76.2 cm) high, 10 × 15 ft. (3.05 × 4.57 m) in diameter.

29.39 Spiral diagram of *The Women's Table*, fig. 29.38. Drawing by Ian Hunt.

Plus ça change . . .

At times, history seems to repeat itself. The French expression *Plus ça change, plus c'est la même chose* ("The more things change, the more they remain the same") well describes this historical paradox. In the visual arts, it is possible to witness this phenomenon unfolding before our very eyes. Themes persist, styles change and are revived. New themes appear, old themes reappear. The media of art also persist; artists still use bronze and marble, fresco, oil paint, encaustic, and stained glass. Nevertheless, modern technology is constantly expanding the media available to artists as well as introducing new subjects and inspiring stylistic developments. This can be illustrated by four trends of the early twentieth century that continue to emerge in contemporary art—Expressionism, the preeminence of the object, the rejection of the object by Conceptual artists, and Surrealism. Technology has also influenced artistic media, and this has given rise to new art forms—among them, video and digital art—although similar themes continue to be represented.

Bob Thompson and the Renaissance

The African-American artist Bob Thompson (1937–1966) died in Rome before the age of thirty. His powerful images, which heralded a promising artistic future, reflect some of the ways in which artists assimilate the past and rework it. Thompson's *Crucifixion* of 1963–1964 (fig. **29.40**) shows the influence of Symbolist color

(see Chapter 23) combined with Renaissance iconography and the racial turmoil of the American civil rights movement of the 1960s. He was influenced by monumental Italian Renaissance painters such as Masaccio and Piero della Francesca, and by the sixteenth-century Northern humanist artists Bruegel and Cranach.

Thompson's *Crucifixion* was inspired by Cranach's *Crucifixion* (see fig. 16.19)—in the arrangement of the figures and in the iconography. The foreshortened red, crucified Jesus on the right corresponds to Cranach's placement of the same figure; the swirling sky, also similar to Cranach's, alludes to nature's ominous response to the death of Jesus. Thompson's Jesus, shown in three-quarter view, is the artist's self-portrait. The yellow figure—the good thief (on Jesus's right)—is seen in front view. The unrepentant thief, depicted in orange, is on Jesus's left (as well as ours) and is turned away from the viewer, which accentuates his anonymity. The blue, red-haired Mary resembles Thompson's Caucasian wife who, as in the Cranach, seems to be conversing with Saint John. The "colored" people in the painting reflect both Thompson's interest in contemporary racial issues and the correlation between his personal artistic identity as a man of color and of colors.

─── **CONNECTIONS** ───

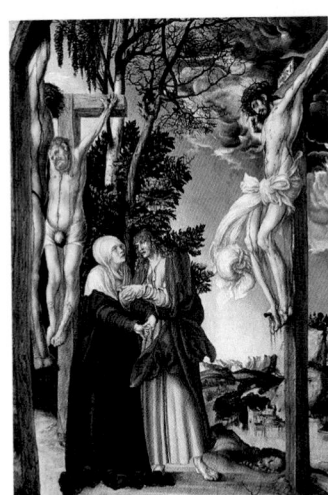

See figure 16.19. Lucas Cranach the Elder, *Crucifixion*, 1503.

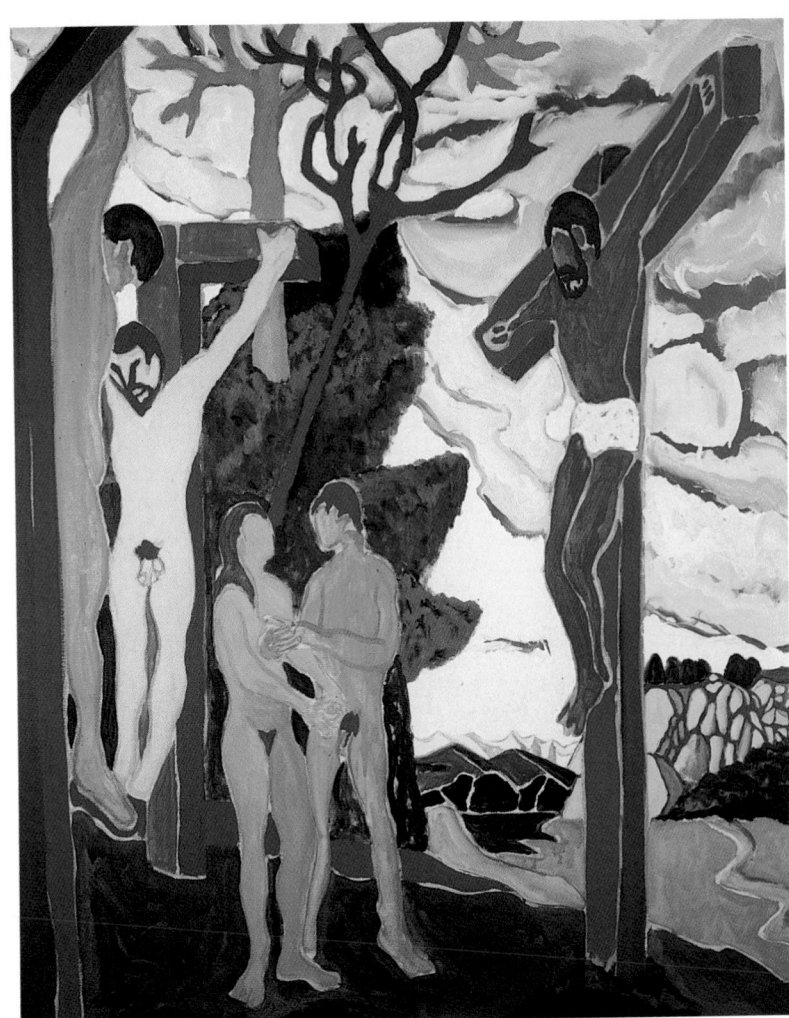

29.40 Bob Thompson, *Crucifixion*, 1963–1964. Oil on canvas; 5 × 4 ft. (1.52 × 1.22 m). Private collection. Photo Maggie Nimkin.

Bruce Nauman and Marcel Duchamp

Another example of artistic appropriation in the 1960s can be seen in the work of Bruce Nauman (born 1941), for whom figuration is part of a more general return to the object. His wide range of media includes neon lighting, holography, video, and audio effects, as well as the more traditional forms of painting and sculpture. He has filmed himself in a variety of performance sequences, using dance, music, and language. His attraction to the object is consistent with Dada, especially the multimedia of Man Ray and the wordplay of Duchamp. "My interest in Duchamp," Nauman has said, "has to do with his use of objects to stand for ideas. I like Man Ray better: there's less 'tied-upness' in his work, more unreasonableness."[5]

Nauman's relationship to Duchamp is evident in his *Self-Portrait as a Fountain* (fig. **29.41**). Illuminated from the right by an eerie green light and from the left by a yellow light, he emerges from a dark background reminiscent of Caravaggio's tenebrism (see Chapter 17). Nauman reflects the twentieth-century trend in which the artist is present in his own work. He spouts water from his mouth, holding up his hands as if to balance himself.

Echoing the visual pun of Duchamp's *Urinal* (see fig. 26.2), Nauman himself is the ready-made in this photograph, which has been "aided" by the artist's action. In addition to visual punning, Nauman is fascinated by philosophical and literary language as well as wordplay—especially of certain modern French writers. He is quoted as saying, "I think the point where language starts to break down as a useful tool for communication is the same edge where poetry or art occurs. . . . If you only deal with what is known, you'll have redundancy; on the other hand, if you only deal with the unknown, you cannot communicate at all. There's always some combination of the two, and it is how they touch each other that makes communication interesting."[6]

29.41 Bruce Nauman, *Self-Portrait as a Fountain*, 1966–1970. Photograph; 19¾ × 22¾ in. (50.2 × 57.8 cm). Leo Castelli, New York.

CONNECTIONS

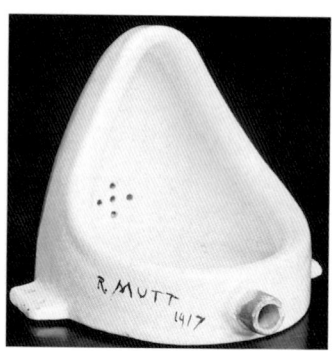

See figure 26.2. Marcel Duchamp, *Fountain (Urinal)*, 1917.

Susan Rothenberg

In a striking break with the geometric abstraction of the late 1960s and early 1970s, the animal imagery of Susan Rothenberg (born 1945), like the work of Nauman, marks a partial return to figuration. This is exemplified in her paintings of horses, which have been a subject of Western art since the Paleolithic era. Rothenberg's *IXI* of 1976–1977 (fig. **29.42**) is figurative, but the impasto character of the paint,

from which the horse literally seems to emerge, has an Expressionist quality. The paint's rich texture, together with the horse's submersion in it, creates the impression that the paint and the horse are one and the same. The two asymmetrical black diagonals enhance the movement of the horse, while the white verticals restrain it. By this dynamic balance, Rothenberg achieves a unique simultaneity of arrest and motion.

29.42 Susan Rothenberg, *IXI*, 1976–1977. Vinyl emulsion and acrylic on canvas; 6 ft. 6⅛ in. × 8 ft. 8 in. (1.98 × 2.64 m). Hirshhorn Museum and Sculpture Garden, Smithsonian Institution (Joseph H. Hirshhorn Purchase Fund, 1990). Rothenberg is married to Bruce Nauman; they live on a ranch in northern New Mexico, where horses continue to be a large part of Rothenberg's life (although she has not painted one since 1979).

Memorial Art: Anselm Kiefer and Maya Ying Lin

Anselm Kiefer Anselm Kiefer (born 1945), a prominent German Neo-Expressionist and a student of Joseph Beuys, creates powerful canvases using aggressive lines and harsh textures. His *To the Unknown Painter* of 1983 (fig. **29.43**) protests the Fascist persecution of artists in Europe and tyranny of all kinds. It also evokes one of the primary impulses to make art—namely, the wish to keep alive the memory of the deceased. The somber colors, jagged surface texture, and dynamic energy of the brushwork evoke the devastation and chaos of war. From beneath the scorched picture plane a large, rectangular structure comes into focus, looming upward to memorialize those who stand for the forces of creativity and to defeat the forces of war and destruction. The image seems to be engaged in its own process of becoming, as if literally forming itself from the formlessness of what has been destroyed.

29.43 Anselm Kiefer, *To the Unknown Painter,* 1983. Oil, emulsion, woodcut, shellac, latex, and straw on canvas; 9 ft. 2 in. × 9 ft. 2 in. (2.79 × 2.79 m). Carnegie Museum of Art, Pittsburgh (Richard M. Scaife Fund and A. W. Mellon Acquisition Endowment Fund, 83.53).

Maya Ying Lin Some eleven years before the dedication of *The Women's Table,* when Maya Lin was still a student at the Yale School of Architecture, she won the commission to design a memorial to those who died in the Vietnam War. Known as the *Vietnam Veterans Memorial* (fig. **29.44**), the work is a more understated form of protest than Kiefer's. On two wings of polished granite, each 246 feet (74.99 m) long, seventy slabs display the names of every American killed in the war. A total of 58,183 names are inscribed in the order of their deaths. Viewers become engaged in reading the names as the reflective nature of the wall mirrors the world of the living. In this work, therefore, it is the name of the deceased, rather than the image or likeness, that conveys immortality.

29.44 Maya Ying Lin, *Vietnam Veterans Memorial,* the Mall, Washington, D.C., 1981–1983. Polished granite.

29.45 Jeff Koons, *New Hoover Convertibles, Green, Blue; New Hoover Convertibles, Green, Blue; Double-Decker,* 1981–1987. Vacuum cleaners, Plexiglas, fluorescent lights; 22 units overall, 9 ft. 8 in. × 3 ft. 5 in. × 2 ft. 4 in. (2.95 × 1.04 × 0.71 m). Collection, Whitney Museum of American Art, New York (Purchase, funds from Sondra and Charles Gilman, Jr., Foundation/Painting and Sculpture Committee).

Jeff Koons: Return to the Object

The "objects" of Jeff Koons (born 1955), sometimes dismissed as kitsch, are clearly derived from Duchamp's Ready-Mades. They are also related to Oldenburg's Pop Art iconography of everyday household objects and Flavin's neon-light sculptures. They lack the Expressionist attraction to the material textures of paint and the traditional media of sculpture. His *New Hoover Convertibles, Green, Blue; New Hoover Convertibles, Green, Blue; Double-Decker* of 1981–1987 (fig. **29.45**), for example, consists of four vacuum cleaners in Plexiglas cases illuminated by fluorescent lights. Koons enshrines the vacuums, revealing them as icons of our technological society. His title is a kind of verbal collage, juxtaposing the brand of vacuum (Hoover) with the formality of color (blue and green) and allusions to modern transportation (convertible—as in cars—and double-decker—as in buses).

Nancy Graves

The influence of Dada and Surrealism, in which content and objects are often playfully infused with ideas, can be seen in *Morphose* (fig. **29.46**) by Nancy Graves (1940–1995). Her linear abstractions of natural form are reminiscent of Calder's witty mobiles. The central part is a turbine rotor from a ship, which integrates the "object" into a sculptural assemblage, as Picasso did in his *Bull's Head* of 1943 (see fig. 25.9). Anthropomorphic quality is created by Graves in a series of visual metaphors—a ball for the head, sardines for hair, bronze bananas for fingers. At the same time, however, the sculpture as a whole resembles a sea animal rotating slowly in space. Graves's title is itself a kind of Surrealist pun, suggesting the words *metamorphosis, anthropomorphism,* and *metaphor.* All are related to the Greek word *morphe,* meaning "shape" or "form," which is a foundation of every work of art.

— **CONNECTIONS** —

See figure 25.9. Pablo Picasso, *Bull's Head,* 1943.

29.46 Nancy Graves, *Morphose,* 1986. Bronze and copper with polychrome patina and baked enamel; 4 ft. 6 in. × 3 ft. 3 in. × 3 ft. 3 in. (1.37 × 0.99 × 0.99 m). Courtesy, M. Knoedler & Co., Inc. Among Graves's earlier works are a series of freestanding abstract forms based on the objects and rituals of Native Americans and other tribal societies. From the late 1970s, she began adding three-dimensional *objets trouvés* to her paintings and surface colors to her sculptures.

Mark Tansey

In *Action Painting II* (fig. **29.47**), Mark Tansey (born 1949) uses conceptual appropriation to create a visual pun combining Abstract Expressionist Action painting with Realism. This large, monochromatic canvas shows a group of eerily static, self-consciously posing male and female artists painting a rocket launch. Here, the "action" is the explosive burst of fire and smoke billowing from the tail of the rocket and its sharp, vertical thrust into space. Echoing the rocket's vertical is the flagpole at the left. The fluttering Stars and Stripes denotes the Americanness of the event. Art history itself is also a subject of the picture, for the artist draws on the theme of paintings within paintings and recalls Courbet's *Studio* (see fig. 21.5). But whereas Courbet's artist is shown painting a calm landscape, Tansey's artists depict an explosive technological event that extends the notion of nature and reality beyond the planet Earth.

CONNECTIONS

See figure 21.5. Gustave Courbet, *Interior of My Studio,* detail: center section, 1855.

29.47 Mark Tansey, *Action Painting II,* 1984. Oil on canvas; 76 × 110 in. (193.0 × 279.4 cm).

Cindy Sherman

The theme of innovation and continuity is expressed literally in some of the work of Cindy Sherman (born 1954). Her medium is photography and she is her own model. She has photographed herself in various guises from fashion model to cadaver. In an early series of black-and-white photographs, she showed herself as if in stills from gangster movies. Her *Untitled* of 1989 (fig. **29.48**) is a photograph of herself as Raphael's *Fornarina* (fig. **29.49**). In what is apparently a satire on its Renaissance inspiration, Sherman attaches a pair of false breasts and shows herself as pregnant. Her left hand replicates the traditional gesture signifying both modesty and seduction (cf. figs. 13.24, 13.25, 13.57). With her right hand she holds up the heavy mesh drapery resembling a household curtain, which contrasts with Raphael's lighter, more diaphanous material. This gesture recalls that of Arnolfini's bride (see fig. 13.67). Instead of the orderly, embroidered headscarf of the For-

narina, Sherman wears a ragged cloth. In such transformations of the Renaissance work, Sherman creates a pregnant, housewifely replacement of Raphael's idealized, Classical muse.

The Fornarina ("baker's wife" in Italian) was reputed to have been one of Raphael's mistresses, a reading that is reinforced by the background leaves of laurel, myrtle, and quince. All are attributes of Venus and therefore associated with love. This work is also one of Raphael's very few signed paintings—the neatly jeweled armband is inscribed "Raphael of Urbino," suggesting his possession of the woman. Cindy Sherman, on the other hand, wears a garter on her arm, as if to declare her independence from men. At the same time, however, she plays on various aspects of the woman's role in society, including the sense that she is weighed down by childbearing and household chores. Sherman's humor lies in her visual punning and in the fine line between aspects of her own role, which shifts between artist and model, self and other.

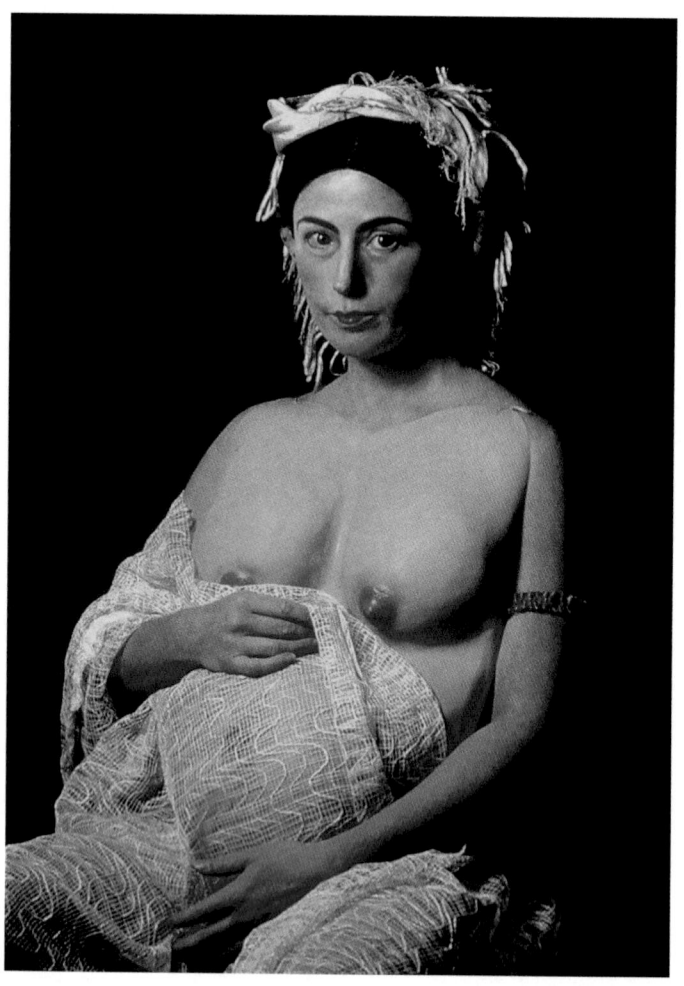

29.48 Cindy Sherman, *Untitled*, 1989. Color photograph, 5 ft. 1½ in. × 4 ft. ¼ in. (1.56 × 1.22 m). Metro Pictures, New York. One of Sherman's best-known projects of the late 1970s was a series of black-and-white film stills, in which she dressed as a stereotypical female character—the heroine, the ingénue, the vamp—in grade-B Hollywood movies.

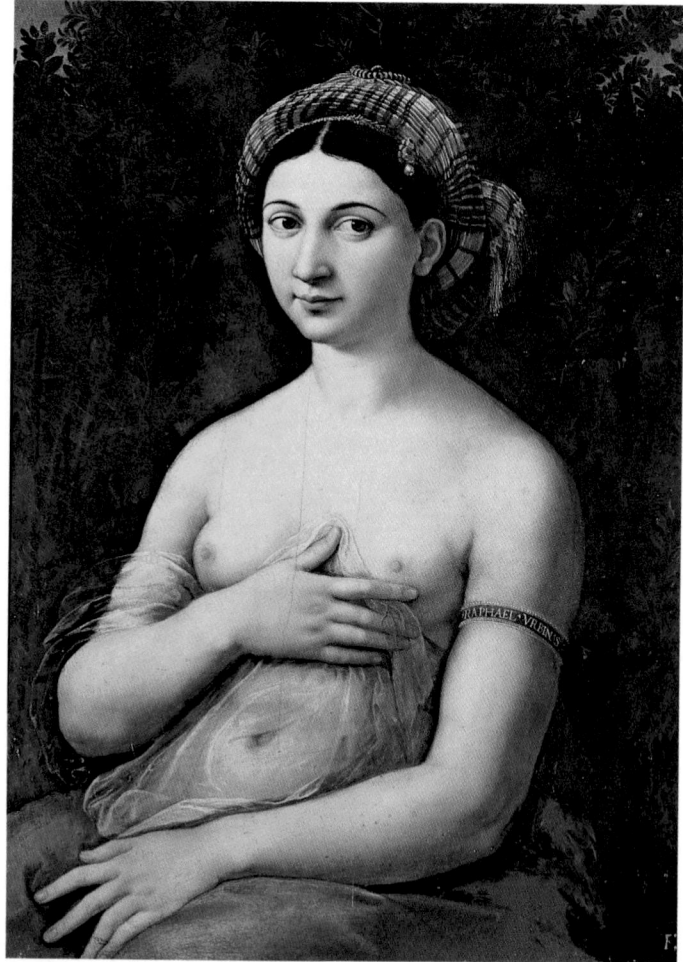

29.49 Raphael, *La Fornarina*, c. 1518. Oil on panel; 33½ × 23½ in. (85.1 × 59.7 cm). Galleria Nazionale (Palazzo Barberini), Rome.

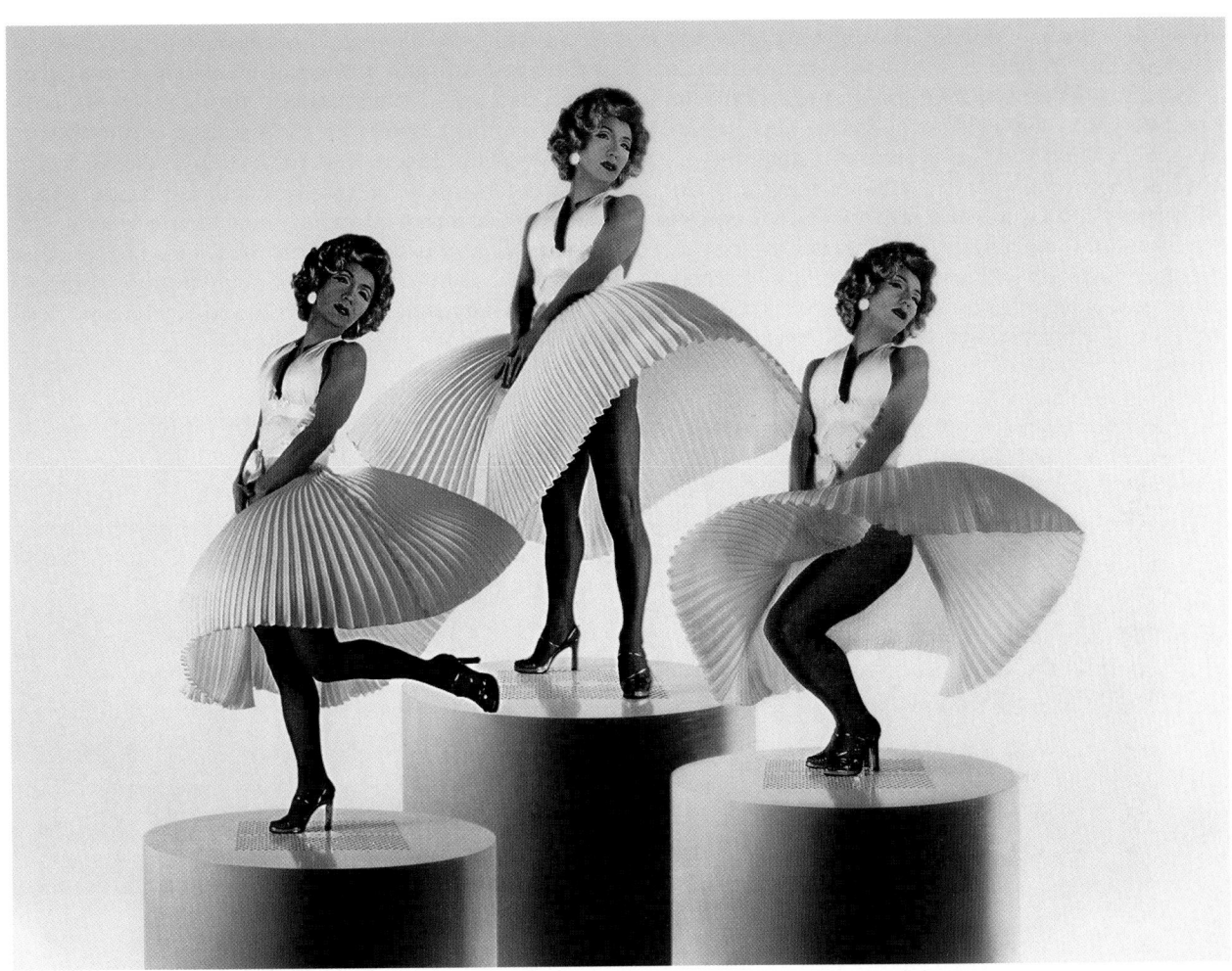

29.50 Yasumasa Morimura, *Self-Portrait (Actress)/White Marilyn*, 1996. Ilfochrome and acrylic sheet; 37¼ × 47¼ in. (94.6 × 120.0 cm). Courtesy Luhring Augustine Gallery, New York.

Yasumasa Morimura

The Post-Modern Japanese artist Yasumasa Morimura (born 1951) remakes European paintings, using himself as the model. He also photographs himself as movie stars, regardless of whether the actual person is male or female. He thus crosses the boundaries of race, gender, and nationality, and uses computers to make digital alterations to the original photograph.

In *Self-Portrait (Actress)/White Marilyn* (fig. **29.50**), Morimura shows himself in three provocative poses, all in imitation of Marilyn Monroe, who is self-consciously aware of being looked at by an audience. "She" stands in silver high-heels on large cylindrical pedestals, her blowing white skirt based on a scene from *The Seven Year Itch*. We also recognize Marilyn Monroe's signature dyed blonde hair and prominent red lipstick, and yet the face is the narrow face of the artist, rather than hers.

Video Art: Nam June Paik, Bill Viola, and Shirin Neshat

The medium of video has offered artists new ways of conveying old, as well as contemporary, themes. One of the leading exponents of video art was the Korean-born composer, performer, and visual artist Nam June Paik (1932-2006). He studied philosophy, aesthetics, and music at the University of Tokyo and in 1956 went to Munich to study music. In Germany, Paik met the avant-garde musician John Cage and worked with Joseph Beuys. In the late 1960s, Paik began to create video sculptures consisting of television monitors arranged in significant shapes and projecting specific, controlled images. He developed a philosophy of cybernetics (the study of communication processes) that he translated into works, merging the transitory character of performance art with the durability of the created object. In a pamphlet entitled *Manifestos* of 1966, Paik wrote: "As the Happening is the fusion of various arts, so cybernetics is the exploitation of boundary regions between and across various existing sciences."[7]

In *TV Buddha* of 1974 (fig. **29.51**), Paik plays with the border between spiritual meditation and the technology of the machine age. Sometimes referred to as the "Zen Master of Video," Paik juxtaposes the religious leader with the new religion of the masses—the TV set. The Buddha sits in a traditional pose and sees himself on the screen, a metaphor, like Picasso's *Girl before a Mirror* (see fig. 25.11), in which the reflection is an instrument of self-contemplation. The rotundity of both the TV set and the Buddha accentuates the narcissistic pun—are we seeing the ideal selfless-ness of Buddhism or the mindlessness of one who is "glued to the television"? *TV Buddha* exemplifies Paik's assertion that "cybernated art is very important, but art for cybernetic life is more important, and the latter need not be cybernated."[8]

In 1996, inspired by a trip to Denmark, Paik produced the *Robot* series—portraits of six famous Danes. Figure **29.52** is *Hamlet Robot,* composed of radios, televisions, and laser-disc players. Paik's *Hamlet,* like Shakespeare's, is a man who would be king but bows his crowned head as if weighed down by despair. The artist conveys Hamlet's proverbial ambivalence by the contrast of the lowered right arm holding the staff of rule with the raised left arm. The skull of Yorick posed on Hamlet's left hand is reminiscent of the warnings inherent in *vanitas* iconography, and its juxtaposition with Hamlet's head seems to foreshadow his tragic end. "The Buddhists also say," according to Paik, that "karma is samsara. Relationship is metempsychosis. We are in open circuits."[9]

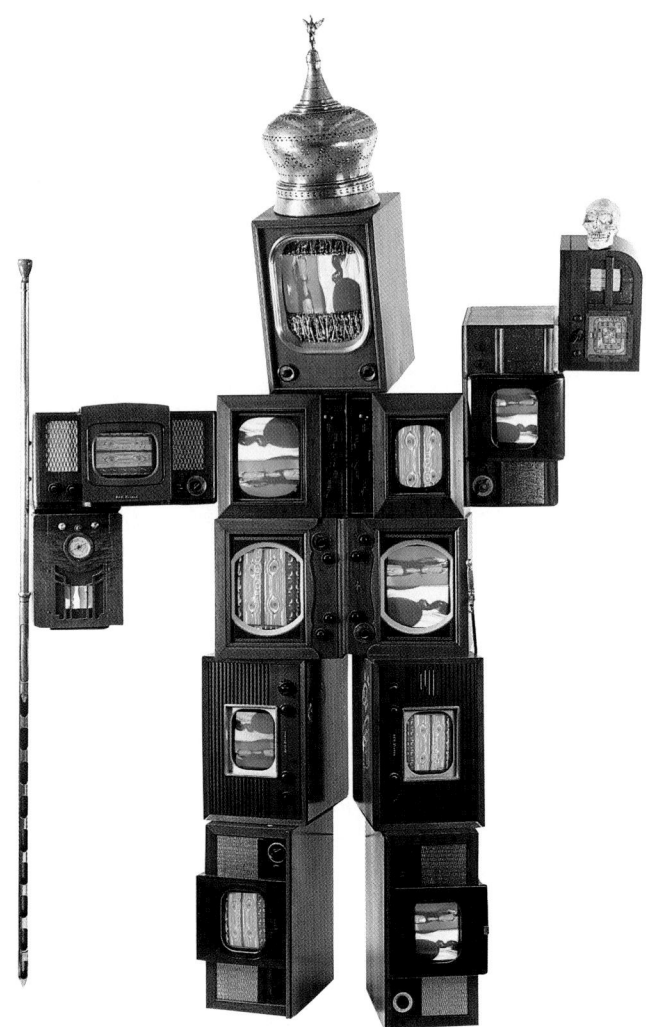

29.52 Nam June Paik, *Hamlet Robot,* 1996. 2 radios, 24 TVs, transformer, 2 laser-disc players, laser discs, crown, scepter, sword, and skull; 12 ft. 1 in. × 7 ft. 4⅕ in. × 2 ft. 7⅞ in. (3.66 × 2.24 × 0.81 m).

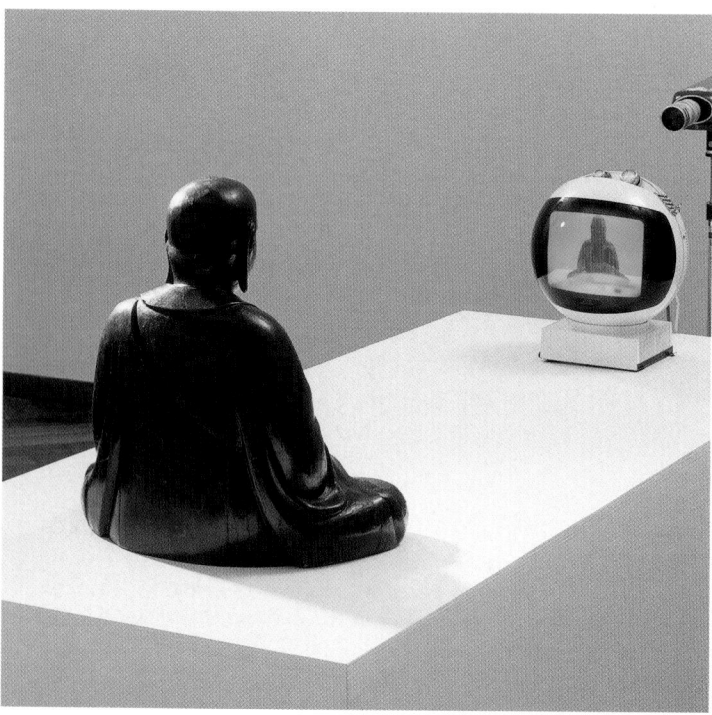

29.51 Nam June Paik, *TV Buddha,* 1974. Video installation with statue. Stedelijk Museum, Amsterdam.

The same year that Paik created *Hamlet Robot* out of radios and television monitors, Bill Viola (born 1951) presented his video installation *The Crossing*. Using sound as well as video, Viola combined the ancient dualism of fire and water with modern media. He projected two sequences, one on either side of a screen, in which a man is consumed and destroyed by the elemental power of nature. Influenced by Eastern religions (including Buddhism and Islam) and interested in the relationship of light and color to form, Viola shows a rapid evolution (a crossing over) from human to nonhuman—and implicitly from physicality to spirituality—as his man disappears into fire or water.

Both sequences are shown simultaneously and begin with a man walking toward the viewer. In the fire sequence (fig. **29.53**), a votive candle at the man's feet becomes a raging fire (accompanied by a roar) and swallows him up. The same sequence occurs on the opposite side of the screen, but with water (fig. **29.54**). At first a few drops fall on the man, but then they become a flood and, also accom-

panied by a roar, engulf him. In contrast to traditional works, found in nearly every culture, that represent various religious and mythical accounts of human creation, Viola reverses the process and undoes the creation of human form. His man thus stands for humanity as a whole, which is destroyed by the elemental forces of fire and water.

In the context of twentieth- and twenty-first-century art history, Viola's video can also be seen as a metaphor for the dissolution of the figure with the rise of abstraction. He begins with figuration—the man—which dissolves into images of unformed light and color. By projecting the sequences onto opposite sides of a screen, Viola creates an anxiety in viewers who cannot apprehend both at once. They must either watch first one sequence and then the other or move back and forth between the two. Thus there is always something happening that the viewer cannot see. The resulting anxiety echoes the panic that results from contemplating one's own physical dissolution.

29.53 Bill Viola, *The Crossing*, fire still, 1996. Video installation, first edition. Collection Solomon R. Guggenheim Museum, New York.

29.54 Bill Viola, *The Crossing*, water still, 1996. Video installation, first edition. Collection Solomon R. Guggenheim Museum, New York.

29.55 Shirin Neshat, *Rapture*, production still of women, 1999. Video. Barbara Gladstone Gallery, New York.

The Iranian-born artist Shirin Neshat (born 1957), like Nam June Paik, combines Eastern and Western themes. Like Viola, she projects videos, but her sequences face each other so that viewers can stand between them and turn from side to side to see them. The shifts required of viewers replicate the social and gender-based oppositions of Neshat's native Iran. They also reinforce the sense of difference between East and West, while at the same time calling for their reconciliation.

The impressive stills of *Rapture* (figs. **29.55** and **29.56**) show a group of women on the beach approaching the ocean and a group of men walking on top of a walled hill overlooking the ocean. Neither group connects with the other, reflecting the gender divide between men and women as well as between the Islamic custom of covering women and allowing men to wear Western dress. In these scenes, the men are more differentiated, even though seen in back view, for they wear white shirts and black pants, and their heads are uncovered. The women, on the other hand, are seen from a greater distance and are mere silhouettes.

In subsequent scenes, the women board a boat and sail away as if into freedom, although their boat is without a sail, a rudder, or a motor. The women are thus left to the mercy of the elements. The men remain on land and are confined by the wall. Here, therefore, Neshat deals with political and religious boundaries, especially as they affect the roles of men and women in contemporary society.

Having entered the twenty-first century, we are presented with a proliferation of artistic styles and expanding definitions of what constitutes art. The pace of technological change, particularly in communications and the media, spawns new concepts and styles at an in-creasing rate. Tastes and styles continue to change, and it will be for future generations to look back at our era and to separate the permanent from the impermanent. How long a work of art must endure for it to claim a place in the artistic canon is a matter of dispute. The little *Venus of Willendorf* has existed for over 25,000 years, the Sistine ceiling for over 450. And yet some of the modern art discussed in this chapter is intentionally transitory. Performance art, for example, lasts no longer than the performance itself, except in memory or on film.

In this survey we have considered some of the artists whose works have stood the test of time. Artists, the "children" of preceding generations of artists, are influenced by their predecessors. This survey will have fulfilled its purpose if readers are affected by some of the best of what has survived.

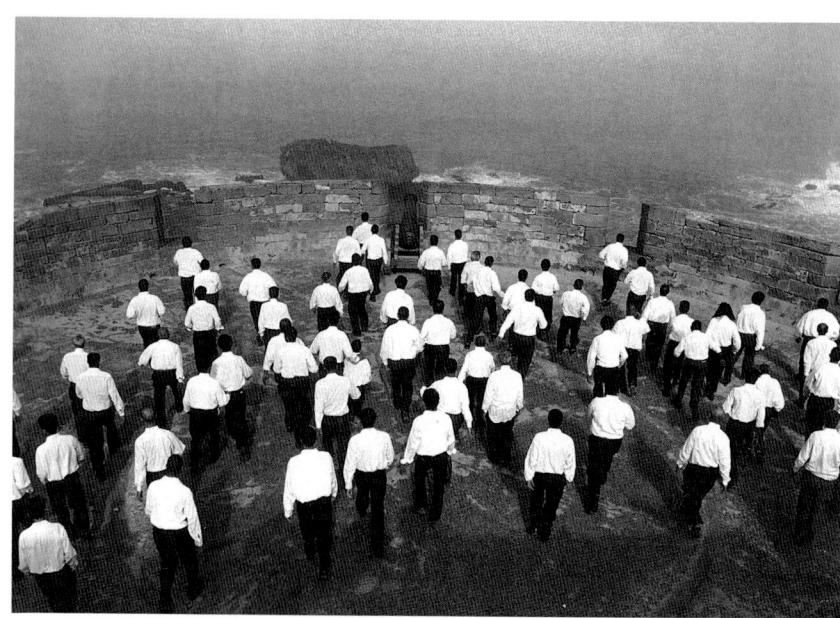

29.56 Shirin Neshat, *Rapture*, production still of men, 1999. Video. Barbara Gladstone Gallery, New York.

Style/Period	Works of Art	Cultural/Historical Developments

1960

| | Raphael, *La Fornarina* (**29.49**) Brancusi, *Sleeping Muse I* (**29.9**) | |

INNOVATION AND
 CONTINUITY
1960–1970

Thompson, *Crucifixion* (**29.40**)
Nauman, *Self-Portrait as a Fountain* (**29.41**)
Breuer, Whitney Museum of American Art
 (**29.13**), New York
Fuller, American Pavilion (**29.14**), Montreal
Close, *Self-Portrait* (**29.4**)
Gilbert and George, *Singing Sculptures*
 (**29.2**)

Fuller, American
Pavilion

1970

1970–1980

Estes, **Solomon R. Guggenheim
Museum**

Smithson, *Spiral Jetty* (**29.25**)
Paik, *TV Buddha* (**29.51**)
Chicago, *The Dinner Party* (**29.36**)
Rothenberg, *IXI* (**29.42**)
Holt, *Stone Enclosure: Rock Rings* (**29.26**)
Moore and Hersey, *Piazza d'Italia* (**29.15**),
 New Orleans
Estes, *Solomon R. Guggenheim Museum*
 (**29.10**)

Paik, **Hamlet
Robot**

Smithson, **Spiral Jetty**

1980

1980–1990

Goldsworthy,
Icicles

Pei, **Louvre Pyramid**

M. Graves, Public Services Building (**29.16**),
 Portland, Oregon
Mapplethorpe, *Self-Portrait* (**29.1**)
Lin, *Vietnam Veterans Memorial* (**29.44**)
Koons, *New Hoover Convertibles* (**29.45**)
Kiefer, *To the Unknown Painter* (**29.43**)
Basquiat, *CARBON/OXYGEN* (**29.34**)
Tansey, *Action Painting II* (**29.47**)
Christo and Jeanne-Claude, *The Umbrellas*
 (**29.28–29.29**)
N. Graves, *Morphose* (**29.46**)
Rogers, *Lloyd's Building* (**29.18**), London
Estes, *Williamsburg Bridge* (**29.6**)
Goldsworthy, *Icicles* (**29.27**)
Pei, *Louvre Pyramid* (**29.17**), Paris
Jaudon, *Long Division* (**29.33**)
Sherman, *Untitled* (**29.48**)
Holzer, *Guggenheim Museum installation*
 (**29.11**)

Norman Mailer, *The Executioner's Song* (1980)
Tom Wolfe, *The Right Stuff* (1980)
Ronald Reagan elected president of the United States
 (1980)
Thomas Keneally, *Schindler's List* (1982)
First patient receives permanent artificial heart
 (1982)
Alice Walker, *The Color Purple* (1983)
David Mamet, *Glengarry Glen Ross* (1984)
Milan Kundera, *The Unbearable Lightness of Being*
 (1984)
Early stages of AIDS epidemic in the United States
 (mid-1980s)
Toni Morrison, *Beloved* (1988)
Communist governments in eastern Europe fall
 (1989)

**Gehry, Solomon R.
Guggenheim
Museum Bilbao**

1990

1990–2005

Close, **Self-Portrait**

Christo, **The Gates**

Gehry, Frederick R. Weisman Museum
 (**29.21**), Minneapolis
Serrano, *Nomads (Sir Leonard)* (**29.35**)
Lin, *The Women's Table* (**29.38–29.39**)
Barney, *Cremaster 4* (**29.12**)
Smith, *Mary Magdalene* (**29.37**)
Anderson, *Nerve Bible Tour* (**29.3**)
Christo and Jeanne-Claude, *Wrapped
 Reichstag* (**29.30**)
Hanson, *The Cowboy* (**29.7**)
Paik, *Hamlet Robot* (**29.52**)
Viola, *The Crossing* (**29.53–29.54**)
Morimura, *Self-Portrait (Actress)/White
 Marilyn* (**29.50**)
Close, *Self-Portrait* (**29.5**)
Gehry, Solomon R. Guggenheim Museum
 Bilbao (**29.20, 29.22–29.24**)
Neshat, *Rapture* (**29.55–29.56**)
Mueck, *Mask II* (**29.8**)
Christo and Jeanne-Claude, *The Gates*
 (**29.31–29.32**)

August Wilson, *The Piano Lesson* (1990)
Apartheid ends in South Africa; Nelson Mandela
 freed (1990)
Iraq invades Kuwait; Operation Desert Shield
 (1990–1991)
Dissolution of the U.S.S.R. (1992)
Bill Clinton elected president of the United States
 (1992)
North American Free Trade Agreement takes effect
 (1994)
Federal office building in Oklahoma City bombed
 (1995)
George W. Bush elected president of the United
 States (2000)
Islamic fundamentalists fly planes into the World
 Trade Center in New York and the Pentagon in
 Washington, D.C. (2001)
United States invades Iraq and topples the
 government of Saddam Hussein (2003)
Pope John Paul II dies; Benedict XVI elected new
 pope (2005)

2000

Notes

Introduction

1. Cited by Martha Joukowsky, *A Complete Manual of Field Archaeology: Tools and Techniques of Field Work for Archaeologists* (Englewood Cliffs, N.J., 1980), p. 1.

Chapter 1

1. Abbé Henri Breuil, *Four Hundred Centuries of Cave Art,* trans. Mary E. Boyle (New York, 1979).
2. James McNeill Whistler, "The Ten o'Clock Lecture," Princes Hall, London, 1885.
3. Jennifer Isaacs, ed., *Australian Dreaming: 40,000 Years of Aboriginal History* (New York, 1980), p. 69.

Chapter 2

1. Cited by Diane Wolkstein and Samuel Noah Kramer, *Inanna, Queen of Heaven and Earth: Her Stories and Hymns from Sumer* (New York, 1983), p. 105.
2. Quoted in James Gardner and John Maier, *Gilgamesh: Translated from the Sîn-leqi-unninnī Version* (New York, 1984), p. 57.
3. Cited by Spiro Kostof, *A History of Architecture: Settings and Rituals* (New York, 1985), p. 60.
4. Cited by Linnea H. Wren and David J. Wren, eds., *Perspectives on Western Art,* 2 vols. (New York, 1987–1994), I, p. 13.
5. Cited by Kostof, pp. 133–134.

Chapter 3

1. Cited by Miriam Lichtheim, *Ancient Egyptian Literature,* I: *The Old and Middle Kingdoms* (Berkeley, 1975), pp. 205–206.
2. T. G. H. James, *An Introduction to Ancient Egypt* (New York, 1979), pp. 149–154.
3. Cited by Lichtheim, pp. 43–44.
4. *Herodotus,* II: *History of Greece,* trans. A. D. Godley, Loeb Classical Library (Cambridge, Mass., 1982), p. 124.
5. Akhenaten, "Hymn to the Sun," in *Ancient Egyptian Literature: An Anthology,* trans. John L. Foster (Austin: University of Texas Press, 2001), p. 6.

Chapter 5

1. Plutarch, "The Life of Pericles," in *Lives,* vol. III, trans. Bernadotte Perrin, Loeb Classical Library (Cambridge, Mass., 1984), p. 36.
2. Cited by John Onians, *Art and Thought in the Hellenistic Age: The Greek World View, 350–50 B.C.* (London, 1979), p. 46.

Window on the World Two

1. *Treasures from the Bronze Age of China: An Exhibition from the People's Republic of China* (New York: Metropolitan Museum of Art, 1980), p. 45.
2. Florian Coulmas, *The Writing Systems of the World* (Oxford, 1989); Georges Jean, *Writing: The Story of Alphabets and Scripts* (London, 1992); Andrew Robinson, *The Story of Writing* (London, 1995).

3. *A Source Book in Chinese Philosophy,* trans. and comp. Wing-Tsit Chan (Princeton, 1963), p. 30.
4. Cited by Bradley Smith and Wan-go Weng, *China: A History in Art* (London, 1973), p. 44.

Chapter 7

1. Virgil, *The Aeneid,* trans. Robert Fitzgerald (New York, 1983), VI.847–853.
2. Cited by William L. MacDonald, *The Architecture of the Roman Empire* (New Haven, 1982), pp. 31–32.
3. Josephus, *Jewish Wars* VII.5.132; cited in J. J. Pollitt, *The Art of Rome, c. 753 B.C.–A.D. 337: Sources and Documents* (New York, 1996), p. 159.
4. Marcus Aurelius, *Meditations* V.1, 2; cited in Pollitt, p. 185.
5. Homer, *Odyssey,* trans. A. T. Murray, Loeb Classical Library (Cambridge, Mass., 1984), pp. 120–126, X.2.

Chapter 9

1. Robert Irwin, *Islamic Art in Context: Art, Architecture, and the Literary World,* Perspective Series (New York, 1997), p. 254.
2. Franz Rosenthal, "Abu Haiyun al-Tawhidi on Penmanship," *Ars Islamica* 13–14 (1948): 18; cited in Anthony Welch, *Calligraphy in the Arts of the Muslim World* (Austin, Texas, 1979).
3. *Beowulf: A Verse Translation,* trans. Frederick Rebsamen (New York, 1991).
4. Cited by H. A. Guerber, *Myths of the Norsemen: From the Eddas and the Sagas* (1909; repr. New York, 1992), p. 3.

Chapter 10

1. William Melczer, *The Pilgrim's Guide to Santiago de Compostela* (New York, 1993), pp. 103–104.

Chapter 11

1. Cited by Erwin Panofsky, *Abbot Suger on the Abbey Church of St.-Denis and Its Art Treasures,* ed., trans., and annotated Erwin Panofsky, 2nd ed. trans. Gerda Panofsky-Soergel (Princeton, 1979), p. 43.
2. Cited *ibid.,* p. 51.
3. Saint Augustine, *The City of God (De Civitate Dei),* bk. 6, trans. George E. McCracken, Loeb Classical Library (Cambridge, Mass., 1978), p. 11.
4. Cited by Bernard McGinn, *Antichrist: Two Thousand Years of the Human Fascination with Evil* (San Francisco, 1994), p. 15.

Chapter 12

1. Cited by Laurie M. Schneider, ed., *Giotto in Perspective* (Englewood Cliffs, N.J., 1974), p. 29.
2. Dante, *Purgatory* II.91–95, in Millard Meiss, *Painting in Florence and Siena after the Black Death* (Princeton, 1951), p. 5.
3. Cited by Linnea H. Wren and David J. Wren, eds., *Perspectives on Western Art,* 2 vols. (New York, 1987–1994), I, p. 270.
4. Cited *ibid.,* pp. 274–277.

Chapter 13

1. Cited by Linnea H. Wren and David J. Wren, eds., *Perspectives on Western Art,* 2 vols. (New York, 1987–1994), II, p. 33.
2. Cited *ibid.,* pp. 36–37.
3. Marsilio Ficino, *Commentary on Plato's Symposium on Love,* trans. Jayne Sears, 2nd rev. ed. (Dallas, 1985), pp. 53–54; cited by Wren and Wren, pp. 35–37.

Chapter 14

1. Giorgio Vasari, *Lives of the Most Eminent Painters, Sculptors, and Architects,* trans. Gaston du C. de Vere, 3 vols. (New York, 1979), II, p. 800.
2. *Ibid.*

Chapter 15

1. John Ashbery, *Selected Poems* (New York, 1985), p. 188.
2. In Elizabeth B. G. Holt, ed., *Literary Sources of Art History: An Anthology of Texts from Theophilus to Goethe* (Princeton, 1947), pp. 245 ff.
3. Giorgio Vasari, *Lives of the Most Eminent Painters, Sculptors, and Architects,* trans. Gaston du C. de Vere, 3 vols. (New York, 1979), II, p. 1045.
4. Cited by Linnea H. Wren and David J. Wren, eds., *Perspectives on Western Art,* 2 vols. (New York, 1987–1994), II, pp. 77–78.

Chapter 16

1. Cited by Linnea H. Wren and David J. Wren, eds., *Perspectives on Western Art,* 2 vols. (New York, 1987–1994), II, p. 105.
2. Cited *ibid.,* p. 109.
3. W. H. Auden, *Collected Poems,* ed. Edward Mendelson (London, 1976), p. 146.
4. Saint Bridget, *Revelations IV*; cited by James Snyder, *Northern Renaissance Art: Painting, Sculpture, the Graphic Arts from 1350 to 1575* (New York, 1985), pp. 149–150.

Chapter 17

1. Cited by Linnea H. Wren and David J. Wren, eds., *Perspectives on Western Art,* 2 vols. (New York, 1987–1994), II, p. 124.
2. Giovanni Pietro Bellori, *The Lives of Annibale and Agostino Carracci,* trans. Catherine Enggass (University Park, Pa., 1968), p. 33.
3. Karel van Mander, *Het Schilder-boeck* (Haarlem, 1604); cited by Howard Hibbard, *Caravaggio* (New York, 1983), p. 344.

Chapter 19

1. Cited by William Howard Adams, *Jefferson's Monticello* (New York, 1983), p. 16.

Chapter 20

1. Edmund Burke, "Philosophical Enquiry into the Origin of Our Ideas of the Sublime and Beautiful," in *The Works of the Right Honorable Edmund Burke,* 9th ed., 12 vols. (Boston, 1889), I, pp. 110–111, 130.

Chapter 21

1. Julia Margaret Cameron, *Annals of My Glass House* (Claremont, Calif., 1996).

Chapter 22

1. See Bradford R. Collins, ed., *Twelve Views of Manet's Bar* (Princeton, 1996).
2. James Baldwin, in an introduction at the opening of Beauford Delaney's exhibition at the Gallery Lambert, Paris, December 4, 1964.
3. Henry Miller, *Remember to Remember* (New York, 1941); repr. in *Air-conditioned Nightmare,* 2 vols. (New York, 1945–1947), II.
4. James McNeill Whistler, letter to Henri Fantin-Latour, 1867; cited by Stanley Weintraub, *Whistler: A Biography* (New York, 1974), p. 124.

Chapter 23

1. Cited by W. H. Auden, ed., *Van Gogh: A Self-Portrait—Letters Revealing His Life as a Painter* (New York, 1989), p. 15.
2. Vincent van Gogh, letter 554, reprinted from *The Complete Letters of Vincent van Gogh, with Reproductions of All the Drawings in the Correspondence,* 3 vols. (Boston, 1991), III, p. 86.
3. Paul Gauguin, in *L'Écho de Paris,* February 23, 1891; cited by Daniel Guérin, ed., *The Writings of a Savage: Paul Gauguin* (New York, 1990), p. 48.
4. Paul Gauguin, in *L'Écho de Paris,* May 13, 1895; cited by Guérin, p. 109.
5. Cited by Arne Eggum, *Symbols and Images,* exh. cat. (Washington, D.C.: National Gallery, 1978), p. 391.

Chapter 24

1. Wallace Stevens, *Collected Poems* (New York, 1954), pp. 165–184.
2. Ernst Kirchner, cited by Leopold Reidmeister, *Das Ursprüngtische und die Moderne* (Berlin, 1964), no. 92; also cited by William Rubin, ed., *"Primitivism" in 20th-Century Art,* 2 vols. (New York, 1984), II, p. 373.
3. Emil Nolde, *Jahre der Kampf;* cited by Donald E. Gordon, "German Expressionism," in Rubin, II, p. 383, as trans. in Herschel B. Chipp, *Theories of Modern Art: A Source Book by Artists and Critics* (Berkeley, 1968), pp. 150–151.
4. Vassily Kandinsky, "Der Blaue Reiter (Rück blick)," *Das Kunstblatt* (1930), as trans. in *Kandinsky, Complete Writings on Art,* ed. Kenneth C. Lindsay and Peter Vergo, 2 vols. (Boston, 1982), II, p. 746; cited by Robert Goldwater, *Primitivism in Modern Art,* rev. ed. (New York, 1967), p. 127, and also cited by Rubin, II, p. 375.

5. Franz Marc, in *Auguste Macke, Franz Marc: Briefwechsel* (Cologne, 1964), pp. 39–41; also cited by Rubin, II, p. 375.
6. Henri Matisse, cited by D. H. Kahnweiler, *Juan Gris, sa vie, son oevre, ses écrits* (Paris, 1946), pp. 155–156; also cited by Rubin, I, p. 216.
7. Pablo Picasso, *La Tête obsidienne;* in André Malraux, *Picasso's Mask,* trans. June Guicharnaud and Jacques Guicharnaud (New York, 1976), p. 18; also cited by Rubin, I, p. 255.
8. Georges Braque, cited by Dora Vallier, "Braque, la peinture et nous," *Cahiers d'art* 29, nos. 1–2 (Oct. 1954): 14; also cited by Rubin, I, p. 307.

Chapter 25

1. Gertrude Stein, *Camera Work* (Aug. 1912): 29–30.
2. Guillaume Apollinaire, "Du Sujet dans la peinture moderne," *Les Soirées de Paris* no. 1 (Feb. 1912): 1–4.
3. Fernand Léger, *Contemporary Achievements in Painting* (Paris, 1914); cited by Edward F. Fry, *Cubism* (New York, 1978), pp. 135–139.
4. From an interview with James Johnson Sweeney, in "Eleven Europeans in America," *Bulletin of the Museum of Modern Art* [New York] 13, nos. 4–5 (1946): 19–21.
5. From the *New York Evening Sun* (1913); cited by Milton W. Brown, *The Story of the Armory Show* (New York, 1963), p. 113.
6. Kazimir S. Malevich, *The World as Non-objectivity: Unpublished Writings 1922–25,* ed. Troels Andersen, trans. Xenia Glowacki-Prus and Edmund T. Little (Copenhagen, 1976).
7. Sidney Geist, in *Artforum* (Feb. 1983): 69.

Chapter 26

1. Cited by Hans Richter, *Dada: Art and Anti-Art,* trans. David Britt (London, 1965), p. 16.
2. Hans Arp, *Dadaland: Zürcher Erinnerungen aus der Zeit des Ersten Weltkrieges* (Zurich, 1948).
3. Cited by Richter, p. 42.
4. Cited *ibid.,* p. 89.
5. Cited *ibid.,* pp. 38, 52–53.
6. Cited by Patrick Waldberg, *Surrealism* (London, 1966), p. 11.
7. Cited *ibid.,* p. 66.
8. Man Ray, "Photography Can Be Art," in *Man Ray: Photographs* (New York, 1982), p. 34.
9. Paul Klee, "Creative Credo," originally published as *Schöpferische Konfession,* ed. K. Edschmid (Berlin, 1920); cited by Herschel B. Chipp, *Theories of Modern Art: A Source Book by Artists and Critics* (Berkeley, 1968), p. 182.
10. Cited by Jean Lipman, with Margaret Aspinwall, *Alexander Calder and His Magical Mobiles* (New York, 1981), p. 53.
11. Cited by Nancy Newhall, ed., *Edward Weston, the Flame of Recognition: His Photographs, Accompanied by Excerpts from the Daybooks and Letters* (New York, 1975), p. 23.
12. Georgia O'Keeffe, letter to Henry McBride, July 1931; cited by Jack Cowart, Juan Hamil-

ton, and Sarah Greenough, eds., *Georgia O'Keeffe: Art and Letters* (Washington, D.C., 1987), p. 203.
13. Cited by Alfred Morang, *Transcendental Painting* (Santa Fe: American Foundation for Transcendental Painting, 1940).

Chapter 27

1. Cited by Willibald Sauerländer, "Un-German Activities," *New York Review of Books,* Apr. 7, 1994.
2. Cited by Herschel B. Chipp, *Theories of Modern Art: A Source Book by Artists and Critics* (Berkeley, 1968).
3. Excerpt from a transcript of an artists' session held in New York, 1948; cited by Chipp, p. 564.
4. Harold Rosenberg, "Getting inside the Canvas," *Art News* (New York) (Dec. 1952): 22–23; repr. in Harold Rosenberg, *The Tradition of the New* (New York, 1959); cited by Chipp, p. 580.
5. Clement Greenberg, "Abstract Representation, and So Forth," in *Art and Culture: Critical Essays* (Boston, 1961), pp. 133–138; cited by Chipp, p. 579.
6. Greenberg, pp. 137–138; cited by Chipp, p. 580.
7. Jackson Pollock, in *Arts and Architecture* 61 (Feb. 1944): 193; cited by Chipp, p. 546.
8. Willem de Kooning, from the symposium "What Abstract Art Means to Me," held at the Museum of Modern Art, New York, 1951.
9. Mark Rothko, "The Romantics Were Prompted," *Possibilities I* (New York) (Winter 1947/48): 84.
10. Francis Bacon, *Statements, 1952–1955,* in *Time* (1952, 1953); cited by Chipp, p. 620.

Chapter 28

1. Cited by Brydon Smith, *Dan Flavin, Fluorescent Light, etc. from Dan Flavin,* exh. cat. (Ottawa: National Gallery of Canada, 1969), p. 206.
2. Cited by Barbara Haskell, *Agnes Martin,* exh. cat. (New York: Whitney Museum of American Art, 1992), pp. 16, 17, 24.
3. Cited by Lucy Lippard, *Eva Hesse* (New York, 1976), p. 5.

Chapter 29

1. Jesse Helms, in *Art in America* (Sept. 1989): 39.
2. Cited in *Newsweek,* Apr. 16, 1990, p. 27.
3. Cited by Linda Chase and Tom McBurnett, "Tom Blackwell," in "The Photo-Realists: Twelve Interviews," *Art in America* (Nov.–Dec. 1972): 76.
4. Cited in the *New York Times,* July 3, 1983.
5. Cited in Robert Storr, *Bruce Nauman,* exh. cat. (New York: Museum of Modern Art, 1995), p. 59.
6. *Ibid.,* p. 55.
7. Nam June Paik, in *Manifestos* (New York, 1966).
8. *Ibid.*
9. *Ibid.*

Glossary

Abacus: the flat slab that forms the topmost unit of a Doric **column** and on which the **architrave** rests.

Abhaya: see *mudrā.*

Abstract: in painting and sculpture, having a generalized or essential form with only a symbolic resemblance to natural objects.

Abutment: the part of a building intended to receive and counteract the **thrust,** or pressure, exerted by **vaults** and **arches.**

Academy: (a) the gymnasium near Athens where Plato taught; (b) from the eighteenth century, the cultural and artistic establishment and the standards that they represent.

Acanthus: a Mediterranean plant with prickly leaves, supposedly the source of foliage-like ornamentation on Corinthian **columns.**

Achromatic: free of color.

Acrylic: a fast-drying, water-based synthetic paint **medium.**

Aedicule: (a) a small building used as a shrine; (b) a **niche** designed to hold a statue. Both types are formed by two **columns** or **pilasters** supporting a **gable** or **pediment.**

Aerial (or **atmospheric**) **perspective:** a technique for creating the illusion of distance by the use of less distinct **contours** and a reduction in color **intensity.**

Aesthetic: the theory and vocabulary of an individual artistic style.

Aesthetics: the philosophy and science of art and artistic phenomena.

Agora: the open space in an ancient Greek town used as a marketplace or for general meetings.

Airbrush: a device for applying a fine spray of paint or other substance by means of compressed air.

Aisle: a passageway flanking a central area (e.g., the corridors flanking the **nave** of a **basilica** or **cathedral.**

Alabaster: a dense variety of fine-textured gypsum, usually white and translucent, but sometimes gray, red, yellow, or banded, used for carving on a small scale.

Allegory: the expression (artistic, oral, or written) of a generalized moral statement or truth by means of symbolic actions or figures.

Altar: (a) any structure used as a place of sacrifice or worship; (b) a tablelike structure used in a Christian church to celebrate the **Eucharist.**

Altarpiece: a painted or sculpted work of art designed to stand above or behind an **altar.**

Āmalaka: a **finial** in the shape of a notched ring (derived from a fruit) atop a northern-style Hindu temple's *shikhara.*

Ambulatory: a **vaulted** passageway, usually surrounding the **apse** or **choir** of a church.

Amphitheater: an oval or circular space surrounded by rising tiers of seats, as used by the ancient Greeks and Romans for plays and other spectacles.

Amphora: an ancient Greek two-handled vessel for storing grain, honey, oil, or wine.

Analogous hues: **hues** containing a common color, though in different proportions.

Anda: the **dome** of a Buddhist **stupa,** its egg shape symbolizing the arc of the heavens.

Aniconic: depicting a figure, usually a deity, symbolically instead of anthropomorphically.

Annular: ring-shaped, as in an annular **barrel vault.**

Apocalypse: (a) a name for the last book of the New Testament, generally known as the Revelation of Saint John the Divine; (b) a prophetic revelation.

Apostle: in Christian terminology, one of the twelve followers, or disciples, chosen by Christ to spread his Gospel; also used more loosely to include early missionaries such as Saint Paul.

Apotropaion: an object or device designed to avert, or turn aside, evil.

Apsaras: celestial dancers seen in south and southeast Asian religious art.

Apse: a projecting part of a building (especially a church), usually semicircular and topped by a half-**dome** or **vault.**

Aquatint: a **print** from a metal **plate** on which certain areas have been "stopped out" to prevent the action of the acid.

Aqueduct: a man-made conduit for transporting water.

Arabesque: literally meaning "in the Arabian fashion," an intricate pattern of **interlaced** or knotted lines consisting of stylized floral, foliage, and other **motifs.**

Arcade: a **gallery** formed by a series of **arches** with supporting **columns** or **piers,** either freestanding or blind (i.e., attached to a wall).

Arch: a curved architectural member, generally consisting of wedge-shaped blocks (**voussoirs**), which is used to span an opening; it transmits the downward pressure laterally.

Archaeometry: a branch of archaeology that dates objects through the use of various techniques such as amino-acid and **radiocarbon dating.**

Architrave: the lowest unit of an **entablature,** resting directly on the **capital** of a **column.**

Archivolt: the ornamental band or **molding** surrounding the **tympanum** of a Romanesque or Gothic church.

Arena: the central area in a Roman **amphitheater** where gladiatorial spectacles took place.

Armature: (a) a metal framework for a **stained-glass** window; (b) a fixed, inner framework supporting a sculpture made of a flexible material.

Arriccio: the rough first coat of plaster in a **fresco.**

Assemblage: a group of **three-dimensional** objects brought together to form a work of art.

Asymmetrical: characterized by asymmetry, or lack of **balance,** in the arrangement of parts or components.

Atmospheric perspective: see **aerial perspective.**

Atrium: (a) an open courtyard leading to, or within, a house or other building, usually surrounded on three or more sides by a **colonnade;** (b) in a modern building, a rectangular space off which other rooms open.

Attic: in Classical architecture, a low story placed above the main **entablature.**

Attribute: an object closely identified with, and thought of as belonging to, a specific individual —particularly, in art, a deity or saint.

Avant-garde: literally the "advanced guard," a term used to denote innovators or nontraditionalists in a particular field.

Axis: an imaginary straight line passing through the center of a figure, form, or structure and about which that figure is imagined to rotate.

Axonometric projection: the depiction on a single **plane** of a **three-dimensional** object by placing it at an angle to the **picture plane** so that three faces are visible.

Balance: an aesthetically pleasing equilibrium in the combination or arrangement of elements.

Baldacchino: a canopy or canopylike structure above an **altar** or throne.

Balustrade: a series of balusters, or upright **pillars,** supporting a rail (as along the edge of a balcony or bridge).

Baptistery: a building, usually round or polygonal, used for Christian baptismal services.

Barrel (or **tunnel**) **vault:** a semicylindrical **vault,** with parallel **abutments** and an identical **cross section** throughout, covering an oblong space.

Base: (a) that on which something rests; (b) the lowest part of a wall or **column** considered as a separate architectural feature.

Basilica: (a) in Roman architecture, an oblong building used for tribunals and other public functions; (b) in Christian architecture, an early church with similar features to the Roman prototype.

Bas-relief: see **low relief.**

Bay: a unit of space in a building, usually defined by **piers, vaults,** or other elements in a structural system.

Beaverboard: a type of fiberboard used for partitions and ceilings.

Bhūmi (literally "earth"): the stacked ridges that horizontally segment a northern-style Hindu temple's *shikhara.*

Bhūmisparsha: see *mudrā.*

Binder, binding medium: a substance used in paint and other **media** to bind particles of **pigment** together and enable them to adhere to the **support.**

Biomorphic: derived from or representing the forms of living things rather than **abstract** shapes.

Bister, bistre: a brown **medium** made from the soot of burnt wood.

Black-figure: describing a style of Greek pottery painting of the sixth century B.C., in which the decoration is black on a red background.

Blind niche: see **niche.**

Bodhisattva: one of many enlightened Buddhist deities who delay their own nirvana in order to help mortals attain enlightenment.

Book of Hours: a prayer book, intended for lay use, containing the devotions, or acts of worship, for the hours of the Roman Catholic Church (i.e., the times appointed for prayer, such as Matins and Vespers).

Broken pediment: a **pediment** in which the **cornice** is discontinuous or interrupted by another element.

Bronze: a metal alloy composed of copper mixed with tin.

Buon fresco: see **fresco.**

Burin: a metal tool with a sharp point to incise designs on pottery and **etching plates,** for example.

Burr: in **etching,** the rough ridge left projecting above the surface of an engraved **plate** where the design has been incised.

Bust: a sculptural or pictorial representation of the upper part of the human figure, including the head and neck (and sometimes part of the shoulders and chest).

Buttress: an external architectural support that counteracts the lateral thrust of an **arch** or wall.

Caduceus: the symbol of a herald or physician, consisting of a staff with two snakes twined around it and two wings at the top.

Calligraphy: handwriting designed to be beautiful; **calligraphic** writing or drawing can be expressive as well as beautiful.

Camera obscura: a dark enclosure or box into which light is admitted through a small hole, enabling images to be projected onto a wall or screen placed opposite that hole; the forerunner of the photographic camera.

Campanile: Italian for bell tower, usually freestanding, but built near a church.

Canon: a set of rules, principles, or standards used to establish scales or **proportions.**

Canopic: relating to the city of Canopus in ancient Egypt.

Canopic jar: a vessel in which ancient Egyptians preserved the viscera of the dead.

Cantilever: a long, low architectural support that enables a **cantilevered** element such as an eave or a **cornice** to project horizontally without vertical support at the far end.

Capital: the decorated top of a **column** or **pilaster**, providing a transition from the **shaft** to the **entablature**.

Caricature: a representation in art or literature that distorts, exaggerates, or oversimplifies certain features.

Cartonnage: layers of linen or papyrus glued together and usually coated with **stucco**.

Cartoon: (a) a full-scale preparatory drawing for a painting; (b) in more modern usage, a comical or satirical drawing.

Cartouche: an oval or **scroll**-shaped design or ornament, usually containing an inscription, a heraldic device, or (as in Egypt) a ruler's name.

Carving: creating an image by removing material from an original material.

Caryatid: a supporting **column** in **post-and-lintel** construction carved to represent a human or animal figure.

Casein: a light-colored, protein-based substance derived from milk, used in the making of paint, adhesives, etc.

Casting: a process in which liquefied material, usually metal, is formed by being poured into a mold; the mold is removed when the material has solidified, leaving a **cast** object in the shape of the mold.

Castrum (pl. *castra*): an ancient Roman fortress; a Roman encampment.

Catacomb: an underground complex of passageways and **vaults,** such as those used by Jews and early Christians to bury their dead.

Cathedral: the principal church of a diocese (the ecclesiastical district supervised by a bishop).

Cella: the main inner room of a temple, often containing the cult image of the deity.

Centering: the temporary wooden framework used in the construction of **arches, vaults,** and **domes.**

Centrally planned: radiating from a central point.

Ceramics: (a) the art of making objects from clay or other substances (such as **enamel** and porcelain) that require **firing** at high temperatures; (b) the objects themselves.

Chaitya **arch:** a splayed, horseshoe-shaped curve derived from the profile of a **barrel-vaulted** *chaitya* **hall;** used to frame doors, windows, and gables, and as a decorative motif in early south Asian architecture.

Chaitya **hall:** a U-shaped Buddhist structural or rock-cut chamber for congregational worship centered on a **stupa.**

Chancel: that part of a Christian church, reserved for the clergy and choir, in which the **altar** is placed.

Chapter house: a meeting place for the discussion of business in a **cathedral** or **monastery.**

Château: French word for a castle or large country house.

Chattra: a royal parasol crowning the **dome** *(anḍa)* of a Buddhist **stupa,** symbolically honoring the Buddha.

Chauri: a royal fly-whisk, symbolically honoring the Buddha.

Chevet: French term for the east end of a Gothic church, comprising the **choir, ambulatory,** and **radiating chapels.**

Chiaroscuro: the subtle gradation of light and shadow used to create the effect of **three-dimensionality.**

Chinoiserie: a Western style popular in the eighteenth century, reflecting Chinese **motifs** or qualities.

Choir: part of a Christian church, near the **altar,** set aside for those chanting the services; usually part of the **chancel.**

Chroma: see **intensity.**

Chromatic: colored or pertaining to color.

Chryselephantine: consisting of, or decorated with, gold and ivory.

Circumambulate: to walk around something, especially an object of worship or veneration.

Circus: in ancient Rome, an oblong space, surrounded by seats, used for chariot races, games, and other spectacles.

Cire-perdue: see **lost-wax bronze casting.**

Citadel: a fortress or other fortified area placed in an elevated or commanding position.

Clerestory: the upper part of the main outer wall of a building (especially a church), located above an adjoining roof and admitting light through a row of windows.

Cloisonné: a multicolored surface made by pouring **enamels** into compartments outlined by bent wire fillets, or **strips.**

Cloister: in a **monastery,** a covered passage or **ambulatory,** usually with one side walled and the other open to a courtyard.

Close: an enclosed space, or precinct, usually next to a building such as a **cathedral** or castle.

Cluster (or compound) pier: a **pier** composed of a group, or cluster, of **engaged column** shafts, often used in Gothic architecture.

Codex (pl. **codices**): sheets of **parchment** or **vellum** bound together—the precursor of the modern book.

Coffer, coffering: a recessed geometrical panel in a ceiling.

Collage: a work of art formed by pasting fragments of printed matter, cloth, and other materials (occasionally **three-dimensional**) to a flat surface.

Colonnade: a series of **columns** set at regular intervals, usually supporting **arches** or an **entablature.**

Colonnette: a small, slender **column,** usually grouped with others to form **cluster piers.**

Color wheel: a circular, two-dimensional model illustrating the relationships of the various **hues.**

Column: a cylindrical support, usually with three parts—**base, shaft,** and **capital.**

Complementary colors: hues that lie directly opposite each other on the **color wheel.**

Compluvium (pl. *compluvia*): a square opening in the roof of a Roman **atrium** through which rain fell into an *impluvium.*

Composition: the arrangement of **formal** elements in a work of art.

Compound pier: see **cluster pier.**

Conceptual art: art in which the idea is more important than the **form** or **style.**

Cone mosaic: a surface decorated by pressing pieces (usually colored and of conical shape) of stone or baked clay into damp plaster.

Content: the themes or ideas in a work of art, as distinct from its **form.**

Contour: a line representing the outline of a figure or form.

Contrapposto (or **counterpoise**): a stance of the human body in which one leg bears the weight, while the other is relaxed, creating an **asymmetry** in the hip-shoulder **axis.**

Contrast: an abrupt change, such as that created by the juxtaposition of dissimilar colors, objects, etc.

Convention: a custom, practice, or principle that is generally recognized and accepted.

Corbeling: brick or masonry **courses,** each projecting beyond, and supported by, the one below it; the meeting of two corbels would create an **arch** or **vault.**

Corinthian: see **Order.**

Cornice: the projecting horizontal unit, usually molded, that surmounts an **arch** or wall; the topmost member of a Classical **entablature.**

Counterpoise: see *contrapposto.*

Courses: horizontal layers of brick or masonry in a wall.

Crayon: a stick for drawing formed from powdered **pigment** mixed with wax.

Crenellated: having a series of indentations, like those in a battlement.

Cromlech: a prehistoric monument consisting of a circle of **monoliths.**

Crosshatching: a pattern of superimposed parallel lines (**hatching**) on a two-dimensional surface used to create shadows and suggest **three-dimensionality.**

Crossing: the area in a Christian church where the **transepts** intersect the **nave.**

Cross section: a diagram showing a building cut by a vertical **plane,** usually at right angles to an **axis.**

Cross vault: see **groin vault.**

Cruciform: shaped or arranged like a cross.

Crypt: a chamber or **vault** beneath the main body of a church.

Cuneiform: a form of writing consisting of wedge-shaped characters, used in ancient Mesopotamia.

Cupola: a small, domed structure crowning a roof or **dome,** usually added to provide interior lighting.

Curvilinear: composed of, or bounded by, curved lines.

Cyclopaean masonry: stone construction using large, irregular blocks without mortar.

Cylinder seal: a small cylinder of stone or other material engraved in **intaglio** on its outer surface and used (especially in Mesopotamia) to roll an impression on wet clay.

Daguerreotype: mid-nineteenth-century photographic process for **fixing** positive images on silver-coated metal **plates.**

Decussis: the Latin numeral ten (X).

Deēsis: a tripartite **icon** in the Byzantine tradition, usually showing Christ enthroned between the Virgin Mary and Saint John the Baptist.

Dendrochronology: a science using the annual rings of trees to determine the chronological order and dates of historical events.

Dharmachakra: see *mudrā.*

Dhyāna: see *mudrā.*

Diorite: a type of dark (black or gray) crystalline rock.

Diptych: a writing tablet or work of art consisting of two panels side by side and connected by hinges.

Dolmen: a prehistoric structure consisting of two or more **megaliths** capped with a horizontal slab.

Dome: a **vaulted** (frequently hemispherical) roof or ceiling, erected on a circular **base,** which may be envisaged as the result of rotating an **arch** through 180 degrees about a central **axis.**

Doric: see **Order.**

Dressed stone: blocks of stone that have been cut and shaped to fit in a particular place for a particular purpose.

Drip technique: a painting technique in which paint is dripped from a brush or stick onto a horizontal canvas or other **ground.**

Drum: (a) one of the cylindrical blocks of stone from which the **shaft** of a **column** is made; (b) the circular or polygonal wall of a building surmounted by a **dome** or **cupola.**

Drypoint: an **engraving** in which the image is scratched directly into the surface of a metal **plate** with a pointed instrument.

Earthenware: pottery that has been either air-dried or **fired** at a relatively low temperature.

Easel: a frame for supporting a canvas or wooden panel.

Echinus: in the **Doric Order,** the rounded **molding** between the **necking** and the **abacus.**

Edition: a batch of **prints** made from a single **plate** or print form.

Egg and dart: a decorative **molding** consisting of alternating oval (egg) and downward-pointing (dart) elements.

Elevation: an architectural diagram showing the exterior (or, less often, interior) surface of a building as if projected onto a vertical **plane.**

Emulsion: a light-sensitive chemical coating used to transfer photographic images onto metal **plates** or other surfaces.

Enamel: a vitreous coating applied by heat fusion to the surface of metal, glass, or pottery. See also *cloisonné.*

Encaustic: a painting technique in which **pigment** is mixed with a **binder** of hot wax and fixed by heat after application.

Engaged (half-) column: a **column**, decorative in purpose, that is attached to a supporting wall.

Engraving: (a) the process of incising an image on a hard material, such as wood, stone, or a copper **plate**; (b) a **print** or impression made by such a process.

Entablature: the portion of a Classical architectural **Order** above the **capital** of a **column.**

Entasis: the slight bulging of a **Doric column,** which is at its greatest about one third of the distance from the **base.**

Etching: (a) a printmaking process in which an impression is taken from a metal **plate** on which the image has been etched, or eaten away by acid; (b) a **print** produced by such a process.

Etching ground: a resinous, acid-resistant substance used to cover a copper **plate** before an image is etched on it.

Eucharist: (a) the Christian sacrament of Holy Communion, commemorating the Last Supper; (b) the consecrated bread and wine used at the sacrament.

Evil eye: a malicious glance which, in superstitious belief, is thought to be capable of causing material harm.

Façade: the front or "face" of a building.

Facing: an outer covering or sheathing.

Faïence: earthenware or pottery decorated with brightly colored **glazes** (originally from Faenza, a city in northern Italy).

Fantasy: imagery that is derived solely from the imagination.

Figura serpentinata: a snakelike twisting of the body, typical of Mannerist art.

Figurative: representing the likeness of a recognizable human (or animal) figure.

Finial: a small decorative element at the top of an architectural member such as a **gable** or pinnacle, or of a smaller object such as a **bronze** vessel.

Fire (verb): to prepare (especially **ceramics**) by baking in a kiln or otherwise applying heat.

Fixing: the use of a chemical process to make an image (a photograph, for example) more permanent.

Fleur-de-lis: (a) a white iris, the royal emblem of France; (b) a **stylized** representation of an iris, common in artistic design and heraldry.

Flutes, fluting: a series of vertical grooves used to decorate the **shafts** of **columns** in Classical architecture.

Flying buttress, or **flyer:** a **buttress** in the form of a strut or open half-**arch.**

Foreground: the area of a picture, usually at the bottom of the **picture plane,** that appears nearest to the viewer.

Foreshortening: the use of **perspective** to represent a single object extending back in space at an angle to the **picture plane.**

Form: the overall plan or structure of a work of art.

Formal analysis: analysis of a work of art to determine how its integral parts, or **formal elements,** are combined to produce the overall **style** and effect.

Formal elements: the elements of **style** (line, shape, color, etc.) used by an artist in the **composition** of a work of art.

Formalism: the doctrine or practice of strict adherence to **stylized** shapes or other external **forms.**

Forum: the civic center of an ancient Roman city, containing temple, marketplace, and official buildings.

Found object (or *objet trouvé*): an object not originally intended as a work of art, but presented as one.

Fresco: a technique (also known as *buon fresco*) of painting on the plaster surface of a wall or ceiling while it is still damp, so that the **pigments** become fused with the plaster as it dries.

Fresco secco: a variant technique of **fresco** painting in which the paint is applied to dry plaster; this is often combined with *buon fresco,* or "true" fresco painting.

Frieze: (a) the central section of the **entablature** in the Classical **Orders;** (b) any horizontal decorative band.

Functionalism: a philosophy of design (in architecture, for example) holding that **form** should be consistent with material, structure, and use.

Gable (or **pitched**) **roof:** a roof formed by the intersection of two **planes** sloping down from a central beam.

Gallery: the second story of a church, placed over the side **aisles** and below the **clerestory.**

Garbha griha (literally "womb chamber"): a small, cubical **sanctuary** that is the sacred core of a Hindu temple.

Genre: a category of art representing scenes of everyday life.

Geodesic dome: a **dome**-shaped framework consisting of small, interlocking polygonal units.

Geometric: (a) based on mathematical shapes such as the circle, square, or rectangle; (b) a **style** of Greek pottery made between c. 900 and 700 B.C., characterized by geometric decoration.

Gesso: a white coating made of chalk, plaster, and **size** that is spread over a surface to make it more receptive to paint.

Gilding: a decorative coating made of gold leaf or simulated gold; objects to which gilding has been applied are **gilded** or **gilt.**

Glaze: (a) in **oil painting,** a layer of translucent paint or varnish, sometimes applied over another color or **ground,** so that light passing through it is reflected back by the lower surface and modified by the glaze; (b) in pottery, a material applied in a thin layer that, when **fired,** fuses with the surface to produce a glossy, nonporous effect.

Glyptic art: the art of carving or **engraving,** especially on small objects such as seals or precious stones.

Gospel: one of the first four books of the New Testament, which recounts the life of Christ.

Gouache: an opaque, water-soluble painting **medium.**

Greek cross: a cross in which all four arms are of equal length.

Grisaille: a **monochromatic** painting (usually in shades of black and gray, to simulate stone sculpture).

Groin (or **cross-**) **vault:** the ceiling configuration formed by the intersection of two **barrel vaults.**

Ground: in painting, the prepared surface of the **support** to which the paint is applied.

Ground plan: a plan of the ground floor of a building, seen from above (as distinguished from an **elevation**).

Guilds: organizations of craftsmen, such as those that flourished in the Middle Ages and Renaissance.

Half-column: see **engaged column.**

Halo: a circle or disk of golden light surrounding the head of a holy figure.

Happening: an event in which artists give an unrehearsed performance, sometimes with the participation of the audience.

Harmikā: a square platform surmounting the **dome** of a Buddhist **stupa.**

Hatching: close parallel lines used in drawings and prints to create the effect of shadow on **three-dimensional** forms. See also **cross-hatching.**

Hierarchical proportion or **scale:** the representation of more important figures as larger than less important ones.

Hieroglyphic: written in a script (especially in ancient Egypt) whose characters are pictorial representations of objects.

Highlight: in painting, an area of high **value** color.

High relief: relief sculpture in which the figures project substantially (e.g., more than half of their natural depth) from the background surface.

Hôtel: in eighteenth-century France, a city mansion belonging to a person of rank.

Hue: a pure color with a specific wavelength.

Hydria: an ancient Greek or Roman water jar.

Hypostyle: a hall with a roof supported by rows of **columns.**

Icon: a sacred image representing Christ, the Virgin Mary, or some other holy person.

Iconography: the analysis of works of art through the study of the meanings of symbols and images in the context of the contemporary culture.

Iconology: the study of the meaning or content of a larger **program** to which individual works of art belong.

Idealized, idealization: the representation of objects and figures according to ideal standards of beauty rather than to real life.

Ideograph: a written symbol standing for a concept, usually formed by combining **pictographs.**

Ignudi (pl.): nude figures (in Italian).

Illuminated manuscript: see **manuscript.**

Illusionism, illusionistic: a type of art in which the objects are intended to appear real.

Impasto: the thick application of paint, usually **oil** or **acrylic,** to a canvas or panel.

Impost block: a block between a **capital** of a **column** and the **springing** of an **arch.**

Impluvium (pl. *impluvia*): a basin or cistern in the *atrium* of a Roman house to collect rainwater falling through the *compluvium.*

Incise: to cut designs or letters into a hard surface with a sharp instrument.

Incised relief: see **sunken relief.**

Inlay: to decorate a surface by inserting pieces of a different material (e.g., to inlay a panel with contrasting wood).

Installation: a **three-dimensional** environment or ensemble of objects, presented as a work of art.

Insula (pl. *insulae*): an ancient Roman building or group of buildings standing together and forming an apartment block.

Intaglio: a printmaking process in which lines are incised into the surface of a **plate** or **print** form (e.g., **engraving** and **etching**).

Intensity: the degree of purity of a color; also known as **chroma** or **saturation.**

Interlace: a form of decoration composed of strips or ribbons that are intertwined, usually symmetrically about a longitudinal **axis.**

Ionic: see **Order.**

Isocephaly, isocephalic: the horizontal alignment of the heads of all the figures in a composition.

Isometric projection: an architectural diagram combining a **ground plan** of a building with a view from an exterior point above and slightly to one side.

Ithyphallic: an image having an erect or prominent phallus.

Jambs: the upright surfaces forming the sides of a doorway or window, often decorated with sculptures in Romanesque and Gothic churches.

Japonisme: the Japanese aesthetic as absorbed by the West in the latter part of the nineteenth century.

Jatakā: a tale recounting an incident in one of the Buddha's lives, frequently depicted in Buddhist art.

Keystone: the wedge-shaped stone at the center of an **arch, rib,** or **vault** that is inserted last, locking the other stones into place.

Kiln: an oven used to bake (or **fire**) clay.

Kondō: the main hall of a Japanese Buddhist temple, where religious images are kept.

Kore (pl. *korai*): Greek word for maiden; an Archaic Greek statue of a standing female, usually clothed.

Kouros (pl. *kouroi*): Greek word for young man; an Archaic Greek statue of a standing nude youth.

Krater: a wide-mouthed bowl for mixing wine and water in ancient Greece.

Kufic: an early form of Arabic script in which letters are relatively uncursive; used later for headings and formal inscriptions.

Kylix: an ancient Greek drinking cup with a wide, shallow bowl.

Lamassu (pl.): in Assyrian art, figures of bulls or lions with wings and human heads.

Lancet: a tall narrow, arched window without **tracery.**

Landscape: a pictorial representation of natural scenery.

Lantern: the structure crowning a **dome** or tower, often used to admit light to the interior.

Lapis lazuli: a semiprecious blue stone; used to prepare the blue **pigment** known as ultramarine.

Lares and **penates:** (a) in ancient Rome, the tutelary gods of the household; (b) figuratively, one's most valued household possessions.

Latin cross: a cross in which the vertical arm is longer than the horizontal arm, through the midpoint of which it passes.

Leaf and dart: a decorative design consisting of alternating leaf- and dart-shaped elements.

Lekythos (or *lecythus*): an ancient Greek vessel with a long, narrow neck, used primarily for pouring oil.

Linear: a style in which lines are used to depict figures with precise, fully indicated outlines.

Linear (or **scientific**) **perspective:** a mathematical system devised during the Renaissance to create the illusion of depth in a two-dimensional image, through the use of straight lines converging toward a **vanishing point** in the distance.

Lintel: the horizontal cross beam spanning an opening in the **post-and-lintel** system.

Lithography: a printmaking process in which the printing surface is a smooth stone or **plate** on which an image is drawn with a **crayon** or some other oily substance.

Load-bearing construction: a system of construction in which solid forms are superimposed on one another to form a tapering structure.

Loggia: a roofed **gallery** open on one or more sides, often with **arches** or **columns.**

Longitudinal section: an architectural diagram giving an inside view of a building intersected by a vertical **plane** from front to back.

Lost-wax bronze casting (also called *cire-perdue*): a technique for **casting bronze** and other metals.

Low relief (also known as **bas-relief**): relief sculpture in which figures and forms project only slightly from the background **plane.**

Luminism: an American nineteenth-century art style emphasizing the effect of light on **landcape.**

Lunette: (a) a semicircular area formed by the intersection of a wall and a **vault;** (b) a painting, **relief** sculpture, or window of the same shape.

Machtkunst: art used in the service of a military or other authority; literally, "power art" in German.

Magus (pl. **Magi**): in the New Testament, one of the three wise men who traveled from the East to pay homage to the infant Christ.

Mandala: a cosmic diagram in Asian art.

Mandapa: a northern-style Hindu temple's assembly hall.

Mandorla: an oval or almond-shaped aureola, or radiance, surrounding the body of a holy person.

Manuscript: a handwritten book produced in the Middle Ages or Renaissance. If it has painted illustrations, it is known as an **illuminated manuscript.**

Martyrium: a church or other structure built over the tomb or relics of a martyr.

Masonite: a type of fiberboard used in insulation and paneling.

Mastaba: a rectangular burial monument in ancient Egypt.

Mausoleum (pl. **mausolea**): an elaborate tomb (named for Mausolos, a fourth-century-B.C. ruler commemorated by a magnificent tomb at Halikarnassos).

Meander pattern: a fret or key pattern originating in the Greek **Geometric** period.

Medium (pl. **media**): (a) the material with which an artist works (e.g., watercolor on paper); (b) the liquid substance in which **pigment** is suspended, such as oil or water.

Megalith: a large, undressed stone used in the construction of prehistoric monuments.

Megaron: Greek for "large room"; used principally to denote a rectangular hall, usually supported by **columns** and fronted by a porch, traditional in ancient Greece since Mycenaean times.

Memento mori: an image, often in the form of a skull, to remind the living of the inevitability of death.

Menhir: a prehistoric **monolith** standing alone or grouped with other stones.

Metonym: an allusion to a subject through the representation of something related to it or a part of it.

Metope: the square area, often decorated with **relief** sculpture, between the **triglyphs** of a **Doric frieze.**

Mezzanine: in architecture, an intermediate, low-ceilinged story between two main stories.

Mezzotint: a method of **engraving** by burnishing parts of a roughened surface to produce an effect of light and shade.

Mihrāb: a niche, often highly ornamented, in the center of a **qibla** wall, toward which prayer is directed in an Islamic **mosque.**

Minaret: a tall, slender tower attached to a **mosque,** from which the *muezzin* calls the Muslim faithful to prayer.

Minbar: a **pulpit** from which a Muslim (Islamic) *imam* addresses a congregation in a *jāmi'* **mosque.**

Miniature: a representation executed on a much smaller scale than the original object.

Mithuna: a loving couple, symbolizing unity, in ancient south Asian art.

Mobile: a delicately balanced sculpture with movable parts that are set in motion by air currents or mechanical propulsion.

Modeling: (a) in two-dimensional art, the use of **value** to suggest light and shadow, and thus create the effect of mass and weight; (b) in sculpture, the creation of **form** by manipulating a pliable material such as clay.

Module: a unit of measurement on which the **proportions** of a building or work of art are based.

Molding: a continuous contoured surface, either recessed or projecting, used for decorative effect on an architectural surface.

Monastery: a religious establishment housing a community of people living in accordance with religious vows.

Monochromatic: having a color scheme based on shades of black and white, or on **values** of a single **hue.**

Monolith: a large block of stone that is all in one piece (i.e., not composed of smaller blocks), used in **megalithic** structures.

Monumental: being, or appearing to be, larger than life-sized.

Mosaic: the use of small pieces of glass, stone, or tile *(tesserae),* or pebbles to create an image on a flat surface such as a floor, wall, or ceiling.

Mosque: an Islamic (Muslim) house of worship of two main types: the **masjid,** used for daily prayer by individuals or small groups; and the *jāmi',* used for large-scale congregational prayer on the Friday sabbath and on holidays.

Motif: a recurrent element or theme in a work of art.

Mudrā: a symbolic hand gesture, usually made by a deity, in Hindu or Buddhist art. Common Buddhist *mudrās* include *abhaya mudrā* (right hand raised, palm outward and vertical), meaning "fear not"; *dhyāna mudrā* (hands in lap, one resting on the other, palms up, thumb tips touching), signifying meditation; *Dharmachakra mudrā* (hands at chest level, palms out, thumb and forefinger of each forming a circle), representing the beginning of Buddhist teaching; and *bhumisparsha mudrā* (left hand in lap, right hand reaching down, palm in and vertical, to ground level), symbolizing Shakyamuni Buddha's calling the earth to bear witness at the moment of his enlightenment.

Mural: a painting on a wall, usually on a large scale and in **fresco.**

Naive art: art created by artists with no formal training.

Naos: the inner **sanctuary** of an ancient Greek temple.

Narthex: a porch or vestibule in early Christian churches.

Naturalism, naturalistic: a style of art seeking to represent objects as they actually appear in nature.

Nave: in **basilicas** and churches, the long, narrow central area used to house the congregation.

Necking: a groove or **molding** at the top of a **column** or **pilaster** forming the transition from **shaft** to **capital.**

Necropolis (pl. **necropoleis**): an ancient or prehistoric burial ground (literally "City of the Dead").

Nemes: a head cloth worn by the pharaohs of ancient Egypt.

Neutral: lacking color; white, gray, or black.

Niche: a hollow or recess in a wall or other architectural element, often containing a statue; a **blind niche** is a very shallow recess.

Nike: a winged statue representing Nike, the goddess of victory.

Nonrepresentational (or **nonfigurative**): not representing any known object in nature.

Obelisk: a tall, four-sided stone, usually **monolithic,** that tapers toward the top and is capped by a **pyramidion.**

Objet trouvé: see found object.

Obverse: the side of a coin or medal considered to be the front and that bears the main image.

Oculus: a round opening in a wall or at the apex of a **dome.**

Oenochoe: an ancient Greek wine jug.

Oil paint: a slow-drying and flexible paint formed by mixing **pigments** with the **medium** of oil.

One-point perspective: a **perspective** system involving a single **vanishing point.**

Opisthodomos (or *opisthodome*): a back chamber, especially the part of the *naos* of a temple farthest from the entrance.

Orant: standing with outstretched arms as if in prayer.

Orchestra: in an ancient Greek theater, a circular space used by the chorus.

Order: one of the architectural systems (**Corinthian, Ionic, Doric**) used by the Greeks and Romans to decorate and define the **post-and-lintel** system of construction.

Organic: having the quality of living matter.

Orthogonals: the converging lines that meet at the **vanishing point** in the system of **linear perspective.**

Pagoda: a multistoried Buddhist **reliquary** tower, tapering toward the top and characterized by projecting eaves.

Painterly: in painting, using the quality of color and **texture,** rather than line, to define form.

Palette: (a) the range of colors used by an artist; (b) an oval or rectangular tablet used to hold and mix the **pigments.**

Palette knife: a knife with a flat, flexible blade and no cutting edge, used to mix and spread paint.

Papyrus: (a) a plant found in ancient Egypt and neighboring countries; (b) a paperlike writing material made from the pith of the plant.

Parapet: (a) a wall or rampart to protect soldiers; (b) a low wall or railing built for the safety of people at the edge of a balcony, roof, or other steep place.

Parchment: a paperlike material made from bleached and stretched animal hides, used in the Middle Ages for **manuscripts.**

Pastel: a **crayon** made of ground **pigments** and a gum **binder,** used as a drawing **medium.**

Patina: (a) the colored surface, often green, that forms on **bronze** and copper either naturally (as a result of oxidation) or artificially (through treatment with acid); (b) in general, the surface appearance of old objects.

Patron: the person or group that commissions a work of art from an artist.

Pedestal: the **base** of a **column,** statue, vase, or other upright work of art.

Pediment: (a) in Classical architecture, the triangular section at the end of a **gable roof,** often decorated with sculpture; (b) a triangular feature placed as a decoration over doors and windows.

Pendentive: in a domed building, an inwardly curving triangular section of the **vaulting** that provides a transition from the round **base** of the **dome** to the supporting **piers.**

Peplos: in ancient Greece, a woolen outer garment worn by women, wrapped in folds about the body.

Peripteral: surrounded by a row of **columns** or **peristyle.**

Peristyle: a **colonnade** surrounding a structure; in Roman houses, the courtyard surrounded by **columns.**

Perspective: the illusion of depth in a two-dimensional work of art.

Pictograph: a written symbol derived from a **representational** image.

Picture plane: the flat surface of a drawing or painting.

Picture stone: in Viking art, an upright boulder with images **incised** on it.

Piece-molding: a complex technique for shaping pottery, metal, or glass objects between an inner core and an outer mold; especially suited to elaborate decoration.

Pier: a vertical support used to bear loads in an **arched** or **vaulted** structure.

Pietà: an image of the Virgin Mary holding and mourning over the dead Christ.

Pigment: a powdered substance that is used to give color to paints, inks, and dyes.

Pilaster: a flattened, rectangular version of a **column,** sometimes **load-bearing,** but often purely decorative.

Pillar: a large vertical architectural element, usually freestanding and **load-bearing.**

Pitched roof: see **gable roof.**

Plane: a surface on which a straight line joining any two of its points lies on that surface; in general, a flat surface.

Plate: (a) in **engraving** and **etching,** a flat piece of metal into which the image to be printed is cut; (b) in photography, a sheet of glass, metal, etc., coated with a light-sensitive **emulsion.**

Plinth: (a) in Classical architecture, a square slab immediately below the circular **base** of a **column;** (b) a square block serving as a base for a statue, vase, etc.

Podium: (a) the masonry forming the **base** of a temple; (b) a raised platform or **pedestal.**

Polychrome: consisting of several colors.

Polyptych: a painting or **relief,** usually an altar-piece, composed of more than three sections.

Portal: the doorway of a church and the architectural composition surrounding it.

Portico: (a) a **colonnade;** (b) a porch with a roof supported by **columns,** usually at the entrance to a building.

Portrait: a visual representation of a specific person, a likeness.

Portraiture: the art of making portraits.

Postament: (a) a **pedestal** or **base;** (b) a frame of **molding** for a **relief.**

Post-and-lintel construction: an architectural system in which upright members, or posts, support horizontal members, or **lintels.**

Prana: the fullness of life-giving breath that appears to animate some south and southeast Asian sculpture.

Predella: the lower part of an **altarpiece,** often decorated with small scenes that are related to the subject of the main panel.

Primary color: the pure **hues**—blue, red, yellow—from which all other colors can in theory be mixed.

Print: a work of art produced by one of the printmaking processes—**engraving, etching,** and **woodcut.**

Print matrix: an image-bearing surface to which ink is applied before a **print** is taken from it.

Program: the arrangement of a series of images into a coherent whole.

Pronaos: the vestibule of a Greek temple in front of the *cella* or *naos.*

Proportion: the relation of one part to another, and of parts to the whole, with respect to size, height, and width.

Propylaeum (pl. **propylaea**): (a) an entrance to a temple or other enclosure; (b) the entry gate at the western end of the Acropolis, in Athens.

Protome (or **protoma**): a representation of the head and neck of an animal, often used as an architectural feature.

Provenience: origin, derivation; the act of coming from a particular source.

Psalter: a copy of the Book of Psalms in the Old Testament, often illuminated.

Pseudoperipteral: appearing to have a **peristyle,** though some of the **columns** may be **engaged columns** or **pilasters.**

Pulpit: in church architecture, an elevated stand, surrounded by a **parapet** and often richly decorated, from which the preacher addresses the congregation.

Putto (pl. *putti*): a chubby male infant, often naked and sometimes depicted as a Cupid, popular in Renaissance art.

Pylon: a pair of truncated, pyramidal towers flanking the entrance to an Egyptian temple.

Pyramidion: a small pyramid, as at the top of an obelisk.

Qibla: a wall inside the prayer hall of a **mosque** that is oriented toward Mecca and is, therefore, the focus of worship.

Quadrant (or **half-barrel**) **vaulting:** vaulting whose arc is one-quarter of a circle, or 90 degrees.

Quatrefoil: an ornamental "four-leaf clover" shape —i.e., with four lobes radiating from a common center.

Radiating chapels: chapels placed around the **ambulatory** (and sometimes the **transepts**) of a medieval church.

Radiocarbon dating: a method of dating prehistoric objects based on the rate of degeneration of radioactive carbon in organic materials.

Rayograph: an image made by placing an object directly on light-sensitive paper, using a technique developed by Man Ray.

Realism, realistic: attempting to portray objects from everyday life as they actually are; not to be confused with the nineteenth-century movement called Realism.

Rebus: the representation of words and syllables by pictures or symbols, the names of which sound the same as the intended words or syllables.

Rectilinear: consisting of, bounded by, or moving in, a straight line or lines.

Red-figure: describing a style of Greek pottery painting of the sixth or fifth century B.C., in which the decoration is red on a black background.

Refectory: a dining hall in a **monastery** or other similar institution.

Register: a range or row, especially when one of a series.

Reinforced concrete: concrete strengthened by embedding an internal structure of wire mesh or rods.

Relief: (a) a mode of sculpture in which an image is developed outward (**high** or **low relief**) or inward (**sunken relief**) from a basic **plane;** (b) a printmaking process in which the areas not to be printed are carved away, leaving the desired image projecting from the **plate.**

Reliquary: a casket or container for sacred relics.

Repoussé: in metalwork, decorated with patterns in **relief** made by hammering on the reverse side.

Representational: representing natural objects in recognizable form.

Reverse: the side of a coin or medal considered to be the back; opposite of **obverse.**

Rhyton: an ancient drinking vessel usually shaped like an animal or part of an animal (typically, the head).

Rib: an **arched** diagonal element in a **vault** system that defines and supports a **ribbed vault.**

Ribbed vault: a **vault** constructed of **arched** diagonal **ribs,** with a **web** of lighter masonry in between.

Romanticize: to glamorize or portray in a romantic, as opposed to a **realistic,** manner.

Roof comb: an ornamental architectural crest on top of a Maya temple.

Rosette: circular stylization of a rose.

Rose window: a large, circular window decorated with **stained glass** and **tracery.**

Rosin: a crumbly resin used in making varnishes and lacquers.

Rotunda: a circular building, usually covered by a **dome.**

Rune stone: in Viking art, an upright boulder with characters of the runic alphabet inscribed on it.

Rusticate: to give a rustic appearance to masonry blocks by roughening their surface and beveling their edges so that the joints are indented.

Sahn: an enclosed courtyard in an Islamic **mosque,** used for prayer when the interior is full.

Salon: (a) a large reception room in an elegant private house; (b) an officially sponsored exhibition of works of art.

Sanctuary: (a) the most holy part of a place of worship, the inner sanctum; (b) the part of a Christian church containing the **altar.**

Sarcophagus: a stone coffin, sometimes decorated with a **relief** sculpture.

Sarsen: a large sandstone block used in prehistoric monuments.

Saturation: see **intensity.**

Satyr: an ancient woodland deity with the legs, tail, and horns of a goat (or horse), and the head and torso of a man.

Schematic: diagrammatic and generalized rather than specifically relating to an individual object.

Scientific perspective: see **linear perspective.**

Screen wall: a nonsupporting wall, often pierced by windows.

Scriptorium (pl. **scriptoria**): the room (or rooms) in a **monastery** in which **manuscripts** were produced.

Scroll: (a) a length of writing material, such as **papyrus** or **parchment,** rolled up into a

cylinder; (b) a curved **molding** resembling a scroll (e.g., the **volute** of an **Ionic** or **Corinthian capital**).

Sculptured wall motif: the conception of a building as a massive block of stone with openings and spaces carved out of it.

Sculpture in the round: freestanding sculptural figures carved or modeled in **three dimensions.**

Secondary colors: hues produced by combining two **primary colors.**

Section: a diagrammatic representation of a building intersected by a vertical **plane.**

Serapaeum: a building or shrine sacred to the Egyptian god Serapis.

Serekh: a rectangular outline containing the name of a king in the Early Dynastic period of ancient Egypt.

Seriation: a technique for determining a chronology by studying a particular type or **style** and analyzing the increase or decrease in its popularity.

Sfumato: the definition of form by delicate gradations of light and shadow.

Shading: decreases in the **value** or **intensity** of colors to imitate the fall of shadow when light strikes an object.

Shaft: the vertical, cylindrical part of a **column** that supports the **entablature.**

Shikhara: (literally "mountain peak"), a northern-style Hindu temple tower surmounting a *garbha griha,* typically curved inward toward the top, with vertical lobes and horizontal segments *(bhūmi),* and crowned by *āmalaka.*

Sibyl: a prophetess of the ancient, pre-Christian world.

Silhouette: the outline of an object, usually filled in with black or some other uniform color.

Silkscreen: a printmaking process in which **pigment** is forced through the mesh of a silkscreen, parts of which have been masked to make them impervious.

Size, sizing: a mixture of glue or resin that is used to make a **ground** such as canvas less porous so that paint will not be absorbed into it.

Skeletal (or steel-frame) construction: a method of construction in which the walls are supported at ground level by a steel frame consisting of vertical and horizontal members.

Skene: in a Greek theater, the stone structure behind the *orchestra* that served as a backdrop or stage wall.

Slip: in **ceramics,** a mixture of clay and water used (a) as a decorative finish or (b) to attach different parts of an object (e.g., handles to the body of a vessel).

Spacer: a small peg or ball used to separate metal, pottery, or glass objects from other objects during processes such as **casting, firing,** and mold-blowing.

Spandrel: the triangular area between (a) the side of an **arch** and the right angle that encloses it or (b) two adjacent arches.

Sphinx: in ancient Egypt, a creature with the body of a lion and the head of a human, an animal, or a bird.

Spolia: materials taken from an earlier building for re-use in a new one.

Springing: (a) the architectural member of an **arch** that is the first to curve inward from the vertical; (b) the point at which this curvature begins.

Squinch: a small single **arch,** or a series of concentric **corbeled** arches, set diagonally across the upper inside corner of a square building to facilitate the transition to a round **dome** or other circular superstructure.

Stained glass: windows composed of pieces of colored glass held in place by strips of lead.

State: one of the successive printed stages of a **print,** distinguished from other stages by the greater or lesser amount of work carried out on the image.

Steel-frame construction: see **skeletal construction.**

Stele: an upright stone slab or **pillar,** usually carved or inscribed for commemorative purposes.

Step pyramid: a pyramid constructed of **mastaba** forms of successively decreasing size.

Stereobate: a substructure or foundation of masonry visible above ground level.

Stigmata (pl.): marks resembling the wounds on the crucified body of Christ (from *stigma,* "a mark" or "scar").

Still life: a picture consisting principally of inanimate objects such as fruit, flowers, or pottery.

Stratigraphy: a technique for determining a chronology by studying the relative locations of layers of material in an archaeological site.

Stringcourses: decorative horizontal bands on a building.

Stucco: (a) a type of cement used to coat the walls of a building; (b) a fine plaster used for **moldings** and other architectural decorations.

Stupa: in Buddhist architecture, a **dome**-shaped or rounded structure made of brick, earth, or stone, containing the relic of a Buddha or other honored individual.

Style: in the visual arts, a manner of execution that is characteristic of an individual, a school, a period, or some other identifiable group.

Stylization: the distortion of a **representational** image to conform to certain artistic **conventions** or to emphasize particular qualities.

Stylobate: the top step of a **stereobate,** forming a foundation for a **column, peristyle,** temple, or other structure.

Stylus: a pointed instrument used in antiquity for writing on clay, wax, **papyrus,** and **parchment;** a pointed metal instrument used to scratch an image on the **plate** used to produce an **etching.**

Sunken (or incised) relief: a style of **relief** sculpture in which the image is recessed into the surface.

Support: in painting, the surface to which the **pigment** is applied.

Suspension bridge: a bridge in which the roadway is suspended from two or more steel cables, which usually pass over towers and are then anchored at their ends.

Symmetria: Greek for **symmetry.**

Symmetry: the aesthetic balance that is achieved when parts of an object are arranged about a real or imaginary central line, or **axis,** so that the parts on one side correspond in some respect (shape, size, color) with those on the other.

Symposium: (a) a drinking party; (b) a social gathering at which there is a free exchange of ideas.

Synthesis: the combination of parts or elements to form a coherent, more complex whole.

Taberna: part of a Roman building fronting on a street and serving as a shop.

Talud-tablero: an architectural **style** typical of Teotihuacán sacred structures in which paired elements—a sloping **base** (the *talud*) supporting a vertical *tablero* (often decorated with sculpture or painting)—are stacked, sometimes to great heights.

Tectonic: of, or pertaining to, building or construction.

Tell: an archaeological term for a mound composed of the remains of successive settlements in the Near East.

Tempera: a fast-drying, water-based painting **medium** made with egg yolk, often used in **fresco** and panel painting.

Tenebrism: a style of painting used by Caravaggio and his followers in which most objects are in shadow, while a few are brightly illuminated.

Tenon: a projecting member in a block of stone or other building material that fits into a groove or hole to form a joint.

Tensile strength: the internal strength of a material that enables it to support itself without rupturing.

Terra-cotta: (a) an **earthenware** material, with or without a **glaze;** (b) an object made of this material.

Tertiary color: a **hue** produced by combining a **primary color** and a **secondary color.**

Tessera (pl. *tesserae*): a small piece of colored glass, marble, or stone used in a **mosaic.**

Texture: the visual or tactile surface quality of an object.

Tholos: (a) a circular tomb of beehive shape approached by a long, horizontal passage; (b) in Classical times, a round building modeled on ancient tombs.

Three-dimensional: having height, width, and depth.

Thrust: the lateral force exerted by an **arch, dome,** or **vault,** which must be counteracted by some form of **buttressing.**

Tondo: (a) a circular painting; (b) a medallion with **relief** sculpture.

Toraṇa: a ritual gateway in Buddhist architecture.

Trabeated: constructed according to the **post-and-lintel** method.

Tracery: a decorative, **interlaced** design (as in the stonework in Gothic windows).

Transept: a cross arm in a Christian church, placed at right angles to the **nave.**

Transverse rib: a **rib** in a **vault** that crosses the **nave** or **aisle** at right angles to the **axis** of the building.

Travertine: a hard limestone used as a building material by the Etruscans and Romans.

Tribhaṅga: in Buddhist art, the "three bends posture," in which the head, chest, and lower portion of the body are angled instead of being aligned vertically.

Tribune: (a) the **apse** of a **basilica** or basilican church; (b) a **gallery** in a Romanesque or Gothic church.

Triforium: in Gothic architecture, part of the **nave** wall above the **arcade** and below the **clerestory.**

Triglyph: in a **Doric frieze,** the rectangular area between the **metopes,** decorated with three vertical grooves (glyphs).

Trilithon: an ancient monument consisting of two vertical **megaliths** supporting a third as a **lintel.**

Trilobed: having three rounded projections.

Triptych: an **altarpiece** or painting consisting of one central panel and two wings.

Trompe l'oeil: **illusionistic** painting that "deceives the eye" with its appearance of reality.

Trumeau: in Romanesque and Gothic architecture, the central post supporting the **lintel** in a double doorway.

Truss construction: a system of construction in which the architectural members (such as bars and beams) are combined, often in triangles, to form a rigid framework.

Tufa: a porous, volcanic rock that hardens on exposure to air, used as a building material.

Tumulus (pl. **tumuli**): an artificial mound, typically found over a grave.

Tunnel vault: see **barrel vault.**

Tympanum: a **lunette** over the doorway of a church, often decorated with sculpture.

Type: a person or object serving as a prefiguration or symbolic representation, usually of something in the future.

Typology: the Christian theory of **types,** in which characters and events in the New Testament (i.e., after the birth of Jesus) are prefigured by counterparts in the Old Testament.

Underpainting: a preliminary painting, subsequently covered by the final layer(s) of paint.

Uraeus (pl. **uraei**): a **stylized** representation of an asp, often included on the headdress of ancient rulers.

Urṇā: in Buddhist art, a whorl of hair or protuberance between the eyebrows of a Buddha or other honored individual.

Ushnīsha: a **conventional** identifying topknot of hair on an image of Shakyamuni Buddha, symbolic of his wisdom.

Value: the degree of lightness (high value) or darkness (low value) in a **hue.**

Vanishing point: in the **linear perspective** system, the point at which the **orthogonals,** if extended, would intersect.

Vanitas: a category of painting, often a **still life,** the theme of which is the transitory nature of earthly things and the inevitability of death.

Vault, vaulting: a roof or ceiling of masonry constructed on the **arch** principle; see also **barrel vault, groin vault, quadrant vaulting, ribbed vault.**

Vedikā: a railing marking off sacred space in south Asian architecture, often found surrounding a Buddhist **stupa** or encircling the **axis**-pillar atop its **dome** *(aṇḍa).*

Vehicle: a term often used interchangeably with **medium** to mean the liquid in which **pigments** are suspended but not dissolved and which, as it dries, binds the color to the surface of the painting.

Vellum: a cream-colored, smooth surface for painting or writing, prepared from calfskin.

Veranda: a **pillared** porch preceding an interior chamber, common in Hindu temples and Buddhist *chaitya* **halls.**

Verisimilitude: the quality of appearing real or truthful.

Vihāra: Buddhist monks' living quarters, either an individual cell or a space for communal activity.

Villa: (a) in antiquity and the Renaissance, a large country house; (b) in modern times, a detached house in the country or suburbs.

Visible spectrum: the colors, visible to the human eye, that are produced when white light is dispersed by a prism.

Vitreous: related to, derived from, or consisting of glass.

Volute: in the Ionic **order,** the spiral **scroll motif** decorating the **capital.**

Voussoir: one of the individual, wedge-shaped blocks of stone that make up an **arch.**

Wash: a thin, translucent coat of paint (e.g., in **watercolor**).

Watercolor: (a) paint made of **pigments** suspended in water; (b) a painting executed in this **medium.**

Wattle and daub: a technique of wall construction using woven branches or twigs plastered with clay or mud.

Web: in Gothic architecture, the portion of a **ribbed vault** between the **ribs.**

Westwork: from the German *Westwerk,* the western front of a church, containing an entrance and vestibule below, a chapel or **gallery** above, and flanked by two towers.

White-ground: describing a style of Greek pottery painting of the fifth century B.C., in which the decoration is usually black on a white background.

Wing: a side panel of an **altarpiece** or screen.

Woodcut: a **relief** printmaking process in which an image is carved on the surface of a wooden block by cutting away those parts that are not to be printed.

Yaksha, yakshī: indigenous south Asian fertility deities, respectively male and female, later assimilated into Buddhist art.

Ziggurat: a trapezoidal stepped structure representing a mountain in ancient Mesopotamia.

Suggestions for Further Reading

General

Adams, Laurie. *Art on Trial: From Whistler to Rothko.* New York: Walker, 1976.
———. *Art and Psychoanalysis.* New York: HarperCollins, 1993.
———. *The Methodologies of Art: An Introduction.* New York: HarperCollins, 1996.
———. *Looking at Art.* Englewood Cliffs, N.J.: Prentice-Hall, 2002.
———. *World Views: Topics in Non-Western Art.* New York: McGraw-Hill, 2004.
Arntzen, Etta, and Robert Rainwater. *Guide to the Literature of Art History.* Chicago: American Library Association, 1980.
Barasch, Moshe. *Theories of Art: From Plato to Winckelmann.* New York: New York University Press, 1985.
———. *Modern Theories of Art, I: From Winckelmann to Baudelaire.* New York: New York University Press, 1990.
Baxandall, Michael. *Patterns of Intention: On the Historical Explanation of Pictures.* New Haven: Yale University Press, 1985.
Bois, Yve-Alain. *Painting as Model.* Cambridge, Mass.: MIT Press, 1990.
Broude, Norma, and Mary D. Garrard, eds. *Feminism and Art History: Questioning the Litany.* New York: Harper & Row, 1982.
———, eds. *The Expanding Discourse: Feminism and Art History.* New York: HarperCollins, 1992.
Bryson, Norman. *Vision and Painting: The Logic of the Gaze.* New Haven: Yale University Press, 1983.
———. *Vision and Painting.* New Haven: Yale University Press, 1987.
———, et al., eds. *Visual Theory: Painting and Interpretation.* New York: Cambridge University Press, 1991.
Cahn, Walter. *Masterpieces: Chapters on the History of an Idea.* Princeton: Princeton University Press, 1979.
Carrier, David. *Principles of Art History Writing.* University Park, Pa.: Pennsylvania State University Press, 1991.
Chadwick, Whitney. *Women, Art, and Society.* 3rd ed. New York: Thames & Hudson, 2002.
Chicago, Judy, and Miriam Schapiro. In *Anonymous Was a Woman.* Valencia, Calif.: Feminist Art Program, California Institute of the Arts, 1974.
Chilvers, Ian, and Harold Osborne, eds. *The Oxford Dictionary of Art.* New York: Oxford University Press, 1988.
Clark, Kenneth M. *The Nude: A Study in Ideal Form.* Garden City, N.Y.: Doubleday, 1959.
Clark, Toby. *Art and Propaganda in the Twentieth Century: The Political Image in the Age of Mass Culture.* New York: Abrams, 1997.
Derrida, Jacques. *The Truth in Painting.* Trans. Geoff Bennington and Ian McLeod. Chicago: University of Chicago Press, 1987.
Ehresmann, Donald L. *Architecture: A Bibliographic Guide to Basic Reference Works, Histories, and Handbooks.* Littleton, Col.: Libraries Unlimited, 1984.
———. *Fine Arts: A Bibliographic Guide to Basic Reference Works, Histories, and Handbooks.* 3rd ed. Englewood, Col.: Libraries Unlimited, 1990.
Eliade, Mircea. *A History of Religious Ideas.* Trans. Willard R. Trask. 3 vols. Chicago: University of Chicago Press, 1978.
Elsen, Albert E. *The Purposes of Art: An Introduction to the History and Appreciation of Art.* 4th ed. New York: Holt, Rinehart & Winston, 1981.

Encyclopedia of World Art. 17 vols. New York: McGraw-Hill, 1959–1987.
Fine, Elsa Honig. *Women and Art.* Montclair, N.J.: Allanheld & Schram, 1978.
Flynn, Tom. *The Body in Three Dimensions.* New York: Abrams, 1998.
Freedberg, David. *The Power of Images: Studies in the History and Theory of Response.* Chicago: University of Chicago Press, 1989.
Gedo, Mary Mathews. *Looking at Art from the Inside Out: The Psychoiconographic Approach to Modern Art.* New York: Cambridge University Press, 1994.
Getlein, Mark. *Gilbert's Living with Art.* 7th ed. New York: McGraw-Hill, 2005.
Gombrich, Ernst. *Art and Illusion: A Study in the Psychology of Pictorial Representation* (1960). Millennium ed., with new preface by author. Princeton: Princeton University Press, 2000.
———. *The Image and the Eye: Further Studies in the Psychology of Pictorial Representation.* Ithaca, N.Y.: Cornell University Press, 1982.
———. *Meditations on a Hobby Horse, and Other Essays on the Theory of Art* (1963). 4th ed. Oxford: Phaidon, 1985.
———. *Shadows: The Depiction of Cast Shadows in Western Art.* London: National Gallery, 1995.
Hall, James. *Illustrated Dictionary of Symbols in Eastern and Western Art.* New York: HarperCollins, 1994.
———. *Dictionary of Subjects and Symbols in Art.* Rev. ed. London: Murray, 1996.
Harris, Ann Sutherland, and Linda Nochlin. *Women Artists, 1550–1950.* Los Angeles: Los Angeles County Museum of Art; New York: Random House, 1976.
Harrison, Charles, and Paul Wood, eds. *Art in Theory, 1900–1990: An Anthology of Changing Ideas.* Cambridge, Mass.: Blackwell, 1993.
Hauser, Arnold. *The Philosophy of Art History.* New York: Knopf, 1958.
———. *The Social History of Art.* 3rd ed. 4 vols. New York: Routledge, 1999.
Hedges, Elaine, and Ingrid Wendt. *In Her Own Image: Women Working in the Arts.* New York: McGraw-Hill, 1980.
Heller, Nancy G. *Women Artists: An Illustrated History.* 4th ed. New York: Abbeville, 2003.
Hess, Thomas B., and Elizabeth C. Baker, eds. *Art and Sexual Politics: Women's Liberation, Women Artists, and Art History.* New York: Macmillan, 1973.
Hinz, Berthold. *Art in the Third Reich.* Trans. Robert Kimber and Rita Kimber. New York: Pantheon, 1979.
Holt, Elizabeth Gilmore, ed. *A Documentary History of Art.* 2 vols. Princeton: Princeton University Press, 1981.
Kemp, Martin. *The Science of Art: Optical Themes in Western Art from Brunelleschi to Seurat.* New Haven: Yale University Press, 1990.
Kleinbauer, W. Eugene. *Modern Perspectives in Western Art History: An Anthology of Twentieth-Century Writings on the Visual Arts* (1971). Toronto: University of Toronto Press, 1989.
Kleinbauer, W. Eugene, and Thomas P. Slavens. *Research Guide to Western Art History.* Chicago: American Library Association, 1982.
Kostof, Spiro. *The Architect: Chapters in the History of the Profession* (1977). Berkeley: University of California Press, 2000.
———. *A History of Architecture: Settings and Rituals* (1985). 2nd ed. Rev. Greg Castillo. New York: Oxford University Press, 1995.
Kris, Ernst, and Otto Kurz. *Legend, Myth, and Magic in the Image of the Artist: An Historical Experiment.* New Haven: Yale University Press, 1979.

Kultermann, Udo. *The History of Art History.* New York: Abaris, 1993.
Lever, Jill, and John Harris. *The Illustrated Dictionary of Architecture, 800–1914.* 2nd ed. Boston: Faber & Faber, 1993.
Levine, Lawrence W. *Highbrow/Lowbrow: The Emergence of Cultural Hierarchy in America.* Cambridge, Mass.: Harvard University Press, 1988.
McCoubrey, John W. *American Art, 1700–1960: Sources and Documents.* Englewood Cliffs, N.J.: Prentice-Hall, 1965.
Mayer, Ralph. *The Artist's Handbook of Materials and Techniques.* 5th ed. New York: Viking, 1991.
———. *The HarperCollins Dictionary of Art Terms and Techniques.* 2nd ed. New York: HarperCollins, 1991.
Mitchell, W. J. T. *Picture Theory: Essays on Verbal and Visual Representation.* Chicago: University of Chicago Press, 1994.
Munsterberg, Hugo. *A History of Women Artists.* New York: Potter, 1975.
Murray, Peter, and Linda Murray. *The Penguin Dictionary of Art and Artists.* 7th ed., rev. New York: Penguin, 1997.
Nochlin, Linda. *Women, Art, and Power: And Other Essays.* New York: Harper & Row, 1988.
Ocvirk, Otto G., et al. *Art Fundamentals: Theory and Practice.* 10th ed. New York: McGraw-Hill, 2005.
Panofsky, Erwin. *Meaning in the Visual Arts: Papers in and on Art History.* Garden City, N.Y.: Doubleday, 1955.
———. *Idea: A Concept in Art Theory.* Columbia: University of South Carolina Press, 1968.
———. *Perspective as Symbolic Form.* New York: Zone Books, 1991.
Parker, Rozsika, and Griselda Pollock. *Old Mistresses: Women, Art, and Ideology.* New York: Pantheon, 1982.
Penny, Nicholas. *The Materials of Sculpture.* New Haven: Yale University Press, 1993.
Petersen, Karen, and J. J. Wilson. *Women Artists: Recognition and Reappraisal from the Early Middle Ages to the Twentieth Century.* New York: Harper & Row, 1976.
Pollock, Griselda. *Vision and Difference: Femininity, Feminism and Histories of Art* (1988). London: Routledge, 2003.
Praz, Mario, *Mnemosyne: The Principle between Literature and the Visual Arts.* Princeton: Princeton University Press, 1970.
Pultz, John. *The Body and the Lens: Photography 1839 to the Present.* New York: Abrams, 1995.
Reid, Jane Davidson, ed. *The Oxford Guide to Classical Mythology in the Arts, 1330–1990s.* 2 vols. New York: Oxford University Press, 1993.
Roth, Leland M. *Understanding Architecture: Its Elements, History, and Meaning.* New York: HarperCollins, 1993.
Saxl, Fritz. *A Heritage of Images: A Selection of Lectures.* Harmondsworth: Penguin, 1970.
Schiller, Gertrud. *Iconography of Christian Art.* Trans. Janet Seligman. 2 vols. Greenwich, Conn.: New York Graphic Society, 1971.
Scully, Vincent. *Architecture: The Natural and the Man-Made.* New York: St. Martin's, 1991.
Sporre, Dennis J. *The Creative Impulse: An Introduction to the Arts.* 7th ed. Upper Saddle River, N.J.: Prentice-Hall, 2005.
Stephenson, Jonathan. *The Materials and Techniques of Painting* (1989). New York: Thames & Hudson, 1993.
Summerson, John. *The Classical Language of Architecture* (1963). Cambridge, Mass.: MIT Press, 1984.

Trachtenberg, Marvin, and Isabelle Hyman. *Architecture, from Pre-History to Postmodernity.* 2nd ed. New York: Abrams, 2002.

Van Keuren, Frances. *Guide to Research in Classical Art and Mythology.* Chicago: American Library Association, 1991.

Verhelst, Wilbert. *Sculpture: Tools, Materials, and Techniques.* 2nd ed. Englewood Cliffs, N.J.: Prentice-Hall, 1988.

Watkin, David. *The Rise of Architectural History.* Chicago: University of Chicago Press, 1983.

Westermann, Mariët. *A Worldly Art: The Dutch Republic, 1585–1718.* New York: Abrams, 1996.

Williams, Raymond. *Culture and Society, 1780–1950* (1958). New York: Harper & Row, 1966.

———. *The Sociology of Culture.* New York: Schocken, 1982.

Winternitz, Emanuel. *Musical Instruments and Their Symbolism in Western Art.* New York: Norton, 1967.

Wittkower, Rudolf. *Allegory and the Migration of Symbols.* London: Thames & Hudson, 1977.

———. *Sculpture.* New York: Harper & Row, 1977.

Wittkower, Rudolf, and Margot Wittkower. *Born under Saturn: The Character and Conduct of Artists, a Documented History from Antiquity to the French Revolution* (1963). New York: Norton, 1969.

Wodehouse, Lawrence, and Marian Moffett. *A History of Western Architecture.* Mountain View, Calif.: Mayfield, 1989.

Wolff, Janet. *The Social Production of Art.* 2nd ed. New York: New York University Press, 1993.

Wölfflin, Heinrich. *Principles of Art History: The Problem of the Development of Style in Later Art* (1932). Trans. M. D. Hottinger. New York: Dover, 1956.

———. *Classic Art: An Introduction to the Italian Renaissance* (1952). 5th ed. Trans. Peter Murray and Linda Murray. London: Phaidon, 1994.

———. *The Sense of Form in Art: A Comparative Psychological Study.* Trans. Alice Muehsam and Norma A. Shettan. New York: Chelsea, 1958.

Wollheim, Richard. *Art and Its Objects: With Six Supplementary Essays* (1980). 2nd ed. New York: Cambridge University Press, 1992.

———. *Painting as an Art.* Princeton: Princeton University Press, 1987.

Wren, Linnea H., and David J. Wren, eds. *Perspectives on Western Art.* 2 vols. New York: Harper-Collins, 1987–1994.

Yates, Frances A. *The Art of Memory* (1966). London: Routledge, 1999.

The Art of Prehistory

Amiet, Pierre, ed. *Art in the Ancient World: A Handbook of Styles and Forms.* Trans. Valerie Bynner. New York: Rizzoli, 1981.

Bandi, Hans-Georg, and Henri Breuil. *The Art of the Stone Age: Forty Thousand Years of Rock Art.* 2nd ed. Trans. Ann E. Keep. London: Methuen, 1970.

Bataille, Georges, *Lascaux; or, The Birth of Art: Prehistoric Painting.* Trans. Austryn Wainhouse. Lausanne: Skira, 1955.

Breuil, Henri. *Four Hundred Centuries of Cave Art* (1952). Trans. Mary E. Boyle. New York: Hacker, 1979.

Castleden, Rodney. *The Making of Stonehenge.* London: Routledge, 1993.

Chauvet, Jean-Marie, Eliette Brunel Deschamps, and Christian Hillaire. *Dawn of Art: The Chauvet Cave, the Oldest Known Paintings in the World.* Trans. Paul G. Bahn. New York: Abrams, 1996.

Chippindale, Christopher. *Stonehenge Complete.* Exp. ed. London: Thames & Hudson, 2004.

Clottes, Jean, and Jean Courtin. *The Cave beneath the Sea: Paleolithic Images at Cosquer.* New York: Abrams, 1996.

Finegan, Jack. *Light from the Ancient Past.* 2 vols. 2nd ed. Princeton: Princeton University Press, 1974.

Gimbutas, Marija. *The Gods and Goddesses of Old Europe, 7000–3500 B.C.: Myths, Legends, and Cult Images.* Berkeley: University of California Press, 1974.

Graziosi, Paolo. *Paleolithic Art.* New York: McGraw-Hill, 1960.

James, Edwin O. *From Cave to Cathedral: Temples and Shrines of Prehistoric, Classical, and Early Christian Times.* London: Thames & Hudson, 1965.

Leroi-Gourhan, André. *Treasures of Prehistoric Art.* New York: Abrams, 1967.

———. *The Dawn of European Art: An Introduction to Paleolithic Cave Painting.* New York: Cambridge University Press, 1982.

Powell, T. G. E. *Prehistoric Art.* New York: Praeger, 1966.

Ruspoli, Mario. *The Cave of Lascaux: The Final Photographs.* New York: Abrams, 1987.

Sieveking, Ann. *The Cave Artists.* London: Thames & Hudson, 1979.

Sandars, N. K. *Prehistoric Art in Europe.* 2nd ed. Pelican History of Art. New Haven: Yale University Press, 1985.

Twohig, Elizabeth Shee. *The Megalithic Art of Western Europe.* New York: Oxford University Press, 1981.

Wainwright, Geoffrey. *The Henge Monuments: Ceremony and Society in Prehistoric Britain.* London: Thames & Hudson, 1989.

The Ancient Near East

Akurgal, Ekrem. *The Art of the Hittites.* New York: Abrams, 1962.

Bottéro, Jean. *Mesopotamia: Writing, Reasoning, and the Gods.* Trans. Zainab Bahrani and Marc Van De Mieroop. Chicago: University of Chicago Press, 1992.

Collon, Dominique. *First Impressions: Cylinder Seals in the Ancient Near East.* London: British Museum Press, 1987.

Crawford, Harriet. *Sumer and the Sumerians.* 2nd ed. New York: Cambridge University Press, 2004.

Ferrier, R. W., ed. *The Arts of Persia.* New Haven: Yale University Press, 1989.

Frankfort, Henri. *The Art and Architecture of the Ancient Orient.* 5th ed. Pelican History of Art. New Haven: Yale University Press, 1996.

Ghirshman, Roman. *The Arts of Ancient Iran from Its Origins to the Time of Alexander the Great.* Trans. Stuart Gilbert and James Emmons. New York: Golden Press, 1962.

Gilgamesh: Translated from the Sîn-leqi-unninnī Version. Trans. James Gardner and John Maier. New York: Knopf, 1984.

Groenewegen-Frankfort, H. A. *Arrest and Movement: An Essay on Space and Time in the Representational Art of the Ancient Near East.* Cambridge, Mass.: Belknap Press, 1987.

Groenewegen-Frankfort, H. A., and Bernard Ashmole. *Art of the Ancient World: Painting, Pottery, Sculpture, Architecture from Egypt, Mesopotamia, Crete, Greece, and Rome.* New York: Abrams, 1972.

Harper, Prudence, Joan Aruz, and Françoise Tallon, eds. *The Royal City of Susa: Ancient Near Eastern Treasures in the Louvre.* New York: Metropolitan Museum of Art, 1992.

Kramer, Samuel Noah. *The Sumerians: Their History, Culture, and Character.* Chicago: University of Chicago Press, 1963.

———. *History Begins at Sumer: Thirty-nine Firsts in Man's Recorded History.* 3rd rev. ed. Philadelphia: University of Pennsylvania Press, 1981.

Leick, Gwendolyn. *A Dictionary of Ancient Near Eastern Architecture.* New York: Routledge, 1988.

Lloyd, Seton. *The Archaeology of Mesopotamia: From the Old Stone Age to the Persian Conquest* (1978). Rev. ed. London: Thames & Hudson, 1984.

Lloyd, Seton, and Hans W. Müller. *Ancient Architecture: Mesopotamia, Egypt, Crete.* New York: Electa/Rizzoli, 1986.

Mellaart, James. *The Earliest Civilizations of the Near East.* New York: McGraw-Hill, 1965.

———. *Çatal Hüyük: A Neolithic Town in Anatolia.* New York: McGraw-Hill, 1967.

Moortgat, Anton. *The Art of Ancient Mesopotamia.* Trans. Judith Filson. New York: Phaidon, 1969.

Moscati, Sabatino, ed. *The Phoenicians* (1988). New York: Rizzoli, 1999.

Muscarella, Oscar W. *Bronze and Iron: Ancient Near Eastern Artifacts in the Metropolitan Museum of Art.* New York: Metropolitan Museum of Art, 1988.

Oates, Joan. *Babylon.* Rev. ed. London: Thames & Hudson, 1986.

Oppenheim, A. Leo. *Ancient Mesopotamia: Portrait of a Dead Civilization.* Rev. ed. Chicago: University of Chicago Press, 1977.

Parrot, André. *The Arts of Assyria.* Trans. Stuart Gilbert and James Emmons. New York: Golden Press, 1961.

———. *Sumer: The Dawn of Art.* Trans. Stuart Gilbert and James Emmons. New York: Golden Press, 1961.

Porada, Edith, and Robert H. Dyson. *The Art of Ancient Iran: Pre-Islamic Cultures.* Rev. ed. New York: Greystone Press, 1967.

Reade, Julian. *Mesopotamia.* 2nd ed. London: British Museum Press, 2000.

Roux, Georges. *Ancient Iraq.* 3rd ed. New York: Penguin, 1992.

Saggs, Henry W. F. *The Greatness That Was Babylon: A Survey of the Ancient Civilization of the Tigris-Euphrates Valley.* Rev. ed. London: Sidgwick & Jackson, 1988.

Woolley, Leonard. *The Art of the Middle East, Including Persia, Mesopotamia, and Palestine.* New York: Crown, 1961.

———. *The Development of Sumerian Art.* Westport, Conn.: Greenwood Press, 1981.

Ancient Egypt

Aldred, Cyril. *Akhenaten and Nefertiti.* New York: Viking Press, 1973.

———. *Egyptian Art in the Days of the Pharaohs, 3100–320 B.C.* New York: Oxford University Press, 1980.

Andrews, Carol. *Ancient Egyptian Jewelry.* New York: Abrams, 1991.

Badawy, Alexander. *A History of Egyptian Architecture.* 3 vols. Berkeley: University of California Press, 1954–68.

Brier, Bob. *Egyptian Mummies: Unraveling the Secrets of an Ancient Art.* New York: Morrow, 1994.

Davis, Whitney. *The Canonical Tradition in Ancient Egyptian Art.* New York: Cambridge University Press, 1989.

Doxiadis, Euphrosyne. *The Mysterious Fayum Portraits: Faces from Ancient Egypt.* New York: Abrams, 1995.

Edwards, I. E. S. *The Pyramids of Egypt.* Rev. ed. New York: Penguin, 1991.

El Mahdy, Christine, ed. *The World of the Pharaohs: A Complete Guide to Ancient Egypt.* London: Thames & Hudson, 1990.

The Egyptian Book of the Dead: The Book of Going Forth by Day, Being the Papyrus of Ani (Royal Scribe of the Divine Offerings). Trans. Raymond O. Faulkner. San Francisco: Chronicle, 1994.

Gardiner, Alan H. *Egypt of the Pharaohs.* Oxford: Oxford University Press, 1978.

Hayes, William C. *The Scepter of Egypt: A Background for the Study of the Egyptian Antiquities in the Metropolitan Museum of Art.* 2 vols. Cambridge, Mass.: Harvard University Press, 1960.

James, T. G. H. *Egyptian Painting and Drawing in the British Museum.* London: British Museum Press, 1985.

James, T. G. H., and W. V. Davies. *Egyptian Sculpture.* Cambridge, Mass.: Harvard University Press, 1983.

Lange, Kurt, and Max Hirmer. *Egypt: Architecture, Sculpture, Painting in Three Thousand Years.* 4th ed. London: Phaidon, 1968.

Lurker, Manfred. *The Gods and Symbols of Ancient Egypt: An Illustrated Dictionary.* Rev. ed. Trans. Barbara Cummings. New York: Thames & Hudson, 1982.

Martin, Geoffrey T. *The Hidden Tombs of Memphis: New Discoveries from the Time of Tutankhamun and Ramesses the Great.* London: Thames & Hudson, 1991.

Panofsky, Erwin. *Tomb Sculpture: Four Lectures on Its Changing Aspects from Ancient Egypt to Bernini.* Foreword by Martin Warnke. New York: Abrams, 1992.

Priese, Karl-Heinz. *The Gold of Meroë.* New York: Metropolitan Museum of Art, 1993.

Redford, Donald B. *Akhenaten: The Heretic King.* Princeton: Princeton University Press, 1984.

Reeves, Nicholas. *The Complete Tutankhamun: The King, the Tomb, the Royal Treasure.* New York: Thames & Hudson, 1990.

Robins, Gay. *Women in Ancient Egypt.* Cambridge, Mass.: Harvard University Press, 1993.

———. *Proportion and Style in Ancient Egyptian Art.* Austin: University of Texas Press, 1994.

Schäfer, Heinrich. *Principles of Egyptian Art.* Rev. ed. Trans. John Baines. Oxford: Griffith Institute, 1986.

Smith, William Stevenson, and William Kelly Simpson. *The Art and Architecture of Ancient Egypt.* Rev. ed. New Haven: Yale University Press, 1988.

Strouhal, Eugen. *Life of the Ancient Egyptians.* Trans. Deryck Viney. Norman: University of Oklahoma Press, 1992.

Taylor, John H. *Egypt and Nubia.* London: British Museum Press, 1991.

Walker, Susan, and Morris Bierbrier. *Ancient Faces: Mummy Portraits from Roman Egypt.* 2nd ed. London: British Museum Press, 2000.

Wilkinson, Charles K. *Egyptian Wall Paintings: The Metropolitan Museum of Art's Collection of Facsimiles.* New York: Metropolitan Museum of Art, 1983.

Wilkinson, Richard H. *Reading Egyptian Art: A Hieroglyphic Guide to Ancient Egyptian Painting and Sculpture.* New York: Thames & Hudson, 1992.

Woldering, Irmgard. *Gods, Men and Pharaohs: The Glory of Egyptian Art.* Trans. Ann E. Keep. New York: Abrams, 1967.

Wolff, Walther. *The Origins of Western Art: Egypt, Mesopotamia, the Aegean.* New York: Universe, 1989.

The Aegean

Barber, R. L. N. *The Cyclades in the Bronze Age.* Iowa City: University of Iowa Press, 1987.

Boardman, John. *Pre-Classical: From Crete to Archaic Greece.* Harmondsworth: Penguin, 1978.

Chadwick, John. *The Mycenaean World.* Cambridge, Eng.: Cambridge University Press, 1976.

Doumas, Christos. *The Wall-Paintings of Thera.* Trans. Alex Doumas. Athens: Thera Foundation, 1992.

Getz-Preziosi, Pat. *Sculptors of the Cyclades: Individual and Tradition in the Third Millennium B.C.* Ann Arbor: University of Michigan Press, 1987.

Graham, J. Walter. *The Palaces of Crete.* Rev. ed. Princeton: Princeton University Press, 1987.

Hampe, Roland, and Erika Simon. *The Birth of Greek Art from the Mycenaean to the Archaic Period.* New York: Oxford University Press, 1981.

Higgins, Reynold A. *Minoan and Mycenaean Art.* New rev. ed. London: Thames & Hudson, 1997.

Hood, Sinclair. *The Arts in Prehistoric Greece.* Pelican History of Art. Harmondsworth: Penguin, 1978.

———. *The Minoans: The Story of Bronze Age Crete.* New York: Praeger, 1981.

Hurwit, Jeffrey M. *The Art and Culture of Early Greece, 1100–480 B.C.* Ithaca, N.Y.: Cornell University Press, 1985.

Immerwahr, Sara A. *Aegean Painting in the Bronze Age.* University Park: Pennsylvania State University Press, 1990.

Jenkins, Ian. *The Parthenon Frieze.* Austin: University of Texas Press, 1994.

McDonald, William. *Progress into the Past: The Rediscovery of Mycenaean Civilization.* 2nd ed. Bloomington: Indiana University Press, 1990.

Marinatos, Spyridon N., and Max Hirmer. *Crete and Mycenae.* Trans. John Boardman. New York: Abrams, 1960.

Morgan, Catherine. *Athletes and Oracles: The Transformation of Olympia and Delphi in the Eighth Century B.C.* Cambridge, Eng.: Cambridge University Press, 1990.

Morgan, Lyvia. *The Miniature Wall Paintings of Thera: A Study in Aegean Culture and Iconography.* Cambridge, Eng.: Cambridge University Press, 1988.

Mylonas, George E. *Mycenae and the Mycenaean Age.* Princeton: Princeton University Press, 1966.

Nilsson, Martin P. *The Minoan-Mycenaean Religion and Its Survival in Greek Religion.* 2nd rev. ed. New York: Biblo and Tannen, 1971.

Palmer, Leonard R. *Mycenaeans and Minoans: Aegean Prehistory in the Light of the Linear B Tablets.* 2nd rev. ed. Westport, Conn.: Greenwood Press, 1980.

Renfrew, Colin. *The Emergence of Civilisation: The Cyclades and the Aegean in the Third Millennium B.C.* London: Methuen, 1972.

Willetts, R. F. *The Civilization of Ancient Crete.* Berkeley: University of California Press, 1977.

The Art of Ancient Greece

Arafat, K. W. *Classical Zeus: A Study in Art and Literature.* Oxford: Clarendon, 1990.

Ashmole, Bernard. *Architect and Sculptor in Classical Greece.* New York: New York University Press, 1972.

Beazley, John D. *Attic Red-Figure Vase-Painters.* 2nd ed. 3 vols. New York: Hacker, 1984.

———. *The Development of the Attic Black-Figure.* Rev. ed. Berkeley: University of California Press, 1986.

Biers, William. *The Archaeology of Greece: An Introduction.* 2nd ed. Ithaca, N.Y.: Cornell University Press, 1996.

Boardman, John. *Greek Art.* New rev. ed. New York: Thames & Hudson, 1985.

———. *The Parthenon and Its Sculptures.* Austin: University of Texas Press, 1985.

———. *Athenian Red-Figure Vases, the Classical Period: A Handbook.* New York: Thames & Hudson, 1989.

———. *Athenian Black-Figure Vases: A Handbook.* Corrected ed. New York: Thames & Hudson, 1991.

———. *Athenian Red-Figure Vases, the Archaic Period: A Handbook.* New York: Thames & Hudson, 1991.

———. *Greek Sculpture, the Archaic Period: A Handbook.* New York: Thames & Hudson, 1991.

———. *Greek Sculpture, the Classical Period: A Handbook.* New York: Thames & Hudson, 1991.

Brilliant, Richard. *Arts of the Ancient Greeks.* New York: McGraw-Hill, 1973.

Camp, John M. *The Athenian Agora: Excavations in the Heart of Classical Athens.* Updated ed. New York: Thames & Hudson, 1992.

Carpenter, Rhys. *The Esthetic Basis of the Greek Art of the Fifth and Fourth Centuries B.C.* Bloomington: Indiana University Press, 1959.

———. *Greek Sculpture: A Critical Review.* Chicago: University of Chicago Press, 1960.

———. *The Architects of the Parthenon.* Baltimore: Penguin, 1970.

Carpenter, Thomas H. *Art and Myth in Ancient Greece: A Handbook.* New York: Thames & Hudson, 1991.

Chitham, Robert. *The Classical Orders of Architecture.* 2nd ed. New York: Rizzoli, 2005.

Cook, Robert M. *Greek Art: Its Development, Character, and Influence.* New York: Farrar, Straus, Giroux, 1973.

Coulton, J. J. *Ancient Greek Architects at Work: Problems of Structure and Design.* Ithaca, N.Y.: Cornell University Press, 1977.

Dinsmoor, William B. *The Architecture of Ancient Greece.* 3rd ed. New York: Norton, 1975.

Francis, Eric David. *Image and Idea in Fifth-Century Greece: Art and Literature after the Persian Wars.* London: Routledge, 1990.

Havelock, Christine M. *Hellenistic Art: The Art of the Classical World from the Death of Alexander the Great to the Battle of Actium.* 2nd ed. New York: Norton, 1981.

Kampen, Natalie Boymel. *Sexuality in Ancient Art: Near East, Egypt, Greece, and Italy.* Cambridge: Cambridge University Press, 1996.

Koloski-Ostrow, Ann Olga, and Claire L. Lyons, eds. *Naked Truths: Women, Sexuality, and Gender in Classical Art and Archaeology.* London: Routledge, 1997.

Kraay, Colin M., and Max Hirmer. *Greek Coins.* New York: Abrams, 1966.

Lawrence, A. W. *Greek Architecture.* 5th ed. Pelican History of Art. New Haven: Yale University Press, 1996.

Onians, John. *Art and Thought in the Hellenistic Age: The Greek World View, 350–50 B.C.* London: Thames & Hudson, 1979.

———. *Bearers of Meaning: The Classical Orders in Antiquity, the Middle Ages, and the Renaissance.* Princeton: Princeton University Press, 1988.

Papaioannou, Kostas. *The Art of Greece.* Trans. I. Mark Paris. New York: Abrams, 1989.

Pedley, John Griffiths. *Greek Art and Archaeology.* 2nd ed. New York: Abrams, 1998.

Pollitt, J. J. *The Art of Greece, 1400–31 B.C.: Sources and Documents.* Englewood Cliffs, N.J.: Prentice-Hall, 1965.

———. *Art and Experience in Classical Greece.* Cambridge, Eng.: Cambridge University Press, 1972.

———. *The Ancient View of Greek Art: Criticism, History, and Terminology.* New Haven: Yale University Press, 1974.

———. *Art in the Hellenistic Age.* Cambridge, Eng.: Cambridge University Press, 1986.

Richter, Gisela M. A. *Archaic Greek Art against Its Historical Background: A Survey.* New York: Oxford University Press, 1949.

———. *Kouroi.* 3rd ed. New York: Phaidon, 1970.

———. *The Sculpture and Sculptors of the Greeks.* 4th ed., rev. New Haven: Yale University Press, 1970.

———. *A Handbook of Greek Art.* 9th ed. New York: Da Capo, 1987.

Ridgway, Brunilde Sismondo. *The Severe Style in Greek Sculpture.* Princeton: Princeton University Press, 1970.

———. *Fifth-Century Styles in Greek Sculpture.* Princeton: Princeton University Press, 1981.

Ridgway, Brunilde Sismondo. *Hellenistic Sculpture, I.* Madison: University of Wisconsin Press, 1990.
———. *The Archaic Style in Greek Sculpture.* 2nd ed. Chicago: Ares, 1993.
———. *Hellenistic Sculpture, II.* Madison: University of Wisconsin Press, 2000.
Robertson, Martin. *A History of Greek Art.* 2 vols. London: Cambridge University Press, 1975.
Roes, Anna. *Greek Geometric Art, Its Symbolism and Its Origin.* London: Oxford University Press, 1933.
Schefold, Karl. *Myth and Legend in Early Greek Art.* Trans. Audrey Hicks. New York: Abrams, 1966.
———. *Gods and Heroes in Late Archaic Greek Art.* Trans. Alan Griffiths. New York: Cambridge University Press, 1992.
Schmidt, Evamaria. *The Great Altar of Pergamon.* Trans. Lena Jaeck. Boston: Boston Book and Art Shop, 1965.
Scully, Vincent. *The Earth, the Temple, and the Gods: Greek Sacred Architecture.* Rev. ed. New Haven: Yale University Press, 1979.
Smith, R. R. R. *Hellenistic Sculpture: A Handbook.* New York: Thames & Hudson, 1991.
Stewart, Andrew. *Greek Sculpture: An Exploration.* New Haven: Yale University Press, 1990.
———. *Art, Desire, and the Body in Ancient Greece.* Cambridge, Eng.: Cambridge University Press, 1997.
Stobart, J. C. *The Glory That Was Greece.* 4th ed. New York: Praeger, 1984.
Vermeule, Emily. *Greece in the Bronze Age.* Chicago: University of Chicago Press, 1972.
———. *Aspects of Death in Early Greek Art and Poetry.* Berkeley: University of California Press, 1979.
Webster, T. B. L. *The Art of Greece: The Age of Hellenism.* New York: Crown, 1966.
Whitley, James. *Style and Society in Dark Age Greece: The Changing Face of a Pre-literate Society, 1100–700 B.C.* Cambridge, Eng.: Cambridge University Press, 1991.

The Art of the Etruscans

Bloch, Raymond. *Etruscan Art.* Greenwich, Conn.: New York Graphic Society, 1965.
Boëthius, Axel. *Etruscan and Early Roman Architecture.* 2nd integrated ed. Rev. by Roger Ling and Tom Rasmussen. New York: Penguin, 1978.
Bonfante, Larissa, ed. *Etruscan Life and Afterlife: A Handbook of Etruscan Studies.* Detroit: Wayne State University Press, 1986.
———. *Etruscan: Reading the Past.* Berkeley: University of California Press/British Museum, 1990.
———. *Etruscan Mirrors.* New York: Metropolitan Museum of Art, 1997.
Brendel, Otto J. *Etruscan Art.* 2nd ed. New Haven: Yale University Press, 1995.
Buranelli, Francesco. *The Etruscans: Legacy of a Lost Civilization from the Vatican Museums.* Memphis, Tenn.: Lithograph, 1992.
de Grummond, Nancy Thomson, ed. *A Guide to Etruscan Mirrors.* Tallahassee Archaeological News, 1982.
Harris, William Vernon. *Rome in Etruria and Umbria.* Oxford: Clarendon, 1971.
Macnamara, Ellen. *Everyday Life of the Etruscans.* Cambridge, Mass.: Harvard University Press, 1991.
Mansuelli, Guido Achille. *The Art of Etruria and Early Rome.* Trans. C. E. Ellis. New York: Crown, 1964.
Pallottino, Massimo. *Etruscan Painting.* Trans. M. E. Stanley and Stuart Gilbert. Geneva: Skira, 1952.
Richardson, Emeline H. *The Etruscans, Their Art and Civilization.* Chicago: University of Chicago Press, 1964.

Spivey, Nigel, and Simon Stoddart. *Etruscan Italy: An Archaeological History.* London: Batsford, 1992.
Sprenger, Maja, Gilda Bartoloni, and Max Hirmer. *The Etruscans: Their History, Art, and Architecture.* Trans. Robert Erich Wolf. New York: Abrams, 1983.
Steingräber, Stephan, ed. *Etruscan Painting: Catalogue Raisonné of Etruscan Wall Paintings.* Trans. Mary Blair and Brian Phillips. New York: Johnson Reprint, 1986.
Ward-Perkins, J. B. *Roman Architecture* (1974). Milan/London: Electa/Phaidon, 2003.

Ancient Rome

Andreae, Bernard. *The Art of Rome.* Trans. Robert Erich Wolf. New York: Abrams, 1977.
Bianchi Bandinelli, Ranuccio. *Rome, the Center of Power, 500 B.C. to A.D. 200.* Trans. Peter Green. New York: Braziller, 1970.
———. *Rome, the Late Empire: Roman Art, A.D. 200–400.* Trans. Peter Green. New York: Braziller, 1971.
Brendel, Otto J. *Prolegomena to the Study of Roman Art.* New Haven: Yale University Press, 1979.
Brilliant, Richard. *Roman Art from the Republic to Constantine.* London: Phaidon, 1974.
———. *Pompeii A.D. 79: The Treasure of Rediscovery.* New York: Potter, 1979.
D'Ambra, Eve. *Roman Art.* New York: Cambridge University Press, 1998.
Feder, Theodore H. *Great Treasures of Pompeii and Herculaneum.* New York: Abbeville, 1978.
Goldscheider, Ludwig. *Roman Portraits.* New York: Oxford University Press, 1940.
Guillaud, Jacqueline, and Maurice Guillaud. *Frescoes in the Time of Pompeii.* New York: Potter, 1990.
Hanfmann, George M. A. *Roman Art: A Modern Survey of the Art of Imperial Rome* (1964). New York: Norton, 1975.
Heintze, Helga von. *Roman Art* (1972). New York: Universe, 1990.
Henig, Martin, ed. *Handbook of Roman Art: A Comprehensive Survey of All the Arts of the Roman World.* Ithaca, N.Y.: Cornell University Press, 1983.
Jenkyns, Richard., ed. *The Legacy of Rome: A New Appraisal.* New York: Oxford University Press, 1992.
Krautheimer, Richard. *Rome: Profile of a City, 312–1308* (1980). Princeton: Princeton University Press, 2000.
Ling, Roger. *Roman Painting.* New York: Cambridge University Press, 1991.
MacDonald, William L. *The Architecture of the Roman Empire: An Introductory Study* (1965). Rev. ed. New Haven: Yale University Press, 1982.
———. *The Pantheon: Design, Meaning, and Progeny* (1976). Cambridge, Mass.: Harvard University Press, 2002.
Pollitt, J. J. *The Art of Rome c. 753 B.C.–A.D. 337: Sources and Documents.* New York: Cambridge University Press, 1983.
Ramage, Nancy H., and Andrew Ramage. *The Cambridge Illustrated History of Roman Art.* Cambridge: Cambridge University Press, 1991.
———. *Roman Art: Romulus to Constantine.* 4th ed. Upper Saddle River, N.J.: Prentice-Hall, 2005.
Robertson, Donald S. *Greek and Roman Architecture.* 2nd ed. Cambridge, Eng.: Cambridge University Press, 1969.
Sear, Frank. *Roman Architecture.* Rev. ed. London: Batsford, 1989.
Strong, Donald E. *Roman Imperial Sculpture: An Introduction to the Commemorative and Decorative Sculpture of the Roman Empire down to the Death of Constantine.* London: Tiranti, 1961.

———. *Roman Art.* 2nd ed. Pelican History of Art. New Haven: Yale University Press, 1995.
Vermeule, Cornelius. *European Art and the Classical Past.* Cambridge, Mass.: Harvard University Press, 1964.
Vitruvius. *The Ten Books on Architecture.* Trans. Morris Hicky Morgan. Reprint of 1914 edition. New York: Dover, 1960.
Ward-Perkins, John B. *Roman Architecture* (1976). New York: Electa/Rizzoli, 1988.
———. *Roman Imperial Architecture* (1981). New Haven: Yale University Press, 1994.
Wells, Colin M. *The Roman Empire.* 2nd ed. Cambridge, Mass.: Harvard University Press, 1995.
Wheeler, Mortimer. *Roman Art and Architecture* (1964). New York: Thames & Hudson, 1985.
Wilkinson, L. P. *The Roman Experience.* New York: Knopf, 1974.
Zanker, Paul. *The Power of Images in the Age of Augustus.* Trans. Alan Shapiro. Ann Arbor: University of Michigan Press, 1988.

Early Christian and Byzantine Art

Age of Spirituality: Late Antique and Early Christian Art, Third to Seventh Century. New York: Metropolitan Museum of Art, 1979.
Beckwith, John. *The Art of Constantinople: An Introduction to Byzantine Art (330–1453).* 2nd ed. New York: Phaidon, 1968.
———. *Early Christian and Byzantine Art.* 2nd ed. New York: Penguin, 1979.
Boyd, Susan A. *Byzantine Art.* Chicago: University of Chicago Press, 1979.
Christe, Yves, et al. *Art of the Christian World, A.D. 200–1500: A Handbook of Styles and Forms.* New York: Rizzoli, 1982.
Demus, Otto. *Byzantine Art and the West.* New York: New York University Press, 1970.
———. *Byzantine Mosaic Decoration: Aspects of Monumental Art in Byzantium.* New Rochelle, N.Y.: Caratzas, 1976.
Ferguson, George W. *Signs and Symbols in Christian Art.* New York: Oxford University Press, 1967.
Gough, Michael. *The Origins of Christian Art.* London: Thames & Hudson, 1973.
Grabar, André. *Byzantium: Byzantine Art in the Middle Ages.* Trans. B. Forster. London: Methuen, 1966.
———. *The Beginnings of Christian Art, 200–395.* Trans. Stuart Gilbert and James Emmons. London: Thames & Hudson, 1967.
———. *The Golden Age of Justinian, from the Death of Theodosius to the Rise of Islam.* Trans. Stuart Gilbert and James Emmons. New York: Odyssey, 1967.
———. *Christian Iconography: A Study of Its Origins* (1968). London: Henley, Routledge & Kegan Paul, 1980.
Kitzinger, Ernst. *Byzantine Art in the Making: Main Lines of Stylistic Development in Mediterranean Art, 3rd–7th Century.* Cambridge, Mass.: Harvard University Press, 1980.
Krautheimer, Richard. *Studies in Early Christian, Medieval, and Renaissance Art.* New York: New York University Press, 1969.
———. *Early Christian and Byzantine Architecture.* 4th ed. Pelican History of Art. New York: Penguin, 1986.
Lane Fox, Robin. *Pagans and Christians* (1987). San Francisco: Harper San Francisco, 1995.
Lowrie, Walter. *Art in the Early Church* (1947). New York: Norton, 1969.
Mainstone, Rowland J. *Hagia Sophia: Architecture, Structure, and Liturgy of Justinian's Great Church.* London: Thames & Hudson, 1988.
Mango, Cyril. *Byzantine Architecture.* New York: Rizzoli, 1985.
———. *The Art of the Byzantine Empire, 312–1453: Sources and Documents* (1972). Toronto: University of Toronto Press, 1986.

Mancinelli, Fabrizio. *Catacombs and Basilicas: The Early Christians in Rome.* Trans. Carol Wasserman. Florence: Scala, 1981.

Mathew, Gervase. *Byzantine Aesthetics.* London: Murray, 1963.

Mathews, Thomas. *Byzantium: From Antiquity to the Renaissance.* New York: Abrams, 1998.

Morey, Charles Rufus. *Early Christian Art: An Outline of the Evolution of Style and Iconography in Sculpture and Painting from Antiquity to the Eighth Century.* 2nd ed. Princeton: Princeton University Press, 1953.

Oakeshott, Walter. *The Mosaics of Rome: From the Third to the Fourteenth Centuries.* London: Thames & Hudson, 1967.

Rice, David T. *The Appreciation of Byzantine Art.* London: Oxford University Press, 1972.

Schapiro, Meyer. *Late Antique, Early Christian, and Mediaeval Art.* New York: Braziller, 1979.

Stevenson, James. *The Catacombs: Rediscovered Monuments of Early Christianity.* London: Thames & Hudson, 1978.

Volbach, Wolfgang, and Max Hirmer. *Early Christian Art.* Trans. Christopher Ligota. New York: Abrams, 1962.

von Simson, Otto G. *Sacred Fortress: Byzantine Art and Statecraft in Ravenna.* Princeton: Princeton University Press, 1987.

Weitzmann, Kurt. *Studies in Classical and Byzantine Manuscript Illustration.* Chicago: University of Chicago Press, 1971.

——. *Art in the Medieval West and Its Contacts with Byzantium.* London: Variorum, 1982.

——, et al. *The Icon.* New York: Knopf, 1982.

The Early Middle Ages

Aldhouse-Green, Miranda. *Celtic Art.* New York: Sterling, 1997.

Alexander, Jonathan J. G. *Medieval Illuminators and Their Methods of Work.* New Haven: Yale University Press, 1992.

Atil, Esin. *Art of the Arab World.* Washington, D.C.: Smithsonian Institution, 1975.

Backes, Magnus, and Regine Dölling. *Art of the Dark Ages.* Trans. F. Garvie. New York: Abrams, 1971.

Backhouse, Janet, ed. *The Lindisfarne Gospels.* Oxford: Phaidon, 1981.

Backhouse, Janet, D. H. Turner, and Leslie Webster. *The Golden Age of Anglo-Saxon Art, 966–1066.* Bloomington: Indiana University Press, 1984.

Barasch, Moshe. *Gestures of Despair in Medieval and Early Renaissance Art.* New York: New York University Press, 1976.

Basing, Patricia. *Trades and Crafts in Medieval Manuscripts.* London: The British Library, 1990.

Beckwith, John. *Early Medieval Art: Carolingian, Ottonian, Romanesque* (1969). New York: Oxford University Press, 1985.

Blair, Sheila S., and Jonathan M. Bloom. *The Art and Architecture of Islam, 1250–1800.* New Haven: Yale University Press, 1994.

Braunfels, Wolfgang. *Monasteries of Western Europe: The Architecture of the Orders.* Trans. Alastair Laing. London: Thames & Hudson, 1972.

Brown, Peter, ed. *The Book of Kells.* New York: Knopf, 1980.

Calkins, Robert G. *Illuminated Books of the Middle Ages.* Ithaca, N.Y.: Cornell University Press, 1983.

Conant, Kenneth John. *Carolingian and Romanesque Architecture, 800 to 1200.* 4th ed. Pelican History of Art. New Haven: Yale University Press, 1993.

Davis-Weyer, Caecilia, ed. *Early Medieval Art, 300–1150: Sources and Documents* (1971). Toronto: University of Toronto Press, 1986.

Diebold, William J. *Word and Image: An Introduction to Early Medieval Art.* Boulder, Col.: Westview, 2000.

Dodwell, C. R. *The Pictorial Arts of the West, 800–1200.* Pelican History of Art. New Haven: Yale University Press, 1993.

Ettinghausen, Richard. *Arab Painting.* Geneva: Skira, 1977.

Ettinghausen, Richard, and Oleg Grabar. *The Art and Architecture of Islam, 650–1250.* New York: Penguin, 1987.

Fernie, Eric. *The Architecture of the Anglo-Saxons.* London: Batsford, 1983.

Finlay, Ian. *Celtic Art: An Introduction.* London: Faber, 1973.

Frishman, Martin, and Hasan-Uddin Khan, eds. *The Mosque: History, Architectural Development and Regional Diversity.* London: Thames & Hudson, 2002.

Grabar, André, and Carl Nordenfalk. *Early Medieval Painting from the Fourth to the Eleventh Century: Mosaics and Mural Paintings.* New York: Skira, 1957.

Grabar, Oleg. *The Formation of Islamic Art.* Rev. and enl. ed. New Haven: Yale University Press, 1983.

Grant, Michael. *The Dawn of the Middle Ages,* A.D. 476–814. New York: McGraw-Hill, 1981.

Grube, Ernst J. *Architecture of the Islamic World: Its History and Social Meaning* (1978). Ed. George Michell. New York: Thames & Hudson, 1984.

Henderson, George. *From Durrow to Kells: The Insular Gospel-Books, 650–800.* London: Thames & Hudson, 1987.

——. *Early Medieval* (1972). Toronto: University of Toronto Press, 1993.

Henry, Françoise. *Irish Art in the Early Christian Period, to 800* A.D. Ithaca, N.Y.: Cornell University Press, 1965.

——. *Irish Art during the Viking Invasions, 800–1020* A.D. Ithaca, N.Y.: Cornell University Press, 1967.

Hinks, Roger P. *Carolingian Art: A Study of Early Medieval Painting and Sculpture in Western Europe* (1935). Ann Arbor: University of Michigan Press, 1966.

Horn, Walter W., and Ernest Born. *Plan of Saint Gall: A Study of the Architecture and Economy of and Life in a Paradigmatic Carolingian Monastery.* 3 vols. Berkeley: University of California Press, 1979.

Hubert, Jean, Jean Porcher, and W. F. Volbach. *Europe of the Invasions.* Trans. Stuart Gilbert and James Emmons. New York: Braziller, 1969.

——. *The Carolingian Renaissance.* New York: Braziller, 1970.

Irwin, Robert. *Islamic Art in Context: Art, Architecture, and the Literary World.* New York: Abrams, 1997.

Kendrick, Thomas D. *Anglo-Saxon Art to* A.D. *900* (1938). New York: Barnes & Noble, 1972.

Kidson, Peter. *The Medieval World.* New York: McGraw-Hill, 1967.

Kitzinger, Ernst. *Early Medieval Art in the British Museum.* Rev. ed. Bloomington: Indiana University Press, 1983.

Laing, Lloyd, and Jennifer Laing. *Art of the Celts.* New York: Thames & Hudson, 1992.

Lasko, Peter. *Ars Sacra, 800–1200.* 2nd ed. Pelican History of Art. New Haven: Yale University Press, 1994.

Martindale, Andrew. *The Rise of the Artist in the Middle Ages and Early Renaissance.* New York: McGraw-Hill, 1972.

Megaw, Ruth, and Vincent Megaw. *Celtic Art: From Its Beginnings to the Book of Kells.* Rev. and exp. ed. New York: Thames & Hudson, 2001.

Mütherich, Florentine, and Joachim E. Gaehde. *Carolingian Painting.* New York: Braziller, 1976.

Nordenfalk, Carl. *Celtic and Anglo-Saxon Painting: Book Illumination in the British Isles, 600–800.* New York: Braziller, 1977.

——. *Early Medieval Book Illumination.* New York: Rizzoli, 1988.

Pächt, Otto. *The Rise of Pictorial Narrative in Twelfth-Century England.* Oxford: Clarendon, 1962.

——. *Book Illumination in the Middle Ages: An Introduction.* London: Miller, 1986.

Panofsky, Erwin. *Tomb Sculpture: Four Lectures on Its Changing Aspects from Ancient Egypt to Bernini* (1964). New York: Abrams, 1992.

Papadopoulo, Alexandre. *Islam and Muslim Art.* Trans. Robert Erich Wolf. New York: Abrams, 1979.

Pevsner, Nikolaus. *An Outline of European Architecture.* 7th ed. Baltimore: Penguin, 1970.

——. *Islamic Art.* London: Thames & Hudson, 1975.

Richardson, Hilary, and John Scarry. *An Introduction to Irish High Crosses.* Dublin: Mercier, 1990.

Rickert, Margaret. *Painting in Britain: The Middle Ages.* 2nd ed. Pelican History of Art. Harmondsworth: Penguin, 1965.

Saalman, Howard. *Medieval Architecture: European Architecture, 600–1200.* New York: Braziller, 1962.

Schimmel, Annemarie. *Calligraphy and Islamic Culture.* New York: New York University Press, 1984.

Snyder, James. *Medieval Art: Painting, Sculpture, Architecture, 4th–14th Century.* New York: Harry N. Abrams, 1989.

Stokstad, Marilyn. *Medieval Art.* 2nd ed. Boulder, Col.: New York: Westview, 2004.

Tasker, Edward G. *Encyclopedia of Medieval Church Art.* Ed. John Beaumont. London: Batsford, 1993.

Verzone, Paolo. *The Art of Europe: The Dark Ages from Theodoric to Charlemagne.* New York: Crown, 1968.

Ward, Rachel. *Islamic Metalwork.* New York: Thames & Hudson, 1993.

Wilson, David M. *Anglo-Saxon Art: From the Seventh Century to the Norman Conquest.* London: Thames & Hudson, 1984.

Wilson, David M., and Ole Klindt-Jensen. *Viking Art.* 2nd ed. Minneapolis: University of Minnesota Press, 1980.

Wormald, Francis. *Collected Writings.* Vol. I: *Studies in Medieval Art from the Sixth to the Twelfth Centuries.* New York: Oxford University Press, 1984–1988.

Zarnecki, George. *Art of the Medieval World: Architecture, Sculpture, Painting, the Sacred Arts.* New York: Abrams, 1975.

Romanesque Art

Busch, Harald, and Bernd Lohse, eds. *Romanesque Sculpture.* Trans. Peter Gorge. London: Batsford, 1962.

Cahn, Walter. *Romanesque Bible Illumination.* Ithaca, N.Y.: Cornell University Press, 1982.

Clapham, Alfred W. *Romanesque Architecture in Western Europe.* Oxford: Clarendon, 1959.

Demus, Otto. *Romanesque Mural Painting.* New York: Abrams, 1970.

Evans, Joan. *Art in Medieval France, 987–1498* (1963). Oxford: Clarendon, 1969.

Focillon, Henri. *The Art of the West in the Middle Ages.* Ed. Jean Bony. Trans. Donald King. 2 vols. Ithaca, N.Y.: Cornell University Press, 1980.

Forsyth, Ilene H. *The Throne of Wisdom: Wood Sculptures of the Madonna in Romanesque France.* Princeton: Princeton University Press, 1972.

Gibbs-Smith, Charles H. *The Bayeux Tapestry.* London: Phaidon, 1973.

Grabar, André, and Carl Nordenfalk. *Romanesque Painting from the Eleventh to the Thirteenth Century: Mural Painting.* Trans. Stuart Gilbert. New York: Skira, 1958.

Grape, Wolfgang. *The Bayeux Tapestry: Monument to a Norman Triumph.* New York: Prestel, 1994.

Hearn, Millard F. *Romanesque Sculpture: The Revival of Monumental Stone Sculpture in the Eleventh and Twelfth Centuries.* Ithaca, N.Y.: Cornell University Press, 1981.

Holt, Elizabeth G. *A Documentary History of Art.* 3 vols. Princeton: Princeton University Press, 1981–1986.

Jacobs, Michael. *Northern Spain: The Road to Santiago de Compostela.* San Francisco: Chronicle, 1991.

Kennedy, Hugh. *Crusader Castles.* Cambridge: Cambridge University Press, 1994.

Kubach, Hans E. *Romanesque Architecture.* New York: Electa/Rizzoli, 1988.

Künstler, Gustav. *Romanesque Art in Europe.* Greenwich, Conn.: New York Graphic Society, 1968.

Little, Bryan D. G. *Architecture in Norman Britain.* London: Batsford, 1985.

Mâle, Émile. *Religious Art in France, the Twelfth Century: A Study of the Origins of Medieval Iconography.* Bollingen Series, 90:1. Princeton: Princeton University Press, 1978.

——. *Art and Artists of the Middle Ages.* Redding Ridge, Conn.: Black Swan, 1986.

Nichols, Stephen G., Jr. *Romanesque Signs: Early Medieval Narrative and Iconography.* New Haven: Yale University Press, 1983.

Petzold, Andreas. *Romanesque Art.* New York: Abrams, 1995.

Platt, Colin. *The Architecture of Medieval Britain: A Social History.* New Haven: Yale University Press, 1990.

Radding, Charles M., and William W. Clark. *Medieval Architecture, Medieval Learning: Builders and Masters in the Age of Romanesque and Gothic.* New Haven: Yale University Press, 1992.

Saxl, Fritz. *English Sculptures of the 12th Century.* Ed. Hanns Swarzenski. London: Faber & Faber, 1954.

Schapiro, Meyer. *Romanesque Art: Selected Papers.* New York: Braziller, 1977.

——. *The Romanesque Sculpture of Moissac.* New York: Braziller, 1985.

Stoddard, Whitney S. *Art and Architecture in Medieval France: Medieval Architecture, Sculpture, Stained Glass, Manuscripts, the Art of the Church Treasuries.* New York: Harper & Row, 1972.

Swarzenski, Hanns. *Monuments of Romanesque Art: The Art of Church Treasures in North-Western Europe.* 2nd ed. Chicago: University of Chicago Press, 1974.

Tate, Robert B., and Marcus Tate. *The Pilgrim Route to Santiago.* Oxford: Phaidon, 1987.

The Year 1200. 2 vols. New York: Metropolitan Museum of Art, 1970.

Thompson, Daniel V. *The Materials and Techniques of Medieval Painting.* New York: Dover, 1956.

Zarnecki, George. *Romanesque Art.* New York: Universe, 1971.

Zarnecki, George, Janet Holt, and Tristram Holland. *English Romanesque Art, 1066–1200.* London: Weidenfeld & Nicolson, 1984.

Gothic Art

Alexander, Jonathan J. G., and Paul Binski, eds. *Age of Chivalry: Art in Plantagenet England, 1200–1400.* London: Royal Academy of Arts, 1987.

Andrews, Francis B. *The Mediaeval Builder and His Methods.* Mineola, N.Y.: Dover, 1999.

Armi, C. Edson. *The "Headmaster" of Chartres and the Origins of "Gothic" Sculpture.* University Park: Pennsylvania State University Press, 1994.

Aubert, Marcel. *Gothic Cathedrals of France and Their Treasures.* Trans. Lionel Kochan and Miriam Kochan. London: Kaye, 1959.

——. *The Art of the High Gothic Era.* Trans. Peter Gorge. New York: Crown, 1965.

Blum, Pamela Z. *Early Gothic Saint-Denis: Restorations and Survivals.* Berkeley: University of California Press, 1992.

Bony, Jean. *The English Decorated Style: Gothic Architecture Transformed, 1250–1350.* Ithaca, N.Y.: Cornell University Press, 1979.

——. *French Gothic Architecture of the Twelfth and Thirteenth Centuries.* Berkeley: University of California Press, 1983.

Bowie, Theodore, ed. *The Sketchbook of Villard de Honnecourt* (1959). Westport, Conn.: Greenwood, 1982.

Branner, Robert. *St. Louis and the Court Style in Gothic Architecture.* London: Zwemmer, 1965.

——. *Chartres Cathedral.* New York: Norton, 1969.

Brieger, Peter H. *English Art, 1216–1307.* Oxford: Clarendon, 1957.

Camille, Michael. *The Gothic Idol: Ideology and Image-Making in Medieval Art.* New York: Cambridge University Press, 1989.

——. *Gothic Art: Glorious Visions.* New York: Abrams, 1996.

Erlande-Brandenburg, Alain. *Gothic Art.* Trans. I. Mark Paris. New York: Abrams, 1989.

Favier, Jean. *The World of Chartres.* Trans. F. Garvie. New York: Abrams, 1990.

Frankl, Paul. *Gothic Architecture.* Rev. ed. Paul Crossley. Pelican History of Art. New Haven: Yale University Press, 2000.

Frisch, Teresa G. *Gothic Art, 1140–c.1450: Sources and Documents* (1971). Toronto: University of Toronto, 1987.

Gerson, Paula Lieber, ed. *Abbot Suger and Saint-Denis: A Symposium.* New York: Metropolitan Museum of Art, 1986.

Grodecki, Louis. *Gothic Architecture* (1976). Trans. I. Mark Paris. New York: Electa/Rizzoli, 1985.

Grodecki, Louis, and Catherine Brisac. *Gothic Stained Glass, 1200–1300.* Ithaca, N.Y.: Cornell University Press, 1985.

Henderson, George D. S. *Gothic.* Baltimore: Penguin, 1967.

——. *Chartres.* Baltimore: Penguin, 1968.

Jantzen, Hans. *High Gothic: The Classic Cathedrals of Chartres, Reims, Amiens* (1962). Trans. James Palmes. Princeton: Princeton University Press, 1984.

Katzenellenbogen, Adolf. *The Sculptural Programs of Chartres Cathedral: Christ, Mary, Ecclesia* (1959). New York: Norton, 1964.

Lord, Carla. *Royal French Patronage of Art in the Fourteenth Century: An Annotated Bibliography.* Boston: Hall, 1985.

Mâle, Émile. *The Gothic Image: Religious Art in France of the Thirteenth Century.* New York: Harper & Row, 1972.

——. *Religious Art in France, the Thirteenth Century: A Study of Medieval Iconography and Its Sources.* Princeton: Princeton University Press, 1984.

——. *Religious Art in France, the Late Middle Ages: A Study of Medieval Iconography and Its Sources.* Princeton: Princeton University Press, 1986.

Martindale, Andrew. *Gothic Art* (1967). New York: Thames & Hudson, 1985.

Meulen, Jan van der. *Chartres: Sources and Literary Interpretation: A Critical Bibliography.* Boston: Hall, 1989.

Panofsky, Erwin, and Gerda Panofsky-Soergel. eds. *Abbot Suger on the Abbey Church of St.-Denis and Its Art Treasures.* 2nd ed. Princeton: Princeton University Press, 1979.

Panofsky, Erwin. *Gothic Architecture and Scholasticism.* New York: World, 1957.

Pevsner, Nikolaus, and Priscilla Metcalf. *The Cathedrals of England.* 2 vols. Harmondsworth: Viking, 1985.

Pope-Hennessy, John. *Italian Gothic Sculpture.* 3rd ed. Oxford: Phaidon, 1986.

Sandler, Lucy Freeman. *Gothic Manuscripts, 1285–1385.* A Survey of Manuscripts Illuminated in the British Isles 5. 2 vols. London: Miller, 1986.

Sauerländer, Willibald. *Gothic Sculpture in France, 1140–1270.* Trans. Janet Sondheimer. New York: Abrams, 1972.

Swaan, Wim. *The Gothic Cathedral* (1969). London: Ferndale, 1981.

Voelkle, William. *The Stavelot Triptych: Mosan Art and the Legend of the True Cross.* New York: Pierpont Morgan Library, 1980.

von Simson, Otto G. *The Gothic Cathedral: Origins of Gothic Architecture and the Medieval Concept of Order.* 3rd ed. Princeton: Princeton University Press, 1988.

Watson, Percy. *Building the Medieval Cathedrals.* Cambridge: Cambridge University Press, 1976.

Wieck, Roger S. *Time Sanctified: The Book of Hours in Medieval Art and Life.* 2nd ed. New York: Braziller, 2001.

Williamson, Paul. *Gothic Sculpture, 1140–1300.* New Haven: Yale University Press, 1995.

Wilson, Christopher. *The Gothic Cathedral: The Architecture of the Great Church, 1130–1530.* Rev. ed. New York: Thames & Hudson, 2000.

Precursors of the Renaissance

Barasch, Moshe. *Giotto and the Language of Gesture.* Cambridge: Cambridge University Press, 1987.

Barolsky, Paul. *Giotto's Father and the Family of Vasari's Lives.* University Park, Pa.: Pennsylvania State University Press, 1992.

Baxandall, Michael. *Giotto and the Orators: Humanist Observers of Painting in Italy and the Discovery of Pictorial Composition, 1350–1450.* Oxford: Oxford University Press, 1971.

Bomford, David. *Italian Painting before 1400.* London: National Gallery Publications, 1989.

Borsook, Eve. *The Mural Painters of Tuscany: From Cimabue to Andrea del Sarto.* 2nd ed. New York: Oxford University Press, 1980.

Borsook, Eve, and Fiorella Superbi Gioffredi. *Italian Altarpieces 1250–1550: Function and Design.* Oxford: Clarendon, 1994.

Burckhardt, Jacob. *The Civilization of the Renaissance in Italy.* New York: Modern Library, 2002.

Campbell, Lorne. *Renaissance Portraits: European Portrait-Painting in the 14th, 15th, and 16th Centuries.* New Haven: Yale University Press, 1990.

Cennini, Cennino. *The Craftsman's Handbook (Il Libro dell'Arte)* (1954). Trans. Daniel V. Thompson, Jr. New York: Dover, 1954.

Chiellini, Monica. *Cimabue.* Trans. Lisa Pelletti. Florence: Scala, 1988.

Cole, Bruce. *Giotto and Florentine Painting, 1280–1375.* New York: Harper & Row, 1976.

——. *Sienese Painting: From Its Origins to the 15th Century.* New York: Harper & Row, 1980.

——. *The Renaissance Artist at Work: From Pisano to Titian.* New York: Harper & Row, 1983.

Davis, Howard McP. *Gravity in the Paintings of Giotto* (1971). 1971. Reprinted in Schneider, 1974.

Maginnis, Hayden B. J. *Painting in the Age of Giotto: A Historical Reevaluation.* University Park, Pa.: Pennsylvania State University Press, 1997.

Martindale, Andrew. *The Rise of the Artist in the Middle Ages and Early Renaissance.* New York: McGraw-Hill, 1972.

——. *Simone Martini.* New York: New York University Press, 1988.

Meiss, Millard. *French Painting in the Time of Jean de Berry: The Late Fourteenth Century and the Patronage of the Duke.* 2nd ed. New York: Braziller, 1969.

——. *Painting in Florence and Siena after the Black Death: The Arts, Religion, and Society in the Mid-Fourteenth Century* (1951). Princeton: Princeton University Press, 1978.

Meiss, Millard, and Elizabeth H. Beatson. *The "Belles Heures" of Jean, Duke of Berry: The Cloisters, the Metropolitan Museum of Art*. New York: Braziller, 1974.

Moskowitz, Anita Fiderer. *The Sculpture of Andrea and Nino Pisano*. Cambridge: Cambridge University Press, 1986.

Rosenberg, Charles M., ed. *Art and Politics in Late Medieval and Early Renaissance Italy, 1250–1500*. Notre Dame, Ind.: University of Notre Dame Press, 1990.

Schneider, Laurie M., ed. *Giotto in Perspective*. Englewood Cliffs, N.J.: Prentice-Hall, 1974.

Smart, Alastair. *The Dawn of Italian Painting, 1250–1400*. Ithaca, N.Y.: Cornell University Press, 1978.

Stubblebine, James H., ed. *Giotto: The Arena Chapel Frescoes*. New York: Norton, 1969.

———. *Ducento Painting: An Annotated Bibliography*. Boston: Hall, 1983.

———. *Assisi and the Rise of Vernacular Art*. New York: Harper & Row, 1985.

Vasari, Giorgio. *The Lives of the Most Eminent Painters, Sculptors and Architects*. Trans. Gaston du C. de Vere. New York: Abrams, 1979.

White, John. *Duccio: Tuscan Art and the Medieval Workshop*. New York: Thames & Hudson, 1979.

———. *The Birth and Rebirth of Pictorial Space*. 3rd ed. Cambridge, Mass.: Belknap, 1987.

The Early Renaissance

Adams, Laurie Schneider. *Key Monuments of the Italian Renaissance*. Boulder, Col.: Westview, 2000.

———. *Italian Renaissance Art*. Boulder, Col.: Westview, 2001.

Alazard, Jean. *The Florentine Portrait*. New York: Schocken, 1968.

Alberti, Leon Battista. *Ten Books on Architecture* (1955). Ed. J. Rykwert. Trans. J. Leoni. New York: Transatlantic Arts, 1966.

———. *On Painting* (1966). Trans J. R. Spencer. Rev. ed. Westport, Conn.: Greenwood, 1976.

Ames-Lewis, Francis. *Drawing in Early Renaissance Italy*. Rev. ed. New Haven: Yale University Press, 2000.

Antal, Frederick. *Florentine Painting and Its Social Background: The Bourgeois Republic before Cosimo de' Medici's Advent to Power, Fourteenth and Early Fifteenth Centuries* (1948). Cambridge, Mass.: Belknap, 1986.

Barolsky, Paul. *Infinite Jest: Wit and Humor in Italian Renaissance Art*. Columbia: University of Missouri Press, 1978.

———. *Walter Pater's Renaissance*. University Park, Pa.: Pennsylvania State University Press, 1987.

Baxandall, Michael. *Painting and Experience in Fifteenth-Century Italy*. 2nd ed. Oxford: Oxford University Press, 1988.

Beck, James. *Italian Renaissance Painting*. New York: Harper & Row, 1981.

Bennett, Bonnie A., and David G. Wilkins. *Donatello*. Oxford: Phaidon, 1984.

Berenson, Bernard. *Italian Painters of the Renaissance*. 2 vols. London: Phaidon, 1968.

———. *Italian Pictures of the Renaissance: Florentine School*. 3 vols. London: Phaidon, 1968.

———. *The Drawings of the Florentine Painters* (1938). 3 vols. Chicago: University of Chicago Press, 1973.

———. *The Italian Painters of the Renaissance*. Ithaca, N.Y.: Cornell University Press, 1980.

Blunt, Anthony. *Artistic Theory in Italy, 1450–1600*. New York: Oxford University Press, 1994.

Bober, Phyllis P., and Ruth O. Rubinstein. *Renaissance Artists and Antique Sculpture: A Handbook of Sources*. New York: Oxford University Press, 1986.

Borsook, Eve. *The Mural Painters of Tuscany: From Cimabue to Andrea del Sarto*. 2nd ed. New York: Oxford University Press, 1980.

Butterfield, Andrew. *The Sculptures of Andrea del Verrocchio*. New Haven: Yale University Press, 1997.

Chastel, André. *The Studios and Styles of the Italian Renaissance*. New York: Odyssey, 1966.

Christiansen, Keith. *Gentile da Fabriano*. Ithaca, N.Y.: Cornell University Press, 1982.

———, Laurence B. Kanter, and Carl Brandon Strehle, eds. *Painting in Renaissance Siena, 1420–1500*. New York: Metropolitan Museum of Art, 1988.

Clark, Kenneth. *The Art of Humanism*. London: Murray, 1983.

Cole, Alison. *Virtue and Magnificence: Art of the Italian Renaissance Courts*. New York: Abrams, 1995.

d'Ancona, Mirella L. *The Garden of the Renaissance: Botanical Symbolism in Italian Painting*. Florence: Olschki, 1977.

Edgerton, Samuel Y., Jr. *The Renaissance Rediscovery of Linear Perspective*. New York: Harper & Row, 1976.

Gilbert, Creighton E., ed. *Renaissance Art*. New York: Harper & Row, 1973.

———, ed. *Italian Art, 1400–1500. Sources and Documents*. Englewood Cliffs, N.J.: Prentice-Hall, 1980.

Goffen, Rona, ed. *Masaccio's Trinity*. Cambridge: Cambridge University Press, 1998.

Goldthwaite, Richard A. *The Building of Renaissance Florence: An Economic and Social History*. Baltimore: Johns Hopkins University Press, 1982.

Gombrich, Ernst H. *The Heritage of Apelles: Studies in the Art of the Renaissance*. Ithaca, N.Y.: Cornell University Press, 1976.

———. *Norm and Form: Studies in the Art of the Renaissance*. 4th ed. Chicago: University of Chicago Press, 1985.

———. *Symbolic Images* (1972). 3rd ed. Chicago: University of Chicago Press, 1985.

———. *New Light on Old Masters* (1986). London: Phaidon, 2000.

Greenstein, Jack M. *Mantegna and Painting as Historical Narrative*. Chicago: University of Chicago Press, 1992.

Grendler, Pl. *Schooling in Renaissance Italy: Literacy and Learning, 1300–1600*. Baltimore: Johns Hopkins University Press, 1989.

Hale, J. R. *Artists and Warfare in the Renaissance*. New Haven: Yale University Press, 1990.

Harbison, Craig. *The Mirror of the Artist: Northern Renaissance Art in Its Historical Context*. New York: Abrams, 1995.

Hartt, Frederick. *A History of Italian Renaissance Art*. 5th ed. New York: Abrams, 2003.

Heydenreich, Ludwig H., and Paul Davies. *Architecture in Italy, 1400–1600*. New York: Yale University Press, 1996.

Hibbert, Christopher. *The House of Medici: Its Rise and Fall*. New York: Morrow Quill, 1980.

Hind, Arthur M. *History of Engraving and Etching*. 3rd ed., rev. Boston: Houghton Mifflin, 1923.

Horster, Marita. *Andrea del Castagno*. Ithaca, N.Y.: Cornell University Press, 1980.

Jacks, Philip. *The Antiquarian and the Myth of Antiquity: The Origins of Rome in Renaissance Thought*. Cambridge: Cambridge University Press, 1993.

Janson, Horst W. *The Sculpture of Donatello* (1957). Princeton: Princeton University Press, 1963.

Kemp, Martin. *Behind the Picture: Art and Evidence in the Italian Renaissance*. New Haven: Yale University Press, 1997.

Kent, Dale. *Cosimo de' Medici and the Florentine Renaissance*. New Haven: Yale University Press, 2000.

Krautheimer, Richard, and Trude Krautheimer-Hess. *Lorenzo Ghiberti*. Princeton: Princeton University Press, 1982.

Lavin, Marilyn A. *Piero della Francesca: The Flagellation* (1972). Chicago: University of Chicago Press, 1990.

Lee, Rensselaer W. *Ut Pictura Poesis: The Humanistic Theory of Painting*. New York: Norton, 1967.

Lightbown, Ronald. *Sandro Botticelli*. 2 vols. Berkeley: University of California Press, 1978.

Lowrey, Bates. *Renaissance Architecture*. New York: Braziller, 1962.

Machiavelli, Niccolò. *Florentine Histories*. Trans. Laura F. Banfield and Harvey C. Mansfield, Jr. Princeton: Princeton University Press, 1988.

Murray, Peter. *Renaissance Architecture*. New York: Rizzoli, 1985.

Panofsky, Erwin. *Renaissance and Renascences in Western Art*. New York: Harper & Row, 1972.

———. *Studies in Iconology: Humanistic Themes in the Art of the Renaissance*. New York: Harper & Row, 1972.

Panofsky, Erwin, and Dora Panofsky. *Pandora's Box: The Changing Aspects of a Mythical Symbol*. 2nd ed., rev. New York: Harper & Row, 1965.

Pater, Walter. *The Renaissance: Studies in Art and Poetry* (1893). Ed. Donald L. Hill. Berkeley: University of California Press, 1980.

Pope-Hennessy, John. *The Portrait in the Renaissance* (1963). Princeton: Princeton University Press, 1979.

———. *An Introduction to Italian Sculpture*. 4th ed. 3 vols. London: Phaidon, 1996.

Prager, Frank D., and Gustina Scaglia. *Brunelleschi: Studies of His Technology and Inventions*. Cambridge, Mass.: MIT Press, 1970.

Rabil, Albert, Jr. *Renaissance Humanism: Foundations, Forms, and Legacy*. 3 vols. Philadelphia: University of Pennsylvania Press, 1988.

Rosenberg, Charles M. *The Este Monuments and Urban Developments in Renaissance Ferrara*. Cambridge: Cambridge University Press, 1997.

Ruggiero, Guido. *Violence in Early Renaissance Venice*. New Brunswick, N.J.: Rutgers University Press, 1980.

Saxl, Fritz. *A Heritage of Images: A Selection of Lectures*. Ed. Hugh Honour and John Fleming. Harmondsworth: Penguin, 1970.

Seidel, Linda. *Jan van Eyck's Arnolfini Portrait: Stories of an Icon*. Cambridge: Cambridge University Press, 1993.

Seymour, Charles, Jr. *The Sculpture of Verrocchio*. Greenwich, Conn.: New York Graphic Society, 1971.

Seznec, Jean. *The Survival of the Pagan Gods: The Mythological Tradition and Its Place in Renaissance Humanism and Art*. Trans. Barbara F. Sessions. Princeton: Princeton University Press, 1995.

Thomson, David. *Renaissance Architecture: Critics, Patrons, Luxury*. Manchester: Manchester University Press, 1993.

Turner, A. Richard. *Renaissance Florence: The Invention of a New Art*. New York: Abrams, 1997.

Valentiner, W. R. *Studies of Italian Renaissance Sculpture*. London: Phaidon, 1950.

Wackernagel, Martin. *The World of the Florentine Renaissance Artist: Projects and Patrons, Workshop and Art Market*. Trans. Alison Luchs. Princeton: Princeton University Press, 1981.

Weiss, Roberto. *The Renaissance Discovery of Classical Antiquity*. 2nd ed. Oxford: Blackwell, 1988.

Wind, Edgar. *Pagan Mysteries in the Renaissance*. Rev. and enl. ed. Oxford: Oxford University Press, 1980.

Wittkower, Rudolf. *Idea and Image: Studies in the Italian Renaissance*. New York: Thames & Hudson, 1982.

———. *Architectural Principles in the Age of Humanism*. 4th ed. New York: St. Martin's, 1988.

Wölfflin, Heinrich. *Renaissance and Baroque*. Trans. Kathrin Simon. Ithaca, N.Y.: Cornell University Press, 1966.

———. *Classic Art: An Introduction to the Italian Renaissance*. Trans. L. and P. Murray. 5th ed. London: Phaidon, 1994.

Woods-Marsden, Joanna. *The Gonzaga of Mantua and Pisanello's Arthurian Frescoes.* Princeton: Princeton University Press, 1988.

The High Renaissance in Italy

Ackerman, James S. *The Architecture of Michelangelo.* 2nd ed. Chicago: University of Chicago Press, 1986.

Barolsky, Paul. *Michelangelo's Nose: A Myth and Its Maker.* University Park, Pa.: Pennsylvania State University Press, 1990.

———. *Why Mona Lisa Smiles and Other Tales by Vasari.* University Park, Pa.: Pennsylvania State University Press, 1991.

Brown, David Alan. *Leonardo's Last Supper: The Restoration.* Washington, D.C.: National Gallery of Art, 1983.

Brown, Patricia Fortini. *Venetian Narrative Painting in the Age of Carpaccio.* New Haven: Yale University Press, 1988.

———. *Art and Life in Renaissance Venice.* New York: Abrams, 1997.

Castiglione, Baldesar. *The Book of the Courtier* (1528). Rev. ed. Trans. G. Bull. Baltimore: Penguin, 1976.

Chastel, André. *The Sack of Rome, 1527.* Trans. Beth Archer. Princeton: Princeton University Press, 1983.

Clark, Kenneth M. *Leonardo da Vinci.* New York: Penguin, 1993.

Collins, Bradley I. *Leonardo, Psychoanalysis and Art History: A Critical Study of Psychobiographical Approaches to Leonardo da Vinci.* Evanston, Ill.: Northwestern University Press, 1997.

de Tolnay, Charles. *Michelangelo.* 2nd rev. ed. 5 vols. Princeton: Princeton University Press, 1969–1971.

Eissler, K. R. *Leonardo da Vinci: Psychoanalytic Notes on the Enigma.* New York: International Universities Press, 1961.

Fischel, Oskar. *Raphael.* Trans. B. Rackham. 2 vols. London: Spring Books, 1964.

Freedberg, Sydney J. *Painting of the High Renaissance in Rome and Florence.* Rev. ed. 2 vols. New York: Hacker, 1985.

———. *Painting in Italy, 1500–1600.* 3rd ed. Pelican History of Art. New Haven: Yale University Press, 1993.

Gilbert, Creighton E. *Michelangelo: On and Off the Sistine Ceiling.* New York: Braziller, 1994.

Goffen, Rona. *Piety and Patronage in Renaissance Venice: Bellini, Titian, and the Franciscans.* New Haven: Yale University Press, 1986.

———. *Giovanni Bellini.* New Haven: Yale University Press, 1989.

———, ed. *Titian's "Venus of Urbino."* Cambridge: Cambridge University Press, 1997.

———. *Titian's Women.* New Haven: Yale University Press, 1997.

Hall, Marcia, ed. *Raphael's "School of Athens."* New York: Cambridge University Press, 1997.

Heydenreich, Ludwig H. *Leonardo: The Last Supper.* London: Allen Lane, 1974.

Hibbard, Howard. *Michelangelo.* 2nd ed. New York: Harper & Row, 1985.

Humfrey, Peter. *Painting in Renaissance Venice.* New Haven: Yale University Press, 1995.

Huse, Norbert, and Wolfgang Wolters. *The Art of Renaissance Venice: Architecture, Sculpture, and Painting, 1460–1590.* Trans. E. Jephcott. Chicago: University of Chicago Press, 1990.

Kemp, Martin, ed. *Leonardo on Painting: An Anthology of Writings.* Trans. Martin Kemp and Margaret Walker. New Haven: Yale University Press, 1989.

Leonardo da Vinci. *The Notebooks.* Trans. Edward MacCurdy. 2 vols. New York: Braziller, 1958.

Levey, Michael. *High Renaissance.* Harmondsworth: Penguin, 1975.

Murray, Linda. *The High Renaissance and Mannerism: Italy, the North, and Spain, 1500–1600.* New York: Oxford University Press, 1977.

Panofsky, Erwin. *Problems in Titian, Mostly Iconographic.* New York: New York University Press, 1969.

Partridge, Loren. *The Art of Renaissance Rome, 1400–1600.* New York: Abrams, 1996.

Partridge, Loren, and Randolph Starn. *A Renaissance Likeness: Art and Culture in Raphael's Julius II.* Berkeley: University of California Press, 1980.

Pedretti, Carlo. *Leonardo da Vinci on Painting: A Lost Book.* Berkeley: University of California Press, 1964.

———. *Leonardo: Studies for the Last Supper from the Royal Library at Windsor Castle.* Ivrea: Olivetti, 1983.

Pope-Hennessy, John. *Raphael.* New York: New York University Press, 1970.

———. *Italian High Renaissance and Baroque Sculpture.* 3rd ed. New York: Phaidon, 1986.

Riess, Jonathan B. *The Renaissance Antichrist: Luca Signorelli's Orvieto Frescoes.* Princeton: Princeton University Press, 1995.

Robertson, Giles. *Giovanni Bellini.* New York: Hacker, 1981.

Rosand, David. *Titian.* New York: Abrams, 1978.

———. *Painting in Cinquecento Venice: Titian, Veronese, Tintoretto.* Rev. ed. New Haven: Yale University Press, 1997.

Ruggiero, Guido. *The Boundaries of Eros: Sex Crime and Sexuality in Renaissance Venice.* New York: Oxford University Press, 1985.

———. *Binding Passions: Tales of Magic, Marriage, and Power at the End of the Renaissance.* New York: Oxford University Press, 1993.

Saslow, James M. *Ganymede in the Renaissance: Homosexuality in Art and Society.* New Haven: Yale University Press, 1986.

———. *The Poetry of Michelangelo: An Annotated Translation.* New Haven: Yale University Press, 1991.

Settis, Salvatore. *Giorgione's Tempest: Interpreting the Hidden Subject.* Chicago: University of Chicago Press, 1990.

Steinberg, Leo. *Leonardo's Incessant Last Supper.* New York: Zone Books, 2001.

Tafuri, Manfredo. *Venice and the Renaissance.* Trans. Jessica Levine. Cambridge, Mass.: MIT Press, 1989.

Turner, A. Richard. *Inventing Leonardo.* Berkeley: University of California Press, 1993.

Vasari, Giorgio. *Vasari on Technique.* Trans. Louise S. Maclehose. New York: Dover, 1960.

Wethey, Harold E. *The Paintings of Titian.* 3 vols. London: Phaidon, 1969–.

Wilde, Johannes. *Venetian Art from Bellini to Titian.* Oxford: Clarendon, 1981.

Mannerism and the Later Sixteenth Century in Italy

Ackerman, James S. *Palladio.* London: Penguin, 1991.

Cellini, Benvenuto. *Autobiography.* Trans. J. A. Symonds. Ed. John Pope-Hennessy. London: Phaidon, 1960.

Cochrane, Eric. *Florence in the Forgotten Centuries, 1527–1800: A History of Florence and the Florentines in the Age of the Grand Dukes.* Chicago: University of Chicago Press, 1973.

Cox-Rearick, Janet. *The Drawings of Pontormo: A Catalogue Raisonné with Notes on the Paintings.* Rev. ed. 2 vols. New York: Hacker, 1981.

———. *Dynasty and Destiny in Medici Art: Pontormo, Leo X, and the Two Cosimos.* Princeton: Princeton University Press, 1984.

———. *Bronzino's Chapel of Eleonora in the Palazzo Vecchio.* Berkeley: University of California Press, 1993.

Freedberg, Sidney J. *Parmigianino: His Works in Painting.* Cambridge, Mass.: Harvard University Press, 1950.

Hauser, Arnold. *Mannerism: The Crisis of the Renaissance and the Origin of Modern Art.* Cambridge, Mass.: Belknap, 1986.

Holt, Elizabeth Gilmore, ed. *A Documentary History of Art.* Vol. 2: *Michelangelo and the Mannerists, the Baroque and the Eighteenth Century.* Princeton: Princeton University Press, 1982.

Pope-Hennessy, John. *Cellini.* London: Macmillan, 1985.

Shearman, John K. G. *Mannerism* (1967). Harmondsworth: Penguin, 1977.

Smythe, Craig Hugh. *Mannerism and Maniera.* 2nd ed. Vienna: IRSA, 1992.

Tomlinson, Janis. *From El Greco to Goya: Painting in Spain, 1561–1828.* New York: Abrams, 1997.

Würtenberger, Franzsepp. *Mannerism: The European Style of the Sixteenth Century.* New York: Holt, Rinehart & Winston, 1963.

Sixteenth-Century Painting and Printmaking in Northern Europe

Benesch, Otto. *The Art of the Renaissance in Northern Europe: Its Relation to the Contemporary Spiritual and Intellectual Movements.* Rev. ed. London: Phaidon, 1965.

———. *German Painting, from Dürer to Holbein.* Trans. H. S. B. Harrison. Geneva: Skira, 1966.

Chastel, André. *The Age of Humanism: Europe, 1480–1530.* Trans. Katherine Delavenay and E. M. Gwyer. New York: McGraw-Hill, 1964.

Cuttler, Charles D. *Northern Painting from Pucelle to Bruegel, Fourteenth, Fifteenth, and Sixteenth Centuries.* Fort Worth: Holt, Rinehart & Winston, 1991.

Davies, Martin. *Rogier van der Weyden: An Essay with a Critical Catalogue of Paintings Assigned to Him and to Robert Campin.* New York: Phaidon, 1972.

Friedländer, Max J. *Early Netherlandish Painting.* 14 vols. Trans. Heinz Norden. New York: Praeger, 1967–1976.

———. *From Van Eyck to Bruegel.* Trans. Marguerite Kay. 3rd ed. New York: Phaidon, 1969.

Fuchs, Rudolf H. *Dutch Painting.* New York: Oxford University Press, 1978.

Gilbert, Creighton E. *History of Renaissance Art: Painting, Sculpture, Architecture throughout Europe.* New York: Abrams, 1973.

Harbison, Craig. *The Mirror of the Artist: Northern Renaissance Art in Its Historical Context.* New York: Abrams, 1995.

Hayum, Andrée. *The Isenheim Altarpiece: God's Medicine and the Painter's Vision.* Princeton: Princeton University Press, 1989.

Hind, Arthur M. *A History of Engraving and Etching from the Fifteenth Century to the Year 1914.* 3rd rev. ed. New York: Dover, 1963.

———. *An Introduction to a History of Woodcut: With a Detailed Survey of Work Done in the Fifteenth Century.* New York: Dover, 1963.

Koerner, Joseph Leo. *The Moment of Self-Portraiture in German Renaissance Art.* Chicago: University of Chicago Press, 1993.

Lane, Barbara G. *The Altar and the Altarpiece: Sacramental Themes in Early Netherlandish Painting.* New York: Harper & Row, 1984.

Melion, Walter S. *Shaping the Netherlandish Canon: Karel van Mander's Schilder-boeck.* Chicago: University of Chicago Press, 1991.

Mellinkoff, Ruth. *The Devil at Isenheim: Reflections of Popular Belief in Grünewald's Altarpiece.* Berkeley: University of California Press, 1988.

Panofsky, Erwin. *Early Netherlandish Painting: Its Origin and Character* (1958). 2 vols. New York: Harper & Row, 1971.

———. *Life and Art of Albrecht Dürer.* Princeton: Princeton University Press, 2005.

Pevsner, Nikolaus, and Michael Meier. *Grünewald.* New York: Abrams, 1958.

Philip, Lotte Brand. *The Ghent Altarpiece and the Art of Jan van Eyck.* Princeton: Princeton University Press, 1971.

Snyder, James. *Northern Renaissance Art: Painting, Sculpture, the Graphic Arts from 1350 to 1575.* 2nd ed. Upper Saddle River, N.J.: Prentice-Hall, 2005.

Stechow, Wolfgang. *Northern Renaissance Art, 1400–1600: Sources and Documents* (1966). Evanston, Ill.: Northwestern University Press, 1989.

The Baroque Style in Western Europe

Adams, Laurie Schneider. *Key Monuments of the Baroque.* Boulder, Col.: Westview, 2000.

Alpers, Svetlana. *The Art of Describing: Dutch Art in the Seventeenth Century.* Chicago: University of Chicago Press, 1983.

——. *Rembrandt's Enterprise: The Studio and the Market.* Chicago: University of Chicago Press, 1988.

——. *The Making of Rubens.* New Haven: Yale University Press, 1995.

Avery, Charles. *Bernini, Genius of the Baroque.* London: Thames & Hudson, 1997.

Bazin, Germain. *Baroque and Rococo.* New York: Thames & Hudson, 1985.

Berger, Robert W. *Versailles: The Chateau of Louis XIV.* University Park, Pa.: Pennsylvania State University Press, 1985.

——. *The Palace of the Sun: The Louvre of Louis XIV.* University Park, Pa.: Pennsylvania State University Press, 1993.

Blunt, Anthony. *Art and Architecture in France, 1500–1700.* 5th ed. New Haven: Yale University Press, 1999.

Blunt, Anthony, et al. *Baroque and Rococo: Architecture and Decoration.* New York: Harper & Row, 1982.

Brown, Christopher. *Scenes of Everyday Life: Dutch Genre Painting of the Seventeenth Century.* London: Faber & Faber, 1984.

Brown, Jonathan. *Velázquez: Painter and Courtier.* New Haven: Yale University Press, 1986.

——. *The Golden Age of Painting in Spain.* New Haven: Yale University Press, 1991.

Carrier, David. *Poussin's Paintings: A Study in Art-Historical Methodology.* University Park, Pa.: Pennsylvania State University Press, 1993.

Clark, Kenneth. *Rembrandt and the Italian Renaissance* (1966). New York: Norton, 1984.

Domínguez Ortiz, Antonio, Alfonso E. Pérez Sánchez, and Julián Gállego. *Velázquez.* New York: Metropolitan Museum of Art, 1989.

Enggass, Robert, and Jonathan Brown. *Italy and Spain, 1600–1750: Sources and Documents.* Englewood Cliffs, N.J.: Prentice-Hall, 1970.

Friedländer, Walter F. *Caravaggio Studies* (1955). New York: Schocken, 1969.

Garrard, Mary D. *Artemisia Gentileschi: The Image of the Female Hero in Italian Baroque Art.* Princeton: Princeton University Press, 1989.

Gerson, Horst. *Rembrandt Paintings.* Trans. Heinz Norden. Ed. Gary Schwartz. New York: Reynal, 1968.

Goldscheider, Ludwig, ed. *Vermeer, the Paintings: Complete Edition.* 2nd ed. London: Phaidon, 1967.

Grimm, Claus. *Frans Hals: The Complete Work.* Trans. Jürgen Riehle. New York: Abrams, 1990.

Haak, Bob. *The Golden Age: Dutch Painters of the Seventeenth Century.* Trans. Elizabeth-Willems-Treeman. New York: Abrams, 1984.

Haskell, Francis. *Patrons and Painters: A Study in the Relations between Italian Art and Society in the Age of the Baroque.* Rev. and enl. ed. New Haven: Yale University Press, 1980.

Haverkamp-Begemann, E. *Rembrandt: The Nightwatch.* Princeton: Princeton University Press, 1982.

Held, Julius, and Donald Posner. *Seventeenth- and Eighteenth-Century Art.* New York: Abrams, 1974.

Hibbard, Howard. *Bernini.* Baltimore: Penguin, 1966.

——. *Caravaggio.* New York: Harper & Row, 1983.

Hill, G. F., and Graham Pollard. *Renaissance Medals from the Samuel H. Kress Collection at the National Gallery of Art.* London: Phaidon, 1967.

Kahr, Madlyn M. *Dutch Painting in the Seventeenth Century.* 2nd ed. New York: HarperCollins, 1993.

Kitson, Michael. *The Age of Baroque.* London: Hamlyn, 1976.

Koning, Hans. *The World of Vermeer, 1632–1765.* New York: Time-Life, 1967.

Martin, John R. *Baroque.* New York: Harper & Row, 1977.

Minor, Vernon Hyde. *Baroque and Rococo: Art and Culture.* New York: Abrams, 1999.

Moir, Alfred. *The Italian Followers of Caravaggio.* 2 vols. Cambridge, Mass.: Harvard University Press, 1967.

——. *Anthony van Dyck.* New York: Abrams, 1994.

Montagu, Jennifer. *Roman Baroque Sculpture: The Industry of Art.* New Haven: Yale University Press, 1989.

Nicolson, Benedict. *The International Caravaggesque Movement: Lists of Pictures by Caravaggio and His Followers throughout Europe from 1590 to 1650.* Oxford: Phaidon, 1979.

Norberg-Schulz, Christian. *Late Baroque and Rococo Architecture.* New York: Rizzoli, 1985.

——. *Baroque Architecture.* New York: Rizzoli, 1986.

Orso, Steven N. *Velázquez, Los Borrachos, and Painting at the Court of Philip IV.* Cambridge: Cambridge University Press, 1993.

Powell, Nicolas. *From Baroque to Rococo: An Introduction to Austrian and German Architecture from 1580 to 1790.* London: Faber, 1959.

Rosenberg, Jakob. *Rembrandt: Life and Work.* Rev. ed. Ithaca, N.Y.: Cornell University Press, 1980.

Rosenberg, Jakob, Seymour Slive, and E. H. ter Kuile. *Dutch Art and Architecture, 1600 to 1800.* 3rd ed. Pelican History of Art. Penguin, 1977.

Schama, Simon. *The Embarrassment of Riches: An Interpretation of Dutch Culture in the Golden Age* (1987). New York: Vintage, 1997.

Schwartz, Gary. *Rembrandt, His Life, His Paintings.* New York: Penguin, 1991.

Scribner, Charles, III. *Peter Paul Rubens.* New York: Abrams, 1989.

——. *Gianlorenzo Bernini.* New York: Abrams, 1991.

Slive, Seymour. *Rembrandt and His Critics, 1630–1730.* New York: Hacker, 1988.

——, ed. *Frans Hals.* Munich: Prestel, 1989.

Snow, Edward. *A Study of Vermeer.* Rev. and enl. ed. Berkeley: University of California Press, 1994.

Stechow, Wolfgang. *Dutch Landscape Painting of the Seventeenth Century.* 3rd ed. Oxford: Phaidon, 1981.

Strong, Roy. *Van Dyck: Charles I on Horseback.* New York: Viking, 1972.

Sutton, Peter C. *The Age of Rubens.* Boston: Museum of Fine Arts, 1993.

Varriano, John. *Italian Baroque and Rococo Architecture.* New York: Oxford University Press, 1986.

Wallace, Robert. *The World of Bernini, 1598–1680.* New York: Time-Life, 1970.

Waterhouse, Ellis K. *Roman Baroque Painting.* Oxford: Phaidon, 1976.

Wedgwood, C. V. *The World of Rubens, 1577–1640.* New York: Time-Life, 1967.

Welu, James A., and Pieter Biesboer, eds. *Judith Leyster: A Dutch Master and Her World.* New Haven: Yale University Press, 1993.

Wheelock, Arthur K., Jr. *Jan Vermeer.* New York: Abrams, 1988.

Wheeler, Arthur K., Jr., Susan J. Barnes, and Julius S. Held. *Anthony Van Dyck.* Washington, D.C.: National Gallery of Art, 1990.

White, Christopher. *Rembrandt.* London: Thames & Hudson, 1984.

——. *Peter Paul Rubens: Man and Artist.* New Haven: Yale University Press, 1987.

Wittkower, Rudolf. *Bernini: The Sculptor of the Roman Baroque.* 4th ed. London: Phaidon, 1997.

——. *Art and Architecture in Italy, 1600–1750.* 6th ed. 3 vols. Pelican History of Art. New Haven: Yale University Press, 1999.

Wright, Christopher. *The French Painters of the Seventeenth Century.* Boston: Little, Brown, 1985.

Rococo and the Eighteenth Century

Abrams, Ann Uhry. *The Valiant Hero: Benjamin West and Grand-Style History Painting.* Washington, D.C.: Smithsonian Institute, 1985.

Alpers, Svetlana, and Michael Baxandall. *Tiepolo and the Pictorial Intelligence.* New Haven: Yale University Press, 1994.

Antal, Frederick. *Hogarth and His Place in European Art.* London: Routledge & Kegan Paul, 1962.

Bryson, Norman. *Word and Image: French Painting of the Ancien Régime.* Cambridge: Cambridge University Press, 1981.

Burke, Joseph. *English Art, 1714–1800.* Oxford: Clarendon, 1976.

Châtelet, Albert, and Jacques Thuillier. *French Painting, from Le Nain to Fragonard.* Trans. James Emmons. Geneva: Skira, 1964.

Conisbee, Philip. *Painting in Eighteenth-Century France.* Ithaca, N.Y.: Cornell University Press, 1981.

Crow, Thomas E. *Painters and Public Life in Eighteenth-Century Paris.* New Haven: Yale University Press, 1985.

Duncan, Carol. *The Pursuit of Pleasure: The Rococo Revival in French Romantic Art.* New York: Garland, 1976.

Frankenstein, Alfred Victor. *The World of Copley, 1738–1815.* New York: Time-Life, 1970.

Grasselli, Margaret Morgan, and Pierre Rosenberg. *Watteau, 1684–1721.* Washington, D.C.: National Gallery of Art, 1984.

Hitchcock, Henry R. *Rococo Architecture in Southern Germany.* London: Phaidon, 1968.

Kalnein, Karl Wend Graf, and Michael Levey. *Art and Architecture of the Eighteenth Century in France.* Harmondsworth: Penguin, 1972.

Kimball, Fiske. *The Creation of the Rococo Decorative Style* (1943). New York: Dover, 1980.

Levey, Michael. *Rococo to Revolution: Major Trends in Eighteenth-Century Painting.* New York: Oxford University Press, 1977.

——. *Painting in Eighteenth-Century Venice.* 3rd ed. New Haven: Yale University Press, 1994.

Manners and Morals: Hogarth and British Painting, 1700–1760. London, Tate Gallery, 1987.

Minguet, J. Philippe. *Esthétique du Rococo.* Paris: Vrin, 1966.

Palladio, Andrea. *The Four Books of Architecture.* 1738. Reprint of the Isaac Ware edition. New York: Dover, 1965.

Paulson, Ronald. *The Art of Hogarth.* London: Phaidon, 1975.

Pignatti, Terisio. *The Age of Rococo.* Trans. Lorna Andrade. London: Cassell, 1988.

Posner, Donald. *Watteau: A Lady at Her Toilet.* New York: Viking, 1973.

Rosenberg, Pierre. *Chardin, 1699–1779.* Ed. Sally W. Goodfellow. Trans. Emilie P. Kadish and Ursula Korneitchouk. Cleveland: Cleveland Museum of Art, 1979.

Rosenblum, Robert. *Transformations in Late Eighteenth-Century Art* (1967). Princeton: Princeton University Press, 1970.

Snodin, Michael. *Rococo: Art and Design in Hogarth's England.* London: Trefoil Books/Victoria and Albert Museum, 1984.

Summerson, John. *The Architecture of the Eighteenth Century.* New York: Thames & Hudson, 1986.

Wittkower, Rudolf. *Palladio and Palladianism* (1974). New York: Thames & Hudson, 1983.

Neoclassicism: The Late Eighteenth and Early Nineteenth Centuries

Arnason, H. H. *The Sculptures of Houdon.* London: Phaidon, 1975.

Boime, Albert. *Art in an Age of Revolution, 1750–1800.* Chicago: University of Chicago Press, 1987.

———. *Art in an Age of Bonapartism, 1800–1815* (1990). Chicago: University of Chicago Press, 1993.

Bryson, Norman. *Tradition and Desire: From David to Delacroix.* New York: Cambridge University Press, 1984.

Burchard, John, and Albert Bush-Brown. *The Architecture of America: A Social and Cultural History.* Boston: Little, Brown, 1966.

Cooper, Wendy A. *Classical Taste in America, 1800–1840.* Baltimore: Baltimore Museum of Art, 1993.

Eitner, Lorenz. *Neoclassicism and Romanticism, 1750–1850: An Anthology of Sources and Documents.* New York: Harper & Row, 1989.

———. *An Outline of Nineteenth-Century European Painting: From David through Cézanne.* 2 vols. New York: HarperCollins, 1996.

Elsen, Albert E. *Rodin.* New York: Museum of Modern Art, 1963.

———. *Auguste Rodin: Readings on His Life and Work.* Englewood Cliffs, N.J.: Prentice-Hall, 1965.

Friedländer, Walter F. *David to Delacroix* (1952). Trans. Robert Goldwater. Cambridge, Mass.: Harvard University Press, 1980.

Honour, Hugh. *Neo-Classicism.* Harmondsworth: Penguin, 1987.

Irwin, David. *English Neoclassical Art: Studies in Inspiration and Taste.* London: Faber & Faber, 1966.

Jaffe, Irma B. *Trumbull: The Declaration of Independence.* New York: Viking, 1976.

Lindsay, Jack. *Death of the Hero: French Painting from David to Delacroix.* London: Studio, 1960.

McLaughlin, Jack. *Jefferson and Monticello: The Biography of a Builder.* New York: Holt, 1988.

Middleton, Robin, and David Watkin. *Neoclassical and 19th-Century Architecture.* 2 vols. New York: Electa/Rizzoli, 1987.

Nanteuil, L. de. *Jacques-Louis David.* New York: Abrams, 1985.

Novotny, Fritz. *Painting and Sculpture in Europe, 1780–1880.* Pelican History of Art. Harmondsworth: Penguin, 1980.

Roberts, Warren E. *Jacques-Louis David, Revolutionary Artist: Art, Politics, and the French Revolution.* Chapel Hill: University of North Carolina Press, 1989.

Rosenblum, Robert. *Transformations in Late Eighteenth-Century Art.* Princeton: Princeton University Press, 1970.

———. *Jean-Auguste-Dominique Ingres* (1967). New York: Abrams, 1985.

Roworth, Wendy Wassyng, ed. *Angelica Kauffmann: A Continental Artist in Georgian England.* London: Reaktion, 1992.

Rykwert, Joseph, and Anne Rykwert. *Robert and James Adam: The Men and the Style.* New York: Electa/Rizzoli, 1985.

Stillman, Damie. *English Neo-classical Architecture.* 2 vols. London: Zwemmer, 1988.

Vaughan, Will, and Helen Weston, eds. *Jacques-Louis David's "Marat."* New York: Cambridge University Press, 1999.

Romanticism: The Late Eighteenth and Early Nineteenth Centuries

Athanassoglou-Kallmyer, Nina M. *Eugène Delacroix: Prints, Politics, and Satire, 1814–1822.* New Haven: Yale University Press, 1991.

Bindman, David. *William Blake: His Art and Times.* New Haven: Yale Center for British Art, 1982.

Born, Wolfgang. *American Landscape Painting: An Interpretation.* New Haven: Yale University Press, 1948.

Börsch-Supan, Helmut. *Caspar-David Friedrich.* 2nd ed. New York: te Neues, 1990.

Brion, Marcel. *Art of the Romantic Era: Romanticism, Classicism, Realism.* New York: Praeger, 1966.

Clark, Kenneth. *The Romantic Rebellion: Romantic versus Classic Art.* New York: Harper & Row, 1973.

Clay, Jean. *Romanticism.* Trans. Daniel Wheeler and Craig Owen. New York: Vendome, 1981.

Courthion, Pierre. *Romanticism.* Trans. Stuart Gilbert. Geneva: Skira, 1961.

Eitner, Lorenz. *Géricault's "Raft of the Medusa."* London: Phaidon, 1972.

———. *Géricault: His Life and Work.* London: Orbis, 1973.

Faxon, Alicia Craig. *Dante Gabriel Rossetti.* New York: Abbeville, 1989.

Gage, John. *J. M. W. Turner: A Wonderful Range of Mind.* New Haven: Yale University Press, 1987.

Harris, Enriqueta. *Goya.* Rev. ed. London: Phaidon, 1994.

Hilton, Timothy. *Pre-Raphaelites.* New York: Abrams, 1971.

Honour, Hugh. *Romanticism.* New York: Harper & Row, 1979.

Jobert, Barthélémy. *Delacroix.* Princeton: Princeton University Press, 1998.

Kroeber, Karl. *British Romantic Art.* Berkeley: University of California Press, 1986.

Licht, Fred. *Goya: The Origins of the Modern Temper in Art.* New York: Harper & Row, 1983.

López-Rey, José. *Goya's Caprichos: Beauty, Reason and Caricature.* 2 vols. Princeton: Princeton University Press, 1953.

Mendelowitz, Daniel M. *A History of American Art.* 2nd ed. New York: Holt, Rinehart & Winston, 1970.

Murphy, Alexandra R. *Jean-François Millet.* Boston: Museum of Fine Arts, 1984.

Nochlin, Linda. *The Body in Pieces: The Fragment as a Metaphor of Modernity.* London: Thames & Hudson, 1994.

Parry, Ellwood C., III. *The Art of Thomas Cole: Ambition and Imagination.* Newark, Del.: University of Delaware Press, 1988.

Pérez Sánchez, Alfonso E., and Eleanor A. Sayre. *Goya and the Spirit of Enlightenment.* Boston: Museum of Fine Arts, 1989.

Powell, Earl A. *Thomas Cole.* New York: Abrams, 1990.

Praz, Mario. *The Romantic Agony.* New York: Oxford University Press, 1983.

The Pre-Raphaelites. London: Tate Gallery, 1984.

Prideaux, Tom. *The World of Delacroix, 1798–1863.* New York: Time-Life, 1966.

Raine, Kathleen. *William Blake.* New York: Oxford University Press, 1970.

Rosenblum, Robert, and Horst W. Janson. *Nineteenth-Century Art.* Rev. ed. New York: Abrams, 2005.

Truettner, William H., and Alan Wallach, eds. *Thomas Cole: Landscape into History.* New Haven: Yale University Press, 1994.

Vaughan, William. *German Romantic Painting.* New Haven: Yale University Press, 1980.

———. *Romanticism and Art.* New York: Thames & Hudson, 1994.

Walker, John. *John Constable.* New York: Abrams, 1991.

Wilton, Andrew. *Turner and the Sublime.* Chicago: University of Chicago Press, 1981.

———. *Turner in His Time.* New York: Abrams, 1987.

Wolf, Bryan Jay. *Romantic Re-vision: Culture and Consciousness in Nineteenth-Century American Painting and Literature.* Chicago: University of Chicago Press, 1982.

Nineteenth-Century Realism

Ashton, Dore. *Rosa Bonheur: A Life and a Legend.* New York: Viking, 1981.

Barger, M. Susan, and William B. White. *The Daguerreotype: Nineteenth-Century Technology and Modern Science* (1991). Baltimore: Johns Hopkins University Press, 2000.

Boime, Albert. *A Social History of Modern Art.* 3 vols. Chicago: University of Chicago Press, 1987–2004.

Cachin, Françoise, Charles S. Moffet, and Michel Melot, eds. *Manet, 1832–1883.* New York: Metropolitan Museum of Art, 1983.

Carrier, David. *High Art: Charles Baudelaire and the Origins of Modernist Painting.* University Park, Pa.: Pennsylvania State University Press, 1996.

Clark, T. J. *The Absolute Bourgeois: Artists and Politics in France, 1848–1851* (1973). Berkeley: University of California Press, 1999.

———. *Image of the People: Gustave Courbet and the 1848 Revolution* (1973). Berkeley: University of California Press, 1999.

Eisenman, Stephen F. *Nineteenth-Century Art: A Critical History.* 2nd ed. New York: Thames & Hudson, 2002.

Elsen, Albert. *Rodin.* New York: Museum of Modern Art, 1963.

Farwell, Beatrice. *Manet and the Nude: A Study of Iconography in the Second Empire.* New York: Garland, 1981.

Fried, Michael. *Courbet's Realism.* Chicago: University of Chicago Press, 1990.

Gosling, Nigel. *Nadar.* New York: Knopf, 1976.

Hamilton, George H. *Manet and His Critics* (1954). New Haven: Yale University Press, 1986.

Homer, William Innes. *Thomas Eakins: His Life and Art.* New York: Abbeville, 1992.

Isaacson, Joel. *Manet: Le Déjeuner sur l'Herbe.* New York: Viking, 1972.

Janson, H. W. *Nineteenth-Century Sculpture.* New York: Abrams, 1985.

Johns, Elizabeth. *Thomas Eakins: The Heroism of Modern Life.* Princeton: Princeton University Press, 1983.

Krell, Alan. *Manet and the Painters of Contemporary Life.* London: Thames & Hudson, 1996.

Lindsay, Jack. *Gustave Courbet: His Life and Art.* New York: State Mutual Reprints, 1981.

McKean, John. *Crystal Palace: Joseph Paxton and Charles Fox.* London: Phaidon, 1994.

Maison, K. E. *Honoré Daumier: Catalogue Raisonné of the Paintings, Watercolours, and Drawings.* 2 vols. Greenwich, Conn.: New York Graphic Society, 1968.

Meredith, Roy. *Mr. Lincoln's Camera Man, Mathew B. Brady.* 2nd rev. ed. New York: Dover, 1974.

Needham, Gerald. *Nineteenth-Century Realist Art.* New York: Harper & Row, 1988.

Newhall, Beaumont. *The History of Photography: From 1839 to the Present.* 5th ed. New York: Museum of Modern Art, 1999.

Nicolson, Benedict. *Courbet: The Studio of the Painter.* New York: Viking, 1973.

Nochlin, Linda. *Realism and Tradition in Art, 1848–1900: Sources and Documents.* Englewood Cliffs, N.J.: Prentice-Hall, 1966.

———. *Realism.* Harmondsworth: Penguin, 1971.

———. *Gustave Courbet: A Study of Style and Society.* New York: Garland, 1976.

Novak, Barbara. *American Painting of the Nineteenth Century.* 2nd ed. New York: Harper & Row, 1979.

O'Gorman, James F. *Three American Architects: Richardson, Sullivan, and Wright, 1865–1915.* Chicago: University of Chicago Press, 1991.

Passeron, Roger. *Daumier.* Trans. Helga Harrison. New York: Rizzoli, 1981.

Reff, Theodore. *Manet, Olympia.* New York: Viking, 1977.

Schneider, Pierre. *The World of Manet, 1832–1883.* New York: Time-Life, 1968.

Sullivan, Louis. *The Autobiography of an Idea.* New York: Dover, 1956.

Touissaint, Hélène. *Gustave Courbet, 1819–1877.* London: Arts Council of Great Britain, 1978.

Tucker, Paul H., ed. *Manet's Le Déjeuner sur l'Herbe.* New York: Cambridge University Press, 1998.

Weisberg, Gabriel P., ed. *The European Realist Tradition.* Bloomington: Indiana University Press, 1982.

Nineteenth-Century Impressionism

Bell, Quentin. *Ruskin.* New York: Braziller, 1978.

Boggs, Jean Sutherland, et al. *Degas.* Exh. cat. New York: Metropolitan Museum of Art, 1988.

Clark, T. J. *The Painting of Modern Life: Paris in the Art of Manet and His Followers.* Rev. ed. Princeton: Princeton University Press, 1984.

Gerdts, William H. *American Impressionism.* 2nd ed. New York: Abbeville, 2001.

Guth, Christine. *Art of Edo Japan: The Artist and the City 1615–1868.* New York: Abrams, 1996.

Hanson, Anne Coffin. *Manet and the Modern Tradition.* New Haven: Yale University Press, 1977.

Hanson, Lawrence. *Renoir: The Man, the Painter, and His World.* London: Frewin, 1972.

Herbert, Robert L. *Impressionism: Art, Leisure and Parisian Society.* New Haven: Yale University Press, 1988.

Higonnet, Anne. *Berthe Morisot's Images of Women.* Cambridge, Mass.: Harvard University Press, 1992.

Kelder, Diane. *The French Impressionists and Their Century.* New York: Praeger, 1970.

Kendall, Richard. *Degas: Beyond Impressionism.* London: National Gallery Publications, 1996.

Locke, Nancy. *Manet and the Family Romance.* Princeton: Princeton University Press, 2001.

Mathews, Nancy Mowll. *Mary Cassatt.* New York: Abrams, 1987.

Nochlin, Linda. *Impressionism and Post-Impressionism, 1874–1904: Sources and Documents.* Englewood Cliffs, N.J.: Prentice-Hall, 1966.

Pissarro, Joachim. *Camille Pissarro.* New York: Abrams, 1993.

Pool, Phoebe. *Impressionism.* New York: Praeger, 1967.

Prideaux, Tom. *The World of Whistler, 1834–1903.* New York: Time-Life, 1970.

Rewald, John. *The History of Impressionism.* 4th rev. ed. New York: Museum of Modern Art, 1973.

———. *Studies in Impressionism.* New York: Abrams, 1986.

Rouart, Denis. *Renoir.* New York: Skira/Rizzoli, 1985.

Smith, Paul. *Impressionism: Beneath the Surface.* New York: Abrams, 1995.

Spate, Virginia. *Claude Monet: Life and Work.* New York: Rizzoli, 1992.

Tucker, Paul Hayes. *Claude Monet: Life and Art.* New Haven: Yale University Press, 1995.

Walker, John. *James McNeill Whistler.* New York: Abrams, 1987.

Post-Impressionism and the Late Nineteenth Century

Andersen, Wayne. *Gauguin's Paradise Lost.* New York: Viking, 1971.

Badt, Kurt. *The Art of Cézanne.* Trans. Sheila Ann Ogilvie. Berkeley: University of California Press, 1965.

Champigneulle, Bernard. *Rodin.* Trans. J. Maxwell Brownjohn. New York: Thames & Hudson, 1986.

Collins, Bradley, Jr. *Van Gogh and Gauguin: Electric Arguments and Utopian Dreams.* Boulder, Col.: Westview, 2001.

d'Alleva, Anne. *Arts of the Pacific Islands.* New York: Abrams, 1998.

Denvir, Bernard. *Toulouse-Lautrec.* New York: Thames & Hudson, 1991.

———. *Post-Impressionism.* New York: Thames & Hudson, 1992.

Edvard Munch: Symbols and Images. Washington, D.C.: National Gallery of Art, 1978.

Eggum, Arne. *Edvard Munch: Paintings, Sketches, and Studies.* Trans. Ragnar Christophersen. London: Thames & Hudson, 1984.

Eisenman, Stephen F. *Gauguin's Skirt.* London: Thames & Hudson, 1997.

Geist, Sidney. *Interpreting Cézanne.* Cambridge, Mass.: Harvard University Press, 1988.

Gogh, Vincent van. *The Complete Letters of Vincent van Gogh.* 2nd ed. Trans. J. van Gogh-Bonger and C. de Dood. 3 vols. Boston: Little, Brown, 1978.

Goldwater, Robert. *Paul Gauguin.* New York: Abrams, 1972.

Gordon, Robert, and Andrew Forge. *Degas.* New York: Abrams, 1988.

Gowing, Lawrence, ed. *Cézanne: The Early Years, 1859–72.* New York: Abrams, 1988.

Hamilton, George H. *Painting and Sculpture in Europe, 1880–1940.* 6th ed. Pelican History of Art. New Haven: Yale University Press, 1993.

Heller, Reinhold. *Edvard Munch: The Scream.* New York: Viking, 1972.

Holt, Elizabeth Gilmore, ed. *The Expanding World of Art, 1874–1902.* New Haven: Yale University Press, 1988.

Huisman, Philippe, and M. G. Dortu. *Toulouse-Lautrec.* Garden City, N.Y.: Doubleday, 1973.

Jullian, Philippe. *The Symbolists.* 2nd ed. New York: Dutton, 1977.

Mainardi, Patricia. *The End of the Salon: Art and the State in the Early Third Republic.* Cambridge, Eng.: Cambridge University Press, 1993.

Pickvance, Ronald. *Van Gogh in Arles.* New York: Metropolitan Museum of Art, 1984.

———. *Van Gogh in Saint-Rémy and Auvers.* New York: Metropolitan Museum of Art, 1986.

Post-Impressionism: Cross-Currents in European and American Painting, 1880–1906. Washington, D.C.: National Gallery of Art, 1980.

Rewald, John. *Post-Impressionism: From Van Gogh to Gauguin.* 3rd ed. New York: Museum of Modern Art, 1978.

———. *Studies in Post-Impressionism.* New York: Abrams, 1986.

Rubin, William, ed. *Cézanne, the Late Work: Essays.* New York: Museum of Modern Art, 1977.

Russell, John. *Seurat.* New York: Praeger, 1965.

Schapiro, Meyer. *Vincent van Gogh.* New York: Abrams, 2003.

———. *Paul Cézanne.* New York: Abrams, 2004.

Shiff, Richard. *Cézanne and the End of Impressionism: A Study of the Theory, Technique, and Critical Evaluation of Modern Art.* Chicago: University of Chicago Press, 1984.

Smith, Paul. *Seurat and the Avant-Garde.* New Haven: Yale University Press, 1997.

Stang, Ragna. *Edvard Munch: The Man and His Art.* Trans. Geoffrey Culverwell. New York: Abbeville, 1988.

Thomson, Belinda, *Gauguin.* New York: Thames & Hudson, 1987.

Thomson, Richard, et al. *Toulouse-Lautrec.* New Haven: Yale University Press, 1991.

Wood, Mara-Helen, ed. *Edvard Munch: The Frieze of Life.* London: National Gallery Publications, 1992.

Turn of the Century: Early Picasso, Fauvism, Expressionism, and Matisse

Arnason, Hjorvardur H. *History of Modern Art: Painting, Sculpture, Architecture, Photography.* 5th ed. Upper Saddle River, N.J.: Prentice-Hall, 2004.

Barr, Alfred H., Jr. *Matisse, His Art and His Public* (1951). New York: Arno, 1966.

Bascom, William Russell. *African Art in Cultural Perspective: An Introduction.* New York: Norton, 1973.

Ben-Amos, Paula G. *The Art of Benin.* 2nd rev. ed. London: British Museum, 1995.

Berlo, Janet, and Lee A. Wilson. *Arts of Africa, Oceania, and the Americas: Selected Readings.* Englewood Cliffs, N.J.: Prentice-Hall, 1993.

Blier, Suzanne Preston. *The Royal Arts of Africa: The Majesty of Form.* New York: Abrams, 1998.

Chipp, Herschel B. *Theories of Modern Art: A Source Book by Artists and Critics.* Berkeley: University of California Press, 1968.

Duncan, Alastair. *Art Nouveau.* London: Thames & Hudson, 1994.

Duthuit, Georges. *The Fauvist Painters.* Trans. Ralph Manheim. New York: Wittenborn, Schultz, 1950.

Elderfield, John. *The Cut-Outs of Henri Matisse.* New York: Braziller, 1978.

Flam, Jack D. *Matisse: The Man and His Art, 1869–1918.* Ithaca, N.Y.: Cornell University Press, 1986.

———. *Matisse on Art.* Rev. ed. Berkeley: University of California Press, 1995.

___. *Matisse and Picasso: The Story of Their Rivalry and Friendship.* Cambridge, Mass.: Westview, 2003.

Gordon, Donald E. *Expressionism: Art and Idea.* New Haven: Yale University Press, 1987.

Hahl-Koch, Jelena. *Kandinsky.* Trans. Karin Brown et al. New York: Rizzoli, 1993.

Herbert, James D. *Fauve Painting: The Making of Cultural Politics.* New Haven: Yale University Press, 1992.

Kerchache, Jacques, Jean-Louis Paudrat, and Lucien Stéphan. *Art of Africa.* Trans. Marjolijn de Jager. New York: Abrams, 1993.

Lloyd, Jill. *German Expressionism: Primitivism and Modernity.* New Haven: Yale University Press, 1991.

Magnin, André, and Jacques Soulillou. *Contemporary Art of Africa.* New York: Abrams, 1996.

Messer, Thomas M. *Vasily Kandinsky.* New York: Abrams, 1997.

Myers, Bernard Samuel. *The German Expressionists: A Generation in Revolt.* New York: Praeger, 1956.

Perani, Judith, and Fred T. Smith. *The Visual Arts of Africa: Gender, Power, and Life Cycle Rituals.* Upper Saddle River, N.J.: Prentice-Hall, 1998.

Prelinger, Elizabeth. *Käthe Kollwitz.* Washington, D.C.: Yale University Press/National Gallery of Art, 1992.

Richardson, John. *A Life of Picasso.* I: *1881–1906.* New York: Random House, 1991.

Rubin, William, ed. *"Primitivism" in 20th Century Art.* 2 vols. New York: The Museum of Modern Art, 1984.

Russell, John. *The World of Matisse, 1869–1954.* New York: Time-Life, 1969.

Schmutzler, Robert. *Art Nouveau.* Trans. Edouard Roditi. New York: Abrams, 1962.

Schneider, Pierre. *Matisse.* Trans. M. Taylor and B. S. Romer. New York: Rizzoli, 1984.

Steinberg, Leo. *Other Criteria: Confrontations with Twentieth-Century Art* (1972). New York: Oxford University Press, 1975.

Taylor, Brandon. *Avant-Garde and After: Rethinking Art Now.* New York: Abrams, 1995.

Vogt, Paul. *Expressionism: German Painting, 1905–1920.* Trans. Antony Vivis. New York: Abrams, 1980.

Cubism, Futurism, and Related Twentieth-Century Styles

Ashton, Dore. *Twentieth-Century Artists on Art.* New York: Pantheon, 1985.

Barr, Alfred H., Jr. *Picasso: Fifty Years of His Art* (1946). New York: Museum of Modern Art, 1974.

———. *Cubism and Abstract Art: Painting, Sculpture, Constructions, Photography, Architecture, Industrial Art, Theatre, Films, Posters, Typography* (1936). Cambridge, Mass.: Belknap, 1986.

Bayer, Herbert, Walter Gropius, and Ise Gropius. *Bauhaus, 1919–1928* (1938). New York: Museum of Modern Art, 1975.

Blake, Peter. *Frank Lloyd Wright, Architecture and Space.* Baltimore: Penguin, 1964.

Brown, Milton. *The Story of the Armory Show: The 1913 Exhibition That Changed American Art.* 2nd ed. New York: Abbeville, 1988.

Chipp, Herschel B. *Picasso's Guernica: History, Transformations, Meanings.* Berkeley: University of California Press, 1988.

Cooper, Douglas. *The Cubist Epoch* (1970). Oxford: Phaidon, 1976.

Cowling, Elizabeth, and John Golding. *Picasso: Sculptor/Painter.* London: Tate Gallery, 1994.

Curtis, William J. R. *Le Corbusier: Ideas and Forms.* New York: Rizzoli, 1986.

Doesburg, Theo van. *Principles of Neo-Plastic Art.* Trans. Janet Seligman. Greenwich, Conn.: New York Graphic Society, 1968.

Elsen, Albert E. *Origins of Modern Sculpture: Pioneers and Premises.* New York: Braziller, 1974.

Fry, Edward F. *Cubism.* New York: Oxford University Press, 1978.

Geist, Sidney. *Brancusi: The Sculpture and Drawings.* New York: Abrams, 1975.

———. *Brancusi: The Kiss.* New York: Harper & Row, 1978.

Golding, John. *Cubism: A History and an Analysis, 1907–1914.* 3rd ed. Cambridge, Mass.: Harvard University Press, 1988.

Gray, Camilla. *The Russian Experiment in Art, 1863–1922.* Rev. and enl. ed. New York: Thames & Hudson, 1986.

Green, Christopher, ed. *Picasso's Les Demoiselles d'Avignon.* Cambridge, Eng.: Cambridge University Press, 2001.

Harrison, Charles, Francis Frascina, and Gill Perry. *Primitivism, Cubism, Abstraction: The Early Twentieth Century.* New Haven: Yale University Press, 1993.

Hilton, Timothy. *Picasso* (1975). New York: Thames & Hudson, 1985.

Hultén, Pontus. *Futurism and Futurisms.* New York: Abbeville, 1986.

Hunter, Sam, and John Jacobus. *American Art of the Twentieth Century: Painting, Sculpture, Architecture.* New York: Abrams, 1973.

Hunter, Sam, John Jacobus, and Daniel Wheeler. *Modern Art.* 3rd ed. Upper Saddle River, N.J.: Prentice-Hall, 2005.

Jaffé, Hans L. C. *De Stijl, 1917–1931: The Dutch Contribution to Modern Art.* Cambridge, Mass.: Belknap, 1986.

Kuenzli, Rudolf, and Francis M. Naumann. *Marcel Duchamp: Artist of the Century.* Cambridge, Mass.: MIT Press, 1989.

Larkin, David, and Bruce Brooks Pfeiffer, eds. *Frank Lloyd Wright: The Masterworks.* New York: Rizzoli, 1993.

Lodder, Christina. *Russian Constructivism.* New Haven: Yale University Press, 1983.

Mondrian, Piet C. *Plastic Art and Pure Plastic Art, 1937, and Other Essays, 1941–1943.* New York: Wittenborn, Schultz, 1951.

Overy, Paul. *De Stijl.* New York: Thames & Hudson, 1991.

Pfeiffer, Bruce Brooks, and Gerald Nordland, eds. *Frank Lloyd Wright in the Realm of Ideas.* Carbondale: Southern Illinois University Press, 1988.

Read, Herbert. *A Concise History of Modern Painting* (1959). 3rd ed. New York: Praeger, 1975.

Richardson, John. *A Life of Picasso. II: 1907–1917.* New York: Random House, 1996.

Rosenblum, Robert. *Cubism and Twentieth-Century Art.* Rev. ed. New York: Abrams, 2001.

Rubin, William, ed. *Pablo Picasso: A Retrospective.* New York: Museum of Modern Art, 1980.

———. *Picasso and Braque: Pioneering Cubism.* New York: Museum of Modern Art, 1989.

Schiff, Gert, ed. *Picasso in Perspective.* Englewood Cliffs, N.J.: Prentice-Hall, 1976.

Silver, Kenneth E. *Esprit de Corps: The Art of the Parisian Avant-Garde and the First World War, 1914–1925.* Princeton: Princeton University Press, 1989.

Taylor, Joshua C. *Futurism.* New York: Museum of Modern Art, 1961.

Tisdall, Caroline, and Angelo Bozzolla. *Futurism.* New York: Oxford University Press, 1978.

Tomkins, Calvin. *Duchamp: A Biography* (1996). New York: Holt, 1998.

Weiss, Jeffrey S. *The Popular Culture of Modern Art: Picasso, Duchamp, and Avant-Gardism.* New Haven: Yale University Press, 1994.

Whitford, Frank. *Bauhaus.* London: Thames & Hudson, 1984.

Wilkin, Karen. *Georges Braque.* New York: Abbeville, 1991.

Wright, Frank Lloyd. *American Architecture.* Ed. E. Kaufmann. New York: Horizon, 1955.

Zhadova, Larissa A. *Malevich: Suprematism and Revolution in Russian Art, 1910–1930.* Trans. Alexander Lieven. London: Thames & Hudson, 1982.

Dada, Surrealism, Fantasy, and the United States between the Wars

Alexandrian, Sarane. *Surrealist Art* (1970). Trans. Gordon Clough. London: Thames & Hudson, 1985.

Arp, Hans. *Arp on Arp: Poems, Essays, Memories.* Ed. Marcel Jean. New York: Viking, 1972.

Baigell, Matthew. *The American Scene: American Painting of the 1930's.* New York: Praeger, 1974.

Barr, Alfred H., Jr., ed. *Fantastic Art, Dada, Surrealism* (1936). New York: Arno, 1969.

Bearden, Romare, and Harry Henderson. *A History of African-American Artists: From 1792 to the Present.* New York: Pantheon, 1993.

Dachy, Marc. *The Dada Movement, 1915–1923.* Trans. Michael Taylor. New York: Skira/Rizzoli, 1990.

Davidson, Abraham A. *Early American Modernist Painting, 1910–1935.* New York: Harper & Row, 1981.

Eldredge, Charles C. *Georgia O'Keeffe.* New York: Abrams, 1991.

Foucault, Michel. *This Is Not a Pipe.* Trans. J. Harkness. Berkeley: University of California Press, 1983.

Franciscono, Marcel. *Paul Klee: His Work and Thought.* Chicago: University of Chicago Press, 1991.

Herrera, Hayden. *Frida Kahlo: The Paintings.* New York: HarperCollins, 1991.

Homer, William Innes. *Alfred Stieglitz and the American Avant-Garde.* Boston: New York Graphic Society, 1977.

Lane, John R., and Susan C. Larsen, eds. *Abstract Painting and Sculpture in America, 1927–1944.* Pittsburgh: Pittsburgh Museum of Art, Carnegie Institute, 1984.

Levin, Gail. *Edward Hopper: An Intimate Biography.* New York: Knopf, 1995.

Lippard, Lucy R., ed. *Surrealists on Art.* Englewood Cliffs, N.J.: Prentice-Hall. 1970.

Lynes, Barbara Buhler. *O'Keeffe, Stieglitz, and the Critics, 1916–1929* (1989). Chicago: University of Chicago Press, 1991.

Masheck, Joseph, ed. *Marcel Duchamp in Perspective* (1975). Cambridge, Mass.: Da Capo, 2002.

Norman, Dorothy. *Alfred Stieglitz, an American Seer* (1973). New York: Aperture, 1990.

Picon, Gaëtan. *Surrealists and Surrealism, 1919–1939.* Trans. James Emmons. New York: Rizzoli, 1977.

Powell, Richard J. *Black Art and Culture in the Twentieth Century.* London: Thames & Hudson, 1997.

Richter, Hans. *Dada: Art and Anti-Art.* New York: Abrams, 1965.

Rubin, William S. *Dada and Surrealist Art.* New York: Abrams, 1968.

Russell, John. *Max Ernst: Life and Work.* New York: Abrams, 1967.

Schwarz, Arturo. *Man Ray: The Rigour of Imagination.* New York: Rizzoli, 1977.

———, ed. *The Complete Works of Marcel Duchamp.* 3rd ed. 2 vols. London: Greenridge, 1997.

Stich, Sidra. *Anxious Visions: Surrealist Art.* New York: Abbeville, 1990.

Sylvester, David. *Magritte: The Silence of the World.* New York: Abrams, 1992.

Waldberg, Patrick. *Surrealism.* New York: Oxford University Press, 1978.

Wheat, Ellen Harkins. *Jacob Lawrence: American Painter.* Seattle: University of Washington Press, 1986.

Abstract Expressionism

Albright, Thomas. *Art in the San Francisco Bay Area, 1945–1980.* Berkeley: University of California Press, 1985.

Alloway, Lawrence. *Topics in American Art since 1945.* New York: Norton, 1975.

Ashton, Dore. *American Art since 1945.* New York: Oxford University Press, 1982.

———. *About Rothko* (1983). Cambridge, Mass.: Da Capo, 2003.

Barron, Stephanie, ed. *Degenerate Art: The Fate of the Avant-Garde in Nazi Germany.* Los Angeles: Los Angeles County Museum of Art, 1991.

Doss, Erika. *Benton, Pollock, and the Politics of Modernism: From Regionalism to Abstract Expressionism.* Chicago: University of Chicago Press, 1991.

Francis, Richard H. *Jasper Johns.* New York: Abbeville, 1984.

Frasina, Frances, ed. *Pollock and After: The Critical Debate.* 2nd ed. New York: Routledge, 2000.

Geldzahler, Henry. *New York Painting and Sculpture: 1940–1970.* New York: Dutton, 1969.

Gordon, John. *Louise Nevelson.* New York: Praeger, 1967.

Greenberg, Clement. *Art and Culture: Critical Essays* (1961). Boston: Beacon, 1965.

Guberman, Sidney. *Frank Stella: An Illustrated Biography.* New York: Rizzoli, 1995.

Herbert, Robert L., ed. *Modern Artist on Art: Ten Unabridged Essays.* 2nd ed. Mineola, N.Y.: Dover, 2000.

Hertz, Richard. *Theories of Contemporary Art.* 2nd ed. Englewood Cliffs, N.J.: Prentice-Hall, 1993.

Hess, Thomas B. *Willem de Kooning.* Exh. cat. New York: Museum of Modern Art, 1968.

Howell, John, ed. *Breakthroughs: Avant-Garde Artists in Europe and America, 1950–1990.* New York: Rizzoli, 1991.

Hughes, Robert. *The Shock of the New.* 2nd ed. New York: McGraw-Hill, 1991.

Hunter, Sam. *An American Renaissance: Painting and Sculpture since 1940.* New York: Abbeville, 1986.

Johnson, Ellen H. *Modern Art and the Object: A Century of Changing Attitudes.* New York: Harper & Row, 1976.

———, ed. *American Artists on Art: From 1940 to 1980.* New York: Harper & Row, 1982.

Krauss, Rosalind E. *The Originality of the Avant-Garde and Other Modernist Myths.* Cambridge, Mass.: MIT Press, 1985.

———. *Passages in Modern Sculpture.* Cambridge, Mass.: MIT Press, 1989.

Lipman, Jean. *Calder's Universe.* Philadelphia and London: Running Press, 1989.

Lucie-Smith, Edward. *Movements in Art since 1945.* New ed. London: Thames & Hudson, 2001.

O'Connor, Francis V. *Jackson Pollock.* New York: Museum of Modern Art, 1967.

Reinhardt, Ad. *Art-as-Art: The Selected Writings of Ad Reinhardt* (1975). Ed. Barbara Rose. Berkeley: University of California Press, 1991.

Rose, Barbara. *Frankenthaler.* New York: Abrams, 1971.

———. *American Art since 1960.* Rev. ed. New York: Praeger, 1975.

———. *Jackson Pollock: Drawing into Painting.* New York: Museum of Modern Art, 1980.

Rosenberg, Harold. *Art on the Edge: Creators and Situations.* New York: Macmillan, 1975.

———. *The De-Definition of Art: Action Art to Pop to Earthworks.* Chicago: University of Chicago Press, 1983.

———. *The Tradition of the New.* New York: Da Capo, 1994.

Rosenblum, Robert. *Frank Stella.* Harmondsworth: Penguin, 1971.

Russell, John. *The Meanings of Modern Art.* Rev. ed. New York: Icon, 1989.

Sandler, Irving. *The Triumph of American Painting: A History of Abstract Expressionism.* New York: Harper & Row, 1970.

———. *American Art of the 1960s.* New York: Harper & Row, 1988.

Selz, Peter. *Art in Our Times: A Pictorial History, 1890–1980.* New York: Abrams, 1981.

Smith, David. *David Smith—Sculpture and Writing* (1968). Ed. Cleve Gray. New York: Thames & Hudson, 1988.

Tomkins, Calvin. *The Scene: Reports on Post-Modern Art.* New York: Viking, 1976.

Waldman, Diane. *Mark Rothko, 1903–1970: A Retrospective.* New York: Abrams, 1978.

Wheeler, Daniel. *Art since Mid-Century: 1945 to the Present.* New York: Vendome, 1991.

Pop Art, Op Art, Minimalism, and Conceptualism

Alloway, Lawrence. *American Pop Art.* New York: Collier, 1974.

———. *Robert Rauschenberg.* Washington, D.C.: Smithsonian Institution, 1976.

Baker, Kenneth. *Minimalism: Art of Circumstance.* New York: Abbeville, 1988.

Battcock, Gregory, ed. *Minimal Art: A Critical Anthology* (1968). Berkeley: University of California Press, 1995.

Bourdon, David. *Warhol.* New York: Abrams, 1989.

Crichton, Michael. *Jasper Johns.* Rev. & exp. ed. New York: Whitney Museum/Abrams, 1994.

Crow, Thomas. *The Rise of the Sixties: American and European Art in the Era of Dissent, 1955–69.* London: Laurence King, 2005.

Frith, Simon, and Howard Horne. *Art into Pop.* London: Methuen, 1987.

Geldzahler, Henry, and Robert Rosenblum. *Andy Warhol: Portraits of the Seventies and Eighties.* London: Anthony d'Offay Gallery/Thames & Hudson, 1993.

Goodyear, Frank H., Jr. *Contemporary American Realism since 1960.* Boston: New York Graphic Society, 1981.

Lippard, Lucy R. *Six Years: The Dematerialization of the Art Object from 1966 to 1972.* New York: Praeger, 1973.

———. *Pop Art.* New York: Thames & Hudson, 1985.

———. *Mixed Blessings: New Art in a Multicultural America.* New York: Pantheon, 1990.

Livingstone, Marco. *Pop Art: A Continuing History.* New York: Abrams, 1990.

Lucie-Smith, Edward. *Art in the Seventies.* Ithaca, N.Y.: Cornell University Press, 1980.

———. *Art in the Eighties.* New York: Phaidon, 1990.

———. *American Art Now.* New York: William Morrow, 1985.

McShine, Kynaston, ed. *Andy Warhol: A Retrospective.* New York: Museum of Modern Art, 1989.

Meyer, Ursula. *Conceptual Art.* New York: Dutton, 1972.

Rose, Barbara. *Claes Oldenberg.* New York: Museum of Modern Art, 1970.

Russell, John, and Suzi Gablik. *Pop Art Redefined.* London: Thames & Hudson, 1969.

Varnedoe, Kirk. *Jasper Johns: A Retrospective.* New York: Museum of Modern Art, 1996.

Varnedoe, Kirk, and Adam Gopnik, eds. *Modern Art and Popular Culture: Readings in High and Low.* New York: Museum of Modern Art, 1990.

Warhol, Andy. *America.* New York: Harper & Row, 1985.

Innovation, Continuity, and Globalization

Alloway, Lawrence. *Christo.* New York: Abrams, 1969.

Auping, Michael. *Susan Rothenberg: Paintings and Drawings.* New York: Rizzoli, 1992.

Baal-Teshuva, Jacob, ed. *Christo: The Reichstag and Urban Projects.* Munich: Prestel, 1993.

Barents, Els. *Cindy Sherman.* Munich: Schirmer/Mosel, 1982.

Barrette, Bill. *Eva Hesse Sculpture: Catalogue Raisonné.* New York: Timken, 1989.

Battcock, Gregory. *Super Realism: A Critical Anthology.* New York: Dutton, 1975.

Beardsley, John. *Earthworks and Beyond: Contemporary Art in the Landscape.* 3rd ed. New York: Abbeville, 1998.

Bourdon, David. *Christo.* New York: Abrams, 1972.

Bruggen, Coosje van. *Bruce Nauman.* New York: Rizzoli, 1988.

Carmean, E. A., Jr., et al. *The Sculpture of Nancy Graves: A Catalogue Raisonné with Essays.* New York: Hudson Hills, 1987.

Carrier, David. *The Aesthete in the City: The Philosophy and Practice of American Abstract Painting in the 1980s.* University Park, Pa.: Pennsylvania State University Press, 1994.

Chicago, Judy. *The Dinner Party: A Symbol of Our Heritage.* Garden City, N.Y.: Anchor/Doubleday, 1979.

———. *The Birth Project.* Garden City, N.Y.: Doubleday, 1985.

Cruz, Amanda, Elizabeth A. T. Smith, and Amelia Jones. *Cindy Sherman: Retrospective.* London: Thames & Hudson, 1997.

Danto, Arthur C. *History Portraits/Cindy Sherman.* New York: Rizzoli, 1991.

Flam, Jack, ed. *Robert Smithson: The Collected Writings.* Berkeley: University of California Press, 1996.

Frank, Peter, and Michael McKenzie. *New, Used, and Improved: Art for the Eighties.* New York: Abbeville, 1987.

Gilmour, John C. *Fire on the Earth: Anselm Kiefer and the Postmodern World.* Philadelphia: Temple University Press, 1990.

Godfrey, Tony. *The New Image: Painting in the 1980s.* New York: Abbeville, 1986.

Goldberg, RoseLee. *Performance Art: From Futurism to the Present.* Rev. ed. New York: Thames & Hudson, 2001.

Haskell, Barbara. *Agnes Martin.* New York: Whitney Museum of American Art, 1992.

Henri, Adrian. *Total Art: Environments, Happenings, and Performances.* New York: Praeger, 1974.

Hobbs, Robert. *Robert Smithson: Sculpture.* Ithaca, N.Y.: Cornell University Press, 1981.

Hobbs, Robert, Wendy Steiner, and Marcia Tucker. *Andres Serrano: Works 1983–1993.* Philadelphia: Institute of Contemporary Art, University of Pennsylvania, 1994.

Hunter, Sam. *Valerie Jaudon: New Masters.* Exh. cat. Berlin: Amerika Haus, 1983.

Koons, Jeff. *The Jeff Koons Handbook.* New York: Rizzoli, 1992.

Laporte, Dominique G. *Christo.* Trans. Abby Pollak. New York: Pantheon, 1986.

Lippard, Lucy R. *Eva Hesse.* New York: New York University Press, 1976.

Marshall, Richard, et al. *Robert Mapplethorpe.* New York: Whitney Museum of American Art, 1988.

———. *Jean-Michel Basquiat.* New York: Whitney Museum of American Art, 1992.

Meyer, Ursula, ed. *Conceptual Art.* New York: Dutton, 1971.

Ratcliff, Carter. *Komar and Melamid.* New York: Abbeville, 1988.

Rosen, Randy, and Catherine C. Brawer, eds. *Making Their Mark: Women Artists Move into the Mainstream, 1970–85.* New York: Abbeville, 1989.

Sandler, Irving. *Art of the Postmodern Era: From the Late 1960s to the Early 1990s.* New York: HarperCollins, 1996.

Smithson, Robert. *The Writings of Robert Smithson: Essays with Illustrations.* Ed. Nancy Holt. New York: New York University Press, 1975.

Stachelhaus, Heiner. *Joseph Beuys.* Trans. David Britt. New York: Abbeville, 1991.

Storr, Robert. *Chuck Close.* New York: Museum of Modern Art, 1998.

Tisdall, Caroline. *Joseph Beuys.* New York: Solomon R. Guggenheim Museum, 1979.

Vaizey, Marina. *Christo.* New York: Rizzoli, 1990.

Wolf, Jahn. *The Art of Gilbert and George; or, An Aesthetic of Existence.* Trans. David Britt. London: Thames & Hudson, 1989.

African Art

Bascom, William Russell. *African Art in Cultural Perspective.* New York: Norton, 1980.

Ben-Amos, Paula G. *The Art of Benin.* 2nd rev. ed. London: British Museum Press, 1995.

Berlo, Janet Catherine, and Lee Anne Wilson, eds. *Arts of Africa, Oceania, and the Americas: Selected Readings.* Englewood Cliffs, N.J.: Prentice-Hall, 1993.

Blier, Suzanne Preston. *The Royal Arts of Africa: The Majesty of Form.* New York: Abrams, 1998.

Kerchache, Jacques, Jean-Louis Paudrat, and Lucien Stéphan. *Art of Africa.* Trans. Marjolijn de Jager. New York: Abrams, 1993.

Magnin, André, and Jacques Soulillou, eds. *Contemporary Art of Africa.* New York: Abrams, 1996.

Perani, Judith, and Fred T. Smith. *The Visual Arts of Africa: Gender, Power, and Life Cycle Rituals.* Upper Saddle River, N.J.: Prentice-Hall, 1998.

Buddhist Art

Bechert, Heinz, and Richard Gombrich, eds. *The World of Buddhism.* London: Thames & Hudson, 1991.
Fisher, Robert E. *Buddhist Art and Architecture.* New York: Thames & Hudson, 1993.
Rowland, Benjamin. *The Evolution of the Buddha Image* (1963). New York: Arno, 1976.
Seckel, Dietrich. *Art of Buddhism.* Trans. Ann E. Keep. New York: Crown, 1964.
Zwalf, W., ed. *Buddhism: Art and Faith.* New York: Macmillan, 1985.

Chinese Art

The Arts of China. 3 vols. Tokyo: Kodansha, 1968–1970.
Barnhart, Richard M., James Cahill, Wu Hung, Yang Xin, Nie Chongzheng, and Lang Shaojun. *Three Thousand Years of Chinese Painting.* New Haven: Yale University Press, 1997.
Confucius. *Analects.* Ed. Bradley Smith and Wan-go Weng. In Bradley Smith and Wan-go Weng. *China: A History in Art.* New York: Doubleday, 1973.
Laozi. *Daode jing.* Ed. Wing-tsit Chan. In Wing-tsit Chan. *A Source Book in Chinese Philosophy.* Princeton: Princeton University Press, 1969.
Loehr, Max. *The Great Painters of China.* New York: Harper & Row, 1980.
Rawson, Jessica, ed. *The British Museum Book of Chinese Art.* New York: Thames & Hudson, 1993.
Sickman, Laurence C. S., and Alexander Soper. *Art and Architecture of China.* Pelican History of Art. Harmondsworth: Penguin, 1971.
Speiser, Werner. *The Art of China: Spirit and Society.* Trans. George Lawrence. New York: Crown, 1961.
Treasures from the Bronze Age of China. Exh. cat. New York: Metropolitan Museum of Art, 1980.
Tregear, Mary. *Chinese Art.* Rev. ed. New York: Thames & Hudson, 1997.
Vainker, S. J. *Chinese Pottery and Porcelain: From Prehistory to the Present.* London: British Museum Press, 1991.

Far Eastern Art (General)

Bussagli, Mario. *Oriental Architecture.* Trans. John Shepley. 2 vols. New York: Electa/Rizzoli, 1989.
Lee, Sherman E. *A History of Far Eastern Art.* 5th ed. New York: Abrams, 1994.
Louis-Frédéric. *The Temples and Sculpture of Southeast Asia.* Trans. Arnold Rosin. London: Thames & Hudson, 1965.
Martynov, Anatoliĭ I. *The Ancient Art of Northern Asia.* Urbana: University of Illinois Press, 1991.

Indian Art

Asher, Catherine B. *Architecture of Mughal India.* New York: Cambridge University Press, 1992.
Basham, Arthur Llewellyn. *The Wonder That Was India.* London: Sidgwick & Jackson, 1987.
Behl, Benoy K. *The Ajanta Caves: Artistic Wonder of Ancient Buddhist India.* New York: Abrams, 1998.
Brown, Percy. *Indian Architecture.* 6th repr. ed. Bombay: Taraporevala, 1976.

Coomaraswamy, Ananda K. *History of Indian and Indonesian Art.* New York: Dover, 1965.
Craven, Roy C. *Indian Art: A Concise History.* Rev. ed. New York: Thames & Hudson, 1997.
Dallapiccola, Anna L., and Stephanie Zingel-Avé Lallemant, eds. *The Stūpa: Its Religious, Historical, and Architectural Significance.* Wiesbaden: Steiner, 1979.
Goetz, Hermann. *The Art of India: Five Thousand Years of Indian Art.* 2nd ed. New York: Crown, 1964.
Harle, James C. *The Art and Architecture of the Indian Subcontinent.* 2nd ed. Pelican History of Art. Harmondsworth: Penguin, 1987.
Huntington, Susan L., and John C. Huntington. *The Art of Ancient India: Buddhist, Hindu, Jain.* New Haven: Yale University Press, 1994.
Lannoy, Richard. *The Speaking Tree: A Study of Indian Culture and Society.* New York: Oxford University Press, 1974.
Meister, Michael W., and M. A. Dhaky, eds. *Encyclopaedia of Indian Temple Architecture.* Philadelphia: University of Pennsylvania Press, 1983.
Michell, George. *The Hindu Temple: An Introduction to Its Meaning and Forms.* Chicago: University of Chicago Press, 1988.
———. *The Penguin Guide to the Monuments of India.* 2 vols. New York: Viking, 1989.
Nou, Jean-Louis, Amina Okada, and M.C. Joshi. *Taj Mahal.* New York: Abbeville, 1993.
Rowland, Benjamin. *Art and Architecture of India: Buddhist, Hindu, Jain.* Pelican History of Art. Harmondsworth: Penguin, 1977.
Sivaramamurti, Calambur. *The Art of India.* New York: Abrams, 1977.
Soundara Rajan, K. V. *Indian Temple Styles: The Personality of Hindu Architecture.* New Delhi: Munshiram Manoharlal, 1972.
Volwahsen, Andreas. *Living Architecture: Indian.* Trans. Ann E. Keep. New York: Grosset & Dunlap, 1969.
Weiner, Sheila L. *Ajaṇṭā: Its Place in Buddhist Art.* Berkeley: University of California Press, 1977.
Zimmer, Heinrich. *Myths and Symbols in Indian Art and Civilization* (1946). Princeton: Princeton University Press, 1992.

Japanese Art

Akiyama, Terukazu. *Japanese Painting.* Treasures of Asia. Geneva: Skira, 1977.
Mason, Penelope. *History of Japanese Art.* 2nd ed. Upper Saddle River, N.J.: Prentice-Hall, 2005.
Paine, Robert T., and Alexander Soper. *The Art and Architecture of Japan.* 3rd ed. Pelican History of Art. Harmondsworth: Penguin, 1981.
Stanley-Baker, Joan. *Japanese Art.* Rev. and exp. ed. New York: Thames & Hudson, 2000.
Yoshikawa, Itsuji. *Major Themes in Japanese Art.* Trans. Armins Nikovskis. New York: Weatherhill, 1976.

Japanese Woodblock Prints

Andō, Hiroshige. *One Hundred Famous Views of Edo* (1986). New York: Braziller/Brooklyn Museum, 1992.
Chibbert, David. *The History of Japanese Printing and Book Illustration.* New York: Kodansha, 1977.
Lane, Richard. *Images from the Floating World: The Japanese Print, Including an Illustrated Dictionary of Ukiyo-e.* New York: Putnam, 1978.
Amy Newland and Chris Uhlenbeck, eds. *Ukiyo-e: The Art of Japanese Woodblock Prints.* New York: Smithmark, 1994.

Mesoamerican and South Pacific Art

Blocker, H. Gene. *The Aesthetics of Primitive Art.* Lanham, Md.: University Press of America, 1994.
Caruana, Wally. *Aboriginal Art.* 2nd ed. New York: Thames & Hudson, 2003.
Coe, Michael D. *The Maya.* 5th ed. New York: Thames & Hudson, 1993.
Coote, Jeremy, and Anthony Shelton, eds. *Anthropology, Art, and Aesthetics.* New York: Oxford University Press, 1992.
Corbin, George A. *Native Arts of North America, Africa, and the South Pacific: An Introduction.* New York: Harper & Row, 1988.
Kubler, George. *The Art and Architecture of Ancient America: The Mexican, Maya, and Andean Peoples.* 3rd ed. Pelican History of Art. New Haven: Yale University Press, 1990.
Mexico: Splendors of Thirty Centuries. New York: Metropolitan Museum of Art, 1990.
Miller, Mary Ellen. *The Art of Mesoamerica: From Olmec to Aztec.* 3rd ed. New York: Thames & Hudson, 2001.
Pasztory, Esther. *Pre-Columbian Art.* New York: Cambridge University Press, 1998.
Spinden, Herbert J. *A Study of Maya Art, Its Subject Matter and Historical Development* (1913). New York: Dover, 1975.
Stone-Miller, Rebecca. *The Art of the Andes from Chavín to Inca.* 2nd ed. New York: Thames & Hudson, 2002.
Townsend, Richard. *The Ancient Americas: Art from Sacred Landscapes.* Chicago: Art Institute of Chicago, 1992.

Native American Art

Corbin, George A. *Native Arts of North America, Africa, and the South Pacific: An Introduction.* New York: Harper & Row, 1988.
Feest, Christian F. *Native Arts of North America.* Rev. ed. London: Thames & Hudson, 1992.
Hunt, Mary Austin. *Taos Pueblo* (1930). Photographed by Ansel Adams and described by Mary Austin. Boston: New York Graphic Society, 1977.
Whiteford, Andrew. *North American Indian Arts.* New York: Golden Press, 1970.

Oceanic Art

Barrow, Terence. *The Art of Tahiti and the Neighbouring Society, Austral and Cook Islands.* New York: Thames & Hudson, 1979.
Corbin, George A. *Native Arts of North America, Africa, and the South Pacific: An Introduction.* New York: Harper & Row, 1988.
Hanson, Allan, and Louise Hanson, eds. *Art and Identity in Oceania.* Honolulu: University of Hawaii Press, 1990.

Persian Painting and Miniatures

Binyon, Laurence, J. V. S. Wilkinson, and Basil Gray. *Persian Miniature Painting* (1931). New York: Dover, 1971.
Canby, Sheila R., ed. *Persian Masters: Five Centuries of Painting.* Bombay: Marg, 1990.
———. *Persian Painting.* New York: Thames & Hudson, 1993.
Titley, Norah M. *Persian Miniature Painting and Its Influence on the Arts of Turkey and India: The British Library Collections.* Austin: University of Texas Press, 1984.

Literary Acknowledgments

Ch. 15, p. 585 John Ashbery, " Self-portrait in a Convex Mirror." Reprinted by permission of Georges Borchardt, Inc., for the author.

Ch. 16, p. 613 W. H. Auden, "Musée des Beaux-Arts" (1938), from W. H. *Auden: Collected Poems*. Copyright ″ 1940, 1952, and renewed 1968 by W. H. Auden. Reprinted by permission of Random House, Inc. and Faber & Faber, Ltd.

Ch. 24, p. 831 Wallace Stevens, "The Man with the Blue Guitar" (1937), from *Collected Poems*. Copyright ″ 1936 by Wallace Stevens and renewed 1964 by Holly Stevens. Reprinted by permission of Alfred A. Knopf, Inc., and Faber & Faber, Ltd.

Ch. 25, p. 865 Kazimir Malevich, from *The World as Non-objectivity: Unpublished Writings, 1922–25*, ed. Troels Andersen, trans. Xenia Glowacki-Prus. English translation copyright © 1976 Borgens Vorlag, Valby, Denmark.

Ch. 27, p. 910 Clement Greenberg, "Abstract, Representation, and So Forth," from *Art and Culture* (1961), pp. 133–38. Reprinted by permission of Beacon Press.

Ch. 28, p. 944 Agnes Martin, selections in Barbara Haskell, Agnes Martin (New York: Whitney Museum of American Art, (1992). Reprinted by permission of Pace Wildenstein for the artist.

Acknowledgments

Many of the line drawings in this book have been specially drawn by Taurus Graphics, Kidlington, and the maps have been rendered or re-rendered by Patti Isaacs of Parrot Graphics. McGraw-Hill is grateful to all who have allowed their plans and diagrams to be reproduced. Every effort has been made to contact the copyright holders, but should there be any errors or omissions, they would be pleased to insert the appropriate acknowledgement in any subsequent edition of this publication.

map p. 32 From Abbé H. Breuil, *Quatre Cents Siècles d'Art*. Montignac: Centre d'Études et de Documentation Préhistorique, 1979.

1.18 From Spiro Kostof, *A History of Architecture: Settings and Rituals*. Oxford: Oxford University Press, 1985. ″ 1985. Drawings by Richard Tobias.

2.5 John McKenna illustration and design.

2.9 From Lois Fichner-Rathus, *Understanding Art*. Upper Saddle River, NJ: Prentice-Hall, Inc., 1986. ″ 1986. Reprinted by permission of Prentice-Hall, Inc., Upper Saddle River, NJ.

2.28 From Henri Frankfort, *Art & Architecture of the Ancient Orient*. London: Yale University Press, Pelican History of Art Series, 1970.

3.3, 3.4 From Quirke and Spencer, eds., *British Museum Book of Ancient Egypt*. London: British Museum Press, 1992.

3.14 From W. Stevenson Smith, *The Art and Architecture of Ancient Egypt*. London: Yale University Press, Pelican History of Art series, 1981.

3.28 From Phipps and Wink, *Invitation to the Gallery*. New York: McGraw-Hill, 1987.

3.29 From Richard Tansey and Fred Kleiner, *Gardner's Art Through the Ages*, 10e. Fort Worth: Harcourt Brace College Publishers, 1996.

4.4 From Reynold A. Higgins: *The Archaeology of Minoan Crete*. Henry Z. Walck, Random House, Inc.,1973.

4.14 From Christos Doumas, *Thera*. London: Thames & Hudson Ltd, 1983.

4.18 Fondazione Giorgio Cini, Instituto di Storia dell'Arte, Venice.

4.19 Drawn by P. P. Platt after Piet de Jong, from Reynold A. Higgins, *Minoan & Mycenaean Art*. London: Thames & Hudson Ltd, 1983.

5.23 John McKenna illustration and design.

5.30 From Boardman et al, *The Oxford History of Classical Art*. Oxford: Oxford University Press, 1997.

5.36 From John Boardman, *Greek Sculpture: The Classical Period*. London: Thames & Hudson Ltd, 1985.

5.37 From John Griffiths Pedley, *Greek Art and Architecture*. New York: Simon & Schuster, 1993.

5.43, 5.44 From John Boardman, *Greek Sculpture: The Classical Period*. London: Thames & Hudson Ltd, 1985.

5.38, 5.39, 5.40, 5.49, 5.64 From Leland M. Roth: *Understanding Architecture*, Boulder, CO: Westview Press, 1994.

5.54 From B. F. Cook, *The Elgin Marbles*. London: British Museum Press, 1984.

6.6b Museo Archeologico, Florence, Italy.

6.11 From Mario Moretti, *Cerveteri*. Instituto Geografico De Agostins, Navaro, 1984.

W2.2 From *Treasures from the Bronze Age of China*. New York: Metropolitan Museum of Art, 1980.

7.10, 7.12, 7.16 From Leland M. Roth: *Understanding Architecture*. Boulder, CO: Westview Press, 1994.

7.21 From Frank Sear, *Roman Architecture*. London: B. T. Batsford Ltd, 1982.

8.5 From Leland M. Roth, *Understanding Architecture*, Boulder, CO: Westview Press, 1994.

8.6 From Lois Fichner-Rathus, *Understanding Art*. Upper Saddle River, NJ: Prentice-Hall, Inc. ″ 1986. Reprinted by permission of Prentice-Hall, Inc., Upper Saddle River, NJ.

8.9 From Richard Tansey and Fred Kleiner, *Gardner's Art Through the Ages*, 10e. Fort Worth: Harcourt Brace College Publishers, 1996.

8.33 From Spiro Kostof, *A History of Architecture: Settings and Rituals*. Oxford: Oxford University Press, 1985 ″ 1985. Drawings by Richard Tobias.

W4.2 British Architectural Library: Royal Institute of British Architects, London.

W4.7 From Robert E. Fisher, *Buddhist Art and Architecture*. London: Thames & Hudson Ltd, 1993.

9.5, 9.36 From Richard Tansey and Fred Kleiner, *Gardner's Art Through the Ages*, 10e. Fort Worth: Harcourt Brace College Publishers, 1996.

9.11 From Godfrey Goodwin, *History of Ottoman Architecture*. London: Thames & Hudson Ltd, 1971. By permission of Mrs G. T. M. Goodwin.

W5.5 From George Kubler, *Art and Architecture of Ancient America*, 3rd ed. London: Yale University Press, 1984.

W5.15 Drawing by Jean Blackburn from Michael D. Coe, *The Maya*, 5th ed. London: Thames & Hudson Inc., 1993.

10.13 From Meyer Schapiro: *The Sculpture of Moissac*. New York: George Braziller, Inc., 1985.

11.4 From Lois Fichner-Rathus, *Understanding Art*. Upper Saddle River, NJ: Prentice-Hall, Inc., 1986. ″ 1986. Reprinted by permission of Prentice-Hall, Inc., Upper Saddle River, NJ.

11.6 From *Dictionnaire raisonné de l'architecture francaise*. Paris, 1859–68.

11.16 John McKenna illustration and design.

11.26 From Richard Tansey and Fred Kleiner, *Gardner's Art Through the Ages*, 10e. Fort Worth: Harcourt Brace College Publishers, 1996.

11.45 From Leland M. Roth, *Understanding Architecture*, Boulder, CO: Westview Press, 1994.

W6.8, W6.9 From Laurence Sickman and Alexander Soper, *The Art and Architecture of China*. London: Yale University Press, Penguin History of Art series, 1971.

W6.11 From Susan Huntington, *Art of Ancient India*. New York: Weatherhill Inc., 1993.

W6.16 From *Traveler's Key to Northern India*. New York: Alfred A. Knopf Inc., 1983.

12.5 John McKenna illustration and design.

13.6 From Peter Murray, *Renaissance Architecture*. New York: Harry N. Abrams, 1975. ″ Electra Archive, Milan, Italy.

17.3 From Lawrence Wodehouse and Marian Moffett, *A History of Western Architecture*. Mountain View, CA: Mayfield Publishing, 1989.

17.5, 19.18, 19.19 From Werner Blaser, *Drawings of Great Buildings*. Basel, Switzerland: Birkhäuser Verlag AG. 1983. © Werner Blaser.

21.8, 25.31 John McKenna illustration and design.

Picture Credits

Index